E F G H

N O P R

W X Y Z

A B C D

I K L M

S T U V

DE GRUYTER

ALLGEMEINES

KÜNSTLER-

LEXIKON

DE GRUYTER

ALLGEMEINES KÜNSTLER-LEXIKON

Die Bildenden Künstler
aller Zeiten und Völker

Herausgegeben von
Andreas Beyer, Bénédicte Savoy
und Wolf Tegethoff

NACHTRAG

BAND 5
CASSINI – CZWARTOS

DE GRUYTER

Redaktion
Sylvia Görke – Ulla Heise – Dagmar Kassek – Felicitas Krohn –
Jeannette Niegel – Christine Rohrschneider – Renate Treydel

Redaktionelle Leitung
Sylvia Görke – Ulla Heise – Felicitas Krohn

ISBN 978-3-11-025443-3

Bibliografische Information der Deutschen Nationalbibliothek
Die Deutsche Nationalbibliothek verzeichnet diese Publikation in der Deutschen
Nationalbibliografie; detaillierte bibliografische Daten sind im Internet über
http://dnb.dnb.de abrufbar.

© 2013 Walter de Gruyter GmbH, Berlin / Boston

Satz: bsix information exchange GmbH, Braunschweig
Druck und Bindung: Strauss GmbH, Mörlenbach
∞ Gedruckt auf säurefreiem Papier

Printed in Germany

www.degruyter.com

V

Autorinnen und Autoren

Gerhard Bissell, Reading
Petra Böttcher, Köln
Barbara Borngässer Klein,
 Dresden
Nicola Buhl, Esslingen
Stephanie Dahn Batista, Hannover

Antonín Dufek, Brno
Jacqueline Duroc, Guichen

Jutta Faehndrich, Leipzig
Axel Feuß, Flensburg
Christine Follmann, München
Volker Frank, Leipzig
Marion Frenger, Bonn
Philipp Freytag, Leipzig
Anke Friedel-Nguyen, Berlin

Tamaz Gersamia, Tbilisi
Sylvia Görke, Leipzig

Sven Hauschke, Coburg
Ulla Heise, Leipzig
Stephan Herczeg, Köln
Regina Höfer, Bonn

Svoboda Jähne, Bernau

Kim Karlsson, Dällikon

Dagmar Kassek, Moskau
Eberhard Kasten, Leipzig
Ekaterini Kepetzis, Münster
Manfred Knedlik, Neumarkt
Thilo Koenig, Zürich
Bohunka Koklesová, Bratislava
Elfi Kreis, Berlin
Felicitas Krohn, Leipzig
Helmut Kronthaler,
 Unterhaching
Miriam Kühn, Berlin

Dorit Malz, Greifswald
Christien Melzer, München
Andrea Mesecke, Düsseldorf
Rosa Micus, Regensburg
Ulrike Middendorf, Heidelberg
Maria Ferreira Morais, Berlin
Maria Antonietta Murgia, Nuoro

Jeannette Niegel, Leipzig
Larisa Jur'evna Nikolaeva,
 Ulan-Ude
Michael Nungesser, Berlin

Paola Pallottino, Bologna
Antje Papist-Matsuo, Berlin
Renate Petriconi, Praia da Luz
Sybille Prou, Guérard

Silke Reiter, München
Catrin Ritter, Leipzig
Christine Rohrschneider, Leipzig

Natal'ja Šalaginova, Chişinău
David Sánchez, Zarzalejo
Bernhard Scheller, Leipzig
Klaus Schikowski, Köln
Kilian Schmidtner, Berlin
Michael Scholz-Hänsel, Leipzig
Katharina Schütter, Hamburg
Stefan Schulze, Leipzig
Andreas Seifert, Tübingen
Raimond Selke, Serdang
Sven-Wieland Staps,
 Schwarzenberg
Tudor Stavila, Chişinău
Ljubinka Stoilova, Sofia
Henriette Stuchtey, London

David E.L. Thomas, Castlemaine
Renate Treydel, Leipzig
Dankmar Trier, Frankfurt am Main

Harald Uhr, Bonn

Christine Wendt, Leipzig
Gerhard Wiedmann, Rom
Agnes Wolf, München

Begründet und mitherausgegeben von Günter Meißner

Unter der Schirmherrschaft des
Comité International d'Histoire de l'Art (CIHA)

Benutzungshinweise

Instructions how to use this book are published in „Allgemeines Künstlerlexikon. Guide", M./L. 2004, 16.

Le Guide de l'utilisateur est publié au „Allgemeines Künstlerlexikon. Manuel", M./L. 2004, 26.

Le istruzioni sono pubblicate nel „Allgemeines Künstlerlexikon. Manuale", M./L. 2004, 36.

Indicaciones para el uso se encuentran en el „Allgemeines Künstlerlexikon. Manual", M./L. 2004, 46.

Укаэания к пользованию опубликованы в 1-ом томе на страницах XXIII/XXIV.

Zeichen und Piktogramme:

* geboren
born
né
nato
nacido
родился

† gestorben
deceased
mort
morto
muerto
умер

∞ verheiratet (mit), Heirat
married
marié
sposato
casado
женат

→ siehe (bei Verweisungen)
see (in case of cross references)
voir (chez renvois)
vide (per rinvii)
véase (en casa de remisiónes)
смотри (при ссылках)

⌂ Werke des Künstlers mit Standorten
The artist's works, with their locations
Œuvres de l'artiste avec le lieu
Opere dell'artista con le ubicazioni
Obras del artista y el lugar
произведения художника с укаэанием прописью места их хранения

✉ Selbstzeugnisse und Schriften des Künstlers
The artist's writings and other forms of personal testimony
Témoignages et écrits de l'artiste
Testimonianze e scritti dell'artista
Documentos autobiográficos y escritos del artista
сочинения и высказывания самого художника

👁 E: Einzelausstellungen
Individual exhibitions
Expositions particulières
Mostre personali
Exposiciones individuales
персональные выставки

👁 G: Gruppenausstellungen und Ausstellungsbeteiligungen
Group exhibitions or participation in exhibitions
Expositions de groupes et participation à des expositions
Mostre di gruppo e participazioni a mostre
Exposiciones colectivas y participaciones en una exposición
групповые выставки и участие в выставках

📖 Bibliographie und Hinweise auf ungedrucktes Quellenmaterial
Bibliography and references to unpublished source material
Bibliographie et renvois à des sources inédites
Bibliografia e indicazioni a fonti non stampate
Bibliografía e indicaciones relativas a fuentes inéditas
библиография и ссылки на неопубликованные источники

I. Ansetzung der Namen

Der als Ordnungswort angesetzte **Name** (in der Regel der Familienname) erscheint im Druck stets **halbfett**. Andere Namensformen sind in Klammern nachgestellt. Die Schreibung des Namens richtet sich in der Regel nach der im Herkunftsland des betreffenden Künstlers üblichen Schreibung, es sei denn, eine andere Form wird von ihm selbst gebraucht oder ist bekannter. Die *Vornamen* (im Russischen und Bulgarischen auch die Vatersnamen) einschließlich ihrer in Klammern nachgesetzten Nebenformen erscheinen *kursiv*. Die Namensansetzung folgt weitgehend den seit 1977 für Bibliotheken verbindlichen „Regeln für die Alphabetische Katalogisierung" (RAK). Künstler werden unter ihrem Pseudonym angesetzt, wenn sie darunter bekannter sind als unter ihrem wirklichen Namen. Künstler der Antike und des Mittelalters sind unter ihrem persönlichen Namen angesetzt. Künstler aus der Periode des Überganges zur Neuzeit ohne gesicherten Familiennamen erscheinen unter ihrem Vornamen, oft zusammen mit einer Herkunftsbezeichnung (z. B. **Agostino da Casanova**); Berufsbezeichnungen (z. B. **Adam** the Mason), geistliche Titel und Adelstitel gelten nicht als Namensbestandteil. Doppelnamen, Namensketten und Namen mit Präfixen, Präpositionen und Artikeln bzw. deren Verschmelzungen werden entsprechend den nationalen Gepflogenheiten behandelt. So sind beispielsweise mehrgliedrige italienische Namen des 19. und 20. Jahrhunderts unter **De, Degli** usw. angesetzt. Bei arabischen Namen vor dem 20.

Jahrhundert erscheint das bekannteste Glied der Namenskette als Ordnungswort; falls dieses unbekannt ist, wird die gesamte Namenskette angesetzt. Im Interesse des Benutzers sind wir jedoch als Nachschlagewerk eines Fachgebietes mit bereits stark verwurzelter Tradition der Namensansetzung nicht in jedem Fall RAK gefolgt, sondern haben, wie überhaupt in Zweifelsfällen, Verweisungen gebraucht.

II. Alphabetische Ordnung der Namen

Die Anordnung der Namen erfolgt nach den 26 Buchstaben des lateinischen Alphabets. Danach sind i und j getrennt und die Umlaute ä, ö, ü als ae, oe, ue behandelt. Das deutsche ß ist wie ss zu lesen, das dänische ø wie oe, æ wie ae und å wie a. Die diakritischen Zeichen und die zuweilen dem Ordnungswort in Normalschrift vorangestellten Berufsbezeichnungen und Titel (z. B. bei arabischen Künstlern Āġā, Ḥāǧǧī, Muʿallim, Sulṭān) sind für die Anordnung ohne Bedeutung. Bei Ordnungswörtern in Form mehrgliedriger Namen bestimmt das erste selbständige Namensglied die Stellung in der Gesamtordnung (z. B. steht **Ai Mitsu** vor **Aia**, *Giovanni dell'*). Dabei ist zu beachten, dass die zu einem mehrgliedrigen Namen gehörenden und daher halbfett gesetzten Präfixe, Präpositionen und Artikel (z. B. **al-, da, de, du, la, le, of, van, von**), beigefügte Ordnungszahlen (z. B. **Alfonso I. d'Este**) sowie arabische Verwandschaftsangaben (z. B. **ben, ibn**) nicht bei der alphabetischen Ordnung berücksichtigt werden. Hingegen werden Präfixe am Anfang eines Namens, die in der Ordnungsgruppe des Familiennamens anzusetzen sind, mit dem nachfolgenden Namensbestandteil als ein Ordnungswort behandelt. Gleichlautende Namen werden wie folgt geordnet:

1. Sammelverweisungen auf andere Namensformen;

2. Familien- oder Gruppenartikel (untereinander chronologisch geordnet, innerhalb einer Familie alphabetisch nach den Vornamen);

3. Namen ohne Vornamen (in chronologischer Folge);

4. Namen mit Vornamen (in alphabetischer Folge der Vornamen);

5. Doppelnamen, Namen mit Herkunftsbezeichnungen und andere zusammengesetzte Namen (alphabetisch geordnet nach dem jeweils folgenden Namensteil).

III. Umschrift

Personennamen, Literaturzitate, teilweise auch geographische Eigennamen, Titel und bestimmte Termini aus Sprachen mit nichtlateinischem Alphabet sind in lateinischer Umschrift wiedergegeben. Verwendete Umschriftsysteme:

1. Für *Russisch* und *Bulgarisch* gilt die von der International Organization for Standardization (ISO) empfohlene Transliteration.

2. Die Wiedergabe des Neugriechischen mit lateinischen Buchstaben erfolgt nach den Bestimmungen der Griechischen Gesellschaft zur Normsetzung (*Ellinkos Organismos Typopoiisis* = ELOT).

3. Für *Arabisch* gelten die Richtlinien der Deutschen Morgenländischen Gesellschaft, wobei Namensformen nach anderen international verbreiteten Umschriften, soweit notwendig, durch Verweisungen berücksichtigt sind.

4. Für das *Chinesisch* der Volksrepublik China gilt die amtliche lateinische Umschrift Pinyin, für die Republik China (Taiwan) dagegen die nach dem englischen System von Wade/Giles. Transkriptionen der jeweiligen anderen Schreibweise erscheinen ggf. als Verweisungen.

5. Für *Japanisch* findet das System von Hepburn Anwendung, das mit dem der Rōmaji-kai (Gesellschaft für Lateinschrift) übereinstimmt.

In allen übrigen Fällen werden für Namensansetzungen und Verweisungen Formen der Umschrift benutzt, die in den jeweiligen Fach- oder Sprachbereichen allgemeine Gültigkeit erlangt haben oder phonetisch relativ eindeutig reproduzierbar sind.

IV. Verweisungen

Der Hinweispfeil (→) wird verwendet bei:

1. voneinander abweichenden Formen des Namens eines Künstlers;

2. Einzelnamen, die in Familien- oder Gruppenartikeln behandelt werden;

3. Pseudonymen;

4. Doppelnamen und zusammengesetzten Namen, bei denen die Möglichkeit verschiedener Ansetzung besteht.

Mit „v. e." werden Verweisungen auf weitere Namensformen und Sammelverweisungen gekennzeichnet.

Mit „cf." wird auf Künstler verwiesen, die in einem anderen Artikel behandelt sind.

Nicht gesondert verwiesen wird in den nachfolgend aufgeführten Fällen. Die Verweise gelten nach beiden Seiten:

H ↔ A, Ch

V. Artikelgliederung

Der Haupttext enthält die Biographie sowie die Werk- und Schaffenscharakteristik. Bei russischen Künstlern sind die Lebensdaten sowohl nach dem älteren Julianischen nach dem Gregorianischen Kalender (in Klammern nachgestellt) angegeben. Im Haupttext genannte *Werktitel* sind in der Regel *kursiv* hervorgehoben.

Der Dokumentationsteil ist durch 4 Piktogramme gegliedert:

🏛 = Werke des Künstlers mit den durch Kapitälchen hervorgehobenen Standorten (in der Regel alphabetisch geordnet nach Orten, in zweckdienlichen Fällen aber auch chronologisch nach Werken oder zusammengefasst zu Werkgruppen). Werktitel in den Weltsprachen sind meist in der jeweiligen Originalform angegeben.

✉ = Selbstzeugnisse und Schriften des Künstlers.

👁 = Ausstellungen, unterteilt in *E:* (Einzelausstellungen) und *G:* (Gruppenausstellungen und Ausstellungsbeteiligungen). Mit (K) wird auf einen Ausstellungskatalog hingewiesen, der im Allgemeinen nicht mehr in der Bibliographie wiederholt wird.

📖 = Bibliographie und Hinweise auf ungedrucktes Quellenmaterial.

VI. Bibliographie

Die Bibliographie ist in zwei Gruppen gegliedert:

1. Lexika, Enzyklopädien und ähnliche Nachschlagewerke (am Anfang stehen die Hinweise auf die Künsterlexika von Thieme-Becker und Vollmer, die anderen sind chronologisch geordnet).

2. Sämtliche übrige Literatur in chronologischer Ordnung (in Ausnahmefällen wurde eine weitergehende Untergliederung vorgenommen).

Zur Zitierweise:

Bei *Büchern* werden aufgeführt: Name des Verfassers bzw. Herausgebers, Titel des Werkes, Bandzahl (römische Zahl), Erscheinungsort und -jahr (mit hochgestellter Auflagenzahl); gegebenenfalls Serientitel in Klammern. Beispiel: *M. Ragon/M. Seuphor,* L'art abstrait, IV, P. 1974.

Bei Artikeln in *Periodika*: Verfassername, (aus Gründen der Platzersparnis wird auf eine Zitierung der Aufsatztitel verzichtet), Titel der Zeitschrift, Band bzw. Jahrgang (arabische Zahl) und Jahr (nach Doppelpunkt), Heft, Nummer oder Monat (in Klammern), Seiten- bzw. Spaltenzahlen, eventuell Abbildungsvermerk. Beispiel: *M. Salmi,* Commentarii 2:1951 (3/4) 172 s.; *P. Bologna,* Arch. stor. ital. Ser. 5, 17:1896, 133–135.

VII. Abkürzungen

Im Haupttext sind allgemeine Abkürzungen sparsam verwendet worden. International bekannte und unmittelbar verständliche Abkürzungen (z. B. für Staatenbezeichnungen, geographische Angaben, akademische Grade) erscheinen nicht im Abkürzungsverzeichnis. Ein Teil der Abkürzungen ist nur begrenzt angewendet, besonders bei Literaturangaben, ferner bei Institutionen, Orts-, Zeit- und Werkangaben.

Abkürzungsverzeichnis

I. Allgemeine Abkürzungen

A.	Anfang
aarsber.	aarsberetning
ABA	Academia das Belas-Artes, Academia de Bellas Artes, Académie des Beaux-Arts, Accademia delle (di) Belle Arti
Abb.	Abbildung
Abh.	Abhandlung
ABK	Akademie der bildenden Künste, Academie voor Beeldende Kunsten
Abschn.	Abschnitt
Abt.	Abteilung
AC	Art(s) Center, Art(s) Centre
acad.	academy, académie ...; academic, académique ...
accad.	accademia
AFA	Academy of Fine Arts
AG	Art Gallery
AIA	American Institute of Architects
AJG	Alšová Jihočeská galerie
AK	Akademie der Künste
Akad.	Akademie
akad.	akademisch
allg.	allgemein
AM	Art Museum
Amer.	American
amer.	amerikanisch ...
amér.	américain ...
and.	andere
angew.	angewandt
angloamer.	angloamerikanisch
Anh.	Anhang
Anm.	Anmerkung
Ann.	Annalen
ann.	annales
anschl.	anschließend
Anz.	Anzeiger
AP	Alte Pinakothek
ap.	apéndice
App.	Appendix
app.	appendice
Aqu.	Aquarell
aqu.	aquarelle ...
Arch.	Archiv
arch.	archief ...
archäol.	archäologisch
archaeol.	archaeological ...
ArchAKL	Archiv Allgemeines Künstlerlexikon
archéol.	archéologique ...
Archit.	Architektur
archit.	architecture ...; architektonisch
arqueol.	arqueológico
arquit.	arquitectura ...
arr.	arrondissement
Art.	Artikel
artist.	artistical ...
artíst.	artístico ...

aserb.	aserbaidschanisch
ASK	Academie voor Schone Kunsten
ASKT	Anotati Scholi Kalon Technon
asoc.	asociación ...
ASP	Akademia sztuk pięknych
Ass.	Assistent
ass.	assistant ...
assoc.	association, associazione ...
Assoz.	Assoziation
AT	Altes Testament
Aufl.	Auflage
Aug.	August
Aukt.	Auktion; Auktions~
Ausb.	Ausbildung
Ausf.	Ausführung
Ausg.	Ausgabe
ausgef.	ausgeführt
ausschl.	ausschließlich
Ausst.	Ausstellung; Ausstellungs~
austral.	australisch
Austral.	Australian
Ausz.	Auszeichnung
av.	avenue, avenida
Ave.	Avenue
b.	bei
BA	beaux-arts, belle arti, belas artes ...
Bd	Band
BD	Baudenkmal
Bde	Bände
Bearb.	Bearbeiter; Bearbeitung
bearb.	bearbeitet
bed.	bedeutend
beg.	begonnen
begr.	begraben
Beih.	Beiheft
Beil.	Beilage
Beitr.	Beitrag
bek.	bekannt
belg.	belgisch ...
Ber.	Bericht
Bes.	Besitz
bes.	besonders
Beschr.	Beschreibung
beschr.	beschreibend; beschrijving
betr.	betreffend; betrifft
Bez.	Bezirk
bez.	bezeichnet
BG	Billedgalleri
BI	British Institution
Bibl.	Bibliothek; Bibliotheks~
bibl.	biblioteca ...
bibliogr.	bibliography ...; bibliographisch, bibliographic ...
Bibliogr.	Bibliographie
bien.	bienal

Bienn.	Biennale	cuad.	cuaderno
bienn.	biennial	cult.	culture, cultura; cultural, culturale
bijdr.	bijdragen		
bild.	bildend	d.Ä.	der Ältere
biogr.	biography ...; biographisch, biographic ...	d.h.	das heißt
Biogr.	Biographie	d.J.	der Jüngere
biul.	biuletyn	dän.	dänisch
BKD	Bau- und Kunstdenkmal	Darst.	Darstellung
Bl.	Blatt	Dat.	Datierung
Bll.	Blätter	dat.	datiert
BM	British Museum	del.	delineavit
BN	Bibliothèque Nationale de France, Biblioteca Nacional ...	dep.	departamento
		dép.	département; départemental
bol.	boletín, boletim ...	dept.	department
boll.	bollettino	ders.	derselbe
brasil.	brasilianisch, brasileiro ...	descr.	description, descrizione ...
Brit.	British	Dez.	Dezember
brit.	britisch, britannique ...	dgl.	dergleichen, desgleichen
BSGS	Bayerische Staatsgemäldesammlungen	DHM	Deutsches Historisches Museum
BTM	Budapesti Történeti Múzeum	dic.	dicionário
buddh.	buddhistisch, buddhistic ...	dicc.	diccionaro
bulg.	bulgarisch	dict.	dictionary, dictionnaire
Bull.	Bulletin	Dipl.	Diplom
bull.	bullettino ...	Dir.	Direktor; Direktions~
BvB	Museum Boymans-van Beuningen	dir.	directeur ...
BW	Baden-Württemberg	Diss.	Dissertation
BWA	Biuro Wystaw Artystycznych	diss.	dissertation ...
Byz.	Byzantine	distr.	district, distretto ...
byz.	byzantinisch ...	diz.	dizionario
bzw.	beziehungsweise	DLMM	Dekoratīvi lietišķās mākslas muzejs
		doc.	document; documentary ...
c.	century	Dok.	Dokument
ca.	circa	dok.	dokumentiert; dokumentarisch
cab.	cabinet	Doz.	Dozent
cah.	cahier	dt.	deutsch
Canad.	Canadian		
canad.	canadien	E.	Ende
cap.	capilla, capela	ead.	eadem (dieselbe)
capp.	cappella	EBA	Escuela de Bellas Artes, Escola de Belas Artes ...
CARS	Centro de Arte Reina Sofia		
čas.	časopis	ebd.	ebenda
cat.	catalogue, catálogo ...	éc.	école
cf.	confer (vergleiche)	EcBA	Ecole des Beaux-Arts
CGIA	Central'nyj Gosudarstvennyj Istoričeskij archiv	Ed.	Editor; Edition
		ed.	ediert, edited ...
chap.	chapel, chapelle	éd.	éditeur ...
Char.	Charakter	ehem.	ehemalig; ehemals
char.	character ...; charakteristisch, characteristic ...	eig.	eigen
		eigtl.	eigentlich
Chin.	Chinese	Einf.	Einführung
chin.	chinesisch, chinois ...	Einl.	Einleitung
Chron.	Chronik	einschl.	einschließlich
chron.	chronicle ...	ENBA	Escuela Nacional de Bellas Artes ...
civ.	civico	enc.	enciclopedia, encyclopédie ...; encyclopedian, encyclopédique ...
cl.	classe		
ČMVU	České muzeum výtvarných umění	engl.	englisch
Cod.	Codex	ENSBA	Ecole nationale supérieure des Beaux-Arts ...
cod.	codice ...		
cód.	códice ...	Entst.	Entstehung
col.	colección ...; Kolumne, columna(e)	Enz.	Enzyklopädie
coll.	collection, collezione ...	enz.	enzyklopädisch
com.	comisión; comunale	erb.	erbaut
comm.	commission, commissione ...; communal ...	Erg.	Ergänzung; Ergänzungs~
		erg.	ergänzt; ergänzend
congr.	congress, congrès ...	ErgH.	Ergänzungsheft
contemp.	contemporary, contemporain ...	erh.	erhalten
crit.	critical, critico ...	Ern.	Erneuerung
crít.	crítico ...	ern.	erneuert
CSW	Centrum Sztuki Współczesnej	ersch.	erschienen

Erw.	Erwähnung		geb.	geboren
erw.	erwähnt		gegr.	gegründet
esc.	escola, escuela		Gem.	Gemälde
escult.	escultura		gen.	genannt; general ...
esp.	español ...		gén.	général ...
espos.	esposizione		geogr.	geographisch, geographical, geográfico ...
est.	estudio, estudo ...		Ges.	Gesellschaft
ét.	étude		ges.	gesellschaftlich
etc.	et cetera		Gesch.	Geschichte; Geschichts~
ETH	Eidgenössische Technische Hochschule		gesch.	geschichtlich; geschiedenis
ethnogr.	ethnographisch, ethnographic ...		Gest.	Gestaltung
etnogr.	etnográfico ...		gest.	gestorben
Europ.	European ...		get.	getauft
europ.	europäisch ...		gew.	geweiht
ev.	evangelisch		gez.	gezeichnet
evtl.	eventuell		GG	Gemäldegalerie
exhib.	exhibition		GG AM	Gemäldegalerie Alte Meister
expos.	exposition, exposición ...		GG NM	Gemäldegalerie Neue Meister
expoz.	expozitie ...		gg.	gody
			GHMP	Galerie hlavního města Prahy
F.	Folge		GI	Royal Glasgow Institute of the Fine Arts
FA	Fine Arts		giorn.	giornale
Fa.	Firma		gist.	gistoryja
fac.	faculty, faculté ...		GMS	Galerija Matice srpske
facs.	facsimilie ...		GN	Galleria Nazionale, Galérie Nationale,
Fak.	Fakultät			Galería Nacional
Faks.	Faksimile		GNAM	Galleria Nazionale d'Arte Moderna
Fam.	Familie		GNM	Germanisches Nationalmuseum
fam.	family ...		gos.	gosudarstvennyj
fasc.	fascicle ...		gouv.	gouvernement; gouvernemental
Fasz.	Faszikel		govt.	government
Febr.	Februar		graf.	grafico ...
fec.	fecit		gráf.	gráfico ...
Festschr.	Festschrift		graph.	graphisch, graphical, graphique ...
FG	Kunstforenings Faste Galleri		griech.	griechisch
FHS	Fachhochschule		GrS	Graphische Sammlung
fl.	florin, Gulden		GVU	Galerie výtvarných umění
fläm.	flämisch			
FNAC	Fonds national d'Art contemporain		H.	Hälfte; Heft
fol.	folio		h.	half
fond.	fondation, fondazione		Hab.	Habilitation; Habilitations~
Forsch.	Forschung; Forschungs~		hab.	habilitation ...
Forts.	Fortsetzung		HAUM	Herzog Anton Ulrich-Museum
Fotogr.	Fotografie		HAZU	Hrvatska akademija znanosti i umetnosti
fotogr.	fotografia; fotografisch, fotográfico ...		Hb.	Handbuch
found.	foundation		hb.	handbook
FRAC	Fonds régional d'Art contemporain		Hbb.	Handbücher
Fragm.	Fragment		hbb.	handbooks
fragm.	fragmentarisch, fragmentaire ...		HBK	Hochschule für Bildende Künste
franç.	français		HdK	Hochschule der Künste
frz.	französisch		Hebr.	Hebraic
FS	Fachschule		hebr.	hebräisch
fund.	fundación, fundação		hébr.	hébraique
			HGB	Hochschule für Grafik und Buchkunst
g.	god		hispanoamer.	hispanoamericano
GA	Galleria d'Arte		hist.	history, histoire ...; historisch, histo-
gab.	gabinetto ...			ric(al) ...
GAC	Galleria d'Arte Contemporanea ...		hl.	heilig
gac.	gaceta		Hl.	Heiliger
Gal.	Galerie		Hll.	Heilige(n)
gal.	galería ...		HM	Historisches Museum, Historical Muse-
gall.	gallery, galleria ...			um ...
GAM	Galleria d'Arte Moderna; Galerie d'art		holl.	holländisch, hollandais ...
	modern ...		Hrsg.	Herausgeber
GAMC	Galleria d'Arte Moderna e Contempora-		hrsg.	herausgegeben
	nea ...		HS	Hochschule
gaz.	gazette		Hs.	Handschrift
gazz.	gazzetta		Hschn.	Holzschnitt
GDS	Gabinetto Disegni e Stampe		Hss.	Handschriften

Hst.	Holzstich		Kat.	Katalog
Hw.	Hauptwerk		katalan.	katalanisch
			kath.	katholisch
iberoamer.	iberoamericano, iberoamerikanisch		KD	Kunstdenkmal
ibid.	ibidem (daselbst)		KG	Kunst-Galerie, Kunstgalleri
iconogr.	iconography, iconographie ...; iconographic, iconographique		kgl.	königlich, kongelig ...
			KGM	Kunstgewerbemuseum
id.	idem (derselbe, dasselbe)		KGS	Kunstgewerbeschule
Ikonogr.	Ikonographie		KH	Kunsthalle
ikonogr.	ikonographisch		KHM	Kunsthistorisches Museum
il.	ilustración ...; ilustrado		KHS	Kunsthochschule
Ill.	Illustration		KIM	Kunstindustriemuseum
ill.	illustrazione ...; illustriert, illustrated ...		Kl.	Klasse
IMM	Iparművészeti Múzeum		KM	Kunstmuseum ...
inc.	incidit		kol.	koloriert
Inf.	Information		Komm.	Kommission
inf.	información ...		Komp.	Komposition
Ing.	Ingenieur		koninkl.	koninklijk
ing.	ingegnere, ingeniero		Korr.	Korrespondenz
Inschr.	Inschrift		korr.	korrespondierend
inschr.	inschriftlich		Kpst.	Kupferstich
inscr.	inscription		Kr.	Kreis
Inst.	Institut		kroat.	kroatisch
inst.	institute ...		KS	Kunstsammlung
internac.	internacional		KSch	Kunstschule
internat.	international		Kt.	Kanton
internaz.	internazionale		kult.	kulturell
introd.	introduction, introduzione ...		Kunstf.	Kunstführer
Inv.	Inventar		Kunstgesch.	Kunstgeschichte
inv.	inventaire ...; invenit		kunstgesch.	kunstgeschichtlich
iscr.	iscrizione		Kunstgew.	Kunstgewerbe
isk.	iskusstvo		kunstgew.	kunstgewerblich
ist.	istituto		kunsthist.	kunsthistorisch
istor.	istorico		Kunstwiss.	Kunstwissenschaft
Ital.	Italian ...		kunstwiss.	kunstwissenschaftlich
ital.	italienisch, italiano ...		KV	Kunstverein
IVAM	Instituto Valenciano de Arte Moderno			
izv.	izvĕstaj, izvestija		LA	Landesarchiv
			Lat.	Latin ...
J.	Journal		lat.	lateinisch ...
j.	journaal, jurnal ...		lateinamer.	lateinamerikanisch
Jan.	Januar		latinoamer.	latinoamericano
Jap.	Japanese		LDM	Lietuvos dailės muziejus
jap.	japanisch, japonais ...		lett.	letteratura, lettere
JAZU	Jugoslavenska akademija znanosti i umjetnosti		Lex.	Lexikon
			lex.	lexicon, lexikón ...
Jb.	Jahrbuch		Lfg	Lieferung
jb.	jaarboek ...		LG	Landesgalerie
Jbb.	Jahrbücher		libr.	library, librairie ...
jbb.	jaarboekje ...		Lit.	Literatur; Literatur~
JBer.	Jahresbericht		lit.	literature ...; literarisch, literary ...
jber.	jaarbericht		Lith.	Lithographie
Jg	Jahrgang		lith.	lithography
JH	Jahresheft		lithogr.	lithographisch, lithographic ...; lithographiert
Jh.	Jahrhundert			
Joh.Bapt.	Johannes Baptista		litogr.	litográfico ...
Joh.Ev.	Johannes Evangelista		litt.	littérature; littéraire
JPM	Janus Pannonius Múzeum		livr.	livraison
JSchr.	Jahresschrift		LM	Landesmuseum
Jugosl.	Jugoslavic		loc.cit.	loco citato (am angeführten Ort)
jugosl.	jugoslawisch ...		lombard.	lombardisch
jun.	junior		Lsch.	Landschaft
			lt.	laut
K	Katalog		Ltg	Leitung
k.k.	kaiserlich-königlich		Lw.	Leinwand
KA	Kunstakademie			
Kab.	Kabinett		M.	Mitte
kanad.	kanadisch		m.	middle
Kap.	Kapelle		MA	Mittelalter, middle ages

ma.	mittelalterlich
MAC	Musée d'Art contemporain, Museo de Arte Contemporaneo
MAD	Musée des Arts décoratifs ...
Mag.	Magazin; Magister
mag.	magazine, magazzino ...
MAH	Musée d'Art et d'Histoire
MAK	Museum für angewandte Kunst
MAM	Musée d'Art moderne, Museo d'Arte Moderna ...
MAMC	Musée d'Art moderne et contemporain, Museo d'Arte Moderna e Contemporanea ...
MAMVP	Musée d'Art moderne de la Ville de Paris
Man.	Manufaktur
MARGS	Museu de Arte do Rio Grande do Sul
MART	Museo d'Arte Moderna e Contemporanea di Trento e Rovereto
Mat.	Material
mat.	material ...
MBA	Musée des Beaux-Arts, Museo de Bellas Artes ...
MBer.	Monatsbericht
MBK	Museum der bildenden Künste
MBl.	Monatsblatt
MBll.	Monatsblätter
MCA	Museum of Contemporary Art
MCiv.	Museo Civico
MCom.	Museo Comunale
Meckl.	Mecklenburg
meckl.	mecklenburgisch
méd.	médaille ...
Med.	Medaille
med.	medal ...
medd.	meddellande, meddelelse(r)
meded.	medede(e)lingen
Mem.	Memoiren
mem.	memoirs ...
mém.	mémoire ...
Metrop. Mus.	Metropolitan Museum of Art
mex.	mexikanisch
MFA	Museum of Fine Art(s)
MfG	Museum für Gestaltung
MH	Monatsheft
Min.	Miniatur
min.	miniature, miniatura ...
Minist.	Ministerium
minist.	ministére ...
misc.	miscellanea, miscelánea ...
Misz.	Miszellen
Mitarb.	Mitarbeit; Mitarbeiter
Mitbegr.	Mitbegründer
Mitgl.	Mitglied; Mitgliedschaft
Mitt.	Mitteilung
MKG	Museum für Kunst und Gewerbe
MLW	Muzeum Leona Wyczółkowskiego
MM	Mākslas muzejs
MMA	Museum of Modern Art
MMK	Museum für moderne Kunst ...
MN	Muzeum Narodowe; Museo Nacional ...
MNAC	Musée National d'Art Contemporain, Museo Nacional de Arte Contemporaneo ...
MNAM	Musée national d'Art moderne ...
MNBA	Museo Nacional de Bellas Artes ...
MO	Muzeum Okręgowe
mod.	modern, moderne, moderno ...
Mon.	Monument

mon.	monumento ...; monumental, monumentale ...
Monogr.	Monogramm; Monographie
monogr.	monogram ...; monogrammiert; monografía ...
mpal	municipal
MRBAB	Musées royaux des Beaux-Arts de Belgique
Ms.	Manuskript
ms.	manuscript, manuscrit ...
Mschr.	Maschinenschrift
MSK	Museum voor Schone Kunsten
MSPC	Muzej Srpske pravoslavne crkve
Mss.	Manuskripte
mss.	manuscripts, manuscrits ...
MSU	Muzej savremene umetnosti/suvremene umjetnosti; Muzej na sovremeneta umetnost
MSZ	Muzeum Sztuki
MTA	Magyar Tudományos Akadémia
mun.	municipal
Mus.	Museum; Museums~
mus.	musée ...
múz.	múzeum ...
muz.	muzeul, muzeum ...
MuzTat	Muzeum Tatrzańskie
MZ	Meisterzeichen
N	Norden; Nord-
n.Chr.	nach Christus
N.F.	Neue Folge
N.R.	Neue Reihe
n.s.	nouvelle série ...
N.S.	Neue Serie
nac.	nacional
nač.	načalo
Nachf.	Nachfolge; Nachfolger
nachg.	nachgewiesen
Nachr.	Nachricht
Nachtr.	Nachtrag
nachw.	nachweisbar
NAD	National Academy of Design
Nat.	National~
nat.	national
naz.	nazionale
NB	Nationalbibliothek
Ndb.	Niederbayern
necr.	necrology ...
nécr.	nécrologe ...
nederl.	nederlands(ch)
Nekr.	Nekrolog
NFG	Nationale Forschungs- und Gedenkstätten der klassischen deutschen Literatur
NG	Nationalgalerie, National Gallery, Národní galerie, Narodna galerija, Nasjonalgalleri, Nemzeti galéria
niederl.	niederländisch
niederösterr.	niederösterreichisch
NM	Nationalmuseum, National Museum, Narodni muzej, Národné muzeum, Nemzeti Múzeum
NMMA	National Museum of Modern Art
NO	Nordosten; Nordost-
NÖ	Niederösterreich
nordamer.	nordamerikanisch
Not.	Notiz; Notiz~
not.	notice, noticia ...
nouv.	nouveau
Nov.	November

NP	Neue Pinakothek	q.v.	quod vide (siehe dies)
Nr	Nummer	quad.	quaderno ...
Nrn	Nummern	Quadrienn.	Quadriennale
NRW	Nordrhein-Westfalen	quadrienn.	quadriennal
NT	Neues Testament; Novum Testamentum	Quart.	Quartal
NW	Nordwesten; Nordwest-	quart.	quarterly
O	Osten; Ost-	R.	Reihe; Royal
o.Ä.	oder Ähnliches	r.	recto
Obb.	Oberbayern	RA	Royal Academy of Arts
oberösterr.	oberösterreichisch	RABA	Real Academia de Bellas Artes ...
öff.	öffentlich	racc.	raccolta
österr.	österreichisch	Rad.	Radierung
Okt.	Oktober	Rapp.	Rapport
OÖ	Oberösterreich	rapp.	rapporto ...
op.cit.	opus citatum (angeführtes Werk)	rass.	rassegna
Orig.	Original	rec.	recueil
orig.	original, originale ...; original~	rech.	recherche ...
Oss.	Zakład Narodowy im. Ossolińskich	Rech.	Recherche
		reconstr.	reconstruction; reconstructed
p.	part, partie ...; Seite, page, pagina ...	red.	redigiert
PAFA	Pennsylvania Academy of Fine Arts	Red.	Redakteur; Redaktion
paint.	painting	Reg.	Regierung; Regierungs~; Register
Pal.	Palast	Rekonstr.	Rekonstruktion
pal.	palace, palais ...	rekonstr.	rekonstruiert
pam.	památky, pamiatky ...	Relig.	Religion
PCiv.	Pinacoteca Civica	relig.	religiös, religieux ...
PCom.	Pinacoteca Comunale	Renaiss.	Renaissance
peint.	peinture	rend.	rendiconto
pér.	périodique ...	Repert.	Repertorium
per.	periodical, periodico ...	repert.	repertoir ...
Pfarrk.	Pfarrkirche	répert.	répertoire ...
Phil.	Philosophie	Repr.	Reprint
phil.	philosophy ...; philosophisch, philosophi-	Reprod.	Reproduktion
	que ...	reprod.	reproduction ...; reproduziert, reprodu-
photogr.	photographic, photographique ...		ced ...
pict.	pictura	Rest.	Restaurierung
Pin.	Pinakothek	rest.	restauration ...; restauriert, restored ...
pin.	pinacoteca	Retr.	Retrospektive
pint.	pintura	retr.	retrospektive
pinx.	pinxit	rev.	review, revue, revista ...; revidiert, revi-
pitt.	pittura		sed, revisé ...
Pl.	Platz, Place	Rez.	Rezension
pl.	plaza, ploščad'	RGADA	Rossijskij Gosudarstvennyj archiv drev-
plast.	plastique		nich aktov
plást.	plástico	RGALI	Rossijskij Gosudarstvennyj archiv litera-
PM	Pinakothek der Moderne		tury i iskusstva
PN	Pinacoteca Nazionale ...	RGIA	Rossijskij Gosudarstvennyj istoričeskij
pol.	polovina		archiv
poln.	polnisch	RIBA	Royal Institute of British Architects
portr.	portrait ...	riv.	rivista
Portr.	Porträt	RKD	Rijksbureau voor Kunsthistorische docu-
portug.	portugiesisch, portugais ...		mentatie
pp.	Seiten, pages, paginas ...	RM	Rijksmuseum
Präf.	Präfektur	röm.	römisch
Präs.	Präsident	RP	Rheinland-Pfalz
pref.	preface	RSA	Royal Scottish Academy
préf.	préface	russ.	russisch
Priv.	Privat~		
priv.	privat ...	S	Süden; Süd-
Prof.	Professur; Professor	S.	Santa, Santo, São ...
prof.	professeur ...	s.	sequens (folgende); siècle, siglo
Prov.	Provinz; Provinzial~	s.a.	sine anno (ohne Jahr)
prov.	province ...	s.l.	sine loco (ohne Ort)
Pseud.	Pseudonym	s.l.e.a.	sine loco et anno (ohne Ort und Jahr)
pseud.	pseudonym ...	s.o.	siehe oben
pubbl.	pubblicazione ...; pubblico	s.u.	siehe unten
Publ.	Publikation	s.v.	sub voce (unter dem Stichwort)
publ.	publication ...; publiziert, published ...	Sa.	Santa

SAfr.	Salon des Artistes français
SANU	Srpska akademija nauka i umetnosti
SB	Sitzungsbericht
sb.	sbornik, sborník
sc.	science, scienza; scientific ...
SchA	School of Art
schott.	schottisch
Schr.	Schrift
schwed.	schwedisch
schweiz.	schweizerisch
scolt.	scoltura
sculps.	sculpsit
sculpt.	sculpture
scult.	scultura
sec.	secolo
séc.	século
sem.	seminario
sen.	senior
Sep.	Separatum (Sonderdruck)
Sept.	September
Ser.	Serie
ser.	series ...
sér.	série ...
SG	Staatsgalerie
SGG	Staatliche Gemäldegalerie
SGS	Staatsgemäldesammlung
SH	Schleswig-Holstein
SI	Smithsonian Institution
Sign.	Signatur; Signum
sign.	signiert
SKH	Staatliche Kunsthalle
SKS	Staatliche Kunstsammlung
Skulpt.	Skulptur
Slg	Sammlung
Slgn	Sammlungen
slov.	slovník, slovar'...
SM	Stadtmuseum
SMPK	Staatliche Museen zu Berlin, Preußischer Kulturbesitz
SO	Südosten; Südost-
So.	Santo
soc.	society, société ...; social ...
sog.	sogenannt
span.	spanisch
sprav.	spravočnik
SPSG	Stiftung Preußische Schlösser und Gärten
SS.	Saints, Santi, Santissimo ...
ss.	sequentes; siècles, siglos
SSG	Staatliche Schlösser und Gärten
ST	Sachsen-Anhalt
St-	Saint-
St.	Sankt
StA	Stadtarchiv
Ste-	Sainte-
sted.	stedelijk
Stellv.	Stellvertreter
stellv.	stellvertretender
StG	Städtische Galerie
Stiftsk.	Stiftskirche
Stip.	Stipendium
StKH	Städtische Kunsthalle
StKS	Städtische Kunstsammlung
StM	Städtisches Museum
Stmk	Steiermark
stor.	storico
Str.	Straße
str.	street, straat ...
StsA	Staatsarchiv
Stud.	Studium

stud.	study ...; studiert
supl.	suplemento
Suppl.	Supplement
suppl.	supplément ...
Sv.	Sveti, Sveta
SW	Südwesten; Südwest-
św.	święty ...
sz.	század
SzM	Szépművészeti Múzeum
Szt.	Szent
t.	tome, tomo ...
Tab.	Tabelle
Taf.	Tafel
tav.	tavola
Teiln.	Teilnahme; Teilnehmer
teilw.	teilweise
teol.	teologico
Test.	Testament
TH	Technische Hochschule
theol.	theologisch, theologic ...
Thür.	Thüringen
tijdschr.	tijdschrift
tipogr.	tipografia; tipografico, tipográfico
Tl	Teil
Tle	Teile
Topogr.	Topographie
topogr.	topography, topografia ...; topographisch, topographic, topográfico ...
Trad.	Tradition
trad.	traditionell ...
trien.	trienal ...
Trienn.	Triennale
trienn.	triennal
tschech.	tschechisch
TU	Technische Universität
Typogr.	Typographie
typogr.	typography ...; typographisch, typographic ...
u.a.	und andere(s); unter anderem
u.a.m.	und anderes mehr
u.ä.	und ähnlich
u.Ä.	und Ähnliche(s)
u.d.T.	unter dem Titel
u.Z.	unserer Zeitrechnung
UdK	Universität der Künste
UG	Um(j)etnička galerija, Umetnostna galerija
ul.	ulica, ulice
UNAM	Universidad Nacional Autónoma Mexicana
unbek.	unbekannt
undat.	undatiert ...
ungar.	ungarisch
Univ.	Universität
univ.	university, université ...; universal, universel ...
unsign.	unsigniert
Unters.	Untersuchung
unveröff.	unveröffentlicht
unvoll.	unvollendet
unvollst.	unvollständig
unwahrsch.	unwahrscheinlich
UPM	Uměleckoprůmyslové muzeum
urkdl.	urkundlich
urspr.	ursprünglich
urug.	uruguayisch, uruguayo ...

V & A	Victoria and Albert Museum	WA	Weltausstellung
V.	Viertel	wahrsch.	wahrscheinlich
v.	vek; verso; vide; vom, von	Wallfk.	Wallfahrtskirche
v.a.	vor allem	Westf.	Westfalen
v.Chr.	vor Christus	Wettb.	Wettbewerb
v.e.	vide etiam (siehe auch)	Wiss.	Wissenschaft
v.u.Z.	vor unserer Zeitrechnung	wiss.	wissenschaftlich
Vbg	Vorarlberg	WK	Weltkrieg
venez.	venezianisch, veneziano	Wkst.	Werkstatt
Ver.	Verein	Wkstn	Werkstätten
Verb.	Verband	Woj.	Wojewodschaft
Verf.	Verfasser	woj.	województwo
verf.	verfasst	WRM	Wallraf-Richartz-Museum
Verh.	Verhandlung	Württ.	Württemberg
verh.	verheiratet; verhandeling	württ.	württembergisch
Veröff.	Veröffentlichung	WV	Werkverzeichnis
veröff.	veröffentlicht		
versch.	verschieden(e, er)	yb.	yearbook
Verz.	Verzeichnis		
vgl.	vergleiche	z.B.	zum Beispiel
viell.	vielleicht	z.T.	zum Teil
VjBl.	Vierteljahresblatt	z.Z.	zur Zeit
VjBll.	Vierteljahresblätter	zahlr.	zahlreich
VjH	Vierteljahresheft	Zchng	Zeichnung
VjSchr.	Vierteljahresschrift	Zchngn	Zeichnungen
vol.	volume ...	Zeitgen.	Zeitgenosse
Voll.	Vollendung	zeitgen.	zeitgenössisch
voll.	vollendet	zerst.	zerstört
vollst.	vollständig	zit.	zitiert
Vors.	Vorsitzender	Zs.	Zeitschrift
Vorw.	Vorwort	Zss.	Zeitschriften
Vrg	Vereinigung	Ztg	Zeitung
Vrgn	Vereinigungen	Ztgn	Zeitungen
vv.	vekov	zugeschr.	zugeschrieben
vyp.	vypusk	zus.	zusammen
		Zuschr.	Zuschreibung; Zuschrift
W	Westen; West-	zw.	zwischen

II. Abkürzungen häufig vorkommender Verlagsorte

Am.	Amsterdam	Mb.	Melbourne
Ant.	Antwerpen	Md.	Modena
At.	Athina, Athinä (Athen)	Méx.	México, D.F. (Mexiko-Stadt)
Au.	Augsburg	Mh.	Mannheim
B.	Berlin	Mi.	Milano (Mailand)
Ba.	Barcelona	Ml.	Montréal
BB.	Baden-Baden	Mo.	Moskva (Moskau)
Be.	Bergamo	Mv.	Montevideo
Bg.	Braunschweig	N.	Napoli (Neapel)
Bgd.	Beograd (Belgrad)	N.Y.	New York
Bj.	Beijing (Peking)	Nü.	Nürnberg
Bo.	Bologna	Ox.	Oxford
Bog.	Santa Fe de Bogotá; Santafé de Bogotá; Bogotá	P.	Paris
		Pd.	Padova (Padua)
Bp.	Budapest	PdM.	Palma de Mallorca
Br.	Bruxelles (Brüssel)	Pe.	Perugia
Bra.	Bratislava	Ph.	Philadelphia
Bs.	Brescia	Pr.	Princeton, N.J.
Bs. As.	Buenos Aires	Qu.	Québec
Bu.	Bucureşti (Bukarest)	R.	Roma (Rom)
C.	Cambridge, England	Rb.	Regensburg
C., Mass.	Cambridge, Massachusetts	Rio	Rio de Janeiro
Car.	Caracas	S.Ch.	Santiago de Chile
D.	Dresden	S.Co.	Santiago de Compostela
D.H.	's-Gravenhage (Den Haag)	S.F.	San Francisco
Da.	Darmstadt	S.P.	São Paulo
Dd.	Düsseldorf	Sal.	Salamanca
E.	Erevan	Sg.	Salzburg
Fa.	Faenza	St.	Stuttgart
Fe.	Ferrara	Sth.	Stockholm
Ffm.	Frankfurt am Main	StP.	Sankt Peter(s)burg
Fi.	Firenze (Florenz)	T.	Torino (Turin)
FiB.	Freiburg im Breisgau	Tb.	Tübingen
Ge.	Genova (Genua)	To.	Tōkyō (Tokio)
Ha.	Hamburg	Tor.	Toronto
He.	Heidelberg	Ud.	Udine
Hn.	Hannover	Va.	Valencia
Inn.	Innsbruck	Vd.	Valladolid
Ka.	Karlsruhe	Ve.	Venezia (Venedig)
Kph.	København (Kopenhagen)	Vi.	Vicenza
L.	Leipzig	Vn.	Vancouver
L.A.	Los Angeles	Vr.	Verona
Le.	Leningrad	W.	Wien
Li.	Lisboa (Lissabon)	Wa.	Washington, D.C.
Lj.	Ljubljana	War.	Warszawa (Warschau)
Lo.	London	Wb.	Wiesbaden
M.	München	Wr.	Wrocław
Ma.	Madrid	Z.	Zürich

III. Abgekürzt zitierte Literatur

Das Verzeichnis der abgekürzt zitierten Literatur in Artikeln über antike Künstler finden Sie in „Allgemeines Künstlerlexikon. Handbuch", M./L. 2004, S. 123 ss.

A *Aa I, 1852 ...* A. J. van der Aa, Biographisch woordenboek der Nederlanden, I–XXI, Haarlem 1852–78
 AAA I, 1986 ... American art analog, compiled by M. D. Zellmann, I–III, N. Y. 1986
 AAF Archives de l'art français (P.) 1:1851/52–12:1859/60; 2. Ser., 1:1861–2:1862; N. Per., 1:1907–22:1959; 23:1968 ss.
 AALL I, 1959 ... Arte e artisti dei laghi lombardi, Como, I 1959, II 1964
 AAW I, 1974 ... D. O. Dawdy, Artists of the American West, I–III, Chicago/Athens, Ohio 1974–85
 Abeler, 1977 ... J. Abeler, Meister der Uhrmacherkunst, Wuppertal 1977; ²2010
 Accascina, Marchi, 1976 M. Accascina, I marchi delle argentiere e oreficerie siciliane, Busto Arsizio 1976
 Accascina, Oreficeria, 1976 M. Accascina, Oreficeria di Sicilia dal XII al XIX secolo, Palermo 1976
 Achleitner I, 1980 ... F. Achleitner, Österreichische Architektur im 20. Jahrhundert, I ss., Sg./W. 1980 ss.
 Acuña, 1964 L. A. Acuña, Diccionaro biográfico de artistas que trabajaron en el Nuevo Reino de Granada, Bog. 1964
 ADB I, 1875 ... Allgemeine Deutsche Biographie, I–LVI, L. 1875–1912 (Repr. B. 1967–71)
 Addleshaw, 1971 G. W. O. Addleshaw, Architects, sculptors, designers and craftsmen, 1770–1970, ..., in: Architectural history 14:1971, 74–112
 Adhémar, Druckgrafik, 1968 J. Adhémar, Populäre Druckgrafik Europas. Frankreich 15.-20. Jahrhundert, M. 1968
 Adhémar, Lith., 1937 J. Adhémar, Les lithographies de paysage en France à l'époque romantique, P. 1937
 Aellen, 1921 ... H. Aellen, Schweizerisches Zeitgenossen-Lexikon, Bern 1921 und Erg.-Bd (Chur/L. 1926); Bern/L. ²1932
 Agghàzy I, 1959 ... M. Agghàzy, A barokk szobràszat Magyarországon, I–III, Bp. 1959
 Agramunt Lacruz I, 1999 ... F. Agramunt Lacruz, Diccionario de artistas valencianos del siglo XX, I–III, Valencia 1999
 Agulló y Cobo, 1981 M. Agulló y Cobo, Más noticias sobre pintores madrileños de los siglos XVI al XVIII, Ma. 1981
 Agulló y Cobo, Doc., 1978 M. Agulló y Cobo, Documentos sobre escultores, entalladores y ensambladores de los siglos XVI al XVIII, Vd. 1978
 Agulló y Cobo, Not., 1978 M. Agulló y Cobo, Noticias sobre pintores madrileños de los siglos XVI y XVII, Granada/Ma. 1978 (Documentos inéditos para la historia del arte, 1)
 AiA Art in America (Springfield, Mass./N. Y.) 1:1913 ss. [9:1921 (Dez.) – 27:1939 (April) u.d.T.: Art in America and elsewhere]
 AIC I, 1965 ... Arte italiana contemporanea, I–VIII, Fi. 1965–77
 Aichelburg I, 2003 ... W. Aichelburg, Das Wiener Künstlerhaus 1861–2001, I ss., W. 2003 ss.
 Ajni, 1972 L. S. Ajni, Iskusstvo Tadžikskoj SSSR, Le. 1972
 AKL1, 1983 ... Allgemeines Künstlerlexikon. Die bildenden Künstler aller Zeiten und Völker, I ss., L. 1983 ss.; Nachdr. der Erstausgabe I–III in 4 Bänden und Weiterführung: M./L. 1992 ss.
 Alauzen, 1984 A. M. Alauzen, La peinture en Provence, Marseille 1984
 Alauzen, 1986 ... A. Alauzen, Dictionnaire des peintres et sculpteurs de Provence, Alpes, Côte d'Azur, Marseille 1986; nouv. éd., ed. L. Noet, Marseille 2006
 Albertina-Kat. I, 1926 ... Beschreibender Katalog der Handzeichnungen in der (Graphischen Sammlung) Albertina, I ss., W. 1926 ss.
 Alcahalí, 1897 J. M. R. de L. Y. de Alcahalí de Mosquera, Diccionario biográfico de artistas valencianos, Valencia 1897
 Aldana Fernández, 1970 S. Aldana Fernández, Guía abreviada de artistas valencianos, Valencia 1970 (Publicaciones del Archivio municipal de Valencia, Ser. 1. Catálogos, guías y repertorios, 3)
 Alizeri I, 1864 ... F. Alizeri, Notizie dei professori del disegno in Liguria dalla fondazione dell'Accademia, I–III, Ge. 1864–66; ²1870–80 (6 Bde)
 Alvarez Emparanza, 1978 J. M. Alvarez Emparanza, La pintura vasca contemporánea, 1935/1978, San Sebastián 1978
 AmArtAnn American art annual (N. Y./Wa.) 1:1898–37:1945/48 (1949)
 AMK Alte und moderne Kunst (W./Sg./Inn.) 1:1956–30:1985
 Andreini, 1971 I. Andreini (Ed.), La pittura italiana del 1970, Mi. 1971
 Andresen, MR I, 1866 ... A. Andresen, Die deutschen Maler-Radierer <Peintres-graveurs> des 19. Jahrhunderts nach ihren Leben und Werken, I–V, L. 1866–74 (Repr. Hildesheim/N. Y. 1971)
 Andresen, PG I, 1864 ... A. Andresen, Der deutsche Peintre-graveur oder die deutschen Maler als Kupferstecher nach ihrem Leben und ihren Werken, von dem letzten Drittel des 16. Jahrhunderts bis zum Schluß des 18. Jahrhunderts ..., I–V, L. 1864–78
 Antaldi, 1805 A. Antaldi, Notizie di alcuni architetti, pittori, scultori di Urbino – Pesaro, Ms., Urbino 1805
 AnzSchwAlt Anzeiger für schweizerische Altertumskunde (Z.) 1:1868/71–8:1896/98; N. F., 1:1899–40:1938
 Apted/Hannabuss, 1978 M. R. Apted/S. Hannabuss (Ed.), Painters in Scotland. A biographical dictionary, Edinburgh 1978
 Araujo Gómez, 1885 F. Araujo Gómez, Historia de la escultura en España desde principios del siglo XVI hasta fines del XVIII y causas de su decadencia, Ma. 1885
 Archer I, 1969 ... M. Archer, British drawings in the India Office Library (K), I–II, Lo. 1969

Archibald, 1980 ...	E. H. H. Archibald, Dictionary of sea painters, Woodbridge 1980 (Repr. 1982); ²1989; ³2000 u.d.T.: The dictionary of sea painters of Europe and America
ArchitForum	Architectural forum (N. Y.) 26:1917–140:1974
ArchitRec	Architectural record (N. Y. u.a.) 1:1891 ss.
ArchitRev	The Architectural review (Lo.) 1:1896 ss.
Areán, 1972	C. Areán, Treinta años de arte español (1943–72), Ma. 1972
Argul, 1966	J. P. Argul, Las artes plásticas del Uruguay, Mv. 1966
Arnáez, 1985	E. Arnáez, Orfebrería religiosa en la provincia de Segovia. En los siglos XVIII y XIX, Ma. 1985
Arnaud/Busignani I, 1961 ...	E. Arnaud/A. Busignani (Ed.), Artisti italiani contemporanei, Arezzo, I 1961, II 1962; ed. A. Guaraldi u.a., Fi., III 1963
Ars Hispaniae I, 1947 ...	Ars Hispaniae. Historia universal del arte hispánico, I–XXII, Ma. 1947–77
ArtB	The Art bulletin (N. Y.) 1:1913 ss.
ArteModItalia, 1967	Arte moderna in Italia 1915–1935 (K), Fi. 1967
ArtInternat	Art international (P.) 1:1956–27:1984; N. S., 1:1987–14:1991
ArtJ	The Art journal (N. Y.) 20:1960/61 ss.
Arto, 1978 ...	Dictionnaire biographique des artistes belges de 1830 à 1970, Br. 1978 *sowie* Biographisch woordenboek der Belgische kunstenaars van 1830 tot 1970, ed. Arto, Br. 1979
Arto, 1987 ...	Dictionnaire biographique illustré des artistes en Belgique depuis 1830, ed. Arto, Br. 1987; erw. Neuausg., ed. A. und I. D. Tommelein, 1995 *sowie* Geïllustreerd biografisch woordenboek der kunstenaars in België na 1830, ed. Arto, Br. 1991
ArtQu	Art quarterly (Detroit, Mich.) 1:1938–37:1974; N. S., 1:1977/78–2:1979
ArtsMag	Arts magazine (N. Y.) 1:1926–66:1991/92
ArtsRev	Arts review (Lo.) 1:1949–45:1993 (3)
ASA Italia I, 1971 ...	Archivio storico degli artisti. Italia -'900, I–XII, Mi. 1971–75
ASL	Archivio storico lombardo (Mi.) 1:1874 ss.
Atterbury/Batkin, 1990	P. Atterbury/M. Batkin, The dictionary of Minton, Woodbridge 1990
Aubert, 1930	M. Aubert, La Bourgogne. La sculpture, I–III, P. 1930
Audin/Vial I, 1918 ...	M. Audin/E. Vial, Dictionnaire des artistes et ouvriers d'art du Lyonnais, I–II, P. 1918–19 (Dictionnaire des artistes et ouvriers d'art de la France par provinces)
Auer, 1985 ...	M. und M. Auer, Encyclopédie internationale des photographes de 1839 à nos jours, Hermance 1985; 1992; 1997
Auerbach, 1954	E. Auerbach, Tudor artists, Lo. 1954
AustralDB I, 1966 ...	Australian dictionary of biography, I ss., Mb. 1966 ss.
Ayala, 1997	W. Ayala, Dicionário de pintores brasileiros, ed. revista e ampliada por A. Seffrin, Curitiba 1997

B

Bacci, 1944	P. Bacci, Documenti e commenti per la storia dell'arte, Fi. 1944
BadBiogr I, 1881 ...	Badische Biographien, I–IV, Ka. 1881–91; V–VI, He. 1906–35; N. F., I ss., St. 1982 ss.
Baglione, Vite, 1642 ...	G. Baglione, Le vite de' pittori, scultori ed architetti dal Ponteficato di Gregorio XIII del 1572 fino a' tempi di Papa Urbano VIII nel 1642, R. 1642 und spätere Ausg.
Baḥnassī, 1980	A. Baḥnassī, Al-fann al-ḥadīṭ fī-l-bilād al-ᶜara-biya, Tūnis 1980
Baillie, 1929 ...	G. H. Baillie, Watchmakers and clockmakers of the world, Lo. 1929; ²1947; ³1951 (Repr. als Bd I, 1976; II [von R. Loomes], 1976 und weitere Repr.)
Bailly-Herzberg, 1972	J. Bailly-Herzberg, L'eau-forte de peintre au dix-neuvième siècle. La Société des Aquafortistes 1862–1867, II, P. 1972
Bailly-Herzberg, 1985	J. Bailly-Herzberg, Dictionnaire de l'estampe en France 1830–1950, P. 1985
Baldinucci, ed. Manni, I, 1767 ...	F. Baldinucci, Notizie dei professori de' disegno da Cimabue in qua ..., ed. Manni, I–XXI, Fi. 1767–73
Baldinucci, ed. Ranalli, I, 1845 ...	F. Baldinucci, Notizie dei professori del disegno da Cimabue in qua ... (1681), ed. F. Ranalli, I–V, Fi. 1845–47 (Repr. 1974)
Baldinucci App., ed. *Barocchi*, 1975 ...	F. Baldinucci, Notizie dei professori del disegno da Cimabue in qua (ed. F. Ranalli 1845–47), App. in 2 Bdn v. P. Barocchi, mit Ind., ed. A. Boschetto, Fi. 1975 (als Bde VI–VII der Repr.-Ausg. Fi. 1974)
Bamford, 1983	F. Bamford, A dictionary of Edinburgh wrights and furniture makers. 1660–1840, Lo. 1983
Baquero Almansa, 1913	A. Baquero Almansa, Artistas murcianos, Murcia 1913
Barbieri, 1972	F. Barbieri, Illuministi e neoclassici a Vicenza, Vi. 1972
Barbosa, 1976	O. Barbosa, Dicționarul artiștilor români contemporani, Bu. 1976
Bargoni, 1976	A. Bargoni, Maestri orafi e argentieri in Piemonte dal XVII al XIX secolo, T. 1976
Barón Thaidigsmann, 1986	J. Barón Thaidigsmann, Diccionario de pintores y escultores, in: Enciclopedia temática de Asturias, VI, Gijón 1986
Baroni, Doc. I, 1940 ...	C. Baroni, Documenti per la storia dell'architettura a Milano nel Rinascimento e nel Barocco, I: Edifici sacri (1), Fi. 1940 (Raccolta di fonti per la storia dell'arte, 4), II: R. 1968 (Fonti e documenti inediti per la storia dell'arte, 2)
Bartsch I, 1803 ...	A. Bartsch, Le peintre-graveur ..., I–XXI und Suppl., W. 1803–21 und L. 1843 (Nachdr. L. 1854–76 in 22 Bdn); Neuausg. Würzburg 1920–22 (Repr. Nieuwkoop/Hildesheim 1970)
Bassegoda Nonell, 1973	J. Bassegoda Nonell, Los maestros de obras de Barcelona, Ba. ²1973
Bauchal, 1887	C. Bauchal, Nouveau dictionnaire biographique et critique des architectes français, P. 1887

Bauer, GEM I, 1976 ...	H. Bauer (Ed.), Die große Enzyklopädie der Malerei, I–VIII, FiB./Basel/W. 1976–78
Bauer/Carpentier I, 1984 ...	A. Bauer/J. Carpentier, Répertoire des artistes d'Alsace des XIX^e et XX^e siècles, I–VI, Strasbourg 1984–91
Bauer/Rupprecht I, 1976 ...	H. Bauer/B. Rupprecht (Ed.), Corpus der barocken Deckenmalerei in Deutschland, I–XIII, M. 1976–2008
BBK/LVB Dok. 1, 1991 ...	Berufsverband Bildender Künstler / Landesverband Bayern, Dokumentation, Tl 1–2 und Erg.-Bd, M. 1991
Bd'A	Bollettino d'arte (R.) 1:1907 ss.
BE, ..., 1951 ...	The buildings of England, ed. N. Pevsner/J. Nairn, Harmondsworth u.a. 1951 ss.
Beard, Georg., 1966	G. W. Beard, Georgian craftsmen and their work, Lo. 1966
Beard, Nat., 1985	G. Beard, The National Trust book of English furniture, Harmondsworth u.a. 1985
Beard/Gilbert, 1986	G. Beard/C. Gilbert (Ed.), Dictionary of English furniture makers. 1660–1840, Leeds 1986
Beaulieu/Beyer, 1992	M. Beaulieu/V. Beyer, Dictionnaire des sculpteurs français du Moyen Age, P. 1992
Bellier/Auvray I, 1882 ...	E. Bellier de La Chavignerie/L. Auvray, Dictionnaire général des artistes de l'Ecole Française depuis l'origine des arts du dessin jusqu'à nos jours, I–II und Suppl., P. 1882–87
Bellori, Vite, 1672 ...	G. P. Bellori, Le vite de' pittori, scultori ed architetti moderni, R. 1672; Faks.-Ausg. R. 1931 und spätere Ausgaben
Bénézit I, 1911 ...	E. Bénézit, Dictionnaire critique et documentaire des peintres, sculpteurs, dessinateurs et graveurs de tous les temps et de tous les pays ..., I–III, P. 1911–24; ²1948–55 (8 Bde); ³1966 (8 Bde); 1976 (10 Bde); 1999 (14 Bde); engl. Ausg. 2006 (14 Bde) u.d.T.: Dictionary of artists
Benko, 1969	N. Benko, Art and artists of South Australia, Adelaide 1969
Bérard, 1872	A. Bérard, Dictionnaire biographique des artistes français du XII^e au XVII^e siècle, P. 1872
Berckenhagen, 1970	E. Berckenhagen (Ed.), Die französischen Zeichnungen der Kunstbibliothek Berlin (K), B. 1970
Berenson, Drawings I, 1938 ...	B. Berenson, Drawings of the Florentine painters, I–III, Chicago 1938 (Repr. Chicago/Lo. 1970)
Berenson, Pictures, C/N Ital. I, 1968 ...	B. Berenson, Italian pictures of the Renaissance. Central Italian and North Italian schools, I–III, Lo./N. Y. 1968
Berenson, Pictures, Flor. I, 1963 ...	B. Berenson, Italian pictures of the Renaissance. Florentine school, I–II, Lo. 1963
Berenson, Pictures, Ven. I, 1957 ...	B. Berenson, Italian pictures of the Renaissance. Venetian school, I–II, Lo. 1957
Berger, 1970	R. Berger (Dir.), Peintres vaudois, Lausanne 1970
Beringer, 1922	J. A. Beringer, Badische Malerei 1770–1920, Ka. ²1922 (Repr. 1979)
Beringheli, 1991	G. Beringheli, Dizionario degli artisti liguri. Pittori, scultori, ceramisti, incisori dell'Ottocento e del Novecento, Ge. 1991
Beringheli, 2001 ...	G. Beringheli, Dizionario degli artisti liguri. Pittori, scultori, ceramisti, incisori del Novecento, Ge. 2001; 2006
Berko, 1981	P. und V. Berko, Dictionary of Belgian painters born between 1750 and 1875, Br. 1981
Berko, Animal painters, 1998	P. und V. Berko (Ed.), Dictionary of Belgian and Dutch animal painters born between 1750 and 1880, Knokke-Zoute 1998
Berko, Seascapes, 1984	P. und V. Berko, Seascapes of Belgian painters born between 1750 and 1875, Knokke-Zoute 1984
Berman, 1974 ...	E. Berman, Art and artists of South Africa, Cape Town/Rotterdam 1974; ²1983; ³1993
Bernhard, 1965	M. Bernhard (Bearb.), Verlorene Werke der Malerei, ed. K. P. Rogner, B. 1965
Bernt I, 1979 ...	W. Bernt, Die niederländischen Maler und Zeichner des 17. Jahrhunderts, M., I–III ⁴1979–80, IV–V ²1979–80
Bessone-Aurelj, DizPitt, 1915 ...	A. M. Bessone-Aurelj, Dizionario dei pittori italiani ..., Città di Castello 1915; R. ²1928
Bessone-Aurelj, DizScultArchit, 1947	A. M. Bessone-Aurelj, Dizionario degli scultori ed architetti italiani, Ge. 1947
Bettelheim I, 1896 ...	A. Bettelheim (Ed.), Biographisches Jahrbuch und deutscher Nekrolog, I–XVIII, B. 1896 (1897)–1913 (1917)
Beuque/Frapsauce, 1964	E. Beuque/M. Frapsauce, Dictionnaire des poinçons de maîtres-orfèvres français du XIV^e siècle à 1838, P. 1964
BHS	Biuletyn historii sztuki [i kultury] (War.) 1:1932 ss.
Bidault, 1971	P. Bidault, Etains religieux XVII^e-XIX^e siècle, P. 1971
Biedrzynski I, 1979 ...	E. Biedrzynski, Bruckmann's Porzellan-Lexikon, I–II, M. 1979
Billcliffe I, 1990 ...	R. Billcliffe (Comp.), The Royal Glasgow Institute of the Fine Arts 1861–1989. A dictionary of exhibitors at the annual exhibitions of the Royal Glasgow Institute of the Fine Arts, I–IV, Glasgow 1990–92
Billedkunsten I, 1969 ...	Billedkunstens Hvem-Hvad-Hvor, Red.: J. Graff/M. Marcussen/M. Rud, Kph., I 1969, II 1970
Bimbenet-Privat, 1992	M. Bimbenet-Privat, Les orfèvres parisiens de la Renaissance (1506–1620), P. 1992
Bjerkoe, 1957 ...	E. H. und J. A. Bjerkoe, The cabinetmakers of America, Garden City/N. Y. 1957; Exton, Pa. ²1978
BK	Bildende Kunst (D.) 1953–64; (B.) 1965–90

Blättel, 1992	H. Blättel, International dictionary miniature painters, porcelain painters, silhouettists, M. 1992
Blas, 1972	J. I. de Blas (Ed.), Diccionario pintores españoles contemporáneos desde 1881, nacimiento de Picasso, Ma. 1972
Bloch/Grzimek, 1978 ...	P. Bloch/W. Grzimek, Das klassische Berlin. Die Berliner Bildhauerschule im 19. Jahrhundert, Ffm. 1978; B. 1994
BLSK I, 1998 ...	Biografisches Lexikon der Schweizer Kunst, I–II, Z. 1998
BMetrMus	Bulletin of the Metropolitan Museum of Art (N. Y.) 1:1905/06–37:1942; N. S., 1:1942/43 ss.
BNB I, 1866 ...	Biographie nationale, ed. Académie Royale des Sciences, des Lettres et des Beaux-Arts de Belgique, I–XXVIII und XXIX (= Suppl. 1) ss., Br. 1866–1944 und 1957 ss.
Boase I, 1965 ...	F. Boase, Modern English biography containing thousand concise memoirs of persons who have died since the year 1850, I–VI, Lo. 1965
Bodart I, 1970 ...	D. Bodart, Les peintres des Pays-Bas méridionaux et de la principauté de Liège à Rome au XVII^ème siècle, I–II, Br./R. 1970 (Etudes d'histoire de l'art publiées par l'Institut historique belge de Rome, 2)
Bøje, 1962	C. A. Bøje, Danske guld og sølv smedemærker før 1870, Kph. 1962
Bøje I, 1979 ...	C. A. Bøje, Danske guld og sølv smedemærker før 1870, I–III, Kph. 1979–82
Börsch-Supan, 1971	H. Börsch-Supan, Die Kataloge der Berliner Akademieausstellungen 1786–1850, I–II und Reg.-Bd, B. 1971 (Quellen und Schriften zur bildenden Kunst, 4)
Börsch-Supan, Baukunst, 1977	E. Börsch-Supan, Berliner Baukunst nach Schinkel 1840–1870, M. 1977 (Studien zur Kunst des 19. Jahrhunderts, 25)
Börsch-Supan, Malerei, 1988	H. Börsch-Supan, Die deutsche Malerei von Anton Graff bis Hans von Marées, 1760–1870, M. 1988
Boesch, 1955	P. Boesch, Die Schweizer Glasmalerei, Basel 1955 (Schweizer Kunst, 6)
Bösel, Jesuitenarchit. I, 1985	R. Bösel, Jesuitenarchitektur in Italien, I: Die Baudenkmäler der römischen und neapolitanischen Ordensprovinz, W. 1985 (Publikationen des Historischen Instituts beim Österreichischen Kulturinstitut in Rom, I. Abt., 7. Bd)
Bösken, 1970	S. Bösken, Die Mainzer Goldschmiedezunft, Diss. 1969, Mainz 1970
Boetticher I. 1, 1891 ...	F. von Boetticher, Malerwerke des neunzehnten Jahrhunderts, I. 1,2 und II. 1,2, D. 1891–1901; unveränderter Neudr. L. 1941; 1944 (II. 1,2) und 1948 (I. 1,2)
Bolton, 1923 ...	T. Bolton, Early American portrait draughtsmen in crayons, N. Y. 1923 (Library of American art) (Repr. 1970)
Bombe, 1912	W. Bombe, Geschichte der Peruginer Malerei, B. 1912
Bombelli, 1957	A. Bombelli, Pittori cremaschi dal 1400 ad oggi, Mi. 1957
Bonacker, 1966	W. Bonacker, Kartenmacher aller Länder und Zeiten, St. 1966
Bonge, 1980	S. Bonge, Eldre norske fotografer, Bergen 1980
Bonnet (Ms., vor 1942), ed. *Richard*, 2004	E. Bonnet, Dictionnaire des artistes et ouvriers d'art du Bas-Languedoc (Ms., vor 1942), ed. J.-C. und N. Richard, Montpellier 2004
Borg, 1935	T. Borg, Guld- och silversmeder i Finland 1373–1873. Deras stämlar och arbeten, Helsingfors 1935
Borisowa/Sternin, 1988	E. A. Borisowa/G. J. Sternin, Jugendstil in Rußland, St. 1988
Borsi/Morolli/Quinterio, 1979	F. Borsi/G. Morolli/F. Quinterio, Brunelleschiani, R. 1979 (Fonti e documenti per la storia dell'architettura, 7)
Boselli, 1977	C. Boselli, Regesto artistico dei notai roganti in Brescia dall'anno 1500 all'anno 1560, Bs. 1977, I: Regesto; II: Documenti
Bosilkov, 1973	S. Bosilkov, Bălgarskijat plakat, Sofija 1973
Bosl, 1983 ...	K. Bosl (Ed.), Bosls bayerische Biographie, Rb. 1983, Erg.-Bd 1988
Bossaglia, 1987	R. Bossaglia (Ed.), Archivi del Liberty italiano. Architettura, Mi. 1987
Bossard I, 1920 ...	G. Bossard, Die Zinngießer der Schweiz und ihr Werk, Zug, I 1920, II 1934 (Neudruck Osnabrück 1978)
Boulton I, 1964 ...	A. Boulton, Historia de la pintura en Venezuela, I–III, Caracas 1964–72
Bourdet-Guillerault, 1979	H. Bourdet-Guillerault, Dictionnaire des peintres, sculpteurs, graveurs de Marseille et de la région, Marseille 1979
Bousquet, 1980	J. Bousquet, Recherches sur le séjour des peintres français à Rome au XVIIe siècle, Montpellier 1980
Bown, 1998	M. C. Bown, A dictionary of twentieth century Russian and Soviet painters, 1900–1980s, Lo. 1998
Bradley I, 1887 ...	J. W. Bradley, A dictionary of miniaturists, illuminators, calligraphers and copyists ..., I–III, Lo. 1887–89 (Repr. N. Y. 1958; Bristol/To. 1999)
Bradshaw, RBA 1824/1892, 1973 ...	M. Bradshaw, Royal Society of British Artists. Members exhibiting 1824–92 ..., Leigh-on-Sea 1973 ss.
Braga, 1942	T. Braga (Ed.), Artistas pintores no Brasil, S. P. 1942
Branca, 1973	R. Branca, Maestri incisori di Sardegna, Cagliari 1973
Brander Dunthorne, 1976	K. Brander Dunthorne, Artists exhibited in Wales, 1945–74, Cardiff 1976
Brauksiepe, 1986	B. Brauksiepe/A. Neugebauer, Künstlerlexikon. 250 Maler in Rheinland-Pfalz 1450–1950, Mainz 1986

Campoy, 1976	A. M. Campoy, 100 maestros de la pintura española contemporánea, Ma. 1976
Cantelli, 1983	G. Cantelli, Repertorio della pittura fiorentina del Seicento, Fi. 1983
Capitanio, 1986	A. Capitanio, Orafi e marchi lucchesi, Fi. 1986
Caramel/Pirovano, 1974	L. Caramel/C. Pirovano, Galleria d'Arte Moderna. Opere del Novecento (K), Mi. 1974 (Musei e gallerie di Milano)
Caramel/Pirovano I, 1975 ...	L. Caramel/C. Pirovano, Galleria d'Arte Moderna. Opere dell'Ottocento (K), I–III, Mi. 1975 (Musei e gallerie di Milano)
Cassan, Auvergne, 1984	C. G. Cassan, Les orfèvres de la juridiction monétaire de Riom – Auvergne, Bourbonnais, Marche, Velay – du XVIe au XIXe siècle et leurs poinçons, P. 1984
Cassan, Avignon, 1984	C. G. Cassan, Les orfèvres d'Avignon et du Comtat Venaissin, P. 1984
Cassan, Normandie, 1980	C. G. Cassan, Les orfèvres de la Normandie du XVIe au XIXe siècle et leurs poinçons, P. 1980
Casson, 1967	M. Casson, Pottery in Britain today, Lo. 1967
Castel/Thomas/Daniel, 1987	Y.-P. Castel/G.-M. Thomas/T. Daniel, Artistes en Bretagne, Quimper 1987
Cat. Veneto I, 1974 ...	Catalogo degli artisti del Veneto, I–II, Mi. 1974
Catalano, 1981	G. Catalano, The years of hope. Australian art and criticism 1959–1968, Mb. 1981
CatBolaffiArch, 1966	Catalogo Bolaffi dell'architettura italiana 1963–66, T. 1966
CatBolaffiArtMod, 1966	Catalogue Bolaffi d'art moderne. Le marché de Paris, T./P. 1966
CatBolaffiGraf I, 1970 ...	Catalogo nazionale Bolaffi della grafica, I–XIV, T. 1970–84; Mi., XV–XVII, 1985–87 u.d.T. Catalogo della grafica in Italia; XVIII–XXI, 1988–1992 u.d.T. Annuario della grafica in Italia; XXII–XV, 1994–97 u.d.T. Grafica. Annuario del mercato della grafica in Italia
CatBolaffiMod I, 1962 ...	Catalogo nazionale Bolaffi d'arte moderna, T., I–XIV, 1962–79; XV–XVI, 1978–80 u.d.T. Catalogo nazionale d'arte moderna; XVII–XXV, 1981–89 u.d.T. Catalogo dell'arte moderna italiana; XXVI–XXXIV, Mi. 1990–98 u.d.T. Arte moderna. Catalogo dell'arte moderna italiana
CatBolaffiNaïf III, 1977	Catalogo nazionale Bolaffi dei naïfs, III, T. 1977
CatBolaffiOtt I, 1964 ...	Catalogo Bolaffi della pittura italiana dell'800, I ss., T. 1964 ss.
CatBolaffiScult I, 1976 ...	Catalogo nazionale Bolaffi della scultura, I–IV, T. 1976–80; Mi., V–IX, 1981–1985 u.d.T. Catalogo della scultura italiana; X, 1994 u.d.T. Scultura. Catalogo della scultura italiana
Catello, Argenti, 1972 ...	E. und C. Catello, Argenti napoletani dal XVI al XIX secolo, N. 1972 (Ausg. Banco di Napoli); 1973
Catello, Oreficeria, 1975	E. und C. Catello, L'oreficeria a Napoli nel XV secolo, N. 1975
CatPittItal'300/'700, 1985	Catalogo della pittura italiana dal'300 al '700, Mi. 1985
Cavalcanti I, 1973 ...	C. Cavalcanti (Ed.), Dicionário brasileiro de artistas plásticos, I ss., Brasília 1973 ss. (Coleção dicionários especializados, 5)
Ceán Bermúdez I, 1800 ...	J. A. Ceán Bermúdez, Diccionario histórico de los más ilustres profesores de las Bellas Artes en España, I–VI, Ma. 1800 (Repr. 1965)
Ceci, 1911	G. Ceci, Saggio di una bibliografia per la storia delle arti figurative nell'Italia meridionale, Bari 1911
Ceci I, 1937 ...	G. Ceci, Bibliografia per la storia delle arti figurative nell'Italia meridionale, I–II, N. 1937
Celio, ed. Zocca, 1967	G. Celio, Memoria delli nomi dell'artefici delle pitture che sono in alcune chiese, facciate, e palazzi di Roma, N. 1638 (Faks. Mi. 1967, ed. Zocca)
Cerny, 1978	W. Cerny, Mitglieder der Wiener Akademie, W. 1978
Červonnaja, 1978	S. M. Červonnaja, Živopis' avtonomnych respublik RSFSR, Mo. 1978
Červonnaja, 1984	S. M. Červonnaja, Chudožniki Sovetskoj Tatarii, Kazan' 1984
Chaffers, 1883	W. Chaffers, Gilda aurifabrorum. History of English goldsmiths and plateworkers and their marks stamped on plate, Lo. 1883
Chamot/Farr/Butlin I, 1964 ...	M. Chamot/D. Farr/M. Butlin, The modern British paintings, drawings and sculpture (K), I–II, Lo. 1964 (Tate Gallery catalogues)
Champeaux, 1886	A. de Champeaux, Dictionnaire des fondeurs, ciseleurs, modeleurs en bronze et doreurs, A-C, P./Lo. 1886
Chan-Magomedow, 1983	S. O. Chan-Magomedow, Pioniere der sowjetischen Architektur, D. 1983 (unveränderter Nachdr. 1988)
Chapuis, 1917	A. Chapuis, Histoire de la pendulerie neuchâteloise, P./Neuchâtel 1917
Chapuis, 1931	A. Chapuis, Pendules neuchâteloises. Documents nouveaux, Neuchâtel 1931
Chatzidakis I, 1987 ...	M. Chatzidakis, Ellines zografoi meta tin Alosi (1450–1830), At., I 1987, II 1997
Chávarri, 1976	R. Chávarri, Artistas contemporáneas en España, Ma. 1976
Ch'en Chih-Mai, 1966	Ch'en Chih-Mai, Chinese calligraphers and their art, Lo./N. Y. 1966
Chodyński, Spis, 1981	A. R. Chodyński, Spis bursztynników gdańskich od XVI do początku XIX wieku, in: Rocznik Gdański 41:1981 (1) 193–214
Christou, 1988	Ch. Christou (Ed.), Greek artists abroad, At. 1988
ChudSSSR I, 1970 ...	Chudožniki narodov SSSR. Biobibliografičeskij slovar', I ss., Mo. 1970 ss.
Cien años I, 1988 ...	Cien años de pintura en España y Portugal (1830–1930), I–XI, Ma. 1988–93
Cipriani, Indice, 1966	R. Cipriani, Indice del codice diplomatico artistico di Pavia dall'anno 1350 al 1550, ed. R. Maiocchi, Mi. 1966
Clapp I, 1970 ...	J. Clapp, Sculpture index, I–II, Metuchen, N. J. 1970
Clark, Ceramics, 1987	G. Clark, American ceramics, 1867 to the present, N. Y. 1987
Clark, Ohio, 1932	E. M. Clark, Ohio art and artists, Richmond 1932

Clarke, 1969	B. F. L. Clarke, Church builders of the 19th century, Newton Abbot 1969
Claussen, 1987	P. C. Claussen, Magistri doctissimi romani, St. 1987 (Forschungen zur Kunstgeschichte und christlichen Archäologie, 14. Corpus Cosmatorum, 1)
Coekelberghs, 1976	D. Coekelberghs, Les peintres belges à Rome de 1700 à 1830, Br./R. 1976
Coll. De Vinck I, 1909 ...	Bibliothèque Nationale, Un siècle d'histoire de France par l'estampe, 1770–1871. Collection De Vinck : inventaire analytique, P. 1909–1979
Colnaghi, 1928 ...	Sir D. E. Colnaghi, A dictionary of Florentine painters from the 13th to the 17th centuries, ed. G. Konody/S. Brinton, Lo. 1928; neue Ausg. (mit Introductory Essays und Indices), ed. C. E. Malvani, Fi. 1986
Colophons I, 1965 ...	Bénédictins du Bouveret, Colophons de manuscrits occidentaux dès origines au XVIe siècle, I–VI, Fribourg 1965–82 (Spicilegii Friburgensis subsidia, 2–7)
Colvin, 1954 ...	H. M. Colvin, A biographical dictionary of English (British) architects 1660 to 1840 (1600 to 1840), Lo. 1954; 21978; New Haven 31995
Comanducci I, 1970 ...	A. M. Comanducci, Dizionario illustrato dei pittori, disegnatori e incisori italiani moderni e contemporanei, I–V, Mi. 41970–74 und I 51982
Concioni/Ferri/Ghilarducci, 1988	G. Concioni/C. Ferri/G. Ghilarducci, Pittori rinascimentali a Lucca, Lucca 1988
ContempArtists, 1977 ...	Contemporary artists, Lo. 1977; 21983 (Contemporary arts series); N. Y. u.a. 41996; 52002
ContempDesigners, 1984 ...	Contemporary designers, Lo./Chicago 1984; 21985; Detroit u.a. 31997
Cora, 1973	G. Cora, Storia della maiolica di Firenze e del contado. Secoli XIV e XV, I–II, Fi. 1973
Cormack, 1985	M. Cormack, A concise catalogue of painting in the Yale Center for British Art, New Haven 1985
Corna I, 1930 ...	A. Corna, Dizionario della storia dell'arte in Italia, I–II, Piacenza 21930
Corresp. des Directeurs I, 1887 ...	A. de Montaiglon/J. Guiffrey (Ed.), Correspondance des directeurs de l'Académie de France à Rome, (1666–1804), I–XVII, P. 1887–1908, XVIII: P. Cornu (Ed.), Table générale, P. 1912; N. S., I: G. Brunel (Ed.), Répertoires, R. 1979; N. S., II: G. Brunel/I. Julia, Directorat de Suvée, 1795–1807, I–II, R. 1984
Cotarelo y Mori I, 1913 ...	E. Cotarelo y Mori, Diccionario biográfico y bibliográfico de calígrafos españoles, Ma., I 1913, II 1916
Cots Morató, 2005	F. de P. Cots Morató, Los plateros valencianos en la Edad Moderna (siglos XVI–XIX), Va. 2005
Couselo Bouzas, 1932	J. Couselo Bouzas, Galicia artística en el siglo XVIII y primer tercio del XIX, S. Co. 1932
Couselo Bouzas, 1950	J. Couselo Bouzas, La pintura gallega, La Coruña 1950
Crd'A	Critica d'arte (Fi.) 1:1935 ss.
Creative Canada I, 1971 ...	Creative Canada, Tor., I 1971, II 1972
Cresti/Zangheri, 1978	C. Cresti/L. Zangheri, Architetti e ingegneri nella Toscana dell'Ottocento, Fi. 1978
Crivelli, 1966	A. Crivelli, Artisti ticinesi in Russia, Locarno 1966 (Artisti ticinesi nel mondo, 1)
Crivelli, 1969	A. Crivelli, Artisti ticinesi dal Baltico al Mar Nero, Locarno 1969 (Artisti ticinesi nel mondo, 2)
Crivelli, 1970	A. Crivelli, Artisti ticinesi in Europa, Locarno u.a. 1970 (Artisti ticinesi nel mondo, 3)
Crivelli, 1971	A. Crivelli, Artisti ticinesi in Italia, Locarno u.a. 1971 (Artisti ticinesi nel mondo, 4)
Croft-Murray/Hulton I, 1960	E. Croft-Murray/P. Hulton, Catalogue of British drawings in the British Museum, I: XVI and XVII centuries, Lo. 1960
Crookshank/The Knight of Glin, 1978	A. Crookshank/The Knight of Glin, The painters of Ireland c. 1660–1920, Lo. 1978
Crowe/Cavalcaselle I, 1903 ...	J. A. Crowe/G. B. Cavalcaselle, A history of painting in Italy, ed. L. Douglas/T. Borenius, I–VI, Lo. 1903–40 und andere Ausg.
ČSM	Časopis Slezského muzea (Opava), Ser. B, 1:1951 ss.; ab 40:1991 u.d.T.: Časopis Slezského zemského muzea
Čuchovski, 1971	P. Čuchovski (Vorw.), Săvremenna bălgarska grafika, Sofija 1971
Cummings, 1966 ...	P. Cummings, A dictionary of contemporary American artists, N. Y. 1966; 21968; 1971; 51988
Czeike I, 1992 ...	F. Czeike, Historisches Lexikon Wien, I–V, W. 1992–97

D

DA I, 1996 ...	The dictionary of art, ed. J. Turner, I–XXXIV, Lo./N. Y. 1996
Dacier, 1925	E. Dacier, La gravure de genre et de mœurs, P./Br. 1925 (La gravure en France au XVIIIe siècle)
Dalla Vestra, 1975	G. Dalla Vestra, I pittori bellunesi prima dei Vecellio, Ve. 1975
Danckert, 1954 ...	L. Danckert, Handbuch des europäischen Porzellans, M. 1954; 1978; 51984; 1992
D'Ancona/Aeschlimann, 1940 ...	P. D'Ancona/E. Aeschlimann, Dictionnaire des miniaturistes du moyen âge et de la Renaissance dans les différentes contrées de l'Europe, Mi. 1940; 21949 (Repr. Nendeln 1969)
Darmon, 1927	J.-E. Darmon, Dictionnaire des peintres miniaturistes sur vélin, parchemin, ivoires et écaille, P. 1927
Davidson I, 1988 ...	M. G. Davidson, Kunst in Deutschland 1933–1945, I–III, Tb. 1988–95
DAVV I, 1982 ...	Diccionario de las artes visuales en Venezuela, Caracas, I 1982, II 1984
Davydova, 1974	M. V. Davydova, Očerki istorii russkogo teatral'no-dekoracionnogo iskusstva XVIII – načala XX veka, Mo. 1974
Day I, 1967 ...	H. A. E. Day, East Anglian painters, I–III, Eastbourne 1967–69

Fanucci Lovitch, 1991	M. Fanucci Lovitch, Artisti attivi a Pisa fra XIII e XVIII secolo, Pisa 1991
Fanucci Lovitch II, 1995	M. Fanucci Lovitch, Artisti attivi a Pisa fra XIII e XVII secolo, II, Pisa 1995
Farr Thompson, 1970	N. R. Farr Thompson, A checklist of artists in New Orleans in the 19th century, Magisterarbeit Louisiana State University, New Orleans 1970
Favaro, 1975	E. Favaro, L'arte dei pittori in Venezia e i suoi statuti, Fi. 1975 (Università di Padova. Pubblicazioni della Facoltà di lettere e filosofia, 55)
Feddersen, 1984	B. H. Feddersen, Schleswig-Holsteinisches Künstlerlexikon, Bredstedt 1984
Fel'kerzam, 1907	A. E. Fel'kerzam'', Alfavitnyj ukazatel' S.-Peterburgskich'' zolotych'' i serebrjanych'' děl'' masterov'', juvelirov'', graverov'' i proč. 1714–1814, StP. 1907 (Beil. der Zs. Starye gody)
Fielding, 1984 ...	Mantle Fielding's dictionary of American painters, sculptors and engravers, new completely revised, enlarged and updated, ed. G. B. Opitz, Poughkeepsie, N. Y. 1984 und spätere Aufl.
Fielding/Carr, 1926 ...	Mantle Fieldings dictionary of American painters, sculptors and engravers, comp. by J. F. Carr, N. Y. 1965 (Repr. der Ausg. von 1926)
Figueroa, 1887	P. P. Figueroa, Diccionario biográfico chileno (1550–1887), S. Ch. 1887
Filangieri I, 1891 ...	G. Filangieri, Indice degli artefici delle arti maggiori e minori, I–II, N. 1891 (Documenti per la storia, le arti e le industrie delle provincie napoletane, V. VI)
Filippini/Zucchini, Sec. XIII–XIV, 1947	F. Filippini/G. Zucchini, Miniatori e pittori a Bologna. Documenti dei secoli XIII e XIV, Fi. 1947 (Raccolta di fonti per la storia dell'arte, 6)
Filippini/Zucchini, Sec. XV, 1968	F. Filippini/G. Zucchini, Miniatori e pittori a Bologna. Documenti del secolo XV, R. 1968 (Accademia Nazionale dei Lincei. Fonti e documenti inediti per la storia dell'arte, 3)
Fincham, 1897	H. W. Fincham, Artists and engravers of British and American book plates, Lo. 1897
Fiori, 1971	G. Fiori, Architetti, scultori e artisti minori piacentini, in: Bolletino storico piacentino 66:1971, 53–70
Fischnaler, 1934	K. Fischnaler, Innsbrucker Chronik, V: Neue Beiträge mit dem Innsbrucker Künstler-Kreis 1209–1928, Inn. 1934
Fisher, 1972	S. W. Fisher, A dictionary of watercolour painters 1750–1900, Lo. 1972
Fisković, 1959	C. Fisković, Zadarski sredovječni majstori, Split 1959
Fleischhauer, 1958	W. Fleischhauer, Barock im Herzogtum Württemberg, St. 1958
Fleischhauer, 1971	W. Fleischhauer, Renaissance im Herzogtum Württemberg, St. 1971
Flemig, 1993	K. Flemig, Karikaturisten-Lexikon, M. u.a. 1993
Fleury, 1969 ...	M.-A. Fleury, Documents du Minutier Central concernant les peintres, les sculpteurs et les graveurs au XVII^e siècle (1600–1650), P. I 1969; II (in Vorbereitung)
Flippo, 1981	W. G. Flippo (Ed.), Lexicon of the Belgian romantic painters, Ant. 1981
FlorMitt	Mitteilungen des Kunsthistorischen Institutes in Florenz (Fi. u.a.) 1:1908/11 (1911) ss.
Focke, 1890	J. Focke, Bremische Werkmeister aus älterer Zeit, Bremen 1890
Forrer I, 1904 ...	L. Forrer, Biographical dictionary of medallists, I–VIII, Lo. 1904–30 (Repr. N. Y. 1970; Lo. 1979–80)
Foskett I, 1972 ...	D. Foskett, A dictionary of British miniature painters, I–II, Lo. 1972
Foster, 1926	J. J. Foster, A dictionary of painters of miniatures, Lo. 1926
Franc I, 2000 ...	J.-M. Franc, Dictionnaire des menuisiers, ébénistes, sculpteurs, tourneurs et doreurs du XVIII^e siècle. Paris et province, I–II, Dijon 2000
Fredericksen/Zeri, 1972	B. B. Fredericksen/F. Zeri, Census of pre-nineteenth-century Italian paintings in North American Public Collections, C., Mass. 1972
Fremantle, 1975	R. Fremantle, Florentine Gothic painters, Lo. 1975
Friedenthal, 1931	A. Friedenthal, Die Goldschmiede Revals, Lübeck 1931 (Quellen und Darstellungen zur Hansischen Geschichte, N. F., 8)
Friedrichs I, 1971 ...	E. Friedrichs (Ed.), Lebensbilder-Register. Alphabetisches Verzeichnis der in den deutschen regionalen „Lebensbilder"-Sammelbänden behandelten Personen, Neustadt an der Aisch, I 1971, II 1985
Fuchs, Geb. Jgg. I, 1976 ...	H. Fuchs, Die österreichischen Maler der Geburtsjahrgänge 1881–1900, I–II, W. 1976–77
Fuchs, Maler (19. Jh.) I, 1972 ...	H. Fuchs, Die österreichischen Maler des 19. Jahrhunderts, I–IV, W. 1972–74; Erg.-Bde I–II, 1978–79
Fuchs, Maler (20. Jh.) I, 1985 ...	H. Fuchs, Die österreichischen Maler des 20. Jahrhunderts, I–IV, W. 1985–86; Erg.-Bde I–II, 1991–92
G *Gabibov/Novruzova*, 1978	N. D. Gabibov/D. G. Novruzova (Ed.), Izobrazitel'noe iskusstvo Azerbajdžanskoj SSSR, Mo. 1978
Gahlnbäck, 1925	J. Gahlnbäck, Zinn und Zinngießer in Finnland, Helsinki 1925
Gahlnbäck, 1928	J. Gahlnbäck, Russisches Zinn, I: Zinn und Zinngießer in Moskau, L. 1928
Gahlnbäck, 1929	J. Gahlnbäck, Zinn und Zinngießer in Liv-, Est- und Kurland, Lübeck 1929 (Quellen und Darstellungen zur Hansischen Geschichte, N. F., 7)
Gaibi, 1978	A. Gaibi, Armi da fuoco italiane dal Medioevo al Risorgimento, Busto Arsizio 1978
Galetti/Camesasca I, 1951 ...	U. Galetti/E. Camesasca, Enciclopedia della pittura italiana, I–III, Mi. 1951
Gall. Uffizi, 1979 ...	Gli Uffizi. Catalogo generale, Fi. 1980
Gallet, 1995	M. Gallet, Les architectes parisiens du XVIII^e siècle. Dictionnaire biographique et critique, P. 1995

Gamulin I, 1987 ...	G. Gamulin, Hrvatsko slikarstvo XX. stoljeća, Zagreb, I 1987, II 1988 (Povijest umjetnosti u Hrvatskoj)
García Chico I, 1940 ...	E. García Chico, Documentos para el estudio del arte en Castilla, I–III, Vd. 1940–46
García Mogollón, 1987	F.-J. García Mogollón, La orfebrería religiosa de la diócesis de Coria (s. XIII–XIX), I–II, Cáceres 1987
Gardner, Stonecutters, 1945	A. T. E. Gardner, Yankee stonecutters. The first American school of sculpture, 1800–1850, N. Y. 1945
Garrison, 1949 ...	E. B. Garrison, Italian Romanesque panel painting, Fi. 1949 (Repr. N. Y. 1976)
Garrut, 1974	J. M. Garrut, Dos siglos de pintura catalana (XIX–XX), Ma. 1974
Garzelli I, 1985 ...	Miniatura fiorentina del Rinascimento 1440–1525, ed. A. Garzelli, I–II, Fi. 1985 (Inventari e cataloghi toscani, 18–19)
Gaya Nuño, 1964	J. A. Gaya Nuño, La pintura española en los museos provinciales, Ma. 1964
Gaya Nuño, 1968	J. A. Gaya Nuño, Historia y guía de los museos de España, Ma. ²1968
GBA	Gazette des Beaux-Arts (P.) 1:1859–140:2002
GEA, ..., 1985	Guide to exhibited artists. Craftsmen. European painters. North American painters. Printmakers. Sculptors, Ox. 1985
Gelsted, 1942	O. Gelsted, Gelsteds kunstner-leksikon, med 1100 biografier af danske billedhuggere, malere, grafikere og dekorative kunstnere fra 1900–1942, Kph. 1942
Gente nostra I, 1968 ...	Gente nostra. Artisti italiani contemporanei, I–III, T. 1968–70
GEPB I, 1936 ...	Grande enciclopédia portuguesa e brasileira, I–XXXVII, Li./Rio 1936–58, Erg.-Bde
Germaine, 1979	M. Germaine, Artists and galleries of Australia and New Zealand, Sydney u.a. 1979
Germaine, 1984 ...	M. Germaine, Artists and galleries of Australia, Brisbane 1984; Neuaufl. I–II, Sydney 1990; 1997 (CD-ROM)
Germaine, 1991	M. Germaine, A dictionary of women artists of Australia, Tortola 1991
Gestoso y Pérez I, 1899 ...	J. Gestoso y Pérez, Ensayo de un diccionario de los artífices que florecieron en Sevilla desde el siglo XIII al XVIII inclusive, I–III, Sevilla 1899–1908
Gesualdo/Biglione/Santos I, 1988 ...	V. Gesualdo/A. Biglione/R. Santos, Diccionario de artistas plásticos en la Argentina, I–II, Bs.As. 1988
Giannone, 1941	O. Giannone, Giunte sulle vite de' pittori napoletani, N. 1941 (R. Deputazione napoletana di storia patria. Memorie e documenti, 2)
Gibertini, 1964	D. Gibertini, Liste des horlogers genevois du XVIᵉ siècle au milieu du XIXᵉ siècle, in: Genava, N. S., 12:1964, 217–246
Gibson, 1975	A. H. Gibson, Artists of Early Michigan, Detroit 1975
Gillet, 1911	L. Gillet, Nomenclature des ouvrages de peinture, sculpture, architecture, gravure, lithographie ..., Saint-Denis 1911
Ginisty, 1916 ...	P. Ginisty, Les artistes morts pour la Patrie (août 1914–décembre 1915), P. 1916; 2. Ser. 1919
Giofyllis I, 1962 ...	F. Giofyllis, Istoria tis neoellinikis technis, At., I 1962, II 1963
Giraudet, 1885	E. Giraudet, Les artistes tourangeaux, Tours 1885
Giubbini, 1976	G. Giubbini, L'acquaforte originale in Piemonte e in Liguria 1860–1875, Ge. 1976
Gläser, 1930	K. Gläser, Berliner Porträtisten 1820–1852. Versuch einer Katalogisierung, B. 1930
Gmeiner/Pirhofer, 1985	A. Gmeiner/G. Pirhofer, Der Österreichische Werkbund, Sg./W. 1985
Gnoli, 1923	U. Gnoli, Pittori e miniatori nell'Umbria, Spoleto 1923
Godefroy, 1965	G. Godefroy, Les orfèvres de Lyon (1306–1791) et de Trévoux (1700–1786), P. 1965
Golubova, 1973	E. I. Golubova, Art of the autonomous republics of the Russian Federation, Le. 1973
González Echegaray, 1991	M. del C. González Echegaray u.a., Artistas cántabros de la Edad Moderna, Santander 1991
Good, BE on CD, 1995	M. Good (Ed.), A compendium of Pevsner's Buildings of England on compact disc, Ox. u.a. 1995
Gorčakov, 1964	V. A. Gorčakov, Chudožniki Kabardino-Balkarii, Le. 1964
Gordon-Brown, 1975	A. Gordon-Brown, Pictorial Africana, Cape Town/Rotterdam 1975
Gorenflo I, 1988 ...	R. M. Gorenflo, Verzeichnis der bildenden Künstler von 1880 bis heute, I–III, Rüsselsheim 1988
Granges de Surgères, 1893	M. de Granges de Surgères, Artistes français des XVIIᵉ et XVIIIᵉ siècles (1681–1787), P. 1893
Grant, ChronolHist I, 1926 ...	M. H. Grant, A chronological history of the old English landscape painters (in oil). From the 16th century to the 19th century, Leigh-on-Sea, I–II 1926, III 1947; rev. und erw. Aufl., I–VIII, 1957–61 (Repr. 1971–74)
Grant, Dict., 1952	M. H. Grant, A dictionary of British landscape painters. From the 16th century to the early 20th century, Leigh-on-Sea 1952 (Repr. mit Suppl. 1970)
Grant, Etchers, 1952 ...	M. H. Grant, A dictionary of British etchers, Lo. 1952; ²1953
Grant, Sculptors, 1953	M. H. Grant, A dictionary of British sculptors. From the XIIIth century to the XXth century, Lo. 1953
Grassi, 1966	L. Grassi, Province del Barocco e del Rococò, Mi. 1966
Graves, BI, 1908	A. Graves, The British Institution, 1806–1867. A complete dictionary of contributors and their work from the foundation of the Institution, Lo. 1908
Graves, Dict., 1884 ...	A. Graves, A dictionary of artists who have exhibited works in the principal London exhibition of oil painting from 1760 to 1893, Lo. 1884; ²1895; ³1901 (Repr. N. Y. 1970)
Graves, LE I, 1913 ...	A. Graves, A century of loan exhibitions, 1813–1912, I–V, Lo. 1913–15

Graves, RA I, 1905 ... A. Graves, The Royal Academy of Arts. A complete dictionary of contributers and their work from its foundation in 1769 to 1904, I–VIII, Lo. 1905–06

Graves, Soc., 1907 A. Graves, The Society of Artists of Great Britain, 1760–1791. The Free Society of Artists, 1761–1783. A complete dictionary of contributors and their work from the foundation of the Society to 1791, Lo. 1907 (Faks.-Ausg. Bath 1969)

Graviroval'naja Palata, 1985 Graviroval'naja Palata Akademii Nauk XVIII veka. Sbornik dokumentov, Le. 1985

Gray, 1985 A. S. Gray, Edwardian architecture. A biographical dictionary, Lo. 1985

Gretenkord, 1993 B. Gretenkord, Künstler der Kolonialzeit in Lateinamerika, B. 1993

Grieb I, 2007 ... M. H. Grieb (Ed.), Nürnberger Künstlerlexikon, I–IV, M. 2007

Grimwade, 1976 A. G. Grimwade, London goldsmiths, 1697–1837. Their marks and lives from the original registers at Goldsmith's Hall and other sources, Lo. 1976

Groce/Wallace, 1957 ... G. C. Groce/D. H. Wallace, The New York Historical Society's dictionary of artists in America, 1564–1860, New Haven/Lo. 1957; 21964; 31966; 41969; 51975; 61979

Grodecki I, 1985 ... C. Grodecki, Histoire de l'art au XVIe siècle, 1540–1600, P., I 1985, II 1986 (Documents du Minutier Central des Notaires de Paris)

Grotkamp-Schepers, 1980 B. Grotkamp-Schepers, Die Mannheimer Zeichnungsakademie (1756/69–1803) und die Werke der ihr angeschlossenen Maler und Stecher, He. 1980

GUDJ I, 1980 ... Genshoku Ukiyo-e Daihyakka Jiten (Allgemeines enzyklopädisches Lexikon des Ukiyo-e), I–XI, To. 1980–82

Guibert, 1908 L. Guibert, Catalogue des artistes limousins, in: Bulletin de la Société archéologique et historique du Limousin 58:1908, 119–209

Guidi, 1932 M. Guidi, Dizionario degli artisti ticinesi, R. 1932

Guiffrey, 1915 ... J. Guiffrey, Histoire de l'Académie de Saint-Luc, P. 1915 (Archives de l'art français, nouv. pér., 9) (Repr. 1970)

Gunnis, 1953 ... R. Gunnis, Dictionary of British sculptors, 1660–1851, Lo. 1953; 21968

Guo Weiqu, 1956 ... Guo Weiqu, Song Yuan Ming Qing shuhuajia nianbiao (Chronologische Tabelle der Kalligraphen und Maler der Song-, Yuan-, Ming- und Qing-Zeit), Hongkong 1956; Bj. 1958; 21962; 1982

Guyot de Fère, 1835 F.-F. Guyot de Fère, Statistique des beaux-arts, P. 1835

Gwinner, 1862 ... Ph. F. Gwinner, Kunst und Künstler in Frankfurt am Main. Vom 13. Jahrhundert bis zur Eröffnung des Städel'schen Kunstinstituts, Ffm. 1862; 1867 (Zusätze und Berichtigungen) (Repr. L. 1975)

H *Hachet I, 2005* ... J.-C. Hachet, Dictionnaire illustré des sculpteurs animaliers & fondeurs de l'antiquité à nos jours, I–II, Luxembourg 2005

Hadfield/Harling/Highton, 1980 M. Hadfield/R. Harling/L. Highton, British gardeners. A biographical dictionary, Lo. 1980

Häberle, 1934 A. Häberle, Die Goldschmiede zu Ulm, Ulm 1934 (Ulmer Schriften zur Kunstgeschichte, 10)

Haftmann, 1954 ... W. Haftmann, Malerei im 20. Jahrhundert, M. 1954 und spätere Ausg.

Haftmann, 1986 W. Haftmann, Verfemte Kunst, Köln 1986

Hagen, 1983 K. Hagen, Lexikon deutschbaltischer bildender Künstler, Köln 1983

Haimann, 2006 P. Haimann, Slovník autorů a zhotovitelů mincí, medailí, plaket, vyznamenání a odznaků se vztahem k Čechám, Moravě, Slezsku a Slovensku (1505–2005), Praha 2006

Hajdecki, 1908 A. Hajdecki, in: Quellen zur Geschichte der Stadt Wien, I. Abt.: Regesten aus in- und ausländischen Archiven, VI, W. 1908

al-Ḫālidī, 1971 Ġ.al-Ḫālidī, Arba῾ūn ῾āman min al-fann at-taškīlī fi-l-quṭr al-῾arabī as-sūrī (40 Jahre bildende Kunst in Syrien), Dimašq 1971

Hall, Cumbria, 1979 ... M. Hall, The artists of Cumbria. An illustrated dictionary of Cumberland, Westmoreland, North Lancashire and North Yorkshire painters, sculptors, draughtsmen and engravers born between 1615 and 1900, Newcastle upon Tyne 1979; 21986 (Artists of the regions series)

Hall, Northumbria, 1973 ... M. Hall, The artists of Northumbria. A dictionary of Northumberland and Durham painters, draughtsmen and engravers, born 1647–1900, Newcastle upon Tyne 1973; 21986 (Artists of the regions series)

Hall, Nottingham, 1953 H. C. Hall, Artists and sculptors of Nottingham and Nottinghamshire, 1750–1950. A biographical dictionary, Nottingham 1953

Hall, Portr., 1963 H. van Hall, Portretten van Nederlandse beeldende kunstenaars, Am. 1963

Hall, Repert. (I), 1936 ... H. van Hall, Repertorium voor de geschiedenis der Nederlandsche schilder- en graveerkunst sedert het begin der 12de eeuw tot het eind van 1932, D. H., (I) 1936, (II) 1949 (betr. 1933–46)

Hamilton, 1958 ... S. Hamilton, Early American book illustrators and wood engravers 1670–1870, Pr. 1958; I–II, 21968

Ḥamūdī, 1973 Ġ.Ḥamūdī, Dalīl al-fannānīn al-῾irāqīyyīn (Verzeichnis der irakischen Künstler), Baġdād 1973

Hanæus, 1976 A. Hanæus, Konstnärer i Medelpad, Sundsvall 1976

Hanebutt-Benz, 1984 E.-M. Hanebutt-Benz, Studien zum deutschen Holzstich im 19. Jahrhundert, Sep. aus: Archiv für Geschichte des Buchwesens 24:1984 (3–6)

Hansen, 1979 H. W. Hansen, Deutsche Holzschnittmeister des 20. Jahrhunderts, Toppenstedt 1979

Harambourg, 1985	L. Harambourg, Dictionnaire des peintres paysagistes français au XIXe siècle, Neuchâtel 1985
Harcos, 1991	L. Harcos, Peintres et graveurs lorrains, 1833–1980, Nancy 1991
Hardouin-Fugier/Grafe, 1978	E. Hardouin-Fugier/E. Grafe, The Lyon School of flower painting, Leigh-on-Sea 1978
Hardouin-Fugier/Grafe, 1989	E. Hardouin-Fugier/E. Grafe, French flower painters of the XIXth century, Lo. 1989
Hardouin-Fugier/Grafe, 1992	E. Hardouin-Fugier/E. Grafe, Les peintres de fleurs en France, P. 1992
Harper, 1970	J. R. Harper, Early painters and engravers in Canada, Tor. 1970
Harris, 1971	J. Harris, A catalogue of British drawings for architecture, decoration, sculpture and landscape gardening, 1550–1900, in American collections, Upper Saddle River 1971
Harris, 1976	P. Harris, A concise dictionary of Scottish painters, Edinburgh 1976
Harvey, 1954 ...	J. Harvey, English mediaeval architects. A biographical dictionary down to 1550, Lo. 1954; 2. rev. Ausg., Gloucester 1984 (Repr. 1987)
Hatje, 1963	G. Hatje (Ed.), Knaurs Lexikon der modernen Architektur, M./Z. 1963
Hatje, 1983 ...	Hatje Lexikon der Architektur des 20. Jahrhunderts, St. 1983; Ostfildern-Ruit 1998
Hautecœur I, 1943 ...	L. Hautecœur, Histoire de l'architecture classique en France, I–VII, P. 1943–57; überarb. Neuausgabe 1963 ss.
Haverstock/Vance/Meggitt, 2000	M. S. Haverstock/J. M. Vance/B. L. Meggitt (Ed.), Artists in Ohio, 1787–1900. A biographical dictionary, Kent, Ohio/Lo. 2000
HBL I, 1983 ...	Hrvatski biografski leksikon, I ss., Zagreb 1983 ss.
HBLS I, 1921 ...	Historisch-Biographisches Lexikon der Schweiz, ed. H. Türler/M. Godet, I–VII und Suppl., Neuenburg 1921–34
Heal, 1931 ...	A. Heal, The English writing-masters and their copy-books, 1570–1800, C. 1931 (Repr. Hildesheim 1962)
Heal, 1935	A. Heal, The London goldsmiths, 1200–1800, C. 1935
Heal, 1953	A. Heal, The London furniture makers, from the Restoration to the Victorian era, 1660–1840, Lo. 1953
Heimbürger Ravalli, 1977	M. Heimbürger Ravalli, Architettura, scultura e arti minori nel Barocco italiano. Ricerche nell'Archivio Spada, Fi. 1977
Heinecken I, 1778 ...	K. H. von Heinecken, Dictionnaire des artistes, dont nous avons des estampes, avec une notice detaillée de leurs ouvrages gravés, I–IV, L. 1778–90
Heller, 1995	J. und N. G. Heller (Ed.), North American women artists of the 20th century, N. Y./Lo. 1995
Helwig I, 1953 ...	H. Helwig, Handbuch der Einbandkunde, I–III, Ha. 1953–55
Herluison, 1873 ...	H. Herluison (Ed.), Actes d'État-Civil d'artistes français, Orléans 1873 (Repr. Genève 1972)
Hesse, 1987	G. Hesse/M. A. Bingel (Bearb.), Künstler der jungen Generation. Literaturverzeichnis zur Gegenwartskunst in der Amerika-Gedenkbibliothek, Berliner Zentralbibliothek, M. u.a. 1987
Hewitt, 1977	J. Hewitt, Art in Ulster, 1. Paintings, drawings, prints and sculpture for the last 400 years to 1957, Belfast 1977
Hickmann/Mode/Mahn, 1975	R. Hickmann/H. Mode/S. Mahn, Miniaturen, Volks- und Gegenwartskunst Indiens, L. 1975
Highwater, 1980	J. Highwater, The sweet grass lives on. 50 contemporary North American Indian artists, N. Y. 1980
Hill I, 1930 ...	G. F. Hill, A corpus of Italian medals of the Renaissance before Cellini, I–II, Ox./Lo. 1930
Hind I, 1938 ...	A. M. Hind, Early Italian engraving, I–VII, Lo. 1938–48 (Repr. Nendeln 1970–78)
Hintze I, 1921 ...	E. Hintze, Die deutschen Zinngießer und ihre Marken, I–VII, L. 1921–31 (Repr. Aalen 1964–65)
Hintze, 1979	E. Hintze, Schlesische Goldschmiede, Osnabrück 1979 (Repr. aus: Schlesiens Vorzeit, N. F.: Jahrbuch des Schlesischen Museums für Kunstgewerbe und Altertümer 6:1912 und 7:1916)
Hitchcock, 1968	H.-R. Hitchcock, Architecture of the XIX and XX centuries, Harmondsworth 1968
Hollstein I, 1949 ...	F. W. H. Hollstein, Dutch and Flemish etchings, engravings and woodcuts, 1450–1700, I ss., Am. 1949 ss.
Hollstein, German I, 1954 ...	F. W. H. Hollstein, German engravings, etchings and woodcuts ca. 1400–1700, I ss., Am. 1954 ss.
Honey I, 1949 ...	W. B. Honey, European ceramic art from the end of the middle ages to about 1815, Lo., I 1949, II 1952
Hoogewerff, 1942	G. J. Hoogewerff, Nederlandsche kunstenaars te Rome (1600–1725). Uittreksels uit de parochiale archieven, D. H. 1942 (Studien van het Nederlandsch Instituut te Rome, 3)
Horn, Cartoons, 1999	M. Horn (Ed.), The world encyclopedia of cartoons, Ph. 21999
Horn, Comics I, 1976 ...	M. Horn, The world encyclopedia of comics, I–II, N. Y. 1976; I–VI, N. Y. 1983; Ph. 1999
Horne, 1994	A. Horne, The dictionary of 20th century British book illustrators, Woodbridge 1994
Houfe, 1978 ...	S. Houfe, The dictionary of British book illustrators and caricaturists 1800–1914, Woodbridge 1978; rev. ed. 1981
Huart, 1908	C. Huart, Les calligraphes et les miniaturistes de l'Orient musulman, P. 1908 (Repr. Osnabrück 1972)
Hüseler I, 1956 ...	K. Hüseler, Deutsche Fayencen. Ein Handbuch der Fabriken, ihrer Meister und Werke, St., I 1956, II 1957, III 1958
Hughes, 1986 ...	E. M. Hughes, Artists in California 1786–1940, S. F. 1986; 21989; Sacramento, Calif. 32002
Hunnisett, 1980	B. Hunnisett, A dictionary of British steel engravers, Leigh-on-Sea 1980
Hunnisett, 1989	B. Hunnisett, An illustrated dictionary of British steel engravers, Aldershot 1989

Huse/Wolters, 1986 N. Huse/W. Wolters, Venedig. Die Kunst der Renaissance, M. 1986

I IBDCEE II. 1, 1983 ... International biographical dictionary of Central European emigrés 1933–1945, II: The arts, sciences, and literature, P. 1–2, M. u.a. 1983 (Biographisches Handbuch der deutschsprachigen Emigration nach 1933, II)

Ibrāhīm, 1971 F. A. Ibrāhīm, Qāmūs mašāhīr al-fannānīn at-tašklīyyīn (Lexikon der berühmten bildenden Künstler), al-Qāhira 1971

IFF, Après1800 I, 1930 ... Bibliothèque Nationale, Département des estampes. Inventaire du fonds français après 1800, I ss., P. 1930 ss.

IFF, GravXVI I, 1932 ... Bibliothèque Nationale, Département des estampes. Inventaire du fonds français. Graveurs du seizième siècle, I–II, P. 1932–38 (Repr. 1971)

IFF, GravXVII I, 1939 ... Bibliothèque Nationale, Département des estampes. Inventaire du fonds français. Graveurs du XVIIᵉ siècle, I ss., P. 1939 ss.

IFF, GravXVIII I, 1931 ... Bibliothèque Nationale, Département des estampes. Inventaire du fonds français. Graveurs du XVIIIᵉ siècle, I ss., P. 1931 ss.

IIN SSSR I, 1971 ... Istorija iskusstva narodov SSSR, I ss., Mo. 1971 ss.

IJP, 1958 ... Index of Japanese painters, compiled by the Society of Friends of Eastern Art, Tuttle Ed., Rutland, Vt./To. 1958; ²1959; ³1968

Immerzeel I, 1842 ... J. Immerzeel jr., De levens en werken der Hollandsche en Vlaamsche kunstschilders, beeldhouwers, graveurs en bouwmeesters van het begin der 15de eeuw tot heden (1840), ed. C. H. Immerzeel, I–III, Am. 1842–43; ²1855 (Repr. 1974)

Incisa della Rocchetta, 1979 G. Incisa della Rocchetta, La collezione dei ritratti dell'Accademia di San Luca (K), R. 1979 (Accademia Nazionale di San Luca, Studi e cataloghi, 4)

Ineichen/Zanoni, 1985 H. Ineichen/T. Zanoni, Luzerner Architekten, Z./Bern 1985

Ingelman, 1983 I. Ingelman, Förteckning över kvinnliga elever i konstakademin 1864–1924, Uppsala 1983

Ingendaay, 1976 M. Ingendaay, Sienesische Altarbilder des sechzehnten Jahrhunderts, Diss., Bonn 1976

INSA Inventar der neueren Schweizer Architektur. INSA. 1850–1920, ed. Schweizerische Gesellschaft für Kunstgeschichte, Z., I 1984, II 1986, III 1982, IV 1982, V 1990, VI 1991, VIII 1996, X 1992, XI 2004

IskČuvašii, 1980 Izobrazitel'noe iskusstvo Sovetskoj Čuvašii, Mo. 1980

IskDagestana, 1981 Iskusstvo Dagestana. Al'bom, Mo. 1981

Islimyeli I, 1967 ... N. Islimyeli, Türk plâstik sanatçilari ansiklopedisi, I–III, Ankara 1967–71

Ivanova, 1971 V. Ivanova, Săvremenna bălgarska skulptura, Sofija 1971

Ivanova, 1978 V. Ivanova, Bălgarska monumentalna skulptura, Sofija 1978

Iwanek, 1967 W. Iwanek, Słownik artystów na Śląsku Cieszyńskim, Bytom 1967 (Rocznik Muzeum Górnośląskiego w Bytomiu. Sztuka, zeszyt 2)

J *Jackson*, 1921 ... C. J. Jackson, English goldsmiths and their marks. A history of the goldsmiths and plate workers of England, Scotland, and Ireland, Lo. 1921; N. Y. ²1964

Jackson, BA, 1999 C. E. Jackson, Dictionary of bird artists of the world, Woodbridge 1999

Jacob, 1975 S. Jacob (Bearb.), Italienische Zeichnungen der Kunstbibliothek Berlin. Architektur und Dekoration 16. bis 18. Jahrhundert, B. 1975

Jacobs I, 1993 ... P. M. J. Jacobs, Beeldend Nederland. Biografisch handboek, I–II, Tilburg 1993

Jacobs I, 2002 ... P. M. J. E. Jacobs, Aktuele kunst. Biografisch handboek, I–II, Tilburg 2002

Jacobs, Benelux I, 2000 ... P. M. J. E. Jacobs, Beeldend Benelux. Biografisch handboek, I–VI, Tilburg 2000

Jacquot I, 1900 ... A. Jacquot, Essai de répertoire des artistes lorrains, I–XI, P. 1900–13

Jakovsky, 1967 ... A. Jakovsky, Peintres naïfs, Basel/Ha./W. 1967; Neuausg. Basel 1976

Jal, 1867 ... A. Jal, Dictionnaire critique de biographie et d'histoire, P. 1867; ²1872

Janneau, 1965 G. Janneau, La peinture française au XVIIᵉ siècle, Genève 1965

Janneau, 1975 G. Janneau, Les ateliers parisiens d'ébénistes et de menuisiers aux XVIIᵉ et XVIIIᵉ siècles, P. 1975

Jansa, 1912 F. Jansa, Deutsche bildende Künstler in Wort und Bild, L. 1912

JbAK Jahrbuch der Kunsthistorischen Sammlungen des Allerhöchsten Kaiserhauses (W.) 1:1883–34:1917

JbBerlMus Jahrbuch der Berliner Museen (Vorgänger: Jahrbuch der Preußischen Kunstsammlungen), N. F., 1:1959 ss.

JbKS Wien Jahrbuch der Kunsthistorischen Sammlungen in Wien (Forts. von JbAK)

JbPrK Jahrbuch (der Stiftung) Preußischer Kulturbesitz (B./Köln) 1:1962 ss.

JbPrKS Jahrbuch der (Königlich) Preußischen Kunstsammlungen (B.) 1:1880–64:1943 (1944)

JbZK Wien Jahrbuch des Kunsthistorischen Instituts der K. K. Zentralkommission für Denkmalpflege (W. u.a.) 1:1907–14:1920 (1922)

Jenny I, 1971 ... Kunstführer durch die Schweiz, begründet von H. Jenny, ed. H. R. Hahnloser/A. A. Schmid, I–III, Bern/Wabern 1971–82

Jeppe, 1963 H. Jeppe, South African artists, 1900–1962, Johannesburg 1963

Jessen, Ornamentstich I, 1922 ... P. Jessen, Meister des Ornamentstichs, I–IV, B. 1922–24

Jessen, Schreibkunst, 1924 P. Jessen, Meister der Schreibkunst aus drei Jahrhunderten, St. 1924

Jianou, 1986 I. Jianou, Romanian artists in the West, L. A. 1986

Jiřík, 1930 — F. X. Jiřík, Miniatura a drobná podobizna v době empirové a probuzenské v Čechách, Praha 1930

Johnson I, 1975 ... — J. Johnson, Works exhibited at the Royal Society of British artists 1824–93 and at the New English Art Club 1888–1917. An Antique Collector's Club research project, I–II, Woodbridge 1975

Johnson, 1980 — D. L. Johnson, Australian architecture 1901–51. Sources of modernism, Sydney 1980

Johnson/Greutzner, 1976 ... — J. Johnson/A. Greutzner (Ed.), The dictionary of British artists, 1880–1940, Woodbridge 1976 (Repr. 1980); 1984; 1986; 1990

Joray I, 1955 ... — M. Joray, La sculpture moderne en Suisse, I–III, Neuchâtel 1955–67 (dt.: Schweizer Plastik der Gegenwart)

Jordan, 1966 — R. F. Jordan, Victorian architecture, Harmondsworth 1966

Jourdan-Barry, 1974 — R. Jourdan-Barry, Les orfèvres de la généralité d'Aix-en-Provence du XIVe siècle au début du XIXe siècle, P. 1974

JWarburg — Journal of the Warburg and Courtauld Institutes (Lo.) 1:1937 ss.

K

Karel, 1992 — D. Karel, Dictionnaire des artistes de langue française en Amérique du Nord, Qu. 1992

Karling, 1943 — S. Karling, Holzschnitzerei und Tischlerkunst der Renaissance und des Barocks in Estland, Dorpat 1943 (Verhandlungen der Gelehrten estnischen Gesellschaft, 34)

Kaur, 1982 — Nideśikā āj kī bhāratīya nārī, Haupt-Red.: A. Kaur, New Delhi 1982

Kazarjan, 1978 — M. M. Kazarjan, Izobrazitel'noe iskusstvo Armjanskoj SSR, Mo. 1978

KChÈ I, 1962 ... — Kratkaja chudožestvennaja ènciklopedija. Iskusstvo stran i narodov mira, I–V, Mo. 1962–81

KD Bulgarien, 1983 — Kunstdenkmäler in Bulgarien, L. 1983

KD ČS, ..., 1978 ... — Kunstdenkmäler in der Tschechoslowakei, I–III, L. 1978–86

KD Jugoslawien I, 1981 — Kunstdenkmäler in Jugoslawien, I–II, L. 1981

KD Rumänien, 1986 — Kunstdenkmäler in Rumänien, L. 1986

KD Schweiz I, 1927 ... — Die Kunstdenkmäler der Schweiz, I ss., Basel 1927 ss.

KD SO-Polen, 1984 — Südostpolen, War./L. 1984 (Kunstdenkmäler in Polen)

KD SU, ..., 1978 ... — Kunstdenkmäler in der Sowjetunion, ..., Mo. u.a. 1978 ss.

KD Ungarn, 1974 ... — Kunstdenkmäler in Ungarn, L. 1974; 21981

Kerr I, 1984 — J. Kerr (Ed.), Dictionary of Australian artists. Working paper I: painters, photographers and engravers 1770–1870, Sydney 1984

Kerr, 1992 — J. Kerr (Ed.), The dictionary of Australian artists. Painters, sketchers, photographers and engravers to 1870, Mb. 1992

Khrum, 1978 — P. von Khrum, Silversmiths of New York City 1684–1850, N. Y. 1978

Kieling, ArchBerlin18. Jh., 1983 — U. Kieling, Berliner Architekten und Baumeister bis 1800, B. 1983 (Miniaturen zur Geschichte, Kultur und Denkmalpflege Berlins, 9)

Kieling, ArchBerlin19. Jh., 1986 — U. Kieling, Berliner Baubeamte und Staatsarchitekten im 19. Jahrhundert, B. 1986 (Miniaturen zur Geschichte, Kultur und Denkmalpflege Berlins, 17)

Kießling, 1979 — H. Kießling, Malerei heute. 127 Künstler und 127 Farbtafeln und Kurzbiographien aus der Kunstszene München von 1953–1978. Ein zeitgenössischer regionaler Überblick für Sammler und Liebhaber, M./W. 1979

Kim Jòng-jun, 1959 — Hankuk sŏhoa inmjŏngasŏ (Enzyklopädisches Wörterbuch der koreanischen Kalligraphie und Malerei), Sŏl 1959 (koreanisch in chinesischer Schrift)

Kindler, ML I, 1964 ... — Kindlers Malerei-Lexikon, I–VI, Z. 1964–71; Köln 21980

Kiričenko, 1978 ... — E. I. Kiričenko, Russkaja architektura 1830–1910-ch godov, Mo. 1978; 1982

Kjellberg, 1987 — P. Kjellberg, Les bronzes du XIXe siècle, P. 1987

Kjellberg, 1989 — P. Kjellberg, Le mobilier français du XVIIIe siècle, P. 1989

Kjellberg, 1994 — P. Kjellberg, Le mobilier du XXe siècle. Dictionnaire des créateurs, P. 1994

KLA I, 2001 ... — R. Vollkommer (Ed.), Künstlerlexikon der Antike, I–II, M./L. 2001–04

Klemm, 1882 — A. Klemm, Württembergische Baumeister und Bildhauer bis ums Jahr 1750 (Sep. aus: Württembergische Vierteljahreshefte für Landesgeschichte 5:1882)

KMML I, 1999 ... — Kortárs magyar művészeti lexikon, I–III, Bp. 1999–2001

Knowles, 1982 — R. Knowles, Contemporary Irish art, Dublin 1982

Kőszeghy, 1936 — E. Kőszeghy, Merkzeichen der Goldschmiede Ungarns vom Mittelalter bis 1867, Bp. 1936

Kohlbach, 1961 — R. Kohlbach, Steirische Baumeister, Graz 1961

Kondakov I, 1914 ... — S. N. Kondakov, Jubilejnyj spravočnik imperatorskoj Akademii chudožestv. 1764–1914, Tl 1 und 2, StP. 1914

Kondakov (1914), ed. *Lapteva/Mordvanjuk*, 2002 — S. N. Kondakov, Spisok russkich chudožnikov k Jubilejnomu spravočniku Imperatorskoj Akademii chudožestv (1914), ed. V. Ja. Lapteva/A. D. Mordvanjuk, Mo. 2002

Konstlex., 1972 — Konstlexikon. Svensk konst under 100 år, Sth. 1972

Kontha, 1985 — S. Kontha (Ed.), Magyar művészet 1919–1945, Bp. 1985

Koroma, 1962 — K. Koroma (Red.), Suomen kuvataiteilijat, Porvoo/Helsinki 1962

Kostin, 1976 — V. I. Kostin, OST (obščestvo stankovistov), Le. 1976

Krackowizer/Berger, 1931 — F. Krackowizer/F. Berger, Biographisches Lexikon des Landes Österreich ob der Enns. Gelehrte, Schriftsteller und Künstler Oberösterreichs seit 1800, Passau/Linz 1931

Kramm I, 1857 ... — C. Kramm, De levens en werken der Hollandsche en Vlaamsche kunstschilders, beeldhouwers, graveurs en bouwmeesters, van den vroegsten tot op onzen tijd, I–VI und Suppl., Am. 1857–64 (Repr. Am. 1974)

Lepage, 2008	J. Lepage, Dictionnaire des peintres, sculpteurs, graveurs, dessinateurs et architectes du Languedoc-Roussillon (1800–1950), Sète 2008
Lepszy, 1933	L. Lepszy, Przemysł złotniczy w Polsce, Kraków 1933
Lever, 1975	C. Lever, Goldsmiths and silversmiths of England, Lo. 1975
Levi D'Ancona, 1962	M. Levi D'Ancona, Miniatura e miniatori a Firenze dal 14 al 16 secolo, Fi. 1962 (Storia della miniatura. Studi e documenti, 1)
Lewis, 1973	F. Lewis, A dictionary of Dutch and Flemish flower, fruit and still life painters 15th to 19th century, Leigh-on-Sea 1973
Lewis, 1974	F. Lewis, A dictionary of British bird painters, Leigh-on-Sea 1974
Lewis, 1979	F. Lewis, A dictionary of British historical painters, Leigh-on-Sea 1979
LGB I, 1987 ...	Lexikon des gesamten Buchwesens, 2., völlig neu bearb. Aufl., I ss., St. 1987 ss.
Linstrum, 1978	D. Linstrum, West Yorkshire architects and architecture, Lo. 1978
Lira, 1902	P. Lira, Diccionario biográfico de pintores, S. Ch. 1902
List, 1967 ...	R. List, Kunst und Künstler in der Steiermark, Ried im Innkreis 1967–82
Lister, 1977	E. Lister/S. Williams, Twentieth century British naive and primitive artists, Lo. 1977
Lister, 1984	R. Lister, Prints and printmaking. A dictionary and handbook of the art in nineteenth-century Britain, Lo. 1984
LivreD'Or, 1914	Le livre d'or des peintres exposants, P. [8]1914
LivreD'Or, 1921	Le livre d'or des peintres exposants morts pour la France pendant la Grande Guerre, P. 1921
LKJL I, 1975 ...	Lexikon der Kinder- und Jugend-Literatur, I–III, Weinheim/Basel 1975–79; [3]1984 mit Erg.- und Reg.-Bd
Llaguno y Amirola I, 1829 ...	E. Llaguno y Amirola, Noticias de los arquitectos y arquitectura de España desde su restauración, I–IV, Ma. 1829
Llano Gorostiza, 1966	M. Llano Gorostiza, Pintura vasca, Bilbao 1966
Llordén, 1959	A. Llordén, Pintores y doradores malagueños, Avila 1959
Llordén, 1960	A. Llordén, Escultores y entalladores malagueños, Avila 1960
Llordén, 1962	A. Llordén, Arquitectos y canteros malagueños, Avila 1962
Lobstein I, 2003 ...	D. Lobstein, Dictionnaire des indépandants, 1884–1914, I–III, Dijon 2003
Loeber, 1981	R. Loeber, A biographical dictionary of architects in Ireland, 1600–1720, Lo. 1981
Löffler, 1955 ...	F. Löffler, Das alte Dresden, Dresden 1955 (Nachdr. L. 1981) und spätere Ausg.
Löfgren, 1927	A. Löfgren, Finländska tenngjutare och deras stämpling före 1809, Helsingfors 1927
Lösel, 1983	E. M. Lösel, Zürcher Goldschmiedekunst vom 13. bis zum 19. Jahrhundert, Z. 1983
Lo Gatto I, 1934 ...	E. Lo Gatto, Gli artisti italiani in Russia, I–III, R. 1934–43 (L'opera del genio italiano all'estero); ed. A. Lo Gatto, I–IV, Mi. 1990–94
Long, 1929 ...	B. S. Long, British miniaturists, 1520–1860, Lo. 1929; [2]1966
Loomes, 1976 ...	B. Loomes, Watchmakers and clockmakers of the world, II, Colchester 1976 (Repr. 1980, 1984); [2]1989 (Repr. 1992)
Loomes, 1981	B. Loomes, The early clockmakers of Great Britain, Lo. 1981
Lopaciński, 1946	E. Lopaciński, Materiały do dziejów rzemiosła artystycznego w Wielkim Księstwie Litewskim (XV–XIX w.), War. 1946
López Martínez, Arquit., 1928	C. López Martínez, Arquitectos, escultores y pintores vecinos de Sevilla, Sevilla 1928 (Notas para la historia del arte)
Lotz, Avant 1800, 1994	F. Lotz, Artistes-peintres alsaciens décédés avant 1800, Kaysersberg 1994
Lotz, 1800–1880, 1991	F. Lotz, Artistes peintres alsaciens d'un temps ancien (1800–1880), Kaysersberg 1991
Lotz, 1880–1982, 1987	F. Lotz, Artistes-peintres alsaciens de jadis et de naguère, 1880–1982, Kaysersberg 1987
Lotz, Jan. 1982, 1985	F. Lotz, Artistes peintres d'Alsace vivant et œuvrant à la date du 1er janvier 1982, Kaysersberg 1985
Loza, 1954	S. Loza, Architekci i budowniczowie w Polsce, War. 1954
LPE I, 1981 ...	Latvijas padomju enciklopēdija, I–X, Rīga 1981–88
LTE I, 1976 ...	Lietuviškoji tarybinė enciklopedija, I–XII, Vilnius 1976–84, Suppl. (A–Ž) 1985
Luciani, 1974	L. und F. Luciani, Dizionario dei pittori italiani dell'800, Fi. 1974
Lukošiūnienė/Manelienė, 1981	L. Lukošiūnienė/Ž.Manelienė, Lietuvos TSR dailė. 1940–1970. Bibliografinė rodyklė, Vilnius 1981
LWBK I, 1992 ...	Lexicon van Westvlaamse beeldende kunstenaars, I–VII, Kortrijk/Brugge 1992–98
Lydakis I, 1975 ...	S. Lydakis, Oi ellines zografoi, At., I 1975/76, II–IV 1976, V: Oi ellines glyptes, 1981
Lydakis, Gesch., 1972	S. Lydakis, Geschichte der griechischen Malerei des 19. Jahrhunderts, M. 1972 (Materialien zur Kunst des 19. Jahrhunderts, 7)
LZSK, 1981	Lexikon der zeitgenössischen Schweizer Künstler, ed. Schweizerisches Institut für Kunstwissenschaft (Red.: H.-J. Heusser), Frauenfeld/St. 1981

M

MAB I, 1995 ...	Māksla un arhitektūra biogrāfiãs, I–IV, Riga 1995–2003
MacDonald, 1967 ...	C. S. MacDonald, A dictionary of Canadian artists, Ottawa 1967 und spätere Ausg.
Machelart, 1987	F. Machelart, Peintres et sculpteurs de la confrérie Saint-Luc de Valenciennes aux XVIIe et XVIIIe siècles, Valenciennes 1987
Mackay, 1977	J. Mackay, The dictionary of Western sculptors in bronze, Woodbridge 1977 (Repr. 1992; 1995)
MacLaren I, 1991 ...	N. MacLaren, National Gallery London. The Dutch School, I–II, Lo. 1991
Macmillan I, 1982 ...	Macmillan encyclopedia of architects, I–IV, N. Y. 1982

Macquoid/Edwards I, 1924 ... P. Macquoid/R. Edwards, The dictionary of English furniture, from the Middle Ages to the late Georgian period, I–III, Lo. 1924–27; ²1954 (Repr. Woodbridge 1986)

Madariaga I, 1971 ... L. Madariaga, Pintores vascos, I–III, San Sebastián 1971–72

Màdaro, 1970 A. Màdaro, Artisti trevigiani dell'900, Treviso 1970

Madsen I, 1946 ... H. Madsen, 200 danske malere og deres værker, I–II, Kph. 1946

MagArt Magazine of art (N. Y. u.a.) 7:1915/16–46:1953 (bis 29:1936 u.d.T. American magazine of art)

Maggiore, '800, 1955 D. Maggiore, Arte e artisti dell'Ottocento napolitano, N. 1955

Maggiore, ArtViventi, 1955 D. Maggiore, Artisti viventi d'Italia, N. 1955

Maggiorotti II, 1936 ... L. A. Maggiorotti, Architetti e architetture militari, R., II 1936, III 1939 (L'opera del genio italiano all'estero)

MagyÉletLex I, 1981 ... Magyar életrajzi lexikon, I–III, Bp. ³1981–85

MagyFestAdat, 1988 G. Seregélyi, Magyar festők és grafikusok adattára. Életrajzi lexikon az 1800–1988 között alkotó festő- es grafikusművészekről, Szeged 1988

MagyKépLex, 1915 J. Szendrei/Gy. Szentiványi, Magyar képzőművészek lexikona, I, Bp. 1915

Maitron I. 1, 1964 ... J. Maitron (Ed.), Dictionnaire biographique du mouvement ouvrier français, I. 1 ss., P. 1964 ss.

Mak van Waay, 1944 S. J. Mak van Waay, Lexicon van Nederlandsche schilders en beeldhouwers (1870–1940), Am. 1944

Malatesta, 1939 E. Malatesta, Armi ed armaioli, Mi. 1939 (Enciclopedia biografica e bibliografica „Italiana", Ser. L)

Mallalieu I, 1976 ... H. L. Mallalieu, The dictionary of British watercolour artists up to 1920, Woodbridge, I 1976, II 1979

Mallett, 1935 ... D. T. Mallett, Mallett's index of artists. International – biographical, N. Y. 1935, Suppl. 1940 (Repr. 1948)

Malpel I, 1910 ... C. Malpel, Notes sur l'art d'aujourd'hui et peut-être de demain, I–II, P./Toulouse 1910

Maltese, 1962 C. Maltese, Arte in Sardegna dal V al XVIII, R. 1962

Mander, 1604 ... C. van Mander, Het schilder-boeck, Haarlem 1604; 2. Ausg.: Het leven der doorluchtighe Nederlandsche en Hoogduitsche schilders, Am. 1618 (1616–17); frz. Ausg., ed. Hymans, I–II, P. 1884; 1885; dt. Ausg., ed. H. Floerke, I–II, M./L. 1906 und andere Ausg.

Mankowitz/Haggar, 1957 W. Mankowitz/R. G. Haggar, The concise encyclopedia of English pottery and porcelain, Lo. 1957

Marcel, 1935 C. L. Marcel, Artistes et ouvriers d'art à Langres avant la Révolution, Langres 1935

Marchal/Wintrebert, 1987 G.-L. Marchal/P. Wintrebert, Arras et l'art au XIXᵉ siècle, Arras 1987

Marconi/Cipriani/Valeriani I, 1974 ... P. Marconi/A. Cipriani/E. Valeriani, I disegni di architettura dell'Archivio Storico dell'Accademia di San Luca, I–II, R. 1974

Marín-Medina, 1978 J. Marín-Medina, La escultura española contemporánea (1800–1978), Ma. 1978

Marinski, 1971 L. Marinski, Nacionalna Chudožestvena Galerija. Bălgarska živopis, 1825–1970 (K), Sofija 1971

Marinski, 1975 L. Marinski, Nacionalna Chudožestvena Galerija. Bălgarska skulptura, 1878–1974 (K), Sofija 1975

Markmiller, 1982 F. Markmiller (Ed.), Barockmaler in Niederbayern, Rb. 1982 (Niederbayern, Land und Leute)

Marrodán I, 1989 ... M. A. Marrodán, Diccionario de pintores vascos, I–V, Madrid 1989

Marta Sebastián, 1994 F. de Marta Sebastián, Historia de la Asociación Española de Pintores y Escultores 1910–1993, Ma. 1994

Martin I, 1912 ... F. R. Martin, The miniature painting and painters of Persia, India and Turkey from the 8th to the 18th century, I–II, Lo. 1912 (Repr. 1971)

Martín de Retana I, 1973 ... J. M. Martín de Retana, Pintores y escultores vascos de ayer hoy y mañana, I–XXV, Bilbao 1973–83

Martins I, 1974 ... J. Martins, Dicionário de artistas e artífices dos séculos XVIII e XIX em Minas Gerais, I–II, Rio 1974

Masetti Zannini, 1974 G. L. Masetti Zannini, Pittori della seconda metà del Cinquecento in Roma, R. 1974 (Raccolta di fonti per la storia dell'arte, Ser. 2, Bd 2)

Matzner, 1987 F. Matzner, Künstlerlexikon mit Registern zur documenta 1–8, Kassel 1987

Maurice I, 1976 ... K. Maurice, Die deutsche Räderuhr, I–II, M. 1976

Mayne, 1970 A. Mayne, British profile miniaturists, Lo. 1970 (Faber collectors library)

Mazalić, 1967 Đ.Mazalić, Leksikon umjetnika slikara, vajara, graditelja, zlatara, kaligrafa i drugih koji su radili u Bosni i Hercegovini, Sarajevo 1967

McCulloch, 1968 ... A. McCulloch, Encyclopedia of Australian art, Lo. 1968; ²1969; 1977; neubearb. und erw. Ausg.: I–II, Hawsthorn 1984; Lo. 1994

McCullough, 1977 B. McCullough, Australian naive painters, Mb. 1977

McEwan, 1994 P. J. M. McEwan, Dictionary of Scottish art and architecture, Woodbridge 1994

McInnes, 1939 G. McInnes, A short history of Canadian art, Tor. 1939

McKechnie, 1978 S. McKechnie, British silhouette artists and their work, 1760–1860, Lo. 1978

McMann, 1981 (Repr. 1997) E. de R. McMann, Royal Canadian Academy of Arts / Académie royale des arts du Canada. Exhibitions and members 1880–1979, Tor. u.a. 1981 (Repr. 1997)

McMann, BI, 2003 E. de R. McMann, Biographical index of artists in Canada, Tor. u.a. 2003

Medaković, 1991 — D. Medaković, Serbischer Barock, W./Köln/Weimar 1991

Medeiros, 1988 — J. Medeiros, Dicionário dos pintores do Brasil, Rio 1988

Meeks, 1966 — C. L. V. Meeks, Italian architecture 1750–1914, New Haven/L. 1966

Meis, 1979 — R. Meis, Taschenuhren, M. 1979

Melchiori, ed. Bordignon Favero, 1968 — N. Melchiori, Notizie di pittori e altri scritti, ed. G. Bordignon Favero, Ve./R. 1968 (Civiltà veneziana. Fonti e testi, 10, Ser. 1. 7)

Mele, 1960 — G. L. Mele, Maestri del Duomo, Mi. 1960 (Sep.)

Mémoires inédits I, 1854 ... — Mémoires inédits sur la vie et les ouvrages des membres de l'Académie Royale de Peinture et de Sculpture, ed. L.-E. Dussieux u.a., I–II, P. 1854; ²1887

MercatoArtItal, 1971 — Il mercato artistico italiano, 1800–1900, T. 1971

Merlino, 1954 — A. Merlino, Diccionario de artistas plásticos de la Argentina. Siglos XVIII–XIX–XX, Bs.As. 1954

Merlo, 1895 ... — J. J. Merlo, Kölnische Künstler in alter und neuer Zeit, ed. E. Firmenich-Richartz, Dd. 1895 (Repr. Nieuwkoop 1966)

Meyer, KL I, 1872 ... — J. Meyer (Ed.), Allgemeines Künstler-Lexikon, I–III, L. 1872–85

Mezzetti/Mattaliano I, 1980 ... — A. Mezzetti/E. Mattaliano, Indice ragionato delle „vite de' pittori e scultori ferraresi" di Gerolamo Baruffaldi, I–III, Ferrara 1980–83

Middeldorf Kosegarten, 1984 — A. Middeldorf Kosegarten, Sienesische Bildhauer am Duomo Vecchio, M. 1984 (Italienische Forschungen, F. 3, Bd 13)

Milanesi, Doc. I, 1854 ... — G. Milanesi, Documenti per la storia dell'arte senese, Siena, I (secoli XIII/XIV) 1854, II (secoli XV/XVI) 1854, III (secolo XVI) 1856

Milner, 1993 — J. Milner, A dictionary of Russian and Soviet artists, Woodbridge 1993

Minghetti, 1939 — A. Minghetti, Ceramisti, Mi. 1939 (Enciclopedia biografica e bibliografica „Italiana", Ser. XLI)

Mireur I, 1911 ... — H. Mireur, Dictionnaire de ventes d'art faites en France et à l'étranger pendant les XVIIIᵉ et XIXᵉ siècles, I–VII, P. 1911–12

Mitchell, 1985 — S. Mitchell, The dictionary of British equestrian artists, Woodbridge 1985

Mithoff, 1885 — H. W. H. Mithoff, Mittelalterliche Künstler und Werkmeister Niedersachsens und Westfalens, Hn. 1885

MLTE I, 1966 ... — Mažoji lietuviškoji tarybinė enciklopedija, I–III, Vilnius 1966–71

ModÉpLex, 1978 — Modern építészeti lexikon, Red.: M. Kubinszky, Bp. 1978

Mongitore, 1977 — A. Mongitore, Memorie dei pittori, scultori, architetti, artefici in cera siciliani, ed. E. Natoli, Palermo 1977

Montaiglon, Procès-verbaux I, 1875 ... — A. de Montaiglon (Ed.), Procès-verbaux de l'Académie Royale de Peinture et de Sculpture, 1648–1792 ... D'après les registres originaux conservés à l'Ecole des Beaux-Arts, I–X, P. 1875–92 und Table ... rédigée ... par P. Cornu, P. 1909

Monte I, 1971 ... — G. Do Monte, Dicionário histórico e biográfico de artistas amadores e técnicos eborenses, I–II, Évora 1971–73

Monteverdi, 1976 — M. Monteverdi, Dizionario critico Monteverdi. Pittori e scultori italiani contemporanei, Mi. 1976

Monteverdi, Storia I, 1975 ... — M. Monteverdi u.a., Storia della pittura italiana dell'Ottocento, I–III, Mi. 1975; ²1984

Moore, 1934 ... — W. Moore, The story of Australian art, I–II, Sydney 1934 (Repr. 1980)

Morales y Marín, 1973 — J. L. Morales y Marín, Diccionario de la pintura en Murcia, Murcia 1973

Morpurgo, 1970 — E. Morpurgo, Nederlandse klokken- en horlogenmakers vanaf 1300, Am. 1970

Morpurgo II, 1962 — E. Morpurgo, Gli artisti italiani in Austria, II, R. 1962 (L'opera del genio italiano all'estero)

Morris/Roberts, 1998 — E. Morris/E. Roberts, The Liverpool Academy and other exhibitions of contemporary art in Liverpool 1774–1867, Liverpool 1998

Moschini Marconi I, 1955 ... — S. Moschini Marconi, Gallerie dell'Accademia di Venezia, I–III, R. 1955–70 (Cataloghi dei musei e gallerie d'Italia)

Moure, 1984 ... — N. D. W. Moure, Publications in Southern California art 1, 2, 3, L. A. 1984

MSCh, 1979 — Molodye sovetskie chudožniki, ed. M. T. Kuz'mina, Mo. 1979

MU, 1992 — Mytci Ukraïny, Kyïv 1992

MU, 1997 — Mystectvo Ukraïny, Kyïv 1997

Muchatova, 1984 — O. Muchatova (Ed.), Izobrazitel'noe iskusstvo Turkmenskoj SSR, Mo. 1984

Mühlpfordt, 1970 — H. M. Mühlpfordt, Königsberger Skulpturen und ihre Meister 1255–1945, Würzburg 1970

MüJb — Münchner Jahrbuch der bildenden Kunst (M.) 1:1906–13:1923; N. F., 1:1924–13:1938/39 (1939); 3. F., 1:1950 (1951) ss.

Mülfarth, 1987 — L. Mülfarth, Kleines Lexikon Karlsruher Maler, Ka. 1987

Müller/Singer I, 1895 ... — H. A. Müller/H. W. Singer, Allgemeines Künstler-Lexikon. Leben und Werke der berühmtesten bildenden Künstler, Ffm., I–VI 1895–1906 und spätere Aufl.

Münchner Maler I, 1981 ... — Münchner Maler im 19. Jahrhundert, ed. H. Ludwig u.a., M., I–IV 1981–83, V–VI [u.d.T.: Münchner Maler im 19./20. Jahrhundert] 1993–94

Müntz, Renaiss. I, 1889 ... — E. Müntz, Histoire de l'art pendant la Renaissance, I–III, P. 1889–95

Műv — Művészet (Bp.) 1:1902–17:1918 sowie 1:1960–31:1990

MűvÉlet, 1968 — G. Pogány, Művész életrajzok, Bp. 1968

MűvÉlet, 1978 — A. Tasnádi/S. Varga/G. Zombory, Művész életrajzok, Bp. 1978

MűvÉlet, 1985 — G. Pogány/A. Tasnádi/G. Zombory/S. Varga, Művész életrajzok, Bp. 1985

MűvÉrt — Művészettörténeti értesítő (Bp.) 1:1952 ss.

MűvLex I, 1965 ...	Művészeti lexikon, ed. A. Zádor/I. Genthon, I–IV, Bp. 1965–68; ³1981
Mulczyński, 1996	J. Mulczyński, Słownik grafików Poznania i Wielkopolski XX wieku urodzonych do 1939 roku, Poznań 1996
Muñoz y Manzano (Viñaza) I, 1889 ...	C. Muñoz y Manzano (conde de la Viñaza), Adiciones al diccionario histórico de los más ilustres profesores de las bellas artes, I–IV, Ma. 1889–94
Myers, DAA I, 1970 ...	B. S. Myers (Ed.), Dizionario dell'arte e degli artisti, I–IV, Mi. 1970 (ital. Ausg. des McGraw-Hill dictionary of art, N. Y./Lo. 1969)
MZK Wien	Mitteilungen der K. K. Zentralkommission zur Erforschung und Erhaltung der Kunst- und Historischen Denkmale (W.) 1:1902 ss. (auch: Mitteilungen der K. K. Zentralkommission zur Erforschung und Erhaltung der Baudenkmale *sowie* Mitteilungen der K. K. Zentralkommission für Denkmalpflege in Wien)

N

NAAF	Nouvelles archives de l'art français (P.) [1:]1872-[6:]1878; 2. Ser., 1=7:1879/80–6=12:1885 (1886); 3. Ser., 1:1884/85–22:1906
NACF Rev.	National art-collectors fund. Review (Lo.) 1:1904 ss.
Nagel, 1986	G. K. Nagel, Schwäbisches Künstlerlexikon, M. 1986
Nagler, KL I, 1835 ...	G. K. Nagler, Neues allgemeines Künstler-Lexicon ..., I–XXII, M. 1835–52 (Repr. Linz 1904–14; L. 1924; W. 1924)
Nagler, Monogr. I, 1858 ...	G. K. Nagler, Die Monogrammisten und diejenigen bekannten und unbekannten Künstler aller Schulen ..., I–VI, M. 1858–79, Generalindex M. 1920 (Repr. Nieuwkoop/Hildesheim 1966)
Naik, 1986	N. S. Naik (Ed.), Kala Kird. Art & artists directory, Bombay 1986
NB	Nihon-no-bijutsu (To.) 1:1966 ss.
NBK	Neue Bildende Kunst (B.) 1:1991 ss.
NBM	Nenkan – Bijutsuka meikan (Jährliches Künstlernamenverzeichnis), To.
NBW I, 1964 ...	Nationaal biografisch woordenboek, I ss., Br. 1964 ss.
NBZ I, 1969 ...	Nihon Bijutsu Zenshū (Collection of Japanese Fine Art), ed. T. Fujita, I–VI, To. 1969
NDB I, 1953 ...	Neue Deutsche Biographie, I ss., B. 1953 ss.
Nebbia, 1908	U. Nebbia, La scultura del Duomo di Milano, Mi. 1908
NEČVU, 1995 ...	Nová encyklopedie českého výtvarného uměni, Praha 1995; Dodatky, 2006
Neumann, 1905	W. Neumann, Verzeichnis baltischer Goldschmiede, ihrer Merkzeichen und Werke, in: Sitzungsberichte der Gesellschaft für Geschichte und Altertumskunde der Ostseeprovinzen Rußlands aus dem Jahre 1904, Riga 1905, 121–195
Neumann, LbK, 1908 ...	W. Neumann (Ed.), Lexikon baltischer Künstler, Riga 1908 (Repr. Hn. 1972)
Neuwirth I, 1977 ...	W. Neuwirth, Porzellanmalerlexikon 1840–1914, I–II, Bg. 1977
Neuwirth, Lex. I, 1976 ...	W. Neuwirth, Lexikon Wiener Gold- und Silberschmiede und ihre Punzen 1867–1922, I–II, W. 1976–77
New McCulloch, 2006	A. McCulloch u.a., The new McCulloch's encyclopedia of Australian art, Fitzroy, Vic. 2006
Nissen I, 1966 ...	C. Nissen, Die botanische Buchillustration. Ihre Geschichte und Bibliographie, I–III, St. ²1966
NKKL, 1991	Natur och Kulturs konstnärslexikon, Sth. 1991
NKL I, 1982 ...	Norsk kunstnerleksikon. Bildende kunstnere, arkitekter, kunsthåndverkere, I–IV, Oslo 1982–86
NNBW I, 1911 ...	Nieuw Nederlandsch biografisch woordenboek, Red.: P. C. Molhuysen/P. J. Blok/F. K. Kossmann, I–X, Leiden 1911–37
Nocq I, 1926 ...	H. Nocq, Le poinçon de Paris. Répertoire des maîtres-orfèvres de la juridiction de Paris depuis le Moyen-Age jusqu'à la fin du XVIIIᵉ siècle, I–V, P. 1926–31 (Repr. 1968)
NÖB I, 1923 ...	Neue österreichische Biographie 1815–1918, I ss., W. 1923 ss.
Nordström, 1926	E. Nordström, Suomen taiteilijat. Maalarit ja kuvanveistäjät, Helsinki 1926
Noris, 2006	F. Noris (Ed.), Dizionario biografico dei pittori bergamaschi, Azzano San Paolo 2006
Norris, 1974 ...	G. Norris (Ed.), Australian artists today, Frankston 1974; ²1979; ³1984
Nostrand, 1980	J. van Nostrand, The first hundred years of painting in California 1775–1875, S. F. 1980

O

Obol'janinov, 1913	N. Obol'janinov, Russkie gravery i litografy. Dobavlenie k „Slovarju russkich graverov" Rovinskogo i k „Opisaniju neskol'kich gravjur i litografij" Tevjašova, Mo. 1913
Obreen I, 1877 ...	F. D. O. Obreen, Archief voor Nederlandsche kunstgeschiedenis, I–VII, Rotterdam 1877–90 (Repr. Utrecht 1971)
ÖBL I, 1957 ...	Österreichisches biographisches Lexikon 1815–1950, I ss., Graz/Köln 1957 ss.
ÖKL I, 1974 ...	R. Schmidt, Österreichisches Künstlerlexikon von den Anfängen bis zur Gegenwart, Lfg I–V, W. 1974–79 (als Bd I 1980 ersch.)
ÖKT I, 1907 ...	Österreichische Kunsttopographie, I ss., W. 1907 ss.
ÖZKD	Österreichische Zeitschrift für Kunst und Denkmalpflege 1:1947 ss.
Offner, Corpus ..., 1930 ...	R. Offner, A critical and historical corpus of Florentine painting, N. Y. u.a. 1930 ss.
Old Hull Artists, 1951	Old Hull artists, in: Early marine paintings and Hull art directory (K), Kingston upon Hull 1951
Olivier, 1975	R. Olivier, Dictionnaire biographique des créateurs de la Région de Joliette, Que. 1975
Olpin, 1980	R. S. Olpin, Dictionary of Utah art, Salt Lake City 1980

Onishi, 1975 — R. Onishi, Shina shoga jinmei jisho (Lexikon der chinesischen Kalligraphen und Maler), To. 1975

Ontario artists, 1978 — The index of Ontario artists, Tor. 1978

Opitz, 1984 — G. B. Opitz (Ed.), Dictionary of American sculptors. 18th century to the present, Poughkeepsie, N. Y. 1984

Oretti, ed. Biagi, 1981 — Marcello Oretti e il patrimonio artistico del contado bolognese, Indice, ed. D. Biagi, Bo. 1981 (Istituto per i beni artistici culturali naturali della Regione Emilia-Romagna, Documenti, 15)

Oretti, ed. Calbi/Scaglietti Kelescian, 1984 — Marcello Oretti e il patrimonio artistico privato bolognese, Indice, ed. E. Calbi/D. Scaglietti Kelescian, Bo. 1984 (Istituto per i beni artistici culturali naturali della Regione Emilia-Romagna, Documenti, 22)

Orlandi, Abcedario, 1704 ... — P. A. Orlandi, Abcedario pittorico ..., Bo. 1704; spätere Ausg. u.d.T. Abecedario pittorico ...: Bo. 1719; N. 1733 und 1763; Ve. 1753; Fi. 1788 (2 Bde)

Orlandoni, 1998 — B. Orlandoni, Artigiani e artisti in Valle d'Aosta. Dal XIII secolo all'epoca napoleonica, Ivrea 1998

Ortega Ricaurte, 1965 ... — C. Ortega Ricaurte, Diccionario de artistas en Colombia, Bog. 1965; 21979

Osborne, 1981 ... — The Oxford companion to twentieth-century art, ed. H. Osborne, N. Y. 1981 (Repr. 1984; 1990)

Ossorio y Bernard, 1883/84 — M. Ossorio y Bernard, Galería biográfica de artistas españoles del siglo XIX, Ma. 1883/84

Osterwalder, ..., 1983 ... — M. Osterwalder, Dictionnaire des illustrateurs, P. 1983; Neuchâtel 1989; 1992; 2005

Oudin, 1970 — B. Oudin, Dictionnaire des architectes, P. 1970 und spätere Ausg.

Oxford DNB, ... — Oxford dictionary of national biography (online)

P *Paatz*, Kirchen I, 1940 ... — W. und E. Paatz, Die Kirchen von Florenz, I–V und Reg.-Bd, Ffm. 1940–54

Padovano, 1951 — E. Padovano, Dizionario degli artisti contemporanei, Mi. 1951

Páez Ríos I, 1981 ... — E. Páez Ríos, Repertorio de grabados españoles, I–IV, Ma. 1981–85

Pailloux, 1962 — E. Pailloux, Orfèvres et poinçons XVIIe-XVIIIe-XIXe siècles, Poitou – Angoumois – Aunis – Saintonge, La Rochelle 1962

Paischeff, 1943 — A. Paischeff (Red.), Suomen kuvaamataiteilijat, Helsinki 1943

Pamplona I, 1954 ... — F. de Pamplona, Dicionário de pintores e escultores portugueses ou que trabalharam em Portugal, I–V, [Li.] 11954 ss.; 21987–88; [Porto] 31991

Panzetta, 1989 ... — A. Panzetta, Dizionario degli scultori italiani dell'Ottocento, T. 1989; überarb. Neuaufl. u.d.T. Dizionario degli scultori italiani dell'Ottocento e del primo Novecento, I–II und App., T. 1994

Panzetta I, 2003 ... — A. Panzetta, Nuovo dizionario degli scultori italiani dell'Ottocento e del primo Novecento, I–II, T. 2003

Paoletti I, 1893 ... — P. Paoletti, L'architettura e la scultura del Rinascimento in Venezia, I–II, Ve. 1893

Park, 1949 — E. A. Park, Mural painters in America, Pittsburgh 1949

Parry-Crooke, 1979 — C. Parry-Crooke (Ed.), Contemporary British artists, Lo. 1979

Pas I, 2000 ... — W. und G. Pas, Biografisch lexicon Arto 2000. Plastische kunst in België. Schilders, beeldhouwers, grafici, 1830–2000, I–II, Ant. 2000

Pas I, 2002 ... — W. und G. Pas, Dictionnaire biographique. Arts plastiques en Belgique. Peintres, sculpteurs, graveurs, 1800–2002, I–III, Ant. 2002

Pasculli Ferrara, 1983 — M. Pasculli Ferrara, Arte napoletana in Puglia dal XVI al XVIII secolo, Fasano 1983

Passavant I, 1860 ... — J. D. Passavant, Le peintre-graveur, I–VI, L. 1860–64

Passeri, Vite, 1772 ... — G. B. Passeri, Vite de'pittori, scultori ed architetti che hanno lavorato in Roma morti dal 1641 al 1673, R. 1772; ed. J. Hess, L./W. 1934 (Repr. Bo. 1976)

Pataky, 1951 — D. Pataky, A magyar rézmetszés története, Bp. 1951

Patrimonio Bologna, 1979 — Il patrimonio artistico e architettonico di Bologna 1792, Bo. 1979 (Istituto per i beni artistici culturali naturali della Regione Emilia-Romagna, Doc. 8)

Patrizzi/Sturm, 1981 — D. Patrizzi/F. X. Sturm, Schmuckuhren 1790–1850, M. 1981

Pavière, Flower I, 1962 ... — S. H. Pavière, A dictionary of flower, fruit and still life painters, I–III, Leigh-on-Sea 1962–64

Pazaurek I, 1925 ... — G. E. Pazaurek, Deutsche Fayence- und Porzellan-Hausmaler, I–II, St. 1925; 21971

Pelliccioni, 1949 — A. Pelliccioni, Dizionario degli artisti incisori italiani (dalle origini al XIX secolo), Carpi 1949

Peppin/Micklethwait, 1983 — B. Peppin/L. Micklethwait, Dictionary of British book illustrators. The 20th century, Lo. 1983

Pereira Salas, 1965 — E. Pereira Salas, Historia del arte en el Reino de Chile, S. Ch. 1965

Pérez Costanti, Dicc., 1930 — P. Pérez Costanti, Diccionario de artistas que florecieron en Galicia durante los siglos XVI y XVII, S. Co. 1930

Petránsky, 1985 — L. Petránsky, Moderná slovenská grafika 1918–83, Bra. 1985

Petrov I, 1864 ... — P. N. Petrov, Sbornik materialov dlja istorii imperatorskoj Akademii chudožestv za sto let ee suščestvovanija, I–III, StP. 1864–66

Petrov/Kamenski, 1991 — V. Petrov/A. Kamenski, „Le Monde de l'Art". Association artistique russe du début du XXe siècle, Le. 1991 (auch in dt. und engl.)

Pfister, 1993 — M. Pfister, Baumeister aus Graubünden – Wegbereiter des Barock, M./Chur 1993

Pieper-Lippe, 1974 — M. Pieper-Lippe, Zinn im südlichen Westfalen, Münster 1974 (Westfalen, Sonderheft 19)

Pieper-Lippe, 1980 — M. Pieper-Lippe, Zinn im nördlichen Westfalen, Münster 1980 (Westfalen, Sonderheft 21)

Pillich, 1959 ...	W. Pillich, Kunstregesten aus den Hofparteienprotokollen des Obersthofmeisters von 1637–1780, in: Mitteilungen des Österreichischen Staatsarchivs 12:1959 ...
Pio, ed. *Enggass*, 1977	N. Pio, Le vite di pittori, scultori et architetti, ed. C. und R. Enggass, Città del Vaticano 1977 (Studi e testi, 278)
Piompinos, 1979 ...	F. L. Piompinos, Ellines agiografoi mechri to 1821, At. 1979; [2]1984
Piron I, 1999 ...	P. Piron, De Belgische beeldende kunstenaars uit de 19de en 20ste eeuw, I–II, Br. 1999
Piron I, 2003 ...	P. Piron, Piron. Dictionnaire des artistes plasticiens de Belgique des XIXe et XXe siècles, I–II, Lasne u.a. 2003
PittItalCinquec I, 1987 ...	Il Cinquecento, I–II, Mi. 1987 (La pittura in Italia); erw. Neuausg. 1988
PittItalDuec I, 1985 ...	Il Duecento e il Trecento, I–II, Mi. 1985 (La pittura in Italia); erw. Neuausg. 1986
PittItalNovec/1 I, 1992 ...	Il Novecento/1–3, I–II, Mi. 1992–94 (La pittura in Italia)
PittItalOttoc I, 1990 ...	L'Ottocento, I–II, Mi. 1990 (La pittura in Italia); erw. Neuausg. 1991
PittItalQuattroc I, 1986 ...	Il Quattrocento, I–II, Mi. 1986 (La pittura in Italia); erw. Neuausg. 1987
PittItalSeic I, 1988 ...	Il Seicento, I–II, Mi. 1988 (La pittura in Italia); erw. Neuausg. 1989
PittItalSettec I, 1989 ...	Il Settecento, I–II, Mi. 1989 (La pittura in Italia); erw. Neuausg. 1990
PKG	Propyläen-Kunstgeschichte, N. F., I–XVIII, B. 1967–74; Suppl.-Bd I ss., 1977 ss.; Sonderband I ss., 1980 ss. und weitere Ausg.
PlástUrug I, 1975 ...	Plásticos uruguayos, I–II, Montevideo 1975
Plüss/Tavel I, 1958 ...	Künstler-Lexikon der Schweiz, XX. Jahrhundert, ed. Verein zur Herausgabe des Schweizerischen Künstlerlexikons, Red.: E. Plüss/H. von Tavel, Frauenfeld, I 1958–61, II 1963–67; Nachtr. von Todesdaten 1967 (Nachdr. 1974 und 1983)
Pons, 1986	B. Pons, De Paris à Versailles 1699–1736. Les sculpteurs ornemanistes parisiens ..., Strasbourg 1986
Pontual, 1969	R. Pontual, Dicionário das artes plásticas no Brasil, Rio 1969
Pope-Hennessy, Sculpt. I, 1955 ...	J. Pope-Hennessy, An introduction to Italian sculpture, I–III, Lo. 1955–62; 2. Aufl. Lo./N. Y., I 1972, II 1971, III 1970; Neuausgabe N. Y. 1985
Popis	Popis slikarskih i vajarskih dela Vojvodine (Novi Sad) 1:1965 ss.
Portal, 1925	C. Portal, Dictionnaire des artistes et ouvriers d'art du Tarn du XIIIe au XXe siècle, Albi 1925
Portalupi, 1973	M. Portalupi, Arte nella Svizzera romanda, Mi. 1973
Postnikova-Loseva, 1974	M. M. Postnikova-Loseva, Russkoe juvelirnoe iskusstvo, ego centry i mastera, XVI–XIX vekov, Mo. 1974
Postnikova-Loseva/Platonova/Ul'janova, 1983	M. M. Postnikova-Loseva/N. G. Platonova/B. L. Ul'janova, Zolotoe i serebrjanoe delo XV–XX vekov, Mo. 1983
Powers, 2000	J. und D. Powers, Texas painters, sculptors and graphic artists. A biographical dictionary of artists in Texas before 1942, Austin, Tex. 2000
Požarskaja, 1970	M. N. Požarskaja, Russkoe teatral'no-dekoracionnoe iskusstvo konca XIX – načala XX veka, Mo. 1970
Prause, 1975	M. Prause, Die Kataloge der Dresdner Akademie-Ausstellungen 1801–1850 (mit Reg.-Bd), B. 1975 (Quellen und Schriften zur bildenden Kunst, 5)
ProgrArchit	Progressive architecture (N. Y.) 26:1946–76:1995
Prokušev, 1982	G. I. Prokušev, Chudožniki Marijskoj ASSR, Le. 1982
Pronina, 1983	I. A. Pronina, Dekorativnoe iskusstvo v Akademii Chudožestv, Mo. 1983
Protić I, 1970 ...	M. B. Protić, Srpsko slikarstvo XX veka, I–II, Bgd. 1970
Prytkova, 1982	L. A. Prytkova (Ed.), Chudožniki Sovetskoj Kirgizii, Frunze 1982
PSB I, 1935 ...	Polski słownik biograficzny, I ss., Krakow 1935 ss.
Puviani, Diz. I, 1974 ...	F. Puviani, Dizionario dei pittori, scultori e incisori, Ferrara, I 1974, II 1975
Pyke, 1973 ...	E. J. Pyke, A biographical dictionary of wax modellers, Ox. 1973; Suppl., Lo. 1981

Q	Quellen Doria-Pamphilj, 1972	Quellen aus dem Archiv Doria-Pamphilj zur Kunsttätigkeit in Rom unter Innocenz X., Gesamt-Red.: J. Garms, R./W. 1972 (Publikationen des Österreichischen Kulturinstituts in Rom, II. Abt., 3. R., Bd 4)
	Quintanilla, 1962	M. Quintanilla, Algunas notas sobre artífices segovianos (1560–1660), Sep. aus: Estudios segovianos 14:1962

R	*Ráfols* I, 1951 ...	J. F. Ráfols, Diccionario biográfico de artistas de Cataluña desde le época romana hasta nuestros días, I–III, Ba. 1951–54
	Ràfols I, 1985 ...	Diccionario „Ràfols" de artistas contemporáneos de Cataluña y Baleares, I–IV, Ba. 1985–89; V: Compendio siglo XX, 1998
	Rambaud I, 1964 ...	M. Rambaud, Documents du Minutier Central concernant l'histoire de l'art (1700–1750), P., I 1964, II 1971
	Ramírez de Arellano, 1920 ...	R. Ramírez de Arellano, Catálogo de artífices que trabajaron en Toledo, y cuyos nombres y obras aparecen en los archivos de sus parroquias, Toledo 1920 (Repr. u.d.T. Catálogo de artífices de Toledo, Toledo 2002)
	Ramsden, 1950	C. Ramsden, French bookbinders 1789–1848, Lo. 1950
	Rasmo, 1966 ...	N. Rasmo, Appunti per un dizionario artistico atesino, in: Cultura atesina – Kultur des Etschlandes (Bolzano) 20:1966, 73–120; 21:1972, 35–99
	Rasmo I, 1980 ...	N. Rasmo, Dizionario biografico degli artisti atesini, I ss., Bolzano 1980 ss.

Rassd'A Rassegna d'arte antica e moderna (Mi.) 1901 ss.; N. S., 1:1914 ss.

Rastawiecki I, 1850 ... E. Rastawiecki, Słownik malarzów polskich tudzież obcych w Polsce osiadłych lub czasowo w niej pracujących, I–III, War. 1850–57

Rastawiecki, SłRytow., 1886 E. Rastawiecki, Słownik rytowników polskich tudzież obcych w Polsce osiadłych lub czasowo w niej pracujących, Poznań 1886

Rathke-Köhl, 1964 S. Rathke-Köhl, Geschichte des Augsburger Goldschmiedegewerbes vom Ende des 17. bis zum Ende des 18. Jahrhunderts, Diss. Hamburg, Au. 1964 (Schwäbische Geschichtsquellen und Forschungen, 6)

RBS I, 1896 ... A. A. Polovcev (Ed.), Russkij biografičeskij slovar', I–XXXV, StP. 1896–1918

RChK II, 1969 ... Russkaja chudožestvennaja kul'tura konca XIX – načala XX veka (1895–1907), kniga 2: Izobraziteľnoe iskusstvo, architektura, dekorativno-prikladnoe iskusstvo, Mo. 1969; kniga 4, Mo. 1980

Rd'A Rivista d'arte (Fi.) 1:1903–36:1961/62 (1963); 37:1984–44:1992

RE I, 1894 ... Paulys Realencyclopädie der classischen Altertumswissenschaft; Neubearb., ed. G. Wissowa u.a., 1. Reihe (A-Q): I–XXIV (47 Halb-Bde), St. 1894–1963; 2. Reihe (R-Z): I A. 1 – X A (19 Halb-Bde), St. 1914–72; Suppl. I–XV, St. 1903–78; Reg.-Bd, M. 1980

Read, 1983 B. Read, Victorian sculpture, New Haven 1983

Reclams Kunstf. ... Reclams Kunstführer, St. 1957 ss. (in versch. Aufl.)

Redgrave, 1874 ... S. Redgrave, A dictionary of artists of the English School, Lo. 1874; [2]1878 (Repr. 1970)

Rees, 1912 T. M. Rees, Welsh painters, engravers, sculptors (1527–1911), Carnarvon 1912

Reid, 1928 ... F. Reid, Illustrators of sixties, Lo. 1928 (Repr. u.d.T.: Illustrators of the eighteen sixties, N. Y. 1975)

Reid, 1973 ... D. Reid, A concise history of Canadian painting, Tor. 1973; [2]1988

Reineking von Bock, 1979 G. Reineking von Bock, Keramik des 20. Jahrhunderts, Deutschland, M. 1979

Reitzner, 1952/53 V. Reitzner, in: Alt-Wien-Lexikon für Österreichische und Süddeutsche Kunst und Kunstgewerbe: Edelmetalle und deren Punzen 3:1952/53, 193 ss.

Renard, 1985 J.-C. Renard, L'âge de la fonte – un art, une industrie 1800–1914, P. 1985

Renouard, 1901 P. Renouard, Documents sur les imprimeurs, libraires, cartiers, graveurs ... ayant exercé à Paris de 1450 à 1600, P. 1901

Renouvier, 1863 J. Renouvier, Histoire de l'art pendant la Révolution, P. 1863

Repert. Gab. Fotogr. I, 1978 ... Istituto centrale per il catalogo e la documentazione Roma, Dipinti dei musei e gallerie di Roma. Repertorio delle fotografie del Gabinetto fotografico nazionale, R. I 1978, II 1981

RepertKw Repertorium für Kunstwissenschaft (B. u.a.) 1:1876–52:1931

RIASA Rivista dell'Istituto Nazionale d'Archeologia e Storia dell'Arte (R.) 1:1952 ss.

RIBAJ Journal of the Royal Institute of British Architects (Lo.) 1:1835/36 ss.

Ribbe/Schäche, 1987 W. Ribbe/W. Schäche (Ed.), Baumeister, Architekten, Stadtplaner. Biographien zur baulichen Entwicklung Berlins, B. 1987 (Reihe Berlinische Lebensbilder)

Ricci, 1983 P. Ricci, Arte e artisti a Napoli, 1800–1943, N. 1983

Riccoboni, 1942 A. Riccoboni, Roma nell'arte. La scultura nell'evo moderno dal Quattrocento ad oggi, R. 1942

Ries, 1992 H. Ries, Illustration und Illustratoren des Kinder- und Jugendbuches im deutschsprachigen Raum 1871–1914, Osnabrück 1992

Rigoni, 1970 E. Rigoni, L'arte rinascimentale in Padova, Pd. 1970 (Medioevo e umanesimo, 9)

Rittmeyer, Lichtensteig, 1944 D. F. Rittmeyer, Von den Goldschmieden in Lichtensteig im Toggenburg und ihren Arbeiten, in: Zeitschrift für schweizerische Archäologie 6:1944, 19–38

Rittmeyer, Luzern, 1941 D. F. Rittmeyer, Geschichte der Luzerner Silber- und Goldschmiedekunst von den Anfängen bis zur Gegenwart, Luzern 1941 (Luzerner Geschichte und Kultur, Tl 3, Bd 4)

Rittmeyer, Rapperswil, 1949 D. F. Rittmeyer, Rapperswiler Goldschmiedekunst, in: Mitteilungen der Antiquarischen Gesellschaft Zürich 34:1949 (3) 1–163

Rittmeyer, Schaffhausen, 1947 D. F. Rittmeyer, Schaffhauser Goldschmiede, in: Schaffhauser Beiträge zur vaterländischen Geschichte 1947, 5–39

Rittmeyer, Sursee, 1936 D. F. Rittmeyer, Hans Peter Staffelbach, in: AnzSchwAlt, N. F., 38:1936 (2) 137–144; (3) 177–207; (4) 274–311

Rittmeyer, Wil, 1963 D. F. Rittmeyer, Die Goldschmiede und die Kirchenschätze in der Stadt Wil, Wil 1963

Rittmeyer, Winterthur, 1962 D. F. Rittmeyer, Die alten Winterthurer Goldschmiede, in: Mitteilungen der Antiquarischen Gesellschaft Zürich 42:1962 (1)

Rittmeyer, Zug, 1943 D. F. Rittmeyer, Zuger Goldschmiede, in: Zuger Neujahrsblatt 1943, 36–38

Rjazancev, 1976 I. V. Rjazancev, Iskusstvo sovetskogo vystavočnogo ansamblja 1917–1970, Mo. 1976

Robb/Smith, 1993 G. Robb/E. Smith, Concise dictionary of Australian artists, Carlton, Vic. 1993

Roberts, DJA, 1976 ... L. P. Roberts, A dictionary of Japanese artists. Painting, sculpture, ceramics, prints, lacquer, To./N. Y. 1976; [2]1977

Röder, 1934 J. Röder, Die Olmützer Künstler und Kunsthandwerker des Barock, I, Olmütz 1934

RömJb Römisches Jahrbuch für Kunstgeschichte (Kunstgeschichtliches Jahrbuch der Bibliotheca Hertziana) (M. u.a.) 1:1937 ss.

Roli, 1977 R. Roli, Pittura bolognese, 1650–1800, Bo. 1977

Romagnoli, Biogr. I (vor 1835), 1976 ... E. Romagnoli, Biografia cronologica de' bellartisti senesi 1200–1800, I–XII, XIII (Index), Ms. Siena, Biblioteca Comunale, vor 1835 (Repr. Fi. 1976)

Rombouts/Lerius I, 1864 ...　P. Rombouts/T. van Lerius, De liggeren en andere historische archieven der Antwerpsche Sint Lucasgilde, I–II, D. H. 1864–76 (Repr. Am. 1961); I–II, Ant./D. H. 1872

Rondot, 1888　N. Rondot, Les peintres de Lyon du XIVᵉ au XVIIIᵉ siècle, P. 1888

Rondot, 1902　N. Rondot, L'art et les artistes à Lyon du XIVᵉ au XVIIIᵉ siècle, Lyon 1902

Roosen-Runge, 1950　M. Roosen-Runge, Die Goldschmiede der Stadt Bern, in: Jahrbuch des Historischen Museums in Bern 30:1950, 5–75

Rosenberg, 1889 ...　M. Rosenberg, Der Goldschmiede Merkzeichen, Ffm. 1889; ²1911; ³1922–28 (4 Bde)

Rott I, 1933 ...　H. Rott, Quellen und Forschungen zur südwestdeutschen und schweizerischen Kunstgeschichte im 15. und 16. Jahrhundert, I–III, St. 1933–38

Roudié, 1958　P. Roudié, Peintres et verriers de Bordeaux à la fin du XVᵉ et au début du XVIᵉ siècle, in: Bulletin et mémoires de la Société archéologique de Bordeaux 59:1958 (1954–56) 122–132

Roudié, 1969　P. Roudié, Répertoire biographique des artistes et artisans d'art ayant travaillé à Bordeaux, en Bordelais et en Bazadais de 1453 à 1550, Bordeaux 1969

Rovinskij I, 1895 ...　D. A. Rovinskij, Podrobnyj slovar' russkich graverov XVI–XIX vekov, I–II, StP. 1895

RoyalAcadExhib I, 1973 ...　Royal Academy Exhibitors 1905–1970. A dictionary of artists and their work in the Summer Exhibitions of the Royal Academy of Arts, I–VI, East Ardsley/Wakefield 1973–82

RoyalHibAcad I, 1986 ...　Royal Hibernian Academy of Arts Dublin. Index of exhibitors and their works 1826–1979, I–III, Dublin 1986–87

RSA Exhibitors I, 1991 ...　C. Baile de Laperriere (Ed.), The Royal Scottish Academy exhibitors 1826–1990, I–IV, Calne 1991

ar-Rubaiʿī, 1972　Š.ar-Rubaiʿī, Al-fann at-taškīlī al-muʿāṣir fi-l-ʿIrāq (Die zeitgenössische bildende Kunst im Irak), Baġdād 1972

ar-Rubaiʿī, 1976　Š.ar-Rubaiʿī, Lauḥāt wa afkār (Gemälde und Ideen), Baġdād 1976

Rubcov, 1962 ...　N. N. Rubcov, Istorija litejnogo proizvodstva v SSSR, Čast' 1, Mo./Le. 1947; Mo. ²1962

Rückert, 1990　R. Rückert, Biographische Daten der Meißener Manufakturisten des 18. Jahrhunderts, M. 1990 (Katalog der Meißener Porzellan-Sammlung. Stiftung Ernst Schneider, Schloß Lustheim, Oberschleißheim vor München, Beiband) (Kataloge des Bayerischen Nationalmuseums München, 20)

Rump, 1912　E. Rump, Lexikon der bildenden Künstler Hamburgs, Altonas und der näheren Umgebung, Ha. 1912

Rump, 2005　K. Rump (Ed.), Der neue Rump. Lexikon der bildenden Künstler Hamburgs, Altonas und der näheren Umgebung, Neumünster 2005

S　*Sabater* I, 1972 ...　G. Sabater, La pintura contemporánea en Mallorca, PdM., I 1972, II 1982

Sailer, 1943　L. Sailer, Die Stukkateure, W. u.a. 1943 (Die Künstler Wiens, 1)

Salerno I, 1977 ...　L. Salerno, Pittori di paesaggio del Seicento a Roma, R. I–II 1977, III 1980

Salerno, NatMorta, 1984　L. Salerno, La natura morta italiana 1560–1805, R. 1984

Salverte, 1985　F. de Salverte, Les ébénistes du XVIIIᵉ siècle, P. ⁷1985

Sampaio de Andrade, 1959　A. Sampaio de Andrade, Dicionário histórico e biográfico de artistas e técnicos portugueses seculos XIV–XX, Li. 1959

Samuels, 1976　P. und H. Samuels, The illustrated biographical encyclopedia of artists of the American West, N. Y. 1976

San Vicente I, 1976 ...　A. San Vicente, La platería de Zaragoza en el bajo renacimiento 1545–1599, I–III, Zaragoza 1976

Sanchez I, 2004 ...　P. Sanchez, Dictionnaire des artistes exposant dans les salons des XVII et XVIIIᵉᵐᵉ siècles à Paris et en province, 1673–1800, I–III, Dijon 2004

Sanchez, Céramistes I, 2005 ...　P. Sanchez, Dictionnaire des céramistes, peintres sur porcelaine, verre et émail, verriers et émailleurs exposant d'art décoratif, et des manufactures nationales 1700–1920, I–III, Dijon 2005

Sanchez, Salon d'automne I, 2006 ...　P. Sanchez, Dictionnaire du Salon d'automne. Répertoire des exposants et liste des œuvres présentées, 1903–1940, I–III, Dijon 2006

Sanchez, Salons de Dijon, 2002　P. Sanchez, Les Salons de Dijon, 1771–1950. Catalogue des exposants et liste de leurs œuvres, Dijon 2002

Sanchez, Tuileries I, 2007 ...　P. Sanchez, Dictionnaire du Salon des Tuileries. Répertoire des exposants et liste des œuvres présentées, 1923–1962, I–II, Dijon 2007

Sanchez, Weill/Devambez, 2009　P. Sanchez, Les expositions de la Galerie Berthe Weill (1901–1942) et de la Galerie Devambez (1907–1926), Dijon 2009

Sanchis y Sivera, 1914　J. Sanchis y Sivera, Pintores medievales en Valencia, Ba. 1914

Sander, 18. Jh., 1926　M. Sander, Die illustrierten französischen Bücher des 18. Jahrhunderts, St. 1926 (Taschenbibliographien für Büchersammler, 3)

Sander, 19. Jh., 1924　M. Sander, Die illustrierten französischen Bücher des 19. Jahrhunderts, St. 1924 (Taschenbibliographien für Büchersammler, 1)

Sandler, 1978　I. Sandler, The New York School. The painters and sculptors of the fifties, N. Y. u.a. 1978

Sanjurjo, 1993　A. Sanjurjo (Ed.), Contemporary Latin American artists. Exhibitions at the Organization of American States 1965–1985, Metuchen, N. J./Lo. 1993

Santos Torroella I, 1985 ...　R. Santos Torroella (Dir.), Enciclopèdia vivent de la pintura i l'escultura catalanes, I ss., Ba. 1985 ss.

Sanyal, 1961　B. C. Sanyal (Ed.), Artists directory, ed. Lalit Kala Akad., New Delhi 1961

Sanz y Díaz, 1953 J. Sanz y Díaz, Pintores hispanoamericanos contemporáneos, Ba. 1953

Sartin, 1978 S. Sartin, A dictionary of British narrative painters, Leigh-on-Sea 1978

Sartori, Doc., 1976 A. Sartori, Documenti per la storia dell'arte a Padova, ed. C. Fillarini, Vi. 1976 (Fonti e studi per la storia del Santo a Padova, Fonti, 3)

Sarullo I, 1993 ... L. Sarullo, Dizionario degli artisti siciliani, I–IV, Palermo 1993 ss.

SBL I, 1925/32 ... U. I. Cankar/F. K. Lukman, Slovenski biografski leksikon, I ss., Ljubljana 1925 ss.

SBS I, 1986 ... Slovenský biografický slovník, I–VI, Martin 1986–94

Scarlett, 1980 K. Scarlett, Australian sculptors, Mb. 1980

Schede Vesme I, 1963 ... A. Baudi di Vesme, Schede Vesme. L'arte in Piemonte dal XVI al XVIII secolo, I–IV, T. 1963–82

Schedelmann, 1972 H. Schedelmann, Die großen Büchsenmacher. Leben, Werke, Marken vom 15. bis 19. Jahrhundert, Bg. 1972

Scheen I, 1969 ... P. A. Scheen, Lexicon Nederlandse beeldende kunstenaars 1750–1950, D. H., I 1969, II 1970; Register van overlijden, von C. A. Scharten, Zutphen 1996

Scheen, 1981 P. A. Scheen, Lexicon Nederlandse beeldende kunstenaars 1750–1880, D. H. 1981

Scheffler, Goldschm. Berlin, 1968 W. Scheffler, Berliner Goldschmiede, B. 1968

Scheffler, Goldschm. Hessen, 1976 W. Scheffler, Goldschmiede Hessens, B./N. Y. 1976

Scheffler, Goldschm. Main/Neckar, 1977 W. Scheffler, Goldschmiede an Main und Neckar, Hn. 1977

Scheffler, Goldschm. Mittel/NO-Dtld, 1980 W. Scheffler, Goldschmiede Mittel- und Nordostdeutschlands von Wernigerode bis Lauenburg in Pommern, B./N. Y. 1980

Scheffler, Goldschm. Niedersachsen I, 1965 ... W. Scheffler, Goldschmiede Niedersachsens, Halb-Bd 1–2, B. 1965

Scheffler, Goldschm. Oberfranken, 1989 W. Scheffler, Goldschmiede Oberfrankens, B./N. Y. 1989

Scheffler, Goldschm. Ostallgäu, 1981 W. Scheffler, Goldschmiede des Ostallgäus, Hn. 1981

Scheffler, Goldschm. Ostpreußen, 1983 W. Scheffler, Goldschmiede Ostpreußens, B./N. Y. 1983

Scheffler, Goldschm. Rhld-Westf. I, 1973 ... W. Scheffler, Goldschmiede Rheinland-Westfalen, Halb-Bd 1–2, B./N. Y. 1973

Scheltema I, 1855 ... P. Scheltema, Aemstels oudheid of gedenkwaardigkeiten van Amsterdam, I–VII, Am. 1855–85

Schidlof, 1911 L. Schidlof, Die Bildnisminiatur in Frankreich im XVII., XVIII. und XIX. Jahrhundert, W./L. 1911

Schidlof I, 1964 ... L. R. Schidlof, The miniature in Europe in the 16th, 17th, 18th and 19th centuries, I–IV, Graz 1964

Schmidt, 1951 R. Schmidt, Das Wiener Künstlerhaus. Eine Chronik 1861–1951, W. 1951

Schmidt, 1967 W. Schmidt, Russische Graphik des XIX. und XX. Jahrhunderts, L. 1967

Schneider, 1976 H. Schneider, Schweizer Waffenschmiede, vom 15. bis 20. Jahrhundert, Z. 1976

Schnell, Kl. Kunstf. H. Schnell (Ed.), Kleine Kunstführer, M./Z.

Schnell/Schedler, 1988 H. Schnell/U. Schedler, Lexikon der Wessobrunner Künstler und Handwerker, M./Z. 1988

Schöny I, 1970 ... H. Schöny, Wiener Künstler-Ahnen, I–IV, W. 1970–94

SChU, 1973 Slovnyk chudožnykiv Ukraïny, Kyïv 1973

Schurr, 1969 G. Schurr, Les petits maîtres de la peinture, valeur de demain, P. 1969

Schurr I, 1975 ... G. Schurr, Les petits maîtres de la peinture, valeur de demain 1820–1920, P., I 1975, II 1972, III 1976, IV 1979, V 1981, VI 1985, VII 1989

Schurr, Guidargus, 1980 ... G. Schurr, Le guidargus de la peinture du XIXe siècle à nos jours, P. 1980–2000

Schurr/Cabanne I, 1996 ... G. Schurr/P. Cabanne, Dictionnaire des petits maîtres de la peinture, I–II, P. 1996

SchwBZ Schweizerische Bauzeitung (Z.) 1:1883–128:1946; 65:1947–96:1978

Schweers I, 1994 ... H. F. Schweers, Gemälde in deutschen Museen, I–X, M. u.a. 1994

Schweers I, 2002 ... H. F. Schweers, Gemälde in deutschen Museen, I–X, M. 32002

Schweers I, 2005 ... H. F. Schweers, Gemälde in deutschen Museen, I–VII, M. 42005

Schweiger, 1982 W. J. Schweiger, Wiener Werkstätte. Kunst und Handwerk 1903–1932, W. 1982

SČSVU I, 1998 ... Slovník českých a slovenských výtvarných umelců, I ss., Ostrava, 1998 ss.

Seling I, 1980 ... H. Seling, Die Kunst der Augsburger Goldschmiede 1529–1868, I–III, M. 1980, Suppl. zu Bd III, 1994

Seling, 2007 H. Seling, Die Augsburger Gold- und Silberschmiede 1529–1868, erheblich erweiterte und überarbeitete Neuauflage von Seling III, 1980 und dessen Suppl. 1994, M. 2007

Service, 1977 A. Service, Edwardian architecture. A handbook to building design in Britain 1890–1914, Lo. 1977 (The world of art library)

Servolini, 1955 L. Servolini, Dizionario illustrato degli incisori italiani moderni e contemporanei, Mi. 1955

Seubert I, 1857 ... A. F. Seubert, Die Künstler aller Zeiten und Völker ..., I–III, St. 1857–64; 21878–79; 31882 (seit 1878: Allgemeines Künstlerlexicon oder Leben und Werke der berühmtesten bildenden Künstler ...)

Severjuchin/Lejkind, 1992 D. Ja. Severjuchin/O. L. Lejkind, Zolotoj vek chudožestvennych ob"edinenij v Rossii i SSSR (1820–1932), StP. 1992

Severjuchin/Lejkind, 1994 D. Ja. Severjuchin/O. L. Lejkind, Chudožniki russkoj ėmigracii (1917–1941), StP. 1994

Seymour, 1988 N. N. Seymour, An index-dictionary of Chinese artists, collectors and connoisseurs, Metuchen, N. J./Lo. 1988

Seyn, Dessinat., 1947 E. M. H. de Seyn, Dessinateurs, graveurs et peintres des anciens Pays-Bas. École flamande et hollandaise, Turnhout 1947

Seyn, Dict. I, 1935 ... E. de Seyn, Dictionnaire biographique des sciences, des lettres et des arts en Belgique, Br., I 1935, II 1936

Sgadari di lo Monaco, 1940 Sgadari di lo Monaco, Pittori e scultori siciliani, dal Seicento al primo Ottocento, Palermo 1940

Shapley I, 1979 ... F. R. Shapley, National Gallery of Art. Catalogue of the Italian paintings, I–II, Wa. 1979

Shapley, Kress Coll., 1966 F. R. Shapley, Paintings from the Samuel H. Kress Collection. Italian schools, XIII–XV century (K), Lo. 1966

Shapley, Kress Coll., 1968 F. R. Shapley, Paintings from the Samuel H. Kress Collection. Italian schools, XV–XVI century (K), Lo. 1968

Shapley, Kress Coll., 1973 F. R. Shapley, Paintings from the Samuel H. Kress collection. Italian schools, XVI–XVIII century (K), Lo. 1973

Shipp, 2003 S. Shipp, Latin American and Caribbean artists of the modern era, Jefferson, N. C./Lo. 2003

Sidorov, 1969 A. A. Sidorov, Russkaja grafika načala XX veka. Očerki i teorii, Mo. 1969

Singer, BK I, 1930 ... H. W. Singer, Allgemeiner Bildniskatalog, I–XIV, L. 1930–36

Singer, NBK I, 1937 ... H. W. Singer, Neuer Bildniskatalog, I–V, L. 1937–38

Siret I, 1924 ... A. Siret, Dictionnaire historique et raisonné des peintres de toutes les écoles depuis l'origine de la peinture jusqu'à nos jours, I–II, B. ³1924

Sitzmann, Ostfr., 1957 ... K. Sitzmann, Künstler und Kunsthandwerker in Ostfranken, Kulmbach 1957; ²1983 (Nachdr. aus: Die Plassenburg, Schriften für Heimatforschung und Kulturpflege in Ostfranken, Bd 12 in Zusammenfassung mit Bd 16,2–3 und Bd 37,4). Erg. und Berichtigungen, Reg., ibid. 1962 (Die Plassenburg, Schriften für Heimatforschung und Kulturpflege, 12. 16)

SłArtPlast, 1972 Słownik artystów plastyków. Artyści plastycy Okręgu Warszawskiego ZPAP 1945–1970, War. 1972

SłArtPolsk I, 1971 ... Słownik artystów polskich i obcych w Polsce działających, ed. Instytut Sztuki Polskiej Akademii Nauk, I ss., Wr. u.a. 1971 ss.; Uzupełnienia i sprostowania do t. I–II, 1979; do t. I–IV, 1993; do t. I–VI, 2003

SłJArt, 1972 J. J. Połatek/J. Paszenda, Słownik jezuitów artystów, Kraków 1972

Smith, AA, 1930 ... R. C. Smith, A biographical index of American artists, Baltimore 1930 (Repr. Detroit, Mich. 1976)

Smith, AP, 1962 B. Smith, Australian painting 1788–1960, Mb. 1962

Smith, AP, 1971 B. Smith, Australian painting 1788–1970, Mb. ²1971

Smith, AP, 1991 B. Smith, Australian painting 1788–1990, Mb. 1991

Smith, AP, 2001 B. Smith, Australian painting 1788–2000, South Melbourne, Vic. 2001

Smith, Clockm., 1921 ... J. Smith, Old Scottish clockmakers from 1453 to 1850, Edinburgh ²1921 (Repr. East Ardsley/Wakefield/N. Y. 1975)

SN Sakuhin nenkan – gendai nihon no bijutsu (Jahrbücher moderner japanischer Kunst), To. 1976 ss.

Snoddy, 1996 ... T. Snoddy, Dictionary of Irish artists. 20th century, Dublin 1996; ²2002

Snodgrass, 1968 American Indian painters. A biographical directory, compiled by J. O. Snodgrass, N. Y. 1968 (Contributions from the Museum of the American Indian Heye Foundation, XXI, P. 1)

Sobko I, 1893 ... N. P. Sobko, Slovar' russkich chudožnikov s drevnejšich vremen do našich dnej (XI–XIX vekov), I–III, StP. 1893–99

Solo, 1996 Solo, 5000 dessinateurs de presse et quelques supports, P. 1996

Soprani, Vite, 1674 ... R. Soprani, Le vite de' pittori, scultori e architetti genovesi e de' forestieri che in Genova operarono, Ge. 1674; ed. G. Ratti, I–II, 1768–69

Soria, 1982 R. Soria, Dictionary of nineteenth-century American artists in Italy 1760–1914, Rutherford u.a. 1982

Soria, 1993 R. Soria, American artists of Italian heritage, 1776–1945. A biographical dictionary, Rutherford u.a. 1993

Sorrenti, 1990 P. Sorrenti, Pittori, scultori, architetti e artigiani pugliesi dall'antiquità ai nostri giorni, Bari 1990

Souchal I, 1977 ... F. Souchal, French sculptors of the 17th and 18th centuries. The reign of Louis XIV, I–III, Lo. 1977–87, Suppl. 1993

SoupPam I, 1898 ... Soupis památek historických a uměleckých v království Českém (seit 1918 u.d.T.: Soupis památek historických a uměleckých v Republice Československé), I–LI, Praha 1898–1938 (z.T. dt.: Topographie der historischen und Kunstdenkmale im Königreich Böhmen; seit 1918: Topographie der historischen und kunstgeschichtlichen Denkmale in der Tschechoslowakischen Republik)

Sousa Viterbo I, 1899 ... F. Marques de Sousa Viterbo, Dicionário histórico e documental dos arquitectos, engenheiros e construtores portugueses, Li., I 1899, II 1904, III 1922 (Repr. 1990)

Spalding, 1986 F. Spalding, British art since 1900, Lo. 1986 (World of art)

Spalding, 1990 ... F. Spalding, 20th century painters and sculptors, Woodbridge 1990 (Dictionary of British
 art, 6) (Repr. 1991)

Spanish artists I, 1993 ... Spanish artists from the fourth to the twentieth century. A critical dictionary, I–IV, N. Y. u.a.,
 1993–96

Sparks, 1971 E. Sparks, A biographical dictionary of painters and sculptors in Illinois 1808–1945, Diss.
 Northwestern University, Evanston, Ill. 1971

Spies I, 1996 ... G. Spies, Braunschweiger Goldschmiede, I–III, B./M. 1996

Spinosa, 1979 N. Spinosa (Ed.), Le arti figurative a Napoli nel Settecento, N. 1979

SSSU, 1967 Slovník súčasného slovenského umenia, Bra. 1967

Stange I, 1967 ... A. Stange, Kritisches Verzeichnis der deutschen Tafelbilder vor Dürer, I–III, M. 1967–78

Starcev I, 1933 ... I. I. Starcev, Detskaja literatura. Bibliografija, I ss., Mo. 1933 ss.

Stchoukine, 1929 I. Stchoukine, Peinture indienne, P. 1929

Stchoukine, 1936 I. Stchoukine, La peinture iranienne sous les derniers ᶜAbbāsides et les Īl-Khāns, Bruges
 1936

Stchoukine, 1954 I. Stchoukine, Les peintures des manuscrits timurides, P. 1954

Stchoukine, 1959 I. Stchoukine, Les peintures des manuscrits ṣafavis, de 1502 à 1587, P. 1959

Stchoukine, 1964 I. Stchoukine, Les peintures des manuscrits des Shá ᶜAbbās Iᵉʳ, à la fin des Ṣafavis, P. 1964

Stchoukine, 1966 I. Stchoukine, La peinture turque d'après les manuscrits illustrés, 1: De Sulaymān Iᵉʳ à
 ᶜOṣmān IIᵉ, 1520–1622, P. 1966

Stchoukine, 1971 I. Stchoukine, La peinture turque d'après les manuscrits illustrés, II: De Murad IV à Mustafa
 III, P. 1971

Stchoukine, 1977 I. Stchoukine, La peinture des manuscrits de la „Khamseh" de Niẓāmī, P. 1977

Stehlíková, 2003 D. Stehlíková, Encyklopedie českého zlatnictví, stříbrnictví a klenotnictví, Praha 2003

Steingräber, 1979 E. Steingräber (Ed.), Deutsche Kunst der 20er und 30er Jahre, M. 1979

Štelin I, 1990 ... Zapiski Jakova Štelina ob izjaščnych iskusstvach v Rossii, I–II, Mo. 1990

Stepanyan I, 1973 ... G. X. Stepanyan, Kensagrakan baṙaran (hay mšakuytᶜi gorčičᶜner), E., I 1973, II 1981, III
 1990 (Biographisches Lexikon armenischer Kulturschaffender)

Stępień/Liczbińska, 1994 H. Stępień/M. Liczbińska, Artyści polscy w środowisku monachijskim w latach 1828–1914,
 War. 1994

Sternberg-Manderscheid, F. von Sternberg-Manderscheid, Beiträge und Berichtigungen zu Dlabacz Lexikon böhmi-
 1913 scher Künstler, Prag 1913

Stewart I, 1997 ... A. M. Stewart, Irish art societies and sketching clubs. Index of exhibitors 1870–1980, I–II,
 Dublin 1997

Stewart/Cutten, 1997 B. Stewart/M. Cutten, The dictionary of portrait painters in Britain up to 1920, Woodbridge
 1997

Stolberg, 1979 L. Stolberg, Die steirischen Uhrmacher ..., Graz 1979

Stone, 1955 ... L. Stone, Sculpture in Britain. The Middle Ages, Harmondsworth 1955, ²1972 (The Pelican
 history of art)

StoriaArteItal (Einaudi) I, Storia dell'arte italiana (Einaudi), I–XII, T. 1979–83
 1979 ...

Strazzullo, Archit., 1969 F. Strazzullo, Architetti e ingegneri napoletani dal '500 al '700, N. 1969

Strazzullo, Corpor., 1962 F. Strazzullo, La corporazione dei pittori napoletani, N. 1962

Strazzullo, Doc. I, 1955 F. Strazzullo, Documenti inediti per la storia dell'arte a Napoli, I, N. 1955

Strickland I, 1913 ... W. G. Strickland, A dictionary of Irish artists, I–II, Dublin/Lo. 1913 (Repr. Shannon 1969)

Ströter-Bender, 1991 J. Ströter-Bender, Zeitgenössische Kunst der „Dritten Welt", Köln 1991 (DuMont-
 Taschenbücher, 265)

Strutt I, 1785 ... J. Strutt, A biographical dictionary; containing an historical account of all engravers, from
 the earliest period of the art of engraving to the present time ..., Lo., I 1785, II 1786

StudInternat Studio international (Lo.) 167:1964–201:1988 (1:1893–167:1964 u.d.T.: The Studio)

Sturm I, 1979 ... H. Sturm (Ed.), Biographisches Lexikon zur Geschichte der Böhmischen Länder, I ss., M./W.
 1979 ss.

Summerson, 1963 ... J. Summerson, Architecture in Britain, 1530 to 1830, Harmondsworth 1963; ⁵1969 (The
 Pelican history of art, 3)

SúpPamSlov I, 1967 ... Súpis pamiatok na Slovensku, I–III, Bra. 1967–69

Suzuki I, 1982 ... K. Suzuki (Ed.), Comprehensive illustrated catalog of Chinese paintings, I–V, To. 1982–83

SvBL I, 1917/18 ... Svenskt biografiskt lexikon, ed. B. Boëthius/B. Hildebrand, I ss., Sth. 1917/18 ss.

SvK, 1974 ... Svenska konstnärer. Biografisk handbok, Sth. 1974; 1990; Vänersborg 1995 sowie Svenska
 konstnärer. Biografisk uppslagsbok, Jönköping 1997; 1999; 2001; Sala 2005; 2007

SvKL I, 1952 ... Svenskt konstnärslexikon, I–V, Malmö 1952–67

SWA I, 1996 ... C. Baile de Laperrière (Ed.), The Society of Women Artists exhibitors 1855–1996, I–IV,
 Calne 1996

Swärd, Skå- G. und K. Swärd, Konstnärer i Skåne/Blekinge, I–II, Klippan 1982; Suppl. [1986]
ne/Blekinge I, 1982 ...

Swärd, Stockholm I, 1984 ... G. und K. Swärd, Konstnärer i Stockholm, I–IV, Klippan 1984

Swärd, Väst-Sverige I, G. und K. Swärd, Konstnärer i Väst-Sverige, I–II, Klippan 1986
 1986 ...

Syrkina/Kostina, 1978 F. Ja. Syrkina/E. M. Kostina, Russkoe teatral'no-dekoracionnoe iskusstvo, Mo. 1978

T

Tannock, 1978	M. Tannock, Portuguese 20th century artists, Chichester 1978
Tardito-Amerio, 1968	R. Tardito-Amerio, Italienische Architekten, Stukkatoren und Bauhandwerker der Barock-zeit in den welfischen Ländern und im Bistum Hildesheim, Göttingen 1968 (Nachrichten der Akademie der Wissenschaften in Göttingen, Philologisch-historische Klasse 1968[6])
Tardy, Horlogers I, 1971 ...	H. L. und H. L. Tardy, Dictionnaire des horlogers français, P., I 1971, II 1972
Tardy, Porcelaines, 1967	Tardy, Les porcelaines françaises, P. 1967
Tardy, Poteries I, 1974 ...	Tardy u.a., Les poteries et les faiences françaises, P., I 1974, II 1969, III 1971
Tasmanian crafts, 1983	Tasmanian crafts. Makers and sellers, Hobart 1983
Tatman/Moss, 1985	S. L. Tatman/R. W. Moss, Biographical dictionary of Philadelphia architects: 1700–1930, Boston 1985
Tazawa, 1981 ...	Y. Tazawa (Ed.), Biographical dictionary of Japanese art, To. 1981; [2]1983
TCI	Guida d'Italia del Touring Club Italiano, I–XXIII, Mi. 1962 ss. (jeder Bd in versch. Aufl.)
Teixeira Leite, 1988	J. R. Teixeira Leite, Dicionário crítico da pintura no Brasil, S. P. 1988
ThB1, 1907 ...	Allgemeines Lexikon der bildenden Künstler von der Antike bis zur Gegenwart, begründet von U. Thieme/F. Becker, I–XXXVII, L. 1907–50
Thomas/de Vries, 1977 ...	K. Thomas/G. de Vries, Du Mont's Künstler-Lexikon von 1945 bis zur Gegenwart, Köln 1977; [3]1981
Thorpe I, 1929 ...	W. A. Thorpe, A history of English and Irish glass, I–II, Lo. 1929 (Repr. 1969)
Thuile I, 1964 ...	J. Thuile, Histoire de l'orfèvrerie du Languedoc : généralités de Montpellier et de Toulouse. Répertoire des orfèvres depuis le Moyen-Age jusqu'au début du XIXe siècle, I–III, Mont-rouge 1964–69
Tiessen I, 1968 ...	W. Tiessen (Ed.), Die Buchillustration in Deutschland, Österreich und der Schweiz seit 1945, I–VI, Neu-Isenburg 1968–89
Tischer, 1928 ...	F. Tischer, Böhmisches Zinn und seine Marken, L. 1928 (Repr. Osnabrück 1973)
Titi, Descr., 1674 ...	F. Titi, Descrizione delle pitture, sculture e architetture esposte al pubblico in Roma ..., R. 1674; [6]1763 (Repr. 1978)
TLE I, 1985 ...	Tarybų lietuvos enciklopedija, I–IV, Vilnius 1985–88
Toesca I, 1927 ...	P. Toesca, Storia dell'arte italiana, T., I 1927, II 1951 (Repr. 1965–71)
Tolstoj, 1978	V. P. Tolstoj (Ed.), Monumental'noe iskusstvo SSSR, Mo. 1978
Toman I, 1947 ...	P. Toman, Nový slovník československých výtvarných umělců, 3. Aufl., Praha, I 1947, II 1950
Toman, Dodatky, 1955	P. Toman, Dodatky ke Slovníku československých výtvarných umělců, Praha 1955
Tomassoni, 1971	I. Tomassoni, Italia, Bo. 1971 (Arte dopo il 1945, 2)
Toussaint, 1965 ...	M. Toussaint, Pintura colonial en México, Méx. 1965; ed. X. Moyssén, Méx. [2]1982
TPChV, 1987	Tovariščestvo peredvižnych chudožestvennych vystavok 1869–1899. Pis'ma, dokumenty, Mo. 1987
Trenschel, 1991	H.-P. Trenschel, Würzburger Büchsenmacher. Zunft, Meister, Werke, Würzburg 1991
Trépanier, 1980	J. Trépanier, Cent peintres du Québec, Ville LaSalle, Que. 1980
Trevisan, 1983	A. Trevisan, Escultores contemporâneos do Rio Grande do Sul, Porto Alegre 1983
Trier/Weyres I, 1980 ...	E. Trier/W. Weyres (Ed.), Kunst des 19. Jahrhunderts im Rheinland, I–V, Dd. 1979–81
Troescher I, 1953 ...	G. Troescher, Kunst- und Künstlerwanderungen in Mitteleuropa 800–1800, BB., I 1953, II 1954
Troickij, 1914	V. I. Troickij, Slovar' mastera chudožniki zolotogo i serebrjanogo dela, almazniki i su-sal'niki, rabotavšie v Moskve pri patriaršem dvore v XVI veke, Mo. 1914
Troickij I, 1928 ...	V. I. Troickij, Slovar' moskovskich masterov zolotogo, serebrjanogo i almaznogo dela XVII veka, Le., I 1928, II 1930
Turnbull, 1976	H. Turnbull, Artists of Yorkshire, Snape Bedale 1976
Turnor, 1950	R. Turnor, Nineteenth century architecture in Britain, Lo. u.a. 1950

U

Učníková, 1980	D. Učníková, Historický portrét na Slovensku. Zo zbierok 13 múzeí (16.-18. stor.), Mar-tin/Bra. 1980
Új MagyÉletLex I, 2001 ...	L. Markó (Ed.), Új Magyar életrajzi lexikon, I ss., Bp. 2001 ss.
ÚjMűv	Új művészet (Bp.) 1:1990 ss.
UPČ I, 1977 ...	Umělecké památky Čech, I–IV, Praha 1977–82
Upmark, 1943	G. Upmark, Guld- och silversmeder i Sverige 1520–1850, Sth. 1943
UPMS I, 1994 ...	B. Samek, Umělecké památky Moravy a Slezska, I ss. Praha 1994 ss.
UPP I, 1996 ...	Umělecké památky Prahy, I–IV, Praha 1996–2000
URCh, 1972	Ukraïns'ki radjans'ki chudožniki. Dovidnik, Kyïv 1972
Uspenskij, 1910	A. I. Uspenskij, Carskie ikonopiscy i živopiscy XVII veka. Slovar', Mo. 1910
Uspenskij, 1913	A. I. Uspenskij, Slovar' chudožnikov XVIII veka, pisavšich v imperatorskich dvorcach, Mo. 1913

V

Vaglia, 1948	U. Vaglia, Dizionario degli artisti e degli artigiani valsabbini, Sabbio Chiese 1948
Valverde Madrid, 1974	J. Valverde Madrid, Ensayo socio-histórico de retablistas cordobeses del siglo XVIII, Cór-doba 1974
van Marle I, 1923 ...	R. van Marle, The development of the Italian Schools of painting, I–XIX, D. H. 1923–38 (Repr. N. Y. 1970)
Van Rompaey, 2006	H. Van Rompaey, Dictionary of bird and wildlife painters, 2 Tle, Edegem 2006

Vargas Ugarte, 1968 — R. Vargas Ugarte, Ensayo de un diccionario de artífices de la América Meridional, Burgos ²1968

Vasari, ed. ... — G. Vasari, Le vite de' più eccellenti pittori, scultori e architetti, Fi. 1550; ²1568 (zit. nach der Ausg. von G. Milanesi [9 Bde, Fi. 1878–85] und nach anderen Ausg.)

Vasiliev, 1965 — A. Vasiliev, Bălgarski văzroždenski majstori, Sofija 1965

Venturi I, 1901 ... — A. Venturi, Storia dell'arte italiana, I–XI, Mi. 1901–40 (Repr. Nendeln 1967)

Venturi, Index I, 1975 ... — A. Venturi, Storia dell'arte italiana, Index: J. D. Sisson, I–II, Nendeln 1975

Vergnet-Ruiz/Laclotte, 1962 — J. Vergnet-Ruiz/M. Laclotte, Petits et grands musées de France. La peinture française des primitifs à nos jours, P. 1962

Verlet I, 1956 ... — P. Verlet, Les meubles du XVIIIᵉ siècle, I–II, P. 1956

Verlet-Réaubourg, 1977 — N. Verlet-Réaubourg, Les orfèvres du ressort de la Monnaie de Bourges, Genève 1977 (Dictionnaire des poinçons de l'orfèvrerie provinciale française, 2)

Vevey, 1985 — F.-P. de Vevey, Manuel des orfèvres de Suisse romande, Fribourg 1985

Vial/Marcel/Girodie I, 1912 ... — H. Vial/A. Marcel/A. Girodie, Les artistes décorateurs du bois. Répertoire alphabétique des ébénistes, menuisiers, sculpteurs, doreurs sur bois, ..., ayant travaillé en France aux XVIIᵉ et XVIIIᵉ siècles, P., I 1912, II (mit Suppl.) 1922

Vicario, 1990 ... — V. Vicario, Gli scultori italiani dal Neoclassicismo al Liberty, Lodi 1990; erw. Neuaufl., I–II, 1994

Villalpando/Vera, 1952 — M. Villalpando/J. de Vera, Notas para un diccionario de artistas segovianos del siglo XVI, Segovia 1952 (Estudios segovianos, 4)

Vinson, 1990 — International dictionary of art and artists, II: Artists, ed. J. Vinson, Chicago/Lo. 1990

Vlček, 2004 — P. Vlček (Ed.), Encyklopedie architektů, stavitelů, zedníků a kameníků v Čechách, Praha 2004

Vol, 1953 ... — H. Vollmer, Allgemeines Lexikon der bildenden Künstler des XX. Jahrhunderts, I–VI, L. 1953–62

VSII Sprav. I, 1965 ... — Vystavki sovetskogo izobrazitel'nogo iskusstva. Spravočnik, I–V, Mo. 1965–81

Vystavki I, 1989 ... — Personal'nye i gruppovye vystavki sovetskich chudožnikov, I ss., Mo. 1989 ss.

W

Waller, 1938 — F. G. Waller, Biographisch woordenboek van Nord Nederlandsche graveurs, D. H. 1938

Ward I, 1989 ... — C. A. Ward, Moscow and Leningrad, M. u.a., I 1989, II 1992

Ware, 1967 — D. Ware, A short dictionary of British architects, Lo. 1967

Warncke, GoLübeck, 1937 — A. Warncke, Lübecker Goldschmiede, Flensburg 1937

Warncke, ZiLübeck, 1922 — J. Warncke, Die Zinngießer in Lübeck, in: Veröffentlichungen zur Geschichte der Freien und Hansestadt Lübeck, VI, Lübeck 1922, 125–234

Wasmuth, LdB I, 1929 ... — Wasmuths Lexikon der Baukunst, ed. G. Wasmuth/L. Adler, I–V, B. 1929–37

Wastler, 1883 — J. Wastler, Steirisches Künstler-Lexikon, Graz 1883

Waterhouse, 1988 — E. Waterhouse, The dictionary of 16th and 17th century British painters, Woodbridge 1988 (Dictionary of British art, 1)

Waterhouse, Dict., 1981 — E. Waterhouse, The dictionary of British 18th century painters in oils and crayons, Woodbridge 1981

Waters I, 1975 ... — G. M. Waters, Dictionary of British artists working 1900–1950, Eastbourne, I 1975, II [ca. 1976]

Watson-Jones, 1986 — V. Watson-Jones, Contemporary American women sculptors, Phoenix 1986

Weber, 1933 ... — S. Weber, Artisti trentini e artisti che operarono nel Trentino, Trento 1933 (Repr. 1974); ²1944; ed. N. Rasmo, 1977

Weihsmann, 2005 — H. Weihsmann, In Wien erbaut. Lexikon der Wiener Architekten des 20. Jahrhunderts, W. 2005

Weilbach I, 1947 ... — Weilbachs Kunstnerleksikon, Red.: M. Bodelsen/P. Engelstoft, I–III, Kph. 1947–52; Neuaufl., I–IX, 1994–2000

Weingartner, KD Südtirols I, 1923 ... — J. Weingartner, Die Kunstdenkmäler Südtirols, I–IV, W./Au. 1923–30; 7. Aufl.: Bozen/Inn./W., I 1985, II 1991

Weise I, 1927 ... — G. Weise, Spanische Plastik aus sieben Jahrhunderten, I–IV, Tb. 1927–39

Weise I, 1957 ... — G. Weise, Die Plastik der Renaissance und des Frühbarock im nördlichen Spanien, I–II, Tb. 1957–59

Weizsäcker/Dessoff I, 1907 ... — H. Weizsäcker/A. Dessoff, Kunst und Künstler in Frankfurt am Main im 19. Jahrhundert, Ffm., I 1907, II 1909

Well, 1988 — W. G. Well, Maler im Fürstenfeldbrucker Land, M. 1988

Westbridge/Bodnar I, 1999 ... — A. R. Westbridge/D. L. Bodnar (Ed.), The collector's dictionary of Canadian artists at auction, I–II, Vancouver 1999–2000

Weyres/Mann, 1968 — W. Weyres/A. Mann, Handbuch zur rheinischen Baukunst des 19. Jahrhunderts, Köln 1968

Whinney, 1964 ... — M. Whinney, Sculpture in Britain 1530 to 1830, Harmondsworth 1964; Lo. ²1988 (The Pelican history of art)

Whitelaw, 1977 — C. E. Whitelaw, Scottish arms makers, Lo. 1977

Wiemeersch, 1973 — A. Wiemeersch, Contemporary painters and sculptors in Belgium, Ant. 1973

Wietek, 1986 — G. Wietek, 200 Jahre Malerei im Oldenburger Land, Oldenburg 1986

Wildenstein, 1966 — D. Wildenstein, Documents inédits sur les artistes français du XVIIIᵉ siècle, conservés au Minutier Central des Notaires de la Seine aux Archives Nationales, P. 1966

Wilenski I, 1960 ... — R. H. Wilenski, Flemish painters 1480–1830, I–II, Lo. 1960

Wilhelmi, 1996	C. Wilhelmi, Künstlergruppen in Deutschland, Österreich und der Schweiz seit 1900. Ein Handbuch, St. 1996
Wilhelmi, 2001	C. Wilhelmi, Künstlergruppen im östlichen und südlichen Europa seit 1900. Ein Handbuch, St. 2001
Wilhelmi, 2006	C. Wilhelmi, Künstlergruppen in West- und Nordeuropa einschließlich Spanien und Portugal seit 1900, St. 2006
Willigen, 1870	A. van der Willigen, Les artistes de Haarlem, Haarlem/D. H. 1870
Wilson, BritMilP, 1972	A. D. P. Wilson, A dictionary of British military painters, Leigh-on-Sea 1972
Wilson, Marine, 1967 ...	A. Wilson, A dictionary of British marine painters, Leigh-on-Sea 1967 (Repr. 1970)
Windsor, 1992	A. Windsor (Ed.), Handbook of modern British painting 1900–1980, Aldershot 1992
Windsor, Sculptors, 2003	A. Windsor (Ed.), British sculptors of the twentieth century, Aldershot 2003
Wingfield, 1992	M. A. Wingfield, A dictionary of sporting artists, 1650–1990, Woodbridge 1992
Wininger I, 1925 ...	S. Wininger, Große Jüdische Nationalbiographie, I–VII, Cernăuti 1925–36
Winkler-Prins I, 1958 ...	A. Winkler-Prins, Van de kunst. Encyclopedie van de architektuur, beeldende kunst, kunstnijverheid, Am./Br., I 1958, II 1959, III 1959
Withey, 1956 ...	H. F./E. R. Withey, Biographical dictionary of American architects (deceased), L. A. 1956; ²1970
Witte, 1932	F. Witte, Quellen zur rheinischen Kunstgeschichte, B. 1932 (Tausend Jahre deutsche Kunst am Rhein, 5)
Witte, 1981 ...	K. Witte, Exlibris-Monogrammlexikon europäischer Künstler, Frederikshavn 1981; ²1984 (3 Bde); ³1986; I–IV, ⁴1991–93
Wittkower, 1958 ...	R. Wittkower, Art and architecture in Italy 1600 to 1750, Harmondsworth u.a. 1958; ²1965; 1978; ital. Ausg.: T. 1972 (Biblioteca di storia dell'arte, 14)
WJbKg	Wiener Jahrbuch für Kunstgeschichte (W.) 1:1921/22 ss. (Forts. des Jahrbuches des Kunsthistorischen Instituts der K. K. Zentralkommission für Denkmalpflege)
Wodehouse, 1978	L. Wodehouse, British architects, 1840–1976, Detroit 1978
Wojciechowski I, 1967 ...	A. Wojciechowski (Red.), Polskie życie artystyczne w latach ..., Wr., I 1967, II 1974, III 1992
Wolf-Hamel, 1977	C. Wolf-Hamel, Verzeichnis saarländischer bildender Künstler und Kunsthandwerker, Hassel 1977
Wolff-Thomsen, 1994	U. Wolff-Thomsen, Lexikon schleswig-holsteinischer Künstlerinnen, Heide 1994
Wollmann, 1992	J. A. Wollmann, Die Willingshäuser Malerkolonie und die Malerkolonie Kleinsassen, Schwalmstadt-Treysa 1992
Wood, 1971 ...	C. Wood, The dictionary of Victorian painters, Woodbridge 1971; ²1978 (Repr. 1991); I–II, ³1995 (Dictionary of British art, 4)
Wood, Animal, 1973	J. C. Wood, A dictionary of British animal painters, Leigh-on-Sea 1973
Wright, 2006	C. Wright u.a. (Ed.), British and Irish paintings in public collections (K), New Haven/Lo. 2006
Wunschheim, OÖ, 1980 ...	J. Wunschheim, Oberösterreichische Künstlerbibliographie 1966–1975 ..., in: Kunstjahrbuch der Stadt Linz 1980 ss.; Ausg. 1986–95 als Erg.-Bd zum Jahrbuch des OÖ. Musealvereins – Gesellschaft für Landeskunde 143:1999 (1) ersch.
Wurzbach, NKL I, 1906 ...	A. von Wurzbach, Niederländisches Künstler-Lexikon, I–III, W./L. 1906–1911 (Repr. Am. 1974)
WWAA, 1936/37 ...	Who's who in American art, N. Y. 1936/37 ss.
WWArt, 1927 ...	Who's who in art. Biographies of leading men and women in the world of art today, Lo. u.a. 1927 ss.
WWAVA, 1991 ...	Who's who of Australian visual artists, Port Melbourne 1991; 1995
WWCCA, 1996	Who's who in contemporary ceramic arts, M. 1996
WWCGA, 1993	Who's who in contemporary glass art, M. 1993
WWGA I, 1962 ...	Who's who in graphic art, Z./Dübendorf, I 1962, II 1982
WWJapArtists, 1961	Who's who among Japanese artists, ed. M. Saburo, To. 1961
WWLA I, 1947 ...	Who is who in Latin America, I–VII, Stanford 1945–51
WwWA I, 1968 ...	Who was who in America, I–IV, Chicago 1966–1968

Y	*Yoshida*, UJ I, 1965 ...	T. Yoshida (Ed.), Ukiyo-e-Jiten (Lexikon des Ukiyo-e), I–III, To. 1965–71
	Young, 1968	W. Young (Ed.), A dictionary of American artists, sculptors and engravers, C., Mass. 1968
	Yu Jianhua, 1981	Yu Jianhua, Zhongguo meishu jiarenming cidian, Shanghai 1981

Z	ZAK	Zeitschrift für Schweizerische Archäologie und Kunstgeschichte (Basel) 1:1939 ss. (Forts. des Anzeigers für Schweizerische Altertumskunde)
	Zampetti I, 1969 ...	P. Zampetti, A dictionary of Venetian painters, I–V, Leigh-on-Sea 1969–79
	Zani I, 1819 ...	P. Zani, Enciclopedia metodica critico-ragionata delle belle arti ..., I–XXVIII, Parma ²1819–22 (1817–24)
	Zarco del Valle I, 1916 ...	M. R. Zarco del Valle, Datos documentales para la historia del arte español, I–II, Ma. 1916
	ZBK	Zeitschrift für bildende Kunst (L.) 1:1866–24:1888/89; N.F., 1=25:1889/90–33=57:1922; 58:1924/25–65:1931/32

Železnov, 1907 — V. Železnov, Ukazatel' masterov, russkich i inozemcev, gornogo, metalličeskogo i oružej-nogo dela i svjazannych s nimi remesel i proizvodstv, rabotavšich v Rossii do XVIII veka, StP. 1907

Zendralli, 1958 — A. M. Zendralli, I magistri grigioni. Architetti e costruttori, scultori, stuccatori e pittori dal 16 al 18 secolo, Poschiavo 1958

Zeri, 1976 — F. Zeri, Italian paintings in the Walters Art Gallery (K), I–II, Baltimore 1976

Zeri, 1980 — F. Zeri, Italian paintings. A catalogue of the collection of The Metropolitan Museum of Art. Sienese and central Italian schools, N. Y. 1980

Zeri, Gall. Spada, 1954 — F. Zeri, La Galleria Spada in Roma. Catalogo dei dipinti, Fi. 1954 (Biblioteca di „Proporzioni")

Zeri/Gardner, 1971 — F. Zeri/E. E. Gardner, Italian paintings. A catalogue of the collection of the Metropolitan Museum of Art. Florentine School, N. Y. 1971

Zeri/Gardner, 1973 — F. Zeri/E. E. Gardner, Italian paintings. A catalogue of the collection of the Metropolitan Museum of Art. Venetian School, N. Y. 1973

Zeri/Gardner, 1986 — F. Zeri/E. E. Gardner, Italian paintings. A catalogue of the collection of the Metropolitan Museum of Art. North Italian School, N. Y. 1986

ZGSHQS — Lu Fusheng (Ed.), Zhongguo shuhua quanshu, I–XIV, Shanghai 2000

Zhongguo gudai I, 1986 ... — Zhongguo gudai shuhua tumu (Illustrated catalogue of selected works of ancient Chinese painting and calligraphy), I–XXIII, Bj. 1986–2000; Index, 2001

Zhongguo xiandai, 1988 — Zhongguo xiandai meishujia (Lexikon moderner chinesischer Künstler), Bj. 1988

Zils, 1913 — W. Zils (Ed.), Geistiges und künstlerisches München in Selbstbiographien, M. 1913

Zimmermann, 1994 — R. Zimmermann, Expressiver Realismus, M. 1994

ZKg — Zeitschrift für Kunstgeschichte (M./B) 1:1932–11:1943; 12:1949 ss.

ZKW — Zeitschrift des Deutschen Vereins für Kunstwissenschaft (B.) 1:1934 ss. (1947–1962 u.d.T.: Zeitschrift für Kunstwissenschaft)

ZLUMS — Zbornik za likovne umetnosti Matice srpske (Novi Sad) 1:1965 ss.

ZNAMUZ — Zbornik radova Narodnog muzeja u Beogradu (Bgd.) 1:1958 ss.

Zülch, 1935 — W. K. Zülch, Frankfurter Künstler 1223–1700, Ffm. 1935 (Repr. 1967)

C

Cassini, *Jean-Dominique de* (C. de Thury, *Jean-Dominique*), Comte, frz. Kartograph, Geodät, * 30. 6. 1748 Paris, † 18. 10. 1845 Thury-sous-Clermont. Entstammt einer bed. ital.-frz. Gelehrtenfamilie. Der Urgroßvater Giovanni Domenico C. (1625–1712), Astronom und Mathematiker, wird von Louis XIV an die Acad. des Sc., Paris, berufen, wo er als Akad.-Mitgl. und Dir. des Observatoriums die wiss. Fam.-Trad. begründet, die C. in vierter Generation fortführt. C.s Vater César C. (1714–1784) widmet sich v.a. der Geodäsie, insbesondere um 1740–47 im Auftrag der Acad. des Sc. der exakten Landesvermessung Frankreichs. In deren Folge wird 1746–47 die erste maßstabsgerechte *Carte gén. de la France* (Maßstab 1:870000) veröffentlicht, die auf der von der Fam. C. entwickelten geodätischen Triangulation beruht. Um 1750 erhält César C. von Louis XV den Auftrag zur Schaffung eines v.a. militärisch nutzbaren Kartenwerks im Maßstab 1:86400. – C. arbeitet nach Stud. (u.a. Mathematik, Physik, Astronomie, Theologie) und wiss. Reisen (u.a. 1768/69 Amerika) wohl ab M. der 1770er Jahre am Kartenprojekt seines Vaters mit, wobei er wahrsch. sowohl an den Vermessungsarbeiten im Gelände beteiligt ist als auch auf die Gest. der Kpst.-Vorlagen Einfluß nimmt. Das Kartenbild C.s besticht durch klare Schriften und harmonisch aufeinander abgestimmte originelle Linien-, Orts- und Flächen-Sign. (u.a. für intakte oder ruinöse Klöster, Kap., Mühlen, Türme, Schlösser; für Plätze gewonnener und verlorener Schlachten; für Herbergen, Weinlokale, Rasthäuser oder Stätten von niederer und höherer Gerichtsbarkeit), v.a. aber durch das in der internat. Kartenkunst bis dahin unerreichte hohe Niveau an Detailtreue und topogr. Genauigkeit. Die Absenz von schmückendem Beiwerk und der präzise Einsatz von Schummerungen markieren C.s Landkarten, an denen viele Kartenstecher beteiligt sind, als Meilensteine auf dem Weg zur mod. Topographiekarte. Nach dem Vaters Tod (1784) führt C. das Werk fort, das als *Carte géométrique de la France* im Jahr 1793 bei der öff. Vorstellung im Nationalkonvent 165 Bll. umfaßt. Das 1815 mit 180 Bll. voll. Werk C.s ist die wiss. und ästhetische Basis des *Atlas nat. illustré des 86 dép. et des possessions de la France* (1847–54). ⌂ PARIS, Inst. géogr. nat. ✉ Mém. pour servir à l'hist. des sc. et à celle de l'Observatoire r. de Paris, P. 1810. ⌷ *M. Pelletier*, Les cartes des C. La sc. au service de l'Etat et des régions, P. 2002 (Lit.). U. Heise

Casson, *Mel (Melvin)*, US-amer. Cartoonist, Comiczeichner und -texter, Illustrator, Werbegraphiker, * 25. 7. 1920 Boston/Mass., † 21. 5. 2008 Westport/Conn. Aufgewachsen in New York. Stud. ebd.: Art Students League, u.a. bei George Bridgman. Veröffentlicht 1937 erste Cartoons im Mag. Saturday Evening Post, kurz darauf auch in zahlr. weiteren Ztgn und Zss. wie Esquire, Ladies Home J. und New York Times. Im 2. WK Dienst in der US Army, u.a. 1944 in der Normandie. Nach der Entlassung aus dem Militär zeichnet C. 1948–52 für das New York Herald Tribune Syndicate den satirischen Comic strip *Jeff Crockett* über das Leben eines Rechtsanwalts in einer Kleinstadt. 1952/53 Teiln. am Koreakrieg. 1953–66 entstehen für das Publishers/Chicago Sun-Times Syndicate die humoristischen Comic strips für Kinder *Angel* und *Sparky*. Zus. mit Alfred James (Pseud. von Alfred Andriola) gestaltet er 1958–62 für das Hall Syndicate zudem den kurzlebigen Girl-Comic strip *It's Me Dilly!* 1965 ∞ Opernsängerin und Schauspielerin Mary Lee Culver C.; läßt sich in Westport nieder. 1972 entsteht für das United Feature Syndicate der zus. mit William Ferdinand Brown konzipierte Comic strip *Mixed Singles* (1975–81 u.d.T. *Boomer* ersch.). 1988–2008 zeichnet C. in der Nachf. von Gordon Bess für das King Features Syndicate den populären parodistischen Comic strip *Redeye* über die Erlebnisse eines Indianerhäuptlings im US-amer. Westen des 19. Jh. (bis 1999 zunächst von Bill Yates, danach von C. selbst getextet). Auch Publ. von Cartoon-Bde (u.a. *Ever Since Adam and Eve. A Pictorial Narrative of the Battle of the Sexes in Orig. Drawings by Famous Cartoonists*, N. Y. 1955, zus. mit A. Andriola), humoristische Ill. zu Büchern and. Autoren (u.a. zu *Guinness Record Keeper*, Tor./N. Y. 1979, von Norris McWhirter und Peter Cardozo; *187 Ways to Amuse a Bored Cat*, N. Y. 1982, von Howe und Ruth Stidger; *Bullwinkle Coloring and Activity Book*, N. Y. 1985, von Michael J. Pellowski; *Do's and Taboos of Humor Around the World. Stories and Tips from Business and Life*, N. Y. 1999, von Roger E. Axtell), Skripts für die TV-Shows „Draw Me a Laugh" und „You Be the Judge" des Fernsehsenders ABC und werbegraphische Arbeiten (u.a. für Black & Decker, IBM und Kodak). Ausz.: u.a. 2003 Legend Award, Nat. Cartoonists Soc., Connecticut Chapter. Mitgl.: Amer. Soc. of Mag. Cartoonists; Nat. Cartoonists Soc.; Newspaper Comics Council. – Routinierte, dem jeweiligen Zeitgeschmack angepaßte, meist stark linienbetonte, z.T. auch kol. Tuschfeder- bzw. Rapidograph-Zchngn. ⌂ COLUMBUS, Ohio State Univ., Billy Ireland Cartoon Libr. & Mus. EVANSVILLE/Ind., Mus. of Arts and Sc. LAWRENCE, Univ. of Kansas, Albert T. Reid Coll. ⌷ WWAA 1956; 1962; EAAm I, 1968; *M. Alessandrini* (Ed.), Enc. des bandes dessinées, P. 1986; *R. Goulart* (Ed.), The enc. of Amer. comics, N. Y./Ox. 1990 (u.a. im Art. Boomer); *Falk* I, 1999; *H. Filippini*, Dict. enc. des héros et auteurs de BD, II, Grenoble 1999; *Horn*, Comics, 1999; *H. Filippini*, Dict. de la bande dessinée, P. 2005. – *S. D. Becker*, Comic art in America, N. Y. 1959; The Nat. Cartoonists Soc. album, N. Y. 1965; 1976; 1980; 1988; Buffalo, N. Y. 1996; Cartoonist profiles 1973 (17) 4–13; *M. Horn*, Wo-

men in the comics, N. Y. 1977; *J. Coma* (Ed.), Hist. de los cómics, Ba. 1982; *J. O'Sullivan*, The great Amer. comic strip. One hundred years of cartoon art, Boston, Mass. u.a. 1990; *R. Goulart*, The funnies. 100 years of Amer. comic strips, Holbrook, Mass. 1995; *J. M. Ellinport*, Collecting orig. comic strip art, Norfolk, Va. 1999; *J. Hurd*, Cartoonist profiles 1999 (123) 10–14 (Interview). – *Online:* Lambiek Comiclopedia; Westport now v. 31. 5. 2008 (Nekr.).

H. Kronthaler

Cassuto, *David,* israelischer Architekt, Fachautor, * 27. 9. 1937 Florenz, lebt in Jerusalem. 1945 Einwanderung in Israel. Stud.: 1958–63 Technion, Haifa (Archit. und Stadtplanung). Doz. am Ariel College for Studies, Jerusalem. Seit 1993 Mitarb. im Jerusalemer Stadtrat; stellv. Bürgermeister für kult. Angelegenheiten. Mitgl. des Management-Komitees des Israel Mus., Jerusalem. – Spezialisierung auf öff. Bauten in Jerusalem. C. ist u.a. maßgeblich an der Renovierung der ital. Synagoge im Stadtzentrum beteiligt. Veröffentlicht in den letzten Jahren v.a. zahlr. Aufsätze zu hist. Synagogen in arabischen Ländern und Italien. ✉ La sinagoga in Italia, in: Storia d'Italia, Annali 11:1996, 321–338; Un confronto. Le antiche sinagoghe di Firenze, in: *M. Luzzati* (Ed.), La sinagoga di Pisa, Fi. 1997; The ancient synagogue of Aleppo, in: Peamîm 72:1997, 85–105; The mikweh of Siracusa, in: Ēt-möl 151:2000, 19–20. ▢ *H. Künzl,* Jüdische Kunst. Von der biblischen Zeit bis in die Gegenwart, M. 1992, 171. – *Online:* AISG (Cassuto); Israeli AC. St. Schulze

Cast, *Jesse Dale (Jessie Dale),* brit. Maler, Zeichner, * 1900 London-Fulham, † 9. 2. 1976 Tunbridge Wells, lebte u.a. dort und in London, 1926–30 in Brügge und in Sóller/Mallorca. Stud. in London: 1914–17 Brixton School of Building (heute London South Bank Univ.; Innen-Archit.); 1920–22 Camberwell School of Arts and Crafts bei Albert Rutherston; 1922–26 Slade School of FA bei Henry Tonks. 1917–20 in den Designstudios der Firmen Maples, Harrods und H. & C. Davis & Co. (alle London) beschäftigt; während des 2. WK für das Ministry of Aircraft Production in Bristol und London tätig. Ab 1945 Lehrtätigkeit in London: bis 1950 Harrow SchA; Central SchA; Hornsey College of Art. U. a. drei Preise der Slade School of FA (1923–25). – Hauptsächlich Portr., Lsch. und Stadtansichten, meist Öl-Gem. und Bleistift-Zchngn, z.B. *The Windmill, Clapham Common* (Öl/Lw., 1934) und *Portr. of an Actor* (Bleistift, Kreide, 1939); zahlr. Gem. während des 2. WK zerstört. ⌖ CAMBRIDGE, Fitzwilliam Mus. LONDON, BM. – Mus. of London. – Nat. Maritime Mus. – Tate. – Univ. College, Art Coll. ◉ *E:* London: 1980 South London AG (K); 1994 Univ. College, Strang Print Room (K); 1995 Jason & Rhodes (K). – *G:* London: 1919, '34–39, '45, '54 RA; ab 1926 New English Art Club; ab 1930 R. Soc. of Portr. Painters / 1936 Dublin, R. Hibernian Acad. ▢ *Waters* II, [ca. 1976]; RoyalAcadExhib II, 1977; RoyalHibAcad I, 1986; *A. Windsor* (Ed.), Hb. of mod. Brit. paint. and printmaking 1900–1990, Aldershot 1998; *Buckman* I, 2006. J. Niegel

Castagneri, *Oreste,* ital. Fotograf, Maler, * 1. 7. 1875 Alessandria, bis 1959 in Turin nachgewiesen. Bruder von Mario C. Stud.: ab 1899 Accad. Albertina, Turin. Zunächst als Maler tätig; 1907 Übernahme eines Fotostudios ebd. (u.a. Karbondrucke; Reprod. von Skulpt. und Akte). C. bewegt sich am Rande des Turiner Futuristenkreises, dem sein Bruder angehört (Portr. u.a. von Marinetti; Studio-Mitarb. ist Guarnieri); 1931 Mitgl. des Organisationskomitees der Futurismus-Ausst. in Turin. ◉ *G:* Turin: 1911 (K), '28 Espos. Internaz.; 1923 Pal. del Giornale: Espos. Internaz. di Fotogr., Ottica e Cinematografia; 1931 Mostra Sperimentale di Fotogr. Futurista (K) / 1995 Venedig: Bienn. (K). ▢ *E. Godoli* (Ed.), Il diz. del futurismo. A-J, Fi. 2001 (Lit.). – *G. Santoponte,* Ann. della fotogr. 1911–13, R. 1913, 379; *G. Lista,* Futurismo e fotogr., Mi. 1979; *id.,* Photogr. futuriste ital. 1911–1939 (K), P. 1981; *M. Miraglia,* Cult. fotogr. e soc. a Torino, 1839–1911, T. 1990; *ead.,* Il '900 in fotogr. e il caso torinese, T. 2001. T. Koenig

Castagnet, *Philippe* → **Castaza,** *Phil*

Castaldi, *Alfa,* ital. Fotograf, * 1926 Mailand, † 16. 12. 1995 ebd. Vater des Mode- und Portr.-Fotografen *Paolo C.* (* 1956 Mailand). Stud.: 1947–52 Univ. Mailand und Florenz, Kunstgesch. bei Roberto Longhi. Lebt danach in Mailand, verkehrt hier 1954–61 in der Bar Giamaica, wo sich Intellektuelle, Maler, Schriftsteller und Journalisten aus dem Umfeld der Accad. di Brera treffen; lernt die Fotografen Ugo Mulas, Carlo Bavagnoli und Mario Dondero kennen. Beginnt z.T. sozialkritische Reportagen in Süditalien, Paris, Algerien und London sowie Persönlichkeiten aus Kunst und Film zu fotografieren (publ. u.a. in L'Ill. ital. und Settimo Giorno). Ab 1958 arbeitet er mit seiner späteren Frau, der Modekritikerin Anna Piaggi, zusammen. Es entstehen fotogr. Stilleben und kubistisch inspirierte Collagen von Objekten, Stoffen und Modeaccessoires, daneben Portr. von Künstlern. E. der 1960er Jahre eröffnet er ein eig. Studio und wendet sich der Mode-Fotogr. zu. 1968 fotografiert er in Prag für die Zs. Arianna Mode und hist. Mon. (z.B. das Geburtshaus von Kafka). Ab 1969 arbeitet er für Vogue Italia; berühmt sind seine Doppelseiten mit A. Piaggi (ab 1988). C. fotografiert auch für Vogue Uomo, Vogue Bambini, Vogue Sposa, außerdem für Vanity, Amica, Panorama und Espresso. Er startet Fotokampagnien für Giorgio Armani, Laura Biagiotti, Fendi, Gianfranco Ferré, Karl Lagerfeld, Ottavio und Rosita Missoni. In seinen Mode-Fotogr. findet C. eine sehr persönliche Sprache, wobei er das Interesse nicht nur auf die Kleidung, sondern auch auf die Models richtet und so die Mode-Fotogr. in Richtung Kostüm-Fotogr. verändert. Oft sind seine Aufnahmen durch feine Ironie charakterisiert. – Foto-Publ.: A. Mulassano, *I mass-moda. Fatti e personaggi dell'Ital. look*; ead., *The who's who of the Ital. fashion,* beide Fi. 1979; S. Giacomoni, *L'Italia della moda,* Mi. 1984. ◉ *G:* 2009 Cesano Maderno, Pal. Arese Borromeo: La moda scritta con la luce. ▢ *L. Sacchi* (Ed.), Diz. di fotogr., 2001. – Corriere della Sera v. 19. 12. 1995 (Nekr.); Premio Afip per la fotogr. di ricerca 1996 dedicato a A. C., Mi. 1997; *M. L. Frisa* (Ed.), Ital. eyes. Ital. fashion photographs from 1951 to today (K), Mi. 2005; Anna Piaggi. Fashion-ology (K V & A), Lo. 2006; *E. Viganò*

(Ed.), Neorealismo. Die neue Fotogr. in Italien 1932–1960 (K Winterthur), Basel 2007. – *Online:* Arch. A. C.; Website Paolo C. E. Kasten

Castaldi, *Paolo* cf. **Castaldi,** *Alfa*

Castañeda (C. Jaramillo), *Víctor Hugo*, mex. Bildhauer, * 30. 8. 1947 La Palma/Michoacán, lebt in Cuernavaca/ Morelos. Bruder des Bildhauers Felipe C. Stud.: 1969–74 Esc. Nac. de Pint. y Escult. „La Esmeralda", Mexiko-Stadt. 13 Jahre Zusammenarbeit mit seinem Bruder und Francisco Zúñiga. – C.s bes. von Zúñiga beeinflußte figurative Werke, fast immer Bronze (manchmal patiniert), zeigen realistische Darst. meist indigener Frauen in statisch-würdevoller Haltung (z.B. *Mujer sentada [Mecedora]; Mujer de pie; Mujer enamorada*, alle 1986). Später weisen sie eher fließende, kompakte Volumen auf und stellen v.a. weibliche Akte in liegender oder kauernder Haltung und mit allegorischer Funktion dar (*Melancolía; Meditación; Soledad; Añoranza*, weißer Onyx), weiterhin die Frau als Mutter mit Kind (*Maternidad*) und typisch indigene Frauen (*Tarasca*). Manchmal neigt C. auch zur Darst. schlanker, aufstrebender Körper (*Flama; Astío; Alavanza*). Eine and. Facette seines Werkes weist expressive, kantig-abstrahierende Formen auf und zeigt ebenfalls symbolisch aufgefaßte Ganzfiguren oft relig. Char. (*Profeta; Resignación; Piedad*) oder große Köpfe (*Septiembre once; Máscara; Viejo*). ATIZAPAN DE ZARAGOZA, Gal. de Arte del Tecnológico de Monterrey, Campus Estado de México. CUERNAVACA, Mus. de la Ciudad. – Jardines de la Sede Mpal: El pensador. DURANGO, MAC A. Zárraga. PUNTA DEL ESTE, MAM. *E:* 1983 Coronado (Calif.), Coronado AG / Mexiko-Stadt: 1984 Fogain; 1988 Gal. Summa Artis; 1990, '92 Club de Banqueros; 2000 Gal. Lourdes Chumacero / 1988 Tucson (Ariz.), Médical Center / 1990 Atizapán de Zaragoza, Inst. Tecnológico y de Est. Superiores de Monterrey, Campus Estado de México / Cuernavaca: 1991 Gal. Yitzel; 1993, '97, '98 Gal. Citlalli; 1994, '95 Las Quintas; 1996 Gal. Siete; 2005 La Casona Gal. / Acapulco (Guerrero): 2000 Gal. Las Brisas; 2006 Gal. Arte al Sur. *L.* Kassner, Dicc. de escultores mexicanos del s. XX, I, Méx. 1997. – *Online:* Website C.

M. Nungesser

Castaño (C. Correa), *Alejandro*, kolumbianischer Bildhauer, Installationskünstler, * 1961 Medellín, lebt dort. Stud. ebd.: bis 1991 bild. Kunst an der Univ. Nac. de Colombia (1991–2000 Doz. für Skulpt.); Laboratorio de Maderas, Servicio Nac. de Aprendizaje; Laboratorio de Moldes y Plásticos, Andercol; 1992 Seminar für Wachsausschmelzverfahren an der Fac. de Ingeniería Mecánica, Univ. de Antioquia. 1992 Doz. für Skulpt. an der Univ. de Antioquia und für Design an der Univ. Pontificia Bolivariana. Ausz.: u.a. 1989 1. Preis Salón Arturo y Rebeca Rabinovich, MAM; 1997 ehrenvolle Erw., Salón Regional Colcultura; 1998 1. Preis im Wettb. Tres Escult. para Jardín Cementerio Campos de Paz, alle Medellín. – C.s Werke weisen anfangs abstrakt-geometrische, kompakte Formen auf (z.B. *Tejiendo vientos*, 1987), dann nehmen sie zeichenhaft-symbolischen Objekt-Char. an, z.B. *¿Porque qué no rueda la rueda en América?* (Beton, Blatt-

gold, 1990), der in Form und Mat. präkolumbische und mod. westliche Elemente verbindet, teilw. als Assemblagen (Serie *Territorios*, 1992; *Tensor*, 1994). Danach tritt die menschliche Figur ins Zentrum des Werkes. Als Ausdrucksmittel für existentielle Probleme weist sie zeitkritische Elemente auf (*Detrás del cristal*, Installation, 1996; Serie *Hitos de ausencia*, Assemblage, 1997), bezieht sich auf Sehnsüchte des Menschen wie das Fliegen (Serie *El volar es para los pájaros*, Zchng, Assemblage, 1999) oder ist als archaisch anmutende, silhouettenhafte Statue dargestellt (*De pie*, Eisen; *Balsero*, Bronze, beide 1999). Außerdem Entwürfe für Trophäen, Preise und Gedenkobjekte: u.a. *Homenaje al maestro Fernando Botero*, 1992; *Trofeos Jornadas Univ.* (Univ. de Colombia, 1995); *Objeto conmemorativo 70 años Fac. de Arquit.* (Univ. Nac., 1996); *Premio El Colombiano Ejemplar* (Ztg El Colombiano, 1999). BOGOTA, Banco de la República. – MAM. MEDELLIN, Bibl. Pública Piloto. – MAM. – Mus. de Antioquia. *E:* Medellín: 1992 Bibl. Pública Piloto; 1993, '97, 2000 Gal. de La Oficina; 1996 Centro Colombo Amer.; 1999 Alianza Colombo Francesa / Bogotá: 1999 Planetario de Bogotá, Gal. Santa Fe (K); 2000 Quinta Gal. (mit Ramiro Ramírez) / 2000 Cartagena, Quinta Gal. – *G:* 1992 Bogotá, Bibl. L. A. Arango: Nuevos nombres (K) / Medellín: 1997 Festival Internac. de Arte; 2001 MAM: Horizontes. Otros paisajes 1950–2001 (K: M. E. Bravo u.a.) / 1997 Quebec City: Internat. Snow Sculpt. Competition. Salón Arturo y Rebeca Rabinovich. Hist. 1981–2003, Medellín 2003. – *Online:* Colarte; Bibl. Luis Angel Arango. M. Nungesser

Castaño, *Guillermo* → **Castaño Ramírez,** *Guillermo*

Castaño (C. Rodríguez), *María José*, span. Malerin, Zeichnerin, * 14. 9. 1966 Burgos, lebt in Cascajares de la Sierra/Burgos. Stud.: Fac. de BA der Univ. de País Vasco Bilbao; Fac. de BA der Univ. Complutense, Madrid (Abschluß 1991). Ausz. (1. Preise): 1991 Premio de Pint. Ayuntamiento de Ayllón; 1993 Premio de Pint. Ciudad Rodrigo; 1996 Concurso de Pint. Rápida Expansión a la Bolsa, Madrid. – C.s Gem. zeigen v.a. in leuchtenden Farben gehaltene Lsch. (*Por donde pasó*, Öl/Lw., 2007) und Marinen (*S'Caballet*, Öl/Lw., 2006) sowie von Grau- und Brauntönen dominierte Stadtansichten (*Bilbao*, Öl/ Lw., 1995) in einem neoexpressionistischen Stil, der zuweilen den Char. abstrakter Farb-Komp. annimmt. 1999 entsteht die aus Stadt- und Archit.-Ansichten bestehende Gem.-Serie *Nueva York*. AYLLON, MAC. LEON, Stadtverwaltung. MADRID, Fund. Univ. Complutense. – Börse. *E:* Madrid: 1992 Gal. Santa Bárbara (Debüt); 1993 Gal. Orfila; 1994 Gal. Arles; 1995 Gal. Milán; 2005 Gal. Amparo Gamir / 1994 Ponferrada, Gal. Siena / 1995–2008 mehrmals Bilbao, Gal. Baysala / 1997, 2000, '02, '04, '06 Burgos, Gal. Paloma 18 / 1998 Florenz, Gall. Art Point / 2001 Salamanca, Gal. Reyes Católicos; 2007 Eivissa, Gal. Vía 2 / 2009 Zamora, Gal. Espacio 36; Mel (Italien), Pal. delle Contesse. – *G:* 1989 Santa Cruz de Tenerife: Bien. DPEE III, 1994; Dicc. de artistas contemp. de Madrid, Ma. 1996. – *Online:* Website C. S. Herczeg

Castaño, *Orlando (José Orlando),* brasil. Maler, Zeichner, * 6. 2. 1945 Mutum/Minas Gerais, tätig in Stuttgart und Belo Horizonte. Stud.: Esc. Guignard der Univ. do Estado de Minas Gerais, Belo Horizonte; 1972, '74 RABA de S. Fernando, Madrid (Wandmalerei); 1975–79 ABK, Stuttgart (Malerei bei Rudolf Hägele); 1975 ABK, Karlsruhe (Malerei); 1982, '84 Haus der Kunststiftung, Stuttgart. Lehrtätigkeit: 1986 Esc. Guignard, Belo Horizonte (Malerei, Zeichnen). Ausz.: 1968 1. Preis für Zchng des Salão da Assoc. Cristã de Moços, ebd.; 1972 Prémio Minist. da Educação, Rio de Janeiro; 1984 Prémio Cidade de Belo Horizonte; 1986 Prémio des Salão Nac. de Artes Plást., Rio de Janeiro. – Abstrakte Malerei (Acryl, Öl/Lw.) und Zeichnung. Seit dem Aufenthalt in Deutschland schafft C. Objekte aus Papier mit linienförmigen Einschnitten, die er als innere Lsch. bezeichnet. Durch Falten und Knicken, z.B. in Form eines Briefumschlages oder Pakets, durch das Bündeln oder Aufkleben des Papiers erhalten sowohl die Schnitte in den versch. Lagen als auch die Objekte selbst eine dreidimensionale, meist geometrischsymmetrische Struktur. Bemalte und mit Zchngn bedeckte Oberflächen imitieren and. Mat. (z.B. Metall) und verstärken den Verweis-Char. auf alltägliche Objekte wie Servietten, Schachteln oder Verpackungen. Die Bleistift-Zchngn strukturiert C. weniger mit klaren, ein Objekt definierenden Linien als mit dunklen, malerisch eingesetzten Flächen und Schatten, die ihnen Schwere, Dramatik und Rätselhaftigkeit verleihen. Eine dunkle, stimmungsvolle Farbigkeit mit hellen Reflexen ist ebenfalls char. für C.s Gem., die figurative Reminiszenzen aufweisen. 2000 fungiert C. als Kurator der Ausst. Gab. de Arte im Mus. Hist. Abílio Barreto, Belo Horizonte. Für die Ausst. Gab. do Lixo (Müll-Kab.) im Zikzira Espaço Ação 2006 inszeniert C. die in einem Jahrzehnt aus dem Abfall gesammelten und bis auf das 17. Jh. zurückgehenden Gem. und Bilderrahmen, denen in Anlehnung an Marcel Duchamp durch ihre individuelle Präsentation ein neuer Wert zugeschrieben wird. Seit 2004 Bühnenbilder für die anglo-brasil. Compagnie Zikzira Physical Theatre, z.B. für die Tragödie *Eu vos liberto* (2008), in der die Stühle und Sessel der Zuschauer als Mobiliar des Stückes einbezogen werden. ⌑ BELO HORIZONTE, Mus. de Arte da Pampulha. RIO DE JANEIRO, Fund. Nac. de Arte. – MNBA. SÃO PAULO, MAM. STUTTGART, Stadtbücherei. VITÓRIA, Mus. de Arte do Espírito Santo. ◉ *E:* Belo Horizonte: 1969 Gal. Adega 1300; 1985 Pal. das Artes; 1989 Chromos Gal.; 1990 Gal. Cidade; 2006 Gal. da Esc. Guignard (mit Mônica Sartori, Eymard Brandão; K); 2007 Gal. da Companhia Energética de Minas Gerais (K) / 1973 Salvador, Gal. Cañizares / Stuttgart: 1978 Gal. Keim; 1981 Gal. Valentien; 1982 Haus der Kunststiftung / 1987 Rio de Janeiro, Gal. Arte Espaço / 1991 Curitiba, MAC. – *G:* 1966 Curitiba: Salão Paranaense; 1986 MAC: Mostra do Desenho Brasil. / Belo Horizonte: 1967, '68, '86 Mus. de Arte da Pampulha: Salão; 1992 Fund. Clóvis Salgado, Pal. das Artes: Utopias Contemp. (K); 1994 Gal. da Companhia Energética de Minas Gerais: Cor e Luz (K); 1997 Fund. Clóvis Salgado, Pal. das Artes: Prospecções. Arte nos Anos 80 e 90 (K); 2001 Itaú-Gal.:

Do Corpo a Terra. Um Marco Radical na Arte Brasil.; 2006 Errol Flynn Gal.: Um Passeio pela Arte Brasil. / São Paulo: 1969 Bien.; 1973, '74 MAM: Panorama da Arte Atual Brasil.; 1987 Salão Paulista de Arte Contemp. / Rio de Janeiro: 1970, '72 Salão de Verão; 1980 Salão Nac. de Artes Plást. / 1975 Baden-Baden, SKH: Forum junger Kunst (K) / 1982 Stuttgart, KV: Jahresgaben / 1986 Porto Alegre, MARGS: Caminhos do Desenho Brasil.; Niterói, Gal. de Arte da Univ. Federal Fluminense: Na Ponta do Lápis (K) / 1996 Schramberg, SM: Einst & Jetzt (K) / 2004 Paris, Brasil. Botschaft: Minas Gerais e Paris. ⌑ *Cavalcanti* I, 1973; *Nagel,* 1986; *Ayala,* 1997. – *F. P. da Silva u.a.,* O. C. Depoimento, Belo Horizonte 2000; *S. Huchet,* C. Situação da pint., Belo Horizonte, 2006. – *Online:* Inst. Itaú Cult., Enc. artes visuais. C. Melzer

Castaño Alvarado, *Guillermo* cf. **Castaño Ramírez,** *Guillermo*

Castaño Correa, *Alejandro* → **Castaño,** *Alejandro*

Castaño Ramírez (Castaño), *Guillermo,* mex. Bildhauer, * 17. 4. 1938 Mexiko-Stadt, lebt in Tijuana/Baja California Norte. Sohn des Bildhauers und Keramikers *Guillermo C. Alvarado.* Stud.: 1955–59 Esc. Nac. de Artes Plást. der UNAM, Mexiko-Stadt, u.a. bei Modesto Barrios, Ignacio Asúnsolo, Germán Cueto, Juan Olaguíbel und Federico Canessi. Seit 1957 als Doz. tätig, u.a. 1962–65 Univ. Iberoamer., 1963–80 Esc. Nac. Preparatoria der UNAM und 1966–70 Secretaría de Educación. 1966 Stip. der US-amer. Regierung. Später in Los Angeles, San Francisco und San Antonio/Tex. ansässig. Mitgl. des Internat. Sculpt. Center und 1980 Gründer sowie bis 2004 künstlerischer Dir. von Industrias de Bronce Artíst. in Tijuana. Zahlr. 1. Preise, u.a.: 1967 Wettb. Ford; 1969 Auditorio Nac., beide Mexiko-Stadt; 1973 Home Builders Assoc., San Antonio. – Gegenständlich-naturgetreue Plastiken, meist in Bronze, teils farbig gefaßt, v.a. figurale und symbolisch-zeichenhafte Denkmäler und relig. Werke. Außerdem in den 1960er und 1970er Jahren folkloristisches Kunsthandwerk in Ton, abstrahiert-expressive, linear geprägte Komp. dynamischen Char. (*Cazador de estrellas,* Eisen, 1972; *Cuauhtémoc,* 1974) und dekorativ-naturalistische Kleinplastik in Bronze mit Darst. populärer Typen (*Carmen; Quijote,* beide 1975; *Charro doma,* 1990) sowie eine Serie von Bonsaibäumen und Portr.-Büsten von Meisterzüchtern. ⌑ WASHINGTON/D. C., AM of the Americas. – *Werke im öff. Raum, meist in Bronze:* ENDSENADA/Baja California, Mon. a monseñor Felipe Torres Hurtado, 1992. LA CONCORDIA/Chiapas: Mon. a la bandera, 1960. LA MIRADA/Ca.: Pantocrator, skulpturales Wandbild, 1993. LAS VEGAS/Nev.: La última cena; La anunciación, beide skulpturale Wandbilder, 1994. LERDO/Durango: Mon. a Guadalupe Victoria, 1990. LOS ANGELES: Mon. a Cuauhtémoc, 1980. – Dizdar Park: Reiterstatue Adolfo Camarillo, 2000. MEXIKO-STADT, UNAM: 4 Büsten von Rektoren, 1979. – Centro Cult. Xochimilco: Mural Quetzalcóatl, Flachrelief, 1981. OAXACA: Mon. al correo prehispánico, 1962. PUERTO SAN CARLOS/Baja California Sur: Mon. al ingeniero Raúl Marsal, 1991. ROSARITO/Baja California Norte: Denkmäler: Benito Juárez,

1990. – Miguel Hidalgo, 1991. – Vicente Guerrero; José María Morelos; Emiliano Zapata; Francisco Villa, alle 1992. Tijuana, Morelos-Park: Mon. a la Gran Tenochtitlán, 1987. – Mon. a la madre, 1988. – Centro Cult. Tijuana: Canto a México, 1990. – Quiñientos años Cristóbal Colón, 1999. – Mon. a los policías caídos, 2004. – Univ. Autónoma de Baja California: Don Quijote, 2006. – S. Jorge y el dragón, 2008. Tuxtla Gutierrez/Chiapas, Pal. de Gobierno: Fassade und Mon. a la cult. maya, 1980. Valladolid/Yucatán: Mon. a Felipe Carrillo Puerto, 1990. Zapopan/Jalisco, Mon. a Valentín Gómez Farías, 1992. ◉ *E:* 1966 New York, Puerta el Sol / Mexiko-Stadt: 1969 Gal. Mer-Kup; 1970 Colegio de Arquitetos / San Diego (Calif.): 1984 Maple Gall.; 1990 Polo Cub Escondido / Tijuana: 1988 Gal. Disarte; 1990 Centro Cult. Tijuana. – *G:* 1969 Mexiko-Stadt, MAM: El objeto de uso (K). ▭ *L. Kassner,* Dicc. de escultores mex. del s. XX, I, Méx. 1997; *H. Musacchio* (Ed.), Milenios de México, I, Méx. 1999. – *Online:* C.s Originals Gall.; Angel Tarrac Virtuel Mus.; Picasaweb. – Mitt. C. M. Nungesser

Castaño Rodríguez, *María José* → **Castaño,** *María José*

Castañón Loché, *Jesús (J. Gregorio),* span. Bildhauer, Keramiker, Graphiker, * 3. 4. 1956 Gijón, lebt dort. Sohn des Schriftstellers Luciano C. Stud.: 1967 Agrupación Gijonesa de BA, ebd., bei Adolfo Bartolomé (Zeichnen), Gonzalo Macias (Skulpt.); später in den Wkstn von Luis Pardo und Alejandro Mieres (beide Zeichnen und Malerei); 1977 Esc. Mpal de Cerámica, Avilés, und versch. Töpfer-Wkstn, z.B. in Faro, Llamas del Mouro, Taborneda/Avilés (bei Martí Rollo und Francisco Arenas) und Oviedo (Daniel Gutiérrez); 1987 Ist. d'Arte per la Ceramica „G. Ballardini", Faenza. Seit 1985 ist C. als Doz. tätig und gibt Keramikkurse in versch. Städten v.a. Spaniens und Italiens sowie in Buenos Aires und Montevideo (2005). Mitbegr. der Wkst. und Schule für Keramik Textura (1985–99), Gijón. Ausz.: u.a. 1968 1. Preis für Skulpt., Certamen Juvenil de Arte; 1974 2. Preis für Graphik, Certamen Nac. Juvenil de Artes Plást., beide Oviedo; 1991 Gold-Med., Concorso internaz. della Ceramica, Gualdo Tadino/Perugia. – Anfangs gestaltet C. geometrisch-abstrakte Eisen-Skulpt. (seit 1995 v.a. aus zusammengesetzten halbmondförmigen Teilen, z.B. *Ancla de arado,* 2007), später arbeitet er meist in Ton mit Email-überzug in wenigen kräftig glänzenden, ineinanderlaufenden Farben (Rot, Orange, Schwarz) und hebt die Grenzen zw. Malerischem, Plastischem und Tektonischem auf. Er gestaltet keramische Werke aus annähernd geometrischen Grundformen mit zahlr. Öffnungen und Einbuchtungen, die an Gebautes denken lassen (Serien *Arquit. en rojo; Escult.*), und Bildplatten, teils mit Lsch.-Char., die durch Farben, Einkerbungen und in die Glasur einbezogene Scherben abstrakte Strukturen aufweisen (Serien *Pint.; Paisaje en rojo*). ▭ Algier, Ayadi (Vrg der Keramiker und Töpfer von Algier). Aviles, Esc. Mpal de Cerámica. Candas, Centro de Escult., Mus. Antón. Castrillon, Patronato Mpal de Cult. Faenza, Mus. Internaz. delle Ceramiche (MIC). Fuping/Prov. Shaanxi, Internat. Ceramic AM.

Gijon, Fund. Metal Asturias. – Stadtverwaltung. Kaoshiung/Taiwan, MFA. Oviedo, Hotel Santo Domingo Plaza, Col. de Arte Asturiano Contemp. Ts'ao-T'un/Taiwan, Inst. of Artist. Research of Taiwan. Varazdin, Croatian Ceramic Assoc. ◉ *E:* Gijón: 1976 Caja de Ahorros de Asturias, Sala de Expos.; 1977 Sala de Arte Vicent; 1978 Banco de Asturias, Sala de Expos.; 1981 Sala Lord; 1987 Sala Cornión; 1999 Centro de Cult. Antiguo Inst.; 2000 Sala Luzernario; 2001 Sala Espacio Líquido / Avilés: 1977, 2000 Casa Mpal de Cult.; 2003 Gal. Amaga / 1989 Oviedo, Gal. Hierro y Azul / 1992 Santiago de Compostela, Gal. Sargadelos / Madrid: 1998 Sala de Expos. Arco de Cuchilleros; 2005 Gal. Sargadelos; 2006 Esc. de Cerámica La Moncloa / 1998 Talavera de la Reina (Toledo), Esc. de Artes / 2003 Castrillón, Fund. Mpal de Cult. / 2004 Candás, Centro de Escult., Mus. Antón (K: R. Rodríguez) / 2009 Porto, Franchini's Gal. – *G:* 1989, '98 Barreiro (Lissabon): Expos. Internac. de Arte Postal / 1991 Vic (Barcelona): Bien. Internac. de Cerámica / 1992 Oviedo: Bien. Nac. de Arte / 1997, '99, 2003 Manises (Barcelona): Bien. Europ. de Cerámica / 2003 Faenza, Mus. Internaz. delle Ceramiche: La forma tra continuita e innovazione (K); Talavera de la Reina: Bien. de Cerámica / 2004 Taipei, Inst. Nac. de Investigación Artíst.: Cerámica esp. contemp. (Wander-Ausst.; K) / 2005 San Nicolás de los Arroyos (Buenos Aires): Bien. Internac. del Mosaico Contemp. / 2006 Boassas (Porto): Encuentro Internac. de Ceramistas; Valencia, MN de Cerámica: La cerámica y su interpretación en el arte / 2007 Aveiro: Bien. Internac. de Cerâmica Artística. ▭ DPEE III, 1994. – El Comercio (Gijón) v. 12. 9. 1970; 31. 3. 1977; 24. 1. 1981; 24. 9. 1998; La Nueva España (Oviedo) v. 28. 10. 1976; 18. 3. 1977; La Voz de Asturias (Oviedo) v. 11. 3. 1977; 17. 3. 1977; *R. Rodríguez,* Asturias. Escultores de cinco décadas, Oviedo 1995; *A. Fernández Braña/M. Rodríguez Cueto,* Paisajes humanos, paisajes industriales de Asturias, Gijón 1997; Escultores asturianos nacidos en las décadas 40 y 50 (K), Oviedo 1997; El País (Ma.) v. 20. 3. 1999; *R. Rodríguez,* J. C. Pint.-escult.-cerámica, Gijón 2006; *A. Alonso de la Torre García,* J. C. Pint.-escult., Gijón 2008. – *Online:* Website C. – Mitt. C. M. Nungesser

Castaza, *Phil* (eigtl. Castagnet, *Philippe*), frz. Comiczeichner, * 7. 7. 1966 Charmes/Vosges. 1990 erscheint C.s erste Veröff., die Fantasy-Trilogie *La Crypte du souffle bleu* (Szenario: René Durand). Nach einem Szenario von Cri-Bleu folgen 1994–95 zwei Bde von *Terre à chaos,* danach versch. Einzelbände. 2001 schließen sich die Serie *Khatedra* (zwei Bde mit Ange [Anne und Gérard Guero]) und 2002 die vierbändige Thrillerserie *Les Teigneux* nach einem Szenario von Philippe Chanoinat an. Mit Mathieu Gallié (Szenario) und Guillaume Sorel zeichnet C. den ersten Bd der Fantasy-Reihe *Contes des Hautes Terres* (dt. *Erzählungen der Hochlande,* Arboris) bei Delcourt. P. Chanoinat wird zum bevorzugten Texter von C., und es entstehen für Soleil versch. Bde, ehe sie 2008 die Sciencefiction-Serie *Les Aventuriers du temps* beginnen. – Realistische Zchngn mit detaillierten Figuren und naturalistischen Details, mit einem Faible für phantastische Elemen-

te. ▭ *H. Filippini*, Dict. de la bande dessinée, P. 2005. – *Online:* Lambiek Comiclopedia. K. Schikowski

Castel (1771) cf. **Castel,** *Philippe*

Castel, *Philippe*, frz. Porzellanmaler, * um 1746 Wachenheim b. Mannheim, † 1797 Paris. In der Porzellan-Man. Sceaux 1771 nachweisbar. 1771–96 (Dobler/Miller u.a.: 1772–97) in der Kgl. Porzellan-Man. Sèvres als Vergolder und Porzellanmaler, bes. als hochbezahlter Spezialist für die Darst. von Lsch., Blumen und Tieren (Vögel, Jagdhunde) tätig. – C. arbeitet auf Stücken aus Weich- und Hartporzellan und dekoriert für aristokratische Auftraggeber v.a. Tafelgeschirre (Dejeuners, Kaffee-, Tee- und Speiseservice) und Zierstücke (u.a. Potpourris, Porzellanbilder, Prunkvasen, z.B. für Schloß Versailles). Meisterschaft erreicht er in der naturalistischen Darst. tropischer und einheimischer Vögel, die er häufig nach Kpst. (bes. von François Nicolas Martinet) aus der vom Comte de Buffon u.a. hrsg. Hist. naturelle des oiseaux (P. 1770–83) anfertigt, z.T. wohl auch nach Vorlagen aus der von Mathurin Jacques Brisson hrsg. Ornithologie (P. 1760–63). C. ist 1778–79 an der Bemalung des großen Tafelservice für die russ. Zarin Ekaterina II ebenso beteiligt wie neben Charles-Eloi Asselin u.a. an den aufwendigen Porzellanbildern mit Jagdszenen für Louis XVI (1782), mit Edme-François Bouillat u.a. am sog. Sudell-Speiseservice (1792–93) oder an dem vom russ. Diplomaten Prinz Ivan Sergeevič Barjatinskij georderten sog. Barjatinskij-Service (1794). Mit C.s Vogelmalerei erreicht die didaktische Porzellandekoration des 18. Jh. einen künstlerischen Höhepunkt. ▭ BOSTON/Mass., MFA. CAMBRIDGE, Fitzwilliam Mus. CHICAGO/Ill., Art Inst. EICHENZELL, Mus. Schloß Fasanerie. HILLWOOD/Va., Mus. and Gardens. LONDON, R. Coll. – Wallace Coll. LOS ANGELES/Calif., J. Paul Getty Mus. PARIS, MAD. ST. PETERSBURG, Ermitage. SEATTLE/Wash., AM: Schale mit Unterschale, 1775–80 (Hafenszene mit Türken und klass. Ruinen). SÈVRES, MN de Céramique. WASHINGTON/D. C., Hillwood-Mus. VERSAILLES, Château. ▭ *M. Brunet*, Versailles 1970 (40) 29–32; 1970 (41) 23–27; *G. de Bellaigue*, French porcelain in the Coll. of Her Majesty The Queen, Lo. 1986; *S. Eriksen/G. de Bellaigue*, Sèvres porcelain. Vincennes et Sèvres 1740–1800, Lo. 1987; *R. Savili*, The Wallace Coll. (K), Lo. 1988; *J. Lemaire*, Des porcelains et des oiseaux. Tournai, Sèvres, Bruxelles, La Haye (K), Tournai 1994; *M.-N. Pinot de Villechenon*, Rev. du Louvre et des mus. de France 43:1995 (3) 54–60; *A. Dobler/M. Miller*, Kgl. Porzellan aus Frankreich (K Wander-Ausst.), Eichenzell 1999; *N. Ju. Birjukova/N. I. Kazakevič*, Sevrskij farfor XVIII v. (K Ermitage), StP. 2005; *J. Gwilt*, French porcelain for Engl. palaces. Sèvres from the R. Coll. (K), Lo. 2009.

U. Heise

Castelein, *Ingrid*, belg. Malerin, Zeichnerin, Graphikerin, * 31. 5. 1953 Deinze, dort tätig. 1968–72 Besuch von Zeichenkursen bei Armand Blondeel an der Sted. ASK in Deinze. Stud.: 1974–79 Koninkl. ASK, Gent, bei Karel Dierickx und Jan Burssens (1974–78 Malerei, 1978–79 Bildhauerie). Lehrtätigkeit: 1998 Hoger Inst. voor Schone Kunsten, Antwerpen (Gast-Doz.); Koninkl. ASK, Gent (Malerei und Zeichnen). – C.s malerisches Œuvre umfaßt stark abstrahierte Lsch. in kräftigen Farben sowie abstrakte, überwiegend flächige Komp. in pastosem Farbauftrag (Öl, Acryl und Gouache), deren Titel ebenfalls Assoziationen zu Natur-Darst. hervorrufen, z.B. *Landschap nr. 3 blauw*. Bis A. der 1990er Jahre dominiert jeweils eine Farbe (z.B. *Onderzoek landschap rood*, Öl/Lw., 1989), später werden verschiedenfarbige Flächen häufig kontrastreich arrangiert. Die geometrisch-abstrakte Gest. früherer Werke ablösend, bestimmen geschwungene, an Wolkenformationen erinnernde Gebilde die Komp. der letzten Jahre. Des weiteren Graphiken (Lith., Siebdruck) und in Kombination versch. Techniken ausgef. Zchngn (Tusche, Aqu., Bleistift, Holzkohle, Pastell). C.s Arbeiten befinden sich u.a. im Bes. der Prov. Oost-Vlanderen, der Stadt Aalst sowie des belg. Kultus-Minist. und des Fläm. Parlaments in Brüssel. ▭ AALST, Sted. Mus. DEINZE, Mus. van Deinze en de Leiestreek. OOSTENDE, KM aan Zee. WASHINGTON/D. C., NM of Women in the Arts. ◉ *E:* Gent: 1978 Gal. Piet Bekaert; 2005, '06 (mit Dolores Bouckaert), '08 Gal. Jan Dhaese / 1992 Amsterdam, Vlaams Cultuurhuis De Brakke Grond (mit José Vermeersch; K) / 1998 Deinze, Mus. van Deinze en de Leiestreek / 2000 Löwen, KBC-Gal. – *G:* 1984 Hasselt, Prov. Centrum voor Beeldende Kunsten: Kunst 80 (K) / 1991 Roeselare, Sted. Mus. Alfons Blomme: 100 kunstwerken van Vlaamse kunstenaars / 1992 Oostende, Prov. MMK: Modernism in Paint. 10 jaar schilderkunst in Vlaanderen (Wander-Ausst.; K) / 2004 Gent, Sint-Barbaracollege: Trends 04. 50 hedendaagse kunstenaars stellen 200 origenele werken tentoon / 2009 Zulte, Roger Raveel-Mus.: Landschappelijk. ▭ *Pas* I, 2002.

F. Krohn

Castella, *Vincenzo*, ital. Fotograf, Videokünstler, Filmemacher, * 21. 4. 1952 Neapel, lebt in Mailand. Stud.: Kunstgesch. und Kulturanthropologie, Univ. Rom. C. spielt ab 1969 Bluesgitarre und beginnt, auch angeregt durch die Farb-Fotogr. von William Eggleston, 1975 zu fotografieren, u.a. bis 1982 priv. Interieurs (*Geografia priv.*). 1976, '78 und '80 dokumentiert er in den USA das Leben von Afroamerikanern, porträtiert Bluesmusiker und macht Aufnahmen der Architekt. der Südstaaten (Film mit Lucio Maniscalchi: *Hammie Nixon's people*, 1979). Teiln. an den Auftragsprojekten Arch. dello spazio der Prov. Mailand (1987–97) und Milano senza confini der Stadt Mailand (1998–2000; u.a. Video *Cliente successivo* mit Nahaufnahmen von Supermarktwaren) sowie Atlante ital. (2003) des ital. Kultus-Minist., DARC (Dir. gen. per l'Archit. e l'Arte Contemp.; Fotogr. vom Flughafen Milano-Malpensa). Ab 1994 Arbeit an der Serie *Buildings*, seit 1997 an *Città nomadi* über das zeitgen. Erscheinungsbild west-europ. Städte (u.a. Mailand, Turin, Neapel, Amsterdam, Rotterdam, Athen, Köln, Graz); auch Mon., Interieurs und Detailaufnahmen. – C. gehört wie Giovanni Chiaramonte, Olivo Barbieri oder Vittore Fossati zur jüngeren Generation ital. Fotografen, die sich nach dem Vorbild der sog. New Topographics (benannt nach einer einflußreichen Ausst. im George Eastman House in Ro-

chester/N. Y., 1975) und in direkter Nachfolge von Luigi Ghirri, Guido Guidi oder Gabriele Basilico mit topogr. Rech. befassen; bereits 1984 nimmt er an Ghirris Ausst. Viaggio in Italia teil. Mit seiner Lsch.-Fotogr. konzentriert sich C. v.a. auf die zivilisatorischen Eingriffe und Strukturen in urbanen, peripheren oder industriellen Umgebungen. Er nimmt Städte oft von erhöhten Standpunkten aus auf und zeigt sie als graph. streng entworfene geometrische Texturen. Entgegen dem trad. Verständnis von Dokumentar-Fotogr. strebt C. danach, die Historizität der Wahrnehmung sowie die Konstruiertheit eines jeglichen Bildes von der Natur zum Ausdruck zu bringen. Um die Distanz des Betrachters zu vergrößern, läßt er seine Fotogr. z.B. in durchsichtige Kunststoffscheiben einschweißen. Ferner wählt er Aufnahmezeiten mit einem neutralen und richtungslosen gelblichen „Hyper-Licht". Farbe versteht er nicht objektbezogen, sondern als kult. „Sprache"; seit 1998 manipuliert C. seine Fotogr. nachträglich durch eine konzeptionell-minimalistische digitale Farb-Bearb., wodurch die Bilder fast monochrom ausgebleicht erscheinen und nur einzelne Bildelemente als Farbakzente hervorgehoben werden; z.T. arbeitet er aber auch char. künstliche Farbtöne heraus, etwa leuchtendes Grün bei Lsch. der Steiermark (1999). In Fotogr. für das Projekt Osservatorio del Territorio Rurale der Region Lombardei setzt sich C. mit den Farb- und Formveränderungen der Agrar-Lsch. durch die mod. Landwirtschaft auseinander (Publ.: *Campi di colore*, Mi. 2002). – Weitere Foto-Publ.: *Mémoire sans Souvenirs*, in: Traverses (P.) 36:1986; *Ritratti firmati* (K Mailand), s.l. 1987; S. Sermisoni (Ed.), *San Siro. Storia di uno stadio*, Mi. 1989; *Output* (K Casalgrande), s.l. 1994; G. Mandery (Ed.), *Sicilia. Memoria del mediterraneo*, Siracusa 1998 (Text: G. Dato); P. Tognon (Ed.), *Photo Works*, Cinisello Balsamo 2003; A. Madesani (Ed.), *Siti 98–08*, Mi. 2009. ⌑ BOLOGNA, Coll. Unicredit. CINISELLO BALSAMO, Mus. di Fotogr. Contemp. MAILAND, Coll. Unicredit. ROM, MAXXI. TURIN, Fond. Sandretto Re Rebaudengo. VIGO, Slg der Stadt. ✉ Paesaggio e sguardo, in: R. F. Tibaldeo (Ed.), Prospettive integrate, Caraglio 2006. ◉ *E:* Rom: 1981 Gall. Vecchia Talpa; 1985 Gall. Rondanini / 1981 Modena, Pal. Com. / 1982 Treviso, Gall. Nuova Fotogr. / 1982 Gall. Fotogr. Arte; 2003 Pal. Bagatti Valsecchi; 1990 Area Ansaldo; 1994, '97, 2004, '06, '08 Le Case d'Arte; 2004 Teatro Armani / 1984 Fusignano, Pal. civ.; Rimini, Gall. dell'Immagine, Pal. Gambalunga / 1991 Reggio Emilia, Civ. Mus. (K) / Arles: 1992 Rencontres Internat. de la Photogr.; 2003 Abbaye Montmajour / 1993 Florenz, Studio Marangoni / 1996 Bellinzona, Centro d'Arte Contemp. / Amsterdam: 2000, '03, '09 (mit Jan van de Pavert) Gal. Paul Andriesse; 2003 Centrum voor Fotogr. / 2001 New York, Lawrence Miller Gall.; Riva del Garda, MCiv. (mit Toni Thorimbert; K) / 2002, '05–06, '09 Madrid, Gal. Fúcares / 2003 Guarene d'Alba, Pal. Re Rebaudengo / 2004 Bergamo, Teatro Soc. / 2005 Köln, Gal. Monika Sprüth; Neapel, Pal. Reale / 2007 Verona, Studio La Città (K). – *G:* 1982 Malmö, KM: La Nuova Fotogr. Ital. a Colori / 1984 Barcelona, Centre Cult. de la Fund. Caixa de Pensions: Fotogr. Mediterranea (K); Bari, Pin. prov.: Viaggio in Italia (Wander-Ausst.; K); Graz, Forum Stadtpark: Penisola / 1985 Toronto, AG of Ontario: The Europ. iceberg. Creativity in Germany and Italy today (K) / Reggio Emilia: 1985 Pal. Civ.: Notte e di (K); 1986 Sale com. Espos.: Esplorazioni sulla Via Emilia (K) / Neapel: 1986 Mus. Diego Aragone Pignatelli Cortes: Napoli '85 (K); 1999 ebd.: Uno sguardo su Napoli (K); 2005 Pal. Reale und Real Bosco di Capodimonte-Cellaio: Obiettivo Napoli (K) / Mailand: 1986 Pal. della Trienn.: Il progetto domestico (K); 1993 Pal. Isimbardi: Arch. dello Spazio 2 (K); 1996–97 Pal. della Trienn.: 1987–97. Arch. dello spazio (K); 1995 Pal. Reale: 100 anni del Touring Club; 2000 Spazio Oberdan: Milano senza confini (K) / 1988 Vicenza, Centro Internaz. Studi d'Archit. A. Palladio: Il paesaggio industriale / Venedig: 1989 Pal. Fortuny: L'insistenza dello sguardo (K; Wander-Ausst.); Bienn.: 1993 I Muri di carta (K); 1997 Venezia-Marghera (K; Wander-Ausst.) / 1989 Vigo, Sala dos Peiraos: Espacios (K) / 1998 Houston (Tex.): Foto-Fest; Florenz, Uffizien: Paesaggi ital. (K); Lugano, Gall. Gottardo: Pagine di fotogr. ital. 1900–1998 (K) / 1999 Turin: Bienn. internaz. di fotogr. (K); Montreal, Canadian Centre for Archit.: 32 ital. photographers / 2001 Albuquerque (N. Mex.), Univ. AM: An eye for the city (K) / 2000 Amsterdam, De Balie: Film interrupted / Rom: 2003 MAXXI: Atlante ital. 003 (K); 2007 Mus. dell'Ara Pacis: Ereditare il paesaggio (K; Wander-Ausst.) / 2004 Cinisello Balsamo, Mus. di Fotogr. Contemp.: Racconti dal paesaggio; Riva del Garda, MCiv.: Sguardi Gardesani (K) / 2006 Rotterdam, Netherlands Archit. Inst.: Spectacular city (K; Wander-Ausst.); Paris, Maison Europ. de la Photogr.: Un été italien; München, Hypovereinsbank Kunst Pal.: New landscapes / 2007 Köln, Die Photogr. Slg SK Stiftung Kultur: Stadt-Bild-Köln / 2008 Genua, Villa Croce MAC: Nostalgie / 2009 Dudelange, Centre nat. de l'audiovisuel: Kaléidoscope d'Italie (K). ⌑ I castelli romani (K), R. 1982; Immagini della fotogr. europ. contemp. (K), Mi. 1983; I. Zannier, Storia della fotogr. ital., R./Bari 1986; Cinque fotografi per l'energia (K Mailand), s.l.e.a. [1987]; R. Valtorta (Ed.), Sull'acqua (K), Verbania 1988; I. Zannier/P. Costantini (Ed.), 150 anni di fotogr. in Italia (K), R. 1989; Du 49:1989 (10) 14 s.; L. Gasparini u.a., In prospettiva. Fotogr. di archit. in Europa (K), Reggio Emilia 1990; Arch. dello spazio (K Mailand), Ud. 1991; Photogr. mag. (P.) 43:1992, 54–61; Casa Vogue 247:1992/93, 134–137; Chimica aperta (K), Mi. 1995; Ad vesperas (K Castelfranco Veneto), s.l. 1995; A. Russo (Ed.), Fotogr. ital. per una coll. (K Turin), Rivoli 1997; A noir (K), Mi. 1998; Nuovo paesaggi ital. (K Wander-Ausst.), Mi. 1998; D. Mormorio, Paesaggi ital. del '900 (K), Mi. 1999; Tema celeste (Siracusa) 73:1999, 63; Inside. Outside (K Gal. Fúcares), Almagro 1999; W. Guerrieri u.a. (Ed.), Luoghi come paesaggi (K Florenz), Rubiera 2000; Artisti suonati (K Trevi/Rom), R. 2001; Mutamenti + analogie (K Centro Cult. Trevi), Bozen 2001; G. Bauret, Color photogr., N. Y. 2001; S. Risaliti, Working insider (K), Fi. 2003; U. Lucas (Ed.), L'immagine fotogr. 1945–2000 (Storia d'Italia. Annali, 20), T. 2004; R. Valtorta, Volti della fotogr., Mi. 2005;

ead., Il pensiero dei fotografi, Mi. 2008; *T. Koenig*, Camera Austria 2009 (107) 36–41. T. Koenig

Castellano, *Vicente* → **Castellano Giner,** *Vicente*

Castellano Giner, *Carmelo,* span. Maler, Graphiker, Zeichner, * 14. 1. 1925 Valencia, lebt in Paris. Sohn des Malers *Carmelo Castellano Ibáñez* (* 1896 Valencia), Bruder von Vicente C. Stud.: Esc. de Artes y Oficios, Valencia; EBA de S. Carlos ebd. bei Salvador Tusset, Ernesto Furió Navarro und Enrique Giner. 1947 Mitbegr. der Grupo Z, an deren Ausst. er regelmäßig teilnimmt. 1949 Graphik-Stip. der Prov.-Verwaltung von Valencia. 1952 mit Stip. in Paris, wo er sich schließlich niederläßt. Ausz.: 1954 Sonderpreis des Colegio de España, Paris; 1955 Preis des span. Konsulats ebd. – C.s Frühwerk ist figurativ und zeigt meist Stadtansichten und urbane Szenen. E. der 1950er Jahre wendet er sich dem Neokubismus zu und malt u.a. Pariser Stadt-Lsch., deren collagehafter Char. durch die Einbeziehung von Karton- und Papierstücken verstärkt wird. Seit M. der 1970er Jahre entstehen farbenfrohe Acryl- und Öl-Gem. im Stil der lyrischen Abstraktion (*Terre de Castille*, Acryl/Lw., 1982). Auch Druckgraphiken (*Fachada de la Iglesia de Sa. Cruz* und *Desnudo de Mujer*, beides Rad., 1949). ◉ *E:* Valencia: 1956 Salon Mateu; 1975, '78 Gal. Nike / Paris: 1964 Gal. Riquelme; 1992 Gal. Ariane; 1999 Centre d'études catalanes / 1986 Castellón de la Plana, Gal. Canem / 1989 Zaragoza, Gal. Goya. – *G:* Barcelona: 1950 Bien. Hispanoamer.; 1955 Bien. Iberoamer.; 1955 Paris: Salon d'Art Libre / 1992 Vigo, Centro Cult. García Barbón: Pintores de la Esc. de Paris. ▭ DPEE III, 1994; *Agramunt Lacruz* I, 1999 (jeweils auch zu C. Ibañez, Carmelo); *Delarge*, 2001.
 S. Herczeg

Castellano Giner, *Vicente,* span. Graphiker, Maler, * 13. 6. 1927 Valencia, lebt dort. Sohn des Malers Carmelo Castellano Ibáñez, Bruder von Carmelo C. Stud.: EBA de S. Carlos ebd.; 1951 mit Stip. der EcBA, Paris, bei Edouard Goerg. Mitbegr. der Künstlergruppen Los Siete und Parpalló sowie der Zs. Arte Vivo. 1957 Übersiedlung nach Paris, wo er für die Zs. Cuadernos des Congr. por la Libertad de la Cult. tätig ist. 1977 Rückkehr nach Valencia, dort ab 1981 Lehrauftrag für Farbtechnik und -konzept an der EBA de S. Carlos. – Zunächst malt C. v.a. in Erd- und Grautönen gehaltene abstrakte Kompositionen. Seit 1968 entstehen Arbeiten im Stil des Nouveau réalisme und des Informel, die u.a. Einflüsse von Antoni Tàpies und Manolo Millares erkennen lassen. Die für ihn typischen reliefartigen Gem.-Oberflächen erzielt er durch das Aufbringen von Mat. und Fundstücken (Holz- und Papierstücke, Sand, Schnüre, Textilien). ▥ VALENCIA, IVAM. – La Generalitat. VILLAFAMES, Mus. Popular. ◉ *E:* Paris: 1955 Gal. de la Cité Univ.; 1962 Gal. du Pont Neuf; 1965 Gal. Odeur du Temps / Valencia: 1956 Pal. de la Generalitat; 1975 Gal. Valle Ortí; 1986, '92 Gal. Leonarte; 1990 Sala Parpalló; 1998, '99, 2001 Gal. Muro / 1986 Sagunto, Fund. Mpal de Cult. / 1990 Madrid, Gal. Jorge Ontiveros / 1999 Castellón de la Plana, Gal. Canem. – *G:* 1958 Barcelona: Salón de Mayo / 2009 Alzuza (Navarra), Fund. Mus. Jorge Oteiza: La sombra de Oteiza en el arte esp. de los años cincuenta.

▭ DPEE III, 1994; *Agramunt Lacruz* I, 1999. – *Wilhelmi,* 2006. – *Online:* Gal. Muro (Ausst., Lit.). S. Herczeg

Castellano Ibáñez, *Carmelo* cf. **Castellano Giner,** *Carmelo*

Castellanos Basich, *Antonio,* mex. Bildhauer, Zeichner, * 5. 3. 1946 Mexiko-Stadt, lebt in Cuernavaca/Morelos. Sohn von Julio Castellanos und Stiefsohn von Federico Canessi. Stud.: 1963–64 Zeichnen an der Esc. Nac. de Artes Plást. der UNAM; Malerei und Skulpt. an der Esc. Nac. de Escult. y Pint. „La Esmeralda", u.a. bei Luis Robledo, beide Mexiko-Stadt. 1964–76 Mitarb. in der Wkst. seines Stiefvaters an versch. Denkmälern, u.a. am Mon.-Wandbild zur Erinnerung an den Bau des Netzahualcoyótl-Staudammes in Malpaso/Chiapas (1964) sowie Statuen oder Büsten von Mahatma Gandhi (1969), Salvador Allende (1973) und Lázaro Cárdenas (1976). Zusammenarbeit mit den Architekten Enrique de la Mora und Pedro Ramírez Vázquez. – Naturgetreue Skulpt., meist Denkmäler, reliefierte Erinnerungsplaketten (z.B. für die Staudämme Vicente Guerrero und José María Morelos, beide 1968) und Trophäen (*Antorcha*, Juegos Centroamericanos, 1990; *Antorcha de plata*, Internat. Olympisches Komitee, 1991); weiterhin Kleinplastik, z.B. behutsam stilisierte weibliche Halbakte und Vögel sowie zur Abstraktion tendierende Werke biomorphen Char. und vollplastischer Form. Auch Ill., u.a. für das Kinderbuch *Y la luna siempre es una* (Méx. 2006) von Alonso Núñez (Premio Internac. del Libro II. Infantil y Juvenil, Consejo Nac. para la Cult. y las Artes, Mexiko-Stadt). ▥ MEXIKO-STADT, Mus. Dolores Olmedo: Büste Diego Rivera, 1972. – Mus. Mural Diego Rivera: Büste D. Rivera, 1988. NEW HAVEN/Conn., Knights of Columbus Mus. – *Arbeiten im öff. Raum und baugebundene Kunst:* ALICANTE/Spanien: Büsten Dr. Ignacio Chávez und Dr. Francisco Xavier de Balmis, 1982–83. ATIZAPAN DE ZARAGOZA/Estado de México, Mausoleo de Adolfo López Mateos: Türen und Medaillons, 1994. DES PLAINES/Ill., Maryville City of Youth: Juan Diego und die hl. Jungfrau von Guadalupe, Skulpt. FRESNILLO/Zacatecas: Mon. a Benito Juárez, 1977. – Mon. a Manuel M. Ponce; Mon. a Francisco Goitia, beide 1982. IXCATEOPAN/Guerrero: Tumba de Cuauhtémoc, 1977. MEXIKO-STADT, Centro Mercantil: Fassadenmosaik. – Pal. Nac., Salón del Congreso de los Constituyentes: 17 Medaillons (Benito Juárez u.a.). – Panteón de Dolores, Rotonda de los Hombres Ilustres: Büste Gerardo Murillo (Dr. Atl), alle 1969. – Hospital de Jesús: 10 Büsten, 1978. – Paseo de la Reforma: 8 Statuen, 1981–82. – Secretaría de Hacienda y Obras Públicas, Sindicato de Trabajadores: Mon. a Abelardo de la Torre Grajales, 1982. – Basilica de Guadalupe: Juan Diego y Fray Juan de Zumárraga, Statuen, 1989. – Seminario de Cult. Mex.: 53 Medaillons der Mitgl., 1993–98. – MN de Antropología: Arquitecto Pedro Ramírez Vázquez, Hochrelief, 1994. – Calzada de los Misterios: Cruz de la evangelización, Skulpt.-Gruppe, 1998. – Colegio Nac.: Büste Dr. Manuel Sandoval Vallarta, 1999. – Park Alameda Central: Alexander Humboldt, Statue, 2000. NAUCALPAN/Estado de México: Mon. a los héroes de la Independencia. – Mercado Mpal: Mon. al pochteca (antiguo merca-

der mex.). – Pl. Principal: Mon. a Juárez, alle 1965. Puebla, Mus. Amparo: Hochrelief zum Thema Mais, 1988. Santo Domingo/Dominikanische Republik: Mon. a fray Antonio de Montesinos, 1982. Tlanepantla/Estado de México: Mon. a la alianza, 1983. Toluca, Inst. Nac. de Protección a la Infancia del Estado de México: Skulpt.-Gruppe, 1965. Zacatecas: Statue Benito Juárez, 1984. ◉ G: Mexiko-Stadt: 1967 (ehrenvolle Erw.), '69 Bien. Nac. de Escult.; 1985 Trien. de Escult. ⌗ Enc. de México, II, 1977; L. Kassner, Dicc. de escultores mexicanos del s. XX, I, Méx. 1997. – Online: Website C.

M. Nungesser

Castellanos Loza, *Bulmaro* (Pseud. Magú), mex. Karikaturist, * 23. 11. 1944 San Miguel el Alto/Jalisco, lebt in Mexiko-Stadt. Stud. ebd.: bis 1967 Jura an der UNAM. Seitdem Karikaturist zahlr. mex. Ztgn und Zss., u.a. El Universal (1966), Sucesos para todos und deren Suppl. El Mitote II. (1966–68), Rev. de revistas (1971), Ultimas Noticias (1972), Proceso (1976), Unomásuno (1977–86) und La Jornada (seit 1984), deren Sonntagsbeilagen Histerietas, El Papá del Ahuizote und El Tataranieto de Ahuizote er gründet und leitet. Gründungs-Mitgl. des humoristischen Weblogs Sacatrapos. Ausz.: u.a. 1967 1. Preis, Karikaturen-Wettb. der Ztg El Universal; 1982 Premio Nac. de Periodismo, beide Mexiko-Stadt. – C. gilt als einer der führenden politischen Karikaturisten Mexikos. Häßlichkeit („feísmo" oder „esperpentismo") wird von Kritikern als Hauptmerkmal seines bildfüllenden, grotesken Stiles hervorgehoben, bei dem Personen und Gegenstände stark deformiert und oft bildlich verschränkt erscheinen. C. kritisiert v.a. die jahrzehntelange korrupte Herrschaft der Partido Revolucionario Inst. (PRI), die erst 2000 gebrochen wird, und die damit einhergehende Verarmung und Desillusionierung weiter Teile der Bevölkerung. V.a. in Büchern bedient er sich auch comicähnlicher Elemente und bezieht Foto-Fragm. mit ein. Seine Satiren behandeln z.B. die rituelle Wahl („dedazo") des jeweiligen Präsidentschaftskandidaten und die Rolle, die Miguel Hidalgo als Held der Unabhängigkeit im 19. Jh. spielt, jeweils begleitet von einem hist.-soziologischen Fachtext. C.s Karikaturen von Hidalgo dienen 2009 auch als Vorlagen für das Puppentheater La Coperacha. Weiterhin Buch-Ill.: u.a. *El ratón del supermercado y ... otros cuentos* (Méx. 2005) und *El niño Triclinio y la bella Dorotea* (Méx. 2008), beide von Juan Ibargüengoitia. ⌗ Mexiko-Stadt, Mus. del Estanquillo. ✉ Magú te ve, Méx. 1979; Las 46 semanas de Magú, [Méx. 1979]; *Magú/E. Krauze*, Hidalgo y sus gritos, Méx. 1993; *Magú/S. Sefchovich*, Las PRIelecciones. Hist. y caricatura del dedazo, Méx. 2000; *Magú u.a.*, El cura Hidalgo. Diez balcones y una balconeada, Méx. 2003; La noche mala de los guajolotes. Cartones y recetas, Méx. 2003. ⌗ Enc. de México, III, Méx. 1987; *A. Sánchez González*, Dicc. biogr. il. de la caricatura mex., Méx. 1997 (s.v. Magú). – *K. L. Ferrer Brabata*, La caricatura de B. C. L., Magú. Su estilo e importancia para la caricatura contemp. en México (Licenciatura), Méx. 1997; *A. Bartra*, Rev. latinoamer. de est. sobre la historieta (Havanna) 1:2001 (4) 225–236; *H. Ortega*, Rev. políticas. Las últimas rev. cómico políticas del s. y del milenio, Méx. 2006; *B. Randrianarijaona*, El humor en la prensa de México, D. F., P. 2007. – *Online:* Wikipedia; Blog Sacatrapos.

M. Nungesser

Castelletti, *Marco*, ital. Architekt, Stadtplaner, Designer, * 1958 Erba/Como, lebt dort. Stud.: bis 1983 Fac. di Archit., Univ. Genua. Danach Mitarb. bei Enrico Davide Bona ebd.; 1987 eig. Büro in Erba. Zahlr. Wettb.-Siege, darunter auch Kooperationsprojekte mit Boris Podrecca. Ausz. u.a.: 1994, '99, 2001, '03 Maestri Comacini, Como; 2004 AR+D, RIBA, London; 2006 Gold-Med. Trienn. Mailand (bes. Erw.); 2006 Neues Bauen in den Alpen, Bozen, Inst. für Alpine Architektur. – C.s innovative Entwürfe sind eine kritische Fortführung der ital. Mod., von rationalistischer Klarheit und zw. Urbanität und Natur ebenso wie zw. Trad. und Mod. vermittelnd. Die Bauten sind zudem stark vom Mat. bestimmt. C. setzt Naturstein, Sichtbeton, Holz, Stahl, Aluminium und Glas kontrastreich gegeneinander, spielt mit Licht und Transparenz und paßt jedes Gebäude individuell in den hist. stadträumlichen bzw. landschaftlichen Kontext ein. Zahlr. Plätze und Stadtzentren in Norditalien haben durch C.s Neustrukturierung und Gest. die urbane Qualität eines öff. Raumes zurückgewonnen. Die Bauten sind kraftvolle, elegante Skulpturen. V.a. die Villen und Einfamilienhäuser setzen sich zeichenhaft aus einfachen geometrischen Körpern zusammen. ⌗ Albese Con Cassano, Piazza Mercato: Neuordnung, 1998–99 (mit Fabio Rabbiosi, Gianmatteo Romegialli). Alzate: Villa, 2008. Brunate: Parkplatz und Parkanlage Franceschini, 2000–04 (mit Alessandro Curti, Lorena Cavalletti). Cadorago: Rathaus, 2008. Cesano Maderno, Pal. Arese: Neu-Gest. der Außenanlagen, 2001–04 (mit Sergio Fumagalli, L. Cavalletti). Como: Villa X, 2000–04 (mit A. Curti); Casa del Masso, 2001–04. Erba, Via Battisti 7: Verwaltung Rigamonti, 1997. – Via Turati 2: Banca BCC, 1997–98. – Via Battisti 7: Archit.-Büro, 1999. – Auditorium Oratorio Casa della Gioventù, 1999–2000. – Via Biffi 7: Einfamilienhaus, 1999–2001. – Friedhof: Tomba dei sacerdoti, 2003–04 (mit A. Curti). – Hauptverwaltung Rigamonti Spa, um 2005 (mit A. Curti, L. Cavalletti). Eupilio, Lido del Segrino: Badehaus, 2002–03 (mit L. Cavalletti). Lecco, Piazza XX settembre: Gest. der Uferpromenade, 1999–2001. – Villa Ponchielli: Zugang zum Park, 2001–03 (mit L. Cavalletti). Lentate Sul Seveso, Piazza San Vito: Neu-Gest., 2000–03 (mit Stefano Santambrogio, L. Cavalletti). San Giuliano Milanese/Lombardei, Stadtzentrum: Neu-Gest., 1998–2001. Tirana/Albanien: Kath. Univ., 2005 (mit A. Curti). Triest, Piazza Goldoni: Neu-Gest., um 2005 (mit S. Santambrogio, L. Cavalletti). ◉ G: 2007 Bozen, IFAA Inst. für Alpine Archit.: Neues Bauen in den Alpen (K 2008). ⌗ ArchitRev 216:2004 (1294) 58–59; Casabella 69:2005 (731) 56–61. – *Online:* Website C. A. Mesecke

Castelli, *Alfredo*, ital. Comiczeichner und -autor, * 26. 6. 1947 Mailand. 1965 debütiert C. mit dem grotesk-humoristischen Comic *Scheletrino* für das Mag. Diabolik (Text und Zchng). 1966 ist er Mitbegr. des ersten ital. Fanzines Comics Club 104 und seitdem als Autor an versch.

Serien beteiligt. 1969 zeichnet er für Tilt und ist Mit-Hrsg. des Mag. Horror, für das er die Reihe *Zio Boris* textet. Auch für das Disney-Mag. Topolino schreibt C. einige Szenarien. 1972–76 ist er Red. der Corriere dei Ragazzi, wo *Zio Boris* fortgesetzt wird; daneben auch Texte für Ferdinando Tacconi mit den Serien *L'Ombra* und *Gli Aristocratici*, letztere läuft als *Gentlemen GmbH* auch erfolgreich im dt. Mag. Zack, für das auch die Serie *Mike Merlin* (Zchngn Enrico Bagnoli) entsteht. Des weiteren schreibt C. auch für Milo Manara und Giancarlo Alessandrini Einzeltitel für die Reihe *Un uomo, un'avventura* (dt. *Ein Mann, ein Abenteuer*, Feest). Für das frz. Mag. Pif entstehen Geschichten über Aladin und Gulliver. Seit 1982 entwickelt C. für Bonelli seine erfolgreichste Figur, *Martin Mystère* (mit G. Alessandrini). – Als Zeichner ist C. von dem parodistischen Stil des US-amer. Satire-Mag. Mad beeinflußt, als Autor verfaßt er klassische Abenteuergeschichten. ◫ *F. Fossati, Das große ill. Ehapa Comic Lex.*, St. 1993; *P. Gaumer/C. Moliterni, Dict. mondial de la bande dessinée*, P. 1997; *H. Filippini, Dict. de la bande dessinée*, P. 2005. – *Online:* Fumetti; Lambiek Comiclopedia; Martin Mystère Mysteries. K. Schikowski

Castelli, *Clément (Clément Marius)*, ital. Maler, Restaurator, * 4. 1. 1870 Premia/Piemont, † 12. 12. 1959 Paris. Ab 1880 mit der Fam. in Paris ansässig. 1912 ebd. Schüler von Jules Adler und Léon Bellemont. Atelier in Montparnasse. Weitere Ausb. an einer priv. Akad. in Rom und ausgedehnte Studienreise durch Italien. Auch im algerischen Constantine tätig. Mitbegr. der Soc. des Amis des Arts ebd.; Präs. der Soc. des Peintres de Montagne. Außerdem offizieller Korrespondent der Soc. des Artistes Orientalistes in Algier und der Kunst-Zs. Les Tendances nouvelles. Ausz.: 1925 Vermeil-Med. als Organisator einer ital.-schweiz. Ausst. in Domodossola (überreicht durch Vittorio Emanuelle III); 1933 Officier d'Acad.; 1948 Officier d'Instruction publique. – Einer recht konventionellen gegenständlichen Darst.-Weise verpflichtet, malt C. in ausgewogener, meist gedämpfter Farbgebung, bei der subtil nuancierte helle Blautöne dominieren (Öl, Tempera, Pastell). Im Frühschaffen mit vielfältigen Themen beschäftigt, fertigt er Stilleben, Portr., genrehafte Szenen (*Lavandières et paysan*, Öl; Aukt. Frankreich, 5. 11. 2005), Gartenansichten (meist aus Paris) und Kircheninterieurs (*Eglise St-Germain l'Auxerrois*, um 1926). In den 1920er Jahren zunehmende Spezialisierung auf Lsch. in Öl, v.a. Gebirgsmotive aus der Schweiz (*Le lac noir à Zermatt*, sign.; Aukt. Blanchet & Associés, Paris, 1. 4. 2009; *Le Breithorn, cabane de Théodule*, 1936; Aukt. Frankreich, 15. 1. 2010) und Italien (*Vallée de montagne avec des vaches au bord d'une rivière dans le Piémont*, 1931; Aukt. Amsterdam, 21. 4. 1994). Dazu kommen Darst. aus Nordafrika (*Soir aux environs de Constantine*, um 1912) und Frankreich, bes. den Pyrenäen. Aufgrund von fundiertem Fachwissen und entsprechenden praktischen Fähigkeiten auch vielbeschäftigter Gem.-Restaurator. ⌂ CONSTANTINE, MN Cirta. DOMODOSSOLA, Mus. di Pal. Silva. ORAN, MN Zabana. PARIS, Louvre. ◉ *E:* 1950 Algier, Gal. Salles-Girons. – *G:* 1912 Algier, Salon des Artistes Orienta-

listes / Paris: 1914–59 häufig, 1960 (postum) Salon des Artistes Indépendants (ab 1913 Mitgl.); 1920, '21 SAfr. ◫ *Edouard-Joseph* I, 1930; *Bénézit* III, 1999; *E. Cazenave*, Les artistes de l'Algérie, P. 2001. – *Online:* Artnet; Artprice. R. Treydel

Castelli, *Wilhelm (Wilhelm August Heinrich Otto)*, jun., dt. Fotograf, * 17. 12. 1901 Lübeck, † 29. 5. 1984 ebd. 1917–20 Fotografenlehre in Hamburg. Stud.: 1921–23 Lehr- und Versuchsanstalt für Photogr., München (Meisterprüfung). Anschl. Spanienreise sowie längere Aufenthalte in Dresden, Düsseldorf und Berlin. 1927 Rückkehr nach Lübeck, wo C. die Foto-Abt. in der Drogerie seines Vaters betreibt (1970 Aufgabe des Geschäfts). 1942 Zerstörung des Negativ-Arch. bei der Bombardierung Lübecks. 1943 Stellungsbefehl; bei Kriegsende in Riga. Ausz.: 1953 Denkmünze in Silber der Ges. zur Beförderung gemeinnütziger Tätigkeit, Lübeck; 1965 Med. der Christian-Albrechts-Univ., Kiel. Mitgl. der Overbeck-Ges. (1961–72 1. Vors.). – Durch das Stud. in München ist C. anfänglich stark von der Kunst-Fotogr. geprägt. E. der 1920er Jahre lernt er durch die Vermittlung von Carl Georg Heise, Dir. des Lübecker Mus. für Kunst und Kultur-Gesch. und früher Förderer C.s, Albert Renger-Patzsch kennen, unter dessen Einfluß er sich der Bildsprache der Neuen Sachlichkeit öffnet. C. macht in dieser Zeit v.a. Aufnahmen von Lsch. und Pflanzen sowie einige Porträts. Von A. der 1930er bis E. der 1960er Jahre arbeitet er als Fotograf für das Mus. für Kunst und Kultur-Gesch. sowie das Amt für Denkmalpflege in Lübeck. In diesem Rahmen entstehen zahlr. Archit.- und Stadtansichten sowie Fotogr. von Skulpt. und Objekten, darunter etliche Aufnahmen in St. Marien und St. Katharinen. In den 1970er Jahren fotografiert C. vornehmlich Bäume. Seine Aufnahmen erscheinen als Ansichtskarten und Fotomappen im Eigenvertrieb sowie als Reprod. in zahlr. Monogr., u.a.: W. Stier/C., *Nieder-dt. Weihnacht in 32 Bildern aus ma. Altären*, Lübeck 1935; C. G. Heise/C., *Fabelwelt des MA. Phantasie- und Zierstücke lübeckischer Werkleute aus drei Jh.*, B. 1936; H. Schröder/C., *Lübeck*, B. 1940; C. G. Heise/C., *Die Gregorsmesse des Bernt Notke*, H. 1941; H. Wentzel/C., *Der Cismarer Altar*, H. 1941; C. G. Heise/C., *Der Lübecker Passionsaltar von Hans Memling*, H. 1950; M. Hasse/C., *Das Triumphkreuz des Bernt Notke im Lübecker Dom*, H. 1952; L. Wilde/C., *Die Katharinenkirche in Lübeck*, M./B. 1971. ⌂ LÜBECK, Mus. für Kunst und Kultur-Gesch. (Nachlaß). SCHLESWIG, Schleswig-Holsteinisches LM, Schloß Gottorf. ◉ *E:* 1947, '50 Lübeck, Öff. Bücherhalle, König-Str. (sog. Kleine Ausst. der Overbeck-Ges.) / 1950 Münster, Westfälisches LM. – *G:* Lübeck: 1929 Mus. für Kunst und Kultur-Gesch.; 1932 Behnhaus / 1995 Hamburg, KH, und Lübeck, Mus. für Kunst und Kultur-Gesch.: Die Neue Sicht der Dinge. Carl Georg Heises Lübecker Foto-Slg aus den 20er Jahren (K: O. Westheider). ◫ *H. Spielmann* (Ed.), 150 Jahre Photographie. Aus der Slg des Schleswig-Holsteinischen LM Schloß Gottorf, Neumünster 1989 (Kunst in SH, 31); *T. Albrecht*, Lübeck, schwarz-weiß. Photofachmann W. C. 1901–1984

(K Mus. für Kunst und Kultur-Gesch.), Lübeck 2002; *A. Bruns* (Ed.), Neue Lübecker Lebensläufe, Neumünster 2009 (Foto-Publ., Lit.). P. Freytag

Castellini, *Claudio*, ital. Comiczeichner, * 3. 3. 1966 Rom. Gewinnt 1986 einen Comic-Wettb. und zeichnet ab 1989 für die ital. Mysteryreihe Dylan Dog. 1991 ist er an der ersten Ausg. von Nathan Never beteiligt. 1993 Debüt in Amerika mit *Fantastic Four. Unlimited* für den Verlag Marvel. 1996 zeichnet er die Graphic Novel *Silver Surfer. Dangerous Artifacts* und vier Hefte von *DC versus Marvel*. Zu seinen Arbeiten zählen seitdem für versch. Großverlage in den USA u. a. Einzelhefte der Reihen Spider-Man, Conan the Barbarian, Wolverine und Star Wars Tales. – Die realistischen und detaillierten Zchngn von C. weisen einen starken Einfluß der US-amer. Comiczeichner Neal Adams und John Buscema auf, die in den 1970er Jahren den Superhelden-Comic prägten. ▭ *H. Filippini*, Dict. de la bande dessinée, P. 2005. – *Online:* Website C.; Lambiek Comiclopedia. K. Schikowski

Castello-Lopes, *Gérard*, frz.-portug. Fotograf, Filmemacher, Kritiker, Schriftsteller, * 1925 Vichy, tätig in Lissabon und Paris. Stud.: Inst. Superior de Ciências Económicas e Financeiras, Lissabon (Wirtschaft); als Fotograf Autodidakt. – 1955 Debüt mit Unterwasser-Fotografie. C. eignet sich die fotogr. Techniken aus Büchern und durch Vergleiche mit Abb. v.a. in internat. Mag. an. C.s Arbeit wird maßgeblich vom Werk Henri Cartier-Bressons beeinflußt, dem er 2005 eine Hommage-Ausst. widmet. Seine intensiven Schwarzweiß-Fotogr. sind Abbilder der meist bürgerlichen Realität, aber auch der Arbeitswelt und der sozialen Bedingungen einfacher Arbeiter, Bauern und Kinder (*Jugendlicher in Lissabon, Portugiesen schauen auf das Meer in Portimão, Eselkutsche,* alle 1957). Sie halten einzelne Personen und Gruppen bei alltäglichen Verrichtungen fest, im Gespräch, beim Spiel, und übernehmen zugleich moralische Verantwortung. Seine oft heiteren, heute nostalgisch wirkenden Bilder spiegeln die Isolation, aber auch die Schönheit und Kargheit des Landes. C. entwickelt sich zu einem der bedeutendsten Chronisten Portugals im 20. Jahrhundert. 1965 stellt C. das Fotografieren zunächst für einige Jahre ein. Die Nelkenrevolution gegen die herrschende Diktatur am 25. 4. 1974 markiert einen künstlerischen Wendepunkt in C.s Arbeiten. So entstehen nun stärker reflektierte Fotogr. von regungslosen Objekten, mit strengen Silhouetten, formaleren Komp. und einem ausgeprägten Gespür für den Moment und das Detail. Sie bilden die Objekte behutsam ab, als ob er sie zum ersten Mal wahrnehmen würde. Die Fotogr. thematisieren weniger soziale Umfelder als zunehmend Archit., menschenleere Lsch. und stillebenartige Ansichten, z.B. *Vittel* (2004), *Alentejo* (2006) und *València* (2006). Seit den 1980er Jahren verlagert C. sein Interesse immer mehr von der alltäglichen Realität hin zu dem, was er Paradox des Anscheins nennt. Seine frühen Ausst. finden in der ersten ausschl. der Fotogr. gewidmeten Gal. Ether in Lissabon statt, die maßgeblich zur Verbreitung seiner Bilder beiträgt. Ab 1989 erscheinen wiederholt Fotogr. in der von der Fund. Calouste Gulbenkian hrsg. Zs. Colóquio Letras sowie Portfolios in K, Marie Claire, O Independente, Público und Vis à vis International. Mehrfach werden seine Arbeiten als Titel-Ill. für Publ. verwendet, so u.a. für Die natürliche Ordnung der Dinge von A. Lobo Antunes (M. 1996), La Tête perdue de Damasceno Monteiro von A. Tabucchi (P. 1997) und für The Book of Disquiet von F. Pessoa (N. Y. 2002). C. schreibt 1964–66 als Filmkritiker für die Zs. O Tempo e o Modo und 1982–84 als Autor für A Tarde und Semanário sowie für versch. Ausst.-Kataloge. Außerdem wirkt er als Regie-Ass. an Kinofilmen, z.B. Os Pássaros de Asas Cortadas (1962), und gemeinsam mit Fernando Lopes und Nuno de Bragança als Autor und Produzent an dem Kurzfilm Nacionalidade. Portug. (1970) mit. 1969 Gründungs-Mitgl. des Centro Portug. de Cinema in Lissabon. C. ist Mitgl. des Conselho Consultivo Culturgest, des diplomatischen Corps der Ständigen Vertretung Portugals beim Europarat in Straßburg und 1991–93 Präs. der Jury des Inst. Portug. de Cinema. – Fotogr. Publ.: J. Cutileiro, *A Portug. rural Soc.*, Ox. 1971; *Perto da Vista*, Li. 1984; M. Esteves Cardoso, *Lorelei. Escult. de João Cutileiro*, Porto 1989; C./V. Graça Moura, *Em demanda de Moura. A la Recherche de Moura*, Li. 2000; *Giraldomachias. Onze Poemas de Circumstância e um Labirinto sobre Imagens de G. C.-L.*, Li. 2000; G. Dussaud u.a., *Portugal et India. Da Luz de Portugal ao Odor da India*, Li. 2000; C./J. M. Rodrigues, *Evora 2001. Discursos fotogr.*, Evora 2001; *Reflexões sobre Fotogr. Eu, a Fotogr., os outros*, Li. 2004. ▭ BARCELONA, Fund. Foto Colectania. CAMBRIDGE/Mass., Carpenter Center for the Visual Arts. CHARTRES-DE-BRETAGNE, Le Carré d'Art. ÉVORA, Arquivo Fotogr. Câmara Mpal. LE MANS, Assoc. le Festival de l'image. LISSABON, Casa Fernando Pessoa. – Col. Caixa Geral de Depósitos. – Fund. Calouste Gulbenkian. – Fund. Luso-Amer. para o Desenvolvimento. – Fund. Pereira, Leal, Martins, Júdice. – Mus. Col. Berardo. PARIS, Col. Caixa Geral de Depósitos. – FNAC. PORTO, Centro portug. de Fotogr. – Fund. Serralves. ◉ *E:* Lissabon: 1982 (K), '87 (K), '93 (K) Gal. Ether; 1986 (K), '96 (K) Fund. Calouste Gulbenkian; 2004 Centro Cult. de Belém (Retr., Wander-Ausst., K) / Paris: 1994 Centre Cult. Calouste Gulbenkian (K); 1998 Théâtre Molière – Maison de la Poésie (K) / Porto: 1997 (K), 2009 (mit Júlio Pomar, José M. Rodrigues, K) Fund. Serralves; 2007 Gal. Fernando Santos / 2003 Reggio nell'Emilia, Pal. Magnani (Retr., K) / 2007 Tavira, Gal. Mpal (Wander-Ausst., K) / 2008 Brüssel, Mus. royaux d'Art et d'Hist. / 2009 Champniers, Médiathèque; Castelnovo ne' Monti, Pal. Ducale (Retr.). – *G:* 1991 Brüssel: Europalia (K) / 1995 Barcelona, Fund. La Caixa: Europa do Pós-Guerra 1945–65. Arte depois do Dilúvio (Wander-Ausst., K) / 2000 Lissabon, Inst. Camões: Portugal e a Europa. Um Olhar portug. (K); Cascais: Bien. de Fotogr. / 2005 Paris, Centre Cult. Calouste Gulbenkian: Dedans-dehors. Le Portugal en Photogr. (K); Valladolid, Sala Mpal de San Benito: Vidas privadas (Wander-Ausst., K) / 2006 Barcelona, Fund. Foto Colectania: Estranyes Parelles. ▭ *J. Calado*, Técnica photogr. Maurício Abreu, Luis Parvão, C., Luiz Carvalho, Augusto Alves da Silva, Li. 2001; *S. Parmiggiani*

(Ed.), C. Vedere. Il sogno di una vita fotogr. 1956–2002, Mi. [2003]. – *Online:* Luminous-lint. World photogr.; Gal. Fernando Santos. C. Melzer

Castells (C. Cots), *Ricard (Ricardo)*, katalan. Illustrator, Comiczeichner und -autor, * 1955 Barcelona, † 17. 1. 2002 ebd. Ab A. der 1970er Jahre Veröff. von Comics in den Zss. Terror Gráf., Horror und Zombie. In den frühen 1980er Jahren Mitarb. des Fanzine Zero und Ill. für die Kinder-Zs. Cavall Fort. Zu Beginn der 1990er Jahre Co-Dir. der Zs. Medios Revueltos. Außerdem Karikaturen und Comics für zahlr. Zss., u.a. Ajoblanco, Avui, Diario de la Semana Negra (Gijón), Dossier Negro, El Ojo Clínico, El Viejo Topo, Penthouse, Playboy, Quimera und Viento del Pueblo. – C. zählt zu den bed. Comiczeichnern Kataloniens, der jenseits kommerzieller Aufträge versuchte, einen eig. träumerisch-poetischen, von Melancholie und Humor geprägten Zeichenstil mit zarter Kolorierung zu entwickeln. Seine bildnerischen Techniken sind komplex. So schafft er für das Album *Norte-Sur* (Vitoria 1989) *Dos estados de una unión* nach einem Skript von Antonio Altarriba Zchngn, für die er Anilin- und Purpurfarbe, Wachs, Pastell, Graphit und Filzstift verwendet. Er zeichnet das Comicalbum *Lope de Aguirre, III. La expiación* (Alicante 1998) nach einem Skript von Felipe Hernández Cava (Mejor Obra, Salón Internac. del Cómic, Ba. 1999) sowie *Made in Tintín. Col. Harry Swerts* (Ba. 1993) und *Tintín y el loto rosa. Homenaje a Hergé en su centenario* (Alicante 2007) von Antonio Altarriba. Erst in den letzten Lebensjahren veröffentlicht C. Bücher als Autor von Bild und Text in Personalunion, z.B. über den unter Amnesie leidenden Vampir *Poco* (zuerst in Japan publ.) und seine ungewöhnliche Freundschaft mit einem armen Mädchen. Außerdem Ill. für Kinderbücher und Bücher der Welt-Lit., z.B. *El burlador de Sevilla* (Ba. 1984) von Tirso de Molina, *Asedio y caída de Troya* (Ba. 1985) von Robert Graves, *Boris Godunov* (Ba. 1986) von Aleksandr Sergeevič Puškin und *Aventuras de Till Eulenspiegel* (Ba. 1987), sowie Werke von Alvar Valls und Miquel Obiols. Außerdem Entwürfe für Kalender, Buchumschläge, Schallplattenhüllen und Plakate. ✉ Poco, Ma. 1999; Huracán. El guardián del mercurio, Ma. 2001; Poco II. El jardín de la luna, Ma. 2001; Araia, Alicante 2003. ◉ *E:* Barcelona: 1975 Gal. Temps; 2005 Sala de Expos. del Districte de Gràcia (Retr.) / 1994 Brüssel, Centre Belge de la Bande Desinée. ☐ DPEE III, 1994; *J. Cuadrado*, Dicc. de uso de la historieta esp. (1873–1996), Ma. 1997. – Viñetas de España (K), Ma. 1992; *J. Cuadrado*, Atlas esp. de la cult. popular. De la historieta y su uso. 1873–2000, I, Ma. 2000; *J. Vidal*, El País (Ma.) v. 19. 1. 2002 (Nachruf). – *Online:* Lambiek Comiclopedia; Tebeosfera. M. Nungesser

Castelnau, *Paul (Pierre-Joseph-Paul)*, frz. Fotograf, Dokumentarfilmer, Geograph, * 17. 5. 1880 Paris, † 29. 6. 1944 (als vermeintlicher Kollaborateur hingerichtet) Montredon-Labessonnié/Tarn. Vor dem 1. WK Geographie-Stud. an der Sorbonne, Paris; 1920 Diss. an der Univ. Fribourg. 1914 mobilisiert: zunächst beim geogr., ab 1915 beim fotogr. und kinematografischen Dienst, wo er die handwerklichen Grundlagen von Film und Fotogr. erlernt.

– C.s fotogr. Werk besteht aus Autochrom-Platten, die er sowohl im 1. WK für die frz. Armee als auch anschl. für kurze Zeit im Auftrag von Albert Kahn für dessen Projekt „Les arch. de la planète" aufgenommen hat. Für die Armee dokumentiert er Truppenbewegungen, den Alltag der Soldaten und die Verwüstungen im Norden und Osten des Landes (u.a. 1917 in Reims) sowie in Belgien; weitere Aufnahmen entstehen 1918 in Arabien, Palästina, Ägypten und Zypern. Von Febr. bis Mai 1919 fotografiert er den Wiederaufbau in den kriegszerstörten Dépt. Aisne und Marne. Nach 1919 entwirft C. für Jean Brunhes, den Koordinator der Arch. de la Planète, eine Karte von Vorderasien (l'Asie occidentale). In den 1920er Jahren dreht er mehrere, teils wiss. Dokumentarfilme, so u.a. im Auftrag des Louvre über Ägypten und für die Expos. coloniale de Marseille in Marokko. 1922–23 nimmt er im Auftrag der Fa. Citroën an einer Durchquerung der Sahara im Auto teil; es entstehen die beiden Filme *Le traversée du Sahara en autochenilles* (1923) und *Le continent mystérieux* (1924); weitere Filme sind *Voyage à la Terre de Feu* (1925) und *La vie des termites*. Ab 1930 arbeitet C. in Montredon-Labessonnié als Vermessungsingenieur. 🏛 BOULOGNE-BILLANCOURT, Albert-Kahn, Mus. et Jardins. IVRY-SUR-SEINE, Fort d'Ivry, Etablissement de Communication et de Production Audiovisuelle de la Défense. MONTIGNY-LE-BRETONNEUX, Fort de Saint Cyr: La Médiathèque de l'Archit. et du Patrimoine, Arch. photogr. ✉ Le Niolo, ét. de géographie physique, in: La géographie 17:1908, 97–108; Les côtes de Corse. Etude morphologique, Diss. Univ. Fribourg, P. 1920. ◉ *G:* 2003–04 Canberra, Australian War Memorial: Captured in Colour. Rare Photographs from the First World War (K) / 2011 Antony (Hauts-de-Seine), Maison des Arts: Guerre et Vie. ☐ *A. Fleischer*, Couleurs de guerre. Autochromes 1914–1918, Reims et la Marne (K Reims), P. 2006; *P. Roberts*, 100 Jahre Farb-Fotogr., B. 2007; *B. Lavédrine/ J.-P. Gandolfo*, L'autochrome Lumière. Secrets d'atelier et défis industriels, P. 2009. – *Online:* La Médiathèque de l'Archit. et du Patrimoine. P. Freytag

Casthofer (Casthoffer), *Johann Heinrich*, schweiz. Goldschmied (möglicherweise identisch mit *Hans Heinrich Kasthofer*, get. 1. 1. 1666 Aarau, am 12. 10. 1694 Heirat mit Salome Imhof, evtl. der Goldschmiede-Fam. Imhof entstammend). – C. ist um 1700 in Aarau tätig. Für den Berner Patrizier Emanuel von Graffenried fertigt er technisch virtuos und von hoher plastischer Qualität ein Trinkgefäß in Gestalt eines kraftvoll schreitenden, heraldisch-steigenden Löwen. In den Pranken hält das Tier eine dem Wappen der Graffenrieds entlehnte gemeine Figur: den brennenden Baumstamm mit fünf Flammen. Der Auftraggeber macht das mit einem Widmungstext (Medaillon) versehene hochbarocke Prunkgefäß anläßlich seines Amtsantritts (1. 1. 1700) als Schultheiß von Bern der Ges. zu Pfistern zum offiziellen Geschenk. 🏛 BERN, HM: Löwe (Trinkgefäß mit abnehmbarem Kopf), Silber, vergoldet, sign. und dat., 1700. ☐ *P. Thormann u.a.*, Die Ges. zu Pfistern in Bern, Bern 1966; *R. L. Wyss*, Handwerkskunst in Gold und

Silber, Bern 1996. – *Online:* Ges. zu Pfistern. U. Heise

Castiglioni (C.-Zeier), *Albin*, schweiz. Bildhauer, * 19. 5. 1922 Basel, † 2007 ebd. Lebt 1937/38 in Chicago, 1945–47 in Bern; läßt sich dann in Basel nieder. Stud. ebd.: 1949–53 Gewerbeschule. 1949–58 Studienreisen (v.a. Provence). – Nach Beginn mit naturalistischen Darst. um 1949 allmählicher Übergang zur Abstraktion; v.a. Stein- und Metall-Skulpt. mit satirisch-ironischen Zügen. ◉ *G:* 1954 Biel: Schweiz. Plastik-Ausst. im Freien / 1956 Basel(?): Schweiz. Nat. Kunst-Ausst. ▢ *Plüss/Tavel* I, 1958; BLSK I, 1998. – *Online:* SIKART Lex. und Datenbank. R. Treydel

Castiglioni, *Luigi*, ital. Maler, Werbegraphiker, Plakatkünstler, Freskant, * 20. 11. 1936 Mailand, † 12. 6. 2003 Maisons-Laffitte/Yvelines. Stud.: 1950–57 ABA di Brera, Mailand; 1954–57 Szenographie-Ausb. am Teatro alla Scala bei Nikolaj Aleksandrovič Benois. 1958/59 in Rom-Cinecittà Mitarb. von Federico Fellini bei der Szenographie der Filme La dolce vita und Il bell'Antonio. 1960 Übersiedlung nach Paris, arbeitet hier als Maler und Graphiker (Umschläge der Wochen-Ztgn L'Express, Le Point, Valeurs actuelles, Entreprise, Salut le Copains, Lui, Jazz Mag.). 1972 entsteht sein erstes Sportplakat (WM-Boxkampf Monzon-Bouttier), in dessen Zentrum er zwei Boxhandschuhe mit den Portr. der Kontrahenten darstellt und so mit der Trad. bricht. Mit seinen farbintensiven, poetisch-phantasievollen, in der Nachf. des Surrealismus stehenden Sportplakaten hat C. diese Gattung revolutioniert und auf ein hohes künstlerisches Niveau gehoben (über die Hälfte seiner ca. 300 Plakate gilt dem Sport; z.B. Boxkampf Muhammad Ali-Ken Norton, 1976; Fußball-WM in Spanien, 1982, und Frankreich, 1998; Tennisturnier von Monte Carlo, 2001). And. Plakate behandeln kult. Ereignisse, Ausst. und humanitäre Fragen (z.B. *Votre Solidarité* für Solidarność, 1989; Zivilopfer des Krieges, für das Internat. Rote Kreuz, 1990; *Sahawari*, 2002). C. war auch als Freskant erfolgreich: 1959/60 malt er in San Remo Fresken in versch. Hotels, 1975 freskiert er eine Hauswand in S. Teodora/Sardinien, 1979 entsteht ein an Motive von René Magritte erinnerndes Wandbild von 500 m² im Polizeikommissariat von Maisons-Laffitte. – Ausz.: 1969 Grand Prix Martini für Plakat *Music Hall-les Beatles*; 1971 Grand prix de peint. de la Côte d'Azur; 1980 Grand prix de l'Affiche franç. für das Plakat des Filmfestivals von Cannes; 1985 Cavaliere dell'Ordine al Merito della Repubblica Ital.; 1988 Ambrogino d'oro, Mailand; 1989 Gold-Med. Solidarność, Warschau; 1994 Palma d'Oro, Salone Internaz. dell'Umorismo, Bordighera. 2004 gründet seine Witwe die Assoc. L. C., die v.a. Ausst. organisiert. ▥ Paris, Bibl. Fornay. – BN. – MAD. – MN du Sport. – Mus. Roland Garros. Rom, Comitato Olimpico Naz. Ital. Saint-Lo, MBA. Toulouse, Centre de l'affiche. Warschau, Muz. Plakatu w Wilanowie. ✉ Le sport en affiches, P. 1986. ◉ *E:* Mailand: 1955 Gall. Baggio (K); Gall. S. Fedele / San Remo: 1958 Casino (K); 1976 Des Etrangers / 1965 Belfast, Gall. Clendining / 1968 London, Center Lamont-Cavendish; Manchester, Gall. Higham Tong / Paris: 1970 Espace Publicis; Gal. Pirandello; 1977 Gal. de

Neuilly (K); 1978 BN (K); 1979, '86 FNAC; Gal. Alliance; 1980 Gal. Artcurial; 1981 Gal. Art visionnaire; 1983 Espace AGF Richelieu; 1985 UNESCO; 1988 MN du sport; 2008 Maison du sport franç. 2009 CNIT / 1971 Berlin, Centre cult. franç. / New York: 1971 Gall. Flushing; 1983 Lincoln Center / 1973 Varese, Gall. La Bilancia (K) / 1975 Rom, Gall. Remo Croce (K); Spoleto, Gall. Fontan'Arte / 1984 Bordeaux, Centre d'arts plast. contemp. / 1987 Rouen, FNAC / 1989 Warschau, Muz. Plakatu w Wilanowie / 1991 Meulun, Mus. Saint-Jean / 1992 Honfleur, Mus. Boudin; Villeneuve-d'Ascq, MAM / 1994, 2000 Maisons-Laffitte, Ancienee Eglise (K) / 1997 Starnberg, Schloßberghalle (K) / 1998 Toulouse, Mus. de l'affiche (K); Saint-Lô, MBA (K) / 2000 Sondrio, Gall. Credito Valtellinese (K) / 2001 Monte Carlo, Grimaldi Forum. ▢ *Bénézit* III, 1999. – *R. Clermont*, La rev. mod. des arts et de la vie 1973 (2) 21; *A. Ginesi*, L. C. Pittore e „affichiste" (K), Macerata 1978; Gal. des arts (P.) 1983 (215–219) 40 ss.; L. C. Peintre et affichiste, P. 1989; *A. Travagliati*, Boll. del Centro Studi Grafici di Milano 2000 (März); *A. Parinaud*, L. C. Peintre et „affichiste", P. 2003; *C. Germak*, Arts gazette internat. Nr 369 v. 24. 3. 2004; *D. H. T. Scott*, The art and aesthetics of boxing, Lincoln 2008; *L. Schena*, in: Pulchrum. Studi in onore di Laura Meli Bassi, Sondrio 2009, 261–276. – *Online:* Website C. (Ausst., Bibliogr.); Artactif, 2010. E. Kasten

Castiglioni, *Piero (Pietro Maria)*, ital. Designer, * 1944 Lierna/Como, lebt in Mailand, wo er ein eig. Designbüro leitet. Sohn von Livio C., Neffe von Achille und Piergiacomo C. Stud.: bis 1970 Univ. Mailand (Archit.; Dipl.). Danach bis 1979 zus. mit dem Vater tätig. Den Durchbruch erzielt C. 1972 zus. mit Ugo La Pietra mit einem Designprojekt auf der Ausst. Italy, the new domes landscape (New York, MMA). Lehrtätigkeit: 1985/86 (experimentelle Licht-Gest.) und ab 1995 (Industriedesign) an der Univ. Mailand, Fac. di Archit.; seit 1995 Univ. Genf, Inst. d'Archit. (Lichtdesign, Archit.), seit 2000 Accad. di Brera, Mailand. – C. ist einer der weltweit führenden Lichtdesigner, der häufig mit Achille C. zusammenarbeitet. Er entwickelt Beleuchtungskonzeptionen für Kunst-Ausst., Messen (u.a. ab 1974 für die Fa. Osram), Gal., v.a. für Mus. (u.a. Paris, Centre Pompidou, 1985, und Mus. d'Orsay, 1986; Barcelona, MN d'Art de Catalunya, 1987; Groninger Mus., 1994), öff. Räume (Hafengelände Genua, 2000; hist. Zentrum von Mantua, 2002) und Gebäude (u.a. der Méridien-Hotels in Saudi-Arabien, 1975–79). Außerdem Entwürfe für Beleuchtungskörper, u.a. Leuchtenserie *Scintilla* für Fontana Arte, 1972–83, ferner für Guzzini, Stilnovo, Venini und Siemens in sparsamen, sachlich-edel wirkenden Formen, bevorzugt aus Aluminium und Edelstahl, wie die 2006 mehrfach ausgezeichnete Hängeleuchte *Diabolo* (mit Achille C.). Zahlr. Beitr. in archit. Fachliteratur. ▥ Paris, MNAM. ✉ C. u.a., Uno spettacolo di luce, Bo. 1984; La lampada. 120 oggetti di produzione contemp., Mi. 1984; L'apparecchio illuminante e l'archit., in: L'opera d'arte e lo spazio archit., Mi. 1988; C. u.a., Lux. Italia 1930–1990. L'archit. della luce, Mi. 1991; Luci sulla stazione, in: Roma Termini, Bo. 2000, 100–106;

Illuminare il centro stor., in: Archit. pisane 2:2004, 36–39. 👁 *G:* 1973 Mailand: Trienn. 📖 *A. Pansera* (Ed.), Diz. del design ital., Mi. 1995; Dict. internat. des arts appliqués et du design, P. 1996. – Italy. The new domestic landscape (K), N. Y. 1972, 224 s.; 1928–1973 domus: 45 ans d'archit., design, art, II, Mi. 1973; 1970–1980, Dal design al post-design, Mi. 1980; *R.-P. Baacke* u.a., Design als Gegenstand, B. 1983; Il sistema Scintilla. Livio e P. C., Mi. 1987; *A. Pausera*, Storia del disegno industriale ital., R./Bari 1993; *S. De Ponte*, Archit. di luce, R. 1996; *L. Falconi*, Fontana arte. Una storia trasparente, Genève/Mi. 1998; *E. Karcher/M. von Perfall*, Ital. Design von den Anfängen bis zur Gegenwart, M. 2000; *D. Scodeller*, Livio e P. C. Il progetto della luce, Mi. 2003; *A. Bassi*, La luce ital. Design delle lampade 1945–2000, Mi. 2003; *id.*, Casabella 68:2004 (727) 90–93. – *Online:* Website C. (WV, Lit.).

D. Trier

Castiglioni-Zeier, *Albin* → **Castiglioni,** *Albin*

Castilhos, *Laura (Laura Gomes de),* brasil. Malerin, Zeichnerin, Illustratorin, * 1959 Porto Alegre, dort tätig. Stud.: 1976–77 Atelier Livre da Prefeitura Mpal, Porto Alegre; 1981–83 Zeichnen u.a. bei Teresa Poester, Jailton Moreira, João Luiz Roth, Cármen Silvia Morales; 1982–86 Inst. de Artes da Univ. Federal do Rio Grande do Sul (UFRGS) ebd.; 1988–90 Univ. Complutense, Madrid (Doktorat). Lehrt am Inst. de Artes da UFRGS, Porto Alegre (Zeichnen, Aqu.). Ausz.: 1982 Prémio des Salão do Jovem Artista, 1995 Preis für den besten Gedichtband der Assoc. Paulista de Críticos de Artes und der Fund. Nac. do Livro Infanto-Juvenil, 1998, '99, 2001 Prémio Açorianos da Prefeitura Mpal und 2005 Prémio Editorial der Fund. Iberê Camargo, alle Porto Alegre. – Fertigt Gem., Collagen und v.a. Ill. für Kinder- und Jugendbücher. Die narrativen, farbenfrohen Ill. entstehen als Aqu., kombiniert mit Tusche oder Wachsstiften. Meist sind sie kleinteilig-mosaikartig, in kindlicher Formensprache gestaltet und zeichnen sich durch überbordenden Detailreichtum aus; teilw. erinnern diese Arbeiten an Motive von Marc Chagall; auch Spielzeugobjekte aus bemaltem Ton, etwa eine Eisenbahn für *Saco de Brinquedos* (1997), oder Collagen fungieren als Vorlagen für Illustrationen. – Buch-Ill. (alle erschienen in Porto Alegre): V. Aguiar u.a., *Poesia fora da Estante* (1995); G. de Souza, *Saco de Mafagafos* (1997); C. Ubim, *O Saco de Brinquedos* (1997); S. Capparelli, *A Árvore que dava Sorvete* (1999); G. Finkler/J. Zambelli, *A Mulher gigante* (2000); G. Finkler, *A Família sujo* (2002); R. Gabrauska/G. Finkler, *Sabrina, 40 Fantasmas e mais uns Amigos* (2005); B. Sica Lamas, *Ampulheta* (2007); R. Gabrauska, *As Hist. mais loucas do Mundo* (2007); H. Bacichette, *T de Ti T de Ta* (2008). 🏛 PORTO ALEGRE, Inst. de Artes da UFRGS. 👁 *E:* 1985, 2008 (mit Elton Manganelli) Porto Alegre, Gal. Arte e Fato / 2008 Cachoeirinha (Rio Grande do Sul), Casa do Leite. – *G:* Rio de Janeiro: 1984 Salão Nac. de Artes plást.; 2009 Centro Cult. Ação da Cidadania: Cores e Formas que contam Hist. / 1986 Curitiba, MAC: Mostra do Desenho Brasil. / Porto Alegre: 2005 Mus. da UFRGS: Pequenos Diálogos. Arte e Intertextualidade (K); 2007 Espaço Cult. Chico Lisboa: Iluminadores;

Pin. do Inst. de Artes da UFRGS: Uma Hist. do Desenho; 2009 Gal. Arte e Fato: Rever 08. 📖 *R. Rosa/D. Presser*, Dic. de artes plást. no Rio Grande do Sul, Porto Alegre [2]2000. – *Online:* Inst. Itaú Cult., Enc. artes visuais; Website C.

C. Melzer

Castillejos (C. Furió), *Andreu,* span. Maler, Zeichner, Wandmaler, Fotograf, * 1942 Elx/Alicante, lebt dort. Autodidakt. Mitbegr. der Künstlergruppen Grup d'Elx (1966) und Esbart Zero (Grupo Cero, 1987), ebd. 1966 Ausst.-Debüt in Cartagena. 1979 wird C. erstmals beauftragt, großformatige Wandbilder für öff. Einrichtungen zu schaffen. In den 1980er Jahren reist er mehrfach nach Nikaragua. – C. malt zunächst in einem dem Expressionismus nahestehenden Stil, später sind auch Einflüsse der Pop-art zu erkennen. Seine sozialkritischen Arbeiten zeigen häufig von Schmerz und Hoffnungslosigkeit gezeichnete Personen. 2009 entsteht die abstrakt-expressionistische Bilderserie *De llums y d'ombres*, in der er auch mit Fotogr. arbeitet. 🏛 ALICANTE, Mus. der Prov.-Verwaltung. BENISA, Pin. Mpal. ELX, MAC. HUESCA, MAC del Alto Aragón. LARRES, Mus. del Dibujo „Castillo de Larrés". SAN SEBASTIAN, Mus. de San Telmo. VILLAFAMES, MAC. 👁 *E:* Valencia: 1968 Sala Hoyo; 1975 Soc. Coral El Micalet / 1972 Murcia, Gal. Delos / Elx: 1974 Sala Estudio; 1980 Sala Lloc d'Art; 2009 Kongreßzentrum / 1975, '80 Madrid, Gal. Novart / Alicante: 1978 Gal. 11; 1993 Pal. Gravina / 1979 Córdoba, Sala Antonio del Castillo; Barcelona, Gal. Matisse / 1980 Burgos, Sala Arlanzón / 1989 Logroño, Mus. de La Rioja / 1991 Avignon, Pal. des Papes. – *G:* 1975 Barcelona: Bien. de Pint. Contemp. 📖 DPEE III, 1994; *Agramunt Lacruz* I, 1999. – *Wilhelmi*, 2006.

S. Herczeg

Castillo, *Eugenio del* (Pseud. Casdel), span. Maler, Architekt, * 1953 Madrid, lebt dort. Stud. ebd.: Zeichnen an der Esc. de Artes Aplicadas y Oficios Artíst.; Innen-Archit. an der Esc. de Artes Decorativas. Als Maler Autodidakt. – Expressive Bilder mit abstrakten und surrealen Elementen, v.a. Lsch., Portr. und Figurenbilder. 🏛 BARCELONA, Fund. Tàpies. MARBELLA, Mus. del Grabado Esp. Contemp. MIAMI, Florida Mus. of Hispanic and Latin Amer. Art. OTTAWA, NG of Canada. PARIS, Centre Pompidou. 👁 *E:* Madrid: 1979 Casa de la Juventud de Vallecas; 1980 Club de Arte Eolo; 1983 Centro Cult. Padre Llanos; 1984 Gal. de Arte Chamartín; 1988 Centro Cult. Alberto Sánchez; 1991 Gal. Zurbarán; 1993 Gal. Torres Begué / 1982 Guadalajara, Centro Cult. / 1986 Albacete, Caja de Ahorros. 📖 DPEE III, 1994.

M. Nungesser

Castillo, *Joel Darío (Joel; Joel D.),* honduranischer Maler, * 16. 7. 1948 Güinope/El Paraíso, lebt in Tegucigalpa. Stud.: bis 1967 ENBA, ebd. Ausz.: u.a. 1966 ehrenvolle Erw., Expos. Juniana; 1968 1. Preis, Salón de Pint., beide San Pedro Sula; 1986 1. Preis, Expos. y Concurso de Pint. Bosques, Univ. Nac. Autónoma de Honduras, Tegucigalpa. – Vom Impressionismus angeregte Gem. in Öl, Acryl und Mischtechnik von honduranischen Lsch., Genreszenen und Stilleben in leuchtenden, pastosen Farben. Außerdem abstrakt-informelle Bilder in z.T. reduzierter, gedämpfter Farbigkeit mit zentral angeordneten dynamisch-

linearen Strukturen. ⌂ TEGUCIGALPA, Banco Central de Honduras. ◉ *E:* Tegucigalpa: 1968 Gal. La Botija; 2002 Club Rotario Tegucigalpa Sur, Centro Cult. Clementina Suárez; 2007 Hotel Honduras Maya / La Ceiba: 1975 Hotel La Quinta; 1979 Claus Gal. / 1975 San Pedro Sula, Centro Cult. / 1977 Miami (Fla.), Midway Mall / 1996 Madrid, Inst. de Cult. Hispánica. – *G:* 1974 Bonn, Ibero-Club: Cuatro pintores hondureños (Wander-Ausst.). ▭ *R. Fiallos S.*, Datos hist. sobre la plástica hondureña, Tegucigalpa 1989; *M. R. Argueta Dávila*, Dicc. de artistas plástica hondureños, Choluteca 1996; Generaciones que marcaron huellas. Antología de la Col. de Arte del Banco Central de Honduras, Tegucigalpa 2007. – *L. de Oyuela*, La batalla pictórica. Síntesis de la hist. de la pint. hondureña, [Tegucigalpa] 1995. – *Online:* Gal. Welmami.

 M. Nungesser

Castillo (C. Cossío), *Lola del*, span. Malerin, Graphikerin, * 1952 La Laguna/Teneriffa, lebt dort. Stud.: 1970–74 EBA der RABA de S. Fernando, Madrid (1990 Promotion); 1987 ASK Antwerpen. Seit 1992 Prof. an der Fac. de BA der Univ. in La Laguna. Ausz.: Premio Cirilo Romero (Zchng) der Expos. Regional de Pint. y Escult., Santa Cruz de Tenerife; 1. Preis (Malerei), Bien. de Artes Plást. ebd. – C.s Gem. (Öl/Lw.) zeigen lichtdurchflutete, häufig menschenleere Interieurs (auch Säle, Foyers, Hallen), die bes. durch präzis ausgef. Schattenbilder gekennzeichnet sind, in einem zw. Realismus und Neoexpressionismus angesiedelten Stil. 2004 entsteht die abstrakte Gem.-Serie *El Viaje de la Semilla* (Öl/Lw.). Auch im graph. Werk (Lith., Rad., Aquatinta) dominieren kontrastreich dargestellte Innenräume, daneben Stadtansichten und urbane Szenen, auch Miniaturen. ⌂ MADRID, BN. SANTA CRUZ DE TENERIFE, Mus. Mpal de BA. ◉ *E:* La Laguna: 1974 (Debüt), '75 Casino; 1978 Sala Conca; 1983, '87, '97 Centro de Arte Ossuna; 1988, 2001 Caja Canarias / Santa Cruz de Tenerife: 1986 Sala de Arte Garoé; 1987, '97 Gal. Magda Lázaro; 1991 Sala de Arte Los Lavederos; 1994 Círculo de BA; 2007 Centro de Arte La Recova / 1987, '97 Antwerpen, ASK / Pamplona: 1992 Gal. Lacava; 1993 Gal. Pintzel / 1996 Alexandria, Centro Cult. Esp. / 1998 Havanna, Casa de la Obra Pía / 2002 Málaga, Centro Cívico de la Diputación / 2004 Beirut, Inst. Cervantes. – *G:* 1994 Madrid, BN: Donaciones de Obra Gráfica / 1998 Bajamas: Bien. de Min. / 1999 Kairo: Trienn. of Graphic Arts / 2000 Buenos Aires, Centro de Arte Mod.: Diez grabadores esp. / 2007 Santa Cruz de Tenerife, Auditorio: Ventana al Arte. ▭ DPEE III, 1994. – *Online:* Website C. S. Herczeg

Castillo, *Naia del*, span. Bildhauerin, Fotografin, * 1975 Bilbao, lebt dort. Stud. (Skulpt.): 1993–98 Univ. del País Vasco ebd.; 1996–97 Koninkl. Acad. voor Kunst en Vormgeving, 's-Hertogenbosch; 1999–2000 Chelsea College of Art and Design, London. Stip.: 2007 Accad. di Spagnia die BA, Rom; 2008 baskische Regierung. – C.s erste Serie *Atrapados* (2000–02), die Stühle, Betten und Kissen zeigt, an welche Frauen mit ihren Kleidern genäht sind, macht die trad. Bindung an die Haushaltsobjekte anschaulich. Diese szenischen Konstruktionen werden in Performances präsentiert und streng formal fotografiert, Fotogr.

und Inszenierungen bilden eine Werkeinheit. Neuere Serien wie *Sobre la seducción* (2002–04) und *Ofrendas y posesiones* (2004–06) nutzen aufwendig ornamentierte weibliche Kleidungsstücke oder skulpturale Objekte. C.s Werke visualisieren damit die soziale Konstruktion von weiblicher Identität sowie die Interaktion zw. den Geschlechtern. ⌂ BILBAO, Stadtverwaltung. HOUSTON/Tex., MFA. MADRID, CARS. – Fund. Caja Madrid. – Prado. MALAGA, Centro de Arte Contemp. PARIS, Maison Europ. de la Photogr. SANTA CRUZ DE TENERIFE, Espacio de las Artes (TEA). VITORIA, Artium. ◉ *E:* 2002 Bilbao, Gal. Bilkin / Madrid: 2002 Gal. Maria Martín; 2004 Alcalá 31 (K) / 2003 Eivissa, Gal. Carl van der Voort / Barcelona: 2003, '06 Gal. dels Angels / 2004 Vitoria, Artium (K) / 2005 Almagro, Gal. Fúcares / 2005, '09 Houston (Tex.), De Santos Gall. / 2008 Logroño, Sala Amós Salvador (K) / 2009 Segovia, MAC „E. Vicente". – *G:* 2002 Toulouse: Festival Printemps de Septembre / 2003 Vigo, MAC: Indisciplinados; Girona: Temps de Flors (K). ▭ *R. Olivares*, 100 fotógrafos esp., Ma. 2005. – Nuevas hist. A new view of Spanish photogr. and video art (K Stockholm), Ostfildern 2008. – *Online:* Website C. D. Sánchez

Castillo Bartolomé, *Carmen*, span. Bildhauerin, Keramikerin, * 7. 11. 1959 Zaragoza, lebt in Cereceda/Asturias. Lebens- und Ateliergemeinschaft mit dem Bildhauer und Keramiker Ernesto Knorr Alonso. In der Kindheit Umzug nach Asturias. 1983 Stud. an einer Keramikschule. 2008 Teiln. am Certamen Nac. de Esculturas Flotantes, Laguna de Duero. Ausz.: u.a. 1996 1. Preis im Ideen-Wettb. Primera Univ. de España, Palencia. – Seit 1979 gestaltet C. Keramik, seit 1988 auch Figürliches, z.T. in and. Mat., schließlich meist in Bronze oder Polyester. Ihre von Henry Moore beeinflußten Plastiken zeigen stilisierte, menschliche Befindlichkeiten zum Ausdruck bringende Figuren, meist mit rundlich-voluminösem, teils glocken- oder bergähnlich asymmetrisch geformtem Rumpf, mit glatter Oberfläche und kleinem Kopf, ausgef. in mon. Form (z.B. *Complicidad; Sedente; Incertidumbre*) oder als Kleinplastik (*Observación y adaptación; Hombres roca*). C. gestaltet auch schlanke und stelenartig in die Länge gezogene Figuren, einzeln, als Gruppe oder dialogartig aufeinander bezogen (*Erinias*, 2001; *Ambivalencia*). Auch zahlr. Werke im öff. Raum, z.T. direkt auf Gehwegen oder Plätzen ebenerdig plaziert, meist mit angedeuteten Körperproportionen und Gliedmaßen. ⌂ AVILES/Asturias, Bibl. La Luz. HUELVA, Mus. de Escult. V Centenario. MADRID, Col. Masaveu. SALAMANCA, MAC. – *Arbeiten im öff. Raum, meist Bronzeplastiken:* ALCALA DE HENARES/Madrid, Mus. de Escult.: Filo, 1992. ARACENA/Huelva, Mus. de Escult. Contemp., Pl. de Sa. Lucía: Diálogo (oder Conversación), 1990. BENIA DE ONIS/Asturias, Pl. Mayor: Al Pastor de los Picos de Europa, 1998. CACERES, Mus. de Escult.: Encuentro, 1997. CORVERA/Asturias: Centro de Salud de Las Vegas: Diferentes pero iguales (oder Contra el racismo), 1995. INFIESTO/Asturias, Jardines de la Obra Pía: Homenaje a la avellanera asturiana, 1990. LA GARRIGA/Barcelona, Gran Hotel Balneario Blancafort: Calma, 2004. Oss/Niederlande, Ziekenhuis Bernhoven: La danza, 1999.

PALENCIA, Aula medieval: Mon. a la primera Univ. de España, 1997. POLA DE SIERO/Asturias, Parque de la Música: A dos músicos de Pola de Siero, 2001. RUBI/Barcelona, Pl. de la Antigua Estación: Dansaire, 2003. SALOU/Tarragona, Calle Pau Casals: A P. Casals, 2007. VALLADOLID, Hacienda Abascal: Temperamento, 2007. ◉ *E:* 1985 Orense, Rincón de Arte / Oviedo: 1987, '91 Gal. Benedet; 1994 Gal. Marta Llanes; 2009 Gal. Texu (mit Javier de la Roza) / Madrid: 1989 Gal. Aldaba; 1996, '99 Gal. Raquel Ponce; 2000 Gal. Pi & Margall; 2005 Gal. de Arte Fruela (mit E. Knorr Alonso; K: C. Pallarés) / 1990 Valladolid, Caja de Ahorros Popular, Sala Fuente Dorada / Gijón: 1990 Gal. Munuza Uno; 2001 (K), '04 Gal. Cornión / 1998 Zaragoza, Urban Gall.; Paris, Gal. Martine Namy Caulier / 1998, 2004, '10 (mit E. Knorr Alonso) Oss, Reinart Gall. / 2000 Elche, Sala Mpal / 2000, '04 Jaén, Pal. Prov., Salas Prov. de Expos. (mit E. Knorr Alonso; K) / 2004 Puerto del Rosario (Fuerteventura), Sala de Expos. Gomer (mit E. Knorr Alonso; K) / 2007 Bilbao, Gal. Xanon. – *G:* 2000 Gijón, Mus. Barjola: El diálogo del arte. ▭ Gran enc. asturiana, Gijón 1982; DPEE III, 1994. – *R. Rodríguez,* Asturias. Escultores de cinco décadas, Oviedo 1995; *L. Feás Costilla,* Cat. de ausencias, in: Artistas asturianos, IX, Oviedo 2002, 20 s.; *A. A. Rodríguez,* El Comercio (Gijón) v. 31. 1. 2002; *J. C. Gea,* La Nueva España (Oviedo) v. 7. 4. 2009. – *Online:* Website C. – Mitt. C.

M. Nungesser

Castillo Cossío, *Lola del* → **Castillo,** *Lola del*

Castillo Garcès, *Mariano,* span. Graphiker, Illustrator, * 1963 Grisén/Zaragoza, lebt in Cartuja Baja. Stud.: Esc. de Arte, Zaragoza, bei Monir Islampur. Mitarb. im Atelier von Maite Ubide ebd. Seit 1990 ausschl. Druckgraphik. – C.s Arbeiten zeigen Lsch., Dorf- und Stadtansichten (z.B. *Casas colgantes,* Rad./Aquatinta) in einem klassisch-naturnahen Stil, daneben auch Figürliches wie die Serien *Goyesca, Música* oder *Reyes medievales.* 2008–09 entsteht die aus zehn Druckplatten zusammengesetzte Rad. *La Gran Vista* (100 x 250 cm), die das Stadtpanorama von Zaragoza zeigt. Auch Ill. für Zss. und Ztgn (z.B. *Heraldo de Aragón*) sowie für Buch-Publ. (*Secretos del tiempo escondido* von Ramón Acín). ▭ MADRID, BN. PANAMA-STADT, MAC. ZARAGOZA, Mus. Prov. – Bibl. de Aragón. ◉ *E:* Zaragoza: 1986, '91 Sala Esc. de Artes; 1987 Sala Bonanza; 1988, 2000 Sala Barbasán; 2006 Bibl. de Aragón / 1990 Fuendetodos, Mus. de Grabado / 1995 Valencia, Gal. de Arte Nave Diez / 1997 Pamplona, Gal. Molmar / 1998 Lissabon, Gal. Tórculo / 2008 Huesca, Sala CAI. – *G:* 1998 Orense: Bien. Internac. de Grabado / 2006 Borja: Bien. de Grabado. ▭ DPEE, Ap., 2002. – *Online:* Website C. S. Herczeg

Castiñeiras Iglesias, *José,* span. Bildhauer, * 1941 Buxán, lebt in La Coruña. Stud.: 1956 Maestría industrial (Holzbildhauerei); Esc. de Artes y Oficios Maestro Mateo, Santiago de Compostela, bei Francisco Asorey (Modellieren) und Manuel López Garabal (Zeichnen). Mitarb. in Wkst. für Ornamentik, relig. Schnitzerei und Kunsthandwerk. In La Coruña an der Gest. der Pl. del Humor beteiligt. Ausz.: u.a. 1980 1. Preis für Skulpt. der Stadt La Co-

ruña; 1985 Premio Tomás Francisco Prieto, Fábrica Nac. de Moneda y Timbre, Madrid. – Angeregt vom Kubismus, v.a. Alexander Archipenko, gestaltet C. fast ausschl. in Holz und Stein zur Monumentalität neigende Skulpt., bei denen die menschliche Gestalt im Zentrum steht, darunter zahlr. Denkmäler und and. Arbeiten für den Stadtraum. Meist verleiht der Wechsel von konvexen und konkaven Formen den Werken Dynamik, teils ergibt sie sich auch aus den Motiven, z.B. bei den Brunnen-Skulpt. von Wellensurfern und Möwen. Die Tendenz zur Abstraktion ist versch. stark ausgeprägt, läßt Figürliches oder Gegenständliches aber immer noch erkennen. Auch Kleinplastik, teils in elegant geschwungenen Formen (*Banderilla,* Bronze, 1982). ▭ LA CORUÑA, Club Financiero. – Col. Caixa Galicia. SANTIAGO DE COMPOSTELA, Univ., Casa da Balconada. – *Skulpt. im öff. Raum:* BAIONA: Lectura solar, Granit, Bronze, 1984. LA CORUÑA: Fuente de las Catalinas. – Pl. de la Estación: Mon. al ferrocarril. – Jardines de Méndez Núñez: Mon. a Wenceslao Fernández Flórez, Granit. – Figura femenina con trenzado, Granit, beide 1985. – Polígono de Sabón: Forma obligada, Granit, Kupfer, 1986. – Pl. de Portugal: Gaviotas, Stahl. – Paseo Marítimo Orzán-Riazor: Surfistas, Bronze, beide Brunnen 1992. – Calle de Barcelona: Mujer sentada sobre columna, Granit, 1993. – Pl. de María Pita: Mon. a M. Pita, Bronze, Granit, 1998. PONTEDEUME: A Rosalía de Castro, Granit, 1998. ◉ *E:* 1983 Madrid, Gal. Mayte Muñoz / 2006 Santiago de Compostela, Fund. Araguaney / 2007 La Coruña, Casino del Atlántico. ▭ DPEE III, 1994. – *C. del Pulgar Sabín* (Ed.), Artistas escultores. Realismos – abstracciones, Vigo 2003. – *Online:* Concellaría de Cult., Santiago de Compostela.

M. Nungesser

Castle, *James,* US-amer. Zeichner, * 24. 9. 1900 Garden Valley/Ida., † 26. 10. 1977 Boise/Ida. Über C. ist wenig bek., Überlieferungen zufolge ist er gehörlos oder als Autist geboren. Er lernt weder Sprechen, Lesen noch Schreiben und verweigert sich auch der Gebärdensprache. Texte, Buchstaben, Zahlen und Symbole haben für ihn jedoch eine gewisse Bedeutung, da sie oft in seinen Arbeiten auftauchen, jedoch bleibt unklar, was er mit ihnen verbindet. Verbringt sein gesamtes Leben bei seinen Eltern auf der Familienfarm in der Nähe von Boise, wo der Vater auch als Postbeamter des Ortes beschäftigt ist. Die bereits seit früher Kindheit entstehenden, obsessiv produzierten Zchngn scheinen für C. zu einer Art Kommunikationsmittel geworden zu sein. Gestaltet seine Arbeiten ausschl. aus vorgefundenen Alltagsmaterialien. Zeichnet mit Ruß, Speichel und angespitzten Holzstöckchen (gelegentlich auch in Kombination mit farbigen Tuschen) auf Papierabfällen Motive aus seiner unmittelbaren Umgebung, z.B. Dorfansichten, Interieurs, Gebäude, Menschen, Tiere, aber auch Zigarettenschachteln, Anzeigen, Trommeln, Herzen und and., teilw. nicht identifizierbare Gegenstände. Mitunter gestaltet er ein bestimmtes Motiv aus unterschiedlichen Blickwinkeln. Einige Arbeiten zeichnen sich durch eine erstaunlich differenzierte Handhabung von Licht und Schatten, kraftvolle Linien und nuancierte, die Oberfläche belebende Texturen aus. Die Beherrschung der Perspekti-

ve und räumlichen Tiefe eignet sich C. selbständig durch Beobachtung und Nachahmung an. Anregungen bezieht er auch aus Ztgn, Zss., Büchern, Kat., Anzeigen, Verpackungen etc. Neben einer Vielzahl von Zchngn hinterläßt C. auch zahlr. selbstgebundene, minutiös ill. Bücher, bei denen er mit Wellenlinien Schrift imitiert (z.B. *Mannings Coffee Book*, nach 1932), Collagen sowie aus Papier und Strick gefertigte, z.T. bemalte Objekte (Figuren, Tiere, Kleidungsstücke). C.s Schaffen, das erst sehr spät bek. wird, ist v.a. geschätzt aufgrund der authentischen, reizvoll-urspr. Art, den zeichnerischen Fähigkeiten und der Vielfalt hinsichtlich Inhalt und Ausdrucksmitteln. Mit Unterstützung der Found. for Self-taught Amer. Artists hat Jeffrey Wolf 2008 einen Film über C. produziert u.d.T. J. C. Portrait of an Artist. ⌂ ATLANTA/Ga., High Mus. of Art. BERKELEY/Calif., Berkeley AM and Pacific Film Arch. BOISE, AM. CHICAGO, Art Inst. COLUMBUS/Ohio, Mus. of Art. MILWAUKEE/Wis., AM. NEW YORK, Amer. Folk AM. – MMA. – Public Libr. – Whitney. ORLANDO/Fla., Mennello Mus. of Amer. Art. PHILADELPHIA/Pa., Mus. of Art. PORTLAND/Ore., AM/The Vivian and Gordon Gilkey Center for Graphic Arts. SALEM/Ore., Willamette Univ. Hallie Ford Mus. of Art. SEATTLE, Univ. of Washington, Henry AG. TACOMA/Wash., AM. ☉ *E:* zahlr. seit 1962, u.a. 1962 Salem, Bush Barn, Salem Art; Portland, Image Gall. / Boise: 1963, '76, '82 (K: S. Harthorn) Boise Gall. of Art; 1989, '96, 2000, '05 (K: S. Harthorn) AM; 1996 Boise State Univ., Idaho Center for the Book; 1996, 2000 J. Crist Gall. / 1965 Oakland, California College of Arts and Crafts / Seattle (Wash.): 1967 The Gall.; 1974 Foster/White Gall.; 2001 Greg Kucera Gall. / 1981 Anchorage (Alaska), Visual AC; Corpus Christi (Tex.), AM of South Texas / 1983 Spokane (Wash.), Cheney Cowles Memorial Mus. (Wander-Ausst.) / 1997 Chicago, Intuit. The Center for Intuitive and Outsider Art / 1998 (K: C. H. Butler/J. Ollman), 2006 Philadelphia (Pa.), Fleisher/ Ollman Gall. / New York: 2000 Amer. Inst. of Graphic Arts; Drawing Center; 2000 (K: J. Yau), '02 (K: F. DelDeo), '06 (mit Walker Evans, K: S. Westfall) Knoedler & Company / 2000 Atlanta, Atlanta Contemp. AC / 2001 London, James Mayor Gall. / 2002 München, Gal. Bernd Klüser / 2005 Jackson (Wyo.), Muse Gall. / 2006/07 Missoula (Mont.), Missoula AM / 2007 San Antonio (Tex.), Lawrence Markey Gall.; San Francisco (Calif.), Gall. Paule Anglim / 2008/09 Philadelphia, Mus. of Art (Retr., K: A. Percy u.a., Wander-Ausst.). ⌁ *T. Trusky*, The Julia poems. J. C., Boise [1999]; *S. Westfall*, AiA 89:2001, 6; *T. Trusky*, J. C. His life and art, Boise 2004. – *Online:* Website C.; Kunstaspekte; Artcyclopedia; Greg Kucera Gall.; J. Crist Gall. C. Rohrschneider

Castrejón Diego, *Carmela*, mex. Fotografin, Mixedmedia-Künstlerin, * 10. 3. 1956 auf US-amer.-mex. Grenze bei Tijuana, lebt in San Diego/Calif. Artist in Residence: 1998–2001 California Arts Council. – C. versteht ihre künstlerische Arbeit als Teil ihres politisch-feministischen Engagements (auch militant) und entwickelt diese hauptsächlich in Künstlerkollektiven wie Grupo Faktor X, Las Comadres (1990–93) oder Colectivo Feminista Binacio-

nal. Frauen- und Arbeiterinnenrechte, Migration, Gewalt und Rassismus sind die Themen ihrer Fotogr., Installationen, Collagen oder Papierarbeiten, oft im Rahmen von Workshops (mit Gefangenen, Kindern, Fabrikarbeiterinnen, Migranten). ☉ *E:* 1995 Madrid, Gal. del Progreso / 1996 Valencia, La Esfera Azul / Tijuana: 2003, '05 Gal. Nina Moreno; 2004 Pasillos del Arte. – *G:* 1992 Sydney: Bienn. / 1998 Austin (Tex), Mexic-Arte Mus.: Reconstruxiones / 2002 Alexandria (Ägypten): Bienn. Imagining the Book / 2007 Mexicali, Univ. Autónoma de Baja California: Ars Latina. ⌁ La Frontera/The Border. Art about the Mexico/United States Border Experience (K), San Diego 1993; Strange new world. Art and design from Tijuana (K Wander-Ausst.), San Diego 2006. – *Online:* Website C.
 D. Sánchez

Castrillo Guzmán, *José Luis*, span. Maler, * 22. 1. 1959 Sevilla, lebt dort. Stud.: EBA de Sa. Isabel de Hungría ebd. (ohne Abschluß). C. unterrichtet an seiner privaten KSch in Sevilla. Ausz.: 1998 ehrenvolle Erw., Premio de Pint. Rural de la Caja Rural; 2003 1. Preis, Premio de Pint. del Ilustre Colegio Notarial, beide ebd. – V.a. farbenfrohe Lsch. (*Entre Patios*, Öl/Lw., 2005) und Portr. (*Retrato de Antonio Roldán*, Öl/Lw., 2002) in impressionistischer Manier, die zuweilen expressionistische Einflüsse erkennen lassen. Auch Marinen, Stilleben und Interieurs sowie urbane und kostumbristische Szenen (*En la Feria de Sevilla*, Öl/Lw., 2003). ⌂ SEVILLA, Caja Rural. ☉ *E:* Sevilla: 1989 Taller Francisco de Paula; 1997, 2004 Gal. Sargadelos; 1998 Gal. Garduño Arte; 1999, 2000, '01, '04, '05 Gal. Abades 47; 2001 La Carbonería; 2005, '07 Gal. San Vicente; 2006 Gal. X Sabio 13; 2008 Studio Hache / 1996 Manresa, Gal. Granero / 2001 Badajoz, Caja de Ahorros. ⌁ DPEE, Ap., 2002. – *Online:* Website C.
 S. Herczeg

Castringius, *Eva*, dt. Fotografin, Malerin, * 1967 München, lebt in Berlin und Los Angeles. Stud.: 1993–99 HdK, Berlin, Malerei und Fotogr. bei Leiko Ikemura. Stip.: 1996 Erasmus-Stip. R. College of Arts, London; 1999 Karl-Hofer-Stip., Berlin; 2001 Atelierpreis der Karl-Hofer-Ges., ebd.; 2006/07 Stip. des Else-Heiliger-Fonds. – C. setzt sich mit dem Verhältnis des Menschen zu Natur und Umwelt sowie den Folgen von Eingriffen auseinander, wie in *Alpenglühen* über die Tagebaugebiete in der Niederlausitz (2005, zwanzigteilige Fotoserie) und *The Great Thirst* (2003, zehnteilige Fotoserie). Oft verwendet C. inszenatorische Elemente, u.a. Plastikschafe auf Grünflächen in Berlin in *Harry-Go-Round* (2002, ein Brief und sieben Fotogr.) oder zwei Autos in *The Big Sky. Los Angeles – Berlin* (2001/02). Die zwanzigteilige Fotoserie *Tschernobyl* (2001) zeigt eine vollständig inszenierte Modellwelt. Unter dem Eindruck der weiten nordamerik. Lsch. und der Zweck-Archit. in Los Angeles entstehen Gem. mit schwebenden, stark fluchtenden Bildelementen, die eine große Bildtiefe in leuchtenden Farbräumen erzeugen (Serie *Liquid Sky*, 2006–08). Weitere Serien: *Supera Galactica* (Gem., 2000–03); *Suckers!* (Zchngn, 2002); *Point Break* (Gem., 2002–05); *gondola suburbia* (Fotogr., 2004/05); *Liquid Sky. Superimposed* (Fotogr., 2008).

👁 *E:* Berlin: 1999 Gal. Kunstruimte; Gal. Dirty Windows; 2002 Martin-Gropius-Bau (K Wander-Ausst.); 2003 Gal. Wieland; 2008 Gal. Kai Hilgemann (K) / 2000, '03, '05 Köln, Gal. Martin Kudlek. 🕮 Kleine Welten (K), B. 1999; *N. Kuhn* u.a., *E. C. The big sky*, Los Angeles-Berlin (K), B. 2002; *Permanent zeitgenössisch*. Atelierpreisträger 1996 bis 2005 (K), B. 2005; *F. Barsch* u.a., *Tanz auf dem Vulkan* (K Wander-Ausst.), St. 2008; *E. C. Liquid sky*, B. 2008. – *Online:* Website C. N. Buhl

Castro, *Celestino Joaquim de Abreu (Celestino de),* portug. Architekt, * 21. 6. 1920 Paranhos/Porto, † 2007. Stud.: Esc. Superior BA, Porto, Dipl. 1944. Esc. BA, Lissabon. Anschl. Zusammenarbeit mit versch. Büros in Lissabon und Porto, Tätigkeit im öff. Dienst. 1963 aus politischen Gründen Übersiedlung nach Paris, dort in versch. Architektengemeinschaften und im Bauamt des Senats. 1974 Rückkehr nach Lissabon, zahlr. öff. Ämter. C.s wenige, aber qualitätvolle Wohnbauten in Porto (Rua Santos Pousada, 1948–50; Rua do Amial, 1949–52) weisen der portug. Archit. den Weg in die Moderne der Nachkriegszeit. 👁 *E:* 1996 Lissabon, Centro de Trabalho Vitória. 🕮 *J. M. Pedreirinho*, Dic. dos arquitectos, Porto 1994. – Arquit. mod. portug., 1920–1970, Li. 2004.
 B. Borngässer Klein

Castro, *Diego* (eigtl. Schindler-Castro, *Dirk Diego*), dt. Konzept-, Performance- und Installationskünstler, * 12. 6. 1972 Hannover, lebt in Genf. Stud.: 1989–92 Fachoberschule für Gest., Hamburg; 1993–97 Muthesius HS für Kunst und Gest., Kiel; 1996 EcBA, Saint-Etienne; 1998–99 EcBA, Nantes; 2005–07 Haute Ec. d'Art et Design, Genf; 2007–10 Ass. ebd. Stip.: 2002 Nordwest Kunstpreis, KH Wilhelmshaven; 2004 Künstlerhaus Schloß Balmoral, Bad Ems; 2007 Künstlerhäuser Worpswede. – Ausgehend von einem konzeptuellen Ansatz, reicht C.s Spektrum weit über die im eigtl. Sinne bild. Kunst hinaus und bezieht viele Bereiche des verzweigten Betriebssystems Kunst mit ein. Im Zentrum steht die Auseinandersetzung mit dem Rollenverständnis des Künstlers und seine zugewiesene oder selbstbestimmte Funktion innerhalb der Gesellschaft. In diesem Kontext tritt der dt.-span. Künstler als Autor kritischer Essays, programmatischer Manifeste und als politischer Aktivist in Erscheinung. U. a. initiiert und kuratiert er eig. Ausst., ist in der Lehre tätig und hält Vorträge. C. arbeitet in den Bereichen Installation, (Video-)Performance, Zchng und Text, wobei die eingesetzte Bildsprache starke Bezüge zur Popkultur, auch zu einflußreichen Werken der jüngeren Kunstgesch. aufweist. In den frühen Performances steht noch die eig. Verortung, das individuelle Selbstverständnis des Künstlers im Zentrum. Seit etwa 2005 beinhaltet das aufgegriffene Formenvokabular jedoch zunehmend Referenzen auf die Trad. der Inst.-Kritik und auf ökonomische und soziopolitische Diskurse. Um u.a. das Urheberrecht oder die Distributionswege der Kunst in Frage zu stellen, initiiert C. 2007 die Künstlerbewegung „Immaterialistische Internationale" und greift damit in ironischer Weise aktivistische künstlerische Strategien der 1960er Jahre auf (*Die Aura des Kunstwerks im Zeitalter der Reproduzierbarkeit der Aura,* Installation, 2009). So können in C.s Installationen ausgelegte Zchngn mit plakativen Kommentaren und Motiven aus der Kunst- und Warenwelt vor Ort am Kopiergerät vervielfältigt und frei als Flug-Bll. in Umlauf gebracht werden. C.s Arbeitsweise ist letztes Endes einem zutiefst der Aufklärung verpflichteten Impetus geschuldet, mit dem er die Möglichkeiten auslotet, der politischen Information einen angemessenen Platz in der erweiterten künstlerischen Produktion zu verschaffen, bes. augenfällig z.B. 2011 in dem installativen Ausst.-Projekt *Memories of Heidelberg. Kriegsblind und Friedenstaub.* 👁 *E:* 2001 Wilhelmshaven, KH (K) / Berlin: 2001 Gal. Eigen+Art (mit Rémy Markowitsch); 2011 Gal. Gitte Bohr / 2002 Brüssel, Gal. Paolo Boselli / 2005 Bad Ems, Künstlerhaus Schloß Balmoral (K: D. Perrier) / 2009 Genf, Pal. de l'Athenée (K). – *G:* 1997 Kiel, Stadt-Gal.: Gottfried-Brockmann-Preis (K) / 2000 Turin: Bienn. d'Arte Emergente (K) / 2002 Berlin, Kunstraum Kreuzberg: Over the moon / 2003 Strasbourg, LAB-Gal.: Out of Berlin (K) / 2007 Lüneburg, Halle für Kunst: Crosskick (K) / 2008 Genf, Centre de la Photogr.: Jeunevois. 🕮 *H.-W. Schmidt/B. Ermacora*, Unsichere Grenzen. Daniele Buetti u.a. (K KH Kiel), Kiel 1999; ERBAN. Post-dipl. 1998–1999. Peio Aguirre u.a. [Nantes, EcBA], 1999. – *Online:* Website C. H. Uhr

Castro, *Hildebrando de,* brasil. Maler, Zeichner, * 1957 Olinda/Pernambuco, lebt in São Paulo. Autodidakt. Seit 1977 künstlerisch tätig, anfänglich figurativ-lineare Zchngn (auch für Schallplattenhüllen und Buch-Ill.), danach v.a. Pastellbilder, seit E. der 1990er Jahre auch große Arbeiten in Öl. C.s Motive basieren auf eig. Fotovorlagen, die er von weiblichen und männlichen Modellen (u.a. Zwergwüchsigen), Lsch. oder Gegenständen (z.B. Spielzeug) anfertigt. Seine Themen sind Drogenexzesse, sexuelle Ausschweifungen, Ängste und Tod, denen er sich in großformatigen Bildern widmet, häufig satirisch und grotesk überhöht, bisweilen der Pop-art nahestehend. So kommentiert er in hyperrealistischer Manier mit Puppenmotiven die Infantilisierung des Erwachsenendaseins. Mit kritischem Humor verweist er dabei auf die Banalisierung von Gewalt, auf Frühreife und Erotisierung von Kindheit sowie deren übertriebene, teilw. perverse Vermarktung, die zum Schrecken wird, wenn das Auge sich über die täuschend harmlose Darst. hinweggesetzt hat. Dicken Frauen oder Verwachsenen in opulenten Betten folgen Bilder von Körperteilen (z.B. Hühnerherzen auf Spieß, 1995) oder unheimlich wirkende Akte und Portr., z.T. mit christlichen Symbolen (z.B. Rosenkränzen) versehen. C.s Verknüpfung von relig. und erotischen Sujets hat verführerische wie abstoßende Wirkung. M. der 1990er Jahre konzentriert er sich auf puppenhafte Geschöpfe, z.B. Barbies oder Kinderkrankenschwestern mit verzerrten Babygesichtern. Seit 2000 widmet er sich der Darst. von Lsch., Portr. und Tieren (alle Öl/Lw.), wobei er die stilistischen Möglichkeiten des Piktoralismus der Fotogr. ebenso exzellent anwendet wie Grisailletechnik und Sfumato, bes. gelungen bei fotorealistischen Portr.-Serien (z.B. *Frau mit Zöpfen,* 2002). 2007 erstmals assemblageartige Experimente mit

doppeltverglasten Pastell-Zchngn (*Hühnerherzen*) zur Erzielung von 3-D-Effekten. 2008 konzeptuelle Wiederaufnahme der Bildmotive amputierter junger Frauen, prothesentragender Kinder oder von Puppen, in denen C. kindlich naive Szenerien u.a. mit verharmlosender Darst. von sexueller Brutalität und Perversion auflädt, z.B. *Barbiepuppe mit Metallprothese, Gärtner beim Analverkehr mit Bambi*. ⌂ RECIFE, MAM. RIO DE JANEIRO, MAM. ☞ *E:* Rio de Janeiro: 1980 MBA (Debüt); 1995 Centro Cult. Banco do Brasil (K); 1998 Paço Imperial; 2006, '08 Gal. Laura Marsiaj / 1988 München, Gal. Irene Maeder / 1989, '90 Zürich, Hard Art Gal. / São Paulo: 1994 Gal. Camargo Vilaça (K: F. Morais); 2001, '04 Casa Triângulo / 2003 Atlanta (Ga.), Fay Gold Gall. – *G:* 1984 Fortaleza: Salão Nac. de Artes Plást. / Rio de Janeiro: 1984 Salão Nac. de Artes Plást; 1985 (1. Preis), '88 Salão Carioca de Artes Plást; MAM: 1993 Arte Erótica; 2001 O Espírito de Nossa Época (Wander-Ausst.); 1995 Além da Taprobana (Wander-Ausst.); 1998 Paço Imperial: A Imagem do Som de Caetano Veloso / 1985 Nürnberg, KH: Internat. Trienn. der Zchng (K: W. Horn) / São Paulo: 1985 (K), '90 Salão Paulista de Arte Contemp.; 1994 MAM: Ainda a Figura; 2003 Itaú Cult.: A Subversão dos Meios / 1990 New York, Pindar Gall.: Brasil Contemp. / 1998 Berlin, Haus der Kulturen der Welt: Der brasil. Blick (Wander-Ausst.; K) / 2006 Belo Horizonte, Pal. das Artes. ⌶ *Ayala*, 1997. – *C. Gerner/S. Vogel*, Der brasil. Blick. Slg Gilberto Chateaubriand / MAM-RJ (K Wander-Ausst.), B. 1998. – Centro de Pesquisa do MAC do Paraná, Curitiba. – *Online:* Inst. Itaú Cult., Enc. artes visuais; Website C.

S. Dahn Batista

Castro, *Isabel de*, brasil. Graphikerin, Zeichnerin, Illustratorin, Fotografin, * 1958 Porto Alegre, dort tätig. Stud.: bis 1984 Zeichnen und Graphik, Inst. de Artes da Univ. Federal do Rio Grande do Sul ebd. (UFRGS); bis 1994 Esc. de Comunicações e Artes da Univ., São Paulo; Kurse bei Carlos Martins, Pamela Barr, Teresa Poester und Jailton Moreira. Lehrtätigkeit: 1985–92, 2003–04, '07–08 UFRGS, Porto Alegre; 1998–2002 Univ. Tuiuti do Paraná, Curitiba; 2003–04 Centro Univ. Feevale, Novo Hamburgo; seit 2006 Esc. Superior de Propaganda e Marketing, Porto Alegre (Zeichnen, Malerei). Ausz.: 1982 Prémio des Salão do Jovem Artista und 2008 Prémio Açorianos da Prefeitura Mpal, Porto Alegre; 1983 Ankaufspreis, Salão Paranaense, Curitiba. – Vorwiegend kleinformatige Graphik, Zchng (Graphit, Ölkreide) sowie Buch-Ill. und Acrylmalerei. Bevorzugte Themen der figurativen Graphik der 1980er Jahre sind Personen, ausschnitthafte Portr. und Akte, die in zarten, trotzdem betont linearen Umrissen, teilw. auch kol., auf weißem Grund ausgeführt sind. Die abstrakte Graphik arbeitet mit einzelnen, frei auf dem Papier stehenden Schlangenlinien (*Cobra cor*, 1994), Scheibenformen (*Mestrado Disco frente*, 1994), an Handschrift erinnernden Elementen (*Mestrado Livre frente*, 1994) und organischen Formen (z.B. Herzen, Muscheln) in an- und abschwellenden Linien (z.B. *Coração*, 2000, oder *Concha*, 2000), aber auch mit dunklen flächigen Verläufen sowie mit der Struktur gefalteten Papiers. Die meist in Graustufen gehaltenen Kreide-Zchngn wiederholen stilisierte technische Geräte wie Rohre, Wasserhähne oder auch Gebäude sowie großflächige Kompositionen. Die Arbeiten in Graphit sind weitgehend linear und abstrakt, erinnern aber ebenfalls an technische Objekte (*Microfone 007*, 2004). Daneben Selbst-Portr. (Abdrücke des Gesichts auf schwarzem oder weißem Grund, 2006) und Fotogr. (2002). Für die Buch-Ill. zu *Les mystères de Paris* von Eugène Sue wählt C. sechs Romanfiguren und stellt sie durch Gesichtsausschnitte (Augen) und einen jeweils char. Gegenstand (Brille oder Münzen) dar (1990). C. ist auch als Kuratorin in Porto Alegre tätig. ⌂ CURITIBA, MAC. PORTO ALEGRE, MARGS. ✉ Reflexões sobre a Gravura contemp., in: Tuiuti Ciência e Cult. 28:2004, 173–186. ☞ *E:* Porto Alegre: 1982 Inst. de Arquitetos do Brasil; 2003 Casa de Cult. Mário Quintana; 2009 Farol Observatório de Arte (mit Adriane Hernandez, Helena Kanaan) / 1994 São Paulo, MAC da Univ. / 2001 Curitiba, Mus. da Gravura. – *G:* Porto Alegre: 1981 Univ. Federal do Rio Grande do Sul: Formandos; 1986 Salão Nac. de Artes plást.; 2006 MARGS: Percurso – Gravura contemp.; 2008 Centro Cult. der Companhia Estadual de Energia Elétrica Erico Verissimo: Gráfica Gaúcha II; Salão de Artes plást.; Subterrânea Atelier: Pequenos Formatos / 1983 Taipei: Internat. Print Exhib. / 2003 Passo Fundo (Rio Grande do Sul), Mus. de Artes Visuais Ruth Schneider da Univ.: Olhar Intimista / 2004 Novo Hamburgo, Pin. do Centro Univ. Feevale: Intervalos / 2002 Curitiba, Gal. Arte Singular – Meyer Pereira: Tum Tum. ⌶ *R. Rosa/D. Presser*, Dic. de artes plást. no Rio Grande do Sul, Porto Alegre ²2000; *A. M. de Araújo*, Dic. das artes plást. no Paraná, Curitiba 2006. – *H. A. Hübner Flores*, Porto Alegre. Hist. e Cult., Porto Alegre 1987. – *Online:* Website C. C. Melzer

Castro, *Jota*, frz.-peruanischer Objekt-, Installations-, Aktions- und Performancekünstler, Dichter, Diplomat, * 1965 Yurimaguas/Lima, lebt in Brüssel. Stud.: um 1983 Politik-Wiss., Collège d'Europe, Brügge. Anschl. im diplomatischen Dienst für die United Nations und die Europ. Union. E. der 1990er Jahre Hinwendung zur Kunst. Lehrtätigkeit an der Europ. Univ., Madrid. Ferner Consulting Editor für das belg. Janus mag. und die span. Zs. Nolens Volens. Ausz.: 1983 Young Peruvian Poet Prize; 2004 Gwangju Bienn. Prize. – C. nutzt unterschiedlichste Medien und Mat., um soziale und politische Fragestellungen visuell erfahrbar zu machen: z.B. *Guantanamo* (begehbare Installation aus Stahlgerüst, Maschen- und Stacheldraht, 2005), *No more No less* (Fotomontage, 2006), *Mooi* (präpariertes, kopfloses Schwein im T-Shirt, 2006), *Tricky* (mit Stacheldraht umwickelte Fußbälle, 2009) oder *Amazonas aka merdolino* (Installation aus farbigen Toilettenpapierrollen, 2009). Sarkasmus ist dabei ein immer wiederkehrendes Motiv, bes. bei *Madre* (Matraze, Stacheldraht, 2006) oder *Mortgage* (Installation von Galgenstricken, gefertigt aus Dollarscheinen, 2009). Auch arbeitet er mit Schrift und Poesie, u.a. *A mi tiempo* (polyglotte Wandbeschriftung, 2005), *China* (Wortassemblage aus importierten Schuhen, 2006). Nach 30jähriger Abwesenheit veranstaltet C. 2008 in seinem Heimatland mit *La pala-*

bra de los mudos (in Lima) seine erste Performance; darin verbindet er autobiographische und politische Inhalte zu einem emotionalen Experiment; Thema der teilw. in Gebärdensprache zw. Bühne und Publikum vermittelten Botschaft sind die Grenzen der Kommunikation und Probleme der Inklusion. In neueren Arbeiten setzt sich C. auch mit seinen indigenen Wurzeln auseinander, z.B. *Hucha de Los Incas* (Mon.-Skulpt. aus Glasfiber, Blattgold, 2008); *The white Nigger; Temor* (beides bemalte Holzmasken, 2009). ◉ *E:* 2005 Paris, Pal. de Tokyo (K: J. Sans); 's-Hertogenbosch, Sted. Mus.; Melbourne, Uplands Gall. / 2006 Madrid, Gal. Oliva Arauna; Helsinki, MMK Kiasma / 2006, '08 Brüssel, Elaine Levy Project / 2007 Neapel, Gall. Umberto Di Marino / 2009 Berlin, Gal. Barbara Thumm. – *G:* 2003, '09 Venedig: Bienn. / 2006 Tirana: Bienn. / 2007 Monterrey, MAC: Construyendo el mundo / 2009 Santa Cruz de Tenerife: Bien. de Canarias. ▫ *Delarge*, 2001. – *Online:* Website C.; Gal. Barbara Thumm; Uplands Gal.

M. Scholz-Hänsel

Castro, *Roland,* belg. Fotograf, * 7. 2. 1948 Oreye, † 3. 8. 2005, lebte in Haneffe. Stud.: zunächst Politik-Wiss., anschl. Fotogr. an der Ec. supérieure des Arts St-Luc in Lüttich (dort auch Lehrtätigkeit). Mitgl. der Fotografengruppe Quanta. – C. fertigt malerisch wirkende Gummidrucke, bevorzugt auf Seiden-, Japan- und Zeichenpapier oder Stoff. Die Motive (v.a. Hände, Gesichter, Steine) erscheinen als undeutliche Schatten, denen die Struktur des Papiers eine dekorative Komponente hinzufügt. – Publ. der Fotogr. z.B. als Ill. der Gedichte von Eric Brogniet (*Parole et empreinte,* P. 2004; *Celle qui s'est levée avec le soleil,* Amay 2004). ▥ CHALON-SUR-SAONE, Mus. de la Photogr. Nicéphore Niépce. CHARLEROI, Mus. de la Photogr. PARIS, BN. ◉ *E:* 1986, '89 Waremme, Gal. Evasion / 1994 Paris, BN / 1996, '99 Toulouse, Gal. du Forum / 2001 Brescia, Mus. Ken Damy di fotogr. / 2004 Fexhe-Slins, Gal. Art'Mony (mit Chantal Bietlot, Albert Eloy) / 2008 Amay, La Maison de la Poésie (Retr.). – *G:* 1996 Visé, Centre Cult.: Photogr. nouvelles / 1997 Royan: Salon internat. de la Recherche photogr. / 2002 Flémalle, Centre wallon d'Art contemp. La Châtaigneraie, und Huy, Centre Cult.: Groupe Quanta; Gent, Sted. Mus. voor Actuele Kunst: Druksel / 2005 Paris, Centre Pompidou: Ombres et Lumiére. Rêves d'Ombres. ▫ *S. Goyens de Heusch* (Ed.), XXᵉ s. L'art en Wallonie, Tournai/Br. 2001. F. Krohn

Castro de la Gándara, *Julio,* span. Maler, Zeichner, Graphiker, Illustrator, Bildhauer, * 1927 Ceuta, † 20. 12. 1983 Madrid. Stud.: EBA der RABA de S. Fernando; mit Stip. des Außen-Minist. und der Fund. March in Paris, Berlin und Italien. 1974–81 Prof. für Zeichnen und Ill. an der Fac. de BA der Univ. Complutense. Berater der Delegación Nac. de Cult., Mitgl. des Beirates des MAC auf Ibiza und 1972 Leiter der Bien. Ibizagrafic. Gründungs-Dir. der Gal. Ebusus in Madrid und Kunstredakteur der Zs. Acento Cultural. Zahlr. Ausz.: u.a. Premio Ejército; Preis Pintores de Africa, beide Madrid; Premio Ibarra für Ill., Editorial Eudeba, Buenos Aires. – C. gestaltet figurative, geometrisch-zeichnerisch bestimmte Gem. in kräftiger

Farbigkeit, Mosaiken (Kirche S. Francisco Javier, Pamplona; Club La Rábida, Huelva), Skulpt. (*Figuras levantando una veleta*), Zchngn, Holz- und Linolschnitte, Med. und in den 1970er Jahren humoristische Vignetten, z.B. für die Zs. Rombo. Etliche Ill. für Bücher: u.a. *Dioses y héroes nórdicos* (Ma. 1957) von Antonio Espina; *Las horas muertas* (Ma. 1960) von Rafael Alberti u.a.; *Libro de las mil y una noches* (Méx. 1961; versch. Aufl.), hrsg. von Rafael Cansino-Asséns. ✉ Dibujo de il. Diez técnicas, Ma. 1979. ◉ *E:* 1985 Madrid, Centro Cult. de Chamartín (Retr.). ▭ DPEE III, 1994; Dicc. de artistas contemp. de Madrid, Ma. 1996. – *Online:* La república cult.

M. Nungesser

Castro Nieto, *Francisco* cf. **Castro Represas,** *Francisco*

Castro Prieto, *Juan Manuel,* span. Fotograf, Fotojournalist, * 1958 Madrid, lebt dort. Stud.: Wirtschafts-Wiss., Univ., Alcalá de Henares (Abschluß 1980). Als Fotograf Autodidakt. Ausz.: 1992 Premio Hoffmann; 2005 César Vallejo Award; Bartolomé Ros Award. – E. der 1980er Jahre wird C. bek. durch authentische Abzüge postumer (Martín Chambi) wie auch zeitgen. fotogr. Werke (u.a. Cristina García Rodero, Chema Madoz). Seine eig. fotogr. Arbeit beginnt 1990 mit einer Reise nach Peru (mit Juan Manuel Díaz Burgos), denen zahlr. weitere folgen. C., seit 2000 bei der Agentur Vu, Paris, fotografiert für diverse Zss. und Mag., u.a. El País, Geo, La Republica, Le Monde, Libération, Nat. Geographic und Mare. In seinen atmosphärischen, wie altertümlich wirkenden, anfangs mit einer Plattenkamera aufgenommenen Schwarzweiß-Fotogr. dokumentiert er v.a. Reportagen und Reisen (Andalusien, Marokko, Cuenca, Äthiopien, Indien), poetische Alltagsmomente oder urbane Themen. Seit etwa 2005 fotografiert C. auch in Farbe und mit digitaler Technik. – Fotobücher: *Perú. Viaje al sol,* Ba. 2001; *Extraños,* Ba. 2003 (Text: P. Ortiz Monasterio); *Cuenca en la mirada,* Ba. 2005; *La seda rota,* Ma. 2006 (Text: A. Trapiello); *Etiopía,* Ba. 2009 (Text: C. Caujolle). ▥ BADAJOZ, Junta de Extremadura. BARCELONA, Fund. Foto Colectania. GRANADA, Prov.-Verwaltung. MOSTOLES, Centro de Arte Dos de Mayo. REUS, Inst. Mpal de Arte Contemp. VALENCIA, IVAM. ◉ *E:* 1986 Segovia, Torreón de Lozoya / Madrid: 1991 Círculo de BA; 2007 Centro de Arte Tomás y Valiente; 2009 Centro Cult. de la Villa (Wander-Ausst.) / 1992 Pamplona, Gal. Nueva Imagen; Cuzco, Casa Cabrera del Banco Continental / 1993 Lima, Inst. Gaudí / 1994 Cartagena, Sala La Muralla Bizantina / 2006 Alcórcon, Centro Mpal de las Artes (K); Sevilla, Fond. Tres Culturas (Wander-Ausst.). – *G:* 1992 Córdoba, Alcázar: Latinoamérica, miradas al interior; Madrid, Jardín Botánico: España abierta / 1993 Valenica, IVAM: Imágenes escogidas / 2004 Madrid, Canal Isabel II: Agua al desnudo (K) / 2005 Badajoz, Mus. Extremeño e Iberoamer. de Arte Contemp.: Vidas privadas; Aichi, WA / 2006 Paris, Mus. d'Orsay: Vu (K). ▭ *J. de la Higuera,* Arte fotogr. 33:1984 (10) 1055; *P. López Mondéjar,* J. M. C. P., Ma. 2007. – *Online:* Agence Vu. D. Sánchez

Castro Represas, *Francisco,* span. Architekt, * 11. 6.

1905 Vigo, † 23. 4. 1997 ebd. Vater des Architekten *Francisco C. Nieto* (* 1947). Stud.: Esc. Superior de Arquit., Madrid. 1932 Gründung des eig. Büros in Vigo, dem sich 1940 *Pedro Alonso Pérez* (* 27. 5. 1908 Madrid, † 20. 4. 1990 Vigo) als ständiger Partner anschließt (bis 1988). Das Büro „C. y Alonso" wird bis heute von den Söhnen der beiden Architekten fortgeführt. 1935 Präs. der Abt. Vigo der Architektenkammer Galiciens. 1993 Ehrenbürger von Vigo. – C. gilt zus. mit Jenaro de la Fuente Alvarez als Wegbereiter der mod. Archit. in Vigo, die sich neben dem offiziell gelehrten Neuklassizismus in Spanien durch internat. Einflüsse erst um 1930 entwickelt. Dem bodenständigen Eklektizismus in Vigo, infolge der lokalen Steinmetz-Trad. durch detailreiche Fassadendekoration in Granit ausgezeichnet, setzt C. gleich mit seinem ersten Projekt 1933 das schmucklose sechsgeschossige Wohnhaus Ribas Barreras ohne stilistische Referenzen entgegen (Calle Marqués de Valladares). Es vereint bereits die char. Merkmale von C.s künftigem Schaffen, sein eigenwilliges Konterkarieren der horizontalen Gewichtung mittels klar herausgestellter Symmetrieachse, den Kontrast von Plastizität und Fläche und die Verortung des Gebäudes in der lokalen Archit.-Trad. durch Granitverkleidung. Der formal reduzierte mod. Ausdruck läßt sich im wesentlichen auf die Schule von Chicago, die zeitgen. Art-Déco-Ästhetik und die Archit. von Erich Mendelsohn zurückführen. 1939 gelingt es C., seine Gest.-Prinzipien erfolgreich auf einen großen Maßstab zu übertragen. Das Wohn- und Bürohaus Curbera (Av. García Barbón 30) ist mit 13 Geschossen das höchste profane Gebäude der Stadt, in dem die vertikale Kraft der Zentralachse mittels frz. Fensterform und durchgängiger Lisenen bis in den getreppten Giebelaufsatz auf die Spitze getrieben wird und sich effektvoll gegen die horizontale Balkonfassade absetzt. Der Konflikt zw. Trad. und Funktionalismus tritt hier, auch mit Blick auf die achsensymmetrische innere Distribution, offen zutage. Gleichwohl entsteht nach dem Span. Bürgerkrieg, von nun an mit P. Alonso Pérez, mit dem Yachtclub C.s bekanntestes Gebäude als Inbegriff des Rationalismus in Vigo (1944–45; Real Club Náutico mit Erweiterungsbau Pañol; mit Ing. Carlos Abanitarte; stark modifiziert). Das Bauwerk ist jedoch in seiner aerodynamischen Bildhaftigkeit konzeptionell inkonsequent und formalistisch. Inspiriert vom Yachtclub in San Sebastián (1929–30; José Manuel Aizpurúa und Joaquín Labayen), dessen mod. Formgebung landesweit vielfach nachgeahmt wird, weist der Club in Vigo stadtseitig einen neuklassizistisch gestalteten Basisbau auf, während er seeseitig wie ein eleganter weißer Schiffsrumpf auf schlanken Rundpfeilern (urspr. im Wasser stehend) in das Hafenbecken hineinragt. Nach einigen mon. Bauten in den repressiven Jahren des Franco-Regimes findet C. 1959 mit dem Bürogebäude Lorenzo Muradás (Av. García Barbón) zu einer sachlichen Ausdrucksform zurück. ⌂ VIGO, Pl. Compostela 4–6: Wohngebäude, um 1934. – Konservenfabrik Rivas, 1935–38. – Calle Policarpo Sanz 22: Wohngebäude Sanchón, 1935–40. – Pl. Portugal 2: Gebäude Cesáreo González, 1938. – Calle Cuba: Gebäude Crespo Filgueira, 1938. – Calle Colón 4: Gebäu-

de Barreras, 1940. – Av. Ramón Nieto: Porzellanfabrik Santa Clara, 1941 (heute Ruine). – Gran Vía/Calle Urzaiz: Wohn- und Bürogebäude Albo, 1942–49. – Calle Magallanes/María Berdiales: Kino Radio (Umbau), 1943. – Calle Tomás a Alonso: Gebäude Seijo Serodio, 1944–45. – Calle Marqués de Valladares: Bürogebäude Casal, 1949. – Calle Velázquez Moreno 6: Wohngebäude. – Pl. América: Sozialer Wohnungsbau. – Camino de la Seara: Villa As Torres (heute Ruine). – Gebäude Santodomingo. – Gebäude Vialmar. – Kolleg und Wohnhaus der Maristen. – Fabrik Larsa. – Fabrik Albo. – Banco de Galicia (Sanierung). – Messegelände Cotogrande. ▭ *X. M. R. Iglesias Veiga*, Arquit. y cinematógrafo en la ciudad de Vigo. Palacios, Gutiérrez Soto, F. C. y Pedro Alonso, in: Espacio, tiempo y forma (Serie VII, Hist. del arte), 5:1992 (1993), 491–534; Arquit. del movimiento mod. 1925–1965. Registro docomomo ibérico, Ba. 1996; *C. del Pulgar Sabín* (Ed.), Artistas gallegos – arquitectos. Del racionalismo a la modernidad, Vigo 2002; *F. Agrasar Quiroga*, Guía de arquit. de Vigo 1930–2000, Vigo 2003; *J. L. Varela Alén*, Arquit. racionalista en Vigo, Vigo 2007. – *Online:* Website C. y Alonso. A. Mesecke

Castrucci, *Andrew*, US-amer. Maler, Zeichner, Graphiker, Objekt-, Installations-, Buch- und Performancekünstler, * 1961 New Jersey, in New York ansässig. ⚭ 2001 Malerin Alexandra Rojas. Stud.: 1979–83/84 (2009 Master of FA) School of Visual Arts, New York. Im Rahmen der „squatter movement" gründet C. 1985 zus. mit Nadia Coen das Künstlerzentrum Bullet Space in Manhattan-Lower East Side ebd. Er gilt als Vertreter der alternativen Kunstszene (bes. „squatter art") in New York, abseits vom dortigen elitären und kommerziellen Kunstbetrieb. Thematischer Schwerpunkt ist das Porträtieren der Metropole New York, bes. dessen „Innenleben", das als faszinierend und bedrohlich empfunden wird. C.s Arbeiten basieren auf sehr persönlichen Wahrnehmungen von postindustriellen urbanen Strukturen, v.a. im Zusammenhang mit der Gentrifizierung. Inmitten riesiger Stahl- und Betonkonstruktionen (Brücken, Wolkenkratzer) „bewegen" sich Naturkräfte (East River, Hudson River), leben Menschen. Bes. interpretiert C. die Auswirkungen städtebaulicher Strukturen (z.B. Verfall alter Industrie- und Hafenanlagen, verwahrloste Wohngebäude, sozial-demographische Verschiebungen) auf die einfache Bevölkerung, deren Lebensbedingungen zunehmend von Gewalt und Kriminalität geprägt werden. Aufgrund des Konzepts „Kunst als Widerstand" ist sein künstlerisches Markenzeichen der Widerhaken (Fisch- und Fleischhaken), welcher oft als Bildmotiv und Installationsobjekt verwendet wird. C. beschäftigt sich auch mit allgemeinen sozialen und ges.-politischen Themen. Sein Œuvre umfaßt semi-abstrakte und symbolische Malereien (bes. Öl/Email auf Metall), Zchngn, Druckgraphik, Text- und Graffiti-Arbeiten, Metallobjekte und Installationen. Bek. sind die aus versch. (oben gen.) Gest.-Formen bestehenden Serien *River, Text & Diagramms, Gold* und *Red* sowie Street-art-Projekte (*Your House is Mine*), Künstlerbücher, Performances und Videos. ▭ AMSTERDAM, Sted. Mus. BERLIN, Kunst-Bibl.

BROOKLYN/N. Y., Brooklyn Mus. of Art. CAMBRIDGE/ Mass., Fogg AM. HAMBURG, MKG. LAWRENCE/Kan., Spencer Mus.of Art. LONDON, V & A. LOS ANGELES/ Calif., Getty Center Libr. MAINZ, Gutenberg-Mus. MINNEAPOLIS/Minn., Walker AC. NEW YORK, MMA: Your House is Mine, Künstlerbuch (mit Metalleinband), ed. C./ Coen, 1992 (enthält Texte und lith. Poster versch. New Yorker Künstler zum Thema Wohnungsnot und Wohnungslosigkeit). – Metrop. Mus. – Public Libr. – Cooper-Hewitt, Nat. Design Mus. – School of Visual Arts: Confusion. Information Overload, 1999; Zero Infinite/Finite, 2000; Tower-1: Above/Below; Tower-2: Above/Below, alles Künstlerbücher. OFFENBACH am Main, Klingspor-Mus. PARIS, Centre Pompidou. PRATO, Centro per l'Arte Contemp. Luigi Pecci. TOLEDO/Ohio, Mus. of Art. WELLESLEY/Mass., Davis Mus. WOLFENBÜTTEL, Herzog-August-Bibl. ⊚ E: u.a. 1990 Cambridge (England), Kettle's Yard Gall. (mit David Hammons) / New York: seit 1990 Bullet Space (z.B. 2009 The Squatter Years); 1996 Margaret Bodell Gall.; 1999, 2001 Generous Miracles Gall.; 1990 Internat. Center of Photogr. (mit Martha Rosler); 2002 A Gathering of the Tribes Gall. / 1997 Cagliari (Italien), Gall. d'arte La Bacheca; Feldkirch (Österreich), Gal. Sechzig (mit Nancy Goldenberg); St. Gallen (Schweiz), Gal. Christian Schneeberger (mit Goldenberg; K: C. McCormick). – G: u.a. New York: 1988 P.P.O.W. Gall.: 100 Years. A Trad. of Social and Political Art on the Lower East Side / 1992–93 Exit Art: Fever; 2000 Whitney Mus.: Visions of America; 2002 MMA: Life of the City; 2010 Bullet Space: And One More Thing / 1990 Brookville (N. Y.), Hillwood AM: Artist As Apolitical Sensor (K) / 2000 Zürich: Kunst Zürich; Plön, Kunstforum Schwimmhalle Schloß Plön e. V.: Zwischen Wasser / 2002 Great Barrington (Mass.), Geoffrey Young Gall.: Ballpoint Inklings. ⊡ Online: Bullet Space, New York; Website C.

C. Ritter

Catalá Lucas, *Rafael Miguel* (Pseud. Karpa), span. Zeichner, Comiczeichner und -autor, Maler, Werbegraphiker, * 22. 9. 1922 Nules/Castellón, † 12. 9. 2000 Valencia. Bruder des Comiczeichners und -autors Francisco C. Lucas. Stud. ebd.: bis 1946 EBA de S. Carlos. Danach als Comiczeichner für Kinder tätig und Mitarb. versch. Zss., meist des Editorial Valenciana, u.a. Jaimito (ab 1947 mehr als 30 Jahre), Pumby, Mariló, Trampolín, SOS, Selecciones de Jaimito, Super Pumby, Almanaques und Zipi y Zape. Ausz.: u.a. 1991 Preis des Saló del Cómic, Barcelona; 1992 Gold-Med. für kult. Verdienste der Generalitat Valenciana, Valencia. – Als einer der bed. Vertreter der sog. Esc. Valenciana del Tebeo erschafft C. als Zeichner und Autor zahlr., teils von Tieren abgeleitete Comicfiguren, u.a. *Kanguritu, Jaimito* (Fortführung und Popularisierung einer schon bek. Figur), *Bolita, La fam. Cañamón, Simbad el Marino, Pulgarín, Jimmy, Flechita, Perico Fantasías* und *Rufo Alicante.* 1979 realisiert C. die Serie *La guerra de los mundos* nach dem gleichnamigen Film von Byron Haskin. Seine Ausdrucksweise ist anfangs von Walt Disney beeinflußt, später entwickelt er einen eig., sorgfältig ausgef. narrativen Stil. Auch graph. Gest. von Spielen für die Fa. Jue-

gos Reunidos Geyper, Entwürfe für Figuren der Fallas und Buch-Ill., u.a. *Aventuras de David Balfour* (Va. 1959) von Robert Louis Stevenson. Ab den 1980er Jahren widmet sich C. v.a. der Malerei, bes. Portr., und der Werbegraphik, u.a. für das Gesundheitswesen. ⊚ E: 2007 Castellón de la Plana, Centre Social de San Isidre. ⊡ Agramunt Lacruz I, 1999; DPEE, Ap., 2002. – A. Porcel/P. Porcel (Ed.), Karpa, Va. 1993; C. Aimeur, El Mundo (Ba.) v. 14. 9. 2000 (Nachruf); J. Cuadrado, Atlas esp. de la cult. popular. De la historieta y su uso, 1873–2000, Ma. 2000. – Online: Lambiek Comiclopedia (abweichendes Geburtsjahr).

M. Nungesser

Catalán, *Aníbal,* mex. Maler, Bildhauer, Architekt, Installationskünstler, * 1973 Iguala/Guerrero, lebt in Mexiko-Stadt. Stud. ebd.: 1993–97 Esc. de Arquit. der Univ. Anahuac; 1999–2000 Centro Cult. Helénico; 2001–06 Esc. Nac. de Pint., Escult. y Grabado „La Esmeralda". 2004–05 Stip. des Fondo Nac. para la Cult. y las Artes. Ausz.: u.a. 2007 Premio Nac. de Pint. José Atanasio Monroy, Autlán de Navaro/Jalisco. – Als ausgebildeter Architekt, inspiriert von Konstruktivismus und Dekonstruktivismus, verwendet C. auch in seinen bildnerischen Arbeiten bauliche Elemente. Die geometrisch-abstrakten Gem. (Acryl/ Lw.) in kühlen, kräftigen Farben enthalten dynamisch sich im Bildraum entfaltende archit. Strukturen zw. Abbild und Abstraktion (Serien *Overland,* 2006; *Free & mobile; Home series,* beide 2007), „eine spielerische Vision, die eine postapokalyptische Zukunft sein könnte" (D. C. Murray). Diese Komp. überträgt C. in dreidimensionale Gestalt und formt aus Aluminium, Stahl, Kunststoff und and. Mat. komplexe Plastiken aus ineinandergeschobenen, meist in Rot, Schwarz und Weiß bemalten Rechteckflächen, z.T. kombiniert mit Leuchtröhren (*Junk space* 2006; *Red cross; Black on white Proun,* beide 2009), die sich dann, ergänzt durch Wand-Zchngn, auch als zusammenhängendes Ganzes in den Raum hineinentwickeln (*Debris project,* 2008). ⊡ LOS ANGELES, Jaus: Morpho, Wandbild, 2010. ⊚ E: Mexiko-Stadt: 2004 Esc. Nac. de Pint., Escult. y Grabado „La Esmeralda", Espacio Alternativo; 2008 Mus. Univ. Contemp. de Arte (MUCA Roma) / 2005, '06 Chihuahua, La Estación Arte Contemp. / 2006 Basel, Brasilea Kulturhaus / 2007 San Francisco, Gall. 415 (mit Jorge Jurado) / 2008 Los Angeles, Steve Turner Contemp. – G: 2001 Morelia: Bien. Nac. de Pint. y Grabado Alfredo Zalce / 2002 Ciudad Juárez (Chihuahua): Bien. de Artes Plást. Paso del Norte / 2002, '06 Mérida: Bien. Nac. de Artes Visuales de Yucatán / 2003 Toluca (Estado de México): Bien. Nac. de Arte Visual Univ. / 2004 Tijuana (Baja Calif.): Bien. Nac. de Pint. Miradas; 2007 Monterrey: Bien. Monterrey FEMSA de Pint., Escult. e Instalación / 2008 Moskau: Internat. Bienn. für Junge Kunst; Mexiko-Stadt: Bien. de Pint. Rufino Tamayo / 2009–10 Tijuana, Mexicali und Los Angeles: MexiCali-Biennial. ⊡ D. C. Murray, AiA 96:2008 (8) 175 s.

M. Nungesser

Catalán (C. Sarrión), *María,* span. Malerin, Bildhauerin, * 1961 Castellón de la Plana, lebt in San Antonio/ Ibiza. Stud.: 1984–88 Esc. d'Arts i Oficis, Eivissa/Ibiza.

1988–2000 als Ass. im Atelier von Eduard Micus in Jesús/
Ibiza tätig. – C. malt in der Trad. des Informel, bes. an-
geregt von E. Micus, das Materialhafte hervorhebende
Bilder in Acryl oder Mischtechnik auf Jute, Holz, Stahl
oder handgeschöpftem Papier, z.T. mit Collage und un-
regelmäßigen Umrissen, Relief-Char. und Rissen. Sie be-
stehen aus flächig-geometrischen Hintergründen in weni-
gen, von warmen Erdtönen, Grün und Blau dominierten
Farben, die von dynamisch-linearen korrespondierenden
Strukturen überlagert werden. Andeutungsweise ergeben
sich gegenständlich-symbolische Assoziationen (z.B. *De-
trás de la reja; A través de la ventana*, beide 2005; *Pu-
ertas de esperanza; Como volutas de humo*, beide 2006).
Auch in Mischtechnik bemalte, freistehende, paravent-
oder blockartige Platten aus Eisen (*Anfiteatro en azules;
Casi una ciudad*, beide 2007) und Holz mit Kupferpa-
pier sowie aus Drähten und Stangen geformte raumgrei-
fende abstrakte, teils installative Arbeiten (*Laberintos de
savia*, 2001) und figurale Plastiken. ⌂ EIVISSA, Fund.
Micus. ◉ *E:* 1990 (K: E. Micus u.a.), '96 (K: S. Knich-
witz) Düsseldorf, Gal. Franz Swetec / 1990 Mannheim,
Gal. am Kleinen Markt / 1990, '94, '97, 2001 Griesheim,
Gal. Franz Swetec / 1991, '95, 2002, '08 Bonn, Gal. Mari-
anne Hennemann / Paris: 1991 Gal. Art Option; 1993 Gal.
Philippe Gravier / 1993 Hamburg, Gal. Keeser (mit E. Mi-
cus; K: F.-J. van der Grinten u.a.) / Eivissa: 1998, 2000 Gal.
Libro Azul; 2000 MAC; Kirche l'Hospitalet (K: E. Ruiz
Sastre) / Palma de Mallorca: 2002 (K: E. Ruiz Sastre), '07
(K: G. Frontera u.a.; Bibliogr.) Casal Solleric; 2007 Gal.
Joanna Kunstmann (mit Margalida Escalas) / 2004, '07
(mit E. Micus), '10 Carretera Jesús-Cala Llonga, Espacio
Micus / 2005 Granada, Gal. Granada Capital / 2008 Mahón
(Balearen), Mus. de Menorca. – *G:* 1998 Eivissa, MAC:
Pintores abstractos de Ibiza (Wander-Ausst.; K: E. Ruiz
Sastre). ▭ *Delarge*, 2001; DPEE, Ap., 2002. – Mediale
(K), Ha. 1993; Diario de Mallorca v. 4. 12. 2007; Diario de
Ibiza v. 14. 12. 2007. – *Online:* Blog C. M. Nungesser

Catalán Tomás, *Ramón*, span. Maler, Wandmaler, Bild-
hauer, * 25. 8. 1922 Caudiel/Castellón, † 17. 4. 2006 Be-
nicasím. Mit 5 Jahren Vollwaise. Stud.: 1940–45 mit Stip.
der Prov.-Verwaltung Malerei und Skulpt. an der Esc. de
Artes y Oficios, Castellón de la Plana, bei Emilio Alia-
ga und Bernardo Artola Soligó; Zeichnen am Colegio de
la Beneficiencia bei Rafael Sanchis Yago; 1940–45 EBA
de S. Carlos, beide Valencia. Dann anderthalb Jahre im
Karmeliterkloster Desierto de las Palmas in Castellón de
la Plana. In den 1950er Jahren mit Stip. in Paris. Lehr-
tätigkeit: u.a. Inst. de Bachillerato, Aranda del Duero;
Esc. de Maestría Industrial; Esc. de Trabajo und Colegio
Univ., alle Castellón de la Plana. Ausz.: u.a. 1942 Pre-
mio Roig für Bildhauerei; 1972 Silber-Med., Bien. de Se-
góvia. – U. a. von Eugenio Hermoso und Fernando Al-
varez de Sotomayor angeregte realistisch-akad. Gem. und
Portr., auch Lsch. (z.B. *Rubielos de Mora, Teruel*), re-
lig. Themen und Genreszenen (*Mesa principal [Refec-
torio]*, 1957), meist mit Kindern (*Niños jugando*, 1959;
Niñas en el patio; La clase de pint.). Außerdem zahlr.
u.a. von Michelangelo und Daniel Vazquez Díaz inspi-

rierte vielfigurige, kubisch stilisierte mon. Wand-Gem. mit
hist.-allegorischen Themen. ⌂ ALMASSORA, Stadtver-
waltung. CASTELLON DE LA PLANA, Caja Rural Credicoo-
op – Fund. Caja Castellón-Bancaja. VILLARREAL, Fund.
Flors. – *Wandbilder:* CASTELLON DE LA PLANA, Conven-
to del Desierto de las Palmas. – Gobierno Civil, Trep-
penhaus: Fresko, 1957 (zerst.). – Stadtverwaltung, Kap.:
Fresko, 1958. – Kooperative Uteco Castellón, 1970. – Ca-
sino Antiguo, Treppenhaus: Tombatossals, 1973. – Ca-
ja Rural San Isidro, Patio de Operaciones, 1980. – Ba-
sílica de la Mare Déu del Lledó, Narthex: Anunciación,
1995. MORELLA, Albergue Nac. Cardenal Ram, 1959. NU-
LES, Iglesia Arciprestal. – Bar Caja Rural, 1988. VILLAR-
REAL, Stadtverwaltung, Treppenhaus, 1968. ◉ *E:* Ca-
stellón de la Plana: 1952, '53 Sala Estilo; 1990 Centro
Cult. de la Caja de Ahorros y Monte de Piedad (Retr.; K:
A. J. Gascó Sidro, C. G. Espresati) / 1997 Almassora, Ca-
ja Rural (Retr.) / 1999 Villarreal, Stadtverwaltung (Retr.;
K: A. Gascó). ▭ *Agramunt Lacruz* I, 1999; DPEE, Ap.,
2002. – El Periódico Mediterráneo (Castellón de la Plana)
v. 21. 4. 2006; 29. 4. 2006 (Nachrufe). M. Nungesser

Catalani, *Massimo*, ital. Maler, Bildhauer, Perfor-
mancekünstler, Architekt, * 2. 4. 1960 Rom, lebt dort.
Stud. der Archit. (1988 Dipl.); 1989 Eintritt in den Berufs-
Verb. der Architekten in Rom. – C.s gegenständliche Gem.
sind meist aus mehreren quadratischen Lw. zusammenge-
setzt. Zunächst malt er v.a. Stilleben mit Blüten, Obst, Ge-
müse und Pastagerichten, später auch Frauenakte und ar-
chit. Ansichten. Häufige Motive sind zudem Segelboote,
Schafe, Fische, Berg-Lsch. sowie der Mond. C. beschränkt
sich oft auf die Darst. eines einzigen Bildgegenstandes,
den er symbolisch auffaßt. Den Farben mengt er Sand, Er-
de und pulverisierten carrarischen Marmor bei und trägt
sie, häufig pastos, mit einem Spachtel auf. Des weiteren
Skulpt. aus Marmor (Früchte) und Performances. 2008 er-
scheint anläßlich der gleichnamigen Ausst. die Publ. Nihil
Nihilism. Diz. dell'Arte mia mit Abb. seiner Werke und
eig. erklärenden Texten. ◉ *E:* Rom: 1992 Gall. Roma
& Arte; 2001 Studio d'Arte Campaiola; 2008 Antica Gall.
Bosi / 1995–2005 regelmäßig Genf, Gal. Nota Bene / 2000
New York, Pescepalla Docks Gall. (K) / 2009 Berlin, Gal.
LackeFarben (K). – *G:* Rom: 1993 Salone di Arte Con-
temp.; 2008 Pal. delle Espos.: L'Arte nell'uovo di Pasqua /
1995 Genf, Gal. Nota Bene: Avant Première / 1997 Bei-
rut, Mus. Sursock: Aspects de la Peint. ital. des Années
'90 (Wander-Ausst.) / 1999 Vasanello, MCiv.: Est'Arte.
▭ *G. Marziani* (Ed.), M. C. La natura naturale (K), R.
2004; *C. Siniscalco* (Ed.), Segnali di primavera. Salone di
maggio (K), R. 2006. – *Online:* Website C. D. Malz

Catalano, *Elisabetta*, ital. Fotografin, * 1941 Rom, lebt
dort. Anfangs Modeaufnahmen für Ztgn und Zss. wie Il
Mondo, L'Espresso, L'Almanacco letterario Bompiani;
für die Vogue in New York und Paris tätig. In den 1970er
Jahren Zusammenarbeit mit Konzept- und Performance-
künstlern (Sandro Chia, Gino De Dominicis, Fabio Mau-
ri, Vettor Pisani, Michelangelo Pistoletto, Mimmo Rotella,
Cesare Tacchi) bei der Realisierung der fotogr. Komponen-
ten und Dok. ihrer Werke. 1973 debütiert sie mit Künstler-

Portr. und avanciert danach zu einer Protagonistin der zeitgen. Künstlerporträt-Fotogr. Italiens. Häufig in Schwarzweiß, als Büsten, Halb- und Sitzfigur, teils skulpturenhaft wirkend oder genrehaft inszeniert, zeigt sie Persönlichkeiten aus Kunst, Lit., Kino- und Theaterwelt, u.a. Serien zu Regisseuren (1978 im Auftrag der Fa. Polaroid, Boston), zu Federico Fellini (1994), Gilbert & George (2005), Alberto Moravia und Musikern (jeweils 2007), außerdem auch Fotogr. von Künstlern in Aktion. 2008 Portr. von prominenten Fußballspielern (*Eroici di calcio*) für einen Kalender des Verlags Mondadori. ▭ MAILAND, Fond. Forma per la Fotogr. PARIS, Centre d'Art et d'Hist. Louis Lartique. VOLTRI, Mus. della Fotogr. Contemp. ◉ *E:* Rom: 1973 Gall. il Cortile; 1975 Marlborough Gall.; 1992 GNAM (K); 1999 Gall. Sperone; 2004 Assoc. Cult. Valentina Moncada; 2005 MAXXI; 2008 Studio d'Arte Contemp. Pino Casagrande; 2009 Gall. Pio Monti / Mailand: 1973 Gall. Milano; 1977 Gall. Diaframma / 1978 Venedig, Gall. Barozzi / 1994 New York, Ist. ital. di Cult. / 2005 Turin, GAM (Retr.; K: L. Cherubini) / 2006 Brescia, Gall. Minini (mit Nanda Lanfranco; K) / 2007 Paris, Ist. ital. de Cult. ▭ *D. Snyder*, Art mag. 1979 (42) 22 s.; 20 anni di Vogue Italia. 1964–1984 (K), Mi. 1984; *A. Imponente* (Ed.), E. C. I ritratti, R. 1992; *M. L. Frisa* (Ed.), Ital. eyes. Ital. fashion photogr. from 1951 to today (K), Mi. 2005. – *Online:* Website C. D. Trier

Catalano, *Ferdinando,* ital. Kartograph, Zeichner, * 16. 4. 1827 Neapel, † 4. 11. 1863 ebd. Ab 1855 im Officio Topogr. Napoletano tätig; 1858 Verbeamtung mit einem Jahresgehalt von 90 Dukaten. Spezialisiert auf Grundriß- und Plan-Zchngn, besteht C.s wichtigste Aufgabe in der kartographischen Umsetzung von Vermessungsdaten. 1857 realisiert er die Grundrisse der Gemeinden Solopaca, Melizzano und Frasso, 1858/59 ebenso von Alife, Alvignano und Gioja (samt deren unterschiedlichen Höhenniveaus). 1860 v.a. zeichnerisch tätig und mit topogr. Vorlagen beschäftigt, deren präzise und technisch souveräne Umsetzung gelobt wird. Nach dem Fall der Bourbonen dient C. auch dem Vereinten Königreich als Beamter im Ufficio Superiore del corpo di Stato Maggiore ital. in Neapel. 1861/62 verringert er die Maßstäbe zahlr. bereits vorhandener Karten und nimmt die Grundrisse von Civitella del Tronto und Giulianova auf. ▭ *V. Valerio,* Soc., uomini e ist. cartografiche nel Mezzogiorno d'Italia, Fi. 1993. S.-W. Staps

Catalucci, *Diomede,* ital. Dekorateur, Restaurator, Maler, * 6. 8. 1859 Ferrara, † 13. 12. 1943 Urbino. Bemüht sich 1877 erfolglos bei der Gemeinde Ferrara um ein Stip. zur Forts. des Stud. an der ABA in Perugia. Lehrtätigkeit: Ist. d'Arte, Pietrasanta; ab 1895 Ist. di BA delle Marche, Urbino. Läßt sich in Urbino nieder, wo er v.a. als Doz., Dekorateur und Restaurator tätig ist. Ausst.-Teiln.: 1904 Senigallia; 1905 Espos. Regionale, Macerata. In Zusammenarbeit mit seiner Tochter und Schülerin Maria C. fertigt er eine malerische Umsetzung der Intarsien des Studiolo von Federico da Montefeltro für die Espos. Internaz. d'Arte in Rom (1911). – In Urbino realisiert C. u.a. Ausstattungen im Teatro Sanzio (1896–97, mit Umberto Gualaccini), in

der Capp. di S. Antonio (1898–1900) und an einer Krippe (1902–03), beide in der Kirche S. Francesco, sowie im Caffè Basili (bis 1906); in San Lorenzo in Campo gestaltet er die Chiesa del Crocefisso aus. Des weiteren gehen die Dekorationen des Springbrunnens der Piazza VIII Settembre (1908) sowie die Ausstattung der Sala Pascolini im Pal. Ducale und des Albergo d'Italia auf C.s Entwürfe zurück. 1901 ist er an der Rest. der Fassade des Oratoriums S. Giovanni beteiligt; 1913 restauriert er die aus vollplastischen Stuckfiguren bestehende Krippe von Federico Brandani in der Kirche S. Giuseppe und 1920 die Holz-Skulpt. einer Verkündigungsgruppe (Urbino, GN). ▭ *A. P. Torresi,* Primo diz. biogr. di pittori restauratori ital., Fe. 1999; *Panzetta* I, 2003. – *A. Nave,* F. D. Boll. della Ferriae Decus, N. S., 20:2003, 139–145. D. Malz

Catania, *Mimmo,* ital. Maler, Graphiker, Zeichner, Installationskünstler, * 30. 5. 1955 Vittoria/Sizilien, lebt seit 1984 in Berlin. Stud.: 1980–84 ABA, Urbino (Malerei). Stip.: 1995 der Omi Internat. Artist Residency in Columbia/N. Y., 1996 der Berliner Kulturfonds Found. in Haifa; 1998/99 der Daimler-Chrysler-Stiftung in der Casa Goethe in Rom (erster Stipendiat dort), 2005 der Pollock-Krasner Found. in New York, 2006 der House Radobolja Colony in Mostar sowie 2007 der Joan Mitchell Found., New York, im Art Ist., Santa Fe/N. Mex. – Die anfangs meditativ-informelle Malerei der chromatischen Abstraktion (*Buon viaggio con le FS,* Mischtechnik, 1981) bindet C. in den späten 1980er Jahren in streng strukturierte, voneinander abgegrenzte, rechtwinklig definierte, ineinander verschränkte Formgerüste ein (*Anti-Oedipus,* Triptychon, Öl, 1987) und kombiniert so die bisherige Malerei mit Elementen des Hard-edge-painting und der Farbfeldmalerei. E. der 1980er Jahre entstehen Boden- (*Floor,* Holzkohle/Holz, 1988) und Wandinstallationen (*Building by night,* Quadrat-Komp. aus Winkelelementen, Fotokopien, 1994) aus geometrischen, häufig modulartigen Komponenten. In den 1990er Jahren verläßt C. das Informelle und inszeniert die dingliche Wirklichkeit. Im Mittelpunkt stehen zunächst Rauminstallationen mit Gegenständen in surrealer Verfremdung und Überhöhung (*Walking the desert,* Buschwerk, Objets trouvés, Wasser, Installation in der Negev-Wüste, 1995) oder nüchtern-lakonischer Sicht (*The red house,* Bett, Bettleuchte, Waschbrett; Columbia, Art Omi, 1995). In den späten 1990er Jahren gestaltet C. Orte und Momente mit Hilfe von Projektionen und läßt offen, ob es sich um reale Situationen oder um Phantasien handelt, zumal wenn Projektionen von Figuren oder Köpfen in die Szenerie einbezogen werden. Gesch. und Gegenwart verquicken 1998 in Rom entstandene Arbeiten (Fotogr., Hschn., Linolschnitte), die Straßenzüge, hist. Bauten und Innenräume aus einer möglichen Sicht Goethes (*Bilderbesuche,* Sequenz mit 16 Diapositiven; *Mann am Balkon*) zeigen und gleichzeitig beliebte Stilleben- und Interieurmotive der Goethezeit (*Blick ins Weiße; Zitronen*) in die Gegenwart übertragen. In jüngerer Zeit vom Neorealismus geprägte holzschnitt- oder collageartig wirkende plakative Darst. zur Massenkultur wie anonymisierte Menschenmassen oder leere Stuhlreihen in Konzert- und

Kinosälen in Verbindung mit Bildprojektoren, Lautsprechern, Mikrophonen, Bühnenscheinwerfern und Leuchtreklame. ⌂ BAGHERIA, GAMC. NEW YORK, Pollock-Krasner Found. ✉ Kolbo (Haifa) v. 23. 2. 1996 (Interview). ☉ *E:* 1986 Hagen, Gal. Kunstraum / Berlin: 1986, '88 Gal. IX; 1990 Gal. Loulou Lasard (K); 1993 Konzept Mus. Gal.; 2004, '05 Mietart Gal. / 1987 Düsseldorf, Gal. Planet (mit Ruprecht Dreher) / 1995 Warschau, Gal. Dziekanka / 1996 Haifa, Pyramida Center for Contemp. Art; Tel Aviv, Ephrat Gall. / 1999 Rom, Casa di Goethe (K) / 2007 Santa Fe (N. Mex.), Art Inst. / 2009 Köln, Ital. Kultur-Inst. (K) / 2010 Beijing, Unit One Art Center. – *G:* 1991 Siracusa: Bienn. Arte Sacra / 2001 Venedig: Bienn. / Berlin, Gal. oqbo: 2008 !First Stop! Backstop; Paperfiled 2. ▭ *M. Apa* (Ed.), Microcosmo macrocosmo. Itinerari di pratiche artist. (K Pal. Ducale), Urbino 1984; Il fare dell'arte (K Rocca Bernarda-Premariacco), Ud. 1987; *E. Baumgart* (Ed.), M. C. Macchine per ascrivere, Bagheria 1990; *H. Fricke*, Tages-Ztg (TAZ) v. 12. 2. 1994; Schattensprung. 11 Künstlerinnen und Künstler aus Berlin (K Warschau), B. 1994; *G. Vianello*, Il nulla liberato, R./Ve. 1995; Art Focus. Contemp. art in Israel (K), s.l. [1996]; Die Grundsteinkiste (K Rheinisches LM), Bonn 1996; *U. Bongaerts* (Ed.), Stipendiaten 1. Casa di Goethe, M. C. u.a. (K), R. 1999. – *Online:* Website C. (Ausst.; Lit.). – Mitt. C. D. Trier

Cataragǎ, *Tudor*, moldawischer Bildhauer, * 4. 8. 1956 Selişte b. Nisporeny. Stud.: 1981–84 und 1990 KA, Leningrad (St. Petersburg), u.a. bei Serghei Kubasov und Michail Konstantinovič Anikušin. Teiln. an Symposien: u.a. 1992 Alba Iulia: Momentul Galda; 1992 Chişinău: Moldexpo; 1993 Bacău: Nouǎ meşteri; 2001 Changchun/Jilin. Ausz.: 1998 Skulpt.-Preis des rumänischen Künstler-Verb.; 2000 Mihai-Eminescu-Med.; 2001 Stern Rumäniens. – C.s stilisierte figürliche Komp. in Holz, Metall und Stein, auch als Kleinplastik, sind z.T. von nat. Folklore geprägt. Im Auftrag der Stadt Chişinău Gest. eines *Mihai-Eminescu*-Denkmals (Bronze, 1992). ⌂ BACĂU, Centrul G. Apostu. BUKAREST, Sala Parlamentul. CHIŞINĂU: Schutzengel (mit Ion Dumenic), Stein, 1994. – Moldova Muz. de Literaturǎ M. Kogǎlniceanu. – Nat. KM. IAŞI, Muz. de Literaturǎ M. Eminescu. UNGHENI: Tron Medieval, Sandstein, 2000. ☉ *E:* 1997 Bukarest, Casa America Latina / 1998 Iaşi, Muz. Literaturii Române V. Pogor. – *G:* 1992–93 Bukarest, Artexpo: Basarabeni la Bucureşti / 1993, '94 Bacău: Saloanele Moldovei. ▭ *A. Cebuc u.a.*, Enc. artiştilor români contemp., II, Bu. 1998 (Ausst.). – T. C. Sculpturǎ, Chişinău 2003. – *Online:* Arta Neonet.
St. Schulze

Catel (Muller, *Catel [Cathy]*; eigtl. Muller, *Catherine*), frz. Comiczeichnerin, Illustratorin, * 2. 8. 1964 Strasbourg. Stud. ebd.: Ill. und Kunstgesch. (1989 Dipl.). Erste Ill. in Kinderbüchern, dann in Kinder-Mag. wie Okapi, Astrapi und J'aime lire für Bayard Jeunesse. Anschl. vorwiegend Kindercomics: Es entstehen mit Paul Martin *Bob et Blop* (1996) in Images Doc und mit Fanny Joly *Marion et Charles* (1999) für Je Bouquine. Mit Véronique Grisseaux als Autorin zeichnet C. 2000 die Serie *Lucie* für ältere Le-

ser, kehrt aber mit dem Indianerfunny *Les Papooses* 2003 (Szenario Sophie Dieuaide) zu den Kindercomics zurück. 2004 schreibt sie das Szenario für den realistischen Einzel-Bd *Le Sang des Valentines* (Zchngn Christian de Metter), der im 1. WK spielt. 2007 erscheint der von José-Louis Bocquet geschriebene Comicroman *Kiki de Montparnasse*, der vielfach ausgezeichnet wird. 2008 folgt *Quatuor*, ein Album über die vier Jahreszeiten. Für Dupuis entsteht 2009 *Rose Valland, Capitaine Beaux-Arts* und für Casterman 2010 *Dolor* (Szenario Philippe Paringaux). Ausz.: 2005 Prix du Public Angoulême; 2007 Prix RTL de la BD; 2008 Prix Essentiell Angoulême. – Die Zchngn für die Comics sind klar und naiv gehalten, im Strich schwungvoll und lebendig. Vorbilder lassen sich ebenso bei frz. Illustratoren der 1950er Jahre finden wie bei Vertretern der Nouv. Ligne Claire. ▭ *H. Filippini*, Dict. de la bande dessinée, P. 2005. – *Online:* Website C.; Lambiek Comiclopedia.
K. Schikowski

Catelani, *Antonio*, ital. Maler, Bildhauer, Installationskünstler, * 23. 3. 1962 Florenz, lebt in Berlin. Stud.: 1981–85 ABA Florenz. 1995/96 Stip. der Akad. Solitude Stuttgart. Ab 1985 befaßt sich C. zus. mit Carlo Guaita und Daniela De Lorenzo mit der künstlerischen Umsetzung normativer Prozesse und Regeln der Plastik und deren Beziehung zur Archit.; das Ergebnis, minimalistische Installationen, stellen sie 1988 auf der Bienn. Venedig aus. 1988–92 realisiert er *Tipologie*, dreidimensionale hölzerne Gitterstrukturen, in die u.a. Pflanzen einbezogen sind. Das Verhältnis zw. Abbild, Struktur und Materie ist nachfolgend Thema seines komplexen künstlerischen Schaffens. Ab den 1990er Jahren versucht er in einer Art Meta-Malerei, den Unterschied zw. Materie und Abbild aufzuheben. In der Folge *Ipercromo* (2002) läßt die klare, durchscheinende, vibrierende Farbe als einziges Komp.-Element eine vage Räumlichkeit von Transparenz und Sfumato entstehen. And. Themen C.s sind die Krise des mod. Empfindens und die biologischen Wurzeln des Menschen, wofür er Parallelen in der Pflanzenwelt sucht. Die Zyklen *Reziario* und *Rizomi* (2008) zeigen mit reduzierten malerischen Mitteln Modelle der Kommunikation, als Netz des Retiarius oder als unkontrolliert wucherndes Rhizom. Ausz.: 2010 Kunstpreis der Messmer Found., Riegel. ⌂ BOLOGNA, GAM. MAILAND, Civ. MAC. – Pal. Reale. – Coll. Banca Commerciale Ital. MONSUMMANO TERME, MAC e del Novecento. PISA, Fond. Teseco. PRATO, Centro per l'Arte Contemp. Luigi Pecci. ROM, GNAM. SIENA, Centro Arte Contemp., Pal. delle Papesse. WIEN, MMK Stiftung Ludwig. ☉ *E:* Bologna: 1986 Studio Malossini (mit D. De Lorenzo, C. Guaita; K); 1991 Studio G7; 2002 Gall. No Code / 1988 Florenz, Gall. Carini (K: E. Grazioli); Turin, Gall. Matteo Remolino / 1989 Valdagno, Gall. Civ. d'Arte Mod. (mit D. De Lorenzo, C. Guaita; K) / 1989, '92 (K) Mailand, Studio Guenzani / 1993 Arezzo, Gall. Marsilio Margiacchi (mit Mario Della Vedova; K) / Rom: 1995 Gall. Oddi Baglioni; 1996 GNAM (K); 2008 Gall. Maria Grazia Del Prete / 1995 Stuttgart, Schloß Solitude / 1996 Cortona, Pal. Casali (K) / 1998 San Giminiano, Gall. Continua; Catania, Gall. Gianluca Colli-

ca / 1999 Pisa, Fond. Teseco (K) / 2000 Berlin, Gal. Kubinski / 2001 Bludenz, Verein aller Art (K) / 2004 Fucecchio, Fattoria Montellori (mit D. De Lorenzo; K: L. Cherubini) / 2005 Bregenz, Künstlerhaus Pal. Thurn und Taxis (K: G. Maragliano) / 2006 Koper, Gal. Contra. – *G:* 1986 Mailand, PAC: Il cangiante (K); 1998 ebd.: Due o tre cose che sono di loro (K) / 1989 Frankfurt am Main, Schirn: Prospect 89 (K); Köln, KV: Die erste Ausst. (K) / 1990 Castel San Pietro Terme: Generazioni a confronto (K) / 1991 Prato, MAC: Una scena emergente (K) / 1991–92 Wien, MMK Stiftung Ludwig: La scena (K) / 1992 Florenz, Villa Romana: Architettonico e pittoresco (K) / 1993 Trient, Gall. Civ. di Arte Contemp.: Emergenze '93 (K) / 1996 Gubbio: Bienn. di scult. / 1996, 2008 Rom: Quadrienn. / 2000 Carrara: Bienn. internaz. / 2002 Prato, Centro per l'Arte Contemp. Luigi Pecci: Continuità (K) / 2006 Monsummano Terme, MAC: Misure del tempo (K). ⌺ Cat. dell'arte mod. ital., XXVII, Mi. 1991; Diz. degli artisti ital. contemp., Mi. 1996; *Delarge*, 2001. – *A. Iannacci*, Artforum 27:1989 (7) 146; Kunst, Europa. 63 dt. KV zeigen Kunst aus 20 Ländern (K), Mainz 1991; *E. Grazioli/G. Verzotti*, A. C. Compresenze, Bo. 1992; Korrespondenzen – Corrispondenze. Zwölf Künstler aus Florenz und Berlin (K), B./San Giovanni Valdarno 1992; PittItalNovec/3, 1994; *L. Beatrice u.a.*, Nuova scena. Artisti ital. degli anni '90, Mi. 1995; *J. Meinhardt*, Kunstforum internat. 133:1996, 383 s.; *C. Christov-Bakargiev*, A. C. Il corpo del colore, St. u.a. 1997; *R. Barilli*, Prima e dopo il 2000. La ricerca artist. 1970–2005, Mi. 2006. – *Online:* Website C.; Exibart. E. Kasten

Catenazzi, *Augusto*, schweiz. Maler, Miniaturmaler, * 5. 5. 1808 Mendrisio, † 27. 7. 1880 ebd. Sohn und Schüler von Francesco C., den C. nach seiner Ausb. bei Dekorationsmalereien unterstützt. Die Angabe in einer Quelle, wonach sich ein Stud. an der ABA di Brera in Mailand anschließt, ist dort nicht nachweisbar. Nach dem Tod des Vaters (1831) wahrsch. ca. 20 Jahre lang auf Reisen durch Frankreich, England, Griechenland, Türkei, Algerien, Spanien; 1833 malt C. in Wisbech/Cambs. Portr. der Fam. des angesehenen Uhrmachers Antonio Mantegani, zunächst von der Tochter *Irene Mantegani* (Min., nach der er 1856 ein Ölbildnis fertigt), *Ritratto di A. Mantegani* und das Gruppenbild *La fam. Mantegani*; kurz danach folgen Min. von *Susanna, Ermelinda* und *Teresa Mantegani.* C. ist als einer der wenigen und zugleich letzten Tessiner Min.-Maler überliefert. Nach einem Unfall 1853 bleibt er bis ans Lebensende in Mendrisio, wo er v.a. Veduten gemalt haben soll. ⌂ LAUSANNE, MBA. LUGANO, Mus. Cantonale d'Arte. ⌺ BLSK I, 1998. – *R. Chiappini* (Ed.), Arte in Ticino (K Lugano), I, Bellinzona 2001 (Lit.). – *Online:* SIKART Lex. und Datenbank. R. Treydel

Caterina, *Dario*, belg. Bildhauer, Maler, Zeichner, Fotograf, * 1955 Seraing, lebt in Lüttich. Stud.: ABA, Lüttich (Bildhauerei, Zeichnen). Lehrtätigkeit: 1984–85 ABA, Verviers; seit 1985 Ec. supérieure des Arts, Lüttich (jeweils Bildhauerei). Ausz.: 1980 Grand Prix quinquennal de Sculpt. de la Ville de Liège; 1981 Grand Prix de Dessin du millénaire de la Prov. de Liège; 1983 Prix Jeunes Talents de Peint. de la Prov. de Liège. – Angeregt durch antike griech. Vorbilder, gestaltet C. zunächst v.a. farbig gefaßte figurative Plastiken (u.a. Terrakotta, Gips). Später wendet er sich verstärkt der Malerei zu und kombiniert in jüngeren Werken collageartig Ausschnitte eig. Fotogr. mit Gem. und Zchngn. Bevorzugtes Motiv der meist rätselhaften Komp. in naiv-vereinfachter Formsprache und Perspektive ist eine nackte oder halb bekleidete Frau. Char. ist zudem die Darst. einzelner oder am Körper anders angeordneter Gliedmaßen; bisweilen fehlen diese auch. Des weiteren Ill., z.B. zu G. Hons, *La morale des abattoirs*, Soumagne 1997. ⌂ BRÜSSEL, Fond. pour l'Art belge contemp. CAGNES-SUR-MER, MAM méditerranéen. LÜTTICH, MAM et d'Art contemp. – Mus. de l'Art wallon. ☉ *E:* 1980 Köln, Gal. Koppelmann / Brüssel: 1986, '88 Gal. Fred Lanzenberg (jeweils K); 2002 Fond. pour l'Art belge contemp. / Paris: 1987 Gal. Etienne de Causans; 1996 Gal. Artmica / 1990 Cagnes-sur-Mer, MAM méditerranéen / 2007 Lüttich, Monos AG. – *G:* 1987 Cagnes-sur-Mer: Festival internat. de la Peint. (Première Palette d'Or) / 1989, '90 Paris: Salon de Mai / 2002 Amay, Château de Jehay: Sculpt. Totems / Lüttich: 2005 Monos AG: Papiers d'hivers; 2009 Mus. de l'Art wallon: Couples à p(art)ager. ⌺ *Bénézit* III, 1999; *Delarge*, 2001; *Pas* I, 2002. – *S. Goyens de Heusch* (Ed.), XXᵉ s. L'art en Wallonie, Tournai/Br. 2001. – *Online:* Website C. F. Krohn

Catrinu, *Margareta*, rumänische Malerin, Zeichnerin, * 9. 8. 1949 Beiuş, lebt in Cluj-Napoca. Stud.: bis 1974 HBK I. Andreescu ebd. Als Kunsterzieherin tätig. – Beginnt u.a. mit lyrischen, reich nuancierten Lsch. und Blumenstilleben. In späteren nonfigurativen und wesentlich expressiveren Arbeiten sind Wasser und Feuer thematisiert. Bes. Inspiration erhält C. durch Klaviermusik. ☉ *E:* Cluj-Napoca: 1999 (Retr.), 2006 MN de Artă; 2000 Gal. Primăriel / 2000 Dej, Gal. Frezia. – *G:* Cluj-Napoca: 1976–2001 Bezirkskunst-Ausst.; seit 1990 Lucian-Blaga-Festival; 2009 MN de Artă: Salon anula de arte plastice şi decorative / 2000 Bacău: Salon de la Moldova. ⌺ *A. Cebuc u.a.*, Enc. artiştilor români contemp., IV, Bu. 2001 (Ausst.). – *Online:* România liberă v. 5. 9. 2006 (Interview). St. Schulze

Cattaneo, *Alice*, ital. Bildhauerin, Installations- und Videokünstlerin, * 27. 2. 1976 Mailand, lebt dort. Stud.: Glasgow SchA (2001 Bachelor of FA); San Francisco Art Inst., San Francisco (2002 Merit, 2003 Murphy Fellowship; 2004 Master of FA). 2004 Ass. ebd. und Ausst.-Debüt. 2006 Artist in Residence, Fond. Antonio Ratti, Como. – Zunächst v.a. Bodenobjekte und -installationen, dann auch Decken- und Wandinstallationen mit einfachsten, von Klebestreifen zusammengehaltenen Grundformen und Mat. (Karton, dünne Holzleisten und -stäbe). Nach dem Prinzip der sukzessiven konstruktiven Akkumulation fügt C. einem ersten, im Raum aufgestellten Element nach und nach weitere Teile hinzu, mit denen Drehungen, Gleich- und Gegengewichte gesetzt und die für den Zusammenhalt nötigen inneren Strukturen austariert werden. So entstehen zunächst auswuchernd komplexe, fragile, schwingende Gebilde im Raum, die wie die Skyline

einer futuristisch-utopischen Stadt oder ins Dreidimensionale übertragene Gem. von Joan Miró anmuten. Bald erzielen gekurvte, unregelmäßig-geometrische und stereometrische Formelemente eine dynamischere Wirkung, die durch den Einsatz von direktem oder indirektem Licht unterstützt wird. Zuletzt Beschränkung auf reduziertere Komp. mit weniger Teilen unter Verwendung neuer Mat. wie Kunststoff, Kabel oder farbig lackierte Aluminiumleisten, auch in Verbindung mit fluoreszierenden Schläuchen. In Videofilmen hält C. Assemblagen aus Gegenständen, Bildern und Zeichen fest. Die aus dem Blickwinkel einer festinstallierten Kamera in kurzen Sequenzen aufgenommenen Filme haben den „Rhythmus kleiner Kalauer" (G. Verzotti), mit denen ein Überraschungsmoment kalkuliert ist, das dem Betrachter die Möglichkeit entzieht, den vorbeilaufenden Bildern eine eindeutige Bedeutung zuzuordnen. ◉ *E:* 2004 San Francisco, Mission 17 / 2005 Mailand, Fabbrica di Vapore; Gall. Suzy Shammah / 2006 Genf, Analix Forever. ▭ *G. Verzotti*, in: Abstract art now, strictly geometrical? (K Wilhelm-Hack-Mus. Ludwigshafen), Bielefeld 2006; *R. Barilli* (Ed.), La Giovane Italia. L'arte ital. rende omaggio a Giuseppe Mazzini ... (K), Mi. [2006]; *A. Bruciati* (Ed.), Video report Italia. 2004–2005 (K), Cinisello Balsamo [2006]; *B. Cora* (Ed.), Premio del Golfo 2006 (K Bienn. europ. arti visive, La Spezia), Prato [2006]; *J. Watkins*, A. C. (K Ikon Gall.; Wander-Ausst.), Birmingham [2007]; *C. Bertola/G. Maraniello* (Ed.), On mobility. Giovani artisti ital. (K Premio Furla), Mi. 2007; *D. Lotta*, Flash art, Ed. ital. 40:2007 (262) 103; *A. Mattirolo* (Ed.), Apocalittici e integrati. Utopia nell'arte ital. di oggi (K Rom), Mi. [2007]; *M. Bazzini* (Ed.), Nessuna paura. Arte dall'Italia dopo il 2000 (K Centro per l'arte contemp. Luigi Pecci, Prato 2007; *E. Zanella*, Le trame di Penelope (K Gallerate), [Busto Arsizio] 2007. – *Online:* Website C. D. Trier

Cattaneo, *Edmondo*, ital. Bildhauer, * 1892 Bergamo, † 1967 ebd., dort und in Rom tätig. Ausb. in Bergamo: 1904–06 Scuola d'Arte Andrea Fantoni; 1906–12 Accad. Carrara. Versch. Ausz., u.a. erhält C. 1910 ein einjähriges Rom-Stip. für seinen Bozzetto *Cristo sorretto dagli angeli*. In den 1920er Jahren versch. öff. Aufträge in Bergamo. 1931 Umzug nach Rom, wo er Reliefs in Bronze und Terrakotta mit Tiermotiven oder nach Werken großer Meister fertigt. Regelmäßige Teiln. an Ausst. der Accad. Carrara, des Circolo artist. di Bergamo und der Sindacali. 1964 Bronzearbeit für den ital. Soldatenfriedhof in El Alamein (Ägypten). ◉ *E:* 1932 Bergamo, Gall. Pro Arte / 1939 Mailand, Casa d'artista. ▭ *Panzetta* I, 2003. – *F. Rossi* (Ed.), Maestri e artisti. 200 anni della Accad. Carrara (K Bergamo), Mi. 1996. C. Follmann

Cattaneo, *Mario*, ital. Fotograf, * 28. 1. 1916 Mailand, † 4. 4. 2004 Indien. Vater des Fotografen *Mario C.* (* 12. 10. 1958 Rom, lebt in Pescara; internat. Reisefotograf [u.a. Indien, Afrika, Rußland], soziale Themen wie koloniales Erbe, Kinderarbeit in der Dritten Welt, Versklavung der Arbeitskraft; sonst Reiseimpressionen, auch Portr.). Nach Stud. (Wirtschafts-Wiss., Univ. Bocconi, Mailand) in Buchhaltung tätig. Als Fotograf Autodi-

dakt. Ab 1950 fotografiert C. das alltägliche Leben in Mailand, v.a. am Markt Fiera di Sinigaglia und am Stadtrand; ab 1952 Aufnahmen auch in Sizilien und in den 1950er/ 60er Jahren Straßenszenen in Neapel. Weitere Serien: *Luna park* und *Juke box*, E. 1950er/A. 1960er Jahre; *Caravaggio*, 1957; *Balera*, 1965–72; *Mondo beat*, 1971; *Festival pop*, 1977. Danach auch zahlr. Reisereportagen, u.a. Indien (1988, '93), Amsterdam (1988, '93, 2000), Guatemala (1995) und Jemen (1997). – C. gehört zur Generation der Nachkriegsfotografen, die mit ihrem Interesse für soziale Themen (Alltag, Jugend) zum Neorealismus gezählt werden. 1955 wird er jüngstes Mitgl. des Circolo Fotogr. Milanese, von dem er Anregungen und fotogr. Hilfestellungen erhält. C.s Arbeiten werden durch Kontakte mit Pietro Donzelli, Pepi Merisio, Cesare Colombo und Mario De Biasi beeinflußt; Vorbilder sind auch Henri Cartier-Bresson, Robert Doisneau, Werner Bischof oder Dorothea Lange. C. beobachtet mit Einfühlungsvermögen, auch mit Witz und Poesie, typische Gesten, Haltungen und Mimiken von Passanten und Händlern. Spielende Kinder, etwa die Gassenjungen im Zentrum von Neapel, sowie Feste oder Freizeitvergnügungen sind wichtige Motive. Foto-Publ.: *Vicoli*, N. 1992; W. Tucci Caselli (Ed.), *Des acquarei e cent fotogr. de la fera del Sinigaglia. 1950–1991*, Anzola d'Ossola 1996; G. Tani (Ed.), *M. C.*, T. 1999. ▭ CINISELLO BALSAMO, Mus. di Fotogr. Contemp. ◉ *E:* 2007 Cinisello Balsamo, Mus. di Fotogr. Contemp. – *G:* Zürich, Kunstgewerbe-Mus. (MfG): 1973 WA der Fotografie. Unterwegs zum Paradies; 1977 WA der Fotografie. Die Kinder dieser Welt (beide Wander-Ausst.; K) / 1997 Toulouse, Cinematheque: Neorealisme (K) / 2001 Turin, Mus. del Automobile: Gli anni del neorealismo (K) / 2007 Winterthur, Foto-Mus.: Neorealismo (Wander-Ausst.; K). ▭ *Auer*, 1992. – *U. Lucas* (Ed.), L'immagine fotogr. 1945–2000 (Storia d'Italia, Annali 20), T. 2004. T. Koenig

Cattaneo, *Mario* (1958) cf. **Cattaneo,** *Mario* (1916)

Cattani, *Bruno*, ital. Fotograf, Fotojournalist, * 16. 11. 1964 Reggio nell'Emilia, lebt dort. Beginnt 1982 mit Fotogr., gründet die Gruppo Fotogr. di Rivalta; 1984 eig. Studio (später mit Giuliano Ferrari). Arbeitet anfangs für lokale und nat. Zss. und Ztgn (u.a. Il resto del Carlino, Visto, Gente, La repubblica) und im Auftrag öff. Inst., z.B. Dok. des Stadtgebietes von Reggio nell'Emilia oder des Jazzfestivals ebd. (Publ.: *Jazz* [K Albinea], s.l. 1995); 1996 Dok. der Slg des MCiv. ebd. Danach Fotogr. von Skulpt., u.a. im Pergamon-Mus., Mus. Rodin oder Louvre (Publ.: M. Quetin, *L'arte dei luoghi* [K Paris], s.l. 2000). Auch Serien von verlassenen psychiatrischen Anstalten (*Luoghi della follia*, vor 2005), Industriedenkmalen (*Officine reggiane*), erodiertem Gestein (*Segni di tempo*) oder Pflanzendetails (*Verde*). – C. gehört zur Fotografengruppe um Vasco Ascolini und zur sog. Scuola di Reggio Emilia. Mit den Bildern von Skulpt., öff. Orten und Zeitspuren an Objekten sucht C. keine sachliche Dok., sondern er will den statischen fotogr. Moment ästhetisch-gestalterisch mit Narration und Emotion aufladen. Hierfür verwendet er dunkle oder nebelhafte Lichtstimmungen und Verschattungen der

Bildränder, ausschnitthafte Fragmentierungen und Verdeckungen, Unschärfen und grobe Bildstrukturen; er arbeitet häufig mit Polaroid-Sofortbildtechnik. Bei den schwarzweißen Mus.-Bildern fotografiert C. zunächst die Kunstwerke mit Besuchern (auch auf Infrarotfilm), die oft in Bewegung verwischt erscheinen. Danach ist er in den Räumen allein, um die Stille und das Geheimnisvolle der Orte zu zeigen. Durch spezielle Aufnahmewinkel suggeriert er das scheinbare Eigenleben der Skulpt. (Blickbeziehungen, Gesten) oder er betont deren erotisches Potential mit Aufnahmen von Körperdetails (*Eros*), wie er u.a. Bruchstellen als Verletzungen ins Bild rückt. Philippe Arbaïzar sieht darin auch eine Thematisierung von Gemeinsamkeiten der mimetischen Funktion von Fotogr. und Skulpt. (in: *Figure nel tempo* [K], Modena 2002). Mit der 2004 begonnenen Serie *Memorie* (Publ. S. Parmiggiani [Ed.], T. 2010) konzentriert sich C. mit ausgeblichenen Farbaufnahmen und einer fiktiven Amateurästhetik auf Orte, die Erinnerungen evozieren können. ⌑ ARLES, Mus. Réattu. – Éc. Nat. de la Photogr. BERLIN, Pergamon-Mus. CAMBRIDGE/Mass., Polaroid Coll. CHALON-SUR-SAONE, Mus. de la Photogr. Nicéphore Niépce. CHARLEROI, Mus. de la Photogr. MODENA, Gall. Civ. NEAPEL, Mus. Archeol. Naz. NEW YORK, The New York Public Libr. for the Performing Arts. NORD-PAS-DE-CALAIS, Centre Régional de la Photogr. PARIS, BN. – ENSBA. – Maison Europ. de la Photogr. – Mus. Carnavalet. POMPEI, Soprintendenza Speciale per i Beni Archeologici di Napoli e Pompei. REGGIO NELL'EMILIA, Bibl. Panizzi. – MCiv. – Pal. Magnani. ROM, Ist. Naz. per la Graf. – Univ. Tor Vergata (Mus. dell'Immagine Fotogr. e delle Arti Visuali). THESSALONIKI, Mus. of Photogr. ◉ *E:* 1995 Albinea, Comune / 1997 Quattro Castella, Bibl. Com. (beide K; Wander-Ausst.); Graz, Dynamic Photoart & Performance / 1998 Nizza, Gal. du Château; Mailand, Spazio San Fedele (K); Cavriago, Sala Com. delle Mostre (K) / 2000 Spilimbergo, Centro di Ricerca e Arch. (CRAF) / 2002 Modena, Gall. Civ. (K; Wander-Ausst.) / Reggio nell'Emilia: 2008 MCiv.; 2010 Gal. Parmeggiani / 2008 Montreal, Gall. Gora / 2010 Castelnovo ne'Monti, Pal. Ducale (K; Wander-Ausst.). – *G:* 1995 Mailand, IF Immagine Fotogr.: Musica in fotogr. / Reggio nell'Emilia: MCiv.: 1990 1980–1990. Un decennio di cronaca a Reggio Emilia (K); 1996 Metti il fotografo al mus. (K); 1997 Un anno di fotogr. (K); 2005 Pal. Magnani: Il volto della follia (K) / 1999 Aurillac, Mus. d'Art et Archéol.: Bianco e nero / Paris: 2000 Louvre: D'après l'antique (K); 2003 ENSBA: Figures de l'ombre (K); 2008 Hôtel de Sauroy: Coll. Reggio Emilia (K) / 2003 Saint-Paul de Vence, Fond. Maeght: Arles et la photogr. (K) / 2005 Rom, DARC: Archit. come paesaggio (K) / 2007 Thessaloniki: Photo Bienn. (K). ⌑ *M. Agnellini* (Ed.), Emilia-Romagna. Artisti e opere dall'Ottocento a oggi, Mi. 1995. – Sinergie emozionali (K), Reggio Emilia 1989; *V. Mirisola*, Giovane fotogr. ital., Palermo 1996; *I. Zannier u.a.* (Ed.), Giovani & sconosciuti, Mi. 1997; *P. Morello* (Ed.), Amen fotogr. 1839–2000, Mi./Palermo 2000; *M. Carmassi u.a.*, Le emozioni della memoria (K), Reggio Emilia 2000; *M. Mussini*, Revisioni (K), Reggio

Emilia 2002; *S. Parmiggiani* (Ed.), Camille Claudel. Anatomie della vita interiore. Auguste Rodin, scult. [...] (K), Mi. [2003]; *E. Grazioli* (Ed.), Movimento emozione (K), Pordenone 2007; *C. Piva* (Ed.), Paesaggi piemontesi (K Bielle), Fi. 2008; *M. Moutashar u.a.* (Ed.), Mus. Réattu. Chambres d'écho (K), Arles 2009. – *Online:* Website C. (Lit.). T. Koenig

Cattani, *Maria Lúcia,* brasil. Malerin, Graphikerin, Videokünstlerin, * 1958 Garibaldi/Rio Grande do Sul, tätig in Porto Alegre. Stud.: 1977–81 Univ. Federal do Rio Grande do Sul (UFRGS), Porto Alegre; 1982–83 Pontifíca Univ. Católica do Rio Grande do Sul ebd.; 1988–90 Pratt Inst., New York (Master of FA); 1994–98 Univ., Reading (Promotion); 2007–08 Univ. of the Arts, London (Post-Doktorat). Lehrt seit 1985 am Inst. de Artes da UFRGS, Porto Alegre (Graphik). Ausz.: 1983 Prémio des Salão do Jovem Artista ebd.; 1984 Prémio Prefeitura Mpal, Santa Maria; Artist in Residence: 1997 Frans Masereel Centrum, Kasterlee; 2001 Nagasawa Art Park, Awaji/Hyōgo; 2002 Prémio Flamboyant des Salão Nac. de Arte de Goiâs, Goiânia; 2005 Förderung Fumproarte, Porto Alegre (für *4 Cantos do Mundo*); 2008 II Prêmio Açorianos de Gravura ebd. – Geometrisch-abstrakte Malerei (Gouache, Acryl/Lw., Papier, Holz oder Metall) in Kombination mit graph. Techniken des Einritzens, Schneidens und Abdruckens. Auf dem meist quadratischen oder rechteckigen Bildträger werden monochrome, helle, oft verlaufende, aber auch geometrisch abgegrenzte Farbschichten aufgebracht. Delikate, in den Untergrund gravierte und mit heller Farbe gefüllte Linien, die teilw. an Schriftzeichen oder Organisches wie Blütenblätter erinnern können, heben sich von der Oberfläche ab und erscheinen wie ein kleinteiliges Farbgitter. Char. sind an geometrische Formen angelehnte, einfache und klare Bildelemente sowie die Arbeit mit regelmäßigen, rhythmisch-strengen Wiederholungen, die durch minimale Variationen und das Spiel zw. konvexen und konkaven Formen irritieren. Das parallele Anbringen gleichartiger schmaler Formate neben- oder übereinander verdoppelt die Wiederholung der graph. Strukturen an der Wand, z.B. *64 Latitude Norte* (2003) oder *40 Raias* (2005). Es entstehen auch großformatige, aber ephemere Wandmalereien mit gemalten, gezeichneten und gedruckten Elementen, z.B. *12 Lines* (1997). Mit der Kombination versch. Techniken versucht C., das Verhältnis zw. Orig., Abbild und Kopie auszuloten. Das Werk *4 Cantos do Mundo* besteht aus vier Teilen (schmale, mit Acryl bemalte und in einer Raumecke angebrachte Aluminiumrahmen), von denen jeweils ein Orig. mit den Fotogr. der übrigen drei Werke in Porto Alegre, Reykjavík, Devonport und Awaji aufbewahrt werden. Die vier Teile ergänzen sich in der Vorstellung des Betrachters zu einem die Welt umspannenden Werk. C.s graph. Arbeiten verwenden große Flächen und Schwarzweißkontraste. Die kurzen Videoarbeiten halten einen Ausschnitt der Natur fest und fokussieren zugleich auf natürlich vorkommende geometrische Formen, etwa die trapezförmigen Schwimmbewegungen von Enten auf einem Teich (*4 Patos*, 2003) oder auf parallelen Stromleitungen sitzende Vögel (*Paralelas*, 2006). Auch das The-

ma der Wiederholung ist in C.s Filmen und Fotogr. präsent, z.B. sich im Wind bewegende Äste (*20 Ventos*, 2003), schwimmende Goldfische (*16 px*, 2005), Kreise, die sich um einen ins Wasser geworfenen Stein bilden (*o o o*, 2007) oder auch sich spiegelnde Schatten. In London beschäftigt sich C. in ihrem Film *Quadrantes-Quadrants* (2008) und anhand eig. gescannter Gem. mit dem Phänomen der digitalen Reproduktion. C. ist auch als Kuratorin und Autorin tätig. ▭ AMERICANA, MAC. AWAJI, Umihira-no-Sato Center. DEVONPORT/Tasmanien, Regional Gall. GOIÂNIA, MAC de Goiás. LONDON, Brit. Libr. – Tate Mod., Artists Book Coll. PORTO ALEGRE, Centro Cult. Assoc. Profissionais Liberais Univ. Brasil. – MAC. – MARGS. – Inst. de Artes da UFRGS. – Pin. Aldo Locatelli. READING, Univ., Dept. of FA. REYKJAVÍK, Nat.- und Univ.-Bibl. RIO DE JANEIRO, MAM. – MNBA. ✉ 4 cantos do mundo/ 4 corners of the world, Porto Alegre 2005. ◉ *E:* Rio de Janeiro: 1985 Gal. Macunaíma (Debüt); 1991 Gal. Anna Maria Niemeyer; 1992 Esc. de Artes Visuais do Parque Lage / Porto Alegre: 2000 Gal. Obra aberta; 2003 Mus. do Trabalho; 2005 Studio Clio / 1997 Brüssel, Espaço Cult. do Banco do Brasil / 1998 Reading, Univ. / 2000 Novo Hamburgo, Pin. do Centro Univ. Feevale / 2002 Criciúma (Santa Catarina), Fund. Cult. / 2005, '07 São Leopoldo, Gestual Gal. de Arte. – *G:* Curitiba: 1982, '92 Mus. da Gravura: Mostra Anual de Gravura; 1987 Salão Paranaense / São Paulo: 1985 MAC da Univ.: Gravura no Rio Grande do Sul. Atualidade; 1991 Mus. de Arte Brasil.: Jovem Gravura Brasil. / 1985 Rio de Janeiro, Salão Nac. de Artes plást. / 1989 Taipei: Internat. Bienn. Print Exhib. / 1990 New York, Sigma Gall.: One of a Kind / Porto Alegre: 1992 MAC: Gesto e Construção; 2000 MARGS: Projeto Acervo 80/90; 2003 Inst. de Artes da UFRGS: Porto Alegre em Foco; 2005 Bien. de Artes Visuais do Mercosul; 2008 Casa da Gravura: III Parede da Casa; 2009 Mus. da UFRGS: Total Presença – Gravura / 1994 Buenos Aires, MN del Grabado: Grabados contemp. Brasil Sur / 1996 Winchester, Winchester Gall.: Repetition (K) / 2002 Tokio, Skydoor Art Place Aoyama: Nagasawa Artists. Challenging Jap. Woodblock Printmaking / 2004 Bagé, Mus. da Gravura Brasil.: 1+1+1; Florianópolis, Mus. de Arte de Santa Catarina: Heterodoxia / 2006 Berlin: Copa da Cult. / 2007 London, Tate Mod.: Video Links Brazil. An Anthology of Brazil. Video Art 1981–2005. ▭ *R. Rosa/D. Presser*, Dic. de artes plást. no Rio Grande do Sul, Porto Alegre ²2000. – *Online:* Inst. Itaú Cult., Enc. artes visuais; Website C. C. Melzer

Cattelan, *Maurizio,* ital. Bildhauer, Objekt-, Aktions- und Installationskünstler, * 21. 9. 1960 Padua, lebt in New York und Mailand. Autodidakt. Beginnt nach versch. Jobs (u.a. Wäscherei, Leichenschauhaus, Andenkenladen eines Klosters) in den 1980er Jahren seine Künstlerkarriere in Forlì. 1990 Übersiedlung nach Mailand, 1993 nach New York. – In C.s Werken, die er in kleinen Auflagen von Handwerkern ausführen läßt, mischen sich Bildhauerei und Happening, Performance und Installation, Inszenierung und Aktion. Sein Schaffen, das skurrile, absurde, provokante oder subversive Züge hat, steht in der Trad.

von Marcel Duchamp. C. spielt respektlos mit tradierten Mustern, häufig behandelt er das Thema Tod. Zur Selbstdarstellung gehört, daß sein Mitarb. Massimiliano Gioni oft an seiner statt Interviews gibt. Die erste Einzel-Ausst. (Bologna 1989) besteht nur aus einem Schild „Torno subito" (Komme gleich wieder) an einer verschlossenen Tür. Bei einer nachfolgenden Installation hängen am geöffneten Fenster des leeren Ausst.-Raumes zusammengeknotete Bettlaken, mit deren Hilfe der Künstler geflohen ist. In Amsterdam stiehlt er am Abend vor der Eröffnung die Ausst. eines Kollegen und präsentiert sie als seine eigene (*Another fuckung readmade*, 1996). Er läßt ein ausgestopftes Pferd an der Zimmerdecke hängen (*Ballad of Trotsky*, 1996), zeigt ein präpariertes Eichhörnchen, das sich erschossen hat, am Küchentisch seines Elternhauses (*Bidibidobidiboo*, 1996), oder stellt Kopien der Arbeiten seines Freundes Carsten Höller in der Pariser Nachbargalerie aus. Berühmt macht ihn die lebensgroße Installation *La Nona Ora* (erstmals gezeigt in der Ausst. Apocalypse, London 1999), die den von einem Meteoriten getroffenen Papst Johannes Paul II. als realistische lebensgroße Wachs-Skulpt. zeigt. Die Plastik löst empörte Reaktionen der kath. Kirche und versch. Politiker aus. 1999 fixiert C. seinen Mailänder Galeristen Massimo De Carlo mit Klebeband an der Wand (*A perfect day*) und läßt seinen Pariser Galeristen Perrotin sechs Wochen lang ein rosa Hasenkostüm tragen (*Errotin, le vrai lapin*). Sich selbst stellt C. als verkleinerte Figur im Filzanzug – eine Hommage an Beuys – an einer von Marcel Breuer entworfenen Garderobe hängend (*La Rivoluzione siamo noi*, 2000), beim Eindringen durch den Fußboden eines Museums (*Ohne Titel*, 2001) oder als lebensgroße Puppe in einem offenen Sarg (*Now*, 2004) dar. 2001 gestaltet er die gespenstisch realistische Skulpt. von Adolf Hitler als knienden, betenden Knaben im Tweedanzug (*Him*), dessen Portr. in Wachs (ebenso wie das des Papstes) von dem frz. Bildhauer Daniel Druet stammt (2009 von Stefan Edlis, einem Überlebenden des Holocaust, für 10 Millionen $ erworben). Für die Bienn. Venedig 2001 schafft C. den Schriftzug *Hollywood* auf einer Mülldeponie in Palermo. 2002 entstehen *Frank and Jamie*, zwei auf dem Kopf stehende New Yorker Cops. 2003 installiert er einen *Trommler* auf dem Dach des Mus. Ludwig in Köln. 2004 werden in Mailand für die Fond. Trussardi geschaffene Skulpt. von drei aufgehängten Kindern nach Protesten entfernt. Für die Ausst. „Bregenz" (2008), deren Plakat an NS-Propagandakunst erinnert, gestaltet C. das Innere des Kunsthauses in eine große Grabkammer um, in der er drei Werkgruppen zum Thema Tod inszeniert (zwei ausgestopfte Labradorhunde mit einem Küken, neun in weiße Tücher aus Carraramarmor gehüllte tote Körper und eine im Türrahmen hängende Frau im weißen Hemd). Bei dem Projekt „Synagoge Stommeln" (2008) läßt C. in der Synagoge zarte Pflanzen aus einem Paar alter Schuhe sprießen, den Kontrast dazu bildet eine Frau im weißen Hemd, die mit Gurten und Zwingen in einer verglasten Holzkiste an der Außenwand der Martinskirche gekreuzigt ist, wohl ein Hinweis auf die selige Christina von Stommeln, einer hier wirkenden ma. Mysti-

kerin. Auch hier ist, wie in vielen Arbeiten C.s, Betroffenheit mit ironischer Distanz gepaart. 1996 gründet C. zus. mit Paola Manfrin die Zs. Permanent Food; auch ist er als Ausst.-Kurator tätig: Seine Wrong Gall. in New York besteht aus einer Eingangstür und einer Ausst.-Fläche von 1 m². Zu der von ihm initiierten sog. 6th Caribbean bienn. 2001 lädt er nur Künstler ein, die bereit waren, keine Arbeit auszustellen; die Ausst. wird damit zur Urlaubsreise der Künstler nach St. Kitts. 2006 ist er Ko-Kurator der 4. Berlin Bienn. für zeitgen. Kunst. Auf dem internat. Kunstmarkt ist C. einer der erfolgreichsten Künstler des letzten Jahrzehnts. – Ausz.: 2000 Nominierung für Hugo Boss Prize, Guggenheim Mus., New York; 2004 Ehren-Dr. der Univ. Trient; Arnold-Bode-Preis, Kassel; 2008 Gold-Med. der 15. Quadrienn. Rom (für Lebenswerk). ▣ ATHEN, Coll. Dakis Joannou. BERLIN, Daimler Contemp. BOLOGNA, MAMbo. CHICAGO, MCA. – Coll. Stefan Edlis. DIJON, Le Consortium. FRANKFURT am Main, MMK. GENF, Attitudes. HOUSTON/Tex., MFA. KITAKYŪSHŪ, Mun. Mus. of Art. LONDON, Tate Modern. NEW YORK, MMA. – Guggenheim. – Coll. Danielle and David Ganek. PARIS, Coll. Niarchos. RAVENNA, Mus. d'Arte della città di Ravenna (Mar). ROTTERDAM, BvB. STOCKHOLM, Mod. Mus. TORONTO/Ont., Ydessa Hendeles Art Found. TREVI, Flash Art Mus. TURIN, Castello di Rivoli Mus. d'Arte Contemp. – Fond. Sandretto Re Rebaudengo. VEJER DE LA FRONTERA, Fund. NMAC. VERONA, GAM. WIEN, Thyssen-Bornemisza Art Contemp. ZÜRICH, KH. – Migros Mus. ✉ Zahlr. Art. und Interviews, v.a. in Flash art. ☉ E: 1989, '90 Bologna, Gall. Neon (K) / Mailand: 1990 Studio Oggetto; 1993, '96, '99 Gall. Massimo De Carlo; 2004 Fond. Nicola Trussardi; 2010 Coll. Peruzzi (K); Pal. Reale und Piazza Affari / 1990 Genua, Leonardo V-Idea (K) / 1993 Neapel, Gall. Raucci Santamaria / 1994 Genf, Gal. Analix / Köln: 1994 Daniel Buchholz; 2003 Mus. Ludwig / London: 1994 Laure Genillard Gall.; 1999 Anthony d'Offay Gall.; 2004 Serpentine Gall. (K); 2007 Tate Modern / New York: 1994 Daniel Newburg Gall.; 1998 MMA; 2000, '02 Marian Goodman Gall.; 2008 New Mus. (mit Roberto Cuoghi und Diego Perrone) / Paris: 1995, '98 Gal. Emmanuel Perrotin; 2004 MAMVP (K) / 1996 Zürich, Ars Futura / 1997 Bretigny-sor-Orge, Centre d'arte (K); Wien, Wiener Secession (K); Turin, Castello di Rivoli (K) / 1999 Basel, KH (K) / 2000 Kitakyūshū, Center for Contemp. Art / 2001 Wien, KH; Zürich, Migros-Mus.; Stockholm, Fargfabriken / 2002, '06 Chicago, MCA / 2003 Los Angeles, MCA / 2004 Trient, Gall. Civ. di Arte Contemp. / 2007 Frankfurt am Main, MMK / 2008 Bregenz, Kunsthaus (K); Stommeln, Synagoge und Alte Kirche. – G: 1987 Faenza, Pal. delle Espos.: Bienn. giovani / 1990 Prato, Mus. Pecci: Improvvisazione libera / 1991 Bologna, GAM: Anni 90 (K) / 1992 Bergamo, GAMC: Ottovolante (K) / 1993 Trevi, Flash AM: L'Arca di Noe (K); Kassel, Mus. Fridericianum: Nachtschattengewächse (K) / Venedig: 1993, '99, 2001, '03, '09 Bienn. (K); 2009 Pal. Grassi: Italics (K) / 1994 Turin, Castello di Rivoli: Soggetto Soggetto (K) / 1995 Graz, Joanneum, Neue Gal.: Das Spiel in der Kunst / 1996 Stockholm, Fargfabriken: Inter-

pol (K); New York, Bard College: a/drift; Marseille, MAC: L'ameau corps (K); Bordeaux, CAPC: Traffic (K) / 1998 Zürich, Migros-Mus.: Ironisch (K) / 1999 Melbourne: Internat. Bienn. / 2000 Hannover: Expo 2000; Paris, Centre Pompidou: Au-delà du spectacle (K); 2005 ebd.: Dionysiac (K) / 2001 Barcelona, Fund. Joan Miró: Irony / 2003 Lyon: Bienn. d'art contemp. / 2004 Bozen, Museion: Flirts. Kunst und Werbung (K) / 2008 Sydney: Bienn. / 2008–09 München, Haus der Kunst: Spuren des Geistigen (K) / 2009 London, Tate Modern: Pop life (K) / 2010 Carrara: Bienn. Internaz. di scult. ▢ Diz. degli artisti ital. contemp., Mi. 1996; *Bénézit* III, 1999; *Delarge*, 2001; Contemp. Artists, I, 2002; *U. Grosenick/B. Riemenschneider* (Ed.), Art now. 81 artists at the rise of the new millennium, Köln 2005; *U. Grosenick* (Ed.), Art now. Vol 2, Köln u.a. 2005. – M. C. biologia delle passioni (K), Ravenna 1989; Arte 21:1991 (217) 70–73; *S. Casciani/G. Di Pietrantonio* (Ed.), Design in Italia. 1950–1990, Mi. 1991; Flash art 25:1992 (166) 90; *D. Buchholz/G. Magnani* (Ed.), Internat. index of multiples. From Duchamp to the present, Köln 1993; *L. Beatrice u.a.*, Nuova scena. Artisti ital. degli anni '90, Mi. 1995; Dall'Italia. M. C., Gennaro Celant, Enzo Cucchi, Ettore Spalletti (K Bienn. di Venezia), Mi. 1997; Fatto in Italia (K Genf/London), Mi. 1997; *B. Casavecchia*, Flash art 32:1999 (215) 80 s.; *G. Verzotti*, M. C. (K Castello di Rivoli), Mi. 1999; *F. Bonami u.a.*, M. C., Lo. 2000; ²2003; *J. Avgikos*, Flash art 34:2001 (227) 82–89; *M. Gioni*, ibid. 34:2001 (227) 78–81; *H. P. Schwerfel*, Art 2002 (3) 14–27; *M. Sciaccaluga*, Arte 355:2003, 128–138; *M. Mattioli*, Arte in 17:2004/05 (91) 62 s.; *G. Politi*, Flash art 37:2004 (247) 92–97 (Interview); *T. Dean/J. Millar*, Ort, Hildesheim 2005 (Art works); *B. Lewis*, M. C., Arte v. 15. 4. 2006 (TV-Portr.); *F. Manacorda*, M. C., Mi. 2006 (frz. P. 2007); Von Mäusen und Menschen (K Berlin, Bienn. für zeitgen. Kunst), Ostfildern 2006; *A. Capasso*, Opere d'arte a parole, R. 2007 (Interview); *J. Collins*, Sculpt. today, Lo./N. Y. 2007; *H. Kontova*, Flash art 40:2007 (257) 66–68 (Interview); *G. Matt u.a.* (Ed.), Traum & Trauma. Werke aus der Slg Dakis Joannou, Athen (K Wien), Ostfildern 2007; *A. Vierck*, in: *I. Stephan/A. Tacke* (Ed.), NachBilder des Holocaust, Köln u.a. 2007, 271–283; *P. Bosetti*, Art 2008 (6); *P. Chan*, Flash art 41:2008 (262) 110–113; *F. Cavallucci*, ibid. (269) 80–82; *R. Diez*, Arte 420:2008, 62–67; 76–81; *A. Di Genova*, Il circo nell'arte. Dagli arlecchini di Picasso al fachiro di C., Mi. 2008; *P. Kipphoff*, Die Zeit v. 11. 2. 2008; *F. Stech*, Kunstforum internat. 190:2008 (März/April) 378–380; *A.-K. Günzel*, ibid. 192:2008 (Juli/Aug.) 316 s.; M. C., P. 2008; *R. Pinto*, Flash art 41:2008 (271) 122 s.; *F. Poli*, Postmodern art. From the post-war to today, N. Y. 2008; *G. Politi*, Flash art 41:2008 (261) 220–223 (Interview); *T. Sehgal*, Flash art 42:2009 (264) 90 s.; *G. BenNer*, ibid. (266) 110–113; *F. Adrià*, ibid. (267) 38–43; (277) 74–77; *H. Bas*, ibid. (268) 54–59; *A. Bee/U. Kittelmann* (Ed.), Punkie. Performance for M. C. by Bernard Wilson 2007 (K MMK, Frankfurt am Main), Köln 2009; *M. Lorber*, Arte in Friuli, arte a Trieste (Ud.) 28:2009, 245–270; *S. Thornton*, Süd-dt. Ztg v. 12./13. 9. 2009;

H. Christmann, Weltkunst 80:2010 (6) 30–34; *L. Perlo*, Arte 2010 (437) 128–133; *R. Diez*, ibid. (440) 110–117; *C. French*, Flash art 2010 (273) 96–98; Pop Life. Warhol, Haring, Koons, Hirst [...] (K), Köln 2010; *F. Sirmans*, M. C. Its there life before death? The Menil Coll., Houston (K), New Haven u.a. 2010; Kunstforum internat. 215:2012 (4–6). – *Online:* Website C.; Ital. area. Ital. contemp. art arch.; kunstaspekte; Artfacts; Gall. Massimo De Carlo, Mailand; Marian Goodman Gall., New York; Gal. Emmanuel Perrotin, Paris. E. Kasten

Cattori, *Edgardo*, schweiz. Maler, Zeichner, Graphiker, Illustrator, * 10. 9. 1942 Locarno, lebt im Tessin. Zur Ausb. liegen keine Inf. vor. Sehr zurückgezogen lebender Künstler, der seit A. der 1980er nur noch selten an die Öffentlichkeit tritt. – Zu den wenigen bek. Beispielen des gegenständlichen Œuvres gehören neben dem *Bildnis eines jungen Mannes* (Öl/Lw.; Fischer Aukt., Luzern, 9. 11. 1990) v.a. Komp. mit eher unspektakulären, minutiös beobachteten und einfühlsam wiedergegebenen Naturmotiven (*Nido*, Pastell, um 1993) sowie Blumen- und Früchtestilleben (*Ricci*, 1997; *Quattro mele*, 2004, beide Öl/Lw.). Zudem graph. Arbeiten und Bleistift-Zchngn zur Buch-Ill.: Piero Bianconi, *Albero genealogico. Cronache di emigranti*, Locarno [ca. 1978] (35 Zchngn); Emilio Zanini, *Lu cont Ugulign in dialett da Cavergn*, Ascona 1985 (sechs Lith.). ⌺ RIAZZINO, Slg Mario Matasci. ✉ E. C., Tenero 1977 (Auto-Biogr.). ◉ *E:* 2005 Tenero, Gall. Matasci Arte (K) / 2006 Emmenbrücke, Gal. Gersag. ⌺⌺ BLSK I, 1998. – *R. Friedrich*, Neue Zürcher Ztg v. 4. 9. 2009. – *Online:* SIKART Lex. und Datenbank. R. Treydel

Causa, *María*, argentinische Bildhauerin, Objekt- und Installationskünstlerin, Malerin, * 1963 Mercedes/San Luis, lebt in Buenos Aires. ∞ Roberto Elía. Stud. ebd.: bis 1981 Esc. Superior de BA „Nicolás Antonio de San Luis" (Lehramt für bild. Kunst); 1982–86 ENBA „Prilidiano Pueyrredón" (Lehramt für Malerei). Mitgl.: Grupo de la X. Zahlr. Ausz.: u.a. 1987 (Reise-Stip. für Aufenthalt in Mexiko) und 1996 Stip. des Fondo Nac. de las Artes; 1990 Preis der Fund. Antorchas; 1991 Preis „Artista Joven del Año" der Asoc. de Críticos Argentinos, alles in Buenos Aires, und der Pollock-Krasner Found., New York; 1992 Preis für Bildhauerei, Fund. Konex, und E.-Shaw-Preis der Acad. Nac. de las Artes, beide Buenos Aires. – In der zeitgen. argentinischen Bildhauerei nimmt C. eine führende Position ein, v.a. wegen ihres Engagements in dem in den 1980er Jahren als „los escultores del recambio" bek. gewordenen Kreis junger Bildhauer, dem sie neben Danilo Danziger, Lorenzo Guzmán und Elba Bairon angehört. Innerhalb der Gruppierung kommt ihr ein wesentlicher Anteil an der Erneuerung der trad. Bildhauerei auf der Basis eines Konzeptes zu, bei dem das Objekt den Ausgangspunkt des Schaffensprozesses bildet. Prinzipiell an der Konzeptkunst, konkret an Joaquín Torres García orientiert, ist C. formal flexibel und verwendet sowohl gegenständliche Objekte, Abfallprodukte und Fundstücke als auch extrem abstrahierte Elemente, bisweilen unter Einbeziehung von Malereien oder Collagen aus mehrfarbigen

Papierflächen. Sie gestaltet v.a. einfallsreiche Konstruktionen aus Holzstücken, die zumeist vertikal ausgerichtet und oftmals sehr schlanke hohe Türme sind. Nach anfangs schlichten Modellen folgen durch die Kombination von teilw. farbig behandelten kleinen Holzstücken in unterschiedlichen, oft kontrastreichen Tönen mit Metall Gebilde, die zunehmend an Totems, Obelisken und Minarette erinnern (*Minarete*, Mischtechnik, Holz, 1996). Diese konstruktiven Prinzipien kommen C. auch beim Spiel mit der Dialektik zw. Assemblage und Fragmentierung zugute. Letztere ist für sie ein wichtiges Gest.-Mittel, um sich mit der Auflösung, Zerstörung bzw. Zerlegung der menschlichen Figur, bes. des weiblichen Körpers als Metapher für die Verletzung und Entwürdigung der Frau, zu befassen (*Femen*, Holz, 1996). Im Gegenzug spielt sie auf die Manneskraft als Ausdruck des Patriarchats an, die durch eine wie ein Phallussymbol anmutende turmartige Konstruktion verkörpert wird (*Construcción masculina*, Holz, Metall, 1996). Seit ca. 2000 entstehen komplexere Arbeiten durch die Nutzung von Abfall- und Fundstücken, u.a. von kaputtem Werkzeug, sowie Alltagsgegenständen wie Topfdeckeln zum Zweck der Verfremdung. Außerdem läßt sich C. von der heimatlichen Fauna und Flora inspirieren, afrikanische Masken und Rituale liefern ihr weitere visuelle und sinnliche Anregungen, um die Grenzen zw. Realität und Fiktion auszuloten. ⌺ BUENOS AIRES, MNBA. – Fondo Nac. de las Artes. NEW YORK, Pollock-Krasner Found. ◉ *E:* Buenos Aires: 1987 Inst. Jung; 1989, '90, '97 (mit Blas Alfredo Castagna und Mariano Cornejo) Gal. Van Riel; 1992 Fund. S. Telmo (mit Tulio Romano; K); 1994 Gal. Tema; 2000 Gal. Del Infinito; 2003 Fondo Nac. de las Artes (K: R. Amigo) / Mexiko-Stadt: 1988 Gal. Kin y Libr. Francesa; 1996 Gal. Kin (Falt-Bl.). – *G:* 1990 Toluca (Estado de Méjico): Encuentro Internac. de Escult. en Madera / Buenos Aires: 1990 Bien. de Arte Joven; 1998, 2000 Arte BA / 1991 Havanna: Bien. de Arte / 1993 Dakar: Bienn. / 1995 Caracas, MNBA: Ensambles en América Latina / 2000 Uppsala: Bienn. ⌺⌺ *E. Oliveras*, Espacio Joven. Rescate de la mem., Bs.As. 1988; *M. Rainuzzo*, M. C., Bs.As. 1988; *A. Tortosa*, Objects large and small, Bs.As. 2001; *M. Sallato/M. Lennon*, El Mercurio (S. Ch.) v. 8. 5. 2009; *W. Sommer*, ibid. v. 24. 5. 2009. – *Online:* Cat. Acceder; Website C. R. Treydel

Causarás Andréu, *Luís* cf. **Causarás Casaña**, *Ricardo*

Causarás Casaña, *Ricardo (Ricard)*, katalan. Bildhauer, Maler, Zeichner, Erfinder, * 23. 2. 1875 Valencia, † 26. 10. 1953 Barcelona. Sohn des Architekten *Luís C. (Jaunzarás) Andréu* (* 1845 Torrente, † 1922 Castellnovo), Vater des Bildhauers Lluís C. Tarazona und Großvater des technischen Zeichners *José Luis C. Castelló*. Stud.: 1890–93 Acad. de S. Carlos, Valencia, bei Ignacio Pinazo Camarlench, José María Fenollera Ibáñez, Vicente March Marco und Francisco Pallás. Freundschaft mit dem Maler Joaquín Sorolla. Ab 1908 Prof. Ayudante Meritorio der Sección Artíst. der Esc. Elemental de Artes e Industrias und des Círculo de BA (Vize-Sekretär der Sección de Expos. und Sección de Aviación), beide ebd., außerdem Mitgl. des Centro Cult. de los Ejércitos y de la Ar-

mada, Barcelona. Ab 1914 Prof. für Modellieren, Zeichnen und dekorative Komp. von Skulpt. an der Esc. d'Arts i d'Oficis „Llotja" ebd. 1916 Gründung der ersten Casa de Arte en Paracera (Wachsfiguren). Ausz.: u.a. 1901 Med. 3. Klasse, Expos. Gen. de BA, Madrid. – C. gestaltet figurativ-naturalistische, vom Modernismo beeinflußte Skulpt. teils symbolischen Char. (*Dolor; El beso*, Marmor, 1904) und zahlr. Portr., u.a. Generäle und Offiziere des Centro Cult. de los Ejércitos y de la Armada in Barcelona. 1900–01 Gest. von Büste und Statue des Malers *J. Sorolla* (letztere 1923–36 in der Gruta de los Jardines de Viveros in Valencia aufgestellt, dann verloren gegangen). 1923 Abguß von Sorollas rechter Hand mit Pinsel, die auf einem Sockel befestigt ist (Silber, Stein, Bronze). C. malt auch Lsch., Portr. und Akte. Nach 1905 beschäftigt sich C. mit dem Flugwesen. 1909 entwirft und konstruiert er zus. mit dem Ing. Alfredo Kindelán Duany den Aeroplano-Monoplano C., das erste in Spanien patentierte, als Pionierleistung geltende Motorflugzeug für zivile Zwecke. Weitere Erfindungen, u.a. Maschine zum Drehen von Zigaretten und Speziallupe sowie Gest. von Wachsfiguren in versch. Größe (z.B. *La muñeca Parisien*; Serie *Toreros esp. y sudamer.*). ⌂ BARCELONA, MN d'Art de Catalunya. VALENCIA, Mus. Hist. ◉ *G:* 1901 (Bronze-Med.), '07 (ehrenvolle Erw.) Madrid: Expos. Gen. de BA / 1905 Paris: Expos. Internat. des BA / 1908 Valencia: Expos. de BA. ⌨ DPEE III, 1994; *Agramunt Lacruz* I, 1999. – *A. del Castillo*, De la Puerta del Angel a la Pl. de Lesseps, Ba. 1945. – *Online:* Blog C. – Mitt. José Luis C. Castelló.

M. Nungesser

Causbroeck, *Guido van*, belg. Maler, Graphiker, Zeichner, Keramiker, Bildhauer, Kunstpädagoge, * 19. 5. 1952 Mechelen, lebt in Nieuwenrode/Vlaams-Brabant. Stud.: Hogeschool Sint-Lukas, Schaerbeek; Koninkl. ASK, Antwerpen. Abschluß mit Lehrbefähigung. Unterrichtet an regionalen und städtischen KSch, zuletzt an der ABK in Wilrijk (hier seit 2008 Dir.). Ausz.: 1971 Preis der Stadt Mechelen; 1995 Maurits Naessens Award (ehrenvolle Erw.). – Figurative und abstrakte Graphik und Malerei (Öl, Acryl). Viele von C.s Arbeiten (u.a. Keramiken, Mosaike) erwachsen aus dem kunstpädagogischen Kontext. Ein Hw. ist die 2003 entstandene sechsteilige narrative Skulpt.-Gruppe *De onmoeting*/Das Treffen (belg. Blaustein), deren fünf lebensgroße, im Kreis aufgestellte Figuren mod. Allegorien darstellen, die zur Auseinandersetzung mit Kunst im öff. Raum einladen: Die archaisch wirkenden Personifikationen der drei Teilgemeinden Kapelle-op-den-Bosch, Ramsdonck und Nieuwenrode (*Neus, Madam, Toekker*) treffen in dieser Figurengruppe auf die Gestalten von *Wording* (Entstehendes) und *Futurist*. C. hat für Besucher und Einheimische, die sich dieser seltsamen Runde zugesellen möchten, als integralem Bestandteil des Kunstwerkes eine leere Sockelplatte im Boden installiert. Dieses Werk gehört zu den bed. freiplastischen Arbeiten des letzten Jahrzehnts in der Region. ⌂ KAPELLE-OP-DEN-BOSCH, Schulplatz. ◉ *E:* 1971 Willebroek, Gal. De Zolder (Debüt) / 1977 Bad Oynhausen, Wandelhalle Staatsbad / 1982 Kapelle-op-den-Bos, Kunstkring Perspektief (K) / 1988 Brüssel,

Oud Korenhuis / 1989 Brasschaat, Gal. Teken-Acad. Sint-Michiel. ⌨ *Online:* Website C. U. Heise

Čaušev, *Michail (Michail Georgiev)*, bulg. Maler, Zeichner, Graphiker, Bildhauer, * 6. 8. 1933 Biser b. Chaskovo, † 1990 Sofia. ∞ Liljana Čauševa. Stud.: bis 1965 KHS Sofia (Malerei bei Nenko Balkanski). Unterrichtet 1969–73 am Kunstgymnasium ebd. Ausz.: 1983 Orden „Kiril i Metodij" 2. Stufe. – Bestimmend für Č.s frühe Arbeiten ist eine insgesamt figürliche Orientierung, meist umgesetzt in einem stark poetisierenden realistischen Duktus. Neben Bleistift- und Tusch-Zchngn, Pastellen, Öl-Gem., plastischen Wandbildern, Sgraffiti sowie druck-graph. Bll. in versch. Techniken entsteht in den 1970er Jahren auch der nach einem alten Brauch benannte lithogr. Zyklus *Enjova Bulja*, der Elemente der bulg. Volkskunst und Volksepik aufgreift. Zunehmend experimentiert Č. jedoch mit versch. Abstraktionsverfahren und arbeitet u.a. mit der dynamischen Kombination divergierender Bildelemente und gleichsam vibrierenden Maloberflächen (*Impulsi; Projekcija*; *V moeto atelie*, alle 1979; *Idea i vreme*, Pastell, 1981; *Tvorčeski akt*, Pastell, 1982). In der Plastik, auch in mon. Entwürfen für den öff. Raum, dominieren konstruktivistische Komp., die häufig auf geometrischen Grundelementen basieren und diese zu teils verspielt-phantastischen Objekten mit dekorativem Char. verbinden. Zus. mit L. Čauševa realisiert Č. mehrere dekorative plastische Wandbilder und Reliefs für öff. Gebäude. ⌂ DIMITROVGRAD, KG. SOFIA, Nat. KG. – Städtische KG. – *Im öff. Raum:* BISER: Denkmal für die im Kampf um das Vaterland gefallenen Einwohner von Biser, Stein, 1974. CHASKOVO, Kreishaus der Gewerkschaften: Fassaden-Gest., Muschelkalk-Relief, 1976. – Kreis-Bibl. „Christo Smirnenski": Fassaden-Gest., Kalksteinrelief, 1978. KRUMOVO/Plovdiv, Christo-Botev-Schule: Sgraffito, 1978. LJUBIMEC, Werk für Verpackungstechnik: Pylon, weißer Beton, 1978. SOFIA, Hotel Rila: Metallplastik, Bronze, 1975. ◉ *E:* 1981 (mit L. Čauševa), 2007 Sofia, Ausst.-Zentrum Šipka 6. – *G:* ab 1966 sporadisch Allg. bulg. Kunst-Ausst., u.a. 1980 Sofia: Bălgarski predanija i legendi / 2006 Dimitrovgrad, KG: Malerei aus dem Gal.-Bestand. ⌨ EIIB III, 2006. – *Ch. Stefanov/M. Kirov* (Red.), Săvremenno bălgarsko monumentalno izkustvo 1956–86, Sofija 1986; Sofijska gradska chudožestvena gal. Kat. živopis, Sofija 2003; *D. Kisjova-Gogova*, Evropa 2001. Spisanie za kultura i socialna politika 2007 (4).

S. Jähne

Čauševa, *Liljana (Liljana Davidova; Lili)*, bulg. Textilkünstlerin, Malerin, * 28. 8. 1939 Sofia, lebt dort. ∞ Michail Čaušev. Ausb./Stud.: bis 1960 Kunstgymnasium Sofia; bis 1965 KHS ebd. (Malerei bei Nenko Balkanski). – Č. bedient sich in ihren Textilarbeiten bevorzugt trad. Webtechniken, die sie mod. interpretiert. Sie benutzt vorwiegend reduzierte, warme Farben wie Terra di Siena, Ocker, Dunkelbraun und Beige, wobei durch geschickt eingefügte kühle Farbakzente wie Himmelblau, Dunkelviolett und Dunkelgrau innere Spannung und Dynamik entstehen. Eine Besonderheit der mon. Komp. liegt im bewußten Verzicht auf formale Präzision zugunsten des krea-

tiven Spiels mit versch. Webstrukturen, in die Rahmungen oder rohe organische Mat. wie Wolle plastisch integriert sind. Dies schafft neue Anschauungsebenen und führt zur Steigerung der materialen Bildhaftigkeit. Beispiele für die Umsetzung solcher Gest.-Ideen sind die Gobelins für den Sitz der Gebietsverwaltung in Chaskovo (Wolle, 1982; mit M. Čaušev) und das Restaurant Ksilifor in Veliko Tărnovo (1982), Č.s Wandteppiche für die World Intellectual Property Organization in Genf (*Nauka*, 1977), das Standesamt in Peštera (1980) sowie die Sofioter Hotels Kempinski-Zografski (*Raste no ne staree*, 1978) und Rila (*Slănce*, *Legenda za Orfej*, *Izgref*, *Den*, *Nošt*, fünfteilige Serie, 1974); weitere Wandteppichserien entstehen für das Nat. HM in Sofia (*Slănce*, *Văzduch*, *Voda*, 1976) und die Ferienanlage „Družba" (heute „Sv. Konstantin") in Varna (*Prolet*, *Ljato*, *Esen*, *Zima*, 1979). Č.s malerisches Werk ist geprägt von einer kontrast- und beziehungsreichen Licht-Farb-Gest. und verweist in der Formensprache auf direkte oder indirekte Anregungen durch die trad. bulg. Volkskunst (*Zavrăštane ot rabota*/Rückkehr von der Arbeit, 1972). ⌨ *E*: Sofia: 1981 (Aqu.-Malerei mit M. Čaušev), '92, '93, '96, 2003 (Aqu.-Malerei/Seide mit Ljudmila Damjanova) Ausst.-Zentrum Šipka 6; 2007 Gal. Chadžistojanovi. – *G*: Sofia: 2005 Ausst.-Zentrum Šipka 6: Private Mythologien; 2008 Nat. Kultur-Pal.: Allg. Kunst-Ausst. ⌨ EIIB III, 2006. – *I. Roggatz* (Ed.), 1. Bulg. Kunst-Ausst. in Hamburg (Auktions-Kat.), Ha. 1973 (s.v. Tschauschewa, Liljana); *Ch. Stefanov/M. Kirov* (Red.), Săvremenno bălgarsko monumentalno izkustvo 1956–86, Sofija 1986; *S. Janakieva*, InfoSBCh 2005 (9) 6.

S. Jähne

Čaušov, *Dimităr* cf. **Čaušov**, *Georgi*

Čaušov, *Georgi* (Georgi Dimitrov), bulg. Karikaturist, Illustrator, Trickfilmzeichner, * 7. 4. 1938 Lom, lebt in Sofia. Bruder des Illustrators und Gebrauchsgraphikers *Dimităr Č.* (* 15. 1. 1941 Lom; Absolvent der KHS Sofia und der HBK Berlin-Weißensee). Stud.: bis 1966 Ill. bei Veselin Stajkov an der KHS Sofia. Er publiziert Karikaturen u.a. im renommierten satirischen Wochenblatt Stăršel sowie in den Zss. Ženata dnes, Karikatura und Naša rodina. Ausz.: u.a. mehrfach Preisträger des Bulg. Künstler-Verb. (1964–66 Preis für Karikatur; 1967 Preis für Ill.; 1980 Ilija-Beškov-Preis für Karikatur und Zchng); 1968 Preis des Bulg. Studios für Animationsfilme; 1974 Preis des Bulg. Journalistenverbandes. – Als Karikaturist widmet sich Č. mit Biß, Schärfe und darstellerischer Klarheit dem alltäglichen menschlichen Miteinander, bes. der Absurdität beruflicher und bürokratischer Hierarchien. Die Zchngn sind reich an Details und ausführlich beschreibenden, erzählerischen Elementen, über die sich der Bildwitz konstituiert, z.T. unterstützt durch den sophistischen Widerspruch zw. Darst. und Bildtitel. In ihrer enormen Fabulierlust erinnern sie entfernt an den moralisierenden und didaktischen Gestus engl. Karikaturisten des 18. Jahrhunderts. Typisch für Č.s bewegt konturierte Figuren ist ihre komisch-unausgewogene Anatomie, bei der große, mäßig deformierte Köpfe von kleinen, untersetzten Torsi getragen werden. Viele der Zchngn kommen ohne jeglichen Text

aus oder beschränken sich auf Titel wie *Bez dumi* bzw. *Bez komentar* (Ohne Worte, ohne Kommentar). Andere sind durch prägnante Texte ergänzt: *Izlezte! Za vas e nužna svoboda!* (1968); *Na kulturni temi* (1970); *Az predlagam da postroim zavod za dobivane na željazo ot spanak!* (1972). Č.s in der Karikatur entwickelter Stil prägt auch seine Ill. (u.a. I. Krăstev, *Chitruša. Stichotvorenija*; E. Pelin, *Torbalanci. Prikazka*, beide Sofija 1987) und findet sich ebenfalls, wenn auch leicht variiert, in seinen Animationsfilmen (u.a. *Groteska*, 1975; *Čovekăt*, 1976; *Miraž*, 1981). 📖 GABROVO, Haus für Humor und Satire. KĂRDŽALI, KG. LEIPZIG, Dt. NB, Dt. Buch- und Schrift-Mus. SOFIA, Nat. KG. ⌨ *E*: 1982 Damaskus. – *G*: seit 1968 Sofia: Allg. Ausst. bulg. Kunst. ⌨ EIIB III, 2006. – *A. Stojkov*, Bălgarskata karikatura, Sofija 1970, 107–110; Săvremenna bălgarska iljustracija, Sofija 1972; Retrospektivna izložba 30 godini bălgarsko socialističesko izkustvo (K), Sofija 1976; Mladi bălgarski chudožnici, II, Sofija 1978; Săvremenni karikaturisti (K), Gabrovo 1980.

S. Jähne

Cauwet, *Thierry*, frz. Maler, Zeichner, Performance-, Video- und Body-art-Künstler, Fotograf, * 30. 3. 1958 Bourg-Saint-Maurice/Savoie, lebt in Paris. Stud.: 1976–80 Ec. nat. supérieure des Arts décoratifs, Paris. 1984–85 Studienaufenthalt in Rom, Stip. des Fonds d'Incitation à la Création (FIACRE), Minist. de la Cult., Paris. Lehrtätigkeit: u.a. 1988–90 Inst. régional d'Art visuel de la Martinique, Fort-de-France. – Die Beschäftigung mit dem menschlichen Körper (häufig als Akt) steht im Mittelpunkt von C.s heterogenem Œuvre. In den frühen Werken ist es häufig der eig. Körper, den er meist nackt, teils vollst. bemalt (in Anlehnung an Performances von Yves Klein) in den Videoarbeiten (1978–81) und Tableaux vivants (1981–86) präsentiert. Des weiteren tritt er als Komparse in den fotogr. dok. Tableaux vivants auf, deren Kulisse eig. Gem. bilden. Seit 1986 widmet er sich der (Öl-)Malerei; zunächst ma. inspirierte Sujets mit Rittern und Heiligen. Während des Martinique-Aufenthalts entsteht u.a. die farbenfrohe, naiv-figurative *Série antillaise*, in der sich C. mit der dortigen Bild-Trad. auseinandersetzt. In einer Mischung aus Malerei, Zchng und Collage entwickelt er eine Bildsprache, die sich stark an kubistischen Komp., insbesondere Werken von Fernand Léger und Pablo Picasso, orientiert. Er verwendet lackierte Bildträger, nutzt die Techniken der Grattage und Rollage (*Hommage à François Rouan*, 2008) und gestaltet die figürlichen Motive zunehmend zergliedert (*Visages*, 1995–96), bevor sie in späteren Werken aus vielen versch. Einzelteilen allmählich wieder zusammengesetzt werden (*L'un l'autre*, 2005–06). In jüngerer Zeit Wiederaufnahme der früheren Performancekonzepte, z.B. in dem Film *Répétition inactivée* (2003–04). 📖 CHARTRES, MBA. EVRY, Mus. Paul Delouvrier. FORT-DE-FRANCE, FRAC Martinique. PARIS, BN. – FRAC Ile-de-France. – Maison Europ. de la Photogr. – MNAM. LES SABLES-D'OLONNE, Mus. de l'Abbaye Ste-Croix. TURNHOUT, NM van de Speelkaart. ⌨ *E*: 1983 Sèvres, Centre cult. / seit 1986 regelmäßig Paris, Gal. à l'Enseigne du Oudin (2003 Retr.) /

1988 Nizza, Gal. Latitude / 1990 Fort-de-France, Théâtre mun. – *G:* Paris: 1980 Bienn. de Paris; 1983 Salon des Indépendants; 1986 Mois de la Photo / 1984 Venedig: Bienn. / 2008 Nizza, Gal. des Ponchettes: Hélène Jourdan-Gassin. Regard sur une Coll. ⌑ *Bénézit* III, 1999; *Delarge*, 2001. – *C. Millet,* Art press (P.) 58:1982; *I. Champey,* ibid. 69:1983; *R. Monticelli/H. Flinne,* T. C. Les fonctions du repentir, Marseille 1997. – *Online:* Website C.

<div style="text-align: right">F. Krohn</div>

Cava → **Cavalcanti,** *Wilson*

Cavada, *Ricardo,* span. Maler, Graphiker, * 1954 Pontejos/Cantabria, lebt in Santander. Ausz., u.a. 1. Preise: 1992 Concurso Internac. de Pint., Escult. y Dibujo, Homenaje a Rafael Zabaleta; 1994 Concurso Nac. de Pint. Ciudad de Tudela; 1999 Certamen de Pint. Gutiérrez Solana. – Nach einer neoexpressiv-figürlichen Phase M. der 1980er Jahre entwickelt sich C.s sensible, meditative Malerei in der Trad. der lyrischen Abstraktion, v.a. von Mark Rothko, und einer in Lateinamerika als „geometría sensible" bez. Tendenz konstruktiv-freier Malerei. Seine stets titellosen Gem. in Acryl/Lw. zeichnen sich durch den Ausgleich von Gegensätzen wie weich und hart, fest und flüssig, gestisch und meditativ, pastos und flächig, transparent und opak aus und stehen zw. Kalkulation und Zufall. Sie basieren auf wenigen, allein durch die meist lasierend aufgetragene Farbe bestimmten Grundformen wie Quadrat und Rechteck. Anfangs sind sie noch mit and. zeichenhaft-geometrischen oder biomorphen Formen kombiniert, doch mit der Zeit ergeben sich aus horizontalen und vertikalen Farbbahnen in immer neuen Zusammensetzungen unterschiedliche streifen-, strich- und bandartige Strukturen, die entfernt gegenständliche Assoziationen zulassen (Fenster, Straßen, Labyrinthe u.a.). C. verwendet meist wenige Farben, abwechselnd kräftige oder zarte, und neigt zur Monochromie, wobei der oft sichtbare Pinselauftrag z.T. minimale, raumsuggerierende Farbmodulationen erkennen läßt. ⌑ Barcelona, Fund. La Caixa, Col. Testimoni. – Fund. Fran Daurel. Camargo, Stadtverwaltung. Castro Urdiales, Stadtverwaltung. Granada, Fund. Caja Granada. – Fund. La General. Madrid, Banco de España. – Col. Fund. Coca Cola de España. – Minist. de Asuntos Exteriores. – Minist. de Sanidad. Malaga, Centro de Arte Contemp. – Col. de Unicaja de Arte Contemp. Pamplona, Col. de Arte Contemp. Ciudad de Pamplona. – Univ. Pública. Quesada, Stadtverwaltung. Salamanca, Domus Artium 2002. Santander, Caja Cantabria. – Cámara de Comercio. – Col. Norte de Arte Contemp., Gobierno de Cantabria. – Col. Parlamento de Cantabria. – Diputación de Cantabria. – Mus. Mpal de BA. Santoña, Mus. Mpal. Torrelavega, Mus. Mpal. Tudela/Navarra, Stadtverwaltung. ◉ *E:* 1982 Castro Urdiales, Sala Mpal de Expos. / Santander: 1984 Mus. Mpal de BA; 1987 Gal. Siboney; seit 1989 mehrfach, '91 (K), 2007 (K: F. Calvo Serraller u.a.) Gal. Juan Silió; 2002 Palacete del Embarcadero (Wander-Ausst.; K: F. Francés); 2006 Sala de Expos. del Mercado del Este (K: J. M. Bonet u.a.) / Madrid: 1992 Gal. Almirante (K: F. Francés); 2001, '03, '06, '09 Gal. May Moré / 1994 (K: M. Fernández-Cid), '99, 2003 Zara-

goza, Gal. Fernando Latorre / 1994 San Sebastián, San Telmo Mus. (K: M. Fernández-Cid/A. Olaizola) / Pamplona: 1994 Univ. Pública de Navarra (K: G. Rodríguez); 2002 Sala de Cult. García Castañón (K) / 1996 Santillana del Mar, Casa del Aguila y la Parra (K: P. Llorca) / 1996, 2009 Bilbao, Gal. Windsor Kulturgintza / 1998 Valencia, Gal. Punto / Barcelona: 1998 Gal. Senda; 2003 Gal. Alejandro Sales / 2000 Pollença (Mallorca), Gal. Maior / 2001 Miengo (Cantabria), Sala de Arte Robayera (K: F. Francés) / 2006 Málaga, Gal. Alfredo Viñas. – *G:* 1986, '93 (Ankaufspreis) Pamplona: Bien. de Pint. / 2002 Zamora: Bien. de Pint. / 2004 Albacete: Bien. de Artes Plásticas. ⌑ DPEE III, 1994. – *M. Fernández-Cid u.a.,* R. C. (K Wander-Ausst.), Santander 1998; *C. Pérez,* Sur (Málaga) v. 29. 3. 2006; *E. Castaño Alés,* ibid. v. 21. 4. 2006; La col. norte en Arco '08. Obras seleccionadas, Santander 2008. – *Online:* Gal. Fernando Silió, Santander; Personajes Cántabros. – Mitt. Gal. Fernando Silió, Santander.

<div style="text-align: right">M. Nungesser</div>

Cavadini, *Agostino* cf. **Cavadini,** *Eugenio*

Cavadini, *Eugenio,* schweiz. Architekt, * 28. 8. 1881 Morbio Inferiore, † 12. 6. 1962 Locarno. Stud.: Technikum Burgdorf. 1907–12 Stadtbaumeister von Locarno. Ab 1912 eig. Archit.-Büro ebd. Vater von *Agostino C.* (* 25. 12. 1907 Locarno, † 20. 10. 1990 ebd.; ab 1932 Zusammenarbeit mit C.). – Neben Wohnhäusern zahlr. öff. Bauten im Tessin (Krankenhäuser, Markthallen, Rathäuser, Kirchen, Industriebauten). Entwicklung vom historistischen Stilpluralismus in der 1. H. des 20. Jh. zum Rationalismus der 1930er Jahre (Lugano, Krankenhaus S. Rocco, 1934–35, mit Agostino C.). ⌑ Cevio: Bezirkskrankenhaus, 1922. Gerra Piano: Pfarrk., 1927/28. Locarno, Via Serafino Balestra 19–21: Kommunaler Schlachthof, 1910/11. – Via Ospedale 1: Krankenhaus La Carita (mit Agostino C.). Re/Piemont: Wallfk. Madonna del Sangue, 1918–58 (mit Edoardo Collamarini, Bologna). ✉ Costruzioni eseguite dagli architetti Eugenio e Agostino C., Locarno 1935. ⌑ HBLS, Suppl., 1934; *I. Rucki/ D. Huber* (Ed.), Architekten-Lex. der Schweiz 19./20. Jh., Basel u.a. 1998. – *P. Disch* (Red.), 50 anni di archit. in Ticino 1930–80, Bellinzona 1983; Schweiz. Archit.-Führer 1920–1995, Bd 3, St. 1996; *M. Daguerra,* Birkhäuser Arch.-Führer Schweiz. 20. Jh., Basel u.a. 1997.

<div style="text-align: right">P. Böttcher</div>

Cavadini, *Raffaele,* schweiz. Architekt, * 12. 7. 1954 Mendrisio, lebt in Locarno. Stud.: 1973–74 ETH, Zürich; 1975–80 Univ. Venedig, Facoltá di Archit. (1980 Promotion bei Vittorio Gregotti). 1980 Tätigkeit bei Aurelio Galfetti, Bellinzona; 1982–85 Mitarb. im Archit.-Büro Luigi Snozzi, Locarno. Seit 1985 eig. Büro ebd.; seit 1986 teilw. Zusammenarbeit mit Michele Arnaboldi. 1990–2001 Mitgl. der kantonalen und 1997–2002 der eidgenössischen Komm. für Denkmalpflege. Lehrtätigkeit: u.a. 1981–82 Ass., Ec. d'archit., Genf; 1982–83 Ass., ETH, Zürich; 1986 Gast-Prof., Southern Calif. Inst. of Archit. (SCI-ARC) of Los Angeles in Vico Morcote; 1987–88 Gast-Prof., Ec. polytechnique fédérale de Lausanne (EPFL); 2002–03 Prof. für Entwurf, Accad. di ar-

chit., Mendrisio. Ausz.: u.a. 1995 Premio internaz. di ar-
chit. di Pietra, Verona; 1999 Premio internaz. di archit.
contemp. alpina; 2003 Premio SIA Tessin. – Als Schüler
von A. Galfetti und L. Snozzi stehen C.s Bauten in der
Nachf. der Tessiner Schule, indem jeweils die respektvol-
le Analyse der hist. und topogr. Eigenarten des Ortes den
Ausgangspunkt der Planungen bilden. Charakteristisch ist
die Verwendung von Sichtbeton und Naturstein der Regi-
on (Granit) in der Kombination von geometrisch rigorosen
Baukörpern mit eingeschnittenen Wandöffnungen, wobei
der Licht-Gest. eine bes. Rolle zukommt. V.a. Wohnbau-
ten, sakrale Gebäude, Außenraum-Gest. und städtebauli-
che Projekte, fast ausschl. im Tessin. Mit M. Arnaboldi
entwickelt C. 1995 den Masterplan für die Expo 2000 in
Hannover. 🏛 Brissago: Casa Cavadini, 1988; Oratori-
um S. Bartolomeo, 1997. Gerra Piano: Casa Calzascia,
1991–92. Giubiasco: Kap. S. Anna und Piazzetta S. Giob-
be, 1993–94; Markthalle, 1996. Iragna: Aussegnungs-
Kap. des Friedhofs, 1993; kommunale Bauten (u.a. Rat-
haus, Piazza della Posta Vecchia), 1994–95. Locarno, Via
Varenna 79: Casa d'appartamenti Pal. Nessi, 1987–89. –
L.-Monti, Via del Tiglio 12: Casa Kalt, 1990–91. Minu-
sio: Case Pasinelli, 1989–94. Olivone: Ethnogr. Mus.,
1998–2000. 📖 C. Humbel, Junge Schweizer Architek-
ten und Architektinnen, Z. 1995; M. Daguerra, Birkhäuser
Archit.-Führer Schweiz. 20. Jh., Basel u.a. 1997; A. Me-
seure u.a. (Ed.), Archit. im 20. Jh. Schweiz (K Frank-
furt am Main), M. u.a. 1998; Detail 39:1999 (6) 973–977;
T. Bamberg/P. Pellandini, Tessin-Archit. Die junge Gene-
ration, M. 2004; R. C. Architetto. Opere dal 1987–2001
(K), Münsingen s.a. [2004]; W. J. Stock, Archit.-Führer.
Christliche Sakralbauten in Europa seit 1950, M. u.a.
2004; R. Stegers, Bibliogr. Sakrale Gebäude. Kirchen,
Synagogen, Moscheen, Häuser der Stille, Friedhofsbauten
1970–2009, B. u.a. 2010. P. Böttcher

Cavadore, *Franck,* frz. Maler, Zeichner, * 22. 8. 1956
Bayonne, lebt in Tarnos. Tischlerlehre. – Farbenfrohe abs-
trahierte Gem. in Acryl/Papier, häufig in Kombination mit
Tusch-Zchngn; kleinteilige ornamentale Gest., z.T. mit an-
gedeuteten figurativen Motiven. 🏛 Begles, Mus. de la
Création Franche. Mont-De-Marsan, Centre d'Art con-
temp. Raymond Farbos. Reggio Emilia, Coll. Menoz-
zi. – Gab. delle Stampe A. Davoli. 👁 E: 1983 Biarritz,
Gal. Sud-Ouest / 1998 Ordizia (Guipúzcoa), Pal. Barrena /
2006 Paris, Centre nat. des Arts plast. / 2008, '09 Aix-en-
Provence, Gal. Rien. – G: Paris: 1990 Salon d'Automne;
1998 Salon des Comparaisons / 1998 Bayonne, Gal. Arb-
re: Hist. d'Ancres (K) / 2008 Saint-Jean-de-Luz: Festival
d'Art singulier. 📖 G. Desport, Répert. des peintres et
sculpteurs du Pays Basque, Biarritz ²2005. – Online: Mus.
de la Création Franche, Bègles. F. Krohn

Cavaglieri, *Giorgio,* US-amer. Architekt, * 1. 8. 1911
Venedig, † 15. 5. 2007, tätig in New York. Nach urspr.
Wunsch Maler zu werden, ab 1932 Stud. der Archit. und
Stadtplanung am Politecnico in Mailand. Dort erste Ar-
beiten und von 1934–38 eig. Büro, anschl. Stud. in Rom.
1939 Emigration in die USA, 1943 US-amer. Staatsbür-
gerschaft und Kriegsdienst u.a. in Europa. Nach kurzer Tä-

tigkeit in Baltimore ist er in New York zeitweilig Mitarb.
von Rosario Candela, bis er 1946 dort ein eig. Büro eröff-
net. 1957–60 ebd. Prof. am Pratt Inst. School of Archit.;
1956 Gold-Med. der Architectural League, New York,
1963 Präs. der Municipal Art Soc.; 1968 Ehrenpreis des
AIA und Präs. der New Yorker Sektion des AIA. – C. spe-
zialisiert sich auf Umbau und Umnutzung hist. Gebäude.
Weithin beachtet wird sein Umbau des Jefferson Market
Courthouse in Greenwich Village (New York) in eine öff.
Bibl., nachdem der Bau vor dem Abriß bewahrt werden
konnte (1964–67). Mit diesem Projekt ändert sich die öff.
Wahrnehmung und Wertschätzung hist. bed. Bauwerke in
New York, und C. wird zu einem der Wegbereiter der US-
amer. Denkmalpflege. Dabei strebt er keine Rekonstr. an,
sondern macht Neues und Ergänztes anhand der Mat. und
Formen kenntlich. E. der 1960er Jahre baut C. die Astor
Libr. (425 Lafayette Str.) in Joseph Papp's Public Theat-
re um. 🏛 New York, Columbia Univ., Avery Architec-
tural and FA Libr.: Zchngn und archit. Nachlaß. – Grand
Central Station: Rest. 📖 Krantz, 1985; Soria, 1993. –
Baltimore views by G. C. (K), Baltimore 1942; D. Young,
Preservation. The mag. of the Nat. Trust for hist. preserva-
tion 59:2007 (5) 68; The New York Times v. 18. 5. 2007
(Nekr.). S. Hauschke

Cavalan, *Pierre,* frz. Schmuckgestalter, * 1954 Paris,
lebt seit 1980 in Sydney/N. S. W. Stud.: 1975–79 Ec. de
la Bijouterie, Joaillerie, Orfèvrerie, Paris; 1980–82 Univ.
of Sydney (Kunstgesch.). Arbeitet 1980–86 im Atelier des
Schmuckgestalters Russel McColough ebd. und eröffnet
anschl. ein eig. Atelier in Sydney-Glebe. Ausz.: 1992, '99
Stip. des Australia Council for the Arts; 1994 Nat. Con-
temp. Jewellery Award, Griffith; 1995 Alice Craft Acqui-
sition Award, Alice Springs; 2008 Glebe Art Prize. Lehr-
tätigkeit: 1997 Haystack Mountain School of Crafts, De-
er Isle/Me.; 1999–2009 Enmore School of Design, Syd-
ney. – C. kreiert aus vielen Einzelteilen assemblageartig
zusammengesetzte Schmuckstücke (v.a. Halsketten, Bro-
schen und Armbänder). Dabei verwendet er überwiegend
Fundstücke wie Muscheln, Glasscherben, Steine, Knöpfe,
Medaillen, Münzen, Schlüssel, Schrauben und Souveni-
rartikel (z.B. ein Eiffelturm als Bestandteil der Kette Air,
1993) sowie Email und Silber. Die char. historisierende
Gest. wird bes. bei den Broschen deutlich, die an gegosse-
nen Eisenschmuck des 19. Jh. erinnern. Weiterhin entste-
hen seit E. der 1990er Jahre aus recycelten Metallteilen und
Fundstücken mosaikhafte Wandbilder, deren bevorzugte
Motive geometrisch abstrahierte maskenhafte Gesichter
sind. 🏛 Adelaide, AG of South Australia. Canberra,
NG of Australia. – NM of Australia. Darwin, Mus. and
AG of the Northern Territory. Edinburgh, NM of Scot-
land. Hobart, Tasmanian Mus. and AG. Houston/Tex.,
MFA. London, Imperial War Mus. Montreal, MAD.
New York, MAD. Sydney, Powerhouse Mus., Mus. of
Applied Arts and Sc. Toowoomba, Regional AG. 👁 E:
1990 Balmain, Punch Gall. / 1993 Canberra, Ben Grady
Gall. / 1994 Adelaide, Jam Factory Gall. / 1999 Ruthin,
Ruthin Craft Centre (K); Philadelphia (Pa.), Helen Drutt
Gall. / 2001 Brisbane, Brisbane City Gall. / Sydney: 2008

Gaffa Gall. (mit Mike Turner); 2009 Frances Keevil AG (mit David Gerstein). – *G:* 1991 Adelaide: First Austral. Contemp. Jewellery Bienn. / 1994 Zürich, Mus. Bellerive: Schmuck unserer Zeit (K) / 1998 's-Hertogenbosch, SM's: Brooching it diplomatically (Wander-Ausst.; K) / 2001 Cambridge (Mass.), Mobilia Gall.: The Ring (Wander-Ausst.; K) / San Francisco (Calif.): 2005 Velvet da Vinci: Anti-War Medals (Wander-Ausst.; K); 2008 ebd.: The Pendant Show / Sydney: 2005–06 Australia Council for the Arts: On Location Overseas; 2007 At The Vanishing Point: The Howard Years / 2009 Ashfield: Austral. Ceramics Trienn. ▭ Dict. internat. du bijou, P. 1998. – Contemp. Austral. craft (K Wander-Ausst.), Sydney/Sapporo 1999; *U. Ilse-Neuman u.a.*, GlassWear. Glass in contemp. jewelry (K Wander-Ausst.), St. 2007; *C. Strauss*, Ornament as art. Avant-garde jewelry from the Helen Williams Drutt Coll. (K Wander-Ausst.), St. 2007. – *Online:* Website C. F. Krohn

Cavalcante, *Jayme*, brasil. Maler, Restaurator, * 7. 7. 1938 Salvador/Bahia, tätig in Niterói. Autodidakt. Ausz.: Gold-Med. des Núcleo de Artistas Fluminenses, Rio de Janeiro; Silber-Med. der Soc. Brasil. de BA; Bronze-Med. der Assoc. Fluminense de BA ebd.; Silber-Med. der Soc. de BA Antônio Parreiras, Juiz de Fora/Minas Gerais; 1982 Gold-Med. des Salão Oswaldo Teixeira, Petrópolis. – Naturalistische Malerei, v.a. Strand- und Küsten-Lsch., die oft menschenleer sind (z.B. *Prainha, Arraial do Cabo*, Öl, 1994), aber auch Seestücke mit Schiffen (*Marinha, Ponta d'Areia*, Öl, 1996) in impressionistischer Manier und Farbgebung. Dabei nimmt C. v.a. die Umgebung von Niterói auf, schafft aber auch Ansichten and. Städte, etwa Rio de Janeiro. 1969 Gründungs-Mitgl. des Núcleo de Artistas Fluminenses (NAF), Rio de Janeiro und Mitbegr. der Gruppe Pintores na Beira do Cais. C. ist auch als Restaurator für versch. Ausst. tätig. ◉ *E:* Niterói: 1979 Espaço Cult. Novotel; 1995 Mus. Antônio Parreiras / Rio de Janeiro: 1980 Gal. Borghese; 1991 Espaço Cult. Moviarte; 1994 Saguão Cult. Bolsa do Rio. – *G:* 1980 Hannover, Gal. im Karstadt-Haus: Gem. und Wandteppiche. Orig.-Werke brasil. Künstler der Gegenwart (K) / 1987 São Paulo, Gal. Ranulpho: O Redescobrimento do Brasil (K) / Niterói: 2002, MAC: Niterói Arte hoje (Wander- Ausst., K); 2005 Espaço Cult. Nippon: Quatro, Quarenta, 432; 2007 Solar do Jambeiro: Paisagem Modificada; 2009 Centro Cult. Paschoal Carlos Magno: Expos. de Bonifácio. ▭ *Cavalcanti* I, 1973; *Medeiros*, 1988. – *J. Louzada*, Artes plást. Brasil. Seu Mercado, seus Leilões, S. P. 1984; *J. A. Akoun*, La cote des peintres, P. 1994. – *Online:* Inst. Itaú Cult., Enc. artes visuais. C. Melzer

Cavalcante (Cavalcante jun.; Cavalcanti), *Maranhão (Osvaldo Maranhão)*, brasil. Maler, Zeichner, * 19. 11. 1956 Uberlândia/Minas Gerais, tätig in Goiânia. Stud.: 1975 Casa Grande de Arte, Goiânia (Kunstgesch.); 1976 Esc. Protec, São Paulo (Archit.-Planung); 1983 Univ. Federal de Goiás (künstlerische Techniken bei Rubens Matuc). – 1976 in São Paulo als Werbezeichner tätig. C. schafft Gem. (Acryl/Lw.), Skulpt. und Wandbilder, u.a. für den Sitz des Ordem dos Advogados in Brasília. Seine

figurative Malerei widmet sich v.a. der Darst. von Figuren und Vögeln, geht über die reine Dokumentation hinaus und nimmt phantastische Züge an. C. findet seine zentralen Motive in Flora und Fauna, v.a. Fische des Araguaia-Flusses in Goiás, häufig ergänzt durch primitive zeichenhafte Symbole, die an archaische Malerei, Hieroglyphen und Maya-Schriften erinnern. ▭ BRASÍLIA, Banco Interamericano de Desenvolvimento. – Fund. Cult. GOIÂNIA, Fund. Jaime Câmara. – Mus. de Arte. – Pal. das Esmeraldas. – Univ. Federal de Goiás. – Av. Cerrado, Parque Lozandes: Tributo ao Indio Goyá, Metall-Skulpt. LARAMIE/Wyo., Univ. of Wyoming Art Mus. RIO DE JANEIRO, Acad. Brasil. de Letras. – Câmara dos Deputados. – Soc. Brasil. de BA. – UNESCO. ◉ *E:* Goiânia: 1985 Multi-Arte Gal. (K); 1995 Casa Grande Gal. de Arte (Retr.); 2000 Fund. Jaime Câmara; 2009 Espaço Cult. Mac Móveis Diferenciados / 1986 Brasília, Performance Gal. de Arte (K) / 1997 Curitiba, Gal. Fraletti e Rubbo (K) / 2007 Florianópolis, Confraria das Artes. – *G:* Rio de Janeiro: 1985 Salão Nac. de Artes Plást.; 2003 Centro Cult. da Justiça Federal: Belchior – Retratos e auto-retratos / 1988 Goiânia: Bien. de Arte Contemp. / 2002 Brasília, Panorâmica Goiana de Arte; Niterói, MAC: Arte Hoje. ▭ *Ayala*, 1997. – *J. Louzada*, Artes Plást. Seu Mercado, seus Leilões, S. P. 1984; *A. Menezes*, Da Caverna ao Mus. Dic. das Artes Plást. em Goiás, Goiânia 1998. – *Online:* Inst. Itaú Cult., Enc. artes visuais. C. Melzer

Cavalcanti, *Maranhão* → **Cavalcante**, *Maranhão*

Cavalcanti, *Wilson (Wilson Furtado*; Pseud. Cava), brasil. Maler, Graphiker, Zeichner, * 2. 3. 1950 Pelotas/Rio Grande do Sul, lebt in Porto Alegre. Ausb.: Graphikkurs bei Assunção Souza, Rio de Janeiro; 1967–79 Kurse im Atelier Livre da Prefeitura Mpal, Porto Alegre, u.a. bei Danúbio Gonçalves, Paulo Peres, Carlos Martins und Marília Rodrigues; 1978–79 ebd. Tiefdruck bei Romildo Paiva; ebd. Lehrtätigkeit für graph. Techniken; 1982 Druckkurs im MAM, Rio de Janeiro, bei Otávio Pereira. – C. zeichnet 1974–78 Comics und Cartoons für lokale und nat. Zss., z.B. Folha de Manhã, Pasquim und Planeta. Seitdem v.a. expressive druckgraphische Arbeiten, v.a. narrative Hschn.- und Linolschnitt-Ill., auf denen z.B. Figurenpyramiden aus skurril-verdrehten Figuren (Akrobaten, Seiltänzer) und Tieren auf Leitern (*Rainha*) zu sehen sind. Im malerischen Werk, das häufig von einem starkfarbigen, gestischen Pinselduktus gekennzeichnet ist, stellt C. Figuren in Kontexte mit graph. Symbolen, häufig Ziffern. Oftmals vermischen sich Zahlen mit and. Symbolen, teils geklebt oder geschnitten, z.B. zu einer Andeutung von Gesichtern (*1234*). C.s Sujets und Motive oszillieren meistens zw. figürlichen und abstrakten Elementen, wobei die menschliche Figur vielfach in existentiellen Situationen des Insichgekehrtseins und Ausgeliefertseins dargestellt wird (*De olhos fechados*). ▭ CURITIBA, MAC. FLORIANOPLIS, MAC de Santa Catarina. PELOTAS, Mus. de Arte Leopoldo Gotuzzo. PORTO ALEGRE, MARGS. – Atelier Livre da Prefeitura Mpal. – Pin. Berta-Locateli. – Mus. do Trabalho. ◉ *E:* Porto Alegre: 1982 Gal. Salamandra; 1990 Gal. Badesul; 1996, '02 Mus. do Trabalho; 2002

Centro Mpal de Cult.; 2007 Arte & Fato Gal.; 2009 Cult. Gall. of Arts Dante Sfoggia / 1995 Pelotas, Mus. de Arte Leopoldo Gotuzzo / 1999 Passo Fundo, Mus. de Artes Visuais Rio Grande do Sul. – *G:* 1975 Londrina: Salão de Arte Relig. Brasil. (Ausz.) / Porto Alegre: 1976 Salão Univ. na Univ. Federal do Rio Grande do Sul (Ausz.); MARGS: 1979 Semana; 1980 (Ausz.), '81 (1. Preis Druckgraphik) Salão do Jovem Artista; 1986 Avant Premiére – Pensando o Papel; 1988 A Jovem Gravura Contemp.; 1989 Arte Sul 89 (K); 2004 Santander Cult.: Impresses. Panorama da Xilogravura Brasil. / 1978 Montevideo, Club del Grabado: 17 Gravadores Gaúchos / 1980 Berlin, Möbel Hübner: Cartoon 80. Karikaturen der Welt (Wander-Ausst.; K) / 1989 São Paulo, MAC: A Jovem Gravura Contemp. / Rio de Janeiro: 2000 Paço Imperial: A Imagem do Som de Gilberto Gil; 2007 Centro de Cult. Casa da Moeda: As Cidades Imaginadas de Érico Veríssimo. ⌑ *R. Rosa/D. Presser*, Dic. de artes plást. no Rio Grande do Sul, Porto Alegre ²2000. – *A. Hermeling Santos/J. F. Alves*, Cat. de artistas plást. do Rio Grande do Sul, Porto Alegre 1998. – Centro de Pesquisa do MAC do Paraná, Curitiba. – *Online:* Inst. Itaú Cult., Enc. artes visuais (Ausst., Lit.); Blog C.

 S. Dahn Batista

Cavallini, *Sauro*, ital. Bildhauer, Maler, Graphiker, Autor, * 4. 3. 1926 (auch 4. 3. 1927) La Spezia, lebt und arbeitet in Fiesole. Autodidakt. Ab 1930 wohnt die Fam. in Florenz, wo C. zur Schule geht. Schon früh sind sein Zeichentalent und seine lit. Interessen erkennbar. Nach dem Abitur arbeitet er als freier Journalist für Tages-Ztgn (auch als Auslandskorrespondent) und bewegt sich im Umfeld von Piero Bargellini und Nicola Lisi. 1955 erstes eig. Bildhauer-Atelier in Florenz (Via di Orsanmichele). 1957 Teiln. an der Gruppen-Ausst. in der Gal. Permanente ebd. mit einigen Terrakotta-Skulpturen. 1960 Bau des eig. Atelierhauses in Fiesole. Ausz.: 1965 1. Preis auf der Mostra Naz. Premio del Fiorino (Florenz); 1978 Fronda d'Oro, Genua; Internat. Award San Valentino, Terni; 1996 Premio Columbus des Rotary Club, Florenz. – In den 1960er Jahren entstehen die ersten Bronzearbeiten (*Genitrice*, 1960; *Grande genitrice*, 1962; *Fine di maternità*, 1962) und 1963 die Steinbüste von Konrad Adenauer für das Bundeshaus in Bonn. 1966 (nach der Überschwemmung des Arno) Rest. zahlr. beschädigter Marmor-Skulpt. im Mus. del Bargello und in S. Croce. 1968 greift C. das Thema der Maternità erneut auf für die *Fontana della maternità* (1968–71; Piazza Ferrucci, Florenz); die fünf weibl. Figuren mit Möwen zeigen hier zum erstenmal in ihrer in den Raum weisenden Ausrichtung und einer fast 360° Rotation eine ins Unendliche gesteigerte Expansion. C.s Arbeiten zeichnen sich durch eine charakteristische Dynamik aus, die nahezu allen Werken eigen ist. Ebenso wie in der Behandlung des entstehenden Lebens wendet sich C. auch dem Thema des Todes zu; er zeigt in seinem *Cavallo morente* (Villa Palmieri, Florenz) und v.a. im Kruzifix von San Miniato (Florenz) einen bis ins Extreme gesteigerten Schmerz. Ab 1972 entstehen zunehmend Skulpt.-Gruppen, in denen sich die Formen mehr und mehr öffnen, erweitern und der Umgebung im öff. Raum anpassen, als

würden sie aus diesem erwachsen. Eine char. Werkgruppe sind C.s markant gestaltetete Ballett-Skulpt., u.a. *Arabesque* (1974) und versch. *Pas de Deux*-Varianten, wobei die einzelnen Figuren zunehmend größere Dimensionen annehmen. Höhepunkt dieser Entwicklung ist das *Mon. alla Pace* (1975–76; Pal. dei Congressi, Florenz), in dem neun stilisierte Figuren in einer gemeinsamen aufstrebenden Bewegung die Vereinigung der gesamten Menschheit symbolisieren, deren Umarmung die Kraft und Potenz des Universums versinnbilicht. Linearität, Reinheit und Kraft sind auch hier wieder die Leitgedanken des Künstlers. E. der 1980er Jahre erfindet C. die außergewöhnliche Abendmahlsszene *L'Ultima Cena* in kolossalen Dimensionen (16 m breit, 6 m hoch), die den Höhepunkt seines künstlerischen Schaffens darstellt und die durch ihre lebendige und dynamische Darst. eine Neuinterpretation des Themas überhaupt bietet. Bisher existiert davon nur ein Gipsmodell in Orig.-Größe und ein kleineres Modell in Bronze. In den 1990er Jahren entstehen so bek. Werke wie der *Ikaros* für die Univ. Florenz (Villa Favard) oder 1999 das *Mon. Fraternità* für das Fürstenhaus von Monaco. Seit 2000 widmet sich C. intensiv seinem graph. Werk; einen Großteil der Skulpt. und zahlr. and. Themen hat er in Tempera (zunächst auf Karton und später auf Holz) umgesetzt. – Monogr. Bearbeitung und WV stehen aus. ⌑ u.a. STRASBOURG, Europarat: Mon. alla Vita (Hymn to Life), Bronze, 1990. ✉ Cantici del mare e della vita, Fi. 1998. 👁 *E:* u.a. 1973 Prato, Mus. dell'Opera del Duomo u.a. (K) / 1987 London, Locus Gall. (K) / 2006 Diano Marina, Pal. del Parco / 2007 Alba (Cuneo), Chiesa di San Giuseppe. ⌑ *H. Reuther*, Adenauer. Bildnis und Deutung, Bonn-Beuel 1963; *U. Baldini* (Ed.), C. Crocifissione 1968. Firenze, Basilica di San Miniato al Monte, Fi. 1977; *U. Baldini/C. Bo*, L'ultima Cena. Cavallini, Lastra a Signa 1990; C. Strasburgo 1991 (K), Fi. [1991]; *M. Casini Wanrooij*, Amici dei Musei 56:1993, 58–60; *T. Paloscia*, Accadde in Toscana, II, Fi. 1997 (* 1927 Florenz). – *Online:* Website C.

 A. Wolf

Cavallo (Chavallo), *Giorgio*, ital. Karikaturist, Illustrator, * 1927 Moncalieri/Turin, † 1994 Turin. Von Beruf Bankangestellter, widmet sich C. ab 1953 ausschl. dem Zeichnen von Karikaturen, politischen Satiren und humoristischen Ill., die in zahlr. ital., aber auch internat. Ztgn und Zss. erscheinen, u.a. in Il Travaso, La Gazzetta del Popolo und Satyricon. 1958–73 werden C.s Karikaturen u.a. wöchentlich in L'Europeo abgedruckt, 1987–94 in Tuttolibri (La Stampa). C. konzentriert sich in seinen abwechslungsreichen und unterhaltsamen Schwarzweiß-Zchngn (selten koloriert) auf das Wesentliche; Figuren erfaßt er mit wenigen Strichen. Die Personen, in der Regel Brillenträger mit großen Nasen, einer lebhaften Mimik und Gestik, sind meist im Dialog dargestellt; pointierte Texte kommentieren die Szenen. 1982–85 Lehrtätigkeit an der Univ. della Terza Età Unitre, Turin. 1984 gründet C. zus. mit Raffaele Palma in Turin das Centro Arti Umoristiche e Satiriche (CAUS). Bed. Ausz.: 1959, '74 Palma d'Oro Disegno Umoristico (Festival dell'Umorismo di Bordighera); 1981 Premio Satira Politica Forte dei Marmi per il Di-

segno Satirico. Seit 1999 vergibt C.s Geburtsstadt alljähr-
lich einen Premio G. C. per la satira e l'umorismo. – Ver-
öff. u.a.: *Pronto ... chi ride*, T. 1959; *Si fa per ... sterzare*, T.
1965; *33 frati e 1/2*, T. 1967; *Cavallo da tiro*, T. 1985; *Equi
libri. Autori e titoli visti umoristicamente per Tutto libri,
La Stampa*, Moncalieri 1989. ⌂ BASEL, Cartoon-Mus.
◉ *E:* 1989 Moncalieri / 2008 Turin. ▭ *Flemig*, 1993. –
D. *Aloi/D. Mellana*, G. C. L'indignato (K), T. 1995. – *On-
line:* Fond. Franco Fossati; Humourcomix. C. Follmann

Cave, *Henry William (Henry W.)*, brit. Verleger, Schrift-
steller, Fotograf, * 23. 2. 1854 Brackley, † 1913, leb-
te 1872–86 in Colombo/Ceylon (Sri Lanka), danach in
Oxford und Brighton. Ab 1872 Privatsekretär des Erzbi-
schofs von Colombo. 1876 Eröffnung eines Buchladens,
1877 Gründung des Verlags H. W. Cave & Company. 1886
Rückkehr nach England, danach weitere Reisen nach Cey-
lon. – Veröff. mehrerer Reiseberichte über Ceylon mit eig.
Fotogr., meist dörfliche Ansichten und Lsch., u.a.: Pictur-
esque Ceylon, 3 Bde. Lo. 1893–95; Golden Tips, Lo. 1900;
The Ceylon Govt. Railway, Lo. 1910. ▭ *H. Cox*, Who's
who in Kent, Surrey, Sussex, Lo. 1911; *C. Hayavadana
Rao* (Ed.), The Indian biogr. dict., Madras 1916; DA VI,
1996. J. Niegel

Cave, *Nick*, US-amer. Textil- und Performancekünstler,
* 4. 2. 1959 Fulton/Mo., tätig in Chicago. Stud.: 1982
Art Inst., Kansas City; 1984–86 North Texas Univ. ebd.;
1989 Cranbrook Acad. of Arts, Bloomfield Hills (Fiber-
art bei Gerhardt Knodel). Lehrt seit 1989 am School of
the Art Inst., Chicago (Fiberart). Ausz.: 1997 Illinois Arts
Council State Grant, Chicago; 2006 Driehaus Award ebd.;
New York: 2002, '04 Creative Capital Grant; 2006 Artadia
Award; Joyce Found. Award; 2008 Joan Mitchell Found.
Award. – C.s Themen kreisen um Mythen, Zeremonien,
Rituale und Identität. Zu seinen bed. Werken gehören die
seit 1986 hergestellten *Soundsuits*, Kostüm-Skulpt. und
Assemblagen, die den ganzen Körper meist bis auf die
Augen bedecken oder mit Masken und Perücken kombi-
niert werden. Sie lassen ihren Träger unsichtbar werden
und verleihen ihm eine neue Identität. Sie dienen als Ver-
kleidung und psychologischer Schutzmantel gegen Vorur-
teile, die C. als Amerikaner afrikanischer Herkunft erfährt.
Als Mat. verwendet C. natürliche Dinge wie Blätter, Zwei-
ge, Haar und Produkte versch. Handwerks-Trad. wie hand-
gewebte Stoffe, Pailletten, Glasperlen, aber auch wertlo-
se Fundstücke wie Kronkorken, verrostete Eisenteile oder
Plastikabfall. Für die zeitaufwendige Herstellung arbeitet
C. mit Ass. zusammen. Dabei werden Stoffe bestickt, mit
Applikationen versehen oder in Patchworktechnik zusam-
mengenäht, es wird gestrickt, geknüpft und gefärbt. Eben-
so entstehen filigrane Gerüste aus Holz oder Metall, an de-
nen wiederum Objekte (z.B. Spielzeug) angebracht wer-
den. Die jüngeren Kostüme zeigen oft Darst. von Tieren,
um auf die bedrohte Umwelt hinzuweisen. Die Oberflä-
chen der überlebensgroßen Kostüme, die beim Tragen und
Bewegen Geräusche verursachen, schimmern oder sind
in bunten Farben gestaltet. Ritualisierte Performances mit
dissonanter Musik und Geräuschen, die auf Video aufge-
zeichnet werden, thematisieren das Tragen der Kostüme

und ihre theatralische Inszenierung. Die *Soundsuits*, die
sowohl ausgestellt als auch getragen werden sollen, ver-
binden den autonomen, aber statischen Status des Kunst-
werks einerseits mit der kontextabhängigen Präsentation
in privaten oder öff. Ritualen andererseits. C.s Kostüme
sind zugleich geschlechts- und klassenneutral; sie verwei-
gern sich einer politischen, relig. oder rassistischen In-
dienstnahme. Zu C.s direkten Vorbildern zählen die Werke
von Joseph Beuys (soziale Plastik) sowie die Performances
und Kostüme von Leigh Bowery. Ebenso sind C.s Wer-
ke inspiriert von Theateraufführungen, Happenings und
dem Cross-Dressing der homosexuellen Aktivistengrup-
pe Angels of Light im San Francisco der 1970er Jahre,
die v.a. durch Fotogr. überliefert sind, aber auch von der
Kostüm-, Musik- und Tanz-Trad. der Mardi Gras Indians
in New Orleans. Eine wichtige Quelle sind rituelle afri-
kanische Stammeskunst, Kostüme und Masken, die dem
einzelnen Objekt eine spirituelle Macht zusprechen. Zahlr.
Tanz- und Bewegungsperformances, an denen C. immer
auch selbst teilnimmt, so im Holter Mus. of Art Helena
(2004), im MCA Chicago (2004) und im Yerba Buena
Center for the Arts, San Francisco (2009, Choreograph Ro-
nald K. Brown), aber auch in Clubs, Theatern und in den
Straßen begleiten seine Ausstellungen. Auch fertigt C. Se-
rien von Objekten, Assemblagen und Collagen, die eine
Mischform aus Textilien und Skulpt., aber keine tragbaren
Kostüme darstellen (*Lucky Charm, Amalgamations*). Eine
frühe Installation (*Lost and Found*) versammelt über 300
gefundene Handschuhe an einer Wand, die durch den Grad
ihrer Abnutzung den langsamen Prozeß der Veränderung
anschaulich machen. C. ist außerdem als Juror und Leh-
rer in zahlr. Workshops tätig. Er hat eine eig. Modekollek-
tion entworfen, hergestellt und vermarktet und in Chica-
go die Robave Clothing Boutique (seit 1993, zus. mit Jeff-
rey Roberts) geleitet, die klassische Damen- und Herren-
mode sowie von Künstlern entworfene und handgefertigte
Einzelstücke anbietet. ⌂ ATLANTA/Ga., High Mus. of
Art. CHARLOTTE/N. C., Mint Mus. of Art. CHICAGO, MCA.
NEW YORK, MAD. – Studio Mus. in Harlem. OVERLAND
PARK, Nerman MCA. PHILADELPHIA, PAFA. PORTLAND,
AM. PROVIDENCE, Rhode Island School of Design, Mus.
of Art. ST. LOUIS/Mo., Mildred Lane Kemper AM. SAN
FRANCISCO, de Young. SEATTLE, AM. ◉ *E:* 1999 South
Bend, Mus. of Art / 2001 Allentown, AM (K) / 2002 Beloit,
Wright Mus. / 2005, '09 New York, Jack Shainman Gall. /
2006 Chicago, Cult. Center Found. (Retr.) / 2007 (K), '08
Jacksonville, MCA / 2008 Alfred (N. Y.), Fosdick-Nelson
Gall. / 2010 Verona, Studio La Città; Los Angeles, Fow-
ler Mus. – *G:* 2001 Chicago, Field Mus.: Faces in the
Field; Hannover, Kestner-Mus.: Zierat. Zeitgen. Schmuck
aus USA, Niederlande und Deutschland (K) / 2002 New
York, MAD: Body and Soul / 2004 Portsmouth (Va.),
Mus.: Cross Currents / 2006 Toronto, Mus. of Contemp.
Canad. Art: Unholy Alliance. Art and Fashion meet again;
Warschau, Zachęta Narodowa Gal. Sztuki: Czarny alfa-
bet (K); San Francisco, Yerba Buena Center for the Arts:
Black Panther Rank and File / 2008 East Islip, Mus. of
Art: Fashion forward; Chicago, Monique Meloche Gall.:

Boys of Summer; Kapstadt, Michael Stevenson Gall.: Disguise. The Art of attracting and deflecting Attention (K) / 2009 Katonah (N. Y.), Mus. of Art: Re-addressing Identities. Clothing as Sculpt.; Bellevue, AM: ÜberPortrait; Rotterdam, BvB: The Art of Fashion. Installing Illusions. 📖 *M. Mensing Shermeta*, Fiberarts 19:1992 (5) 38–42; *K. Searle*, ibid. 19:1992 (2) 44–47; *K. Westphal*, The surface designer's art. Contemp. fabric printers, painters and dyers, Asheville 1993; Men of the cloth (K Loveland Mus. and Gall.), Loveland 1999; *D. T. Dawson*, The new mosaics, Asheville 1999; *K. D. Aimone*, The Fiberarts book of wearable art, N. Y. 2002; *D. Spencer*, Found object art, Atglen 2002; *J. W. McLaughlin*, The nature of craft and the Penland experience (K Mint Mus. of Craft + Design, Charlotte), N. Y. 2004; *T. Golden/C. Y. Kim* (Ed.), Frequency (K Studio Mus. Harlem), N. Y. 2005; *M. Leventon*, Artwear. Fashion and anti-fashion, Lo. 2005; *H. Cotter*, The New York Times v. 25. 2. 2005; *J. Sanders u.a.*, N. C. Soundsuits, Chicago 2006; *id.*, J. of gay and lesbian issues in education 4:2007 (1) 5–12; *J. Livingston/J. Ploof*, The object of labor. Art, cloth and cult. prod., Chicago 2007; Hot house. Expanding the field of fiber at Cranbrook 1970–2007 (K Cranbrook AM), Bloomfield Hills 2007; *L. Tung*, Crafty. Elaine Bradford, N. C. u.a. (K Mass. College of Art), Boston 2007; *G. Brown*, Ornament 31:2007 (2); *M. Thomas*, Pittsburgh Post-Gaz. v. 23. 1. 2008; *B. Genocchio*, The New York Times v. 11. 1. 2009. – *Online:* The hist. makers (Interview v. 22. 7. 2004). C. Melzer

Cavefors, *Cecilia*, schwed. Graphikerin, Malerin, * 1955, lebt in Malmö. Stud. ebd.: 1974–79 Konstskolan Forum; 1977–80 Grafikskolan Forum (beide heute KHS). Seit 1997 Rektorin an der Kunst- und Designschule Lund. Stip.: u.a. 1986 Aase och Richard Björklunds Fond, Malmö. – U. a. Farb-Lith. mit vereinfachten, häufig silhouettenhaften Menschen-, Tier- und mythologischen Figuren, z.B. *Assyrisk häst*. Daneben Gem. mit ähnlichen Motiven, z.B. *Sfinxen och mannen* (Öl, Tempera) und *Schack* (Öl/Lw., 1989). Auch Ausschmückungen priv. und öff. Gebäude (teils in Gruppenarbeit), z.B. Wand-Gem. am Östra Sjukhus, Malmö (1984). 🏛 BORÅS, Mus. KARLSTAD, Värmlands Mus. MALMÖ, Mus. STOCKHOLM, Statens Konstråd. ☉ *E:* Malmö: 1980 Lilla Konstsalongen; 1984, '87 Gall. Holm; 1989 Gall. Konstnärscentrum / Göteborg: 1990, '94 Gall. Aveny; 1993, '94 KM, Grafikgången / 1992 Kalmar, KM; Trollhättan, KH (mit Maj-Lis Agbeck und Jan-Anders Hansson) / 2004 Umeå, Konstfrämjandet i Västerbotten. – *G:* 1990, '91, '93 Stockholm, Liljevalchs KH: Frühjahrssalon / 1999 Mariefred, Grafikens Hus: 60 konstnärers barn- och vuxenverk / 2004 Karlskrona, Galleriväggen Skottet: Borrgatan 3 / 2010 Sollentuna, Edsvik KH: KKV Grafik Malmö. 📖 *S. Kling/N. Östlind*, Om C. C.s bilder, Sth. 1977. – *Online:* Website Lunds Konst och Designskola. J. Niegel

Cavellat, *Pierre*, frz. Richter, Zeichner, Maler, Keramiker, * 4. 12. 1901 Pontrieux, † 17. 8. 1995 Morlaix. Jurastudium in Rennes. Beginnt 1929 ebd. seine Berufslaufbahn als stellv. Richter, hat versch. Richterämter in den Regionen Bretagne und Pays de la Loire inne, zu-

letzt Oberlandesgerichts-Präs. in Caen (1956–69). Anschl. läßt C. sich in Carantec nieder und widmet sich verstärkt der künstlerischen Tätigkeit. Ausz.: Commandeur dans l'ordre des Arts et des Lettres. – Bevorzugt Zchngn und Aqu. (auch Öl-Gem.), darunter v.a. Genreszenen (auch Gerichtsszenen, z.T. als Karikaturen) und Landschaften. In den 1920er Jahren entstehen versch. Keramiken, inspiriert durch polynesische Kunst, sowie Entwürfe für Tapisserien in Carantec. In den letzten Lebensjahren Teiln. am Salon de Peint. ebd. 🏛 CAEN, Fonds Cadomus. PONT-AVEN, Mus. mun. ☉ *E:* 2000 Carantec, Centre Socio-culturel / 2006 Quimper, Mus. dép. breton (K). 📖 *L. Le Roc'h Morgère* (Ed.), Artistes contemp. en Basse-Normandie, 1945–2005, [Caen] 2005. F. Krohn

Cavelti, *Urs*, schweiz. Maler, Zeichner, Installationskünstler, Fotograf, * 2. 1. 1969 Sagogn/Graubünden, lebt in Basel. Stud.: 1991–95 Schule für Gest. ebd. bei Hannah Villiger und Jürg Stäuble. Stip.: 1995 Kiefer-Hablitzel-Stip.; 1999 Künstleratelier des Kt. Basel-Lsch. und Cité internat. des Arts in Paris; 2000 Basler Künstler-Stip.; 2003 Stadt Chur zum Aufenthalt in Kairo 2004; 2005 Internat. Austausch- und Atelierprogramm Region Basel (iaab) in London. – Im Frühschaffen v.a. Malerei in Sprühtechnik und leuchtendem Kolorit mit fiktiven Lsch., zumeist einer Kombination von Elementen aus Fauna und Flora mit imaginären Planetenkonstellationen. Später erhebliche Dämpfung der Farbigkeit bei Komp. mit wenigen gezielt ausgewählten, oftmals sehr filigran wirkenden Motiven aus der Natur. Der intensiven Naturbeobachtung treu bleibend, fertigt C. im Prozeß der Auseinandersetzung mit räumlichen Aspekten auch komplexe, medienübergreifende Arbeiten zumeist im Zusammenspiel zwei- und dreidimensionaler Darst., v.a. von Installationen, Bleistift-Zchngn, Malerei, skulpturalen Objekten und Assemblagen. Dazu läßt sich C. auch von Kinder-Lit. inspirieren, so daß mitunter eine traum- bzw. märchenhaft-surreal anmutende Atmosphäre entsteht (*Nach dem Regen*, Installation, 2007). 🏛 BASEL, Slg Kunstkredit Basel-Lsch. – *Baugebundene Werke:* LIESTAL, Kantonsspital. MUTTENZ, Altersheim im Park. ☉ *E:* 1998 Bern, Kunstkeller / 1999 Paris, Atelier M. Chanel / 2001 Freiburg (im Breisgau), Alter Wiehrebahnhof / 2007 Biel, CentrePasquArt. – *G:* seit 2001: Regionale. 📖 Kürschners Hb. der Bild. Künstler. Deutschland, Österreich, Schweiz, I, M./L. 2007. – *A. Zwez*, Bieler Tagblatt v. 20. 12. 2007. R. Treydel

Cavestany (C. Pardo-Valcarce), *Enrique* (Pseud. Enrius), span. Maler, Zeichner, Graphiker, * 7. 2. 1943 Madrid, lebt dort. Enkel des Kunstkritikers Julio C. Stud.: Archit. an der Esc. Técnica Superior de Arquit., Madrid. 1966 als Pressezeichner tätig. Entwirft auch Möbel und schreibt regelmäßig Kolumnen für die Ztg El País. – C. malt zunächst abstrakt, wendet sich aber später einem figurativen, zeichenhaften Stil zu, der zuweilen expressionistische und surrealistische Einflüsse erkennen läßt. Seine Gem. zeigen meist urbane Lsch., Straßenszenen und Portr., die durch einen klar strukturierten Bildaufbau charakterisiert sind. Auch Wandmalereien. 🏛 ALBACETE, Mus. MADRID, CARS. ☉ *E:* Madrid: 1966 Gal. Abril

(Debüt); 1979 Gal. Taniarte; 1984 Sala El Coleccionista; 1990, '93, '97 Gal. La Kabala / 1985 Albacete, Mus. Mpal. ⌂ DPEE, Ap., 2002. – *E. Alaminos López/M. Rivera*, Col. Mpal de arte contemp. Pint. y escult. (K), Ma. 1999. S. Herczeg

Caviezel, *Kurt,* schweiz. Fotograf, Video-, Objekt- und Installationskünstler, * 5. 12. 1964 Chur/Graubünden, lebt in Zürich. Autodidakt. Ausz.: 2002 Manor-Kunstpreis Graubünden. – C. beschäftigt sich mit dem Verhältnis von Privatheit und Öffentlichkeit mittels fotogr. Beobachtung des Menschen im Straßenraum und im Internet. In dem Buch *Red light* (Z. u.a. 1999) veröfflicht C. 1997 mit einem Teleobjektiv fotografierte Einblicke in Autos, die an einer roten Ampel warten. Danach verwendet C. durch das Internet öff. verfügbare Webcam-Aufnahmen, die zufällig und unpersönlich wirken. Er druckt sie in der ursprünglichen Größe aus und vergrößert sie anschließend stark. So wirken die Fotogr. verfremdet, teilw. bis zur Abstraktion. Die Bilder stellt C. unter formalen oder thematischen Gesichtspunkten zu Serien zus., darunter *Walker* (2006, mit Paaren, die sich im öff. Raum aufhalten), *Insects* (2007, mit Insekten, die zufällig auf dem Webcam-Objektiv krabbeln) und mehrere Serien von *Portraits* (2006, Personen mit spiegelnden Brillengläsern, mit geneigten Köpfen u.a.). Auch das Verhältnis des Menschen zur Natur wird untersucht, z.B. *Riverside* (11 Fotogr., 2006). Weitere Serien: *Bus Stop* (40 Fotogr./Leuchtkästen, 2000–06); *No video* (40 Fotogr., auch als Film, 2000–07); *Birds; Drops; Niesen* (alle 2007). ◉ *E:* 2002 Chur, Bündner KM (K) / 2011 Winterthur, Fotostiftung Schweiz. ⌂ BLSK I, 1998. – Amanfang. Carte blanche von Hans Danuser (K Helmhaus), Z. 1997; *I. Chappuis*, Junge Bündner Fotogr. Grauer Star (K Bündner KM), Chur 2001; Fernweh und Reiselust (K Mus. Georg Schäfer), Schweinfurt 2001; CTRL space. Rhetorics of surveillance from Bentham to big brother (K Zentrum für Kunst und Medientechnologie), Ka. 2002. – *Online:* Website C. N. Buhl

Caviezel-Gebert, *Maria Antonia* → **Gebert,** *Toni*
Caviezel-Gebert, *Toni* → **Gebert,** *Toni*

Cavigelli, *Reto,* schweiz. Maler, Zeichner, Graphiker, * 1945 Siat, lebt in Sils im Domleschg/beide Graubünden, zeitweilig wohl auch in Basel. Seit 1978 künstlerisch tätig. 1985 Förderungspreis des Kt. Graubünden. – Malerei in Öl und Mischtechnik, entweder gegenständlich und offensichtlich an expressionistischen Vorbildern orientiert (*Schrei*, 1993) oder stark schematisiert (*Frau mit Fisch*, um 1996, beide Öl/Lw.). Dazu kommen abstrahierte, zumeist dramatisch-explosiv wirkende Komp., bei denen Köpfe als Hauptmotiv immer wieder eine Rolle spielen (*Kopfähnlich*, Mischtechnik, 1987; *Stierkopf*, Öl/Lw., 2001), was auch für das druckgraphische Werk (Lith., Rad.) gilt (*Zu Kopf verdichtet*, Rad., 1991). Inhaltlich setzt sich C. zumeist schonungslos direkt und eindringlich in prägnanten, emotional tiefgründigen Werken mit existentiell bedrohlichen Befindlichkeiten wie Verletzung, Angst und Tod und Möglichkeiten zu deren Bewältigung auseinander. Im späteren Schaffen auch Tendenz zu lebensbejahenden Darst. mit eher entspannter erscheinenden Gestalten. Eine wach-

sende Bedeutung kommt nun dem Umgang mit der Farbe zu, deren einzelne Schichten C. so behandelt, daß der Malvorgang deutlich sichtbar nachvollziehbar bleibt, um Entstehen und Vergehen zu symbolisieren. ⌂ Chur, Bündner KM. – Fund. Capauliana (11 Werke). ◉ *E:* Chur: 1981 Gal. im Bärenloch (Falt-Bl.); 1983 Gal. Provisorium; Gal. Aqua sana; 1984 Gal. Claudia Knapp (mit Michael Fontana und Gaudenz Signorell) / Pontresina: 1990 Gal. Nova (K); 1996, '99 Gal. Elisabeth Costa / 1993 Basel, Gal. Mesmer / 1997 Domat-Ems, Gal. Fravi / 2010 Uerikon (Zürich), Slg und Gal. S/Z. ⌂ KVS, 1991; BLSK I, 1998. – *B. Stutzer*, Aspekte aktueller Bündner Kunst. R. C., Gioni Signorell (K Bündner KM), Chur 1988; *id.*, in: Übergänge. Kunst aus Graubünden 1936–1996 (K Bündner KM), Chur 1996. – *Online:* Fund. Capauliana. Bündner Bild-Arch.; SIKART Lex. und Datenbank. – Mitt. B. Stutzer, Chur. R. Treydel

Cavin, *Hannah Mirjam,* rumänisch-dt. Bildhauerin, Textilgestalterin, * 1918 Wien, † 2002 Düsseldorf. Wächst als Tochter von Dr. jur. Joseph Schauer und seiner Frau Marta (geb. Kreindler) in Wien auf, die aus der Bukowina stammen und rumänische Staatsbürger mit jüdischen Wurzeln sind. Früh macht sich C.s künstlerisches Talent bemerkbar. Nach Abschluß des Gymnasiums studiert sie drei Semester an der Wiener Frauen-Akad. bei dem Bildhauer Heinrich Zita. Nach der Annexion Österreichs durch die dt. Wehrmacht kann sie mit ihren Eltern nach Rumänien ausreisen. 1938 ist sie in Stockholm und setzt dort ihr Kunst-Stud. bei dem bereits 1933 emigrierten und sich im Freien Dt. Künstlerbund in Schweden engagierenden dt. Maler, Kunstgewerbler und Bildhauer *Karl Helbig* (* 15. 8. 1897 Bayreuth, † Mai 1951 Tyresö/Schweden) fort. Heiratet 1939 in Bukarest den Architekten Alfred Kaniuk Cavin (zwei Kinder). Beteiligt sich in den 1950er Jahren an Kunst-Ausst. in Bukarest. Um 1960 verläßt C. mit ihrer Fam. Rumänien und läßt sich nach einem Zwischenaufenthalt in Israel ab 1961 in Deutschland (Düsseldorf) nieder. Danach zeitweise als Kunstpädagogin tätig. – V.a. einfühlsam geformte Portr.-Büsten (Bronze, Gips, Lehm, Holz) von Künstlern (Pablo Casals, Max Brod) und Persönlichkeiten des öff. Lebens aus aller Welt, darunter von versch. Theologen und Relig.-Wissenschaftlern aus Israel und Deutschland, die sich um den christlichjüdischen Dialog verdient machten (Martin Buber, Shalom Ben-Chorin, Albrecht Goes). ⌂ BERLIN, Martin-Buber-Oberschule: Büste Martin Buber (2012 nicht mehr erh.). HAIFA, Musik-Mus.: Büste Max Brod. ◉ *G:* 1963 Essen, Mus. Folkwang: Lea Steinwasser, H. M. C., Joel Taffy. Bilder, Plastiken, Grafiken (K). ⌂ *H. Brenner*, Jüdische Frauen in der bild. Kunst, II, Konstanz 2004. – Die Kunst und das schöne Heim (M.) 61:1962/1963 (12) 8.

Cavinato, *Paolo,* ital. Maler, Bildhauer, Zeichenlehrer, * 8. 3. 1911 Belluno, † 10. 4. 1992 ebd. Ausb./Stud.: Ist. Tecnico Industriale Segato, Belluno; ABA, Venedig, bei Guido Cadorin. 1934 Einberufung (lt. Costaperaria/ Girardelli). Stationiert u.a. in Äthiopien und Griechenland. Nach schwerer Verwundung in Bozen, dort 1943 Gefangennahme durch die SS, danach Konzentrationslager und

Zwangsarbeit. Nach dem 2. WK erneute Auseinandersetzung mit versch. Tendenzen der Moderne, bes. mit Felice Casorati, Modigliani, Cézanne und der Pitt. metafisica. Lehrt am Ist. Segato in Belluno technisches Zeichnen; längere Aufenthalte in Paris und Venedig. 1949 erstmals in den Medien genannt, einer breiteren Öffentlichkeit ab M. der 1960er Jahre bekannt. – Malt v.a. Frauen, Musiker, Figurengruppen, Mönche, Lsch. und Variationsfolgen einzelner Objekte. Als Bildhauer arbeitet C. in Holz, Terrakotta, Bronze und Stein, thematisch oft bezogen auf seine Bilder. C.s Arbeiten sind geprägt durch eine maßvolle, verinnerlichte, bisweilen spirituell wirkende Atmosphäre. Aufeinander oder auf den Betrachter bezogene Personen verharren häufig in allg. Posen; weiche (dennoch klare) Formen, vibrierende Farbigkeit und flirrendes Licht. � MEL, Pal. delle Contesse. VITTORIO VENETO, Gall. Civ. di Arte Medievale Vittorio Emanuele II: Discesa del frate paracadutista in piazzetta S. Marco, Tempera, 1949. ☉ E: 2006 Mel, Pal. delle Contesse (K: A. Alban). ▭ F. Costaperaria/F. Girardelli (Ed.), La coll. Maria Fioretti Paludetti (K), Vittorio Veneto 2002. – *Online:* Webdolomiti. S.-W. Staps

Cawkwell, *Sarah,* brit. Zeichnerin, Graphikerin, Bildhauerin, * 1950 Oxford, lebt in London. 1969–71 tätig in der Kunst-Abt. des Arts Council, 1971–74 in der Whitechapel AG. Stud.: 1980–83 Central SchA, London, bei Cecil Collins, David Haughton, Marc Vaux, William Turnbull und Patrick Reyntiens. – Im Mittelpunkt des Schaffens (Zchngn mit Kohle und Bleistift, Monotypien, Collagen, Assemblagen, Reliefs, Plastiken) steht die Darst. der Frau (zahlr. Köpfe) sowie die Auseinandersetzung mit deren Rolle und Selbstverständnis. C. greift dabei wiederholt trad. mit Weiblichkeit assoziierte Motive auf wie Haar und Frisieren (*Putting my hair up,* Zchng, 1992), zeigt Frauen bei typisch weiblichen Arbeiten wie Nähen, Stricken, Waschen und bedient sich sinnbildlicher Elemente wie z.B. des Fadens (*Biting the thread,* 1991; *Cutting the thread,* beides Zchngn, 1992; *Ariadne's Thread,* bemaltes Relief, Wolle, 2009). In zahlr. Werken kommt Gewändern bzw. Tüchern eine wichtige Rolle zu, mit denen sie Befindlichkeiten von Frauen ausdrückt (*Wrapped,* 1998; *Shrouded thoughts,* 2000, beides Relief; *Three x Three,* bemaltes Relief, 2008) bzw. mit der Dualität von Ver- und Enthüllen spielt. Diese Reliefs sind häufig in der Art von Tableaus gestaltet, bei denen ein Bildelement (z.B. ein mit einem Tuch verhüllter Kopf) in leicht variierter Form wiederholt wird. Mehrfach zeigen Arbeiten auch mit überwiegend weiblicher Tätigkeit assoziierte Produkte (*Drapery,* bemaltes Relief, 2006; *Metope: right side; Metope: wrong side,* beides bemaltes Relief und Stricknadel, 2008). ⌖ CAMBRIDGE, Univ. of Cambridge, Murray Edwards College, Coll. of Contemp. Women's Art: Large Plait No 1, Kohle, Bleistift, 1992; Focus, 1992. DETROIT, Receiving Hospital: Blue cornucopia, 1997. LONDON, Arts Council: I bind my hair, 1992. OXFORD, Wolfson College, New Hall: Shirtshape No 2, 1996. ☉ E: London: 1987 Whitechapel; 1995 Standpoint Gall.; 2009 Millinery Works Gall. / 1988 Gillingham, Adult Education Centre / 1995 Cambridge,

New Hall; Taunton, Stansell Gall. / 1996 Norwich, King of Hearts / 1998 King's Lynn, Fermoy Gall. (K) / 2001 Oxford, Christ Church Picture Gall. / 2004–05 Ely, Babylon Gall. (mit Jacqueline Morreau; Wander-Ausst., K). ▭ *Buckman* I, 2006. – *Online:* Website C.

C. Rohrschneider

Cawston, *William (W.),* brit. Fotograf, * um 1828 England, lebte 1849–91 in Tasmanien. In Bury St. Edmunds zur Strafarbeit in Australien verurteilt. 1856 inseriert C. in Hobart Town als Schnitzer, Vergolder und Rahmenmacher; ca. 1860–91 eig. Atelier in Launceston (ab 1888 als Fa. Cawston & Sons), bis 1870 auch in Hobart Town und Stanley tätig. – Neben Portr. (u.a. als Cartes-de-visite, Albuminabzüge, Ambrotypien) auch großformatige Aufnahmen von Lsch. und Gebäuden, z.B. *St. John's Street, Launceston;* außerdem Stereoskopien. Ab ca. 1887 hauptsächlich Atelier-Fotogr. ⌖ CANBERRA, NG of Australia. – Nat. Libr. of Australia. HOBART, Arch. Office of Tasmania. MELBOURNE, State Libr. of Victoria. SYDNEY, Libr. of New South Wales: Will Carter Papers, Album mit Cartes-de-visite mehrerer Fotografen. ☉ G: 1862 Hobart Town: Art Treasures Exhib. / 1866 Melbourne (Vic.): Melbourne Intercolonial Exhib. (Preis für Archit.-Fotogr.). ▭ *Kerr,* 1992. – Hobart, Arch. Office of Tasmania.

J. Niegel

Cayla (Fuzier-Cayla), *Jean-Louis,* schweiz. Architekt, Politiker, * 19. 8. 1858 Petit-Saconnex/Genf, † 2. 3. 1945 Genf. Stud.: ETH, Zürich; EcBA, Paris, bei Jean Louis Pascal. 1889 Mitgl. der SIA (Soc. Suisse des Ing. et des Architectes) Genf und eig. Büro mit seinem Schwager Charles Gampert (bis 1899) ebd., 1900–33 in Partnerschaft mit seinem Neffen Henri Gampert. C. ist auch politisch aktiv: 1889–1931 Gemeinderat von Petit-Saconnex, 1906–18 (stellv.) Bürgermeister ebd., 1915–23 Abgeordneter des Parti Nat. démocratique im Großen Rat des Kantons Genf. Sein archit. Werk reflektiert die jeweils herrschenden Stilrichtungen und Bauaufgaben in der BA-Trad., dem Schweizer Stil, dem Art Déco und der Formensprache der konservativen Moderne. Zus. mit H. Gampert errichtet er 1926 anläßlich des Genfer Autosalons den ersten Pal. des Expos. aus Beton nach Berechnungen von Robert Maillart (zerst.). ⌖ GENF, Rue Amélie-Munier-Romilly 4–8: drei Villen, 1897. – Rue du Général-Dufour 5–7: Verwaltung und Druckerei des J. de Genève, 1897. – Rue Rodolphe-Toepffer 11–19: Wohngebäude, 1897–98. – Rue de la Croix-d'Or 17: Wohngebäude, 1903–04. – Rue de St-Jean 24: Reformierte Kirche, 1933. – Rue du Devin-de-Village 23–25: Wohngebäude, 1934–39. VANDŒUVRES, Route de Vandœuvres 89–90: Schloßvilla, 1910–13. ✉ Immeuble de la Croix-d'Or/Hôtel Micheli, in: Album de fête, 42e assemblée gén. de la SIA Genève 1907, Genève 1907, 65–69. ▭ *Delaire,* 1907; *I. Rucki/ D. Huber* (Ed.), Architekten-Lex. der Schweiz 19./20. Jh., Basel u.a. 1998. – *Jenny* I, 1971; INSA IV, 1982.

A. Mesecke

Caymax, *Katrien (Catharina Jacoba Maria),* belg. Malerin, Graphikerin, * 1951 Meeuwen-Gruitrode/Limburg, lebt in Vorselaar/Antwerpen. Stud.: bis 1973 KHS, Has-

selt (Graphik, Malerei); 1979–80 Belgrad (graph. Techniken). Mehrjährige Auslandsaufenthalte, u.a. Marokko, später Spanien, Schweiz, Jugoslawien. Seit E. der 1980er Jahre Atelier und Lebensmittelpunkt in Vorsellar. – C. widmet sich der Darst. weiblicher Figuren, v.a. deren psychologischer Verfaßtheit, die sie als Existenzial von Weiblichkeit vor Augen führt. Anfangs fertigt C., inspiriert vom dt. Expressionismus, strenge Schwarzweiß-Radierungen. Seit E. der 1970er Jahre arbeitet sie in einem eig. narrativen Stil auch in and. Techniken (Pastell, Öl, Acryl, Gouache). Es entstehen vielfarbige Aquatinten mit intensiver malerischer und trotz vordergründiger Linienführung nahezu aquarellhafter Wirkung, die formal z.T. auf Chagall, in ihrer scheinbaren Naivität auch auf die Art brut verweisen. Die u.a. mit melancholischen, träumerischen oder introvertierten Ausdruckshaltungen ausgestatteten Figuren sind betitelt u.a. mit *Mimosa, Help, Dreaming, He loves me, De nieuwe maan*; bisweilen sind sie von Kunstzitaten (u.a. aus der islamischen Buchmalerei und von Matisse) oder bedeutungstragenden Darst. von Katzen, Herzen, Eulen, floralen Ornamenten oder magischen Zeichen umgeben, die die Figur oder deren Seelenzustand hintergründig-humorvoll und teilw. ironisch kommentieren. Mit Zitaten arbeitet C. auch im nonfigurativen Bereich (u.a. Lsch., Stilleben, typogr. und kalligraphische Arbeiten), z.B. entsteht nach Matisse die Farbgraphik *The Joy of Waiting* (2008) oder mittels chin., arabischer und indischer Schriftzeichen die Serie *Het onbekende I-IV*. Auch Kleingraphik (z.B. Weinetiketten, Exlibris) und Buch-Ill. (A. Malibran, *Een parelmoeren doek*, Leuven 1978; G. van Istendael, *Bomen wijzen niet maar wuiven*, Leuven 1978). Seit den 1990er Jahren nutzt C. zunehmend digitale Drucktechniken (*Tina op een pard*, 2006). ⌂ BRÜSSEL, Koninkl. Bibl. EINDHOVEN, Mus. Kempenland. ◉ *E:* 1982, '83 Schelderode, Kunstforum / 1985 Genf, Gal. Hôtel de Ville / 1987 Basel, Gal. Art Connection / 1989, '94 Kasterlee, Frans Masereel Centrum / 1995, '97, '99, 2003 Leuven, Gal. Embryo / Antwerpen: 1995–97 Gal. Szymon; 2000, '04 Gal. Epreuve d'artiste; 2004 Gal. Van Campen / London: 1995–2000 (jährlich) Gall. Zella Art; 1996 Blackheath Gall. / Brüssel: 1995, '96 Gal. Dimmers; 2004 Mus. René Carcan / 1996, 2003 Bad Essen, Gal. Schafstall / 1997 Chalon-sur-Saône, Mus. Denon / 1999 Eindhoven, Mus. Kempenland (Retr.; K) / 2000 Breda, Gal. Jas / 2005 Mol, Jakob Smits Mus. / 2009 Deinze, Gal. Anima (mit Ann Speybrouck). – *G:* 1982 Leuven, Koninkl. Univ., Jubileumzaal: Mysterie en materie (K: M. Rademakers u.a.) / 2006 Hoorn, Kunstcentrum Boterhal: Venus of de transcendentie van een eeuwig ideaal / 2008 Hasselt, CGH Gal.: Womenart. ⌂⌂ *Pas* I, 2002. – *H. Devroe*, De Standaard v. 30. 10. 1982; *M. Mes*, De Stem v. 24. 11. 2000; *P. Thoben/P. Cox*, Vrouwen als zelfbeeld. Grafiek (K), Eindhoven 2000. – *Online:* Website C. U. Heise

Cayol, *Pierre,* frz. Maler, Graphiker, Zeichner, Illustrator, * 14. 8. 1939 Salon-de-Provence, lebt seit 1968 in Tavel/Gard. 1956 Unterricht bei Marcel Féguide, Eygalières. Stud.: 1957–60 Ec. des Arts décoratifs, Grenoble; 1960–62 Ec. des Arts appliqués, Paris; 1964–66 ENSBA

und Acad. Julian ebd. Ausz.: 1965 Grand Prix de la Ville, Arles; 1970 Prix de la Ville, Saint-Paul-de-Vence. – C.s Werke sind durch seine Auseinandersetzung mit den Kulturen der nordamer. Ureinwohner beeinflußt, die er seit 1981 auf zahlr. Reisen nach Arizona und New Mexico studiert. Dort besucht er regelmäßig Reservate der Apachen, Navajo und Hopi, bemüht sich um die Bekanntmachung ihrer Geschichte und Kultur und unterstützt die dort lebenden Künstler. 1985 initiiert er z.B. eine Ausst. in der Médiathèque Ceccano in Avignon und ist seit 1993 Präs. einer Vrg, die Ausst. und Vorträge organisiert. In seinen bisweilen stark abstrahierten, in Aqu., Öl oder Acryl (letzteres z.T. mit Sand) ausgeführten Lsch.-Darst. bezieht er sich auf bestimmte Orte und Sehenswürdigkeiten der Reservate im Südwesten der USA (z.B. *Monument Valley; Canyon de Chelly*, jeweils Aqu.). Seltener widmet sich C. frz. Regionen (z.B. *Provence*, Aqu.). Häufig nutzt er Collagetechniken und konzipiert auch die Gem. nach demselben Prinzip, indem er sie in mehrere kleine, unterschiedlich gestaltete Flächen unterteilt. Neben indianischen Symbolen integriert C. char. Muster in seine farbenfrohen Arbeiten. Zudem entstehen Akte, geometrisch-abstrakte Komp. und expressive Stilleben. Des weiteren fertigt C. Bühnenbilder für die Kompanie Ça ira (z.B. *Dans le mystère des natures immobiles* von Jo Pacini, 2007) sowie Ill. (v.a. Linolschnitte, z.T. aquarelliert, zudem Rad., Aqu. und Tusch-Zchngn), z.B. zu A. Loirat, *Au gré des jours*, Solignac 1998; J. Joubert, *Dans le jardin d'Eros*, Rochefort-du-Gard 2001; N. J. Salameh, *Baalbek. Les demeures sacrificielles*, P. 2007. ⌂ BAGNOLS-SUR-CEZE, Mus. Albert André. CHATEAUNEUF-LE-ROUGE, MAC Arteum. MÜNCHEN, Alpines Mus. SALON-DE-PROVENCE, Mus. de Salon et de la Crau. TOULON, Mus. d'Art. ✉ *C./M. Cayol,* Apaches. Le peuple de la femme peinte en blanc, Monaco 2006. ◉ *E:* seit 1965, u.a. 1971, '73 Bagnols-sur-Cèze, Gal. Midi-Libre / 1974 Toulon, Mus. d'Art (mit Gérard Delpuech) / 1991 Salon-de-Provence, Mus. de Salon et de la Crau / 1997 Châteauneuf-le-Rouge, MAC Arteum / 2003 Aix-en-Provence, Amana Gal. d'Art / 2009 Paris, Gal. Orenda (mit Carlos Torres); Le Landeron (Neuchâtel), Hôtel de Ville. – *G:* Paris: seit 1972 regelmäßig Salon d'Automne (seit 1984 Mitgl.); seit 1980 regelmäßig SAfr. (seit 1981 Mitgl.) / 1983 Le Revest-les-Eaux: Bienn. (1. Preis) / 2006 Meyrals, Gal. Le Domaine Perdu: Carte blanche à Pierre Loeb / 2009 Sauveterre (Gard), Château de Montsauve: Salon d'arts (invité d'honneur); Pont-Saint-Esprit, Prieuré St-Pierre: 700 ans du Pont. ⌂⌂ *Bénézit* III, 1999. – *Online:* Website C. F. Krohn

Cazalet, *Mark,* brit. Maler, Zeichner, Graphiker, * 1964 London, lebt dort. Stud.: 1982–83 Chelsea SchA, London; 1983–86 Falmouth SchA (Bachelor of FA), Falmouth; 1986–87 ENSBA, Paris; 1988–89 Univ., Baroda/Indien. Nach seinem Indienaufenthalt beginnt C. sich mit relig. Motiven auseinanderzusetzen, die zu einem Schwerpunkt seines Schaffens werden. Pilgerreisen führen ihn 2003 nach Ägypten und 2004 nach Israel/Palästina. Seit E. der 1990er Jahre erhält C. Aufträge versch. christlicher Konfessionen, u.a. für Kirchenfenster. Zudem ist er seit einigen

Jahren in anglikanischen und kath. Gremien zu mod. Kunst im Kirchenraum beratend tätig. Lehrtätigkeit: West Dean College, West Dean/West Sussex; The Prince's Drawing School, London. – C.s durchgehend gegenständlich Arbeiten sind von zeichnerischem Charakter in leuchtender Farbigkeit. Seine Sakralkunst umfaßt Wand- und Tafelbilder, Glasfenster, Tapisserie, Mosaik sowie Graphik und transponiert biblische Stoffe in die Gegenwart. Ein besonderer Umgang mit Licht und Farbe prägt auch seine postindustriellen Lsch. wie die Serie Londoner Gasbehälter *Kensal Rise Gas Holders* (Öl/Lw., 1996) ebenso wie die Baumstudien *Hampstead Heath Oak* (Kreide/Papier, 1996). Jüngste Arbeiten zeigen Alltägliches in ungewohnter Perspektive, z.B. *Puddle, Fence, Grill, Playhouse* (Öl/Lw., 2005). Ill. zu Gedichten von Thomas Hardy (*Green blades from her mound*, Llandogo 2008). ⌘ AL KU-WAYT, Kuwait Nat. Coll. BATH, Victoria AG. CAMBRIDGE, Fitzwilliam Mus. LONDON, Guildhall AG. – Hammersmith and Fulham Borough Council Coll. – Nehru Centre. – Mus. of London. – Roehampton Univ. – World Rugby Mus. MANCHESTER, Methodist Church Coll. of Mod. Christian Art. MUMBAI, Brit. Council. OXFORD, Lady Margret Hall. WEST DEAN/West Sussex, Edward James Found. – *Sakralkunst u.a.*: BUCKINGHAM/Bucks., Stowe School's Chap.: The Calling of the Four Prophets, Glas, 2008. CHELMS-FORD/Essex, Chelmsford Cathedral: The Tree of Life, Öl/ Holz, 2003. LONDON, Our Lady of Grace and St. Teresa of Avila: Kruzifix, Öl/Holz, 2001. – Wesley's Chap.: God as Fire & God as Water, Glas, 2001–03. MANCHESTER, Manchester Cathedral, Fraser's Chap.: Bleiglasfenster, 2001; Altarretabel, Öl/Holz, 2001. ROMFORD/Essex, St. Alban's: The Angels of the Four Elements of Creation, Öl/Holz, 2005. ◉ *E:* London: 1992 Christopher Hull Gall.; 1993 The Nehru Centre; 1994 Rocket Contemp. Art (Wander-Ausst., K); 1995 East West Gall. (K); 2008 Beardsmore Gall. (K). – *G:* London: 1991 Albemarle Gall.: Images of Christ (K); 1992, '96 Mall Gall.: The Discerning Eye (K); 2004 St. Paul's Cathedral: Presence – Images of Christ for the Third Millennium (K) / 2005 Nottingham, Castle Mus. Gall.: Faith (K). ☒ *Buckman* I, 2006. – Cathedrals of industry (K Mus. of London), Lo. 1998; The sound of the trees (K Six Chapel Row Contemp. Art), Bath 2001. – *Online:* Website C. J. Faehndrich

Cazanave, *Raymond (Raymond Guillaume Auguste*; Pseud. Raycaz), frz. Comiczeichner, Illustrator, Journalist, * 23. 12. 1893 Fleury d'Aude/Aude, † 10. 10. 1961 Caunes-Minervois/Aude, tätig in Auxerre und Paris. Nach schwerer Verwundung und Gefangennahme im 1. WK beginnt C. 1919 als Dekorateur der Soc. gén. Transatlantique in St-Nazaire. Erste Comics erscheinen 1922 in der Zs. Les Petits Bonshommes und der Ztg Excelsior Dimanche. 1923 verfaßt C. seinen ersten autonomen Comic strip, *Cascarin*. 1928 stellt er mit der Union des Artistes Dessinateurs und während des Salon des Humoristes in der Gal. La Boëtie, Paris, aus. C. ist in Auxerre als Journalist für die Tages-Ztg Le Bourguignon tätig und veröffentlicht neben Comics und Zchngn auch Artikel. Zugleich Mitarb. versch., teilw. humoristischer Mag. und Kinder-Zss., u.a.

Jeunesse Mag. und Pierrot, für die C. die *Aventures des Fifrelin, petit Journaliste* (1938–39), *Le beau Voyage d'Henry* (Text von J. Mauclère, 1941), *Le Chevalier mystère* (1941) und *Boubou, le sportif* (1941–42) verfaßt. 1940–41 erarbeitet er Kurz-Gesch. und Ill. für die Zs. Lisette, so *Les Gaietés de la Campagne* und *Bobette, Bobine et Bobby*. In den 1940er Jahren ist C. für versch. Zss. und Mag. tätig und tritt 1946 dem Kinder-J. Le Coq Hardi bei, für das er *Chasse au Corsaire* und *Capitaine Fantôme* (Text von Jacques François alias Marijac) kreiert. 1947 illustriert C. für Vaillant die Gesch. *Le Fifre de Valmy* und *Fifi, Gars du Maquis* (begonnen von Auguste Liquois). Für das Mag. L'Intrépide adaptiert C. gemeinsam mit George Fronval 1948–49 die Filme *Rocambole* (von J. de Baroncelli) und *Le Secret de Monte-Christo* (von A. Valentin) als Comic. Außerdem illustriert er versch. Gesch. für L'Intrépide, so *Le Messager de la Reine* (1949–50) und *La Course au Milliard* (Text von Montaubert, 1951–54). In den späten 1940er und 1950er Jahren ist C. für Coll. Jeunesse und Le petit Canard tätig. In den 1950er Jahren schreibt er eig. Texte, die im J. Paris Paradise erscheinen. Seine letzten Ill. für Mag. entstehen 1954–61 für Vigor und Pilote. 1977 adaptiert C. den Roman *Les mystères de Paris* von Eugène Sue als Comic. Thematisch beschäftigt sich C. wiederholt mit Abenteuer- und Piraten-Gesch. sowie mit sich dramatisch zuspitzenden Gewalt- und Angstszenen. Sein gefälliger Stil ist bis M. der 1930er Jahre durch Art Déco beeinflußt. In den 1940er Jahren gewinnen seine u.a. in Tusche ausgeführten Zchngn zunehmend an Realismus und graph. Qualität. Char. sind nach dem 2. WK außerdem starke, fast fotogr. Helldunkel-Kontraste, die Reduzierung der Farbigkeit und der kompositorische Einsatz der Farbe Schwarz. Seine Figuren sind durch einen teilw. übertriebenen Gestus gekennzeichnet. Neben Einzel-Ill. entstehen Serien, Alben, Buch-Ill. und Comic strips, die vorwiegend in Mag. und J. veröff. werden, aber auch für Verlagshäuser wie die Ed. Mondiales oder Librairie Croville in Paris. – Ill.: L. D. de Floran, *Robin des Bois et autres Chroniques du Cycle breton*, P. 1929; H. Marechal, *Babadoul, le pauvre Tailleur*, P. 1943; M. Vidil/E. Klem, *Auf Gassen und Wegen*, P. 1946; A. Troux, *Hist. de la France, des Origines à 1919*, P. 1942; M. Vidil/J. Renard, *Karl und Käthe*, P. 1944. ☒ *P. Gaumer/C. Moliterni*, Dict. mondial de la bande dessinée, P. 1997; *Osterwalder*, 1905–1965, 2005; *H. Filippini*, Dict. de la bande dessinée, P. 2005. – *J. Fourié/M. Denni*, Le collectionneur de bandes dessinées 68:1991. – *Online:* Lambiek Comiclopedia.

C. Melzer

Cazarré, *Luis Olmer (Luiz Olmer)*, brasil. Maler, * 27. 5. 1943 Rio de Janeiro, tätig in São Paulo. Stud.: 1973 Fac. de Comunicação Social Anhembi Morumbi, São Paulo. Lehrtätigkeit: ebd.; Fac. de Comunicação, Santos. Ausz.: 1973 Prémio de Incentivo à Pesquisa der Bien., São Paulo; 1985 Gold-Med. der Mostra de Arte Contemp., Lissabon. – Flächig-abstrakte und figurative Malerei, meist Lsch., Stadt-Lsch. und Portr., aber auch Assemblagen und Objekte. ⌘ SÃO PAULO, Fund. Armando Álvares Penteado. – Mus. de Arte do Parlamento. – Soc. dos Amigos

da Arte. ⊙ *E:* São Paulo: 1978 Gal. Eucatexpo; União Cult. Brasil-Estados Unidos / 1983, '86 Ribeirão Preto, Gal. Jardim Contemp. – *G:* São Paulo: 1967, '69, '75, '79 Bien.; 1987 Chapel Art Show: Expos. de Arte Contemp.; 2004 Esporte Clube Sírio: Expos. de Artistas Contemp. / 2003 Rio de Janeiro, Almacén Gal. de Arte: Projeto Brazilianart (K). ⌑ *Ayala*, 1997. – *M. B. Ferreira Lima*, Brazil. art, vol. 4, S. P. 2002. C. Melzer

Ccala Quispe, *Américo,* peruanischer Maler, Zeichner, * 31. 1. 1964 Cuzco, lebt in San Juan de Lurigancho/ Lima. Stud.: 1985–89 ENBA, Lima (später Doz.). Mitgl. der Gruppe Wayra Yachay Perú und der Asoc. de Artistas de las BA del Perú ebd. Ausz.: u.a. 2006 1. Preis für Malerei, 56 Aniversario de la Creación Política del Distrito de San Martín de Porres, Lima; 2008 3. Preis, Bien. de Pint., Huancayo. C. verarbeitet in seiner abstrakten, von Rottönen dominierten farbenprächtig-dynamischen Malerei (meist Querformate) u.a. ikonogr. Elemente aus der Keramik der alten Kulturen des Altiplano (Tiahuanaco, Wari, Lucre) und den Mustern handgefertigter Kleidung seiner Kindheit, die geheimnisvoll-zeichenhaft in enger Durchdringung vor flächig strukturierten Hintergründen erscheinen (z.B. *Vasos ceremoniales; Jarrones incaicos; Guerrero inca*). ⊙ *E:* Lima: 1998 Centro Cult. Los Olivos; Caja Mpal de Crédito Popular del Perú; 2004 Fund. del Banco del Comercio, Gal. de Arte; 2005 Gal. de Arte Internac. América 92; 2009 Gal. de Arte Las Américas / 2002 Bern, Peruanische Botschaft / 2003 Stanford (Conn.), Gal. de Fiesta / 2009 München, Inst. Cervantes, Kultursaal (mit Pascual Mogollón und Juan Carlos Ñañake; Wander-Ausst.). – *G:* 2005 São Paulo: Bien. de Cult. e Arte do União Nac. dos Estudantes / 2009 München, Zoologische Staats-Slg München: Peru, neue Kunst mit alten Wurzeln / 2010 Lima, Gal. de Arte Sérvulo Gutiérrez: Tributo a los 100 años del arte abstracto. ⌑ *R. Heise*, Applaus (M.) 2009 (10); *A. Weber*, Süd-dt. Ztg v. 12. 10. 2009. – *Online:* Inst. Cervantes, München. – Mitt. Estela Velazco-Tamas, Winterthur. M. Nungesser

Čchenkeli, *Merab* cf. **Chadžibejli,** *Valerija*

Ceausu, *Ion,* rumänisch-dt. Maler, Zeichner, Restaurator, Kunsterzieher, * 1940 Bukarest, lebt in Olpe. Sohn eines Luftwaffengenerals, der 1958/59 wegen „staatsfeindlicher" Tätigkeit zu einer mehrjährigen Haftstrafe verurteilt wurde und C. deshalb aus ideologischen Gründen sein begonnenes Stud. (Bau-Ing.) abbrechen und sich 1959–61 als Bauarbeiter „bewähren" mußte. Stud.: 1963–69 HBK N. Grigorescu, Bukarest, u.a. Wandmalerei und Mosaik bei Ştefan Constantinescu (Abschluß mit Lehrbefähigung für höhere Schulen). C. ist als Zeichenlehrer 1969–79 am Dt. Lyzeum in Bukarest angestellt. In einer speziellen kunstdidaktisch inspirierten Werkgruppe beschäftigt er sich dort u.a. mit Motiven aus der Renaiss. (*Der Großinquisitor*, 1972). 1979 Übersiedlung nach Deutschland. 1981–85 in Olpe als Kunsterzieher tätig. 1987 gibt C. die gymnasiale Lehrtätigkeit aufgrund von Krankheit auf. 1989 Gründungs-Mitgl. des Künstlerbundes Südsauerland. Häufige Studienreisen ins Ausland, v.a. nach Frankreich und Italien (Apulien, Dolomiten, Neapel, Siena). Ausz.: 2005 Kulturpreis der Stadt Olpe. – C.s heterogenes malerisches und zeichnerisches Œuvre umfaßt sowohl abstrakte Komp., die u.a. auf musikalische (*Kunst der Fuge*, Tempera, 1978) und archit. Formen rekurrieren und bisweilen an Arbeiten von František Kupka erinnern, als auch gegenstandsbezogene Malerei in versch. expressiv-gestischen oder konstruktiv-geometrisierenden, zunehmend farbintensiven Stilen. Bei Porträts und Figurenbildern (*Bildnis in Blau*, Acryl, 1983) sind gelegentlich formale Einflüsse der rumänisch-orthodoxen Ikonenmalerei byz. Prägung zu spüren. Auch Akte, (Wald-)Lsch. und (Blumen-)Stilleben. Im Spätwerk dominieren von süd-europ. Lsch. inspirierte lyrisch-abstrakte Komp. (*Castello in Orcia*, vor 2008). Auch Rest. (z.B. von ma. Skulpt.) und plastische Arbeiten, u.a. Masken aus beklebter und bemalter Pappmaché. Zahlr. regionale Ausst.-Beteiligungen. ⊙ *E:* 2005 Olpe, Kreishaus (Retr. zum 65. Geburtstag; mit Anneliese Schmidt-Schöttler) / 2009–10 Siegen, Gal. der Industrie- und Handelskammer. ⌑ Landshuter Ztg v. 9. 7. 1984; *U. Monreal*, Kunst und Künstler im Kr. Olpe, II, Olpe 2001.

U. Heise

Ceballos (Marín C.), *Tomy (Tomás),* span. Fotograf, Bildhauer, Installations- und Videokünstler, * 10. 6. 1959 Caravaca de la Cruz/Murcia, lebt in Murcia. Kurse Fotogr. in Madrid; Film in Murcia. Ansonsten Autodidakt. Ausz.: 1987 Premio Nac. Jóvenes Fotógrafos; 1994 Ankaufspreis, Bien. de Esc., Murcia; 1998 Premio Nac. de Escult., Punta Umbría. – Bes. durch Fotogramme bek., erweitert C. sein künstlerisches Spektrum um Skulpt., Installation, Performance und Video. Viele der großformatigen schwarzweißen Fotogramme zeigen dramatisch beleuchtete, traumartige Szenen oder lebensgroße Umrisse von Menschen (oft Frauen) und Objekte, die in inszenierten Performances entstehen. Andere transportieren Ideen oder Emotionen durch abstrakte Texturen (*Leteo*, 1993) und stillebenartige Kompositionen. ⌖ ALCOBENDAS, Stadtverwaltung. CUENCA, Mus. Internac. de la Electrografía. MADRID, Círculo de BA. – CARS. – Fund. Arte y Tecnologia. VALENCIA, Univ. Politécnica. ⊙ *E:* Murcia: 1988 Sala Yesqueros; 1990 Kirche S. Esteban (K); 1991 Consejeria de Cult. (K); 1996 Sala Caballerizas (K); 1999 La Muralla; 2004 Sala Puertas de Castilla; 2007 Gal. Fernando Guerao / Zaragoza: 1994 Tarazona Foto (K); 1995 Gal. Spectrum (K) / 2007 Valencia; Gal. Argenta. – *G:* 1992 Berlin: Europ. Photogr. Award (K) / Madrid: 1994 Canal Isabel II: La fotogr. sin cámera (K); 1998 PhotoEspaña / 1997 Alcobendas, Stadtverwaltung: Géneros y tendencias en los albores del s. XXI (K); Cadiz: Bien. Internac. (Ausz.) / 2007 Bogotá, MAM: Cazadores de Sombras (K Wander-Ausst.). ⌑ *R. Olivares*, 100 fotógrafos esp., Ma. 2005. – Cuatro direcciones. Fotogr. contemp. esp., 1970–1990 (K), I, Ma. 1991. – *Online:* Website C. D. Sánchez

Čebotar', *Sergej Jur'evič,* russ. Maler, Kunstpädagoge, * 25. 6. 1956 Murmansk, lebt dort. Stud.: bis 1976 Kunst-FS Kazan'. Lehrt ab 1981 in der Kinder-KSch Murmansk, die seine Frau *Vera Konstantinovna Č.* (* 1954, lebt in Murmansk; Stud.: Kunst-FS Leningrad; Malerin) leitet. 1992–93 ebd. Vors. der Filiale des Künstler-Verb. des Russ.

Föderation. In den 1990er Jahren zahlr. Reisen nach Skandinavien (Teiln. an Ausst.). – Neben Genre-Darst. auch Lsch., Stillleben und Portr. (u.a. seiner Frau und Töchter). Meist kleinformatige, emotional intensive, bisweilen auch ironisch intonierte Darst. von Situationen aus dem urbanen Alltag sowie ländliche Szenen. Bemerkenswert sind Č.s Murmansker Motive (Straßen, Haltestellen, eilende Passanten), bevorzugt im Winter (z.B. *Osen'*; *Konec janvarja*; *Minus 30*; *Veter*) sowie in abendlich-nächtlicher Beleuchtung. Auffallend ist Č.s subtile Gest. von Lichteffekten (u.a. phantastisch anmutender Wandel des Nordlichts; grelle Sommersonne; sanftes Lampenlicht in intimen Portr.) und Zuständen von Wasser (u.a. ruhige oder stürmische Oberflächen von Seen oder Flüssen, u.a. *Ozero*; *Reka Černava*; *Reka Vorgol*). Char. sind verallgemeinerte Darst. ohne Redundanzen, präzise Komp. und Farb-Gest. sowie markantes Kolorit. ⌐ Murmansk, KM. ◉ *E:* 1996 Luleå (Schweden) / Murmansk: 1997, 2001, '06 (zus. mit Michail Viktorovič Lapin, Evgenij Vasil'evič Baranov), '09 KM (Vera Konstantinovna Č.), '11 KM. ⌑ *Bown*, 1998 (s.v. Chebotar, Sergei Yurevich).

D. Kassek

Čebotar', *Vera Konstantinovna* cf. **Čebotar'**, *Sergej Jur'evič*

Čebykin, *Aleksej*, russ. Fotograf, Architekt, Designer, * 1961 Lys'va/Gebiet Perm', lebt in Kaliningrad. Stud.: ab 1978 Bau-FS, Perm'. 1979–81 Armeedienst im russ. Grenzbezirk Fernost. Stud.: 1981–89 Archit. und Städtebau an der Bau-Ing.-HS, Leningrad (St. Petersburg). 1990–91 im Archit.-Büro Archproekt Kostroma tätig. Ab 1993 Dir. der Werbeagentur Ėliks ebd. 1981–93 Gest. von ca. 20 Interieurs. 1987 Teiln. an der ersten Auktions-Ausst. für Malerei in Leningrad. 1995 Kurator der Ausst. Vinylkunst in der Werbung. – Bereits während des Stud. beschäftigt sich Č. mit professioneller Projektpräsentation (u.a. Software 3D Studio MAX 2). Danach betrachtet er die 3D-Projektierung als konstitutiven Bestandteil seiner künstlerischen Bemühungen (z.B. Modellierung, Rendering, Video; Programmalgorithmen) und zählt zur wachsenden Zahl von Künstlern, die den Computer künstlerisch nutzen. Für das Projekt *Venecianskaja ljustra* (2007; Finalist des Wettb. Heart of Venice, Venedig, Kategorie Glasleuchten) arbeitet Č. ein früheres unabgeschlossenes Projekt (Uhr) in eine Leuchte um, die dann in Murano produziert wird. Č.s Projekt *Security style/Olympic Security Style* (2004; Titel im Orig. engl.) thematisiert die virulente Gefahr des Terrorismus aus neuer Perspektive: Fotomontagen aus klassisch fotografierten Motiven (Akropolis in Athen; San Marco in Venedig; Pal. Madama in Turin; Seehafen in Soči) und martialisch-monströsen Darst. von phantastisch modifizierten Waffen (Panzer, U-Boote, Fluggeräte). Bemerkenswert ist ferner die Darst. *House of Councils* (2004; Titel im Orig. engl.), die unter Verwendung eines Fotos der Sportlerparade 1946 von S. Loskutov einen sowjetischen Hochhausbau mit versch. Symbolen kombiniert (u.a. Sowjetwappen, Luftschiffe mit UdSSR-Aufschrift). 2007 zeigt Č. computergenerierte Arbeiten zur Sicherheitsobsession der westlichen Länder auf der Bienn.

in Prag und auf der Artissima in Turin. ◉ *G:* u.a. 2005 Moskau: M'Ars / 2006 Biškek: Trans-Russian Art Project (Wander-Ausst.); Kaliningrad: Contemp. Art from Kaliningrad / 2007 Venedig: Bienn. / 2008 Wiesbaden, Nassauischer KV: Russ. Roulette (K); Berlin, Gal. Feinkost: Schengen. ⌑ Prague-Bienn. 3 (K), Mi. 2007. – *Online:* Zs. 3Domen, 2012.

D. Kassek

Cecato, *Roberto*, brasil.-ital. Fotograf, Fotojournalist, Filmemacher, * 9. 6. 1953 São Paulo, tätig in Mailand. Stud.: Esc. de Comunicações e Artes der Univ. de São Paulo (Film); 1975 MAC da Univ., ebd. (Fotogr.). Ausz.: 1981 Stip. der Secretaria de Cult. do Estado de São Paulo; 1995 Stip. der Fond. Ital. per la Fotogr. 1980–83 Präs. der União dos Fotógrafos do Estado de São Paulo und 1990 Dir. de Projetos especiais der Assoc. Brasil. de Fotógrafos de Publicidade. Außerdem Autor und Dozent. – C. beginnt 1976 mit Kinofilmen und Regieassistenz, wechselt aber, angeregt durch eine Reise nach Argentinien und Chile, 1978–82 in den Fotojournalismus. Seit den 1980er Jahren ist er als Werbefotograf u.a. für Vogue und Casa Vogue Brasil tätig. 1991 siedelt C. nach Mailand über und arbeitet für versch. ital. und frz. Werbeagenturen. Auf Reisen nach Indonesien und Japan (1993, '95) entstehen u.a. Fotogr. von relig. Skulpt. und der indigenen Bevölkerung (*Atma*, 1993). 2002 und 2004 dreht C. die Dok.-Filme *Il Maestro de la Favola* über den ital. Regisseur Ermanno Olmi und *Território Liberdade* über das Werk des brasil. Künstlers Antonio Dias. Über die Arbeit zu Olmi erscheint das Buch *Cantando dietro i paraventi. Un film di Ermanno Olmi* (Mi. 2003) mit Fotogr. von C. Viele seiner Werke basieren auf der Wiederholung von Formen, etwa kahle Bäume, Zäune, Netze, und dem abrupten Wechsel von Schwarz und Weiß. Die Motive lösen sich zu organischen Strukturen und dynamisch-abstrakten Liniengeflechten auf und erreichen graph. und zeichnerische Qualitäten. Außerdem entstehen neben experimentellen Arbeiten, für deren Entwicklung C. Schwämme benutzt oder Überblendungen und Collagetechniken einsetzt, ausschnitthafte Portr. und Akte. Die zumeist farbigen Werbe-Fotogr. (Kleidung, Accessoires, Kosmetik, Möbel, Einrichtung) konzentrieren sich auf Einzelobjekte, die ebenfalls wiederholt oder im leeren Raum bzw. vor monochromen, meist weißen Flächen präsentiert werden. Hier verfremdet C. teilweise bis zur Unkenntlichkeit durch Vereinzelung und Unschärfe. Auch monochrome Fotogr. von wiederum meist einzeln aufgenommenen Nahrungsmitteln (Obst, Gemüse, Fisch) und Pflanzen in grell-weißem, manchmal durchscheinendem Licht. ⌐ Paris, BN. São Paulo, Mus. de Arte, Col. Pirelli. Toulouse, Gal. Mun. du Château d'Eau. Turin, Fond. Ital. per la Fotogr. ◉ *E:* 2008 São Paulo, Gal. Virgílio (mit Marina Camargo, Renata Pedrosa). – *G:* São Paulo: 1983 Bien.; 1990 Mus. de Arte: Dez Fotógrafos; 1995 MAM: Livro-Objeto. A Fronteira dos Vazios; Mus. de Arte: 5. Col. Pirelli (K); 2008 Gal. Virgílio: br 2008 / 1983 Paris, Centre Pompidou: Brésil des Brésiliens (K) / 1993 Florenz, BN: Brasile. Segni d'Arte (Wander-Ausst., K) / 1994 Köln: Internat. Photoszene; Mailand, Gall. Diaframma: Metamorphoses (K) / 2008 Évora, Pal. de Don Ma-

nuel: Um Olhar sobre o Mundo. ⊡ *M. Auer*, Enc. internat. des photographes de 1839 à nos jours, Hermance 1985; *G. A. Goodrow* u.a., Internat. Fotogr. Ursula-Blickle-Preis 94, Kraichtal 1994. – *Online:* Inst. Itaú Cult., Enc. artes visuais; Website C. C. Melzer

Ceccarelli, *Carmela* → **Ceccherelli,** *Carmela*

Ceccaroli, *Alain,* frz. Fotograf, * 21. 1. 1945 Rabat, lebt in Malemort du Comtat/Vaucluse. C. wendet sich 1982 der Fotogr. zu und nimmt in der Folge an zahlr. öff. beauftragten Fotokampagnen zur Dokumentation der Lsch. und Archit., meist in Frankreich, teil: so u.a. an der Mission du Patrimoine photogr. (1984), der Mission photogr. de la Datar (1985) sowie Erkundungen der Pyrenäen (FRAC Midi-Pyrénées, 1985–86), der Schweizer Alpen (1988–89) und Polens (1990; jeweils im Auftrag des Mus. de l'Elysée, Lausanne). Während er anfänglich ausschließlich in Schwarzweiß arbeitet, entstehen zuletzt auch Farb-Fotogr., seit E. der 1990er Jahre u.a. in Syrien, Palästina und Griechenland. 2001–02 Artist in Residence, Mus. du Touquet. – *Fotobücher: Les sablières de Bédoin,* s.l. 1982; *Cicatrices,* P. 1991; O. Bergeron/J.-L. Fabiani, *La petite mer. Portr. de l'étang de Berre,* s.l. 1996 (mit Bernard Plossu, Aldo Soares); *Bethléem. Territoire photographié,* Marseille 2000; *Entre-deux-mondes. J. d'un paysage méditerranéen,* Arles 2001; *Ventoux. Comtat Venaissin. J. d'un paysage,* Marseille 2010. ⊡ ARLES, Mus. Réattu. CHALON-SUR-SAONE, Mus. de la Photogr. Nicéphore Niépce. CHARLEROI, Mus. de la Photogr. LANGON, Centre cult. des Carmes. LAUSANNE, Mus. de l'Elysée. LYON, Bibl. mun. (ehem. Fond. nat. de la Photogr.). MARTIGUES, Mus. Ziem. PARIS, BN. – Conservatoire du Littoral. – FNAC. – Maison Europ. de la Photogr. – Médiathèque de l'Archit. et du Patrimoine. – MNAM. TOULOUSE, Le Château d'Eau. ◉ *E:* Arles: 1985 Mus. Réattu (K); 2003 Abbaye de Montmajour (mit Jean-Louis Elzéard, Jeff Wolin) / Paris: 1990 Espace photogr. (mit Alain Balmayer, Michel Kempf; K); 2000–01 Hôtel Scribe (K) / 1995 Marseille, Hôtel du Dép. des Bouches du Rhône (K) / 2002 Le Touquet, Mus. du Touquet (K) / 2009 Thessaloniki, Archaeological Mus. / 2010 Carpentras, Chapelle du Collège / 2011 Malaucène, Gal. Martagon. – *G:* Paris: 1984 Chapelle Saint-Louis-de-la-Salpêtrière: Objectifs. Monuments (Wander-Ausst.; K); 1994 Cité des sciences et de l'industrie: L'observatoire photogr. du paysage (K); 1999–2000 Hôtel de Sully: Le désir du Maroc (K) / 1991 Lausanne, Mus. de l'Elysée: Nouveaux itinéraires (K) / 1994, 2003 Arles: Rencontres internat. de la Photogr. / 2003 Thessaloniki, Mus. of Byz. Culture: Archaeologies (im Rahmen der Photosynkyria; K) / 2005 Łódź: Fotofestiwal / 2009 Caen, MBA: Voyages pittoresques Normandie, 1820–2009 (K). ⊡ Paysages photographies. Travaux en cours 1984–1985. La mission photogr. de la Datar, P. 1985; Paysages photographies. En France les années quatre-vingt, P. 1989; *G. Calvenzi* (Ed.), Italia. Ritratto di un paese in sessant'anni di fotogr., R. 2003 (dt. Ausg.: M. 2003). – *Online:* Icôn. Centre europ. de l'image (Lit., Ausst., Werkstandorte). P. Freytag

Ceccherelli (Ceccarelli), *Carmela,* ital. Malerin, Minia-

turistin, * 23. 10. 1876 Siena, † 6. 10. 1933 ebd. Schwester von Architekt Gaetano C. (1872–1919). Ausb./Stud.: ab 1890 an der ABA, Siena, zunächst bei Giorgio Bandini, 1892–93 bei Alessandro Franchi; belegt bis 1903 Malereikurse. Gemeinsam mit ihren Lehrern ist C. auch an Dekorationen und Rest. Sieneser Pal. und Mon. beteiligt (Pal. Bichi Ruspoli, Loggia della Mercanzia u.a.). Stark beeinflußt von der Renaiss. entwickelt sie einen persönlichen dekorativen, dem Liberty nahestehenden Stil, mit dem sie bei der Gest. von Urkunden und Diplomen ihr Bestes schafft. Um 1900 entsteht ein Temperabild im Cimitero Monumentale von Siena. Bekannt wird sie 1904 durch das Ausst.-Plakat „Antica Arte Senese". 1907 gestaltet sie mehrere Einbanddecken von Bankbüchern des Monte dei Paschi di Siena (Siena, Arch. der Bank). Das Rektorat der Univ. Siena bewahrt Diplome, die zw. 1922 und 1924 entstanden sind. Ab 1920 lehrt C. an der Akad. in Siena am Lehrstuhl für Architektur. Eine umfangreiche Slg ihrer Werke befindet sich im Besitz der Erben in Biella (v.a. Tier-Darst. und Stilleben). ⊡ SIENA, Fond. Monte dei Paschi di Siena. ◉ *E:* 1996 Siena, S. Maria delle Nevi. ⊡ *E. Spaletti,* Il secondo Ottocento, in: La cultura artist. a Siena nell'Ottocento, Mi. 1994, 544; *A. Leoncino,* C. C. Una miniaturista senese allieva di Alessandro Franchi e Giorgio Bandini (K), Siena 1996; *id.,* Bull. senese di storia patria 103:1996 (1997), 643 s. G. Wiedmann

Cecchetto, *Alberto,* ital. Architekt, Autor, * 1. 3. 1949 Venedig. Stud.: Univ., Venedig. Lehrtätigkeit: u.a. ebd. seit 1975; 1976–80 Internat. Laboratory of Archit. and Urban Design; 1982–85 Univ. of Miami, Coral Gables; 1996–99 Univ., Ferrara. Ausz.: u.a. 1989 Premio internaz. di archit. Andrea Palladio. Seit 1976 eig. Archit.-Büro in Venedig (Studio C., ab 2003 C. & Associati). – V.a. stadtplanerische und archit. Entwürfe in Norditalien, oft Bauten im hist. Bestand und Erweiterung bestehender Gebäude. Dabei paßt C. die Bauten in das Umfeld ein und entwickelt komplexe Beziehungen zw. Archit. und Umgebung. Bei der Erweiterung der Mensa der Univ. in Trient umbaut C. Bäume mit kleinen Innenhöfen, deren Verglasung Licht nach innen leitet (Entwurf 1994, Bau 1996–99). Die Cittadella del vino in Mezzocorona ist ein weitläufiger flacher Gebäudekomplex mit Weinkeller, Verwaltungsbau und Kundenbereich (drei Bauphasen 1995–2005). Eine Erweiterung durch Umhüllung eines alten Gebäudes sind der Showroom für einen Autohändler in Trient mit einer abgerundeten, transparenten Fassade (Entwurf 1996, Bau 1998–2000) und das Modacenter in Montebelluna mit großflächiger Verglasung (1999/2000). Die Büro- und Arbeitsräume der Fa. Thetis im Gebiet Arsenale von Venedig bestehen aus einem großflächigen Stahl- und Glaseinbau in ein altes Lagerhaus (2001/02). Weitere Werke: temporärer schwimmender Pavillon für die Città d'aqua auf der Archit.-Bienn. Venedig 2004; Erweiterung des Hotels Lido Pal. in Riva del Garda (2012 voll.). Außerdem zahlr. Projekte und städtebauliche Planungen, u.a. für Ala, Pergine, Rovereto, Riva del Garda, Assisi und Triest. Daneben Publ. über Archit. und Städtebau. ✉ La costruzione della qualità urbana,

R. 1991; Progetti di luoghi. Paesaggi e archit. del Trentino, Vr. 1998; Leaf, flame, crystal, Ba. [2007]. ⊙ *G:* u.a. 1996, 2002 Venedig, Archit.- Bienn. ⊞ Spazio e società 13:1990 (49) 58–69; La costruzione della qualita urbana, R. 1991; *C.,* Recuperare, 11:1992 (1) 34–43; *C.,* Le nuove cantine Rotari e Mezzacorona, Mi. 1997; Paesaggio in bottiglia, Vr. 1997; *C.,* Casabella 62:1998 (656) 14–21; Analogie. C., N. 2000; *P. Fiorentini,* Industria delle costruzioni 34:2000 (340) 28–37; Next school new entrances, Ve. 2002; Area. Riv. europ. per la cultura del progetto 14:2003 (69) 140–147, 15:2004 (77) 22–29; *G. Cappellato* (Ed.), Auditorium. 10 architetti per Padova, Bo. 2007. – *Online:* Website C. N. Buhl

Cecchetto, *Giorgio,* ital. Goldschmied, Schmuckgestalter, * 8. 3. 1958 Padua, lebt dort. Stud.: 1973–77 Ist. Statale d'Arte Pietro Selvatico, Padua, bei Giampaolo Babetto, Francesco Pavan und Piergiuliano Reveane. 1980–82 Mitarb. im Atelier von G. Babetto. Lehrtätigkeit: 1980–93 Internat. Sommer-Akad. art didacta, Innsbruck. – C. gestaltet vorwiegend geometrisch-abstrakten, häufig minimalistischen Schmuck (v.a. aus Gold, weiterhin aus Silber und Bronze) in der Trad. der Paduaner Schule. Abgesehen von zaghaften Andeutungen wie z.B. bei den wellen-, muschel- und fischförmigen Schmuckstücken der Serie *mondo marino* finden sich in C.s Werk im Gegensatz zu den Arbeiten seines Lehrers G. Babetto keine figürlichen Motive. Eine durch kalligraphische Zeichen inspirierte Ringserie ist beispielhaft für die reduzierte formale Gest. in Kombination mit stark strukturierten Oberflächen (z.B. *alfa; beta; gamma;* alle Gelbgold, 2002). Auch die als Referenz auf antike Kulturen konzipierten Schmuckstücke der Serie *lontano nel tempo* bezeugen C.s variantenreiche Oberflächengestaltung. Weniger typisch sind einige ironische Arbeiten wie der Armreif *femme fatal 2* (Stahlwolle, Gold, 2000), der aus einem mit Goldeinlagerungen versehenen Putzschwamm aus Stahlwolle gefertigt ist, sowie der mit einem Zahnbürstenkopf bekrönte *anello da denti* (Silber, Gold, Kunststoff, 2000) aus der Serie *ludica.* ⌂ MÜNCHEN, PM, Neue Slg. WIEN, Slg Inge Asenbaum. ⊙ *E:* 1985 Padua, Gioielleria Callegari / 1988 Amsterdam, Gal. Louise Smit / 1989, '90 Karlsruhe, Gal. Cardillac / 1996 Washington (D. C.), Gal. Jewelers' Werk / 1999 Wien, Gal. Slavik. – *G:* Pforzheim, Schmuck-Mus.: 1980 Armschmuck; 1983 10 orafi padovani (K; Wander-Ausst.) / 1987–88 Linz, LM: Schmuck – Zeichen am Körper (K) / 1996 Vicenza: Gold Trends 1996–97 (K) / 1997 London, Crafts Council Gall.: Jewelry in Europe and America. New times, new thinking (K) / 2000–01 Zürich, MfG: Alles Schmuck (K) / München: 2001 Gal. für Angew. Kunst: Mikromegas (K; Wander-Ausst.); 2009 Gal. Handwerk: Schmuck aus Padua / 2011 Padua, Oratorio di San Rocco: Premio internaz. Mario Pinton. Castelli, min., astri ed alchimia; Melbourne (Vic.), RMIT Gall.: Gioielli d'autore. Padova e la scuola dell'oro. ⊞ Amer. craft (N. Y.) 47:1988 (6) 36–41; *A. Quattordio,* Arte in 10:1997 (51) 100–102; *G. Folchini Grassetto,* Contemp. jewellery. The Padua School, St. 2005; *R. Slavik/H. Welz* (Ed.), Art meets jewellery. 20 Jahre Gal. Slavik Wien, St. 2010. – *Online:* Website C. F. Krohn

Cecchi, *Carlo,* ital. Zeichner, Maler, Graphiker, Installationskünstler, * 1949 Jesi, lebt dort und in Rom. Stud.: bis 1969 (Dipl.) Ist. d'Arte, Ancona; 1969–73 ABA, Urbino, bei Alberto Boatto und Renato Bruscaglia. Tätig als Kunsterzieher. – Als Schüler u.a. von Pierpaolo Calzolari und Tommaso Trini anfangs Beschäftigung mit Konzeptkunst und Arte povera. Ab den 1970er Jahren entwickelt C. eine eig. zeichnerisch geprägte, mit Skripturen durchsetzte, auf wenige symbolhafte Bildelemente beschränkte neorealistische Bildsprache in Zchngn (auch als Teile von Installationen) und Gem. (Öl/Lw.). ⌂ ANCONA, Mus. Archeol. delle Marche. CORINALDI, MCiv. CUPRAMONTANA, Mus. Etichette del Vino. JESI, Assoc. Naz. Partigiani d'Italia (ANPI). MAIOLATI SPONTINI, Mus. G. Spontini. OFFAGNA, Mus. Sc. Naturali. SERRA DE'CONTI, Mus. Arti Monastiche. ⊙ *E:* Mailand: 1984 Gall. De Ambrogi; 1991 Gall. Care/Off; 1998 Gall. Bordone / Jesi: 1984 Centro Doc. Arti Visivi (K: G. Bonasegale); 2003 Pal. della Signoria; 2009 Fond. Colocci / Falconara Marittima: 1991 Gall. Progetto Arte (K); 2009 Centro per la Doc. dell'Arte Contemp. Pal. Pergoli / 1992 Rom, Gall. De Florio Arte / Ancona: 2000 Rettorato dell'Univ.; 2007 Teatro delle Muse / 2004 Morro d'Alba, Auditorium di S. Teleucania / 2005 Cingoli, Chiesa di S. Filippo / 2006 Bologna, Desia Agenzia per l'Arte / 2007 Montecassiano, Spazio espos. ⊞ *S. Sbarbati* (Ed.), Mani-fattura, laboratorio d'arte (K Chiaravalle), [Jesi] 1987; *E. Longari,* C. C. La tela, la tavola, la carta sono un'occasione (K), Jesi 1990; Difronte. C. C., Bruno Mangiaterra (K), Ancona 1991; Immagini, seduzioni, riflessi. I disegni di Marcello Dudovich e l'intervento di C. C. (K), Falconara 1993; C. C. Alba di pitt., al tramonto (K Arte Incontro), Falconara 1994; *L. Mozzoni* (Ed.), C. C. Ripabianca (K Gall. degli Stucchi), Falconara 1995; *L. Monaldi/I. Monti* (Ed.), Il bianco il nero. Disegni (K), Ascoli Piceno 1996; Contest art 10 (K Andromeda Hotel), Oostende 2007. D. Trier

Cecchini, *Loris,* ital. Bildhauer, Fotograf, Zeichner, Installations- und Videokünstler, * 7. 5. 1969 Mailand, lebt in Prato und Beijing. Ab 1977 in Siena. Stud.: 1985–89 Ist. d'Arte ebd. (Dipl.); 1989–91 ABA, Florenz; 1991–94 ABA di Brera, Mailand (Malerei; theoretische Abschlußarbeit über die Filme von Wim Wenders). Danach zwei Jahre in einem Fotolabor in Monza tätig, wo er sich mit digitaler Fotogr. und Bildbarbeitung beschäftigt. Ausz.: 2005 Bienn. Venedig: Premio per la giovane arte ital. 2004–2005; 2006 Premio Francesca Alinovi, Bologna/ Mailand. – In seinem vielseitigen, medienübergreifenden Schaffen setzt sich C. mit der Erfahrung von Objekt und Raum, von Idee und Materie, von Abstraktion und Wirklichkeit, von Spekularität und Funktionalität auseinander. In seinen Kreationen möchte er auch Prozesse von Zerst. und Rekonstruktion präexistenter Bilder sichtbar machen. Zunächst formt er plastische Arbeiten aus weichen, geschmeidigen Mat. (Kunststoff, Harz, Gummi, Zellulose), fotografiert sie nachfolgend und fügt am Computer menschliche Figuren ein. In großformatigen Fotogr., die an Filmstands oder Widescreens erinnern, zeigt

er dann die virtuelle Realität mit vorgetäuschten Räumen und realen Personen (z.B. *Pause in background*, 1996). 2001 zeigt er auf der Bienn. Venedig atmende Kuben aus Gummi, die an Isolierzellen für zum Tode Verurteilte denken lassen, und in München einen Raum, auf dessen Boden, wohl als Folge einer Katastrophe, aschefarbener Schaum zerstörte Alltagsgegenstände und Zivilisationsrückstände bedeckt. Seine virtuellen Modelle mit fotogr. Szenarien, Plastiken und Installationen zeigen z.B. transparente Innenräumen mit Möbeln und alltäglichem Zubehör (*No casting-Transparencies*, 2000–03), Wohnhüllen und -module (*Monologue Patterns* und *Matrici*, 2003), gepreßte organische Wesen, die an Viren (*Blaublobbing*, 2004–06) oder Larven (*Morphic Resonance*, 2004–07) erinnern, oder 3D-Modelle von Bäumen mit Fotos von Eisbergen und phantastischen Archit. (*The painted distances*, 2008; *Sliding constructions and drifting thoughts*, 2008/09). In neueren Arbeiten setzt sich C. mit den Beziehungen zw. Kunst, Wiss. und Poesie in einer zunehmend unsicher werdenden Welt auseinander und der Notwendigkeit, zw. Fiktion und Natur, zw. Imaginärem und Realität zu unterscheiden. Er gestaltet Installationen mit vorgefertigten Modulen aus Polyäthylen oder Stahl, die die Raumwände als Welle erscheinen lassen (*Morphing Wave*, 2005–07), oder freistehende Installationen, die er als archit. Übungen bezeichnet. Im letzten Jahrzehnt ist C. einer der internat. meistbeachteten ital. Künstler der mittleren Generation. ⌷ COLLE VAL D'ELSA, Sonar. La Casa della Musica. DÜSSELDORF, KS NRW, K21 KS im Ständehaus. ISTANBUL, iS. CaM. MAILAND, Isola Art Center. PRATO, Centro per l'Arte Contemp. Luigi Pecci. ROM, Nomas Fond. ◉ E: Mailand: 1996 Gall. Bordone; 1999 Gall. Claudia Gian Ferrari; 2005, '09, '11 GA Photology (K) / 1997 Caserta, Gall. Studio Legale (K) / 1998 Siena, Pal. delle Papesse. Centro Arte Contemp. / 1999 Köln, Ist. Ital. di cult. (K: A. Pieroni/L. Pratesi) / 2000 Busto Arsizio, Fond. Bandera; Neapel, Assoc. Percorsi (K); Santiago de Compostela, Centro Galego de Arte Contemp. / 2000, '05 Madrid, Gal. Max Estrella / 2000, '03, '07, '10 San Gimignano, Gall. Continua (K) / 2001 Heidelberg, KV (K: H. Gercke) / Paris: 2001 Gall. Ghislaine Hussenot; 2007 Paris, Pal. de Tokyo / 2002 Pisa, Fond. Teseco / Rom: 2002 Casa Musumeci Greco; 2007 Pal. Fendi / Turin: 2003, '05 Pal. Bricherasio; 2006 GAM (mit Pietro Consagra); 2011 Velan (mit Sabrina Torelli) / 2004 Florenz, Quarter Centro Produzione Arte; Palma di Mallorca, Casal Solleric (K); Pesaro, Pal. Montani-Antaldi / 2006 Beijing, Gall. Continua (K); Long Island, P. S. 1 Contemp. Art Center; Shanghai, Duolun MMA / 2007 Bologna, MAM / 2008 London, Laure Genillard / 2009 Prato, Centro per l'arte contemp. Luigi Pecci (K) / 2010 Saint-Etienne, MAM; Montelimar, Château des Adhèmar, Centre d'art contemp.; Suzzara, Gall. del Premio Suzzara / 2011 Genua, Fond. Edoardo Garrone (K); Le Moulin (Boissy-le-Chatel), Gall. Continua; Toruń, CoCa: Spaceship Earth. – G: Rom: 1999 Fond. Adriano Olivetti: Molteplicittà (K); 1999, 2008 Quadrienn. / 2000 Prato, Centro per l'arte contemp. Luigi Pecci: Futurama (K); Taipei: Bienn. / 2001 Bozen, StG: Poetiche del quotidia-

no 2 (K); München, Lenbachhaus: Leggerezza. Ein Blick auf zeitgen. Kunst in Italien (K: H. Friedel u.a.); Valencia: Bien. / Venedig: 2001 Bienn. (K); 2005 Premio per la giovane arte Ital. (K) / 2003 Bozen, Museion: Moltitudini-Solitudini; Trento, MART: Nuovo spazio ital. (K) / 2004 Verona, GAM: Orrizonti aperti (K) / Mailand: 2004 PAC: Spazi atti (K); 2010 Fond. Arnaldo Pomodoro: La scult. ital. del XXI sec. (K) / 2005 Pistoia: Uscita Pistoia 2004 (K) / 2006 Carrara: Bienn. di Scult. (K); Gambettola, GA: La Giovine Italia (K); Shanghai: Bienn. / 2009 Gallarate, GAM: The group show (K). ⌷ G. Politi (Ed.), Diz. della giovane arte ital., Mi. 2003. – L. Beatrice/C. Perrella, Nuova arte ital., R. 1998; A. Pieroni, Per. del Pal. delle Papesse Centro Arte Contemp. (Siena) 1998, 51–54; G. Scardi, Flash art Italia 215:1999 (April/Mai); M. Meneguzzo, Artforum internat. 2000 (Dez.) 153; A. Verdin, Accent/Diario 16 v. 25. 5. 2000, 16 s.; S. Chiodi, Tema celeste 18:2001 (86) 66 s.; M. Chlumsky, Frankfurter Allg. Ztg v. 5. 2. 2001; K. Lee, The art mag. Wolgan Misool (Seoul) 4:2001 (April) 106–111; G. Foschi, Zoom internat. (Mi.) 2002 (50) 46–51; F. Poli, Tema celeste 90:2002 (März/April) 96; S. Risaliti (Ed.), Arte in Toscana 1982–2002 (K), Fi. 2002; D. Bigi, Arte e critica 34:2003 (April-Juni) 41; A. Bonito Oliva/S. Risaliti, L. C. Sketchbook, drawings, projects, works, 2000–2003, Fi. 2003; S. Cinicinelli, Flash art Italia 239:2003 (April/Mai) 148; P. Solans, Lapiz 23:2004 (207) 24–31; A. Micaletti, Titolo 15:2004 (44) 28 s.; L. Spagnesi, Arte 375:2004, 178–182; L. C./D. Faccioli, Monologue patterns, Mi. ²2005; M. L. Frisa (Ed.), Ital. eyes. Ital. fashion photogr. from 1951 to today (K), Mi. 2005; Premio Agenore Fabbri 2005. Aktuelle Positionen ital. Kunst (K), Göppingen 2005; R. Barilli, Prima e dopo il 2000. La ricerca artistica 1970–2005, Mi. 2006; S. Foschini, Arte 393:2006, 158–162; D. Paparoni, Mentalgrafie. Viaggio nell'arte contemp. ital. (K), Mi. 2007; J. Collins, Sculpt. today, Lo./N. Y. 2007; P. Gagliano L. C., Bs. 2008; M. Bezzini/S. Pezzato (Ed.), L. C. Dotsandloops (K), Genf u.a. 2009; R. Rugoff (Ed.), The new decor (K), Lo./N. Y. 2010. – *Online:* Artext, 2007 (Interview); Ital. area. Ital. contemp. art arch.; PARC. – Mitt. Gall. Continua.

E. Kasten

Cecco di Francesco (Francesco di Francesco), ital. Maler aus Pistoia, ab 1420 dok. in Lucca. Mietet hier 1421 ein Haus vom Rektor des Ospedale del Fondaco in der Contrada di S. Donato. Ab 1422 arbeitet er zus. mit seinem Landsmann Salvatore di Santo, u.a. bei der Dekoration von Cassoni. 1423 soll er die Malerei eines hl. Sebastian in der Kirche S. Benedetto ersetzen. 1426 bemalt er zwei Cassoni für Angelo del Giorgio, ist einer der Schlichter in einem Rechtsstreit zw. den Malern Francesco di Andrea Anguilla und Antonio di Ciambino und begutachtet Arbeiten von Salvatore di Santo und dessem Sohn Pietro für Priamo della Quercia. 1427 fordert er von dem Arzt Matteo di Davino die Bezahlung eines Tabernakels u.a. Arbeiten, die von P. della Quercia und F. di A. Anguilla geschätzt werden. Vermutlich ist er identisch mit dem Maler *Cecco Nicolai di Pistoia*, der bereits vorher zus. mit Anguilla den Auftrag für eine Taf. für den Hauptaltar der Kirche S. Pietro

Maggiore in Villa Basilica/Lucca erhält. Das Werk bleibt unvoll., wahrsch. weil C. um 1428/29 in seine Geburtsstadt Lucca zurückkehrt. ▢ *M. Paoli*, Arte e committenza priv. a Lucca nel Trecento e nel Quattrocento, Lucca 1986; *G. Concioni u.a.*, Arte e pitt. nel Medioevo lucchese, Lucca 1994; *M. T. Filieri* (Ed.), Sumptuosa tabula picta (K Lucca), Livorno 1998. E. Kasten

Cecco Nicolai di Pistoia cf. **Cecco di Francesco** (1420)

Ceccoli, *Raffaello* (Tsekoli, *Rafail*), ital. Maler, Arzt, Archäologe, * um 1800 Neapel, † nach 1852 London. Kommt 1839 als politischer Flüchtling nach Kerkyra (Korfu) und bringt seine kranke Tochter im Kloster auf der Insel Koros unter. Geht dann nach Athen und lehrt 1843–52 an der KSch Malerei. 1844 ebd. Mitbegr. des Ver. für schöne Künste, für den er ein großes allegorisches Gem. mit fünf weiblichen Gestalten malt (Lydakis, 1972). Zu seinen Schülern gehören Dimitär Dobrovič, der C.s Ehefrau porträtiert (Sofia, Nat. KG), Nikolaus Gysis, Nikiforos Lytras und als Privatschülerin Eleni Altamoura-Boukoura. Als Antikenverehrer und begeisterter Philhellene nimmt er regen Anteil am politischen und kult. Leben. Malt Lsch. und Portr., u.a. von Kämpfern des griech. Unabhängigkeitskrieges. Nach dem Tod seiner Tochter schenkt er dem Kloster auf Koros eine Madonna mit ihren Gesichtszügen und kehrt 1852 nach Italien zurück; sein Nachf. an der KSch wird Ludwig Thiersch. ▥ ATHEN, Nat. AG: Akropolis, Öl/Lw., 1845–50. – Benaki Mus.: Athen von Südwesten, Aqu., um 1850. LONDON, Aukt. Sotheby's v. 10. 5. 2007: Ansicht der Akropolis mit dem Odeion des Herodes Atticus. ◉ *G*: 1855, '56 London, RA. ▢ *Graves*, RA I, 1905; *Lydakis* IV, 19760 (s.v. Tsekoli, Rafail); DA XIII, 1996, 360 (s.v. Greece); LEK IV, 2000 (s.v. Tsekoli, Rafail; Lit.). – ArtJ 1855, 181; *S. de Biasis*, Pinakothiki (At.) 10:1910/11 (116) 148–151; *Lydakis*, Gesch., 1972; *F.-M. Tsigakou*, The rediscovery of Greece. Travellers and painters of the Romantic era, Lo. 1981; Risorgimento greco e filellenismo ital. (K), R. 1986; *F.-M. Tsigakou/A. S. Dollinger*, Glanz der Ruinen (K Bonn), Köln 1995. – *Online:* Fond. Banca del Monte Foggia. E. Kasten

Ceccolini, *Carlo*, schweiz. Architekt, * 1961 Bern, lebt in Gentilino (heute zu Collina d'Oro). Stud.: 1982–88 ETH, Zürich (Dipl.); daneben Praktika bei Hans Kollhoff, Berlin, Carlo Aymonino, Rom, und in den USA. 1989–2001 gemeinsames Büro mit Luca Gazzaniga in Lugano, danach eig. Büro in Gentilino. 2001 Mitarb. an der Erweiterung der ETH auf dem Hönggerberg (Haus der Chemie), Zürich, im Büro von Mario Campi und Franco Pessina. Seit seiner Trennung von L. Gazzaniga, der sich durch Kooperationen bei Wettb. (mit Josep Lluís Mateo, Barcelona, Mecanoo architects, Delft, u.a.) ein internat. Wirkungsfeld erarbeitet, betätigt C. sich vornehmlich lokal, auch als freier Künstler. Die mit L. Gazzaniga ausgef. ländlichen Wohnhäuser stehen in der Trad. der Tessiner Mod. und sind streng rationalistisch: als klar definierte, sich teilw. durchdringende geometrische Baukörper mit horizontaler Gewichtung und Bezugnahme auf die sie umgebende Landschaft. Der konzeptionell innovative Kursaal des Casinò in Lugano (Wettb. 2000) wurde 2005 mit dem 3. Preis Archi-Europe prämiert (mit L. Gazzaniga, Bruno Huber). ▥ BREGANZONA: Casa Fumagalli, 1994–96. CARONA/Lugano: Casa Petrini, 1999–2001. FIGINO: Casa Redaelli, 1993–95; Casa Beltrami, 1993–95. LUGANO: Diskothek Prince, 1999. PREGASSONA: Casa Guglielmini, 1999–2002. VICO MORCOTE: Casa Zürcher-Poma, 1995–98; Casa Keller (Erweiterung), 1998–2002. ◉ *E*: 1998 Rom, A. A. M. Archit. Arte Moderna (mit L. Gazzaniga; K). ▢ *T. Bamberg/P. Pellandini*, Tessin-Archit. Die junge Generation, M. 2004 (irrtümliche Namensvariante). A. Mesecke

Cecere, *Ada Rasario* (geb. Rasario, *Ada*), US-amer. Malerin, Wandmalerin, Zeichnerin, * 1893 (lt. AskART), 1894 (lt. Falk) oder 24. 2. 1895 New York (lt. Soria), † 1981 (lt. AskART). Tochter des Ornamentbildhauers und Schnitzers Stanislaus Rasario; Ehefrau des Bildhauers Gaetano C. Stud.: Art Students League; NAD; BA Inst. of Design, alle New York. Reise nach Europa, wo sie KSch in Paris und Rom besucht. In Rom lernt sie ihren späteren Ehemann kennen; lebt mit ihm anschl. in New York, in den Sommermonaten in Milford/Pa., wo ihr Haus ab 1971 zum Treffpunkt des Kuratoriums der Organisation Pike County Arts and Crafts wird. Lehrerin an der Leonardo Da Vinci School, New York. Mitgl.: u.a. Audubon Artists (1962–64, '68–69 Dir.; 1948–52 Ausst.); Nat. Assoc. of Women Artists (1959–60, '62, '64, '68 im Beirat; 1930–55 Ausst., zw. 1943 und 1968 mehrere Preise); Allied Artists of America (ab 1961 in der Preisjury; 1968 Maria Cantarelle Memorial Prize); Knickerbocker Artists (1957–59 stellv. Präs.); Amer. Watercolor Soc. (1928–67 Ausst.-Beteiligungen). – Portr., Lsch., Ateliermotive, maritime Darst., z.B. der Unterwasserwelt, und Blumenstücke (Öl, Aqu., Pastell) mit einem Hang zum Dekorativen. Gestaltet 1941 im Auftrag des US Treasury Dept. ein Wand-Gem. für das von der Navy genutzte Passagier- und Transportschiff S. S. President Jackson (ab 1940 USS Zeilin), 1947 ein Sgraffito im Nat. Wettb. dieses Minist.; weitere Wandbilder entstehen für New Yorker Hotels, u.a. das Broadway Central Hotel. ▥ NORFOLK/Va., Chrysler Mus. of Art. OKLAHOMA CITY/Okla., Mus. ◉ *E*: 1963 Madison (N. J.), Fairleigh Dickinson Univ. (Preis). – *G*: 1939 New York: WA. ▢ *Soria*, 1993; *Falk* I, 1999. – Washington, D. C., SI, Arch. of Amer. Art: Fotogr. ihrer Werke, Ausst.-Kat., Korr. u.a. Schriften (* 1893, † 1971). – *Online:* AskART; Turner Bennett; Wikipedia (s.v. Pike County Arts and Crafts). C. Rohrschneider

Cecere, *Guido*, ital. Fotograf, * 30. 1. 1947 Bari, lebt in Pordenone. Stud.: Corso Superiore Speciale di Arte Grafica, Urbino; Schüler von Albe Steiner und Michele Provinciali. 1971 Dipl. am College of Printing, London, bei Jorge Lewinski. Beschäftigt sich ab 1972 mit Fotogr. und Kommunikation sowie Kunstfotografie. Hält ab 1984 Fotogr.-Seminare am Ist. Superiore per le Industrie Artist. (ISIA) in Urbino, lehrt dort 1996–2002. Seit 1989 Mitgl. des wiss. Komitees des Mus. Alinari di Storia della Fotogr., Florenz; ab 1993 Mitarb. des Centro Iniziative Cult., Pordenone. Seit 2002 Mitgl. des Beirats der Gall. Regionale in

Gradisca Isonzo. Lehrt 1993–97 Fotogr. an den ABA Urbino und Bologna; seit 1998 Inhaber des Lehrstuhls für Gesch. der Fotogr. der ABA Venedig und seit 2001 der Villa Manin. Tätig für versch. Gal. und Verlage, z.B. Electa, Fabbri, De Agostini, Gribaudo, DuMont und teNeues sowie als Ausst.-Kurator. Ausz.: 1994 Preis der Buchmesse Frankfurt am Main für den besten europ. Fotokalender; 2006 Premio San Marco, Pordenone; 2009 Premio Friuli Venezia Giulia Fotogr. des Centro Ricerca Archiviazione Fotogr. (CRAF). – C. publ. Bücher und Fotokalender (bisher über 70) mit Aufnahmen von aneinandergereihten oder zu dekorativen Stilleben arrangierten Alltagsgegenständen, Sammlerstücken, Blumen, Blüten oder Früchten. ✉ *G. C./D. Cimorelli* (Ed.), Giocattoli ital. in metallo, 1908–1955, Mi. 1992; La fotogr. in cartolina, Fi. 1996; Bambini e animali, Fi. 1998; Dal dagherrotipo al digitale. Fotogr., immagini, doc. 1839–1999, Pordenone 1999; Dodici fotografi del Friuli Venezia Giulia, Ud. 2007; Segni del presente. Giovani fotografi dall'ABA di Venezia e Villa Manin, Ud. 2007; *G. C./S. Scabar*, Silenzio di luce, s.l. 2008; *G. C./A. Garlini*, Occhi nuovi sul Veneto, Treviso 2009; Eros in cartolina, Fi. [1999]. ◉ *E:* 1984 Verona, Gall. Cinquetti (K) / Pordenone: 1985 Gall. Sagittaria (K); 2006 Golden Prisma; 2009 Assoc. La Roggia / 2004 Salzburg, Ist. Ital. di Cult. / Triest: 2004 Spazio Espositivo Knulp; 2005 Gall. Minimal; 2010 Sala mostre Fenice / 2007 Padua, Aprile Fotogr. (K). – *G:* 1983 Bari: Fiera internaz. di arte contemp. / 2008 Nancy: Bienn. internat. de l'image. ⌶ *T. Carpentieri*, G. C. 1970–1985. Quindici anni di fotogr. (K), Pordenone, 1985; *T. Maniacco*, Artisti in musica (K), Gradisca d'Isonzo 1986; *E. Gusella* (Ed.), G. C. Cityscapes (K), s.l. 2007; *D. Santamaria* (Ed.), Bienn. di Alessandria (K), Albissola Marina 2008. – Mitt. C.
E. Kasten

Cecere, *Saverio*, ital. Bildhauer, Maler, Objektkünstler, Kurator, * 23. 10. 1951 Santa Paolina/Avellino, lebt in Solofra/Avellino. Übersiedelt 1954 mit der Fam. nach Venezuela. Stud.: Malerei an der Esc. de Artes Plast. in Maracay. Hat Kontakt zu avantgardistischen Künstlern in Venezuela, beschäftigt sich mit Konstruktivismus und kinetischer Kunst. 1968 gründet er die Gruppe Dubeca und malt erste konstruktivistische Bilder. 1969 Ausst.-Debüt in der Gal. Artes Visuales in Maracay. C. schließt sich der bereits 1944 im Umkreis der argentinischen Zs. Arturo von Carmelo Arden Quin gegr. künstlerischen Bewegung Madí an (später gedeutet als MADI [Mouvement, Art abstrait, Dimension, Invention]). Die Vertreter der MADI-Ästhetik sprengen den klassischen Bildrahmen und versuchen, Bewegung in abstrakt-geometrischen Kunstwerken zu verdeutlichen. C., der vorwiegend mit farbigem Plexiglas und lackiertem Holz arbeitet, ist ein engagierter Repräsentant dieser Kunstrichtung und auch als Ausst.-Kurator und Hrsg. von Ausst.-Kat. tätig (z.B. *Madi all'alba del terzo millennio* , N. 2000; *Universo esprit de geometrie* , San Nicola la Strada 2004; *In-forma geometrica*, Penta 2009; beide zus. mit R. Pinto). – Ausz.: Premio Terna 02. ⌂ DALLAS/Tex., Mus. of Geometric and MADI art: Trans-form cromia 43, 2001; Transforma-

ble sculpt., 2002. LA PLATA, MAC Latinoamericano (MACLA). ✉ *C./R. Pinto* (Ed.), Bolivar, Portici [2004]; *S. und M. C.*, Nervo vago. An antology of madi 1996–2007, Penta 2007. ◉ *E:* 2006 Saarlouis, Treffpunkt Kunst (K: B. und U. Giebel). – *G:* 1970 Caracas, Ateneo: Confrontacion 70 / 1996 Zaragoza, Centro de expos. y congresos: 1946–1996. Madi internac. 50 años despues (K) / 1997 Madrid, MN Centro de Arte Reina Sofía: Arte Madí (K) / 2001 San Giorgio a Cremano, Villa Bruno: Madì. Movimento astrazione dimensione invenzione (K) / 2002 Pieve di Cento: Opere dal 1991 al 2002 arte madì Italia (K) / Dallas: 2004 Mus. of Geometric and MADI art: Omaggio all'arte geometrica (K); 2008–09 ebd.: Tres artistas MADI venezolanos (mit Angel Hernandez und Octavio Herrera) / Neapel: 2005 Assoc. Arte Madì Movimento internaz.: Proiezioni avanzate dell'astrazione geometrica (K: R. Pinto); 2006 Spazio Arte: 4 artisti Madì: Silva, Milo, Herrera, C. (K); 2007 Tracce di luce / 2010 Pieve di Cento: Madì. Magi 90 (K). ⌶ Madi. Movimento Internaz. Madi Italia (K), Mi. 1996; Arte MADI (K Madrid/Badajoz), Ma. 1997; Da Madì a Madì (1946–1999), Mi. 1999; *G. Di Genova*, Storia dell'arte ital. per generazioni del '900, Bo. 2000; *R. Pinto*, La pitt. napoletana del XX sec., N. 2002; Terzoocchio 28:2002 (102); *L. Turco Liveri*, Arte Madì Italia (K), Bo. 2002; *P. Ermini* Introd. to Venezuelan abstract geometric art (K), Dallas 2004; *R. Pinto u.a.*, Struttura/oggetto (K), [Caserta] 2005; *C. Pirone* (Ed.), Rass. Madì. Movimento Internaz. – Oltre la geometria (K), N. 2009. – *Online:* Website C.; Pensieri Madi, in: Stanze d'arte, 2010.
E. Kasten

Čechová, *Zdeňka*, tschech. Licht-, Video- und Multimediakünstlerin, Choreographin, Regisseurin, Publizistin, * 4. 6. 1944 Prag, lebt dort. Stud.: bis 1968 ebd. an der Karls-Univ. bei Cyril Bouda, Karel Lidický, Zděnek Sýkora und Karel Šmíd (Kunst, Mathematik) und D. Fiedlerová (Musikanalyse); postgraduales Stud. der Informatik, Elektronik und Lasertechnik. 1979–90 wiss. Mitarb. am Inst. für Wohn- und Bekleidungskultur (ÚBOK) in Prag. 1980 Promotion. 1993 Studienaufenthalt an der Univ. für Kunst und Design in Kyoto/Japan bei Shigenobu Nakamura. Langjährige Doz. an der Fak. für Elektrotechnik der TH Prag. Darüber hinaus als Expertin für Industriedesign bei der United Nations Industrial Development Organization (UNIDO) tätig. Mitgl.: Unie výtvarných umělců (UVU); Syndikát novinářů České republiky; Sdružení českých grafiků František Kupka. Präs. der Unie českých počítačových a multimiálních umělců, Vize-Präs. der Masarykova akad. umění. Ausz.: 1990, '97 Prix Ars Elektronika, Linz; 1994 Preis der Masarykova akad. umění, Prag; 2000 Silber-Med. Graphik-Trienn. ebd.; 2004 European Grand Prize, The European Union of Arts. – Č. gestaltet unter Verwendung computergestützter Entwürfe und Konstruktionen (CAD) sowie computergestützter Fertigung (CAM) u.a. Textilmuster (*Fontána lásky*, 1985), Tapisserien (*Struktura*, 1982), Teppiche (*Vesmír*, 1984), Dekore für Glas (*Emblém*; *Duha*, beide 1982) und Porzellan (*Jaro, léto, podzim*, 1981). Daneben Kunstwerke (u.a. *Ikarus*, 2000; *Vesmírná komunikaze*, 2001) und öff. Präsentationen vol-

ler Poesie und Phantasie. Neben der Licht- und Wasser-Choreographie der sog. Singenden Fontäne in Mariánské Lázně und der Lichtfontäne (Křižíkova fontána) auf dem Prager Messegelände Výstaviště weitere multimediale Arbeiten mit eig. Musik- und Video-Animationen (u.a. *Contrasts of Life*, 1993; *Cosmos*, 1994; *Bohemica – Má vlast mělo*, 2000, gezeigt auf der EXPO Hannover; *Praha – Evropské město kultury*, 2000). Auch Gest. multimedialer Konzerte (z.B. *Missa Ecumenica*, nach der Musik von Jaromír Vogel, Prager Gemeindehaus, 2006). 🏛 GENF, MAH. ŁÓDŹ, MSZ. LOUNY, Gal. Benedikta Rejta. NEW YORK, Franklin Furnace Arch. OSTRAVA, GVU. – Dům umění. PARMA, Centro documentazione organizzazione comunicazioni visive. PRAG, NG. – UPM. ✉ Aplikace počítačové grafiky v textilním průmyslu ČSSR, Praha 1981; My computer art, Praha 1983; Nová technika ve výtvarných oborech, Praha 1987 (mit Miroslav Klivar); Textil v bytě i ve veřejném interiéru, Praha 1987 (mit Miroslav Svejda u.a.). 👁 *E:* u.a. Prag: 1982 Klementinum; 1987 ÚKDŽ; 1989 Malá gal. Melantrich; 1996 Gal. Nový horizont / 1993 Kyoto: Kyoto Salon / 1996 Brno, Messepalast (Brněnské výstaviště). – *G:* u.a. 1981 São Paulo: Bien; Paris: Mail art / Prag: 1988 Bruselský: Salon 88; 1991 Gal. Vincence Kramáře / 1993 Madrid: Video Arco / 1993 Québec, Acad. Sutton: Arts Sutton '96. 🗀 NEČVU, 1995 (s.v. Počitačová grafika; Počitačový design); SČSVU I, 1998. – *M. Klivar*, Nové tendence v českém výtverném umění, Praha 1994; *Z. Čechová*, Multimedia Art, Praha 1997. – *Online:* Website Č. M. Knedlik

Cecil, *Hugh* (eigtl. Saunders, *Hugh Cecil*), brit. Fotograf, * 14. 12. 1892 (evtl. März 1890 Surrey), † März 1974 Brighton. C. besucht die Tonbridge School und das Queens' College in Cambridge, wo er sich für Fotogr. zu interessieren beginnt. Nach dem Schulabschluß absolviert er eine Lehre bei dem Fotografen H. Essenhigh Corke in Sevenoaks/Kent b. London. 1912 eröffnet er ein eig. Atelier in London unter der Adresse 100 Victoria Street; 1913 Mitgl. der R. Photogr. Soc.; 1923 Umzug nach 8 Grafton Street. C. stellt zwei Ass. ein, Paul Tanqueray und Angus McBean, die ab den 1930er Jahren viele der Aufnahmen des Ateliers anfertigen, während er sich zunehmend mit technischen Erfindungen, nicht nur auf dem Gebiet der Fotogr., beschäftigt. Zu Beginn des 2. WK schließt das Atelier. – A. der 1910er Jahre stellt C. einige Lsch.-Fotogr. in der Cambridge Photogr. Soc. aus. In London etabliert er sich schnell als erfolgreicher Porträtfotograf; u.a. ab 1925 zahlr. Bildnisse von Prinz Edward, Duke of Windsor, dem späteren König Edward VIII, und and. Mitgl. des brit. Königshauses sowie von der Schauspielerin Gertrude Lawrence. Darüber hinaus veröffentlicht C. regelmäßig Fotogr. in den Zss. Sketch und Tatler. 1926 erscheint das *Book of Beauty* mit 37 Fotogravüren und ausgewählten Gedichten. 🏛 DURHAM/N. C., Duke Univ. Libr. LONDON, Nat. Portr. Gall. LOS ANGELES/Calif., J. Paul Getty Mus. ROCHESTER/N. Y., George Eastman House. 👁 *G:* 1912–15 London, R. Photogr. Soc. / 1977 New York, Internat. Mus. of Photogr.: The Hist. of Fashion Photogr. (Wander-Ausst.; K: N. Hall-Duncan) / 2010 Durham (N. C.), Duke Univ. Libr.:

The Power of Refined Beauty. Photographing Soc. Women for Pond's, 1920s-1950s. 🗀 *T. Pepper*, Monday's children. Portr. photogr. in the 1920s and 1930s (K Impressions Gall. of Photogr.), York 1977; *J. R. Taylor/J. Kobal*, Portr. of the Brit. cinema. 60 glorious years, 1925–1985, Lo. 1985; *C. Beaton/G. Buckland*, The magic image. The genius of photogr., Lo. 1989; *M. Rogers*, Camera portr. Photogr. from the Nat. Portr. Gall. 1839–1989 (K), Lo. 1989. – *Online:* Nat. Portr. Gall. P. Freytag

Cecula, *Marek*, poln. Keramiker, Designer, Bildhauer, * 1944 Kielce, lebt in New York und Kielce. Ab 1960 in Israel, lernt Töpferei im Kibuz; 1972 eig. Wkst. in Tel Aviv. Anschl. Industriedesigner, Schmidt Porzellanfabrik, São Paulo. Seit 1977 in New York, dort Atelier „Contemp. Porcelain" und Gründung der Fa. Modus Design. Lehrtätigkeit: u.a. 1985–2004 Keramik-Fak., Parsons School of Design, New York (ab 1994 Ltg); seit 2003 Prof. an der KHS in Bergen/Norwegen. – C. ist zunächst als Designer für Gebrauchskeramik tätig (Kunden: Barneys, New York, Donna Karan, Creative Bath, Internat. China, Croscill) und fertigt Tafelgeschirr in limitierter Aufl., seit 1997 entwirft er Gebrauchsgeschirr für Modus Design und Prototypen für europ. Keramikfirmen. Nach einem Aufenthalt am Europ. Ceramic Work Centre, 's-Hertogenbosch, 1993, ist er auch im Bereich Kunsthandwerk erfolgreich. Entscheidend hierfür sind die Keramikserien *Scatology* (1993) und *Hygiene* (1999), in denen er Designmerkmale (Mat.-Schönheit, Funktionalität, serielle Herstellung) in Porzellanobjekte einbringt. Bei *Scatology* sind es elegante, medizinischen Geräten oder menschlichen Körperteilen ähnelnde, präzis gefertigte Objekte, die er auf Edelstahltableaus präsentiert, bei *Hygiene* eine Reihe von beckenartigen Gießgefäßen auf Metallgestellen. Die jeweils in multiplen Reihen ausgestellten Skulpt., wie z.B. eine Nachformung des menschlichen Unterleibs oder ein Becken mit rüsselartigem Auslauf (*Untitled II*, 1996, Los Angeles, County Mus. of Art, Smits Coll.), sind trotz formaler Schönheit als Behälter für Körperflüssigkeiten im Zeitalter von Aids zugleich Objekte der Angst. Eine modernistische Ästhetik zeigt die Serie *Interface* (2001), bei der z.B. zwei wie aufgeblasene Gummihandschuhe geformte Porzellanhände an den Fingerspitzen ineinander übergehen. Seit 2001 arbeitet C. auch direkt mit Industrieprodukten, z.B. bei einem aus mit fortlaufendem Teppichmuster bedruckten Tellern arrangierten „Teppich" (*The Porcelain Carpet*, 2001) oder bei der Serie *Dust real* (2003–05), für die er Erzeugnisse europ. Porzellanmanufakturen nochmals brennt und sie anschl. deformiert. 2006 Eröffnung des Ateliers in Kielce. 2007 gestaltet C. im Auftrag der Stadt Kielce das Denkmal zur Erinnerung an die Liquidierung des jüdischen Ghettos 1942 und die Ermordung von etwa 20000 Juden in Form einer in den mit originalen Pflastersteinen bedeckten Boden versinkenden oder aus ihm aufsteigenden großformatigen *Menorah* aus Stahl (Aleja IX Wieków Kielc). C. experimentiert mit dem ästhetischen Wert und kulturellen Status von Keramikobjekten und den Überschneidungen von Industrieprodukten und kunsthandwerklicher Keramik. Er ist ein einflußreicher Lehrer und kuratiert 2004

die 3. Bienn. for Israeli ceramics und 2008 zus. mit Daga Kopala die Ausst. „Object factory I./II. The art of industrial ceramics" (Toronto, Gardiner Mus.; New York, Mus. of Arts and Design). 🏛 BOSTON, MFA. CHARLOTTE/N. C., Mint Mus. of Craft + Design. KANSAS CITY/MO., Kemper MCA. PITTSBURGH, Carnegie Mus. of Art. MORLANWELZ, Mus. royal de Mariemont. NEWARK/N. J., Newark Mus. NEW YORK, Cooper-Hewitt Mus. – Mus. of Arts and Design. SHEBOYGAN/Wis., John Michael Kohler AC. 'S-HERTOGENBOSCH, Mus. Het Kruithuis. TRONDHEIM, KIM. WASHINGTON/D. C., Smithsonian Amer. AM. ✉ Postindustrial ceramics, in: Ceramics. Art and perception 46:2001 (Dez.) 35–40; Mass production and originality, in: Studio potter 36:2008 (2) 85–87. 👁 E: 1993–2007 New York, regelmäßig Garth Clark Gall. (K) / 1993 Rotterdam, Gal. Maas / 1995, '97 San Francisco, Modernism Gall. / 1996 Ferndale (Mich.), Revolution Gall. Project / 1997 Mannheim, Gal. Karin Friebe / 1998 Tel Aviv, Periscope Gall. / 1999 Warschau, CSW / 2000 Oslo, Gal. Ram / 2002 Kansas City (Mo.), Grand Arts / 2003 Racine (Wis.), AM / 2006 Kielce, Gal. w. Ramach / 2008 Wrocław, BWA Gall. of Contemp. Art. 📖 Amer. craft 44:1984 (5) 32–39; Functional glamour. Utility in contemp. amer. ceramics (K Mus. Het Kruithuis), 's-Hertogenbosch 1984; Design j. (Seoul) 7:1988 (Sept.) 37; V. Geibel, Metropolis (N. Y.) 9:1990 (10) 26; Ceramics monthly 40:1992 (4) 25; T. Merino, Ceramics. Art and perception 14:1993, 67–69; L. Tugendrajch, ibid. 18:1994, 39–41; Ceramics monthly, 42:1994 (8) 52; G. Dewald, Keramikmagazin 19:1997 (2) 20–23; ead., Contact 109:1997 (Sommer) 27–29; D. Ebony, AiA 85:1997 (12) 92; K. Chambers, Amer. ceramics 13:1998 (1) 52; R. Lord, Ceramics. Art and perception 39:2000 (März) 16–18; J. Lauria u.a., Color and fire. Defining moments in studio ceramics, 1950–2000 (K Wander-Ausst.), N. Y. 2000; M. Del Vecchio, Postmodern ceramics, Lo. 2001; id., Ceramics. Art and perception 46:2001 (Dez.) 35–40; G. Clark, The artful teapot, Lo. 2001; P. J. Smith u.a., Objects for use. Handmade by design (K Amer. Craft Mus.), N. Y. 2001; G. Atkins, Ceramic rev. 189:2001 (Mai-Juni) 46–49; G. R. Brown, Amer. craft 62:2002 (4) 74 s.; S. K. Beare, Ceramics technical 17:2003 (Nov.) 73–77; J. Pagliaro (Ed.), Shards. Garth Clark on ceramic art, N. Y. 2003; R. Lord, Ceramics. Art and perception 53:2003 (Sept.) 27–29; J. Perreault, Amer. ceramics 14:2003 (2) 22 s.; S. de Vegh, ibid. 14:2003 (2) 54; Ceramic rev. 218:2006 (März/April) 28–31; L. Jönsson, Form (Sth.) 5:2006, 44–51, 64, 67 s.; G. R. Brown, Ceramic rev. 218:2006 (März/April) 28–31; Z. Hanaor (Ed.), Breaking the mould, Lo. 2007; G. Clark, Amer. craft 68:2008 (2) 56–63; E. Cooper, Contemp. ceramics, Lo. 2009. – Online: Website C.; Israeli AC (* Israel, seit 1968 in N. Y.); Bergen, Nat. Acad. of the Arts. H. Stuchtey

Cedroni, Carlo (Pseud.: West, Pete), ital. Comiczeichner, Maler, * 23. 2. 1925 Velletri, † 24. 10. 2009. Ab 1953 zeichnet der Autodidakt C. die Westernserie Colorado Kid für den ital. Verlag Erre-CI und eine Comicversion des Westerns Una pistola di vendita. Weite-

re Veröff. in Albi Romoletto (1955), der Heftreihe Albi dell'Impavido (1958) und im Science-fiction-Mag. Il Pioniere (55–58). Ab 1956 arbeitet C. v.a. für frz. Verleger: Für Éditions Aventures et Voyages zeichnet C. an den Serien Bayard, Nick Barrier (Nic Reporter) und Rouletabille. In den 1960er Jahren ist er für das Barman Studio tätig, das für den frz. Verlag Lug produziert. In den Reihen Rodeo, Hondo, Kiwi und Nevada von Lug zeichnet C. Serien wie Don Juan L'Épervier, Jim Lasso, Blek, Appolon, Trapper John und Drago. 1968 entstehen für den ital. Verleger Fratelli Spada Kriegsgeschichten sowie einige Episoden von Mandrake und Cover für Phantom. 1988 zeichnet er eine Episode für die Bonelliserie Martin Mystére. Die letzten zwanzig Jahre seines Lebens widmet sich C. der Malerei. – Die Comics von C. zeichnen sich durch einen realistisch-naturalistischen Strich aus. 📖 H. Filippini, Dict. de la bande dessinée, P. 2005. – Online: Lambiek Comiclopedia. K. Schikowski

Cegla, Rachel (geb. Viktor, Lotte), israelische Malerin dt. Herkunft, * 5. 12. 1912 Altona (heute zu Hamburg), † 25. 7. 2011 Tel Aviv. Der Vater Willi Viktor ist Rechtsanwalt, die Mutter Lisbeth Pianistin. Die gutsituierte, dt.-nat. und liberaldemokratisch orientierte Fam. gehört der Dt.-israelitischen Gemeinde von Hamburg an, die 1933 zu den größten in Deutschland zählt. C. ist musisch begabt und erhält u.a. Geigenunterricht; bedingt durch das persönliche Umfeld der Eltern verkehren sie und ihre zwei Brüder früh im Kreis aufgeklärter Kunstliebhaber. Gegen den Wunsch der Mutter beginnt sie 1930 ein Stud. der Malerei an der Hamburger Landes-KSch (ehem. KGS), das sie jedoch aufgrund antisemitischer Anfeindungen 1933 aufgeben muß. Noch im selben Jahr emigriert die Fam. nach Palästina und entgeht so der Eskalation des nat.-sozialistischen Terrors; zahlr. ihrer in Deutschland verbleibenden Verwandten werden ermordet. In Palästina heiratet sie den emigrierten dt. Kaufmann Yehuda C.; 1950 Geburt der ersten Tochter Michal. – In Israel nimmt C. die vor der Emigration begonnenen künstlerischen Bemühungen und Studien wieder auf. Ausgebildet wird sie v.a. in Petah Tikva bei Zvi Schorr und anschl. in Tel Aviv bei Jacob Eisenscher, durch den sie die Gedankenwelt des Orients entdeckt und für ihre Bilder fruchtbar macht. Zunehmend etabliert sich C. als Malerin im israelischen Kunstbetrieb, stellt 1951 erstmals eig. Arbeiten aus und wird 1957 Mitgl. des israelischen Künstler-Verb., an dessen Ausst. sie fortan regelmäßig teilnimmt. Ab 1960 verbringt sie nur noch die Wintermonate in Tel Aviv. Ansonsten lebt sie in Safed in Galiläa. Auf die kunsthist. bed. Gesch. des hoch in den Bergen gelegenen Ortes wird sie v.a. durch den Maler Yosef Kossonogi aufmerksam, der als Lehrer den wohl nachhaltigsten Eindruck für die Entwicklung ihres Werkes hinterläßt. In der Künstlerkolonie des Ortes erwirbt sie ein Haus mit Atelier und Verkaufsgalerie. Sie wird mit zionistischen Vorstellungen vertraut und orientiert ihre romantischen Bildkonzepte mehr und mehr an den lokalen ikonogr. Traditionen. 1965 schließt sich C. in Safed einer kleineren Künstlergruppe an; im selben Jahr Europareise. Trotz der tiefgreifenden Emigrationserfah-

rung bleibt sie der Sprache und Kunst ihres Geburtslandes stets verbunden, achtet bes. die jüdischen Beitr. zur dt. Kunstgeschichte. In Anerkennung dieser Verbundenheit erhält C. den Auftrag für ein Portr. zum 70. Geburtstag des ehem. Botschafters der Bundesrepublik Deutschland in Israel (*Portr. Niels Hansen*, Gouache, 1986), die sie in einem aufgesplitterten, expressionistischen Duktus malt. Dieses Portr. ist zu ihren herausragendsten Arbeiten zu rechnen. Über die Porträtmalerei hinaus sind ihre Sujets weit gefächert. Neben mehrfigurigen Komp., Stillleben, Interieurs und relig. Motiven umfassen sie auch Atelierszenen sowie erotisch konnotierte oder modisch inszenierte Frauen-Darst., hauptsächlich formuliert in harmonischer, selten greller Farbgebung und meist ausgef. in einer Kombination von Aqu., Tempera, Gouache, Monotypie sowie lokal verbreiteten Malmitteln mit bes. Fließeigenschaften. Graphik und Zchng bleiben peripher. 1986 wird C.s malerisches Œuvre mit einer umfangreichen, in Zusammenarbeit der Univ. München und Tel Aviv erarbeiteten Werkschau u.d.T. „R. C. Ölbilder und Aquarelle. Musik, Tanz, orientalische Szenen" im Foyer der Bayerischen Staatsoper gewürdigt. ▫ EIN HAROD, Mus. of Art. JERUSALEM, Israel Mus. SAFED, Arch. der Künstlerkolonie. TEL AVIV, Mus. of Art. ⊙ *E:* 1960 Safed, Chemerinski AG / 1963 Jerusalem, Artists' House / Tel Aviv: 1978, '81, '92 (K) Artists' House; 1981 Guy AG / 1985 Hamburg, Bank für Gemeinwirtschaft. – *G:* 1960 Safed: Künstler aus Safed / 1966 (Israelische Aquarellisten), '92 (Interieurs) Tel Aviv, Artists' House. ▭ *M. Bruhns*, Kunst in der Krise, II, Ha. 2001; *H. Brenner*, Jüdische Frauen in der bild. Kunst, II, Konstanz 2004. – Gazith. Art and literary j. (Tel Aviv) 1962/63, 237–240; 1979, 385–390; Sirtei Rachel (Kurzfilmproduktion des israelischen Arch. für Malerei und Skulpt.), s.a. [A. der 1960er Jahre]; *M. Kol u.a.*, The artists colony Safed, Safed 1971; Bll. der Bayerischen Staatsoper 1987 (1); *M. Bruhns*, Geflohen aus Deutschland. Hamburger Künstler im Exil 1933–45 (K Hamburg), Bremen 2007 (Lit.; Ausst.; mit Reprod. von drei Aqu., alle undat.). – *Online:* Israeli AC. V. Frank

Çekli, *Nazmi,* türkischer Maler, Offizier, * 1884 İzmir, † 1958 Istanbul. Militärmaler. Beendet 1909 die militärische Ausb. und unterrichtet drei Jahre Kunst an einer weiterführenden Schule. C. nimmt als Offizier am 1. WK und am türkischen Unabhängigkeitskrieg teil und ist bis 1931 beim Militär tätig (zuletzt im Majorsrang). 1931–41 arbeitet er in einem Krankenhaus. Der Staatsgründer Mustafa Kemal Atatürk verleiht ihm für sein Kunstschaffen eine Silbermedaille. C. nimmt an der jährlichen Ausst. der Maler-Vrg des Militärs teil. – Seine vom Impressionismus beeinflußten realistischen Lsch. und Stilleben sind meist in Öl/Lw. und als Aqu. ausgeführt. M. Kühn

Cekov, *Ognjan* (Ognjan Petrov; auch: Zekoff, Ognian), bulg. Maler, * 4. 9. 1964 Pleven, lebt seit 2007 hauptsächlich in Montreal. Ausb./Stud. in Sofia: 1979–83 Kunstmittelschule; 1985–90/91 KHS bei Svetlin Rusev. Anschl. Reisen nach Australien, Großbritannien und Italien. Lehrt einige Zeit an der priv. KA Jules Pascin in Sofia. – C. experimentiert in einer zunächst lockeren Formensprache mit den modellierend-plastischen Möglichkeiten der Farbe. In klar definierten geometrisch-dekorativen Strukturen, die er durch skulpturhafte Elemente mehr verdichtet als auflockert, sucht er nach Übereinstimmung von Bildinhalt und Bildform (u.a. *Zemja*, 2004). Neuere Gem. (v.a. Öl/Lw.), verstärkt seit der Übersiedlung nach Kanada, zeigen einen weiter verfeinerten Umgang mit Tonigkeit, Bildausschnitt und Lichtsetzung und nähern sich Darst.-Weisen des Fotorealismus (u.a. Akte, Stilleben, auch Variationen von Motiven aus der antiken bzw. christlichen Ikonogr.). ▫ PLEVEN, KG. SOFIA, Nat. KG. – Slg der Kultur-Abt. des bulg. Außen-Minist. ⊙ *E:* 1991 London, Grove Gall. / Sofia: 1994, '98 Gal. Krida Art; 1997 Gal. Artos; 1999 Gal. Ata-Raj; 2001 Gal. Car Osvoboditel; 2004 Gal. Šipka 6; 2006 Gal. Natali / 2005 Plovdiv, Kulturzentrum Trakart. – *G:* ab A. der 1990er Jahre sporadisch Allg. bulg. Kunst-Ausst. / 2004 Wachtberg-Berkum b. Bonn, Turm-Gal.: 35 Jahre Turm-Gal. / 2005 Beijing: Bienn. ▭ EIIB III, 2006. – *R. Dove* (Regie), Fragments of Eden. Art by Ognian Zekoff, 2008 (Kurzfilm); *S. Genov*, Ek. Kulturen dvumesečnik. Dăržavna agencija za bălgarite v čužbina (Sofija) 2009 (3) 14 s. S. Jähne

Celati, *Gianni,* italienischer Bildhauer, Maler, Zeichner, Schmuckgestalter, * 4. 7. 1936 Ferrara, lebt dort. Zunächst als Buchhalter tätig. Stud.: Ist. Superiore d'Arte Venturi, Modena; Liceo Artist., Bologna, bei Ugo Guidi, und ABA ebd. bei Umberto Mastroiani (Skulpt.). 1962 übersiedelt er nach Rom, arbeitet als Bühnenbildner am Teatro dell'Opera und in einem Werbeatelier, dann als Kunsterzieher. Prägende Begegnungen mit Giorgio De Chirico und Franco Gentilini. – C. widmet sich einer auf Raumwirkung und Perspektive verzichtenden lebhaften Malerei (Öl/Lw., Mischtechnik) mit figürlichen und abstrakten Komp., Köpfen, auch Landschaften. Wenige schwungvolle Linien prägen Gem. wie auch Zchngn in Tusche und farbigen Tinten (*Testa di ragazza; La caduta di Icaro; Rievocazione*). Des weiteren auch in expressivem, breitem Pinselstrich aufgetragene Motive, bes. bei Lsch. (*Palude*) und abstrakten Kompositionen. In den 1980/90er Jahren entstehen von Kubismus, Futurismus und Surrealismus beeinflußte, teils bis zur Abstraktion geführte kontemplative weibliche Akte, Mutter- und Paar-Darst. (Bronze, Marmor, Terrakotta, patinierter Gips-, Zement- und Marmorguß). Mit fließenden bis stromlinienartigen, glatten, häufig polierten Oberflächen sind die Figuren auf Körperhaltung und sparsame Andeutungen von Körperteilen wie der Brüste und die auf Details verzichtenden Kopfes reduziert. Als Schmuckkünstler konzentriert sich C. auf Halsschmuck aus Silber und Silberdraht, der auf Schlichtheit und Eleganz der Linie setzt. ▫ AKRON/Ohio, Gall. Mus. Denis Conley. ALTAMURA, Comune. ANCONA, Ente prov. per il Turismo. ESTE/Veneto, Pal. Munic. FERRARA, Assessorato alle Ist. Cult. – Cassa di Risparmio. FOGGIA, Pin. Club degli Artisti. GARDA, Comune. KAUFBEUREN, Stadt. PORTOMAGGIORE, Comune. WARREN/Ohio, Second Nat. Bank. ⊙ *E:* Bologna: 1961 Circolo Artist.; 1963 Gall. Due Torri; 1967, '70 Gall. Europa / 1965 Verona, Arte Scagliera / Ferrara: 1969 Gall. Il Bulino; 1971 Gall. Es-

tense; 1978 Gall. Alba; 1988 Centro artist. Ariosto; 1991 GAM e Contemp.; 1993 Pal. Massari, Padiglione d'Arte Contemp.; 1999 Casa Zappaterra / 1972 Belluno, Gall. La Radice / 1974, '83 Foggia, Centro cult. dell'Artista / 1975 Rom, Gall. Michelangelo; Ravenna, Gall. Guidarello / Este: 1975 Centro cult. S. Rocco; 1976 GAC / Bardolino: 1985, '89 Gall. Benaco; 1995 GAM / 1984 Altamura, Gall. Com. / 1987 Marzabotto, Gall. Civ. / 1992, '98, 2002 Akron (Ohio), Conley Gall. / 1994 Kaufbeuren, Kulturzentrum / 1996 Brentonico, Pal. Com. – G: 1960, '64 Bologna: Bienn. d'Arte Sacra / 1964 Mailand: Naz. Acqu. ital. / 1970, '74 Rom, Pal. delle Espos.: Quadrienn. / 2000 Sabbioneta, Pal. Ducale: Il sacro nel contemp. ▭ Gente nostra I, 1968; *Falossi*, PPC, 1975; *M. Agnellini* (Ed.), Emilia-Romagna. Artisti e opere dall'Ottocento a oggi, Mi. 1995. – *F. Puviani* (Ed.), Cat. d'arte contemp. 1976, Fe. 1976; *L. Serravalli* (Ed.), G. C. Scult., disegni, dipinti, s.l. ca. 1998. – *Online:* Website C. D. Trier

Celayir, *Mahmut,* türkischer Maler, Fotografiker, * 1951 Bingöl, lebt in Stuttgart. Stud.: 1972–76 Staatliche HS für angew. Künste, Istanbul (Graphik, Druckgraphik); 1976–78 TV-Inst. in Eskişehir (Design, Bühnenbild). 1982–84 Bühnenbildner am Staatstheater in Istanbul. Seit 1986 freischaffend. Häufige Reisen nach Deutschland. Seit 1998 Wohnsitz in Stuttgart. – C.s bevorzugte Motive sind Lsch. und die Natur von Ostanatolien. Diese setzt er fotorealistisch und großformatig in Öl/Lw. und Acryl/Lw. um bzw. nutzt Fotogr. als Vorlagen. Dabei arbeitet er bes. die harten Kontraste heraus. C. gestaltet auch Serien von Druckgraphik. ◉ *E:* Istanbul: 1977 Gal. Taksim; 1985 Gal. Vakko; 1992 Gal. Arkeon; 2004 Atatürk Kulturzentrum; 2009 C. A. M. Gal. / Ankara: 1978 Gal. Akdeniz; 1989 Gal. Vakko; 1992 Gal. Halkbank (K); 1997 Gal. Ziraat (K: B. Lipps) / Stuttgart: 1994 Gal. Zapata; 2005 Gal. Fluctuating Images; 2006 Gal. Tanner; Gal. Südwestbank (K) / 1987 Berlin, Gal. Oberlicht / 1996 Leipzig, Gal. Hennig / 1998 Tübingen, Ugge-Bärtle-Haus; Biberach, Gal. Uli Lang / 1999 İzmir, Selçuk Yaşar AG / 2002 Waiblingen, StG / 2007 Bonn, Gal. Angelika Kallenbach / 2008 Kornwestheim, Mus. (K: I. Seidler) / 2011 Mailand, Spazio Studio (K). – *G:* Stuttgart: 1992, 2004 Württ. KV: Jahres-Ausst.; 1993 Gal. Unterm Turm: Vor Ort (K) / 1999 Tübingen, Ugge-Bärtle-Haus: Kontext Lsch. / 2004 Esslingen, Kunst im Heppächer: Roads and Roots; Ehingen, Schloß Mochental: Fünf Künstler aus Nahost; Istanbul, Goethe-Inst.: Passage / 2005 Kirchheim unter Teck, StM im Kornhaus: Lsch. / 2007 Paris, Gal. La Capitale: Un certain regards. ▭ Die Gesch. der türk. Malerei, Genf 1989; *B. Lipps-Kant*, M. C. Mitos Mazara – Mythos Lsch., Istanbul 1999; Kunstförderung des Landes BW. Erwerbungen 2001–2004 (K Wander-Ausst.), Schwäbisch Gmünd 2006; Hürriyet Seyahat v. 15. 11. 2010; *C. F. Vogel*, Artistanbul, Lüdenscheid/B. 2011. – *Online:* Website C. (Ausst./Lit.); art info (St.) 1:2004, 18–21. K. Schmidtner

Çelem, *Altan,* türkischer Maler, * 1969 Mülheim an der Ruhr, lebt in Istanbul. Stud.: 1987–92 Malerei an der Marmara Univ., Istanbul; ebd. bis 1995 Teiln. am Graduiertenprogramm (Master). Ausz.: u.a. 1993 Tekel Mal-Wettb.;

1993 Kültür Bakanligi; 2001 Preis bei einem Wettb. der türkischen Marine. – Ç. schafft mittelformatige Gem. (Öl/ Lw.), die stark vom Postimpressionismus beeinflußt sind. Zwar stammen die Motive aus dem mod. Alltag (Stadtansichten, Straßen und Autos, Badende im Swimmingpool, Strand), enthalten aber auch durch ihre collageartige Komp. malerische Referenzen an Vorbilder, v.a. an Paul Gauguin. ◉ *E:* Istanbul: 1993, '95, '97, '99, 2001, '06, '11 Tesvikiye Art Gall.; 2010 Art Galerim / 2000 Ankara, Emlak Bank AG. ▭ *K. Özsezgin*, Türk plastik sanatçıları, Istanbul 1994. K. Schmidtner

Çelik, *Isa,* türkischer Fotograf, * 1944 Mersin, lebt in Istanbul. Stud.: bis 1970 Akad. für Handel und Wirtschafts-Wiss., Ankara (Betriebswirtschaft). Lehrtätigkeit: Doz. für Fotogr. an der Bilgi Univ., Istanbul; Lehrauftrag für Werbung an der Kültür Univ. ebd. Mitgl.: u.a. Assoc. of Visual Artists (GSD). Gründet mit and. an der Mimar-Sinan-Univ. in Istanbul das Inst. für Fotografie. – Fotografiert seit seiner frühen Jugend. Kennzeichnend für das Werk ist die Ästhetisierung der Motive (meist Menschen in ihrer alltäglichen Umwelt) durch formalisierten Bildaufbau und starke Farbkontraste. Auch Portr.-Fotogr. sowie Plakat- und Umschlag-Gest. für Bücher, Schallplatten u.ä. ▭ *K. Özsezgin*, Türk plastik sanatçıları, Istanbul 1994. – *Online:* Website Ç. K. Schmidtner

Çelık, *Murat,* türkischer Maler, * 1966 Çorum. Stud.: 1991 Gazi Univ., Ankara (Erziehungs-Wiss., Malerei); 1993 Hacettepe Univ. ebd. (Masterabschluß). Seit 1995 Doz. an der Univ. für Bild. Künste in Mersin. Ausz.: u.a. 2001 2. Preis der Umwelt-Stiftung (Çevre Vakfı). – Ç. schafft Gem. mit stark texturiertem Farbauftrag. Seit 1995 nimmt er an nat. Kunst-Ausst. und -festivals teil, u.a. an der Bienn. in Istanbul. ◉ *E:* Ankara: 1993, '94 Dörüt Hangar Sanatevi; 1996 Vakıfbank Köroğlu Sanat Gal.; 1997 Sanatyapım Sanat Gal. / 2003 Mersin, Devlet Resim Heykel Müz. ▭ *Online:* Orig. turkish paint gall. (Ausst.). K. Schmidtner

Çelik, *Timur,* türkischer Maler, * 1960 Gumushane, lebt in Berlin. Stud.: 1980–84 Malerei an der Marmara Univ., Istanbul. Ausz.: 1988 1. Preis Tekel Mal-Wettb. ebd. – Ç. schafft großformatige Arbeiten (Öl/Lw.). Die Motive (Figurenbilder, Portr., Stadtansichten, Lsch., Stilleben) sind häufig fotorealistisch wiedergegeben. ◉ *E:* Ankara: 1985 Gal. Turkuvaz; 1992 Gal. Sanat Yapim / Istanbul: 1986 Gal. Dört Boyut; 1996 Gal. Maltepe / Berlin: 1998 Saalbau Neukölln; 1999 Gal. IF; 2010 Gal. Juliane Hundertmark. – *G:* Istanbul: 1985, '86, '87 Gal. Dört Boyut; 2010 Gal. Merkur: Contemp. Istanbul / Berlin: 1995 Foyer der Berliner Ztg: Wasser ist Leben; 2008 Verdi-Haus: Berlin-Istanbul; 2010 Gal. Juliane Hundertmark: Berliner Liste. ▭ *K. Özsezgin*, Türk plastik sanatçıları, Istanbul 1994. – *Online:* Website Ç. K. Schmidtner

Çelıker, *Halım,* türkischer Maler, Hochschullehrer, * 1961 Balıkesir, lebt in der Türkei. Stud.: bis 1985 (Dipl.; 1992 Promotion) Mimar Sinan Univ. (Dep. Malerei), Istanbul, bei Adrian Coker; 1986 Teiln. an der Sommer-Akad. in Salzburg, bei Raimund Girke; 1987 Forsch.-Ass. an der Anadolu Univ., Eskişehir. Seit 1997 Lehrauftrag an

der Marmara Univ., Istanbul. Ausz.: u.a. 1985 Şeref Akdik Mal-Wettb. (Erfolgspreis); 1991 (2. Preis) Mevlana-Wettb. des Kultus-Minist.; 1993 Staatlicher Mal- und Skulpt.-Wettb., Ankara (lobende Erw.). – Im Mittelpunkt vieler Arbeiten (v.a. Öl/Lw.) steht das Verhältnis des sich bewegenden menschlichen Körpers zum Raum, wobei sich C. dabei von versch. Vorbildern inspirieren läßt. Zu Beginn der 1980er Jahre malt er vom Realismus beeinflußte Portr. und postimpressionistische Landschaften. M. der 1980er Jahre dominieren expressive Aktstudien vor starkfarbigen, flächigen Hintergründen. E. der 1980er Jahre bevorzugt C. kalte Farben und löst teilw. den Hintergrund durch geometrische, collageartige Gest. auf. Am A. der 1990er Jahre arbeitet C. fast ungegenständlich expressiv in gedeckten Tönen. Gleichzeitig behält er expressive Akt-Darst. bei, die z.T. vor grünen Flächen, z.T. in als Lsch. zu erkennenden Räumen verortet werden. E. der 1990er wird der Bildraum meist durch Natur- oder Stadt-Lsch. definiert, die teilw. surreal wirken; in and. Fällen wird der Bildraum collageartig aufgelöst. A. der 2000er Jahre überwiegen an den Akademismus angelehnte Akt-Darst., die, über Stadt-Lsch. schwebend, Posen aus Werken der europ. Kunstgesch. aufgreifen. Im zeichnerischen Werk dominieren Akte, es finden sich aber auch Tiere, Lsch. und Stillleben. An zahlr. Gruppen-Ausst., u.a. auch in Österreich (Graz, Wien), beteiligt. ◉ *E:* 1977 Balıkesir, Devlet Güzel Sanatlar Gal. (Debüt) / 1979, '80 Bursa, Devlet Güzel Sanatlar Gal. / Istanbul: 1986 Moda Deniz Kulübü Gal.; 1989, '90 Sanfa Sanat Gal.; 1994, '96 Ekol Sanat Gal.; 2010 Teksin Sanat Gal.; 2011 Düş Yolcusu Sanat Durağı / 1989 Eskişehir, Yapı Kredi Bankası Resim Sergisi / 1994, '97 Ankara, Vakko Sanat Gal. / 1995, 2000 İzmir Vakko Sanat Gal. / 1997 Berlin, Gal. Am Urban / 2010 Ankara, Takı Antik Sanat Gal. ⊡ *K. Özsezgin*, Türk plastik sanatçıları, Istanbul 1994. – *Online:* Website C. (Ausst.).

M. Kühn

Cella, *Gianni,* ital. Bildhauer, Maler, * 4. 3. 1953 Pavia, lebt dort. Autodidakt. 1982 Mitbegr. und bis 2000 Mitgl. der Gruppe Plumcake (zus. mit Romolo Pallotta und Claudio Ragni). Diese konzentriert sich auf die Gest. von Kunststoff und etabliert sich auf dem ital., dt. und niederl. Kunstmarkt mit an Subkultur, Alltagskunst (z.B. Sammelfigürchen von Handelskonzernen) und Pop-art anknüpfenden Trivialfiguren und Reliefs (Figürchen, Masken, Früchte) in realistisch-summarischen Formen und z.T. skurrilen Zügen. Gleichermaßen beeinflußt zeigen sich C.s starkfarbige Gem. mit Motiven des mod. Alltags, wie *Sogno lucido* (Öl, 2002), bei dem um einen poppigen Kopf eine Farbspirale mit darauf verstreuten Pillen, Kapseln und Tabletten kreist. ⊡ MACCAGNO, MCiv. Parisi-Valle. ◉ *E:* Mailand: 1983, '85 Gall. Diagramma; 1993 Studio Spaggieri; 2002 (K: M. Sciacaluga), '04 Gall. Maria Cilena; 2008 Teatro dell'Arte viale Alemagna / 1987, '92 Verona, Gall. Ponte Pietra Arte Contemp. / 1988 Bari, Gall. Zelig; Köln, Gal. Torch-Onrust; Stuttgart, Gal. Kaess-Weiss; Turin, Gall. Noire / 1989 Forlì, Oratorio S. Sebastiano; Groningen, Groninger Mus. / 1990, '94 Bern, Gal. Patrik Fröhlich / 1992 Amsterdam, Torch Art Gall. / 1993

Piacenza, Gall. Placenta Arte / 1996 Pavia, Castello Visconteo / Mannheim: 1999, 2003 Gal. Falzone; 2007 KV (mit Corrado Bonomi) / 2005 Alessandria, Studio Vigato. ⊡ Plumcake. C., Pallotta, Ragni. 1983–1996 (K Wander-Ausst.), [Vigevano 1996]; 5. Trienn. Fellbach 1992. Kleinplastik in Mexiko, Spanien, Italien, Deutschland (K Fellbach/Duisburg), St. 1992; *V. Deho* (Ed.), Vespa. Arte ital. (K Pietrasanta), Pisa 2006; Civ. Mus. Parisi valle. Acquisizioni 2007 (K), Gavirate [2007]. – *Online:* Website C.

D. Trier

Cellarius, *Andreas,* dt.-niederl. Kartograph, Mathematiker, Historiker, * um 1596 Neuhausen (heute Worms), † 1665 Hoorn/Noord-Holland. Biogr. kaum bekannt. Bis 1599 in Neuhausen ansässig, wo sein Vater 1596–99 die ev. Pfarrstelle innehat. Danach in Heidelberg. Stud. ebd. 1614–18 (oder bis 1622). Er verläßt die Univ. spätestens mit der Rekatholisierung Heidelbergs (1622). Danach Reise durch Polen; wohl ab 1625 als Lateinlehrer in Holland ansässig. 1625 (Heirat) bis 1628 in Amsterdam, 1630–37 in Den Haag an der Schule des ehem. Agnesklosters, 1637–65 in Hoorn, hier Rektor am Gymnasium des säkularisierten Cäcilienklosters. – C. beschäftigt sich E. der 1630er Jahre mit mod. Kriegsbautechnik, v.a. dem durch den Dreißigjährigen Krieg aktuellen Archit.-Thema der Geometrisierung von Stadtgrundrissen durch Bastionierung. Nach der Herausgabe einer kompilatorischen *Architectvra militaris [...] Auss den besten Authoribus zusammengetragen* (Am. 1645) widmet sich C. ab ca. 1647 der Gesch. von Astronomie und Kosmologie. In einer Art Lehrbuch kompiliert er die Kenntnisse seit der Antike und läßt sie bei dem auf Kartenwerke spezialisierten Verleger und Buchdrucker Johannes Janssonius im Großfolioformat u.d.T. *Harmonica Macrocosmica sev atlas Universalis et Novus* (Am. 1660, 1661; 1708 Neudruck der Karten ohne Text) als Suppl.-Bd. zu dessen Atlas Novus (1638–57) erscheinen. C.s Himmelsatlas enthält 29 Kpst. mit umfangreichen Kommentaren; 21 davon geben die Weltbilder von Ptolemäus, Kopernikus und Tycho Brahe wieder. Das Werk bleibt zwar wiss.-kartographisch hinter detaillierteren Kartenwerken der Zeit (z.B. der 1603 von Johann Bayer hrsg. Uranometria) zurück, stellt aber unzweifelhaft den künstlerischen Höhepunkt der Himmelskartographie des 17. Jh. dar. Welchen Anteil C. an der Karten-Gest. selbst hat, ist nicht bekannt. Die klassischen Sternkonstellationen zumindest gehen z.T. auf Vorlagen von and. Stechern zurück. Zehn Kpst. tragen die Sign. des Kartenstechers Johannes van Loon (u.a. auf Bl. 21 „Ioh. van Loon fecit"). Die Karten, auf denen das astronomische Wissen bis zur M. des 17. Jh. phantasievoll zusammengefaßt ist, bestechen durch dramatische Komp., Figurenreichtum und lebhafte Kolorierung, v.a. aber durch den Kontrast zw. der präzisen geometrischen Konstruktion der Planisphären (Linienführung, virtuose Durchzeichnung der stereographischen Projektion) und der sinnenfrohen Gest. der Sternbilder, Tierkreiszeichen sowie der Personnage an den Kartenrändern, die u.a. aus allegorischen Figuren, aber auch aus Lehrern bzw. Lehrerinnen und Schülern besteht, die Karten studieren oder um einen Globus versammelt sind.

Auf zwei Karten (Nrn 22, 23) sind die seit der Antike überlieferten Sternbilder durch christliche Figuren ersetzt, die wohl 1622 erstmals von dem niederl. Kartographen Pieter Platevoet (Petrus Plancius, 1562–1622) erdacht, auch vom dt. Astronomen Julius Schiller zus. mit J. Bayer in einem christlichen Sternatlas (Coelvm Stellatvm Christianvm, Au. 1627) veröff. wurden. ✉ Regni Poloniae, Magnique Ducatus Lituaniae [...], Am. 1659. ☐ W. B. Ashworth, The Science 25:1985 (5) 34–37; R. H. van Gent, Caert-Thresoor (Middelburg) 19:2000 (1) 9–25; id., A. C. Harmonia macrocosmica of 1660. The finest atlas of the heavens, Hongkong u.a. 2006. U. Heise

Celotti, *Vittorio,* ital. Bildhauer, * 20. 7. 1866 San Fior di Sotto, † 16. 1. 1942 Conegliano. Von 1868 bis 1915 lebt C. in Colle Umberto. Der Vater betreibt eine Kunstschreinerei, wo C. erste Erfahrungen mit dem Handwerk macht. In Vittorio Veneto besucht er die öff. Schule und gewinnt 1884/85 einen Preis für eine Skulpt.; er soll auch an der Akad. in Venedig gewesen sein. Zw. 1891 und 1898 führt er kleinere Arbeiten für Kirchen in Colle Umberto und San Vendemiano aus (Baldachine). C.s gesamtes Schaffen umfaßt sowohl Möbel als auch Stein- und Holz-Skulpt. (Sitzbänke der Kirchen in Colle Umberto, *Geschichten aus dem Leben Christi und Maria,* 1905; Portal der Abtei von Follina, 1907–09). Auch Treibarbeiten in Silber für die Pfarrk. von Bibano (1909). 1917 zieht er nach Conegliano. In dieser Zeit erhält er auch Aufträge von Zar Nikolaus II. aus Rußland, für den er Arbeiten ausführt, aber wegen des Krieges nicht mehr ausreisen kann. Vor der österr. Besetzzung flieht er 1917 nach Monza. Nach seiner Rückkehr in die Heimat ist er mit der Ausf. von Kriegerdenkmalen beschäftigt: Visnà di Vazzola (1920), Gaiarine, Ramera und Vazzola (alle 1921), Bugnera, Miane, San Michele di Piave, San Vendemiano und Zoppè (alle 1922), Cimpello (1924), San Leonardo Valcellina (1925). Am Wiederaufbau der Kirchen arbeitet er zus. mit dem Architekten Domenico Rupolo. 1923 erhält er nach der Patentierung seiner Erfindung eines didaktischen Prinzips der Modellierung einen Lehrauftrag an der Scuola di Arti e Mestieri in Conegliano. Einer seiner Schüler ist Riccardo Granzotto (seit 1936 Fra Claudio), nach dessen Entwurf C. 1928 ein Weihwasserbecken in Muschelform gestaltet. In den 1930er Jahren entstehen nur noch bescheidenere Werke, v.a. Grabsteine. 1935 fertigt er noch den *Markuslöwen* für das Stadttor von Conegliano. ⌑ Casarsa Della Delizia, Madonna del Roisario: Statue der Madonna Nicopaia, 1921. Cimadolmo, Pfarrk.: Hl. Anna mit Maria als Kind, 1917. Colle Umberto, Pfarrk.: Beichtstühle, 1921. Conegliano, Chiesa dei SS. Martino e Rosa: Statue des hl. Ludwig Gonzaga, 1926. Falz Di Piave, Pfarrk.: Statue der Madonna von Lourdes, 1916. – Santuario di Lourdes: Statuen der Madonna von Lourdes und der hl. Bernadette, 1934. Lancenigo, Pfarrk.: Statuen des hl. Antonius von Padua und des hl. Valentin, 1936. Mareno Di Piave, Pfarrk.: Engel des Hochaltars, 1917; Statue der Madonna von Lourdes, 1919. San Fior, Pfarrk.: Bildnis des Don Giulio Camilotto, 1940. San Michele Di Piave, Pfarrk.: Figur des hl. Michael, 1925. San Vendemiano, Pfarrk.:

Cherubim, 1926. Santa Lucia Di Piave, Pfarrk.: Beichtstühle, 1914. Tezze Di Piave, Pfarrk.: Altar, Statue des hl. Antonius, 1925–27. ◉ G: 1907 Treviso, I. mostra d'arte Trevigiana. ☐ G. Terzariol Fabrizio, V. C. scultore (1866–1942), Mariano del Friuli 2006.

G. Wiedmann

Celotto, *Afro,* ital. Glaskünstler, * 24. 8. 1963 Venedig, lebt in Murano. Beginnt als 14jähriger eine Lehre bei Lino Tagliapietra, wo er die trad. Techniken der Herstellung und Bearbeitung von Muranoglas erlernt. Als dessen Ass. entwickelt er bei der Fa. Effe tre Internat seine künstlerische Eigenständigkeit. In der Wkst. La Murrina erwirbt er nachfolgend die Qualifikation des „Primo maestro vetraio". Als E. der 1980er Jahre L. Tagliapietra die Fa. Effe tre Internat verläßt und nach Amerika geht, bekommt C. die Chance, eine eig. Glasbläser-Wkst. zu betreiben. 1999 ist er Mitarb. in der Wkst. Schiavon; außerdem arbeitet er eng mit dem Bildhauer und Glaskünstler Pino Signoretto zusammen. Mit den Freunden Carlo Tagliapietra und Luca Vidal gründet er nachfolgend ein eig. Studio, in dem er die trad. Produktions- und Bearbeitungsverfahren von Muranoglas innovativ weiterentwickelt. Neben Vasen, Glasobjekten u.a. fertigt C. auch thematische Serien, z.B. *Ammolite Collection* (farbliche Nachempfindungen von Ammoliten), *Magic* (trad. Stengelgläser, Pokale), *Doge of Venice* und *Roman Empire,* in denen er hist. Personen Objekte widmet. In seinen phantasievollen, farbenprächtigen Kreationen verwendet C. Fadenglas, farbloses Glas mit Fadenaufschmelzungen aus versch.- farbig getöntem Glas (reticella), transparentes Kristallglas mit eingeschmolzenen Milchglasfäden (vetro a filigrana), Glasperlen (murrini) oder mit alternierend eingewalzten, z.T. netzartigen Stäben (zanfirico) sowie zweiseitig angelegten Dekor mit vertikalen Einschmelzungen aus feinen, mehrfarbigen Glasfäden (tessuto). Neben der Bearbeitung des Glases im heißen Zustand wird nachfolgen die erkaltete Oberfläche zusätzlich beschliffen oder in Battuto-Technik bearbeitet, bei der durch mehrfaches Schleifen eine Oberfläche entsteht, die wie gehämmert aussieht. C. gilt gegenwärtig als einer der besten Muranoglaskünstler. Seine Werke sind als Unikate und Sammlerstücke in Italien, Ostasien, Mitteleuropa und seit 2004 bes. in den USA außerordentlich erfolgreich. 2010 gründet er die Fa. Art Glass Studio. ⌑ Amstelveen, Mus. Jan van der Togt. Murano, Coll. Signoretti. Venedig, Murano Glass Gall. – Vetreria Ducale. ◉ E: 2006 Wien, Pal. Ferstel / 2007 Amstelveen, Mus. Jan van der Togt / 2008 Cincinnati (Ohio), Marta Hewett Gall. – G: 2011 Rom, Le Artigiane: Coll. Signoretti di Murano / 2012 Murano, Mus. del Vetro. ☐ A. C. Contemp. glass, s.l. 2005; E. Castelli, A. C. Murano isola di fuoco e colori, Carbonate 2005; A. C. Murano art glass the magic of Murano (DVD). – Online: Kela's Glass Gall.; Website C. E. Kasten

Čeluškin, *Kirill (Kirill Borisovič;* Pseud. Bajjar, *Maks),* russ. Zeichner, Illustrator, Bildhauer, * 9. 5. 1968 Abramcevo b. Chot'kovo/Gebiet Moskau, lebt in Moskau. Stud.: bis 1994 Archit.-HS, Moskau. Zahlr. Ausz.: u.a. 1998 Golden Pen, Belgrad; 2000 1. Preis für Puškin-Ill.;

2003 für die beste russ. Ed. des Jahres. – C. ist v.a. für seine Kinderbuch-Ill. bek., die märchenhaft-ungewöhnlich sind und thematisch ein breites Spektrum umfassen. Bes. bemerkenswert sind die Ill. für *Japonskie skazki* (Mo. 1994) und *Svjatogor. Bogatyri zemli russkoj* (Mo. 1996) sowie für die russ. Übersetzungen der Werke von J. R. R. Tolkien (*Kuznec iz Bol'šogo Vuttona. Skazka* oder *Fermer Džajls iz Chema [...] i korolja Malogo korolevstva*, beide Mo. 2002). Auch plastische Arbeiten aus Schaumstoff, den Č. mit einer speziell entwickelten Technik bearbeitet (glühende Sehne, eingespannt in Säge oder Katapult); char. sind reduzierte, verallgemeinerte Formen sowie im Kontext des mod. Urbanismus provokant wirkende Figuren. C. schuf die Projekte *Module*, *Phantom limb pains* und *Konstruktorskij bjuro ili dokumental'noe proektirovanie*, alle Kunststoff, Graphit, 2001. ⌕ BOZEN, Museion. ITABASHI, AM. KÖLN, Mus. Ludwig. MOSKAU, Tret'jakov-Gal. – Ščusev-Archit.-Mus. – Ekaterina-Kulturfonds. ◉ *E:* u.a. Moskau: 1985 Archit.-HS; 1995 Ausst.-Saal Beljaevo; 1999, 2000 Novaja kollekcija; 2004 Sam Brook Gal. (Vysockij-Kulturzentrum); 2006 Krokin Gal. / 1999 Prag, Mod. book / 2001 Ivanovo, KM (Wander-Ausst.) / 2005 Paris, Gal. Rabouan Moussion. – *G:* u.a. 2001 Bologna: Internat. Bienn. der Buchgraphik; 2005 Bratislava: Internat. Bienn. der Ill. (K [* Moskau]). ▭ *M. Dmitriev*, Detskaja literatura 1998 (4). – *Online:* Krokin Gall. Moskau (s.v. Chelushkin, Kirill; Ausst.).

D. Kassek

Cemnoz (eigtl. Kamerer, *David*), dt. Graffittikünstler, * 26. 4. 1967 München, lebt in Berlin. Ausb./Stud.: 1986 Abitur; 1991–96 ABK, München, angew. Graphik (Dipl.). Ab 1983 sprüht er unter wechselnden Namen (u.a. SCUM) illegale Graffitti im öff. Raum von München. Seit 1987 nimmt er unter dem Namen C. als Mitgl. der 1985 in Paris gegr. Sprühergruppe FBI (Fabulous Bomb Inability) an internat. Graffitiprojekten teil (Wand-Gest.; Ausst.). Gehört auch den Gruppen MBG und TFP an. Organisiert seit 1995 in offiziellen Funktionen legale internat. Graffiti-Wettb. und Treffen. Gemeinsame Arbeit mit and. bek. Graffittikünstlern am ersten dt.-sprachigen dok. Kinofilm zum Thema Graffiti (*Wholetrain*, 2006; Regie: Florian Gaag; 2009 Adolf-Grimme-Preis). – C.s dynamisches Writing verrät neben dem mon. Potential viel artifiziellen Bildwitz, v.a. in den dahineilenden oder scheinbar desasträs vom Himmel fallenden typogr. inszenierten Buchstabenclustern. Bemerkenswert ist v.a. die vieldeutige Behandlung und Deutung der Serifen, die C. zu einem char. Stilelement entwickelt, das ihn neben seinen kreativen Bilderfindungen zu einem führenden Writer der dt. Graffitti-Szene in den 1980er Jahren werden läßt. ▭ *B. van Treeck*, Das große Graffiti-Lex., B. 2001. – *Online:* Wholetrain.

U. Heise

Čemus, *Otakar*, tschech. Maler, Zeichner, Illustrator, * 25. 2. 1928 Prag, lebt in Kozomín b. Úžice. Lehre als Dekorateur. Stud.: 1952–59 ABK, Prag, bei Vlastimil Rada; dazwischen Studienreise nach Italien. Zunächst als Illustrator für versch. Zss. (Pionýrské noviny; Kulturní tvorba; Svět práce) tätig; Zusammenarbeit mit Jan Drda. 1969–89 Künstlerischer Leiter der Zs. Květy. Ausz.: 1988 Verdienter Künstler. 1989 Übersiedlung nach Kozomín. Mitgl.: Středočeské sdružení výtvarníků (SSV). – Neben Akt-Darst., Genrebildern (*Zátiší s hodinami*; *Zátiší s cylindrem*, beide 1992) und Lsch., die die Erinnerung an südliche Eindrücke heraufbeschwören (*Benátky*, 1998; *Na pláži*, 1999; *Cypřiše*, 2003), entstehen symbolistische Gem. mit emotionalem, traumhaftem Gehalt (*Vzpomínka*, 1987; *Snění*, 1998; *Zrcadlení*, 2003). Auch visuelle Übersetzung musikalischer Motive und Themen (*Fuga*, 1986; *Koncert*, 2003). Zahlr. Buch-Ill. (V. Palivec, *Pověsti karlštejnského podhradi*, 1970), darunter häufig Kinderbücher (S. Rudolf, *Něžně háčkovaný čas*, 1983; K. J. Erben/B. Němcová, *České pohádky*, 2008, alle Praha). Arbeitet u.a. für die Verlage Československý spisovatel, Práce, Olympia, Středočeské nakladatelství, Melantrich, Fragment. Ferner Gest. von Grußkarten, Ausmalbüchern (*Dobré kmotřinky*; *O červené Karkulce*) und Leporellos für Kinder (*Zvířátka a Petrovští*). ⌕ PRAG, ČMVU. ◉ *E:* Kralupy nad Vltavou: 1978 Kulturní a společenské středisko Vltava (K: O. Špecinger); 1997, '99, 2001 Kulturní dům; 1998 Městské muz. / Prag: 1984 Gal. Československý spisovatel (K: J. M. Boháč); 1990 Gal. Bratří Čapků (K: V. Vinter); 2002 Klub Siesta; 2006 Středočeská energetická; 2007 Gal. MEF / 2001, '03 Poděbrady, Gal. L. Kuby / 2004 Rakovník, Rabasova gal. / 2005 Louny, Oblastní muz. / 2006 Mělník, Masarykův kulturní dům. – *G:* ab 1966, u.a. Prag: 1977 Středočeská gal. (ČMVU): Der Gemeinsame Weg ... Zum 60. Jahrestag der Großen Sozialistischen Oktoberrevolution; 1988 Středočeská gal.: 1948–1988. Obrazy, sochy, grafika ... / 2002 Český Brod, Podlipanské muz.: Salon / 2005 Kralupy nad Vltavou, Městské muz.: Jiří Corvin a jeho kralupští přátelé. ▭ SČSVU I, 1998. – *F. A. Razetto u.a.*, Socialistický realismus Československo 1948–1989, Praha 2009; *P. Kmošek*, Středočeské ateliéry 1:2008, 34–38.

M. Knedlik

Cen *Guangyue* (eigtl. Cen *Xiaoxian*; Minzhong; Hechan; Yuanjing daoren), chin. Kalligraph, Siegelschneider, Dichter, Prosaist, Pädagoge, Beamter, * 25. 5. 1876 Guizhou b. Shunde/Prov. Guangdong, † 17. 8. 1960 Hongkong. Stammt aus angesehener Gelehrtenfamilie. Der Vater Cen Wen war bes. als Dichter bekannt. Die trad. Ausb. in den konfuzianischen Schriften erfolgt in der Familie. Zw. 1889 und 1891 studiert C. klassische Lieddichtung (ci) bei einem Onkel väterlicherseits. Ab 1891 zus. mit dem älteren Bruder Cen Guangyong Ausb. an der Dushu caotang-Akad. (Dushu caotang) des namhaften Guangdonger Gelehrten und Kalligraphen Jian Chaoliang. 1898 erfolgreiche Prüfung zum Acht-Reihen-Tänzer (Yiwu sheng) am Konfuzius-Tempel. 1899 Examina auf Prov.-Ebene in Archäologie und Geschichte. 1901 Juren-Examen. 1904 nach bestandenen Vorprüfungen Jinshi-Examen. Danach Erwählter Gelehrter (Shujishi) der Hanlin-Akad. 1906–08 Stud. an der Tokioter Hōsei-Univ. (Hōsei Daigaku). Nach Studienabschluß in Japan erneut tätig in China an der Hanlin-Akad., u.a. als Kompilator (Bianxiu), Grandee der Umfassenden Ermahnung (Tongyi Dafu) sowie Kolla-

tionator und Kompilator im Archiv für Staatsgeschichte (Guoshiguan). 1912 nach Abdankung des letzten chin. Kaisers Puyi (Reg.-Zeit 1908–12) Niederlegung aller Ämter und Rückzug aus dem Staatsdienst in die Heimat Guangdong. Zeitweiliger Aufenthalt in der Shanghaier Frz. Konzession. 1922 wieder in Shunde, nimmt C. den Beinamen „Hechan" an und widmet sich fortan pädagogischen Aufgaben. Ab 1925 Lehrer an der Hongkonger Sing Tat Acad. (Chengda shuyuan). 1926–38 ebd. Lehrer an der Vernacular Normal Middle School (Guanli Hanwen zhongxue, heute Clementi Secondary School). 1938 Pensionierung, jedoch Forts. der Lehrtätigkeit an der Southwestern Normal Middle School (Xi'nan zhongxue). Im Febr. 1941 zus. mit dem bek. Kanton-Opern-Darsteller Ma Shizeng Begr. des Ver. der Hongkonger Landsleute aus Guizhou b. Shunde (Lü Xiang Shunde Guizhou tongxiang hui). Bei der Begründungsfeier des Ver. am 7. 9. 1941 Inauguration der Zs. Guizhou yuebao (Guizhou Monthly), deren Titelkalligraphie aus der Hand C.s stammt. 1945–47 kurzer Aufenthalt in der Heimat. Ab 1947 wieder in Hongkong. Begr. der Priv. Sing Tat Middle School (Sili Chengda zhongxue), ab 1948 mit Zweigstellen in versch. Hongkonger Stadtteilen, und Schulrektor (Xiaozhang) bis zur Schließung 1960. Im Aug. 1960 verstirbt C. nach Krankheit. Die Beisetzung erfolgt auf dem Tsuen Wan Chin. Permanent Cemetery. – Der versierte Dichter und Prosaist mit buddh. und daoistischen Neigungen hinterläßt mit Hechan ji (Slg des Hechan) eine Auswahl an Prosa, Dichtung, Inschr. und Elogen sowie Spruchpaare und Kostproben seiner Kalligraphie. In Shunder und Hongkonger Kunst- und Kulturkreis verkehrt C. mit Schriftkünstlern und Kritikern wie Chen Botao, Ou Dayuan, Wu Daorong und Zhu Ruzhen. Er macht sich bes. durch seine Kursivschrift (xingshu) und Konzeptschrift (caoshu) einen Namen. Die satt aufgetragene Tusche und der feste Strich verleihen dem in Kursivschrift kalligraphierten Sieben-Wort-Spruchpaar (qiyan dualian) Huanghun (Dämmerung, Tusche/Papier, Hängerollenpaar, sign., zwei Siegel; Xianglong, Hongkong, Aukt., 28. 11. 2009, Los 164) ungewöhnliche Vitalität und Kraft. Die von dem zeitgen. Kalligraphen und Kritiker Zhou Guandeng gelobte Mächtigkeit und Dichte kontrastiert bei diesen Zeilen, die trad. mit dem von Huairen (tätig zw. 627 und 649) im Schriftduktus Wang Xizhis (* 307, † 365) geschriebenen Da Tang sanzang Shengjiao xu (Vorw. zu den hl. Lehren des Tripitaka der Großen Tang) von Tang-Taizong (Reg.-Zeit 626–49) assoziiert sind, suggestiv mit dem leeren Raum des Bl.-Weiß und den ästhetisch wirksam plazierten baiwen-Siegeln (weiße Schriftzeichen auf rotem Grund). Paradoxerweise, jedoch der Logik der Umkehrung entsprechend, stabilisiert C.s Schriftkunst die in den Versen zum Ausdruck kommende Ephemerität der Dingwelt und wendet diese in Dauer. C.s robuste Kursivschrift ist nach Zhou Guandeng von Normalschrift (kaischu)-Vorbildern wie der anonymen Kalligraphie der Gao Zhen bei (Gao Zhen-Stele, 523; Qufu/Prov. Shandong, Stelenwald der Konfuzius-Fam.) der Nördlichen Wei (386–535) und dem anonymen tang-zeitlichen Dengcisi bei (Stele

am Dengci-Kloster, 628, Fragm.; Baoji, City Mus.) geprägt. Sie zeigt jedoch auch Spuren des Einflußes von Zhao Mengfu (* 1254, † 1322). C.s Striche sind jedoch weniger schlank, die Punkte (dian) betont gerundet. Die rechtsgeneigten Schrägstriche mit manierierter, am Ende in einen Haken mündender Linksbewegung, läßt die Zeichen geschlossen, sehr kompakt und manchmal gedrungen erscheinen. C.s Verehrung der Tang-Meister Zhang Xu (* um 675, † 759) und Yan Zhenqing (* 709, † 785), deren Schriftkunst C. vermutlich durch Jian Chaoliang vermittelt wird, drückt sich in einer Fächeraufschrift (Tusche/Goldsprenkelpapier, sign., drei Siegel) aus. Ein Fünf-Wort-Kurzgedicht (wuyan jueju) in Konzeptschrift (Tusche/Papier, Hängerolle, sign., 1940; Hongkong, Taiyilou Coll.) steht exemplarisch für C.s Bestreben, Dunkelheits- und Druckunterschiede zur Erreichung von Ebenmäßigkeit zu vermeiden. Dies wird unterstützt durch die in einem gedachten Raster positionierten, parallel geführten Zeichenkolumnen. In kleinerer Schrift gehaltene Kolumnen mit Widmung rechts sowie Datum, Sign. und zwei Siegeln links betonen die Binarität der Komp. und deren symmetrischen Grundgedanken. ✉ Hechan ji (Slg des Hechan), Xianggang 1984. 🕮 Chin. paint. and calligraphy by Guangdong and Hong Kong artists from the Taiyilou coll. (K), Hong Kong 1992; Zhuang Mengxue u.a. (Ed.), Zhongguo jindai shuhua jicui, Taizhong 1993; Xu Youchun (Ed.), Minguo renwu da cidian. Zengding ben, I, Shijiazhuang 2007, 651 s. – Online: p. 367art; wiki. 0757family. U. Middendorf

Cen Xuegong, chin. Maler, * Juni 1917 Hohhot/Innere Mongolei, † 27. 7. 2009 Chengdu. Stammt aus einer Mandschu-Familie. Geht mit 17 Jahren nach Nanjing, wo er drei Jahre arbeitet und nebenbei Bücher zur Malerei studiert. Bei Kriegsausbruch (jap. Invasion) flüchtet C. zu Fuß nach Sichuan. Später Stud. der Malerei an der Nat. Central Univ. (Guoli Zhongyang Daxue; heute Nanjing Univ.) bei den bed. Malern Xu Beihong und Huang Junbi (Examen 1944). Davor bereits Sekretär in der All-China Art Association. 1948 Doz. für trad. chin. Malerei am Nat. College of Art in Hangzhou. 1949 Umzug nach Congqing/Prov. Sichuan, wo er in der neu gegr. China Federation of Lit. and Art Circles arbeitet. 1972 Umzug nach Chengdu, wo er bis zu seinem Tod für die Chengdu Art Acad. tätig ist. Ab 1949 Mitgl. im Chin. Künstler-Verb. (Zhongguo meishujia xiehui; ab 2001 Ehren-Mitgl.). Ferner Ausschuß-Mitgl. der Politischen Konsultativkonferenz des Chin. Volkes für die Stadt Chengdu. Rege nat. und internat. kult. und wiss. Tätigkeiten. Erste Ausst. 1943 in Chengdu. 1945 Ausst.-Beteiligung in London und Kalkutta (Kolkata). Bereits ab 1946 Einzel-Ausst. u.a. in Chengdu, Nanjing, Chongqing, danach zahlr. nat. Ausst. (1954, '62, '65, '72, '78), die ihn bek. machen. 1982, '84 und '85 kuratiert C. in Nanjing Ausst. von bed. innovativen Malern im Guohua-Stil wie Huang Junbi, Huang Chunyao und deren Schülern. Seit 1988 zunehmend internat. Ausst. (Hongkong, Seoul anläßlich der Olympischen Sommerspiele). In Japan ausgezeichnet mit der Gold-Med. für Drei Schluchten des Jangtse; 1988 Gold-Med. der Ausst. Kunst der Minderheiten. –

Spezialisiert auf mon. Lsch. im trad. chin. Tuschestil (guohua). Char. für C.s Malerei ist die reichhaltige Verwendung schwerer Tuschen sowie kräftiger Farben. Vorbilder findet er insbesondere in der Mal-Trad. der Nördlichen Song-Dynastie; in der Behandlung des Horizonts ist westlicher Einfluß spürbar. Häufige Motivquelle ist die Topogr. Sichuans (Bashan Shushui). Wiederkehrende Themen sind Lsch., die durch ihre reiche hist. Vergangenheit auch für das Neue China identitätsstiftende Bedeutung haben (*Drei Schluchten des Jangtse, Dujiangyan*; Beijing, Imperial Pal. Mus.). Häufig finden sich auch Kiefer-Bilder (Fächerformat). In China bek. als „C. der Drei Schluchten" und Begründer der gleichnamigen Malrichtung. ☐ BEIJING, Imperial Pal. Mus. ☐ Zhongguo xiandai, 1988; *E. J. Laing*, An index to reprod. of paint. by twentieth-c. Chin. artists, Ann Arbor 1998; *Bénézit* III, 1999.

A. Papist-Matsuo

Cencin, *Vincenzo*, ital.-brasil. Maler, Ingenieur, * 13. 5. 1925 Venedig, tätig in São Paulo. Autodidakt. 1943 Gefangennahme durch dt. Truppen, 1949 Immigration nach Brasilien, dort zunächst in São Paulo Tätigkeit als Ing. und Mitgl. der ABA, Rio de Janeiro. 1981 Eröffnung der eig. Gal. Velha Europa, São Paulo. Ausz.: 1982 Gold-Med. des Salão Nac. de Artes Plást. Jean Baptiste Debret und des Salão Nac. de Artes Plást. Pablo Picasso; 1983 Diploma Gente de Destaque der Ztg O Globo; 1985, '86 Gold-Med. des Salão Oficial de Artes Plást., alle ebd. – Figurative Malerei, zumeist ital. Veduten, darunter Ansichten von Häfen, Stränden und Städten, aber auch Stilleben und Seestücke. Häufige Motive sind seine Heimatstadt Venedig sowie heimkehrende Segelboote und Fischer bei der Arbeit. C.s naturalistisch-poetische Gem. (Öl/Holz und Lw.) sind nostalgisch geprägt und in impressionistischem Duktus mit bes. Interesse für Spiegelungen und intensive Lichtreflexe ausgeführt. ☐ BUENOS AIRES, Mus. Naval de la Nácion. MADRID, Prado. RIO DE JANEIRO, MNBA. SÃO PAULO, Acad. Paulista de BA. – Banco Cidade. ◇ *E:* 1983, '88, '94 Rio de Janeiro, Gal. Borghese / São Paulo: 1992 Gal. Grossmann (Retr., K); 1999 Gal. de Arte Val Santinho / 2000 Blumenau (Santa Catarina), Espaço BA / 2001 Curitiba, Nini Barontini Gal. / 2002 Joinville (Santa Catarina), Espaço Cult. Leonardo da Vinci. – *G:* São Paulo: 1997 Casa de Minas: Visões do Brasil; 1998 Gal. de Arte André: Paisagens; 2002 Nova André Gal. de Artes: Paisagens do Imaginário; 2009 Gal. Mali Villas-Bôas: Artistas Consagradas Brasil. / 2005 Belo Horizonte, Gal. Errol Flynn: Grandes Acadêmicos no Brasil. ☐ *E. Sacramento*, 30 Artistas brasil. na col. do Banco Cidade, S. P. 1995. – *Online:* Inst. Itaú Cult., Enc. artes visuais.

C. Melzer

Cendoya Oscoz, *Eugenio Pedro* (Cendoya, *Eugenio*), span. Architekt, * 6. 9. 1894 Villabona/Guipúzcoa, † 29. 3. 1975 Barcelona. Stud.: bis 1917 (Abschluß; ab 1926 Prof.) Esc. Tècnica Superior d'Arquit. ebd., Schüler von Lluís Domènech i Montaner und August Font i Carreras. Kurzzeitig Wohnsitz in der baskischen Prov. Guipúzcoa, dann in Barcelona. Ab 1967 Dekan der Architektenkammer (COACB) ebd. – C. bewegt sich innerhalb des Noucentisme, einer den Modernisme ablösenden Archit.-Strömung, die, im Kern neuklassizistisch, progressive bis reaktionäre Tendenzen unter einem katalan.-nationalistischen Überbau vereint. Neben zahlr., wenig beachteten Bauten der konservativen Linie entwirft C. den bed. Pal. Nac. (1925–29, mit Enric Catà Catà und Pere Domènech i Roura) für die WA 1929 auf dem Hügel Montjuïc in Barcelona (seit 1934 MN d'Art de Catalunya). Das mon. eklektizistische Prunkgebäude verbindet versch. span. Archit.-Stile und fordert eine archit.-theoretische Kritik geradezu heraus. Gleichwohl führt die Mißachtung klassischer Kanons mit Blick auf die Proportionierung zu wohlkalkulierter räumlicher Einheit. Beachtenswert sind v.a. das Vestibül, das Treppenhaus und der mon. ovale Kuppelsaal. ☐ BARCELONA, Pl. Catalunya: Banco de Vizcaya, 1928 (mit Manuel Galíndez Zabala). – Pavillon der Span. Ges. für Schiffsbau, WA 1929. – Pfarrk. S. Francisco de Paula, 1946. – Banco de Bilbao. – Calle Escorial 155: Pfarrk. S. Miguel de los Santos. – Pl. Ferran Casablancas: Krypta der Pfarrk. Virgen de la Paz. CASTELLAR DEL VALLES: Wohngebäude. L'ARBOÇ (Tarragona), Pfarrk. S. Julián: Presbyterium. MATARO: Grabstätte Ribas, 1925. SAN SEBASTIAN, Calle Oquendo 12: Wohngebäude, 1920–22. VILLARREAL (Valencia), Calle Mayor San Jaime: Caixa d'Estalvis, 1930. ZARAGOZA, Calle Joaquín Costa 3: Wohnblock, 1926. ☐ *Ráfols* I, 1951; *J. Martínez Verón*, Arquitectos en Aragón, I, Zaragoza 2000. – *J. E. Hernández-Cros u.a.*, Arquit. de Barcelona, Ba. ²1973; *J. M. Montaner*, Barcelona. Archit. und Stadt, Köln 1992.

A. Mesecke

Cenicacelaya (C. Marijuán), *Javier*, span. Architekt, Stadttheoretiker, * 1951 Bilbao, lebt dort. Stud.: bis 1975 (Abschluß) Esc. Técnica Superior de Arquit., Pamplona (Univ. de Navarra); bis 1978 School of Archit., Oxford. 1983 Bürogründung mit Iñigo Saloña Bordas in Bilbao. Seitdem Prof. der Esc. Técnica Superior de Arquit., San Sebastián (Univ. del País Vasco); Gast-Prof. und, 1990–92, Dekan der School of Archit., Miami/Fla.; 1993 Gast der J. Paul Getty Found., Los Angeles/Calif. (mit I. Saloña Bordas). Zahlr. Vorträge in Europa und den USA, u.a. in der Accad. Britannica, Rom, und im Inst. Tecnológico, Monterrey (Mexiko). 1988 Gründer und Dir. der Fach-Zs. Composición arquit., art & archit. (1988–93); Kurator versch. Ausst.; Mitgl. im Expertenkomitee des span. Bauministeriums. Ausz. u.a. (mit I. Saloña Bordas): 1992 und 1995 Europ. Award for the Reconstr. of the City, Brüssel. – Das umfangreiche und vielfältige archit. Schaffen von C. und Saloña Bordas konzentriert sich im wesentlichen auf das Baskenland. Internat. engagieren sich die Partner in der Organisation Congress for the New Urbanism (CNU), deren Wegbereiter in den USA seit den 1980er Jahren als Reaktion auf die Zersiedelung eine Rückkehr zur verdichteten trad. Stadt „der kurzen Wege" einfordern. Aus diesem Blickwinkel heraus stellt C. hist. und theoretische Untersuchungen zu Bilbao an. Gegen den funktionalistischen Stadtentwurf der CIAM gerichtet, ist mit der nachhaltigen durchmischten Nachbarschaftsstadt zwar nicht zwingend, aber überwiegend auch

eine traditionalistische Archit.-Konzeption verbunden. Bereits C.s frühe Bauten zeigen seine Sympathie für die plakativ-historistische Postmoderne und geringes Interesse an funktional konzipierten Grundrissen, die er, auch ohne Bezug zur Außenhülle, stereotypischen Regeln der Symmetrie unterordnet. Das ländliche Kultur- und Freizeitzentrum in La Rigada/Muskitz (1985–87) ist als röm. Basilika mit Säulenumgang und palladianischen Motiven entworfen und soll mit seinem Sockel aus Bruchsteinmauerwerk und formaler Kargheit den Bezug zur bodenständigen baskischen Archit. herstellen. In einer Wohn- und Büroanlage in Burgos (1989–93) wird hingegen die expressionistische Art-Déco-Ästhetik der 1930er Jahre in Erinnerung gerufen. Von städtebaulicher Dimension ist der komplexe, nicht ausgef. Wettb.-Entwurf für die Univ.-Bibl. von Amiens (1991). Er weist neben versch. Zitaten aus der europ. Archit.-Gesch. eine der Umgebung entsprechende kleinteilige Fassadenabwicklung aus Giebelhäusern auf, die im Gebäudeinnern von drei die Lesesäle überspannenden Turmaufbauten in Anspielung an das Kloster El Escorial überragt werden. Trotz lokaltypischer Referenzen wie Farbgebung und die Installation eines Wasserbeckens entsteht auch im Fall der antikisierenden kath. Kirche St. John Neumann mit flacher Hängekuppel in Miami/Fla. (1990–92) der Eindruck von Beliebigkeit. Die Orientierung an der jeweiligen regionalen Archit.-Trad. zählt zu den Forderungen des New Urbanism nach archit. und typologischer Vielfalt im Rahmen eines städtebaulichen Regelwerks. Daß dies v.a. infolge ökonomischer Interessen zum Verlust gegenwartsbezogener kritischer Auseinandersetzung mit dem Ort und zum Verschwinden von Identifikationsmerkmalen führen kann, zeigen C.s und and. internat. Beiträge zum Berliner Quartier am Tacheles an der Oranienburger Str. (2000; Baubeginn mehrfach verschoben). Das nach dem Masterplan von Andrés Duany und Elizabeth Plater-Zyberk entworfene luxuriöse Wohn- und Geschäftsviertel im Stadtzentrum soll im historisierenden Stil US-amer. Metropolen der 1920er Jahre errichtet werden. Im Gegensatz hierzu läßt C. mit dem nach mod. rationalistischen Gest.-Prinzipien erbauten Nahverkehrsbahnhof und dessen Bahnsteigüberbauung in Santurtzi (2003–05) einen abstrakten Umgang mit dem klassizistischen Formenrepertoire erkennen. ⌂ ALYS BEACH/Fla.: Einfamilienhäuser, ab 2005. BILBAO, Calle Zamakola 116–118: Wohn- und Geschäftshaus, 1996. – Gran Vía 25: Pal. de la Diputación Foral de Vizcaya (Rest.), 2001. – Wohngebäude Atxuri, 2005–08. BRÜSSEL, Rue de Laeken: Wohnhaus (Rekonstr.), 1992–95. DERIO: Mehrzweckhalle Sagrada Familia, 1987–89. DURANGO: Kulturzentrum Astarloa, 1990–95. GALDACANO: Villa Elexalde, 1995–97. IZARRA: Wohnungsbau, 2004–06. SAN IGNACIO: Wohn- und Geschäftshaus, 1997. ✉ Arquit. neoclásica en el País Vasco, Bilbao 1994; C./A. Román/I. Saloña, Bilbao 1300–2000. Una visión urbana, Bilbao 2001; Bilbao. Guía de arquit. metropolitana, Bilbao 2002; Bilbao study (Spain), in: Council report V. The eurocouncil. Europ. urbanism, Gaithersburg, Md. 2003; C. (Ed.), Trelles cabarrocas architects, Bilbao 2008. ◉ G: 1992 Venedig: Archit.-Bienn. / 2008 London, Prince's Found. Gall.: New Palladians (K). ⌨ Dict. de l'archit. du XXe s., P. 1996. – H. Bodenschatz, Bauwelt 2003 (8) 18; J. Borja/Z. Muxí (Ed.), Urbanismo en el s. XXI. Una visión crítica. Bilbao, Madrid, Valencia, Barcelona, Ba. 2004. – Online: Website C.; Saloña. A. Mesecke

Cennetoğlu, *Banu,* türkische Fotografin, Buch-, Konzept- und Installationskünstlerin, * 1970 Ankara, lebt in Istanbul. Stud.: Psychologie (Bachelor); 1994–96 Fotogr. in Paris. Danach arbeitet C. 1996–2002 als Mode- und Pressefotografin in New York. 2002–04 Atelier-Stip. an der Rijks-ABK, Amsterdam. 2006 kehrt sie in die Türkei zurück. Im gleichen Jahr eröffnet sie den Kultur- und Kunstraum BAS in Istanbul, in dem türkische Künstlerbücher gesammelt, ausgestellt und verkauft werden. Mit der niederl. Fotografin *Philippine Hoegen* (* 14. 12. 1970 Kitzbühel; bis 1997 Koninkl. ABK, Den Haag; lebt in Rotterdam) gründet sie die Künstlerbuchreihe *Bent.* – C.s Œuvre umfaßt Printmedien (*False Witness,* 2003; *15 Scary Asian Men,* 2005), Fotogr. und Videoarbeiten. In ihren Installationen, in denen sie diese Medien inszeniert, legt sie die Diskrepanz zw. der Erwartung des Betrachters auf Abb. der Realität und der diesen Medien inhärenten Eigenschaft der Vervielfältigung und Manipulation offen. Neben der Thematisierung der Nachrichtenflut (*20. 8. 2010*; *Swiss Newspapers 14. 2. 11*) und der Erörterung von Landaneignung und Verlust (*Determined Barbara,* Fotoserie, 2002–04) setzt sich C. auch mit weiteren Fragen der individuellen und kollektiven Erinnerung sowie deren Medien bzw. Speicherformen auseinander (*Catalog,* 2009; mit dieser Arbeit auch auf der Bienn. in Venedig). ◉ E: zuletzt 2010 Istanbul, Rodeo Gal. / 2011 Basel, Kunsthalle. – G: 2004, '08 Berlin: Bienn. / 2005 Paris, Pal. de Tokyo: Emergency Bienn. Chechnya/Grozny (mehrjährige Welttour) / 2007 Istanbul: Bienn.; Athen: Bienn.; Minneapolis, Walker AC: Brave New Worlds; Codroipo, Villa Manin: EurHope 1153 / 2008 Frankfurt am Main, Dt. Archit.-Mus.: Becoming Istanbul; Istanbul, Akbank Sanat: States of Ecstasy; Bergamo, Gall. d'Arte Mod.: Data Recovery / 2009 Venedig: Bienn. / 2010 Genf, Centre de la Photogr.: La Revanche de L'archive Photogr.; Toruń, Zentrum für zeitgen. Kunst (CoCA): The Past is a foreign Country / 2011 Tallinn, KUMU: Beyond. ⌨ A. Stepken (Ed.), Sisters and brothers and birds (K), Ka. 2004; V. Kortun/E. Kosova, Szene Türkei. Abseits, aber Tor!, Köln 2004. – Online: Website C. M. Kühn

Centner, *Jessica,* dt. Bildhauerin, Malerin, Installationskünstlerin, * 10. 10. 1971 Ludwigshafen, lebt in Berlin. Stud.: 1994–96 KHS, Kassel (bei Silke Leverkühne und Rob Scholte); 1996–99 ABK, Karlsruhe (bei Helmut Dorner). 2005–06 Lehrauftrag KHS, Berlin-Weißensee, Fachbereich Bildhauerei. – C.s Interesse gilt der Farbe im Raum. Ihre künstlerische Praxis umfaßt einen konzeptuellen Umgang sowohl mit der Malerei als auch mit der Bildhauerei, wobei sie das spannungsvolle Wechselverhältnis dieser Gattungen bis hin zu raumbestimmenden Installationen untersucht. Dabei bedient sich C. der Formensprache der Minimal art, verzichtet jedoch nicht

auf eine erzählerische Komponente. Die zwölfteilige Siebdruckserie *Femmage* (2005) etwa huldigt den wenigen sich im Kunstbetrieb behauptenden Künstlerinnen, indem ihre Namen als Logo auf Goldgrund erscheinen. Serielle Skulpt. aus weiß lackierten Keilrahmen stellen eine Reverenz an Sol LeWitts Rasterkuben dar. Die Arbeit *Texas ist der Grund* (2006), deren Titel an die Wirkungsstätte von Donald Judd erinnert, besteht aus acht monochromen Stelen, die in einem Raum präzise auf Sichtachsen komponiert sind. Die Stelen aus handelsüblichen Legosteinen verlängern als Türme die gleichfarbigen Sockel – die Grenze zw. Skulpt. und Sockel ist fließend. Mit ihrer „Kunst über Kunst" bezeugt C. einen spielerischen Umgang mit der ernsten Strenge minimalistischer Konzepte. ⌷ WALDENBUCH, Mus. Ritter (Slg Marli Hoppe-Ritter). ◉ *E:* 2004 Düsseldorf, Konsortium (Wander-Ausst.) / Berlin: 2005 Glue; 2006, '07 Gal. Asim Chughtai / 2007 Erfurt, Kunsthaus / 2008 Stuttgart, Gal. Mueller-Roth. – *G:* 2004 Genf, MAH: Yellow Pages / Berlin: 2004 Schickeria: Fax (Wander-Ausst.); Glue: 2005 Outsorting; 2006 Value; Showroom Berlin: Wir hätten das Land gern rund und weit und Sie ...; 2010 Temporäre KH: Zeigen – Eine Audiotour durch Berlin von Karin Sander / 2005 München Gal. Hobbyshop: me, myself and I (Wander-Ausst.) / 2007 Dresden, Büro für Kunst: ablesen (Wander-Ausst.); Amsterdam, PS projectspace: PDP / 2008 Stuttgart, Gal. Mueller-Roth: Höhe – Breite – Tiefe. ⌶ *T. Wall*, in: Hommage an das Quadrat (K Mus. Ritter), He. 2009. – Mitt. C. – *Online:* Website C. H. Uhr

Cento, *Giuseppe*, ital. Architekt, Zeichner, Fachautor, * 30. 4. 1899 Turin, † 24. 4. 1992 ebd. Stud.: 1915–22 Accad. Albertina ebd. 1922 Dipl. als Lehrer für archit. Entwurfszeichnung. Später dort und am Liceo artist. ebd. Lehrer für geometrisches und perspektivisches Zeichnen, außerdem Autor von archit. Lehrbüchern. Als Archit.-Zeichner an Publ. and. Autoren beteiligt (G. M. Pugno, *La chiesa del Carmine in Torino*, T. 1966). – Von Neuer Sachlichkeit und Bauhaus geprägte Landhausentwürfe und Messestände (Fa. Emanuel, Mailänder Messe, 1934) setzen auf die asymmetrische Gliederung des Baukörpers und der Fassaden. Entwürfe der 1930er Jahre für Sakralgeräte und Kirchenausstattung (Altar, Lampen und Leuchter für die Turiner Kirche Madonna di Campagna) geben historistisches Formengut vereinfacht und versachlicht wieder. ⌷ TURIN, Accad. Albertina, Plan-Slg: zahlr. Projektpläne, 1929–50. ✉ Rilievo archit., T. 1944; Prospettiva ed ombre geometriche, T. 1946; Prospettiva con indirizzo all'applicazione pratica ..., T. 1947; Rilievo edilizio archit., Ge. 1959 (jeweils mehrere Aufl.). ⌶ Bessone-Aurelj, DizScultArchit, 1947; *G. Vaccaro* (Ed.), Panorama biogr. degli ital. d'oggi, I, R./Fi. 1956. – *A. R. Masiero/ E. Dellapiana* (Ed.), in: *G. M. Lupo* (Ed.), Gli architetti dell'Accad. Albertina (K), T. 1996. D. Trier

Ceppi, *Maria*, schweiz. Malerin, Graphikerin, Installations- und Konzeptkünstlerin, * 7. 3. 1963 Visp, lebt dort. Als Werbegraphikerin u.a. 1991 Wahlplakat für die Frauenbewegung in der Schweiz, 1992 Plakat für den Orchesterverein in Visp. 2003 realisiert C. zus. mit 40 Stickerin

nen u.d.T. *Zeitdokument* einen Gobelin (345 x 532 cm), der einen Tunnelbau abbildet. Seit Jahren beschäftigt sich C. mit der Poesie des Alltäglichen, indem sie Gebrauchsgegenstände „entnutzt", daraus Kunstobjekte kombiniert und diese als *Objets Cultes* fotografiert. ◉ *E:* 2009 Zermatt, Gal. Kunsträume. – *G:* 2008 Lugano, KM: Enigma Helvetia (K: P. Bellasi u.a.); Bex: Bex & Arts. ⌶ KVS, 1991; BLSK I, 1998. – *R. Friedrich*, Neue Zürcher Ztg v. 23. 5. 2008. – *Online:* SIKART Lex. und Datenbank.
 S.-W. Staps

Ceprián (C. Cortés), *Víctor*, span. Maler, Bildhauer, Zeichner, Graphiker, Fotograf, * 13. 1. 1946 Aldeaquemada/Jaén, lebt in Las Rozas/Madrid. Stud.: 1968–73 EBA der RABA de S. Fernando, Madrid; Acad. Artium; Modellieren bei Jorge Oteiza. 1988 mit Andrés Gil Miguel und Jordana Jimeno del Viso Gründung der Gruppe Triángulo in Madrid; Ausf. von vier Wandbildern in der U-Bahnstation Velázquez (1991 Auflösung der Gruppe). 1989 Serie von Skulpt. für die Correduría de Reaseguros Skandia und 1991 für Sema-Group ebd. Seit 2003 Mitgl. der Gruppe Equivalentes. 2004 span. Kommissar für die Internat. Bienn. zeitgen. Kunst in Arad/Rumänien. Ausz.: u.a. 1969 Premio de Est. en Dibujo; 1970 Premio de Est. en Paisaje, beide Madrid; 1988 Expos. Nac., Valdepeñas. – C. arbeitet in versch. Techniken. Die Gem., meist Mischtechnik auf Lw. oder Karton, sind in ihrer Grundstruktur geometrische Komp., teils mit gegenständlichen Elementen, die irreale, sich durchdringende Räume und teils wie schwebend erscheinende archit. Körper andeuten. Eher flächig-malerischen Char. weisen die farbigen Tuschfeder-Zchngn auf. Es sind freie Komp. aus wenigen großen, wie Rippen oder Äste erscheinenden Linien, rasterartigen, mit Schablonen erzeugten Strukturen, manchmal auch biomorphen Formen, die über meist dunklen diffusen Farbgründen liegen. Auch C.s Fotogr. sind komplexe Komp. aus mehreren Bildebenen. Neben verfremdeten Panorama-Aufnahmen von Madrid und urbaner Staffage stehen Spiegelungen, Durchblicke und ungewöhnliche Perspektiven, Licht- und Schattenspiele, Stoff- und Mauerstrukturen, Graffiti und Silhouetten. Sie ergeben ungewöhnliche, schwer lesbare und geheimnisvolle Bilder (Serien *Escaparate*; *Vitrina*; *Ventana*). Ihnen verwandt sind C.s digitale Komp., in die teils fotogr. Vorlagen eingearbeitet sind. C.s Plastiken bestehen aus hochgebranntem Ton oder Porzellan (z.T. kombiniert), sind farbig gefaßt, manchmal mit Email, Papier oder and. Mat. ergänzt. Sie deuten Figürliches an, ähneln Geräten, haben denkmalhaften oder totemistischen Char. und weisen zeichenhaft-skripturale Elemente auf, verbunden mit einer lyrisch-spielerischen, manchmal auch humorvollen Note. Etliche Plastiken besteht aus hellen und dunklen Tonwürsten, aus denen dichte kubische Ballen versch. Volumens oder schmale und hohe Rundtürme geformt sind. ⌷ BAEZA/Jaén, MAC. CIUDAD REAL, Prov.-Verwaltung. JAÉN, Mus. Prov. – Univ. MADRID, Banco de Santander. – BN. – Mus. Postal y Telegráfico. – Mus. de la RABA de S. Fernando. – Pin. de la Empresa Metropolitana. MÓSTOLES/Madrid, Univ. Rey Juan Carlos. QUESADA/Jaén, Mus.

Rafael Zabaleta. Santiago de Chile, Fund. Víctor Jara. Vélez-Málaga, Fund. María Zabrano. – MAC. ◉ E: Madrid: 1971 Colegio Mayor Juan Luis Vives (K); 1975, '86, '96 Gal. Seiquer (K); 1977 Gal. Bética; 1988 Centro Cult. Rafael de León; 2008, '09 Espacio Pepa Jordana (K) / 1975 Navacerrada (Madrid), Gal. Doña Endrina (K) / 1980 Valencia, Gal. Crismon (K) / Jaén: 1989 Sala General (K: J. Jimeno); 1994 (K: J. Viñals), '95, 2004 Gal. Jabalcuz; 2004 Mus. Prov. (K); 2005 Centro Cult. Casa Almansa (K) / 2009 Toledo, Ar+51 Gal. de Arte (K). – G: Madrid: 1989 Estación de Velázquez: Triángulo (K); 1990 Gal. Taller de Arte: Triángulo G (K: J. Sáiz y Luca de Tena) / 2003 Florenz: Bienn. Internaz. d'Arte Contemp. / 2004 Potenza Picena: Ventipertrenta04. Internat. Digital Art Festival / 2007 Torredelcampo (Jaén), IES (Inst. de Enseñanza Secundaria) Torre Olvidada: Muestra arte digital. ▢ J. V. Córcoles de la Vega, Bol. del Inst. de Est. Giennenses (Jaén) 2003 (185) 99–110; P. A. Galera Andreu/M. Viribay, Grupo hispano it. Equivalentes (K), Jaén 2006; J. Miranda Ogando, Cerámica esp. para el s. XXI (K Wander-Ausst.), Ma./Taipeh 2011. – Online: Website C. – Mitt. C. M. Nungesser

Cerati, Carla (geb. Tironi), ital. Fotografin, Schriftstellerin, * 3. 3. 1926 Bergamo, lebt in Mailand. Autodidaktin. Schon als Jugendliche künstlerisch tätig (Prosa, Poesie, Skulpt., Zchngn). 1947 Heirat mit Roberto Cerati (zwei Kinder). Ab 1952 in Mailand, wo C. seit E. der 1950er Jahre fotografiert. 1959 lernt sie beim Circolo Fotogr. Milanese. Ab 1960 als Bühnenfotografin tätig (u.a. Teatro Manzoni), auch als Fotoreporterin (u.a. 1962 für L'Ill. Ital.; auch für Vie nuove, L'espresso, Du, Leader, New York Times, Time-Life, Die Zeit, La fiera letteraria, Abitare). Ihre Fotogr. erscheinen in Büchern und auf Buchumschlägen. Auch fotografiert sie in Mailand mögliche Filmdrehorte (Milano di sopra e di sotto, Mi. 1964). 1965 Reise nach Süditalien (Industrie-Reportage in Sizilien; trad. Riten in den Abruzzen und Lsch. (Nove paesaggi ital., 1965 [K], Text: Renato Guttuso). 1966 Fotogr. von der Überschwemmung in Florenz. 1969–75 porträtiert sie regelmäßig in Spanien Oppositionelle gegen Franco. 1970–74 fragmentierende Akt-Fotogr. (Forma di donna, Mi. 1978; Nudi [K], Palermo 2007), vergleichbar u.a. den „Perspectives of nudes" von Bill Brandt (1961); auch Tanz-Fotogr. (u.a. von Antonio Gades). Ab 1973 arbeitet C. überwiegend als erfolgreiche Schriftstellerin und Lyrikerin. 1977 für die Expo Arte in Bari Fotocollagen mit Tempera- und Decalcomanie-Interventionen. 1981 dreht C. für die RAI eine Serie von 13 TV-Filmen über zeitgen. ital. Fotografen (Dietro l'obiettivo) und Film-Portr. von Frauen. 1999 Fotogr. von mod. Wohnbauten an der Côte d'Azur (Le vele). Ausz.: zahlr. Lit.-Preise, u.a. 1975 Premio Campiello (für Un matrimonio perfetto); 1990 Premio Comisso (für La cattive figlia) 2004 Premio Feudi di Maida und Premio Padula (für L'intruso). C. ist lange Jahre Sekretärin der Assoc. Ital. Reporter Fotografi. – C. ist (vergleichbar etwa Mario de Biasi, Nino Migliori oder Gianni Berengo Gardin) eine bed. ital. Fotografin der 1960er/70er Jahre. Ihre strukturbetonten Lsch. (z.B. Serie Lang-

he, 1964) stehen auch Mario Giacomelli nahe. Neben ihren formalen Bild-Gest. fotografiert C. als „concerned photographer" engagiert eingreifend und mit vitalem Bezug zu den beobachteten Menschen, auch mit sozialen, psychologischen und ethnogr. Interessen. C. arbeitet auch jenseits der journalistischen Beschreibung surreale Momente heraus, in den 1970er/80er Jahren verläßt sie zunehmend die Narration zugunsten von symbolisch verdichteten Bildern. Als Porträtistin und Chronistin hält sie Arbeit und Leben in Mailand sowie den Stadtraum und die Peripherie fest. Regelmäßig begleitet sie fotogr. die kult. Ereignisse v.a. in den Buchhandlungen Einaudi und Feltrinelli; es entstehen spontane journalistische Portr. von Schriftstellern und Intellektuellen (u.a. Roland Barthes, Umberto Eco, Elio Vittorini, Italo Calvino, Pier Paolo Pasolini). Nach ersten Anfängen als Theaterfotografin dokumentiert C. 1967 am Teatro Duroni, Mailand, das Living Theatre, das sie auch nach Parma, Modena, Avignon und Rimini begleitet (F. Quadri [Ed.], Paradise now, T. 1970). Später fotografiert sie auch US-amer. Theatergruppen. 1968 lernt sie den Reform-Psychiater Franco Basaglia kennen und fotografiert in geschlossenen psychiatrischen Anstalten in Italien, für deren Auflösung sie plädiert (Publ. zus. mit Gianni Berengo Gardin: F. Basaglia/F. Ongaro [Ed.], Morire di classe, T. 1969; Retr. 1998). 1968–75 dokumentiert C. die politischen und soz. Ereignisse in Mailand, auch Demonstrationen und Prozesse (Milano 1960–1970, Manduria 1997); 1970 werden Gerichtsfotos von ihr beim Film Processo politico (Francesco Leonetti) verwendet. 1970–72 entlarvt C. wie Larry Fink oder André Gelpke mit kritischem Blick die mondäne Mailänder Ges. in der Publ. Mondo cocktail (Cinisello Balsamo 1974; Mi. 2007). In den 1970er Jahren beginnt C. auch in Farbe zu arbeiten (u.a. Werbe- und Mode-Fotogr.). 1976–82 fotografiert sie in Spanien Archit.-Details des Komplexes La Manzanera von Ricardo Bofill (La Muralla Roja); in den 1980er Jahren entstehen Körper- und Bewegungsaufnahmen mit der Tänzerin Valeria Magli (Forma, movimento, colore, 1988). – FotoPubl.: Culturalmente impegnati (K), Mi. 1968; F. Gallo (Ed.), Scena e fuori scena, Mi. 1991; F. Ongaro/F. Basaglia (Ed.), Per non dimenticare, T. 1998; U. Lucas (Ed.), Punto di vista (K), Mi. 2007; M. Mussini (Ed.), C. C., Mi. 2007 (Bibl.). – Auch Ill. in Kinderbüchern, u.a. G. Bufalari, La barca gialla, T. 1966; id., Scellamozza, T. 1969; L. Martini, Cara Assuntina, T. 1969. ▣ Cinisello Balsamo, Mus. di Fotogr. Contemp. Parma, Univ., Centro Studi e Arch. della Comunicazione. ◉ E: Mailand: 1962 Circolo Fotogr. Milanese; 1968 (K), '72, '79 (Wander-Ausst.) Gall. Il Diaframma; 1983 Fond. Corrente; 1986, '90 IFImmagine Fotogr.; 1988 Gall. del Milione; 1996 (K), 2003 (mit Uliano Lucas; Wander-Ausst.) Univ. Bocconi; 2007 Bel Vedere Fotogr. (K); Spazio Entratalibera (K); 2008 Gall. Jannone / 1965 Rom, Libreria Einaudi (K) / 1968 Parma, Ex Gabinetti Pubbl. / 1974 Turin, Gall. Primopiano (K) / 1977 Bari: Expo-Arte (Wander-Ausst.) / 1981 (Wander-Ausst.; K), '83, '86 Brescia, Multi Media Arte Comp. / 1984 Ivrea, Gall. Il Manifesto / 1986 Stockholm, Ist. Ital. di Cult., Mira Gall. / 1991 Paternò, GAM

(K) / 1999 Foggia, Palazzetto dell'Arte / 2000 Viadana, Gall. Bedoli / 2007 Parma, Centro Studi e Arch. della Comunicazione (K). – *G:* zahlr. u.a. 1972 Bologna, MCiv.: Tra rivolta e rivoluzione / Chalon-sur-Saône, Maison Europ. de la Photogr.: 1976 Photogr. ital.; 1977 Dieci anni del Diaframma / 1977 Paris, Expo Photo: Il gesto come comportamento soc. (Wander-Ausst.) / 1979 Venedig: Bienn. / New York: 1980 P. S. 1: Politics & photogr. Italy 1968–1980; 1994 Guggenheim: The Ital. metamorphosis 1943–1968 (Wander-Ausst.; K) / Mailand: 1982 Pal. Dugnani: Reporter a Milano 1968–1982 (K); 1989 Fond. Corrente: Fotogr. anni Ottanta; 1993 Arch. di Stato: I vizi capitali / 1982 Bari, Pin. Prov.: Fotogiornalismo ital. dal '45 al '82 (K); Paris, Centre Pompidou: Ospedali Psichiatrici / 1983 Grignan, Mus. Ancien: Fotogr. Ital. comtemp. / 1984 Köln, Photokina: 11 donne fotografe donne ital. (Wander-Ausst.) / Turin: 1985 BN: 50 fotogr. di poeti; 2005 Bienn. Internaz. di Fotogr. (K) / 1994 Ravenna, Bibl. Classense: Segni di luce (K) / 1995 Holderbank, Lagerhalle Alte Zementfabrik: Der geduldige Planet (Wander-Ausst.; K) / 1998 Lugano, Gall. Gottardo: Pagine di fotogr. ital. 1900–1998 / 2005 Reggio Emilia, Pal. Magnani: Il volto della follia (Wander-Ausst.; K). ▭ *C. Colombo* (Ed.), L'occhio di Milano 1945–1977, Mi. 1977; *A. Gilardi*, Photo ital. 1978 (38); *A. C. Quintavalle*, Enc. pratica per fotografare 1:1979 (7), 4:1979 (44), 5:1979 (59, 64); *U. Lucas/M. Bizziccari* (Ed.), l'informazione negata, Bari 1980; *G. Cesareo*, Inventario di una psichiatria (K Rom), Mi. 1981; *A. Accornero u.a.*(Ed.), Storia fotogr. del lavoro in Italia 1900–1980, Bari 1981; *E. Pellegrini*, Reporter a Milano 1968–1982, Mi. 1982; Percorsi (K Centro Futura), Saronno 1983; *I. Zannier*, Storia della fotogr. ital., R./ Bari 1986; *G. Capaldi/U. Lucas* (Ed.), 1981–2001. Ritratti e lavoro dalla grande impresa alla fabbrica del software, R. 2001; *N. Leonardi* (Ed.), L'altra metà dello sguardo, T. 2001; *U. Lucas* (Ed.), L'immagine fotogr. 1945–2000, T. 2004; *R. Valtorta*, Volti della fotogr., Mi. 2005; *P. Morello*, C. C. Nudi, Palermo 2007; *id.*, La fotogr. in Italia 1945–1975, R. 2010; *C. Leanti* (Ed.), Oltre la soglia. I manicomi nelle foto di „Morire di classe", Pavia 2011 (Film-DVD). – Mailand, Arch. C. C. – *Online:* Lombardiabeniculturali (Ausst., Lit.). – Mitt. C. T. Koenig

Cerdà (C. Alemany), *Pilar*, katalan. Bildhauerin, Keramikerin, Malerin, Graphikerin, * 1954 Mercadal/Menorca, lebt in Pollença/Mallorca (seit 1955) und Barcelona. Stud.: 1972 Graphik an der Esc. „Massana" ebd.; bis 1976 Keramik und Bildhauerei an der Esc. d'Arts i Oficis in Palma de Mallorca. 1977 ebd. Lehrtätigkeit. Zw. 1981 und 1996 Forsch.-Stud., u.a. Esc. de Ceràmica de la Bisbal, Girona; Taller-Esc. de Ceràmica „Textura", Gijón; Esc. Superior de BA de Sant Jordi, Barcelona; Ist. d'Arte per la Ceramica „G. Ballardini", Faenza. Weiterbildung in Palma de Mallorca: 1997/98 Kunstgesch., Univ. de las Islas Baleares (U. I. B.); 2000 Graphikkurse, Fund. Pilar i Joan Miró; 2005/06 Webdesign, Ausb.-Zentrum SOIB. Mitgl.: Asoc. d'Artistes Visuals de Catalunya; Asoc. de Ceramistes de Catalunya; Fomento de las Artes y del Diseño, Barcelona. Dauer-Ausst. in zahlr. Gal. auf den Balearen, in Barcelona und Madrid. – C. gestaltet v.a. skurrile Objekte, Figuren und Figurenensembles, deren bes. ästhetischer Reiz in der Kombination von Mat. mit unterschiedlich wirkender Oberflächentextur liegt, v.a. von Eisen und Stahl mit Keramik und Porzellan. Die zumeist mon., dennoch filigran wirkenden, vertikal ausgerichteten, lang gestreckten und schlanken Gebilde verkörpern stark stilisierte Gestalten (*Kunadalini i dona esperant al seu fill*, Eisen, Keramik, Porzellan, Stahl) oder sind abstrakt-geometrische Konstruktionen (*Solidaritat I, II, III, IV*, Stahl, Eisen). C.s Malerei ist flächig-abstrakt und wird von subtil nuancierten Farbspielen in Ocker-, Gelb- und Rottönen bestimmt. Viele Komp. werden durch formal an die oben geschilderten Figuren erinnernde, jedoch miniaturenhaft kleine Personen und Gegenstände belebt; durch eine virtuos ausgef. tonige Malweise scheinen sie mit dem häufig fast monochrom gehaltenen Hintergrund zu verschmelzen. Auch graph. Arbeiten und keramische Wanddekorationen für öff. Gebäude. ▭ ALARO/Mallorca, Stadtverwaltung. ANDRATX, Stadtverwaltung. DAMASKUS, NM. FELANITX/ Mallorca, Stadtverwaltung. PALMA DE MALLORCA, Consellería de Cult. del Gobierno de la Comunidad Autónoma de las Isla Balerares (C.A.I.B.). – Consell Insular de Mallorca. Dep. de Cult. (C. I. M.). – Stadtverwaltung. POLLENÇA, Stadtverwaltung. – *Werke im öff. Raum:* PALMA DE MALLORCA: Tornada a l'origen, Skulpt., 2008. – *Keramische Wanddekorationen:* PALMA DE MALLORCA, Centre Mater Misericordiae, Espiral, 1990. SANTANYI/Mallorca, Cala Barca Trencada, Joc modular blanc i grisos; Barques trencades; beide 1989. ⊙ *E:* Palma de Mallorca: 1984 Gal. Bearn; 1996, '98 Gal. Joan Oliver „Maneu"; 1999 Sala de Expos. „Es Jonquet"; 2007 Gal. Coll Aguilar / 1992 Sevilla, Gal. Jan / Barcelona: 1996 Gal. Les Punxes; 2000 Sala de Expos. de la UNESCO; 2004 Casa Elizalde; 2006 Asoc. de Ceramistes de Catalunya; 2007 Gal. Punto Arte / 1999 Sóller, Gal. Can Puig / 2003 Madrid, Gal. Dionis Bennassar. – *G:* 1995 Holte, Søllerød Mus.: Mallorca desde Miró hasta hoy / 1997 Havanna, MNBA: Bien. Internac. de Arte Contemp.; Pollença: Certamen Internac. de Artes Plást. (Finalistin) / 1998, 2002 Barcelona, Gal. J. O. „Maneu": Artexpo / 2008 Marratxi (Mallorca) u.a.: Cerámica Contemp. a les Illes Balears (Wander-Ausst.). ▭ DPEE, Ap., 2002. – *Online:* Website C. R. Treydel

Cerdá y Rico, *Arturo*, span. Fotograf, Arzt, * 11. 10. 1844 Monóvar/Alicante, † 15. 2. 1921 Cabra del Santo Cristo/Jaén. Stud.: bis 1869 Medizin an der Fac. de S. Carlos der Univ. Central; EBA der RABA de S. Fernando, beide Madrid. 1871–1902 als Chirurg und Gerichtsmediziner tätig, danach nur noch als Fotograf. Freundschaft mit zahlr. Malern, Schriftstellern und Intellektuellen, u.a. Joaquín Sorolla Bastida, Cecilio Pla und Santiago Ramón y Cajal. C. widmet sich zeitlebens als Autodidakt der Fotogr., für deren Ausübung er 1900 ein geeignetes Haus im regionalistischen Stil errichten läßt. Er ist enger fotogr. Mitarb. der Zs. Don Lope de Sosa (Jaén) und veröff. Fotos in versch. Zss. wie La fotogr. und Graphos il. (beide Madrid), Photos und Photograms of the year (London u.a., 1908 und 1910). Ausz.: u.a. 1903 Gold-Med.,

Wettb. für Stereoskop-Fotogr.; 1904, '08 Silber-Med., alle Real Soc. Fotogr. de Madrid; 1905 Gran Dipl. de Honor, Expos. Nac. de Fotogr., Valencia. 2001 postumer Ehrenbürger von Cabra del Santo Cristo/Jaén und ständige Ausst. in der Casa de la Cult. ebd. Die ebd. 2001 gegr. Asoc. Cult. „A. C. y R." führt seit 2003 den Certamen de Fotogr. C. y R. durch und ist seit 2004 Hrsg. der Zs. Contraluz (zahlr. Beitr. über ihn). Die Univ. in Granada vergibt den Premio Internac. de Fotogr. C. y R. – C. arbeitet v.a. mit der Stereoskop-Fotogr. unter Verwendung von Verascope Richard oder Taxiphote und der Autochromie von Lumière und ist ein Pionier der Farb-Fotogr. in Spanien. Er ist vom Piktoralismus beeinflußt, bedient sich aber auch der direkten, dok.-nüchternen Bestandsaufnahme. Um 1900 v.a. Reportage-Fotogr.; so hält er wichtige Ereignisse fest, z.B. die Einweihung einer Eisenbahnbrücke, eine Sonnenfinsternis (Santa Pola/Alicante), Prozessionen u.a. in Barcelona, das Begräbnis des Politikers und Schriftstellers Emilio Castelar in Madrid oder den neu ernannten König Alfons XIII inmitten einer Menschenmenge. C. bereist häufig Granada und hält sich 1907 längere Zeit in Tanger auf. Diese Erlebnisse inspirieren ihn zu zahlr. Aufnahmen orientalischen Char., meist Portr. in Künstlerateliers oder vor maurischen Interieurs. Ausgiebig widmet sich C. seinem Heimatort Cabra del Santo Cristo (Portr., Lsch.- und Stadtpanoramen, Ansichten einzelner Straßen und Gebäude) und dem Alltagsleben der Einwohner (Feldarbeit, Feste, Prozessionen, Handwerk u.a.). C. ist sich des dok. Char. und der Bedeutung seiner Aufnahmen für die Kultur-Gesch. bewußt, er dat. und lokalisiert sie genau und legt großen Wert auf Komp. und Beleuchtung. Er macht auch vom Film inspirierte Sequenzen mit gestellten Szenen, die oft humorvoll-satirische Züge tragen, z.B. in Bildern mit seinen Enkeln, mit Meßdienern sowie mit dem Maler José María López Mezquita und dem Bildhauer Pablo Loyzaga Gutiérrez, die als Betrunkene in einer Bar posieren. Weitere Themen sind weibliche (z.T. erotische) Akte sowie autochrome Stilleben, in denen barocke Muster neu interpretiert sind; auch Lsch.-Szenen an Meer, Flüssen und Seen. ▱ CABRA DEL SANTO CRISTO/ Jaén, Asoc. Cult. „A. C. y R.". JAÉN, Inst. de Est. Giennenses. – Mus. de Artes y Costumbres Populares. ☞ E: 2001 Sevilla, Casa de Jaén / 2006 Granada, Fund. Albaizín, Carmen Ajibe del Rey (K: I. L. Martín-Portugués u.a.) / 2011 Monóvar (Alicante), Kursaal Fleta (K). ▱ L. Fontanella, La hist de la fotogr. en España desde sus orígenes hasta 1900, Ma. 1981; J. A. Cerdá Pugnaire u.a., Del tiempo detenido. Fotogr. etnográfica giennense del Dr. C. y R., Jaén 2001; J. M. Sánchez Vigil, La fotogr. en España de los orígenes al s. XXI, Ma. 2001 (Summa artis, 47); M. U. Pérez Ortega, Registro de memorias. La obra fotogr. del Dr. Cerdá y Rico, Jaén 2002; E. L. Lara López, Reseña de la obra „Del tiempo detenido". Una aportación a la historiografía contemp. jiennense a través de la fotogr. etnográfica, Jaén 2002; id./M. J. Martínez Hernández, Espacio, tiempo y forma 16:2003 (7) 159–178; E. L. Lara López, El africanismo a través de la fotogr. de A. C. y R. Tánger 1907, Jaén 2003; id., Sierra Mágina en los archiv. fotogr., Grana-

da 2003; id., C. y R. y la fotogr. estereoscópica. Andalucía, Torredonjimeno, Jaén 2005; S. Contreras Gila (Ed.),C. en color, Jaén 2008; M. Gómez Laínez, El color del sol. La placa autocroma en España, Ma. 2009. – Online: Asoc. Cult. Cerdá y Rico. – Mitt. Julio A. Cerdá, Cabra del Santo Cristo. M. Nungesser

Cerdán Fuentes, *Enrique*, span. Zeichner, Illustrator, Comiczeichner, * 15. 6. 1937 Valencia, lebt dort. Stud. ebd.: EBA S. Carlos bei Genaro Lahuerta und José Amérigo. – Debütiert 1953 mit einem täglichen Western-Comic strip in der Ztg Levante, danach Mitarb. u.a. der Ztgn Jornada de Valencia, Supl. Lapicerín (1954), Levante, Supl. La Hora del Recreo (1959), der Wochen-Mag. Jaimito und Pumby im Verlag Valenciana (1962–83), Din Dan und Zipe y Zape im Verlag Bruguera in Barcelona (1974–79), Harakiri und El Cuervo im Verlag Iru in Barcelona (1986). Auch zeichnet er mehrere Comicbücher zur Figur Simón von Elsa Ortells (u.a. *Simón, el pequeño castor*, Verlag Alfredo Ortells, Valencia, 1982–86). Seit 1977 Teiln. am Salón del Comic in Valencia. Über Agenten und Verlage wie Rolf Kauka, Hannah Barbera und Bardon Art finden C.s Comics seit den späten 1970er Jahren auch in Deutschland, Dänemark, den Niederlanden, Großbritannien und Italien Verbreitung (u.a. in den Mag. Donald Duck, Fix und Foxi, Shemeed, Yps & Co, Dr. Snuggles). Mitgl.: Club DHIN (Dibujantes de la Historieta y la Il. Nac.) und Teiln. an dessen Ausstellungen. Ein Comic-Wettb. der Vrg Lo Rat Penat in Valencia trägt C.s Namen. Ausz.: u.a. 2005 Notarios del Humor, Univ. de Alicante. – C. zeichnet anfangs v.a. politische Witze und Ill., später meist Comics, die zur sog. Schule von Valencia (Esc. Valenciana) gerechnet werden. Auch Zeichner und Autor zahlr. Serien und Figuren, die manchmal autobiogr. Züge tragen. Zu den bekanntesten zählen El Grumete Timoteo und El Hotelito Calamar sowie Lobito Navy, La alegre tripulación del barquito Cascarón und der in Spanien große Popularität erreichende Indianerjunge Plumita im Mag. Pumby. A. der 1980er Jahre gestaltet C. die Comicfigur Pepillo Flequillo (Pipa, Supl. des Diario de Valencia), später Marujita. C. zeichnet auch Portr. und Karikaturen, illustriert Bücher (z.B. Marco. De los Apeninos a los Andes [Ba. 1977] von Edmondo De Amicis) und gestaltet Umschläge und die Llibrets Falleros, hrsg. von der Comisió Els Rarets. ☞ G: 2003 Valencia, Bibl. Valenciana: Tebeo Spain. Orig. del pasado, presente y futuro del cómic español (K). ▱ DPEE III, 1994; Agramunt Lacruz I, 1999. – P. Porcel Torrens, Clásicos en jauja. La hist. del tebeo valenciano, Alicante 2002. – Online: Autores de comic; Lambiek Comiclopedia. M. Nungesser

Cerdán Martínez, *Pedro*, span. Architekt, * 21. 7. 1863 Torre-Pacheco/Murcia, † 17. 6. 1947 Murcia. Stud.: bis 1889 (Abschluß) Esc. Superior de Arquit., Madrid. Anschl. eig. Büro in Murcia. 1891–1901 dort Stadtarchitekt. Gründer der Architektenkammer von Murcia. – C.s vielseitiges Schaffen fällt in die Zeit der wirtschaftlichen Blüte in der Agrar- und Bergbauregion Murcia. Seine städtebaulichen Maßnahmen (Paseo del Malecón, Murcia; Paseo de la Concha, Los Alcázares) sowie öff. und priv.

Prachtbauten dienen der Selbst-Darst. des Industriebürgertums und sollen an progressive Tendenzen der europ. Archit.-Entwicklung anknüpfen. Ausgehend von seiner Ausb. im Eklektizismus entwirft C. zunächst im von ihm so betitelten Stil der „mod. Renaissance". Die Pavillons für die Expos. Agrícola, Minera, Industrial y de BA 1900 in Murcia errichtet er unter dem Eindruck der WA in Paris jeweils in einem and. Stil. Ab der Jh.-Wende bemüht C. sich um eine archit. Erneuerung nach dem Vorbild des Jugendstils, der Wiener Secession und des Art nouveau und wendet sich dem span. Modernismo zu. Dies führt jedoch zu einer weitgehend formalistischen Mischung organischer und geometrischer Formen mit klassizistischen und regionalspezifischen Motiven (u.a. Neumudéjar). Die Grundstruktur des akad. Eklektizismus verläßt C. am ehesten im luxuriösen priv. Wohnungsbau; seine überzeugendste Raum-Komp. zeigt sich im eleganten Treppenhaus der Mansión Navarro (ab 1901; Calle Mayor 24, heute Casa-Mus. Modernista) in Novelda/Alicante, das unter Einbeziehung vielfältiger kunsthandwerklicher Gest.-Mittel als offenes, ganzheitliches Gesamtkunstwerk entworfen ist. Dagegen nehmen sich die konzeptionell weniger experimentellen öff. Gebäude als oberflächlich um modernistische Ornamentik bereicherte Zeugnisse der Beaux-Arts-Archit. mit vielfältigen, auch ägyptischen und byz. Motiven aus. Gleichwohl handelt es sich insgesamt um höchst qualitätvolle Bauten, die gestalterisch strikt nach Aufgaben unterschieden sind. Zweckbauten und weniger repräsentative öff. Gebäude, zu denen auch Schulen zählen, sind funktionalistisch konzipiert und in offener Ziegelbauweise mit wenig Dekor errichtet. Von städtebaulicher Bedeutung ist die große kreuzförmige Markthalle aus Stahl und Glas mit modernistischer Fassade in La Unión, 1901 von Victor Beltri entworfen und von C. unter Abwandlung bis 1907 ausgef. (heute Internat. Festspielhaus für Bergbaugesang). ⌂ AGUILAS, Pl. España: Mehrfamilienhaus, 1914. ALHAMA DE MURCIA: Markthalle, 1928. CARTAGENA, Alameda de San Antón: ehem. Hotel (heute Notaufnahme des Hospital Central), 1902. EL ALGAR: Teatro Circo Apolo, 1905–09 (Rest. 2009). LA UNION: Casa del Piñón (heute Rathaus), 1899–1905. – Casa Zapata Maestre, 1899 (heute Jugendzentrum). – Erziehungsheim Liceo Obrero, 1901 (heute Bergbau-Mus.). MURCIA, Hauptfriedhof: Eingangsportal und Grabstätte Guirao-Almansa, ab 1894. – Städtischer Schlachthof, Entwurf 1896, Bau 1907 (zerst.). – Casino (Fassade und Erweiterung), 1899–1902 (Rest. 2006–09). – MBA, 1903–05. – Kirche S. Bartolomé: Cap. Servet, 1910. – Markthalle Verónicas, 1912–16. – Schulen: Baquero-Almansa, 1905; Las Luisas, 1905; Carmen; Cierva Peñafiel; García Alix, 1911. – Parkanlage Floridablanca: Eingangsgitter. SAN PEDRO DEL PINATAR, Carretera Nac. 332/Av. Doctor Artero Guirao: Casa del Reloj (auch: Quinta de San Sebastián), 1888–95. TORRE-PACHECO, Friedhof Roldán, 1890. – Rathaus (Umbauten). ⌂ Dicc. de arte esp., Ma. 1996. – A. Urrutia, Arquit. esp. s. XX, Ma. 1997. – Online: Región de Murcia digital. A. Mesecke

Cereceda Martínez, *Angeles,* span. Malerin, Zeichnerin, * 1962 Santander, lebt seit 1998 in Santa Maria del Cami/Mallorca. Stud.: 1981–84 Publizistik an der Esc. de Artes y Oficios; ab 1982 an der Esc. Libre del Mediterráneo bei Joaquín Torrents Lladó (dort ab 1991 Doz., 1993–97 Dir.), beide Palma de Mallorca. 1985 Bühnenbildentwurf (Stefan Zweig, 24 Stunden aus dem Leben einer Frau), aufgeführt vom Ballett in Monte Carlo. 1993 beteiligt an den Wandbildern im Haus von J. Torrents Lladó in Palma de Mallorca. – C.s malerisches Werk (Öl, Aqu.) umfaßt insbesondere harmonische menschenleere Lsch., Meeresbilder, Parks und Gärten mit üppiger Blumenpracht in kräftigen warmen Farben und poetischer Stimmung. V.a. Darst. von Mallorca und and. span. Regionen, bes. Granada, aber auch von Venedig, teils mit gemalter Rahmung. In den Zchngn neben Natur- und Lsch.-Darst. auch Portr., meist von Kindern. ✉ A. C./T. Palmer (Ed.), Minora. Del taller de J. Torrents Lladó, PdM. 1997. ✆ E: Palma de Mallorca: 1990, '96 Gal. Costa; 1992 Esc. Libre del Mediterráneo; 2001 Luca Massari Gal. de Arte; 2003 Gal. Standarte / 1991, '93 Santander, Gal. Simancas / 1993 Monte Carlo, Monaco FA / 1994 Valencia, Gal. Garbi / 1995, '99, 2002 Barcelona, Gal. Montcada / Tokio: 1997, '98, 2000 Daimaru Gall.; 2007 Prova Gall. / 1997, '99, 2002, '04 Kyōto, Daimuru Gall. / 1999 Segovia, Univ. / Madrid: 2000, '03 Gal. Margarita Summers; 2004, '06 Estudio Alicia Peláez / 2006 San Lorenzo del Escorial (Madrid), Gal. Mellado. – G: 1996 Kasterlee (Belgien), Frans Masereel Centrum: Etsen in Mallorca / 2003 Florenz: Bienn. Internaz. d'Arte Contemp. ⌂ DPEE III, 1994. – A. Colinas, Venecia, s.l. 2001; A. de Senillosa u. a., A. C. Arquit., PdM. 2003. – Online: Website C. M. Nungesser

Cerezo Moreno, *Francisco,* span. Maler, Zeichner, Restaurator, * 19. 1. 1919 Villargordo (heute Villatorres/Jaén), † 10. 10. 2006 Jaén. Stud.: ab 1933 Zeichnen an der Esc. de Artes y Oficios ebd., bei Pablo Martín del Castillo und Pedro Márquez Montilla; 1947–50 mit Stip. der Prov.-Verwaltung bei dem Maler Julio Moisés Fernández de Villasante; Zeichnen am Círculo de BA; Rest. bei Enrique Rodero, alle Madrid; 1958 EBA de Sa. Isabel de Hungría, Sevilla; 1963 Inst. Central de Rest., Madrid. Ab 1950 eig. Rest.-Wkst. in Jaén. Zahlr. Rest.-Aufträge: z.B. 1960 Mus. Diocesano, 1969 Kathedrale, Prov.-Mus., alle ebd.; ab 1970 Denkmäler und Werke in Mus. und Kirchen in Cáceres, Fuensalida, Sevilla, Huelva, Logroño und Cuenca. 1966 Gründungs-Mitgl. des Grupo de Jaén und Mitgl. der Gruppen La Bohemia und Los Nazaritas. Ab 1974 auch Atelierhaus in Segura de la Sierra/Jaén (1995 erhält eine Straße seinen Namen). 1978 Ehren-Mitgl. der Amigos de San Antón (Ill. ihrer Publ. Senda de los huertos und Cena jocosa). Berater des Inst. de Est. Jienenses. 1981 Ehrenbürger von Villargordo und Benennung einer Straße mit seinem Namen sowie 1990 eines Malereiwettbewerbes. 1998 mit Schenkungen des Künstlers Eröffnung des nach ihm benannten Mus. in Villatorres. Zahlr. Ausz.: 1958 1. Nat.-Preis für Malerei, Expos. Nac. des Ayuntamiento, Jaén; 1961 Gold-Med., Expos. de Andalucía; Olivo de Oro, Poetas Jienenses; 1998 Giennense del Año, Diario Jaén. – C. zählt zu den bed. Künstlern der Prov. Jaén,

der v.a. die Trad. des costumbrismo in die Gegenwart fort-
führt. Er malt in Öl auf Lw. oder Holz, anfangs in schwe-
ren, düsteren, später in aufgehellten Farbtönen von der Ba-
rockmalerei inspirierte realistische Portr. (z.B. *Monseñor
Agustín de la Fuente González*, 1960), Genreszenen (*Acei-
tuneros*, 1961) sowie bes. Stilleben mit Früchten, Blumen,
Glas- und Porzellangefäßen sowie Lsch. (z.T. Min.) aus
der heimatlichen Region, v.a. um Segura de la Sierra. Un-
ter den Zchngn v.a. Darst. von Bauten und Mon. aus der
Prov. Jaén, die in eig. Publ. veröff. sind. Auch Buch-Ill.:
u.a. F. Molina Verdejo, *Epico Jaén, lírico Jaén*, Jaén 1994;
M. Alquife, *Calicanto*, Ma. 1995. ⌂ JAÉN, Mus. Prov. –
Univ. VILLATORRES/Jaén, Mus. Cerezo Moreno. ✉ Mis
cuad. de dibujo, Jaén 1981; *J. Eslava Galán*, Castillos y
atalayas del Reino de Jaén. Nuevo album de dibujos, Jáen
1989; Castillos y murallas del Santo Reino, Jaén 1990;
Evocando Jaén, Jaén [ca. 1990]; *P. Galera Andreu*, Jaén,
emblema del renacimiento. Cuad. de dibujos, Jaén 1996.
👁 *E:* Jaén: 1978 Sala Del Castillo; 1984 Sala de Expos.
(K); 1996 Pal. Prov., Salas Prov. de Expos. (Retr.; K);
2002 Univ. (K: V. Salvatierra Cuenca/A. Visedo Rodrí-
guez); 2010 Centro Cult. Pal. de Villardompardo (K: M. A.
Navarro Jiménez/R. M. Morales Ocaña). ⌷ DPEE III,
1994. – *M. Capel Margarito*, El pintor C., Jaén 1961;
C. 1999–2000. Tensiones, incisiones, Ba. 2000; *Wilhelmi*,
2006. – *Online:* Portal de Arte en Jaén. M. Nungesser

Cering (Tsering), *Lhaba*, tibetischer Maler, * 1978 Shi-
gatse, lebt dort. Stud.: bis 1999 (Abschluß) Dept. of FA
der Tibet Univ. in Lhasa. Mitgl.: China Artists Assoc.
(stellv. Vors.); Tibetan Artists Association. Unterrichtet
als Kunstlehrer an der Prefecture No. 1 Senior Middle
School in Shigatse. Ausz.: 1999 (höchste Ausz.) Kunst-
Ausst. der Autonomen Region Tibet, Lhasa; 2006 Preis
der Kalligraphie-, Mal- und Fotogr.-Ausst. in Shigatse. –
C. arbeitet mit trad. Mineralpigmenten auf Lw. und verar-
beitet Alltagseindrücke und Lsch.-Elemente seiner tibeti-
schen Heimat (z.B. Drachenfliegen). Seine unpolitischen
und farbenfrohen Bilder sind weltlichen Inhalts und ori-
entieren sich stilistisch an naiver und expressionistischer
Malerei, vermischt mit trad. Elementen. ⌂ LHASA, Ti-
bet Mus.: Red Sun Over The Snow Mountain (Gemein-
schaftswerk mit and.). 👁 *G:* 2004 Beijing, Chin. AM:
The Colourful Chain from the Snowland. Contemp. Tibe-
tan Art Exhib. (Wander-Ausst.) / 2005 Singapur, SG Priv.
Banking Gall.: New Tibetan Art Exhib. (mit Wanggya und
Li Zhibao); Lhasa, Univ. of Tibet: Invincible Youth / 2008
Art Singapore: Realms of Purity. Realms of Experience.
From Divinity to Humanity. R. Höfer

Cering (Tsering), *Namgyal* (Pseud. Panor), tibetischer
Maler, Installationskünstler, * 1976 Sog/Prov. Nagchu,
lebt in Lhasa. Stud.: bis 1999 (Abschluß) am Dept. of FA
an der Tibet Univ., Lhasa. Mitgl.: Tibet Autonomous FF
Assoc.; Gedun Choephel Artists' Guild, beide Lhasa. Als
Kunstlehrer unterrichtet er an der Lhasa City No. 1 Primary
School. Er ist verheiratet mit der bek. tibetischen Malerin
Dedron (* 1976 Lhasa, lebt dort), mit der er auch gemein-
same Werke schafft. Ausz.: 1999 Nat. Exhib. of Minority
Regions of China, Beijing. – C.s Arbeit ist inhaltlich stark

buddh. geprägt. Seine Öl- und Acrylmalereien auf Lw.
weisen eine gedeckte Farbpalette auf. In einer teilabstra-
hierten, kleinteiligen Manier zeigt er verzerrte menschli-
che Körper oder auch Buddhas, die teilw. an tibetische und
indische Mal-Trad. erinnern. ⌂ BEIJING, Li Keran Art
Found. GUANZHOU, Guangzhou AM. 👁 *G:* 2004 Bei-
jing, Chin. AM: The Colourful Chain from the Snowland.
Contemp. Tibetan Art Exhib. (Wander-Ausst.) / 2005 Sin-
gapur, SG Private Banking Gall.: New Tibetan Art Exhib. /
2006 Königswinter, Siebengebirgs-Mus.: Mod. Kunst vom
Dach der Welt. Zeitgen. Malerei aus Tibet / 2008 Singa-
pur: Art Singapore (Realms of Purity. Realms of Experi-
ence. From Divinity to Humanity. An Exhib. of Contemp.
Tibetan Art). ⌷ Visions from Tibet. A brief survey of
contemp. paint. (K Contemp. Tibetan AG), Lo. 2005; Ti-
betan encounters. Contemp. meets trad. (K), Lo. 2007.
R. Höfer

Čerkezov, *Georgi (Georgi Ivanov)*, bulg. Maler, Zeich-
ner, * 28. 2. 1880 Sofia, † 24. 4. 1962 ebd. 1904–15 mit Un-
terbrechungen wegen fehlender finanzieller Mittel Stud. an
der KGS Sofia bei Petko Klisurov und Ivan Mărkvička.
Als Zeichenlehrer in Ruse, Trän und Sofia tätig. Weiterhin
künstlerische Mitarb. im bulg. Minist. für Volksbildung so-
wie gelegentlich bei der 1927–44 in Sofia erscheinenden
makedonischen Emigranten-Zs. Ilustracija Ilinden. Mitgl.
der Vrg unabhängiger Künstler (1919–44), Sofia. – Č. mal-
te repräsentative Portr. von zeitgen. Persönlichkeiten, Ver-
tretern des öff. Lebens, bekannten Politikern, Kämpfern
für die nat. Unabhängigkeit und prominenten Kulturschaf-
fenden. Die vorwiegend in Öl ausgef. Bildnisse zeugen
von handwerklicher Meisterschaft und akad. Akribie und
entsprachen im Streben nach Authentizität den Bedürfnis-
sen der Zeit. Bei den meisten Arbeiten handelt es sich um
zurückhaltend idealisierende Brustbilder en face, u.a. von
Dr. Petăr Beron, Vasil Aprilov, Kostadin Miladinov, Stefan
Karadža, Angel Kănčev, Panajot Volov, Georgi Benkov-
ski, Zachari Stojanov. Mehrmals (u.a. 1890, 1916, 1936,
'37) porträtierte Č. den bed. bulg. Nationalhelden Vasi-
li Levski. Weiterhin entstand eine Reihe von Portr.-Gem.
bulg. Schriftsteller, darunter Konstantin Veličkov, Micha-
laki Georgiev, Penčo Slavejkov und Elin Pelin. Č. gehörte
zu den wenigen bulg. Künstlern, denen der wohl größte
bulg. Schriftsteller Ivan Vazov Modell stand (u.a. *I. Vazov
nabljudava generalnata repeticija na „Chăšove"*, Zchng,
1907; *Portret na I. Vazov*, Pastell, 1916; *I. Vazov predi Jubi-
leja*, Bleistift, 1920; *I. Vazov*, Studie nach der Natur, 1920;
I. Vazov čete, 1920). Des weiteren schuf er Bildnisse von
Kliment Ochridski (1922), Jane Sandanski und Karl Marx
(1953). Einigen Arbeiten kommt ausschl. hist.-dok. Wert
zu, z.B. *Penčo Slavejkov v Skopie prez septemvri 1908*. In
Portr. von nichtoffiziellem Char. zeigen sich ein ungebun-
denerer Umgang mit der Bildgattung sowie das Bestre-
ben, über die exakte Wiedergabe der Physiognomie hin-
aus auch die Individualität der Dargestellten zu erfassen
(*Portret na žena mi*, 1921; *Portret na Roza*; *Madonata*,
1924; *Avtoportret*, 1940). Auch in den Lsch. und Stilleben
ging Č. freier und ungezwungener mit seinen künstleri-
schen Gest.-Mitteln um (*Tărnovsko ždrelo „Blagodenst-*

vie"; Čereši, beide 1953; *Grozde*, 1957). 🏛 PLOVDIV, KG. SOFIA, Städtische KG. ▭ EIIB III, 2006. – Gradska chudožestvena gal. Plovdiv. Kat. Živopis, Plovdiv 2002; Sofijska gradska chudožestvena gal. Kat. živopis, Sofija 2003. S. Jähne

Čermáková, *Aneta* → **Chodina,** *Aneta*

Černický, *Jiří*, tschech. Konzept-, Video- und Performancekünstler, Maler, Fotograf, * 1. 8. 1966 Ústí nad Labem, lebt in Prag. Stud.: 1983–87 KGS, Jablonec nad Nisou (Schmuck-Gest.); 1987–90 Univ., Ústí nad Labem (Pädagogische Fak.); 1990–93 HS für angew. Kunst, Prag, bei Adéla Matasová; 1993–97 ABK ebd. bei Miloš Šejn und Jiří David. Seit 1991 über 100 nat. und internat. Ausst.-Beteiligungen. Ausz.: 1996 George-Soros-Preis; 1998 Jindřich-Chalupecký-Preis; 2007 Preis 48. Oktober Salon Belgrad. – Erste Aufmerksamkeit gewinnt Č. mit dem sozialkritischen, auf die Hungersnöte in Afrika bezogenen Projekt *Slzy postiženým třetího světa* (1994). Über ambivalente Objekte, die durchweg den Konflikt zw. Natur und Zivilisation thematisieren (*Fontána na odlévání ran z červánků*, 1993), gelangt der Künstler zu glänzenden Assemblagen, darunter plastisch wirkende Bilder und Pseudoreliefs, von expressivem Ausdruck. Einprägsam kontrastiert er dabei den fast bombastischen „Glanz" der Objekte mit ihrem unheilverkündenden Schein (*Heroin Crystal*, 1996; *Foto Flesh*, 1996; *Módní výbuch – Tanec fundamentalistky*, 1997). Auch groteske Installationen (*Gagarinova věc* /Gagarin's Ding, Birmingham, 2006). Selten Buch-Ill. (z.B. Fotogr. für das Kinderbuch *About Anemone. Documents from a fairy-tale*, Prague 2004). 🏛 MIAMI, MCA. NEW YORK, Found. for Contemp. Arts. PRAG, GHMP. – NG. SAINT-ETIENNE, MAM. WIEN, MAK. ◉ *E:* u.a. 1990 Roudnice nad Labem, Gal. moderního umění (mit Martin Raudenský) / Ústi nad Labem: 1991 Otevřená hranice bytu (mit Pavel Kopřiva); 1995, '96 (mit P. Kopřiva; K), 2008 Gal. Emila Filly / Prag: 1996 Gal. Pecka (K); 1999 GHMP; 2000 Gal. Václava Špály; 2002, '05 Gal. Jiří Švestka; 2007 Gal. Futura; 2009 Atelier Josef Sudek; 2010 Gal. Woxart; Gal. Václava Špály; 2011 Studio Dynamo design / 1997 Klatovy, Gal. U Bílého jednorožce (mit P. Kopřiva) / Berlin: 1998 AK; 1999 Gal. Dorow / 1998 Orońsko, Zentrum für poln. Skulpt. / 2000 Los Angeles, Czech Front Gall. / 2001 Zagreb, Gal. Miroslav Kraljevic / Rotterdam, Showroom MaMA (Media and Moving Art) / 2002 Ostrava, Gal. 761; Rotterdam, Noname gall.; Paris, Gal. Lara Vincy / 2003 Ostrava, Výstavní síň Sokolská / 2005, '06 Birmingham, Vivid Centre for Media Arts / 2006 Wien, Gal. Steinek; Liberec, Gal. Die Aktualität des Schönen / 2007 London, artsdepot; Venedig, Gall. Traghetto / 2008 Cleveland, Space gall. / 2009 Košice, Múz. Vojtecha Löfflera / 2010 Blansko, Gal. města Blanska. – *G:* 1991 Barcelona: Bienn. / Prag: 1995 Gal. Mánes: Zkušební provoz; Richterova vila: Respekt – Vzpomínky na budoucnost; 1998 Gal. Václava Špály: Harmonie 98; ČMVU: ... o přírodě ...; 2010 Gal. NoD: Absurdita? Groteska? Ironie?; 2011 Gal. Rudolfinum: Mutující médium. Fotogr. v českém umění 1990–2010; 2012 NG: The Islands of Resistance / 2001 Fellbach: Trienn. Kleinplastik;

Berlin, Gal. Chromosome: ... to flow to ... / Saint-Etienne, MAM: 2004 Passage d'Europe; 2008 Micro-narratives / 2004 Budapest, Liget Gal.: 1/4 Hungarian; Siena, Pal. delle Papesse: Ipermercato dell'arte / Neapel, Pal. delle Arti di Napoli (PAN): 2005 Il dono dell'artista; 2006 Giardino / 2006 Warschau, NG: Hot, Cold – Summer Loving; Wrocław, Gal. Awangarda: Shadows of Humor / 2008 Dresden, Motorenhalle: Du Dialogue Social; Graz, rotor: Land of Human Rights; Poznań: Bienn. (Mediations) / 2010 New York, White Box: Minimal Differences; Chelsea Art Mus.: A Part of No-Part; Wien, Mus. auf Abruf: Formate der Transformation 89–09. ▭ SČSVU I, 1998; NEČVU, Dodatky, 2006. – *B. Pejić/D. Elliott* (Ed.), After the wall (K Stockholm/Budapest), I-II, Sth. 1999; *L. Le Quesne*, Contemp. mag. 78:2006, 74; *T. Jeppesen*, Disorientations. Art on the margins of the „contemporary", Lo. 2008. – *Online:* Website Č. M. Knedlik

Černogolova, *Natal'ja Arsen'evna* → **Čornagalova,** *Natallja Arsenc'eŭna*

Černousenko, *Inna* cf. **Černousenko,** *Vladimir Petrovič*

Černousenko, *Marina Vladimirovna* cf. **Černousenko,** *Vladimir Petrovič*

Černousenko, *Vladimir Petrovič*, russ. Maler, * 22. 12. 1932 Rostov-na-Donu, † 2000 ebd. (?). Neffe von Fedor Matveevič Č.; war verh. mit der Malerin *Inna* Č. (Stud.: Kunst-FS, Rostov-na-Donu); Vater der Malerin *Marina Vladimirovna* Č. Stud.: bis 1964 Surikov-KHS, Moskau. Lehrte u.a. 1990–99 an der künstlerisch-graph. Fak. der Pädagogischen HS, Rostov-na-Donu. – V.a. Schlachten-Darstellungen. Unter Ltg von Nikolaj Vasil'evič Ovečkin ist Č. beteiligt am Panoramabild *Plevenskaja ėpopeja. 100-letie osvoboždenija ot Osmanskogo iga* (Pleven/Bulgarien), das 1977 anlässlich des 100. Jahrestages der Befreiung der Stadt im russ.-türkischen Krieg errichtet wurde (Architekten: Plamen Cačev, Ivo Petrov) und zu den größten Panoramen der Welt zählt (mehrere Säle; sechs Gem. 4 x 3,6 Meter, Panoramabild 115 x 15 Meter, Diorama 17 x 5 Meter). In Č.s Nachlaß finden sich zahlr. Studien und Skizzen zu diesem und and. mon. Werken; char. ist eine spezielle Farbanmischung (Aqu., Pastell, Gouache, Öl). Auch Industrie-Lsch. (z.B. *Strojka*; *Industrial'nyj pejzaž*, 1970er Jahre) und Portr. (u.a. *Ataman Platov* und *Michail Šolochov*). 🏛 STAVROPOL', KM. ROSTOV-NA-DONU: Fam.-Slg (Nachlass). ◉ *E:* 2008 Rostov-na-Donu, Ausst.-Saal des Künstler-Verb. (auch Werke des Onkels sowie von Č.s Frau und Tochter). – *G:* 2009 Rostov-na-Donu, MBK na Dmitrovskoj: Glücksschmiede. ▭ Bown, 1998 (s.v. Chernousenko, Vladimir Petrovich). D. Kassek

Černý, *David*, tschech. Bildhauer, Installations- und Aktionskünstler, * 15. 12. 1967 Prag, lebt dort. Stud.: 1988–94 HS für angew. Kunst (VŠUP) ebd. bei Kurt Gebauer. 1991 mit Stip. Aufenthalt im Künstlerhaus Boswil/ Schweiz. 1994–95 Artist in Residence am P. S. 1 Contemp. AC, Long Island City/N. Y.; 1995–96 ebd. Aufnahme in das Studienprogramm des Whitney MMA. Mitbegr. der Gruppe Úchvatní. Ausz.: 1990 Preis Bienn. Kor-

trijk/Belgien; 1996 Stip. Pollock Krasner Found.; 2000 Jindřich-Chalupecký-Preis. – Mit seinem schwarzen Humor und seinen geistreichen Persiflagen nimmt C. eine authentische Position in der zeitgen. tschech. Kunst der jüngeren Gen. ein. Neben „klassischen", figürlichen Ausdrucksformen (z.B. Zyklus *Hlavy*, 1987–89) oft provozierende bildhauerische Arbeiten (häufig Bronze), Installationen (*The Pose*, Paris, MMA, 1988; *Polcajt k pronájmu*, Prag, 2002; *Entropa*, Brüssel, EU-Ratsgebäude, 2009 [spielerische Auseinandersetzung mit Klischeevorstellungen von den 27 Mitgliedsstaaten]), Aktionen, Happenings und Performances mit politischer Thematik (*Růžový tank*, 1991 [rosa Bemalung eines Panzer-Denkmals in Prag-Smíchov]; *Den zabíjení*, gezeigt in London und Madrid, 1992; *The solo show*, 2009). Auch Animationen (*Vychovatel ke strachu*, 1987) und Ausstattung von Filmen (*Knoflíkáři*, 1997; *Praha očima*, 1998) sowie szenographische Arbeiten für Theaterproduktionen (*Odpočivej v pokoji*, Činoherní studio, Ústí nad Labem, 1999; *Vídeňký řizek*, Divadlo Na zábradlí, Prag, 2001). 🏛 BERLIN, Mauer-Mus. – Mus. Haus am Checkpoint Charlie. ČELADNÁ: Crychloids, 2011. CHARLOTTE/N. C.: Metalmorphosis, Brunnen, 2006. LEŠANY, Vojenské technické muz. LIBEREC: Zastávka, 2005. PRAG, Dt. Botschaft: Quo vadis, 1990. – Lucerna-Passage: Svatý Václav, 1999. – Fernsehturm (Žižkovská televizní věž): Mimina, 2001. – Herget-Ziegelei: Proudy. Streams, 2004. – Theater Na Zábradlí: Embryo, 2008. SAN DIEGO/Calif., MCA. WASHINGTON/D. C., Tschech. Botschaft. WOLFSBURG, Škoda-Pavillon. ✉ Den zabíjení, in: Výtvarné umění 1993 (2–3), 58. 👁 E: Prag: 1990 Klub Delta (mit Tomáš Pospiszyl); 1992 Rubin klub (mit Markéta Baňková); 1993 ČMVU; Gal. Václava Špály; 2000 New York Univ.; 2011 MeetFactory, Gal. Kostka / 1991 Medzilaborce, Muz. mod. umění Andyho Warhola; Znojmo, Gal. města / 1999 London, Tschech. Botschaft / 2002 Bruntál, Gal. V Kapli; Berlin, Gal. Chromosome (mit Mara De Luca); Rotterdam, Gal. MAMA / 2007 Chicago, Tschech. Zentrum / 2009 Rom, CO2 / 2010 Olomouc, Gal. Mona Lisa (mit Lukáš Rittstein und František Skála); Poznań, Gal. Arsenal. – G: Prag: 1989 Gal. Mánes: Listopad 89; Kulturpalast: Úsměv, škleb a grimasa; NG: 1995 Orbis Fictus; 2000 Konec světa?; 1996 Richterova vila: Respekt; 2006 Gal. NoD: CzechPoint; 2009 GHMP: Po Sametu; 2010 UPM: Dekadence now! / 1992 Madrid: Edge '92. Internat. Bienn. of Visual and Performance Art / 1994 São Paulo: Bien.; New York, Ronald Feldman FA: You Must Remember This; Düsseldorf, KM: Junge tschech. Künstler / 1995 Chicago, MCA: Beyond Belief; New York, The Clocktower Gall.: P. S. 1 94–95 Studio artists / Dresden: 1996 Technische Slgn: The Thing Between; 2000 Kunsthaus StG: Bohemian Birds / 1998 Brno, Dům umění: Nad možnosti / 1999 Stockholm, Mod. Mus.: After the Wall (internat. Wander-Ausst.; K: B. Pejić/D. Elliott) / 2009 Katowice: Bienn. / 2010 Amsterdam, Arti et Amicitiae: AntiBeeld; Warszawa, NM: Homo Erotica / 2011 Bratislava, Gal. mesta: Mapy; Hengelo: Twente Bienn. 📖 SČSVU I, 1998; NEČVU, Dodatky, 2006. – Europe without walls (K), Manchester 1993; *T. Pospis-*

zyl, Vytvarné mmění 1993 (2–3) 51–57; *C. Tröster*, art 1999 (3); *L. Lindaurová*, Labyrint revue 2000 (7–8) 105 s.; *T. Pospiszyl*, D. Č., Promrdané roky – pravdivý příběh, Praha 2000; *I. Mečl*, Umělec 2001 (2) 20; *J. Török*, Arte in 17:2004/05, 68–70; *T. Pospiszyl/*D. Č., Promrdané roky III, Praha 2009; *A. Bordács*, Praesens 2009 (4) 23–30. – *Online:* Website Č.; artlist cz. M. Knedlik

Černý, *Rudolf*, tschech. Fotograf, Elektroingenieur, * 16. 4. 1906 Šumperk, † 4. 8. 1998 Plzeň. Č. verläßt Šumperk bereits in jungen Jahren; Plzeň wird zum hauptsächlichen Lebens- und Wirkungsort. Ab 1924 intensive Beschäftigung mit Fotogr.; ab ca. 1931 Mitgl. des Klub fotografů amatérů (KFA) in Plzeň. Bis 1939 Ing.-Stud. im Bereich Elektrotechnik an der Tschech. TH, Prag. – Als einer der herausragenden Kunstfotografen der Zeit außerhalb Prags vertritt Č. populäre Tendenzen der Amateur-Fotogr. der 1930er Jahre. Er publiziert in den Jbb. Československá fotogr. sowie in der Zs. Fotografický obzor. In vielen seiner Arbeiten kommt das Streben nach einer perfekt durchgestalteten, dem Konstruktivismus nahestehenden Komp. sowie ein sensibler Umgang mit Lichtsituationen zum Ausdruck. Neben Portr. und Lsch. fotografiert Č. auch Menschen bei der Arbeit (z.B. *Žebříky*/Leitern, 1933). 🏛 BRNO, Moravská gal. 👁 G: 1932, '33, '34, '36, '37 Plzeň: Jahres-Ausst. des Klub fotografů amatérů / 1933 Luzern, Rathaus: Internat. Kunst-photogr. Ausst. (K) / 1981 Brno, Moravská gal.: Tschech. Fotogr. 1918–1938 (K: A. Dufek, F. Šmejkal, J. Anděl) / Prag: 1982 UPM: Tschech. Fotogr. 1918–1938 (K ed.: A. Dufek); 2000 Obecní dům: Soc. through the lens 1918–1989. Photographs from the coll. of the Moravian gall. Brno (K: A. Dufek). 📖 EČSF, 1993; NEČVU, Dodatky, 2006. – *A. Dufek u.a.*, Full spectrum. Fifty years of collecting photography. The Moravian gall. in Brno (K), Brno/Prague 2011. A. Dufek

Ceroni, *Pietro*, ital. Architekt, Ingenieur, * 9. 2. 1737 Verona, letzte Erw. 24. 8. 1802. Nach Abschluß als Maurermeister ist C. im Dienste der Stadt Verona als Ing. tätig. 1758 signiert er auf einer Zchng erstmals als Architekt. Er entwirft den Hauptaltar von S. Zeno in Verona (1929 zerst., Zchng in der Bibl. Civ. Verona, sez. stampe, 3. c. 84). 1786–96 zeichnet er wahrsch. für den Neubau der Pfarrk. von Villafranca di Verona verantwortlich, deren Gestalt sich an Palladios Redentore in Venedig orientiert. Ferner werden ihm der Pal. Rossi agli Scalzi und die Villa Guarienti-Carteri in Valeggio zugeschr.; die von C. begonnene Villa Serego Alighieri in Garganago wird nach seinem Tod von Giulio C., einem Verwandten, vollendet. 🏛 VERONA, Bibl. Civ. 📖 *L. Camerlengo/L. Rognini*, in: *P. Brugnoli/A. Sandrini* (Ed.), L'archit. a Verona, II, Vr. 1988, 303–305 (Lit., Quellen). C. Follmann

Cerracchio, *Enrico Filiberto*, US-amer. Bildhauer ital. Herkunft, * 14. 3. 1880 Castelvetere in Val Fortore, † 20. 3. 1956 New York. Vater der Malerin *Genevieve J. C.*, verh. O'Keefe (* ca. 1910, ansässig in Houston/Tex.). Stud.: bis 1898 Ist. Avellino; danach bei Raffaele Belliazzi ebd. 1900 Auswanderung und bis ca. 1940 in Houston/Tex. ansässig (1905 Einbürgerung), dann in New York; un-

terhält jedoch Ateliers in beiden Städten. – Büsten und Statuen (Bronze, Marmor) in heroisch-pathetischer Auffassung. Gewinnt nach dem 1. WK Anerkennung mit zwei Skulpt. von amer. Infanteristen (als Geschenke der ital. Reg. bzw. General John J. Pershing von der Stadt Houston übereignet). C.s wohl bekanntestes Werk ist die große Reiterstatue von *General Sam Houston* (Bronze, 1925) am Eingang des Hermann Park in Houston. ▣ ANSON/Tex., Jones County Courthouse: Sitzstatue von Anson Jones, letzter Präs. der Republic of Texas. AUSTIN/Tex., Capitol: Vize-Präs. John Nance Garner, Büste; Gouverneur Miriam A. Ferguson, Marmorbüste, 1926. – Texas State Cemetery: General John A. Wharton, Bronzebüste. WASHINGTON/D. C., Capitol: Büsten von Christopher Columbus, Thomas Jefferson, Americus Vespucius, George Washington. ▭ Vol, 1953. *Opitz*, 1984 (s.v. Cerracchi, Enrico Filiberto); *Powers*, 2000 (auch zu Genevieve J. C.); *Panzetta* I, 2003 (irrtümlich C., Eugenio Filiberto). – The New York Times v. 22. 3. 1956 (Nachruf). – *Online: K. Curlee*, in: The hb. of Texas, 2008; Texas escapes online mag.

<div align="right">C. Rohrschneider</div>

Cerracchio, *Genevieve J.* cf. **Cerracchio,** *Enrico Filiberto*

Cerredo, *Fabian*, argentinisch-frz. Maler, * 20. 11. 1957 Buenos Aires, † 2. 3. 2005 Pontoise, lebte in Paris. Stud.: 1974–77 EBA Manuel Belgrano, Buenos Aires (bei Antonio Oliva, Antonio Pujia); 1978–79 EBA Prilidiano Pueyrredón ebd.; 1980–85 ENSBA, Paris (Malerei bei Michel Gemignani). 1985 als Ass. bei Jacques Vañarsky, 1988 bei Karel Appel tätig, 1997 Zusammenarbeit mit dem Bildhauer Denis Monfleur. Ausz.: 1986 Prix Jeunes Artistes du Conseil Régional d'Ile-de-France; Preis der Internat. Bienn. für Zchng, Rijeka. – C. beginnt seine Laufbahn mit Aktstudien und Stilleben, in den 1980er Jahren folgen in Paris erste Serien (*Les Musiciens*, 1982; *Les Mariés*, 1987–91). 1984–87 entstehen über 200 von García Márquez' Roman Hundert Jahre Einsamkeit inspirierte Gem. Auch setzt sich C. mit Voltaires Candide (1999), Rabelais' Gargantua (2001–02) und Ibsens Peer Gynt auseinander. Später entstehen Bildnisse von großbrüstigen, üppigen Frauen, wollüstigen Bräuten (*Mariée californienne*, Mischtechnik, 1991), Witwen an offenen Särgen und provokanten Jungfrauen. C. thematisiert den Mythos der Frau, die hl. und die erotische Weiblichkeit sowie Schöpfungsund Zerstörungsmythen. Ab 1992 modelliert C. den Malgrund, indem er welligen Karton, Gewebe oder Abfälle integriert. Es folgen weitere Serien, etwa *Football* (1997), *De la Boucherie au Massacre* (1998, mit Monfleur) und *Genesis* (2000–01). E. der 1990er Jahre schafft C. zunehmend Altar-Gem. und Polyptychen, teilw. mit Außenflügeln in Grisaille, die paradiesische Lsch. verschließen (*La Création*, 2000) oder Bibelszenen thematisieren (*Adam, Eva*, Mischtechnik/Lw., 2000). Seine Portr. und Genreszenen (Bandoneonspieler, Tangotänzer, Bälle, Sänger, Bar-Interieurs) bilden meist nur eine oder wenige, scheinbar vibrierende Figuren frontal in einem Ausschnitt vor einer Lsch. oder neutralem Hintergrund ab. C.s Malerei mit großen Pinselzügen und runden, teilw. groben, ungeschliffe-

nen Formen ist pastos, reliefartig, z.T. mit Collageelementen. So fügt er Haare oder Murmeln in Gem. ein, um ihre materielle Präsenz zu erhöhen, und stellt sie so in die Trad. barocker Reliquienschreine. Zu C.s Motiven zählen außerdem dichte tropische Lsch. (ab 2003 besitzt er ein Atelier im Regenwald) sowie blasphemisch angelegte relig. Szenen, etwa eine in den Himmel fahrende Frau mit offenem Rock oder eine Kreuzigung im Innern einer Kirche. Seine von Überfluß, Begehren und Vitalität strotzende Malerei weist Parallelen zum Magischen Realismus in der Lit. auf. Auch als Musiker tätig. ◉ *E:* 1987 Antibes, Mus. archéol. du Bastion Saint-André / 1997 Bordeaux, Gal. Annie Varga / 1999 Buenos Aires, Centro Cult. General San Martín / Paris: 1983 Gal. d'art internat. (K); 1994, '96 Gal. Renaud Richebourg; 2002 (K), '03 Gal. Guigon; 2004, '05, '06 Gal. Koralewski / 2004 Beirut, Gal. Fadi Mogabgab. – *G:* Paris: 1990 Mus. du Luxembourg: Le visage dans l'art contemp. (Wander-Ausst., K); 2000 Orangerie du Sénat: Jardin des Délices / 1999 Massy, Oper: Regards sur l'opéra / 2005 Aix-sur-Vienne: Bienn. Au delà du corps. ▭ *Delarge*, 2001. – *F. Monnin*, Cimaise 2000 (265) 9–22; *G. Lascault*, ibid. 23–32; *G. Xuriquéra*, F. C. Rêves argentins 1985–1999, P. 2001; *E. Daydé*, F. C., Auberive 2008. – *Online:* Website C.

<div align="right">C. Melzer</div>

Cerri, *Giancarlo*, ital. Maler, Zeichner, Graphiker, * 1938 Mailand, lebt dort. Vater von Giovanni C. Ausb. zum Werbegraphiker am Ist. Cesare Correnti ebd. Beginnt ca. 1954 mit Ölmalerei. Seit 1977 freischaffender Maler. – Am Anfang stehen an der Klassischen Moderne orientierte und an der Tektonik interessierte archit. Motive (*Case sotto il sole*, 1960; *La mansarda*, 1964, beides Tinte/Papier) sowie im Naturvorbild wurzelnde Lsch. (*Ultimi luci dul fiume*, Kohle, 1967; *Notte di luna*, Kohle, 1967; *Antico Po*, Öl/Lw., 1969). In den 1970er Jahre erfolgt eine zunehmende Formauflösung mit Konzentration auf die Farbe. Mit Lsch. der 1980er Jahre (*Collina d'inverno*, 1985; *Cava d'autunno*, 1986; *Collina rossa*, 1986, alles Öl/Lw.) bildet C. im impulsiv wirkenden, lebhaften und kräftigen Duktus nur noch ab, ehe er 1990 völlig zum Informel übergeht (*Estate*, 1990; *Dopo la foresta*, 1991). Ab 1992 widmet er sich einer informellen Farbmalerei unter dem Serientitel *Sequenze*. Die informelle Ausrichtung unterbricht 1994/95 eine Reihe von Gem. in einer essentiellen und synthetischen Wiedergabe der Wirklichkeit. Synthetisch-abstrakte, aber einfachere, fester umrissene Formen mit vertikaler oder horizontaler Betonung und flächigem Auftrag kräftiger Farben bestimmen die ab 1995 gemalten *Sequenze*. Um 2000 beschränken sich die Komp. auf meist zwei Farben in Kombination mit Schwarz. Zudem klingen mit dem Gem.-Zyklus *Per amore del paessagio* (2001) in Form und Titel wieder Lsch. an. Dazu beschäftigen C. christliche Motive, bes. Kreuzigung und Auferstehung Christi, die an die spannungsreichen Komp. der *Sequenze* anknüpfen, aber in den figürlichen Andeutungen eine gesteigerte Dynamik und Expressivität aufweisen. ▣ BOZEN, Museion. CASALPUSTERLENGO, Pal. Com. CASTELLANZA, MAM Pagani. CESANO MADERNO, World Mus. FERRARA, Mus. Boldini. GALLARATE, Civ. GAM. LA SPEZIA, MAM. LECCO,

MCiv. Lodi, Mus. della Prov. Maccagno, MCiv. Mailand, Mus. della Permanente. – Fond. D'Ars. – Fond. Lajolo. Melegnano, Pal. del Broletto. Nova Milanese, Pal. del Comune. Novara, Civ. GAM Giannoni. Pieve Di Cento, Mus. Bargellini. San Pietro In Cerro, Mus. in Motion. Stradella, Pal. Isimbardi. ☉ E: Mailand: 1977 Pal. dell'Arengario; 1985 Gall. Le Arcate (K); seit 1994 häufig Cortina d'Arte; 2008 Mus. della Permanente (mit Giovanni C.) / 1980 Reggio Emilia, Pal. del Capitano / 1981 Monza, Gall. Civ. / 1982 Stradella, Pal. Isimbardi / 1983 Modena, Gall. Nuova Mutina (K) / 1989 Melegnano, Castello Mediceo / 1993 Lodi, MCiv / 2005 Gallarate, Civ. MAM / 2007 Castellanza, MAM Pagani. – G: seit 1966 regelmäßig Mailand, Pal. della Permanente / 1998 Castell'Arquato, Antica Pretura: Di padre in filio, generazioni a confronto / 2002 Urbino, Accad. und Casa di Raffaelo: Arte a Milano oggi / 2003 Vigevano, Castello Sforzesco: Viaggio dell'arte / 2004 S. Donato Milanese, GAC: Arte a Cascina Roma / 2008 Shanghai, MNAM: Maestri di Brera. ⌑ Pavullo. Generazioni anni '50–60 (K), Pavullo [1985]; G. C. Le mostre di Pal. Ducale (K), Modena [1991]; G. C. Opere dal 1983 al 1993 (K), Lodi 1993; T. Gipponi, G. C. Opere 1992–1994 (K), Mi. 1994; E. Muritti, G. C. Le sequenze astratte. Opere 1995–1996 (K), Mi. [1996?]; G. C. 10 quadri per la storia di un pittore. Opere 1966–1998 (K), Mi. [1998?]; G. C. Disegni 1959–1999 (K), Bo. 2001; G. C. Un percorso, una storia, opere 1978–2001 (K), Mi. 2003; R. Bossaglia (Ed.), G. C. La pitt. dipinta (K), Gallarate 2005; M. Monteverdi, G. C. Le grandi foreste (K Pagani), Mi. 2007; I C. Giancarlo e Giovanni. La pitt. di generazione in generazione (K), Mi. 2008; L. P. Nicoletti (Ed.), G. C. Dalla figurazione all'astrazione (K), Mi. 2010. – Online: Website C. D. Trier

Cerri, *Giovanni*, ital. Maler, Zeichner, * 1969 Mailand, lebt dort. Sohn von Giancarlo C. Autodidakt. Anregung und Förderung durch den befreundeten Bildhauer Giuseppe Scalvini. 1995 Mitbegr. der Gruppe Polittico; ab 1996 Zusammenarbeit mit Stefano Cortina. 1998 Freundschaft mit Raul Montanari, dessen Texte C. in seine Kat. aufnimmt. – Die Motive der Gem. (Öl, Mischtechnik) findet C. am Stadtrand von Mailand mit Gewerbegebieten, Industrieanlagen und Arbeitersiedlungen in einer tonigen Malweise, die im Neorealismus wurzelt und expressive Züge aufnimmt; in den 1990er Jahren Einbezug von Assemblage und Collage, z.B. Fragm. von Fotogr. und Zeitungen. Damit einher geht eine Vereinfachung in Motivik und Form: Würfelartige Baukörper, Schornsteine, Kräne, Verkehrsschilder, aber auch schematische Figuren (*Trinity*, Öl/Lw., 2010) in klaren, teils plakativen Formen nehmen eine exponierte Stellung ein und gewinnen eine zeichenhafte Bedeutung. Seit E. der 1990er Jahre wird die Bildwirkung durch helles, gleißendes Licht gesteigert. Neben diesen Gem. mit wenigen, simplifiziert ausgef. Bildmotiven entstehen einige komplexe, collageartige und nuancenreiche Komp. aus archit.-abstrakten Formen, teils überlagert durch Pinsel-Zchngn mit Portr. oder Köpfen. ⌑ Castellanza, Mus. Pagani. Cesano Maderno, Swatch World Mus. Gazoldo Degli Ippoliti,

MAM. Gorla Maggiore, Fond. Torre Colombera. La Spezia, MAC. Mailand, Unione Ital. del Lavoro (UIL): Nuova umanità, 2002. – Mus. della Permanente. – Fond. DARS. San Donato Milanese, GAC. San Pietro In Cerro, Mus. in Motion. Santa Maria Di Leuca, Mus. Vito Mele. Sant'angelo Lodigiano, GAC. Seregno, Gall. Civ. ☉ E: Mailand: 1987 Sala Artecultura; 1990 Centro Cult. De Gasperi (K); 1992 Centro Cult. Ponte delle Gabelle (K); 1994 Centro Cult. La Goccia (K); 1994 (K), 2000 Artistudio; 1995 Gall. Cortina (K); 2005 (K), '10 Cortina Arte; 2006 Gall. Blanchaert; Gall. Cappelletti; 2008 Avanguardia Antiquaria; Spazio Tadini; 2009 Gall. Eroici Furiri; 2010 Spazio Arte / 2002 Lodi, Centro E. Vanoni (K); Rom, Gall. Monogr. Arte Contemp. (K) / 2004 Castellanza, Mus. Pagani / 2005 Ferrara, Casa G. Cini / 2007 Busto Arsizio, Gall. Palmieri / 2008 Rho, Officia dell'Arte / 2009 Paris, Gal. Orenda; Gazoldo degli Ippoliti, MAM / 2010 Toronto, Gall. De Luca FA. – G: Mailand: 1997 Mus. della Permanente: Figurazioni; 2009 Spazio Tadini: Luci della ribalta; 2010 Gall. Accad. Contemp.: Disegno ital. / 2000 Gorla Maggiore, Fond. Torre Colombera: Metamorphica / 2001 Pavia, Castello Visconteo: Giovane arte europ. / 2006 Francavilla al Mare, Mus. Michetti: Premio Michetti / 2008 Shanghai, MNAM: Maestri di Brera. ⌑ Premio S. Carlo Borromeo regione Lombardia 1993 (K Mus. della Permanente), Mi. 1993; A. D'Amico (Ed.), Ri-tratti dalla memoria (K Montecorsaro), Mi. 2007; I Cerri. Giancarlo e Giovanni. La pitt. di generazione in generazione (K Mus. della Permanente), [Mi.] 2008 (weitere Ausst., Lit.). – Online: Website C. D. Trier

Cersósimo (C. Picado), *Emilia (Emilia María)*, kostarikanische Malerin, Graphikerin, Textilkünstlerin ital. Herkunft, * 24. 10. 1944 San José, lebt dort. Stud. ebd.: 1963–67 Fac. de BA der Univ. de Costa Rica bei Francisco Amiguetti, Lola Fernández, Margarita Bertheau und Juan Portugués; 1981 Malerei an der Esc. Esempi; 1987 Taller de Expresión Técnica bei Roberto Cabrera; 1990 Zeichnen an der Fac. de BA bei Thomas Lüchinger; 1992 Druckgraphik im Atelier de la Tebaida bei Remy Bucciale, 1996–98 bei Jorge Crespo; 1999 in La Nueva Esc., Centro de Artes Visuales bei Catherine Bolle. Mitgl.: Asoc. de Pintores y Escultores de Costa Rica (APEC). Ausz.: 2000 Gold-Med., Internat. Malerei-Wettb. San Benedetto „Luce e Natura", Rom. – C.s Gem. zeigen Lsch. und Natur von Costa Rica in expressiven Bildern und wenig warmen, leuchtenden Farben, die mit kräftigen Pinselstrichen aufgetragen sind. Die oft wüstenähnlichen Ansichten und die dominierende, an Feuer erinnernde rote Farbe gemahnen an die seit M. des 20. Jh. durch übermäßige Abholzung gefährdete Natur, deren Ursprünglichkeit mit bildnerischen Mitteln beschworen wird. Die serielle Darst. von Vulkanen (bei Tag und Nacht) und von Wäldern als panoramahafte Lsch.-Welten nähern sich der monochromen Abstraktion; auch ganz vom Gegenständlichen befreite Komp. (*Anillos*; *Energía pura*, beide 2003). ⌑ San Jose, Mus. de Arte y Diseño Contemp. ☉ E: San José: 1981 Esc. Esempi; 1982 Colón, Gal. de Arte; 1990 Gal. Joaquín García Monge; Gal. Real; 1991 MN; 1995 Gal. Enrique Echandi; 1999 Centro Cos-

tarricense de Ciencia y Cult., Gal. Nac.; 2002 Gal. Valanti / 1991 München, Bayerische Hypotheken- und Wechsel-Bank (K) / 1994 Coronado, Inst. Inter-amer. de Cooperación para la Agricultura / 2007 San Miguel de Escazú (San José), Gal. 11–12. – *G:* San José: 1994 Centro Costarricense de Ciencia y Cult.: Homenaje a Francisco Amighetti; 2000 Mus. de Arte y Diseño Contemp.: Grafica de fin de s. / 2000 Madrid, Mus. de América: Arte de Costa Rica. 20 mujeres del s. XX (K: J. M. Rojas) / 2007 Fabriano (Ancona), Mus. della Carta e della Filigrana: Arte Natura / 2009 San Miguel de Escazú (San José), Costa Rica Country Club: Inter-versiones II. ⧖ Art en Costa Rica III. Guía de la plástica costarricense, San José 2003. – *R. Cabrera,* E. M. Una coll. di Arezzi e Pittura. Serie Vulcani di Costa Rica (K Ist. Italo-Latinoamericano), R. 2002; *B. Rodríguez,* Arte en Colombia (Bog.) 2003 (93) 138 s. – *Online:* Gal. 11–12, San Miguel de Escazú.

 M. Nungesser

Čerstvilov, *Vladimir Aleksandrovič* → **Čestvilov,** *Vladimir Aleksandrovič*

Certes, *François Adolphe* cf. **Choiselat,** *Marie-Charles-Isidore*

Certo, *Ulrich (Ullrich),* Schreiber, Mönch, tätig um 1500. Stud. an der Univ. Erfurt, wo sich C. am 4. Nov. 1471 immatrikuliert. Profeßmönch der Kartause Engelgarten in Würzburg. Kommt 1484 zum Aufbau der Kartause St. Vitus nach Prüll (heute zu Regensburg). – Überliefert sind drei Sammel-Hss. (heute Bayerische Staats-Bibl., Cod. latini monacenses [Clm]), von denen Clm 12115 und Clm 26811 mit den Texten für die Tagzeiten urspr. zusammengehörten. Clm 12121 stellt den zweiten Teil eines Breviers dar. Alle Bände enthalten weitere Gebrauchstexte wie Gebete, Segensformeln oder Rezepte. Teile der sog. A-Chronik des Andreas von Regensburg sind in Clm 12115 überliefert. Clm 12115 und Clm 26811 enthalten bisher unbek. Paraphrasen der Marienantiphon Salve regina und der Pfingstantiphon Veni sancte spiritus reple, Clm 12115 ein bisher unbek. Tintenrezept. ⧖ MÜNCHEN, Bayerische Staats-Bibl. ⧖ *F. J. Grienewaldt,* Ratispona oder Summarische Beschr. der Stadt Regensburg, Tl 1, Rb. 1615, 247v/248r (Hs.; Abschrift in Regensburg, Bischöfliche Zentral-Bibl.); *A. M. Kobolt,* Baierisches Gelehrten-Lex., Landshut 1795, 125; *id.,* Erg. und Berichtigungen zum Baierischen Gelehrten-Lex., Landshut 1824, 55 s.; *K. Halm/W. Meyer,* Cat. Codicum manu scriptorum Bibliothecae Regiae Monacensis, IV. 2, M. 1874 (Repr. Wb. 1968, 57); IV. 4, M. 1881 (Repr. Wb. 1969, 215; in Clm 26811, f 267R nennt sich C. ein einziges Mal selbst); *H. J. C. Weissenborn* (Bearb.), Acten der Erfurter Univ., I, Halle 1881, 346; *G. Leidinger,* Andreas von Regensburg. Sämtliche Werke, M. 1903, XXXVII; *R. Micus,* Jb. für Liturgik und Hymnologie 36:1997, 218–226; *C. De Backer,* Die Kartäuser und das Hl. Röm. Reich, II, Sg. 1999, 106–108 (Analecta Cartusiana, 140); *R. Micus,* Die Bibl. der ehem. Kartause Prüll b. Regensburg, Sg. 2003 (Analecta Cartusiana, 186).

 R. Micus

Cervantes, *Enrique A,,* mex. Fotograf, Zeichner, Bauingenieur, Restaurator, Kunsthistoriker, * 11. 2. 1898 Agu-

ascalientes, † 1953 Puebla. Vater des Architekten und Urbanisten Enrique C. Sánchez. Ausb. als Bauingenieur, Mexiko-Stadt. Danach Inspector de la Secretaría de Industria, Comercio y Trabajo. Als Zeichner und Fotograf vermutlich Autodidakt. Gründungs-Mitgl. versch. Institutionen: u.a. Soc. Mex. de Bibliogr., Comisión de Puertos Libres Mex., Soc. Mex. de Geografía y Estadística, Comisión de Planificación de la Ciudad de México und Geological Survey of Washington. – C. ist als Archivar, Buchliebhaber und (Kunst-)Historiker (v.a. der mex. Kolonialzeit) tätig, wobei ihm Zeichnen und Fotografieren zur Dok. von Städtebau, Archit., Malerei, Skulpt., Kunsthandwerk und Kunstgew. dient. Auf seinen Reisen durch Mexiko fotografiert er zahlr. Städte in Panoramaansichten, ihre Bauten, Straßen, Plätze und Innenhöfe (u.a. Taxco, Cuernavaca, Morelia, Tepic, Oaxaca, Puebla, Querétaro, Guanajuato, Mérida) und veröff. die Aufnahmen im Eigenverlag (*Albumes de ciudades coloniales,* 9 Bde, zw. 1928 und 1942). Er setzt sich intensiv für den Erhalt des kult. Erbes ein, sichert schriftliche hist. Dok. und sorgt für die Rest. kolonialer Bauwerke, z.B. Casa de Alfeñique in Puebla, Pal. Federal in Oaxaca und die Conventos Franciscanos in Tzintzuntzan und Querétaro (entsprechende Dok. als Col. E. A. C. im Centro de Est. de Hist. de México). Außerdem veröff. er zahlr. Bücher in meist bibliophiler Ausstattung mit eig. Zchngn und Fotos zur mex. Kunst (v.a. Schmiedekunst, Keramik, Kunstgew.). ⧖ MEXIKO-STADT, MN de Arquit. PUEBLA, Fototeca Antica. ⧖ Sinopsis del distrito de Atlixco, Estado de Puebla, Puebla 1922; Monogr. del municipio de Tehuacán, Estado de Puebla, Méx. 1926; Hierros de Oaxaca, Méx. 1932; Herreros y forjadores poblanos, Méx. 1933; Catedral metropolitana. Sillería del coro, Méx. 1936; Loza blanca y azulejo de Puebla, 2 Bde, Méx. 1939; Bosquejo del desarrollo de la ciudad de Guanajuato, Méx. 1942 (Neu-Aufl. Guanajuato 2004); Pint. de Juan O'Gorman en la Bibl. „Gertrudis Bocanegra" de Pátzcuaro, Mich., Méx. 1945; Bosquejo del desarrollo de la ciudad de Mérida, Méx. 1945. ⧖ *Toussaint,* 1965; Dicc. Porrua de hist., biogr. y geografía de México, Méx. 1965–66; Enc. de México, Méx. 1987; *H. Musacchio,* Milenios de México, I, 1994; *G. Tovar de Teresa,* Repert. de artistas en México, I, Méx. 1995; *V. Jiménez,* Cuatro ss. de ciudades mex. Visión de E. A. C. (K MN de Arquit.), Méx. 1996; *E. Treviño* (Ed.), 160 años de fotogr. en México, Méx. 2004. M. Nungesser

Cervera, *André,* frz. Maler, * 22. 10. 1962 Sète/Hérault, lebt dort. Stud.: Ec. mun. des BA, Sète; Ec. supérieure des BA, Marseille, bei Aldo Biascamano. 1982–86 Mitgl. der Künstlergruppe Yaro (mit A. Biascamano und Christophe Cosentino), die gemeinsam Gem., Performances und Happenings gestaltet und zus. ausstellt. – C.s expressive figurative Gem. (bevorzugt Acryl/Packpapier mit Collage- und versch. Abdrucktechniken) sind v.a. durch Reisen inspiriert. In Motivik und Formsprache orientiert er sich bes. an afrikanischer Stammeskunst (z.B. in der Darst. schamanistischer Rituale) und kombiniert diese Anregung mit Elementen aus Pop-art und Comic (z.B. *Le purgatoire,* 2005). Geprägt von Aufenthalten in Shanghai zeichnen

sich die jüngeren Arbeiten durch eine zurückhaltendere Farbgebung und vereinfachte formale Gest. aus (z.B. *Le calligraphe*, 2007). Auch Animations- und Kurzfilme (M. der 1980er Jahre) sowie Plakat-Gest. (z.B. für Fiest'à Sète 2006). ☉ *E:* Sète: 1986 Gal. Peschot; 2005 Mus. Paul Valéry / Paris: 1991, '92 Gal. Jean-Pierre Harter; 1999–2002 regelmäßig Gal. Les Singuliers / 2006, '07 Shanghai, Hong Merchant Gall. / 2007, '09 Montpellier, Gal. Hambursin Boisanté. – *G:* 1992 Bilbao, MBA: De la Nouv. Figuration à la Figuration Libre / 2003 Paris, Gal. Fraîch'Attitude: Les Epouvantails; Figeac, Gal. Le Rire bleu: Figurations Libres / 2006 Shanghai, MCA: MoCA Envisage 2006 / 2007 Perpignan, Espace Maillol: Face à Don Quichotte. ▢ *Delarge*, 2001. – A. C. Divagation, Sète 2005. – *Online:* Website C. F. Krohn

Cervi Kervischer, *Paolo,* ital. Maler, Installations- und Multimediakünstler, * 31. 3. 1951 Triest, lebt dort. Ausb. und Tätigkeit als Geometer; ab 1969 Scuola Libera del Nudo im Mus. Revoltella, Triest, bei Nino Perizi. 1975 führt ihn eine Lebenskrise nach London. Dort beschließt er unter dem Eindruck des Gem. Study of a dog von Francis Bacon (Tate Gall.), Maler zu werden. Stud.: 1977–81 ABA, Venedig, bei Emilio Vedova (Malerei; Dipl.) und Fulvio Roiter (Fotogr.); Forts. der Kursbesuche bei N. Perizi. 1980 erste Installation, ein als *Dalla pitt. del simbolo al simbolo della pitt.* betitelter Kreuzweg in der Capp. del Crocifisso der Pfarrk. in Muggia. 1983 realisiert C. mehrere Performances, zunächst *Fashion* im Savoia Excelsior Palace in Triest. Mit von ihm entworfener und von seiner Ehefrau Cosetta C. genähter Garderobe wird die trad. Modenschau zum provozierendem Happening, bei dem drei Laienmodels mit unvermuteter Gestik und Mimik nach einer von C. komponierten Geräuschkulisse agieren. Wenig später folgen im Auditorium Pollini in Padua in Zusammenarbeit mit dem gleichnamigen Orchester die Performances *Pitt. con orchestra, il giallo è del clarinetto*, bei der C. unter Musikbegleitung malt, und *Improvvisazione: suonare se stessi*, bei der C. von den Musikern Polaroid-Fotos aufnimmt, die im szenischen Ritual auf die Notenpulte gelegt und wieder entfernt werden. Seit 1984 bildet Malerei den Schwerpunkt. Zunächst entstehen großformatige, phil.-relig. inspirierte Lw. im Abstrakten Expressionismus. 1989 gelangt C. mit Portr. (Aqu.) von zeitgen. ital. Dichtern für die Madrider Zs. Equívalencías, zur wirklichkeitsbezogenen Malerei und bildet sich in Wien an der ABK bei Arnulf Rainer und an der HS für angew. Kunst (auch Aktkurse) bei Maria Lassnig weiter. In jüngerer Zeit entstehen v.a. weibliche Portr. und Akte in einer reduzierten, flächigen, mitunter nicht deckenden Malweise. Hervorzuheben ist eine 2004–06 entstandene umfangreiche Werkserie *Corpi vacanti* (Mischtechnik/ Papier, ab 2005 auf Lw.): torsohafte weibliche Akte und Paare in erotischer Pose oder beim Liebesspiel in einer auf Körperstellungen verknappten, formatfüllenden Sicht mit Anschneidungen und kräftigen Pinselstrichen. Der dünnflüssige Auftrag kräftiger Farben hinterläßt herabrinnende Farbverläufe, die das Bildmotiv schemenhaft, wie durch einen durchsichtigen Schleier verborgen, wirken lassen.

🏛 Pirano, Obalne Gal. ☉ *E:* 1980 Koper (Slowenien), Gal. Meduza / 1981, '86 Triest, Sala Com. d'Arte / 1982 Venedig, Fond. dell'Opera Bevilacqua La Masa (mit *Silvano Bertaggia* [* 17. 3. 1948 Venedig-Mestre] und Antonio Martinelli; K) / 1983 Wien, Atelier Irene Andessner / 1983, '94 Graz, Kath. Studentengemeinde / 1985 Klagenfurt, Kunsthaus; Gal. Freud / 1986 Treviso, Gall. Torbandena / 1987 Viktring, Neues Musikforum / Mailand: 1988 Gall. Kriterion; 2002 Lattuada Studio (K) / 1991 Cortina d'Ampezzo, Limbo Art Section / 1998 Kanal ob Soci (Slowenien), Gal. Rika Debenjaka / 2002 Pordenone, Exconvento di S. Francesco; Kopenhagen, Gal. Krebsen. – *G:* 1978, '79 (Preis), '80 (Stip.) Venedig, Mostra dell'Opera Bevilacqua La Masa / 1979 Campione d'Italia: Concorso naz. tra le ABA ital. (Gold-Med.); Pirano: Ex Tempore Internaz. di Pitt. (1. Preis) / 1980 Mestre: Vedova e il laboratorio. ▢ All is here now (K), Pirano 1980; *A. Rosada* (Ed.), Per altre vie, per altri porti ... La nuova pitt. nel Friuli-Venezia Giulia, Pordenone 1986; *M. de Angelis*, P. C. K. Taccuino di viaggio. Ritratti di poeti, Trieste [2002]; *F. Dell'Agnese*, Pneumorama 12:2006 (1) 100 s.; *I. Valente*, P. C. K. Cat. ragionato (1978–2002), Diss. Univ. Triest 2007; *M. Braun u.a.* (Ed.), Internat. Malersymposium Casino Velden. Eine Slg (K), Klagenfurt 2007. – *Online:* Website C. D. Trier

Cerviño, *Angel,* span. Maler, Dichter, Fachautor, Kurator, * 2. 3. 1956 Lezoce/Lugo, lebt in Vigo. Mit-Hrsg. der Zs. Sinal der Asoc. Galega de Artistas Visuais. 2009 Kurator der Ausst. Teleprompter (Centro Torrente Ballester) in Ferrol/La Coruña. Ausz.: u.a. 1998 1. Preis, Salón de Otoño, Real Acad. Gallega de BA, La Coruña; 2. Preis, Certamen de Artes Plást., Lugo; 1999, 2004 Ankaufspreise, Certamen de Artes Plást. Isaac Díaz Pardo, La Coruña; 2009 Premio de Poesía Ciudad de Mérida. – C.s Gem. haben phil.-konzeptuellen Char., sind meist quadratisch und in wenigen Farben ausgeführt, beziehen Texte oder Logos mit ein und bilden Serien. Es sind rätselhafte, bisweilen humorvoll-satirische oder witzige Bilder, die oft wie große Negativdrucke wirken. In der Serie *Play-Back* (Mischtechnik oder Öl/Lw., 2001) stehen vor meist einfarbigen Hintergründen Comic- oder Märchengestalten zus. mit Worten oder zeichenhaften Gegenständen. In der Serie *Pinturas negras* (2003–04) treten aus schwarzem Hintergrund schemenhaft gerasterte Gesichter bed. Personen der Kunstund Zeit-Gesch. hervor, kombiniert mit and. Namen, z.B. Elvis Presley (Celan), Beuys (Sinatra), Hitler (Dante); ein Bild Goyas aus C.s Serie der „schwarzen Bilder" trägt in C.s Gem.-Zitat die Unterschrift „Espacio reservado para su publicidad". Ähnlich sind auch die Serien *Pago por visión* (2002–03), *Valor de cambio* (2003–06) und *Remate de males* (2007) angelegt, in denen sich zahlr. Anspielungen auf die Kunstgesch. finden (vgl. auch Titel wie *Rococó, Pop, Op-art* oder *Dadá*), gemischt mit Elementen der Alltagsmedien. C.s *Purgatorio suite* (2009) für die Ausst. Teleprompter, die neue Tarnungen des Malerischen erforscht, besteht aus einer Serie von digital erzeugten Portr. anhand eines vom FBI entwickelten Programms für Phantombilder. Auch Texte zur zeitgen. Kunst (z.B. über Bosco Ca-

ride, Jesús Valmaseda, Rosalía Pazo, Luis Seoane) sowie kritische Texte über neue Kunstpraktiken und die Tendenz zum Spektakel innerhalb der Kulturindustrie. ⌂ LA CORUÑA, Col. de Arte Caixa Galicia. – MAC de Unión Fenosa. – Prov.-Verwaltung. – Real Acad. Gallega de BA. – Stadtverwaltung. LUGO, Stadtverwaltung. MADRID, Col. Caja Madrid. ORENSE, Prov.-Verwaltung. VIGO, Col. de Arte Caixa Nova. ✉ Kamasutra para Hansel y Gretel, Ma. 2007; El ave fénix solo caga canela (y otros poemas), Ba. 2009 (DVD). ◉ E: 1993, '96 (K: A. González-Alegre), 2000, '02 (K: id./A. Ruiz de Samaniego) Vigo, Gal. Ad Hoc / Orense: 1995 Gal. Volter (K: A. González-Alegre); 2005 Prov.-Verwaltung, Centro Cult. (K: I. de la Torre Amerighi/J. M. Lens) / 1997 Porto, Gal. por Amor a Arte; La Coruña, Stadtverwaltung / 1998 Zaragoza, Gal. Odeón; Pontevedra, Espacio Caja Madrid (K: A. Ruiz de Samaniego) / 2006 Granada, Gal. Sandunga. – G: 1987 Murcia: Bien. de Pint. / 1988 Pontevedra: Bien. Internac. de Arte / 1995, 2009 Vila Nova de Cerveira: Bien. Internac. de Arte / 1996 Zamora: Bien. Internac. / 1997 Barcelona: Bien. Internac. del Deporte en las BA / 1999, 2001, '03 Lalín (Pontevedra): Bien. Laxeiro / 2008 Pamplona: Bien. de Artes Plásticas. ▭ DPEE, App., 2002. – M. Oliveira, Arte y parte (Ma.) 1988 (14); J. Rubio Nomblot, El punto de las artes (Ma.) v. 7. 2. 1997; A. Azpeitia Burgos, El Heraldo de Aragón (Zaragoza) v. 5. 2. 1998; M. Rozas, La Voz de Galicia (La Coruña) v. 3. 2. 2000; 17. 4. 2005; C. Vidal, A Nosa Terra (Vigo) v. 10. 2. 2000; I. de la Torre Amerighi, ABC (Ma.) v. 3. 6. 2006. – Online: Website C. – Mitt. C. M. Nungesser

César, Jean → **Cézard,** Jean

Ceschin, Livio, ital. Graphiker, * 28. 11. 1962 Pieve di Soligo/Veneto, lebt in Collalto di Susegana/Treviso. Stud.: 1978–82 Ist. d'Arte, Venedig; 1991 erste graph. Arbeiten; ab 1992 Teiln. an Kpst.-Kursen an der Accad. Raffaello, Urbino. Mitgl.: 2002 R. Soc. of Painter-Printmakers, London. Zahlr. Auszeichnungen. – C. fertigt v.a. Kpst. und Rad., seit 2003 auch Aquatinten, deren techn. Variationsbreite er meisterhaft beherrscht. In der Regel druckt C. nicht direkt auf weißes Papier, sondern legt Seidenpapier zw. Platte und Papier, so daß die Darst. nach dem Druck nach feiner und präziser erscheint sowie eine malerische Wirkung erhält. Der gelbliche oder bräunliche Papierton soll gewollt an vergilbte Fotogr. erinnern. Abgesehen von Bsp. wie La vecchia (1993) oder Omaggia Gombrich (2000) ist C.s zentrales Thema die Lsch., die er als Panorama oder ausschnitthaft mit char. Vegetation abbildet. Für die detaillierten Darst. scheinbar unberührter Lsch. bedient sich C. Fotogr., die er in der Umgebung aufnimmt, verändert oder collageartig kombiniert. Alle graph. Arbeiten zeichnen sich durch das spannungsreiche Zusammenspiel von Licht und Schatten sowie die einerseits fotogr. genau erfaßten Partien und andererseits nur skizzenhaft angelegten oder ganz frei gelassenen Stellen ebenso aus wie durch die präzise Darst. von Stofflichkeiten wie deren feine tonale Abstufungen. Weite Lsch., z.B. Sulla neve, tra pini e betulle (1996) oder Angoli dimenticati (2002), strahlen Ruhe und Ursprünglichkeit aus, wir-

ken jedoch nicht statisch. An die Anwesenheit des Menschen erinnern bisweilen u.a. Fischerboote, Gartenmöbel oder Fahrräder wie in La bicicletta (1995) oder Barca arenata (2002/03). Gelegentlich fügt C. Texte ein (Gedichte, Briefe), die gleichzeitig als Hommage an Dichter, Schriftsteller, Musiker und andere Künstler zu verstehen sind. Seit 1998 Buch-Ill., u.a. zu Andrea Zanzotto und Mario Rigoni Stern. ⌂ BAGNACAVALLO, MCiv., Gab. Naz. di Stampe. BOLOGNA, ABA, GDS. CREMONA, MCiv., Racc. Stampe. FERRARA, MCiv. di Arte Antica. FLORENZ, Uffizien, GDS. GENUA, Villa Croce MAC. LONDON, Nat. Portr. Gall., Print Cab. MAILAND, Civ. Racc. delle Stampe Achille Bertarelli. MÜNCHEN, Staatliche GrS. PARIS, BN, Cab. des Estampes. REGGIO EMILIA, Bibl. Panizzi, Gab. Stampe. ROM, Ist. Naz. per la Grafica. SAN CROCE SULL'ARNO, GDS. WIEN, Albertina. ◉ E: 1997 Lauf, Sparkasse (Wander-Ausst. der Soc. Dante Alighieri) / 1998 Mailand, Gall. Linati / 2002 Paris, Gal. Michèle Broutta / Florenz: 2004 Gall. Falteri; 2010 Gall. Bisonte / 2007 Radford, AM / 2007 Ferrara, Casa Ariosto. – G: 1994 Krakau: Internat. Print Trienn. / 1997 Charkiv: Internat. Trienn. of Graphic / 1998, '99 Paris, Gall. del Leone: Saga / 2001 London: Summer Exhib. / 2008 Ourense: Bienn. Internaz. di Grafica Caixanova. ▭ F. Lucchini, Grafica d'arte 12:2001 (46) 22 s.; C. Comentale, Nouvelles de l'estampe 183:2002, 34–38; L. C. Opera graf. (K Gall. Falteri), Fi. 2004; D. Papemberg, Graph. Kunst N. F. 2:2004, 21–25; A. Piras (Ed.), C. L'opera incisa 1991–2008, Mi. 2009 (WV, Lit.). – Online: Gall. del Leone.

C. Follmann

Cestac, Florence, frz. Comiczeichnerin und -autorin, Illustratorin, Verlegerin, * 18. 7. 1949 Pont-Audemer/Eure. Stud.: ab 1965 EcBA, Rouen und Paris. Sie veröffentlicht Ill. in versch. Mag. und lernt Etienne Robial kennen, mit dem sie 1972 Futuropolis, den ersten Comic-Buchladen in Paris, eröffnet. 1975 Gründung des innovativen Verlags Futuropolis, als dessen Maskottchen ihre Comicfigur Harry Mickson dient, von der ab 1976 auch im Mag. L'Echo des Savanes Geschichten erscheinen. Seitdem veröffentlicht C. in allen großen frz. Comicmagazinen. Ausz.: 1989 L'Alph'art de l'humour (für Les Vieux Copains pleins de pépins); 1997 2. Preis (für Le Démon de midi); 2000 Grand Prix de la ville d'Angoulême. Die Erzählung Le Démon de midi wird auch als Theaterstück adaptiert. C. zeichnet Comics auch für jüngere Leser, z. B. Les Débloks (Szenario: Nathalie Roques) für das J. de Mickey. Sie beginnt verstärkt autobiographisch zu arbeiten. Es erscheinen 2002 La Vie d'artiste und 2007 La véritable histoire de Futuropolis. C. gilt als eine der einflußreichsten frz. Comiczeichnerinnen. Ihre Arbeiten sind eine Mischung aus dem US-amer. Funny-Comic und den Underground comix. Ihre Figuren haben große char. Nasen und beziehen sich eher auf das Werk von Elzie Chrisler Segar als auf frz. Schulen. Durch den schrägen Humor wird in den Geschichten die Nähe zu parodistischen Inhalten gesucht. ◉ E: 2001 Angoulême, Centre nat. de la Bande dessinée et de l'Image (Retr., K). ▭ P. Gaumer/C. Moliterni, Dict. mondial de la bande dessinée, P. 1997; H. Filippini, Dict. de la bande dessi-

née, P. 2005. – *Online:* Website C. (Lit.); Lambiek Comiclopedia. K. Schikowski

Čestvilov (Čerstvilov), *Vladimir Aleksandrovič*, russ. Bildhauer, * 15. 2. 1925 Balachi/Kreis Orša, † 1992 Perm'. Stud.: 1949–50 Kunst-FS, Erevan; 1950–53 KHS ebd. Ab 1953 in Krasnokamsk ansässig; in diesem Jahr erste von zahlr. folgenden Ausst.-Beteiligungen. War im Kunstfonds Perm' tätig. Teiln. an Wettb. (u.a. Denkmal für die Opfer der Stalinschen Verfolgungen, 1989, 2. Platz). – V.a. Skulpt. zu Motiven aus Gesch. und Gegenwart des Ural, im Frühwerk meist mit romantisch-pathetischem Grundgestus (*Gusljar*, 1954; *Zoja Kosmodem'janskaja*, 1955; *Šel parniška v tu poru...*, 1957). Als programmatische Werke jener Zeit gelten u.a. *Staryj Ural* (Heimatkunde-Mus., Perm') und *Malachotivaja škatulka* (beide 1955), die Affinitäten zu den Werken des Schriftstellers P. P. Bažov aufweisen. Auch in den 1960er Jahren arbeitet Č. zu revolutions-hist. Themen (u.a. *Pochod V. K. Bljuchera*; *Uznik konclagerja*; *Sen'ka-sokol*). Zugleich erstmals Beschäftigung mit Portr. (z.B. *Poslednij locman reki Čusovoj*; *Portret V. Kosivcova*). M. der 1970er Jahre Reise nach Pereslavl'-Zalesskij und Begegnung mit dem Bildhauer Vladimir Aleksandrovič Vachrameev. In den Werken der zweiten H. der 1970er Jahre bevorzugt Darst. von Zeitgen. und Portr., in denen Č. individuellen und typischen Zügen nachspürt (Portr. der Mutter; des Geophysikers V. Kustov; der Arbeiter der Goznak-Papierfabrik V. Rogačev und V. Tregubov; des Kriegsveterans V. Petrov, 1977). Auch Denkmäler (u.a. für *V. K. Bljucher*, 1980er Jahre, Station Ferma/Kreis Perm') und Gedenktafeln u.a. für *Michail Kalinin* (ehem. Gebäude der Landwirtschafts-Akad. Perm'; entwendet). ⌂ KYLASOVO/Kreis Kungur: Memorialkomplex. PERM', KG. – Heimatkunde-Mus. – Sverdlov-Motorenwerk: Flugzeugkonstrukteur A. D. Švecov, Büste, Bronze, 1950er Jahre. ◉ *E:* 1985 (zus. mit Aleksandr Ivanovič Repin, Ivan Stepanovič Borisov; K), '87 Perm', Zentraler Ausst.-Saal. ⌑ *A. Ždanova*, V. Č., Perm' 1975; *ead.*, Monumental'noe isk. Prikam'ja, Perm' 1984; *N. V. Kazarinova*, Chudožniki Permi, Le. 1987.

D. Kassek

Cetica, *Aurelio*, ital. Architekt, * 25. 6. 1903 Marciano della Chiana/Arezzo, † 1984. Stud: ABA, Florenz (1926 Dipl.). Lehrt an der Scuola Superiore di Archit. ebd., Ass. von Raffaello Brizzi. Später v.a. in Florenz als Architekt tätig. Teiln. an Wettb. für Gebäude und Städtebau. V.a. öff. Aufträge, darunter Umbau des Teatro Comm. Vittorio Emanuele II, Florenz (1931/32, mit Alessandro Giuntoli), Badepavillons in Viareggio (1932) und Casa della Gioventù Ital. del Littorio, Florenz (1934/35, 1938 eingeweiht, nicht erh., mit Fiorenzo De Reggi). Mitarb. bei zahlr. Stadtplanungen, u.a. Florenz (1936), Wiederaufbau von Arezzo (1945) und Borgo S. Lorenzo (1946), Florenz-Sorgane (ab 1960) und Val di Chiana (ab 1966, mit Sohn Pier Angelo C.). In den 1950er Jahren errichtet C. mit Domenico Cardini und Rodolfo Raspollini preiswerte Wohnhäuser, darunter die sog. Case Minime in Florenz-Rovezzano. 1955–60 ebd. Wohn- und Geschäftsgebäude (mit Sohn). Außerdem zahlr. kirchliche Aufträge, u.a. in Florenz die

Kirche Madre della Divina Provvidenza (1947–59) und das Gemeindezentrum Nostra Signora del Sacro Cuore (mit Sohn). ⌂ FLORENZ: Scuola Centrale dei Reali Carabinieri, 1939 (mit A. Giuntoli). – Centro Studi della Confederazione ital. sindacati lavoratori, 1959. ⌑ L'arte di Filippo Brunelleschi, in: Firenze. Rass. mensile del comune 12:1943 (10) 209–218. ⌑ Arte cristiana 58:1970, 181–182; *E. Insabato/C. Ghelli*, Guida agli arch. di architetti e ingegneri del Novecento in Toscana, Fi. 2007, 120–125. – Florenz, StsA: Dok., Zchngn, Fotogr.; StA.

N. Buhl

Çetin, *Orhan Cem*, türkischer Fotograf, Publizist, * 1960 Istanbul, lebt dort. Als Künstler Autodidakt. Stud. in Istanbul: bis 1982 Psychologie an der Boğaziçi Univ.; 2009 Abschluß in Visual Communication Design an der Bilgi Univ.; ebd. Doz. für Fotogr. und Video. Weitere Lehraufträge u.a. an der Galata Acad. of Photogr., der Yıldız Technical Univ. sowie der Yeditepe Univ. (Fak. für bild. Kunst). Arbeitet auch als Hrsg., Übersetzer und Autor von Publ. über Fotografie. – Ç. gliedert seine Arbeiten in Werkserien. Erste Aufmerksamkeit erhält er für *Familiaria* (1988), eine Serie von hand-kol. Negativdrucken. Bis 1995 experimentiert er mit farblichen Verfremdungen sowie Schärfe-Effekten. Auch Collagen. Seine Motive zeigen Gruppen-Portr. und Lsch.-Darstellungen. Mit der Serie *Bilet* (2001) werden die Aufnahmen schnappschußartiger und zeigen Beobachtungen im Alltag. Seit *Yakın* (2004) wendet sich Ç. verstärkt der Makro-Fotogr. von Alltagsgegenständen und organischen Strukturen zu. Die Titel der Serien wecken Assoziationen an Vergangenheit, Traum und Schlaf. Ç. begleitet als Fotograf häufig Tanz- und and. künstlerische Performances. ⌑ Renk'arnasyon, Istanbul 2000; Bedava Gergedan, Istanbul 2004. ◉ *E:* Istanbul: 1988 Refo Fotoğraf Gal.; 1989 Vakkorama; 1993 Aksanat; 2003 Bienn. Kuledibi; 2006 Staatstheater; 2011, '12 Sanatorium Gal. / 2002 İzmir, Atatürk Cult. Center; Wien, Theater des Augenblicks. ⌑ *Online:* Website Ç. (Ausst.).

K. Schmidtner

Çetınkaya, *Hikmet*, türkischer Maler, * 1958 Konya, lebt in Paris und Ankara. Stud.: bis 1982 Pädagogische Fak. der Gazi Univ., Ankara (Malerei). Gründet danach ebd. ein eig. Atelier und eine Gal.; 2002 eröffnet er ein Atelier in Paris. Ç. führt mehrere Aufträge für staatliche Einrichtungen aus. – Häufigstes Motiv sind Mohnblumen in Wiesen vor teilw. monochromen, aber auch Lsch.-Hintergründen (Öl/Lw.). ◉ *E:* u.a. Ankara: 1994 Kardelen Sanat Gal.; 1996 Milo Sanat Gal.; 1997 Çetinkaya Sanat Gal.; 2002, '03 RD Sanat Gal.; 2003, '05 Valör Resim Gal.; 2005, '06 Gal. Baraz; 2007, '11 Nurol Sanat Gal. / Istanbul: 2001 Artium Sanat Gal.; 2006 Toprak Sanat Gal. / 2001 Balıkesir, Çakınberk Sanat Gal. / 2003 Mersin, İçel Sanat Kulübü / 2004 Paris, Le Centre Cult. Anotolie; Caen, Château De Beauregard / 2006 Antalya, Gal. Desti / 2010 Toronto, Hittite Gall. / 2011 Bodrum, Villa Rustica. ⌑ *Online:* Website Ç. (Ausst.). K. Schmidtner

Čevalkov, *Miroslav Pavlovič*, russ. Maler, Zeichner, * 6. 6. 1929 Šebalino/Altaj-Region, † 2006. Ab 1930 in Gorno-Altajsk ansässig. Stud.: Pädagogische HS ebd.; bis

1956 Kunst-FS, Kostroma. War u.a. für die Ztg Zvezda Altaja und für Verlage tätig. Ab 1959 zahlr. Ausst.-Beteiligungen. – Č.s Werk ist geprägt von der russ. Schule der Lsch.-Malerei, vom Œuvre des Malers Viktor Michajlovič Vasnecov von russ. Dichtung (u.a. I. N. Nikitin, I. Z. Surikov). Hauptthemen seiner Werke, deren Detailreichtum die umfassenden, wiss. fundierten archäol. und hist. Kenntnisse Č.s belegt, sind die griech. Mythologie und die Legenden aus dem Altaj (*Ulgen'*; *Kogutej i Sujla-chan*; *Falken*; *Ėrlik sudit i rjadit*; *Ot Ėėzi*; *Suu-Ėėzi* [Geist des Wassers]; *Maj-Ėne*). Meist Gest. von heroischen Char.; Č. schuf z.B. eine Gem.-Serie zum Epos *Oči-Bala*, dessen Heldin die zweifellos markanteste Frauenfigur der Heldendichtung des Altaj ist. Č. widmet sich der hist. Entwicklung des Altaj auch in mehreren Gem. der Skythen-Serien *Stereguščie zoloto grify* (1970er Jahre) und *Skify Altaja* (1979; hierzu zahlr. Skizzen und Vorstudien; ethnogr. exakte Darst. von Trachten). In seinen Lsch. kommen die Begeisterung für die Natur und der Respekt vor ihrer Kraft und Schönheit zum Tragen. Auch lyrische Lsch. (u.a. *Uč-Sumer*). Bemerkenswert sind ferner Č.s Portr. von Schriftstellern aus dem Altaj (mehrere Bildnisse von P. V. Kučijak, dessen Vater ein bek. Legendenerzähler war; u.a. *Kučijak u kajči*) sowie seine Gem. zu russ. (Soldaten-)Liedern, die häufig Ill. (meist schwarzweiß) ähneln. Im Frühwerk meist farblich markante Komp., später leichte, gleichsam transparent wirkende Farbigkeit (Aqu.). ▭ BARNAUL, NM der Altaj-Region. BIJSK, Heimatkunde-Mus. GORNO-ALTAJSK, Heimatkunde-Mus. NOVOSIBIRSK, Rerich-Mus. ☉ *E:* u.a. 2009 Novokuzneck, K. / 2011 Novosibirsk, Rerich-Mus. (ehem. KM). ▭ Sibirskij mif. Golosa territorij (K), Omsk 2005.

D. Kassek

Cewang (Tsewang), *Tashi*, tibetischer Maler, * 1963 Lhasa, lebt dort. Bis 1980 Lhasa Middle School. Stud.: bis 1984 FA Dept. der Central Univ. for Nat. Minorities, Beijing (Abschluß in Ölmalerei); bis 2002 KHS, Oslo (Graduierten-Stud.). Seit 2009 ist C. Doktorand an der Fak. für Archit. und Bild. Kunst an der Univ. in Trondheim. Zudem ist er als Doz. an der SchA der Tibet-Univ. in Lhasa tätig und dort Vizerektor. 2003 ist er ebd. Mitbegr. der Gedun Choephel Artist's Guild. Auch kuratorisch tätig. – C.s Ölmalerei orientiert sich thematisch an zeitgen. Fragestellungen und am Alltagsleben im mod. Tibet. So zeigen seine oft fotorealistischen Arbeiten z.B. Tibeter in chin. Sportanzügen oder mit westlichen Markenartikeln bekleidet. Dadurch betont er das Spannungsfeld mod. tibetischer Identität. C. bevorzugt große Formate, zeigt Gesichter stark vergrößert und monochrom in Nahaufnahme oder auch verlassene tibetische Landschaften. ▭ 20th c. Tibetan paint., in: *R. Barnett/R. Schwartz* (Ed.), Tibetan modernities. Notes from the field on cult. and social change, Leiden u.a. 2008. ☉ *E:* 2000 Oslo, 21:24/21:25 Gall. / 2009 London, Rossi & Rossi Gall. – *G:* 2004 (Contemp. Tibetan Art), '06 (Lhasa Train) Santa Fe (N. Mex.), Peaceful Wind Gall. / 2006 London, Rossi & Rossi: Lhasa Express; Boulder (Co.), Univ. of Colorado: Waves on the Turquoise Lake. Contemp. Expressions

of Tibetan Art; Königswinter, Siebengebirgs-Mus.: Mod. Kunst vom Dach der Welt. Zeitgen. Malerei aus Tibet / 2007 Lhasa, Gedun Choephel Gall.: Inside out. Tibetan Contemp. Art; Beijing, Red Gate Gall.: Lhasa. New Art from Tibet. ▭ Contemp. Tibetan paint., Bj. 2001; Visions from Tibet. A brief survey of contemp. paint. (K Contemp. Tibetan AG), Lo. 2005; Tibetan encounters. Contemp. meets trad. (K New York u.a.), Lo. 2007; Untitled identity (K), Lo. 2009.

R. Höfer

Cézard, *Jean* (eigtl. César, *Jean*), frz. Comiczeichner und -autor, * 23. 3. 1924 Membrey/Haute-Saône, † 8. 4. 1977 ebd. C. veröffentlicht 1946 in der Kinder-Zs. Francs-Jeux Ill. und ab 1948 die Gagserie *Monsieur Toudou*. Für Mon J. entstehen die Episoden des *Prof. Pipe*. Zw. 1949 und 1954 zeichnet er für den Verlag Adventures et Voyages zunächst realistische Comicserien, *Brik* und *Yak*, und später Funnyserien, 1959 *Jim Minimum* und 1973 *Billy Bonbon*. Ab 1951 arbeitet C. für das Mag. Vaillant, für das er humoristische Serien (*Les Compagnons de la section noire*, *La Quête de l'Aruda*, *Le Chevalier de Lagardère* und *Terre de héros*) zeichnet und schreibt. In Vaillant Spécial Noël 1953 erscheint erstmals *Arthur le fantôme justicier*, die zu seiner erfolgreichsten Serie wird (bis zu seinem Tod 1977 fortgeführt). Zw. 1955 und 1968 zeichnet er für Editions Lug den Pechvogel *Kiwi*. Für Dakota nimmt er 1959 *Prof. Pipe* wieder auf. Nach der Umbenennung von Vaillant in Pif Gadget (1969) erhalten die aus *Arthur* hervorgegangenen Comic strips *Les Tristus et les Rigolus* eine eig. Reihe, die C. bis 1973 zeichnet. Ab 1973 erscheint *Surplouf le petit corsaire*. – C. gehört zu den wichtigsten Künstlern des Mag. Vaillant. Seine realistischen Serien beziehen sich stilistisch auf die Illustratoren der US-amer. Comic strips aus den 1930er Jahren. Sein Funnystil ist detailreich und läßt sich keiner der großen franko-belg. Comicschulen zuordnen. ▭ *P. Gaumer/C. Moliterni*, Dict. mondial de la bande dessinée, P. 1997; *H. Filippini*, Dict. de la bande dessinée, P. 2005; *G. Förster*, Die Sprechblase 204:2006. – *Online:* Lambiek Comiclopedia.

K. Schikowski

Cha, *Hak Kyung* → **Cha,** *Theresa Hak Kyung*

Cha (C.-Oh), *Ouhi* (*Ou Hi*; *Ou-Hi*), südkoreanische Malerin, Zeichnerin, Installationskünstlerin, * 29. 6. 1945 Busan, lebt seit 1981 in Seoul und Berlin. Stud.: 1964–69 Chung-Ang Univ., Seoul. 1977 Europareise und Aufenthalt in Paris. Ausz.: 1995 Stip. des Dt. Akad. Austauschdienstes (DAAD); 1996 Stip. des Minist. für Kultur und Bildung, Berlin; 2001 Seok-Ju Art Award. – C.s eig. Odyssee ist Schlüsselthema im Grenzgang zw. lyrischer Abstraktion und konstruktiv-konkreter Kunst. Poetische Textfragmente als z.T. verborgene Bildelemente transportieren Gedankenmuster. Baupläne und Teile von Segelschiffen sind Ausgangspunkte von geometrischen Formen oft serieller Bilder. Fundstücke dienen C. als Mat. für Bildobjekte und Rauminstallationen (z.B. *Stray Thoughts on Sail*, Öl/Lw., 1992 und 1999; *Sail as a Wing*, Collage auf Papier, 2010; *La boîte de la mém.*, Installation, 2010). Auch Lith. für Buchillustrationen. ▭ BERLIN, Berlinische Gal. – Kpst.-Kab. – KS der Landesbank Berlin. BUSAN, Metrop.

AM. Görlitz, Kultur-hist. Mus. Gwacheon, NMCA. Seoul, Leeum, Samsung Mus. of Art. ✉ *C./J. Sartorius/R. Wiegenstein*, Imagination, B. 1990. 👁 *E:* Seoul: 1977 Gall. Hyundai; 1979 Kwanhun Gall.; 1990–2008 mehrmals Jean AG (1994 K); 2009 Shinsegae Gall. (K); 2010 Watergate Gall. / Berlin: 1982–83 Künstlerhaus Bethanien; 1985 KH (K); seit 1990 mehrmals Gal. Georg Nothelfer / 1984 Amsterdam, Gal. Suspect / Tokio: 1986 Gall. Q; 1994, '97, 2001 Gall. Shirota / Kyōto: 1989 Gall. Marronnier; 2001 Gall. Miwazaki / 1991 Düsseldorf, Gal. Mühlenbusch-Winkelmann (K: C./W. Schmied) / 2000 Görlitz, Gal. Klinger / 2010 Beijing, Chang Art (K). – *G:* 1988/89 Berlin, AK: Balkon mit Fächer / 1990 Sydney: Bienn.; Berlin, Berlinische Gal.: Kunstszene Berlin (West) 86–89 (K) / 1993 Venedig: Bienn. (offizieller türkischer Beitrag: Inbetween; danach Wander-Ausst.; K: A. Yilmaz/ J. Geismar). ⌑ *W. Schmied u.a.*, O. C., Ha. 1985 (mit Beitr. von Nam June Paik und C.); *H. Ohff*, Das Kunstwerk 38:1985 (6) 69; *P. Spielmann* (Ed.), Das and. Land, B. 1986; Zeitberliner: 6 Gäste des Berliner Künstlerprogramms (K Forum für Kulturaustausch, Inst. für Auslandsbeziehungen, Stuttgart), B. 1987; *A. Bonito Oliva u.a.*, Asiana (K Venedig), Mi. 1995; Kunst in Görlitz – Jetzt! (K), Görlitz 2002; Objet trouvé. Dialogue – between the lines, Seoul 2004; *M. Grütters* (Ed.), Die KS der Landesbank Berlin, B. 2007. E. Kreis

Cha, *Theresa Hak Kyung*, südkoreanisch-US-amer. Konzept-, Video-, Film-, Installations- und Performancekünstlerin, Schriftstellerin, * 4. 3. 1951 Busan, † 5. 11. 1982 (von einem Wachmann des Puck Building in So-Ho ermordet) New York. Heiratete im Mai 1982 den Fotografen Richard Barnes. 1962 emigriert ihre Fam. über Hawaii in die USA. Stud.: 1968 Univ. of San Francisco; Univ. of California, Berkeley: 1969–75 Keramik bei Peter Voulkos und beim Bildhauer Jim Melchert, 1975 (Abschluß) Bild. Kunst; 1969 Semiotik und frz. Filmtheorie bei Bertrand Augst, 1973 (Abschluß) in Vergleichender Lit.-Wiss.; 1976 Centre d'Etudes Amér. du Cinéma, Paris, Filmtheorie bei Christian Metz, Raymond Bellour, Thierry Kuntzel. 1977 Einbürgerung in die USA; 1977–79 Vorstand-Mitgl. des Künstlerkollektivs Line, das sich v.a. mit Künstlerbüchern beschäftigte. 1979 erste Reise nach Südkorea, 1980 dort zu Dreharbeiten für den Film *White Dust from Magnolia* (unvoll., Kamera: C.s Bruder James). 1980 Umzug nach New York. 1981 Doz. für Videokunst, Elizabeth Seton College, Yonkers/N. Y.; Verwaltungs-Ass. im Design Dept., MMA, New York. Ausz.: 1975 Eisner Prize for video and film, Univ. of California, Berkeley; 1977 Stuart McKenna Nelson Memorial Award for the Photogr. Medium, Univ. of Nevada, Las Vegas; 1982 Artist in Residence, Nova Scotia College of Art and Design, Halifax/Kanada. – Basierend auf der Performance- und Videokunst der 1970er Jahre gelangt C. über die Beschäftigung sowohl mit der eig. Gesch. als auch mit politischen Themen zur Konzeptkunst. Exil, Wechsel zw. versch. Kulturen und Sprachen (Koreanisch, Englisch, Französisch, Latein) bilden den Hintergrund für Themen wie Erinnerung und Entfremdung. Zu C.s Œuvre gehören Künstler-

bücher, Visuelle Poesie, Mail-art, Papier- und Stoffarbeiten, Objekte, Performances, Diaprojektionen, Filme, Videos und Installationen. Zentrum ihrer poetischen Konzeptkunst ist die Sprache, deren identitätsstiftendes, aber auch dekonstruierendes Potential sie durchforscht. Der Einsatz von Sprache dient dabei bes. auch als emotionales Instrument, z.B. *Mouth to Mouth*, Video, 1975; *Exilée*, Film-/ Videoinstallation, 1980. ⌑ Berkeley/Calif., Berkeley AM and Pacific Film Arch.: Nachlaß. New York, Electronic Arts Intermix. ✉ Apparatus. Cinematographic Apparatus. Selected Writings, N. Y. 1980; Dictée, N. Y. 1982; *C./C. Lewallen* (Ed.), Exilée and Temps Morts. Selected Works, Berkeley 2009. 👁 *E:* 1989 Oakland, Mills College AG / 1990, 2001 (The Dream of the Audience: T.H.K.C. [1951–1982], Retr., Wander-Ausst., K; auch 2004 Wien, Generali Found. [erweiterter K: S. Breitwieser Ed.; Lit.]) Berkeley, Berkeley AM and Pacific Film Arch. / 1993, '95 New York, Whitney. – *G:* 1975 Berkeley, Worth Ryder Gall., Univ. of California: Mouth to Mouth / 1980 Reykjavík, Nýlistasafnið (Living AM): Bókasýning (K) / 1981 Amsterdam, Sted. Mus.: Kunstenaarsboeken – Other Books and So Arch. (K) / 1982 Den Haag: World wide video festival / 1999–2000 New York, Whitney: The Amer. c.: Art and cult. 1900–2000 (K: B. Haskell/ L. Phillips) / 2007 Los Angeles, MCA: WACK! Art and the feminist revolution (Wander-Ausst., K). ⌑ The Asian Amer. enc., I, N. Y. 1995; *S. Ware u.a.*, Notable Amer. women. A biogr. dict. completing the twentieth c., V, C., Mass. 2005; Enc. of Asian Amer. artists, Westport, Conn. 2007. – *S. Wolf*, Afterimage 14:1986 (1) 11–13; *L. Higa*, Contact II 7 (1986) 38–40; *L. Rinder*, The theme of displacement in the art of T.H.K.C. and a cat. of the artist's oeuvre, M. A. Thesis, Hunter College, City Univ. of New York 1990; *E. Kim u.a.*, Writing self, writing nation, Berkeley 1994; *E. Kim*, Arte Internac. MAM de Bogata, Colombia 1994 (Jan.-März) 65–67; *L. Rinder* (Ed.), Searchlight. Consciousness at the millennium, N. Y./S. F. 1999; *C. Lewallen u.a.*, The dream of the audience: T. H. K. C (1951–1982) (K), Berkeley 2001; *U. M. Probst*, Kunstforum internat. 171:2004 (Juli/Aug.) 388–390. – *Online:* OAC, Online Arch. of California (Nachlaß). E. Kreis

Chaaltiel, *Eldad* cf. **Chaaltiel,** *Ora*
Chaaltiel, *Ohad* cf. **Chaaltiel,** *Ora*
Chaaltiel (Lahav-C.; Lahav-Shaaltiel; Shaaltiel), *Ora*, israelische Graphikerin, Zeichnerin, Malerin, Papierkünstlerin, Kunstpädagogin, Lyrikerin, * 1936 Kibbuz Mizra, lebt in Ein Hod. Verh. mit dem Maler Joseph C.; Mutter des Bildhauers *Eldad C.* (* 1958 Ein Hod) und des Malers und Kunstpädagogen *Ohad C.* (* 1961 Ein Hod). Ausb.: Zeichen-Stud. bei Marcel Yanco, Malunterricht bei Zvi Meirovitoh, beides in Israel. In Paris Lith.-Stud. in der Wkst. von Moshe Cohen und Jacqueline Larieau. Teiln. am Uncle Bob Lesley Paper Workshop in Beer Sheva. Gründet die Kunst-Abt. an einer Schule in Reot und im Jugenddorf Yemin Orde. C. ist Leiterin des Lith.-Workshops in Ein Hod und Kuratorin nat. Ausstellungen. Mitgl.: Israel Painters and Sculptores Ass.; Internat. Ass. Of Handmade Paper Artists (IAPhfA). Ausz.: u.a. 1973 Yad Vashem Med. für

25 Lith. (zu Y. Catzenelson, *A Song about the Jewish People that were killed*); 1982 Preis des israelischen BildungsMinist. für ihre Arbeit als Kunstpädagogin; 1986 Preis der Haifa Municipality Cult. Found.; 1990–92 Israel Endowment Fund; 1992 Hermann-Struck-Preis; 1996 The Israel President Fund for Poet. – In ihren Lith., auch als Ill., überwiegen expressiv-figürliche Kompositionen. Zusätzliche optische Reize erzeugt sie z.B. beim Überdrucken von Notenblättern oder Zeitungspapier. Neben weiblichen Akten (auch als Tusch-Zchng) gestaltet sie zunehmend abstrakter in mediterranen Farben (Acryl/Lw.) Portr. von Frauen. Zu ihrem Schaffen gehören ferner (Portr.-)Hschn. (bes. in den 1960er Jahren), Assemblagen (Papier, Textil) und kleingraph. Arbeiten. Ihre bes. Aufmerksamkeit gilt seit vielen Jahren der Herstellung von Papier. ⌑ KIBBUTZ LOHAMIE HAGHETAOT, Art Coll. of the Ghetto Fighters House. ◉ *E:* u.a. Haifa: 1960, '74, '94 Chagall Artists' House; 1986, '87 (Lith.) Mod. Art Mus.; 1993 Yad Lebanim House (mit J. Chaatiel) / ab 1965 Ein Hod, Artists' House / 1969 Eilat, Mus. / 1970 Besançon, Holocaust Mus. / 1975 Jaffa, Ancient Jaffa Gall. / Tel Aviv: 1978 Tsavta; 1986 Eked Gall.; 1997 Artists' House; 2006 Bein Ariela Libr. (mit Eldad, Ohad und Joseph C,, Margalit Pery, Ya'ara und Marom Sinuani) / 1981 Jerusalem, Artist's House / Paris: 1985 Centre Rashi; 1994 Gal. Saphir; 1998, '99 Cité internat. des Arts / 2002 Afula, City Gall. – *G:* u.a. 1981 Cleveland: Bienn. for Drawings / 1985 Haifa: Reprint Bienn. / 1986 Lebon: Exlibris-Bienn. / 1986, '99 Sarcelles: Graphik-Bienn. / 1989 Valparaiso: Bien. / 1994 Paris: Internat. Buchmesse / 1996 Kopenhagen: Mail art / 1991 Budapest: Creative Paper Exhib. / 1997 Bologna: Ex – Alibis / 1998 Boston, Star Gall.: 5 Artists from Ein Hod / 2002 Jerusalem u.a.: Feminina 2002 / 2003 Chamalières (Auvergne): Bienn. ⌑ *Online:* Ein Hod Artists' Village; Israel AC. St. Schulze

Chabičev, *Magomed (Magomet) Ismailovič*, Bildhauer, Maler aus Karačaevo-Čerkessien/Russ. Föderation, * 22. 2. 1953 Gebiet Džambul/Kasachstan, lebt in Kislovodsk. Nach der Rückkehr seiner unter Stalin nach Kasachstan deportierten Eltern in Malyj Karačaj ansässig. Frühzeitiges Interesse für Schnitzwerk und Kunst (Ch.s Vater war Kunsttischler). Stud.: Pädagogische HS, Karačaevsk, u.a. bei Georgij Vasil'evič Beda, Grigorij Semenovič Ostrovskij, Anatolij Semenovič Chvorostov; später bei Chamzat Baschanokovič, Nal'čik. Ausz.: u.a. 2003 Stolypin-Nat.-Preis (Bestes Werk zum Agrarthema). – Bevorzugt Mon.-Skulpt. (z.B. *1943 god*) sowie Denkmäler für bed. Persönlichkeiten des Volkes der Karataschajer (s.u.); auch Büsten für die Helden der Arbeit (*Z. Bajramkulova, Pati'ja Šidakova, Nuzule Kubanova*). Von Ch. stammen ferner Komp., die thematisch der Mühsal und Schwere des Landlebens gewidmet sind (z.B. *Kosary*; *Kozopas*; *Byčok*). Auch Portr.-Plastiken, z.B. des Volksdichters *Azamat Sujunčev*, des Komponisten *Madžit Nogajliev* und des Lit.-Historikers *Kazi-Magomet Totorkulov*. Freie Skulpt. wie *Vdovy, Chameleon* oder *Aksakal v puti* sowie die Kleinplastiken *Zavisimost' ot želtogo, Čaban* oder *Gumanoid* bezeugen Ch.s Suche nach neuen Ausdrucksfor-

men und sein Bestreben, den Raum durch eine dynamischere Gest. der Formen zu erschließen. Auch Gem., in denen sich Ch. von alltäglichen Szenen und hist. Materialien inspirieren lässt (u.a. *Doč' Apsaty – Fatima; Strana Alanija; Gošajach bijče; Sovet starejšin; Tatark"an; Krymšamchalov Islam*). Bemerkenswert sind ferner seine dekorativen Skulpt. in Möbelform, so ein nach hist. Überlieferungen gestalteter Dschingis-Khan-Thron (u.d.T. *Korona Kazanskij caricy*/Krone der Herrscherin von Kazan', ca. 2002–05). Der Thron (Hw.) besteht aus einer Holz-Komp. (Bergahorn) mit zeichenhaftem Dekor (u.a. mit Verweisen auf Machtsymbolik), deren unterer Teil eine Jurte assoziiert, während die Sitzfläche an Gesimse mongolischtibetischer Bauwerke erinnert; hinter dem Thron ist eine in Ehrfurcht vor dem Herrscher verharrende Kriegerfigur angeordnet. Der Thron wurde anlässlich der Tausendjahrfeier von Kazan' als Staatsgeschenk der Republik Karačevo-Čerkessien dem Präs. von Tatarstan überreicht (heute im Kreml'-Mus. von Kazan'). ⌑ KARAČAEVSK: Kaspot Kočkarov; Mudalif Batčaev, Denkmäler, Bronze, 2002. KAZAN', Kreml'-Mus. KRASNYJ KURGAN/Kreis Malokaračaevsk: Trauer, Skulpt. UČKEKENE: Allee der Helden des 2. WK. ⌑ *A. Jakimovič*, Molodye chudožniki vos'midesjatych, Mo. 1990; Edinyj chudožestvennyj rejting, vyp. 4, Mo. 2001. D. Kassek

Chablais, *Vincent*, schweiz. Maler, Graphiker, Zeichner, Kunstpädagoge, Kurator, * 1962 St. Maurice, lebt in Bern. 1994 Ausst.-Debüt in Sierre. Lehrtätigkeit: 1997 Prof. an der Éc. Cantonale d'Art in Valais; 2007 Doz. an der HdK in Bern; 2001–03 Gast-Doz. an der EcBA in Genf. Stip.: 1989 Stadt und Kanton Bern (Atelier in New York); 1992 Stiftung Pro Arte; 1993 Aeschlimann Corti Stip.; 1998, 2004 Kanton Wallis; 2002 Braziers internat. artist workshop. – C.s Arbeiten sind charakterisiert durch einen sensiblen und gleichzeitig versachlichenden Umgang mit den Spuren von Archit. im Alltag. Visuell Unspektakuläres wird bildwürdig: eine unbelebte, gewöhnliche, bisweilen langweilig und trostlos wirkende Architektur. In kühl-distanzierter Grundhaltung präsentiert C. nach fotogr. oder and. technisch erstellten Vorlagen zufällig wirkende Fensterausschnitte, Bauelemente, Gitter, Fassaden(teile) usw. Seine Malerei betreibt er auf jenem Grat, von der aus sowohl vertraute Realität als auch neue Qualitäten als Teil des entstandenen Bildes sichtbar sind (Stadttauben, Dominosteine). Immer wieder beschäftigt sich C. in seinen großformatigen Papierarbeiten (häufig Aquatinten) mit der Grenze zw. Innen und Außen, zw. Vorder- und Hintergrund sowie mit deren Auflösung. Die puzzleartig gesetzten Archit.-Elemente materialisieren Assoziationen und Stimmungen in spielerischer Manier. 2001 zeigt er im KM Thun v.a. großformatige Arbeiten; bemerkenswert dabei sind die installativen Ansichten einer Taube und einer Ansammlung von Dominosteinen. Dabei wird die „pointierte Körperlichkeit der Taube der gebrochenen Illusion von Volumen und Raum bei den Dominosteinen gegenübergestellt" (M. Schuppli). Abstraktion und Repräsentation kommen gleichwertige Rollen zu. C. erhebt das Massentier Taube durch die porträtähnliche Darst. zum wür-

devollen Einzelwesen und unterläuft damit die alltägliche Wahrnehmung. Die Dominosteine malt er hingegen in einer fast unüberblickbaren Fülle. Das Spiel mit Ambivalenzen, mit Ordnung und Zufall, Individualität und Masse, Lebendigkeit und toter Materie, realer und wahrgenommener Größe ist prägend für sein Werk. Auch als Kurator tätig. ⌂ BERN, KM. – NB der Schweiz. BIEL, Centre PasquArt. SION, MBA. ◉ *E:* Bern: 1995 KH; 1996 Gal. Francesca Pia; 1998 Kab.; 2003 Schweiz. Landes-Bibl. (K: S. Biri); 2008 Kunstraum Oktogon (K: F. Eggelhöfer); 2011 Edgar Frei Priv. Gal. / 2000 Genf, Hall Palermo (Ausz.) / 2001 Thun, KM / 2002 Moutier, Mus. jurassien des arts / 2010 Porrentruy, Espace d'art contemp. les halles. – *G:* 1993 Basel, Kunsthaus Glarus: A la recherche du temps présent / 2002 Liestal, KH Palazzo: Boomerang / 2004 Basel, KH und Stadtkino: Grand prix; Bern, Zentrum für Kulturproduktion: Excentricités / 2005 Sierre, Forum d'art contemp.: que du vent… / 2007 Sion, Dépôt d'art contemp.: Le bal / 2011 Biel, Centre PasquArt: À l'eau – Aqu. heute. ▭ KVS, 1991; BLSK I, 1998. – *D. Spanke*, Berner Kunst-Mitt. 1993 (Nov./Dez.) 17 ss.; *U. Look*, KH Bern, Bern 1994; Kunst – Berner Almanach, I, Bern 1996; V. C. Mus. jurassien des arts, Moutier 2002; Grand-prix. Ed. photogr. de 12 artistes suisses, Basel 2003; Braziers. Internat. artist workshop 2002, I. I, Limehouse Arts Fond., Lo. 2003; Que du vent… (K), Sierre 2007; *M. Caffari/S. Omlin/P. Kaenel* (Beitr.), V. C.. Aus versch. Gründen, Bern 2010. – *Online:* Website C. (M. Schuppli); KM Thun; Zeitgen. Kunst Wallis. S.-W. Staps

Chable, *Thomas*, belg. Fotograf, * 1962 Brüssel, lebt und arbeitet in Poulseur. Stud.: 1981–85 Inst. Supérieur des BA St-Luc, Liège, Fotogr. bei Hubert Grooteclaes. Seitdem freiberuflich als Fotograf. Ausz.: u.a. 1995 Prix Photogr. Ouverte, Mus. de la Photogr., Charleroi. – C. debütiert 1986–88 mit einer industrie-archäol. Serie (*Site*) über die Hinterlassenschaften der Kohle- und Stahlindustrie im ehem. Lütticher Revier, wobei er sich von der malerischen, durch Unschärfe geprägten Bildsprache seines Lehrers inspirieren läßt, die auch in vielen seiner zukünftigen Arbeiten, v.a. in der Schwarzweiß-Fotogr., eine char. Rolle spielt. Seit seinem ersten Afrika-Aufenthalt 1987 ist er häufig (auch im Auftrag) monatelang als respektvoller Reisefotograf weltweit unterwegs, um Bildreportagen v.a. von Lsch., randständigen Kulturen und sozialen Brennpunkten zu machen. Den Fokus richtet C. dabei sowohl auf abgelegen existierende Ethnien, z.B. indigene Gruppen in Äthiopien, als auch auf das Heer von Landflüchtlingen in übervölkerten Millionenstädten. Zw. Okt. 1989 und April 1992 hält sich C. jeweils über mehrere Monate in der Türkei auf, wo er u.a. in Anatolien in einer Felsenwohnung ein Fotoatelier betreibt und zeitweise mit Yörük-Nomaden lebt. 1993 fotografiert er in einem Flüchtlingslager in Slowenien (*Expectative Bosniaque*) und verbringt erneut sechs Monate in Afrika (Burkina Faso, Mali), um an seiner umfänglich angelegten Bildreportage *Odeurs d'Afrique* zu arbeiten (1994 Prix Jeunes artistes). In Dakar befaßt er sich 1996 mit den sozialen Folgen der Landflucht. 1999–2000 entsteht in Ostjerusalem die Serie *Bor-*

derline, in der C. die bedrückenden Alltagsprobleme von Palästinensern ins Bild rückt, die an der Grenzmauer wohnen. Auch in der Serie *Les Brûleurs* (2003–04) beschäftigt er sich auf verhaltene und empathische Weise mit einem politischen Problem, nämlich dem der illegalen Immigration an der Straße von Gibraltar. C.s Arbeiten (die meisten in Schwarzweiß) vermeiden trotz ihres z.T. ambitionierten (sozial-)politischen Engagements nahezu jede Art von Klischee und Sensation. Meistens konzentriert er sich auf die einfache Begegnung mit Menschen, mit denen er eine längere Zeit zusammenlebt, sowie auf Atmosphäre, Bewegung und Licht, bes. nachdrücklich in den Lsch.-Fotogr. u.a. des ostafrikanischen *Rift Valley*. – Foto-Publ.: *Odeurs d'Afrique*, Br. 2001; A. Chouaki, *Brûleur*, Br..u.a. 2006; M.-E. Maréchal u.a., *Sweet sixtien. Paroles d'adolescents*, P. 2011 (mit Chantal Vey). ⌂ BRÜSSEL, Communauté franç. de Belgique. CHARLEROI, Mus. de la Photogr. DUDELANGE, Centre nat. de l'audiovisuel. LÜTTICH, Space. ◉ *E:* 1992 Lüttich, Café Couleur (Debüt) / 1997, 2001, '04 Brüssel, Espace Photogr. Contretype / 2004 Gap, Théâtre la Passerelle / 2005, '08, '12 Lyon, Gal. Le Réverbère / 2005 Flémalle, La Châtaigneraie (mit Michel Beine) / 2008 Gentilly, Maison de la Photogr. Robert Doisneau. – *G:* Paris, Centre Wallonie-Bruxelles: 1994 La ville en éclats; 2005 Intime conviction (K: D. Mathieu u.a.) / Brüssel: Espace Photogr. Contretype: 1997 Carnets de route; 2006 Mar Mater Materia; 2011 Pal. de BA: Beyond the document. Hedendaagse Belg. fotografen / 1999 Charleroi, Mus. de la Photogr.: Afrique / Lyon, Gal. Le Réverbère: 2006 La montagne en vues; 2009–10 L'imaginaire culinaire / 2007 Dudelange, Centre nat. de l'audiovisuel: De l'Europe / Lüttich: 2008 Monos Gall.: Ultimate photogr.; 2011 Les Chiroux: Borders, no borders; 2012 MAMC: Only you, only me. ▭ Belg. fotografen, 1840–2005 (K), Ant. u.a. 2005. U. Heise

Chaboissier, *Florent*, frz. Glaskünstler, * 1948 Vernouillet/Yvelines, ab 1974 in Pantin/Seine-Saint-Denis, seit 2007 in La Varinière/Calvados ansässig. Stud.: ab 1969 Ec. supérieure d'Arts graphiques Penninghen, Paris; bis 1971 (Dipl.) Ec. nat. supérieure des Arts appliqués et des Métiers d'Art ebd.; anschl. Lehramt (bild. Kunst). Seit 1974 eig. Atelier für Glasmalerei. Ausz.: 1987 je ein Grand Prix régional d'Art et de Création, Conseil gén. Ile-de-France und Seine-Saint-Denis; 1991 Gold-Med. im Salon de Printemps, Clichy-la-Garenne; 1996 Silber-Med. der Lounsberg Found., verliehen von der Acad. d'Archit., Paris. 1988 Ankauf eines Werkes durch die frz. Reg. als Geschenk für Papst Johannes Paul II. – Für Sakral- und Profanbauten fertigt C. Glasfenster mit abstrakten Motiven, zumeist nach selbst entworfenen Kartons. Einer nahezu gleichbleibenden gestalterischen Grundkonzeption folgend, ordnet er die einzelnen Elemente so auf der weiß grundierten Gesamtfläche an, daß sie sich in der Mittelachse jedes Fensterflügels überschneiden bzw. überlappen. Die Farbgebung paßt er hingegen dem Char. des Bauwerks sensibel an, damit Fenster und Baukörper eine symbiotische Einheit bilden. Seit M. der 1990er Jahre entstehen auch eigenständige, nicht

baugebundene gerahmte und auf Sockeln installierte Glasarbeiten auf der Basis der trad. musivischen Technik, die C. unkonventionell weiterentwickelt. Für die vorzugsweise in beige-braunem Kolorit gehaltenen „stèles phylactères" ordnet er zw. zwei Glasscheiben rasterartig ein dichtes Geflecht aus Bleiruten an, in das er flache Fundstücke und and. Objekte einfügt, v.a. vertrocknete Tier- und Pflanzenteile wie Blätter, Blattnerven, Schlangenhaut, Insektenflügel und Vogelfedern. Zudem Ausf. von Glas-Skulpt., Druckgraphik, Auf- und Hinterglasmalereien (Acryl/Goldgrund). ▥ *Glasarbeiten in Sakralbauten:* BOURG-SAINT-ANDEOL/Ardèche, Stiftsk., 1988–90, '98/99. MONTREUIL, Kap. St-Antoine, 1996. NANTES, Séminaire interdiocésain des Pays de Loire, Kirche St-Jean, 1999/2000. PANTIN, Kirche St-Germain l'Auxerrois, Kap. Ste-Croix, 1995. PARIS, Kirche St-Vincent de Paul, Kap. St-Jean des Sœurs, 1994, '99. PUTEAUX/Hauts-de-Seine, Notre-Dame de la Pitié, 1982. ROSNY-SOUS-BOIS/Seine-Saint-Denis, Kirche Ste-Geneviève, 1987. TREMBLAY-EN-FRANCE/Seine-Saint-Denis, Kirche Marcel-Callo (hier auch gesamte liturgische Ausstattung, v.a. Glas und Stein), 1990–92. VILLEPINTE/Seine-Saint-Denis, Kirche Notre-Dame de l'Assomption, 1991. – *Glasarbeiten in Profanbauten:* CHERBOURG, Marineverwaltung. PARIS, Eiffelturm, Restaurant La Belle France, 1981 (1987 versteigert). – Pl. Vendôme, Arab Banking Corporation. VILLETANEUSE/Seine-Saint-Denis, Kulturzentrum, 1984. ๏ *E:* 1990 Florenz, Inst. franç. / 1992 Paris, Gal. Koralewski / 1994 Rouen, Gal. Complément d'Objet / 1995 La Roche-Gyon, Schloß / 1997 Coutances, Mus. Quesnel-Morinière / 1999 Granville, Gal. de Courcy / 2000 Chartres, Gal. du Vitrail / 2001 Caen, Gal. Art 4 / 2004 Paris, Gal. d'Es / 2010 Lisieux, Au. Quai. Dock. – *G:* 1989 Chartres, Centre internat. du Vitrail: Salon internat. du Vitrail / 1989/90 Brüssel: L'art pour l'Europe. Le nouv. art verrier (Wander-Ausst.) / 2004–06 Versailles, Château: Sculpt. de tempêtes (Wander-Ausst.) / 2005 Parc du Pilat (Rhône-Alpes): Bienn. du Verre / 2012 Caen: Rencontres internat. d'Art contemp. Arkan les Arts. ▭ *L. de Finance,* Un patrimoine de lumière, 1830–2000, P. 2003 (Cah. du patrimoine, 67). – *Online:* Website C. R. Treydel

Chabouté, *Christophe,* frz. Comiczeichner, * 8. 2. 1967 Altkirch/Haut-Rhin. Stud.: KHS Mulhouse, Angoulême und Strasbourg. Mit der Beteiligung an dem Album *Les Récits. Arthur Rimbaud* gibt C. 1993 sein Debüt beim Verlag Vents d'ouest. Seine ersten eigenständigen Comic-Bde sind 1998 *Les Sorcierès* bei der Ed. du Téméraire und bei Paquet *Quelques Jours d'été,* für den er L' Alph art Coup de cœur auf dem Festival in Angoulême erhält. Bei Vents d'ouest erscheinen 1999 *Zoé,* 2000 *Pleine lune,* 2001 *La Bête* und 2003 der erste Teil der Trilogie *Purgatoire,* bei der C. auch erstmals farbig arbeitet. Für den 2006 gezeichneten *Henri Désiré Landru* über den gleichnamigen Serienmörder erhält er den Grand Prix RTL. Neben seinen vielen weiteren Comics hat C. auch Kinderbücher illustriert. – C. gehört zu den wichtigsten zeitgen. Autoren des roman graphique in Frankreich. Seine Arbeiten sind gekennzeichnet durch einen expressiven Strich und weisen neben phan-

tastischen auch sozialkritische Momente auf. ▭ *H. Filippini,* Dict. de la bande dessinée, P. 2005. – *Online:* Lambiek Comiclopedia; Bedetheque. K. Schikowski

Chabrier, *Gilles,* frz. Glaskünstler, Bildhauer, * 1959 Riom-és-Montagnes, lebt in Paris. Ausb. in der (groß-) väterlichen Wkst. in Paris. – C. fertigt sandgestrahlte Skulpt. aus Farb- und Kristallglas, z.T. in Verbindung mit Metall, Beton und Holz. Bevorzugtes Motiv sind Köpfe, häufig mit mehreren stilisierten Gesichtern in abstrahierter, fragmentarischer Darst. (vereinzelt auch in Marmor und Bronze). Weiterhin abstrakte Skulpt., u.a. mon. Arbeiten im öff. Raum (z.B. *Notre Victoire Olympique,* Glas, Aluminium, Stahl, 2010, in Morzine) sowie Totems (z.T. mit Gesichtern, bisweilen beleuchtet). Neben baugebundenen Arbeiten entstehen Möbel, v.a. Tische (z.B. *Bureau ministre,* Glas, patinierter Stahl, 2006) und Konsolen (häufig mit gebogenen oder ineinandergesteckten Metallbeinen), auch Stühle, Waschtische, Wandspiegel und Leuchten. ▥ SEVRES, MN de Céramique. ๏ *E:* Paris: 1987, '89 Gal. D. M. Sarver; 1996, '97, '98 Gal. Sordello; 2001, '02 Gal. Silice; 2010 Gal. Frank Picon (mit Véronique Paulet) / 1995 New York, Miller Gall.; Utrecht, Art Glass Center / 2000 Ebeltoft, Glas-Mus. / 2005 Monaco, Gal. Artemisia / 2010 Oisterwijk, Etienne Gall.; 2011 Toulouse, Gal. d'Art Next (mit Laurence Nolleau). – *G:* Paris: 1986 Hôtel de Sens: Hommes de Verre; 1997 Gal. Sordello: Sculpteurs de Verre / 1990 Köln, Gal. Kunsthandwerk: Glas-Metamorphosen (K) / 1991 Montpellier, Gal. Polack: Le Chemin des Verriers / 1992 Marseille, Gal. Hyaline: Le Verre, la Création contemp. / 1993 Marcq-en-Barœul, Fond. Septentrion: La Sculpt. en Verre depuis 1985 en France / 2008 Reims, Villa Demoiselle: 100% fait main / 2011 Béthune, Médiathèque Elie Wiesel und Médiathèque Jean Buridan: Identités Partagées. ▭ *J. Miller u.a.,* Glas des 20. Jh., Starnberg 2005. – *Online:* Website C. F. Krohn

Chacho, *Juce* cf. **Chacho,** *Lope*

Chacho, *Lope,* Baumeister, Zimmermann maurischer Herkunft, ansässig in Zaragoza, † vor 1590 ebd.(?). Vermutlich Nachfahre weiterer dort tätiger Baumeister, z.B. von *Mahoma C.* und *Juce C.* (beide 1513–26 nachw.; 1513 an Hausbauten für den Bürger Juan de León beteiligt). C. ist einer der wenigen überlieferten maurischen Baumeister des 16. Jh. in Zaragoza. Sein Hauptauftraggeber ist der mächtige Artal de Alagón, Conde de Sástago (ab 1574 Vizekönig von Aragon), für den er in den 1570er Jahren mehrere herrschaftliche Bauwerke im Renaiss.- bzw. Mudéjarstil errichtet. Infolge des dabei erworbenen hohen Ansehens wird C. 1574 zum „maestro extraordinario de ciudad" (außerordentlicher Stadtbaumeister) ernannt, allerdings ist von dieser Tätigkeit nichts bekannt. ▥ PINA DE EBRO/Zaragoza, Pfarrk. Sa. María la Mayor: Erweiterungsbau und Turmaufstockung, Mudéjarstil, 1570 (zus. mit dem Baumeister Martín de Mitença; im 17. Jh. barock umgebaut). ZARAGOZA, Calle del Coso: Casa Pal. de los Condes de Sástago (Casa de Don A. de Alagón), 1570 Vertrag, 1574 voll. (später mehrfach umgestaltet; weitgehend original erh. geräumiger rechteckiger Patio mit be-

merkenswertem zweigeschossigem umlaufenden Säulengang, der zu den elegantesten und harmonischsten erh. Pal.-Innenhöfen in Zaragoza gezählt wird; Hw., heute Veranstaltungszentrum). – Pl. del Justicia, Casa del Conde de Sástago: versch. Arbeiten, bis 1574 (heute Gebäude des Colegio Notarial de Aragón). – Kloster S. Francisco: diverse Arbeiten, bis 1574. ⌑ *J. Martínez Verón*, Arquitectos en Aragón, II, Zaragoza 2001 (Lit.). – *Online:* Gran enc. aragonesa. R. Treydel

Chacho, *Mahome* cf. **Chacho,** *Lope*

Chacjanoŭski, *Kanstancin Uladzimiravič* → **Chotjanovskij,** *Konstantin Vladimirovič*

Chadjisotiriou, *Xanthos* → **Chatzisotiriou,** *Xanthos*

Chadoulis (Hadoulis), *Giorgos (George)*, griech. Maler, Graphiker, * 25. 3. 1966 Athen, lebt und arbeitet dort. Stud.: 1984–92 ENSBA, Paris, u.a. Malerei bei Antonio Seguí. 1991–92 als Bühnenbildner und Kostümdesigner bei Theaterfestivals in Epidavros und Athen tätig. – C. fertigt trad.-verbundene, figurative Ölbilder und Zchngn in den Gattungen Lsch., Porträt und Stilleben, daneben bemalt er Keramik. Leuchtende Farben sind in seinen Gem. in postimpressionistischer Manier mit lebhaftem Pinselduktus nebeneinander gesetzt. Seine bisweilen an Motive von David Hockney erinnernden Arbeiten zeigen Akte, Menschen und Bildnisse sowie lichtdurchflutete, sommerliche Sujets, welche ein mediterranes Lebensgefühl vermitteln, beispielsweise Stilleben mit aufgeschnittenen Melonen oder Palmen am Strand. ⌑ *lt. Website* ANDROS, Goulandris Found. ATHEN, Frissiras Mus. RHODOS, Mun. Gall. of Rhodes. MESOLOGGI, Christos & Sophia Moschandreou Gall. of Contemp. Art. PAIANIA/Attika, Vorres Mus. ⊙ *E:* Athen: 1996, '99, 2004, '06, '09 Skoufa Gall.; 2002 Gall. Zoumboulaki; 2012 Thanassis Frissiras Gall. / 1994 Paris, Gal. Flak (mit Yorgos Rorris und Alexis Veroucas) / 1998 Thessaloniki, Metamorfosis Gall. (mit Ioli Xifara) / 2007 Sifnos, Ausst.-Halle Giomusti Kefali. – *G:* Paris: 1992 Grand Pal.: Grands et jeunes d'aujourd'hui / Athen: 1997 Pierides MCA: AdvArtising – Comments and References; 2001 Zoumboulakis Gall.: Parathyro me thea (Zimmer mit Aussicht); 2009 Städt. Kulturzentrum Melina Mercouri: Synevi stin Athina (Es geschieht in Athen) / 2007 Moskau, Internat. House of Music: Wege der griech. Malerei / 2008 Beijing, Hellenic House: Experiencing Greece. ⌑ LEK IV, 2000. – *A. Fassianos*, Agkathi (K Gal. Agkathi), At. 1991; *G. Maniotis*, To Vasileio ton Neon (K Skoufa Gallerie), At. 1992; *M. Durand/C. Kampouridis*, G. C. Werke 1990–2000 (K Frz. Kultur-Inst.), At. 2000. – *Online:* Website C. E. Kepetzis

Chadwick, *Daniel (Dan)*, brit. kinetischer Künstler, Bildhauer, Installationskünstler, Designer, * 1965 Gloucester, lebt in Lypiatt Park b. Stroud/Glos. Sohn von Lynn Russell C. Als bild. Künstler Autodidakt. C. studiert zunächst Maschinenbau am South Bank Polytechnic, London. Danach 1987 Mitarb. bei Lister Petter Diesel Engines und 1987–91 Konstruktionszeichner im Archit.-Büro Zaha Hadid Architects. 1994 Zusammenarbeit mit David Medalla. – C. gestaltet seit A. der 1990er Jahre archit.- bzw. raumbezogene kinetische Skulpt. und Instal-

lationen, häufig als Kunst am Bau bzw. im öff. Raum im Auftrag von Unternehmen wie z.B. Tetra Pak (*Liquid Ceiling*, 1993, Konstruktion aus 48 Solarzellen, 12 Motoren, 24 transparenten Elementen und einer Kugel), Prudential Corporation (1994), Heineken (1996), Enron (2000) oder Hermes Asset Management (2002). Gleichzeitig entstehen auch freie Arbeiten, u.a. oft verspielt anmutende Mobiles (z.B. *Georgia I*, 1992, kinetisches Objekt aus Körperabgüssen von Georgia Byng; *Organism 3*, 2010); kinetische Konstruktionen (z.B. *Satellite 1*, 2006); dekorative raumbezogene Wandarbeiten (z.B.*Cranham Woods*, 2004, Holz, Keramik, Acrylfarbe); pneumatisch betriebene, z.T. mit fluoreszierenden Farben bemalte Objekte (z.B. *Fluorescent Pneumatic for Sc. Mus.*, 2001); oft organisch anmutende, statische Objekte bzw. Skulpt. (z.B. *I Am the Greatest*, 2000, Bronze und Wolle). Zudem künstlerisch gestaltete Gebrauchsobjekte wie z.B. ein Backgammon-Set oder ein *C. Oven* (2011). ⌑ LONDON, Kinetica, Mus. of Kinetic Art. ⊙ *E:* London: 1993 Concord; Merril Lynch; 1999, 2001 Lefevre Gall. (K); 2005 Beaux Arts Gall. (K); 2010 Eleven FA / 2009 Boca Raton (Fla.), Elaine Baker Gall. (mit Lynn C.). – *G:* London: 2000 Houldsworth Gall.: Sexy; 2006 Kinetica, Mus. of Kinetic Art: Life Forms / 2010 Gloucester: Crucible 2010. ⌑ *Windsor*, Sculptors, 2003; *Buckman* I, 2006. – *G. Portelli*, Mod. Brit. sculpt., Atglen, Pa. 2005. – *Online:* Pangolin, London; Website C. H. Kronthaler

Chadwick, *Don (Donald T.)*, US-amer. Möbeldesigner, * 1936 Los Angeles, lebt dort. Stud.: bis 1959 Univ. of California, Los Angeles (Industriedesign). Anschl. tätig im Archit.-Büro Victor Gruen; ab 1964 eig. Büro; ab 1977 mit William (Bill) Stumpf Ltg der Fa. C., Stumpf and Assoc., Winona/Min., um 2000 Don C. and Assoc., Santa Monica, seit ca. 2005 in Los Angeles. Ausz.: 1970, '71, '73, '74 Design Excellence Award, ID mag.; 1984 IBD Gold Award für den *Equa Chair*. – C. arbeitet ab 1974 zus. mit dem Büromöbelhersteller Hermann Miller und konzipiert das Polstermöbelsystem Modular Seating aus fünf einfachen, komplett mit Stoff bezogenen Elementen, die sich zu versch. Sofas zusammensetzen lassen. Mit dem stellv. Leiter der Forsch.-Abt. dieser Fa., W. Stumpf, entwickelt C. anschl. eine Reihe von innovativen Bürostühlen. *Ergon* (1970–76) setzt neue Maßstäbe für ergonomisches Sitzen; eine Weiterentwicklung bietet 1984 der Stuhl *Equa* mit flexibler, noch komfortablerer Rückenlehne. Bahnbrechend ist 1992 der vielseitig verstellbare Stuhl *Aeron* mit einer neuartigen Sitz- und Rückenlehnenbespannung aus atmungsaktivem Polyesternetzgewebe, die sich der Sitzposition anpaßt. Dieser bisher erfolgreichste Stuhl der Fa. H. Miller gewinnt mehrere Designpreise (1999 Design of the Decade, Industrial Designers Soc. of America and Business Week Mag.). Für die Fa. Knoll entsteht 2005 der elegant-schlichte *Chadwick Chair* mit hohem Komfort und effektiver Mat.-Ausnutzung. C. gilt aufgrund des Einsatzes neuer Mat. sowie neuer konstruktiver Mechanismen und Herstellungstechniken als einer der erfindungsreichsten und visionärsten Designer für Büromöbel in der zweiten H. des 20. Jahr-

hunderts. ⌂ DENVER/Colo., AM. HOUSTON/Tex., MFA. MONTREAL, MAD. NEW YORK, MMA. SAN FRANCISCO, MMA. ⌺ Dict. internat. des arts appliqués et du design, P. 1996; ContempDesigners, ³1997; *M. Byars*, The design enc., Lo./N. Y. 2004. – California design eleven (K), Pasadena 1971; MD 2:1975 (Febr.) 18 s.; *A. Truppin*, Interiors 144:1984 (Aug.) 42; *P. Viladas*, Progressive archit. 65:1984 (12) 17 s.; High styles. Twentieth-c. Amer. design (K Whitney), N. Y. 1985; *M. Eidelberg* (Ed.), Design 1935–1965. What mod. was, N. Y. 1991; *M. Zelinsky*, Interiors 151:1992 (Aug.) 62 s.; 153:1994 (Dez.) 36 s.; Interior design 65:1994 (Nov.) 66 s.; *C. Pearlman*, ID 41:1994 (Sept./Okt.) 56–63; *P. Antonelli*, Mutant mat. in contemp. Design, N. Y. 1995; *A. Bryant*, Graphis 299:1995 (Sept./Okt.) 50; *J. R. Berry*, Hermann Miller. Classic furniture and system designs for the working environment, Lo. 2005; Art and antiques 28:2005 (Jan.) 52–56; *J. Pallister*, Archit. j. 230:2009 (19) 41 s. H. Stuchtey

Chadžibejli, *Valerija (Valerija Kerimovna),* georgische Architektin, * 20. 5.(2. 6.) 1914 Tiflis (Tbilisi), † 14. 1. 1995 ebd. Verh. mit Ivane Čchenkeli, Mutter von *Merab Čchenkeli* (* 24. 10. 1939 Tbilisi), beides Architekten. Stud.: 1930–36 Transkaukasische Industrie-HS Tiflis. 1934–41, '44–78 im Projektierungs-Inst. Gruzkommunproekt (ab 1954 Gruzgiprogorstroj) ebd. tätig (zuletzt als Chefprojektarchitektin). 1941–44 Ing.-Gutachterin für den Wohnungsbestand im Republik-Büro zum Kampf gegen Holzwilderer. 1967 Titel Verdienter Architekt der Georgischen SSR. – Ch. entwirft bevorzugt öff. Bauten, von denen das Gebäude am Važa Pšavela Prospekt 1 zu den wichtigsten städtischen Bauwerken in Tbilisi zählt. In ihrem Schaffen nutzt sie Elemente der nat. Architektur. ⌂ ARANISI: Dorfklub, 1978. DUŠETI: Kulturhaus mit Saal für 250 Zuschauer, 1955. SAGAREDŽO: Kulturhaus mit Saal für 600 Zuschauer, 1981. TBILISI, Stadtteil Vake, Campus: Komplex von Studentenwohnheimen, 1968. – Inst. für Metallurgie der Georgischen Akad. der Wiss., 1969. – Prospekt Važa Pšavela 13: Wohnhaus, 1969. – ebd. Nr 1: Hist. Arch. und Archit.-Verwaltung, 1970 (jetzt Georgisches Nat.-Arch.). TETRI-CKARO: Verwaltungsgebäude, 1947 (2. Preis des nat. Wettb. um die besten Wohn- und Verwaltungsgebäude des Jahres). ⌺ Kartuli sabčota ènc., XI, Tbilisi 1987, 610. T. Gersamia

Chadžiev (Chandžiev), *Minčo (Minčo Ivanov),* bulg. Maler, * 10. 3. 1869 Elena, † 1921 Veliko Tărnovo. Während des Russ.-Türkischen Krieges 1878 Bekanntschaft mit dem russ. Kriegsmaler Vasilij Vasil'evič Vereščagin, in dessen Auftrag Ch. Kopien der Wandmalereien in den Kirchen auf dem Trapezica-Hügel in Veliko Tărnovo anfertigt (nach Vereščagins Tod 1904 verschollen). 1891–93 Stud. der Malerei in Florenz (nachg. anhand von dat. und bez. Akt- und Kopfstudien aus dieser Zeit). Danach mehrere Jahre Zeichenlehrer am Gymnasium von Veliko Tărnovo. Um 1905 erneuter Aufenthalt in Italien; die Reiseeindrücke verarbeitet Ch. im Gedichtband Italjanski rozi (verlegt durch den Turističesko Družestvo [Fremdenverkehrs-Ver.] Trapezica, Veliko Tărnovo 1905). – Ch.s Werk, von zeitgen. Künstlern wie Ivan Mărkvička, Anton Mitov, Oto

Chorejši oder Boris Denev geschätzt, ist durch zeichnerische Perfektion, präzise Modellierung mittels Farbe und einen poetisch verfremdenden Realismus geprägt. Bes. die Detailfreude der Portr.- und Lsch.-Gem. sowie ihre warme, leuchtende Farbigkeit erinnern an die ital., insbesondere die florentinische Malerei der Renaissance. Erh. sind neben 52 Studien (HM Veliko Tărnovo) ein nach der Natur gemaltes Portr. des bulg. Freiheitskämpfers *Filip Totju* in bürgerlicher Kleidung sowie eine Portr.-Büste des bulg. Revolutionsführers gegen die osmanische Fremdherrschaft Georgi Sava Rakovski, Ch.s einzige bek. plast. Arbeit. Weitere Öl-Gem.: *Boljarska kăšta v Asenova machala* und *Vojni-svetci* (Kopien von Fresken aus Veliko Tărnovo; beide KG Veliko Tărnovo), *Portret na mlad măž, Portret na săprugata mu, Nošten pejzaž ot Venecija*; weiterhin zwei Kopien nach fläm. und engl. Künstlern (im Bes. von Ch.s Nachkommen). ⌂ VELIKO TĂRNOVO, HM. – KG. ◉ *E:* 1911 Sofia. ⌺ EIIB III, 2006. – *Ch. Karamichova*, 100 godini turistіčesko družestvo „Trapezica 1902". Bibliogr., Veliko Tărnovo 2002 (s.v. Chandžiev, Minčo). S. Jähne

Chadžistojanov, *Stefan* (eigtl. Conev, *Stefan Chadži Stojanov*), bulg. Architekt, * 22. 1. 1906 Nova Zagora, † 9. 4. 1983 Sofia. Vater der Architektin *Vesela Chadžistojanova*. Stud.: 1928–30 (fünf Semester) Dt. TH Brünn (Brno; immatrikuliert als Zoneff, Stephan Chadji Stojanoff) u.a. bei Ferdinand Hrach, Alfred Hawranek, Emil Tranquillini; in den Sommerferien Praktikum im Archit.-Büro von Ivan Zidarov in Stara Zagora (1929) bzw. auf einer Baustelle von Aleksandăr Kurtev in Jambol (1930); 1930–32 (vier Semester) TH Dresden (zus. mit seinen Mitschülern aus Stara Zagora, den später bek. Architekten Angel Damjanov und Nikolaj Kazmukov; immatrikuliert als Zoneff, Stephan) u.a. bei Hans Freese, Walter Mackowsky, Alphons Schneegans; im April 1933 Dipl. und Titel Ing.-Architekt. Lehnte die vom Prof. für Wohnungsbau angebotene Ass.-Stelle ab, da er seinen Verwandten das für das Stud. geborgte Geld schnell zurückzahlen wollte. Gründete in Sofia ein priv. Archit.-Büro und änderte seinen Nachnamen (1933), um sich von gleichnamigen Kollegen mit schlechtem Ruf zu unterscheiden. 1942 ließ er eine Fa. mit den Arbeitsgebieten Entwurf von Genossenschaftswohnungen, Verkauf von Geschäften und Apartments, priv. und öff. Bauaufsicht sowie Koordination von Archit.-Entwürfen registrieren. Wurde im gleichen Jahr ordentliches Mitgl. des Verb. der Projektanten und Aufsichtsführenden. Nach dem Verbot priv. Gewerbetätigkeit ab 1948 Projektant im Staatlichen Projektierungs-Inst. CAPO (später Glavproekt), Teiln. an Entwurf und Bau von Wohnhäusern in der neu gegr. Stadt Dimitrovgrad. Nach der Liberalisierung priv. Tätigkeit (1952) wieder beim Bau von Mehrfamilienhäusern für Genossenschaften in Sofia tätig, ab ca. 1961 im Staatlichen Projektierungs-Inst. für Fabrikbauten Zavodproekt. 1965 Mitbegr. des Bulg. Architekten-Verb. (SAB); gleichzeitig Gutachter für die Archit.-Entwürfe im Forsch.- und Projektierungs-Inst. des Minist. für Binnenhandel und Dienstleistungen. Konnte erst 1979 in Pension gehen, da der sozialistische Staat

seine Selbständigkeit vor dem Krieg nicht anerkannte. Wurde 1981 zur Kooperation mit dem Entwurfsbüro des Inst. für Elektronik eingeladen, was aber E. 1982 wieder rückgängig gemacht wurde. Dies und die damit einhergehende Forderung nach Rückgabe des bereits gezahlten Lohnes führte zu enormen finanziellen und psychischen Belastungen. – Ch. ist v.a. für seinen Vorkriegs-Wohnungsbau in Sofia bek. sowie für seine landesweiten Entwürfe in der Tabak- und Getreideindustrie nach dem 2. WK, darunter Typenentwürfe für Futtersilos (erb. u.a. in Blagoevgrad, Pazardžik, Stara Zagora, Jambol, Plovdiv, Burgas, Nova Zagora, Tolbuchin [Dobrič], Varna, Tărgovište, im Team) sowie für Tabakfabriken und Lagerhäuser (in Topolovgrad und Charmanli [selbständig], Stara Zagora, Jambol, Plovdiv, Šumen, Vidin, Chaskovo, Pazardžik und Blagoevgrad [im Team]). Seine Entwurfspraxis orientiert sich insgesamt am stilistischen Kanon der gemäßigten Moderne. Die größeren Wohnkomplexe werden von glatten, schmucklosen Fassaden dominiert, während Ch. im Einfamilienhausbau auch Elemente lokaler Archit.-Trad. aufgreift (u.a. Erkerfenster, Schrägdächer, Kragsteine) und mit ausgewogenen Kombinationen von ortsbezogenen Naturbaustoffen arbeitet. – Ch.s Tochter *Vesela Chadžistojanova* (* 1938; 1962 Abschluß an der HS für Zivil-Ing. Sofia) arbeitete als Architektin im Staatlichen Forsch.- und Projektierungs-Inst. Glavproekt, zunächst im Entwurfsbüro von Petär Ikonomov, später bis 2002 selbständig. Gegenwärtig ist sie freischaffend tätig. Sie entwarf zahlr. öff. Bauten, z.B. Krankenhäuser (Sveta Marina, Varna, 1972, im Team; Kardiologische Klinik Sveta Ekaterina der Medizin-Akad. Sofia, 1994–98) und Hotels (Šťastliveca, Vitoša-Gebirge b. Sofia, mit P. Ikonomov, 1968). ⌂ DEVNJA: Wohnsiedlung der Sodafabrik, zw. 1961 und 1976. KREMIKOVCI, Metallurgiewerk: Administratives Zentrum (im Team) sowie Verwaltungsgebäude, Kantine, Haupteingangsgebäude, Wäscherei, zw. 1961 und 1976. KRIČIM: Wohnsiedlung der Konservenfabrik, zw. 1961 und 1976 (im Team). PAZARDŽIK: Theater Konstantin Veličkov, 1968–69. PETRIC: Futtersilo, 1960–63. RADNEVO: Kino. RESILOVO: Grundschule, 1936–37. RUSE: Kunststoffwarenfabrik Petär Karaminčev, zw. 1961 und 1976 (um 2008/09 abgerissen). – Wohnhochhaus Gagarin, 1966 (mit dem Architekten Ivankin). SOFIA, Genossenschaftswohnhäuser: ul. Car Simeon 87 (mit der ersten automatischen Backstation aus Deutschland), 1934–35; ul. Christo Smirnenski 18, 40; ul. Sándor Petőfi 34; bul. Vasil Levski (ehem. Ferdinand) 35, 1939. – bul. Evlogi Georgiev 93: Einfamilienhaus, 1941–43. – ul. Dobri Vojnikov 49: Villa Ch., 1942–43. – Genossenschaftswohnhäuser mit vier Etagen, 1952: ul. Elin Pelin 16; ul. Christo Smirnenski 38; ul. Milin Kamăk 8. – ul. Săborna 4: Genossenschaftswohnhaus mit Zentralem Kinderkaufhaus Detmag, 1953 (mit B. Christov). – S.-Krasno Selo: Wohnblock Nr 3 (1967 vom Sofioter Stadtrat ausgezeichnet). VIDIN: Autoreifenfabrik, 1961–63. ⌂ *L. Tonev u.a.* (Ed.), Architekturata v Bălgarija sled 9. IX. 1944 g., Sofija 1954, 115 s.; *A. Stojčkov*, Architektura 1958 (2) 24–29; *I. Ivanov u.a.*, ibid. 1966 (1) 4–11; ibid. 1968 (1) 40; *S. Kovačevski/P. Io-*

kimov, in: Architekturata na Bălgarija 1878–1944, Sofija 1978, 206–236; *I. Ivančev*, in: Bălgarskata architektura prez vekovete, Sofija 1982, 286; *P. Iokimov u.a.*, Architektura i gradoustrojstvo na Tretoto bălgarsko carstvo, Sofija 1999. – Sofia, Bulg. Architekten-Verb., Bibl.: K. Žekov, Tvorci na bălgarskata architektura, Ms. – Mitt. V. Chadžistojanova, Sofia. L. Stoilova

Chadžistojanova, *Vesela* cf. **Chadžistojanov,** *Stefan*

Chadžistojčev, *Stefan (Stefan Cankov)*, bulg. Architekt, * 15. 1. 1892 Gabrovo, † 26. 1. 1976 ebd. Nachfahre einer für die Stadt in Handel, Kultur und Befreiungskampf bed. Fam.; Vater des Architekten Canko Stefanov Ch. Stud.: 1911/12–15, 1920–22 (Dipl.) TH Dresden (1915–19 unterbrochen wegen Teiln. am 1. WK); soll lt. mündlicher Überlieferung in Frankeich studiert haben. 1922–29 Projektant bei der Staatlichen Eisenbahn in Sofia. 1929–48 freischaffend; aus diesen Jahren stammen u.a. Entwürfe für priv. Wohnhäuser in Gabrovo, Sevlievo und Trjavna, Schulen in den Dörfern Stančov Chan, Belica und Potoka sowie für mod. Viehstallungen in der Umgebung von Gabrovo. Verantwortlich für die Bauaufsicht beim Prophylaxeheim für Kinder-Lungenkrankheiten „Car Boris" in Trjavna (1938–43; Entwurf Jordan Sevov; eingeweiht im Frühjahr 1943). Ab 1. 3. 1948 Projektant in der Regionalen Projektierungsorganisation in Gabrovo; diese Tätigkeit führt Ch. auch noch nach seiner Pensionierung (1962) weiter. 1965 Mitbegr. des Bulg. Architekten-Verb. und langjähriger Vors. der Ortsgruppe in Gabrovo. – Ch.s Werk umfaßt Entwürfe für insgesamt ca. 1000 Wohnbauten und 100 öff. Gebäude. Anfänglich gekennzeichnet durch den stilistischen Übergang zw. Art Déco und Modernismus, folgt seine archit. Praxis in der Reduktion von Bauschmuck und der strukturellen Vereinfachung des Baukörpers zunehmend dem Formenvokabular eines konsequenten Funktionalismus. Dabei bezieht er Elemente der lokalen Archit.-Trad. des 19. Jh. ein und kombiniert regionale Baustoffe, trad. Bogenkonstruktionen und Steinmetzarbeiten mit flachen, schmucklosen Putzfassaden und klar konturierten Fensterausschnitten. ⌂ DRJANOVO: Kulturhaus; Sommerkino; Internat für Schulkinder, alle nach 1948. GABROVO: Städtisches Schlachthaus (1927 1. Wettb.-Preis; mit Ivan Dančov); Stadtbad, 1929. GOSTILICA b. Drjanovo: Kulturhaus, nach 1948. JAMBOL: Schlachthaus, zw. 1929 und 1948. KAZANLĂK, Buzludža-Nationalpark: Hotel Buzludža, zw. 1929 und 1948. PETRIČ: Schlachthaus, zw. 1929 und 1948. STOKITE b. Drjanovo: Schule, nach 1948. VELKOVCI b. Pernik: Bibl. und Theater, zw. 1929 und 1948. ZELENO DĂRVO/Gemeinde Gabrovo: Erholungsheim „Dr. Tota Venkova", zw. 1929 und 1948 (später genutzt als Berufsschule für Forstwirtschaft). ⌂ Spisanie na BIAD 1927 (8) 168; (17) 367–369; Architekt 1927 (10) 16 s.; Dăržaven vestnik 1936 (54) 827; *P. Iokimov u.a.*, Architektura i gradoustrojstvo na Tretoto bălgarsko carstvo, Sofija 1999; *D. Coneva/M. Conev*, Imalo edno vreme v Gabrovo, Gabrovo 2008; 100 vesti v. 17. 10. 2009, 9.

L. Stoilova

Chaffart, *Erica (Erika)*, belg. Keramikerin, Malerin, Bildhauerin, Hochschullehrerin, * 20. 12. 1943 Berchem/

Antwerpen, lebt dort. Stud.: Malerei und Bossiertechniken an der Koninkl. ASK, Antwerpen; Keramik und Bildhauerei am Hoger Inst. ebd. bei Gustave de Bruyne, Achiel Pauwels und Jan Vaerten. Ausz.: 1971 Karel Verlatprijs; 1982 Prijs Ferstenberg. Seit 2000 Atelier in Stekene. Lehrt bis zur Pensionierung als Prof. für Malerei und Bossiertechniken an der Koninkl. ASK, Amsterdam. – V.a. abgußartig wirkende skulpturale Keramiken, darunter häufig farbig gefaßte realistische Portr.-Köpfe und Büsten, deren Gesichter von tiefer Melancholie und Hoffnungslosigkeit gezeichnet sind. Mit schonungsloser Detailtreue formt C. in Tücher gehüllte Kinderkörper oder von Mumienbinden umhüllte krude Reste menschlicher Körper in keramischen Mat. aus. Gelegentlich Entwürfe für (Tier-)Plastiken im öff. Raum, so für das mon. Pinguinrelief (1997) im Zoologischen Garten von Antwerpen. Daneben Malerei, Graphik und Zchngn, häufig im didaktischen Kontext der akad. Lehre. ⌂ ANTWERPEN, Prov. Antwerpen. – Vlaamse Raad. ◉ E: zuletzt 2010 Antwerpen, Gal. Molensloot. ▭ Bénézit III, 1999; C. Engelen/M. Marx, Beeldhouwkunst in België, I, Br. 2002; Pas I, 2002. – J. Walgrave, Ars ceramica. Céramique contemp. en Belgique, Liège 1992. – Online: Website C. (Ausst.). U. Heise

Chaffee, Olive Holbert (Olive Ruth Holbert), US-amer. Malerin, * 9. 1. 1886 Woodville/Ky., † 9. 4. 1980 St. Louis/Mo. Ehefrau des Malers und Architekten Roy O. C. (s.u.). Aufgewachsen in Woodville, beginnt C. im Alter von zehn Jahren zu malen. Erster Kunstunterricht auf der Highschool im nahegelegenen Paducah/Ky. Später Schülerin von Chauncey Foster Ryder und George Conroy in New York. Stud. an der Corcoran AG School in Washington/D. C. Beeinflußt auch von Francis Humphry William Woolrych in St. Louis/Mo. und W. A. Pratt in Denver. In erster Ehe verh. mit William Gibson, mit dem sie in Cairo/Ill. lebt. M. der 1920er Jahre Übersiedlung nach St. Louis/Mo., wo ihre Kunst einen Aufschwung erfährt. 1926 Heirat mit Roy O. C. ebd. M. der 1930er Jahre vorübergehend in Jefferson City/Mo. ansässig; 1940 zweiter Wohnsitz in Glendale/Calif. – Vom Impressionismus geprägte Lsch. (überwiegend in Öl) v.a. von Missouri, aber auch von Alabama, den Green Mountains in Vermont und White Mountains in New Hampshire, von Kentucky, St. Petersburg/Fla. sowie vom US-amer. Westen. Da Bäume in ihren Darst. eine wesentliche Rolle spielen bzw. auch häufig als Einzelmotive auftreten, wird C. als „painter of the trees" bezeichnet. – Roy O. C. (* 2. 5. 1887 St. Louis/Mo., † März 1969 ebd.) studiert dort an der Washington University. Neben seiner Tätigkeit als Architekt (u.a. Entwurf eines Hauses im Tudor-Stil für die Fam. Federer, 3863 Holly Hills Boulevard, St. Louis) malt er Landschaften. Ob der im Hist. Dir. of Amer. Architects des AIA erw. gleichnamige Architekt (ab 1941 Mitgl. des AIA, tätig in Michigan, † März 1978) mit Roy O. C. identisch ist bzw. eine Verwechslung der Daten vorliegt, bleibt noch zu klären. ⌂ COLUMBIA/Mo., Christian College. INDEPENDENCE/Mo., Harry S. Truman Libr. and Mus.: Missouri Vetch Field. JEFFERSON CITY/Mo., Public Libr. ◉ E: St. Louis: 1931 Wacha Gall.; 1937 Noonan-Kocian Gall.;

1949 Barn Gall. / 1931 Chicago, Grable Gall. / New York: 1935 Gramercy Park Art Club Gall.; 1938 Tricker Gall. (mit Roy O. C.). – G: St. Louis: 1926 Women's Nat. Expos. (First Landscape Prize); 1933 Nat. League of Amer. Pen Women (Preis). ▭ Hughes, 1989 (* Paducah/Ky.; auch zu Roy C.); P. Kovinick/M. Yoshiki-Kovinick, An enc. of women artists of the Amer. West, Austin 1998; Falk I, 1999 (* Paducah/Ky.; auch zu Roy C.). – Online: Kentucky women artists; AskART (auch zu Roy O. C.); AIA Hist. Dir. of Amer. Architects; The Soc. of Archit. Historians. Missouri Valley Chapter 16:2010 (2) 9 (beide zu Roy O. C.). C. Rohrschneider

Chaffee, Roy O. cf. **Chaffee,** Olive Holbert

Chago (eigtl. Armada Suárez, Santiago Rafael), kubanischer Zeichner, Karikaturist, Gebrauchsgraphiker, Maler, Autor, * 20. 6. 1937 (2. 6. 1937 lt. Lambiek) Palma Soriano, † 6. 6. 1995 Havanna. Als Künstler Autodidakt. Stud. ebd.: 1954 Esc. Profesional de Comercio, Santiago de Cuba. 1955 erste Ill. für die Zs. Mercurio, 1956 künstlerischer Leiter der Zs. Ahora. Während der Kubanischen Revolution Mitkämpfer in der Columna 1 José Martí in der Sierra Maestra; Komponist zahlr. Lieder für Radio Rebelde; zeichnerischer Mitarb. der von Ernesto Che Guevara ab Sept. 1958 hrsg. Untergrund-Ztg El Cubano Libre. Später Mitarb. des Mag. Revolución. 1960 Gründer der humorvollen Wochenbeilage El Pitirre der Ztg La Calle. Ab 1965 für die Zss. Bohemia, El Caimán Barbudo und Palante tätig. Mitgl.: u.a. 1961 Gründungs-Mitgl. Unión de Escritores y Artistas de Cuba; ab 1962 Unión de Periodistas de Cuba. Künstlerischer Dir. von Ediciones R (1964) und Ediciones Granma (1966). Zchngn auch in der internat. Presse, u.a. Opus internat. (Frankreich), Il Caffé (Italien), Sucesos (Mexiko), Liberation und New York Times (USA). Ausz.: u.a. 1962 1. Preis, Jugendfestival, Helsinki; 1965 Bronze-Med., Leipziger Buchmesse; 1987 Réplica del Machete de Máximo Gómez, Minist. de las Fuerzas Armadas; Med. Raúl Gómez García, Sindicato Nac. de Trabajadores de la Cult., beide Havanna. – C. zeichnet Ill. und Karikaturen seiner Mitkämpfer für El Cubano Libre und entwirft 1958 die legendäre Comicfigur Julito 26 (Anspielung auf Beginn des Aufstandes gegen die Batista-Diktatur), die ab 1959 im Mag. Revolución fortgeführt wird. Später entwickelt er Serien über El eterno hombre und Julioto Yarey sowie 1961 für Revolución die Figur Salomón, die als Repräsentant des ges. Wandels auch die Comicästhetik Kubas erneuert. – C.s kontrastreiche Zchngn und Gem. sind häufig erotischer Natur mit politischen Anspielungen (Como un torbellino o el rojo follar de ideología, Mischtechnik, 1967). Im Mittelpunkt steht die männliche Sexualität und der Kult um den Phallus, der auf ironisch-satirische Weise als Zeichen des Machismo kritisiert wird. Als 1967 in Havanna der Salón de Mayo de París mit einem kollektiven Wandbild gefeiert wird, beteiligt sich C. mit dem Bild La llave del golfo, in dem Kuba als der amer. Phallus dargestellt wird, dessen Dauererektion Ausdruck seiner schwierigen hist.-politischen Situation ist. In den 1970er Jahren werden C.s Bilder expressiver und grotesker, reduzieren sich auf wenige Far-

ben (*Camaleón de cierta vocación de lagarto*, Mischtechnik/Papier) und sind von lit. Texten inspiriert wie die Serie *Lintérnagos, camaleones y calibanes* (nach R. Fernández Retamar, Calibán y otros ensayos, Havanna 1979). Auch Buch-Ill.: u.a. El regalo (Havanna 1964) von Nelson Rodríguez Leyva. ⌨ HAVANNA, MNBA. ✉ C., El humor otro, Havanna 1963; Supermal. Los creadores de Superman superviven en la supermiseria, in: Granma (Havanna) v. 16. 6. 1984 und 23. 6. 1984; Gnosis, información y humorismo gráfico de genuina vanguardia, in: Centros de Est. de Medios de Difusión Masiva (Havanna) 1985 (Mai-Juni) 6 s. 👁 *E:* Havanna: 1975 Granma; 1978 Univ., Gal. L; 1980, '98 Gal. Habana; 1982 Gal. de Arte del Cerro (mit Antonio Eligio Fernández [Tonel]); 1986 Gal. Juan David; Gal. Servando Cabrera; 1995, '96 Espacio Aglutinador; 2000 Centro de Desarrollo de las Artes Visuales / 1978 Palma Soriano, Gal. Carlos Manuel de Céspedes / 2001 New York, The Drawing Center (K: L. Camnitzer/ S. Ceballos); Vancouver, Univ. of Brit. Columbia, Morris and Helen Belkin AG / 2007 Richmond (Va.), Virginia MFA. – *G:* Havanna: 1959 Soc. Cult. Nuestro Tiempo: Dibujos humorísticos; 2007 Centro Hispanoamer. de Cult.: Almas comunes. ⌨ *D. Balderston u.a.* (Ed.), Enc. of contemp. Latin Amer. and Caribbean cult., I, N. Y. 2000. – Kubanische Zeichner (K Kulturhaus Hans Marchwitza), Potsdam 1988; *A. E. Fernández (Tonel)*, Arte cubano (Havanna) 1998 (1) 13–19; *C. Blanco de la Cruz*, Internat. j. of comic art (Drexel Hill, Pa.) 2:2000 (1) 178–189; *ead.*, Rev. latinoamer. de estudios sobre la hist. (Havanna) 1:2001 (2) 108–118; *J. Veigas-Zamora u.a.*, Memoria. Cuban art of the 20th c., L. A. 2002; *M. Rojas*, Granma (Havanna) v. 20. 9. 2007. – *Online:* Gal. Cubarte; Lambiek; Mirarte. M. Nungesser

Chahin, *Arriet (Arriet Alves)*, brasil. Malerin, Zeichnerin, Graphikerin, * 28. 11. 1942 São Paulo, dort tätig. Stud.: 1984 Pratt Graphics Center, New York. Lehrtätigkeit: 1988 Univ. de Ribeirão Preto (Metallstich); 1989 Casa de Cult. de Uberlândia (Metallstich). Ausz.: 1962 Prêmio Moinhos Unidos Brasil-Mate. – C. beginnt als Graphikerin und wendet sich in den 1980er Jahren auch der Malerei zu. Sie nimmt Unterricht in Druckgraphik und Zchng bei Lívio Abramo, Maria Bonomi, Marcelo Grassmann und Carlos Fajardo sowie in Malerei und Aqu. bei Ubirajara Ribeiro und Nélson Nóbrega. 1982–84 ist C. als Ass. von Sergio Fingermann tätig und unterrichtet bis 2008 in dessen Atelier Zchng und Druckgraphik. 1990–93 lehrt C. die Technik des Kpst. im Atelier von Ely Bueno, 1996 Monotypie im Centro Cult. de Diadema ebd. 2001 gestaltet sie den Einband der Zs. Percurso – revista de psicanálise (Ed. Inst. Sedes Sapientiae). 2009 ist sie mit zahlr. and. Künstlern am Àlbum de Gravura Comemorativa der Gal. Gravura Brasil. in São Paulo beteiligt. – C.s Graphiken und Gem. sind sowohl figurativ (*Rote Kanne*, 1984; *Sofa*, 1985, beide Rad.; São Paulo, MAM) als auch – in den meisten Fällen – abstrakt. C. arbeitet mit Linien und der Idee von Fäden; in ihren Werken entstehen oft baum- und netzartige Strukturen. Aber auch Pflanzen, Stillebenobjekte, Boote oder Lsch. sind u.a. Motive, die sie weitgehend auf ih-

re wesentlichen Flächen oder Umrisse reduziert. C. verwendet vorrangig warme Farben (Rot, Orange, Gelb). In ihren meist monochromen Graphiken setzt sie auch tiefes Schwarz und differenzierte Grautöne sowie Akzente in Blau ein, wobei sie die Techniken von Kpst., Rad. und Aquatinta (bes. die Reservage) bevorzugt, die unregelmäßige Konturen und scheinbar raue Oberflächen entstehen lassen. Für ihre Gem. verwendet C. auf die Lw. gebrachtes nepalesisches Papier, um dessen Texturen, die an Tapisserien erinnern sollen, besser zur Geltung zu bringen. ⌨ CHAMALIÈRES/Frankreich, Assoc. Mouvement d'Art Contemp. CURITIBA, Mus. da Gravura. JOINVILLE, Univ. da Região de Joinville. SÃO PAULO, Casa de Gravura. – MAM. UBERLÂNDIA, Casa de Cult. 👁 *E:* São Paulo: 1985 Gal. Suzanna Sassoun; 1987 (K), '89, '97, 2002–03 Mônica Filgueiras Gal.; 1988 Itau Gal. (K) / 1994 Campinas, Gal. Unicamp des Mus. de Artes Visuais (Retr.) / 1998 Rio de Janeiro, Coletânea Gal. – *G:* 1984 Krakau, Internat. Bienn. der Druckgraphik / São Paulo: 1987 MAM: Panorama de Arte Atual Brasil.; 1989 Bien.; 2000 MAM: 15 anos do Clube de Gravura; 2003 Escritório de Arte Augusta 664: Gravura em metal; 2011 Casa de Gravura: Livro de artista 2011 / 1991, '94 Chamalières: Trienn. Mondiale d'Estampes Petit Format / 1993 Maastricht: Internat. Bienn. der Druckgraphik / 2007 London, Saatchi Gall.: Bien. Guadalupana. ⌨ *Cavalcanti* I, 1973. C. Melzer

Chaia, *Lia*, brasil. Malerin, Fotografin, Video- und Installationskünstlerin, * 1978 São Paulo, dort tätig. Stud.: bis 2001 Fund. Armando Álvares Penteado, São Paulo. Ausz.: 2004 Artist in Residence, Cité des Arts, Paris; 2005 Stip. Iberê Camargo, Mexiko-Stadt. – C. setzt sich mit dem Spannungsverhältnis zw. Natur und Kultur auseinander; die Interaktion von Mensch und Stadt, die sich wandelnden, ephemeren Relationen zw. Körper, Raum und ihren Abbildern sind Leitmotive ihrer Arbeiten (Installation, Video, Fotogr., Malerei, Collage). So verzehrt im Video *Comendo Paisagens* (2005) eine Frau Fotos von Städten und Lsch. und verleibt sich diese somit ein. Im Film *Cidade pictórica* (2003) werden Bilder einer Stadt bei Regen durch die Windschutzscheibe eines stehenden Autos aufgenommen. Temporalität und Wiederholung sind wichtige Elemente der Filme und Fotos: Um der Hast mod. Menschen langsame Momente entgegenzusetzen, schaukelt C. drei Stunden in einer Hängematte in der Gal. Vermelho, São Paulo (*Rede*, 2003). Neben der Hängematte liegen die aufgeschlagenen Bekenntnisse des hl. Augustinus mit dessen Reflexionen über Zeit. Eine Serie von 103 kleinformatigen Fotos dok. das wiederholte Bauen von Sandburgen am Strand, die vom Wasser zerstört werden, und zielt auf das Sichtbarmachen von Vergänglichkeit (*Castelo de areia*, 2002). In dem Video *Desenho-corpo* (2002) wird Zeit als Dauer wahrgenommen, indem C. ihren Körper 51 Minuten mit einem roten Stift bemalt, bis die Tinte aufgebraucht ist. Im Video *Na cama formigando com um tango* (2002) liegt C. nackt auf ihrem Bett, ihr Körper ist mit Zchngn von Ameisen übersät. Während dreier Stunden läuft ein Tango, von dem einige Partien wiederholt werden. Bei jeder Veränderung der Musik ändert sich auch die

Position des Körpers. Für *Vereda* (2004) kratzt C. vegetabile Formen in feuchten Zement, der auf grüne Wände aufgebracht wurde. Die Umrisse der Blätter legen die Untergrundfarbe frei; die Wände dienen wiederum als Hintergrund für geometr. zugeschnittene Fotogr. von Pflanzen, die in Form von Totems aufgestellt werden. Auf ähnliche Weise entsteht die Installation *Verdejar: verde no branco no verde* (2003): Die Wände der Gal. Vermelho werden an einige Stellen mit weißen Lw. abgedeckt und anschließend komplett mit repetitiven, abstrahierten Pflanzenmotiven in versch. Grüntönen urwaldartig bemalt. Die Lw. werden abgenommen und an umliegenden, weiß belassenen Wänden aufgehängt, während an den bemalten Wänden weiße Leerstellen freigelegt werden; dieses Fragmentieren und Deplazieren assoziiert die Rodung des brasil. Urwalds. C.s Werke sind zudem durch Momente subtiler Irritation gekennzeichnet, wenn etwa auf einem dreiteiligen großformatigen C-Print ein Laubblatt die ausgestreckte Zunge im Gesicht der nackten Künstlerin ersetzt (*Folíngua*, 2004). Die Arbeit spielt zum einen auf die Doppeldeutigkeit des Begriffs língua (Zunge, Sprache) und die linguistische und kulturelle Vielfalt in Brasilien an, zum anderen werden die Antropofagia-Bewegung des brasil. Modernismus und surrealistische Trad. aufgerufen. C. inszeniert und hinterfragt weiterhin ihren eig. Körper und sein Verhältnis zu Raum und Zeit, etwa im Video *Glam* (2010), in dem sich die Künstlerin schwanger und nackt in rotem Flitter wälzt. ▯ SÃO PAULO, MAM. ◉ *E:* São Paulo: 2002 Inst. Tomie Ohtake (mit Fernando Lindote); 2004 Base7; 2006 Paço das Artes (mit André Komatsu, Sara Ramo, K); 2008, '10 Gal. Vermelho / 2003 Campinas, Ateliê Aberto / 2005 Bazouges la Pérouse, Centre de Création / 2006 Rom, Mus. Laboratorio d'Arte Contemp. – *G:* 2004 Stuttgart, Künstlerhaus: Entre Pindorama. Zeitgen. brasil. Kunst und die Adaption antropofager Strategien (K) / São Paulo: 2005 MAM: O Retrato como imagem do Mundo; Festival internac. de arte eletrônica vídeo; 2006 Inst. Tomie Ohtake: Geração da virada; 2008 Gal. Vermelho: Provas de Contato; 2009 Gal. Millan: Vértice; 2011 MAM: Ordem e Progresso / 2005 Los Angeles, Los Angeles Contemp. Exhib.: Marking Time / 2006 Berlin, Die Neue Aktions-Gal.: Urban Scapes / 2007 Istanbul: Bienn. / 2008 Ceará: Bien. Internac. de Dança do Ceará / 2010 Paris, CNAC: Vidéo et après. ▯ *E. aus dem Moore/G. Ronna* (Ed.), Entre Pindorama, Nü. 2005; Brasil + Berlin. Zeitgen. brasil. Kunst in Berlin-Mitte (K), B. 2006; Desidentidad. Arte brasil. contemp. no acervo do MAM de São Paulo (K Valencia), S. P. 2006. – *Online:* Website C. **C. Melzer**

Chaillet, *Gilles*, frz. Comiczeichner, Comicautor, * 3. 6. 1946 Paris, † 14. 9. 2011 Margency. 1965 debütiert C. als Kolorist im Studio Dargaud und hilft für einige Seiten der Serie *Barbe Rouge* als Zeichner aus. Ab 1966 veröffentlicht er Cartoons im Mag. Tintin, doch zunächst zeichnet er für das Studio Idéfix 14 Bücher der Kinderreihe *Idéfix* (Texte: Guy Vidal). Erst 1977 bekommt er die Chance, *Lefranc* (dt. L. Frank) von Jacques Martin weiterzuführen. Bis 1996 erscheinen neun Alben um den Reporter. 1980 startet er die im 14. Jh. spielende Serie *Vasco* in Tintin, für die

C. 22 Alben schreibt und zeichnet. Mit J. Martin arbeitet er an *Les voyages d'Orion*, und in den 1990er Jahren gestaltet er zwei Bde der Serie *Les voyages d'Alix* (dt. Alix), die das Leben in der Antike beschreiben. Für Glénat ist er ab 2000 einer der Zeichner der hist. Thrillerserie *Le triangle secret* (dt. Das geheime Dreieck), und ab 2002 schreibt und zeichnet er die Reihe *La dernière prophétie*. Bei Tombelaine von Casterman ist er 2001 nur für das Szenario zuständig (Zchngn von Bernard Capo). Für Glénat schreibt er zw. 2003 und 2008 das Szenario zum Thriller *Intox*. 2004 veröffentlicht er den Bildband über das antike Rom *Dans la Rome des Césars*. Den Zweiteiler *Vinci* (dt. Vinci) textet und zeichnet C. selbst. Für die in der Antike spielende Reihe *Les Boucliers de Mars* bei Glénat ist er als Szenarist zuständig. – C.s Zchngn sind stark von der Ligne Claire geprägt, jedoch stärker am Realismus angelehnt. Sowohl als Zeichner als auch als Autor besitzt er eine bes. Vorliebe für antike und hist. Stoffe. ▯ *P. Gaumer/C. Moliterni*, Dict. mondial de la bande dessinée, P. 2001; *H. Filippini*, Dict. de la bande dessinée, P. 2005. – *Online:* Lambiek Comiclopedia. **K. Schikowski**

Chainaye, *Achille (Achille Jean François)*, belg. Bildhauer, Zeichner, Journalist, * 26. 8. 1862 Lüttich, † 20. 12. 1915 Richmond/London. Bruder des Schriftstellers Hector C. und des Bildhauers und Malers *Armand C.* (* 1. 1. 1864 Lüttich, † 9. 8. 1889 Brüssel; Stud.: ABA, Lüttich; Wand-Gem. in Brüssel und Portr.-Büsten). Stud.: 1877–82 ABA, Lüttich; um 1883 auf Einladung im Atelier von Thomas (Baron) Vinçotte, Brüssel. Studienreise nach Italien. 1883 Mitbegr. der anti-akad. Künstlergruppe Les XX (Austritt 1888), 1884 Mitbegr. der Graphikergruppe Les Hydrophiles (Austritt 1886), beide in Brüssel. Freundschaft mit James Ensor und Jef Lambeaux. E. der 1880er Jahre gibt C. wegen öff. Mißerfolgs (u.a. wird 1884 sein Werk *Vredige oever* nicht für den Brüsseler Salon zugelassen, und bei einer Les-XX-Ausst. muß er Auguste Rodin den Vortritt lassen) das künstlerische Schaffen endgültig auf. In den folgenden Jahren ist er als Kunstkritiker und Journalist (Pseud. Champal), u.a. für die Zss. Le Wallon (ab 1884), Le Nat. belge und La Réforme (ab 1886) tätig. Ab 1906 engagiert er sich politisch als belg.-wallonischer Aktivist. Bis zum Ausbruch des 1. WK gibt er die Zs. Ligue wallonne du Brabant heraus, 1914 emigriert er nach England. – C.s schmales Werk umfaßt realistische, teilw. symbolistische Skulpt., u.a. Porträtbüsten (*Père Jacques*, 1883) und Figurenplastiken (*De Visvangst*; *Het onderbroken bad*, beide Gips, 1881), daneben Med. sowie aquarellierte Zchngn, die zw. 1880 und 1887 entstehen und auf Ausst. gezeigt werden. ▯ BRÜSSEL, Mus. d'Ixelles: Een rabbijn, Gips, 1883. DENDERMONDE, Rathaus: Büste S. Giovannino, Bronze, 1886/87. LÜTTICH, Mus. d'Art wallon: De misdienaar, Büste, Gips. ◉ *G:* Lüttich: 1880 (Debüt), '81 Salon Cercle Artist. / Brüssel: 1881 Salon; 1887 Expos. General (K) / Amsterdam: 1883 WA; 1884 Pal. de BA: Expos. annuelle Les XX. ▯ Biogr. coloniale belge, I, Br. 1948 († Kew/Richmond); *Bénézit* III, 1999; *C. Engelen/M. Marx*, Beeldhouwkunst in België, I, Br. 2002; *Pas* I, 2002; NBW, XVIII, 2007. – *O. G. Destrée,*

The renaiss. of sculpt. in Belgium, Lo. 1895; *M. A. Stevens/ R. Hoozee* (Ed.), Impressionism to symbolism. The Belgian avant-garde 1880–1900 (K R. Acad. of Arts), Lo. 1994.

U. Heise

Chainaye, *Armand* cf. **Chainaye,** *Achille*

Chaise, *Pierre-Jules*, frz. Zeichner, Juwelier, Schmuckgestalter, Geschäftsmann, * 1807 Paris, † 1870 ebd. Sohn eines Kpst.-Händlers, Cousin und Lehrer von Frédéric Boucheron. Läßt sich 1830 in Paris als Juwelier mit eig. Geschäft nieder. Baldiger Erfolg ermöglicht die Expansion, 1841 den Umzug in ein größeres Haus in exponierter Lage (Rue de Richelieu) und später die Einstellung von Mitarb. wie des Goldschmieds, Juweliers und Emailmalers Charles Duron als Ass. beim Zeichnen von Entwürfen, des Vogelmalers Giacomelli sowie des Goldschmieds und Juweliers Alphonse Fouquet (1854/55). C. arbeitet für mehrere renommierte Pariser Firmen, v.a. als einer der Hauptlieferanten von Janisset, dessen Betrieb er 1860 übernimmt. Von da an tritt die eig. künstlerische Betätigung zugunsten von kaufmännischen Aufgaben in den Hintergrund. – Nach Beginn mit Schlüsseln, Stempeln, Siegeln, Uhr- und Halsketten sowie sonstigem Zierat spezialisiert sich C. zunehmend auf die Fertigung von phantasievollem Modeschmuck nach eig. Entwürfen, bes. von Armbändern, Fingerringen, Ziernadeln und Korsagendekor. Die zumeist in Gold ausgef. Stücke wertet er zusätzlich auf durch Emailmalerei und geschickt kombinierten Edelstein- und Perlenbesatz. Er bevorzugt fließende, gerundete Formen, ineinander verschlungene oder verknotete Bänder und v.a. das Spiel mit einfallsreich variierten vegetabilen Motiven: zumeist stark verästelte Zweige, die in großen Blüten oder Blattwerk enden, von dem oftmals durch Perlenschnüre verlängerte Blütengehänge herabfallen. Mit bemerkenswertem Gespür für dekoratives Gestalten in Verbindung mit soliden zeichnerischen Fertigkeiten entwirft C. eine Vielzahl abwechslungsreicher, eleganter Modelle mit sehr persönlichem Gepräge, so daß er im kunsthandwerklichen Bereich zu den Hauptvertretern des Second Empire gerechnet wird. ▭ LONDON, V & A: Schmuckarmband mit Portr.-Min. von M. Pandeli Ralli und Mme E. Ralli, Emailmalerei, Gold, Diamanten, Elfenbein, Perlmutt, um 1850. ▭ Dict. internat. du bijou, P. 1998.

R. Treydel

Chaix, *Philippe*, frz. Architekt, * 14. 1. 1949 Saint-Mandé. Stud.: 1967–72 EcBA, Univ., Paris; 1972/73 Univ., Otaniemi/Finnland. Ausz.: u.a. 1996 Créateurs de l'année, Salon du Meuble, Paris. Anfangs Zusammenarbeit mit Jean Le Couteur und Bernard Guillaumot (u.a. beteiligt bei den Theaterbauten La Criée, Marseille, und Espace Duchamp-Villon, Rouen Saint-Sever). Seit 1976 eig. Büro in Paris (seit 1983 mit Jean-Paul Morel assoziiert; heute Chaix & Morel et associés). Projekte mit François Confino, Marc Delanne, Jean-Pierre Duval und J.-P. Morel (u.a. Wettb.-Entwurf für La Défense, Paris, 1983). C. beschäftigt sich mit leichten, demontierbaren und selbsttragenden Strukturen und Zeltkonstruktionen, teilw. mit großer Spannweite, v.a. für Kultur- und Sportveranstaltungen; oft Entwürfe für ephemere Konstruktionen (Zelt

im Jardin des Plantes, Paris; temporäres Kulturzentrum, Billière/Pyrénées-Atlantique). Zusammenarbeit mit J.-P. Morel für die temporär geplante Konzerthalle *Zénith* im Parc de la Villette, Paris, eine Stahlträgerkonstruktion mit Gewebebespannung (1982–84, Bespannung 2000 erneuert); *Zénith*-Hallen errichten C. & Morel in Montpellier (1985/86), Orléans-la-Source (1993–96), Dijon (2003–05) und Nantes (2003–06). Das Zelt *Tepee* ist Empfangsbereich für das Grand Pal. (Ausst. Toulouse-Lautrec, 1992), für die Fa. Semapa (1994–96) und das Centre Pompidou (1997–2000; alle in Paris). Zahlr. nicht verwirklichte Wettb.-Beiträge, teils als transparente, skulptural wirkende Bauten. Außerdem Designentwürfe mit experimentellen Prototypen, v.a. aus Verbund-Mat. (u.a. Stuhl aus Karbonfaser, 1993; zwei Glastische, 1991, 1995), und Ausst.-Gest., u.a. Abt. La matière et le travail de l'homme, Mus. des Sc., Techniques et Industries, Parc de la Villette (1985/86) sowie Umbau und Ausst.-Gest. des Petit Pal. (1999–2006, beide in Paris). ▭ AMIENS: Fußballstadion, 1996–99. BOULOGNE-BILLANCOURT:: Inst. nat. du cancer, Verwaltungsgebäude, 2005. CARMAUX: Sport- und Freizeitzentrum, 2000–02. ESSEN: Verwaltungsgebäude Fa. Thyssen Krupp, 2006–10 (mit JSWD Architekten). GRENOBLE: Stadion, 2000–06. GUYANCOURT: Renault Technocentre, Empfangsbereich L'Avancée, 1991–96 LILLE: Bürogebäude Souham, 2000/01. MARNE-LA-VALLÉE: Ec. Nat. des Ponts et Chaussées et Ec. Nat. des Sc. Géographiques, 1989 Wettb., 1996 voll. MONTPELLIER: Skatingbahn, 1998–2000. NANTERRE: Verwaltungsgebäude der Firmengruppe Hervet, 2003. PARIS, Gebäudekomplex rue Pommard 37–43/rue Paul-Belmondo 46, 1993/ 94. – P.-La Défense: Colline de l'automobile, Salle Omnimax, 1988–90. – P.-Bercy: Wohngebäude, 1990–92. – P.-Roissy, Flughafen Charles de Gaulle: Europ. Zentrum der Fa. Fedex, 1996–99. – Metrostation St-Germain-des-Prés: Umgestaltung, 1998–2000. – Univ. Paris VII Denis Diderot, 2001–06. – Büro des Kulturministers, 2005. SAVONA/Italien: Univ.-Gebäude, 1997–2000 (mit 5+1 architetti). SAINT-OUEN: Hôtel des Impôts, 1988–92. SAINT-ROMAIN-EN-GAL: Mus. archéol. (1988 Wettb., 1995 voll.). STRASBOURG: Maison de la Région Alsace, 1999–2005. TOULOUSE-Blagnac: Restaurant R06, 2004–06. – Bürogebäude B 22, 2003–06. ▭ Dict. de l'archit. du XXᵉ s., P. 1996; Dict. internat. des arts appliqués et du design, P. 1996 (s.v. Chaix et Morel); *M. Byars*, The design enc., Lo./N. Y. 2004; *M. Poisson*, 1000 immeubles et mon. de Paris, P. 2009. – *C./A. Lavalou*, Techniques & archit. 310:1976, 34–141 (Sonderheft über Bühnen-Archit.); Acier pour Construire 1:1985, 2–19; *O. Boissiere*, L'arca 1:1986 (1) 40–45; *P. Goulet*, L'archit. d'aujourd'hui 245:1986, 66–81; Werk, Bauen und Wohnen 75:1988 (5) 44–51, 63; *J. Chollet/M. Freydefont*, Les lieux scéniques en France 1980–1995, P. 1996; *F. Leyge*, Archeologia 327:1996, 26–35; *J.-P. Robert*, L'archit. d'aujourd'hui 309:1997, 31–63, 98 s.; *S. Brandolini*, Domus 831:2000, 92–103; *F. Chaslin*, ebd. 827:2000, 40–45; *B. Quaquaro*, L'arca 152:200, 91, 153:2000, 54–59; *C. Slessor*, Archit. rev. 208:2000 (1244), 83–85; *P. Stür-*

zebecher/S. Ulrich, Archit. für Sport, B. 2001; *M. A. Anaboldi*, L'arca 197:2004, 62–67; *E. Cardani*, ebd. 216:2006, 72–77; C. & Morel. Années lumière, P. 2006; *J.-P. Robert*, Bauwelt 97:2006 (7) 26–35; *L. Blaisse*, Archit. intérieure, crée 339:2008, 80–83; 353:2011, 86–92; La défense en quête de sens, P. 2008; *F. Meyer*, Bauwelt 99:2008 (35) 12–14; *E. Sfar*, Domus 920:2008, 41–44; *C. Maillard*, Les Zénith en France, P. 2010; *M. J. Purzer*, Baumeister 108:2011 (7) 62–70; ThyssenKrupp Quartier, B. 2011; *K.-D. Weiß*, Archit. aktuell 2011 (4) 98–109.

N. Buhl

Chajrulin, *Jakun (Jakun Ismailavič; Jakun Ismailovič)*, weißrussischer Gebrauchsgraphiker, Plakatkünstler, Maler usbekischer Herkunft, * 21. 5. 1931 Samarkand, lebt in Minsk. Stud.: bis 1960 Kunst-FS „Pavel Petrovič Ben'kov", Taškent (Toshkent), bei Nigmat Kuzibaev, Pavel Viktorovič Gan und Viktor Petrovič Sosedov. Ab 1966 regelmäßige Teiln. an Republik- und Allunionsausstellungen. Seit 1988 Mitgl. des weißrussischen Künstlerverbandes. 2005 weißrussisches Staats-Stip. für bild. Kunst. – Neben der seit der Studienzeit kontinuierlich fortgesetzten Beschäftigung mit Öl- und Aqu.-Malerei, die allerdings kaum Gegenstand von Ausst. wird, tritt Ch. seit den 1970er Jahren hauptsächlich als Plakatgestalter in Erscheinung. Zunächst arbeitet er v.a. im Auftrag des Kombinats für künstlerische Produktion in Minsk. Die hier realisierten Siebdrucke, u.a. Aufrufe zur Steigerung der Arbeitsproduktivität (*Dosaafovcy! Aktivizirujte svoju dejatel'nost', povyšajte uroven' oboronno-massovoj raboty!*, 1972) oder politische Bekenntnisplakate zur Sowjetarmee (*Naš dolg. Bereč' Otčizny svjato, Sovetskoj Armii soldaty!*, 1972; *Slava saveckim voinam-peramožcam*, 1985), folgen häufig sowohl in bezug auf typogr. Elemente und reduzierte Farbschemata als auch in der typisierenden Aufrufung von staatskonstituierenden Symbolen und Personifikationen den Trad. der sowjetischen Agitpropästhetik der 1920er Jahre. Im Zuge der politischen Öffnung der Sowjetunion und der zunehmenden Emanzipation Weißrußlands vom sowjetischen Staatenverbund wendet sich Ch. ab E. der 1980er Jahre auch ges.-kritischen Themen von bes. regionaler Bedeutung zu. Seine Plakatentwürfe zur AIDS-Prävention und zur Nuklearkatastrophe im benachbarten ukrainischen Čornobil' (*Čarnobyl'. Što pakinem naščadkam*, 1990) öffnen sich mit der veränderten inhaltlichen Gewichtung auch neuen ästhetischen Konzepten, u.a. dem Fotorealismus. ⌑ MINSK, MMK. – Mus. der Gesch. des Großen Vaterländischen Krieges. – Weißrussische NB. ✆ *E:* Minsk: 2006 Kunst-Pal. (Retr. zum 75. Geburtstag); 2010 Univ., Foyer des Rektorats (mit Evgenij Georgievič Korobuškin). – *G:* 1989 Kiev: Republik-Ausst. des politischen Plakats „Der Mensch, Schöpfer der Perestrojka". ⌑ BSM, 1998. – *L. Cimošyk*, Zvjazda (Minsk) v. 6. 7. 2006; Vestnik kul'tury (Minsk) 2006 (7) 8; Litaratura i mastactva (Minsk) 2010 (23) 3. S. Görke

Chaki, *Hanamaro*, jap. Malerin, Zeichnerin, * 1976 Tokio, lebt in Barcelona. Stud.: 1994–97 Univ. of Brighton (Malerei, Druckgraphik); 1995 Esc. Massana, Barcelona. – In figurativen Gem. (Acryl), Zchngn (v.a. Bleistift, Kreide,

Tusche), Collagen und Graphiken stellt C. Seelenzustände dar, die häufig auto-biogr. Natur sind. Nach eig. Aussage porträtiert sie Gefühle und Erinnerungen. Dabei entstehen phantastische, skurrile und geheimnisvolle Figuren, häufig Mischwesen mit menschlichem Körper und Tierköpfen, die meist alptraumhaft verstörend wirken wie in dem Gem. *Paranoia* (Acryl/Tafel, 2006), welches einen angedeuteten Tierkörper zeigt, der anstelle eines Kopfes eine Ansammlung von rot umrandeten Augen trägt. Daneben gibt es auch heitere, ironische Motive wie ein ballonartig aufgeblasenes, fast die gesamte Bildfläche ausfüllendes Schaf (*Sheep does not stop eating*, Acryl/Lw., 2003) sowie den *Bathing Lion* (Acryl/Tafel, 2004), welcher der Badewanne seine Löwenfüße leiht. C. arbeitet häufig in Mischtechnik, ergänzt Zchngn durch Wandfarbe, Firnis und Lack. Char. sind eine fragmentarische Darst., einfarbige Hintergründe und die Beschränkung auf wenige Grundfarben sowie die bevorzugte Verwendung von Weiß und Schwarz. Letztere verleiht den Gem. in Kombination mit filigranen, linearen Strukturen eine graph. Wirkung (z.B. *Lady Wolf*, Acryl/Lw., 2003). Ein häufig wiederkehrendes Motiv sind stilisierte Augen (z. B: *In-Out*, Bleistift/Pappe, 2005; *Incendiary Look*, Bleistift, Lack/Pappe, 2006). ✆ *E:* Barcelona: 2004, '05 Lletraferit; 2009 Casinet d'Hostafrancs; 2011 Centre Cult. La Casa Elizalde / 2004 Brighton, Media Centre Gall. / 2006 Banyoles, Gal. Estudi Blanc / 2006, '07 Kyōto, Ishida Tasei Gall. / 2007 Yokohama, Gall. Simon / 2010 Alicante, Mus. de la Univ. (K) / 2011 Alcoi, Centre Ovidi Montllor (K). – *G:* 1997 Brighton: Festival Fringe: Peep Show; Sussex Art Club: The Box / 2005 London, A & D Gall.: Irresistible Paint / 2008 Yokohama, Gall. Simon: Yokohama Art & Home Coll. / 2009 Alicante, Mus. de la Univ.: Corpórea; Barcelona, Gal. Safia: Krudakammer; Bayreuth, Brit. Amer. Tobacco Campus-Gal.: 10 Jahre BAT Campus-Gal. / 2010 Vilafranca del Penedès, La Caixa: Bienn. de Pint. Jove; L'Hospitalet de Llobregat, Fund. Arranz-Bravo: HospitalitArt. ⌑ H. C. (K Bayreuth), Bayreuth/Ha. 2006. – *Online:* Website C.

F. Krohn

Chakir, *Jean*, frz. Comiczeichner, Comicautor, * 4. 6. 1936 Paris, lebt dort. Im Alter von 15 Jahren debütiert C. in Publ. von Bonne Presse; in Bernadette erscheint *Le secret de la Pyramide* und *Casimir XXVIII*. In Bayard veröffentlicht er *À travers les Siècles*, *Tacotac* und *Les Enquêtes de l'Inspecteur Saboum* (bis 1971 in Record). In der Folge zeichnet C. u.a. für Âmes Vaillantes 1964 die Serie *Jean Rytouceul*. In den 1970er Jahren arbeitet er für die Mag. Tintin, Lucky Luke und Pif Gadget. Die Reihen *Héroïko et les Dog-boys*, *Inspecteur Saboum*, *Tracassin* und *Les télé-aventures de Boucan* sind als Album nachgedruckt worden. 1983–94 leitet C. die Comic-Abt. an der EcBA in Angoulême. – C. zeichnet in dem typischen Funnystil, der die franko-belg. Comic-Mag. der Nachkriegszeit dominiert. ⌑ *P. Gaumer/C. Moliterni*, Dict. mondial de la bande dessinée, P. 1997; *H. Filippini*, Dict. de la bande dessinée, P. 2005. – *Online:* Lambiek Comiclopedia.

K. Schikowski

Chakraborti, *Jayashree* → **Chakravarty**, *Jayashree*

Chakravarty (Chakraborti, Chakravarti), *Jayashree (Jaishree, Joyshree)*, indische Malerin, Installationskünstlerin, * 1956 Khoai/Tripura, lebt in Kolkata. Stud.: 1978 Santiniketan (Schülerin von Suhas Roy); 1978–82 Fac. of FA, Maharaja Sayajirao Univ., Baroda (Schülerin von Kalpathi Ganapathi Subramanyan); 1979–81 Stip. der indischen Reg.; 1989 Reise-Stip., Brit. Council; 1991 Stip. der frz. Reg.; 1994–96 Artist in Residence, Éc. superieure d'art, Aix-en-Provence. Ausz.: u.a. 1979, '80 Bombay Art Soc.; 1980 All-India FA and Crafts Soc., New Delhi; 1988 Bienn. Bharat Bhavan, Bhopal/Madhya Pradesh; 1997 Asian Art Bienn., Dhaka/Bangladesh; 2008 Raza Found., New Delhi (Syed-Haidar-Raza-Preis). – C.s Frühwerk steht noch im Bann der narrativen, dekorativ-figürlichen Ausdrucksformen, mit denen sie als Studentin in Baroda in Berührung kam; in kurzen Stupfern aufgetragene Farbe und ein ausgeprägter Sinn für Farbwirkung erzeugen Formen, die auf dem Bildgrund zu schweben scheinen. E. der 1980er Jahre gewinnt die Textur der Gem. an Bedeutung. M. der 1990er Jahre beginnt C. während eines Frankreich-Aufenthalts, mit Reispapier, Zellophan und Papiertaschentüchern zu experimentieren; es entstehen lange, breite Rollen aus leimgetränkten Papieren, die C. von beiden Seiten bemalt und von der Decke hängend ausstellt; mit ihren spiraligen, in sich verdrehten Formen überschreitet C. die Grenze zur Dreidimensionalität. Ihren Malgrund baut sie nun in einem langwierigen Prozeß aus versch. bemalten Schichten von Papier und Stoff auf. In dieser Zeit überlagert C. die menschliche Figur mit einer Vielzahl von Symbolen und Zeichen; die Farben sind jetzt matter und beschränken sich vorwiegend auf Grau, Weiß und kühle Blautöne; die Gem. gewinnen eine lyrisch-zurückgenommene Qualität. In Arbeiten ab den späten 1990er Jahren (z.B. in der Reihe *Memory records*) tritt der Mensch wieder deutlicher aus dem vielschichtigen Nebel angedeuteter floraler und archit. Formen hervor, mit denen C. Fragmente banaler Alltagsformen wie Bahnschienen, Straßenschilder und Grafittis verwebt. Inspirationsquellen ihrer Bilder sind die Geschichten, Erinnerungen und Erlebnisse ihrer Kindheit, aber auch die Erfahrungen mit den Veränderungen ihrer direkten Umwelt, dem unregulierten Wachstum ihrer Heimatstadt Kolkata und dem konstanten Wechsel, der sie umgibt. Krankheit und Tod ihres Vaters verarbeitet sie in einer Reihe von Gem., in die sie Formen aus dem medizinischen Bereich (z.B. Ultraschallbilder) einbezieht. Seit 2000 auch Kuratorin von Ausst. in Kolkata. ▣ CHANDIGARH, Mus. NEW DELHI, NGMA. – Lalit Kalā Akad. WASHINGTON/D. C., NM of Women in the Arts. ◉ *E:* 1982 Baroda, Urja AG / Calcutta (Kolkata): 1983 AFA; 1989 Chitrakoot AG; 1999 CIMA Gall.; 2006 Gall. 88 / New Delhi: 1988 Art Heritage (K); 1992 Gall. Espace; 2000 Vadehra AG / Mumbai: 1990 Gall. Seven; Sakshi Gall. / 1995 Aix-en-Provence, Éc. superieure d'art / New York: 1998, 2007 The Drawing Center; 2004 Bose Pacia Mod.; 2007 Bodhi Art / 2009 London, AICON Gall. – *G:* New Delhi: 1989 SAHMAT: Artists alert (K); 2003 Gall. Chemould (NGMA): Crossing generations. Diverge (K: G. Kapur/C. Sambrani) / Calcutta:

1989 Birla Acad. of art and cult.: Ann. exhib. (K); 1996 CIMA Gall.: Highlights. Lines, images, perspectives / 2000 Mumbai, The Guild: A Rare Coll. / 2000 New York, Bose Pacia Mod. Art: Boundlessly Various & Everything Simultaneously. ▢ *A. Jhaveri*, A guide to 101 mod. and contemp. Indian artists, Mumbai 2005. – *R. Chawla*, Surface and depth. Indian artists at work, New Delhi 1995; *M. A. Milford-Lutzker*, Women artists of India (K Oakland/New York), Oakland, Calif., 1997. – *Online:* Saffronart (Ausst.). M. Frenger

Chalayan, *Hussein* (Çağlayan, *Hüseyin*), brit. Modegestalter, Designer, Konzept- und Videokünstler türkisch-zypriotischer Herkunft, * 1970 Nikosia, lebt seit 1982 in London. Stud.: bis 1993 Central St. Martins College of Art and Design ebd. Seit 1994 eig. Label. Ausz.: 1995 Absolut Creation Award; 1999, 2000 Designer of the Year, Brit. Fashion Awards; 2004 FX Internat. Interior Design Award; 2009 Outstanding Lifetime Achievement FX Award. 1998–2000 Chefdesigner der Kaschmir-Fa. TSE, New York; 2001–03 Kreativ-Dir. des Londoner Unternehmens Asprey; 2002 Artist in Residence, Wexner Centre for the Arts, Columbus/Ohio; seit 2008 Kreativ-Dir. des dt. Sportartikelherstellers Puma. – C.s für die Modebranche ungewöhnlicher konzeptueller Ansatz bestimmt seine Modekollektionen und -präsentationen ebenso wie die Videoarbeiten. Die Werke haben z.T. einen auto-biogr. Hintergrund und sind oft als kritische Stellungnahme zu aktuellen politischen und sozialen Themen zu verstehen (z.B. Verschleierung [Kollektion *Between*, Frühjahr/Sommer 1998] und Klimawandel [Kollektion *Airborne*, Herbst/Winter 2007]). Bereits mit seiner Abschlußarbeit *Tangent Flows*, bestehend aus mit Eisenspänen präparierten und monatelang in der Erde vergrabenen Kleidungsstücken, findet er Beachtung in der Modewelt. Ein Höhepunkt in C.s Œuvre ist die unter dem Eindruck des Kosovokrieges entstandene Kollektion *After Words* (Herbst/Winter 2000), die sich dem Thema Flucht und Vertreibung widmet. C. präsentiert seine Arbeiten (häufig minimalistische und monochrome Kleidung, z.T. mit ungebräuchlichen Mat. wie z.B. Leuchtmitteln) in effektvollen performanceartig inszenierten Shows mit reduzierten modernistischen Bühnenbildern und (z.T. experimenteller) Livemusik. Die von einem bulg. Frauenchor begleitete Show zu *After Words* findet in einem angedeuteten Wohnzimmer statt, in dem sich zunächst eine fünfköpfige Fam. aufhält. Am Ende entfernen vier Models die Hüllen der Sitzmöbel und ziehen sie als Kleider an. Die Stühle werden zu Koffern zusammengeklappt, und ein weiteres Model steigt in den kreisförmigen hölzernen Couchtisch, um ihn als Rock überzustreifen. In innovativer Form stellt C. hier einerseits die trad. Funktion von Kleidung in Frage und weist zudem symbolisch auf das Schicksal von Flüchtlingen hin. Sowohl in den Modepräsentationen als auch in den Videoarbeiten verwendet er bisweilen Computeranimationen (z.B. in der Show zur Kollektion *Ventriloquy*, Frühjahr/Herbst 2001, sowie in der Videoinstallation *Place to Passage*, 2003). Viele der in den Shows angedeuteten Sujets greift C. in den Videoarbeiten erneut auf, um sie ausführlicher zu behandeln.

Die Videoinstallation *Absent Presence* (2005), eine enigmatische Zukunftsvision mit der brit. Schauspielerin Tilda Swinton in der Rolle einer Wissenschaftlerin, ist eine Auseinandersetzung mit den Themen Identität, Genetik und Migration. ⏏ LEON, MAC. LUXEMBURG, MAM Grand-Duc Jean (Mudam). STOCKHOLM, Mod. Mus. WOLFSBURG, KM. ⏺ *E:* London: 1994 West Soho Gall.; 2009 Design Mus.; 2010 Lisson Gall. / 1997 Prag, Window Gall. / 2004, '10 (K) Istanbul, iS. CaM / 2005 Utrecht, Centraal Mus. / 2005–06 Wolfsburg, KM / 2006 Mannheim, KH / 2008 Bergen, Stiftelsen 3,14 / 2010 Tokio, MCA (K) / 2011 Paris, MAD (K). – *G:* London, V & A: 1997 The Cutting Edge (K); 2001–02 Radical Fashion (K) / 2001 Instanbul: Bienn. / 2005 Venedig: Bienn. / 2007 Luxemburg, MAM Grand-Duc Jean (Mudam): Tomorrow now (K) / 2007–08 Tokio, MCA: Space for your Future / 2008 Lausanne, Mus. de Design et d'Arts appliqués contemp.: Dysfashional (K) / 2010–11 Köln, WRM: Auf Leben und Tod. Der Mensch in Malerei und Fotogr. (K) / 2011 Zürich, Bellerive: Neue Masche. Gestrickt, gestickt und anders / 2011–12 Wolfsburg, KM: Die Kunst der Entschleunigung (K). ⏛ *M. Wellershoff*, Der Spiegel 2000 (41) 92–94; *S. Frankel*, Visionaries. Interviews with fashion designers, Lo. 2001; *C. Evans*, Fashion at the edge. Spectacle, modernity and deathliness, New Haven u.a. 2003; *ead.*, H. C. (K Wander-Ausst.; Retr.), Rotterdam 2004; *S. Hallström Bornold* (Ed.), Fashination (K), Sth. 2004; *N. Bätzner* (Ed.), Urbane Realitäten. Fokus Istanbul (K), B. 2005; *J. Lambert*, H. C., 2009 (Film Arte; Dok. aus der Reihe Künstler hautnah); *J. Ortmann*, Form (Basel) 226:2009, 96; *J. Clark*, H. C., N. Y. u.a. 2011; *H. Walker*, Less is more. Minimalismus in der Mode, M. 2012. – *Online:* Website C.
F. Krohn

Chalfant, *Henry*, US-amer. Bildhauer, Fotograf, Filmemacher, Filmautor, * 2. 1. 1940 Sewickley/Pa., lebt seit 1973 in New York. Stud.: Stanford Univ., Palo Alto/Calif. (Altphilologie); San Francisco Art Inst. (Malerei); ab 1964 Bildhauerei in Barcelona (1968–69 bei Enric Gelpí). Mitgl.: 1975–83 Nat. Sculpt. Guild, New York. Ausz.: 1984 Amer. Film Inst., Bester Dok.-Film (*Style Wars*); 2006 Alma Award, Bester Dok.-Film (*From Mambo to Hip Hop. A Bronx Tale*). – C. schafft in den 1960er und 1970er Jahren ein bildhauerisches Werk, das sich stilistisch u.a. an David Smith und Eduardo Chillida orientiert. Seit etwa 1976 fotografiert er aus vorrangig kalligraphischem Interesse in New York Graffitis, nach einigen Jahren auch deren „writer". Die Fotobücher *Subway art* (Lo./N. Y. 1984, mit Martha Cooper) und *Spraycan art* (Lo./N. Y. 1987, mit James Prigoff) gelten bis heute als Pionier- und Referenzwerke, in denen die Arbeiten der New Yorker Sprüherszene auf öff. Verkehrsmitteln und Wänden der 1970er und frühen 1980er Jahre als Protestkunst dokumentiert sind. Char. dabei sind C.s Serienaufnahmen (von etwa 500 besprühten, vorbeifahrenden Zügen), die er mittels feststehender Kamera und automatischem Filmtransport anfertigte, um die Einzelaufnahmen nachträglich zu detailgetreuen Gesamtaufnahmen zu montieren. C. ist Co-Autor des 1984 uraufgeführten Kultfilms *Style Wars*, in dem nicht nur die Protagonisten der Hip-Hop-Szene wie die Graffitikünstler Dondi, Case, Skeme, Shy und Cap oder der Breakdancer Crazy Legs gezeigt werden, sondern auch deren Gegenspieler wie Bürgermeister, Polizei, Angestellte der Metro und Straßenpassanten zu Wort kommen. – Weitere Filme: *All City* (1983); *Flyin' Cut Sleeves* (mit Rita Fecher, 1993); *Visit Palestine. Ten Days on the West Bank* (2002). ⏏ NEW YORK, MMA. PITTSBURGH, Carnegie Mus. of Art.. WASHINGTON/D. C., Corcoran Gall. of Art. ⏺ *E:* 1970 Padua, Gall. A 10 (Skulpt.) / 1978 New York, 55 Mercer Str. Gall. / 2004, '06 (K) Paris, Gal. Speerstra. – *G:* New York: 1980 OK Harris: Graffiti in New York; 1999 The Bronx Mus.: Urban Mythologies; 2002 The Prosper Gall.: Ten Years 1977–1987 / 1984 Washington, Hirshhorn Mus.: Content. A Contemp. Focus / 1985 Lewisburg (Pa.), Bucknell Univ.: Since the Harlem Renaissance. 50 Years of Afro-Amer. Art / 1999 Cleveland (Ohio), Rock and Roll Hall of Fame: Hip Hop. A Cultural Expression. ⏛ *B. van Treeck*, Das große Graffiti-Lex., B. 2001; *A. Witten/M. White*, Style master general. The life of graffiti artist Dondi White, N. Y. 2001; *J. Chang*, Can't stop won't stop. A hist. of the Hip Hop generation, N. Y. 2005. – *Online:* Graffiti news (Interview 2009); Arrested motion (Interview C. und M. Cooper, 2009). S. Prou

Chalkiadakis (Halkiadakis), *Manousos*, griech. Keramiker, Maler, Fotograf, * 1948 Chania, lebt und arbeitet dort. Als Künstler Autodidakt. Stud.: 1968–72 Wirtschafts- und Politik-Wiss. an der Aristoteleio Univ., Thessaloniki. 1978–88 Zusammenarbeit mit der Athener Keramikerin Christina Morali. 1987 Rückkehr nach Kreta. Seit 1989 betreibt C. eine eig. Wkst. in Paidochori Apokoronou in Chania. Dort ist er 1995 Mitbegr. des Kunstraums Tzamia-Krystalla (Gläser-Kristalle), der 2008 nach Fira auf die Insel Santorin verlegt wird. Ausz.: 1989 2. Preis, '90 1. Preis, '93 3. Preis bei der Panhellenic Ceramics Exhib. in Marousi/Athen. – Als Mat. nutzt C. ausschließlich kretischen Ton, den er nach dem Töpfern bei ca. 1000 Grad zunächst unglasiert erhitzt und dann bei Temperaturen bis 1200 Grad ein zweites Mal brennt. Bisweilen arbeitet er vegetabile Strukturen wie Blätterranken auf das Mat. auf oder ritzt graph. Linien oder Schraffuren ein, die den Eindruck zufälligen Gebrauchs erzielen und den Objekten in einigen Fällen den Eindruck von Alter verleihen. Die durch die metallhaltigen Glasuren (Eisen-, Kobalt- oder Kupferanteile) erzielten Farbwirkungen changieren in Tönen, die an Erde und Meer seiner Heimat erinnern sollen. In and. Fällen ähnelt die Textur des Tones bisweilen oxidiertem Metall. Als zweite Technik hat C. eine archaische Fertigungsform des Tons adaptiert: Das gebrannte Mat. wird nicht glasiert, sondern die Poren des Gefäßes werden durch Abreiben, z.B. mit Kieseln, abgeschliffen und so geschlossen. Auf dem Ton ergeben sich dadurch Effekte, die an Baumrinde erinnern, zudem das Mat. eine entsprechend dunkle Färbung annimmt. Der Künstler nutzt diese Technik v.a. für seine großformatigeren Werke. Seine Inspiration bezieht C. aus mehreren Quellen, z.B. verbindet er Einflüsse antiker minoischer Keramik mit tradiertem, volkstümlichem Kunsthandwerk.

Im Ergebnis besitzen seine Gefäße eine gleichermaßen altertümlich wie mod. wirkende Optik. Seine Formen sind schlicht und bleiben, bei aller skulpturalen Qualität, letztlich in aller Regel dem Gebrauch verbunden: Vasen, Öllampen, Teller, Schalen. In einigen Fällen arbeitet er skulptural: Neben bemalten Gebäudeformen hat er Baumstämme aus Ton geschaffen, die in Astansätzen auslaufen. Aus diesen wiederum erheben sich zahlr. Drähte, die so gedreht und in Form gebracht sind, daß sie an Geäst erinnern. In Gruppen arrangiert, wirken diese bis zu drei Meter hohen Baum-Skulpt., für deren Bearbeitung er die Technik des Abschleifens nutzt, wie versteinerte Wälder. In seinen an naive Malerei erinnernden Gem. greift er v.a. auf Trad. seiner Heimat zurück, während sich die gelegentlich digital bearbeiteten Fotogr. mit der griech. Lsch. auseinandersetzen. ⌷ ATHEN, Inst. of study of Greek contemp. ceramic art. SADIRAC (Frankreich), Maison et Mus. Mun. de la Poterie. ◉ E: 1983 Athen: 1983 Gal. Creonides; 2006 Astrolavos Gal. (mit Catherine Loiret) / Chania: 1984 StKH; 1991 Ausst.-Halle Mylonogianni; 1994 Gal. Fayum; Gal. Tzamia-Krystalla. – G: 1989, '90, '93, '97 Marousi: Panhellenische Kunst-Ausst. / 1993 Hagen, Gal. Kunstraum: Künstler aus Chania / 2003 Athen, KHS: Internat. Keramik-Ausst. / 1996 Calgary, Banff Centre Gall.: Canad. and Greek Ceramists / 2010 Chania, Pin.: 52 Chaniotes Kallitechnes. ⌷ LEK IV, 2000. – Kerameiki Techni 13:1993, 24–25; A. Tamvaki, Apo Choma kai Fotia/Aus Erde und Feuer (K Athen/Volos/Hania/Ålborg), At. 1995. – Online: Greekceramics; Website C.

E. Kepetzis

Challenger, *Michael (Mike),* brit. Maler, Bildhauer, Graphiker, * 2. 10. 1939 Ramsgate/Kent, lebt in London. Stud. ebd.: 1960–64 Goldsmiths' College of Art; 1964–66 Slade School of FA. Lehrtätigkeit: 1968–70 Goldsmiths' College of Art; 1970–72 Slade School of FA. Ausz.: 1966 Sainsbury Prize for Sculpt. – In der Trad. von Maurits Cornelis Escher und Josef Albers erforscht C. kuriose visuelle Erscheinungen und optische Illusionen sowie deren Wahrnehmung. Er malt in äußerst präziser Weise aus glatten, scharfkantigen, farbigen Elementen (Würfel, Gitter, Quader) konstruierte komplexe, dreidimensionale Strukturen in einem leeren Raum. Dabei nutzt er einfache und verzerrte Perspektiven, so daß die geometrischen Formen ineinander zu greifen scheinen. Neben Gem. und Graphiken entstehen auch Skulpt. aus emaillierten Stahl- oder farbig gestrichenen Holzplatten. ⌷ BOSTON, Boston College. – MFA. – Public Libr. BRADFORD/Yorks., City AG. BRUNSWICK/Me., Bowdoin College of Art. CARDIFF, Univ. of Wales. DETROIT, Wayne State Univ. DURHAM/N. C., Duke Univ. EASTBOURNE, Towner AG. GOODWOOD/West Sussex, Cass Sculpt. Found. LEWISBURG/Pa., Bucknell Univ. LONDON, Arts Council. – BM. – Brit. Council. – Slade School of FA. – Tate. – V & A. LOS ANGELES, California State College. MANCHESTER, AG. OLDHAM/Lancs., City AG. ORONO, Univ. of Maine. PERTH, Western Australian AG. PLYMOUTH/Devon, City Mus. and AG. SHEFFIELDS/S. Yorks., Graves AG. SOUTHAMPTON/Hants., City AG. VERONA, Mus. del Castelvecchio. VILLANOVA/Pa.,

Villanova Univ. ◉ E: London: 1968 Fenna de Vries Gall. / 1970, '72 Arts Gall. (K); 1983 Hamiltons Gall.; 1996 Rebecca Hossack Gall. / 1972 Atlanta, Reflections AG; McLean (Va.), Foliograph Gall. / 1973, '74 Verona, Studio la Citta / 1975 Venedig, Gall. del Cavallino; Rom, Studio Haz / 1990 Jeddah (Saudi-Arabien), Art Vision Gall. ⌷ *Spalding,* 1991; *Buckman* I, 2006. – B. *Denvir,* Art internat. 14:1970 (Dez.) 51; *W. Packer,* Art and artists 5:1970 (Nov.) 38; *J. Burr,* Apollo 96:1972 (Juli) 74; (Nov.) 447; Goya 114:1973 (Mai-Juni) 369 s.; Tradition aside. Slade printmakers of the 1960s, Lo. 2007; UCL Art Coll., Lo. 2008. – Online: Website C.; Cass Sculpt. Found. – Mitt. C. H. Stuchtey

Chamberlain, *Elwyn* → **Chamberlain,** *Wynn*

Chamberlain, *William Gunnison (W. G.),* US-amer. Daguerreotypist, Fotograf, * 9. 11. 1815 Newburyport/Mass., † 19. 3. 1910 Denver/Colo.(?). 1824 Umzug der Fam. nach Boston/Mass. Als junger Mann unternimmt C. eine Schiffsreise nach Südamerika. Anschl. läßt er sich 1839 in Lima nieder, wo er zunächst in der Seidenherstellung und 1848 kurzzeitig im Bergbau arbeitet. 1852 endgültige Rückkehr in die USA; 1853–55 als Daguerreotypist in Chicago/Ill. nachg.; im Anschluß an eine Reise durch Kalifornien ab 1861 eig. Studio in Denver/Colo.; ab 1864 betreibt C. eine Dependance in Central City/Colo. unter der Ltg von Frank M. Danielson. 1881 führt er das Atelier in Denver gemeinsam mit seinem Sohn Walter A. C. (Chamberlain & Son), bevor er es im selben Jahr an den Fotografen Francis D. Storm verkauft. 1887–90 ist C. Angestellter von William Henry Jackson in Denver. Ausz.: 1853 Silber-Med., Chicago Mechanics' Institute. – C. beschäftigt sich ab 1847, zunächst nebenberuflich, mit der Fotografie. Während der 1860er und 1870er Jahre unternimmt er von Denver aus regelmäßig Touren durch die Rocky Mountains, auf denen zahlr. Stereoskopien entstehen. 1873 erscheinen Holzstiche nach seinen Aufnahmen der Stadt Denver in Frank Leslie's Ill. Newspaper. Um 1880 widmet sich C. intensiv der Fotolithographie. Er fotografiert überwiegend Lsch., aber auch Archit.- und Stadtansichten sowie Porträts. Seine gesamten Negative, zuvor von dem Fotografen Charles Weitfle erworben, fallen 1883 einem Brand zum Opfer. ⌷ BERKELEY, Bancroft Libr., Univ. of California. DALLAS/Tex., DeGolyer Libr., Southern Methodist Univ. DENVER, State Hist. Society of Colorado. NEW YORK, Public Libr. ROCHESTER/N. Y., George Eastman House. SANTA FE, Mus. of New Mexico. WASHINGTON/D. C., Libr. of Congress, Prints and Photographs Division. ⌷ *P. E. Palmquist/T. R. Kailbourn,* Pioneer photographers of the Far West, Stanford 2000. – *T. W. Mangan,* Colorado on glass. Colorado's first half c. as seen by the camera, Denver [1975]; *P. R. Fleming,* Native Amer. photogr. at the Smithsonian. The Shindler cat., Wa. u.a. 2003. – Online: George Eastman House. P. Freytag

Chamberlain, *Wynn (Elwyn),* US-amer. Maler, Filmemacher, Schriftsteller, * 19. 5. 1927 Minneapolis/Minn., lebt in Marrakesch. Stud.: Minneapolis SchA; 1944–46 (Offizierstraining für die Navy), 1946–49 Univ. of Idaho; danach Phil. an der Univ. of Wisconsin. Umzug nach New

York, wo er sich mit Andy Warhol anfreundet. 1965 heiratet er Sally Stokes. Von der New Yorker Untergrundbewegung angezogen, wird C. 1967 Produzent des Bühnenstücks „Conquest of the Universe" von Charles Ludlam. Danach verlegt er sich auf das Filmemachen und dreht 1968–69 die Satire auf das US-amer. Fernsehen „Brand X", die, jahrzehntelang unter Verschluß, erst ab 2011 erneut auf Filmfestspielen gezeigt wird. 1970 zerst. C. zahlr. seiner Gem. und zieht nach Indien, wo er sich Gurus anschließt. 1975 infolge der indischen Staatspolitik zur Ausreise gezwungen, geht er ins ländliche Kalifornien und bringt sein erstes Buch Gates of Fire über die Erfahrungen in Indien zum Abschluß. Ab 1983 erneut in Indien, schließlich Ruhestand in Marokko. – C.s frühe realistische Malweise (z.B. *Bradford Friedrich after Swimming*, 1946) nimmt unter dem Einfluß von John Wilde in den 1950er Jahren leicht surrealistische Züge an und wird auch als Magischer Realismus angesprochen, z.B. das zarttonige *Self-Portrait with Cat* (1959). Er malt u.a. auch Lsch. und Interieurs. Ab den frühen 1960er Jahren vereinfacht er die Komp. unter dem Eindruck der Pop-art. Er beginnt, sich für Nackt-Darst. zu interessieren und kopiert zunächst Fotos aus Nudisten-Mag., in denen er die Freude an der Körperlichkeit thematisiert. Einer Serie von Nackt-Port. aus dem Kreis der New Yorker Beat Poets verschafft ihm einen größeren Bekanntheitsgrad. 1964 entsteht das Gem.-Paar *Poets Dressed and Undressed* (Slg Earl McGrath, New York), in dem Joe Brainard, Frank O'Hara, Joe LeSueur und Frank Lima in jeweils gleicher Pose bekleidet und in selbstsicherer, fröhlicher Nacktheit dargestellt sind. Sind die Portr. realistisch, so ist die Räumlichkeit einzig durch Schattenschlag und undifferenzierte blaue bzw. grüne Farbflächen angedeutet, die eine Horizontlinie evozieren. Dieses Schema und Farbklima findet sich auch in and. Arbeiten der Zeit, z.B. *Totem* (1963–64), in der C. selbst, John Giorno und Ruth Kligman nackt übereinander gruppiert sind. Ein and. Gruppenbildnis nimmt die Komp. des „Déjeuner sur l'herbe" von Edouart Manet auf. Eine weitere Werkgruppe ist als Hommage an Thomas Eakins konzipiert. ⌂ COLUMBUS/Ohio, Mus. of Art: Burial of the Hero, 1954. NEW YORK, Whitney: Celebration, 1954–55. WASHINGTON/D. C., Smithsonian Amer. AM: Interior. Late August, 1955; The Barricade, 1958, beide Tempera/Faserplatte; Christian in the Slough of Despond II, Öl/Lw. 1961. ◉ *E:* 1951 Milwaukee, Bresslar Gall. / New York: 1954, '57 Edwin Hewitt Gall.; 1959 G Gall.; 1961 Nordness Gall. (K); 1965, '66 (mit Lorenz Gude) Fischbach Gall. ⌶ *Cummings*, 1968; *Falk* I, 1999. – *S. Preston*, New York Times v. 2. 5. 1954; 18. 11. 1961; *H. Stix*, Los Angeles Times v. 22. 9. 1978; *D. MacCarthy*, Arch. of amer. art j. 38:1998 (1–2) 28–38; *J. D. Katz/D. C. Ward*, Hide/seek. Differences and desire in Amer. portraiture (K), Wa. 2010. – *Online:* Brand X movie; Kadmos Publishing.

G. Bissell

Chambers, *Eddie,* brit. Collagekünstler, Kurator, Kunstkritiker, * 9. 9. 1960 Wolverhampton, lebt in Bristol. Stud.: 1979–80 Coventry Lanchester Polytechnic; 1980–83 Sunderland Polytechnic. 1998 Promotion am Goldsmiths' College, London. 1995–96 Curator in Residence, Univ. of Sussex, Falmer. Lehrtätigkeit: 2003–09 Emory Univ., Atlanta; Metropolitan Univ., London; seit 2010 Univ. Texas, Austin. – C. gestaltet in den 1980er Jahren mit zeitgen. Dok. (Ztgn, Fotos) politisch motivierte Collagen, die sich v.a. mit dem Schicksal der schwarzen Bevölkerung auseinandersetzen, z.B. im Kampf gegen die Apartheit in Südafrika (*How much longer you bastards*, 1983, Sheffield, Graves AG). Mit and. schwarzen Künstlern der Pan-Afrikan Connection (ab 1984 Gruppe Blk) organisiert er ab 1981 Ausst. und gründet 1989 das African and Asian Visual Artists' Arch. (AAVAA) zur Dokumentation und Erforschung von in Großbritannien lebenden zeitgen. schwarzen Künstlern (bis 1992 Ltg, seit 2005 im Diversity Art Forum und als online-Arch. weitergeführt). C. ist einer der bed. und häufig kontrovers diskutierten brit. Kunstkritiker (über 20 Jahre lang Beitr. für die Zs. Art Monthly) und Kuratoren für Black art (1988 Oldham, AG: Black art. Plotting the course; 1993 London, Cornerhouse: Black people and the Brit. flag; K). ⌂ LONDON, Arts Council. ✉ Run through the jungle, Lo. 1999. ◉ *E:* 1983–84 Sunderland, Polytechnic, Fac. of Art and Design Gall. / London: 1984 Black AG; 1988 Africa Centre / 1985 Dublin, Grapevine AC; Bristol, Watershed Concourse Gall. – *G:* 2011 Sheffield, Graves AG: Blk Art Group. ⌶ *Buckman* I, 2006. – *R. Araeen*, The other story. Afro-Asian artists in post-war Britain (K Wander-Ausst.), Lo. 1989; *P. Archer-Straw*, Art and design 10:1995 (März/April) 49–57; *N. Ratnam*, Third text 46:1999 (Frühjahr) 104–107. – London, Nat. Art Librr.: Dokumentation. – *Online:* Diaspora-artists.

H. Stuchtey

Chambers, *Robert,* US-amer. Bildhauer, Objektkünstler, Kurator, * 1958 Miami/Fla., lebt in Miami und New York. Bis 1983 Univ. of Miami; bis 1990 New York Univ. 1999 Heirat mit Malerin Mette Tommerup. Lehrtätigkeit: New York Univ.; Univ. of Miami. 2009 Artist in Residence, Fabric Workshop Mus., Philadelphia. Ausz.: 2002 Louis Tiffany Award. – C. setzt sein natur-wiss. Interesse spielerisch-experimentell in dynamische Skulpt. und Installationen um. Die Bronze-Skulpt. *Sugabus* (2004, St. Louis, Laumeier Sculpt. Parc) besteht z.B. aus einer überdimensionalen Darst. der 45 Atome (Kugeln) der molekularen Struktur von Sucrose; and. Arbeiten beziehen sich auf die Keplerschen Gesetze der Planetenbewegung (*Ryoanji Mobile*, 2008). Char. ist Interaktivität (Ton, Geruch, Bewegung), häufig die Nutzung von digitalen Medien und eine futuristische und zugleich sozial verträgliche Aussage. Daneben engagiert sich C. für die Kunstszene in Miami u.a. mit Ausst. (z.B. Globe Miami Island; Miami Beach, Bass Mus. of Art, 2001). ⌂ KANSAS CITY, Kemper Mus. MIAMI, AM. – South Miami-Dade Cult. AC. NEW YORK, MMA. NORTH MIAMI, MCA. ◉ *E:* Miami: 1987 Sculpt. Space, South Miami; 1998 North Miami MCA; 2001 Miami AM; 2003, '04 Frederick Snitzer Gall. / New York: 1991 Sculpt. Center; 1999 West Chelsea Arts Building / 1998 Mexiko-Stadt, La Torre De Los Vientos / 2003 Kansas City, Byron Cohen Gall. / 2004 St. Louis (Mo.),

Laumeier Sculpt. Parc. – *G:* 2009 Philadelphia (Pa.), Fabric Workshop Mus.: New Amer. Voices (K). ⌑ *P. Harper*, AiA 2002 (Juni) 70–73; *B. Clearwater*, Defining the nineties, Consensus making in New York, Miami and Los Angeles, Miami, Fla. 1996; *A. Barclay Morgan*, Art papers 4:1996 (Juli/Aug.) 10–13; *J. Garden Castro*, Sculpture 23:2004 (2) 34–39; *P. Clemence/J. Davidow*, Miami contemp. artists, Atgen, Pa. 2007; Fortunate Objects. Objetos Afortunados, Mi. 2007. – *Online:* Website C.

H. Stuchtey

Champagnat, *Jean-Claude,* frz. Juwelier, * 1923 Paris, † 1980 ebd. Sohn und Schüler eines Pariser Juweliers. Nach der Ausb. zunächst in einer Filiale des Modedesigners Pierre Cartier tätig, dann Übernahme der väterlichen Firma. Entwurf und Fertigung von Schmuck für die Modegestalter Madame Grès und Christian Dior. Nach eig. oder Entwürfen von Jean Dubuffet entstehen auch Unikate aus Gold, kombiniert mit Anthrazit-, Eisen- und Schieferelementen. ⌑ LONDON, V & A. PARIS, MAD. ⊙ *G:* 1961 London: Internat. Exhib. of Mod. Jewellery 1890–1961 / 1962 Paris, MAD: Antagonismes II. ⌑ Dict. internat. du bijou, P. 1998. R. Treydel

Champieux, *Marc,* frz. Maler, * 1947 Montpellier, tätig in Sète und Agde. Stud.: 1966–71 Ec. supérieure des BA, Montpellier, bei Camille Descossy. 1969–78 als Kunstlehrer in Sète tätig. Ausz.: 1985 Méd. de la Ville de Montpellier. – Abstrakte Öl-Gem. in gestisch-expressiver Malweise und reduzierter Farbigkeit; vorherrschend sind Braun- und Grautöne sowie Schwarz und Weiß. ⌑ SETE, Mus. Paul Valéry. ⊙ *E:* 1974–75, '78 Aigues-Mortes, Gal. Z / 1980 Lachassagne, Centre d'Art contemp. La Cuvée / Sète: 1990 Mus. Paul Valéry (K); 2011 Gal. Dock Sud / 2005 Frontignan, Mus. mun.; Bons-en-Chablais, Espace Bétemps (mit Martine Kerbaol) / 2006 Avignon, Gal. Sérignan / 2008 Lyon, Gal. St-Firmin. ⌑ *Bénézit* III, 1999.

F. Krohn

Champillou, *Jeanne,* frz. Graphikerin, Keramikerin, Zeichnerin, Malerin, Musikerin, * 4. 4. 1897 Saint-Jean-le-Blanc/Loiret, † 22. 5. 1978 Orléans, dort tätig. – Klavier-Stud. an der Ec. de Musique in Orléans. C. verdient sich ihren Lebensunterhalt durch Klavierstunden und widmet sich intensiv der Graphik, Malerei und Keramik. Sie nimmt Unterricht bei den Graphikern Králíček (1916) und Maurice Bastide du Lude (in Jouy-le-Potier). Bis M. der 1940er Jahre entstehen hauptsächlich Graphiken in Tiefdrucktechnik (Kpst., Rad. [Vernis mou], Aquatinta, Kaltnadel), weiterhin Zchngn und Gem. mit Lsch., ländlichen Genreszenen (u.a. Ernte-Darst.), Portr. (u.a. von Bauern, Handwerkern und Künstlern, z.B. Georges-Henri Blanchard und Pierre Fillette) sowie Stadtansichten von Orléans in realistischem Stil. Regelmäßig Ausst. in Orléans und Teiln. an Pariser Salons (1929, 1934–36). 1947 eröffnet C. zus. mit Henry Aimé (Zusammenarbeit bis 1955) ein Keramikatelier in Orléans. Zunächst gestalten sie v.a. Gebrauchskeramik (Gefäße), später bevorzugt figürliche Arbeiten (u.a. Hll.-Figuren) sowie archit.-gebundene Keramik für öff. Gebäude (wie z.B. Schulen) und Sakralbauten. – Ill.: J.-L. Béchu, *L'auberge du poisson d'argent*, Orléans 1954;

M. Leseur, *Vers l'an 2000*, Clisson 1972; id., *Eau de vie*, 1973; A. Ribot, *Chez nous par là*, Fontenay-sur-Conie 1981. ⌑ BRINON-SUR-SAULDRE, Eglise St-Barthélemy: Kreuzweg (Keramik). CHATEAUNEUF-SUR-LOIRE, Mus. de la Marine de Loire (Keramik). MONTARGIS, Chap. Ste-Thérèse des Cloisiers, Tympanon: Auferstehung (Keramik). ORLEANS, Chap. Notre-Dame-des-Miracles: Jeanne d'Arc, 1972 (Keramik). – Eglise St-Martin: Kreuzweg (Keramik). – MBA. – Pfarrk. Notre-Dame de Consolation: Reliquienschrein, Mosaik (Keramik). PARIS, BN (Graphiken). SAINT-JEAN-DE-BRAYE, Mairie: Wand-Gest. (Keramik). WORMHOUT, Mus. comm. Jeanne Devos (Graphik, Keramik). ⊙ *E:* 1977 Orléans, Collégiale St-Pierre-Le-Puellier (Retr.; Med. de la Ville d'Orléans) / 2002 Beaugency, Eglise St-Etienne / 2007 Olivet, Espace Charles Pensée. ⌑ *Edouard-Joseph* I, 1930; *Bénézit* III, 1999. – *A. Bouzy*, La Grand'place. J. C., Chartres 1986; J. C. L'œuvre gravé, Orléans 1994. – *Online:* Palissy. Patrimoine mobilier; Website C. F. Krohn

Champion, *Jeanne,* frz. Malerin, Schriftstellerin, * 25. 6. 1931 Lons-le-Saulnier (Jura), lebt in Paris und Montchauvet. C. übt zunächst versch. Berufe aus (u.a. Verkäuferin, Fremdsprachensekretärin), bevor sie sich nach einem Stud. an der Ec. des Métiers d'arts (Section Vitrail) seit 1956 autodidaktisch der Malerei und seit 1961 der Schriftstellerei widmet. Ausz.: 2001 Officier dans l'ordre des Arts et des Lettres. – Farbenreiche abstrakte Gem. in gestischer Malweise, z.T. in Anlehnung an kubistische Formsprache, häufig in Kombination mit Collage- und Assemblageelementen (u.a. mit afrikanischen Masken, Textilien, Pflanzen- und Metallteilen). Die frühen Werke sind größtenteils von C. zerst. oder übermalt. Erhalten sind v.a. abstrakte Gem. (Gouache, Tusche) in harmonischer Farbgebung (v.a. Brauntöne). Weiterhin figurative Arbeiten (Tusch- und Kreide-Zchngn sowie Pastelle), bisweilen als Referenz auf bed. Gem. u.a. von Holbein, Ingres, Dürer, Cranach (*Judith songeant à Holopherne d'après Cranach*, Pastell, 1977). Die Integration von Papierfragmenten (u.a. aus Werbeplakaten) in Gem. und Zchng läßt sich bereits im Frühwerk nachweisen und wird auch in aktuellen Arbeiten beibehalten (*Jeux du ventre*, 1957; *Couloir de métro 2*, 2011). Auch in den „reinen" Gem. und Zchngn verfolgt C. eine collageartige Gest.-Weise mit sich überlagernden Bildfragmenten, z.B. von einzelnen Körperteilen, die häufig im Bereich des Kopfes plaziert sind, wodurch surreal wirkende, fratzenhafte Erscheinungen entstehen (*Un jeune moine obsédé par le bain turc*, Pastell, 1977). Auch Teppichentwürfe (u.a. für Saint-Cyr). ⌑ *Romane:* Le cri, P. 1967; Ma fille Marie-Hélène Charles Quint, P. 1974; Suzanne Valadon ou la Recherche de la vérité, P. 1984; La maison Germanicus, P. 1996; Le Terrible, P. 2004; Là où tu n'es plus, P. 2009. ⊙ *E:* Paris: 1963 Gal. Suzanne de Coninck; 1970 Gal. de l'Univ.; 1984 Gal. La Pochade; 1995, '97, '99 Gal. Transversale; 2001, '10 Espace Châtelet Victoria; 2011 La Bellevilloise / 2009 Cerisy-la-Salle, Centre Cult. Internat. – *G:* Paris: 1964 MAD: 50 ans de Collage (Wander-Ausst.); 1967 Salon de Mai ; 1972 Soc. Art et Prospective: La Tapisserie actuelle; 1975 Salon des

Femmes Peintres; 2011 Espace Châtelet Victoria: L'Art et la Pensée dans un Monde en Mutation. ⊐ *P. de Boisdeffre*, Hist. de la litt. de langue franç. des années 1930 aux années 1980, II, P. 1985; *Bénézit* III, 1999; *Delarge*, 2001. – *M. Jarry*, Wandteppiche des 20. Jh., M. 1975; Gal. Jardin des arts 175:1977, 126; *P. Monsel* (Ed.), Idoles. J. C. Yann Queffélec, P. 2002 (Wendebuch, enthält außerdem: Avantdernières toiles). – *Online:* Website C. F. Krohn

Champion, *Maurice*, frz. Innendekorateur, Möbelgestalter, * 5. 12. 1899 Le Raincy/Seine-et-Oise, † 24. 4. 1962 Levallois-Perret/Hauts-de-Seine. Sohn eines Möbelhändlers in Le Raincy. Autodidakt. Eröffnet 1930 in Paris die Verkaufs-Gal. L'Atelier 75 für Gem., Skulpt. und selbst entworfenc Möbel. Verwalter der Zs. L'Art vivant. Vize-Präs. der Soc. nat. des BA. – Das Frühwerk der 1930er Jahre umfaßt schlichtes, funktionales, schmucklos und ausgewogen gestaltetes Massivholzmobiliar, mit dem sich C. zunächst in die Avantgarde des frz. Möbeldesigns einreiht. Der Nachfrage entsprechend fertigt er in den 1940er Jahren edelholzfurnierte Luxusmöbel mit Rückgriffen auf Vorbilder des Art Déco der 1930er Jahre und wendet sich verstärkt Radio- und Fernsehmobiliar zu. Zahlr. Auftragswerke, oftmals komplette Zimmereinrichtungen oder Sitzgruppen, entstehen für staatliche Behörden, Schulen, Industriebetriebe, Geschäfte, Hotels und Privathäuser in Frankreich und and. Ländern. Zu C.s Hw. gehört ein neunteiliges Art-Déco-Speisezimmer aus Zitronenholz mit ledergepolsterten Armlehnstühlen (1926 im Pariser Salon d'Automne ausgestellt; Abb. im Kat. der Abt. Mobilier & Décoration; Kunsthandel, 2004). ⌖ Paris, MAMVP (lt. Temerson). ◉ *G:* 1937 Paris: Expos. internat. des Arts et Techniques dans la Vie mod. (Gold-Med.) / 1939 New York: WA. ⊐ *H. Temerson*, Biogr. des principales personnalités franç. décédées au cours de l'année 1962, P. [1962]; *Kjellberg*, 1994. – *P. Kjellberg*, Art Déco. Les maîtres du mobilier. Le décor des paquebots, P. 2011.
 R. Treydel

Champy-Schott, *Nani*, dt. Keramikerin, * 1959 Ulm, lebt seit 1986 zus. mit ihrem Ehemann, dem Keramiker Claude C., in Plaisir/Yvelines. Stud.: 1980–84 Freie KHS Nürtingen; 1985–86 Ec. nat. supérieure des Arts appliqués et des Métiers d'Art, Paris; 1986 Weiterbildung bei Camille Virot (Raku). Präs. der Assoc. Potiers de Paris. Jury-Mitgl. Westerwaldpreis 2009. – C. gestaltet meist doppelwandige, frei aufgebaute voluminöse Gefäße (Schalen, Schüsseln, Dosen) und Objekte bevorzugt in Rakutechnik. Die z.T. archaisch anmutenden Keramiken weisen überwiegend asymmetrische Formen auf und sind mit einer glatten Innenseite ausgestattet, die durch die äußere stark strukturierte, rauhe Oberfläche kontrastiert wird. Einige Arbeiten evozieren Erinnerungen an Muscheln, Blütenblätter und Schneckengehäuse, so z.B. die halbkugelförmigen Keramiken mit dem nach innen gebogenen Rand (*Fleur de peau rouge*) sowie die Schalen aus runden oder eckigen flachen Tonscheiben mit eingerollten Rändern. C. verwendet dickflüssige Glasuren (z.T. Craquéléglasur) und farbige Engoben. ◉ *E:* 2002 Kaub, Gal. Thiesmeyer & Sälzer / 2007–10 Nançay, Gal. Capazza / 2008 Höhr-

Grenzhausen, Keramik-Mus. Westerwald / 2010 Hüfingen, Rathaus-Gal. – *G:* 1996 Soissons, Mus. mun.: Céramique contemp. (K) / 2001 Châteauroux: Bienn. de Céramique contemp. / 2002 Selb, Porzellanikon: Subjektiv-Objektiv / 2003 Le Grand-Pressigny: Bienn. de Céramique contemp. / 2004 Chartres-de-Bretagne: Bienn. de Céramique contemp. / 2007 Chicago (Ill.): SOFA (Internat. expos. of sculpt., objects and functional art) / 2008 Augsburg, H2 – Zentrum für Gegenwartskunst im Glaspalast: Danner-Preis (K); Paris, Ateliers d'Art de France: Retour de Fuping (K) / 2010 Freiburg im Breisgau: Freiburger Keramiktage / 2011 Cabrières d'Avignon, Gal. 22: Céramique. ⊐ *B. Thiesmeyer*, Neue Keramik 2002 (5) 32 s.; *O. Thormann* (Bearb.), Gefäß – Skulpt. Dt. und internat. Keramik seit 1946 (K Grassi MAK, Leipzig), St. 2008.
 F. Krohn

Chamsang (Jhamsang), tibetischer Maler, * 1971 Lhasa, lebt dort. 1987 beginnt C. eine trad. Malerei-Ausb. bei dem tibetischen Thangka-Meister Tenpa Rabten, die er 2003 durch ein Kunst-Stud. an der Tibet Univ. ergänzt. Als Kunstlehrer tätig. Mitgl.: Gedun Choephel Artists' Guild. – Der Ausb. entsprechend, verwendet C. viele technische und stilistische trad. Elemente, die er jedoch originell und v.a. dekorativ einsetzt. Dabei ist die farbenfrohe Malerei oft profanen Inhalts. Neben Acrylfarbe und Mineralpigmenten arbeitet C. auch mit ungewöhnlichen Mat. wie schwarzem Tee. ◉ *G:* 2006 Königswinter, Siebengebirgs-Mus.: Mod. Kunst vom Dach der Welt. Zeitgen. Malerei aus Tibet / 2008 Haarlem, Gall. ArtSite: Insight Tibet. ⊐ Visions from Tibet. A brief survey of contemp. paint. (K Contemp. Tibetan AG), Lo. 2005; Tibetan encounters. Contemp. meets trad. (K), Lo. 2007. – *Online:* Asianart. R. Höfer

Chan, *Paul*, US-amer. Installations- und Videokünstler, Zeichner, Schriftsteller, * 1973 Hongkong, lebt in New York. Ab 1981 in Omaha/Nebr. ansässig. Stud. in Chicago/Ill.: bis 1996 Chicago Art Inst., bis 2002 Bard College (Film, Video). – C.s Arbeiten sind von seiner Tätigkeit als politischer Aktivist inspiriert, aber nicht zweckorientiert; er trennt beide Bereiche, die nach seiner Auffassung auf versch. Weise funktionieren. Zunächst gestaltet er großformatige Videoinstallationen mit einer Mischung aus Mythologie, mod. Medien, Popkultur sowie apokalyptischen und utopischen Visionen, wobei er geschickt neue Medientechnologien nutzt, insbesondere digitale Animation. Das bunte Video *Happiness (Finaly) After 35000 Years of Civilization* (2003) wird auf eine längliche Lw. projiziert und verbildlicht utopische Wünsche und dystopische Phantasien in einer Art apokalyptischem Poprealismus. Zentrale Themen sind Machtmißbrauch und imperiale Dominanz, wie C. sie besonders unter der Regierung von George Bush empfindet. Collageartige Videos wie *Baghdad In No Particular Order* (2003) dokumentieren im Auftrag der Menschenrechtsorganisation Voices in the Wilderness das Alltagsleben in Bagdad vor den US-amer. Angriffen und werden in New York und auf C.s Website gezeigt. 2005 hilft C. in New Orleans nach den Zerstörungen durch den Hurrikan Katrina, eine Auffüh-

rung des Stückes Warten auf Godot von Samuel Beckett zu realisieren. Bek. und erfolgreich wird C. mit dem siebenteiligen Zyklus *The 7 Lights* (2005–08) aus mon. Projektionen, Kohle-Zchngn, Kollagen und digitalen Studien, die u.a. auf die im Westen etablierte Verbindung von Wissen und Ursprung mit Helligkeit anspielt sowie auf den Zwiespalt zw. Kapitalismus und Idealismus. Schemenhaft erkennbare Schattenobjekte des Alltagsleben und Motive der Kunst- und Relig.-Gesch. fallen oder schweben nach oben durch einen projizierten Lichtschacht. Ab 2008 beginnt C. mit sexuell konnotierten Arbeiten, z.B. der Installation *My laws are my whores* (2008), in denen er sich mit den Schriften und dem Schicksal des Marquis De Sade auseinandersetzt und sie mit dem heutigen Umgang mit Sex und Gewalt und der Rechtsprechung in den USA vergleicht. Zu bewegten Bildern kommen Tusche- und Kohle-Zchngn, Skulpt. und ein mit Tusche gezeichneter Letternsatz, der Buchstaben durch pornographische Wörter, Phrasen und Bilder ersetzt und über C.s Website frei verfügbar ist. Mit diesen sog. Alternumerics verwirklicht C. weitere Kunstprojekte und limitierte Drucke. In der kontemplativen Projektion *Sade for Sade's Sake* (2009) versammeln sich mon., animierte Schattenfiguren zu sexuellen Orgien, sprechen, gehen und kriechen und verwirklichen relig. Rituale zw. wahllos verteilten geometrischen Schattenformen. C. gehört zu den bed. zeitgen. US-amer. Installationskünstlern. ⌂ AMSTERDAM, Sted. Mus. BOSTON, Inst. of Contemp. Art. DÜSSELDORF, Coll. Julia Stoschek. NEW YORK, Apexart. – Guggenheim. – MMA. – Whitney. OSLO, Astrup Fearnley MMK. ✉ The essential and incomplete Sade for Sade's sake, N. Y. 2009; Waiting for Godot in New Orleans. A field guide, N. Y. 2010. ◉ E: New York: 2003 MMA; 2004, '09 Greene Naftali Gall. / 2005 Los Angeles, UCLA Hammer Mus. (K); Boston, Inst. of Contemp. Art / 2006 Austin (Tex.), Blanton Mus. of Art; Mailand, Gall. Massimo; Stockholm, KH: Magasin 3 (K); Frankfurt am Main, Portikus (K) / 2006–07 Philadelphia (Pa.), Fabric Workshop and Mus. / 2007 Vancouver, Western Front; Amsterdam, Sted. Mus. (K); London, Serpentine Gall. (K; Wander-Ausst.) / 2008 Cambridge (Mass.), Carpenter Center for the Visual Arts / 2009 Chicago (Ill.), Renaiss. Soc. at the Univ. of Chicago. – G: 2009 Venedig: Bienn. / 2012 Kassel: documenta. ▭ *M. Kerr*, Flash art 37:2004 (Mai/Juni) 106–109; *P. Eleey*, Frieze 89:2005 (März) 104; *N. McClister*, Bomb 92:2005, 22–29; *J. Burton*, Artforum 43:2005 (Jan.) 181 s.; *S. Rothkopf*, ibid. 44:2006 (10) 304–311; *J. B. Korotin*, ArtRev 3:2005 (9) 100–103; *H.-U. Obrist*, Contemporary 84:2006, 34–37; Between artists. P. C., Martha Rosler, N. Y. 2006; *K. Horsfield/L. Hilderbrand* (Ed.) Feedback, Ph. 2006; Frankfurter Allg. Sonntags-Ztg v. 22. 10. 2006; *C. Chiu*, Art Asia Pacific 51:2006 (Winter) 116 s.; *R. Kent*, ibid. 56:2007 (Nov./Dez.) 140–143; Art news 106:2007 (9) 225; *A. Wiarda*, Flash art 40:2007 (Juli/Sept.) 138; *G. Matt u.a.* (Ed.), Traum und Trauma. Werke der Slg Dakis Joannou, Athen (K Wien), Ostfildern 2007; *A. Coulson*, ArtRev 8:2007 (Febr.) 136; *A. Soloski*, Mod. painters 19:2007 (9) 112; *T. Griffin*, Artforum 46:2007 (4) 51;

M. Sharpe, Art on paper 11:2007 (6) 28–31; *M. Larner/ B. Fergusson* (Ed.), P. C. The seven lights, Köln 2007; *A. Rottmann*, Texte zur Kunst 17:2007 (67) 153–159; 18:2008 (71) 288 s.; *A. Wiarda*, Flash art 40:2007 (Juli/Sept.) 138; *M. Cattelan*, ibid. 41:2008 (262) 110–113; *J. Zellen*, ArtUS 23:2008 (Sommer) 19; *Y. McKee*, October 123:2008 (Winter) 110–115; *M. Kröner*, Kunstforum internat. 189:2008 (Jan./Febr.) 94–107; Destroy, she said (K Düsseldorf), Ostfildern 2008; Fragile (K Düsseldorf), Ostfildern 2009; *A. Eler*, Art papers 33:2009 (Mai/Juni) 46 s.; *J. Yood*, Art on paper 14:2009 (2) 105; *J. Kastner*, Artforum internat. 48:2010 (5) 199 s.; *L. Hoptman u.a.* (Ed.), The art of tomorrow, B. 2010; Parkett 88:2011, 66–109; *N. Trezzi*, Flash art 44:2011 (277) 68. – Online: Website Nationalphilistine. H. Stuchtey

Chan *Yuk-keung* (Chan *Yuk Keung*), chin. Mixed-media-Künstler, * 1959 Hongkong, lebt dort. Stud.: Chin. Univ., Hongkong (Abschluß 1983); anschl. Malerei an der Cranbook Acad. of Art, Bloomfield Hills/Mich. Lehrt seit 1989 an der Chin. Univ., Hongkong; auch als Kurator und Berater versch. Kunst-Mus. tätig. Ausz.: 1999 1. Preis Public Art Scheme Competition, Tai Po Central Town Square, Hongkong. Öff. Kunstprojekte: 1991 *Environmental Drawing* (Hongkong, AM, Chin. Univ.); 2000 *Collecting Star Dust* (Heritage Mus./Provisional Regional Council ebd.); 2003 *The Sea Says* (Singapur, Kepple Port). – Fertigt anfänglich Gem. und Druckgraphiken. In seiner aus versch. Anregungen (u.a. von René Magritte, Antoni Tàpies, Franz Kline) gewachsenen Ausdrucksweise der späteren Multi-media-Arbeiten (Skulpt., Installation, Ready-mades) sucht C. spirituelle, physikalische und kult. Dimensionen in dadaistisch-surrealistischer Weise zu verbinden, wobei tiefgründige soziale und gelegentlich auch politische Reflexionen im Vordergrund stehen. 2005 zus. mit anothermountainman (Wong Ping-pui) Teiln. an der Bienn. von Venedig mit der Arbeit *Investigation of a journey to the west by micro + polo* (Installationen), die die Vermischung und Abweichung der Kulturen erforscht. ✉ *C./H. Mok*, Hong Kong visual arts yearbook 2003, Hong Kong 2003. ◉ E: Hongkong: 1992, 2003 Hong Kong AC; 1995 Agfa Gall., German Cult. Centre; 2001 G. O. D (Art Window Project); 2003 Para/Site Art Space (Retr., K). – G: Hongkong: 1992 AM: City Vibrance. Recent Works in Western Media by Hong Kong Artists; 1997 Hanart TZ Gall.: 6. 30 Exh.; AM, Chin. Univ. of Hong Kong: The Faculty Show in Commemoration of the 40th Anniversary of the Dep. of FA; 1998, 2001 Bienn. of Contemp. Art; 1998 AC: New Voices. Contemp. Art from Hong Kong, Taipei and Shanghai (Wander-Ausst.); 2000 Para/Site Art Space: My Personal Skyscraper (K); 2001 John Batten Gall.: The Gambling Show; 2004 Heritage Mus.: Building Hong Kong. Redwhiteblue / 1996 Brisbane, Queensland AG: Asia-Pacific of Contemp. Art Trienn. (K) / 1997 Tokio, Watari MCA: Contemp. Art of China (K) / 1999 Taipei, MFA: Internat. Bienn. Print & Drawing Exhib.; Hofbieber-Kleinsassen, Kunststation: Bienn. Neues Aqu. / 2000 Hannover, Nord Landesbank:Art for EXPO 2000 (2. Preis) / 2005 Venedig: Bienn. (K).

▭ *M. Sullivan*, Mod. Chin. artists, Berkeley u.a. 2006 (s.v. Chen, Yuqiang). – *P. Hinterhud/N. Corazzo* (Ed.), Mod. art in Hong Kong, Hong Kong 1985; *D. Clarke*, J. of the Oriental Soc. of Australia 29:1997, 1–21; *A. Bennett*, Art Asia Pacific 19:1998, 35 s; Hong Kong art. Cult. and decolonization, Hong Kong 2001; Para/Site Art Space, Hong Kong, QK – A Specimen Coll. of Chan Yuk Keung, Hong Kong 2003; Investigation of a journey to the west by micro + polo, ed. *Hong Kong Arts Development Council*, Hong Kong 2005; *S. Lai*, Yishu. J. of contemp. Chin. art 4:2005 (3) 43–47. – *Online:* Hong Kong Art.

 K. Karlsson

Chanarin, *Oliver,* brit. Fotograf, Konzeptkünstler, * 1971 London, lebt dort. Seit E. der 1990er Jahre Zusammenarbeit mit *Adam Broomberg* (* 1970 Südafrika, Stud.: Soziologie und Kunstgesch.) unter dem Namen Broomberg & Chanarin. C. studiert Phil. und Künstliche Intelligenz (Informatik). Die beiden lernen sich in London kennen, wo sie für die Zs. Color arbeiten. Gemeinsame Lehrtätigkeit: London College of Communication (Dokumentar-Fotogr.); School of Visual Arts, New York. Ausz.: 2004 Vic Odden Award, R. Photogr. Society, Bath; 2005 Arts Council Grant. 2011 Kuratoren des Festivals Photomonth in Kraków. – Broomberg und C. setzen sich in einer betont medienreflexiven Form der Dokumentar-Fotogr. wiederholt mit bewaffneten Konflikten, u.a. in Afghanistan, dem Irak, Sudan und Palästina, auseinander. Mehr noch als den Ereignissen selbst, widmen sie sich dabei den geläufigen Bildmustern der Kriegsberichterstattung und deren Rhetorik authentischer fotogr. Repräsentation. In *The Day Nobody Died* (2008) begleiten sie als sog. embedded journalists eine Einheit der brit. Armee in Afghanistan. Anstatt gängiger fotogr. Dok. von Kampfhandlungen oder Zerstörungen produzieren Broomberg und C. abstrakte Fotogramme, indem sie mehrere sechs Meter lange Abschnitte von Fotopapier jeweils 20 Sekunden lang belichten. Zuletzt nutzen sie oft vorgefundene Mat., wie etwa für *War Primer 2* (2011), wo sie die Texte von Bertolt Brechts Kriegsfibel mit Fotogr. aktueller Kampfhandlungen kombinieren. – Fotobücher: *Trust,* Lo. 2000; *Ghetto,* Lo. 2003; *Mr Mkhize's Portr. & Other Stories from the new South Africa,* Lo. 2004; *Chicago,* Göttingen 2006; *The Red House,* Göttingen 2007; *Fig,* Brighton/Göttingen 2007. ▭ AMSTERDAM, Sted. Mus. LAUSANNE, Mus. de l'Elysée. LONDON, Nat. Portr. Gall. – Tate Modern. V & A. NEW YORK, Internat. Center of Photogr. ◉ *E:* 2000 Göteborg, Hasselblad Center / 2003 Johannesburg, Johannesburg AG / London: 2004 The Photographers' Gall.; 2005 Nat. Portr. Gall. / 2006 Amsterdam, Sted. Mus.; New York, Steven Kasher Gall. / 2008–09 Bradford, Impressions Gall. / 2009 Lausanne, Mus. de l'Elysée / 2010 Kairo, Townhouse Gall. – *G:* 2001 Bradford, NM of Photogr., Film and Television: In a Lonely Place (K) / London: 2003 (Stepping in and out. Contemp. Doc. Photogr.), '11 (Figures & Fictions. Contemp. South African Photogr.; K) V & A; 2008–09 Courtauld Inst. of Art: On Time. East Wing Coll. VIII (K) / 2004 Madrid: Photo España / 2004–05 Kopenhagen, Nat. Foto-Mus.: Unsett-

led. 8 South African Photographers (Wander-Ausst.; K) / 2005–06 Reggio Emilia, Pal. Magnani, und Corregio, Pal. dei Principi: Il volto della follia. Cent'anni di immagini del dolore (K) / 2006 Venedig: Archit.-Bienn. / 2006–07 New York, Internat. Center of Photogr.: Trienn. of Photogr. and Video / 2008 Brighton: Photo Bienn. / 2009 Berlin, AK: Embedded Art (K) / 2010 Arles: Rencontres d'Arles / 2011 Amsterdam, Foam Fotogr.-Mus.: Antiphotojournalism; Darmstadt, Mathildenhöhe: Serious Games (K) / 2012 Chicago, Mus. of Contemp. Photogr.: Peripheral Views. States of America; Leipzig: F/Stop. Festival für Fotografie. ▭ *D. Campany,* Aperture (N. Y.) 185:2006; *J. Pitman,* The Times (Lo.) v. 23. 9. 2008; *L. Rexer,* The edge of vision. The rise of abstraction in photogr. (K Aperture Found.), N. Y. 2009. – *Online:* Website Broomberg & C. P. Freytag

Chancel, *Philippe,* frz. Fotograf, * 28. 3. 1959 Issyles-Moulineaux/Hauts-de-Seine, lebt in Paris. Stud.: Wirtschafts-Wiss. und Journalismus (Dipl.) in Paris. Beginnt früh zu fotografieren. Um 1981 endgültige Hinwendung zur Fotogr.; anfangs Schwarzweißaufnahmen vom Alltag in den Pariser Vororten. C. verbindet künstlerische und dok. Fotogr. mit journalistischen Ansätzen. Frühe Bildreportagen aus Osteuropa (u.a. Polen, 1981) werden in zahlr. Mag. veröffentlicht. E. der 1980er Jahre entsteht die Serie von Künstler-Portr. *Regards d'artistes.* Außerdem Foto-Dok. über Fabienne Verdier (auch Film *Fabienne Verdier. Flux),* Anselm Kiefer, Roman Opalka und Pierre Soulages. A. der 1990er Jahre bis 1995 ausschließlich Videoarbeiten und Fernseh-Dokumentationen. Für C.s Arbeiten char. ist eine distanzierte, dok. wirkende Abb. von Stadtraum, Details und Menschen u.a. in ihrer Arbeitsumgebung, so bei den Aufnahmen aus Nordkorea (2005, Wander-Ausst.) und den Vereinigten Arabischen Emiraten (2007–10, darunter die Werkgruppen *Workers* und *Emirages)* sowie *Comman-de Mosaïque. Mag. général* (um 2010). Weitere Werkgruppen: *Souvenirs de* mit Blicken in die Schaufenster von Paris, London, New York und Tokio (gemeinsam mit Valérie Weill), *En construction* für das Centre Pompidou Metz mit teilw. rapportähnlicher Wiederholung desselben Bildes (2008), *La Tourette* und *Datazone* (in Arbeit). – Buch-Veröff. u.a.: *The face of art,* Mi. 2004; C./V. Weill, *Paris in store,* Lo. 2004; C./I. Gludowacz/S. van Hagen, *Kunstsammler und ihre Häuser,* M. 2005; C./V. Weill, *London in store,* Lo. 2005; C./M. Poivert/J. Fenby, *North Korea,* Lo. 2006; *Dubai,* P. 2008; C./D. Sausset/L. Le Bon, *Arirang. Nordkorea,* Lausanne 2008; C./F. Morellet u.a., *La Tourette, le cinquantenaire,* P. 2009; Q. Bajac/C., *Desert spirit,* P. 2010. ▭ BIÈVRES, Mus. franç. de la photogr. LYON, Stadtverwaltung. PARIS, BN. – FNAC. ◉ *E:* Paris: 1997, '98, 2000 Gal. Les Singuliers; 2003 Gal. Ariane Dandois; 2004, '05 Gal. Artcurial; 2005, '06, '07, '08 Gal. LC; 2006 Soc. franç. de la photogr.; 2010 Gal. Chaume / 2002 Bratislava, Inst. franç. / 2006 Tokio, Inst. franç. / 2008 Brüssel, Gal. Young / 2010 Lyon, Gal. le ciel du bleu / 2011 New York, Columbia Univ.; Limerick, Limerick City Gall. of Art. ▭ Connaissance des arts 539:1997, 52–55; *A. L. E. Bach,* The art book 13:2006 (3) 69; Brit. j. of pho-

togr. 7593:2006, 17–21; Rencontres d'Arles 2006. 37ᵉ éd. (K Rencontres Internat. de la Photogr.), Arles 2006; Dt. Börse photogr. prize 07, Lo. 2007; *A. Langen*, Photonews 20:2007 (2) 18; *J.-F. Lasnier*, Archit. contemp. à Paris et en Ile-de-France, P. 2007 (Fotogr.); *D. Sausset*, Connaissance des arts 653:2007, 68–73 (Fotogr.); *M. Boutoulle*, ebd. 657:2008, 50–55 (Fotogr.); *R. Berg*, Kunstforum internat. 191:2008, 408 s. – *Online:* Website C. N. Buhl

Chand, *Roop*, indischer Maler, * 21. 1. 1936 Dhundahera/Haryana, lebt in Gurgaon/Haryana. Stud.: Sir Jamsethji Jijibhai SchA, Bombay (Mumbai). Um 1960 Kunstlehrer, Govt. College of Art und College of Home Sc., beide Chandigarh/Punjab. 1972 wegen aktiver Teilnahme an Studentenprotesten Ende der Lehrtätigkeit. 1973 Einrichtung eines Keramikstudios in Gurgaon. Exzessive Reise- und Ausst.-Aktivität in Indien, Asien, dem Mittleren Osten und Europa. Kurzfristig an der Etablierung eines Kunststudiengangs an der Jawaharlal Nehru Univ., New Delhi, beteiligt. Mitgl.: Upsurge artists group, Chandigarh; Haryana Lalit Kalā Akad. ebd.; Indian nat. trust for art and cult. heritage, New Delhi. – C. schafft abstrakte Öl-Gem. in intensiven, dunklen Farben, in denen er persönliche Erfahrungen und Reiseeindrücke artikuliert. Die Begegnung mit Le Corbusier in Chandigarh inspiriert nach 1960 die Serie *Time and Space* mit abstrakt-geometrischen Sujets. E. der 1960er Jahre greift er thematisch u.a. die Hungersnot in Bihar auf; in den 1970er Jahren Beschäftigung mit phil. Fragen und Annäherung an neotantrische Kunstkonzepte (Serien *Bindu, Bindu radiance, Bindu reflection,* alle Öl, 1970–79). Mit zunehmendem Alter immer stärkere Hinwendung zur Spiritualität und Konzentration auf den Aufbau des eig. Kunstzentrums in Gurgaon. Engagement in der Kunsterziehung. ⌂ CHANDIGARH/Punjab, Govt. Mus. CHENNAI, Govt. Mus. and AG. ◉ *E:* 1992 New Delhi, Lalit Kalā Akad. (Retr.). ▭ *P. Sheth*, Dict. of Indian art and artists, Ahmedabad 2006. – *Online:* Website C. M. Frenger

Chanda, *Hiranmay (Hiranmoy),* bangladeschischer Maler, Zeichner, Graphikdesigner, * 20. 1. 1964 Jessore, lebt in Dhaka. Stud.: bis 1987 Dept. of Paint., Inst. of FA der Univ. ebd.; 1991 Promotion. Ausz.: 1982 Water Colour Best Award, Annual Art Exhib., Inst. of FA der Univ. Dhaka; 1984 Wettb. für das Politische Plakat in Moskau und Plakat-Wettb. in Dhaka. – Assoziativ-gegenständliche Malerei mit abstrahierenden flächig-expressiven Strukturen (z.B. *Window,* 2007; *Nature,* 2008). Char. sind eine intensive, kontrastreiche Farbgebung und z.T. dekorativ-plakative Formen. Häufiges Motiv bei C.s Tier-Darst. ist der Elefant (*Elephant & Kingfishers,* Gouache, 2006; *Elephant & Crane,* Gouache, 2008). Neueste Arbeiten thematisieren Ereignisse der jüngeren Gesch. Bangladeschs unter Einbindung von Schriftpassagen und Portr.-Zeichnungen. Als Graphikdesigner illustriert C. zahlr. Publ. für nichtstaatliche Organisationen und internat. Institutionen. C. ist ein vielseitiger, technisch versierter Künstler mit feinem Gespür für graph. Wirkung und rhythmische Linienführung. ✉ Child art of Bangladesh, Dhaka 1991. ◉ *E:* 2000 Dhaka, Alliance Franç. (Falt-Bl.). – *G:* Dhaka: 1991, '93

Asian Art Bienn.; 2002 Gall. 21: Art for Children; 2003 Nat. Art Exhib.; 2011 Gall. Jolrong: Mukhtijuddho o Bangabandhu / 2002 Vientiane (Laos): Kunst-Ausst. / 2004 Mumbai, Jehangir AG: Bangladesh festival / 2010 Nairobi, Univ.: Maker fair Africa. ▭ *T. Khan*, The daily star (Dhaka) v. 16. 4. 2011. – Mitt. C. M. Frenger

Chandhanaphalin *Nonthivathn* (Nonthivathn C.), thailändischer Bildhauer, * 16. 10. 1946 Thonburi, lebt in Bangkok. Stud. ebd.: 1962–64 College of FA; 1965–70 (Bachelor), 1975–79 (Master) Fac. of Paint., Sculpt. and Graphic Arts, Silpakorn Univ. (Skulpt.). Dort 1971 Doz., 1971–79 Sekretär und 1980–84 Vorstand der Abt. Skulpt.; 1984–88 und 1995–99 Dean der Fak.; 1989–90 Dir. der zur Fak. gehörenden PSG Gallery. 1979–80 Teiln. an einem Workshop für Marmorreliefs in Carrara. 1987 Reise in die USA. In versch. Funktionen tätig: u.a. ab 1983 Präs. der Thai Sculptors Assoc.; ab 2001 bei der Art Promotion Found. (Gen. Prem Tinsulanonda Statesman Found.); 2003 Präs. des Council of Fine and Applied Arts Deans of Thailand; ab 2003 Dean der Fac. of Fine and Applied Arts der Mahasarakham Univ., Mahasarakham. Ausz.: 1969, '71, '72 Silber- und 1974, '77 Bronze-Med. auf der Nat. Art Exhib., Bangkok.; 2006 Ernennung zum „Nat. Artist" durch das Erziehungsministerium. – C. arbeitet 1970–75 abstrakt in spindel- und kugelartigen Formen, die Früchten, Samenkapseln oder der weiblichen Brust nachempfunden sind und die er zu voluminös aufstrebenden Formen, Vierergebilden oder verschränkten Clustern verbindet (Holz, Gips, Bronze). Themen sind natürliche Wachstumsprozesse, aber auch Beziehungen abstrakter Formen zueinander und solche menschlicher Natur. Ab 1975 arbeitet er mit weiblichen Modellen und gestaltet seitdem fast ausschl. z.T. lebensgroße weibliche Akte. Erste Bronzen zeigen noch kauernde, hockende und in sich verschränkte Körper mit übersteigerten Volumina. Ab 1978 sind die meist aufgerichteten, das Haar ordnenden oder sich entkleidenden Mädchenfiguren schlank und idealisiert. Die Oberflächen der Bronzen sind glatt und goldbraun, die Titel bleiben abstrakt (*Volume. Form*). Seit 1980 abstrahiert er die weiblichen Körper zu sich stark verschlankenden dann übermäßig ausbuchtenden Formen, wohl auch um dem an Henry Moore geschulten „internat. Geschmack" gerecht zu werden. Es entstehen gereihte oder verschränkte Zweier- und Dreiergruppen von tanzenden, sich küssenden oder umarmenden Figuren mit psychologisierenden Titeln (*Desire; Lover in love*) in Bronze und Messing. Bei öff. Aufträgen greift C. auch auf die frühen abstrakten Formen mit „wachsenden" Volumina zurück, die neuerdings ges. Prozesse symbolisieren sollen. Auch Entwürfe für Med. und Münzen: 1995 *Agricola*-Münze anläßlich des 50jährigen Jubiläums der Food and Agriculture Organization (FAO); 1996 Gedenkmünze für König Bhumipol Adulyadej Rama IX. (*Mahajanaka*); 1999 thailändische FAO-Gedenkmünze (*Telefood*). Im Auftrag entstehen u.a. in Bangkok 1991 eine Skulpt. der Serie *Growth* im Benjasiri Park und 1992 ein Hochrelief im Park King Rama IX; zuletzt 2010 die Bronzeplastik *Growth of moral soc.* im Park Wachirabenchatat (Suan rot-fai) in Bangkok-

Chatuchak. 🏛 BANGKOK, Sculpt. Center: Relationship, Bronze, 1974; Desire, Messing, 1982; Meditation, Bronze, 2003. – Kasikorn Bank: Suwannavat, Messing, vergoldet, 1995. – Silpakorn Univ.: Growth no. 3, 1971/72; Relationship, 1973 (beide Gips). – TISCO art coll.: Meditation, Bronze, 2003. 👁 E: Bangkok: 2001 AG der Fac. of Paint., Sculpt. and Graphic Arts, Silpakorn Univ. (K); 2010 NG (mit Decha Warashoon; K). – G: Bangkok: AG der Fac. of Paint., Sculpt. and Graphic Arts, Silpakorn Univ.: 1993 50 years. 50 images (K); 1994 Thai-Images (K); 2000 Couple (K); 2002 Silpakam + See Silpakorn (K); 2003 From inside to outside (K); 1997 Queen Sirikit Nat. Convention Center: 50 years of Thai art (K); 2001 Vieng Tavern gall.: META Multiple expression Thai artists (K); 2004 Thai Cult. Center: Thailand-USA (internat. Wander-Ausst.); 2005 Queen's Gall.: Silpa. Buddha (K); 2008 Bangkok Art and Cult. Centre: Traces of Siamese smile (K); 2009 Gall. N: Mini matters / 2008 Brescia, Villa Glisenti: Brescia-Bangkok. 📖 A. Poshyananda, Mod. art in Thailand, Singapore/N. Y. 1992, 126–128; H. P. Phillips, The integrative art of mod. Thailand (K Wander-Ausst.), Berkeley, Calif. 1992; V. Mukdamanee/ S. Kunavichayanont, Rattanakosin art. The reign of King Rama IX, Bangkok ²1997, 133, 199; Krungthep Muang Fa Amorn art expos. (K Asian Games Art Project), Bangkok 1998, 76 s., 229; The small world. Thai contemp. art 2002 (K AC, Silpakorn Univ.), Bangkok 2002, 41, 106, 166; Art for Suwannaphum (K Jamjuree AG, Chulalongkorn Univ.), Bangkok 2003, 44 s.; S. Kunawong, The passion of Thai sculpt. (K Sculpt. Center), Bangkok 2005, 48–53; N. C. From abstract to concrete (K Ardel Gall.), Bangkok 2008; Thai-Ital. art (K AC, Silpakorn Univ.), Bangkok 2009, 60–63, 90; Our best recent works & glass art project (K PSG AG), Bangkok 2009, 20, 32, 129; A. J. West, FA mag. (Chiang Mai/Bangkok) 7:2010 (65/März) 71–73; 8:2011 (76/Febr.) 96–98; Project sculpt. installation between Bangkok metropolitan administration and Silpakorn Univ. (K), Bangkok 2010, 88–101. 　　A. Feuß

Chandra, *Mohini,* brit. Installations- und Videokünstlerin, * 7. 7. 1964 Chanvey Island/Essex, lebt in London. Kindheit in Gloucester, Fidschi und Brisbane. Stud.: 1985 Univ. of Queensland, Brisbane (Soziologie); 1992 Univ. of Westminster, London; 1994–97 West Surrey College of Art, Farnham (Montage bei Peter Kennard); 1997–99 R. College of Art, London (Promotion). 2000–03 Research Fellow ebd. – C. befaßt sich in Foto- und Videoinstallationen mit der Gesch. von Migration und der Verschiebung kultureller Identitäten. Die doppelte Diasporasituation ihrer indischen Fam., die während der brit. Kolonialherrschaft als Teepflücker auf die Fidschi-Inseln kam und 1987 durch den Militärputsch wieder vertrieben wurde, ist der Ausgangspunkt ihrer Arbeiten. Die Installation *Travels in a New World 1* (1994) zeigt Teekisten mit beleuchteter Oberseite und Fotos, die C. in den 1970er Jahren von ihrer Fam. auf den Fidschi-Inseln aufgenommen hat, hinzu kommen Beschriftungen und eine Tonspur mit der Frage: Woher kommst Du? Die Videoprojektion von einem schwarzweißen Fam.-Foto und fünf Portr.-Fotos in Far-

be vor einer Ozeankulisse sind Bestandteil der Installation *Travels in a New World 2* (1997), in der die Porträtierten über ihre indische Fam. in Fidschi-Hindi sprechen. Für die Installation *Album Pacifica* (1997) hängt C. vergrößerte Rückseiten (Gelatine-Abzüge) von alten Fam.-Fotos mit Beschriftungen und Ateliermarken in einem Raum auf. ✉ Cannibals and coolies, in: S. Merali/J. Mulvey (Ed.), Radical postures, Lo. 1995; Performing photogr., in: Creative camera 361:1999/2000 (Dez.-Jan.) 32–35; Album pacifica, Lo. 2001. 👁 E: 1996 Newcastle upon Tyne, Zone Photogr. Gall., Old Post Office / 1997 Liverpool, Bluecoat Gall. (K). 📖 J. Farver, Out of India. Contemp. art of the South Asian diaspora (K Queens Mus.), N. Y. 1997; T. McEvilley, AiA 86:1998 (19) 75–79; S. Cubitt, Make. The mag. of women's art 78:1998 (Dez.-Febr.) 6–8; I. Mahnke/A. Osterwalder (Ed.), „Crown jewels". Brit.-indische und brit.-pakistanische Kunst aus London (K Hamburg/Berlin), Ha. 1999; D. Yeh, a-n mag. 2004, 32 s.; Paradise now? Contemp. art from the Pacific (K Asia Soc. Mus.), N. Y. 2004; E. Edwards, in: A. Schneider/C. Wright (Ed.), Contemp. art and anthropology, Ox./N. Y. 2006; id./ id. (Ed.), Between art and anthropology, Lo. 2010. – London, Brit. Libr.: Oral hist. of Brit. photogr., Interview mit Shirley Read, 27. 4. 2000. – Tate, Arch. Audiovisual Coll.: Contemp. arts and globalisation. Study day 12. 4. 2005.
　　　　　　　　　　　　　　　　　　　　H. Stuchtey

Chandris (Handris), *Pantelis (Pandelis),* griech. Maler, Bildhauer, Installationskünstler, * 13. 4. 1963 Athen, lebt und arbeitet dort. Stud.: 1982–87 HBK, Athen, anfangs Graphik, dann bild. Kunst bei Dimitris Mytaras. Seit 2007 unterrichtet er dort. Mitgl.: Epimelitiriou Eikastikon Technon Ellados/Vrg bild. Künstler Griechenlands (EETE). Ausz.: 1992 1. Preis der Yannis and Zoe Spyropoulos Found.; 2010 1. Preis der Internat. Art Critics Assoc. (IACA), Hellenic Section (für die Ausst. Ens Solum in der Gal. a. antonopoulou.art, Athen 2007). – Von Beginn an fertigt C. Installationen, die an der Decke befestigt sind und im Raum schweben. Er verbindet dabei organische Mat. (Holz, Erde, Gräser, Baumwoll- und Leinenstoffe etc.) mit mechanischen bzw. künstlichen Elementen. In der Serie *Trophäen* (1993) kontrastieren z.B. die zu Vogelnesterkonstruktionen verbundenen natürlichen Mat. mit gläsernen und metallischen Werkstoffen. Das mit Gips ausgekleidete Nest soll dabei den vergänglichen menschlichen Körper symbolisieren und bedeutet für den Künstler eine Allegorie der Seele. In der 1995 entstandenen Serie *Blackboard Notices/Kaleidoscopic images* (Athen, Kreonidis AG) thematisiert C. das Verhältnis von Untergrund und Nachricht in einer mehr dem tradierten „Bild" entsprechenden Form. Auf Tafeln sind hier bewegliche Zeichen und Bilder montiert, welche der Betrachter aufgefordert war, durch Versetzen zu neuen Konstellationen zu formen und damit zu einer jeweils individuellen subjektiven Bedeutungsgebung zu finden. Für den Künstler legt das wechselnde Arrangement der polysemantisch aufgeladenen Symbole auf den Tafeln Aspekte individueller Erinnerung offen, die er in einer dialektischen Beziehung von Ordnung und Chaos sieht. Die *Parallelen Bilder* (1996)

führen diese Überlegungen fort, indem die Betrachter mit drei kaleidoskopischen Videoloops konfrontiert werden, die Tiere, Soldaten und Insekten zeigen. E. der 1990er Jahre entsteht die Werkgruppe *Med/lent*, wobei der Begriff ein Neologismus aus den Worten Medium und Talent ist und etwa „Durchschnittsmensch" bedeutet. Der Betrachter sieht die „Träume" einer aus Gips, Papier, Farbe und Metall gefertigten Figur dem *Med/lent* gegenüber als Projektionen auf Papier oder auf schwarzen Tafeln. C. steht deutlich in der Trad. der Konzeptkunst der 1970er Jahre; er beschäftigt sich mit dem wiederkehrenden Thema der Erinnerung sowie den Gegensätzen bewußt/unbewußt, sichtbar/unsichtbar, Realität/Traum, Natur/Kunst und spürt der Komplexität des mod. Lebens nach. ⌂ ATHEN, Frissiras Mus. THESSALONIKI, Macedonian MCA. ☉ *E:* Athen: 1991 Doma AG; 1993, '95, '97 Kreonidis AG; 1999 Epikentro AG; 2003, '05, '07, '10 Gal. a. antonopoulou.art / Thessaloniki: 1996 Gal. Kalfayan; 2003 TinT Gal. – *G:* 1991 Aachen, Ludwig Forum: Germination 6 / Athen: 1998 24 AG: Minor Zoology; Frissiras Mus.: 2001 Glossalgia; 2003 Anthropography; 2004 Kath' eikona kai kath' smoiosin; 2005 Anthropography III.; 2012 Face to Face. The artists and the collector; 2010 Benaki Mus.: 2010 O choros, oi anthropoi, oi istories tous; 2011 Athens Bienn. / 1987 Barcelona: Bienn. junger Künstler im Mittelmeerraum / 1988 Bologna: Bienn. Off / 1994 Nikosia, Mun. AC: The Tree. A Source of Inspiration. A Cause of Creation / 1996 Rom, Pal. delle Espos.: Messageri Degli Die / Thessaloniki: 2006 MCA: Eikastiko panorama stin Ellada; 2011 Gal. Space 18: New Places. ▯ LEK IV, 2000. – *E. Hamalidi* (Ed.), Contemp. Greek artists, At. 2004; To skiachtro. The scarecrow (K Metsovo), At. 2006, 176–177, 208. – *Online:* Blog C.; Frissiras Mus. E. Kepetzis

Chandžiev, *Minčo* → **Chadžiev,** *Minčo*

Chang, *Arnold* (Zhang *Hong*; Juchuan), chin.-US-amer. Maler, Kunsthistoriker, Kurator, * 1954 New York, lebt dort. Stud.: 1972–76 (Sinologie) Univ. of Colorado, Boulder; 1976–78 Univ. of California, Berkeley, Kunst-Gesch. bei James Cahill; 1978–2003 trad. chin. Malerei bei dem Maler und Kunstsammler C. C. Wang (Wang Chi-ch'ien) in New York sowie bei Guo Yanqiao (Kuo Yen-ch'iao) in Taiwan. Arbeitet u.a. 1980–97 als Experte für chin. Malerei bei Sotheby's und 1996–2005 in der Kaikodo Gall. in New York; 2006 beratender Kurator an der Mactaggart Art Coll., Univ. of Alberta, Edmonton. Lehrt u.a. an der Univ. of Colorado und an der Princeton Univ., N. J. Seit 1999 eig. Atelier, wo C. auch unterrichtet. Zahlr. Aufsätze zur zeitgen. chin. Malerei u.a. in den Zss. Orientations, Kaikodo J. und Asian Art News sowie Hrsg. mehrerer Ausst.-Kataloge. – C. gehört zu den prominenten chin. Künstlern in den USA, die sich der Erforschung bzw. Weiterführung der klass. chin. Gelehrtenmalerei (wenrenhua) verschrieben haben. Inspiriert von der Ästhetik der v.a. yuan-zeitlichen (1279–1368) Meister, fertigt C. majestätische, hoch aufragende und von Nebelschwaden sanft durchbrochene imaginäre Bergpanoramen, die durch eine anmutige, zeitlos-stille Atmosphäre das spirituelle Wesen einer Lsch. vermitteln. C.s dichte Komp., zumeist im

trad. Hängerolle-Format, sind bestimmt von disziplinierter Pinselführung und zahllosen Nuancen von Form, Kolorit, Linien und Texturen. Seine langjährige, beinahe obsessive Beschäftigung mit den trad. Techniken und Bildelementen gründet in C.s Bestreben nach einem Fortbestehen dieses trad. Genres sowie der Idee von der Malerei als Mittel zur moralischen Selbstkultivierung. Auch Kooperationen, so 2009–10 mit dem amer. Künstler Michael Cherney, *After Huang Gongwang* (Fotogr. und Tusche/Papier). ⌂ CAMBRIDGE/Mass., Harvard Univ. AM. CHENGDU, Contemp. AM. CHICAGO, Art Inst. EDMONTON/Alberta, Univ. of Alberta. HONGKONG, Tsui Mus. – Goldman Sachs. ITHACA/N. Y., Herbert F. Johnson Mus. of Art, Cornell Univ. LONDON, BM. MINNEAPOLIS, Minneapolis Inst. of Arts. NEW HAVEN/Conn., Yale Univ. AG. NEW YORK, Brooklyn Mus. of Art. – Godwin-Ternbach Mus., Queens College. PHOENIX/Ariz., AM. SAN FRANCISCO, Asian AM. SACRAMENTO/Calif., Crocker AM. SHANGHAI, Duoyun Xuan. TAICHUNG, Taiwan FA Mus. WEST PALM BEACH/Fla., Norton Mus. of Art. ✉ Paint. in the People's Republic of China. The politics of style, Boulder, Colo. 1980. ☉ *E:* New York: 1996, 2004 Kaikodo; 2004 Sotheby's / 2002 Lancaster (Pa.), Phillips Mus. of Art, Franklin & Marshall College / 2004 New London (Conn.), Charles Chu Asian Art Reading Room, Connecticut College / 2010 Hongkong, Plum Blossoms Gall. (K). – *G:* Shanghai: 1981 Shanghai Exhib. Center: Wu Hufan and Disciples; 1996 Duoyun Xuan: Contemp. Chin. Paint. (Wander-Ausst.); 2001 ebd.: Seven Chin. Artists From North America; 2002 Liu Haisu Mus.: Mountains and Rivers; 2004 AM: Tall Mountains and Flowing Rivers / New York: 1984 Asia Soc.: Ink Paint.; 1989 Hanart Gall.: Beyond the Magic Mountains (Wander-Ausst.) / 1998 Beijing, Nat. AM of China: The World of Chin. Calligraphy and Paint. (Ausz.) / 2007 Chengdu: Bienn. / 2010–11 Boston, MFA: Fresh Ink. Ten Takes on Chin. Trad. ▯ *M. Sullivan*, Mod. Chin. artists, Berkeley u.a. 2006 (s.v. Zhang Hong). – *M. Sullivan*, Art and artists of twentieth-c. China, Berkeley u.a. 1996; *J. F. Andrews/K. Shen*, A c. in crisis (K New York/Bilbao), N. Y. 1998; *L. Whitman*, Arts of Asia 2006 (Jan./Febr.) 152–157; Embracing trad. ink landscapes by C. (K), Sacramento, Calif. 2005; *J. Silbergeld*, Outside in. Chin. Amer. contemp. art (K Princeton, N. J.), New Haven/Lo. 2009; *id./D. C. Y. Ching* (Ed.), ARTiculations. Undefining Chin. contemp. art, Princeton 2010. – *Online:* Website C. (Lit., Ausst.). K. Karlsson

Chang *Changwei,* chin. Bildhauer, * 18. 8. 1973 Luoping/Prov. Yunnan, lebt in Kunming. Stud.: Bildhauerei an der Yunnan AFA ebd. (Abschluß 2000). Seither dort Lehrtätigkeit. Organisiert 2005 das erste Skulpt.- Festival Chinas (Daguan Park ebd.). Ausz. u.a.: 1999 (2. Preis), 2002 (3. Preis) The Art Exhib. of Yunnan Prov.; 2002 Preis für hervorragende Werke, Nat. Art Exhib., Beijing; 2004 Preis für hervorragende Künstler, The First Independent Youth Image Festival, Xi'an. -Bek. für seine zumeist kleinformatigen Büsten von leicht deformierten Menschen (*Close at Hand Series*) und v.a. für phantasievolle, in versch. Mat. (v.a. Kunststoff) gefertigte und mit Autolack grell

und glänzend bemalte Totemtiere und Mischwesen (*Zo-diac Series*, 2004–08). C.s Werk ist gekennzeichnet von einer spielerisch-humoristischen Grundhaltung, gelegentlich auch mit politischen Implikationen wie bei dem Werk *Guobao – Xiongmao*/Nat.-Heiligtum Pandabär, das einzelne und in Gruppen masturbierende Pandabären zeigt. C. läßt sich im weiteren Umfeld der 2004 von Victoria Lu benannten Animamix-Bewegung (dongman yishu) einordnen, deren medienübergreifende Fantasy-Ästhetik (Animation und Comic) stark geprägt wird vom neuen asiatischen Jugendkult, symbolträchtigen Ikonen der Populärkultur sowie Computer-Technologien. ☉ E: 2004 Hongkong, Schoeni AG / 2005 Shanghai, Contrasts Gall. / 2006 Beijing, Contrasts Gall. – G: (zahlr. Beteiligungen) 2004 Taipei, MCA: Fiction @ Love (Wander-Ausst.; K) / Shanghai, 2004 Duolun MMA: Ultraviolet Ray; 2005 City Sculpt. AC: One Hundred Years of Sculpt.; 2008 Linda Gall.: Surfing Animamix. ▢ V. Lu, Fiction Love. Ultra new vision in contemp. art (K Taipei/Shanghai/Singapur), Taipei 2004; J. Frèches (Ed.), Créateurs du nouveau monde. Artistes chinois d'aujourd'hui (K Bienn. Montpellier-Chine: MC1), Gallargues-Le Montueux 2005; C. Yü, Yishu 6:2007 (1) 85–90; Wang Lin u.a., Yishujie (Art Life) 2:2009. K. Karlsson

Chang *Chao-tang* (*Zhang Zhaotang*), taiwanesischer Fotograf, Dokumentarfilmer, * 17. 11. 1943 Panchiao, lebt in Tainan. Stud.: 1961–64 Civil Engineering, Nat. Taiwan University. Ab 1971 führendes Mitgl. der V-10 Visual Art Group (V-10 Shijue yishu qun) zur Förderung künstlerischer Unabhängigkeit und kultureller Modernisierung. 1968–81 Arbeit als Fotograf, Nachrichten- und Dokumentarfilmer für die China Television Company. Ende der 1980er Jahre umfassende Erforschung der Gesch. der frühen taiwanesischen Fotogr. und deren Protagonisten mit mehreren monographischen Publ. (z.B. 1987 zu Chang Tsai) im Rahmen der von C. ins Leben gerufenen Bücherreihe Taiwan Taiwan yingxiangjia qunxiang (Taiwanesische Fotografen). Kuratorische Tätigkeiten: 1990 Seeing – Perspectives of Nine Photographers; 1998 Images of Ha- a; Taipei – Pass away; 2000 The Homeland – After the 921 Earthquake; 2003 V-10 Revisited. 30 Years of Group Visual-10 (alles Foto-Ausst. in Taipei). Ausz.: 1980 Best TV Cinematographer / Ed. of the year (Golden Bell Award) für *Wang chuan ji dian* (The Boat Burning Ceremony); Best Documentary Cinematographer (Golden Horse Award) für *Gu cuo* (An Old House – Chin. Trad. Archit.); 1981 Silver Bell Award für *Yingxiang zhi lü* (Impressions of a Journey); 1999 Nat. Lit. and Art Award, alle Taiwan. Seit 1997 Prof. am Graduate Inst. of Sound & Image Studies in Documentary, Tainan Nat. Univ. of the Arts. – C., der sich um 1958 der Fotogr. zuwandte, gehört zu den bedeutendsten Vertretern der frühen mod. Fotogr. Taiwans und gilt als Pionier der sozialrealistischen schwarzweißen Dokumentarfotografie. Mit seinen in konservativ-offiziellen Kulturkreisen umstrittenen fotogr. Arbeiten der 1960er Jahre (*Mt. Wuchi, Hsinchu*, 1962) sowie seinen experimentellen Filmen (*Riji*/Tagebuch, schwarzweißer Kurzfilm, 1966) forderte er im Rahmen der avantgardistischen Bewegung Taiwans neue, unpolitisch motivierte künstlerische Konzepte. Zu seinem Motivrepertoire innerhalb der Fotogr. gehören v.a. einfache Menschen (*Nüren Taipei*/Frauen aus Taipei; *Kanjian yuan xiangren*/Das urspr. Leben der Dorfgemeinschaft) aber auch Lsch. (*Kanjian Tanshui he*/Betrachtung des Flusses Tansui). Als angesehener Filmemacher erstellte C. während seiner Arbeit für die China Television Company 1968–81 zahlr. viel beachtete Dokumentationen und Reportagen, u.a. *Too Beautiful for Words* und *Impressions of a Journey*. Seine innovative Kameraführung verhalf ihm zu bed. Aufträgen als Kameramann in Spielfilmen wie *Woman of Wrath* (1985, Regie: Zeng Zhuang Xiang) und *Last Train to Tamshui* (1986, Regie: Yi-cheng). 1989 drehte er den Film *Mainland China 1989*, der wegen der kurzen (45 Sekunden-Segment u.d.T. „Sie schreiben Gesch.") Thematisierung der Studentenbewegung auf dem Tiananmen-Platz in Beijing im Juni 1989 von den chin. Behörden anläßlich einer Veranstaltung im Hong Kong AC (Dez. 1989) zensiert wurde. Zu C.s jüngsten Filmen gehören *Faces of the C.*, *Echoes of Taiwan* und *Taiwan C. Lookback* (Post Vision Studio, 2002). ▥ KAOHSIUNG, MFA. TAIPEI, FA Mus. – NM of Hist. ✉ Ying xiang di zhui xun. Taiwan she ying jia xie shi feng mao/In search of photos past, übersetzt v. P. Eberly, Taipei 1988; Xiangchou, jiyi. Deng Nanguang, Kaohsiung 2002. ☉ E: Taipei: 1965 Two Men Contemp. Photogr. Exhib. (mit Cheng Sang-hsi); 1983 FA Mus. (Human Grace and Forgiveness); 1986 ebd. (Trip. Reverse) / 2009 Tokio, Place M; Epson Imaging Gall. – G: Taipei, FA Mus.: 2003 V-10 Revisited. 30 years of Group Visual-10; 2004 Reflections of the seventies. Taiwan explores its own reality (K); 2007 The first Photo Gall. of Taiwan. A legend of Rose Marie Gall. 1953–1973; 2009 Faces Talk; 2003 NM of Hist.: A Retr. of one hundred years' of Taiwan photogr.; 2007 ebd.: Photogr. from the Coll. of the Taiwan NM of Hist.; 2009 Taipei Xinyi Public Assembly Hall: Is it real?; 2009 Taiwan Photo Bazaar / 1994 Hongkong, AC: Contemp. Photogr. from China, Hong Kong & Taiwan / Kaohsiung, MFA: 2003 Impression of the age. The Mus. Photogr. Coll. (K); 2008 Masterpieces by artists of Taiwan; Home. Taiwan Bienn. / 2006–07 Beijing und Shanghai: Retrospective. Taiwan Photogr. / 2000 Cambridge (Mass.), MIT-List Visual AC: Global conceptualism. Points of origin, 1950s-1980s (K) / 2007 Guangzhou, Guangdong AM: Guangzhou Photo Bienn. (K [s.v. Zhang Zhaotang]) / 2008 Daegu (Südkorea): The hidden 4 (Daegu Photo Bienn.). ▢ C. Taiwan sheyingjia cixiang, Taipei 1989; M. Scott, Fear thy neighbour, Far Eastern economic review v. 1. 2. 1990, 28 s.; Kanjian Tanshui he/Contemplating the Tansui River, Kaohsiung 1994; Lai Yingying, Taiwan qianwei. Liuling niandai fuhe yishu (Taiwan. Avant-Garde complex art in the 1960s), Taipei 2003; Tchen Yu-chiou (Ed.), Facetten Taiwans. Die Schönheit der Kultur Taiwans, Taipei 2003; V-10 Visual Art Group (K), Taipei 2003; Deng Nanguang baisui jinian zhan (K), Taipei 2008. K. Karlsson

Chang *Chien-chi* (Chang *Chien Chi*; Zhang *Qianqi*), taiwanesischer Fotograf, * 1961 Wuri Village, lebt in Tai-

pei und New York. Stud.: bis 1984 Soochow Univ., Taipei (Lit.); Indiana Univ., Education Dept., Bloomington/Ind. 1991–93 tätig für Tages-Ztg The Seattle Times, 1994–95 für The Baltimore Sun. Seit 1995 Mitgl. der Magnum Photo Agency mit Aufträgen u.a. für The New York Times Mag., Time, Nat. Geographic, Der Spiegel und Figaro. Ausz.: u.a. 1999 W. Eugene Smith Memorial Fund for Humanistic Photogr.; Visa d'Or, Visa Pour L'image, Perpignan; 2003 1. Preis bei Best of Photogr. Book (für *The Chain*), Pictures of the Year Internat. (USA). – Als Dokumentarfotograf bei Magnum (dort Voll-Mitgl. seit 2001) widmet sich C. sozial-humanistischen Themen. 1992 beginnt er mit seiner seitdem ununterbrochenen Beobachtung und Chron. des Lebens illegaler, massenhaft verfügbarer, für jede Arbeit einsetzbarer und vom Alltag isolierter Immigranten in den Straßen von Chinatown in New York, indem er in die Prov. Fujian nach China reiste und deren dortigen Fam.-Angehörigen die einzigartigen Gesch. dieser am Rand der Ges. existierenden Menschen erzählte (*China Town*, Silbergelatinedrucke und C-Prints, 1992–2008). Zu seinen bekanntesten Arbeiten gehört die Serie *The Chain* (17 Silbergelatinedrucke, 1998), die 2001 auf der Bienn. in Venedig für Aufsehen sorgte. Sie zeigt Portr. von den Insassen des Long Fa Tang (Drachentempel) in Taiwan, wo mehr als 600 angeblich Geisteskranke auf einem Hühnerhof, meist paarweise aneinandergekettet, arbeiten. Die Serie *Double Happiness* (66 Silbergelatinedrucke, 2003–05) schildert die boomende Heiratsindustrie in Taiwan und zeigt mittels intim-persönlicher Aufnahmen den Ablauf (Auswahl, Antrag, Bewerbung, Interviews, Hochzeitszeremonie) der durch eine Heiratsvermittlungsagentur in Hanoi ausgehandelten Vermählungen zw. taiwanesischen Männern und Frauen aus Vietnam. Mehrere Fotobücher liegen vor. ⊙ *E:* New York: 1999 The Alternative Mus.; 2004 Julie Saul Gall. / Taipei: 2001 FA Mus.; 2006 Chi-Wen Gall. / 2004 Penarth (Wales), Turner House; Daytona Beach (Fla.), Southeast Mus. of Photogr. / 2005 Southend-on-Sea (Essex), Focal Point Gall.; London, Photofusion / 2006 Columbus (Ohio), Mus. of Art / 2008 Singapur, NM; Hongkong, AC. – *G:* 2001, '09 Venedig: Bienn. / 2002 São Paulo: Bien. / 2003 Prag, Gal. Rudolfinum: A strange heaven. Contemp. Chin. photogr. (Wander-Ausst.; K) / 2005 Taipei, Chi-Wen Gall.: A peep into contemp. Taiwanese photogr. / 2005–06 Essen, Mus. Folkwang: Nützlich, süß, museal. Das fotografierte Tier (K) / 2006 Hereford, Courtyard AC: Hereford Photogr. Festival 2006 / 2008 Amsterdam, Sted. Mus.: Magnum. 60 years of photogr. / 2009 Taichung, Taiwan Mus. of Art: Asian Art Bienn. ▭ *C. Lai u.a.*, I do, I do, I do, Taipei 2001; *D. Halberstam* (Ed.), New York Sept. 11 von Magnum-Fotografen, St./M. 2002; The Chain, Lo. 2002; *C. Boot*, Magnum stories, B. 2004; C. Double Happiness, N. Y. 2005; I grandi fotogr. die Magnum Photos, P. 2006; *P. Seawright u.a.*, So now then? (K), Cardiff 2006; Wan zhende! 13 wei Taiwan yishujia chuangzuo yu shengming, Taipei 2007; *B. Lardinois*, Magnum Magnum, M. 2008. – *Online:* Magnum photos; Nat. Geographic Photo Gall. K. Karlsson

Chang, *Gary* (Zhang *Zhiqiang*), chin. Architekt, Designer, * 7. 11. 1962 Hongkong, lebt dort. Stud.: Hong Kong Univ. (Abschluß 1987). Anschl. bei P & T Architects and Engineers (HK) in Hongkong tätig. 1994 zus. mit Michael Chan Gründung des Archit.- und Designbüros Edge (seit 2003 Edge Design Inst.). Lehrtätigkeit: u.a. 1995–2000 Hong Kong Univ.; 1997 TU, Delft; 1999 R. College of Art, London; 2000–02 Space, Univ. of Hong Kong; 2002 Politecnico, Mailand und Turin. Seit 1996 namhafter internat. Referent zahlr. Symposien, Kongresse und Workshops. Seit 1997 vielfach auch Berater und Juror von internat. Wettb. für Archit. und Design. Ausz.: u.a. 1985 Milan Trienn./Internat. Design Competition; 1993, '94, '98–2001 Asia-Pacific Interior Design Awards, Hongkong; 1997 Grohe Design Award, Singapur; 2002 Dedalo Minosse Internat. Prize, Vicenza. – Mit multidisziplinärer (Innen-)Archit. und ungewöhnlichem Design gehört C. zu den bed. Architekten Asiens. Seinen Ruf hat er sich bes. mit der innovativen Nutzung limitierter Raumsituationen erworben, die er im Kontext der neuen urbanen Dynamik und der dichten Besiedlung asiatischer Städte entwickelt hat. Ausgehend von den persönlichen Erfahrungen, geprägt von einem bescheidenen familiären Lebensstil und beengten Wohnbedingungen, versucht C., einfache und zugleich praktische Lebensräume zu schaffen. Zu seinen Bauten gehören vornehmlich priv. Wohnhäuser und Apartments, Clubhäuser und Hotels. Internat. Beachtung erfährt C. für seine im Rahmen des Luxus-Hotel-Projekts Commune by the Great Wall Kempinksi (nahe der Chin. Mauer in Badaling) realisierte Arbeit Suitcase House Hotel (2000–01), die trad. Vorstellungen von Wohnen mit der mod. Flexibilität von Räumen verbindet. Sämtliche Flächen (einschließlich des Dachs) des auf einer Betonplatte vom Boden abgehobenen Baukörpers sind flexibel, um Mehrfachnutzungen zu erlauben. So ermöglichen bewegliche Bodenlatten zahlr. Variationen der inneren Aufteilung, deren Räume sich beliebig verschließen lassen. Sowohl Wände als auch Böden sind austauschbar und beweglich, und nur wenige Räume haben festgelegte Funktionen. Für großes internat. Aufsehen sorgt die spektakuläre futuristische, 2006 voll. Umgestaltung seiner ortstypischen, 32 qm kleinen Hongkonger Wohnung (Gary Chang's Apartment), die in seiner Jugend von seiner sechsköpfigen Fam. bewohnt wurde und nun durch verschiebbare, modulare Elemente in 24 versch. Räume eingeteilt werden kann. Ein einfaches Verschieben der Wand macht aus der Bibl. eine Küche, ein Badezimmer oder einen Wohnraum mit einem eingerichteten Heimkino. Einen unverwechselbaren Char. hat ebenfalls seine Gest. des preisgekrönten Broadway Cineplex (Tin Shui Wai/Hongkong, 1999), ein Multiplexkino mit acht Sälen und einer Bar, das durch Glaselemente sowie betonte Licht- und Farbeffekte eine attraktive glitzernd-urbane Anlage bildet. Ein ähnliches Konzept liegt der Innengestaltung des Organic Pharmacy Hong Kong Store (2006) zugrunde. Auch tritt C. im Bereich Produktdesign hervor. Bek. ist sein turmartiges Teeservice *Kung Fu Tea Set* (rote Keramik, Silber, 2003), das er in limitierter Auflage für Alessi ent-

warf (vgl. auch *Treasure Box for Urban Nomads*, 2007, ebenfalls für Alessi; *Tile. Modular Lightening System* und *Skateboard On a Curve*, beide für Yanko Design). Ferner entstehen Konzepte für Wohnsiedlungen und Entwürfe im Bereich Städteplanung: Master Planning, Convention and Leisure Facilities, Hualien/Taiwan 1999; West Gate, 10th Asia Design Forum, Taipei 1999; Harbour Lightening Plan, Victoria Harbour, Hongkong 2002. Seine Erfahrungen als Weltreisender und seine Leidenschaft für Hotelräume als künstlerische Ausdrucksform versammelt C. in mehreren Publ. (Fotogr., Skizzen, Text). ⌑ BEIJING: Studio City Cineplex, 1997–98. CHONGQING: Dimension & Games Center, 1998. GIFU/Japan: Kitagata Housing 2, 2001–02. GUANGZHOU: Cannes Garden Clubhouse, 2002. HONGKONG: Mega Advantage Data Centre; Workstation, Ogilvy & Mather Asia-Pacific; Broadway Cinematheque, 1995–96; Hong Kong Inst. of Architects, 1997; Broadway Cineplex, 1998–99; AC, 2000 (Neu-Gest.); Bar/Restaurant Red, 2000; Hong Kong Movie City, 2000; Hillgrove Clubhouse, 2005; Samuel Kung Store, 2006; Gary Chang's Apartment, 2006; The Organic Pharmacy HK Store, 2006; The Organic Spa, 2007; Queens Garden Clubhouse, 2007; Acts Happy Valley (Apartments mit Service), 2007. PARIS, MNAM. QINGDAO, Q-Hotel, 2004. ✉ Hotel as home, Hong Kong 2005; Hotel as home, Bj. 2006; Hotel as home. The art of living on the road, Princeton 2005; My 32 m^2 apartment, a 30 year transformation, Hong Kong 2008. ◉ E: 2000 Hongkong, AC. – G: 1997–99 Wien, Secession: Cites on the Move (Wander-Ausst.; K) / Hongkong: 2000 Para Site: Personal Skyscraper; 2004 Heritage Mus.: Building Hong Kong. RedWhiteBlue; 2010 Hong Kong Design Centre: Hong Kong. Creative ecologies. / 2000 Orléans: Archilab 2001 / 2000, '02 Venedig: Bienn. / 2002 Shanghai: Bienn. / 2003 New York, Max Protetch Gall.: Coffee and tea towers; Mailand, Pal. dell'Arte: Bienn. / 2004 Taipei, MCA: Rumor of China towns. Contemp. Chin. archit. exhib. / 2005 Gwangju: Design Bienn.; Shenzhen: Bienn. of Urbanism/Archit. / 2007 Melbourne, RMIT Gall.: New trends of archit. in Europe and Asia-Pacific 2005–2007 (Wander-Ausst.; K); Moskau: Bienn. of contemp. art. ⌁ *Hou Hanru/H. U. Obrist*, Cities on the move (K), Ostfildern-Ruit 1997; *D. Mandrelli* (Ed.), Città. Less aesthetics more ethics (K), Ve. 2000; *V. Portefaix/C.* (Ed.), Gary C. Suitcase House, Hong Kong 2004; *L. Ruggeri/V. Portefaix* (Ed.), Hk Lab 2, Hong Kong 2004; *J. Cargill Thompson*, 40 architects around 40, Köln u.a. 2006 (s.v. Edge); *B. Münch*, in: *G. Jansen* (Ed.), Totalstadt. Beijing case (K ZKM Karlsruhe), Köln 2006, 232–239; *P. Jodidio*, CN, archit. in China, Köln u.a. 2007 (s.v. Edge Design Inst.); *P. Weiß*, Tea and coffee, piazza and tower (K Münster), Bönen 2007; *I. Luna/T. Tsang*, On the edge. Ten architects from China, N. Y. 2007. – *Online:* Website C. K. Karlsson

Chang *Hsia-Fei*, taiwanesische Performance-, Mixed-media- und Konzeptkünstlerin, * 11. 12. 1973 Taipei, lebt in Paris. Stud.: 1988–93 Inst. Spécialisé des Langues et des Lit. Etrangères de Wen Zao, Kaohsiung; 1994–99 EcBA, Bordeaux (1999 Dipl.); 1999–2000 EcBA, Nantes. Artist-

in-Residence: 2004 La Box Gal., Bourges; 2007 im Uijae Art Studio, Gwangju/Südkorea. – C.s. aus versch. Anregungen (u.a. Hermann Nitsch, Schriftsteller Yasunari Kawabata, Rockgruppe Drahdiwaberl) gespeisten Arbeiten sind stark geprägt von der Populärkultur (Fernsehen, Varieté, Chansons, Manga) sowie feministischen Fragestellungen. Ihre schrillen Performances und Aktionen (*Dirty used panties market*, Pal. de Tokyo, Paris, 2006; *Strawberry Wine Project*, Iljae Art Studio, Gwangju, 2007) werden häufig als Konzerte gestaltet, wobei die Künstlerin als betont amateurhafte und exotische Popsängerin mit frz. Chansons (u.a. von Brigitte Bardot) auftritt (Tirana, Bienn., 2001; Brooklyn Mus., Brooklyn/N. Y., 2007). Arbeitet daneben in sehr unterschiedlichen Medien: Skulpt. (*Lady Hsia-Fei*, mon. Pferde-Skulpt. mit nackter Reiterin, Harz, Jinan/Prov. Shandong, 2004), Installation (*Heidi*, Styropor, Kunststoffblumen, 2004; *Piñata Forever. Jour d'hypnose*, Lyon, 2004; *32 Portr., Place du Tertre, Montmartre*, Gal. Laurent Godin, Paris, 2006; *Black Cross Piñata*, Pappmaché, Holz, Bonbons, Ballons, Zigaretten u.a., 2009), Mixed-media (*Lolita*, Leder, Holz, Metall u.a., 2009), Malerei (*The Van*, Wandmalerei, 2004; *True Religion*, Öl/Lw., 2007; *Petit Poney*, Tusche/Papier, 2009), Video (*Lili Marlène*; *Solo Valse*, beide 1999; *Ne pleure pas Jeannette*, 2002) und Fotogr. (*Suspendue*, Farb-Fotogr., 2001). ◉ E: Paris: 2002 Paris Project Room; 2004 Gal. Quang; 2006, '09 Gal. Laurent Godin (K); 2009 Hôtel Particulier de Montmartre / 2003 Salamanca, Espacio de Arte Contemp. El Gallo; Bordeaux, Gal. Numérique de FNAC / 2004 Bourges, Gal. La Box / 2005 Luxemburg, Gal. Nei Liicht, Dudelange / 2007 Montpellier, FRAC Languedoc-Roussillon (mit Christian Robert-Tissot). – G: u.a. Bordeaux: 1997 Gal. du CAPC: J'aurais fait autrement; Gal. du Triangle: Du côté de chez... (Wander-Ausst.); 2002 La Faïencerie: Buy-Self (Wander-Ausst.) / Paris: 1998 Centre d'Art Contemp. La Ferme du Buisson: You talk, I listen (Wander-Ausst.); 2000 Bar OPA: Service Compris; 2001 MAM de la Ville de Paris: Traversée (K); 2002 Pal. de Tokyo: Lostflamingos; 2003 Espace Paul Ricard: Propaganda (K); 2006 Les jardins du Luxembourg: Taille humaine (K); 2009 La Maison Rouge: Vraoum! / 1998 Moskau, Internat. Forum of Art Initiatives: +8+7+3+1–1-5; Lissabon, Gal. da Mitra: Where I am (K) / 1999 Humlebæk, Louisiana: Cities on the move (Wander-Ausst.; K) / 2000 Taipei, FA Mus.: Bienn. (K) / 2001 Tirana: Bienn. (K); London, Atlantis Gall.: My Generation. 24 Hours of Video Art; Barcelona, Centre d'Art Santa Monica: Trans Sexual Express (Wander-Ausst.; K) / 2003 Seoul, AM: City-net Asia (K); Berlin, Gal. Loop: Imposture / 2005 Mailand, La Fabrica del Vapore: Inabituel (K); Luzern, Kunstpanorama: Hier – Anderswo / 2007 Brooklyn (N. Y.), Brooklyn Mus.: Global Feminism / 2008 Cincinnati (Ohio), Cincinnati Contemp. AC: Amer. Idyll / 2009 Vancouver: Bienn.; Verbania (Italien), Villa Giulia: Flower Power. ⌁ *Delarge*, 2001. – *B. Casavecchia*, Flash art 215:2000 (Nov./Dez.); *A. Rosenberger*, ibid. 221:2001 (Nov./Dez.); *D. Sausset*, Art press 296:2003 (Dez.) 88; *F.-A. Blain*, BA mag. 239:2004 (April); *F. Clairinival*, Le

Quotidien v. 5. 8. 2004; La biogr. de Sandra, P. 2004; Hsia-Fei Chang 32 portraits. Place du Tertre, Montmartre (K Gal. Laurent Godin), P. 2007. – *Online:* Website C.

K. Karlsson

Chang *Jin*, chin. Maler, * 1951 Nanjing, lebt dort. Stud. der trad. Tuschemalerei (guohua) an der Acad. of Arts ebd. (1982 Examen). Anschließend ebd. Doz., später Dir. an der Jiangsu Chin. Paint. Academy. Seit 1985 zahlr. Ausst. im In- und Ausland. Mitgl.: Chin. Künstler-Verb. (Zhongguo meishujia xiehui). – C. wird zu den sog. Neo-Traditionalisten der chin. Tuschemalerei gezählt, die eine Wiederbelebung klassischer Formen der Lsch.-Malerei anstreben. In den Werken der 1990er Jahre erreicht er mittels delikater Pinselführung, zurückhaltender Tuschelavierung und kompositorischer Strenge die formale Schönheit trad. Literatenmalerei (*Wolken*, undat.; Privat-Slg). Stilistisch spiegeln C.s Werke damit auch die künstlerischen Trad. des Jiang'nan-Gebietes wider, mit Nanjing und Shanghai als Zentren. Neben der trad. monochromen Lsch.-Malerei strebt C. in späteren Arbeiten eine Symbiose von chin. und westlichen Mal-Trad. an. Beliebte Motive sind weibliche Akte und Stilleben unter Verwendung pastoser Farben. ⊠ C. J. shanshui huaji, Bj. 1991. ⊙ *G:* 1990 Hongkong, Luen Chai Curios Store: Metamorphosis. Contemp. Chin. Paint. / 1992 Shenzhen, FA Research Inst.: Internat. Ink-Wash Paint. Exhib. / 1994 Singapur, Soobin AG: Ten Chin. Ink Painters / 1998 Shanghai: Bienn. (K) / 1998 New York/Bilbao, Guggenheim: China. 5000 Years / 2004 New York, Kaikodo FA: Spring in Jingling (alle K). ⌶ *M. Sullivan*, Mod. Chin. artists, Berkeley u.a. 2006. – New literati paint. of contemp. China, Jiangsu 1990; *J. F. Andrews/K. Shen*, A c. in crisis (K New York/Bilbao), N. Y. 1998. A. Papist-Matsuo

Chang, *Patty*, US-amer. Performancekünstlerin, * 3. 2. 1972 San Leandro/Calif., lebt seit 1994 in Brooklyn/N. Y. Stud.: bis 1994 Univ. of California, San Diego (Malerei). 2008 Guna S. Mundheim Fellowship in the Visual Arts, Amer. Acad., Berlin. 2011 Artist in Residence, Fogo Island/Neufundland. Lehrtätigkeit: 2003/04 Skowhegan School of Paint. and Sculpt., Madison/Me. – C. befaßt sich in Performances, Video-Arbeiten, Fotogr. und Filmen mit Themen wie Identität, Geschlechterrollen, Sexualität und Sprache und nutzt als Medium v.a. ihren Körper bis an die Grenze der Geschmacklosigkeit und Akzeptabilität. Im Video *Melons (At a loss)*, 1998, zeigt sie sich mit einer vollbusigen Korsage, und als sie in ein Körbchen schneidet, erscheint allmählich eine Melone, die sie auslöffelt. Sie filmt sich mit Aalen unter ihrer Bluse oder schlürft Wasser vom Boden eines Toilettenbeckens; im Video *Shaved (At a loss)*, 1998, rasiert sie blind ihr Schamhaar und spielt auf das obsessive und zwanghafte Verhalten von Frauen an, soziale, sexuelle und westlich geprägte Stereotypen zu erfüllen. Emotionales Unbehagen beim Betrachter weckt auch das Video *Untitled (for Abramovic, Love Cocteau)*, 2000, in dem sich zwei weinende chin. Frauen (C. und Freundin) zu küssen scheinen, jedoch gemeinsam eine Zwiebel kauen, was aber erst allmählich deutlich wird, da das Film-Mat. rückwärts läuft. Die von

der Body art der späten 1960er und 1970er Jahre beeinflußte C. zitiert dabei direkt eine Videoarbeit von Marina Abramović (The Onion, 1996) sowie eine Filmtechnik von Cocteau und wird wie im Zweikanal-Video *Love*, 2001, inspiriert vom jap. Kabuki-Theater und seinen strengen Rollen- und Darst.-Vorgaben. Seit 2005 realisiert sie kult. und ortsgebundene Projekte und ist darin weniger selbst präsent. In der Videoinstallation *Sangri-La*, 2005, spürt sie dem Mythos eines Paradieses auf Erden filmisch nach, indem sie Menschen und Szenen in dem nach dem Buch Lost Horizon (1933) von James Hilton aus touristischen Gründen in Sangri-La umbenannten chin. Ort Zhongdian/Yunnan zeigt. Inspiriert von Sven Hedins Bericht (Der wandernde See) reist sie kurz nach den Konflikten zw. Uiguren und Han-Chinesen durch die Wüsten von Xinjiang zum ausgetrockneten See Lop Nur und dokumentiert im Video *Minor* (2010 abgeschlossen) die vergänglichen Verbindungen von Kultur und Lsch. z.T. mit temporären, vom Wind geformten „Skulpturen" wie durch Fallschirmflüge mit lokalen Bewohnern. C.s visuell beeindruckende und melodramatisch sehnsuchtsvolle Performances und Videos erhalten internat. Aufmerksamkeit. ⌂ DENVER, AM. DÜSSELDORF, Julia Stoschek Coll. ITHACA/N. Y., Johnson Mus. of Art. METZ, FRAC Lorraine. NEW YORK, Guggenheim. – MMA. PARIS, Kadist Art Found. PURCHASE/N. Y., Neuberger Mus. of Art. WILLIAMSTOWN/Mass., Williams College Mus. of Art. ⊙ *E:* New York: 1999, 2001 Jack Tilton Gall.; 2009 Mary Boone Gall. / Los Angeles: 1999 Ace Gall.; 2004 Roberts and Tilton / Paris: 1999, 2002, '06 Gal. Gabrielle Maubrie; 2003 Project Space / 2000 Madrid, MN Centro de Arte Reina Sofia; Honolulu, Contemp. Mus.; San Francisco, Yerba Buena Center / 2001 Visby, Baltic AC; London, Entwistle Gall.; Fribourg, Fri-AC d'Art Contemp. / 2005 Manchester, Chinese AC / 2006 Stockholm, Mod. Mus. / 2007 Turin, Franco Soffiantino Arte Contemp. / 2008 Brunswick, Bowdoin College Mus.; Berijing, Arrow Factory / 2011 München, Gal. Rüdiger Schöttle. – *G:* 2011 New York, Guggenheim: Found in translation (Wander-Ausst.). ⌶ *M. Sundell*, Artforum 38:1999 (1) 171; *E. Leffingwell*, AiA 87:1999 (11) 145; New observations 124:2000 (Winter) 7; *M. Cohen*, Flash art 33:2000 (213) 90–93; *B. Golonu*, ibid. 33:2000 (214) 107 s.; *M. Rush*, Fashion theory 5:2001 (3) 331–341; *L. Wei*, AiA 90:2002 (6) 121 s.; *ead.*, Art news 102:2003 (10) 176; Im/balance (K Johnson Mus. of Art), Ithaca 2003; *E. Oishi*, Camera obscura 54:2003, 118–129; *ead.*, x-tra 5:2003 (4) 14–17; Moving pictures. Contemp. photogr. and video from the Guggenheim Mus. coll. (K), N. Y. 2004; *S. Nys Dambrot*, Artweek 35:2004 (5) 18; *J. E. Kaufman*, Art newspaper 14:2004 (147) 13; *E. Arratia*, Art asia pacific 44:2005, 68–74; *S. O'Reilly*, Art monthly 291:2005, 33 s.; *C. Cardon*, ArtRev 3:2005 (10) 32; *F. Pietropaolo*, Flash art 38:2005 (Okt.) 77; *E. Forgács*, X-tra Contemp. art quart. 8:2005 (2) 70–72; *C. P. Shangri*-La (Wander-Ausst., K Chicago MCA), Chicago 2005; *C. Berwick*, Art news 105:2006 (2) 104 s.; *K. Biesenbach*, Flash art 39:2006 (249) 78–81; *S. Merali*, New York

states of mind. Art in the city, Lo. 2007; *A. Liu*, artUS 16:2007 (Jan./Febr.) 60; Dt. Guggenheim mag. 2:2008, 10–15; Hugo Boss Prize 2008 (K Guggenheim) N. Y., 2008; *R. Bosco*, Giornale dell'arte 26:2008 (März) 62, 70; *D. Velasco*, Artforum 48:2009 (Sept.) 289 s.; *B. Pollack*, AiA 97:2009 (8) 140; Fragile (K Düsseldorf), Ostfildern 2009 (Julia Stoschek Coll., 2); *K. Kitamura*, Art monthly 346:2011 (Mai) 20 s. – *Online:* Website C.

H. Stuchtey

Chang, *Peter*, brit. Schmuckkünstler, Designer, Bildhauer chin. Herkunft, * 1. 12. 1944 London, lebt in Glasgow. Verh. mit der Textildesignerin Barbara Santos-Shaw. Stud. (Graphikdesign, Bildhauerei): 1962–67 Liverpool College of Art; 1967 Druckgraphik in der als „Atelier 17" bez. Wkst. von Stanley William Hayter in Paris (Liverpool Senior City Scholarship); 1968–71 Slade School of FA, London. Anschl. Atelier in Liverpool und seit 1987 in Glasgow. Ausz.: 1989 Scottish Gold Award, NM of Scotland, Edinburgh; 1991 Merseycraft Prize, Walker AG, Liverpool; 1995 Jerwood Applied Arts Prize, London; 1998 Scottish Design Award; 2000 Creative Scotland Award, Scottish Arts Council, Edinburgh; 2003 Herbert-Hofmann-Preis, München; 2005–09 Wingate Scholarship, London. – Zunächst v.a. als Bildhauer (geometrisch-abstrakte Plastiken aus Holz, später aus Kunststoff), Innenarchitekt und Möbeldesigner tätig, beginnt C. Ende der 1970er Jahre mit der Gest. von Schmuck. Er verwendet hauptsächlich Kunststoffe (v.a. Acryl, Polyester, Polyvinylchlorid, Polymethylmethacrylat, Kunstharz) und akzentuiert diese sparsam mit Elementen aus Silber, Gold oder Bronze. In frühen, anfangs eher flächigen Arbeiten integriert er Fundstücke wie Fragmente von Zahnbürsten, Rasierern, Linealen, Stiften und Spielzeug. C.s char. skulpturale Schmuckstücke (v.a. Armreifen und Broschen, auch Ohrringe und Ringe, selten Colliers und Manschettenknöpfe) sind häufig assemblageartig aus zahlr. Einzelteilen zusammengesetzt. Sie entstehen in einem langwierigen und komplexen Arbeitsprozeß, der meist mit einem geschnitzten Kern aus Polystyrolschaumstoff (bei kleineren Arbeiten aus Holz) beginnt, auf den versch. Kunststoffteile und -schichten aufgebracht werden. Nach dem Bemalen und Lackieren werden die Werke abschließend gewachst und poliert. C. verwendet Hobel, Feilen, Drähte, elektrische Werkzeuge (u.a. medizinische Bohrer) und nutzt Verfahren aus versch. Bereichen wie thermoplastische Verformung, Intarsierung, Laminierung sowie jap. Lacktechnik (Tsugaru-nuri). Kennzeichnend sind neben der auffälligen Farbigkeit v.a. die bizarren Formen, die Assoziationen an Insekten (Fühler, Augen), Meereslebewesen (Tentakel, Flossen) und exotische Pflanzen evozieren sowie die prächtigen mosaikartigen Muster, die an Kaleidoskopbilder und venezianisches Glas mit Murrinen- und Millefioridekor erinnern. Angesichts der vielseitigen Inspirationsquellen und des großen und vielfältigen Formen- und Farbenreichtums überrascht die Homogenität und char. Handschrift in C.s Œuvre, die auch bei den Plastiken und den Arbeiten aus dem Bereich der angew. Kunst erkennbar ist. Hierzu gehören Innenausstat-

tungen (z.B. Geländer, Glasfaser, Holz, Kunstharz, Acryl, 1997–98, Art. TM Gall., Inverness), Möbel (z.B. Tisch, mitteldichte Holzfaserplatte, Holz, Glasfaser, Kunstharz, Acryl, 1994, Brit. Council Coll., Hongkong) und Gebrauchsgegenstände wie Spiegel, Dosen, Leuchter, Schalen, Teller, Salz- und Pfeffermühlen. BOSTON/Mass., MFA. EDINBURGH, NM of Scotland. GLASGOW, Kelvingrove AG and Mus. HAMBURG, MKG. HANAU, Dt. Goldschmiedehaus. HELSINKI, Design-Mus. KÖLN, MAK. LIVERPOOL, Walker AG. LONDON, Crafts Council. – V & A. MONTREAL, MAD. MÜNCHEN, PM, Neue Slg. NEW YORK, Cooper-Hewitt, Nat. Design Mus. PFORZHEIM, Schmuck-Mus. PHILADELPHIA/Pa., Mus. of Art. SYDNEY, Powerhouse Mus. *E:* 1988 Amsterdam, Gal. Ra / 1990 New York, Helen Drutt Gall. / 1992, 2000 Philadelphia (Pa.), Helen Drutt Gall. / 1993 London, David Gill Gall. / 1993, '96 (K), 2002 München, Gal. Biró / 2000 Helsinki, Design-Mus. (Wander-Ausst.; K); Edinburgh, The Scottish Gall. / 2002 Pforzheim, Schmuck-Mus. (Retr.; Wander-Ausst.; K) / 2007 Liverpool, Walker AG (Retr.). – *G:* 1966 Manchester, Whitworth AG: Northern Young Contemporaries / 1988 Los Angeles (Calif.), Craft and Folk Art Mus.: The New Spirit in Brit. Craft & Design (K) / 1995 London, Crafts Council: Furniture Today. It's Design & Craft (Wander-Ausst.; K); Mainz, LM: Schmuckkunst der Mod. Großbritannien (K) / 1997 Montreal, MAD: Designed for Delight (Wander-Ausst.; K) / 1998 's-Hertogenbosch, SM's: Brooching it diplomatically (Wander-Ausst.; K); Edinburgh, NM of Scotland: Jewellery moves (K) / 2001 München, Bayerischer KV: Mikromegas (Wander-Ausst.; K) / 2002 New York, Amer. Craft Mus.: Zero Karat / 2005 Lucca, Villa Bottini: Lucca preziosa (K) / 2008 Hanau, Dt. Goldschmiedehaus: Ausgepackt. DA XXV, 1996, 27; Dict. internat. du bijou, P. 1998. – Ornamenta 1. Internat. Schmuckkunst (K Pforzheim), M. 1989; *F. Falk/C. Holzach*, Schmuck der Mod. 1960–1998 (K Pforzheim), St. 1999; *R. Ludwig* (Ed.), Schmuck 2000. Rückblick, Visionen, Ulm 1999; *C. Holzach u.a.*, P. C. Jewellery, objects, sculpt., St. 2002; *B. Maas*, Kunsthandwerk und Design 2002 (3) 4–11; *C. Strauss*, Ornament as art. Avant-garde jewelry from the Helen Williams Drutt Coll. (K Wander-Ausst.), St. 2007; *L. den Besten*, Metalsmith 28:2008 (2) 24–38. – *Online:* Website C.

F. Krohn

Chang *Tzu-lung (Zilong)*, taiwanesischer Bildhauer, Landschaftsgestalter, * 1947 Tanshui, lebt in Taipei. Stud.: Nat. Taiwan Acad. of the Arts (Abschluß 1969); Graduate School of FA, Tama Art Univ., Tokio (Abschluß 1980). Seit seiner Rückkehr nach Taiwan 1987 lehrt C. an der Taipei Nat. Univ. of the Arts. 1982–89 nimmt er als Designer an der Gest. des Tokyo Disneyland Amusement Parks teil. 1986 Mitgl. der Jap. Artists League. 1988–91 Juror und Mitgl. im Organisationskomitee mehrerer Prov.-Ausst. in Taiwan. 1993–96 Designer und Dir. des Tanshui Center of Arts and Cult. und des Tanshui Fort San Domingo Park. Gründet 1995 die Tanshui Cult. Found. zur Förderung lokaler Kulturen. 2002 verantwortlich für die Lsch.-Gest. des Geländes der Nat. Taiwan Acad. of the Arts. Lehraufträge

1999 an der Wollongong Univ., Wollongong/N. S. W. und 2000 an der Univ. of Hawaii, Manoa. 2005–06 Artist in Residence, Hilo Gall. ebd. Zahlr. öff. Aufträge, u.a. *Tiao II* (Viewing II, mon. Aluminium-Skulpt., 1998, MRT Station, Peitou). Ausz.: u.a. 1984 Asia Arts Friendship Assoc. Exhib., Yokohama; 1985, '86 Grand Prize, Ichiyo Ichioyhkai Exhib., Tokio-Taitō, Metrop. AM; 1996 Outdoor Sculpt. Prize ebd.; 2000 Bronze Med., Eastern America Hawaii Cult. Center Art Exhib., Manoa. – Als Vertreter der frühen mod. Bildhauerkunst Taiwans der 1980er Jahre fertigt C. kleinformatige bis mon. Skulpt. in Metall (Aluminium, Bronze, Kupfer), Holz sowie Stein (Granit, Marmor, Dazit), häufig für den öff. Raum. Schwerpunkt seines Schaffens ist der weibliche Körper, für ihn eine Metapher für die „unvergängliche und mysteriöse lebensspendende Kraft der Frau". Char. sind voll-plast. Abstraktionen des rundlich-üppigen Unterkörpers (auch Torsi), liegend und stehend, mit glatter, weich anmutender Oberfläche (*Tiao xilie*/Viewing Series, getöntes Kupfer, 1988; *Hei furen II*/Black Lady II, Bronze, 1998). Erstellt auch reine abstrakte Formen (*Xi*/Rast, Lärchenholz, 1995; *Madame*, 1995; *Xiao*/Wissen, 1996, beide Marmor). In jüngster Zeit auch abstrakte Skulpt.-Installationen (*Youji zhi ling*/Der Geist des Organischen, Bronze). ☐ HUALIEN, Hualien County Stone Sculpt. Mus. KAOHSIUNG, MFA. TAIPEI, 228 Memorial Mus.: The Earth and Mother, Granit, 1997. – Rainbow Garden. – Nat. Univ. of the Arts. – FA Mus.: Silence, Marmor, 1986. TANSHUI, Hongmao Castle Park. ✉ Wo de kongjian (My space), Kaohsiung 1994; Diaoke he wo (My sculpt.), Taipei 1998. ⊙ *E:* Taipei: 1988 Hsiung Shih Gall.; 1996 Taipei County Cult. Center; 1998 Eslite Gall.; Home Gall.; 2009–10 Kuandu MFA, Nat. Univ. of the Arts / 1994 Tanshui, Tanshui Center of Art & Cult. / 2009 Shipai, Yang Ming Univ. (K). – *G:* u.a. Taipei: 1991 Dimension AC: The selected Paint. of the Nineties; 1996 Nat. Taiwan Normal Univ. Gall.: Taiwanese-Jap. Sculpt. Exhib.; Howard Salon: Mini Sculpt. by 20 Artists; 1997 Eslite Gall.: Mini Sculpt.; 2002 President Hall AG: 228 Anniversary Art Exhib. A Gaze at Taiwan / 1998 Tainan: Nat. Cheng Kung Univ.: Outdoor Sculpt. Exhib. / 1999 Singapur: Internat. Art Exhib. / 2005–06 Taichung, Providence Univ.: Pose in the Wind (Wander-Ausst.). ☐ *J. Kuo*, Asia-Pacific Sculpt. News 1:1995 (1) 34–40; The transitional eighties. Taiwan's art breaks new ground (K), Taipei 2004; *NiZaiqin*, Taiwan dangdai yishu zhi mei (The beauty of Taiwanese art), Taipei 2004; Diaosu zai taiyang: C., Shuipai 2009. – *Online:* Main Trend Gall., Taipei. K. Karlsson

Chang, *Ucchin,* koreanischer Maler, Zeichner, Graphiker, Holzschnittzeichner, * 8. 1. 1918 Yongi, † 27. 12. 1990 Seoul. Stud.: 1939–43 Tokyo Imperial Art School (Teikoku bijutsu gakkô; heute Musashino Art Univ.) (westl. Malerei). 1941 Heirat mit Lee Soonkyung, Tochter des renommierten Historikers Lee Pyungdo. 1945–47 wiss. Tätigkeit am NM Korea. 1948 Gründung der Künstler-Vrg Neo-Realisten (zus. mit Yoo Youngkuk u.a.) und Teiln. an deren Ausst. (bis 1953). 1954–60 Prof. an der Seoul Nat. Univ. (College of FA). Seitdem regelmäßige nat. und in-

ternat. Ausst.-Beteiligung (u.a. 1955 bei der 1. Ausst. der Hundred Artists' Group, Lee-Bumrae-Preis für *Suha*; 1957 Asian Art Exhib. in San Francisco; 1958 Contemp. Korean Paint. New York). Als Juror tätig bei den Nat. Art Competitions of Korea (1956, '59, '69). Ab 1960 fast völliger Rückzug aus dem öff. Leben, um sich ganz der Malerei zu widmen. Ch.s wechselnde Umzüge signalisieren jeweils neue künstlerische Schaffensperioden (s.u.). Ab den 1970er Jahren Hinwendung zum Buddhismus (*Zinzinmyo*, 1970; *Palsangdo*, 1976). 1977 erhält Ch. den buddh. Namen Bigong. 1979 stirbt ein Sohn an Leukämie. Ausz.: 1986 Großer Kunstpreis Joong Ang Daily News. 1987, '88 Reisen durch SO-Asien (Taiwan, Thailand, Indien, Bali). 1990 stirbt er an einem Asthmaanfall. Ihm zu Ehren 1998 Gründung der Chang Ucchin Found. und 1999 des Chang Ucchin Museums. – Vielseitiger koreanischer Künstler mit Individualstil (Öl, Hschn, [Tusch-]Zchng, Lith., Rad.). Auch Entwürfe für Porzellan (1978). Ch. malte die Dinge des Alltags, wobei er buddh. und auch indigene volkstümlich-schamanistische Motive (z.B. Tiger, Vögel, Berge, Sonne und Mond) in einem häufig hieroglyphenartig vereinfachtem Stil verarbeitet (*Symbiotic Garden*, 1985, Öl/ Lw.; Ch. Found.). Scheinbar unberührt von mod. westlichen Stilen und Kunstströmungen handhabt Ch. die ganze Spannbreite trad. und mod. Kunsttechniken. Bis 1960 besitzen seine Werke fließende Formen, leuchtende Farbtexturen und eine ernsthaftnostalgische Aura, die auch im Kontext des Koreakrieges gesehen wird (*Selbstporträt*, Öl/Papier, 1951). Danach zunehmend lyrisch-abstrakter Stil (*Bird at Night*, 1961) und Experimente mit Formen und Stilen. Seine Vorliebe für geometrische Formen und Diagramme führt zu einer reduzierten Liniensprache und stark vereinfachtem Bildvokabular, das an Kinder-Zchngn und -malerei erinnert (*Zinzinmyo*, 1970). Im Spätwerk Hinwendung zur trad. Tuschemalerei mit spirituell-relig. Konnotationen (*The Eight Great Miracles*, 1976) und klassischen Themen der Literatenmalerei, jedoch in naiv-surrealer Manier (*Sunrise*, 1987; Ch. Found.). ☐ NAMYANGJU, Chang Ucchin Mus. SEOUL, Samsung Mus. of Art Leeum. SINGAL, Chang Ucchin Found. ⊙ *E:* Seoul: 1964 Bando Gall. (K); Space Gall.: 1974, '81; Hyundai Gall.: u.a. 1978 (K), 2000 (K), '01 (K), '11 (K); 1983 Yon Gall. (K); 1986 Kukje Gall.; 1987 Duson Gall. (K); 1995 Hoam AM (K); Gana Art Gall.: 1995, '97 (K); 2010 Nat. Univ. AM (K). – *G:* 1989 Teaneck (N. J.), Mus. of Art and Sc.: Contemp. Korean Paint. (K) / 1990 Los Angeles, Andrew Shire Gall.: Prints (K) / Seoul: Hyundai Gall.: 2003 Prince and Princess (K); 2005 The 35th Anniversary Exhib. (K); 2007 Nat. MCA: Noah's Ark (K); Samsung Mus. of Art: 2007 Void in Korean Art (K); 2011 Korean Rhapsody. A Montage of Hist. and Memory (K); 2010 Gana AG: Yoo Youngkuk's 1950s and The First Modernist Gen. (K). ☐ Golden ark. Paint. and thoughts of Ch., N. Y. 1992; *H. Kim*, Ch. The painter who wished to fly like a bird, Seoul 2004; *id.*, Ch. Mod. painter or artisan?, Seoul 2004; Nat. MCA, Korea. Coll. Anthology, Seoul 2004. A. Papist-Matsuo

Chang, *Wah Ming,* US-amer. Filmdesigner, Kostüm-,

Marionetten-, Trickfilmgestalter, Bildhauer, Maler, Graphiker, * 2. 8. 1917 Honolulu/Hawaii, † 22. 12. 2003 Carmel/Calif. Sohn des Graphikers *Dai Song C.* (* 28. 2. 1891 Hawaii, † 6. 10. 1974 Monterey/Calif.) und der Gebrauchsgraphikerin, Kostümbildnerin und Schauspielerin *Sue Wong C.* (auch Fai bzw. Fei Sue C.; * 1895 San Francisco/Calif., † 2. 11. 1927 ebd.). Ab A. der 1920er Jahre in San Francisco aufgewachsen, wo die Eltern den in lokalen Künstlerkreisen beliebten HoHo Tea Room betreiben. C.s künstlerisches Talent wird bereits in der Kindheit erkannt und v.a. von Blanding Sloan und dessen Ehefrau, der Schriftstellerin und Galeristin Mildred Taylor, gefördert. 1928 Stip. an der Peninsula School of Creative Education, Menlo Park/Calif. Danach neben der High School Schüler und Mitarb. von Sloan in Hollywood; gestaltet u.a. Bühnenbilder für Aufführungen in der Hollywood Bowl, Marionetten und Werbe-Mat. (u.a. 1936 für die von Sloan geleitete „Cavalcade of Texas" anläßlich der Texas Centennial Fair). 1938 im Auftrag der Works Progress Administration kurzzeitig Kunsterzieher in Honolulu. 1939–40 im Effects and Model Dept. der Walt Disney Studios in Anaheim/Calif. tätig, wo u.a. Holzmodelle zu Figuren der Zeichentrickfilme *Bambi, Fantasia* und *Pinocchio* entstehen. Eine schwere Erkrankung an Poliomyelitis beendet C.s Karriere bei Disney. Ab 1941 Mitarb. von George Pal an dessen Puppetoons. 1945 Einrichtung des eig. East-West Studios in Los Angeles; produziert in Zusammenarbeit mit Sloan u.a. die Filme *Leadbelly* (über den Folksänger Huddie Leadbetter) und *The Way of Peace* (1947). 1956 gründet C. zus. mit Tim Barr und Gene Warren das Studio Project Unlimited, das Szenenbilder, Kostüme, Special effects und Trickfilmsequenzen für zahlr. Kino- und Fernsehproduktionen gestaltet, u.a. zu *The King and I* (1956); *Tom Thumb* (1958); *The Time Machine* (1960; Acad. Award für Special effects); *The Wonderful World of the Brothers Grimm* (1962); *The Planet of the Apes* (1968). Auch für die populäre TV-Serie *Star Trek* entwirft C. mehrere Requisiten, u.a. den sog. Communicator, der als Vorbild für das Design mod. Klapphandys gilt. Ab 1970 in Carmel/Calif. ansässig. Seither auch zahlr. realistische Tierplastiken (Bronze; Stein). Im Auftrag von Hank Ketcham entsteht 1987 zudem eine lebensgroße Bronze-Skulpt. der Cartoonfigur *Dennis the Menace*. Mitgl.: ab 1975 Carmel Art Assoc. ⌂ CARMEL, Carmel Art Assoc. SAN FRANCISCO, Chin. Hist. Soc. of America. ⊙ *E:* San Francisco: 1928 East West Gall.; 2003 Chin. Hist. Soc. of America (mit Tyrus Wong; K: I. Poon u.a.) / 1981, '89, '93 Carmel, Carmel Art Assoc. / 2000 Monterey (Calif.), Mus. of Art (Retr.). – *G:* 1925 San Francisco, City of Paris Dept. Store Gall. / 1927 Brooklyn (N. Y.), Brooklyn Soc. of Etchers / 1928 Honolulu, Acad. of Arts / ab 1983 regelmäßig Carmel, Carmel Art Assoc. / 2000 Los Angeles, County Mus. of Art: Made in California. Art, Image and Identity 1900–2000. ⌑ *Falk* I, 1999; *Hughes*, 2002. – *A. Kistler*, San Francisco Chron. v. 29. 7. 1928; *G. Donovan*, Carmel Art Assoc. today, Carmel, Calif. 1988; *D. Barrow/G. Chang*, The life and sculpt. of C., Carmel, Calif. 1989; *M. D. Brown*, Views from Asian California, S. F. 1992; *G. B. Riley*, C. Artist and master

of special effects, Springfield, N. J. 1995; *I. Poon*, Leading the way. Asian Amer. artists of the older generation, Wenham, Mass. 2001; Monterey Herald v. 23. 12. 2003 (Nekr.); *G. H. Chang u.a.* (Ed.), Asian Amer. art. A hist., 1850–1970, Stanford, Calif. 2008. – *Online:* Internet Movie Database; The Time Machine Project.

H. Kronthaler

Chang, *Woo-soung* (Studioname: Woljeon), koreanischer Maler, Kalligraph, Dichter, * 1912 Chungju, † 28. 2. 2005 Seoul. Aufgewachsen in Yeoju. Bereits als Kind Unterricht in den chin. Klassikern. Stud.: Kalligraphie bei Kim Don-hui; 1932–40 Malerei bei Kim Unho. Mitgl. der Vrg Huso-hoe, die zw. 1936 und 1943 sechs Ausst. organisiert und wichtige Impulse zur Erneuerung der trad. Tuschemalerei in Korea gibt. Zahlr. nat. Ausst.-Teiln.: Art Exhib. of Korea (1941–44 je Sonderpreis); 1949–76 Nat. Art Exhib. (Kukchŏn) (hier auch in der Jury). Ab 1949 internat. Ausst.-Beteiligungen. Lehrtätigkeit: 1946–61 Prof. Seoul Nat. Univ. (College of FA). Ab 1963 in den USA. 1965 Eröffnung des Oriental Art Inst. in Washington. Ab 1970 Mitgl. der Nat. Acad. of Arts. 1971–74 Prof. an der Hongik Univ. (College of FA). 1989 Gründung der Woljeon Art Cult. Found. 1991 Eröffnung des Woljeon Mus. of Art und Stiftung des seitdem jährlich verliehenen Woljeon Art Prize. Zahlr. Preise und Ausz. u.a.: 1959 Kulturpreis Seoul; 1971 Nat. Acad. of Arts Award; 1995 Ehrendoktorwürde der Wonkwang Univ.; 2001 Orden für kult. Verdienste (Goldkrone). – Ch. ist einer der führenden mod. Maler und Kalligraphen in der Trad. der koreanischen Tuschemalerei. Er etabliert eine neue Literatenmalerei, v.a. nach der Befreiung Koreas durch die jap. Besatzung. Ch.s Œuvre stellt eine Synthese trad. Themen und Techniken mit mod. Bildauffassungen, insbesondere in der Farbsensibilität und den klaren graph. Konturlinien dar (*Studio*, Pastell/Papier, 1942; Hoam AM). Sowohl trad. als auch westliche Formate. Vielseitige Sujets: Figuren, häufig Bildnisse (*Portrait of Admiral Yi*; Cheonji, Hyeonchungsa), aber auch trad. Darst. von Tänzerinnen (kisaeng), Blumen-und-Vögeln, Tieren sowie der Vier Edlen. Daneben zahlr. Lsch. sowie Kalligraphien in Tusche. Ch.s Lsch. zeichnen sich durch sinnliche Farben, erfrischende Komp. und eine Kombination von westlichem Realismus mit der koreanischen Trad. der Wahren Lsch. (chin. gyŏng) aus. Deutlich wird auch die Re-Interpretation des Künstlers von mod. chin. Schul-Trad. wie der Shanghaier Malschule des 19. Jahrhunderts. ⌂ CHEONJI, Hyeonchungsa. GWACHEON, Nat. MCA. ICHEON, Woljeon Mus. of Art. KÖLN, Mus. für Ostasiatische Kunst. LONDON, BM. ROM, Vatikanische Mus. SEOUL, Hoam AM – Korea Univ. Mus. – Nat. Univ. Mus. – Samsung Mus. of Art Leeum. – Sogang Univ. Mus. TOKIO, Fuji AM. ✉ *U.-s. Chang*, Hwasil susang, Seoul 1999; *id.*, Hwadan p'ungsan ch'ilsimnyŏn. Wŏljŏn hoegorok, Seoul 2003. ⊙ *E:* 1980 Paris, Mus. Cernuschi (K) / 1982 Köln, Mus. für Ostasiatische Kunst (K) / 1988 Tokio, Seibu AG / 1994 Seoul, Hoam AM (K) / 2009 Icheon, Woljeon Mus. of Art (K). – *G:* u.a. 1949 Rom, Vatikanische Mus.: The Virgin and Blessed Martyrs of Korea / Gwa-

cheon, Nat. MCA: 1985 Senior Painters (K); 2003 Chang Woo-soun and Li Keran (K) / 1992 Seoul, Jean AG: Exhib. of 11 artists of today (K) / 2010 Icheon, Woljeon Mus. of Art: Masters of Korean ink paint. Chang Woosoung, Pak Nosoo (K). ⌑ *K.-s. Yi*, Chang U-sŏng: chakka wa chakp'um, Seoul 1976; Koreana 15 (2001) 40–45; *Y.-na Kim*, 20th c. Korean art, Lo. 2005; *S.-c. Kim*, Wŏlchŏn Chang U-sŏng sisŏhwa yŏn'gu, P'aju-si 2012.

A. Papist-Matsuo

Chang *Xugong*, chin. Maler, * 1957 Tangshan/Prov. Hebei, lebt in Beijing. Stud.: Tangshan Normal School (Abschluß 1980). Ausz.: 1993 Preis für hervorragende Werke, Bo Ya Oil-Paint. Competition, Central AFA, Beijing. 1994 Übersiedlung nach Beijing, dort Mitgl. des Künstlerdorfs Yuanmingyuan. – Gehört zus. mit Xu Yihui, Feng Zhengjie, Wang Jinsong, den Luo-Brüdern u.a. zu den Vertretern der sog. Gaudy-art/Kitschkunst (yansu yishu), die an die im internat. Ausst.-Betrieb erfolgreiche Polit-pop-art anknüpft. Weniger sozialkritisch als parodierend gilt Gaudy-art als Anbiederungsversuch an den (schlechten) Geschmack der chin. Neureichen, den neuen Idolen der kapitalistischen Konsum-Ges. Chinas. C. ist für seine grellbunten Seidenstickereien bek., die er von professionellen Seidenstickerinnen nach seinem Konzept seriell anfertigen läßt. Dargestellt sind lachende, einfältig und derb wirkende Snobs, meist neureiche Männer und Frauen vom Lande, mit ihren Statussymbolen (Mobiltelefone, Karaoke-Mikrofone, Hunde, Designerkleider) vor einem nimbusähnlichen Hintergrund oder auf gestickten Geldscheinen (*Dollar – Eurocurrency Series*, 2003). Erstellt auch im selben Medium und ähnlichem Stil Portr. internat. Persönlichkeiten (George W. Bush, Michael Schumacher, Uli Sigg u.a.). ⌑ MAUENSEE, Slg Sigg. ⊙ *E:* Beijing: 1998 MMA; 2006 Xin Dong Cheng Gall. / 2003 Sydney, Sydney Opera House / 2007 Amsterdam, Willem Kerseboom Gall. – *G:* 1992 Guangzhou: Bienn. / Beijing: 1996 Yun Feng Gall.: Colourful Life; Xin Dong Cheng Space for Contemp. Art: 2006 Brothers; 2008 3. 15 Let's Consume (K); Red, Smooth and Luminescent (K) / 1997 Chongqing, AFA Mus.: Urban Personality. Contemp. Chin. Art / Sydney, Ray Hughes Gall.: 2000 The New Face of China; 2002 Something like China Pop / 2000 Weimar, ACC Gal. Weimar & Gal. der Bauhaus-Univ. Weimar: Our Chin. Friends (K) / 2001 Luzern, Gal. Urs Meile: Take Part. Zeitgen. chin. Kunst / 2006–07 Amsterdam, Willem Kerseboom Gall.: A Ticket to Beijing / 2007 Cork (Irland), Lewis Glucksman Gall.: The Year of the Golden Pig; London, The Mayor Gall.: 7 Characters. New Art From China / 2008 Athen, City of Athens Technopolis: Beijing-Athens. Contemp. Art from China (K) / 2009–10 Havanna, MNBA: Beijing-Havana. New Contemp. Chin. Art Revolution. ⌑ *Y. Force/C. Zita* (Ed.), 4696/1998: Contemp. Art from China, Vn. 1998; *K. Smith*, Asian art news 8:1998 (3) 81 s.; *Liao Wen/Li Xianting* (Ed.), Oh La La Kitsch (K), Wuhan 1999; *B. Fibicher/M. Frehner* (Ed.), Mahjong. Chin. Gegenwartskunst aus der Slg Sigg (K Bern/Hamburg), Ostfildern-Ruit 2005; *Zou Yuejin*, Xin Zhongguo meishu shi, 1949–2000, Changsha 2005. –

Online: Willem Kerseboom Gall., Amsterdam; Xin Dong Cheng Gall., Beijing.

K. Karlsson

Chang, *Yeon-Tak* (Yeon-Tak Chang), kanad. Bildhauer, * 1939 Korea, lebt in Toronto. Vater des Designers David C. Aufgewachsen in einer ländlichen Gegend von Südkorea. Stud.: bis 1964 College of FA, Seoul Nat. Univ.; bis 1980 Ontario College of Art, Toronto; 1979–80 in Pietrasanta und Carrara (Arbeit mit Marmor). Mitgl.: seit 1981 Sculptors Soc. of Canada; Ontario Soc. of Arts. Ausz.: 1983 Korean Soc. Award for Art; 2005 Ontario Arts Council Grant. – Skulpt. v.a. in Stein (Marmor, Alabaster, Sandstein, Granit) in reduzierten, von der Natur inspirierten Formen (*Happy Cloud*); über einen längeren Zeitraum liefern ihm Bergformationen Anregungen für seine Gestaltungen (*Mountain family*). C. beginnt ein Werk ohne vorgefertigtes Konzept oder Bildhauer-Zchng, sondern ist bestrebt, aus dem Stein die adäquate Form herauszuarbeiten. Geprägt von fernöstlicher Spiritualität, bildet für ihn der schöpferische Prozeß gleichsam eine meditative Suche nach Einklang zw. Mensch und Natur (*Harmony*, portug. Marmor) bzw. nach Selbsterkenntnis. ⌑ CASTELLANZA, MAM Pagani. ETOBICOKE/Ont., Sacred Heart of Jesus Korean Roman Catholic Church (ehem. St. Sosa Lee Roman Catholic Church). MARSHALL, Southwest Minnesota State Univ. SEOUL, NMMA. ⊙ *E:* seit 1979, u.a. Toronto: 1979 Macdonald Gall.; 1993 Theodore Mus. of Contemp. Art; 1996 Canad. Sculpt. Centre; 2002, '06 Trias Gall. / 1980 Mailand, Gall. Il Mercante (K) / 1982 New York, West Broadway Gall. / 1983 Marshall, Southwest Minnesota State Univ., William Whipple Gall. / 1985 Omaha (Nebr.), Gall. 72 / Seoul: 1988 Shinsegye Gal.; 2000 Hyundai AG (K) / 2005 Washington (D. C.), Gall. Korea / 2008/09 Stroudsburg (Pa.), Gall. 705. ⌑ *MacDonald* I, ⁵1997. – *Online:* Sculptors Soc. of Canada; Andres Inst. of Art; Trias Gall.; Gall. 705.

C. Rohrschneider

Chang *Yung Ho* (Zhang Yonghe), chin.-US-amer. Architekt, Innenarchitekt, Installationskünstler, Designer, * 18. 4. 1956 Beijing, lebt dort und in Boston/Mass. Sohn des bek. Architekten Zhang Kaiji. Stud.: 1971–74 Nanjing Inst. of Technology; 1983 Ball State Univ., Muncie/Ind.; Univ. of California, Berkeley (Abschluß 1984). Lehrtätigkeit u.a.: 1985–88 Ball State Univ.; 1988–90 Univ. of Michigan, Ann Arbor (Walter B. Sanders Fellow); 1990–92 Univ. of California, Berkeley; 1992–96 Rice Univ., Houston/Tex.; 2002–03 Kenzo Tange Chair, Graduate School of Design, Harvard Univ.; seit 2004 Prof. und Leiter des von ihm 1999 gegründeten Graduate Center of Archit., Beijing Univ.; seit 2005 Prof. am Massachusetts Inst. of Technology (MIT) in Cambridge. Zahlr. Ausz.: u.a. 2000 UNESCO Prize for the Promotion of the Arts; 2003 China Archit. Arts Award (Pingod Shopping Street, Beijing). 1993 gründetet C. zus. mit seiner Frau Lu Lijia das renommierte Atelier Feichang Jianzhu (FCJZ [Atelier für außergewöhnliche Archit.]) in Beijing, das erste priv. Archit.-Büro in China. 2005 kuratiert C. die Bienn. (Urbanism and Archit.) in Shenzhen. – C. gehört zus. mit Toyo Ito, Kazuyo Sejima, Sohn-Joo Minn, Chi Ti-Nan und Kay Ngee

zu den bedeutendsten asiatischen Architekten, die angesichts der radikalen Urbanisierung und Dichte asiatischer Städte mit innovativen und alternativen Konzepten nach gezielter Intervention suchen. Im Vordergrund steht dabei die Schaffung humaner Räume, die durch C.s Strategie des Mikro-Urbanismus (weiguan chengshi guihua), der Intervention auf kleinster Ebene (z.B. die Reorganisation trad. Wohnhöfe, si he yuan), realisiert wird. Bek. sind auch seine Bemühungen um eine „basic archit." sowie Bauten in ländlichen Gebieten, die sich durch eine Rückbesinnung auf regionale landschaftliche Bezüge, natürliche Baustoffe (z.B. Bambus), trad. Handwerk und ökologische Nachhaltigkeit auszeichnen. C. arbeitet auch im Bereich Innen-Archit., Design, Installation und Ausst.-Archit. (z.B. Cities on the Move, Wien, 1997) sowie an gemeinsamen Projekten mit and. Künstlern (Small Mus. of Contemp. Art, Quanzhou, mit Cai Guoqiang). ⌂ ANREN/Sichuan, Bridge Mus. for Posters. – Jianchuan Mus. Town, beide 2003. BEIJING, Beijing Tokyo Art Projects: Installation. – Xishu Bookstore, 1996. – Cummins Asia Headquarters, Interior, 1997. – Morningside Center for Mathematics, Chin. Acad. of Sc., 1998. – Villa Shanyujian, 1999. – Glass Onion Bistro, 1999. – Beijing Univ. Nuclear Magnetic Resonant Instrument Laboratory, 2001. – Villa Shizilin, 2004 (WA Archit. Prize). CHONGQING, Southwest China Bio-Tech Pilot Base, 2001. DALINOR, Tourist Center, 2004. DONGGUAN/Sichuan, Shipai Town Hall, 2002. GIFU, Kitagata Housing, 2001. PARIS, MNAM. SHIJIAZHUANG, Hebei Education Publishing House, 2004. WUCHANG, Water Town (Urban Master Plan), 2001. ✉ Feichang Jianzhu, Harbin 1997; Pingchang Jianzhu. For a basic archit., Bj. 2002; Atelier Feichang Jianzhu, Lo./N. Y. 2004; Zhongguo shijian, Taipei 2005. ◉ E: 1999 New York, Apex Art / 2002 Harvard, Harvard Univ. Graduate School of Design / 2003 Paris, MAM (K) / 2008 London, V & A. – G: 1997, 2002 Kwangju: Bienn. / 2000 Shanghai: Bienn. / 2000, '02, '03, '05 Venedig: Bienn. / 2001 Berlin, Hamburger Bahnhof: Living in Time (K); Beijing, Nat. AM of China: Liang Sicheng Centennial Archit. Exhib. / 2002 Guangzhou, Guangdong AM: Trienn. / Paris: 2003 Centre Pompidou: Alors, la Chine? (K) / 2004 Taipei, MFA: Bienn. / 2005 Shenzhen: Bienn. ▭ M. Sullivan, Mod. Chin. artists, Berkeley u.a. 2006 (s.v. Zhang Yonghe). – H.-U. Obrist (Ed.), Cities on the move (K; Wander-Ausst.), Ostfildern-Ruit 1997; R. Vine, AiA 86:1998 (7) 34–41, 43; Hou Hanru, Flash art 209:1999 (11–12) 73 s.; Tan Kok Meng (Ed.), Asian architects, I, Singapore 2000; L. Gutierrez/V. Portefaix (Ed.), C. Atelier Feichang Jianzhu. A Chin. practice, Hong Kong 2003; H. U. Obrist, Yishu 2:2003 (3) 64–67; The Phaidon atlas of contemp. world archit., Lo. 2004; R. Choochuey/S. Mirti (Ed.), C. Luce chiara, camera obscura, Mi. 2005; C. Klein/E. Kögel, Made in China. Neue chin. Archit., M. 2005; P. Jodidio, Archit. in China, Köln u.a. 2007; Ai Weiwei u.a., Art and cult. policy in China. A conversation between Ai Weiwei, Uli Sigg and C., W. u.a. 2009. – Online: Website C. (fczy); Baidu baike; World-architects (Lit.). K. Karlsson

Chang Yung-tsun (Chang Yung Tsun; Zhang Yong-

cun), taiwanesischer Installationskünstler, Maler, * 1957 Changhua, lebt in Taoyuan. Kunst-Stud. an der Nat. Taiwan Normal Univ., Taipei (Abschluß 1981). Lehrt 1981–86 am Hsinchu Teachers College. 1987 zus. mit Kuan Chih-chung Mitbegr. der Ges. zur Förderung mod. taiwanesischer Kunst (Zhonghua minguo yishu gexin cujin hui). Ausz.: 1984 1. Preis, Exhib. of Abstract Art, FA Mus., Taipei; 1986 1. Preis, Taiwan Mod. Paint. Nat. Exhib. ebd. Seit 1995 Mitgl. des Künstler-Ver. Taichung Mod. Eyes (Taichung xiandai yanhua hui). Gründet 1998 das Dadao-Mus., Taoyuan, wo er seither als Dir. wirkt. – Neben Chen Hsing-wan, Tsong Pu u.a. namhafter Exponent der taiwanesischen Avantgarde der 1980er Jahre. Bes. bek. für seine experimentellen Installationen unter Verwendung der trad. Medien Tusche und Papier, die von der durch Lin Shou-yu in Taiwan eingeführten Kunstströmung des Minimalismus angeregt sind (Yuan yuanliu chang/Auf eine lange Trad. zurückblicken, 2000 Meter lange, mit Tuschepunkten bemalte, von der Decke herabhängende Papierbahnen). C.s obsessive konzeptuelle Erforschung des trad. Mediums Tusche (als Symbol des chin. Geistes und der Kultur) steht im Zentrum seiner neuabstrakten Kunstpraxis: Bemaltes Papier wird zu Gegenständen (z.B. Pinsel) geformt (Bianhua yu zhuangzhi – chaodu kongjian bianzou/Transformation and Installation of a Changing Melody, Papier, Acryl, Tusche, Plastikschachteln, 1984–88; Yin Yang, 1986; Mo D. N. A./The DNA of Ink, 2007); Abb. von Kulturmonumenten (z.B. Große Mauer) und ganzen Städten (Taipei) werden mit Tuschepunkten bedeckt (Digitalfotos); ein Mensch wird in ein tuschebeflecktes Laken gehüllt (Mohai cengren/Der Mensch war früher ein Tuschemeer, Performance, 1995). Neuerdings auch semi-abstrakte Malerei in kräftigen Farbtönen, v.a. geometrische, Städte und Lsch. suggerierende Konfigurationen in Mixed-media-Technik (Wenming yuesheng [san]xitong yishu xilie/Cult. Leap III. Systematic Art Series, 1999–2000; Xiangtu yu ziran xilie/Bodenständig und natürlich, beide Acryl und Sand/Lw.), die nach wie vor grundsätzliche Fragen zur geistigen und materiellen Entwicklung der menschlichen Zivilisation reflektieren. In den letzten Jahren auch im Bereich Musik (u.a. Hrsg. von Volksliedern) sowie als Veranstalter (Events, Ausst.) engagiert. ⌂ TAIPEI, FA Mus. – Nat. Taiwan Arts Education Center. TOKIO-SHINAGAWA, Hara MCA. ◉ E: Taipei: 1981, '86 Spring AG; 1988 Asia AC; 1983 Dragon Gate Gall.; 1989 Crown AC; 2007 Taipei County Art and Cult. Center / 1989 Shibukawa, Hara Mus. ARC / 2001 Kaohsiung, Zen 50 AG; Hsinchu, Accton Arts Found.; Changhua, County Cult. Center / 2009 Tainan, Mun. Cult. Center; Shinju, Sunny Art & Cult. Mus. – G: Taipei: FA Mus.: 1984 Contemp. Abstract Paint.; 1985 Avant-Garde, Installation, Space; 1986 Contemp. Art Trends in the Republic of China; 1987 Environment Art, Action, Space; Spring Gall.: 1984 The Play of Space; 1985 Beyond the Space; 1990 Chiang Kai-shek Mem. Hall: Screw the Mass Media, Roxy II Pub (Performance) / 1988 Taichung, Nat. Taiwan MFA: Media, Environment, Installation / 1989 Shibukawa, Hara Mus. ARC: Message from Taipei / 1995 Macao,

MMA: Contemp. Art from Taiwan. ▭ *Zhong Zhen*, Yishujia (Artists mag.) 234:1994 (11) 541; *N. Jose/Yang Wen-i* (Ed.), Art Taiwan. The contemp. art of Taiwan (K), Sydney 1995; Open flexibility. Innovative contemp. ink art (K), Taipei 1998; The transitional eighties. Taiwan's art breaks new ground (K), Taipei 2004; Shuimo DNA. C. de shuimo bianfa, Yishujia 390:2007 (Nov.). K. Karlsson

Chani, *Miguel,* peruanischer Fotograf, * 1860 Quiquijana/Quispicanchi, † 1951 Cuzco. Wahrsch. Ausb. im Fotostudio Fotogr. Inglesa, Cuzco, bei Thomas Penn. C. führte dann eig. Fotostudios unter dem Namen Fotogr. Universal in Cuzco, Puno und Arequipa. 1904 Übernahme des Fotostudios in Cuzco durch Juan Manuel Figueroa Aznar, später durch Martín Chambi. Im Kongreßzentrum des Centro Bartolomé de las Casas ebd. trägt ein Auditorium C.s Namen (auch bek. als Centro de Convenciones M. C.). – C. war einer der Begründer der sog. Esc. Cusqueña de Fotogr. (Pablo Macera). Er widmete sich v.a. der Porträt-Fotogr. und and. Studioaufnahmen (z.B. *Alegoría patriótica,* ca. 1900, Tableau mit nat., relig. und militärischen Insignien), nahm aber auch Stadtansichten, Kirchen, Volksfeste, Militärparaden und wichtige hist. Ereignisse sowie Szenen aus dem Leben der indigenen Bevölkerung auf, mit denen er den Wandel einer bäuerlichen zur städtischen Ges. um 1900 festhielt. Er dokumentierte Perus Modernisierung durch die Darst. von Brauereien, Textilfabriken, Eisenbahnen (ab 1908), Straßenbahnen und Motiven der Elektrifizierung (ab 1914) sowie den ersten öff. Sanitärprojekten. Unter dem Einfluß des Indigenismus, der sich seit 1910 an der Univ. Nac. de S. Antonio Abad in Cuzco etablierte, fotografierte er wichtige Mitgl. der Ges. von Cuzco in indianischer Kleidung und vor Kulissen mit Inka-Architektur. C. vertrieb auch A. des 20. Jh. als einer der ersten peruanischen Fotografen sog. postales incaicas mit Aufnahmen von inkaischen Ruinen (z.B. Sacsayhuamán, Machu Picchu, Ollantaytambo) und archäol. Stätten (Tiahuanaco). Eine intensive Schaffensphase bildeten die Jahre zw. 1919 und 1935, als das Land unter Präs. Augusto B. Leguía modernisiert wurde. ▥ Cuzco, Fototeca Andina del Centro Bartolomé de las Casas. Haverford/Pa., Haverford College Libr. Lima, Mus. de Arte. ◉ *G:* 1992 Houston (Tex.), Convention Center: Peruvian photogr. 1900–1930 / 1994 New York, Americas Soc.: Visions of modernity. Photographs from the Peruvian Andes, 1900–1930 (Broschüre: F. Castro) / Cuzco: 1993 Casa Jerónimo Luis de Cabrera, Centro Cult. del Banco Continental: Fotogr. hist. andina. 1875–1950 (Wander-Ausst.; K: A. Fuertes); 2006 Centro Guamán Poma de Ayala: Cusco, miradas y espacios. Concurso de fotogr. antigua del Centro Hist. (K: L. Nieto Degregori/ O. Paredes). ▭ *E. Billeter,* Canto a la realidad. Fotogr. Latinoamer. 1860–1993 (K Wander-Ausst.), Ba. 1993; *S. Aguilera u.a.*Reflejos de medio s. Imágenes fotogr. andinas 1990/1950, S. Ch. 1994; *A. Benavente,* Peruvian photogr. Images from the Southern Andes, 1900–1945 (K Univ. of Essex, Univ. Gall.), Colchester 1996; *W. Watriss/ L. P. Zamora* (Ed.), Image and memory. Photogr. from Latin America, 1866–1994 (K Houston), Austin, Tex. 1998;

N. Majluf u.a., La recuperación de la mem. El primer s. de la fotogr., Perú 1842–1942 (K Mus. de Arte), Lima 2001; *L. Nieto Degregori,* Moment (Cuzco) 2009 (3); *P. Trevisan/L. Massa,* Aisthesis (S. Ch.) 2009 (46) 39–64; *N. Velardi/A. Sadurní* (Ed.), Fototeca Andina. Fotogr. y cult. en el Cuzco del s. XX, Cuzco 2012. – *Online: M. Penhall,* Almost Indian, Earthwatch Inst., 2012. M. Nungesser

Chaniotaki (Chaniotaki-Kafousia; Haniotaki), *Maria,* griech. Kostüm- und Bühnenbildnerin, Malerin, Installationskünstlerin, Autorin, Illustratorin, * 3. 1. 1958 Iraklion, lebt und arbeitet in Athen und London. Stud.: 1979–83 Ing.-Wiss. in Larissa; danach Musik und Klavier sowie Bühnenbild auf Kreta und in Athen: 1995 (Master of Art) Szenographie an der Wimbledon SchA, London. 1998–99 Ass. des Szenographen Antonis Daglidis in Theaterproduktionen in Griechenland. C. arbeitet vorwiegend als Bühnen- sowie Kostümbildnerin und unterrichtet u.a. in Athen in dem von ihr gegr. Laboratory of Scenography (LSA). Mitgl.: The Soc. of Brit. Theatre Designers (SBTD); Internat. Inst. of Theatre (IIT); Epimelitiriou Eikastikon Technon Ellados/Vrg bild. Künstler Griechenlands (EETE). – C. kombiniert in ihren malerischen Werken unterschiedliche Materialien., die sie so auf den Bildträger aufbringt, daß dieser manchmal eine rauhe, fast reliefartige Qualität gewinnt. In Assemblagen werden reale Gegenstände wie Kunst-Reprod. oder Objekte des alltäglichen Lebens (Schuhe, Modeschmuck, Federn) durch die Erg. mit Farben und durch die Präsentation in einer Vitrine oder auf einer Lw. zu Kunstwerken erhoben. Ihre Arbeiten sollen beim Betrachter ein Bewußtsein für das mystisch-weibliche Element und relig.-spirituelle Assoziationen wecken. Ihre Kostüme und Bühnenbilder für antike und mod. Dramen zeichnen sich durch eine große künstlerische Spannweite aus: Es finden sich parallel Arbeiten mit einer lyrisch-poetischen Aura, so 2011 für Aristophanes' *Ploutos* (Regie: Aggeliki Girginoudi, Theater Vraxon, Aufführungen an mehreren Orten in Griechenland). Das Bühnenbild für die 2011 aufgeführte Tanzperformance *6 moires kato apo ton orizonta* (Regie: Rena Konstantaki, Athen, M. Kakogiannis Found.) ist hingegen futuristisch, fast steril, und beschränkt sich auf einen dunklen Boden, der durch weiße und graue glatte Wände begrenzt wird. C. verfaßt ebenso Gedichte und Kinderbücher, die sie z.T. selbst illustriert. – Publ. (Text/Ill.): *Aerika* [Feen], At. 1998; *O hartoaetos pou ton elegan karcharia* [Der Papierdrache, den man Hai nannte], At. 1999; *To Louloudi pou ithele na ginei petalouda* [Die Blume, die ein Schmetterling werden wollte], At. 2001. ◉ *E:* Athen: 1998 Stavlos Gal.; 2004 Gal. Monochoro / 2011 Iraklion, Ausst.-Halle Basilica San Marco. ▭ LEK IV, 2000. – *Online:* Website C. (Ausst.; Produktionen); Saatchi Gal. (Malerei); The Soc. of Brit. Theatre Designers (s.v. Chaniotaki). E. Kepetzis

Chanonnart *Kiettisak* (Kiettisak C.), thailändischer Maler, * 23. 9. 1943 Bangkok, lebt dort. Stud.: 1963–79 Malerei an der Fac. of Paint., Sculpt. and Graphic Arts, Silpakorn Univ., Bangkok. Anschließend freischaffend tätig. 1992–2009 Assoc. Prof. und Leiter des Dept. of

FA am King Mongkut's Inst. of Technology, Bangkok-Ladkrabang. Ausz.: 1969, '71, '74, '92–94 Silber-, 1980, '95 Gold-Med. für Malerei auf der Nat. Art Exhib., Bangkok; 1981 Award, Thai Farmers Bank; 1982 Art Prize, Bank of Thailand; 1995 „Artist of Distinction"; 2006 Ernennung zum „Nat. Artist" durch das Erziehungsministerium. – C. setzt sich schon in den ersten Studiensemestern intensiv mit dem Surrealismus auseinander und findet in Bildsujets von Salvador Dalí und Giorgio de Chirico Bestätigung für die eig. Erlebnis- und Gefühlswelt. Im zw. 1968 und 1976 entstandenen Frühwerk dominieren Bilder mit Totenschädeln, Skeletten, fahrenden Zügen und monströsen Fabelwesen mit weit aufgerissenen Mündern, deren Einzelmotive er dem gesamten Spektrum der europ. surrealistischen Malerei entnimmt und die er zu eigenständigen, illusionistisch gemalten Komp. verarbeitet. Anregungen durch ikonenhafte Werke der symbolistischen Malerei (Edvard Munch, Francis Bacon) sind erkennbar. Im Kontext seiner theoretischen Studienabschlußarbeit (The silent mystery, 1979) erneut intensive Auseinandersetzung mit der Gesch. des Surrealismus, der Pitt. Metafisica und der Psychoanalyse. In der Folge beschäftigt sich C. ab 1980 in versch. malerischen Sujets mit dem Unterbewußtsein. Kopflose, aus Hemden und Anzügen bestehende Figuren spiegeln die Trennung des Ichs in Bewußtes und Unbewußtes. Mischwesen in gespiegelten Räumen reflektieren die gespaltene Identität. Nach dem Vorbild von René Magritte konstruiert er visuelle Fallen und Vexierspiele, die den Betrachter mit dem Entschlüsseln von Fiktion und Realität beschäftigen. Seit den 1990er Jahren benennt er seine weiterhin surrealistischen Bilder mit Titeln, die auf alltägliche Eindrücke (Imagination from nature, 1992), allg. Menschliches (The strength of life, 1997), Familiäres und sogar auf politische und ges. Themen Thailands Bezug nehmen. Neben surrealen Lsch., u.a. nach Joan Miró, folgen ab 2000 immer neue Variationen gesichtsloser Gliederpuppen nach G. de Chirico, die C. seit 2006 auch zw. Phantasieblumen und erneut mit weit aufgerissenen Mündern auftreten läßt. Zuletzt auch Bronzefiguren mit ähnlichen Motiven. ⌑ BANGKOK, Sculpt. Center: Life and subconscious mind 8, Öl/Stahl, 2001. – Kasikorn Bank: Subconscious 3, Öl/Lw., 1981. – Chulalongkorn Univ. art coll.: Classical masks, Öl/Lw., undat. – Silpakorn Univ.: Painting, Mischtechnik, 1969; From subconscious mind 4, Öl/Lw., 1974; State of sub-consciousness I, Öl/Lw., 1980. – TISCO art coll.: Remains, 1977; The inner feelings, 1991, beide Öl/Lw. ☉ E: 2001 (Retr.), '06, '08 Bangkok, NG (alle K). – G: Bangkok: NG: 1968–69, '71, '72, '74, '76–77, '79–80, '82–84, '86–87, '89, '92–99 Contemp. art expo (K); 1995 Asian watercolours; 2000–03 Nat. Art Exhib.; 2003 Different wall. Different way. Different work (K); Bhirasri Inst. of Mod. Art: 1973 Contemp. Art 1964–1974 (K); 1979, '81 Contemp. art competition (K); AC, Silpakorn Univ.: 1984 Paper work by 20 artists (K); 1986 Contemp. drawing; 2000 Body and face (K); 10 Artists of Distinction (K); Art for Silpa Bhirasri 2000 (K); Thailand Cult. Centre: 1989 Asian watercolours; 2004 Internat. exchange exhib. Thailand-USA (Wander-Ausst.);

1997 Queen Sirikit Nat. Convention Center: 50 years of Thai art (K); 2010 Art and Cult. Centre: Imagine peace / 1971–72 Kopenhagen: Thai artists / 1985 Fukuoka, AM: Asian art show / 1986 Gwacheon, NMCA: Contemp. Asian art show / 1986, '88 Bagdad: Internat. festival of art / 1988 Pasadena (Calif.), Pacific Asia Mus.: Contemp. artists from Thailand / 1989 Havanna: Bien. / 2005 Köln, Gal. Rachel Haferkamp: Thai-German contemp. art exchange (K) / 2008 Los Angeles (Calif.), Artcore Brewery Annex: Internat. exchange exhib. Thailand-USA. ☐ S. van Beek/L. Invernizzi Tettoni, An introd. to the arts of Thailand, Hongkong 1985; An art exhib. by Kamol Tassananchalee, K. C. [...], Bangkok 1990; A. Poshyananda, Mod. art in Thailand, Singapore/N. Y. 1992, 155–157; V. Mukdamanee/S. Kunavichayanont, Rattanakosin art. The reign of King Rama IX, Bangkok ²1997, 124, 162 s.; Krungthep Muang Fa Amon art expos. (K Asian Games Art Project), Bangkok 1998, 72 s., 229; 19 Artists of Distinction (K AC, Silpakorn Univ.), Bangkok 1999, 121–125; V. Mukdamanee, Mixed media and installation art in Thailand, Bangkok 2002, 54–59; The small world. Thai contemp. art 2002 (K AC, Silpakorn Univ.), Bangkok 2002, 38, 103, 165; Art in box (K Silom Gall.), Bangkok 2003, 31, 116, 198; S. Kunawong, The passion of Thai sculpt. (K Sculpt. Center), Bangkok 2005, 170 s.; S. Chaiprasathn/J. Marcel, The influence of europ. surrealism in Thailand, Bangkok 2006, 14, 18, 23–27, 29, 75–78; K. C. Art. Life energy (K NG), Bangkok 2008. A. Feuß

Chanton, *Elmar,* schweiz. Maler, * 23. 7. 1961 Brig/ Valais, lebt in Sion. Stud.: 1981–85 Biologie an der Univ. in Fribourg; 1986–91 (Dipl.) Ec. cantonale des BA in Sion. Ausz.: 1991 Alfred-Grünwald-Preis. – Ein vom Suchen und von der Sehnsucht nach Übersinnlichem geprägter unaufhörlicher Selbstfindungsprozeß ist die Triebkraft für C.s Schaffen. Nach einer experimentell-abstrakten Anfangsphase entscheidet er sich für eine weiterhin durch abstrakte Elemente ergänzte figurativ-symbolische Malweise. Durch die Kombination, Überlagerung und Verschachtelung abstrakter und gegenständlicher Bildkomponenten artikuliert er die ihn umtreibende innere Rast- und Ruhelosigkeit. Diese Aspekte unterstreicht er materiell durch eine Mischtechnik mit Acryl, Kreide und Farbpigmenten und unterstützt deren Zusammenspiel bzw. Wechselwirkung. Den prozeßhaften Char. seiner Tätigkeit verdeutlichen Übergänge von diffusen zu klar definierten Konturen, von Heftigkeit zu Ruhe und von Tristesse zu Heiterkeit. Gelegentlich auch mit Zchngn, fotogr., druckgraphischen und plastischen Arbeiten beschäftigt. ☉ E: Sion: 1992 Gal. Grande Fontaine; 1993 Théâtre du Valère / 2010 Brig, SZ Consulting AG Schwery & Zurbriggen. ☐ BLSK I, 1998. – Online: SIKART Lex. und Datenbank; Website C. R. Treydel

Chanton, *Jacqueline (Jacqueline Theresia),* schweiz. Malerin, Zeichnerin, Bildhauerin, * 13. 6. 1957 Sarnen/ Obwalden, lebt seit 1987 in Wien. 1977–80 Ausb. als Restauratorin an der KGS, Bern; 1984–87 Schule für Gest., Luzern (Malerei; Bildhauerei bei Anton Egloff); 1987–98 ABK, Wien (Bildhauerei bei Bruno Gironcoli). Seit 1986

als freischaffende Künstlerin tätig. – Ausgangspunkt der figurativen Gem. (in Öl und/oder Acryl auf Lw., Papier und Holz) bilden Fotogr., die C. den Massenmedien entnimmt. Die z.T. fotorealistischen Darst. werden häufig durch Unschärfe verfremdet (z.B. die Serie *Phantom der Lust*). Im Gegensatz zu den traditionelleren, farbigen Lsch. und Stadtansichten (z.B. *Donaukanal*, Öl/Lw., 1998; *Bergsee*, Öl/Holz, 2001) sind C.s figurative Gem. bevorzugt in Schwarzweiß ausgeführt, wodurch sie z.T. wie Zchngn wirken (z.B. Arbeiten der Serie *Inside-Outside*). Oft plaziert sie die figurativen Motive vor monochromen oder geometrisch-abstrakten Hintergründen (z.B. *180 Grad*, Öl/Lw., 2005, aus der Serie *Scharfes Auge*) oder kombiniert gegenständliche und abstrakte Darst. auf mehrfach geteilten Lw. (z.B. *Die Kunst des Verschwindens*, Öl/Lw., 2006, aus der Serie *Das Spiel des Erscheinens*). In ihre meist seriell angelegten Bildfolgen integriert sie auch abstrakte farbige Komp., die bisweilen an Werke der Op-art erinnern, wie z.B. Gem. der Serie *Scharfes Auge*. Verbindendes Sujet vieler Arbeiten ist die Bewegung von Tieren und Menschen (z.B. *Make the Run*, Öl/Holz, 2004), die auch in abstrakten, dynamischen Spritzbildern zum Ausdruck kommt. In Auseinandersetzung mit der „Künstlichkeit der Medienwelt und der Künstlichkeit der Kunst" (C. zur Ausst. Do one thing at a time 2005 in Wien) stellt sie Persönlichkeiten aus Politik, Film- und Kunstszene dar. In der Serie *Portr.* malt sie bild. Künstler, zitiert deren Werke und stellt sie einander gegenüber, um u.a. ihre „Ikonisierung" in Frage zu stellen. Weiterhin Graphit-Zchngn/Lw., Collagen und Tonfiguren. ⌂ GRAZ, Joanneum, Neue Gal. WIEN, Artothek des Bundes. ⊚ *E:* Luzern: 1992 Gal. Kesselturm; 1993 Atelier René Liefert; 1994–95 Gal. Gütsch (mit Adrian Knüsel) / 2001, '04 Zürich, Gal. Ursula Wiedenkeller / Wien: 1995 KH Exnergasse (mit Anna Meyer); 2001 Atelier Sylvie Proidl (mit S. Proidl, Elisabeth Sula); 2007 Sicherheits-Akad.; 2008 Christine König Gal. (mit Margherita Spiluttini); 2011 Österr. Beamtenversicherung / 2002 Graz, Joanneum, Neue Gal. (K). – *G:* 1999 Zürich, Gal. Ursula Wiedenkeller: Vor allem Blau / Wien: 2001 Christine König Gal.: Ich Tarzan – Du Felix Austria?; 2005 Hermesvilla: Tiere in der Großstadt (K) / 2003 Graz, Joanneum, Neue Gal.: Phantom der Lust. Visionen des Masochismus in der Kunst (K); Lüneburg, Kunstraum der Univ.: Die Regierung. Paradiesische Handlungsräume (Wander-Ausst.) / 2003–04 Krems, KH: Mimosen, Rosen, Herbstzeitlosen (K) / 2006 Stadtschlaining, Burg Schlaining: 3 Generationen, 3 Regionen. Künstlerinnen aus Wien, NÖ, Burgenland. ⌻ Kürschners Hb. der Bild. Künstler. Deutschland, Österreich, Schweiz, I, M./L. 2007. – *Online:* Website C. F. Krohn

Chantrell, *Tom (Thomas William)*, engl. Plakatkünstler, Illustrator, Gebrauchsgraphiker, Maler, Zeichner, * 20. 12. 1916 Manchester, † 15. 7. 2001, lebte ab 1933 in London. Sohn eines Trapezkünstlers. Als 13jähriger gewinnt er einen nat. Poster-Wettb. des Völkerbundes zum Thema Abrüstung. Nach kurzzeitigem Stud. an der KSch arbeitet C. ab ca. 1932 für die Werbeagentur Rydales in Manchester. Ab 1933 in London, wird er ab 1935 für die

Werbeagentur Bateman Artists tätig und fertigt zunächst v.a. archit. und maschinentechnische Illustrationen. 1938 erstes bek. Filmplakat für *The Amazing Dr Clitterhouse* im Warners Filmtheater am Leicester Square in London. Während des 2. WK zunächst Bombenentschärfer, danach Graphiker für Propagandamaterial. 1946–72 künstlerischer Leiter für Unterhaltungswerbung der Agentur Allardyce Palmer in London, danach freischaffend tätig. Er spezialisiert sich fast ausschließlich auf Filmplakate. 1962 besucht C. Aktklassen an der St. Martin's SchA, wo er seine zweite Ehefrau Shirley trifft. Ab den 1980er Jahren konzentriert er sich zunehmend auf Covers für Videos. – C. ist von den 1940er bis in die 1970er Jahre für die Plakate fast aller in Großbritannien gezeigten Kinofilme der Hollywood-Filmstudios Warner Brothers und 20th Century Fox verantwortlich. Daneben tritt er mit Entwürfen für brit. Produktionen hervor, bes. Horrorfilme von Hammer Films (z.B. *Dracula Has Risen from the Grave*, 1968), „Carry On"-Filme (z.B. *Carry On Cleo*, 1965) und frivole Teenager-Sex-Komödien (z.B. *Come Play with Me*, 1977). Für Hammer fertigt er auch Konzeptentwürfe, um die Finanzierung eines Filmprojekts zu sichern. Er arbeitet allein auf der Basis einer Synopse der Handlung und von Filmstills, die er malerisch mit kontrastierender Farbigkeit umsetzt. Gelegentlich ersetzt er fehlende Stills durch inszenierte Fotos, für die Freunde, seine Ehefrau und er selbst Modell stehen. Die Personen sind häufig in dramatischer Pose erfaßt und ein wenig karikaturhaft überzeichnet. Das Hauptgewicht liegt auf einem unmittelbaren, aktionsgeladenen Eindruck. Typischerweise verknüpft er die mon. hervorgehobenen Rollenporträts der Hauptdarsteller mit kleinen Szenen-Darst. und einem mit der Figuration verwobenen, sparsamen Text. Herausragende Beispiele der ca. 600–800 Filmplakate C.s sind die für *One Million Years B. C.* (1966), *Bonnie and Clyde* (1967), *Bullitt* (1968) und bes. *Star Wars* (1977), das sich zu einem internat. berühmten Kultbild entwickelt. Gelegentlich malt C. auch Porträts. ⌻ *Buckman* I, 2006. – *S. Branaghan*, Guardian v. 28. 7. 2001 (Nekr.); *id.*, Brit. film posters, Lo. 2006, 134–153. – *Online:* Chantrellposter. G. Bissell

Chao *Chung Hsiang* (Chao *Chung-hsiang*; Zhao *Chunxiang*), taiwanesischer Maler, * 1910 (auch 1913) Taikangxian/Prov. Henan, † Dez. 1991 Miaoli/Taiwan. Ausb. (Malerei) ab 1920 beim Vater. Stud.: 1932–35 Henan Teachers Normal School, Zhengzhou; 1935–39 Nat. Acad. of Art, Hangzhou, bei Pan Tianshou und Lin Fengmian. 1941–47 Abt.-Leiter für Bild. Künste am Northwest China Training League, Prov. Shaanxi. 1948 Übersiedlung nach Taipei. 1951–55 Ass. Prof. of Arts, Nat. Normal Univ. und College of Politics and Combat, Taipei. 1956–57 mit Stip. der span. Reg. in Madrid (dort Mitgl. der Künstler-Vrg); 1958 (nach sechsmonatiger Reise durch Europa, u.a. Paris) Übersiedlung nach New York. 1984–89 häufige Reisen zw. Taipei (Atelier ab 1984) und New York. 1989 Übersiedlung nach Hongkong, später nach Chengdu/Prov. Sichuan und schließlich 1990 nach Taiwan. Hält Gastvorlesungen, u.a. 1972 am Garrison AC, Russell Sage College in New York, 1974–75, '78 ebd. an der City Univ. und

1980 an der Nat. Normal Univ., Taipei. Ausz.: 1939 Watercolour Figure Paint. Prize, Nat. Exhib. of FA, Nanjing; 1959 Non-Member Award, Annual Exhib. of the Amer. Watercolour Soc.; 1972 Creative Artists Public Service Program Award, New York. 1995 organisiert das Dimension AC, Taipei, zwei Symposien zu seinen Ehren (Eastern Philosophy, Western Language). Weitere posthume Ausst. und Ehrungen folgen. – Durch seine fundierte Ausb. in chin. Malerei bei den prominenten reformistischen Künstlern Pan und Lin erhält C. erste Einblicke in westliche Kunstästhetik. Über seine Freundschaft mit Franz Kline und die spätere Begegnung mit Mark Rothko und Sam Francis in New York rezipierte C. in den 1960er Jahren den abstrakten Expressionismus. Seither verfolgt er das Ziel, eine Synthese zw. Ost und West zu schaffen und die chin. Tuschemalerei in die internat. Kunstströmungen einzubringen. In den frühen 1960er Jahren kombiniert er häufig geometrische „rationale" westliche Formen, v.a. an Frank Stella und Kenneth Noland erinnernde Kreise, mit spontanem chin. Pinselduktus (*Kao jin ni*/Close to you, 1963; *Jia*/Family, 1972, beide Tusche, Acryl/Papier, auf Lw. montiert). E. der 1960er Jahre beginnt er, mit leuchtenden Acrylfarben zu experimentieren. Tusche, erst als lavierte Fläche aufgetragen, dann durch mehrfache Überlagerung von Texturstrichen zu tiefem Schwarz verdichtet, bleibt jedoch das wichtigste Ausdrucksmittel. Bestimmend ebenfalls die Verwendung des (auf Lw. montierten) chin. Papiers. Die durch die gestische Pinselführung willkürlich entstehenden (getropften und gespritzten) Farb- und Tuschespuren, deren visueller Reiz an die Drippingtechnik von Jackson Pollock gemahnt, sind zugleich aber der altehrwürdigen chin. Technik der „hingespritzten Tusche" (pomo) verpflichtet. Inhaltlich ist C.s expressionistische Bildwelt stark vom chin. Geist geprägt. In den weitgehend abstrakten und partiell gegenständlichen Komp. integriert er symbolträchtige, auf ethische Werte anspielende Pflanzenmotive der trad. Gattung der Blumen- und Vogelmalerei (Kiefer, Bambus, Lotus, Päonien) sowie Fische und Vögel, die entfernt an Bada shanren (Zhu Da) anknüpfen. Diese und and. tiefgründige, aus der chin. Phil. und Kosmologie entnommenen abstrakten Symbole (u.a. Acht Triagramme, Sonne, Mond, Yin und Yang) und das Motiv der Kerze (*Huangse cai po yu si zhu*/Yellow Splash with four candles, 1989) erhalten in C.s Werk starke persönliche Konnotationen, die auf seine ethnische Herkunft und problematische familiäre Situation Bezug nehmen. Zeitlebens auf der Suche nach einer Synthese von zwei Kultur-Trad. spiegeln C.s Schaffen das künstlerische Spannungsverhältnis jener Zeit (vgl. Zao Wuki, Walasse Ding), aber auch sein persönliches Dilemma, zw. Ost und West, Trad. und Mod. zu stehen. In der New Yorker Kunstwelt bleibt C. so mehr oder weniger ein Außenseiter und findet nach einer langen Odyssee erst am Ende des Lebens zurück zu seinen Wurzeln. ▥ ALBANY/N. Y., Russel Sage College. BALTIMORE/Md., Univ. of Maryland. BEIJING, Nat. AM of China. CHICAGO, Art Inst. EAST HAMPTON/N. Y., Guild Hall Mus. ELMIRA/N. Y., Arnot AM. GREENVALE/N. Y., Long Island Univ. HONGKONG, Mus. of

Art. KINGSTON/N. Y., Kingston Coll. NEW YORK, Brooklyn Mus. – Columbia Univ. – Metrop. Mus. – New York Univ. – Queens Mus. of Art. NORWALK/Ct., Norwalk Mus. SHANGHAI, AM. STAMFORD/Conn., Stamford Mus. TAICHUNG, Nat. Taiwan MFA. TAIPEI, FA Mus. YONKERS/N. Y., Hudson River Mus. ◉ *E:* 1957 Barcelona, Layetanas Gal. / New York: 1967 Contemp. Gall.; 1969–70 Hemingway Gall.; 1977 Queens Mus. of Art; 1981 Brooklyn Mus. / 1972 Southampton (N. Y.), Parrish Mus. (K) / 1973 Albany, Russell Sage College / 1975 Elmira, Arnot AM / 1976 New Brunswick (N. J.), Rutgers Univ. / 1980 Toronto, Gall. 80 / Taipei: 1980 Spring Gall.; 1981 Chin. Cult. Univ. Mus.; 1984 FA Mus.; 1991 Miao Li Cult. Centre; 1993 Cheng Piin Gall. (K); 1995 Dimensions AC; 1997 Colorfield Art Space; 2004 Mus. of Hist. (Wander-Ausst.) / Hongkong: 1985 Alisan FA; 1992, 2000 AC / 1993 Singapur, Gall. 21 / 1994 London, Godfrey Far Eastern Art; Taichung, Nat. Taiwan MFA (Retr.; K) / 1999–2000 Shanghai, Chin. Paint. Acad. (Wander-Ausst.; K). – *G:* New York: Guggenheim: 1963 Internat. Exhib. on Abstract Expressionism; 1998 China 5000 Years (K: H. Brinker u.a.); 1996 Asian Amer. AC: Milieu. Part II / 1985 London, Warwick Arts Trust: Mod. Chin. Paint. Abstract Expression of the Brush / Taipei: 1995 Lung-Men Gall.: Beauty of Abstract Paint.; 1999 Asia AC: Pioneers of Chin. Abstraction ... (Wander-Ausst.) / 1995 Århus, KM: The Empire of the Dragons. 4000 Years of Chin. Art / 1995–96 Hongkong, AM: Twentieth C. Chin. Paint. Trad. and Innovation (Wander-Ausst.; K) / 1997 Taichung, New Vision Gall.: The Fifties ... by Artists of the Chin. Diaspora; Shanghai, AM: Chin. Roots. Works from Mainland and Chin. Overseas Artists. ▢ *M. Sullivan*, Mod. Chin. artists, Berkeley u.a. 2006 (s.v. Zhao Chunxiang). – *F. Calvo Serraller*, España, I-II, Ma. 1985; Paint. by C., Taipei 1986; Chao Chunhsiang (Zhao Chunxiang), Hong Kong 1992; *J. Clark*, Orientations 23:1992 (7) 28–36; *ead.*, China and Chin. artists overseas. Asian artist interview transcriptions, 1, Sydney 1992; *Chang Tsong-zung*, Art and Asia Pacific (Australien) 1:1993 (1) 9–11; *K. Chieh* (Ed.), An absolute artist. The artistic world of C., Taipei 1997; *J. Wechsler* (Ed.), Asian traditions. Mod. expressions. Asian Amer. artists and abstraction 1945–1970 (K; Wander-Ausst.), N. Y. u.a. 1997; *H. Kotzenberg/C. Chu*, Chin. Tuschmalerei im 20. Jh. (K Köln), M. u.a. 1996 (s.v. Zhao Chunxiang); Chao Chunhsiang (Zhao Chunxiang) 1910–1991, Hangzhou 1999; *I. Findly*, Asian art news 10:2000 (2) 50–55; *Pan Yaochang*, Beyond the babel, Bj. 2004, 297–303; *Wang Yung*, Transplantation and variation, Bj. 2004, 43, 172–174; 20th c. Chin. landscape paint. (K), Shanghai 2006, 192 s.

K. Karlsson

Chao *Hai*, chin. Maler, * Aug. 1955 Xingping/Prov. Shaanxi, lebt in Xi'an. Stud.: (chin. Malerei) Xi'an AFA (Abschluß 1982). Lehrtätigkeit dort. Mitgl.: Chin. Künstler-Verb.; Künstler-Verb. Beijing. – Als Vertreter der trad. chin. Tuschemalerei (guohua) erstellt C. konventionelle Quer- und Hängerollen mit Lsch. und Tieren in expressiver Xieyi („Niederschreiben einer Konzeption")-Manier. Bedeutender sind seine experimentellen, großfor-

matigen semi-abstrakten Darst. von Menschen (Gesichter, Torsi) und Rindern in Tusche (gemischt mit Ocker und Steinpulverpartikeln) auf Papier (*Niepan*/Nirvana, 1996). Kennzeichnend für die dunklen, wuchtig und suggestiv wirkenden Figurationen, deren verschwommene Umrisse und Binnenstrukturen sich erst mit Abstand erkennen lassen, ist die Verwendung von wässrigen, mehrschichtig aufgetragenen Tuscheabstufungen. Wegen kreativer Auseinandersetzung mit dem ästhetischen und konzeptuellen Potential der Tusche kann C. im Umfeld der in Reaktion auf den Ansturm der Neuen Medien in der chin. Gegenwartskunst A. der 1990er Jahren aufkommenden Kunstströmung Mod. Tuschekunst (xiandai shuimo yishu) angesiedelt werden. ⌨ BEIJING, China AG. CHENGDU, MCA. GUANGZHOU, Guangdong AM. HANGZHOU, Zhejiang Provincial Mus. HONGKONG, AM. NANJING, Nanjing Mus. SHANGHAI, AM. SHENZHEN, AM. ◉ *E:* 1996 Shenzhen, AM / Beijing: 1998 China AG (K); Central AFA / 1999 Foshan, Libr.; Shanghai, Shanghai Univ. Art Acad. / 2000 Guangzhou, Guangdong AM; Nanjing, Nanjing Mus. / 2001 Hangzhou, Zhejiang Provincial Mus. / 2003 Hongkong, Univ. – *G:* Beijing, China AG: 1984, '89, '94, '97, '99 (Preis): Nat. Kunst-Ausst.; 1998 Chin. Figure and Portr. Paint.; 2002 Yanhuang AM: True Colours of Ink / 1997 Nanjing, AM: Contemp. Chin. Paint. from Shaanxi (Wander-Ausst.) / Shanghai: 1998 AM: Bienn. / 2001 Guangzhou, Guangdong AM: 20 Years of Chin. Experimental Ink and Wash Art (K); Chengdu, MCA: Bienn. of Contemp. Art. ⌨ Zhongguo dangdai mingjia huaji – C. H., Bj. 2005; *M. Siemons*, Kunstforum internat. 193:2008 (Sept./Okt.) 228–233; Zeichen im Wandel der Zeit. Chin. Tuschemalerei der Gegenwart (K Berlin/Dresden), Bj. 2008. K. Karlsson

Chap, *Nur Chap*, brasil. Malerin, Bildhauerin, * 1937 São Paulo, dort tätig. C. belegt Kurse u.a. bei Habuba Farah Riccetti (Farbtheorie), Waldemar da Costa (Zeichnen), Armando Sedin, Danilo Di Prete und Antonio Vitor. Besucht zudem Kurse der EBA in São Paulo. – Abstrakte Malerei (Acryl/Lw., Mischtechnik, Gouache, Pastell) in leuchtenden, oft monochromen Farben und differenzierten Tonlagen. Die meist tropischen, warmen Farben verteilen sich spiralförmig, in fließenden Bewegungen und organischen Formen über die Lw., teilw. auch an Lsch. erinnernde Farbverläufe in Blautönen. Oft dominiert eine weiße runde, halbrunde oder schneckenförmige Form das Zentrum eines Gem., die nach außen über Abstufungen in Gelb, Rot und Blau abgedunkelt wird (*Flock Series*). Die mit Pinsel und Spatel pastos aufgetragene, nebulös wirkende Farbschicht wird mit Lichtern in Weiß und Tupfern in Rot gehöht. Weiße und gelbe vibrierende Formen mit verschwommenen Konturen stehen aber auch vor dunkelblauem Grund (*The Nest's Color III*). C. widmet sich in jüngster Zeit auch der figuralen Skulpt. und verwendet Bronze, Aluminium, durchscheinendes Acrylharz und Marmor. Die einfarbigen Skulpt. (weiß, rot, orange, metallfarben) weisen meist glänzende Oberflächen auf. Zu den bevorzugten Themen zählen stilisierte tanzende Paare, die eng umschlungen zw. Himmel und Erde zu schweben scheinen (*Bailando*); auch

überlebensgroße Formate. ⌨ SÃO PAULO, Mus. de Art do Parlamento. ◉ *E:* São Paulo: 1981 Gal. Renot (K); 1984, '90 (K) Espaço Cult. Chap Chap; 1998 Mus. de Arte Brasil. – Fund. Armando Alvares Penteado; 2003, '07 Gal. de Arte Jô Slaviero & Guedes; 2011 (mit Cecília Centurion) World Trade Center / 1998 Salvador, Mus. de Arte Mod. da Bahia. – *G:* 1974, '80 Tabauté, Salão de Artes Plást. / 1974, '78, '79 Piracicaba, Salão de Arte Contemp. / 1981 Rio de Janeiro, Salão de Arte da Aeronáutica / 1994 Goiânia, Mus. de Arte: 15 paulistas – 15 expressões / 1997 Campinas, MAC: Ninhos Brancos em Nesa Posta / 1998 São Paulo: Bien. ⌨ *Online:* Inst. Itaú Cult., Enc. artes visuais, 2008. C. Melzer

Chapelle, *Chantal*, belg. Malerin, Zeichnerin, Graphikerin, * 1954 Mortsel/Antwerpen, lebt in Antwerpen. Stud.: Sint Lucaspaviljoen ebd. (heute: Karel de Grote-Hogeschool, Dept. Sint Lucas; dort Lehrtätigkeit). – C. vermischt malerische und graph. Techniken, z.B. verwendet sie in den Gem., die häufig aus mehreren Lagen Acrylfarbe bestehen, auch Holzkohle. Zu ihren bevorzugten Motiven gehören v.a. (Berg-)Lsch., Marinen und Stadtansichten, die häufig in Vogelperspektive dargestellt sind (z.B. *Deep Sea*, 2005; *Calm*, 2010, beide Acryl/Lw.); daneben stilleben. Selten beleben fragmentarisch wiedergegebene schemenhafte Figuren oder deren Silhouetten die stimmungsvoll gemalten Naturdarstellungen. Auch Rad., abstrahierte Zchngn sowie Plastiken mit abstrahierten Figuren. – Ill.: G. Mebs, *Birgit*, Leuven 1983. ⌨ ANTWERPEN, Mus. van Hedendaagse Kunst. BADEN-BADEN, Mus. Frieder Burda. BRÜSSEL, Vlaams Parlament. ◉ *E:* 1978 Hekelgem, Centre cult. / Antwerpen: 1996 Jordaenshuis; 2003, '05 Gal. Jörg Hasenbach; 2007, '09, '10–11 Gal. Het Vijfde Huis / 1998 Gordes, Chap. des Pénitents Blancs / 1998, 2000, '01 Lokeren, Gal. Di-Art / 2001 Schwarzheide, Gal. der BASF (mit Yves Beaumont, Fernand Vanderplancke; K) / 2003, '06 (K) Dordrecht, Gal. Blom / 2007 Aalst, Gal. Denise Van de Velde. – *G:* 1997 Davos, World Economic Forum: Reality Revisited. In Between Walls (K) / 1999 Tytsjerk, Park Groot Vijversburg: De Boot van Dionysos; Sint Niklaas, Sted. ASK, Vierkante Zaal: Dialogen met het waarneembare / 2001 Hasselt, Prov. Centrum voor Beeldende Kunsten: Het versluierd beeld (K) / 2003 Horsens, KM: MUKA – Kunst for børn og unge; Antwerpen, Gal. Jörg Hasenbach: Summer Party / 2006 Auckland, Muka Gall.: Treasure Trove. ⌨ *Pas* I, 2002. F. Krohn

Chaplin, *Robert (Robert-Charles)*, frz.-ital. Maler, Zeichner, * 13. 6. 1926 Fontainebleau/Seine-et-Marne, † 1937 San Domenico di Fiesole. Neffe der Malerin Elisabeth C. Kommt 1927 als Kleinkind in die Villa seiner Tante in Settignano, um von einer schweren Muskeldystrophie zu genesen. Gefördert durch Tante, die Großmutter und Ida Capecchi, beginnt der ungewöhnlich frühbegabte C. bereits als Sechsjähriger zu zeichnen. In seinen beiden letzten Lebensjahren entstehen zahlr. poesievolle, sensible Zchngn, Pastelle und Aqu. von bemerkenwerter Qualität. Zus. mit der Tante gestaltet er u.a. einen Karton für die Ec. Professionelle in Metz. Ab 1954 bezieht Elisabeth C.

auf ihren Ausst. regelmäßig Arbeiten von C. mit ein. C.s außergewöhnliches Talent wurde von André Gide, Carlo Carrà und Nello Roeselli geschätzt. �push FLORENZ, Uffizien, GDS. ◉ *E:* Florenz: 1938 Lyceum; 1999 Accad. Economico-Agraria dei Georgofili (K). – *G:* 1936 Paris, Salon Nat. des BA (K). ▭ *T. Paloscia* (Ed.), R. C., Elisabeth Chaplin. La natura [...] prima ispiratrice (K), Fi. 1999; *id.* (Ed.), R. C. Disegni, Fi. 2000; *M. Fagioli,* Elisabeth Chaplin. Tra simbolismo e neo-spiritualismo, Fi. 2001; *A. Bullock* (Ed.), La fam. Chaplin, storia di un'epoca, IV (1931–1935). Il carteggio, Fi. 2007; *J. Fortune/L. Falcone,* Invisible women. Forgotten artists of Florence, Fi. 2010.

E. Kasten

Chapman, *Arthur D. (Arthur Douglas),* US-amer. Amateurfotograf, Drucker, * 12. 8. 1882 Bakersfield/Calif., † 5. 6. 1956 Hackensack/N. J. In New York arbeitet C. als Drucker in versch. Zeitungsverlagen. 1910 besucht er die Sommerschule von Clarence H. White in Maine (Seguinland School of Photogr.) und 1915–17 die Clarence H. White School of Photogr. in New York. Während des 1. WK in Frankreich stationiert. Ab 1917 Mitgl. der Pictorial Photographers of America (PPA). 1921 Umzug nach New Jersey. – C. ist Teil der breiten amateur-fotogr. Bewegung um C. H. White. Geprägt von den Motiven und den kompositorischen Prinzipien der New Yorker Piktoralisten fotografiert er von der 1910er bis A. der 1920er Jahre ausgiebig in den Straßen seiner Nachbarschaft im Greenwich Village und in Lower Manhattan. Mit Hilfe eines selbstgebauten Weichzeichnerobjektivs entwirft er dabei ein malerisch beschauliches Bild der Großstadt. 1915 veröffentlicht er das Album *Greenwich Village. Eight Portr.* (Philip Goodman Co., N. Y.). Um diese Zeit erscheinen einige seiner Fotogr. in der Zs. Platinum Print, weitere A. der 1920er Jahre in den Jbb. der PPA sowie 1924 in der Zs. Camera Pictures. A. der 1950er Jahre fertigt C. Neuabzüge von den alten Glasplattennegativen. ⌷ NEW YORK, Hist. Soc., A. D. C. Photograph Coll. – Mus. of the City of New York. NORTHAMPTON/Mass., Smith College, Sophia Smith Coll., Marion Barnes Meisel Papers. WASHINGTON/ D. C., Libr. of Congress, Prints and Photographs Division. ✉ Travel, in: Amer. ann. of photogr. 32:1918, 235–239 (ill. mit drei eig. Fotogr.). ◉ *E:* 1916 Brooklyn (N. Y.), Brooklyn Inst. of Arts and Sciences. – *G:* New York: 1912 Montross AG: An Exhib. Illustrating the Progress of the Art of Photogr. in America; 1914 Print Gall.: Internat. Exhib. of Pictorial Photogr. / 1914, '15 London: R. Photogr. Soc. / 1918 Detroit, Mus. of Art: Sculpt. by Mrs. Gertrude Vanderbilt Whitney and Pictorial Photographs by Amer. Artists. ▭ *M. Fulton* (Ed.), Pictorialism into modernism (K Wander-Ausst.), N. Y. u.a. 1996; *C. A. Peterson,* After the photo-secession (K Wander-Ausst.), N. Y. u.a. 1997; *V. P. Curtis,* Libr. of Congress inf. bull. 60:2001 (12). – *Online:* Libr. of Congress; Mus. of the City of New York; New York Hist. Soc., Guide to the Arthur D. Chapman Photograph Coll. P. Freytag

Chapman, *Jake* und *Dinos,* brit. Künstlerduo, Bildhauer, Installationskünstler, Maler, Zeichner, Graphiker; *Jake C.,* * 1966 Cheltenham/Glocs., lebt in Filkins/Oxon. und

London; *Dinos C.,* * 1962 London, lebt dort. Söhne eines brit. Kunstlehrers und einer orthodox griech. Zypriotin. Aufgewachsen in Cheltenham und Hastings/Sussex. Dinos studiert 1979–81 am Ravensbourne College, London, Jake 1985–88 am North East London Polytechnic, beide gemeinsam 1988–90 am R. College of Art (Dinos: Malerei; Jake: Skulpt.) und arbeiten von nun an stets zusammen. Während der Studienzeit ist zunächst Dinos, dann auch Jake Ass. von Gilbert and George. Wenngleich sie nicht Absolventen des Goldsmith's College sind, werden die C. Brüder rasch der sensationalistisch orientierten Strömung der Young Brit. Artists zugerechnet und vom Sammler Charles Saatchi protegiert. Ausz.: 2003 Charles Wollaston Award der RA und Nominierung für den Turner Prize; 2010 Premio Pino Pascali. – Die Brüder C. richten ihre Kunsttätigkeit von Anfang an bewußt provozierend auf eine größtmögliche Schockwirkung aus und werden oft als Meister des schlechten Geschmacks gesehen. Mit einem bisweilen bis zum blanken Spott gesteigerten beißenden Witz teilen sie subversive Seitenhiebe gegen die Vorstellung einer moralischen Gesellschaft und der sie leitenden Prinzipien in Politik, Religion und Wirtschaft aus. Eigenen Äußerungen zufolge funktionieren ihre Werke am besten, wenn sie den Betrachter in einen Zustand absoluter moralischer Panik versetzen. Bereits das pseudointellektuell formulierte Manifest *We are Artists* (1990) ist ein antiästhetisches Statement. 1992 im Londoner Inst. of Contemp. Art ausgestellt, suggeriert die grob verspritzte braune Wandfarbe Schlamm oder Exkremente und tritt in Kontrast zum klar geschnittenen Schablonentext, der negativ konnotierte Werkcharakteristika wie Voyeurismus, Marktorientierung, künstlerische Minderwertigkeit, Widersprüchlichkeit von Gehalt und Gestalt proklamiert und ihnen damit gleichzeitig einen Wert zugesteht. Die vielfältigen Arbeiten der C. lassen sich oft bestimmten Themenkomplexen zuordnen, die sich jedoch vielfach überlappen. Das Paar nackter Schaufensterpuppen *Mummy and Daddy Chapman* (1993; zerst.) bringt ein prokreatives Konzept zum Ausdruck, das unmöglich funktionieren kann, da die Frau mit einer Vielzahl männlicher wie weiblicher Geschlechtsorgane bestückt ist, während der Mann nur eine Anhäufung von Aftern aufweist und damit geschlechtsunfähig ist. Nachdem sich der Mailänder Galerist Franco Toselli weigert, das zur Ausst. bestimmte Werk 1994 in seiner Gal. zu zeigen, konzipieren die C. aus Rache das Werk *Bring me the Head of Franco Toselli* (1995). Hierfür schlagen sie der männlichen Puppe den Kopf ab und ersetzen die Nase durch einen Penis; zudem drehen sie einen gleichnamigen Pornofilm, bei dem zwei professionelle Schauspielerinnen den Kopf als Sexobjekt verwenden. Das Prinzip von beliebig angebrachten Genitalien (oft statt Nasen oder Mund, z.B. *Fuck Face,* 1994) bildet die Grundlage für einen ausgreifenden Werkkomplex. Erweiternd sind Gruppierungen mutierter oder willkürlich zusammengewachsener Körper auch als kritischer Kommentar zur Genforschung gemeint, z.B. *Zygotic acceleration, Biogenetic de-sublimated libidinal model (enlarged x 1000)* (1995) und die pseudoparadiesische Installation *Tragic Anatomies* (1996). *Little Death Machi-*

ne (Castrated) (1993; Liverpool, Tate) war ursprünglich eine funktionierende Maschine, in der ein Hammer auf ein Gehirn einschlägt und daraufhin ein Penis Flüssigkeit verspritzt; nach Fehlfunktionen fixieren die C. die Maschine und fügen den Untertitel „Castrated" hinzu. Auf diesem Vorbild basierend entsteht 2008 die Serie skurriler Konstruktionen *Little Death Machines* aus Bronze. Den ersten vielbeachteten kritischen Erfolg ernten sie mit dem Werk *Disasters of War* (1993; London, Tate), einem Tableau mit Spielfigürchen als plastische Umsetzung der Graphikserie „Los desastres de la guerra" von Francisco de Goya, die, nach eig. Äußerungen, die tiefe Ernsthaftigkeit des Originals bewußt unterminiert. Goyas Desastres bleiben auf Jahrzehnte ein ständiger Bezugspunkt für das Brüderpaar, bes. das berühmte Blatt „Grande hazaña! Con muertos!" mit verstümmelten Leichen und abgeschlagenen Körperteilen, die demonstrativ an einem Baum zur Schau gestellt sind. Zunächst stellen sie diese Komp. mit Schaufensterpuppen als *Great Deeds against the Dead* (1994) nach und paraphrasieren dabei Goyas originalen Titel, den sie jedoch durch Weglassen der Ausrufungszeichen von einer ursprünglich ausgedrückten Entrüstung zu einer potentiell positiven Erklärung modifizieren. Eine weitere Variante der Szene mit dem subversiven Titel *Sex* (bemalte Bronze, lebensgroß, 2003) zeigt die Körper im Zustand fortgeschrittener Verwesung und dient als Pendant zu *Death* (bemalte Bronze, 2003), einem Paar von Plastik-Sexpuppen beim oralen Geschlechtsakt. Für *Insult to Injury* (2003) überarbeiten und „verbessern" die C. eine komplette Serie der Desastres (Abzüge von Goyas originalen Platten), indem sie einzelne Gesichter mit clownhaften Fratzen, die bisweilen an Phantasiegestalten von Hieronymus Bosch erinnern, übermalen; dies hat einen Aufschrei in der Presse zur Folge, der sich nicht gegen die Drastik des Sujets richtet, sondern gegen dessen Banalisierung und den Vandalismus an „wirklichen" Kunstwerken. Da sich die Zusammenarbeit der C. nicht als Suche nach einem Konsensus, sondern stets als ein Wetteifern miteinander ausdrückt, sind hier die einzelnen Blätter jeweils unabhängig von einem der Brüder überarbeitet. Zeitweise arbeiten sie sogar in getrennten Ateliers und manifestieren die unterschiedlichen Persönlichkeiten in der Rad.-Serie *Exquisite Corpse* (2000), basierend auf dem surrealistischen Spiel, einen Teil eines Blattes zu bearbeiten, während der vom anderen bearbeitete Teil verborgen bleibt. Die Gewaltmotive weiterführend, wenden sich die C. auch der Symbolwelt der Nazionalsozialisten zu. Diese findet ihren ersten anspruchsvollen Ausdruck in *Hell*, einem in neun hakenkreuzförmig arrangierten Vitrinen präsentierten Tableau von Greueltaten mit mehr als 10000 Figürchen (1999; 2004 verbrannt und 2008 durch das noch ambitioniertere *Fucking Hell* ersetzt). Zu den Slogans der Titel gesellt sich nun ein häufiges Auftreten moralisch besetzter Zeichen wie dem Hakenkreuz, dessen bloße Allusion jedoch bereits genügt und es somit durch ein das Gegenteil ausdrückendes Symbol austauschbar macht, z.B. ein Smiley-Emblem auf der Armbinde eines SS-Offiziers in *Fucking Dinosaurs* (2011). Ebenso austauschbar sind

Täter und Opfer. Der Approbation und „Verbesserung" der Goya-Drucke vergleichbar, überarbeiten die Brüder schließlich Lsch.-Aqu. und Veduten von Adolf Hitler mit naiven Regenbogenmotiven u.ä. für die Serie *If Hitler Had Been a Hippy How Happy Would We Be* (2008). *Arbeit McFries* (2001) verknüpft das berüchtigte Motto „Arbeit macht frei" des Konzentrationslagers Auschwitz mit dem globalen Fast-Food-Konzern McDonald's und macht die vergleichbaren imperialistischen Tendenzen deutlich. Diese führen die C. eindrücklich mit *The Chapman Family Collection* (2002; London, Tate) vor Augen. Diese vorgebliche Slg primitiver afrikanischer Skulpt. trägt deutliche, aber nicht auf den ersten Blick erkennbare Markenzeichen wie den gelben M-Bogen, ein Gesicht als Big Mac oder den Kopf des Konzernmaskottchens Ronald McDonald. Wie hier setzten sich die C. auch anderweitig mit versch. Formen von Kunst auseinander und implizieren oft eine Kritik an der Selbstreferenzialität und Überschätzung von Kunst. Der Rückbezug auf Kinderkunst beginnt mit *GCSE Art Exam* (1999), bei dem Jake und Dinos (als individuelle Person) kindlich ungelenke Kunstwerke für ein Hauptschulexamen im Fach Kunst einreichen. Diese Ausrichtung führen sie mit Serien grober farbiger Skulpt. aus Wellpappe fort, z.B. *Hell Sixty-Five Million Years BC* (2004–05) mit Dinosauriern und *Two legs bad, four legs good* (2007). Für die Berliner Ausst. *Shitrospective* (2009) gestalten sie eig. ältere Werke im Kleinformat aus Pappe nach, während sie in *Painting for Pleasure and Profit: A Piece of Site-Specific, Performance-Based Body Art in Oil, Canvas and Wood (Dimensions Variable)* (2006; ad hoc erstellte Portr. von zahlenden Besuchern der Kunstmesse Frieze in London) auch Malstile anderer Künstler persiflieren. Für die Serie *The Milk of Human Weakness* (2011), ihrer bislang umfangreichsten Auseinandersetzung mit Religion und insbesondere häuslicher Devotion, verleihen sie Figuren in alten Gem. und Statuetten Anzeichen von Verwesung. Dieselbe Verfalls- und Dämonisierungs-Ikonogr. kennzeichnet auch ihre Überarbeitung alter Ölbildnisse für die Serie *One Day You Will No Longer Be Loved* (2008). Bei den durchgängigen Themen anatomischer und pornographischer Verzerrung und dem Aufzeigen der Banalität von Gewalt werden die ausgesprochen guten technischen Fähigkeiten der C., z.B. in der Rad., leicht übersehen. Einer vorgezeigten Grobheit steht eine differenzierte, detailgenaue Durcharbeitung zur Seite. Oft sind die Skulpt. entgegen der anschaulichen Materialität aus Bronze. ⌂ ABERDEEN, AG. CAMBRIDGE, Fitzwilliam Mus. CHELTENHAM, AG and Mus. LIVERPOOL, Tate. LONDON, Brit. Council. – BM. – Tate. MINNEAPOLIS/ Minn., Walker AC. NEW YORK, MMA. ✉ *J. C.*, in: Peter Doig. Udomsak Krisanamis (K), Bristol 1998; Disasters of war, Lo. 2002; *J. C.*, in: Nigel Cooke. The new spirit in death painting (K), Lo. 2002; *id.*, Insult to injury, Göttingen 2003; *id.*, Meatphysics, Lo. 2003; *id./B. O'Brien* (Regie/ Produktion), Artshock. Is bad art for bad people?, Lo. 2006 (Film für Channel 4); *J. C.*, Memoirs of my writer's block, Lo. 2010. ◉ E: London: 1992 Hales Gall.; 1993, '94, '95 Victoria Miro Gall.; 1995 Ridinghouse Editions; 1996

Inst. of Contemp. Art (Wander-Ausst.; K); 1999, 2002 (K), '05 (K), '08 (K), '11 White Cube; 1999 Fig. 1; 2001 Modern Art; 2003 Saatchi Gall. (K); 2006 RS & A; 2007 Tate Britain; 2007 Paradise Row; 2010 Whitechapel AG (K) / Liverpool: 1992 Bluecoat Gall.; 2006, Tate (Retr.; K) / Mailand: 1994 Gall. Franco Toselli; 1996, '99 Gall. Giò Marconi; 2010 Project B Contemp. Art / 1995 Stockholm, Gal. Andréhn-Schiptjenko / New York: 1995 Gavin Brown's Enterprise; 1997 Gagosian Gall. (K); 2000 PS1; 2008 L & M Arts / Tokio: 1996 P-House; 2000 The Art Ginza Space / 1998 Paris, Gal. Daniel Templon / Berlin: 2000 Kunst-Werke; 2009 Contemporary Fine Arts / 2002 Groningen, Groninger Mus. (Wander-Ausst.; K) / 2003 Oxford, MMA (K) / 2004 Malaga, Centro de arte contemp. (Wander-Ausst.; K); Coburg, Veste Coburg; Essen, Slg Thomas Olbricht / 2005 Bregenz, Kunsthaus (K) / 2006 Victoria (B. C.), AG of Greater Victoria / 2007 Moskau, Triumph Gall. / 2008 Hanover, Kestner-Ges. (K); Cambridge, Jesus College / 2009 Hastings, Mus. and AG / 2010 Polignano a Mare (Apulien), Mus. Pino Pascali; Zürich, Cabaret Voltaire; Katowice, Ars Cameralis; München, Gal. Daniel Blau (K). – *G:* 1997 Venedig: Bienn. / 2003, '07 London, RA / 2010 Sydney: Bienn. / 2011 Moskau: Bienn. ⟐ *C. Prut,* Dict. de arta mod. si contemp., Bu. 2002; *Windsor,* Sculptors, 2003; *U. Grosenick/B. Riemschneider* (Ed.), Art now. Vol 2, Köln u.a. 2005; *Buckman* I, 2006. – *A. Renton,* Show hide show. Jake Chapman, Alex Hartley, Abigail Lane, Sam Taylor-Wood (K Anderson O'Day Gall.), Lo. 1991; Brilliant! New art from London (K Minneapolis/Houston), Minneapolis 1995; The Dakis Joannon Coll. (K), Ostfildern 1996; Sensation. Young Brit. artists from the Saatchi Coll. (K), Lo. 1997; *D. Green/J. Lowry,* in: *D. Brittan* (Ed.), Creative camera. Thirty years of writing, Manchester 1999; *J. Stallabrass,* High art lite. Brit. art in the 1990's, Lo. 1999; Apocalypse. Beauty und horror in contemp. art (K RA), Lo. 2000; *S. Folie/M. Glasmeier,* Eine barocke Party. Augenblicke des Welttheaters in der zeitgen. Kunst, W. 2001; Turner Prize 2003 (K), Lo. 2003; *S. Baker,* Papers of surrealism 1:2003, 17 ss. (Interview); *P. Shaw,* Art hist. 26:2003, 478–504; To ski-achtro. The scarecrow (K Metsovo), At. 2006; *J. & D. C.,* Lo. 2007 (New art up-close 3); *M. Gisbourne,* Double act. Künstlerpaare, M. u.a. 2007; End game. Brit. contemp. art from the Chaney fam. coll. (K Houston), New Haven/Lo. 2008; Goya, Les caprices & Chapman, Morimura, Pondick, Schütte (K Lille), P. 2008; *R. Eikmeyer/T. Knoefel* (Ed.), J. & D. C. From hell to hell. Orig. recordings, Pforzheim/Nü. 2009 (CD); *J. Harris* (Ed.), Inside the death drive. Excess and apocalypse in the world of the C. Brothers, Liverpool 2010; Flogging a dead horse. The life and works of J. & D. C., N. Y. 2011. – London, Nat. Art Libr.: Information File. G. Bissell

Chapman-Taylor (eigtl. Taylor), *James Walter,* neuseeländischer Architekt, Baumeister, Möbeldesigner, Fotograf, Astrologe, * 24. 6. 1878 London, † 28. 10. 1958 Lower Hutt/N. Z. 1880 folgt C.s Mutter mit ihm und dem Bruder dem 1879 nach Neuseeland ausgewanderten Vater. Die Fam. unterhält eine Farm in Ngaere b. Stratford. C.

wird bei lokalen Baumeistern (Boon Brothers) in Stratford ausgebildet. Als erster eigenständiger Bau entsteht das einstöckige Holzhaus für die Eltern in Stratford. Um 1903 schreibt er sich für einen Archit.- und Designkurs an den Internat. Correspondence Schools of the United States ein. 1904 Bau des Bahnhofs von Taihape. 1905 Umzug nach Wellington, wo er sich unter dem Namen Chapman-Taylor als Baumeister, Möbeldesigner, Zimmermann und Architekt profilieren kann. Ab 1919 in Havelock North, ab 1922 in Auckland, M. der 1930er Jahre in Silverstream/Hutt Valley ansässig. Mitgl.: 1920er Jahre Auckland Camera Club; Wellington Camera Club; 1948 R. Photogr. Soc. of Great Britain. – C. hat in erheblichem Maß dazu beigetragen, die Ideen der Arts and Crafts Movement in Neuseeland zu verbreiten. Bek. sind seine qualitätvoll gebauten Wohnhäuser (Entwurf und Bau von 97 Gebäuden, größtenteils erh.), die weitgehend im Sinne dieser Bewegung dem schlichten trad. engl. Cottage-Stil verpflichtet sind und für die er auch die Innenausstattungen (robuste Möbel wie Kleider- und Geschirrschränke, Tische, Schreibtische sowie Zubehör wie Klinken, Schlösser etc.) entwirft und fertigt. Während der ersten Jahre in Wellington verwendet er fast ausschl. das dunkle austral. Jarrah-Holz für die Verkleidung der Innenwände sowie für Möbel, was ihm den Beinamen „Jarrah-Taylor" einträgt. Auf Reisen nach England 1909 und '14 studiert C. die Bauten der von der Arts and Crafts Movement beeinflußten Architekten Charles Francis Voysey, Mackay Hugh Baillie Scott, Sir Edwin Lutyens, Ernest William Gimson, Ernest und Sidney Barnsley, Charles Robert Ashbee sowie die trad. engl. Cottages. Im Zusammenhang damit entwickelt sich sein reifer Stil, die Entwürfe werden komplexer, und er bevorzugt nun Beton als Bau-Mat., experimentiert dabei mit wabenartigen Wandkonstruktionen, Blöcken etc., greift aber immer wieder auf den Cottage-Stil zurück. Neben der Bautätigkeit hat C. mit Lsch.- und Archit.-Aufnahmen sowie mit Portr. einen bed. Beitr. zur neuseeländischen Fotogr. geleistet. Seine Aufnahmen erscheinen ab 1907 im Mag. Progress (1914 umbenannt in New Zealand Building Progress), z.T. als Ill. der von ihm verfaßten Art., sowie in der Ed. von H. Mace, *Egmont and the children of the mountain mist,* New Plymouth 1931 (21 Bilder). C.s Fotogr. erhalten eine zunehmende künstlerische Qualität, als er mit speziellen Linsen experimentiert und versch. Effekte durch die Belichtung und die Wahl des Fotopapiers erzielt. In den 1930er Jahren kreiert er mit den in Annoncen als „Portr. in your home" bez. Ablichtungen einen neuen Porträttyp, der im Gegensatz zu Studioaufnahmen natürlicher und weniger formal angelegt ist. ▯ HAVELOCK NORTH/Hawke's Bay: Whare-Ra, neuseeländisches Zentrum des Hermetic Order of the Golden Dawn, 1913–15 (erster Betonbau). NEW PLYMOUTH: Tupare Cottage. UPPER HUTT: Brentwood Manor, 1931. WAIITI/Taranaki: Wilkinson's Castle. WELLINGTON, Tinakori Road: eig. Wohnhaus, um 1905. – Mus. of New Zealand Te Papa Tongarewa: v.a. Fotogr., auch Entwürfe, Möbel. ▯ *W. Main,* New Zealand pictorialists (Wander-Ausst.), Wellington 1991; *J. Siers,* J. W. C.-T. in the Hawke's Bay 1913–1922 (K), Napier 1992;

ead., The life and times of J. W. C.-T., Napier, N. Z. 2007. – *Online:* Dict. of New Zealand Biogr.; Puke Ariki; New Zealand Historic Places Trust. C. Rohrschneider

Chapon, *Jules,* niederl. Maler, Graphiker, Entwurfszeichner, * 4. 9. 1914 Heemstede/Noord-Holland, † 6. 1. 2007 Saint-Cyprien/Dordogne. Entstammt einer jüdischen Familie. Als Künstler Autodidakt. 1940 priv. Malunterricht bei Kees Verweij in Haarlem. Heiratet 1940 die spätere Galeristin Ruth Bat (Polly) Abraham. C.s Vater, der Publizist, Stadtverordnete und Vors. der jüdischen Gemeinde in Haarlem Barend C. wird im 2. WK Opfer der dt. Besatzungsmacht; am 2. 2. 1943 wird der Vater mit neun and. Geiseln von Mitgl. der Waffen-SS erschossen; die Mutter, der Bruder und zwei Schwestern werden deportiert und in Auschwitz umgebracht. C. überlebt den Holocaust, indem er 1943–45 untertaucht. Nach der Befreiung hält er sich im Sommer mehrfach in Cagnes-sur-Mer auf, wo er u.a. 1947 Kontakt zu den dänischen Malern Ejler Bille und Egill Jacobsen hat. 1948–56 jährlich in Saint-Rémy-de-Provence. 1953–54 Malunterricht bei dem wegen Kollaboration mit der dt. Besatzungsmacht mit sieben Jahren Ausst.-Verbot belegten realistischen Maler Henri Frédéric Boot. Ab 1956 beteiligt sich C. mehrfach an Ausst. in der von Polly C. und Eva Bendien gegr. Gal. Espace in Haarlem (ab 1960 in Amsterdam). 1957 Reise nach Israel. Mit Franciscus Wilhelmus Aloysius Funke-Küpper, Poppe Damave u.a. gründet C. die Künstler-Vrg De Groep. Da er in Haarlem ständig einem niederl. Faschisten, dem ehem. Bannführer Nederkoorn begegnet, dem er eine Mitschuld an der Vernichtung seiner Fam. gibt, exiliert er 1973 mit seiner zweiten Frau und nimmt endgültigen Wohnsitz in Coux-et-Bigaroque. – Anfangs naiv-realistische Stillleben, Lsch. und Figurenbilder (Öl, Gouache, Zchng), auch (Fam.-)Portr. und Motive der nat.-sozialistischen Gewaltherrschaft, u.a. ein Memorial-Portr. des 1943 zus. mit C.s Vater ermordeten *Rabbijn Philip Frank* und das Gem. *Concentratiekamp II* (beide Öl/Lw., 1950). Ab M. der 1950er Jahre wendet sich C. unter Einfluß der CoBrA-Bewegung zunehmend von der Gegenständlichkeit ab und experimentiert mit abstrakten Farb- und Formgebungen (*Kosmos*, 1957; *Compositie met rood en geel*, 1958). In den 1960er/1970er Jahren erhält er mehrere große Aufträge für mon. (Trenn-)Wand-Gest., die er u.a. mittels einer dem Schiffbau entlehnten doppelwandigen Konstruktion aus Stahlplatten ausführt, in deren gefrästen oder mit dem Schweißbrenner geschaffenen Öffnungen u.a. farbige Glaselemente eingefügt sind. Solche Trennwände entstehen in Amsterdam 1959–61 für das Verwaltungsgebäude von Fokker in Schiphol, 1963–67 für die Empfangshalle der Nederl. Bank und um 1973–77 (1995 abgebrochen) für das Gefängnis Overamstel (Bijlmerbajes). In der Malerei ab den 1980er Jahren deutliche Aufhellung der Palette und Rückkehr zu figurativen Komp. (*Orange s'amuse*, 1981). In den letzten Jahren Gem. mit spannungsvoll verknüpften simplen Linien und Farben. ⌂ AMSTERDAM, Joods Hist. Mus. – Nederl. Bank. – Rijks-Coll. DEN HAAG, Gemeente-Mus. ⊙ *E:* 1950 Haarlem, Mus. Huis van Looy (K) / Amsterdam: 1981 Gal. Espace (mit Ben Guntenaar, K);

1996 Joods Hist. Mus. (Retr., K). – *G:* 1991 Amsterdam, Joods Hist. Mus.: De nieuwe vrijheid. Joodse kunstenaars in Nederland 1945–1960 (K). ▭ *Scheen* I, 1969 (s.v. Chapchal, Jaques); *Jacobs* I, 2000. – *C. Hoogveld u.a.*, Glas in lood in Nederland 1817–1968 (K Wander-Ausst.), D. H. 1989, 221; *A. Matena*, Bewogen verleden. Beelden van verstoord leven stilgezet, Zwolle 1995, 22 s.; De groene Amsterdamer v. 2. 10. 1996, 32 s. (Interview); *B. Witman*, De Volkskrant v. 4. 10. 1996; *M. Hoogendonk u. a.*, Gal. Espace 40 jaar. Ruimte voor eigentijdse kunst (K Haarlem), Abcoude u.a. 1997; *T. Haartsen*, De wand des tijds. Mon. Kunst rond de jaren 50, Nuth [2002]; *W. de Wagt*, in: Haerlem jaarboek 2007, Haarlem 2008, 258–260 (Nachruf). – *Online:* RKD; Documentatie van Beeldende Kunst in Limburg. U. Heise

Chappert-Gaujal, *Patrick,* frz. Maler, Bildhauer, Collagekünstler, * 1959 Bédarieux/Hérault, lebt in Leucate/Aude. Stud.: 1975–80 EcBA, Perpignan. M. der 1980er Jahre Aufenthalt in Malmö. – Abstrakte Acryl-Gem. in harmonischer Farbgebung sowie Kohle-Zchngn mit char. dekorativer kleinteiliger Musterung; weiterhin mit Pastellkreiden kolorierte Collagen. Für seine plastischen Arbeiten verwendet C. bevorzugt angeschwemmtes Holz u.a. Strandgut. Aus diesen maritimen Fundstücken gestaltet er Assemblagen und totemartige Skulpt., die er in seiner typischen Formsprache in pastosem Auftrag mit Acryl- und Ölfarben bemalt. Zudem entstehen in jüngerer Zeit großformatige, flache, silhouettenhafte Eisen- und Stahlplastiken (u.a. für den öff. Raum). ⊙ *E:* Malmö: 1986 Inst. franç.; 1990 (K), 2000, '07 Gall. GKM Siwert Bergström / 1991 Paris, Gal. Otsuka / 1998 Toulouse, Espace Croix-Baragnon / 2003 Villeneuve-sur-Lot, Mus. de Gajac (K) / 2006, '08, '09 Revel, Gal. Courants d'Art / 2011 Brüssel, Mazel Gal.; Mansencôme, Château du Busca-Maniban. – *G:* Malmö: 1988 KM: La Révolution franç.; 2000 Gall. GKM Siwert Bergström: Please do touch / 1991 Montrouge: Salon / Paris: 1992 Salon de Mai; 1994 Gal. Différence: Installation. 1001 petits Totems / 2011 Brüssel, Mazel Gal.: Remix. ▭ *Delarge*, 2001. – *Online:* Website C. F. Krohn

Chappuis, *Philippe* (Pseud. Zep), schweiz. Comiczeichner und -texter, Cartoonist, Illustrator, Plakatgestalter, * 15. 12. 1967 Onex, lebt in Genf. C. beginnt als Kind mit dem Zeichnen von Comics und publiziert um 1979/80 ein selbst verlegtes Fanzine, dessen von der Rockgruppe Led Zeppelin inspirierten Titel *Zep* er später als Pseud. verwendet. In den 1980er Jahren Stud. an der Ec. des Arts Décoratifs, Genf. Veröff. erste Cartoons in der Tages-Ztg Courrier de Genève. Ab 1987 Mitarb. des Mag. Spirou, für das er die Comics *Au bout du monde* (1987) und *Victor* (1988–91; Album u.d.T. *Victor n'en rate pas une*, 1988) zeichnet. Für die Zs. Jeudi Sports & Loisirs entsteht der Strip *Kradok* (1988; Text v. Leglode/Claude Delabays; Album u.d.T. *Amanite Bunker*, 1991). 1990 gestaltet C. nach einem Szenario von Christophe Gilli das vom pazifistischen Groupe pour une Suisse sans armée (GSSA) hrsg. Album *Léon Coquillard*. Gleichzeitig auch politische Plakate und Ill. für Ztgn und Zss. wie L'Hebdo und

Le Nouv. Quotidien. Für das alternative schweiz. Comic-Mag. Sauve qui peut kreiert C. 1992 die humoristische Serie *Titeuf*, die seit 1993 als Albenreihe im Verlag Glénat erscheint (bisher 12 Bde und zahlr. Sonder-Ausg.). Die in satirisch-anarchistischer Manier Motive präpubertärer Adoleszenz, z.T. aber auch aktuelle ges. Themen aufgreifenden Gags um einen acht- bis zehnjährigen Schuljungen und seine Kumpane finden bald internat. Beachtung und dienen u.a. als Vorlage für eine Zeichentrickfilmserie und einen abendfüllenden Animationsfilm (2011). Mit seiner Lebensgefährtin *Hélène Bruller* (* 1. 1. 1968 Paris) gestaltet C. u.a. das Album *Guide du zizi sexuel* (2001) und die Kinderbuchreihe *Les Minijusticiers* (15 Bde; 2003–08). Zahlr. weitere ill. Bücher und Comics: u.a. *Les Filles électriques* (1997); *L'Enfer des concerts* (1999); *Chansons pour les pieds* (2002; mit Ill. zu Liedern von Jean-Jacques Goldman); *Mes héros de la bande dessinée* (2002); *Happy Sex* (2009); *Happy Girls* (2010). Als Szenarist betreut er u.a. die Comicserie Captain Biceps (seit 2004; gez. von Tébo/Frédéric Thébault) und Les Chrono Kids (seit 2008; gez. von Stan/Stanislas Manoukian und Vince/Vincent Roucher). Zahlr. Ausz.: u.a. 1996 Alph'Art Jeunesse; 2004 Grand Prix de la Ville, beide Angoulême. – Strichbetonte, meist dynamisch-bewegt angelegte Zchngn, die stilistische Elemente der sog. Ec. Marcinelle um André Franquin mit Einflüssen US-amer. Underground-Comics, aber auch frz. Zeichner wie Marcel Gotlib kombinieren. ◉ E: 2010 Lausanne, Mus. de Design et d'Arts appliqués contemp. (K: P. Duvanel). ▭ *M. Feige*, Das große Comic-Lex., B. 2001; *P. Gaumer*, Dict. mondial de la BD, P. 2010 (s.v. Zep). – Dossier Zep, P. 2000 (Les dossiers de la bande desssinée, 8; WV); Dossier Zep, in: DBD 2004 (25) 48–71; *M. Béra u.a.*, Trésors de la bande dessinée. Cat. enc. 2007–08, P. 2006; *L. Grove*, Comics in French. The Europ. bande dessinée in context, N. Y. 2010. – *Online:* Bedetheque; Lambiek Comiclopedia; Zeporama. H. Kronthaler

Chapron, *Henri*, frz. Automobildesigner, Karosseriehersteller, * 30. 12. 1886 Nouan-le-Fuzelier, † 14. 5. 1978 Levallois-Perret. Gründet 1919 in Levallois-Perret die Fa. Ateliers H. C., die sich auf die manuelle Herstellung von Karosserien und Innenausstattung für Luxuxautos (u.a. Talbot, Delage, Delahaye) spezialisiert. Nach dem 2. WK arbeitet C. eng mit dem Autohersteller Citroën zus., für den er auf der Grundlage eines Entwurfs von Flaminio Bertoni zw. 1960 und 1971 eine zweitürige Cabriolet-Karosserie für das sog. Werkscabriolet (*Cabriolet Usine*) in seiner Wkst. fertigt. Bek. geworden ist C. v.a. durch seine eleganten, stromlinienförmigen Karosserien für die Baureihe Citroën DS („La Déesse" = Die Göttin) und die neben den Modellen für Citroën entwickelten eig. Cabriolets. Zw. 1958 und 1970 werden in C.s Wkst.-Atelier ca. 120 Chapron-Cabriolets in fünf Baureihen hergestellt (u.a. *La Croisette*, 1958–62, 52 Exemplare; *Palm Beach*, 1963–70, 30 Exemplare; *La Caddy*, 1960–68, 34 Exemplare), außerdem Coupés (*Le Paris*, 1958–60, 9 Exemplare; *Le Léman*, 1965–72, 25 Exemplare; *Le Dandy*, 1960–68) und Limousinen, darunter die *DS Présidentielle* (1968)

für Charles de Gaulle sowie einige Sondermodelle (*SM Mylord*, 1971; *SM Opera*, 1972, 8 Exemplare; *SM Présidentielle*, 1972). Zw. 1956 und 1962 fertigt C. außerdem Karosserien für den Grégoire Sport. Das extravagante, zukunftweisende Karosserie-Design macht C.s in kleiner Aufl. gefertigte Modelle zu gesuchten Sammlerobjekten. Nach C.s Tod führt seine Witwe die Fa. weiter, die noch bis 1985 besteht. ▣ AULNAY-SOUS-BOIS, Conservatoire Citroën. FRACKVILLE/Pa., JWR Automobile Mus. WOLFSBURG, Volkswagen Auto Mus. ▭ Dict. internat. des arts appliqués et du design, P. 1996. – H. C. carrossier (K), s.l. 1968; *N. van Wilgenburg*, H. C. carrossier, Arkel 1985; *H.-K. Lange*, Maserati. Der and. ital. Sportwagen, W. 1993; *D. Sparrow/A. Kessel*, Citroën DS, Lo. 1994; *D. Pagneux*, H. C., Boulogne 2002; *H. O. Meyer-Spelbrink*, Citroën DS, Brilon 2003; *H. Lehbrink*, Gericke's 100 Jahre Sportwagen 1905–2005, Dd. 2004; *M. Bobbit*, Citroën DS. Design icon, Dorchester 2005; *B. Long*, SM. Citroën's Maserati-engined supercar, Dorchester 2006. – *Online:* Website H. C. Carrossier; Motorlegend; Citroënet; Yesterdayauto.
 E. Kasten

Chapuis (Chapuis-Bräunig), *Dominique*, frz. Malerin, Graphikerin, Installations- und Objektkünstlerin, * 1952 Chalon-sur-Saône, lebt in Frankfurt am Main. Stud.: 1972–77 Univ. Dijon; 1984–87 Acad. Toulouse; 1987–89 Studienaufenthalte in den USA (u.a. New York, Washington); 1989–92 Abendkurse an der Staatlichen HBK Städel, Frankfurt am Main. – C.s Œuvre umfaßt abstrakte und konkrete Werke. Mit ihren konstruktiv-geometrisierenden zwei- und dreidimensionalen Arbeiten gehört sie seit den 1980er Jahren zu den konsequentesten Vertreterinnen der Konkreten Kunst in Hessen. In Tafelbildern, kubischen Objekten versch. Größe und gelegentlichen Installationen beschäftigt sie sich v.a. mit dem Problem von Fläche und Raum, das sie in versch. Werkgruppen und Techniken (Öl, Aqu., Gouache, Pastell u.a. auf Lw., Holz, [Transparent-]Papier; Mixed media) in einer Art forschender Kunstausübung immer wieder bearbeitet, wobei sie beim Aufbau ihrer Farbräume die konkret-konstruktiven Mittel in z.T. stringent reduzierter Weise auslotet. Horizontale Lineaturen, breite und schmale Streifen sowie v.a. horizontal ausgerichtete Flächenteilungen stehen bei C. für meditative Inhalte, die nahezu ausschließlich auf sich selbst verweisen. Char. ist die Absenz von Primärfarben; häufig verwendet sie mehr gedeckte Farben, v.a. lasiertes Rot, Blau („Maschinenblau"), Grün, Ocker und Violett. In einer umfangreichen Werkgruppe spürt sie dem Übergang zw. Fläche und Raum durch das Anbringen von geringes Profil bildenden Streifen (aus Holz, Kunststoff, Pappe, Textilien) nach, in einer and. nutzt sie ostasiatische Transparentpapiere als Bildträger, um (lt. Selbstäußerung) zu starke Farbkontrastwirkungen zu vermeiden. In einer weiteren Werkgruppe, in der C. monochrome Farbflächen in Beziehung setzt (*60x60x6 cm*; *80x80x6 cm*; *110x110x6 cm*; alle Acryl/Lw., 2007), gestaltet sie deren Übergänge häufig sfumato. Ihre skulpturalen, meist seriell angefertigten Objekte bestechen im Aufbau durch simple schachtel- und kastenähnliche Formen, die u.a. mit texti-

len Bandagierungen oder dynamisch aufgetragenen Texturen und Skripturen versehen sind und bisweilen sozialkritische Botschaften enthalten (Serien *Femmes* und *Les objets oubliés*, um 2002–03). Daneben u.a. auch narrativ-expressive Figurenbilder mit politischen Inhalten (*La Guerre*, 2003) sowie Objekt-Gest. für Performances mit Musikern und Tänzern (u.a. 2003 im Gallustheater in Frankfurt am Main). 2009–10 stellt C. einige ihrer Arbeiten gemeinsam mit Reinhard Roy, Hellmut Bruch und Gerhard Frömel in Kielce/Polen in der Ausst. Czworo spod znaku geometrii (Vier im Zeichen der Geometrie) an der dortigen Univ. aus. ▱ AMERSFOORT, Mondriaanhuis. DARMSTADT, Marienhospital. DÜREN, Kreishaus. ERFURT, Forum Konkrete Kunst. GÖRLITZ, Kultur-hist. Mus. Kaisertrutz. INGOLSTADT, Mus. für Konkrete Kunst. ROCKENHAUSEN, Mus. Pachen. ◉ E: Frankfurt am Main: 1997 (mit Rolf Bleymehl), 2001 (mit R. Roy) Gal. im Verwaltungsgericht; 1999, 2000 Gallustheater / 2000 Montceau, Centre Cult. le Car / 2002, '03 (K) Mainz, Haus Burgund / 2003 Berlin, Gal. für Konkrete Kunst (K). – G: 1999 Groß-Umstadt, Rathaus: Wahrheit ist, was empfunden wird / 2000 Lüdinghausen, Münsterland-Mus.: Forum 2000 (K) / Schwerin, KV Wiligrad: 2000 Die Farbe Weiß (K); 2008 Die Farbe Schwarz; 2009 Horizontal. Konkrete Kunst aus Europa / 2001 Bled (Slowenien): Worldfestival Art on Paper (K) / 2005 Gießen, Gal. Wosimsky: Konkrete Positionen. Rot+Schwarz+Weiß; Hünfeld, MMA: 1 Jahr – 40 Positionen – 31 Räume / 2007 Berlin, Heidrichs Kunsthandlung: Thema und Variation. ▭ Kürschners Hb. der Bild. Künstler. Deutschland, Österreich, Schweiz, I, M./L. 2007. – *G. Gappmeyer*, D. C. Farbraum und Bilderwelt (K), B. 2003. U. Heise

Charaba, georgischer Baumeister, 11. Jh. Errichtete die Georgskirche in Savane/Region Saččhere. Ch. wird zus. mit dem Stifter in einer Inschr. über dem W-Portal der Kirche erwähnt, eine weitere Inschr. nennt neben dem Stifter das Baujahr 1046. Die Kirche ist einschiffig und verfügt an der S-Seite über einen großen Anbau (Vorhalle). Motive und Char. der Verzierungen des Anbaus weisen auf einen and., wahrsch. etwas später wirkenden Baumeister hin. Die Georgskirche gilt ungeachtet ihrer relativ geringen Ausmaße als eines der herausragendsten georgischen Bauwerke des Hochmittelalters. Aufgrund ihrer technisch und konzeptionell kunstvollen Verzierung (Tür- und Fensterverkleidungen, Gesimse, Rosetten), die harmonisch auf die einfachen Bauformen abgestimmt sind, steht die Kirche in einer Reihe mit so bed. Bauten wie den Kathedralen in Kacchi (E. 10./A. 11. Jh.) und Nikorcminda (1014) sowie der Nikolauskirche in Patara-Oni (11. Jh.). ▭ Kartuli sabčota ènc., XI, Tbilisi 1987, 601. – *V. Beridze*, Dzveli kartuli ostatebi, Tbilisi 1967, 239. T. Gersamia

Charaf, *Rafic* (Šaraf, *Rafīq*), libanesischer Maler, * 5. 8. 1932 Baalbek, † Jan. 2003 Beirut (?). Stud.: 1952–55 Acad. Libanaise des BA; 1955–58 RABA de S. Fernando, Madrid (mit Stip. der span. Reg.); 1960–61 ABA Pietro Vannucci, Perugia (mit Stip. der ital. Reg.). Ab 1962 in Beirut tätig. Lehrtätigkeit: 1982–87 am Inst. FA der Lebanes Univ. (hier auch Dir.). Zahlr. Auslandsaufenthalte

in Frankreich, Spanien, Italien, Deutschland, den Niederlanden, England. Ausz.: 1955 1. Preis UNESCO-Ausst., Beirut; 1959 ebd. 1. Preis des Minist. für Bildung; 1963 Preis der Ile de France, Paris; 1973 Libanesischer Staatspreis. Mitgl. des mit der UNESCO verbundenen Komitees für libanesische Kunst. – C. arbeitet anfänglich meist in Kohle und stellt v.a. die ärmere Bevölkerung im Libanon, etwa Holzarbeiter oder Bauern, in expressiven Zchngn dar. Seine Darst. vom Bürgerkrieg führt er ebenfalls als Kohle-Zchngn aus. Ab M. der 1970er Jahre verwendet er in seinen Arbeiten arabische Kalligraphie und Talismane, Amulette und Symbole. Später experimentiert er mit versch. Medien: u.a. Holz und Goldblättern, die er in den frühen 1980er Jahren für eine Serie byz. Ikonen benutzt. Danach wendet er sich arabischen Helden zu, die v.a. in der Volkskunst und -kultur verbreitet sind und wird deshalb als Pionier der Umdeutung trad. arabischen Handwerks in die Hochkunst angesehen. Er stellt diese Heldenfiguren stark farbig und flächig (an Scherenschnitte erinnernd) dar. Er gilt zudem als einer der ersten libanesischen Künstler, der männliche Akte dar- und ausstellt. 1951 Ausst.-Début in Baalbek; bis 1961 jährliche Teiln. an den UNESCO-Ausst. in Beirut. Des weiteren 1963–72 regelmäßige Ausst. im Hotel Carlton und 1973–75 in der Gal. Contact in Beirut. Insgesamt stellt C. seine Werke auf 45 Einzel-Ausst. aus und nimmt an zahlr. Expositionen im Libanon und im Ausland teil, u.a. an den Bienn. von Venedig, Moskau (1959), Tokio, Sofia und Wien (1973). ◉ G: 1963, '65 Paris: Bienn. / 1973 São Paolo: Bien. / 2009 Beirut, Beirut AC: The Road to Peace. Paint. in Times of War 1975–1991; Maqam AG: Landscapes. Cityscapes. ▭ *M. Fani*, Dict. de la peint. au Liban, Beyrouth/P. 1998; *Bénézit* III, 1999; *L. und G. Cazabat d'Hauteville*, Ardalil. L'argus des artistes libanais, Beyrouth/P. [2001]. – *E. Lahoud*, L'art contemp. au Liban, Beyrouth 1974; *R. A. Chahine* (Ed.), Cent ans d'art plast. au Liban 1880–1980, I, Beyrouth 1982; *D. Bellmann*, Arabische Kultur der Gegenwart, B. 1984; Lebanon. The artist's view (K), Lo. 1989; La rev. du Liban v. 1.–8. 2. 2003. M. Kühn

Charag-Zuntz, *Hanna* (geb. Zuntz), dt.-israelische Keramikerin, * 15. 9. 1915 Hamburg, † 29. 4. 2007 Haifa, lebte dort. Mutter der Keramikerin Michal Alon (* 1951 Haifa, lebt in Hadar-Am). C.s eigentlicher Berufswunsch (Ärztin) bleibt unerfüllt, da sie als Jüdin nach 1933 an der Immatrikulation an einer dt. Univ. massiv gehindert wird. 1932–33 Gasthörerin an der Univ., Hamburg (Kunstgesch. bei Erwin Panofsky, Gustav Pauli, Willibald Sauerländer); 1934–35 Besuch der KSch Reimann in Berlin; 1935–39 keramische Ausb.: 1935 bei Siegfried Möller in Kupfermühle b. Hamburg und 1936 bei Gudrun Schenk in Stuttgart-Degerloch; ab Sept. 1936 bis Herbst 1938 Keramik-FS, Teplitz-Schönau; 1938 ABA, Florenz; 1939 KA, Prag. 1940 Emigration nach Palästina (dort schwer erkrankt). Unterricht an Schulen in Tel Aviv und Jerusalem sowie Arbeit in der Wkst. von Hedwig Grossmann ebd. (bis Jan. 1943). Betreibt anschl. zus. mit arabischen Töpfern eine Wkst. in Bait Dschala b. Bethlehem. 1943 Übersiedelung nach Haifa, dort bis 1944 Betriebsleiterin

bei der Fa. Kühns Ceramics. Bis 1946 fertigt sie Musterserien für Sanitärkeramik und entwirft Wandverkleidungen für keramische Firmen. Ab 1945 eig. Wkst. auf dem Berg Carmel ebd. C.s. soziales Engagement zeigt sich in der Arbeit mit Straßenkindern, Kriegsverletzten sowie körperlich und geistig Behinderten (z.B. 1949–51 keramische Arbeitstherapie mit Kriegsblinden, zus. mit Prof. Michaelson). Lehrtätigkeit: 1948–49 Planung der Ausb. an der neu gegr. Berufs-FS Kfar Batya, Raánana; 1954–78 Oranim Art Inst., Kiryat Tivon; 1956–65 TH und Univ. (1979 Prof.), Haifa, sowie TH, Tel Aviv. Ausz.: 1964 Industrial Design Centre, TH, Haifa; 1967 Industrial Design Centre, TH, Tel Aviv; 1969 Eretz Israel Mus. ebd.; 1968 Ernennung zum Mitgl. der Acad. Internat. de la Céramique, Genf. 1964 Gründungs-Mitgl. des World Craft Council der UNESCO und Repräsentantin für Israel bis 1968; 1979 Mitgl. des Israel Inst. of Industrial Design. – C. gehört zu den Begründerinnen einer israelischen Keramikkunst. Durch ihre Studien, Forschungen und Experimente schafft sie wichtige Grundlagen für nachfolgende Keramikergenerationen. Sie gestaltet v.a. frei gedrehte Gefäße (u.a. Vasen, Krüge, Schalen) in einfachen, klaren Formen mit glatter Oberfläche und dünnem Überzug in blassen sowie kräftig leuchtenden Farbtönen. C. arbeitet mit Irdenware, Steinzeug, Porzellan und schamottehaltigen Scherben und verwendet selten Glasuren. Der Dekor beschränkt sich auf zurückhaltende, mit dem Pinsel ausgeführte horizontale Linien. Des weiteren beschäftigt sie sich mit der Wiederbelebung der antiken Terra sigillata, die sie selbst häufig fertigt und deren Herstellung sie ihren Schülern vermittelt. Zu C.s. Zielen gehört u.a. die Entwicklung eines guten Designs für die Massenproduktion im Sinne des Bauhauses. ⌂ HAIFA, MMA. RENDSBURG, Jüdisches Mus. TEL AVIV, Eretz Israel Mus. ◉ E: 1959, ’66 Hazorea, Wilfrid Israel Mus. / 1960 Ramat Gan, Beit Zvi / 1961, ’70 (mit Tova Berlinski; K) Haifa, MMA / 1967 Tel Aviv, Eretz Israel Mus. / Tokio: 1972 Mitsukoshi AG; 1973 Takashimaya AG / 1976 Hamburg, MKG (mit Ruth Duckworth; K) / 1998 Düsseldorf, Hetjens-Mus. (mit Varda Yatom; K). – G: 1936 Hamburg, Buchhandlung und Kunstgew.-Stube Dunk-Marcus: Töpferarbeiten von jüdischen Keramikkünstlern / 1952 (Cramer-Preis), ’56 (1. Preis) Jerusalem, Israel Mus.: Israelisches Kunsthandwerk / 1955 Haifa, MMA: Israelische Keramik (1. Preis) / 1958 Brüssel: WA / 1961 Tel Aviv: Internat. Ausst. für Angew. Kunst (1. Preis) / 1967 Montreal: WA. ▭ M. Bruhns, Kunst in der Krise, II, Ha. 2001 (Lit.); H. Brenner, Jüdische Frauen in der bild. Kunst, II, Konstanz 2004. – A. Soléau, Neue Keramik 6:1998/99 (7) 406; ibid. 2007 (4) 4. F. Krohn

Charalambous (Charalambus; Charalampous; Haralambos), *Andreas*, griech.-zyprischer Maler, Bühnenbildner, Übersetzer, * 1947 Nikosia, lebt und arbeitet dort. Stud.: 1969–75 Malerei an der Moskauer Surikov-KHS mit einem Stip. der Sowjetunion. Lehrt 1976–77 als Kunstlehrer auf Zypern und zw. 1978 und 1980 als Ass. an der Surikov-KHS, Moskau. 1980 Rückkehr nach Zypern. Dort 1981 Gründung der eig. priv. KSch To spiti tou kallitechni (Das Haus des Künstlers) in Nikosia. 1983 Gast-Doz.

für zyprische Kunst am Pratt Inst. in New York. Mitgl.: Epimelitiriou Kalon Technon Zypern/Vrg bild. Künstler Zypern; 1983–86 deren Präsident. Mehrere Reisen nach Schweden (u.a. 1993, 2003, ’09), dort gemeinsame Ausst. mit dem in N-Zypern lebenden türkischen Maler Emin Çizenel (2003 in Visby). – C. malt in unterschiedlichen, v.a. realistischen Stilrichtungen Figurenbilder, Akt-Darst., Portr., Stilleben, Lsch. sowie mythologisch-hist. Sujets. Hierbei finden sich immer wieder Rückgriffe auf tradierte kunstgesch. Motive oder spezifische Werke, so rekurriert sein Tondo *Allegorie des Millenniums* auf Dürers *Melancolia*. Daneben gibt es z.B. Stilleben, in denen eine an das Surrealistische grenzende, überdimensionierte Präsenz unbelebter Gegenstände zu konstatieren ist. In seinen Werken hat er sich teilw. auch kritisch zur politischen Situation des geteilten Zypern und zum Nationalismus geäußert, so in der triptychonartigen Bildserie *Kaffee*: Auf der Mitteltafel ist eine in zwei Hälften zerbrochene Tasse dargestellt, eingerahmt von fragmentierten Farbflächen (Weiß-Blau und Weiß-Rot) als Verweise auf Unfrieden (Scherben) sowie die Nationalfarben von Griechenland und der Türkei. Auf den Außentafeln stehen je eine unversehrte und mit Kaffee gefüllte Tasse mit den identitätsstiftenden Symbolen beider Länder (u.a. Kreuz und Halbmond auf der Crema). C. zeigt damit, daß beide Staaten den Kaffee (fälschlich) als „ursprüngliches Nationalgetränk“ reklamieren, dieser wird somit zum Zeichen für (Non-)Kommunikation, Krieg und Frieden. Gelegentlich auch Buch-Ill. (Lyrik Yiorgos Philippou Pierides, Nikosia 1995). Daneben hat C. auch Erzählungen von Gabriel García Márquez und Anton Čechov ins Griechische übersetzt und als Kostüm- und Bühnenbildner gearbeitet, u.a. 1977 für „Die Insel“ von Athol Fugard (Theatrikou Organismou Kyprou/Cyprus Theatre Organisation) oder 1981 für „Baltazars unvergeßlicher Tag“ und „Die Frau, die genau um sechs kam“ von G. G. Márquez (Nikosia, Theatro Dramatos kai Komodias; hier auch Werkübersetzung und Regie). Im Jahre 2006 zerst. ein Brand C.s Atelier in Nikosia, was zum Verlust von ca. 1700 Werken führt, so daß ein großer Teil seiner früheren Arbeiten heute nur noch durch Fotos dok. ist. C. ist 2010 an der politisch bedeutsamen Wander-Ausst. Cyprus Art for Peace beteiligt, die sowohl im türkisch besetzten N-Zypern als auch im griech. Landesteil in mehreren Städten gezeigt wurde. – Nicht zu verwechseln mit dem in Zypern aufgewachsenen gleichnamigen griech.-US-amer. Maler, Fotografen und Designer *Andreas Charalambous* (* 1960 London, lebt in Washington). ⌂ GÄLLIVARE, Mus. NIKOSIA, State Gall. of Mod. Cypriot Art. PRILEP, Muz. ◉ E: Nikosia: 1973, ’90 Argo Gal.; 1977 Zygos Gal.; 1984 Rembrandt Gal.; 1986 StKH; 2003 Gloria Gal. (mit Emin Çizenel) / Limassol: 1981 Polytopo Gal.; 2007 Studio 55 / 2002 Larnaka, Kypriaki Gonia Gal. ▭ LEK IV, 2000. – A. Chrysochos, Kyprioi kallitechnes, Lefkosia 1982, 235; 33 kyprioi kallitechnes, Lefkosia 1987 (Kypros, 2), 215–217; L. Å. Everbrand/K. Linder, Avesta art 2010 (K), Avesta 2010, 9–10. E. Kepetzis

Charalambous (Charalampous, Haralambous), *Panos*, griech. Maler, Konzept- und Installationskünstler, Hoch-

schullehrer, * 1956 Akarnania, lebt und arbeitet in Athen. Wächst in einer Tabakbauern-Fam. auf. Stud. in Athen: 1981–83 Univ.(Soziologie); 1983–88 HBK (Malerei bei Nikos Kessanlis); hier seit 1992 Lehrtätigkeit (2002 Prof. für Malerei). 1996–97 an der Fac. de BA in Madrid (Socrates Exchange Program; Kooperation mit Manuel Parraio Dorado). – V.a. drei große Themenkomplexe (Tabak, Fischerei, Volkstanz). Debütiert ab 1987 mit Arbeiten, die er unter den Begriff *Kapnologio* (Die Gesch. des Tabaks) subsumiert. Er beschäftigt sich in Malerei und Installationen mit der Tabakpflanze, ihren Aufbereitungsverfahren (u.a. Trocknen der Blätter) und dem Endprodukt. Die Anordnungen werden ergänzt durch Fotos, Texte, Grafiken und Landkarten, so daß der Betrachter aufgefordert ist, die möglichen Implikationen der Arrangements und damit der Gesch. der griech. Tabakproduktion zu reflektieren. 1990–95 entsteht die installative Serie *Über die Fischerei*, in der sich C. dem Fischereihandwerk am heimatlichen See Amvrakia zuwendet, indem er entsprechende alltägliche Gegenstände (Netze, Harpunen, Gewichte, Köder, Haken, Eiskästen) mit weiterem Mat. u.a. neuen subjektiven Narration verbindet. Hierbei geht es C. auch um eine Auseinandersetzung mit der Rolle der Kunst und des Künstlers: So entsteht ein fotogr. Selbstbildnis, das ihn am Ufer des Sees zeigt, wie er auf zwei Bündel mit Fischen in seinen Händen blickt. Dieses Portr. ist eine spiegelverkehrte Nachstellung eines berühmten antiken Freskos (Akrotiri, Santorin), das als Schwarzweiß-Reprod. ebenfalls in die Installationen integriert wird und die lange Gesch. des Fischfangs in der menschlichen Entwicklung illustriert. Auch in and. Arbeiten setzt sich C. mit der griech. Kunst in Zitatform auseinander. E. der 1990er Jahre wendet er sich dem griech. (Volks-)Tanz zu, der als tradierte Freizeitgestaltung unter Einbeziehung u.a. von eig. Videoproduktionen und Fotos (u.a. C. als Volkstänzer) installativ erkundet wird. Im Zentrum der Arbeit steht die Frage nach der Konstituierung der griech. Identität und ihrer Verortung zw. den Trad. der Vergangenheit und den Brüchen der mod., urbanen Gegenwart. 1998 stellt C. alle drei Themen in einer Ausst. (Gal. Foka, Thessaloniki) als eine Trilogie der menschlichen Erfahrungen vor; seither lotet er die gleichen Themen in weiteren Varianten aus. ⌂ ATHEN, Nat. AG. THESSALONIKI, Macedonian MCA. TRIKALA, Beltsios Coll. ⊙ *E:* Athen: 1988, '90, '92, '93, '95, '98, 2001, '03, '06 Gal. Artio; 2006 Batagianni Gal.; 2009 Gal. Donopoulos (mit Nick Tranos und George Charvalias) / 1991 Berlin, Redmann Gal. – *G:* Athen: 1989 Ergostasiakos Choros Piräus 256: Anti Festival. Story of tobacco; 1992 Nat. AG: Transformations of the Modern – The Greek Experience; 2006 Metrostation Chalandri: Urban Totems / 1991 Antwerpen, Nine AG: Texture / 1997 Montrouge: Salon / Thessaloniki: Macedonian MCA: 2002 (The Pioneers (Beltsios Coll.).; 2007 (Who is here); 2005 Mus. of Photogr.: Photosykyria. ▭ LEK IV, 2000; *Delarge*, 2001. – Arte factum 1988 (24) 60; Kunst, Europa. 63 dt. KV zeigen Kunst aus 20 Ländern (K), Mainz 1991; Egoismos (K Spititis Kyprou), At. 1991; Makedoniko Mouseio Synchronis Technis (K), I, Thessaloniki 1999, 444–447; C. 1997–2001

(K Gal. Artio), At. 2001; C. Phonopolis (K Gal. Artio), At. 2004; *E. Hamalidi* (Ed.), Contemp. Greek artists, At. 2004, 40–41; To skiachtro. The scarecrow (K Metsovo), At. 2006. – ; – *Online:* Donopoulos Internat. FA; Thessaloniki MCA. E. Kepetzis

Charara, *Adnan*, US-amer. Maler, Graphiker, Zeichner, Bildhauer, * 1962 Libanon, lebt in Detroit/Mich. Aufgewachsen in Sierra Leone, wo er sich autodidaktisch mit Zeichnen (Tusche) und Malerei beschäftigt. Stud.: ab ca. 1981 Univ. of Washington, Seattle; Yakima Valley Community College, Yakima/Wash.; bis 1986 Massachusetts College of Arts, Boston (Archit.). Zunächst tätig als Regionalplaner für den Staat Massachusetts, danach freischaffend als Künstler. Gelegentliche Zusammenarbeit mit der Gruppe OTHER: Arab Artists Collective Detroit bei kommunalen Kunstprojekten. – C.s farbenfrohe Bilder, mitunter mit afrikanischen Einflüssen, wirken auf den ersten Blick anziehend, narrativ, verspielt und humorvoll, sprechen jedoch – oft in sinnbildhafter Weise – fundamentale Probleme wie Ungerechtigkeit, Ängste u.a. Defizite der zeitgen. Ges. oder auch die Thematik der Emigration an. Zchngn (u.a. Aqu., Tusche) und Gem. (Acryl) nehmen stilistische Anleihen aus versch. Perioden und Richtungen auf (z.B. Renaiss., Kubismus, Futurismus in *Migrating*, Mixed media) und zeigen eine Vielzahl über die gesamte Bildfläche verstreute, grotesk verformte, cartoonhafte, mitunter miteinander verwobene Gesichter und Figuren, oft in einer chaotisch wirkenden Stadtlandschaft. Für eine Reihe von Zchngn wählt C. gebrauchte Briefumschläge als symbolisch verstandene Bildträger. Darüber hinaus Rad. und Siebdrucke (*I am an Arab American*, Giclee, Siebdruck, 2005) sowie Skulpt. aus auf Flohmärkten erworbenen Fundstücken (Hämmern, Schraubenschlüsseln u.a. Werkzeugen) oder auch Plastiken aus Wachs bzw. Ton (für einen späteren Bronzeguß). ⌂ BOSTON, Public Libr. DEARBORN/Mich., Arab Amer. NM. – Univ. of Michigan. DETROIT, Inst. of Art. LOWELL/Mass., Lowell Public Libr. – Whistler House Mus. of Art. PROVIDENCE, Rhode Island Black Heritage Soc. Mus. WASHINGTON/D. C., Corcoran College of Art and Design. ⊙ *E:* seit 1992, u.a. 2007 Dearborn (Mich.), Arab Amer. NM / 2008 Sheboygan, John Michael Kohler AC, Art Space / 2010 Boston, Gurari Coll. Gall. – *G:* u.a. 2005 Washington (D. C.), Corcoran College of Art and Design: Re-Interpreting the Middle East. Beyond the Hist. Stereotype. ▭ *F. S. Oweis*, Enc. of Arab Amer. artists, Westport, Conn./Lo. 2008 (Lit). – Diversity in harmony (K Alfred Berkowitz Gall.), Dearborn 2003. – *Online:* Website C.; The Detroiter v. 4. 5. 2007; *J. F. Ficara*, Canvas guide v. 29. 6. 2012. C. Rohrschneider

Charbel, *Hanna El Otra*, brasil.-libanesischer Maler, * 4. 4. 1951 Baslukit/Libanon, lebt und arbeitet in São Paulo. Dort seit seinem zweiten Lebensjahr ansässig. Als Künstler Autodidakt. Ausz.: 1977 Große Gold-Med. des Salão de Arte, São Bernardo do Campo. – C.s Werk, das sich durch Ironie und schwarzen Humor bes. in den Bildtiteln auszeichnet (*Elmo coletivo*, Acryl, Aluminium/Holz, 1974), entwickelt sich von einer dunklen, opaken Farbig-

keit hin zu einer helleren, freundlicheren Palette (meist Blau und Braun mit wenigen hellen Akzenten). Die zunächst aggressive Malerei, die an die écriture automatique der ersten Surrealisten angelehnt ist, wird zunehmend beruhigt. Die Bilder werden mehr und mehr konstruiert. Seine Figuren entwirft C. nun vorher und plaziert sie in klarer definierten Szenarien (*Lennon*, 1980). Die Gem. (Acryl/Lw.) und Zchngn mit phantastischer, symbolträchtiger Ikonogr., die eine gewisse Härte aufweisen, sind dem Magischen Realismus zuzuordnen (*Viva, o Mistério Acabou*, 1982; *Sumo Sacerdote*, 1977) und schwer zu entschlüsseln. 1983 präsentiert C. in der Gal. ELF in Belém Werke aus Papier und Briefumschlägen, die aus der Korr. des Künstlers mit Gileno Chaves, Kurator und Kritiker, anläßlich einer Reise nach Belém und in den Folgejahren entstanden. Der Briefwechsel enthält Kommentare, Reiseerinnerungen und Reflexionen über zeitgen. Kunst und das Publikum. Dieser Dialog wird 2009 mit einer neuen Ausst. (Retorno a Belém) mit ähnlichen Werken (14 Briefumschläge, teilw. übermalt mit Acryl, gefaltet) wieder aufgenommen und von Chaves' Witwe kuratiert. C. schafft zudem Assemblagen, etwa *Mon. à Batman e ás bactérias* (2008) aus einem wie Fledermausflügel gespannten Stück Stoff und Metallschienen, und Collagen wie *Dama de Espadas* (2010), eine Spielkarte mit dem doppelt angeordneten Bild der Mona Lisa. C. spielt in seinen Werken auf die Trad. der alten Meister an, etwa in *Releitura de Arcimboldo* (2007), eine Assemblage, die aus Fundstücken und Metallfolien einen Kompositkopf des Prager Hofmalers aus der Mitte des 16. Jh. nachstellt. In jüngster Zeit beschäftigt sich C. auch mit Digital-Fotogr. und montiert z.B. Teile eines and. Gesichtes in sein eig., so daß eine Serie mit ähnlichen Portr. entsteht und eine Art Verwandlung abbildet (*Xadrez genético*, 2010). ▭ SÃO BERNARDO DO CAMPO, Pin. ◉ *E:* São Paulo: 1975 Clubinho; 1979, '81 (K), '84 (K) Gal. Paulo Prado / 1979 Santos, Gal. do Centro Cult. Brasil Estados Unidos / 1984 Belém, Gal. ELF. – *G:* 1971 Santo André, Salão de Arte Contemp. (Debüt) / 1979 São Bernardo do Campo, Paço Mpal: Rotativarte / São Paulo: 1980 Salão Paulista de Artes Plást. e Visuais; MAM: Panorama da Arte Atual Brasil. / 1981 São José dos Campos, Gal. da Caixa Econômica Estadual: Arte Fantástica / 1982 Rio de Janeiro, Salão Nac. de Artes Plást. / 1983 Brasília, Gal. Oscar Seraphico: 5 artistas / 2005 Santa Cecília, Espaço Cult. Unisanta: Artistas plást. ▭ *Ayala*, 1997. – *Online:* Inst. Itaú Cult., Enc. artes visuais, 2008.

C. Melzer

Charbonel, *Jean-Claude,* frz. Maler, Bildhauer, Illustrator, Objektkünstler, * 1938 Clichy/Hauts-de-Seine, lebt in L'Hermitage-Lorge/Côtes-d'Armor. Verh. mit der Schriftstellerin Monique C. Nach einem kunstgew. Stud. arbeitet C. zunächst als Dekorateur. 1959–60 Beteiligung an Ausst. und and. Aktivitäten der Gruppe La Nep. 1964 Mitbegr. der surrealistischen Gruppe RUpTure (mit Pascal Colard, Monique C., Pierre Nesterenko, Claude Boileau, Robert Radford), deren gleichnamige Zs. er ab 1965 herausgibt. 1965 und 1973 Aufenthalte auf Martinique und Guadeloupe. C. verläßt 1972 die Gruppe RUpTure und ist ab 1975 Mitgl. der Gruppe Phases, an deren Ausst. er regelmäßig teilnimmt und die er z.T. organisiert (z.B. 2002 Saint-Brieuc, Gal. Frédéric Thibault: 26 Images du Mouvement Phases; 2008 ebd., MAH: Phases à l'ouest [K]). In den 1970er Jahren Stud. der Kunstpädagogik. C. läßt sich 1986 in der Bretagne nieder (zunächst in Plœuc-sur-Lié) und engagiert sich für die kulturelle Autonomie der Bretonen (1995 Mitbegr. des Collectif des Artistes plast. des Côtes-d'Armor, welches u.a. 2003 die Bienn. Armoricaine d'Art vivant/contemp. ins Leben ruft). – E. der 1950er Jahre debütiert C. mit der malerischen Darst. von Träumen und experimentiert fortan in surrealistischer Trad. mit automatischen Verfahren. In geometrisch-abstrakten, dem Surrealismus nahestehenden Werken, die mit archaischen, totemähnlichen Figuren und Symbolen bevölkert sind, stellt er Geschichte und Mythen der Bretonen dar. Für die plastischen Arbeiten (Assemblagen, Skulpt., Objektkästen) verwendet er häufig objets trouvés (Strandgut, Steine, Maschinenteile). Diese Fundstücke integriert C. auch in die Gem. (meist in Acryl und Öl, häufig Mischtechnik), die bevorzugt in Kratz- und Wischtechnik entstehen. Dort nutzt er sie als Schablonen (auch Pflanzenteile, v.a. Blätter von Farnen), deren Umrisse mittels Farbsprühverfahren festgehalten werden. Auch Ill., u.a. zu: Ludovic Tac, *Entre deux âges*, P. 2001; Jacques Lacomblez, *Pages de Mégarde*, Nevers 2008. ◉ *E:* seit 1960, u.a. 1995 Saint-Brieuc, Gal. d'Art contemp., Lycée Eugène Freyssinet / 2004 Dinard, Espace Pablo Picasso / 2011 Aberystwyth, Nat. Libr. of Wales (mit John Welson). – *G:* 1968–69 Paris, Gal. Ranelagh: En contrechamps. La main à propulseur / 1988 Le Havre, Mus. Malraux: Phases. L'expérience continue (K) / 1994 Plémet, Collège public Louis Guilloux: Planisphère Phases (K; Wander-Ausst.) / 2009 Lorient, Gal. Faouëdic: Salon Bretagne, Terre des Arts (Ehrengast). ▭ Imagination. Internat. Ausst. bildnerischer Poesie (K), Bochum 1978; *Wilhelmi*, 2006; *L. Tac*, Les voyageurs du temps des rêves armorigènes, 2006 (Film).

F. Krohn

Charbonnier, *Yann,* frz. Fotograf, * 4. 11. 1964 Angers/Maine-et-Loire, lebt in Paris. Anfangs versch. Tätigkeiten (u.a. 1982 Mitarb. in einem Fotolabor in Missoula/Montana; 1984–88 Ass. bei mehreren Fotografen in New York und Paris). Ausz. und Stip.: 1991 Fond. Jean-Luc Lagardère; 1992 Festival des jeunes créateurs, Tignes; Prix Villa Medicis Hors-les-Murs; 1995 Bourse du Fiacre. Seit 1989 freiberuflicher Fotograf. 1991 Kurzfilme. Zahlr. Reisen, u.a. 1996–98 in Asien. 1991–2001 weltweit fotografiertes Langzeitprojekt über Tiere und das Verhältnis von Mensch und Tier, v.a. bei der Jagd (u.a. 1998 Ausst. in Deutschland, Österreich und USA). C.s körnige Schwarzweißaufnahmen von Lsch., Details, Menschen- und Tier-Portr. erzeugen einen teilw. surrealistischen Eindruck. 2003 Reportage über Prag. Außerdem Künstler-Portr. und Auftragsarbeiten. Zur Zeit Portr.- und Naturaufnahmen. ◉ *E:* 1991 Montpellier: Bienn. / 1992, '94 New York, Gal. Cadé / 1993 (K), '94 Düsseldorf, Gal. Curtze / 2000 Köln, Gal. Greve / Paris: 2000 Gal. Greve; 2006 Gal. Gaillard (mit Edouard Boubat und Louis Swi-

ners); 2009 Gal. Artheme / 2008 Aix-en-Provence, Flâne-
ries d'art. – *G:* 2010 Köln, Gal. in focus: exposed. Ero-
tische Fotogr. des 20. Jh. ⌑ *Delarge*, 2001. – Vivre le
sport!, P. 2006 (Fotogr. von C. u.a.); Archit. postale. Une
hist. en mouvement, P. 2010 (Fotogr. von C. u.a.). – *On-
line:* Website C. N. Buhl

Charbov, *Petăr,* bulg. Architekt, * um 1903 Dobrič, tätig
in Sofia. 1930 Archit.-Dipl. der Univ. in Gent. Erhielt 1933
die offizielle Erlaubnis zur priv. Entwurfstätigkeit vom Mi-
nist. für öff. Bauten, Wege und Stadtplanung. Ca. 1935–46
in der Archit.-Abt. des Minist. tätig. 1935 Vertreter der
Ges. Bulg. Architekten in der Jury zum Wettb. um ein Fe-
rienhaus in Varna, E. 1946 Mitgl. einer von der Reg. einge-
setzten Komm. zur Inventarisierung der Möbel der ehem.
bulg. Königin. ⌑ BELGRAD: Bulg. Botschaft, 1939–40
(mit A. Benčev). SOFIA, bul. Penčo Slavejkov, Medizin-
Akad.: 1. Chirurgische Klinik, Entwurf 1935–36 (mit Vik-
torija Angelova-Vinarova, Boris Kapitanov), Bau bis 1941
(Aufstockung um ein Geschoß 1944–47 durch Marija Sa-
pareva; erneute Aufstockung 2009–10). ✉ Tipovi pro-
ekti za chigienni bani, in: Komunalno stopanstvo 1967
(6) 21–24. ⌑ Dăržaven vestnik 1933 (138); 1936 (54)
827; Architekt 1935 (2–5) 22; Spisanie na BIAD 1939
(19) 250; *L. Tonev u.a.* (Ed.), Architekturata v Bălgarija
sled 9. IX. 1944 g., Sofija 1954, 66; *G. Repninski,* in:
Architekturata v Bălgarija 1878–1944, Sofija 1978, 130;
S. Kovačevski/P. Iokimov, in: Architekturata v Bălgarija
1878–1944, Sofija 1978, 206–236. – *Online:* C. Kjose-
va, Monarchičeskoto nasledstvo na Bălgarija, bei: Nov
bălgarski universitet (www.nbu.bg). L. Stoilova

Chardon, *Nicolas,* frz. Maler, Bildhauer, * 1974 Cla-
mart/Hauts-de-Seine, lebt in Paris. Stud.: 1992–97 ENS-
BA, Paris; 2006–07 Ec. supérieure des BA, Nantes
(Forsch.-Programm); 2008–09 Villa Medici, Rom. – C.s
Werke stehen sowohl in der Trad. von Suprematismus als
auch Konkreter Kunst und Minimal art. Als Bildträger
für seine abstrakten Acryl-Gem. verwendet C. meist auf
Rahmen gespannte, bedruckte Stoffe (v.a. mit Karomus-
ter). Vorherrschend sind einfarbige geometrische Formen
(v.a. Quadrate) mit unregelmäßigen Umrissen (häufig in
Schwarz auf weißem Grund und umgekehrt), die teils ein-
zeln, teils gruppiert auf der Lw. angeordnet sind. Auch
(geometrisch-)abstrakte Plastiken. ⌑ CHÂTEAUGIRON,
FRAC Bretagne. DIJON, FRAC Bourgogne. LUXEMBURG,
MAM Grand-Duc Jean (Mudam). PARIS, FNAC. STRAS-
BOURG, MAMC. ◉ *E:* 2002, '05, '08, '10 Paris, Gal.
Jean Brolly / 2003, '07, '09, '11 Luxemburg, Nosbaum &
Reding Art Contemp. / 2004 Gennevilliers, Gal. Edouard
Manet / 2006 Seoul, Gaain Gall.; Berlin, Gal. 2yK (K) /
2007 Brétigny-sur-Orge, Centre d'Art contemp. / 2007,
'10, '11 Amsterdam, Gal. van Gelder / 2008 Nantes, MBA
(mit Karina Bisch). – *G:* 1999 Brest, Centre d'Art Passe-
relle: Philia / 2003 Ivry-sur-Seine, Centre d'Art contemp.:
La Partie continue 1 / 2005 La Seyne-sur-Mer, Villa Ta-
maris: Une Peint. sans Qualités / 2006 Berlin, Martin-
Gropius-Bau: Peint. – Paint. / 2008 Dijon, FRAC Bourgo-
gne: Dimensions variables / 2010 Paris, MAMVP: Secon-
de Main / 2011 Karlsruhe, SKH: Lumière Noire – Neue

Kunst aus Frankreich; Calais, MBA et de la Dentelle:
L'art est un sport de combat / 2012 Luxemburg, MAM
Grand-Duc Jean (Mudam): Les Détours de l'Abstraction.
⌑ *Delarge*, 2001. – N. C. Cat., Ffm. 2005; N. C. Pain-
tings from the future (K Düsseldorf), Strasbourg 2005. –
Online: Website C. F. Krohn

Charen (Hofmann), *Beatrice,* schweiz. Bildhauerin,
* 26. 2. 1945 Zürich, lebt in Schöftland/Aargau. Führt bis
2011 ebd. mit ihrem Ehemann Fred C. ein Specksteinate-
lier. – Stilistisch wandlungsfähig, arbeitet C. je nach An-
liegen gegenständlich, formal vereinfacht, stilisiert oder
abstrakt und bevorzugt Stein (Marmor, Travertin, Alabas-
ter, Speckstein; seltener wählt sie Ton oder Bronze). Ihre
einfühlsam gestalteten, teils hintergündig-geheimnisvoll
wirkenden, Melancholie oder Gelassenheit ausstrahlenden
Arbeiten, die sich dem Betrachter erst auf den zweiten
Blick erschließen (z.B. durch halb verborgene, verschlei-
erte oder anderweitig verhüllte Gesichter) und ihn damit
auch zu innerer Einkehr bewegen sollen, bringen C.s Sehn-
sucht nach Transzendenz zum Ausdruck (*Blick ins Uni-
versum*). ⌑ HAMBURG, Ohlsdorfer Friedhof, Gedenk-
platz für nicht beerdigte Kinder: Skulpt., Marmor, 1999.
◉ *E:* 2003 Maur, Werk-Gal. (mit der Malerin Mirjam
Thomen, * 12. 2. 1949 Zürich) / 2006 Gontenschwil, Gal.
Schlössli. ⌑ BLSK I, 1998. – *N. Zurbuchen,* Maurmer
Post v. 6. 6. 2003. – *Online:* SIKART Lex. und Datenbank;
Specksteinatelier. R. Treydel

Charfi M'Seddi (Charfi), *Fatma,* tunesische Multime-
diakünstlerin, * 29. 1. 1955 Sfax, lebt seit 1987 in Bern.
Stud.: ab 1975 Inst. supérieur des BA, Tunis; 1980 Pro-
motion am Inst. d'Esthétique et des Sc. de l'Art, Univ.
Paris-1 Sorbonne; 1990 Weiterbildung an der Ec. supéri-
eure d'Art visuel, Genf. – In politisch und sozialkritisch
motivierten Arbeiten setzt sich C. intensiv mit dem tra-
dierten Frauenbild ihrer afrikanischen Heimat auseinan-
der. Dafür gestaltet sie Installationen und Performances,
zudem plastische, Foto- und Videoarbeiten sowie oftmals
in Serien ausgef. gegenständliche Gemälde. ✉ *C. u.a.,*
En quête de liberté (K Frauen-Kunstforum), Bern 1995.
◉ *E:* Bern: 1998 Frauen-Kunstforum; 2001 Kunstkeller;
2002 Stadt-Gal. / Lausanne: 1999 Pal. de Rumine / 2006
Univ.-Klinikum (CHUV) / Tunis: 1999 Maison des Arts;
2006 Gal. El Marsa / 2007 Baltimore (Md.), Mus. of Art. –
G: 1998–2004 Dakar: Bienn. Dak'Art (2000 Grand Prix
Léopold Sédar Senghor) / 1999 Alexandria: Internat. Bi-
enn. für zeitgen. Kunst (Preis der Jury) / 2000 Hannover:
WA (Expo) / 2003 Kairo: Bienn. ⌑ BLSK I, 1998. –
S. Albrecht u.a., So wie die Dinge liegen (K Phoenixhal-
le), Dortmund 2004; Einander. Osnabrücker und tunesi-
sche Künstler (K Osnabrück), Bramsche 2007. – *Online:*
SIKART Lex. und Datenbank; Website C. (2007).

 R. Treydel

Chari (Hari), *Charikleia (Harikleia; Joyce),* griech. Archi-
tektin, Konzeptkünstlerin, Fotografin, * 1970 Athen,
lebt und arbeitet dort. Stud.: Univ., Thessaloniki (Archit.);
HBK, Athen (bild. Kunst). Ist seit 1995 als Architektin
tätig. – C.s konzeptuelle Arbeiten greifen v.a. die Theo-
rien des Philosophen Georg Simmel zur Konstituierung

des Raumes durch den Betrachter auf. Ihre fotogr. Selbstbildnisse vor versch. griech. (Stadt-)Lsch. (später auch im Ausland) sind als Auslotung von Stimmungen, subjektiven Eindrücken und als persönliche Interaktion zw. Mensch und Ort zu verstehen. So zeichnet sie auch in dem Projekt *Reveries du promeneur solitaire*, das auf einen Text von Jean-Jacques Rousseau zurückgeht, den Weg durch Athener antike Stätten vom Turm der Winde über die Viertel Monastiraki und Kerameikos zum Dimosio Sima mit Fotos, Skizzen und Auszügen aus entsprechender Reise-Lit. des 19./20. Jh. nach. Ziel ist eine Reflektion des Zusammenspiels persönlicher Eindrücke mit den hist. und lit. toposgeprägten Erwartungen. C. ist daneben in mehreren sozialreformerischen Urbanisierungsinitiativen engagiert, die sie als künstlerische Interventionen im öff. Raum begreift. Bes. wichtig ist hier das *PPC_T/ Farkadona*-Projekt, das seit 2003 unter ihrer Ltg operiert (Workshops, Ausst., Happenings, Blogs u.a.). Ursprung dieses Engagements ist die Existenz einer Siedlung von emigrierten Schwarzmeer-Griechen im thessalischen Farkadona b. Trikala. Die Aussiedler leben dort seit A. der 1990er Jahre in Not-Containern und sind vom öff. urbanen Raum abgeschnitten. Ziel dabei ist die Mobilisierung der Bewohner zur Verbesserung ihrer Situation. And. Arbeiten seit 2000 sind u.a. die Projekte *NoMAD* (Non Metropolitan Areas Data) und *PPC-T* (Post Programmed City-Territory), deren Schwerpunkte auf einer Erfassung der Transformationen der griech. Lsch. und sozial-geogr. Regionen liegen. Daneben beteiligt sich C. an künstlerischen und archit. Konferenzen (City and Utopia, Pantios Univ., Athen, 1998) sowie an öff. Diskussionen über die Zukunft des Städtebaus (documenta, Kassel 2002). Auch publizistisch tätig. ⌂ Trikala, Beltsios Coll. ✉ Nea dedomena stin architektoniki erevna [Neue Erkenntnisse in der archit. Forsch.], in: Architektones 45:2004 (B) 29–31. ⊙ *G:* 2001 Athen: Bienn. junger Architekten / 2004 Venedig: Bienn. di archit. / 2005 Larisa, Contemp. AC: Going Public 05. Communities and Territories / 2007 Thessaloniki: Bienn. ▭ *B. Hoffmeister*, Greek realities. Eine neue Künstler-Gen. in Griechenland (K Gal. im Marstall), B. 1996; *S. Bahtsetzis* (Ed.), Women only. Greek women artists from the Beltsios Coll. (K Amfilochia), At. 2008, 195–196; Collective Work. Omada Filopappou Traces 01–11, At. 2011. – *Online:* Blog C.; PPC-T / Farkadona. E. Kepetzis

Charidimos, *Christos* (Haridimos, *Hristos*; eigtl. Charitos, *Christos*), Maler, Karagiozikünstler, * 1895 Athen, † 1970 ebd. Vater des Karagiozikünstlers Giorgos C. Erlernt die Schattenfiguren-Theaterkunst (Karagiozi) bei *Ntinos Theodoropoulos* (* 1890 Aggeloni Manis, † 1975 Patras). 1910 beginnt C. mit der Anfertigung von Karagiozifiguren (Lederschnitt, Bemalung etc.). Erster Auftritt 1912 und Annahme des Pseud. Charidimos, weil die Berufswahl eines Puppenspielers, so erläutert es C. später, seine Fam. entsetzte. Danach Auftritte in Cafés, Kleintheatern und auf öff. Plätzen in Athen und Umgebung. 1920 leistet er seinen Militärdienst und spielt für die Truppen, es folgen Tourneen durch Griechenland. Anschließend arbeitet er mit Unterbrechungen bis 1949 in dem von ihm gegr. Theater Hermes in Piräus, lediglich während des 2. WK spielt er, mittlerweile zus. mit seinem Sohn Giorgos, im Athener Cinema Ellis, welches dem eigentlich konkurrierenden Karagiozispieler Adonis Mollos gehört. 1950 beendet C. seine Karriere als Schattenfigurenspieler. Mitgl.: Somateion Ellinon Karagiozopaichton/Korporation griech. Karagiozispieler (Mitbegr. und erster Vorsitzender); Somateio Ellinon Ithopoion/Hellenic Actors Union. Das im 19. Jh. von den Türken übernommene (dort Karagös) und in Patras und Athen hellenisierte und popularisierte Schattenfigurentheater weist einen festen Figurenstamm um den Protagonisten, den buckligen kleinen Gauner Karagiozis, auf. Inhaltlich richten sich die derb-volkstümlichen Puppentheaterstücke häufig kritisch-satirisch gegen die Regierenden. Viele der subversiven Geschichten spielen während der osmanischen Herrschaft, die ins Lächerliche gezogen wird. Die von C. und and. Spielern zumeist selbst gefertigten bis zu 50 cm hohen Flachfiguren sind aus dünnem Leder (auch Pappe) gearbeitet und bisweilen transparent. Der Spieler bewegt die Figuren, die an den Gelenken, im Hals- und Taillenbereich mobile Verbindungen aufweisen, mit Stäben. C. hat seine Figuren und Bühnenbilder stets selbst gestaltet und bemalt, darüber hinaus viele Variationen des bek. Figurenpersonals und der trad. Konstellationen verfaßt. V.a. hat er sich um die Mechanik der Flachfiguren verdient gemacht. So hat er z.B. das dem Karagiozispieler Levteris Kelarinopoulos zugeschriebene System der Richtungsänderung der Figuren durch Metallfedern vervollständigt und verbessert. C.s Figuren zeichnen sich durch eine bemerkenswerte Bandbreite an Charakteren aus, welche er durch malerische Mittel, v.a. aber durch den plastischen, expressionistischen Ausdruck unmittelbar dem Publikum vermittelt. Er verzichtet auf die älteren, zumeist aus durchbrochenem Leder gefertigten und nur sparsam farbig gestalteten Figuren zugunsten geschlossener und durchgehend bemalter Charaktere, die er durch graph. Reduktion im Ausdruck dem Zeitgeschmack des frühen 20. Jh. angleicht. Bes. gut beherrscht C. als Stimmkünstler die jeder Figur vorbehaltenen markanten Modulationen sowohl in versch. Tonlagen als auch in der brillanten Imitation natürlicher (u.a. menschlicher, tierischer, atmosphärischer) und technischer Geräusche. Seine überdimensionierten Plakate für die Aufführungen zeigen sein Talent als Maler und visueller Erzähler. 2006 wird im Athener Kulturzentrum Melina das ihm und seinem Sohn Giorgos gewidmete Theatro Skion C. (Schattenfigurentheater-Mus. C.) eröffnet. Durch eine Fam.-Schenkung sind dort über 1000 Objekte versammelt (Figuren, Bühnenbilder, Plakate, Werkzeuge, Mat., Bücher); es finden Sonder-Ausst. und Workshops zur Figurenfertigung und Aufführungspraxis dieser alten Volkskunst statt, die in Vergessenheit zu geraten droht. ⌂ Athen, Kulturzentrum Melina, Theatro Skion C. ▭ LEK IV, 2000. – *G. Ioannou*, O Karagiozis, At. 1974; *L. S. und K. Myrsiades*, Karagiozis. Culture and comedy in Greek puppet theatre, Univ. Press of Kentucky, [Lexington] 1992; Dimos Patron. To gaitanaki tou Karagiozi (K), At. 1997. E. Kepetzis

Charidimos (Haridimos), *Giorgos* (eigtl. Charitos, *Giorgos*), griech. Maler, Karagiozikünstler, Autor, * 1924 Kifisia (heute Athen), † 11. 4. 1996 ebd. Sohn und Schüler des Schattenfigurenspielers Christos C. Bereits als Kleinkind leiht C. seine Stimme der Puppentheaterfigur Kolitiri (Sohn des Protagonisten Karagiozis) in dem von seinem Vater verfaßten Stück *Die Geburt von Kolitiri*. 1942 debütiert er im Café Panellinio in Athen. Während des 2. WK spielen Vater und Sohn im Cinema Ellis ebd., kehren nach dem Krieg aber in das eig. Puppentheater Hermes nach Piräus in den Stadtteil Pasalimani zurück. 1948 beendet C. seinen Militärdienst und tritt bis 1950 gemeinsam mit dem Vater auf, danach nur noch Solist. 1957 wird das Hermes-Theater abgebrochen und C. unternimmt eine Tournee durch die USA. In den folgenden Jahrzehnten tritt C. sowohl in eig. als auch fremden Karagiozitheatern auf (u.a. 1959 Kaminia, 1961 Theatro Veri, 1961–65 Theater Charoumeni in Peiraiki, 1966 Theater Chrisostomidi in Tambouria). In der zweiten H. des 20. Jh. gilt er als berühmtester Karagiozikünstler des Landes und verkauft täglich bis zu 400 Eintrittskarten. 1969 gründet er in der Athener Plaka sein Theater To fanari to Diogeni/ Die Laterne des Diogenes, in dem er bis 1988 in den Sommermonaten täglich spielt, während er im Winter an Wochenenden im Theater Avlea in Piräus auftritt. 1972 ehrt ihn das Goethe-Inst. in Athen für seine Verdienste um die Erhaltung der Kunst des griech. Schattenfigurentheaters. 1973 gibt er eine berühmte Vorstellung im Amer. College in Athen mit seinem Stück *Karagiozi, Alexander der Große und die verfluchte Schlange*, was von L. S. und K. Myrsiades (1992) als eine Sternstunde der Performance dieser aussterbenden Kunst beschrieben wird. Mitgl.: Somateion Ellinon Karagiozopaichton/Korporation griech. Karagiozispieler (neunmaliger Präs. und Ehren-Vors.). C. benutzt für seine Aufführungen nicht nur Figuren und Kulissen aus dem Bestand des Vaters, sondern auch noch wesentlich ältere, die er systematisch sammelte. Ansonsten fertigt er seine Figuren aus geglättetem und bemaltem Lammleder, seltener aus Pappe, und bevorzugt, wie sein Vater, die nichtdurchbrochene und starkfarbene Variante der Flachfiguren, die im Bühneneinsatz weniger von hinten als von der Seite her beleuchtet werden mußten, um effektvolle Schatten zu erzielen. Anfangs textile Kulissen, nach 1961 auch aus Pappe hergestellt. Die trad. Bemalung der Figuren und Kulissen, die C. von seinem Vater erlernt hatte, erweitert er mit graph. Lineaturen und geschlossener Gest. von Farbflächen. Die Ankündigungsplakate sind häufig in Schwarzweiß (teilw. Linolschnitt) gehalten, so daß sich die expressionistisch anmutenden Silhouetten unmittelbar als ein Verweis auf Karagiozi-Aufführungen lesen lassen. C. behauptet sich mit den trad. subversiv-satirischen Inhalten seiner Kunst bis zum Ende seiner Karriere, auch noch ab den 1970er Jahren, als das Karagiozitheater in Griechenland seinen politischen Witz und seine artistische Brillanz verliert und mit harmloseren Inhalten zunehmend auf ein Fam.- und Kinderpublikum zugeschnitten wird. C. hat während seiner aktiven Zeit weder das Fotografieren noch den Verkauf oder die Musealisierung seiner Figuren

zugelassen, auch verbot er jedwede filmische oder akustische Dok. seiner Aufführungen. Die wichtigste Quelle für sein Leben und seine Arbeit sind heute die Interviews, die er 1987 dem Lit.-Wissenschaftler Kostas Myrsiades gab (Gesamtlänge 18 Stunden) und die von diesem und dessen Frau 1988 und 1992 im künstlerisch-ethnogr. Kontext in den USA publiziert und gewürdigt wurden. 2006 Eröffnung des C.-Mus. in Athen. ⌂ ATHEN, Kulturzentrum Melina, Theatro Skion C. � LEK IV, 2000. – *G. Ioannou*, O Karagiozis, At. 1974; *L. S. Myrsiades*, The Karagiozis heroic performance in Greek shadow theatre, Hanover u.a. 1988; *L. S. und K. Myrsiades*, Karagiozis. Culture and comedy in Greek puppet theatre, Univ. Press of Kentucky [Lexington] 1992; Dimos Patron. To gaitanaki tou Karagiozi (K), At. 1997. E. Kepetzis

Charissiadis (Charisiadis; Harissiadis), *Dimitrios (Dimis; Dimitris; Dimitris A.)*, griech. Fotograf, * 15. 8. 1911 Kavala, † 1993. Als Künstler Autodidakt. Chemie-Stud. in Lausanne. Erste Fotogr. als Jugendlicher. 1940 beginnt der Reserveoffizier C. in Albanien als offizieller Fotograf der Armee das Leben der Soldaten und das Kriegsgeschehen in Nord-Epiros festzuhalten. Dokumentiert danach in Athen die schwierigen Lebensbedingungen während der Besatzungszeit, des weiteren die sog. Dezember-Kämpfe (Dez. 1944 bis Jan. 1945 zw. linksgerichteten Widerstandskämpfern, brit. Truppen und griech. Reg.-Truppen) und den Bürgerkrieg. Tätig als Fotojournalist u.a. für Associated Press, Life Mag. und CBS Network. Nach 1945 fotografiert er im Auftrag der Hilfsorganisationen die Verteilung der amer. Hilfsgüter in Griechenland. 1945 erscheint das bek., in zahlr. Sprachen übersetzte Buch von Alexandros Papagos *Griechenland im Kriege 1940–41*, das mit C.s Fotos illustriert ist. Im Auftrag des griech. Wiederaufbau-Minist. hält C. die Erholung des Landes und die großen offiziellen Bauprojekte fest, bes. bek. werden dabei seine Bilder vom Bau der griech. Handelsflotte in Piräus. 1952 ist er einer der Mitbegr. der Fotografen-Vrg Elliniki Fotografiki Etaireia (EFE). C. nimmt 1955 als einziger Grieche an der von Edward Steichen kuratierten internat. Wander-Ausst. The Family of Man teil (zuerst MMA, New York). Im selben Jahr reist er im Auftrag der Reg. ein Jahr lang durch Griechenland, um (vergleichbar den Aufnahmen Walker Evans' aus den 1930er Jahren) den Zustand des Landes zu dokumentieren; er legt im Anschluß bedrückende Aufnahmen des ländlichen Elends ebenso wie hoffnungsvolle Bilder einer Nation im Aufbruch vor. 1956 gründet C. gemeinsam mit Dionysis Tamaressis die Fotoagentur D. A. Harissiadis. In den folgenden Jahren arbeitet er als offizieller Fotograf des Nat.-Theaters bei den Festivals in Epidavros. Seine Aufnahmen zeigen hier die grell ausgeleuchteten Schauspieler isoliert vor fast schwarzen Hintergründen in mon.-dramatischer Wirkung. Internat. Bekanntheit erringt C. darüber hinaus mit Fotogr. aus Israel, die Leon Marcus Uris' Buch *Auf den Spuren von Exodus* (M. 1962) illustrieren, sowie mit seinen markanten Aufnahmen der griech. Antiken, welche in zahlr. Publ. über Jahrzehnte das Bild der klassischen Archit. und Skulpt. prägen (P. Kollas, *Die Akropolis von Athen. Führer und voll-*

ständige Beschreibung, At. [1950]; *Geburt der Götter. An den Quellen griech. Kultur*, Bern u.a. 1972). Daneben fotografiert er für Reiseführer und Kalender byz. Überreste und orthodoxe Gotteshäuser (z.B. die Klöster auf Athos und an den Meteorafelsen) sowie Landschaften. Zeit seines Lebens dokumentiert C. das tägliche Leben der Menschen auf dem Lande wie in der Stadt und zeigt die Freuden, v.a. aber die Mühsal des Daseins. Seine Arbeiten sind schwarzweiße, selten farbige Fotogr. mit markanten Hell-Dunkel-Kontrasten, häufig mit angeschnittenen, diagonalen Perspektiven sowie Blickwinkeln von oben oder aus der Froschperspektive. C. arbeitete mit einer Rolleiflex-Kamera, einer Linhof 4x5 Master Technika sowie einer Hasselblad. Sein 120. 000 Negative zählendes Archiv gilt als eine der wichtigsten bildnerischen Dokumentationen der Nachkriegsgeschichte Griechenlands und befindet sich seit 1997 im renommierten Benaki Mus.; hier finden regelmäßig Präsentationen von C.s Arbeiten statt, u.a. 2004 die Ausst. Apo tyn prova sto cheirokrotima/Von der Probe zum Applaus (mit Arbeiten aus Epidavros). ⌨ ATHEN, Benaki Mus. THESSALONIKI, Mus. of Photogr. ☉ *G:* 1957 Chicago, Art Inst.: Greece by Eleven Photographers / Thessaloniki, Mus. of Photogr.: 2003 Repositories of Time; 2004 Photosynkiria / 2005 Ithaca, Public AG Eikones: 1955–1967 Ta istorika exofilla (Die hist. Titel-Bll.). ⌨ *C. Naggar*, Dict. des photographes, P. 1982; *Auer*, 1985; *M.-L. Sougez/H. Pérez Gallardo*, Dicc. de hist. de la fotogr., Ma. 2003. – *A. X. Xanthakis*, Hist. of Greek photogr. 1839–1960, At. 1988; *D. Tzimas*, D. A. H. Photogr. 1919–1993, At. 1995; *N. Karamanea/V. Ioakeimidis*, Leaving behind the wartime years 1940–1960 (K), Rethymno 2001; *K. Antoniadis*, Faces in the shadows [...] D. H. From the coll. of the photogr. arch. of the Benaki Mus., At. 2002. – *Online:* Benaki Mus.; Bridgeman (s.v. Harissiadis). E. Kepetzis

Charisis (Charissis), *Christos* (Harisis; Harissis, *Hristos*), griech. Maler, Objekt- und Installationskünstler, Fotograf, * 7. 3. 1966 Ioannina, lebt und arbeitet in Athen. Stud.: 1988–91 Vakalo SchA and Design, Athen (bild. Kunst); 1991–96 HBK ebd., Malerei bei Demosthenes Kokkinidis. Seit 2004 Lehrauftrag (Malerei) an der Univ. in Ioannina. – In spielerisch-ironischer Weise setzt sich C. mit der populären Massenkultur der 2. H. des 20. Jh. auseinander. Sein wichtigster Referenzpunkt ist die US-amer. Kultur der 1950er und 1960er Jahre. Künstlerische Voraussetzung seiner Arbeiten sind die Ready-mades von Marcel Duchamp. C. arrangiert harmlose Elemente des Alltags (geblümte Wachstuchdecken, Playmobilfiguren, Turnschuhe) zu narrativen Szenen, die er mit Malerei und and. Medien (Kork) ergänzt und aus diesen Fragm. eines „verkitschten" Konsumalltags z.T. beunruhigende Geschichten formt (*She was Pop, that's why I killed her*, 2002; Ausst. Metsovo/Ioannina). Häufig zitiert C. in seinen Installationen Formprinzipien und Motive der Kunstgesch. und rekurriert u.a. auf Werke von Klimt, Schiele oder Lichtenstein. Wenn Disneys Schneewittchen auf einem Stück Plastikrasen mit einem Skelett tanzt, evoziert dies das Motiv vom Tod und dem Mädchen. Aus C.s Arbeiten werden so Reflektionen über die Vergänglichkeit. In and. Werken arrangierte er ausgediente Sitzmöbel (u.a. verschlissene Plüschsessel, einen Krankenhausrollstuhl inkl. Öffnung für den Stuhlgang, einen Kaffeehausstuhl) mit Reliken der ehemals darauf Sitzenden; ein Anzug, Schuhe und eine Perlenkette werden zu den einzigen Indizien der Menschen, die aus dieser Welt verschwunden zu sein scheinen und auf die von ihnen benutzten Gegenstände reduziert werden. Schließlich finden sich fotogr. Selbstbildnisse, in denen C. mit ausdrucksloser Miene in absurden Situationen auftaucht oder z.B. mit Fotogr. von dreidimensionalen anatomischen Modellen von Geschlechtsorganen posiert, die er an die entsprechende Stelle seines Körpers hält. Es scheint sich dabei um ironische Kommentare zur Sexualisierung des Menschen zu handeln, dessen Körper so zu einem Objekt reduziert wird. ⌨ ATHEN, Beltsios Coll. ☉ *E:* 1998, 2000, '03, '06 Athen, Gal. AD / Ioannina: 1994 Frz. Kultur-Inst.; 1997 Ammyone Gal. – *G:* Athen: 1996 Melina Merkouri Found.: Cinema and the Visual Arts; Mun. AC: Language; 2004 Eugenides Found.: The Other Body / 2001 Ioannina, Mun. Cult. Centre: Amities – Body / 2001 Thessaloniki, Vafopoulio Cult. Centre: Work – Matter/ Matter – Work I. ⌨ *L. Tsikouta-Deïmezi*, Diagrafontas to simera, to avrio, to chthes. Neoi ellines kallitechnes (K Metsovo/Ioannina), At. 2002; *S. Bachtsetzis* (Ed.), Stin exochi (K Beltsios Coll. Trikala), At. 2006. E. Kepetzis

Charisis (Charissis), *Ilias* (Harisis; Harriss, *Elias*) , griech. Maler, Installationskünstler, Lithograph, * 11. 2. 1957 Volos, lebt und arbeitet in Athen. Stud.: 1977–82 HBK ebd., Malerei bei Dimitris Mytaras, Ioannis Moralis und Demosthenes Kokkinidis. Mitgl.: Epimelitiriou Eikastikon Technon Ellados/Vrg bild. Künstler Griechenlands (EETE). – Debütiert mit Collageexperimenten (Malerei, Plakate, Druckgraphik), wendet sich jedoch schon früh ganz der Malerei zu und beginnt mit einer über mehrere Jahre entstehenden Motivserie zum Thema Mensch im Wasser. Dabei handelt es sich um überlebensgroße, zumeist in Acryl gearbeitete Werke, deren thematische Vielfalt z.T. an Arbeiten von David Hockney erinnert. Die Bilder werden dominiert von Blau und Blaugrün bis Türkis, häufig die gesamte Bildfläche einnehmend und das Meer oder ein Schwimmbad suggerierend. Im Zentrum der Wasserfläche erscheint eine menschliche, in der Regel weibliche Figur, schwimmend oder von den Wassermassen bedroht. C. trägt die Farben in feinen Strichen nebeneinander auf, so daß sie sich erst im Auge des Betrachters zu einer vibrierenden Fläche schließen; die Formen der Figuren werden durch markante Konturlinien hervorgehoben; hier lassen sich Reminiszenzen an den späten Impressionismus erkennen. Eine bes. Rolle spielt das Licht, das auf die Wasserfläche fällt und die Schwimmer grell ausleuchten kann. Die v.a. durch die unterschiedliche Farbpalette vermittelte Stimmung dieser Arbeiten umfaßt das ganze Spektrum vom unbeschwerten Badespaß bis hin zu Bedrohung durch die nicht beherrschbare Natur. In and. Fällen kombiniert C. entsprechende Darst. mit konkreten Gegenständen (z.B. einem Wasserbehältnis) und verwischt so die

Grenze zw. Malerei und Rauminstallation. Eine weitere Werkgruppe vom E. der 1990er Jahre (*Der Kuß, Der Trinker, Der Flaschensammler*) setzt sich mit tragischen Momenten auseinander. Die menschliche Figur steht erneut im Mittelpunkt, aber die Bilder zeigen Dramen und verzweifelt scheinende Individuen vor undefinierbaren Räumen in dunklen Farben. Die Figuren küssen sich, weinen, trinken, schreien; sie sind verformt, überdehnt, verzerrt. Immer wieder sind es Ausgestoßene. Thematisiert werden die existentielle Agonie des Menschen und zugleich die letztliche Aussichtslosigkeit seines Daseins, aus der auch die scheinbare Zweisamkeit einer sexuellen oder amourösen Beziehung nichts zu ändern vermag. In seinen Lithogr. setzt sich C. häufig mit dem weiblichen Akt auseinander. ◉ *E:* Athen: 1983 Gal. Desmos; 1988 Gal. Zoumboulaki; 1991 Gal. Ileana Tounta; 1992 Gal. Skoufa / 1992 Patras, Ioannis und Euterpi Topalis Found. / 1994 Chania, Gal. Fajum. – *G:* 1984 Alexandria: Bienn. (Silber-Med.) / Athen: 1985 Nat. AG: Quests; 2001 Jewish Mus. of Greece: Search for a Face / 1999 Florenz: Bienn. (lobende Erw.) / 2001 Bled: World Festival of Art on Paper (lobende Erw.) / 2002 Larisa, Visual Center of Contemp. Art: All Fashioned (Wander-Ausst.) / 2005 Brüssel, Berlaymont-Gebäude: Berlaymont Summa Artis Exhib. / 2012 Patras, Archaeol. Mus.: Truth is always absurd. Art tribute to Alexandros Papadiamantis. ▭ LEK IV, 2000. – *A. M. Darmon*, Autour de l'art juif, Chatou/N. Y. 2003 (s.v. Harrisis, Elias). – *Online:* The Amer. College of Greece. E. Kepetzis

Charitos, *Christos* → **Charidimos**, *Christos*

Charitos, *Giorgos* → **Charidimos**, *Giorgos*

Charles, *Etzer*, haitianischer Maler, * 25. 6. 1945 Jacmel, lebt seit 1974 in Paris. Stud.: Wirtschafts-Wiss. in Port-au-Prince und Politik-Wiss. an der Univ. de Paris. Danach Diplomat für die Republik Haiti u.a. ab 1991 bei der UNESCO in Paris, zuletzt bei der Welthandelsorganistaion in Genf. Parallel dazu seit ca. 1962 als Autodidakt künstlerisch tätig. 1986 Gründungs-Mitgl. der Assoc. nat. des Artistes haïtiens (SNAPH), Port-au-Prince; bis 1990 Präsident. – Zunächst figurative Öl- und Acryl-Gem., u.a. dörfliche Alltagsszenen aus Haiti, teils in der Manier der Hell-Dunkel-Malerei, z.B. *Le repas*. Später überwiegend abstrahierte Gem. mit Anklängen an kubistische Bildsprache, häufig Frauentorsi als zentrales Motiv, z.B. *Nu à la serviette rouge*; daneben u.a. Stilleben und Marinen in ähnlicher Ausf., z.B. *Nature morte aux mangues* und *Coucher de soleil*. ▥ PORT-AU-PRINCE, Mus. d'Art Haïtien. – Mus. Nader (zerst.). ▨ Le pouvoir politique en Haïti, P. 1994. ◉ *E:* Port-au-Prince: 1968, '80 Gal. Nader; 1988 Mus. d'Art Haïtien; 1990, 2006 Gal. Jean René Jérôme / 1970 Kingston (N. J.), Suzuki Gall. / 1973 Montreal (Que.), Gal. Picasso / New York: 1973 Gal. Taj Caribe; 1974 Nader AG / Paris: 1982 Gal. Confluences; 1990 Atelier Espace Ganymède; 2007 Internat. AG; 2010 Gal. Bansard / 1985 Nantes, Gal. du Centre Roger Portugal; Orleans, Gal. de la Libr. du Lycée / 1992 Tokio, Gall. Nasen / 2011 Fernay-Voltaire, Maison Fusier. – *G:* 1965 Port-au-Prince, US-amer. Konsulat: Salon Esso / 1986 Havanna: Bien. (K) / 1990 Vittel: Salon Internat. de Peint. et de Sculpt. (Silber-Med.) / 1991 Nancy, Gal. Poirel: Salon internat. (Grande Coupe de la Fond. Paul Ricard) / 1998 Paris: Salon d'Automne (K). ▭ Le livre des artistes contemp., P. 2007 (s.v. Etzer, Charles). – *M. P. Lerebours*, Haïti et ses peintres, II, Port-au-Prince 1989; *G. Alexis*, Peintres haïtiens, P. 2000. – *Online:* Website C.

J. Niegel

Charles, *Jean-François,* belg. Comiczeichner und -texter, Karikaturist, Illustrator, Maler, * 19. 10. 1952 Pont-à-Celles, lebt in Wallonien. Nach einem zweijährigen Stud. an der ABA Brüssel ab A. der 1970er Jahre unter dem Pseud. Bof als Karikaturist für die Tages-Ztgn La Libre Belgique und La Nouvelle Gaz. tätig. Ab 1975 entstehen Comics für das Mag. Spirou, zunächst einige Episoden der Serie *Les belles hist. de l'Oncle Paul*, ab 1977 die Abenteuer-Gesch. *Les Chevaliers du pavé* (Text v. Jean-Marie Brouyère und Thierry Martens; Album 2000). Gleichzeitig Ill. für Kinderbücher und -Zss. des Verlages Averbode. Zus. mit dem Szenaristen Jan Bucquoy gestaltet C. ab 1978 einige Comics für das Mag. Spatial (u.a. *Le Bal du rat mort*, 1979; Album 1980). Ab 1982 entsteht die zus. mit seiner Ehefrau Maryse C. konzipierte, im Amerika des 18. Jh. angesiedelte Serie *Les Pionniers du Nouv. Monde* (bis 2011 18 Alben; ab Bd 7 gezeichnet von Ersel [Pseud. v. Erwin Sels]). Zahlr. weitere Comicalben: u.a. *Sagamore Pilgrimage* (1988); *Fox* (7 Alben; 1991–98; Text v. Jean Dufaux); *India Dreams* (6 Alben und mehrere Bde mit Skizzen; 2002–10; Text v. Maryse C.); *Kama Sutra* (2003); *War & Dreams* (4 Alben; 2007–09; Text v. Maryse C.). Auch als Szenarist für Comics and. Zeichner tätig, u.a. zu „Les mystères d'Osiris" (2006–11) v. Benoît Roels und „Red Bridge" (2008–09) v. Gabriele Gamberini. – Detailreich-realistische, z.T. aufwendig direkt kol. bzw. aqu. Zchngn (Bleistift; Tuschfeder und -pinsel); auch freie Malerei und Zchngn, häufig mit erotischen Motiven. ◉ *E:* 2008 Brüssel, Gal. Les dessous du dessin. ▭ *H. Filippini*, Dict. de la bande dessinée, P. 2005; *P. Gaumer*, Dict. mondial de la BD, P. 2010. – *P. Herman* (Ed.). C. Esquisses et toiles, Grenoble 2001; *M. Béra u.a.*, Trésors de la bande dessinée. Cat. enc. 2007–2008, P. 2006; L'atelier de Maryse et Jean-François C., Br. 2009. – *Online:* Bedetheque; Lambiek Comiclopedia; Website C. H. Kronthaler

Charles, *Michael Ray*, US-amer. Maler, Graphiker, Bildhauer, Filmemacher, * 1967 Lafayette/La., lebt in Austin/Tex. Stud.: bis 1985 Werbegraphik an der McNeese State Univ. Lake Charles/La.; bis 1993 Malerei an der Univ. of Houston (Master of FA). Danach Lehrtätigkeit an der Univ. of Texas, Austin, sowie versch. Lehraufträge an der Univ. Houston, zuletzt als Professor. Ab 1993 gefördert vom New Yorker Galeristen Tony Shafrazi. – In seinen neoexpressiven, naiv erscheinenden, auf Papier, Holz, Blech oder Lw. gemalten Bildern, die an ältere Werbeschilder, Filmplakate oder Comics erinnern, demontiert der Afroamerikaner C. auf satirische (*The family of seals*, 1996) oder provokante Weise (*Hello, I'm your new nighbor*, 1997) vertraute Symbole aus den Massenmedi-

en. Er bricht Tabus und stellt, wie bereits Robert Colescott in den 1970er Jahren, rassistische Stereotypen in Frage (z.B. *The greatest show on earth,* 1997), was ihm und seiner „pickaninny art" auch von afro-amer. Seite heftige Kritik einbrachte. Die von C. gesammelten und als künstlerische Vorlagen verwendeten Postkarten, Posiealbumbilder, Nippesfiguren oder Programmhefte sind für ihn Zeugnisse, „wie tief das Bild des dummen, dicklippigen Negers in den amer. Alltag eingesickert ist" (Thon, 2002). Seine karikaturartigen, der Reklame entlehnten Figuren, z.B. den trotteligen Neger *Sambo* oder die dicke Pfannkuchenfrau *Tante Jemina* kombiniert er manchmal mit verwirrenden Texten (Serie *Forever Free*). Mitunter fügt er ein 1-Cent-Stück in seine Bilder ein, denn „der Penny ist die einzige schwarze Münze. Sie ist beinah wertlos und trägt das Porträt des großen Sklavenbefreiers Abraham Lincoln" (M. R. C., 1997). Ein häufig behandeltes Thema ist die Erziehung der Schwarzen. C. wendet sich in seiner Kunst nicht nur gegen den Rassismus, sondern auch gegen jegliche Klischees, Vorurteile und Intoleranz. Auch Skulpt. aus Bronze (*The Mammi,* 2006; Aukt. Sotheby's, London v. 20. 10. 2008), Ton und Fiberglas und Mitarb. an Filmen. ⌂ AUSTIN/Tex., Mus. of Art. BUFFALO/N. Y., AlbrightKnox AG. HOUSTON/Tex., MFA. NEW YORK, MMA. SAN ANTONIO/Tex., Mus. of Art. TEMPE, Arizona State Univ. AM. ✉ Ich will mich der Ängste vergewissern, die Frieden und Kommunikation verhindern, in: Kunstforum internat. 1996 (135) 322–330. ☞ *E:* Houston (Tex.): 1991 Barnes-Blackman Gall.; 1997 Blaffer Gall. (K) / 1994, '96, '97, '98 (K), '99 New York, Tony Shafrazi Gall. / 1994 Dallas (Tex.), Barry Whistler Gall. / 1995, '98 Düsseldorf, Gal. Hans Meyer (K) / 1997 Buffalo (N. Y.), AlbrightKnox AG / 1999 Tempe, Arizona State Univ. AM (mit Jean-Michel Basquiat); Boca Raton (Fla.), Schmidt Center Gall. (mit Joyce Scott) / 1999 Knokke, Gall. Cotthem; Paris, Gal. Enrico Navarra / 2002 Brüssel, Cotthem Gall.; Barcelona, Cotthem Gall. / 2003 Wimberley (Tex.), D. Berman Gall. / 2004 Greensboro (N. C.), Weatherspoon AM. – *G:* 2003 Houston, Contemp. AM: Splat boom pow! The influence of comics in contemp. art / 2004 Austin, Arthouse at the Jones Center: Comic release / 2005 Salzburg, Mus. der Moderne: Les grands spectacle / 2006 Oostende: Beaufort Trienn. / 2012 Milwaukee (Wis.), Haggerty Mus. of Art: Thenceforward, and forever free. ⌸ *N. Bless,* New art examiner 25:1997 (Sept.) 67; *T. Gooden,* Internat. Rev. of African Amer. art 14:1997 (3) 62; *M. R. C.* 1989–1997. An Amer. artist's work (K), Houston 1997; *R. Smith,* New York Times v. 3. 10. 1997; *S. Heller,* Print 52:1998 (3) 66–69; *S. Sielke,* in: *G. Genge* (Ed.), Sprachformen des Körpers in Kunst und Wiss., Tb./Basel 2000, 63–74; Art. 21 Art in the twenty-first c., N. Y. 2001; *S. Heller,* Trace 1:2001 (3) 85 (Interview); *F. Gysin/C. Mulvey,* Black liberation in the Americas, Münster 2001; School arts (Worcester, Mass.) 101:2002, 37 s.; *U. Thon,* Art 2002 (2) 14–29; *O. Oguibe,* Culture game, Minneapolis 2004; *H. J. Elam/K. Jackson* (Ed.), Black cult. traffic. Crossroads in global performance and popular culture, Ann Arbor 2005; *C.-M. Bernier,* African Amer. visual

arts, Edinburgh 2008; *R. L. Schur,* Parodies of ownership. Hip-hop aesthetics and intellectual property law, Ann Arbor 2009; *J. Ellenbogen/A. Tugendhaft* (Ed.), Idol anxiety, Stanford, Calif. 2011. E. Kasten

Charles, *Westen,* US-amer. Maler, Bildhauer, Videound Installationskünstler, * 1971 Miami/Fla., lebt dort. Stud.: Pratt Inst., New York; bis 1998 Univ. of Miami. Lehrtätigkeit: New World SchA; 2011 Design and Archit. Magnet School, Miami. – C. befaßt sich zunächst mit Arbeiten aus Ton und arbeitet am Pratt Inst. konzeptionell. 1998 ist er Mitbegr. der Locust Projects, Miami, einem nichtkommerziellen Ausstellungsort für Künstler. Zentral für seine vielschichtigen Installationen (aus Zchngn, Gem., Skulpt., Videos) sind Doppelbedeutungen, Assoziationen und Metaphern, die er mit bes. Detailgenauigkeit und Farbwahl durch Manipulation von gefundenen Alltagsobjekten entwickelt. Mehrfach integriert er Tier-Skulpt. (*Bagged Cheetah,* 2000) oder stellt Bezüge zu Tieren her wie 2002 in der Serie *Lipstick and Doggie Dick,* die auf Gemeinsamkeiten von Menschen und Tieren basiert. Für die Installation *Retirement* nutzt C. 2004 gebrauchte Bowlingkugeln, die er zu Würfeln beschnitt und die Schnittflächen (bis auf eine oben liegende, die Gravur des ehem. Eigentümers zeigende gewölbte Restfläche) mit Holzimitatfurnier bezog. ⌂ MIAMI/Fla., AM: Foolâs Gold, 2000. ☞ *E:* 1999 Miami, Locust Projects / 2005 Nashville, Cheekwood Mus. of Art / 2011 Miami Beach, AC South Florida: Installation (mit Ramon Bofill und Brian Reedy). ⌸ Flash art 34:2001 (Nov./Dez.) 3; *A. B. Morgan,* Sculpt. (Wash.) 20:2001 (8) 16 s.; *J. Weinstein,* Art papers 28:2004 (Juli/Aug.) 18–21; *P. Clemence/ J. Davidow,* Miami contemp. artists, Atglen, Pa. 2007.
 H. Stuchtey

Charlo, *Aurora,* span. Malerin, Innenarchitektin, * 1949 Zaragoza, lebt dort. Stud.: bis 1969 Innen-Archit. am Inst. de Artes Decorativas; Design am Centro de Altos Est. FAE (Fomento de las Artes y de las Estéticas), Madrid; Aqu.Malerei bei José Luis Cano in Zaragoza. 1970–79 Leiterin der Abt. Projektierung und Industriedesign bei der Immobilien-Fa. Urbesa ebd. Ehren-Mitgl. der Agrupación de Fabricantes de Muebles in Barcelona. Mitgl.: Agrupación Esp. de Acuarelistas; Asoc. Esp. de Pintores y Escultores; Acad. Europ. des Arts; Gründungs-Mitgl. und zeitweise Vize-Präs. der Agrupación Aragonesa de Acuarelistas. Seit 1990 Doz. für Aqu. in Zaragoza. Zahlr. Ausz., u.a. 1. Preise: 1992 Concurso Pí, Palma de Mallorca; 1998 Certamen Peña Solera Aragonesa, Zaragoza; 2003 Certamen de Artes Plást. Bodegón y Naturaleza Muerta, Mus. Ulpiano Checa, Colmenar de Oreja/Madrid; 2003, '07 Certamen Nac. de Acuarela, Caudete/Albacete. – C. malt v.a. Aqu. in sanften Farbabstufungen, erdigen und blauen Tönen und luftig-schwereloser Atmosphäre, die traumhafte, auch melancholische Züge trägt. Sie widmet sich intensiv den Themen Lsch. und Natur, zeigt in poetisches Lichtspiel getauchte und vom Wechsel der Jahreszeiten geprägte Bilder von Wäldern, Bergen, Seen, Bächen und dem Meer, teils in panoramaartiger Weite, teils in Nahsicht (*La cascada; Aqua entre las cañas; Reflejos en el bosque*). Men-

schen erscheinen nur selten als kleine, ganz von der Natur absorbierte Figuren; C. verwendet dafür z.T. extrem schmale Hoch- oder Querformate. V.a. span. Lsch. (Valle del Aragón; Río Ebro; Serie *Visiones Pirenaicas*), manchmal mit städtischem Hintergrund (Avila; Tarragona), sowie Ansichten von Reisen (*Brujas*; *Vista del Támesis*). Außerdem Stilleben und Blumenbouquets, meist Rosen, in wenigen sanften Farbtönen als ein komplexes, von Licht und Schatten erzeugtes Spiel aus splittrig-dynamischen Formen. C.s Portr., Gesichter oder Halbfiguren, zeigen wohl konkrete Personen, besitzen aber auch symbolischen Char. (z.B. *Desesperanza*; *El aroma*; *El pensamiento*). Auch Buch-Ill.: u.a. J. María Serrano, *Vestigios áfonos*, Zaragoza 2005. ⌂ ALBARRACÍN/Teruel, Fund. Santa María de Albarracín. BURGOS, Prov.-Verwaltung. CAUDETE, Mus. de la Acuarela Rafael Requena. – Stadtverwaltung. FUENCARRAL-EL PARDO/Madrid, Pal. de la Zarzuela. GRANADA, Stadtverwaltung. HUESCA, Fund. Beulas. LLANÇA/Girona, Fund. Martínez Lozano, Mus. de la Acuarela. MADRID, Col. Caja Madrid. – Patrimonio Nac. SAN LORENZO DE EL ESCORIAL/Madrid, Stadtverwaltung. SÁSTAGO/Zaragoza, Monasterio de Rueda. TOLEDO, Junta Castilla-La Mancha. ZARAGOZA, Asoc. Cult. Peña Solera Aragonesa. – Mus. Pablo Serrano. ⊙ E: Zaragoza: 1988, '90 Caja de Madrid; 1993–95 Gal. Decor-Art; 1998 Fund. Caja Rioja; 2000 Gal. de Arte Goya; 2002 Mus. Pablo Serrano (K: A. Azpeitia/G. Fernández); 2004, '07 (K: I. García Valiño), '09 (Falt-Bl.) Gal. Salduba / 1991 Logroño, Caja Rioja / 1992 Pamplona, Caja de Ahorros de Navarra / 1999 Valencia, Gal. San Vicente / 2002 Albarracín, Mus. (K) / 2004 Tarragona, Sala Arimany / 2005, '09 (K: A. Castro) Burgos, Consulado del Mar / 2006 (Falt-Bl.), '08 (K) Barcelona, Gal. d'Art Mar / 2009 Avila, Gal. Calir. – G: 2008 Bellagio (Como): Festival Internaz. dell'acquarello / 2010 Antwerpen, Internat. Aqu.-Festival (2. Preis). ⌷ *Online:* Website C. – Mitt. C.

M. Nungesser

Charnaux, *Georges*, schweiz. Fotograf, Verleger, * 30. 3. 1864 Genf, † 9. 2. 1939 ebd. 1881 übernimmt C. mit seinen Geschwistern, Charles C. (1852–1937), Marie Marcinhes-C. (1854–1932) und Auguste C. (1862–1930), das wahrsch. 1857 gegr. Fotoatelier Charnaux & Simond in Genf vom Vater, *Joseph Florentin C.* (* 1819, † 26. 6. 1883 Genf). Lt. Sütterlin betreiben die Geschwister vermutlich bereits ab ca. 1873 ein eig. Atelier unweit des väterlichen Geschäfts. – C., von dem der größte Teil der Aufnahmen stammt, fotografiert 1886 stereoskopische Ansichten vom Mont Blanc; es folgen weitere Gebirgs-Lsch. der Romandie und Savoyens, welche die Geschwister in den folgenden Jahren im Zuge des florierenden Alpentourismus unter dem Namen Charnaux Frères & Cie (auch F. Charnaux) mit großem Erfolg als Cartes-de-visite und Postkarten vertreiben. Später dokumentiert C. auch bed. Geschehnisse der schweiz. Nat.-Gesch. wie die Genfer Landes-Ausst. 1896. Um die Jh.-Wende verlegen sich die Geschwister auf das Verlagsgeschäft und veröffentlichen zahlr. fotogr. Alben, darunter *Panorama pris du sommet des Rochers de Naye* (Genf 1902). Ihre Stereoskopien,

Postkarten und Alben finden sich in zahlr. internat. Sammlungen. ⌂ BERN, Schweiz. NB, GrS. CLARENS, Arch. communales de Montreux, Soc. du Montreux-Oberland-Bernois. GLARUS, Landes-Arch. des Kt. Glarus. LAUSANNE, Mus. hist. PARIS, Soc. franç. de Photogr. ⊙ G: Paris: 1870 Soc. franç. de Photogr.; 1878 WA (Ausz.); 2004–05 Maison Europ. de la Photogr.: L'Utopie photographique. Regard sur la Coll. de la Soc. franç. de Photogr. (K) / 1876 Philadelphia (Pa.): WA / 1883 Zürich: Schweiz. Landes-Ausst. / Genf: 1889 Soc. Genevoise de Photogr.; 1896 Schweiz. Landes-Ausst. (Ausz.) / 1995 Lausanne, Mus. hist.: L'ère du chamboulement. Lausanne et les pionniers de la photogr. 1845–1900 (K). ⌷ B. Fritzsche/P. Keckeis, Damals in der Schweiz. Kultur, Gesch., Volksleben der Schweiz im Spiegel der frühen Photogr., Frauenfeld/St. 1980; F. Guichon, Montagne. Photogr. de 1845 à 1914 (K Chambéry), P. 1984; K. Iten (Ed.), Uri damals. Photogr. und Zeit-Dok. 1855–1925, Altdorf 1984; C. Roger, Les miroirs qui se souviennent (K), s.l. 1987; R. Perret, Frappante Ähnlichkeit. Pioniere der Schweizer Photogr., Brugg 1991. – Online: D. Girardin, Hist. Lex. der Schweiz (über die Fam. C.); Foto CH; G. Sütterlin, Fotostiftung Schweiz, Lex. Fotogr. P. Freytag

Charnaux, *Joseph Florentin* cf. **Charnaux**, *Georges*
Charneca, *António José* cf. **Charneca**, *Francisco*
Charneca, *Francisco (Francisco João Ourives)*, portug.-brasil. Maler, Bildhauer, Zeichner, * 11. 9. 1959 Évora, tätig in Cuiabá. Wächst bis zum 15. Lebensjahr in Moçambique auf, wo er Ausst. einheimischer Künstler besucht. Stud.: 1979–82 Univ. Évora (Lsch.-Archit.). 1984–89 Militärdienst, 1989 wird C. vom Militär mit der Organisation der Feierlichkeiten anläßlich des 850. Jahrestags der Schlacht von Ourique beauftragt. Seit 1996 lebt C. in Brasilien in der Region Mato Grosso. Lehrtätigkeit: 2003/04 Prof. für Zchng und Malerei am Inst. Várzeagrandense de Educação, Várzea Grande. C. gründet eine eig. KSch sowie die F. E. Gal. de Arte; auch ist er als Kurator und Dichter tätig. 2006 Aufnahme in die Acad. Brasil. de BA. – C. debütiert in der jungen portug. Demokratie mit politischen Karikaturen für das J. de Évora, es folgen erste Portr. (Graphit, Öl, Acryl, Kohle), ab 1984 aquarelliert er auch Lsch. und Tiere. 1983 erste Teiln. an einem nat. Wettb. zur Gest. einer Keramiktafel für einen öff. Garten in Grândola/Portugal (2. Preis). C. beginnt mit realistischen Arbeiten, die sich zum Hyperrealismus und letztlich zum Abstrakten hin entwickeln. In seinen Gem. (Aqu., Öl, Acryl), Zchngn (Pastell, Kohle) und Skulpt. dominieren Kontraste und Diversitäten. C. beschäftigt sich z. B. mit der Monumentalität und Schönheit der urbanen Lsch. in Évora und fängt in seinen fotorealistischen Aqu. die von der gleißenden Sonne beschienene, menschenleere Stadt ein (*Arcadas da Praça do Giraldo I*). Ein Schwerpunktthema ist die Darst. der Ureinwohner Brasiliens (*Índia Yanomani*). C.s jüngere Arbeiten sind in leuchtenden Farben gehalten und weisen meist figurative Reminiszenzen auf, etwa allegorische Figuren (*Columbina*), eine Gitarre, eine Türklinke oder eine Uhr, Tiere, Augen oder Körperteile, die sich in Farbstrudeln und -feldern aufzulösen scheinen

oder aus diesen hervorbrechen. Dabei greift C. auf kubistische und surrealistische Trad. zurück (*Cry me a river*; *Portal do sonho*). Es entstehen aber auch völlig abstrakte Gem., meist mit pastosem Farbauftrag, bei denen oft Blau- und Rottöne dominieren. Dabei können geometrische Formen Verwendung finden, frei schwebende Linien- und Wellenbewegungen in kräftigen Farben vor blaß lasiertem Hintergrund. Seit E. der 1990er Jahre schafft C. Werke mit christlich-relig. Inhalten, häufig für Sakralräume, z.B. das Fresko *Sagrada família* in der Kap. São José in São José do Sepotuba/Barra do Bugres (2001), die Skulpt. *Ecce Homo* in polychromem Beton in Guiratinga (2001), großformatige Wandpaneele für die Kap. S. Rita in Cuiabá sowie das Fresko *Cristo eucarístico* in der Kirche Matriz da Cidade in Sorriso (2004, alle im Bundesstaat Mato Grosso). C.s Brüder *Pedro (Pedro Miguel) C.*(* 11. 3. 1961 Maputo) und *António José C.* sind ebenfalls künstlerisch tätig, wobei Pedro C. bes. Lsch. und Alltagsszenen in Aqu. malt. Mit António José fertigt C. überlebensgroße Skulpt. (Zement mit Überzug in Bronze oder farbiger Fassung) für den öff. Raum, so das Reiterstandbild *Mon. a José Mestre Batista* (2010) in São Marcos do Campo, das *Mon. ao Matilheiro Português* in Alqueva (2008) und das *Mon. aos Bombeiros* (2010) in Mun. de Redondo. ⌂ CUIABÁ, Kirche Mãe dos Homens: Fresko, 1998. – Kap. Noviciado de São Francisco: Cristo no Pantanal, Fresko, 2001. SINOP, Kirche Matriz de Sinop: S. Antônio mit dem Jungen, Skulpt., 2002. VÁRZEA GRANDE, Gal. de Ate F & E: Fassaden-Gem., 1999. ⌖ *E:* 1984 Évora, MN (Debüt); 2003 Salão Nobre do Inatel / 1998 Brasília, Gab. do senador Carlos Bezerra / 2000 Sorriso, Lu Gal. / Cuiabá: 2006 Espaço Cult. Lar Shopping; 2007 Sesc Arsenal. – *G:* 1999 Cáceres: Festival Internac. de Pesca; London, Canning House: Brazilian Art Exhib. / 2000 Campos do Jordão: Salão de Artes Plást. / 2007 Henri-Chapelle, Atelier-Gal. Lúcia Hinz: Brasilidades. ⌑ *Online:* Website C. 					C. Melzer

Charneca, *Pedro* cf. **Charneca,** *Francisco*

Charoensupkul *Kanya* (Kanya C.), thailändische Graphikerin, Malerin, Installationskünstlerin, * 20. 9. (nicht 10. 11.) 1947 Nakhon Ratchasima, lebt in Bangkok. Stud. ebd.: 1963–66 Poh Chang School of Arts and Crafts, Bangkok; 1966–72 Fac. of Paint., Sculpt. and Graphic Arts, Silpakorn Univ.; mit thailändischem Reg.-Stip. 1975–77 AC, West Virginia Univ., Morgantown; SchA Inst. of Chicago (SAIC). 1979–80 Studienreise nach Japan mit Stip. (u.a. Stud. von Drucktechniken in Kyōto). 1991 Reise in die USA. Ab 1977 Doz. für Graphik, Fac. of Paint., Sculpt. and Graphic Arts, Silpakorn Univ., Bangkok (1982 Ass.-Prof.; ab 1992 Prof.); 1985 führt C. Lith. als Lehrfach erneut ein. Ausz.: 1972 (Druckgraphik), '79 (Malerei) Bronze-Med. auf der Nat. Art Exhib., Bangkok. – C. debütiert mit kalligraphieartigen Studien, in denen sie die chin. Schriftkunst ihres Vaters kopiert. In der ersten Ausst. 1987 zeigt sie die Folge *Statements* (Tusche oder Lith.), deren Einzel-Bll. aus nicht mehr als drei Pinselstrichen oder Bewegungen (breite chin. Pinsel) erzeugt sind und das Verhältnis des eig. kreativen Ausdrucks zu Rahmen und Fläche reflek-

tieren. Von Zen-Kunst und Taoismus beeinflußt, besteht ihre Nähe zu Werken des europ. bzw. US-amer. Action paint. und Informel (Franz Kline, Jackson Pollock, Hans Hartung) nur aufgrund ähnlicher Voraussetzungen. In der 1989–90 entstandenen Serie *Flower-Stone-Season* (Wasserfarben, Monoprints, Tempera/Lw.) vertieft sie sich meditativ in die Farben der Jahreszeiten und die Farbspiele von Steinen aus dem Mekong; der Ausdruck bleibt jedoch gestisch-abstrakt. Übergriffe des thailändischen Militärs auf Demonstranten und Menschenrechtsverletzungen im Mai 1992 veranlassen C. zu Gem. und Installationen, in denen sie Nat.-Symbole zu Sinnbildern von Gewalt, Tod und Widerstand umdeutet; Bodeninstallationen (Gips, Erde) nehmen Bezug auf die von Soldatenstiefeln malträtierten Demonstranten. Monoprints setzt sie als Mittel der Weitergabe von Kunst ein, um die Zensur zu umgehen. Die Nat.-Farben (Blau, Weiß, Rot) dominieren auch bis 1993 in den an Action paint. erinnernden Serien *Cocoon, Bangkok* und *Chao-Phraya River* (pastos-trockene Malerei, Kratztechnik, Collage, Monoprint), in denen sie u.a. die Ermordung flüchtender Demonstranten thematisiert. Politische Themen wie Korruption (*Whitewash*, 1995) und die Finanzkrise 1997 verarbeitet sie in abstrakten Gem. und Mat.-Bildern. Mit der Serie *Slash* (Acryl/Lw., schwarzweiß, großformatig) findet C. 2003 zu kalligraphieähnlichen meditativen Übungen zurück. 1998/99 bezieht sie mit einer großen Installation aus weißen Gipstauben am Platz der Großen Schaukel in Bangkok und seit 2008 in umfangreichen Innenraum-Installationen unter Verwendung von char. thailändischen Symbolen (*Thai pigeon. Thai durian,* 2008), Monoprints oder farbigen Spiegel- und Glassplittern eindeutig Stellung gegen soziale Ungerechtigkeit und die innenpolitische Spaltung des Landes. ⌂ BANGKOK, Dt. Bank. – Japan Found. Language Center. – NG. – TISCO art coll. ⌧ Possibilities of lith. in Thailand, Bangkok 1991; Self-spirit of nature, in: *Pongsak Buddhacharoen*, Self-spirit of nature (K), Bangkok 1996, 9–11; Lithograph. Textbook, Bangkok 2006. ⌖ *E:* Bangkok: 1987 Bhirasri Inst. of Mod. Art; 1990, '93 NM AG; 1997 AG, Fac. of Paint., Sculpt. and Graphic Art, Silpakorn Univ. (K); 2003 AC, Chulalongkorn Univ.; 2008 TPI Tower, OCAC AG (alle K). – *G:* 1979, '87 Ljubljana: Internat. Graphik-Bienn. / 1983 Nürnberg, Albrecht-Dürer-Ges.: Zeitgen. Grafik aus Thailand / Bangkok: 1986 Bhirasri Inst. of Mod. Art: Thai reflections on Amer. experiences; NG: 1989 Inspiration from Japan; 1995 Asian watercolours (K); AG, Fac. of Paint., Sculpt. and Graphic Art, Silpakorn Univ.: 1993 50 years. 50 images (K); 1994 Thai-Images (K); 1997 Print as print (K); 2000 Couple (K); 2001 As years went by (K); 2002 Silpakam + See Silpakorn (K); 2003 From inside to outside (K); 2004 Women (K); 2003 Jamjuree AG, Chulalongkorn Univ.: Art for Suwannaphum (K); PSG AG: 2008 The earth loves artists. Artists love the earth (K); 2009 Our best recent works & glass art project (K); Art and Cult. Centre: 2008 Traces of Siamese smile (K); 2010 Imagine peace (K) / 1987 Dhaka (Bangladesh), Shilpakala Acad.: Asian art bienn. / 1987, '90 Berlin: Intergrafik (K) / 1990 Bagdad: Internat. festival

of art / 1993 Jyväskylä, Alvar Aalto Mus.: Graphica Crea-
tiva / 1995 Singapur, NM: Asian internat. art exhib. / 1996
Frechen: Grafik-Trienn. / 2007 Tokio, MCA: Show me
Thai / 2008 Christchurch, Design and Arts College: Ma-
de in Bangkok. Common currency. ⌷ *A. Poshyananda*,
Bangkok Post v. 17. 7. 1987, 32; *S. Koonphol*, The Nation
(Bangkok) v. 25. 7. 1990; *H. Phillips*, The integrative art of
mod. Thailand (K Lowie Mus. of Anthropology), Berke-
ley, Calif. 1992, 105, 120 s.; The Season Mag. (Bangkok)
5:1992 (6) 53–56; *A. Poshyananda*, Mod. art in Thailand,
Singapore 1992, 123–125; *K. Daroonthanom*, Silpakorn
Univ. j. 14:1993/94, 218–225; *K. Knithichan*, The Nation
(Bangkok) v. 24. 4. 1995; 4. 10. 2003; *G. R. Brown*, Asian
art news (Hong Kong) 5:1995 (6) 51–53; The small world.
Thai contemp. art (K AC, Silpakorn Univ.), Bangkok 2002,
43, 107, 167; Thai-Japan art and cult. exchange (K AC, Sil-
pakorn Univ.), Bangkok 2006, 28, 90; K. C. Kanya dialo-
guing with Kanya (K OCAC AG), Bangkok 2008; TISCO
art coll., Bangkok 2009, 68, 71, 74, 76, 80–82, 99 s.; *M. A.
Kirker*, Printmaking as an expanding field in contemp. art
practice, Diss. Queensland Univ. of Technology, Brisbane
2009, 217, 226, 228, 305; Vijit Silpa. Silpa Thai (K Art and
Cult. Centre), Bangkok 2011, 74 s., 116, 128 s. – *Online:*
rama9art. A. Feuß

Charolet (C. López), *Blanca*, mex. Fotografin, * 30. 11.
1953 Chahuites/Oaxaca, lebt in Mexiko-Stadt. Als Autodi-
daktin seit 1966 fotogr. tätig. 1973–76 Beitr. für die Ztgn
Avance und El Universal. 1977–82 offizielle Fotografin
der Frau des mex. Präs., Carmen Romano de López Por-
tillo, 1983–85 der Reg.-Partei PRI (Partido Revoluciona-
rio Institucional). U. a. im Auftrag der Reg. der Bundes-
staaten Puebla und Chiapas tätig sowie für versch. Ver-
lage und zahlr. Zss., u.a. Voices de México, Cosmopoli-
tan, Nat. Enquire, Hola, People, Caras, Play Boy Méxi-
co und Vanidades. Mitarb. der Asoc. Cult. Xquenda. Seit
2006 Mitgl. des Salón de la Plást. Mex. in Mexiko-Stadt
(2010 in Ltg). Ausz.: u.a. 1999 Palma de Oro. Reconocimi-
ento a la excelencia profesional; 2000 El Sol de Oro, beide
Círculo Nac. de Periodistas; 2002 Gráfica de Oro; Diosa
de Luz; 2005 El Hombre Cósmico, Rev. Fotozoom. – C.
zählt zu den ersten mex. Pressefotografinnen (v.a. Foto-
reportagen u.a. von Polizei, Sport, Politik, Kultur). Später
v.a. Aufnahmen von Schauspielern, Tänzern, Malern und
Schriftstellern bei versch. Veranstaltungen u.a. für Mag.-
Interviews, Titel-Bll., Schallplattencover. Zu den meist
farbigen Portr., in denen die Dargestellten häufig bestimm-
te Rollen übernehmen, zählen u.a. Aufnahmen von Sal-
ma Hayek, Diana Bracho, Cecilia Toussaint, Pita Amor,
Natalia Toledo Paz, Armando Zayas, Jaime Sabines und
Bruno Bichir. Bes. engen Kontakt hält C. zu ihrem Hei-
matstaat Oaxaca. So begleitet sie z.B. jahrelang den von
dort stammenden Schriftsteller und Politiker Andrés He-
nestrosa und veröff. ein sehr persönlichen Buch darüber
(*Henestrosa, el otro Andrés. El mío*, Méx. 2005). In Seri-
en von Farbfotos dokumentiert sie die Kultur der schwar-
zen Bevölkerung in Oaxaca, v.a. Feste, Märkte, Sitten und
Bräuche der versch. Ethnien (z.B. *Alma de Oaxaca*; *Ju-
chitán*). In den letzten Jahren beschäftigt sich C. auch mit

den Problemen des Alterns und gestaltet u.a. eine insze-
nierte satirisch-groteske Serie über Schönheitsoperationen
(*Torturas de fin de siglo. La belleza no conoce el dolor*).
Fotobeiträge in zahlr. Büchern: u.a. *El libro de la moda en
México* (1999) von Desirée Navarro; *Cara y cruz de una
ciudad* (2001) von Andrés Henestrosa; *Mariano en tu vida*
(Méx. 2005) von Mariano Osorio; *Latinoamérica enveje-
ce. Visión gerontológica/geriátrica* (Méx. 2008) von Zoila
Trujillo de los Santos. ⌷ Mexiko-Stadt, Centro de la
Imágen. ◉ *E:* Mexiko-Stadt: 1998 Mus. Casa de León
Trotsky; 2003 Contraloría Gen. del Gobierno del Distrio
Federal; 2007 Esc. Nac. de Artes Plást. der UNAM (K);
2009 Auditorio Nac. (Retr.; K) / 1998 Juchitán, Casa de la
Cult. / 2007 Morelia, Fábrica de imágenes. – *G:* 2002 Mé-
rida (Yucatán): Bien. de Fotogr. / Mexiko-Stadt: 2005 Bi-
en. de Fotoperiodismo; 2010 Salón de la Plást. Mex.: Seis
décadas de luz. ⌷ *E. Treviño* (Ed.), 160 años de fotogr.
en México, Méx. 2004. – *Online:* Website C.
M. Nungesser

Charpentier, *Jacques* cf. **Charpentier,** *Louis-Marie*
Charpentier, *Jean-Marie*, frz. Architekt, * 27. 4. 1939
Paris, † 24. 12. 2010 ebd. Großneffe des Komponisten
Gustave C. Stud.: Archit. und Städtebau, Univ., Paris
(1966 Dipl. Städtebau); EcBA (1969 Dipl. Archit.). Ausz.:
u.a. Ritter der Ehrenlegion, 2003 Honorary Fellow Amer.
Inst. of Architects. Mitgl.: u.a. Acad. d'archit.; Assoc.
des amis d'Angkor (zeitweise Präs.). 1967–69 Lehrtätig-
keit in Phnom Penh/Kambodscha. C. gründet 1969 in Pa-
ris sein Büro Arte C. & Associés mit Niederlassungen
in Lyon und Shanghai, zeitweise auch in Kambodscha.
Arbeitet v.a. in Frankreich und ab M. der 1980er Jahre
in China. Anfangs v.a. städtebauliche Entwürfe, u.a. für
Val Maubuée (1973), ab M. der 1980er Jahre auch In-
dustriegebiete und Bürogebäude. Gleichzeitig zahlr. stadt-
planerische Projekte in China (verwirklicht: Central Pla-
za, 1996, und Century Ave., 1998, beide in Shanghai-
Pudong), teilw. als Umgestaltung hist. Bez. (Umwand-
lung der Nanjing Lu in Shanghai in eine Fußgängerzone,
1999). Auch Verwaltungsgebäude von Firmen (Hauptver-
waltung General Motors, Shanghai, 2004). Zu den mar-
kantesten Entwürfen zählen der Eingang der Metrostati-
on Saint-Lazare in Paris mit einem linsenförmigen Glas-
dach (1991 Wettb.-Sieg, 2003 voll.), das Opernhaus in
Shanghai, dessen gewölbtes Dach trad. chin. Bauformen
widerspiegelt (1994–98), und die Tour Oxygène in Ly-
on (2010). Die Bürogebäude Tour Elithis in Dijon (2000)
und Le Cristallin in Boulogne-Bilancourt (2006) sind en-
ergieeffizient gestaltet. ⌷ Nanterre: Verwaltungsge-
bäude Axa, 2006. Paris: Hotel Hyatt Regency, 1992 (mit
Murphy/Jahn). – Hist. Gebäudekomplex Chaussée d'Antin
24/21–23 Boulevard Haussmann, Hôtel Moreau: Umge-
staltung, 2005. – Imprimerie nat.: Umbau für Büronut-
zung, 2008. ⌷ Formes et structures 1991 (2) 41–44;
(3) 23–25; (4) 75–78; 1992 (4) 22–30; 1993 (3) 46–50,
60–64; 1994 (2) 28–31; Bauwelt 89:1998 (24) 1328;
S. Pavarini, L'Arca 132:1998, 40–45; *N. Turner*, World
archit. 67:1998 (Juni) 58–63; *S. Weissinger*, Glasforum
48:1998 (4) 13–18; *N. Baldassini*, L'Arca 137:1999,

20–23; *M. Krampen/D. Schempp*, Glasarchitekten, Ludwigsburg 1999; Archit. intérieure crée 305:2002, 64 s.; 310:2003, 44–47 (Interview); 312:2004, 72–75; Techniques & archit. 472:2004, 67–69; *P. Clément*, Arte C. and partners. Architects, P. u.a. 2005; *Y. Nussaume/M. Mosiniak*, Construire en Chine, P. 2005; *C. Néron u.a.*, Bâtir la ville et créer l'urbanité. Arte C. Architects, P. 2009. – *Online:* Website Arte C. Architectes. N. Buhl

Charpentier, *Louis-Marie*, frz. Architekt, * 19. 10. 1897 Paris, † 18. 4. 1974 ebd. Sohn von Alexandre-Louis-Marie C., Vater des Architekten *Jacques C.* Stud.: 1922/23–32 EcBA, Paris. Ausz.: u.a. Ritter der Ehrenlegion. Mitarb. im Archit.-Büro seines Schwagers Henri Sauvage in Paris, das C. nach dessen Tod 1932 übernimmt. 1950–70 Zusammenarbeit mit dem Sohn *Jacques (Jacques-Alexandre-Raymond) C.* (* 1924, † Sept. 1990) sowie 1964–70 auch mit dem Schwiegersohn, dem Architekten *Jean Caniffi.* – C. ist bei Sauvage an mehreren wichtigen Entwürfen beteiligt, u.a. Umbau und Erweiterung der bed. Kaufhäuser La Samaritaine in Paris (1925–29; 1935 Erweiterung durch C. allein; bis 1977 ist er als Architekt für das Kaufhaus tätig) und Decré in Nantes (Rue de la Marne 2, 1931/32, 1943 zerst., ab 1949 Wiederaufbau durch C., *Victoire Durand-Gasselin* und *Charles Friesé*); das Gebäude Le Vert-Galant in Paris (Pl. Dauphine/Quai des Orfèvres 42, 1929–32) wurde nach Sauvages Tod von C. und *Lucien d'Escrivan* vollendet. 1946–54 ist C. u.a. beim Wiederaufbau in den Dép. Seine und Manche tätig. 1951–70 Stadtbaumeister in Créteil/Val-de-Marne. Dort errichtet sein Archit.-Büro Wohnsiedlungen (u.a. La Croix-des-Mèches, 1958 bis ca. 1976; Cité du Colombier, 1966–74; Halange, 1972–76), öff. Einrichtungen (Schwimmbad, 1973) und Schulgebäude. C. selbst werden die Entwürfe in den 1950er und A. der 1960er Jahre zugeschr., u.a. für die Schulen Louis-Allezard in Créteil-Mont-Mesly und Charles-Beuvin in C.-Bordières sowie das Collège Plaisance (av. Laferrière 97, 1994–96 Umbau). Jacques C. und Caniffi werden die Entwürfe u.a. für die Schulen Albert-Camus, La Habette und Maillé (1968–77) sowie für das Collège d'enseignement secondaire St-Simon (um 1970) zugeschrieben. 1932 organisieren C. und *Frantz Jourdain* eine Ausst. über Sauvage beim Salon d'Automne. Weiteres Werk: Grand Hôtel in Calvi/Korsika, 1964. ⌂ Arch. d'archit. du XXe siècle, Bd 1, Liège 1991, 162 s.; *S. Gaubert/R. Cohu*, Archit. d'architectes, P. 1996; *J.-B. Minnaert*, Henri Sauvage ou l'exercice du renouvellement, P. 2002; *id.*, Henri Sauvage, P. 2011 (Carnets d'architectes, 7). – Paris, Inst. franç. d'archit., Fonds C.: Dok., Zchngn, Fotografien. N. Buhl

Charpentier, *Philippe*, frz. Maler, Graphiker, Zeichner, Musiker, * 3. 3. 1949 Paris, lebt in Savigny-en-Sancerre/ Cher. Stud.: 1969–71 Univ. Paris-Dauphine (Ökonomie); 1975–80 Malerei und Graphik bei Henri Goetz. 1970–80 Schlagzeuger in versch. Jazz-Bands. Anschl. widmet sich C. hauptsächlich der Malerei. Seit 1986 Teiln. an Pariser Salons (u.a. Salon des Réalités Nouv., Salon des Comparaisons, Salon de la Jeune Peint., Salon des Grands et Jeunes d'Aujourd'hui). – Zunächst figurativ-expressive

Öl-Gem. (Akte, Stilleben, Lsch.) sowie Gouachen und Arbeiten in Mischtechnik mit abstrahierten Formen. Inspiriert durch Werke des abstrakten Expressionismus entwickelt C. ab M. der 1980er Jahre seine char. Formsprache. Er gestaltet v.a. farbenfrohe abstrakte Gem. (v.a. Acryl/Lw.) in gestischer Malweise mit Farbklecksen und -spritzern, verwischten Partien und teilw. pastosem Farbauftrag. Bisweilen integriert C. in die abstrakten Komp. Collageelemente sowie figurative Motive (bes. Frauenakte). Weiterhin entstehen ungegenständliche Acryl-Gem. in stark reduzierter farblicher Gest. (v.a. in Schwarzweiß, z.T. mit Brauntönen) sowie farbige Graphiken (Lith., Rad.). – Sign.: Ch. ⌂ CARCASSONNE, MBA. DUNKERQUE, Lieu d'Art et d'Action Contemp. MONTCEAU, Mairie. MONTLUÇON, Fonds d'Art Mod. et Contemp. PARIS, BN. VILLENEUVE-D'ASCQ, MAM. ◉ *E:* Paris: 1981 Gal. Peint. Fraîche; 1995 Gal. Area; 1997 Gal. Arnoux / 1982 Veurne, Gal. Hugo Godderis / 1988–89 Dunkerque, MAC / 1997, 2007, '08 Nançay, Gal. Capazzy (K) / 2006 Montceau, Centre de Cult. et de Congrès (K) / 2007 Brüssel, Gal. Synthèse / 2008, '11 Toucy, Gal. 14 / 2009 Marrakesch, Inst. franç. – *G:* 1982 Gisors: Festival d'Arts Contemp. / 1984 Bourges, Mus. du Berry: Hist. de Peint. (K) / 1986 Montrouge: Salon / 1995 Paris, Gal. La Pochade: Eventails d'Artistes contemp. (K). ⌂ *Bénézit* III, 1999; *Delarge*, 2001. – *Online:* Website C. F. Krohn

Charpin, *Marc* cf. **Charpin,** *Pierre*

Charpin, *Pierre*, frz. Designer, * 16. 6. 1962 Saint-Mandé/Val-de-Marne, lebt in Ivry-sur-Seine. Sohn des Bildhauers und Graphikers *Marc C.* (* 1935 Paris, lebt dort). Stud.: bis 1984 Ec. nat. supérieure d'Art, Bourges (Bildhauerei). 1987–93 Zusammenarbeit mit der Soc. Algorithme (Dir.: Nestor Perkal), Entwurf von silbernem Tafelgeschirr sowie einer Leuchte. Arbeitet 1993–94 in Mailand bei George Sowden. Lehrtätigkeit: 1998–2008 Ec. supérieure d'Art et de Design, Reims; seit 2006 regelmäßig Kurse an der Ec. cantonale d'Art, Lausanne. Ausz.: 1993 Appel spécifique; 1995 Bourse Carte Blanche, beide VIA (Valorisation de l'Innovation dans l'Ameublement), Paris; 2005 Créateur de l'Année 2005, Salon du Meuble, Paris. – Seit A. der 1990er Jahre v.a. Möbel- und Objektdesign. C.s minimalistische Entwürfe sind häufig so konzipiert, daß die Produkte mehrere Verwendungsmöglichkeiten zulassen (z.B. die Serien *Stands*, 2002, und *Oggetti Lenti*, 2005, für die Design Gall. in Mailand). Möbel gestaltet er oft aus lackiertem Holz mit farblich abgesetzten, laminierten Konturen bzw. aus lackiertem Aluminium. Auch die Glas- und Keramikentwürfe sind meist mit graphischem Dekor geschmückt, z.B. die *Vases ruban*, welche von der Man. Nat. in Sèvres gefertigt werden. Neben der Herstellung von Prototypen für die Produktion, u.a. für Alessi, Pamar, Ligne Roset, Venini, Montina, Tectona und Zanotta, widmet sich C. intensiv der Erforschung und Entwicklung neuer Designideen. In Zusammenarbeit mit dem Centre internat. de Rech. sur le Verre et les Arts plast. (CIRVA) entstehen 1998–2001 farbenfrohe Gläser und Vasen in geometrischen Formen; 2003–2005 entwirft er im Centre de Rech. sur les Arts du Feu et de la Terre (CRAFT) die mit

fragmentarischen erotischen Szenen verzierten Vasen der Serie *Coram X*. Seit 2005 entstehen zahlr. Prototypen und Kleinserien im Auftrag der Gal. Kreo Paris (z.B. die Serie *Ignotus Nomen*, 2011). Weiterhin Ausst.-Design (z.B. Mobi Boom, MAD, Paris; Quali Cose Siamo, Trienn., Design Mus., Mailand, beide 2010–11). ⌂ PARIS, FNAC. – MAD. – MNAM. ◉ E: Paris: 1990 Gal. Perkal; 2000, '06, '08 (mit Alessandro Mendini), '09, '11 Gal. Kreo; 2001 Gal. des Curiosités (MAD) / Mailand: 1998 Gall. Post Design (K); 2002, '05 (K) Design Gall. / 2000 Vallauris, Mus. Magnelli – Mus. de la Céramique (K) / 2005–06 (K), '11 (Retr.) Hornu, Grand-Hornu Images / 2011–12 Lausanne, Mus. de Design et d'Arts appliqués contemp. (mit Ettore Sottsass). – G: 1991 Paris, Centre Pompidou: Capitales europ. du nouveau Design / 1996 Ivry-sur-Seine, Centre d'Art contemp. d'Ivry (Crédac): Assembled in Ivry (K) / 2005 Limoges, MN Adrien Dubouché: CRAFT. 10 Ans de Création et de Recherche en Céramique / 2008 Paris, Gal. Kreo: 16 new pieces (K). ▭ *Kjellberg*, 1994; Dict. internat. des arts appliqués et du design, P. 1996; *M. Byars*, The design enc., Lo./N. Y. 2004. – *L. Salmon*, Intramuros (Issy-les-Moulineaux) 101:2002, 42–47; *G. Gardette/M. Baverey* (Ed.), Des designers à Vallauris 1998–2002, P. 2003; *C. Fayolle*, Beaux-arts mag. (P.) 247:2004, 84–89; *E. Védrenne*, Connaissance des arts (P.) 627:2005, 56–61; *H. Maier-Aichen* (Ed.), New talents. State of the arts, Ludwigsburg 2009; *C. Prod'Hom/A. Koivu*, P. C. Entre les vases (K Lausanne), Basel u.a. 2009. – *Online:* Website C. F. Krohn

Charrat, *Louis*, frz. Maler, Zeichner, Graphiker, * 19. 10. 1903 Fontaines-sur-Saône/Rhône, † 12. 8. 1971 Lyon, lebte dort. Ab 1920 Stud. an der Ec. nat. des BA ebd., bei Georges Décôte, Régis Deygas und Robert Eugène Pougheon (Lehrtätigkeit ebd.). 1926–29 Lungenkrankheit, Aufenthalt im Sanatorium in Briançon. 1928 Mitgl. der Soc. Lyonnaise des BA (1931 Méd. d'honneur; 1969–71 Präs.); 1934 Prix Chenavard; 1934–36 Paris; 1954 Premio der Villa d'Este (Aufenthalt in Rom und Tivoli); 1964–71 Mitgl. der Acad. des Sc., Belles Lettres et Arts, Lyon. 1927–70 Ausst. in Lyon, ab 1934 Teiln. am Pariser SAfr. (ab 1936 Mitgl.). – Portr., Interieurs, Lsch. und Stilleben in expressiver Malweise (z.B. *Sur la Terasse*, Öl/Karton, 1950); v.a. Öl-Gem., auch Aqu. (z.B. *Venise*, 1965), Zchngn (Bleistift, Rötel, Tuschfeder; z.B. *Selbst-Portr.*, 1961), Graphiken (Kpst., Monotypien) sowie Entwürfe für Glasmalerei, u.a. für die Eglise St-Paul in Lyon. ⌂ LYON, Eglise St-Bonaventure (Glasfenster). – MBA. ◉ E: 1973 Lyon, Salon de Printemps (Retr.). ▭ *Hardouin-Fugier/Grafe*, 1978; *Bénézit* III, 1999. – *P. Cailler*, L. C., Genève 1966; *J.-J. Lerrant u.a.*, L. C., Roanne 2005 (* 19. 9. 1901). F. Krohn

Charrière, *Gérard*, schweiz. Buchkünstler, Maler, Graphiker, Autor, * 24. 5. 1935 Fribourg, lebt in Berlin. Ausb. zum Buchbinder. Stud.: 1956–65 Ec. des Arts et Métiers, Basel; Lycée Technique Estienne, Paris (künstlerischer Bucheinband). 1964 Übersiedlung nach Chicago; ebd. 1965–68 für die Newberry Libr. tätig. Ab 1968 dort freischaffend. 1999–2001 in New York ansässig, seit 2002 in Berlin. – Anfänglich kunsthandwerklich gediegene, auch experimentelle künstlerische Handeinbände (Bücher, Mappen), (Geschenk-)Kassetten und Schuber für wertvolle Inhalte (Mss., Orig.-Graphik, Dok.) im Auftrag von Bibl., Verlagen (hier bes. limitierte Vorzugs-Ausg. wie 40 Expl. von M. Beard, *Utah reader*, N. Y. 1986) und öff. Institutionen. Für Privat-Slgn entstehen hochkarätige Einzelausgaben (*Lost Africa*, Papier/Sand/Kies, 1989). Auch Gest. und Ill. (Druckgraphik, Aqu.) von limitierten Buchobjekten und Pressendrucken. Seit 1974 Malerei (Öl, Acryl) und Graphik, die sich v.a. dem erkenntnistheoretischen Problem von (Ab-)Bild und Schrift widmet, dem C. auf versch. Wegen u.a. in skripturalen Formen und Figurationen nachspürt. Ausz.: 1990 Pro Helvetia, Zürich. ⌂ CAMDEN/N. J., Rutgers Univ. Libr. FRIBOURG, Univ. NEW YORK, MMA, Libr. ZÜRICH, Bellerive. ◉ E: New York: 1970 Gall. Gimpel & Weitzenhoffer (K); 1982 Metrop. Mus., Thomas J. Watson Libr. (K); 1986 Colophon Gall.; 1993 Diana Burke Gall.; 1996 Richart Gall. / 1972 Zürich, Bellerive / 1975 Ascona, Gall. del Bel Libro (K) / 1989 Genf: Salon de Livre (K) / 1990 Basel, Gal. Zem Zwaite Gsicht / 1992 Essen, Gal. von Geymüller / 1994, '97, 2000, '03 Fribourg, Gal. J. J. Hoffstetter / 2004 Yverdon, Gal. du Solstice. – G: 1997 New York, Center for Book Art: Coptic and collage. Ancient technique, mod. application (K). ▭ KVS, 1991. – *D. Roylance*, Amer. Craft 40:1980 (4) 24–28; *E. Louie*, The New York Times v. 7. 9. 1989; G. C. Unique books and reliures d'art (K), N. Y. 1990. – *Online:* Website C. U. Heise

Charrin, *Philibert (Paul Philibert)*, frz. Collagekünstler, Maler, Zeichner, Karikaturist, Bühnenbildner, Bildhauer, * 14. 4. 1920 Montmerle-sur-Saône, † 22. 6. 2007 Pierrefitte-sur-Seine. Sohn eines Malers. C. studiert einige Monate an der Ec. nat. des BA in Lyon sowie 1949 einige Wochen im Atelier von André Lhote in Paris; dort zunächst als Bühnenbildner tätig. Zuvor arbeitet C. als Illustrator und Karikaturist für versch. Ztgn und Zss. (u.a. für die satirische Zs. L'os à moëlle sowie für die Wochen-Ztg La Voix Ouvrière). Als Zwangsarbeiter ist er ab März 1943 bis Kriegsende in Sankt Marein in der Steiermark interniert. Die dort entstandenen zahlr. Skizzen und Karikaturen bestechen durch ihre reduzierte Darst. sowie durch hintergründigen Humor und minimalistische Wortwitz. Da C. mit versch. Wortbedeutungen und Reimen der frz. Sprache spielt und Liedzeilen als Anspielung nutzt, bleiben die Arbeiten von der Zensur verschont und somit erhalten. Ab 1946 fertigt er v.a. Collagen, für die er sowohl ausgerissene und ausgeschnittene Papierschnipsel als auch Stoffe und Blätter verwendet. Meist enthalten die durch eine formal reduzierte, am Kubismus orientierte und pointierte Gest. gekennzeichneten Collagen Andeutungen an menschliche Gestalten und Tiere (v.a. Vögel). Weiterhin expressive Gem. (Lsch., Stadtansichten, Portr.) sowie Zchngn und Metallplastiken, die abstrahierte Tiere und Figuren darstellen. – Sign.: Philibert-Charrin. ⌂ PARIS, FNAC. VILLEFRANCHE-SUR-SAONE, Mus. Paul Dini. ◉ E: Lyon: 1946 (mit André Cottavoz), '53, '57, '59 Gal. Marcel Michaud; 1957, '58 Gal. des Jacobins;

2001, '04, '06–07, '08 (Retr.) Gal. Le Soleil sur la Place / 1970 Bobigny, Centre cult. communal / 1978, '79, '81, '84, '89, '90, '95, 2000 (Retr.; K), '11 Nançay, Gal. Capazza / Paris: 1988 Gal. Peint. Fraîche; 1996, '97 (K), '99, 2000 Gal. 26 / 2005 Wien, Gal. Augustin. – *G:* Lyon: 1937, '48, '58, '59, '60 Salon des Humoristes Lyonnais; 1948 Gal. des Jacobins: Le Groupe Contraste; 1960 Gal. Malaval: Les Lyonnais de Paris / 1964 Saint-Etienne, Mus. d'Art et d'Industrie: Cinquante Ans de Collages (K) / 1964, '68, '70 Menton: Bienn. / Paris: 1965 MAD: Cinquante Ans de Collage; 1966, '70, '71, '74 Salon Grands et Jeunes d'Aujourd'hui; 1975, '81 Salon des Dessinateurs humoristes; 1984 Salon des Réalités Nouvelles; 1995–2004 regelmäßig Salon Comparaison; 2001 Mus. de la Poste: Les Artistes prennent le Pli / 2010 Morestel, Maison Ravier: Le Sanzisme d'Hier à Aujourd'hui. ☐ *Bénézit*, 1999; *Delarge*, 2001 (* 1936 Bourg-en-Bresse). – *J. Strasser*, P. C. Stift trifft oft. Der Skizzenblock eines Zwangsarbeiters, W. 2008. – *Online:* Website C. F. Krohn

Charters de Almeida (Charters de Almeida e Silva), *João*, portug. Bildhauer, Medailleur, Bühnenbildner, * 12. 7. 1935 Lissabon, tätig in Alcainça und Malveira. Stud.: bis 1962 Esc. Superior de BA, Porto (Bildhauerei bei Salvador Barata Feyo). Lehrtätigkeit: ab 1962 ebd. (Ass., 1971–72 Prof.). Ausz.: 1962 Prémio de Escult. Mestre Manuel Pereira des Secretariado Nac. de Informação, Lissabon; 1966 Prémio Teixeira Lopes. – In den 1970er Jahren verwendet C. für seine zunächst figurativen Skulpt. vorwiegend Bronze. Die an Giacometti orientierten Werke sind in dieser ersten Werkphase kleinformatig und zumeist für den Innenraum bestimmt. In den 1980er Jahren erweitert C. sein Mat.-Spektrum um Eisen und Stein und schafft in einer zweiten Phase abstrakte Werke. 1983 beginnt mit *Janela*, einer senkrecht stehenden Stahlplatte mit einer wellenförmig ausgeschnittenen und abgewinkelten Form (Fund. Calouste Gulbenkian, Lissabon), eine weitere Werkphase. Ab M. der 1980er Jahre v.a. mon. Skulpt. im öff. Raum, die aufgrund ihrer Größe und Höhe (bis zu 40 Metern) die Grenze zur Archit. überschreiten und die Zus.-Arbeit mit Ingenieuren, Architekten und Technikern erfordern. Diese Groß-Skulpt. (v.a. aus Stahl, Marmor, Granit, Stahlbeton) widmen sich den Motiven der Tür, der Passage und der imaginären Stadt (*Cidade Imaginária Mar de Abrantes*, rot bemalter Beton, 2006; Abrantes). In jüngster Zeit spielt auch Aluminium eine Rolle (Entwurf für die Preispokale der Fund. Luso-Brasil. Lisboa, 2010). C. bedient sich meist geometrischer Grundformen und verwendet Kreise, lang gestreckte, hoch aufragende oder am Boden liegende Steinsäulen, deren Oberflächen durch horizontale Einkerbungen rhythmisch gegliedert sind (Brunnen Marco e Fonte, Granja, 1999), meist rot gestrichene Metallsäulen mit geschlossener Oberfläche (*Porto Passagem*, Bahnhof Campolide in Lissabon, 1998) oder in Gerüstform sowie runde und viereckige Bogen- und Türformen. Die Offenheit seiner Skulpt., die aufgrund ihrer Größe regelrechte urbane Zeichen setzen, lädt zum Durchgehen und Umschreiten ein. Oft setzt C. mehrere Säulen versch. Größe nebeneinander, die sich durch Querbalken

berühren und dadurch wiederum Öffnungen und Durchblicke entstehen lassen. Doch er schafft auch kleinformatige Med., etwa 1995 *La Cidade Imaginária* (Mischtechnik, Überzug aus Chrom, Emaille) für die Lissaboner U-Bahn, die wiederum auf die gravierte Steinplatte in der U-Bahn-Station Marquês de Pombal zurückgeht. – C. wirkt in seiner Frühzeit auch an Bühnenbildern, z.B. entstehen für die Gulbenkian Ballet Company 1972 Zchngn für Figurinen und Ausstattung eines von John Butler choreographierten Balletts, die auf der Bien. in São Paulo prämiert werden. 1973 folgen die Entwürfe für das Ballett Tekt (Choreographie: Milko Sparenbleck) und 1979 für Dimitriana (Choreographie: Carlos Trincheiras). 1973 entwirft C. das Logo für Encontros da Música Contemp. der Fund. Calouste Gulbenkian in Lissabon. 1984/85, '87/88 und '94/95 zeichnet er die Ausstattung für Tosca am Teatro Nac. de S. Carlos ebd. (Inszenierung: Sarah Ventura, Paolo Trevisi). – Zahlr. Ausz., Orden und Ehrenbürgerschaften (z.B. von Rhode Island 1984, El Paso 1985); 1988 Chevalier im Ordre des Arts et Lettres; 1992 Officier im Ordre de Léopold du Royaume de Belgique; 2011 Ehrendoktortitel der Univ. Lusíada Lissabon. ▣ ABRANTES, Mus. Ibérico de Arqueologia e Arte. ÁGUAS SANTAS, Autobahnraststätte Brisa: Sonnenuhr. ALCAINÇA, Park des Atelier As Chãs: Skulpt. LEIRIA, Bibl. Afonso Lopes Vieira: Skulpt., Bronze. LISSABON, Park Ribeira das Naus: Skulpt.-Gruppe, Stahl, 1995. – Kreisverkehr S. Francisco de Assis: Cidade Imaginária, rot bemalter Beton, 2000. – Expo Park: Passagem numa porta habitável, grün und rot bemalter Stahl, 2002. MONTREAL, Parc Jean-Drapeau: La ville imaginaire, weißer Granit, 1997. OEIRAS, Jardim Parque dos Poetas: Skulpt., Granit, rot bemalter Stahl, 2005. PALMELA, Bahnhofsvorplatz: Porta, Passagem, Stahl, 2007. PROVIDENCE, Gardner-Jackson Park: Skulpt., Stahl, 1985. VILLA VIÇOSA, Núceo mus. Solobema Etma: Skulpt., Marmor. ⊙ *E:* 1970, '72 Lissabon, Gal. São Mamede (K) / 1986 Washington (D. C.), Osuna Gall. (K) / 2007 Porto, Mus. Nac. de Arqueol. / 2011 Abrantes, Gal. Mun. de Arte. ☐ *Y. K. Centeno*, Porta do entendimento, Macau 1994; *J. C. Monteiro*, C. La costruzione della forma tra archit. e scult. Alcune opere 1983–2004, Bo. 2004; *M. J. Bahia/R. Cunha*, C. [...] visto por Maria João Bahia e Rodrigo Cunha, Li. 2006; *M. J. Alves Chaves*, C. Lugares para um Novo Lugar, Li. 2011. – *Online:* Website C. C. Melzer

Chartier, *Albert,* kanad. Comiczeichner, * 16. 6. 1912 Montréal/Québec, † 21. 2. 2004 Joliette/Québec. Stud.: EcBA, Montreal. 1930 erster täglich erscheinender Comic strip *Bouboule* (Szenarist René Boivin) in der Tages-Ztg La Patrie. Ab 1940 arbeitet C. in New York als Illustrator (Humor- und Witz-Zchngn) für die Columbia Comics Corporation. Ab 1943 entsteht für Le Bulletin des agriculteurs du Québec seine bekannteste Serie *Onésime*, ein Familienstrip über das ländliche Leben in der kanad. Provinz. Für diese Zs. zeichnet er auch 1950–68 die Serie *Séraphin* (Szenarist Claude-Henri Grignon). Ab 1968 folgt für den Toronto Telegram News Service die zweisprachige Reihe *Les Canadiens*. Seine Ill. erscheinen u.a. in den Zss. Le Samedi, La Revue Populaire, Weekend Mag. und The Mont-

real Star. C. gilt als einer der populärsten kanad. Comic-Künstler; 2007 wird er bei dem Joe Shuster Canad. Comic Book Creator Awards in die Hall of Fame aufgenommen. – C. pflegt einen simplen, aber eleganten, rundlichen Cartoonstil, seine Comicstrips behandeln häufig die alltäglichen Probleme im kanad. Alltag. ☐ *J. Boisvert*, A. C., Montréal 1992; *P. Gaumer/C. Moliterni*, Dict. mondial de la bande dessinée, P. 1997; *H. Filippini*, Dict. de la bande dessinée, P. 2005. – *Online:* Lambiek Comiclopedia; Drawn & Quarterly. K. Schikowski

Chartier, *Jaq*, US-amer. Malerin, * 1961 Albany/Ga., lebt in Seattle/Wash. Stud.: 1980–81 Syracuse Univ., N. Y.; bis 1984 Univ. of Massachusetts, Amherst; bis 1994 Univ. of Washington, Seattle. – C. versteht ihre Arbeit an Gem. (Öl, Acryl, Wachs) als „Tests", bei denen sie Kenntnisse über unterschiedliche Farb-Mat., deren Reaktionen aufeinander, auf Licht und Zeitverlauf zu erlangen sucht; schreibt dabei Notizen direkt auf die Gem. (*Sun Test: 27 Greens*, 2007; *88 Cultures*, 2008; *Density Tests [11 Whites]*, Acryl, 2011). Inspiriert durch Bilder der DNA-Gelelektrophorese, untersucht C. z.B. die Migration versch. Farbstoffe durch Farb- und Acrylgelschichten. Sie möchte damit Aussagen sowohl über die visuelle Kultur als auch die alltägliche wiss. Forsch. treffen und Ähnlichkeiten zw. künstlerischer und wiss. Praxis aufzeigen (cf. Website C.). C. gestaltet sinnliche Bilder mit geometrischen oder organischen Formen bzw. auch verlaufenden Mustern aus Farbflecken, Klecksen und Streifen. ⌂ Tacoma/Wash., AM. ⊙ *E:* Seattle: 1995–98, 2001 William Traver Gall.; 2006, '09 Platform Gall. / 2000, '02 Scottsdale (Ariz.), Cervini Haas Gall. / 2002, '04, '05 San Francisco (Calif.), LIMN Gall. / 2003 Tacoma, William Traver Gall. / 2003, '04, '07 Brooklyn (N. Y.), Schroeder Romero / 2005, '08, '10 Portland (Ore.), Elizabeth Leach Gall. / 2006 Ann Arbor, Univ. of Michigan, Inst. for the Humanities (K) / 2011 New York, Morgan Lehman Gall. – *G:* 2002 Seattle, Henry AG: Gene(sis). Contemp. Art Explores Human Genomics (Wander-Ausst.). ☐ Testing. J. C., Seattle 2004; *B. Leismann/R. Scherer* (Ed.), Diagnose [Kunst]. Die Medizin im Spiegel der zeitgen. Kunst (K Ahlen/Würzburg), Köln 2006. – *Online:* Website C.

C. Rohrschneider

Charuvi (Harubi; Haruvi), *Shmuel (Samuel*; eigtl. Bokser, *Šmuèl'*), israelischer Maler, Zeichner, * 1897 Michajlovka/Ukraine, † 1965 in Israel. Besucht 1914 die KSch in Odessa. Emigriert 1914 von Odessa aus nach Palästina. Stud.: 1914–18 Bezalel Akad., Jerusalem, bei Abel Pann; zu seinen Kommilitonen zählen u.a. Nachum Gutman, Joseph Levin und Menaham Shemi. Bis 1918 gehört Ch. den Jüdischen Brigaden an. Mitbegr. der Hebrew Artist's Association. – „Das Land Israel so zu malen, wie ich es mir vorgestellt habe", beschreibt er 1953 sein Credo. In frischen, klaren, fast immer menschenleeren Lsch.-Darst. (Aqu; Pastell) wird er zeitlebens die Schönheit seines Landes bewahren. Frühe Darst., wie die von Jerusalem, sind noch stereotyp und akademisch geprägt. Später wird er, durch A. Pann beeinflußt, die Freilichtmalerei für sich entdecken. In frühen Jahren gestaltet er ferner deko-

rative florale Motive und ornamentale Dekorationen (u.a. Früchte, Tiere) im Jugendstil. ⊙ *E:* u.a. 1990 Jerusalem, Mayanot Gall. (K: G. Ofrat). – *G:* zuletzt Jerusalem: Israel Mus.: 1998 To the East. Orientalism in the Arts in Israel; 2006 The Botanist's Brush (K: T. Manor-Friedman) / 2005 Berlin, Martin-Gropius-Bau: Die neuen Hebräer. 100 Jahre Kunst in Israel (K: D. LeVitte Harten/Y. Zalmona). ☐ *A. M. Darmon*, Autour de l'art juif, Chatou/N. Y. 2003 (s.v. Haruvi, Samuel). – Gordon Gall. (Aukt.) 44, Tel Aviv 1999 (s.v. Harubi, Sh.). – *Online:* Israeli AC.

St. Schulze

Charvalias, *Giorgos* (Harvalias, *Yiorgos [Yorgos]*), griech. Maler, Installationskünstler, * 1956 Athen, lebt dort. Stud.: 1976–83 HBK, Athen, Malerei bei Dimitris Mytaras und Demosthenes Kokkinidis; hier 1987–91 Ass.; ab 1991 Doz., 1998–2007 Prof. für Digital Arts. Mitgl.: Epimelitiriou Eikastikon Technon Ellados/Vrg bild. Künstler Griechenlands (EETE). – Zunächst neoexpressionistische Gem., deren abstrakter und energischer Pinselduktus bzw. Farbauftrag Parallelen sowohl zum Action painting wie zu den dt. Neuen Wilden aufweist. Dominante, reine Farben stehen in fast aggressivem Kontrast nebeneinander und scheinen eine Auseinandersetzung um Sinn und Substanz des malerischen Prozesses selbst führen zu wollen. In den 1980er Jahren v.a. Gem.-Serien (*Körper*, 1983–86; *Repräsentation*, 1987–89; *Formen der Kontinuität*, 1990–91; *Entwicklungen*, 1990–91). Sukzessive erscheinen um 1990 in den Bildern die Umrisse alltäglicher Objekte (Schachteln, Hüte, Eimer, Maschinen, Kissen), die chiffrehafte Bedeutung anzunehmen scheinen, ohne allerdings zu einer tatsächlichen Narration geformt zu werden. Es bleibt bei einem seriellen Arrangement von Gegenständen. 1993 vollzieht er in einer Ausst. (Gal. Artio) einen radikalen Wandel seiner Kunst: Er beendet die Nutzung von Lw. als Malgrund; stattdessen bevorzugt er einfache Decken, die er vom Militär oder vom Flohmarkt bezieht. Diesen überlebensgroß dimensionierten Malgrund versieht er mit der Darst. von Broten, Schalen und v.a. Kissen, die manchmal die Namen europ. Städte in engl. Sprache tragen. In and. Arbeiten verbindet er diese Motive mit volkstümlichen oder kunsthist. Elementen, die er im Siebdruck auf den Stoff aufbringt (Serie *Inhalations-Exhalations*, 1995; Thessaloniki, Macedonian MCA). Nach M. der 1990er Jahre entstehen zunehmend installative Arbeiten. Er montiert Kissen mithilfe von Stahlleisten und Schrauben an die Wand, setzt sich mit der Bedeutung digitaler Technologie auseinander und beginnt, mit Videokunst zu experimentieren, die er mit Rauminstallationen kombiniert. Der Gegensatz hartweich, den er mit seinem Kissenmotiv experimentell in versch. Medien auslotet, spielt dabei eine ebenso wichtige Rolle wie die sukzessive Einbeziehung konkreter Überbleibsel der mod. Kultur, die sich aus den künstlerischen Wurzeln von Pop-art, Arte povera und der Minimal art speist. Hinterfragt werden die Normen und Werte der westlichen Konsum-Ges. ebenso wie die psychologische Befindlichkeit des Menschen an der Wende zum 21. Jahrhundert. ⌂ Athen, Bildungs-Min. – Frissiras Mus. – NM

of Contemp. Art. – Vorres Mus. RHODOS, Mod. Greek AM. THESSALONIKI, Macedonian MCA. ◉ *E:* Athen: 1985 Polyplano 1985; 1991 Gal. Eleni Koronaiou; 1993, '95, '96, 2000, '03 Gal. Artio; 2009 Batagianni Gall. (mit Panos Charalambous). – *G:* Athen: 1985 Mus. Vorres: Neoi Ellines kallitechnoi; 1988 Mun. AG: Synantiseis – Episimanseis – Antiparatheseis. I Genia tou '80; 1991 Pierides Mus.: Frissiras Col. Synchroni Elliniki Zografiki; 2009 Gal. Donopoulos: Locked Time / Thessaloniki, Macedonian MCA: 1986 Antipodes; 2007 Locations (auch Benaki Mus.) / 1987, '97 Alexandria: Bienn. / 2007 Guernica: In the Labyrinths of the Winds. ▭ LEK IV, 2000. – *N. Missilri,* A selection of works from Vorres Mus. Young Greek artists (K), At. 1985; Kunst. Europa. 63 dt. KV zeitgen Kunst aus 20 Ländern (K Wander-Ausst.), Mainz 1991; *B. Hoffmeister/Y. Tzirtzilakis* (Ed.), Greek realities (K Gal. im Marstall), B. 1996; *A. Schina,* Esties tou vlemmatos (K), Larisa 1997; Makedoniko Mouseio Synchronis Technis (K), I, Thessaloniki 1999 (s.v. Harvalias, Yorgos); *E. Hamalidi* (Ed.), Contemp. Greek artists, At. 2004, 87–88 (s.v. Harvalias, Yorgos). – *Online:* Batagianni Gall. (Ausst.; Lit.). E. Kepetzis

Chase-Daniel, *Matthew,* US-amer. Fotograf, Objekt-, Land-art- und Performancekünstler, * 1965 Cambridge/ Mass., lebt seit 1990 in Santa Fe/N. Mex. 1984–86 Lehre beim Bildhauer Loren White, Southworth/Wash. Stud.: 1987 Sorbonne, Paris; 1988 Sarah Lawrence College, Bronxville/N. Y (Kunst, Anthropologie); 1988–89 Ec. Pratique des Hautes Etudes (Fotogr., ethnogr. Filmproduktion). 1988–89 Artist in Residence, Mus. Adzak, Paris. – C. verarbeitet experimentell v.a. visuelle Selbsterfahrungen und sucht den Dialog mit dem Betrachter. Ein zentrales Thema ist die Beziehung zw. Mensch und Natur. Die Foto-Assemblagen bestehen aus Lsch.- und Portr.-Aufnahmen, die an einem Ort, oft aus dem gleichen Blickwinkel, und annähernd zur gleichen Zeit aufgenommen und rasterartig zu einem neuen Gesamtbild zusammengestellt sind (Serie zu Ozeanen, Flüssen, Landwirtschaft etc.). In der Serie *Pod Sculpt* (2006–10) bildet C. aus gesammelten Sonnenblumen-, Alfalfa- und Ulmentrieben und -zweigen deutlich vergrößert anthropomorphe Pflanzen(-Teile) nach, v.a. Samenschoten. Für die Serie *Pole Sculpt.* (2006–12) errichtet C. Pfähle, an denen er mit Schnur gebündelte, z.T. von Besuchern gefundene Natur-Mat. (Gräser, Tannenzapfen, Blätter, Muscheln, Kartoffeln) hängt, die im Laufe der Zeit wieder Teil der Lsch. werden (z.B. 2009 Land/Art at Albuquerque Open Space Visitor Center, Albuquerque, N. Mex.). 2010 gründet C. mit dem Künstler Jerry Wellman in einem ausgedienten Kastenwagen aus Aluminium eine mobile Kunst-Gal. (AXle Contemp.) für Ausst., Performances und Installationen. ▭ ALBUQUERQUE, Dept. of Human Services. GRAND JUNCTION, Colorado Mesa Univ. MANAHAWKIN/ N. J., Southern Ocean County Hospital. NEPTUNE, Jersey Shore Univ., Medical Center. PARIS, Mus. Adzak. PHNOM PENH, US-Amer. Botschaft. SANTA FE, Capitol Art Found. ST. LOUIS, Missouri Baptist Medical Center. – US-Notenbank Tallahassee/Fla., Finanzbehörde. ◉ *E:*

1989 Paris, Mus. Adzak / 1991 Claremont (Calif.), Pitzer College, Salathé Gall.; Del Mar (Calif.), David Lewinson Gall. / Santa Fe: 2001 Evo Gall.; 2005 Price-Dewey Gall.; 2007, '09 Victoria Price Art and Design / Santa Monica: 2002, '10 Craig Krull Gall.; 2005 Jonathan Club und Reno, Univ. of Nevada / 2005 Erie, Photomedia Center; Lakeville (Conn.), Morgan-Lehman Gall. / 2009 Tesuque (N. Mex.), Salon MarGraff. – *G:* 2006–07 Sleen, Stichting Natuurkunst Drenthe. ▭ *D. Abram,* Orion mag. Juli/Aug. 2007; THE. Santa Fe's monthly mag. 2009 (April) 14 s.; Body. M. D.-C., Santa Fe 2011. – *Online:* Website C.; Luminous-lint. World photogr., 2008. H. Stuchtey

Chašnov, *Lukan* cf. **Chašnov,** *Vladimir*

Chašnov, *Vladimir (Vladimir Lukanov),* bulg. Architekt, Architekturhistoriker, * 16.(29.) 1. 1908 Sofia, † 20. 8. 1959 ebd. Entstammt einer Fam. von Unabhängigkeitskämpfern aus Loveč; Sohn des Ing. und Projektanten *Lukan (Lukan Gečov) Ch.* (* 7. 3.[23. 2.]1862 Loveč, † 8. 5. 1917 Sofia), der als einer der ersten Stipendiaten des Bulg. Volksbildungs-Minist. an den TH in Prag und Wien (Abschluß 1887) studierte und zu einem der ersten Spezialisten für Eisenbahn- und Wasserbau im nachosmanischen Bulgarien wurde. 1893 war Lukan Ch. Mitbegr. der Bulg. Ing.- und Architekten-Ges. (BIAD). Ch. absolviert 1928–31 ein Archit.-Stud. in Paris. 1933 erhält er die offizielle Erlaubnis zur priv. Entwurfstätigkeit vom Minist. für öff. Bauten, Wege und Stadtplanung. Im gleichen Jahr Jury-Mitgl. beim Wettb. um den Bau einer HS in Jambol. Preise in Archit.-Wettb.: 1934 3. Preis, Erweiterung des Offiziersklubs in Sofia; 1935 2. Preis, Post- und Telegraphengebäude in Plovdiv (beide mit Dimitär Fingov); 1936 Ankaufpreis, Waisenhaus in Pleven (mit D. Fingov, Angel Damjanov). 1945–52 Doz. für Stil-Gesch. und Archit.-Theorie an der TH Sofia, wo er von den Studenten für seine umfassende Allgemeinbildung, terminologische Exaktheit und sein kultiviertes Auftreten geschätzt wird. 1952 aus politischen Gründen aus dem Lehramt entlassen. – Zu den herausragenden realisierten Bauten in Ch.s schmalem archit. Werk gehört der Neubau eines größeren Bibl.-Komplexes in Veliko Tärnovo, der in eklektizistischer Stilmischung historische und sachliche Formen verbindet. Bed. ist er v.a. als Lehrer und Archit.-Historiker und forscht hauptsächlich zur Stadtentwicklung in Bulgarien im 18. und 19. Jh. unter bes. Berücksichtigung von Einflüssen der osmanischen bzw. muslimisch geprägten Kultur. ▭ VELIKO TÄRNOVO: Bibl. (seit 1958 benannt nach P. R. Slavejkov) mit Mus. für Archäologie und Kunsthalle, 1939–54 (mit A. Damjanov; 1938 1. Wettb.-Preis). ▭ *M. Conev,* Dejci na Bălgarskoto Inženerno-Architektno Družestvo, 1893–1949, Sofija 2001 (falsches Geburtsjahr; auch zum Vater). – Spisanie na BIAD 1914 (6–8) 44, 62; Däržaven vestnik 1933 (138); 1936 (54) 827; Architekt 1934 (7) 116; 1935 (4/5) 5, 11; Spisanie na BIAD 1938 (16/17); *L. Tonev u.a.* (Ed.), Architekturata v Bălgarija sled 9. IX. 1944 g., Sofija 1954, 24–29; *S. Kovačevski/P. Iokimov,* in: Architekturata v Bălgarija 1878–1944, Sofija 1978, 206–236; *M. Pisarski u.a.,* in: Almanach. Părvite studenti i prepoda-

vateli po architektura 1943, Sofija 1993, 209 s.; *K. Kostov*, Homo sciens (Sofija) 2010 (4) 7 (zum Vater).

L. Stoilova

Chast, *Roz (Rosalind)*, US-amer. Cartoonistin, * 26. 11. 1954 Brooklyn/N. Y., lebt in Ridgefield/Conn. Stud.: Rhode Island School of Design. Erste veröff. Cartoons in Christopher Street und The Village Voice. 1978 erscheinen Cartoons im Mag. The New Yorker, ein Jahr später wird C. zur festen Mitarb. und ist seitdem hier regelmäßig vertreten. Sie arbeitet auch für and. Zss. und fertigt Werbeillustrationen. Seit 1992 auch Buch-Ill., darunter zahlr. Kinderbücher. Ihre Cartoons sind seit 1982 in Büchern häufig nachgedruckt worden, etwa *Unscientific Americans, Parallel Universe, Mondo Boxo, The Four Elements, Proof of Life on Earth* und *The Party after you left. Collected Cartoons 1995–2003.* Zahlr. Einzel- und Gruppenausstellungen. Ausz.: u.a. Ehrendoktortitel 1998 Pratt Inst.; 2010 Lesley Univ., Art Inst. Boston. – Die Cartoons von C. behandeln den amer. Alltag, den sie in einem illustrativen, sketchartigen Stil wiedergibt, ohne allerdings comicähnliche Elemente (z.B. Sprechblasen) zu nutzen. Ein Merkmal ihrer Cartoons sind die wiederkehrenden Figuren. C. gilt als eine der wichtigsten und einflußreichsten amer. Cartoonistinnen des ausgehenden 20. Jahrhunderts. ▭ *Horn,* Cartoons, 1999. – *Online:* Website C.; *R. Gehr,* R. C. The comics j. v. 14. 6. 2011 (Interview). K. Schikowski

Châtelain-Friolet, *Jacqueline* → **Friolet,** *Jacqueline*

Chatzida-Gavriilidou (Hatzida-Gavriilidou; Hadjida-Gabrielidou), *Vera*, griech.-zyprische Malerin, Kunstpädagogin,* 1936 Nikosia, † 18. 3. 2012 ebd. Stud.: 1955–59 Kingston College SchA & Design, Surrey (Malerei, Dekoration). Lehrtätigkeit: Kunstpädagogik an Gymnasien auf Zypern; 1983–86 Malerei an der Pädagogischen HS, Nikosia. Gründungs-Mitgl. (1964) der Vrg bild. Künstler Zyperns. – Bis E. der 1960er Jahre v.a. Lsch. und Stilleben. Ab A. der 1970er Jahre setzt sich C. in Nachf. der Konstruktivisten und im Stil der Op-art mit geometrischen Formen und Farbanordnungen auseinander, die im Bildraum zu schweben scheinen oder flächig nebeneinandergesetzt sind. Ihre Arbeiten weisen eine deckende, vergleichsweise dunkle Farbpalette auf; die Spuren des Malprozesses werden in der Regel getilgt. Immer wieder experimentiert sie mit Farbbändern, die sich in versch. Richtungen auf der Oberfläche der Lw. zu bewegen und die Fläche zum Vibrieren zu bringen scheinen. Nach ca. 1975 wendet sich C. wieder verstärkt der Lsch. und dem Stilleben zu, die sie abstrahiert und stilisiert, aber dennoch erkennbar bleiben läßt. Einige Arbeiten sind vom Magischen Realismus (insbesondere von René Magritte) inspiriert; diese zeichnet eine symbolisch-bedeutsam aufgeladene Stille und bisweilen eine surreale Präsenz des Raumes aus. Daneben beschäftigt sich C. auch mit rein abstrakten Formkonstellationen. Versch. Arbeiten entstehen im kunstpädagogischen Kontext. ▭ NIKOSIA, Bildungs-Minist. – Loukia & Michael Zambelas AM. – Nicosia Mun. Centre of Mod. Art. ◉ *E:* 1962 Nikosia, Nikosia-Trust; 1967 Hilton; 1979 Zygo Gal. – *G:* Nikosia: ab 1964 Panzyprische Kunst-Ausst. (jährlich); 2004 Nicosia Mun. Centre of Mod. Art:

1960–1974. Young Cypriot Artists at the Dawn of the Republic / 1968 New Delhi: Trienn. / 1970 São Paulo: Bien.; Athen, Gal. Ora: Dekatesseris kyprioi kallitechnes (K); London, Commonwealth Inst.: Contemp. Cypriot Art (Wander-Ausst.) / 1979 Thessaloniki: Festival Demetria / 1983 Paris, Acad. diplomatique internat.: Peint. cypriote contempemporain. ▭ LEK IV, 2000. – Forteen contemp. Cypriot artists (K), At. 1970 (s.v. Hadjida, Vera); Zeitgen. Malerei aus Zypern (K), B. [1981]; *A. Chrysochos*, Kyprioi kallitechnes, Lefkosia 1982, 43–44; 33 Kyprioi kallitechnes (Kypros, 2), Lefkosia 1987, 227–229; Neoteri & sychronoi Techni. Ellines kai Kyprioi Dimiourgoi (K Gal. AlphaZmart), Nikosia 2009, 92. E. Kepetzis

Chatziioannou (Hadjioannou; Hatziioannou), *Stavros*, griech. Maler, Graphiker, Plakatkünstler, Werbegestalter, Freskant, * 1949 Athen, lebt und arbeitet dort. Stud.: 1967–70 Technologisches Inst., Athen (ATI), Graphikdesign u.a. bei Anastasios Alevizos (gen. Tassos), Elias Dekoulakos und Dimitrios Mytaras; 1970–72 Bühnenbild und Werbe-Gest. an der HBK ebd. bei Vasilis Vasileiadis. Mitgl.: Epimelitiriou Eikastikon Technon Ellados/ Vrg bild. Künstler Griechenlands (EETE). Ausz.: 1968 2. Preis (Plakat) Panhellenische Kunst-Ausst., Athen. – In seinem malerischen Werk (zumeist Öl/Lw., auch Seiden- und Wandmalerei) geht es v.a. um die menschliche Figur, die C. isoliert oder in Gruppen darstellt. Die Formen sind reduzierend vereinfacht und stilisiert, der psychologische Ausdruck oder die Stimmung stehen im Mittelpunkt. Manchmal erinnern seine Darst. von stehenden weiblichen Figuren an frühe Werke von Pablo Picasso. Thematisch und stilistisch sind ansonsten die in urbanen Räumen isolierten Figuren erkennbar von Arbeiten Edward Hoppers inspiriert. C. beschäftigt sich wie dieser mit Café-Szenen, Warteräumen, Theatern. Die Maske und das Kostüm sind zentrale Motive und sollen wohl auf die Verstellung des Individuums in der heutigen Ges. anspielen. Auch mythologisierende Darst. (*Entführung der Europa*, 2006; Titanium Yiayiannos Gal. 2009), in denen, wie in and. Bildern auch, eine implizierte kalte Erotik zu konstatieren ist. Stille, Handlungsarmut und Statik beherrschen im allgemeinen seine melancholisch aufgefaßten Sujets. ◉ *E:* Athen: 1980 Gal. Egonopoulos; 1988 Gal. Zigos; 2002, '04, '06, '09 Titanium Yiayiannos Gal. / 2005 Nikosia, Gal. K / 2006, '08 München, Gal. Drissien / 2008 Lausanne, Gal. Catherine Niederhauser. – *G:* 2001 Athen, Titanium Yiayiannos Gal.: To Kapelo / 2005 Florenz: Bienn. ▭ *Lydakis* IV, 1976 (Supp.); LEK IV, 2000. – *Online:* Titanium Yiayiannos Gal. Athen. E. Kepetzis

Chatzinikoli-Sarafianou (Hatzinikoli; Hadjinikoli), *Mairi*, griech. Keramikkünstlerin, Malerin, Kunsterzieherin, Publizistin, * 1928 Athen, lebt und arbeitet dort. Verh. mit dem Maler und Keramikkünstler Panos Sarafianos (* 1919, † 1968). Stud.: 1947–51 HBK, Athen, bei Andreas Georgiadis (Malerei); 1956–58 ABA, Rom (Design), 1956–57 Ist. Statale d'arte ebd. (Keramik). Neben dem Betreiben einer eig. Keramik-Wkst. mit zahlr. Schülern (u.a. Maria Chatzitheodorou, Kostas Davaris, Iakovidou Giota) ist C. als Lehrerin an versch. Gymnasien tä-

tig. Mitgl.: Epimelitiriou Eikastikon Technon Ellados/Vrg
bild. Künstler Griechenlands (EETE). Ausz.: 1962 Silber-
Med. auf der Internat. Keramik Ausst. in Prag; 1964 2.
Preis auf der Panhellenischen Keramik-Ausst. in Marou-
si (1973 3. Preis, 1992 1. Preis); 1972 Gold-Med. auf der
Internat. Handwerksmesse in München. – C. arbeitet mit
Ton, Email und Porzellan. Ihre skulptural aufgefaßten ke-
ramischen Arbeiten streben aus organischen Formen zur
Abstraktion, ein bes. Merkmal ist der Versuch, eine mög-
lichst hohe Lichtdurchlässigkeit und Transparenz des Mat.
zu erzielen. Vor diesem Hintergrund kommen ihre Plasti-
ken v.a. in der räumlichen Präsentation zur Geltung. Bis-
weilen montiert C. Lichtquellen hinter den Werken, um
die Feinheit der Modellierung und der Glasuren heraus-
zustellen. In griech. Ztgn und Zss. veröffentlicht sie Es-
says zur mod. Keramik und Porzellankunst; 1980 äußert
sie sich in einem Buch über Probleme der griech. Päd-
agogik. 1998 wurde C.s Lebenswerk auf der alljährlich
im Athener Stadtteil Marousi stattfindenden Panhelleni-
schen Keramik-Ausst. gewürdigt. ⌂ FAENZA, Mus. In-
ternaz. delle Ceramiche (MIC). ✉ Provlimata tis elli-
nikis ekpaidevsis, At. 1980. ⊙ E: Athen: 1961 Gal.
Nees Morfes; 1998 Gal. Aithussa A. Gardelis (Retr.). –
G: 1960, '63, '75, '87 Paris: Salon de l'art libre / 1965
Genf, Mus. Ariana: Les èmaux dans la Ceramique Actuel-
le / 1972 Vallauris: Internat. Keramik-Ausst. / Athen: zahlr.
Beteiligungen Mun. AG (Zeitgen. Kunstkeramik) und in
Marousi (Panhellenische Keramik-Ausst.). ⌺ LEK IV,
2000. – Ch. Christou/M. Koumvakali-Anastasiadi, Mod.
Greek sculpt. 1800–1940, At. 1982, 153. E. Kepetzis

Chatzis (Hadsis, Hatzis), *Giannis (Ioannis)*, griech.
Karagiozikünstler, Volksmaler, Autor, * 1945 Thessa-
loniki, lebt und arbeitet dort. Als Schattenfigurenspie-
ler Autodidakt. Seit den 1980er Jahren Vorführungen in
Griechenland und Europa. Das tradierte Repertoire des
griech. Schattenfigurentheaters (Karagiozi) hat C. durch
neue Varianten erweitert. Daneben wiss.-ethnogr. Beschäf-
tigung mit Herkunft, Aufführungspraxis etc. dieser po-
pulären Theaterform (Ausst., Vorträge, Beitr. für Radio-
und Fernsehsender). Er veröffentlicht mehrere Bücher,
u.a. die Untersuchung *Thriskeutikes antavgeies ston Kara-
giozi*/Religiöse Bezüge im Karagiozitheater (Thessaloniki
1995). Regelmäßig veranstaltet C. Workshops zur Figuren-
herstellung und Bühnen-Gest. des Karagiozitheaters. Er
fertigt seine eig. (teilw. durchbrochenen) bemalten Flachfi-
guren aus Leder und Pappe sowie die Kulissen und Ankün-
digungsplakate. Stilistisch sind Figuren, Texte und stimm-
liche Modulationen der einzelnen Charaktere weitgehend
als Fortführungen der großen Karagiozi-Trad. der ersten
H. des 20. Jh. zu sehen (vgl. Art. zu Christos und Giorgos
Charidimos). Seine Figurenbemalungen der Protagonisten
(u.a. Karagiozis, Aglaia und Veziropoula [dessen Frau und
Tochter], Hadziavatis, zwei Paschas, zwei Beys, Diony-
sios) weisen starke Lokalfarben, bisweilen satirisch über-
höhte Charakter-Zchngn auf und sind in der naiven Kunst
zu situieren. Die Ankündigungsplakate enthalten Elemen-
te klassischer Comics; die mit Text kombinierten figürli-
chen Darst. bieten dabei bisweilen in der direkten Kon-

frontation der Hauptakteure eine humoristische Pointie-
rung des im jeweiligen Stück dargebotenen Geschehens.
✉ u.a. Karagiozis kai scholeio, Thessaloniki 1982; Kara-
giozis kai Kinimatografos, Thessaloniki 1983; To Humor
tou Karagiozi, Thessaloniki 1985. ⊙ E: Thessaloniki:
1997 Aristoteleio Ausst.-Zentrum; 2000 Alatza Imaret;
2004 Internat. Kulturzentrum Bafopouleio / 2000 Athen,
Goulandris Found. / 2001 Veria, Byz. Mus. / 2003 Nauplia,
Politistikos Syllogos. – G: Athen: 1998 Städtisches Kul-
turzentrum: Figoures, skinika, afises kai ergaleia tou thea-
trou skion (Figuren, Kulissen, Plakate des Schattenfigu-
rentheaters); 2004 Hellenic Lit. and Hist. Arch., Technou-
polis: Elliniko Theatro Skion. Figures apo fos kai istoria
(Griech. Schattentheater. Figuren aus Licht und Geschich-
ten); Byz. Mus.: Akrites tis Evropis (Grenzgänger Euro-
pas) / 2001 Lamia, Städtisches Kulturzentrum: Se chroma
mesogeiako (In der Farbe des Mittelmeers) / 2001 Kame-
na Vourla, Ausst.-Halle: Krasi, Psomi, Ladi (Wein, Brot,
Öl) / 1997, '98, 2000, '02, '04 Prousa (Türkei): Internat.
Karagiozi-Festival. ⌺ LEK IV, 2000. – To gaitanaki tou
Karagiozi (K), At. 1997. – *Online:* Website C. (Ausst.).
 E. Kepetzis

Chatzisavva (Hatzisavva; Hadjisavva), *Erato*, griech.-
zyprische Malerin, Video- und Installationskünstlerin,
* 1966 Nikosia, lebt und arbeitet in Athen. Stud.: 1983–85
Univ., Athen (Wirtschaft); 1985–90 HBK ebd., Malerei bei
Ilias Dekoulakos und Dimosthenis Kokkinidis sowie byz.
Malerei bei Konstantinos Xinopoulos. Hier seit 2000 Lehr-
auftrag für Malerei. Mitgl.: Epimelitiriou Eikastikon Tech-
non Ellados/Vrg bild. Künstler Griechenlands (EETE). –
V.a. Malerei und Videoarbeiten. In beiden Medien sind ih-
re Werke von Originalität und einem persönlichen Stil ge-
prägt. Die Öl-Gem. zeichnen sich durch expressive Pin-
selführung und reliefartigen Farbauftrag aus. C. geht bei
ihren Bildern v.a. von Lsch.-Strukturen und der mensch-
lichen Gestalt in Nahansicht aus, deren Gegenstandsbezo-
genheit auch in der Abstraktion sichtbar bleibt. In Werken
wie *Kreuzigung* (2003; Ausst. Athen) setzt sie sich kritisch
mit Dogmen des christlichen Glaubens auseinander, des-
sen Trad. sie hinterfragt, indem sie den relig. Motiven mod.
natur.-wiss. Erkenntnisse entgegensetzt (geometrische For-
men und mathematische Formeln). C. bevorzugte dunk-
le, satte Farben, in denen oft der Kontrast von Rot und
Schwarz dominiert. Ihre 2012 in der geteilten Stadt Niko-
sia (Apocalypse Gal.) gezeigten Gem. zeigen in verwüs-
tet scheinenden Lsch. an Stacheldraht gemahnende Kon-
struktionen und lodernde Flammen, die Assoziationen an
Krieg und Gewalt aufrufen. Ihre Videoinstallationen zie-
len, ausgehend von einer Darst. der Natur bzw. der Ein-
beziehung natürlicher Phänomene, auf wahrnehmungsäs-
thetische Fragestellungen. In der Installation *Wave*, für die
sie 2005 auf der Bienn. in Alexandria mit einem 1. Preis
ausgezeichnet wurde, zeigt sie z.B. auf mehreren Bild-
schirmen einen Vogelschwarm in Bewegung; jeder Schirm
zeigt dabei einen zeitlich leicht verschobenen Moment die-
ser Szene, so daß der in der Installation herumgehende Be-
trachter gezwungen ist, seine Wahrnehmung jeweils neu
anzupassen. ⌂ ATHEN, HBK. ⊙ E: Athen: 1991 Pa-

padopoulou Gal. (mit Panagiotis Siagri); 2003 Gal. Yagianos; 2009 Spiti tis Kyprou / Nikosia: 1992, 2002, '10 Gloria Gal.; 2012 Apocalypse Gal. / 2009 Rethymno, MCA. *G:* Thessaloniki: 1986 Bienn. junger Mittelmeerkünstler; 2005 Mus. of Photogr.: Photosynkyria /1987, '93 Nikosia, Kulturzentrum Famagusta Gate: Pancyprian Exhib. of Cyprus / 2001 Florenz: Bienn. / 2005 Alexandria (Ägypten): Bienn. / 2012 Florina, Florina MCA: Mnimes kai Pragmatikotites [Erinnerungen und Wirklichkeiten]. ⌶ LEK IV, 2000. – Eikastikes maties sto ergo tou /Blicke auf das Werk von Yiorgos Ioannou (K Benaki Mus.), At. 2006.

E. Kepetzis

Chatzisotiriou (Hadjisotiriou; Hadjisoteriou), *Fotos (Photos)*, zyprischer Maler, Bildhauer, Autor, Regisseur, * 1919 Famagusta, † 2004 Agia Napa. Als Maler Autodidakt. Stud.: 1937–39 Univ. Beirut (Jura). C. gründet während des 2. WK das Ensemble Elevteri skini/Freie Bühne, mit dem er eig. und fremde Theaterstücke in eig. Regie aufführt. Emigriert 1974 aus N-Zypern, nachdem ein großer Teil seiner Arbeiten dort zerst. wurde; lebt seitdem in Limassol und in Agia Napa im südlichen Teil von Zypern. Ausz.: 1954 Gold-Med., Internat. Kunst-Ausst., Famagusta. – In seinen Lsch. und Szenen des bäuerlichen Alltags verbindet er kubisch reduzierte Gebäudeformen mit Menschen. Charakteristisch für seine zumeist in Acrylfarben geschaffenen Werke sind volkstümliche Motive wie Frauen in zyprischer Tracht oder Bauern bei der Arbeit, die er in klaren, häufig mit Schwarz konturierten Umrissen und in plakativen Farben ausführt. Die flächige Reduktion der Darst. zielt auf einen graph. Gesamteindruck. Auch bildhauerische Arbeiten. ⌂ FAMAGUSTA, Mun. AG. NIKOSIA, Pin. Archbishop Makarios III. Found. Cult. Center. 👁 *E:* 1947 Famagusta, Lykeio Ellinidon / Nikosia: 1957 Ledra Palace; 1976, '79, '81, '91 Hilton; 1978 Hotel Kourio / 1962 Limassol, Pin. / 1976 Paphos, Städt. Ausst.-Halle / 1978 Athen, Kollegio Athinon. ⌶ LEK IV, 2000; *Lydakis* IV, 1976. – Sychronoi Kyprioi Zografoi kai Glyptes, At. 1975; *A. Chrysochos*, Kyprioi Kallitechnes, Nikosia 1982, 247–248; *H. Klein*, Kat. der Kunstwerke des 20. Jh. in der KS des Auswärtigen Amtes, Bonn 2003, Kat. 1354 (s.v. Hadjisoteriou); Symantikoi Ellines kai Kyprioi Kallitechnes, Nikosia 2010, 57.

E. Kepetzis

Chatzisotiriou (Chadjisotirio; Hadjisotiriou; Hatzisotiriou), *Xanthos*, griech.-zyprischer Maler, * 1920 Famagusta, † 2003 Limassol. Stud.: 1938–40 Univ., Beirut (Wirtschaft); 1951–53 SchA and Crafts, London (Malerei); 1959 Byam Show SchA ebd. (Design). 1969 Eröffnung der eig. Gal. Manastiri in Famagusta. 1974 Verlust zahlr. Werke beim Gang ins Exil in den südlichen Teil Zyperns, seitdem in Limassol ansässig. Mitgl.: Epimelitiriou Kalon Technon Zypern/Vrg bild. Künstler Zyperns. – C. verbindet in seinen Öl- und Acrylbildern Einflüsse und kunsthandwerkliche Trad. der griech.-zyprischen Volkskunst. Er arbeitet mit den Stilmitteln der naiven Malerei, die er gekonnt paraphrasiert. So verwendet er stark deckende Lokalfarben, vorwiegend in Tönen von Grün, Blau, Beige und Weiß, die in ihrer Gesamtwirkung bisweilen an

die anti-naturalistische Stilisierung byz. Ikonen erinnern. In seinen flächigen, mit betonten Konturen vorgetragenen Komp. dominieren senkrechte und vertikale Linien, so daß eine statische und zeitlose Wirkung von seinen weitgehend handlungslosen Szenen ausgeht. Motivisch setzt er sich mit der zyprischen Lsch. und den kult. Trad. auseinander. Häufig stellt er weibliche Figuren im Vordergrund vor trad. Archit. dar; manche transportieren irdene Krüge auf den Köpfen, and. verrichten Feldarbeit. Ihre in Rundungen aufgefaßten oder bisweilen in manierierter Stilisierung gezeigten Bewegungen kontrastieren mit der strengen Architektur. Die Köpfe scheinen häufig direkt auf den Schultern zu ruhen, die oft goldblonden Haare legen sich in einem an einen Heiligenschein erinnernden Bogen um den Kopf. In aller Regel sind die Augen der Frauen geschlossen, so daß C.s Figuren von einer verinnerlichten, ruhigen und melancholischen Stimmung beherrscht zu sein scheinen. Auch erinnern archaisch wirkende blaue Gewänder und Körperhaltungen bisweilen an trad. Madonnendarstellungen. Daneben einzelne Porträts und Stilleben. ⌂ ATHEN, Bildungs-Minist. – Nat. AG. – Nat.-Bank. FAMAGUSTA, Mun. AG. MONTBARD, MBA. LARNAKA, Mun. Pin. NIKOSIA, Loukia & Michael Zambelas AM. – State Gall. of Mod. Cypriot Art. 👁 *E:* 1962, '85 Nikosia, Ledra Pal. / 1989 Limassol, Peter's Gal. / 1990 Brüssel, Pal. de l'Europe. – *G:* 1963, '68 Alexandria: Bienn. (K) / 2004, '05 Larnaka, Gal. Kypriaki Gonia: Zyprische Maler. ⌶ LEK IV, 2000. – *A. Chrysochos*, Kyprioi kallitechnes, Lefkosia 1982, 245–246; *J. Monneret*, Cat. raisonné du Salon des Indépendants 1884–2000, P. 2000. – *Online:* PBase (s.v. Hadjisotiriou, Xanthos). E. Kepetzis

Chaudouët, *Yves*, frz. Maler, Graphiker, Illustrator, Fotograf, Installations-, Performance-, Video- und Multimediakünstler, * 18. 3. 1959 Neuilly-sur-Seine, lebt in Paris. Stud.: bis 1985 ENSBA, Paris. Lehrtätigkeit: Ec. supérieure de l'Image, Angoulême. – Zunächst v.a. Gem. und kleinformatige Monotypien. Später arbeitet C. bevorzugt gattungsübergreifend. Sein heterogenes Werk besteht u.a. aus Graphiken, abstrakten Zchngn, figurativen Gem., Fotogr., Videoarbeiten, Installationen (z.B. mit beleuchteten Meereswesen aus Glas, *Les poissons des grandes profondeurs*, 2007) und Performances, die häufig um Musik (oft von ihm in Anlehnung an John Cage), Lesungen und theatralische Sequenzen erweitert werden (z.B. *Sonoguidée; Conférence Concertante*). C. erhebt v.a. Unscheinbares zum Motiv (u.a. Flechten) und löst diese unspektakulären Gegenstände und Erscheinungen aus dem ursprünglichen Kontext heraus, um so Raum für neue Interpretationszusammenhänge zu schaffen (z.B. Fotogr. von Kontrolleuchten technischer Geräte). ⌂ BIRMINGHAM/Ala., Mus. of Art. GENF, MAH. LIMOGES, FRAC Limousin. PARIS, BN. – Centre Pompidou, Bibl. Kandinsky. – Fonds mun. d'Art contemp. – FNAC. WIEN, Albertina. – Bundeskanzleramt Österreich. 👁 *E:* Paris: 1986, '91, '93 Paris, Gal. Pons; 2001 MN des Arts d'Afrique et d'Océanie; 2006, '11 Gal. Christophe Daviet-Thery / 1987 New York, Urban Gall. / 1994 Bayonne, Mus. Bonnat / 1999 Birmingham (Ala.), Mus. of Art / 2008 Limoges, FRAC Li-

mousin / 2009 Strasbourg, Mus. Zoologique / 2010 Belfort, Gal. du Granit. – *G:* Paris: 1996 Gal. Satellite: Happy End; 2008 Gal. Defrost: Cent / 1999 Wien, Gal. Charim: Endzeit Transart / 2001 Lyon: Bienn. d'Art contemp. / 2002 Linz, LG: Aquaria / 2005 Arles: Rencontres internat. de la Photogr. / 2006 Ljubljana: Internat. Graphik-Bienn. / 2009 Altkirch, Centre régional d'Art contemp. Alsace: Chhttt... (K) / 2010 Mulhouse, La Filature: Le décor à l'envers. ⌑ *Bénézit* III, 1999. – *M.-H. Gatto,* Nouvelles de l'estampe (P.) 151:1997, 64; *M.-C. Miessner,* ibid. 191/192:2003/04, 70–72; *A. Bertrand,* Y. C., Arles 2010. – *Online:* Website C. F. Krohn

Chaumeil, *Aristide* cf. **Chaumeil,** *Henri*

Chaumeil, *Henri,* frz. Keramiker, * 1877 Chennevilliers/Hauts-de-Seine oder Paris, † 1944. Mitgl. einer trad.-reichen Keramiker-Fam.: Sohn und Schüler von *Aristide C.,* Vater und Lehrer von *Paul C.* (* 1902, † 1984). Im 1. WK 1914–18 bei einem Hersteller von feuerfester Keramik tätig. Stud.: Ec. des Arts décoratifs, Paris. Gelangt als Aussteller in den dortigen Salons d'Automne (Mitgl.) und des Artistes Décorateurs rasch zu Ansehen. Führt bis 1939 zus. mit seinem Sohn ein von ihren Vorfahren übernommenes Geschäft in Paris weiter, in dem nach Vorbildern aus dem 18. Jh. selbst gefertigte Fayenceimitationen verkauft werden. Später Vertrieb ihrer Werke durch die Pariser Gal. Géo Rouard. – Nach Beginn im Stil des Art nouv. wendet sich C. dem Art Déco zu und fertigt neben Gebrauchs-v.a. Zierkeramik, größtenteils Steinzeug- und Fayencevasen und -fußschalen (glasiert, unglasiert, craqueliert, patiniert). Er bevorzugt wohl proportionierte gerundete Gefäßformen (bauchig, ei- und kugelförmig). Nach Entwurf von Léon Albert Marie de Leyritz entsteht eine bemerkenswerte Fußschale mit Schmuckmedaillon, das einen flötespielenden Frauenakt auf craqueliertem beigefarbenen Grund zeigt (Aukt. Aguttes, Paris, 24. 11. 2004). Bek. sind auch einige freikünstlerische Werke, bes. ein *Masque russe* gen. Frauenkopf (nach Entwurf der Bildhauerin Fanny Rozet, sign. von ihr, monogr. von C.; Aukt. Ader, Paris, 5. 12. 2007). ⌑ SEVRES, Cité de la Céramique (Werke von *Paul C.*). ◉ *G:* bis 1914 Paris, Salon des Indépendants. ⌑ *Edouard-Joseph* I, 1930; *Bénézit* III, 1999. – *E. Pelichet,* Céramique art déco, P. 1988. – *Online:* Céramiques contemp. franç., 1955–2005. Coll. du MN de Céramique, Sèvres (zu Paul C.). R. Treydel

Chaumeil, *Paul* cf. **Chaumeil,** *Henri*

Chauski, *Moshe,* israelischer Maler, Zeichner, * 1935 Vilnius, lebt seit 1959 in Israel. Stud.: KA, Vilnius; 1953 1. Preis für Junge Künstler. 1959 Emigration nach Israel. 1960–65 Porträtist bei der Tages-Ztg Yediot Aharanot. 1965–95 Tätigkeit für das Computing Center des Weizmann Inst. of Science in Rehovot. – Mit heiterkarikierenden, z.T. auch sozialkritischen Genrebildern taucht Ch. in den städtischen Alltag ein. Deutlich von Daumier inspiriert, findet er seine Themen z.B. in Wartezimmern, Kunst-Ausst., in Cafés oder Frisiersalons. In lockerem Duktus entstehen ferner postimpressionistische Stilleben und (Selbst-)Porträts. ◉ *E:* u.a. Tel Aviv: 1968, '71, '75 Lim Gall.; 1976, '79, '92 Sara Kishon Gall. / 1978

Köln, Gal. Leonhard / 1984 Jaffa, Gall. 13 ½ / 1998 Tennessee, Davishire Gall. – *G:* seit 1968 im In- und Ausland, u.a. seit 1990 New York: Artexpo / 1997 Düsseldorf: Art Multiple. ⌑ *Online:* Website Ch. St. Schulze

Chauvassaignes, *Franck-François-Genès* (*Franck; Franc*; Chauvassaigne, *Frank*), frz. Amateurfotograf, * 22. 3. 1831 Condat-en-Combraille/Puy-de-Dôme, † nach 1900. Sohn von Louis-Génie C. und Elisabeth Besson; Bruder von Paul-Antoine-Marie C., Telegraphie-Ingenieur und Ritter der Ehrenlegion. C. entstammt einer bed. Fam. aus Clermont-Ferrand. Er ist Bürgermeister von Saint-Genès-Champanelle (1864–1900) und Departementsrat von Puy-de-Dôme. 1876 eröffnet er auf seinem Anwesen Chateau de Theix eine für die damalige Zeit vorbildhafte Fischzucht und publiziert in der Folge zahlr. Schriften zum Thema. – Ab M. der 1850er Jahre beschäftigt sich C. mit der Fotografie. Zu seinen Motiven zählen Aktstudien und Selbst-Portr. in versch. Kostümierungen, z.B. in orientalischen Gewändern, sowie Lsch.-Aufnahmen, darunter Ansichten der umliegenden Wälder. ⌑ KANSAS CITY/MO., Nelson-Atkins Mus. of Art. LOS ANGELES, J. Paul Getty Mus. NEW YORK, Metrop. Mus. ✉ Le repeuplement des eaux. Réponse au questionnaire publié par la Commission d'enquête nommée par le Sénat, ..., Clermont-Ferrand 1880; Rapport sur la pisciculture en Grèce, ..., Clermont-Ferrand 1895. ◉ *G:* 2004 Paris, Gal. Baudoin Lebon: Un dilettante chez les Primitifs. Un tour de France de la photogr. de paysage, 1850–1865 (K) / 2006 Jerusalem, Israel Mus.: Beyond Time. Photographs from the Gary B. Sokol Coll. (K) / 2012 New York, Metrop. Mus.: Naked before the Camera. ⌑ *D. Canguilhem,* Le merveilleux scientifique. Photogr. du monde savant en France, 1844–1918, P. 2004; *K. Jacobson,* Odalisques and arabesques. Orientalist photogr. 1839–1925, Lo. 2007; *S. Aubenas* (Ed.), Primitifs de la photographie. Le calotype en France 1843–1860 (K), P. 2010. P. Freytag

Chauvin, *Daniel* (Pseud. Dan), belg. Comiczeichner und -texter, Illustrator, * 25. 5. 1939, † 1. 8. 1995, war tätig in Brüssel. Autodidakt. Ab 1967 Ass. von Joseph Gillain (Jijé), für dessen Fliegercomic *Tanguy et Laverdure* C., selbst passionierter Liebhaber der Fliegerei, Flugzeuge zeichnet und später auch das Lettering sowie Tusche-Zchngn übernimmt. Für die Mag. Spirou, Super Pocket Pilote und Tintin entstehen in den 1970er Jahren kürzere eig., z.T. mit dem Pseud. Dan sign. Comics, u.a. mehrere Episoden der Serie *Les belles hist. de l'Oncle Paul* und einige Fliegergeschichten. Anstelle des erkrankten Victor Hubinon zeichnet C. zudem einige Seiten des *Buck Danny*-Albums *Le Pilote au masque de cuir* (1971). Zus. mit dem Szenaristen Jean-Yves Brouard konzipiert er in den 1980er Jahren Kurz-Gesch. für Tintin-Reporter und einen nicht publ. längeren Fliegercomic für Spirou. Veröffentlicht mehrere Alben: *Bob Browning* (1984); *L'énigme W* (1986); *Chassé-croisé* (1987; die beiden letzten nach Szenarien von Albéric de Palmaert). 1985 Ass. von Marcel Uderzo an dessen Album *Missiles et sous-marins*. Gestaltet zudem einige Episoden der Fliegerserie *Biggles raconte*, Rätselcomics für das frz. Mag. Télé 7 Jeux (*Com-

missaire Tanquerel) und Ill. für das Bull. de sécurité des vols. – Routinierte realistische, z.T. auch semirealistisch-humoristische Zchngn mit deutlichen stilistischen Anleihen an Jijé. ▭ *Delarge*, 2001. – *M. Béra u.a.*, Trésors de la bande dessinée. Cat. enc. 2007–2008, P. 2006. – *Online:* Bedetheque; Lambiek Comiclopedia.
H. Kronthaler

Chauzy, *Jean-Christophe*, frz. Comiczeichner und -texter, Illustrator, Plakatgestalter, Kunsterzieher, * 16. 5. 1963 Toulouse, lebt in Paris. C. veröffentlicht in den 1980er Jahren neben der hauptberuflichen Tätigkeit als Zeichenlehrer zunächst Ill. und Comics in Independent-Rock-Mag. wie Combo (Paris) und Nineteen and Going Loco (Toulouse). 1988 erscheint in der vom Verlag Futuropolis hrsg. Reihe Coll. X das erste Album *Vengeance*, dem in rascher Folge weitere Comics folgen: u.a. *Bayou Joey* (1990; Text: Matz/Alexis Nolent); *Les Ecorchés* (1991); *Sans Rancœur* (1993). In den 1990er Jahren entstehen zahlr. Plakate für versch. Rockgruppen. Ab 1992 Mitarb. des belg. Comic-Mag. (à suivre), für das er zus. mit Matz mehrere Kurz-Gesch. gestaltet (Album *Peines perdues*, 1993). Gleichzeitig auch Ill. für Zss. wie Best, Max und Wind sowie für das Kinderbuch *J'ai tué mon prof!* (1993) von Patrick Mosconi. Seither zahlr. weitere Comicalben: u.a. *Parano* (1995); *Béton armé* (1997); *La Peau de l'ours* (1998); *Clara* (3 Bde; 1999–2002; Text v. Denis Lapière); *L'Age ingrat* (2000); *La Vigie* (2001; Text v. Thierry Jonquet); *Rouge est ma couleur* (2005; Text v. Marc Villard); *Petite nature* (3 Bde; 2007–09); *La Guitare de Bo Diddley* (2009; Text v. M. Villard); *Bonne arrivée à Cotonou* (2010; Text v. Anne Barrois). Ab 1997 entstehen zudem Comics für das Independent-Mag. Ogoun!, seit 2005 für die satirische Comic-Zs. Fluide Glacial. – Vertreter eines dynamisch-linienbetonten, oft zum Karikaturhaften neigenden, anfangs auch düster-expressiven Zeichenstils. C. beschäftigt sich in den oft als Kriminal-Gesch. angelegten und in der populären Musikszene spielenden Comics mit Themen wie Rassismus und ges. Intoleranz. ▭ *H. Filippini*, Dict. enc. des héros et auteurs de BD, II, Grenoble 1999; *id.*, Dict. de la bande dessinée, P. 2005; *P. Gaumer*, Dict. mondial de la BD, P. 2010. – Les cah. de la bande dessinée 1990 (89) 8; Bachi-Bouzouk 1999 (1) 59 s., 92; *J.-C. Menu* (Ed.), Comix 2000, P. 1999; *M. Béra u.a.*, Trésors de la bande dessinée. Cat. enc. 2007–08, P. 2006; *M. McKinney*, Hist. and politics in French language comics and graphic novels, Jackson, Miss. 2008. – *Online:* Bedetheque; Lambiek Comiclopedia. H. Kronthaler

Chavallo, *Giorgio* → **Cavallo**, *Giorgio*

Chavan (Chauhan), *Bhagwan (Bhagwan Shankar)*, indischer Maler, * 3. 6. 1958 Kurduvadi/Maharashtra, lebt in Chikmagalur/Maharashtra. Stud.: 1982 Sir Jamsethji Jijibhai SchA, Bombay (Stip.). 1988–90 Stip. der frz. Reg.; 1991, 2000–03 Stip. der indischen Regierung. Um 2010 Kunstlehrer in Maharashtra. Ausz.: 1982 Lalit Kalā Akad., New Delhi (Nat.-Preis). – C.s Werk umfaßt abstrakte Komp. in Öl und Acryl, denen er mit Pinsel, Rolle, Spachtel und Stoffballen Struktur und räumlich wirkende Tiefe gibt. Über dem pastosen Grundauftrag erzielt

C. mit dünnen, transparenten Schichten subtile Farbwirkungen. Die Entstehung eines großformatigen Gem. während der Kalā Mela in Chennai und dessen spätere vollständige Überarbeitung als Reaktion auf ein schweres Erdbeben in C.s Heimatstadt ist Thema eines Kurzfilms des Dokumentarfilmers R. V. Ramani (Through the window, Indien, 1993). ⌂ NEW DELHI, NGMA. – Lalit Kalā Akad. ⊙ *E:* 1989 Paris, ENBA / 1991 Mumbai, Jehangir AG (mit Yogesh Rawal und Bharati Kapadia) / New Delhi: 1993 Gall. Espace; 1994 Pundole AG / 1995 Calcutta (Kolkata), Centre for internat. mod. art. – *G:* New Delhi: 1982, '91, 2004 (Golden Jubilee exhib.) Lalit Kalā Akad.: Nat. exhib.; 1997 SAHMAT: Gift for India / 1988 Mumbai, Jehangir AG: Monsoon Show / 1990 Bhopal (Madhya Pradesh), Bharat Bhavan: Bienn. (Ausz.) / 1987, '92 Paris, Gall. de Cygne: Indian artists in Paris. ▭ *P. Sheth*, Dict. of Indian art and artists, Ahmedabad 2006. – *R. Dhamija*, Award winners. Nat. exhib. of art 1955–1990, New Delhi 1990. M. Frenger

Chavanon, *Albert*, frz. Maler, Restaurator, * 4. 4. 1931 Paris, † 21. 5. 2008 Saumur/Maine-et-Loire, lebte in Paris, Versailles/Yvelines und Saumur. Sohn des Forschers und Homöopathen Paul Isidore C. Stud.: ab E. der 1940er Jahre ENSBA, Paris, bei Jean Souverbie, Edmond Amédée Heuzé. Ausz.: 1960 Aufenthalts-Stip., Casa Velázquez, Madrid; 1973 Prix de Peint., 1979 Prix Pierre Ballue, beide Fond. Taylor; 1979 Chevalier, 2004 Officier dans l'ordre des Arts et des Lettres; 1983 Prix de Peint., Salon du Medec. Als Restaurator im Versailler Schloß sowie in Pariser Museen tätig. – V.a. expressive Gem. in Öl. C. malt bevorzugt Marinen und (Fluß-)Lsch., weiterhin Stadtansichten, Portr. und Akte. Die (Blumen-)Stilleben sind von einer durch die restauratorische Arbeit beeinflußte realistischere Malweise gekennzeichnet. ⌂ NOGENT-LE-ROTROU, Mus. du Château St-Jean. PARIS, MAMVP. ⊙ *E:* Paris: 1964 Gal. St-Placide; 1983 Gal. St-Luc / 1970 Nogent-le-Rotrou, Mus. du Château St-Jean / 1971 Bretoncelles, Centre d'Art / 1987 Les Baux-de-Provence, Hôtel de Manville / 2010 Grenoble, MBA. – *G:* Madrid: 1960 Mus. Mpal.: Interpretacion de la Casa de Campo (K); 1961 Sociedad esp. de Amigos del Arte: Expos. de la Casa de Velazquez / Paris: 1963 Salon des Indépendants; 1964, '79 Salon de la Marine; 1965, '73 Salon de l'Ec. franç. (Mitgl.); 1965, '68 (ehrenvolle Erw.), '69, '71, '80 SAfr.; 1966 Salon de la Jeune Peint. ▭ *Bénézit* III, 1999. – *Online:* Website C. F. Krohn

Chaveli Carreres (Chaveli), *Ramón*, span. Bildhauer, Bildschnitzer, * 1879 Valencia, † 17. 3. 1947 Jerez de la Frontera/Cádiz. Vater des Bildhauers *Tomás Chaveli Gibert* (* 1912, † 1976), der C.s Wkst. übernimmt. Ausb. in Valencia. Kurzzeitig in Barcelona tätig, ab 1922 mit eig. Wkst. in Jerez de la Frontera ansässig. Nach Beginn mit Bronzeplastik spezialisiert sich C. aufgrund großer Nachfrage von Bruderschaften, Kirchgemeinden und and. relig. Gemeinschaften auf naturalistische, polychrom gefaßte Prozessionsfiguren aus Holz und macht sich damit über Jerez de la Frontera hinaus einen Namen in weiteren andalusischen Prov., bes. in Cádiz. – C. gelingt es mit sei-

nen sakralen Figuren und Figurengruppen in bes. Weise, dem Anliegen der in Andalusien tief verwurzelten Trad. der relig. Andacht und des christlichen Prozessionsgedankens gerecht zu werden. Seine Gestalten sind stilistisch geprägt durch eine Symbiose aus Einflüssen von Vorbildern aus dem 17. Jh. und Elementen des andalusischen Barock (Hw. *Nuestro Padre Jesús de la Vía Crucis*, 1940; Jerez de la Frontera, Kloster S. Francisco; *El Cristo del Amor*, 1941; ebd., Cap. de los Remedios). Neben den zahlr. sakralen Figuren entstehen Büsten (*Luis Coloma*, Jesuitenpater; *Julio González Hontoria*, Bürgermeister von Sanlúcar de Barrameda) und einige Stein-Skulpt. als bauplastischer Schmuck. ▱ *Stein-Skulpt. an öff. Gebäuden:* JEREZ DE LA FRONTERA, Rathaus: El Sagrado Corazón de Jesús, Medaillon, Hochrelief, 1929. – Pal. Domecq de la Riva, Hauptportal: 2 Krieger. – Esc. Universitaria de Relaciones Laborales. – Inst. de Educación Secundaria de Sa. Isabel de Hungría. – *Prozessionsfiguren (Hw.):* ARCOS DE LA FRONTERA, Pfarrk. S. Francisco. HUELVA, Pfarrk. La Purísima Concepción. – Kirche Sa. María de la Esperanza, 1939. JEREZ DE LA FRONTERA, Kirche Nuestra Señora del Carmen. – Kirche S. Lucas. – Pfarrk. S. Mateo. PRUNA/Sevilla, Pfarrk. S. Antonio Abad, 1942. ROTA/Cádiz, Pfarrk. Nuestra Señora de la O. SAN MARTIN DEL TESORILLO/Cádiz, Pfarrk. Martín de Tour, 1945. ▱ Dicc. enc. ilustrado de la Prov. de Cádiz, II, Jerez de la Frontera 1985; *Agramunt Lacruz* I, 1999 (falsches Geburtsjahr). – *A. M. Romero Coloma*, Arch. de arte valenciano 75:1994, 91–96; *ead.*, Est. hist.-artíst. de los Nazarenos de Jerez de la Frontera, Jerez de la Frontera 2001; *A. de la Rosa Mateos*, El escultor R. C. (1879–1947), Jerez de la Frontera 2005; *id.*, Jerez Inf. v. 8. 3. 2008. R. Treydel

Chaveli Gibert, *Tomás* cf. **Chaveli Carreres,** *Ramón*

Chavent, *Claude,* frz. Goldschmied, Schmuckgestalter, Bildhauer, * 1947 Lyon, tätig in Puéchabon/Montpellier. Verheiratet mit der Goldschmiedin und Schmuckgestalterin *Françoise C.* (* 1947). Beide absolvieren nach dem Stud. (Claude C.: Chemie; Françoise C.: Lit.-Wiss.) eine Goldschmiedelehre in Lyon und arbeiten 1972–76 dort im gemeinsamen Atelier, anschl. in Puéchabon. Seit 2007 führt C. das Atelier allein weiter. – In Zusammenarbeit mit seiner Frau fertigt C. zunächst figurative skulpturale Schmuckstücke (Unikate, Kleinserien). Eines der letzten Beispiele dieses Frühwerks ist der Ring *Pont* von 1983 aus brüniertem Stahl, Gold und Nylon. Es entstehen bevorzugt Broschen und Ringe sowie Ketten und Ohrschmuck aus Gold, Silber, Platin, Eisen und Stahl. Werke, die Alltagsgegenstände (Buch, Spiegel), Pflanzen (Baum) sowie architektonische Motive (Tür, Fenster, Treppe, Säule) in stark vereinfachter Form aufgreifen, markieren den Übergang zur geometrischen Abstraktion, z.B. *Pilliers*, Gold, Eisen, 1992; *Livre de Poche*, Eisen, Feingold, 1997; *Fenêtre à l'Arbre*, Gold, Eisen, 2000. C.s char. geometrisch-abstrakte Schmuckstücke irritieren die Sehgewohnheiten durch das Spiel mit Perspektiven und Dimensionen. Typisch für diese Trompe-l'œil-Arbeiten ist eine durch Metallbürste oder Hammer strukturierte Oberfläche und die Kombination farblich kontrastierender Mat. wie z.B. Gold und Silber oder Gold und Eisen, die so eingesetzt werden, daß räumliche Tiefe suggeriert wird wie bei der dreidimensional wirkenden Brosche *Cube*, Platin, Gold, 1998. Weniger bek. ist C.s bildhauerisches Werk, v.a. Arbeiten aus Stahl. ▱ DUNKERQUE, FRAC Nord-Pas-de-Calais. NEW YORK, MAD. PARIS, MAD. ◉ *E:* 1992 Lausanne, Gal. Ipsofacto (seit 1998 Gal. Viceversa) / 1992, 2000 Paris, Gal. Hélène Porée / 1993 Zürich, Schmuck Forum / 1996, 2003 Barcelona, Ramon Oriol / 1999 Cagnes-sur-Mer, Espace Solidor (mit Henri Gargat, Frédéric Braham; K) / 2004 Karlsruhe, Gal. Der goldene Schnitt / 2010 Lyon, Gal. Il était une fois des créateurs. – *G:* 1992 Paris: Trienn. du bijou / 1994 Cagnes-sur-Mer, Château Mus. Grimaldi: Orfèvrerie et Bijoux contemp. / 2001 München, Gal. Isabella Hund: Künstler der Gal. (K) / 2002 Cambridge (Mass.), Mobilia Gall.: Jewelry from paint. / 2008 Santa Fe (N. Mex.), Patina Gall.: Adornment for the 21st c. / 2010 Lyon, LafabriQ: L'atour enchanté / 2011 Baccarat, Pôle Bijou Baccarat: Effets de Matière; New York, Aaron Faber Gall.: In line/In metal. ▱ Dict. internat. du bijou, P. 1998. – *R. Ludwig* (Ed.), Schmuck 2000. Rückblick, Visionen, Ulm 1999; *M.-B. Eich*, Schmuck-Mag. 2000 (5) 96–99; *R. Ludwig*, Schmuck-Design der Moderne, St. 2008. F. Krohn

Chavent, *Françoise* cf. **Chavent,** *Claude*

Chaves, *Diógenes* (eigtl. Chaves Gomes, *Diógenes*), brasil. Maler, Karikaturist, Graphiker, Zeichner, Publizist, * 28. 11. 1959 Araçagi/Paraíba, lebt in João Pessoa. Stud.: Phil. (Abschluß) und 1974–75 Kunstgesch. an der Univ. Federal da Paraíba, João Pessoa. Als Prof. für Modedesign und Autor tätig. – C. widmet sich v.a. der Zchng und Druckgraphik (Siebdruck), wobei letztere häufig als Ausgangspunkt für seine Acryl-Gem. dient. Inspiriert von Reisen nach Südfrankreich entsteht 2003 die *Azul* betitelte Lsch.-Serie, in der sich C. mit Farbstudien beschäftigt. ◉ *E:* Rio de Janeiro: 1990 Gal. do Ibeu; 1992 Gal. da Bibl. Popular de Botafogo / João Pessoa: 1991, '97 Gal. Archidy Picado; 1993, '98 Gal. da Aliança Francesa; 2003 Bibl. do Centro Federal de Ensino Tecnológico / 1993 Maceió, Gal. da Aliança Francesa / 1997 Marseille, Gal. Le-Hors-Là. – *G:* João Pessoa: 1988, '90 Fund. Espaço Cult.: Arte Atual Paraibana; 1988 Salão de Humor (lobende Erw.); 1992 Gal. Gamela: Abismos 5; 1998 Centro de Artes Visuais Tambiá: Pedras do Fogo / 1990 Rio de Janeiro, Esc. de Artes Visuais Parque Lage: Mostra do Clube de Gravura da Paraíba / 1992 Campina Grande, Mus. Assis Chateaubriand: Pintura Contemp. / 1995 Barcelona: Internat. Mini Print Exhib. / 1997 Florianópolis: Salão Vitor Meireles / 1998 Sobral: Salão de Abril. ▱ *Online:* Inst. Itaú Cult., Enc. artes visuais, 2011. M. F. Morais

Chaves (C. Dailhe), *Jorge,* chilenischer Maler, Zeichner, Restaurator, * 1905 Chillán, † 1999 (März 2002 lt. Grupo Panagra) Santiago de Chile. 1918 Ausb. beim Maler Gumercindo Oyarzo und später bei Carlos Dorlhiac in Chillán. Stud.: Pädagogik ebd. Mitgl. der ebd. 1929 gegr. Soc. de BA Tanagra (zeitweise Präs.). In den 1950er Jahren Übersiedlung nach Santiago de Chile. Ausz.: 1956 Ehrenpreis, Salón de Pintores Chilenos, Concepción; 1976 Gold-

Med., Salón Nac., Santiago de Chile; 1977 Bronze-Med., Certamen Nac. de Artes Plást. Lircay. – C. stellt unter dem Einfluß der zw. Realismus und Impressionismus stehenden Maler Juan Francisco González und Benito Rebolledo v.a. Öl-Gem. mit Lsch. und ländlichen Szenen vom Süden Chiles dar, häufig den Strand von Dichato und die Orte Tomé und Talcahuano, außerdem Stilleben und Blumenbilder. In Santiago de Chile widmet er sich bes. der Rest. von Öl-Gem. von Pedro León Carmona, Cosme San Martín, Pascual Ortega und José Mercedes Ortega. ⌂ CHILLÁN, Liceo de Hombres Narciso Tondreau. – Soc. de BA Tanagra. CONCEPCIÓN, MAC de la Univ. de Chile. – Pin. de la Univ. MÜNCHEN, Bayerisches NM. ✉ Francés (1 Bd und 4 Kassetten), S. Ch. 1987. ☞ *E*: 1924 Chillán, Cuerpo de Bomberos / Santiago de Chile: 1981 Salones del Pal. de la Alhambra; 1985, '89 Casa de la Cult. del Parque Metropolitano; 1989 Soc. Nac. de BA, Pal. de la Alhambra; Fund. Nac. de la Cult., Gal. Fundación (K). ⌨ *M. Orellana Riquelme*, Casa Colorada. Club 20 de Agosto de Ñuble. Encuentro de pintores chillanejos. Soc. de BA 1981 Tanagra, S. Ch. 1982; *B. Hernández R.*, Arte y artistas de Ñuble, Chillán 1989; Fund. Nac. de la Cult., 10 años memoria 1982–1992, S. Ch. 1992; *B. Hernández R.*, Arte mural de Chillán, Chillán 1996; Pint. chilena, II, Univ. de Concepción, 1997. – *Online:* Artistas plast. chilenos; Grupo Tanagra. M. Nungesser

Chaves, *Marcos*, brasil. Fotograf, Installations- und Videokünstler, Architekt, * 1961 Rio de Janeiro, dort tätig. Stud.: Bloco Esc. des MAM, Rio de Janeiro; Esc. de Artes Visuais Parque Lage ebd.; ab 1979 Univ. de Santa Úrsula ebd. (Archit., Stadtplanung). Ausz.: 1998 Reise-Stip. des Salão Nac. de Artes Plást.; 2006 Prêmio Univ. Estácio de Sá. – C. verwendet versch. Medien, zw. denen sich sein Werk (Objektinstallation, Fotogr., Video, Zchng, Sprache, Ton) bewegt. Auch Lichteffekte sind kennzeichnend (*Solar Grandjean de Montigny*,1989; MAM, Rio de Janeiro). Für seine Objekte werden alltägliche Gegenstände in knalligen Primärfarben, z.B. eine Wärmflasche, Taschenmesser, Spiegel oder Rasiergeräte, in neue Zusammenhänge gestellt: Zwei mit den Borsten ineinander gesteckte Schuhbürsten zeigen ein zähnefletschendes Lächeln (*Irene laughs*, 1994), zwei mit den Sohlen symmetrisch aneinander befestigte rote Pumps symbolisieren einen Uterus (*Untitled*, 1992). C.s Fotogr. konzentrieren sich auf Details, etwa Baumwurzeln, Steinformationen, Wandstrukturen, Spiegelungen oder farbige Armaturen. In Serien lichtet C. Nippesfiguren (*Figure Series*, 2007) oder Details von u.a. hist. Skulpt. ab (*Eclectic Series,* 2001), deren Körperteile er zuvor z.B. mit angeklebten roten Fußnägeln, falschen Wimpern und nachgezogenen Augen oder Masken manipuliert. In den *Holes Series* dokumentiert er baufällige Straßen und Schlaglöcher, die durch alte Möbel, Bau-Mat. oder Müll in den Blick des Betrachters gehoben werden. Es entstehen aber auch aus mehreren Teilfotos zusammengesetzte großformatige Panoramaansichten oder Wiederholungen des gleichen Motivs (*Vanishing Points*, 2008; *Archipelago*, 2010). Für seine erste Ausst. in England 2005 konzipiert C. ein Video (*Laughing Mask*), das einen kör-

perlos schwebenden Kopf mit einer grotesken lachenden Clownsmaske, die kurz unterhalb der Augen endet, vor schwarzem Hintergrund zeigt. Der Film ist einer von drei Selbstporträt-Sequenzen mit Maske, die sich mit der Grenze zw. realer Künstlerperson und fiktivem Werk befassen. Ohne Ton bleibt es dem Betrachter überlassen, den Film zw. Humor und Angst zu verorten. Weitere, meist nahsichtige Videos zeigen Ausschnitte oder sich wiederholende Vorgänge, etwa aufziehbares Spielzeug (*Foca!*, 2007), den sich bewegenden Mund eines sprechenden Radios (*Talking Radio*, 2007) oder die Doppelprojektion eines fliegenden Insekts neben einem Flugzeug (*Frequéncias*, 2008). Die Ausst. *Retratos* (Portr.) in der Gal. Artur Fidalgo in Rio de Janeiro 2009 zeigt nicht Fotogr. von menschlichen Gesichtern, sondern 25 Abzüge von nach oben gehaltenen Wischmops, deren herabfallende Stricke an Haare erinnern. Während einer Reise in Dubai hatte C. Wischmops gesehen, die zum Trocknen verkehrt herum an eine Wand gelehnt waren. Das Spiel mit der Ähnlichkeit fördert in einer Parade maskenhafter „Gesichter" regelrechte Persönlichkeiten mit Frisuren und Haltungen zutage. C. bedient sich hier der Methode von Marcel Duchamp, objets trouvés als Kunstwerke (hier als images trouvés) zu inszenieren. Jedoch illustrieren die Fotos nicht eine exotische Realität oder komponierte, ethnologische Porträts aus der arabischen Welt, sondern die Verschiedenartigkeit alltäglicher Gegenstände. 2011 entstehen für den Pal. da Aclamação Casa Cerimonial e Mus. in Salvador drei Installationen, in die der Raum des Gebäudes einbezogen wird: C. läßt Wind durch offene Fenster strömen und Gardinen blähen oder hängt Möbelstücke an Seilen von der Decke ab. Mit schwarz-gelbem Absperrband, das ohne Abstand in versetzten Streifen spiral- oder sternförmig auf Wände, Böden und Decken geklebt wird, stattet C. ganze Räume aus, etwa in der Gal. Itaú Cult. in São Paulo (*Logradoura,* 2005). Die entstehenden tapetenartigen Installationen haben psychedelisch wirkende Effekte und ähneln optischen Täuschungen. Immer wieder verwendet C. Einrichtungsgegenstände oder Gebäudeteile, so in *Spare Seats / Enough Room* (2002), wobei in der Gal. Paço Imperial in Rio de Janeiro leere Stühle und Hocker im Raum verteilt werden, oder für *Welcome* (2006) eine Tür in die Decke eines Raumes eingearbeitet wird. Zahlr. Workshops; 2005 auch eine Bühnenbildinstallation für die Moskauer Aufführung von Ensaio Hamlet (Enrique Diaz/Bruno Beltrao). ⌂ RIO DE JANEIRO, MAM, Col. Gilberto Chateaubriand. ☞ *E*: Rio de Janeiro: 1993 (mit André Costa, Raul Mourão), 2000 Gal. IBAC Sérgio Milliet/Funarte; 1995 Paço Imperial; 2005 Laura Marsiaj Arte contemp.; 2011 Gal. Laura Alvim / São Paulo: 2001 Paço das Artes (K); 2002, '11 Gal. Nara Roesler; 2009 Mus. da Imagem e do Som / 2002 Vitória, Mus. Vale do Rio Doce / 2005 London, Butcher's / 2008 Madrid, Gal. Blanca Soto / 2009 Friedrichshafen, Zeppelin Univ. –. *G*: Bahia: 1996 MAM: Esc. Plural (K); 1997, '99 Salão da Bahia / Rio de Janeiro: 1996 Funarte: Mensa = Mensae (K); 2000 Salão Nac. de Artes Plást.; 2003 Mus. da República: Bandeiras do Brasil; 2006 MAM: Um século de arte brasil. (K) / São Paulo: 2001 (K), '02

MAM: Panorama da Arte Brasil.; 2002 Bien.; 2011 Gal. Fortes Villaça: destricted.br / 2005 Cardiff, g39: On Leaving and Arriving (K); Koblenz, Ludwig Mus. im Deutschherrenhaus: Discover Brazil (K) / 2007 Tokio, Mori Art Mus.: All about Laughter. Humour in Contemp. Art / 2008 Helsinki, Vantaa Art Mus.: +40°-30° / 2009 Prato, Centro per l'arte contemp. Luigi Pecci: After Utopia. A View on Brazilian Contemp. Art; Berlin, Martin-Gropius-Bau: Die Tropen. Ansichten von der Mitte der Weltkugel (K). ▢ Zeitgen. Fotokunst aus Brasilien (K Wander-Ausst.), He. 2006; *A. Navas*, M. C., Rio 2007; *S. Barreto/A. Saraiva*, M. C., Rio 2008. – *Online:* Inst. Itaú Cult., Enc. artes visuais; Website C. C. Melzer

Chaves, *Raimond (Raimond Puiqui),* span.-kolumbianischer Zeichner, Gebrauchsgraphiker, Performancekünstler, * 1963 Bogotá, lebt seit 2002 in Lima. Als Sohn eines Kolumbianers und einer Katalanin bis 1990 mit der Fam. in Barcelona ansässig. 1996–99 Doz. an der Univ. de los Andes und der Univ. Jorge Tadeo Lozano, Bogotá. 2000–01 Mitgl. der Gruppe Cambalache (span. und kolumbianische Künstler). Mehrere Stip.: u.a. 2001 Hangar-Kaus Australis, Rotterdam; 2003 M & M Proyectos Fortaleza 302, San Juan/Puerto Rico; 2007–08 Capete, Rio de Janeiro. Seit 2001 gemeinsame Projekte mit der peruanischen Künstlerin Gilda Mantilla (2008–09 Stip. der Fund. Marcelino Botín, Santander). – Anfangs ist C. als Aktionskünstler, auch als DJ tätig. Dank zahlr. Atelier-Stip. arbeitet er u.a. in Liverpool, London, Lima, Amsterdam, Venedig, Chicago, Lissabon und Paris. – Seine Performances entstehen im direkten Kontakt mit Passanten, die zur eig. Kreativität aufgefordert werden. Diese Arbeiten, die zumeist auf dem Zusammenstellen (Sampeln) von Medien- und Straßenästhetik beruhen, verarbeitet C. zu unabhängigen kult. und politischen Aussagen. Mit Cambalache macht er Verkaufsaktionen auf den Straßen von San Juan und Bogotá (El Mus. de la Calle) sowie in europ. Städten. Außerdem widmet er sich bes. dem Zeichnen (z.B. *Dibujos marihuanas*, 1997), meist ebenfalls im Sinne des Sampelns, indem er abzeichnet und kopiert sowie Fotokopie, Collage, Spray und Schablonen mit einbezieht. In seinen Serien geht er kritisch auf politische Themen ein (*Crónicas de la coca*, 2002; *Lo que yo traigo no se vende en la marqueta*, 2004). Mit G. Mantilla gestaltet er in Puerto Rico Straßen-Ztgn, die an Kordeln zum Verkauf angeboten werden und in Zusammenarbeit mit Einwohnern entstehen (*Hangueando. Periódico con patas*, 2002–03). Aus Reisen durch Südamerika (u.a. Venezuela, Kolumbien, Ekuador, Peru) geht die umfangreiche Serie *Dibujando América* (2005–08) hervor, in der C. und Mantilla in der Trad. der Reisezeichner des 19. Jh. in unterschiedlicher Form und versch. Techniken Beobachtungen über Entwicklungen und Spannungen des Kontinents, über Kultur und Politik darstellen. In mehreren internat. Ausst. wird die aus neun thematischen Tln bestehende Serie raumbezogen und in jeweils modifizierter Form (z.B. Einbeziehung bemalter Zeitungsausschnitte) gezeigt. Beide Künstler setzen sich in Installationen, Videos und Tondokumenten auch mit Fragen von Ökologie und Klima im politisch-kult. Kontext

auseinander (*Observaciones sobre la ciudad del polvo*, Lima, 2008–10). C. verbindet seine künstlerische Arbeit mit versch. eig. Texten, publ. in Kat., Zss. und Büchern. Außerdem gestaltet er seit 1999 Plakate, Flugblätter, Anzeigen und Internetgraphik für die Musik-Fa. Arco y Flecha in Barcelona. 🏛 LEÓN, MAC de Castilla y León. LIMA, Mus. de Arte. LONDON, Tate Mod. MADRID, Fund. ARCO. NEW YORK, MMA. SANTIAGO DE COMPOSTELA, Centro Galego de Arte Contemp. VALLADOLID, Patio Herreriano. ✉ Los ladrones de dinamita, Ba. 2000. ☉ *E:* Barcelona: 1995 Fund. Joan Miró, Espai 13 (K: M. Regàs); 1997 Gal. Ferrán Cano (K: M. Clot); 2007, '10 ProjecteSD (mit G. Mantilla) / Bogotá: 1996 Univ. de los Andes; 2003 Valenzuelay Klenner Arte Contemp.; 2004 Alianza Francesa (K: J. Roca) / 1997 Rijeka, Mod. Gal.; Ljubljana, Gal. Skuc / 2001 London, Flat 37 (mit Carolina Caycedo) / 2002 Rotterdam, Fund. Klaus Australis / Lima: 2004 Gal. Punctum; 2007 Gal. Pulga; Centro Cult. de España (mit G. Mantilla); 2010 Gal. Revolver (mit G. Mantilla) / 2005 Madrid, Casa de América (mit G. Mantilla; K: V. Torrente) / 2006 Valladolid, Mus. Patio Herreriano (mit G. Mantilla; K: R. Quijano). – *G:* Barcelona: 1992 Univ., Fac. de BA: Noves de BA (K); 1993 Univ., Sala Balmes: El blanc negre (K) / 2001 Istanbul: Internat. Bienn. / 2003 Santo Domingo: Bien. de Pint. del Caribe y Centroamérica / 2004, '09 San Juan: Trien. Poli / 2005 Prag: Internat. Bienn. Gegenwartskunst / 2006 São Paulo: Bien. / 2007 Cartagena de Indias u.a.: Cart[ajena] (K: J. Díaz/J. Roca) / 2011 Berlin, IfA Gal.: Cut & Mix ... Zeitgen. Kunst aus Peru und Chile (Wander-Ausst.; K: B. Barsch u.a.). ▢ *M. Botero Thierez*, El Tiempo (Bog.) v. 21. 11. 1996; *S. Osmanagić*, Delo (Ljubljana) v. 9. 8. 1997, 7; *S. Pagé u.a.*, De l'adversité nous vivons (K MAMVP), P. 2001; *D. Blamey* (Ed.), Here, there, elsewhere. Dialogues on location and mobility, Lo. 2002; *J. M. G. Cortés u. a.*, Arquitecturas para el acontecimiento (K Espai d'Art Contemp. de Castelló), Va. 2002; *J. Gili*, Lápiz (Ma.), 2002 (182); *M. Marxuach u.a.*, Hangueando. Periódico de cordel, Lima 2004; *M. Oliveira*, Procesos abiertos (K), Terrassa, Ba. 2004; *A. Cuesta u. a.*, P_O_ complot: www.p-oberts.org (K), Terrassa 2004; *O. Alonso Molina*, ABC de las Artes (Ma.) v. 17. 12. 2005; *J. Burton u.a.*, Vitamin D. New perspectives in drawing, Lo./N. Y. 2005; *C. Martínez*, Whenever it starts it is the right time. Strategien für eine unstetige Zukunft (K KV), Ffm. 2007; *A. Molina*, El Páis, Supl. Babelia (Ma.) v. 28. 7. 2007; *G. Schöllhammer* (Ed.), Documenta Mag. 1–3 (Sammel-Bd), Köln 2007; Dibujando América. G. Mantilla & C. (K), San Juan 2009 (9 Bde im Schuber); *N. Smirnoff*, Flash art (Mi.) 2010 (274) 129. – *Online:* Website C. M. Nungesser

Chaves Dailhe, *Jorge* → **Chaves,** *Jorge*

Chávez, *Humberto,* kubanischer Maler, Zeichner, Mixed-Media-Künstler, * 1937 Havanna, lebt in Brooklyn/N. Y. Verläßt 1957 Kuba, lebt in Puerto Rico und gelangt 1960 über Miami/Fla. in die USA. Stud.: bis 1970 New School for Social Research und Parsons School of Design, beide New York. Ausz.: 1983 Nat. Endowment for the Arts Fellowship, Washington/D. C.; 1984 New

York Found. for the Arts; 1986 Pollock-Krasner Found., New York; New York State Council on the Arts Fellowhip Ciontas Found. Fellowship. 2001 Reise nach Kuba. – Überwältigt von der in New York angetroffenen Kultur und Kunst, läßt C. sich von den in den 1970er Jahren dort vorherrschenden Kunstströmungen (u.a. Kinetische Kunst, Pop-art) und vom russ. Konstruktivismus beeinflussen und gestaltet abstrakte Acryl-Gem. und Pastelle. M. der 1970er Jahre beginnt er unter Einbeziehung von Fundstücken mon., farbig bemalte dreidimensionale Arbeiten zu konstruieren. Die Skulpt. *The Window Remembers. Double Self-Portr.* (Mixed media, 1981), ein Blick durch ein Fenster in den Garten seines Hauses in Havanna, ist eine wichtige Zäsur in C.s Schaffen, da er sich seitdem mit der Vergangenheit, seinen Träumen und Erinnerungen an die Kindheit auseinandersetzt. Kehrt dabei in zunehmendem Maße zur Figuration zurück bzw. integriert figurative Elemente. Inspiriert von kubanischer Archit. und Lsch., gestaltet C. farbintensive Lsch. und Seestücke in Acryl, bei denen das Licht und die üppige Natur seiner Heimat bedeutsam sind (*Seven Pieces for Cuba. Isle of Palm Trees and Columns*, 1999). Häufig kombiniert er karibische und europ. Motive wie span. Fächer, Farbglasfenster, ornamentale schmiedeeiserne Arbeiten oder and. Archit.-Details, um aufzuzeigen, daß von außen aufgezwungene Elemente die urspr. Kultur nicht verdrängen können. 2005 entstehen mehrere Acrylbilder nach Gedichten von Nicolás Guillén (z.B. *Resisted by the Wind; Beaten by Stormy Waves*) und Dulce María Loynaz (u.a. *Night; I Am the House – Memories Through Time*). ⌂ EAST ISLIP/N. Y., Islip AM. LISSABON, Centro de Arte Mod. da Fund. C. Gulbenkian: Caldas in my heart, Holz, mit Acryl farbig gefaßt, Blattgold, 1989. ◉ *E:* New York: 1981 Frank Marino Gall.; 1983 Intar Latin Amer. Gall. – *G:* 1989 Caldas da Rainha: Bien. Internac. de Escult. e Desenho. ⌂ *I. Fuentes-Pérez u.a.* (Ed.), Outside Cuba/Fuera de Cuba (K), New Brunswick, N. J. 1988. – *Online:* Website C. C. Rohrschneider

Chávez Mayol, *Humberto,* mex. Fotograf, Video- und Installationskünstler, Hochschullehrer, Kurator, * März 1951 Mexiko-Stadt, lebt dort. Stud.: Film am Inst. Latinoamer. de Comunicación Educativa ebd; Fotogr. in Japan (Univ. Chiba, Univ. Nihon, Tokio). 1994 Austauschkünstler im Bemis Center for Contemp. Art in Omaha/Nebr. und 1999 im Banff Centre for the Arts in Banff/Alberta. Als Forscher am Centro Nac. de Investigación, Documentación e Información de Artes Plást. und als Doz. u.a. für Semiotik, Bildanalyse und Fotogr. an der Esc. Nac. de Pint., Escult. y Grabado „La Esmeralda" in Mexiko-Stadt und in Mérida/Yucatán tätig. Seit 1988 Kurator und Leiter des Foto-Slg Encuentros. – C.s künstlerisches Werk hat enge Beziehungen zu Lit., Semiologie und Strukturalismus. Es besteht u.a. aus konzeptuell aufgebauten, oft lit. inspirierten symbolischen Bilderserien, die sich meist mit den Mechanismen des Gefangenseins, dem Irrealen und den Bedingungen der Wahrnehmung beschäftigen. *Sábado, durante todo el día* und *La araña negra* (beide 1977) handeln vom Verhältnis von Archit. und menschlichem Körper

und dem Sichtbarmachen von Zchngn auf Mauern. In *Sistema seccionado* (1981) untersucht er Gesichter, die sich aus Einzelaufnahmen zusammensetzen. *Dispositivo imaginario* (1986) beschäftigt sich mit dem Kind-Menschen und seinen Erfahrungen im Gitterbett, *Ocha time* (*Tiempo del té*, 1990) von der Einsamkeit, dargestellt mit Puppen als Protagonisten, und *La casa. Rumores de un poder cristalizado* (mit María Inés Gracía, 1993) von der in alten Gebäuden gespeicherten Erinnerung. *Presencia y memoria* (1998) dokumentiert in Portr. versch. Mexikaner, die in den USA leben, und *Michael* (1999) den letzten Lebensmonat eines Aidskranken. In *Boxes* (2002) reflektiert C. das Verhältnis von An- und Abwesenheit. Das sich über Jahre entwickelnde Hw. ist die Installation *Tiempo muerto* (seit 2004), die auf dem gleichnamigen, wie ein Drehbuch fungierenden Buch basiert; miteinbezogen sind u.a. bewegte und unbewegte Bilder, Fotogr. und Videos, in die Tagebuchnotizen, ein Rechner mit interaktivem Programm, endoskopische Aufnahmen des eig. Körpers, ausgestopfte Tiere und and. Objekte integriert sind. Es geht um die Begegnung des Künstlers mit der Welt und um ihre Befragung, ausgelöst durch die eig. Erfahrung eines plötzlichen Stimmenverlusts. Der Ausst.-Raum verwandelt sich in eine Art Wiederverwertungs-Kamera (oder -Kammer), die Träume und Erinnerungen an nicht gelebte Zeiten und Augenblicke hervorruft. Auch fotogr. Beiträge für Bücher (u.a. L. I. Helguera, *La música contemp*, Méx. 1997). ⌂ MEXIKO-STADT, Centro de la Imagen. ✉ *C./M. I. García Canal,* El tiro de gracia, Méx. 1998; Tiempo muerto, proyecto de instalación. Libro (modo de empleo), Méx., 2004; Del tiempo muerto. Registro de exploraciones, Méx. 2007. ◉ *E:* 1980 Barcelona, Gal. Spectrum-Cannon / Mexiko-Stadt: 1980 Gal. José Guadalupe Posada; 2004 Centro Nac. de las Artes / San Luis Potosí: 1991 Inst. Potosino de BA; 2010 Gal. del Centro de las Artes / Omaha (Nebr.): 1995, 2005 Bemis Center for Contemp. Arts; 1996, 2001 Zodiac Gall.; 1997 Creighton Univ., Dpt. of Fine and Performing Arts; Mus. Latino / 1999 Mulhouse, ENSBA / 2000 Alberta, Banff Centre / 2002 Cholula (Puebla), Univ. de las Américas, Casa del Caballero Aguila (K) / 2004 Quebec, La Chambre Blanche / 2005 Toluca, Univ. Autónoma del Estado de México, Esc. de Artes (Wander-Ausst.; K) / 2006 León (Guanajuato), Gal. Grisell Villasana / 2007 Guanajuato, Univ. de Guanajuato; Mérida (Yucatán), Gal. Manolo Rivero; Freiburg im Breisgau, Gal. Foth. ⌂ *E. Treviño* (Ed.), 160 años de fotogr. en México, Méx. 2004. – *M. E. O'Neill,* Síndrome de la moneda perdida. Lost coin syndrome (K), Méx. 1995; *A. Castellanos,* Dispositivos imaginarios. Ensayo crítico sobre la imagen fotogr. A propósito de las ser. fotogr. de H. C., Méx. 1995; *M. I. García Canal,* Secret et silence, œuvre photogr. de Vera Mercer, Marc Fare, H. C. (K Wander-Ausst.), P. 2002; *N. Everaert-Desmedt,* Interpréter l'art contemp., Br. 2006; *D. Roeschmann,* Badische Ztg (FiB.) v. 17. 10. 2007. – *Online:* J. Torres Kato, Discurso visual, Rev. digital, April 2006. M. Nungesser

Chávez de la Mora, *Gabriel (Fray G.),* mex. Architekt, Designer, Benediktinermönch, * 26. 11. 1929 Gua-

dalajara, lebt in der Abtei von Tepeyac, Lago de Guadalupe (Cuautitlán Izcalli); Neffe des Architekten Enrique de la Mora y Palomar. Stud.: 1947 Esc. de Ing., Guadalajara; 1948–54 Esc. de Arquit., Univ. ebd. bei Julio de la Peña Lomelí (C. arbeitet als Zeichner bei ihm) und Ignacio Díaz Morales. 1965 Priesterweihe in Mexiko-Stadt; 1972 theol. Stud. in Medellín/Kolumbien, Rom und Paris. Gast.-Doz. an versch. Univ. (u.a. UNAM, Univ. Iberoamericana) sowie am Inst. Tecnológico y de Estudios Superiores de Monterrey. Ausz.: 1971 Med. de Plata del Premio Nac. de Diseño, Inst. Mex. de Comercio Exterior; 2010 Med. Antonio Attolini Lack, Esc. de Arquit. Univ. Anáhuac, Mexiko-Stadt. – Bereits 1947 gewinnt C. den Wettb. für das Mon. de la Bandera, das 1949 in Guadalajara errichtet wird. Seine Religiosität und der enge Kontakt zum Onkel E. de la Mora y Palomar, einem renommierten Experten für sakrale Archit., fördert C.s Interesse am Kirchenbau. Er knüpft Kontakte zur Esc. de Arquit. der UNAM und zu José Villagrán García und Pedro Ramírez Vázquez. Mit Kommilitonen gründet er am Studienort das Atelier Ars Sacra für Kunsthandwerk. Nach Eintritt in das Benediktinerkloster Sa. María de la Resurrección in Ahuacatitlán (Cuernavaca) im Jahr 1955 widmet sich C. verstärkt der Erneuerung der relig. Ikonogr. in versch. Techniken (Bildschnitzerei, Textil- und Möbeldesign, Goldschmiedarbeiten, Glasmalerei, Druckgraphik, Kalligr.). Seine theoretische Auseinandersetzung mit der Liturgie führt zur archit. Neuordnung des kath. Sakralraums. In der von ihm entworfenen Kloster-Kap. in Ahuacatitlán (1957) wird erstmals in Lateinamerika der Altar vom Ende des trad. Langhauses in die Mitte eines Zentralraumes versetzt, um die Begegnung von Priester und Gemeinde von Angesicht zu Angesicht zu ermöglichen. Diese elementare Veränderung findet 1964 Eingang in die Beschlüsse des Zweiten Vatikanischen Konzils. 1967 siedelt C. in die Abtei von Tepeyac in Lago de Guadalupe um, deren Neubau er 1968–69 entwirft und ausführt, wobei er hier wie anderenorts (z.B. am Wallfahrtsort Sa. María de Guadalupe im Bezirk Gustavo A. Madero in Mexiko-Stadt) die sakrale Gest. als Gesamtkunstwerk anlegt (zuletzt in Zamora de Hidalgo, wo er 1999 im Santuario Guadalupano sowohl Altarraum, Altar, Tabernakel und Taufbecken als auch zwei Kap. gestaltet). Unter den profanen Arbeiten bemerkenswert sind die Entwürfe für die Olympiade 1968 (Med. und Souvenirartikel). Ab den 1970er Jahren befaßt sich H. mit der Rest. und dem liturgiegerechten Umbau von ca. 27 Kirchen, u.a. in Naucalpan de Juarez (Ciudad Satélite), Pfarrk. La Asunción, 1972; Bogocyna-Sisoguichi, Kathedrale, 1975; Monterrey, Basílica de Guadalupe, 1981–85; Tula, Kathedrale, 1983; Guadalajara, Kathedrale, 1984–2000; Monclova, Pfarrk. Santo Santiago, 1988). Auch errichtet er etliche Gebäude nach eig. Entwürfen. C.s Kirchen, Kap. und Gemeindezentren sind unter Berücksichtigung der unterschiedlichen klimatischen Verhältnisse und Lichtwirkung offene, funktionale Bauten von struktureller Expressivität und relig. Symbolkraft. Bekannt ist v.a. im Wallfahrtsort Sa. Mária de Guadalupe die kreisrunde Neue Basilika (1973–76, mit P. Ramírez Vázquez, José Luis Benlloure),

deren Betonstruktur offen dargelegt ist. Unter den profanen Werken ragen zwei mit der Abtei von Tepeyac in Verbindung stehende Bauwerke in Lago de Guadalupe heraus: das Schulzentrum El Lago (1972, mit Angel Negrete) und das Theater San Benito Abad (1998–2001); letzteres ist die bevorzugte Spielstätte des mexikan. Symphonieorchesters. In eleganter kubischer Formensprache repräsentieren sie die Zeitlosigkeit der mod. Architektur. Auch Bauten in Nord- und Südamerika sowie in Europa. 🔲 ACAPULCO DE JUAREZ: Cap. Ecuménica La Paz, 1970–71. ATIZAPAN DE ZARAGOZA: Cap. S. Cayetano, 1994. CIUDAD OBREGON: Kathedrale (Umbau Presbyterium), 1993–2001. CUERNAVACA: Kathedrale (Rest., liturgische Anpassung), 1957. – Ahuatepec: Kap. der Abtei Sa. María de Guadalupe (liturgische Anpassung), 1980, 1986. GUADALAJARA: Pfarrzentrum La Santísima Trinidad, 1973–76; Pfarrzentrum La Madre de Diós, 1976–84. MEXICALI, Kathedrale: Pastorat, 1976. MEXIKO-STADT-Gustavo A. Madero, Santuario de Sa. María de Guadalupe: Cap. del Pocito (Rest. und liturgische Anpassung), 1968. – Konvent Divina Providencia: Cap. de S. Peregrino, 1992–93. – M.-Miguel Hidalgo: Kap. Cristo de la Paz (liturgische Anpassung), 1998. NEZAHUALCOYOTL-STADT: Kathedrale (mit P. Ramírez Vázquez), 1983. OCEANSIDE/Calif.: Prince of Peace Abbey, nach 2000. TEQUISQUIAPAN: Santuario Nuestra Señora del Perpetuo Socorro, 1985. VATIKANSTADT, Petersdom: Capp. Nostra Signora di Guadalupe, 1988–89 (mit P. Ramírez Vázquez). VILLAHERMOSA, Kathedrale: Pastorat, 1975–80. ◇ E: 2004 Cuautitlán Izcalli, Centro Escolar del Lago / Mexiko-Stadt; 2005 Colegio de Arquitectos; 2010 Mus. Nac. de Arquit. ▭ Ciudad de México. Arquit. 1921–1970 (K Mexiko-Stadt/Sevilla), Sevilla u.a. 2001; *A. González Pozo*, G. C. de la Mora, Guadalajara 2005. A. Mesecke

Chaviaras (Haviaras), *Paris*, griech. Maler, Mixedmedia- und Collagekünstler, Plastiker, * 1963 Athen, lebt und arbeitet dort. Stud.: 1983–85 HBK ebd. (Graphik, Fotogr.); 1985–91 Malerei bei Dimitrios Mytaras. Mitgl.: Epimelitiriou Eikastikon Technon Ellados/Vrg bild. Künstler Griechenlands (EETE). – Das Œuvre umfaßt v.a. Collagen und Assemblagen. C. verbindet vorgefundene triviale Alltagsgegenstände und Abfälle (objets trouvés, Buchseiten, alte Postkarten, Werbung, Müll) mit Kunstreproduktionen, Fotogr., eig. Zchngn, Tagebuchseiten und gemalten Flächen. Immer wieder integriert er Selbstbildnisse, die persönlich Bedeutsames fokussieren, so daß die manchmal bizarr wirkenden Verbindungen Tagebuchcharakter annehmen. Erinnerungen, Erfahrungen und Kommentare werden so vom Künstler zu einer subjektiven Weltsicht verarbeitet, wobei die dreidimensionalen Assemblagen in Glaskästen oder Vitrinen zusammengestellt sind und auf diese Weise zusätzlich mit einer gewissen musealen Aura versehen werden (*Der Tag des extraordinären Realismus*, Mixed media, 1998; Thessaloniki, Macedonian MCA). C. ist von Joseph Cornell ebenso inspiriert wie sich Einflüsse dadaistischer Trad., der Pop-art und der individuellen Mythologien eines Christian Boltanski bemerkbar machen. In einer zweiten Werkgruppe kombiniert C. ein-

zelne Gegenstände, wobei es sich dabei vielfach um die ironische und gewissermaßen postmoderne Reflektion der künstlerischen Formierung des 20. Jh. überhaupt handelt. Eine Arbeit, die er 2002 auf seiner Ausst. *Popics. The Ultimate Pop Topics* (Athen, Artio Gal.) vorstellt, ist eine Figur von Mickey Mouse, die eine von C. gefertigte Replik des Duchamp'schen Urinals von 1913 (komplett mit „R Mutt"-Sign.) in Händen hält. Die Verbindung des ehemals provokantesten Werkes der mod. Kunst mit der bekanntesten Figur der massenmedialen Popkultur entlarvt Avantgarde ihrerseits als längst kommerzialisierten und banalisierten Mythos. ⌂ ATHEN, HBK. THESSALONIKI, Macedonian MCA. ◉ *E:* 1994 (K), '96, '98, 2000, '02 Athen, Artio Gal. / 1996 (K), '99 Thessaloniki, Forum of Keen Art. – *G:* Athen: 1994 Mun. AG: Panhellenisches Comicfestival; 1997 Skyronian Mus.: Internat. Sculpt. Bienn. / 1994 London, Lethaby Gall.: Bienn. del Sud. ⌑ LEK IV, 2000; *E. Hamalidi* (Ed.), Contemp. Greek artists, At. 2004. – Makedoniko Mouseio Synchronis Technis (K), I, Thessaloniki 1999, 442–443 (s.v. Haviaras, Paris). E. Kepetzis

Chayla, *Frédérick du*, frz. Designer, Innenarchitekt, * 20. 9. 1957 Lyon, dort tätig. Lehrt seit 1994 an der Ec. supérieure des BA, Marseilles. – In der Trad. des 1976 in Mailand gegr. Studio Alchimia und der 1980 daraus hervorgehenden ital. Memphis Gruppe schließen sich C., Jacques Bonnot (* 14. 12. 1950 Lyon, lebt dort) und Claire Olivès 1980 anläßlich einer ersten gemeinsamen Ausst. in Lyon zur Gruppe Totem zusammen. Anfänglich widmen sie sich v.a. der Möbel-Rest., bevor sie mit der Kreation eig. Möbel beginnen, welche sie im Febr. 1981 erstmalig in der Gal. Envers in Lyon und anschl. (Juni 1981) in der Gal. der Assoc. Valorisation de l'Innovation dans l'Ameublement (VIA) in Paris präsentieren. Gezeigt werden dort u.a. C.s Sitzmöbel *Caméléon* und *Guillotine* (beide 1981, beide aus lackiertem Holz). Im selben Jahr wird die Gruppe durch Vincent Lemarchands erweitert, und ab 1982 führen sie gemeinsam öff. Aufträge aus, z.B. die Möbel für die Direction régionale des Affaires cult. d'Auvergne in Clermont-Ferrand. Dazu gehört u.a. der Tisch *Totem exquis*, bei dem jedes Mitgl. ein Bein in unterschiedlichen Form- und Farbvarianten gestaltet (1982, Platte aus Kalkstein, drei Beine aus lackiertem Metall, eines aus lackiertem Holz). Neben gemeinsamen Arbeiten gestaltet jeder einzeln Unikate oder Kleinserien, so daß die Werke mit einer Doppel-Sign. bez. sind (Totem und der jeweilige Name). Diese frühen skulpturalen Werke sind meist aus lackiertem Holz in eigenwilligen Formen gefertigt, die einen Gegenentwurf zum zeitgen. Industriedesign bilden. Sie sind überwiegend farbenfroh lackiert (häufig eine Farbe je Fläche); bisweilen mit graphischem Dekor. Vielfältige Anregungen, von Pop-art, Comics über Punkrock bis zu Science-fiction und Werbung, fließen in die Gest. ein. In der ersten Lampenserie für die Fa. Drimmer zeichnet sich bereits eine Veränderung der Formensprache ab (1983; C.: Modell *Dinosaure*, Keramik, lackiertes Metall, Kunststoff). Char. werden nun eine reduziertere Farb-Gest. und sachlichere, klarer strukturierte geometrische Formen. A. 1984 beginnt die Professionali-

sierung der Gruppe. Die Mitgl. gründen eine GmbH, geben die Produktion größtenteils ab, nehmen als Studio Totem auch Aufträge für Innenausstattung an und kreieren die erste nicht limitierte Kollektion (*Grenade*, 1984; C.: Stehlampe *Mars*, lackiertes Metall, Glas). Zudem rufen sie die Assoc. Caravelles zur Organisation von Ausst. ins Leben, die 1986 namensgebend für die erste internat. Design-Quadriennale ist, welche das Studio Totem parallel in Lyon, Sainte-Etienne und Grenoble organisiert. Eine Weiterentwicklung und den Höhepunkt bilden 1986 die letzte gemeinsame Kollektion *Lilas*, bei der monochrome Möbel in Grau-, Lila- und Rosatönen mit einem farbenfrohen Teppich kombiniert werden (C.: Standuhr und Guéridon, lackiertes Metall, Glas). 1986 verlassen C. Olivès und 1987 V. Lemarchands die Gruppe. Den 1984 erteilten Auftrag des Corporate Designs für das zukünftige MAM in Sainte-Etienne realisieren C. und J. Bonnot 1986–87 (C.: u.a. Sessel *Manitoba*, lackiertes Metall, Kunstleder; Tische des Mus.-Cafés, Holzfaserplatte, lackiertes Metall). Seit 1991 führt C. das Studio Totem allein weiter. In Zusammenarbeit mit Architekten und Lsch.-Gestaltern widmet er sich v.a. der Innen-Archit. öff. und priv. Gebäude (Nikolaisaal, Potsdam, 1996–2001, mit dem Architekten Rudy Ricciotti; Lyonnaise de Banque, 1999–2000), der Gest. öff. Plätze (Place Gabriel Péri, Lyon, 2001–03, mit dem Lsch.-Architekten Bruno Tanant) sowie archit. Aufgaben wie Sanierung, Modernisierung und Erweiterung (Médiathèque, Genas, 2007–09). Zudem ediert er kleinere Möbelkollektionen, z.B. *Collection de Printemps*, 1992–93. ⌂ ANGOULEME, FRAC Poitou-Charentes. BORDEAUX, FRAC Aquitaine. GRENOBLE, Mus. de Grenoble. PARIS, FNAC. – Centre Pompidou. – Fond. Cartier pour l'Art contemp. – MAD. – Mobilier nat. – VIA. SAINT-ETIENNE, MAM. THIERS, Mus. de la Coutellerie. VILLEURBANNE, FRAC Rhône-Alpes. ✉ Totem 1980–1983. Totem et le mystère de la vieille boulangerie, Lyon 1983. ◉ *E:* 1982 Strasbourg, Gal. Adeas / 1983 Bordeaux, MAD; Avignon, Gal. Saluces; Lyon, Studio Canubis / 1984 Groningen, Groninger Mus.; Amsterdam, Gal. Swart; Pecs, Gal. Pecsi / 1985 Poitiers, Le Confort mod.; Nizza, Gal. Le Chanjour / 1986 Villeurbanne, Hôtel de Ville (K) / Paris: 1986 Gal. Néotù; 1987 Centre Pompidou: Studio Totem et Museo Design. – *G:* 1982, '93 Mailand: Salone internaz. del Mobile / Paris: 1982, '83, '94 Salon internat. du Meuble; 1983 Salon des Arts ménagers; 1991 MAD: Les Années VIA, 1980–1990 (K); 2004 Fond. Cartier pour l'Art contemp.: 20 ans de la Fond. Cartier (K) / 1984 Toronto (Ont.), Queen's Quay Terminal: Phoenix. New attitudes in design (K) / 1985 Kyoto, Kyoto Kokuritsu Kindai Bijutsukan: Contemp. landscape. From the horizon of postmodern design (K); Jouy-en-Josas, Fond. Cartier pour l'Art contemp.: Vivre en Couleur (K) / 1987 Kassel: documenta / 1995 Sainte-Etienne, MAM: Design, Naissance d'une Coll. ⌑ *Kjellberg*, 1994; Dict. internat. des arts appliqués et du design, P. 1996. – *R.-P. Baacke u.a.*, Design als Gegenstand, B. 1983; Design franç. 1960–1990. Trois décennies (K), P. 1988; *C. Fayolle*, Totem 1980–87 (K Sainte-Etienne),

P. 2000. – *Online:* Website (Studio Totem). F. Krohn

Chazal, *Malcolm de*, mauritischer Schriftsteller, Maler frz. Abstammung, * 12. 9. 1902 Vacoas, † 1. 10. 1981 Curepipe. Reist 1918 mit seinem Bruder nach Baton Rouge/La., dort Stud. an der Louisiana State Univ. (1924 Abschluß als Landwirtschafts-Ing.), anschl. als Ing. zunächst auf Kuba, ab 1925 auf Mauritius tätig (in der Zucker- sowie Textilindustrie); 1937–57 Mitarb. im Fernmeldewesen. – Bes. Bedeutung erlangt C. als Verfasser versch. Texte (darunter sein Hw. Sens plastique [P. 1947], eine Slg von Gedanken und Aphorismen), die der Strömung des Surrealismus zuzurechnen sind und die Schriftsteller- sowie Künstlerkollegen wie Georges Bataille, Jean Paulhan, Francis Ponge, Georges Braque und Jean Dubuffet beeinflußten. Auch Veröff. auf dem Gebiet der politischen Ökonomie (unter dem Pseud. Medec), mystische und theosophische Schriften, Dramen sowie zahlr. Presseartikel. Begeistert von Publ. C.s Sens plastique ermutigt Georges Braque ihn, mit der Malerei zu beginnen. – C.s bildnerisches Werk entsteht ab E. der 1950er Jahre. Es besteht aus farbenfrohen Gouachen auf Papier, die in kindlich-naiver Formsprache Lsch., Portr., Stilleben (Früchte und Blumen) sowie Tiere (v.a. Fische) abbilden. Ausst. der Gem. finden 1958 auf Mauritius, 1960 in Paris, 1966 in Grenoble sowie 1967 in London und San Francisco statt. In Curepipe befindet sich eine nach C. benannte Gal.; 2002 wird der C. Trust Fund errichtet; 2011 wird C. zum Ehrenbürger der Stadt Curepipe ernannt. ✉ Pensées, Bde I-VII, Port-Louis 1940–45; La vie filtrée, P. 1949; Pertusmok, Port-Louis 1951; Judas, Port-Louis 1953; Sens magique, Port-Louis 1957; Sens unique, Port-Louis 1974. ◉ *E:* 1973 Dakar, Mus. Dynamique / 1996 Marseille, Vielle Charité / Curepipe: 1996 Centre cult. franç.; 2006 Hôtel de Ville und Gal. Malcolm de Chazal / 2011 Réduit, Allied Motors (Retr.). - ▭ *P. de Boisdeffre,* Dict. de litt. contemp., P. 1963; *A. Rouch/G. Clavreuil,* Litt. nat. d'écriture franç., P. 1987; *S. Selvon,* Historical Dict. of Mauritius, Metuchen ²1991; *Bénézit* III, 1999; *Delarge,* 2001. – *Online:* Website C. F. Krohn

Chazanov, *Michail (Michail Davidovič),* russ. Architekt, Hochschullehrer, * 26. 3. 1951 Moskau, lebt und arbeitet dort. Sohn des Architekten und Bau-Ing. *David Borisovič Ch.* (* 17. 5. 1914 Moskau, † 25. 3. 1983 ebd.) Bis 1968 Schüler der Spezialschule Nr 50 (vertiefte Archit.-Ausb.) ebd. Stud.: bis 1976 Archit.-HS ebd. 1976–79 im Archit.-Büro Mosproekt 1 tätig; 1980–83 leitender Architekt bei Mosproekt 2; 1984 Chefprojektant im Inst. Sojuzkurortproekt, alle ebd. Zus. mit seinem Vater plant er 1983 die Rekonstr. des Pavillons an den legendären Moskauer Patriarchenteichen als Ziegelbau; dieser war 1938 von seinem Vater als Speise- und Aufenthaltsraum für Straßenbahnfahrer und -schaffner in Holzbauweise errichtet worden. 1989 Ltg eines Büros beim russ. Architekten-Verband. Ab 1990 Ltg des Archit.- und Planungsbüros Sojuzkurortproekt Moskau (später ZAO Kurortproekt), in dessen Rahmen Ch. ein eig. Büro unterhält. Zahlr. Ausz., u.a. 1. Preise: 1977 Wettb. Paris (Theater für die künftigen Gen.); 1978–80 Wettb. Ar-

chit. und Natur Stuttgart; 1987 Wettb. Theater Amsterdam; 1999 Festival Zodčestvo Moskau; 2002 1. Bauabschnitt des Bürokomplexes der Duma und Stadt-Reg. von Moskau (Moskva-City). Lehrtätigkeiten, u.a. Prof.: 2002 Internat. Archit.-Akad. (IAA); 2007 Archit.-HS Moskau. 2005 Titel Architekt des Jahres (ARCH Moskva). Seit 2006 Mitgl. der IAA (hier 2009 Vize-Präs., 2012 Titel Akademiker). Ab 2009 Vize-Präs. des Architekten-Verb. Moskau. – Bevorzugt öff. Großprojekte (meist Multifunktionsbauten) in Moskau und Umgebung, in denen sich Ch. für eine innovative Formensprache und den Einsatz mod. Materialien wie Glas engagiert; bewusste Absetzung von verbreiteten historisierenden Baumustern, die teils inflationär Säulen, Pylonen und Pilaster einsetzen (sog. Lužkov-Empire, nach dem 1992–2010 amtierenden Bürgermeister Ju. M. Lužkov). Bemerkenswerte Bauten Ch.s sind ferner: Erholungs- und Hotelkomplex Solnečnyj ostrov; Landgut Koralovo b. Zvenigorod (Rekonstr.); Cottagesiedlung Vysokij bereg (2006–11) am Istrastausee b. Moskau. Des weiteren zeitweise beteiligt an der Rekonstr. des Bol'šoj-Theaters Moskau (1999–2002). ⌂ CHOSTA/Gebiet Krasnodar: Cottagesiedlung Gorki, 2006–11 (zus. mit Kompanija AST). KRASNOGORSK, Pavšinskaja pojma: Skihalle SnežKom, 2002–08 (Ltg). – Mjagkinskaja pojma: Haus der Reg. des Moskauer Gebiets, 2004–07 (Ltg). MOSKAU, Bol'šoj Patriaršij pereulok 7, Pavillon: Rekonstr., 1983–85. – Volgogradskij prospekt 92: Bankfilialgebäude, 1993–99. – Ostoženka 6/2: Zahnklinik, 1996–2000 (zus. mit Anton Nagavicyn, Sergej Plužnik, Ljudmila Lopčeeva). – Bol'šaja Gruzinskaja ul. 62: Bürogebäude, 1998–2002. – Serebrjanyj bor: Stadthaus-Siedlung Silver Place, 1996–2003. – Zoologičeskaja ul. 13/2: Umbau einer Fabrik zum Zentrum für mod. Kunst GCSI, 2002–04 (zus. mit Nikita Šangin, Marina Rebrova, Michail Mindlin). – Gagarinskij pereulok 25, Verwaltungsgebäude: Rekonstr. und Erweiterung, 2002–09. – 5-ja ul. Jamskogo polja 22–24: Russ. Mediazentrum FGUP VGTRK, 2004–09. SMOLENSK: Memorialkomplex „Katyn'skij les" für die Opfer des Stalinschen Terrors, 1997–2001 (1. Bauabschnitt). TBILISI: Bürokomplex, 1996–2001 (zus. mit Fa. InterServis). ▭ *B. Goldhoorn/P. Meuser,* Capitalist realism. New archit. in Russia, B. 2006. – *Online:* Website C.; IAA (s.v. Khazanov, Mikhail). D. Kassek

Chazaraki-Papatheodorou (Chazaraki; Hazaraki; Hazaraki-Papatheodorou; Papatheodorou-Chazaraki), *Antigoni,* griech. Malerin, Bildhauerin, Autorin, * 1. 7. 1932 Chalkida, lebt und arbeitet in Athen. Stud.: 1952–55 Panteios HS, Athen (politische Wiss.); 1960–63 West-Berlin (Theater-Wiss.). Als Künstlerin Autodidaktin. Mitgl.: Epimelitiriou Eikastikon Technon Ellados/Vrg bild. Künstler Griechenlands (EETE); Etaireia Ellinon Logotechnon/Vrg griech. Schriftsteller (EEL). – C.s bildkünstlerische Arbeiten sind eigenständig. Sie arbeitet mit Farb- und Bleistiften. Durch kontinuierliche Schraffur entsteht ein Netz feiner Linien, das sich auf den zweiten Blick zu einer Form schließt. Durch dieses char. Liniengeflecht schimmern menschliche Figuren. Sie sollen die Entstehung menschlichen Lebens aus der noch ungeformten Ur-

materie versinnbildlichen und thematisieren philosophische Grundprobleme wie Werden und Vergehen. Existenz ist für C. eine bisweilen qualvolle Loslösung des Geistes aus der Materie. Ihre plastischen, aus Ton geformten Arbeiten sind abstrakt aufgefaßte Strukturen in rhythmisch-organischer Bewegung. In ihren (selbst illustrierten) symbolistisch aufgeladenen, häufig esoterischen Texten greift sie die Fragen ihrer malerischen Werke auf. ⌂ ATHEN, Nat. AG. – Pierides MCA. CHALKIDA, Pin. ✉ To Fos ... tou Chronou, At. 2001; Ston Icho … tis Simasias, At. 2006. ◉ E: Athen: 1975 Gal. Astor; 1983, '91, '97 Gal. Kreonidis. – G: Athen: 1975, '77 Gal. Astor: Ellines Zografoi; 1982 Gal. Syllogy: Parousia Simantikon Ellinon Zografon; 2001 Technoupolis: Minas eikastikon technon / 1997 Schwetzingen, Palais Hirsch: Künstler aus Griechenland. ▭ Lydakis IV, 1976; LEK IV, 2000. – N. Antonakatou, A. C.-P. (K Chrysothemis Gal.), At. 1991; Synchroni elliniki glyptiki (K Pyrgos), At. 1997; Synchroni elliniki glyptiki (K Pevki), At. 1998. – Online: Art 22. E. Kepetzis

Chazov, *Ivan Jakovlevič* (in Moldawien: Hazov, *Ivan*), russ. Maler, * 25. 8. 1885 Krasnoe/Gouv. Vladimir, † 1957 Kostroma. Stud.: bis 1908 Stroganov-KGS Moskau bei Konstantin Alekseevič Korovin. Lehrtätigkeit: 1920er-40er Jahre Kunststudio der Roten Armee beim Garnisonsklub, Tomsk; Kunst-FS Kostroma; 1946–53 Kunst-FS Kišinev (Chişinău). Mitgl.: 1931 Assoz. der Künstler des revolutionären Rußland (AChRR); Ges. Moskauer Künstler (OMCh). – Ch. ist v.a. als Lehrer bed.; zu seinen bekanntesten russ. Schülern gehören Vladimir Petrovič Tomilovskij und Gennadij Michajlovič Lamanov; in Moldawien unterrichtete er u.a. Mihail Grecu, Victor Rusu-Ciobanu, Gleb Sainčuk, Igor Vieru und Eleonora Romanescu. Von seinen Werken sind nur zwei im Nat. KM Moldawiens erh. Portr. bekannt (Bildnisse des Akad.-Mitgl. *N. Dimo*, 1950, und des Kriegshelden *Boris Glavan*, 1952). Sie folgen der Trad. der russ. Peredvižniki (Wanderaussteller), arbeiten die Individualität der Dargestellten heraus und sind psychologisch aufgefaßt. ⌂ CHIŞINĂU, Nat. KM. ▭ Literatura şi arta Moldovei, II, Kišinêu 1986. – D. D. Gol'cov (Ed.), Izobraziteľnoe isk. Sovetskoj Moldavii, Kišinev 1987; I. Colesnic, Colegiul Republican de Arte Plastice „A. Plămădeală", Chişinău 2008, 119.

T. Stavila

Chedburn, *James*, brit. Bildhauer, * 8. 5. 1957 Kuala Lumpur, lebt in Charenton le Pont. Stud.: 1975–76 Somerset College of Art; 1976–79 Central SchA, London; 1981–82 Bristol Univ. Lehrtätigkeit: Internat. School of Paris. – C. gestaltet in einer Art von dreidimensionalem Zeichnen skurrile und lustige mechanische Draht-Skulpt. vergleichbar den Arbeiten von Alexander Calder. Oft integriert er Fundstücke wie Zigarrenkisten, Blechdosen und Teebüchsen, in die er Mechanik (z.T. elektrifiziert) einbaut. ⌂ DAYTON/Ohio, Wright State Univ.: Snail, 2005. NELSON/Neuseeland, WOW Mus. PARIS, Mus. de l'Erotisme. SOULLIAC, Mus. de l'Automate. – Stadthalle: Sanglier, 2000. YERRES, Millennium-Brunnen, 2000. ◉ E: Paris: 1994 Gal. Saint-Sabin; 1997 Espace Le Couvent; 2001 Mus. de l'Erotisme; 2003 Gal. Médiart; 1999, 2000, '03

Gal. Treger; 2008, '11 Gal. Lélia Mordoch / 1994 Châlons-en-Champagne, Chap. des Capucines / 1995 Yerres, Salle A. Malraux; Lac de Der, Maison de l'Oiseau et du Poisson / 1996 Genf, Gal. 3000 Grenouilles; Metz, Gal. Nature et Découvertes / 1997 Lyon, Gal. Nature et Découvertes; Strasbourg, Gal. Péradel / 1998 Nancy, Gal. La Parenthèse / 1999 Brüssel, Gal. Claude André; Montréal, World Trade Centre, Gall. Club Art / 2000 Souillac, Mus. de l'Automate / 2002 Berlin, Gal. Kühn / 2004 Tokio, Gall. Futura. ▭ Delarge, 2001. – Y. Rivais, L'Art HOP l'humour noir, P. 2004; Is art an anti-depressant? (K Lélia Mordoch Gall.), P. 2011. – Online: Website C. – Mitt. C.

H. Stuchtey

Chefetz, *Yaacov*, israelischer Bildhauer, Maler, Zeichner, Fotograf, Installations-, Video- und Performancekünstler, * 1946 Rehovot, 1974–99 im Kibbutz Eilon beheimatet. Stud.: 1967–69 Kalisher Art School, Tel Aviv; 1970–71 bei Raffi Lavie. Lehrtätigkeit: u.a. Oranim Art Inst., Tivon; Art Teachers College, Ramat Hasharon; Gaaton Dance Inst.; Haifa Technion (Archit.); Galil Maaravi College. Ausz.: 1986 Nahum Guttman Histadrut Prize for Sculpt. (zus. mit Yehezkel Streichman). – Schon in installativen Arbeiten der 1970er Jahre führt Ch. mehrere Kunstformen zusammen, z.B. Fotogr. und Assemblage. In *Even a Slight Rustle Awakens the Muse* (1994) sind eig. plastische Objekte mit Ready Mades räumlich verbunden. Vielgestaltigkeit ist ein Kennzeichen seines Gesamtwerkes. Mehrteilige, oft geometrisch konzipierte, auch symbolhafte Mon.-Plastiken (u.a. in Arad, Haifa, Herzliya, Petach Tikva, Tel Aviv) lassen sich durch Dualismen wie statisch und dynamisch oder organisch und anorganisch charakterisieren. Geometrische Abstraktion bestimmt desgleichen die Bleistift- und Kreide-Zchngn sowie Bilder in Mischtechnik. Sparsamer Umgang mit gestalterischen Mitteln kennzeichnet auch Ch.s performatives Schaffen, das etwa im Jahr 2000 beginnt. In der Performance *Naked Soup* (2009; Musik: Shaj Tan) verwandelt er z.B. mit minimalen Aufwand eine alltägliche Handlung (das Kochen einer Suppe) in eine absurde Szene. Ch. ist ferner Kurator nat. Ausst., u.a. für das Pyramida Center for Contemp. Art, Haifa. ⌂ Skulpt.: BEER SHEVA, Negev Mus. CHICAGO, Marcus Coll. EIN HAROD, Mus. HERZLIYA, MCA. JERUSALEM, Israeli AC. NEW YORK, Allenger Coll. – The Brooklyn Mus. RAANANA, Skulpt.-Park. TEFEN, The Open Mus. ◉ E: u.a. Tel Aviv: 1981 (Zchngn), '89 Sara Levi Gall. / 1995 Haifa, MMA (K); Mizpe-Ramon, The Artist Mus. (K) / 1998 New York, Lubelsky Gall. / Tel Aviv, Golda Center (Digital Prints) / 2003 Tefen, The Open Mus. (Zchngn; K). – G: u.a. 1984 Chicago, Culture Center: Israeli Art / 1990 Ein Hod: Bienn.; Tokio, Hara Mus.: Israeli Art / Haifa: 2007, '08 Pyramida Center for Contemp. Art; 2009 Bienn. Installation / 2001 Venedig: Bienn. / 2003 Oum El Fachem, AG: Artist Against the Occupation / 2004 Łódź: Łódź Festival / 2005 Tel Aviv: Bienn. Performance. ▭ Online: Israeli AC; Website Ch. (Lit.; WV).

St. Schulze

Cheimonidis (Chimonidis; Himonides; Himonidis), *Stelianos (Stelios; Stylianos)*, griech. Maler, * 27. 1. 1929

Veria, † nach 1982, lebte und arbeitete in Athen. Stud.:
1954–59 Akad. für angew. Kunst, Wien, bei Karl Unger
und *Franz Herberth* (27. 9. 1907 Wien, † 2. 8. 1973 Pul-
kau); 1960 Freskenmalerei und Enkaustik bei dem Futu-
risten Gerardo Dottori in Perugia. Reisen nach Skandina-
vien und London. 1960 Rückkehr nach Griechenland und
Niederlassung in Athen, wo sich seine Arbeit bis in die
frühen 1980er Jahre an wenigen Beispielen nachweisen
läßt. Mitgl. (zeitw. Generalsekretär): Epimelitiriou Eikas-
tikon Technon Ellados/Vrg bild. Künstler Griechenlands
(EETE). – C. malt anfangs impressionistisch, später ex-
pressionistisch. In manchen Werken zeigt er sich stilistisch
von Surrealismus beeinflußt und strebt bisweilen (so v.a.
in der Wiener Zeit) bis zur Abstraktion in Nachf. von Piet
Mondrian oder verarbeitet asiatische Einflüsse. Nach 1982
verliert sich jede Spur. Arbeiten bisweilen im Kunsthan-
del. – ⊙ *E:* 1961 Piräus, Staatstheater. – *G:* Athen: 1960,
’63 Zapeion: Panellinies; 1962 Ital. Kultur-Inst.: Panella-
diki Ekthesi Neon; 1982 Mun. AG: Ekthesi Charaktikis.
▢ *Lydakis* IV, 1976. LEK IV, 2000. – Aukt.-Kat. Niko-
sia. Gal. AlphaZmart. Neoteri & sychronoi Techni. Elli-
nes kai Kyprioi Dimiourgoi [Neuere und zeitgen. Kunst.
Griech. und zyprische Künstler], Nicosia 2009, 14.

E. Kepetzis

Chelbin, *Michal*, israelische Fotografin, * 1974 Haifa,
lebt in New York. Stud.: 1997–2001 Wizo Acad. of Design
and Education, Haifa. 2003 Artist in Residence, Hameau
des Artistes, Paris. Seit 2006 in den USA tätig. Ausz.:
2002 America–Israel Cult. Found. Grant; 2002, ’03 Jos-
hua Rabinowitz Found. Grant; 2004 Israeli Lottery Board
Grant; 2004 Oscar-Hendler-Prize, Kibbutz Lohamei; 2005
1. Preis Raphael Angel Competition for the Young Photo-
grapher; 2007 Leon Constantiner Award for Photogr., Tel
Aviv. – Breite Popularität erlangt Ch. durch berührende
Portr. und Reportagefotografien. Während einer Reise in
die Ukraine sind es nicht nur Alte, Kinder und Jugendli-
che, die sie in teils poetischen Aufnahmen festhält, sondern
auch Ringer und Zirkuskünstler in ihren jeweiligen Mi-
lieus. Ihre Affinität für Kostüm und Pose wird auch in an-
schließenden Arbeiten deutlich. ▢ HAIFA, Mus. of Art.
JERUSALEM, AC. PARIS, Kadist Art Foundation. TEL AVIV,
City Hall: Aristoteles (Fassaden-Portr.), 2004. – Mus. of
Art. ⊙ *E:* u.a. Tel Aviv: 2000, ’02 Rosenfeld Gall.; 2008
Mus. of Art / New York: 2002 Yossi Milo Gall.; 2008 An-
drea Meislin Gall. / 2004 Lohamei Haghetaot Gall.; Los
Angeles, Fahey and Klein Gall. / 2007 Portland, Blue Sky
Gall. – *G:* u.a. 2002 Tel Aviv, Mus. of Art: New Purcha-
se in Photogr. (K); Verona, Gall. d’Arte Mod. e Contemp.,
Pal. Forti: Artists of the Ideal (K) / 2003 Pärnu, Uue KM:
Naked before God (K) / Ramat Gan, Mus. of Art: Artic 5
(K) / London: 2003 Luke and A Gall.: The Rape of Eu-
rope (K); 2004, ’05 Nat. Portr. Gall.: Schweppes Photogr.
Portr. Prize (K); 2006, ’07 ebd. The Portr. Competition /
2004 Athen, Frissiras Mus.: Gods Becoming Men (K); Tel
Aviv, Zman Le’Omanut: Love is in the Air (K) / Herz-
liya, MCA: 2005 Dialogue with the Classics (K); 2006
Uniforms and Costumes / 2006 New York, Kashya Hil-
debrand Gall.: Women. Self Portraits. ▢ *Online:* Israeli

AC; Website Ch. (Lit.; Ausst.). St. Schulze

Chelmis (Helmis), *Periklis (Periclis)*, griech. Porträt-
und Historienmaler, * 1818 Amolochos, † 1888 Athen,
lebte und arbeitete dort. Stud.: KHS ebd. Von seinem Le-
ben und seiner künstlerischen Tätigkeit sind nur wenige
Einzelheiten bekannt. Sein Œuvre konzentriert sich auf
Porträts sowie die in der zweiten H. des 19. Jh. wei-
terhin populären Themen aus dem griech. Aufstand ge-
gen die Türken 1821–27 (*Bildnis Hatzichristou*, Benaki
Mus.; *Gregoris Papaflessas‘ Tod*). Lsch. und Darst. von ar-
chäol. Stätten finden sich insbesondere in kontrastreichen,
ausdrucksstarken Bleistiftzeichnungen. Seine malerischen
Werke verbinden akad. Realismus mit volkstümlichem Stil
und ethnogr. Motiven, wie zwei kleinformatige Bildnis-
se einer Athenerin und eines Mannes in chiotischer Tracht
in der Nat. AG in Athen dokumentieren. Lt. zeitgen. Un-
terlagen ergeht 1862 an C. der Auftrag, eine symbolische
Komp. für die Bibl. des serbischen Parlamentes zu malen,
die sich heute jedoch nicht nachweisen läßt. ▢ ATHEN,
Benaki Mus. – Koutlidis Coll. – Nat. AG. ▢ *Lydakis* IV,
1976; LEK IV, 2000. – *T. Spitéris*, Three c. of mod. Greek
art 1660–1967, At. 1979, vol. 1, 276, vol. 2, 311; *C. A.
Christou*, I Elliniki Zografiki 1832–1922, At. 1981, 57;
A. Delivorrias, Guide to the Benaki Mus., At. 1988, 118;
A. Kotidis/G. Christopulos , Helliniki techni. Zographiki
19. aiona, At. 1995, 30, 211, 265; *D. Fotopoulos/A. Deli-
vorrias*, Greece at the Benaki Mus. (K), At. 1997; Sta adyta
tis Ethnikis Pinakothikis [Unknown treasures from the NG
Coll.], At. 2011. E. Kepetzis

Chen *Can* (Changqing; Lan’gu; Xue’an Daoguang;
Xueguzi), chin. Maler, Literat, Beamter, * 1524 Chang-
zhou (Suzhou)/Prov. Jiangsu, † nach 1615. C. wurde bes.
als Blumen-und-Vogel(huaniao)-Maler bekannt. Er gehör-
te lt. dem ming-zeitlichen Sammler und Kritiker Gu Nin-
gyuan zwar weder zu den herausragenden „Gentlemen-
Malern“ (shidafu), wie die älteren Zeitgen. Shen Zhou oder
Wen Zhengming, noch erreichte er den Rang der „berühm-
ten Maler mit lit. Bildung“ (wenshi mingjia) wie Lu Zhi
und Wen Jia, galt aber doch als Meister von Talent und Stil-
gefühl. Xu Qin schätze v.a. den Tiefsinn der symbolisch-
zeitlosen Bilder, deren „Eleganz“ (ya) und „Altertümlich-
keit“ (gu) bewundert wurden. C.s Arbeiten, die vom „Le-
bendigen abschreiben“ (xiesheng), stehen in der Trad. der
song-zeitlichen Akad.-Malerei, unterscheiden sich jedoch
stilistisch von den Blumen- und Pflanzen-Darst. der eben-
falls von dieser Richtung beeinflußten Zeitgen. Zhou Zhi-
mian und Sun Kehong durch freiere Gest. der Naturfor-
men. C.s Komp. wirken trotz Komplexität nicht überladen,
was ein dekorativ-farbenprächtiges Glückwunschbild mit
Blütenbäumen unter Beweis stellt. Die Hängerolle *Yutang
beitu* (Jadehallen-Säule, Tusche, Farben/Papier, Priv.-Slg)
zeigt einen rosa blühenden Pfirsich, eine Magnolie mit gro-
ßen weißen Blüten und Knospen sowie einen Holzapfel-
strauch, dessen kleine rote Blüten reizvoll mit den leichten
Farben der anderen Bäume kontrastieren. Am Fuß des zen-
tralen Gartenfelsens wachsen Lingzhi-Pilze und Orchide-
en. Die mit dem Frühling assoziierten Blütenbäume sym-
bolisieren Jugendlichkeit und frische Lebensenergie. Pfir-

sichblüten und Lingzhi-Pilze drücken den Wunsch nach bzw. die Hoffnung auf Unsterblichkeit aus. Die Kombination der ersten Silbe des chin. Wortes für Magnolie (yulan) und der zweiten Silbe des Wortes für Holzapfel (haitang) ergibt das Wort yutang (Jadehalle), was metaphorisch die renommierte kaiserliche Hanlin-Akad. bezeichnet, in die nur wenige Gelehrte nach erfolgreichem Jinshi-Examen aufgenommen wurden. Magnolie und Holzapfel sind daher Sinnbilder für die hohe Beamtenkarriere, während Orchideen für den bescheidenen Gelehrten und der Stein für die Tugenden der Standhaftigkeit, Integrität und Aufrichtigkeit stehen. So verspricht das Glückwunschbild dem Adressaten nicht nur eine glänzende Karriere und Langlebigkeit, sondern preist ihn auch als Edlen (junzi) und Stütze des Staates. Brillante Pinselführung und ein ausgezeichnetes Gefühl für Kolorierung zeigt C. auch bei der Querrolle *Xiesheng huaben* (Blumen und Gräser vom Lebendigen abgeschrieben, Tusche, Farben/Seide, sign., 1578, Aufschrift mit Dichtung von Gao Shiqi, 1698; Beijing, Imperial Pal. Mus.), bei welcher der Betrachter „Schöpfung und Wandlung (zaohua) hervorgebracht durch den Pinsel spürt" (Gao Shiqi, in: Zhang Zhao u.a., II, 1041). Ähnliche Qualitäten gelten für C.s Hängerollen *Guishi lanzhi tu* (Zimtbaum an Felsen mit Orchis und Lingzhi-Pilzen; Beijing, Imperial Pal. Mus.) und *Chunjing yuanyang tu* (Mandarinenenten in Frühlings-Lsch., beide Tusche, leichte Farben/Seide, sign.; Shenyang, Liaoning Prov. Mus.) und dürften auch für die in der Lit. erw. Album-Bll. *Lanzhu tu ce* (Orchis und Bambus, 1615) und *Songmei yulan tu* (Kiefer, Pflaume und Magnolie) zutreffen. Das Vogelbild *Sixi tu* (Vierfaches Glück, beide Hängerolle, Tusche, leichte Farben/Seide, sign., Siegel von C., 1585; Jiabao Internat., Beijing, Aukt., 18. 6. 2006, Los 479) nimmt sich des beliebten Motivs der glückverheißenden Elstern in Blütenbäumen an. Bei der stimmigen Komp. mit Betonung der Mittelvertikalen gelingt C. durch geschickte Anordnung der naturnah gemalten Vögel die Verbindung zw. Stasis und Kinesis, die dem Bild spannungsreiche Dynamik verleiht. Subtil erfaßt sind die Naturobjekte des Album-Fächerbildes *Shizhuhua* (Felsen, Bambus und Blumen, Tusche, Farben/Papier, sign., Aufschrift von C.; Taipei, Nat. Pal. Mus.), bei dem die versch. fein kol. Blatt- und Blütenformen wirkungsvoll miteinander harmonieren. ▢ *Yu Jianhua*, 1981, 1030; *Seymour*, 1988 (s.v. Ch'en Ts'an); *Bénézit* III, 2006. – Xu Qin (* 1626, † 1683), Minghua lu, Shanghai 2000 (Zhongguo shuhua quanshu, 10), 6/29; Liaoning sheng bowuguan canghua ji, II, Bj. 1962; *Zhang Zhao u.a.* (Ed.), Shiqu baoji (1745), Taipei 1971 (Faks.), I, 334, 493 s.; II, 1041; Gugong shuhua lu, IV, Taipei 1935, 4/165; *E. M. J. Laing*; Chin. paint. in Chin. publ., 1956–68. An annotated bibliogr. and an index to the paint., Ann Arbor 1969 (Michigan papers in Chin. stud., 6), 159; *L. Ledderose* (Ed.), Im Schatten hoher Bäume. Malerei der Ming- und Qing-Dynastien (1368–1911) aus der Volksrepublik China (K), BB. 1985, 138; Zhongguo shuhuajia yinjian kuanshi, II, Shanghai 1987, 1070 s.; *A. Lutz/A. von Przychowski* (Ed.), Wege ins Paradies oder die Liebe zum Stein in China, Z. 1998. U. Middendorf

Chen *Chieh-jen* (Chen Jieren), taiwanesischer Foto- und Videokünstler, * 1960 Taoyuan, lebt in Taipei. Kunst-Stud. an der Fuhsin Trade and Art School, Taipei (Abschluß 1978). 1980–82 Militärdienst. Ausz.: 2000 Special Award, Kwangju Bienn.; 2009 nominiert für den Artes-Mundi-Preis (Cardiff). – Der Sohn eines vom Festland (Prov. Fujian) stammenden Soldaten der Kuomintang-Armee und einer taiwanesischen Arbeiterin wächst in einer Zeit von Diktatur und Kriegsrecht (1947–87) auf. Prägend für seine Kindheit sei das in unmittelbarer Nähe gelegene Gefängnis für politische Häftlinge (heute Taiwan Human Rights Memorial). Die Erinnerungen daran wird er später verarbeiten (*Military Court and Prison*, Video, 2007–08; Auftrag des CARS, Madrid). Während der 1980er und frühen 1990er Jahren trat C. als Mitgl. versch. alternativer Künstlergemeinschaften (Xi Rang Art Group u.a.) zunächst mit seinen bahn- und tabubrechenden kontroversen Installationen und v.a. mit Performances als Mittel politischen Protestes hervor (*Jineng sangshi 3*/Losing Function No 3, 1983). So zeigte er 1983 ein Projekt in Xi Mun Ting, bei dem fünf Menschen, deren Köpfe und Gesichter durch das schwarze Gewand eines Henkers verhüllt und die an Armen und Beinen mit Verbänden aneinander gefesselt waren, über den zentralen Platz der Stadt strauchelten und brüllten, bis sie festgenommen wurden. Das symbolträchtige Motiv des Henkers blieb weiterhin ein Leitmotiv seiner Arbeiten. 1996 beginnt C. die vielschichtige, internat. beachtete Serie von digitalen Fotomontagen *Revolt in the Soul & Body 1900–1999*, die sich mit politischer Repression, verdrängter Gesch. und der Rolle der Fotogr. (als „seelenstehlendes Instrument") in ihrem Verhältnis zum fotografierten Subjekt in zwei Teilen beschäftigt. Die erste Hälfte basiert auf hist. Fotogr. von extremer Folter, Massakern und Hinrichtungen aus China in der Zeit 1900–50 (*Genealogy of Self*, 1996; *Being Castrated*, 1996; *Self Destruction*, 1996; *Rule of Law series*, 1997; *Lost Voice series*, 1997), die von C. ins Monumentale gesteigert und digital bearbeitet werden, indem er sich selbst als Akteur (Opfer, Folterer oder Zuschauer) ins Bild bringt. Die zweite Hälfte (*Image of An Absent Mind*, 1998; *The Image of Identical Twins*, 1998; *Na-Cha's Body*, 1998; *A Way Going to An Insane City*, 1999) zeigt C.s eig. (an Joel-Peter Witkin und Hieronymus Bosch erinnernde) fiktive Visionen von den grausamen Auswüchsen sanktionierter Gewalt, körperlicher Verstümmelung, Angst, Schmerz und Chaos. Hierbei bezieht er auch Inspiration von buddhistisch-folkloristischen Konzepten der Hölle und deren weit verbreiteten bildlichen Umsetzungen. Nach einer ersten Serie von inszenierten Fotogr., die eine Erforschung der „virtuellen Zukunft" beinhalten (*The Twelve Karmas Under the City*, 2000), setzt C. auch im Medium Video (16- oder 35mm-Film, v.a. tonlose Schwarzweißaufnahmen in slow motion, auch als Installation präsentiert) in seiner ersten, von einem hist. Foto inspirierten Arbeit die „Ästhetik des Grauens und des Schmerzes" fort (*Lingchi. Echos of a Hist. Photograph*, 2002). Das von einem frz. Soldaten um 1905 aufgenommene Foto zeigt die in China übliche brutale Folter- und Hinrichtungsmethode (lingzhi; Töten durch Zerschneiden), bei

der Verurteilten, durch Opium in Trance versetzt – für C. als Metapher für den individuellen und kollektiven blinden, schlafähnlichen Bewußtseinszustand der Menschen in der heutigen taiwan. Ges. im Film ausgiebig thematisiert -, vor großem Publikum nach und nach Körperteile abgeschnitten wurden. Im Film stellt C. diese Exekutionsmethode mit Hilfe von Laien (vorwiegend Arbeitslose) nach. Die tiefgründige Interpretation des hist. Fotos, das im Westen relativ bek. war (u.a. durch Georges Bataille, Les larmes d'eros, 1961) und die westliche Vorstellung des „grausam- barbarischen" China geprägt hat, jedoch in China und Taiwan bisher unbekannt blieb, wirft viele Sinnbezüge auf. In der Ansicht, daß das Medium Fotogr. oft zur Manipulation der Gesch. und der kollektiven Erinnerung mißbraucht wurde, will C. mit dieser Arbeit an eine vergessene und verdrängte Wirklichkeit erinnern. Gleichzeitig wird die Todesstrafe als Metapher für die Machtverhältnisse zw. Starken und Schwachen im Zeitalter der Globalisierung unter der Hegemonie der westlichen Welt verwendet. Zuletzt setzt C. die Hinrichtungsmethode (lingzhi) – und die am Schluß des Filmes eingesetzten zeitgen. Szenen, Ortschaften und Protagonisten – in Zusammenhang mit dem Schicksal Taiwans: „Through the process of modernization, history has been lingchi-ed; that is, chopped up and severed just like a human body." Seit 2003 richtet C. das Augenmerk auf die komplexen politischen, sozialen und wirtschaftlichen Aspekte des Inselstaates im Laufe seiner bewegten Geschichte. Dabei versucht er Wege zu definieren, um vergessene Realitäten an die Oberfläche zu holen. On Going (2006) erforscht die taiwanesische Politik und die Beziehungen mit den USA während des Kalten Krieges. Auch wird das Phänomen der Globalisierung und ihrer dramatischen Auswirkung auf das Leben der arbeitenden Bevölkerung aufgegriffen (Factory, 2003; Bade Area, 2005). Das für die Liverpool-Bienn. realisierte Video The Route (2006) erzählt die fiktive Gesch. eines Hafenarbeiterstreiks während der Thatcher-Ära, der sich von Liverpool aus wie ein globales Fieber ausbreitete und nach zehn Jahren auch Taiwan erreichte. In den Gesprächen mit den unter miserablen Bedingungen schuftenden taiwanesischen Arbeitern will C. die Protesthaltung überhaupt erst auslösen. Die jüngste, auf der Bienn. in Venedig gezeigte Videoarbeit Empire's Borders I (35 mm Film, 27 Min., 2008–09) dokumentiert die umständlichen Überprüfungen, denen sich Bürger Taiwans unterziehen müssen, wenn sie ein Visum der USA beantragen. Damit reflektiert C. die Verinnerlichung des imperialen Bewußtseins in der taiwanesischen Ges. sowie das komplexe Verhältnis zu den Vereinigten Staaten. Als Vorreiter der Body Art, Performance- und Konzeptkunst in Taiwan und auf dem internat. Kunstparkett etabliert, zählt C. zu den wichtigsten Vertretern der zeitgen. Kunst in Taiwan. ◫ MADRID, CARS. LIVERPOOL, Tate Liverpool. TAIPEI, FA Mus. ZÜRICH, Union de Banques Suisses (UBS) Art Coll. ◉ E: Taipei: 1984 Amer. Cult. Center (nach einem Tag zwangsweise geschlossen); 1996 Lin & Keng Gall.; 1997, '98 FA Mus.; 2004 IT Park Gall.; 2006 Main Trend AG / Paris: 2001 Gal. Nat. du Jeu de Paume; 2004 Gal. Alain le

Gaillard; 2008 Gal. Olivier Robert / 2003 Los Angeles, Otis College of Art and Design / 2004 Lucca, Claudio Poleschi Arte Contemp. / 2005, '09 Madrid, La Fábrica Gal. / 2006 Haarlem, Hallen / 2007 Wien, KH (Ursula-Blickle-Videolounge); New York, Asia Soc. and Mus. / 2009 London, Rivington Place / 2010 Los Angeles, Redcat / 2011 Bergen, Hordaland Internat. AG. – G: Taipei: FA Mus.: 1998, 2002 (K: S. Yu) Bienn.; 2001 Cherng Pin Gall.: From Iconoclasm to Neo-Iconolatry; 2007 Naked Life; 2004 Eslite Vision Art Space: Ruins and Civilization; MCA: Spellbound Aura / 1998 São Paulo: Bien. / 1999, 2005, '09 Venedig: Bienn. / 2000 Lyon, Bienn.; Gwangju: Bienn. / 2001 Berlin, Haus der Kulturen der Welt: Translated Acts (Wander-Ausst.; K) / 2003 Vilnius, Contemp. AC: Slow Rushes; Seoul, Mus. of Art: Citynet Asia; Zürich, Kunstraum Walcheturm: Shifting Time/Space; Paris, Light Cone: Vidéoart et Cinéma Expérimental de Chine Populaire et de Taiwan / 2004 Shanghai, AM: Bienn. Techniques of the Visible; London: Film Festival: Experimental Short Films (Wander-Ausst.) / 2005 Fukuoka: Asian Art Trienn.; Brüssel, Aeroplastics Contemp.: Boost in the Shell / 2006 Liverpool, Tate: Bienn.; Hongkong, Internat. Film Festival Avant-Garde / 2007 London, Nat. Film Theatre: After the Fact; Istanbul: Bienn.; Wien, Thyssen-Bornemisza Art Contemp.: Shooting Back; San Francisco, Art Inst.: World Factory. Resistance and Dreams / 2008 Rennes: Bienn.; Linz, Offenes Kulturhaus: Bienn. Cuvée 08; New Orleans, Bienn.; Guangzhou, Guangdong AM: Trienn.; Rotterdam: Internat. Film Festival / 2011 Mannheim, Ludwigshafen, Heidelberg: Fotofestival. ⌶ M. Sullivan, Mod. Chin. artists, Berkeley u.a. 2006 (s.v. Chen Jieren). – Xiao Shouju, Xiongshi meishu 164:1984 (Okt.) 162 s; E. Heartney, Art in America 86:1998 (12) 38–43; M. Pai, Asian art news 8:1998 (3/Mai-Juni) 36–47; (4/Juli-Aug.) 92 s.; Li Weijing, Yishujia 293:1999 (Okt.) 448–455; A. Poshyananda u.a., Fresh Cream, Lo. u.a. 2000, 190–195; Lin Chi-ming, Mem., hist., genealogie. Introduction a l'art de C. (K), P. 2001; M. Warner Marien, Photogr. A cult. hist., Lo. 2002, 488; S. Acret (Ed.), A strange heaven. Contemp. Chin. photogr. (K Wander-Ausst.), Hong Kong 2003; A. H. Cheng, Yishu. J. of contemp. Chin. art 2:2003 (1/März) 77–81; ; J. Chu/J. Tsai (Ed.), Contemp. Taiwan. art in the era of contention (K Ithaca/NY), Taipei 2004, 156–163; B. Taylor, Art today, Lo. 2004, 192 s.; id., Collage. Practice and theory in mod. art, Lo. 2004, 212 s.; B. Vanderlinden (Ed.), Do you believe in reality? (K Bienn.), Taipei 2004, 58 ss.; The multiform nineties. Taiwan's art branches out (K), Taipei 2005; C./Hong Hao u.a., Double-kick cracker (K), Bj. 2006; W. Rhee u.a. (Ed.), Thermocline of art. New Asian waves (K Karlsruhe), Ostfildern 2007. – Online: Kunstaspekte; photogr. now (Ausst.). K. Karlsson

Chen Chien-Pei (Chen Jianpei), taiwanesischer Maler, Installations- und Videokünstler, * 1955 Taipei, lebt in Tainan. Stud.: Nat. Taiwan Arts College, Western Paint. Dep., Taipei (Abschluß 1982); Univ. of Bilbao, Art College; Fac. de BA, Univ. Complutense de Madrid. 1989 Artist in Residence, Arteleku AC, Gipuzkoa (Spanien). Seit 1992 kunstpublizistisch tätig mit zahlr. Beiträgen im Ar-

tist Mag. (Yishujia). Lehrtätigkeit: 1995–98 Dep. of FA, Tunghai Univ., Taichung; 1996–98 Dep. of FA Education, Nat. Taichung Teachers College; 1997–98 Art Studio, FA Mus., Taipei; seit 1998 Prof. am Graduate Inst. of Plastic Arts, Tainan Nat. Univ. of the Arts. Seit 1999 Dir. der Assoc. of the Visual Arts in Taiwan sowie aktiv in zahlr. offiziellen Komitees zur Förderung von Kunst im öff. Raum. Reisen: 2004 Nepal, New York, Tokio; 2005 London. – C.s frühe abstrakt-expressionistischen Werke der Ölmalerei, wie *Xin xiang* (Dem Herzen ähnlich, Slg. Weng Longxian), nehmen Bezug auf phil. Grundsätze der trad. chin. Lsch.-Malerei. Seit den 1990er Jahren widmet er sich vorrangig raumgreifenden, von Licht (v.a. Kerzen) durchfluteten Mixed-media-Installationen. C.s Arbeiten, die auch vom Katholizismus sowie von den altarähnlichen Einrichtungen von Christian Boltanski angeregt sind, muten geheimnisvoll, meditativ und religiös-feierlich an. Sich mit Fragen zum Leben und Tod beschäftigend, nimmt C. eine ehrfurchtsvolle und lebensbejahende Haltung ein, die im buddhistischen Grundsatz der Unendlichkeit des Seins durch die Wiedergeburt verankert ist. So ist die (leuchtende) Lotosblüte, buddh. Symbol für Reinheit und Erlösung, ein häufiges Motiv (*Qiu yuan*/Praying for Heaven's Charm, 1990; *Tian tang*/Heaven, 1993; *Wu yuan*/Wu Garden, 1999), das C. auch veranlaßt, über ökologische Fragen sowie über das Schwinden von Selbsterkenntnis und Spiritualität im Informationszeitalter immer wieder neu zu reflektieren (*Interface – The Interiority and Exteriority of a Circle*, 2007). In den jüngeren Videoarbeiten gibt C. anhand filmisch festgehaltener Reiseimpressionen zudem ironische Statements zu den Auswirkungen der Globalisierung (Armut, Diskriminierung, kult. Vereinheitlichung) ab: *A House on Fire*, 2004; *New York. The Sacred Capital*, 2004; *Wonderland*, 2005. ▥ TAICHUNG, Nat. Taiwan MFA: Imprisoned Soul, Installation, 1997 (Venedig, Bienn.). TAIPEI, FA Mus.: War? Basic dignity of Human?, Installation, 1996. ▣ Madeli de gonggong yishu/Public art in Madrid, Taipei 1994. ◉ *E:* 1986 San Sebastián, Pasajes Ancho Cult. Center / 1987 Bilbao, Fudicion Gall. / 1991 Gipuzkoa, Arteleku AC / Taipei: 1990, '93 IT Park Gall.; 1990 Apartment No. 2; 1990, '97, 2004 FA Mus.; 1995 Traveling Mus.; Leisure AC; Bamboo Curtain Studio; 1998 Taipei Cult. Center; 2001 Huashan Cult. Park / 1997 Kaohsiung, Yencheng Gall.; 1997 Taichung, Gal. Pierre. – *G:* Taipei: 1996 FA Mus: Taipei Bienn.; 2003 IT Park Gall.: 64 Languages of Love and Lust, when SARS is Rampant; 2007 Shin Leh Yuan Art Space: Braking through the Surface. Dialogue between Design and Art / 1997 Venedig: Bienn. / 1998 Chiayi: Taiwan Installation Art Exhib. – Symphony of Cities; Fukuoka, Artium: The New Identity. Taipei Contemp. Arts Exhib. / 1999 New York, Taipei Gall.: Ritual in the Fin de Siècle: Contemp. Taiwanese Art (Wander-Ausst. K) / Taichung: 2000 Nat. Taiwan MFA: Grateful. The Reconstr. of Humanity after 921 Earthquake; 2005 Soaring Cloud AC: Art Transcends Boundaries; 2006 TADA Center: A Bud in the Dark. Celebrating the 85th anniversary of Taiwan Cult. Assoc.; Nat. Taiwan MFA: 2006 Macroscopic, Microscopic, and Multiple

Mirror Reflections; 2007 Asian Art Bienn. Have You Eaten Yet / 2004 Ithaca (N. Y.), Herbert F. Johnson Mus. of Art: Contemp. Taiwanese Art in the Era of Contention (K) / 2005 Marrickville (N. S. W.), Marrickville City Council Gall.: Encounter / 2006 Nantou, 99 Art and Ecological Park: 24, A Cinematography Creation Exhib. of the Integration of Ecology and Art. ▢ *Marrodán* I, 1989. – *R. Kent*, Art Asia Pacific (Hongkong) 1998 (18) 20 s; The multiform nineties. Taiwan's art branches out (K), Taipei 2005. – *Online:* Viewing of Contemp. Art Taiwan MFA (Ausst.). K. Karlsson

Chen *Fang* (Chen Zhiting; Pseud. Huangzhai), chin. Maler, politischer Aktivist, Publizist,* 4. 6. 1896 (oder 1897) Pingshan/Jiangxi, † 1962 Taiwan Als Maler Autodidakt. Stammt aus einer armen Gelehrten-Fam.; sein Vater war Lehrer und hatte den Gelehrtengrad Xiucai inne. C. kann bereits sehr früh aus den klass. Schriften des Konfuzianismus vorlesen und besitzt fundiertes Wissen. Nach dem Examen wird er als Lehrer an einer Mittelschule tätig, danach Umsiedlung nach Shanghai und Beijing, wo er sich intensiv mit wirtschaftspolitischen Fragen beschäftigt. Um 1920 erste politische Schriften. Förderung durch den damaligen Abgeordneten und späteren Guomindang-Funktionär Yang Yongtai (1882–1936) sowie durch Jiang Jieshi (Chiang Kai-shek, 1887–1975), der ihn A. der 1930er Jahre zu einem führenden Sekretär in seinem Beraterstab macht. Bis 1949 bekleidet C. hohe politische Funktionen innerhalb der Chin. Nat.-Partei (GMD) in der Prov. Hubei. Mitgl. in der 1926 gegr. Hushe Paint. Soc. (Hushe huahui), die Bilder-Ausst. von klassischen Literatenmalern und zeitgen. Maler in China und Japan organisiert. Ansässig ab 1949 in Hongkong, ab 1953 in Taiwan. Dort ist er 1955 zus. mit Tao Yunlou (1898–1964), Zhang Gunian (1906–1987), Zheng Manqing (1902–75) u.a. Gründungs-Mitgl. der Seven Friends Paint. Soc. (qi you huahui), die zu einer der (auch kulturpolitisch) einflußreichsten Künstler-Vrgn in Taiwan wird; Jahres-Ausst. im NM of Hist. Taipei. – Ab den 1920er Jahren Bilder im trad. chin. Tuschestil (guohua). Als Spezialität gelten seine Bambusbilder in monochromer Tusche, die von Malerkollegen hoch gerühmt werden (*Bamboo and stones*, 1947, zus. mit Huang Junbi). ◉ *G:* 2009 Taipei, NM of Hist.: A Fraternity of Cultivation. The Seven Friends Paint. Soc. 50th Anniversary Memorial Exhib. (K). ▢ *E. J. Laing*, An index to reprod. of paint. by twentieth-c. Chin. artists, Eugene, Ore. 1984. – *Y. Lin*, The seven friends paint. club and its art, Taibei 1997; *A. Yang*, Why Asia? Contemp. Asian and Asian Amer. art, N. Y./Lo. 1998; From the ground up. Artist assoc. in 1950s Taiwan (K), Taipei 2002.

A. Papist-Matsuo

Chen *Guangming* (Chen Guang Ming), chin. Maler, Zeichner, Lithograph, Radierer, * 3. 6. 1947 Nanjing, lebt seit 1990 in Brüssel. Stud.: 1988–90 Univ., Shanghai, Malerei bei Zhou Youwu; 1991–95 Acad. R. des BA, Brüssel, bei Daniel Pelletti; 1995–97 Ec. Supérieure des Arts Plast. et Visuel, Mons, bei Yvon van Dyck. Lehrt 1987–90 als Prof. an der Railway Univ., Shanghai (FA Dep.). 1990 Übersiedlung nach Brüssel. Ausz.: 1988 Eh-

renpreis der Stadt Shanghai; 1989 Beijing, Großer Nat. Wettb. für Chin. Tuschemalerei. Mitgl.: 1986 AK Shanghai; Chin. Künstler-Verb., 2000 Soc. Nat. des BA de France. Unterrichtet gegenwärtig an der Acad. de Musique, Théâtre, Danse et BA in Mouscron (u.a. Zeichnen). Teiln. an Ausst. in Frankreich, Deutschland, Belgien, Singapur, Taiwan, Hongkong und in den USA. – Fertigt v.a. lyrische, kalligraphisch anmutende Abstraktionen mit Tusche auf Papier. Auch Zchng., Lith., Aquarell. ⌂ LE LOCLE, MBA. LA LOUVIÈRE, Mus. Ianchelevice. MOUSCRON, MBA. PLOIEŞTI, Muz. de Artă. SHANGHAI, MCA. SINT-NIKLAAS, Internat. Exlibris Centre. TOURNAI, MBA. ◉ E: 1997 Paris, Gal. Etienne de Causans / 1999 Mons, MBA / 2000 Mouscron, MBA (K). – G: 1999 Ploieşti: Internat. Graphik-Bienn. (K) / 2000 Paris: Salon d'Automne (K). ▭ Piron I, 1999; Pas I, 2002. – M.-J. Pollet, C. Voyage vers l'intérieur, Mouscron 2000. – Mitt. C.

 K. Karlsson

Chen *Guangwu*, chin. Schriftkünstler, Maler, * Juni 1967 Liuzhou/Prov. Guangxi, lebt in Beijing. Bruder des Malers *Chen Guanghui* (* 1960 Prov. Hunan). 2007 zus. mit diesem Reise in die Schweiz (u.a. Sursee). Als Künstler Autodidakt. Seit M. der 1980er Jahre intensive Beschäftigung mit trad. chin. Schriftkunst. Fortan entstehen innovative abstrakte, konzeptuell-kalligraphische Arbeiten (Aqu., Stempelfarbe und v.a. Tusche/Papier), die durch visuelle Rhythmen der zumeist in mehreren Schichten gestalteten Schriftzeilen sowie durch ein Interesse an formaler Wiederholung, Struktur und Präzision charakterisiert sind. Als Grundlage seiner großformatigen, zumeist an chin. Hängerollen erinnernden Werke dienen mitunter Beispiele der klassischen Schriftkunst (*Facsimile Wang Xizhi*, 2004; *Preface to the Poems composed at the Orchid Pavilion*, Tusche/Holzplatte, 2009) und Texte der konfuzianischen und buddh. Lit. (*The Great Learning; Jingang Sutra*); minimalistisch und puristisch zeigt sich C., wenn er in einem Werk dasselbe Zeichen wiederholt (*Eight Ways of Writing Yong*, 2000) oder eine Palette von versch. Schriftzeichen mit demselben Radikal gestaltet. Erstellt in jüngster Zeit auch Drip Paint. (*2008 Series*, Öl/Lw., 2008) sowie skulpturale Arbeiten (*Dancing Phoenix*, Bronze, 2009). ⌂ BASEL, Novartis Found. GENF, The Olenska Found. HONGKONG, Liang Jiehua Art Found. MAUENSEE, Slg Sigg. ◉ E: 1993 Beijing, Armonna Gall. (mit Xu Ruotao) / 1999 Manchester, Chin. AC / 2005 Shanghai, U Gall. (K) / 2006 New York, Goedhuis Contemp. (K) / 2007 Sursee (Schweiz), Stadtcafé (mit Chen Guanghui) / Berlin: 2008 Mus. für Asiatische Kunst (mit Fang Lijun und Liu Wentao); 2009 Gal. Aleander Ochs (K). – G: 1991 Nanjing, AG: China – Shanghai. Mod. Calligraphy / Beijing: 1999 Dt. Botschaft: The Trad. and Rethought; 2003 Beijing Tokyo Art Projects (BTAP): Prayer Beads and Brush Strokes; 2006 798 SPACE: C., Luo Brothers, Wang Nengtao. Back to Xuan Paper; Today AM: Comprehensive Art Exhib.; 2008 White Space Beijing: Under the Sky / 2000 Chicago (Ill.), Rhona Hoffmann Gall.: The Art of Scholar. Ming Dynasty and Chin. Contemp. Art; Hongkong, Cult. Center: The Disintegration of Ink Calligraphy / 2001 Luzern, Gal. Urs Meile: Take Part II / 2002 Denver (Colo.), Arvada Center, Lower Gall.: Avant Garde Calligraphy; Oberhausen, Gal. Ludwig: China – Trad. und Mod. / 2007 Shanghai, Creek Art: Lines. Chin. Abstract Art; Humlebæk, Louisiana: China onward, the Estella Coll. – Chin. Contemp. Art, 1966–2006 / 2008 Taipei, MFA: Form, Idea, Essence & Rhythm. Contemp. East Asian Ink Paint.; Berlin, Gal. Alexander Ochs: Die wahren Orte I / 2009 Augsburg, KV: China. Ein and. Blick. ▭ Im Spiegel der eig. Trad., Ausst. zeitgen. chin. Kunst (K), Bj. 1998; Variations of ink. A dialogue with Zhang Yanyuan (K), N. Y. 2002; *B. Fibicher/M. Frehner* (Ed.), Mahjong. Chin. Gegenwartskunst aus der Slg Sigg (K Bern/Hamburg), Ostfildern-Ruit 2005; Entry Gate. Chin. aesthetics of heterogenity (K), Shanghai 2006. – *Online:* Gal. Alexander Ochs, Berlin. K. Karlsson

Chen *Guangyi*, chin. Zeichner, Comiczeichner, * 1915 (auch 1919) Nanjing/Prov. Jiangsu, † 5. 9. 1991 Shanghai. In jungen Jahren erhält C. Unterricht in trad. volkstümlicher Malerei (Motive, Technik). 1934 Anstellung in der Mal- und Design-Abt. einer Shanghaier Porzellanfabrik; arbeitet ab 1936 als freier Zeichner, u.a. für die Werbung. Nach Kriegsausbruch engagiert sich C. kurzzeitig politisch und gibt 1938 eine Zs. heraus, die zum Widerstand gegen Japan aufruft. Veröffentlicht A. der 1940er Jahre in Shanghai seinen ersten Comic (chin.: lianhuanhua) *Löwen* und zeichnet bald darauf für versch. Verlage. Nach 1949 nimmt er an einer lianhuanhua-Schulung teil und wird im Verlag Neue Kunst (Xinmeishu) eingestellt (ab 1956 Volkskunstverlag Shanghai). Zu Beginn der Kulturrevolution 1966 wird er als Vertreter „bourgeoiser Kunst" massiv angegriffen und bis 1975 kaltgestellt. Erst ab 1978 zeichnet er wieder Bildgeschichten, die veröff. werden. – Als herausragende Gestalt unter den chin. Comickünstlern prägt C. die Entwicklung dieses Mediums in den 1940er Jahren maßgeblich mit. Er gehört mit über 200 lianhuanhua zu den produktivsten Zeichnern seiner Zeit. Das Œuvre umfaßt die drei Schaffensperioden von vor 1949, 1950–66 und nach 1978. Die frühen lianhuanhua der 1940er Jahre adaptieren den Stil chin. Neujahrsbilder und des klassischen Hschn. durch einfache Strich-Zchngn in manchmal grober Ausf. mit fehlerhafter Perspektive, wobei C. volkstümliche Figuren (z.B. Schwertkämpfer) bewußt überzeichnet und in komischen, absurden Situationen schildert. Seine Produktivität und die Beliebtheit seiner Comics machen ihn zum Vorbild für viele junge Zeichner. Man zählt ihn mit Zhao Hongben (1915–2000), Shen Manyun (1911–1978) und Qian Xiaodai (1912–1965) zu den „vier großen Schulen" (chin.: si da ming dan) Shanghais. Nach Gründung der Volksrepublik China 1949 muß sich C. neu orientieren, da seine Arbeiten vom neuen Regime kritisch gesehen werden. Die Teilnahme an einer „Schulungsklasse" für lianhuanhua 1952 ist als Versuch zu werten, sich dem neuen System anzupassen, was ihm z.B. mit den Zchngn *Da nao tian gong*/Aufruhr im Himmelspalast (Shanghai 1955) erfolgreich gelingt. Auch wenn er sich mit den von der Politik geforderten Themen auseinandersetzt und einige mod. lianhuanhua zeichnet (z.B. *Der Nachrichtenbaum*,

einer Gesch. aus dem Vietnamkrieg, 1965), liegt sein inhaltlicher Schwerpunkt in der Bearbeitung klass. chin. Romane und Opern, deren hist. Zeitkolorit er so „authentisch" wiedergibt (z.B. Archit., Mode), daß diese Arbeiten für viele Chinesen als realistische Abb. vergangener Epochen gelten. Im Volkskunstverlag, in dem bis zu 100 Zeichner tätig sind, gilt C. als Autorität für alle Fragen der Bearbeitung klassischer Lit. und Themen; hier betreut er u.a. große Publ.-Projekte wie die 60-bändige Comicversion des Romans *San guo yanyi* /Die drei Reiche (Shanghai 1957–61). In der Kulturrevolution wirft man ihm aufgrund seiner Themen u.a. die Verherrlichung des Feudalismus vor. Wie viele and. Künstler wurde er 1966–67 in „Rente" geschickt und „umerzogen". Erst M. der 1970er Jahre wird er in den Verlag zurückgeholt. Die letzte Schaffensphase nach 1978 ist wiederum von der Konzentration auf die chin. Klassik gekennzeichnet. Allerdings bleiben ihm nun die großen Erfolge versagt, und er muß miterleben, wie das von ihm mitgestaltete Medium lianhuanhua immer mehr an Popularität einbüßt und weitgehend verschwindet. – Publ. u.a.: *Niu* (Rind), 1946; *Shi dixiong* (Zehn Brüder), 1946; *Hai* (Zur See), 1948; *Yuechuan* (Gesch. Yue Feis), 15 Bde (Mitarb.), 1958–63, alle Shanghai. ▢ *Wang Guangqing u.a.,*, Lao lianhuanhua (Alte lianhuanhua), Shanghai 1999;*Mai Lihong*, Zhongguo lianhuanhua (Chin. Comics), Guangzhou 2006; *A. Seifert*, Bildgeschichten für Chinas Massen, Köln u.a. 2008 (WV).

A. Seifert

Chen *Hsing-wan* (Chen Xingwan), taiwanesische Malerin, * 1951 Taichung, † 2004 Paris. Tochter des bek. Portr.-Bildhauers Chen Hsia-yü. War mit dem Künstler *Cheng Yan-ping* (* 1951) verheiratet. Stud.: Taiwan Nat. Acad. of Arts, bei Tu Jing-lun; 1981 Weiterbildung bei Li Chungsheng, Protagonist der bek. Künstlergemeinschaft Ton Fan/Osten (Dongfang huahui). Ausz.: 1984 1. Preis, Taipei FA Mus. ; 1985 3. Preis ebd.; 1989 1. Preis, Li Chungshen Found.; 1991 Reise-Stip. des Erziehungs-Minist. (Paris, Cité Internat. des Arts); 1995 Asian Cult. Council's Taiwan Arts Fellowship Program (sechs Monate in den USA); 1999 Gedok-Stip., Lübeck. Reisen: 1990 Schweiz; ab 1991 mehrmals Sahara (Ägypten); 1999 Paris. – Vertreterin der taiwanesischen Avantgarde der 1980er Jahre mit Teiln. an Ausst. und Aktivitäten der 1978 von Hsu Po-yun (Komponist) und Fan Man-nong (Musikerin) gegr. New Aspect Group (Xinxiang wenjiao jijinhui). Inspiriert von ihrem Mentor Li Chung-shen begann sie A. der 1980er Jahre mit neuen Techniken (Dripping, Collage) und Mat. (Holzstäbe, Zeitungsausschnitte, Gips, Ölfarbe) zu experimentieren; sie fertigte abstrakt-expressionistische großformatige Bilderserien in farbigen Mixed-media-Techniken (*Zuopin 8411*/Arbeit 8411, Gips, Acryl, 1983; FA Mus., Taipei). Ab den 1990er Jahren auch Wandinstallationen sowie Tendenz zu geometrischen Formen in Schwarz-, Weiß- und Rottönen und Verwendung zusätzlicher Mat. (Fotos, Stricke, Seile, Stoffetzen): *Dadi zhi ge*/Ode an die Erde, ab 1990; *Zhanzheng yu heping*/Krieg und Frieden, 1995; *Shang Hanna Wilke zhi jing*/Hommage an Hanna Wilke, 1995–96). Auch großformatige, mit heftigen Pinselhieben

geschaffene, ausdrucksstarke kalligraphische Tuscheabstraktionen auf Papier (*Arbeiten 9410, 9411 ...*, 1994). Fertigte 1999 während ihres Aufenthalts in Deutschland (u.a. mit Besuchen der Konzentrationslager in Dachau, Sachsenhausen und Ravensbrück) eine eindrückliche Bilderserie, die existentielle Fragen zu Leben und Tod reflektierten (*Deguo yinxiang*/Dt. Impressionen, Tusche und Farbe/ Papier). C. gehörte zur dritten Künstler-Gen. Taiwans, die (nach dem 2. WK geboren) durch die politischen Ereignisse der 1980er-90er Jahre in ihrem künstlerischen Schaffen stark in die Debatte um das „groß-chin." versus „taiwanesische" Kulturkonzept involviert wurde. Sie gehörte zugleich zur dritten Gen. der chin. Maler des 20. Jh., die auf der Grundlage reflektierter chin. Kultur-Gesch., v.a. der trad. chin. Malerei, zukunftsweisende künstlerische Ausdrucksformen gefunden hat. Die Lebenskraft der Tuschemalerei erlangte im Werk von C. eine überzeugende visionäre Qualität. ▢ TAIPEI, FA Mus. ☉ *E:* Taipei: 1984 Yi Gall.; 1989 Lung-Men AG.; 1997, 2007 (Retr., K) FA Mus.; 2000 Hanart Gall.; 2008 Lee Gall. (mit Ye Shi-Qiang) / Taichung: 1989 Contemp. AG; 1990 Taiwan Mus. of Arts; 1993 King Brick Gall.; 2000, '01, '03 Ke-Yuan Gall. / 1991 Kairo, Mashrabia Gall. / 1992, '93 Paris, Cité des Arts / 1994 Tainan, New-Phase Gall. / 1999 Lübeck, Gedok Atelierhaus. – *G:* Taipei: 1987 Nat. HM: New Aspects of Mod. Chin. Art; NM for Contemp. Art: Contemp. Chin. Paint.; 1991 Yuon-Han Internat. AC: Abstract: Seven Artists; 1995 Lung-Men (Dragon Gate) AG: Wonderful Abstract Art; FA Mus.: 1998 Commemorative Exhib.; 2004 Contemp. Ink Paint. and Ink in Contemp. Art / Taichung, Taiwan Mus. of Art: 1988 Media, Environment, Installation; 1994 Chin. Contemp. Ink Paint. / 1988 Fukuoka, Nat. MCA: Third Asian Art Exhib. / 1989 Tokio, Hara Mus.: Message from Taipei (internat. Wander-Ausst.) / Paris, Chin. Cult. Center: 1996 Autoplasty in Contemp. Art; 1997 Taipei-Paris / 1998 Lübeck, St. Petri: Vision 2000. Chin. Gem. und Skulpt. der Gegenwart (Wander-Ausst.; K: U. Toyka-Fuong) / 2003 London, Goedhuis Contemp.: Inner Nature / 2006 Kaohsiung, MFA: Clematis in the Wind. ▢ *M. Sullivan*, Mod. Chin. artists, Berkeley u.a. 2006 (s.v. Chen Xingwan). – *Ts'ai Hung-ming*, Hsing-shi art monthly 155:1984 (Jan.) 116 s.; *J. Clark*, Orientations (Taipei) 23:1992 (7) 28–36; Taiwan art 1945–1993 (K FA Mus.), Taipei 1993; *N. Jose/Yang Wen-i* (Ed.), Art Taiwan. The contemp. art of Taiwan (K MCA), Sydney 1995; *Yang Wen-I*, in: *D. Dysart/H. Fink* (Ed.), Asian women artists, Roseville, N. S. W. 1996, 42–51; Asian avant-garde (K Christie's), Lo. 1998; *C. Werner u.a.* (Ed.), Die Hälfte des Himmels (K Bonn/Offenburg), Bonn 1998; *W. Becker u.a.*, Continental shift. Eine Reise zw. den Kulturen (K Aachen/ Maastricht/Heerlen/Liège), Freiburg 2000; The transitional eighties. Taiwan's art breaks new ground (K), Taipei 2004; Ink (K Goedhuis Contemp.), N. Y. 2005; *C. jinian zhan* (Memorial Exhib. of C.; K), Taipei 2007.

K. Karlsson

Chen *Hui-chiao* (Chen Huiqiao), taiwanesische Malerin, Objekt-, Video- und Installationskünstlerin, * 19. 2. 1964 Tanshui, lebt in Taipei. Stud.: Yu-Te FA High School,

Taipei (Malerei, Abschluß 1982). Ab 1986 Unterricht bei Tsong Pu in dessen Studio of Contemp. Art (SOCA) ebd. Gründet 1988 zus. mit ihm und Liu Ching-tang die Fotostudio-Gal. IT Park ebd. 1989 Reise nach Paris. 2005 Artist in Residence, Glenfiddich Gall., Dufttown (Schottland). Versch. öff. Aufträge, u.a. 2000 *The Dreamer and the Dreamed II- Starry Moment*, Taipei, Stadtverwaltung ; 2005 *The Fire from Within*, Taipei Muzha Refuse Incineration Plant; 2007 *Flitting*, Taipei Rapid Transit System. – Als Kunstschaffende und Leiterin des alternativen Kunst-Inst. IT Park ist C. Vertreterin und Förderin der zeitgen. Kunst. Anfänglich Malerei. Seit 1986 wendet sie sich unter Einfluß von Tsong Pu (Minimalismus) der konzeptuellen Mixed-media-Installation zu, die char. ist durch einen emotional beladenen, persönlich-intimen Ansatz. Unter Verwendung von Mat. mit symbolischen (weiblichen) und taktilen Eigenschaften erforscht C. die Wechselbeziehung zw. äußerlichen Realitäten und innerem Bewußtsein, zw. Form, Materie und Sinngehalt sowie die Welt der menschlichen Wahrnehmung, Empfindung, des Instinkts und des Unterbewußtseins. Dabei werden „weiche" (Rosen, Federn, Baumwolle, Nähfaden, Wasser) mit „harten" (Chromstahl, Acrylplatten, Glas und Nadeln) Mat. kombiniert und kontrastiert, die das dualistische Prinzip von Yin und Yang und die Koexistenz von Genuß und Schmerz suggerieren. Bek. sind ihre Installationen mit getrockneten Rosen, die mit (Akupunktur-)Nadeln durchstochen sind (*Thought of Flowers Go Deeper than Looking, You are the Rose, I am the Needle*, beide 1993) sowie Installationen mit flaumig einladenden Betten mit versteckten Nägeln (*Then Sleep, My Love...*, 1998). Inspiriert von westlicher Lit. (Octavio Paz, Carlos Castaneda), Astrologie, Psychologie und v.a. von ihren gezeichneten Träumen gewinnen ihre Arbeiten seit E. der 1990er Jahre einen spirituell-suggestiven Charakter. Wolken (mit blauem Himmel und Wasser) und Federn als Metaphern für Freiheit, Kraft und Schwerelosigkeit des Bewußtseins sind wiederkehrende Motive (*The Dreamer and the Dreamed*, 1995; *Within Me, Without me in Space, Within Space*, 1997; *Swirling Night and Shadow of the Wind I & II*, 1997, '99). Die Arbeiten *Ancient Feeling* (getrocknete Disteln, Garne, Vinylgrafiken, 2006) und *Inside of Memories & The Silver Dust* (Wasser, Videoprojektion, LED-Lichter, Wandmalerei, Glas, 2006) verweisen auf eine symbolische Welt, erfüllt von C.s Sehnsucht nach der ursprünglichen Natur und der Quelle des Kosmos. In ihren jüngsten Wandinstallationen (farbige Näherei/Steppung mit Computer auf Gemsleder, Samt) Tendenz zu abstrakt-geometrischen Formen (*The Double Flame*, 2008). ⬕ Dufttown, The Glenfiddich Distillery. Hongkong, Hanart Gall. New York, Pace Wildenstein Gall. Taichung, Gal. Pierre. Taipei, FA Mus. – Main Trend Gall. – Dimension Endowment of Art. ✉ In search of art's way, in: Asian art news (Hong Kong) 7:1997 (1) 54 s. (Interview), 68 s.; Magnetic writing. Marching ideas. Works on paper (K IT Park Gall.), Taipei 1999. 👁 *E*: Taipei: 1992, '95, '97, '98 (mit Ku Shih-Yung), 2008 IT Park Gall.; 2006 MCA (K). – *G*: Taipei: 1991 Lung Men AG: Taiwan Contemp. Female Artists' Exhib.; 1993 Han-

art Gall.: New Art, New Tribes; 2004 Eslite Art Space: Reading the Labyrinth; FA Mus.: 1987 Avant-Garde Installation Space; 1992 Bienn.; 2005 MCA: Pseudo Hackers' Art in Parallel Zones / Hongkong: 1994 Hanart Gall.: Voices from the Edge. 10 Chin. Women Artists; 1998 AC New Voices: Contemp. Art Dialogue Among Taipei, Hong Kong and Shanghai (Wander-Ausst.) / 1996 Osaka: Trienn. / 1999 Surfers Paradise (Australien), Gold Coast City AG: Face to Face (Wander-Ausst.; K) / 1999 Beijing, Nat. AM of China: Visions of Pluralism. Contemp. Art in Taiwan / 2000 Kaohsiung, MFA: Journey of the Spirit / 2003 Seoul, Total MCA: The Gravity of The Immaterial / 2006 Nagoya, Univ.: Pass. Rhythm of the Space / 2007 Istanbul: Bienn. / 2009 Taichung, Taiwan Mus. of Art: Dual Regard. The Views from Taiwan. Women's Arts. 📖 *M. Sullivan*, Mod. Chin. artists, Berkeley u.a. 2006 (s.v. Chen, Huiqiao). – *S. Cheng*, Asian art news 4:1994 (Juli/Aug.) 56–59; *N. Jose/Yang Wen-i* (Ed.), Art Taiwan. The contemp. art of Taiwan (K), Sydney 1995; *Yang Wen-I*, in: *D. Dysart/H. Fink* (Ed.), Asian women artists, Roseville, NSW 1996, 42–51; *Wu Mali*, Mountain art 90:1997 (Sept.) 74 s.; *Gao Minglu* (Ed.), Inside out. New Chin. art (K Wander-Ausst.), Berkeley 1998; *M. Pai*, Asian art news 8:1998 (Mai/Juni) 90 s; *J. Clark*, Yishu. J. of Chin. contemp. art 2:2003 (1/März) 62–76; The multiform nineties. Taiwan's art branches out (K), Taipei 2005; C. Here and now (K MCA), Taipei 2006; *Chia Chi Jason Wang*, Yishu 8:2009 (5/Sept.-Okt.) 69–74. K. Karlsson

Chen *Jinyan* (Xiaoyan), chin. Karikaturistin, Holzschnittkünstlerin, Malerin, * Dez. 1924 Liaoyang/Liaoning, † Juni 1978 Beijing. Stud. der westlichen Ölmalerei an der Furen Univ. in Beijing (1948 Examen). 1950 Gründungs-Mitgl. der Gründungs-Kl. an der Central AFA ebd. Danach Karikaturistin bei der Tages-Ztg Beijing Ribao, später ebd. stellv. Leiterin des Kunstressorts. Gilt als erste Karikaturistin in der Volksrepublik China. Ausst. (1960). Mitgl.: Chin. Künstler-Verb. (Zhongguo meishujia xiehui). Verh. mit dem bek. Karikaturisten Cheng Fang. Während der Kulturrevolution Repressalien ausgesetzt. Neben den Karikaturen auch Hschn., Ölbilder und Schnitzereien. 📖 Zhongguo xiandai, 1988; Zhongguo meishuguan, 1993. – *M. Horn*, The world encyclopedia of cartoons, 1999; Internat. j. of comic art 7:2005 (2) 97.

A. Papist-Matsuo

Chen *Julai* (Chen *Jia*; Pseud.: Quezhai; Anchi; Anchi Laoren; Modaoren), chin. Siegelschneider, Schriftkünstler, Maler, * 23. 4. 1905 Pinghu/Prov. Zhejiang, † 15. 2. 1984 Shanghai. Entstammt einer Fischer-Fam. und beschäftigt sich als junger Mann autodidaktisch mit Siegelschnitzerei. 1918 Siegelschneider in der Porzellanproduktion von Jiaxing/Prov. Zhejiang. 1924 wird der renommierte Maler und Siegelschneider Zhao Shuru (1874–1945) sein Lehrer und Protegé und empfiehlt ihm u.a. das Sammeln von Steinabreibungen des Paläographen Chen Jieqi (1813–1884) als Lehr-Mat. (Shizhong shanfang yinju). 1926 Bekanntschaft mit dem Kunstkenner und Maler Wu Hufan (1894–1968). Im Mai 1927 Beginn der lebenslang anhaltenden engen Bekanntschaft mit

dem Maler Zhang Daqian (1899–1983), der seine Bilder ab 1927 meist mit von C. angefertigten Siegeln stempelt. Nach 1946 zunehmende Anerkennung im In- und Ausland. Als Maler am Shanghai Inst. of Chin. Paint. (Shanghai Zhongguo Huayuan) beschäftigt. Mitgl.: Xilin Seal Soc. in Hangzhou (Xilin Yinshe); Verb. der Schreibkünstler und Siegelschneider der Stadt Shanghai (früher Shanghai zhongguo shufa zhuanke yanjiuhui). – C. gilt als einer der bedeutendsten chin. Siegelkünstler des 20. Jh. Über 30000 Siegel soll er angefertigt haben. In diesen verbinden sich Poesie und Schriftkunst. Viele bed. chin. Künstler und Gelehrte der Moderne haben bei C. Siegel in Auftrag gegeben, u.a. Wu Hufan, Ye Gongchuo (1881–1968), Zhang Boju (1998–1982). C.s Siegel werden v.a. von Sammlern alter Inschriften (Jinshi xue) geschätzt. Für alle NM und die wichtigsten Bibl. in China hat er Nachschnitte von hist. Künstler- und Gelehrtensiegeln zu Forschungszwecken angefertigt. Darüber hinaus gilt er als versierter Schreibkünstler, bes. im Stil der Siegelschrift. ⌂ HONGKONG, Taiyilou Coll. MACAU, Mus. of Art. WASHINGTON/D. C., Freer & Sackler Gall., SI. ✉ Anchi jingshe yinju, Shanghai 1981. ⟐ Mod. Chin. paint. and calligraphy from the Taiyilou coll. (K), Hong Kong 1991; *D. Jia* (Ed.), C. J. yinji, Bj. 1998. A. Papist-Matsuo

Chen *Kai-huang* (Chen Kai Huang; Chen Kaihuang; K. H. Chen; Pseud. Tchenogramme), taiwanesischer Konzeptkünstler, Kurator, * 1960 Chiayi, lebt in Tapei. Stud.: Nat. Taiwan Acad. of Arts, Taipei (Abschluß 1986); 1986–90 ENSBA, Paris (Dipl.). Ausz.: 1998 Creation Grant, Nat. Cult. and Arts Found., Taiwan; 2001 Project Grant of Artistic Lab Establishment, EARTH, New York. Lehrtätigkeit: 1992–2006 Prof. an der Nat. Univ. of the Arts, Tainan; seit 2007 Abt.-Leiter für Bild. Kunst an der Nat. Univ. of the Arts, Taipei. Seit 1991 auch kuratorisch tätig, z.B. 2008 Kaohsiung Iron & Steel Sculpt. Festival. – Ab 1990 zus. mit Chen Shun-chu, Chen Hui-chiao, Chu Chiahua u.a. Teiln. an avantgardistischen Aktivitäten des Kunst- und Kulturzentrums IT Park, Taipei. Seither vertritt C. (alias Tchenogramme) eine experimentelle, interdisziplinäre Kunstpraxis, die die Medien Zchng, Video, Fotogr., Skulpt., Archit., Performance, Collage, Installation, Environment und Land-art umfaßt. Bek. ist seine 62-teilige Serie *Wenhua zeliang*/Cult. Measurement (Skizzen, Entwürfe, Zchngn, Objekte, Texte, Landkarten, 1989–91), in der C. die Beziehungen zw. Ästhetik und Politik sowie die zw. Mensch und Umwelt erforscht. Neben der Hervorhebung des sozialen Aspekts der Kunst sucht C. die Verbindung von Kunst und Lsch.-Erfahrung: mehrere Projekte realisierte er in den Küstenregionen Taiwans, wie *Fengdong. Women de qianmian?*/Wind Cave. In Front of Us?, Hsinchu, 1998, und *Zhou. Hai jing – yueliang shi taiyang*/The Circumference – Moon is Sun, 1998; präsentiert als Multimedia-Installation in Hualian 2003 und Gatineau 2004. ⊙ *E:* 1988 Paris, Jin Dong Cult. Center / Taipei: 2001 Hanart Gall.; 2004 IT Park Gall.; 2006 Main Trend Gall. / 2001 Tanshui, The Bamboo Curtain Studio / 2003 Hualian, Nat. Dong Hua Univ. AC / 2004 Batineau (Ottawa), Daimon Media AC. – *G:* 2001 Hamburg, Kunsthaus: Polypolis. Art of Asian Pacific Megacities (K: C. Friede u.a.) / 2002 Tanshui, Post Office u.a.: Puding Project; Kaohsiung, Dogpig Art Cafe: City Search II / 2003 Seoul, AM: City Net Project Exhib.; Chiayi, Chiayi Railway Warehouse: Witness of the Day / Taipei: FA Mus.: 2003 Flow of Spiritual Lights; 2005 The Multiform Nineties. Taiwan's Art Branches Out (K); 2006 Taipei 23 Project Exhib. – 2005 NG und Nat. Dr. Sun Yat-sen Memorial Hall: The Inheritance and Development Taiwan. Art Hist. 1955–2000 / 2006 Kuandu MFA und Taipei Nat. Univ. of the Arts: Dialogue between Taiwan. Contemp. Art and Phil. (Wander-Ausst.) / 2006 Hongkong, Chin. Univ.: Zero Coordinate Territory (Wander-Ausst.) / 2007 Fukuoka: Fukuoka X Taipei Art Exhib. / 2009 Dongju Island: Matsu Environmental Sculpt. Exhib. (K); Paris, ENSBA Gal: Taïwanpics. doc. Art Contemp. Taïwanais (K: E. Féloneau u.a.). ⟐ Art and Asia Pacific 1993 (Sept.) 40–46; *Tchenogramme*, A propos du Tchenogramme, Taipei 1995; *Ni Zaiqin*, Taiwan dangdai yishu zhi mei (The beauty of Taiwan art), Taipei 2004; The multiform nineties. Taiwan's art branches out (K), Taipei 2005.
 K. Karlsson

Chen *Ke*, chin. Malerin, * 1978 Tongjiang/Prov. Sichuan, lebt in Beijing. Stud.: 1998–2005 Sichuan Inst. of FA, Chongqing. 2005 Heirat mit dem Künstler Cao Jingping und Übersiedlung nach Beijing als freischaffende Künstlerin. 2006 nominiert für den Chin. Contemp. Art Award. – Die multimediale Künstlerin (Ölmalerei, Installation, Fotogr., Skulpt.) gilt als prominente Vertreterin der jungen Kunstszene in China. Ihre frühen, etwas inhaltslos anmutenden Arbeiten (2001–03) sind mit ihrer schrillen Chromatik und den skurril-figürlichen Bildmotiven stark beeinflußt von Cartoons und Animationsfilmen, die ihre Kindheit prägten. Um 2004 entwickelt C. ihre eig. Fantasy-Ästhetik, in deren Mittelpunkt eine biogr. motivierte zarte Mädchengestalt als Protagonistin steht; zunächst in leeren Bühnenräumen, später in komplexen und vielschichtigen Szenerien, die sich in surrealistisch wirkenden romantisch-düsteren Traumwelten abspielen (*Aneroxia*, Öl/Lw., 2005; *Matador*, Öl/Lw. 2006). In diesen mit engl. und chin. Titeln versehenen Gem. lotet C. die psychische Dynamik ihrer Heldinnen aus, wobei Emotionen wie Melancholie, Einsamkeit, Unentschlossenheit oder Gleichgültigkeit evoziert werden. Neuerdings stellt C. ihr eig. Papier her, bestickt Leinwände mit Perlen (*Game over*, Öl und Perlen/Lw., 2008) oder läßt handbedruckte Baumwollstoffe, Steine und v.a. Möbelstücke (*With you, I Will Never Feel Lonely*, *Quartet*, beide Installationen, 2007) zum Bildträger werden. Ihre jüngsten, kleinformatigeren Werke (häufig im Rundformat) zeigen inhaltlich erweiterte Figurenkonstellationen vor einem craqueléartig aufgebrochenen grauen Hintergrund (*Hug*, Öl/Lw., 2010). Daneben Skulpt., z.B. in Fiberglas. – C.s Einordnung in das derzeit internat. boomende Genre „Animamix" („Anime und Comics"; dongman meixue, von der Kuratorin Victoria Lu geprägte Bezeichnung) oder in die Kunst der nach Zhang Qing sog. Jelly-Generation (guodong shidai) scheint wegen der künstlerischen Mehrdimensionalität von C.s Arbeiten zu

kurz zu greifen. ▯ CHENGDU, Contemp. AM. LUGA-
NO, BSI Bank. SHENZHEN, AM. ⊚ *E:* 2007, '08, '10
Beijing, Star Gall. / 2008 Mailand, Marella Gall. / 2009
Viernheim, KV (K). – *G:* Beijing: 2005 Star Gall.: The Sky
of Bad Children; Top Space Gall.: A Cartoon Exhib.; 2008
Nat. AM of China: Facing Reality / Shanghai: MCA: 2006
The Originals. Neo-Aesthetics of Animamix; 2008 Cou-
ples in Contemp. Art / 2005 Nanjing: Trienn.; Chengdu:
Bienn. / 2007 New York, Thomas Erben Gall.: C., Li Ji-
kai, Wei Jia; Berlin, Pferdeställe des alten Postfuhramtes:
Your view – My story / 2009 Mailand, Pal. Reale: China.
Contemp. Rebirth. ▭ New interface art – Landing of up
generation (K), Shanghai 2006; China – facing reality (K),
W. 2007; *C. Noe u.a.,* Young Chin. artists. The next gene-
ration, M. u.a. 2008; *C. Albertini,* Avatars and antiheroes.
A guide to contemp. Chin. artists, To. u.a. 2008; *C. Fe-
derico,* Aesthetica 29:2009, 34–347; *C. Noe u.a.,* C. Paint.
2003–2009 (K Viernheim), He. 2009; *C.* Hard-boiled won-
derland and the end of the world (K), Bj. 2010.

<div align="right">K. Karlsson</div>

Chen *Kun* (Zai'an), chin. Maler, Dichter, Prosaist, Be-
amter aus Changshu/Prov. Jiangsu, tätig im 17./18. Jh.
C.s bevorzugte Sujets sind Blumen und Vögel (huaniao)
im „knochenlosen Stil" (wu gu) nach Yun Shouping, der
die Changshuer Mal-Trad. beeinflußte. Ein sign. Album-
Bl. mit Pflaumenblüten und Felsen nimmt sich des Mo-
tives der Winterpflaume an, die als Metapher und Sym-
bol versch. Konzepte versinnbildlicht, von keuscher Un-
berührtheit, Ruhe, Dauer im Wechsel und Glück bis hin
zu sexuellen Freuden, aber auch damit verbundenen Lei-
den wie Syphilis. C.s Bl. ist konventionell gearbeitet und
gibt dem Sehnen nach Stille jenseits des weltlichen Trei-
bens Ausdruck. Beispiele seiner Figurenmalerei sind nicht
erhalten. ✉ Lingnan zashi shichao (Vermischte Ange-
legenheiten und Gedichtabschriften aus Lingnan), o. O.
Guangxu (1875–1909); Zhili jiyao (Gesammelte Abrisse
zur Reg. des Volkes), Guangzhou 1889; Yuedong jiaofei
jilü (Aufz. zur Beseitigung von Banditen in Yuedong), Bj.
2000 (Faks.; Siku weishu jikan. Di san ji, 13). ▭ *Yu
Jianhua,* 1981, 1004; *Seymour,* 1988 (s.v. Ch'en K'un);
Bénézit III, 2006. – *Jia Lunkui* (um 1821), Yushan huazhi,
Shanghai 2000 (Zhongguo shuhua quanshu, 10), 1022;
Cheng Shuqing, Qingdai huashi zengbian, Shanghai 1927;
Ding Helu, Qing ershi jia huamei jice, Shanghai 1937;
O. Sirén, Chin. paint., VII, Lo./N. Y. 1973.

<div align="right">U. Middendorf</div>

Chen *Li* (Lanfu; Dongshu; Jiangnan juanke), chin. Kal-
ligraph, Maler, Paläograph, Dichter, Essayist, Sprachwis-
senschaftler, Beamter, * 23. 3. 1810 Panyu (Kanton)/Prov.
Guangdong, † 11. 3. 1882. C.s Fam. stammte aus Nanjing.
Sein Großvater verlegte den Wohnsitz nach Panyu, wo C.s
Vater als Kaufmann tätig war und gegen Lebensende den
Titel des Kreisaufsehers (Xianzhi) erkaufte. Nach Stud.
an versch. Akad. in Panyu 1832 Juren-Examen; danach
Mitgl. der von Ruan Yuan geleiteten Kantoner Xuehaitang-
Akad. (Xuehaitang shuyuan) und Stud. der Klassiker un-
ter Hou Kang. Zw. 1837 und ca. 1839 arbeitete C. als
Priv.-Lehrer im Haushalt des bed. Dichters und Gelehr-

ten Zhang Weiping. 1840–60 ist er Leiter der Xuehaitang-
Akad., daneben zw. 1849 und 1851 Lehrer (Xundao)
an der Konfuzius-Schule im Kr. Heyuan (b. Huizhou)/
Prov. Guangdong. Trotz Scheiterns beim hauptstädtischen
Jinshi-Examen 1852 im siebten und letzten Versuch, ge-
noß C. hohe Reputation in der Beijinger Gelehrtenwelt
und bei einflußreichen Staatsbeamten wie Cheng Enze und
Mo Youzhi. 1854 Aufenthalt in der Residenz des Nanhai-
er Magistraten Hu Xiang. Ab 1855 von Li Futai mit der
Kompilation des Panyu xianzhi (Lokal-Chron. von Panyu,
1871) unter Aufsicht von Shi Cheng und He Ruoyao be-
auftragt. 1858 bei Zerstörung der Xuehaitang-Akad. durch
frz.-brit. Truppen Flucht in die Kantoner Außenbezirke.
1859–60 Wiederaufnahme der Kompilationstätigkeit. Ab
1860 Leiter der Longxi-Akad. (Longxi shuyuan) in Dong-
guan/Prov. Guangdong. Zw. 1864 und 1867 Mitwirkung
an der Neu-Aufl. des Guangdong tongzhi (Lokal-Chron.
von Guangdong) und dem topogr. Werk Guangdong tus-
huo (Karten der Prov. Guangdong mit Erläuterungen; Kar-
ten von Gui Wencan). 1867–82 Leiter der vom Guang-
donger Salzkontrolleur Fang Junyi begr. Jupo-Akad. (Jupo
jingshe). Während dieser Zeit ließ C. 1871–72 unterstützt
von lokalen Sponsoren sowie Schülern und Kollegen die
Wuyingdian-Ed. des Shisan jing zhushu (Dreizehn Klas-
siker mit Kommentaren und Unterkommentaren) nachdru-
cken; 1872–73 folgte der Nachdruck des Tongzhitang jing-
jie (Erläuterungen der Klassiker aus der Tongzhi-Halle).
1872–74 edierte und druckte C. zwei Sammelwerke mit
raren Klassiker-Studien: das Gu jingjie huihan (Slg alter
Erläuterungen zu den Klassikern) und Xiaoxue huihan (Slg
philologischer Studien). Weitere editorische Projekte um-
faßten Lokal-Chron., z.B. die von Xianshan, und Kollek-
tanea, z.B. Xuehaitang ji (Slg aus der Xuehaitang-Akad.,
1886), Jupo jingshe ji (Slg aus der Jupo-Akad., 1897), die
beide posthum von Jin Xiling bzw. Liao Tingxiang voll.
wurden. 1881 kurz vor seinem Tod wurde C. ein Ehren-
titel für sein Lebenswerk verliehen. – C. gilt als heraus-
ragende Figur unter den Kantoner Gelehrten des 19. Jh.,
die eklektische Lehren zw. sung-zeitlicher Li-Lehre (Neo-
konfuzianismus) und Han-Gelehrsamkeit (Hanxue) ent-
wickelten. Er verfaßte ca. 60 Werke, von denen nur et-
wa 25 veröff. wurden. Herausragend unter den Klassi-
kerstudien sind Hanru tongyi (Umfassende Auslegungen
der Han-Konfuzianer, 1858), Zhuzi yulei richao (Tägli-
che Aufz. zu den Worten Meister Zhus nach Kategori-
en, 1850) und Dongshu dushu ji (Lesenotizen des [Chen]
Dongshu, 1880–82; erweiterter Nachdruck 1898). Dane-
ben entstanden Unters. zu Geographie, Philologie, Ma-
thematik und Musik. C.s Prosa erschien in Zhongshan ji
(Slg vom Glockenberg) und Dongshu ji (Slg des [Chen]
Dongshu). Die Dichtung wurde von Wang Zhaoyong ge-
sammelt und in dessen Weishangzhai congshu (Slg aus
dem Weishang-Studio, 1908–14) abgedruckt. C.s philolo-
gisches Interesse war gepaart mit wiss. Unters. von Siegel-
(zhuanshu), Klerikal- (lishu), Normal- (kaishu) und Kur-
sivschrift (xingshu), die er alle selbst kunstvoll beherrsch-
te. Seine Beschäftigung mit Großer (dazhuan) und Klei-
ner Siegelschrift (xiaozhuan) stand unter dem Einfluß der

Schriftkritik von Ruan Juan und dessen bed. Traktaten Nanbei shupai lun (Über die Schrift-Schule im Süden und im Norden) und Beibei nantie lun (Über die nördlichen Stelen und südlichen Musterschriften, beide 1823), welche die ideologisch-programmatische Basis für die qingzeitliche Stelen-Schule (beixue) schufen. Lt. Kang Youwei war C.s Siegelschrift angeregt vom Vorbild des älteren Zeitgen. Huang Zigao, der wie C. aus Panyu stammte, unterschied sich jedoch von dessen Duktus durch größere Kraft und Dynamik. Der Kritiker Ma Zonghuo lobt bes. C.s sorgfältige, den Regeln der Kunst folgende Ausführung. Auch der Vergleich mit dem Tang-Meister Li Yangbing (* um 721, † um 787) wurde unternommen, wobei C.s Siegelschrift durch Minderung der Zeichenbreite und betonte Längung der vertikalen Striche, bei denen „überflogenes Weiß" (feibai) durchscheint, schlanker, flüssiger und ornamentaler wirkt und so in die Nähe von Wu Xicai rückt. Ein Spruchpaar zu jeweils acht Zeichen, in zwei Phrasen à vier Zeichen (je ein gedoppeltes Zeichen am A. der unteren Vierergruppe als Ligatur) in der Hongkonger Lechangzai Xuan Coll. (Tusche/Papier, sign., Aufschrift von C., dem siebtälteren Bruder Xun'an zugeeignet) hebt sich jedoch von Wu Xicai durch eckigere Haken und größeren Abstand der Zeichen zueinander ab, die dadurch an ästhetischem Eigenwert gewinnen. Der Hang zu Ordnung und Präzision zeigt sich auch bei einer Kopie der fragm. erh. 219 v. Chr. im Auftrag des ersten chin. Kaisers Qin Shihuang (Reg.-Zeit 221–10 v. Chr.) gemeißelten Stein-Inschr. Langyetai keshi (Stein-Inschr. der Yangye-Terrasse, oolithischer Sandstein; Beijing, Mus. of Chin. Hist.) nach Vorlagen der Kleinen Siegelschrift aus der Hand des Qin-Kanzlers Li Si (* um 280, † 208 v. Chr.). C.s Hängerolle transformiert die wenigen auf dem korrodierten Bruchstück erh. Zeichen mit kräftigen aufgerauten Konturen in eine durch geschmeidigere Pinselführung elaborierte Variante, die das Orig. an Eleganz bei weitem übertrifft. Ein Sieben-Wort-Kurzgedicht (qiyan jueju) (Tusche/Goldsprenkelpapier, Hängerollenpaar, sign., Aufschrift und Siegel von C., Siegel von Deng Cangwu und R. H. Ellsworth; R. H. Ellsworth Coll., New York) zeigt ausgewogenen Rhythmus und balanciertes Spiel der Kräfte bei der Gest. der versch. Striche, die teilw. kräftig verdickt sind, ohne den Ausdruck der fein ausgezogenen Vertikal- und Horizontalstriche zu schmälern, was C. in der Kritik Lob für „Vornehmheit und (Gleich)maß" (yadu) einbrachte. C.s Arbeiten im Geiste der Stelen-Schule waren Ausdruck des Widerstandes und der Unzufriedenheit mit dem im 19. Jh. niedergehenden Qing-Regime und forderten in politischer Hinsicht Besinnung auf fundamentale Werte der chin. Kulturtradition. ✉ *Weitere Schr.: u.a.* Hu sanjiao pingshi fa (Methoden der Ebenen und sphärischen Trigonometrie); Moyin shu (Darlegung zu den alten kaiserlichen Normsiegeln [der Qin]); Qieyun kao (Unters. der durch Silbentrennung dargestellten Reime); Santong shu xiangshuo (Detaillierte Unters. des Santong-Kalenders); Shenglü tongkao (Umfassende Unters. der Stimmpfeifen); Shuijing zhu xi'nan zhushui kao (Unters. der südwestlichen Flüsse [Chinas] im Kommentar zum Klassiker der Wasserläufe). ▭ *Yu*

Jianhua, 1981, 1042 (2); *Seymour*, 1988 (s.v. Ch'en Li) *E. J. Laing*, An index to reprod. of paint. by twentieth-c. Chin. artists, Ann Arbor 1998; *Bénézit* III, 2006. – Qingshi liezhuan, IX, Taipei ²1983 (Faks.), 69/54a-56a; Qingdai Yueren zhuan, III, Bj. 2001 (Faks.) (Zhongguo gonggong tushuguan guji wenxian zhenben huikan. Shibu), 1423–1433; *Zhao Erxun u.a.*(Ed.), Qingshi gao, XLIII, Bj. 1977, 482/13285 s.; *Wang Zongyan*, Lingnan j. 4:1935 (1); *H. Momose*, in: *A. W. Hummel* (Ed.), Eminent Chin. of the Ch'ing period, I, Wa. 1943, 90–92; *Qian Mu*, Zhongguo jin sanbainian xueshushi, Taipei 1957; Ch'en Chih-Mai, Chin. calligraphers and their art, Lo./N. Y. 1966; *L. Ledderhose [Ledderose]*, Die Siegelschrift (chuan-shu) in der Ch'ing-Zeit. Ein Beitr. zur Gesch. der chin. Schriftkunst, Wb. 1970; *Ma Zonghuo*, Shulin zaojian, Taipei 1962 (Repr.; Yishu congbian. Diyi ji, 6), 12/48a; *Liang Piyun* (Ed.), Zhongguo shufa da cidian, I, Hongkong 1984, 935 s.; *R. H. Ellsworth*, Later Chin. paint. and calligraphy, 1800–1950, I, III, N. Y. 1987; *Chen Yutang* (Ed.), Zhongguo jin xiandai renwu minghao da cidian, Hangzhou 1993; *Jin Kaicheng/ Wang Yuechuan* (Ed.), Zhongguo shufa wenhua daguan, Bj. 1995, 607; Qingdai xuezhe fashu xuanji, Bj. 1995; *Lu Fusheng* (Ed.), Jindai zihua shichang shiyong cidian, Shanghai 1999; *J. C. Kuo/P. C. Sturman* (Ed.), Double beauty. Qing dynasty couplets from the Lechangzai Xuan coll., Hongkong 2003; *Huang Guosheng* (Ed.), C. L. ji, VI, Shanghai 2008; *Wang Huirong*, C. L. sixiang yanjiu, Bj. 2008. U. Middendorf

Chen, *Lihi*, israelische Installations- und Videokünstlerin, Zeichnerin, * 1977 Ramat Gan, lebt in Tel Aviv. Stud.: 1997–2001 Hamidrasha College of Arts, Ramat HaSharon (Bachelor of Education); 2002–04 Bezalel Acad. of Arts and Design, Jerusalem (Master of FA). Gemeinsame Projekte mit Künstlern aus Glasgow (Glasgow SchA). Ausz.: u.a. 2003 Prize for Encouraging Creation, The Bella Brisel Sioma Baram Garant; 2004 Stip. der Hebräischen Univ., Jerusalem. – Wenn Ch. in einer Wandinstallation Vergrößerungsspiegel gegeneinander richtet (*Belle de Jour*, 2004) oder Bäume innerhalb eines Gartenhauses zum Blühen bringt (*Late Bloomer*, 2006), zitiert sie bewußt vertraute Werke des Surrealismus. Ihre skizzenhaften, dennoch anatomisch genauen (Tier-)Zchngn weisen sie zudem als genaue Beobachterin aus. ▣ HAIFA, Mus. of Art: On the Rocks, Installation, 2003. TEL AVIV, Mus. of Art. ◉ *E:* 2002 Ramat Gan, Mus. of Art / Tel Aviv: 2002 Haheder Gall.; 2003 Beit Haomanim. – *G:* seit 2000 zahlr. nat., u.a. Petach Tikva, Mus. of Art: 2005 Transpositions (K); 2006 Apropos les Demoiselles / 2006 Haifa, Mus. of Art: Fatamorgana. Illusion and Deception in Contemp. Art (K) / 2008 New York, Moti Hason Gall.: Untitled (On Paper). ▭ Visual culture mag. (Israel) 2001 (Aug.). – *Online:* Israeli AC. St. Schulze

Chen *Lingyang*, chin. Malerin, Foto- und Videokünstlerin, * 1975 Prov. Zhejiang, lebt in Beijing. Stud.: 1991–95 Affilated High School of China Acad. of Art, Hangzhou; 1995–99 Central AFA, Beijing. Ausz.: 2002 Chin. Contemp. Art Award (CCAA, Beijing); 2003 Preis der Bienn. von Sharjah (Vereinigte Arabische Emirate). – C. sorgte

zunächst in der Beijinger Kunstszene für Furore mit ihrer 1999 erstellten Arbeit *Scroll* (Schweiz, Privat-Bes.), in der sie eine abstrakte, an ein trad. chin. Lsch.- Panorama erinnernde Darst. mit ihrem Menstruationsblut auf eine sechs Meter lange, auf Seide aufgezogene Papierrolle gemalt hatte. Ebenfalls als Meilenstein in der Entwicklung der chin. Gegenwartskunst (und als Meisterwerk feministischer chin. Kunst schlechthin) wird ihre Fotoserie *Twelve Flower Months* (2000) erachtet, eine reflexive Zurschaustellung ihres Menstruationszyklus anhand von zwölf Bildern, deren versch. Formate (Kreis, Quadrat, Fächer, Raute u.a.) an trad. chin. Tür- und Fensteröffnungen erinnern. Für die als Stilleben konzipierten, von sanftem Licht umhüllten und poetisch wirkenden Aufnahmen ihrer Scheide verwendete C. einen Spiegel, der in den Bildern gelegentlich zu sehen ist. Jedem Bild bzw. Monat wird (ähnlich wie in der klassischen chin. Malerei) eine Blume (u.a. Narzisse, Orchidee, Kamelie) zugeordnet, wobei der Zyklus der blühenden Blumen die Harmonie der Natur sowie den Monatszyklus einer Frau suggeriert. Dasselbe Thema wird in der experimentellen Video-Installation *Yue Jingjing* (2002) aufgegriffen. In der großformatigen Fotoserie *25. 00* (2002) erforscht C. ihr seelisches Befinden in einer Gegenüberstellung von der Schönheit des nackten weiblichen Körpers mit der urbanen Umwelt. Mit ihren von weiblichen Überlegungen erfüllten Werken gilt C. als Vertreterin eines seit M. der 1990er Jahre (Fourth Internat. Women's Congress, Beijing) aufkommenden explizit weiblichen Bewußtseins in der chin. Gegenwartskunst. Gleichzeitig gehört sie zu den namhaften Vertretern der experimentellen Kunst (shiyan yishu). ⌗ BEIJING, Three Shadows Photogr. AC. MAUENSEE, Slg Uli Sigg. ✉ An interview with C. by C. no. 2, in: *Ai Weiwei* (Ed.), Chin. artists, texts and interviews. Chin. contemp. art awards 1998–2002, Hongkong 2002, 28–33. ◉ E: Beijing: 1998 Central AFA / 2008 Three Shadows Photogr. AC / 2004 Berlin, Gal. A. Ochs. – G: u.a. Beijing: 1999 Basement of Building No. 2, Peony Recidential District: Post-Sense Sensibility. Distorted Bodies and Delusion (K) / 2000 Fukuoka, Mus. of Asian Art: Documentation of Chin. Avant-Garde Art in the 1990s / 2001 Oulu (Finnland), AM: Cross Pressures (Wander-Ausst.) / 2003 Paris, Centre Pompidou: Alors, la Chine (K) / 2004 New York, Internat. Center of Photogr.: Between Past and Future (Wander-Ausst.; K) / 2005 Venedig: Bienn. / 2008 Houston (Tex.): Fotofest 2008 – Photogr. from China 1934–2008 / 2009 Arnhem, MMK: Rebelle. Kunst & Feminisme 1969–2009 (K). ▭ L. *Warren* (Ed.), Enc. of twentieth-c. photogr., I–III, N. Y./Lo. 2006. – *Feng Boyi/Ai Weiwei* (Ed.), Fuck off (K), Shanghai 2000; *Liao Wen*, in: *Wu Hung u.a.* (Ed.), The first Guangzhou bienn. Reinterpretation. A decade of experimental Chin. art 1990–2000 (K), Guangzhou 2002, 60–66; *F. Jordan/P. Marella*, China art now. Out of the red, Mi. 2003; *P. Lewis/Hoor Al-Qasimi* (Ed.), Sharjah Intern. Bienn. (K), Sharjah 2003, 34–38; *Wu Hung*, Art Asia Pacific 37:2003, 92; *E. Battiston*, Zoom 65:2004, 24–33; Visual Gall. at Photokina (K Köln), Ha. 2004; *B. Fibicher/M. Frehner* (Ed.), Mah-

jong. Chin. Gegenwartskunst aus der Slg Sigg (K Bern/Hamburg), Ostfildern-Ruit 2005; *T. J. Berghuis*, Performance art in China, Hong Kong 2006; *C. Albertini*, Avatars and antiheroes. A guide to contemp. Chin. artists, To. u.a. 2008; *M. H. C. Bessire*, Stairway to heaven. From Chin. streets to mon. and skyscrapers (K), Hanover, N. H. 2009.

K. Karlsson

Chen *Long-bin (Long Bin; Longbin)*, taiwanesischer Bildhauer, Papierkünstler, Installationskünstler, * 1964 Taipei, lebt dort. Stud.: Fushin Commercial and Technical School, Dep. of FA, Taipei (Abschluß 1983); 1987 BFA, Tunghai Univ., Dep. of FA, Kaohsiung; 1994 MFA, School of Visual Arts, New York. Ausz.: 1985 Nat. Print Prize, Taiwan; 1987 Shih Hsiung New Artist Prize, Taipei; 1988 Tunghai Univ. FA Prize, Taichung; 1995 Trienn. Kleinplastik, Ostfildern; 1996 Grant Award, Joan Mitchell Found., New York; 1997, '98, 2001 Grant of the Nat. Endowment for Arts, Taiwan; 1998 Silber-Med., Osaka Trienn.; 2003 Freeman Found. Fellowship. Mehrfach Artist-in Residence (USA, Brasilien). Auch als Kurator tätig, u.a. 1994 Ausst. Under Naked (465 Gall., New York). 2006 Teiln. am Project Kidspace im Mass MoCA, North Adams mit *Reading Sculpt..* – C. erstellt seit 1993 Papier-Skulpt. aus – von Bibl., Verlagen, Telefon-Ges. u.a. – ausrangierten Büchern, Zss., Ztgn. oder Drucksachen wie Computerpapier. Zum Motivrepertoire gehören dabei v.a. Replikationen antiker Stein-Mon. und -Skulpt. (Mount Rushmore, Julius Caesar, Homer), auch Mumien, Waffen, Geräte, Büsten alttestamentlicher Propheten, Krieger (Azteken, chin. Soldaten), buddhistische Hll. (Damo, Guanyin) und v.a. Buddhafiguren, zumeist kleinformatig ausgef., gelegentlich auch als raumgreifende Installationen (*Reading Room*, 2003; *Twisted Angel*, 2004; *Buddha Hurricane*, 2005). Dabei werden die Mat. zusammengeklebt und anschließend mit einer Säge bearbeitet. Der realistische, an Holz- und Stein-Skulpt. anmutende Effekt wird durch den Auftrag von Farben verstärkt. Die Verwendung von Recycling-Mat. – die kult. Trümmer der mod. Informations- und Wegwerfgesellschaft – ist geprägt von C.s Affinität zur Lit.; neben vielen ges., sozialen und persönlichen Bezügen verweist C. dabei auch auf die Tatsache, daß Bücherverprichtungen in China ebenso wie im Westen praktiziert wurden und die Kraft des gedruckten Wortes sowie die Angst vor dem geschriebenen Wort in beiden Welten nebeneinander existieren. C. bez. sich als „intern. artistic nomad" und tritt für die Vermittlung der Kulturen ein. Dies kommt v.a. in seinem 2003 begonnenen *World Buddha Project* zum Ausdruck. Die vorwiegend aus Telefonbüchern (aus New York, Los Angeles, Rio de Janeiro, Rom, Hongkong, Mumbai u.a.) erstellten Buddhafiguren sind ein persönlicher Kommentar zu der friedens- und heilstiftenden Kraft der aus Asien stammenden, im Westen aufgenommenen (häufig mißverstandenen) Ikone sowie zu der problematischen Kulturverständigung zw. Ost und West. Dabei trauert C. um die große Zahl von abgeschlagenen Buddhaköpfen in westlichen Museen und Gal., deren Körper in relig. Stätten Asiens geblieben sind. ⌗ NEW YORK, Allan Chasanoff Coll. PHILADELPHIA/Pa.,

West Coll. SOUTH BEND/ Ind., Libenn Aroma Inc. TAIPEI, Suho Paper Mus. – Shih Hsiung FA Mag. – Nat. Taiwan Mus. ◉ *E:* Taipei: 1992 Space 2 Gall.; 1994 Amer. Inst. in Taiwan; 1997 FA Mus.; 1998 Cult. Affairs Dep. of Taiwan Prov. Govt. / New York: 1994 SVA Gall. (mit Ross Chambers und John Lavin); 1995 Eight Floor Gall.; 2003, '06, '08 Frederieke Taylor Gall. / 2004 North Adams, Massachusetts MCA; Rom, Gall. Ca' d'Oro; Johnson (Vt.), Vermont Studio Center / 2005 Santa Monica (Calif.), Lowe Gall. / 2006 Hongkong, Plum Blossoms Gall. – *G:* Taipei: 1998 Nat. Taiwan Arts Education Inst.: New Voice. Contemp. Art Dialogue among Taipei, Hong Kong and Shanghai (Wander-Ausst.); 2000 Amer. Cult. Center: Landscape on the Shelf; FA Mus.: 1995 A Dialogue of Contemp. Sculpt. in Asia; 2001 New Minds / New York: 1993 Visual AG: Curious Structures; 2003 Snug Harbor Cult. Center: The Invisible Tread; 2004 Plum Blossoms Gall.: Do a Book; 2009–10 Mus. of Chin. in America: Here & Now / 1995 Ostfildern: Trienn. Kleinplastik (K) / 1998, 2001 Osaka: Trienn. Contemp. Art Space / 1999 Singapur, Nat. Libr.: Volume & Form; Beijing, China AG: Vision of Pluralism – Contemp. Art in Taiwan 1988–1999 / 2002 Seoul, Total Mus.: The Gravity of the Immaterial / 2006 Tokio, Morio AM: Dalai Lama Portr. Project (Wander-Ausst.); Rochester (N. Y.), Univ., Memorial AG: Extreme Materials / 2009 Havanna, MBA: Chelsea Visits Havana. ▢ *Ni Zaiqin*, Taiwan dangdai yishu zhi mei (The beauty of Taiwan. art), Taipei 2004; The multiform nineties. Taiwan's art branches out (K),Taipei 2005; *W. Rhee u.a.* (Ed.), Thermocline of art. New Asian waves (K Karlsruhe), Ostfildern 2007. K. Karlsson

Chen, *Lucas* → **Chen**, *Xu* (1905)

Chen, *Luoke*, taiwanesischer Maler, Graphiker, Designer, Fotograf, Innenarchitekt, Hochschullehrer, Taijiquan-Meister, * 15. 1. 1957 Taipei, lebt dort und in Wuppertal. Stud.: 1975–78 Taiwan Nat. Acad. of Arts, Taipei. Ab 1985 in Deutschland ansässig. Zweit-Stud.: 1986–92 Bergische Univ. Gesamt-HS Wuppertal, Industriedesign bei Karl-Heinz Hölscher und Klaus Cech (Abschluß 1997 Magister Artium). Daneben 1987–96 freiberuflich als Designer in versch. Ateliers tätig. Lehrtätigkeit: ab 1988 u.a. Chin. Kalligraphie und Tuschmalerei an der Volks-HS Wuppertal; 1990–95 Figürliches Zeichnen an der Bergischen Univ. ebd.; seit 1995 versch. Gastdozenturen, u.a. 2001 an der Kunst- und Filmschule in Kabelvåg/Norwegen. 2003–09 Prof. an der Jin Wen Univ. for Technology und an der Nat. Taiwan Univ. of Art. Häufige Reisen, auch als Doz., z.T. mit Stip. und mehrmonatigen Atelieraufenthalten (Europa, USA, Kanada). Daneben ist C. auch ein internat. geachteter Taijiquanlehrer, der auch Waffenformen (u.a. 42er Schwert- und 60er Säbelform) unterrichtet sowie als Schiedsrichter und seit 2007 als stellv. Generalsekretär der World Taijiquan Federation Taiwan tätig ist. C. leitet regelmäßig Mal- und Taijiquankurse u.a. auf Taiwan und in Spanien. Mitgl.: 1992 Hagenring. – Anfangs arbeitet C. im Stil der trad. chin. Tusch- und Aqu.-Malerei. In den späten 1980er Jahren rezipiert er in meist großformatigen Aqu. und Gem. (Öl, Acryl) vorerst den Stil und das Formenrepertoire des europ. expressiven Realismus. Bald löst er sich davon und versucht z.B. in seiner wichtigen Werkgruppe *Akt-Lsch.* zu einer Synthese zw. ostasiatischer und europ.-westlicher Kunstauffassung zu finden, indem er meschliche Körper (meist weibliche oder männliche Akte) als Lsch. bzw. Paraphrasierung von Lsch. in z.T. mon. Formaten gestaltet. Dies tut er anfänglich in weichen, sanft geschwungenen und fließenden Formen, seit 1999 auch durch tektonisch anmutende Strukturierungen, strichelnde Lineamente, Skripturen oder die Darst. von archit. Versatzstücken. Häufig oszillieren die stark abstrahierten Figurationen aufgrund der angewandten extremen Perspektive oder der gewählten Ausschnitthaftigkeit zw. Raum und Körper. 2009 fertigt C. im Kontext eines Benefizprojektes das mon. Öl-Gem. *Taiwan Art 100* mit den Portr. von 100 taiwanesischen Künstlerpersönlichkeiten. Als Fotograf spürt er häufig graph. Strukturen in Stadt-Archit., in Kultur-Lsch. oder vom Menschen unberührten Regionen 2009 Sanddünen in der Sahara) sowie auf natürlichen Oberflächen nach (Flora, Fauna). Auch Beteiligung an Performances. ◉ *E:* Wuppertal: 1980 Stadtbücherei; 1990 Gal. Hündling; 1992 Baum'sche Villa; 1996 Haus Mendel / 1991, 2000 (mit Stuart Frost) Hagen, Gal. Hagenring / 1993 Altena, Stadt-Gal. / 1995, '98 Svolvær, Kunstnerhuset / 1995 Berlin, Gal. ARC-Factory / 1996 Taichung, Taiwan Mus. of Art / 2000 Montreal, Studio Outremont / 2004, '06 Tokio, K's Gall. / 2005 Seoul, Seoul AC / 2007 Zürich, Gal. A. M. Andersen (mit Sibylle Pasche) / 2009 Taipei, Dt. Kulturzentrum. ▢ *U. Garweg*, Wuppertaler Künstler-Verz., Wuppertal 2000. – L. C. Drawing, paint. an graphics, Wuppertal 1997; L. C. Arbeiten auf Papier 1996–2001, Andernach 2001; *S. Tan u.a.*, Figure landscape. L. C. (K Taipei FA Mus.), Taipei 2001; *N. T. Lu*, Taiwan News v. 28. 4. 2009. – *Online:* Website C. (Ausst.). U. Heise

Chen *Ping*, chin. Maler, Schreibkünstler, Siegelschnitzer, Autor, * Dez. 1960 Beijing, dort tätig. Von Kindheit an in klassischer chin. Malerei, Schreibkunst und Siegelschnitzerei unterrichtet. Stud.: bis 1984 (Examen) Chin. AFA. 1987 dort als Doz. für chin. Malerei tätig, seit 1989 am neugegründeten Calligraphy Research Workshop (heute dort Prof.). Nat. und internat. Ausst., u.a. in ganz China (Hongkong), Japan, USA, Belgien, Frankreich, Brasilien, insbes. als Vertreter der Post-Mao-Ära. Zahlr. nat. Preise, u.a. 1986 1. Preis Siegelschnitzkunst. Mitgl.: seit 1985 Künstler-Verb. (Zhongguo meishujia xiehui); Verb. chin. Schreibkünstler (Zhongguo shufajia xiehui); Schriftsteller-Verb. (Zhonghua shici xiehui). – Prominenter Vertreter des sog. New Literati Paint. (Xin wenren hua) in China, in dem Techniken, Themen, Formate und Stile der Malerei im trad. chin. Tuschstil (guohua) mit zeitgen. Blickwinkel umgesetzt werden. Bei C. entstehen so aus orthodox konzipierten Lsch. Transformationen einer poetisch inspirierten und idealisiert erscheinenden Moderne. Die Zusammenstellung einfacher, alltäglicher Bildelemente (Berghütten, Fahrräder u.a.) mit bizarren Bildformen (Bäume, Wolken) und ungewöhnlicher Farbgebung bewirkt nicht selten eine fast surreale Bildwelt (*Countryside*,

1983; Beijing, Nat. AM of China). Meisterhaft sind sein Umgang mit den tonalen Nuancen dunkler Tusche und seine Wolkenbilder, die in ihrer fast dreidimensionalen Darst. auch mit westlichen Bild-Trad. spielen, so in der Serie *Mengdijia Mountain* (1998; Beijing, Nat. AM of China). Zugleich stilistische Bezugnahme (Wolkentextur) auf den bed. Literatenmaler Gong Xian (1618–1689). Wiederkehrendes Bildmotiv ist die Berg-Lsch. des imaginären Feiwashan. Er symbolisiert nach innen gerichteten, phantastischen Rückzugsort des Malers und steht somit auch thematisch in der Trad. des chin. Topos vom ungebundenen, einsamen, aber im Einklang mit den Kräften der Natur lebenden Literatenmalers. Daneben ist C. anerkannter Schreibkünstler, Siegelschnitzer und Autor (1997 chin. Oper, aufgeführt vom Chin. Drama Inst.). ☐ BEIJING, Nat. AM of China. ✉ Dangdai zhongguohua jifa, shangxi. C. P. shuimo shanshuihua chuangzuo, Nanning 1993. ◉ *E:* 1988, '96 Tokio, Univ. of FA / 1992 Hongkong, Hongkong City Hall / 1998 Atlanta (Ga.), Kiang Gall. / 2010 Beijing, Nat. AM of China. – *G:* 1988 Seoul, Olympische Spiele: Zeitgen. Tuschemalerei aus China / Beijing, Nat. AM of China: 1993 (Critics Nomination Exhib. of 15 Best Chin. Artists); 1997 (New Literati Paint.); 2009 (Scroll Exhib. by Masters) / 2000 Shenzhen: Internat. Kunst-Bienn.; Shanghai: Internat. Kunst. Bienn. ☐ *E. L. Davis,* Enc. of contemp. Chin. culture, Lo. u.a. 2005; *M. Sullivan,* Mod. Chin. artists, Berkeley u.a. 2006. – *S. Tang,* C. P., Hongkong 1992; *F. Dal Lago,* ART AsiaPacific 1998 (17) 32–34; *J. F. Andrews/K. Shen,* A c. in crisis (K New York/Bilbao), N. Y. 1998. A. Papist-Matsuo

Chen, *Qi* → Chen, *Zifen*

Chen *Qi* (Pseud. Yaoseng), chin. Maler, * März 1906 Qinyang/Prov. Henan, † Sept. 1979. Ab dem 16. Lebensjahr Unterricht im trad. Tuschestil, u.a. bei Wang Mengbai in Beijing. Seit 1924 Mitgl. in der Beijing Chin. Paint. Research Assoc. (dort bis 1937 zahlr. Ausst.-Beteiligungen). Spezialisiert sich auf Lsch.-Malerei sowie Blumen-Vogel-Malerei. Nach 1937 Einzel-Ausst. in Xi'an. Nach 1949 an überregionalen Ausst. beteiligt. Tätig als Prof. am Xi'an Art College. Mitgl.: Chin. Künstler-Verb. (Zhongguo meishujia xiehui). ☐ Zhongguo xiandai, 1988.
 A. Papist-Matsuo

Chen *Qikun* (Tangxi; Wushan), chin. Kalligraph, Sammler, Dichter, Gelehrtenbeamter, * 1792 Panyu (Kanton)/Prov. Guangdong, † 1861. Gebürtig aus einer konfuzianischen Gelehrten-Fam. erhielt C. eine trad. Ausb. und legte 1826 das Jinshi-Examen ab. Danach tätig als Kreisvorsteher (Xanzhi). Unzufrieden mit der politischen Lage legte C. seine Ass. im Riten-Minist. (Libu Zhushi) nieder und zog sich in die Heimat nach Panyu ins Privatleben zurück, wo er in Literaten-, Künstler- und Gelehrtenkreisen verkehrte und ca. 30 Jahre an der Yangcheng-Akad. (Yangcheng shuyuan) lehrte. C.s sozialem Engagement ist die Errichtung zahlr. öff. Schulen und Kornspeicher sowie karitativer Einrichtungen zur Armutsbekämpfung zu verdanken. C. hinterließ Dichtung und Prosa in der Anthologie Chen Libu wenji (Lit.-Slg des Chen Libu [Qikun]). Er war befreundet mit dem einflußreichen Kan-

toner Kunstförderer Wu Chongyao (Howqua) und Künstlern wie Bao Hou, Pan Bolin, Pan Jun und Zhao Ziyong. 1827 entstand ein Gemeinschaftswerk der vier Freunde mit Orchideen und Bambus von Bao Jun und Zhao Ziyong, zu dem Pan Bolin und C. Aufschriften kalligraphierten. Bes. geschätzt wurde C.s Normal- (kaishu), Kursiv- (xingshu) und Konzeptschrift (caoshu), die an den Musterschriften (tie) Wang Xizhis (* 307, † 365) und der Tang-Kalligraphen Ouyang Xun (* 557, † 641), Chu Suiliang (* 597, † 658) und Yan Zhenqing (* 709, † 785) orientiert waren, welche vom Daoguang-Kaiser (Reg.-Zeit 1821–51) hoch geschätzt wurden. Ein Spruchpaar zu jeweils neun Zeichen (jiuyan lian), in zwei Phrasen à fünf und vier Zeichen, drückt mittels des kräftigen, satten Tuscheauftrags viell. die Freigebigkeit des Auftraggebers Fushan aus. Die Komp. des in Kursiv-Konzeptschrift (xingcao) kalligraphierten Verspaares (Tusche/Goldsprenkelpapier, Hängerollenpaar, sign., Aufschrift und Siegel von C., Sammlersiegel; Hongkong, Lechangzai Xuan Coll.) wirkt trotz beherrschtem Pinselduktus durch Größenvariation der Einzelzeichen bewegt. Während bei diesem Beispiel der Eigenwert der Schriftzeichen durch deutliche Abgrenzung voneinander unterstrichen wird, fließen diese bei den vier Hängerollen (Tusche/Goldsprenkelpapier, sign., Aufschrift und Siegel von C., Sammlersiegel, 1847; New York, R. H. Ellsworth Coll.) in Konzeptschrift nach Schriftvorlagen von Wang Xizhi und Wang Xianzhi (* 344, † 386/388) ineinander und bedecken das Papier flächendeckend. Bei diesen Abschriften im Auftrag des Freundes Jiechen handelt es sich um Exzerpte aus Wang Xizhis *Zhou Changchi* (Zhou Changchi), *Zhuhuai* (Alle Gedanken), *De xi wen* (Den Westen einnehmen, nach [nichts anderem] fragen) und *Dare* (Große Hitze) sowie Wang Xianzhis *Fa Wuxing* (Aufbruch aus Wuxing), *Jiangzhou* (Jiangzhou) und *Dare* (Große Hitze), alle enthalten in dem von Song-Taizong (Reg.-Zeit 976–97) in Auftrag gegebenen und von Wang Zhu († um 990) kompilierten Chunhuage tie (Musterschriften aus dem Chunhua-Pavillon, 992). C. steht damit der qing-zeitlichen Musterschriften-Schule (tiexue) nahe, welche die seit Kaiser Taizong der Tang (Reg.-Zeit 629–49) zum ästhetisch-ethischen Maßstab erklärten Kalligraphien der Zwei Wangs und ihrer Nachf. in den Mittelpunkt des schriftkünstlerischen Schaffens stellte. Als Liebhaber und Sammler hinterließ C. zahlr. Kolophone, bes. zu Kalligraphien, die kunstkritische Noten, auch zur Authentizität, enthalten, z.B. Sieben-Wort-Kurzgedicht (qiyan jueju), Song-Kaiser Gaozong (Reg.-Zeit 1127–62) zugeschr., in Konzeptschrift (Tusche/Seide, Rundfächer, montiert als Album-Bl., Aufschriften von C. und Luo Tianchi) und *Ziren zhuan* (Biogr. eines Zimmermanns) von Kangli Naonao (* 1295, † 1345) in Konzeptschrift (Tusche/Papier, Querrolle, Kolophone von C. [o. D.], Wu Rongguang [1836], Pan Shicheng [1850] u.a.; beide Princeton, John B. Elliott Coll.). ✉ Chen Libu shigao (Abschriften von Dichtungen des Ritenministers Chen [Qikun]),s.l. 1853. ☐ *Yu Jianhua,* 1981, 1003; *Seymour,* 1988 (s.v. Ch'en Ch'i-k'un). – *H. Momose,* in: *A. W. Hummel* (Ed.), Eminent Chin. of the Ch'ing period, II, Wa-

1943, 868; *S. C. Y. Fu*, Traces of the brush (K New Haven/Berkeley), New Haven/Lo. 1977; *Liang Piyun* (Ed.), Zhongguo shufa da cidian, I, Hongkong 1984, 946 s.; *R. H. Ellsworth*, Later Chin. paint. and calligraphy, 1800–1950, I, III, N. Y. 1987; *R. E. Harrist, Jr./W. C. Fong*, The embodied image. Chin. calligraphy from the John B. Elliott coll. (K Wander-Ausst.), Pr./N. Y. 1999; *J. C. Kuo/P. C. Sturman* (Ed.), Double beauty. Qing dynasty couplets from the Lechangzai Xuan coll., Hongkong 2003.

U. Middendorf

Chen *Qiulin*, chin. Performance- und Medienkünstlerin, * 1975 Yichang/Prov. Hubei, lebt in Chengdu. Stud.: 1995–2000 Sichuan Inst. of FA, Chongqing (trad. chin. Hschn.). Daneben Gest. von Filmplakaten. 2001 Übersiedlung nach Chengdu. Ausz.: 2005 Emerging Artist Prize, Montpellier; 2006 Asian Cult. Council, Starr Found. Fellowship (sechs Monate Aufenthalt in den USA). – In ihren multimedialen Arbeiten, die zw. Sozialkritik, Nostalgie, Ohnmacht und Zukunftsvision schwanken, thematisiert C. die rasanten Umbrüche im heutigen China, u.a. die gänzliche Transformierung ihrer Heimatregion, d.h. von Orten und Lsch. (durch staatliche diktierte Abriß-, Umsiedlungs- und Neubauprozesse) im Zuge der Errichtung des Drei-Schluchten-Staudamms. In analytischen wie poetischen Bildern gibt C. in einer vierteiligen Filmfolge (Video, Performance, Fotogr., 2002–07) die über die Jahre fortschreitenden krassen Veränderungen wieder und reflektiert deren Auswirkungen auf das menschliche Leben. Char. dabei ist die Kombination von Dokumentationen der brutalen Realität mit traumähnlichen, imaginären Sequenzen: Lsch.-Szenen sowie Episoden aus der trad. Peking- und Sichuan-Oper inmitten surrealistisch anmutender Abbruchgelände oder Baustellen, wobei sich C. auch selbst in Szene setzt, indem sie u.a. in tragische Rollen aus der chin. Bühnenkunst schlüpft (Konkubine Yu). Auch schreitet sie in einem aus der allgegenwärtigen rot-blau gestreiften Baustellenabdeckplane gefertigten Kleid, als trad. Opernfigur geschminkt und mit Engelsflügeln versehen, über ein Brachland, das im Begriff ist, durch Überflutung zu verschwinden (*Color lines*, 2006); die sprachlose Begegnung des rätselhaften Engels mit einer Gruppe von Jungen Pionieren zeigt einmal mehr, wie stark Erinnerungen aus der Jugend C.s experimentelle Kunstpraxis prägen. Für *Xinsheng Town no. 275–277 2009* (2009) baut sie demontierte trad. Gebäude aus ihrer überfluteten Heimat wieder auf. Die Videoarbeit *Peach Blossoms* (2009) reflektiert voller Empathie die Veränderungen, die das Leben der Menschen nach dem verheerenden Erdbeben in Sichuan (Mai 2008) prägen. ⌂ Denver/Colo., AM. Houston/Tex., MFA. New york, Bohen Found. Oslo, Astrup Fearnley MMK. Vail/Colo., Logan Coll. Wien, Thyssen-Bornemisza Art Contemp. Worcester/Mass., AM. ◉ *E:* 2004 Chengdu, Landing Art Centre / 2005 Shanghai, Big Factory / 2006 Beijing, Long March Space / 2007 Albany (N. Y.), Univ. of Albany / 2007, ’09 New York, Max Protetch Gall. / 2008 Worcester, AM (mit Yun-Fei Ji) / 2009 Los Angeles, Univ. of California, Hammer Mus. – *G: (zahlr. nat. und internat. Beteiligungen)* 2001 Chengdu: Bienn. /

Beijing: 2002 Agricultural Mus.: Harvest. Chin. Contemp. Art Exhib.; 3/4 Gall.: Loft of Language. Eight Female Artists in China / 2004 San Fransisco, Internat. Mus. of Women: Celebrating Women / 2007 Houston (Tex.), MFA: Red Hot. Asian Art Today from the Chaney Fam. Coll. / 2009 Brisbane: Asia Pacific Trienn. of Contemp. Art; Heidelberg, KV: Up Close – Far Away / 2010 Manchester, Whitworth AG: The Land Between Us. Place, Power & Dislocation / 2010–11 Turin, Pin. Agnelli: China Power Station. ⌧ *J. Freches* (Ed.), Createurs du nouveau monde. Artistes chin. d’aujourd’hui (K Bienn. Montpellier-Chine: MC1), Gallargues-Le Montueux 2005; *Gao Minglu* (Ed.), The Wall. Reshaping contemp. Chin. art (K), Buffalo, N. Y. 2005; *Wu Hung*, Displacement. The three gorges dam and contemp. Chin. art (K), Chicago 2008; *C. Noe u.a.*, Young Chin. artists. The next generation, M. u.a. 2008.

K. Karlsson

Chen *Rong* (Xiezhi; Yong’an; Songzhai; Yongyuan; Qiushan; Yongyuan laoren), chin. Kalligraph, Siegelschneider, Dichter, Gelehrter, Politiker, * 11. 9. 1876 Panyu (Kanton)/Prov. Guangdong, † 15. 11. 1955 Hongkong. C.s Vorfahren stammten aus Jiangsu. Nach Umsiedlung zählte die Fam. zur Elite von Panyu. C.s jüngere Schwester Chen Shuzi heiratete 1902 den späteren Vors. des Zentralkomitees der Guomindang (Nat. Volkspartei) Hu Hanmin. Stud. an der renommierten Jupo-Akad. (Jupo jingshe) und Mitbegr. der Kantoner Intellektuellen-Ges. (Qunzhihui) an der Xi’an-Akad. (Xi’an shuyuan). 1904 Forts. der Ausb. an der Hōsei Univ. (Hōsei Daigaku) in Tokio. 1905 Mitgl. der von Sun Yatsen u.a. begr. Revolutionären Allianz (Tongmenhui). Im April 1911 Teiln. am Huanghuagang-Aufstand. Nach dem Wuchang-Aufstand im Okt. desselben Jahres und der Unabhängigkeit der Prov. Guangdong durch Protektion des Schwagers Hu Hanmin Mitgl. des Zentralen Geheimbüros der Militär-Reg., danach bis 1931 Positionen in Politik und Inst. höherer Bildung: Abt.-Leiter des Vorbereitenden Büros für das Finanzwesen der Prov. Guangdong (Guangdong sheng Sifa Choubeichu Chuzhang), Aufsichtsbeamter der Guangdonger Akad. für Recht und Politische Wiss. (Guangdong Fazheng xuexiao Jiandu), Dir. der Guangdonger Polizei-Akad. (Guangdong Jingcha Xuexiao Xiaozhang), Vors. des Guangdonger Gerichtshofes (Guangdong Shenpanting Tingzhang), Abt.-Leiter des Politbüros des Verwaltungsrates der Prov. Guangdong (Xingzhengyuan Zhengwuchu Chuzhang). 1931 Leiter des Sekretariats der Kantoner Volks-Reg. (Guangzhou Renmin Zhengfu Mishuzhang). Nach der brit.-amer. Besetzung von Kanton 1937–38, der C.s Bibl. zum Opfer fiel, vorübergehend Exil in Vietnam. Um 1945 Rückkehr nach Kanton. Ab 1946 Tätigkeit im Guangdonger Archiv. 1948 Berater für Nat.-Politik der Nat. Volkspartei (Minguodang Zongtongfu Guoce Guwen). 1949 nach Machtübernahme durch die KP China Umsiedlung nach Macao; später ansässig in Hongkong, wo C. sehr wahrschlich verstarb und auf dem Aberdeen Chin. Permanent Cemetery (Zihua renmin yongyuan fenchang) beigesetzt wurde. Als Sterbeort wird in der Lit. auch Macao angegeben (s. Minguo renwu da cidian). – Unter C.s lit.

Werken ragen Du Lingnan ren shi jueju (Lesungen Lingnaner Regel- und Kurzgedichte, posthum 1965), Huang meihua wu shigao (Gedichtentwürfe aus dem Zimmer der Gelben Pflaumenblüten, 1948) und Yuexiu ji (Slg Yuexiu, posthum 1987) sowie die Poetiken Yongyuan shihua (Gespräche über die Dichtung des Yongyuan) und Qiumenglu shihua (Gespräche über die Dichtung aus der Herbsttraumhüttc) heraus. Das Projekt Qingshi jishi (Dichtungen der Qing mit hist. Hintergrund) blieb unvollendet. Nur ein Teil des ambitionierten Werkes erschien in 46 Forts. im Shanghaier Lit.-Mag. Qinghe (Azurkranich), dessen Publ. 1937 zu Beginn des Sino-Jap. Krieges eingestellt wurde. C. kultivierte in seinem Kantoner Priv.-Garten Yongyuan im Kreis regional und überregional bed. Gelehrter, Litcraten, Künstler und Politiker, darunter Huang Binhong, Hu Hanmin, Zhang Guang und Zhang Mojun, den Geist trad. chin. Gesellschaft mit „Eleganten Treffen" (yaji, yahui), zu denen die gemeinsame Beschäftigung mit Malerei und Kalligraphie gehörte. C.s Kanzleischrift (lishu) und Normalschrift (kaishu) sind im Geiste der spätqingzeitlichen Stelen-Schule (beixue) an Vorbildern der Späteren Han-Zeit und den Stelen-Inschr. der Nördlichen Dynastien orientiert, weisen jedoch auch Mischformen auf. Ein Fünf-Wort-Spruchpaar in Kanzleischrift (Tusche/Goldsprenkelpapier, Hängerollenpaar, sign., Aufschrift von C., 1950; Chengdu, Dajia shuhua yuan) zeigt die für die Bafen der Han-Zeit typische Betonung der Vertikalstriche und Stauchung der Zeichen, welche sorgfältig kalligraphiert durch die Technik des „überflogenen Weiß" (feibai) an den Strichansätzen und –enden in ihrer archaischen Strenge aufgelockert wird. Dichtung in Kleiner Normalschrift (xiaokai) ziert ein Rundfächer-Bl. (1928), dessen zweite Seite einen von Zhang Guang gemalten Wasservogel im Schilf (Tusche, leichte Farben/Seide, beide sign., Siegel der Künstler; Xiling yinshe, Hangzhou, Aukt., 18.–20. 12. 2009, Los 237) zeigt. C.s Kleine Normalschrift wirkt maßvoll und geschlossen. Sie ist vermutlich von der über Wang Xizhi (* 307, † 365) überlieferten Xuanshi biao (Denkschrift zur Bekanntmachung [des Dokumentenmeisters]) von Zhong Yu (* 151, † 230) beeinflußt. In C.s Alterswerk herrschen Kursivschrift (xingshu) und Konzeptschrift (caoshu) vor. Zwei Beispiele, Hängerollenpaar mit Sieben-Wort-Spruchpaar (qiyan lian, 1949), und Hängerolle mit Sieben-Wort-Kurzgedicht (qiyan jueju, 1959; beide Tusche/Papier, sign., Aufschrift und Siegel von C.; Macao, Mus.), bedienen sich Konstruktionselementen der Stelen-Inschr., wenden diese jedoch durch gezielte Effekte des „überflogenen Weiß" ins Spielerische und schaffen so ein lockeres Gesamtbild. C.s konzeptueller Ansatz der Verschmelzung von kalligraphischen „Bausteinen" der qingzeitlichen Stelen-Schule und Musterschriften-Schule kann mit He Shaoji verglichen werden, erreicht jedoch nicht dessen geniale Virtuosität. Als Siegelschneider folgte C. seinem Lehrer Liu Qingsong. In der Slg Yongyuan cangshi (Siegelsteine aus dem Yong-Garten) gab C. Abb. der von Liu und Huang Shiling für ihn geschnittenen Steine heraus. Das von C.s Freund Ma Kanghou ¯edierte Konvolut Yinchuan jiabao yinpu (Siegel-Verz. von Fam.-Schätzen aus

Yinchuan, auch bek. u.d.T. Feng Kanghou yingao [Siegelmanual des Feng Kanghou]) enthält Abb. von hundert Siegeln, die Feng dem Freund C. zum sechzigsten Geburtstag überreichte. ▢ Yu Jianhua, 1981, 1043. – Liang Piyun (Ed.), Zhongguo shufa da cidian, I, Hongkong 1984, 981 s.; Mod. Chin. paint. and calligraphy from the Taiyilou coll. (K), Hong Kong 1991; Minguo mingren moji, Xianggang 2003; Xu Youchun (Ed.), Minguo renwu da cidian. Zengdɪng ben, I, Shijiazhuang 2007, 1375 s.; Zhongguo shuhua jingpin shangxi, Bj. 2008. U. Middendorf

Chen Ruo Bing, chin. Maler, * 1970 Nantong/Prov. Jiangsu, lebt und arbeitet in Düsseldorf und Beijing. Stud.: 1988–91 China Acad. of Art, Hangzhou (trad. chin. Malerei); 1992–98 KA Düsseldorf (Malerei bei Gotthard Graubner). Mehrere (Reise-)Stip., u.a. 1993 und 2000 in die USA (Josef and Anni Albers Found.). – C. verbindet in seinen malerischen und zeichnerischen Werken unterschiedlicher hist. Trad. der Abstraktion und des Minimalismus. Prominente Farbkonzepte der mod. westlichen Kunst wie die reine Farbmalerei (Farbkissen) seines Lehrers Graubner, die strengen Farbgeometrien von Josef Albers sowie das amer. Hard Edge Paint. liegen ebenso zugrunde wie trad. ostasiatische Malkonzepte (monochrome Tuschemalerei, Verhältnis von Form, Fläche, Licht, Minimalismus. Zentrales Thema bei C. ist die spannungsvolle Zusammensetzung von formal unterschiedlichen Farbfeldern, deren Körperlichkeit (Inner light) aus der Tiefe der Maltextur emporwächst. ▢ DÜSSELDORF, Mus. Kunst Pal. NEUSS, Mus. Insel Hombroich. SHANGHAI, Shanghai AM. JIAXING/Prov. Zhejiang, C. Mus. House of Light (2006 von Priv.-Sammlern gegr.). ◉ E: 2001 Paris, Gal. Philippe Casini / 2003 Saarbrücken, Saarländisches Künstlerhaus (K) / 2004 Dortmund, Mus. am Ostwall (K) / 2005 (K), '09 Tokio, Taguchi FA / 2006 Shanghai, Shanghai AM (K); Köln, Kunstraum Fuhrwerkswaage (K) / 2007 Beijing, Onemoon (K) / 2008 Seoul und Shanghai, Wellside Gall. (K) / 2008 Hamburg, Elke Droescher – Kunstraum Falkenstein / 2009 Den Haag, Gal. De Rijk / 2010 Essen, Gal. Frank Schalg. – G: Shanghai: 2005 Shanghai AM: Metaphysics Black and White; 2007 Creek Art: Lines. Chin. Abstract Art (K); 2010 Wellside Gall.: Communication Beyond the Times / 2006 Beijing, Onemoon: Visibleinvisible (K) / 2006 Tokio, Shiseido Gall.: An Existence C. u.a. (K) / 2008 Den Haag, Gal. De Rijk: Quiet Quest. Realism to Abstraction / 2010 Wuhan, Hubei Mus. of Art: Array with no Objects. Acad. Inviting Exhib. of Contemp. Abstract Art. ▢ Delarge, 2001. – Online: Website C.
 A. Papist-Matsuo

Chen Ruoju, chin. Keramikerin, Graphikerin, * Okt. 1928 Anxin/Prov. Hebei. Stud.: 1946–50 Beiping Nat. Art School (seit 1950 China Central AFA, Beijing); danach dort als Doz. tätig. Prof. an der Central Acad. of Arts and Design, Beijing (später Leiterin der Keramik-Kl.). – C.s Œuvre umfaßt Keramiken und angew. Graphik (u.a. für den Verlag China Youth Press), bes. im Stil didaktischer Volkskunst (Alter Handwerker vom Volk der Miao im Süden Hunans, Farben/Papier, 1958 (mit Zhou Lingzhao); Nat AM of China. Auch zahlr. Entwürfe für Briefmar-

ken (1960er Jahre), Textilien, Wandmalereien (Beidaihe) und Lackkunst. Nat. und internat. Ausst.-Beteiligungen (1957 Weltfestspiele Moskau, Preis für Neujahrsbild *Huan qun qu*). Mitgl.: Chin. Künstler-Verb. (Zhongguo meishujia xiehui); im Vorstand des Chin. Verb. für Angew. Kunst (Zhongguo gongyi meishu xiehui). Wird zur zweiten Geneneration von chin. Keramikkünstlern gezählt, die von der reinen Gebrauchskunst abweichen und ab den 1980er Jahren innovative Konzepte einführen. Technische und stilistische Vielfalt (Geschirr, Wandrelief, Skulpt.). In den späten 1950er Jahren noch trad. volkstümliche Themen in farbenprächtiger, malerischer Umsetzung. Später reduzierte Farbigkeit; zunehmende Einheit von Keramikkörper und Motiv, die ein starkes skulpturales Interesse zeigen (*Gaoshan liushui*, 1994). ⌂ Beijing, Nat. AM of China. ☉ *E:* 2000 Beijing, Qinghua Univ.: Internat. Keramik-Ausst. ⌑ Zhongguo xiandai, 1988.

A. Papist-Matsuo

Chen *Shuliang (Shouyi)*, chin. Maler, Holzschnittkünstler, Kalligraph, * April 1902 Huangyan/Prov. Zhejiang, † Juli 1991 Beijing. Stud. in den 1930er Jahren, Shanghai FA School (Examen). Als Lehrer an Grund- und Mittelschulen tätig. Nach der jap. Invasion 1937 Teiln. am Langen Marsch nach Yan'an. 1938 Lehrer an der Lu-Xun Acad. of Art in Yan'an. 1942 Teiln. an den „Yan'an-Gesprächen über Lit. und Kunst", die zur ideologischen Grundlage der Kunstproduktion im kommunistischen China werden. Ab 1946 Kulturfunktionär (u.a. Verlagsleiter, 1951 stellv. Abt.-Leiter im Kultur-Minist., danach dort für die Kunst-Ausb. zuständig). Nach 1958 stellv. Dir. der Central Acad. of Arts and Design, Beijing. Mehrere Jahre Vorstands-Mitgl. des Künstler-Verb. (Zhongguo meishujia xiehui) und des Verb. für Schreibkünstler (Zhongguo shufajia xiehui). Zahlr. wiss. Veröff. zur chin. Kunst und Malerei (u.a. früheste Abh. über chin. Scherenschnitte). Während der Kulturrevolution politisch verfolgt. 1994 Eröffnung einer permanenten Ausst. mit seinen Werken (Shuliang shuhuaguan) in Huangyan. – C. gilt in China als bek. Vertreter der Neuen Chin. Malerei (xin guohua) sowie als renommierter Schreibkünstler. Seine Lsch. sind verbunden mit revolutionären Themen (*Changzheng loushang*). Als Kalligraph arbeitet er bevorzugt in Kursivschrift (xingshu). Auch Hschn. (z.B. *Yingong*). ⌂ BEIJING, Nat. AM of China. – Volkskongreßhalle. ⌑ Zhongguo xiandai, 1988.

A. Papist-Matsuo

Chen *Shun-Chu (Ch'en Shun-chu; Chen Shunzhu)*, taiwanesischer Maler, Fotograf, Installationskünstler, * 1963 Penghu, lebt in Taipei. Stud.: 1982–86 Chin. Cult. Univ., Taipei; 1995 Stip. des Vermont Studio Center, Johnson/Vt. Ausz.: 1995 Taipei Award, Annual Arts Competition. 1997 Teiln. am Taipei-San Francisco Künstleraustausch. 2005–06 Juror der Tatun Arts Competition, Taichung. Lehrt als Ass.-Prof. an der Nat. Univ. of the Arts und am De Lin Inst. of Technology, Taipei. – Als Pionier der zeitgen. Fotogr. in Taiwan zählt C. in den 1990er Jahren durch die Besinnung auf seinen familiären Hintergrund und seinen Heimatort zu den namhaften Vertretern des „Taiwanismus" (Nativism, Native soil movement/

Bentu) mit dessen Hinwendung zu einer bewußt wahrgenommenen, eigenständigen taiwanesischen kult. Identität. In seiner bek. Arbeit *Jihui. Jiating youxing*/Fam.-Parade, 1992–99, kombiniert er Fotogr. mit Land-art und Installation. Dabei werden gerahmte, von C. fotografierte Schwarzweiß-Portr. von Fam.-Mitgl. und engen Freunden zu Hunderten willkürlich miteinander kombiniert und in unterschiedlichen „Heimen" auf Feldern oder in verlassenen Häusern seiner Heimatregion installiert. Existentielle Fragen zu Leben und Tod sowie der Versuch, kollektive Erinnerungen und seine persönlichen, in Vergessenheit geratenen familiären und lokalen Wurzeln anhand verblaßter Lebensfragmente (alte Fam.-Fotos) wiederzubeleben, bleiben Schwerpunkte seines späteren auto-biogr. Schaffens (*Jiating hei hezi xilie – fudi*/Fam. Black Box Series. Promised Land, Installation, 1992). 2004 entsteht eine Serie von vergrößerten Schwarzweiß-Fotogr. mit intarsierten Keramikfliesen (häufig mit Portr. des Künstlers), die einzeln in zinküberzogenen Rahmen (*Siji youzong xilie*/Journeys in Time) oder als mon., puzzleartige Wandinstallationen erscheinen (*Fengzhong de jiyi – danian chusan*/Memory in the Wind [...]) und betont fragmentierte, z.T. manipulierte Kindheitserinnerungen heraufbeschwören. Zu C.s jüngsten Arbeiten gehören neben Installationen (*Path to Homeland*; *Swimming Over*, Mixed media, Video, 2008) auch verschwommen-abstrahierend und lyrisch anmutende Aufnahmen u.a. von Ortschaften, Pflanzen und Gebäuden (Schwarzweiß-Fotogr. und Mixed media, 2009). ⌂ FUKUOKA, Asian AM. KAOHSIUNG, MFA. TAICHUNG, Nat. Taiwan MFA. TAINAN, District Court. TAIPEI, Dimension Endowment of Arts. – FA Mus. ☉ *E:* Taipei: 1992, '96, 2001, '04, '08, '10 IT Park Gall.; 1998 FA Mus.; 1999 Hanart Gall. (K); 2009 Taiwan Internat Visual AC; 2007 Chi-Wen Gall. / 1995 Paris, La Laverie Photo Space / 1999 Fukuoka, Moma Contemp. Art Gall. / Hongkong: 2001 Kwang Hwa Information and Cult. Center; 2010 Lumenvisum / 2009 Tainan, Inart. – *G:* Taipei: 1996 FA Mus.: Bienn.; 2006 Dt. Kulturzentrum: Intimacy / Taichung: Taiwan Mus. of Art: 2006 Macroscopic, Microscopic and Multiple Reflections on Mirrors; 2008 Home; 2010 Continuation; 2010 Sakshi Gall.: Between Hist. and Tale / 1996, 2000, '02 Kwangju: Bienn. / 1998 Paris, Buisson Contemp. AC: You Talk – I Listen / 1999 Beijing, China AG: Visions of Pluralism ... 1988–1999 / Surfers Paradise (Australien), Gold Coast City AG: Face to Face (Wander-Ausst.; K) / 2004 Toronto, Lee Ka-sing Gall.: Dislocation re-launch exhib. (Wander-Ausst.; K); Shanghai, AM: Bienn. (K) / 2005 Dieppe, Le Port: Le remps d'une marée. ⌑ *Delarge*, 2001; *M. Sullivan*, Mod. Chin. artists, Berkeley u.a. 2006 (s.v. Chen Shunzhu; *L. Warren*, Enc. of twentieth-c. photogr., N. Y 2005. – Taiwan. Kunst heute (K Aachen u.a.), Taipei 1996; *S. Rowley*, Art Asia Pacific 15:1997, 36–38; *Gao Minglu* (Ed.), Inside out. New chin. art (K Wander-Ausst.), Berkeley 1998; *S. McIntyre*, Art Asia Pacific 28:2000, 62–65; *S. Acret* (Ed.), A strange heaven. Contemp. chin. photogr. (K Wander-Ausst.), Hong Kong 2003; C. Journeys in time, Taipei 2004; Taiwan dang dai yi shu zhi mei (The beauty

of contemp. Taiwanese art), Taipei 2004; The multiform nineties. Taiwan's art branches out (K),Taipei 2005; *Jian Zhengyi* (Ed.), Open city. Archit. in art, Taipei 2008; „Is it real?" Taiwan photo bazaar, Taipei 2009. – *Online:* IT Park Gall., Tapei; shun-chu (Ausst.). K. Karlsson

Chen, *Teresa*, US-amer.-schweizer. Fotografin, Installationskünstlerin, Kuratorin, * 12. 6. 1963 Spokane/Wash., lebt in Zürich. Ausb.: 1981–85 Computer-Wiss., Brown Univ., Providence/R. I.; 1993 Sommer-Akad., Salzburg, Workshop bei Nan Goldin; 1996/97 Gast-Stud., California College of Arts and Crafts, Oakland/Calif.; 1994–98 Fotogr.-Stud., HS für Gest. und Kunst, Zürich; ebd. seit 2006 Promotionsprojekt. Mitgl.: u.a. 1999–2009 im Vorstand der Shedhalle, Zürich. Stip.: 1999, 2000 (Paris-Aufenthalte), 2001 Stadt und Kanton Zürich; 2003 Landis & Gyr (Berlin-Aufenthalt, 2005). – In Fotoserien und Videoarbeiten Beschäftigung mit der eig. Identität (*Selfportr. with bruises*, 1997; *Dream of a non-blonde*, 2003, beide Fotoserien) und der Fam.-Gesch. (*See the world with Ma and Pa Chen*, Installation, 2001). Davon ausgehend auch Auseinandersetzung mit ges.-politischen Themen wie Stereotypen (*The yellow peril*, Installation, 2001, mit Cat Tuon Nguyen), Frauenbild, Schönheitsideal und der Wahrnehmung von Immigranten in der westlichen Ges. (*It ain't where you're from, it's where you're at: BE(COM)ING SWISS*, Video mit Interviews, 2007–09). Teilw. Selbstinszenierung und Verwendung von Fam.-Fotos. Ab etwa 2004 auch serielle Natur-Fotogr. zum Begriff der Schönheit und als Metapher für Vergänglichkeit (*Gorgeous*, 2004–06; *Captured*, 2010). Weitere Arbeiten: *Indeterminate body*, 1998; *Merry Christmas with the Chens*, 2000, Fotoserien; *Beltsville, Maryland*, Installation, 2001; *Turning blonde*, 2003; *Searching for Blonde on the Internet*, 2003; *Memory*, 2005, Videos; *Projections*, Fotoserie, 2007. Außerdem Mitarb. an Konzept und Organisation mehrerer Ausst.-Projekte und Kunst am Bau in Zürich (*Fluid movement*, Credit Suisse, Zürich-Oerlikon, 2002; Univ.-Spital, Hörsaal, 2003; Altersheim Kalchbühl, 2007). ⌖ *E:* 1997 Oakland (Calif.), Top Hat Shine Project / 1999 München, Gal. Christa Burger (mit Adidal Abou-Chamat); San Francisco, Southern Exposures / Zürich: 2000 Röntgenraum (mit Cat Tuong Ngyuen); 2002, '04 (K), '10 (K), '10 Gal. Bob Gysin; 2002 Scalo; 2012 Artfoyer Cavigelli (mit C. T. Ngyen) / 2001 Aarau, Kunstraum / 2002 Tampere, Photogr. Centre Nykyaika / 2003 Schaffhausen, Vebikus / 2007 Solothurn, Künstlerhaus S 11. ⌗ Kürschners Hb. der Bild. Künstler. Deutschland, Österreich, Schweiz, I, M./L. 2007. – *C./ T. Kobler/D. Wimmer*(Ed.), Morphing, Z. 1999; *U. Stahel* (Ed.), Young. Neue Fotogr. in der Schweizer Kunst (K Winterthur), Basel 1999; Charles Wyrsch mit Cécile Wick und C. (K Nidwalden), Stans 2000; *B. Polzer/ C.*, Kunst-Bull. (Z.) 2002 (5) 32–36; Welcome to polkamotion with Ma and Pa Chen, Z. 2002; Art at work, Basel/Z. 2006; *P. Stohler/S. Rüttimann*, Reiz und Risiko (K Altdorf), St. 2006; Kunst-Bull. (Z.) 2007 (10) 68; *E. A. Shanken* (Ed.), Art and eletronic media, Lo. 2009. – *Online:* Website C. N. Buhl

Chen *Tianran*, chin. Schreib- und Holzschnittkünstler, Publizist, Dichter, * 20. 4. 1926 Gongxian (heute Gongyi)/Prov. Henan. Entstammt einer Bauernfamilie. Seit seiner Jugend Beschäftigung mit klassischer chin. Lit. und Kunst (1942–44 Kopien des Mallehrbuchs *Senfkorngarten*). 1945–48 als Dorfschullehrer tätig, daneben Fern-Stud. (Hschn.) bei der All-China Woodcut Association. 1948–53 künstlerischer Leiter versch. Ztgn und Zss. der Prov. Henan (u.a. Hubei Daily). 1953–60 Kunstlehrer in Henan; mit Hschn. erste Ausst.-Beteiligungen in China und Osteuropa. 1960–66 Doz., u.a. an der Hubei Art Acad., erste Veröff. zum zeitgen. chin. Holzschnitt. 1966–77 Kulturarbeit, während der Kulturrevolution auch vier Jahre in der Landwirtschaft. Rege (inter-)nat. Ausst.-Beteiligung und versch. Ausz. (u.a. 1996 Gold-Med. Internat. Woodcut Research Assoc. of Japan). Seit 1978 Mitgl. (z.T. im Vorstand) in zahlr. Verb.: u.a. Chin. Künstler-Verb. (Zhongguo meishujia xiehui); Verb. der Hschn.-Künstler (Zhongguo banhuajia xiehui); Verb. der chin. Schreibkünstler (Zhongguo shufajia xiehui). 1978 erster Präs. der neu-gegr. Henan Shufa. Paint. and Calligraphy Academy. Mehrfach Delegierter des Nat. Volkskongresses. – In China bek. Hschn.- und Schreibkünstler. Im Hschn. Darst. revolutionärer Themen, aber auch Wiedergabe des ländlichen Lebens seiner Heimatprovinz Henan (*Rinder*, 1957). ⌂ WUHAN, Hubei Mus. of Art. ⌾ *G:* 2010 Wuhan, Hubei Mus. of Art: Retrospect and Prospect. ⌗ Zhongguo Xiandai, 1988. A. Papist-Matsuo

Chen *Tianxiao* (Fanglu; Tianxiao waishi; Yehe), chin. Maler, Kalligraph, Lithograph, Dichter, * 11. 4. 1898 Anbu zhen/Prov. Guangdong, † 1978 Qingdao/Prov. Shandong. Stammte aus einer Zimmermannsfamilie. Sein Lehrer Lin Youmei vermittelte dem jungen C. nicht nur Lit. und Dichtkunst, sondern führte ihn auch in Kalligraphie und Malerei ein. 1916–23 Aufenthalt in Shanghai, wo C. Kontakte zu Dichtern und Künstlern knüpfte. Ab 1923 Doz. für Lith. im renommierten Hongkonger Verlag Tianzhen shiyinju. 1930 auf Einladung Liu Haisus Doz. für Nat. Malerei (guohua) an der Shanghai Art Acad. (Shanghai meishu zhuanke xuexiao); zugleich Doz. für Lit. und Kunst an der Dong-Wu Univ. (Dong-Wu Univ., heute Suzhou Univ.) in Suzhou/Prov. Jiangsu. Lernte dort Chen Banding kennen. 1934 Tätigkeit an der Shanghai Chin. Paint. Acad. (Shanghai Zhongguohua xueyuan) und der AG of the China Acad. of Art in Hangzhou (Hangzhou Zhongguo meishuguan). 1934 Ausst. in Singapur; 1935–44 zahlr. Ausst. in Indonesien, Birma, Singapur, Malaysia, Indien, Thailand, auf den Philippinen und in Vietnam sowie versch. europ. Ländern, u.a. England und Italien. 1939 Verkaufs-Ausst. in Ilolio City/Philippinen, deren Erlös dem Widerstandskrieg gegen Japan gespendet wurde und C. den Ruf eines „patriotischen Malers" (aiguo huajia) einbrachte. 1956 anläßlich des 2. Nat. Ausst. Chin. Malerei von Zhou Enlai belobigt. Danach Tätigkeit in Beijing. 1970–74 während der Kulturrevolution Landverschickung in den Kr. Huimin/Prov. Shandong. Ab 1974 wohnhaft in Qingdao, wo er im Hause seines zweiten Sohnes 1978 verstarb. Im Mai 1988 wurde C.s Werk posthum weite Aner-

kennung durch Shao Yus Artikel Yide yongcun (Die Kraft der Kunst ist ewig) in der Zs. Huashengbao (Asia Today) zuteil. 1990 fand eine Retr. in Zhaozhou/Prov. Guangdong statt. Im Aug. 2008 wurde C.s Gesamtwerk mit zahlr. erstmals ausgestellten Arbeiten anläßlich der Olympischen Spiele in Beijing gewürdigt. – C.s Vorbilder in der Malerei waren Daoji (* 1641, † 1718), Xu Wei (* 1521, † 1593) und Chen Chun (* 1483, † 1544 oder * 1482, † 1539), deren Ästhetik des „Unbeholfenen" (zhuo) auch C.s Werk prägt, das Lsch. im Stil versch. Meister umfaßt. Nach Mi Youren (* 1086, † 1165) entstanden Kuppel- und Kegelberge (Album-Bl., Tusche, leichte Farben/Papier, sign., Aufschrift von C.; C. T. zuopin ji, Lsch.-Album, Bl. 11) in regenschwerer Atmosphäre, während Yushan tu (Regenberge, Tusche, leichte Farben/Papier, sign., Aufschrift und Siegel von C.; ebd., Bl. 10) dem gleichnamigen Werk Gao Kegongs (* 1248, † 1310) im Taipeier Nat. Pal. Mus. nachempfunden ist. Daneben finden sich Mon.-Lsch. mit archaisierender Blaugrün-Kol. (ebd., Hängerolle, Nr 2), Hochgebirgspanoramen (ebd., Querformat, Bll. 3–5), monochrome Tusche-Lsch. (ebd., Bll. 6, 7) sowie Gartenidyllen (ebd., Bl. 15), die C.s Vielseitigkeit unter Beweis stellen. Dekorativ wirken Album-Bll. mit skizzenhaft hingeworfenen Darst. von Früchten und Gemüse, z.B. Duozi tu (Granatapfel, Tusche, leichte Farben/Papier, 1960; ebd., Früchte-Album, Bl. 5) und Baicai tu (Chinakohl, Tusche/Papier, beide sign., Aufschrift und Siegel von C.; ebd., Bl. 7). Das trad. Repertoire der Blumen und Blütensträucher der vier Jahreszeiten hält sich im Rahmen des Konventionellen. Bemerkenswert ist eine von Wang Gais „Jupu" (Chrysanthemen-Verz.) im Jieziyuan huapu (Lehrbuch der Malerei aus dem Senfkorngarten, 1679) inspirierte Slg von Chrysanthemen-Darst. (1949–54) mit einem in Kursiv-Konzeptschrift (xingcao) kalligraphierten Vorw. (Tusche/Papier, Album-Bl., sign., Siegel von C., 1954). Kompositorisch gelungen sind Bilder mit knospendem und blühendem Lotos im Stil Qi Baishis und Wu Changshuos. C.s Tuschebambus (mozhu) als Symbol des „Edlen" (junzi) und des Künstlers selbst variiert bek. Motive: Bambus bei ruhigem Wetter, im Sturm, an Felsen, im Mondschein und schneebedeckt. Chang Dai-chien galt C. als „Freund der Pflaumenblüten" (meihua zhi you). Zahlr. Arbeiten widmen sich dem Blütenbaum, der monochromen Tuschepflaumen, über weiß, hell- und dunkelrosa blühende Zweige bis hin zum Miniaturbaum in flacher Schale und kunstvoll schlicht arrangiertem Gesteck. Flüchtig und leicht, mit dem Blick für das Typische, fängt C. Federtiere (Gänse, Enten, Mynah-Vögel, Sperlinge), Säuger (Büffel, Pferde, Esel, Pandabären, Katzen) sowie Krustentiere und Fische ein (alle mit Abb. in C. T. zuopin ji), worunter eine Hängerolle mit rot schillernden Fischen zw. grüner Elodea (Tusche, leichte Farben/Papier, sign., Aufschrift und Siegel von C., Sammlersiegel, 1935) im Ashmolean Mus. Oxford in Komp. und Kolorierung herausragt. Unter C.s Figuren ist der legendäre Dämonenbezwinger Zhong Kui in rotem Gewand mit Regenschirm in Form eines übergroßen Lotus-Bl. als Symbol der Würde und Reinheit mit wenigen, abgekürzten Strichen effektvoll dargestellt. In Nach-

ahmung Liang Kais (E. 12./A. 13. Jh.) entstand die Hängerolle Liuzu sijing tu (Der 6. Patriarch [Huineng (* 638, † 713)] zerreißt ein Sūtra, Tusche/Papier, sign., Aufschrift und Siegel von C.) sowie weitere von der zen-buddh. Figurenmalerei inspirierte Bilder wie das querformatige Erzu diaoxin tu (Der 2. Patriarch [Huike (* 487, † 593)] beruhigt sein Herz, Tusche, leichte Farben/Papier, sign., Aufschrift und Siegel von C.; alle mit Abb. in C. T. zuopin ji) nach dem song-zeitlichen Maler Shi Ke (tätig um 965). C.s kalligraphische Ausb. umfaßte das Stud. der Musterschriften von Zhong Yu (* 151, † 230), Wang Xizhi (* 307, † 365), Yan Zhenqing (* 709, † 785), Su Shi (* 1037, † 1102) und Mi Fu (* 1052, † 1107). Zum Curriculum gehörten ferner Stelen-Inschr., darunter die spät-han-zeitliche Xia Cheng bei (Stele für Xia Cheng, 170), deren Kalligraphie trad. Cai Yong (* 132, † 192) zugeschr. wird. Daneben studierte C. Sütren-Schrift, die Wilde Konzeptschrift (kuangcao) des Huaisu (* 737, † 799) und Zhang Xu (* um 675, † 759) sowie die Siegelschrift (zhuanshu) und Kanzleischrift (lishu) des qing-zeitlichen Gelehrten-Kalligraphen Yi Bingshou, der innerhalb der Stelen-Schule (beixue) neben Deng Shiru zu den bed. Frühmeistern zählt. Ye Gongchuo lobte die „glanzvolle" Kunst des durch die Kulturrevolution gebrochenen und zurückgezogen lebenden Künstlers C., dessen Arbeiten von Cai Yuanpei und Wang Zhen wiederholt gewürdigt worden waren. Die in der Republikzeit veröffentlichte Slg C. Guohua cunjin (Fundus der Nat. Malerei von C.), Fanglu yikan (Drucke des Fangu, 2 Bde) und Tianxiao zhi hua (T.s Malerei, 2 Bde) zählen heute zu den Raritäten und sind wiss. noch nicht ausgewertet. ▢ Yu Jianhua, 1981, 993. – C. T. yishu jinian ce, Shanghai 1934; Zhongguo meishu nianjian, Shanghai 1948; C. T. huaji, Bj. 1978; C. T. zuopin ji, Bj. 1988; C. T. shu qianzi wen, Guiyang 1996; S. Vainker, Chin. paint. in the Ashmolean Mus. Oxford (K), Ox. 2000; Yang Dehong (Ed.), Lidai Chaoren mingjia shuhua, Guangzhou 2009.

U. Middendorf

Chen Weimin, chin. Maler, * Dez. 1959 Prov. Fujian, lebt in Chongqing. Stud.: Sichuan AFA, Chongqing (Ölmalerei, Abschluß 1982). Danach in Gesangs- und Tanzensembles tätig. Später Lehrtätigkeit an der Sichuan AFA. Mitgl.: Chin. Oil Painters Association. – C. experimentiert zunächst mit versch. Stilrichtungen westlicher Künstler (z.B. Anselm Kiefer) und fertigt expressionistisch-symbolistische Öl-Gem. an, zumeist Stilleben in düsterer Farbgebung. Seit den 1990er Jahren thematisiert er vermehrt die fortschreitende und radikale Urbanisierung, Modernisierung und Kommerzialisierung der Gesellschaft, v.a. die Entstehung typischer chin. Vororte, in denen Altes und Neues, Ländliches und Städtisches aufeinander prallen. Seit 2000 entstehen Bilderserien (Öl, Acryl/Lw.) in einer eigenwilligen Mischung von chin. Pop-art und volkstümlicher Malerei mit Darst. fröhlich-bunter, bewußt unbeholfen gestalteter Ansichten von Mosaikwelten; bescheidene Ziegeldachhäuser umgeben von roten Ziegelmauern, Getreidefelder, Fabrikschornsteine, Autos, Baukräne und Flugzeuge. Auf Hausfassaden und Mauern prangen bek. westliche Markenzeichen (für Autos, Zigaret-

ten, Uhren, Sportartikel), Schriftzüge mit ideologisch-offiziellen Parolen sowie das in China allgegenwärtige Zeichen für „abreißen" (chai). ⌺ BEIJING, China AG. SHANGHAI, AM. ◉ E: 2005 Beijing, Beijing Art Now Gall. (mit Li Zhanyang; K); Shenzhen, Musheng Mod. AG (mit Bai Hai); 2009 Sydney, Ray Hughes Gall. – G: u.a. Beijing: 1991 Inst. of Chin. Paint.: Chin. Contemp. Art Study; 1993 China AG: Chin. Oil Paint. Bienn.; 1999 HM: Chin. Oil Paint. Exhib. / 2001 London, Bloxham Gall.: Post-Politics / 2007 Guangzhou, Guangdong AM: Contemp. Art from the Northwest 1985–2007. ⌺ *Huang Junqing* (Ed.), Dream of China. '97 Chin. contemp. art, Bj. 1997; *Liao Wen*, Personal touch (K), Tianjin 1998; Chongqing-lajiao. Chilis aus Chongqing (K Kassel), Ffm. 2001; *Zhang Zhaohui*, Asian art news 15:2005 (6) (Review). – *Online:* Artnet (Ausst.). K. Karlsson

Chen *Wenbo*, chin. Maler, * 9. 6. 1969 Chongqing/Prov. Sichuan, lebt in Beijing. Stud.: Sichuan AFA, Chongqing, Ölmalerei bei Ye Yongqing und Zhang Xiaogang (Abschluß 1991). Seither als freischaffender Künstler in Beijing tätig. – C. fertigt in den 1990er Jahren Darst. von künstlich-virtuellen, geklonten Zwitterwesen u.v.a. von Frauen, die mit ihrer schrillen blauen, rosafarbenen oder grünen Plastikhaut C.s Interesse für künstliche Schönheit offenbaren (*Test*, 1997; *Vitamine Z*, 1998–2000). Seit 2000 verschwinden die „Menschen" aus dem Motivrepertoire zugunsten großformatiger Nahansichten von Alltagsobjekten (u.a. Schlüssel, Streichhölzer, Billardkugeln, Spielwürfel, Autos) und menschenleerer Stadtansichten (Passagen, Tunnel, Brücken, Archit.), welche Träume, Illusionen, Oberflächlichkeit, Faszination, Trostlosigkeit und Instabilität der mod. urbanen Umwelt und des Lebensstils evozieren und die der Künstler als „urban poetics" bezeichnet. Dabei interessiert er sich nicht für das Objekt an sich, sondern für dessen oberflächliche, lichtreflektierende Erscheinung und ikonenhafte Wirkung, die mittels einer char. glatten Malweise (Verzicht auf sichtbare Pinselführung) und einer reduzierten, grellen Farbpalette (gelegentlich auch Grisaille) erzielt wird. Nach 2000 entstehen auch magisch-energetisch anmutende Abstraktionen (*Ten Thousand Times of Love*, 2005) in warmen, leuchtenden Farben, die von C.s Faszination für kaleidoskopische Farbtransformationen inspiriert sind. Arbeitet auch in den Medien Skulpt., Fotogr., Performance und Video (*Moisture Content*, 1996). ⌺ BEIJING, Guy & Myriam Ullens Found.; Guan Yi Coll.; Long March Found. DUISBURG, Slg Grothe. GENF, Olenska Found. GUANGZHOU, Guangdong AM. HONGKONG, Chow Hallam Coll. MAUENSEE, Slg Sigg. SHENZHEN, He Xiangning AM. ◉ E: 2000 Paris, Gal. Loft / 2003 Shenzhen, He Xiangning AM / 2006 Beijing, Courtyard Gall. / 2008 Berlin, Gal. Michael Schultz (K) / Shanghai, Shanghai Gall. of Art. – G: u.a. Beijing: 1993 China AG: China Oil Paint. Bienn.; 1997 Gall. Central AFA: Chin. Video Art 1997; 2004 LA Gall.: Temporality; 2007 Today AM: Energy. Spirit, Body, Material; 2008 Guy & Myriam Ullens Found.: Our Future / Guangzhou: 2000 Guangdong AM: Personality and Sociability in Arts; 2002 ibid.: Guangzhou Trienn. (K); 2007 ibid.: Depar-

ting from the Southwest / 1994 Chongqing, Sichuan AFA: Fragmentation / 2000 Périgueux, L'Espace Cult. François Mitterand: Chin. Portraits / 2002 Duisburg, Mus. Küppersmühle – Slg Grothe: Chinart (internat. Wander-Ausst.) / 2005 Tokio, Mori AM: Follow Me / Shanghai: 2006 AM: Bienn.; 2007 MCA: Sport in Art / 2007 Karlsruhe, ZKM, Medien-Mus.: Thermocline of Art. New Asian Waves (K) / 2010 Chicago, Walsh Gall.: Monumental. ⌺ *Delarge*, 2001. – *S. Champion*, Representing the people (K), Manchester 1999; *Chen Tong*, in: *Wu Hung* (Ed.), Chin. art at the crossroads. Between past and future, between east and west, Hong Kong 2001, 305–309; *J.-M. Decrop/C. Buci-Glucksmann*, Modernités chinoises, Mi. 2003; Alles onder de hemel (K Antwerpen), P. 2004; *B. Fibicher/M. Frehner* (Ed.), Mahjong. Chin. Gegenwartskunst aus der Slg Sigg (K Bern/Hamburg), Ostfildern-Ruit 2005; *J. Frèches* (Ed.), Créateurs du nouveau monde. Artistes chinois d'aujourd'hui (K Bienn. Montpellier-Chine: MC1), Gallargues-Le Montueux 2005; *P. Tinari* (Text)/*M. Ciampi* (Fotogr.), Artists in China inside the contemp. studio, Lo. 2007; C. W. Epidemiology (K Gal. Michael Schultz), B. 2008; C. W. Urban Verses, Bj. 2009. – *Online:* Website C. K. Karlsson

Chen *Xian* (Zili; Daize; Chuntai; Lianting; You'an; Meijing waishi), chin. Kalligraph, Maler, Sammler, Dichter, * 1785 aus dem Kr. Xiushui (Jiaxing)/Prov. Zhejiang, † 1859. Der als Dichter und Sammler von Kunst und Antiquitäten bek. C., dessen Studioname Yangai shanfang lautete, studierte die Malerei bei Zhai Jichang. Neben Lsch. und Bildern mit Blumen und Vögeln (huaniao), die „vom Lebendigen abschrieben" (xiesheng), ragen bes. C.s Tuschepflaumenblüten (momei) hervor. Eine Hängerolle mit Pflaumenblütenzweigen und Kalligraphie in Konzeptschrift (Tusche, leichte Farben/Papier, sign., Aufschrift und Siegel von C.; Poly, Beijing, Aukt., 20. 11. 2010, Los 3830) zeigt, daß das Malen der „vier Edlen" (sijun), d.h. Pflaumenblüten, Orchideen, Chrysantheme und Bambus, ein geeignetes Exerzitium der Pinseltechnik darstellte, da die Prinzipien der Pinseltechnik und des Duktus sehr eng an die Kalligraphie anschließen. Zu den bes. gelungenen Pflaumenblütenbildern, die C. das Prädikat des „Ungebundenen" (yi) einbrachte, gehört die Hängerolle *Momei tu* (Tuschepflaumenblüten, Tusche/Papier, sign., Aufschrift und Siegel von C., 1840) im Kantoner Prov. Mus. Der kalligraphische Duktus bestimmt auch C.s *Sanyou tu* (Drei Freunde, Tusche, leichte Farben/Papier, Hängerolle, sign., Aufschrift und Siegel von C., 1849; Honghai, Shanghai, Aukt., 6. 1. 2009, Los 417) mit Bambus und Narzissen an Gartenfelsen sowie das monochrome *Quexie tu* (Elster und Krebs, Hängerolle, sign., Aufschrift und Siegel von C.; Poly, Beijing, Aukt., 17. 9. 2007, Los 1779). Kalligraphie studierte C. unter dem bed. qingzeitlichen Schriftmeister Liang Tongshu und befaßte sich mit den trad. Musterschriftvorlagen eines Wang Xizhi (* 307, † 365) und Wang Xianzhi (* 344, † um 386/388) sowie den Arbeiten der Tang-Kalligraphen Ouyang Xun (* 557, † 641), Chu Suiliang (* 597, † 658) und Yan Zhenqing (* 709, † 785), war jedoch auch geschult an den Stelen-Inschr. der

Späteren Han-Zeit und Nördlichen Dynastien. C.s Kalligraphien in Konzeptschrift (caoshu) zeichnen sich durch stark variierende Strichdicke und Druckunterschiede aus. Neben sehr fein gezogenen Linien finden sich Verklecksungen, wodurch Strichverlauf und Zeichenstruktur unklar werden. Die einzelnen Zeichen fließen jedoch selten ineinander über. Durch die häufig verwendete, sich aus raschem Schreiben ergebende ästhetisch geschätzte Technik des „überflogenen Weiß" (feibai) wirken viele Zeichen ephemer und kontrastieren spannungsvoll mit tuscheschweren Schriftelementen, wie z.B. bei den Paneelen eines vierteiligen Stellschirmes (Tusche/Papier, alle sign., Siegel von C.; Qingliange, Shanghai, Aukt., 18. 7. 2009, Los 574). Auffällig ist die expressive Linksneigung der Zeichen, wodurch diese an die Grenzen der Stabilität gebracht werden, jedoch durch geschickte Anordnung auf der Blattfläche trotz Schieflage nie „umkippen", z.B. Traktat über die Kalligraphie Ouyang Xius (* 1007, † 1072), zit. nach Su Shi (* 1037, † 1102; mit Varianten im Wortlaut), kalligraphiert in Kursiv-Konzeptschrift (xingcao, Hängerolle, Tusche/Papier, sign., Aufschrift und Siegel von C., 1858; Xiling yinshe, Yangzhou, Aukt., 20. 6. 2009, Los 1084). Die Siegel auf den Arbeiten C.s stammen teilw. von befreundeten Malern, Kalligraphen und Siegelschneidern der Zhe-Schule, u.a. Zhao Zishen, Chen Song, Shen Aixuan und Li Chongji. Zu Ehren des Lehrers Liang Tongshu ließ C. das Banxianglou Liang tie (Musterschriftvorlagen des Liang [Tongshu] aus dem Banxiang-Turmgemach) drucken. ✉ Jiuchai shiji (Lyrik-Slg eines Reisigsammlers), Tianjin 2009 (Faks.; Tianjin tushuguan zhencang Qingren bieji shanben congshu). 📖 *Yu Jianhua*, 1981, 1037; *Seymour*, 1988 (s.v. Ch'en Hsien); *Bénézit* III, 2006. – *Jiang Baoling* (* 1781, † 1840), Molin jinhua, Bj. 1996 (Faks.); *Tao Xiang* (* 1871, † 1940; Ed.), Zhaodai mingren chidu xuji, s.l. 1911; *Li Fang* (* 1883 oder 1884; Ed.), Huang Qing shushi, Shenyang 1985 (Faks.) (Liaohai congshu, 3), 8/15a; *Ge Sitong*, Airiyin lu shuhua bielu, Shanghai 1995 (Xuxiu siku quanshu. Zibu zalu lei, 1088), 4/13b-14a; *Ma Zonghuo*, Shulin zaojian, Taipei 1962 (Repr.; Yishu congbian. Diyi ji, 6), 12/420a; *Chen Shutong* (Ed.), Baimei ji, [Shanghai] 1927; *Cheng Shuqing*, Qingdai huashi zengbian, Shanghai 1927; *V. Contag/Wang Chi-ch'ien*, Seals of Chin. painters and collectors of the Ming and Ch'ing periods, Hong Kong 1966; *O. Sirén*, Chin. paint., VII, Lo./N. Y. 1973; *Guo Weiqu*, Song Yuan Ming Qing shuhuajia nianbiao, Bj. ³1982, 483, 491; *Liang Piyun* (Ed.), Zhongguo shufa da cidian, I, Hongkong 1984, 941.

U. Middendorf

Chen *Xinghua*, chin. Graphiker, Maler, Zeichner, Karikaturist, * März 1924 Qingxu/Prov. Shanxi, † 14. 7. 1997 Lanzhou/Prov. Gansu. Autodidakt. Tritt mit 13 Jahren der Nat. Revolutionsarmee bei; Teiln. am Langen Marsch. Bis 1945 in der Armee als Propagandamaler beschäftigt. Nach 1945 als Redakteur und Künstler für zentrale Mag. (u.a. Renmin Ribao und Dongbei Huabao) sowie 1951–58 für den Volkskunstverlag in Beijing tätig. 1951 Teiln. am Korea-Krieg. 1958 Doz. an der Gansu Normal Univ. (Kunst-Fak.). Repressalien während der Kultur-

revolution. Nach 1978 wieder als Künstler und Doz. tätig (1979 Prof. an der Northwest Normal Univ. in Lanzhou). Ab 1954 Mitgl. im Chin. Künstler-Verb. (Zhongguo meishujia xiehui), mehrfach im Vorstand; ab 1978 stellv. Vors. des Künstler-Verb. der Prov. Gansu. Ab 1979 Mitgl. der Kommunistischen Partei Chinas. – In China v.a. als Propagandakünstler bekannt. Nach 1945 zahlr. Ausst.-Beteiligungen in ganz China. Intensive Beschäftigung auch mit der trad. buddh. Kunst in der Prov. Gansu (*Dunhuang mogaoku*). V.a. trad. Tuschebilder, Ölbilder (*Huang Jiguang*, 1953; Militär-Mus.), Zchngn, Neujahrsbilder, Propagandaposter und Karikaturen. 🏛 AMSTERDAM, Internat. Inst. of Social Hist. BEIJING, Militär-Mus. der chin. Volksrevolution. 📖 Zhongguo xiandai, 1988; Zhongguo meishuguan, 1993. – *S. R. Landsberger/M. van der Heijden*, Chin. posters. The IISH-Landsberger Coll. (K Internat. Inst. of Social Hist. Amsterdam), M. u.a. 2009.

A. Papist-Matsuo

Chen, *Xingwan* → **Chen,** *Hsing-wan*

Chen *Xinmao*, chin. Maler, Schriftkünstler, Akademielehrer, * 1954 Shanghai, lebt dort. Ausb. beim Vater (Schriftkunst, klassische chin. Lit.). Stud.: 1976–82 Chin. Paint. Research Class, Shanghai Conservatory of Drama; 1983–87 Nanjing AFA. Ausz.: 1981, '89 Nat. Youth Art Exhib. in Beijing und Shanghai. Mitgl.: Chin. Künstler-Verb. in Shanghai. Lehrt ebd. an der Art Acad. of East China Normal Univ. (dort auch Dir.). Debütiert in der Shanghaier Avantgardeszene der 1980er Jahre. Während C.s frühe Gem. noch im Bereich der Tuschemalerei (Tusche auf trad. Xuan-Papier) anzusiedeln sind, wendet er sich ab M. der 1980er Jahre zunehmend originellen, collageartigen Mixed-media-Techniken zu (Tusche kombiniert mit Acryl, Digital-Fotogr., Hanffaser, Gipspulver, Kautschuk, Plastik, Bambus, Pferdehaare, Pflanzensamen). Ähnlich wie bei einigen and. bed. chin. Gegenwartskünstlern (Xu Bing, Huang Yongping, Gu Wenda), die, in ihrer Rückorientierung auf Werte der eig. Trad., sich mit der chin. Schrift und dem Schrifttum als Symbole der chin. Kultur kritisch auseinandergesetzt haben (vgl. Wu Hung, 2006), ist die konzeptuelle Verwendung von alten hist. Dok. eine übergeordnete Komponente in C.s Arbeiten. 1990 beginnt er mit seiner bek. Bilderserie *Shi shu xilie*, in die er fragm., an altertümliche Hschn. und Steinabreibungen erinnernde Texte der klassischen chin. Archäol. und Lit. (Lunyu, Zizhi tongjian) integriert, die auf einem monochromen oder farbigen, komplex strukturierten und bemalten semiabstrakten Hintergrund teilw. verzerrt und verdeckt erscheinen. C. reflektiert damit das Schicksal der während versch. politischen Bewegungen des 20. Jh. mehrfach angegriffenen chin. Kultur, deren Vergangenheit, „Neuerfindung und Wiedergeburt" er aufzuarbeiten sucht. 🏛 SHANGHAI, AM. NEW YORK, Chambers FA. ✉ Zoujin yishu dashi shenghuo congshu, 14. Zhu Da, Shanghai 1998; Zonghe huihua. Cailiao he meijie, Shanghai 2005. 👁 *E:* 1987 Nanjing, AFA / 1991 Oxford, Cult. Center / Shanghai: 1997 East China Normal Univ.; 2003, '06 Art Scene Warehouse. – *G:* u.a. Shanghai: AM: 1971 Shanghai Sketch Exhib.; 1984, '94 Nat. Art Exhib.; 1998 Bienn.; 2002 Metaphysi-

cal Abstract Art Exhib.; Duolun MMA: 2004 Reflection. China-Japan-Korea Mod. Art Exhib.; 2005 In the Name of 1985; 2009 New Ink Art / Nanjing: 1974 Jiangsu Prov. Mus.: Nat. China Paint. and Comic Exhib.; 2006 South Vision AM: Exhib. of Chin. Paint. Documentaries / Guangzhou, Guangdong AM: 2001 (20 Years of Experimentation – Contemp. Chin. Ink Paint.; K); 2002 (Reinterpretation. A Decade of Experimental Chin. Art 1990–2000; K) / 2005 Miami, Reed Savage Gall.: Art Scene in China; Chicago, Walsh Gall.: Contemp. Ink Paint. Exhib. / 2006 Tianjin, Hui Tai AC: Expression of Contemp. Chin. Ink Paint. ▭ *M. Sullivan*, Mod. Chin. artists, Berkeley u.a. 2006. – *M. Sullivan*, Art and artists of twentieth-c. China, Berkeley u.a. 1996; Variations of ink. A dialogue with Zhang Yanyuan (K), N. Y. 2002; *Wu Hung*, Shu. Reinventing books in contemp. chin. art (K), N. Y. 2006; C. Shi shu xielie, Shanghai 2007. – *Online:* Website C.; Art Scene Warehouse (Ausst.); Walsh Gall., Chicago.

K. Karlsson

Chen *Xu* (Chen, *Lucas*; Chen Yuandu, *Luke*; Pseud. Meihu), chin. Maler, * März 1902 (1905 bei Laing) Meixian/Prov. Guangdong, † Dez. 1967. Stud. der trad. Lsch.- und Tiermalerei ab 1917 bei Jin Beilou (Jin Cheng, 1878–1926), dem Gründer der Hushe Paint. Society. Später auch Figurenmalerei. Mitgl.: ab 1923 Chin. Paint. Research Soc. (Zhongguo huaxue yanjiuhui); später im Vorstand der New Chin. Paint. Research Soc. (Beijing xin guohua yanjiuhui) und des Chin. Künstler-Verb. (Zhongguo meishujia xiehui). Ab 1923 Doz. an der Nat. Beijing Art School. C. wird vom apostolischen Gesandten in China, Kardinal Celso Costantini, protegiert, der ihn 1929 als talentierten Maler des trad. Tuschestils in einer Ausst. in Beijing entdeckt und ihn zu christlich inspirierter Malerei anregt. Ab 1929 werden C.s Werke in kath. Mag. in Hongkong (Kung Kao Po) sowie in westlichen Zss. (The Field Afar, Life Weekly) veröffentlicht. 1932 tritt C. zum Katholizismus über und wird Mal-und Zeichenlehrer an der Kunst-Fak. der Kath. Univ. (Fu Ren/Furen) in Beijing. In der Folgezeit wird er unter dem Namen Lucas Chen (Luke Chen Yuandu) bekannt. Er ist Mittelpunkt einer Gruppe von kath. Kunststudenten an der Furen-Univ. und and. Künstlern (darunter Lu Hongnian, 1914–1989), die in Beijing und im Westen für einige Jahre Erfolg haben (*Madonna mit Kind*, 1935, Schnitzlackarbeit aus C.s Schule). Über 180 christliche Kunstwerke der Gruppe sind überliefert, die u.a. 1935–38 in Ausst. in Beijing, Budapest, Wien und im Vatikan gezeigt werden. Nach 1949 erhält C. eine Prof. an der Beijing Normal Univ. (Kunst-Fak.) sowie an der Central Acad. of Applied Arts (Keramik) in Beijing. Zahlr. Ausst. in Japan und Europa (in Belgien Gold-Med.). Auch als Zeichner und Dichter tätig. C. soll den Folgen von Mißhandlungen zu Beginn der Kulturrevolution erlegen sein. – Im trad. Stil der chin. Tuschemalerei v.a. Lsch., Figuren, Blumen-und-Vögel sowie Tiere. Nach 1932 setzt C. die Malerei auch als bewußtes didaktisches Mittel ein, um seine Landsleute mit biblischen Inhalten vertraut zu machen. So überträgt er christliche Sujets in die Bildsprache der trad. Tuschemalerei (*Christi Einzug*

in Jerusalem; *Jungfrau Maria mit dem Jesuskind*, 1938), wie er zugleich den Versuch unternimmt, die trad. chin. Malerei den christlichen Europäern durch vertraute Motive nahezubringen. In den 1950er Jahren entstehen zahlr. Bilder mit hist.-legendären Sujets (*Die Räuber vom Liang-Shan-Moor*; *Die Legende der Weißen Schlange*; *Die Reise nach Westen*), die in einem eleganten, detaillierten und eingängigen Stil zugleich die heroisch-nat. Stärke Chinas betonen (Qi Jiguang). Über 500 von C.s Arbeiten werden in Buchausgaben veröffentlicht. ▭ Assisi, Gall. d'arte sacra contemp. della Pro Civitate Christiana. Maria Enzersdorf/NÖ, Missionshaus St. Gabriel, Ethnogr. Mus. ▭ Vo5, 1961 (s.v. Ch'en, Lucas); AKL XVIII, 1998, 402 (s.v. Chen, Lucas). *E. J. Laing*, An index to reprod. of paint. by twentieth-c. Chin. artists, Ann Arbor 1998; *M. Sullivan*, Mod. Chin. artists, Berkeley u.a. 2006. – *F. Bornemann*, Ars sacra Pekinensis. Die chin.-christliche Malerei an der kath. Univ. (Fu Ren) in Peking, Mödling b. Wien 1950; *M. S. Lawton*, Monumenta Serica (St. Augustin) 43:1995, 469–489; *M. Sullivan*, Art and artists of twentieth-c. China, Berkeley u.a. 1996.

A. Papist-Matsuo

Chen *Yanyin*, chin. Bildhauerin, Installations- und Objektkünstlerin, Malerin, Zeichnerin, Hochschullehrerin, * 1958 Shanghai, lebt dort. Stud.: 1983–88 Zhejiang AFA, Hangzhou (Bildhauerei); 2000 Sydney College of Arts. Lehrtätigkeit: 2001 (Design) Nat. Acad. of Art, Shanghai; 2001–04 Shanghai Oil Paint. and Sculpt. Inst., seit 2004 dort stellv. Direktorin. Mitgl.: Chin. Künstler-Verb.; Shanghai Künstler-Verb. (dort im Vorstand). – Seit M. der 1980er Jahre ist C. auf nat. Kunst-Ausst. vertreten (zahlr. Preise für bildhauerische Arbeiten). A. der 1990er Jahre etablierte sie sich in der experimentellen Kunstszene mit abstrakten Holzobjekten in Kastenform (*Xiang zi*/Box series), die – von Innen beleuchtet – zunächst einladend wirken, durch nach außen und innen gerichtete „Dornen" jedoch Abwehr symbolisieren, womit sie zugleich eine der ersten Künstlerinnen war, die das Thema der weiblichen Identität in China aufgriffen. Seither sind die Motive Licht und Dornen eine immer wiederkehrende Komponente ihrer zumeist großformatigen, raumspezifischen multimedialen (Video-)Installationen, wie *Qi dian*/The Starting Point (1996). 1998 entsteht die erste Version ihrer auch internat. zelebrierten poetisch anmutenden Installation *Yi nian zhi jian de chabie* /Discrepancy Between One Idea, bei der welkende Blumen trotz „lebenserhaltender Maßnahmen" (Infusionsflaschen) als Sinnbild für Liebe, Vergänglichkeit und Unberechenbarkeit der Realität stehen. Die vielseitige und originale Künstlerin richtet ihr Augenmerk auf ges. (gelegentlich auch gesch.) Themen. Im Vordergrund steht nach wie vor die Auseinandersetzung mit den Empfindungen von Frauen, gelegentlich mit Bezügen zur eig. Fam.-Gesch., so bei der Skulpt.-Installation *Wo de muqin*/My mother. Auch kleine, bisweilen humorvoll anmutende figürliche Bronzeplastiken: *Kai da hui*/At a Big Meeting, 1998; *Wang zi cheng long*/Parents Repose High Hopes in their Children, 2000; *Huochekou deng huoche jinguo*/Waiting for the Train Passing, 2006. Auch Zeichnerin und Malerin (Öl, Tusche, Aqu. auf Seide und

Papier). ⌑ BREDA, Fundament Found. BEIJING, China AG. BONN, Frauen-Mus. SHANGHAI, Lianyang Archit. AM.; Wu Jiao Chang 800 Art Space. VANCOUVER, Annie Wong Art Found. – Western Front Soc. ◉ E: 1994 Shanghai, Shanghai Oil Paint. and Sculpt. Inst. / 1995 Århus, Frauen-Mus. (mit Jiang Jie) / 1998–99 Vancouver, Contemp. AG / 2000 Sydney, Univ. FA Inst. – G: Beijing: 1986 China AG: Nat. Art Exhib. (Bronze-Med.); First Chin. Youth Exhib. (Kunstpreis); 1995 AG Central AFA: Exhib. of Three Artists / 1996 Brisbane: Asia-Pacific Trienn. of Contemp. Art (K) / 1997 Breda, Chassé Kazerne: Another Long March (K: C. Driessen u.a.); Kassel, Documenta (K) / 1998 Bonn, Frauen-Mus.: Die Hälfte des Himmels (K: C. Werner u.a.) / Shanghai: 2000, '02 AM: Bienn. (K); 2003 Lianyang Archit. AM: Junction (K) / 2008–09 Chengdu, A Thousand Plateaus Art Space: It is I Too. ⌑ M. Sullivan, Mod. Chin. artists, Berkeley u.a. 2006. – J. Chia u.a., Art Asia Pacific 2:1995; K. Smith, Art monthly 186:1995 (Mai) 24 s; Xu Hong, Art Asia Pacific 2:1995 (2) 44–51; Zeng Xiaojun/Ai Weiwei (Ed.), Bai pi shu, Bj. 1995; H. Bull u.a., Shanghai Fax. Let's talk about money, Shanghai 1996; J. Clark u.a., The Rose Crossing. Contemp. art in Australia, Sydney 1999; Liao Wen /Zhang Xiaoling (Ed.), Contemp. Chin. art criticism series. A study on women's art in China, Changchun 1999; Guo Xiaochuan/Han Chao (Ed.), Chin. art today, I, Bj. 2001; J.-A. Birnie-Danzker u.a. (Ed.), Shanghai Modern 1919–1945 (K), Kiel 2005; I. Henmo/Wang Baoju, Post Nora (K), Bj. 2006; R. Vine, New China new art, M. u.a. 2008.

K. Karlsson

Chen Yin (Yongfu; Pseud. Ou'er), chin. Maler, Zeichner, Graphiker, Kalligraph, * Nov. 1921 Xixiang/Prov. Shaanxi. Ab 1938 Teiln. am Bürgerkrieg auf Seiten der Kommunisten (Yan'an). 1939 Stud. an der Lu-Xun Art Acad. in Yan'an. Danach als Lehrer tätig. Übernimmt versch. kulturpolitische Ämter auf Provinzebene. In dieser Zeit reges Kunstschaffen (u.a. Zchngn, Neujahrsbilder) sowie Veröff. zur Kunsterziehung. Zunehmende Bekanntheit und in der Folgezeit zahlr. Ausst. in China sowie im Ausland (1958 Polen, 1963 Afrika). Ausz.: 1951 1. Preis „Kejing aideren", Hebei Art Exposition. Nach 1948 leitende Positionen in der China Federation of Lit. and Art Circles (Nordchina) sowie im Chin. Künstlerverband (Zhongguo meishujia xiehui) und dem chin. Verband der Schreibkünstler (Zhongguo fashujia xiehui); ferner Partei-Sekr. des Kulturamtes von Tianjin; Dekan der Art Acad. von Tianjin. – Gilt in China als bek. Guohua-Maler und fähiger Kalligraph. Fertigt ebenfalls Holzschnitte.

A. Papist-Matsuo

Chen Yongzhen (Ch'en Yung-chen), chin. Maler, Illustrator, * Sept. 1936 Wenzhou/Zhejiang. 1954 (Examen) Central AFA (CAA), Huadong Campus, Hangzhou. Danach als Illustrator und Karikaturist in Beijing tätig (Manhua). Ab 1956 zunehmend Ill. für Kinder (weit über 100 Kinderbücher). Chefredakteur (Kinder- und Jugendbuchverlag Anhui) und Prof. am Zhangjiakou Art Inst., Hebei. Mitgl.: Chin. Künstler-Verb.(Zhongguo meishujia xiehui). – Bek. Buch-Ill.: Dongnaojin yeye , 1963; Xiaoma

guohe, 1973. In europ. Sprache u.a.: Vier dicke Freunde, 1979; The magic boat, Shanghai 1985. ⌑ Zhongguo xiandai, 1988.

A. Papist-Matsuo

Chen Yuxian, chin. Maler, * 14. 10. 1944 Huainan/Prov. Anhui. Autodidakt. In den 1960er Jahren auch Unterricht bei bek. Malern, u.a. Li Keran (1907–1989). Hauptsächlich als Kultur-Red. (später Chef-Red. der Armee-Ztg Jiefang junbao) und freischaffender Künstler tätig (u.a. zahlr. Titelseiten von Zss.; Plakatentwürfe für chin. Opern). Häufige im Künstlerkollektiv tätig. Mitgl.: Chin. Künstler-Verb. (Zhongguo meishujia xiehui). Versch. Ämter, u.a. stellv. Vors. des Komitees für chin. Comic-Kunst (Zhongguo lianhuanhua yishu weiyuanhui). Zahlr. Einzel- und Gruppen-Ausst. und versch. Preise, u.a. auf der All China Art Exhib. 1967 für Old Soldiers (Nat. AM of China) und 1985 für den Comic strip Garlands at the foot of the mountain. Auch in Ausst.-Komitees (Preisvergabe) und seit 1990 als Prof. für Kunst tätig. – Malt im Stil der sog. Neuen Mal. Tuschemalerei (xinguohua), daneben auch in Öl. Vielfältige Sujets, v.a. revolutionäre Themen, Porträtserien; folkloristische Frauen-Darst. von Minderheitenvölkern (Tanz) oder hist.-revolutionäre Ereignisse, die sämtlich als didaktische Abbilder einer Heroisierung des vorbildhaften Einzelnen in der neuen, kommunistischen Ges. verstanden werden können (Autumn Harvest Uprising, Öl, 1973). Auch Lsch. sowie realistische Alltagsszenen (Öl). Präziser, feinteiliger Stil mit kräftiger Tusche und Wasserfarben. Repräsentative Werke sind Long March – Rivers and Mountains (Tusche, leichte Farben, 1996) und Yan'an Rectification Report (Öl, 1972; alle Militär-Mus.). ⌑ BEIJING, Militär-Mus. der chin. Volksrevolution. – Nat. AM of China. ◉ E: 2010 Beijing, Nat. AM of China. ⌑ Zhongguo xiandai, 1988.

A. Papist-Matsuo

Chen Zaiyan, chin. Schrift- und Installationskünstler, * 20. 10. 1971 Yangchun/Prov. Guangdong, lebt in Yangjiang. Stud.: China Acad. of Art, Hangzhou (Schriftkunst; Abschluß 1994). Seit 2002 zus. mit Sha Yeya (bis 2005), Sun Qinglin und Zheng Guogu Mitgl. der Yangjiang Group (bis 2005 Yangjiang Calligraphy Group), einer internat. renommierten und in der zeitgen. aktiven Künstlergemeinschaft, deren Hauptanliegen es ist, die klass. Schriftkunst mit der zeitgen. Kunstpraxis zu verbinden, um auf spielerisch-subversive Weise neue Formen auszuloten. Dabei werden mon., z.T. in betrunkenem Zustand geschriebene „Kalligraphien", die zumeist belanglose Texte aus Ztgn, der Werbung oder der Populärkultur zitieren, mit and. Medien (Performance, Video, Fotogr., Malerei, Installation) verbunden. Für die bek. Performance Waterfall (2003; seither mehrere Versionen) wurden Hunderte von Laien eingeladen, um unzählige „Schriftkunstwerke" anzufertigen. Diese wurden anschließend feierlich in Wachs getaucht und zu einem tropfkerzenartigen, in seiner Bewegung erstarrten trad. Lsch.-Motiv (Wasserfall) umgestaltet und unsichtbar gemacht. Die Installation Are You Going to Enjoy Calligraphy or Measure Blood Pressure (Pflanzen, Gartenfelsen, Skizzen, unleserliche [u.a. mit Blut geschriebene] Texte, Massagegerät u.a,. 2002) ist die ironi-

sche Interpretation eines trad. konzipierten chin. Gartens. Ähnlich angelegt ist auch *Interior Courtyard – The First Line of Couplet* (2007 Graz, mehrere Versionen). Jüngere Werke erweitern das Themenspektrum, wie die von Sportwetten angeregte Installation *Horse, Goat, Monkey, Rooster, Dog, Pig* (Kalligraphie, Malerei, Baum, Video, Performance; Art Basel 2008). Für die Eröffnung der Ausst. *The Real Thing* in der Tate Liverpool (2007) präsentierte die Yangjiang Group das Feuerwerkspektakel *If I Knew the Danger Ahead, I'd Stayed Well Clear*. Innerhalb der Gruppe beschäftigt sich C., der eine akad. Ausb. in trad. Schriftkunst absolviert hat, in seinen eig. experimentellen Arbeiten weiterhin mit der Frage nach Form, Inhalt, Stellenwert und Fortbestehen dieser ehem. elitären Kunstform im mod. China. In *Three Famous Xingshu Documents* (Tusche/Papier, 2004: Slg Sigg) kopiert C. berühmte kalligraphische Vorlagen alter Meister und brennt anschl. alle Tuschespuren der Schriftzeichen mit Feuer aus. C.s grenzüberschreitender Umgang mit der trad. chin. Schriftkunst läßt ihn in das Umfeld der Vertreter der zeitgen. Kalligraphie (xiandai shufa) einordnen. ⌖ GUANGZHOU, Vitamin Creative Space. MAUENSEE, Slg Sigg. ◉ *E:* 2002 Shanghai, ShanghAG / 2010 Beijing, Tang Contemp. AC. – *G:* 2003 Venedig: Bienn. / Bern, KM: 2005 Mahjong. Chin. Gegenwartskunst aus der Slg Sigg (internat. Wander-Ausst.) / K: B. Fibicher u.a.) / 2007 Liverpool, Tate Liverpool: The Real Thing. Contemp. Art from China (K: S. Groom u.a.); Kassel: documenta / 2008 London, Saatchi Gall.: The Revolution Continues (K) / 2009 Shenzhen und Hongkong: Bi-city Bienn. of Urbanism / 2010 Beijing, Iberia Center for Contemp. Art: Glass Factory. Chin. Art Under the New Financial Order (K). ⌻ *P. Pakesch* (Ed.), China welcomes you. Sehnsüchte, Kämpfe, neue Identitäten (K Graz), Köln 2007; *R. Peckham*, Yishu. J. of Contemp. Chin. Art 10:2011 (1) 32–51; *E. Wear*, ArtAsiaPacific 58:2008 (May/June) 114–121. – *Online:* Vitamin creative space, Guangzhou. K. Karlsson

Chen *Zhen*, chin. Maler, Bildhauer, Objekt- und Installationskünstler, * 4. 10. 1955 Shanghai, † 13. 12. 2000 Paris. Stud.: 1973–76 Shanghai FA and Crafts School; 1978–82 Shanghai Drama Inst. (u.a. Bühnenbildnerei; hier 1982–86 Lehrauftrag); 1986–89 ENSBA, Paris. Lehrtätigkeit: 1991 ENSBA ebd.; 1993–95 Inst. des Hautes Et. en Arts Plast. ebd.; 1995–99 EcBA, Nancy. Stip./Ausz.: u.a. 1990, '95 The Pollock-Krasner Found., New York; 1991 Stiftung Erwin und Gisela von Steiner, München; 1992, '93, '96, '98 Fonds d'incitation à la création, Kultur-Minist., Paris; 1996, '97 Penny McCall Found., New York; 1998 Annie Wong Art Found., Hongkong. Artist in Residence: 1991 Villa Waldberta, Feldafing; 1997 Centre for Visual Arts, Jerusalem. – Neben Huang Yongping, Cai Guoqiang und Gu Wenda zählt C. zu jenen herausragenden Künstlern der frühen chin. Avantgarde, die in den 1980er Jahren, desillusioniert von der nachmaoistischen Reformpolitik, China verlassen haben. Nach der Übersiedlung nach Paris wandte sich C. ab 1986 skulpturalen und installativen Arbeiten aus versch. Mat. (Mixedmedia, auch Glas) zu, die mit ihren ethisch- sozialen,

interkulturellen und ges.-kritischen Inhalten (Globalisierung, chin. Hochgeschwindigkeitsurbanisierung) sein internat. Renommee als Pionier des „Hybriden" und der kult. Vielfalt der Kunst festigten. In großen, interaktiven Soundinstallationen kombinierte C. häufig unterschiedliche, aus versch. Kulturen und Epochen entliehene Objekte (z.B. Alltagsgegenstände und sakrale Geräte) und Symboliken zu eindrücklichen Materialallianzen, die neue Verbindungswege zw. fernöstlichen Trad. und westlichen Avantgardebewegungen knüpften. C. benutzte oftmals den menschlichen Körper, Krankheit (seine eig., an der er seit seinem 25. Lebensjahr litt und an der er frühzeitig verstarb), relig. Rituale und Heilpraktiken als Metaphern, um die komplexen und bisweilen paradoxen Verbindungen zw. dem Materiellen und Spirituellen, dem Gemeinschaftlichen und Individuellen, dem Inneren und Äußeren sowie die Verortung der eig. ethnischen Identität im Widerstreit kult. Unterschiede auszuloten. ⌖ ALBI, Centre d'Art le Lait. ATHEN, Deste Found. for Contemp. Art. BEIJING, Guy & Myriam Ullens Found. BRISBANE, Queensland AG. GRENOBLE, Centre Nat. d'Art Contemp. HONGKONG, Annie Wong Art Found. LEIDEN, Mus. Boerhaave. MONTPELLIER, Stadtverwaltung. NANCY, Éc. Nat. Supérieure de Géologie. NEW YORK, Penny McCall Found. OTTERLO, Kröller-Müller Mus. PARIS, MNAM. PISA, Fond. Teseco per l'Arte. PUTEAUX, FNAC. SAINT-DENIS/Reunion, Mus. Léon Dierx. TEL AVIV, AM. TURIN, GAM. VERONA, Gall. d'Arte Mod. Palazzo Forti. ZAGREB, MCA. ◉ *E:* 1986 Shanghai, Drama Inst. / 1989 Verdun, Hôtel des Sociétés / Paris: 1991 ENSBA (K); 1998 Gal. Ghislaine Hussenot (K); 2001 MAMVP; 2003 Pal. de Tokyo / 1991 Rom, Gall. Valentina Moncada (K) / 1992 Grenoble, Magasin (K); Saint-Rémy-de-Provence, Centre d'Art Contemp. (K) / 1993 Utrecht, Centraal Mus.; München, Gal. D. Keller / New York: 1994 MCA (K); 1996 Deitch Projects; 2003 P. S. 1 Contemp. AC (K) / 1996 Montreal, Centre internat. d'Art Contemp. (K) / 1997 Kitakyushu, Center for Contemp. Art / 1998 Tel Aviv, AM / 1999 Périgueux, ADDC – Espace cult. François Mitterrand (K) / 2000 Turin, GAM (K); Zagreb, MCA (K) / 2001 London, Serpentine Gall. (K) / 2002 Athen, NM of Contemp. Art; Boston, Inst. of Contemp. Art; Milano, Padiglione d'Arte Contemp.; Münster, LWL-LM (K) / 2004 San Gimignano, Gall. Continua; Den Haag, Gemeente-Mus.; Rom, Acad. de France / 2005 Beijing, Gal. Continua (K) / 2006 Shanghai, AM (K) / 2007 Wien, KH (Retr.; K). – *G:* u.a. Paris: 1987, '88 Grand Pal.: Salon des Réalités Nouvelles; 2000 MAMVP: Paris pour escale / New York: 1991 Asian Amer. AC: East Wind; 1997 P. S. 1 Contemp. AC: Artist Projects; 2006 ebd.: Into Me – Out Of Me / 1993 Frankfurt am Main, Schirn: Prospect 1993; Oxford, MMA: The Silent Energy; Termoli, Mus. Internat. d'Arte Contemp.: Thalatta, Thalatta / Venedig: 1993, '95, '99, 2001, '07, '09 Bienn.; 2009 Ist. Veneto die Sc., Lettere ed Arti: Glass Stress / 1996 Saitama, MMA: Origin and Myths of Fire: Shanghai, AM: Bienn. / 1997 Wien, Wiener Secession: Cities on the Move (Wander-Ausst.); Johannesburg: Bienn.; Kwangju: Bienn. (Ausz.) / 1998 Taipei, MFA: Bienn.;

Montréal, Centre Internat. d'Art Contemp.: Passage(s) / 1999 Köln, Mus. Ludwig: Kunstwelten in Dialog / 2000 Salvador da Bahia, MMA: The Quiet in the Land / 2001, '03 Valencia: Bienn. / 2002 Saint-Denis, MAH: Prière(s) / 2004 Barcelona, Fond. Mirò: The Beauty of Failure – The Failure of Beauty / 2005 Florenz, Pal. Strozzi: Donne Donne; Karlsruhe, ZKM: Lichtkunst aus Kunstlicht / 2007 San Gimignano, Gall. Continua: Jardin mémorable / 2007–08 Beijing, Ucca: Guy & Myriam Ullens Found. Coll. ⌑ *Delarge*, 2001; *M. Sullivan*, Mod. Chin. artists, Berkeley u.a. 2006; *U. Grosenick/C. H. Schübbe* (Ed.), China art book, Köln 2007. – *Gao Minglu*, Zhongguo dangdai meishu shi, 1985–1986, Shanghai 1991; Gebrochene Bilder – Junge Kunst aus China, Unkel am Rhein/ Bad Honnef 1991; *S. Cincinelli*, Flash Art 168:1992 (Juni/ Juli) 124; *W. Pöhlmann* (Ed.), China Avantgarde (K Berlin), He. 1993; *Hou Hanru*, NBK 5:1995 (1) 58–61; *Zeng Xiaojun/Ai Weiwei* (Ed.), Hui pi shu, Bj. 1997; *A. Yang*, Why Asia? Contemp. Asian and Asian Amer. art, N. Y. u.a. 1998; *C./M. A. Mendo*, Perchè io nascessi, T. 2000; *Hou Hanru/H.-U. Obrist*, Art Asia Pacific 25:2000, 73 s; *S. Cincinelli*, Flash Art 226:2001 (Febr./März) 131; *H.-U. Obrist*, Eutropia 2001 (Jan.) 101–108; *J.-M. Decrop/ C. Buci-Glucksmann*, Modernités chin., Mi. 2003; *D. Rosenberg*, Art game book. Hist. des arts du XX s., P. 2003; *id./Xu Min* (Ed.), C. Invocation of washing fire, Siena 2003; *J. Sans*, C. Les entretiens (K), Dijon 2003; Alles onder de hemel (K Antwerpen), P. 2004; *J. Frèches* (Ed.), Créateurs du nouveau monde. Artistes chin. d'aujourd'hui (K Bienn. Montpellier-Chine: MC1), Gallargues-Le Montueux 2005; *P. Tinari/M. Ciampi*, Artists in China inside the contemp. studio, Lo. 2007; *G. Matt* (Ed.), C. The body as landscape (K Wien/Rovereto), Nü. 2007. – *Online:* Website C. (Biogr., Lit., Ausst.). K. Karlsson

Chen *Zhenhui* (Dingsheng), chin. Maler, Kalligraph, Dichter, Prosaist, Beamter, * 27. 1. 1605 Yixing/Prov. Jiangsu, † 11. 6. 1656. Nachkomme von Cheng Fuliang; Sohn von Chen Yuting. Mitgl. einer bek. Gelehrten-Fam., die den Wohnsitz von Yongjia/Prov. Zhejiang nach Yixing/ Prov. Jiangsu verlegt hatte. Der Vater Chen Yuting war Mitgl. der Tonglin-Akad. (Tonglin shuyuan), als Zensor eloquenter Gegner der Korruption in der Mandschu-Reg. und mußte 1632 nach Agitation gegen den mächtigen Hofeunuchen Wei Zhongxian alle Ämter niederlegen. C. studierte in seiner Jugend zus. mit dem Freund Wu Yingji in Bocun b. Yixing/Prov. Jiangsu und absolviert 1621 das Dingsheng-Examen. Trotz Scheiterns bei der Prov.-Prüfung erlangte C. als Mitgl. der Restaurationsgesellschaft (Fushehui) politischen Einfluß. Zus. mit Fang Yizhi, Mao Xiang und Hou Fangyu gehörte C. zu den „Vier Herrensöhnen" (si gongzi). Er unterstützte die Veröff. des polit., gegen die Intrigen Ruan Dachengs gerichteten Manifests Liudu fangluan gongjie (Öff. Erklärung zur Unterbindung von Unruhen in der ehem. Hauptstadt, 1638), das Ruans Kollaboration mit Hofkreisen anprangerte. Die zunächst Erfolg versprechende Aktion wendete sich bei der Thronbesteigung des Hongguang-Kaisers (Zhu Yousong, auch Prinz Fu, Reg.-Zeit 1607–45) als erster Herrscher

der Südlichen Ming-Dynastie (Reg.-Zeit 1645–46) gegen die Mitgl. der Restaurationsgesellschaft. C. wurde im Okt. 1644 inhaftiert, jedoch durch Intervention des hochrangigen Beamten im Kriegs-Minist. Lian Guoshis wieder auf freien Fuß gesetzt. Nach dem Vorfall zog sich C. ins Priv.-Leben nach Bocun zurück, wo er vorwiegend mit Lit. und Kunst beschäftigt war. Zu C. bed. lit. Werken gehören das anekdotische Huang-Ming yulin (Wald der Reden aus der Leuchtenden Ming-Dynastie), Xuecen ji (Slg des Xuecen) sowie Shanyang lu (Aufz. aus Shanyang), Qiuyuan zabei (Kostbarkeiten aus dem Herbstgarten) und Shushi qize (Sieben hist. Episoden), welche in Zhaodai congshu (Zhaodai-Slg) nachgedruckt wurden. Von C.s malerischem Werk ist wenig erhalten. Ein in der Lit. erw. Bl. mit Kiefer, Bambus und dürrem Baum steht in die Trad. der Literatenmalerei. In diesem Geist ist auch die Hängerolle *Qiushan fangyou tu* (In den Herbstbergen einen Freund besuchen, Tusche, leichte Farbe/ Goldsprenkelpapier, sign., Aufschrift und Siegel von C.; Guardian, Beijing, Aukt., 23. 11. 2009, Los 1598) gemalt, welche die Reise einer Figur auf einem Esel mit Diener in einer Hochgebirgs-Lsch. darstellt, die in das abgelegene Domizil des einsiedelnden Freundes führt und z.B. auch bei Dong Qichang und Cha Shibao thematisiert wird. Die Darst. einer Tuschepäonie (Hängerolle, sign., Aufschrift und Siegel von C.; Hanhai, Beijing, Aukt., 18. 12. 1997, Los 637) mit flüchtig hingeworfener Konzeptschrift (caoshu) zeigt einen spröden Charme. Ein Fächer-Bl. mit Aufschrift in flüssiger Kursiv-Konzeptschrift (xingcao, Tusche/Papier, sign., Siegel von C.; Dingxing tianhe, Beijing, Aukt., 15. 1. 2011, Los 523) ist konzentriert gearbeitet und betont den dekorativen Effekt. ⌑ *Seymour*, 1988 (s.v. Ch'en Chen-hui); *Bénézit* III, 2006. – Zhongguo minghua, XXII, Shanghai 1908; *J. C. Yang/T. Numata*, in: *A. W. Hummel* (Ed.), Eminent Chin. of the Ch'ing period, I, Wa. 1943, 82 s.; *O. Sirén*, Chin. paint., VII, Lo./N. Y. 1973; *Xie Guozhen*, Ming-Qing zhiji dangshe yundong kao, Bj. 1982 (Repr.).

U. Middendorf

Chen *Zhinong*, chin. Maler, Zeichner, Illustrator, Scherenschnittkünstler, Publizist, * Okt. 1912 Beijing, † 6. 4. 2007 ebd. C.s Vorfahren sind ehemals wohlhabende Mongolen (Xinjiang) im Beijing der ausgehenden Qing-Dynastie. Aufgrund der verarmten Fam.-Verhältnisse verdient C. bereits als Jugendlicher seinen Lebensunterhalt mit Werbeentwürfen u.a. für Banken. Daneben Beschäftigung mit Zeichnen (Silhouetten) und Kunstgeschichte. Stud.: 1929 Lsch.-Malerei an der Beijing Chin. Paint. Research Association. Ab 1930 Hinwendung zum volkstümlichen Scherenschnitt (jianzhi) und eig. Werke in dieser Tradition. Bereits in den 1930er Jahren Ausst.-Beteiligungen in London und Ōsaka, ab 1946 regelmäßig Ausst. in China und im Ausland. 1933 für das Beijing Geological Bureau tätig, wo er natur-wiss. Rekonstr.-Zchngn vom Schädel des Peking-Menschen anfertigt. Daneben legt er eine Slg von han-zeitlichen Kunstwerken an, die er teilw. kopiert (beides heute Bestandteil des Nachlasses). 1949 als Zeichner an versch. akad. Kunst-Inst. beschäftigt (u.a. Art Research Inst. of the Chin. Acad. of Art).

Mehr als 2000 Zchngn von han-zeitlichen Steinabreibungen für das Chin. Inst. of Sorbonne in Beijing (1950er Jahre). Während der Kulturrevolution Repressalien ausgesetzt, u.a. wurde seine Kunst-Slg konfisziert. Mitgl.: Chin. Künstler-Verb. (Zhongguo meishujia xiehui); beratendes Mitgl. in der Akad. für Scherenschnitt-Volkskunst (Zhongguo minjian jianzhi xuehui). Mehrere Veröff. (u.a. zum Scherenschnitt und zu den Sitten und Gebräuchen im alten Beijing). – C. ist bek. als Maler im trad. Tuschestil (guohua) sowie für seine zeichnerischen Skizzen aus dem alten Beijing und des Alltagslebens vor der Revolution. V.a. gilt er als Pionier des mod. chin. Scherenschnitts, bei denen u.a. die präzise Ausarbeitung und strenge Konturierung char. sind; Vorbilder sind hier u.a. hanzeitliche Steinreliefs und -abreibungen. ▣ BEIJING, Capital Mus.: Nachlaß. ◉ E: 1946 Shanghai (Debüt) / 1984, '90 Beijing. – G: 2007 Wenzhou: China Arts Festival. Chin. Paper-cutting Art Exposition. ▢ Zhongguo xiandai, 1988. – *Meishu guansha* 2007 (7).

A. Papist-Matsuo

Chen *Zifen* (eigtl. Chen *Qi*; Pseud.: Wumei, Shuisou, Zhufeng), chin. Maler, Siegelschneider, * 11. 5. 1898 Changle/Fujian, † 20. 2. 1976 Fuzhou (?). Autodidakt. Lernt in jungen Jahren die Siegelschnitzerei und studiert die klass. chin. Malerei. Neben den Hschn. des Chen Hongshou (1598–1652), die er kopiert, wird C. von Malerei und Schreibkunst des Ren Bonian (1840–1896) beeinflußt. Lehrtätigkeit: Ab dem 16. Lebensjahr als Kunstlehrer in Fuzhou tätig; später dort Prof. (Fujian Art Inst.). Lebenslange Freundschaft mit dem bed. Maler Xu Beihong, den er 1928 in Fuzhou kennenlernt. Dieser läßt fortan die meisten seiner Siegel von C. schnitzen; auch rät er ihm, sich auf Malerei mit feinen Umrißlinien zu konzentrieren. Seit den 1930er Jahren Ausst.-Beteiligungen u.a. in Paris, Moskau, Leningrad; nach 1949 in ganz China. Zahlr. Funktionen in kulturpolitischen und akad. Institutionen (u.a. Vors. der Sektion Fujian im Chin. Künstler-Verb.; Vors. der Chin. Paint. Research Soc. in Fuzhou; Mitgl. Research Center of Lit. and Hist. Fujian). Setzte sich zeitlebens für die Bewahrung der trad. chin. Malerei ein. – C. ist ein in China und Taiwan gleichermaßen bek. Siegelschnitzer und Maler des trad. Tuschestils (guohua), bes. für (Blumen-)Bilder in ausschl. feinen Umrißlinien (baimiao). Auch Vögel, Insekten, Lsch. und Figuren. Repräsentative Werke sind das *Album mit Blumen in Baimiao-Technik*, die Bildserie *Hundert Blumen*, *Junger Bambus mit roten Krabben* und *Zehntausend Jahre langes Leben* (fünfteiliger Stellschirm, 1956; Beijing, Volkskongreßhalle). Die kräftige oder sanft gezogene Linie hat bei C. immer Vorrang vor der Farbe. Ebenfalls char. ist der gleichzeitige Gebrauch von kräftiger und leichter Tusche (*Narzissen*, Tusche/Papier, NAMOC). ▣ BEIJING, Nat. AM of China (NAMOC); Volkskongreßhalle; Halle der Prov. Fujian. VICTORIA/B. C., AG of Greater Victoria. ✉ C. baimiao tufu, Shanghai Renming Meishu Chubanshe, Shanghai 1959; C. bai miao hua hui ce (di 1 ban.), Shanghai Renming Meishu Chubanshe, Shanghai 1979; C. Rong bao zhai hua pu. 89, Hua niao bu fen (2 ban),

Rongbao zhai, Beijing 1996. ◉ G: 1929 Shanghai: All-China-Art-Exhib. ▢ E. J. *Laing*, An index to reprod. of paint. by twentieth-c. Chin. artists, Eugene, Ore. 1984; Zhongguo xiandai, 1988; M. *Sullivan*, Mod. Chin. artists, Berkeley u.a. 2006. A. Papist-Matsuo

Chen *Zuhuang* (Ch'en, *Tsu-huang*), chin. Graphiker, Holzschneider, * Aug. 1942 Linan (Changhua)/Prov. Zhejiang. Stammt aus einer alteingesessenen adeligen Gelehrten-Fam. bei Hangzhou. Seit frühester Kindheit Interesse für Kunst. Seit 1965 freischaffender Künstler. Jeweils für kurze Zeit Unterricht in versch. künstlerischen Techniken (u.a. Holzdruck bei Lu Meng, Comiczeichnen bei Zhao Hongben, Ölmalerei bei Yu Yunjie, Aqu. bei Jui Guoliang). 1980 Examen an der China Central AFA Beijing (Druckgraphik). Beteiligung an zahlr. in- und ausländischen Kunstausstellungen. Ausz.: 1979 1. Preis (Sektion Fujian), 3. Preis (Gesamtchina) auf Ausst. zum 30. Jahrestag der Volksrepublik China. Mitgl.: Chin. Künstler-Verb. (Zhongguo meishujia xiehui); Gründungs-Mitgl. des Verb. der Holzdruckkünstler (Zhongguo banhuajia xiehui); Künstler-Verb. der Sektion Jiangxi (Vors.). – In China bek. Graphiker. Repräsentatives Werk ist *Spring Tide* (Hschn., 1979). Expressive monochrome Hschn. mit surrealen Bildelementen. Starke Hell-Dunkel-Kontraste, die der Erhöhung des Spannungsbogens einer teilw. phantastisch-grotesken Bildsprache dienen und z.T. an die Dynamik von Comic-Zchngn erinnern. In Lsch. erfolgt die Positionierung des Menschen häufig in einer unbändigen, nicht selten feindlich erscheinenden Natur, deren wilde Kraft nur im Kollektiv gebändigt werden kann. ▣ HONGKONG, Mus. of Art. KAMAKURA & HAMYAMA, MMA. ▢ Zhongguo xiandai, 1988. – H. *Li*, Chin. woodcuts, China books and periodicals, S. F. 1995.

A. Papist-Matsuo

Chen Yuandu, *Luke* → **Chen**, *Xu* (1905)

Chenet, *Burton*, US-amer.-haitianischer Maler, * 22. 1. 1958 Suffern/N. Y., † 20. 3. 2012 Port-au-Prince, lebte dort und in Miami/Fla. Stud.: 1978 Le Centre d'Art, Port-au-Prince; bis 1980 Thiel College, Greenville/Pa.; bis 1984 School of Visual Arts, New York. Doz. an der Ec. nat. des Arts, Port-au-Prince. – Expressive Öl- und Acryl-Gem., die sich in Themen, Motiven, Technik und Farbgebung an die trad. naive haitianische Malerei anlehnen und von mod. Kunstgattungen wie Streetart und Graffiti beeinflußt sind, z.B. *Defacto President* (Öl/Lw., 2009). Inspiriert von der haitianischen Natur und Folklore, u.a. arabeskenhafte Darst. von Blumen und teils mit Vögeln besetzten Bäumen, z.B. *Les Perroquets Bleus sur l'Arbre* (Öl/Lw., 2006), sowie grotesk-phantastische Wesen, z.B. *Dragon Apocalyptique* (Öl/Lw., 1994). Daneben abstrakte und abstrahierte Gem., teilw. mit Anklängen an impressionistische Bildsprache, z.B. *Bougainvilleas* (Acryl/Lw., 2007). ▣ PORT-AU-PRINCE, Mus. d'Art Haïtien du Collège de Saint Pierre. – Mus. du Panthéon Nat. Haïtien. ◉ E: Port-au-Prince: 1985, 2000, '01 Le Centre d'Art; 1991 Mus. du Panthéon Nat. Haïtien / 1991 Los Angeles (Calif.), Gall. Malraux / 1994 New Canaan (Conn.), Gall. Pa Nou; Coral Gables (Fla.), ArtSpace Virginia Miller Gall. –

G: Port-au-Prince: 1988 (Support papier), '90 (Abstractions) Mus. du Panthéon Nat. Haïtien; 1992 (Symbolism of the Cross), '97 (Renouvellement-Continuité), '98 (Droit de l'Homme, Utopie, Défi, Réalités) Mus. d'Art Haïtien du Collège Saint Pierre / Los Angeles: 1990 Gall. Malraux: Mod. Haitian Masters (K); 2008 Mun. AG: Tropics, A Contemp. View of Haiti, Cuba and Brazil / 1992 Austin (Tex.), Mexic-Arte Mus.: Myths Redefined / 1995 Miami, South Florida AC: Contemp. Expressions of Haitian Art / 1998 Punkaharju, Retretti AC: Haitian Art and Voodoo (K) / 2006 Dallas (Tex.), Cerulean Gall.: Stories Told. ⌷ *Delarge*, 2001. – B. C. Un monde à Partager, Port-au-Prince 2000; *G. Alexis*, Peintres haïtiens, P. 2000. – *Online:* Website C. J. Niegel

Cheney, *Edward* cf. **Cheney,** *Robert Henry*

Cheney, *Harriet Carr* cf. **Cheney,** *Robert Henry*

Cheney, *Robert Henry (Henry)*, brit. Amateurfotograf, Aquarellist, Zeichner, Landschaftsgärtner, get. März 1800 Badger Hall, Shifnal (heute Badger)/Shrops.(?), † 30. 12. 1866 ebd. Onkel von Alfred Capel Cure, Sohn der Aquarellistin *Harriet Carr C.* (* 1770/1771, † 5. 8. 1848), Bruder des Kunstsammlers und Zeichners *Edward C.* (* 1803, † 16. 4. 1884 Badger Hall). C. entstammt einer wohlhabenden Fam. mit Ländereien in Shropshire und Derbyshire. Lt. Gamble (2008) studiert er 1820 am Oriel College in Oxford, als er von seinem Vater, Lieutenant-General Robert C., den Fam.-Sitz Badger Hall erbt. 1823 besuchen C. und Edward C. mit Harriet Carr C. Neapel und folgen ihr zwei Jahre später nach Rom. Auf vielen weiteren Reisen, vornehmlich in Italien, entstehen Zchngn und Aqu. (cf. Aukt.-Kat., 2005). Um 1830 Rückkehr nach Badger Hall, wo C. sich u.a. der Lsch.-Gärtnerei widmet. Eine erste Auseinandersetzung mit der Fotogr. ist für 1845 belegt, als C. William Henry Fox Talbots Sun Pictures in Scotland subskribiert und zugleich um den ersten Faszikel von The Pencil of Nature nachsucht (cf. Taylor, 2007, 98). Erste eig. Fotogr. entstehen ab etwa 1850. – C.s fotogr. Werk besteht mehrheitlich aus Ansichten von Landhäusern, es finden sich aber auch Seestücke (darunter eine Ansicht der Küste vor Torquay) und Aufnahmen vom Bau des Brit. Museum. C. lernt das fotogr. Handwerk vermutlich gemeinsam mit seinem Neffen A. C. Cure, mit dem er vielfach zusammenarbeitet; so enthalten die meisten erh. Alben Albuminabzüge Cures von E. der 1850er Jahre nach Papiernegativen von C., wobei die Zuschr. einzelner Aufnahmen oft unklar ist (cf. Taylor, 2007). Anders als die meisten Amateurfotografen der Zeit gehören die beiden keiner fotogr. Ges. an, stellen ihre Arbeiten nicht aus und veröffentlichen keinerlei Beitr. in fotogr. Zeitschriften. ⌷ ALBUQUERQUE/N. Mex., Univ. AM. BOSTON, MFA. CHICAGO, Art Inst. CLEVELAND/Ohio, Mus. of Art. MONTREAL, Canad. Centre for Archit. STANFORD/Calif., Cantor Arts Center, Stanford Univ. ◉ *G:* 1982 Köln, Gal. Lempertz: Photogr. and Archit. 1839–1939 (Wander-Ausst.; K) / 1999 Cambridge (Mass.), Houghton Libr., Harvard Univ.: Salts of Silver, Toned with Gold. The Harrison D. Horblit Coll. of Early Photogr. (K). ⌷ Oxford DNB, 2004 (zu Edward C.). – Gentleman's mag. (Lo.),

Feb. 1867, 258 (Nachruf; * 1799); *A. H. Eskind* (Ed.), Index to Amer. photogr. coll., N. Y. ³1996; Watercolours of the Grand Tour from a Priv. Coll., Aukt.-Kat., Christie's, London, v. 12. 10. 2005; *R. Taylor*, Impressed by light. Brit. photogr. from paper negatives, 1840–1860 (K Wander-Ausst.), N. Y. u.a. 2007; *C. J. Gamble*, John Ruskin, Henry James and the Shropshire lads, Lo. 2008. – Morpeth, Northumberland County Council, Northumberland Arch.: Carr-Ellison Fam. of Hedgeley, Northumberland / Shrewsbury, Shropshire Arch.: Cheney Fam.
P. Freytag

Cheng, *Lin* → **Cheng,** *Yanqiu*

Cheng Qinwang (eigtl. Aisin-Gioro *Yong Xing* ; Aixin-Jueluo *Yongxing*; Yongxing; Jingquan; Shao'an; Yijinzhai zhuren), chin. Kalligraph, Maler, Sammler, * 22. 3. 1752 Beijing, † 7. 5. 1823 ebd. 11. Sohn des Qianlong-Kaisers; jüngerer Bruder von Zhi Qinwang und Yi Qinwang; älterer Bruder des Jiaqing-Kaisers. Prinz C. zeigte bereits als Kind große Begabung für Kalligraphie, was den Qianlong-Kaiser (Reg.-Zeit 1735–96) beeindruckte und 1804 lobend in einer Inschr. des Jiaqing-Kaisers erwähnt wird. Nach trad. Ausb. durch Hoflehrer wurde C. 1779 zum Generaldirektor (Zongcai) der Kompilation des Siku quanshu (Gesammelte Werke der Vier Lit.-Abt.) unter editorischer Ltg von Ji Yun berufen. C. begleitete den Qianlong-Kaiser auf mehreren der sechs Inspektionsreisen in den Süden (nanxun), die von Hofmalern dok. wurden. 1789 wurde C. der Prinzentitel ersten Grades „Qinwang" und der Name „Cheng" verliehen. 1795 übernahm er die Aufsicht über ein Mandschu-Banner. Nach Thronbesteigung des Jiaqing-Kaisers fungierte C. ab 1799 als Beratender Grandee (Yilang) und übernahm leitende Ämter im Staatsrat, daneben Vorsteher der Drei Abt. im Finanz-Minist. (Hubu Sanku). C. löste damit den Qianlong-Günstling und mächtigen Minister Heshen ab, der wegen Korruption inhaftiert worden war. Ein Teil dessen konfiszierten Eigentums nahe dem Beijinger Sommer-Pal. (Yuanmingyuan) ging in den Bes. C.s über. Nach nur wenigen Monaten in Ämtern, von denen kaiserliche Prinzen juristisch ausgeschlossen waren, und Verwicklung in den Fall des Hong Liangji, der Kritik an der Reg. geübt hatte, zog sich C. aus der Politik zurück, um fortan Kunst und Dichtung zu pflegen. Posthum erhielt C. den Ehrenname Zhe („Der Kenntnisreiche"). Sein lit. Œuvre findet sich in Yijinzhai ji (Slg des Yijinzhai) und dem Suppl. Yijinzhai suibi (Prosa des Yijinzhai). Das umfangreiche kalligraphische Werk mit Arbeiten in Normal- (kaishu), Kursiv- (xingshu) und Konzeptschrift (caoshu) verknüpft der Kritiker Yang Han mit der qingzeitlichen Musterschriften-Schule (tiexue). Der Meister sei geschult an den Kalligraphien in Pal.-Bes. und Stücken der Priv.-Slg, habe jedoch weder Bronze- noch Stelen-Inschr. studiert. Dies trifft in dieser Ausschließlichkeit nicht zu, was eine Kopie der in Bafen (Variante der Kanzleischrift [lishu]) kalligraphierten *Cao Quan bei* (Grabstele für Cao Quan, Album mit 13 Bll., Tusche/Papier, sign., Aufschrift und Siegel von C., 1793; Daoming, Shanghai, Aukt., 22. 12. 2007, Los 495) und ein Studien-Bl. mit Siegelschrift (zhuanshu, Tusche/Papier, sign., Siegel von

C.; Hongsheng, Shanghai, Aukt., 18. 6. 2010, Los 298) belegen. Lt. C.s eig. Angaben leitet sich die Ausdruckskraft (shi) und „nüchterne Strenge" (duanzhuang), „Balance und Geradheit" (pingzhi) der „konzentriert" (suo) und „verhalten" (shou) wirkenden Kleinen Normalschrift (xiaokai) des von ihm kopierten *Jiuchenggong Liquan ming* (Inschr. für den Quell des Süßen Mosts am Pal. der Neun Vervollkommnungen, Tusche/Papier, sign., Siegel von C., Sammlersiegel; Taipei, Nat. Pal. Mus.) nach Ouyang Xun (* 557, † 641) von einer Adaption Ke Jiusis (* 1290, † 1343) via Zhao Mengfu (* 1254, † 1322) ab. C. griff bei Anfertigung seiner Kopie allerdings nicht direkt auf Ke Jiusis Orig. in der Pal.-Slg zurück, sondern benutzte eine Kopie des Qianlong-Kaisers von einer Version in kleinen Zeichen, bei der „Form" (xing) und „innere Ordnungsprinzipien" (li) perfekt harmonierten. C.s präzise Kleine Normalschrift ziert auch ein Fächer-Bl. mit Aufschrift eines Fünf-Wort-Regelgedicht (wuyan lüshi) (Tusche/Goldsprenkelpapier, sign., Auschrift und Siegel von C., 17. 6. 1801; Hongkong, Chin. Univ. AM). Eine undat. Hängerolle mit einem in Normalschrift kalligraphierten Aphorismus (Tusche/Papier, sign., Siegel von C.; Shanghai, Mus.) zur Lsch.-Malerei des Guan Tong (tätig 895–923) und Jing Hao (* um 870, † um 930) wirkt weniger flüssig und läßt den eckigen Stil der Stelen-Inschr. und Sütren-Abschriften anklingen. Kalligraphiekritiken über versch. Meister in Kursivschrift (Tusche/Papier, sign., Siegel von C., 1806; Kunshan, Kunlutang MFA) scheinen nachträglich auf vier Stellschirmpanele montiert zu sein. Die Schriftkunst eines persönlich verf., dem Sammler Yunmen (He Linghan) zugeeigneten, in sehnig, kompakter Kursiv-Konzeptschrift (xingcao) kalligraphierten Sieben-Wort-Kurzgedichts (qiyan jueju) (Tusche/gewachstes Papier mit Pflaumenblütendekor, sign., Aufschrift und Siegel von C., Sammlersiegel; Beijing, Xiaomang cangcang zhai) ist dem Vorbild Zhao Mengfus und danach viell. Dong Qichang (* 1555, † 1636) verpflichtet. Dies gilt ebenso für ein von Zhang Liangchen (um 1174) verfaßtes und von C. geschriebenes Sieben-Wort-Kurzgedicht (Tusche/Seide, sign., Aufschrift und Siegel von C.) im Shenyanger Liaoning Prov. Mus. Eine Kalligraphie des von C. nach Besteigung des Zhongshan b. Nanjing/Prov. Jiangsu entstandenen Fünf-Wort-Regelgedichtes in Konzeptschrift (Tusche/gewachstes Goldsprenkelpapier, sign., Aufschrift und Siegel von C., Sammlersiegel) in der R. H. Ellsworth Coll. (New York) wirkt elegant und setzt bewußt Akzente durch versch. Strichdicken, Schwärzen und Druckunterschiede. Bis auf wenige Zeichengruppen, die inhaltlich eng gekoppelt sind, fließen die Zeichen nicht ineinander über. Jedes wirkt für sich, eingebunden in ein geschlossenes Gesamtbild des Schriftverlaufes, formuliert mit Sicherheit und Konzentration, auch bei eher losen Bindungen von Zeichenkomplexen. Daneben sind zahlr. Kolophone von C. erh., z.B. Sieben-Wort-Regelgedicht (qiyan lüshi) in Normalschrift auf dem anonymen yuanzeitlichen *Tongbao yiqi tu* (Von gemeinsamen Eltern, ein und derselbe Atem, Hängerolle, Tusche, Farben/Seide, Sammlersiegel; Taipei, Nat. Pal. Mus.). Die Bewunderung des Jiaqing-

Kaisers für die Kalligraphie des älteren Bruders drückte sich in der Auftragserteilung zur Kompilation einer Musterschriften-Slg aus. In Yijinzhai tie (Musterschriften des Yijinzhai, 1805) führte C. als einer der bed. Meister der Jiaqing-Periode wichtige Kalligraphien der chin. Trad. zusammen, die zu Modellen zeitgen. Schriftziehung wurden. Die in der Lit. erw. Malerei beschränkt sich auf kleinformatige Bilder in der Literati-Tradition. Das Shiqu baoji xubian (Forts. des Kat. der kaiserlichen Kunst-Slg, 1793) verzeichnet ein Album mit acht Bll. (Tusche/Papier, sign., Sammlersiegel), die „vom Lebendigen abschreiben" (xiesheng) und Lingzhi-Pilze, Orchideen, Pflaumenblüten sowie Bambus als Symbole der Langlebigkeit, Reinheit, Integrität und Standfestigkeit darstellen. Ein ähnliches Alb. mit acht Bll. (Tusche/Papier, sign., Aufschriften und Siegel von C., Sammlersiegel) befindet sich unter den in Shiqu baoji sanbian (3. Ser. des Kat. der kaiserlichen Kunst-Slg, 1816) aufgelisteten Werken sowie einen Topforchidee (penlan) mit einem Fünf-Wort-Gedicht in der Kalligraphie des Jiaqing-Kaisers (Tusche/dreifarbiges Goldsprenkelpapier, sign., Aufschrift und Siegel von C., Sammlersiegel). Eine Querrolle mit Epidendrum ist im Suzhouer Mus. erh., das *Meitu* (Pflaumenbäume, Querrolle, Tusche/Papier, sign., Aufschrift und Siegel von C., 1777, Frontispiz kalligraphiert von He Shaoji, zahlr. Kolophone) mit Pflaumenbäumen in einer Lsch. nach Mi Fu für den hohen Beamten, Dichter und Sammler Xie Yong in Chen Shutongs Baimei ji (Slg der Hundert Pflaumenblüten, 1927) publiziert. ▱ *E. J. Laing*, Chin. paint. in Chin. publ., Ann Arbor 1969, 308; *Yu Jianhua*, 1981, 166 s. (s.v. Yongxing); *Seymour*, 1988 (s.v. Yung Hsing); *Bénézit* III, 2006. – *Wang Jie u.a.* (Ed.), Shiqu baoji xubian (1793), Taipei 1971 (Faks.), II, 841, 1168; IV, 2177; V, 2872; VI, 3400 s.; VII, 3924; *Hu Jing u.a.* (Ed.), Shiqu baoji sanbian (1816), Taipei 1969 (Faks.), II, 583, 909, 936; V, 2937; VI, 2961; VII, 3092, 3331, 3333, 3513; IX 4259, 4327, passim; *Zhaolian* (* 1780, † 1833), Xiaoting zalu, Bj. 1980 (Faks.; Qingdai shiliao biji congkan); *Zhao Erxun u.a.* (* 1844, † 1927; Ed.), Qingshi gao, XXX, Bj. 1977, 221/9094 s.; *Li Fang* (* 1883 oder 1884; Ed.), Huang Qing shushi, Shenyang 1985 (Faks.; Liaohai congshu, 3), 1/5b-6b; *Chen Shutong* (Ed.), Baimei ji, [Shanghai] 1927; Gugong shuhua ji, XXVIII, Bj. ³1934–35; *W. Hung*, Ho-shen and Shuch'un-yüan. An episode in the past of the Yenching campus, [Bj.] 1934; *C. Fang*, in: *A. W. Hummel* (Ed.), Eminent Chin. of the Ch'ing period, II, Wa. 1943, 962 s.; Suzhou bowuguan canghua ji, o. O. 1963, 95 s.; *V. Contag/ Wang Chi-ch'ien*, Seals of Chin. painters and collectors of the Ming and Ch'ing periods, Hong Kong 1966; *Th. Lawton*, Chin. figure paint., Wa. 1973 (Freer Gall. of Art. Fiftieth anniversary. exhib., 2); *O. Sirén*, Chin. paint., VII, Lo./ N. Y. 1973; in: Eight dynasties of Chin. paint. The coll. of the Nelson Gall.-Atkins Mus., Kansas City, and The Cleveland Mus. of Art (K), Cleveland, Ohio/Bloomington, Ind. 1980; *K. S. Wong*, Masterpieces of Sung and Yuan dynasty calligraphy from the J. M. Crawford Jr. coll., N. Y. 1981; *Liang Piyun* (Ed.), Zhongguo shufa da cidian, I, Hongkong 1984, 912 (s.v. Yongxing); *Imai Rōsetsu* (Ed.), Ryōnei-shō

hakubutsukan, To. 1986 (Chūgoku shoseki taikan, 5); *R. H. Ellsworth*, Later Chin. paint. and calligraphy, 1800–1950, I, III, N. Y. 1987; Shin, To. 1988 (Chūgoku shodō zenshū, 8), 218, Abb. 82; Gugong shuhua tulu, V, Taipei 1990, 207 s.; *Xue Yongnian* (Ed.), Kunluntang cang shuhua ji, Bj. 1994, 150 s.; Xiaomang cangcangzhai cang Qingdai xuezhe fashu xuanji, Bj. 1995, 254, Abb. 21.; *M. Gao* (Ed.), Chengxun tang cang shanmian shuhua, Xianggang 1996, 368, Abb. 169; Zhuang Wanli jiazu juanzeng Sanghai bowuguan Liangtuxuan shuhua jicui, Shanghai 2002, 197; *Huang Dun*, in: *Wang Youfen* (Ed.), Chin. calligraphy, New Haven/Lo. u.a. 2008. U. Middendorf

Cheng *Shan-hsi* (Zheng Shanxi), taiwanesischer Maler, Schriftkünstler, Keramikmaler, * 1932 Longqixian/Prov. Fujian. Emigrierte 1950 nach Taiwan. Stud.: Nat. Tainan Teachers College (Abschluß 1953); 1957–60 Nat. Taiwan Normal Univ., Taipei. Anschl. Lehrtätigkeit (chin. Malerei) in der Taichung Teachers Acad., später u.a. auch an der Nat. Taiwan Normal Univ., Taipei. Ab 1982 auch als Keramiker tätig (Ci Yang Pottery, Guang Da Pottery, Zi Ran Pottery, China Art Ceramics Co. Ltd., Ah Leon Pottery, Tai Hwa Pottery Co.). Ab 1961 Mitgl. der Art Soc. of Taiwan Center (Abt. für westliche Kunst). Ausz.: 1951, '52 2. und 3. Preis Kunst-Ausst. der Stadt Tainan; 1965, '66, '68, '69 je 1. Preise in Provinz-Wettb. für Lehrer; 1968 Cult. and Art Award IX sowie Trad. Chin. Paint. Prize IX des Taiwan Cult. and Art Council; 1978 Golden Award Nat. Study Soc. for Folk Arts (für das Buch *Jiantie yishu*/The art of papercutting); 1997 First Nat. Arts and Cult. Award. Reisen: 1970 USA, 1971 Japan, 1983 Indien, 1990 Südkorea (mit Vorlesungen). – V.a. als Exponent der sog. Heimatbodenbewegung (Xiangtu yundong) der 1970er Jahre bek., die sich durch ihre „Ablehnung der blinden Modernisierung nach westlichem Modell" (fan manmu xi hua, xiandai hua) zugunsten von „Loyalität und Einfachheit" und „Betonung der Heimatkultur" (qiang jiu ben tu) auszeichnet. Seinem Vorbild Qi Baishi folgend, wandte sich C. früh von der elitären Trad. der klassischen chin. monochromen Literatenmalerei (wenrenhua) ab und propagierte eine reformierte Malerei taiwanesischer Prägung. Fortan widmet er sich idyllisch-romantisch anmutenden volkstümlichen Darst. von Figuren, Pflanzen, Tieren und v.a. rustikalen ländlichen Genre- und Lsch.-Szenen (Tusche und Farben/Papier), die stilistisch wie thematisch ein starkes Lokalkolorit besitzen (*Hengguan gonglu shangu youshen*/Auf dem Weg durch ein tiefes Tal; *Quche shang qiu*/A Drive in the Autumn, 1973; *Rongyin mufang*/Pasture in the Shade of a Banyan, 1978). Bestimmend für C.s lebhafte Komp. ist der expressive, ungekünstelte Pinselduktus, der dynamische Kontrast zw. kräftigen, breitflächig aufgetragenen Farben und dunkler Tusche sowie in beschwingter Manier geschriebene umgangssprachliche Aufschriften. Seit A. der 1980er Jahre viele Entwürfe für bemalte Keramik (kleinformatige Teller), v.a. expressive, polychrome Darst. von Frauen (Gesichter, Akte) wie *Jinan nühuajia Niki cipan*/In Erinnerung an Niki de St. Phalle, 2000. Auch Ill. und Neujahrsbilder. 🏛 NEW LONDON/Conn., Connecticut College. TAIPEI, FA Mus. – Yingge Ceramics Mus. –

Nat. Taiwan Arts Education Center. ✉ Jiantie yishu, Taichung 1974. 👁 *E:* Tainan: 1969 Nat. Taiwan Mus.; 1983 Sendale Yong Fu Hotel / 1970 New York, Baiter Gall. (mit Pan Tseng-Ying) / 1976 Taichung, Amer. Inf. Center / Taipei: 1979 Spring Gall.; 1983 Nat. HM; 1992 Wen Mo Xuan Center of Paint. (mit Lin Yu-shan); 1996 Kuai Xue Tang / 1988 Keelung, Nat. Cult. Center. – *G:* 1979 Tokio, AM: Contemp. Asian Art Exhib.; New Milford (N. J.), AC of Northern New Jersey: Famous Painters from the Rep. of China (K) / Taipei: 1982 Spring Gall.: Pottery Exhib. by Famous Painters; 1991 Hsiung Shih Gall.: Taiwan the Mother. A Five-Man Exhib.; 1995 FA Mus. (und Paris, Taipei Inf. and Cult. Center): Mod. Ink Art from Taiwan / Taichung, Cult. Center: 1989 Kunst-Ausst. [Sechsjähriges Bestehen] (K); 1996 Contemp. Art Space (Keramik; mit Juan Carlos Quintana) / 1993 St. Petersburg, Russ. Mus.: Mod. Chin. Ink Art Exhib. 📖 *Delarge*, 2001; *M. Sullivan*, Mod. Chin. artists, Berkeley u.a. 2006 (s.v. Zheng Shanxi). – C. huaji/Selected paint. by C., Taipei 1980; C. zuopin xuanji/Selection of works by C., Tainan 1981; Hsiung Shi monthly art mag. 172:1985 (6); C. cai ci hua ji/Colorful paint. on pottery by C., Taipei 1986; C. zuopin ji/Selection of works by C., Taipei 1989; Taiwan art 1945–1993 (K FA Mus.), Taipei 1993; Chin. contemp. ink – color paint. exhib. (internat. Wander-Ausst.), Taipei 1995; Taiwan jindai shuimohua daxi. C., Taipei 2004; Reflections of the seventies. Taiwan explores its own reality (K), Taipei 2004. K. Karlsson

Cheng *Taining*, chin. Architekt, Designer, * 9. 12. 1935 Nanjing/Prov. Jiangsu. 1956 Abschluß am Nanjing Inst. of Technology. Neben Qi Kang, Peng Yigang und Dar Fudong gehört C. zur ersten Architekten-Gen., die an einer Univ. in der noch jungen Volksrepublik China ausgebildet wurden. Heute ist C. einer der bekanntesten Architekten des Landes. In den 1980er Jahre gelang ihm der persönliche Durchbruch mit dem Entwurf für das Dragon Hotel in Hangzhou. Durch die gelungene formale Einpassung des Gebäudes in die dominierende Umgebung des West Lakes bekam er dafür 1991 den Nat. Perfect Design Prize und 1992 den Creation Award of the Archit. Soc. of China (ASC). – Zu C.s markanten Entwurfscharakteristika zählt die Abkehr von der „nat. Form" und bek. trad. Stile, weshalb er als mod. Architekt gilt. Zu seinen bekanntesten Entwürfen gehören das Nat.-Theater von Ghana 1992 (1994 Creation Award of the ASC; Nat. Perfect Design Award of the Minist. of Construction in China) und der Hauptbahnhof von Hangzhou 1999. Für C. bedeutet Archit., eine bestimmte Atmosphäre zu erzeugen und keinen bestimmten Stil vorzugeben. So geht jedem Entwurf u.a. die Beschäftigung mit den lokalen Voraussetzungen (v.a. der Orts-Gesch.) voraus. Als sich A. der 1990er Jahre die Architekten in China selbständig machen durften, gründete C. sein eig., auch internat. agierendes Büro. 🏛 BAMAKO, Internat. Conference Centre of Mali. HANGZHOU, Zhejiang AM, 2009. – Holiday Inn Hotel. – Jin Du Hua Ting (Wohnanlage). – Jin Douhua Govt. Area. NANJING, Yangtze River Bridge (Kollektiventwurf). SHANGHAI, Jinshan District Administrative Center. – Shanghai

Public Security Bureau Office Building und Command. SHAOXING, Civic Plaza. WENZHOU, Schuh-Mus. ⌑ C. Contemp. Chin. Archit., ed. by China archit. and building press, 1 (1997); 2 (2002); *C. Q. L. Xu*, Building a revolution. Chin. archit. since 1980, Hongkong 2006.

R. Selke

Cheng *Tsai-tung* (Zheng Zaidong; Cheng Tsaitung), taiwanesischer Maler, Keramiker, Bildhauer, * 1953 Taipei, lebt seit 1999 in Shanghai und Taipei. 1972 Unterricht (Malerei) bei Yang Hsing-shen. Ab 1977 Film-Stud. am World College of Journalism (heute Shih Hsin Univ.), Taipei. Danach Ass. von Regisseur Wang Chu-chin bei der Filmproduktion von *The Legend of the Six Dynasties* (1979). 1986 Reise nach New York. 1994 Mitarb. beim Film von Ang Lee *Eat Drink Man Woman*. Ausz.: 1992 Hsiung-shi (Lion Art) Creation Award; 1993 Kunstpreis des Kaohsiung AM für die Bilderserie *Romance in Peitou*. – Aktiv im avantgardistischen Kunstgeschehen der 1980/90er Jahre ist C. ein Repräsentant des sog. taiwanesischen Bewußtseins (Taiwan yishi). Stets von Nonkonformismus und Individualismus geprägt, profiliert er sich zunächst mit figurativen Öl-Gem. in kräftiger, z.T. expressiver Farbigkeit. Die häufig vereinzelt dargestellten oder aber nicht miteinander kommunizierenden Personen in flächig-reduzierten Lsch. oder Interieurs thematisieren u.a. die Vereinsamung und das Altern des Menschen. Die zahlr. Portr. von Fam.-Mitgl. (*My Pale Mother*, 1983) und v.a. von sich selbst drücken mitunter innere Qualen und Schmerzen aus. Prägend für das Schaffen der 1990er Jahre sei nach eig. Aussage die Begegnung mit dem Surrealismus in einem Film von Salvador Dali (in New York 1986). In einer orig. Mischung von tagebuchähnlicher Intimität und von nihilistischem Gedankengut geprägter Distanziertheit konzentriert er sich fortan auf düster-melancholische Lsch., die durch die Integration seines Selbst-Portr. (auch als Ganzfigur mit Ehefrau) und einzelner Figuren verfremdet und surreal wirken. Beeindruckt von Lebensstil, Naturverständnis und der Weltanschauung der trad. chin. Gelehrten (wenren), sucht C. neuerdings den Dialog mit der Vergangenheit. So zeigt seine jüngste Bilderserie ein Interesse an trad. chin. Mat. (Tusche und Farbe/Papier), Stilmitteln und Motiven (u.a. Vögel, Blütenzweige, Kiefern, Penjing [Bonsai], Figuren in Lsch.); auch läßt er einzelne klassische Verszeilen in die Bildtitel einfließen. Zudem malt er im Stil yuanzeitlicher Meister wie Huang Gongwang (* 1269, † 1354) und Zhao Mengfu (* 1254, † 1322), deren abgebildete Lsch. er auf seinen zahlr. Reisen aufsspürt. Mit seinen eigenwilligen und subtilen Interpretationen der Ästhetik der Literatenmalerei (wenrenhua) gilt C. als bed. Vertreter der gegenwartsorientierten sog. chin. Ästhetik der Neo-Literati (Carol Lu, 2006). Auch keramische und plastische Arbeiten in Holz, Bronze und Papier (*Xiang Long Stone*, 2006). ⌑ BEIJING, Nat. AM of China. TAIPEI, FA Mus. ◉ *E:* Taipei: 1980, '81 Amer. Cult. Centre; 1983, '88 Wistaria Teahouse; 1986 The Empty House; 1988 Yuan Nung Teahouse; 1993 Hsiung Shih Gall.; 1994 Crown AC; 1990–97 Hanart Gall.; 1998, 2000 Lin and Keng Gall.;

2001 Mulan Arts / 1987 New York, Sherkat Gall. / 1984, 2001 Hongkong, Hanart TZ Gall. / 1995 Sydney, Ray Hughes Gall. / Shanghai: 2006, '09 Shanghai Gall. of Art; 2007 Red Bridge Gall.; 2010 Yard Gall. / 2007 Mailand, Gall. Paolo Curti, Annamaria Gambuzzi & Co. – *G:* Taipei: 1985 Spring Gall.: Taiwan New Paint.; 1986 Howard Salon: Cheng Tsai-Tung & Chiu Ya-Tsai (Wander-Ausst.); NM of Hist.: 1986 Taiwan-Korea Exhib.; 1988 Contemp. Ink Paint.; 1989 Contemp. Art Works Exhib.; 1992 FA Mus.: Discontinuity and Continuity; Hanart Gall.: 1993 New Tribes ; 1994 Open Cult.; 1996 A Contemp. View of Taiwanese Arts; 1996 FA Mus.: Bienn.; 2009 Chi-Wen Gall.: A Peep into Taiwan Contemp. Works on Paper / Hongkong: Hanart 2 Gall.: 1991 AC: Individual Movement; 2005 Four Taiwan Artists / 1996–99 Edinburgh, Fruitmarket Gall.: Reckoning with the Past (Wander-Ausst.; K) / 1997–98 Prag, Rudolfinum: Faces and Bodies from the Middle Kingdom (Wander-Ausst.) / Beijing: 2001 Nat. AM of China.: Towards a New Image. Twenty Years of Contemp. Chin. Paint. (Wander-Ausst.); 2009 Unnatural / Shanghai: 2004 Shanghai Gall. of Art: Trad. Poetry and Sensibilities (mit Liu Wei und Zhou Chunya); Jing AG: Shanghai Attitude; 2009 Around Space Gall.: Standard. Chin. Trad. Aesthetics and „No Border" Art Pieces; Broad Gall.: Our Love. ⌑ Arts of Asia (Hongkong) 15:1985 (3) 95–98; *V. Doran*, Free China rev. 39:1989 (7) 66–72; *J. Clark*, Orientations 23:1992 (7) 28–36; *J. C. Kuo*, in: *J. Clark* (Ed.), Modernity in Asian art, Broadway, N. S. W. 1993; *S. Prakash*, Asian art news 1993 (Nov.-Dez.) 122 s.; Man and earth. Contemp. paint. from Taiwan (K), Denver, Colo., 1994; *L. Jaivin*, Art and Asia Pacific 2:1995 (4) 32 s.; *N. Jose/Yang Wen-i* (Ed.), Art Taiwan. The contemp. art of Taiwan (K), Sydney 1995; *M. Sullivan*, Art and artists of twentieth-c. China, Berkeley u.a. 1996; *M. Pai*, Asian art news 8:1998 (4/Juli-Aug.) 86; *J. C. Kuo*, Art and cult. politics in postwar Taiwan, Seattle, Wash., 2000; *Ni Zai-Qin*, The beauty of contemp. Taiwan. art, Taipei 2004; The transitional eighties. Taiwan's art breaks new ground (K), Taipei 2004; The multiform nineties. Taiwan's art branches out (K), Taipei 2005; *Carol Lu*, in: *Gong Minguang*, Entry gate. Chin. aesthetics of heterogeneity (K MCA), Shanghai 2006.

K. Karlsson

Cheng *Yanqiu* (Cheng Lin; Junong; Pseud. Yushuang), chin. Schauspieler, Regisseur, Autor, Maler, Schreibkünstler, * 1. 1. 1904 Beijing, † 9. 3. 1958 ebd. Entstammt einer Mandchu-Fam. und gehört zu den sog. Vier Großen Dan-Schauspielern der trad. Peking-Oper, die sich auf weibl. Rollen spezialisierten. Aus armen Verhältnissen stammend, erhält C. ab seinem sechsten Lebensjahr Schauspielunterricht für die Peking-Oper. 1915 erste Bühnenerfahrung und kurz darauf Mitgl. einer professionellen Theatergruppe. Schauspiellehrer sind u.a. Mei Lanfang (1894–1961) und ab 1917 der Gelehrte Luo Yinggong (1872–1924), der ihn auch in Dichtkunst, Kalligraphie und Malerei unterrichtete. C. beherrscht ein breites Repertoire populärer (tragischer) Frauenrollen. Seine Schauspiel- und Regiekunst wird neben dem chin. Kino auch durch eine zweijährige Auslandserfahrung in Europa ab 1932 (1923

irrtümlich bei Ellsworth) geprägt, u.a. mit einer Gesangs-Ausb. an der Akad. HS für Musik in Berlin und Bekanntschaft mit Max Reinhardt ebd. Seit den 1920er Jahren verfaßt C. neue Stücke für die Peking-Oper. Typisch für seine Schauspielkunst ist die psychologisierende Char. seiner Rollen, die als Cheng-Schule bek. wird. 1934 Gründungs-Mitgl. einer Theaterschule in Beijing; auch Dir. mehrerer Opern-Ausb.-Stätten. Während des Chin.-Jap. Krieges verweigert C. die Teilnahme am öff. Leben und zieht sich von der Bühne zurück. Landaufenthalt in der Nähe von Beijing (Qinglong Qiao). 1946 erster Wiederauftritt in Shanghai. In den 1950er Jahren Vize-Präs. des Inst. zur Erforschung der chin. Oper. – C.s bildkünstlerisches Œuvre umfaßt Vogel- und Blumenmalerei sowie Schreibkunst, v.a. klassische Gedichte auf hauptsächlich kleinformatigen Alben- und Fächerblättern. ☐ *R. H. Ellsworth*, Later Chin. paint. and calligraphy,1800–1950, I, N. Y. 1987; *J. K. Murray*, Last of the Mandarins. Chin. calligraphy and paint. From the F. Y. Chang Coll. (K), C., Mass. 1987.

A. Papist-Matsuo

Chenu, *Didier,* frz. Maler, Graphiker, Illustrator, Bildhauer, * 11. 7. 1956 Melun, lebt in El Jadida (Marokko). In den 1980/90er Jahren Teiln. an Ausst. der Groupe 109 in Paris. – Vertreter des Art brut. Gem. in Mischtechnik (Kreide, Tusche, Acryl) in kindlich-naiver Formsprache. Die farbenfrohen Komp. sind z.T. aus mehreren kleinen rechteckigen Farbfeldern zusammengesetzt (*Arc-en-ciel-2*). Beliebte Motive sind Regenbogen (*La création du monde*) und typische frz. Lebensmittel wie Brot, Wein und Käse (*Fromage*), häufig widmet er sich der Darst. mythologischer Themen (*Chute d'Icare*; *Le grand minotaure*; *Pegaze*; *Thétis*). Bisweilen verwendet C. bedrucktes Papier (Landkarten, Ztgn) als Bildgrund (*Carte-scolaire*) und integriert Schrift (*à toi*). Zudem entstehen Plastiken (u.a. Bronzen), Graphiken und Illustrationen (z.B. zu Jako, *Brèves de l'intérieur, vues de l'extérieur*, P. 2004). ☐ BREST, MBA, L'Artothèque. LAPALISSE, Mus. L'Art en Marche Lapalisse Art Brut. PARIS, BN. ◉ *E:* 1982 Paris, Gal. Diagonale / 1985 New York, Lasser Gall. / 1988, '90 Bordeaux, Gal. Chapon / 1994 Metz, Gal. Le Cercle Bleu / 1997 La Flèche, Mus. de la Providence / 2000 Boulogne-Billancourt, La Mire / 2005 Valaurie, Maison de la Tour / 2006 Lyon, Gal. Les Canularts / 2011 Rabat (Marokko), Gal. Fan-Dok. – *G:* 1991 Reims: Les Grands de l'Art contemp. / 1992, '93 Paris: Salon de Mai / 2001, '03 Praz-sur-Arly: Festival Hors les Normes / 2003, '04 Banne: Festival d'art singulier / 2005 London: Raw Arts Festival / 2005, '07 Lyon: Bienn. Hors les Normes / 2008 Esvres-sur-Indre, Gal. Artgument: La Faim de l'Art / 2009, '11 Saint-Etienne: Bienn. d'Art singulier Burlesque. ☐ *Bénézit* III, 1999. – *Online:* Assoc. A.m.I.s. Art marginal, insolite, singulier; Website C. F. Krohn

Chepstow-Lusty, *Lill-Ann,* norwegisch-brit. Fotografin, * 19. 1. 1960 Oslo, aufgewachsen in Eastbourne/Sussex, lebt seit 1980 in Oslo. Stud.: 1976–80 Eastbourne College. Stip.: u.a. 1988, '92 Staatl. Künstler-Stip. des Norsk Kulturråd; 1992, '97 Norsk Fotografisk Fond; 1997 Stip. des Außen-Minist., alle Oslo. Als Fotografin am

Münz-Kab. des Kulturhist. Mus. ebd. tätig. 2005 Initiatorin des Projektes Gay Kids, eine Slg von priv. Kinder-Fotogr. norwegischer homo- und bisexueller Personen, teils bek. Persönlichkeiten, das 2008 in einer Buch-Publ. und einer Ausst. vorgestellt wird. – . Meist serielle Schwarzweiß- und Farb-Fotogr., die teilw. auch in Buchform publiziert werden, z.B. Akt-Fotogr. übergewichtiger Frauen *Kroppens Sug, Hjertets Savn* (Oslo 1985). Hauptsächlich Arbeiten zur Geschlechterthematik; neben humorvollen Akten und Portr. von meist posierenden homo- und transsexuellen Personen u.a. 1984 und '86 zwei Aktkalender mit dem Titel *Pin Downs*, die inszenierte Aufnahmen von Fotografinnen und deren männlichen Aktmodellen zeigen und so das Genre der Pin-up-Ill. karikieren. Des weiteren Betrachtungen nat. Stereotypen, u.a. Fotogr. von norwegischen Touristen im Vergnügungspark Disney World in Orlando/Fla., und Portr. bulg. Frauen, z.B. *Bulg. Woman Smoking by a Stuffed Don* (Farb-Fotogr., 1992). Außerdem der Foto-Roman *På LaRoid* (Oslo 1987). ☐ HORTEN, Preus Mus. OSLO, Norsk Kulturråd. – Robert Meyers Slg, NM. ◉ *E:* Oslo: 1984 Gall. Kamelon; 1985 Café de Stijl; 1986 Café Våra; 1994 Foto-Gall.; 2008 Kulturhist. Mus. / 1985 Høvikodden, Henie-Onstad Kunstsenter / 1997 Tromsø, Tromsø Mus.; Bratislava, Gal. Profil (Wander-Ausst.) / 2002 Bøstad, Lofotr Viking-Mus. (Wander-Ausst.) / 2003 Fredrikstad, Østfold Kunstnersenter (Wander-Ausst.). – *G:* London: 1980 Inst. of Contemp. Arts: Women's Images of Men; 1994 The Gall. at John Jones: Revelations / Oslo: 1983 Akers Mek: Kulturen lever; 1984 Gall. UKS: Eksponert; 1986 Foto-Gall.: Vårutstillingen (K); 2007 Stenersen-Mus.: Mod. Norwegian Art Photogr. / 1988 Edinburgh, Stills Gall.: Behold the Man (Wander-Ausst.; K) / 1994 New York, Internat. Center of Photogr.: Stranger than Paradise (Wander-Ausst.); Nottingham, Nottingham Castle Mus. and AG: Our Bodies, Ourselves; Notodden, Telemark Fylkes-Gall.: Hypp alle mine hester / 1995 Helsinki, Nordic AC: Borealis (Wander-Ausst.; K) / 1996 Bratislava, Gal. Medium: Voluptas / 1999 Lillehammer, KM: Konstruksjon eller virkelighet / 2003 Horten, Preus Foto-Mus.: The Golden Age of Norwegian Photogr. / 2012 Bergen, KM: Desire. ☐ *S. Kent/J. Morreau* (Ed.), Women's Images of Men, Lo. 1985; Fotogr. (s)om forskning (K Høvikodden) Oslo 1997; *J. Veiteberg* (Red.), Kunst fotogr. Norge, [Oslo 1999]; *C. M. Brundtland,* Norwegian art photogr. 1970–2007, St. 2007. – *Online:* Website C.

J. Niegel

Chéret, *André,* frz. Comiczeichner, Illustrator, Plakatgestalter, * 27. 6. 1937 Paris, lebt dort. Autodidakt. 1952 zunächst Ausb. als Drucker; später Mitarb. einer Werbeagentur in Paris, für die C. Filmplakate entwirft. Während des Militärdienstes in Deutschland 1958 erste Publ. von Ill. in den Armee-Zss. Le Bled und Cinq sur Cinq. Bekanntschaft mit Jean Giraud. 1960 entsteht für die Ztg Paris-Jour die Comic strip *L'Etonnant Monsieur K.*, eine Adaption des Buches „Nikita Khrouchtchev" von Victor Alexandrov. 1961 gestaltet C. Ill. für das Mag. Radar und zeichnet versch. Comics für die Mag. L'Intrépide (*Rock L'Invincible*) und Mireille (*Monica, hôtesse de l'air*) so-

wie für die Tagespresse (*Sherlock Holmes*; *Réfugiés*). Ab 1962 Mitarb. der Zs. Vaillant, für die er u.a. die von Rémy Bourlès kreierte Abenteuer-Ser. *Bob Mallard* fortsetzt (Text v. Jean Sani). 1966 entsteht der Flieger-Comic *Karl* für das Mag. J2 Jeunes (Text v. Jean-Paul Benoît). Für die Zs. Pif Gadget zeichnet er ab 1969 nach Szenarien von Roger Lécureux die populäre, in einem fiktiven prähist. Zeitalter angesiedelte Ser. *Rahan* (mehrere Nachdrucke als Alben und ab 1992 auch in einer Gesamt-Ausg.). Zahlr. weitere Comics: u.a. *Domino* (1973–80, für Tintin; Text v. Greg/Michel Regnier und Jean van Hamme); *Michel Brazier* (1979, für Spirou; Text v. Jean-Michel Charlier); *Protéo* (1985; 1996). 1982–85 auch Mitarb. an der vom Verlag Philippe Auzou hrsg. didaktischen Buchreihe *L'Enc. en bandes dessinées*. In jüngerer Zeit zeichnet C. neben neuen Episoden von *Rahan* v.a. die Ser. *Ly-Noock* (2003/04; Text v. Michel Rodrigue), die TV-Adaptionen *Homo Sapiens* und *Le Sacre de l'homme* (2005–07) sowie den Comic *Le Dernier des Mohegans* (2009; Text v. Pierre-François Mourier). – Detailreich-realistische, oft mit idealisierten Körper-Darst. und dynamischen Panel-Komp. arbeitende Zchngn in der stilistischen Trad. von Zeichnern wie Burne Hogarth, Frank Frazetta oder Alex Raymond. ▭ *H. Filippini*, Dict. enc. des héros et auteurs de BD, I, Grenoble 1998; *id.*, Dict. de la bande dessinée, P. 2005; *P. Gaumer*, Dict. mondial de la BD, P. 2010. – *H. Filippini/M. Bourgeois*, La bande dessinée en 10 leçons, P. 1976; *Y. Frémion*, Le guide de la bédé francophone, P. 1990; *A. C. Knigge*, Comics. Vom Massenblatt ins multimediale Abenteuer, Reinbek 1996; *M. Béra u.a.*, Trésors de la bande dessinée. Cat. enc. 2007–08, P. 2006; *L. Cance/J.-P. Tibéri*, C., Soissons 2009; *N. Ruddick*, The fire in the stone. Prehistoric fiction from Charles Darwin to Jean M. Auel, Middletown, Conn. 2009. – *Online:* Bedetheque; Lambiek Comiclopedia; Rahan. H. Kronthaler

Cherfaoui, *Affif*, algerischer Maler, Zeichner, * 5. 3. 1948 Oran, lebt in La Meilleraye-de-Bretagne. Enkel eines Holzbildhauers. Stud.: ab 1962 Ec. nat. des BA, Oran (1975–92 Lehrtätigkeit); ab 1966 in Frankreich: Ec. régionale supérieure d'Expression plast., Tourcoing; Ec. régional des BA, Nantes (Abschluß: Dipl. de DécorationVolume). – V.a. farbenfrohe Lsch. und Stadtansichten sowie Akt-Darst. in Öl, Gouache, Aqu., Tusche und Rötel, z.T. in expressiver Formsprache (*Printemps*, Öl/Lw., 2002). Seit 1992 in Frankreich ansässig, malt C. weiterhin bevorzugt Motive aus der algerischen Heimat (v.a. idealisierte Ansichten seiner Geburtsstadt Oran). Die von Zeichen mod. Zivilisation wie Autos und Hochhäusern sowie von Menschen weitgehend befreiten Darst. konstruiert er anhand von Fotografien. Häufig überzieht er bestimmte Flächen der aquarellierten Lsch. und Stadtansichten mit orientalisch anmutenden mosaikartigen Mustern (z.B. *La Passerelle de l'Embarcadère [Le Caire]*, 1997; *Belle Ile*, 2003, beide Aqu. und Tusche). ⌂ ALGIER, MNBA. ORAN, MN Zabana. PARIS, BN. ☉ *E:* Oran: 1965 Libr. Monaco; 2007 MN Zabana (Retr.) / 1992 Paris, Centre cult. Algérien / 1997 Kairo, Gal. Douroub / 1998 Nantes, Gal. La Découverte / 2003 Rezé, Espace Diderot

(Retr.) / 2011–12 Bouguenais, Médiathèque Condorcet. – *G:* 1986 Monaco: Prix internat. d'Art contemp. / 1989 Algier: Bienn. internat. des Arts plast. / 1990 Riom: Salon internat. (Ausz.) / 1997–2002 Sorinières: Salon de Peint. et de Sculpt. ▭ *Bénézit* III, 1999; *M. Abrous*, Les artistes algériens, Alger 2002; *M. Abrous*, Dict. des artistes algériens 1917–2006, P. 2006. F. Krohn

Cherinet, *Loulou*, schwed.-äthiopische Video- und Objektkünstlerin, Fotografin, Malerin, * 1970 Göteborg, lebt in Stockholm und Addis Abeba. Zunächst Mitarb. des KM Göteborg. 1992–94 Aufenthalt in Indonesien, danach in New York und Washington, ab 1996 in Äthiopien. Stud.: 1996–2000 Addis Ababa Univ. School of FA, Addis Abeba; 2001–05 KHS, Stockholm. Stip.: 2005 KV Hötorget; IASPIS, beide Stockholm; Stiftelse Anna-Lisa Thomson till Minne, Uppsala; 2006 Sveriges Bildkonstnärsfondet. 2002–04 Rollenspiele und Videoprojekten mit Schulklassen im Rahmen des Projektes Kulturkontoret in Vårby Gård b. Stockholm. 2004–08 Mitarb. bei Good TV in Stockholm. – In Indonesien zunächst abstrakte Gem. mit Anklängen an expressionistische Bildsprachen sowie Blechskulpturen. Bereits an der Univ. School of FA beginnt C., sich mit Fragen der Ethnizität, Nationalität und kult. Identität sowie der Geschlechterthematik auseinanderzusetzen, zunächst in figurativen Gem., dann hauptsächlich in seriellen Fotogr. und mehr oder weniger stark inszenierten Videofilmen, die aufgrund ihrer hohen Authentizität oftmals dok. wirken. In teils anthropologischer Herangehensweise kehrt sie u.a. europ. Sichtweisen auf den afrikanischen. Kontinent und seiner Bevölkerung um, z.B. in der humorvollen Fotogr.-Serie *White Man Series* (2001), die einen weißen Touristen an versch. Orten Addis Abebas inmitten der einheimischen Bevölkerung zeigen und ihn so als Exoten darstellen. In dem Video *Minor Field Study* (2006) stellt sie unkommentiert Szenen aus Video-Dok. des kongolesischen Anthropologen Marius Billy über die Babongo-Pygmäen ähnlichen Szenen eig. Videoaufnahmen aus Schweden gegenüber wie z.B. einen Spaziergänger, eine Häuserreihe oder eine Tanzveranstaltung. Eine bek. Arbeit von C. ist die Trilogie *Bleeding Men* (2003–07), deren erster und zweiter Teil Assoziationen an Bürgerkriege wecken, während der dritte Teil, in dem eine Gruppe bekleideter Männer eine schlafende nackte Frau betrachten, das Thema der sexuellen Diskriminierung anspricht. Ein weiteres bek. Werk ist der nat. Stereotypen hinterfragende, fast einstündige Videofilm *White Women* (2002), der durch eine in der Mitte positionierte, sich langsam drehenden Kamera acht schwarze Männer in Matrosenhemden beobachtet, die in einem Lokal, bedient von einer weißen Frau, über ihre Liebesbeziehungen zu weißen Frauen diskutieren. Daneben rein dok. Fotogr., z.B. die Schwarzweiß-Folge *The Barber Series* (2000). ⌂ ADDIS ABEBA, Addis Ababa Univ. ALEXANDRIA, Bibl. Alexandrina. JAKARTA/Java, MFA and Ceramics. LUANDA, Sindika Dokolo African Coll. of Contemp. Art. STOCKHOLM, Mod. Mus. ☉ *E:* Jakarta: 1993 MFA and Ceramics; 1994 Taman Ismail Marzuki AC / Addis Abeba: 1999 Addis Ababa Univ; 2000, '01, '07 ASNI Gall. / Gö-

teborg: 2003 Yeans; 2008 KM; 2011 Röda Sten / 2004 Lü-
neburg, Halle für Kunst / 2005 Gävle, Konstcentrum (mit
Nathalie Djurberg und Jesper Nordal)/ 2006 Härnösand,
Läns-Mus. Västernorrland (mit Matias Olofson und Sara
Brolund Carvalho) / 2007 Krakau, Bunkier Sztuki (K) /
Stockholm: 2010 Stockholm, Gal. Niklas Belenius; Cen-
trum för fotogr. – G: 2001, '03, '07 Bamako: Rencontres
Africaine de la Photogr. (alle K) / 2002 Mailand, Spazio
Oberdan: Made in Africa (K) / 2003 Zürich, Migros Mus.:
The African Exile Mus.; Norrköping, KM: Om, berättan-
de i svensk samtidskonst (Wander-Ausst.) / Stockholm:
2004 (Svenska Hjärtan), '06 (Modernautställning) Mod.
Mus.; 2009 Centrum för fotogr.: Fotogr., nu 2009 / 2004
Göteborg, Världskultur-Mus.: Horisonter / 2005 Alexan-
dria: Internat. Bienn. / 2006 Wien, Secession: I (Ich), Per-
formative Ontology; São Paulo: Bien.; Luanda: Trien. /
2007 Perth, AG of Western Australia: Raised by Wolves
(K); Durban (Natal), Durban AG (Wander-Ausst.); Vene-
dig: Bienn.; Bologna, MAMbo: Time Code / 2009 Ad-
dis Abeba, Mod. AM, Addis Ababa Univ.: Predicting the
Past / 2010 Barcelona, Centro de Cult. Contemp.: Atopia,
Art i ciutat al segle XXI; Murcia: Manifesta / 2011 Luleå,
Gall. Syster: Gall. Systers Val. ▭ Mém. intimes d'un
nouv. millénaire. IVes Rencontres de la photogr. africai-
ne, Bamako 2001 (K), P. 2001; *S. Njami* (Ed.), Afrika re-
mix. Zeitgen. Kunst eines Kontinents (K Wander-Ausst.),
Ostfildern-Ruit 2004; *I. Carlos* (Ed.), Bienn. of Sydney
2004. On reason and emotion (K), Sydney 2004; Masculin-
ities (K Berlin), Ffm. 2005; *F. Alvim u.a.* (Ed.), Next flag.
The African sniper reader, Z. 2005; Observatorio SD (K),
Valencia 2006. – *Online:* Website C. J. Niegel

Chermont, *Fausto (Fausto Ribeiro),* brasil. Fotograf,
Kurator, * 4. 1. 1961 São Paulo, lebt dort. Stud.: 1980–84
Unternehmensverwaltung an der Pontifícia Univ. Católica
sowie 1981–86 u.a. bei João Luiz Musa an der Esc. Focus
de Fotogr., São Paulo. Eröffnet 1983 zus. mit Luigi Stavale
das Fotolabor Os Vesgo. 1984 Foto-Ass. von Vania Toledo.
1987 gründet er zus. mit Mark James das Nonsense-Studio
sowie 1991 zus. mit Nair Benedicto, Rubens Fernando Jú-
nior und Roseli Nakagawa die Gruppe Núcleo de Amigos
da Fotogr. 1987–91 Langzeitdokumentation *Villares-Amyr
Klink* mit Schwarzweiß- und Farb-Fotogr., die den Bau des
Segelschiffs Paratii des Weltumseglers Amyr Klink vom
Beginn der Fertigung bis zum Stapellauf festhält. 1988–91
Dir. der União dos Fotogr. de São Paulo. Versch. Praktika
in Europa, z.B. 1990 am Centre Nat. de la Photogr., Pa-
ris, 1994 am Mus. de l'Elysée, Lausanne, sowie am Cham-
bre Claire, Neuchâtel und 1996 im George Eastman Hou-
se, Rochester. Mitarbeit an Fotobänden, u.a. 1992 für Va-
nia Toledo sowie 1994–96 für die Verlage Burti und Terra
Virgem. 1993, '95, '97 Kurator des Mês Internac. de Fo-
togr. in São Paulo. 1999 Kameramann für den Film *Fute-
bol no Escuro – Lucíferos Vestíveis.* Veröff. 2003 den Fo-
toband *Em busca dos Dinossauros.* Als Fotograf u.a. Bera-
tertätigkeit für das brasil. Kultusministerium. Ausz.: 1998
Prêmio de Fotogr. der Assoc. Paulista de Críticos de Arte;
1999 Prêmio J. P. Morgan de Fotogr.; 2003 Prêmio Porto
Seguro de Fotogr. – In den 1990er Jahren beginnt C. sei-

ne Themenpalette zu reduzieren, um schließlich nur noch
Lsch. und Stadt-Porträts (v.a. Archit.) zu fokussieren. Da-
bei experimentiert C. häufig mit versch. Effekten, etwa bei
seinen Stadt-Serien, in denen er durch den Einsatz versch.
Brennweiten oder die Verwendung spezifischer Papiere bei
den Abzügen mit den Farbtonalitäten spielt, z.B. *Um Pass-
eio pelo Centro* (1999/2003). In seinen Lsch.-Aufnahmen
unterstreicht C. die ruhige Klarheit der Motive hingegen
auch durch die Technik des Inkjet Prints, so z.B. in *Duna*
(2001) oder *Lençóis Maranhenses* (2002). ▭ SÃO PAU-
LO, Centro Cult. – Inst. Cult. Itaú. – MAC. – MAM. –
Mus. da Imagem e do Som. – Núcleo dos Amigos da Fo-
togr. ⊙ *E:* 1994 São Paulo, Casa das Rosas; Mus. da
Imagem e do Som. – *G:* São Paulo: 1997 MAM: Verde
Lente; 2002 Casa das Rosas: México Imaginário. O olhar
do artista brasil.; ; 2002 Espaço MAM Villa-Lobos: Ci-
dadeprojeto/cidadeexperiência; 2003 Gal. de Arte do Se-
si: Negras Memórias, Memórias de Negros; 2004 Espaço
Cult. Nossa Caixa: Carpe Diem; 2007 Gal. Asia 70: Ent-
repanos / 2003 Rio de Janeiro, Mus. Nac.: Em Busca dos
Dinossauros. M. F. Morais

Cherry, *Vivian,* US-amer. Fotografin, * 1920 New York,
lebt dort. C. arbeitet als Tänzerin für Broadwayshows und
Nachtclubs und nimmt A. der 1940er Jahre, zunächst pa-
rallel, eine Tätigkeit als Dunkelkammer-Ass. bei Under-
wood & Underwood auf. Nachdem sie den Tanz infolge
einer Knieverletzung aufgeben muß, tritt sie 1946/47 der
New Yorker Photo League bei und nimmt Unterricht bei
Sid Grossman und Fons Iannelli. In der Folgezeit veröf-
fentlicht C. Fotogr. in Zs. wie Life, Look, Parade, Page-
ant, Popular Photogr., Sports Illustrated und Ebony. – C.
ist in erster Linie für ihre Schwarzweiß-Fotogr. der 1940er
und 1950er Jahre aus den Straßen New Yorks, insbesonde-
re Brooklyn, Lower East Side und Harlem, bekannt. Dar-
über hinaus fotografiert sie auch im US-Bundesstaat Geor-
gia sowie in Mexiko. Eine ihrer bekanntesten Serien, *Ga-
me of Guns* (1948), über die erschreckende Brutalität kind-
licher Spiele in den Straßen New Yorks erscheint zunächst
in der frz. Zs. Regards und wird 1952 in Photogr. (Chi-
cago) nachgedruckt. 1955 entstehen, kurz vor und wäh-
rend deren Abriß, zwei Serien über die bek. New Yorker
Hochbahnlinie Third Avenue El. Von E. der 1950er bis E.
der 1980er Jahre wendet sich C. weitgehend von der Fo-
togr. ab, dreht mehrere Kurzfilme und arbeitet als Stand-
fotografin bei der Produktion eines Films des Fotografen
Arnold Eagle über Lee Strasbergs bek. Actors Studio (Ac-
ting. Lee Strasberg and the Actors Studio, 1981). Ab E.
der 1980er Jahre arbeitet sie überwiegend in Farbe, wendet
sich aber um 2000 erneut dem Schwarzweiß zu und setzt
ihre fotogr. Arbeit bis weit in die 2000er Jahre hinein fort.
▭ BROOKLYN/N. Y., Brooklyn Mus. NEW YORK, Inter-
nat. Center of Photogr. – Jewish Mus. – MMA. WASHING-
TON/D. C., Nat. Portr. Gall. ✉ Vignettes. Chapters from
a life, 2012. ⊙ *E:* 2000 Brooklyn (N. Y.), Brooklyn
Mus. (Retr.) / 2001 Winchester (Mass.), Lee Gall. / 2004
New York, Soho Photo Gall. – *G:* New York: 2003–04 In-
ternat. Center of Photogr.: Only Skin Deep. Changing Visi-
ons of the Amer. Self (K); 2006–07 New York Public Libr.:

Where do We go from Here? The Photo League and its Legacy 1936–2006; 2009 Higher Pictures Gall.: The Women of the Photo League / 2001 Venedig, Gall. Contemp.: Photo League. New York 1936–1951 (K) / 2009 Madrid, Casa Encendida: Picturing New York. Photographs from the MMA (Wander-Ausst.; K). ▭ *A. W. Tucker u.a.*, This was the Photo League. Compassion and the camera from the depression to the cold war, Chicago 2001; *B. Head Millstein*, Helluva town. New York City in the 1940's and 50's, Brooklyn, N. Y. 2007; *J. Van Haaften*, V. C.'s New York, Brooklyn, N. Y. 2010; *C. Evans*, As good as the guys. The women of the Photo League, in: *M. Klein u.a.*, The radical camera. New York's Photo League 1936–1951 (K Wander-Ausst.), New Haven, Conn. u.a. 2011. – *Online:* Brooklyn Mus.; Jewish Mus. P. Freytag

Cherubini, *Nicole,* US-amer. Keramikerin, Fotografin, * 1970 Boston, lebt in New York. Ehefrau des Keramikers Patrick Purcell. Stud.: 1990–93 Rhode Island School of Design, Providence (Keramik); 1996–98 New York Univ. (Fotogr.); 2002 Skowhegan School of Paint. and Sculpt., Skowhegan/Me. Lehrtätigkeit: Hunter College, City Univ. of New York. Ausz.: u.a. 1994 Reise-Stip. für Mexiko, Arts internat., Nat. Endowment for the Arts; 1995 The New England Found. for the Arts Fellowship; Massachusetts Arts Council, Nat. Endowment for the Arts; 1998 Jack Goodman Award for Art and Technology, New York Univ.; 2000 Artist in Residence, Greenwich House Pottery; 2001–02 dgl., Henry Street Settlement, beide New York; 2007 Louis Comfort Tiffany Award; 2009 Artist in Residence, EKWC (Europ. Ceramic Work Center), 's-Hertogenbosch. – C. wird bek. durch ihre Keramikobjekte, mit denen sie den Stellenwert von Wohlstand und materiellem Reichtum in der US-amer. Kultur ironisch hinterfragt. In Übergröße und bar jeder Funktion sind ihre von Hand gebauten Gefäße (häufig in klassischen Formen, aber mit unregelmäßigen Oberflächen) reizvoll glasiert und in geradezu barocker Manier üppig mit versch. Mat. bzw. Fundstücken verziert (*Gem-Pot, Red; Vanitas #1*, Keramik, Porzellan, unechter Gold- und Silberschmuck, Kette, weißer Fuchspelz, brauner, schwarzer und pinkfarbener Kaninchenpelz, Email, Sperrholz, farbiges Acrylglas, Lüster, Tar-Gel, 2005). Im Kontrast zu diesen opulenten Stücken stehen die schlichten, nüchternen Sockel, die integraler Bestandteil des Kunstwerks sind. Häufig präsentiert C. auf Ausst. die Keramikplastiken in installativer Weise mit Fotogr., selbst gemalten Bildern in Mischtechnik, Holz oder Marmor (*Hydra with a Lethykos*, Keramik, Porzellan, verschiedenfarbiges Acrylglas, Sperrholz, Mahagoni, C-Print, Gouache, Graphit, Tusche, Aqu., Wachspastell, Email, 2008). Mehrere Werke sind in Zusammenarbeit mit der Bildhauerin Taylor Davis entstanden, wobei beide ihre Erfahrungen mit unterschiedlichen Mat. und Gest.-Weisen einbringen (*Roma*, Keramik, farbiges Acrylglas, Bleistift, Karton, Spiegel; *Grey*, Alabaster, Sprayfarbe, Email, Kunstharz, blaues Band, Tar-Gel, Kiefer, Buche, beide 2007). Neben der Keramik beschäftigt sich C. mit Fotogr. (Serie mit Farb-Fotogr. [C-Prints] von der umfangreichen Porzellan-, Glas- und Lüster-Slg ihrer 94jäh-

rigen ital.-stämmigen Großmutter, 2004) und Arbeiten in Mischtechnik (*Am4OhrA with black drip*, Email, Tusche, Gouache, Wachspastell, Graphit, C-Print auf Aqu.-Papier; *Kissbite*, Aqu., Tusche, Gouache, Email, Graphit, Wachspastell auf Aqu.-Papier, beide 2008). ▭ CAMBRIDGE, Massachusetts Inst. of Technology. ⊚ *E:* 2001 Mexiko-Stadt, La Panaderia (mit Nancy Barton und Carol Bove) / 2004 Jersey City (N. J.), Jersey City Mus. / 2005 Richmond (Va.), ADA Gall. / 2005, '07, '10 (mit T. Davis), '11 (mit Beverly Semmes) Boston, Samson Projects / 2007 Philadelphia (Pa.), Inst. of Contemp. Art / New York: 2006 Klemens Gasser and Tanja Grunert, Inc.; Greenwich House Pottery, Jane Harstook Gall.; 2007 Nassau County Mus. (mit Valerie Hegarty); 2008 D'Amelio Terras; Smith-Stewart; 2011 Newman Popiashvili (mit T. Davis) / 2009 Santa Monica (Calif.), Mus. of Art, Project Space / 2010 Berlin, Gal. Michael Janssen; Miami (Fla.), Locust Projects. – *G:* 1999 Mailand, OpenSpace: New York, NY. Big City of Dreams / 2002 Tokio, Tomoyo Saito Gall.: 4 Brooklyn Artists / New York: 2005 Sculpt. Center: Make it now. New Sculpt. in New York; 2006 The Armory Show / 2009 Guadalajara (Mexiko), Mus. de Arte Raúl Anguiano: Misfeasance. ▭ *E. Cooper*, Contemp. ceramics, Lo. 2009; Davis, Cherubini. In Contention (K Massachusetts Inst. of Technology, List Visual AC), C., Mass. 2009. – *Online:* Website C.; Gal. Michael Janssen; *C. Nadelman*, ARTnews 2007 (April); Samson projects; Artnet; ICA, Univ. of Pennsylvania. C. Rohrschneider

Chervin, *Louis,* frz. Maler, * 3. 6. 1905 Paris, † 17. 1. 1969 ebd., dort tätig. Verdient seinen Lebensunterhalt zunächst als Mitarb. der Versicherungs-Ges. Le Nord. Beginnt 1926 autodidaktisch mit der Aqu.-Malerei. Frequentiert die Ateliers etablierter Maler (v.a. André Utter, Gen Paul, Charles Camoin, Bernard Lorjou und Yvonne Mottet) in seinem Wohnviertel, dem Quartier des Epinettes. Ab 1930 Ausst. in Boston (Gooddspeed's Bookshop). 1939 Einberufung, 1940 Kriegsgefangenschaft. Nach dem 2. WK läßt sich C. in Montmartre nieder. C.s Werke werden regelmäßig in der Gal. seiner Frau Marie Wild ausgestellt (1945–68 gleichnamige Gal. in der Rue de Chevalier de la Barre Nr 57 ebd.); dort befindet sich zeitweise C.s Atelier. Ausz.: 1953 Prix de la Critique; 1957 Peintre Officiel de la Marine; 1965 Chevalier dans l'ordre des Arts et des Lettres; Grand Prix de la Salon nat. des BA (Mitgl.). – C. malt v.a. expressive Lsch., Stadtansichten (bes. in Montmartre), Marinen, Stilleben und Akt-Darst. in Aqu., Öl und Gouache. Im Frühwerk orientiert er sich hinsichtlich der Malweise und Sujetwahl an Werken von Vincent van Gogh. Der befreundete Maler Gen (eigtl. Eugène) Paul porträtiert C. mehrfach. ▭ HELSINKI, Ateneum. PARIS, MAMVP. – Mus. Carnavalet. ⊚ *E:* Paris: 1952 Gal. St-Placide; 1990 Paris, Mus. de Montmarte (K) / 1990 Guebwiller, Mus. du Florival (K). – *G:* Paris: ab 1923 Salon d'Automne; 1927–28 Salon des Independants; 1944 Salon des Tuileries / 1971 Saint-Louis, Gal. Au Souffle de Paris: Hommage à L. C. et ses amis (K) /. ▭ *Edouard-Joseph* I, 1930; *L. Harambourg*, L'Ec. de Paris 1945–1965, Neuchâtel 1993; *A. Roussard*, Dict. des peintres à Mont-

martre, P. 1999; *Bénézit* III, 1999; *Falk* I, 1999; *Delarge*, 2001. F. Krohn

Cheshin, *Leora,* israelische Fotografin, Publizistin, * 1949 Jerusalem, lebt dort. Autodidaktin. Stud.: bis 1974 Hebräische Univ., Jerusalem (Hebraistik, Linguistik, Kommunikations-Wiss.); 1977–97 Fotogr.-Kurse am Israel Mus. ebd.; Abendkurse u.a. Kunstgesch. und Interieur-Design an der Bezalel Acad. of Arts and Design, Jerusalem. Mitgl.: Jerusalem Artist's Association. – Seit vielen Jahren beobachtet Ch. mit der Kamera die Pflanzenwelt ihres Landes. In einer Serie bewußt neutral gehaltener Schwarzweiß-Fotogr. (*Opuntia vulgaris*) fragmentarisiert sie z.B. 2008 einen Säbelkaktus. Die Detailaufnahmen dieser symbolisch mehrdeutigen Pflanze assoziieren bizarre Lsch. und animalische Wesen. Ch. veröffentlicht ihre Fotogr. in Botanik-Mag., Büchern, Kalendern und auf Postkarten; sehr populär sind ihre *Green Series.* Bekanntheit erlangte sie außerdem mit Portr.-Aufnahmen, u.a. von Eltern mit ihren Kindern, sowie der fotogr. Dokumentation von Street art in Tel Aviv (2009). ◉ *E:* u.a. 1988 Ramat Gan, Man and the Living World Mus. / Jerusalem: 1989 Israel Mus.; 1990 Cinemathèque. Israel Film Archives; 1999, 2004 Jerusalem Theatre Gall.; 2001, '09 Jerusalem Artist's House / Tel Aviv: 1991 Suzanne Dellal Centre; 2001 Eretz Israel Mus.; 2008 Performing AC; 2008, '09 Tova Osman AG. – *G:* zahlr. im In- und Ausland. ⌺ *Online:* Website Ch. (Ausst.); Israel AC; Tova Osman AG. B. Scheller

Chesnay, *Louis-Olivier,* frz. Maler, Zeichner, Bildhauer, * 28. 5. 1899 Paris, † 6. 5. 1999 Buix/Jura. C. erhält vom Vater, einem Architekten, ersten Zeichenunterricht. 1917 bereitet er sich auf die Aufnahme an der EcBA vor (Archit.); 1918 zum Wehrdienst eingezogen; Ausmusterung aus gesundheitlichen Gründen und Aufenthalt in Sanatorien; nach Genesung A. der 1920er Jahre in der Landwirtschaft tätig. Parallel dazu künstlerische Ausb. bei den Malern Bergès und Jules Adler sowie bei den Bildhauern Robert Wlérick und Charles Malfray. Atelier-Ltg an der Acad. Colarossi sowie an der Acad. de la Grande Chaumière in Paris. C.s Lebenslauf ist durch zahlr. Ortswechsel gekennzeichnet, zu den wichtigsten Stationen zählen Suresnes (ab 1929 mit Unterbrechungen) und Marrakesch (ab 1947; dort Zeichenlehrer); ab 1947 unternimmt er Reisen nach Schweden und Dänemark und läßt sich 1964 in der Schweiz nieder (zunächst in Gstaad, ab 1995 in Buix), wo er erneut unterrichtet. – V.a. Öl-Gem. und Aqu., weiterhin Gem. in Acryl (Spätwerk), Pastell-, Tusch- und Kreide-Zchngn sowie Akt-Skulpturen. Ab M. der 1930er Jahre entstehen expressive Akt-Darst., später Stadtansichten, Lsch., Stilleben und Portr., deren Formsprache zunehmend abstrahierter wird, bis in den 1970er Jahren eine geometrisch-abstrakte Gest. überwiegt. C. kombiniert seine Arbeiten häufig mit eig. Gedichten (z.B. die Serien *Unité* und *Synergies*). Ein Großteil der Werke ist durch Plünderung des Ateliers in Suresnes (1942) und einen Brand (1962) zerstört. ◉ *E:* Paris: 1964 Gal. Claude Desgaches; 1946 Gal. Roux-Henschel / 1975 Villeneuve, Gal. d'Art du Vieux-Villeneuve / 1992 Vevey, Gal. Bleue / 1998 Payerne, Mus. de l'Abbatiale (Retr.) / 2000

Chevenez, Espace Courant d'Art / 2006 Abbeville, Mus. Boucher-de-Perthes / 2008 Pérouges, Maison des Princes. – *G:* 1926 Paris: SAfr. / Genf: 1983 Gal. Editart: Hommage à Miro; 1989 Gal. Cigarini: Fête de Couleur / 2002 Luxemburg, Banque et Caisse d'Epargne de l'Etat, Gal. d'Art contemp.: Le Sport dans l'Art d'aujourd'hui. ⌺ *P.-G. Persin,* L.-O. C., 1899–1999, P. 2002. F. Krohn

Chesneau, *Louis,* frz. Amateurfotograf, * 25. 9. 1855 Rouen, † 3. 10. 1923 ebd., war dort tätig. 1891 Gründungs-Mitgl. des Photo-Club Rouennais, einer Vrg von Amateurfotografen, die Ausst. und Exkursionen veranstaltet und den Mitgl. ein Labor und eine Bibl. zur Verfügung stellt. – C. fotografiert als Amateur ab 1875, zunächst im Kollodiumverfahren. Später verwendet er Gelatine-Trockenplatten. Als Pionier der Reportage-Fotogr. hält er in zahlr. Momentaufnahmen neben Ereignissen in seiner Heimatstadt Rouen (Festumzüge, Jahrmärkte, Sportveranstaltungen, Auftritte von Politikern, z.B. *Félix Faure recevant un bouquet, gare de Rouen*) Stadtansichten und alltägliche Straßenszenen sowie spektakuläre Begebenheiten wie den Sturz eines Pferdes oder die Entgleisung eines Zuges fest (z.B. *Déraillement Petit-Couronne, Wagon internat., 21 août 1877*). Für Außenaufnahmen nutzt C. eine Handkamera der Marke Véga (Fa. Hansen, Paris). In inszenierten Studio-Fotogr., für die häufig seine Kinder oder Mitgl. des Photo-Clubs, verkleidet und mit Accessoires ausgestatt, als Modelle fungieren, nimmt er, teils ironisch, Bezug auf aktuelle politische Themen (z.B. *Enfant, une tête à la main. Massacre des arméniens. Marcel et Pierre, 1897*). An den regelmäßigen öff. Veranstaltungen des Photo-Clubs beteiligt er sich 1892–1919 mit Vorführungen seiner Fotogr. (z.B. *Quelques tranches de Rouen,* 1896; *La vie à grande eau,* 1901; *Court-circuit de la Grande Guerre à Rouen, 1914–1918,* 1919). Aufschluß über die dort gezeigten Fotogr. liefern die erh. Notizbücher mit einer Numerierung der Abb. und meist ironischen Kommentaren. C.s Fotogr., fotogr. Geräte und Aufzeichnungen befinden sich im Bes. der Familie. ⌺ ROUEN, Arch. dép. de Seine-Maritime. ◉ *G:* 1996–97 Paris, BN: La Révolution de la Photogr. instantanée 1880–1895 (K) / 2004 Le Havre, Mus. Malraux: Vagues 2. Hommages et Digressions (K) / 2005–06 Louviers, Mus. mun.: Photos de Famille. Regards d'Artistes contemp. (K) / Rouen: 2007 Mus. maritime: Le Pont transbordeur de Rouen; 2010 Arch. dép. de Seine-Maritime: Impressionnistes et Photographes. Regards croisés. ⌺ *D. Mouchel,* Etudes photogr. 11:2002, 69–91; *id.,* Rouen. L. C., un photographe amateur. Le voyage à Saint-Sever en 1899, Bonsecours 2002. – *Online:* Photo-Club Rouennais (Lit.); Pôle Image Haute-Normandie. F. Krohn

Chesnel, *Jacques,* frz. Maler, Zeichner, Musikkritiker, * 1928 Lisieux/Calvados, lebt seit 1948 in Caen. 1953–72 in Archit.-Büros tätig (v.a. als Zeichner); ab 1974 arbeitet C. als Musikkritiker: Mitgl. der Acad. de Jazz; 1974–82 Redakteur der Zs. Jazz-Hot; Berater für das Inst. Nat. de l'Audiovisuel; 1978–93 Präs. der Assoc. Branché-Jazz; Organisation von Konzerten (u.a. im Café des Images in

Hérouville-Saint-Clair) und Konferenzen (Les Rapports entre le Jazz et les autres formes d'Art); zahlr. Veröff. zum Thema Jazz. C. beginnt 1958 zu malen und nimmt Unterricht bei Louis-Edouard Garrido am Lycée Malherbe in Caen. – In versch. Stilen und Techniken (u.a. Acryl, Gouache, Öl) transformiert C. Jazzmusik in Malerei. In den 1960er Jahren malt er Lsch., die durch Jazz beeinflußt sind. Während er die Musik hört, widmet er sich bevorzugt dem Action painting. In Anlehnung an Gem. der Pop-art gestaltet C. Porträts bed. Jazzmusiker und bezieht sich in abstrakten Arbeiten häufig auf bestimmte musikalische Werke, z.B. entsteht eine Serie mit Farbfeldmalereien zum Album A Love Supreme von John Coltrane. ⌂ CAEN, FRAC Basse-Normandie. ✉ C./G. Arnaud, Les grands créateurs de jazz, P. 1989; Le jazz en quarantaine, 1940–1946, Occupation-Libération, Cherbourg 1994; C./R. Carr, La légende du jazz, P. 1998; Plans-séquences. Hist. brèves, P. 2010. ☞ E: Caen: 1958 Gal. Ménard; ab 1961 regelmäßig Gal. Cadomus / Paris: 1960, '63 Gal. Le Soleil dans la Tête; 1976 Gal. Maître Albert / 1989 Malakoff, Centre cult. (mit Jean Berthier) / 1991 Brazzaville, Centre cult. / 1993, '98 La Seyne-sur-Mer, Fort Napoléon / 2008 Condé-sur-Noireau, Espace Mus. Charles Léandre (Retr.) / 2011 Evrecy, Collège Paul Verlaine. – G: Caen: 1959 Gal. Cadomus: 25 Peintres ont vu la Pêche; 1993 MBA: Henri Dutilleux et les Peintres / 1967 Paris, Mus. de la mode de la Ville de Paris: L'Âge du Jazz / 1996 La Seyne-sur-Mer, Fort Napoléon: Jazz & Peint. ⌑ Bénézit III, 1999. – L. Le Roc'h Morgère (Ed.), Artistes contemp. en Basse-Normandie, 1945–2005, [Caen] 2005. – Online: Website C. F. Krohn

Chetrit, *Marcel*, israelischer Maler, Zeichner, Architekt, Lyriker, * 1936 Paris, lebt seit 1969 in Jerusalem. Stud.: 1955–69 in Paris, u.a. bis 1960 Éc. de Metiers d'Art. Mitgl. der Vrg Israelischer Künstler; Vors. der internat. Künstlergruppe Kesher. Ausz.: 1994 Marc-Chagall-Preis, Vitebsk. – In abstrakten Arbeiten der späten 1960er und frühen 1970er Jahre sind Lsch. meistens fiktiv und Figuren nur angedeutet. Im Laufe der ersten Israel-Jahre werden beide faßbarer, wahrsch. auch durch Ch.s eingehende Auseinandersetzung mit hist., biblischen und kabbalistischen Themen. Des weiteren dient klassische Musik als Inspirationsquelle. Aus vielen der in Israel entstehenden Bilder dringt Chagallsche Heiterkeit. Andere atmen die Leichtigkeit jap. Tuschzeichnungen. Zu seinem immer heterogenen Schaffen gehört aber auch ein spontaner Wechsel in mon. und aggressive Farbabstraktionen. ⌂ KERAVA, KM. MOSKAU, Puškin-Mus. ✉ Pour un anniversaire, poèmes et peintures, s.l. 2005; Dans l'Alternance, poèmes et peintures, s.l. 2007. ☞ E: seit 1965, u.a. 1994 Moskau, Minist. für Kunst und Kultur / 1997 St. Petersburg, Manege / 1999 Kerava, KM (K); Ramat Gan, Mus. of Israeli Art / 2000 Paris, Gal. Artemim / Jerusalem: 2000 Menahem Begin Centrum; 2005 Yedidia Centrum. – G: zahlr., u.a. 1993 Osaka: Trienn. (K) / 1993–94 Paris, Mus. d'Art juif: Spiritual matters (K) / 1994 Vitebsk: Internat. Chagall-Festival / 1996 Sofia: Internat. Malerei-Ausst. ⌑ Online: Israeli AC; Website C. B. Scheller

Cheung, *Lin*, britische Gold- und Silberschmiedin, Schmuckgestalterin, * 1971 Basingstoke/Hants., lebt in London. Stud.: 1989–91 Southampton Inst. of Higher Education (seit 2004: Southampton Solent Univ.); 1991–94 Univ. of Brighton; 1995–97 R. College of Art, London. Lehrtätigkeit: seit 2009 Central St. Martins College of Art and Design ebd. (Senior Lecturer for Jewellery Design). Ausz.: 1997 Renaiss. Art Awards; The Goldsmiths' Company Award for Jewellery; Deloitte & Touche Award for Excellence; 2001 The Arts Found. Award for Jewellery design; 2008 Jerwood Contemp. Makers. – In Auseinandersetzung mit persönlicher und allgemeiner Bedeutung von Schmuck sowie seiner sozialen Komponenten gelangt C. zu einer konzeptuell geprägten Gest. von Schmuckstücken und Objekten (bevorzugt in Gold und Silber). Sie geht z.B. der Frage nach, was mit Schmuck passiert, der nicht mehr getragen wird und verewigt diesen durch in Gold gerahmte Abdrücke (*Porträt*, 2003). In den Broschen der Serie *Worn again* (2003) reaktiviert C. solche Fundstücke, in diesem Fall Ringe. Häufig stehen C.s Arbeiten in Verbindung mit persönlichen Erlebnissen, Erfahrungen und Gefühlen. Char. ist zudem der oftmals ironisch intendierte Rückgriff auf scheinbar banale Gegenstände (z.B. die Brosche *Equanimous*, die einer Wasserwaage nachempfunden ist, sowie die an ein Reisenähset erinnernde Brosche *Emotional repair*, beide 1998). Dies wird auch in den *Memoria*-Ohrringen deutlich (Gold, 1999). Sie sind einerseits Erinnerung an C.s Mutter und erheben andererseits ein üblicherweise unbeachtetes, simples Detail, nämlich die Verschlüsse von Ohrsteckern, zum eigtl. Schmuckelement. Die Vielfalt zwischenmenschlicher Beziehungen thematisiert sie in den Ringgruppen *Trilogy* und *Stress* (jeweils Silber, 1997), die sowohl Verbindung als auch Trennung veranschaulichen. ⌂ GÖTEBORG, Röhsska mus. 's-HERTOGENBOSCH, SM's. LONDON, Contemp. Art Soc. – Crafts Council. MIDDLESBROUGH, Middlesbrough Inst. of Mod. Art. STOKE-ON-TRENT, Potteries Mus. and AG. ✉ C./B. Clarke/I. Clarke, New directions in Jewellery II, Lo. 2006. ☞ E: 2001, '02, '05 (mit Laura Potter, Manuel Vilhena) Nijmegen, Gal. Marzee / 2003 Tielrode, Gal. Sofie Lachaert / 2005, '07 Tokio, Gall. Deux Poissons / 2008 Idar-Oberstein, FH Trier / 2010 Göteborg, Gall. Hnoss. – G: 1998 Heckington, Pearoom Centre for Contemp. Crafts: Mavericks. Jewellery for the Brave / 2000 Tielrode, Gal. Sofie Lachaert: Table de fin de s. / 's-Hertogenbosch: 2003 Mus. voor Hedendaagse Kunst, Het Kruithuis: Tafel Plezier; 2007 SM's: Rituals / 2004 Bristol, City Mus. and AG: Jewellery Unlimited (K) / 2007 Hatfield, Univ. of Hertfordshire, Art and Design Gall.: Process works (Wander-Ausst.; K); Sheffield, Sheffield Hallam Univ., End Gall.: In their own Words (K) / 2008 Padua, Marijke Studio: Influenze Confluenze – oriente occidente / 2010 Cagnes-sur-Mer, Espace Solidor: L'Education sentimentale (K) / 2011 Göteborg, Gall. Hnoss: The Ring. Jewel forever; Gustavsberg, Konsthall: Embraced – Jewellery sites. ⌑ L. C. Jewellery & objects, Lo. 2005; Jewelry design, Köln 2008. – Online: Website C. F. Krohn

Chevalier, *Etienne*, frz. Maler, * 30. 1. 1910 Paris,

† 1982 Veyrac/Haute-Vienne, tätig in Algerien und in der Region Poitou. Sohn des Malers *Henry C.* (* 19. 7. 1886 Poitiers/Vienne, † 1945 Algier; Stud.: ENSBA, Paris, bei Joseph Blanc; ab 1921 Prof. am Grand Lycée, Algier; Werk-Bes.: MNBA ebd.). Stud.: ab 1924 EcBA, Algier, bei Léon Cauvy. Als 19jähriger nominiert für den Prix Fénéon. 1931–35 Aufenthalt in Paris, dort Stud. bei Marcel Gromaire an der Acad. Scandinave. Ausz.: 1938 Aufenthalts-Stip., Casa Velázquez, Madrid. C. verläßt die Stadt aufgrund des Bürgerkriegs, reist nach Portugal und hält sich anschl. in Florenz auf, wo er sich die Technik der Freskomalerei aneignet. 1940 Grand Prix artist. de l'Algerie. Lebt in El-Biar, malt dort zahlr. Lsch. (*Neige à El-Biar*) sowie Stadt- und Hafenansichten. 1939 und erneut 1944 Einberufung, 1944–46 als Peintre des armées in Südtunesien und Florenz, 1947 demobilisiert. Lehrtätigkeit: 1947–64 EcBA, Algier; 1964–77 Ec. des Art décoratifs, Limoges. 1990 wird C. posthum mit einer Retr. in Paris gewürdigt. – Von der zeitgen. Kritik für die Lebendigkeit und Wahrhaftigkeit seiner Werke gelobt, gestaltet C. v.a. detailgetreue Lsch. (*Un coin de la Mitidja*) und Marinen (*Sidi-Ferruch, plage ouest avec les cabanons*). Auch Stilleben (u.a. Blumen, Musikinstrumente; z.T. großformatig) nehmen einen wichtigen Platz in C.s Œuvre ein (*Pain, verre et bouteille*; *Nécessaire de fumeur et fleurs sur une table*). Weiterhin entstehen Portr. und Genreszenen. ▣ ALGIER, MNBA. FONTENAY-LE-COMTE, Mus. Vendéen. NARBONNE, MAH. ORAN, MN Zabana. PARIS, FNAC. POITIERS, Mus. Ste-Croix. ◉ *E:* Paris: 1934 Gal. Jeanne Castel; 1935 Gal. Marcel Bernheim; 1938 Gal. Sans Pareil. – *G:* 1925 Algier: Salon des Artistes algériens et orientalistes / Paris: ab 1927 Salon d'Automne (Mitgl.); Salon des Indépendants; Salon des Tuileries; 1935 Pavillon de Marsan: Expos. artist. de l'Afrique franç.; 1937 WA; 1957 Gal. Leleu: Les Peintres de l'Algérie / 2003 Bordeaux, MBA: L'Ec. d'Alger (K). ▥ Vol, 1953. *Edouard-Joseph* I, 1930; *Bénézit* III, 1999; *E. Cazenave*, Les artistes de l'Algérie, P. 2001. – *G. Martin*, Les peintres Nord-Africains, Algier 1947; *M. Charley*, Un grand peintre du Sahel, 1960 (Film); *A.-M. Briat u.a.*, Des chemins et des hommes. La France en Algérie, 1830–1962, Hélette 1995; *M. Vidal-Bué*, L'Algérianiste 116:2006 (Dez.). F. Krohn

Chevalier, *Henry* cf. **Chevalier,** *Etienne*

Chevalier, *Jean*, frz. Maler, Zeichner, Kunstlehrer, Autor, * 11. 4. 1913 Saint-Pierre-de-Chandieu/Rhône, † 27. 2. 2002 Lyon, lebte dort. 1929–32 Ausb. zum Grundschullehrer (Schwerpunkt Zeichnen) an der Ec. Normale d'Instituteurs in Grenoble; weiterhin besucht C. Kurse am Mus. de Grenoble und kunsthist. Vorlesungen von René Jullian an der Acad. in Lyon. Im Sommer 1933 Aufenthalt in Paris. C. verfaßt Artikel über Künstler, u.a. über Johann Barthold Jongkind und Robert Delaunay (z.B. „Jongkind et le Dauphiné" für die Zs. Les Alpes, Grenoble). Angeregt von einem Artikel lädt R. Delaunay ihn 1938 ein und vermittelt den Kontakt zu Albert Gleizes, dessen Schüler, Ass. und Vertrauter C. wird. Durch A. Gleizes kommt er in Berührung mit den Gruppen Méjades, Moly-Sabata und Témoignage und schließt Bekanntschaft

mit inspirierenden Künstlerpersönlichkeiten. C. unterrichtet als Kunstlehrer an versch. Grundschulen, u.a. in Saint-Romain-de-Jalionas und Décines und wird hierfür 1962 mit dem Prix Eugène Monnier der Acad. d'Archit. ausgezeichnet. In den 1960er Jahren leitet C. Malkurse an der Maison de la Jeunesse et de la Cult. des Etats-Unis in Lyon und gründet ebd. ein Malatelier in der Tagesklinik der Mutuelle Générale de l'Education Nat., in dem er kunsttherapeutisch arbeitet. 2000 Gründung der Assoc. Les Amis de J. C. in Lyon, die 2007 mit der Gal. Olivier Houg den Prix J. C. ins Leben ruft. Die Assoc. Les Amis de J. C. bewahrt zahlr. unveröff. poetische und kunsthist. Schriften C.s zwei Publ. mit Texten und Ill. befinden sich im Bes. der Univ. Lumière Lyon (*Intervalles*, 1968–85; *Dialectique du regard*, 1992–95). – Im Frühwerk geometrische Komp., ab den 1950er Jahren von R. Delaunay und A. Gleizes beeinflußte Arbeiten, die in ein gestisches, zunehmend abstraktes Œuvre münden (Gem. in Öl, Acryl und Gouache sowie Tusch-, Kohle-, Rötel- und Pastell-Zchngn). ▣ GRENOBLE, Mus. de Grenoble. LYON, MBA. – Univ. Lumière Lyon. SAINT-PIERRE-DE-CHANDIEU, Bibl. mun. Pierre Gamache. VILLEFRANCHE-SUR-SAONE, Mus. Paul Dini. ✉ *C. u.a.*, A. Gleizes et le Cubisme, St. 1962. ◉ *E:* Lyon: 1960, '67 Gal. Folklore; 1972 Gal. Coutureau; 1979, '81, '83, '84 Gal. Le Pantographe; 1987 Auditorium Maurice Ravel; 2001–02 Gal. Olivier Houg; 2010 Univ. Lumière Lyon; 2011 MBA / 1965 Grenoble, Gal. Parti Pris / 1977 Hauteville, Centre d'Art contemp. de Lacoux. – *G:* Paris: 1946, '47, '56 Salon des Réalités Nouvelles; 1953–54 Gal. Cimaise: Ec. de Gleizes; 1956 Gal. de l'Inst.: Six Disciples de Gleizes / Lyon: 1949 Lycée Ampère, Chap.: Les Réalités Nouvelles; 1949, '52–58 Salon d'Automne; 1965, '67, '69 Salon Regain; 1985 Ancienne Ec. du Service de Santé Militaire: Art sans Ec.; 2000 MBA: Les Modernes. De Picasso à Picasso (K) / 1966 Annecy, Mus. Château: Cent Ans de Peint. lyonnaise / 1971 Vénissieux, Maison du Peuple: Peintres lyonnais du XIXe s. à nos Jours. ▥ *Bénézit* III, 1999. – *P. Dazord u.a.*, J. C. Peintre à Lyon (1913 – 2002), Lyon 2003. – *Online:* Website Assoc. Les Amis de J. C. F. Krohn

Chevalier, *Marc*, frz. Maler, Objekt-, Installationskünstler, Zeichner, * 28. 8. 1967 Paris, lebt dort, in Nizza und Berlin. Stud.: 1988–93 (Dipl.) Ec. Pilote internat. d'Art et de Rech., Villa Arson, Nizza. Mitgl. der dortigen Künstler-Vrg La Station. 1998 Preis der Stiftung Vordemberge-Gildewart, Rapperswil. – Im Kontext der Auseinandersetzung mit symbolträchtigen Werten und im Umkehrschluß mit wertlosen Symbolen untersucht C. die Assoziationen, die er mit dem Wort Malerei verbindet. Dazu praktiziert er im weitesten Sinn eine abstrakte „Malerei", die er von ihrem trad. Medium, der Farbe, trennt. Stattdessen arbeitet er mit Klebeband, das er entweder auf ebenfalls aus diesem Mat. gefertigten gerahmten Bildträgern fixiert oder mit dem er Computermonitore „bemalt". And. Werke bestehen ausschl. aus Klebeband ohne Bildträger. Die durch das Band entstandenen linearen Strukturen betrachtet C. als bedeutungslose Schrift, die einer nicht in Worte faßbaren Realität entspricht. Um den Mal-

prozeß umfassend zu analysieren, kehrt er diesen um und verwendet auch wieder Farbe, die er zuerst trocknen läßt, ehe er die krümeligen Partikel aufträgt. Zudem collageartige Darst. aus zerrissenen Werbeplakaten, deren Teile C. überlappend wieder zusammensetzt und lackiert, sowie Zchngn auf der Basis von Pixeln nachempfundenen Elementen. ⌺ ANGOULEME, FRAC Poitou-Charentes. MARSEILLE, FRAC PACA (Provence-Alpes-Côte d'Azur). NIZZA, MAM et d'Art contemp. PARIS, FNAC. ◉ *E:* Nizza: 1995 Villa Arson; 1997 Gal. Sintitulo; 2000 Gal. Françoise Vigna (mit Arnaud Maguet); 2007 Maison abandonnée (Villa Cameline) / 1997 Aix-en-Provence, Mus. des Tapisseries (K) / 1998 Paris, Gal. Eof (mit Cédric Teisseire) / 2001 Tarbes, Le Parvis. ⌑ *Delarge,* 2001. – C. *Flécheux,* M. C. La limitation de l'imitation (K), N. 1995; *J.-P. Vienne* (Vorw.), M. C. (K), La Seyne-sur-Mer 1995; Prêts à prêter. Acquisitions et rapp. d'activités 2000/ 2004, FRAC Provence-Alpes-Côte d'Azur, P./Marseille 2005. – *Online:* Website C. (Ausst., Lit.). R. Treydel

Chevalier, *Marcel (Marcel Ghislain),* belg. Maler, Zeichner, * 26. 4. 1911 Forrières, † 5. 11. 2005 Dinant, ab 1979 in Bouvignes-sur-Meuse ansässig. C.s Fam. läßt sich 1926 in Brüssel nieder, wo C. zu malen beginnt. Ab 1930 militärische Laufbahn, die er als Stabshauptmann (Capitaine-commadant) 1962 beendet. 1940–45 Gefangenschaft in Deutschland, 1945 Befreiung, Rückkehr (schwer verletzt) nach Belgien und Entschluß, sich verstärkt der Malerei zu widmen. 1951 Premier Prix, Concours dépt. de Peint. du Limbourg. 1953–64 Abendkurse an den ABA in Dinant und Namur; Arbeit mit Ton. Lebt 1968 in Paris, im Dép. Hérault und auf Korsika. 1977–79 in London tätig; dort Mitgl. des Centre of Contemp. Art. – Zunächst expressive Lsch. und Stadtansichten sowie geometrisch-abstrakte, vom Kubismus beeinflußte Komp. in Öl. Ab den 1980er Jahren verwendet C. vermehrt Acryl- und Gouachefarben. Mittels Grattage und Rakel verleiht er nun den geometrisch-abstrakten Darst. char. Strukturen und erzeugt den Eindruck von Dynamik und räumlicher Tiefe. Figurative Elemente integriert C. ab A. der 1990er Jahre in seine Werke. Hierfür nutzt er Werbe-Fotogr. aus Ztgn und Zss. sowie Ausschnitte aus Werbeplakaten und -prospekten. Die meist weibl., durch z.T. starke Übermalung schemenhaft wirkenden Gesichter kontrastieren die abstrakten Partien der Gemälde. Zudem entstehen Selbst-Portr. in versch. Techniken und abstrakte Zchngn. ⌺ LÜTTICH, Mus. de l'Art wallon. OOSTENDE, KM aan Zee. PARIS, MAMVP. ◉ *E:* Brüssel: 1951 Gal. Ex-Libris; 1997 Gal. Arets / Paris: 1964 Gal. La Passerelle; 1967 Gal. Jean Camion; 2001 Gal. Art Présent; 2007 La Capitale Gal. / 1972 Saint-Etienne, Maison de la Cult. / 1979 Bouvignes-sur-Meuse, Maison Espagnole / 1985 Dinant, Maison de la Cult. / 1990 Schaerbeek, Maison des Arts (Retr.) / 1992 Köln, Petite Gal. 72 (K). – *G:* 2009–10 Paris, La Capitale Gal.: Poétique du Regard 1960–80. ⌑ *Bénézit* III, 1999; *Pas* I, 2002. – *S. Goyens de Heusch* (Ed.), XXᵉ s. L'art en Wallonie, Tournai/Br. 2001. – *Online:* De Belgisch-Limburgse kunstschilders en tekenaars, 2006; Website C. F. Krohn

Chevalier, *Miguel,* mex. Computer- und Installationskünstler, * 1959 Mexiko-Stadt, tätig in Ivry-sur-Seine. 1978–83 Stud. in Paris (ENSBA; Ec. nat. supérieure des Arts décoratifs; Univ. Paris I [Bild. Kunst und Archäologie]), wo er sich 1985 niederläßt. Weiterführende Stud.: 1983–84 Pratt Inst. und School of Visual Arts, New York; 1988 Inst. des Hautes Etudes en Arts plast., Paris; 1989 Musashino Univ., Tokio. 1986 Gründer und Dir. des Atelier pilote d'Infographie, Paris. Artist in Residence: 1991 Casa Velázquez, Madrid; 1993–94 Villa Kujoyama, Kyōto; 2004 Riad Denise Masson, Marrakesch. Lehrtätigkeit: 1994 Univ. de los Andes, Bogotá; 1995–96 Ltg des Atelier d'Infographie der Ec. Supérieure d'Art et de Design, Reims; 1997–99 EcBA in Rennes und Metz. – C. widmet sich seit 1978 der digitalen Kunst und gilt als Pionier auf dem Gebiet der Computerkunst. In interaktiven Arbeiten (häufig als Teil von Installationen, z.B. *Oro Negro*) gestaltet C. digitale Welten und lotet damit die Grenze zwischen natürlichem und künstlichem Dasein aus. Gesteigert wird die Wirkung der virtuellen Mikrokosmen häufig durch die Kombination mit akustischen und bisweilen auch olfaktorischen Reizen (z.B. *Fractal Flowers in Vitro*). C. kreiert u.a. digitale Städte, Lsch. und Pflanzenwelten (z.B. *Sur-Natures*), die auf die Bewegungen des Betrachters reagieren. Bei den *Fractal Flowers* löst der Besucher die vom Samenkorn ausgehende Entwicklung der einzigartigen Pflanzen aus und kann so den Kreislauf von Werden und Vergehen nicht nur mitverfolgen, sondern auch steuern. Die digitalen Arbeiten werden an Wände projiziert oder auf großformatigen Bildschirmen sowie als Cibachromdrucke präsentiert. ⌺ BELFORT, MAH. BOULOGNE-BILLANCOURT, Mus. des Années 30. BRETIGNY-SUR-ORGE, Centre d'Art contemp. CARACAS, Mus. de Artes Visuales „A. Otero". CERET, MAM. CUENCA, Mus. Internac. de Electrografía. MARACAIBO, MBA. MÉXICO-STADT, Mus. de Arte Alvar y Carmen T. de Carrillo Gil. PARIS, BN. – FNAC. – MAMVP. VITRY-SUR-SEINE, MAC Val-de-Marne. ◉ *E:* Paris: 1985 ENSBA; 2009–10 Mus. de la Chasse et de la Nature / 1991 Nantes, Ec. régional des BA (K) / 1993 Caracas, Mus. de Artes Visuales „A. Otero" (K; Wander-Ausst.) / 2000 Genf, MAMC / 2005–06 Casablanca, Espace d'Art Actua (mit Najia Méhadji; K) / 2006 Pittsburg (Pa.), Wood Street Gall. / 2010 São Paulo, Mus. da Imagem e do Som / 2011 Köln, Inst. franç. – *G:* seit 1982, u.a. 1986 Rennes: Festival des Arts électroniques / Paris: 1988 MAMVP: Ateliers 88 (K); 1990–91 Centre Pompidou: Art & Publicité 1890–1990 (K); 2005 Gal. Akié Arichi: Cartographies, Paysages (K) / 1997 Stuttgart, SG: Magie der Zahlen in der Kunst des 20. Jh. (K) / 2003 Arles, Mus. de l'Arles et de la Provence antiques: Les matériaux de la sculpt. (K) / 2006 Montrouge: Salon d'Art contemp. / 2009 Auxerre, Centre d'Art de l'Yonne: On a marché sur la Terre (K) / 2010 Singapur, Singapore AM: Digital Nights. ⌑ *Bénézit* III, 1999; *Delarge,* 2001. – *P. Restany/L. B. Dorléac/P. Imbard,* M. C., P. 2000; L'algorithme pixélisé, P. 2003; *M. Costa u.a.,* M. C., Blou 2008. – *Online:* Website C. F. Krohn

Chevalier, *Yvonne*, frz. Fotografin, * 18. 1. 1899 Paris, † 22. 6. 1982 ebd. Erste Fotogr. als Kind. Autodidaktin. Ab 1929 ausschließliche Beschäftigung mit Schwarzweiß- und Farb-Fotogr. in eig. Studio in Paris. Vertreterin des Neuen Sehens. – Char. sind sorgfältige Bild-Komp., starke Licht-Schatten-Wirkung, das Hervorarbeiten von Strukturen und ungewöhnliche Perspektiven wie starke Untersicht. V.a. Portr. von Dichtern, Komponisten und bild. Künstlern wie Paul Claudel, Francis Poulenc, Arthur Honegger und Max Jacob. Ab 1930 als Fotogr. für Georges Rouault tätig (Portr., Dok. der Werke). Außerdem Theater-Fotogr. (1938 für das Théâtre des Ambassadeurs, Paris), Akte und die Darst. von Musikinstrumenten. Um 1939 Ill. zu dem Roman Le lys dans la vallée von Honoré de Balzac. 1949 Aufnahmen in span. Klöstern für ein Buch von Marcelle Auclair über Theresa von Avila. Bis 1970 Zus.-Arbeit mit Zss. (Fotoreportagen). Mitgl.: 1936 der von Emmanuel Sougez gegr. Gruppe Rectangle, 1946 Mitbegr. der Groupe des XV.; Nähe zur Assoc. des Ecrivains et Artistes Révolutionnaires. Beteiligung an vielen Gruppen-Ausstellungen. Zahlr. ihrer Arbeiten wurden im Krieg zerstört. ⌂ PARIS, Bibl. Marguerite Durand. – BN. – MNAM. ☉ E: 1990 Chalon-sur-Saône, Mus. de la Photogr. Nicéphore Niépce (K). ⌕ *Auer*, 1985. – *R.-H. Barbe*, Ma joie terrestre où donc es-tu?, P. 1947 (Fotogr.); *Teresa de Jesús*, Le livre des fondations, P. 1952 (Fotogr.); *M. Auclair*, La vie de sainte Thérèse d'Avila, P. 1953 (Fotogr.); Georges Rouault visionnaire (K), Basel 1971 (Fotogr.); *M. de Thézy u.a.*, Paris 1950. Photogr. par le Groupe des XV (K), P. 1982; *Q. Bajac/C. Cheroux* (Ed.), Coll. photographs (K MNAM Paris), Göttingen 2007. N. Buhl

Chevallaz, *Edouard (Edouard David)*, schweiz. Architekt, Zeichner, * 12. 9. 1875 Genf, † 8. 6. 1926 ebd. Über die Ausb. ist nichts bekannt, eine Lehre jedoch wahrsch.; um 1895 Beginn der Berufstätigkeit. 1902–07 sechs prämierte Wettb.-Entwürfe für Fassaden-Gest. in Genf (Wohnbauten wie öff. Gebäude). Ab 1907 Mitgl. im SAI (Schweiz. Ing.- und Archit.-Verein). C. zeigt sich als moderater Traditionalist, dessen bis ins Detail sorgfältig ausgef. Bauten den jeweiligen Zeitgeschmack spiegeln. Anfangs baut er in der eklektizistischen Beaux-Arts-Trad. oder, in Anlehnung an den Rundbogenstil, in einem romanisch-byz. Historismus. 1903–07 wendet C. sich dem pittoresken Schweizer Stil zu, der sich durch steile Dächer sowie polychrome und dynamisch komponierte Fassaden aus unterschiedlichen Mat. auszeichnet. Er entspricht hiermit avantgardistischen Forderungen, denenzufolge die Erneuerung der Archit. durch Abkehr vom akad. Regelwerk und Besinnung auf regionale, auch handwerkliche Trad. zu erreichen ist. C.s offenbar einziges Gebäude, das auch formale Elemente des Art nouveau aufweist, ist das Wohn- und Geschäftshaus in der Av. Pictet de Rochemont 2, Ecke Pl. des Eaux-Vives von 1906. Ab 1910 nähert sich C. einem geklärten Neuklassizismus mit verhaltener Dekoration und lokalspezifischen Jugendstilelementen, womit er nunmehr der zeitgen. Bemühung um Sachlichkeit, wie sie sich v.a. in Deutschland entwickelt, entspricht. ⌂ COLLONGE-BELLERIVE, Route d'Hermance 110: Schule und Rathaus,

1910–11. GENF: *Wohngebäude*: Boulevard Carl-Vogt 87, 1898; 89, 1902; 95–101, 1902; Rue des Bains 22–26, 1901; 25, 1903–04; Rue des Maraîchers 53–55, 1901; Rue Patru 4, 1903; Rue des Pavillons, 1903; Route de Chêne 2/ Av. Théodore Weber 1–3, 1910–13; Rue Imbert Galloix 4, 1911; Route de Chêne 15, 1912; Rue de Villereuse 1 + 4, 1912. – Rue des Voisins 21: Kirche St-François-de-Sales, 1902–04. – Boulevard de la Cluse 24: Schule Roseraie, 1906–07. ⌕ *I. Rucki/D. Huber* (Ed.), Architekten-Lex. der Schweiz 19./20. Jh., Basel u.a. 1998. A. Mesecke

Chevallier, *Florence*, frz.-marokkanische Fotografin, * 25. 2. 1955 Casablanca/Marokko, lebt in Paris. Stud.: Univ., Paris, Inst. d'ét. théâtrales (Dipl. 1978). Mitbegründerin der Gruppe Noir Limite (1986–93). Stip.: Villa Medici, Rom; Fiacre Centre nat. du livre, Paris; 1996 Gastkünstlerin ENSBA, Paris. Lehrtätigkeit: u.a. 1995–2005 Ec. supérieure d'art et de design, Reims; Ec. régionale des BA, Rouen. Ausz.: 1998 Prix Niépce; 2009 Chevalier des arts et lettres. – V.a. Fotoserien. In den frühen Arbeiten setzt sich C. mit dem menschlichen Körper und seiner Darst. im Raum auseinander. Neben Akt-Fotogr. (*Corps auto-portr.*, 1979–86; *Corps à corps*, 1987; *Nus de Naples*, 1988) auch Portr. (*Troublée en verité*, 1987; *Visages tombeaux*, 1989), teilw. Selbst-Porträts. Ab etwa 1989 Serien von Farb-Fotogr. mit Menschen (oft Akte) in inszenierter, symbolisch aufgeladener Umgebung (*La mort*, 1989) oder in freier Natur (*Le bonheur*, 1991/92); starre Körperhaltung, Licht-Schatten-Wirkung und ein erzählerischer Eindruck, der jedoch keine stringente Gesch. ergibt, erzeugen eine magische bis surreale Stimmung (*Les philosophes*, 1996; *Les songes*, 2000). Themen sind der Mensch, seine Wünsche und sein Verhältnis zu and. Menschen und zur Umgebung (*Enchantment 1–3*, 1996–98; *Toucher terre*, 2010; *1955 Casablanca*, autobiografisch, 2000). Weitere Serien: *La chambre invisible* , 2005; *Serifos* , 2007; *Rivière*, 2010; *Atlas*, 2011. Seit 2005 auch Videos: *Où finit la terre*, *Les enervées*, *L'île aux laminaires*, *Lumière acoustique*, alle 2005; *Ritournelles*, 2007; *Toucher terre*, 2010; *Native nue*, 2012. ⌂ CHALON-SUR-SAÔNE, Mus. de la Photogr. Nicéphore Niépce. CHARLEROI, Mus. de la Photogr. PARIS, BN.- FNAC. – Maison Europ. de la Photogr. – MNAM. ☉ E: 1986 Hamburg, Gal. Moment / 1987 London, Inst. cult. franç.; Montpellier, Gal. Bazille / 1988 Rouen, EcBA / 1989 Le Havre, MBA / 1999 Chalon-sur-Saône, Mus. de la Photogr. Nicéphore Niépce / 2001, '09 Casablanca, Villa des arts / 2001 Pontault-Combault, Centre photogr. d'Ile-de-France / 2003 Charleroi, Mus. de la Photogr. / 2004 Brüssel, Gal. Les filles du calvaire / 2005 Vitry-sur-Seine, Gal. mun.; Toulouse, Château d'Eau, Gal. mun. (K) / 2009 Aix-en-Provence, Gal. du conseil général (mit Aurore Valade; K)/ 2011 Saint-Omer, Espace 36 / 2012 Saint-Rémy, Moulin des arts. – Mit Noir Limite: 1987 Bourges, Maison de la culture / 1989 Antibes, Gal. Suzel-Berna / 1990 Evreux, Maison des arts / 1991 Le Havre, Anciens Abbattoirs (K); Rennes: Transmusicales. ⌕ *Delarge*, 2001. – C. Nus. de Naples. Œuvres photogr. 1988–1989 (K), Montigny 1984; *C./B. Lamarche-Vadel*, Le bonheur,

P. 1993; *A. Giffon/S. Kivland* (Ed.), Le double, Saint-Fons 1995; Dans l'atelier du Mus. Zadkine. L'enchantement. Premier couplet de C., P. 1996; *P. Abaïzar* (Ed.), Portr. Singulier pluriel 1980–1990, P. 1997; Camera Austria 68:1999, 62 s.; La confusion des genres en photogr., P. 2001, 116–121; *D. Brudna*, Photonews 12: 2000 (4) 10 s.: 13:2001 (7/8) 18; *C./M. Berrada*, 1955 Casablanca, Tré-zélan 2003; *M. Donnadieu* (Ed.), Dans un jardin, Sotte-ville-lès-Rouen 2010. – *Online:* Website C. N. Buhl

Chevojon, *Jacques* cf. **Chevojon,** *Paul Joseph Albert*
Chevojon, *Louis* cf. **Chevojon,** *Paul Joseph Albert*
Chevojon, *Paul Joseph Albert* (*Albert*; Studio Chevo-jon; Maison Durandelle), frz. Fotograf, * 22. 10. 1864 Ro-mainville (mehrfach, wohl irrtümlich, * 1865), † 7. 4. 1925 Paris. C. lernt das Handwerk ab 1885 bei Louis-Emile Du-randelle in dessen Atelier Maison Durandelle (1861 gegr. und bis 1875 gemeinsam mit *Hyacinthe-César Delmaet* [* 21. 12. 1828 Roubaix, † 11. 7. 1862] unter dem Namen Maison Delmaet Durandelle geführt), welches er 1890 samt dem Fotogr.-Bestand übernimmt. In der Trad. seiner Vorgänger dokumentiert C. v.a. große lokale Bauprojek-te wie die Errichtung von Sacré-Cœur (1877 unter der Ltg von Durandelle begonnen). Zw. 1903 und 1907 führt er das Atelier gemeinsam mit seinem Cousin Jean-Baptiste Dufour unter dem Namen Chevojon et Dufour. Wie Del-maet und Durandelle dokumentiert C. in erster Linie die archit. Umgestaltung von Paris um die Jh.-Wende. Dar-über hinaus entstehen Fotogr. im Auftrag von Industrie-firmen und Verkehrsgesellschaften. Nach seinem Tod wird das Studio von den Söhnen *Louis C.* [* 1902?] und *Jacques C.* sowie später von den Enkeln Bernard und Gérard C. fortgeführt. – Lt. Baillargeon (2011) läßt sich für die Jahre bis 1903 nicht entscheiden, welche Aufnahmen von C. und welche von *Achille-Paul-Léonce Delmaet* (1860–1914), dem Sohn des Mitbegr., später leitender Ass. von Duran-delle und Kompagnon von C., stammen. ▭ PARIS, BN. – Bibl. hist. de la Ville de Paris. – Orsay. ROCHESTER/N. Y., George Eastman House. ☉ *G:* 1893 Chicago: WA (Mai-son Durandelle) / Paris: 1988–89 Mus.-Gal. de la Seita: Des grands chantiers ... hier (im Rahmen des Mois de la Photogr.; K); 2010 Gal. des bibl., Ville de Paris: Paris inon-dé 1910. ▭ *F. Denoyelle*, Le marché et les usages de la photogr. à Paris pendant l'entre-deux-guerres, Diss. Univ. Paris 3 Sorbonne Nouvelle, P. 1991; *J. Audouze u.a.,* Le Studio C. Une dynastie de photographes parisiens (K), P. 1994; *M. Frizot* (Ed.), Neue Gesch. der Fotogr., Köln 1998; *C. Baillargeon*, Construction photogr. and the rhetoric of fundraising, in: Visual resources 27:2011 (2) 113–128.
 P. Freytag

Chevrette, *Alain,* frz. Maler, Zeichner, * 1947 Lyon, dort tätig. 1963–64 Stud. an der Ec. nat. des BA, Lyon, bei René Chancrin. – In reduzierter Farbigkeit und ex-pressiver, flächiger Malweise mit pastosem Farbauftrag gestaltet C. bevorzugt Lsch., weiterhin stilisierte Portr., darunter zahlr. Selbst-Portr. (z.B. *Auto-Portr. à la Blou-se blanche*, Öl/Lw., 2007), Akt-Darst. (z.B. *Offerte*, Öl/ Lw., 2002), Stadtansichten, Marinen und Stilleben, v.a. in Öl (im Frühwerk auch Aqu.). In jüngerer Zeit zunehmend

abstrakte Komp. mit angedeuteten gegenständlichen Mo-tiven (z.B. *La Ronde des Poissons*, Öl/Lw., 2009). Auch Zchngn (u.a. Tusche, Faserstift). ▭ VILLEFRANCHE-SUR-SAONE, Mus. Paul Dini. ☉ *E:* Lyon: seit 1977 re-gelmäßig Gal. St-Georges (1994 K); 2000, '02 (K), '04, '07, '10 (K) Gal. Le Soleil sur la Place / 1983 Douvai-ne, Mus. des Granges de Servette / Paris: 1996 Gal. Ber-nard Bouche; 1997 Gal. Guénégaud; 2006 Gal. Déprez-Bellorget / 1999 Metz, Maison de la Cult. – *G:* seit 1976 Lyon, Pal. mun. des Expos.: Salon de Lyon et Sud-Est / 1978 Nizza: Bienn. de la Jeune Peint. Méditerranéenne / 1996 Paris: Salon de Mars / 2000 Décines-Charpieu, Cent-re cult. Le Toboggan: Le Nu / 2004 Bourg-en-Bresse: Bi-enn. d'Art contemp. / Villefranche-sur-Saône, Mus. Paul Dini: 2005 Paysages et Jardins (K); 2007 Portr. et Figu-res (K). ▭ *Bénézit* III, 1999; *Delarge,* 2001. – *Online:* Website C. F. Krohn

Chevrier, *Claire,* frz. Fotografin, * 21. 6. 1963 Pau/ Basses-Pyrénées, lebt in Mayet und Paris. Stud.: 1982–87 Ec. d'art, Grenoble. Stip. und Arbeitsaufenthalte: u.a. 1989, '92, '98, '99 Fiacre; 1995 Collège Marcel Duch-amp (1996 Ausst.), Châteaurouge (Aufenthalt in Indi-en); 2007/08 Villa Medici, Rom; 2010–11 Centre Régio-nale de la Photogr., Douchy-les-Mines. Lehrtätigkeit: seit 2005 Ec. spéciale d'archit., Paris. – Beschäftigt sich in Fotoserien mit dem Verhältnis des Menschen zum um-gebenden Raum, v.a. der von Archit. geprägten Stadt-Lsch. sowie der vom Menschen gestalteten Lsch. (*Rési-dence „Saxiphrage"*, Pays de Loire, 2011). Aufnahmen von Archit. und Städtebau (*Commande Euroméditerra-née Ville de Marseille*, 2002/03) und von öff. Räumen (*Espace de représentation*, Rom 2007). Außerdem Darst. des Menschen in seiner künstlich geschaffenen Umge-bung (zwei Serien *Personnage espace*, Romans-sur-Isère [2005] und Rom [2007/08]) sowie des Menschen bei der Arbeit (*Geste-Regard*, 2005 Romans-sur-Isère). 2001–05 Fotoprojekt mit Aufnahmen aus vier Metropolen (Bom-bay, Kairo, Lagos, Los Angeles), die zu Fotoserien mit versch. Themen zusammengefaßt werden, die Unterschie-de und Gemeinsamkeiten herausarbeiten (*Travail, Ras-semblement ville, Espace et construction, Croisement-ville*). ▭ CHALON-SUR-SAONE, Mus. de la Photogr. Nicéphore Niépce. CLERMONT-FERRAND, MBA. EPINAL, Mus. de l'Image. PARIS, FNAC. – Maison Europ. de la Pho-togr. – MNAM. NANTES, MBA. ROMANS SUR ISÈRE, Mus. ☉ *E:* u.a. 1990 Edinburgh, ABK / 1991 Poitiers, Mus. Sainte-Croix (K) / 1997 Paris, Centre Nat. de la Photogr. (Wander-Ausst., K); Thiers, Mus. de la coutellerie (K) / 2006 Chalon-sur-Saône, Mus. de la Photogr. Nicéphore Niépce / 2007, '08 Paris, Gal. Peyroulet / 2009 Nantes, MBA / 2011 Strasbourg, Appolonia / 2012 Douchy-les-Mines, Centre Régionale de la Photogr. (K). ▭ La val-lée des rouets, Thiers 1997 (Fotogr.); *E. Lapierre,* Archit. du réel, P. 2003 (Fotogr.); *Y. Youssi,* D'archit. 153:2006, 6 s.; *F. Cheval u.a.,* C. Un jour comme les autres, Cinisello Balsamo 2009; *M. Sadion u. a.,* C. photogr. Images indien-nes (K Mus. de l'Image), Epinal 2010. – *Online:* Website C. (Ausst.). N. Buhl

Chhachhi, *Sheba,* indisch-äthiopische Fotografin, Videokünstlerin, * 1958 Harare/Äthiopien, lebt in Delhi. Stud.: Delhi Univ.; Nat. Inst. of Design, Ahmedabad. 2005 Stip. Townsend Center for the Humanities, Univ. of Calif., Berkeley. – C. debütiert um 1980 mit dok. Fotograf. zur Situation von Frauen und der Frauenrechtsbewegung in Indien. Die frühe Arbeit *Where the gun is raised, dialogue stops* (vor 2000) widmet sich den Frauen im umkämpften Kashmir. Aus der Beschäftigung mit manipulativen Techniken der Repräsentation entstehen um 1990 die ersten künstlerischen Arbeiten. Nach 1990 erste Videoinstallationen, in denen C. Fotos, Texte, Skulpt. und Zufallsfunde zu komplexen Aussagen über die politisch-hist. Situation Indiens und der Frau in den asiatischen Ges. verdichtet. Die Serie *Ganga's daughters* (1992–2002) thematisiert das ges. kaum akzeptierte Dasein weiblicher Asketen und Einsiedler im heutigen Indien. In Videoinstallationen wie *Winged pilgrims. A chronicle from Asia* (2006–07) spielt C. mit Versatzstücken versch. hist. Epochen und Kunstformen. Als politische Aktivistin verknüpft C. ihre Ausst. oft mit Veranstaltungen zu ges.-politischen Belangen. ✉ Women of the cloth. Photogr. conversations (K Nature morte), New Delhi 2007. 👁 *E:* New Delhi: 2000 India Habitat Centre; 2002 Pragati Maidan; 2004, '07 Nature morte; 2010 Khoj Studio / 2008 New York, Bose Pacia / 2009 Chicago, Walsh Gall.; Mailand, Gall. Paolo Curti, Annamaria Gambuzzi & Co (K). – *G:* 2006 Singapur: Bienn. / New Delhi: 2008 Vadehra AG: Clik! Contemp. photogr. from India; Lalit Kalā Akad.: 2009 Lo real Marvelliso; 2011 Against all odds / 2008 Gurgaon, Devi Art Found.: What in the world; Paris, Studio Citta: Landscape as dream; New York, Bose Pacia: Neti, neti / 2009 Taipei, NM of contemp. art: Viewpoints and viewing points; Wien, Gal. Kritzinger: Republic of Illusion / 2010 Winterthur, Foto-Mus.: Where three dreams cross. 📖 *A. Jhaveri,* A guide to 101 mod. and contemp. Indian artists, Mumbai 2005. – *I. Chandrasekhar/P. C. Seel* (Ed.), Body.city. Siting contemp. cult. in India, B./New Delhi 2003; *P. Sood/J. Pijnappel* (Ed.), Video art in India (K Apeejay Media Gall., New Delhi), Kolkata 2003; *W. Rhee u.a.* (Ed.), Thermocline of art. New Asian waves (K Karlsruhe), Ostfildern 2007; *P. Nagy/V. Collins,* The audience and the eavesdropper. New art from Indian & Pakistan (K Phillips de Pury), Lo. 2008. **M. Frenger**

Chí, *Nguyễn Hải* (Nguyễn Hải C.; Pseud.: CAP; Choé; Kit; Trần Ai), vietnamesischer Karikaturist, Maler, Schriftsteller, Komponist, * 11. 11. 1943 Cái Tàu/An Giang, † 12. 3. 2003 Arlington/Va. Autodidakt. C. stammt aus ärmsten Verhältnissen. Mit neun Jahren verläßt er die Schule, um zum Unterhalt der Fam. beizutragen. 1960 beginnt er in einer Werbefirma in Mỹ Tho zu arbeiten und erlernt dort die Grundlagen der künstlerischen Gestaltung. Von 1964 an in Saigon, arbeitet C. ab 1969 als Illustrator für die Zss. Diễn Đàn und Báo Đen, später unter Pseud. als Karikaturist und Feuilletonist für Sóng Thần, Hòa Bình, Đại Dân tộc. Ab M. 1972 sehr erfolgreich, werden seine Karikaturen auch in der internat. Presse abgedruckt, so in The Times, Newsweek, The New York Times,

Ashahi Shimbun. Wegen der kompromißlos-sarkastische Darst. von Politikern und aktuellen politischen Ereignissen wird C. unter dem Thiệu-Regime für einige Monate inhaftiert. Ab 1976 zwölf Jahre Umerziehungslager in Chí Hòa und Gia Trung, Pleiku. Von 1990 an, wie bereits 1975 für einige Monate, freiberufliche Tätigkeit für Lao động, wo er eine eig. Rubrik „Choé's Ecke" erhält, sowie für zahlr. weitere Ztgn und Zeitschriften. Da C. durch schwere Diabetes erblindet, widmet er sich am Lebensende dem Verfassen von Erzählungen, Lyrik und Liedern. – C. gilt als der bedeutendste Karikaturist Vietnams sowohl vor als auch nach 1975. Mit pointierten Zchngn wendet er sich gegen Krieg (*After the victory,* 1972; *Präs. Nixon*), Korruption (*Korruption,* 1990), soziales Unrecht sowie Ausbeutung und Unterdrückung der Frauen (*Körbe,* 1995). Daneben malt er Serien humorvoll karikierter Portr. in Öl (*Internat. Persönlichkeiten,* 1992; *Nobelpreisträgerinnen,* 1996; *Künstler*) sowie Natur- und Genrebilder auf Seide. ✉ Lai rai vẽ viết. Bút ký (Mühen des Malens und Schreibens), Hanoi 1992 (Essays); Từ tội (Den Tod verdient), Falls Church/Va. 2001. 👁 *E:* Ho-Chi-Minh-Stadt: 1992, '96 Künstler-Verb. Ho-Chi-Minh-Stadt; 2006 Tu Do AG / 1996 Đà Nẵng / 1998 Savigny le Temple, Hôtel de ville / 2002 Westminster (Calif.), Nguoi Viet Daily Office / 2004 Stockholm, Stadshus, Gyllene salen. – *G:* 1995 Tokio, ASEAN Cult. Centre u.a.: Asia Pacific Cartoon Exhib. 📖 The world of Choé, Glade Publications 1973; Ho Chi Minh City Art Diary 96–97, Ho-Chi-Minh-Stadt 1996; *H. H. Sơn,* Thể thao & văn hóa 21:2002 (71) 36; *Ý Nhi,* ibid. 22:2003 (21) 35; *B. Tuyết,* ibid. (22) 42; *L. T. Văn,* Lao động v. 14. 3. 2003, 5; *V. Quyền,* ibid. v. 7. 2. 2005, 11; 25. 2. 2006; *H. D. Nhân,* ibid. v. 2. 3. 2006, 5; *L. T. Dũng,* Thể thao & văn hóa v. 9. 12. 2007, 17. – *Online:* Dai Tu dien; Tu Do AG; Viet bao; Vietnam and Asia.

A. Friedel-Nguyen

Chi Peng, chin. Fotograf, Installationskünstler, * 1981 Yantai/Prov. Shandong, lebt in Beijing. Stud.: 2001–05 Central AFA, Beijing, bei Miao Xiaochun (Malerei, Fotografik, digitale Medien). – V.a. mon. (z.T. meterlange, friesartige), digital bearbeitete Fotoserien mit Darst. von miteinander verschmelzender Realität und Fiktion in einer romantisch-surrealen Scheinwelt. Protagonist ist immer C. selbst, zumeist in vielfacher und geklonter Ausführung, wobei das Alter Ego zur Projektionsfläche einer Auseinandersetzung mit der als faszinierend-bedrohlich empfundenen urbanen Realität des heutigen China sowie mit der eig. (homo-)sexuellen Identitätssuche wird (*Consubstantiality,* 2004; *I fuck me,* 2005). Orientierungslosigkeit, Oberflächlichkeit, Einsamkeit, Weltflucht und Zukunftsangst stehen dabei zeitdiagnostisch für die chin. Großstadtjugend. Die Nacktheit des Protagonisten, in China noch immer ein heikles Thema, wird als Sinnbild des „echten Lebens" sowie der Suche nach der eig. Identität in einer Mischung aus Rebellion und Willfährigkeit konzipiert (*Sprinting Forward,* Digitaldruck, 2004). In der zwölfteiligen Fotoreihe *Journey to the West* (2007) schlüpft C., theatralisch kostümiert, in die Rolle des über Zauberkräfte verfügenden heldenhaften Affenkönigs Sun Wu-

kong und spielt in realen Stadträumen oder in phantastischen Berg-Lsch. ausgewählte Episoden der lit. Vorlage aus dem 16. Jh. nach. Zu C.s jüngsten Arbeiten gehören neben der Rauminstallation *Soft* (700 Bettdecken, begehbar, 2008) die ebenfalls auf Geborgenheit anspielende Fotoserie *Hugging me, Feeling me*, 2009, sowie die digital gedruckten lyrischen Lsch.-Panoramen der Küstenregion seiner Heimatstadt Yantai (*Mood is never better than memory*, 2010). ⌂ BUDAPEST, Ludwig Múz. EBERDINGEN-NUSSDORF, Slg Alison & Peter W. Klein. FUKUOKA, Asian AM. KLOSTERNEUBURG/NÖ, Slg Essl. MAUENSEE/Schweiz, Slg Sigg. MELBOURNE, NG of Victoria. SHENZHEN, He Xiangning AM. ⊙ *E:* 2005 New York, Chambers FA (K) / Beijing: 2006, '07, '08, '10 White Space Beijing; 2010 Today AM / 2006 Shanghai, Zhu Qizhan AM / 2006, '08 Singapur, Art Seasons / 2007 Stockholm, Olsson Gall.; Budapest, Ludwig Múz. / Berlin: 2007, '10 Gal. Alexander Ochs; 2011 Haus der Kulturen der Welt / 2008 Taipei, Lin & Keng Gall. / 2009 Shenzhen, He Xiangning AM; Tokio, Diesel Denim Gall. – *G: (zahlr. Beteiligungen)* 2006–07 Klosterneuburg, Slg Essl: China Now (Wander-Ausst.; K) / Beijing: 2007 Arario: Refresh; 2010 Nat. AM of China: The State of Things / 2008 Groningen, Groninger Mus.: New World Order. Contemp. Installation Art and Photogr. from China (K); Melbourne, NG of Victoria: Body Language – Contemp. Chin. Photogr.; Prag, NG: Trienn. für zeitgen. Kunst / 2009 Brüssel, Pal. des BA: The State of Things / 2010–11 Bern, KM: Mahjong. Chin. Gegenwartskunst aus der Slg Sigg (K). ⊡ *E. Heartney*, Art in America 2004 (Juni-Juli) 172 s.; Visual Gall. at Photokina (K Köln), Ha. 2004; *B. Pollak*, Modern painters 10:2005, 90; China now (K Slg Essl), Klosterneuburg 2006; *U. Münter*, Eikon 57:2007, 8–13; *B. Pollak*, Photogr. (Sheying) 9:2007 (4) 90–99; Chinas Kunst-Avantgarde. Die Zukunft ist jetzt!, 2007 (Dok.-Film, TV-Ausstrahlung Arte 24. 8. 2008); *Feng Boyi*, Art China/Yishu dangdai 7:2008 (44) 62–65; *C. Noe/X. Piëch/C. Steiner*, Young Chin. artists, M. u.a. 2008; *H.-N. Jocks*, Kunstforum internat. 194:2008 (Nov.-Dez.) 196–207; *B. Pollak*, Art criticism/Yishu pinglun 10:2008, 50–56; *R. Vine*, New China new art, M. u.a. 2008; *I. Walton*, Yishu. J. of contemp. Chin. art 7:2008 (7) 95–99; *Feng Boyi u.a.*, C. Me, myself and I (K Groningen), Ostfildern-Ruit 2011.

K. Karlsson

Chí, *Quan Tôn* → **Cường,** *Quan*

Chi *Ti-nan* (Ji Tienan), taiwanesischer Architekt, Urbanist, Designer, Kurator, Installationskünstler, * 1957 Taipei, lebt in Beijing. Stud.: Tunghai Univ., Taichung; Yale Univ., New Haven/Conn., bei Frank O. Gehry und dem Archit.-Theoretiker Karsten Harries (Abschluß 1986). 1993 eig. Archit.-Büro in Taipei. 1999 gründet er die Human Environment Group NGO und leitet fortan das internat. Forsch.-Projekt *Urban Flashes* mit zahlr. Workshops, Konferenzen und Ausst. an Univ. und Inst., u.a. 2002 in London, Linz und Taipei, 2003 in Istanbul und am FA Mus. in Taipei, 2004 in Istanbul, 2006 in Mumbai oder 2007 in Tallinn. Lehrtätigkeiten: 1986–88 State Univ. of New York, Buffalo; 1988–91 Nat. Cheng Kung

Univ., Tainan; 1989–97 Tunghai Univ.; 1999–2000 Nat. Chiao Tung Univ., Hsinchu; 2000 Univ. of Melbourne; 2000–02 Tamkang Univ., Tanshui; seit 2005 an versch. Schulen in der ind. Region Maharashtra. Ausz.: 1985 2. Preis Shinkenchiku Internat. Competition mit *Style for the Year 2001*; 1995 Asakura Award of Space Design (SD) Review (Japan) mit *Z House Project* (Kaohsiung); 1996 1. Preis, Nat. Artist Village Competition, Taichung County. 2004 Eröffnung des Archit.-Büros chi ti nan Archit. in Beijing (vornehmlich Städteplanung und priv. Wohngebäude). Unterhält seit 2006 eine Kolumne im Art World Mag. (Yishu shijie, China). – Zählt zu den innovativsten Architekten Asiens. Realisiert öff. Projekte (Bauten, Plätze, Parkanlagen), Interieurs, priv. Wohngebäude sowie Entwürfe für Städteplanung, – design, Umgestaltung und Wiedererstellung industrieller Anlagen und Stätten. Bes. bek. ist sein Projekt *Urban Flashes*, das er seit 1999 in Zusammenarbeit mit intern. Architekten, Künstlern, interdisziplinären Wissenschaftlern und der jeweiligen lokalen Gemeinschaft (Behörden, Einwohnern, Studenten, Aktivisten etc.) zur Förderung seines Micro-Urbanism-Konzept organisiert. C.s Entwürfe des Micro-Urbanism (weiguan doushi) beruhen auf fernöstlichen vorwissenschaftlichen ganzheitlichen Kulturkonzepten, ges. Aktivismus und der europ. Phil. des Phänomenalismus. So integriert C. mitunter komplexe Prinzipien der trad. chin. Geomantik (fengshui) und Medizin (Akupunktur), „um das durch konventionelle Kulturpolitik abservierte und in Vergessenheit geratene therapeutisch- selbstheilende Potential eines städtischen Gebildes voranzutreiben". Auch internat. als Berater für städteplanerische Projekte tätig, u.a. in Tokio (*Hamarrikyu Garden Area*, 2000), Brüssel (*Brussels' Core Area Regeneration Project*, 2003) oder Istanbul (*Uskuda Public Space Project*, 2004). Erstellt zudem Multimedia-Installationen (häufig mit Wandmalereien und Graffiti) mit Bezügen zu seinen z.T. radikalen Zukunftsvisionen (*Neon Structure*, AA Gall., London, 1998; *Z Tunnel Project*, Arch.-Bienn., Venedig, 2000; *Great Wall Project*, Shenzhen, 2005). Auch Ausst.-Design. ⌂ CHIAYI, Chiayi Cult. Center. HSINCHU, Glass AM. TAIPEI, Love City Boutique. – Financial Times Taipei Branch Office. ✉ Thinking archit., Taipei 1993; Neo-Oriental experience, Taichung 1994; Tangibleintangible – chi ti nan's archit., Taipei 1998; Trans-Prophecy, Taipei 1999; Urban flashes, Taipei 2002. ⊙ *E:* 1991, '98 Taipei, IT Park. – *G:* Taipei: 1993 Eslite Art Space: Sub-Tropical Plant Exhib.; 1997 FA Mus.: IT Park Exhib.; IT Park: River – New Asian Art. Taipei Dialogue / 1996 Osaka, Osaka City Govt.: Innovative Archit. in Asia; Tainan, Tainan Public Forum: Tainan Phenomena Exhib. / 1998 London, AA Gall.: Ke Da Ke Xiao Exhib. Three Asian Practices (K) / Beijing: 2004, '06 Archit.-Bienn.; 2005 Chin. Centennial Altar: Chin. Character Art Exhib. (K) / 2004 Istanbul, Garanti Gall.: Micro-Urban Istanbul Exhib. / 2005 Shenzhen: Archit.-Bienn.; Kaohsiung, Weiwu Camp Site: Taiwan Design Expo. Future Pavilion. ⊡ *Watanabe Shin Makoto et al.* (Ed.), Innovative archit. in Asia, To. 1994; *Hou Hanru/ H. U. Obrist* (Ed.), Cities on the move (K internat. Wander-

Ausst.), Ostfildern-Ruit 1997; *S. McIntyre*, Art Asia Pacific 19:1998, 68–73; *N. Boyarsky/P. Lang* (Ed.), Urban flashes. Simultaneous spontaneous archit., Lo. 2003; *S. Helsel*, Taipei operations, Taipei 2004. – *Online:* Website C.

K. Karlsson

Chi *Ying* (He Lilan), chin. Malerin, Hochschullehrerin, * 1944 Wuhan/Prov. Hubei. Stud.: 1962–67 ABK Guangzhou (Ölmalerei). 1978–84 Doz. an der Univ. Jianghan, Fak. für Bild. Kunst. 1984 Gründungs-Dir. der Abt. Kunst, Lehre und Forschung an der Pädagogischen HS Shenzhen. 1993 Gründungs-Dekanin der Abt. Umweltkunst am Inst. für Technologie ebd. 1995 Gründung der Sonder-Abt. Umweltkunst und Design an der Univ. Shenzhen (dort Leiterin der Abt. Forschung und Lehre). – Ursprünglich Ölmalerei. Sukzessive hat C. das Medium sowohl der Ölfarbe als auch der monochromen Tusche weiterentwickelt. Stilistisch erinnern ihre Arbeiten an die trad. chin. Technik des Aufspritzens der Tusche (pomo), die sie jedoch mittels Aufsprühens der Farbe erzielt. Thematisch ist in den Arbeiten der 1990er Jahre eine Hinwendung zur abstrakten Lsch.-Malerei erkennbar. ◉ *E:* 1992 Hongkong, KH / 1993 Guangdong, ABK / 1996 Bonn, Frauen-Mus. – *G:* 1963 Guangzhou, ABK: Ölmalerei. ▢ *C. Werner u.a.* (Ed.), Die Hälfte des Himmels (K Bonn/Offenburg), Bonn 1998.

A. Papist-Matsuo

Chiang *Chao-shen* (Jiang Zhaoshen; Shuyuan), chin.-taiwanesischer Maler, Kalligraph, Siegelschnitzer, Dichter, Kunsthistoriker, * 26. 10. 1925 Shexian/Prov. Anhui, † 5. 12. 1996 Shenyang. Entstammte einer Gelehrten-Fam., von deren älteren Mitgl. er die klassische Ausb. erhielt. 1949 Übersiedlung nach Taiwan; dort anfangs als Lehrer an versch. Mittelschulen tätig sowie Stud. der Dichtung und chin. Malerei bei Pu Ju (Pu Hsin-yü), der bis zu seinem Tod 1963 an der Taiwan Normal Univ. lehrte. 1965–92 versch. Tätigkeiten im Nat. Pal. Mus. (NPM), Taipei (Abt. für Kalligraphie und Malerei), u.a. bis 1972 Forsch.-Mitgl.; 1972–83 Kurator und 1978–91 Vize-Dir. des NPM. Kuratierte dort mehrere bed. Ausst., z.B. Ninety Years of Wu School Paint. (1973–74). Hrsg. zahlr. Publ. (auch zus. mit Joan Stanley-Baker) zur Slg des NPM. Als hervorragender Kenner der ming-zeitlichen Wu-Schule verfaßt er bed. Artikel und Monogr. u.a. zu den Malern Tang Yin und Wen Zhengming, auch zahlr. Beiträge in NPM Quarterly. Ausz.: 1969 Huojia-Buchpreis (für Publ. zu Tang Yin); Zhongshan Art Prize (für das Malereialbum *Hualian youji*/Album of Travels to Hualien, 1968); 1974 Kalligraphie-Preis (für *Yiyan*/Am Felsvorsprung, mon. Schrifttafel). Eng befreundet mit dem Künstler Zhang Daqian (Chang Dai Chien), mit dem er gelegentlich zusammenarbeitete. Reisen: ab 1968 regelmäßig in die USA mit Vorlesungen an Univ. und Teiln. an Symposien sowie Aufenthalte in bed. Museen und Priv.-Slgn chin. Kunst; 1970 Kanada; ab 1973 Korea, Japan, Hongkong; 1985 Europa; ab 1992 China. Beteiligung an zahlr. Ausst. in Taiwan, Japan, Korea und Hongkong. Mehrere öff. Aufträge (Kalligraphie, Malerei und Siegel) u.a. für das NPM. Verstarb 1996 an einem Herzinfarkt. Im Mai 2002 wurde ihm zu Ehren vom NPM und der Taipei Nat.

Univ. of the Arts ein internat. Symposium veranstaltet. – Als bed. Repräsentant der klassischen chin. Tuschemalerei vertrat C. unter Einfluß seines Lehrers Pu Ju einen traditionalistischen Ansatz. Zum Motivrepertoire gehörten neben imaginären Lsch. v.a. semi-topogr. Ansichten Chinas (*Xi zi hu*/The West Lake; *Huangshan*/Huangshan-Gebirge; *Qian dao hu*/One-Thousand-Island Lake) und Taiwans (*Batong guan*/Patung Paß; *Hualian jiyou*/Album of Travels to Hualien, 1968). Char. sind der Verzicht auf trad. formalistisch-kodifizierte Pinselstriche (cun) zugunsten eines lebhaft-persönlichen und realistischeren Pinselduktus für die zumeist dicht strukturierten Lsch.-Elemente (Felsen); Kontraste zw. dunkler Tusche und leeren, weißen Bildflächen (Nebelschwaden, Gewässer, Strohhütten) sowie der Einsatz von Farben, v.a. Blau- und Grüntöne für die Silhouetten von Bergen und Bäumen. Bez. ist ebenfalls die Kombination von Malerei und klassischer Dichtung. Nach seiner Pensionierung 1991 zog sich C. in sein Gartenanwesen (Qishe) in Puli (Nantou) zurück und schuf weiterhin mehrere bek. von der regionalen Szenerie inspirierte Werke, z.B. *Trees in Retreat Garden*, Querrolle, 1992; *Dwelling in a Garden*, 1994; *Wanmu lianlin*/Ein Wald mit zehntausend Bäumen, 1996. *Fenggui tou* (Hängerolle, 1993) ist eine lyrische Schilderung eines Ausflugs mit Freunden ins Dorf Hsin-yi (Nantou) auf der Suche nach Pflaumenblüten, beschriftet mit einem Gedicht von Lu Yu (* 1125, † 1210). C.s kalligraphischen Werke (vorwiegend in Kursivschrift [xingshu]) zeugen von seiner lebenslangen Erforschung des Stils von Ouyang Xun (* 557, † 641) und Chu Suiliang (* 595, † 658). Seine Siegel zeigen den Einfluß der qing-zeitlichen Hui Schule (Hui pai, Prov. Anhui) und der Zhe-Schule (Zhe pai, Prov. Zhejiang). Zu seinen Schülern gehörten u.a. Lee Yi-hong, Chou Cheng und Hsu Kuohuang. ▯ HONGKONG, Slg Chiueh Zhai. KANSAS CITY/ Mo., Nelson-Atkins Mus. of Art. LAWRENCE/Kan., Spencer Mus. of Art. LONDON, BM. TAIPEI, NPM. – FA Mus. WASHINGTON/D. C., Twin Oaks Estate. ◉ *E:* Taipei: 1965 Zhongshan Memorial Hall; 1984 Apollo AG; 1990, 2006 NM of Hist.: A Memorial Exhib. of Works by C. (K); 1990 Ching Yun AC; 1992 FA Mus. (Wander-Ausst.); NPM: 2002 Landscapes of the Soul. C. 1925–1996. (Retr.; K); 2010 The Art of C. Paint., Calligraphy and Seals (K) / 2002 Kaohsiung, Mus. of Art (K). – *G:* u.a. 1992 London, BM: The Verdant Cliff. Chin. Paint. by Fourteen Celebrated Taiwan. Artists; 1993 Taipei, FA Mus.: Taiwan Art (1945–1993) (K) / 1996 Köln, Mus. für Ostasiatische Kunst: Chin. Tuschmalerei im 20. Jh. (K). ▢ *Delarge*, 2001; *M. Sullivan*, Mod. Chin. artists, Berkeley u.a. 2006 (s.v. Jiang Zhaoshen). – Jiang Zhaoshen shiwen shuhua zhuanke xuan, Taipei 1974; *Chu Ge* (Ed.), Jiang Zhaoshen zuopin ji (C. Selections of his works of art), Taipei 1979; Mingjia Han mo 1992 (34–35/Nov.-Dez.); Jiang Zhaoshen shu hua zhan, Hongkong 1993; *J. C. Kuo*, Heirs to a great trad. Mod. Chin. paint. from the Tsien-hsiang-chai coll. (K), College Park, Md., u.a. 1993, 54–56; Taiwan art 1945–1993 (K FA Mus.), Taipei 1993; *A. Farrer*, Apollo 139:1994 (384) 7–10; *I. Findlay*, Asian art news 4:1994 (1); *Li Xiaokun*, Wen ren, si jue C., Taipei 2002;

Zhu Geliang, C. de huihua yishu, Taipei 2006; *Bai Qianshen*, Meishushi yu guannianshi (Hist. of art and hist. of ideas) 2009 (7) 179–195; The NPM monthly of Chin. art 325:2010 (April). K. Karlsson

Chiang *Paul* (Jiang Xian'er), taiwanesischer Maler, Bildhauer, Licht- und Installationskünstler, * 1942 Taichung, lebt in Taipei. Stud.: Nat. Taiwan Normal Univ., Taipei (Abschluß 1965). Übersiedlung nach Paris, 1966 nach New York. 1976–85 alternierend in Paris und New York ansässig. Seit 1998 wieder in Taipei. – C. zählt zu den namhaften Vertretern der abstrakten Malerei in Taiwan. Viele seiner zumeist großformatigen Gem. (Öl/Lw.) sind Überarbeitungen von früheren Werken, die in einem introspektiven Arbeitsprozeß mittels komplexer Strukturen und dichter Farbschichten teilw. bis gänzlich übermalt werden. C.s spätere Arbeiten haben einen meditativen, spirituellen Charakter (*Hundred Years Temple 96–02*, Öl/Lw., 1996), der verstärkt wird durch die Integration buddh. Texte und Symbole, z.B. Lotusblüten oder mandalaartig gestaltete Buddhafiguren (*Lianhua de lianxiang*/Imagination of Lotus, 1999, 2001). Seit 1998 setzt sich C. auch mit dreidimensionalen Formen auseinander und erstellt u.a. mon. Stahl-Skulpt. oder Lichtinstallationen. ⌂ TAIPEI, Taishin Bank Found. for Arts and Cult. – Pierre T. M. Chen Coll./Yageo Found. – IT Park Gall.. ◉ E: Taipei: 1966 Taiwan Provincial Mus.; 1997, '98, 2000, '01, '02, '03, '05 Eslite Gall. (K); 2007 Taishin Bank Found. for Arts and Cult. / New York: 1975 Lamagna Gall.; 1994 O. K. Harris Gall. – G: 1965 São Paulo: Bien. / Taipei: 1997 Fubon Art Found.: Feast of Mind – Buffet of Art; 2005 MCA: Membrane Onto Magic; 2008 IT Park: Sweeties / 1998 Taitung, AG: Without Form / 2008–09 Dresden, KH Lipsiusbau: Madonna meets Mao. Ausgewählte Werke aus der Slg der Yageo Found., Taiwan (K: M. Wagner). ▭ *Wang Jiaji*, Mod. and contemp. art mag. 91:2000 (4) 260–263; *Ni Zaiqin*, Taiwan dangdai yishu zhi mei (The beauty of Taiwanese art), Taipei 2004; *Huang Lijuan*, Taiwan xiandai meishu daxi. Shuqing chouxiang huihua, Taipei 2005; The multiform nineties. Taiwan's art branches out (K), Taipei 2005. K. Karlsson

Chiappe, *Filippo*, ital. Goldschmied, Juwelier, * 1864 Massa, † 16. 11. 1936 Genua. Lehre in Massa-Carrara. Stud.: ABA, Carrara. Anschl. Wanderschaft mit Tätigkeit in Algier und Paris sowie als Vorarbeiter bei Vassallo in Capaci/Sizilien. 1886 gründet C. ein Wkst.-Geschäft in Genua, das nach eig. Entwürden neben Schmuck zunächst auch Silbergegenstände fertigt, danach v.a. opulenten Goldschmuck, Arm- und Halsschmuck, Ringe sowie Accessoires mit Perlen- und Edelsteinbesatz. Bek. für Eleganz und sorgfältige Ausf. seiner Stücke, beliefert C. bald den ital. Adel und Königshof sowie eine europ. Klientel. Das unter Mitarb. seiner Neffen *Aristide C.*, *Alberico Fiori* (* 1889, † 1974) und *Gino Fiori* (* 1893, † 1960) geführte, renommierte Geschäft wurde von diesen später übernommen und besteht noch heute mit Filialen in Mailand, Rom und (seit 1940) in Paris. ▭ Dict. internat. du bijou, P. 1998. – *Online:* Website C. Gioielliere. D. Trier

Chiappetti (Chiapetti; De Chiappettis), *Vincenzo*, Fra (eigtl. Chiappetta, *Angelo Augustino*), ital. Architekt, Ingenieur, Architekturtheoretiker, Schriftsteller, Franziskaner, * 21. 10. 1660 Parma, † 1730 Bologna. Tritt 1676 in Bologna in den Franziskanerorden ein und übt ab 1865 in nord-ital. Konventen (Cremona, Pavia, Piacenza, Vicenza, Rimini und Ferrara) versch. Ämter aus (u.a. Prior in S. Maria del Quartiere in Parma, wo er auch die Bibl. leitet; 1702 Revisor der Mss. vor dem Druck für die Hl. Inquisition der Prov. Vicenza). Lehrt Philosophie in Mailand, Cremona, Lodi und Piacenza sowie Theologie in Parma. Beschäftigt sich daneben schon früh mit Mechanik, Mathematik, Zivil- und Militär-Archit. und macht versch. mechanische Entdeckungen, v.a. für Kriegsgerät, wobei er z.T. ältere Kriegsmaschinen als seine eig. ausgibt. Zw. 1699 und 1727 verfaßt er als Dilettant eine Reihe wiss. Mss. (alle unveröff.) zur Zivil- und Militär-Archit., die er mit eig. Zchngn versieht. Er analysiert dort Bautypen, -ordnungen und -techniken, gibt praktische Hinweise, verfaßt ein *Alfabeto di Architettura* mit Zchngn, beschäftigt sich mit Garten-Archit. und zeichnet Bauten der Farnese, war aber wohl selbst nicht als ausübender Architekt tätig. 1708 entsteht im Konvent S. Maria della Carità in Bologna, wo der Franziskaner-Architekt Giovanni Battista Bergonzoni sein Lehrer war, der erste Bd seiner in 5 Bdn konzipierten *Architettura militare*. In Parma hat C. enge Kontakte zum Hof und verfaßt hier die meisten Traktate für seine Protektoren, die Herzöge Francesco und Antonio Farnese. Zw. 1708 und 1723 beschäftigt er sich wiederholt mit Fragen der Hydrographie; 1822 schlägt er in seiner Schrift *Idrografia fisico-pratica* dem Herzog das Projekt eines schiffbaren Kanals zw. dem kleinen Fluß Enza und dem Po vor. C. steht mit zahlr. Persönlichkeiten im Briefwechsel, u.a. mit dem berühmten venez. Geographen Vincenzo Maria Coronelli und dem Bologneser Senator Girolamo Albergati Capacelli, dem er Entwürfe für eine Villa in Zola Predosa b. Bologna unterbreitet. ✉ Parma, Bibl. Palatina: 23 theoretische Schriften (alle Mss.), u.a. Riflessi sopra del moto perpetua; Idee varie d'Archit. civile [...] 1709; Archit. civile, ove de'Teatri et Palagi [...], 1710; Archit. civile studio nel genere di scale [...], 1712; Misc. di guerra, e militare, dell'archit. civile, di Meccanica[...], 1716; Meccanica teorico-sperimentale [...] , 1718; Physico Mathematicum, 1724. Neapel, Bibl. Vittorio Emanuele III: drei Mss. (ehem. Bibl. Farnesiana). ▭ *G. B. Janelli*, Diz. biogr. dei parmigiani illustri, Ge. 1877; *L. A. Maggiorotti*, Breve diz. degli architetti ed ing. militari ital., R. 1935; *Lasagni* II, 1999 (s.v. Chiappetti, Angelo Augustino). – *I. Affò/A. Pezzana*, Mem. degli scrittori e letterati parmigiani, VII, Parma 1833 (Verz. der Schr.); *P. Conforti*, Arch. stor. per le prov. parmensi 37:1985, 59–69 (Mss. in Parma); *A. Coccioli Mastroviti*, in: *M. Pigozzi* (Ed.), Itinerario critico. Fonti per la storia dell'arte nel Seicento e Settecento, Bo. 1994, XXXII-LXIX (C.s Gartentheorie); *F. Siclari*, Arch. stor. per le prov. parmensi 50:1998, 279–301; *ead.*, Il disegno di archit. 7:1997 (16) 44–49; *P. Spotti*, Per prof. che s'imbrattano di calcina. Gli scritti teorici di V. C. da Parma, architetto e ingenere francescano (1660–1730), R. 1999. E. Kasten

Chiarelli, *Matteo*, ital. Maler, * 1698, † 1742, tätig in Salerno. C. wird vermutlich an der Amalfiküste geb. und von seinem Vater in die Malerei eingeführt. Die Ausb. erhält er, seinem Stil nach zu urteilen, in der neapolitanischen Wkst. des Francesco Solimena. Das erste Werk, die klassizistische und in kühler formaler Komp. angelegte *Geburt Christi* (1728, sign, dat.), entstand für die Bruderschaft SS. Rosario, gen. S. Domenico, in Maiori. Die Ähnlichkeit zu Gem. von Solimena in S. Maria Donnalbina in Neapel wird in der Lit. hervorgehoben. Auch weitere Gem. lassen sich unmittelbar auf Werke von Solimena zurückführen. Um 1729/30 führt C. v.a. großformatige Lw. für Fam.-Kap. in der zu dieser Zeit renovierten Kathedrale von Salerno aus, so für den Altar S. Nicola delle carceri der Kap. De Ruggiero, die Kap. della Purificazione der Fam. Della Calce (*Christus im Tempel*) und die Kap. S. Giuseppe (*Der Tod Josefs*). C.s Gem. zeichnen sich durch eine klare Komp., formale Vereinfachung und ausgeglichene Farbigkeit sowie durch realistische anatomische Beschreibungen der Körper aus. Alle Einzelelemente ordnen sich der Gesamt-Komp. unter, bestimmend ist der disegno. Im Diözesan-Mus. von Salerno hat sich das Gem. für die De Ruggiero-Kap. (*Die Einsetzung des hl. Nicola als Bischof durch Christus und Maria*) erhalten; der entsprechende Bozzetto befindet sich im Mus. della Badia in Cava de' Tirreni und eine bisher dem Solimena-Kreis zugeschr. Vor-Zchng (Feder in Braun) mit helldunkel ausgef. Draperien im MN di S. Martino in Neapel. In den 1730er Jahren ist C. einer der gefragtesten Maler in Salerno. 1733 wird er beauftragt, Fresken für S. Maria della Grazie ad Occiano in Montecorvino auszuführen, die jedoch nicht erh. sind. Zugleich schafft C. Portr. der Bischöfe von Salerno, so für Paolo de Vilana Perlas (Metropolit 1723–29) und Fabrizio de Capua (1730–38), die im Kapitelsaal des Domes aufbewahrt wurden, heute aber ebenfalls als verloren gelten. ⌂ SALERNO, Diözesan-Mus.: Maria zw. den Hll. Vito und Domenico, Öl/Lw.; Die Hl. Fam. mit den Hll. Rosa da Lima, Anna und Joachim, Öl/Lw. ⌸ *T. Mancini,* Rassegna stor. salernitana 16,1:1999 (31) 273–285; *ead.,* in: *E. Borsellino* (Ed.), Roma. Il tempio del vero gusto, Fi. 2001, 307–312. *C. Melzer*

Chiari, *Gabriele*, österr. Malerin, Graphikerin, * 1978 Hallein, lebt in Paris. Stud.: ENSBA Paris (2002 Dipl.); Seminar bei Cristian Bernard. V.a. großformatige Aquarelle. Bildträger ist loses, aufgespanntes, nasses, trockenes oder in Form gelegtes Papier; Malwerkzeuge sind Pinsel, Besen, Gießkanne, Schablone, Wellblech, „Regen". Im Vordergrund von C.s Arbeiten steht weniger die künstlerische Handschrift im klassischen Sinne, sondern das Sichtbarmachen von gemalt-geronnener Farbe in Verbindung mit dem Bildträger Papier. Zufall und Kontrolle sind dafür die wesentlichen Faktoren, z.B. formt C. nasses Papier über Wellblech, streicht es mit Farbe ein, läßt es kurz antrocknen und anschließend im Freien beregnen, wodurch scheinbar absichtslos Formen und Bilder entstehen. C.s Arbeiten liegt ein experimenteller Umgang mit den Medien Farbe und Papier zugrunde. Die Resultate werden später in verkleinertem Maßstab mit Farbstif-

ten auf Bristolkarton und Umrechnungstabellen gezeichnet. Es entsteht ein neues Orig. als unwiderlegbarer Ausflug in die mathematische Abstraktion, um das Zufällige des Aqu. zu reproduzieren. In ihrer Malerei setzt sich C. mit dem Wesen von Einzigartigkeit und reflexiver Wiederholung auseinander. Sie fühlt sich als Impulsgeberin ihrer Arbeiten, die sich schließlich in gewisser Weise selbständig machen. Ausz.: 1998 Stip. der Internat. Sommer-Akad. für bild. Kunst, Salzburg; 2001 Preis für Zchng der Stiftung Diamond; 2005 Malerpreis der Stadt Vitry-sur-Seine. ⌂ SALZBURG, Traklhaus. VITRY-SUR-SEINE, Slgn der Stadt. ☉ *E:* 2003 Hallein, Gal. Pro Arte / 2005, '07 Paris, Gal. Pitch / 2006 Vitry-sur-Seine, Gal. Mun. (zus. mit Emmanuel Grenard) / 2007, '10 Créteil, Gal. du Temps Présent / 2008 Wien, Gal. Frey / 2009 Montpellier, Gal. AL-MA; Zürich, Gal. Bernhard Jordan / 2011 Salzburg, Café Cult; Weifen, Kuenburggewölbe; Beaune, EcBA. – *G:* Paris: 2003 La Vitrine: Focus; 2004 Gal. Pitch: Parcours autour de dessin / 2006 Salzburg, Gal. 5020: Ortung '05 / 2007 Wien, Gal. Frey: Red / 2009 Salzburg, Traklhaus: Kunstankäufe des Landes Salzburg 2007–09. ⌸ *M. Barascud,* Ordonner la peint. (K), Vitry-sur-Seine 2006; *F. Steininger,* Abstract papers (K), W. 2006; *C. Loire,* Surfaces de passage, Vézely 2007. – *Online:* Website C.; Salzburger KV. *S.-W. Staps*

Chiarolla, *Alessandro*, ital. Comiczeichner, Maler, Graphiker, Freskant, * 11. 9. 1942 Mogadischu/Somalia, lebt in Rom. Ab 1960 veröff. C. seine erste Serie *La bella petroia* in Il Vittorioso, dort weitere Arbeiten auch in Il Giornalino. Zunächst aber illustriert C. Storyboards für Filme. Ab 1974 Comic-Veröff. außerhalb Italiens. Für Fleetway in Großbritannien arbeitet er an den Serien *Tiger, Tina, Hurricane* und *Buster*, in Frankreich ist er Mitarb. an der Serie *Lancelot* und in Deutschland an den Serien *Buffalo Bill* und *Reno Kid*. Ab 1970 zeichnet C. für Alfredo Castelli zahlr. Serien, u.a. *Bassa Marea, Fortini sul Fiume* und 1979 *Central Hospital*. Nachdem er für Verleger wie Lancioi oder Edifumetto arbeitete, beginnt er Serien für Bonelli zu zeichnen: 1984 *Bella & Bronco*, 1987–93 *Martin Mystère* und 1995–2008 *Zagor*. – C. zeichnet in einem detailliertem realistisch-naturalistischen Stil, bes. bei Abenteuercomics. Daneben ein umfängliches graph. und malerisches Werk. Auch Fresken. ⌸ *H. Filippini*, Dict. de la bande dessinée, P. 2005. – *Online:* Lambiek Comiclopedia; Website C. *K. Schikowski*

Chiasera, *Paolo*, ital. Video-, Installations- und Performancekünstler, Bildhauer, Maler, Zeichner, * 1978 Bologna, lebt in Berlin. Stud.: 1997–2002 ABA Bologna und HBK Berlin-Weißensee. C. setzt sich mit der ganzen Vielfalt kultureller Menschheitszeugnisse auseinander und reflektiert über deren versch. Bedeutungsebenen. Diese Aufarbeitung vollzieht sich u.a. durch Prozesse von Destruktion, Umformung und erneuter Annäherung. C. inspirieren die komplexen Beziehungen und Erinnerungen, die Menschen mit ihren Vorbildern und Trad. aus Philosophie, Politik und den Künsten einerseits verbinden, andererseits trennen (letzteres um neue Ideen zu befördern). C.s Inszenierungen vertreten ein hohes intellektuelles Niveau und

sind gleichzeitig geprägt durch emotionale Ausstrahlungs-
kraft und Freude an ihrer Gestaltung. In der Malerei kre-
iert C. häufig trad. malerische Formen zu neuen obsku-
ren, eindrucksvollen Inhalten (*Black brain 3*, 2008, Bre-
scia, Gall. Massimo Minini). In *The Trilogy* (2006–10)
macht C. eine Studie über sich selbst als Künstler und
tritt in Dialog mit Maurits Cornelis Escher, Vincent van
Gogh und Peter Brueghel d.Ä. Die Arbeit ist eine An-
sammlung von Skulpt., Videos und Gouachen. In seinem
komplexen Projekt hinterfragt C. den „Künstlermythos",
versetzt die alten Meister in die Gegenwart und konzen-
triert sich auf deren Schwächen und Obsessionen. In ei-
ner and. Arbeit untersucht C. die Theorien des dt. Philoso-
phen Martin Heidegger zum Thema „Zeit und Sein" und
dreht das Video *Condensed Heideggers Hut* (2009). Die
Asche der verbrannten Hütte benutzt er zu einer mono-
chromen Malerei. Das Derivat erzeugt zusätzliche Bedeu-
tung, Heidegger wird neu kontextualisiert und individuell
interpretiert. Ab 2000 zahlr. Videoinstallationen, u.a. *Li-
nea 8* (Berlin, Dez. 2000), *Pensieri in sospensione* (Bo-
logna, Febr. 2001), *Young dictator's village* (2004), *The
following days* (2005), 2008 beteiligt an Videoreport Ita-
lia (Montefalcone, GAC). Weltweite Teiln. an bed. Video-
Events. Häufig opponiert C. mit seinen Arbeiten gegen die
Verindustrialisierung und Kommerzialisierung von Kunst
und Kultur. ⌖ BOLOGNA, GAM. ROM, MAC. TURIN,
Gall. Civ. d'Arte Mod. e Contemp. ✉ *C./M. Le Blanc/
S. Prinz*, Rotes Schauspielhaus, B. 2011. ⌖ *E:* 2002
Turin, Gall. Civ. d'Arte Mod. e Contemp. (K: E. Volpa-
to) / 2003, '08, '11 Brescia, Gall. Massimo Minini / 2005
Amsterdam, W139 / 2006 Bologna, GAM (K: A. Villia-
ni u.a.); Gent, Hoet Bekaert Gall.; New York, Columbia
Univ. SchA / 2007 London, Limehouse Arts Found.; New
York, Smith Stewart Gall. / 2008 Rom, MAC / 2009 Ber-
lin, PSM Gall.; Herford, MARTa (K: S. Ferrara); Turin,
Artissima 16 / 2010 Gent, Sted. Mus. voor Actuele Kunst;
Berlin, Rotes Schauspielhaus / 2011 Oslo, Univ. – G: 2005
Turin, T1: La sindrome di Pantagruel / 2008 Florenz, Vil-
la Romana: Adesso siamo qua / 2009 Thessaloniki: Bi-
enn. of contemp. art / 2010 Middelburg, de Vleeshal: Psy-
chosculptures / 2011 Wien, freiraum quartier21: Totem and
Taboo; Berlin, GG: Kritische Ebene. ⌑ *G. S. Brizio*,
Arte e critica 9:2002 (30); *C. Laubard* (Ed.), Così va il
mondo (K), P. 2003; *G. di Gropello u.a.*, Young artists
in Italy at the turn of the millennium, Mi. 2005; *D. Bigi*,
Arte e critica 13:2006 (46) 26–29; *L. Beatrice*, Duellanti
2006 (März); Ma non al Sud (K Syrakus), Cinisello Balsa-
mo 2006; *A. Mattirolo* (Ed.), Apocalittici e integrati. Uto-
pia nell'arte ital. di oggi (K Rom), Mi. 2007; Tupacproject
(K), Lo. 2007; *L. Benedetti u.a.*, P. C., Bielefeld 2010. –
Online: Website C.; Artfacts (Ausst.). S.-W. Staps

Chiat, *Jay (Morton Jay)*, US-amer. Werbegraphiker,
* 25. 10. 1931 New York, † 23. 4. 2002 Marina del Rey/
Calif. Aufgewachsen in Fort Lee/N. J. Stud.: bis 1953 Rut-
gers Univ., Camden/N. J. (2000 aufgenommen in die Hall
of Distinguished Alumni); Columbia Graduate School of
Broadcasting, Vienna/Va.; Univ. of California, Los Ange-
les (Executive Program). Ab 1958 Werbetexter, dann bis

1962 Creative Dir. bei der Leland Oliver Company im
Orange County. 1962 Gründung einer Werbeagentur in
Los Angeles, ab 1968 in Partnerschaft mit Guy Day als
Chiat/Day, die rasch mit Filialen in New York, San Fran-
cisco, Chicago, Dallas, Toronto und London expandierte.
Aufgrund finanzieller Probleme Verkauf der Agentur 1995
an die Werbeholding Omnicomm, bei der C. als Berater tä-
tig ist. 1998 Einstieg bei der Internet-Fa. Screaming Me-
dia. Ausz.: 1980, '88 Agency of the Year, 1989 Agency
of the Decade der Zs. Advertising Age; 1992 Silber-Med.,
Kategorie Plakatwerbung, 2004 Aufnahme in die Hall of
Fame, beide Art Dir. Club; 1994 One Club Creative Hall
of Fame; 1999 Amer. Advertising Federation Hall of Fa-
me. – Die Agentur Chiat/Day arbeitet unter C.s Ltg als
eine der ersten Agenturen in den USA mit dem sog. Ac-
count Planning (der Strategischen Planung) und erstellt
Werbestrategien im Dialog mit dem Kunden, um eine ge-
nau auf die Zielgruppe abgestimmte Werbung zu gewähr-
leisten. Im Zuge der „creative revolution" (Staniszewski,
1988) in der amer. Werbung der 1960er Jahre greift C. An-
regungen von William Bernbach auf, z.B. Werbung sprit-
ziger und humorvoller zu gestalten sowie Text und Bild
als Einheit zu konzipieren. Neben der Produktinformati-
on spielen bei C. Design, Pop-art, Musik und Film eine
große Rolle (cf. Riering, 2002). Einen bes. Namen haben
sich C. und Day in den 1970er/80er Jahren durch origi-
nelle Werbekampagnen gemacht, z.B. für Apple (Kampa-
gne *1984* in Anlehnung an den Roman von George Orwell)
und Nike (*I love LA* anläßlich der Olympischen Spiele in
Los Angeles, beide 1984). Mit der Einf. des „event mar-
keting" haben sie zu Veränderungen in der Werbeindus-
trie beigetragen. C. zu Ehren werden die Jay Chiat Awards
von der Amer. Assoc. of Advertising Agencies verliehen.
⌖ PARIS, MNAM: Insight, Fotogr., 1989. ⌑ *M. A. Sta-
niszewski*, Flash art 141:1988, 91–95; *J. Bergin*, Graphis
(N. Y.) 48:1992 (282) 66–81; *S. Elliott*, The New York
Times v. 24. 4. 2002; *G. Raine*, San Francisco chron. v.
24. 4. 2002 (beides Nekr.). – *Online: B. Riering*, Welt on-
line v. 4. 5. 2002 (Nekr.); Art Directors Club.
 C. Rohrschneider

Chiba, *Akio* cf. **Chiba,** *Tetsuya*

Chiba, *Teisuke*, jap. Fotograf, * 19. 10. 1917 Kakunoda-
te/Akita, † 29. 12. 1965 Yokote/Akita. Autodidakt. Nach
dem Schulabschluß (1932) betreibt C. bis in die 1950er
Jahre einen Kimonoladen, später ein Geschäft für Fotozu-
behör in Yokote, das er in den 1960er Jahren krankheits-
halber aufgeben muß. Ab 1935 erste Fotogr. von der länd-
lichen Umgebung von Akita. In den 1950er Jahren Teil-
nahme an Foto-Wettb. und Veröff. in Foto-Mag. für Ama-
teure, u.a. in der renommierten jap. Foto-Zs. Camera. Be-
kanntschaft mit Fotografen wie Kimura Ihei (1901–1974)
und Hamaya Hiroshi (1915–1999). Ab 1952 nebenberuf-
lich als Bildjournalist tätig, v.a. Dok. der Sitten und Ge-
bräuche der ländlichen Bevölkerung von Akita. 1966 post-
hume Ausst. und Veröff. seiner Bilder durch Freunde. Erst
seit den 1990er Jahren wird C. als einer der Pioniere des
jap. Bildjournalismus wiederentdeckt und erstmals 1992
im Miyagi Mus. of Art (Sendai) in einer Ausst. zur jap.

Nachkriegs-Fotogr. prominent vorgestellt. – C. gehört zur Gen. der New Photogr. Movement (Shinkô shashin). Seine präzisen Aufnahmen des ländlichen Alltags in Akita zeigen einen realistischen Blick auf das wenig erschlossene und kulturell eigenständige jap. Hinterland (Tôhoku). In ihrer thematischen Konzentration auf das trad. Landleben haben die Aufnahmen sowohl dokumentarischen Wert wie sie auch eine Kritik am westlich orientierten Lebensstil der jap. Nachkriegs-Ges. beinhalten. ⌨ Tokio, Metrop. Mus. of Photogr. ⊙ E: Tokio: 1966 Fuji Photo Salon; 2008 Portrait Gall. (Japan Photo Cult. Assoc.). – G: 1996 Tokio, Metrop. Mus. of Photogr.: Jap. Photogr. Form In/ Out (1 From Its Introduction to 1945) (K). ⌨ K. Sekiji, in: Nihon shashinka jiten. 328 Outstanding Jap. photographers, Kyôto 2000; Biogr. dict. of Jap. Photogr., To. 2005. – C. T. Isakushū Kankōkai (Ed.), C. T. Isakushū, To. 1966; C. T., To. 1998; The founding and development of mod. photogr. in Japan (K), To. 1995; C. T., To. 1998 (Nihon no shashinka, 24); Shashinshū o yomu 2. Besuto 338 kanzen gaido, To. 2000. A. Papist-Matsuo

Chiba, *Tetsuya*, jap. Mangazeichner und -texter, * 11. 1. 1939 Tokio, lebt in Tsukiji/Tokio. Bruder des Mangaka *Akio C.* (* 20. 1. 1943 Shenyang, † 13. 9. 1984[Freitod]). Verbringt die Kindheit in der jap. besetzten Mandschurei und kehrt nach E. des 2. WK nach Tokio zurück. Autodidakt. 1956 zeichnet C. den ersten als Leihbuch publ. Manga *Fukushu no Semushiotoko (Revenge of the Hunchback)*. Für das Mädchen-Mag. Shojo Kurabu entstehen 1958 die Bild-Gesch. *Odettojo no Niji (The Rainbow of Odetto Castle)* und *Mama no Violin (Mama's Violin)*. Ab A. der 1960er Jahre erscheinen C.s Manga hauptsächlich in der Jungen-Zs. Weekly Shonen Mag.: u.a. die Basketball-Serie *Chikai no Makyu* (1961–62; Text v. Kazuya Fukumoto); die Kriegs-Gesch. *Shidenkai no taka (The Hawk in the Violet Lightning Fighter*; 1963–65); *Harisu no Kaze (The Whirlwind Boy of Harisu School*; 1965–67); die Boxer-Gesch. *Ashita no Joe (Tomorrow's Joe*; 1968–73; Szenarien v. Asao Takamori); *Hotaru Minako* (1972); *Ore wa Teppei* (1973–80); *Ashita Tenki ni Naare* (1981–91); *Shonen yo Racket o Idake* (1992–94). Für eine weibliche Leserschaft entstehen parallel die im Mag. Weekly Shojo Friend publ. Serien *Yuki no Taiyo (Yuki's Sun*; ab 1963), *Misokkasu* (1966–67) und *Akane-chan* (1968). Der in der Zs. Big Comic Spirits veröff. Manga *Notari Matsutaro* (1973–93 und 1995–98) richtet sich dagegen an erwachsene Leser. – C., der sich vornehmlich auf Manga mit gewöhnlichen Helden aus dem Sport spezialisiert, aber auch humoristische Episoden sowie Abenteuer- und Kriegs-Gesch. (z.B. *Yane ura no ehonkaki/The Ill. in the Attic*, 1973) zeichnet, arbeitet in einem detailreich-realistischen, oft sehr dynamisch angelegten, z.T. auch vor drastischen Gewalt-Darst. nicht zurückschreckenden Stil. ✉ Minminzem no uta, To. 1981 (Autobiogr.). ⌨ Horn, Comics, 1999; *P. Gaumer*, Dict. mondial de la BD, P. 2010. – *F. L. Schodt*, Manga! Manga! The world of Jap. comics, To./N. Y. ³1988; *P. Gravett*, Manga. Sechzig Jahre jap. Comics, Köln 2006; *M. W. McWilliams*, Jap. visual culture. Explorations in the world of manga and anime, Armonk, N. Y. 2008;

T. Johnson-Woods, Manga. An anthology of global and cult. perspectives, N. Y. 2010. – *Online:* Anime News Network; Lambiek Comiclopedia. H. Kronthaler

Chichester Clark, *Emma*, brit. Zeichnerin, Illustratorin, Autorin, * 1955 London, bis 1975 in Irland ansässig, lebt in London. Stud.: 1975–78 Chelsea SchA, London; 1980–83 R. College of Art ebd., bei Quentin Blake. Ausz.: 1988 Mother Goose Award (für *Listen to This*, 1987); Nominierungen: 1998 Kate Greenaway Medal; 2007 Blue Peter Book Award. – Beeinflußt von Q. Blake, Charles Addams und Kinderbuchklassikern wie Babar und Madeline illustriert C. neben Buchcovern v.a. Kinderbücher, die sie häufig auch selbst verfaßt (z.T. als fortgeführte Serie angelegt, z.B. *Blue Kangaroo*, seit 2002; *Melrose and Croc*, seit 2005). Die oft abenteuerlustigen und humorvollen Geschichten werden aus der Sicht des Kindes erzählt und verbinden deren vertrauten Alltag mit phantastischen Elementen. Sie handeln oft von Freundschaft und thematisieren subtil die Gefühle der kindlichen Erfahrungswelt. Die Protagonisten sind v.a. Kinder und vermenschlichte Tierfiguren, deren Charaktere sich innerhalb der Erzählung weiterentwickeln. Ihre Welt wird in oft kräftigen Farben (Bleistift, Wasserfarben) und vereinfachten Formen geschildert, wobei den Details und den atmosphärischen Qualitäten der Farbgebung bes. Aufmerksamkeit geschenkt wird. Die zahlr. Kinderbücher sind in versch. Sprachen (dt., frz., ital., niederl., katalan., schwed.) übersetzt. Als Illustratorin auch für versch. Zss. wie Cosmopolitan, New Scientist und The Sunday Times tätig. – Ill.: J. Lunn, *Shadow in Hawthorn Bay*, 1986; D. W. Jones, *Castle in the Air*, 1990; A. Turnbull, *Too Tired*, 1995; *Shakespeare's Verse*, 2005; L. Carroll, *Alice in Wonderland*, 2009 (alle Lo.). – Ill. und Text: *Catch that Hat!*, 1988; *Tea with Aunt Augusta*, 1991; *No more Kissing!*, 2001; *Eliza and the Moonchild*, 2007 (alle Lo.). ⊙ E: 1984, '87 London, Thumb Gall. –. G: 2008 London, Chris Beatles Gall.: The Illustrators. The brit. Art of Ill. 1800–2008; Q. Blake and Friends at Nunnington Hall. ⌨ Horne, 1994. – *V. Watson*, The Cambridge guide to children's books in England, C. 2001; *J. Carey*, The Guardian v. 17. 12. 2005. – *Online:* Brit. Council.

P. Böttcher

Chierchini, *Giulio (Giulio Ernesto)*, ital. Comiczeichner und -texter, Trickfilmzeichner, * 22. 5. 1928 Genua, lebt dort. Stud.: Ist. d'Arte Duccio di Buoninsegna, Siena (abgebrochen). Ab 1946 als Trickfilmzeichner u.a. in der Werbung tätig; Mitarb. am Animationsfilm *Volpino e la Papera Ribelle* (1946/47). Ab 1953 entstehen erste humoristische Comics für die Verlage Alpe (*Castorino*; *Dan Lepre*; *Tik Corvo*) und Bianconi (u.a. *Mao & Okey*; *Volpetto*, zus. mit Tiberio Colantuoni). Ab 1954 regelmäßiger Mitarb. des Verlages Mondadori, für den C. bis 2008 zahlr. Comics mit Walt-Disney-Figuren wie *Donald Duck* und *Mickey Mouse* gestaltet, die zum größten Teil im Mag. Topolino veröff. werden. Bis 1956 übernimmt er zunächst die Tusch-Zchngn für Gesch. von Giovan Battista Carpi, danach zeichnet er selbst, meist nach Texten von Guido Martina, ab 1964 gelegentlich auch nach eig. Szenarien. Gleichzeitig gestaltet C., z.T. zus. mit Carpi, zahlr. weitere

Comics, u.a. die Ser. *Chico Cornacchia, Geppo* und *Nonna Abelarda* für den Verlag Bianconi, *Rodicchio e Clodovea* für Fesani. 1966–72 sowie 1981–88 entstehen zudem mehrere Gesch. mit den Figuren *Fix und Foxi* für den dt. Kauka-Verlag. Ausz.: 2007 Premio Anafi, Reggio Emilia; 2009 Premio Papersera. – C.s konturbetonten, meist sehr dynamisch angelegten Zchngn stehen in der Trad. von Carpi und tendieren z.T. zu ungewöhnlich düsteren Szenerien. Bes. populär sind seine Disney-Parodien nach lit. Klassikern (u.a. *I promessi paperi*, 1976, nach Alessandro Manzoni; *Paperino nei panni di Tarzan*, 1979, nach Edgar Rice Burroughs; *L'inferno di Paperino*, 1987, nach Dante). C.s Comics zeigen zudem häufig Motive aus der Heimatstadt Genua. Seit 1988 koloriert er seine Arbeiten z.T. mit Airbrush. ◉ *G:* 2008 Rapallo, Antico Castello sul mare: Strisce di terra e strisce di carta. I fumetti dei Liguri nel mondo (K: C. Chendi/S. Badino). ▭ *H. Filippini,* Dict. enc. des héros et auteurs de BD, I, Grenoble 1998; *id.,* Dict. de la bande dessinée, P. 2005; *P. Gaumer,* Dict. mondial de la BD, P. 2010. – *J. Coma* (Ed.), Hist. de los cómics, Ba. 1982; *S. Badino,* Conversazione con Carlo Chendi. Da Pepito alla Disney e oltre, Latina 2006; *S. Brancato* (Ed.), Il sec. del fumetto. Lo spettacolo a strisce nella soc. ital., 1908–2008, Latina 2008. – *Online:* Duckipedia; Lambiek Comiclopedia. H. Kronthaler

Chierici, *Vittoria (Maria Vittoria),* ital. Malerin, Zeichnerin, Graphikerin, Videokünstlerin, Kunstkritikerin, * 7. 4. 1955 Bologna, lebt in Italien und den USA. Stud.: Univ. Bologna, an der von Umberto Eco u.a. neu gegr. Fak. DAMS (Discipline delle arti, della musica e dello spettacolo; 1979 Dipl. in Kunstgesch.); 1979–80 Univ. of California, Berkeley, anschl. Columbia Univ., New York; parallel dazu Parsons School of Design und School of Visual Arts ebd. (Kurse in Photogr. und Kinematographie). Kontakt mit David Salle. 1982 Dipl. der New Yorker School of Film Producing. In New York ist sie mit Manuela Filiaci Kuratorin des Ausst.-Raumes The Parallel Window. 1983 Rückkehr nach Bologna und Mitgl. von Enfatisti. 1984 Übersiedlung nach Mailand. Arbeitet mit Künstlergruppierungen zus., u.a. Zeffiri Milanesi, Cartello 99 und Maledetti Toscani. 1989 vertritt sie Italien in Tokio auf einer von INFAS und Hanae Mori organisierten Ausst. mit der Installation *Coca Cola Classic.* 1990 Mitbegr. der Kunst-Zss. Slam und Infarto sowie des Unternehmens Art & Mass (zus. mit Stefano Arienti und Amedeo Martegani); 1992 Mitarb. des Mag. Rendiconti. 1994/95 produziert sie in New York die Kurzfilme *Street Fight* und *One's Case.* 1995 Lehrtätigkeit an den KA Bologna, Florenz und Mailand. Setzt sich intensiv mit neuen Mitteln der Kommunikation und Reproduktion auseinander und verbindet häufig filmische mit malerischen Gest.-Elementen. E. der 1990er Jahre beginnt C. an einem Mixed-media-Projekt zu arbeiten, in dem sie die Schlacht von Anghiari malerisch und digital bearbeitet (*Leonardo Scomparso*). 2001 Premio Dams der Univ. Bologna. 2003–06 Prof. am Politecnico Mailand, Fak. für Design, Mode und Installation. Seit 2004 Zusammenarbeit mit amer. Künstlern versch. Gattungen, u.a. 2006 mit der Choreographin Liz Gerring

und jüngst mit der Komponistin Eve Beglarian. C.s Arbeiten beschäftigen sich bes. mit der Reflektion von Zeitereignissen in Kunst und Kultur. Freundschaft mit Corrado Levi, in dessen Bes. sich zahlr. Werke von C. befinden. ▭ ANGHIARI, Pal. del Marzocco: Leonardo Scomparso, 2000. AREZZO, MAMC. ASCONA, Mus. Com. d'Arte Mod. BOLOGNA, Fond. Carisbo della Cassa di Risparmio. MAILAND, Padiglione d'Arte Contemp. NEW YORK, New York Univ. PIEVE DI CENTO, Mus. delle eccellenze artist. e stor. MAGI'900: Nello spazio di una mostra, 1992; Rosso, di giorno e di notte, 2008/09. ROM, GNAM. ROVERETO, Mus. Stor. Ital. della Guerra: Battaglia e specchi, 1996. SAN MARINO, Gall. Naz. d'Arte Mod. e Contemp. UMBERTIDE, Centro per l'Arte Contemp. VICENZA, Libr. La Vigna: Rosso – Verde, 2001. ✉ Aftermath, Mi. 1997; Burt Barr, in: Dialoghi Internaz. 13:2010. ◉ *E:* Bologna: 1984 Nuvolari Arte; 1988 Gall. Studio Cristofori; 1993 Teatri di Vita; 2001 Studio Mascarella / 1992 Madrid, Gal. Buades / Mailand: 2005 Circolo della Rosa; 2011 Lucie Fontaine / 2001 Siena, MCiv. / 2005 Florenz, Pal. di Parte Guelfa; New York, Esso Gall. – *G:* 1999 Venedig: Bienn. / 2011 Grottaferrata, Abbazia: Arte in forma di libri. ▭ PittItalNovec/3, 1994. – *G. Di Pietrantonio,* Flash art (125) 1985; *D. Trento,* Structure, codes, signals in V. C. works, Bo. 1988; *G. Quaroni,* Flash art (158) 1990; *P. Bellasi/R. Roversi,* V. C.'s soldiers, Faenza 1997; *D. Trento* (Ed.), V. C.. Battaglie, Mi. 2003; *C. Levi,* Via Dogana (68) 2004. – *Online:* Website C. S.-W. Staps

Chiesi, *Andrea,* ital. Maler, Zeichner, Graphiker, Illustrator, Fotograf, Videokünstler, * 6. 11. 1966 Modena, lebt dort. Bildet sich autodidaktisch im Klima von Gegen- und Independentkultur (Punk, Industrial, New Wave) der frühen 1980er Jahre. Zeichnet für Fanzines und Underground-Publ. menschliche Figuren und Räume in schwarzer oder violetter Tusche; arbeitet für den Verlag Stampa Alternativa. Trifft Wainer Vaccari, unter dessen Einfluß er sich A. der 1990er Jahre der Lsch.-Malerei zuwendet. Dabei geht er von Fotogr. aus, auf denen er leerstehende, zum Abriß bestimmte Fabrikgebäude, öde Stadtränder, Industrie- und Hafenanlagen, Bahnhöfe, Baustellen u.ä. dokumentiert, die einen evident sozialen Bezug haben (z.B. zu Arbeit, Klassenkämpfen, Streik, Betriebsbesetzungen, Umweltzerstörung, Verfall). Diese Motive setzt er mit breitem Pinselstrich in Schwarzweiß-Gem. um, wobei er neue Räume und Strukturen schafft, die nur entfernt an die orig. Schauplätze erinnern. Nachfolgend kommt C. zu einer zunehmenden Betonung der Linie. Seine raffiniert konstruierten, zw. Hyperrealismus und Abstraktion angesiedelten Gem. von Archit. (*Kali Yuga 35,* Öl/Lw., 2006) oder menschenleeren Räumen (*Parkslope 3,* Öl/Lw., 2010) sind, ebenso wie die Rad. und Aquatinten, durch eine kraftvolle, die suggestive Perspektive unterstützende Linienführung und starke Schwarzweißkontraste charakterisiert (*Luna park,* 2011). Mitunter widmet er einem Objekt oder Gebäudekomplex (u.a. Autofabrik, Tabak-Man.) oder einem topogr. erkennbaren Ort einen ganzen Zyklus von Gem. und Graphiken; in der Ausst. *Perpetuum mobile* (Berlin, 2011) zeigt er z.B. Berliner Motive zw. Kreuzberg und

Ostkreuz. In den neueren Arbeiten bezieht er den Faktor der Zeit ein: von der Fotogr. eines Blickes aus seinem Fenster ausgehend, malt er eine Folge dieses Sujets zu versch. Tages- und Nachtzeiten in der Art eines Tagebuchs. 1991 realisiert C. sein erstes orig.-graph. Künstlerbuch (*Camere del silenzio*). Daneben CD-Cover-Gest. (*Taccuini*. *Collana di musica aliena*, 1996/97) und Videos (*Come un suono, dal suono del mondo*, Kantate: Martino Traversa, Malerei: Vasco Bendini, Parma 1998; *Giovanni Lindo Ferretti. C. S. I. L'apocalisse di Giovanni*, 2009). Multimediaarbeiten realisiert er u.a. mit der Musikgruppe Officine Schwartz und dem Künstlerkollektiv Kom Fut Manifesto in Reggio Emilio. Die Zs. Arte zählt ihn 1997 zu den zehn talentiertesten ital. Künstlern. Ausz.: 1998 Premio Suzzara, Suzzara; 2004 Premio Cairo Communication, Mailand; 2008 Premio Terna. – Buch-Ill.: W. Vaccari, *Camere del silenzio*, Md. 1991; G. Molinari/A. Riva, *No tears for the creatures of the night* Prato 1998. ⌂ Modena, Laboratorio d'Arte Grafica. ✉ G. R. U. Grande Rumore Universale. Una corrispondenza fra A. C. e Luca Beatrice, Mantova 2000; Riconvertire i luoghi, Mi. 2008. ◉ *E:* Modena: 1993, 2002 Gall. Civ. (K); 1995 Gall. Rossana Ferri (K); 2009 Gall. D406 (K); 2011 Arte su Carte / 1997, 2000 Turin, Gall. ES (K) / 1996 Mailand, Spazio Occupato / 1998 Prato, Gall. Sergio Tossi (K: G. Molinari) / 1999 Piacenza, Gall. Marazzini Visconti Terzi (K); Nonantola, Sala delle Colonne (K) / Bologna: 1999 (K: L. Beatrice); 2001 (K: V. Tassinari) GAM; 2004, '09 Otto Gall. (K) / 2000 Lodi, Gall. Marco Mazzi (K); Mantua, Gall. Maurizio Corraini (K) / 2004 Triest, LipanjePuntin Artecontemp. (K); Losone, Fond. La Fabbrica / 2005, '08 Mailand, Corsoveneziaotto Tega Arte Contemp. (K) / 2007, '11 Genua, Guidi & Schoen (K: M. Sciaccaluga) / 2008 San Martino Secchia, Centro Sociale Ekidna (K) / 2009, '10 New York, Nohra Haime Gall. (K) / 2010 Kapstadt, Misael / 2011 Berlin, XLAB Corrosive Art Farm. – *G:* 1990 Marseille: Bienn. des jeunes créateurs d'Europe de la Méditerranée (K) / 2000 La Spezia, Gall. Com.: Profili della giovane pitt. contemp. / 2001 Nuoro, MAC: Pay attention, man / 2002 Rom, Mus. del Corso: Verso il futuro. Identità nell'arte ital. 1990–2002 (K); Udine, GAM: Four ways / 2002–03 Modena, Gall. Civ. (mit Giuliano Guatta, Beatrice Pasquali; K: W. Guadagnini) / 2003 Prag: Bienn. (K) / 2005 Bologna, GAM: Bologna contemp. 1975–2005 (K) / 2007 Mailand, Pal. Reale: Arte ital. 1968–2007 (K) / 2007 Francavilla al Mare: Premio Michetti / 2008 Perugia, Pal. della Penna: Viva l'Italia; Turin, Castello di Rivara: Archit. sensibili / 2009 San Marino, GAM: Plenitudini (K). ⌺ Diz. della giovane arte ital., I, Mi. 2003. – *A. Chiesi/D. Liccardo*, Titolo 8:1997 (23) 38 s.; *L. Beatrice u.a.*, L'apocalisse di Giovanni. Cantiere artist. di fine millennio, dipinti di A. C. (K), Mi. 1998; *ead./C. Perrella*, Nuova arte ital., R. 1998; *ead./C. A. Bucci*, In forma di libro. I libri di A. C. (K), Md. 2000; *M. Sciaccaluga*, Arte 328:2000, 140–147; *F. Pola*, Titolo 12:2001 (37) 4–7; *M. Sciaccaluga*, Arte 377:2005, 96–100 (Premio Cairo); Ligeia 65–68:2006, 96–98; *M. Vescovo* (Ed.), L'opera al nero dall'astrazione alla costruzio-

ne dell'immagine (K Ancona), Falconara 2005; *A. Barbieri*, A regola d'arte, Md. 2008; *L. Beatrice*, A. C. La divisione del piacere (K), T. 2006; *D. Gullì*, Paesaggio urbano 17:2008 (4) 58 s.; *L. Spagnesi*, Arte 414:2008, 86–90; *E. Gravagnuolo*, ibid. 450:2011, 52 s. – *Online:* New York, Nohra Haime Gall.; Modena, Laboratorio d'arte grafica (Druckgraphik). E. Kasten

Chiezo, *Taro*, US-amer. Objekt- und Installationskünstler, Maler, Kurator, * 1962 Tokio, lebt in New York. Stud.: 1980–84 Tisch SchA, New York Univ. – C. kreiert roboterartige Skulpt. und futuristische, cartoonartige Gem. (*Father and Son II [Schipol Airport]*, 1999), in denen er spielerisch und ironisch mit Ikonen der Populärkultur und Hochtechnologie umgeht. Er nutzt intensive, z.T. fluoreszierende Farben, Computersoftware und Mat. wie Laserdiscs (*A robot to fall in love*, 1994). Die fünf Meter hohe, grellgelbe Skulpt. *Super Lamb Banana*, eine Verschmelzung von einer Banane mit einem Lamm, entsteht im Auftrag der Art Transpennine Ausst. 1998 in Liverpool zum Thema der Gefahr, die von genetisch veränderten Lebensmitteln ausgeht. 2011 kuratiert er im Rahmen des Berlin-Tokio Austauschprogramms die Ausst. Crisis und Mod. Art Manner im Kunstraum Bethanien in Berlin-Kreuzberg, bei der er sich wie drei weitere Künstler mit dem verheerenden Erdbeben in Ostjapan (2011) befaßt. ⌂ Kumamoto, Contemp. AM. Oita, AM. Tokio, Fuchu AM. Tokushima, Mod. AM. ◉ *E:* Tokio: 1992 Shiraishi Contemp. Art; 1994, 2001 SCAI The Bathhouse; 1996 Ginza Komatsu; 1996, '99 Tomio Koyama Gall.; 1997 Kirin Art Space Harajuku; 1999, 2008 Daiichi Life Gall.; 2008 Wander Site Hongo / 1993, '94, '96, '99–2000 New York, Sandra Gering Gall. / Nagoya: 1993, '94, 2000, '03 Gall. Cellar; 2000, '01 Kohji Ogura Gall. / 1994 Eltville am Rhein, Gal. Rippentrop / 2002 Osaka, Shinkyone Art Space. ⌺ *Bénézit* III, 1999. – *A. Munroe*, Flash art 163:1992 (März/April) 71–74; *D. Blair*, ibid. 170:1993 (Mai/Juni) 86; *L. Dompierre* (Ed.), The age of anxiety (K), Tor. 1995; *J. Spring*, Artforum 34:1996 (Sommer) 111; *D. Lee*, ArtRev 50:1998 (Juli/Aug.) 60–62; *M. Matsui*, Flash art 199:1998 (März/April) 123; *J. Robinson*, Blueprint 152:1998 (Juli/Aug.) 26–29. – *Online:* Website C. H. Stuchtey

Chilai, *Jigmei*, tibetischer Maler, * 1. 7. 1961 Lhasa, lebt dort. Bis 1981 (Abschluß) Kunst-Stud. am Dep. of Arts an der Tibet Univ. in Lhasa. Weitere Ausb. am Ethnic FA Dep. der Central AFA in Beijing. Heute ist er Generalsekretär der Tibet Artists Assoc. und Mitgl. der Chin. Artists Association. – In semi-abstraktem und in gedeckten Tönen gehaltenen Stil zeigen C.s Ölmalereien Szenen trad. tibetischen Lebens wie Bogenschießen, Archit.-Darst. oder auch romantische Liebe. ⌂ Beijing, China Nat. Gall. Tokio, Tokyo Shaping Art Acad. ◉ *G:* 2004 Beijing, Chin. AM: The Colourful Chain from the Snowland. Contemp. Tibetan Art Exhib. (Wander-Ausst.). ⌺ Contemp. Tibetan paint., Bj. 2001. – *Online:* Tibetinformation. R. Höfer

Chilcott, *Gavin*, neuseeländischer Maler, Zeichner, Graphiker, Dekorateur, Designer, Installationskünstler,

Bildhauer, * 1950 Auckland, lebte dort und in Wellington, zuletzt in Masterton. Stud. in Auckland: 1967 Technical Inst. (heute Univ. of Technology); 1968–70 Elam School of FA. Stip.: u.a. 1980–89 mehrfach Queen Elizabeth II Arts Council of New Zealand Grants. – Eklektische Arbeiten in versch. Gattungen und Techniken, u.a. Aqu., Pastell, Buntstift, auch Mischtechniken und Collagen; bek. v.a. für die von Textilmustern der 1950er und 1960er Jahre und ethnischen, darunter indianischen, Mustern inspirierten Werke, z.B. *Spring Cleaning the Teepee, Red Indian Series* (ÖL/Lw., ca. 1979). Anfänglich farbenfrohe abstrakte Gem., z.B. *Hong Kong Honeymoon* (Acryl/Lw., 1977); danach zunehmend Gem., Zchngn und Graphiken mit vereinfachten Darst., u.a. von Gefäßen und holzblockartigen, sich bewegenden Torsi mit Gliedmaßen; teils silhouettenhaft, z.B. *Opiated Wine Jars and Heart Pot* (Farb-Lith., 1989), oftmals im Stil der Art brut, z.B. *The Awakening Conscience?* (Wachsstift/Papier, 1987). Seit A. der 1990er Jahre Malerei auf Papiertüten unterschiedlicher Größe, u.a. Tiermotive, z.B. *Birds Bocage and Horses* (Acryl). Des weiteren Gest. und Installation eines Raumes mit dem Möbeltischler David White, Auckland, für die Ausst. Setting a Table (1989, Auckland, City AG; K), Dekore für keramische Arbeiten von Errol Barnes sowie Teppichentwürfe für die Fa. Dilana Rugs, Christchurch. Außerdem Plakate und Buchumschläge sowie Skulpturen. ⌂ AUCKLAND, AG Toi o Tāmaki. – James Wallace Arts Trust. BRISBANE, Queensland AG/Gall. of Mod. Art. CANBERRA, NG of Australia. CHRISTCHURCH, Christchurch AG. DUNEDIN, Hocken Libr. LONDON, BM. LOWER HUTT, Dowse AM. NEW PLYMOUTH/N. Z., Govett-Brewster AG. SYDNEY, Powerhouse Mus. WELLINGTON, Muz. of New Zealand Te Papa Tongarewa. ◉ *E:* Auckland: 1976 Barry Lett Gall.; 1981–84 RKS Art; 1985 Red Metro Gall.; 1987, '88 Sue Crockford Gall.; 1989 Fisher Gall. / Christchurch: 1976, '83, '85, '86, 2006 Brooke Gifford Gall., 1992 Robert McDougall AG (K) / Wellington: 1982, '83, '85, '86, 2001 Janne Land Gall.; 1988, '89 Southern Cross Gall.; 1990 (mit Ralph Paine), '91 (mit Bill Hammond) Gregory Flint Gall.; 1992 City AG (mit R. Paine; K) / 1983, '84, '89 Brisbane, Ray Hughes Gall. / 1984 Hamilton, Hamilton Centre Gall.; New York, Pam Adler Gall. / 1985, '86, '88, '90 Sydney, Ray Hughes Gall. – *G:* Auckland: 1977 (39 Drawings; Falt-Bl.); '83 (New Image; K) City AG; 2006 AG Toi o Tāmaki: Summer Daze / 1991 Brisbane, Queensland AG: Decorated Clay; Hamilton, Waikato MAH: Cross Currents / 1992 Sevilla: Expo (K) / 1993 (Distance Looks Our Way; K), 2001 (Telecom Prospect) Wellington, City Gall. / 2001 Manukau City, Te Tuhi Centre for the Arts: Interior Horizons (K); Horsens, KM: MUKA Kunst for børn og unge / 2005 Whangarei, AM: In Flower. ⌷ *K. McGahey*, The concise dict. of New Zealand artists, Wellington 2000. – *M. Dunn*, New Zealand paint., Auckland 2004. – *Online:* Website C.

J. Niegel

Child, Abigail, US-amer. Film- und Videokünstlerin, Dichterin, * 1948 (lt. Blaetz; lt. Centre Pompidou: * 1. 1. 1950) Newark/N. J., lebt in New York. Stud.:

1964–68 Radcliffe College, Harvard Univ, Cambridge/Mass. (engl. Gesch. und Lit.; 1967 1. Preis für Fotogr.); 1968–70 Yale Univ. School of the Arts, New Haven/Conn. (Fotogr., Film). Lehrtätigkeit: 1980–85 New York Univ. SchA; 1985 Massachusetts College of Art, Boston; 1986, '89 San Francisco, Art Inst.; 1989–90 School of Visual Arts, New York; 1990–91 Hampshire College, Amherst/Mass.; 1991–99 Sarah Lawrence College, Bronxville/N. Y.; seit 1999 School of the MFA, Boston. Künstlerresidenzen: u.a. 1978 State Univ. of New York; 1983–99 mehrfach MacDowell Colony, Peterborough/N. H.; 1990 California Inst. of Art, Los Angeles; 1991–2004 mehrfach Virginia Center for the Creative Arts, Amherst/Va.; 1992 Kootenay SchA, Vancouver; 1992–93 Aufenthalt in St. Petersburg (Fulbright Fellowship); 1996 Art Inst. of Chicago; 1996, 2002, '05 Yaddo Residency; 2001 Bundeskanzleramt, Wien; 2006 Beijing Film Inst.; 2009–10 Rompreis der Amer. Acad. of Art. – C. will zunächst Dokumentarfilme drehen, findet den Ansatz jedoch bald zu beschränkt und geht zu künstlerischen Kurzfilmen über. *Some Exterior Presence* (1977) besteht aus Outtakes eines ihrer Dokumentarfilme. Bald legt sie bes. Gewicht auf einen filmischen Rhythmus, z.B. *Ornamentals* (1979). *Prefaces* (1981) und *Mercy* (1989) sind die Anfangs- und Endpunkte der siebenteiligen Serie Is This What You Were Born For?, in der sie eine Vielfalt von Quellen-Mat. dekonstruiert und in bedrohlicher, direkter Weise neu zusammenfügt. Die Fragmentierung in rasch wechselnde, springende Bild- und Tonschnipsel wird ein wesentliches Merkmal dieser Videos. Feministische Aspekte stehen neben sexueller Spannung, industrieller Entfremdung und Abstraktion. Mehrfach greift sie hierbei auf Mat. aus alten Spielfilmen, bes. Stummfilmen zurück. Eine Reihe von Filmen wie *8 Million* (1992) sind mit Musik von Ikue Mori unterlegt und greifen märchenhaft romantische Konzepte auf, während *B/side* (1996) ein sozialer Kommentar zur Obdachlosigkeit ist. Eine Gegenüberstellung von hist., hoffnungsvoller Utopie und zeitgen. Realität prägt Filme wie *Below the New: A Russian Chronicle* (1999) und *The Future Is Behind You* (2004). In jüngster Zeit konzentriert sich C. erneut in fast dokumentarischer Weise auf spezifische soziale Gruppen, z.B. *The Party* (2004) und *On the Downlow* (2007) über eine heimliche bisexuelle Lebensweise von Farbigen in Cleveland sowie *Surf and Turf* (2008–11; Teil der Serie *The Suburban Trilogy*) über syrischstämmige orthodoxe Juden. ⌂ AMHERST/Mass., Hampshire College. BERKELEY/Calif., Berkeley AM and Pacific Film Arch. BERLIN, Arsenal. Inst. für Film und Videokunst. BROOKLYN/N. Y., Public Libr. CAMBRIDGE/Mass., Harvard Univ. Film Arch.: A. C. Coll. CHICAGO, Art Inst. – Public Libr. MIAMI, Dade County Public Libr. NEW YORK, Donnell Public Libr. – MMA. OBERHAUSEN, Archiv der Kurzfilmtage. PARIS, MNAM. SAN FRANCISCO, San Francisco State Univ. ✉ A motive for Mayhem, Elmwood, Conn. 1989; Flesh. Poems for Sarah Shulman, Am./N. Y. 1990; This is called moving. A critical poetics of film, Tuscaloosa, Ala. 2005. ◉ *E:* 2006 Minneapolis, Walker AC / 2006, '07 (Retr.) Cambridge/Mass.,

Harvard Cinematheque / 2008 Seoul, Exis (Retr.) / 2010 Madrid, CARS (Retr.). ▭ *K. Horsfield/L. Hilderbrand* (Ed.), Feedback, Ph. 2006; *R. Blaetz*, Women's experimental cinema, Durham, N. C. 2007. – *Online:* Website C.

G. Bissell

Child, *Heather (Josephine Heather)*, brit. Kalligraphin, Malerin, Zeichnerin, * 3. 11. 1911 Winchester, † 18. 6. 1997 Petersfield/Hants. Stud.: 1928 Chelsea SchA bei Mervyn Oliver (Kalligraphie, Ill., Wappenkunde), daneben Westminster College of Arts bei Blair Hughes-Stanton; 1934 Torquay, Domestic Sc. Course und Stip. für das R. College of Art, London (nicht angetreten). Arbeitet ab 1948 freiberuflich in London, ab 1977 in Petersfield. Mitgl.: 1932 Soc. of Scribes and Illuminators (Chairman 1964 und 1971); 1936 Arts and Crafts Soc.; 1968 Brother, Art Workers' Guild. Ausz.: 1974 Member of the Brit. Empire. Ab 1934 ist C. bei der Gas Light and Coke Company tätig, mit deren Dir. Sir David Milne-Watson sie sich befreundet und in dessen Wohnsitz Hadley Chase/Dorset sie Ferien und die Kriegsjahre verbringt. Dort begründet und leitet sie den Dorset Bluttransfusions-Dienst, u.a. zus. mit ihrer Lebensgefährtin, der Malerin Dorothy Colles. – C. interessiert sich v.a. für heraldisches Zeichnen und fertigt nach 1945 für Londoner Zünfte zahlr. Wappen, u.a. 1951 für den Informationsstand auf dem Festival of Britain. Sie arbeitet unter Alfred Fairbank an den R. Air Force und Amer. Air Force Books of Rememberance und entwirft die Heraldik für das Lifeboat Service Memorial Book. Für das Informationszentrum der St.-Paul-Kathedrale in London gestaltet sie ein auf Holz gemaltes Spiel über die Grundlagen der Heraldik. Ein and. Spiel entsteht mit botanischen Ill., die sie, wie auch die 245 Ill. im *Collins Pocket Guide to Wild Flowers* (1956), künstlerisch bes. geschickt ausführt. Auch spezialisiert sie sich auf ornamentale Landkarten (*Map of Hadley Chase, Map of the Wessex of Thomas Hardy's novels*, beide 1934; *Map of the printing schools of England*, Lo. 1961) und verfaßt darüber ein Buch. C.s größtes Verdienst sind zwei mehrfach aufgelegte Hbb. zur Kalligraphie (*Calligraphy today*, Lo. 1963; 1976; 1988; *The Calligrapher's hb.*, Lo. 1976; 1985) und die erstmalige Veröff. der von Edward Johnston über lange Jahre verfaßten Hbb. der Schrift (Formal Penmanship, Lo. 1971; Lessons in Formal Writing [mit Justin Howes] Lo. 1986). – C. ist eine begabte, trad. arbeitende Kalligraphin, die den Übergang von Gest. von Johnston zur zeitgen. Kalligraphie ebnet. ✍ CAMBRIDGE/Mass., Harvard Univ., Houghton Libr.: Some wild Orchids in Britain. DITCHLING/East Sussex, Ditchling Mus. FARNHAM/Surrey, Univ. for the Creative Arts, Crafts Study Centre: Heraldic Badge of the Tudor sovereigns. LONDON, Nat. Art Libr.: Sun in splendour. – Guildhall Libr.: Wappen der Londoner Zünfte, Pergament, 1960. ✉ Decorated maps, Lo. 1956; *C./D. Colles*, Christian symbols, Lo. 1971; *C. u.a.*, More than fine writing. Irene Wellington, Lo. 1986. ◉ *E:* 1998 Bath, Holburne Mus., Crafts Study Centre. – *G:* London: ab 1936 regelmäßig Ausst. der Soc. of Scribes and Illuminators; 1971 V & A: The decorated page (K). ▭ *Buckman* I, 2006. – *M. Gullick*, Calligraphy rev. 7:1989 (2) 49–51;

N. Barker, Independent v. 30. 6. 1997; *L. Hoare*, Crafts 148:1997 (Sept./Okt.) 65; Times v. 21. 6. 1997; *H. Collins*, Letter arts rev. 14:1998 (4) 4–11; Scribe (Soc. of Scribes and Illuminators) 70:1998 (Frühjahr) 3–7.

H. Stuchtey

Child, *Thomas*, brit. Ingenieur, Fotograf, * 27. 1. 1841 Coalbrookdale/Shrops., † 27. 5. 1898 Chelsfield/Kent. C. zieht 1851 mit den Eltern nach Greenwich, studiert Geologie und Chemie in Woolwich und arbeitet anschl. für die Chrystal Palace Gas Company; parallel erteilt er an einer Abendschule Unterricht im Technischen Zeichnen. Ab 1870 in Peking angestellt beim Imperial Maritime Customs Service, vertreibt C. priv. fotogr. Ausrüstungen. 1889 Rückkehr nach England; 1891 in Deptford/South London nachg.; ab 1898 in Chelsfield. – C. widmet sich bereits in England der Fotografie. Heute sind ca. 200 Aufnahmen aus der Zeit in Peking in den 1870er und 1880er Jahren bek., darunter Stadtansichten, aber auch zahlr. Portr., in erster Linie von europ. Immigranten und Touristen, aber auch von Einheimischen. Damit gilt C.s Werk als frühestes umfassendes fotogr. Zeugnis der Stadt. Er vermarktet seine Fotogr. erfolgreich an ausländische Bewohner Pekings wie auch an Touristen. 1877–78 erscheinen vier Fotogr. in der Zs. The Far East (Shanghai). Die meisten Negative sind dat. und sign.; einige Abzüge sind darüber hinaus gestempelt; lt. Bennett (2010) verwendet C. folgende Sign.: Thomas Child; T. Child; Thos. Child; T. C. ✍ LOS ANGELES, J. Paul Getty Mus.NEW YORK, Internat. Center of Photogr. – Public Libr. ✉ Peking, in: J. of the soc. of arts 43:1895 v. 1. 2. 1895, 207–221; The oldest observatory in the world, in: Pearson's mag., 1898 (beide ill. mit eig. Fotogr.). ◉ *G:* 2004 New York, Internat. Center of Photogr.: China and the Chinese in Early Photographs. ▭ *J. Hannavy* (Ed.), Enc. of nineteenth-c. photogr., I, N. Y./Lo. 2008. – *C. Osman*, T. C. Photographer of Peking (K), Bath 1989; *R. Thiriez*, Barbarian lens. Western photographers of the Qianlong Emperor's Europ. palaces, Am. 1998; *T. Bennett*, Hist. of photogr. in China 1842–1860, Lo. 2009; *id.*, Hist. of photogr. in China. Western photographers, 1861–1879, Lo. 2010 (publ. Fotogr., eig. Schriften, Lit.); *J. W. Cody* (Ed.), Brush and shutter. Early photogr. in China (K), L. A. 2011. – *Online:* Hist. photographs of China.

P. Freytag

Childish, *Billy* (eigtl. Hamper, *Steven John*; Pseud.: u.a. Hamper, *William [Bill; Charlie; Guy]*; Ketch, *Jack*; Danger, *Bill*), brit. Maler, Graphiker, Collagekünstler, Fotograf, Musiker, Lyriker, * 1. 12. 1959 Chatham/Kent, lebt dort. Bruder des Malers *Nicholas Hamper* (s.u.). Kurzzeitig Steinmetzlehre, Naval Dockyard, Chatham. Stud.: 1977–78 Medway College of Art and Design; 1978, 1980–81 St. Martins SchA, London (Ausschluß). 1982–87 Lebensgefährte von Tracey Emin. Mitgl.: A. der 1980er Jahre Medway Poets; 1999–2001 Künstlergruppe Stuckists (Mitbegr.). – C. ist ein produktiver und kompromißloser Künstler (über 100 Musikalben, 40 Gedichtbände, mehrere Romane und mehr als 3000 Bilder), der v.a. auto-biogr. inspirierte Gem. (viele Selbst-Portr. und Portr.) und Hschn. anfertigt, die sich u.a. auf traumatische Kind-

heitserlebnisse beziehen. Sie entstehen fast ausschließlich sonntags in einem Zimmer im Haus seiner Mutter in Whitstable/Kent. Char. sind Arbeiten in der Art des dt. Expressionismus mit starken schwarzen Konturen und Impasto (wie Ernst Ludwig Kirchner, Karl Schmidt-Rottluff, Kurt Schwitters), z.T. auch direkte Anspielungen an van Gogh oder Edvard Munch. In den letzten Jahren basieren Gem.-Zyklen auf Biogr. versch. Persönlichkeiten wie z.B. von Robert Walser und 2010 von Hans Fallada, zu dem er in drei Monaten über 80, auf alten Fotogr. basiernde Gem. malt (*Fallada Cycle*). – *Nicholas (Nichollas) Hamper*, älterer Bruder von C., * 1956 Chatham/Kent, lebt in Verteuil-sur-Charente. Stud. in London: 1975–79 Slade School of FA; 1980–82 R. College of Art. 1983–84 Australienreise. Lehrt in Oxford 1988–91 am Polytechnic und als Gast-Doz. an der Ruskin School of Drawing and FA. Ausz.: 1991/92 1. Preis John Moores Exhib., Liverpool (für das Gem. *The Intervention of the Döner Kebab*). V.a. farbintensive gegenstandsbezogene Malerei (Öl, Acryl) mit Tendenz zum Surrealismus zu versch. Themen (*Memlings Garden*, Öl/Lw.; R. College of Art Collection). ✉ On Kurt Schwitters, in: Tate etc. 2006 (6) 98 s. ◉ *E:* London: 1994, ʼ95 Cubitt Gall.; 1999 Gall. 108; 2002 Dryden Street Gall.; 2003 Print Studio Gall.; 2005, ʼ08 Aquarium L-13 Gall. (K); 2010 Inst. of Contemp. Art / 1999–2000 Folkestone, Metropole AC / 2000 Barnstable (North Devon), Broomhill Art Hotel / 2002 Maidstone, Kent Inst. of Art and Design, George Rodger Gall. / 2005 Medway (Kent), Rochester Gall. (Wander-Ausst.) / 2010 Berlin, Neugerriemschneider Gal. (K); New York, White Columns. ▭ *Buckman* I, 2006 (irrtümlich * 1960). – *M. Hodgkinson*, Guardian v. 14. 9. 1999; *M. Brown*, Telegraph mag. v. 29. 1. 2000; *K. Evans* (Ed.), The Stuckists. The first remodernist art group, Wokingham 2000; The arts in Medway (K Urban Fox Press), Medway 2004; *F. G.*, Mod. painters 17:2004 (1) 121; The Stuckists. Punk victorian (K Walker AG), Liverpool 2004; C. Paintings of a backwater visionary (K Aquarium Gall.), Lo. 2005; *Wilhelmi*, 2006; *N. Brown*, B. C. A short study, Lo. 2008; *S. Williams*, Guardian v. 6. 6. 2009. – London, Nat. Art Libr.: Dokumentation. – *Online:* Website C.

H. Stuchtey

Childress, *Nina,* frz. Malerin, Zeichnerin, Videokünstlerin US-amer. Herkunft, * 1961 Pasadena/Calif., lebt seit ihrem 5. Lebensjahr in Paris. Stud.: 1981–86 ENSBA, Paris; Univ. Paris VIII, Saint-Denis (Abschluß: 2006 Master [Arts plast.]; lehrt dort 1997–99). Weitere Lehrtätigkeit: Ec. régionale d'Art, Dunkerque; Ec. supérieure d'Art et de Design, Amiens; Ec. supérieure d'Art, Le Havre; Ec. nat. supérieure d'Art, Nancy (seit 2007 Prof. de Peint.). Mitgl. des Pariser Künstlerkollektivs Les Frères Ripoulin und der Punkband Lucrate Milk (1980–83). – Als Quelle für die seit A. der 1980er Jahre entstehenden Gem. (v.a. Öl/Lw. oder Holz, auch Acryl und Mischtechnik; weiterhin Kohle-Zchngn) dienen C. bevorzugt Fotogr. aus Zss., Büchern und von Filmszenen sowie Postkarten. Die Vorlagen werden auf den Bildträger projiziert, um dann häufig durch eine starke Unschärfe verfremdet

wiedergegeben zu werden (u.a. die A. der 2000er Jahre gemalten Lsch., Portr., Akte, Blumen- und Früchtestillleben). C.s vielseitiges Œuvre besteht aus gegenständlichen Werken, die bisweilen in hyperrealistischem Stil (z.B. die Arbeiten der 1990er Jahre mit Motiven wie mon. Tupperdosen, Süßigkeiten und Seifenstücken) und z.T. in expressiver Manier ausgeführt sind (z.B. eine Serie mit erotischen Akt-Darst. einer Frau in Grün mit einem Schwan, Öl/Lw., 2009); weiterhin vereinzelte abstrakte Komp. (z.B. *Mystère bulgare*, Acryl/Lw., 2010). In der Trad. der Figuration Libre kombiniert sie z.T. collageartig versch. Motive und Techniken. In mehrteiligen Komp. (häufig Diptychen) thematisiert C. die Grenzen des Bildträgers, dessen Ränder bisweilen das Motiv durchtrennen (z.B. *Red Hair*, Öl/Lw., 2004). Auch Videoarbeiten. ⌂ Chateaugiron, FRAC Bretagne. Genf, Fonds cantonal d'Art contemp. – MAMC. Limoges, FRAC Limousin. Montpellier, FRAC Languedoc-Roussillon. Paris, FRAC Ile-de-France. ◉ *E:* 1984 Nantes, Gal. Arlogos / Paris: 1991 Gal. Le Bail-Viaud; 1996 Gal. Philippe Rizzo; 2007, ʼ11 Gal. Bernard Jordan / 2004 Genua, Gall. Artra / 2005 Lille, Gal. Frontières / 2009 Limoges, FRAC Limousin / 2009, ʼ11 Genf, MAMC / 2010 Valence, Ec. régionale des BA; Ettlingen, Gal. Heinz-Martin Weigand. – *G:* Paris: 1999 Gal. L'Aquarium: Accrochage abstrait; 2000 Glasbox: Made on Mars; 2008 Salon du dessin contemporain / 2001 Sète, Mus. internat. des Arts Modestes: King Size / 2005, ʼ06 London: Portobello Film Festival / 2008 Salzburg, Hangar-7: Délicatesse des Couleurs (K) / 2010 Valenciennes, MBA: Tenir debout / 2011 Dole, MBA: Courbet contemp. / 2012 Limoges, FRAC Limousin: Narrative, critique, libre. ▭ *Delarge*, 2001. – *Online:* Website C.

F. Krohn

Childs, *David M.,* US-amer. Architekt, Stadtplaner, * 1941 Princeton/N. J., lebt in New York. Stud.: bis 1967 Yale School of Archit., New Haven/Conn. Danach wird er Entwurfs-Dir. in der Pennsylvania Avenue Comm. in Washington/D. C., die für die Neuordnung des bed. Boulevards zuständig ist; 1971–75 Mitarb. in der renommierten, weltweit agierenden Archit.-Fa. Skidmore, Owings & Merrill (SOM); 1975–81 Vors. der Nat. Capital Planning Comm. ebd. Seit 1984 ist C. leitender Mitarb. und Partner von SOM in New York, seit 2003 auch Vors. der U. S. Comm. of FA, Washington/D. C. Mitgl.: Amer. Inst. of Architects (AIA); Smithsonian Nat. Portrait Gall.; Nat. Building Mus.; Design Futures Council (seit 2010), alle Washington/D. C.; Amer. Acad. in Rome; Mpal Arts Soc. of New York; MMA, New York. Ausz.: zahlr. Archit.-Preise; 2006 Ehrendoktorwürde, New York Inst. of Technology. – In der Trad. von SOM vertritt C. eine funktionale Archit., deren Ästhetik eng mit den technologischen Errungenschaften der Ing.-Kunst verknüpft ist. Die Bauvorhaben, darunter zahlr. Wolkenkratzer, haben meist städtebauliche Ausmaße und zeitigen in der Verbindung von Funktionalität, Technik und Kontext komplexe pragmatische Lösungen, z.T. postmodern verkleidet (z.B. US-Botschaft in Ottawa, 1994–99). Zu C.s frühesten bed. Projekten zählt der Generalplan für die Nat. Mall und Con-

stitution Gardens in Washington/D. C. (Ausf. 1976). Gegenwärtig hat C. die Gesamt-Ltg für das Areal des 2001 zerst. Handelszentrums in New York (Masterplan: Daniel Libeskind). Seit 2006 errichtet er dort das obeliskenartige One World Trade Center (1 WTC; auch: Freedom Tower; Fertigstellung 2013). Der schlanke, in sich um 45 Grad gedrehte Glasturm wird nach extremen bautechnischen Sicherheitsaspekten ausgef. und mit 541 Metern das höchste Gebäude der USA sein. ⌂ CHANGI/Singapur, Internat. Airport: Bahnterminal, 2001; Terminal 3, 2007. CHANTILLY/Va., Dulles Internat. Airport: Erweiterung Hauptterminal, 1997. CHARLESTON/W. Va.: Gerichtsgebäude. DEERFIELD/Mass., Deerfield Acad.: Natatorium, 1991; Wiss.- und Technologie-Zentrum, 2007. LONDON, Westferry Circus 7: Bürohaus (im Rahmen des SOM Masterplans für Canary Wharf seit 1985). NEW YORK, MMA. – 8th Ave.: Hochhauskomplex Worldwide Plaza, 1986–89. – Broadway 1540: Bertelsmann-Hochhaus, 1989–90. – Madison Ave. 383: Wohn- und Geschäftsturm (ehem. Bear Stearns), 1999–2001. – Broad Str. 30: New York Stock Exchange (Interieur), 2000. – John F. Kennedy Internat. Airport: Ankunftshalle, 2001. – Park Ave.: Lever House (Fassadenerneuerung), 2001. – Times Square: Times Square Tower, 2002–04. – Columbus Circle: Time Warner Center, 2002–04. – Greenwich Str./Vesey Str.: 7 WTC, 2006. STAMFORD/Conn.: Gebäude der Swiss Bank. TORONTO, Pearson Internat. Airport: Terminal 1, 2014. WASHINGTON/D. C., 13th Street 607: Umsteigebahnhof Metro Center, 1976. – New York Ave. 1300: Hochhaus. – Hauptsitz Nat. Geographic Soc.; Hauptsitz U. S. News and World Report; Evening Star (Umbau, Erweiterung); *Hotels*: Four Seasons, Regent, Park Hyatt. TEL AVIV: Ben Gurion Internat. Airport, 2002. ✉ *C./T. Nakamura* (Ed.), D. M. C., SOM 1976–1993 (A+U Archit. and Urbanism, special issue 9), To. 1993. ⬜ *I. Gournay/J. C. Loeffler*, J. of the Soc. of Archit. Historians 61:2002 (4) 480–507; *J. Dupré*, Skyscrapers, N. Y. ²2008. – *Online:* Website Fa. Skidmore, Owings & Merrill LLP, 2011. A. Mesecke

Chillida Belzunce, *Eduardo,* span. Maler, Zeichner, Graphiker, Bildhauer, Keramiker, * 15. 3. 1964 San Sebastián/Guipuzcúa, lebt dort. Sohn von Eduardo C. Juantegui, Bruder der Malerin *María C. Belzunce* (* 1960). Stud.: 1980–82 Esc. de Artes, Deba/Guipúzkoa; 1984 Zeichnen am Círculo de BA bei Antonio López García; Esc. de Artes y Oficios, beide Madrid. 1985 nach schwerem Motorradunfall lange Zeit im Koma, anschl. Linkshänder. 1987–88 halbjähriger Aufenthalt in New York. – C.s gegenständliches bildnerisches Werk umfaßt versch. Medien. Am Beginn stehen neben Zchngn von Personen und Händen auch zahlr. teils vom Vater beeinflußte Plastiken, meist Terrakotta, mit Menschen-Darst. in einfach-archaischen, voluminösen Formen. Es handelt sich u.a. um Köpfe (*Aitá,* 1973; *Cabeza con mano,* 1976), eine Serie von offenen Händen mit klar artikulierten Fingern, Ganzfiguren (*Mujer sentada,* 1969; *Pensador,* 1984) oder Gruppen (*Cuatro amigos,* 1983) sowie Reliefs (*Aitá y yo,* 1982; *Mi hermano Luis,* 1983, beide Bronze). Char. für seine von kräftigen Konturen bestimmten, klar gebauten Öl-Gem. in

hellen Grautönen mit farbig schimmernden Oberflächen und heiter-melancholischer Atmosphäre ist das Verhältnis von Innen und Außen, von Archit. und Lsch., meist mit dem eig. großräumigen, vielfenstrigen Atelier als zentralem Schauplatz, das einen weiten Blick auf die Bucht von San Sebastián erlaubt. Oft handelt es sich um Bilder im Bild durch die gleichzeitige Präsenz von offenen Türen, Fenstern, Spiegeln und bemalten Lw. auf der Staffelei. In immer neuen Varianten geht der Blick aus dem Atelier in die Stadt-Lsch., oft in schmalen Querformaten (*La concha de mi estudio,* 1985; *Mi rincón,* 2005), manchmal auch aus erfundenen Blickwinkeln (*Estudio y terraza imaginaria,* 2008). Daneben Darst. von sich selbst und Fam.-Mitgl. (*Mujer en la ventana,* 1997; *Autorretrato con las dos manos,* 2005). Auch zahlr. Interieurs, die Räume oder Gänge an versch. Orten darstellen (Zabalaga, Menorca, Ainoa), meist in verwinkelten Perspektiven, panoramaartig, lichtdurchflutet, voller Mobiliar, aber menschenleer. Manchmal rücken dabei auch Stilleben in den Mittelpunkt der Komp. (*Las cosas del pintor,* 1992; *Dentro y fuera,* 2006). Ähnliche Themen auch in Rad., Lith. und Serigraphien (teils mit Öl übermalt). Seit E. der 1990er Jahre bemalt C. auch Keramikteller, Terrakotta- oder Sandsteinplatten, die fixiert und aufgesockelt werden. Außerdem (Keramik-)Wandbilder (u.a. Gres de Valls, 2000) sowie Gest. u.a. von Speisekarten, Fächern oder Textilien. ⌂ ADRA/Almería, Mus. BILBAO, Norbolsa. DONOSTIA-SAN SEBASTIAN, Plaza de Ignacio Zuloaga: Auf der and. Seite (Beste aldean), Wandbild, Terrakotta, 2004. – Kirche San Sebastián Mártir, Hauptaltar: Huldigung an den Herrn, Wandbild, 2006. HUESCA, Caja Rural. – Prov.-Verwaltung. MADRID, Außen-Minist. – Col. Unión Española de Explosivos. VITORIA, Artium. ⊚ *E:* Donostia-San Sebastián: 1988, '92, '99 (K) Gal. Dieciséis; 2005 Mus. de San Telmo (Retr.; K: N. Fernández/E. Kortadi); 2008 Arteko, Gal. de Arte(K: E. Iglesias) / 1989 Turku, Gal. Kaj Forsblom / 1989, '91, 2003 (K) Santander, Fernando Silió, Gal. de Arte / Madrid: seit 1992 mehrfach, '99 (K) Gal. Nieves Fernández; 2001 Torre Caja Madrid (mit E. C. Juantegui; K) / 1994 Zaragoza, Gal. Antonia Puyó (K) / 1995 (K), '98 (K), 2000 (K: J. L. Merino) Bilbao, Gal. Colón XVI / 2003 Adra, Mus. (K); Almería, Centro Cult. Caja Granada (Retr.; Wander-Ausst.; K: P. Belzunce de Chillida u.a.) / Barcelona: 2004, '07 Gal. Jordi Barnadas; 2007 Fund. „La Caixa"; Palma de Mallorca, Caixa Forum (K: C. Aurtenetxe) / 2009 Santa Cruz de Tenerife, Fund. Cristino de Vera (K: N. Sánchez Torres) / 2010 Mexiko-Stadt, Fund. Cult. Sebastián (K) / 2011 Damaskus, Inst. Cervantes (K: N. Fernández). – *G:* 1995, '97 Gijón: Trien. de Arte Gráfico. ⬜ DPEE IV, 1995. – *M. J. López Díaz,* El País (Ma.) v. 1. 5. 2003; *R. García,* ibid. v. 5. 6. 2010. – *Online:* Website C. M. Nungesser

Chimenti, *Pino,* ital. Maler, * 1952 Spezzano Albanese, lebt dort. Stud.: ABA Urbino bei Concetto Pozzati. Debütiert M. der 1970er Jahre. Nach kurzer Hinwendung zur Konzeptkunst gewinnt C. in der 2. H. der 1970er Jahre größere kompositorische Freiheit und visuelle Komplexität (Zyklus *Fabule mitopoetiche*). Er bleibt in kritischer

Distanz zu mod. Kunstströmungen, seine Arbeiten sind charakterisiert durch märchenhafte Atmosphäre und subtile Ironie. Inspirationsquelle sind ihm steinzeitliche Höhlenmalereien ebenso wie Pop-art. In die Darst. der phantastischen, bisweilen tierähnlichen Gestalten und piktogrammartigen Symbole werden in einer zweiten Schaffensphase zunehmend Träumen entlehnte, mythologische, techn. inspirierte, geometrische und humorvoll-spielerische Elemente integriert. A. der 1990er Jahre gesteigerte Phantastik sowie Einbeziehung persönlicher Utopien und ungewöhnlicher Geschichten (Zyklus *Entelechie immaginifiche*, 1991). Seltsame Kreaturen und Grotesken verweisen auf Verzerrungen in der Realität. In einer dritten Schaffensphase setzt sich C. vorrangig mit strenger Abstraktion und Bildschöpfung auseinander. Bes. überzeugend verbindet er Mythos, Realität und Geheimnisvolles in dem Zyklus *Cartigli ermetici* (2000). Gegenwärtig beschäftigt sich C. mit der Darst. symbiotischer Konfliktbeziehungen (Zyklus *Nuove Icone dell'invisibile*). – C. arbeitet mit unerwarteten Farbwechseln und Nuancierungen einer kräftigen und psychologisierenden Palette, die von kleinteiligem Liniengeflecht durchwoben ist, das einer Art „Farbmoiré" vergleichbar ist und eine phantastische Erzählatmosphäre vermittelt. Voller Skepsis gegenüber der zunehmenden Vereinnahmung des Menschen durch Kommunikation und Konsum lädt C. ein zu Selbsterkenntnis, zur Vermittlung von Außen- und Innenwelt, zur Aussöhnung zw. Wiss. und Kunst. Seine originelle und gleichzeitig komplexe Weltsicht ist schwer zu decodieren und zu interpretieren. ⌂ TURIN, Fond. Sandro Penna. ◉ *E:* 1990, 2005 Venedig, Gall. Bac Art Studio / 1996 Ascoli Piceno, Centro d'Arte l'Idioma / Mailand: 1997 Gall. Ammiraglio Acton; 2002 Studio D'Ars (K: T. Trini) / 1997 Montese, Forum Arrtis Mus. (K: G. Cortenova/Ascoli Piceno) / 2003 New York, Gall@49 / 2004 Genua, Studio B2; Bologna, Gall. l'Ariete / 2007 Taverna, MCiv. (K: A. D'Elia). – *G:* 1979 Mailand, Gall. S. Fedele: Quadro-giovani / 1982, '83, '84 Anacapri: Incontri internaz. d'arte contemp. / 1988 Neapel, ABA: Rass. d'arte contemp. all'ABA / 1989 Gallarate, Civ. GAM: Premio Naz. arti visive / 1993 Syrakus, Ex Chiesa dei Cavalieri di Malta: Bienn. Internaz. d'Arte sacra / 2005 Bologna, Gall. Milan AC: Doppio singolo / 2011 Venedig: Bienn. ⌷ *F. Gallo* (Ed.), C., Ascoli Piceno 1996; *F. Gualdoni*, C. Arcani fumetti, Mi. 1997; *E. Santese*, La panarie 35:2002 (135) 65–70; La Prov. Cosentina v. 14. 4. 2003; *L. Caccia*, Titolo 14:2003/04 (43) 42 s.; Terzoocchio 30:2004 (110) 33 s.; *P. De Marco*, Gazz. del Sud v. 29. 7. 2011. – *Online:* Website C. S.-W. Staps

Chimeri, *Paolo,* ital. Goldschmied, Stecher, Bildhauer, Maler, * 1. 9. 1933 Genua, lebt dort. Entstammt einer Bildhauer- und Stukkateurfamilie. Ausb. bei dem Goldschmied Baldo Barbarossa. Bald beherrscht C. auf hohem handwerklichem Niveau versch. künstlerische Techniken. Eig. Wkst. in Genua. Arbeitet in Gold, Silber, Bronze, Eisen und Draht; nach 1980 Verwendung von Schiefer. Widmet sich v.a. der Fertigung von Schmuck und liturgischem Gerät. 1980 Eröffnung eines zweiten Ateliers in Uscio, um sich dort v.a. großformatiger Plastik zuzuwenden. Bei dieser wechselt er häufig zw. konvexen und konkaven Flächen bzw. organisch inspirierten Formen (Blütenblätter, Insektenpanzer) mit Anlehnungen an den „stile auricolare" der Goldschmiedekunst des 17. Jahrhunderts. 1996 fertigt er eine Reihe kleiner Flachreliefs in Bronze, die als Druckplatten dienen (Genua, Gall. S. Bernardo). Auch Graphik. C.s Malereien sind oft der Taxonomie entlehnte, ironisch verfremdete Zeichenfolgen auf Vinavil-Malgründen. – Originelle, bevorzugt abstrakte Formen und geometrische Strukturen verschmelzen trotz teils expressiver, teils spielerischer Bewegtheit zu überzeugender formaler Einheit. Mittels Wachsausschmelzverfahren verleiht C. seinen Goldschmiedearbeiten ein breites Spektrum abstrakter Ausdrucksmöglichkeiten. C. bekleidet zahlr. Ämter in Handwerker- und Künstlerverbänden. ⌂ BROOKLYN/ N. Y., Brooklyn-Mus. of Art: Pettorale oro. GENUA-Voltri: Alga Marina, Bronze, 1987 (Gefallenen-Mon.). LA SPEZIA, Cassa di Risparmio: Skulpt., Bronze, 1988. PIEVE DI CENTO, Mus. delle generazioni ital. '900 G. Bargellini (MAGI '900). ◉ *E:* Genua: 1978, '81, '85 Gall. Il Punto / 1986 Lexington (Ky.), Headley-Whitney Mus. / 1996, '99 Albissola Marina, Circolo Cult. G. Bonelli / 2005 Vendone, Fond. Kriester / 2006 Uscio, Sala Polivalente Regina Margherita. –. *G:* Genua: 1970 Arte sacra Premio Montemoro; 1982 Gall. Il Punto: Primavera 82; '89 Expo Fontanabuona; '92 Studio Ghiglione: Transiti intersezioni; 2003 Cantro G. Buranello: Rass. d'arte contemp. N. Barabino; 2006 Pal. Ducale: Liguria spazio aperto; 2009 ebd.: Dumping art / 2001 Pistoia, Chiesa S. Leone: Mobile d'artista / 2005 Scopoli, MAC: Bienn. scult. in ferro / 2009, '10 Arenzano: FlorArte. ⌷ *F. Boggero/F. Simonetti* (Ed.), Arte trad. dei Fraveghi, Ge. 1983; *R. Laneve* (Ed.), C. Dal gioiello alla scult., Mi. 1985; *R. Grozio* (Ed.), La Casana. La scult. di C. a La Spezia, Ge. 1991; *C. Bonino* (Ed.), Quadri e scult., R. 1993; Artigianato fra arte e design. Chimeri e l'ardesia (K), Mi. 1996; *C. Caselgrandi/T. A. Conti*(Ed.), Il gruppo dell'Acquasola. Una stagione dell'arte genovese (1953–1972), Ge. 1996; *G. Di Genova*, Storia dell'arte ital. del '900. Generazione anni Trenta, Bo. 2000; C. Nella valle del tempo, Recco 2006. – *Online:* Website C. S.-W. Staps

Chimkevitch, *Sacha,* frz. Maler, Graphiker, Zeichner, * 17. 8. 1920 Paris, † April 2006, tätig in Paris und Merville-Franceville-Plage/Calvados. Sohn einer armenisch-persischen Mutter und eines poln. Architekten. Stud.: ab 1938 ENSBA, Paris (Archit.). 1937 entdeckt C. den Jazz (v.a. Bebop) für sich. Sein erster öff. Auftrag ist 1938 eine Plakat-Gest. für den Pariser Swing Club. 1940–45 Kriegsgefangener in Kassel, anschl. in Paris Wiederaufnahme des Stud.: besucht 1946–47 Aktzeichenkurse an der Acad. de la Grande Chaumière und studiert Graphik bei Paul Pierre Lemagny und 1948–51 bei Edouard Goerg an der ENSBA. Ab 1951 finden regelmäßig Ausst. seiner Werke statt, u.a. beim 1. Salon du Jazz in Paris (Maison de la Chimie). – In überwiegend figurativen Gem., Zchngn und Druckgraphiken (Gem. in Gouache und Öl, weiterhin Aqu., häufig in Kombination mit Tusch-Zchngn sowie Rad., Lith. und Monotypien) widmet sich C. bevor-

zugt dem Thema Jazz. In Bildaufbau, Farbwahl und einer geometrisch-abstrahierten Formsprache spiegeln sich Prinzipien der Jazzmusik und deren Stimmung wider. Zudem gestaltet er zahlr. Plakate und CD-Booklets und fertigt vereinzelt Portr. von Jazzmusikern (z.B. von Charlie Parker, Duke Ellington und Erroll Garner), die C. wiederum bisweilen ihre Werke widmen (z.B. „Chez Sacha" von Claude Tissendier und „Sacha blues" von Pierre-Yves Sorin). Weitere Motive sind Lsch., Marinen und Frauen (häufig erotische Akt-Darst.); auch Ill. (z.B. zu: G. Apollinaire, *Œuvres poétiques*, P. 1978). In den 1960er Jahren entstehen auch abstrakte Komp. ❍ NOGENT-SUR-SEINE, Mus. P. Dubois-A. Boucher. PARIS, BN. ◉ *E:* 1957–61 jährlich Caen, Gal. Cadomus / 2001 Nogent-sur-Seine, Mus. P. Dubois-A. Boucher (Retr.; K) / 2007 Saint-Aignan, Gal. La Prévôté. – *G:* 1958 Caen, Gal. Cadomus: Gravures. ▭ *Bénézit* III, 1999. – *F. Hofstein*, S. C., P. 1995; *G. Arnaud*, Elles & jazz. S. C., P. 2005; *L. Le Roc'h Morgère* (Ed.), Artistes contemp. en Basse-Normandie, 1945–2005, [Caen] 2005. F. Krohn

Chin *Jun-tso* (Jin Runzuo), taiwanesischer Maler, * 15. 1. 1921 Tainan, † 16. 1. 1983 Taipei. 1935 Übersiedlung nach Osaka. Stud.: ab 1939 Osaka College of Art bei Koiso Ryohei (Graphik). 1944 Rückkehr nach Taiwan, dort als Werbedesigner tätig. Ab 1946 mehrere Preise auf der Prov. FA Exhib. (shengzhan). Mitgl.: 1948 Mitbegr. der Blue Sky Paint. Assoc. (Qingyun huahui); 1949–56 Taiyang Art Soc.; 1954 zus. mit Hung Rui-ling, Chen Te-wang, Liao Te Cheng Mitbegr. der Era Art Assoc. (Jiyuan meishu hui), an deren Ausst. er ab 1955 regelmäßig teilnahm; 1953–62 Art Assoc., Southern Taiwan (Taiwan nanbu meishu xiehui). 1956–63 Juror für westliche Malerei (Prov. FA Exhib.). Auch im Bereich Kunsthandwerk tätig, u.a. im Taiwan Handicraft Promotion Center (1958–66 im MuZha Experimental Workshop); ab 1958 im Rahmen der von ihm mitgegründeten Handicraft Society. – Bek. Vertreter und Förderer der westlichen Ölmalerei in Taiwan. Malte anfängl. Gem. (Lsch., Stilleben, Blumen) im realistischen Stil; später unter Einfluß des Kubismus (u.a. Georges Braque), von Henri Matisse sowie seines Verwandten Yan Shui-lung. ❍ KAOHSIUNG, MFA. TAIPEI, FA Mus. ◉ *E:* Taipei: 1987 Nat. HM; 1994 FA Mus. (Retr.; K). – *G:* Taipei: 1955 Zhongshan Memorial Hall: Era Art Assoc. / 2008–09 Taichung, Nat. Taiwan MFA: Recurrence of the Aura. A Retr. on the 80 years Taiwan arts exhib. (K). ▭ C. hui gu zhan (The retr. exhib. of C.), Taipei 1994; From the ground up. Artist assoc. in 1950s Taiwan (K), Taipei 2002; *Xiao Qiongrui* (Ed.), Taiwan meishu quanji 26. C., Taipei 2007. K. Karlsson

Chin *Sung* (Qin Song), chin. Graphiker, Maler, Dichter, Schriftsteller, Kunsterzieher, * 1932 Xuyi/Prov. Anhui, † April 2007 US-Bundesstaat New Jersey. 1947–49 Malerei-Stud. in Nanjing. 1949 Übersiedlung nach Taiwan. Stud.: 1949–51 Nat. Taipei Teachers College, FA Dep. (Hschn., Rad.). Ab 1953 Unterricht bei Li Chung sheng, einem bed. Vertreter der Avantgarde in Taiwan. 1957 Mitbegr. der Mod. Print Assoc. (Xiandai banhua hui) zus. mit Chuang Han-tung und Yang Ying-feng (dort bis

1969 im Vorstand). Ab 1959 Mitgl. der internat. agierenden Ton Fan Art Assoc. (Dongfang huahui). 1966 Gründung der Zs. Avant-Garde Monthly (Xiandai yishu ji). 1969 Übersiedlung nach New York, u.a. aufgrund von politischen Repressalien, denen er in Taiwan ausgesetzt ist, nachdem ihm Widerstand gegen das Regime vorgeworfen und einige Arbeiten (*Yuanhang*; *Chun deng*, 1960) konfisziert werden. 1977 Fortbildung an der Iowa Univ., Iowa City. 1980–82 Vors. der Assoc. of Artists of Chin. Origin in New York. 1982 und 2006 (Vorlesungs-)Reisen nach China; ab 1989 häufige Reisen nach Taiwan. Ausz.: 1993 Nat. Award, Nat. HM, Taipei. Veröff. mehrere lit. Anthologien und Zs.-Aufsätze. – Zunächst romantisch-realistische Lsch. im Medium der trad. chin. Tuschemalerei (guohua). Unter dem Einfluß westlicher Kunst sowie von Li Chunshan entwickelt er in den späten 1950er Jahren einen char. ausdrucksvollen (semi-)abstrakten Stil (Malerei, Hschn.); z.B. verwendet er abstrahierte archaische Piktogramme der chin. Schrift in kraft- und emotionsgeladenen symbolträchtigen Komp. (*Yue zhi hua*/Die Pracht des Mondes, Öl/Lw., 1965; Kaohsiung, MFA). Nach einer kurzen Experimentierphase in den USA (auch Mode und Fotogr.) kehrt C. in den 1980er Jahren zu seinen abstrakten Ursprüngen zurück und schafft fortan v.a. geometrisch strukturierte Arbeiten in lebhaft-kontrastreichem Kolorit (Aqu.; Mixed media; Tusche und Farbe/Papier; Öl/Lw.). C. gilt als Pionier und aktiver Befürworter der frühen mod. Kunst Taiwans. ❍ CAMBRIDGE/Mass., Harvard Univ. NEW HAVEN/Conn., Yale Univ. Libr. KAOHSIUNG, MFA. TAIPEI, Nat. HM. – FA Mus. – Min. of Justice. - ◉ *E:* Taipei: 1993 Nat. HM; 2003 Art Treasure Gall. of the Ka Fam. / 2005 Taoyuan, Chan Liu AM (K). –. *G:* 1959 São Paulo: Bien. (Ausz.). ▭ *M. Sullivan*, Mod. Chin. artists, Berkeley u.a. 2006 (s.v. Qin Song). – *J. C. H. Chung* (Ed.), The contemp. Chin. artist C. Paint. and poems primitive black, Taipei 1967; *M. Sullivan*, Art and artists of twentieth c. China, Berkeley u.a. 1996; From the ground up. Artist assoc. in 1950s Taiwan (K), Taipei 2002; *Lai Yingying*, Taiwan qianwei liuling niandai fuhe yishu/Taiwanese avant-garde complex art in the 1960s, Taipei 2003; World of C. (K), Taoyuan 2005. K. Karlsson

Chinchalkar, *Vishnu Dinkar,* indischer Maler, Zeichner, Graphiker, Bühnenbildner, Publizist * 5. 9. 1917 Aalot/Madhya Pradesh, † 30. 7. 2000 Indore/Madhya Pradesh, lebte dort. Stud.: Sir Jamsethji Jijibhai SchA, Bombay (Schüler von D. D. Deolalikar). 1955–66 Doz. an der Indore SchA. Danach freischaffend tätig. Ausz.: 1973 Madhya Pradesh State Silver Jubilee Felicitation, Bhopal; 1985 All-India FA and Crafts Soc., New Delhi (Lebenswerk). Schon als Student gewinnt C. nat. Mal-Wettb. und erhält ein Stip. der Calcutta FA Society. – C. debütiert mit ausdrucksstarken Portr. und Lsch.-Gemälden. Vor 1947 engagiert er sich im Unabhängigkeitskampf und arbeitet für versch. Ztgn, Gewerkschaften und politische Organisationen. Geprägt von den Erfahrungen elterlicher Sparsamkeit in der Kindheit und von den Überzeugungen Mahatma Gandhis wendet sich C. nach 1950 der Motivsuche in der Natur zu und experimentiert u.a. mit den Formen

von Zweigen, Treibholz, Wurzeln, aber auch von Müll. Daneben kalligraphische Experimente (Devanagari-Schrift in Natur-Mat.) sowie Aqu. und Öl-Gem. (Kashmir-Lsch. und städtische Alltagsszenen). Als Auftragsarbeiten gestaltet C. u.a. 1969 zehn Gem. zu Frauenrechten sowie Portr. von Politikern und Militärs. In den 1980er Jahren gibt C. die Malerei auf. Auch als Bühnenbildner, Buchillustrator, Autor und Kunstkolumnist tätig, u.a. für die Zs. Naiduniya. Neben der künstlerischen Arbeit engagiert sich C. in sozialen Projekten. ▯ BHOPAL/Madhya Pradesh, Bharat Bhavan, Roopankar MFA. ◉ E: 1959 Indore, Chinkalkar Atelier / 1971 New Delhi, All-Indian FA and Crafts Soc. / 1977 Bombay, Jehangir AG. G: 1945–55 New Delhi: Nat. Exhib. ▭ P. Sheth, Dict. of Indian art and artists, Ahmedabad 2006. – J. Appasamy, An introd. to mod. Indian sculpt., New Delhi 1970. – Online: Website C.

M. Frenger

Chinese, *Luciano,* ital. Maler, Galerist, * 2. 9. 1942 Mariano del Friuli/Gorizia, lebt dort und in Venedig. Stud.: Ist. d'Arte, Venedig; ABA ebd. (Malerei), Schüler von Bruno Saetti; Archit. an der Univ. ebd.; besucht u.a. den Kurs von Carlo Scarpa. Teiln. an der Sommer-Akad. Salzburg bei Emilio Vedova. 1967 erste Einzel-Ausst. in dem Bergdorf Folgaria b. Trient; gründet dort die Gall. Nuovo Spazio und fördert zus. mit dem Dichter Alfonso Gatto den nat. Wettb. Premio Folgaria. Setzt sich intensiv mit Neokonstruktivismus, Spazialismus und dem von Lucio Fontana entwickelten Raumgedanken auseinander. 1971 gründet er die Gall. Nuovo Spazio in Venedig (später in Mestre), stellt dort Maler der ital. klassischen Moderne, aber auch junge Künstler aus; die Gal. entwickelt sich zu einem bed. kult. Zentrum. Nach dem Erdbeben von 1976 organisiert er in Mariano del Friuli eine Ausst. mit Werken bek. ital. Künstler zu Gunsten der Erdbebenopfer. 2000 Gal.-Eröffnung in Udine. C. ist befreundet u.a. mit Giuseppe Zigaina und dem Fotografen Italo Zannier. – In seinen frühen Arbeiten versucht C., Gegenständliches in geometrische Formen umzusetzen. Nach einer Phase abstrakt-poetischer Malerei folgt er in den 1980er Jahren der Strömung des sog. Iperspazialismo. Die farbintensiven Arbeiten sind oft durch klare, geometrische Strukturen geprägt, die gekurvten Linien dabei teilendes oder verbindendes Gest.-Mittel (*Elementi di poesia nello spazio,* Öl/Lw., 2007; Aukt. Finarte, Ve. 20. 1. 2008). Den Bruch der Harmonie zw. Mensch und Natur soll der Gem.-Zyklus zum Motiv der „anthropomorphen Bäume" (1994/95) verdeutlichen. Die Gest. des bewegten Raumes bleibt jedoch Hauptthema seiner Malerei, die neben geometrischen auch aufgebrochene Strukturen zeigt und darin mitunter an futuristische Vorbilder erinnert (*Ontologia dello spazio,* Öl, Acryl/Lw., 2006; Aukt. Finarte, Ve. 19. 10. 2008). Die Beziehung und Spannung zw. Objekt und Raum realisert C. auch in Objekten aus versch. Mat. (z.B. Murano-Glas, Kunstglas). Ausz.: 2008 1. Preis Internat. Festival Charkiv. ▯ CASTELLANZA, MAM Pagani. CHARKIV, Charkovskij Chudožestvennyj Muz. DETROIT/Mich., Inst. of Arts. GORIZIA, Bibl. Statale Isontina. LUCCA, Fond. Ragghianti. VENEDIG, GAM Ca' Pesaro. ◉ E: 1994 S. Giovanni al Natisone, Villa De Bran-

dis / Mestre: 1995 Gall. Nuovo Spazio (K); 2008 Villa Settembrini / 1995 Gmünd, Gal. in der Alten Burg / Venedig: 1995 Pal. delle prigioni vecchie (K); 2004 Mus. Candiani; 2007 GAM Ca' Pesaro (Installation) / 1996 Stra, Villa naz. Pisani (K) / 1997 Pordenone, Villa Galvani; Dossobuono, Gall. Artisti oggi; Abano Terme, Kursaal / 1998 Udine, Centro Friulano Arti Plastiche / 1999 Gorizia, BN Isontina; Treviso, Villa Ca' Zenobio / 2003 Mariano del Friuli, Comune / Paris: 2003 Gal. Artis; Gal. Sauveur Bismuth; 2009 Univ. Denis Diderot / 2004 Castellanza, MAM Pagani (K); Moraro, Comune; Barcelona, Dates Automóvil España / 2006 Madrid, Mus. Thyssen-Bornemisza / 2007 Forchheim, Gal. Artodrome; Mannheim, Gal. Boenher / 2008 Triest, Antico Caffè San Marco / 2009 Udine, Gall. Laboratorio 2 / 2010 Charkiv, Charkovskij Chudožestvennyj Muz. (K: T. Toniato); Ascoli Piceno, Pal. dei Capitani / 2011 Kiev, Nat. KM; Treviso, Casa dei Carraresi (K). ▭ DizESA I, 1968. – T. Toniato, L. C., Ve. 2007. – Venedig, Arch. Stor. della Bienn. – Online: Website C.

E. Kasten

Chính, *Nguyễn Đức (Đức; Nguyễn Đức C.;* Pseud.: *Anh, Nguyễn Chí; Vân, Bằng; Vân, Chính),* vietnamesischer Fotograf, Journalist, * 2. 5. 1931 Phúc Yên/Vĩnh Phúc, lebt in Ho-Chi-Minh-Stadt. Bereits 1947 arbeitet C. für die Ztg Tin Phúc Yên, später für die Foto-Red. der nordvietnamesischen Nachrichtenagentur. Ab 1964 Lehrtätigkeit als Leiter einer Journalistenschule in Südvietnam. Hier hält C. 1968 als Fotoreporter die Straßenkämpfe in Saigon fest. Seit 1982 stellv. Chef-Red. der Zs. Tạp chí Nhiếp ảnh. Ausz.: 1968 1. Preis, '70 Sonderpreis, '76 2. Preis für Fotogr. der Internat. Journalistenföderation; 1975 1. Preis des Vietnamesischen Journalisten-Verbandes. – C. wird v.a. durch seine Aufnahmen vom täglichen Leben der Frontkämpfer und von deren Unterstützung durch die Landbevölkerung bekannt. Später entstehen zahlr. stimmungsvolle Lsch.-Aufnahmen, bes. von Gebirgen. ✉ C./V. Khiêm, Bước Đầu chụp ảnh (Erste Schritte des Fotografierens), Hanoi 1963; Tổng quan Nhiếp ảnh (Überblick über die Fotogr.), Ho-Chi-Minh-Stadt 2001; Nhiếp ảnh sáng tạo (Schöpferische Fotogr.), Ho-Chi-Minh-Stadt 2002; Ảnh báo chí (Presse-Fotogr.), Ho-Chi-Minh-Stadt 2003; Văn hóa Nhiếp ảnh (Kultur des Fotografierens), Hanoi 2008. ◉ E: Hanoi: 1980 Nachrichtenagentur Vietnam; 1983 Fotografen-Verb. / Ho-Chi-Minh-Stadt: 1984 Journalistenklub; 2005 Städt. Ausst.-Halle. – G: 1962, '64 Hanoi: Nat. Foto-Ausst. (2 Bronze-Med.). ▭ Vietnam art photogr., Hanoi 1988; Lịch sử Nhiếp ảnh Việt Nam (Gesch. der vietnamesischen Fotogr.), Hanoi 1993; Lao động v. 3. 5. 2005; Vietnamese photogr. in the 20th c., Hanoi 2006. – Online: Que huong ngay nay.

A. Friedel-Nguyen

Chinn, *Benjamen,* US-amer. Fotograf chin. Abstammung, * 30. 4. 1921 San Francisco/Calif., † 25. 4. 2009 ebd. Aufgewachsen ebd. 1942–46 Militärdienst als Fotograf des U. S. Army Air Corps auf dem Luftwaffenstützpunkt Hickam Field (später Hickam Air Force Base) b. Honolulu/Hawai. Stud.: 1946–49 California School of FA, San Francisco, im ersten Jg der von Ansel Adams neu gegr.

Foto-Kl. (zu den Lehrern zählten A. Adams, Minor Whi-
te, Edward Weston, Dorothea Lange, Ruth Bernhard und
Imogen Cunningham); 1949–50 Acad. Julian, Paris, bei
Alberto Giacometti (parallel hört C. auch Vorlesungen in
Geographie und Phil. an der Sorbonne). 1950 Rückkehr
nach San Francisco, wo C. zunächst für die U. S. Pipe and
Steel Company und 1953–84 in wechselnden Funktionen
für ein Fotolabor der Armee tätig ist. Dort lernt er Paul
Caponigro kennen, den er in Fototechnik und Laborar-
beit unterweist und mit seinen ehem. Lehrern bek. macht.
– C. ist in erster Linie für Fotogr. bek., die er während
seiner Studienzeit in San Francisco (bes. Chinatown) und
Paris aufgenommen hat. Darunter befinden sich im Hin-
blick auf Lichteinfall und Bildausschnitt sorgfältig kompo-
nierte Stadtansichten und Portr. sowie schnappschußartige
Straßenszenen. Eines der Parisbilder verwendet M. White
1952 als Titelbild der zweiten Nr der Zs. Aperture. Wei-
tere Aufnahmen entstehen auf Reisen durch China, Israel
und Mexiko. E. der 1950er Jahre gibt C. die freie künstle-
rische Arbeit auf. ⌂ KANSAS CITY/Mo., Nelson-Atkins
Mus. of Art. SAN FRANCISCO, Chin. Hist. Soc. of Ameri-
ca. TUCSCON, Univ. of Arizona, Center for Creative Pho-
togr. ◉ E: 1965 Cupertino (Calif.), De Anza College
Gall. / San Francisco: 2003 Chin. Hist. Soc. of Ameri-
ca (K); 2005–06 Scott Nichols Gall. –. G: San Francisco:
1948 (Mendocino), '54 (Perceptions) MMA; 1981 Focus
Gall.: Alumni Exhib., San Francisco Art Inst., Anniversa-
ry Exhib.; 1998 Transamerica Pyramid Gall.: San Francis-
co Art Institute. Fifty Years of Photogr. ⌺ K. F. Davis,
An Amer. c. of photography. From dry-plate to digital, 2.
überarb. und erweiterte Aufl., N. Y. 1999; J. Thurber, Los
Angeles Times v. 25. 5. 2009 (Nachruf); G. H. Chang u.a.
(Ed.), Asian Amer. art. A hist., 1850–1970, Stanford, Ca-
lif. 2008 (Lit.). P. Freytag

Chinyo *Netikorn* (Netikorn C.), thailändischer Maler,
* 8. 12. 1966 Kalasin, lebt in Nonthaburi. Ausb./Stud.:
1983–86 College of FA, Bangkok; 1986–96 Fac. of Paint.,
Sculpt. and Graphic Arts, Silpakorn Univ., Bangkok, Ma-
lerei bei Ithipol Thangchalok, Preecha Thaothong, Cha-
lood Nimsamer. Seit 1996 freischaffend. Lehrtätigkeit:
1996–98 Thai-Kunst am King Mongkut's Inst. of Tech-
nology, Bangkok-Ladkrabang; 2002–04 Fac. of FA der
Chiang Mai Univ.; seit 2005 Doz. (Grundlagen) an der Du-
rakij Pundit Univ., Bangkok-Lak Si. Reisen: 1996 Nieder-
lande, Frankreich, Italien; 1997 Perth/Australien (Sprach-
reise); 2005 Indien. Ausz.: 1991 Silber-Med., Silpa Bhiras-
ri exhib. of contemp. art by young artists, Bangkok; 1991,
'94 3. Preise, Bua Luang exhib. ebd.; 1991, '94 Bronze-
Med. (Malerei), Nat. Art Exhib. ebd.; 1994 Preis für realis-
tische Malerei, Thai Farmers Bank ebd.; Certificate prize,
Art competition of Thailand, Phillip Morris Co. Ltd. ebd. –
In seiner ersten, 1996 begonnenen und rund 100 Gem. um-
fassenden Werkgruppe schildert C. hist. Szenen aus dem
thailändischen Alltagsleben in einem naiven, an die al-
te Tempelmalerei angelehnten Stil; die Bilder wirken, als
seien sie auf Türen, Fensterflügel und Wandpaneele alter
Thai-Häuser gemalt (*She's crying*, Acryl/Lw., 1991; Silpa-
korn Univ. Coll.). In den in großen und mittleren Formaten

ausgef. Arbeiten (Öl oder Acryl/Lw.) sind die Gebäude-
ausschnitte und geschnitzten Archit.-Elemente sowie der
Alterungsprozeß der wiedergegebenen Holzmalereien in
Trompe-l'œil-Technik nachempfunden (*Lana Period Hou-
se*, Öl/Lw., 1991; 2011 im Kunsthandel). Viele dieser Wer-
ke befinden sich heute in Privatbesitz. 1995 wird C. von
König Bhumibol Adulyadej Rama IX. ausgewählt, an des-
sen Buch *Mahajanaka* mitzuwirken; die ab 1996 entste-
henden Ill. zu dieser Übertragung des buddh. Mahajanaka-
Textes sind in einem nach westlichem Empfinden mär-
chenartigen, von ornamentalen Blumen und Tieren durch-
setzten idealisierten Figurenstil gehalten. 1996–99 ent-
steht eine Serie mittelformatiger Gem. mit zweidimensio-
nal aufgefaßten arabisch und indisch anmutenden Bild-
nisfiguren, deren Gewänder zu Flächenmustern abstrahiert
sind, womit C. die Einwanderung fremder Völker nach
Thailand thematisiert. Inspiriert von buddh. Schriften und
indischen Buddha-Figuren verändert er seit 2005 seinen
Stil hin zu einer glatten, idealisierenden, buntfarbigen Öl-
malerei mit tiefen Lsch.-Räumen und starken Lichtwirkun-
gen. Er schildert Szenen aus dem Leben Buddhas, in denen
dieser statuenhaft entrückt auftritt. Die seit 2008 entste-
henden Bildnisse des thailändischen Königs sind fotorea-
listisch gemalt. Auch Buch-Ill., u.a. zu *Monkeys, garden
keeper* (Bangkok 2008). ⌂ BANGKOK, Kasikorn Bank:
River, Acryl, 1993. – Silpakorn Univ.: Neranchara, Acryl,
1994; zwei Portr. von König Bhumibol Adulyadej Ra-
ma IX. als Mönch, Öl/Lw., 2008. ◉ E: Bangkok: 1999
Amari Atrium Hotel; 2001 Thavibu Gall.; 2007 Jamjuree
AG, Chulalongkorn Univ. / 1999 Phuket, Boathouse AG /
2000 Hua Hin, Prachuab Khiri Khan, Chiva-som Internat.
Health Resorts. – G: Bangkok: 1991, '94 AC, Silpakorn
Univ.: Nat. Art Exhib.; Musical AC: 1991 (K), '94 Bua
Luang art exhib.; 1994 NG: Contemp. art expo (K); Thai
Farmers Bank: Realistic paint.; Queen Sirikit Nat. Con-
vention Center: 1995 Thai art exhib.; 1997 50 years of
Thai art (K); City Gall., Siam City Hotel: 1997 Soul of
the Siamese; 2001 East ...? Thai painters art exhib.; 2005
Goethe-Inst.: Wheel Group art exhib. (Wander-Ausst.; K);
Fortune Hotel: Dream of the rain (K) / 1996 Khon Kaen,
Mus.: Thai-Esarn Group (Wander-Ausst.). ⌺ Hi-class
(Bangkok) 11:1994 (123/Juli) 104–112; 25:2007 (263/
Dez.) 4, 85; V. Mukdamanee/S. Kunavichayanont, Ratta-
nakosin art. The reign of King Rama IX, Bangkok ²1997,
255; Phrabāt Somdet Phračhaoyūhūa kap ngān sinlapa
læ kān'ǫkbæp, Bangkok 2007, 30 s. (Publ. der Silpakorn
Univ.); Priew Mag. 2009 (657/Nov.) 18 s., 153; Lips Mag.
(Bangkok) 11:2010 (Juli) 470 s. A. Feuß

Chiomenti, *Antonio* cf. **Chiomenti,** *Vicenzo*
Chiomenti, *Vicenzo (Enzo)*, ital. Comizeichner, * 24. 5.
1930. Stud.: Accad. di Brera, Mailand. Erster Comic 1948
mit *Pantera Bionda* für Edizioni Arc, dort auch einige
Gesch. von *Tom Bill*. Veröff. auch in Il Vittorioso und Il In-
trepido. 1951–57 mit seinem Bruder *Antonio C.* (* 1925)
für die Verlage Tomasina und Edizioni Alpe tätig. Es ent-
stehen Serien wie *Raca l'eroe del 2000* (dt. Raka) oder *Je-
zab il Fenicio* (dt. Jezab), die in Deutschland im Piccolo-
format veröff. werden. Zudem arbeitet C. an *Fulgor* mit.

Für den frz. Markt entstehen kleinformatige Serien, etwa *Capitan Miki* oder *Marco Polo* für Éditions Aventures et Voyages. V.a. arbeitet C. für Lug und zeichnet die Serien *Johnny Bourask, Jean Brume, Ivan Karine, Bob Stanley* oder *Mac*. – Die Arbeiten von C. sind in zahlr. europ. Ländern erschienen, in Deutschland v.a. in Piccoloserien. Stilistisch ist C. ein solider Handwerker, der es versteht, schnell und dynamisch Abenteuercomics aller Genres umzusetzen. ⌨ *H. Filippini*, Dict. de la bande dessinée, P. 2005. – *Online:* Lambiek Comiclopedia.

K. Schikowski

Chiorino, *G. (Giuseppe) Eugenio* (Pseud. Gech), ital. Maler, Illustrator, Karikaturist, Autor, * 12. 6. 1871 Biella, † 1941 Rivalta di Torino. Sprach- und Musikstudien in Turin, 1894 Rückkehr zum Fam.-Sitz in Rivalta di Torino, dort Natur-Stud. und zeichnerische Weiterbildung. 1897–1901 erscheinen C.s ebenso elegante wie dekorative, von Art nouveau geprägte Ill. in der Madrider Zs. Blanco y negro, ab 1898 auch humorvolle Zchngn in den ital. Zss. L'Ill. ital. und Scena illustrata. Arbeitet für zahlr. (meist für Kinder bestimmte) Zss., z.B. Il Giovedì, La Lettura, Il sec. XX, Numero, Il Giornalino, Domenica und Corriere dei piccoli, aber v.a. für die Turiner Wochenschrift La Domenica dei Fanciulli, für die er 1900–20 auch geistreichwitzige Kolumnen schreibt (Quel che bolle in Pentola oder I cent'occhi di Argo). Ill. etwa 20 Bücher, u.a. *Flick, o tre mesi in un circo e Barbarus*; *I regali della fata Celestina*, 1902 (von E. Perodi); *Fili d'erba*, 1908 (von L. Sclaverano); *Il libro del perché*, 1930 (von G. Fanciulli). Autor zahlr. Bücher mit Spielen und Erzählungen für Kinder. Seine 1920 unter dem Titel *L'Italia ignorata. Percorsa da un ignorante* in der Zs. La Domenica dei Fanciulli erschienenen Artikel wurden 1991 in Turin erneut veröffentlicht. Ab 1929 für die ital. Radio-Ges. EIAR tätig; auch Drehbuchautor für die Casa cinematografica Ambrosio. ☐ BAROLO, Fond. Tancredi: Sorrisi di primavera, 1911 (ab 1909 als Folge in La Domenica dei Fanciulli erschienen). RIVALTA DI TORINO, Casa Chiorino. ✉ Manuale del mod. falconiere, Mi. 1906; Sorrisi di primavera, T. 1911 (Auto-Biogr.); Anch'io ho un giardino, T. 1924; Comero e Cetriola, T. 1924 (Text und Puppenentwürfe); In 4 e 4, otto, T. 1928 (Ill. von C.); Scarabocchio e Scarabocchia, R. 1938 (Ill. von A. Galli). ◉ *E:* 2002 Rivalta di Torino, Casa Chiorino. – *G:* 1911 Rivoli, Frigidarium: Umorismo e umoristi. ⌨ *J. Carrete Parrondo u.a.*, El grabado en España (ss. XIX y XX), Ma. 1988 (Summa artis, 32); DPEE IV, 1995. – *G. Cottini*, Ars et labor 8:1911, 586; *G. I. Arneudo*, Il Risorgimento graf. 12:1921, 563; *L. A. Rati*, Vita d'arte (71/72), 1913, 6; *Gec (Enrico Gianeri)*, La vita è dura ma e comica, Mi. 1940, 147; *P. Pallottino*, Storia dell'ill. ital., Bo. 1988; *F. Arrasich*, Cat. degli illustratori di cartoline ital., R. 1991, 115; *P. Vagliani*, C., in: Almanacco piemontese, T. 1991, 27–37; *S. Lama*, I per. per l'infanzia (1812–1932), Fi. s.a. [2000], 22, 28.

P. Pallottino

Chipman, *Jack*, US-amer. Maler, Bildhauer, Collage-, Assemblagekünstler, Kunstkritiker, Sachbuchautor, * 1943 Los Angeles/Calif., lebt in Venice/Calif. Stud.: bis 1966 Chouinard Art Inst., Los Angeles/Calif., bei Harold Kramer und Emerson S. Woelffer; bis 1968 San Francisco Art Inst., San Francisco/Calif. In den 1970er Jahren schreibt C. kunstkritische Texte für die Zs. Artweek, ab den 1980er Jahren widmet er sich verstärkt der Erforschung der Gesch. der Keramik in Kalifornien und veröffentlicht mehrere Standardwerke zu diesem Thema. Bezieht E. der 1980er Jahre ein Atelier im Angels Gate Cult. Center, San Pedro/Calif. 1990–93 in Long Beach/Calif. ansässig. – In den frühen 1970er Jahren entstehen sog. *Rippings*, Arrangements aus in Streifen gerissenen und dann bemalten Lw.-Bahnen, die nebeneinander auf einer Holzlatte oder einem Bambusstab befestigt werden und auf diese Weise frei von der Wand hängen (z.B. *Adharma 14*, 1971). Gleichzeitig gestaltet C. sog. *Soul Totems*, an die Wand gelehnte fetischartige Bambusstäbe, die in unregelmäßigen Abständen mit bemalten Lw.-Streifen umwickelt sind (z.B. *Superstition Poles*, 1976). In den 1980er Jahren gestaltet er u.a. Collagen und Assemblagen aus Kartonagen und and. z.T. auf Flohmärkten gesammelten Mat. (u.a. Werkgruppe *Loss Angeles*, eine Serie von Gem. mit applizierten keramischen Objekten). In jüngerer Zeit entstehen v.a. farbintensive geometrisch-abstrakte Streifen-Komp. auf Lw. und Papier (u.a. *Utropia Series*; *Root Series*). ☐ LONG BEACH/Calif., Mus. of Art. OAKLAND, Oakland Mus. of California. SANTA CLARA/Calif., De Saisset Mus. ✉ *C./ J. Strangler*, The complete collectors guide to Bauer pottery, Stamford, Conn. 1982; Collector's enc. of California pottery, Paducah, Ky. 1992; Collectors enc. of Bauer pottery. Identification & values, Paducah, Ky. 1998. ◉ *E:* 1971 Long Beach (Calif.), Mus. of Art / 1972 Santa Clara (Calif.), De Saisset Mus. / 1973 Glendale (Calif.), Brand Libr. AG (mit David Mackenzie) / Los Angeles (Calif.): 1973 Jodi Scully Gall. (mit Lynn Hershman); 1998, 2006 Orlando Gall.; 2009 MorYork Gall. / San Francisco (Calif.): 1973 William Sawyer Gall.; 1975 Grapestake Gall. (mit William Wareham) / 1991 San Pedro (Calif.), Angels Gate Cult. Center, Gate Gall. – *G:* 2001 Oceanside (Calif.), Mus. of Art: Chouinard. A Living Legacy / 2009 Glendale (Calif.), Brand Libr. AG: The Materiality of Color. ⌨ *K. Stiles*, AiA 63:1975 (5) 197 s.; *T. Albright*, Art in the San Francisco Bay area. 1945–1980, Berkeley, Calif. u.a. 1985. – *Online:* Website C. H. Kronthaler

Chirea (Chirea-Hermeneanu), *Viorel*, rumänisch-dt. Maler, * 5. 5. 1960 Cuza Vodă/Călăras, lebt in Aachen. Stud.: 1981–85 (Dipl.) HBK N. Grigorescu, Bukarest (Malerei, Textilkunst, Design). 1985–90 als Designer und Entwurfskünstler in Rumänien tätig. 1990 Übersiedlung nach Deutschland und hier vorerst als Gebrauchsgraphiker beschäftigt. Seit 1998 freiberuflich. Gibt Malkurse, u.a. an Sommer-Akad. in Aachen und Meerbusch. Zahlr. Ausst.-Beteiligungen. – V.a. dem Informel nahestehende sowie gegenstandsbezogene und realistische Malerei (meist Acryl/Lw. und Acryl/Holz). Auch Graphik (u.a. Kohle-Zchngn mit Autobahnmotiven). Einen char. Beitrag in der überregionalen Kunstszene leistet C. mit seiner Gem.-Serie *Autopia*. In dieser beschäftigt er sich seit etwa 2005 in z.T. groß- und meist querformatigen Bildern mit

fotogr.-gestützter, bisweilen impressionistisch anmutender Darst. von Autostraßen in vagen Lsch., die er als *Flüchtige Lsch.* (2010 Ausst.-Titel) zu versch. Tages- und Nachtzeiten sowie bei versch. Witterungsbedingungen (Regen, Nebel, Dämmerung) aus dem Blickwinkel des Autofahrers erfaßt. C. thematisiert damit die Alltagssituation der eingeschränkten bzw. fokussierten Wahrnehmung eines am Straßenverkehr teilnehmenden Autofahrers, v.a. das komplexe Phänomen von Geschwindigkeit und Flüchtigkeit (*A 4*; *Regen*; *Aachener Land*, alle Acryl/Lw.). ⊙ *E:* 1988 Tîrgu Jiu, Gal. de artă mod. / 1989 Bukarest, Gal. Orizon / 2001, '03 (K), '07 Koblenz, Gal. Laik / 2003, '10 Zürich, Gal. Nievergelt / 2007 Eschweiler, KV / 2009 Middelburg, Gal. T / 2010 Aachen, Gal. 45 (mit Michael Dohle, Gerlinde Zantis) / 2012 Stolberg (Rheinland), Industrie-Mus. – *G:* 1981–85 Bukarest: Bienn. für Malerei und Skulpt. / 2000 Regensburg: Pax Danubiana / 2005 Aachen, Drei-Länder-Haus: Impulse / 2008 Plzeň: Internat. Bienn. der Zchng / Düsseldorf: 2010 Kunstforum: Parallel; 2012 Mus. Kunst-Pal.: Große Kunst-Ausst. NRW. ⌑ Kürschners Hb. der Bild. Künstler. Deutschland, Österreich, Schweiz, I, M./L. 2007. – Artă 1988 (5) 30/31; ibid. 1988 (11) 33; *J. Göricke*, Kunstzeit (Pulheim) 2001 (1) 74–77. – *Online:* Website C.

U. Heise

Chiriacka (Chiriaka), *Ernest* (*Ernest Darcy*; eigtl. Kyriakakos, *Anastassios*), US-amer. Maler, Zeichner, Illustrator, Bildhauer, * 11. 5. 1913 New York, † 26. 4. 2010 Great Neck/N. Y. Beginnt 1927 als Schildermaler zu arbeiten. Stud. in Abendkursen: 1932–35 Mechanics Inst. (Entwurfs-Zchng; Lettering; Ill.); 1935 NAD; Art Students League; 1936–40 Grand Central SchA, bei Harvey T. Dunn (Ill.; Malerei), alle New York. Gleichzeitig zunächst für die Fa. Advertisers Sign & Display, später für die Agentur Variety Display Company tätig; gestaltet u.a. Ladenschilder und Kinowerbung. Ab 1937 in Brooklyn/N. Y. ansässig. 1939–50 entstehen, meist unter Verwendung der Pseud. bzw. Sign. A. D. und E. C. Acka, mehr als 400 Cover-Motive für versch. Pulp-Mag., u.a. für Ace-High Western; Adventure; Big Book Western; Detective Fiction Weekly; Exciting Detective; Love Story; Phantom Detective; Texas Rangers; Western Aces. Ab 1950 Mitgl. der Amer. Artists Agency. Seither malt C., z.T. unter den Pseud. d'Arcy, Darcy oder James Fennimore Darcy Jr., v.a. farbige Ill. und Titelbilder für Mag. wie Amer. Mag., Argosy, Collier's, Coronet, Cosmopolitan oder Saturday Evening Post. Bes. Popularität erlangt er mit erotischen Motiven für Pin-up-Kalender des Mag. Esquire (1953–57; sign. als E. Chiriaka). Außerdem Gest. von Cover-Motiven für versch. Taschenbuchreihen. 1952 Umzug nach Great Neck/N. Y. 1953 Entwurf des Plakates zum Kinofilm *The Robe*. 1965 beendet C. die Tätigkeit im Bereich der kommerziellen Ill. und widmet sich fortan der freien Malerei. – Im Gegensatz zu den routinierten, aber häufig zeittypischen bzw. genrespezifischen Klischees folgenden Pulp-Motiven zeigen die meist nach Fotogr. oder mit Hilfe von Modellen gemalten Mag.-Ill. sorgfältig und detailreich ausgestaltete Arrangements und Komp. (Gouache/Karton). C.s freie Gem., meist Lsch. und narrativ-historisierende Genreszenen aus dem US-amer. Westen, stehen in der Trad. impressionistischer, z.T. auch visionär-atmosphärischer Malerei (z.B. *The Frontiersman*, 1976; *Fam. Moving Onward*, 1986; *North Folk Pastoral*, 2002, alle Öl/Lw.). Auch Portr. von Filmstars und figürliche Bronze-Skulpt. ⊙ *E:* 1975, '76, '79 New York, Kennedy Gall. (K). – *G:* 2003 Brooklyn (N. Y.), Brooklyn Mus.: Pulp Art. Vamps, Villains and Victors from the Robert Lesser Coll. ⌑ *Samuels*, 1976; *P. und H. Samuels*, Contemp. western artists, N. Y. 1985; *Falk* I, 1999; *F. Turner Reuter, Jr.*, Animal & sporting artists in America, Middleburg, Va. 2008. – *R. H. Saunders*, Collecting the west. The C. R. Smith Coll. of western Amer. art (K), Austin, Tex. 1988; *A. Gilbert*, The official identification and price guide to Amer. illustrator art, N. Y. 1991; *C. G. Martignette/L. K. Meisel*, The great Amer. pin-up, Köln u.a. 1996; *D. Cardwell*, New York Times v. 14. 5. 2003; *D. Saunders*, Illustration (St. Louis) 2003 (8) 6–37 (mit Interview und WV der Pulp-Cover); *G. Lovisi*, Dames, dolls & delinquents. A collector's guide to sexy pulp fiction paperbacks, Iola, Wis. 2009. – *Online:* Field Guide To Wild Amer. Pulp Artists.

H. Kronthaler

Chiricozzi, *Elvio*, ital. Maler, Zeichner, Collage- und Installationskünstler, * 25. 1. 1965 Livorno, lebt in Rom. Stud.: 1983–87 ABA Rom. C.s malerische Anfänge sind in der etruskischen Kultur verwurzelt („l'unico artista etrusco ancora vivente", A. Romani Brizzi, 1998). Ihr sind seine frühen Gem. zum Thema *Etruria* (Mischtechnik, 1986–88) gewidmet, deren warme Farbigkeit und Motive (v.a. der hohe Himmel mit fliegenden Vögeln) an die Wandmalereien etruskischer Nekropolen in Tarquinia erinnern. Auch seine Akte sind durch die Darst. der musizierenden und tanzenden Gestalten dieser Fresken angeregt, etwa in dem Zyklus *Potrebbe essere sera* (1994) mit der Gesch. zweier Liebender. Einen magisch-sakralen Char. hat die 1996 auf der röm. Quadrienn. ausgestellte Installation *Sacello*: Ein großes, oben offenes konisches Gefäß (Holz, Gips) mit kleiner Eingangsöffnung zeigt auf der Innenwand einen gemalten männlichen und einen weiblichen Akt (die endgültige Ausf. war in Zement und im Inneren mit Mosaiken vorgesehen). Inspirationsquellen für C.s Kunst sind auch die Fresken des frühen Quattrocento mit ihrer betonten Körperlichkeit sowie die Malerei des Novecento, bes. die kristalline Klarheit der Figuren von Felice Casorati. Dies belegen die bewegten männlichen Akte vor dunklem Grund in der Serie *Né cielo né terra* (1998/99), die weißen Schattenrisse der *Migranti* (1999; zus. mit Roberto Pietrosanti) oder die Akt-Zchngn auf Textilbahnen für die Ausst. *Occhi con le piume* (2000). Einen umfassenden Einblick in C.s komplexes Schaffen, das auch Zchngn, Skizzen und Collagen umfaßt, gibt die Ausst. *Mi apparisti vestita* (2000). Um 2008 greift C. das Vogelmotiv wieder auf, unter dem Eindruck des Himmels über Rom jedoch in veränderter Form. Er montiert kleine, schwarze, ausgestanzte Papierschwalben auf großformatige Holzplatten oder Leinwände, wobei er die Anzahl der Vögel variiert und mit dem jeweiligen Raum abstimmt; mitunter sind es ganze Vogelschwärme, die Innenräume vibrierend bele-

ben und als Installationen oder als Kunst am Bau Verwendung finden. – Daneben auch Autor versch. archit. Projekte: 2000 siegt er im Wettb. für die Gest. der Piazza Augusto Imperatore in Rom (zus. mit Roberto Pietrosanti, Fabrizio Bastoni und Roberta Postiglioni); 2004 entwirft er die Innen-Gest. der Capp. dell'Oratorio in Vallerano/Viterbo. ⌂ GENF, Pal. der Vereinten Nationen: Gem. THESSALONIKI, Hospital Achepa: Innen-Gest. des Eingangsbereichs, 2004. ◉ *E:* Rom: 1994 Mus. Laboratorio di Arte Contemp. (K: L. Pratesi); 1998 Gall. Il Polittico (K Arnaldo Romani Brizzi u.a.); 1999 Studio Andrea Gobbi (K); 2000 Gall. del Teatro India (K); Gall. A. A. M. Archit. Arte Mod. (K); 2000 (zus. mit R. Pietrosanti), '02 Studio d'arte contemp. Pino Casagrande; 2010 Fond. Volume (K); Casa delle Letterature (K) / 2001 London, Andipa Gall. / 2004 Cosenza, Gall. Vertigo / 2011 Turin, Castello di Rivara (K). – *G:* Rom: 1989 Gall. Rondinini: Arte a Roma 1980–89. Nuove situazioni ed emergenze (K); 1999 Mus. Risorgimento: La pitt. ritrovata 1978–1998; Fori Imperiali: Giganti; 2006 Studio Angeletti: Murales (K) / 2001 Oostende, Prov. MMK: Between earth and heaven. New classical movements in the art of today (K); Stockholm, Väsby Konsthall: Shapes of mind / 2002 Francavilla al Mare: Premio Michetti / 2003 Brüssel, Europ. Parlament: Futuro ital. / 2006 Venedig: Bienn. di archit. / 2007 Berlin, Gall. artMbassy: SPQR. ▭ *E. Lucie-Smith*, Art tomorrow, P. 2002; *L. Canova* (Ed.), Arte ital. per il XXI sec. (K), R. 2004; Roma punto uno (K Wander-Ausst.), R. 2004; *G. Di Genova*, Generazione anni Quaranta, Bo. 2009. – *Online:* Website C. (Werke, Ausst., Lit.); You tube. E. Kasten

Chiţac, *Marcel,* rumänischer Maler, Zeichner, * 8. 5. 1953 Horodişta/Bez. Botoşani, lebt seit 1978 in Bukarest. Stud.: bis 1978 HBK N. Grigorescu, Bukarest (Malerei). Ausz.: Orden Meritul Cultural. – Ch. gestaltet realistische, öfter dunkelfarbige, z.T. an altmeisterlicher Malerei orientierte Portr., poetische Lsch. (bes. Wälder, Baumgruppen, Alleen) und Ansichten alter rumänischer Dörfer und Städte, wobei manchmal ma. Archit.-Details bes. hervorgehoben werden. Des weiteren Stilleben und Akte. – Personal- und Gruppen-Ausst. in Belgien, Frankreich, Österreich, Rumänien, Tschechien, Ungarn und der Schweiz. ⌂ BOTOŞANI, Muz. Judeţean Botoşani. BUKAREST, Gal. de Artă al Municipiului Bucureşti. GENF, Mus. du Petit Pal. ŞTEFĂNEŞTI, Muz. Ştefan Luchian. ▭ *A. Cebuc u.a.*, Enc. artiştilor români contemp., I, Bu. 1996; *V. Florea,* Enc. artiştilor români contemp., I, Bu. 1996; *A. Rigas/D. Kukunas Demosthenes,* Who's Who in the Balkans, s.l. 1997; *M. Deac,* Lex. Critic şi documentar. Pictori, sculptori şi desenatori din România, Secolele XV-XX, Bu. 2008. – *D. Grigorescu,* Idee şi sensibilitate, 1991; *V. Ciucă/C. Prut,* Ipoteşti. Topos eminescian, 2000; *V. Marinescu,* Curierul Naţional v. 27. 8. 2005; *C. Ostahie,* Artişti, ateliere, galerii (Ghid facultative de încântat privirea), Ploieşti 2009. – *Online:* Website Ch.

St. Schulze

Chiu, *Caroline (Yu Yin),* chin.-US-amer. Fotografin, Video- und Filmkünstlerin, * 1967 Hongkong, lebt dort. Aufgewachsen in Hongkong. Stud. in den USA: bis 1993 New York Univ., Abschlüsse in Visual Arts Administration und Mus. Studies. Zw. 1989 und 1997 div. Tätigkeiten in Gal. und Mus., u.a. 1996 Ass.-Kuratorin der offiziellen Hongkong-Präsentation auf der Bien. in São Paulo. 1997–98 Fotogr.-Stud. am Rockport Coll. in Maine; versch. Weiterbildungen im Filmbereich. 1998–2001 arbeitet sie in den USA mit Film und Video. 2001 kehrt sie nach Hongkong zurück und widmet sich ausschl. der Kunst. Seit 2005 moderiert sie Kunstsendungen bei Radio Television Hongkong. – In ihrer Fotogr. arbeitet C. vorwiegend mit einer sehr großen Polaroid-Kamera und Negativgrößen von 61 x 51 cm. Dadurch betont sie die Feinheit, aber auch die Abstraktionsqualitäten ihrer häufig kleinteiligen Motive und stellt deren mystische Qualitäten heraus, z.B. in der Serie mit tibetischen Skulpturen. Ihre Motivwahl ist von Fragestellungen zu chin. Identität und Kultur geprägt, bes. in den ab 2004 entstehenden Serien *Chin. Wunderkammer.* ✉ A Chin. Wunderkammer, Hongkong 2005; Dreaming. A Chin. Wunderkammer, Hongkong 2006. ◉ *E:* 1996 Singapur, Cicada Gall. / 2004–05 Taipei, MFA / 2006–07 Hongkong, Hanart TZ Gall. / 2010 South Bend (Ind.), Snite Mus. of Art. – *G:* 2006 Wiesbaden, Nassauischer KV: The Pearl River Delta / 2007 Lianzhou: Internat. Photo Festival; Vilnius, Contemp. AC: Pearl River City. ▭ Gods and monsters. Portr. of the Nyingjei Lam Coll. (K Rossi & Rossi), Lo. 2008.

R. Höfer

Chiu *Huan-tang* (Qiu Huantang), taiwanesischer Keramiker, Hochschullehrer, Fachautor, * 2. 6. 1932 Hsinchu, lebt in Taipei. Stud.: Nat. Taiwan Normal Univ., Taipei (Anglistik, Master 1956). 1961–97 Doz./Prof. für engl. Lit. (Nat. Taiwan Normal Univ.; Nat. United Univ.). 1971–74 Kolumnist der Zs. Artist (Yishujia), in der er versch. Artikel über Keramik veröff., die 1979 u.d.T. Taoyi jiangzuo (Vorträge über Keramikkunst) in Buchform erscheinen. Betreibt 1974–84 das Tao-Jan-Keramikstudio (zahlr. Schüler). 1992 gründet er zus. mit Schülern die Lien Ho Friends of Ceramics Group, die seither Ausst. organisiert. Gewinnt 1999 den vom Yingge Ceramic Mus. organisierten Wettb. für Kunst im öff. Außenraum mit der mon. Arbeit *Fumen/Millennium Arc* (voll. 2000; ebd.). Ausz.: 2005 Achievement Award, Taipei Ceramics Awards. – C. entdeckt für sich die Keramikkunst während eines Studienaufenthaltes in Manoa (1964–65 East-West-Center, Univ. of Hawaii) in einem experimentellen Workshop bei Claude Horan, wo er auch die freihändige Formgebung von Harue Oyama McVay rezipiert. Technisch und stilistisch vielseitig fertigt C. fortan figürliche und abstrakte Ton-Skulpt., häufig mit lit., phil. oder satirischen Anspielungen (*Shi bei/Strandgutjäger,* Tontafeln mit Strandmotiven, 1977; *Caihong wu yuezhang/Fünf Sinfonien des Regenbogens; Tongnian de meng/Kindheitstraum,* 1976; *Ding de biancou. Liu quan/Transformation of the Three-legged Sacrificial Vessel. Spring,* 1999; Taichung, Nat. Taiwan MFA) sowie kleinformatige, mit typischen Motiven Taiwans und lokalen Lsch. bemalte Teller und Gefäße. Mit seinen frühen experimentellen Arbeiten sowie als Lehrer und Hrsg. didaktischer Texte hat C. einen beträchtli-

chen Beitrag zur Entwicklung der mod. Keramik in Taiwan geleistet. ☐ TAICHUNG, Nat. Taiwan MFA. TAIPEI, FA Mus. – Yingge Ceramic Mus. ☉ E: Taipei: 1982 Tao-peng-she (mit Shih Nai-yueh); 1985 Spring Gall.; 1999 San-yi Gall. of Contemp. Ceramics. – G: 1977 Faenza: Internat. Ausst. für zeitgen. Keramik (Ausz.) / 1984 Vallauris: Internat. Ceramic Arts Bienn. / Taipei: 1981 Nat. HM: Taiwan-Japan Ceramics Exhib.; FA Mus.: 1985, '86 Ceramics Exhib.; 1992 Four Decades of Ceramics in Taiwan: A Research Exhib.; 1996 Nat. Taiwan Arts Education Center: Ceramics and Life / 1999 Châteauroux: Bienn. de Céramique Contemp. ☐ Reflections of the seventies. Taiwan explores its own reality (K), Taipei 2004. – *Online:* Contemp. Taiwan Ceramics. K. Karlsson

Chiu *Ya-tsai* (Qiu Yacai), taiwanesischer Maler, Schriftsteller, Dichter, * 6. 6. 1949 Yi-lan, lebt in Taipei. Nach Mittelschule und Wehrdienst intensive Beschäftigung mit chin Gesch. und westlicher Lit. (Shakespeare, Dostoevskij). In den 1980er Jahren Anschluß an den einflußreichen lit. Salon Wistaria Tea House (Ziteng lu) in Taipei. Seit A. der 1990er Jahre verfaßt C. Romane und Novellen (1994 Preis Wu Chou-liu). – Als Maler konzentriert sich C. seit den 1980er Jahren auf Porträts (Tusche und Farbe/Papier und v.a. Öl/Lw.) von namenlosen, häufig androgyn wirkenden zeitgen. „Vagabunden" (liulang) sowie von Intellektuellen (Dichter, Lehrer, Maler), deren Darst. formale Anregungen von Amadeo Modigliani und den Fauvisten, z.T. auch von der trad. chin. Figurenmalerei u.a. der Tang-Zeit erkennen lassen. C.s vereinfachte char. Darst. von einzelnen, betont länglich gez. Gestalten, die sich durch Farbgebung und -konturierung sowie blasse Gesichter mit markanten Augen deutlich vom monochromen Hintergrund abheben, faszinieren durch ihre emotionslose Eleganz, die Zerbrechlichkeit und Melancholie in einer von Veränderungen gekennzeichneten mod. Ges. evozieren. ☉ E: Taipei: 1979, '80, '81 Amer. Cult. Centre; 1982 Wistaria Tea House; 1993–96 (jährlich) Gal. Elégance; 2006 Goethe AG / Hongkong: 1989 Hanart 2 Gall. (mit Cheng Tsai-tung); 2007 Anna Ning FA / 1991 Tainan, R. Lin AG / 1993 Taichung, New Phase Art Space / 1995 Gstaad (Schweiz), Gal. Saqqârah / 1998–99 Monaco, ABN AMRO Bank (mit Ju Ming) / 2001 New York, Plum Blossoms Gall. (mit Ju Ming; K) / 2009 Beijing, Ming AG. – G: Taipei: 1985 Spring Gall.: Taiwan New Paint.; 1988 NM of Hist.: Contemp. Ink Paint; 2005 Kuandu MFA: Extravaganza / 1987 New York, Asian Arts Inst.: The Mind's Eye / 1990 Taichung, Taiwan Mus. of FA: 300 Years of Taiwan Arts / 2005 Hongkong, Hanart TZ Gall.: Four Taiwan Artists. ☐ *M. Sullivan,* Mod. Chin. artists, Berkeley u.a. 2006 (s.v. Qiu Yacai). – *I. Findlay,* Arts of Asia 15:1985 (3) 95–98; Cheng Tsai-tung and C. (K), Hong Kong 1988; *M. Sullivan,* Art and artists of twentieth c. China, Berkeley u.a. 1996; *J. C. Kuo,* Art and cult. politics in postwar Taiwan, Washington, D. C. 2000. K. Karlsson

Chiu, *Yu Yin* → **Chiu,** *Caroline*

Chiuaru, *Mihai,* rumänischer Maler, * 17. 8. 1951 Hangu/Bez. Neamț, lebt in Bacău. Stud.: bis 1976 HBK N. Grigorescu, Bukarest (Mon.-Kunst). Ausz.: 1979, '81,

'94 Voronețiana Kunst-Wettb.; 1994 Gheorghe-Tättärascu-Preis; 1998 Preis des rumänischen Künstler-Verb. für relig. Kunst; 1999 Preis des moldawischen Künstler-Verb.; 2001 Preis des moldawischen Kultur-Minist.; 2008 Preis der Republik Moldawien; 2009 Großer Preis der Lascăr-Vorel-Bienn., Piatra Neamț. – Ch. gestaltet in Mischtechnik, z.T. collageartig, in einem breiten Farbspektrum v.a. dynamische, semiabstrakte figürliche Kompositionen. Gesichter bleiben meistens nur angedeutet, weibliche Akte erscheinen oft nur umrißhaft. Mon. Arbeiten zu relig. Thematik (u.a. Kreuzigungsszenen) befinden sich in versch. Kirchen und Klöstern. Zw. 1988 und 1992 führt er z.B. die Fresken im Kloster Horaița/Bez. Neamț aus. 1996 ist er mit Wandbildern für die St. George Church in Kapstadt in Südafrika beauftragt. ☐ *Mon.-Kunst Auswahl:* BACĂU, Agricola Internat.: Sgrafitto, 1988. MEGEDIA, Zentraler Platz: Mosaik, 1975–76. PIATRA NEAMȚ, Bancorex: Sgrafitto, 1997. ☉ E: u.a. Piatra Neamț: 1976, Gal.; 1994 KM / Bukarest: 1986 StG; 2001 Gal. Apollo / 1987, '99 Bacău, KM und Gal. Alfa; 2008 Kunstzentrum G. Aopostu / / 2004 Koga (Japan), SM / 2006 Iași, Gal. Cupola / 2007 Timișoara, Gal. Calina / 2008 Chisinău, Brâncuși-Halle. – G: zahlr. seit 1974, u.a. 1985 Paris: Paul Louis Weiller (Portr.-Wettb.) / 1990 Vernillion, Univ. AG: Mail Art / seit 1990 Chisinău: Moldawien-Salon (1992, '98 Ausz.) / 2001 Bukarest: Nat. Salon / 1996 Osaka: Malerei-Trienn. / 2001 Sarjah: Bienn. / 2007 Mogoșoaia, Palatele Brâncovenești: Artitudini (mit Mihai Bejenariu, Ioan und Ionela Lazureanu, Dany und Gheorghe Zarnescu) / 2007–09 Internat. Bienn. in Rumänien, Ungarn, Tschechien und Österreich. ☐ *A. Cebuc u.a.,* Enc. artiștilor români contemp., I, Bu. 1996; *C. Prut,* Dicț. de artă mod. și contemp., Bu. 2002. – *Online:* Website Ch. St. Schulze

Chkoutova, *Sevda,* bulg.-österr. Malerin, Zeichnerin, * 1978 Sofia, lebt in Wien. Gymnasium f. Angew. Kunst in Sofia. Stud.: 1998–2002 ABK Wien (Malerei, Graphik) bei Sue Williams und Markus Muntean & Adi Rosenblum. 2004–05 Chicago-Aufenthalt. – V.a. zarte, feingliedrige und großformatige Graphit- und Kreide-Zchngn in fotorealistischer Manier, die während ihrer ersten Schaffensjahre das Thema Kindheit behandeln, z.B. in den Zyklen *Family Album, „nackt"* oder *Child's Play* (2006). Ausgehend von priv. Fotogr. inszeniert C. Kindheitserinnerungen. „Ausradierungen und Schraffuren [...] verdichten sich zu üppig-biomorphen oder feingliedrig-floralen Mustern", in denen sich Erinnerung, Phantasie, Realität und Wünsche verschränken und Klischees gebrochen werden (S. Mostegl, Kunstnet 2006). Virtuose Mat.-Beherrschung. Parallel zu den Zchngn greift C. das Thema „Flecken" auf, die an florale Schatten gemahnen. Schraffuren schließen sich wie gerissene Papierstücke versch. Größe und Grauwerte zu virtuos-bruchstückhaften Gefügen zusammen, erinnern an Collagen und irritieren die geläufige Vorstellung von Zeichnung. Später puristische Linienführung und härtere Kontraste. Bis um 2005 kleinformatige, minimalistisch reduzierte Bll. in Tusche, die bevölkert sind mit einer Fülle von meist weiblichen, oft nackten Figuren. Neuerdings stilistisch und inhaltlich sehr divergente, oft großformatige,

technisch bestechende Zchngn von Frauen. Die Thematik bleibt, die Formate wechseln. Häufig stellt C. durch ihre Frauenbilder (patriarchale) Doppelmoral in Frage. 2006 Ausz. mit dem Strabag Artaward. 2011 nominiert für den Kardinal-König-Kunstpreis. ⌺ WIEN, Strabag Kunstforum. ☉ *E:* Sofia: 1996 Gal. Nava; 2000 Gal. 11 / Wien: 2002, '04, '06, '07, '08, '10 Gal. Chobot; 2006 Strabag Kunstforum; 2011 Gal. Peithner-Lichtenfels; Parlament Wien; Projektraum Viktor Bucher / 1996, 2000, '05 Chicago, Gall. Griffin / 2009 Dornbirn, Gal. Art House; Lauterach, Alte Seifenfabrik; Ljubljana, Visconti FA / 2010 Basel, H95 Raum für Kultur (zus. mit Muyan Lindena). – *G:* 1996 Thessaloniki, UNESCO-Ausst.: Woman creators of the two seas / Wien: 1999 ABK: Meister-Kl. Sue Williams; 2004 Gal. Chobot: Malerin male mir; 2008 Eroticon Gal. Lang: Moment – Begebenheit – Mythos; 2010 Projektraum Viktor Bucher: Walk the line / 2004 Hamburg, Gal. Margret Kruse: „und das nicht nur zur Weihnachtszeit" / 2009 Bratislava, Danubinana Meulensteen AM: Bienn. ▭ Die Presse online (W.) v. 17. 5. 2002; 6. 3. 2006; 11. 4. 2007; *M. Knofler/M. Reinhard* (Texte), S. C. (K), W. 2010. – *Online:* Website C.; Strabag Kunstforum; Kunstnet Österreich. S.-W. Staps

Chmielewski, *Bogdan,* poln. Maler, Zeichner, Performance-, Aktions- und Installationskünstler, * 1946 Toruń, lebt in Bydgoszcz. Bruder von Witold C. Stud.: bis 1970 Nikolaus-Kopernikus-Univ., Fak. für Bild. Künste, Toruń. Lehrtätigkeit ebd., seit 1999 Prof. (Malerei, Zeichnen). Ab 1976 Zusammenarbeit mit Witold C., Andrzej Maziec, Wiesław Smużny und Stanisław Wasilewski, die sich 1978–81 zur Grupa Działania zusammenschließen. Ab 1981 setzen C., Witold C. und Smużny ihre gemeinsamen Aktionen fort, 1989–93 als Grupa 111-Lucim. Ausz.: 1981 Staatspreis 2. Kl. für die Verbreitung der Kunst (für die gesamte Gruppe für deren Aktionen in Lucim). – Im Bestreben, Kunst nicht in den ihr trad. vorbehaltenen Institutionen zu belassen, sondern mit der Alltagswelt zu verbinden, veranstaltet C. auf dem Hauptbahnhof in Bydgoszcz Ausst. von Gem. und Zchngn (1974) bzw. Transparenten mit von ihm aufgeschriebenen Gedichten (1975) zum Thema Reisen, wobei für ihn die Einheit von Thema und Ausst.-Ort bedeutsam ist. Mit Mitgl. der künftigen Grupa Działania wird die Aktion *Podróż*/Reise (1976) realisiert, bei der Gem., Fotogr. und räumliche Arrangements in einem Zug und auf versch. Bahnhöfen gezeigt wurden. Ab 1977 wird das pommersche Dorf Lucim Zentrum ihrer künstlerischen Aktionen, in die auch die dortige Bevölkerung einbezogen wird: 1977–2006 realisiert C. selbständig oder mit der Gruppe über 200 interdisziplinäre Projekte (Happenings, Performances, Darst. von lebenden Bildern, Zchngn, Objekte etc.) als *Akcja Lucim* (1977/78), *Działanie w Lucimiu* (1979–93) bzw. danach *Działania Lucimskie (Nostos).* Seit den 1980er Jahren verfolgen C. und seine Künstlerkollegen damit konsequent das von ihnen erarbeitete Programm der „sozialen Kunst" (*Sztuka społeczna,* 1980), das in der Folgezeit weiterentwickelt wird (Konzeptionen *Neo-etno,* 1983; *Postkultura,* 1983; *Trzecia droga,* 1987; *Paraliturgia,* 1986; *Podsa-*

crum – szósty wymiar, 1989). In der 2. H. der 1980er Jahre stehen die künstlerisch-sozialen Aktivitäten im Zusammenhang mit dem Rhythmus der Natur, kirchlichen und weltlichen Fest- und Gedenktagen. Ab M. der 1990er Jahre beschränkt sich die Tätigkeit der Gruppe auf individuelle Auftritte einzelner Mitglieder. Ab 1991 stellt C. das Konzept *Oikomancja* in einer Reihe von Ausst., Installationen und Künstlertreffen im Rahmen des Zyklus Rok polski// Poln. Jahr vor: Auf persönlichen Erfahrungen und Intuition beruhend, entwickelt er ein dem Rhythmus der Natur und des Kosmos folgendes „Naturvorbild" als Alternative zur Zivilisation. Die visuelle Umsetzung erfolgt in Form von kreisförmigen „Kalendern", die Zeitdiagramme mit Ideogrammen von den den Künstler beschäftigenden Problemen verbinden. ⌺ TORUŃ, CSW. ▭ *A. Kaleta/ J. u.a.,* Społeczność wiejska, Wr. 1996. ☉ *G:* 2009 Toruń, CSW: Lucim żyje. ▭ *A. Lewicka-Morawska u.a.,* Słownik malarzy polskich, II, War. 2001. – Akcja Lucim, s.l. 1979. – *Online:* Akjca Lucim; Uniwersytet Mikołaja Kopernika; CSW, Toruń. C. Rohrschneider

Chmielewski, *Jacek* cf. **Chmielewski,** *Witold*

Chmielewski, *Witold (Witold Andrzej),* poln. Maler, Zeichner, Bühnen- und Szenenbildner, Aktionskünstler, Ausst.-Gestalter, Hochschullehrer, * 27. 1. 1949 Toruń, lebt dort. Bruder von Bogdan C.; Vater des Fotografen *Jacek* C. (* 1975, lebt in Toruń). Stud. ebd.: 1970–75 Nikolaus-Kopernikus-Univ., Fak. für Bild. Künste bei Stanisław Borysowski. Seit 1975 Lehrtätigkeit ebd. (2001 Prof.; derzeit Leiter des Fachbereichs Intermediale Kunst). 1977 und '78 künstlerischer Leiter des Festivals von Studenten der KSch in Szczawno-Zdrój. Mitgl. der Grupa Działania (1978–81) und der Grupa 111-Lucim (1989–93; zu Aktivitäten und Konzeptionen dieser Gruppe siehe Art. von Bogdan C.); C. macht sich bes. verdient, dieses Projekt durch Propagierung und Inf. einem breiteren Publikum bek. zu machen. 1981 Staatspreis 2. Kl. für die Verbreitung der Kunst (für die gesamte Gruppe für deren Aktionen in Lucim). Seit 1993 Dir. des Programms der Kulturstiftung Akad. małych ojczyzn/Akad. der kleinen Vaterländer, die lokale Kultur- und Bildungsinitiativen fördert. Gehört zu den wichtigsten Persönlichkeiten der Toruñer Kunstszene. – Debütiert 1974 als Vertreter des „podrealizm" (Unterrealismus) – eine von ihm gewählte Bezeichnung in Abgrenzung zur offiziellen Kunstrichtung des Sozrealismus (Sozialistischer Realismus) – mit Gem., in denen mit kühlem Blick Menschen und ihre Umgebung erfaßt, aber weder deformiert noch gefühllos dargestellt sind. Stilistisch und atmosphärisch steht diese Malerei den Werken der Gruppe Wprost sowie Andrzej Wróblewski nahe. In der Komp. und bestimmten perspektivischen Überzeichnungen zeigen sich Einflüsse des Fotorealismus. Ab M. der 1980er Jahre beschäftigt sich C. mit Bühnen- und Szenenausstattungen (z.B. *Romeo und Julia* von Shakespeare, 1987, Teatr im. Wilama Horzycy in Toruń; *Stół z powyłami nogami,* 1990, Teatr Współczesny in Szczecin; *Der Spieler* von Dostojewski, 2002, Fernsehanstalt TVP in Gdańsk und Bydgoszcz). Ausst.-Gest.: z.B. 1991 Epitafium i siedem przestrzeni, Gal. Zachęta, Warschau; 1999 W pos-

zukiwaniu środka świata, Gal. Wozownia, Toruń. Daneben auch Entwürfe von Innenausstattungen, Archit. sowie Werbegraphik. ⊚ *E:* 1975 Gdańsk, Lenin-Werft: Wystawa podrealizmu. – *G:* 2009 Toruń, CSW: Lucim żyje. ▭ *A. Lewicka-Morawska u.a.*, Słownik malarzy polskich, II, War. 2001. – Akcja Lucim, s.l. 1979; *J. Malinowski u.a.* (Red.), Kształcenie artystyczne w Wilnie i jego tradycje (K), Toruń/Wilno 1996. – *Online:* CSW Toruń; Akcja Lucim. 						C. Rohrschneider

Cho, *Shinta,* jap. Kinderbuchillustrator, Comiczeichner, Autor, * 24. 9. 1927 Tokio, † Juni 2005 ebd. Ausb.: KGS, Kamata/Tokio. Arbeitet anfänglich als Reklamezeichner für ein Kino sowie als Graphiker und Manganka u.a. für die Ztg Tokyo Daily Press, für die er v.a. Mangas für Jugendliche und Erwachsene zeichnet. 1950 debütiert er mit ersten Buch-Ill. (*Shimbun ga dekiru*/Wie eine Ztg gedruckt wird, 1950), wendet sich danach zunehmend der freieren Kinderbuch-Ill. zu und tritt auch bald als (Kinderbuch-)Autor in Erscheinung. Seine skurril-phantastischen Erzählungen und Essays, die er auch selbst illustriert, sind wie seine Ill. für and. Autoren von tiefgründiger Lebensweisheit und Humor, erfrischendem Esprit und kindlich-abseitigen Assoziationen gleichermaßen gekennzeichnet, ohne je ironisch oder satirisch zu werden. Zahlr. nat. Ausz.: 1959 Bungei Shunju Manga Award (für *Chatty Fried Egg*); 1977 Kodansha Cultur. Award Picture Book (für *It's Spring Mrs. Owl*); 1981, '98 Nippon Eho Taisho (Bestes Buch Japans); 1984 Shogakukan Award; 1987 Chiwaya Sazanami Award; 1994 Purple Ribbon; 2002 Exxon Mobil Children's Cult. Award. Mehrfach wird C. für den renommierten Hans-Christian-Andersen-Preis nominiert, der vom einflußreichen Internat. Board on Books for Young People (IBBY) vergeben wird. Auf dessen Ehrenliste steht C. 1974 mit seinen Ill. für *Oshaberi na Tamagoyaki* (T. Teramura, The king and his fried egg, 1972) und 2002 für *Tengu no Hauchiwa* (Y. Kayama, The magical fun of the long-nosed ogre, 2000). Zweimal wird C. als Repräsentant Japans für die Vergabe des IBBY-Hauptpreises nominiert (1998, 2000). Das Gesamtwerk umfaßt die Hrsg. und Ill. von über 400 (Kinder-)Büchern. – C.s Ill. sind in Komp. und Ausf. häufig von einfachen, linienbetonten Kinder-Zchngn inspiriert, wobei C. in seinen Arbeiten weniger auf deren scheinbar unvollkommene Form, sondern auf deren unbefangene und freie Imagination rekurriert. Sein bisweilen hemmungsloser narrativer Drang zum spielerisch-poetischen Nonsens, der ursächlich von einem präadulten und subversiv schrägen Humor gespeist wird, macht sich bereits früh bemerkbar, z.B. in dem tabubrechenden Kinderbuch *The gas we pass. The story of farts* (1958), wo C. das Phänomen von Blähungen nicht nur beim Menschen oder Elefanten, sondern auch beim Stinktier erläutert. C. gehört zu den bed. Kinderbuchillustratoren der zweiten H. des 20. Jh. in Japan. ▭ *Online:* IBBY. 						U. Heise

Cho, *Simsa* (eigtl. Kasema, *Shinji*), jap. Glas- und Performancekünstler, * 20. 12. 1962 Narita/Chiba-ken, lebt in Amsterdam. Stud.: 1982–86 Tama Art Univ., Tokio-Setagaya; 1986–89 Gerrit Rietveld Acad., Amsterdam, bei Richard Meitner und Mieke Groot. – C.s meist im Wachsausschmelzverfahren gefertigte Glasplastiken sind z.T. emailliert und werden oft durch and. Mat. (u.a. Stein, Metall) ergänzt. Meist tragen die Werke abstrahierte anthropomorphe oder tierähnliche Züge, wodurch sie bisweilen an gespensterhaft verzerrte und deformierte Wesen erinnern. Die in den 1990er Jahren beg. Serie *Shoerealism* vereint farbenfrohe, phantasievolle Plastiken in Schuhform (v.a. Pumps). Als Resonanzkörper und Überträger von Licht setzt C. das Mat. Glas in Meditationsobjekten (Glasplatte mit Handabdrücken) und Performances ein (mit Glasrequisiten, u.a. Masken, Kopf- und Wandschmuck; z.B. *Akadama,* Kopfschmuck aus gegossenem und emailliertem Glas, Aluminium, Kork und Leder, 2003), die oft spirituellen Zeremonien nachempfunden sind. ⌂ COESFELD, Glas-Mus. Herding. GENT, Design Mus. LEERDAM, Nat. Glas-Mus. ⊚ *E:* 1994, '95 Doesburg, Gooijer FA / Amsterdam: 2001 Braggiotti Gall.; 2009 Martin-Lutherkerk / 2001 Wageningen, Mus. De Casteelse Poort / 2007 (mit Melvin Anderson), '11 (mit Xandra Paijmans-Bremers) Epe, Gal. De Aventurijn / 2009 Coesfeld, Glas-Mus. Herding (mit Menno Jonker und Winnie Teschmacher). – *G:* 1991 Amsterdam, De Oude Kerk: Emotie Japan. De onbewuste factor (K) / 2004 Roermond, Sted. Mus.: Glas 04. Van ruimtelijkheid tot intimiteit / 2006 Amstelveen, Mus. Jan van der Togt: De nieuwe garde en jonge gasten (K) / 2008–09 Nieuw-Roden, Kunstpaviljoen: Glas nu / 2010 Louisville, Kentucky Mus. of Art and Craft: Glass Jewelry. An Internat. Passion for Design. ▭ *T. M. Eliëns/ M. Singelenberg-van der Meer,* Lex. Nederl. glaskunst van de twintigste eeuw, Lochem 2004. – *U. Ilse-Neuman u.a.,* GlassWear. Glass in contemp. jewelry (K Wander-Ausst.), St. 2007. – *Online:* Website C. 						F. Krohn

Cho, *Sung-Mook,* koreanischer Bildhauer, Installationskünstler, * 1. 1. 1939 Daejeon. Stud.: Hongik Univ., Seoul (Bildhauerei). Preise: u.a. 1960, '63 Korean FA Grand Prix. – C.s Œuvre umfaßt mehrere Werkserien, die er *Messenger/Message* und *Communication* nennt. Zentrales Motiv ist der Stuhl, über dessen (häufig deformierte) Figurationen sich C. mit post-mod. Objekt-Subjekt-Beziehungen auseinandersetzt (*Messenger,* Holz, 1966; *Messenger,* Bronze/Glas/Stein, 1966). In den 1980er Jahren verstärkt minimalistische Skulpt. in Acryl, die in ihrer Konstruktion und Farbwirkung die Trad. der Tafelmalerei zitieren und zugleich negieren (*Message,* 1983). In der Folge ebenfalls Skulpt., die in ihrer ontologischen Zusammenfügung natürlicher Mat. entfernt an buddh. Figurationen erinnern (*Festival of the stones,* 1986; alle Nat. MCA). Im Spätwerk Auseinandersetzung mit kult. Grenzen und Ausgrenzungen (*Communication,* Installation mit Nudeln, 2003). ⌂ DAEJEON, Expo Sc. Park. JEJU, Shinchonji AM. SEOUL, Korean Cult. & Art Found. AC. – Nat. MCA. – Olympic Mus. of Art, Sculpt. Park. – Samsung Mus. of Art. – Total MCA. ⊚ *E:* Seoul: 1981 Korea Arts Found.; 1994 Total MCA (K); 1999 Bhak Gall.; 2011 Kumho Mus. of Art (K) / 1995 Kiel, KH u.a. (K) / 2012 Jeju, MCA (K). – *G:* Seoul: 1972 Dt. Kulturzentrum: Drei koreanische Künstler; 2004 Total MCA: You Are My

Sunshine (K); 2008 Olympic Mus. of Art: 8808 Outside In (K) / 1981 São Paulo: Bien. / 1988 Düren, Leopold-Hoesch-Mus.: Papier macht Raum (K) / 1990 Venedig: Bienn. / 1997 Daegu, Cult. and AC: Contemp. Art, Korea-China-Japan / 2003 Honolulu, Univ. of Hawaii AG: Crossings Korea-Hawaii (K) / 2004 Gwangju: Bienn. / 2007 Ansan, Gyeonggido Mus. of Art: The Sculpt. Project. Lines in Space (K) / 2007 Beijing, Keumsan Gall.: Interaction (K) / 2012 Changwon, Leeahn Gall.: Edition (K). ▭ *Delarge*, 2001. – *V. N. Desai* (Ed.), Asian art hist. in the twenty-first c., Williamstown, Mass. 2007.

A. Papist-Matsuo

Choate, *John Nicholas*, US-amer. Fotograf, * 1848, † 1902. Gebürtig aus Maryland, erlernt C. die Fotogr. wahrsch. von seinem Schwager, dem Fotografen Edson McKillip. 1875 läßt er sich in Carlisle/Pa. nieder und übernimmt das Fotoatelier von Charles Lochman, wo er neben Portr. auch Lsch.-Aufnahmen aus der Region anbietet. 1879 wird C. der offizielle Fotograf der neu gegründeten Carlisle Indian School und dokumentiert bis zu seinem Tod das Leben an der Schule in Portr. des Lehrkörpers, der Schüler und ihrer Verwandten sowie and. indianischer Gäste, Ansichten der Schulgebäude und Aufnahmen schulischer Aktivitäten, die er in Form von Kabinett- und Stereokarten vertreibt. ▭ GREENWICH/N. J., Cumberland County Hist. Soc. LONDON, BM. NEW HAVEN/Conn., Yale Univ., Beinecke Rare Book and Ms. Libr., Yale Coll. of Western Americana. PRINCETON/N. J., Princeton Univ., Western Americana Coll. SUITLAND/Md., Nat. Anthropological Arch. WASHINGTON/D. C., NM of the Amer. Indian. ▭ *L. M. Malmsheimer*, „Imitation white man". Images of transformation at the Carlisle Indian School, in: Studies in visual communication 11:1985 (4) 54–75; *A. L. Bush/L. C. Mitchell*, The photograph and the Amer. Indian, Princeton, N. J. 1994; *M. A. Sandweiss*, Print the legend. Photogr. and the Amer. West, New Haven, Conn./Lo. 2002; *L. Turner*, in: *M. Fraust u.a.* (Ed.), Visualizing a mission. Artifacts and imagery of the Carlisle Indian School (K), Carlisle, Pa. 2004. P. Freytag

Chocholáč, *Jiří*, tschech. Fotograf, Fotojournalist, Kameramann, * 10. 10. 1942 Prag, lebt dort. 1959 Schulabschluß. 1959–62 Kamera-Ass. beim Tschech. Fernsehen. 1962–64 Kamera-Stud. an der Film- und Fernseh-Fak. (FAMU), Prag, bei Ján Šmok. 1965–92 Fotojournalist bei der Zs. Zápisník, seit 1992 freischaffend; betreibt in Prag das Fotoatelier Studio Max. 1967–85 Teiln. an den Ausst. der World Press Photo Found. (1969 Ehrenpreis); 1967–86 regelmäßig in den Ausst. des Klubs der Fotoreporter im tschechoslowakischen Journalisten-Verb. vertreten; 1990–2011 Beteiligung an den Ausst. des tschech. Verb. der Berufsfotografen (AF ČR). – Ch. gehört zu den weniger bek. Fotografen, die im Aug. 1968 die Besetzung Prags durch Truppen der Staaten des Warschauer Pakts fotogr. dokumentieren. Hauptsächlich widmet er sich dem Portr. und fotografiert bevorzugt prominente Persönlichkeiten aus Theater, Film und bild. Kunst, wobei sich Komp., Farb- und Kontrast-Bearb. durch den Surrealismus inspiriert zeigen. Zusammenarbeit mit dem

bek. Dichter und Liedtexter Pavel Vrba; Fotogr. zu dessen Versen werden 1987 u.d.T. Vody Vzduchy Světla (Wasser Lüfte Lichter) im Prager Ausst.-Raum Květy präsentiert. Auch Farbaufnahmen von Bäumen und Baumallen. ◉ *E:* 1989 Krásný Dvůr, Schloß / 2009 Prag, Foyer des Kinos Lucerna (Portr.). – *G:* Prag: 1994 Mánes: Česká fotografie 1989–1994 (K); ebd. 2008 1945 Liberation, 1968 Occupation. Soviet troops in Czechoslovakia (K); '11 Prague Photo; 2008 Franziskanerkloster an der Kirche St. Maria Schnee: Jan Palach / 2000 Prag und Bologna, Ist. Ital. di Cult.: 1945 Befreiung, 1968 Okkupation / 2008 Wrocław, Dolnośląskim Centrum Fotografii „Domek Romański": Okkupation 1968. ▭ SČSVU IV, 1999.

A. Dufek

Chodina (verh. Čermáková; Chodina-Čermáková; Hodina-Čermáková), *Aneta*, bulg. Malerin, Zeichnerin, * 5. 5. 1878 Konstantinopel (Istanbul), † 24. 6. 1941 Prag. Stud.: 1897–1902 Staatliche Zeichenschule (ab 1921 KA), Sofia (Malerei bei Jaroslav Věšin). Ch. und die Malerin Elisaveta Konsulova-Vazova, mit der sie eine enge Freundschaft verbindet, gehören zu den ersten Frauen, die an dieser Einrichtung ausgebildet werden. 1903–1906 Vertiefung der Studien in München und Paris. Mitgl.: 1903–46 Künstler-Vrg Săvremenno izkustvo (Mod. Kunst); 1904–12 Verb. südslawischer Künstler LADA. Bekanntschaft mit ihrem späteren Ehemann, dem Journalisten Emil Čermák, 1893–95 Chefredakteur der in Brno hrsg. Ztg Lidové noviny, der wegen seiner politischen Tätigkeit ausgewiesen worden und nach Bulgarien geflüchtet war. Unter seinem Einfluß beginnt Ch. 1905/06 ihre freie Mitarb. an der Wochen-Ztg für Humor und Satire Bălgaran mit politischen Karikaturen und satirischen Pressezeichnungen. Die Stellung des Vaters bei der Eisenbahn ermöglicht ihr mehrere Reisen durch Europa, häufig in die Kunstmetropolen München und Paris. Neben dem Erlernen der jeweiligen Landessprachen besucht sie dort Mus. und Gal., die ihre bildnerische Kultur und Erfahrung essentiell bereichern und ihr Kunstverständnis für zeitgen. Tendenzen schulen. Mit einem an der Münchener Börse erzielten Gewinn erwirbt sie ein Haus in Mariánské Lázně, das sich bis heute im Fam.-Bes. befindet. Wahrsch. zur Sicherung des Lebensunterhalts läßt sich Ch. neben den Kunststudien in Paris zur Modistin ausbilden. Später betreibt sie im Stadtzentrum von Sofia ein in gehobenen Kreisen sehr geschätztes und einträgliches Atelier für Damenhüte. Nach der Proklamation der Ersten Tschechoslowakischen Republik fordert Tomáš Garrigue Masaryk (1918–35 Staats-Präs.) E. Čermák zur Rückkehr auf, um beim Aufbau der Tschechoslowakischen Presseagentur mitzuwirken. 1919 übersiedelt die Fam. nach Prag, wobei auch der größte Teil von Ch.s Œuvre nach Tschechien gelangt. – Zu Lebzeiten ist Ch. v.a. als Porträtistin anerkannt. Sie malt aber auch kleinformatige, farblich harmonische Landschaften. In ihren Bildern geht sie ungezwungen mit den malerischen Gestaltungsmitteln und akad. Konventionen um. Schon lange frei von der Starre des naturalistischen Objektivismus ihres Lehrers J. Věšin, pflegt sie eine an Nuancen, Vitalität und Sinnlichkeit reiche Freilichtmalerei. Im

Unterschied zu den männlichen Portr., meist von prominenten Persönlichkeiten, sind die Frauenbildnisse wenig repräsentativ, dafür voll von innerer Wärme und femininer Melancholie, von subtilem Reiz und leichter Eleganz und drücken die differenzierte Gefühlswelt der Dargestellten aus (*Portret na japonez*, 1905; *Portret na profesor d-r Dimităr Michalčev*, ein bek. bulg. Philosoph und Diplomat, 1910; *Damski portret*, Verbleib unbek.; *Portret na gospožica Olga de P.*, Verbleib unbek.; *Zales krei rekata*, Privat-Slg). ▭ SOFIA, Nat. KG. ◉ *E:* 2009 Prag, Salon der Tschech. Akad. der Wiss. (Retr. mit Werken von E. Konsulova-Vazova; K). – *G:* 1906 Sofia: Ausst. des Verb. südslawischer Künstler LADA. ▭ *Toman* I, 1947 (s.v. Čermáková, Aneta); EIIB III, 2006 (abweichendes Geburtsjahr). – *I. Michalčeva*, Portretăt v bălgarskata živopis, I, Sofija 1968; *M. Georgieva*, Jubilejna izložba Săjuzăt na Južnoslavjanskite Chudožnici „Lada" (1904–1912). Bălgarskoto izkustvo na južnoslavjanskite izložbi (K), Sofija 1994; *R. Marinska/P. Štilijanov* (Ed.), Sofija – Evropa. Bălgarskata živopis (1900–1950) v konteksta na evropejskoto izkustvo (K), Sofija 1999; *M. Georgieva*, Južnoslavjanski dialozi na modernizma, Sofija 2003; Magnetičnite ženi v bălgarskoto izkustvo, in: Kultura (Sofija) v. 1. 12. 2006; *R. Marinska*, V pamet na Aneta Chodina (1878–1941), in: *M. Černý/D. Grigorov* (Ed.), Úloha české inteligence ve společenském životě Bulharska po jeho osvobození, Praha 2008; *Z. Popov/R. Marinska* (Ed.), A. Ch.-Čermakova 1878–1941 i bălgaro-češkata vzaimnost (K), Praga 2009; *L. Solenkova* (Ed.), Ženata kato fenomen v bălgaro-češkata vzaimnost (sredata na XIX – sredata na XX v.), Beil. in: Bălgari (Praha) 2011 (5/6). S. Jähne

Chodurski, *Jerzy*, poln. Glaskünstler, Bühnenbildner, Graphiker, Fotograf, * 9. 9. 1942 Zakopane, lebt in Wrocław. Stud. ebd.: bis 1970 Państwowa Wyższy Szkoła Sztuk Plastycznych (heute ASP), bei Stanisław Dawski. Seit 1971 Lehrtätigkeit ebd. (seit 1995 Prof.). Ausz.: 1982 und '86 Abb. von Werken in der New Glass Review des Mus. of Glass, Corning/N. Y. – In den 1970er Jahren in den Glashütten in Polanica-Zdrój und Stronie Śląskie tätig; dort u.a. Gefäße aus Fadenglas sowie skulpturale Glasobjekte, z.B. die Zyklen *Głowy* und *Popiersa*. Ende der 1970er Jahre erste Experimente mit versch. Schmelz- und Farbglasurtechniken; als erster poln. Künstler fertigt C. mittels Fusing-Technik vollplastische Skulpturen. In den 1980er Jahren u.a. eine Reihe von Glasfenstern, für die er zunächst Glasplatten kalt verleimt und danach im Brennofen verschweißt. Im gleichen Verfahren auch Gefäße und abstrakte Skulpt., häufig mit versch. Struktureffekten; am bekanntesten ist die Werkgruppe *Anioły*, abstrahierte, aus versch., meist geometrischen Glaselementen zusammengesetzte Engelsfiguren, teils mattiert und glasiert, z.B. *Anioł lotny* (2004). In den letzten Jahren u.a. Arbeiten in Pâte-de-verre-Technik. Des weiteren Bühnenbilder für Puppentheater, u.a. in Wrocław und Łódź. Außerdem Graphiken, Fotogr. und Ill., u.a. in: *M. Maliński*, Idę do Ciebie, Wrocław 1984. ▭ JELENIA GÓRA, Muz. Karkonoskie. WROCŁAW, MN. ◉ *E:* 1975 Kłodzko, Gal. BWA / Wrocław: 2004 BWA Gal. Szkła i Ceramiki (K);

2010 Gal. Domus. – *G:* 1979 Katowice: Ogólnopolska Wystawa Szkła Artystycznego i Użytkowego (K) / Jelenia Góra: 2001 Muz. Okręgowe: Polskie szkło współcześnie ostatniej dekady XX wieku (K); 2009 Muz. Karkonoskie: Unikaty, Szkło polskie XXI wieku (K) / 2005 Poznań, MN: Szkło zbliża (Wander-Ausst.) / 2007 Bolesławiec, Muz. Ceramiki: Szklany Depozyt Wyobraźni / 2009 Częstochowa, Muz.: Sztuka Młodej Polski, Młoda Polska Sztuka / Wrocław: 2010 Teatr Lalek: Oblicza lalek; 2011 BWA Gal. Szkła i Ceramiki: Po setce. 100 lat ZPAP 1911–2011 / 2011 Jablonec na Niscu, Gal. N: Made in Wrocław (Wander-Ausst.) / 2012 Rzeszów, BWA: Wrocław = Szkło. ▭ Ceramika i szkło polskie XX wieku (K MN), Wr. 2004; *A. Maksymiak*, Dla jednego gestu. Scenografia we Wrocławskim Teatrze Lalek, Wrocław 2006.
 J. Niegel

Chodželani, *Leo Germanovič* (Khodzhelani, *Leo*; Khojelani, *Levan*; Xoǰelani, *Levan*), georgischer Maler, Kunsthandwerker, * 11. 12. 1934 Lagami/Mestia, † 23. 11. 2009 ebd. Stud. in Tbilisi: 1954–60 KSch; 1961–68 KA (künstlerische Glas-Gest.). Die mehrfach preisgekrönte, urspr. im Mus. der Akad. bewahrte Dipl.-Arbeit (mehrteiliges Ensemble von Glasobjekten) geht in den Unruhen der ethnischen Konflikte in Georgien A. der 1990er Jahre verloren und gilt seither als verschollen. 1968 begründet Ch. in Mestia die erste KSch der Region Swanetien und bleibt dort bis um 1976 einer der einflußreichsten Lehrer. Ab 1970 Mitgl. des Künstler-Verb. der Grusinischen SSR. Nach 1976 bis 2005 in Tbilisi tätig. Danach Rückkehr in den Geburtsort Lagami und bis zum Tod 2009 erneut Doz. an der KSch in Mestia. – Eine präzise Dokumentation der zahlr. Beteiligungen an Republik- und Allunions-Ausst. sowie ausgedehnter Studienreisen und der damit verbundenen offiziellen Anerkennungen durch Dipl. und Ausz. ist nach der Zerstörung des Arch. des Künstler-Verb. der Grusinischen SSR im georgischen Bürgerkrieg kaum noch möglich. Dennoch belegt v.a. die Bewahrung der Werke in Mus. und Privat-Slgn Swanetiens die exemplarische Bedeutung des Œuvres für die Region. Zunächst auf Glaskunst spezialisiert (v.a. meisterliche Beherrschung von Prägetechniken), widmet sich Ch. hauptsächlich der Malerei. Neben Stilleben, Portr. und Genreszenen stehen hier v.a. Lsch.- und ländliche Archit.-Motive im Vordergrund, bes. jahreszeitliche Impressionen in neusachlich interpretierter akad. Auffassung (*Zima*, Öl/ Holz, 1981), zunehmend auch stark farbig akzentuierte Archit.-Details (mehrfach ausschnitthafte Darst. der für die Region typischen Wehrtürme mit reduzierter menschlicher Staffage), die im flächigen Aufbau der Komp. sowohl regionale Volkskunst-Trad. als auch die freie Verarbeitung von Natur- bzw. Formerleben in der Malerei der europ. klassischen Moderne aufrufen. ▭ MESTIA, Mus. für Volkskunde und Gesch. Swanetiens. TBILISI, NM. ▭ *V. Beridze/N. Ezerskaja*, Isk. sovetskoj Gruzii 1921–70, Mo. 1975; IIN SSSR IX. 2, 1984. – Mitt. M. Chodželani. S. Görke

Chodzko, *Adam*, brit. Konzeptkünstler, Fotograf, Filmemacher, * 1965 London, lebt in Whitstable/Kent. Sohn

des Schauspielers Joseph C. Stud.: 1985–88 Univ. of Man-chester (Kunstgesch.); 1992–94 Goldsmiths College, Lon-don (Kunst). Ausz.: 1998 Brit. School, Rom, Stip.; 2002 Paul Hamlyn Award. 2010 Artist in Residence Cove Park, Cove/Argyll and Bute. – Träume, Rituale, Glaubenssys-teme oder das zwischenmenschliche Verhalten bilden C.s nahezu anthropologen Ansatz, mit dem er das eigentlich Unbeschreibbare und Sublime visualisieren will. Häufig basieren die konzeptionellen Kunstprojekte (Video, Instal-lation, Performance, Zchngn, Dokumentarfim) auf parado-xen Studien, in denen er zunächst naiv oder absurd erschei-nende Fragen an bestimmte Bevölkerungsgruppen stellt. Für den *God Look-Alike Contest* (1992–93) sucht C. durch Inserate in Londoner Ztgn und Mag. nach Personen, die denken, wie Gott auszusehen (ebenso *Internat. God Look-Alike Contest*, 1996). In der Londoner Saatchi Gall. präsen-tiert er anschl. ausgesuchte Portr.-Fotogr. sowie die origi-nalen Inserate und fordert die Betrachter auf, in den Ge-sichtern das Ebenbild Gottes zu entdecken. Zumeist filmt bzw. dokumentiert er mit ironischem Unterton Antwor-ten, so z.B. im Video *Nightvision* (1998, London, Tate) zur Frage, wie Lichttechniker den Himmel erleuchten würden, von ersten Ideen bis zu deren Umsetzung. C. befaßt sich mit der Veränderlichkeit der Welt und Gleichzeitigkeit von Ort und Zeit, wie z.B. in der Installationsserie *Better Sce-nery* (2000, Tate; 2001; '02) mit jeweils einem Paar von an zwei unterschiedlichen Orten aufgestellten Plakatwänden, auf denen die Wegbeschreibung zu der jeweils and. Pla-katwand zu lesen ist. Er übernimmt ferner Aufträge von Mus. und Organisationen (*Us and Them*; *Pyramid*, bei-de 2009). ⌺ AUCKLAND, City AG. BOLOGNA, MMA. EASTBOURNE, Towner AG. FARGO/N. D., Plains AM. LON-DON, Arts Council. – Brit. Council. – Brit. Film Inst. – Contemp. Art Soc. – Saatchi Coll. – Tate. MONTPELLIER, FRAC Languedoc-Roussillon. TURIN, Gall. d'arte moder-na. ◉ *E:* London: 1996 Lotta Hammer; 1997 Anne-xed: Recall – Strange Child (Installation); 1998 Camden AC; 2002–03 Cubitt Gall. and Studio / 1998 Bradford, Univ., Gall. II. (Wander-Ausst., K) / 1999 Birmingham, Ikon Gall. (K) / 2000 Rom, Acad. Britannica / 2001 Ve-nedig, Sandroni Rey Gall. / 2002 Phoenix, Arizona State Univ.; Brighton, Fabrica Gall. / 2003 Canterbury, Herbert Read Gall. (K) / 2007 Malmö, Signal; Dublin, City Gall. The Hugh Lane; Bologna, MMA (K) / 2008 St. Ives, Tate (K) / 2010 Athen, Siakos, Hanappe / 2011 Frankfurt, Neue Alte Brücke. ⌺ *Delarge*, 2001; *Buckman* I, 2006. – Sen-sation. Young brit. artists from the Saatchi coll., Lo. 1997; *J. Slyce*, Flash art internat. 32:1999 (Okt.) 120 s.; *M. Bra-cewell/J. Higgie* (Ed.), A. C., Lo. 1999; *M. Carboni*, Art-forum 38:2000 (8) 149; *J. Jones*, Frieze 52:2000 (Mai) 95; A. C. Plans and spells, Lo. 2001; *I. Hunt* (Ed.), Roma-nov. A. C., Lo. 2002; *D. Smith*, Art monthly 263:2003, 29 s.; A. C. Whitstable Interiors, Whitstable 2003; *M. Bird*, Mod. painters 2003 (Frühjahr) 116; *M. Beasley*, Frieze 82:2004 (April) 84 s.; *S. Neubauer* (Ed.), Documentary creations (K Luzern), Ffm. 2005; *T. Dean/J. Millar*, Ort (Art works), Hildesheim 2005; *R. Ainley*, A. C. Then, Dub-lin 2008; *N. A. Kelly*, Art monthly 315:2008 (April) 30

s.; *D. Barrett*, ibid. 318:2008 (Juli) 1–6; *S. Thorne*, Frieze 117:2008 (Sept.) 186 s.; *P. Lutz/K. Vogel* (Ed.), Kraftwerk Religion (K Dt. Hygiene-Mus.), Göttingen 2010. – *Online:* Website C. H. Stuchtey

Choé → **Chí,** *Nguyễn Hải*

Choe, *David,* US-amer. Street-art-Künstler, Graphiker, Illustrator, Comiczeichner, Maler, Musiker, * 1976 Los Angeles/Calif., lebt in New York. Ausb.: 1998–2000 Cal-ifornia College of Arts and Crafts, Oakland (Kunsthand-werk). C., koreanischer Herkunft, wird als Jugendlicher in Los Angeles von rassistischen Vorbehalten gegenüber Ein-wanderern geprägt. Als Teenager beginnt er aus Zorn dar-über mit dem Sprühen von Graffiti. 1996–98 unternimmt er seine erste große Reise u.a. in Krisenregionen (Gaza-streifen, Kongo, Vietnam), auf der er großflächige „mu-rals" sprüht. – C.s graph. und malerisches Werk auf Lw., Holz und Papier ist von der Graffitikultur inspiriert und ist dabei immer stark autobiogr. geprägt. Ungehemmt mixt und zitiert C. versch. Vorbilder (u.a. Robert Rauschen-berg, Barron Storey), Medien und Mat., v.a. dokumen-tiert er als ständig Reisender seine Obsessionen (Comic, Kriminalität, Essen, Sex, Körpersäfte) u.a. in dem Buch *Cursiv. Giant Robot presents a book of dirty drawings* (2003) oder dem Gem. *Between Incestual Lovers* (2009). C.s grimmige Bildsprache will provozieren, es geht brutal, anarchisch, rebellisch, chaotisch, bei Kunstzitaten biswei-len hintergründig witzig zu. Eine viermonatige Einzelhaft 2004 in Tokio beschreibt C. als lebensveränderndes Ereig-nis, das er mit Zchngn aus Soja-Sauce und Urin u.a. in sei-ner Ausst. *Tokyo Prison Art* (2005) künstlerisch umsetzt. C. arbeitet als Illustrator für versch. Mag. und führt Auf-tragsarbeiten aus (u.a. für Marvel Comics, Levi's, IBM, Nike). – Künstlerbücher: *Slow Jams* (1996); *Bruised Fruit* (2002). ◉ *E:* 2003, '06 San Jose (Calif.), Gall. Anno Domini / New York: 2005 Powerhouse Gall.; 2007 Jona-than Levine Gall. – *G:* 2008 Walsall (West Midlands), The New Art Gall.: Outsiders (K). ⌺ BLK/MRKT Gall. one, B. 2006. – *Online:* Website C. S. Prou

Chöpel (Choephel; Chöpel Amdo), *Gendün (Gendun)*, tibetischer Maler, Zeichner, Historiker, Autor, Mönch, * 1905 Rebgong/Prov. Qinghai (tibetisch: Amdo), † Okt. 1951 Lhasa. Als Künstler Autodidakt. In jungen Jahren Eintritt in das Kloster Labrang (ab 1927 in Drepung). C. erhält die der buddh. Gelug-Schulrichtung entsprechen-de Ausb., die er jedoch aufgrund seines rebellischen Char. und seiner kritischen Reflektionsfähigkeit 1934 vorzeitig abbricht. Seinen Lebensunterhalt verdient C. durch trad. Thangka- (Rollbild-)Malerei. Er ist jedoch auch offen für nicht-relig. Kunst und stellt unter dem Einfluß westlicher Kunst mit großem Erfolg lebensechte Porträts her. 1934 begleitet er den indischen Gelehrten Rahul Sankrityayan auf einer Forsch.-Reise durch Tibet und Nepal. Ab 1935 verbringt er als Pilgerreisender zwölf Jahre in Indien und Sri Lanka. Dort trifft er einflußreiche Intellektuelle und setzt sich mit westlichem und indischem Modernismus auseinander. Sein hist., lit., politisches und künstlerisches Interesse schlägt sich z.B. in zahlr. Übersetzungen ins Ti-betische wie im Verfassen eig. Schriften (z.B. eines Reise-

führers durch Indien) nieder, die zur Aufklärung und Modernisierung der in Trad. erstarrten tibetischen Landsleute beitragen wollen. Sein kritischer, unkonventioneller Geist stößt auf harte Kritik im tibetischen Establishment. 1945 ist er an der Gründung der Tibetischen Fortschrittspartei beteiligt, die eine Demokratie anstrebt und deren Logo er entwirft. Deshalb wird er 1946 nach seiner Rückkehr in Tibet verhaftet und unter and. Vorwänden bis 1949 in Haft genommen. Zwei Jahre später stirbt er verwahrlost. – C.s aufklärerisch inspirierte Vorreiterrolle bezieht sich auch auf seine künstlerische Produktion, so daß er durch die Hinwendung zu weltlichen Themen und Stilen als Pionier der mod. tibetischen Kunst gilt, obwohl das erh. Œuvre von so geringem Umfang ist, daß detaillierte Werkcharakteristiken schwer fallen. Sein Skizzenbuch (Priv.-Slg Nachlaß Gustav Roth) enthält etwa reduzierte, flüssige und schwungvolle Darst. mit wenigen Strichen, die kalligraphisch beeinflußt scheinen. Die u.a. auf Reisen angefertigten Aqu. und Skizzen (u.a. heute in tibetischer Priv.-Slg Pema Byams in Gtsos/Prov. Gansu; versch. Mat. auch in der Libr. of Tibetan Works and Arch., Dharamsala) zeichnen sich durch einen klaren und direkten Blick auf den Menschen und seine Lebensumwelt und eine große sinnliche Zugewandtheit aus. – Die 2003 gegr. G. C. Artists' Guild bezieht sich hinsichtlich ihres Namens und Programms auf ihn. Vielen tibetischen Intellektuellen, Künstlern und Literaten gilt C. bis heute als Vorbild. ✉ The white annals, Dharamsala 1978; Tibetan arts of love. Sex, orgasm & spiritual healing, Ithaca 1992; Guide to sacred places in India, Wa. 1997; The guide to India. A Tibetan account, Dharamsala 2000. ⌑ *C. Harris*, In the image of Tibet. Tibetan paint. after 1959, Lo. 1999; *H. Stoddard*, Le mendiant de l'Amdo, P. 1986; *E. Hessel*, Die Welt hat mich trunken gemacht. Die Lebens-Gesch. des Amdo G. C., B. 2000; *R. Höfer*, G. C. Patre of Tibetan modernism, in: *A. B. Renger/J. H. Lee-Kalisch* (Ed.), Meister und Schüler. Master and disciple. Trad., transfer, transformation, Weimar 2012.

R. Höfer

Choi, *Wook-kyung,* koreanische Malerin, * 1940 Seoul, † 1985. Bereits als Kind Unterricht bei bek. Künstlern wie Kim Ki-chang und Park Re-hyun. Stud.: Seoul Nat. Univ. (College of FA); ab 1963 Cranbrook Acad. of Art in Detroit. Ab A. der 1970er Jahre Interesse für trad. koreanische Folkloremalerei. 1976 Residenz-Stip. des Roswell Mus. & AC (Roswell, N. Mex.). Lehrtätigkeit: ab 1978 Yeongnam Univ. in Gyeongsan; ab 1981 Duksung Women's Univ. in Seoul. Zahlr. Reisen durch Korea. 1985 Tod durch Herzinfarkt. – Aufgrund ihres unabhängigen Lebensstils und ihres Werkes gilt C. heute als wichtige Pionierin post-mod. weiblichen Kunstschaffens in Korea. Ihr Werk der Frühphase ist vom amer. Minimalismus und der Farbfeldmalerei geprägt (*Curiousity*, 1972; NMCA, Gwacheon). Daneben Experimente mit Collagen (*Experiment No. 2* , 1968; NMCA). In den 1970er Jahren Hinwendung zum abstrakten Expressionismus (v.a. Öl/Lw.). Char. sind in dieser Zeit dynamische Formen, grelle Farben und rasante Linien. Ihre systematische Beschäftigung mit Farben und Komp. führen in der Folge zu einem lyrischen Expres-

sionismus mit transluzenten, reinen Farben und rhythmischen Bildfeldern (*Unfinished Story*, 1977; NMCA), die suggestiv an Vögel, Fische, Blumen und Lsch. erinnern. Weiterhin einige Mehrfeldbilder, die sich durch ovale oder halbkreisförmige Komp. auszeichnen (*Love in the Egg*). In den 1980er Jahren entstehen Bild-Lsch., die mit ihren floral-organische Formen erotische Wahrnehmungen evozieren (*Beginning of the opening*, 1978; NMCA) und als Symbole weiblicher Identität sowie Freiheit gedeutet werden können. Häufige Verwendung der Farbe Rot. ⌂ GWACHEON, Nat. MCA. GYEONGJU, Artsonje Mus. ROSWELL/N. Mex., Mus. & AC. SEOUL, Hoam AM. – Samsung Mus. of Art Leeum. ◉ *E:* 2005 Seoul, Kukje Gall. (K). – *G:* Seoul: Hyundai Gall.: 2003 Prince and Princess (K); 2010 In the Midst of the Korean Contemp. Art / 2011 Deoksugung, Nat. MCA: Abstract it! (K) / 2007 Gwacheon, Nat. MCA: Noah's Ark (K) / 2008 Oakland, Mills College AM: The Offering Table. Women Activist Artists from Korea (K) / 2010 Gyeongju, Artsonje Mus.: The Vision of Contemp. Art (K). ⌑ *D. Dysart/H. Fink*, Asian women artists, Roseville, N. S. W. 1996; *Y. Kim*, Mod. and sontemp. srt in Korea, Seoul 2005.

A. Papist-Matsuo

Choi *Yan-chi* (Choi Yau-chi; Cai Renzi), chin. Malerin, Performance-, Environment- und Installationskünstlerin, Kunsterzieherin, Kuratorin, * 1949 Hongkong, lebt dort. Verh. mit dem Maler und Graphiker Hon Chi-fun. Stud.: 1967–69 Northcote College of Education, Hongkong; 1969–70 Grantham College of Education ebd.; 1973 Columbus College of Art and Design, Columbus/Ohio; 1974–78 Art Inst. of Chicago (MFA). Ausz. u.a.: 1989–91 Fellowship of Asia Cult. Council; 1992 Artist in Residence Heinrich-Böll-Stiftung, Berlin; 1994 Artist Grant, Ontario Art Council; 1998 Artist of the Year, Hongkong Arts Development Council. Lehrtätigkeit in Hongkong: 1978–86 Hongkong Polytechnik; 1985–93 Arts and Acad. of Performing Arts, School of Technical Arts; 1998–2003 Inst. of Vocational Education (Design Dep.); seit 2003 Baptist University. Lebte 1993–97 in Toronto. Seit 1998 Vorstands-Vors. der von ihr mitbegründeten bed. alternativen Non-profit-Kunst-Organisation „1A Space Hongkong". Als Beraterin in öff. Kunstgremien und als Kuratorin tätig. Gelegentliche Zusammenarbeit mit ihrem Ehemann. – C. vertritt seit den 1970er Jahren (Einfluß der Fluxus-Bewegung in Chicago) eine vielseitige und experimentell-konzeptuelle Kunstpraxis. In den frühen 1980er Jahren leistet sie mit ihren innovativen Arbeiten und Aktionen einen wichtigen Beitr. zur Entstehung der offiziell nicht anerkannten und stark marginalisierten avantgardistischen Kunst- und Kulturszene Hongkongs. Seither ist sie als Künstlerin, Kunsterzieherin und Kuratorin eine wichtige Vertreterin und Förderin der dortigen Gegenwartskunst. In ihren häufig stark emotional geladenen Arbeiten, die alle Medien umfassen (Malerei, Fotogr., Installation, Performance, Graphik), setzt sich C. vorwiegend mit Hongkongs politischer und sozialer Identität, der Bürde der Trad. und dem Konzept „Chineseness" sowie internat. politischen Fragestellungen auseinander. Zu

ihren bek. Arbeiten – alle immer wieder neu inszeniert und inhaltlich erweitert, zuletzt anläßlich ihrer Retr. 2006 in Hongkong – gehören *Dongxi youxi*/Object-activity (Performance, 1989) und *Chenni*/Drowned (Serie von Mixed-media-Installationen, 1989–97), beide urspr. mit Bezügen zur Protestbewegung und zu dem Massaker auf dem Tiananmen-Platz (Beijing) im Juni 1989 sowie *Si qian xiang hou*/Past and Future (Mixed-media-Installationen, 1997–2000), urspr. ein Kommentar auf die Misere des Hongkonger Erziehungssystems. ⌂ HONGKONG, AM. – Heritage Mus. ◉ *E:* Hongkong: 1979, '80, '85 AC; 1986 Hongkong Univ.; 2006 Para/Site Art Space und 1A Space (Retr.; K) / 1979 New York, Asia American AC / 1993 Berlin, Haus der Kulturen der Welt (K) / Toronto: 1994 Mercer Union Gall.; 1995 Red Head Gall. / 2008 Los Angeles, Lindhurst Gall. – *G:* u.a. Hongkong: AC: 1983 Into the 80s; 1985 10 Years of Hongkong Paint.; 1989 Turn of the Decade; AM: 1992 City Vibrance; 2000 Contemp. Hongkong Art / 1993 Brisbane, Queensland AG: First Asia-Pacific Trienn. / 1997 Frankfurt am Main, MAK: Verpachtetes Erbe / 1998 Taipei, Taipei County Cult. Center: River. New Asian Art. A Dialogue in Taipei / 1999 Taipei, Damen Art Found.: Bad Rice (Wander-Ausst.). ▭ *M. Sullivan*, Mod. Chin. artists, Berkeley u.a. 2006 (s.v. Cai Renzi). – An exhib. into space, Hong Kong 1986; C. paint. 1976–1986, and works of art in dialogue with poetry and dance, Hong Kong 1987; Raumfarben (K Berlin), St. 1993; *S. McIntyre*, Art Asia Pacific 19:1998, 68–73; Space and passion. The art of C., Hong Kong 1998; Books are breathing. C.s installation series 1989–1998, Hong Kong 1999; Behind the eyeballs, Hong Kong 2000; *L. Lai* (Ed), [Re-]Fabrication. C.s 30 years, paths of interdisciplinarity in art (K), Hong Kong 2006.

K. Karlsson

Choiselat, *Marie-Charles-Isidore (Charles)*, frz. Daguerreotypist, * 13. 2. 1815 Paris, † 20. 12. 1858 ebd. Assoziiert mit dem frz. Daguerreotypisten *Stanislas (Frédéric Patrice Clément Marie Stanislas) Ratel* (* 20. 3. 1824 Paris, † 30. 8. 1904 Saint-Hilaire-le-Châtel/Orne). C. ist Sohn des Bronzegießers und Ziseleurs Louis-Isidore C. und seiner Frau Ambroisine Gallien. Wie eine gemeinsame Mitt. mit Paul Pretsch an die Acad. des Sciences über ein Verfahren zur Fixierung von Daguerreotypien von A. 1840 belegt, befaßt er sich vermutlich bereits seit 1839 mit der Daguerreotypie (cf. Bajac, 2003). Bajac vermutet angesichts seiner hervorragenden Kenntnisse auf diesem Gebiet, daß C. von Beruf Chemiker war. Ratel besucht 1842–46 die Ec. r. des mines, Paris (Dipl.); 1850 heiratet er C.s Schwester, Marie Ange Zoé. C. lernt den späteren Schwager möglicherweise über das gemeinsame Interesse an der Alchemie kennen. Zw. 1840 und 1849 experimentieren sie gemeinsam mit dem neuen Verfahren der Daguerreotypie und tragen wesentlich zu dessen Verbesserung bei (cf. Bajac, 2003, und Hannavy, 2008); 1843 erhalten sie dafür eine Med. der Soc. d'encouragement à l'industrie nationale. 1848 siedelt Ratel nach Tours um, wo er bis 1894 als Ingenieur für die Eisenbahn-Ges. Paris-Orléans arbeitet. Anschl. setzt er sich im Château de Mauregard in Saint-Hilaire-le-Châtel

b. Mortagne-au-Perche/Orne zur Ruhe. In Tours beschäftigt sich Ratel auch mit Archäologie und macht sich u.a. um die Wiederentdeckung der alten Basilika und des Grabes vom Hl. Martin verdient. – C. und Ratel zählen zu den Pionieren der Daguerreotypie in Frankreich. Ihre frühesten bek. Aufnahmen, Ansichten des Hafens von Le Tréport/Seine-Maritime, stammen aus der Zeit um 1842. Ab Herbst 1845 bereisen sie anläßlich des Stud.-Abschlusses von Ratel zus. mit zwei Kommilitonen der Ec. r. des mines für dreieinhalb Monate die Auvergne, die Alpen und Südfrankreich, um den Stellenwert der Daguerreotypie für die Disziplinen Geografie, Geologie und Archäologie unter Beweis zu stellen. Auf dieser Rundreise entstehen Ansichten der Stadt Die/Drôme, der Alpen und mehrerer Hafenstädte wie Marseille, Séte/Hérault und Toulon/Var sowie Aufnahmen von Baudenkmälern in der Provence (z.B. die Arena von Nîmes/Gard, das Amphitheater von Arles und die Kathedrale von Rodez/Aveyron); viele dieser Ansichten gestalten sie als jeweils aus mehreren Platten zusammengesetzte Panoramen. Dieses Konvolut bildet den Großteil der nur knapp 30 erh. Daguerreotypien. Neben den Lsch.- und Archit.-Aufnahmen sind auch zwei Selbst-Portr. der beiden bek. (jeweils Mus. Carnavalet, Paris). Die letzte erh. Arbeit stammt aus dem Jahr 1849 (*Le Pavillon de Flore et le Jardin des Tuileries*). Für die Zeit danach existiert bislang kein Nachweis weiterer Tätigkeit im Bereich der Daguerreotypie. – Im ersten Jahrzehnt des neuen Bildmediums hoch geschätzt, geriet das Werk von C. und Ratel zwischenzeitlich in Vergessenheit, so daß ihre Arbeiten in den 1980er Jahren verschiedentlich dem gemeinsamen Schwager François Adolphe Certes zugeschr. wurden. ⌂ ARLES, Mus. Réattu. BIEVRES, Mus. franç. de la Photogr. KÖLN, Mus. Ludwig, Slg Agfa. LOS ANGELES/Calif., J. Paul Getty Mus. MONTREAL, Canad. Centre for Archit. NEW YORK, Metrop. Mus. PARIS, Mus. Carnavalet. – Orsay. ◉ *G:* Paris: 1843 Expos. des Produits de l'Industrie de Paris; 1989–90 Mus. Carnavalet: Paris et le daguerréotype (K); 1999–2000 Maison Europ. de la Photogr.: Une passion française. Photogr. de la coll. Roger Therond (K) / 1989 Erlangen, StG: Die Pioniere der Photogr. 1840–1900 (Wander-Ausst.; K; s.v. Certes, François-Adolphe) / 1993 (The Waking Dream. Photogr.'s First Century. Selections from the Gilman Paper Company Coll.; Wander-Ausst.; K), 2002 (Gilman Gall.: As it Happens) New York, Metrop. Mus. / 1996–97 Köln, Agfa-Foto-Historama im Wallraff-Richartz-Mus., Mus. Ludwig: Alles Wahrheit! Alles Lüge! (s.v. Certes, F.-A.) / 1997–98 Ottawa, NG of Canada: Photogr. et science. Une beauté à découvrir (K) / 2011 München, SM, Slg Fotogr.: Industriezeit Fotogr. 1845–2010 (Wander-Ausst.; K). ▭ *J. Hannavy* (Ed.), Enc. of nineteenth-c. photogr., I, N. Y./Lo. 2008 (Lit.). – *J. Wood*, The scenic daguerreotype. Romanticism and early photogr., Iowa City, Ia. 1995; Arles & la photogr. Portr. de la coll. du mus. Réattu (K), Arles 2002; *Q. Bajac*, C. et Ratel. Une décennie de daguerréotypie. In: Rev. de l'art 141:2003, 31–38; *Q. Bajac/D. de Font-Réaulx* (Ed.), Le daguerréotype français. Un objet photogr. (K Paris/New York), P. 2003 (Lit.; Ausst.); *R. Perret*

(Ed.), Kunst und Magie der Daguerreotypie (K Winterthur), Brugg 2006. – *Online: M. Parise*, Visages „mangés" par les détails. Réflexions autour d'une double rhétorique de la ressemblance aux débuts de la photogr., in: Images re-vues 2006 (3). P. Freytag

Choisy (C., *Claude*; eigtl. Pautré, *Claude*), frz. Bildhauer, Restaurator, * zw. 1744 und 1748 Paris, † Mai oder Juni 1795 ebd.(?). Entstammt einer Fam. aus Soisy sous Etiole (heute Soisy-sur-Seine/Essonne), leitet sein Pseud. wahrsch. von diesem Ortsnamen ab und ist vermutlich verwandt mit den ebenfalls Choisy gen. Malern *Joseph Pautré* (* um 1744 Paris, † 9. 11. 1815 [71jährig] ebd.) und *Joseph Etienne Pautré* (* um 1783, † 23. 11. 1815 [32jährig] Paris). Nach eig. Angabe lernt C. im Alter von 12 oder 13 Jahren auf Reisen England, Holland und Flandern kennen. Stud.: Acad. r. de Peint. et de Sculpt. in Paris, wahrsch. ab 1765 bei Jean-Baptiste Pigalle, 1770 bei Augustin Pajou. Geht anschl. nach Rom, wo er lt. Aussage seines späteren Schwiegervaters, des Malers Filippo Fidanza, im Nov. 1771 eintrifft, eine Tätigkeit in dessen Atelier aufnimmt und am 27. 7. 1774 die Tochter Maria Fidanza (* 1746, † 18. 7. 1789 Rom) heiratet. C. verkehrt dort mit zahlr. angesehenen Künstlern, u.a. mit dem Architekten Charles Percier und dessen Bekanntenkreis; um 1787 stattet er zus. mit dem Bildhauer Christopher Hewetson einen Atelierbesuch bei Antonio Canova ab. Eine bes. enge und anregende Freundschaft verbindet ihn mit dem frz. Architekten Léon Dufourny, der ab 1785 in der Nähe von C.s Wohnung lebt, wo sich dieser größtenteils der Rest. antiker Skulpt. widmet. Aus der umfangreichen, minutiös geführten Korr. mit Dufourny während dessen Aufenthalt auf Sizilien 1789–93 geht hervor, daß C., der sich sehr für ma. Kunst interessiert, eigenhändig rest. Skulpt. aus dieser Zeit zumeist an engl. Sammler verkauft und zahlr. Aufträge von Dufourny erhält, v.a. zur Rest. von Abgüssen nach Antiken aus Rom und Tivoli. 1790 wird C. von letzterem nach Palermo gerufen, um die Außenwände eines Gewächshauses (des Lehrgebäudes), in dem von Duforuny erb. Botanischen Garten (Orto Botanico), mit Stuckbasreliefs der Tierkreiszeichen zu schmücken (vier Stück in situ; Entwürfe nach Zchngn von Dufourny modelliert, die dieser nach Vorlagen aus einem hist. Ms. fertigt). E. 1790 ist C. wieder in Rom. 1792 schickt er dem Architekten Pietro Trombetta nicht näher bez. Gipsabgüsse nach Palermo. Nach der politisch bedingten Ausweisung der Franzosen aus Rom kehrt er 1793 nach Frankreich zurück. 1794 wird C. Mitgl. der Soc. populaire et républicaine des Arts und mehrfach in den Protokollen der Comm. temporaire des Arts und den Reg. des Mus. des Mon. franç. in Paris erw., v.a. im Zusammenhang mit der Rest. antiker Marmorstatuen für den dortigen Tuileriengarten. Unter Ltg des Architekten Auguste Hubert arbeitet er nun wahrsch. noch bis zum Tod als Restaurator. – Von C.s größtenteils verschollenem Œuvre sind einige Werke urkdl. überliefert: Basrelief mit einer Darst. der *Geburt Christi* (1786 in C.s Atelier in Rom präsentiert); mehrere 1790 in Palermo entworfene oder ausgef. Arbeiten: *Medusenkopf* (Marmor; wahrsch. für den Botanischen Garten ebd.); *Löwenmäuler* und *Metopen*; nach Entwür-

fen von Dufourny modellierter Ornamentschmuck wie Fleurons und verschlungenes Bandwerk. Aufgrund dieser Sachlage ist eine stilistische Einschätzung schwierig, und bei den nach strengen Vorgaben und unter Aufsicht von Dufourny gestalteten Basreliefs in Palermo hat C. kaum Spielraum zur Verwirklichung persönlicher Vorstellungen. Ansonsten sind lediglich zwei qualitätvolle, von Pajou beeinflußte spätbarocke Terrakottastatuetten erh. (*Bacchus; Amphitrite*, wahrsch. um 1780; Bayonne, Mus. Bonnat), die auf einen talentierten Bildhauer mit solider akad. Ausb. verweisen, dessen Identität erst vor wenigen Jahren geklärt wurde (cf. Michel, 2005). ⌑ *Lami* I, 1910. – *O. Michel*, BSHAF 2004 (2005), 159–180. – Paris, Arch. nat.: 138 AP (Fonds Daru), Aktenbündel 212 (Korr. mit Dufourny, 1789–93). R. Treydel

Chojna, *Elżbieta (Ela)*, poln. Plakatkünstlerin, Graphikerin, Illustratorin, * 1969 Warschau, lebt dort. Stud. ebd.: bis 1995 ASP, bei Mieczysław Wasilewski (Plakat), Maciej Bustewicz (Typographie) und Lech Majewski (Verlagsgraphik). Stip.: Ec. superieure d'art et design, Amiens; Schule für Gest., St. Gallen; Univ. Veracruzana, Xalapa/Veracruz. 1993–96 für die Werbeagenturen Leo Burnett und DMB & B in Warschau tätig. Seit 1998 Mitarb. in versch. Verlagen. Preise: u.a. 2007 1. Preis beim Ogólnopolski Przegląd Plakatu Muzealnego i Ochrony Zabytków, Przemyśł. – U. a. Plakate für die Gal. Plakatu in Krakau, für Museen und Theater (Teatr Polonia, Teatr Polski und Teatr Współczesny, alle Warschau) sowie zu ökologischen und ges.-politischen Themen, z.B. *The Contemp. Man and the Environment* (2009; 3. Preis auf der Poster-Bienn., Teheran) und *Body Size Discrimination XXS vs XXL* (2010). Häufig als expressive Collagen aus Fotogr. und gerissenem und geschnittenem Buntpapier in kräftigen Farben und starken Farbkontrasten gestaltet; oftmals stilisierte Figuren (Menschen, Tiere) als zentrales Motiv. Daneben Künstlerbücher in ähnlicher Ausf., z.B. *Atlas Psów* und *Smuteczek – Kabaret starszych panów*. Des weiteren Ill. in Kinderbüchern sowie Buchumschläge für belletristische, Sach- und Lehrbücher poln. und internat. Autoren. Außerdem Gest. von Exlibris, Kalendern, Postkarten, Theaterprogrammen, Verpackungen u.ä. sowie Logos für Buchreihen, Firmen und Veranstaltungen. ⌑ COTTBUS, KM Dieselkraftwerk. WARSCHAU, Muz. Plakatu w Wilanowie. ✉ E. B. (Un)limited Posters, Wr. 2006. ◉ E: 2006 Cottbus, Brandenburgische KS (mit Anke Feuchtenberger) / 2008 Warschau, Sushi Café Skorupka. – G: 1995 Turin, Ist. Europeo di Design: Resistenza Resistenze (Wander-Ausst.) / Warschau, Muz. Plakatu w Wilanowie: seit 1996 mehrfach: Międzynarodowe Bienn. Plakatu (alle K); seit 1997 mehrfach: Salon Plakatu Polskiego (alle K); 2001 Gal. Kufcik: Pro Bolonia (K) / 1998 Falun, Dalarnas Mus.: Polska Plakat (K) / 1999, 2001, '05 Katowice, Gal. Sztuki Współczesnej BWA: Bienn. Plakatu Polskiego (alle K) / 1999, 2005 (K) Žilina, Považská gal. umenia: Ekoplagát / 2001, '05 Krakau: Międzynarodowy Festiwal Plakatu / 2000 Toyama, MMA: Internat. Poster Trienn. (K) / 2003, '05 Lahti, KM: Internat. Poster Bienn. (beide K) / 2004, '09 Teheran, MCA: Internat. Poster

Bienn. / 2004 (K), '10 Mexiko-Stadt: Bien. Internac. del Cartel / 2004 (K), '07, '10 (K) Sofia: Meždunarodno Trien. na Sceničnija Plakat / 2008 Paris: 27 graphistes pour l'Europe / 2008, '10 Chicago (Ill.), Internat. Poster Bienn. (beide K) / 2009 Cottbus, KM Dieselkraftwerk: Humor, Plakate aus aller Welt (K) / 2010 Ithaca (Griechenland), Gall. of the Municipality of Ithaca: Look, don't judge. ▫ *B. Martin*, Verlockung. Erotik in der Plakatkunst (K), Cottbus 2005; *M. Kurpik/A. Szydłowska* (Ed.), Plakaty w zbiorach Muz. Plakatu w Wilanowie, Wr. [2008]. – *Online:* Website C. J. Niegel

Chojnacka, *Anna* (geb. Chrzanowska), poln. Fotografin, * 2. 12. 1914 Sosonowiec, † 15. 12. 2007 Katowice, lebte dort. Nach dem 2. WK zunächst Sekretärin, dann Leitcrin dcr Werbe- und Propaganda-Abt. des Verlags Śląsk, wo sie den Fotografen Adam Bogusz und den Kunsthistoriker Alfred Ligocki kennenlernt. Fotografische Ausb. bei Bogusz; in Katowice Teiln. an mehreren von Ligocki gehaltenen Vorlesungen in Kunstgesch. der ASP Krakau. Ermutigt durch Bogusz und Ligocki seit 1952 künstlerisch tätig; erste Fotogr. veröff. in der Zs. Wiadomości górniczych. Mitarb. in weiteren Verlagen, u.a. Wydawnistwo Arkady, Warschau, sowie im Inst. Naukowy, Katowice; außerdem Kunstsachverständige für das poln. Kulturministerium. – Hauptsächlich Schwarzweiß-Fotogr., teils auch als Negativabzug, die das Leben in C.s oberschlesischer Heimat, dem heutigen Górny Śląsk, dokumentieren, u.a. Archit.- und Stadtansichten, insbesondere der Stadt Katowice, Lsch., Industrieobjekte wie Berg- und Stahlwerke sowie Szenen aus dem Arbeitsleben der Bergleute und Alltagsszenen, z.B. *Grube Andaluzja* und *Bergleute vor der Arbeit* (beides Bromsilberabzüge). Häufig thematische Zyklen, teils mit Antikriegs-, ab A. der 1970er Jahre auch mit ökologisch-kritischen Aussagen, z.B. *Teofil Ociepka* und *Wśród plastyków śląskich* (1961), beides Portr.-Serien über schlesische Künstler. Daneben Werbe-Fotografien. Des weiteren Fotobücher, z.B. *Barwy i rytmy Sląska* (Wr. 1967, mit A. Bogusz) und *Piękno polskiej ziemi* (Katowice, 1969). ⌘ KATOWICE, Muz. Hist. – Slg des Związek Polskich Artystów Fotografików (ZPAF), Okręg Sląski. NEW YORK, MMA. ⊙ *E:* Katowice: 1979, '84 (zweimal), '88, 2006 (K) Gal. Katowice ZPAF; 1996 (Retr.), 2003 Muz. Hist. – *G:* Warschau: 1958–64, '74 CBWA: Ogólnopolska Wystawa Fotogr. ZPAF (mehrere Ausz.); 1961, '73 (Silber-Med.) Międzynarodowa Wystawa Fotogr. ZPAF; 1963 (Człowiek w Polce Ludowej; Wander-Ausst.; K), '87 (Krajobrazy świata w fotogr. polskich podróźników; K) Zachęta; 1971 Gal. Współczesna: Fotografowie poszukujący; 2006 Gal. XX1: Miasto binarne, Warszawa Łódź / Katowice: 1960, '68 (Okręgowa Wystawa Fotogr. Artystycznej), '79 (Powstała w polskim krajobrazie), 2006 (Specyfika śląskiego pejzażu; K) Gal. Katowice ZPAF; 2009 Okręg Śląski ZPAF: Listopadowe Zaduszki / 1967 Montréal: Expo / 1970 Ōsaka: Expo. ▫ *Auer*, 1985. – Das poln. Lichtbild, Halle/Wr. 1961; *M. Matusińska* (Red.), A. C. Marek Holzman; Zofia Reydet, Zygmunt Szargut-Szarek. Wystawy fotogr., Wr. 1964; *J. Lewczyński*, Antologia fotografii polskiej 1839–1989,

Bielsko-Biała 1999; *K. Lewandowski* (Ed.), Dokumentalistki. Polskie fotografki XX wieku (K Warschau), Olszanica 2008. – Mitt. Muz. Hist., Katowice. J. Niegel

Chondros (Hondros), *Thanasis (Thanassis)*, griech. Medien-, Performance- und Videokünstler, * 1953 Thessaloniki, lebt dort. Lebens- und Arbeitspartner der Medien- und Konzeptkünstlerin *Alexandra Katsiani* (* 1954 Siatista). Stud.: 1972–76 (Phil.) an der Univ. Thessaloniki. Als Künstler Autodidakt. Seit 1974 lebt er mit A. Katsiani zus., die an derselben Univ. Archäol. und Kunstgesch. studierte. Sämtliche künstlerischen Werke entstehen seitdem gemeinsam, so daß kein jeweils individuelles Œuvre vorliegt. Ihre Arbeiten sind hinsichtlich der Entstehungsprozesse vergleichbar mit denen von Gilbert & George. In ihren Performances und Installationen lassen sie sich von Einflüssen des Fluxus und der Konzeptkunst der 1970er Jahre ebenso leiten wie von dadaistischen Elementen. Immer wieder ist ihre Kritik an der kapitalistischen Konsum-Ges. ein zentrales Anliegen. Eine ihrer ersten Aktionen findet 1980 statt, als sie in Sami/Kefalonia den Verlag Tsaba (griech. „umsonst") gründen, in dem sie drei Bücher über sie inspirierende Künstler (Gilbert & George, Christo, Lüthi), eine Erzählung und ein Gedicht veröffentlichen und anbieten, jedem Interessierten ein Exemplar umsonst (tsaba) zu schicken. In ihren Installationen werden häufig alltägliche Mat. (Papier, Metall, Holz, Stoffe u.a.) mit Gegenständen verbunden, die aus ihrem alltäglichen Kontext gerissen werden; z.B. Fahrräder, deren Gummireifen durch Eis ersetzt sind (*Parembaseon stin Poli*/Interventionen in der Stadt, 1995; Demetria Festival, Thessaloniki). Auch veranstalten sie Performances, die in einer direkten Interaktion des Künstlerpaares mit dem Publikum bestehen, um dieses zu Reaktionen zu bewegen; so reichen sie mit zugeklebten Mündern während einer solchen Aktion den Zuschauern Brotstücke (Symposion der Poesie, Univ. Patras, Juli 1981). Daneben komponieren C. und A. Katsiani elektronische Musik; 1990 erhalten sie eine Ausz. für das Stück *Contrapunto* auf dem Contest of Musical Works for Radio (Spanien). Unterstützt durch Musik und Lichteffekte sollen ihre Arbeiten eine (im Gegensatz zur trad.-musealen Kunst stehende) alternative Ästhetik vermitteln. Ihre Installationen in Mus.-Räumen sind auf Publikumsbeteiligung hin konzipiert, so die Arbeit *To pleonektima afora to melon*/The Advantage Relates to the Future (1996, Thessaloniki, Macedonian MCA): Auf einem hohen Holztisch stehen zwei Bonbongläser, das eine mit frischen, das and. mit zerkauten Kaugummis. Der Besucher soll sich aus dem einen Glas bedienen und den benutzten Kaugummi anschließend in das and. Glas ablegen. Hinterfragt wird mit dieser Arbeit – in der Trad. seit Duchamp – die Ästhetisierung und der Kunst-Char. eines Objektes. Die Reaktionen des Publikums reichten von Zustimmung über Belustigung und Ignoranz bis hin zu offener Feindseligkeit. Sowohl die Künstler als auch ihre Werke sind wiederholt Ziele von Aggression geworden. – Performances u.a. 1989 Stockholm, Kulturhuset (Nostimos Eros); 1995 Florenz: Electronic d'arte (Self portr.); 1996 Thessaloniki, Gal. Alli Poli (51 Saturdays); 2007 Athen: Opa. Internat. Perfor-

mance Festival. ⌂ Thessaloniki, Macedonian MCA.
⊙ *G:* 1989, '92 Budapest: Internat. Trienn. of Patterns /
2005 Florenz, Fond. Fabbrica Europa: The Gesture / 2012
Athen, NM of Contemp. Art: Avto einai ena poima. Oma-
da Optikis Poiisis 1981–2011 [Dies ist ein Gedicht. Grup-
pe Optische Poesie 1981–2011]. ▭ LEK IV, 2000. –
Makedoniko Mouseio Synchronis Technis (K), I, Thessa-
loniki 1999, 452–454 (s.v. Hondros, Thanassis; Lit.).

E. Kepetzis

Chopin, *Florent,* frz. Collage- und Assemblagekünst-
ler, Maler, Graphiker, Illustrator, * 1958 Caen, lebt seit
1994 in Saint-Ouen/Seine-Saint-Denis. A. der 1980er Jah-
re studiert C. zunächst Sozial-Wiss., anschl. bild. Kunst
in Caen. Seit 1986 widmet er sich vorrangig der künst-
lerischen Tätigkeit. Ausz.: 1998 Prix Fénéon. Seit 2006
Mitarb. an der von Künstlern in Saint-Ouen herausgege-
benen Zs. La Fabrique des Icebergs. – Beeinflußt von Sur-
realismus und Situationismus kreiert C. heterogene Komp.
in Collagetechnik, kombiniert mit Acrylmalerei. Neben
Ausschnitten aus aktuellen Ztgn, Zss. und Plakaten ver-
wendet er bevorzugt hist. Mat. (u.a. Aufkleber, Schilder),
welche er v.a. auf Flohmärkten sammelt. Auch für die
Assemblagen nutzt C. solche Fundstücke (u.a. Spielzeug,
Knöpfe, Souvenirartikel) aus den 1950er bis 1970er Jah-
ren, die seinen Arbeiten einen nostalgischen Char. verlei-
hen. Buchstaben und Textfragmente in versch. Sprachen
und Schriftzeichen sind char. Elemente der komplexen Ar-
beiten und geben ebenso wie die anspielungsreichen und
rätselhaften Titel Anreiz zu Assoziationen (z.B. *Les essuie-
glaces de Pandora,* Mischtechnik/Lw., 2010). Durch eine
harmonisch abgestimmte Farbigkeit, die den Werken ei-
nen einheitlichen Char. verleiht, wird die v.a. durch die
Vielzahl der Einzelelemente und deren Kleinteiligkeit her-
vorgerufene chaotisch wirkende Uneinheitlichkeit ausge-
glichen. Zudem entstehen Ill. (z.B. zu N. Jones-Gorlin,
La beauté est dans la rue, P. 2008) und Graphiken (v.a.
Rad., z.B. die Serie *Les fantômes se nourrissent de baies,*
2010). ⌂ Caen, FRAC Basse-Normandie. ⊙ *E:* Pa-
ris: 1993 Gal. L'Usine; seit 2001 regelmäßig Gal. Déprez-
Bellorget / 1996 Aulnay-sous-Bois, Espace Gainville (K) /
1999 Avignon, Gal. Les Teinturiers (K) / 2005 Barcelona,
Gal. Favre / 2009 Sceaux, Gal. Pierrick Touchefeu / 2010
Metz, Gal. Cri d'Art / 2011 Courtenay, Gal. des Ormes
(mit Pierre Yermia). – *G:* 1988 Caen, Théâtre: Dix jeunes
Artistes à découvrir / 1995 Maubeuge, Espace Sculfort:
Repères du Surréalisme / 2000 Montauban, Mus. Ingres:
L'Eloquence des Loques / 2006 Coye-la-Forêt, Gal. Su-
ty: La Saison du Blanc / 2007 Nogent-sur-Marne, Maison
d'Art Bernard Anthonioz: Artificialia. Un Cabinet de Cu-
riosités contemp. / 2011 Chinon, Chai Pierre et Bertrand
Couly: La Vi(ll)e en Rose. ▭ *Delarge,* 2001.

F. Krohn

Choplet, *Nadeige J.,* US-amer. Keramikerin, Bildhaue-
rin, * ca. 1972 Frankreich, lebt in Brooklyn/N. Y. Stud.
in Paris: 1991 Ec. Nat. Supérieure des Arts Appliqués
Oliver de Serres (Textildesign); bis 1993 Ec. Supérieure
des Arts Appliqués Duperré; bis 1996 ENSBA (Malerei
und Skulpt.); in New York: 1999 Lehman College, Ci-

ty Univ. (Keramik). Anschl. Wkst. und Gal. C. Ceramics
Studio, Brooklyn. Lehrtätigkeit in New York: seit 1997
Lehman College; 1999–2001 und seit 2003 Manhattan-
ville College. – C. gestaltet dünnwandiges Gebrauchsge-
schirr (Steinzeug mit Terra Sigillata, Glasur) mit dekorati-
vem, zumeist floral inspiriertem gemaltem Dekor, das ih-
re Ausb. im Textildesign und Malerei wiederspiegelt. Da-
neben entstehen Fliesen und Keramik-Skulpt. in versch.
Techniken und Mat. (Raku, Porzellan) mit phantasievollen
Oberflächenstrukturen wie z.B. *Sea Creatures* und Skulpt.,
die männliche und weibliche Reproduktionsorgane wie-
dergeben (*Untitled,* 1997). C. arbeitet ferner projektbezo-
gen mit Architekten und Designern zus. (u.a. stattet sie
2001 das Hilton Garden Inn New York mit großen Skulpt.
aus) oder fertigt Tischdekor für bes. Anlässe. ⊙ *E:* Pa-
ris: 1996 BA Gall.; 1997, 2000 Gal. Claude Samuel / New
York: 2000 60 Gall.; 2004 Union Square Center / 2001
Berouth, Alice Magabgab Gall. / 2002 Brooklyn, Brook-
lyn MMA. ▭ *Bénézit* III, 1999. – Ceramics monthly
55:2007 (5) 45. – *Online:* Website C.; J. Martin Hill, Art-
net v. 22. 8. 1997.

H. Stuchtey

Chopping, *Richard (Richard Wasey; Richard W.; Di-
ckie; Dicky),* brit. Graphiker, Illustrator, Maler, Autor,
* 14. 4. 1917 Colchester/Essex, † 17. 4. 2008 Wivenhoe/
Essex. Lebensgefährte (2005 civic partnership) des brit.
Graphikers und Lsch.-Malers Denis Wirth-Miller. Sohn
eines Getreidemühlen-Unternehmers. Nach Besuch der
Gresham's School, Holt/Norfolk erhält C. ab ca. 1935/
36 eine Bühnenmalerei-Ausb. am Londoner Theatre Stu-
dio von Michel Saint-Denis; danach ist er Student (neben-
bei Kochgehilfe und Hausmeister) an der 1937 gegr. East
Anglian School of Paint. and Drawing von Cedric Mor-
ris und Arthur Lett-Haines in Dedham/Essex. Wird dort
von C. Morris porträtiert (Bildnis 1984 in der Londoner
Tate ausgestellt). Auf Empfehlung der Graphikerin Kath-
leen Hale, die Zchngn von C. gesehen und ihn wohl 1938
an der Morris'schen Schule kennengelernt hatte, erhält er
seinen ersten größeren Ill.-Auftrag (Lith. für die Publ. *But-
terflies in Britain,* West-Drayton/N. Y. 1943). Mit seinem
Partner Wirth-Miller läßt sich C. 1945 in Wivenhoe nieder
und begründet dort eine als exzentrisch-homophil gelten-
de Künstlerszene von Malern und Schriftstellern, zu der in
den 1950er Jahren u.a. Francis Bacon als Ateliernach-
bar oder der Novellist Angus Wilson gehören. Gelegentli-
che künstlerische Kooperation mit dem Lebensgefährten,
so 1946 bei dem Kinderbuch *Heads, bodies & legs.* Enge
Freundschaft verbindet beide mit den schott. Malern und
Bühnenbildnern Robert Colquhoun und Robert MacBry-
de. Ab 1956 steht C. in häufigem Arbeitskontakt zu dem
James-Bond-Autor Ian Fleming. Ab 1961 Lehrtätigkeit am
R. College of Art in London. – V.a. Aqu., Gem. (häu-
fig Trompe-l'œils), Buchumschläge und (Kinderbuch-)
Illustrationen. C. debütiert in den 1940er Jahren mit souve-
rän vorgetragenen naturgetreuen natur-wiss. Ill. (Pflanzen,
Schmetterlinge, Vögel). Einen hohen internat. Bekannt-
heitsgrad erreichen seine neun Umschlag-Gest., die er zw.
1957 und 1966 für die im Verlag von Jonathan Cape ver-
öff. Erstausgaben der James-Bond-Romane von I. Fleming

liefert (u.a. *Goldfinger*, 1959; *Thunderball*, 1961; *You on-ly life twice*, 1964; *The man with the golden gun*, 1965). Als Stil-Ikone der 1950er Jahre gilt heute C.s markan-te Umschlag-Zchng für die Bond-Novelle von 1957 *From Russia, with love*. Daneben auch eig. Textveröffentlichun-gen. – Buch-Ill.: *A book of birds*; *The old woman and the pedlar*; *The tailor & the mouse*; *Wild flowers*, alle Lo./N. Y. [1944]; *Mr. Postlethwaite's reindeer and other stories*, Lo. 1945 (auch Text). ✉ The Fly, Lo. 1965; The Ring, Lo. 1967. ◉ *E:* London: 1939 Goupil Gall.; 1956 Hanover Gall.; 1977 New Art Centre; 1979 Aldeburgh Festival Gall. (Retr.). 📖 *Johnson/Greutzner*, 1976; RoyalAcadExhib II, 1977; *Peppin/Micklethwait*, 1983; *Horne*, 1994; *Buck-man* I, 2006. – G. *Gordon*, Aren't we due a royalty state-ment?, Lo. 1993; *C. Hawtree*, The Guardian v. 14. 6. 2008 (Nekr.). U. Heise

Chopra, *Nikhil*, indischer Performancekünstler, Zeich-ner, Graphikdesigner, * 1974 Calcutta, lebt in Mumbai. Stud.: 1997–99 Fac. of FA, Maharaja Sayjirao Univ., Baro-da; 1999–2001 Maryland Inst., College of Art, Baltimore/ Maryland (2000 Santa Farinella Sangiamo Stip.); 2001–03 Ohio State Univ., Columbus (bis 2002 Doz.; 2002–03 Ass. bei Ann Hamilton). 2003–04 als Graphikdesigner in New York tätig. 2005–08 Doz. an der Rachna Sansad Acad. of Art and Craft, Mumbai. 2008 Artist in Residence, Khoj ar-tist assoc., New Delhi; seither freischaffend tätig. – Die Auseinandersetzung mit der kolonialen Gesch. und Le-benswirklichkeit Indiens beginnt während des Stud. in Ohio. Erste Arbeiten (*Sir Raja I-III*, 2002–06) haben noch eher statischen Charakter. C. dokumentiert sich selbst in eine Art lebender Bilder. In einer Reihe von Performances (*Memory drawing I-XI*, 2006–10) lotet er die Grenzen zw. Theater, Installation, Malerei, Fotogr. und Bildhauerei aus. In jeder Performance kreiert er einen fiktiven Char., für den er sowohl Inspirationen aus seiner eig. Fam.-Gesch. als auch aus der Kolonial-Gesch. Indiens verarbeitet. Als Teil des Prozesses fertigt er dabei u.a. großformatige Kohle-Zchngn, deren Lsch. und Stadtansichten in die Performan-ces eingebunden sind. Dokumentationen, die mit versch. Fotografen entstehen (*What shall I do with all this land*, Gelatine prints, 2005), kreisen ebenfalls um die Themen der Performances. C. gilt als Vorreiter der Performance-kunst in Indien; seine Arbeiten haben binnen weniger Jahre internat. Anerkennung gefunden. ◉ *E:* 2003 Columbus (Ohio), Kinnear Warehouse / Mumbai: 2005 Kitab Mahal, Fourth floor; 2007, '10 Chatterjee and Lal Gall.; 2010 Dr. Bhau Daji Lad Mus. / 2009 New York, New Mus. – *G:* 2004 Bishkek (Kyrgyztan): Internat. video art in Kyrgyz-tan / New York: 2005 Apexart: Maurizio couldn't be he-re. The taste of others; 2006 Brooklyn Mus.: Asia soc. Asian contemp. art week; 2007 Abrons AC: Posing; 2008 Thomas Erben: In N. Y. city; Bodhi Art: Emerging dis-courses II; 2009 Performa Bienn. / London: 2007 Gros-venor Vadehra: House of mirrors; 2008 Serpentine Gall.: Indian Highway / 2008 Yokohama: Trienn. / 2009 Vene-dig: Bienn.; Brüssel: Kunstenfestivaldearts / 2010 Chica-go, MCA: Production Site. The Artist's Studio Inside-Out. 📖 Chalo! India. Eine neue Ära indischer Kunst (K Klos-

terneuburg), M. u.a. 2009; *A. Dua*, The Telegraph (Kolka-ta) v. 19. 7. 2009. – *Online:* Website C. M. Frenger

Chorafa (Chorafas; Horafa), *Theodora*, griech. Bild-hauerin, Keramikerin, Installationskünstlerin, * 1959 Lon-don, lebt auf Aigina. Stud.: 1977–78 Camberwell School for Arts and Crafts, London; 1978–79 Centro di Addestra-mento Professionale, Faenza; 1979–84 Éc. des Arts Dé-coratifs, Genf. Zwischenzeitlich 1981–82 Lehrtätigkeit an der Desert Sun School in S-Kalifornien und Arbeit mit in-dianischen Keramikern in Arizona. 1984 Rückkehr nach Griechenland, seit 1990 auf Aigina ansässig. Lehrtätig-keit: seit 1984 nat. und internat. Keramik-Workshops (u.a. 2008 in Ponteverda). 2009 Ko-Organisation des internat. Keramik-Symposiums auf Aigina. 2010 kuratiert sie im dortigen Archäol. Mus. die Ausst. Keramische Dialoge. Mitgl.: 1986 Künstlergruppe Afi (griech. Berührungssinn), bis heute beteiligt sie sich an den Gruppen-Ausst. (zu-letzt 2012 in Berlin); 1990 Internat. Acad. of Ceramics (IAC). Ausz.: 1995, 2009 1. Preis auf der Panhellenischen Keramik-Ausst., Marousi/Athen; 1998 Preis Ateliers d'art de France, Tunis; 2006 1. Preis (Kategorie Established Artists) beim Europ. Ceramic Context, Bornholm. – C.s wichtigstes Grund-Mat. ist gebrannter Ton, der im Stil der jap. Raku-Keramik gefertigt und bisweilen mit and. Mat. wie Metall, Knochen, Seil, Papier und Federn kom-biniert wird. Ihre Werke zeigt sie in komplexen Raum-Installationen, in denen die oft archaisch wirkenden Ar-beiten und Motive das Zeitlose des Werkstoffs Keramik betonen. C. beschäftigt sich insbesondere mit dem Aus-druck formalstilistischer Prinzipien in der Plastik, wie of-fen/geschlossen, konkav/konvex, flächig/räumlich, die sie als dualistische Gegensätze in versch. Werken zum Aus-druck bringt. In ihrer ersten repräsentativen, eigenständi-gen Arbeit *Die Ikonen* setzt sie sich mit der Idee des Hei-ligen und des Idols abseits existierender Religionen aus-einander und spürt dem spirituellen Ausdruck der Form nach. In der Serie *Konen* thematisiert sie die symbolische Dimension der geometrischen Grundform des kegelförmi-gen Gefäßes und beginnt den Gebrauchscharakter ihres Werkstoffes zugunsten seiner skulpturalen Qualitäten hin-ter sich zu lassen. C. verzichtet, darin indianischen Arbei-ten folgend, auf eine Glasur ihrer Werke und legt so die Art ihrer Entstehung offen. Ziel scheint hier und in and. Arbeiten eine grundsätzliche Beschäftigung mit menschli-chen Urfragen zu sein – Geburt, Leben, Tod. In *Perasma/ Übergang* (1988–89) zeigt sie bootartig geformte kerami-sche Objekte, die (über einer dunklen, z.T. hell akzentu-ierten Fläche befestigt) zu schweben scheinen. Durch das Zusammenspiel der einzelnen Elemente im dämmrig be-leuchteten Raum wirken die Keramiken wie Schiffe auf der Reise in eine jenseitige Welt. C. verarbeitet in diesem Werk Einflüsse aus den altägyptischen, jedoch allgemeiner auch aus and. vorchristlichen Religionen und Jenseitsvor-stellungen. Den Aspekt des Übergangs greift sie in *Meta-morphose* (1993–95) wieder auf, indem sie (z.T. lebens-große) Sarkophagformen schafft. Diese suggerieren Moti-ve der Erhöhung und Überwindung wie Berg, Treppe oder Lebensbaum. Ein Hauptthema der ebenso an Kokons erin-

nernden Arbeiten ist dabei die titelgebende Verwandlung von einem Zustand in einen anderen. In den Jahren 1995 bis 2010 hat C. in der Serie *Koutia*/Schachteln Variationen zum Thema des Kästchens bzw. der kleinen Truhe vorgelegt. Es handelt sich im weitesten Sinne um Gefäße mit abnehmbarem Deckel, die menschliche Grundbedürfnisse des Bergens, Verbergens und Schützens versinnbildlichen und, wie ihre and. Arbeiten, ein transkulturelles Motiv anklingen lassen. ⌂ ATHEN, Benaki Mus. – Emfiezoglou Art Coll. AUXERRE, Conseil Général de l'Yonne. BORNHOLM, KM. KECSKEMÉT, Internat. Ceramic Studio. MÂCON, Mus. des Ursulines. MAROUSI, Gemeindeverwaltung. ◉ *E:* 1997 Athen, Panorama Kulturzentrum / 1999 Genf, Gal. Equinoxe. – *G:* u.a. 1987 Barcelona: Bienn. junger mediterraner Künstler / 1988 Bologna: Bienn. junger mediterraner Künstler / Athen, Pierides MMK: 1988 Tanimanidis, Petridis, Michailidis, C.; 1994 Pilos kai plastiki Dimiourgia (Ausst. gleichzeitig in Levkosia und in Rethimnon) / 1989–90 Auxerre, Abbaye Saint-Germain: L'Europe des céramistes (internat. Wander-Ausst.) / 2002 Rethimnon, Ibrahim Han Moschee: Gruppe Afi / 2009–12 New Delhi [u.a.] Internat. Wander-Ausst. unter UNESCO-Patronat: 1001 bols, 100 artistes créateurs, 100 techniques, 5 continents / 2012 Hannover, Handwerksform: Gruppe Afi. Kunsthandwerk aus Griechenland. ▭ LEK IV, 2000. – *A. Schina*, Synchroni Kallitechniki Kerameiki (K Mun. AG), At. 1989; *A. Margetts*, Internat. crafts, Lo. 1991, 41; *T. Mavrotas*, Pilos kai plastiki dimiourgia (K Coll. Pierides), At. 1993; *A. Tamvaki*, Apo Choma kai Fotia (K Athen/Volos/Hania/Ålborg), At. 1995; *id.*, Keramisk Unika (K Dän. Inst.), At. 1998; Ceramic art (Taiwan) 30:2001 (Winter) 58–61. – *Online:* Website C.

E. Kepetzis

Chorbachi, *Wasma Khalid (Wasma'a Khalid)*, irakische Keramikerin, Kalligraphin, Hochschullehrerin, * 1944 Kairo, lebt in Cambridge/Mass. Aufgewachsen in Bagdad. Stud.: American Univ., Beirut (Kunst, Phil.); danach zeitw. in Florenz; wird 1989 in islamischer Kunstgesch. an der Harvard Univ. in Cambridge (Mass.) promoviert. Ebd. Lehrtätigkeit (Prof. für Keramik) sowie am Massachusetts Inst. of Technology. – C. beginnt in den 1960er Jahren mit abstrakter Malerei; in Reaktion auf den Sechstagekrieg wendet sie sich von dieser jedoch ab, um sich mit den eig. arabischen und islamischen Wurzeln zu beschäftigen. Seitdem befaßt sie sich künstlerisch mit Gebrauchskeramik (Schalen) und Archit.-Keramik und orientiert sich dabei stark an Vorbildern aus dem islamischen Kulturkontinent. Ihre Arbeiten werden in Ausst. zur islamischen Kunstgesch. gezeigt. C. setzt sich formal v.a. mit geometrischen Komp.-Schemata (Ranken) auseinander, in die sie häufig relig. Inschriften integriert. Zudem forscht sie zu Brand- und Glasurtechniken. ⌂ AMMAN, Nat. Mus. ✉ Beyond the symmetries of islamic geometric patterns. The sc. of practical geometry and the process of islamic design, Diss. Harvard Univ., C., Mass. 1989; In the Tower of Babel. Beyond symmetry in islamic design, in: Computers & mathematics with applications 17:1989 (4–6) 751–789. ◉ *E:* seit 1966 zahlr., zuletzt 2001 Cambridge (Mass.),

Arthur M. Sackler Mus. – *G:* 2000 London, Brunei Gall.: Strokes of Genius (K) / 2003 Bar Harbour, College of the Atlantic, Ethel H. Blum Gall.: Ancient Traditions, Contemp. Visions. ▭ *F. S. Oweis*, Enc. of Arab Amer. artists, Westport, Conn./Lo. 2008. – *S. M. Nashashibi*, Forces of change. Artists of the Arab world (K Wander-Ausst.), Lafayette, Calif./Wa. 1994; *M. Faraj* (Ed.), Strokes of genius. Contemp. Iraqi art, Lo. 2001; *V. Porter*, Word into art. Artists of the mod. Middle East (K BM), Lo. 2006. – *Online:* Website C. K. Schmidtner

Chordakis (Hordakis), *Dimitris*, griech. Maler,* 1956 Larisa, lebt und arbeitet in Athen und Florenz. Stud.: 1976 Doxiadis School of Decorative and Graphic Arts, Athen, Graphikdesign bei Dimitris Mytaras; 1977–80 ABA, Florenz, Malerei bei Silvio Loffredo; 1980 Univ. Internat. dell'Arte ebd., Rest. und Konservierung; 1981–83 Opificio delle Pietre Dure, Rest. bei Umperto Baldini; 1983–84 Internat. School of Graphic Arts, Florenz, Lith. bei M. Luigia Guaita. 1991–99 Aufenthalt in Paris, seit 1999 in Athen und Florenz ansässig. Mitgl.: Epimelitiriou Eikastikon Technon Ellados/Vrg bild. Künstler Griechenlands (EETE). Ausz.: 1987 2. Preis Premio naz. d'Arte contemp., Città di Campobello di Mazara; 2. Preis Onda Verde' Exhib., Pal. del Congressi, Florenz. – V.a. gegenständliche, von der Pittura metafisica des Giorgio De Chirico und vom Magischen Realismus René Magrittes beeinflußte Gemälde. Der persönliche malerische Ausdruck ist zurückgenommen und der Stil von C. nähert sich bisweilen dem Fotorealismus an. Seine Portr., Lsch. und Stilleben sind in gedeckten Farben gehalten, manchmal durch markante Hell-Dunkel-Kontraste gekennzeichnet. In einfachen, sehr streng organisierten Komp. zeigt er menschliche Gestalten, die in einigen Fällen an de De Chiricos „manichini" erinnern und sich wie Gliederpuppen in präzise konstruierten archit. Kulissen bewegen. Die Gest. des Raumes richtet sich dabei bloß scheinbar nach den Gesetzen der Zentralperspektive, bei genauerer Betrachtung offenbaren die archit. oder topogr. Strukturen eine nur vermeintlich vertraute, tatsächlich höchst rätselhafte Bildtopographie. Durch den weitgehenden Verzicht auf Narration, Aktion und Bewegung schafft C. den Eindruck handlungslosen Stillstands seiner in beunruhigend und surreal wirkenden Bildräumen arrangierten Szenen. In seinem Œuvre lassen sich mehrere Schwerpunkte aufzeigen. Zum einen die Beschäftigung mit dem vermeintlich mimetischen Abbildcharakter der Malerei. So finden sich immer wieder Stilleben im Stile des klassischen Trompe-l'oeil, welche als kunstvolle Augentäuschungen die Wahrnehmung des Betrachters herausfordern. Diese selbstreferenzielle Auseinandersetzung geschieht vielfach unter Adaption des insbesondere von R. Magritte popularisierten Bild-im-Bild-Sujets (*Argo*, 2010) sowie durch explizite oder implizite Verweise auf Themen und Kunstwerke der Vergangenheit (*Hommage De Chirico*, 1984). Zum anderen ist die griech. Skulpt. und Lit. der Antike und damit eine Reflektion der eig. Herkunft und künstlerischen Verortung zentrales Thema seiner Arbeiten (*Stilleben mit griech. Relief*, 1998). In diesen Sujets konfrontiert C. Kunst und Natur, Vergan-

genheit und Gegenwart, Versehrtheit und Unversehrtheit. 👁 *E:* u.a. Florenz: 1984, '85 (K) Gall. Artequattro; 1986 Soc. Dante Aligheri / 1987 Genua, Gall. Guidi; Catania, Gall. L'Angolo / 1989 Avignon, Gal. Ducastel; Annemasse (Haute-Savoie), Gal. Xarof. / 1991 Rom, Gall. Parametro / Lyon: 1992 Gal. Tomas Vitale; 1999 Gal. Hermes / 1995 Bassano del Grappa, Gall. Il Fiore / 1999 Paris, Sibman Gall. / 2002 Athen, Gal. Ersis / 2010 Volos, AC Foudouli / 2011 Quarrata, Gall. Overlook Agenzia d'Arte (mit Cristos Sipsis, Cherish Gaines). – *G:* 1984 Neapel, Castello dell'Ovo: Mare e Mare / 1994, '95, '96 Volos, Frz. Inst.: Musik- und Kunst-Festival / 2000 Athen, Gal. Pieridis: Artists of Glyfada / 2001 Monte-Carlo: Internat. Ausst. zeitgen. Kunst / 2007 Florenz: Bienn. 📖 LEK IV, 2000. – *M. Venturoli,* D. H. Meraviglie del quotidiano, Bo. 1986; *P. Levi,* Arte ital. contemp., Fi. 1990, 128, 324; *G. Di Genova,* in: *M. Scalise/P. Kaloussian Velissiotis,* Ritorno al Mediterraneo. Dalla cult. greco-romana alla cult. dell' Euro. Quale ricchezza per l' umanità? (K Spazio Tadini), Mi. 2012, 24–29. – *Online:* Website C. (Ausst.).

E. Kepetzis

Chorozov, *Nikola (Nikola Kesarev),* bulg. Architekt, * 23. 9. 1893 Razgrad, † 31. 10. 1972 Varna. Bis 1920 (Dipl.) Stud. an der TH Dresden, unterbrochen 1914–18 durch Teiln. am Balkankrieg und am 1. WK. 1920–22 Praktikum in Kjustendil; 1922 offizielle Erlaubnis zur priv. Entwurfstätigkeit vom Minist. für öff. Bauten, Wege und Stadtplanung. 1925 Jury-Mitgl. beim Wettb. um die St. Mina-Kirche in Kjustendil. 1927 Umzug nach Varna und Registrierung einer gemeinsam mit dem Ing. Stefan Saparev betriebenen Baufirma, die bis 1935 bestand. 1927 bis zum Austritt 1935 Mitgl. der Bulg. Ing.- und Architekten-Ges. (BIAD); 1935 Wechsel in die unabhängige Ges. bulg. Architekten (DBA). Ab 1935 Leiter der technischen Abt. in der Stadtverwaltung Varna, ab 1948 (Verbot der priv. Gewerbetätigkeit) ebd. Mitarb. in der regionalen Projektierungsorganisation. 1955 Chefarchitekt von Varna. 1956–58 verantwortlich für die Investmentaufsicht über den Auf- und Ausbau des Erholungsgebietes Zlatni pjasaci b. Varna. 1958–60 Chefarchitekt von Šumen und Razgrad. 1960–63 Leiter der Projektierungsorganisation in Razgrad. Auch nach seiner Pensionierung (1963) weiter im Beruf tätig. – Das Frühwerk steht im Zeichen des Übergangs von Bau- und Zierformen des Art Déco zu einem gemäßigten Modernismus. Spätere Arbeiten zeigen sich in Bauschmuck und -körper stärker reduziert und zeichnen sich durch klar strukturierte Fassaden mit scharf geschnittenen Tür- und Fensteröffnungen in horizontal verlängerten Proportionen aus. 🏛 GOREN BLIZNAK/Gemeinde Avren b. Varna: Berggasthaus „Rodni balkani", 1933. IZVOR b. Radomir: Grundschule „Ivan Vazov", 1923–25. KIPRA/Gemeinde Devnja b. Varna: Grundschule, 1935–36. VARNA, ul. Archimandrit Filaret 15: eig. Wohnhaus, um 1925. – ul. Šopska 17: Haus für John Zolas, 1927. – ul. Slavjanska 21: Haus für Pietro Tercetta, 1930. – ul. Archimandrit Filaret 9: Mehrfamilienhaus, um 1930. – ul. Knjaz Boris I/ul. Michail Koloni: Wohnhaus für Damjan Angelov, 1931. – bul. Knjaginja

Marija Luiza/ul. Dragoman: Haus für Maria Naudascher, 1932. – bul. Saborni: Haus für Dimităr Genov, 1932. – ul. Dragan Cankov/pl. Nezavismost (ehem. ul. V. Zajmov): Wohn- und Geschäftshaus für Nikola Labakov, 1933–34. – bul. Knjaz Boris I: Wohnhaus „Königin Joanna" für Georgi Bošnakov, 1933–38. – Haus mit Geschäften für D. Bujnov und D. Dimitrova, 1939 (später erweitert). – bul. Knjaginja Marija Luiza: Genossenschaftswohnhaus, um 1947 (um 1990 in ein Pionierhaus umgewandelt, um 2001 privatisiert). – ul. Lejtenant Minkov 5: Einfamilienhaus, um 1940. 📖 Dăržaven vestnik 1922 (282); 1936 (54) 827; Spisanie na BIAD 1925 (12) 192–195; Architekt 1927 (10) 16 s.; *S. Kovačevski/P. Iokimov,* in: Architekturata v Bălgarija 1878–1944, Sofija 1978, 211; Regional reflections of the Mod. Movement in Bulgaria between the two World Wars. Contribution of women, III, Sofia 2000; *A. Angelov,* Kipra. Sledi ot minaloto, Varna 2003; *G. Kacarski u.a.,* Varna. Architektura. Architekti, Veliko Tărnovo 2010, 56. – Mitt. Božidara Koleva (Ch.s Tochter), 1999–2002. L. Stoilova

Chotjanovskij, *Konstantin Vladimirovič* (weißrussisch: *Chacjanoŭski, Kanstancin Uladzimiravič*), weißrussischer Gebrauchsgraphiker, Buch- und Plakatgestalter russ. Herkunft, * 22. 5. 1954 Leningrad (St. Petersburg), lebt in Minsk. Stud. ebd.: bis 1976 HS für bild. und Bühnenkunst (heute weißrussische AK) bei Pavel Apanasavič Semčanka (v.a. Typogr.) und Leŭ Ivanavič Talbuzin. Seit 1980 Teiln. an Allunions-, Republik- und internat. Ausst.; 1988 Aufnahme in den weißrussischen Künstler-Verb.; Mitgl. des weißrussischen Designer-Verbandes. Seit 1994 Geschäftsführer der Fa. Kavaler, eines in Minsk ansässigen Studios für Graphikdesign, das auch als Buchverlag in Erscheinung tritt (Publ. zur Nat.- und Regional-Gesch.; bibliophile Buch-Ausg. sowie Kinder- und Jugend-Lit.); u.a. erscheint 2000 bei Kavaler die achtteilige Reihe Skazočnaja Šekspiriad/Phantastische Shakespeareiade mit ill. Prosanachdichtungen ausgewählter Dramen von W. Shakespeare. – Ab M. der 1980er Jahre arbeitet Ch. vornehmlich auf dem Gebiet der Plakat-Gest., bis etwa 1990 v.a. für das Minsker Verlagshaus Polymja. Neben versch. Solidaritäts- und politischen Bekenntnisplakaten für staatliche Institutionen (u.a. *1 Maja. Dzen' mižnarodnaj salidarnasci pracoŭnych* zum Tag der Arbeit im Auftrag des Künstler-Verb. der weißrussischen Sowjetrepublik, 1988; *Sud'ba planety, tvoja sud'ba/*Das Schicksal des Planeten ist dein Schicksal, 1989) zeigt bes. das Theaterplakat *Vernyj Ruslan* (Aufführung am Gorkij-Theater, Minsk, 1989; dramatische Bearb. der gleichnamigen Erzählung des Dissidenten Georgij Nikolaevič Vladimov; Regie: Valeryj Vasilevič Masljuk) den dezidiert graph. Duktus der Arbeiten dieser Dekade. Nach dem Zerfall der Sowjetunion übernimmt Ch. gemeinsam mit Sjargej Viktaravič Al'vinski die künstlerische Gest. der Banknoten (1992–2001 gültig) des neu eingeführten weißrussischen Währungssystems; die hierfür entwickelten markanten Tiermotive in naturalistisch-detailreicher Ausf. sind weiterer Beleg für den versierten Umgang mit trad. druck-graph. Techniken. Seit M. der 1990er Jahre entstehen im Bereich Plakat- und

Umschlag-Gest. jedoch vermehrt fotobasierte, zunehmend digital bearbeitete und stärker typisierte Entwürfe, deren stilistische Variabilität auch die Ansprüche der nunmehr v.a. aus der regionalen Privatwirtschaft stammenden Auftraggeber widerspiegelt (u.a. Betonung von Nat.-Farben und -symbolen in Plakatkampagnen für die weißrussische Tourismusindustrie). Damit geht auch die Erweiterung des Wirkungsfeldes hin zu komplexeren Corporate Designs, häufig mit betont typogr. Elementen einher (u.a. Firmensignet für das eig. Verlagshaus; Logotype für die dem weißrussischen Innen-Minist. unterstellte Eskorteinheit Strela; zahlr. Etiketten und repräsentative Umverpackungen für lokale Getränkehersteller). – Buch-Gest.: u.a. A. M. Atruškevič, *Dorožkami starogo parka*, Minsk 1988; *Raubiči. Otdych, turizm, sport*, Minsk 2006 (russ.-sprachige Imagebroschüre für den olympischen Wintersportkomplex Raübičy b. Minsk); A. Marcinovič, *Gerb, snjag i gimn Belaruskaj dzjaržavy*, Minsk 2011 (mit Svjatlana Uladzimiraŭna Nečunaeva). ⌷ MINSK, Nat. KM. – Weißrussische NB. TOYAMA, MMA. WARSCHAU, Muz. Plakatu w Wilanowie. ◉ *G:* 1987 Moskau, Zentralhaus des Künstlers: Internat. Wettb. des politischen Plakats „Für Frieden und ges. Fortschritt" / 1991 Toyama, MMA: Internat. Poster Trienn. ⌷ BSM, 1998. – *D. Surskij* (Ed.), Znak. Logotip, Minsk 2000. S. Görke

Chott (eigtl. Mouchot, *Pierre*; Pseud.: Nicolas, *Pierre*), frz. Comiczeichner und -texter, Illustrator, Verleger, * 7. 6. 1911 Montbard, † 1966. Vermutlich Autodidakt. Zeichnet ab 1940, z.T. unter dem Pseud. Pierre Nicolas, zunächst Comics für die im Verlag Sagédition ersch. Zss. Aventures (u.a. *Fantôme d'acier*), L'Aventure réunis und Jumbo, Jumbo. Für die Reihen Jeunesse Nouvelle und Victoire entstehen Titelbilder. Bis A. der 1950er Jahre gestaltet C. zudem zahlr. Bild-Gesch. für frz. Mag. wie Cendrillon (1943), Pic et Nic (1943–46; u.a. *Ramon le Rouge*; *Tristan et Iseult*), Sélection le Corsaire (1944), Les Aventures fantastiques (1945), Les Héros de l'Aventure (1947), Cow-Boy und Texas Bill (beide 1952). Für die belg. Zs. Wrill zeichnet er 1947–49 die Ser. *Buffalo Bill, Mowg Fils de la Brousse* und *L'Or des Omahan*. 1946 gründet C. den eig. Verlag Ed. Pierre Mouchot, der 1951 in Soc. d'éd. rhodaniennes (S. E. R.) umbenannt wird. Hier erscheinen im sog. Petit format u.a. die Comics *Fantax* (1946–49; Texte v. J. K. Melwyn-Nash/Marcel Navarro), *Gus et Gaëtan* (ab 1946), *Big Bill le Casseur* (1947–55) und *Robin des Bois* (ab 1947). Neben den von C. selbst konzipierten Ser. publiziert der Verlag zahlr. weitere Heftreihen, für die C. aber meist nur die Titelbilder illustriert, während die Inhalte von den zahlr. Mitarb. seines Studios gestaltet werden, u.a. von den Zeichnern Bob Roc (eigtl. Robert Rocca), Rémy Bordelet, Bertrand Charlas, André Reynet und *Claudy* (eigtl. *Claude Bordet*, * 27. 8. 1920 Givors, † 27. 5. 2001; Stud.: 1936–39 EcBA Lyon; zeichnet v.a. realistische Abenteuer- und Wildwest-Comics, zunächst für die Ed. Fleurus und die Scouts de France, später u.a. für Mag. der Verlage Impéria, Lug und Willeb). 1960 beendet C. die zeichnerische und verlegerische Tätigkeit. – Konventionell-routinierte, meist realistische, ge-

legentlich auch humoristische Tuschfeder-Zchngn in der Nachf. US-amer. Comiczeichner wie Hal Foster oder Alex Raymond, wobei C. v.a. in den 1940er Jahren oft einzelne Paneels, manchmal auch ganze Seiten seiner Vorbilder kopiert bzw. plagiiert. Wegen ihrer für die Entstehungszeit ungewöhnlich drastischen Darst. von Gewalt werden einzelne Comics des Verlages S. E. R. in den 1950er Jahren auch Gegenstand von Gerichtsverfahren und staatlicher Zensur. ⌷ *G. Thomassian*, Enc. des bandes dessinées de petit format, III, P. 1996; *H. Filippini*, Dict. enc. des héros et auteurs de BD, I, Grenoble 1998; *id.*, Dict. de la bande dessinée, P. 2005; *P. Gaumer*, Dict. mondial de la BD, P. 2010. – *Y. Frémion*, Le guide de la bédé francophone, P. 1990; *M. Béra u.a.*, Trésors de la bande dessinée. Cat. enc. 2007–08, P. 2006. – *Online:* Bedetheque; Lambiek Comiclopedia. H. Kronthaler

Chotteau, *Thérèse*, belg. Bildhauerin, Zeichnerin, * 1951 Etterbeek, tätig in Wavre. 1972–75 Stud. an der Acad. royale des BA, Brüssel. Lehrtätigkeit an den Inst. St-Luc sowie am Inst. Ste-Marie ebd. Ausz.: 1997 Premier Prix de Sculpt. mon. de la Commune d'Uccle. – V.a. figurative Plastiken in Bronze (z.T. patiniert oder bemalt) und Gips (z.T. polychrom), bisweilen in Marmor, bevorzugt weibliche Figuren, die C. zuvor häufig in Tusche skizziert. Die kleinformatigen Plastiken werden oft von mon. Fotogr. begleitet, die den vergrößerten Schatten der Figur zeigen, wodurch die Wahrnehmung des Betrachters irritiert wird. Neben einzelnen Plastiken gestaltet C. szenische Darst. (*La Quadrature de l'Arbre*) und Installationen wie z.B. *Extraits de Presse*, bestehend aus kleinen Papiermaché- und Bronzeplastiken, die auf Stapeln von Büchern, Zss. und Ztgn angeordnet sind. Zudem zahlr. mon. Skulpt. im öff. Raum. ⌷ KITAKYŪSHŪ, Mun. Mus. of Art. LOUVAIN-LA-NEUVE, Mus. – *Im öff. Raum:* AUDERGHEM, Av. de Tervuren: La Quadrature de l'Arbre, 1994. UCCLE, Le Doyenné: Le Cycle du Temps, 2008. WATERMAEL-BOITSFORT, Parc Tournay-Solvay: Mémorial Kelda, 1997. LOUVAIN-LA-NEUVE, Parc scientifique Einstein: Le Porteur d'Eau, 1999. ✉ *C. u.a.*, Rencontres entre artistes et mathématiciennes, P. 2001. ◉ *E:* Brüssel: 1983 Pal. des BA; 1988 MRBAB; 2010 Théâtre de la Pl. des Martyrs; 2011 Gal. DS (mit Stéphane Dauthuille) / 1984 Louvain-la-neuve, Mus. (mit Veerle Pinckers, Christine Wilmès; K) / 1994 Woluwé-Saint-Lambert, La Médiatine (K) / 1996 Paris, Inst. Henri Poincaré / 2003 Koksijde, Wyland Gall. – *G:* Brüssel: 1976 Parc de Bruxelles: Sculpt. mon.; 2008 Gal. Antonio Nardone: Figura Umana / 1987 Lüttich, MAM et d'Art contemp.: Surface Sculpt. / 2011 Vence, Gal. DS: Art Makes You Happy; Woluwé-Saint-Lambert, Artothèque Wolubilis: Corps Voyageurs / 2012 La Louvière, Centre Daily Bul & C°: Escargots à Gogo. ⌷ *C. Engelen/ M. Marx*, Beeldhouwkunst in België, I, Br. 2002; *Pas I*, 2002. – *Online:* Website C. F. Krohn

Chou *Meng-te* (Zhou Mengde), taiwanesischer Maler, Graphiker, Zeichner, * 1953 Chang-hua, lebt in Taipei. Anfänglich Autodidakt (Öl, Aqu., Holzstich im Selbst-Stud.). Lehrte 1973 in der Nat. Chang-hua Ren'ai Experimental School (für körperlich Behinderte). 1980 Übersiedlung

nach Taipei, wo er seither als Taxichauffeur arbeitet. Ab M. der 1980er Jahre Graphikunterricht bei Dawn Chen-ping am Nat. Taiwan College of Arts. – Bek. für seine seriellen Dokumentationen des Nachtlebens von Taipei (*Bu hui ye shenghuo xilie*/Urban Night Life 1987–2003) mittels Malerei (v.a. Kreide, Kugelschreiber, Öl/Lw.) und Druckgraphik (monochrome Hschn., Lith., Rad., Mezzotinto). Die etwas unreflektiert und naiv wirkenden Bildserien mit Szenen von Menschen (v.a. Jugendliche, einzeln oder in Gruppen) in Tanz- und Musiklokalen, Kneipen und Bilardhallen in bunter, postimpressionistischer Manier spiegeln C.s persönliche Faszination für die stetige Entwicklung der kommerziellen Großstadtkultur Taipeis und deren jugendlicher Subkulturen wider. Neuerdings thematisiert C. auch städtische Parkszenen. ⌂ TAICHUNG, Nat. Taiwan MFA. ◉ *E:* Taipei: 1986 American Cult. Center; 1988 Yuen Nung Teahouse; 1991 Moo-Shih Yuen Gall.; 1992 Hsiung Shih Gall.; 1994 Lake AC; 2007 Gall. 41 / Taichung: 1989, 2000 Jing Shih Gall.; 1993, '97, '99 Jing Zuang Gall. / 1995 Kaohsiung, Tzaung-Men Art Studio / 2008 Taitung, Taitung Railway Art Village. – *G:* 1991 Kaohsiung Up AG / Taipei: FA Mus.: 1998 Reflection and Reconsideration (K); 2005 Figurative Paint. in Taiwan / 1994 Tokio: China – Japan Print Exchange Exhib. ⌷ *M. Pai*, Asian art news 8:1998 (3) 92 s.; C. huaji ban quan ye, Taichung 1998; *S. Yu/F. Chou* (Ed.), 2006 Taipei Bienn. Dirty yoga (K), Taipei 2006. K. Karlsson

Choulot (Lavenne, Comte de C.; eigtl. Lavenne), *Paul de (Paul-Bernard de)*, frz. Landschaftsarchitekt, * 31. 1. 1794 Nevers, † 4. 4. 1864 Schloß Mimont b. Pougues-les-Eaux/Nièvre. 1814–24 übt C. im Rang eines Kavallerieleutnants das Amt des Leibwächters von König Ludwig XVIII. aus, das ihm den Titel Comte de Choulot einbringt. Unter Karl X. 1824–30 Generalkapitän der Jagdreviere von Chantilly und Kammerherr des Duc de Bourbon, Prince de Condé. Durch die Revolution 1830 wird C. in die Opposition und die Illegalität gedrängt. 1832 unterstützt er die Duchesse de Berry bei ihrem gewagten Unternehmen zur heimlichen Rückkehr nach Frankreich und ist in den folgenden drei Jahren deren Geheimagent an versch. europ. Höfen. Danach spezialisiert sich C. auf die Garten-Gest. und entwirft Pläne, die seine Frau Elisabeth de Chabannes La Palisse koloriert. Er wohnt nun bis ans Lebensende im Schloß Mimont (Park nach C.s Entwurf). – Obwohl bis heute weitgehend unbek. geblieben, gilt C. als bed. Lsch.-Architekt. des 19. Jh., der mit Leidenschaft und großem Einfallsreichtum sowie im respektvollen Umgang mit den natürlichen Gegebenheiten ca. 280–300 Parks v.a. in Frankreich, zudem in Italien und der Schweiz, gestaltete. Er lässt sich v.a. von den zeitgen. engl. Lsch.-Architekten Humphry Repton und John Claudius Loudon beeinflussen. Eine sehr romantische Stilauffassung zeigt sich bei Baulichkeiten wie Pavillons, überdachten Sitzplätzen, Hütten, Kalvarienbergen und Grotten. Ein bes. Anliegen ist ihm die geschickte Einbindung der Parks in die umgebende Lsch., indem er Grundstücksgrenzen optisch öffnet und weitet. In der 1863 veröff. Abh. L'Art des Jardins (oder: Et. théorique et pratique de l'Art

des Jardins) legt er u.a. seine Auffassungen zur engen Verflechtung von Malkunst, Phil. und mod. ökologischen Grundsätzen in urbanen und ländlichen Räumen dar. Nach seinen Vorstellungen sollen Parks generell öff. zugänglich sein, und anstelle der Abschottung der Anlagen von der Außenwelt mit nur durch wenige Öffnungen durchbrochenen Mauern lässt er sie mit der umgebenden Lsch. zu einer Einheit verschmelzen. Dabei berücksichtigt er in bes. Maß die Gesetze der Optik (Berechnung der Wirkung von Licht und Schatten, Unters. der Charakteristika der Baumarten, Abstimmung von deren Profilen auf die Horizontlinien, die Konturen der Wälder, Einbeziehung von Hügelketten und Tälern). C. erachtet die Anpassung des Parks an die grandiosen Proportionen der Natur und die Herstellung eines in sich stimmigen, harmonischen Gesamtbildes als primär, damit der Spaziergänger die wohltuenden Beziehungen zw. Garten und Umgebung spürt. Unter Vermeidung gerader Linien und symmetrischer Anlagen modelliert er die Lsch. in sanft geschwungenen Formen. Sein Hw. ist der 1858 im Auftrag von Napoleon III. entworfene, mehr als 400 ha große Park der kaiserlichen Residenz von Le Vésinet/Yvelines, bei dem er einen gelungenen Kompromiß zw. städtisch-eleganter Residenz und ländlichem Park findet (auch „ville-parc" gen.) und der bis heute in der frz. Lsch.-Gest. als vorbildhaft gilt. Einer der wenigen weitgehend im Orig.-Zustand erh. Parks ist die 1862–70 am Schloß La Brosse in Farges-Allichamps/ Cher gestaltete Anlage, deren urspr. „landwirtschaftlich-landschaftlicher" Char. bewahrt wurde. ⌷ *P. Amelot*, Le Vésinet. Rev. mun. 1980 (52); *D. Hervier* (Ed.), Le Vésinet. Modèle franç. d'urbanisme paysager 1858–1930, P. 1989 (Cah. de l'Inv., 17). – Mitt. B. de Choulot, Thauvenay. R. Treydel

Choumansky (C. de Courville; Choumanski), *Olga* (geb. Šumanskaja, Ol'ga Vasil'evna), russ. Malerin, Dekorations- und Scherenschnittkünstlerin, Bühnen- und Kostümbildnerin, Übersetzerin in Frankreich, * 8. 3. 1896, † M. oder E. der 1970er Jahre Paris(?). Nach 1919 Emigration aus Rußland. Spätestens ab 1927 ansässig in Paris, wo C. bis in die 1950er Jahre mit einer Adresse in der Rue Notre-Dame-des-Champs nachw. ist. Parallel zu ersten dok. Ausst.-Beteiligungen E. der 1920er Jahre, in denen sie noch irrtümlich als Rumänin geführt wird, arbeitet sie im 1927 von Xavier de Courville gegr. Théâtre Ambulant de la Petite Scène als Kostümbildnerin (u.a. 1928 Gastspiel mit einer von C. ausgestatteten Aufführung am Schauspielhaus Zürich) und unterrichtet angew. künstlerische Techniken in einem Atelier in der Pariser Rue Falguière. Die 1930 mit X. de Courville geschlossene Ehe besteht wohl nur kurz; bereits 1936 heiratet er die Sängerin und Schauspielerin Jacqueline Casadesus. In den 1930er und 1940er Jahren stattet C. Inszenierungen von vorrangig zeitgen. dramatischer Lit. an versch. Pariser Theaterhäusern aus, mehrfach unter den Regisseuren Gaston Baty (u.a. Kostüme für *Prosper* nach Lucienne Favre; 1934 Théâtre Montparnasse) und Pierre Valde, für den neben Gesamtausstattungen der Uraufführungen von *Les amants de Noël* nach Pierre Barillet (1947 Théâtre de Poche) und *Les mains sa-*

les nach Jean-Paul Sarte (1948 Théâtre Antoine) auch das Bühnenbild zu *Hyménée* nach Nikolaj Vasil'evič Gogol' (1944 Théâtre du Vieux Colombier) und Kostümentwürfe für die Aufführung von *Un inspecteur vous demande* (1949) nach John Boynton Priestley am Théâtre des Célestins in Lyon entstehen. In den 1940er Jahren auch Kostümentwürfe für frz. Filmproduktionen, darunter *Trente et quarante* (1945/46; Regie: Gilles Grangier), *La kermesse rouge* (1947; Regie: Paul Mesnier; dt. Verleihtitel: Feuer im Bazar) und *Maya* (1949; Regie: Raymond Bernard; dt. Verleihtitel: So endete eine Dirne). Ab 1950 soll C. in Paris eine eig. Kleinkunstbühne betrieben haben (vgl. Rossijskoe zarubež'e vo Francii [...], 2010). Zuletzt ist sie 1973, vermutlich kurze Zeit vor ihrem Tod, mit einer Schenkung an die BN belegt. Im Kontext ihrer Arbeit für das frz. Theater wird C. auch mit Übersetzungen russ. Lit. betraut; bek. sind die Übertragung eines Librettos von Aleksandr Onisimovič Ablesimov (mit X. de Courville und Gabriel Alphaud) für eine Aufführung am Théâtre Ambulant de la Petite Scène (1929) und eine Übersetzung der Komödie Revizor von N. V. Gogol' (mit Jules Delacre; o. J., erh. in zwei Typoskripten, BN, Paris); weiterhin Mitautorin einer Hörfunkadaption der Novelle Dubrovskij von Aleksandr Sergeevič Puškin beteiligt (mit Frédéric de Heeckeren; Ausstrahlung auf France-Culture, Nov. 1973). – Zunächst tritt C. v.a. mit farbigen Scherenschnitten öff. in Erscheinung. Eine ausschl. dieser Technik gewidmete, 1927 in Paris ausgerichtete Einzel-Ausst. erregt internat. Interesse, wobei bes. die malerische Qualität der Arbeiten, die im Unterschied zu kubistisch-geometrischen Strukturen auf freieren Formen basieren, als innovativ herausgestellt wird (vgl. The Adirondack News, 1927). Wahrsch. handelt es sich auch bei der 1928 im Salon d'Automne ausgestellten Lsch.-Darst. *En Bretagne* um einen Scherenschnitt. Während sich für diesen Teil des Frühwerks keine Beispiele in Slgn erhalten haben, ist das bühnen- und kostümbildnerische Œuvre der 1930er und 1940er Jahre in zahlr. Entwurfs-Zchngn überliefert. Neben dem umfangreichsten öff. zugänglichen Konvolut in der BN Paris finden sich im Kunsthandel u.a. mit Gouache kolorierte, sign. und dat. (1935) Maketten zum Ballett *Le malheur d'avoir trop d'esprit* nach einem Libretto von Aleksandr Sergeevič Griboedov in einer Inszenierung von Nikolaj Nikolaevič Evreinov für das Nationaltheater in Prag (vgl. Aukt.-Kat. Espace Tajan, Paris, 2008, Lot 37–40). Erh. ist weiterhin ein Portr. des Schauspielers *Lucien Nat* (Öl/Lw.) in der Rolle des Raskol'nikov, das wohl ins zeitliche Umfeld der Aufführung von *Crime et châtiment*, einer Adaption nach Fedor Michajlovič Dostoevskij, zu datieren ist (1933 Théâtre Montparnasse, Paris; Regie: G. Baty). Portr. des Schauspielers. ⌂ PARIS, BN, Dép. des arts du spectacle, Fonds O. C. ◉ *E:* 1928–29 Zürich, KGS (mit Paul-Ami Bonifas, Fedor Chmetz, Carl Ottiker; Begleit-Publ.) / 1929 Paris, Gal. Bernheim-Jeune / 1939 Den Haag, Ausst.-Saal Kunst unserer Zeit. – *G:* Paris: 1928, '33, '38 Salon d'Automne; 1934 Salon des Tuileries; 2008 Espace Tajan: Art russe (K). ▭ *Edouard-Joseph* I, 1930; *Bénézit* III, 1999; Rossijskoe zarubež'e vo Fran-

cii. 1919–2000. Biografičeskij slovar', III, Mo. 2010 (s.v. Šumanskaja, Ol'ga Vasil'evna). – The Adirondack News (St. Regis Falls/N. Y.) v. 17. 12. 1927; La petite ill. (P.) v. 2. 9. 1933; L'art et la mode (P.) 58:1937 (2614[Jan.]) 22; Opéra (P.) v. 26. 5. 1948; *A. Simon*, Gaston Baty. Théoricien du théâtre, P. 1972; *A. Loewenberg*, Ann. of opera. 1597–1940, Totowa, N. J. ³1978. – Paris, Bibl. hist. de la Ville de Paris, Slgn der Assoc. de la Régie théâtrale: Fonds Georges Vitaly. – *Online:* Internet movie database.

S. Görke

Chowdhary, *Lubna*, brit. Keramikerin, Plastikerin, * 1964 Tansania, lebt in London. Tochter pakistanischer Eltern, die 1970 nach Großbritannien übersiedeln. Stud.: 1985–88 Manchester Polytechnic; 1989–91 R. College of Art, London. Lehrtätigkeit ebd.: 1991–2002 Tower Hamlets College of Further Education; 1994–97 West Thames College; 1998–2001 London College of Fashion. Ausz.: u.a. 1990 Eduardo Paolozzi Travel Award, R. College of Art (für Indienaufenthalt); 1999 London Inst. Research Award. – Formschöne Gebrauchskeramik (Gefäße, Untersetzer); Keramikarbeiten mit installativem Char. (z.B. *Metropolis*, ein komplexes Arrangement aus über 1000 kleinen Keramikplastiken, das sich mit menschlicher Produktion zu versch. Zeiten und überholten Produktionsmethoden, Kultur, Werten, Gedächtnis etc. auseinandersetzt, 1990er Jahre); baugebundene Werke (v.a. Wandbilder bzw. Fassadendekorationen, handbemalte Fliesen). Von Gest.-Reichtum und einer ausgeprägten Schmuckfreudigkeit, wie sie auch für den arabischen und indischen Raum char. ist, sind die Wanddekorationen bestimmt. Deren abstrakte, meist auf geometrischen Formen beruhende Komp. zeigen unterschiedliche Einflüsse, die von europ. Kunstströmungen der Moderne bis hin zu orientalischer Dekorationskunst reichen (*Script*, 2005, im Auftrag von Sony für die Ausst. Beautiful Script in der Dray Walk Gall., London), und sind damit Ausdruck ihrer Verwurzelung in versch. Kulturkreisen. Die Werke zeichnen sich durch ein exzellentes Gespür für Farben, Komp., Textur und Glasuren aus. ⌂ ABINGDON/Oxon., Abingdon Mus. BRADFORD, Cartwright Hall AG: u.a. Bradford City, 1995; Tactile Table, 1999. GATESHEAD, Shipley AG. WARWICK, Mead Gall. WIGAN, Drumcroon AC. – *Baugebundene Arbeiten (wenn nicht anders erw., Fassaden- bzw. Wand-Gest.):* CAMBRIDGE, Wohnanlage Orchard Park: Flächen-Gest. mit Sitzgelegenheiten. CARDIFF, Wales Millenium Centre, Hoddinutt Hall. LONDON-Haringey, Tiverton Estate, Seven Sisters. – L.-Hillingdon, Fußgängerunterführung in der Nähe des Bahnhofes Hayes und Harlington. – St. Georges Hospital. – Brixton Market, Hof, 2003. – Athenaeum Hotel, 2004. – Wigmore Str., Geschäft von Margaret Howell, 2008. NEWBURY, Priors Court School, 2004. NEW DELHI, Park Hotel. PARIS, Restaurant Alcazar, 1998. SLOUGH, Tesco-Supermarkt, Lantern Tower, 2007. ◉ *E:* 1993 London, Commonwealth Inst. / 1994 Leicester, City AG / 1995 Heckington (Lincs.), Pearoom Centre for Contemp. Crafts / 1996 Paris, Clara Scremini Gall. / 1998 Oldham (Lancs.), Oldham AG; Nottingham, Angel Row Gall.; Kopenhagen, Udstillingsted for Ny Keramik /

1999 Southampton, Millais Gall. / 2003 Walton on Thames, Robert Phillips Gall. – *G:* London: 2001–02 Crafts Council: Jerwood Prize for Applied Arts (Wander-Ausst.); 2004–06 V & A: import export; 2011 Saatchi Gall.: Collect 2011 / 2004 Limoges, Fond. Bernadaud: L'obsession du détail. ▢ *E. Cooper*, Contemp. ceramics, Lo. 2009. – *Online:* Website C.; Crafts Council Photostore; PSP – The beautiful script. C. Rohrschneider

Chowtadapong *Somsak* (Somsak C.), thailändischer Maler, * 22. 12. 1949 Bangkok, lebt dort. Stud.: 1969–78 Fac. of Paint., Sculpt. and Graphic Arts, Silpakorn Univ., Bangkok (Malerei); 1978–79 ABA, Urbino; 1983–85 Yokohama Nat. University. 1974–89 Doz. für Malerei am College of FA, Bangkok. Ab 1997 Dir. des College of FA in Nakhon Si Thammarat. 2003 Interims-Dir. des AC, Office of Contemp. Art, Kultur-Minist., Bangkok. Seither ist C. in leitender Position im Kultur-Minist. tätig und nimmt am Ausst.-Betrieb nicht mehr teil. Ausz.: 1972 (2. Preis), '74 (3. Preis) Nat. Art Exhib., Bangkok. – Während der ersten Studienjahre reflektiert C.s Malerei Impressionismus und Kubismus. Bis E. der 1970er Jahre entwickelt er einen eig. flächigen Stil mit vereinfachten Natur- und Lsch.-Formen, der sich an der Malerei seines Lehrers Chalood Nimsamer und an chin. Rollbildern orientiert. Unter dem Einfluß der US-amer. Farbfeldmalerei (Morris Louis, Helen Frankenthaler) entstehen erste großformatige Öl-Gem. mit frei fließenden abstrakten Formen in vibrierender, reichhaltiger Farbigkeit, die inhaltlich mit spirituellen Erfahrungen sowie mit buddh. Symbolen und Sinnbildern in Verbindung gebracht werden können. Während des Aufenthalts in Japan erwecken Zen-Malerei und -gärten C.s bes. Interesse und führen ihn bis E. der 1980er Jahre zu einer Lsch.-Malerei zurück, in der sich seither frontal-flächig erfaßte, abstrahierte Naturausschnitte, ornamentale sowie gänzlich abstrakte Felder auf einer Bildfläche gegenüberstehen. ▥ BANGKOK, Bank of Thailand: Space power, Acryl und Öl/Lw., 1989–92. – Dt. Bank. – NG: Atmospheric space, Öl/Lw., 1982. – Siam Commercial Bank: Atmospheric space No. 2, Acryl, Öl/Lw., 1982. – TISCO art coll.: Gray memories, Acryl/Lw., 1973; Green stripe, 1976; Atmosphere in space II, 1977; Atmosphere, 1977; Atmosphere in space, 1978; Dimension of time, 1984, alle Öl/Lw. ◉ *E:* Bangkok: 1983 NG; 1987 Artist's gall. / 1985, '86 Yokohama, Sairin gall. – *G:* Bangkok: 1971, '72 NB: Nat. Art Exhib. (K); 1973 Bangkok art festival; Mekpayap AC: 4 young artists; Bhirasri Inst. of Mod. Art: 1983 Life. White group; '84 White group watercolour exhib. (beide K); 1974, '80 AC, Silpakorn Univ.: Nat. Art Exhib.; 1982 Thammasat Univ.: Art since 1932 (K); 1986 Amarin AG: Colour and form; 1987 Artist's gall.: In memory of Suchao Sisganes; 1989 NG: Inspiration from Japan; 1994 Contemp. art expo (K); 1995, '97 Ausst. von Mitgl. des College of FA (K); 1998 Report from the forest (K); 1997 Queen Sirikit Nat. Convention Center: 50 years of Thai art (K); 2003 Silom Gall. exhib. hall: Art in box (K) / 1973 Chiang Mai, United States Information Center: Contemp. painting / 1976 Berlin: Intergrafik; Frechen: Grafik-Bienn. / 1978, '80 Singapur, Nat. AG: Singapore art

festival / 1979 Urbino, Collegio Raffaello: Young foreign artists / 1986 Mannheim, Kulturzentrum Hauptfeuerwache: Zeitgen. Graphik aus Thailand und Deutschland (K) / Kuala Lumpur, Nat. AG: 1990 Asian internat. art exhib.; '94 Asian watercolour confederation (K) / 1991 Berkeley, Univ. of California, Robert H. Lowie Mus.: The integrative art of mod. Thailand (K) / 2007 Tokio-Kōtō, MCA: Show me Thai. Thai contemp. art (K). ▢ First solo exhib. of paint. by S. C. (K NG), Bangkok 1983; Poetic garden. S. C. (K Artist's gall.), Bangkok 1987; *A. Poshyananda*, Mod. art in Thailand, Singapore/N. Y. 1992; *V. Mukdamanee/ S. Kunavichayanont*, Rattanakosin art. The reign of King Rama IX, Bangkok ²1997, 138, 175; TISCO art collection. 4 decades of Thai contemp. art, Bangkok 2009, 52, 55, 58, 60, 70. A. Feuß

Choyal, *Surjeet (Surjeet Kaur)*, indische Malerin, Graphikerin, * 24. 9. 1948 Jaipur/Rājasthān, lebt in Udaipur/ Rājasthān. Verh. mit dem Maler und Graphiker Shail C., Mutter von Akash C. Stud.: 1968 Banasthali Vidyapeeth, Jaipur; 1970–71 Fac. of FA, Maharaja Sayajirao Univ., Baroda/Gujarat. 1975–76 Studienaufenthalt in London. 1991 Stip. der indischen Reg. Ausz.: u.a. 1970, '93 All India Award, Rājasthān Lalit Kalā Acad., Jaipur; 1990 All India FA and Crafts Soc., New Delhi. – C. arbeitet an der Verfeinerung ihres expressiv-fotorealistischen Malstils. Um 2005 schafft sie großformatige Öl-Gem. mit Motiven aus Rājasthān; vereinzelte Frauengestalten stehen in minutiös wiedergegebenen Stadtszenerien. Die vordergründig dekorativen Bilder transportieren subtile Kommentare zur Situation und Stärke der indischen Frau. Arbeiten von 2009 greifen ges.-politische Themen auf; Rad. und Öl-Gem. spielen mit visuellen Versatzstücken der indischen Geschichte (*Those glorious days*, Aquatinta, 2008). ▥ FUKUOKA/Japan, MMA. MUMBAI, Air India. – Taj Mahal Hotel. NEW DELHI, NGMA. – Sahitya Kalā Parisad. – Lalit Kalā Akad. ◉ *G:* New Delhi: 1991 Lalit Kalā Akad.: Trienn. India; 2009 Dhomimal AG: The celestial six / 2009 Colombo, High Commissioner of India: Art from India (K). ▢ *Krishnan*, 1981; *P. Sheth*, Dict. of Indian art and artists, Ahmedabad 2006. – *K. Bansal*, Udaipur Times v. 20. 10. 2010. – *Online:* artchill.
 M. Frenger

Choynowski, *Mieczysław*, poln. Psychologe, Fotomontagekünstler, Fotograf, * 1. 11. 1909 Polen, † 1. 10. 2001 Mexiko, lebte u.a. in Krakau, Warschau und Mexiko-Stadt. 1928–37 u.a. Stud. der Mathematik und Philosophie an der Univ. Warschau, daneben Beschäftigung mit Fotogr. und Fotomontage. 1946 Promotion an der Uniw. Jagielloński, Krakau; E. der 1940er Jahre Ltg des Epistemologischen Konversatoriums (Konwersatorium Naukoznawcze) ebd., an dem er auch dem Schriftsteller Stanisław Lem Privatunterricht erteilte und ihn als Forsch.-Ass. beschäftigte. Nach dem Krieg ausschl. wiss. Tätigkeit: ab 1946 Hrsg. der Zs. Życie naukie (1953 eingestellt); 1950–56 Gründer und Leiter des Psychologischen Labors des Psychiatrischen Krankenhauses in Kobierzyn bei Krakau; 1959–70 Leiter des Labors für Psychometrie (Pracownia Psychometryczna) an der poln. Akad. der Wiss., Warschau. Nach Liqui-

dierung des Labors Übersiedlung nach Mexiko, dort u.a. an der Univ. Pedagogico Nac. in Mexiko-Stadt tätig. 1998 Offizierskreuz des Verdienstordens der Republik Polen. – Beeinflußt von Avantgardekünstlern wie László Moholy-Nagy, John Heartfield und Mieczysław Berman 1931–32 Veröff. erster Fotomontagen in der lit. Wochen-Zs. Wiadomości Literackie; weitere Veröff. bis 1933 in der Zs. Naokoło Świata. U. a. politisch-propagandistische, häufig anti-amer., und ges.-kritische Fotomontagen in Schwarzweiß, meist übersichtlich angeordnete Komp. aus Figuren versch. Größe unter Verwendung graph. Elemente wie Kreise und Balken; bek. ist v.a. die Arbeit *Ameryka* (1932), die zwei gefesselte Hände zeigt, die aus einer Ansammlung von Wolkenkratzern nach der Freiheitsstatue greifen. Daneben auch philosophisch-betrachtende und humorvolle Arbeiten, u.a. Frauengesichter auf halbbekleideten Männerkörpern in Bodybuilding-Posen. Ab der 2. H. der 1930er Jahre bis zum E. des 2. WK hauptsächlich Fotograf; während des 2. WK Eröffnung eines Ateliers für Portr.-Fotografie. ⌱ WARSCHAU, MN. ✉ u.a. Samotność i wyobraźnia, Lo. 1989. ◉ *G:* Warschau: 1970 Klub Międzynarodowej Prasy i Książki: Fotomontaże 1924–1934 (K); 2003 Zachęta: Fotomontaż polski w XX-leciu międzywojennym (K); 2011 Muz. Pałac w Wilanowie: Witkacy i inni. ▭ La photogr. polonaise 1900–1981 (K MNAM), P. 1981; *J. Lewczyński*, Antologia fotografii polskiej 1839–1989, Bielsko-Biała 1999; Foto. Modernity in Central Europe. 1918–1945 (K Wander-Ausst.), N. Y. 2007. J. Niegel

Chraïbi, Ali, marokkanischer Fotograf, * 13. 4. 1965 Marrakesch, dort tätig. Autodidakt. Widmet sich seit 1995 der Fotografie. Er erhält mehrere, auch internat. Ausz., u.a. ist er 1999 in Marokko Preisträger der nat. Ausst. für Fotogr. und empfängt 2002 in Frankreich den Preis Au Sud du Sud des Sarev-Kulturzentrums von Marseille. – C. stellt in seinen ästhetisierenden Schwarzweiß-Fotogr. marrokanische Küsten-, Wüsten- und Stadt-Lsch. und deren Bewohner dar. Zeigt seine Arbeiten regelmäßig in nat. und internat. Gal., u.a. in Spanien, Italien und in den Niederlanden, und nimmt an internat. Ausst. teil. ◉ *E:* Marrakesch: 2002 Gal. Bab Doukalla; 2003 Gal. Tadghart; 2008 Gal. 127 / 2003 Rabat, Frz. Inst. / 2005 Amsterdam, Stadtbezirksbüro Bos & Lommer. *G:* 2002 Dakar: Bienn. / New York: 2005 kbp in Williamsburg Gall.: Purity and danger; 2008 Open Soc. Inst.: Moving Walls. ▭ *Delarge*, 2001. – The Sunday Times v. 10. 6. 2001; Mém. intimes d'un nouv. millénaire. IV^es Rencontres de la photogr. africaine, Bamako 2001 (K), P. 2001; *O. Enwezor*, Snap judgments. New positions in contemp. African photogr. (K New York/Miami/Amsterdam), Göttingen 2006. – *Online:* Website C. (Ausst.); photogr.-now, 2012. M. Kühn

Chrétin (Crestin), *Maximilien Théodore*, frz. Bildhauer, Mosaikkünstler, Maler, Architekt (?), Archäologe (?), * um 1797 oder 1801 Paris , † vermutlich um 1872 ebd. C.s Biogr. ist nur lückenhaft erschlossen durch größtenteils nicht urkdl. belegte Angaben, die auf überlieferten Nachr. und z.T. obskuren bzw. widersprüchlichen persönlichen Auskünften beruhen. So gibt er 1835 sein Alter mit

34 Jahren an, nennt aber zugleich 1797 als Geburtsjahr und bezeichnet sich als Patensohn von Maximilien Robespierre. Nach einer Ausb. bei Paulin Guérin (Malerei) und Charles Simon Pradier (Kpst.) in Paris(?) sei er nacheinander Matrose, Schreibwarenhändler und beim Militär, dann Zeichenlehrer am Gymnasium in Auch gewesen. Anschl. habe er Kirchenbilder und Portr. gemalt sowie eine bemerkenswerte Slg mit Büchern, Druckgraphik und Med. zusammengetragen. Nach der Tätigkeit in Auch soll C. mit einer fahrenden Schauspielertruppe aufgetreten sein und auch deren Dekorationen gemalt haben. Auf diese Weise sei er nach Nérac/Lot-et-Garonne gelangt, wo er mit der Ausmalung eines Veranstaltungssaals beauftragt wird, die Truppe ziehen läßt und bleibt. Urkdl. nachw. wird er 1833 dort zu archäol. Grabungen im Park der ehem. Villa La Garenne hinzugezogen; in diesem Zusammenhang verkauft er der Soc. archéol. in Toulouse mehrere Medaillons, Basreliefs und Inschr. als von ihm in Nérac entdeckte Originalfundstücke, die von den maßgeblichen Fachleuten, darunter Prosper Mérimée, Inspecteur gén. des Mon. hist., zunächst für echt befunden werden; C. wird dafür von der Soc. archéol. mit einer Silber-Med. geehrt. Kunsthist. bes. bed. sind zwei Basreliefs mit Darst. des gallischen Kaisers Tetricus I. (beide in Toulouse, Depot des Mus. St-Raymond; erh. sind dort auch Lith. nach Zchngn C.s und dessen gefälschte Inschr. auf den Rückseiten der beiden Reliefs). 1835 wird C. jedoch der Fälschung überführt und verklagt; nach einem Geständnis wird er allerdings freigesprochen. 1835 bis ca. 1838 lebt er wohl in Agen, arbeitet als Bildhauer in Toulouse, Bordeaux, Laon und Paris. Dort läßt er sich spätestens 1844 nieder (9 rue Neuve Saint-Denis), befaßt sich mit der Mosaikkunst und entwickelt eine kosten- und zeitsparende Methode zum Verlegen von Mosaiken. In einem um 1845/46 verfaßten Text (Orléans, Arch. du Loiret) schlägt er die Gründung einer „man. royale des mosaïques artist. en France" vor und nennt sich u.a. Erfinder eines Mosaikverfahrens, das die Vorfabrikation in der Wkst. ermöglicht. Einige nach seinem System gefertigte Musterproben zeigt C. 1846 auf einer Ausst. in Paris, wo der Architekt Etienne-Albert Delton auf ihn aufmerksam wird und mit der Forts. der von einem Mosaizisten namens Ciuli beg. Freilegung und Rest. des wertvollen Deckenmosaiks in der Kirche von Germigny-les-Prés/Loiret beauftragt (ausführlich dazu cf. Meyvaert, 2001). 1847 beginnt C. und entdeckt dabei am unteren Rand des Mosaiks eine fragm. Inschr., die bis dahin nicht bek. war im Unterschied zu einer weiteren schadhaften Inschr. von Abt Theodulf von Orléans auf einem Pfeiler im Glockenturm. Eigenmächtig nimmt er die Vervollständigung der Inschr. des Mosaiks in Angriff, begeht dabei aber aufgrund unzureichender Kenntnisse über die Historie und die röm. Epigraphik mehrere grundlegende Fehler, bes. bei der Angabe der Jahreszahl 806 in arabischen Ziffern und der Nennung der hl. Genoveva (stattdessen ist die Kirche dem Heiland gewidmet). Die Inschr. auf dem Pfeiler setzt C. ebenso kühn auf einen and. Pfeiler fort. Seine „Entdeckungen" präsentiert er Vertretern der Soc. royale des Sc., Belles-Lettres et Arts d'Orléans, für die er 1847 eine Zchng des

Mosaiks fertigt, die veröff. wird und ein wichtiges Zeugnis für die Gesch. der Mosaikkunst ist. Berechtigte Zweifel von Archäologen an der Echtheit der komplettierten Inschr. werden in diesem Fall unterdrückt. A. 1848 veranlaßt Mérimée jedoch die Unterbrechung der von C. beg. Rest. des Mosaiks, der dieses wegen mangelnder fachlicher Eignung wohl unwiederbringlich zerst. hätte (erst E. des 19. Jh. voll.). Zur Revolutionszeit 1848 ist C. wieder in Paris. Die letzte Inf. über ihn stammt 1856 ebd. vom Architekten Albert Lenoir, nach der C. kurz zuvor mit der Gest. von plastischem Ornamentschmuck für den Louvre beschäftigt war (Bull. du Comité de la langue, de l'hist. et des arts de la France 3:1857, 390 s.). ▭ DBF VIII, 1959. – *P. Meyvaert*, GBA 137:2001 (Mai/Juni) 203–220 (auf zahlr. Archivalien gestützte Studie). R. Treydel

Chrisopulos, *Jani* (*Jani Georgiev*; auch *Janis*), bulg. Maler, Zeichner griech. Abstammung, * 6. 4. 1901 Sozopol, † 25. 8. 1985 ebd. Schüler von Aleksandăr Mutafov. Ausz.: 1970 Orden „Kiril i Metodij" 1. Stufe. – Ähnlich wie Mutafov, der zweifellos nachhaltigen Einfluß auf sein Schaffen ausübte, war Ch. in erster Linie Marinemaler. Die realistisch gemalten maritimen Motive sind manchmal von pathetischer Monumentalität, manchmal elegisch ruhig, von kühner Farbintensität und voller Lichteffekte (*Burno more*, 1949, Nat. KG Sofia; *Sărdito more*, 1957, KG Burgas; *More*, 1958, Vachtangov-Theater Moskau; *More*, versch. Fassungen, 1960er Jahre). Ch.s naturgetreue Bearb. and. Sujets zeigen eine Tendenz zu monochromer Tonalität und beeindrucken durch ihre Einfühlsamkeit (*Ot atelieto*, 1957; *Utro*, 1958; *Bora, Sozopolska zima, Esen. Ropotamo, Prolet, Măglivo utro*, alle 1970; *Kăsti i gemii*, 1973). Darüber hinaus entstehen mehrere Zchngn zu Motiven aus Ch.s Heimatstadt Sozopol, darunter die Reihe *Stari kăsti*/Alte Häuser (v.a. ortstypische Bebauung aus der bulg. Wiedergeburtszeit, 1970er Jahre). ▭ BURGAS, KG. KAZANLĂK, KG. PLOVDIV, KG. SOFIA, Nat. KG. – Slg der Kultur-Abt. des bulg. Außen-Minist. SOZOPOL, KG (Hauptteil des künstlerischen Nachlasses). VARNA, KG. ☉ E: 1934, '70 Sozopol / 1935, '43, '57, '63 Burgas / 1936, 2006 Kazanlăk, KG / 1937 Plovdiv / 1949 Sofia. – G: Burgas: 1934 Künstler aus dem Gebiet Burgas; ab 1960 mehrfach Prijateli na moreto/Freunde des Meeres / nach dem 2. WK sporadisch Sofia: Allg. bulg. Kunst-Ausst. ▭ EIIB III, 2006. S. Jähne

Chrispeels, *Didier* → **Crisse**

Christakis, *Tassos* (*Tasos*), griech. Maler, Bildhauer, Installationskünstler, * 1947 Anatoliki Ioannina, lebt in Athen. Stud.: 1967–72 HBK, Athen, Malerei und Bühnenbild in den Wkstn von Giannis Moralis und Vassilis Vassiliadis; 1979–82 Boston Univ., Boston/Mass. (Master of FA; 1980–82 wiss. Ass. ebd.). Lehrtätigkeit: ab 1983 HBK, Athen (1999 Prof. für Malerei). – C.s Werk ist gekennzeichnet durch radikale Reduktion und Konzentration auf die Motivkomplexe Mensch, Berg, Fels und Baum. Das jeweilige Objekt wird ins Zentrum eines sonst nahezu leeren Raumes gerückt, sowohl im Bildraum wie im realen Ausst.-Raum. C.s weitgehend auf Schwarz, Weiß und Grau beschränkte Farbskala korrespondiert mit dem minimalistischen Ausdruck seiner seriellen Arbeiten (v.a. Kohle und Graphit/Papier, seltener Acryl). Ein Aufenthalt auf der Santorin-Inselgruppe 1980 bringt ihn zur Auseinandersetzung mit Felsen und Steinen der griech. Landschaft. Es entsteht eine große Anzahl von Skizzen, die er in den folgenden Jahren weiter bearbeitet, abstrahiert und motivisch reduziert. 1987 erste Einzel-Ausst. in Athen; im Mittelpunkt der Bilder erscheint häufig eine stelenartige Struktur, die an einen Grabstein oder ein archaisches Idol erinnert und die Kargheit der Lsch. symbolisiert. Zeitgleich entstehen Zchngn, bei denen eine menschliche Silhouette ohne erkennbaren Gesichtsausdruck in einem ansonsten leeren Raum erscheint. Schließlich studiert C. in einem Bilderzyklus eine Bergsilhouette vor einem räumlich nicht definierten Hintergrund. Der weiße Grundton des Papiers kontrastiert in all diesen Arbeiten als blendend helle Fläche mit der dunklen Graphitfarbe des jeweiligen Motivs oder bleibt umgekehrt als greller Umriß stehen, der die Figurationen aus dem schwarzen Grund hebt. In den seit 1991 ausgestellten installativen Werken setzt sich C. mit ähnlichen Fragestellungen auseinander, u.a. werden teilw. angesengte Holzstücke, deren Rinde reliefartige Strukturen aufweist, wie Skulpt. an die Wand gelehnt und teilw. mit Kohle bemalt. Auch arrangiert er Metallstreben, u.a. in *Glypto* (1991), über einem kegelförmig aufgeschichteten Erdhaufen, der an die geomorphen Strukturen in seinen Zchngn ebenso erinnert wie er Assoziationen an heroische antike Trümmer-Lsch. aufkommen läßt. E. der 1990er Jahre erweitert C. seine Kunstmittel, so beginnt er mit dem Ausbrennen einzelner Flächen oder dem sparsamen Aufbringen von Blattgold in dem ansonsten monochromen Kosmos seiner Bildwelten. Jedoch bleibt die Motiv- und Formwelt der Arbeiten konstant. Beeinflußt von der Konzeptkunst und von Elementen der Minimal- und Land-art hat C. zu einer individuellen Sprache gefunden. Konsequent setzt er sich – darin Cézannes Vorgehen vergleichbar – über Jahrzehnte hinweg in unterschiedlichen künstlerischen Medien mit denselben Motiven auseinander, die er immer wieder in neuen Variationen untersucht. ▭ ATHEN, Frissiras Mus. – Nat. AG. ☉ E: Athen: 1991, '95 Ileana Tounta Contemp. AC; 1997 Zoumboulakis Gal.; 2008 Benaki Mus. / 1990 Helsinki, Lindblom Gal. / 1996 Kopenhagen, Krebsen Gal. – G: 1992 Sevilla: WA / 1997 Larisa, Kulturzentrum für zeitgen. Kunst: Esties tou blemmatos / Athen: 2000 Onassis Cult. Centre: Classical Mem. in Mod. Greek Art (auch NG, Beijing); 2008 NM of Contemp. Art (EMST): Transexpriences Greece 2008 (auch Space, Beijing); 2011 Zoumboulakis Gal.: Reference – Representation; 2011 Frissiras Mus.: Black & White; 2012 Nat. Glyptothek: Sta adynata tis Ethnikis Pinakothikis. Metapolemiki kai synchroni techni. ▭ LEK IV, 2000. – Paletten (Schweden) 1989 (1) 14–17; *A. Kafetsi*, Metamorfoseis tou monternou. I elliniki empeiria (K), At. 1992; *A. Tamvaki*, Contemp. Greek art. Three gen. (K), At. 1998; *C. Kampourideis/G. Levounis*, Mod. Greek art. The 20th c. [...], At. 1999; *M. LeBot*, Frissiras Mus. Coll. of drawings, At. 2000; *B. Robertson*, Frissiras MCA, At. 2000; *E. Hama-*

lidi (Ed.), Contemp. Greek artists, At. 2004, 45–46; C. (K Benaki Mus.), At. 2008. E. Kepetzis

Christakos (Hristakos), *Yiannis (Giannis)*, griech. Maler, Graphiker, Computer- und Mixed-media-Künstler, Hochschullehrer, * 1966 Athen, lebt und arbeitet dort und in London. Ausb./Stud.: 1984–88 Technological Inst., Univ. Athen; 1989–94 HBK, Thessaloniki (bild. Kunst bei Vagelis Dimitreas); 1998–99 SchA and Design, Univ. of East London (Malerei); 1999–2003 Promotions-Stud. ebd. Seitdem Lehrtätigkeit: 2003–05 an der Univ. in Ioannina; seit 2004 am Technological Inst. in Athen und seit 2007 an der Univ. in Volos. Mitgl.: Epimelitiriou Eikastikon Technon Ellados/Vrg bild. Künstler Griechenlands (EETE); Deptford Art Development Assoc.(DADA), London; Gründungs-Mitgl. der Künstlergruppe Capsule (Multimedia-Installationen in Athen und London). Ausz.: 1994 Heineken Award for Young Artists; 1995 Preis der Astir Gal., Athen. – Ab M. der 1990er Jahre v.a. überlebensgroße Darst. des menschlichen Körpers in expressiven Farben, die in bewegtem Pinselduktus vorgetragen werden (Öl/Lw.). Die Figur wird stets in Bewegung gezeigt, ist fragmentiert und z.T. lediglich als Torso erkennbar. Um 1998 erweitert sich das Spektrum um Linien und Schnörkel, die zu abstrakten Mustern arrangiert werden; auch Menschengruppen nehmen in nervöser, schwarzer Kontur vor einem blassen Hintergrund Form an. Daneben Auseinandersetzungen mit der klassischen Mod., bes. mit der Malerei von Pablo Picasso. Nach 2000 fast ausschließliche Hinwendung zum Motiv der Landkarte, die malerisch verfremdet wird; Grundlage ist die Beschäftigung mit der sog. Psycho-Geogr., v.a. mit deren theoretischen Grundlagen (u.a. von Ivan Chtcheglov) und dem ersten situationistischen Kunstwerk (Guy Debord, Guide psychogéographique de Paris, 1957). Dabei geht es C. um den möglichen Einfluß von Archit. und Geogr. auf Wahrnehmung, Empfindung und Verhalten der Bewohner. C.s Arbeiten bestehen aus Überblendungen von Karten-Mat., Satelliten- und Computerbildern und archit. Zchngn, die er mit malerischen Mitteln be- und überarbeitet, so daß eine Synthese der benutzten Quellen erreicht wird. In vielen Fällen legt er über die so generierten Bilder buntes Garn zu Strukturen und Schleifen, die Wege zu suggerieren scheinen. Vergleichbare, letztlich auf der Konzeptkunst basierende künstlerische Überlegungen finden sich in den Arbeiten des Amerikaners Joyce Kozloff, des Argentiniers Guillermo Kuitca oder der Irin Kathy Prendergast. ⌂ ATHEN, Dakis Joannou Coll. – Verteidigungs-Minist. – Vorres Mus. NEW YORK, Exit Art Cult. Center. ▢ Personal mapping memories and imaginary maps, Diss. Univ. of East London, Lo. 2002; Personal geogr., At. 2005. ◉ *E:* 1995 Thessaloniki, Myrovolos AG / Athen: 1997 Antinor AG; 2005 Gal. Gazon Rouge / 2005 Ioannina, Gal. Amimoni / London: 2001 Greengate Gall.; 2003 UEL Gall.; 2004 Gall. (K) / 2003 Nikosia, Gal. K / 2012 Patras, Gal. Cube. – *G:* Thessaloniki: 1994 Intervention in the Town; 1995 MCA: Young Emerging Artists; 2006 Kodra-06 Gal.: A4; 2010 Gal. Container: Copy Paste / London: 1999 34 Underwood Street Gall.: Mind your Lan-

guage; 2001 East 73 Gall.: Nexus; 2001 Five Years Gall.: Self Service; 2002 Strand Old Tube Station: Next Station; 2002 The Bishopsgate Goodsyard: Chaos; Gal. K: 2006 (The Angel); 2009 (Lost Heritage) / Athen: 2002 Gal. Gazon Rouge: Water; 2006 UNESCO: Hartaetoi; 2008 Bonikos Gal.: Meta tin afairesi; 2009 Art Prisma Gal.: Erotika / 2003 Hastings, Mus. & AG: Its all Greek to Me. ▭ LEK IV, 2000. – *V. Dimitreas*, Antinor (K), At. 1997. – *Online:* Eleventh Plateau; Website C. (Ausst.). E. Kepetzis

Christea (Hristea), *Maria*, griech. Malerin, Installationskünstlerin, * 1949 Athen, lebt und arbeitet dort. Stud.: 1967–73 HBK, Athen, bild. Kunst bei Nikos Nikolaou und Giannis Moralis; 1973–75 Staatliche HdK, Berlin-West, bei Raimund Girke. Seit 1990 lehrt sie Zeichnen an höheren Schulen. Mitgl.: Epimelitiriou Eikastikon Technon Ellados/Vrg bild. Künstler Griechenlands (EETE). – Debütiert mit großformatigen Figurenbildern in expressionistischem Pinselduktus, mit dominanten Farbkontrasten und dynamisierenden Verkürzungen und Diagonalkompositionen. Den abstrahierend und überdimensional Dargestellten verleiht C. eine bisweilen archaische Anmutung. In einer zweiten Schaffensperiode entstehen unter Einfluß der Konzeptkunst v.a. räumliche Installationen. In ihren häufig stelenförmigen Arbeiten kombiniert C. Farbe mit Metall oder Spiegeln. Daneben finden sich installative Werke aus alten Bau-Mat. (Holzbalken, Eisenstangen) in Kombination mit diversen Objets trouvés (u.a. Plastik, Papier, elektrische Lampen). Die Wirkung des Lichts, das durch die teilw. transparenten Teile ihrer in einigen Fällen durch einen Motor in Bewegung gesetzten Installationen fällt, ist ein wesentlicher Faktor, das Thema der Transformation bzw. Metamorphose (z.B. von Materie in Energie) wiederzugeben. Ähnliche Themen spielen in ihren Videos eine Rolle, mit denen sie sich seit etwa 2000 beschäftigt. ⌂ THESSALONIKI, Macedonian MCA. ◉ *E:* Athen: 1987 Athens AG.; 1989 Ekphrasis Gal.; 1996 Kreonidis Gal.; 2003 Gal. Stigma. – *G:* 2001 São Paulo: Video Brasil. ▭ LEK IV, 2000. – M. C. Ek Vatheon (K Kreonidis Gal.), At. 1992; Synchroni elliniki glyptiki (K), Thessaloniki 1997; Athens by art (K), At. 2004. E. Kepetzis

Christen, *Franck*, frz. Fotograf, * 18. 1. 1971 Heimsbrunn/Haut-Rhin, lebt seit 1997 in Paris, seit 2001 auch in Brüssel. Stud. ebd.: 1992 Kunstgesch., Univ. libre; 1993–98 Fotogr., Ec. nat. supérieure des Arts visuels de La Cambre. Ab 2000 Fotogr. für das Mag. Nano; Portr. für Le monde des livres, L'œil, Cosmopolitan, View on color, Le monde; auch Aufnahmen für Firmen und Modehäuser sowie Aktfotografie. Lehrtätigkeit: Acad. royale des BA, Brüssel. Ausz.: 1998 Nat. Photogr. Ouverte, Fotogr.-Circuit Vlaanderen; 2001 Prix HSBC pour la photographie. – C. fotografiert in Schwarzweiß und Farbe v.a. Portr., aber auch trad. Lsch. und Stilleben. 1994/95 porträtiert er *Les collectionneurs en Belgique*, 1995/96 Personen im Elsaß (Serie *Les Alsaciens*), 1996/97 in Paris (*Portr. parisiens.* 1999 und 2002 arbeitet er im Libanon, 2000 wieder im Elsaß und 2003 in der Türkei. C. ist früh beeinflußt von Minimalismus, Konzeptkunst und Josef Beuys. Er fotografiert einfühlsame Portr. mit von den Dargestell-

ten selbst gewählten Posen häufig in Dreiviertelansicht im weiteren Umraum. Poetisch stille ausschnitthafte Beobachtungen im Alltag zeigen formale graph. Details, aber auch kleine surreale Konstellationen. – Foto-Publ.: *F. C.* (K), Arles 2001; *Fotogr.* (K), M. 2005. ☉ *E:* Brüssel: 1999 Gal. Bernier/Tanit Windows; 2005 Gal. R. Janssen / 2002 (mit Balthasar Burkhard), '04 München, Gal. Tanit (K) / 2002, '06 Paris, Gal. A. Gaillard / 2004 Riedisheim, Maison Jaune / 2006 Terbol (Libanon), Mus. / 2009 Beirut, Gal. K. Kunigk. – *G:* 1998 Charleroi, Mus. de la Photogr.: Prix nat. Photogr. ouverte / 2001 Mulhouse, La Filature: Photogr. rhénane contemp. / 2002 Toulouse, Gal. mun. du Château d'Eau: Les laureats du Prix HSBC 2001 pour la photogr. / 2007 Arles, Rencontres Internat. de la Photogr.: Photogr. contemp. (K) / Brüssel: 2008 Mus. d'Ixelles: Bruxelles, Territoire de convergences; Fond. Boghossian; 2010 Itinéraires de l'élégance entre l'Orient et l'Occident; 2012 Art is the answer. ⌑ *P. Remy/M. Trautmann*, Desire, Göttingen 2000; *D. Sausset*, Œil 2001 (529); Biz 9, Hayatia Ilgili Hersey 2005; *L. Mesplé*, L'aventure de la photo contemp. de 1945 à nos jours, P. 2006. – *Online:* Webseite C. T. Koenig

Christen, *Friedrich Samuel,* schweiz. Goldschmied, get. 11. 4. 1709 Bern, † nach 5. 8. 1749 (letzte Erw.). Sohn des Berner Stadtarztes Wolfgang Christen (1680–1745). 1738 erhielt C. das Zunftrecht zu Schmieden. Die Meistermarke, die mit C. in Verbindung gebracht wird, zeigt die Buchstaben FC im Queroval. 1746/47 wurde er von der Zunft-Ges. zu Schmieden beauftragt, die Innenvergoldung des Zunftgefäßes in Form einer Vulkanfigur zu erneuern. 1749 erhält C. von Schmieden eine große Menge silbernes Geschirr (1922 Lot im Wert von rund 1350 Kronen), wofür er der Zunft-Ges. 900 Kronen anzahlt. Im gleichen Jahr nimmt er von der Ges. Ober-Gerwern 1668 Lot vergoldetes und 524 Lot weißes Silber entgegen, um daraus sechs Paar Kerzenleuchter und 36 Kaffeelöffel mit dem frz., d.h. hohen Feingehalt zu fertigen. Doch er konnte den Auftrag nicht mehr ausführen, denn er war an der sog. Henzi-Verschwörung beteiligt, die darauf abzielte, das regierende Patriziat zugunsten der im Rat nicht repräsentierten Bürgerschaft zu entmachten. Infolgedessen wurde C. im Juni 1749 verhaftet, seine Wkst. aufgrund einer gerichtlichen Verfügung wurde geschlossen und seine Besitztümer wurden beschlagnahmt. Das städtische Strafgericht verbannte C. für 99 Jahre aus Bernischen Landen. Lt. Kleiner (1989) ging er nach Holland, fortan fehlt jede Nachricht über ihn. C. scheint v.a. silberne Tafelgeschirre und -geräte gefertigt zu haben. Erwähnenswert ist ein kleines Tablett mit konturiertem Rand, dessen achteckige Form als ungewöhnlich für Bern gewertet werden kann. Überdies schuf er ein birnförmiges Milchkännchen (Privatbesitz) mit glatt belassener Wandung und einem hohen, hölzernen Henkel, das auf drei geschwungenen Füßchen ruht, die oben in Maskarons enden. Insgesamt sind seine Werke dem Rokoko verpflichtet, zeigen aber schon Anklänge klassizistischer Formgebung. ⌑ BERN, HM: Teedose, 1740–49; Tablett, um 1746. ZÜRICH, LM: Schale (zu einem Paar gehörig), 1740–49. ⌑ *Brun*, SKL IV, 1917. – *A. v. Tillier*, Gesch.

des eidgenössischen Freistaates Bern von seinem Ursprunge bis zu seinem Untergange im Jahre 1798, Bd 5, Bern 1839, 208; *C. Herzog*, Gesch. des Berner-Volkes, Bern 1844, 651; *Roosen-Runge*, 1950, 11–12, 59, 67, 70; *A. C. Gruber/A. Rapp*, Weltliches Silber (K LM), Bd 1, Zürich 1977, 213, Nr 321; *P. Kleiner*, Weltkunst 1989 (8) 1214, Abb. 14; *C. Arminjon*, Les orfèvres franç. sous l'Ancien Régime, Nantes 1994, 110; *R. L. Wyss/H. Matile*, Jb. des Bernischen HM (Bern) 41–42:1961–62 (63), 43, 60; *R. L. Wyss*, Handwerkskunst in Gold und Silber, Bern 1996, 94, 101, 114, 292. S. Reiter

Christen, *Michele,* schweiz. Architekt, * 1965 Sorengo, lebt in Lugano. Stud.: 1984–90 Ec. polytechnique fédérale de Lausanne (EPFL); 1991 Dipl. bei Luigi Snozzi ebd. Seit 1992 freischaffend in Lugano (eig. Studio seit 1996 ebd.). Seit 1996 Kooperationen mit Philippe Bertschy aus Bulle. Mitgl.: Schweiz. Ing.- und Architekten-Ver. (SIA). – V.a. priv. Wohnbauten (u.a. in Fribourg) im Stil der in den 1970er Jahren etablierten Tessiner Schule. C.s Hw., das als wichtiger internat. Beitrag der zeitgen. Schul- und Hochschul-Archit. angesehen werden kann, ist das mehrgeschossige Lehrgebäude der Fac. di Teologica di Lugano (1999–2002), das auf dem Luganeser Campus der Univ. della Svizzera Italiana errichtet wurde: Um einen klar konzipierten zentralen, aus Beton errichteten dreigeschossigen Kubus hat C. ab dem ersten Obergeschoß eine zugleich wuchtig wie filigran wirkende streng geometrische Rasterstruktur gelegt, hinter der die hochrechteckigen Fenster liegen; die Erdgeschoßzone ist etwas zurückgesetzt und durchgängig verglast, was dem Gesamtbau die Schwere nimmt. ⌑ LUGANO, Via Giacomo e Filippo Ciani: Fac. di Teologica di Lugano, 1999–2002. ☉ *G:* 2008 Bielefeld, Mus. Waldhof (KV): Lernräume. ⌑ Neue Zürcher Ztg v. 22. 4. 2002; *G. Zannone Milan* (Red.), Premio SIA Ticino 2003, Bellinzona 2003; *T. Bamberg/P. Pellandini*, Tessin-Archit. Die junge Generation, M. 2004.
 U. Heise

Christen, *Moritz Herbert (Herbert),* schweiz. Maler, Zeichner, Radierer, Objektkünstler, * 5. 9. 1952 Schaffhausen, † 22. 11. 2000 Frankfurt am Main. Stud.: 1975–80 FHS für Gestaltung, Zürich. Zunächst in Thayngen und bis 1984 in Schaffhausen ansässig. 1981 Arbeitsaufenthalte in Umbrien und 1983 in Frankfurt am Main, wohin er 1985 übersiedelt. Malt, zeichnet und radiert zunächst Lsch., wobei der in sattem Blau wiedergegebene *Chapf*, der Hausberg von Thayngen, ein häufig wiederkehrendes Motiv seiner frühen Gem. ist. Die Probedrucke der Rad. übermalt er manchmal. Es folgt eine semiabstrakt-expressive Phase großformatiger Bilder mit bewegten Formen und leuchtenden Farben; danach beruhigt sich seine Formsprache zunehmend, wird subtiler und ist mitunter zeichenhaft-verschlüsselt. ☉ *E:* Schaffhausen: 1981 KV; Gal. an der Stadthausgasse; 2002 Gal. Repfergasse; 2008 Hallen der CMC (zu Gunsten des WWF) / 1983 Stein am Rhein, Gal. Susanne Jaeggi / 1984, '87, '92 Città di Castello, Forum Lama / Frankfurt am Main: 1989 KV; Forum Töngesgasse; 1991 Kunst e. V., B. und J. Wiesner; 1995, 2000, '02 Foyer Neues Theater Höchst; 2007 Gal. Frankfurt / 1995

Vaasa, Tikanojas Kunsthaus / 2009 Thayngen, Kulturzentrum Sternen (zus. mit Hans Bächtold). – *G:* 1989 Winterthur, KH: Kunst aus Schaffhausen (K) / 2002 Schaffhausen, KV. ▭ BLSK I, 1998. – *E. Bächtold/M. Baumann*, M. H. C. Bilder und Objekte (K), Schaffhausen 2008 (Privatdruck). – *Online:* SIKART Lex. und Datenbank.

E. Kasten

Christensen, *Jeannette*, norwegische Installations- und Objektkünstlerin, Fotografin, * 6. 2. 1958 Oslo, lebt dort. Stud.: 1978–79 KGS; 1979–82, '84–85 Vestlandets KA Bergen (beide jetzt Kunst- og designhøgskolen; hier 2000–07 außerordentliche Prof.); 1982–83 ENSBA Paris. Weitere Lehrtätigkeit: 1998–2000 KA, Kopenhagen. Stip.: u.a. 1982 Frz. Staats-Stip.; 1986 Anton Christian Houens og Conrad Mohrs legat, Oslo; 1992 P. S. 1 Internat. Studio Program, Long Island City/N. Y.; 1992–2001 mehrfach Billedkunstnernes Verderlagsfond, Oslo. – C. beschäftigt sich in ihren Arbeiten hauptsächlich mit versch. Aspekten der Zeit, u.a. mit Vergangenheit und Vergänglichkeit, was sich z.T. in den Titeln ihrer Werke widerspiegelt und für die sie oftmals auch Mat. mit begrenzter Haltbarkeit verwendet. So beziehen sich einige der Arbeiten auf Gem. der Alten Meister, z.B. die in der Art der Helldunkel-Malerei gestaltete Serie von Polaroid-Fotogr. *The Passing of Time* (1994–98), auf denen zunächst weibliche, später auch männliche Protagonisten die Handlungen der auf Vermeers Genre-Gem. dargestellten Frauen nachstellen, z.B. *Woman Reading a Letter.* Ein häufig wiederkehrendes Motiv in C.s Werken ist das Fließende; bek. sind u.a. ihre ephemeren Objekte und Installationen aus Götterspeise, z.B. ihre klein- und großformatigen rechteckigen und unbetitelten *Gelémonokromer* sowie die Installation *Tider lager alle sår* (1996), bei der auf sieben Stahlbänke gefüllte rote Gelatine dem Verfall preisgegeben wird und vier Wochen lang stoffliche und farbliche Veränderung teils fotogr. dok. werden. Des weiteren Objekte, bei denen der Moment des Zerfließens zeitlich eingefroren ist, so zwei aus Glas ausgef., von einem Tisch und einem Hocker tropfende Lachen in *The Birth of Liquid Desire* (1997). Außerdem meist fotogr. Darst. von Körperteilen, z.B. *Points* (1999), eine Serie von Schwarzweiß-Aufnahmen von menschlichen Nabeln; teilw. neben einem Objekt aus Gelatine gestellt, wie z.B. in *Ostentatio Vulnerum* (1995) eine fotogr. Vergrößerung des Ausschnittes aus Caravaggios Gem. Der ungläubige Thomas, auf dem Thomas einen Finger in Jesus offene Wunde legt, über einer Tafel, die mit blutroter Götterspeise bedeckt ist und vom Besucher, wie auch in C.s and. Installationen, berührt werden darf. 1999 im Ausst.-Raum des Kunstnernes Hus, Oslo, das Wand-Gem. *Burning Down the House.* ▥ KRISTIANSAND, Sørlandets KM. – Univ. of Agder, Beat Art Coll. OSLO, Mus. for Samtidskunst. – Norsk Kulturråd. TRONDHEIM, KM. ◉ *E:* Bergen: 1986 Café Opera; 1997 KV / 1992 Pori, KM (mit Jyrki Siukonen; Wander-Austst.; K) / 1994 Moss, Gall. F15 / 1995 Helsinki, KH / New York: 1995 Room (K); 1999 Bill Maynes Gall. (mit Catherine Howe and Robin Kahn) / Oslo: 1995 Gall. UKS; 1996 (K), '98 (mit Anders Tomren) c/o Atle Gerhardsen; 2006 Vigeland-Mus.; 2009 Kunstner-

forbundet / 2000 Kopenhagen, Overgaden (mit Hege Nyborg und Line Wælgaard) / 2004 Kristiansand, Sørlandets KM (mit denselben; K) / 2006 Høvikodden, Henie Onstad Kunstsenter (mit denselben; K) / 2008 Asker, Gall. Trafo. – *G:* Bergen: 1980 Gall. 1: Halvparten; 1985 Hordaland Kunstsenter: Eröffnungs-Ausst. (K); 1987 (K), '96 (Brudd), '97 (Two to two; K) KV / 1984 Odense, KH Brandts Klæderfabrik: Arbeider fra Tuscania / Oslo: 1986, '91 (K), '94 UKS Gall.: Vårutstilling; 2005 NM: Alle snakker om museet; 2010 Stenersen-Mus.: God natt da du ... (K) / 1990 Hannover: Sommeratelier. Junge Kunst in Europa (K) / 1993 Long Island City, P. S. 1 Contemp. AC: In their own Image (K) / 1996 Borås, KM: Carl von (K) / 1997 Johannesburg: Bienn. (K); Kiel, Stadt-Gal.: nor. a. way (K); Lund, KH: 10 (K) / 1998 Oulu, KM: Misplaced Mentalities / Reykjavík, Nýlistasafnið (Living AM): Not just for fun / 2001 Lillehammer, KM: Syv ambivalente fortellinger om kjønn og identitet (Wander-Ausst.; K); Yokohama: Internat. Trienn. of Contemp. Art (K) / 2009 Horten, Preus Mus.: Kunsten å falle (K). ▭ *M. Bal*, J. C.'s time, Bergen 1998; *id.*,Quoting Caravaggio, Chicago u.a. 1999; *J. M. Bernstein*, in: *I. Heywood/B. Sandwell* (Ed.), Interpreting visual culture, Lo./N. Y. 1999; *F. Ertl (Ed.)*, J. C, Kim Soo-Ja (K KH), Feldbach 1999; *J. Lund*, Norsk kunstårbok 9:2000,20–25; *A. K. Jortveit*, J. C. og Anders Tomren (K Mus. for Samtidskunst),Oslo 2002;*M. Bal*, Kulturanalyse, Ffm. 2002; *S. Siegel*, in: *M. Lepper* u.a. (Ed.), Jenseits des Poststrukturalismus?, Ffm. 2005;*M. Bal*, J. C. Fragments of matter, Bergen 2009. J. Niegel

Christensen, *Nadine*, austral. Malerin, Installationskünstlerin, Zeichnerin, * 1969 Traralgon/Vic., lebt in Melbourne/Vic. Stud.: 1991–93 Monash Univ., Churchill/Vic. (2006–07 dort Doz.); 1996–97 Victorian College of the Arts, Melbourne (ab 1999 dort mehrfach Gast-Doz.; 2006–11 Doz.); ab 2006 Monash Univ., Caulfield/Vic. (2010 dort Doz.). Weitere Lehrtätigkeit: u.a. 2007–11 SchA, RMIT Univ., Melbourne. Ausz.: u.a. 2002 Aufenthalts-Stip. für das 18th Street AC, Santa Monica/Calif., des Australia Council for the Arts, Canberra; 2008 Fletcher Jones Art Prize, Geelong/Vic. Seit 1998 auch als Autorin und Kuratorin tätig. – Figurative Öl- und Acryl-Gem., teilw. als Serie ausgef., die C. häufig zus. mit Alltagsgegenständen in installative Aufbauten präsentiert. C.s Komp., die häufig eine digitale Ästhetik aufweisen, zeigen meist eine Ansammlung versch. natürlicher und gefertigter Gegenstände in einer flächigen, vereinfacht dargestellten Lsch. oder einem Innenraum, z.B. eine Stehlampe, Stühle, aufgetürmte Steine und zwei heranfliegende Vögel in einer Wüsten-Lsch. in *Soya Beans & Sweet Potatoes 1* (synthetische Polymerfarbe/Karton, 2006). Daneben auch Installationen aus Alltagsgegenständen, z.B. *Dead and Gone* (Seil, Bambusstangen, Stein, Becken, Windspiel, 2009). Des weiteren Bleistift- und Buntstift-Zeichnungen. ▥ CAULFIELD, Monash Univ. Mus. of Art. MELBOURNE, City of Port Phillip Coll. – NG of Victoria. MORWELL/Vic. Latrobe Regional Gall. Coll. ◉ *E:* Melbourne: 1998 Lovers Gall.; 1999 Studio 12, 200 Gertrude Street; 2001, '03, '05, '07, '09 Uplands Gall. / 2002, '03, '05, '08 Sydney

(N. S. W.), Kaliman Gall. / 2003 Los Angeles, Solway Jones Gall. (mit Delphine Coindet; K) / 2004 Canberra, Contemp. Art Space (mit Kate Rohde; Wander-Ausst.) / 2010 Adelaide (South Australia), Hugo Michell Gall. – G: Melbourne: 1997 Stripp Gall.: Feeling Machines (K); 1999 200 Gertrude Street: Make it yourself (K); Same as it ever was (K); 2001 Ian Potter Mus. of Art, Univ. of Melbourne: Paint., an Arcane Technology (K); 2002 Gertrude Contemp. Art Space: Octopus 3 (K); 2003 Heide MMA: This was the future ...; 2004 Austral. Centre for Contemp. Art: New 04 (K); 2005 SchA Gall., RMIT Univ.: Frieze (K); Ian Potter Centre, NG of Victoria: This & Other Worlds (K) / 1999 Hobart (Tas.), Plimsol Gall.: Liquid Evasions (K) / 2000 (No Noise; K), '02 (Mutable Spaces; K) Brisbane (Qld.), Metro Arts / 2002 Caulfield, Monash Univ. Mus. of Art: Into the Blue (K) / 2006 Mornington (Vic.), Mornington Peninsula Regional Gall.: Nat. Works on Paper (K); Healesville (Vic.), TarraWarra Mus. of Art: TarraWarra Bienn. (K); Glendale (Calif.), Glendale College AG: U-Turn (K) / 2007 Churchill, Switchback Gall., Monash Univ.: Electric Valley Studios (K) / 2008 Sydney (N. S. W.), Peloton Gall.: Drawing a Conclusion (Wander-Ausst.) / 2012 Casula (N. S. W.), Powerhouse AC: Panorama. ▭ Silenzi (K Venedig), Cinisello Balsamo 2006; S. Payes, Untitled. Portr. of Austral artists, South Yarra, Vic. 2007. J. Niegel

Christi, *Friedrich*, dt. Porzellanmaler, † 25. 8. 1916. Als künstlerischer Mitarb. der Porzellan-Man. Nymphenburg ist C. spätestens ab 1904 nachweisbar. Dort führt er v.a. die polychrome Unterglasurbemalung von figürlicher Plastik bed. Tierbildhauer und Modelleure aus (u.a. von Hans Behrens). Bek. Arbeiten sind die Vogelplastiken *Junge Amsel* (Entwurf: Christian Wittmann, 1909) und *Rabe*, 1912 (Entwurf: Wilhelm Neuhäuser, 1911) sowie die Figurengruppe *Hermelin im Kampf mit einem Rebhuhn*, 1911 (Entwurf: Theodor Kärner, 1906). Mit seiner char. Bemalung unterstützt C. bisweilen in markanter Weise den kurz nach 1900 einsetzenden Trend des „liebevollen Naturalismus" in der süd-dt. Porzellantierplastik. Malerzeichen: F. Ch. und F. CH. – Monogr. Bearbeitung und WV stehen aus. ▯ HOHENBERG an der Eger, Dt. Porzellan-Mus. MÜNCHEN, Staatliche Porzellan-Man. Nymphenburg. ▭ *G. Woeckel*, Die Tierplastik der Nymphenburger Porzellan-Man. 1905–1920, M. 1978; *R. Lotz u.a.*, Theodor Kärner 1884–1966 (K), Hohenberg an der Eger 1984; Faszination Tier. Meisterwerke europ. Tierplastik (K), Hohenberg an der Eger 2004. U. Heise

Christiano Júnior, *José* (eigtl. Freitas Henriques Júnior, *José Christiano* de), portug. Fotograf, Maler, Graphiker in Brasilien und Argentinien, * 1832 Ilha das Flores/ Azoren, † 19. 11. 1902 Asunción/Paraguay (lt. Enc. Itaú Cult. de Artes Visuais † 18. 12. 1902). Vater der Fotografen *José Virginio Freitas Henriques* (* ca. 1851) und *Federico Augusto Freitas Henriques* (* ca. 1853). C. siedelte 1855 mit der Fam. nach Brasilien über, zunächst nach Maceió/ Alagoas, wo er 1862 ein eig. Fotoatelier betrieb, 1863 weiter nach Rio de Janeiro; dort war er in versch. Fotostudios tätig: 1864–65 Photogr. do Comércio (mit Fernando An-

tônio de Miranda); 1866 Gal. Fotogr. e de Pint.; 1866–75 Christiano Jr. & Pacheco (mit Bernardo José Pacheco), alle ebd.; weitere eig. Ateliers: ca. 1866–69 in Mercedes/ Uruguay, 1867–78 in Buenos Aires und ab ca. 1872 Fotogr. de la Infancia ebd. (1875 abgebrannt; an neuem Ort von José Virginio Freitas Henriques weitergeführt). 1875–78 Mitgl. und offizieller Fotograf der Soc. Rural Argentina. 1878 Verkauf von Fotostudio und Arch. (25000 Negative) in Buenos Aires an Alejandro S. Witcomb & Guillermo Mackern (später Casa Witcomb). 1879–83 in versch. argentinischen Städten ansässig und Eröffnung mehrerer Porträtstudios, meist in Partnerschaft mit lokalen Fotografen. 1883 Kauf des Landguts Azurmendi in Arroyo Hondo/Tucumán. Aufgabe der fotogr. Tätigkeit und Fabrikation von Likören in Argentinen, Brasilien und Paraguay. Ab 1901 in Corrientes als Kolorist von Fotos ansässig und Publ. von auto-biogr. Art. in der Ztg La Provincia. Ausz.: u.a. 1866 Expos. Nac., Casa da Moeda, Rio de Janeiro; 1871 Expos. Nac., Córdoba; 1876 Expos. Científica, Buenos Aires. – In Rio de Janeiro schuf C. u.a. Serien von Menschen mit Elefantiasis und Carte-de-visite-Portr. von Schwarzen, teils ehem. Sklaven, meist als Handwerker oder Händler posierend, deren Bildnisse als exotische Andenken an Europäer verkauft wurden. In Buenos Aires porträtierte er Großgrundbesitzer, Politiker, Diplomaten und Generäle, u.a. Adolfo Alsina und Lucio V. Mansilla sowie die Präs. Carlos Pellegrini, Bartolomé Mitre und Domingo Faustino Sarmiento (Serie *Celebridades de la República del Plata*). C.s wichtigstes Projekt war das *Album de vistas y costumbres de la República Argentina*, mit dem er den technologischen Fortschritt seiner Zeit würdigen wollte und zu einem der bedeutendsten Fotografen Argentiniens wurde. 1876 und '77 veröffentlichte er zwei der Prov. Buenos Aires gewidmete Alben mit je zwölf Fotos und viersprachigem erläuterndem Text von Mariano Antonio Pelliza und Angel Justiniano Carranza; geplante Alben zu weiteren Prov. kamen nicht zustande. C. machte für diese allerdings ab 1879 zahlr. Aufnahmen während seines, lt. eig. Anzeige, „viaje artíst.", als er u.a. in Rosario, Córdoba, Mendoza, Tucumán und Jujuy lebte und von dort die zentralen und nördlichen Landesteile bereiste. C. schuf auch Gem. auf Lw., Porzellan und Elfenbein, u.a. ein Portr. des Generals San Martín (Öl/Lw., 1875), sowie Graphik. ▯ BRASILIA, Außen-Minist. BUENOS AIRES, Arch. Gen. de la Nación. – Bibl. Manuel Gálvez. – BN, Fototeca Benito Panunzi. – Centro de Documentación de Arquit. Latinoamer. – Mus. Hist. Sarmiento. MENDOZA, Arch. Prov. – Mus. del Pasado Cuyano „Dr. Edmundo Correas" – Mus. Hist. General San Martín. PETROPOLIS/Rio de Janeiro, Mus. Imperial. RIO DE JANEIRO, Inst. Brasil. do Patrimônio Cult. – Mus. Hist. Nac. – Mus. Imperial. – Secretaria do Patrimônio Hist. e Artíst Nac. SÃO PAULO, Inst. Moreira Salles. ✉ *C./E. Stein* (Ed.), Buenos Aires il. Almanaque comercial y guía de los forasteros para 1877, Bs.As. 1876; *C.* (Ed.), Gal. biogr. argentina, Bs.As. 1877 (Zchngn von Ricardo Albertazzi, Lith. wahrsch. von C.); Tratado práctico de vinicultura, destilería y licorería, Bs.As. 1899. ◉ *E:* 1997 Lissabon, MN-

BA / 2002 Buenos Aires, Fund. Antorchas. – *G:* 1981 Zürich, Kunsthaus: Fotogr. Lateinamerika von 1860 bis heute (Wander-Ausst.; K: E. Billeter; s.v. Júnior, Christiano) / 1997 Campinas (São Paulo), Inst. Cult. Itaú: O Brasil na máquina do tempo. Col. referencial da hist. da fotogr. brasil. (Wander-Ausst.; K: P. K. Vasquez) / 1999 Rio de Janeiro, Paço Imperial: O Brasil redescoberto (K: C. Martins u.a.). □ Dict. mondial de la photogr., P. 2001 (s.v. Júnior, Christiano);*B. Kossoy*, Dic. hist.-fotogr. brasil., S. P. 2002; *J. Hannavy* (Ed.), Enc. of nineteenth-c. photogr., I, N. Y./Lo. 2008 (s.v. Júnior, Christiano). – *B. Kossoy*, Origens e expansão da fotogr. no Brasil, s. XIX, Rio 1980; *G. Ferrez*, A fotogr. no Brasil. 1840–1900, Rio ²1985; *J. Gómez*, La fotogr. en la Argentina. Su hist. y evolución en el s. XIX, Bs.As. 1986; *P. C. de Azevedo/M. Lissovsky* (Ed.), Escravos brasil. do séc. XIX na fotogr. de C. J., S. P. 1988; *A. Alexander*, Hist. de la fotogr. Memoria del 2° Congreso de Hist. de la Fotogr. en la Argentina, Bs.As. 1993; *S. Facio*, La fotogr. en la Argentina. Desde 1840 a nuestros días, Bs.As. 1995 (s.v. Júnior, Christiano); *R. Gutiérrez Viñuales/R. Gutiérrez* (Ed.), Pint., escult. y fotogr. en Iberoamérica, ss. XIX y XX, Ma. 1997 (s.v. Júnior, Christiano); *C. R. Un país en transición*. Fotogr. de Buenos Aires, Cuyo y el Noroeste, 1867–1883, Bs.As. 2002; *G. Ermakoff*, O negro na fotogr. brasil. do séc. XIX, Rio 2004; Fotogr. latinoamer. Col. Anna Gamazo de Abelló, Méx. 2008; *V. Tell*, Rev. crítica cult. (Palhoça, Santa Catarina) 4:2009 (1) 151–169; *M. C. Boixadós*, Córdoba fotografiada entre 1870 y 1930. Imágenes urbanas, Córdoba 2011. – *Online:* Inst. Itaú Cult., Enc. artes visuais, 2008.

M. Nungesser

Christianou (Hristianou), *Aglaïa*, griech. Malerin, Graphikerin, Objektkünstlerin, Kunstpädagogin, * 1954 Larisa, lebt und arbeitet in Athen. Stud.: in Paris 1975–76, '80–82 EcBA (Malerei und Zchng bei Marta Gili und Jacques Yankel); 1982–83 Univ. Paris I-Sorbonne (Kunst-Phil. und Ästhetik bei Olivier Revault d'Allonnes); in Florenz: 1976–79 ABA (Malerei bei Fernando Farulli); 1977–79 Rest. der Piccola Accad. di Pitt. Lo Spronte. Bis 2004 Ass. in Theodor Papagiannis Wkst. an der Athener HBK. C. unterrichtet Kunst an höheren Schulen in Athen. Mitgl.: Epimelitiriou Eikastikon Technon Ellados/ Vrg bild. Künstler Griechenlands (EETE). – In den Werkgruppen *Animalia*, *Endoterra* und *Argumentia* montiert C. einfache, alltägliche Gegenstände (Holz, Metallobjekte, Flaschen, Bürsten, Schuhe) auf Holzplatten oder arrangiert diese in Vitrinenkästen. Sie konstruiert damit ein scheinbar archivalisch bzw. museal wirkendes Gedächtnismosaik sowie Bilder einer vorgeblichen Gesch., deren einzelne Elemente vom Betrachter mit bestimmten Stimmungen, Situationen und Gefühlen assoziiert werden sollen. In and. Arbeiten werden Gegenstände, Kritzeleien auf Papier oder Müll in Schachteln und Kästen gelegt, so daß sie nur teilw. sichtbar bleiben und ein sinnentleertes Archiv vorstellen. In größeren Installationen werden Momente persönlichen Lebens (z.B. ein Wohnraum) nachgestellt, jedoch entpuppen sich die zusammengefügten Gegenstände wiederum als Müll oder als nur scheinbar funktionstüch-

tig. In all ihren Werken bleiben bloß die Relikte menschlicher Präsenz als Indizien seiner Existenz zurück, während der Mensch selbst nie in Erscheinung tritt. Damit setzt C. die in Michel Foucaults Theorie der Archäol. des Wissens adaptierten Fragestellungen der Erinnerung und Präsenz künstlerisch um. Immer wieder geht es um das Nachzeichnen von Spuren, wie sie auch in Arbeiten von Christian Boltanski auftauchen, und die archivalische Organisationsform musealer Kunstpräsentation, die in Frage gestellt wird. Bei C. kommt eine kritisch-ironische Distanz hinzu, da ihre Arbeiten zwar die Formen der „Gedächtniskunst" imitieren, jedoch tatsächlich nur scheinbar sinnstiftend sind. □ ATHEN, Mun. AG. ⊙ *E:* Athen: 1985 Gal. Ora; 1985, '88, '91 Gal. Pleiades; 1998, 2008, '09 Mun. AG / 1979 Florenz, Pal. Strozzi / 1981 Larisa, Gal. Lytra / 1983 Paris, Maison de la Grèce. – *G:* 1983 Paris, Grand Palais: Salon des Artistes Franç.; Salon d'Automne / 1988 Lamia: Cult. Summer of Kefalonia / 1996 Sofia: Trienn. / 1999 Larisa, AC: Course IIV /Athen: 2001 Technopolis: Trash Art; 2002 Mun. AG: In search of the Olympic Idea; 2010 Benaki Mus.: O choros, oi anthropoi, oi istories tous. □ LEK IV, 2000. – *C. Kampouridis*, Ora (K), At. 1985; *N. Iliopoulou-Rogkan*, Epipeda (K), At. 1986; *C. Dravtaki*, Pleiades (K), At. 1991; *A. C. Animalia 1996–1998* (K), At. 1998; *A. Schina*, Dromologio III (K), Larisa 1999. – *Online:* Website C.

E. Kepetzis

Christiansen, *Ole Kirk*, dän. Spielzeuggestalter und -hersteller, * 7. 4. 1891 Filskov/Jütland, † 11. 3. 1958 Billund(?), war dort ab 1916 tätig. Ausb. zum Tischler und Zimmermann beim älteren Bruder. 1916 Kauf einer Tischlerei in Billund; vorerst hauptsächlich Herstellung von Wohn- und Kleinmöbeln. – C. fertigt zunächst in der Freizeit aus Abfallholz für Puppenstuben u.a. Min.-Möbel. Ab 1932 entsteht in C.s Wkst. Holzspielzeug, das z.T. auch von seinem Sohn *Godtfred Kirk C.* (* 8. 7. 1920, † 13. 7. 1995) entworfen wird, u.a. Autos, Eisenbahnen, Ziehenten und Jo-Jos. 1934 gibt er der Tischlerei, die 1942 vollständig niederbrennt, den Namen LEGO; 1944 wird die Wkst. juristisch in eine Aktiengesellschaft mit dem Namen Legetøjsfabrikken LEGO Billund A/S (heute LEGO A/S) umgewandelt. Nach dem 2. WK beginnt C. mit Kunststoff zu experimentieren und erwirbt 1947 als erster Spielzeughersteller in Dänemark eine Kunststoff-Spritzmaschine; als erste Prototypen entstehen eine Kinderrassel und ein zusammensetzbarer Spielzeug-Traktor. 1949 werden neben ca. 200 weiteren Holz- und Plastik-Spielzeugen erstmals die mittels Noppen zusammensteckbaren Kunststoff-Bauklötze *Automatic Binding Bricks* angeboten (1953 in *LEGO Mursten* umbenannt; 1954 Eintrag des Namen LEGO als Warenzeichen) und 1958, kurz vor C.s Tod, nach zahlr., maßgeblich vom Sohn bewirkten Weiterentwicklungen und Verbesserungen schließlich zum Patent angemeldet. □ NEW YORK, MMA (s.v. Godtfred Kirk C.). □ *M. Byars*, The design enc., Lo./ N. Y. 2004. – *M. Uhle*, Die LEGO Story, W. 1998; *C. Sievers/N. Schröder*, Design des 20. Jh., Hildesheim 2001 (50 Klassiker); *P. Antonelli* (Ed.), Objects of Design from the MMA, N. Y. 2003 (s.v. Godtfred Kirk C.).

J. Niegel

Christianson, *Linda*, US-amer. Keramikerin, * 1952 Rice Lake/Wis., lebt in Lindstrom/Minn. Stud.: 1970–75 Hamline Univ., St. Paul/Minn.; 1975–77 Banff School of FA (jetzt Banff Centre for the Arts), Banff/Alta. Umfangreiche Lehr- und Vortragstätigkeit, u.a. 1999, 2001, ’05 Arrowmont School of Arts and Crafts, Gatlinburg/Tenn.; 2001–03 Carleton College, Northfield/Minn.; 2002 Univ. of Hartford, Hartford Art School, Conn.; Penland School of Crafts, Penland/N. C.; 2008 Appalachian Center for Craft, Smithville/Tenn. Außerdem Durchführung von Workshops im In- und Ausland. Ausz.: 1974 Eliza A. Drew Award for Ceramics, Hamline Univ., St. Paul; 1990 McKnight Found. Visual Arts Fellowship; 1990 Minnesota State Arts Board Career Opportunity Grant; 1992, ’96, 2001 East Central Arts Council McKnight Found. Fellowship; 1993 Nat. Endowment for the Arts Fellowship; 1996 Metropolitan State Univ. Faculty Grant; 1997 McKnight Found. Ceramic Fellowship; 1999 Minnesota State Arts Board Fellowship. – Rustikal wirkende Gebrauchsgefäße in z.T. extravaganten Formen, gelegentlich mit Streifendekor, die von C. auch als optisch ansprechende Objekte wahrgenommen werden wollen (*Black Striped Ewer*, Steinzeug, Holzbrand, 2007). Die gedrehten und nachbearbeiteten Stücke aus Steinzeugton werden mit einer dicken Schicht Kaolinengobe überzogen und beim Brand im holzgefeuerten Ofen salzglasiert, wobei die endgültige Beschaffenheit der Oberfläche von Holz und Salz sowie den Bedingungen des Brennofens abhängt. ☐ BANFF/Alta., Banff Centre for the Arts. CALGARY/Alta., Glenbow Mus. FAYETTEVILLE, Univ. of Arkansas. GATLINBURG/Tenn., Arrowmont School of Arts and Crafts. MARSHALL/Minn., Southwest State Univ. MINNEAPOLIS/Minn., Frederick R. Weisman AM. – Northern Clay Center. POMONA/Calif., Amer. Mus. of Ceramic Art. ST. PAUL, Minnesota Hist. Soc. TEMPE, Arizona State Univ. ◉ *E:* St. Paul: 1976 Hamline Univ. (mit William Cole); 1988, ’92 Raymond Avenue Gall. / St. Louis (Mo.): 1984, ’86, ’88, ’90, ’93 ProArt; 1997 Laumeier Sculpt. Park / 1986 Sherman (Tex.), Austin College Gall. (mit Christy Wert) / 1987 Caracas, Assoc. Venezolana de las Artes del Fuego / 1998 Chicago, Lill Str., Gall. 1021 (mit Silvie Granatelli und Eric Jensen) / 2001 London, Contemp. Ceramics / 2002 Hartford (Conn.), Univ. of Hartford, Joseloff Gall. (mit Doug Jeck und Bruce Winn) / 2003 Cranston (R. I.), Doug Peck Gall. / 2004 Concord (Mass.), LaCoste Gall. (mit Jan Johnston); Atlanta (Ga.), Signature Gall.; Port Chester (N. Y.), Clay AC / 2007 Red Lodge (Mont.), Red Lodge Clay Center; Kansas City (Mo.), Red Star Gall. / 2008 Iowa City, Akar (mit Michael Connelly). ☐☐ *E. Cooper*, Contemp. ceramics, Lo. 2009. – *Online:* Akar design; MudFire; Minnesota Potters; 18 Hands Gall. C. Rohrschneider

Christidi, *Katerina*, griech. Zeichnerin, Malerin, Graphikerin, * 29. 11. 1966 Athen, lebt und arbeitet in Paris. Stud.: 1986–91 HBK, Thessaloniki, bei Vangelis Dimitreas und Makis Theofilaktopoulos; 1993–96 EcBA, Versailles, Malerei und Graphik (mit Stip. der Athener ABK). Mitgl.: Epimelitiriou Eikastikon Technon Ellados/Vrg bild. Künstler Griechenlands (EETE). Ausz.: 1997 Charles Oulmont Award, Paris. – Neben Öl-Gem. entstehen v.a. Graphit- und Kohle-, seltener Farbstift-Zchngn sowie Druckgraphiken. C.s Œuvre speist sich aus einer Ästhetik des Grotesken und des Informel, ihre Figuren sind oft den Märchen und Mythen der Populärkultur entnommen und zeichnen sich in aller Regel durch ein den Normen der Ges. widersprechendes Verhalten aus (Piraten, Clowns). Debütiert u.a. mit ironisch-spielerischen Varianten märchenhafter Themen (*Rotkäppchen*, 1996), in denen sie durch einzelne kollagierte Elemente die Gesichter der Figuren karikaturesk verändert und narrativ die tradierten Rollenzuordnungen und Beziehungen hinterfragt (Täter/Opfer, naiv/verschlagen). In späteren Werken nehmen schemenhafte, manchmal puppenartige Gestalten aus dunklen Hintergründen sukzessive Form an. Die scheinbare Narration früherer Arbeiten tritt zugunsten einer Dramatisierung in markanten Hell-Dunkel-Kontrasten in den Hintergrund. Gegenüber solchen, in die Fläche orientierten Werken findet sich in and. Arbeiten eine fokussierte Betonung der schwarzen Kontur der Figuren vor einer rein weißen Hintergrundfolie. Immer wieder steht die Beziehung zw. den Geschlechtern im Mittelpunkt, deren tradierte Machthierarchie thematisiert wird, indem z.B. die männliche Figur größer erscheint als ihr weiblicher Gegenpart. Ein wichtiger künstlerischer Einfluß sind die Arbeiten von Paul Klee, dessen grotesk-subversiv-kindlichen Ausdruck sie mit humoresken Anleihen aus der Popkultur ergänzt und zugleich bis zu einer düsteren Bedrohlichkeit führt, die an Füsslis Zchngn und Goyas Graphiken erinnert. Unterbewußtes, Träume, Ängste aber auch kindlich Spielerisches sind ihre wichtigsten Themen. – Publ.: *Mes amours*, P. 2002; *C'est pas angoissant*, Nieves 2009. ◉ *E:* 2000, ’03, ’05 Athen, Gal. Illeana Tounta / Paris: 1996 Gal. Dark and Wild; 1998 Gal. De toutes les couleurs / 2010 Tinos, Kulturzentrum Arnadou (mit Dimitris Christidis). – *G:* u.a. 1992, ’93, ’99 Brüssel, BP OIL Europe Gal.: Young Europ. Artistes Coll. / 1995, ’97, ’99 Versailles, Carrè: Cheap Art / Athen, Gal. Illeana Tounta: 1997 Young Artists; 2003 Art Athina; 2004 Brave New World; 2007 Emergency Room; 2011 ReMap 3 und Drawing Stories; NM of Contemp. Art (EMST): 2007 In Present Tense; 2008 Trans-experiences (Wander-Ausst.) / Paris: 2003 Yvonamor Palix: Printemps; 2012 Friville Ed.: Atmosphère de transformation 3 / 2006 Patras (Europ. Kulturhauptstadt): What Remains is Future / 2007 Putbus, Gal. des Land-Kr. Rügen (KV Rügen): Keine Zchng, kein Zeichner (Falt-Bl.). ☐☐ LEK IV, 2000. – *Online:* Blog C.; Illeana Tounta Gal. E. Kepetzis

Christidis (Hristidis), *Achilleas*, griech. Maler, Zeichner, Illustrator, Bühnenbildner, Installationskünstler, * 1959 Piräus, lebt und arbeitet in Athen. Stud.: Film- und Theaterschule KEA, Athen (Musik, Bühnenbild). Als Maler Autodidakt. Mitgl.: Epimelitiriou Eikastikon Technon Ellados/Vrg bild. Künstler Griechenlands (EETE). – C.s Œuvre umfaßt v.a. Figurenbilder und Portr. (zumeist Öl/Lw.). Er formt, z.T. figurativ, z.T. abstrahierend, aus narrativen, häufig isolierten Einzelmotiven seinen persönlichen Kosmos. Die Figuren bewegen sich anfangs durch

merkwürdige Räume, sitzen an Tischen und in Zimmerecken, als würde der Betrachter sie von oben beobachten. Durch die Vogelperspektive wird der Betrachter zum Voyeur der malerischen Wirklichkeit, die fast puppenstubenhaft reduziert erscheint. Es offenbaren sich jedoch immer lediglich Fragm. eines anscheinend umfassenderen Geschehens, Bruchstücke aus Geschichten von Furcht, Gewalt und Terror. Riesige Pilze wuchern in Ecken, sexuelle Handlungen gehen in Perversionen über, Tiere schleppen sich verletzt aus dem Bild, Figuren weinen, starren und verzweifeln. Der Betrachter wird zum Detektiv, der aufgefordert ist, ein nicht lösbares Mysterium zu entschlüsseln. 1989–91 legt C. eine installative Serie überdimensionaler Konstruktionen aus alltäglichen Gegenständen vor, die mit Hilfe von Solarenergie in Bewegung gesetzt werden können und vom Betrachter zu humoristischen Geschichten verknüpft werden sollen. Auch Buch-Ill., so die zu Dylan Thomas' Text über den Marquis de Sade (At. 1995) bewußt roh und wild gehaltene Zchngn (Bleistift, Feder), die die sexuell-sadistischen, von Folter und Tod erzählenden Texte illustrieren, wobei der voyeuristische Aspekt wiederum ein Rolle spielt. In den folgenden zwei Jahren setzt sich C. in einer Reihe von Porträts mit umstrittenen und berühmten Schriftstellern auseinander: Charles Baudelaire, Franz Kafka, William S. Burroughs, Samuel Beckett u.a. treten dem Rezipienten in frontal gezeigten Psychogrammen entgegen und scheinen seinen Blick zu erwidern. Die überlebensgroßen Porträts sind in expressiven, breiten Pinselstrichen und aufgesetzten Farbspritzern in aggressiven Farbkombinationen ausgef., die den unruhigen Geist dieser lit. Protagonisten zum Ausdruck bringen sollen. E. der 1990er Jahre vollzieht C. einen neuerlichen Stil- und Themenwechsel und entfernt sich fast gänzlich von den phantastischen, auf die menschliche Figur fokussierten gemalten Dramen seiner ersten Schaffensperiode. Jetzt dominieren aus der Vogelperspektive gezeigte Lsch., jedoch bleiben diese surreal und träumerisch; verwüstete Areale bar allen Lebens vermitteln einen Eindruck von Melancholie und existenzieller Bedrohung. ⌂ ATHEN, Mus. Vorres. RHODOS, Mod. Greek AM. ◉ E: u.a. 1978 Piräus, Rathaus (Debüt) / Athen: 1984 Iktinos Gal.; 1987, '91 Medusa Gal.; 1993, '96 Titanium Gal.; 1996, '97, 2001 Agathi Gal.; 1998, 2000, '04, '06, '07 Nees Morfes Gal.; 2009, '11 Skoufa Gal. / Thessaloniki: 1996, '98, 2010 Villa Art Forum; 2000 Terracotta Gal.; 2002 Kalfayan Gal. / 1998 Chania, Tzamia Cristala Gal. / 2011 Brüssel, Theorema Gal. – G: u.a. Athen: 1989 Mun. AG: Zografiki gia ens trapezi (K); 1995 Pieridis Gal.: Absolut Cult; 1996 Astrolavos Gal.: Teachers and Students / Metsovo, Averof Gal.: 1994 To Dentro (Wander-Ausst.); 1995 Psaria (Wander-Ausst.) / 2011 Monaco, Sem AG: Greek Art. ⌷ LEK IV, 2000; *Delarge*, 2001. – *R. Wollen*, Greek horizons. Contemp. art from Greece (K New York/Carlisle/London), N. Y. 1998; *E. Hamalidi* (Ed.), Contemp. Greek artists, At. 2004, 46–47. – *Online:* Website C. (Ausst.).

E. Kepetzis

Christidis (Hristidis), *Dimitris*, griech. Maler, Graphiker, * 1965 Athen, lebt und arbeitet dort. Verh. mit der Malerin *Katerina C.* Stud.: 1984–89 HBK, Thessaloniki, bild. Kunst bei Vangelis Dimitreas; 1991–94 Slade School of FA, London, Graphik bei Bartolomeu Dos Santos, David Leverett, Stanley Jones und Peter Daglish. Lehrt seit 1996 (u.a. Zeichnen) am Technological Inst. der Univ. Athen. Mitgl.: Epimelitiriou Eikastikon Technon Ellados/ Vrg bild. Künstler Griechenlands (EETE). – C.s bisweilen surreal wirkenden Bilder in kräftigen Farben (v.a. Acryl/ Lw.) zeigen subjektive Narrationen und chiffrehaft nebeneinander gesetzte Versatzstücke menschlicher und tierischer Figurationen vor undefinierten Landschaften. Der Koch sowie Darst. von Essen und Trinken sind häufige Motive. Ein Schwerpunkt des Schaffens ist die Druckgraphik (v.a. Kpst., auch Acrylstich, Fotogravur u.a.). Hier spürt er häufig der Gesch. der Kunst und einzelnen Werken nach, so 1994 in der Stichserie zu Leonardos Abendmahl, in der durch den sehr dunkel gehaltenen Hintergrund im Kontrast zu einzelnen, grell ausgeleuchteten Partien eine Dramatisierung und Mystifizierung des davor gespannten Figurenfrieses erfolgt (Thessaloniki, State MCA). Daneben Akte, Paare (hier auch gemeinschaftliche Arbeiten mit seiner Frau Katerina C.) sowie Bildnisse. 2009 fertigt er für die Athener Künstler-Vrg Lo And Behold die Jahresgabe *Habermas's sweet delight* (Stich/Acrylglas, 2009). C.s Arbeiten sind als Auseinandersetzung mit der etablierten Hochkunst und der populären Massenkultur des ausgehenden 20. Jh. zu lesen. ⌂ ATHEN, Coll. Alpha Bank; Athens Engraving AC. THESSALONIKI, State MCA. ◉ E: 2001 Agios Stefanos, Städt. Kulturzentrum / Athen: 1997 Gal. 24; 2007 Gal. E 31. – G: 1992 London: R. Acad. Summer Exhib. / 1993 Almadora: Bienn. / Athen: 1997 Adams Gal.: 5 young artists; 2000 Nees morphes Gal.: All six are young / 1998 Thessaloniki, Kulturzentrum Mylos: Cheap Art; 1999 Tint Gal.: New Creators / 2001 Rethymnon, Center of Contemp. Art: Ariston. ⌷ LEK IV, 2000. – D. C. Haraktiki (K Art Space 24), At. 1996; *K. Drakopoulou*, Arti 34:1997 (3) 170–171; Syllogiko Ergo. Charaxeis (K State MCA), Thessaloniki 2007. – *Online:* Thessaloniki, State MCA. E. Kepetzis

Christidis (Hristidis), *Sotiris (Sotirios*; Pseud. Zitiades, *Chris Salvatore (Chris S.)*, griech. Maler, Illustrator, Lithograph, * 1858 Thessaloniki, † 1940 Athen. Nach kurzzeitigem Medizin-Stud. an der Univ. in Athen (1858) und einer Stippvisite an einem Technikum, wo er im techn. Zeichnen unterrichtet wird, wendet sich C. der bild. Kunst zu. An der KHS ebd. hat er Malunterricht u.a. bei Nikiforos Lytras, der seit 1865 die Prof. für Höhere Malerei innehat. Die Steindruckerei erlernt er wohl ab E. der 1880er Jahren von dem in Athen tätigen dt. Künstler *Karl Haupt* (s.u.). Ab 1904 eig. Atelier in Athen. Von 1890 bis 1938 entstehen hauptsächlich Ill. (Alben, Ztgn, Zss., Postkarten) sowie Arbeiten für die Werbung (Plakate), einzelne Karagiozis-Entwürfe und Buchgraphik, v.a. Umschlag-Gest. für Romane und musikalische Schriften. Häufig arbeitet C. für Athener Verlagshäuser (z.B. Dimitrios Papadimitriou). Seine bevorzugte Technik ist die (Farb-)Lithografie. Seine Themenschwerpunkte sind Historien aus dem antiken Griechenland (*Die Hochzeit von*

Alexander und Roxane, um 1910; Priv.-Slg) sowie patriotische Szenen der neu-griech. Geschichte: der Aufstand gegen die osmanische Herrschaft 1821, die griech.-türkischen Auseinandersetzungen bis 1921 (*Schlacht von Giannitsa*, 1912; *Kapitulation osmanischer Truppen in Saloniki*, 1913, beide Lith.). Daneben auch Porträts (*König Konstantin I.*; Athen, Nat. HM). Um 1934–35 läßt sein Augenlicht aufgrund einer Star-Erkrankung nach, worauf sein Sohn Giorgos versch. Lithogr. nach seinen Entwürfen ausführt. Stilistisch verbindet C. in seinen farbigen oder nachkol. Graphiken tradierte Ikonogr. mit einem volkstümlich vereinfachten Ausdruck, v.a. in seinen Kriegs-Darst. ist das pathetisch-dramatische oder sentimental aufgeladene Geschehen in bisweilen naiv anmutendem Detailreichtum und starken Lokalfarben vorgetragen. Hierin folgt C. dem Vorbild seines Lehrers K. Haupt, der auch ähnliche Themen bearbeitet. Seine Lith. zeichnet eine breite Farbpalette aus, da er die lithogr. Stifte auf der Steinplatte mischt und so den Druck mit mehreren Platten vermeidet oder einschränkt. Neben seinen graph. Arbeiten finden sich einige in volkstümlichem Stil gehaltene Bilder in Öl und Tempera sowie ausdrucksstarke Kohlezeichnungen. Zahlr. seiner Arbeiten befinden sich in der Slg des Künstlers Apostolos Dourvaris, der diese ausstellt (u.a. 1993 Athen, Nat. AG; 1993 Thessaloniki, Cult. Center of the Nat. Bank). –
Karl Haupt (* 1866, † 1937 Athen) kommt 1888 auf Einladung der Kgl. Hofdruckerei nach Athen. Er arbeitet hier für mehrere lithogr. Anstalten als Entwurfs- und Ausführungskünstler, hat Kunden aus den besten Kreisen der Ges. und zahlr. Schüler. 1896 entsteht anläßlich der ersten mod. Olympischen Spiele eine Lith.-Serie mit Ansichten von Athen , die 2003 im Vorfeld der Olympiade 2004 inklusive einer biogr. Skizze als Kalender neu ed. werden (*Twelve Colour Lithogr.*, 1896 und 2003). 1910 erleidet K. Haupt eine Lähmung der rechten Hand, bleibt aber bis zu seinem Tod weiter als Lithograph in Athen tätig. Seine Farb-Lith. *Ottoman Hasan Tashin Pasha übergibt Saloniki an Kronprinz Konstantin* (1913) ist ein direktes Vorbild für die in Personal und Lsch.-Ausblick reduzierte, zeitgleich entstehende Arbeit seines Schülers C. (*Kapitulation osmanischer Truppen in Saloniki*, 1913; alle Athen, Nat. HM). 🏛 ATHEN, Benaki Mus. – Hist. Found. of Elevtherios Venizelos. – Lit. and Hist. Archive. -Nat. HM. – Mus. of the City (Vouros-Eftaxia). – War Mus. / MYKONOS, Laografiko Mus. 👁 E: Athen: 1938 Stratigopoulou Gal.; 1999 Kulturstiftung der Nat.-Bank. – G: 2012 Athen, Arch. der Mod.: Ellines eikonografoi ton archon to 20ou aiona (Griech. Illustratoren des frühen 20. Jh.). ▭ *Lydakis* IV, 1976; LEK IV, 2000. – *S. Karachristos*, Ellenikes afises, At. 1984, 47, 48; *K. D. Kassis*, C. O megalos laikos zografos, At. 1984; *A. Dourvaris*, C. (1858–1940), At. 1993; *C. Christou*, Neoelliniki charaktiki and Zografiki 20ou Aiona, At. 1994, 217–218; *id.*, Mod. Greek engraving, At. 1994. E. Kepetzis

Christinat, *Olivier*, schweiz. Fotograf, * 19. 12. 1963 Lausanne, lebt dort. Stud.: 1979–80 Ec. des Arts Appliqués in Vervey. 1980–84 Ausb. zum Fotografen in Lausanne. Seit 1986 ebd. selbständiger Fotograf. 1991–96 Lehrtätig-

keit an der Ec. d'Art Lausanne (audiovisuelle Kunst). – C. prüft Wirklichkeit auf ihren Wahrheitsgehalt und verfolgt dabei versch. stilistische Richtungen, u.a. mittels inszenierten Lichtes und der optischen Illusion. Erzeugt durch eine aufwendige Technik im Polaroid-Negativ-Verfahren malerische Schwarzweiß-Effekte, die bes. weiche Konturen zeichnen. Seine zeitweise bevorzugt behandelten biblischen Themen erinnern an ma. Hll.-Bilder und setzen sich mit Vergänglichkeit und Transfiguration auseinander. Zeigt 1998 in Lausanne den Fotozyklus *Apocryphe Photogr.*(Das Mahl) als gelungene Synthese von Realismus und von durch Licht geschaffenem Abstrahismus (Licht als konsubstantielle Materie an der Grenze zw. Geist und Fleisch). C.s Modelle sind häufig weibliche Akte, die verhalten vor hellen Hintergründen posieren und eine würdevolle Ruhe ausstrahlen. Rätselhaft hingegen wirken seine inszenierten Szenen. Die Folge *Evénements* (1999–2002) zeigt Menschengruppen in Geschäftsbekleidung, deren Gleichförmigkeit dem Gesichtsausdruck und der individuellen Gestik der jeweils Dargestellten entgegen steht. C. verzichtet auf alles Beiwerk und komponiert seine Arbeiten mit seinen speziellen Entwicklungstechniken aus Modell und Licht. Beteiligt an Fernsehfilmen. Eig. Videos u.a. 2002 *L'entrée en corps* und *Les amants*. Ausz.: 1991 1. Prix Nat. Europ. Kodak Award; 1993 1. Prix Nat. Agfa Portr. Award; 1995 Eidgenössisches Stipendium. 2004 entsteht ein Portr.-Film über C. von Jean-Stéphane Bron. 🏛 BELFORT, MAH. BRESCIA, Mus. Ken Damy di fotogr. CHARLEROI, Mus. de la Photogr. LAUSANNE, Mus. de l'Elysée. PARIS, BN. – Maison Europ. de la Photogr. ✉ Photogr. apocryphes, P. 2000. 👁 E: 1994 Nyon, Gal. du Rocher / 1996 Lausanne, Mus. de l'Elysée / 1997, '99 Berlin, Gal. Lutz Fiebig / 1998 Paris, Gal. Polaris; Leipzig, Kamera- und Foto-Mus. Mölkau; Mailand, Centro Cult. Svizzero / 2000 Biel, Photoforum PasquArt; Brüssel, Gal. Pascal Polar / 2001 Berlin, Gal. Bodo Niemann; Ōsaka, Picture Photo Space / 2002, '03 Los Angeles, Paul Kopeikin Gall. – G: 1997 Paris, BN: Portr., singulier, pluriel 1980–1997 / 1999 Triest, Lipanje Puntin: Still (in) motion / 2002 Lausanne, Mus. de l'Elysée: photo. romande. elysee / Zürich, EWZ-Unterwerk Selnau: The Selection 2001 (Wander-Ausst.) / 2003 Erfurt, Gal. Rothamel: Body's building / 2004 Brescia, Mus. Ken Damy di fotogr.: 30 years old / 2007 Krakau, Gal. Sztuki Współczesnej Bunkier Sztuki: A Selection of Swiss Photographers / 2010 Halle, KH Villa Kobe: Lust und Begehren. ▭ BLSK I, 1998; *Delarge*, 2001 (* 19. 9. 1963); Kürschners Hb. der Bild. Künstler. Deutschland, Österreich, Schweiz, I, M./L. 2007. – ZOOM 36 (Portfolio), Mi. 2000; *W. A. Ewing*, Les du corps. Photogr. 1900–2000 (K), P. 2000; Evènements (K), Lausanne 2002; *D. Girardin*, Petite(s) hist.(s) de la photogr. à Lausanne, Lausanne 2002; Le mois de la photo, Montréal 2002; Enthüllt (K Heilbronn), [He.] 2004; *D. Santamaria* (Ed.), Bienn. di Alessandria (K), Albisola Marina 2008. – *Online:* Website C. (Ausst., Lit.). S.-W. Staps

Christmann, *Sabine*, dt. Malerin, * 1960 Offenbach am Main, lebt in Bartenstein/Württ. Ausb./Stud.: 1980–81

Freie KSch, Stuttgart; 1981–83 ABK, Karlsruhe, Malerei bei Peter Dreher; 1983–86 ABK, Stuttgart, Malerei bei Rudolf Haegele. – C.s Œuvre umfaßt v.a. (foto-)realistische Stilleben (Acryl, Öl), auf denen sie zeitgen. Transportgefäße und -behälter aus der mod. Konsumwelt – d.h. die Massenwegwerfprodukte Plastik- und Glasflasche, Metall- und Kunststoffdose, Kaffee-, Gewürz- oder Bonbontüte, Papiersack oder Tragetasche – in den Fokus rückt. Zumeist sind ihre Protagonisten, die häufig Gebrauchsspuren (Knitter, geglättete Falten, abgerissene Schilder usw.) zeigen oder mit mehr oder weniger lädierten statustransportierenden Markennamen versehen sind, auf spiegelnden Glasplatten vor neutralem Hintergrund behutsam arrangiert (*Tütenbild*, Öl/Lw., 2010). Lt. Selbstäußerung betrachtet C. die auf ihren Stilleben dargestellten Objekte als Subjekte im realen Alltag, insbesondere „als Stellvertreter für Personen mit eig. Vergangenheit, die Beziehungen zueinander eingehen, Zueinanderrücken, Sich-Anlehnen, Vordrängen, Sich-Entziehen, Enge oder Geborgenheit innerhalb einer Gruppe, Einsamkeit in einem Raum, Ausgeliefertsein auf der Bühne" (2010) ausdrücken. Im Kontext des mod. Stillebens in Süddeutschland stellen diese Arbeiten einen originellen Beitrag dar. 🏛 FREIBURG im Breisgau, Reg.-Präsidium. STUTTGART, BW-Bank. 👁 *E:* Stuttgart: 1990, '94 Kunsthaus Schaller / 1993 Ellwangen, KV / 1995 Tauberbischofsheim, KV / 1997 Frankfurt am Main, Gal. Gering (K) / 2000 Augsburg, KV (mit Oliver Christmann) / 2002, '04, '11 (K) München, Gal. von Braunbehrens / 2007 Seoul, Gana AG (K) / 2010 Wien, Gal. Frey. – *G:* 1986 Stuttgart, Gal. Kultur unterm Turm: Visuelle Erfahrungen / 1996 Echterdingen, Badhaus: In Wirklichkeit (K); München, Haus der Kunst: Große Kunst-Ausst. (K) / 2005 Aachen, Ludwig Forum: Zur Kasse bitte (K) / 2008 München, Gal. von Braunbehrens: 30 Jahre. 📖 *M. Hauskeller/E.-M. Schumann-Barcia*, S. C. Die Welt hinter den Dingen (K), M. 2002; *R. Boker/E.-M. Schumann-Barcia*, S. C. Neue Arbeiten 2002–2004 (K), M. 2004; *H. Langer*, S. C. Der Zauber des Gewöhnlichen oder warum die Tüten auf den Zehenspitzen stehen (K), M. 2009; *H.-J. Müller*, S. C. Schläft ein Lied in allen Dingen (K), M. 2011. U. Heise

Christodoulou (Hristodoulou), *Eleni*, griech. Malerin, Installationskünstlerin,* 4. 10. 1965 Athen, lebt und arbeitet dort. Stud.: 1985–89 HBK, Athen (bild. Kunst); 1990–92 New York Univ. (u.a. Environmental Art). Mitgl.: Epimelitiriou Eikastikon Technon Ellados/ Vrg bild. Künstler Griechenlands (EETE). – C. arbeitet mit Farbflächen und Mustern, die sie in den Grundfarben sowie Schwarz und Weiß in abstrakten Figurationen auf den Malgrund aufbringt. Sie formt in mon. Tableaux Liniaturen, Kanten und Wirbel aus Farbe (*Wave Optics*, 2006, 360 x 600 cm; Ausst. The Breeder, Athen). Diese sind u.a. von Roy Lichtenstein inspiriert und scheinen ironisch mit dem Betrachter vertrauten Strukturen zu spielen. Eine konkrete Formwerdung des Dargestellten bleibt jedoch aus. Die längere Betrachtung ihrer Arbeiten führt zu Wahrnehmungsverschiebungen und einem scheinbaren Vibrieren des Dargestellten, das sich konsequent den Ge-

setzen linearer Perspektive zu entziehen scheint (*Linear Room*, 2006). In C.s Bildern findet eine ironische Auseinandersetzung mit dem Hard Edge und dem Pattern Painting ebenso statt wie mit der Pop-art. Seit ca. 2005 arbeitet sie zunehmend mit wachsbasierten Farben auf Holzplatten, so daß sich enkaustische Effekte konstatieren lassen. 🏛 ATHEN, Athenaeum Inter Continental. 👁 *E:* Athen: 1995 Jean Bernier Gal.; 2000 Stigma AG (mit Dimitrios Antonitsis); 2006 The Breeder Projects / 1995 Thessaloniki, Multi-Space Mylos. – *G:* 1992 New York, Washington Square East Gall.: Spring Coll. / Athen: 2003 Ileana Tounta Contemp. AC: Brave New World; 2004 The Breeder Projects: Tenderloin / 2004 Madrid, Alcala 31: Break Through / 2005 Beijing, Contemp. Art Inst.: The Art of Greece meets China / 2006 Thessaloniki, State MCA: Crossing the Borders. 📖 LEK IV, 2000. – *Online:* Breeder. E. Kepetzis

Christodoulou (Hristodoulos), *Vasilis*, griech. Zeichner, Cartoonist, Karikaturist, Autor, * 1917 Piräus, † 7. 9. 2010 Athen. Autodidakt. Erste Veröffentlichung einer Zchng 1936 in der Tages-Ztg Icho tis Elladas. Nach dem 2. WK regelmäßige Veröff. von Cartoons und Karikaturen in griech. Mag., Ztgn und Zss., u.a. in den landesweit und in hohen Aufl. erscheinenden Bll. Thysauros, Romantso, Pagkosmios Typos, Savvatokyriako, Ellinismos, Efimeris ton Ellinon, Radio-Athinai und Eikones. Zunächst dominieren ges.-kritische Themen, danach widmet er sich v.a. der politischen Karikatur. 1951–62 arbeitet C. für die Ztg Athinaiki, auch für die im Norden des Landes erscheinende Tages-Ztg Makedonia (dort als Nachf. des Karikaturisten Fokion Dimitriadis). 1962–88 (Einstellung des Bl.) ist er fester Mitarb. bei der Ztg Vradyni. Als diese 1998 neuerlich zu erscheinen beginnt, übernimmt der 71jährige sofort wieder die Position als leitender politischer Karikaturist. Mitgl.: Epimelitiriou Eikastikon Technon Ellados/ Vrg bild. Künstler Griechenlands (EETE); Enosis ellinon Efthymografon kai Geloiografon/Vrg griech. Humoristen und Karikaturisten (ESHEA). Ausz.: 1991 Ehrenpreis der Athanasios-Botsis-Stiftung zur Förderung des Journalismus, Athen; 2006 Phönixorden (Kommandeur) für das Lebenswerk. – In schwarzweißen wie kol. Zchngn (v.a. Feder, Tusche, Deckfarben), für die er in aller Regel auch die Texte und Bildunterschriften verfaßt, stellt er seine Themen in ausdrucksstarken Konturlinien vor einen neutralen Hintergrund. Körperteile und einzelne Körperpartien können satirisch überzeichnet sein. So stattet er seine *Faßdenker*-Figuren, die der „Partei der Faßdenker" angehören (*Komma ton Varelofronon*), mit geröteten und geschwollenen Alkoholtrinkernasen aus; über Jahrzehnte entlarvt C. mit dieser satirischen Serie Politiker und Trunkenbolde gleichermaßen. Sein bissig-tiefgründiger Blick richtet sich bes. auf griech. Politiker, Staatsbeamte und Militärs aller politischen Richtungen, wodurch er mit seinen Arbeiten Anteil hat bei der Formierung der öff. Meinung in der zweiten H. des 20. Jahrhunderts. Während der Militärjunta 1967–74 kann C. mit seinen Karikaturen aufgrund der Pressezensur und der allgemeinen Umstände nur eingeschränkt und in Anspielungen agieren. In diesen Jah-

ren kreiert er zwei distinktive, aus der Volks-Trad. geborene Figuren: den Evzonen (Mitgl. der ehemaligen kgl. Leibgarde, seit 1974 Präsidialgarde) in der trad. Fustanella (Männerfaltenrock) mit einem Fuß im Gips als Zeichen der Behinderungen des Bürgers durch Zensur und Kontrolle sowie den kretischen Lyraspieler, der die Politik der Militärs einem Hofnarren gleich kommentiert. Bisweilen kombiniert C. die beiden Typen auch zu einer Figur. Daneben entstehen über Jahrzehnte für die überregionale Sport-Ztg Athlitiki Icho sportbezogene Cartoons und Karikaturen. Auch wird C. als Autor tätig, u.a. verfaßt er zus. mit dem Humoristen Alekos Sakellarios Sketche und Drehbücher; auch Arbeiten für TV-Sender und Revuetheater. Bis zu seinem Tod ist C. für die wichtigsten Ztgn des Landes tätig, seine Karikaturen erscheinen mehr als 50 Jahre lang regelmäßig auf den Titelblättern. Er ist einer der bedeutendsten Karikaturisten seiner Zeit in Griechenland. – Sammelalben: u.a. *Geloio ... graphika !!*, At. 1987 (mit A. Sakellarios); *Ola gia ti gynaika*, At. 2011; *I thrylikoi „Varelofrones" xanarchondai*, At. 2011. ⌂ ATHEN, Mun. Gal. ☺ *E:* 1994 Thessaloniki, Kulturzentrum Mylos. – *G:* 1948–2010 Athen: Panhellenische Kunst-Ausst. (jährlich) / 2000–01 Forte dei Marmi, Mus. della Satira e della Caricatura: O sorrisi della guerra. La guerra Italo-Greca del 1940. ⌶ LEK IV, 2000. – *C. Zachopoulos* (Ed.), Elliniki politiki geloiografia, At. 2002; Ekthesi politikis geloiografias (K Parlament), At. 2005; I Geliografia stin Evropi ton 27 (K Zappeio Megaro), At. 2008, 104–105.

E. Kepetzis

Christoff, *Konstantin,* bulg.-brasil. Maler, Zeichner, Illustrator, * 1923 Strajitza, † 21. 3. 2011 Montes Claros. Stud.: 1948 Medizin, Belo Horizonte. Zunächst als Chirurg tätig. Ab 1960 Hinwendung zur Malerei und Zeichnung. Charakteristisch für C.s expressionistisch anmutende Gem. ist die kontrastreiche Farbpalette. Auch experimentiert er mit Pastelltönen. Eine bes. Stellung nehmen die zahlr. Selbst-Portr. ein, in denen sich der Künstler im Kreis von Fam. und Freunden zeigt. Zuweilen gleiten die Motive ins Karikaturhafte, etwa in den humorvoll-ironischen Darst. von Marilyn Monroe und Albert Einstein in amer. Pop-art-Manier. ☺ *E:* Rio de Janeiro: 1984 Gal. de Arte do Banerj; 1997 MAM / 1986 São Paulo, Paço das Artes / Belo Horizonte: 1986 Gal. do Palácio das Artes; 1991 Gal. Novotempo / 1986 Florianópolis, Mus. de Arte / 1993, '97 Uberlândia, Gal. Elizabeth Nasser / 1997 Uberaba, Gal. da Fund. Cult.; Itaiutaba, Casa da Cult. –. *G:* Belo Horizonte: 1982, '84 Salão Nac. de Arte Contemp.; 1986 Salão Nac. de Artes Plást. sudeste; 1992 Fund. Clóvis Salgado Pal. das Artes: Utopias Contemp. / São Paulo: 1989 Sadalla Gal. de Arte: Arte e Medicina; 2004 Esporte Clube Sírio: Expos. de Artistas Contemp. ⌶ *Ayala*, 1997. – *Online:* Inst. Itaú Cult., Enc. artes visuais, 2011 (Ausst.).

M. F. Morais

Christopei, *J. Tront,* dt. Architekt, Maler, Graphiker, Freskant, * 26. 6. 1938 Darmstadt, lebt in Merzig/Saar. Ausb./Stud.: 1960–61 Werk-KSch., Darmstadt (Gebrauchsgraphik, Innen-Archit.); 1962–64 TH ebd. als Hilfs-Ass. bei Bruno Müller-Lünow am Lehrstuhl für

Zeichnen, Malen und Graphik. 1964–96 eig. Archit.-Büro. Ab M. der 1970er Jahre freie Malerei und Graphik, Beteiligung an Kunst-Ausst. und Lehrtätigkeit als Doz. für Malerei. Seit 1995 Doz. (Malerei, Graphik) am Kunstzentrum Bosener Mühle. – V.a. gegenstandsbezogene und abstrakte Komp., Portr., Lsch. und Figurenbilder (Öl, Acryl). Auch Collagen, von denen viele im kunstdidaktischen Kontext entstehen. Auch illusionistische Wandbilder von lokaler Bedeutung (in Priv.-Häusern und gastgewerblichen Räumen). ⌂ MERZIG, Mus. Fellenbergmühle. – Mus. Schloß Fellenberg. ☺ *E:* 2010 Losheim am See, Schlößchen. ⌶ Kürschners Hb. der Bild. Künstler. Deutschland, Österreich, Schweiz, I, M./L. 2007. U. Heise

Christopher, *Tom,* US-amer. Maler, Zeichner, Gebrauchsgraphiker, * 1952 Hollywood/Calif., lebt in New York. Stud.: 1974 Pasadena Mus. of California Art; bis 1979 AC College of Design ebd. bei Lorser Feitelson und Ward Kimball. Ab 1981 in New York ansässig. 2010 Mitbegr. des Lift Trucks Project, eines alternativen Kunstraumes in Croton Falls/N. Y. – Debütiert mit werbe- und gebrauchs-graph. Arbeiten (u.a. Plakate für CBS Records in Kalifornien, Ill. für Ztgn und Zss. wie Motor Trend Mag., New York Times, People, Fortune und Wall Street J.), denen er sich auch im späteren Schaffen wiederholt widmet (z.B. 2002 Entwurf des Umschlags für den offiziellen Stadtführer von New York, Gest. des Designs für eine Snowboardserie von Burton sowie Hüllen von iPhones). 1982 als Gerichtszeichner im Auftrag der CBS Network News tätig. M. der 1980er Jahre Hinwendung zur Malerei mit stark vergrößerten Darst. von alltäglichen Gegenständen. Außerdem fertigt er Skulpt. aus Eisenguß. Seit A. der 1990er Jahre konzentriert sich C. v.a. auf New Yorker Motive in expressivem Gestus (meist Acryl, wobei die Bleistiftlinien der Vor-Zchng sichtbar bleiben), bes. Taxi- und Kraftfahrer, Silhouetten der Stadt bzw. Straßenszenen, die das char. Flair dieser Metropole einfangen, darüber hinaus aber auch in universeller Form Leben und Lebensgefühl des Menschen in einer mod. Großstadt wiedergeben wollen. Zahlr. Arbeiten seit 2005 sind dem Times Square Project gewidmet. Inspirationen erhält C. nach eig. Aussage (cf. Website C.) bes. vom dt. Expressionismus, von den Künstlergruppen Blauer Reiter und Die Brücke. In jüngster Zeit experimentiert er mit collageartig angelegten Gem., in denen auch Fabelwesen wie Nixen auftauchen können. In Zusammenarbeit mit Gary Lichtenstein entstehen Siebdrucke wie *Like Popeye After a Can of Spinach. Never Saw Anybody Move So Fast. Ever* (2004). Auch stellt er 2009 eine Gem.-Serie in Schwarzweiß aus (*New York is Noir again*). ⌂ NEW YORK, Mus. of the City of New York. – New York Hist. Soc. Mus. – New York Times, Inc. – Rockefeller Center. SOUTH HADLEY/Mass., Mount Holyoke College. STOCKHOLM, Vin och Sprithistoriska Mus. WASHINGTON/D. C., Nat. Building Mus., Hechinger Coll. YOUNGSTOWN/Ohio, Butler Inst. of Amer. Art. ☺ *E:* New York: 1990 St. Marks Gall.; Eastman Wahmendorf Gall.; Helio Gall.; 1993, '94 Tamenaga Gall.; 1996 Michael Owen Gall.; 1997, '98, 2000, '02, '05 (K) David Findlay Gall.; 2005 Lab Gall.; 2008 J. N. Bartfield Gall. / 1997,

'99, 2002, '05, '07, '10 Tokio, Gal. Tamenaga / 1999, 2001, '04, '06 (K: G. Haggerty), '09, '11 Paris, Gal. Taménaga / 2004, '06, '10 Düsseldorf, Gal. Vömel / 1999, 2007–09, '12 Frankfurt am Main, Gal. Barbara von Stechow / 2008 Youngstown (Ohio), Butler Inst. of Amer. Art / 2011 Osaka, Gal. Tamenaga (K). ☐ *Bénézit* III, 1999. – *A. Rossenbach*, Kunstzeit (Pulheim) 2001 (1) 32–37; Neue Bilder (K Gal. von Stechow), Ffm. 2002; *B. von Stechow* (Ed.), New York (K Gal. von Stechow), Ffm. [2003]. – *Online: Website C.* C. Rohrschneider

Christou (Hristou), *Despina*, griech. Malerin, Installationskünstlerin, * 1973 Nikosia, lebt und arbeitet in Athen. Stud.: 1993–98 HBK, Athen, u.a. Malerei bei Dimosthenis Kokkinides und Marios Spiliopoulos. – V.a. großformatige bis überlebensgroße Darst. von Personen und Situationen (Öl/Lw., Mixed-media), in denen sich das Konfliktpotential der mod. Ges. ausdrücken soll: Migranten beim Auspacken ihrer Habe, erschöpft eingeschlafen über monotonen Tätigkeiten (*European Dream*, Öl/Lw., 2006), soziale Randgruppen in ihrer alltäglich gewordenen Nicht-Sichtbarkeit in den gentrifizierten urbanen Zentren, die Scheinidyllen vorstädtischen Kleinbürgertums mit ihrem unterschwelligen, von Ressentiments aller Art gespeisten Nationalismus. Die Künstlerin bedient sich bei der Darst. dieser ges.-kritischen Themen u.a. der Formensprache der realistisch-propagandistischen Malerei der 2. H. des 20. Jh. sowie von Comics in Nachf. der Pop-art, so daß sich dem Betrachter der häufig installativ im Raum präsentierten Arbeiten das hintergründig-kritische Potential ihrer scheinbar bunt-fröhlichen, narrativen Tableaux erst auf den zweiten Blick erschließt. Ihre Bilder, in denen die Spuren des Malprozesses weitgehend getilgt werden, spielen damit zugleich mit den oberflächlichen Vorstellungen einer massenmedial geschulten Konsumhaltung und den Erwartungen von Normalität und Konformität. ◉ *E:* 2003, '06 Athen, a. antonopoulou.art Gal. / 2002, '04 Nikosia, Apokalypsis Gal. – *G:* 2003 Nikosia, Univ.: The Languages of Gender / 2004 New York, White Box Gall.: Everyday Hellas / 2009 Kalamata, Mun. AG: Migrations. ☐ Kyprioi zografoi tis 3is chilietias, Lefkosia 2002; *S. Bachtsetzis* (Ed.), Stin exochi (K Beltsios Coll. Trikala), At. 2006. – *Online:* Website C. E. Kepetzis

Chromiec, *Osmar (Osmar Dirceu)*, brasil. Maler, * 1948 Curitiba, † 1993 ebd. Stud.: 1971 Esc. Alfredo Andersen, Curitiba (Zeichnen, Malerei). Mitbegr. der Assoc. Profissional dos Artistas Plást. do Paraná. – Sind C.s frühe überwiegend in Schwarzweiß gemalte Arbeiten noch der Op-art verpflichtet, darunter z.B. das Triptychon *Ilusão* (1970), wendet er sich E. der 1970er Jahre verstärkt der geometrischen Abstraktion zu. Hierbei beschäftigt ihn bes. das Verhältnis von Farbe und Form, so z.B. in den Werken *Sem título II* (1978) oder *Geométrico IV* (1980). Eig. Aussagen zufolge leitete C. die Farben seiner Arbeiten von der Natur ab, so daß sie synonym auch für Baum, Sonne, Wasser oder Himmel stehen können. ☐ CURITIBA, Mus. Alfredo Andersen. – MAC. ◉ *E:* Curitiba: 1973, '76 Banco Nac.; 1975 Gal. do Centro Cult. Brasil Estado Unidos; 1978 Gal. Eucatexpo; 1980 Gal. Acaiaca; 1982

MAC / 1982 Rio de Janeiro, Gal. Macunaíma. –. *G:* Curitiba: 1970 Salão dos Novos (1. Preis); 1973, '75, '80 (Prêmio Prefeitura Mpal), '81 (Prêmio Governo do Estado do Paraná) Salão Paranaense de BA / 1974 Porto Alegre, MARGS: Mostra de Artes Visuais do Estado do Rio de Janeiro. ☐ *Cavalcanti* I, 1973; *Ayala*, 1997.

M. F. Morais

Chromov, *Nikolaj Nikolaevič*, russ. Bildhauer, * 3. 3. 1949, † 13. 1. 2008. Verh. mit der Bildhauerin *Ol'ga Borisovna Chromova* (s.u.). Stud.: bis 1972 Kunst-FS, Nižnij Tagil (künstlerische Metallbearbeitung). In den 1990er Jahren Ltg der Filiale Perm' des russ. Künstler-Verbandes. – Ch. hinterläßt ein vielseitiges Œuvre, das vom teleologischen Gedankengut der Einheit und Interdependenz der gesamten Noosphäre getragen wird. V.a. freie, dekorative und mon. Skulpt. für den öff. Raum. Daneben Büsten (u.a. *I. I. Mečnikov*, für das Skulpt.-Ensemble Otcy mediciny, Perm', 1973–86), auch dekorative Park-Skulpt. (u.a. *12 Tierkreiszeichen*, Granit; Restaurant Aėlita ebd.) sowie Gedenkzeichen (z.B. anläßlich des 200jährigen Bestehens des Gouv. Perm', aufgestellt auf dem Berg Saklaimsori-Čachl' an der Grenze zw. der Republik Komi und dem Gebiet Sverdlovsk). Auch Gedenktafeln, z.B. für die Malerin *Nadežda Vasil'evna Kašina*, für den Wegbereiter des sowjetischen Jazz *Genrich Terpilovskij* (um 1995; Soldatov-Kulturhaus Perm'), für den Politiker *P. K. Struve* oder die Schauspielerin *L. V. Mosolova* (1998 eingeweiht) sowie Grabmale (z.B. für den Boxweltmeister *Vasilij Solomin*. Von Ch. stammt auch das erste Denkmal in Perm' zu einem lit. Motiv, nämlich für den Sitzenbleiber Ivan Semenev, die Zentralfigur eines Kurzromans von Lev Davydyčev (u.a.). Bemerkenswert sind ferner Ch.s Skulpt.-Komp. *Golgatha* und *Car'ryba*, die Skulpt.-Gruppe *Dožd'* sowie seine expressiven, psychologisch genauen Portr.-Plastiken (z.B. *Selbst-Portr. mit Ol'ga*). Auch als Schauspieler tätig, u.a. spielt er die Hauptrolle im Film Vozvraščenie (Regie Viktor Najmušin) über den 1922 aus der UdSSR ausgewiesenen Publizisten Michail Osorgin. – *Ol'ga Borisovna Chromova* (* 1949; Stud.: bis 1972 Kunst-FS, Nižnij Tagil), häufige Zusammenarbeit mit Ch., u.a. bei den Arbeiten *Solnyško* (Gußeisen, 1980) oder *Oduvančik* (Kupfer, 1983). ☐ ČUSOVOJ, Ethnogr. Mus. zur Gesch. des Čusovaja-Flusses: Mal'čik. KURGAN, GG. ORDA, Kirche: 16 Fassadenreliefs, Sandstein mit Metallintarsien. PERM', KG. – Foyer der Stadtverwaltung: Denkmal V. N. Tatiščev. – Gor'kij-Park: Derevo detstva, Granit. – Kardiologisches Inst.: Herz, Rhodonit. – Gebiets-Bibl.: Büste D. D. Smysljaev. – Eisstadion Orlenok, Fassade: Triumf pobeditelej. – Pädagogische Univ., Fassade: Heldin der Sowjetunion Tat'jana Baramzina. – Djagilev-Gymnasium (Gymnasium Nr. 11): Portr. S. P. Djagilev. – Puppentheater: Sitzenbleiber Semenev, 2003. ◉ *E:* 2005, '09 Perm', Haus des Künstlers. ☐ *N. V. Kazarinova*, Chudožniki Permi, Le. 1987. D. Kassek

Chromova, *Ol'ga Borisovna* cf. **Chromov**, *Nikolaj Nikolaevič*

Chromy, *Anna*, tschech.-österr. Bildhauerin, Malerin, Zeichnerin, Installationskünstlerin, * 18. 7. 1940 Český

Krumlov, lebt in Roquebrune-Cap-Martin, arbeitet in Italien. Wächst in Salzburg und Wien auf. Erste Ausb. in Wien. Stud.: 1968–75 Acad. de la Grande Chaumière, EcABA und Sorbonne Paris. Maßgebliche Prägung durch die künstlerischen Strömungen der Rive Gauche sowie von Philosophen, Schriftstellern und Chansonniers dieser Zeit. Lebt danach in der internat. Künstlerkolonie von Pietrasanta b. Carrara. Geht später an die Côte d'Azur, wo sie zahlr. Denkmäler zw. Nizza und Menton realisiert. Ab 1990 arbeitet sie in ihrem Atelier in Pietrasanta, wo sich auch die Bronzegießereien Mariani und Massimo Del Chiaro befinden. In Carrara nutzt sie das Atelier von Franco Barattini. 1993 entsteht die *Equus-Trophäe* für den Bayerischen Reitsportverband. Schwerer Unfall 1992; kann sich etwa sechs Jahre lang nicht der Malerei widmen. Zeigt bis heute auf ca. 100 Ausst. v.a. ihre Plastiken (Bronze, Marmor, Stahl). – C.s populärstes Werk ist die Skulpt. *Mantel des Friedens* (bek. auch u.d.T. *Leerer Mantel, Cloak of Conscience, Pietà* oder *Komtur*), deren Repliken sich u.a. im Park des Fürsten-Pal. in Monaco (1996), vor dem Salzburger Dom (1999), vor dem Prager Ständetheater (2000), im Mus. die Bozzetti von Pietrasanta (2001) und vor dem Archäol. NM Athen (2007) befinden. 2000 umfangreiche Retr. in Prag (damals europ. Kulturhauptstadt). Präsentiert 2005 auf der Pariser Pl. Vendôme 20 Mon.-Skulpt. u.d.T. *Mythos Europa.* 2008 gestaltet C. den *Olivier d'Or* (mit dem u.a. 2009 Elie Wiesel geehrt wird) und gründet die Internat. World Conscience Assoc. (IWCA). 2011 vom Vatikan mit einem Gem. von Johannes Paul II. beauftragt. – Thematisch läßt sich C. von ihren Kindheitserinnerungen und Träumen ebenso inspirieren wie von Gesch., griech. Mythologie, der Bibel, Oper, Ballett und Musik sowie dem Zeitalter des Barock und dessen Umgang mit Skulpt. (auch hinsichtlich der Bemalung mit Gold-, Violett- und Mauvetönen, die den Figuren ein magisches Aussehen verleiht). Orientierung an Salvador Dalí und der Wiener Schule des Phantastischen Realismus. Obwohl C. eine meisterhafte Porträtistin ist, skulptiert sie ihre thematischen Arbeiten ohne Gesichter, um deren Universalität zu unterstreichen. Häufig Darst. von bewegten Figuren in Lebensgröße und in zweifarbiger Bronze (nach Körper und Kleidung unterschieden). Ihre jüngsten Gem. sind *The Door* und *Violoncello*. C. engagiert sich intensiv für Völkerverständigung, Versöhnung und Toleranz. Ausz.: 2002 Masaryk-Preis; 2003 Franz-Kafka-Med.; 2006 Premio Voce delle Apuane; 2008 Premio Michelangelo von Carrara (für ihr Lebenswerk). ⌂ Assisi, S. Francesco, Giardino delle Novizi: S. Francesco, Aufstellung 2008. Bad Gastein: Denkmal Franz Schubert, 2009. Florenz, Pal. Guadagni Strozzi Sacrati (Pal. della Regione Toscana): La Bella Elvira, Skulpt.-Gruppe, Aufstellung 2004. Forte dei Marmi: Odysseus, Aufstellung 2001. Garching, St. Severin: Kruzifix, Bronze, um 2008. Guangzhou, MMA: Sisyphus, Aufstellung 2006. Menton, MAM et d'Art Contemp.: Oscar Wilde, Büste, Aufstellung 2001. Monaco-Ville, Pal. Princier. – Hafen: Odysseus. Nürnberg, Staatstheater: Christoph Willibald Gluck, Aufstellung 2005. Pisa, Scuola Superiore di S. Anna: Sisyphus, Aufstellung

2004. Prag, Senovážné náměstí: Böhmische Musikanten, Brunnen, 2002 (zus. mit Jan Wagner). Ulm, Staatstheater: Herbert von Karajan, Büste, Aufstellung 1999. Wien, Stiftung Menschen für Menschen: Karlheinz Böhm, Büste, 2003. ⊙ *E:* 2007 Athen, Archäol. NM / 2010 Peking, NM; Margate, Turner Contemp. / 2011 St. Tropez: Les mythes de la Méditerranée. ▭ *Delarge*, 2001 (* 1948). – ArtsMag 59:1984 (Dez.) 18; *G. Cordoni* (Ed.), A. C. Le son du bronze Pietrasanta 1999; Donna scult. 4 espressioni per 4 artiste (K), Pietrasanta 2003. – *Online:* Website C.; Studio Michelangelo. S.-W. Staps

Chroni (Hroni), *Athina,* griech. Fotografin, * 1968 Ioannina, lebt und arbeitet in Athen. Stud.: 1986–92 Univ. Athen (Archäologie; Kunstgesch.); 1992 Diss. am Polytechnikum ebd. zu den Anwendungsmöglichkeiten von Luftbildinterpretation und Fernerkundung in der Archäologie. Ausz.: 2000 Kounio-Pentax Award, Photosynkria, Thessaloniki (für die Serie *Stereopsis*). – V.a. (Selbst-) Portr., menschenleere Interieurs und Aufnahmen des Alltags. Das häufig quadratische Format ihrer Schwarzweiß-Portr. bewirkt eine Stilisierung der dargestellten Personen. Gesteigert wird dieser Eindruck durch neutrale, meist schwarze Hintergründe, wodurch zugleich eine Distanzierung des Betrachters erfolgt. Auch fotografiert C. ihre Modelle in deren persönlicher Umgebung. Die psychologisierende Nähe vieler Aufnahmen erinnert an die Portr. der amer. Fotografin Diane Arbus; beide zeigen ihre Modelle mit in sich gekehrtem, neutral scheinendem Gesichtsausdruck, der den Rezipienten zur Konstruktion einer Stimmung oder Narration reizt. Ein wesentliches Moment ihrer Arbeiten ist der Faktor Zeit; immer wieder sucht sie, die dem Medium eigentlich inhärent scheinende Statik und das Augenblickhafte des fotografierten Moments zu negieren. Bisweilen verlängert sie die Belichtungszeit und fängt so Bewegungen ein. Auch arbeitet sie zur weiteren Verfremdung ihrer Bilder mit mehreren Belichtungsphasen (ähnlich Ralph Eugene Meatyard). Dies führt zu Unschärfeeffekten, aber auch zu geisterhaft bewegten Umrissen wie in der Fotogr. des 19. Jahrhunderts. Ein Bsp. hierfür ist das Foto *Women and Book* (1995; Thessaloniki, Macedonian MCA), auf welchem im Sessel zu sehen ist, neben dem ein Hocker steht, auf dem ein Buch über mod. Malerei liegt; geisterhaft schimmert über dem Sessel eine sitzende Frauengestalt, die ernst ins Objektiv blickt. Daß die Künstlerin zur Produktion ihrer analogen Fotos mit der (heute zunehmend weniger angewandten) Technik des Silbergelatineabzugs arbeitet, verstärkt die Suggestion, alte Fotogr. zu betrachten. Dies gilt v.a. für die Serie *Stereopsis* (40 schwarzweiße Stereoskopie-Aufnahmen), die z.T. ebenfalls mit verfremdenden Effekten wie Überblendungen operieren und durch die scheinbare Verdopplung des Motivs alt und beunruhigend zugleich erscheinen. C.s Fotogr. sind als Auseinandersetzungen nicht nur mit dem scheinbaren Objektivitätsanspruch der Fotogr., sondern ebenso mit der Zuverlässigkeit menschlicher Wahrnehmung und der Vergänglichkeit zu lesen. ⌂ Thessaloniki, Macedonian MCA. – Mus. of Photogr. ⊙ *E:* Athen: 1997 Greek Cinema Dir. Assoc.;

2009 Cats & Marbles Gall. / 2009 Cobh (Irland), Sirius AC / 2009 Warschau, Yours Gall. – *G:* 2009 Łodz: Fotofestiwal / 2005, '07 Teneriffa: Fotonoviembre / Thessaloniki, Mus. of Photogr.: 2004 Greek Photographs of the 20th c.; 2008, '09 Bienn. of Contemp. Art. ⌑ Makedoniko Mouseio Synchronis Technis (K), II, Thessaloniki 1999, 130. – *A. Georgiou u.a.*, New images, Thessaloniki 2001; *K. Ioannidis u.a.*, Contemp. Greek photography. One c. in thirty years, At. 2008. – *Online:* Website C. (Ausst; eig. Publ.). E. Kepetzis

Chroussaki (Chrousaki; Chroussachi; Hrousaki), *Maria*, griech. Fotografin, * 1899 Smyrna, † 1972 Athen. Als Fotografin Autodidaktin. Nimmt Malunterricht bei Pavlos Mathiopoulos, der ab 1915 eine Prof. für Malerei an der HBK in Athen innehat. Ab 1926 ist C. Mitarb. des griech. Roten Kreuzes. Im Rahmen von Hilfseinsätzen reist sie in den nächsten Jahrzehnten durch Griechenland und dokumentiert dabei ihre Eindrücke fotografisch. Mitgl.: 1954 Fotografen-Vrg Elliniki Fotografiki Etaireia (EFE). – C. gehört neben Kostas Balafas, Dimitris Charisiadis, Spyros Meletzis und Boula Papaioannou zu den bed. griech. Fotografen der 1920er bis 1950er Jahre. Sie überliefert Eindrücke der Zwischenkriegszeit, u.a. bedrückende Aufnahmen des Elends nach den katastrophalen Erdbeben 1932 von Ierissou und Korinth. Akribisch fotografiert sie danach die kriegerischen Auseinandersetzungen, die Verletzten unter Soldaten und Zivilbevölkerung sowie die Zerstörungen während der Kämpfe in Nordgriechenland 1940–41 und im Bürgerkrieg. Zu ihren Arbeiten zählen einige der bekanntesten Bilder des Widerstandes gegen die dt. Besatzung in Athen und Epiros. Bek. wurden auch ihre Aufnahmen der vor dem Panorama des griech. Mittelgebirges auf einem Feld stehenden ital. Kriegsgefangenen und der sich endlos, über schlammige Straßen hinwindende Troß der Kavallerie. Nach 1945 fotografiert C. den Wiederaufbau in der Hauptstadt. In den 1950er Jahren hält sie sich auf Korfu auf; es entstehen über 400 Aufnahmen von Lsch., bäuerlichem und städtischem Leben, auch Porträts. Dabei handelt es sich um die umfassendste fotogr. Erfassung einer griech. Insel vor der Zeit des Massentourismus. C. hat ausschließlich in Schwarzweiß fotografiert. Darunter Nahaufnahmen von Gesichtern, Einzel- und Gruppenporträts, Dok. des Alltagslebens oder weite Lsch.-Panoramen; letztere häufig mit einem Repoussoir (Gegenstand oder Gestalt) im Vordergrund. Grell ausgeleuchtete Partien im Kontrast zu nahezu schwarzen Schatten verleihen ihren Bildern eine bis ans Reliefhafte grenzende Tiefe. In and. Arbeiten setzt sie Unschärfe als Mittel einer Tiefensuggestion ein. 1971 übergibt sie der Nat. AG in Athen ihr etwa 15 000 Negative und 35 Alben mit Schwarzweiß-Fotogr. umfassendes Arch., das als eines der wichtigsten fotogr. Konvolute in öff. Hand gilt und eine zentrale Dokumentation Griechenlands zw. 1917 und 1967 darstellt; hier regelmäßig Ausst. mit ihren Arbeiten. ▯ ATHEN, Nat. AG. ◉ *E:* 2004 Athen, Nat. AG: Fotogr. apo tin Kerkyra tis M. C. – *G:* Athen: 2004 Diana Gal.: 1940–1960. Coming Out of the War Years 1940–1965 (Wander-Ausst.); 2004 Benaki Mus.: East of Attica. Photogr. 1930–1970 / 2009 Thessaloniki, Mus. of Photogr.: Revmata klasikis dimiourgias (Wander-Ausst.). ⌑ *M. Katsimati*, M. C. Photographs 1918–1965. People and places of the Greece we loved, At. 2008; *J. Stathatos*, M. C. Photographs 1917–1958 (K Nat. AG), At. 2000. – *Online:* Photothessaloniki.

E. Kepetzis

Chruxin, *Christian*, dt. Graphiker, Illustrator, Buchgestalter, Typograph, Setdesigner, Regisseur, Redakteur, * 13. 12. 1937 Hannover, † 11. 1. 2006 Berlin. Stud.: 1958–60 Staatliche Werk-KSch, Kassel (1960 Schulverweis), ab 1961 HdK, Berlin (hier später Lehrauftrag für TV-Setdesign). – C.s von Dadaismus und De Stijl sowie der visuellen und konkreten Poesie inspiriertes Œuvre umfaßt die breite Palette inszenierter, häufig experimenteller Typogr. (auch Schriftzeichnen und -schreiben) und angewandter Graphik (Plakate, Buch-Gest., Zs.-Graphik). Noch als Student eröffnet er 1959 seine erste eig. Gal. in Kassel, kurze Zeit später die ebenso innovative (wie erfolglose) Gal. Situationen 60 in West-Berlin, in der sich auf die Wiederentdeckung konstruktiver und konzeptioneller Kunst konzentriert und z.B. 1963 die Mechano-Fakturen von Henryk Berlewi ausstellt. Ab A. der 1960er Jahre arbeitet er für linksgerichtete und mit der außerparlamentarischen Oppositon (APO) sympathisierende west-dt. und (West-)Berliner Verlage und Kultur-Inst. (z.B. Haus am Waldsee), denen er u.a. typogr. dekonstruierte Buch-Gest. oder typogr. inszenierte Buchtitel und -reihen liefert. Ab 1961 gestaltet er z.B. für den Verlag Wolfgang Fietkau die „Schritte“-Buchreihe. In den 1968er Jahren folgt für die Edition Voltaire die damals bed. Flugschriftenreihe (G. Amendt, *China. Der dt. Presse Märchenland*, B. 1968; H. M. Enzensberger, *Staatsgefährdende Umtriebe*, B. 1968); *Friede mit der DDR. Ein ev. Sendschreiben*, B. 1968). Viele Arbeiten erscheinen im Rowohlt-Verlag (dort u.a. Gest. der Reihe Das neue Buch) oder im Verlag Neue Kritik (hier 1967 auch das Verlagslogo). Zus. mit Joachim Krausse gibt er 1968–70 die Buchreihe „Projekte und Modelle“ heraus, in der vier Bde erscheinen. Ein Schwerpunkt in den 1960er und 1970er Jahren sind daneben Entwürfe für Szenen- und Bühnenbilder sowie Kostümentwürfe für Fernsehfilme; auch Regiearbeiten. Seine bekannteste, ins öff. Bewußtsein dringende Arbeit von A. der 1970er Jahre ist die Studio-Archit. der TV-Sendung Beat-Club (Radio Bremen). In den 1970–80er Jahren obliegt C. das visuelle Erscheinungsbild des Künstlerhauses Bethanien in Berlin, dessen Publ. er z.T. auch als Redakteur betreut. Neben Plakaten (Konzert- und Ausst.-Plakate) und Einladungskarten gestaltet C. hier auch mehrere der großen Ausst.-Kat. (u.a. *Wohnsitz. Nirgendwo. Vom Leben und vom Überleben auf der Straße* [K], B. 1982). Auch Künstlerbücher, so das 1984 als bibliophiler Priv.-Druck in 100 Expl. hrsg. *Schnittmusterbüchlein* zum 25jährigen Bestehens des Fietkau-Verlages. C. gehört zu den bed. (west-) dt. Buchgestaltern, in derem Werk sich die 1968er-Bewegung widerspiegelt. ✉ Fietkaus Schritte durch ein Vierteljahrhundert. Ein Schrittmusterbüchlein, vorgelegt von den Autoren und Freunden ... des Verlages von Wolfgang und Erika Fietkau, B. 1984. ◉ *E:* 2009 Güstrow, Gal. Rambow

(Plakate, Buch-Gest.). – *G:* 2011 Berlin, Neuer Berliner KV: One plus One. ▭ *H. Jost/P. Weibel* (Ed.), Die Teile der Summe. Begegnungen mit C. C. Visueller Gestalter 1937–2006, Köln 2008. – *Online:* J. Stürzebecher, Die Gest. der Revolte (design report 5/2008). U. Heise

Chrysidou (Chrissidou; Hrissidou), *Elli,* griech. Malerin, Graphikerin, Installationskünstlerin, * 1956 Kilkis, lebt und arbeitet in Thessaloniki. Stud.: 1975–80 EcBA, Nancy (bild. Kunst). Seit 1991 lehrt C. Malerei an der Saint-Etienne School of FA in Thessaloniki. Ausz.: 1986 1. Preis (Plakat) auf der Bienn. junger Mittelmeerkünstler; 1987 1. Preis Demetria Festival, beide Thessaloniki. Mitgl.: Assoc. of artists in the Greek region of Macedonia. – C. legt expressionistische Formstudien in intensiven Farben vor, die sie bis zur Abstraktion führt. Ab M. der 1980er Jahre gewinnen die zunehmend großformatig werdenden Arbeiten symbolische Qualität, indem z.B. die Farbe Blau im oberen Bildteil mit dem Himmel und Braun im unteren Bildteil mit der Erde assoziiert werden oder die abstrakte Reduktion aus noch erkennbaren tierischen bzw. menschlichen Figuren entwickelt wird. Ihre dreidimensionalen Installationen stellen häufig eine Kombination von malerischen Werken und Objekten im Raum dar. In viele Arbeiten transplantiert C. natürliche Mat. (Holz, Knochen, Papier, Federn), so daß ihre Bildwerke eine haptische Struktur erhalten und die Grenze der Fläche durchbrechen. Die Themen Geburt und Tod rücken in den letzten Jahren zunehmend in das Zentrum ihrer Arbeit, dabei wird z.B. der überzeitliche Anspruch des (musealisierten) Kunstwerks kritisch hinterfragt: So besteht das abstrakte Gem. *Dawn* (Macedonian MCA) aus einer nicht aufgespannten Lw., die durch die aufsteigende Wärme, die von einer darunter plazierten Ölleuchte erzeugt wird, sukzessive zerst. werden soll. Immer wieder setzt sich C. mit Motiven des menschlichen Schädels und des menschlichen Herzens in deren anatomischer Gestalt auseinander (*Requiem pour Johnny Rouk,* 2010; Nizza, Gal. Depardieu). Dabei finden sich sowohl Arbeiten, die in der Mementomori-Trad. der klassischen Ikonogr. stehen, als auch Bilder, in denen ein anatomisch fundiertes Close-up versucht wird. Durch die antinaturalistische Farbgebung wiederum ist eine Verschiebung solcher Arbeiten in den Bereich des Surrealen und Bedrohlichem zu konstatieren. 2011 kuratiert C. gemeinsam mit Theofanis Nouskas die Ausst. Actions By Heart beim Moni Lazariston Festival, Thessaloniki. ▭ THESSALONIKI, Macedonian MCA. ◉ *E:* Athen: 1984, '90 Gal. Nees Morfes / 2010 Nizza, Gal. Depardieu / Thessaloniki: 1986, '89 Gal. Kochlias; 1989 Internat. Kulturzentrum Bafopouleio; 1992 (K), '98 Gal. Paratiritis; 1999 Ethniko Archaiol. Mus.; 2011 Gal. Lola Nikolaou / 1981 Volos, Mun. Pin. – *G:* Athen: 1987 Panhellenische Kunst-Ausst.; 2004 Athens by Art (Festival) / 1986 Thessaloniki: Bienn. junger Künstler im Mittelmeerraum / 1988 Toronto, Del Bello Gall.: Min.-Art. / 2010 Tbilisi: Artisterium 2010. ▭ LEK IV, 2000. – Makedoniko Mouseio Synchronis Technis (K), I, Thessaloniki 1999, 455–456 (s.v. Chrissidou, Elli; Lit.); *E. Mavrommatis,* I Zografiki sti Thessaloniki, Thessaloniki 1995; *T. Marko-*

glou/A. Mykoniati (Ed.), Collage. Cut + paste, Thessaloniki 2008. E. Kepetzis

Chu, *Anne,* US-amer. Bildhauerin, Malerin, Graphikerin, * 1959 New York, lebt dort. Tochter chin. Einwanderer aus Shanghai. Stud.: bis 1982 Philadelphia College of Art, Philadelphia/Pa.; bis 1985 Columbia Univ., New York. Ausz.: u.a. 2001 Penny McCall Award; Anonymous Was A Woman Award. – C.s Arbeiten verbinden zwei- und dreidimensionale Darst. und ignorieren die trad. Trennung von Skulpt. und Malerei. So arrangiert sie beides in gemeinsamen Objektinstallationen und kombiniert plastische Arbeiten mit Malerei. Thematisch knüpfen die Werke an europ. und asiatische Mythologien, Volkskunst und Kultur-Trad. an. Die Skulpt. und Objekte aus vielen versch. Mat. wie Holz, Bronze, Aluminium, Ton, Textilien, Pappmaché oder Kunstharz, häufig bemalt, sind u.a. inspiriert von chin. Grabfiguren der Tang-Dynastie, romanischen Grabplatten, höfischen Figuren des MA und von Figuren des europ. Marionettentheaters. Daneben fokussieren abstrahierende Arbeiten wie *Mountain Studies* (farbig glasierte Keramik, 2007) oder *Seven Views of Landscape* (Öl, Kasein auf Holz, 1999) die Wahrnehmung auf die Form und kontrastreiche Farben. Auch Arbeiten auf Papier, u.a. Aqu. und Monotypien sowie Collagen, z.B. *Listen* (Acryl, Pigment, Bleistift, Stickerei, 1994). ▭ AMIENS, FRAC Picardie. ARNHEM, MMK. AUSTIN/Tex., Jack S. Blanton Mus. of Art. LOS ANGELES, MCA. NEW YORK, MMA. PRINCETON/ N. J., Univ. AM. SAN FRANCISCO, MMA. ◉ *E:* 1993 Purchase (N. Y.), Neuberger Mus. of Art / New York: 1996, '98 (mit Kiki Smith und Byron Kim), '99 AC Project Room; 2003, '08 303 Gall. / 1998 Cleveland (Ohio), Contemp. AC; Dallas (Tex.), Mus. of Art (mit Bonnie Collura) / 1999, 2002, '07 Chicago (Ill.), Donald Young Gall. / 1999, 2007 Mailand, Monica De Cardenas Gall. / 2000 Berkeley (Calif.), AM; Indianapolis (Ind.), Mus. of Art / 2001, '06 London, Victoria Miro Gall. / 2005 North Miami (Fla.), MCA (K); Greensboro (N. C.), Weatherspoon AG. – *G:* 1988 New York, Sculpt. Center: Annual Small Works Show / Pittsburgh (Pa.): 1991 Carnegie Mellon AG: New Generations. New York (K); 2004 Carnegie Mus. of Art: Carnegie Internat. / 1998 Seattle (Wash.), Henry AG: Surrogate / 2001 (Fast Forward), '03 (Turning Corners) Berkeley, AM / 2003 Princeton, Univ. AM: Shuffling the Deck / 2006 Austin, Blanton Mus. of Art: New Now Next; Chicago, MCA: Figures in the Field; Queens (N. Y.), Queens Mus. of Art: Everything All at Once / 2007 Aspen (Colo.), AM: Sculptors Drawing (K) / 2008 Philadelphia, Inst. of Contemp. Art: The Puppet Show (Wander-Ausst.; K). ▭ *G. Volk,* AiA 85:1997 (2) 96; *B. Schwabsky,* Art on paper 2:1997 (1) 20 s.; *S. Valdez,* AiA 90:2002 (10) 163 s.; *J. Helferstein/J. Fineberg* (Ed.), Drawings of choice from a New York coll. (K Wander-Ausst.), Champaign, Ill. 2002.
 J. Faehndrich

Chu *Chia-hua* (Zhu Jiahua), taiwanesischer Konzeptkünstler, * 1960 Hsinchu, lebt in Tainan und Beijing. Stud.: bis 1982 Nat. Taiwan Acad. of Arts; ABA Brera, Mailand (Abschluß 1990). Lehrtätigkeit: Ass.-Prof. an der Chung Yuan Christian Univ., Chungli; Tainan Nat. Univ. of the

Arts. Seit 2006 auch freischaffender Künstler in Beijing. – 1991 schließt sich C. dem alternativen Kunst-Inst. IT Park in Taipei an und gilt seither (zus. mit Chen Hui-chiao, Chen Shun-chu, Chen Kai-huang u.a.) als bed. Vertreter einer von Pop-art, Dada und Arte povera beeinflußten konzeptuellen, „neo-eklektizistischen" (xin zhezhong zhuyi) Kunstpraxis in Taiwan. Zunächst geprägt von seiner Vorstellung eines „ästhetischen Materialismus" verwendet C. in seinen installativen Arbeiten Ready mades mit Bezügen auf das konsumorientierte urbane Leben Taiwans sowie auf die Beziehung zw. Natur und Menschlichkeit, wie in *Canzhao*/Comparison (echte und Metall-Eier, Porzellan- und Metallteller, 1994). Seit 1999 richtet C. sein Augenmerk vermehrt auf die trad. chin. Kunst und Kultur und beginnt Formate, Motive (Lsch., Pflanzen) und Stile der trad. chin. Malerei aufzugreifen, so in einer mon., von Gu Kaizhi (* ca. 345, † 406) inspirierten Querrolle *(Caoshan wang Taibei/Looking at Taipei from the Grassy Mountain*, Öl/Lw., 2007) oder in einer von den Pferde-Darst. Giuseppe Castigliones abgeleiteten Arbeit *(Minghua de dangdai quanshi*/Contemp. Interpretation of an Old Masterpiece, 3D-Animation, 2006–08). Auch Digitalfotografie. ☐ TAICHUNG, Nat. Taiwan MFA. TAIPEI, FA Mus. – Dimension Endowment of Art. – Yeh Rong Jai Cult. & Art Found. ☉ *E:* 1991 Mailand, Gal. Bel Vedere / Taipei: 1992, '94, '99, 2008 IT Park Gall.; 1993 FA Mus. / 1998, 2000 Fukuoka, MMA Contemp. –. *G:* Taipei (Auswahl): 1994 Dragon Gate Gall.: Post-Martial Law Conceptual Art; NM of Hist.: 1994 Asian Art Exhib.; 1996 FA Mus.: Taipei Contemp. Art Bienn.; 2004 Taipei County Govt.: CO4 Taiwan Avant-Garde Documenta; IT Park: 1992 IT Kitsch; 2002 Reality of the Distant Place; 2008 Sweeties; 2010 Every Chalice is a Dwelling Place / 1995 Sydney, MCA: The Contemp. Art of Taiwan (Wander-Ausst.) / 1996–97 Aachen, Ludwig Forum: Taiwan. Kunst heute (Wander-Ausst.; K) / 1999 Beijing, Nat. AM of China: Visions of Pluralism / 2001 Tokio, Shiseido Gall.: Promenade in Asia. August in the Northern Hemisphere / 2002 Gwangju: Bienn. / 2007 Shanghai, MCA: Animamix. From Modernity to Eternity (K). ☐ *M. Sullivan*, Mod. Chin. artists, Berkeley u.a. 2006 (s.v. Zhu Jiahua). – Urban nature. A dialogue between humanism and materialism (K), Taipei 1994; Taiwan. Kunst heute (K Aachen/Berlin), Taipei 1996; *Gao Minglu* (Ed.), Inside out. New Chin. art (K New York/San Francisco), Berkeley u.a. 1998; *Ni Zaiqin*, The beauty of contemp. Taiwanese art, Taipei 2004; *Zhang Qingwen*, Yishujia 392:2008 (Jan.) 318 s. – *Online:* IT Park, Taipei. K. Karlsson

Chu *Hung*, chin. Maler, * 1960 Suzhou/Prov. Jiangsu, lebt und arbeitet in San Francisco. Erhält im Alter von 12 Jahren Unterricht in chin. Schreibkunst, ab 1978 in trad. chin. Malerei. Stud.: 1983–87 KA, Hangzhou (Zhongguo Meishu Xueyin). Nach dem Examen dort als Lehrer tätig. 1991 Übersiedlung nach Hongkong, dort freischaffender Maler und Lehrer für chin. Malerei an der Chin. Univ. of Hongkong. Seit 1992 zahlr. Ausst. im In- und Ausland. 1997 Übersiedlung in die USA. 2003 Promotions-Stud. an der KA Hangzhou (chin. Lsch.-Malerei). Mehrere Ausz.,

u.a. 1984 3. Preis Nat. Chin. Paint. Competition, Beijing. – Hauptsächlich Lsch.-Maler. Themen sind lyrische Entwürfe heimatlicher und dörflicher chin. Lsch. sowie trad. Interieurs, die durch eine volkstümliche, fast naive Narration das Ideal der Vergangenheit postulieren. Häufige Einzelmotive (wie Vögel im Käfig, Porzellane und Lotosblumen, chin. Dekorornamente und Archit.-Elemente) können als emblematische Metaphern einer vergangenen materiellen und geistigen Kultur Chinas stehen. C.s Werke charakterisieren sich durch einen flächigen Bildraum mit häufigen Perspektivwechseln, dem auch der trad. chin. Bildaufbau nach Zonen zugrunde liegt. Detailreiche, min.-hafte Bildsprache. Im Ergebnis erscheinen die teilw. farbenprächtigen, den Bildgrund komplett ausfüllenden Malereien (v.a. Mischtechniken auf koreanischem Reispapier) wie Tapisserien. ☐ HONGKONG, Yau Ma Tei Station (MTR Corporation). ☉ *E:* 1988 Quanzhou, Huaqiao Univ. / Hongkong: 1990 Seibu AG; 2001 Yan Gall. / 2011 Singapur, Mus. of Art and Design. – *G:* 1990 Saarbrücken, Stadt-Gal.: Junge Kunst aus China (K) / 1994 Hongkong: Contemp. Hong Kong Bienn. Art Exhib. ☐ *Online:* Yan Gall., Hongkong; Cheng AC, Beijing. A. Papist-Matsuo

Chu *Teh-i* (Chu The-i; Qu Deyi), taiwanesischer Maler, Kurator, * 1952 Jeongeup (Südkorea), lebt in Taipei. Stud.: um 1974 bei Li Chung-sheng; Nat. Taiwan Normal Univ., FA Dep.; ENSBA, Paris (Master 1984). 1998–2001 Leiter FA Dept. Taiwan Nat. Univ. of the Arts, Taipei (Prof.). Gast-Doz.: 2000 Univ. of Wollongong, N. S. W.; 2001–02 ENSAD, Paris; 2006 Chosun Univ. und Chonnam Nat. Univ., Gwangju. 2002–05 Dir. Kuandu Mus. of FA, Taipei. Kuratorische Tätigkeiten u.a.: 2004 Scylla and Charybdis in Love. The Challenges Facing Contemp. Taiwanese Artists, Nat. Taiwan MFA (internat. Wander-Ausst.), Taichung; 2005 Looking into Tomorrow – China Contemp. FA, Kuandu MFA, Taipei. Ausz.: 2004 Award of Excellence, Dubai Internat. Paint. Creation Camp. Vorstands-Mitgl. der Lee Chun-shan Found. und Dir. des Internat. Exchange Center. – Stark beeinflußt von der frz. Künstlergruppe Supports/Surfaces sowie vom Suprematismus (v.a. Kazimir Malevič) widmet sich C. seit seinem Paris-Aufenthalt der abstrakten Malerei (Acryl/Lw.). Dabei werden klar abgegrenzte monochrom-geometrische Farbfelder dynamisch komponiert, gelegentlich mit den Fingern gemalten Bildflächen mit kalligraphisch-gestisch anmutendem Liniengefüge neben-, gegen- oder übereinander gestellt (häufig triptychonartig). Die Betonung liegt auf der plastischen Hervorhebung der Farben Schwarz/Weiß und v.a. Rot, Blau, Gelb und Grün. ☐ KAOHSIUNG, MFA. TAICHUNG, Nat. Taiwan MFA. TAIPEI, FA Mus. ☉ *E:* Taipei: 1988 Gall. Triform; 1992 Cherng Piin Gall.; 1993 Crown AC; 1997 Fairmate Art Gall.; 2003, '06 Main Trend Gall. / 1990 Kaohsiung, Chatting Man Gall. / Taichung: 1992, '93, '95, '98 Gal. Pierre; 1999, 2006 Providence Univ. AC. – *G:* Taipei: FA Mus.: 1984 Overseas Chin. Artists Exhib.; 2004 The Transitional Eighties. Taiwan's Art Breaks New Ground (K); The Lyricism of Form Geometric Abstraction; NM of Hist.: 1987 Chin. Contemp. Paintings; 2005 Kuandu MFA: Extravaganza. / Paris: 1982 Grand

Pal.: Salon Grands et Jeunes d'Aujourd'hui; 1999 Centre Cult. et d'Information de Taipei: Taipei-Paris / 1987 Seoul, Korea Mod. AM: Chin. Contemp. Paint. Exhib. / 1990 Kuala Lumpur, NM of Art: Asian Internat. Art Exhib. / Taichung: Nat. Taiwan MFA: 1990 300 Years of FA in Taiwan; 1995 The Speculation and Demonstration of FA in Taiwan; 2000 The Chichi Ark Installation Art Exhib., Commemoration of the 921 Earthquake Anniversary; 2001 Simple Shapes, Multiple Visions. Images of Circle & Square in Contemp. Taiwan; 2005 Between Mod. and Postmodern: Master Chun-Shen Li and Mod. Art in Taiwan / 1993 Tokio: Tokyo Internat. Art Show (TIAS) / 2001 Macau, Camara Mpal de Macau Provisoria: Identity Transformation. A Collective Exhib. of Installations and Abstract Paint. ⌶ *Delarge*, 2001. – *NiZaiqin*, Taiwan dangdai yishu zhi mei (The beauty of Taiwanese art), Taipei 2004; The transitional eighties. Taiwan's art breaks new ground (K), Taipei 2004 (s.v. Chu The-I); Beyond the frontier of color and form. Subversion and reconstruction (K Main Trend Gall.), Taipei 2007. K. Karlsson

Chu *Yun*, chin. Installationskünstler, * 1977 Jiangxi, lebt und arbeitet in Beijing. Stud.: Chin. Paint. Dep. Sichuan FA Inst. (1997 Abbruch wegen Meinungsverschiedenheiten mit dem Lehrer). Danach bis 2000 Aufenthalte in Beijing (1999; hier sah er die einflußreiche Ausst. „Post-Sense Sensibility"), Guangzhou und Shenzhen, wo er als Wanderarbeiter und als Designer für Internetfirmen tätig war. Seit 2002 zunehmend internat. Erfolg. – C.s Installationen zeigen alltägliche Referenzen aus dem persönlichen Umfeld, die eine Kritik postmoderner Ges.-Strukturen darstellen. Seine Vorliebe für eine simplifizierte, post-minimalistische Ausst.-Form kann als dem weitgehend leeren Gal.-Raum zugrundeliegende Gestik verstanden werden. Char. für C.s künstlerische Strategien ist eine spielerische Offenheit für physische Räume und soziale Umgebungen, die er in Installationen mittels unprätentiöser Materialität (u.a. Verwendung von massenhaften Bilddokumenten [*1607*, 2003], wertlosen Abfallprodukten u.ä.) visualisiert und damit reflektierend auf die post-mod. Ges. Chinas verweist (*Soap Piece*, 2002; *Who stole our bodies?*, 2003). Die kritische Auseinandersetzung mit globalen Arbeitswelten, die durch den Menschen gestaltet werden und zugleich seine verlorene Autonomie aufzeigen, ist ein weiteres Themenfeld, wobei der Produktionsprozeß oftmals selbst als Teil des Kunstwerks zu betrachten ist (*Love*, 2005; Siemens VDO). C.s künstlerische Sprache kann als real-poetisch bez. werden, bei der das Verborgene offenbar wird und den Blick auf das Reale freigibt, wobei Dunkelheit, Stillstand und Bewegung wichtige ästhetische Kategorien im Werk darstellen (*Constellation No. 3*, 2009). Im Spannungsfeld von Öff. und Privatsphäre nähert sich C. mit seinen Arbeiten bisweilen dem Happening; so stellte er die Intimität des Schlafens aus (*This is xx*, 2006). ◉ *E:* 2005 Huizhou, Siemens VDO / 2007 Guangzhou, Vitamin Creative Space / 2009 Frankfurt am Main, Portikus. – *G:* 2005 New York, Chambers FA: Body and Objects / 2007 Oslo, Astrup Fearnley MMA: China Power Station 2; London, Frieze Art Fair / 2008 Stock-

holm, Bonniers Konsthall: Sprout from White Nights. A Meeting with Chin. Contemp. Art (K) / 2008 Beijing, Ullens Center for Contemp. Art: Our Future / 2008 Florenz, Pal. Strozzi: China China China!; Berlin, Esther Schipper Gal.: CYLWXZ / 2009 Venedig: Bienn.; New York, The New MCA: The Generational. Younger Than Jesus. ⌶ *P. Tinari*, Artforum 48:2009 (1). – *Online:* Website C.
 A. Papist-Matsuo

Chuang, *Ying-Yueh*, kanad. Keramikerin, Installationskünstlerin taiwanesischer Herkunft, * 20. 9. 1971 Taipei, lebt in Toronto. Stud.: 1987–90 Fu-Tsin Trade and Arts Vocational High School, Taipei; 1994–97 Langara College (mit Thomas Kakinuma Memorial Scholarship); 1997–99 Emily Carr Inst. of Art and Design, beide Vancouver/B. C.; 1999–2001 Nova Scotia College of Art and Design Univ., Halifax (daneben tätig als Ass.; 2004 Gastlehrerin bei den Sommerkursen). Weitere Lehrtätigkeit: u.a. 2006–09 Burlington AC, Burlington/Ont.; 2006–09 Ontario College of Art and Design, Toronto; seit 2007 Sheridan College Inst. of Technology and Advanced Learning, Sheridan/Ont. Außerdem zahlr. Vorträge und Workshops in ganz Kanada. Artist in Residence: 2001–04 Harbourfront Centre (mit Unterricht im Ceramic Studio), Toronto; 2007 Banff Centre for the Arts, Banff/Alta.; 2008 Sanbao Ceramic Art Inst., Jingdezhen/Prov. Jiangxi. Ausz.: 2003, '04 (Best Ceramics Award), '05 (Honorable Mention) Annual Toronto Outdoor Art Exhib.; 2004–06, '08, '09 Canada Council Travel Grant; 2004, '06–09 Ontario Arts Council Craft Artists Creative Development Grant; 2005 Canada Council Emerging Artist Grant; 2006 Winifred Shantz Award for Ceramists; 2010 Canada Council Grant. – Inspiriert von vegetabilen und zoomorphen Formen, bes. der Unterwasserwelt, kreiert C. farbenprächtige, präzis bearbeitete, symmetrische oder auch asymmetrische, phantastische biomorphe Gebilde (*Plant-Creature*, Keramik, mehrfach gebrannt, zwei zusammengefügte Teile, 2003), mitunter auch in Kombination mit and. Mat. (*It blooms on the day*, Keramik, Plexiglasstäbe, 2004). Aber auch Naturalien wie Gemüse, Früchte, Gewürze oder Knochen liefern ihr Anregungen für Strukturen und Texturen. In ihren Installationen läßt C. ganz eig. Welten, bevölkert mit keramischen „Kreaturen", entstehen. ▣ BURLINGTON/Ont., Burlington AC. HALIFAX, AG of Nova Scotia. ICHEON/Korea, World Ceramic Centre. OTTAWA, Canada Council Art Bank. ◉ *E:* 1999 Vancouver (B. C.), Ceramic Gall. / Halifax (N. S.): 2000, '04 Anna Leonowens Gall.; 2004 Mary E. Black Gall. / 2003 Philadelphia (Pa.), The Clay Studio / 2004 New York, Plum Blossoms (mit Yi Chen) / Toronto: 2004 Harbourfront Centre; 2006 A Space Gall.; New Gall. / 2006 Burlington (Ont.), Burlington AC / 2006, '09 (mit Xiaoze Xie) Seattle (Wash.), Davidson Contemp. Gall. / 2007 Banff (Alta.), The Other Gall. / 2009 Haliburton (Ont.), Rails End Gall. and AC / 2010 Regina Beach (Sask.), Elsie Scherle AG. – *G:* 2001, '03, '05, '09 Cheongju (Korea): Cheongju Internat. Craft Bienn. / 2001, '03 Icheon: World Ceramic Bienn. Korean Internat. Competition (CEBIKO) / 2002, '08 Shepparton (Vic.), Shepparton AG: Sidney Myer Fund Internat. Ce-

ramic Award / 2003 Surfers Paradise (Qnsld.): Gold Coast Internat. Ceramic Art Award / 2005 Kecskemét, Erdei-Ferenc-Kulturzentrum und KSch: Internat. Trienn. of Silicate Arts; San Francisco (Calif.), Herbst Internat. Exhib. Hall: Bienn. Internat. Juried Exhib. / 2008 Jingdezhen, Ceramic Hist. Mus.: Internat. Contemp. Ceramic Exhib. ⌑ *E. Cooper*, Contemp. ceramics, Lo. 2009. – *Online:* Website C.; artaxis; Davidson Gall.; John Coulthart. – Mitt. C. C. Rohrschneider

Chudzik, *Rotraud*, dt. Zeichnerin, Objekt-, Collage- und Installationskünstlerin, Kunsterzieherin, * 1936 Kandel, lebt in Wörth. Nichte des Malers *Emil Ludwig* (* 1913 Glan-Münchweiler, † 1942 Stalingrad). Nach Meisterprüfung und Erzieherexamen als Kunstpädagogin tätig. Mitgl. der 1990 gegr. dt.-frz. Groupe Keffenach, zu der u.a. Michel Boetsch, Damien Foltzer, Henri Heinis und Sybille Onnen gehören. – C.s Œuvre umfaßt u.a. geometrisierende, von konkreter Kunst inspirierte graph. Arbeiten auf Papier (Aqu., Bleistift, Tusche), skulptural aufgefaltete Papierobjekte sowie große, z.T. mon. Materialcollagen (*Aus Kreis*, Eisen, Holz, Segeltuch, Lacke, Sand, 1988); auch raumgreifende Hängungen und Verspannungen. Daneben u.a. (Stadt-)Lsch. nach der Natur mit dem häufigen Motiv der sakralen (Kruzifixe) und profanen Plastiken aus dem Stadtraum von Wörth (Denkmale, Friedhofsplastiken, Skulpt.). ◉ *E:* 1988, '98 Karlsruhe, Gal. Hilbur / 1991 Schramberg, Schloß / 1989 Kaiserslautern, Pfalz-Gal. / 2006 Wörth, Gal. Altes Rathaus (mit Astrid Fleig) / 2010 Bad Bergzabern, Art-Gal. am Schloß. – *G:* 1992 Karlsruhe, Badischer KV: Nebeneinander (K: A. Vowinckel) / Schramberg, Schloß: 1996 Einst und Jetzt; 1997 Gruppe Keffenach; 2004 25 Jahre Podium Kunst / 2000 Speyer, Heiliggeistkirche: Stückwerke – Werkstücke (K) / 2005 Kusel, Fußgängerzone: Gespannte Kunst. ⌑ Anstösse. 1989 Kunst in Karlsruhe (K), Ka. 1989; Kirchgänge. Kunst der Gegenwart in Landauer Kirchen (K), Landau 1993.
U. Heise

Chumwong *Thanomchit* (Thanomchit C.), thailändischer Bildhauer, Objekt- und Installationskünstler, * 27. 9. 1965 Phayao, lebt in Bangkok. Stud.: 1983–94 Fac. of Paint., Sculpt. and Graphic Arts, Silpakorn Univ., Bangkok. Dort ab 1994 Doz., ab 2003 Ass.-Prof., seit 2008 Leiter der Abt. Skulptur. Reisen: 1990 Japan, 2001 Europa, 2006 Indien. 2003 Teiln. am Internat. Skulpt.-Symposium in An Giang/Vietnam. Ausz.: 1987 2. Preis, Kunst-Ausst. der Petroleum Authority of Thailand, Bangkok; 1989 Silber-Med., Silpa Bhirasri exhib. of contemp. art by young artists ebd.; 3. Preis (Skulpt.), Nat. Art Exhib. ebd. – C. debütierte 1992–95 mit stark abstrahierten Menschen- und Tierplastiken, die er aus geometrisch zugeschnittenen Metallplatten zusammenschweißt. Ihre unbehandelten, korrodierenden Oberflächen reflektieren den buddh. Kreislauf von Werden und Vergehen. Seit 1996 fertigt er lebensgroße Tierplastiken (u.a. Kühe, Ochsen, Büffel, Bisons) aus Karosserieschrott, Konserven- und Getränkedosen, Radfelgen und Reifen, womit er den Gegensatz zw. dem Leben auf dem Land und in der Stadt thematisiert. Unter dem Eindruck fortschreitender Zerstörung von Wäl-

dern und Wildreservaten konstruiert er seine Tierplastiken, nun auch Hirsche, seit E. der 1990er Jahre aus Natur-Mat. (Baumabschnitte, Holzreste, Maiskolben und -stroh; neuerdings auch Wiederholungen in Bronze), deren allmählichen Zerfall er zum natürlichen Kreislauf der Kreatur in Beziehung setzt. Mit Installationen, bei denen C. zerbrochene Keramiken, Blätter und Sand in den Umrissen von Tieren auf dem Boden auslegt, reflektiert er den Kreislauf von Leben und Tod und die natürliche Ordnung der Dinge im buddh. Sinne (*Dharma*, 2002). Seit 2000 entstehen großformatige Tier-Zchngn (Farbstift auf Papier und Lw.); auch tiergestaltige Objekte aus Abfall- und Recycling-Mat. wie *Merry cruise* (Teile einer Holztrommel, Kronkorken, Bierflaschen, 2008). Mit der 2001 von ihm gegründeten Bronzegießerei Montol Art produziert er in priv. und öff. Auftrag Statuetten, Porträtplastiken, Büsten, Standbilder (*König Taksin der Große*, Bronze, 2001; Chum Seng, Prov. Nakhon Sawan; *König Chulalongkorn, Rama V*, Bronze, 2009; Bangkok, Prov. Electricity Authority) und ganze Denkmalanlagen vorwiegend in einem an der Herrschaftsplastik des ausgehenden 19. Jh. orientierten realistisch-idealisierenden Stil. Für Tempel in Thailand und China führt er u.a. nach hist. Vorlagen bronzene Buddha-Plastiken von handlichem Format über Lebensgröße bis hin zu einer Länge von 200 Metern aus (Projekt *Reclining Buddha*, 2011). Gelegentlich auch Replikate aus dem hist. Fundus der Silpakorn Univ. oder Realisierung von Skulpt. für den öff. Raum (*Project sculpt. installation*, 2010). ⌸ BANGKOK, Sculpt. Center: Kuh, Eisen, 1992. ✉ Metal in sculpt., 2000; Welding, 2001; Metal casting, 2003; Sculpt. and environment, 2004 (alle universitäre Lehrskripte, Bangkok); Sculpt. FA Mag. (Chiang Mai) 1:2004 (1) 41–43 u.a.; Project sculpt. installation between Bangkok Metropolitan Administration [BMA] and Silpakorn Univ. (K), Bangkok 2010 (Projekt-Ltg; Kat.-Design). ◉ *E:* 2002 Bangkok, NG: Wild animal-forests (K). – *G:* Bangkok: Silpakorn Univ.: 1987, '89, '92 AC: Nat. Art Exhib. (K); AG, Fac. of Paint., Sculpt. and Graphic Arts, Silpakorn Univ.: 1994 Thai-Images (K): 1995 Mini sculpt. exhib.; 1999 Thai-Vietnam contemp. art exhib. (K); 2000 Couple (K); 2001 As years went by (K); 2003 From inside to outside (K); Silpakam + See Silpakorn (K); NG: 1993 Sculpt. expos.; 1996 City. Cobalt Blue Group (K); 1997 Queen Sirikit Nat. Convention Center: 50 years of Thai art (K); Exhib. Hall, Silom Gall.: 2002 Drawing (K); 2003 Mini sculpt. expos. Art in box (K). – 2005 Queen's Gall: Silpa. Buddha (K); King Mongkut's Inst. of Technology: 2007, '10 Mini sculpt.; 2008 KTB AG: 32 Thai sculptors / 1998 San Luis Obispo (Calif.), Polytechnic State Univ.: Thai vision I / 2001 Rom, MN d'Arte Orientale: Thai-Ital. art space 2000 / 2006 Busan: Bienn.; Santiniketan, Visva-Bharati Univ. Gall.: Thai-India art and cult. exchange. ⌑ *V. Mukdamanee/S. Kunavichayanont*, Rattanakosin art. The reign of King Rama IX, Bangkok [2]1997, 222; Thai-Ital. art space 2000 (K AC, Silpakorn Univ.), Bangkok 2002, 56, 70 s.; *V. Mukdamanee*, Mixed media and installation art in Thailand, Bangkok 2002, 248–255; Art for Suwannaphum (K Jamjuree AG), Bangkok 2003,

106 s.; Women (K PSG Gall.), Bangkok 2004, 56 s.; *S. Kunawong*, The passion of Thai sculpt. (K), Bangkok 2005, 130 s.; Vijit Silpa. Silpa Thai (K Art and Cult. Centre), Bangkok 2011, 61, 115, 127. A. Feuß

Chun, *David P. (David Paul)*, US-amer. Illustrator, Maler, Graphiker, * 17. 2. 1898 Honolulu/Hawaii, † 24. 10. 1989 San Francisco/Calif., lebte bis 1905 und ca. 1920–24 in Honolulu, 1905 bis ca. 1920 in Guangzhou/China, ab 1924 in San Francisco. Während des Aufenthalts in China erhielt C. ersten Malunterricht. Stud.: 1920er Jahre San Francisco Continuation School. 1935 erster Präs. der Chin. Art Assoc. (später Chinatown Artists Club; Ausst. in den 1930er/40er Jahren im De Young Mus., San Francisco). In den 1930er Jahren entstehen während der Weltwirtschaftskrise mit Unterstützung des Federal Art Project Lithographien. Im Rahmen eines Projektes der Downtown Assoc. 1935 engagiert sich C. für eine Verschönerung der Chinatown von San Francisco im Sinne trad. chin. Ästhetik; u.a. gestaltet er einen Teegarten am heutigen Portsmouth Square und liefert Entwurfsskizzen für das Tor in der Grant Ave. am Eingang zur Chinatown. – Ölbilder, Aqu., Hschn. und Lith. in realistischer Auffassung mit Archit.- bzw. Stadtansichten, Lsch., Marinen, Genreszenen, Stilleben. Wiederholt setzt sich C. thematisch auch mit sozialen und politischen Problemen auseinander (u.a. *Waiting for a job*, Lith., 1930er Jahre; *A Shortcut to Destruction*, Darst. der jap. Invasion in China; *War Toll*). Zum Schaffen nach 1949 ist wenig bekannt. ⌂ ANN ARBOR, Univ. of Michigan Mus. of Art. MINNEAPOLIS, Frederick R. Weisman AM. MISSOULA, Univ. of Montana. MONTEREY/Calif., Monterey Peninsula Mus. of Art Assoc. SAN FRANCISCO/Calif., de Young. – MMA. WASHINGTON/D. C., Smithsonian Amer. AM: Lith., 1930er Jahre. ◉ *E:* 1939, '40/41 San Francisco (Calif.), Mus. of Art. – *G:* u.a. 1939 San Francisco: Golden Gate Internat. Expos. / 2000 Los Angeles, County Mus. of Art: Made in California. Art, Image, and Identity 1900–2000. ▢ *Hughes*, 1989; *Falk* I, 1999 (beide mit falschem Geburtsjahr). – *M. D. Johnson*, At work. The art of California labor, S. F. 2003; *G. H. Chang u.a.* (Ed.), Asian Amer. art. A hist. 1850–1970, Stanford, Calif. 2008. – *Online:* Smithsonian Amer. AM. C. Rohrschneider

Chun, *Kaili (Ka'ili)*, US-amer. Bildhauerin, Installationskünstlerin, * 1962 Honolulu/Hawaii, lebt dort. Stud.: bis 1986 Princeton Univ., Princeton/N. J. (Archit.), u.a. bei Toshiko Takaezu; bis 1999 Univ. of Hawaii at Mānoa, Honolulu (1997–2004 Lehrtätigkeit dort). 1996–2003 trad. Ausb. bei dem Holzschnitzer und Kanubauer Wright Elemakule Bowman Sr. in Nu'uanu. Seit 1999 Dozentin am Kapi'olani Community College, Honolulu. Ausz.: u.a. 1998 Alfred Preis Memorial Award for the Visual Arts; 2006 Catherine E. B. Cox Award for Excellence in the Visual Arts, beide Honolulu; 2010 Joan Mitchell Found. Grant for Painters and Sculptors, New York. – C. verwendet in ihren meist großräumigen, teils interaktiven Installationen neben industriellen Gebrauchs- und Alltagsgegenständen u.a. auch selbstgeschaffene organische Formen aus Stein und in trad. Verfahren hergestellte, indigene Artefakten

nachempfundene Skulpt. aus Holz wie Speere, z.B. *Janus* (Stahl, Schlösser, Ketten, Schlüssel, Lautsprecher, 2010). In den Arbeiten, die sie teilw. mit Texten versieht, setzt sie sich vorrangig mit hawaiianischer Gesch., Kultur und Spiritualität sowie den Einflüssen christlicher Religion und westlicher Kultur auf diese auseinander, z.B. in der Arbeit *Ka'ai a Kaia'upe* (US-amer. Flagge, Holz, Baumbaststoffe, 1997), in der sie die US-amer. Kolonisation Hawaiis, symbolisiert durch die Flagge, und den erstarkenden Rückbesinnungsprozeß auf die trad. Kultur in der hawaiianischen Bevölkerung thematisiert. ⌂ HONOLULU, Hawaii State Found. on Cult. and the Arts. – Hawaii State AM. ◉ *E:* 2006 Honolulu, Henry R. Luce Gall. – *G:* Honolulu: 1997 East-West Center Gall.: Ho'okū'ē (Wander-Ausst.); 2003 Contemp. Mus.: Bienn. of Hawaii Artists (K); 2007 (Mixed Media Min.), '10 (The True Enlightenment of White Walls) Koa AG; 2012 Mus. of Art: Bienn. of Hawaii Artists (K) / 2005 New York, MAD: Changing Hands 2 (Wander-Ausst.; K) / 2011 Kahului (Hawaii), Schaefer Internat. Gall.: I Keia Manawa, In This Time. ▢ *A. A. H. Drexel*, Art j. 57:1998 (3) 56–59; Ho'ōku'ē', Widerstand. Mod. Kunst aus Hawai'i (K Linden-Mus.), St. 1998; Reconstructing memories (K Univ. of Hawaii AG), Honolulu 2006. – *Online:* Website C. J. Niegel

Chung, *David (Y. David)* , US-amer. Multimedia-, Installations- und Filmkünstler, Zeichner, * 1959 Bonn, lebt in Washington/D. C. Kommt A. der 1970er Jahre nach Amerika. Stud.: bis 1980 Univ. of Virginia, Charlottesville (Medizin); bis 1988 Corcoran College of Art and Design (BFA), Washington/D. C.; bis 2002 George Mason Univ., Fairfax/Va. (Master of FA). Arbeitet zwischenzeitlich 1980–82 als kommerzieller Graphiker in New York. Lehrtätigkeit: 1998–2004 George Mason Univ.; anschl. Univ. of Michigan, Ann Arbor. Artist in Residence: 1990 Univ. of California, Berkeley; 1992 William's College, Wellesley College; 1998 Mary Lou Wiliams Center for Black Culture, Duke Univ., Durham/N. C.; 2001 Whitecliffe College of Art and Design, Auckland/N. Z. – In Wand-Gest., Performances, Aqu., Kohle-Zchngn, Hschn., Videos und Installationen visualisiert C. Erfahrungen, Diskriminierungen, interethnische Konflikte und kult. Zwiespälte von in den USA lebenden Koreanern (wie er selbst), ohne dabei politische Ziele zu verfolgen. Bezogen auf Auseinandersetzungen zw. Koreanern und Afro-Amerikanern in Los Angeles 1992 zeigt das Video der Multimediainstallation *Turtle Boat Head* (1992) einen Koreaner, der in seinem Laden Lebensmittel verkauft hinter einer schußsicheren Scheibe, die wie eine kult. Trennungslinie zw. ihm und seinen afro-amer. Kunden wirkt. Im Video gehen die Lebensmittelregale später in Szenen von der jap. Besatzung in Seoul über, an die sich der Verkäufer erinnert. C.s energischer, dynamischer Zeichenstil (Kohle, Ölstift) ist von Comics und seiner Tätigkeit als graph. Animateur von Dokumentarfilmen geprägt und schöpft aus der Bildwelt der amer. Massenmedien und Stadtkultur sowie aus koreanischer Gesch., Volkskunst und dem Alltagsleben (*The Ten Immortals*, 2005). Erfahrungen eines Immigranten offenbart die mon. Serie *Hoodoos* (1998), in

der C. die Wände eines Raumes mit schwarzweißen Siebdrucken von Szenen und Figuren aus trad. afro-amer. Erzählungen überzieht. Zus. mit and. Künstlern, Schriftstellern, Filmproduzenten und Musikern übernimmt er ferner öff. Aufträge, z.B. mit Tom Ashcraft die Wand-Gest. *Continuum and reposto* (2003, Arlington, 1800 North Oak Str.). 2007 entsteht u.a. mit Matt Dibble der Dokumentarfilm *Koryo Saram – The Unreliable People* über die unter Stalin aus den ost-russ. Grenzgebieten nach Kasachstan deportierten Koreaner. ◫ ALEXANDRA/Va., Huntington Metro Station: Wand-Gest., 1990. ARLINGTON/Va., Rosslyn-U-Bahnstation: Wand-Gest., 1997. – Virginia Square Metro Plaza: Platz-Gest. (mit Tom Ashcraft), 2000. NEW YORK, City of New York Dept. of Cult. Affaires: Wand-Gest., 1997. PHILADELPHIA/Pa., Fabric Workshop and Mus. ◉ *E:* 1988 Fayetteville (Va.), Univ. of Arkansas, FA Center Gall.; Farmville, Longwood College / Washington (D. C.): 1987–2001 regelmäßig Gal. K; 2005 Flashpoint Gall. / 1992 New York, Whitney (K) / 1998 Durham, Duke Univ., Mary Loo Wiliams Center / 2003 Riverdale (Md.), Harmony Hall Regional AC. – *G:* 2009 Los Angeles, County Mus. of Art: Your bright future. 12 Contemp. artists from Korea (K). ◫ *K. K. Hallmark,* Enc. of Asian amer. artists, Westport, Conn./ Lo. 2007. – *K. Stiles/S. Fleming,* High performance 11:1988 (Herbst) 34–38; *L. R. Lippard,* Mixed blessings. New art in a multicultural America, N. Y. 1990; *E. Heartney,* AiA 81:1993 (7) 35–41; 82:1994 (9) 47; *J. W. Boyd,* Un/Common ground. Virginia artists Richmond (K Virginia MFA), Richmond 1996; *A. Young,* Why Asia? Contemp. Asian and Asian Amer. art, N. Y./Lo. 1998; *G. Howell,* Art papers 23:1999 (6) 47–49; *E. H. Kim/M. Machida,* Fresh talk – Daring gazes. Conversations on Asian Amer. art, Berkeley 2003. – *Online:* Website C. H. Stuchtey

Chứng, *Mai* (eigtl. *Nguyễn Mai*; Mai Chứng), vietnamesischer Bildhauer, Maler, * 1940 Bồng Sơn/Bình Định, † 1. 9. 2001 Dallas. Stud.: 1957–58 (mit Đinh Cường, Hồ Hữu Thủ) und 1962–63 KA Gia Định, 1958–61 (mit Trịnh Cung) KA Huế bei Lê Ngọc Huệ, dessen Meisterschüler C. wird und dem er bei der Fertigung der Marien- und Jesus-Fig. in Zement für die Kirche La Vang in Quảng Trị zur Hand geht. 1966 Gründungs-Mitgl. des Verb. Junger Maler Vietnams (1973–75 Vorsitzender). Lehrtätigkeit: ab 1968 KA Huế, 1974–75 HS für Archit. Saigon. Ausz.: 1975 1. Preis für ein Denkmal im Park am Saigoner Flughafen (nicht realisiert). 1975–78 wird C. als ehemaliger Offizier des Amtes für Psychologische Kriegsführung der Republik Vietnam im Umerziehungslager inhaftiert. 1981 flieht er in die USA über San José und Hawaii nach Dallas. Seinen Unterhalt verdient C. dort als Fastfood-Verkäufer, später als Taxifahrer. 1990 Nachzug der Familie. – C. gilt als einer der bedeutendsten Bildhauer Südvietnams vor 1975. Nach schlichten, ausdrucksstarken Skulpt. und Reliefs in Gips, Terrakotta und Zement (*Der Schlafwandler; Portr. einer jungen Frau,* 1962) Hinwendung zu Arbeiten in Metall. Seine von Zoltán Kemény inspirierten z.T. mon. Arbeiten aus Kupferschrott sind formal wegweisend und zugleich eindringliche Bekenntnisse

gegen den Krieg (*Krieg; Keim,* 1973). Nach langer Unterbrechung gestaltet C. in den 1990er Jahren v.a. abstrakte und stilisiert-figürliche Kleinplastik in Terrakotta (*Vater und Kinder,* 1993; *Kreatur,* 1995). Die Absicht, diese Plastiken in Bronze gießen zu lassen, kann er auf Grund schwerer Erkrankung nicht mehr realisieren. ◫ LONG XUYÊN: Bông lúa con gái (Junge Reisähre), verschweißte Kupferschrottplättchen, 1970 (1975 gesprengt). SAIGON, Kaufhaus Tam Đa: Hai chị em (Schwestern); Sinh lục dân tộc (Lebenskraft), beide Terrakotta, 1967 (beide nach 1975 verschollen). ◉ *G:* Ho-Chi-Minh-Stadt: 1974 Gal. La dolce vita: Junge Künstler; 2001 Gal. Vĩnh Lợi: Die Ehemaligen / 2010 Westminster (Calif.), Người Việt Gall.: Converge (K). ◫ Ho Chi Minh City Art Diary 96–97, Ho-Chi-Minh-Stadt 1996; Điêu khắc gia Mai Chứng, Cuộc Đời và Nghệ Thuật (Leben und Werk), s.l. 2005; *H. H. Úy,* Nghệ thuật tạo hình Việt Nam hiện đại (Mod. vietnamesische Kunst), Westminster 2008; *Ng. Quân,* Mỹ thuật Việt Nam thế kỷ XX (Vietnamesische Kunst des 20. Jh.), Hanoi 2010. A. Friedel-Nguyen

Chung, *Tiffany D. (Tiffany),* vietnamesisch-US-amer. Konzept-, Installations-, Performance- und Videokünstlerin, Malerin, Graphikerin, Fotografin, Bildhauerin, * 1969 Đà Nẵng, lebt ab A. der 1980er Jahre in Kalifornien und seit etwa 2000 in Ho-Chi-Minh-Stadt. Stud.: bis 1997 California State Univ., Long Beach (Fotogr.); 1997–2000 Univ. of California, Santa Barbara (Master in Studio Art). Lehrtätigkeit: 2002 Chulalongkorn Univ., Bangkok. 2005 ARC Grant der Durfee Found. Seit 2005 Künstlerresidenzen u.a. in Fukuoka, Ibaraki, Singapur, Seoul, Yamaguchi. – In ihrer Vielseitigkeit ist C. eine der internat. am stärksten wahrgenommenen zeitgen. Künstler Vietnams. Ihre von Pop-art geprägten und z.T. von kommunistischen Propagandaplakaten inspirierten inszenierten Fotografien beleuchten verspielt und ironisch die stylish-imitative Jugendkultur in den Millionenmetropolen v.a. Asiens (*Bubble Double Bazooka,* 2005; *Play,* 2008). Seit 2007 übermalt, bestickt, beklebt C. Landkarten und Stadtpläne und setzt sich so mit den dramatischen Folgen der Spaltung von Ländern (*Scraching the walls of memory,* 2010), mit Kriegsverwüstung (*Nagasaki,* 2010) sowie mit der zerstörerischen Wirkung ungehemmter Urbanisierung auseinander (*1°40'N 1°36'S 89°16'E 92°01'W,* 2009). Die Bedrohung der natürlichen und sozialen Lebensräume durch den Menschen thematisiert C. auch in Rauminstallationen und Videos. ◉ *E:* 1997 Long Beach, Gall. C; Manhatten Beach, Hungry Mind Art Gall. / 1997, '99 Santa Barbara, Gall. 1434 (alle K) / 2003 Ho-Chi-Minh-Stadt, Mai's Gall.; Gall. Quỳnh / 2005 Fukuoka, Asian AM / 2006 Los Angeles, LMan Gall. / 2008, '10 New York, Tyler Rollins FA (beide K) / 2009 Berlin, Gal. Christian Hosp (K) / 2011 Tokio, Fukagawa Tokyo Modan Kan. – *G:* 2004 Berlin-Dahlem, Ethnologisches Mus.: Identität versus Globalisierung? Zeitgen. Kunst aus Südostasien (K) / 2005 Fukuoka, Asian AM: Asian Art Triennl. / 2008 Shanghai, KeCenter for Contemp. Arts: Strategies from within / 2009 Incheon: Internat. Women Artists Bienn.; Shanghai, Zendai MMa: Intrude 36. ◫ The Indepen-

dent v. 30. 5. 1999; 18. 5. 2000; Lao động v. 21. 10. 2003, 4. 10. 2007; The Saigon Times Daily v. 21. 10. 2003; Asian art news 14:2004 (2); 14:2004 (6); Thể thao & văn hóa v. 20. 8. 2008; Tuổi trẻ v. 9. 11. 2008; 13. 6. 2009; An ninh Thủ đô v. 19. 5. 2009; Kunst-mag. 2009 (Nov.); Vietnam News v. 27. 6. 2009. – *Online:* Gal. Christian Hosp; Tyler Rollins FA. A. Friedel-Nguyen

Church, *Sharon,* US-amer. Goldschmiedin, Schmuckgestalterin, * 1948 Richardland/Wash., lebt in Philadelphia/Pa. Stud.: 1966–67 Bucknell Univ., Lewisburg/Pa.; 1967–70 Skidmore College, Saratoga Springs/N. Y., bei Earl B. Pardon; 1971–73 Rochester Inst. of Technology, School for Amer. Crafts, Rochester/N. Y., bei Hans Christensen, Albert Paley, Kener Bond. Lehrtätigkeit: 1973–76 Skidmore College; seit 1979 Philadelphia College of Art and Design (heute Teil der Univ. of the Arts). Ausz.: 1999 Lindback Distinguished Teaching Award; Richard C. von Hess Faculty Award; Venture Fund Award, Univ. of the Arts, Philadelphia (zweimal); 2008 James Renwick Alliance Distinguished Educator Award; 2010 Med. of Achievement, Philadelphia Art Alliance. – In den 1970er Jahren fertigt C. v.a. üppige Colliers aus farbigen Glas- und Edelsteinperlen, die mit geschmiedeten Schmuckelementen aus Silber und auffälligen Verschlußlösungen versehen sind. Später schmiedet und schnitzt sie figurative Schmuckstücke aus Silber (meist geschwärzt) und Gold in Verbindung mit exotischen Holzarten, Leder, Horn oder Knochen, häufig akzentuiert mit kleinen Edelsteinen (v.a. Diamanten). In Form von Broschen, Ketten und Ohrringen gestaltet C. symbolische Motive aus dem Tier- und Pflanzenreich (z. B die Broschen *Shimmer*, Buchsbaum- und Zitronenholz, geschwärztes Silber, Diamanten, Lack, 2004; *Forgotten Corsage*, Buchsbaumholz, Email, geschwärztes Silber, 2007). ⌂ BOSTON/Mass., MFA. CANBERRA, NG of Australia. HOUSTON/Tex., MFA. NEW PALTZ/N. Y., Samuel Dorsky Mus. of Art. NEW YORK, MAD. PHILADELPHIA/Pa., Mus. of Art. RACINE/Wis., Charles A. Wustum MFA. WILMINGTON, Delaware AM. ✉ *C./J. Zugazagoitia/M. A. Corzo,* Misterios (K), Ph. 2007; *C./L. Bach/M. A. Corzo,* The Mace Project. Craft Practice for the 21st c., Ph. 2008. ◉ *E:* 1977 (mit Bonnie Asher-Doar), '83 Philadelphia (Pa.), Sign of the Swan Gall. / 1978 New York, Aaron Faber Gall. (mit Gayle Saunders) / 1982 Scottsdale (Ariz.), The Hand and the Spirit Gall. / 1985 Carmel (Calif.), Concepts Gall. / 2003 Sheboygan (Wis.), John Michael Kohler AC (mit Mary Preston; K). – *G:* Philadelphia: 1989 (Skidmore College. Five Goldsmiths [K]), '98 (Brooching it Diplomatically [Wander-Ausst.; K]) Helen Drutt Gall.; 2005 Mus. of Art, Samuel S. Fleisher Art Memorial: Field Notes. Objects & Notations used in Creative Practice / 1997 Edinburgh, The Scottish Gall.: New Jewellery from the USA / 1998 Racine (Wis.), Charles A. Wustum MFA: Dress Up! Artists Address Clothing and Self Adornment (K) / 2000 Cambridge (Mass.), Mobilia Gall.: Structure, Symbol and Substance. The Power of Jewelry / 2002 Bowling Green (Ohio), Bowling State Univ.: Inventing Contemp. Ornament (K) / 2004 Melbourne (Vic.), Gold Treasury Mus.: A View from America. Contemp.

Jewelry / 2005–06 Canberra, NG of Australia: Transformations. The Language of Craft (K) / 2007 Bloomington (Ind.), Indiana Univ.: Field of Vision. Contemp. Jewelry and Hollowware (K). ⌂ *C. Strauss,* Ornament as art. Avant-garde jewelry from the Helen Williams Drutt Coll. (K Wander-Ausst.), St. 2007. – *Online: M. Simon,* Metalsmith 19:1999 (1) 14–25; *F. C. Lewis,* ibid. 24:2004 (2) 50; Website C. F. Krohn

Chusuwan *Amrit* (Amrit C.), thailändischer Maler, Objekt-, Installations- und Videokünstler, * 22. 4. 1955 Nakhon Si Thammarat, lebt in Bangkok. Stud.: 1978–87 Malerei an der Fac. of Paint., Sculpt. and Graphic Arts, Silpakorn Univ., Bangkok; 1988–89 ASP, Krakau. 1990–93 eig. Fotostudio (Modeaufnahmen) in Bangkok. Lehrtätigkeit: ab 1994 Doz. und stellv. Dekan an der Fac. of Paint., Sculpt. and Graphic Arts, Silpakorn Univ., Bangkok; ab 2010 Dir. des AC der Silpakorn University. Ab 2001 jährliche Reisen nach Europa, Japan und Australien, die C. mit Workshops (u.a. zu Kunst und Umwelt), Symposien und Lehrtätigkeiten verbindet, u.a. 2002–03 in Köln (Bangkok meets Cologne) und 2009 an der Accad. di BA, Florenz. Ausz.: 1984, '86 Silber-Med. (Malerei), Nat. Art Exhib., Bangkok; 1987 Hauptpreis, Contemp. art competition of the Thai Farmers Bank Ltd. ebd; 2002 Silpa Bhirasri Creativity Grant. – C. beginnt in den frühen 1980er Jahren mit einer kühlen fotorealistischen Ölmalerei, mit der er Eindrücke von Bangkok durch Spiegelungen in Schaufenstern sowie in Metall- und Glaskonstruktionen mod. Fassaden wiedergibt. Ab 1988 wendet er sich während des Krakau-Aufenthaltes der konstruktivistischen Malerei und archit. Strukturen zu. Anläßlich von Studienreisen nach Berlin und Paris (hier trifft er den thailändischen Künstler Montien Boonma) rückt die Objektkunst in den Mittelpunkt. Unter dem Eindruck wachsenden Umweltbewußtseins in Thailand entstehen ab 1991 großformatige Objekte aus natürlichen Mat. und Abfallstoffen, um an das soziale Bewußtsein zu appellieren. Ab 1995 steht die kritische Auseinandersetzung mit der ges. Wirklichkeit Thailands in Installationen, ab 1997 in zunächst ungeschnittenen Videos im Vordergrund seiner Arbeit. Seit 2005 verstärkt sich durch intensive Beschäftigung mit den Lehren Buddhas (Vier Edle Wahrheiten) bei ihm die Überzeugung, daß Kunst Ausdruck übergeordneter Ansichten und Werte sei. Seither kombiniert er Video- und Objektkunst zu Mixed-media-Installationen, stellt diese in einen inhaltlichen Zusammenhang (*Suffering,* 2010) und beschäftigt sich in skulpt. Portr. mit der eig. Rolle als Künstler. ⌂ BANGKOK, Kasikorn Bank: Reflection no. 3. – Silpakorn Univ.: Reflection no. 1. – Thairat Newspaper: Reflection no. 6. – United Overseas Bank: Reflection no. 8, alle Acryl/Lw., 1984. ◉ *E:* 1989 Krakau, Gal. Pryzmat / 2004 Helsinki, Gall. Leena Kuumola / Bangkok: 2005 Tadu Contemp. Art; 2010 DOB Hualamphong gall. (K) / 2007 Venedig: Bienn. (vertreten mit *Globalization ... Please slow down,* mit Nipan Oranniwesna). – *G:* Bangkok, AG, Fac. of Paint., Sculpt. and Graphic Arts, Silpakorn Univ.: 1993 50 years. 50 images (K); 1994 Thai-Images (K); 1999 Thai-Vietnam contemp. art

exhib.(K); 2000 Couple (K); 2001 As years went by (K); 2003 From inside to outside (K); AC: 2001 Image of Dharma; 2006 Thai-Japan art and cult. exchange; 2008 Getting to know your neighbours (K); 2011 Asian pulse. 10+1 art tactic; 2008 PSG gall.: More to love. The art of living together (Wander-Ausst.; K); NG: 1994 Contemp. art expo (K); 2001 Something about nude; 2009 The Banyan tree (internat. Wander-Ausst.) / Tokio: 1999 Ginza 5 gall.: Thailand-Japan; 2006 Sunshine City gall.: World art exchange Thailand-Japan-Sweden (Wander-Ausst.); 2007 Tama Art Univ.: Silpakorn + Tama Univ. art exchange / 1999 Sydney, SCA gall.: No guarantee / 2001 Rom, MN d'Arte Orientale: Thai-Ital. art space 2000 (K) / 2010 Songzhuang: Art festival (K). ⌑ *V. Mukdamanee u. a.*, Rattanakosin art. The reign of King Rama IX, Bangkok [2]1997, 174, 210 s.; Krungthep Muang Fa Amorn art expos. (K Asian Games Art Project), Bangkok 1998, 134 s., 237; The small world (K AC, Silpakorn Univ.), Bangkok 2002, 55, 120, 171; Fusion-Vision. Thai-Austral. artistic connections (K Gall. of Art and Design, Silpakorn Univ.), Bangkok 2002, 25, 34; *V. Mukdamanee*, Mixed media and installation art in Thailand, Bangkok 2002, 140–147; Silpa Bhirasri Creativity Grants 2002 (K), Bangkok 2002, 29, 46–49, 67; Art in box (K Silom Gall.), Bangkok 2003, 52, 137, 202; Art for Suwannaphum (K Jamjuree AG, Chulalongkorn Univ.), Bangkok 2003, 84 s.; *J. Abbott* (Ed.), The middle way. The art of exchange, Thailand-New Zealand 2003–2005 (K), Bangkok, 2004, 42 s., 56; *S. Nusang*, FA Mag. (Chiang Mai/Bangkok) 2:2005 (15) 120–122; From (different) horizons of rockshelter (K NG), Bangkok 2008, 116–119; Inside out ... Outside in (K Ardel's Third Place Gall.), Bangkok 2008, 10–13, 40 s.; Thai-Ital. art (K AC, Silpakorn Univ.), Bangkok 2009, 72–75, 95; A. C. Suffering (K), Bangkok 2010; *S. Pettifor*, Asian Art News (Hong Kong) 20:2010 (3) 60–63. A. Feuß

Chvorinov, *Illiodor Gennad'evič*, russ. Architekt, * 1835, † 8. 12. 1914 Omsk. Vater von *Nikolai Ch.* (s.u.). Entstammt einer Künstler-Fam. Stud.: ab 1848 Anwärter der Bau-FS der Hauptverwaltung St. Petersburg, 1850–56 ebd. Student. 1856 zum Kollegiensekretär ernannt und ins Gouv. Perm' entsandt, wo er als Gehilfe des Vorstehers der Straßenbau-Komm. tätig ist. 1866 versetzt ins Gouv. Nižnij Novgorod (zunächst Unterarchitekt, ab 1868 Gouv.-Architekt und Architekt des Handelshauses für die Messe ebd.). Ab 1894 (evtl. auf Einladung der Kaufmannsfrau Marija Šanina) in Omsk tätig. 1894–1901 (?) als Beamter für Sonderaufträge der Straßenbau-Komm. bei Generalgouverneur ebd. tätig. 1901–06 Stadtarchitekt von Omsk (unter seiner Ltg entsteht 1901–03 u.a. der Internatsanbau des Knabengymnasiums). Unterrichtet 1908–12 am Mädchen-Gymnasium und ab ca. 1912 Zeichnen und Modellieren am Priv.-Gymnasium seiner Frau. 1911 ist Ch. als Experte für den Bau der Wasserleitung in Omsk tätig. – Ch.s Werk fällt in eine dynamische Entwicklungsphase von Omsk, die vom Bau der Transsibirischen Eisenbahn bis zum Irtyš-Fluss geprägt war. Ch. war faktisch an allen bed. Neubauten in Omsk beteiligt (s.u.; ferner Bau des Hauses Terechov/Hotel Rossija ebd., ab

1905; 1911 abgebrannt). Für seine Bauten, die in eklektizistischer Manier unterschiedliche Stilelemente verbinden und das Stadtbild von Omsk bis heute prägen, sind kraftvoll wirkende, üppige Formen, Farben und Dekor char. (z.B. Barock- und klassizistische Motive am Schauspieltheater Omsk, das zu Ch.s Hw. gehört). Ch.s Autorschaft an der Diözesanschule konnte erst 1989 belegt werden (als Autor galt bisher A. I. Chmara). Gleiches gilt für das Haus Batjuškov (Irtyšskaja nab., 1901–02; während des Bürgerkrieges 1918–19 Residenz von Admiral Kolčak; heute Standesamt), das wiederholt Otto von Dessien zugeschr. wurde (Zuschr. archivalisch nicht verifizierbar), formal jedoch sehr stark Ch.s. Baustil ähnelt. – Ch.s Sohn *Nikolaj Ch.* (* 15. 11. 1903 Omsk, † 7. 11. 1987 Kladno/ČSSR; 1919 Emigration nach England, ab '22 in der Tschechoslowakei ansässig; Stud.: 1923–28 Berg-Akad., Příbram; KSch von Kalman Kemény, Plzen) ist als Maler belegt (bevorzugt Portr., ab den 1960er Jahren auch abstrakte Darst. und Collagen; Mitgl. des tschech. Künstler-Verb. [Ausst.]), hauptberuflich jedoch Metallurge (Inhaber von Patenten). ⌑ OMSK, Muzejnaja ul.: Mus. der Filiale Westsibirien der Reichs-Ges. für Geographie (heute Volkskunst-Zentrum), 1896–1900. – Schauspieltheater, 1901–05 (2002–04 hist. Rekonstr.). – ul. Lenina 11–13: Haus Šanina (heute Kaufhaus Ljubinskij), 1897–1902. – ul. Oktjabr'skaja: Diözesanschule (heute Fak.-Gebäude der Agrar-Univ.), 1907–09. – ul. Gusarova: Wasserturm, 1911. – ul. Internacional'naja: Feuerwehrturm, 1914–15 (postum voll.). ⌑ *Toman* I, 1947; *Toman*, Dodatky, 1955; *Lejkind/Machrov/Severjuchin*, 1999 (alle zum Sohn). – *N. I. Lebedeva*, Vestnik Omskogo universiteta 1996 (2) 67–70; *J. Hučka*, Z dějin hutnictví 34:2004, 78–86 (zum Sohn). – Almaty, StsA der Republik Kasachstan. D. Kassek

Chvorinov, *Nikolaj* cf. **Chvorinov,** *Iliodor Gennad'evič*

Chwoles, *Rafał (Rafael)*, poln. Maler, Zeichner, * 25. 4. 1913 Wilno (Vilnius/Litauen), † 31. 3. 2002 Paris. Schüler von Mojzesz Lejbowski, Zygmunt Packiewicz, Marian S. Kulesza und Aleksander Szturman sowie Besuch von Malkursen an der vom Ing. Abram Klebanow gegr. Jüdischen Handwerkerschule „Hilf durch arbet" in Wilno. In den 1930er Jahren Kunstlehrer an Schulen ebd. Mitgl.: Związek Żydowskich Artystów Plastyków (Sekretär); jüdische Künstler- und Literatengruppe Jung Wilne. Debütiert 1933 auf der Ausst. Junger Maler (1. Preis für das beste Portr.) in Wilno, 1935 Teiln. an der renommierten Internat. Ausst. Jüdischer Maler ebd. 1940 Dir. der KSch in Wilejka. Während des Krieges in die Umgebung von Gorki (Nižnij Novgorod) evakuiert, wo er bei der Eisenbahn arbeitet. Gestaltet in Gorki Bühnenbilder für Theateraufführungen poln. Emigranten und Russen am Kulturhaus, das von seiner zukünftigen Frau geleitet wird. Zum Broterwerb malt er nach Fotogr. Bildnisse von an der Front gefallenen Soldaten für deren Ehefrauen bzw. Mütter. Nach einer Ausst. 1941 im Kulturhaus von Krasnye Baki an der Wolga nach Moskau gesandt, wo er als Anstreicher arbeitet. 1944 Rückkehr nach Wilno. 1946 Mitgl. des litauischen Künstlerverbandes. 1959 im Rahmen der Re-

patriierung Übersiedlung nach Warschau; engagiert sich dort im jüdischen Zentrum, u.a. tätig in der Towarzystwo Społeczno-Kulturalne Żydów w Polsce (1964 Leiter der Kulturkommission). 1966–67 und 1969 Reisen nach Spanien und Marokko, wo er im Auftrag der UNESCO einen Gem.-Zyklus zum Thema Kinder gestaltet (hrsg. als Postkarten). 1969 läßt er sich in Paris nieder. Zahlr. Reisen, z.B. nach Polen, mehrmals nach Italien, fast jährlich nach Israel. Ausz.: 1981 Med. der Acad. Europ. des BA; 1983 Med. der Stadt Paris; 1994 Itzik-Manger-Preis; 1995 Scholem-Alejchem-Preis, beide Israel. – C.s Œuvre umfaßt Lsch., Stadt- und Archit.-Ansichten, Portr., Blumenstücke (einige 1966 vom Verlag Ruch als Postkarten reprod.), jüdische Sujets sowie abstrakte Komp. (Öl, Aqu., Gouache, Mischtechnik). Im Frühschaffen malt (Aqu., Öl) und zeichnet er lyrisch gestimmte Ansichten von Wilno, der Stadt, die ihn lebenslang inspiriert und die er später aus der Erinnerung malt. Nach dem Krieg hält er als erster und wahrsch. einziger Künstler in zahlr. detaillierten, dok. genauen Zchngn und Gem. (v.a. Gouachen) die Zerstörungen im ehem. Ghetto bzw. jüdischen Stadtteil fest (Zyklen *Wileńskie Getto*; *Getto zniszczone – architektura starego Wilna*). In den 1950er Jahren entwickelt C. den für ihn char. expressiv-dynamischen Gestus, arbeitet mit breiten, lockeren Pinselstrichen und vibrierenden kräftigen Farbflecken, die häufig durch schwarze Konturen akzentuiert sind. E. der 1950er/A. der 1960er Jahre wendet er sich verstärkt dem tragischen Schicksal des jüdischen Volkes zu (Zyklus *Vernichtung*, um 1962) und malt in einem strengen düsteren Kolorit. Nach der Übersiedlung nach Paris und auf Reisen gestaltet er weiterhin Lsch. und Stadt- bzw. Archit.-Ansichten (u.a. von Jerusalem, Safed u.a. israelischen Ortschaften, mitunter mit lokaltypischen Staffagefiguren). Im Spätschaffen der 1980er/90er Jahre entstehen kubistische und abstrakte Komp. mit collagehaften Elementen (*Red Collage*, 1986–87; *Meditation*, 1992). Auch Monotypien (ab den 1950er Jahren, z.B. Zyklus *Motyw biblijny*, um 1964), ferner Ill. für Zss. und Bücher (u.a. für den Warschauer Verlag Jidis Buch, z.B. zum Gedichtband *Borwese trit* von D. Sfard, 1966) sowie Entwürfe für Film- und Theaterplakate. ⌨ BEIT LOHAMEI HAGHETAOT, Ghetto Fighters' House Mus. JERUSALEM, Yad Vashem. KAUNAS, Čiurlionis NM of Art. MOSKAU, Tret'jakov-Gal. TEL AVIV, Scholem-Alejchem-Mus. TORUŃ, Univ.-Bibl., Arch. der Emigration. VILNIUS, LDM (27 Werke). – Lietuvos NM. WARSCHAU, MN. – Muz. Żydowskiego Inst. Hist. 👁 E: 1938 Wilno / 1960 Wander-Ausst., organisiert vom Klub MPiK, in Wrocław, Gliwice, Białystok, Łódź, Nowa Huta, Warschau / Warschau: 1961 Gal. Kordegarda (Retr.); 1963 Klub TSKŻ / Paris: 1963 Gal. du Passeur; 1976 Jüdisches Kulturzentrum; 1981 Rachi Centre / 1986 Jerusalem, Yad Vashem / 1987 Beit Lohamei Haghetaot, Ghetto Fighters' House Mus. / 2004 Vilnius, KG (Retr.) / 2005 Toruń, Muz. Uniwersyteckie; Warschau, Żydowski Inst. Hist. (K) / 2007 Gorzów Wielkopolski, Muz. – G: ab 1933 zahlr. nat. und internat. ⌨ A. M. *Darmon*, Autour de l'art juif, Chatou/N. Y. 2003. – R. C. 30 reprodukcji. Tematy żydowskie i Getto w Wilnie, War. 1962 (Bildband); A. *Suz-*

kever, Baym leyenen penemer (Face reading), Jerusalem 1993; Muz. Żydowskiego Inst. Hist. Zbiory artystyczne (K), War. 1995; Mała Gal. Sztuki Emigracyjnej (K), Toruń 2002; Wilno i cały świat w malarstwie R. C. (1913–2002) (K Wander-Ausst.), Toruń 2006 (Ausst.-Verz.).

C. Rohrschneider

Cialli, *Domenico*, ital. Keramiker, * um 1703, † 26. 2. 1780, tätig in Rom-Trastevere. Seit den 1750er Jahren ist C. als Hersteller und Händler für Majolika in Rom belegt. 1760 gründet er eine eig. Majolika-Man. im Stadtteil Trastevere (Via S. Gallicano). 1754 heiratet er Violante Maria, die Tochter des bed. Fayencemalers Bartolomeo Terchi. C. unterhält in Rom mehrere Verkaufsläden. 1780 geht die Man. an seine Söhne *Antonio C.* und *Lorenzo C.* († 1807) über, die sich über die Majolika-Herst. und -bemalung hinaus auch um die Herstellung von gesinterten Scherben (Bisquit) bemühen; 1784/85 werden erste Bisquitfiguren aus ihrer Brennerei erwähnt. Zu Beginn der 1780er Jahre dürfte der Fayencemaler Antonio Terchi für begrenzte Zeit in der Man. tätig gewesen sein. – C. beliefert u.a. römische Patrizier-Fam. wie die Borghese und die Odescalchi. Für die Borghese sind Aufträge für weiße und bemalte Geschirre sowie für Fliesen zur Innenauskleidung eines Kamins (1775, nicht erh.) in deren Stadt-Pal. belegt. Wahrsch. stammen auch die sechs Kaminverkleidungen in der Gall. Borghese aus C.s Man. (1780er Jahre). Die in lebhaften, vielfältigen Farben bemalten Fliesen zeigen Girlanden, Pflanzen und Früchte sowie antike Portr. und geometrische Muster. Ebenfalls werden heute zwei mit „D. C./Roma 1780" sign. Deckelvasen mit Blütendekor in den Kapitolinischen Mus. der Man. zugeschrieben. Die von C. und seinen Söhnen hergestellten ausgewogenen und gefragten Rokoko-Keramiken mit floralen Dekoren fügen sich einerseits qualitativ in die zeitgen. ital. Majolikaproduktion (etwa von Pesaro) ein, andererseits bedienen sie einen internat. Geschmack. ⌨ G. *Santuccio*, Faenza 87:2001 (1–3) 235–252; *ead.*, Faenza 90:2004 (1–6) 131–147.

C. Melzer

Ciamarra Cammarano, *Elena*, ital. Malerin, Zeichnerin, * 23. 12. 1894 Neapel, † 10. 9. 1981 ebd., tätig in Torella del Sannio. Autodidaktin. C. besucht zunächst das Konservatorium (Neapel, Rom) und ist 1916 eine der wenigen in Klavier, Violine, Komp. und Dirigieren diplomierten Frauen in Italien. C. eignet sich die Malerei auf Initiative von Angelo Conti (Konservator an den kgl. Mus. in Neapel) als Kopistin an, indem sie in den Mus. von Rom, Neapel, Venedig, Berlin, München und Wien Werke u.a. von Tizian, van Dyck, Michelangelo, Raffael oder Tintoretto kopiert. Nach dem 2. WK reist C. häufig nach Paris, wo sie eine Zeichen-Akad. besucht und 1956 Mitgl. der Gruppe L'Eveil wird. Während ihrer Reisen in Europa und Afrika lernt sie zahlr. Künstler (u.a. Oskar Kokoschka) und Musiker kennen, mit denen sie intensiven Briefwechsel pflegt. Viele ihrer Werke befinden sich heute in ihrem ehem. Wohnsitz in Torella del Sannio sowie im Bes. der Tochter in Ferrara. – Neben Lsch. und Stilleben (z.B. Teekannen, Blumen) v.a. (Selbst-)Porträts. Die menschliche Figur und das Gesicht stehen im Zentrum ihres Schaf-

fens. Die realistischen Gem. in gedeckten, warmen Far-
ben und die Zchngn (Kohle, Bleistift) zeigen häufig Ge-
sichter von Bäuerinnen und Kindern der Region Molise,
die mit psychologischer Finesse dargestellt werden. Da-
bei konzentriert sich C. auf die Volumen und Formen der
Körper. Den Einfluß des neapolitanischen Sozialrealismus
blendet C. in ihren klassizistisch-realistischen Gem. aus.
Sie orientiert sich vielmehr an der Pinselführung Cézan-
nes und dem dt. Expressionismus. Aufgrund einer zuneh-
menden Erblindung im Alter vergrößern sich die Formate
ihrer Arbeiten; das Spätwerk ist zudem eher chromatisch
und linear angelegt. ⌂ GENUA, Coll. Wolfson. LATINA,
MCiv. RAVENNA, Pin. com. VERONA, GAM. ◉ G: 1937
Rom, Mercati Traianei: Littoriali dell'Arte. ⌨ L. Scar-
dino (Ed.), E. C. C. (1894–1981). Pitt. e graf., Fe. 1996;
M. Cammarano/E. Pinto, E. C. C. pittrice (1894–1981).
Cat. delle opere conservate a Ferrara, Fe. 1999.

C. Melzer

Ciampi, *Antonia*, ital. Performance- und Installations-
künstlerin, Kunstpädagogin, * 31. 8. 1959 Bologna, lebt
dort. Ausb.: Gesang (Gospel, Spiritual, Blues) in Bolo-
gna und klassischer Tanz (Graham-Cunningham-Technik)
in London (R. Acad.). Entscheidend wird ihre Begegnung
mit Concetto Pozzati und dessen Malschule an der ABA
Bologna. 1990 Dipl. (Malerei) und Ausst.-Debüt auf der
Bienn. in Niort. Im gleichen Jahr Gründung der Künstler-
gruppe Free mit dem Ziel des Zusammenwirkens von Ma-
lerei, Musik, Tanz und Fotografie. Seit 1991 Lehrtätigkeit
an den KA in Bologna, Venedig, Rom, Palermo und Lecce.
1992 realisiert C. zus. mit Vico Dallai in der GAM Bolo-
gna ihre erste Lehr-Wkst. für angew. Kunstpädagogik und
ist in den Folgejahren mehrfach am Musikfestival Spoleto
beteiligt. Ab 1994 künstlerische Dir. von Events wie Liber
Téchnè (Bologna, Bibl. Com., 1994), Ultrasegno (Caera-
no San Marco, Villa Benzi-Zecchini, 2000), FigurAzione
(Santa Sofia, GAM, 2001) oder Il giardino inganni (Bo-
logna, Giardini del Baraccano, 2003). Performances u.a.
1995 Perugia (Free. Living Pictures), Rom (Free. Avviso
di chiamata), 2001 Bologna (Free. Mindscape Heartscape)
und 2006 Rom (Differente). Vorlesungen und Seminare
über Farblehre an zahlr. Univ. des In- und Auslands. Seit
2000 entwickelt C. neue Unterrichtsmethoden für moto-
risch und psychisch behinderte Kinder mittels Einsatz von
Farbe, Gesten und visueller Musik. ⌂ SPOLETO, GAM.
✉ C./V. Gioellieri, Riquadricromia. La natura sostenibi-
le, Triest 2008. ◉ E: 1992 Voghera, Gall. Gardelli /
1997 Monte-Carlo, Gildo Pastor Center Gal. / 1998 Spel-
lo, Villa Fidelia / 2000 New York, Univ. / 2002 Bologna,
Gall. Paolo Nanni (K: F. Gallo) / Rom: 2004 Gall. Il Sole
Arte Contemp.; 2006 R. Accad. di Spagna (K). – G: 1990
Niort, Mus. Taire: Europa d'Art – Rencontre europ. des
jeunes artistes / 1991 New York, Inst. for Foreign Trade:
Art of Living / 1994 Riccione, Pal. delle Espos.: Art and
Tabac / 1998 La Spezia, Circolo Cult. Il Gabbiano: Cra-
vatta d'artista ai quattro venti / 1999 Mailand, Gall. Il Tem-
po Ritrovato: Nel Segno del Gioco / 2000 Florenz, Gall.
Via Larga: Art Exhib. 2000 / 2003 Bologna, Gall. Pao-
lo Nanni: Pict. and an exhib. / 2004 Rom: Quadrienn. /

2005 Modigliana, Ex Convento Frati Cappuccini: Ora et
labora / 2006 Bologna, Europolis: Bienn. Urban Design.
⌨ A. Bonito Oliva, Oggetti di turno. Dall'arte alla critica,
Ve. 1997; M. Paraventi, Titolo 8:1997 (24) 34 ss.; S. Evan-
gelisti u.a., Differente (K), Bo. 2006 (mit DVD); M. Pa-
lasciano, L'abbecedario del potere (K: Ill. von A. C.), Ca-
pua 2009. – Online: Website C. S.-W. Staps

Ciana, *David*, schweiz. Maler, Zeichner, * 6. 8. 1971
Monthey/Valais, lebt dort. Stud.: 1988–91 Ec. des Arts dé-
coratifs in Genf. Praktika in den Ateliers der Maler Jean
Balitran in Tours (1994/95) und Michel Piotta in Mon-
they (1996). 1999, 2001 ebd. Zeichenkurse bei Peter Bac-
say. Mitgl.: 1994 Assoc. internat. des Arts plast. (A.I.A.P.)
und Soc. des Peintres, Sculpteurs et Architectes suisses
(SPSAS; seit 2000 Visarte); 1997 Art visuel Monthey
(A. V. M.). – Von Experimentierfreude geprägte, stilistisch
heterogene Malerei, die sowohl abstrakte als auch figura-
tive Arbeiten umfaßt und deren Wurzeln bis zu Matthias
Grünewald und Jan Vermeer zurückreichen. Die C.s künst-
lerische Bestrebungen einende Klammer besteht neben
der bes. Aufmerksamkeit für Form und Farbe v.a. im in-
haltlichen bzw. thematischen Anspruch, der die intensive
Auseinandersetzung mit den individuellen Möglichkeiten
der Bewältigung existentieller Probleme im gesamt-ges.
Kontext betrifft. Unter diesem Aspekt führt das geschick-
te Spiel mit Gegensätzen, starken Licht- und Schattenef-
fekten, frappierenden Kontrasten greller Farbspritzer und
scheinbar beliebig arrangierten Bildelementen zu span-
nungsgeladenen, oftmals explosiv wirkenden Kompositio-
nen. Auch Installationen, Performances, Skulpt., Zchngn,
Collagen und baugebundene Werke. ◉ E: 1995 Bex,
Gal. Charpentier / Sion: 1995 SPSAS; 2000 Dolmen Fes-
tival (mit dem Fotografen Jan Saudek); 2006 Gal. Gran-
de Fontaine / 1996 Lausanne, Gal. Blanc des Cieux; Ber-
gen, Gal. 99 / 2000 Genf, Gal. Krisal / 2008 Bern, Gal.
Kunstkeller. – G: 1996 Montreux, Auditorium Stravins-
ky: 100 artistes suisses / seit 2001 mehrfach Ausst. Visar-
te. ⌨ BLSK I, 1998; Kürschners Hb. der Bild. Künst-
ler. Deutschland, Österreich, Schweiz, I, M./L. 2007. –
N. Kunz, in: Poétique du corps (K Gal. La Ferme de la
Chap.), Grand-Lancey 2011. – Online: SIKART Lex. und
Datenbank; Website C. R. Treydel

Ciaponi, *Stefano*, ital. Maler, Graphiker, * 15. 4. 1957
Montenero, tätig in Livorno. Stud.: Ist. d'arte, Lucca;
ABA, Florenz (Malerei bei Ferdinando Farulli, Graphik
bei Domenico Viggiano). Lehrtätigkeit: ABA, Carrara;
ABA Sassari (graph. Techniken). – In seinen figurativen,
teilw. surreal anmutenden Gem., die in dunklen Braun-,
Rot- und Gelbtönen mit wenigen leuchtenden blauen oder
grünen Akzenten gemalt sind, behandelt C. Portr. oder
Gruppen von wenigen, meist in sich versunkenen und sta-
tuarisch gegebenen Figuren sowie seltener Lsch. und Still-
leben. Auffällig sind wiederkehrende, symbolische Kür-
zel, die auf einem Sims im Vordergrund oder auch im Bild-
raum plaziert werden, etwa ein Fisch, ein Vogel, ein Zweig
oder ein Ei. Zu den sich wiederholenden, archaisch wir-
kenden Motiven zählt ein Mensch mit Vogelkopf, der an
ägyptische Glyphen erinnert. C.s lyrische Malerei zeich-

net sich zudem durch Assoziationen an christliche Sujets aus, etwa Verkündigungen und Hll.-Legenden (*Francesco, gli uccelli e il lupo*, Acryl/Lw., 2004). Der Farbauftrag ist pastos, wird teilw. abgekratzt und übermalt, so daß die Oberflächen der Gem. wie der Intonaco eines Freskos erscheinen. Die v.a. in Feder ausgef. Zchngn werden in dichten dunklen Schraffuren und mit oft großflächigen Lavierungen angelegt. Seine Druckgraphiken, bevorzugt Zink-Rad., thematisieren ebenfalls einzelne Figuren (oft Kinder) oder kleine Gruppen, die in archit., teilw. kulissenhaften Rahmungen erscheinen, etwa aus einem Fenster schauend oder in einem Portal stehend. Die frühen Graphiken zeigen Männer und Tiere in beunruhigender Umgebung und irrealen Räumen. Seine späteren, einfacher komponierten Werke mit märchen- und traumhaft-mysteriöser Atmosphäre weisen meist stark verschattete Partien auf. C. verarbeitet hier Einflüsse von Giacometti und Rembrandt. ⊙ *E:* 2006 Francavilla, Mus. Michetti / 2009 Mantua, Gall. Arianna Sartori; Florenz, Gall. Falteri / 2011 Livorno, Gall. d'Athena (mit Renzo Galardini). – *G:* 2007 Rom, Villa Pacchiani: Premio Santa Croce Grafica / 2008 Francavilla, Mus. Michetti: Bienn. Incisione / 2009 Latina, Casetta della musica: In cartis. Una carta conquistata / 2010 Pescara, MAM Vittorio Colonna: Pescarart 2010; Rosignano Marittimo, Centro per l'arte Diego Martelli: Coincidenze allievo – maestro. ⌨ *D. Micacchi/S. Orlandini*, I quaderni dell'arte 4:1994 (7) 45–49; *O. Biagioni*, Grafica d'arte 11:2000 (44) 34–35. – *Online:* Website C. C. Melzer

Cibic, *Aldo*, ital. Architekt, Designer, Innenarchitekt, Ausstellungsgestalter, Designtheoretiker, * 6. 10. 1955 Schio/Vicenza, lebt in Mailand und Arcugnano/Vicenza. 1978 Übersiedlung nach Mailand. Tritt als Mitarb. in das Büro von Ettore Sottsass ein und wird 1980 zus. mit Matteo Thun und Marco Zanini Partner von Sottsass Assoc. (bis 1989). Hier beschäftigt sich C. v.a. mit Industriedesign (u.a. Mitarb. am Projekt der Kaffeemaschine *Tronic* für Faema). 1981 Mitbegr. der Gruppe Memphis, die das etablierte Industriedesign ablehnt und mittels einer oft provokativen und von der Funktionalität befreiten Experimentierlust sowie in der Konfrontation unterschiedlichster Mat. und mitunter schrillen Farbigkeit eine Erneuerung der Designkultur anstrebt. Für Memphis realisiert C. u.a. die Konsole *Belvédère* (Marmor, Granit, Holz, 1982), die Bibl.-Elemente *Castilian* (Kunststoff, 1984), die Lampe *Buenos Aires* (1986), den Schreibtisch *Desk* (1986), den runden Tisch *Louis* (Holz, 1987), die Etagere *Sandy* (Kunststoff, 1987), das Buffet *Andy* (lackiertes Holz, 1987). Im Unterschied zu Arbeiten von and. Mitgl. der Gruppe sind C.s Entwürfe dieser Zeit harmonisch und proportioniert. 1989 verläßt er die Memphis-Gruppe und gründet mit Antonella Spiezio in Mailand sein eig. Studio Cibic & Partners (später kommen Luigi Marchetti und Chuck Felton hinzu), das konsequent dem ganzheitlichen Verständnis des ital. Design folgt. 1991 kreiert er die Marke „Standard" für qualitätvolle Alltagsgegenstände und (farbige) Möbel; zugleich gestaltet er bisher vernachlässigte Gebrauchsgegenstände neu (z.B. Bügelbrett, 1992). Das Mailänder Studio befaßt sich v.a. mit Archit.

(u.a. Umbau des Kaufhauses Rinascente, Mailand, 2006), Ausst.-Design (u.a. *Glamroom*, Fiera di Vicenza, 2008; *Palladio 500 anni*, Vicenza 2008) und Innen-Archit. (u.a. Mövenpick Restaurants in Hannover, Berlin und Luzern, 2004; Selfridges-Kaufhäuser in Manchester und Birmingham, 2002-'04; Saatchi & Saatchi in Mailand; Medusa-Multiplex-Kinos in versch. ital. Städten). Der CibicWorkshop in Vicenza ist v.a. für Design, die Entwicklung neuer Typen und Lehrveranstaltungen zuständig. Daneben arbeitet C. auch für and. Firmen als Designer, u.a. für Boffi (Möbel-Kollektion *Antologia*, 1992), Bisazza (u.a. Stuhl *Antalya*, 1995), Mazzega (Lampe *Cascata*, 1996), Paola C. (Geschirr, Glas, 1999), Foscarini (Lampen *Cocò* und *Lampoon*, 2000–02), Cappellini (Hocker, 2002), Artemide (Lampe *Click*, 2002), Ottone Meloda (Bad-Ausstattung, 2004), Millepiedi (Mosaik-Bank, Gärten der Trienn., Mailand, 2005). 2006 ist C. künstlerischer Leiter der Archit.-Bienn. in Venedig. In den letzten Jahren richtet sich C.s Interesse zunehmend auf das Verhältnis des Menschen zu seiner Umwelt, die sozialen Beziehungen in den Städten (Projekt *Citizen City. Ricerca sulle persone e sulle città*, 2003), das Design von Dienstleistungen (Projekt *New stories, new design*, Mailand, 2002), das Funktionieren von Räumen für die Gemeinschaft (z.B. Projekt *Microrealities*, 2004), die Einbeziehung der Natur in städtebauliche Projekte (z.B. *Città degli Orti*, Bologna, 2008; Bienn. Venedig 2010) und das Leben auf dem Land (*Rethinking Happiness*, 2010). – Seit 1989 hat C. Lehraufträge für Industriedesign an der Domus Accad. und dem Politecnico in Mailand, der Fac. di Design dell'Ist. Univ. di Archit. (IUAV) in Venedig und der Tongji Univ. Shanghai (Honorar-Prof.); 2005 Dir. der Design-Abt. von Fabrica, dem Forschungs- und Entwicklungszentrum für Kommunikation von Benetton. – Ill.: *F. Ferrari Delfino, Poesie per ospiti*, Mi. 2005; *G. Copiello* (Ed.), *Manifesto per la Metropoli Nordest*, Ve. 2007. ⌂ LONDON, Design Mus. MAILAND: British Telecom, 2001; Verlagsgebäude für Abitare Segesta, 2003. MONTECCHIO MAGGIORE/Vicenza: Büros der Fa. Della Verde. NOVENTA VICENTINA/Vicenza: Erweiterung der Niederlassung Diesel, 2008. SUZHOU/China: Sitz der Fa. Positec. ✉ Chairs, Modo 2004 (238) 54; The alchemy of design, ibid. 2005 (247) 48 s.; Rethinking happiness. Fai agli altri quello che vorresti fosse fatto a te, Mantova 2010. ⊙ *E:* Vicenza: 1999 Basilica Palladiana (K: A. Branzi u.a.); 2003 Mazal Gall.; 2006 Mus. Palladio / 2009 Mailand, Gall. Antonia Jannone / 2010 Padua, Liston (zus. mit Enrico Bossan). – *G:* Mailand: 1993, 2005 Trienn.; 2011 Verso Expo Milano 2015 (K) / Venedig: 2004 Bienn. di archit.; 2010 Mostra internaz. di archit. / 2008 Bologna, Gall. Hyperstudio: Postmodernoceramica. Arte e design degli anni '80 / 2010 Neapel, PLART: 30 anni di Memphis. ⌨ *J. Jagger/R. Towe*, Designers internat. index, I, Lo. [1991]; *Kjellberg*, 1994; *A. Pansera* (Ed.), Diz. del design ital., Mi. 1995; Dict. internat. des arts appliqués et du design, P. 1996; *M. Byars*, The design enc., Lo./N. Y. 2004. – *B. Radice*, Memphis. Ricerche, esperienze, risultati, fallimenti e successi del nuovo design, Mi. 1984; Blueprint 1986 (30) 29–33; *F. Shimi-*

zu/B. Munari, The Ital. design, To. 1987; N. Bellati, New Ital. design, N. Y. 1990 (dt. Ausg. 1992); Memphis. Céramique, argent, verre, 1981–1987 (K), Marseille 1991; C. Morozzi/S. San Pietro, Contemp. Ital. furniture, Mi. 1996; A. Boisi, Interni 1999 (489) 120–125; The Internat. design yb. 16:2000; M. Romanelli, Il vetro progettato. Architetti e designer a confronto con il vetro quotidiano, Mi. 2000; Designbegegnungen bei der Sparda-Bank Münster (K), Münster 2001; Wilhelmi, 2001; Domus 2002 (844) 137; C. Morozzi, Intramuros. Internat. design mag. (Issy-les-Moulineaux) 2002 (102) 50–53; A. De Angelis, Modo 2005 (243/244) 57–64; F. Doveil, A. C., Mi. 2005; Ville giardini 2005 (409) 80–91; A. Burigana/ M. Ciampi, Lebensträume. Wie ital. Designer wohnen, M. 2006; L. Tozzi (Ed.), Microrealities. A project about places and people, Mi. 2006; F. Scullica/L. Collina (Ed.), Designing designers. Unbranded design for new user expectations in East and West, Mi. 2007; L. Barontini, Archit. Livorno 7:2008, 30–33; S. Nani, Corriere della Sera v. 20. 5. 2009; K. W. Forster, Domus 2010 (935/April); P. Kelly, Blueprint 2010 (296) 46–54; C. Morozzi, Interni 2011 (609) 64–66. – Online: Website C.; Designboom (Interview v. 6. 6. 2000); H. U. Obrist, Interview v. 24. 8. 2010 (Video). E. Kasten

Cicarè, Mauro, ital. Comiczeichner, Illustrator, Maler, * 1957 Macerata, lebt in Civitanova Marche. Liefert Ill. u.a. für die Zss. Il caffè illustrato, Origine, Frigidaire, Frizzer, Global Mag., Heavy Metal U. S. A., Panorama, Tempi supplementari und Il falcone maltese. Auch Buch-Ill., u.a. zu Il mistero della cripta stregata (E. Mendoza, 1978), La partita (A. Celestini, 2001) und Saltatempo (S. Benni, 2001). Daneben Einband-Gest., u.a. für Werke von S. Benni, E. Cavazzoni und P. Nori. C. realisiert zahlr. Comic-Bde, darunter Fuori di Testa (Lecce 1993), Le forbici di Paolino (ebd. 1999; mit Vincenzo Mollica), Quasi (ebd. 2001), Fellini sognato (ebd. 2002), L'enigma del condomio (R. 2007), Zero tolleranza (Padua 2008) und Eddy mano pesante (Lecce 2009). Auch Videoclips oder Gest. von Telefonkarten für Telecom Italia, die auch Graphiken von C. ankauft. Mitbegr. des Laboratorio di Fumetto in Civitanova Marche, wo er fünf Jahre lang unterrichtet hat. Tätig für die Agentur Iceberg in Macerata. Öff. bek. ist C. v.a. durch die Verwendung seiner Arbeiten in zahlr. TV-Sendungen. Kandidiert 2010 für das Parteienbündnis Sinistra Ecologia Libertà und will v.a. neue Räume und Perspektiven für Kunst und Kultur (durch Netzwerke) schaffen. 2011 Mitorganisator der Graphikmesse Cartacanta in Civitanova Marche. – C. fühlt sich inspiriert u.a. durch Zchngn von Jason Lutes und den Maus-Comics von Art Spiegelman und bedient sich bei den eig. Arbeiten souverän eines unterschiedlichen stilistischen, häufig ironisch-metaphorischen und surrealistischen Vokabulars; sicherer Strich, reichhaltige Farbigkeit. C. ist ein kritisch-distanzierter Beobachter der sozialen Verwerfungen, Mißstände und Risiken der Gegenwart. Als Maler u.a. rätselhaft-mystische Szenen vor dem Hintergrund kahler Neubaufassaden. ◉ E: 2005 Macerata, Gall. Antichi Forni (K: W. Pedullà). – G: 2011 Rom, Gall. Tricromia: BaCinema; Tolentino, Pal.

Parisani-Bezzi: Bienn. Internaz. dell'Umorismo dell'Arte. ▭ R. Roda (Ed.), Dopo Buzzati. Artisti tra pitt. e fumetto (K Feltre), Mantova 2002. – Online: Website C.

S.-W. Staps

Ciccarone, Julia, austral. Malerin, Zeichnerin, Filmemacherin, * 21. 11. 1967 Melbourne/Vic., lebt dort. Stud. ebd.: bis 1986–88 Victorian College of the Arts. Lehrtätigkeit ebd.: u.a. Western Inst. for Technology; Monash University. Ausz.: u.a. 1988 Dora Wilson Award for Painting, Melbourne; 1991 Aufenthalts-Stip. des Visual Arts and Craft Board of the Austral. Council für das Verdaccio Studio, Castellina in Chianti/Siena; 2007 Melbourne Savage Club Invitation Art Prize for Painting. – Meist großformatige figurative Öl-Gem., u. a mit Anklängen an Bildsprachen des Manierismus und des Surrealismus; häufig als Serie gegenseitig in Beziehung stehender Arbeiten ausgef., z.B. die von Robert Paltocks fiktiver Reisebeschreibung „The Life and Adventures of Peter Wilkins, a Cornish Man" (1751) und Gabriel de Foignys Utopie „La Terre australe connue" (1676) inspirierten Serien Ficticious Voyages (1995 und 1996). In die häufig mythisch anmutenden fiktiven Lsch. bindet C. oftmals kostümierte Figuren ein, z.B. Contessa (Öl/Lw., 1999) oder verwendet sie in surrealen Komp., wie z.B. in Comfortably Numb (Öl/Lw., 1999), in dem sich eine auf dem Boden liegende Person eine auf einem Gem. befindliche Lsch. wie eine Decke über den Körper zieht. Ein weiteres wiederkehrendes Motiv in C.s Arbeiten ist die Glaskugel, u.a. als okkultisches Requisit in The Fortune Teller (Öl/Lw., 2001), als in eine karge Lsch. eingebettete, gebäudeartige Halbkugel in Biosphere III (Öl/Lw., 2002) oder als ein Biotop enthaltendes, tragbares Utensil in Keepsake (Öl/Karton, 2009). Des weiteren Portr.-Aufträge. Außerdem Zchngn, z.B. June (Kohle, 1994) sowie mit Kasimir Burgess die Kurzfilme 67 (2007) und Lily (2010; Gläserner Bär, Berlinale, 2011). ▭ CANBERRA, Parliament House Art Coll. MORNINGTON/Vic., Mornington Peninsula Regional Gall. SYDNEY/N. S. W., Artbank. ◉ E: Melbourne: 1994 (K), '96 (K), '98 (mit Gabrielle Brauer), 2000 Robert Lindsay Gall.; 2002, '05, '07 (alle K), '09 Niagara Gall. / 1998 Canberra, Drill Hall Gall. (mit Anne Wallace; K) / 1998, 2000 Adelaide (South Australia), BMG AG. – G: Melbourne: 1986–88 Victorian College of the Arts: Graduate Exhib.; 1990 200 Gertrude Street: Witness (K); 1995 NG of Victoria: Our Parent's Children; 1996 (Colonial Post Colonial; K), 2004 (The Plot Thickens; Wander-Ausst.; K) Heide MMA; 2009 Ian Potter Mus. of Art: The Shiloh Project; 2010 Niagara Gall.: Muster. A Round-up of Works from the Stockroom / Geelong (Vic.): 1991 Deakin Univ. Gall.: Contemp. Landscapes (K); 1996, 2001 Geelong Gall.: Geelong Art Prize / 1995 Adelaide, Central Gall.: Focus, 17 Australian Women ... the past 100 Years (K) / 1996 (Food in Art), '98 (Mulch and Metaphors; Metamorphosis) Mornington, Mornington Peninsula Regional Gall. / 2000 Canberra, NG of Australia: Doug Moran Nat. Portr. Prize (Wander-Ausst.) / Sydney: 1998 S. H. Ervin Gall.: Site and Sensibility; 2001 Austral. Nat. Maritime Mus.: Stitches, Fare il punto (K). ▭ Germaine,

1991; WWAVA, 1991; *Delarge*, 2001. – *L. Murray Cree/ N. Drury* (Ed.), Austral. paint. now, Lo. 2000. – *Online:* Website C., 2012. J. Niegel

Cích, *Ivan* cf. **Cích,** *Koloman*

Cích, *Koloman*, slowakischer Fotograf, Fotojournalist, * 11. 9. 1916 Račišdorf (Bratislava-Rača), † 22. 4. 1993 Bratislava. Vater des Fotografen *Ivan C.* (* 17. 8. 1944 Račišdorf, lebt in Bratislava). 1934 Schulabschluß. Ausb. in Bratislava: 1934–37 Fotografenlehre bei František Jánoška; parallel vertiefende Studien an der weiterführenden Berufsschule für Auszubildende des Fotogewerbes sowie 1935–37 Abendkurse für Fotogr. an der KGS (bis zu dessen Weggang im Sommer 1935 bei Jaromír Funke, danach bei Ladislav Kožehuba). Bis 1939 ist C. für F. Jánoška in dessen Fotostudio Štefánia in der hist. Altstadt von Bratislava tätig. 1939–40 Kriegsdienst; Einsatz als Luftbildfotograf. Ab 1940 technischer Angestellter in einem Fotolabor der Slowakischen Presseagentur (Slovenská tisková kancelár; STK), für die er ab 1941 als Fotojournalist arbeitet. Im Auftrag der STK entstehen u.a. Aufnahmen eines in Bratislava-Rača stationierten Regiments der Roten Armee (Mai 1946), später auch von sowjetischen Soldaten in Österreich. Ebenso wie der Fotojournalist Jozef Teslík führt C. seine Tätigkeit nach der Auflösung der ersten Slowakischen Republik bei der Nachrichtenagentur Zpravodajská agentúra Slovenska (ZAS) und beim Tschechoslowakischen Pressedienst (Československá tisková kancelár; ČSTK) weiter. Dort leitet er ab 1957 bis zur Berentung 1977 die Abt. Fotojournalismus; den inhaltlichen Schwerpunkt seiner Arbeit bildet die Berichterstattung über die Landwirtschaft, bes. über Entwicklungen im Zuge der Zwangskollektivierung. Über das Spätwerk ist nur wenig bekannt. Ab 1946 Mitgl. des Slowakischen Journalisten-Verb. (1956–57 Erster Vors. der Sektion Fotojournalismus). Ausz.: 1960 Preis der Ausst. Interpressfoto, Berlin; nach 1966 AFIAP. Teiln. an nat. und internat. Ausst. zum Fotojournalismus. – 1936 ist C. auf der Internat. Foto-Ausst. in Košice mit der Studienarbeit *Štruktúra vlneného koberca* (Struktur eines Wollteppichs) vertreten; die Anwendung von Gest.-Prinzipien der Neuen Sachlichkeit geht offensichtlich auf den Unterricht an der KGS Bratislava zurück. In den Jahren des Bestehens der ersten Slowakischen Republik verwendet er Gest.-Mittel der New Photogr., arbeitet etwa mit Top- und Bottom-shots sowie diagonalen Komp. bei Aufnahmen von Militärparaden oder kombiniert in der Bildberichterstattung von offiziellen Festlichkeiten Großaufnahmen mit Totalen (u.a. in einer Fotoreportage zur Feier des 4. Jahrestages der slowakischen Unabhängigkeit in Bratislava am 14. 3. 1943). Unter den wenig bek. Fotografen des ersten slowakischen Nationalstaates (u.a. Jozef Cincík, Ladislav Roller, Anton Tarkoš, J. Teslík) nimmt C.s Wirken eine herausragende Stellung ein. – Foto-Publ.: *E. Lazišťan u.a.*, Dedina na Slovensku včera a dnes [Das Dorf in der Slowakei gestern und heute], Martin 1958. ◉ *E:* 1975 Bratislava, Mestský dom kultúry a osvety: Sovietskí vojaci osloboditelia (K: M. Vojtek). – *G:* 1936 Košice, Východoslovenské múz.: Internat. Foto-Ausst. (K) / 2008 Bratislava, Ružom-

berok, Žilina: Begleit-Ausst. zum Weltkongreß der FIAP (K) / 2010 Bratislava, Stredoeurópsky dom fotogr.: In the shadow of the Third Reich. Official photographs of the Slovak state 1939–1945 (im Rahmen des Monats der Fotogr.). ▭ EČSF, 1993; SČSVU I, 1998. – *B. Koklesová*, V tieni Tretej ríše. Oficiálne fotogr. Slovenského štátu, Bra. 2010. – *Online:* abART. A. Dufek/B. Koklesová

Cicvárek, *Miloslav*, tschech. Maler, Zeichner, * 1. 10. 1927 Písek, † 12. 7. 2007 České Budějovice. Autodidakt. Nachhaltige Eindrücke hinterlassen die Begegnung mit den Malern Jan Zrzavý (1944) und Jiří Kolár (1945) sowie einige Ausst.-Besuche in Prag: Skupina 42 (1943), Die spanische Avantgarde der sog. Escuela de Paris (1946) und Der europ. Surrealismus (1947). 1962 Mitbegr. der Skupina 62. Studienreisen nach den Niederlanden und Frankreich (1969), Paris (1984), Niederlande und Belgien (1989); zw. 1990 und 1994 wiederholt in Deutschland. Mitgl.: Asoc. jihočeských výtvarníků; 1967 Klub konkrétistů (zw. 1968 und 1998 regelmäßige Ausst.-Beteiligung); 1995 Künstlerhaus Wien. Ausz.: 1968 Joan-Miró-Preis, Barcelona; 1996 Irene-und-Peter-Ludwig-Preis, Künstlerhaus Wien; 1999 Goldener Lorbeer, Künstlerhaus Wien. – Im Einklang mit der in den 1950er Jahren einsetzenden, maßgeblich von der südböhmischen Aleš-Gal. (AJG) in Hluboká nad Vltavou beförderten Opposition gegen das offizielle Kunstdogma des sozialistischen Realismus sucht C. früh den Anschluß an die nat. und internat. Trad. der Avantgarde und schuf, ohne die natürliche Realität zu leugnen, Lsch. und Ansichten in formaler Reduzierung (*Krajina*, 1960; *Nocní město*, 1960er Jahre). Bald zählt er zu den wichtigsten Vertretern abstrakter Kunst seines Landes. Bisweilen zeigen seine Komp. (*Bubliny*, 1963) eine gewisse Nähe zum tschech. Elementarismus der Zwischenkriegszeit, wie ihn z.B. František Foltýn repräsentierte; radikalisiert erscheint seine abstrakt-geometrische Ästhetik in Serien elementarer, zellartiger Formen. Gleichzeitig macht sich E. der 1960er Jahre ein neuer Realismus bemerkbar. Einen satirisch-surrealistischen, provozierenden Kommentar zur objektiven Welt bildeten die weiblichen Schaufensterpuppen, mit denen C., in direkter Konfrontation des leb- und emotionslosen Panoptikums mit lebendigen Menschen, auf die militärische Niederschlagung des „Prager Frühlings" 1968 reagierte. Die Rückkehr zu realistischen Bildwelten, ohne abstrakte Formvorstellungen aufzugeben, zeigt sich in den Frauen-Portr. der Jahre 1980–85 (*Portrét staré dámy*), mehr noch in den Bildern des Zyklus *Paríž* (1985–90), die die Hauptattraktionen der frz. Hauptstadt (u.a. Notre-Dame, Arc de Triomphe, Tour Eiffel, Rue Saint-Denis), darunter auch berühmte Kunstwerke u.a. von Jean Tinguely und Alexander Calder vorführten. Respektvolle Interpretationen mod. und alter Kunstwerke (u.a. von Hans Arp, Salvador Dalí, Henri Matisse, Piet Mondrian, Niki de Saint Phalle wie auch von Leonardo und Michelangelo) bot der Zyklus *Pocty*. Der für C. char. Versuch, einen harmonischen Ausgleich zw. den inneren und äußeren Schauplätzen der persönlichen Erfahrung zu finden, trat auch in den figurativen Zyklen der späteren Jahre hervor: *Malír a model* (1990–93), *Červen* (1995–99)

und *Šed v šedé* (2001–03). ⌂ HLUBOKÁ NAD VLTAVOU, AJG. ◉ *E:* 1968 Prag, Gal. na Karlově náměstí (Gal. Lidové demokracie) / České Budějovice: 1969 Dům umění (K: A. Hartmann); 1988 Výstavní síň Krajského střediska památkové péče a ochrany přírody; 1999 Gal. Pod kamennou žábou / 1970 Tilburg (mit Dalibor Chatrný) / 1973 Brno, Gal. Jaroslava Krále (K) / 1983 Tábor, Bechyňská brána (K) / 1989 Prag: 1989 Frz. Kultur-Inst.; 2002 Gal. Fronta / 1990, '91, '92 Düsseldorf, Kunst- und Aukt.-Haus Peter Karbstein / 1993 Paris, Hôtel Drouot / 1996 Wien, Künstlerhaus, Gal. K / 1997 Plzeň, Gal. Maecenas / 1998 Salzburg, Schloß-Gal. (mit Leon Abramowicz) / 2001 Olomouc, Gal. G. / 2002 Hluboká nad Vltavou, AJG (K: V. Tetiva) / 2007 Prachatice, Gal. Dolní brána. – *G:* u.a. Prag: 1963 Laterna magika; 2006 Gal. La Femme: Vyhnání z ráje / 1965 Písek, Vlastivědné muz.: Grafika 65 / 1968 Jihlava: Graphik-Bienn.; Cheb, GVZ: Trienn. / 1987 Kronberg, Gal. Rafay: Klub der Konkretisten 1967–1987 / České Budějovice: 1992 Dům umění: Skupina 1962 po 30 letech; 1998, '99, 2000, '01 Intersalon; 2005 AJG: Kresba a grafika 60. let / Wien, Künstlerhaus: 2001 Sinnlicher Sommer; 2002 Salon / 2010 Weistrach, Blau-gelbe Viertels-Gal.: Starke Köpfe. ⌑ SČSVU I, 1998. – *V. Tetiva*, in: Výroční zpráva AJG za rok 2007, Hluboká nad Vltavou 2007, 14–16 (online). M. Knedlik

Cidade, *Marcelo*, brasil. Performance-, Installations- und Konzeptkünstler, * 1979 São Paulo, lebt dort. Stud.: Fund. Armando Alvares Penteado, São Paulo. Beteiligung an Street-art-Kunstprojekten und Grafitti-Gruppen. – In seinen Arbeiten experimentiert C. mit versch. Medien und künstlerischen Strategien. Zentrales Thema ist dabei die Vereinnahmung des öff. Raums angesichts einer von Überwachung und sozialer Kontrolle geprägten Ges., in der das Scheitern von Utopien ein neues kollektives Bewußtsein hervorbringt. In z.T. schockierenden Bildern (z.B. in der Performance und Videoarbeit *Fuzilamento*, 2002), aber auch in installativen Arbeiten wie *Direito de Imagem* (2004) oder *Transestatal* (2006) sowie der Skulpt. *Impossible Accomplishment or the power as addition of seductions 2* (2006) macht C. zudem die Notwendigkeit einer politischen Haltung in der Kunst deutlich. ⌂ DIJON, FRAC. PARIS, Kadist Art Found. ◉ *E:* 2005 São Paulo, Base 7; Grapixo. –. *G:* São Paulo: 2003 Gal. Fortes Vilaça: A Nova Geometria; Gal. Vermelho: 2003 (Giroflexxxx); 2005 (Verbo); 2008 (Provas de contato); 2004 Gal. Luisa Strina: Fragmentos e Souvenirs Paulistanos; 2005 Paço das Artes: Vorazes, Grotescos e Malvados; 2006 Bien. / 2003 Duisburg, Wilhelm Lehmbruck Mus.: Bitteres Gras; Rio de Janeiro: Espaço Bananeiras: In-classificados / 2004 Recife: Salão Pernambucano de Artes Plást. / Rotterdam: 2005 Archit.-Bienn.; 2009 BvB: Brazil Contemp. / 2006 Berlin, DNA Gal.: Urban Scapes; Weimar, ACC Gal.: Die Kunst erlöst uns von gar nichts / 2007 Frankfurt am Main, KV: Strategien für eine unstetige Zukunft / 2008 Paris, Gal. Georges-Philippe & Nathalie Vallois: Seja marginal, seja herói. ⌑ Brasil + Berlin. Zeitgen. brasil. Kunst in Berlin-Mitte (K), B. 2006. M. F. Morais

Cidlinský, *Vladimír*, tschech. Maler, Graphiker, * 12. 8.

1934 Benešov b. Prag, lebt dort. Stud.: 1956–61 Karls-Univ. Prag, Pädagogische Fak., u.a. bei Cyril Bouda (Malen, Zeichnen), Karel Lidický (Modellieren) und Vladimír Blažek (Kunstgesch.). Danach Lehrtätigkeit an den Grundschulen in Poříčí und Benešov; später Leiter der Volks-KSch (Lidová škola umění) in Benešov; 1973 ebd. Gründung einer Kunst-Abt. an der Musik- und KSch (Základní umělecká škola) Josef Suk. Mitgl.: Středočeské sdružení výtvarníků (SSV); Kontakte zur Gruppe AXE 66. Bekanntschaft mit den belg. Malern André Lapiere (1967) und Willy Lecomte (1969). Nach frühen Öl- und Tempera-Gem. (Blumen-Stilleben, Lsch.) v.a. Hinwendung zur Monotypie und Lith. (*Zámek Konopiště*; *U pobřeží*, um 1990), die er bei František Bobek und Tomáš Svoboda erlernte. Häufig Gest. musikalischer Themen (*Meditace nad dílem Maurice Ravela Bolero*, 1999; *Meditace na dílo Carlo Orffa Carmina Burana*, 2003; *Meditace nad dílem Josefa Suka Vesnická serenáda*, 2007). ◉ *E:* u.a. 1967 Malonne (Namur), Kath. Inst. / 1972 Benešov, Šímova síň / 1973 Tienen, Koninkl. Atheneum / Vlašim: 1974, '79 Výstavní síň Anny Roškotové; 2003 Muz. Podblanicka / 1978 Mělník, Gal. ve věži / 1983 Prag, Gal. Zlatá lilie / 1989 Bratislava, Gal. Praha / 1990 Graz, Zentralsparkasse / 1992 Grenoble, Gal. Maureen O'Hare. – *G:* 2003 Český Brod, Podlipanské muz.: Salon středočeských výtvarníků; Rakovník, Rabasova gal.: Jahres-Ausst. SSV. ⌑ SČSVU I, 1998. – *S. Rýdlova*, Pod Blaníkem 11:2007 (1) 27–29; *T. Fassati*, Středočeské ateliéry 1:2008, 29–33. M. Knedlik

Cidrás (C. Robles), *Salvador*, span. Bildhauer, Maler, Installationskünstler, * 1968 Vigo/Pontevedra, lebt dort. Stud.: ab 1990 Fac. de BA, Univ. Vigo; 1998 Arteleku, San Sebastián, bei Angel Bados und Txomin Badiola. Zahlr. Stip., u.a. Erasmus (Irland), 2003 Gastkünstler bei Trans Artists in Amsterdam, 2000 Fund. Caja Madrid. Ausz.: 1990 Preis Arte Xoven Galega; 1995 1. Preis, Certame de Pint. Consello de Cambre; 1. Preis Certamen Malvar, Santiago de Compostela. – C.s Kunst reflektiert die durch mod. techn. Medien und Repr. gefilterte Wahrnehmung und ihre ikonogr.-ideologischen Implikationen. Malerei und Skulpt. der 1990er Jahre stehen in der Trad. der Abstraktion und zeigen morphologische Spuren, die an Fingerabdrücke, Holzmaserungen (Serie *Hixiénicos*) und mikroskopische Strukturen oder an menschliche Körperformen erinnern. Danach gestaltet er meist multimediale, ortsspezifische Installationen, in denen sich Video, Malerei, Wandbild und Zchng verbinden, wobei C. häufig vorgefundenes Mat. (Werbung, Massenmedien) verarbeitet. Sie stellen assoziative Reflexionen über ges. Probleme dar, bes. das Verhältnis von Kultur (Archit.) und Natur, Kunst und Realität, Künstlichem und Natürlichem. Zu den Installationen gehören u.a. *TLOT* (*The land of tomorrow*, 2001) und *Consumiendo juventud* (2005). Bei *El otro* und *Situaciones* handelt es sich um Ansammlungen von Zchngn, teils mit applizierten Drahtgittern, die sich mit ikonogr. Anleihen (populäre Musikkultur, Comics, Internet) ironisierend auf den Mythos der ewigen Jugend beziehen. Auch die Installation *24 horas 10 minutos* (2008) setzt sich mit der Identität der Jugend, v.a. der männlichen, und ihren

medialen Stereotypen auseinander und kombiniert groß-
formatige Zchngn, ein Video, das 24 Stunden aus dem Le-
ben eines Teenagers zeigt, sowie Wandbilder aus einzelnen
posterähnlichen Bildern und Einblendungen von Popmu-
sik. *Bloody nose/El prisionero Blanco* (mit Vicente Blan-
co) nimmt Bezug auf mod. Wohnsiedlungen in den USA,
ihre Uniformität, Künstlichkeit und mon. Größe inmitten
unwirtlicher Natur. ⌂ LA CORUÑA, Prov.-Verwaltung.
LEÓN, MAC. MADRID, Fund. Coca-Cola España. PON-
TEVEDRA, Prov.-Verwaltung. SADA, Mus. Carlos Maside.
SANTIAGO DE COMPOSTELA, Centro Galego de Arte Con-
temp. – Univ. VIGO, Col. Caixanova. ⊚ *E:* 1993, '94
La Coruña: Mostra Unión Fenosa / 1996 (K: A. Gonzáles-
Alegre Burgueño/C.), '99 (K: D. Baro), 2000 (mit Alberto
Barreiro und Andrés Pinal; K: A. Barreiro u.a.), '03 (K:
J. Marín-Medina), '08 Orense, Marisa Marimón, Gal. de
Arte / 1997 Santander, Gal. Juan Silió / 1998 Vigo, Casa
das Artes (K: S. Penelas) / Santiago de Compostela: 2001
Centro Galego de Arte Contemp. (K: V. Blanco u.a.); 2008
Artedardo (K: D. Barro) / Madrid: 2001 CARS; 2005 Es-
pacio Distrito Cua4tro; 2009 Gal. Casado Santapau / La
Coruña: 2004 Fund. Caixa Galicia (mit Mónica Alonso; K:
J. M. Lens); 2007 MAC Unión Fenosa (K: J. Swartz) / 2000
Pontevedra, Espacio para a Arte (K) / 2008 Valladolid, Pa-
tio Herreriano / 2009 León, MAC (K: S. M. Momim/T. Par-
do). – *G:* Madrid: 1996 Círculo de BA: Salón de los XVI
(K: M. Fernández-Cid); 2000 Fund. Caja Madrid: Genera-
ción 2000 (K) / 2001 Santander, Fund. Marcelino Botín:
Itinerarios 1993–2000. Un camino compartido (K: F. Cas-
tro Flórez); La Coruña, Estación Marítima: Arte emergente
(K: J. M. Bonet u.a.) / 2002 Pontevedra: Bien. / 2006 Vi-
go, MAC: Pinturamutante (K: I. Pérez-Jofre/E. Juncosa) /
2009 Lugo, Mus. Prov.: Rexistros abiertos. Materias, con-
textos e narrativas na arte galega actual (K: R. Lens u.a.).
⌷ DPEE, Ap., 2002. – *A. Lazkoz/J. Sabater/C. u.a.*, Tal-
ler dirigido por Txomin Badiola, Ángel Bados (K), San
Sebastián 1998; Outra mirada (K Wander-Ausst.), S. Co.
1999; *R. A. Agrelo*, Interesarte (S. Co.) 2000 (8) 22; *D. Bar-
ro*, El Mundo, Supl. El Cult. (Ma.) v. 5. 12. 2001; *C. del
Pulgar Sabín* (Ed.), Artistas escultores. Neofiguraciones –
abstracciones, Vigo 2004. M. Nungesser

Cieciura, *Piotr*, poln. Schmuckgestalter, Objektkünst-
ler, * 1951 Bytom, lebt in Łódź. Verh. mit der Schmuck-
künstlerin Magdalena Radosława Horbaczewska-Cieciura.
Stud. in Łódź : 1970–75 Państwowa Wyższa Szkoła Sztuk
Plastycznych (heute ASP). Lehrtätigkeit an der Wyższa
Szkoła Sztuki i Projektowania ebd. Seit 1980 regelmäßige
Teiln. an der gesamt-poln. Schmuckschau Srebro in Leg-
nica (1980 3. Preis mit M. R. Horbaczewska-C., 1994 2.
Preis). – Überwiegend Metallschmuck wie Armreife, Rin-
ge und Broschen, teils in Zusammenarbeit mit der Ehefrau,
v.a. aus Gold und Silber, auch Kupfer und Messing; an-
fänglich oft eckige Formen, z.B. zwei von einem Schiebe-
puzzle inspirierte quadratische Broschen, die jeweils neun
kleinere Quadrate umfassen (Silber, Gold, Kupfer; 1982).
Daneben auch Arbeiten in Metall in Kombination mit un-
gebräuchlichen Mat. wie Papier, Holzkohle oder Meteo-
ritengestein, z.B. die Brosche *Marlow* (Silber, Gold, Me-

teoritengestein, 1998). Außerdem ab M. der 1980er Jahre
eine Reihe phantasievoller dreirädriger Fahrzeuge als ki-
netische Skulpt. in der Werkgruppe *Vehicykle*, die C. aus
Metallen und Metall-Legierungen formt, u.a. Silber, Alu-
minium und Alpaka, und z.T. mit Farbe oder farbigen Mus-
tern versieht, z.B. *Vehicykl Millennium* (Gold, Koks, Holz-
kohle). ⌂ KAZIMIERZ DOLNY, Muz. Sztuki Złotniczej.
LEGNICA, Muz. Miedzi. ŁÓDŹ, Centralne Muz. Włókien-
nictwa. PFORZHEIM, Schmuck-Mus. ⊚ *E:* 1987 Łódź,
Gal. 86 (mit M. R. Horbaczewska-C.; Wander-Ausst.);
2002 Legnica, Gal. Sztuki (K); Wrocław, Gal. Sztuki Złot-
niczej (Retr.). – *G:* Łódź: 1980 Muz. Archeologiczne: Mo-
da pradziejowa Europy; 2001 Miejska Gal.: Spojrzenie na
koniec wieku (K); Gal. Christine: P. C., Jacek Skrzyński
i ich studenci / 1983 (Sztuka Przedmiotu), '86 (Czarne
i białe), '87 (Style, kierunki, tendencje) Legnica, BWA /
1985 Pforzheim, Schmuck-Mus.: Schmuck für Kopf und
Haar (K) / 1986 Tokio und Ōsaka: Internat. Jewellery
Art Exhib. (K) / 1988 Linz, SM: Silver Top from Poland
(K) / 1994 Krakau, Gal. Ofir und Gal. Skarbiec: Camelot
(K) / Poznań: 1998 Gal. Yes: Retrospektywa; 2005 MN:
Współczesna polska sztuka złotnicza (Wander-Ausst.; K) /
2000 Bielsko-Biała, Gal. Bielska BWA: Mały obiekt, duży
obiekt (K). ⌷ Dict. internat. du bijou, P. 1998. – Zeit-
gen. Schmuck aus Polen (K), Pforzheim 1980; Schmuck
82, Tendenzen? (K), Pforzheim 1982. J. Niegel

Čierna (Fichta Čierna), *Pavlína*, slowakische Video-
und Installationskünstlerin, Graphikerin, * 26. 12. 1967 Ži-
lina, lebt in Rosina. Verheiratet mit dem Bildhauer Anton
Čierny. Stud.: 1987–93 HS für Bild. Künste (VŠVU), Bra-
tislava. 1995–2000 ebd. Lehrtätigkeit (Dept. II in Ružom-
berok; 1997–2000 Pädagogische Fak.). 2000–02 Kurato-
rin an der Považská gal. umenia in Zlín. Seit 2010 ebd.
Lehrauftrag an der Tomáš-Baťa-Univ. sowie postgraduales
Stud. an der Akad. umení in Banská Bystrica. Ausz.: 1996
lobende Erw. auf Ausst. zeitgen. Graphik in der Slowa-
kei, SG Banská Bystrica; 2002 Oskár-Čepan-Preis, Bratis-
lava; 2010 Preis beim Kurzfilmfestival Short and Savory,
The City Univ. of New York (CUNY). – In ihren Digi-
taldrucken (*Bird's-eye view*, 2006; *Attributes of Equali-
ty*, 2007), Installationen und Videos setzt sich Č. mit den
komplexen und widersprüchlichen Realitäten der Gegen-
wart auseinander. Ausgehend von sozialen Gegebenhei-
ten, zeigt sie Veränderungen in der tschech. und mitteleu-
rop. Ges. auf und präsentiert, mit differenziertem Blick-
winkel, gleichsam Ideogramme der Transformation. Den
Problemen sozialer Bindungslosigkeit und Entfremdung
geht sie z.B. 2002 in der Installation *Disturbed privacy*
nach. Immer wieder befragt Č. ihre unmittelbare Umge-
bung. So sind die tragikomischen (Anti-)Helden ihrer 2005
entstandenen Videos *Mail for you* und *Report on Eva Č.'s
realia*, zwei alkoholkranke ältere Menschen, die als Nach-
barn der Künstlerin emotional bedeutsame Kindheitserin-
nerungen aufrufen, die im Kontrast zu deren aktueller Le-
benssituation stehen. Mit Hilfe kartographischer Markie-
rungen im öff. Raum, konkret: im Wiener Volkert- und
Alliiertenviertel, folgt Č. den persönlichen Wegen aus-
gewählter Bewohner, um so deren jeweilige Lebenszu-

sammhänge (*Vertraute Orte*, 2006) zu rekonstruieren. In Video-Portr. (*Release notes*, 2009) erforscht die Künstlerin in der Rolle des Beobachters die Verhaltens- und Kommunikationsregeln in der spezifischen Umgebung einer belebten Wiener Straße, wobei sie den Kontrast zw. dem Empathiebedürfnis und der Entsensibilisierung im Sozialleben einer mod. Großstadt zeigt. In jüngerer Zeit vermehrte Zusammenarbeit mit ihrem Ehemann (*Directions to create necessary things and impressions*, 2010). ⌂ Banská Bystrica, Štátna gal. Barcelona, MAC. Bratislava, Gal. mesta Bratislavy. Krakau, Malopolska Fundacja Muz. Sztuki Współczesnej. Tokio, MCA. Žilina, Považská gal. umenia. ✉ Denník, in: Výtvarny život – Art Life 39:1994 (1) 84 s.; Three men for life and me, in: Umělec 9:2005 (1) 43–45. ◉ *E:* u.a. 1994 Žilina, Považská gal. umenia / 1997 Košice, Múz. Vojtecha Löfflera / 1999 Banská Bystrica, Štátna gal.; Šamorín, At Home Gall. / Bratislava: 2000 CC Centrum; 2003, ' 10 (mit Mark Ther); 2010 Space Gall. (mit Anton Čierny) / 2002 Ústi nad Labem, Gal. Emila Filly (mit Zdena Kolečková; anschl. Trnava, Gal. Jána Koniarka); Brno, Dům umění / 2005 Žilina, Považská gal. umenia; Ostrava, Důl Michal (mit Lenka Klodová) / 2009 Wien, Mus.-Quartier, Quartier 21 / 2010 New York, WAH Center / 2011 Prag, MeetFactory, Gall. Cube (mit A. Čierny). *G:* u.a. 1999 Ljubljana: Graphik-Bienn. / 2000 Nanjing, Jiangsu AG: The spirit of image / 2004 London, Gall. Anthony Reynolds: Welcome!; Wien, Gal. Grita Insam: Begegnung auf höchster Ebene / 2005, '08, '11 Zlín, Krajská GVU: Nový zlínský salon / 2005 Osaka, NM of Art: Positioning in the new reality of Europe (anschl. Hiroshima, MCA) / Ústí nad Labem, Gal. Emila Filly: 2005 We are what we are; 2011 The art of urban intervention / Prag: 2005, '11 Bienn.; 2006 Gall. Art Factory: 22 minút 50,28 sekundy (anschl. Helsinki, CAISA); 2008 GHMP: Súčasné slovenské výtvarné umenie 1960–2000 / 2008 Bukarest: Bienn. / 2009 Brno, Dům umění: Formats of transformation (anschl. Wien, Mus. auf Abruf) / 2010 Graz, KV Rotor: Unerwartete Wendungen. ⌷ Check Slovakia! Junge Kunst aus der Slowakei (K Berlin), B./Trnava 2004; *K. Rusnáková*, História a teória mediálneho umenia na Slovensku, Bra. 2006. – *Online:* Website Č. (Ausst.; Lit.). M. Knedlik

Cierpisz, *Bogdan*, poln. Maler, * 1930 Puławy, † 1994 Gdańsk. Stud.: 1951–57 Staatliche HBK ebd., Malerei bei Jan Wodyński, Stanisław Borysowski und Jan Cybis. Ab 1970 Lehrtätigkeit an der Univ. Gdańsk. – Realistische ländliche Lsch. und Stadtansichten in verhaltenem, auf wenige fein nuancierte Farbtöne beschränktem Kolorit. ⌂ Elbląg, Muz. Frombork, Muz. Mikołaja Kopernika. Gdańsk, Centralne Muz. Morskie. ◉ *E:* u.a. Gdańsk: 1971 Salon Malarstwa Współczesnego; Dom Kultury Handlowca; 1977 Gal. Przymorze; 1979 Ratusz Staromiejski / 1980 Frombork, Muz. Mikołaja Kopernika. ⌷ Malarstwo B. C. (K), Puławy 1982; Poln. Kunst heute (K Wander-Ausst.), Singen 1983. – Mitt. M. Mendrowski, Bad Buchau. C. Rohrschneider

Çiftçi, *Feza*, türkische Malerin, * 1969 İzmir, lebt dort. Stud. der trad. türkischen Kunst mit Hauptfach Vergol-

dung (tezhip) an der Dokuz Eylül Univ. ebd. – Im Mittelpunkt ihrer dekorativen psychedelischen Malerei stehen Figuren (ohne Gesicht) oder Fische. Ç. verwendet Öl- und Aqu.-Farben, pflanzliche Farbstoffe, auch Kaffee und Tee. 24-karätiges Gold wird von ihr ausdrucksverstärkend und als Symbol für Licht und Wahrheit empfunden. Die Gem. tragen Titel wie *Leben*, *Geburt* oder *Schmetterling*. Mit ihren Komp. rezipiert sie häufig persische Buchmalerei (Motive vor farbigem Hintergrund, gefärbtes Papier). ⌂ Çanakkale, Military Mus. ◉ *E:* İzmir: 1994 Rotary Sanat Gal.; 2001 Adnan Franko Sanat Gal.; 2002 Adidya Sanat Gal.; 2003 Halil Rifat Paşa Köşkü Sanat Gal. / 1994 Istanbul, Beyoğlu Vakko Sanat Gal. / 2000 Ankara, Middle East Technical Univ. / 2000 Eskişehir, State FA Gall. ⌷ *Online:* Orig. Turkish paint. gall.
 K. Schmidtner

Cihodaru, *Liviu*, rumänischer Maler, Zeichner, Graphiker, Werbefilmer, * 15. 3. 1933 Cernăuţi, lebt in Braşov. Stud.: bis 1957 Univ. Transilvania, Braşov; 1984 Dipl. des Polytechnikums Bukarest (u.a. Kybernetik). Autodidakt. Seit 1951 Malunterricht, u.a. bei Valeriu Maximilian, Stavru Tarasov, Friedrich Bömches, Ştefan Mironescu, Eftimie Modâlca und Harald Meschendörfer. Mitgl. des rumänischen Künstler-Verb.; mehrere nat. Preise. – C. gestaltet, häufig in Aqu., postimpressionistische Lsch. und Stadtansichten, teils auch stärker abstrahiert (Blumen-) Stilleben, Portr. und Frauenakte. Zw. 1965 und 1985 dreht er etwa 25 Werbefilme zum Thema „Tractoarele româneşti pe meridianele". Auch Ill. und Buchgestaltung. ⌂ Braşov, Muz. de Artă. – Kirche St. Georg. – Gal. der Zs. Brassoi Lapok. Den Haag, Rumänische Botschaft. ◉ *E:* seit 1958, u.a. zahlr. in Braşov: 1978, '80 Gal. Artă; 1983, '85, '88, '91 Gal. Victoria; 2000, '05, '07 (Portr., K) Muz. de Artă / 1992 Antwerpen, Gal. Gisbergen / 1996 Vorst, Gal. Ten Weyngaert / 1997 Nederweert, Gal. Christiana. – *G:* seit 1957, u.a. seit 1984 öfter Bukarest, Sala Dalles (nat. Malerei- und Graphik-Salons) / 1991 Galaţi, Muz. de Artă: Salon moldawischer Malerei / 2007 Braşov, Muz. de Artă: Colecţia Sârbu. ⌷ *P. Matei*, Artişti plastici braşoveni contemp., Braşov 2000; *V. Ciucă*, Un secol de arte frumoase în Bucovina, Suceava 2005. St. Schulze

Çıkıntaş, *Sabahat*, türkische Malerin, * 1955 Eskişehir, in Istanbul tätig. Ç. beginnt 1991 ihre künstlerische Ausb. in der Wkst. von Yusuf Taktak und eröffnet danach ihr eig. Atelier. Ausz.: 1999 Turkcell Mal-Wettb., Istanbul (lobende Erw.). Mitgl.: u.a. Internat. Plastic Arts Assoc. – Sie gestaltet monochrome, vorwiegend in Blau-, Grau- und Rottönen gehaltene kleinteilige Komp. (Öl/Lw.), die sie aus der geometrischen Form des Quadrates entwickelt. Dieses arrangiert sie in Gruppen teils flächig ineinandergreifend, teils übereinander gelagert, so daß teilw. ein räumlicher Eindruck entsteht. ◉ *E:* Istanbul: 1994, '95 Foks Fun Plastic AG; 2002, '03 Nelli Sanat Gal.; 2005 Gal. X; 2009 Mine Sanat Gal. / 1995 Bursa, Teyyare Plastic AG / 1996 Eskişehir, Devlet Güzel Sanatlar Gal. /1997 Balıkesir, Akbank Sanat Gal. / 1998 Ankara, Assoc. of Turkish-Amer. Soc. – *G:* Istanbul: 2001 Nelli Sanat Evi: At Least Important; 2005 CRR: Asia is Crying; 2006 Istanbul Sa-

nat Gal.: İz-amorf; 2008 Anka Sanat Gal.: Sakladıklarım; 2010 Harbiye Askeri Müzesi: Art Bosphorus Contemp. Art Fair. ▭ *Online:* Website Ç. (Ausst.). M. Kühn

Cilento, *Matteo*, ital. Maler, * 26. 9. 1829 San Mauro Cilento/Salerno, † 1916. Stud.: 1845–50 ABA Neapel bei Camilla Guerra; 1850 Rückkehr in den Heimatort. Als 34jähriger Heirat und Übersiedlung nach Rutino/Salerno. Tätig v.a. für kirchliche Auftraggeber der Prov. Salerno; daneben entstehen für versch. Herrenhäuser in der Region ebenfalls in der Trad. der neapolitanischen Malerei stehende Freskodekorationen mit allegorischen Themen, z.T. unter Mitarb. von Mitgl. der Dekorationsmaler-Fam. Giannella aus Serramezzana, die C. zugleich ihre Ausb. verdanken. ▭ CANNICCHIO, Kirche: Orgelprospekt. CASAL VELINO-Acquavella, Kirche S. Michele Arcangelo: Wunder der Madonna delle Grazie. CELSO DI POLLICA, Pal. Mazziotti: Dekoration. MONTECORICE, Confraternita del Rosario: Madonna del Rosario. POLLICA, Pal. della Cortiglia: Allegorien der Schönen Künste, Fresken. – Kirche S. Nicola: Deckendekoration, 1890. SAN MAURO CILENTO, Kirche S. Mauro: Martyrium des S. Mauro, Lw. SERRAMEZZANA-San Teodoro, Kirche: Zyklus mit dem Martyrium des S. Teodoro. ▭ *C. Schiavone,* M. C., Acciaroli 1996. – *Online:* Digilander. Libero. E. Kasten

Cilia, *Franco,* ital. Maler, Bildhauer, Kunstpublizist, Autor, * 1940 Ragusa, lebt ebd. Sucht E. der 1960er Jahre Antworten auf Fragen der Spaltung des Ichs und läßt sich dabei durch die Doppelbödigkeit der Werke von William Turner anregen. Ab den 1970er Jahren Auseinandersetzung mit Radierfolgen von Francisco de Goya und dessen Schilderungen psychischer Labyrinthe mittels Kombination aus informellen und figurativen Darst.-Mitteln. Auch Interesse für Skulptur, wobei C. sizilianischen Stein als beseeltes Gegenüber auffaßt. Char. für das Schaffen der 1980er Jahre sind die Bildfolgen *Trasfigurazione allusiva* und *Cilia ist Tot* (thematisiert hier den eig. Tod), mit denen er Anschluß an die internat. Kunstszene findet. Ab 1992 Auflösung der Figur vor dem gedanklichen Hintergrund sozialer und globaler Veränderungen (mit den Zyklen *Nuovi Confini d'Europa* und *Apocalisse*). Ab M. der 1990er Jahre Bildfolgen von großer Intensität zu versch. Himmels- und Lichterscheinungen; deren Formen, Bewegungen, Spiegelungen, Bildungen und Auflösungen sind für ihn Sinnbilder von Welt. C. spricht von der „Intelligenz der Wolken"; auch läßt sich durch Gedichte von Stanley Moss inspirieren (*L'alba*; *Purgatorio*; *Canto Primo* , alle 1999). Findet hier nach anfänglichem „Sturm und Drang" seiner Palette zu einer neuen Qualität der Ruhe. C. hinterfragt die Welt des künstlich konstruierten Scheins und unnötiger Lebensillusionen, indem er an unsere Vergänglichkeit erinnert und sich auf universale Kräfte und Wahrheiten bezieht. Bei dem von C. geschriebenem Drama „È ancora Natale" führte er 1995 auch die Regie in Chiaramonte Gulfi und Clermont de L'Oise. ▭ CLERMONT DE L'OISE, Cathédrale St. Samson. DUBROVNIK, MN. PESCARA, Mus. dantesco Fortunato Bellonzi. PIEVE DI CENTO, Mus. delle eccellenze artist. e stor. MAGI '900. PISTOIA, Mus. all'aperto di Castagno di Piteccio. RAGUSA, Muni-

cipio. SÃO PAOLO, MAC. SULMONA, PinCom. SYRAKUS, Giardini di Piazzale Lepanto. ▭ Innocenza, R. 1995; Oltremare, Ragusa 1997; Ritratto post – mortem, Rimini 1999. ◉ E: Ragusa: 1970 La Ruota; 1975 Ponte 2; 1983 Pal. di Città; 1991 Mus. Diocesano; 1992 Camera di Commercio; 1997 Centro Servizi Cult.; 2002 Chiese Rettoriale del Collegio; 2008 Costone roccioso / Florenz: 1973 La Ghibellina; 1978 Gall. Pananti / 1979 Catania, Gall. Cavallotto / 1981 Mailand, Gall. Schettini; Bergamo, Gall. Lorenzelli (K: A. Veca) / 1983, '84 Brescia, Gall. S. Michele / 1987 Buenos Aires, Mus. del Correo Central / 1989 Lissabon, Forum Picoas / Rom: 1998 Gall. Lazzari; 2000 Gall. Giulia (K: R. Bossaglia); 2003 Performance Studio Ennio Calabria; 2006 Complesso del Vittoriano / 2000 Florenz, Studio Fedi Mineo / 2002 Neapel, Pal. Serra di Cassano / 2006 Bergamo, Sala Manzù (K: F. Noris) / 2007 Donnafugata, Castello; Odense, Gall. Solvognen / 2008 Saltum, Gall.; Weimar, ACC Gal. / 2009 Pescara, Ex Aurum / 2011 Roncade, Castello. ▭ *Online:* Website C.; Prov. di Bergamo. S.-W. Staps

Cimbura, *Emil (Emil Jan),* tschech. Tapisserier, Maler, Kunsthandwerker, * 18. 7. 1922 Prag, lebt dort. Stud. ebd.: 1934–39 KGS; 1939–46 HS für angew. Kunst bei Jaroslav Benda, Antonín Strnadel, Antonín Pospíšil und Alois Fišárek (zwei Jahre dessen Ass.). Mitgl.: 1958 Skupina 7 (neben Věra Drnková, Bohuslav Felcman, Květa Hamsíková, Jan Hladík, Alice Kuchařová und Ladislav Vacek); 1970 Radar; 1991 Spolek výtvarných umělců (SVU) Mánes. – Außerordentlich vielseitiger Künstler. Neben Keramik- und Glasarbeiten sowie Mosaiken (u.a. 1956 für das Wasserwerk Orlík) häufig als Tapisserier tätig (u.a. 1952 Gobelin für das Jirásek-Mus. Prag; 1968 Gobelin für das Kulturhaus der Škoda-Automobilwerke in Mladá Boleslav; 1974 Tapisserie für die Tschech. Staatsbank Prag). Arbeitet 1968–70 als Raumplaner für die Platz-Gest. der Siedlung Pankrác in Prag, wo er auch die rechteckigen Bassins mit flachen Schüsseln und drei Fontänen für einen Brunnen (Entwurf: Jiří Lasovský) schafft. 1982 entsteht ein mon. Keramik-Relief für das Postgebäude in Prag-Jižní Město. Künstlerische Begleitung (u.a. Plakatentwürfe, Gest. der Programmhefte) des Internat. Archit.-Kongresses UIA in Prag (1966–67) sowie des Musikfestivals Mladé pódium in Karlovy Vary (1979–88). Zahlr. Buch-Ill. (u.a. Z. Rón, *Přítel nejvěrnější*, Blatná 1944; V. Šrobár, *Zázraky na lavici*, Praha 1953; M. Pasek, *Modrý leopard*, Praha 1961; M. Sedláčková, *Maminko mě bolí bříško*, Praha 2004). Auch allegorische, oft mon. Gem. (*Válka II*, 1943; *Veritas*, 1993). Ferner Rest. der Fresken im Benediktinerstift Břevnov in Prag. ◉ E: Prag: 1967 Gal. Jaroslava Fragnera; 1982 Gal. U Řečických; 1984 Klub Motorlet; 1993 Hotel Jalta (K); 2007 Gal. Diamant (SVU Mánes) / 1983 Vodňany, Městské muz. a gal. (K) / 2008 Chlumec nad Cidlinou, Schloß Karlova Koruna (Jubiläums-Ausst. zum 85. Geburtstag). – G: u.a. 1959–60, '64 Prag: Skupina 7 (K) / 1962 Lausanne: Bienn. Internat. de la Tapisserie / 2009–10 Česká Skalice, Muz. Boženy Němcové: Bytový textil z ÚBOKu Praha. ▭ *Toman* I, 1947; SČSVU I, 1998. – *V. Luxová,* Československá tapiséria 1945–75,

Bra. 1978; *J. Kotalík*, Skupina 7 (K Gal. Vltavín), Praha 1994; DČVU V, 2005 (s.v. Skupina 7). M. Knedlik

Cimbura, *Vít*, tschech. Innenarchitekt, Möbelgestalter, Graphiker, Fotograf, * 28. 3. 1950 Prag, lebt in Bukovina b. Úštěk. Stud.: 1968–75 HS für angew. Kunst, Prag (VŠUP), bei Pavel Smetana, Jaroslav Svoboda und Zdeněk Kuna (Atelier für Archit. und Inneneinrichtung). Zunächst entstehen v.a. Reklamearbeiten (u.a. für Palác Koruna; Dům dětské knihy; Dům módy) sowie Fotogr. für die Zs. Camera in der Schweiz; auch freie Graphik (*PF 1984*, Lith., 1983). Seit 1980 Interieurs von Läden in Prag (Dům oděvů, 1987; Prodejna českého skla, 1989), Restaurants, Privathäusern und Gemeinschaftsräumen (Benešov: Gebetsraum der Českobratrské církve evangelické [ČCE]). 1987 Gründungs-Mitgl. (neben Bohuslav Horak, Jiří Javurek, Jiří Pelcl und Jaroslav Susta) von Atika, einer Gruppe postmoderner Designer, die sich dem sozialistischen Stil verweigerten. Grundzüge von C.s Entwürfen für Stühle (*Manhattan*, 1988; *Rosalinda I* und *Rosalinda II*, 2009), Sekretäre und Tische (*Hájek*, 2007) sind ihr totemartiger Char., die expressive Farbigkeit und die ausgeprägte Kombination der Mat. (z.B. *Malý & velký šnek*, 2006; Zweisitzer in Form einer kleinen und einer großen Schnecke, Ahorn, mit schwarzen Lederpolstern und einer Rückenlehne aus Blattaluminium). 2009 nominiert als Designer des Jahres. Seit 2009 Jury-Mitgl. beim Foto-Wettb. Život a cestovní ruch v Českém středohoří. ⌂ BRNO, Moravská gal. OLOMOUC, Muz. umění. PRAG, UPM. ◉ *E:* 1994 Amorbach (Odenwald), Gal. Kreuzer / 1995 Prag, Gal. Genia loci / 1996 Nürnberg, Prager Kunstsalon; Klagenfurt, Gal. Ars Temporis; Úštěk, Pikartská věž / 2009–10 Benešov, Muz. umění a designu / 2010 Ploskovice, Schloß (mit František Janovský). – *G:* u.a. Prag: 1987, '89 Gal. v Karlovce; 1988 Gal. Dilo (Na můstku) / 1989 Paris, Gal. Neotu; Gal. Via / 1990 Wien, Gal. Tiller; Berlin, Gal. Contra Forma; Amsterdam, Gal. Binnen (alle mit der Gruppe Atika); Prag, UPM: Cesty k postmoderně. Průzkum osmdesátých let / 2007 Pardubice, Východočeské muz.: Atika 1987–1992. Emoce a Forma (Wander-Ausst.; K). ⌷ SČSVU I, 1998; NEČVU, Dodatky, 2006. – *Online:* Website C. M. Knedlik

Cimit, *Ünal*, türkischer Keramiker, * 1934 Karadeniz Ereğli, † 23. 11. 1993 Istanbul. Verh. mit der Keramikerin *Naile C.* (* 1951 İzmir); Vater des Fotografen *Teoman C.* (* 1968 Istanbul). Stud.: ABK, Istanbul, Malerei bei Halil Dikmen und Bedri Rahmi Eyüboğlu; drei Semester an der HS für Gest., Offenbach am Main; 1960–62 FS für Keramik, Höhr-Grenzhausen (1962 Abschluß als Modelleur). Ausz.: u.a. 1983 Abdi Piekçi Freundschafts- und Friedenspreis (ehrenvolle Erw.); 1992 Künstler des Jahres, beide Istanbul. Während seines Aufenthalts in Deutschland arbeitet C. in versch. Keramik- und Porzellanfabriken. 1964 Rückkehr in die Türkei und nach dem Militärdienst als Manager im Unternehmen Eczacıbaşı (Innen- und Kücheneinrichtungen) tätig. Lehraufträge: u.a. ab 1976 Doz. an der ABK, Istanbul (Keramik- und Gipsplastik); bis 1984 an der Hacettepe Univ., Ankara (bild. Kunst und Keramik). 1984 beendet C. seine akad. Karriere und ist fort-

an ausschließlich als Künstler tätig. – C. entwickelt aus natürlichen Substanzen eig. Keramikglasuren, die er in seinen Gefäßkeramiken anwendet (v.a. Teller, Schalen). Die Motive seiner Wandbilder und Plastiken findet er in der Kultur- und Kunstgesch. der Türkei. 1989 entsteht das Keramikwandbild für die Abdi İpekçi Arena, Istanbul. ⌂ ESKİŞEHIR, Anadolu Univ. İZMIR, State Art and Sculpt. Mus. ◉ *E:* 2000 Eskişehir, Anadolu Univ. (Retr.). – *G:* 1986 İzmir: Große Ausst. des Stadtrates / Istanbul: 1988 Ayasofya Müz.: Keramik-Skulpt.; 2007 Tophane-i Amire Kültür ve Sanat Merkezi: Türkische Keramik. ⌷ *K. Özsezgin*, Türk plastik sanatçıları, Istanbul 1994. – Milliyet Aktüalite v. 19. 12. 1982. M. Kühn

Cimochaŭ, *Sjargej Aljaksandravič* (auch *Sjaržuk; Seržuk;* russ.: Timochov, *Sergej Aleksandrovič*), weißrussischer Maler, Zeichner, Graphiker, * 8. 9. 1960 Krotov (Krotaŭ/Gebiet Gomel'), lebt in Minsk. Verh. mit Ryta Michajlaŭna Cimochava. Ausb./Stud. in Minsk: bis 1979 Kunst-FS „Aleksej Konstantinovič Glebov"; bis 1984 HS für bild. und Bühnenkunst (heute weißrussische AK), Abt. für Mon.-Malerei bei Gaŭryil Charytonavič Vaščanka. Anschl. als Angestellter in den Kunstkombinaten in Gomel' und Vitebsk (Vicebsk) Mitwirkung an Gest.-Konzepten für öff. und Arbeitsräume. Ab 1986 ansässig in Polock (Polack/Gebiet Vicebsk), wo C. zunehmend auch als Kulturfunktionär Einfluß auf das künstlerische Leben der Stadt nimmt. Ab 1989 Chefkünstler von Polack; 1990 Eintritt in den weißrussischen Künstler-Verb. (z.Z. stellv. Vors. und Ltg der Ausst.-Aktivitäten); 1992 Mitbegr. und einige Jahre Ltg der Gal. Rysa in Polack. 1999 zus. mit der Ehefrau Übersiedlung nach Minsk. Ausz.: u.a. 2003 Großer Preis der internat. Bienn. der Ill. „Goldene Feder", Belgrad. – In Weiterführung wesentlicher Themen im Spätwerk des Lehrers G. Ch. Vaščanka, gleichzeitig bestärkt durch das in den 1980er Jahren erwachende Interesse an der Bild- und Sprach-Gesch. einer weißrussischen Nationalkultur beziehen sich C.s Komp. häufig auf vorchristliche ikonogr., kultische und mythologische Trad. der Region. Seine Arbeiten, meist ausgef. in Kombinationstechniken (Öl, Acryl, Kratz- und Wischspuren) auf Lw. oder Papier, verschränken figürlich-abstrahierte mit zeichenhaften, geometrisierenden bzw. archit. Elementen, wobei sich graph. und malerische Strukturen gegenseitig durchdringen und ergänzen. Im Wechselspiel von verknappten Linien und Körperlichkeit andeutenden, bes. in den Farbwerten betonten Flächen variiert C. mit archaischer Symbolik aufgeladene, stilisierte Einzelmotive, oft in Polyptichen aufgefächert oder in Bildfolgen verbunden, die über das direkte Formzitat oder über Werktitel und Detail-Ausf. Kulte bzw. Kultgegenstände und -räume assoziieren (u.a. altslawische Bildsteine, Tempel-Archit., naturmythische Motive wie Ei oder Sonne, weibliche Akte als Verkörperungen von Fruchtbarkeit und Sinnlichkeit). ⌂ MINSK, MMK. – Nat. KM. MOSKAU, Kunstfonds des russ. Kultur-Minist. POLACK, Kultur-Pal. der Glasfabrik: Polock. Staražytny gorad, Enkaustik. – KM im kultur-hist. Mus.-Komplex. VICEBSK, Chagall-Mus. ◉ *E:* Polack: 1992, '94 Gal. Rysa / 1994

Brèst, Ausst.-Saal des Künstler-Verb. / Minsk: 2000 Gal. Zolata; 2010 MMK / 2002 Wiehl (NRW), Stadtbücherei / 2007 Gomel', Vaščanka-GG; Minsk, Nat. KM (K) / 2008 Wałbrzych, Gal. Schloß Fürstenstein / 2009 Łódź, Muz. Kinematografii / 2010 Moskau, Zentralhaus des Künstlers / 2011 Magileǔ, Bjalynicki-Birulja-Mus. – *G:* 1997 Vicebsk: Internat. Chagall-Pleinair / Minsk: 2007 Weißrussische NB: Internat. Kunst-Ausst. Der Mensch und das Rad„; 2008 Kunst-Pal.: Weißrussische Bienn. für Malerei, Graphik und Skulpt. / 2011 Frankfurt (Oder), St. Marienkirche: Künstler aus Vicebsk / 2012 Polack, KM im kulturhist. Mus.-Komplex: Weißrussische Künstler aus Polack. ▭ BSM, 1998. – Majstar i majstry. Gaǔryil Vaščanka i škola (K Mus. für weißrussische Gesch. und Kultur), Minsk 2004; *A. Beljavec,* Mastactva (Minsk) 2007 (7) 18 s.; Naša niva (Minsk) v. 8. 9. 2010; *A. Kavalenka,* Mastactva (Minsk) 2011 (4) 27–31. S. Görke

Cimochava, *Ryta Michajlaǔna* (russ.: Timochova, *Rita Michajlovna*; geb. Rybačok), weißrussische Illustratorin, Buchgestalterin, * 4. 2. 1962 Gebiet Vitebsk (Vicebsk), lebt in Minsk. Seit 1984 verh. mit Sjargej Aljaksandravič Cimochaǔ. Bis 1980 Besuch der Internatsschule für bild. Kunst und Musik in Vitebsk. Noch während der Schulzeit erste Veröff. von Zchngn in der in Minsk erscheinenden Kinder- und Jugend-Zs. Bjarozka. Bis 1985 Stud. der Buchgraphik an der Polygraphie-HS in L'vov (L'viv). 1986 übersiedelt C. mit ihrem Ehemann nach Polock (Polack/Gebiet Vicebsk); seit 1999 leben sie in Minsk. Ausz.: 1994, '95, '96 Dipl. des internat. Wettb. für Buchkunst, Minsk. – Nach dem Stud. wird C. für das in Minsk ansässige staatliche Verlagshaus Junactva tätig, wo sie unter der künstlerischen Ltg von Nikolaj Romanovič Kozlov mit renommierten Illustratoren wie Mikalaj Michajlavič Seljaščuk, Valeryj Pjatrovič Slavuk und Uladzimir Pjatrovič Savič zusammenarbeitet. Zunehmend etabliert sie sich bes. mit ihren an graph. erfaßten Details, Farben und Farbnuancen reichen, oft ins Phantastisch-Arabeskenhafte ausgreifenden Ill. (v.a. Aqu.) zur zeitgen. Kinder- und Jugend-Lit. und gehört seit den 1990er Jahren zu den bekanntesten weißrussischen Künstlerinnen in diesem Bereich. Seit ca. 2004 wendet sich C. verstärkt dem Künstlerbuch zu und experimentiert mit Handbindungen, versch. Mat. für Buchdeckel und -block (u.a. Leder, textile Stoffe) sowie einer stärker beschränkten, zur Monochromie (häufig Braun- und Blautöne) tendierenden Farbpalette. Damit verbindet sich eine weitgehende Emanzipation von lit. Vorlagen. So entwickelt sie für das Buchobjekt *Veršy pra ptušak* (Gedichte über Vögel) eine von der Poesie des weißrussischpoln. Literaten Jan Barščěuski inspirierte, gleichwohl frei über Figuren und Handlungen extemporierende Bildwelt, die auch in der Buch-Gest. eine Entsprechung findet (Aqu.; Handbindung, Buchblock mit Lochungen und textilen Applikationen, 2005/06). – Ill. zu: Ja. Samalevič (Ed.), *Belaruskija zagadki,* Minsk 1989; G. Tumaš, *Lisica z Rasochi,* Minsk 2001; A. Minkin (Ed.), *Dobryja veršy. Belaruskaja veršavanka-zapaminanka dlja dzjacej,* 3 Bde, Minsk 2005; M. Kontoleon, *Polytima dora,* Athena 2009; E. A. Landin (Ed.), *Skazki detej Belarusi,* Minsk 2010.

▭ MÜNCHEN, Internat. Jugend-Bibl. POLACK, Mus. des weißrussischen Buchdrucks. ◉ *E:* Minsk: 2008 MMK; 2011 Gal. Belart; 2012 Kunst-Pal. – *G:* 2008 Minsk, Weißrussische NB: Wort und Bild / 2011 Belgrad: Internat. Bienn. der Ill. „Goldene Feder" / 2012 Lissabon, Mus. da Electricidade: Ilustrarte. ▭ 20. Bien. il. Bratislava (K), Bra. 2005 (s.v. Tsimokhava, Ryta); *M. Berlež,* Litaratura i mastactva (Minsk) 2010 (50) 8; *V. Paǔljučёnka,* ibid. 2011 (9) 8 (Interview); *A. Kavalenka,* Mastactva (Minsk) 2012 (4) 10 s. S. Görke

Činčerová, *Eva,* tschech. Graphikerin, Illustratorin, * 16. 11. 1943 Pelhřimov, † 31.(3.?) 1. 2005 Bystřice nad Pernštejnem. Stud.: 1962–68 ABK, Prag, bei Vojtěch Tittelbach. Danach ebd. freischaffend, ab 1991 in Jihlava. Ihr bevorzugtes Motiv ist der menschliche (nackte) Körper (*Dvě damy,* 1971; *Dvolice*), wobei sie oft in Zyklen arbeitet (u.a. *Dvojice,* 1976; *Portréty,* 1977/1988; *Činnost,* 1978; *6 aktů,* 1990). Häufig lenken scharfe Farbkontraste die Aufmerksamkeit des Betrachters auf die Figuren, die sich deutlich von einem unbestimmten, imaginierten Raum abheben; manchmal erscheinen sie starr und bewegungslos, manchmal dagegen wild, voller Grimassen, die das ganze Spektrum menschlicher Erlebnisse und Schicksale widerspiegeln. Auch großformatige Entwürfe für Textilkunst (Art protis), Tapisserien und Glas. Ferner Buch-Ill. (u.a. E. Zola, *Tereza Raquinová,* 1968; J. Moucha, *Sbirame motyly,* 1972; G. Flaubert, *Salambo,* 1973, alle Praha). Ausz.: 2009 (in memoriam) Preis der Stadt Jihlava. ▭ BRNO, Moravská gal. JIHLAVA, Oblastní gal. Vysočiny. OLOMOUC, Muz. umění. PRAG, NG. – GHMP. – Národní technické muz. ▭ Mein Zyklus Hiobsnacht, in: BK 1976 (2) 98 s. ◉ *E:* Prag: 1971 Gal. mladých (K); 1974 Gal. Československý spisovatel; 1982 Nová síň (K); 1987 Gal. Zlatá lilie (K: J. Mašín); 1999 Gal. Fronta (K: J. Mašín) / Jihlava: 1971, '82 Oblastní gal. Vysočiny; 2002 Gal. Jána Šmoka (mit Soňa Jurkovičová); 2009 Dům Gustava Mahlera / 1971 Brno, Dům pánů z Kunštátu (K) / 1973 Havlíčkův Brod, GVU (K) / 1974 Cheb, GVU (K). – *G:* ab 1969, u.a. 1972 Stockholm, NM: Tjeckoslovakisk grafik av idag / 1972, '76 Brno: Graphik-Bienn. / Prag, Gal. Hollar: 1977 Ilustrace v grafických technikách; 1999 Eros v evropské grafice v průběhu staletí; 1992 Gal. R: Česká kresba; 1989 Gal. Mánes: Současná česká grafika / 1986 Kladno, GVU: České výtvarné umění 20. století; Brno, Dům umění: Výzva 1986 / 1987 Biella, Pal. Ferrero della Marmora: Premio Internaz. / 1991 Krakau: Internat. Trienn. der Druckgraphik. ▭ SČSVU I, 1998; NEČVU, Dodatky, 2006. – *S. Petrová,* Mladá grafika, Praha 1980.

M. Knedlik

Cingolani, *Marco,* ital. Maler, * 21. 1. 1961 Maslianico/Como, lebt seit 1978 in Mailand. Bringt sich anfangs intensiv in die alternative Mailänder Kunstszene ein, die Kunst mit Mode und Punk verbindet. Vertritt eine neue künstlerische Haltung, welche die Wirklichkeit und v.a. deren verzerrte Vermittlung durch die Massenmedien kritisch befragt. Es entstehen anfänglich eine Folge von Interview-Darst. namhafter Persönlichkeiten, die für ihre Integrität bek. sind und durch Mikrofone bedrängt werden, sowie

Szenen zum Tod von Aldo Moro († 1978) und zum Papst-Attentat (1981). Ab E. der 1980er Jahre neoexpressionistische Gem., die Probleme und Konflikte der Städte thematisieren, z.T. unter Nutzung von Ausdrucksmitteln der Massenkommunikation. Später greift C. aus der Flut der TV-Informationen einzelne Fakten heraus, um diese in eine beziehungsreich-symbolische Dimension zu stellen (*Il ritrovamento del corpo di Aldo Moro*, 1996). Er ist fasziniert von Wirkungen, die Gesch. und deren Darst. wechselseitig aufeinander ausüben. Arbeitet ebenfalls an lit. und relig. inspirierten Themen. 2007 findet C.s bemerkenswerte Ausst. „Di che colore sono" (Modena, Gal.. Emilio Mazzoli) mit 51 bildlichen Reflexionen über Farben und Verkleidungen der Macht statt (z.B. Blauhelme, Wall-Street-Diagramme, Uniformen, Parteifahnen). 2009 bekennt er sich zu seiner christlichen Grundhaltung in der Ausst. „Percorsi della Fede", worin er Marienerscheinungen in Lourdes und Fatima schildert. C. ist Prof. an der Accad. Carrara di BA in Bergamo. Nicht zu verwechseln mit dem gleichnamigen Bildhauer (* 1985 Recanati). ⌂ GENT, Sted. Mus. voor Actuele Kunst. PRATO, Centro per l'Arte Contemp. Luigi Pecci. ◉ *E:* 1987, '89 Mailand, Gall. Diagramma / 1992, 2001 Turin, Gall. In Arco; Valdagno, Gall. Loft / 1995 Modena, Gall. Mazzoli (K: G. Romano) / Como: 1996 Villa Olmo; 2011 Pal. del Broletto / 1997 San Gimignano, GA Continua; Rom, Univ. La Sapienza, Mus. e Laboratorio di Arte Contemp. / 1998 Berlin, Gal. Raab / 1999 Siena, Gall. Bagnai (K: A. Bonito Oliva) / 2000 Nuoro, Mus. d'Arte (K: L. Beatrice u.a.) / 2002 Florenz, Pal. Strozzi; Rom, Gall. Borghese (K: L. Cherubini u.a.) / 2004 Rimini, Gall. Fabjbasaglia / 2007 Mailand, Antonio Colombo Arte Contemp.; Modena, Gall. Mazzoli / 2009 Verona, Boxart Gall. – *G:* Mailand: 1986 Gall. Diagramma: Some like it cold; 1993 Studio Cannaviello: Immagini di pitt. / 1988 Lanciano, Ponte di Diocleziano: Italia nuova (K: L. Mango) / 1991 Wien, Mus. des 20. Jh.: Zeitgen. Kunst aus Norditalien; Prato, Mus. Pecci: Una scena emergente (K: A. Barzel/E. Grazioli); 2000 ebd.: Futurama / 1993 Modena, Gall. Mazzoli: Pentalogo / 1995 Pescara, Ex Liquorificio Aurum: Fuori Uso / 1996 Como, MCiv.: Mitologie e archetipi (K: L. Caramel) / 2001 Triest, Mus. Revoltella: Odissea dell'arte / 2004 Siena, Pal. delle Papesse: De gustibus / 2005 Rom, GNAM: Quadrienn. / San Gimignano, Gall. Continua: Senza Confine / 2006 Turin, Pal. della Promotrice delle BA: Senza famiglia / 2008 Perugia, Pal. della Penna: Viva l'Italia / 2009 Venedig: Bienn. ⌷ Arte contemp. ital., Novara 1996; Cat. dell'arte mod. ital., Mi. 1996; Diz. degli artisti ital. contemp., Mi. 1996. – *E. Grazioli*, Flash art 1987 (136); *G. Ciavoliello*, ibid. 1990 (158); *N. Cobolli Gigli/M. Zanelli*, Arte 22:1992 (233) 90–97; *E. Grazioli u.a.*, C., Genf 1992; *F. Nyffenagger*, Opus internat. 1993 (131) 27 ss.; PittItalNovec/3, 1994; *L. Beatrice/C. Perella*, Dodici pittori (K), T. 1995. – *Online:* Website C. – Mitt. N. Corradini. S.-W. Staps

Cinto, *Sandra*, brasil. Installationskünstlerin, Fotografin, Zeichnerin, Malerin, Graphikerin, * 1968 Santo André, tätig in São Paulo. Stud.: 1990 Fac. Integrada Teresa D'Ávila, Santo André. Lehrtätigkeit: 1991 Laboratorio de Est. e Criação der Pin. do Estado und MAC der Univ., São Paulo; seit 1998 Fac. de Artes Plást. der Fund. Armando Álvares Penteado und Ateliê Fidalgo ebd. Ausz.: 1989 Prêmio Canson de Arte com Papel, São Paulo; 2005 Artist in Residence, Civitella Ranieri Found., Umbertide. – C. debütiert mit leuchtend blau-weißen Darst. von Wolken, Himmel und Nachthimmel, die zunehmend stilisiert werden. Es entstehen großformatige Gem. (Acryl/Holz oder Lw.), die meist monochrom in Schwarz, Weiß und Dunkelblau gehalten sind und wellen-, voluten- und sternförmige, strudelnde, netzartige, manchmal auch kristalline und dicht strukturierte Motive aufweisen. Einige ihrer frühen phantastischen Werke erinnern an René Magritte. C.s Zchngn zeigen Treppen, Leitern, Brücken, Abgründe, Kandelaber, brennende Kerzen, Bäume ohne Blätter und Früchte, die wiederum an das Werk von José Leonilson Bezerra Diaz erinnern. Einige Farb-Fotogr. der späten 1990er Jahre lichten Körperteile wie Fuß oder Arm vor einer hautfarbenen Wand ab; Haut und Wand sind durchgängig mit Bäumen und and. Motiven bezeichnet, so daß erst auf den zweiten Blick die versch. Träger und das subtile Spiel der Bildebenen auffallen. Ähnlich angelegt sind *Memory* oder *Table* (beide 1999), bei denen weiß gestrichene Möbelstücke (Bücherschrank, Hocker, Badewanne) vor weißen Wänden plaziert werden und auch hier phantastisch-surreale, leichthändige Zchngn mit sich wiederholenden Elementen in schwarzem Kugelschreiber tapetenartig über Wände und Möbel hinweg ausgef. werden. C. schafft fein ziselierte, dünnlinige Zchngn auch auf mit Acryl grundierten MDF-Platten, die teilw. Wandgröße erreichen. Zudem verwendet sie Fotogr. mit ihrem eig. Portr. oder liegenden Körper, die sie mit and. Objekten wie Holz-Skulpt. in Form von Betten oder Büchern in Zusammenhang bringt. Wichtiges Element sind auch die Bilderrahmen, deren Schmalseiten oftmals bez. oder bemalt sind; diese Objekte eröffnen meist mehrere unabgeschlossene Narrative und bleiben einer bewußt unbestimmten Sprache verhaftet; sie stellen Realität und Traum nebeneinander vor. Für die Installation *Under the Sun and the Stars* (2004) baut C. in einen größeren Gal.-Raum einen schmalen, von oben beleuchteten Raum aus blau gestrichenen Holzpaneelen, an denen 55 gerahmte Fotogr., u.a. von Händen und Möbelstilleben hängen, die in eben jenem Raum fotografiert wurden. Es entstehen auch skulpturale Arbeiten wie *Untitled (Self-Portr.)*, 2001, bei der ein großer querformatiger, monochromer C-Print im bemalten Holzrahmen mit einem bronzenen Arm verbunden wird, der von der unteren Rahmenleiste auf den Boden zu hängen scheint. Für die Ausst. Imitação da água im Inst. Tomie Ohtake 2010 greift C. wiederum die Wellen- und Sternformen auf und gestaltet Meeresbilder in Blau und Weiß mit delikat-poetischen, jugendstilhaften Umriß-Zchngn und in Streifen gestaffelten Farbverläufen. In jüngerer Zeit entsteht außerdem die Installation in Hellblau (*Solar*, 2011), die versch. Möbelstücke, eine große Kugel und ein Karussellpferd vor mit bunter Folie abgeklebten Fenstern vereint. – 2002 Gest. des Prêmio Multicult. Estadão, der in São Paulo vergeben wird. Auch Kinderbuch-Ill. (K. Canton, *Os Desenhos*

Mágicos , S. P. 2003). ⌂ Brumadinho, Centro de Arte Contemp. Inhotim. Rio de Janeiro, MAM, Col. Gilberto Chateaubriand. San Diego, MAC. Santiago de Compostela, Centro Galego de Arte Contemp. São Paulo, MAM. – Pin. Mpal. ⊙ *E:* 1992 Rio de Janeiro, Gal. Macunaíma da Funarte (Debüt) / São Paulo: 1998 (K), 2001, '02 (K) Casa Triângulo; 2003 MAM; 2010 Inst. Tomie Ohtake (K); 2011 Espaço Cult. Edmundo Vasconcelos / 2003 Belo Horizonte, Mus. de Arte da Pampulha / 2004, '08, '11 New York, Tanya Bonakdar Gall. / 2005 Waltham, Mass., Rose AM (K). –. *G:* 1997 Salvador, Salão da Bahia / São Paulo: 1998 Bien.; MAM: 2000 Desenho contemp. Módulo I; 2005 O Retrato como imagem do Mundo; 2006 Sem título 2006. Comodato Eduardo Brandão e Jan Fjeld / 2000 Belo Horizonte, Itaú Cult.: Investigações. São ou não são gravuras (Wander-Ausst.); Paris, CNAC: Elysian Fields / 2001 Washington (D. C.), NM of Women in the Arts: Virgin Territory. Women, Gender and Hist. in Contemp. Brazil. Art / 2002, '04 Rio de Janeiro, MAM: Col. Gilberto Chateaubriand Novas Aquisições / 2004 Providence, David Winton Bell Gall.: Invisible Silence (K). ▢ *N. Israel*, Artforum 38:2000 (8) 132 s.; *T. Chiarelli*, Arte contemp. atelier do artista. A experience de fazer arte no Brasil. S. C., Mônica Nador, S. P. 2001; *D. Barro/ P. Reis*, S. C. A Travessia difícil, Santiago de Compostela 2006; *D. Perez*, Flash art 2009 (264) 105; *P. Reis*, Art nexus 2010 (75) 74–79. C. Melzer

Ciobanu, *Mircea*, rumänisch-schweiz. Maler, Bildhauer, Entwurfszeichner, Bühnenbildner, Autor, * 15. 4. 1950 Bukarest, † 9. 1. 1991 Genf. Stud.: 1969–73 HBK N. Grigorescu, Bukarest, u.a. Malerei bei Corneliu Baba. Studienreisen 1978 nach Paris und 1980 nach Brüssel. 1981 emigiert C. seiner Frau Ada-Michaela in die Schweiz mit Wohnsitz in Lausanne, ab 1989 in Genf. Wird 1983 dort Mitgl. der Freimaurerloge Horatio Nelson im Grand Orient von Italien. Ab M. der 1970er Jahre arbeitet er an einem Roman zur Ästhetik des Todes. Motive und Sujets für seine bildkünstlerischen Arbeiten entnimmt C. den Grenzbereichen zw. jüdisch-christlicher Relig. und Ikonogr., freimaurerischem Ideengut, antiker und ma. Philosophie sowie buddhistischen Strömungen. In pastosem, starkfarbigem Pinselduktus schafft er narrativ-visionäre, symbolhaltige Figurenbilder, Stilleben, Lsch. und (Selbst-)Portr., die sich formal und inhaltlich häufig an Meisterwerken (Bosch, Rembrandt, Greco, Goya, Gogh) und Epochen der Kunstgesch. orientieren (z.B. Manierismus, venez. Malerei). Ein oft auftretendes Motiv ist der traurig-melancholische Harlekin. Für seine kraftvollen Bilder läßt sich C. häufig vom neutestamentlichen Buch der Offenbarung inspirieren. Ab 1985 auch bildhauerische Arbeiten, v.a. Skulpt. und Portr.-Büsten (Ton, Gips, Holz, Keramik, Bronze), teilw. in byz.-orthodoxer Trad. mit Blattgold belegt. Der Nachlaß ist verstreut. – Monogr. Bearbeitung und WV stehen aus. ⌂ Saint-Sulpice/Waadt, Chap. St-Claire: Wandfresken, Glasmalereien, 1983. ⊙ *E:* 1979 Bukarest, Rathaus-Gal. / 1980 Brüssel, Gal. Baron René Steens / 1983 Bern, Gal. Nydegg; Basel, Gal. Daniel Blaise Thorens / 1984 Paris, Gal. Katia Granoff / 1990 Lausanne, Gal.

Valsyra / 1996 Bukarest, Parlament, Ausst.-Saal (Retr.). ▢ KVS, 1991; BLSK I, 1998. – *M. C./P. Ferla*, Ciobanu dit, Lausanne 1985 (Interview); *G. Nerét*, M. C. (K), Lausanne 1985. – *Online:* Website C. U. Heise

Ciobanu, *Radu*, rumänischer Bildhauer, * 20. 3. 1963 Brașov, lebt seit 1987 in Satu Mare. Stud.: bis 1986 ABK G. Enescu, Iași. Ausz.: 1997 Stip. des rumänischen Künstler-Verb.; 1996 Preis des Kultur-Minist., Gheorghe-Petrascu-Bienn. Târgoviște. Zw. 1986 und 1990 Teiln. an nat. Bildhauersymposien in Săliște, Oarba de Mureș, Străulești und Satu Mare. – Einflüsse Moores, Brâncușis und Rodins sind schon früh, auch in kleinplastischen Arbeiten, auszumachen. Seit 1990 Spezialisierung auf Freiraumplastik in Bronze, darunter mehrere mon. Portr.-Büsten bed. rumänischer Persönlichkeiten. Im Laufe der 1990er Jahre entstehen zahlr. (mon.) Skulpt. zu relig. Themen, häufig Madonnen-Darst., auch für öff. Standorte in Dortmund, Düsseldorf und New York City. C. arbeitet häufig im Auftrag der niederl. Fa. Stadelmaier, Nijmegen. ⌂ *Büsten (Bronze):* Craidorolt-Satu Mare: Iuliu Coralanu, 1995. Gherta Mica: Decebal, 1993. Satu Mare: Iuliu Maniu, 1994. Tușnad, Grigore Moïse, 1995. – *Monumente:* Moftiu – Satu Mare: Denkmal Mihai Viteazul, Obelisk, Relief, 1996. Ploiești, Denkmal Ion Luca Caragiale, 2012. Satu Mare: Denkmal zu Ehren ehem. politischer Gefangener, Zement, 1996. – Statuia Lupoaicei, Stein, Bronze, 1992. ⊙ *E:* zahlr. seit 1986, u.a. 1995 Budapest: Rumänisches Kulturzentrum / 1997 Cluj-Napoca, Muz. Naț. de Artă / 2004 Toronto: Arts on King and Queen Gall. / 2006 Satu Mare, Muz. de Artă (Plastiken C.s aus der Slg Heller). –. *G:* zahlr., u.a. 1993 Ravenna: Bienn. Dantesca / 1995, '97, '99 Arad: Nat. Kleinplastik- und Graphik-Ausst. / 2000 Budapest: Hungexpo. ▢ *A. Cebuc u.a.*, Enc. artiștilor români contemp., III, Bu. 2000; *P. Matei*, Artiști plastici brașoveni contemp., Brașov 2000. – Informația Zilei (Satu Mare) v. 30. 1. 2011. B. Scheller

Ciol, *Elio*, ital. Fotograf, Filmemacher, * 3. 3. 1929 Casarsa della Delizia, lebt dort. Vater des Fotografen *Stefano* C. Ausb. beim Vater (Lokalfotograf). Arbeitet danach zunächst als Ortsfotograf. 1951 erste Reise nach Assisi, wo er fortan wiederholt fotografiert. Ab M. der 1950er Jahre dreht C. auch Dokumentarfilme und nimmt an Film-Wettb. teil. 1956 trifft er Carlo Mutinelli und wird Mitbegr. der Ass. per un Arch. Artist. del Friuli. Reist 1957 nach Süditalien, 1960 nach Lourdes. 1961 lernt er Luigi Crocenzi kennen, dessen narrative Bildmethode er sich aneignet und mit dem er 1963 in Mailand die kurzlebige Fond. Arnaldo e Fernando Altimani per lo studio [...] realisiert. 1963 Fotogr. von der Überschwemmungskatastrophe in Vajont. 1962 im Auftrag von David Maria Turoldo offizieller Fotograf für den Film Gli ultimi (Turoldo e „Gli ultimi". E. C. *fotografo di scena*, Mi. 2001). 1967 in Palästina (A. Spada, *Palestina. Porta del mondo*, Ge. 1978). Arbeitet auch in der Schweiz, in Frankreich, Griechenland, den USA (Yosemite-Park), im Jemen und in Kenia. 1975 vermittelt der Kritiker Alistair Crawford C. eine Wander-Ausst. in Großbritannien. 1991 wird C. mit Fotogr. der Skulpt. von

Donatello in der Basilica di Sant' Antonio in Padua beauftragt (J. Pope-Hennessy, *Donatello scultore*, T. 1993). In den letzten Jahren versch. gemeinsame Buch-Publ. mit seinem Sohn. Ausz. u.a.: 1992, '96 Kraszna-Krausz, London; 1993 Premio San Marco, Pordenone; 1995 Premio Speciale Friuli-Venezia Giulia, CRAF Spilimbergo. Mitgl.: 1953 Mitbegr. des Circolo Foto-artist. Casarsese (bis 1962), der sich der Dok. des bäuerlichen Friaul widmet; 1955–60 Circolo Fotogr. La Gondola, Venedig; 1955–64 Cineclub, Udine. – C. ist ein bed. ital. Fotograf der Nachkriegszeit. Zu seinen wesentlichen Themen gehören neben Lsch., Kunst-Reprod., Archit., Fresken und Archäol. auch Menschen und deren Leben, Arbeit, Handwerk und Brauchtum (u.a. Hochzeiten, Beerdigungen, Prozessionen). C. dokumentiert (und publ.) das Land, das Alltagsleben und bes. das kulturelle Erbe von Friaul. U. a. hilft sein umfassendes Arch. bei der Rekonstr. nach den Erdbebenschäden von 1976. Er fotografiert aber auch Venetien, die Lsch. um Mailand, Süditalien sowie Sakral-Archit. in and. Regionen. A. Crawford (*Assisi*, 1991) vergleicht C. mit Vorläufern aus dem 19. Jh. wie den Fratelli Alinari oder James Anderson. In den 1950er Jahren arbeitet C. zunächst – den zeitgen. Stilformen etwa der Gruppe La Gondola oder der Subjektiven Fotogr. entsprechend – mit graph.-formalen Komp.; frühe abstrahierende Bilder zeigen Spuren, Abdrücke und Schatten; auch arbeitet er mit Bildsequenzen. C. fotografiert zunehmend mit beobachtenden Bildern Straßenleben (Kinder, Alte, Mimiken, Gesten) sowie Portr.; stärker als ein kritisches soziales oder politisches Interesse ist aber seine Suche nach Ausgewogenheit, Schönheit und einer graph. Transformation von Licht in Bild-Gest. (u.a. in den Publ. *Ascoltare la luce*, Sottomarina di Chioggia 2003; *La luce incisa* [K], Pieve di Soligo 2008). Silvia Paoli hält daher den Begriff „Neorealismus" bei C. für weniger geeignet (in: *Gli anni del Neorealismo*, 2009). Wichtigstes Langzeit-Thema C.s ist die Basilika von Assisi, die er mehr als 40 Jahre detailliert erfaßt und umfassend publiziert. Zeigt C. zunächst den Bau und das Leben um Assisi noch dramatischer und gestalterisch überhöht, so werden seine Darst. zunehmend ausgewogen und menschenleer; in Gegenüberstellungen der Kirchen-Archit. und Ausmalung mit der umgebenden Lsch., den Orten und ihren Bewohnern sucht er nach einer zeitlosen bildlichen Einheit von Raum, Leben und Kult. Lt. Crawford (1991) hat C. mit Assisi ein Beispiel für einen Ort gefunden, „an dem die Beziehung zw. Mensch und Erde, zw. dem Menschen und den Werten des Lebens ihre Harmonie wiederentdeckt". Mit seinem „relig. Naturalismus" (Paoli, 2009) und technischen Perfektionismus wird C. auch mit Ansel Adams verglichen. C. arbeitet häufig mit Infrarot-Schwarzweißfilm, der Grauwerte v.a. von Naturmotiven verfremdet und die fotografierten Lsch. aus dem Realkontext rückt; seit den 1970er Jahren arbeitet C. auch in Farbe. – Foto-Publ. u.a.: *Assisi*, Pd. 1969; G. Chiaramonte (Ed.), *Italia black and white*, Mi. 1978; *Venezia*, Mi. 1995; *Dove l'infinito è presente*, Tricesimo/Ud. 1996; *La provincia bella*, Mi. 1998 (mit Stefano C.); G. Bergamini (Ed.), *Cinquant'anni di fotogr* (K), Mi. 1999; R. Mutti (Ed.), *L'enchantement de la vision* (K), Ud. 2000; *Il fascino del vero* (K), Cornuda 2004; *Naturali armonie*, Feltre, 2005; *Nel soffio della storia* (K) und *Concrete astrazioni* (K), beide Pieve di Soligo 2007; *Friuli Venezia Giulia*, Sommacampagna 2007; *Tornare a Venezia*, Pieve di Soligo 2008; *Terre di poesia – fotogr. 1950–2007* (K), Ve. 2009; *Gli anni del Neorealismo* (K), T. 2009; *Il volto e la parola* (K), T. 2009; *Assisi. La densità del silenzio* (K), Pieve di Soligo 2011. ⌂ ABERYSTWYTH, Univ. ASSISI, GAC. AUSTIN, Univ. of Texas, Humanities Research Center. CHARLEROI, Mus. de la Photogr. CHICAGO, Art Inst. LONDON, V & A. MONTREAL, Canad. Centre for Archit. NEW YORK, Metropol. Mus. PRINCETON /N. J., Univ. AM. ROCHESTER/N. Y., George Eastman House. ST. PETERSBURG, RosPhoto. TUCSON/Ariz., Center for Creative Photogr. UDINE, Mus. Diocesano & Gall. del Tiepolo. ⊙ *E:* Mailand: 1962 Bibl. Com.; 1963 Ambroseaneum / 1963 Sesto San Giovanni, Centro Cult. Ricerca / Pordenone: 1968 Gall. Sagittaria (Wander-Ausst.; K); 2004 Provincia di Pordenone (Wander-Ausst.; K); 2009 Convento di San Francesco (K) / 1977 Aberystwyth, Univ. of Wales (Wander-Ausst.; K) / 1993 Dakar, Ist. Ital. di Cult. (Wander-Ausst.) / 1996 Assisi, Gall. Le Logge (K) / Udine: 1999 Civ. Mus., Ex Chiesa di S. Francesco (K); 2006 Mus. Diocesano & Gall. del Tiepolo / 2000 Paris, Cité Internat. Univ. (K) / 2000, '01 New York, J. Bateman Gall. / 2002 Padua, Pal. del Monte di Pietà (Wander-Ausst.) / 2005 Feltre, Gall. De Faveri Arte / 2007 Motta di Livenza, Centro arti visive La Castella und Pal. La Loggia (K); Rimini, Meeting per l'amicizia tra i popoli (mit Pepi Merisio) / 2008 Muggia, Comune di Muggia (K) / 2009 Mestre, Centro Cult. Candiani (K); Sejny (Polen), Biała Synagoga (Wander-Ausst.); Passariano, Villa Manin (K); Casarsa della Delizia, Centro Studi P. P. Pasolini / 2010 Brescia, Gall. dell'Incisione / 2011 Moskau: Russ. ASK (Wander-Ausst.; K). – *G:* 1959 Rom, Assoc. Fotogr. Romana: Circolo Fotogr. La Gondola / 1960 Venedig, Fond. Bevilacqua La Masa: Circolo Fotogr. La Gondola / 2003 Padua: Fotopadova / 2006 Pordenone: In hoc signo / 2011 Triest, Magazzino 26: I fotografi di Zannier. ⌸ *Falossi*, PPC, 1975. – *V. Babington Smitz* (Ed.), Internat. directory of exhibiting artists, II, Ox./Santa Barbara 1982. – *E. Belluno*, Il Duomo di San Marco a Pordenone, Ud. 1969; *G. Bergamini*, Giovanni Antonio Pilacorte lapicida, Ud. 1970; *A. Forniz* (Ed.), Arte poco nota dell'Ottocento nel Friuli occidentale (K), S. Vito al Tagliamento 1971; *G. Clonfero*, La cerchia murata di Venzone, Ud. 1971; L'Ospedale civile S. Maria degli Angeli Pordenone, s.l. 1971; *P. Goi*, Lapicidi del Rinascimento nel Friuli occidentale (K), San Vito al Tagliamento 1973; *M. Buora*, Arte prov. romana nel Friuli (K), San Vito al Tagliamento 1974; *L. Perissinotto*, Archit. sacra nella Diocesi di Udine, Ud. 1975; *C. Gaberscek* (Ed.), Scult. in Friuli. L'alto Medioevo (K), San Vito al Tagliamento 1977, '78; *G. Milossevich/M. Bianco Fiorin*, I Serbi a Trieste, Ud. 1978; *C. Gaberscek* (Ed.), Scult. in Friuli. Il Romanico (K), San Vito al Tagliamento 1981; *M. Pozzetto*, Il Nuovo Giorno, Ud. 1982; *E. Bartolini u.a.*, Raccontare Udine, Ud. 1983; *M. Buora* (Ed.), Dall'epoca roma-

na al gotico, Sequals 1985; *I. Zannier*, Storia della fotogr. ital., R./Bari 1986; *G. Mazzariol/A. Dorigato*, Donatello, Pd. 1989; *A. Crawford*, Assisi. E. C., Mi. 1991; Segni del sacro (K), Pordenone 1998; *G. Fiaccadori* (Ed.), Arte in Friuli-Venezia Giulia, Ud. 1999; *L. Perissinotto*, Atti dell'Accad. San Marco di Pordenone 1999 (1) 153–180; *E. Fuchs-Hauffen*, in: *U. Jung-Kaiser* (Ed.), Laudato si, mi Signore [..], Bern u.a. 2002, 319–335; *G. Malafarina* (Ed.), La Basilica di San Francesco ad Assisi, Md. 2005; *G. Fossaluzza*, Gli affreschi della scuola dei battuti di Conegliano, Conegliano 2005; *D. Santamaria* (Ed.), Bienn. di Alessandria (K), Albissola Marina 2008. – Publ. mit Stefano C. u.a.:*U. Trame* (Ed.), L'abbazia di Santa Maria di Sesto al Reghena, Genf 2000; *G. Benazzi* (Ed.), Pintoricchio a Spello, Cinisello Balsamo 2000; *G. Bonsanti* (Ed.), La basilica di San Francesco ad Assisi, Md. 2002; La facciata del duomo di Orvieto, Cinisello Balsamo 2002; Friuli Venezia Giulia, Vr. 2007. – Casarsa della Delizia, Arch. C. – *Online:* Website C. T. Koenig

Cipullo, *Aldo,* US-amer. Schmuckgestalter, Designer ital. Herkunft, * 1935 Rom, † 31. 1. 1984 New York. Entstammt einer Fam., die eine Fa. für Modeschmuck betrieb. Nach Stud. an der Univ. in Rom geht er 1959 nach New York zur weiteren Ausb. an die School of Visual Arts. Anschl. für David Webb, Tiffany und ab E. der 1960er Jahre für Cartier tätig. 1974 Eröffnung des eig. Ateliers. Ausz.: 1974 Coty Amer. Fashion Critic's Award for Men's Wear Jewelry. – Berühmtheit erlangt C. mit dem 1969 für Cartier entworfenen Armreif *Love Bracelet* aus Gelbgold, der paarweise als Symbol der Zusammengehörigkeit verkauft wird. Nach der Idee des ma. Keuschheitsgürtels wird jeder Reif durch zwei winzige Schrauben mit eigens mitgelieferten vergoldeten Schraubendrehern am Handgelenk des Partners verschlossen. Zu prominenten Besitzern des *Love Bracelet* gehörten u.a. Elizabeth Taylor und Richard Burton, Sophia Loren und Carlo Ponti oder auch das Herzogspaar von Windsor. 1979 gab Cartier eine mit Diamanten besetzte Version heraus. Inspirationen für C.s originelle, elegante Schmuckkreationen liefern neben dem Interesse an Gesch. und hist. Entwürfen auch Alltägliches wie Nägel, Seile, Knoten, Dollarzeichen, Pastaformen etc. Kräftige Farbkontraste entstehen durch die Einbeziehung von Edel- und Halbedelsteinen (häufig Onyx, Karneol). Von C. stammen darüber hinaus Entwürfe für Silbererzeugnisse, Textilien, Porzellan sowie Schreibwaren. ▭ Dict. internat. du bijou, P. 1998. – *W. R. Greer*, The New York Times v. 3. 2. 1984 (Nekr.). – *Online:* Fashion for jewelry; Jewelry day v. 11. 4. 2009 (* 1936). C. Rohrschneider

Ciracì, *Sarah,* ital. Computer-, Video- und Installationskünstlerin, * 1972 Grottaglie, lebt in Mailand und New York. Ihre fotogr. Arbeiten und Videos sind u.a. maßgeblich inspiriert durch Sience-fiction-Filme und -Lit. mit ihren pseudo-wiss. Theorien über and. Welten sowie durch die sog. Fuzzy-Theorie. C. realisiert visionäre Konstrukte von Zukunft und stellt Verbindungen zw. Gehirn, künstlicher Intelligenz und Mystik her, deren Grenzen oft fließend sind, um neue Fenster der Phantasie und Kreativität in einer immer technisierteren Welt zu öffnen. C.s Ar-

beiten sind charakterisiert durch die Schaffung von Parallelwelten aus Realität und Metaphern, die die aus versch. Zusammenhängen entnommenen Bilder zerlegt, manipuliert und neu komponiert. Mittels digital bearbeiteter Fotos, bildüberlagernder Skripte, Videos und Installationen kreiert sie extreme Lsch. und lebensfeindliche Umgebungen, deren Wahrnehmung unsere gegenwärtige Weltsicht vertiefen kann. Mit ihrem auf Marcel Duchamp verweisenden Projekt *Glass-Box* (1999) erzeugt sie (mit digital bearbeiteten Fotos auf einer Art Tapete) Wüsten- und Wasser-Lsch., die von einem and. Planeten aufgenommen zu sein scheinen. 2003 u.d.T. *Archit. fluttuanti su scorrimenti energetici della terra* erste Vorarbeiten zu ihrem Video *2012.* In Venedig 2011 am Projekt BYOB (Bring your own beamer) im Internet Pav. beteiligt. Ausz. u.a.: 1995 1. Preis der Ratti Stiftung; 2003 Premio New York (Auslands-Stip. des ital. Außen-Minist.). ◉ *E:* Rom: 1998 GNAM; 2002 Gall. Sales; 2004 MAC (K: D. Eccher/K. Gregos) / 1999 Mailand, Gall. Emi Fontana / 2003 Kiel, Gal. Enja Wonneberger / 2006, '08 Neapel, Blindarte Contemp. / 2008 Tarent, Pal. Pantaleo. – *G:* 1995 Trevi, Flash AM: We are moving; Savona, Centro S. Andrea: Femmine folli (K: F. Pennone) / 1998 Amsterdam, De Appel: Seamless / 1999 Bellinzona, Centro d'Arte Contemp. Ticino: 999; Paris, Centre Cult. Suisse: Anderweit 3 / 2001 Vilnius, Contemp. AC: Magic & Loss / 2003 Berlin, Kunst-Werke Berlin: Animations / 2004 Belgrad, BELEF Center: Articulation; Kanazawa, MCA: Polyphony – Emerging resonances / 2005 Verona, Studio La Città: aniMotion / 2006 Benevento, MAC: Ai confine dell realtà / 2007 Rom, MN delle arti del XXI sec.: Apocalitti e integrati – Utopia nell'arte ital. di oggi (K: A. Matteoli); Viterbo, S. Maria della Salute: Cantieri d'Arte – La città dei biSogni / 2010 Neapel, MAC Donna Regina (MADRE): Transparency. Art for Renewable Energy / 2011 Venedig: Bienn. ▭ Diz. degli artisti ital. contemp., Mi. 1996. – *H. Kontova*, Flash art 1995 (192); *G. Dorfles*, Corriere della sera v. 31. 10. 1996; *R. Barilli* (Ed.), Officina Italia. Rete Emilia Romagna (K); Bo. 1997; *T. Conti*, tema celeste 1998 (68) 48–79; *L. Beatrice*, Flash art 1999 (215); *L. Cerizza* u.a., Espresso. Arte oggi in Italia, Mi. 2000; *J. Chert/S. Menin*, Flash art 2002 (233); *S. Tholund*, Kieler Nachr. v. 16. 3. 2002; *K. Gregos*, S. C., Mi. 2003; *V. Tanni*, Flash art 2004 (247); *S. Brunetti*, Juliet 2004 (120). – *Online:* Ital. area. Ital. contemp. art arch.; Blindarte Contemp.; Vimeo. S.-W. Staps

Ciscato, *Sonia,* ital. Malerin, * 8. 4. 1942 Schio, lebt in Bergamo. Ausb.: Ist. Adolfo Venturi in Modena (1960 Dipl. Maestro d'Arte). Stud.: 1958–64 Accad. Carrara in Bergamo, bei Trento Longaretti; Accad. di Brera in Mailand (Teiln. an Kursen für Bildhauerei bei Marino Marini und Alik Cavaliere). 1964 Ausst.-Debüt in Bergamo (Gall. La Garitta). 1962–64 kurze Hinwendung zu Informel mit zahlr. Mat.-Experimenten (Sand, Farbpigmente, Gold). – C. beschäftigt sich seit ihren künstlerischen Anfängen bis heute mit dem menschlichen Körper als Archetypus von Leben. Anfangs, geprägt durch ihre bildhauerischen Exkurse, voluminöse, sehr präsente Körperlichkeit mit dem

Hang, die Bildgrenzen zu sprengen. Im Laufe ihres Schaffens bedient sich C. zunehmend wärmerer Farben und klarerer Formen; bevorzugt quadratische Bildformate. Bes. Augenmerk richtet sie auf Schmerz und Zerst. des menschlichen Körpers, wobei ihre Körper-Darst. Realitäten jenseits unserer Wahrnehmung kommunizieren. 2011 in Bergamo bei ArtDate zus. mit Mario Benedetti und Claudio Sugliani vertreten. ✉ *B. Pietroni/S. C.*, Tempi gemelli, Mi. 2005. ◉ *E:* 1982 Savona, Il Brandale Centro d'arte e cult. / Bergamo: 1971 Gall. 38; 1978 Gall. Fiumana; 1983 Gall. La Bottega del Quadro; 1990 La Diade Centro Studi; 1996 Teatro Sociale (K: M. G. Recanati); 1999 Gall. Ceribelli; 2005 GAMC / 1994 Pavia, Collegio Cairoli / 2000 Mailand, Gall. Ceribelli-Albini / Tarragona: 2000 Mus. d'Art (K); 2010 Moll de Costa / 2001 Barcelona, Avinguda de la Catedral (K) / 2008 Schio, Pal. Fogazzaro. – *G:* 1990 Calcio, Centro Cult. Don Giovanni Ramanzoni: Pensando all'oglio / Bergamo: 1993 Ex Chiesa della Maddalena: Disegni di pace per scenari di guerra; 1995 Centro Cult. delle Grazie: Varcare la soglia della speranza; 1999 Centro Cult. S. Bartolomeo: Un luogo per nascere; 2003 Pal. della Ragione: Arte a Bergamo 1970–1981; 2006 Chiostro di S. Marta: Dissonanze / 2010 Villanoaferru, Mus. Genna Maria: Sebbenchesiamadonne; Ranica, Villa Camozzi: 7 artiste per la ricerca; Treviglio, Mus.: Premio Città di Treviglio; Moskau, Nat. Centre for contemp. arts: Khlebnikov and visuality. ▭ Pitt. e scult. dell'Italia contemp., Mi. 1968; Otto Marzo. È per la donna (K), Be. 1986; *F. Rossi* (Ed.), Maestri e artisti. 200 anni della Accad. Carrara (K Bergamo), Mi. 1996; *S. Galimberti* (Ed.), Onori di casa. Artisti bergamaschi con l'Aler (K), Be. 2000. – *Online:* Prov. Bergamo; Diputacio de Tarragona. S.-W. Staps

Cissé, *Soly,* senegalesischer Maler, Zeichner, Bildhauer, Fotograf, Installations- und Videokünstler, * 1969 Dakar, lebt dort. Stud.: 1996 ENBA, Dakar; Ec. de Recherche Graphique, Brüssel. – Wie viele afrikanische Künstler setzt sich auch C. mit trad. und mod.-westlichen Wertvorstellungen auseinander. Er thematisiert u.a. die Folgen der Globalisierung, nat. Notstände, die Debatte um die sog. afrikanische Identität sowie die Selbst- und Fremdbestimmung des menschlichen Individuums im Allgemeinen. Im Zentrum seiner Werke (v.a. Acryl- und Ölbilder auf Lw. oder Papier, Pastelle, Kohle-Zchngn, Arbeiten in Mischtechnik) stehen Darst. von Menschen und Tieren, oft als Mischwesen bzw. in hypriden Formen gezeigt. Die Bildsprache ist offensiv, strapaziös, meist mystisch und alptraumhaft geprägt. Bandagierte Köpfe, fratzenartige Gesichter und entstellte Körper stehen symbolisch für Leid, Angst und Hilflosigkeit. Stilistisch verwendet C. gegenständliche und abstrahierende Formen, die er in spannungsgeladene Komp. zusammenfügt, oft auf anarchisch-spontane Weise. ▥ APT/Vaucluse, Fond. Blachère. ◉ *E:* u.a. Dakar: 1997 Centre Cult. Franç.; 1997, '99, 2001, '02, '05, '06 Gal. ATISS; 2008 Mus. de l'Inst. Fondamental d'Afrique Noire; 2010 Gal. Le Manège (mit Barthélémy Toguo) / 1999 Köln, Rautenbach-Joest-Mus. (K) / 2000 Leipzig, maerzgalerie / 2002 Douala (Kamerun), Gal. Mam / 2004 Saint-Brieuc (Côtes-d'Armor), MAH / 2005

Prato, Centro per l'Arte Contemp. Luigi Pecci / 2006, '07, '09 Paris, Mus. des Arts Derniers / 2008 München, Dany Keller Gal. / 2010 San Francisco (Calif.), Bekris Gall. (mit Malick Sidibé) / 2010, '11 Lissabon, Influx Contemp. Art / 2012 Seattle (Wash.), M. I. A Gall. – *G:* u.a. 1998 São Paulo: Bien. / 2000 Havanna: Bien. / Dakar: seit 2000 Dak'Art. Bienn. de l'art africain contemp. / 2002 La Laguna (Teneriffa), Ermita de San Miguel: Multiculturel / 2003 Brüssel, De Markten: Plasticiens en Mouvement; Espace Vertebra: L'Europe Fantôme / Paris: 2005 Mus. des Arts Derniers: Africa Urbis. Perspectives Urbaines; 2006 Mus. Dapper: Sénégal Contemp. / 2007 Kapstadt: Trans Cape / 2009 Berlin, Kunstraum Kreuzberg/Bethanien: Eine Tür, so schmal ? – La Porte étroite ?. ▭ *A. Gottberg,* Lex. afrikanischer bild. Künstler südlich der Sahara, L. 2009. – *O. Sultan,* Les Afriques. 36 artistes contemp. (K), P. 2004; *S. Njami,* Afrika remix. Zeitgen. Kunst eines Kontinents (K Wander-Ausst.), Ostfildern-Ruit 2004; *A. Delannoy* (Ed.), Terre Noire (K Saint-Germain-en-Laye), P. 2007.
C. Ritter

Çitçi, *Yildiz,* türkische Malerin, Textilgestalterin, * 1964 Istanbul. Stud.: 1981–85 Malerei an der Marmara Univ. ebd.; 1988 ebd. Dipl.; 1996–97 ebd. Kurse Mode-, Textil- und Kostümgeschichte. 1992–2000 Vorträge über abstrakte Malerei ebd. – Ç. beginnt 1984 mit abstrakten Gem. (Acryl/Lw.), deren Komp. geometrische Muster im Hintergrund und freie Tropfen und Striche im Vordergrund kontrastieren. Nach eig. Aussage möchte sie so einen expressiv-emotionalen und geometrisch-rationalen Ansatz verbinden. Mit dem Überschreiten der rechteckigen Lw.-Grenzen versucht sie zudem, ihre Gem. auch als dreidimensionale Objekte zu Skulpt. zu erweitern; seit 1989 auch als freistehende Objekte. Ab 1988 überträgt sie die Gest.-Elemente auch auf Textilien, Kleidung und Schmuck und faßt somit ihre Werke als allansichtige, bewegte Objekte auf. 1999–2000 gestaltet sie Installationen für Firmen bei Textilmessen in Istanbul. ◉ *E:* 1988 Stockholm, Gal. Puckeln (Debüt) / Istanbul: 1988 Gal. Baraz; 1989 Taksim Sanat Gal.; 1992, '08 Atatürk Cult. Center; 1999 Cercle d'Orient; 2004 Devlet Güzel Sanatlar Gal. / 1990 Ankara, Devlet Sanat Gal. / 2009 Wien, Mus. of Young Art (MOYA). – *G:* 2011 Florenz: Bienn. ▭ *K. Özsezgin,* Türk plastik sanatçıları, Istanbul 1994. – *Online:* Website Ç. (Ausst.). K. Schmidtner

Cito, *Claus* (eigtl. Cito, *Nicolas Joseph;* gen. *Josy*), luxemburgischer Bildhauer, Bühnenbildner, * 26. 5. 1882 Bascharage, † 5. 10. 1965 Pétange/Esch-sur-Alzette. Als Gymnasiast Besuch abendlicher Zeichenkurse an der städtischen KA in Arlon; anschl. Lehre bei einem Maler in Bascharage (Sommer 1899) sowie bei einem Kirchenmaler in Düsseldorf (ab Aug. 1900), wo C. ebenfalls Abendkurse an der KGS besucht (1901–03 Dekorationsmalerei bei Peter Behrens). Im Reg. der Stadtverwaltung Düsseldorf ist C. unter dem Namen Nikolaus Cito am 15. 8. 1900 als Anstreicher eingetragen. Durch die Vermittlung von P. Behrens erhält er Aufträge von der Dekorations-Abt. des Kaufhauses Tietz ebd. Ab Herbst 1900 Stud. an der KA ebd. (zunächst Malerei, aufgrund einer leichten Farbblind-

heit Wechsel zur Bildhauerei bei Karl Janssen); weiterhin Besuch von Abendkursen an der KGS (1903–04 Archit. bei P. Behrens; ab 1905 Bildhauerei bei Rudolf Bosselt). In Düsseldorf schließt C. Bekanntschaft mit Wilhelm Lehmbruck und befreundet sich mit August Macke, mit dem er ab 1906 zeitweise zus. wohnt und an Bühnenbildentwürfen für das neue Schauspielhaus arbeitet (C. wird zum künstlerischen Beirat ernannt, nachdem sein Bühnenbild für Elektra 1906 realisiert wird). 1908 Rückkehr nach Bascharage und Einrichtung eines Ateliers. Anläßlich eines Besuchs von A. Macke modelliert C. dort im Aug. dessen Portr.-Büste (verschollen; Abb.: Photothèque, Luxembourg). Läßt sich 1909 in Ixelles nieder und arbeitet dort im Atelier eines Bildhauers (lt. Braun-Breck vermutlich Charles Samuel); zudem besucht er Abendkurse an der KA in Brüssel (Aktzeichnen und Bildhauerei bei Paul Du Bois). 1912 Umzug nach Watermael-Boitsfort; dort eig. Atelier. – V.a. Grabmäler (z.B. *Kniende Grabfigur mit Blumengirlande*, 1926, Friedhof, Differdange), Denkmäler (v.a. Kriegerdenkmäler, z.B. *Mon. Hondsbësch*, 1945, Differdange; *Mon. aux Morts*, 1949, Rodange), Portr.-Büsten, bevorzugt aus Marmor (z.B. von General Albert Thys, dem Großherzogin von Luxemburg [u.a. 1912] und dem Dichter Nikolaus Welter [Bronze, 1930]) sowie Hll.-Figuren (z.B. *Herz-Jesu-Statue* [Grabmal A. Huss], Liebfrauenfriedhof, Luxemburg; *Statue der hl. Magdalena*, 1935, Pfarrk., Lamadeleine); weiterhin Reliefserien an öff. Gebäuden (z.B. 1937 Gemeindehaus, Esch-sur-Alzette; 1938 Rathaus, Pétange). C. wird ab E. der 1920er Jahre zeitweise durch drei Gehilfen unterstützt, die Bildhauer Emile Goedgen, Aloyse Weins und Aurelio Sabbatini. C.s Hw. ist das 1923 auf dem Luxemburger Konstitutionsplatz errichtete, aufsehenerregende *Mon. du Souvenir* (gen. *Ons Gëlle Fra*; 1921 Wettb.-Gewinn und Auftrag; 1940 Abriß; 1985 Wiedererrichtung). Nach Parisreisen im Sommer 1925 wandelt sich C.s bisher klassisch geprägte Formsprache, v.a. bei der Grabplastik und den Hll.-Figuren, deren gestreckte Körper Vergeistigung symbolisieren. Unverändert bleibt C.s Stil jedoch bei den v.a. 1925–31 zahlr. entstandenen Portr.-Büsten, für die eine starke Ähnlichkeit mit den Modellen kennzeichnend ist. ⌂ ESCH-SUR-ALZETTE, Friedhof: Grabmal der Fam. Franck-Cito (Maria Magdalena), Luxemburger Sandstein, 1908/09. LUXEMBURG, MN d'Hist. et d'Art. SCHAERBEEK, Parc Josaphat, Mon. Ernest-François Cambier (1914 fertiggestellt, 1919 eingeweiht). ◉ G: Luxemburg: 1989 MN d'Hist. et d'Art: 150 Ans d'Art Luxembourgeois (K); bis 1930 regelmäßig: Cercle artist.; 1927, '29, '30 Salon de la Sécession / 1910 (1. Preis), '35 Brüssel: WA / 1939 New York: WA / 2010–11 Bascharage, Hall 75: Gëlle Fra. ⌶ *Bénézit* III, 1999; C. Engelen/M. Marx, Beeldhouwkunst in België, I, Br. 2002. – L. Braun-Breck, C. C., 1882–1965, und seine Zeit, Luxemburg 1995. F. Krohn

Citroen, *Joseph Bernard (Bern. J.),* niederl. Schmuckgestalter, Juwelier, Fachautor, * 24. 8. 1891 Amsterdam, † 28. 3. 1972 Bergen/Noord-Holland. Vater von Bernard C. Stud.: 1908–10 Großherzogliche KGS, Pforzheim; Studienaufenthalte in Paris. – C. gestaltet Schmuck, v.a. Einzel-

stücke aus Gold und Silber, häufig kombiniert mit Edelsteinen, Perlen und Korallen (u.a. Broschen, Anstecknadeln), die auf internat. Ausst. ehrende Anerkennungen erhalten (z.B. 1925 auf der Expos. Internat. des Arts Decoratifs, Paris). Um 1920 übernimmt C. von seinem Vater in vierter Generation die Ltg der Import-Export-Handelsfirma und Schmuckfabrik „Joseph B. Citroen, Juweliers te Amsterdam". C. beteiligt sich an Ausst. (zuletzt Amersfoort 1969, '72) und ist in versch. Berufs-Verb. und als Fachautor nat. und internat. tätig. ✉ Nederl. monogr.-boek voor gouden zilversmeden, s.l. [Tilburg] 1941. ⌶ *Scheen* I, 1969; *Scheen*, Reg. van overlijden, 1996; Dict. internat. du bijou, P. 1998. – R. Barnde, J. C. Creator of jewels. Ontwerper van sieraden, Am. 1966. – *Online:* Joods Hist. Mus., Amsterdam; RKD. U. Heise

Ciuffi, *Wanderley,* brasil. Maler, Zeichner, Bildhauer, * 31. 1. 1942 Guaranésia/Minas Gerais, lebt in São Paulo. Autodidakt. 1969–78 in Embu ansässig. Illustriert 1976 den Volkswagen-Kalender Brasil. Fertigt 1978 die Wandmalerei *Arupembaria* im Hotel Urupema in São José dos Campos, wo er sich bis 1985 niederläßt. 1980 Umschlag-Ill. für das Buch *Cantar meu Povo* von Renata Pallottini. 1985 Übersiedelung nach São Paulo. 2001 Wandmalerei an der Außenfassade des Hauptsitzes des Partido Democrático Trabalhista in Embu. – In seinen dem Neoexpressionismus verpflichteten Malereien und Skulpt. setzt sich C. thematisch mit dem zwiespältigen Verhältnis des Menschen zu Natur und Kultur auseinander, der Liebe zum Ursprünglichen sowie dem Gefühl, ges. Zwängen ausgesetzt zu sein. ⌂ GUARARAPES, Pin. Mpal. SÃO PAULO, Mus. de Arte Carlos Ayres de Itapetininga. ◉ E: São Paulo: 1964 Bar do Alemão; 1968 Gal. Varanda; 1970, '83 Assoc. dos Amigos do MAM; 1983, '86 Gal. Casa e Jardim; 1996 Secretaria de Estado da Cult. / 1970 Teresópolis, Gal. Abelha / 1984 São José dos Campos, Pró-Cult. / 1986 Barueri, Gal. Tony Antiguidades / 1990 Itanhaém, Câmara Mpal / 1991 Lissabon, Hotel Le Meridien. –. G: 1965 (2. Preis), '68, '75, '76, '79 Embu: Salão de Artes / São Paulo: 1966 Gal. Ultra Arte: Ultra Arte; 1968 Gal. KLM: Expos. de Mini Quadrados / 1989 Lissabon, Gal. Tempo: 13 Brasil. na Tempo. ⌶ *Online:* Inst. Itaú Cult., Enc. artes visuais, 2011. M. F. Morais

Civiale, *Aimé* (eigtl. Civiale, *Pierre-Joseph),* frz. Geologe, Amateurfotograf, * 1821 Paris, † 6. 7. 1893 ebd. Sohn des Arztes und Mitgl. der Acad. des Sciences Jean C. Stud.:1841–45 Ec. polytechnique, Paris; anschl. beim Ingenieurcorps der frz. Armee, mit dem er einige Zeit in Algerien verbringt. 1854 Entlassung aus dem Militärdienst und Heirat mit Camille Touchard; anschl. Privatier. Ab 1857 Mitgl. der Soc. franç. de Photographie. – C. zählt zu den frühesten Fotografen hochalpiner Gebirgslandschaften. 1857 und 1858 entstehen erste Aufnahmen in den Pyrenäen, die er 1859 an die Acad. des Sciences schickt. Ermutigt vom Geologen Léonce Elie de Beaumont, unternimmt C. mit seinem Ass. Auguste Corberon zw. 1859 und 1868 den Versuch einer vollst. fotogr. Dokumentation der Alpen. Eine Unternehmung, die v. Brevern als die erste umfangreiche Anwendung des Mediums

mit systematischem Anspruch im Dienste der Geologie be-
zeichnet (cf. v. Brevern, 2012, 41). Angesichts der extre-
men klimatischen Bedingungen im Hochgebirge verwen-
det C. Gustave Le Grays Wachspapier-Verfahren, das er
mehrfach weiterentwickelt. Mit einer selbst entworfenen
Kamera fotografiert er auch über 40 Panoramaansichten,
darunter das *Panorama circulaire pris de la Bella Tola*
(1866–82). Nach 1882 ist keine weitere fotogr. Tätigkeit
bekannt. – Fotogr. Alben: *Le Mont Blanc et la Vallée de
Chamounix*, 1860/61 (Bibl. de l'Inst. de France); *Les Al-
pes au point de vue de la géographie physique et de la géo-
logie*, 1882. ◻ LOS ANGELES/Calif., J. Paul Getty Mus.
PARIS, BN. – Inst. de France. – Soc. franç. de Photogr. RO-
CHESTER/N. Y., George Eastman House. WIEN, Albertina.
✉ Méthodes photogr. perfectionnées. Papier sec, albumi-
ne, collodion sec, collodion humide, P. 1859; Notes sur
l'application de la photogr. à la géographie physique et à
la géologie, 1860; Rapport sur la description photogr. des
Alpes, P. 1882. ⊚ *G:* 1858 London: R. Photogr. Soc. /
Paris: 1859, '61, '63, '65, '69 Soc. franç. de Photogr.; 1867
WA; 1979 (A l'Origine de la Photographie. Le Calotype
au passé et au présent; K), '98 (Gal. Colbert: Les Voya-
geurs Photographes et la Soc. de Géographie 1850–1910;
K) BN / 1864 Wien, Photogr. Ges. / 1865 Berlin: Inter-
nat. photogr. Ausst. ⊡ *A. Jammes/E. P. Janis* (Ed.), The
art of French calotype, Pr. u.a. 1983; *Auer*, 1985; Dict.
mondial de la photogr., P. 1994; *J. Hannavy* (Ed.), Enc.
of nineteenth-c. photogr., I, N. Y./Lo. 2008. – *A. Tho-
mas*, Beauty of another order. Photogr. in science (K Ot-
tawa), New Haven, Conn. 1997; *M. Faber/K. A. Schröder*
(Ed.), Das Auge und der Apparat. Die Foto-Slg der Alber-
tina, P. 2003; Eclats d'histoire. Les coll. photogr. de l'Inst.
de France, Arles u.a. 2003; *A. Gunthert/M. Poivert* (Ed.),
L'art de la photographie. Des origines à nos jours, P. 2007;
J. v. Brevern, Counting on the unexpected. A. C.'s moun-
tain photogr., in: Science in context 22:2009 (3) 409–437;
S. Aubenas (Ed.), Primitifs de la photographie. Le caloty-
pe en France 1843–1860 (K), P. 2010; *J. v. Brevern*, Blicke
von Nirgendwo. Geologie in Bildern bei Ruskin, Viollet-
le-Duc und C., Paderborn 2012 (fotogr. Alben, eig. Schrif-
ten); *M. Durand*, Doc. du Minutier central des notaires de
Paris. Photographes et hist. de la photographie. De l'image
fixe à l'image animée, P. 2012 (Verlagsankündigung).
P. Freytag

Civitelli, *Fabio*, ital. Comiczeichner, * 9. 4. 1955 Lu-
cignano/Arezzo. Debütiert 1974 im Studio von Graziano
Origa als Comiczeichner mit der Serie *Lady Dust*. Es fol-
gen Kriegscomics in der Reihe *Super Eroica* für Dardo
und erotische Taschenbücher für Edifumetto und Edipe-
riodici. 1977 veröffentlicht er die Reihe *Doctor Salomon*
(Szenario: Silveriu Pisu) sowie in den Mag. Corriere Boy,
Il Intrepido und Il Monello. Für das Superhelden-Mag.
SuperGulp! von Mondadori zeichnet er 1979 *Spider-Man*
und *Fantastic Four*. Im selben Jahr wechselt er zu Sergio
Bonelli Editore. Ab 1979 entsteht *Mister No* und ab 1983
für das Mag. Orient Express *Pomeriggio Cubano* (Szena-
rio: Giuseppe Ferrandino). Seit 1984 gehört C. zu den re-
gelmäßigen Zeichnern der Westernreihe *Tex* (dt. *Tex Wil-

ler*). – C. pflegt einen präzisen, realistischen Strich und ar-
beitet v.a. im Abenteuergenre. ⊡ *H. Filippini*, Dict. de
la bande dessinée, P. 2005. – *Online:* Lambiek Comiclo-
pedia. K. Schikowski

Civitelli, *Giuseppe*, ital. Keramiker, Zeichner, Maler,
* Aug. 1907 Aiello Calabro/Cosenza, † 30. 11. 1990 Rom.
Nach Schulabschluß in Cosenza als Grundschullehrer tä-
tig; beginnt daneben zu malen und zu zeichnen. Unterrich-
tet an versch. Schulen in Italien und im Ausland (Barce-
lona, Belgrad, Bern, Budapest, Metz, München und Ti-
rana); 1943 Rückkehr nach Italien. 1945 Ernennung zum
Dir. einer Grundschule in Rom mit einer eig. Keramik-
werkstatt. Unterstützt von dem Keramiker und Unterneh-
mer Alvaro Ciancamerla reaktiviert er diese Wkst. und ge-
staltet erste keramische Arbeiten. Ab 1952 Teiln. am Con-
corso naz. della ceramica in Faenza; mehrere Preise (u.a.
1956 Premio del Ministero della Industria e Commercio).
Der befreundete Bildhauer Marino Mazzacurati führt ihn
in die röm. Kunstszene ein; Kontakte zu Tito Balestra, Li-
bero De Libero, Renato Gianni, Tanino Chiurazzi, Alfon-
so Gatto und Carlo Levi. Auch nach seiner Pensionierung
(1973) ist C. weiterhin künstlerisch tätig; er malt, zeich-
net, radiert, lithographiert, entwirft Möbel und beschäftigt
sich mit Rest.-Arbeiten, u.a. restauriert er ein ma. Haus
in Umbrien. – C.s bemalte und glasierte Terrakottavasen
und -schalen haben eine überraschend mod. Formgebung,
die mit der farbigen Gest. und dem Dekor eine harmoni-
sche Einheit bildet. Die Bemalung mit stark stilisierten
sitzenden oder fliegenden Vögeln und anthropomorphen
oder geometrischen abstrakten Formen zeigt eine stilisti-
sche Nähe zu Arbeiten von Mitgl. der avantgardistischen
röm. Künstlergruppen Forma 1 und Origine, v.a. den Wer-
ken von Giuseppe Capogrossi und Piero Dorazio. Anre-
gungen verdankt C. aber auch Amedeo Modigliani (*Fla-
che Schale mit abstrahierender Darst. eines Gesichts*, um
1955; Bremen, Slg Hockemeyer) und Pablo Picasso (*Va-
se mit stilisierten Vögeln und geometrischem Muster*, um
1956, ebd.). ◻ BREMEN, Slg Bernd und Eva Hockemey-
er. FAENZA, Mus. Internaz. delle Ceramiche (MIC). ROM,
Mus. di Roma. ⊚ *E:* 1955 New York, Bonnier Gall. /
1957 Venedig, Gall. il Cavalllino (K) / 1958 Padua, Gall.
La Chiocciola / Rom: 1966 Gall. Don Chisciotte (K); 1973
Gall. San Marco-Marguttiana (K) / 2011 Aiello Calabro,
Pal. Cybo-Malaspina. – *G:* 1954, '55 Florenz: Mostra mer-
cato naz. dell'artigianato (Ehren-Dipl. bzw. Silber-Med.) /
1954 Vicenza: Mostra naz. della ceramica; Mailand: Tri-
enn. / 1955 Rom, Gall. del Vantaggio: Omaggio a Mo-
digliani di dodici ceramisti; 100 pittori a Via Margutta /
2009 London, Estorick Coll. of mod. Ital. art: Terra inco-
gnita. Italy's ceramic revival. ⊡ *H. Blättler*, La cerami-
ca in Italia, R. 1958; *A. Mardersteig*, Die Kunst und das
schöne Heim 57:1959, 418–422; *G. Dorfles/L. Hockemey-
er*, The Hockemeyer Coll. 20th. c. Ital. ceramic art (K),
M. 2009; *M. Thibaut*, Handelsblatt v. 8. 1. 2010. – *Online:*
B. Pino, Aiello calabro v. 30. 11. 2010. E. Kasten

Çizel, *Hayri*, türkischer Maler, Kunstpädagoge, * 1891
Dimetoka, † 13. 10. 1950 Istanbul. Stud.: Malerei an der
ABK, Istanbul, u.a. bei Joseph Warnia-Zarzecki, Salvator

Valéri und Adil Bey (1914 Dipl.). Mit einem Ausz.-Stip. reist Ç. nach München, wo er im Atelier von Hans Hofmann studiert. Ç. dient danach in der Armee und nimmt u.a. 1915–16 an der Schlacht von Gallipoli und am türkischen Unabhängigkeitskrieg (1919–23) teil. Nach seiner Rückkehr nach Istanbul eröffnet er ein eig. Atelier und arbeitet viele Jahre als Kunstlehrer an Gymnasien in Istanbul. – Ç. verarbeitet anfangs hist. Themen. Während seines Militärdienstes stellt er das Heldentum, die Resignation und das alltägliche Leben an der Front dar, hält aber auch die Lsch seiner Einsatzgebiete auf dem Balkan und in der Türkei in Skizzen und Aqu. fest. In seinen späteren Lsch.-Darst. von Göksu, Hisar, Edirne, Eyüp und Istanbul orientiert sich Ç. am Impressionismus. ⌑ *A. Demırbulak*, Çağdaş Türk resmınde otoportreler, İstanbul 2007.

M. Kühn

Çızgen, *Gültekın,* türkischer Fotograf, * 29. 2. 1940 Istanbul, dort tätig. Stud.: ABK ebd. Entwickelt sich in den 1960erJahren zu einem der bedeutendsten Fotografen und Initiatoren der Fotokunst in der Türkei. Ç.s anfänglich vorwiegend in Schwarzweiß gehaltenen Arbeiten zeigen v.a. Motive aus Istanbul und vom Arbeitsalltag der Bevölkerung (häufig Fischer zu allen Tages- und Nachtzeiten). Später auch Reise-Fotogr., darunter stimmungsvolle Lsch. (z.B. aus Afrika, 1995). 2010 leitet er ein Fotogr.-Projekt für die Initiative „Europ. Kulturhauptstadt Istanbul". Er gründete den Verlag Fotoğraf Yayınları und die Zs. für Fotogr. Yeni Fotoğraf. Zudem ist er u.a. Gründungs-Mitgl. des Inst. für Fotogr. an der Mimar-Sinan-Univ. für Bild. Künste. Er veröffentlicht seit 1967 zahlr. Fotobände, und seine Arbeiten werden in internat. Zss. abgebildet und auf internat. Ausst. gezeigt. ⌑ LONDON, V & A. OTTAWA, NM. PARIS, BN. ⌑ *Auer*, 1985; *K. Özsezgin*, Türk plastik sanatçıları, Istanbul 1994. – *R. Hetz* (Ed.), Fotoalmanach internat., Ffm. 1966; *T. Parla* (Ed.), Yurt ansiklopedisi III, Istanbul 1982. – Online: Website Ç. (Lit.).

M. Kühn

Claassen, *Tom (Thomas Johannes Franciscus),* niederl. Bildhauer, Objektkünstler, * 4. 10. 1964 Heerlen, lebt und arbeitet in Breda und Dänemark. Stud.: 1984–89 Acad. voor Kunst en Vormgeving St. Joost, Breda. Bis 2008 u.a. dort ansässig, seitdem auch Wohnsitz in Dänemark. Ausz.: 1994 Charlotte-Köhler-Preis. – C.s Skulpt. und dreidimensionalen Objekte changieren in allen Werkgruppen zw. Abstraktion und Gegenständlichkeit und suggerieren sowohl „zeitlose Stille" (Ruyters) als auch hintergründigen Humor, der gelegentlich bis zur Karikatur gesteigert wird. Für seine Figurationen läßt sich C. v.a. von der Gestalt des Menschen und der Tiere inspirieren. Aber auch Teppiche, Unfallautos, ein Einkaufskorb oder ein Kuchen regen ihn an, die jeweilige Ausgangsform im „prekären Realismus" (Folie, 2004) wiederzugeben oder deren Wesen in mehr oder weniger stark reduzierter Weise nachzuspüren, ohne die Gegenstandsbezüglichkeit aufzugeben. So bestehen 18 Holz-Skulpt. aus der Werkgruppe der sog. *Hölzernen Männer* (ab E. der 1990er Jahre), die im Skulpt.-Park von Otterlo in verstörender Weise wie Tote nach einer Schlacht, einem Massaker oder einem Flugzeugabsturz

verstreut unter Bäumen liegen, aus je sechs gleichartig aus Stamm und Ästen gesägten und elementar gefügten Rundhölzern, die den Witterungseinflüssen so überlassen sind, daß die Figuren in wenigen Jahrzehnten verrottet sein werden. Eine char. Besonderheit vieler Skulpt. – die aus Eisen(-Blech), Aluminium, Bronze, Beton, Gips, Keramik, Silikonkautschuk oder Kunststoff gefertigt sind – ist deren scheinbar weiche Oberflächengestaltung. C. täuscht auf vielen seiner Arbeiten Textureffekte vor, die samt-, leder-, leinen- oder juteartig (*Säcke*, Bronze, 2001) wirken oder an zähfließende oder wässrige Flüssigkeiten denken lassen, was C. durch Latexauftrag oder spezielle Pigmentantragungen und -beimischungen erzielt. Bisweilen rekurriert C. in seinen großformatigen Skulpt. auch auf Urängste des Menschen durch die überdimensionierte bio- und psychomorphe Ausformung u.a. von Würmern, Schlachtgeflügel oder „niedlichen Tieren" (Kaninchen, Maulwurf). Ein diesbezügliches Hw. ist die aus scheinbar ungeordnet auf einer Wiese liegenden kieselsteinförmigen Volumina gefügte 14 Meter lange Mon.-Skulpt. *Rocky Lumps* (Beton, 2006), die u.a. Assoziationen an ein gigantisches Tierskelett weckt (Otterlo, Kröller-Müller Mus.). Gegenwärtig befinden sich C.s Werke im Besitz von nahezu drei Dutzend niederl. Städten, Gemeinden und Institutionen (häufig Auftragswerke). Zu den bekanntesten Arbeiten im öff. Raum gehören im Amsterdamer Flughafengebäude *Zwei Sitzende (Schnee-)Männer* (Bronze, 2000; Schiphol) und die ebenfalls mon. *Elefanten*-Gruppe direkt an der Autobahn (2000; A 6/A 27 zw. Lelystad und Almere). – In den Niederlanden gehört C. zu den bed. Bildhauern der Gegenwart, der sich auf eine originellunprätentiöse Weise der Mon.-Kunst widmet, indem er in seinen Arbeiten auf jeden mon.-heroischen Gestus verzichtet (z.B. bleiben alle Werke im öff. Raum ungesockelt) und in vielen Arbeiten ein melancholisches Potential aufbaut. ⌑ ALMERE, Mus. De Paviljoens. AMSTERDAM, Sted. Mus. ARNHEM, Akzo Nobel Art Found. BREDA, Stadscollectie. DEN HAAG, Mus. Beelden aan Zee. EINDHOVEN, Rabobank. 's-HERTOGENBOSCH, Noordbrabants Mus. HOOFDDORP, Burgemeester Stamplein. OTTERLO, Kröller-Müller Mus. ROTTERDAM, Kunsthal. ST. LOUIS/MO., Gateway Found. TILBURG, Nederlands Textiel-Mus. UTRECHT, Centraal Mus. ZWOLLE, Anninghof. ⦿ E: 1992, '94, '97, '99, 2001, '04, '09 Amsterdam, Gal. Fons Welters / 2001 Kranenburg (Niederrhein), Mus. Katharinenhof / 2010 Amersfoort, Kunsthal (Retr.). – G: 1992 Rotterdam, BvB: Peiling '92 / Den Haag: 1994 Grote Kerk: Het Grote Gedicht; 2004, '05 Den Haag Sculptuur / 1995 Otterlo, Kröller-Müller Mus.: Raw Mat. / 1996 São Paulo: Bien. / 1999 Amsterdam, Sted. Mus.: Glad Ijs / 2000 Bremen, Gerhard-Marcks-Haus: Mythos Wasser; Hannover: Expo WA / 2003 Lisse, Keukenhof: Gnome Sweet Gnome / 2004 Amstelveen, Cobra MMK: Bestiae Animatae / 2006 Oostende, KM aan Zee: Beaufort Outside. ⌑ *R. Malasch*, Het Parool v. 6. 3. 1992; *P. Tegenbosch*, ibid. v. 18. 1. 1993; *M. Rive*, in: De Steen Vliegt (K Arti et Amicitiae), Am. 1997, 68–73; *A. C. Lütken Glitre*, T. C. (K Bergkerk), Deventer 1997; *P. Kyander*, T. C., Am. 1998;

S. Folie, Skulpt. Prekärer Realismus zw. Melancholie und Komik (K KH), W. 2004; *H. den Hartog Jager u.a.*, T. C. (K Gal. Fons Welters), Rotterdam 2009 (Ausst.; Lit.). – *Online:* Website C. U. Heise

Claassen, Udo, dt. Graphiker, Zeichner, Maler, * 1949 Itzehoe, lebt in Bonn. Stud.: 1969–74 FHS Köln; 1974–78 Univ. Bonn (Kunstgesch.). Seit 1974 freischaffend. 1974–75 und 1983–84 Lehrauftrag (Graphik) an der FHS Köln. – Anfangs Zchngn, Gem. und Druckgraphik (*Baumgruppe*, Rad.) mit akribisch durchgezeichneten Motiven (häufig Solitärbäume), deren Darst. inspiriert sind von numinosen Naturvorstellungen, u.a. von Caspar David Friedrich. Unter dem Eindruck des Werkes von Hamaguchi Yōzō entstehen ab 1978 aufwendig gearbeitete Schab-Bll. mit dramatisch inszenierten, visionär aufgefaßten Lsch. (*Isländische Lsch.*, 1984; *Delta*, 1985, beide Mezzotinto). In den 1980er Jahren zunehmende Abstrahierung der Motive (*Informelle Lsch.*, 1986). Mehrfach reist C. nach Japan, um sich von Zenmeistern unterrichten zu lassen und Bonsai als Natur- und Weltanschauung zu studieren. Seit den 1990er Jahren fertigt C. großformatige, farbintensive abstrakte Gem., deren Bildtitel häufig auf reale Topogr. rekurrieren wie *Cumbrecita* (2001), *Misen* (2004) oder *Myrdal* (2007, alle Öl/Lw.). Nach 2000 stellt C. seine Bilder mehrfach zus. mit Bonsaipflanzen aus, um eine Verbindung zw. trad. jap. Kunst und zeitgen. europ. Malerei zu schaffen. Auch Zchngn (z.B. Ill. zu Hans Jakob Christoffel von Grimmelshausens Roman Simplicissimus, um 1983) und eine orig.-graph. Publ. (50 Exemplare) zus. mit der dt.-jüdischen Schriftstellerin Lotte Paepcke (*Im leeren Feld vor der Stadt*, vier Mezzotinto-Rad., Ka. 1980). ⌑ MAINZ, LM. RENCHEN, Simplicissimushaus. WOLFENBÜTTEL, Herzog August Bibl. ◈ *E:* 1978 Siegburg, SM / Bonn: 1980, '83, '85 Gal. Helga Paepcke; 1986, '88 Kunsthof / 1984 Frankfurt am Main, Gal. im Verwaltungsgericht / 1992 (K), '94 Köln, Baukunst-Gal. –. *G:* 1979 Heidelberg: Europ. Graphik-Bienn. ⌑⌑ *G. Caspary*, U. C. Malerei des Augenblicks (K SM), Siegburg 2007; General-Anz. (Bonn) v. 6. 10. 2007; *E.-M. Hanebutt-Benz u.a.* (Ed.), „Die also genannte Schwarze Kunst in Kupfer zu arbeiten". Technik und Entwicklung des Mezzotintos (K Wander-Ausst.), B. u.a. 2009. – *Online:* Website C. U. Heise

Claerbout, David, belg. Video-, Foto- und Installationskünstler, Zeichner, * 9. 4. 1969 Kortrijk, lebt in Antwerpen und Berlin. Stud.: 1992–95 Nat. Hoger Inst. voor Schone Kunsten, Antwerpen (Malerei); 1996 ABK, Amsterdam. Ausz.: 2002 Stip. des Dt. Akad. Austauschdienstes (DAAD) für einen Aufenthalt in Berlin; 2007 Will-Grohmann-Preis, AK Berlin; 2010 Peill-Preis, Düren. – C. gestaltet seit M. der 1990er Jahre Videoarbeiten auf der Grundlage manipulierter Fotografien. So verwendet er etwa für das 1997 entstandene Video *Ruurlo, Bocurloscheweg, 1910* eine alte Postkarte, die als Loop an eine Wand projiziert wird. Das statische Ausgangsmotiv wird dabei jedoch vom Betrachter zunächst kaum wahrnehmbar, mittels digitaler Überarbeitung in eine Sequenz mit sich im Wind bewegenden Bll. überführt. In der Arbeit *Vietnam,*

1967, near Duc Pho (reconstruction after Hiromichi Mine) von 2001 montiert C. das hist. Foto eines abstürzenden US-amer. Frachtflugzeuges in eine in der Gegenwart selbst aufgenommene Filmsequenz der Lsch., in der sich der Abschuß ursprünglich ereignet hat. Die Konfrontation der statischen, gleichsam eingefrorenen Momentaufnahme von 1967 mit der bewegten Lsch.-Kulisse von 2001 vergegenwärtigt das hist. Ereignis somit als zeitloses Geschehen. Eine Irritation alltäglicher Seh- bzw. Wahrnehmungsgewohnheiten und die damit verbundene Reflexion über gängige Vorstellungen von narrativen Zeitabläufen erreicht C. allerdings nicht nur durch das In-Bewegung-setzen statischer Bilder, sondern auch durch and. Manipulationsstrategien wie etwa das extreme Verlangsamen filmischer Sequenzen oder die Aneinanderreihung hunderter Aufnahmen eines einzigen Augenblickes, die nacheinander in einer bestimmten Reihenfolge und in einem bewußt arrangierten Rythmus auf eine Lw. projiziert und somit in einen scheinbaren zeitlichen Ablauf überführt werden (z.B. *Arena*, 2007). Auch Zchngn und komplexe, z.T. mit mehreren parallelen Projektionen bzw. Monitoren arbeitende Videoinstallationen (z.B. *Amer. Car*, 2004). ⌑ ALCOITAO, Ellipse Found. AC. ANTWERPEN, Mus. van Hedendaagse Kunst. BASEL, Schaulager. BERLIN, Hamburger Bahnhof, Christian Friedrich Flick Coll. – Slg Haubrok. BRISBANE, Queensland AG. DÜREN, Leopold-Hoesch-Mus. DUNKERQUE, FRAC Nord-Pas de Calais. GENT, Sted. Mus. voor Actuele Kunst. HORNU, MAC's. KARLSRUHE, ZKM, Medien-Mus. LUXEMBURG, MAM Grand-Duc Jean (Mudam). MÜNCHEN, Mus. Brandhorst. – Slg Goetz. NEAPEL, Fond. Morra Greco. NEW YORK, Dia Art Found. PARIS, Centre Pompidou. – FRAC Ile-de-France. ST. GALLEN, KM. STRASBOURG, MAMC. TILBURG, De Pont, Mus. voor Hedendaagse Kunst. ◈ *E:* Antwerpen: 1997 Montevideo Gall.; 2000, '03, '10 Gal. Micheline Szwajcer / Brüssel: 1997 Argos, Kanal 20; 1998 Etablissement d'en Face; 2007 MRBAB; 2011 WIELS / 1999 Gent, Sted. Mus. voor Actuele Kunst / New York: 2000 DIA Center for the Arts; Nicole Klagsbrun Gall.; 2005, '08, '11 Gal. Yvon Lambert / 2001, '02 Köln, Gal. Johnen + Schöttle / München: 2001, '03, '10 Gal. Rüdiger Schöttle; 2004 Lenbachhaus und Kunstbau (K); 2010 PM (K) / 2002 Amsterdam, Annet Gelink Gall. / Hannover, KV (K) / 2003 Oslo, Gall. K; Rotterdam, BvB; Santiago de Compostela, Centro Galego de Arte Contemp. (K); Zürich, Hauser & Wirth / 2004 Canterbury, Herbert Read Gall. (K); Windsor, AG of Windsor / 2005 Berlin, AK; Dundee, Contemp. AC; Eindhoven, Van Abbe-Mus.; Grenoble, Le Magasin, Mus. Dauphinois; Providence, Rhode Island School of Design / 2006 Tokio, NCA Gall. / 2007 Paris, Centre Pompidou (Wander-Ausst.; K) / 2007, '09 Tilburg, De Pont / 2008 Athen, NM of Contemp. Art; Cambridge (Mass.), List Visual AC (Wander-Ausst.); St. Gallen, KM; Vancouver, Univ. of Brit. Columbia, Belkin Gall. / 2009 Lissabon, MNAC / London: 2009 Hauser & Wirth; 2012 Parasol Unit (K) / 2010 Kopenhagen, gl Holtegaard / 2011 San Francisco (Calif.), MMA / 2012 Düren, Leopold-Hoesch-Mus.; Rovereto, MAMC; Tel Aviv, Mus. of Art; Wien, Secession (K). – *G:* 2004

Taipei: Bienn. Do You Believe in Reality? (K: B. Vander-
linden) / 2009 Chur, Bündner KM: Gefrorene Momente.
Daniel Spoerris Fallenbilder im Dialog mit Judith Albert,
C., Caro Niederer, Beat Streuli, Jeff Wall (K: K. Ammann/
B. Stutzer). ▭ *Delarge*, 2001; *Pas* I, 2002. – *M. Sto-
eber*, Kunstforum internat. 2002 (162) 306 s.; *M. Eng-
ler*, Kunst-Bull. 2003 (3) 32–37; *U. Kittelmann*, in: Cream
3. Contemp. art in cult., Lo./N. Y. 2003; *D. Green*, Con-
temporay 2005 (71) 38–41; *M. Muracciole*, Les cah. du
MNAM 2005 (94) 124–134 (Interview); *I. Goetz/S. Urba-
schek*, Fast forward. Media Art Slg Goetz (K Karlsruhe),
Ostfildern 2006; *S. Martin/U. Grosenick* (Ed.), Video art,
Köln u.a. 2006; *D. Ulrichs*, Lapiz 25:2006 (219) 56–71 (In-
terview); Vitamin Ph. New perspectives in photogr., Lo.
2006; *T. Weski* (Ed.), Click doubleclick. Das dok. Mo-
ment (K München/Brüssel), Köln 2006; *V. Da Costa*, Art
press 2007 (337) 36–40; Gehen bleiben. Bewegung, Kör-
per, Ort in der Kunst der Gegenwart (K Bonn), Ostfildern
2007; *O. Zybok* (Ed.), Idylle. Traum und Trugschluss (K
Wander-Ausst.), Ostfildern 2007; *W. Smerling* (Ed.), Der
eig. Weg. Perspektiven belg. Kunst (K Duisburg), Köln
2008; *D. Snauwaert u.a.*, C. The time that remains, Ant.
2011; *D. Ulrichs*, Mod. painters 2011 (4) 64–66. – *Online:*
Hauser & Wirth. H. Kronthaler

Claerbout, *Marc*, frz. Maler, Collagekünstler, Bild-
hauer, Bühnenbildner, * 4. 7. 1949 Ciboure/Pyrénées-
Atlantiques, dort tätig. Stud. an der Ec. d'Art in Bayon-
ne sowie in Paris, wo er in den 1970er Jahren lebt. Ausz.:
1972 Grand Prix des Arts plast., Bordeaux; 2002 Cheva-
lier dans l'ordre des Arts et des Lettres. – Seit 1969 gestal-
tet C. Collagen aus versch.-farbigen Papierstücken, die er
zu gegenständlichen Motiven zusammensetzt (u.a. Mari-
nen, Sport-Darst., v.a. Cesta Punta, sowie Sujets mit Musi-
kern). Häufig wiederholt er die Motive in Öl-Gem., wobei
er die formalen Merkmale der Collage in die Gem. über-
trägt. Diese Verfremdung führt C. in einem von ihm als
„Abstrafiguration" bez. Stil weiter (z.B. *Les pinceaux*, Öl).
Zudem Entwürfe für Bühnenbilder (z.B. zu *L'Heure es-
pagnole* von Maurice Ravel, Théâtre du Centre mun. des
Loisiers, Montfort l'Amaury, 2011), Plakat-Gest. (u.a. für
das Festival Musique en Côte Basque in Saint-Jean-de-Luz
und für die dortige Acad. Maurice Ravel) sowie plastische
Werke aus Holz und Bronze. ◉ *E:* u.a. 2007 Marmande,
Mus. Albert Marzelles. – *G:* Paris: 1977 Salon des Indé-
pendants; Salon d'Automne; 1980 Salon du Dessin et de
la Peint. à l'Eau / 2000, '02, '03 Saint-Jean-de-Luz, Vil-
la Ducoténia: Salon des Amis d'Ortzadarra / 2010 Ci-
boure, Chap. des Récollets: Jeux et Fêtes en Pays Basque.
▭ *G. Desport*, Répert. des peintres et sculpteurs du Pays
Basque, Biarritz ²2005. – *Online:* Website C.
 F. Krohn

Claesson, *Mårten*, schwed. Architekt, Innenarchitekt,
Designer, * 1970 Lidingö. Stud.: 1990–94 Konstfack,
Stockholm; 1992 Parsons The New School of Design,
New York. Gründet 1995 in Stockholm das Archit.-Büro
Claesson Koivisto Rune zus. mit den schwed. (Innen-)
Architekten und Designern *Eero Koivisto* (* 1958 Karl-
stad; Stud.: 1992 Parsons The New School for Design;

1993, '95 HS für Kunst und Design, Helsinki; bis 1994
Konstfack) und *Ola Rune* (* 1963 Lycksele; Stud.: 1987
Tillskärar-Akad., Stockholm; 1990 Southwark College,
London; 1992 KA Kopenhagen; bis 1994 Konstfack).
Ausz. des Büros: u.a. 1993–96, 1998–2000, '02 Utmärkt
Svensk Form, Stockholm; 2004 Premio Catas, Mailand;
2008 Design S, Svensk Form, Stockholm. Einzelpreise:
u. a 1995 Forsnäspriset für C. – Das erste der stets ge-
meinsam projektierten Gebäude in einer Reihe von Wohn-
und Geschäftshäuser ist das 60 m² große, spartanisch ein-
gerichte Einfamilienhaus *Vila Wabi*, 1994 errichtet als ei-
ne Art großstädtisches Refugium inmitten von Sergels
Torg, einem Verkehrsknotenpunkt mit hoher (Drogen-)
Kriminalität in Stockholm, 1995 ab- und auf der Stock-
holmer Schäreninsel Torö wiederaufgebaut; bek. auch das
2003 gebaute fünfgeschossige *Sfera Building* in Kyo-
to, dessen Fassade aus lochgestanztem Titan mit einem
Muster aus grün illuminierbaren Kirschbaumblättern von
trad. jap. Wohntrennwänden inspiriert ist. Daneben vorran-
gig Inneneinrichtungen, oftmals minimalistisch, häufig je-
doch unter Verwendung von Spiegeln und Trennwänden
als optisch vergrößernde bzw. Komplexität suggerieren-
de Gest.-Mittel; u.a. die Residenz des schwed. Botschaf-
ters in Berlin (mit dem Büro Arkitekt Magasinet; 1996–99)
und das Restaurant *Operkällaren* der Kgl. Oper in Stock-
holm (2005). Die Gruppe verbindet häufig trad. schwed.
Wohnstile mit ethnischen Stilelementen, z.B. die in Marra-
kesch handgefertigten, von arabischen geometrischen Or-
namenten inspirierten Zementfliesen-Serien *Casa, Dande-
lion* und *Stone* (alle 2012) und verwendet in ihren Arbeiten
gleichzeitig trad. und mod. Mat., z.B. Holzmöbel und wei-
ße Wandfarbe neben säuregeätzten Glaspaneelen und ver-
zinkten Stahlbeschlägen im Restaurant *One Happy Cloud
in Stockholm* (1997). Außerdem Ausst.-Gest. und 2002 ein
Bühnenbild für ein Musikvideo der austral. Sängerin Ky-
lie Minogue. Des weiteren zahlr. Entwürfe für Herstel-
lerfirmen weltweit, u.a. Asplund, David Design, Cappel-
lini, Offecct und Swedese; meist schlichte geometr. For-
men und teils unter Verwendung neuer Technologien wie
Selektives Lasersintern und ungewöhnlichen Mat. wie Pa-
pierzellstoff ausgef., u.a. Möbel, (z.B. 1998 der bek. Klub-
sessel *Bowie* aus Formvollholz), Bezugsstoffe, Lampen,
Gebrauchsgegenstände wie Gläser, Vasen und Wanduhren
sowie Schmuck, insbes. die Armband-Serien *Eve* (Alumi-
num, 2008) und *Torus* (Plastik, 2012). Daneben auch eig.
Produkt- und Möbelentwürfe der jeweiligen Gruppenmit-
glieder. ▭ STOCKHOLM, NM. ◉ *E:* (als Gruppe): To-
kio: 2001 Axis Gall.; 2003 Time & Style Gall. (Wander-
Ausst.; K) / New York: 2002 Totem Tribeca (K); 2009
Design Within Reach (Wander-Ausst.) / 2005 Göteborg,
Röhsska Mus. (Wander-Ausst.; K) / 2010 Stockholm, Ho-
tel Skeppsholmen (Wander-Ausst.); Mailand, Sfera Gall. –
G: (als Gruppe): 2000 Paris, Inst. suédois: Angles suédois
(Wander-Ausst.) / 2001 Mailand: Salone Internaz. del Mo-
bile / 2004 Venedig: Bienn. (K). ▭ *B. Polster*, Design-
Lex. Skandinavien, Köln 1999 (s.v. C. Koivisto Rune);
M. Byars, The design enc., Lo./N. Y. 2004. – *S. Helge-
son/K. Nyberg*, Svenska former, Sth. 2000; s.v. C. Koivisto

Rune: Cafés und Restaurants, Kempen 2000; C. Koivisto Rune, Ba. 2001; *J. Cargill Thompson*, 40 architects around 40, Köln u.a. 2006; *P. Antonelli*, C. Koivisto Rune. Archit., Basel u.a. 2007; *M. Isitt*, C. Koivisto Rune. Design, Basel u.a. 2007; *D. Sokol*, Nordic architects, Sth. 2008. – *Online:* Website Fa. C. Koivisto Rune. J. Niegel

Claesson Koivisto Rune → Claesson, *Mårten*

Claeys, *Jean-Claude*, frz. Comiczeichner, Illustrator, * 16. 10. 1951 Paris. Anfänglich arbeitet C. als Werbezeichner. 1975 entstehen die ersten Comics. Er debütiert mit einer vom Film noir inspirierten Geschichte über den Privatdetektiv Jonathan Foolishbury für Mormoil Mag., die 1977 als Album *Whisky's Dreams* erscheint. Weitere Alben im Kriminalgenre sind u.a. 1978 *Magnum Song* (vorab im Mag. À suivre erschienen) und 1984 *L'été noir*. 1981 entsteht der Thriller *Paris Fripon*, davon erscheinen auch zwei Portfolii. 1986 veröffentlicht C. in Métal Hurlant die Serie *Lüger et Paix* (Szenarist Richard D. Nolane), von der zwei Alben erscheinen. Daneben auch Umschlag-Zchngn u.a. für Kriminalromane. – C. arbeitet in einem schwarzweißen fotorealistischen Stil, indem er Fotos überzeichnet. Seine Alben sind beeinflußt vom Film noir, in ihrer expliziten Darst. von Sex und Gewalt für ein ausschließlich erwachsenes Publikum. ⌑ *P. Gaumer/C. Moliterni*, Dict. mondial de la bande dessinée, P. 1997; *H. Filippini*, Dict. de la bande dessinée, P. 2005. – *Online:* Lambiek Comiclopedia. K. Schikowski

Claflin, *Donald*, US-amer. Schmuckgestalter, Entwurfszeichner, * 1935 in Massachusetts, † 1979. Stud.: Parsons School of Design, New York. Nach anfänglicher Tätigkeit als Illustrator und Textilentwerfer arbeitet C. für David Webb, wo er sich einen Namen als talentierter Schmuckdesigner erwirbt. 1966–77 bei Tiffany & Co., anschl. bei Bulgari beschäftigt. – C.s Schmuck ist stilistisch heterogen, wobei er zu opulenten, farbkräftigen Gest. tendiert. Neben Gold und Edelsteinen setzt C. auch für exklusiven Schmuck ungewöhnliche Mat. wie Holz, Leder und Elfenbein ein, mit denen er bes. Effekte erzielt (z.B. Armreifen aus Holz, in den in Gold gefaßte Diamantbänder eingesetzt sind). Während seiner Tätigkeit als Designer bei Tiffany & Co. wird er v.a. bek. durch seine witzig-skurrilen Schmuckstücke aus hochglanzpoliertem Gold mit Edelsteinen in Gestalt von Tieren, mitunter auch Fabelwesen bzw. Figuren aus beliebten Kinderbüchern wie Alice in Wonderland (z.B. *Dragon Brooch*, 1960er Jahre), die zu Klassikern in der Schmuckbranche werden. Daneben entstehen auch bemerkenswerte konventionellere Entwürfe für Ringe, Armreifen etc. mit gefaßten Edelsteinen. C. verwendet als einer der ersten in den USA Tansanit, ein Stein von intensiv purpur-bläulicher Farbe aus Tansania, der bei Tiffany ab 1969 eingesetzt wird. Seine Schmuckentwürfe für Tiffany werden größtenteils von Carven French umgesetzt. ⌑ Dict. internat. du bijou, P. 1998. – *C. Phillips* (Ed.), Bejewelled by Tiffany, 1837–1987 (K), New Haven, Conn. u.a. 2006. – *Online:* Macklowe Gall.

 C. Rohrschneider

Clare (Claré), *Etienne*, schweiz. Maler, Graphiker, Plakatkünstler, Illustrator, * 2. 12. 1901 Paris, † 2. 1. 1975 Thun. Ausb.: KGS in Bern; Lithographenlehre in Thun. Wird ebd. ansässig, wo er im Haus Freienhof Nr 7 ein Atelier bezieht; Ateliernachbarn sind hier u.a. Paul Gmünder und Knud Jacobsen. Mitgl.: ab 1953 Xylon Schweiz. – C.s malerisches und graph. Œuvre umfaßt (Berg-)Lsch., (Selbst-)Portr. und z.T. mon. Hschn. (*Reiter in der Camargue*, 1971), daneben archit.-bezogene Arbeiten (Mosaiken, Wandmalerei) und spätestens ab 1930 auch Werbegraphik (Plakate, Postkarten) und Buch-Illustrationen. Die Plakate, v.a. die der Tourismuswerbung dienenden Entwürfe für die Stadt Thun, zeigen C. als routinierten Reklamezeichner, der die attraktive, sportliche und unabhängige junge Frau als Werbefigur ebenso wirkungsvoll in Szene zu setzen vermag (z.B. im roten Badeanzug am Thunersee in *Strandbad Thun*, Farb-Lith., 1933) wie er gleichsam zur Entfachung von Reisesehnsüchten die romantische Thuner Schloßbergsilhouette effektvoll vor den umliegenden Schweizer Bergen aufsteigen läßt (*Thun Plage/Strandbad*, 1938; *Thun, Grande plage*, 1942; *Thun Strandbad*, 1946, alle Farb-Lith.). Alljährlich fertigt C. für die Armbrustschützen das Scheibenbild, u.a. die *Gesslerbilder* (Öl/Holz, 1935, '36) oder ab den 1950er Jahren bis 1974 die *Karl-der-Kühne-Scheibe*. Auch Buch-Ill., z.B. für *Eine Autostraße über den Gemmipaß* [...] *nach Leukerbad* (Interlaken 1952) oder für *150 Jahre Waffenplatz Thun und seine Zeit 1819–1969* (Thun 1969). Beteiligt sich mehrfach an orig.-graph. Mappenwerken, die von der internat. Holzschneider-Vrg ediert werden (Xylon 72, 19 Hschn., Z. 1971). ⌗ BERN, Schweiz. Nat.-Bibl., GrS. OBERHOFEN, KS Hans & Marlis Suter. THUN/Bern, Atelierhaus C.: Nachlaß. – KM. – Knabenschützenhaus: Wandbild. ☉ E: Thun: 1972 KS (K); 2001 Gal. Rosengarten / 1975 Bern, Gal. Art + Vision (K) / 2005 Oberhofen, KS Hans & Marlis Suter (mit Paul Gmünder, Alfred Glaus; K). – G: Thun: 1960 Gal. Aarequai (mit Roman Tschabold, Knud Jacobsen, Willi Max Huber); 2000 KM: Zweisamkeiten / 2011 Oberhofen, KS Hans & Marlis Suter: Von Angesicht zu Angesicht. ⌗ BLSK I, 1998. – E. C. Jub.-Ausst. (K), Thun 1972; E. C. Hschn. (K), Bern 1975; 50 Jahre sammeln. Akzente der Slg (K KM), Thun 1988; *P. Killer/ I. Stoll*, 160 Werke aus der Slg Suter (K Oberhofen), Bern 2005; Der Bund v. 27. 8. 2005. U. Heise

Claret, *Joseph*, frz. Maler, * 30. 9. 1924 Bordeaux, lebt in Villenave d'Ornon/Gironde. Nach versch. Tätigkeiten (u.a. Postbote und Zollbeamter) mit 30 Jahren Eintritt in den Polizeidienst. Beginnt erst im Alter von 35 Jahren autodidaktisch zu malen. – C.s figurative Gem. (Öl/Lw.) vereinen Merkmale naiver Malerei, von Kinderbuch-Ill. und Comic-Zchngn. In vereinfachten Formen und bevorzugt in Grundfarben malt er u.a. Portr., Lsch. und Stilleben (v.a. Blumen). Es dominieren ein- und zweifarbige Hintergründe, auf denen die Bildgegenstände häufig zentral plaziert sind. Zu C.s Lieblingsmotiven gehören v.a. Katzen, weiterhin Frauen und Blumen. Oft integriert der Maler sein eigenes Konterfei (mit dunklem Haar und Schnauzbart) in die symbolhaften, bisweilen detailreichen Darstellungen. Zudem farbenfrohe, mosaikartig zusammengesetzte abstrakte Komp. mit schwarzen Konturen. ⌗ BEGLES, Mus. de

la Création Franche. BERAUT, Mus. d'Art Naïf, marginal et populaire. FIGUERES, Mus. de l'Empordà. SOULAC-SUR-MER, MAM. ◉ *E:* seit 1973, u.a. 2009 Bègles, Mus. de la Création Franche. – *G:* 2006 Verneuil-sur-Avre: Festival d'Art Naïf / 2011 Béraut, Mus. d'Art Naïf, marginal et populaire: Les grands Peintres naïfs du Monde entier. ☐ *Online:* Mus. de la Création Franche, Bègles; Website C. F. Krohn

Clarhäll, *Lenny,* schwed. Bildhauer, Graphiker, * 17. 5. 1938 Timmersdala, lebt seit 1981 in Hölö b. Södertälje. Stud.: 1959–63 Konstfackskolan, Stockholm; 1964–67 KA, Kopenhagen. 1967 in Mexiko und den USA tätig. 1989–99 zahlr. gemeinsame Ausst. mit Gösta Backlund und Michael Söderlundh. – Anfänglich überwiegend große figurative Skulpt. aus Holz (z.T. bemalt), Bronze und Blech, häufig menschliche Figuren und Tiere in reduzierter Formensprache und mit Anklängen an volkstümliche Schnitzkunst, daneben auch tableauartige Figuren-Komp., z.B. *Tre damer* (Holz, 1974, zerst.) sowie Figurengruppen in installativen Aufbauten, z.B. *Folkbildaren* (bemaltes Holz). Seit E. der 1980er Jahre zunehmend abstrahierte Figuren, z.B. *Young Negro at Tate* (Holz, 1976) und organische Formen, z.B. *Melancolia* (Holz, Blech); daneben auch gegenständliche Reliefs. Seit 1966 zahlr. mon. Skulpt. im öff. Raum; bek. sind v.a. *Minnesmärket över de stupade i Ådalen 1931* (Bronze, 1981) in Kramfors, ein Mon. zum 50. Gedenktag der gewalttätigen Beendigung eines Arbeiterstreiks im nordschwedischen Ådalen, sowie die 1994 für die Oper in Göteborg geschaffenen Skulpt. *Snäckan* (Cortenstahl), *Venus hemlighet* (Gußeisen) und *Båten.* Des weiteren figurative Graphiken, u.a. (Farb-) Lith., z.B. *Päron och citroner.* Außerdem Ill. in: M. Wirmark, *Giv doft i blomma,* Sth. 2011. ☐ STOCKHOLM, Statens Konstråd. ◉ *E:* Stockholm: seit 1972 mehrfach Doktor Glas; 1976 Konstnärshuset; 2001 Gall. Bergman; 2007 KA; 2011 Gall. Överkikaren / 1977 Umeå, Västerbottens Mus. / 1983 Södertälje, KH (mit Jan Manker); Uppsala, Bror Hjorths Hus / Lund: 1983 Arkiv för Dekorativ Konst; 1989 KH (K) / 1986 Falun, Dalarnas Mus. (Wander-Ausst.; K) / Nyköping: 1991 Läns-Mus.; 2006 Sörmlands Mus. / 1992 Växjö, KH (Wander-Ausst., K) / 2002 Skara, Västergötlands Mus. / 2011 Skövde, KM; Katrineholm, KH. – *G:* 1974 Södertälje, KH: Fem träskulptörer (Wander-Ausst.) / Stockholm: 1976 Doktor Glas: Kläder som konst; 1982 Liljevalchs KH: Sveriges Allmänna Konstförening 150-årsjubileum / 2011 Limnham, Sveriges Konstföreningar: 15 från Grafikens Hus (Wander-Ausst.). ☐ NKKL, 1991. – *G. Hillman,* Vem är vem i svensk konst, 1993; *B. Håkansson u.a.,* L. C. Skulptör, Sth. 2007. – *Online:* Website C. J. Niegel

Clark, *Christophe,* frz. Fotograf, Computerkünstler, * 1963 Paris, lebt dort. Seit 1998 Zusammenarbeit mit der Malerin *Virginie Pougnaud* (* 1962 Angoulême, tätig in Paris; ab E. der 1980er Jahre Stud. in New York: Parsons The New School for Design; New York Acad. of Art). Die Fam.-Trad. fortführend gründet C. Mitte der 1980er Jahre sein eig. Fotostudio und arbeitet v.a. als Werbe- und Pressefotograf. Seit M. der 1990er Jahre beschäftigt er sich mit der digitalen Bearb. von Fotografien. Ausz.: 2000 Prix Arcimboldo, Fond. Hewlett Packard und Gens d'Images (für *Hommage à Edward Hopper*); 2006 Prix de la Fond. HSBC pour la Photogr., Paris. – Für ihre inszenierten Fotogr. bedienen sich C. und V. Pougnaud selten professioneller Modelle, sondern arbeiten meist mit Freunden und Fam.-Mitgl. zusammen. Nach der Auswahl eines Protagonisten fertigen sie Skizzen an und V. Pougnaud kreiert die passende Kulisse in Form von Gem. und Min.-Bühnen, die bisweilen an Puppenstuben oder Lsch. von Modelleisenbahnen erinnern (z.B. *Elliot et Deborah,* 2003, Serie: *Contes de fées*). C. fotografiert zunächst das Gem. bzw. die Bühne und anschl. die Personen (meist ein bis zwei, überwiegend Frauen), bevor er die analogen Fotogr. digital zusammenfügt. Das Ergebnis sind Fotoserien mit irritierenden collageartigen Bildern, bei denen die Grenzen der Medien Fotogr. und Gem. verschwimmen. Die surreal wirkenden Hintergründe erzielen eine geheimnisvolle, künstliche Stimmung, die erg. wird durch die unnatürlichen Posen der einsam und abwesend erscheinenden Figuren. Char. sind motivische Referenzen an Hauptwerke der Kunstgesch. sowie an Film und Lit. (bes. Märchen), z.B. *Anne-Charlotte, Arnaud et Stephane* (2000, Serie: *Hommage à Edward Hopper*), welches sich auf E. Hoppers Gem. Nighthawks (1942) bezieht. Weitere Serien: *Dorothy et l'enfance*; *Les bourgeoises d'Angoulême*; *Voyages d'amour; Intimité; C'est la vie; Adolescence; Lost in meditation* und *Immobilis.* ◉ *E:* Paris: 2000 Maison Europ. de la Photogr.; 2003 Gal. Bruno Delarue (K); 2004 Gal. Esther Woerdehoff (K); 2006 Gal. Baudoin Lebon / 2005 Epinal, Mus. de l'Image (K); Chicago (Ill.), Catherine Edelman Gall. / 2007 New York, Claire Oliver Gall. (mit Julie Blackmon) / 2009 Brescia, Gall. Paci Contemp. (K) / 2010–11 Mulhouse, Gal. La Filature / 2011 Lannion, Gal. L'Imagerie (Retr.). – *G:* 2001 Nancy: Bienn. / 2004 Epinal, Mus. de l'Image: Les Vilains / 2005 (Off the Wall), '10 (Proof) Chicago (Ill.), Catherine Edelman Gall. / 2006 Brüssel, Mus. communal de Woluwe-Saint-Lambert: Le Petite Chaperon Rouge; Luxembourg, MN d'Hist. et d'Art: Un tableau peut en cacher un autre / 2007 New Orleans (La.), Contemp. AC: Gulf Coast Artists at la Napoule / 2008 Lincoln (Mass.), DeCordova Mus. and Sculpt. Park: Presumed Innocence. Photogr. Perspectives of Children (K) / 2011 Brescia, Gall. Paci Contemp.: Staged Photogr.; Paris, UNESCO: Go West (Wander-Ausst.). ☐ *N. Collet,* Clark et Pougnaud, Arles 2006; Rencontres d'Arles 2006. 37ᵉ éd. (K Rencontres Internat. de la Photogr.), Arles. – *Online:* Website C. & Pougnaud. F. Krohn

Clark, *Laurence* (Pseud.: Helen Cross; Klarc), neuseeländischer Cartoonist, Karikaturist, Comiczeichner, Illustrator, Graphikdesigner, * 1949 Whangarei, lebt dort. Ab 1967 Mitarb. des Art Dept. der Tages-Ztg New Zealand Herald. Gleichzeitig Kunst-Stud. in Auckland an der Auckland Univ. und am Auckland Technical Institut. Zeichnet Cartoons für studentische Mag. und zeigt in den 1970er Jahren Gem., Zchngn und Skulpt. in versch. Ausstellungen. 1972 publiziert C. den psychedelisch an-

mutenden Comic *The Flying Fish*. 1976–87 ist er Mitherausgeber der alternativen neuseeländischen Comic-Zs. Strips, für die u.a. die selbstreferentielle Comic-Ser. *The Frame* (1978–84; unter dem Pseud. Helen Cross), die Superheldenparodie *The Mawpawk* (frühe 1980er Jahre; zus. mit Keith Jenkinson) und der humoristische Strip *Fast Food* (1986) entstehen. Ab 1987 Editorial Cartoonist des New Zealand Herald, für den C. unter dem Pseud. Klarc bis 1996 täglich, danach bis 2000 wöchentlich einen politischen Cartoon gestaltet. Seither freischaffend u.a. für das Scene Mag. (Whangarei) tätig. Auch Buch-Ill. (u.a. zu R. Neumann, *Basic Values for Kiwis*, Auckland 2004), werbe-graph. Arbeiten; Webdesign. Mitgl.: New Zealand Cartoonists and Illustrators Assoc. – Routinierte, linienbetonte, meist bunt kol. Tuschfeder- bzw. Rapidograph-Zchngn in der Trad. US-amer. und europ. humoristischer Comics, z.T. auch mit stilistischen Reminiszenzen an das Werk US-amer. Underground-Zeichner wie Robert Crumb oder Gilbert Shelton. ⌂ WELLINGTON, Nat. Libr. of New Zealand; Alexander Turnbull Libr.; New Zealand Cartoon Arch. ⌷ Deutschlandbilder. Das vereinigte Deutschland in der Karikatur des Auslands, Bielefeld 2003. – *Online:* New Zealand Cartoon Arch.; Website C.

H. Kronthaler

Clark, *Lester (Les),* US-amer. Trickfilmzeichner, * 17. 11. 1907 Ogden/Utah, † 12. 9. 1979 Santa Barbara/Cal. 1927–76 arbeitet C. in den Disney-Studios. Er gehört dort zu den bek. Nine Old Men („key animators") der Studios. In den 1940er-Jahren arbeitet er an den Zeichentrickserien *Oswald the Lucky Rabbit, Micky Mouse, Silly Symphony* und *Donald Duck* mit. Danach ist er auch an abendfüllenden Zeichentrickfilmen wie *Pinocchio, Dumbo, Alice in Wonderland* oder *Peter Pan* beteiligt (insgesamt an ca. 18 Filmen und etwa 100 Kurzfilmen). Bei einigen Animationssequenzen und Filmen hat er auch Regie geführt. Später übernimmt er TV-Specials, so 1959 *Donald in Mathmagic Land*. – C. gilt als routinierter und versierter Animator, der die Disney-Filmproduktionen bis in die 1960er Jahre mapgeblich beeinflußt hat. 1992 wird ihm posthum der Winsor McCay Award verliehen. ⌷ *J. Lenburg*, Who's who in animated cartoons, N. Y. 2006.

K. Schikowski

Clark, *May,* brit. Entwurfszeichnerin, Schmuckgestalterin, * 1898, † 1981, in London tätig. Autodidaktin. Lehrtätigkeit: 1940er Jahre Central SchA and Crafts ebd. Ausz.: Preise der Goldsmiths' Company. – C. entwirft seit E. der 1930er Jahre Modeschmuck u.a. für Norman Hartnell und Mitchel Maer, der 1952–56 Schmuck für Dior fertigt; ferner für das Modehaus Worth. Char. sind florale Komp. mit verschlungenen Bändern (v.a. für Broschen) sowie mit Strass und Glassteinen besetzte Zweige mit vergoldeten oder versilberten Blättern und Glassteinen (Brosche, ca. 1955, London, V & A). Ende der 1950er Jahre lebt C. ein Jahr auf den Bahamas und gestaltet Schmuck mit lokalen Mat. wie Muscheln, Schildpatt, Kalkschulp und Seesternen. Anschl. entwirft sie Brillengestelle aus Kunststoff. ⌂ BIRMINGHAM, Mus. and AG: Brosche. LONDON, V & A. ◉ *E:* 1988 Birmingham, Mus. and AG.

⌷ Dict. internat. du bijou, P. 1998. – London, Goldsmiths' Hall, Libr.: Korrespondenz. – Mitt. F. Slattery, Birmingham Mus. and AG.

H. Stuchtey

Clarke (eigtl. Seron, *Frédéric*), belg. Comiczeichner und -texter, Illustrator, * 16. 11. 1965 Lüttich, lebt in Belgien. Neffe von Pierre Seron. Nach einem vierjährigen Stud. an der ABA in Lüttich zunächst als Mode-Illustrator tätig. Erste Comics erscheinen in den Anthologien *Qui a tué F. Walther?* (1985) und *BD mode, c'est belge* (1988) sowie in der Zs. Ekwé Chal. Zus. mit dem Szenaristen François Gilson konzipiert C. 1987 das humoristische Comicalbum *Rebecca – Bon anniversaire, Papy!!* Ab 1990 Mitarb. des Mag. Spirou, für das er u.a. die Comics *Les Cambrioleurs* (Text v. Crosky), *Africa Jim* (Text v. F. Gilson) und *Mélusine* (seit 1992; bisher 20 Alben; Text v. F. Gilson) zeichnet. Unter dem Pseud. Valda gestaltet er ab 1994 zudem die Serie *Les Baby-sitters* (3 Alben, 1997–99; Text v. Christian Godard). Seit 1998 zeichnet C. außerdem Kurz-Gesch. für das satirische Comic-Mag. Fluide Glacial. Zahlr. weitere Comics: u.a. *Durant les travaux, l'exposition continue...* (3 Alben, 1998–2000; Text v. Midam [Pseud. v. Michel Ledent]); *Thérapies en vrac* (1999); *P. 38 et bas nylon* (2000); *Château Montrachet* (2001); *Cosa Nostra* (3 Alben, 2003–11); *Le Miracle de la vie* (2004; Text v. Midam); *Mister President* (5 Alben, 2004–09); *Luna Almaden* (2005); *Urielle* (2009; beide Text v. Denis Lapière). – Routinierte linienbetonte, meist karikaturhafthumoristische, z.T. auch semihumoristische Zchngn in der Trad. der sog. Ec. Marcinelle. ⌷ *H. Filippini*, Dict. de la bande dessinée, P. 2005; *P. Gaumer*, Dict. mondial de la BD, P. 2010. – *M. Béra u.a.*, Trésors de la bande dessinée. Cat. enc. 2007–2008, P. 2006. – *Online:* Lambiek Comiclopedia; Website C.

H. Kronthaler

Clarke, *Jonathan,* brit. Bildhauer, * 1961 Bury St. Edmunds/Suffolk, lebt dort. Sohn und Schüler (ab ca. 1977) des Bildhauers Geoffrey C. Mitgl.: 1994 R. Soc. of Brit. Sculptors. – C. übernimmt die vom Vater entwickelte Technik des Aluminiumsandgusses unter Verwendung von Styroporformen (z.B. *Warrior heads*), die er ohne Vor-Zchngn zuschneidet; arbeitet aber auch mit and. Metallen wie Silber (*Disconfigure*, 2006) oder Edelstahl (*Judges III*, in Verbindung mit Aluminium, 2007) bzw. integriert and. Mat. (*Venetian Head [male]*, Aluminium und Eiche, 2004; *Oltrepassare*, Aluminium und Muranoglas, 2007). C.s figürlich-abstrahierte bzw. gänzlich abstrakte Skulpt. weisen kompakte Formen auf, sind gelegentlich farbig gefaßt (*Giallo verde*, 2008) und nehmen häufig Bezug auf politische und soziale Probleme. ⌂ CAMBRIDGE, Trinity Hall: Twelve, Aluminium, 2006. ELY, Kathedrale: Way of Life, Aluminium, farbig gefaßt, 2001. FALMOUTH, Nat. Maritime Mus. LONDON, New St. Square: New St. Square Browsers, Aluminium, 2006–08. – New Fetter Lane: New St. Square Gateway, Aluminium, 2006–08. NORWICH, Castle Mus. SOUTHWELL b. Nottingham, Münster: Kreuzwegstationen. ◉ *E:* 1996, 2000, '05 Chappel (Essex), Chappel Gall. / 2001 Sudbury, Gainsborough's House / 2005 Aldeburgh, Strand Gall. (K) / 2008 Gubbio, Pal. Ducale. ⌷ *Windsor*, Sculptors, 2003; *Buckman* I,

2006. – *D. Buckman*, Head on (K), Chappel 2000. – *Online:* Website C.; New AC, Salisbury.

C. Rohrschneider

Claro, *Émile,* algerischer Maler, Zeichner, Freskant, * 29. 3. 1897 Oran, † 1977 Nîmes. Bruder des Architekten Léon C. Stud.: Ec. nat. des BA, Algier, bei Léon Cauvy; 1919 ENSBA, Paris, bei Fernand Cormon. Ausz.: 1931 Aufenthalts-Stip., Casa Velázquez, Madrid; 1951 Grand Prix artistique de l'Algérie. C. bereist Spanien (u.a. Alicante, Toledo, Cordoba) und die Balearischen Inseln. 1937 ist er an der Ausmalung des Foyer Civique in Algier beteiligt, welches sein Bruder entworfen hat. Ab 1949 in Paris ansässig. – Portr., Stilleben, Stadtansichten und Lsch. in Öl. ▢ ALGIER, MNBA. ORAN, MN Zabana. PARIS, MAMVP. ◉ *G:* Paris: 1924, '26 SAfr.; 1925 Salon d'Automne; 1929 Salon des Tuileries; 1957 Gal. Leleu: Les Peintres de l'Algérie / 1927 Algier: Salon d'Hiver / 1951 Monte-Carlo: Expos. artistique de l'Afrique franç. ▢ *Edouard-Joseph* I, 1930; *Bénézit* III, 1999; *E. Cazenave,* Les artistes de l'Algérie, P. 2001. – *A.-M. Briat u.a.,* Des chemins et des hommes. La France en Algérie, 1830–1962, Hélette 1995 (hier Vermischung von C.s Biogr. mit der seines Bruders). F. Krohn

Claro, *Léon,* algerischer Architekt, * 24. 6. 1899 Oran, † 1991 Gien. Bruder des Malers und Zeichners Emile C. Stud.: Ec. nat. des BA, Algier, bei Gabriel Darbeda und Gaston Redon. 1926 Architecte diplomé par le gouv. (DPLG). – C. läßt sich 1927 ebd. nieder, wo er an der Ec. nat. des BA unterrichtet und zahlr. öff. Bauaufgaben ausführt, u.a. Maison indigène (1930); Foyer Civique (1935; Sitz der Union Générale des Travailleurs Algériens; heute: Maison du Peuple); Entwurf eines neuen Gebäudes für die EcBA (1950–54; gemeinsam mit seinem Schüler Jacques Darbeda); sowie L'hôpital de Tizi-Ouzou (1958–64; heute: Centre hospitalo-universitaire). Lebte seit seiner Pensionierung 1964 in Frankreich. ▢ Beaux-Arts 1936 (173) 3. – *A.-M. Briat u.a.,* Des chemins et des hommes. La France en Algérie, 1830–1962, Hélette 1995 (s.v. Claro, Emile; hier Vermischung von C.s Biogr. mit der seines Bruders). F. Krohn

Claro (C. Swinburn), *Patricia,* chilenische Malerin, Videokünstlerin, * 1960 Santiago de Chile, lebt dort. Stud. ebd.: 1978–82, 2003–05 mit Stip. bild. Kunst und Gest. an der Pontificia Univ. Católica de Chile (1982–84 Ass.); 2007 Stip. Fondart (Fondo Nac. de Desarrollo Cult. y las Artes) für visuelle Kunst; 2008–09 Theorie an der Univ. de Chile bei Gonzalo Pedraza. – C. beschäftigt sich in Malerei und Video mit der Lsch., v.a. mit dem Element Wasser, dessen ständig wechselnde formale und farbliche Erscheinung als unendliche Bilderquelle und Reflektor der umgebenden Natur dient. Von digitaler Fotogr. inspiriert, stellt sie in Serien großformatiger Öl-Gem. in kräftigen Blau- und Grüntönen horizontlose Wasseroberflächen mit Wellenbewegungen und verzerrten Baum- und Wolkenspiegelungen dar, die einen meditativen Char. besitzen und zw. Abbild und Abstraktion, zw. Wahrheit und Illusion changieren (in Ausst. z.T. auf dem Boden liegend präsentiert, wodurch Oben und Unten sich verkeh-

ren und das Schwebende der Komp. unterstrichen wird). Ähnlich angelegt sind auch ihre Videos, die z.B. in festen Einstellungen eine spiegelbildlich gedoppelte Ansicht auf eine Wasseroberfläche mit gespiegeltem Astwerk zeigen (*Agua,* 2008; Musik von Max Zegers). ✉ Corte y reconstitución del paisaje. Una sinécdoque pictórica (Tesis, Pontificia Univ. Católica), S. Ch. 2005. ◉ *E:* Santiago de Chile: 2007 Centro Cult. de Las Condes (mit María José Concha Salí); 2008 Gal. Animal (K: M. O. Giménez); Coyhaique, Espacio Arte Aysén (mit María José Concha und José Viviani; K: B. Huidobro Hott) / 2009 Miami (Fla.), Kelly Roy Gall. – *G:* 2009 Ushuaia u.a.: Intempérie. Bien. del Fin del Mundo; Brüssel, Maison de l'Amérique Latine: Focus Chili. Expo des jeunes créateurs contemp. (K). ▢ Pintando la Patagonia (K Wander-Ausst.), S. Ch. 2007; *W. Sommer,* El Mercurio (S. Ch.) v. 15. 7. 2007; 29. 7. 2007; 30. 12. 2007; 28. 12. 2008; *M. Arenas Zapata,* ibid. v. 7. 12. 2008; Arte al límite 2008 (30) 22–23 (Interview); *C. Díaz,* East Side (S. Ch.) 2008 (33) 56 s.; *G. Quiroga u.a.* (Ed.), C/temp arte contemp. mendocino, Mendoza, Argentinien 2008; *M. J. Carvallo,* Rev. ED (S. Ch.) 2009 (161) 90 s. (Interview); *G. Benvenuto,* Al Límite 2010 (61) 16 s.; *D. Colson,* Art district (Miami, Fla.) 1:2010 (4) 10 s. – *Online:* Website C. M. Nungesser

Classen, *Michaela,* dt. Malerin, Kunstpädagogin, * 1947 Kronberg/Taunus, lebt in Essen-Werden. 1966–69 Lehre. 1968–87 freischaffend und Erziehungszeit (5 Kinder). Stud.: 1991–95 Univ. Essen, Fachbereich Kunst; 1995–99 Novalis HS-Ver. Kamp-Lintfort. 2002–04 Mitarb. im Mus. Folkwang. Seit 2004 freischaffend. – V.a. Portr., Figuren- und Kinderbilder (Öl/Lw., Acryl) mit häufig beunruhigendem und verstörendem Inhalt, z.T. in einem am dt. Verismus geschulten realistischen Stil. In dem Gem.-Zyklus *Sternenkinder* bzw. *Die Reise nach Jerusalem* (2009–11) gibt C. mit über 50 (nach Fotogr. gefertigten) z.T. lebensgroßen Bildern von Kindern, die dem Holocaust zum Opfer fielen, diesen eine nachträgliche Lebensgeschichte. ◉ *E:* Essen: 2006 Gal. KK; 2009 (beide mit Heike Feddern), '11 Kunstraum Scheidt'sche Hallen / 2011 Halberstadt, Moses-Mendelssohn-Akad. – *G:* 2006 Gelsenkirchen, Wiss.-Park: Wandlungsprozesse / 2011 Essen: Gal. KK: Traum und Traumata. Fünf Malerinnen und ihr Blick auf die Welt. ▢ *B. Figgemeier* (Ed.), Begegnungen (K Bochum), Dortmund 2005. U. Heise

Clauce, *Jean Ernest (Johann Ern[e]st),* dt. Porzellanmaler, * 24. 3. 1761 Berlin, † 6. 2. 1808 ebd. Sohn von Isaac Jacob C. und Bruder von Franz Ludwig Close. Die Fam. unterhält enge Kontakte zum Kunstsammler und Gründer der Berliner Porzellan-Man. Johann Ernst Gotzkowsky, der C.s Patenonkel ist. Ausb.: 1769–75 Malerlehre, wohl beim Vater in Berlin. Danach ebd. in der Kgl. Porzellan-Man. (KPM) als Maler mit der Spezialisierung für „Figuren, Ovid:Hist. & Allegorien" (1787) tätig. Trotz interner fachlicher Vorbehalte wird C. bei der KPM 1789 zum Nachf. seines Vaters als Malereivorsteher bestimmt. Reist auf Kosten der Man. zur Weiterbildung von Sept. 1790 bis Mitte Mai 1791 nach Italien, wobei er den jungen Berliner Architekten Heinrich Gentz

von Dresden über Prag, Wien, Venedig, Mantua, Bologna und Florenz bis nach Rom begleitet. Er trifft während der Reise auf Künstler wie Jakob Philipp Hackert in Neapel oder Angelica Kauffmann, Jean-Baptiste-Claude-Bénigne Gagneraux oder Friedrich Wilhelm Gmelin sowie Peter Ludwig Burnat und Abraham Abramson in Rom. Die Arbeitsbesuche der Porzellan- und Fayence-Man. u.a. von Wien, Treviso, Florenz, Neapel und Nymphenburg dokumentiert er in flüchtigen, teilw. auch präzisen Reiseberichten. Wird nach seiner Rückkehr in Nachf. des Vaters u.a. 1792–93 Vorsteher des Dekorationsfaches und 1792–1802 Vorsteher der Figurenfaches an der KPM; alle Funktionen muß er abgeben, da er den Anforderungen nicht gewachsen ist. Ab 1802 befindet sich C. de facto im Ruhestand und bezieht bis zum Tod das volle Gehalt. – Eigenhändige Arbeiten sind bisher nicht bekannt. Mitgewirkt hat C. (lt. Schütze, 2004, 361 ss.) u.a. 1788–89 an der Bemalung von zehn bis zwölf Paar Gobelet-Tassen mit Motiven nach David Teniers, an der Bemalung von fünf großen Vasen mit „etruskischen Figuren" (1788, '89 auf der Berliner Akad.-Ausst.) sowie 1793 an der figürlichen Bemalung von 96 Vasen für den Orangeriesaal in Potsdam. In der Lit. wird er z.T. mit seinem Bruder F. L. Close verwechselt (Schütze, 2004, Anm. 1). ⌑ *Scheffler*, Goldschm. Berlin, 1968, 97, Nr 511; *C. M. Vogtherr* (Ed.), Friedrich Wilhelm II. und die Künste. Preußens Weg zum Klassizismus (K), B. 1997 (Kat.-Nr 128 mit Abb.); *A. Siebeneicker*, Offizianten und Ouvriers. Sozial-Gesch. der Kgl. Porzellan-Man. und der Kgl. Gesundheitsgeschirr-Man. in Berlin 1763–1880, B./N. Y. 2001, 477; *K.-R. Schütze*, Der Porzellanmaler J. E. C., in: *M. Bollé/K.-R. Schütze* (Ed.), Heinrich Gentz. Reise nach Rom und Sizilien 1790–1795. Aufzeichnungen und Skizzen eines Berliner Architekten, B. 2004, 361–366; *N. S. Schepkowski*, Johann Ernst Gotzkowsky. Kunstagent und Gem.-Sammler im friderizianischen Berlin, Diss. Freie Univ. Berlin 2007, B. 2009. – Berlin, Kgl. Porzellan-Man.: Personalakte. U. Heise

Claude, *Gérard*, luxemburgischer Maler, Graphiker, Bildhauer, Objektgestalter, Land-art-Künstler, Kunstpädagoge, * 10. 3. 1956 Esch-sur-Alzette, lebt in Bettel und Roth an der Our/RP (Atelier). Stud.: 1977–81 (Dipl.) Univ. de Sc. Humaines, Strasbourg; 1978–79 Ec. des Arts Décoratifs ebd. (Bildhauerei, u.a. bei Jean-Marie Krauth). Seit 1981 als Kunstpädagoge (1984 Prof.) am Lycée Classique in Diekirch tätig. Ausz.: 1975 1. Prix de la Peint., Bienn. des Jeunes, Esch-sur-Alzette; 1979 Prix Grand-Duc Adolphe, Luxembourg; 2003 1. Preis, Bienn. d'Art Contemp., Strassen. – C.s Œuvre umfaßt die Werkgruppen Malerei, Graphik, Objekt-Gest. und Land-art. Er debütiert in den 1970er Jahren mit abstrakter farbflächiger Malerei (Acryl, Aqu.), mit der er sich im Rahmen seiner Ausb. auch theoretisch beschäftigt. Seit E. der 1970er Jahre fertigt er aus Holz und Kunststoffschaum u.a. erotische konnotierte organoide Objekte, behälterartige Objektkästen und Assemblagen, die bisweilen Schreincharakter annehmen. Bald entstehen skulpturale und filigrane (Wand-)Objekte aus Holz, Leder, Draht, Fundstücken (Federn, Tierschädel) und Verspannungen, die in Materialität und Symbolik

bisweilen von indigenen Kulturen inspiriert zu sein scheinen. Häufig läßt sich C. bei diesen Arbeiten seit E. der 1980er Jahre von exo- und endoskelettartigen Strukturen aus Fauna (v.a. Wirbelsäule) und Flora (u.a. Blattrippen) anregen, um biomorphe, zunehmend filigraner gestaltete Wand- und Decken-Objekte zu erschaffen (*Raumfühler*, 2005). Seit 2000 beschäftigt sich C. mehrfach mit Landart: Im öff. Raum des Großherzogtums und des grenznahen Bereichs in Deutschland plaziert er u.a. saisonale Landart-Gest. auf großen offenen oder innerhalb von bewaldeten Flächen. Seine im Jahr 2000 im Rahmen des Projektes Champs Elysées im Our-Tal im Rhythmus des landwirtschaftlichen Jahres entstehenden Arbeiten auf offenen Flächen faßt er als Werkgruppe *Agr Art* zusammen. Zeitgleich entsteht inmitten des dortigen Hochwaldes die minimalistisch angelegte anamorphetische Arbeit *Hexenring* (2000), für die C. 500 Fichtenstämme mit weißer Kalkfarbe ringförmig markiert. Ins *Blickfeld (Agr Art II)* der Besucher der Landesgartenschau in Trier rückt er 2004 auf zehn Hektar Konversionsfläche die Aussaat von blau blühender Phacelia und gelber Gerste auf parallel angelegten Schlägen, womit C. auf unspektakuläre wie originelle Weise eine vieldeutige und assoziationsreiche Verbindung zw. lokaler Gesch., Natur und Kunst im Lsch.-Raum herstellt. Mit ebenso elementaren Arbeiten interpretiert C. auch konkrete urbane Räume (Stadtplätze) oder imaginäre Linien (Landesgrenzen). So plaziert er auf der Our-Brücke, die die dt.-luxemburgische Grenze zw. Roth und Bettel bildet, zwei hohe, je bis unter die Kronen längs gespaltene Eichen als symbolträchtige *Grenzbäume* (2007). Seit 2008 widmet er sich als Ausgangs-Mat. sehr altem Obstbaumholz, dessen natürlich ge- und verwachsene Strukturen er u.a. durch Behauung falten- und wellenartig offenlegt. C. ist mit seinen char. Arbeiten ein wichtiger Vertreter der gegenwärtigen naturnahen Environmental-art im Großherzogtum. ⌑ BETTEL, Gemeindeverwaltung. LUXEMBURG, Banque et Caisse d'Epargne de l'Etat. STRASBOURG, KS der Univ. ◉ E: Esch-sur-Alzette: 1977 (Debüt), '83, '85 Gal. Municipale; 1989, 2011 Gal. du Théâtre / Luxembourg: 2003, '06 (K) Gal. Schweitzer; 2012 Gal. Puits Rouge (mit Gabriele Eickhoff). – G: 1973–2011 Strassen: Bienn. d'Art Contemp. / 1977 Belgrad: Internat. Bienn. / 2001 Frankfurt am Main, Europ. Zentralbank: Zeitgen. Kunst aus Luxemburg / 2003 Beaufort (Lux.): Art in Beaufort / 2012 Luxemburg, Pl. de Paris: Gare Art Festival. ⌑ *M. M. Burghagen* (Ed.), Luxart. Lex. der zeitgen. Luxemburger Künstler, Luxemburg 1999. – Hart an der Grenze. Ein interregionales Projekt, Saarbrücken 2007. – *Online:* Website C. U. Heise

Claude-Henri (eigtl. Juillard, *Claude-Henri*), frz. Comiczeichner, Autor, * 2. 8. 1915 Valentigney, † 27. 4. 1990 Montcuq. Ab 1946 erste Kurzgeschichten u.a. für Jugend-Mag. wie Petit Canard oder Zorro. Für Zorro entstehen die Serien *Capitaine Tornade* und *Ivanhoé*. Ab 1948 für Vaillant tätig, dort zeichnet C. die Serien *Hourrah Freddi* (1948–53), *Lynx Blanc* (1952–54, 1957–61) und *P'Tit Joc* (1961–62). 1954 veröff. er im Mag. 34 Caméra *Charles Oscar*. Ab 1961 auch Veröff. in Spirou (*Histoires de*

l'oncle Paul), Pilote und Record. Ab 1965 hauptsächlich in Mag. für junge Mädchen zu finden, so in J2 Mag., Line oder Lisette. In seiner späten Karriere auch Ill., etwa für Art. in Aventures et Voyages. – Routinierter Strich mit realistischen Figuren, typisch für Comic-Ill. der 1950er Jahre. ▭ *P. Gaumer/C. Moliterni*, Dict. mondial de la bande dessinée, P. 1997; *H. Filippini*, Dict. de la bande dessinée, P. 2005. – *Online:* Lambiek Comiclopedia.

<div align="right">K. Schikowski</div>

Claudy cf. **Chott**

Clausel, *Alexandre-Jean-Pierre (Alexandre),* frz. Daguerreotypist, Fotograf, Maler, Aquarellist, * 15. 10. 1802 Troyes/Aube, † 12. 3. 1884 Neuilly-sur-Seine/Hauts-de-Seine. E. der 1810er Jahre Umzug der Fam. nach Toulouse; Stud. an der EcBA ebd. 1825 Heirat und Antritt einer Lehrerstelle am Collège in Pamiers/Ariège. Während der folgenden Jahre malt C. Portr., relig. Bildthemen und Lsch. in Öl und Aquarell. 1836 Rückkehr nach Troyes, wo C. 1837 Jacques-Nicolas Paillot de Montabert kennenlernt, der ihm die Technik der Enkaustik vermittelt, auf die er sich in den nächsten Jahren erfolgreich spezialisiert. Die Daguerreotypie erlernt C. möglicherweise bei Auguste Belloc, mit dem er 1852 in Paris einen Wachsüberzug für dessen Salzpapierabzüge entwickelt; ab M. der 1850er Jahre arbeitet er mit Kollodium-Naßplatten. 1857–62 auf Wanderschaft im Nordosten Frankreichs. 1862–68 Zusammenarbeit mit seinem Sohn, Léon C., in Troyes. Anschl. versucht sich C. erneut als Porträtmaler in Troyes, bevor er sich 1879 in Neuilly-sur-Seine zur Ruhe setzt. Das heute bek. fotogr. Werk besteht vornehmlich aus Lsch. und Stadtansichten von Troyes und Umgebung, darunter ein Panorama aus ca. 20 Einzelbildern (1860). 1902 verlegt Jules Sorlot eine Ed. von 40 Postkarten nach Fotogr. von C. mit Ansichten der Stadt u.d.T. *Troyes d'autrefois.* ⌂ Los Angeles/Calif., J. Paul Getty Mus. Paris, Orsay. Rochester/N. Y., George Eastman House. Troyes, MBA et d'Archéologie: 110 Kollodium-Negative und ca. 100 Papierabzüge. ◉ *G:* Paris: 1842, '44 Salon de Paris; 1855 WA (Med.) / Troyes: 1860 Expos. de Troyes; 1978 Bibl. mun.: Autrefois Troyes (K); 1988 MBA et d'Archéologie: Troyes, ses fortifications, portes, tours, arches (K) / 2003–04 Paris, Orsay, und New York, Metrop. Mus.: Le daguerréotype français. Un objet photogr. (K: Q. Bajac). ▭ *L. Morel-Payen,* Souvenirs d'A.-J.-P. C., peintre et photographe troyen, in: Annuaire de l'Aube, 1912; *M. Weaver* (Ed.), The art of photogr. 1839–1989 (K), Lo. 1989; *J. Wood,* The scenic daguerreotype. Romanticism and early photogr., Iowa City, Ia. 1995; *R. Perret* (Ed.), Kunst und Magie der Daguerreotypie (K Winterthur), Brugg 2006. – *Online: J. Fournier,* Peintre et photographe du s. dernier. A.-J.-P. C., in: Luminous-lint. World photogr.

<div align="right">P. Freytag</div>

Clausen, *Susanne,* dt. Konzept-, Installations-, Video- und Performancekünstlerin, * 11. 5. 1967 München, lebt in London und München. Stud.: 1988–94 ABK, München; 1997–99 Slade School of FA, London. Lehraufträge: seit 2000 HdK, Zürich; 2001–04 Middlesex Univ., SchA and Design, London; 2001–04 Central St. Martins Col-

lege of Art and Design; 2001–07 Loughborough Univ., SchA and Design; seit 2007 Univ. of Reading. Stip.: u.a. 1997 Inst. für Auslandsbeziehungen, Stuttgart; 1998/99 Stip. Bayrisches Kultur-Minist.; 2000 Stanley Picker Fellowship in Intermedia; 2001 Stiftung Kunstfonds, Bonn. 1997 Gründungs-Mitgl. der Künstlergruppe Szuper Gallery, München/London (zus. mit Christian Hilt, Ruth Maclennan, Pawlo Kerestey). Seit 2001 arbeiten nur noch C. und P. Keresty unter diesem Namen. – Szuper Gallery beschäftigt sich mit den Bedingungen und Möglichkeiten von Kunstproduktion. Dabei versteht sie sich als ständig mutierende Institution, die sich je nach Kontext neu inszeniert und in multimedialen Installationen, Videos, Fotogr. und Performances den selbstreflexiven Fragen nachgeht, die das sich wandelnde Berufs- und Arbeitsfeld von Künstlern und Kulturschaffenden zu Beginn des 21. Jh. aufwirft. Für ihre Interventionen arbeitet Szuper Gallery mit and. Künstlern, Kuratoren und Personen aus unterschiedlichsten sozialen Zusammenhängen wie Ökonomen oder Beamten zusammen. Beim Projekt *Parasitic Archit. – Gall. Fiction* (2001–04) werden Perspektiven und Visionen für ein zukünftiges Kunstsystem untersucht. Ausgangspunkt ist eine Ausschreibung für Architekten, Entwürfe für eine nomadische Gal.-Archit. zu entwickeln. Daran knüpft sich eine Recherche an mit aufgezeichneten Gesprächen und Diskussionen zw. Kuratoren und Museumsmitarbeitern sowie Workshops mit Kunststudenten. Als Auftragsarbeit entsteht für das Münchner Kreisverwaltungsreferat das *Liftarchiv* (2001–05), eine Skulpt., die als Plattform für Veranstaltungen und Projekte dient. Eine gläserne fahrbare Aufzugskabine im Foyer der Behörde wird mit wechselnden Installationen bestückt. ▥ London, Whitechapel AG. ◉ *E:* London: 1998 30 Underwood Street Gall. (K); 1999 Inst. of Contemp. Arts; 2000 South London Gall.; 2001 Whitechapel AG; 2007 Artists' Studio (K) / 1998 Paris, Gal. Brighi / 1999 Moskau, Gal. Marat Guelman / 2001, '02 Bremen, Künstlerhaus / 2004 Hongkong, Para/Site Art Space / 2006 Helsinki, KH / 2007 Zürich, Les Complices. – *G:* 1999 München, KV: Dial „M" for ...; Zürich, Shedhalle: Programm Fernsehen / London: 1999 Inst. of Contemp. Arts: Crash!; 2000 Stanley Picker Gall., Kingston Univ.: Working Title; 2001 Whitechapel AG: Temporary Accommodation (K) / 2001 Wien, KH: Televisions / 2002 München, Kunstraum: Am Anfang der Bewegung stand ein Skandal / 2003 St. Petersburg, Russ. Mus.: Electric Earth (Wander-Ausst.) / 2008 Helsinki, MMK (Kiasma): Loving Revolution. ▭ *Szuper Gall.* (Ed.), Gallery Talks, M. 2001; *Szuper Gall.* (Ed.), Liftarchiv. Warum begeben Sie sich nicht auf den Boden der Tatsachen?, Ffm. 2007. – *Online:* Szuper Gall. – Mitt. C.

<div align="right">H. Uhr</div>

Claussen (Claußen), *Claus-Frenz,* dt. Metallplastiker, Maler, Mediziner, Hochschullehrer, Autor, * 28. 5. 1939 Husum, lebt in Bad Kissingen und Eisenbühl/Bayern. C. ist 1965–2004 (emeritiert) als renommierter Forschungsmediziner und HS-Lehrer an versch. Univ.-Kopfkliniken tätig. Als Künstler Autodidakt. Ab 1973 unterhält er eine Metall-Wkst., seit 1997 ein Atelierhaus mit eig. Freiluft-Gal. im oberfränkischen Eisenbühl. – C. formt aus Ble-

chen, Stahl- und Eisenplatten, Metallbändern und -gittern, auch aus Metallfundstücken und -schrott, durch mechanische Bearbeitung (Biegen, Stanzen, Schweißen u.a.) mit anschließender Verzinkung (Ausf. Voigt & Schweitzer, Landsberg/Halle) und ein- bzw. mehrfarbiger Lackierung fragil erscheinende, meist narrativ-burleske Figurationen (*Gandolf, der Meister & seine drei Geister*, 2003), die vom US-amer. Metallbildwerker David Smith inspiriert zu sein scheinen. Viele von C.s Skulpt. thematisieren Mythen und Legenden. Dabei rekurriert er auf die Grenzbereiche zw. Psychologie, Kunst und Wiss., v.a. auf Archetypen und Symbole, so auf die sog. Urpflanze (*Jugendgeist des Gingkos*, 2002) oder den Weltenbaum *Yggdrassil* (2009) aus der germanischen Mythologie, auf die er sich häufig bezieht. C.s medizinisches Spezialgebiet (Erforschung von Sinnesstörungen wie Taumel oder Doppelsehen) schlägt sich thematisch bisweilen auch direkt in der Titelgebung der z.T. mon. Metall-Skulpt. nieder (*Cerebralo*, 1996; *Der Blitzblicker*, 2009; *Caput Vacui*, 2009; *Der menschliche Sensoriktunnel*, 2010, alle Stahl). Sein künstlerisches Konzept bezeichnet C. als „narrativen Sensologismus". ▭ *Skulpt. im öff. Raum:* BERLIN, Charité, Innenhof: Gingko, Stahl, 1993. EISENBÜHL: Eisenpark. WÜRZBURG-Heuchelhof: Frankenapostel, Stahl, 2003. ▭ Feuer, Stahl und Logik. Über Zusammenhänge zw. Wiss. und Kunst, Ha./Neu Isenburg [1979]; Stahl-Skulpt. im Berger Winkel. Stählerne Zeichen des Seins über Wasser und Land in C.s Eisenpark zu Eisenbühl, Bad Kissingen 2005; Drehen, Laufen, Leben (Gedichte), Bad Kissingen 2005. ▭ *Online:* Website C. U. Heise

Clauzel, *Jacques*, frz. Maler, Fotograf, Graphiker, Buchkünstler, * 4. 5. 1941 Nîmes, lebt in Montpellier. Stud.: Ec. régionale des BA ebd.; EcBA Tourcoing; ENSBA, Paris, bei Roger Chastel. 1965–73 Doz. für Malerei an der ENSBA, Abidjan/Elfenbeinküste. Nebenher malt C., ist aber bald von der phantasievollen afrikanischen Volkskunst fasziniert, deren Einfluß seinen weiteren Werdegang bestimmt. Er beginnt autodidaktisch zu fotografieren, veröffentlicht zwei Fotobücher über Abidjan (u.a. über das Markttreiben der Stadt) und spezialisiert sich ab 1968 auf Reportagefotografie. Auf zahlr. Reisen durch Afrika fotografiert C. für Reportagen u.a. in Mali, Ghana, Niger, Burkina-Faso, Togo und im heutigen Benin. 1973 Rückkehr nach Frankreich; neben der Forts. der Reportage-Fotogr. führt er nun ein eig. Atelier für Industrie- und Werbefotografie. 1974 Berufung an die Ec. régionale des BA in Montpellier zwecks Aufbau eines Ateliers für Fotogr. und bis 1986 dessen Leiter. Ab 1976 kehrt er über die Beschäftigung mit dem automatischen Zeichnen (Filzstift) auch zur Malerei zurück. Ab M. der 1980er Jahre intensive Ausst.-Tätigkeit im internat. Maßstab. Beginnt mit fast allen verfügbaren graph. Techniken zu experimentieren; Anschaffung einer Druckpresse; Veröff. mehrerer Serien mit druck-graph. Arbeiten durch das Graphik- und Kunstdruckatelier von Rémy Bucciali in Colmar. Ab 1993 Gest. von Künstlerbüchern, zu denen Schriftsteller und Dichter passende Texte liefern; Hrsg. von mehr als 250 Gemeinschaftswerken, u.a. mit Andrée Chedid, Pierre Dhainaut,

Bernard Noël, Michel Butor (z.B. *La cérémonie du café*, 2006). Seit 1999 durch Naturbeobachtungen spontan ausgelöste Rückbesinnung auf die Fotogr.; die nun entstehenden Naturaufnahmen werden in mehreren Fotobüchern veröff. (z.B. *Par temps sec ou lisible*, Text: P. Dhainaut). – Eine strenge, minimalistisch verknappte Darst.-Weise, deren wichtigstes Gest.-Mittel die Linie ist, zieht sich wie ein Leitfaden durch C.s technisch vielfältiges Œuvre. Das malerische Frühwerk (1965–68) umfaßt Komp., bei denen er aus mehreren Bll. bestehende weiße Papierbahnen in reinen Farben bemalt. Diese schneidet er anschl. in Streifen, die er nach einem and. Ordnungsprinzip wieder zusammenklebt, so daß sich eine geflechtartige Struktur ergibt. In der sich anschließenden Reportage-Fotogr. beschränkt sich C. nicht auf die reine Dokumentation, sondern betrachtet die Motive in einer von piktorialistischen Auffassungen geprägten Sichtweise. M. der 1980er Jahre setzt eine Neuorientierung ein mit der Wiederaufnahme der Malerei, als deren Bildträger C. fortan grobes Packpapier verwendet, das er faltet, zerknüllt, zerreißt oder schichtweise stapelt und auf das er ausschl. mit Acrylfarbe minimalistische, streng und klar aufgebaute Komp. malt. Im Rahmen seiner Unters. auf dem Gebiet der graph. Techniken, die C. häufig miteinander kombiniert (Rad., Kaltnadel, Aquatinta, Lith., Hschn., Linolschnitt, Serigraphie) entstehen zeichenhafte Darst., v.a. in Schwarz-, Grau- und Weißschattierungen auf ungerahmtem, manchmal unregelmäßig geformtem Papier, deren Anregungen C. möglicherweise von der Gruppe Support-Surface aufgreift, mit der er aber nicht in Verbindung steht. ▭ ARLES, Mus. Réattu. KAISERSLAUTERN, Mus. Pfalz-Gal. ▭ Nouvelles de l'estampe 188:2003, 36–44. ◉ *E:* 1988 Montbéliard, Centre régional d'Art contemp. (K) / 1991 Pau, Le Parvis III (K) / 1992 Issoire, Bibl. Médiathèque (K) / 1996 Montpellier, Château d'O (Retr.; K) / 1997 Lunel, Espace Louis Feuillade (K) / 2002 Grasse, Bibl. Médiathèque (K); Uzès, Gal. L'Entrepôt (K) / 2002, '03 , '06 Tokio, MMG Gall. / 2006 Nîmes, Gal. des Arènes (K: C. Skimao); Paris, BN (K: M. Butor) / 2010 Arles, Mus. Réattu (Schenkung von 180 Graphiken; K: P. Plouvier [unveröff.]) / 2012 Paris, Gal. Berès. – *G:* Paris: 1998, '99, 2002 Salon Page(s); 2004 Bienn. internat. de la Photogr. et des Arts visuels; 2010 Grand Pal.: Salon internat. de l'Estampe / 2007 Lüttich, MAM et d'Art contemp.: Bienn. internat. de Gravure contemp. / 2010 Brüssel, Gal. Philippe Samuel: Art on Paper. Le Salon du Dessin contemp. ▭ *Bénézit* III, 1999; *Delarge*, 2001. – *Online:* Website C. (Ausst.). R. Treydel

Clavé (C. Jové), *Florenci*, span. Comiczeichner und -autor, * 26. 3. 1936 Barcelona, † 1. 8. 1998 Madrid. Ab 1953 Arbeiten für Selecciones Illustradas in Barcelona. M. der 1960er-Jahre geht C. nach Frankreich und wird dort für Dargaud tätig. Für das Mag. Pilote entstehen *Rémy Herphelin* und *Les Dossiers du Fantastique*. Aus der Zusammenarbeit mit Guy Vidal als Szenarist erwachsen u.a. *Ned Kelly* und *Les Innocents d'El Oro*. C. ist ebenfalls in den Mag. Charlie Mensuel, TV Gadget und Circus vertreten. In Circus arbeitet er zus. mit Christian Godard an *La Bande à Bonnot* (1978) und *Les Dossiers de l'Archange* (1987). A.

der 1980er Jahre Rückkehr nach Spanien, dort veröff. er *Cronicas de la IIIe guerra mundial* (1981) in De La Torre. Weitere Arbeiten in Frankreich: *Les Chroniques du Temps de la Vallée des Ghlomes* (1990), *Voyages en Amertume* (1992), *Crimes d'Art – Opera* (1995) für Vents d'Ouest und *Le Bras du Démon* (1996) für Soleil. – C. zeichnet in einem realistischen bis semirealistischen Stil, den er häufig in das Phantastische übergehen läßt. ⌑ *P. Gaumer/C. Moliterni*, Dict. mondial de la bande dessinée, P. 1997; DPEE, Ap., 2002; *H. Filippini*, Dict. de la bande dessinée, P. 2005. – *Online:* Lambiek Comiclopedia.

<div align="right">K. Schikowski</div>

Claveau, *Emile (Emile François Paul)*, frz. Autodesigner, Ingenieur, * 23. 1. 1892 Langeais/Indre-et-Loire, † 10. 5. 1974 Paris. Entstammt einer ab 1900 in Tours ansässigen Bäckerfamilie. Stud.: EcBA Tours (Malerei). 1913 als Dekorationsmaler dok., 1921 und '26 als Händler, 1928 Fa. „Claveau Automobile". 1926 präsentiert C., der keine Ausb. als Automobil-Ing. hatte, im Pariser Automobilsalon den Entwurf eines stromlinienförmigen Heckmotorwagens, der durch vorausgegangene Modelle von Edmund Rumpler (Tropfwagen, 1922) und Paul Jaray (stromlinienförmige Karosserie, 1921) beeinflußt ist. 1927 und '28 zeigt er im Salon Weiterentwicklungen dieses Modells. Seine nächste Kreation ist der *Autobloc Claveau* (1930) mit Frontantrieb, selbsttragender Karosserie und Einzelradaufhängung, den er in den Salons 1931, '32 und '33 (mit Modifikationen) vorstellt. Im Autosalon 1947 folgt ein Modell mit selbsttragender Aluminiumkarosserie, 1948 der Prototyp des *Descartes*. Auch er wird, wie die vorhergehenden visionären Entwürfe, nur in kleinen Stückzahlen und nicht in Serie produziert. Eine Weiterentwicklung dieses Typs ist C.s letzter Entwurf, der 1955 vorgestellte aerodynamische *Claveau 56*. Von dem Prototyp dieses Modells ist dank eines frz. Sammlers ein Exemplar überliefert (jetzt Pinellas Park/Fla.). – Mitgl.: Soc. des Ing. de l'Automobile; Chambre Syndicale des Constructeurs d'Automobiles. ⌂ PINELLAS PARK/Fla., Tampa Bay Automobile Mus. ⌑ Who's who in France. 1959–1960, P. 1959; *G. N. Georgano*, The new enc. of motorcars. 1885 to the present, N. Y. 1982; Dict. internat. des arts appliqués et du design, P. 1996. – *R. J. F. Kieselbach*, Stromlinienautos in Europa und USA, St. 1982; *O. von Fersen*, Ein Jh. Automobiltechnik. Personenwagen, Dd. 1986; *C. Lichtenstein/F. Engler* (Ed.), Stromlinienform (K Zürich u.a.), [Baden] 1992; *S. Ballu*, Hist. mondiale de l'automobile, P. 1998; Automobilia 95:2009 (Aug.). – *Online:* Pinellas Park/Fla., Tampa Bay Automobile Mus.; Dieselpunk + Steampunk Culture; GTÜ – Oldtimer-Datenbank.

<div align="right">E. Kasten</div>

Clavel, *Gilbert*, schweiz. Architekt, Autor, * 29. 5. 1883 Basel, † 6. 9. 1927 ebd. Stud.: Univ. Basel (Archäol., Ägyptologie, Kunstgesch., Phil.). – C., der an einer Wirbelsäulenverkrümmung leidet, ist in der frühen futuristischen Bewegung aktiv und betätigt sich in der bild. Kunst sowie in der Lit. (v. a. kunsttheoretische Aufsätze). Zahlr. Reisen führen ihn v.a. nach Südeuropa und Nordafrika. 1907 zieht er nach Italien, wo er in Positano und Capri lebt. 1907 begründet er mit Carl Albrecht Bernoulli und Hermann Kurz eine in Basel erscheinende „Mittel-Europ. Monats-Schrift", die Carl Burckhardt gestaltet. Entscheidenden Einfluß auf seinen Werdegang nimmt die Begegnung mit den Ballets russes und den ital. Futuristen. 1917 lernt er Fortunato Depero kennen, mit dem sich über zwei Jahre eine enge Kooperation entwickelt. Gemeinsam arbeiten sie am „plastischen Theater", das eine klare Formen-, Farb- und Lichtsprache mit Musik und Bewegung sowie narrative mit abstrakten Momenten verbinden soll; es entsteht ein Schauspiel (Balli Plastici) für Marionetten, das im April 1918 im Teatro dei Piccoli in Rom aufgeführt wird. Depero ill. C.s phantastische Novelle *Un ist. per suicidi* (R. 1917). Ab 1919 läßt C. seinen bereits 1909 erworbenen Wachturm (Torre di Fornillo) und den angrenzenden Felsen in Positano zu einem Gesamtkunstwerk umbauen (dazu Siegfried Kracauer, Felsenwahn in Positano, 1925), wo ihn u.a. Emmy Ball besucht. Über den Umbau informiert die umfangreiche Korr. mit dem Bruder René C.-Simonius. Der Umbau, für den C. jeden einzelnen Raum bis hin zum Mobiliar selbst plant, beschäftigt ihn mehrere Jahre. So wird u.a. ein Spiralgang in den Felsen gesprengt und eine Grotte zu einem Musiksaal ausgebaut (unvoll.). – C. ist mit Picasso, Diaghilev, Cocteau und Marinetti befreundet. 1919 wird er Mitgl. der schweiz. Gruppe Valori Plastici, in deren gleichnamiger Zs. er zwei Art. zu Picasso und zum „plastischen Theater" publiziert. 1927 Rückkehr in die Schweiz. Seit 2006 erinnert ein nach C. benannter Preis für in Capri lebende Schweizer vergeben. ✉ *H. Boeringer* (Ed.), G. C. Mein Bereich. Auswahl aus den nachgelassenen Tagebüchern, Basel 1930. ◉ *G:* 1991 Zürich, Kunsthaus: Visionäre Schweiz (internat. Wander-Ausst.; K). ⌑ *E. Godoli* (Ed.), Il diz. del futurismo. A-J, Fi. 2001. – *H. Szeemann*, Artis 43:1991 (10) 25. – Basel, StA: Nachlaß.

<div align="right">C. Melzer</div>

Clavel, *Olivia (Olivia Télé;* Pseud. Electric Clito), frz. Malerin, Comiczeichnerin und -texterin, Graphikerin, Illustratorin, Graphikdesignerin, Trickfilmgestalterin, * 14. 10. 1955 Paris, lebt dort. Stud.: ab 1973 ENSBA, Paris. 1974 gründet sie zus. u.a. mit Lulu Larsen (eigtl. Philippe Renault), Kiki Picasso (eigtl. Christian Chapiron) und Loulou Picasso (eigtl. Jean-Louis Dupré) die der Punk-Bewegung nahestehende Künstlergruppe Bazooka. Gestaltet Comics und Ill. für versch. Zss. und Anthologien der Gruppe, u.a. für Bazooka; Loukoum Breton (beide 1975); Activité Sexuelle Normale (1976); Bull.-pér. (1976–78); Les Animaux Malades (1977–78); Bazooka Production (1977); Un regard mod. (1978); L'art dégénéré 83 (1983); Croquemitaine (1985). Auch Beitr. für zahlr. and. Ztgn und Mag., u.a. für Actuel; (à suivre); Charlie mensuel; L'Echo des savannes; Hahaha; Hara-kiri; Libération; Métal hurlant; Nouvel Observateur; Sandwich; Wimmen's Comix. Veröffentlicht die Comicalben *Matcho Girl* (1980) und *Télé au royaume des ombres* (1983). Außerdem Plakate, Siebdrucke und Gest. von Schallplatten- bzw. CD-Hüllen (u.a. für Jean-François Cohen, Brigitte Fontaine, Rita Mitsouko und Sapho). Seit den 1980er Jahren ent-

stehen zudem mehrere kurze Animationsfilme und Film-
clips (z.B. *Les aventures de super meuf* für den TV-Sender
Canal+). – C.s frühe, meist mit kräftigen Schwarzweiß-
kontrasten arbeitende Zchngn und Comics sind stark von
radikaler Punk-Ästhetik geprägt und erinnern an zeitglei-
che Arbeiten US-amer. Underground-Zeichner wie Mark
Beyer, Rory Hayes oder Gary Panter. In den bewußt sprö-
de gez. und dilettantisch-naiv anmutenden Strips erscheint
häufig die Figur *Télé*, eine Gestalt mit einem Fernsehbild-
schirm als Kopf, die simple Alltagserfahrungen von C.
kommentiert. In den 1980er und 1990er Jahren auch zahlr.
gemeinsame Arbeiten mit and. Künstlern, u.a. mit Pascal
Doury, Max (eigtl. Maxime Perramon) und Jacques Py-
on. C.s figurativ-narrative Malerei zeigt meist grellbun-
te, wild-expressive, zum Horror vacui neigende organi-
sche und abstrakte Formen in post-mod. Manier mit Zita-
ten aus der Pop- und Hochkultur vermengende, z.T. auch
Schrift und Sprechblasen inkorporierende Komp. (z.B. *La
nuit est ma nudité*, Acryl/Lw., 2007). Die neuesten Arbei-
ten präsentiert sie als *Olivia no sport C.*. ⌨ BUDAPEST,
SzM. ◉ *E:* Paris: 1981 Elisabeth de Senneville; 2007
Gal. des Saints Pères; 2009 Gal. Les Singuliers / 2010 St-
Sauveur-en-Puisaye, Gal. R9. – *G:* 1987 Toulouse, Nouv.
Gal. Atomium: Infrarot & seine Bande (K) / 2004 Rennes,
Festival Périscopages: Bazooka fout la merde! (Wander-
Ausst.) / 2005 Hérouville St-Clair, Wharf, Centre d'Art
Contemp. de Basse-Normandie: Bazooka. Un regard mod.
(Wander-Ausst.; K: J. Seisser) / 2008 Pau, MBA: Bazoo-
ka. ⌨ *M. Alessandrini* (Ed.), Enc. des bandes dessinées,
P. 1986; *Schurr*, Guidargus, 1989; *Bénézit* III, 1999; *H. Fi-
lippini*, Dict. enc. des héros et auteurs de BD, III, Grenoble
2000. – *F. Lambert*, (à suivre) 1978 (5) 20–25; *J. Seis-
ser*, La gloire des Bazooka, P. 1981; *Y. Frémion*, Le guide
de la bédé francophone, P. 1990; *G. Perneczky*, The mag.
network. The trends of alternative art in the light of their
per. 1968–1988, Köln 1993; *M. Screech*, Masters of the
ninth art. Bandes dessinées and Franco-Belgian identity,
Liverpool 2005. – *Online:* Artnet; Lambiek Comiclopedia;
G. Perneczky, Network Atlas, I, 2003. H. Kronthaler

Claveloux, *Nicole* (Pseud. Vallonoux, *Cécile*), frz. Il-
lustratorin, Kinderbuchautorin, Comiczeichnerin und -
texterin, Werbegraphikerin, Malerin, * 23. 6. 1940 St-
Etienne, lebt in Moëlan-sur-Mer. Stud.: EcBA, St-Etienne.
Befreundet mit Bernard Bonhomme und Françoise Darne.
Ab 1966 in Paris ansässig. Publ. von Zchngn zunächst in
den Zss. Planète, Marie-France und Marie-Claire. 1968 il-
lustriert C. das Kinderbuch *Le Voyage extravagant de Hu-
go Brise-Fer* von François Ruy-Vidal. 1968–73 unterhält
sie zus. mit B. Bonhomme ein Werbeatelier in Boulogne-
Billancourt; u.a. Gest. von Theaterplakaten und Schall-
plattenhüllen. Für den US-amer.-frz. Verleger Harlin Quist
entstehen weitere ill. Bücher: u.a. *Alala, les télémorpho-
ses* (1970) v. Guy Monréal; *La Forêt des lilas* (1970) v.
der Comtesse de Ségur; *Le Chat de Simulombula* (1971)
v. Jacqueline Held (zus. mit B. Bonhomme und Maurice
Garnier); *Gertrude et la Sirène* (1971) v. Richard Hug-
hes. 1973–95 zeichnet C. regelmäßig für die Kinder-und
Jugend-Zs. Okapi (u.a. Comicserie *L'insupportable Gra-

bote et le lion Léonidas*). Neben zahlr. weiteren ill. Kinder-
und Jugendbüchern (u.a. *Les aventures d'Alice au Pays
des merveilles*, 1974) publiziert sie in den 1970er Jah-
ren auch Comics für Erwachsene in den Mag. Ah! Nana
(*Planche-Neige*) und Métal Hurlant sowie mehrere Comic-
alben, u.a. *La Main verte* (1978); *Morte saison* (1979; bei-
de nach Szenarien von Edith Zha [Pseud. v. Elisabeth Sa-
lomon]); *Le petit légume qui rêvait d'être une panthère et
autres récits* (1980). Seither weitere Mag.-Beitr. (u.a. zu
Astrapi; Les belles hist.; J'aime lire), zahlr. ill. Kinder-
und Jugendbücher (u.a. *La Belle et la bête* v. Madame
Leprince de Beaumont, 2001; *Toujours devant* v. Chris-
tian Bruel, 2003; *Vladimir Poltron, vampire de la troisiè-
me classe* v. Jack Chaboud, 2007) und erotische Bilderbü-
cher bzw. Comics (*Morceaux choisis de la Belle et la bête*,
2003; *Confessions d'un monte-en-l'air*, 2007, Text v. Mar-
cel Lerouge; *Contes de la Fève et du Gland*, 2010, Text v.
Charles Poucet). Unter dem Pseud. Cécile Vallonoux illus-
triert C. zudem die erotischen Bücher *Les Frasques d'une
femme fidèle* (2005) v. Roseline Parny und *L'ingénue lub-
rique* (2007) v. Dimitri Bolyev. Mehrere Ausz.: u.a. 1976
Goldener Apfel, Bien. il., Bratislava; 2006 Prix Goncourt
du Livre pour la jeunesse. – Surreale, anfangs v.a. von
Heinz Edelmann und den Zeichnern der Push Pin Stu-
dios um Seymour Chwast und Edward Sorel beeinfluß-
te, meist in kräftigen Farben kol. Arbeiten. Auch freie
Malerei und z.T. stark konturbetonte Zeichnungen. ◉ *E:*
1995 Villeurbanne, Maison du livre, de l'image et du son
(Retr.; Wander-Ausst.; K: C. Bruel; Lit.) / 1995–96 Bo-
bigny, Bibl. mun. (K) / 2004 Noisy-le-Sec, Médiathèque
Roger Gouhier / 2007 St-Herblain, Médiathèque Herme-
land. ⌨ *D. Dupont-Escarpit/C. Lapointe*, Guide des il-
lustrateurs du livre de jeunesse franç., Montreuil/P. 1988;
H. Filippini, Dict. de la bande dessinée, P. 2005. – Imagi-
naires. Sept illustrateurs en Seine-St-Denis (K), Bobigny
1991; 20. Bien. il. Bratislava (K), Bra. 2005; *P.-J. Catinchi
u.a.*, La rev. des livres pour enfants 2008 (242) 79–126. –
Online: Lambiek Comiclopedia; Website C.

H. Kronthaler

Clavère, *Frédéric*, frz. Maler, Installationskünstler,
* 1962 Toulouse, lebt seit 1980 in Marseille. Stud.:
1980–86 Ec. supérieure des BA, Marseilles. Lehrtätigkeit:
Ec. nat. supérieure d'Art (Villa Arson), Nizza. – In Gem.
(oft in fluoreszierender Farbe, auch in Öl und Acryl) und
Installationen kreiert C. provozierende surreale Darst., de-
ren Hauptthemen Gewalt und Sex sind. In Vorbereitung
auf seine Arbeiten sammelt er Bild-Mat., u.a. aus Büchern,
Ztgn, Zss. und Comics. Diese abfotografierten Abb. proji-
ziert er als Vorlage meist direkt auf die Leinwand. C.s Wer-
ke enthalten häufig Anspielungen und Bildzitate. Zu den
char. Motiven gehören Uniformierte, Hakenkreuze, Hitler-
Portr. und überdimensionierte menschliche Geschlechts-
teile (z.B. *WTC Party*, 2008). Häufig stattet C. seine Fi-
guren (Menschen, Tiere) mit hermaphroditischen Merk-
malen aus oder vertauscht weibliche und männliche Ge-
schlechtsteile (z.B. *Slow fucking*, Öl/Lw., 2008). In zahlr.
Gem. verwendet C. sein eig. Konterfei, als ein lediglich mit
einer Melone und einer Augenmaske bekleideter Mann,

der z.T. mehrfach in einer Szene auftaucht (z.B. *Les limites de l'amour, c'est qu'il y faut toujours un complice... Votre ami savait bien que le raffinement du libertinage, c'est d'être en même temps bourreau et victime!*, Öl/Lw., 1998). ☐ Ceret, MAM. Marseille, Fonds communal de la Ville. – FRAC Provence-Alpes-Côte d'Azur. ◉ *E:* Marseille: 1993, '97, 2001, '04 Gal. Athanor; 1998 FRAC Provence-Alpes-Côte d'Azur; 2011 Gal. ToGu / 1999 Nizza, Gal. Françoise Vigna (K) / 2000 Saint-Martin-d'Hères, Espace Vallès (K) / 2003 Toulon, Gal. de l'EcBA / 2008 Bordeaux, Gal. La mauvaise Réputation / 2010 Malaucène, Gal. Martagon. – *G:* 1987 Ivry-sur-Seine, Centre d'Art contemp.: Dates de péremption (Wander-Ausst.; K) / 1998 Hamburg, Kunsthaus: Montags nie (K) / Marseille: 1999 Château Borély: Rêves ou réalités (K); 2000 Gal. La Friche la Belle de Mai: Chair de Paille et autres Poussières (K) / 2009 Aix-en-Provence, Numéro Six: Desir Emoi / 2011 Toulouse, Gal. Sollertis: Mauvais Genre. ☐☐ *Bénézit* III, 1999 (* 1960); *Delarge*, 2001. – *C. Laemmle*, Von nah und fern. Eine Gegenüberstellung (K Wander-Ausst.), St. 1992; *E. Mangion*, F. C. (K Belfort), Marseille 2007. – *Online:* Documents d'artistes. F. Krohn

Claverie, *Jean,* frz. Kinderbuchillustrator, Illustrator, Musiker, * 1. 4. 1946 Beaune/Côte d'Or, lebt in Lyon. Stud.: EcBA ebd.; L'Ecole des Arts Décoratifs, Genf. Arbeitet zunächst als Werbeillustrator, seit 1977 ist er spezialisiert auf Kinderbücher. Verh. mit der Schriftstellerin und Illustratorin Michele Nikly. Lehrtätigkeit in Lyon: ENBA; Ec. Emile Cohl. Ausz.: 1981 Prix Graphique Loisirs Jeunes; 1983 Gold-Med., Bienn. der Ill. (BIB), Bratislava; 1991 Prix Sorcière de l'album, Paris. – C. illustriert Erzählungen und Märchen (Ludwig Bechstein, Oscar Wilde, Charles Perrault) und schreibt bek. Geschichten zeitgemäß um, ohne den Erzählstrang zu verändern (Rotkäppchen, 1994). Außerdem verfaßt und illustriert er Kinderbücher allein oder zus. mit seiner Frau, wobei er stets eine Einheit von Text und Bild anstrebt. Daneben entstehen Buchumschläge und Plakate. Die graph., karikaturesken Ill. (Aqu., Pastell, Bleistift) mit deutlicher Kontur-Zchng. und zarter Farbgebung sind geprägt von warmherzigem Humor und einem großen Verständnis für die Welt der Kinder von heute. Char. sind eine einprägsame Darstellungsform mit Einfügung von kleinen lit. Anspielungen oder sich speziell auf sein Œuvre beziehenden Details. Wohl aufgrund seiner Tätigkeit als Sänger, Gitarrist und Pianist hat er eine Vorliebe für musikalische Themen (Buchserie *Little Lou*, 1990 und 2003). C. gehört zu den bekanntesten und besten Kinderbuchillustratoren in Frankreich. ☐ Marseille, Bibl. l'Alcazar. Moulins, Mus. de l'Ill. Jeunesse. Tokio, Chihiro AM. ◉ *E:* 2006–07 Moulins, Mus. de l'Ill. Jeunesse / 2009 Lyon, Gal. Novelle Echelle d'Or. ☐☐ *D. Dupont-Escarpit/C. Lapointe*, Guide des illustrateurs du livre de jeunesse franç., Montreuil/P. 1988; Oxford enc. of children's lit., Ox. 2006. – *S. L. Beckett*, Recycling red riding hood, N. Y./Lo. 2002. – *Online:* Website C.
H. Stuchtey

Clavuot, *Conradin,* schweiz. Architekt, * 1962 Davos, lebt in Zernez und Chur. Stud.: 1982–87 ETH, Zürich; 1988 Dipl. bei Fabio Reinhart. Seit 1988 eig. Archit.-Büro in Chur. Lehrtätigkeit: 2003–06 Gast-Doz. an der ETH, Zürich; 2010/11 Gast-Prof. an der Univ. Lichtenstein, Vaduz (Masterkurs: Sustainable Design – Alps). Ausz. u.a.: 1995, 2001 Preis für Gute Bauten im Kanton Graubünden (Unterwerk Vorderprättigau, Seewis, 1993/94; Einfamilienhaus Wieland-Held, Felsberg, 1999–2000); 1999 Schweiz. Holzbaupreis Prix Lignum (Schulanlage St. Peter/Graubünden, 1994–98); 2011 Internat. Brunel Award (Bahnhofsbauten, Chur, 2000/2008). – C.s vielgestaltiges Werk umfaßt v.a. Neu- und Erweiterungsbauten von Wohnhäusern, öff. und gewerblichen Gebäuden, zudem Projekte wie die Wiederaufbauplanung nach Dorfbrand in Flims-Dado (2006/07). Gewinnt den Wettb. für den schweiz. Ausst.-Pavillon für die Kunstmesse Arco 2002 in Madrid. Signifikant ist eine klare, unprätentiöse Formensprache, die von einem behutsamen und bewußten Umgang mit bestehenden Trad. (z.B. Strickbauweise) und einer intensiven Auseinandersetzung mit den städtebaulichen Bedingungen des Ortes, dessen hist. und landschaftlicher Eigenart zeugt. In deren Folge werden u.a. trad. Elemente zeitgen. interpretiert und weiterentwickelt und bei der Mat.-Wahl berücksichtigt. Darüber hinaus soll die Archit. der „Erfahrung ihres Ortes eine Form geben" (M. Steinmann) und auf diese Weise sinnliche Qualitäten demonstrieren. ☐ Chur: Gartenhaus Clavuot, 1990; Wohnsiedlung in den Lachen, 1991; Rossboden Garage, 2000; Bistro Café Merz, 2008; Gewerbebau Sesvenna AG, 2012. Flims: Wohnhaus Dado, 2011. Lenz: Wohnhaus Roethe-Hollenstein, 2008. Lugano: Erweiterung Bahnhof, 2009. Poschiavo/Graubünden: Wohnhaus Raselli Kalt, 2002. Strada/Graubünden: Schulhaus mit Turnhalle, 1989. Uri, Autobahn Uri: Ort der Besinnung, 1996. ☒ *C./J. Ragettli,* Die Kraftwerkbauten im Kanton Graubünden, Chur 1991; C. Architekt, Sulgen 2008 (Vorw. M. Steinmann). ☐☐ *A. Meseure u.a.* (Ed.), Archit. im 20. Jh. Schweiz (K Frankfurt am Main), M. u.a. 1998; *H. Adam*, Archithese 28:1998 (6) 58–63; Detail 45:2005 (10) 1108–1111; *M. Tschanz*, werk, bauen + wohnen 61:2007 (7/8) 32 s.; *N. Caviezel*, ibid. 62:2008 (6) 12–19; *H. Adam*, Bauwelt 48:2009 (6) 32–37. – *Online:* Website C. P. Böttcher

Clayman, *Daniel (Dan),* US-amer. Glaskünstler, * 1957 Lynn/Mass., lebt in East Providence/R. I. Ausb./Stud.: Southern Connecticut State College, New Haven; Univ. of Massachuetts, Amherst; 1983–86 Rhode Island School of Design, Providence (Glas-Gest.); 1987–89 Studio-Ass. bei Michael McCoy Glancy ebd. Seit 1986 eig. Glasatelier in East Providence. Ausz.: 1989, '95, '97 Artist's Grant, Rhode Island State; 2001 Urban Glass Award (Innovative Use of Glass in Sculpt.), Brooklyn/N. Y. – C. arbeitet zunächst an Theatern u.a. als Beleuchter und Lichtdesigner. Ab 1978 fertigt er erste narrative, lichtkinetisch inszenierte Glaskunstwerke. Aufsehen erregt C. in der regionalen Glaskunstszene gegen E. der 1980er und A. der 1990er Jahre mit Mat.-Kombinationen aus gegossenem Studioglas und Metall. U. a. entstehen in einer Werkgruppe pastellfarbene (meist nicht opake) kleinere Glasobjekte, die

vorerst randständig mit Metallmuffen, -manschetten oder -griffplatten (z.B. aus Kupfer) kombiniert sind und bisweilen aufgrund ihrer Kompaktheit zur Monumentalität neigende Paraphrasierungen von banalen Haushaltsgegenständen (*Crowned*, Glas/Kupfer, 1990) vorzustellen scheinen (z.B. von Bügeleisen, Tischglocken, Handtaschen), was innerhalb der internat. Studioglasbewegung als neuartig angesehen wird. Der Anteil von Metall (Bronze, Kupfer, Draht) nimmt bei der zunehmend minimalistischen Objekt-Gest. zu, wobei C. dem Metall in einigen Werkgruppen eine scheinbar stützende oder schützende Funktion zuweist (*Meniskus*, Glas/Bronze/Stahl/Graphit, 1998). Seit etwa 2000 lotet er in seinem eig. Studio in einer weiteren umfangreichen Werkgruppe die technischen und ästhetischen Möglichkeiten aus, mon. Glasobjekte und -installationen (liegend, stehend, hängend) aus modularen, z.T. hunderten von gegossenen Einzelteilen zu fügen. Dabei spürt C. dem skulpturalen Potential von elementaren, v.a. geometrischen Grundformen nach (u.a. Kreis, Kegel, Rhomben) und leitet daraus abstrakte, fast immer monochrome (ab 2004 reinweiße) und überdimensional gefertigte Glasvolumina von z.T. mehreren Metern Durchmessern ab (*Pierced Volume* , *Empty Volume*, beide Glas, 2007), deren räumliche Ausdehnung er bisweilen durch illusionistische Beleuchtungseffekte dramatisch steigert (*Suspended Shadows*, 2008; Glasabhängung in einem Priv.-Haus). Auch Objekt-Gest. für den öff. Raum, z.B. in Empfangsräumen. C. gehört mit seinem ambitionierten Werk zu den wichtigen Repräsentanten der zeitgen. skulpturalen Glaskunst im Bundesstaat Rhode-Island. ⌺ BOSTON, MFA. CHARLOTTE/N. C., Mint Mus. of Craft + DesignCHATTANOOGA, Hunter Mus. of Amer. Art. CLEVELAND/Ohio, Mus. of Art. CORNING/N. Y., Mus. of Glass. MILWAUKEE/Wis., AM. NEW YORK, Mus. of Art and Design. PROVIDENCE, Rhode Island School of Design, Mus. of Art. SAN FRANCISCO, MFA. WASHINGTON/D. C., Smithsonian Amer. AM. ◉ *E:* 1993 Chicago, Betsy Rosenfield Gall. / 2006 Brockton, Fuller Craft Mus. (K) / 2007–08 Charlotte (N. C.), Mint Mus. of Craft + Design (K: J. Koplos) / 2009 Tacoma (Wash.), Mus. of Glass. *G:* zuletzt 2010 New Port (R. I.), Newport AM: Networks 2009–2010. ⎙ *S. Luecking*, Amer. craft 54:1994 (2) 80; Christie's internat. mag. (Lo.) 13:1996 (10) 89; *J. Koplos*, New Glass (Englewood, N. J.) 2008 (2) 18–25. – *Online:* Website C. U. Heise

Cleary, *Shay*, irischer Architekt, Stadtplaner, * 1951, lebt in Dublin. Stud.: bis 1974 Univ. College Dublin School of Archit., Dublin (1977–96 Doz.). Danach Mitarb. in den Pariser Büros von Marcel Breuer und Georges Candilis sowie im London Borough of Camden bei Neave Brown. 1977–80 Partner von Grafton Architects in Dublin; 1981–86 Partnerbüro Cleary & Hall ebd., seit 1987 dort eig. Büro. 1989 Gast-Prof. an der Princeton Univ. Graduate School, Princeton/N. J. 1990 Gründungs-Mitgl. (und bis 1998 Dir.) des Dubliner Stadtplanungskollektivs Group 91. Ausz. u.a.: 1988, '89, '92, 2000, '02 AAI Award (Archit. Assoc. of Ireland); 1992, '97, 2002 RIAI (R. Inst. of Architects of Ireland) Regional Award; 2009 RIBA Inter-

nat. Award. – C.s Werk zeichnet sich durch die klare geometrische Strenge des Rationalismus aus. Mit eleganten Proportionen und einer präzisen Detaillierung begegnen die Bauten dem städtischen und kulturellen Kontext ebenso individuell wie integrativ. Dies zeigt sich im hist. Stadtzentrum von Dublin v.a. an dem subtil eingefügten Arthouse Multimedia Centre for the Arts (Curved Str.; 1995) oder am Project Arts Centre (Essex Str.; 1996–2000). Das Infill-Bürogebäude (1998–2002) unmittelbar neben dem denkmalgeschützten Mansion House (Dawson Str.) vermittelt durch ein komplexes Zus.-Spiel aus Mat. und Farbe, Fassadenstruktur und Gliederung der Baukörper mit negativer Eckausbildung mühelos zw. herrschaftlicher Villa und Straßenrandbebauung. Unter C.s zahlr. Aufträgen von versch. irischen Regierungsbezirken bildet der Verwaltungscampus in Cork ein in Komp. und Ausdruckskraft an die Trad. der Mod. anknüpfendes städtebauliches Ensemble. Dem feingliedrigen schlanken Glasturm der County Hall aus den 1960er Jahren – von C. 2006 saniert und erweitert – setzt die County Libr. (2006–09) als mon. Steingebäude in L-Form ruhige Eleganz entgegen. Die beiden Flügel, zwei- und sechsgeschossig, erzeugen zus. mit dem Hochhaus einen geschützten Innenbereich mit hellem Bodenbelag, in den zwei begrünte Atrien zur Belichtung der unterirdischen Mag. eingelassen sind. Neben den Masterplänen für das Dubliner Siedlungsgebiet Fosterstown North (2004) und das Dun Laoghaire Inst. of Art Design & Technology (2006) präsentiert C. im Rahmen der Neustrukturierung innerstädtischer Industriebrachen Gebietsentwicklungspläne für die Dublin Docklands (2007) und die Spencer Docks (2009) ebd. Dort soll auch das 36 Geschosse umfassende Convention Centre Dublin Hotel mit doppelter Sonnenschutzfassade entstehen. 2010 nimmt C. erstmals an internat. Wettb. für Stadtteilentwicklungen in Bukarest und Prag teil. ✉ DONEGAL, Stadtverwaltung, 1996. DUBLIN, Chapelizod: Wohngebäude, 1980. – Swan Pl.: Wohnhäuser, 1983. – Point Depot: Bars und Restaurant, 1989 (Abbruch 2007). – Irish MMA: Umbau O-, W- und S-Flügel (ehem. R. Hospital Kilmainham), 1991–92; New Gall. (Umbau Dir.-Haus), 2000. – Beggars Bush: Wohngebäude, 1989. – Kildare Str.: Erweiterung Landwirtschaftsbehörde (Foyer und Konferenzräume), 1994–95. – Queen Str.: Wohngebäude, 1996–2003. – Internat. Financial Services Centre: Harbourmaster Bar, 1998. – City Univ.: Präs.-Villa (Umbau, Erweiterung), 2001. – Griffith Hall: Wohnsiedlung, 2002. – Grand Canal Quay: Malt Tower Office Building, 2002. – Santry Cross: Stadtneuordnung (Geschäfte, Wohnungen, Hotel), 2007. – Pearse Str./Gran Canal Quay: Alto Vetro Tower, 2008. – South Leinster Str.: Trinity Point, 2009. – Upper Sheriff Str.: Liffey Trust Center, 2009. DUNGARVAN (Waterford): Schule, 1996. DUN LAOGHAIRE: Blackrock Education Centre, 1996–97. NAVAN, Athlumney: Navan Education Centre, 2000. ◉ *E:* 2002 Dublin, Archit. Centre (K). ⎙ Designers' j. 1992 (74) 38–41; *A. Becker u.a.* (Ed.), Archit. im 20. Jh. Irland (K Frankfurt am Main), M. u.a. 1997. – *Online:* Website C. A. Mesecke

Cleeremans (Cleereman, Clereman, Cleremans, Cleer-

mans, Cleerman), *Ralph (Raf, Ralf, Raph)*, belg. Maler, Graphiker, Zeichner, Mixed-media-Künstler, Illustrator, * 13. 10. 1933 Halen/Limburg, lebt in Gent. Stud.: ASK, Brüssel; Acad. Julian, Paris. Gründet 1959 zus. mit and. belg. Künstlern (u.a. Giancarlo Crivellaro, Arié Mandelbaum, Octave Landuyt, Jules Lismonde, Hugo Claus) die Gruppe Belg. Aluchromisten (1961–65 eig. Wkst. in Brüssel). Häufig reist er nach Italien. Die Vielfalt seiner Vor- und Nachnamensvarianten, mit denen er u.a. seine Graphiken und Bilder sign., gehört zum ebenso spielerischen wie tiefgründig-konzeptuellen Ansatz seiner Kunst. – V.a. Malerei und Graphik, anfänglich starkfarbig, realistisch und figurativ. Ab 1961 bis ca. 1970 versch. Arbeiten auf Aluminiumplatten (Aluchromien), die als archit.-bezogene Kunst (Wandbilder, Paneele) im öff. Raum angebracht sind, u.a. in Sporthallen oder öff. Gebäuden wie dem Finanz-Minist. in Brüssel (2006 zerst.). Etliche dieser z.T. reliefierten mon. Aluminiumobjekte aus den 1960er Jahren (an Säulen, Fahrstuhltüren u.a.) sind in Belgien bis heute erh., u.a. im Bahnhof von Hasselt. Ab den 1970er Jahren v.a. Hinwendung zu Kalligraphie, skripturaler Graphik (u.a. Wortbilder und Einsatz fremder Schriften [Hieroglyphen u.a.]) und typogr. Inszenierungen (Jo Verbrugghen, *Erlik, een v'o'or-scheppingsverhaal*, Deurle 1974). Am Bild- und Schriftträger Papier interessiert ihn seit den 1980er Jahren v.a. dessen Potential als Palimpsest. Es entstehen durch Übermalung und Überarbeitung von hist. bzw. benutzten Papieren vorerst semiabstrakte, bald nonfigurative, im Spätwerk häufig subtil geschichtet wirkende geometrisierende Arbeiten (Aqu., Frottagen, Collagen), die Assoziationen an archaische Geheimnisse, archäol. oder hist. Themen, an florale Strukturen oder längst vergangene Archit. (*40 katedralen*, 1990er Jahre) zulassen. Häufig arbeitet C. mit Tusche (Feder, Pinsel) und Wasserfarben sowie diffizilen Mat.-Antragungen (u.a. Asche, Pigmente, Blattgold). Auch Buch-Ill. und Künstlerbücher. – Internat. Renommee genießt C. als Vertreter der Aluchromisten in den 1960er Jahren, an deren internat. Gruppen-Ausst. (u.a. München, New York) er beteiligt ist. ⌂ METZ, FRAC Lorraine. ◉ *E:* Brüssel: 1966 Gal. Montjoie; 1986 Gal. Fred Lanzenberg; 1996 Mus. d'Ixelles; 2007 Gal. P. Karp / 1986 Deurle, Mus. Dhondt-Dhaenens / 1989 London, Hull Gall. / 1997 Aalst, Oude Hospitaal / 2000 Gent, Gal. Arcade / 2008 Koksijde, Gal. Wijland / 2011 Geel, M Gall. / 2012 Nieuwenrade, Oude Pastorie, Kap. Op den Bos (mit Michel Janssens). –. *G:* 1969–70 Osaka: WA (belg. Pavillon) / 1976 Prag, Gal. Art Centrum / 1984 Brüssel, Le Botanique: Hommage Amnesty Internat. (K) / 1998 Lissabon: WA (belg. Pavillon) / 1999 Gent, Paule de Boeck FA: Les intensités du gris. ⌑ DPB I, 1995; *Bénézit* III, 1999; *Pas* I, 2002.

<div align="right">U. Heise</div>

Cleeren, *Colette*, belg. Malerin, Graphikerin, Zeichnerin, * 1953 Hasselt/Limburg, lebt und arbeitet in Antwerpen. Stud.: Sint Lucaspaviljoen, Antwerpen (freie Graphik); Sted. ASK, Hasselt (Malerei, Graphik). Weitere Ausb. in renommierten belg. Künstlerpressen, u.a. im Inst. Sint-Maria an der Karel de Groote-Hogeschool in Ant-

werpen, wo sich C. in speziellen graph. Techniken und künstlerischen Druckverfahren und -vorgängen unterrichten läßt, u.a. im jap. Hschn. (bei Minoru Yoneda), in Chine collé (bei Craig Zammiello) oder in Collographie (bei Kim Berman). Ausz.: 1979 Preis der Stadt Leuven. Beteiligt sich seit den 1990er Jahren regelmäßig an nat. und internat. Graphik-Bienn. und -Trienn., u.a. in Kairo, New York, Québec, London, Lahti, Maastricht, Paris oder Varna, wo sie zahlr. Anerkennungen erhält. – Anfänglich Malerei (Öl, Pastell) und Graphik in einem umrißlinienbetonten, häufig symbolistisch aufgeladenen formreduzierten Stil (Lsch., Figurationen). Schon im Frühwerk der 1970er Jahre setzt sich C. mit ostasiatischen Kunsttechniken und -auffassungen (u.a. Literatenmalerei) auseinander. Seit den 1980er Jahren entstehen in versch. malerischen und (druck-)graph. Techniken auf unterschiedlichen Träger-Mat. heterogene Werkgruppen, bei denen Lineaturen und geometrisierende Flächenteilungen eine ebenso häufige Rolle spielen wie collographierte Schichtungen (z.B. von Laubblättern oder Grashalmen), Überlagerungen oder Auf- und Zudeckungen. Gelegentlich untersucht C. die jeweils angewandte Mal- oder Drucktechnik auf deren künstlerisches Potential in den Arbeiten selbst, indem sie u.a. versch. Platten unterschiedlicher Größe und Farben collographiert oder übereinanderdruckt, um komplexe sinnliche Wahrnehmungen als im Detail klare oder verschwommene Erinnerungsüberlagerungen zu visualisieren (*Tapisserie crépuscule*). Ihre Inspirationen bezieht sie häufig aus and. Bildmedien (u.a. wiss. und populärwiss. Buch-Ill., Fam.-Fotos, Fundstücke). Die Bezugnahme auf Werke der Kunstgesch. (z.B. auf das bek. Doppelporträt der nackt im Badezuber sitzenden Gabrielle d'Estrées und ihrer Schwester um 1600 oder auf ein Figurenbild von Ferdinand Khnopff) vollzieht C. häufig ebenso geheimnisvoll-symbolisierend wie elementar und radikal (*Joy of Secrets*, Pastellkreide, 1987; *Khnopff Revisited Large*, um 2010). Auch hist. (Lehr-)Buch-Ill. oder Presse-, Werbe- oder Mode-Fotogr. aus Ztgn und Zss können nen Basis ihrer konzeptuellen Arbeiten sein. Als exemplarisch dafür ist die großformatige Serie *Model, Identity, History* (20 Aqu.) anzusehen, in der C. dem sozialpsychologischen Kontext der jeweiligen Ausgangs-Fotogr. und dessen bewußter Verunklärung in den abgeleiteten Figurationen nachspürt und u.a. Fragen von Schein und Sein, Vergangenheit und Gegenwart aufwirft, deren Komplexität sie zudem durch Bildtexte in mehrere Metaebenen lanciert. Ein wichtige Werkgruppe der letzten Jahre stellen die Postkartenbearbeitungen *In another Context* dar; C. collagiert und übermalt hist. (Ansichts-)Postkarten (u.a. Schwarzweiß-Fotogr., Chromo-Lith., Kupfertiefdrucke) mit heutigen Versatzstücken und Artefakten zu irritierenden, häufig humoristischen, auch ges.-kritischen Kommentaren und Inhalten. So implantiert sie in die hist. Schwarzweiß-Ansichtskarte eines wildromantischen Wasserfalls die Farb-Abb. eines klinisch reinweißen Sanitärartikels (Urinal). Gegenwärtig spürt C. in ihrer politisch engagierten mon. Bildserie *Project C. Meunier* (Aqu., Zchngn/Lw. und Baumwolle) der Darst. von unmittelbar

beieinander liegenden menschlichen Körpern (Schlafen-de und Tote) nach, wobei sie die Figurationen in den Kontext der sozialkritisch-realistischen Kunst des 19. Jh. und den der Bilderflut über Schicksale von Flüchtlingen und Migranten in den mod. Medien stellt. Auch Künst-lerbücher, u.a. *Anaesthesia III* (s.l.e.a. 2006, 32 Exempla-re) zus. mit dem Graphiker Gay Paterson und der Gra-phikerin und Druckerin *Luce Cleeren* (* 1953 Hasselt, hier unter Pseud. Luce [06]). ⌂ ANTWERPEN, MSK. BRÜSSEL, Coll. Vizo. DEN HAAG, Vlaamse Gemeenschap. DETMOLD, Stadtverwaltung. HASSELT, Mus. Stellingwerff-Waerdenhof. – Provinciale Kunstcollectie Limburg. KAS-TERLEE, Frans Maseerel Centrum. LEUVEN, Stadtverwal-tung. ◉ E: Antwerpen: 1977 Taverne Groenenborg (Debüt); 2005 Gal. Jaques Gorus; 2011 Gal. Martin van Blerk (mit Filip Schrooyen); 2012 Gal. Theo / 1981 Maas-tricht, Gal. Artifort (mit Luce Cleeren) / 1990 Detmold, Lippisches LM / 1991 Brüssel, Gal. John de Coster / 2000 Temse, Gal. 40 / 2006 Tienen, Suiker-Mus. / 2008 Me-chelen, Gal. PinArt / 2012 Abele-Watou, Gal. De Queeste Art. – G: u.a. 1975 Hasselt, Begijnhof: Limburgse Kunst-enaars jonger dan 25 / 1990 Nantes: Salon internat. de la Gravure / 1996 Sint-Niklaas, Zwijgershoek Cultuurcen-trum: Prentenmaaksters / 2003 Kasterlee, Frans Maseere-el Centrum: 2008 Hout – Lover, Laub – Holz (Wander-Ausst.; K) / 2005 Aalst, Sted. Mus.: Letterlijk – Figuurlijk / 2008 2009 Oostende, Bibl. Kris Lambert: Hout – Lover, Steen – Zand / 2011 Antwerpen, Gal. TzarArt: Transmis-sion. ⌷ *Pas* I, 2002. – *Online:* Website C.; Erfgoedplus.

U. Heise

Cleijne, *Edgar,* niederl. Fotograf, Installationskünstler, * 1963 Eindhoven, lebt in Rotterdam und New York. Musik-Stud. bis 1990 (Abschluß) am Konservatorium in Rotterdam. Als Fotograf Autodidakt. – C.s sozial.-dok. intendierte Fotogr. befaßt sich v.a. mit identitätsstiften-den Mikro- und Gegenwelten im öff. Raum, denen C. im afrikanischen und europ. Alltag nachspürt. Daneben v.a. Archit.-Fotogr., auch Luftaufnahmen. Ab 1997 arbei-tet C. als Fotograf und Koordinator mehrere Jahre für Rem Kohlhaas u.a. in Lagos/Nigeria an dessen *Harvard Project on the City,* das den soziologisch basierten Versuch un-ternimmt, anhand komplexer menschlicher Ansiedlungen, die als Eingriffe in die Natur aufgefaßt sind, ein zeitgemä-ßes und adäquates Vokabular für die extrem wuchernden urbanen Raumausdehnungen zu entwickeln, für die es bis-lang in der trad. Archit.-Beschreibung keine Begrifflich-keiten gab. Darüber kooperiert C. mehrfach mit der amer. Malerin und Multimediakünstlerin Ellen Gallagher, u.a. bei deren Ausst.-Projekt *Orbus,* das 2005 in den fünf um-fangreichen (ca. 990 Seiten) Fotobüchern *Orbus 1–5* von der Fruitmarket Gall. in Edinburgh veröff. wird (*Orbus*; *Super boo*; *Monster*; *Watery ecstatic*; *Blizzard of white*). Gemeinsam mit E. Gallagher entsteht 2009 (CCA Wattis Inst. for Contemp. Arts, San Francisco) eine Rauminstal-lation mit Film- und fragmentierten Diaprojektionen, die sich mit dem in absoluter submariner Finsternis lebenden, erst wenige Jahre zuvor entdeckten Knochenfresserwurm *Osedax* beschäftigt, wobei hier u.a. der konzeptuelle An-

satz zugrundeliegt, daß Dunkelheit ein Ausgangspunkt für Klarheit (Erkenntnis) sein kann, was auch in dem 2006 entstandenen Projekt *Heart of darkness* eine Rolle spielt. Ebenfalls gemeinsam mit E. Gallagher entwickelt C. die 2010 auf der Whitney-Bienn. in New York gezeigte afrofu-turistische, multimedial-akustische Rauminstallation *Bet-ter Dimension* (Siebdruck/Glas, Holz, mehrere trad. Dia- und Filmprojektoren, Projektionsflächen), die im mehr-perspektivischen Low-Tech-Stil u.a. polemische Texte aus den 1920er/30er Jahren mit Jazzrhythmen von Sun Ra aus den 1960er bis 90er Jahren und eine auf einem Platten-teller rotierende Kennedy-Büste installativ verbindet, wo-mit u.a. auf die Faszination von Kosmos und Raumfahrt im Kontext des Kalten Krieges verwiesen wird. C. ge-hört mit seinen ambitionierten (Archit.-)Dokumentationen zu den bed. Recherche-Kunst-Fotografen seiner Genera-tion in den Niederlanden. ⌂ LONDON, Tate Modern. ◉ E: 2003 Berlin, Gal. Max Hetzler. – G: 2002 Köln, Gal. Ulrich Findler: Suburban options / Rotterdam: 2002 BvB: Fotodocs. Long leg is evil; 2006 Nederl. Archit. Inst. (NAI): Spectacular city. Photogr. the future (internat. Wander-Ausst.) / London: 2006 Inst. of Contemp. Arts: Alien nation (Wander-Ausst.; K: J. Gill u.a.); 2007 Tate Modern: Passages from history. Recent contemp. acquisi-tions / 2010 Oslo, Mus. for Samtidskunst: Take me to your leader! The great escape into space (Wander-Ausst.) / 2011 Beverly Hills (Cal.), Gagosian Gall.: Ad Lib. ⌷ *P. Ver-gne* (Ed.), Heart of darkness. Kai Althoff, Ellen Gallag-her and E. C., Thomas Hirschhorn (K Walker AC), Min-neapolis, Minn., 2006; *E. Schmitz,* Kunstforum internat. 184:2007, 376; *T. W. Kuhn,* ibid. 202:2010, 284.

U. Heise

Clements, *Dawn,* US-amer. Zeichnerin, Malerin, * 1958 Woburn/Mass., lebt in Brooklyn/N. Y. Stud.: bis 1986 Brown Univ., Providence/R. I.; bis 1989 State Univ. of New York, Albany. Lehrtätigkeit: Princeton Univ., Lewis Center of Visual Arts. – C. konzentriert sich nach Male-rei auf detailliertes Zeichnen von monochromen Stilleben und von Interieurs, die auf Szenenbildern aus Fernseh-serien oder auf Hollywood-Rührstücken der 1940er und 1950er Jahre basieren. *Oval* (1995–2000, Kugelschreiber und Gouache/Papier) ist eine mon. 3 x 3,12 Meter nahezu runde, an den Rändern unregelmäßig gewölbte Zchng mit von Filmen inspirierter kleinteilig-erzählerischer Darst. und gekritzelten Wörtern aus Filmszenen. Seit 2000 zeich-net sie mon. Panorama-Darst. von häuslichen Interieurs, die aus mehreren Bll. zusammengesetzt sind und Räu-me aus versch., nahtlos ineinander übergehenden Blick-winkeln wiedergeben (*Kitchen and Bathroom,* 2003; *Mrs. Jessica Drummond's ['My Reputation,' 1946],* 2010). Die Objekte sind ohne Berücksichtigung der perspektivischen Plazierung oft originalgroß abgebildet. Projektbezogen und interaktiv arbeitet sie seit 2009 häufig mit dem Bild-hauer Marc Leuthold zus., dessen Skulpt. sie zeichnet. ⌂ ALBANY, Univ. AM. LONDON, Saatchi Coll. NEW YORK, MMA. – Whitney. PRINCETON/N. J., Univ. AM. SARAGOTA SPRINGS/N. Y., Skidmore College, Frances Young Tang Teaching Mus. and AG. SEATTLE, Western

Bridge Coll. ◉ *E:* 1990, 2002 Troy (N. Y.), Vertical Gall., Rensselear Polytechnic Inst. / 1990 Pittsfield (Mass.) Berkshire Community College / Albany: 1992 Capital Repertory Theater; 1995 Albany Center Gall. / 2002 Troy (N. Y.) Greene Gall., Rensselaer Polytechnic Inst. / Brooklyn: 2003, '04, '07, '12 Pierogi; 2010 Boiler Gall. / 2004 New York, Feigen Contemp. / 2006 Middlebury (Vt.), College Mus. of Art; Amherst, Herter AG, Univ. of Massachusetts / 2007 Chapel Hill, Univ. of North Carolina, John and June Allcott Gall. / 2008 Leipzig, Pierogi / 2009 Watertown (Conn.), Taft School, Mark W. Potter Gall. / 2010 London, Hales Gall.; Los Angeles, Acme Gall. / 2011 Sint-Kruis (Brügge), Kasteel van Male (Sint-Trudoabdij). ☐ *F. Bonami*, Flash art 25:1992 (164) 100–102; 26:1993 (168) 78; *P. Hege*, ArtRev 1:2003 (7) 50–53; *C. Kotik/T. Mosaka* (Ed.), Open House. Working in Brooklyn (K Brooklyn Mus.), Brooklyn 2004; *J. Philbrick*, PAJ. J. of performance and art 76:2004 (Jan.) 82–93; *S. Maine*, AIA 2005 (Mai) 169 s., *E. Bryant*, Art news 107:2008 (1) 130; Western motel. Edward Hopper and contemp. art (K KH Wien), Nü. 2008; *G. R. Brown*, Ceramics monthly 57:2009 (3) 36–39. – *Online:* Saatchi Gall. H. Stuchtey

Clemot (C. Escobar), *Luis (Luis Miguel)*, span. Maler, Zeichner, * 1955 Casasimarro/Cuenca, lebt in Alicante. Seit der Kindheit dort ansässig. Stud.: EBA de S. Carlos, Valencia; technisches Zeichnen an der Esc. de Maestría Industrial, Alicante; Pädagogik an der Univ. de Murcia; Kunstgesch. und Graphik u.a. am Inst. Juan Gil-Albert, Alicante. Mitgl.: Asoc. Cult. Espejo de Alicante. Als Zeichenlehrer an Schulen in Alicante und San Vicente del Raspeig sowie als Doz. an versch. Institutionen tätig. – Naturalistisch-detailreiche Malerei, v.a. Stilleben, Figurenbilder, heimatliche Lsch. und meist menschenleere Stadtansichten, darunter einzelne Gebäude (v.a. Kirchen) und archit. Details. ◉ *E:* Alicante: 1978 Sala Mutua Unión Patronal; 1997 Stadtverwaltung, Sala Polivalente Monte Tossal; 1999 Sala de Expos. Renfe; 2003 Colegio de Aparejadores; 2008 Colegio de Enfermería; 2010 Sala de Expos. del Centro Comercial Panoramis / 1996 El Campelló, Casa de Cult. / 1997 Benidorm, Caja de Ahorros del Mediterráneo / 2003 Aspe, Sala de Expos. Teatro Wagner / 2005 Orihuela, Caja de Ahorros del Mediterráneo / 2006 Caravaca de la Cruz (Murcia), Casa de la Cult. / 2008 Santa Pola, Sala Centurión. ☐ *Online:* Rev. Perito.

M. Nungesser

Clemson, *Katie (Kay Christine)*, austral. Graphikerin, Malerin, * 14. 11. 1949 Temora/N. S. W., † 23. 11. 2007 London-Hammersmith, lebte seit 1971 in Großbritannien, war zuletzt in Fremantle (Western Australia) und London-Chiswick tätig. Stud. in London: 1972 Croydon College of Art; 1973–78 Central School of Art and Design, bei Blair Hughes-Stanton, Michael Rothenstein und Gertrude Hermes; 1978–79 Whitelands College (heute Roehampton Univ.) (Kunsterziehung); 1995–97 Univ. of East London. Lehrtätigkeit: u.a. 1979–80 Eton College, Windsor; 1979–83 College of Art, Glasgow; 1983–84 College of the Arts, Sydney/N. S. W.; Curtin Univ., Perth/Western

Australia; 1992–94 SchA, Winchester. 1979–81 Mit-Hrsg. der Zs. Printmakers Council Mag., London. 1987 Gründung der White Gum Press, Minstead/Hants., einer bibliophilen Wkst. für Hochdrucktechniken und Papierherstellung. 2005 Kuratorin der Gruppen-Ausst. The Artist and Radio 4, Bankside Gall., London.- Hauptsächlich Farb-Linolschnitte im Reduktionsverfahren; teils handkoloriert, als Mischtechnik mit Graphit, Aqu., Pastell und Tusche oder mit Ätzeffekten. Überwiegend vereinfachte bis abstrahierte Lsch., häufig Marinen und Küstenszenen, meist in kräftigen Farben, teilw. in unnatürlicher Farbgebung, z.B. *First Day of the Season* und *High Tide*. Außerdem Gem., u.a. Aqu. und Mischtechniken, und Künstlerbücher, z.B. *30 Ways to Tie a Turban* (Farb-Linolschnitte, Leporello, 1997) sowie Arbeiten im öff. Raum, u.a. 1998 ein Wanddruck für das Foyer des British High Commission-Gebäudes in Canberra. ▥ BROOKLYN/N. Y., Brooklyn Mus. OXFORD, Ashmolean Mus. PERTH, State Libr. of Western Australia Art Coll. SYDNEY/N. S. W., Artbank. ✉ *C./R. Simmons*, The complete manual of relief printmaking, Sydney 1988. ◉ *E:* London: 1978 5 Dryden Street; 1985 Intaglio Printmaker; 1996, '97 Redfern Gall.; 2007 Bankside Gall. (mit Karyn White und Edwina Ellis) / 1981 Windsor, Eton College Drawing Schools / 1987, '91 Sydney, Blaxland Gall. / 2000, '02, '06 Canberra, Beaver Gall. – *G:* London: 1976 Inst. of Contemp. Art: Young Contemporaries; 1977–94, 2001, '02, '06 RA: Summer Exhib.; 1994–97 Mall Gall.: Nat. Print Exhib. (alle K) / 1981–87, 2003 Fremantle, AC: Fremantle Print Award (Wander-Ausst.) / 1986 (Preis), '88 Bradford: Brit. Internat. Print Bienn. (beide K) / 1995 (Indian Encounters), '96 (6 Printmakers) Farnham (Surrey), New Ashgate Gall. / 1998 New York, Nat. Arts Club: RE Exchange Exhib. (Wander-Ausst.) / Caulfield (Vic.): 1998 Glen Eira AC, 2006 Glen Eira City Council Gall.: Silk Cut Award for Linocut Prints Exhib. (beide K). ☐ *Germaine* 1984; *Germaine*, 1991 (beide irrtümlich * 1950); *Buckman* I, 2006 (irrtümlich * 1951). – *Online:* White Gum Press.

J. Niegel

Clerbois, *Michel*, belg. Maler, Fotograf, Bildhauer, Installationskünstler, Performancekünstler, * 7. 9. 1958 Soignies, lebt in Brüssel. Stud. ebd.: 1978–79 Ec. Superieure L'Atelier 75 (Bildhauerei); 1979–84 Ec. Nat. Supérieure des Arts Visuelles La Cambre (Glasmalerei). – C. dokumentiert mit Frottage, Zchng, Fotogr., Gem. und Performance verborgene Zeichen und Erinnerungen z.B. aus der Gesch. oder von Menschen z.B. aus Industriegebieten (*Usine 2*, 1991–92; *Le Charbonnage de Heusden-Zolder*, 1997) sowie Spuren aus seiner persönlichen Welt (*Empreintes, peint. corporelles*, 1980–91). Char. sind minutiös ausgef. Kohle-Frottagen, die er in Plastikfolien laminiert und aufhängt, z.B. vom Brustkorb eines Kohlezechenarbeiters kombiniert mit der Fotogr. eines Förderturms (*Bollen, Jos [2] 31/12/65*, 1997). Seit 2002 zeichnet er Portr. auf Spiegel. ▥ Brüssel, Univ. Libre de Bruxelles. ◉ *E:* 1980 Soignies, Gal. Capricorne / 1984 Namur, Gal. Detour / Brüssel: 1987 Salle Allende, Univ. Libre; 1989 Gal. Suppés; 1990 Gal. Dépot Design; 1992

Centre Cult. de la Communauté franç. le Botanique; 1994 Gal. Salon d'art; 2002 Gal. Quadri; 2006, '09 Bureau de Port / 1988 Mazy, Espace Mazycien / 1989 Le Havre, Gal. Delange / 1991 Metz, Caves Ste Croz / 1993 Mailand, Gal. Piero Cavellini & Maria Cilena / 1994 Paris: Maison du Geste et de l'image; Gal. Brigitte Négrier / 1997 Havanna, Casa Juan José / 2011 Bangkok, Art and Cult. Centre: Oô myth two (Performance). ▭ *Pas* I, 2002. – Parcours (K Centre d'art contemp.), Br. 1988; *B. Marcelis*, Art press 168:1992 (April) 89; Belgique (K Herbert Read Gall.), Canterbury 1994; *C. Laurent*, Art et culture 11:1997 (Febr.) 24; 13:1998 (4) 25; Bruxelles 98. Contemp. art from Bruxelles (K Centre for Contemp. arts), Glasgow 1998; *P. Perdrizet* (Ed.), Usine (K Wander-Ausst.), P. 2000; *S. Goyens de Heusch* (Ed.), XXᵉ s. L'art en Wallonie, Tournai/Br. 2001. – *Online:* Website C.

H. Stuchtey

Clever, *Friederike*, dt. Malerin, Zeichnerin, * 1971 Berlin, lebt in Belize. Stud.: 1992–93 Arts Students League, New York; 1993–96 ABK, Wien; 1996–98 HS für Gest., Karlsruhe, bei Günther Förg. Danach wieder in Berlin, um 2008 in Mexiko-Stadt ansässig. Ausz.: 2003 Stip., Kunstfonds Bonn; Stip., Villa Romana, Florenz. – C. malt und zeichnet ab E. der 1990er Jahre touristische Ansichten und Lsch.-Motive aus „exotischen" Urlaubsländern nach Fotovorlagen aus Reiseprospekten (z.B. *Sheraton Doha Hotel und Resort, Quatar*, 1998, Filzstift; *Balinesischer Tempel*, 2000, Öl/Papier). Durch diese Aneignung und bewußte künstlerische Verfremdung der Werbebilder thematisiert sie gleichzeitig das Klischeehafte eines gleichsam kulturimperialistischen Blickes auf das Fremde. In jüngerer Zeit konzipiert C. u.a. mon., wie Wandteppiche präsentierte Gem., die als frottageartiger Abdruck des Estrichs des Bodens im Atelier entstehen (Acryl/Lw.). 👁 *E:* 2000 Berlin, Starship Mag. / Hamburg: 2002 Gal. Nomadenoase; 2002, '08 Gal. Karin Guenther / 2003 Köln, kjubh-Raum / 2004–05 Kiel, KH in der Antiken-Slg (K: D. Luckow/ M. Muehling) / 2006 New York, Broadway 1602. – *G:* 1999 Dresden, Coopera: Homo ludens / 2002 Leverkusen, Mus. Morsbroich: Villa Romana 2003 / 2006 Basel, KH: Quauhnahuac. Die Gerade ist eine Utopie (K: A. Szymczyk u.a.); Hamburg, KV: Spiralen der Erinnerung / 2010 Hohenlockstedt, Arthur-Boskamp-Stiftung M. 1: Right Right Now Now. ▭ *P. Kind u.a.* (Ed.), Lsch. 300 qm (K), M. 2002 (CD-ROM); *A. Kempkes*, Mod. painters 2003 (2); *L. Launhardt*, Texte zur Kunst 13:2003 (49) 197–200. – *Online:* Gal. Karin Guenther, Hamburg; *J. Voorhoeve*, De:Bug 68:2002.

H. Kronthaler

Climachauska, *Paulo*, brasil. Maler, Zeichner, Graphiker, * 25. 7. 1962 São Paulo, lebt dort. Bruder des Installationskünstlers und Filmemachers *Eduardo C.* (* 1958 São Paulo). Stud. der Gesch. und Archäologie an der Univ. ebd. Als Künstler Autodidakt. – C.s frühe Werke sind symbolhafte Objektinstallationen aus einfachen industriellen Mat., deren oft gegensätzliche ästhetische, ikonogr. und stoffliche Qualitäten einen Dialog in Gang setzen (z.B. *Levanta! Levántate*, 1995; *Ghost/Fantasma*, 1998; *Marcos*

de posse, 1999). Später wendet sich C. v.a. der ortsspezifischen mon. Zchng auf Wänden zu, wobei sich die Linien aus Zahlenreihen zusammensetzen, die immer mit Null resultierende Subtraktionen bilden. Es sind schematisch-konstruktive, transparent und leicht wirkende Darst. mod. Archit., die bei Ausst. häufig auf Gebäude in der direkten Umgebung rekurrieren bzw. diese wiedergeben, z.B. als Repräsentant des tropischen Modernismus Brasiliens das Bienn.-Gebäude in São Paulo (*Palácio*, 2004, im Gebäude selbst) oder Tyghuset (*Moderna mirror*, 2004) im Mod. Mus. in Stockholm, das ihm gegenüber liegt. Außerdem gestaltet C. einzelne Bilder mit Chinatusche, Filzstift oder Acryl auf Holzplatten, Lw. oder Papier. Im Umkehrverfahren wird gleichsam die Welt durch Zeichnen neu angeeignet und das Etablierte sowie seine Wahrnehmung auf paradoxe Weise in Frage gestellt. Dem Verhältnis von Kunst, Ges. und Leben wird nachgespürt und auf eine nicht auf Maximierung, sondern Reduktion bedachte ges. Ordnung angespielt. Indem C. mit Zahlenreihen alltägliche Gegenstände markiert, z.B. sandgefüllte Flaschen (*Sem título*, 2005), eine Spiegelfläche mit Steinen, auf der sie wie Wellen erscheinen (*Profundo*, 2008) und Papiertüten (*Em sacos*, 2009), verwandelt er diese in phil.-ästhetische Objektplastiken. ▣ BOGOTÁ, Mus. del Arte del Banco de la República. FORTALEZA, MAC da Ceará. RIO DE JANEIRO, MAM, Col. Gilberto Chateaubriand. SÃO PAULO, Inst. Cult. ITAU. – MAC da Univ. – MAM. – Pin. do Estado. – Pin. Mpal. VALENCIA, IVAM. VIGO, Fund. Barrié de la Maza. 👁 *E:* São Paulo: 1992 Centro Cult. São Paulo; 1996 Galeria Camargo Vilaça (K); 2000, '10 Paço das Artes; 2001 Gal. Casa Triângulo; 2002 Parque Lage; 2003, '07, '09 Gal. André Millan; 2004 MAM; 2005 Gal. Millantonio; 2010 Paço das Artes / Rio de Janeiro: 1996 Espaço Cult. Sérgio Porto; 2005 Lurixs, Arte Contemp. (K); 2006 Paço Imperial / 2004 Stockholm, Mod. Mus. (K: C. Calberg) / 2005 Fortaleza, MAC do Ceará / 2009 Brüssel, Casa do Brasil, Gal. Marcantônio Vilaça. – *G:* 1997 Lima: Bien. Iberoamer. / 2000 Havanna: Bien. / Fortaleza: 2002 Bien. Ceará Américas; 2006 Bien. Internac. Ceará de Gravura / 2004 Rijeka: Internat. Bienn. of Drawings (K); San Juan: Bien. del Grabado Latinoamer. y del Caribe; Cuenca: Bien.; São Paulo: Bien. / 2008 Tijuana: Bien. Internac. de Estandartes / 2009 Ushuaia u.a.: Intempérie. Bien. del Fin del Mundo (K: A. Hug u.a.). ▭ Panorama da arte brasil. (K MAM), S. P. 1995; O fio da trama/The thread unraveled. Contemp. Brazilian art (K El Mus. del Barrio), N. Y. 2001; *P. Herkenhoff*, P. C. Subtrações, Rio 2005; *G. Mosquera u.a.*, 20 desarranxos. Panorama da arte brasil. (K MAC), Vigo 2005; *S. Feeke u.a.*, Espaço aberto, espaço fechado. Sites for sculpt. in mod. Brazil (K Henry Moore Inst.), Leeds 2006; Experiências contemp. Col. Marcantonio Vilaça no MAC USP (K Tribunal de Contas da União, Espaço Cult. Marcantonio Vilaça), Brasilia 2009. – *Online:* Website C. – Mitt. C.

M. Nungesser

Clinch, *Robert*, austral. Maler, Graphiker, * 4. 8. 1957 Cooma/N. S. W., lebt in Melbourne. Als Künstler Autodidakt. In der Kindheit geprägt von klassischer und Bühnenmusik, spielte C. dann in einer Garagen-Rockband;

kehrte unter dem Einfluß des amer. Komponisten Aaron Copeland zur klassischen Musik zurück. 1993 Reise nach Großbritannien, Belgien und in die USA. 2000 und '02 erneut in New York, 2010 in Großbritannien, Polen, Deutschland und Frankreich; 2011 in Hongkong. Ausz.: 1984 R. Overseas League Art Award; 1989, '93 Wynne Trustees Water Colour Prize, AG of New South Wales, Sydney; 1993 Reise-Stip. des Marten Bequest; 1994 Bega Art Awards, Peoples Choice. Auftragswerke: Buchumschläge für *A Knockabout Priest*, North Mb. 1985; *Bolte by Bolte*, Mb. 1990; *They Trusted Men*, Mb. 1996, alle von Tom Prior. 1989–94 zahlr. Gem. für Linfox Transport; weiterhin entstanden Auftragsarbeiten für den mit ihm befreundeten Kunstsammler Joseph Brown (1991), die NG of Victoria, Melbourne (1995) und die Westfield Coll. (1999). – Lsch. und Portr. in reiner Eitempera sowie als Aqu. und Lithographien. C.s hyperrealistische Kunst mit satin-artigen Oberflächen entsteht imaginativ. Sie ist reich an symbolischen und musikalischen Anspielungen und widmet sich auf humorvolle Weise menschlichen Problemen. Motive sind v.a. innerstädtische Archit., Gassen, Hafenviertel, Hochhäuser und Straßenzüge mit viktorianischen Häusern. ⌑ BALLARAT, AG of Ballarat. BANGKOK, Chaiyong Limthongkul Found. FA Mus. BRISBANE, State Libr. CANBERRA, NG of Australia. – Nat. Libr. of Australia. CASTLEMAINE/Vic., AG and HM. GEELONG, Geelong Gall. HAMILTON/Vic., Hamilton AG. LANGWARRIN/Vic., McClelland Gall. and Sculpt. Park. MELBOURNE, Bank of Melbourne. – Boroondara, Town Hall Gall. – Deakin Univ. Mus. of Art. – Ian Potter Mus. of Art, Univ. of Melbourne. – La Trobe Univ. Gall. – NG of Victoria. – State Libr. of Victoria. SYDNEY, AG of New South Wales. – Artbank. ◉ *E:* 1988, 2006, '09 Sydney, Robin Gibson Gall. / 1994 Langwarrin (Vic.), McClelland Gall. / 2007 Melbourne, Dickerson Gall. / 2008 Adelaide, Hill Smith Gall. / 2009 Shepparton (Vic.), Shepparton AG / 2010 Manningham, Manningham Gall. (K mit Interview mit C.) / 2011 Brisbane, Philip Bacon Gall.; Morwell (Vic.), Latrobe Regional Gall. – *G:* Sydney: 1989 Ray Hughes Gall.: Sir William Dobell Art Award; AG of New South Wales: 1985–87, '89, '91–95, '97–98, 2000 Wynne Prize; 1998 Archibald Prize / Melbourne: 1991 La Trobe Univ. Gall.: Portr. of Joseph Brown; Lancaster Press Gall.: 2004 Between a Rock and a Hard Place; 2005 Expansion; 2006 Passion Printing; 2007 Works From The Studio; 2009 Collaborations / New York: 2000 Hammer Gall.; 2001–08 Horn-Ashby Gall. (u.a. 2004 City Life) / 2002–09 Nantucket (Mass.), Horn-Ashby Gall. / 2005 Ballarat, Ballarat FA Gall.: Ballarat and Beyond / Castlemaine, AG and HM: 2006 Austral. Print Making: 1960s to Present; 2007 The Art of the Dog / Geelong, Geelong Gall.: 2006, '09–11 Acquisitive Print Awards; 2008, '10 Fletcher Jones Art Prize. ▭ New McCulloch, 2006. – *J. Fagan*, Uncommon Australians. Towards an Austral. Portr. Gall. (K Wander-Ausst.), Sydney 1992; *K. Fox*, The Linfox Letter 1996 (26) 8 s.; *N. Drury*, Images 3. Contemp. Austral. paint., Sydney 1998, 39 s., Taf. 35; *G. Morrison*, Ballarat in pictures (K Ballarat FA Gall.), Ballarat 2006; *P. Steele*,

The whispering gall., Mb. 2006; *D. E. L. Thomas*, d'Art. The art of R. C., Stoke-on-Trent 2007; *D. Thomas*, Urban myths (K Wander-Ausst.), Castlemaine 2007; *D. Hurlston*, Preserving the past. Enriching the future. Hugh Williamson's legacy (K NG of Victoria), Mb. 2008; *B. Nainby u.a.*, The CBus coll. of Austral. art, Mb. 2009. – *Online:* Website C.; Metropolis Gall. D. E. L. Thomas

Clinckx, *Christine*, belg. Video-, Installations- und Performancekünstlerin, Bildhauerin, Zeichnerin, * 1969 Merxem/Antwerpen, lebt in Ekeren/Antwerpen. Stud.: 1989–92 Koninkl. ASK, Antwerpen (Bildhauerei). Ausz.: 1991 Prijs van Lerius, Antwerpen; 1992 Prijs Verrept ebd. Artist in Residence: 1995 Listasafn Reykjavíkur (AM), Reykjavík; 1996 De Fabriek, Eindhoven; 2000 San Francisco Art Inst., San Francisco/Calif. – C. debütiert mit sozialkritischen Installationen; später v.a. Video- und Audioinstallationen sowie Performances (z.T. interaktiv; weiterhin Plastiken, Objekte und Zchngn), in denen sie sich engagiert und differenziert mit gesellschaftspolitischen Themen wie Rassismus, Sexismus, Machtmißbrauch und Umweltverschmutzung auseinandersetzt. Häufig verwendete Mat. bzw. Motive sind Haare und Lippenstift (z.B. versch. Haarteppiche sowie in *I tried to wash him of me*, 1996; *Bubbles*, 2006). Typisch sind befremdlich wirkende, durch Haare (Perücken), Tücher oder Masken verdeckte Gesichter (z.B. *Penelope*, 2004). ⌑ BRÜGGE, Groeninge-Mus. SITTARD, Mus. Het Domein. ◉ *E:* Antwerpen: 1994 Jacob Jordaenshuis (mit Sven 't Jolle); 1998 Vera Van Laer Gall. (mit Katharina van Hoffs); 2006, '08, '09, '10 Dagmar De Pooter Gall.; 2008 Rode Zeven / 1996 Eindhoven, De Fabriek (mit Sander Haccou, Jeroen Kooijmans) / 2001 Sittard, Mus. Het Domein (K) / 2004 Dendermonde, Sint-Blasius Hospitaal (K) / 2010 Paris, Gal. Vanessa Quang (mit Chris Gillis). –. *G:* 1992 Antwerpen, Provinciale Cult. Centrum Arenberg: Jong Talent 38 (K) / 1994 Löwen, Univ.-Bibl.: 5 voor 12 (K) / 1996 Lübeck, Overbeck-Ges.: Junge Kunst internat. '96 (K) / 1997 Graz, Rotor, Verein für zeitgen. Kunst: As large as Life / 2000 San Francisco (Calif.), Art Inst.: The World on Its Head (K) / 2008 Aalst, Sted. Mus.: Van Provo tot Nu. Kunst in een sociaal en politieke context / 2009 Geel, De Halle: Drawing Actions (K) / 2011–12 Kemzeke, Verbeke Found.: Cutting Edge Women. ▭ *Pas* I, 2002. – *J. Peeters/H. Wegmann* (Ed.), Germinations 8 (K Wander-Ausst.), Breda 1994. – *Online:* Inst. voor beeldende, audiovisuele en mediakunst, Gent; Website C. F. Krohn

Clinton, *Margery (Marjorie I.)*, brit. Keramikerin, Malerin, Graphikerin, * 1931 Glasgow, † Mai 2005. Stud.: 1949–53 Glasgow SchA (Malerei). 1973–74 R. College of Art, London, bei David Queensbery. 1978–95 Wkst. in Newton Port (bis 1981 zus. mit Jan Williamson), danach in Templelands/Dunbar. Lehrtätigkeit: Jordanhill College of Education. Mitgl.: 1957–58 Glasgow Group; Soc. of Designer Craftsmen; Fellow, Craftsmen Potters Assoc. – Nach Malerei und Graphik und einigen keramischen Arbeiten konzentriert sich C. ab 1969 auf Lüsterglasuren und gestaltet Gebrauchswaren, sakrale Objekte und v.a. Fliesen. Diese sind handbemalt und im Siebdruck de-

koriert, z.B. 1967 für den Saslalah Place in Oman oder 1993–94 für eine Keramikwand zum 300jährigen Jubiläum der Mary Erskine School in Edinburgh, deren Motive auf dem Edinburgh Physic Garden und einem typischen Knotengarten des 17. Jh. basieren. Daneben reproduziert C. Fliesen von William de Morgan und ma. Fliesen (Glasgow, Burrell Coll.). ⌂ ABERDEEN, AG and Mus. EDINBURGH, Oxgang Primary School: Keramikplakette, 1968. – R. Scottish Mus. – Scottish Nat. Portr. Gall. GLASGOW, Burrell Coll. – Kelvingrove Mus. and AG. LONDON, Tate. – V & A. MUSSELBURGH/East Lothian, Schwimmbad: Fliesenwand, 1995. ✉ Elusive lustres, in: Ceramic rev. 103:1987 (Jan./Febr.) 6–8; Lustres, Lo. 1991. ⊙ *E:* 1987 Edinburgh, Scottish Gall. (K). ▭ *Billcliffe* I, 1990; *McEwan*, 1994; *Buckman* I, 2006. – Design 332:1976 (Aug.) 24; *J. Orr*, Ceramic rev. 41:1976 (41) 12; ibid. 159:1996 (Mai/Juni) 42 s. – Edinburgh, Nat. Libr. of Scottland. H. Stuchtey

Clivio, *Franco,* schweiz. Industriedesigner, Produktgestalter, Hochschullehrer, * 1942, lebt in Zürich. Stud.: 1963–68 HS für Gest. in Ulm, u.a. bei Walter Zeischegg und Abraham Moles (Dipl.); ab 1968 ebd. Ass. mit Lehrauftrag. Seit 1968 als Produktdesigner tätig u.a. für Gardena, Erco (u.a. Stella Strahler; Büroleuchte Lucy), Siemens, Schleicher und Rodenstock. Lehrtätigkeit: seit 1972 Gastvorlesungen an Univ. in den USA, Finnland und Deutschland; 1980–2002 Doz. an der HS für Gest. und Kunst (HGKZ) in Zürich; seit 2002 am Ist. Univ. di Archit. in Venedig. Befreundet mit dem Designer Achille Castiglioni. Ausz.: über 200 Preise, u.a. 2004 Designpreis der Bundesrepublik Deutschland (für Kugelschreiber Lamy pico, 2001); 2009 Good Design Award des Chicago Athenaeum (für Kugelschreiber Lamy dialog 3, 2009). – C.s Œuvre umfaßt ausgeklügelt einfache wie zweckmäßige, häufig raffiniert-elegante wie intelligente und verblüffende Gest. für unterschiedliche Branchen (Licht, Elektro, Bau), wobei die Produkt-Gest. (u.a. Leuchten, Schreibgeräte, Gartentechnik) den Schwerpunkt bildet. 1968 debütiert er zus. mit Dieter Raffler als Gestalter bei der jungen Fa. Gardena mit Entwürfen, die so erfolgreich wurden, daß sie z.T. bis heute produziert werden (u.a. Stecksysteme). Neben Designern wie Johannes Potente, Jasper Morrison, Dieter Rams oder Philipp Starck entwirft C. wie diese für die renommierte Beschläge-Fa. Franz Schneider in Brakel ein durchgängiges Griffprogramm. Für die Fa. Lamy gestaltet C. Schreibgeräte mit einem harmonisch-puristischen, konsequent auf das Wesentliche reduzierten Design von beeindruckender Schönheit und Eleganz wie den sog. Hydraulikkugelschreiber (Lamy pico), der mit einem verchromten Messinggehäuse ausgestattet ist, aus dem per minimalem Druck auf die Spitze die Schreibmine herausgleitet, die das Gerät paßgerecht um ca. ein Viertel verlängert. 1990 gewinnt C. zus. mit Heinz Wondra, Rolf Müller u.a. den internat. Wettb. zur Gest. der Internat. Bau-Ausst. im Ruhrgebiet (IBA Emscherpark 1990–99). – Darüber hinaus ist C. als Sammler aktiv; aus aller Welt trägt er die banalen, z.T. millionenfach hergestellten Alltagsgegenstände des täglichen Gebrauchs zusammen, die von anonymen Gestaltern stammen und u.a. über eine perfekte Funktionalität verfügen (Scheren, Bleistifte, Kameras, Verpackungen etc.). Diese „verborgene Gest." (hidden forms) dient C. nicht nur als Anregung für eig. Entwürfe, sondern er benutzt sie v.a. im Hochschulunterricht als Anschauungs-Mat. für seine Überzeugung, daß Problemlösungen und die Suche nach der perfekten Funktion und Anmutung ein Allgemeingut menschlichen Strebens sind. – C. gehört als „Funktionalist" zu den bed. Produktdesignern der 2. H. des 20. Jh., die ihre Inspirationen von Charles Eames, Bruno Munari und Enzo Mari beziehen. ⌂ HANNOVER, Mus. August Kestner. STUTTGART, Design Center. ✉ Griffprogramm, Brakel [1994]; *C./ H. Hansen/P. Mendell*, Verborgene Gestaltung. Dinge sehen und begreifen, Basel u.a. 2009 (engl. Hidden forms. Seeing and understanding things). ▭ *M. Byars*, The design enc., Lo./N. Y. 2004. – Coll. Calderara (K), Vacciago 1978; *T. F. Bruns u.a.*, Design is a journey. Positionen zu Design, Werbung ..., B./He. 1997 (Interview); Der Kleingrosse. Der Industriedesigner F. C. und der Ing. Stephan Hauri kritisieren den Smart, in: Hochparterre. Zs. für Design, Archit. und Umwelt (Z.) 1998 (11); Produkte. Bilder und Vorbilder, HS für Gest., Schwäbisch Gmünd 2001 (Video). U. Heise

Clod (eigtl. Onesti, *Claude*), ital. Comiczeichner, * 18. 09. 1949 Modane. 1970 erste Comics. C. übernimmt *Capitan Posapiano e Ciurma* (Szenario: Enzo Meschieri). 1972 kreiert er die Serie *Gli Olimpiastri,* die in Sorry, Stadio und Il Lavoro erscheint. 1973 tuscht er die Zchngn von Bonvi für *Nick Carter,* ein Jahr später übernimmt er die Serie. Ab 1979 auch Arbeiten für das frz. Mag. Pif Gadget, wo er die Titelreihe zeichnet und *Agence Exsplorax* (Szenario: Goux). 1980 *Gangster Story* für das dt. Mag. Zack. Für Il Giornalino zeichnet er *Nicoletta* (Szenario: Claudio Nizzi). In den 1980er-Jahren arbeitet er verstärkt für frz. Verleger, etwa Vaillant. 1992 entsteht zus. mit Bonvi die Serie *Sturmtruppen,* die er 1998 nach dessen Tod allein weiterführt. – C. zeichnet in einem Semifunny-Stil, trifft aber bei den übernommenen Serien ganz den Stil des Vorgängers. ▭ *H. Filippini,* Dict. de la bande dessinée, P. 2005. – *Online:* Lambiek Comiclopedia.

K. Schikowski

Cloepfil, *Brad,* US-amer. Architekt, * 1956 Portland/ Ore. Stud.: Archit., Univ. of Oregon (Abschluß 1980); Columbia Univ. Graduate School of Archit., New York (Abschluß 1985). Einfluß von Ing.-Bauwerken und Land-art. In der Schweiz (Mitarb. von Mario Botta), in Los Angeles, New Orleans und New York tätig. C. gründet 1994 das Büro Allied Works Archit. in Portland; seit 2002/03 Dependance in New York. Das Büro entwirft in den USA v.a. Gebäude für Kultureinrichtungen wie Mus. und Kunstschulen. Char. ist eine skulpturale Wirkung der Archit.-Elemente durch Form und Anordnung im Raum. Oft Umnutzung, Umbau und Erweiterung von älteren, teilw. hist. Gebäuden (umstrittene Umgestaltung des 1964 von Edward Durell Stone errichteten Gebäudes Columbus Circle 2 in New York für das Mus. of Arts and Design, 2008). Erstes bed. Werk ist der Umbau eines alten Lagerhauses

im Auftrag der Werbeagentur Wieden & Kennedy, das Portland Inst. for Contemp. Art und and. Nutzer in Portland (2000). Wettb.-Siege, u.a. 2004 East River Walk (New York, mit den Lsch.-Architekten Gustafson Guthrie Nicol) und 2011 Nat. Music Centre of Canada in Calgary. Außerdem Wohngebäude (Blue Lake Ferienhaus, Sisters/Ore., 2000; Haus Sun Valley, Ketchum/Idaho, 2003). C. entwickelt 1993 das Konzept Sitings Project für eine Serie von Lsch.-Installationen im Nordwesten der USA (Maryhill Overlook am Columbia River bei Goldendale/Wash., 1998). Auch als Gast-Doz. tätig. ⌼ ANN ARBOR: Univ. of Michigan Mus. of Art, auch Ausst.-Archit., 2009. DALLAS, Booker T. Washington High School for the Performing and Visual Arts: Umbau und Erweiterung, 2008. DENVER, Clyfford Still Mus., 2011. SAN FRANCISCO, MMA: Zchngn. SEATTLE, AM: Erweiterung des Baues von Robert Venturi, 2007. SISTERS/Ore., Caldera AC: Generalplan, seit 1998, und Hearth Building, 2004. ST. LOUIS: Contemp. Art Mus., 2003. ▨ Allied works archit., Baden/Lo. 2009. ◉ E: 2007 Portland/Ore., PDX Gall. ⌺ A. Betsky, Archit. 1999 (Aug.) 64–69; 10x10, Lo. 2000; A. Betsky, Archis 2000 (7) 20–29; C., Casabella 64:2000 (678) 54–57, 93 s.; A. Freedman, Archit. 2000 (Juni) 104–115; Ville giardini 356:2000, 42–49; Interior design 72:2001 (4) 92–98; Techniques and archit. 462:2002, 80–83; T. de Monchaux, Archit. record 192:2004 (3) 30; (6) 62; Preservation 56:2004 (6) 20–25; M. Webb, Archit. rev. 215:2004 (1283) 29–35; M. Zeiger, Museen heute. Neue Häuser für die Kunst, M. 2006; T. Abrahams, Blueprint 267:2008 (Juni) 90–100; H. Adam, Bauwelt 99:2008 (44) 3; Archit. and urbanism 2009 (Juli) 80–87; F. A. Bernstein, Archit. record 197:2009 (2) 80–85; L'Arca 245:2009 (März) 74–81;M. Webb, Archit. rev. 2009 (Febr.) 60–65; D. Dillon, Archit. record 2010 (Jan.) 100–103; K. Frampton u.a., B. C. Allied works archit. Occupation, Ostfildern u.a. 2011. – Online: Website Allied Works Archit.

<div align="right">N. Buhl</div>

Clokey, *Arthur* (*Art*; geb. Farrington, *Arthur Charles*), US-amer. Trickfilmgestalter, Animationsfilmzeichner, Regisseur, * 12. 10. 1921 Detroit/Mich., † 8. 1. 2010 Los Osos/Calif. Adoptivsohn des Komponisten Joseph C. Nach dem 2. WK beginnt C., erste Werbefilme zu produzieren, ehe er ein Stud. an der Univ. of Southern California (Film School), Los Angeles, beginnt. Er experimentiert mit Lehm-Animation in der Stop-motion-Technik. 1953 produziert er den vierminütigen Film *Gumbasia*, der ihm zum Durchbruch verhilft. Nach seinem Stud.-Abschluß dreht er weitere Filme mit der Knetfigur Gumby, die ab 1956 in NBC's morgendlicher Fernsehshow für Kinder (*The Howdy Doody Show*) laufen. 1957 erhält C. mit *The Gumby Show* seine eig. wöchentliche Show (einige Episoden laufen 1961–62 auch im dt. Fernsehen). 1960 erscheint eine weitere animierte Serie unter dem Titel *Davey and Goliath*, die ethische und relig. Fragen behandelt. Neben frühen Musikvideos produziert C. bis in die 1970er Jahre weitere Gumby-Cartoons. Dann widmet er sich östlicher Religion und fertigt den Film *Mandala*. 1988 dreht er für das Fernsehen *The All-new Gumby*, und 1995 erscheint *Gumby. The*

Movie. 2004 läuft der Film *Davey and Goliath's Snowboard Christmas*. 2005 findet eine Jubiläums-Ausst. statt (50 Jahre Gumby). C. erhält zahlr. Preise und Anerkennungen für sein Werk. – C. gilt als Animationspionier des Fernsehens. Mit seinen Knetfiguren und der Stop-motion-Technik hat er starken Einfluß auf den amer. Animationsfilm. ⌺ L. Kaplan, Gumby. The authorized biogr. of the world's favorite clayboy, Harmony, N. Y. 1986; J. Lenburg, Who's who in animated cartoons, N. Y. 2006. – Das Magazin 2006 (11) 68–70.

<div align="right">K. Schikowski</div>

Closky, *Claude*, frz. Konzept-, Video-, Computer-, Collage- und Installationskünstler, Maler, Zeichner, Bildhauer, Fotograf, * 22. 5. 1963 Paris, lebt dort. Stud.: Ec. nat. supérieure des arts décoratifs ebd. 1984 u.a. neben Pierre Huyghe Mitbegr. der Künstlergruppe Les Frères Ripoulin (1984–88 aktiv). 1999 Grand Prix nat. d'arts plast. des frz. Kultus-Minist., 2005 Prix Marcel Duchamp. Seit 2005 Lehrtätigkeit an der ENSBA, Paris. – Mitte der 1980er Jahre malt C. als Mitgl. der Frères Ripoulin Werke auf Plakatpapier, die daraufhin wie Graffiti im Stadtraum (bes. Paris und New York) angebracht werden. Nach dem Auseinandergehen der Gruppe setzt er sich intensiv mit alltäglicher Kommunikation durch Objekte, Zeichen und Bilder auseinander. Unter Verfremdung des Kontexts, geringfügiger Manipulation, Neuanordnung und Anwenden von selbst auferlegten Regeln regt er zur Reflexion über selbstverständlich akzeptierte Konzepte an. 1989 fertigt C. zahlr. geschriebene Werke von Ordnungen und Klassifikationen, die logische, aber banale Sequenzen von Buchstaben, Zahlen, Formen oder Beschreibungen präsentieren, z.B. *Les 1000 premiers nombres classés par ordre alphabétique* (1989). Mit der Installation *Toutes les façons de fermer une caisse en carton* (1989; Marseille) variiert er die Möglichkeiten des Überlappens von Deckelklappen eines Kartons. Zahlenreihungen und Durchnumerieren bleiben Konstanten in C.s Œuvre. Rasch treten auch Werbung (u.a. aus Printmedien) und Konsumgüter in das Blickfeld und liefern das Mat. für Collagen. So erstellt er Alphabete aus den Logos internat. Konzerne (*AA, AB*, 1993; Carquefou) oder reiht Verkaufsanzeigen entsprechend des Preises der jeweiligen Produkte aneinander (*De 1 à 1000 F*, 1993; Paris, Centre Pompidou). Mit einer Vorliebe für Luxusartikel wie Parfums und Make-ups betont C. v.a. das Streben nach körperlicher Schönheit, das er jedoch mit verfremdenden Effekten wie der Spiegelung einer Gesichtshälfte unterminiert (Serie *Beaux Visages*, 1997). Die Serie *10 h 10* (1996) kristallisiert die Verknüpfung von Werbung und sexueller Stimulation des Unterbewußtseins durch die perfekte Inszenierung einer Herren- und Damenarmbanduhr heraus. Familie und die Wertschätzung zwischenmenschlicher Beziehungen thematisiert C. in Internetprojekten wie *Do you want love or lust?* (1997) für den Dia Center for the Arts in New York. Wie auch in and. Textarbeiten und Internetspielen C.s (u.a. www.sittes.net) spielt hierbei die scheinbar endlose Wiederholung eines Prozesses, der zu keinem klaren Ende führt, eine wesentliche Rolle. Ab ca. 2003 fertigt er wieder zunehmend Gem., die zunächst Liniendiagrammen, bald Kreisdiagrammen (um 2005) ähneln

und schließlich – als Akkumulation monochromer rechteckiger Leinwände – Säulendiagramme suggerieren (um 2006). Daneben interaktive Monitorinstallationen. 2010 entstehen plakativ farbige Acryl-Gem., in denen C. erneut auf Buchstabenkombinationen zurückgreift. Das zeichnerische Werk ist umfangreich und dient ihm häufig als Basis zur Ideenfindung. C. ist auch der Designer der offiziellen Websites des MAM Grand-Duc Jean (Mudam), Luxemburg. ⌘ CAEN, FRAC Basse-Normandie. CARQUEFOU, FRAC des Pays de la Loire. ECATEPEC/Mexiko, Coll. Jumex. LEEDS, R. Armories Mus. LIMOGES, FRAC Limousin. LUXEMBURG, MAM Grand-Duc Jean (Mudam). MARSEILLE, FRAC Provence-Alpes-Côte d'Azur. MINNEAPOLIS/Minn., Walker AC. NEW YORK, MMA. PARIS, Centre Pompidou. – FNAC. – MAMVP. SOTTEVILLE-LÈS-ROUEN, FRAC Haute-Normandie. STUTTGART, KM. VITRY-SUR-SEINE, MAC du Val-de-Marne. ◉ E: Paris: 1991 Hôpital Ephémère; 1993, '94, '98, 2000, '02 Gal. Jennifer Flay; 1993, 2006 (K) Centre Pompidou; 1997 Caisse des Dépôts et Consignations; 1999 Colette; 2000 Union Centrale des Arts Décoratifs; 2004 Gal. de Multiples; 2007, '10 Gal. Laurent Godin; 2011 Gal. mfc-Michèle Didier / 1993 Limoges, FRAC Limousin; Brétigny-sur-Orge, Centre Jules Verne / 1994 Dôle, Mus. de Dôle / Genf: 1994 Centre de Gravure Contemp. Genevois; 2001, '05 Gal. Edward Mitterand / 1995 Delme, CAC La Synagogue de Delme; Montpellier, FRAC Languedoc-Roussillon; Périgueux, Bibl. mpal / 1996 (K), 2002 Pau, Le Parvis (K) / 1996 Rennes, BA de Rennes und Passage de la Poste; Glasgow, CCA / 1997, '98, 2005, '07, '10 Berlin, Gal. Mehdi Chouakri / 1997 Herzliya (Israel), MCA / 1998 Sotteville-lès-Rouen, FRAC Haute-Normandie; Le Havre, Le Spot. Studio d'Art Contemp. / 1999 Tours, Centre de Création Contemp.; Limoges, FRAC Limousin; Chatou, Maison Levanneur / 2000 Ljubljana, Mod. Gal. / 2001 Dundee, Dundee Contemp. Arts, Centre for Artists Books; Florenz, Base / 2003 Turin, Gall. Nicola-Fornello; New York, Location 1; Lyon, La salle de bains; Bignan, Domaine de Kerguéhennec / 2004 Barcelona, Fund. Miró; Marseille, Gal. Roger Pailhas / 2005 Den Haag, GEM / 2007 Neapel, Mus. Madre / 2008 Vitry-sur-Seine, MAC du Val-de-Marne (K); Thiers, Le Creux de l'Enfer (K) / 2009, '11 Zürich, Mitterand + Sanz / 2010 Istanbul, Akbank Sanata / 2012 Caen, FRAC Basse-Normandie. – G: 1996 Sydney: Bienn. / 2000 Taipei: Bienn. ☐☐ Bénézit III, 1999; Delarge, 2001. – O. Zahm, C. C. Magazines, P. 1998; F. Paul, C. C., P. 1999; C. Boulbès u.a., C. C. Hello and welcome, Bignan/Pau 2005; Q. Bajac/C. Cheroux (Ed.), Coll. photogr. (K MNAM Paris), Göttingen 2007. – Online: Gal. Mehdi Chouakri, Berlin; Gal. Laurent Godin, Paris; Website C. G. Bissell

Cloutier, S. Paul (Sylvio Paul), kanad. Maler, Graphiker, * 18. 2. 1919 Lafleche/Sask. 1939–45 Armee- und Kriegsdienst, u.a. bei der kanad. Air Force (vier Jahre im Einsatz in Europa und Nordafrika). 1945 Rückkehr nach Kanada. Stud.: 1945–48 Vancouver SchA (jetzt Emily Carr Inst. of Art and Design), Vancouver/B. C.; 1955–56 Univ. of Saskatchewan, Regina College SchA, Regina, bei Kenneth

Lockhead; 1970 Banff School of FA, Banff/Alta., bei Ilda Lubane; 1975 Summer SchA, Fort Qu'Appelle/Sask., bei Joe Fafard. 1957 (bei Will Barnet und Joe Plaskett), 1958 (bei Bruce Parsons) und 1973 (bei William Wiley) Teiln. am Emma Lake Artists' Workshop. Zunächst tätig als Werbegestalter, u.a. 1949–51 in Kimberley/B. C., 1951–54 bei Cooper's General Store, Swift Current/Sask. 1954–79 Leiter der Kunst-Abt. bei der Saskatchewan Power Corporation, Regina. Nach der Emeritierung 1979 zieht er nach Parkview b. Tuxford/Sask., wo er sich vollst. der Malerei widmet. – C. arbeitet bevorzugt in Öl, Acryl und Aquarell. Seine Lsch. mit Motiven von Saskatchewan und Brit. Columbia sind in sparsamer, mitunter fast zur Monochromie tendierenden Farbgebung gehalten (Lafleche in Winter, 2001; Windmill, 2011, beide Aqu.). Von A. der 1990er Jahre bis Sommer 2005 entsteht eine Serie mit Darst. von Getreidespeichern entlang der Autobahn zw. Regina und Saskatoon. Des weiteren stammen von C. bed. Porträts. ⌘ MOOSE JAW/Sask., Moose Jaw Mus. und AG. REGINA, Govt. of Saskatchewan, Legislative Building: Portr. Lieutenant-Governor R. L. Hanbridge und Premier Ross W. Thatcher, beide Öl/Lw., 1969. – Saskatchewan Arts Board. – Saskatchewan Power Corporation. – Saskatchewan Press Club: offizielle Portr., 1971–92. – Saskatchewan Sports Hall of Fame: offizielle Portr., 1971–92. – Holy Cross Church: Kreuzwegstationen, Mosaiken aus byz. Farbglas, 1961. ◉ E: 1968 (K), '73, '79, '85 Regina, Gall. on the Roof / 1973, '75, '86–88, '91 (mit John C.) Calgary (Alta.), La Flamme Gall. / 1990 Saskatoon, Arlington Frame Gall. / 2012 Moose Jaw, Moose Jaw Cultural Centre, Mosaic Gall. ☐☐ M. Newman (Ed.), Biogr. dict. of Saskatchewan artists. Men artists, Saskatoon 1994. – The Saskatchewan Arts Board Coll. (K), Regina 1978; Artists in Canada, Ottawa 1988. – Online: Saskatchewan NAC; Moose Jaw Mus. and AG; Moose Jaw Cultural Centre. C. Rohrschneider

Clóvis Júnior (eigtl. Dias Júnior, Clóvis), brasil. Maler, Illustrator, Graphiker, * 22. 6. 1965 Guarabira/Paraíba, lebt in João Pessoa. Stud.: 1985–89 Kunstpädagogik an der Univ. Federal da Paraíba, João Pessoa; dort auch Graphik bei Hermano José. Versch. Ill., u.a. für das Buch Misturas Poéticas (1988). Ausz.: 1987 (1. Platz), '90 (3. Platz) beim Wettb. Listel-Telpa, Catálogo Telefônico da Paraíba; 1993 1. Platz Internat. UNO-Wettb. (Plakataktion gegen Drogenmißbrauch), Brasília; 1995, '96 Troféu Paraíba als Künstler des Jahres, João Pessoa. – C.s naive Malereien sind von einem ornamentalen Stil geprägt. Neben relig. Motiven herrschen thematisch idealisierte Lsch.- und Stadtidyllen vor. ⌘ ASSIS, Mus. de Art Primitiva. CAMPINA GRANDE, Mus. Assis Chateaubriand. JOÃO PESSOA, Pin. – Univ. Federal da Paraíba. RIO DE JANEIRO, Mus. internac. de Arte Naïf. SÃO PAULO, Serviço Social do Comércio. VICQ/Yvelines, Mus. internat. d'Art naïf. ◉ E: João Pessoa: 1984 Bibl. da Univ. Federal da Paraíba; 1987 Escritório de Arte; 1990 Escritório de Arte Suzete Forte; 1992 Gal. Banco do Brasil 1817; 1993 Gal. BA; 1994 Gal. Art-220; 1995 Gal. Aliança Francesa; 1996, '98, 2001, '03 Gal. Gamela; 1999 Espaço Cult. Vila Romana; 2004 Gal.

Espaço Criativo; 2008 Gal. Solo / 1988 Guarabira, Gal. Antônio Sobreira / Natal: 1992 Gal. Convicart; 1993, 2008 Gal. Taba / Brasília: 1996 Espaço Cult. Banco Central; 1998 Gal. de Arte LBV; 2007 Gal. Pe Palito / 1996 Buenos Aires, Gal. Volpe Stessens / 1997 Campinas Grande, Mus. Assis Chateaubriand; Rio de Janeiro, Espaço Cult. dos Correios / 2001 New York, Art Format SoHo / 2005 Vicq, Mus. internat. d'art naïf / 2008 São Paulo, Gal. Romero Britto / 2009 Orlando (Fla.), Univ. of Valencia. –. *G:* zahlr. u.a. João Pessoa: Gal. Gamela: 1983 (Todas as Cores do Homem); 1985 (Arte Sobre Papel); 1984, '85, '88 Salão Mpal de Artes Plást.; 1984 Salão São João; 1985 Gal. Pedro Américo: A Presença do Mar nas Artes Plást. (3. Preis); 1990 Fund. Espaço Cult. da Paraíba: Arte Atual Paraibana; 2007 Gal. dos Naïfs: Trilhas do Tempo / 1983 Recife: Salão de Artes Plást. de Pernambuco / Piracicaba: 1988 Salão Nac. Pintura Ingênua e Primitiva (Ankaufs-Preis); 1992–98 Bien. Brasil. de Arte Naïf; 2004 Centro Canagro: Violeiros e Canaveiros / 1993 Kassel, Kulturhaus Dock 4: Plakate gegen Rassismus / 1994 Salvador da Bahia: Salão MAM Bahia de Artes Plást. / 1996 Buenos Aires: Salão Mercosul de Arte Sacra (lobende Erw.) / 1998 Figueiras, Mus. de Arte Naïf: Expos. de Inauguração / São Paulo: 1998–2006 Bien. Naïfs do Brasil / 2004 Jundiaí, Bien. Internac. de Gravuras. ▭ *Online:* Inst. Itaú Cult., Enc. artes visuais, 2008. M. F. Morais

Clowes, *Daniel Gillespie (Dan),* US-amer. Comiczeichner, Comic- und Drehbuchautor, * 14. 4. 1961 Chicago. Stud.: Pratt Inst., New York. – 1985 veröff. C. bei Fantagraphics Books seine erste eig. Heftserie *Lloyd Llewellyn.* 1989 erscheint ebd. das erste Heft der Reihe *Eightball,* in der alle Geschichten von C. als Kurz- oder Fortsetzungsgeschichten gestaltet werden. Aus dieser Reihe gehen viele von C.s Graphic Novels hervor. So werden die Erzählungen *Like a Velvet Glove Cast in Iron* (dt. *Wie ein samtener Handschuh in eisernen Fesseln*), *Ghost World* oder *David Boring* in *Eightball* vorab serialisiert und später als Buch herausgegeben. 2001 wird *Ghost World* von Terry Zwigoff verfilmt (Drehbuch von C.). 2006 schreibt und produziert C. den Film *Art School Confidental* (Regie: T. Zwigoff). 2007 erscheint die Comicerzählung *Mr. Wonderful* in Fortsetzungen im New York Times Magazin. 2010 veröff. C. die Graphic Novel *Wilson.* Daneben zahlr. Ill.; auch Entwürfe für Plattencover. Ausz.: u.a. Eisner, Ignatz und Harvey Awards; 2011 PEN-Prize, Graphic Literature. – C. gilt als einer der wichtigsten zeitgen. Comiczeichner der USA. Sein Werk ist von den amer. Underground Comix und von der Popkultur der 1950er Jahre beeinflußt. Zeichnen sich seine frühen Arbeiten durch surreal-groteske Überspitzung und Genre-Crossover aus, so findet in neueren Werken eine Rückbesinnung auf klassische Comicerzählmuster statt, in der er sich zeitgen. Themen zuwendet. ▭ *G. Meyer,* The art of D. C. Mod. cartoonist, N. Y. u.a. 2012 (Lit.; WV). – *Online:* Lambiek Comiclopedia. K. Schikowski

Cnaani, *Ofri,* israelische Medien-, Installations- und Performancekünstlerin, Zeichnerin, * 1975 Tel Aviv, lebt in New York City. Tochter der Malerin *Yael C.* (* 1947, geb. Shemi); Enkelin des Bildhauers Yehil Shemi. Stud.:

1997–2000 Beit Berl College, SchA Midrasha (Videokunst); 2002–04 Hunter College, New York. Stip.: 2000, '03 America–Israel Found.; 2007 Six Point, New York; HBI (Hadassah-Brandies Inst.) Research Award. – In raumgreifenden, mehrteiligen Videoinstallationen, comicverwandten Zchngn sowie Performances, z.B. in einem israelischen Gefängnis (*Dungeon,* 2003–04), setzt sie sich mit Machtstrukturen, Geschlechterrollen und der Frage nach menschlicher Integrität auseinander. Verrat innerhalb der Fam. oder eines Systems wird z.B. in *The Sota Project* (Videoinstallation) und *Betrayal in Three Acts* (Performance; beide 2011) behandelt. Zur Ill. ihrer Fragen greift sie u.a. auf die Odyssee, antike Dramen oder Erzählungen aus dem Talmud zurück. Bildteppiche der Renaiss. oder bemalte Keramik des Altertums beeinflussen zudem ihr gestalterisches Herangehen. And. Arbeiten gelten der Wahrnehmung städtischer Räume und ihrer Archit. sowie der Manipulation durch Werbung, z.B. auf Plakaten für Palästina-Reisende in den 1920er Jahren (*Oriental Landscapes*). ⌂ HAIFA, Mus. of Art. ◉ *E:* u.a. Tel Aviv: 2000 Peer Gall.; 2002 Kalisher AG (mit Yael Cnaani und Yehil Shemi; K); 2002 (mit Dror Daum), '03 Alon Segev Gall.; 2007 Braverman Gall. / 2003 Herzliya, MCA / Mailand: 2004, '05 (K) Pack Gall.; 2006 Gall. d'Arte Contemp. (K) / New York: 2005, '07 (K) Andrea Meislin Gall.; 2012 Dumbo Brooklyn, KH Galapagos / 2006 Haifa, Mus. of Art / 2012 Los Angeles, Fisher Mus. of Art. – *G:* seit 2001 zahlr. nat. und internat. (alle K), u.a. 2005 New York, Bronx Mus. of Art: AIM25 / 2006 Barcelona: LOOP Video Art Festival / 2007 Bat-Yam, Mus. of Art: Sweet Sixteen; Jerusalem, Artist House: Nat. Bienn. of Drawing; Petach-Tikva, Mus. of Art: The Space Between / 2008 Jerusalem, Israel Mus.: Real Time. Art in Israel 1998–2008; Prag: Internat. Trienn. zeitgen. Kunst; Tel Aviv: Internat. Video Art Bienn. / 2009 Haifa, Mus. of Art: Wild Exaggeration. The Grotesque Body in Contemp. Art; Moskau: Internat. Bienn. zeitgen. Kunst. ▭ *C. Zanfi* (Ed.), Going public '06. Atlante Mediterraneo (K), Mi. 2006. – *Online:* Braverman Gall. (Lit.); Website C. (Ausst.); Israeli AC (* 1975 Kibbutz Kabri; auch zu Yael C. und Yehil Shemi).
 B. Scheller

Cnaani-Sherman, *Gali,* israelische Textilkünstlerin, Designerin, * 1968 Herzliya. Stud.: Shenkar College of Engineering, Design and Art, Ramat Gan; 1998–2000 College of Art and Design, Kanazawa (Japan). Lehrtätigkeit: Bezalel Acad. of Arts and Design, Jerusalem; Shenkar College of Engineering, Design and Art, Ramat Gan. Ausz.: 1995, '99 Preis der America-Israel Found.; mehrere Auslands-Stip. Mitgl.: Assoc. of Israel's Decorative Arts. – Wie in ihren Kleiderunikaten kombiniert C. auch in (Wand-)Tapisserien versch. Mat., z.B. Woll- mit Kupferfäden. Geprägt sind ihre Arbeiten von jap. Ästhetik, bes. wichtig sind ihr der Bezug zu Natur und trad. Handwerk. In unregelmäßigen Linien erzeugt sie (auch kleinformatige) abstrakte Gewebestrukturen. Die jeweilige Wirkung der Textilien bei bestimmten Lichtverhältnissen wird bei der Herstellung genauso bedacht wie spätere Veränderung durch Alterungsprozesse, z.B. wenn metalli-

sche Bestandteile Oxidationsspuren hinterlassen. ⊚ *G:*
2000 Como: Miniarttextile / 2001 München, Gal. Hand-
werk: Textil aus Israel / 2004 Łódź: Internat. Trienn. of
Tapestry / 2008 Philadelphia (Pa.), Mus. of Art: Craft
Show. ▭ *M. Mostovy-Eisenberg*, Jewish Exponent v.
26. 11. 2008; *A. Busch u.a.*, 10th Wave III. Art textiles and
fiber sculpt. featuring (K), Wilton, Conn. 2009. – *Online:*
Browngotta. B. Scheller

Cơ, *Trần Hoàng* (Trần Hoàng Cơ), vietnamesischer
Bildhauer, * 5. 6. 1961 Nam Định, lebt in Hanoi. Verh.
mit der Schriftstellerin Y Ban. Stud.: 1985–90 KHS, Hanoi
(Abschluß). Seitdem eig. Wkst., für die er in den 1990er
Jahren auf Grund des Mangels an Arbeits-Mat. Altmetall
aufkauft und dieses in allen Teilschritten selbst bearbei-
tet. Anfangs v.a. semi-abstrakte Arbeiten aus Draht und
Blech (Eisen, Kupfer), mit denen C. rasch zu einer unver-
wechselbaren Formensprache findet. Die skurrilen Gebil-
de, die gleichermaßen an Pflanzen, Insekten, Vögel oder
menschliche Figuren erinnern, zeigen in betont schmaler,
aufrechter Gest. und geistreicher Verspieltheit Bezüge zu
Alberto Giacometti und Paul Klee. C. thematisiert Werden
und Vergehen, Mühsal und Harmonie der kreatürlichen
Existenz (*Vögel und Reis*, 1994; *Existenz*, 1996; *Endlose
Reise*, 1997). Daneben kompakte allegorische Skulpt. in
Bronze (*Umweltzerstörung*, 1994), Portr.-Büsten in Gips
und Kleinplastik in Ton. Infolge der wirtschaftlichen Öff-
nung arbeitet C. seit 2001 in Stein und Marmor. Zunächst
Tiermotive, aus wenige Zentimeter dicken Gesteinsplat-
ten geschnitten, teilw. mit Gravuren versehen und im Bau-
kastensystem ineinandergesteckt. Später von Lit., vietna-
mesischer Mythologie und trad. Archit. inspirierte Groß-
plastiken. ▭ Fukuoka, Prefectural Mus. of Art: Trans-
formation in creativity; Two standing figures, beide Me-
tall. Hanoi, Sóc Sơn: Stilles Dorf, Bienenwabenstein. Hy
Lang/phú Thọ, Đền Hùng: Đông Sơn Bushido, Granit,
2009. Mayen, Lapidea-Skulpt. Park: Zwei Kinder; Don
Quichote, beide Basalt, 2006. Singapore, Singapore AM:
Memory and shadow, Bronze. ⊚ *E:* u.a. Hanoi: 1987
Gal. des Künstler-Verb.; 1995 Büro des Internat. Mone-
tary Fund; 2002 Hotel Sofitel Metropole. – *G:* Hanoi:
1990 Nat. Kunst-Ausst.; 1993 Nat. Bildhauer-Ausst.; 1997
Gal. Tràng An: All the rivers are running; 1999 KM Viet-
nams: New space (alle K) / 1994 Fukuoka, AM: Rea-
lism as an attitude (K) / 1995 Singapore, AM: Modernity
and beyond / 2005 Nagoya, Aichi MA: Asian potential.
▭ Vietnamese contemp. sculpt., Hanoi 1997; Nghệ sĩ
Tạo hình Việt Nam hiện đại – Ký yếu Hội viên (Mod. bild.
Künstler Vietnams), Hanoi 1999; Lao động v. 29. 10. 2002;
Thể thao & văn hóa 21:2002 (84) 36; World sculpt. news
8:2002 (4); *Ng. Quân*, Mỹ thuật Việt Nam thế ký XX (Viet-
namesische Kunst des 20. Jh.), Hanoi 2010. – Mitt. C.
A. Friedel-Nguyen

Coadou, *Jean-François*, frz. Bildhauer, Zeichner,
Schriftsteller, * 16. 9. 1948 Carmaux/Tarn, lebt in Pertuis/
Vaucluse. C. verfaßt regelmäßig Artikel für die Presse (u.a.
für die Tages-Ztg La Marseillaise sowie für die Zs. Tak-
tik), weiterhin schreibt er Romane, auch Poesie (unver-
öff.). Gehört der Kunstbewegung MADI an. Kunstthera-

peutische Tätigkeit: 1993–97 Atelier-Ltg, 3 bis f, Hôpital
Montperrin, Aix-en-Provence; 1994–96 Atelier du Coin,
Montceau-les-Mines. Stud.: Abendkurse an der Ec. nat.
des BA, Lyon. – C.s abstrakte Stahlplastiken sind häufig
aus einzelnen geometrischen Formen zusammengesetzt,
die ineinandergesteckt oder aneinandergereiht sind, v.a.
die 2007 begonnene Serie *Equations*. Zu einer früheren Se-
rie gehören gitterartige, flache Plastiken (*Claustra 1*, 2004)
mit geometrischen Durchbrüchen und fensterähnliche Ob-
jekte mit floral wirkendem Mittelteil (*Claustra 4*, 2005)
sowie kastenförmige Arbeiten (z.B. *Sculpt. silencieuse 44*,
2005), die bisweilen an Sepulkralplastik erinnern. Zudem
konstruiert er komplexere maschinenartige Plastiken. C.s
Werke haben meist einen rostroten Farbton, z.T. sind sie
geschwärzt, selten farbig bemalt, wie z.B. die in Signal-
rot leuchtende mon. Plastik *Oui!* von 2006, welche aus
den Umrissen von drei unterschiedlich großen, miteinan-
der verbundenen Kuben besteht. ▭ Istres, Centre d'Art
contemp. – Mus. Marseille, Fonds communal de la Vil-
le. ▱ Le cogitomaton, Barjols 2010; Le complexe de
Vauban, Peyrus 2010. ⊚ *E:* 1989 Carcassonne, Tour
du Tréseau / 1992, 2000, '04, '07, '09 Marseille, Gal.
du Tableau / 1998 Saint-Martin d'Hères, Espace Vallès
(K) / 2003 Six-Fours-les-Plages, Maison du Cygne / 2005
Mougins, Gal. Sintitulo / 2010 Aix-en-Provence, Atelier
Cézanne / 2011 Carcès, La Maison des Arts (mit Elisa-
beth Lemaigre-Voreaux). – *G:* seit 1981, u.a. 1986 Nîmes,
Espace Gard: Pour les Droits de l'Homme / Marseille:
1992 Gal. Athanor: Territoires ou la peur du Beau; 1998
Artothéque Antonin Artaud: Messieurs les Artistes, don-
nez de vos Nouvelles / Paris: 2006 Centre d'Art géomé-
trique internat. Madi: Monochrome Madi; 2007, '08 Sa-
lon des Réalités nouvelles / 2009 Asperen, Land en Beeld:
Carpe artem, carpe hortem / 2011 Carros, Centre internat.
d'Art contemp.: De Carmelo Arden Quin à Madi contemp.
(K). ▭ *Delarge*, 2001 (* 1949). – *Online:* Documents
d'artistes. F. Krohn

Coates, *Gregory* (Gregory W.), US-amer. Maler, Ob-
jektkünstler, * 5. 3. 1961 Washington/D. C., lebt in Al-
lentown/Pa. 1980–84 Corcoran SchA, Washington/D. C.;
1985–87 KA Düsseldorf; 1990 Skowhegan School of
Paint. and Sculpt. Artist in Residence: 1996 Studio Mus.
in Harlem; 2011 Verbier 3-D Found. Ausz.: 2002 The
Edward Mitchell Bannister Award for Excellence in Art.
– Angeregt durch seinen Freund und Mentor Al Loving
konzentriert sich C. ab E. der 1980er Jahre auf abstrak-
te Wand-Skulpt., Assemblagen, Gem. und Installationen
aus Fahrradschläuchen, ferner aus Plastikfolie, Klebeband,
Industriepaletten oder Federn. Ein *Self-Portr.* (1996) be-
steht aus Paletten, die ganz mit Klebeband umwickelt und
braun gestrichen sind. Er verweist häufig auf and. Kunst-
richtungen und Künstlerarbeiten, so ist *How Do You Like
Me Now* (2006) mit weiß besprühten Fahrradschläuchen
eine Anspielung auf das gleichnamige Gem. von David
Hammons von 1989 mit einem weißhäutigen, blauäugigen
und blonden Jesse Jackson. Mit Bezug auf die „Zip"-Gem.
von Barnard Newman kreiert C. in der großformatigen Ar-
beit *Kiki, Short for Christine* (2007) aus zwei übereinan-

der montierten, rechteckigen Holzpaletten, die mit dicht mit blauem Pigment bestrichenen Gummischläuchen beschichtet sind, einen hellen horizontalen Streifen zw. den Paletten. C. beginnt in Folge emotionaler und gesundheitlicher Begebenheiten ab 2007 eine Serie von eher kleinformatigen Feder-Gem. und beschäftigt sich mit der Bed. von Farbe und Effekten bei verschiedenartig aufgebauter Oberflächenstruktur (*Nighttime*, 2007). Mit ideenreichen Mat.-Metamorphosen, konzeptuellem und minimalistischem Vorgehen konstruiert er außergewöhnliche, dynamische und provokative Arbeiten. ⌂ DÜSSELDORF, Stadt. NEW YORK, The Studio Mus. in Harlem. PHILADELPHIA, PAFA. WASHINGTON/D. C., SI. ◉ *E:* New York: 1991 Cinque Gall.; 1994 Wilmer Jennings Gall.; 1997 Christiane Nienaber Contemp. Art; 1999 Broan Gall. (K); 2000 Atmosphere Gall.; 2000 Threadwaxing Space (K); 2004 Wilmer Jennings Gall.; 2005 Rubin-Chapelle Design; 2006, '08 Magnan Projects / 1995 London, Gas Works Gall. / 1997 Albany (N. Y.), Rathbone Gall., Sage Junior College of Albany / 1998 San Francisco, Bomani Gall.; San Diego, Porter Troupe Gall. / 1999 Berlin, Kunsthaus Tacheles; München, Kunsthandel Leidel / 2002 Providence, Rhode Island College, Bannister Gall. / 2004 Lancaster (Pa.), Franklin and Marshall College, Phillips Mus. of Art / Wien: 2004 Studio Sinnvoll; 2006 Gal. Denkraum / 2007, '09 Chicago, G. R. N'Namdi Gall. / 2008 Albany, Sage Colleges, Opalka Gall. (K). ⌷ *S. Schults*, Kunstforum 86:1986 (Nov./Dez.) 297; *K. Sajet*, The chemistry of color (K PAFA), Ph. 2005; *L. Donaldson*, Amer. legacy mag. 2008 (Herbst) 26–33. – *Online:* Website C.; Magnanmetz Gall. H. Stuchtey

Coates, *Marcus,* brit. Performancekünstler, Videokünstler, Fotograf, * 18. 1. 1968 London, lebt dort. Stud.: 1987–90 Kent Inst. of Art and Design; 1990–93 RA, London. Ausz.: 2008 Paul Hamlyn Found. Award for Artists; 2009 Daiwa Found. Art Prize, Tokio. – C. befaßt sich in Fotogr. und Videos spielerisch mit der Grenze und Beziehung zw. menschlichem und tierischem Bewußtsein, mit der zeitgen. Haltung zu indigenen Glaubenssystemen sowie mit der Macht von Ritualen. Häufig imitiert oder verwandelt er sich in Waldtiere. So zeigt die Fotogr. *Goshawk* (1999) wie er, in sechs Meter Höhe an eine Tanne gebunden, die Sicht eines Habichts nachvollzieht. Im Video *Dears* (2001) bewegt er sich mit einem auf den Rücken gebundenen toten Reh auf dem Waldboden. Während eines Künstleraufenthalts im zum Abriß vorgesehenen Wohnblock Shiell Park, Liverpool, vollzieht er 2004, mit Fell und Hirschgeweih verkleidet, für die Bewohner ein schamanisches Ritual der sibirischen Tuvak und erfaßt filmisch z.B. den kurzen Augenblick zw. Ungläubigkeit und Akzeptanz bei den Zuschauern (*Journey to the lower world*, Video). Als Kenner der Ornithologie nimmt C. mehrfach Vogelgesänge auf und kreiert Videoinstallationen wie *Dawn Chorus* (2007), bei der auf mehreren Bildschirmen Menschen zu sehen sind, die Vogelstimmen nachahmen. Aufnahmen von orig. Vogelgesängen wurden digital verlangsamt, von Sängern einstudiert und wieder beschleunigt. 2011 präsentiert das Video *The trip* C.s. Befragungen von Bewohnern eines kleinen Dorfes im Amazonas-Regenwald, mit denen er den Wunsch eines unheilbar kranken Mannes erfüllt und Erfahrungen und Bilder dieser für den Kranken unerreichbaren Welt mit ihm teilt. C.s spielerische und außergewöhnliche Methodologie und sein Ideenreichtum finden Vorlagen in Werken von Joseph Beuys und Rebecca Horn oder Franz West. ⌂ LONDON, Wellcome Trust. ◉ *E:* 2003 Berwick on Tweed, The Gymnasium / London: 2004 Café Gall. Projects (K); 2007 Whitechapel Laboratory; 2010 Kate Maggarry; 2011 Serpentine Gall. (K) / 2005 Newcastle, Side Cinema / 2007 Gateshead, Baltic Centre for Contemp. Art; Bristol, Arnolfini: Dawn Chorus / 2009 New Orleans, Mus. of Art; Tokio, Tomio Koyama Gall.; Zürich, KH / 2010 Newlyn, Newlyn AG; Milton Keynes (Bucks.), MK Gall. – *G:* 2005 London Pump House Gall.: Human nature (K) / 2007 Norwich, Castle Mus.: Waterlog (K) / 2010–11 Tokio, MCA: Transformation (K). ⌷ M. C., Amblesilde 2001; *P. Usherwood*, Art monthly 267:2003 (Juni) 32 s.; *P. Eleey*, Frieze 89:2005 (März) 104; To skiachtro. The scarecrow (K Metsovo), At. 2006; In profile: M. C., Interview mit Tracey Warr, DVD, Bristol 2007; *J. Griffin*, Frieze 108:2007 (Juni-Aug.) 220; *V. Groskop*, Guardian v. 25. 1. 2007; *S. Sherwin*, ArtRev 13:2007 (Juli/Aug.) 106 s.; *L. R. Lippard*, in: *A. Schneider/C. Wright* (Ed.), Between art and anthropology, Lo. 2010; *D. Smith*, Art monthly 338:2010 (Juli/Aug.) 11–14; *M. Fuller*, J. of visual art practice 9:2010 (1) 17–33; *H. Beckitt*, C mag. 107:2010 (Herbst) 34–39; *R. Dorment*, Telegraph v. 1. 2. 2010. H. Stuchtey

Çobanli, *Zehra,* türkische Keramikerin, Hochschullehrerin, * 1958 Bandirma, arbeitet in Eskişehir. Stud.: 1976–81, 1984 (Dipl.) Marmara Univ., Istanbul (Dep. Keramik); 1986–87 Prom. ebd. Seitdem Lehrtätigkeit an Univ.: u.a. ab 1996 Prof. für Keramik an der Anadolu Univ., Eskişehir; 2005 ebd. Dekanin der Schule für Design und seit 2007 Dekanin des Dep. für Keramik. Zahlr. nat. und internat. Ausz. und Preise: u.a. ab 1990 mehrfach beim Staatlichen Keramik-Wettb. des Minist. für Kultur, Ankara; 1995 Japan, Mino-Wettb. (lobende Erw.); 2001 Seoul, World Ceramic Bienn. (ehrenvolle Erw.); 2005 Kunstpreis der Anadolu Univ., Eskişehir. Mitgl.: seit 1993 Internat. Verb. für Keramik-Ausb., Tokio; Türkische Keramik-Ges.; Intern. Verb. der plastischen Künste, Istanbul. Häufige Auslandsaufenthalte, u.a. 1986 in Australien oder 1993 in Tokio an der Univ. der Bild. Künste und Musik (mit Monbusho-Stip.); zudem führt sie Keramik-Untersuchungen in versch. Mus. in Italien, Deutschland, Finnland, den USA und Polen durch. – Ç.s Werk umfaßt sowohl Gefäßkeramik, skulpturale Keramikobjekte als auch zu Installationen zusammengefaßte keramische Plastiken. Das Werk wird in fünf Themengebiete und Phasen (1. bis 5.) unterteilt, die sich aus der jeweils dominierenden Farbpalette ergeben. Im Frühwerk (1.) experimentiert sie mit Formen und Farben. Die Objekte werden bereits zu Installationen kombiniert. In der „braunen" Phase (2.) dominieren Brauntöne. In der sog. Erd-Phase (3.) entstehen Installationen, bei denen 40–200 kleinformatige

plastische Arbeiten türkische Redewendungen wiedergeben. Der an türkischen Textilmustern bzw. Alltagsgegenständen orientierte Dekor wird mit Airbrush oder Pinsel
aufgetragen. In der „blauen" Phase (4.) benutzt sie blauen Ton und gestaltet diesen mit trad. Motiven osmanischer
Keramik, angeregt durch das 700jährige Jubiläum des Osmanischen Reiches. So schafft sie Keramikteller, die Siegel der Sultane und deren Portr. tragen. Die osmanisch
inspirierten Motive in Blau behält sie auch in der „wei
ßen" Phase (5.) vor monochrom weißen Hintergründen
bei, gibt diese aber auch in Lüster wieder. In einigen ihrer kleinplastischen Arbeiten, bei denen sie sich auf Formung von Schuhen und Füßen konzentriert, setzt sie sich
speziell mit der Rolle der Frau auseinander. ⌂ BURSA,
Devlet Güzel Sanatlar Gal. ESKİŞEHIR, KS der Anadolu
Univ. ◉ *E:* 1981, '86, '92 Bursa, Devlet Güzel Sanatlar Gal. / Ankara: 1991 Vakıfbank Küçükesat Sanat Gal.;
1993, '95,'99 Emlakbank Sanat Gal.; 1995 HalkBank Sanat Gal.; 1999 İngiliz Kültür Merkezi; 2003 Zerdüşt Sanat Gal.; 2008 Çağdaş Sanatlar Merkezi / Istanbul: 1984
Atatürk Sanat Gal.; 1998, 2000 Menkul Kıymetler Borsası
Sanat Gal. / 1991 Erdek, Erdek Belediyesi Sergi Salonu /
1992, 2001, '04 Eskişehir, Eskişehir Devlet Güzel Sanatlar
Gal. / 1998 İzmir, Adnan Franko Sanat Gal. / 1999 Lancaster, Peter Scott Gall. / 2002 Auckland, Green Gall. / 2009
Konya, Selçuk Univ., Süleyman Demirel Kültür merkezi. –
G: zahlr. nat. und internat. ⌼ *K. Özsezgin*, Türk plastik
sanatçıları, Istanbul 1994. – *Online:* Website Ç.; Albareh
AG (Ausst.). M. Kühn

Cobb, *Henry N. (Henry Nichols; Harry),* US-amer. Architekt, Stadtplaner, * 8. 4. 1926 Boston/Mass., tätig in
New York. Stud.: bis 1949 Harvard Graduate School of
Design, Cambridge/Mass. (1980–85 Prof., seit 1988 Gast-
Prof.). 1949–50 Mitarb. im Archit.-Büro von Hugh Stubbins ebd.; 1950–55 in der Wohnungsbau-Ges. Webb &
Knapp, New York. Seit 1955 mit Ieoh Ming Pei und Eason H. Leonard Gründungspartner von I. M. Pei & Associates (seit 1989 Pei Cobb Freed & Partners) ebd. Gast-
Prof.: 1973, '75, '78 Yale Univ., New Haven/Conn.; 1992
Amer. Acad. of Rome. Mitgl. mehrerer nat. Akad., Verbände und Inst., u.a. Amer. Inst. of Architects (AIA),
Washington/D. C.; Inst. for Archit. and Urban Studies,
New York; Soc. of Archit. Historians, Chicago/Ill.; Archit. League of New York. Ehrendoktorwürde: 1985 Bowdoin College, Brunswick/Me.; 1990 ETH, Zürich. Ausz.
u.a.: 1968 AIA Archit. Firm Award, Washington/D. C.;
1982 Ehren-Med., AIA New York; 1992 Lifetime Achievement Award, New York Soc. of Architects; 2010 President's Award AIA New York. – C.s Werk wurzelt in
der Mod., was sich an den abstrakten Hochhäusern der
1960er Jahre, aber auch an expressiven Bauten wie dem
Acad. Center der State Univ. of New York in Fredonia,
einem skulpturalen Komplex aus Sichtbeton (1968), abbildet. Sein Schaffen, z.T. in Kooperation mit den Büropartnern Yvonne Szeto, Michael W. Bischoff, Ian Bader
und José Bruguera, führt ihn konsequent zu hochtechnischen und hybriden Bauwerken, deren Gest. sowohl postmodernen als auch rein technisch-funktionalen Kriterien

folgt. Archit. ist für C. ein Spiegel sozialer Kräfte, eingebettet in einen größeren Kontext, was eine Hierarchie
der Bedeutung einschließt. Insofern umfaßt sein umfangreiches Werk neben städtebaulich oder landschaftlich integrierten Bauten, zu denen v.a. diverse Univ.-Ensembles
gehören, zahlr. autonome Gebäude von einer angenommenen höheren Signifikanz. Exemplarisch für diesen Widerspruch steht der John Hancock Tower in Boston/Mass.
(1971–76), der mit 241 Metern die niedrige Stadtsilhouette monolithisch überragt. Das Hochhaus erhebt sich über
dem Grundriß eines Parallelogramms mit glatter Oberfläche aus Glas, was ihm gegenüber der hist. Innenstadtbebauung einen immateriellen Anschein verleiht. C. begründet seine Konzeption mit der Absicht, das Paradoxon der
conditio humana illustrieren zu wollen. Die große Anzahl
von Wolkenkratzern und Großprojekten, die C. seitdem
errichtet hat, reflektieren in subtil-spektakulärer Formgebung den weltweiten Wettstreit um Originalität und
das technisch-konstruktiv Machbare. ⌂ AMSTERDAM:
Hauptsitz ABN AMRO Bank, 1999, 2006 (zwei Bauphasen). BALTIMORE/Md.: World Trade Center, 1977. BAR
CELONA: World Trade Center mit Grand Marina Hotel,
1999, 2002. BOSTON/Mass.: U. S. Courthouse und Harborpark, 1998. CAMBRIDGE/Mass., Harvard Univ.: Center
for Govt. and Internat. Studies, 2005. CHICAGO/Ill.: Hyatt
Center, 2005. CINCINNATI/Ohio, Univ. of Cincinnati: College Conservatory of Music, 1999. DALLAS/Tex.: AR
CO Tower (heute First Interstate), 1983. – Bürohochhaus
Fountain Place (vormals Allied Bank Tower), 1986. DEN
VER/Colo., 16th Street: Transitway Mall (Umgestaltung
in eine Fußgängerzone), 1982. FARMERS BRANCH/Tex.:
Mobil Exploration and Production Research Laboratory,
1983. HAIDERABAD/Indien: Bürokomplex Wave Rock, seit
2006. HAMMOND/Ind.: U. S. Courthouse, 2002. KANSAS
CITY/Mo.: Federal Reserve Bank, 2008. LONDON, Canary Wharf: Credit Suisse First Boston, 1991. LOS ANGELES/
Calif.: U. S. Bank Tower (vormals Library Tower), 1989. –
Univ. of Calif.: John E. Anderson Graduate School of Management, 1995. MADRID: Torre Espacio, 2004–08. MAI
LAND: Regierungssitz Palazzo Lombardia, 2011. MEL
BOURNE, Collins Place: ANZ Bank Tower und Regent Hotel, 1978–81. MONTREAL: Büro- und Geschäftszentrum
Place Ville Marie mit Hochhaus der R. Bank of Canada,
1962. NEW BRUNSWICK/N. J., Hauptsitz Johnson & Johnson, 1983. PARIS-La Défense: Tour EDF, 2001. – Hauptsitz der OECD, 2008. PHILADELPHIA/Pa.: Zwillingstürme
Commerce Square, 1988, '93 (zwei Bauphasen). – Nat.
Constitution Center, 2003. PORTLAND/Me., Portland MA:
Charles Shipman Payson Building, 1983. PRINCETON/
N. J., Princeton Univ.: Friend Center for Engineering Education, 2001; Butler College Dormitories, 2009. SCOTTS
DALE/Ariz.: Arizona State Univ. Innovation Center, seit
2006. SHANGHAI: Bürohaus POS Plaza (vormals Silver
Crown Tower), 1999. – China Europe Internat. Business
School, 1999, 2004 (zwei Bauphasen). STAMFORD/Conn.:
Hauptsitz Pitney Bowes, 1986. TAIPEI/Taiwan: Wohnturm
The Ellipse 360 Tower, seit 2010. WASHINGTON/D. C.: Bürokomplex Columbia Square, 1987. – Verwaltungsgebäu-

de Amer. Assoc. for the Advancement of Sc., 1996; Pennsylvania Ave. 2099: Bürohaus, 2001; Hauptsitz 2 Internat. Monetary Fund (IMF), 2005. ✉ Ethics and archit., in: Harvard archit. review 1992, 44–49; Archit. education, in: Archit. record 1985 (10) 43–51. 👁 G: 2004 New York, MMA: Tall Buildings (K). 🕮 L. Krantz, Amer. architects, N. Y./Ox. 1989. – S. Abercrombie, A+U Archit. and Urbanism 1976 (1/61) 33–183; A. Hasegawa, I. M. Pei and Partners, To. [1983]; P. Jodidio, Contemp. Amer. architects, III, Köln 1997 (s.v. Pei Cobb Freed); A. Meseure/W. Wang (Ed.), Die Neue Slg. Schenkungen und Akquisitionen 1995–1999 (K Dt. Archit.-Mus. Frankfurt am Main), Tb./B. 1999. – Online: Website Pei Cobb Freed & Partners. A. Mesecke

Cock, Jan de, belg. Bildhauer, Installationskünstler, Fotograf, * 2. 5. 1976 Brüssel, lebt dort. Stud.: Koninkl. ASK, Gent. Bezeichnet sich selbst jedoch als Autodidakt. – C. strebt nach einem Gesamtkunstwerk in der Art eines monumentalisierten kollektiven Gedächtnisses, für das er auf die Gesch. der mod. Skulpt. von Auguste Rodin bis Donald Judd als auch der rationalen mod. Archit. in der Art von Ludwig Mies van der Rohe zurückgreift. Mit seinen großformatigen Installationen aus Spanplatten reinterpretiert C. Bauwerke, indem er das Äußere verschalt und labyrinthische Konstruktionen im Innenraum schafft, in denen Skulpt., Objekte, Fotos o.ä. präsentiert werden. C. sieht die Entwicklung der Form im Raum als wesentlich an, wobei er insbesondere auf Umberto Boccionis Plastik „Forme uniche della continuità nello spazio" verweist. Unter Berufung auf phil. Konzepte u.a. von Gilles Deleuze und Henri Bergson inkorporiert er eine zeitliche Komponente und konzipiert, einen zentralen Ansichtspunkt negierend, versch. Perspektiven sowie einen filmischen, sich in Einzelbildern entwickelnden Ablauf der Betrachtererfahrung, für den er u.a. Jean-Luc Godard und Eadweard Muybridge als Vorbilder nennt. Repetition und Fragmentierung sind zentral für seinen Ansatz. Als zusätzlich verunsicherndes Element verwendet er stark reflektierendes Glas vor den Fotos. Viele Werke tragen den Titel Denkmal, dessen Bedeutung er als „Form für das Denken" interpretiert, und die Hausnummer des jeweiligen überarbeiteten Gebäudes, z.B. Denkmal 4 (2006; mit Daniel Buren) für die Casa del Fascio in Como (Piazza del Popolo 4), und Denkmal 11 (2008) für das MMA in New York (11 West 53 Street). 2011–12 arbeitet er am Projekt Jacqueline Kennedy Onassis, deren Biogr. als Folie für eine von C. als „romantisch" angesprochene Skulpt. dient. C. dokumentiert seine Tätigkeit in umfangreichen Künstlerbüchern. 👁 E: Brüssel: 1999 Argos; 2004, '08 Pal. des BA; 2007 Artbrussels; Sint-Lukas Hogeschool / Amsterdam: 2001, '02, '03, '08, '10 Gal. Fons Welters; 2003 De Appel (K) / Gent: 2002 S.M.A.K. und MSK; 2004 Univ.-Bibl. Henry van de Velde; 2011 KIOSK / 2003 Wien, Gal. Kerstin Engholm / 2004, '08, '09 Köln, Gal. Luis Campaña / 2004, '06, '08 Antwerpen, Gal. Stella Lohaus / 2005 Tokio, Minato-ku (mit Comme des garçons); Frankfurt am Main, Schirn; London, Tate Modern (K) / 2006 Como, Casa del Fascio (mit D. Buren; K); Brescia, Gall. Massimo Minini (mit D. Buren); Mia-

mi Beach, Convention Center; Zürich, Haus Konstruktiv / 2006 (mit D. Buren), '10 Mailand, Gall. Francesca Minini / 2007 East Hampton (N. Y.), Glenn Horowitz Bookseller / 2008 New York, MMA (K) / 2011 Knokke-Heist, White-Out Studio / 2012 Baden-Baden, SKH und SM (K); Lissabon, Gal. Filomena Soares. 🕮 I. Bombelli, Flash art 40:2006 (261) 112–114. – Online: Website C.; Gall. Francesca Minini, Mailand; SKH Baden-Baden. G. Bissell

Cockrum, Dave (David Emmett), US-amer. Comiczeichner und -texter, Illustrator, * 11. 11. 1943 Pendleton/Ore., † 26. 11. 2006 Belton/S. C. Aufgewachsen auf einer Farm in Illinois. A. der 1960er Jahre Kunst-Stud. an der Southern Illinois Univ., Carbondale, und an der Univ. of Colorado. Danach sechsjähriger Militärdienst in der US Navy; u.a. auf Guam stationiert. Ab 1968 Publ. von Zchngn in versch. Fanzines wie z.B. Fantastic Fanzine und Star-Studded Comics. Ab 1970 entstehen, vermittelt durch Neal Adams, zunächst einige Comics für die Mag. Eerie, Creepy und Vampirella des Verlages Warren. Kurz darauf Ass. von Murphy Anderson bei DC Comics. Ab 1972 zeichnet C. die Serien World of Krypton und The Legion of Super-Heroes, wobei er letzterer durch ein zeitgemäßes futuristisches Neudesign zu großer Popularität verhilft. 1974 Wechsel zum Konkurrenzverlag Marvel, wo er zunächst einige Hefte der Avengers gestaltet, 1975–77 dann zus. mit den Textern Len Wein und Chris Claremont die Superheldenserie X-Men u.a. durch die Einf. neuer Protagonisten modernisiert. Ab 1978 v.a. als Covergestalter tätig, übernimmt er 1981–82 erneut die Zchngn der X-Men. 1983 erscheint mit The Futurians C.s erste eig. Serie, zunächst als sog. Graphic novel bei Marvel, ab 1985 als Heftreihe in den Kleinverlagen Lodestone und Eternity. Ab M. der 1980er Jahre zeichnet er neben wenigen weiteren Beitr. für DC und Marvel auch einige Serien für versch. Independent-Verlage (u.a. Soulsearchers, Inc. für Claypool Comics). Außerdem Ill. für Frauen-Zss. und zu Science-fiction-Romanen von Edward Packard (u.a. Alien Invaders, 1991; The Fiber People, 1992). C. zieht sich E. der 1990er Jahre krankheitsbedingt weitgehend aus der Comic-Branche zurück. – Vertreter eines dynamischen, z.T. sehr aufwendig und detailreich ausgef., realistischen Zeichenstils in der Trad. von M. Anderson, Carmine Infantino und Gil Kane. 🕮 H. Filippini, Dict. enc. des héros et auteurs de BD, III, Grenoble 2000; M. Feige, Das große Comic-Lex., B. 2001; H. Filippini, Dict. de la bande dessinée, P. 2005; M. Czerwionka (Ed.), Lex. der Comics, Erg.-Lfg 63, Meitingen 2007 (WV). – L. Daniels, Marvel. Five fabulous decades of the world's greatest comics, N. Y. 1991; A. G. Malloy (Ed.), Comic book artists, Radnor 1993; C. Claremont (Einf.), The C. treasury, Morristown, N. J. 1996; G. Cadigan, The Legion companion, Raleigh, N. C. 2003. – Online: Lambiek Comiclopedia; Website C. H. Kronthaler

Cocksedge, Paul, brit. Designer, * 30. 5. 1978 London, lebt und arbeitet dort. Stud.: Sheffield Hallam Univ. (Industriedesign); 2000–02 R. College of Art, London, bei Ron Arad (Produktdesign). Seit 2003 eig. Designatelier mit Joana Pinho (Dir.) ebd. Ausz.: 2003 Bombay Sapphire

Preis. – C. wird bereits während des Stud. von Issey Miyake und Ingo Maurer gefördert, die sein ideenreiches Lichtdesign u.a. durch Ausst. internat. bek. machen. Er arbeitet interdisziplinär und experimentiert für außergewöhnliche, ganz unterschiedliche Entwürfe mit den neusten Mat.- und Technologieentwicklungen. Beispiele sind die Hängelampe *Styrene* (2002, Abschlußarbeit am R. College of Art), die aus durch Hitze verformten Styroporbechern besteht, sowie die mysteriöse Lichtinstallation *Watt* (2003), die ein den Stromkreis schließender Bleistiftstrich zum Leuchten bringt. Kommerziell hergestellt wird die Lampe *Life 01* (2003) aus einer dickbauchigen Vase, die von einem an den Vasenrand angelehnten frischen Blumenstengel von unten beleuchtet wird. C. nutzt optische Lichtverfärbung (*NeOn*, 2003, London, V & A; *Swell*, 2006) und v.a. LED-Technik, wie z.B. für die Leuchte oder Skulpt. *Skin* aus einem an einer Ecke aufgehängten dünnen Metallblatt, dessen unterste Ecke aufgeblättert eine rote Innenseite und die Lichtquelle offenbart. Auch verwirklicht C. innovative Ideen bei der Entwicklung von Designkonzepten und konzeptionellen Installationen für Firmen (u.a. Flos, Hermes) und Institutionen (u.a. Brit. Council). Über die langgestreckte Schaufensterfront der medizinischen Forschungsstiftung Wellcome Trust in London erstreckt sich 2007 die Fotogr. von zwei ausgebreiteten menschlichen Armen, deren innere Venen und Arterien zeitweise aufleuchten, den Körper bildet das Glasgebäude der Stiftung. Im Rahmen der London Design Week 2010 hängt C. im V & A 3000 verformte Blätter aus dem Markenwerkstoff Corian auf, die von einem Papierstapel verweht erscheinen (*A gust of wind*). In den ständig die Lichtqualität verändernden konischen Leuchten (Fa. Flos) der Installation *Sestosendo* auf der Mailänder Designwoche 2011 ist das Video des neuesten 6er BMW Coupés zu sehen. Jüngst entwirft C. auch Schmuckstücke und eine Möbelkollektion. – Mit großer künstlerischer und experimenteller Kreativität sowie einem flexiblen, interaktiven, von Präzision und Ästhetik bestimmten Designverständnis gehört C. zu den führenden zeitgen. Lichtdesignern. ⌂ LONDON, Design Mus. MÜNCHEN, PM. NEW YORK, MMA. ⌂ *L. Brown*, New design 19:2004, 60–64; *ead.*, Azure. Design architect. and art 21:2005 (159) 66–70; *J. Ebner*, Design report 2004, 44 s., 64; *K. Nakajima*, Axis (To.) 10:2004, 22–24; *R. Such*, Archit. record 193:2005 (11) 217–219; *J. Khiu*, Surface 61:2006, 150–152; *A. Bates*, Icon lighting 69:2009 (März) 8 s.; MD 9:2009 (Sept.) 31; *H. Maier-Aichen* (Ed.), New talents. State of the arts, Ludwigsburg 2009; Metrop. home 41:2009 (7) 84–86; *J. Spokojny*, Frame (Am.) 71:2009 (Nov./Dez.) 190–193; *K. Nakajima*, Axis 145:2010, 32; *A. Richardson*, Design week 25:2010 (9) 16 s.; *T. Wilson*, New design 90:2011, 58 s. – *Online:* Website C.; C. Beckmann, Stylepark v. 26. 2. 2008. H. Stuchtey

Coda Zabetta (Zabetta), *Roberto*, ital. Maler, Bildhauer, 22. 1. 1975 Biella, tätig in London, Singapur, Mailand und Ancona. Stud.: 1990–95 Ist. Tecnico, Biella; Ist. d'Arte, Rom; ab 1996 ABA, Brera; 2005–06 Central Saint Martins College of Art and Design, London. Ausz.: 2000

Premio Passaggi a Nord-Ovest der Fond. Pistoletto, Biella; 2003 Premio Arte Fiera, Bologna; 2009 Premio Fabbri, Bologna; 2010 Premio Banca Aletti, Verona. – C. arbeitet 1996–2000 als Ass. des Malers Aldo Mondino. 1998 reist er nach dem Tod seines Bruders nach Marokko und beginnt dort, v.a. Portr. zu malen. Die großformatigen, zerrissenen Köpfe vor weißem oder schwarzem Grund füllen die Lw. meist vollständig aus; sie werden in schwarzen, weißen und grauen Schattierungen gemalt. Nur wenige Werke weisen farbige Höhungen auf, so *Colors* (2005). C. verwendet pastose Lackfarben, die in großen Schlieren mit dichten, schweren Pinselstrichen aufgebracht werden, wobei die Darst. ohne feste Konturen aus Spritz- und Verlaufsspuren entstehen. Die mon. Köpfe mit teilw. aufgerissenen Mündern, gebleckten Zähnen und schmerzverzerrten Augen haben eine große physische Präsenz. Viele von C.s Arbeiten thematisieren menschliches Leid, auch Diskriminierungen (z.B. von Albinos in Afrika). Sein erstes Kat.-Projekt *Identità anonime* (2000) beschäftigt sich mit während des Genozids ermordeten Kindern in Ruanda. Auch malt er angeschwollene Köpfe krebskranker Patienten im Londoner R. Marsden Hospital, in Indonesien und Bali und sucht nach Ausdrucksmöglichkeiten für den (psychologischen) Heilungsprozeß, aber auch für die göttliche Vorsehung. Seit seiner Ausst. mit Filippo Sciascia 2008 in der NG in Jakarta beschäftigt sich C. mit südostasiatischer Ikonogr. und Kultur. Dabei stellt er seinen großen, dunklen Portr.-Köpfen comichafte Versatzstücke der asiatischen Kultur, etwa rote Drachensymbole oder eine Figur mit Fächer, auf einer Lw. gegenüber. Seit 2011 entstehen auch säulenartige, in Grau gehaltene Objekte und Figuren aus Schaumgummi, Stahl und Harz. Ihre porös und gebrochen wirkenden Oberflächen werden mit Chrom überzogen. Der Gem.-Zyklus *Nuvole Sacre* (2010) beschäftigt sich mit dem Abwurf der Atombombe in Hiroshima und zeigt schwarz-weiße Lsch. mit aufsteigenden Rauchwolken und Atompilzen. Auch (Portr.-)Zchngn (Feder, Bleistift, Kreide). ✉ *C./F. Sciascia*, Koi dan Trinacria (K), Jakarta 2008. ☉ E: 2003 Brescia, Gall. Paolo Majorana (K) / 2004 Arezzo, L'Immagine GAM; Padua, Gall. Estro (K) / Rom: 2004 Pal. Venezia (K); 2005 Fond. Bandera per l'Arte (K); 2006 Teatro India (K) / 2005 Florenz, Gall. Poggiali e Forconi (K) / 2010 Mailand, Pal. Reale (K); Jakarta, Langgeng Gall. / 2011 Neapel, Pal. delle Arti (K). –. G: 2004 Turin: Quadrienn. / 2005 Buenos Aires, MAM: Inchiostro Indelebile (K); Florenz, Pal. Strozzi: Inverno a Firenze 10+10 / 2006 London, Nat. Portr. Gall.: BP Portr. Award / 2007 Mailand, Gall. Obraz: Lo stato dell'arte nel 2007 / 2011 Caserta, MAC: F for Fake. ⌂ *L. Beatrice*, R. C. Z., Mi. 2004; *M. Sciaccaluga*, R. C. Z. PPP – primissimo primo piano, Mi. 2004; *R. C. Morgan/S. Risaliti*, R. C. Z. Psychic persona, Mi. 2005. – *Online:* Website C. C. Melzer

Codeak (eigtl. Man, *Daniel [Daniel Kin Young]*), brit. Graffiti- und Street-art-Künstler, Maler, Zeichner, Installations- und Performancekünstler, * 9. 2. 1969 London, aufgewachsen in Hongkong, lebt seit 1977 in Deutschland (Augsburg, heute München). Ausb./Stud.: 1993 Sieb-

drucker (Gesellenbrief), 1999–2003 HBK, Braunschweig, bei Walter Dahn; 2004–05 ABK, München, Meisterschüler von Markus Oehlen. 2004 Stip. des Bayrischen Staats-Minist. für Kunst und Wissenschaft. – C. ist geprägt vom Graffitiboom der 1980er Jahre, u.a. von den Filmen Beat Street oder Style Wars. Als Sprüher und Organisator von Graffiti-Ausst. 1984–2002 aktiv. C.s figürliche Darst. („characters") und „murals", häufig biogr. geprägt, unterscheiden sich vom New Yorker Graffitistil u.a. durch Verwebung asiatischer Elemente (z.B. Versatzstücke aus der Pekingoper) mit westlicher Ornamentik und Symbolik (The pain booster, 1996; Dragon mirror, 1997). Zahlr. Graffiti-Auftragsarbeiten und Beteiligung an internat. Wandmalaktionen, u.a. 2001 Graffiti Worldtour (u.a. Bangkok, Auckland, Sydney, São Paulo) oder 2002 Projekt Chromopolis. Auch Performances (1995 Staatsoper Berlin, 2000 Rathaus Hildesheim). Seit etwa 2000 ist C. mit Malerei und Installationen auch unter seinem eigtl. Namen Daniel Man tätig. C. rekurriert dabei häufig wie zuvor bei den Graffitiarbeiten auf ostasiatische Vorbilder (z.B. durch Übermalung von hist. Akupunkturvorlagen) oder fernöstliche Phil. (Taoismus) und Ikonogr. (Fruity juicy; Manch Vorfahr; She's not morra, alle Aqu./Papier, 2008). Einflüsse u.a. von Max Ernst, Matthew Ritchie, Andreas Gehlen oder Mike Kelley sind erkennbar. ◉ E: 2003 Derneburg, Gal. Glashaus; Braunschweig, Gal. auf Zeit (mit Hae Yung Lee); München, Die Färberei / 2004 Lahr, Gal. Feuerstein (mit Os Gemeos [Otavio und Gustavo Pandolfo]) / 2006 Hamburg, Künstlerhaus Frise. – G: 1997 Augsburg, Toskanische Säulenhalle: Aufstand der Zeichen / 1999 Braunschweig, Staatstheater: Wiesionen / Hamburg: 2000 Phonodrome: Graffiti-Art; 2001 Alte Postsortierhalle: Urban Discipline (K); 2006 City-Nord-Park: Sculpture@City Nord / 2002 Bad Birnbach, Atrium: Apokalpse / 2003 Wedel, Ernst-Barlach-Mus.: Dasein (K) / 2004 Genf, MAMC: Yellow pages (Wander-Ausst.; K) / München: 2005 Lenbachhaus: Favoriten (K: S. Gaenshseimer u.a.); 2008 Gal. der Künstler: Out there somewhere in the middle of nowhere / 2007 Wuppertal, KH Barmen: Still on and non the wiser (K) / 2009 Leipzig, Gal. Nusser & Baumgart: Continuous Perpectives. ▭ B. van Treeck, Das große Graffiti-Lex., B. 2001. – N. Ganz, Graffiti world, Lo. 2004; A. Lindhorst/R. Reinking, Fresh air smells funny (K KH Osnabrück), He. 2005; R. Reinking (Ed.), Call it what you like! Coll. Rik Reinking (K), Silkeborg 2008. – Online: Website C. (Daniel Man). S. Prou

Codeghini, Gianluca, ital. Performance-, Installations- und Videokünstler, Maler, Fotograf, Designer, Komponist, * 2. 9. 1968 Mailand, lebt dort. Stud.: Accad. di Brera, Mailand (Malerei); Civ. Scuola di Musica ebd. (1997 u.a. elektronische Musik); Univ. Bologna und Mailand (Semiotik). Beginnt 1984 mit Schallforschungen, um Hintergründe von Performances und Installationen im städtischen Raum und in Ausst.-Räumen zu kreieren. Ab 1986 Theatererfahrungen; Performances, Straßenimprovisationen. 1992 Gründung des Verlages Laciecamateria Edizioni. Auseinandersetzung u.a. mit den Themen Geräusch, Licht und Blindheit, Spiele, Zeit und Hintergrundmusik,

oft in Zusammenarbeit mit and. Künstlern. 1996 gründet er zus. mit Emilio Corti und Emilio Prini Internaso, einen Kunstprojekten vorbehaltenen virtuellen Raum im Internet. 2005 Mitinitiator des synoptischen Projektes Warburghiana (Internet, Ausst. und Performances: MAC di Trento Rovereto, GAMC Bergamo, Fond. Mailand, Mus. Laboratorio Univ. la Sapienza Rom und Gall. Neon Bologna). 2006 Preisträger im internat. Wettb. der Fond. Pomodoro Mailand. Seit 25 Jahren vielfältige Musik- und Tonproduktionen, z.B. Music for air (2001) oder Respiratory protection program (2005); 2007 und 2011 realisiert er zus. mit Dario Bellini Crudeltà inaudite im MAMC di Trento von Rovereto (Video, Sound, Performance, Installation). Auch produziert er Begleitmusiken zu Videos and. Künstler. Zu C.s wichtigsten Videos gehören u.a. Dalle stelle (1993), Next (2000), Dialogo senza sguardo (2004). Auch als Macher von (Computer-)Spielen erfolgreich, u.a. Miss-Media (zus. mit Pietro Braione, 2002) oder Warburger word game (2005). Außerdem entwirft C. Geschenkartikel. Er arbeitet intensiv zus. mit Aurelio Andrighetto, Dario Bellini und Elio Grazioli. ▭ AREZZO, Gall. Mariottini. MAILAND, Gall. Via Farini. – Neon. La Fabbrica del vapore. ◉ E: 1991 Brescia, Ex-Chiesa S. Zenone / Mailand: 1992 Spazio Viafarini; 1996 Spazio Tondolo; 2003 A+M Bookstore; 2009 Studio Maraniello / 1993 Rivara, Castello / 1995 Genua, Spazio Satura / 1998 Rom, Libro Gall. il Ferro di Cavallo (K: F. Basso) / 2005 Bologna, Villa delle Rose. – G: Mailand: 1990 Accad. di Brera: Oltre il muro; 1993 Spazio Viafarini: A scatola chiusa; 1997 Pal. della Trienn.: Generazione media; 1998 Teatro: Teatri 90 (K: C. Corbetta); 2006 Prometeogall.: Capital cult.; 2007 Casa della Poesia Pal. Liberty: Murene (Performance); 2008 Gall. Neon: book crossing; 2009 Fabbrica del Vapore: Crossing-public/art-zones; 2010 MN della Scienza e della Tecnologia Leonardo da Vinci: Do not try this at home; 2011 Assoc. cult.: Contaminazioni; 2011 Gall. Artra: Cose cosmiche # 2 / 1992 Maastricht, Gal. Henn: Art shop / 1995 Wien, Art Club: One interface; München, Rathaus-Gal.: Video vision / 1996, '97, '99 San Gimignano, Gall. Continua: Il punto / 2001 Brescia, Gall. Cavellini: Guerra Materia / Rom: 2004 Accad.: InsideOUT; Assab One Milano: La polvere nell'arte; 2005 Fond. Baruchello: Arte e poesia. ▭ L. Beatrice u.a., Nuova scena. Artisti ital. degli anni '90, Mi. 1995; G. Bonomo/G. Furghieri (Ed.), John Cage, Mi. 1998; E. Grazioli/M. Belpoliti (Ed.), Alberto Arbasino, Mi. 2001; E. Grazioli (Ed.), La polvere nell'arte, Mi. 2004; M. Belpoliti, Crolli, Mi. 2005; F. Gualdoni (Ed.), Premio Internaz. (K), Mi. 2006; C. Subrizi (Ed.), L'esperienza divenire delle arti (K), R. 2006; E. Grazioli/R. Panattoni (Ed.), Fotografia europ. (K), Bo. 2007; L. Severi (Ed.), Intellettuale, Md. 2007; E. Grazioli (Ed.), Kurt Schwitters, Mi. 2009. – Online: Website C.; Warburghiana. S.-W. Staps

Codesal, Javier, span. Fotograf, Videokünstler, Dichter, Fachautor, * 6. 7. 1958 Sabiñánigo/Huesca, lebt in Madrid. Stud. ebd.: bis 1983 visuelle Informations-Wiss. an der Univ. Complutense; 1982–83 mit Stip. Praktika u.a. in regionalen Radio- und Fernsehstudios. 1993–96 im Auf-

trag der Filmacoteca de Andalucía Rekonstr. und Vollendung des Films Acariño galaico (del barro; 1961–81) von José Val de Omar. 2004 Stip. Ramón Acín der Prov.-Verwaltung von Huesca. Ausz.: u.a. 1985 1. Preis für Video, Primeras Jornadas de Cine y Vídeo de Castilla y León, Salamanca; 1999 Premio al Sonido, Premio a la Fotogr. und 1. Preis der Comunidad de Madrid, Festival de Cine de Alcalá de Henares; Mikeldi de Plata de Documental, Festival Internac. de Cine de Bilbao. – C. ist in Spanien ein Pionier der Videokunst, der seine Kreativität auch in and. Bereichen (Radio, Fernsehen, Kino, Fotogr., Aktionen, Installationen, interaktive Medien, Dichtung, ästhetische Theorie) einsetzt und diese miteinander verbindet. In dem u.a. von Carl Theodor Dreyer, Pier Paolo Fellini und John Cage beeinflußten bildnerisch-poetischen Werk, das meist einen komplex-symbolischen, verschlüsselten Char. besitzt, spielt das Religiöse und Mythische in Bezug auf Eros und Thanatos eine bes. Rolle. Die frühe Serie *Días de Sida* (1988), die aus inszenierten Fotos (Dialichtkästen) von einem jungen und einem alten Mann besteht, reflektiert auf metaphorischer Ebene die tödliche Krankheit Aids. Im Zentrum von C.s Werk stehen (teils mehrkanalige) Videos, wobei sich Stimme und Musik wie ein thematischer Leitfaden hindurchziehen. Gesang spielt z.B. eine wesentliche Rolle in *Centauro* (1988), in der Videoinstallation *El manto de Verónica* (1992) und im Film *Bocamina* (1999). Der Klang des gesprochenen Wortes, Weinen und Schweigen charakterisieren *La habitación de Rada* (1995), in dem eine im Exil lebende Frau aus Sarajevo ihr persönliches Schicksal während des Balkankrieges schildert. Das Projekt *In_ter_va_lo* (2004–08) versteht sich als Annäherung an die Musik des Flamenco. Um Dichtkunst geht es in so unterschiedlichen Werken wie *Lectura de Ibn Quzmán* (2002) über den gleichnamigen antiken andalusischen Dichter und *50 versos exactos* (2008) über ein einzelnes, im Kurzvideo als Text präsentes Gedicht. Vom Abschiednehmen und Verlust eines Menschen durch den Tod handelt *El monte perdido* (2003–04; drei Videos, Installation und Fotoserie). Kindheit und Alter bestimmen die Videos *Mario y Manuel* (2005) und *Longevos* (2008), filmische Beobachtungen eines Geschwisterpaares und von hochbetagten Menschen im Heim. Die Beziehung von Mann und Frau in versch. Lebensstationen ist Thema des Videovierteilers *Viaje de novios* (2004–06), in dem C. ein befreundetes Ehepaar auf Reisen begleitet. Auch Texte über Künstler in versch. Kat., z.B. J. Val de Omar, Luis Marco und Alex Francés. ⌂ ALICANTE, Prov.-Verwaltung. BARCELONA, Cal Cego Coll. – MAC. – Univ. LLEIDA, Stadtverwaltung. MADRID, Kultur-Minist. SANTANDER, MBA. ✉ Imagen de Caín, Ba. 2002; Feliz humo, Murcia 2004; Ha nacido Manuel, Ba. 2005; Feliz humo, Cáceres 2009; Dos películas, Cáceres 2010 (mit DVD). ◉ *E:* Madrid: 1984 Gal. Villalar; 1993 Gal. XXI; 1999 CARS, Espacio Uno / 1985 Valladolid, Sala Borja (mit Raúl Rodríguez) / 1994 Murcia, Sala Caballerizas de los Molinos del Río Segura (K) / Zaragoza: 1995 (K: J. V. Aliaga u.a.), 2011 Mus. Pablo Serrano / 1999 Salamanca, Casa de las Conchas / Huesca: 2001 Mus.; 2005 Prov.-Verwaltung (K: V. Espa u.a.) /

2002 Lleida, Sala Mpal d'Expos. El Roser (K); La Paeria (K) / Sevilla: 2002 Caja San Fernando (K: M. Rodríguez Garzo/C.); 2008 Cajasol, Obra Social (K: G. Picazo) / Barcelona: 2004 Gal. Estrany – de la Mota; 2009 La Virreina, Centre de la Imatge (K: A. M. López Alvarez u.a.) / 2005 Alicante, Mus. de la Univ. (K: J. L. Martínez Meseguer/A. López) / 2010 Cáceres, Gal. Casa sin Fin. – *G:* Madrid, CARS: 1987 La imagen sublime. Video de creación en España 1970–1987 (K); 1995 Señales de Vídeo. Aspectos de la videocreación esp. en los últimos años (K) / Mexiko-Stadt: 1993 Mus. de Arte Carrillo Gil: Visiones priv. (K); 2009 Centro Cult. de España: Cazadores de sombras (Wander-Ausst.; K) / 1998 St. Albans, Univ. of Hertfordshire, Margaret Harvey Gall.: Far and close to here (K) / 1999 St. Petersburg (Fla.), Dalí Mus.: Between the skin and the distance (K) / 2002 Barcelona, Fund. „La Caixa": Pantalles sensibles. Videoart dels anys 90 (K: N. Miró) / Zaragoza: 2005 Paraninfo de la Univ.: Identidades (K: S. Blas u.a.); 2008 WA, Pav. Aragón: El agua y sus sueños contemp. / 2010 Vitoria, Artium: Video (S)tories. ◫ DPEE, Ap., 2002; *R. Olivares* (Ed.), 100 artistas esp., Ma. 2008; ead. (Ed.), 100 videoartistas, Ma. 2009. – *C./ M. de Oliveira*, Textos, ca. 1990 (Filmoteca de Andalucía); *J. V. Aliaga*, Artforum (N. Y.) 32:1993 (4) 98; *A. Murría, Lápiz* (Ma.) 1993 (94) 91; *C. u.a.*, SIDA. Pronunciamento e acción (K Univ.), S. Co. 1995; *J. Rey*, Cielo negro (La Coruña) 1995 (1) 23 s.; El Mundo, Supl. El Cult. (Ma.) v. 7. 11. 1999; *J. M. G. Cortés u.a.*, Heroes caídos. Masculinidad y representación (K Espai d'Art Contemp. de Castelló), Va. 2002; *L. Llorca*, Artforum 43:2004 (3) 232; *S. Barrón u.a.*, El arte látex. Reflexión, imágenes y sida (K Univ.), Va. 2006; *V. Espa/B. Otal* (Ed.), Panorámica y paisaje. Huesca 1850–2006 (K Pal. Montcada, Fraga), Huesca 2007; *C. Gianetti* (Ed.), The discreet charm of the technology. Arts in Spain (K Badajoz/Zürich), Ma. 2008; *I. Vidal-Folch*, El País (Ma.) v. 20. 3. 2009, 45; *J. Peñafiel*, Veu entre línies (K Centre d'Art La Panera), Lleida 2010. – *Online:* Website C. – Mitt. C. M. Nungesser

Codognato, *Attilio* (1867) cf. **Codognato**, *Simeone*

Codognato, *Simeone*, ital. Goldschmied, Juwelier, * 1822 Venedig, † 1897 ebd. Ab 1844 tätig als Kunsthändler. 1866 eröffnet er ebd. ein Juweliergeschäft mit Wkst. und eig. Herstellung. Zu europ. Rang gelangt die Fa. unter C.s Sohn *Attilio I C.* (* 1867 Venedig, † 1928 ebd.) mit den den etruskischen Stil imitierenden Schmuckkreationen der sog. ital. archäol. Goldschmiedekunst. Die Gioielleria C. domiziliert heute in dritter Generation unter Ltg des Kunstsammlers und Schmuckdesigners *Attilio II C.* (* 1930 Venedig) am Markusplatz. ◫ Dict. internat. du bijou, P. 1998 (s.v. C.). – *P. Hebey/L. Hamani*, C., P. 2002. – *Online:* Website C. D. Trier

Coelho, *Kirsten*, austral. Keramikerin dän. Herkunft, * 1966 Kopenhagen, lebt in Ethelton/South Australia. Stud.: 1984–88 (Bachelor of Design, Ceramics), 2000–04 (Master of Visual Art) Univ. of South Australia, Adelaide; seit 2000 daneben auch Doz. am Ceramics Dept. ebd. 1991–98 tätig im Clapham Arts Workshop, London. 1999–2001 Atelier im JamFactory Centre for Contemp.

Craft and Design, Adelaide. Ausz.: 1999 Emerging Visual Artists Award, Adelaide (Kategorie Keramik); 2002 Tea Tree Gully Art Prize, Tea Tree Gully/South Australia; 2003, '05, '08 Australia Council for the Arts. – C.s Gefäße in Porzellan zeichnen sich durch schlichte, elegante Formen mit äußerst sparsamem abstrakten Dekor aus. Sie verwendet meist mattweiße Celadon-, aber auch farbige Glasuren und arbeitet mit Reduktionsbrand. In London nimmt sie bes. Anregungen von den Trad. der brit. Studiokeramik auf, die u.a. durch die Theorien von Bernard Leach geprägt ist. Arbeiten der jüngeren Zeit sind von Emailwaren des 19. und frühen 20. Jh. inspiriert, wie sie in einfachen Haushalten als Ersatz für Porzellan üblich waren. C. ahmt nun ihrerseits einige dieser Metallgefäße einschließlich deren Abnutzungserscheinungen auf der Oberfläche in Ton nach. Die Stücke kombinieren einfachste Formen mit bizarren Abstraktionen auf der Oberfläche, die abgeschlagenes Email und Roststellen (v.a. am Gefäßrand) imitieren, und schlagen damit eine ganz eig. Verbindung zur austral. Kolonialgeschichte. ⌂ ADELAIDE, Univ. of South Australia, Anne and Gordon Samstag Mus. of Art. – AG of South Australia. CANBERRA, NG of Australia. GOLD COAST CITY/Qnsld., AM. PERTH, AG of Western Australia. SHEPPARTON/Vic., Shepparton AG. TEA TREE GULLY, City Council. ◉ E: Adelaide: 2002, '11 (mit Helen Fuller) JamFactory Centre for Contemp. Craft and Design; 2005, '07, '10 BMG Art / Melbourne: 2004 Craft Victoria; 2011 Helen Gory Gal. / Sydney (N. S. W.): 2004, '06 All Hand Made Gall.; 2008 Helen Stephens Gall. / 2009 Los Angeles, Matin. – G: 2005 Gold Coast City (Qnsld.), AM: Gold Coast Internat. Ceramic Award (Josephine Ulrick Ceramic Art Award for Excellence) / 2007–09 London, Adrian Sassoon: Internat. Ceramics Fair and Seminar / 2008 Shepparton (Vic.), Shepparton AG: Sydney Myer Internat. Ceramic Award. ⌷ E. Cooper, Contemp. ceramics, Lo. 2009. – Online: Website C.; Gadfly Gall.; Srivilasa.

C. Rohrschneider

Coelho (C. Gomes de Abreu), *Rita*, portug. Architektin, Landschaftsarchitektin, Designerin, * um 1974, lebt in Lissabon. Stud. ebd.: Ist. Superior de Agronomia an der Techn. Univ.; 2000 Design am Centro portug. de Design. 1994 Erasmus-Stip. der Univ. Wageningen/Gelderland. Nimmt bereits 1995 an öff. Lsch.-Gest. teil. 1997–99 Mitarb. von Sodia Castelo und Vera Ramos am Projekt der öff. Anlagen in Condeixa. 1998 an der Planung des Parque Expo '98 in Lissabon beteiligt. 2000–02 Mitarb. der Lsch.-Gestalterin Maria João Gomes. Ab 2004 Ass. bei der Planung von vier Grünanlagen in New York (u.a. Park Mohegan, Crotona Malls, Park Morris Mesa). Dabei bringt C. die typischen portug. polychromen Pflasterarbeiten in den Gehbereichen ein. Seit 2006 Prof. an der Esc. Superior de Tecnologias e Artes, Lissabon. ⌷ V. Ramos, arquit. e vida 92:2008, 50–54. R. Petriconi

Coffey, *Susanna*, US-amer. Malerin, * 2. 6. 1955 New London/Conn., lebt in New York und Chicago. Stud.: 1975–77 Univ. of Connecticut, Storrs; 1980–82 Yale Univ., New Haven. Lehrtätigkeit: seit 1982 SchA, Inst. of Chicago. 2006 Artist in Residence, Rockefeller Found. Bellagio

Center. Ausz.: 2003 Henry Ward Ranger Prize; 2009 The John Hultberg Memorial Prize for Paint., Nat. Acad. Mus., New York; Ehrendoktorwürde, Pennsylvania College of Art. Mitgl.: 1999 NAD, New York. – Mit Kopf-Selbst-Portr. verarbeitet C. eig. Empfindungen und Emotionen, Schicksalsschläge und dramatische Geschehen. 1977 thematisiert sie den Tod ihrer Mutter, 1998 den Mythos der Göttin Demeter und seit 2001 bes. Weltgeschehen wie den Krieg im Irak und die Gewalt in Haiti. Ihr von hinten beleuchtetes und stets in zentraler Bildachse fixiertes Gesicht zeigt die Spuren des Geschehens, das sich wie in *Night Vision* (2003) im Hintergrund entfaltet. Sie malt vor einem Spiegel, in dem sie die hinter ihr aufgehängten vergrößerten Fotogr. aus den Medien oder Abb. von bek. Gem. sieht, trägt üppig Farbe auf, kratzt, schleift und übermalt. Ein weiteres Thema sind Nachtbilder von versch. von ihr bereisten Lsch. und Städten sowie Himmelsformationen. Daneben entstehen seit 2001 intime, kleinformatige Blumen-Gem. mit sorgfältig plazierten einzelnen Gartenblüten vor hellem Hintergrund (Osterglocken, Stiefmütterchen, Rosen), seltener Zweige oder Blüten im Gartenbeet. ⌂ AKRON/Ohio, Mus. of Art. BOSTON, MFA. BRYN MAWR/Pa., Bryn Mawr College, Mariam Coffin Canaday Libr. CHICAGO, Catherine T. and John D. McArthur Found. EVANSTON/Ill., Northwestern Univ. GREENSBORO/N. C., Weatherspoon AM. HONOLULU, Honolulu Acad. of Art. MINNEAPOLIS, Mus. of Art. NEW YORK, NAD. ROCKFORD/Ill., AM. SEVILLA, MCA. VALPARAISO/Ind., Brauer Mus. WILLIAMSTOWN/Mass., Williams College Mus. of Art. WELLESLEY/Mass., Davis Mus. and Cult. Center. ◉ E: Chicago: 1986 Cult. Center of the Chicago Public Libr.; 1987 SXC Gall.; 1988, '91, '92 Sazema Gall.; 1996 Lyons Weir Gall.; 2001 Beacon Street Gall.; 2004 Maya Polsky Gall.; 2013 Valerie Carberry Gall. / 1990 Eleusis, Cult. Center; Athen, Hellenic-Amer. Union und Gall. Engonopoulos / New York: 1994 Gal. Three Zero; 1997, '99, 2001, '03 Tibor De Nagy Gall. (K); 2008 New York Studio School; 2012 Ateven Harvey FA Projects / 1997 Chapel Hill (N. C.), Ackland AM; Provincetown, Bangs Street Gall.; Storrs, Univ. of Conneticut, Atrium Gall. / 1998 Charleston (S. C.), Halsey Gall. / Hanover (N. H.), Dartmouth College, Hopkins Center (K) / 1995, '98 Barcelona, Gal. Alejandor Sales / 2000 New Orleans, Maguerite Oestricher Gall. / 2001 Greensboro (N. C.), Weatherspoon Gall. / 2002 Albany (N. Y.), The College of Saint Rose / Boston: 1995, 2000, '04, '12 Alpha Gall. / 2006 Sevilla, Isabel Ignacio Gall. (K) / 2009 Charlotte (N. C.), Jerald Melberg Gall. / 2011 Dayton, The Robert & Elaine Stein Gall. at Wright State Univ.; New Bedford (Ma.), Mus. of Art. ⌷ B. A Brown/A. Raven, Exposures. Women and their art, Pasadena, Calif. 1989; E. Condon, New art examiner 1992 (Nov.) 29 s.; E. Myles, AiA 82:1994 (7) 90; J. Whittle, A j. of art (Cornell Univ.) 1997 (Mai) 22 s.; R. Fine/R. R. Hernández-Durán/M. Pascale, Contemp. Amer. realist drawings from the Jalane and Richard Davidson Coll. at the Art Inst. of Chicago, Chicago 1999; N. Krauss, AiA 87:1999 (9) 122 s.; E. Ferris, F news mag., SchA Inst. of Chicago 2004 (Sept.) 20

s.; Looking at herself (K Lyme Acad. of Art), Old Lyme, Conn. 2005; Visual arts in Greece (K NM of Contemp. Arts), Thessaloniki 2006; Outwin Boochever portr. competition (K SI, Nat. Portr. Gall.), Wa. 2006; *C. Becker*, Art j. 65:2006 (4) 78–95; *B. O'Brien*, Art New England 27:2006 (4) 18 s.; *S. C./Suzanne Walters* (K Pi 37 Gall.), Athen 2006; Slowness (K Heaven Gall.), Chicago 2006; Unexpected reflection. The portr. reconsidered (K Meridian Gall.), San Fransisco 2009. – *Online:* Website C.

H. Stuchtey

Coffin, *Elizabeth Rebecca,* US-amer. Malerin, * Sept. 1850 Brooklyn/N. Y., † 21. 6. 1930 Nantucket/Mass. Nachfahrin von Tristram und Dionis Stevens C., die im 17. Jh. zu den ersten Siedlern von Nantucket gehörten. Stud.: ab 1865 Vassar College, Poughkeepsie /N. Y., bei Hendrik van Ingen (Malerei, Zeichnen); 1872–75 ABK Den Haag (erhält dort die Erlaubnis, die bislang männlichen Studenten vorbehaltenen Fächer wie Anatomie, Perspektive und Archit.-Gesch. zu belegen; in studienfreien Zeiten ausgedehnte Europareisen, u.a. nach Florenz und Venedig); ab 1875 erneut Vassar College (1876 wird ihr als erster Amerikanerin der Titel Master of FA zugesprochen); 1877–80, '88/89 Art Students League, New York, bei William Merritt Chase; 1883 PAFA, Philadelphia, bei Thomas Eakins (mit ihm und dessen Frau Susan Macdowell Eakins lebenslang befreundet). 1897 sechsmonatige Europareise und Nilkreuzfahrt in Ägypten. Ab 1900 ständig in Nantucket ansässig. Eröffnet dort 1903 die Coffin School wieder, die 1827 von einem Verwandten gegr. worden war. Mit ihrem Lehrplan, der Fächer wie Holz- und Metallarbeiten, Korbflechten, Nähen etc. umfaßt, reagiert C. auf die Forderung der Arts and Crafts movement nach Wiederbelebung des Kunsthandwerks. Durch ihr Engagement in der Schule und weitere ges. Aktivitäten tritt ihr eig. künstlerisches Schaffen ab 1900 in den Hintergrund. Mitgl.: Art Students League, New York; Gründungs-Mitgl. der Brooklyn Art Guild (1886–95 Präs.; Teiln. an Ausst.). – Ölmalerei mit Portr., Genreszenen, Marinen und Stilleben. Bereits ab den 1880er Jahren verbringt C. die Sommermonate in Nantucket und malt hervorragende Portr. und Genreszenen von einer im Schwinden begriffenen, ehem. mit dem Walfang verbundenen Lebensweise. Die Bilder in realistischer Auffassung mit Licht-Schatten-Kontrasten und Wiedergabe atmosphärischer Bedingungen zeigen den Einfluß v.a. von T. Eakins. Nach 1900 hellt sich ihre Palette auf; unter dem Einfluß des Impressionismus sowie ihrer Reisen nach Nordafrika entstehen Darst. in lockererem Duktus und lebhaften Farben (*Arab Boy*, 1905). Um 1900 malt T. Eakins ihr Portr. (Nantucket, Slg der Coffin School Trustees of the Coffin School). ▫ NANTUCKET, Nantucket Hist. Assoc. (umfangreichste Slg). – Coffin School Trustees. POUGHKEEPSIE, Vassar College, Frances Lehman Loeb AC. ⊙ *E:* 1920 Poughkeepsie, Vassar College (Retr.) / Nantucket: 1920 Taylor Hall; 2007 Whitney Gall. – *G:* 1876–94 New York, NAD (1892 Norman W. Dodge Prize für *Hanging the Nets* als das beste von einer Frau in den USA gemalte Bild) / 1893 Chicago: World's Columbian Expos. ▱ *Falk* I, 1999; *F. Turner Reuter,*

Jr., Animal & sporting artists in America, Middleburg, Va. 2008. – *M. M. Booker*, Nantucket spirit. The art and life of E. R. C., Nantucket, Mass. [2001] (Rez.: *P. H. Simpson,* Woman's art j. 23:2002[1]41 s.). – *Online:* Vassar. The alumnae/i quart. 98:2001 (1). – Mitt. B. Simons, E. Oldham, beide Nantucket Hist. Assoc. C. Rohrschneider

Coffin, *Peter,* US-amer. Konzeptkünstler, * 1972 Berkeley/Calif., lebt in New York. Stud.: bis 1995 Univ. of California, Davis; 1996–2000 Carnegie Mellon Univ., Pittsburgh/Pa. – Mit Skulpt., Installationen, Fotogr. und Videos untersucht C. etablierte Auffassungen, Denksysteme und Bräuche und v.a. die Dominanz des logischen Denkens in der heutigen Welt. Mit Neugier, Kreativität, Humor und Witz bedient er sich versch. Disziplinen wie Kunstgesch., Natur-Wiss., Psychologie oder Soziologie, zieht Experten heran und verwirklicht ganz verschiedenartige konzeptionelle Ideen und kommuniziert neue künstlerische Erfahrungen. Er beschäftigt sich z.B. mit Modernismus und Konzeptkunst, so wird aus der Endlosen Säule von Constantin Brancusi (1918) bei C. der *Endless Beanstalk* (2002), und für die freistehende Neonlichtdraht-Skulpt. *Untitled (Line after B. Nauman's The True Artist Helps the World by Revealing Mystic Truths)* (2004; New York, MMA) greift C. Wahrnehmungs-Experimente von Künstlern wie Bruce Nauman und Robert Smithson während der späten 1960er Jahre auf. Bei versch. Ausst. der Installation *Untitled (Greenhouse)* läd C. in den Jahren 2002–07 versch. Musiker (u.a. Black Dice, Christian Marclay, Tom Verlaine, Jutta Koether, Alan Licht), Klangkünstler und Besucher ein, für Pflanzen in einem aufgestellten Gewächshaus wohltuende Musik zu kreieren. 2008 läßt er ein ferngesteuertes *UFO* aus Aluminium (sieben Meter Durchmesser) über Gdańsk in Polen fliegen; die Stadt New York hatte zuvor seine Anfrage abgelehnt. 2009 stellt er in der Tate Britain, London, eine neue Gal. mit Gem., Fotogr. und Skulpt. aus der ständigen Slg zus. und projiziert auf diese abwechselnd Videos und Ton, wie z.B. Regen über eine dramatische Gewitterszene von Samuel Colman. Wie dort gibt er auch in der Serie *Sculpt. Silhouette* (seit 2007, Stahl) existierenden Kunstwerken ein neues Erscheinungsbild und and. Wirkung, indem er schwarze Schattenbilder von bek. plastischen Kunstwerken anfertigt, z.B. der Venus von Willendorf, dem Denker von Auguste Rodin und dem Fettstuhl von Joseph Beuys. ▫ LONDON, Saatchi Gall. NEW YORK, MMA. ROM, Nomas Found. ▱ *M. Pollack,* Flash art 37:2004 (Nov./ Dez.) 67; *A. Huberman*, ArtRev 3:2005 (11) 116–119; *M. Gronlund,* ibid. 3:2006 (Sept.) 40 s.; *A. L. Lynch*, Art New England 28:2007 (3) 24; *K. Greenberg*, Mod. painters 2007 (April) 99; *B. Ramade*, L'Oeil 590:2007 (April) 65 s.; *L. Triming*, Flash art 40:2007 (Mai/Juni) 136; *M. Cattelan*, ibid. (Okt.) 106–110; *J. DeNike*, ibid. 41:2008 (Juli/Sept.) 260; *S. Cash*, AiA 96:2008 (Sept.) 161; *G. Williams*, Artforum internat. 47:2008 (Okt.) 394; *A. Berardini*, ArtRev 21:2008 (April) 137; *C. Turner*, Mod. painters 20:2008 (9) 46–48; *V. Croci*, Archit. design 79:2009 (4) 118–121; *M. Glover*, ArtRev 32:2009 (Mai) 109; *E. Williams*, Art monthly 326:2009 (Mai) 36 s.; *S. Santacatte-*

rina, Flash art 43:2010 (Jan./Febr.) 87; *C. Sharp*, ArtRev 43:2010 (Sept.) 122; *L. Hoptman u.a.* (Ed.), The art of tomorrow, B. 2010; *A. Hindry*, Art press 378:2011 (Mai) 44–49. – *Online:* Website C.; Saatchi Gall.

H. Stuchtey

Cogan, *Šneer* (russ.: Kogan, *Šneer Gercevič*), jüdischer Maler, Graphiker, * 30. 4. 1875 Orgeev/Bessarabien, † 2. 3. 1940 Chişinău. Bruder von Moisej Kogan. Stud.: A. 1890er Jahre Kunst-FS Odessa; 1897–1903 ABK München (im Matrikel als Schneer Kagan) u.a. bei Johann Caspar Herterich. Lebte bis 1916 in Königsberg, 1917 Rückkehr nach Bessarabien. Lehrte ab 1918 an der Kunst-FS Chişinău (Schüler u.a. Jakov Averbuch, Moisej Gamburd, Viktor Ivanov). 1921/22 Mitbegr. der Bessarabischen Ges. der schönen Künste (Ausst. bis 1939). – Talentierter Vertreter der realistischen Schule, der die heimatliche Natur und Archit. poetisch darstellte und den Zauber der moldawischen Vergangenheit einfing (*Inzova gora*, Rad., 1918; *Dvor v Kišineve*, Öl, 1923; *Dom v starom Kišineve*, Rad., 1932). Schuf auch sensible Portr. (*Staryj evrej; Starucha; Cyganočka*, Öl, 30er Jahre) sowie während seiner Aufenthalte 1923 in Bulgarien und 1934 in der Türkei interessante Lsch. und Archit.-Ansichten (*Vostočnyj pejzaž. Balčik*, Öl; *Konstantinopol'. Dvor mečeti*). Arbeitete auch in Kaltnadel und Aquatinta. ▫ CHIŞINĂU, Nat. KM. – Fam. C. ⊚ *G:* ab 1918 v.a. Chişinău / 1935 Bukarest: Salonul oficial. ▯ Literatura ši arta Moldovej, I, Kišinėu 1985; DA XXI, 1996, 811 (im Art. Moldova, als Kogan Sh. G.); ChudSSSR V, 2002 (Lit.). – *T. Stavila*, Gorizont 1986 (11) 53 s.; *Severjuchin/Lejkind*, 1992; *S. Spitalnic*, Evreii în literatura, artă şi ştiinţa Moldovei, Chişinău 1995, 122. N. Šalaginova

Cogliatti, *Maria Bettina*, mex.-schweiz. Bildhauerin, Malerin, Graphikerin, Bauzeichnerin, * 23. 10. 1957 Mexiko-Stadt, lebt in Zug. Als Graphikerin v.a. Lith.; als Bildhauerin u.a. architekturbezogene Plastik. Seit 2000 Kunstberatung und Seminare. ⊚ *E:* 2004, '07 Baar, Z-Gal. – *G:* 1988 Cham, Forum junge Kunst / 1990 Zug, Kunsthaus: 3 x 3 Junge Kunst (K: S. Banz u.a.). ▯ KVS, 1991; BLSK I, 1998. – Neue Zürcher Zeitung v. 31. 1. 2004; 11. 5. 2007. – *Online:* SIKART Lex. und Datenbank (Ausst.). S.-W. Staps

Cognet, *Roland*, frz. Bildhauer, Installationskünstler, Zeichner, Maler, * 1957 Désertines/Allier, lebt in Jussat/Puy-de-Dôme und Paris. Stud.: Ec. supérieure d'Art, Clermont-Ferrand (dort Lehrtätigkeit). – Zunächst abstrakte Skulpt., v.a. aus Holz und Metall, später integriert C. recycelte Mat. wie Reifen, Flaschen, Kanister in diese plastischen Werke. Seit A. der 1990er Jahre gestaltet er gegenständliche Plastiken, deren Formen und Motive der Natur entlehnt sind. Häufig verwendet C. Baumteile und verfremdet diese durch Ummantelung mit Metall oder Beton, um die Wechselbeziehungen und Bedeutung zw. Natur und Kunst zu hinterfragen. Weiterhin Tierplastiken (u.a. Affenköpfe aus Bronze, hölzerne Hirsche und Hunde sowie Pferdeköpfe), die in jüngeren Installationen mit abstrakten Skulpt. kombiniert werden. In Ergänzung entstehen kleinformatige Öl-Gem. sowie Kohle-

Zchngn, Fotogr. und Videoarbeiten mit ähnlichen Motiven. ▫ AURILLAC, Mus. d'Art et d'Archéologie. BOBIGNY, Fonds dép. d'Art contemp. Seine-Saint-Denis. CAEN, Artothèque. CLERMONT-FERRAND, Fonds dép. d'Art contemp. du Puy-de-Dôme – FRAC Auvergne. – Mus. d'Art Roger Quilliot. PARIS, BN. – FNAC. ⊚ *E:* Clermont-Ferrand: 1986 Dir. régionale d'Art contemp.; 1992 Fonds régional d'Art contemp. (K); 1998, 2001, '10 Gal. Claire Gastaud; 2004 Mus. d'Art Roger Quilliot (K) / 1987 Aberdeen, AG / Paris: 1990 (K), '98 Espace d'Art contemp.; 1991, '93, '95 Gal. Jorge Alyskewycz / 1996 Saint-Vaast-la-Hougue, Mus. Maritime de l'Ile de Tatihou (mit Anne Delfieu, Bob Verschueren; K) / 2004 Troyes, Centre d'Art contemp. Passages / 2011 Thiers, Centre d'Art contemp. Le Creux de l'Enfer. – *G:* 1987, '90, '91 Montrouge: Salon d'Art contemp. / Paris: 1990 Salon de la Jeune Sculpt.; 2005 Gal. Nathalie Gaillard: Les sculpt. sont dans le jardin; 2008 Gal. Defrost: Impossible to capture / 1995 Thiers, Centre d'Art contemp. Le Creux de l'Enfer: Pour le couteau / 2000 Mont-de-Marsan, Mus. Despiau-Wlérick: Libre choix / 2004 Clermont-Ferrand, Mus. d'Art Roger Quilliot: Soleil vert / 2010 New York, Parker's Box: Ten Year's Hunting (III). The Trophy Room. ▯ *Bénézit* III, 1999. – *C. Nédellec/N. Roux*, R. C. Point de vue, P. 2004. F. Krohn

Cogswell, *John*, US-amer. Silberschmied, Hochschullehrer, * 24. 8. 1948 Cortland/N. Y., lebt in Clintondale/N. Y. Stud.: 1966–68; 1979 Bachelor; 1984 Master of FA, State Univ. of New York at New Paltz (Gold- und Silberschmiedekunst bei Robert Ebendorf, Kurt Matzdorf). 1968–76 tätig bei Fiorentini Jewelers Inc., Cortland; 1979–95 Entwerfer und Silberschmied für K. J. M. Silversmiths Inc., New Paltz/N. Y.; seit 1979 Wkst. in New York. 1985–96 Dir., Schmuck-Abt., Kultur-Inst. 92nd Street Y, ebd. Lehrtätigkeit ebd.: 1980, '81, '84–85, '93, 2001–10 State Univ. of New York, New Paltz; 1987–88 Pratt Inst.; 1992–2000 Parsons School of Design (ab 1985 Dir., Jewelry and Metalsmithing Dept.); 1993–94 Hofstra Univ., Hempstead/N. Y. Mitgl.: Artisan, Soc. of Amer. Silversmiths. Ausz.: 2007 Artist of the Year, Touchstone Center for Crafts, Farmington/Pa. – C. gestaltet schlichtes, ästhetisch anspruchsvolles Gebrauchssilber (bes. Servierschaufeln, Kerzenleuchter), zeremonielle Gerätschaften sowie Schmuck, v.a. aus elegant geschwungenen Silberstreifen geschmiedeter Halsschmuck. Er vermittelt seine ausgezeichneten handwerklichen Fähigkeiten (bes. Handschmieden) mit großem Engagement in Veröff. und in der Lehre. ▫ CHAPEL HILL/N. C., Ackland AM. NEW YORK, Jewish Mus. SHEBOYGAN/Wis., John Michael Kohler AC. ✉ Creative stonesetting, Lo. 2008. ⊚ *E:* 2004 Ann Arbor, Inst. for the Humanities. ▯ *M. Simon*, Metalsmith 17:1997 (3) 42; *S. Rabinovitch/H. Clifford*, Contemp. silver, Lo. 2000; Metalsmith 25:2005 (4) 23; *M. Simon*, ibid. (5) 20 s.; *M. Le Van*, Penland book of jewelry, N. Y. 2011. – Mitt. C. H. Stuchtey

Coheleach, *Guy (Guy Joseph)*, US-amer. Maler, Illustrator, * 1933 Baldwin/N. Y., lebt in Bernardsville/N. J. und in Florida. Bereits als Kind studiert und zeichnet C. Vö-

gel. Stud.: bis 1956 Cooper Union for the Advancement of Sc. and Art, New York, bei Don Richard Eckelberry. Häufige Reisen nach Alaska, Europa, Südamerika und Afrika. Ausz.: 1979–85 (außer 1980) Soc. of Animal Artist's Award of Excellence. – Auf Anraten von Eckelberry spezialisiert sich C. Anfang der 1960er Jahre auf die Darst. von frei lebenden Tieren nach eig. Beobachtung. In naturnaher Auffassung malt er in Öl, Tempera, Acryl und Aqu. bes. afrikanisches Großwild (Löwen, Tiger, Leoparden, Elefanten etc.), aber auch (Raub-)Vögel. Neben der ganzfigurigen Wiedergabe von Tieren in ihrem Habitat entstehen eindrucksvolle Kopf-Portr. (*Mbogo. Cape Buffalo Portr.*, um 2002). Ill. für Ztgn und Zss., u.a. für Saturday Evening Post, Nat. Wildlife Mag. und Readers Digest (alle ab 1967) sowie für Internat. Wildlife Mag. (ab 1971). ⌂ JAMESTOWN/N. Y., Roger Tory Peterson Inst. of Natural Hist. NEW YORK, Amer. Mus. of Natural Hist. ORADELL/N. J., Hiram Blauvelt AM. SHREVEPORT/La., R. W. Norton AG. WASHINGTON/D. C., Nat. Wildlife Gall. WAUSAU/Wis., Leigh Yawkey Woodson AM. ✉ The African lion as man-eater, s.l. 2003 (mit eig. Ill.). ◉ *E:* zahlr. ab 1991, u.a. 1992 Shreveport, R. W. Norton AG / 1992, 2005 Salisbury (Md.), Ward Mus. of Wildfowl Art / 1995 (Retr.), '98, 2005 (Retr.), '10 Oradell, Hiram Blauvelt AM / 1997, 2002, '03, '08 Jamestown, Roger Tory Peterson Inst. of Natural Hist. / 1999, 2000 Rockford (Ill.), Burpee Mus. of Natural Hist. / 2008 Amiston (Ala.), Amiston Mus. – *G:* seit 1967 New York, Soc. of Animal Artists. ☐ *Falk* I, 1999; *F. Turner Reuter, Jr.*, Animal & sporting artists in America, Middleburg, Va. 2008. – *N. A. Neff*, The big cats. The paintings of G. C., N. Y. 1982; *T. Wieland*, C. Masters of the wild, Camden, S. C. 1990; *id.*, G. C.s animal art, Cleveland, Ohio 1994. – *Online:* Website C.

C. Rohrschneider

Cohen, *Ayelet Hashacher*, israelische Fotografin, * 1965 Nazareth, lebt in Tel Aviv. Stud.: 1985–86 Emek Jezreel College (Skulpt.; Fotogr.); 1986–90 Art Teachers' College, Ramat Hasharon; 1993–94 Moller Centre (Kurs für Maskenbildnerei). Lehrtätigkeit: Kunststudio Ramat Eliahu; Meimat School, Tel Aviv; Bezalel Acad. of Arts and Design, Jerusalem (Fotogr.). Ausz.: 1992, '95 Preis der America-Israel Cult. Found.; 2000 Kunstpreis des israelischen Minist. für Wiss., Kultur und Sport. – C.s heterogenes fotogr. Werk erwächst häufig aus einem kunstdidaktischen Kontext, der hist. Recherchen und die Möglichkeiten digitaler Techniken einbezieht. Durch die Verwendung von Farben, Lacken, Lw., Holz und recyceltem (Bild-)Mat. betritt sie von Zeit zu Zeit and. Kunstbereiche. Das (fotogr.) Bild der Frau in der 2. H. des 20. Jh. ist für ihre Arbeitskonzepte genauso von Interesse wie Hll.-Darst. auf Ikonen. Auch (farb-fotogr.) Serien mit Natur- und Archit.-Motiven. ⌂ HAIFA, MCA. JERUSALEM, America-Israel Cult. Found. – Discount Bank Art Coll. – Israel Mus. ◉ *E:* u.a. Tel Aviv: 1999 Limbus Gall.; 2002 Avni SchA, New Gall. / 2000 Kibbutz Nachshon, AG / Haifa: 2000 Mus. of Art; 2003 WIZO Neri Bloomfield College of Design, Drefler Gall. / 2001 Jerusalem, Musara School of Photogr., Medi and New Music / 2002 Kalmaniya, Beit

Berl College / 2007 Ramat Gan, Mus. of Israeli Art. – *G:* u.a. 2003 Jerusalem, Israel Mus.: Revelation. Representations of Christ on Photogr. (K: N. N. Perez). ☐ *Online:* Israeli AC. St. Schulze

Cohen, *David (Dave)*, US-amer. Keramiker, Metallkünstler, * 1932 Milwaukee (Wis.), lebt in North Berwick (East Lothian). 1947–51 Tischlerlehre. Stud.: 1953–54 US Navy, Metalsmith School, Norfolk/Va.; 1957–58 Layton SchA, Milwaukee; 1958–62 Edinburgh College of Art. 1962–63 Stip., Scripps College, Claremont/Calif. Ab 1965 Keramik-Wkst. Kilncroft pottery in Juniper Green b. Edinburgh, 1975–85 und ab 1992 in North Berwick, ab 2009 als Pitclay Gall., ab 2012 als Tantallon Studios. Lehrtätigkeit: 1965–86 Edinburgh College of Art; 1986–91 Ltg der Keramik-Fak., Glasgow SchA. – C. übernimmt zunächst Auftragsarbeiten wie die Gest. einer Keramikwand im East Kilbride Computer Centre (1966), eines Kriegsdenkmals im Inverness Post Office (Aluminiumrelief, 1970) und in Edinburgh eines Brunnens (Bronze, 1974; Princess Str./ Waverley Station) sowie eines Taufbeckens (St. Marks Unitarian Church, 1978). Daneben konstruiert er u.a. Maschinen für Tonverarbeitung (Tonschneider, Töpferscheibe, Ofen), bevor er diese ab 1973 für Keramik- und anfangs auch Metall-Keramik-Skulpt. verwendet. Es entstehen v.a. Arbeiten aus Steinzeug (*Gefäß*, 1988; London, V & A) und flexible Module, die er mit einem Vakuumtonschneider herstellt und standortspezifisch arrangiert. Char. sind Garten-Skulpt. wie *Dynamic Growth* (2000) mit Abstimmung auf die Lichtverhältnisse und Lsch.-Archit. sowie v.a. Raku-Keramik mit naturbezogener Dekoration. Zumeist auf die Archit. bezogene Wandobjekte bestehen aus mit linearen oder abstrakten geometrischen Mustern dekorierten Tellern oder Platten, die zusammengesetzt ein wirksames Gesamtbild oder z.T. ein neues Motiv (*Winter tree*, 1996, Aberdeen AG) erzeugen. Weitere Arbeiten sind freistehende Skulpt., die Formen des weibl. Körpers wiedergeben, sowie zahlr. Teller mit skulpturalem oder gemaltem Apfeldekor. Mit herausragender Kenntnis und Beherrschung keramischer Techniken und visueller Sprache ist C. ein vielseitiger und kunstfertiger Keramiker. C.s Tochter *Kirstie C.* (* 1963 Edinburgh, lebt in Beauly b. Inverness; Stud.: Edinburgh College of Art; 1983–88 Glasgow SchA) malt von den schott. Highlands inspirierte atmosphärische Lsch.-Impressionen (Öl). ⌂ ABERDEEN, City AG. AYR, Maclaurin Gall. BALTIMORE, Art Inst. DUNDEE, City AM. EDINBURGH, Heriot-Watt Univ. – Huntley House Mus.-NM of Scotland. GLASGOW, City AM. – Milngavie AC. JERUSALEM, Univ., Mus. KOPENHAGEN, KIM. LEEDS, City Mus. LONDON, V & A. MILWAUKEE, Art Inst. NORTH BERWICK, Mus. and AG. OBAN, Argyll and Bute Council, Argyll Coll. OHIO, Univ. PAISLEY, Mus. PORTLAND/Ore., Hood Community College. STOKE-ON-TRENT, City Mus. ✉ The basics of throwing, Lo. 2008; Arbeiten an der Töpferscheibe, Bern 2009; *D. C./S. Anderson*, A visual language. Elements of design, Lo. 2012. ◉ *E:* Edinburgh: 1965, '68 57 Gall.; 1974 Scottish Craft Centre / 1979 London, Brit. Craft Centre / 1995 Glasgow, SchA / 1996 Aberdeen, AG / 1998 North Berwick, Mus. and AG / 1999 Pais-

ley, Mus. and AG / 2000 East Kilbride AC / 2003 Haddington, Peter Potter Gall. (mit Kirstie C.). *McEwan*, 1994; *E. Cooper/E. Lewenstein* (Ed.), Potters, Lo. [8]1989; *Buckman* I, 2006. – Scottish Crafts (Ausst.), Edinburgh 1971; *E. Owen*, Ceramic rev. 1991 (131) 8 s.; Continental shift (K Peterborough Mus. and AG), Peterborough 1998; *J. Robison*, Large scale ceramics, Lo. 2005. – *Online:* Pitclay Gall.; Studio Pottery. H. Stuchtey

Cohen, *Jeanine*, belg. Malerin, Fotografin, * 30. 4. 1951 Brüssel, lebt dort. Stud.: 1977–81 Ec. nat. supérieure des Arts visuels de La Cambre, Brüssel; ABA, Watermael-Boitsfort. Ebd. Lehrtätigkeit. Arbeitet in Belgien, Portugal und Island. – C. gilt als konkrete und konstruktivistische Künstlerin. In ihrer Malerei, die sich v.a. skulptural und installativ in den Raum entwickelt, und bei ihren Kunst-am-Bau-Projekten verwendet sie Holzleisten, Aluminium, Klebeband, Neonröhren, seit E. der 1990er Jahre auch fluoreszierende Acrylfarben. Sie setzt sich mit dem Verhältnis zw. Malerei und Raum sowie der Betrachtung von Kunst auseinander. Dabei sucht sie Wege, wie Farbe als abstrakt strukturierendes Element in minimalistische geometrischen Konstruktionen indirekt wirken kann, ohne daß ein eigentlicher Bildträger wie etwa eine Lw. gestaltet wird. Sie lagert der Wand (auch übereinandergelegte) demontierte Rahmenformen, Farbflächen oder Leistenbündel mit rückseitigem monochromem Farbauftrag vor; die sekundäre Wahrnehmung der von der Ausst.-Wand reflektierten Farbe ist dabei vom Licht und vom Betrachtungswinkel abhängig (*Plenty of empty; Unplanned density*, beide 2008). Schon bei frühen Werken verwendet C. industriell vorgefertigte Materialien und Farbflächen (*Inside-outside*, 2001–06); zudem widmet sie sich Arbeiten mit Papier, Wandmalereien (z.B. 1997, Gal. Etienne Tilman) und Serigraphien. Auch in ihren streng formalen Farb-Fotogr., die u.a. in Tel Aviv, Lissabon (Artist's Residency, 2012), Island und den USA entstehen, zeigt sie geometrische und konstruktive Elemente von Archit., Materialien und Farben, Objekte und Zeichen im öff. Raum. BRÜSSEL, Communauté franç. de Belgique. – Winterthur Insurance Company. – Zurich Insurance Company. CAMBRAI, MBA. REYKJAVIK, Safn Asgrims Jónssonar. STOCKHOLM, Slg Statenkonsträd. *E:* 1997 Aalst, Gal. In Situ / Brüssel: 1985 Ec. nat. supérieure des Arts visuels de La Cambre, Hôtel Van de Velde; 1986 Gal. X+; 1989 Gal. 175; 1997 Gal. E. Tilman; 1999 Archétype; 2000 Center for Contemp. Non-Objective Art; 2001 Espace 251 Nord; 2010 Nomad Gall., CO21 Centre de Couleur contemp. asbl / 2004 Reykjavik, i8 Gall. / Lissabon: 2006 The Art Room; 2007, '11 C. Pagès Gall.; 2011 Gal. Presença. – *Kunst am Bau:* Brüssel: 2000 Agoria Group Headquarters; 2005 Quai 55 Office Building / 2004 Tournai, Mus. de la Tapisserie / 2008 Charleroi, Mus. de la Photogr. – *G:* 1984 London: Brit. Internat. Print Bienn. / Brüssel: 1985 Pal. des BA: Young Belgian Paint.; Center for Contemp. Non-Objective Art: 1998 9+1 – works on paper & sculpt.; 2004 Molti multipli; 2006 Parlament de la Communauté franç. de Belgique: Abstractions construites en Communauté franç. de Belgique de 1980 à nos jours (K) / 2011

Cambrai, MBA: Escaut. Rives. Dérives. *Pas* I, 2002; *Delarge*, 2001. – *Online:* Website C. T. Koenig

Cohen, *Julius*, US-amer. Schmuckgestalter, * 1914 New York, † 18. 7. 1995 ebd. Neffe des Juweliers Oscar Heyman, in dessen Fa. er 1929–42 beschäftigt ist und von Adolph Hentschel ausgebildet wird. 1942–55 für Harry Winston in New York tätig. 1955 gründet C. die Julius Cohen Jeweler Inc. ebd. (East 53d Str., ab 1974 in 699 Madison Ave.), die zu einer der angesehensten und mehrfach mit dem Diamonds Internat. Award ausgezeichneten Firmen für Schmuckentwurf und -Gest. in den USA avanciert. Nach C.s Tod wird die Fa. von Tochter und Schwiegersohn, Marjory und Leslie Steinweiss, weitergeführt. – C.s Schmuck zeichnet sich durch perfekte handwerkliche Ausf. und ansprechendes Design aus; zum großen Teil entsteht er nach speziellen Wünschen seiner exklusiven Kundschaft. Bei den Kreationen setzt C. bevorzugt weiße und gelbe, häufig hochkarätige Diamanten sowie Edelsteine verschiedenster Farben ein. Manche Schmuckstücke, bes. Colliers, weisen stilisierte vegetabile Motive aus Gold und verschiedenartig geschliffenen Diamanten auf. Berühmt sind C.s Ohrringe in Form einer stilisierten Blume aus Diamanten in Kombination mit einer Perle oder einem Edelstein. Vom Zeichentrickfilm Fantasia von Walt Disney ist die Brosche *Dancing Hippopotamus* (Diamanten, Smaragde, Rubine, großer gelber Beryll) inspiriert. Dict. internat. du bijou, P. 1998. – *W. Saxon*, New York Times v. 19. 7. 1995 (Nachruf). – *Online:* Website C.

 C. Rohrschneider

Cohen, *Kirstie* cf. **Cohen**, *David* (1932)

Cohen, *Piet (Piet Izak)*, niederl. Designer, Innenarchitekt, * 19. 10. 1935 Arnhem, lebt in Amsterdam. C. entstammt einer alteingesessenen niederl.-jüdischen Familie. Während der dt. Besatzung (1940–45) wird er von einer kath. Fam. in Südholland versteckt und entkommt dadurch dem Holocaust. 1948–50 Lehre als Möbeltischler in Maastricht. Lebt ab 1950 in einem Kibbutz in Israel. Nach dem Militärdienst arbeitet C. in Jerusalem bei dem 1935 aus Deutschland emigrierten Architekten Joseph Schönberger (1912–1982), der in Israel v.a. im Synagogenbau tätig ist. Stud.: bis 1960 Industriedesign am Technion in Haifa. 1960–70 Aufenthalt in den USA, anfangs Stipendiat am Philadelphia Mus. College of Art, Philadelphia/ Pa.; anschl. in New York tätig. 1970 Rückkehr nach Amsterdam und Gründung des eig. Designateliers. Lehrt ebd. ab 1979 Industriedesign an der Gerrit Rietveld Academie. – In den 1970er/80er Jahren v.a. Entwürfe von eleganten Interieurobjekten, u.a. zweischalige Wandleuchten für den niederl. Hersteller Raak (*Raak schelpdier*, Aluminium). Seit den 1980er Jahren auch mehrfach Innenraum-Gest. von jüdischen Einrichtungen, z.B. Separatraum (Bijsjoel, 1997) der Raw-Aron-Schuster-Synagoge in Amsterdam. Den maurischen Archit.-Stil der Groninger Synagoge (erb. 1906 von Tjeerd Kuipers, 1943–73 umgenutzt) adaptiert C. im Rahmen der Rest.-Arbeiten (1975–81) für die Innenraum-Gest.; u.a. durch dekorativ aufgemaltes farbig kontrastierendes Sichtziegelwerk. Daneben auch mod. Design für synagogales Mobiliar, Vorhänge, Thoramän-

tel oder Chanukkaleuchter. Seit 1993 hauptsächlich Gest. von hochwertigen Zeremonialgegenständen in zeitlos eleganten, von der Metallkunst des Bauhauses und der Neuen Sachlichkeit inspirierten Formen aus Silber (Sterling, häufig vergoldet). Für den liturgischen Gebrauch entstehen u.a. mod. Thorazeiger und -schilde. Für den jüdischrelig. Priv.-Haushalt entwirft C. u.a. eine zweiteilige Etrog Box (1995) und ein achtteiliges Kiddushset (1997). Seit etwa 2000 auch Entwürfe zur Ausf. in Kunststoff (z.B. Tassen für die rituelle Handwaschung) und Edelstahl, darunter ein Mezuzah-Behälter in Form eines Olivenzweiges, dessen florale Gest. die trad. Schrägaufhängung am Türrahmen auch formal unterstützt. Jüngste Arbeit ist der Entwurf für das *Anne-Frank-[Onderdoken Kind]*-Denkmal (Stahl, 2011) für den Anne Frank Memorial Park in Jerusalem. Zu C.s Verdiensten gehört der gelungene Versuch, trad. jüdischen Kultgeräten eine mod. Form zu geben. ☗ AMSTERDAM, Joods HM. BERLIN, Jüdisches Mus. GRONINGEN, Folkingestraat Synagoge: Innen-Gest., 1981. JERUSALEM, Israel Mus. NEW YORK, Jewish Mus. SCHOONHOVEN, Nederlands Zilver-Mus. ◉ G: 2006 Groningen, Folkingestraat Synagoge: Mod. Joods Leven / 2010 Limburg, Regionaal Hist. Centrum: Gevonden verleden. ▭ *M. Warhaftig*, Dt. jüdische Architekten vor und nach 1933. Das Lex., B. 2005. – *E. van Voolen/P. Meijer*, Synagogen van Nederland, Zutphen 2006; *S. van der Poel*, 100 jaar Folkingestraat-synagoge 1906–2006, Groningen 2006; *L. Born*, Friesch Dagblad v. 9. 3. 2006. – *Online:* Website C. U. Heise

Cohen, *Preston Scott,* US-amer. Architekt, * 1961 Asheville/N. C., lebt in Cambridge/Mass. Stud.: bis 1983 Rhode Island School of Design, Providence (1993–98 Gast-Doz. des Sommer-Kurses in Rom); bis 1985 Harvard Univ. Graduate School of Design, Cambridge/Mass. (seit 2003 Prof.). Mitarb. 1978–89 in versch. Archit.-Büros, u.a. 1984 bei Peter Eisenman, New York. 1989 Ass. an der Ohio State Univ., Columbus. Lehrtätigkeit: 1997 Princeton Univ., Princeton/N. J.; 2002 Univ. of California, Los Angeles; 2004 Univ. of Toronto/Ont. Teiln. an internat. Wettb., z.B. 1996 für den Anbau des Prado in Madrid. Ausz. u.a.: 1992 Young Archit. Award (Archit. League, New York); 1998, 2000, '04, '10 Progressive Archit. Award (Amer. Inst. of Architects, Washington/D. C.); 2004 Acad. Award in Archit. (New York); The Visionary Award (MA, Tel Aviv). – C. vertritt in Lehre und archit. Entwurf ein neues Ordnungskonzept, das sich gegen Symmetrien und and. trad. Entwurfsgrundlagen richtet. Seine ab A. der 1990er Jahre entwickelten Methoden der „digitalen Modellierung" bauen auf der darstellenden Geometrie des 17. Jh. auf, führen aber dank spezieller Software zu verformten Projektionen, die C. mit dem Aufspüren der Leistungsfähigkeit natürlicher Systeme rechtfertigt. Die gebauten Resultate unterscheidet er dezidiert von der scheinbaren Naturnachahmung skulpturaler zeitgen. Architektur. C. sieht in der durch das rechnergestützte Entwerfen unabhängig gewordenen Geometrie nicht nur ein Mittel, sich von den technologischen Zwängen des Industriezeitalters zu befreien und Wahrnehmungsmuster

zu durchbrechen, sondern auch ein innovatives Instrument zur Einbindung von Solitärbauten in ihre Umgebung. Beispielhaft hierfür ist das 2000–02 entstandene kleine Haus Wu in Burson/Calif. (mit Cameron Wu). Der Baukörper besteht aus drei parallel angeordneten gewölbten Quadern, die von elliptischen Zylindern und Kegeln in unterschiedlicher Weise durchkreuzt werden. Die entstehenden Sinuskurven korrespondieren mit der Topogr. des Ortes. Im zweigeschossigen Innern ergeben sich lasso- und spiralartige Öffnungen in den Deckenwölbungen, wodurch der Anschein eines sanften Ineinanderfließens der Räume erweckt wird. Geometrisch strenger hingegen wirkt der Erweiterungsbau (gen. Herta and Paul Amir Building) des KM in Tel Aviv (2003–11; u.a. mit Amit Nemlich), den C. durch Ausrichtung und Farbgebung zum Haupthaus in Beziehung setzt. Zudem versteht er seinen Entwurf als Neuinterpretation der Formensprache von Erich Mendelsohn, dessen Bauten in Tel Aviv (1935–40) den Grundstein für die progressive archit. Kultur des Landes gelegt haben. Die Außenwände des flachen Gebäudes auf dreieckigem Grundstück werden durch parametrisch entwickelte Betonpaneele definiert, was zu einer dynamischen, die Kompaktheit des Baus aufhebenden Faltung der Fassaden führt. Unterschiedliche Funktionsbereiche sind auf separaten rechtwinkeligen Grundrissen angeordnet und durch „gestapelte geometrische Episoden", das heißt leicht verdrehte, auf hyperbolischen Paraboloiden basierende Oberflächen, die natürliches Licht bis in die Untergeschosse leiten, miteinander verknüpft; ein spektakuläres spiralförmiges Atrium bildet die vertikale Achse des Gebäudes. Zu den dynamischen Gesten der spitzwinkelig verformten Bauten für das Performing Arts Center in Nanjing/China (2007–09; mit Atelier Zhang Lei u.a.) und dem Mus. of Art in Taiyuan/China (2007–10) kommt bei ersterem die Umsetzung energetischer Kriterien des Passivhauses hinzu. ☗ AUSTIN/Tex., Haus Cohen, 1980–82. BRIDGEHAMPTON, N. Y., Haus Hikari Hathaway, 2003–05. CAMBRIDGE/Mass., Fogg Mus. of Art. – Inge Hoffman Studio, 2003–04. – Haus Inman, 2009. LOS ANGELES, MCA. LOS GATOS/Calif., Haus Fahmy, 2007–11. MONTAGUE/N. J., Haus Boscarino, 1997–2001. NEW YORK, MMA. – Cooper-Hewitt, Nat. Design Mus. – Battery Park City: Multifunktionszentrum Arcade Canopy, 2005–09. ORDOS/China, 20+10 Office Building, 2007–10. – Haus Ordos, 2008–09. PINE PLAINS/N. Y., Haus Goodman, 2001–04. RYE/N. Y., Haus Adam Lindemann, 2003–05. SAN FRANCISCO, MMA. TRENTON/N. J., Robbins Elementary School, 2005–10. ✉ Contested symmetries and other predicaments in archit., N. Y. 2001. ◉ G: 1985, '96, 2004 Venedig: Bienn. (K) / New York: 1999 MMA: The Un-Private House (K); 2002 Max Protetch Gall.: A New World Trade Center (K) / 2001 Pittsburgh (Pa.), Carnegie Mus. of Art: Folds, Blobs and Boxes (K). ▭ *G. Glueck*, The New York Times v. 11. 7. 2004; The Phaidon atlas of contemp. world archit., Lo. u.a. 2004; *N. Spiller*, Digital archit. now, Lo. 2008; *P. Jodidio*, Archit. Now! Museums, Köln 2010. – *Online:* Website C. A. Mesecke

Cohen, *Shibetz,* israelischer Fotograf, Zeichner, Installationskünstler, Bildhauer,* 17. 11. 1967 Rehovot, lebt in Tel Aviv. Stud.: 1994–97 Bezalel Acad. of Arts and Design, Jerusalem (Abschluß mit Ausz.); 1996 School of Visual Arts, New York. Lehrtätigkeit: seit 2004 SchA Hamidrasha, Beit Berl. Ausz.: 2007 Kunstpreis des israelischen Minist. für Wiss., Kultur und Sport; 2003 Isracard Award, Mus. of Art, Tel Aviv; 2006 Kunstpreis des Minist. für Bildung. – Mit dunkel gehaltenen, mysteriös wirkenden und z.T. erotischen fotogr. Arbeiten (digital bearbeitet) erweist C. mehreren alten Meistern (bes. Rembrandt und Caravaggio) seine Reverenz. Bes. in schattenhaften weiblichen Akten sind die Medien Malerei, Zchng und Fotogr. eng miteinander verschmolzen. In unruhigen, linear strukturierten Bleistift- oder Kohle-Zchngn hingegen sucht C. die expressive Abstraktion, z.B. auch bei Wand-Zchngn, die während einer Fahrt auf dem Skateboard entstehen. ▢ TEL AVIV, Mus. of Art. ◉ *E:* u.a. Tel Aviv: 1993 Mary Fauzi Gall.; 2003 Alon Segev Gall. / 1999 Beit Berl, Hamidrasha SchA Gall. / 2001 Herzliya, MCA. – *G:* zahlr. nat. und internat., u.a. Tel Aviv, Mus. of Art: 2000 Ladies and Gentlemen; 2002 The Land of Shadow / 2004 Bat Yam, Mus.: The Benno Kaleb Coll. / Jerusalem: Israel Mus: 2004 Sport and Art; 2008 Real Time / 2006 Haifa, Mus. of Art: Fatamorgana / 2008 Herzliya, MCA: DIY. The Michael Adler Coll. ▢ *Online:* Israeli AC.

St. Scheller

Cohen-Caspi, *Mirit,* israelische Malerin, Zeichnerin, Plastikerin, Installations-, Video- und Computerkünstlerin, * 1960 Kiryat Hayim, lebt in Tel Aviv. Stud.: 1980–84 Beit Berl Acad.; 1995–2000 Bezalel Acad. of Arts and Design, Jerusalem. Lehrtätigkeit: u.a. 1982–89 Tel Aviv Univ.; 1987–88 Technion, Haifa; 1988–90 Wizo College ebd. Ausz.: 1983 Preis der America–Israel Found.; 1990 Preis des israelischen Bildungs-Minist. für junge Künstler; 1991 Hermann-Struck-Preis, Haifa; 1994 Preis der Haifa Cult. Found. für junge Künstler. – Von Anfang an nimmt die menschliche Figur das Zentrum ihres vielfältigen Schaffens ein, explizit oder verborgen, manchmal auch in hybrider Erscheinung. Physische und psychische Struktur eines Menschen sind für C. gleichermaßen relevant, insbesondere im Kontext mod. Technologien. Geschlechtsspezifische Fragen tauchen dann auf, wenn sie sich z.B. mit trad. „Frauenberufen" beschäftigt. Dem Beziehungsgeflecht von Kunst, Mensch und Natur begegnet sie mit einem Konzept, in dem sich die Verwendung von Computersoftware oder digitaler Drucktechnik und natürlichen Mat. nicht ausschließen. ▢ HAIFA, MMA. JERUSALEM, Israel Mus. ◉ *E:* u.a. 2002 Tel Aviv, Tmuna Theatre / 2003 Herzliya, MCA / 2004 Ein Hod, Mus. of Art / 2010 Kibbutz Givat Haim, Gall. –. *G:* zahlr. nat. und internat. seit 1982 , u.a. Haifa, Mus. of Art: 1982 Young Artists's Bienn. (Debüt); 2004 Prizes in Art and Design / 2003 Łódź: Homemade (Video-Festival) / 2008 Den Haag, Beelden aan Zee: Territorial Bodies. Contemp. sculpt. from Israel (K). ▢ *Online:* Website C.

St. Schulze

Cohnitz, *Werner,* dt. Fotograf, Fotojournalist, * 8. 8. 1909, † 1952 (Suizid) Frankfurt am Main. Ab 1928 Pressefotograf in Berlin; 1936 als Bildberichterstatter bei den Olympischen Spielen sowie auf der faschistischen Seite im Spanischen Bürgerkrieg tätig; 1938 wegen geheimdienstlicher Sonderaufgaben Löschung aus der Berufsliste der Bildberichter; um 1940 längerer Japan-Aufenthalt (1942/43 mehrere Ausst. von Japan-Fotogr.; zahlr. Reprod. in der Publ.: E. Fürholzer, Freundesland im Osten. Ein Nipponbuch in Bildern, B. 1943); Ausbilder von Fotografen bei der Marine-Propagandakompanie (PK) der Wehrmacht; als Bildberichterstatter bei der Kriegsmarine; 1944 wegen „Wehrdienstverweigerung", „Feindbegünstigung" und „Landesverrat" in Abwesenheit zum Tode verurteilt; 1947 Flucht von Spanien nach Venezuela, wo C. für die größte Illustrierte des Landes arbeitet und dt. Fotofirmen vertritt; ab 1951 in Frankfurt am Main. – Eine monogr. Bearb. steht aus. ▢ *D. Kerbs,* in: *W. Niehl* (Red.), Musik, Theater, Lit. und Film zur Zeit des Dritten Reichs, Dd. 1987; *R. Sachsse,* Die Erziehung zum Wegsehen. Fotogr. im NS-Staat, [D.] 2003 (Lit.). – Albany, M. E. Grenander Dept. of Special Coll. and Arch., State Univ. of New York: Fritz Neugass Papers (Fotogr.).

P. Freytag

Coimbra, *José* (eigtl. Coimbra Sobrinho, *José*), brasil. Maler, * 19. 1. 1916 São Sebastião do Paraíso, † 27. 7. 1985 Ribeirão Preto. Autodidakt. Hält sich 1941–43 in Pouso Alegre (Minas Gerais) auf. Anschl. ein Jahr in Santos, wo er als Nachtwächter arbeitet. 1944–49 in Fernandópolis, dort als Bediensteter einer staatlichen Schule tätig, wo er in den unterrichtsfreien Zeiten die Tafeln der Schulklassen zum Zeichnen nutzt. 1949–60 in São José do Rio Preto, wo C. den Maler José Antonio da Silva kennenlernt, der ihn in der Ölmalerei unterweist. Steht 1955–60 in engem Kontakt mit der Kunstszene von Ribeirão Preto. 1960 Übersiedelung nach Mococa. – C.s naiv anmutende Malereien zeichnen sich v.a. durch ihren expressiven Gestus aus, sowohl in der Farbgebung als auch im Stil. Hauptthema der Arbeiten ist das Leben der einfachen Landbevölkerung, ihr tägliches Ringen ums Überleben, aber auch ihre relig. Feste und Freizeitvergnügen, z.B. in Bildern wie *Procissão, Folia dos Reis* und *As Visitas* (alle undat.). ◉ *E:* 1978 Mococa, Mus. de Artes Plást. / 1981 São Paulo, Gal. Brasiliana / 1983, '86 Ribeirão Preto, Itaú-Gal. –. *G:* São Paulo: 1957, '60 Salão Paulista de Arte Mod.; 1980 Paço das Artes: Gente da Terra; 2002 Centro Cult. Banco do Brasil: Pop Brasil / 1961, '62, '65 (alle lobende Erw.) Santa Cruz do Rio Pardo: Semana Euclidiana / 1978 Monte Santo: Salão de Monte Santo (Ausz.) / 1980 Mexiko-Stadt, Inst. Nac. de BA Mus. Carrillo Gil: Pintores Populares y tres Grabadores de Brasil / 1983 Ribeirão Preto, Itaú-Gal.: Expos. Pró Sinfónica de Ribeirão Preto / 2002 Piracicaba: Bien. Naifs do Brasil. ▢ *Online:* Inst. Itaú Cult., Enc. artes visuais, 2012.

M. F. Morais

Coindet, *Delphine,* frz. Installationskünstlerin, Bildhauerin, * 1969 Albertville, lebt in Lausanne. Stud.: 1992 Ec. régional des BA, Nantes; 1993 Inst. des Hautes Etudes en Arts plast., Paris. Artist in Residence: 1998 La Box, Bourges; 2002 18th Str. AC, Los Angeles; 2011–12 Villa Medici, Rom. – Anhand von digitalen Entwürfen ge-

staltet C. aus versch. Mat. (häufig Kunststoff) mon. Versionen von Alltagsgegenständen, Pflanzen und Naturerscheinungen wie Trillerpfeife, Hammer, Feder, Wolke, Blume (z.B. *Fleurs*, Schaumstoff, 1994), überträgt diese in geometrisch-abstrakte Plastiken (z.B. *Harpe*, laminiertes Holz, Satinbänder, 2005) und integriert sie in komplexe und verschlüsselte Installationen (z.B. *Chérie-Chérie*, Kunststoff, lackiertes Metall, verspiegelter Stahl, 2006). C.s Assemblagen widmen sich bevorzugt bestimmten Frauengestalten (z.B. *Scarlet*, Spiegel, Polystyrol, Papier, Federn, 2007). In Zusammenarbeit mit der Autorin Chloé Delaume entsteht 2011 ein Werkzyklus, dessen mit Fächern bestückte Assemblagen 13 Frauen der antiken Mythologie thematisieren. ⌂ ANGOULEME, FRAC Poitou-Charentes. CAEN, FRAC Basse-Normandie. LIMOGES, FRAC Limousin. ORLEANS, FRAC Centre. PARIS, FNAC. – FRAC Ile-de-France. SELESTAT, FRAC Alsace. SOTTEVILLE-LES-ROUEN, FRAC Haute-Normandie. VITRY-SUR-SEINE, MAC du Val-de-Marne. ◉ *E:* Paris: 1994 Gal. Chez Valentin; 1998, 2000, '03 Gal. Michel Rein; 2007 Gal. Laurent Godin / 1997 Brüssel, Gal. de l'Observatoire / 1998 Bourges, La Box (K) / 2003 Los Angeles, Solway Jones Gall. (mit Nadine Christensen) / 2005 Gennevilliers, Gal. Edouard Manet (mit Vincent Beaurin) / 2006 Genf, Gal. Evergreene / 2008 Thiers, Centre d'Art contemp. Le Creux de l'Enfer / 2011 Zürich, Gal. Anne Mosseri-Marlio. – *G:* 1994 Orléans, MBA: Jour de Fête (K) / 1999 Tokio, Bunkamura Gall.: Paris en Création (K) / 2002 Brooklyn, Smack Mellon Gall.: Rendez-Vous / 2003 Rochechouart, Mus. dép. d'Art contemp.: Spéciale dédicace / 2004 Dôle, MBA: La Lettre Volée / 2006 Muttenz, Kunsthaus Baselland und Ivry-sur-Seine, Le Centre d'Art d'Ivry: Midnight Walkers / 2007 Lyon, MAC: The Freak Show / 2009 Thun, KM: Aufgeräumte Zimmer / 2011 Paris, MAMVP: Aparté. ▭ *Delarge*, 2001. – *E. Zabunyan/P. Régnier*, D. C. (K), Tours 2000; *B. Eliot/S. Rioland*, Plantations (K Jumièges), P. 2001; *X. Douroux/M. Gauthier/J. Fronsacq*, D. C., Dijon 2006. F. Krohn

Coins, *Raymond,* US-amer. Bildhauer, * 1904 Stuart/Va., † 1998 North Carolina. Autodidakt. Um 1914 übersiedelt C.s Fam. in die Nähe von Winston-Salem/N. C. Zunächst arbeitet C. dort als Landarbeiter; nach der Heirat 1950 erwirbt er eine eig. Farm, wo er u.a. Tabak anbaut. Ab 1976 (Ruhestand) beginnt er mit Schnitzarbeiten; zunächst fertigt er indianische Pfeilspitzen und Tomahawks, später Menschen- und Tierfiguren in Holz (v.a. Zeder) und Stein im Sinne der Art brut. Seine Werke weisen je nach vorgefundenem Mat. ganz unterschiedliche Größen auf und reichen von den kleinen, idolartigen *Doll Babies* in Flußstein bis hin zu ca. 350 Kilogramm schweren mon. Gestalten in Zedernholz. Zahlr. Arbeiten sind von seiner tiefen Spiritualität inspiriert, u.a. die Basreliefs zu relig. Themen (*Adam and Eve*, Flußstein). 1990 gibt C. aus Altersgründen die künstlerische Betätigung auf. Ausz.: 1995 North Carolina Folk Heritage Lifetime Achievement Award. ⌂ ASHVILLE/N. C., Asheville AM. CHAPEL HILL, Univ. of North Carolina, Ackland AM. WASHINGTON/D. C., Smithsonian Amer. AM: Doll

Baby, Flußstein, 1988. ◉ *G:* 2002 Largo (Fla.), Gulf Coast Mus. of Art: Folk Art from the City of Orlando and the Mennello Mus. ▭ *Delarge*, 2001. – Kunstforum Internat. 1991 (112) 201; *B.-C. Sellen*, Self taught, outsider and folk art, Jefferson, N. C. u.a. 2000. – *Online:* Petullo art coll.; AskART; Ginger Young Gall.; Orange Hill Folk AG and Outsider AG; Robert Cargo Folk AG.
C. Rohrschneider

Cointet, *Guy de,* frz. Maler, Zeichner, Installations-, Performance- und Buchkünstler, * 1934 Paris, † vor 12. 8. 1983 Los Angeles, lebt dort ab 1968. 1965 geht er nach New York, 1968 nach Kalifornien. Dort ist er Ass. von Larry Bell. 1975–77 Lehrtätigkeit am Otis Art Inst., Los Angeles. – C. macht die Sprache zum Hauptinhalt seines Werks. Er greift auf Strategien von Dada und Surrealismus sowie homonyme Komp.-Methoden von Raymond Roussel zurück und entwickelt eig. kryptische Sprachen und Alphabete, mit denen er Bücher schreibt. Sein erstes Buch *ACRCIT* (1971) enthält u.a. tabellarisch angelegte Zahlen, abstrakte und halbfigurative Raster, geometrische Linien-Zchngn, fein kalligraphierte Spiegelschrift, von chin. und Blindenschrift inspirierte Zeichen.*A Captain from Portugal* (1972) ist in einem aus Kombinationen kurzer, geschwungener Striche entwickelten Alphabet verfaßt, während er in *Espahor Ledet Ko Uluner !* (1973) eine Geschichte in Prosa erzählt, in der sich eine Handlung entfaltet, zu einem Höhepunkt kommt und dann ausklingt. Mit dem Problem der Interpretation seiner Arbeiten konfrontiert, greift C. auf Performances zurück, um sie zu erklären. So liest eine Schauspielerin C.s Buchstaben-Gem. wie eine normale Erzählung, z.B. *At Sunrise a Cry Was Heard* (1974) und *Going to the Market* (1975). In ähnlicher Weise werden in *Huzo Lumnst* (1973) Schriftbilder C.s wie trad. figurative Gem. beschrieben. Manche Performances enthalten Dialoge frz. Lit. oder banaler amer. Soap Operas, in denen Schauspielerinnen mit C.s Elementen des Bühnenbilds aus überdimensionierten Buchstaben, einfachen geometrischen Körpern und Möbeln agieren, z.B. *Tell Me* (1979; Objekte in Paris, MNAM). Die Zchngn entwickeln sich von Variationen von Schriften versch. Kulturen (z.B. arabisch und hebräisch) zu stets abstrakteren, strengen Liniengeflechten (z.B. *The race was over*, 1978) und Rastern (z.B. *I have been reading the philosophical poems of Miss Ackermann*, 1979), in denen er auch Buntfarben verwendet. In späten Arbeiten wie *Here you'll see the Chinese Soldiers* (ca. 1982) werden die Umrisse freier und vielfältiger. C. transformiert die in ihre konstituierenden Elemente zerlegte Sprache und Schrift in ein visuelles Erlebnis. Beginnend mit der Ausst. in der Cirrus Gall., Los Angeles (1999), wird sein Werk in den USA wie in Europa wiederentdeckt und seine Bedeutung, bes. für die Konzept- und Performancekunst in Kalifornien, neu bewertet. Einfluß u.a. auf Mike Kelley und Paul McCarthy. ⌂ DUNKERQUE, FRAC du Nord-Pas-de-Calais. LOS ANGELES, County Mus. of Art. – MCA. NEW YORK, MMA. PARIS, Bibl. Kandinsky. – MNAM. REIMS, FRAC Champagne-Ardenne. RENNES, FRAC Bretagne. ◉ *E:* Los Angeles: 1999 Cirrus Gall.; 2011 MCA / 2005 Genf,

MAMC / 2006, '08, '11, '12 Paris, Air de Paris / 2006 Sète, Centre rég. d'art contemp. Languedoc-Roussillon / 2007 Barcelona, MAC / 2008 Nizza, Villa Arson / 2009 New York, Greene Naftali / 2011 Quimper, Le Quartier; León, MAC de Castilla. ▢ *H. Drohojowska*, Los Angeles weekly v. 12. 8. 1983 (Nekr.); *P. Franck*, in: 19 artists. Emergent Americans (K Guggenheim), N. Y. 1981, 20–23; *M. de Brugerolle*, G. C., Z. 2011. – *Online:* Air de Paris; *J. Hoffberg*, in: ArtSceneCal, 1999. G. Bissell

Cojocaru, *Miriam*, israelische Malerin, Zeichnerin, * 27. 12. 1945 Rumänien, lebt seit 1973 in Israel. Bis 1969 Chemie-Stud. in Rumänien. 1982 Promotion (Chemie) in Israel. 1983–2003 als Laborleiterin und Doz. an der Bar-Ilan Univ., Ramat Gan, tätig; 1989–91 Gast-Doz. an der Univ. Heidelberg. Zahlr. wiss. Publikationen. Besucht Kurse in Kunstgesch. u.a. an der Bar-Ilan Univ. und nimmt Malunterricht in Tel Aviv am Avni Art Inst. und Meimad Art Inst. sowie in den Ateliers von Jan Rauchwerger, Ira Reichwerger und Tzwi Tadmor. Mitgl.: ab 1991 Israel Painters and Sculptor Assoc.; ab 2000 Ten Women. Seit 2002 ist C. Kuratorin nat. Ausst., z.B. im Bible Mus., Tel Aviv, und der Congress Hall, Haifa. – C. beginnt mit ruhigen Darst. israelischer Lsch. und Stilleben (Blumen, Granatäpfel) in Aquarell. Jüngere Arbeiten, jetzt häufiger in Öl/Lw., zeigen auch Interieurs, v.a. aber, expressiver stilisiert, Frauenbildnisse und -Portr., z.B. *Ballerina*, 2003. ◉ *E:* seit 1992 zahlr. nat., u.a. Ramat Gan: 1993, 2004 Bar-Ilan Univ., Wurtzweiler Libr. / 1997 Natanya, City AG / 2002 Ra'anana, Moris Topaz Gall. / Tel Aviv: 2003 Mus. of the Bible; 2005 Sara Kishon Gall.; 2012 Romanian Cult. Inst. / 2007 Old Jaffa, Horace Richter Gall. –. *G:* seit 1991 zahlr. in Israel und Italien, u.a. Tel Aviv, Mus. of the Bible: 1999 Holocaust; 2002 The Song of the Songs / Florenz: 2002 Bienn.; 2004 Art Point. ▢ Studio. Art mag. 1997 (86) 148; 1999 (107) 164; 2004 (155) 87; *D. Schor*, Orient Express v. 31. 5. 2004, 18. – *Online:* Artisho; Israel AC; Saatchi Gall. St. Schulze

Cokes, *Tony (Anthony)*, US-amer. Video-, Multimedia- und Installationskünstler, Hochschullehrer, * 1956 Richmond/Va., lebt in Providence, R. I. Stud.: bis 1979 Goddard College, Vermont (Fotogr., kreatives Schreiben); 1983–84 Whitney Mus. Independent Study Program, New York (Video); 1984–85 Virginia Commonwealth Univ., Richmond (Bildhauerei). 2008–09 Artist in Residence, Getty Research Inst., Los Angeles. Lehrtätigkeit: seit 1993 Brown Univ., Providence (seit 2007 Prof. für Media Production, Dept. of Mod. Culture and Media). – Mit analytischem Vorgehen thematisiert C. seit 1984 mit Videos und Multimediainstallationen rassistische Strukturen und Anschauungen in den Medien und der Populärkultur und offenbart die Wechselbeziehung zw. ethnischer Identität und kult. Wahrnehmung. C.s Arbeiten sind oft Assemblagen von archiviertem Film-Mat. aus Hollywood sowie Dokumentationen, Textkommentaren, Stimmen aus dem off und Populärmusik. Im Video *Black Celebration. Subtitled A Rebellion against the Commodity* (1988) zeigt C. Filmszenen aus Nachrichten, zitiert den Text von Guy Debord The Decline and Fall of the Spectacle-Commodity Econo-

my (Situationist internat. No 10), unterlegt es u.a. mit Musik der Elektronikband Skinny Puppy und zelebriert damit den zivilen Ungehorsam während der US-amer. Rassenunruhen in den 1960er Jahren. Die Installationen, Videos, Fotogr., Gem., Skulpt. und Tonbänder, die er mit der von Mitgl. versch. Hautfarben gebildeten „art band" X-PRZ (1991–2000) bzw. den Künstlern Doug Anderson, Kenseth Armstead und Mark Pierson gestaltet, setzen Alltagsbilder und -sprache in einen neuen Sinnzusammenhang und hinterfragen damit kult. Praktiken. Mit der 1995 gegr. Negro Artist Collective (zus. mit Jo Wilson, Renee Cox) hängt er in Manhattan, Brooklyn und Los Angeles schwarze Plakate mit weiß gedrucktem Schriftsatz auf, die stereotype Ansichten über die schwarze Bevölkerung in verdrehter Form zitieren (*Mama, I Thought Only Black People Were Bad*, 1995). Als Mitgl. der Band Swipe (1997–2000) verfaßt C. 1997–98 kurze Texte über die Popmusik und entwickelt daraus die Videoserie *Pop-Manifestos* (fünfteilig, 1999–2004). Mit minimalistischer Graphik vermitteln und erörtern sie Mythen und Ideologien der populären Musik ohne den für Pop-Videos üblichen Werbezweck. Seit E. der 1990er Jahre setzt sich C. neben Sozialkritik und Gewalt (*Evil*-Serie, 2003–06) auch mit Kunstkritik auseinander. So z.B. im Videoprojekt *Shrink.demos 1–4* (2001), das Ansichten von der Umschiffung von Manhattan und Musik der bayrischen experimentellen Popgruppe The Notwit mit über den Bildschirm laufenden horizontalen Textlinien von Walter Benjamin und Susan Buck-Morss, Andy Warhol und David Hammons kombiniert; die Länge einer Filmeinstellung entspricht der eines Musikstücks. Im Video *Leeds.talk. trailer* (2008), das auf dem Art. Leeds talk des Kunsthistorikers Andrew Perchuk basiert und die Beziehung zw. Kunst und Kunstkritik in den USA und Großbritannien in den 1960–70er Jahren thematisiert, erscheint der gesamte Text Linie für Linie auf schwarzem Hintergrund. C. ist ein wegweisender afro-amer. Künstler und Postkonzeptualist im Bereich der dem Aktivismus gewidmeten Videokunst. ▣ ALBUQUERQUE, Univ. of New Mexico, ASA Gall. BOSTON, Massachusetts College of Art Libr. – School of the MFA. BRISBANE, Queensland AG. BUFFALO, Hallwalls Contemp. AC. COLUMBUS/Ohio, Wexner Center for the Arts. HALIFAX, Saint Mary's Univ., Internat. Education Center. KOPENHAGEN, KH. LONG BEACH/Calif., Mus. of Art. LOS ANGELES, School of Cinema, Univ. of Southern California. MADISON/Wis., AC. MELBOURNE, Cinemedia. NEW YORK, Bobst Libr., Avery Fisher Center. – New York Univ. – Public Libr., Donnell Media Center. – MMA. PARIS, MNAM. PORT WASHINGTON/N. Y., Public Libr. PROVIDENCE, Brown Univ. Libr. – Rhode Island School of Design. RICHMOND, Virginia Commonwealth Univ. SAN FRANCISCO, New Langton Arts. STANFORD/Calif., Stanford, Univ. Green Libr. VALENCIA, California Inst. of the Arts. ◉ *E:* (ohne Installationen) 1991 San Francisco, New Langton Arts; Berkeley, Univ. of California, Pacific Film Arch. / 1992 Atlanta (Ga.): World Video Festival / 1996 Lincoln (Mass.), DeCordova Mus. and Sculpt. Park (K); Löwen, STUC Kunstencentrum / 2001 Amsterdam, New Media Room / 2003

New York, Momenta Art / 2006 Toronto, Gall. 44 Centre for Contemp. Photogr. / 2007 Flint (Mich.), Inst. of Arts; Providence (R. I.), RISD Mus. – *G:* 1997 Kassel: documenta. ☐ *A. Moshayedi*, X-TRA 12:2010 (3) 28 s; 42, 48, 58, 69; Better worlds. Activist and utopian projects by artists (Agnes Etherington AC), Kingston, Ont. 2002; Whitney Bienn. 2002 (K Whitney Mus.), N. Y. 2002; Video hits. Art and music video (K Queensland AG), Queensland 2004; *A. Kubler*, Art monthly Australia 171:2004, 3–6; *K. Horsfield u.a.*(Ed.), Feedback, Ph. 2006; Rencontres internat. Madrid-Paris-Berlin (K roARaTorio transmédia), P. 2009. – *Online:* Website C. H. Stuchtey

Col (Coll), *Juan (Giovanni)*, ital.-argentinischer Bauingenieur, Architekt, Stadtplaner, * 1847 Turin, † 24. 2. 1902 Buenos Aires. Stud.: bis 1869 (Abschluß) Scuola Politecnica und Real Scuola di Applicazione per Ing., beide Turin. Anschließend als Ing. bei der Südbahn (Wien-Triest) tätig. 1879 erstmals in Argentinien dok., als er den Baugrund von Landhäusern und Betrieben für die Colonia Resistencia (seit 1885 Hauptstadt der Prov. Chaco) festlegt. Etwa zeitgleich ist C. am Projekt der Stadtgründung von Formosa beteiligt. 1880 Teiln. an der Expedition von Luis Jorge Fontana zur Wegerschließung zw. den Prov. Chaco und Salta. Danach Übersiedlung nach Corrientes, wo er 1891–93 als Inspektor (später Dir.) des Amtes für öff. Arbeiten und stellv. Dir. der topogr. Abt. tätig ist. 1897 Stadtrat und 1900 Dir. des Katasteramtes ebd. Gründungs-Mitgl. und erster Dir. der wiss. Ges. der Landvermesser. – C. erbaut in der Stadt Corrientes, der gleichnamigen Prov. und den benachbarten Prov. neben prachtvollen Villen zahlr. Schulen, Kirchen und öff. Gebäude, die das aufblühende mod. Argentinien symbolisieren. In der Stadt Corrientes u.a. den Pal. Gómez (Stadtverwaltung), das Hospital Juana Francisca Cabral, die Bibl. Popular, ein Waisenhaus und Salesianerhospiz; auch entwirft er ebd. die neue Fassade für die Iglesia de la Merced. Die Bautätigkeit fällt mit der maßgeblichen Mitwirkung an der infrastrukturellen (Eisenbahnnetz) und städtebaulichen Erschließung der nordöstlichen Landesgebiete zusammen. Archit. ist C. dem ital. Eklektizismus verhaftet, dessen typologische Konventionen er durch neuartige Lösungen variiert. In Anlehnung an die Renaiss. erschafft C. unverwechselbare Bauten von geometrischer Strenge in korinthischer Ordnung, z.B. die flache, breit angelegte Casa de Gobierno in Corrientes (1881) und den grandiosen Reg.-Pal. der Prov. Misiones in Posadas (1882–83) mit Bogenfrontispiz und Arkadenhof. Auch die neugotischen Kirchen Santa Rita de Cassia (1882–84) und Santísima Cruz de los Milagros (1888–97) oder die burgenartige Haftanstalt (1888), alle Corrientes, sind originäre Interpretationen innerhalb des akad. Kanons ital. Prägung. ☐ CORRIENTES: Esc. Nr. 2 Domingo F. Sarmiento, 1880. – Plaza 25 de Mayo: Pal. Cabral (Minist. de Gobierno y Justicia), 1880. – Soc. Ital. de Soccoros Mutuos, 1886. – Seniorenheim Juana Costa de Chapo (ehem. Bettlerasyl), 1886. – Esc. Nr. 2 Manuel Belgrano, 1887. – Friedhof San Juan Bautista: Grabstätten für Juan Resoagli, José L. Fernández, Casto Vedoya, die Fam. Gallino und

die Soc. Ital. de Soccoros Mutuos. ☐ *L. Patetta* (Ed.), Architetti e ing. ital. in Argentina, Uruguay e Paraguay, R. 2002 (s.v. Col, Giovanni). A. Mesecke

Colabucci Balla, *Igina*, ital. Malerin, Bildhauerin, Graphikerin, Zeichnerin, Schmuckgestalterin, Pharmazeutin, * 1942 Rom, lebt dort. Bis 1993 als Pharmazeutin (mit Lehrbefähigung) in Rom am Pharmakologischen Inst. tätig. Daneben malt sie in Öl und Aqu. v.a. Porträts. Seit 1968 auch bildhauerisch tätig. 1973 begegnet sie dem bulg. Bildhauer Assen Peikov und arbeitet in dessen Atelier in Italien. 1974 Ausst.-Debüt in Rom (Accad. di Romania). Seit 1993 ausschl. künstlerisch tätig, u.a. Weiterbildung an der Scuola Libera del Nudo der ABA Rom bei Gino Marotta. 1996 Mitarb. an der Zs. Punto di contatto. 1999 Wettb.-Teiln. um die Gest. der hl. Katharina in einer Außennische von St. Peter in Rom. 2001 entsteht die umfangreiche Folge *Pesci* (Aqu., Tusche). Nach 2000 verstärkte Hinwendung zu christlichen Themen. 2004 schenkt C. dem Vatikan u.d.T. *La maschera della sofferenza* eine Bronzebüste von Papst Johannes Paul II. – V.a. (Blumen-)Stilleben, Tierbilder, Natur, Portr., (weibliche) Figuren, relig. Motive (bes. Madonnen), Hände und Mutter-Kind-Gruppen (z.B. *Primi passi*, 1990). Arbeitet als Bildhauerin in Terrakotta, Kunstharz, Bronze und Aluminium, als Malerin in leuchtenden Ölfarben und Aqu., als Schmuckgestalterin v.a. in Silber, wobei sie hier organische Formen bevorzugt (z.B. inspiriert durch Algen und Flechten). 1992 fertigt sie eine überlebensgroße Bronzefigur *Donna vela* anläßl. der Expo in Genua. Ihre kleinplastischen Arbeiten sind häufig char. durch weiche, in sich geschlossene Formen und intim wirkende Atmosphäre bei gleichzeitiger Vitalität. C. vertritt eine emotional betonte, weiblich-intensive, bisweilen hymnisch preisende und sozial einfühlsame Sicht der Welt. Befreundet u.a. mit Fabio Sargentini. Ausz. u.a. 1993 Premio Personalità Europ. per l'Arte (Campidoglio), 2000 Premio Manzù; 2002 Med. d'argento per meriti artistici (für ihr Gesamtwerk). ☐ MONTELAPIANO, Piazza Pal.: Mahnmal für die Märtyrer des 16. 11. 1943 (Ricordiamoli insieme), Aufstellung 2005. ROM, BN Centrale: Adam und Eva, Bronze, Aufstellung 2006. SERRAPETRONA, Mus. d'Arte sacra contemp.: Madonna, 2006. SIENA, S. Rocco: Pilgerdenkmal. SAINT-PAUL-DE-VENCE, Unisys Europea: Nike Alata. TORRENIERI, Pfarrk. S. Maria Maddalena: Kreuzweg, Aufstellung 2001. – Via Cassia Francigena: Pilgerdenkmal, Bronze. ⊙ *E:* Rom: 1993 Complesso Mon. del S. Ripa (Retr.; K: M. Cristaldi); 1999 Gall. Sale del Bramante; 2000 Ist. Latino Americano; 2002 Tempio di Adriano (K: C. Strinati); La Gioielleria Rocchi; La Gioielleria Ansuini; 2005 MIC Studio; 2007 MN di Pal. Venezia (K: C. Strinati u.a.); MN di Castel Sant'Angelo / 2000 Mailand, Gall. Il Tempo Ritrovato / 2006 Bukarest, Ital. Botschaft. – *G:* 1992 Genua, Pal. Ducale: V Centenario della scoperta dell'America (mit Ugo Attardi) / 2002 Siena: Bienn. d'arte sacra / 2005 Fermo, S. Rocco: Le radici cristiane della spiritualità. ☐ *S. M. Soldini u.a.*, Via Crucis (K), s.l. 2001; *D. Ciotola* (Ed.), Primo distacco. Un progetto di quattro mostre più uno spazio (K), Teramo 2005. – *Online:* Website C.; Bibl. Palatina Parma; Accad.

Gatti Magici; Mus. Com. Serrapatrona; Min. per i Beni e le Attività Cult. S.-W. Staps

Colazzo, *Marco,* ital. Maler, * 1963 Rom, lebt dort. In den 1980er Jahren v.a. Darst. von Reihungen abstrakter oder konkreter Objekte. In der Folge *Ritratti unici* (1990er Jahre) verbindet C. Portr. mit den graph. überhöhten Fingerabdrücken der dargestellten Personen, in *Me medesimo* verbindet er einzelne menschliche Körperteile mit impressionistisch wirkenden abstrakten Hintergründen. Ab etwa 2000 spezialisiert er sich auf hyperrealistisch gemalte Puppen und Marionetten, die trotz scheinbarer Zerbrechlichkeit von seltsamer Präsenz und grotesker Komik sind. Sie sind nach fotogr. Vorlagen auf Lw. oder Papier gestaltet und posieren vor aquarellartig verschwimmenden, lichten, „neutralen" Hintergründen. Ihre clowneske, liebenswürdige und zugleich ernüchternde Existenz stellt unsere „Normalität" in Frage, ist voller ironischer Merkwürdigkeit und versucht Merkmale des Informel mit fotorealistischen Elementen zu verbinden. Die Folge *Spazi* zeigt abstrakt-expressive Zeichen in leuchtenden Farben, und um 2009 werden in *Audiofonovisivi* roboterhafte Gestalten, Menschen und Tiere mit expressivem Tuschepinsel auf farbige Papiere gebannt. – Im Mittelpunkt von C.s Arbeit stehen versch. Aspekte der Beziehungen zw. menschlicher Innen- und Außenwelt, die zwangsläufig fragmentarisch und oft unvermittelt geäußert werden. Teil dieses Versuches ist es, festgestellte Unvereinbarkeiten zu widerlegen und mögliche Harmonien mit der äußeren Welt aufzuzeigen. ⌂ PRATO, Centro per l'Arte Contemp. Luigi Pecci. ⊙ *E:* Rom: 1991 Gall. Eralov; 1994 Gall. La Nuova Pesa; 1997 Assoc. Cult. L'Attico; 2009 Gall. Maniero (K: L. Canova) / 1994 Pozzuoli, Gall. Alfonso Artiaco / 2005 Palermo, Gall. Francesco Pantaleone Arte Contemp. / 2008 Trento, Arte Contemp. – *G:* Rom: 1993 Studio Stefania Miscetti: Palle; 1996, '08 Pal. delle Espos: Quadrienn.; 2000 Assoc. Cult. L'Attico: Bandiera rossa; 2003 ebd.: Pagine nere; 2004 Archit. Arte Mod.: On paper; Pal. della Farnesina: Arte ital. per il XXI sec. (K: L. Canova); 2007 Auditorium Parco della Musica: Interni romani (K: G. Ceresa); 2008 Ist. Superiore Anticendi: Impronta globale – Ex Magazzini generali; 2009 Assoc. Cult. L'Attico: Hard art; Studio Angeletti: Fabula / 2000 Prato, Centro per l'Arte Contemp. Luigi Pecci: Futurama (K) / 2002 Florenz, Gall. Alessandro Bagnai: Antologia romana / 2005 Caserta, Gall. delle Arti contemp.: Il senso del male / 2007 New Delhi, NG of Mod. Art: On the edge of vision / 2010 Genazzano, Centro Internaz. per l'Arte Contemp.: Impresa pitt. / 2011 Venedig: Bienn.; Palermo, Zelle arte contemp.: Sweet sheets IV. ▭ *A. Bonito Oliva,* Imprimatur, Mi. 1992; *C. Perrella,* Tema celeste 1993 (40) 45 ss.; *L. Beatrice u.a.,* Nuova scena. Artisti ital. degli anni '90. Mi. 1995; *R. Lambarelli,* Arte e critica 5:1997 (11/12) 24 s.; *S. Spada,* Tema celeste 1997 (59/60) 62 s.;*F. Sargentini,* Rom. 4 young painters (K), N. Y. 1997; *R. Gavarro,* Costretti ai margini, R. 1997; *L. Canova,* Visione romana. Percorsi incrociati nell'arte del novecento, Pisa 2008; *G. Cerasa* (Ed.), Donne di Roma (K), R. 2009; *L. Canova,* Corrispondenze, R. 2009. –

Online: Website C.; GiaMaArt Studio. S.-W. Staps

Colburn, *Martha,* US-amer. Filmkünstlerin, Malerin, Installationskünstlerin, Musikerin, * 1971 Gettysburg/Pa., lebt in New York und Amsterdam. Stud.: 1990–94 Maryland Inst. College of Art, Baltimore: 2000–02 Rijks-ABK, Amsterdam. 2010 Visiting Artist, MassArt Film Soc., Boston. Lehrtätigkeit: 1998 San Francisco Art Inst.; 2003 Bergen (Norwegen), KA; Oslo, Staatliche KA.; Enschede, Dutch Art Inst.; 2004 Valencia, California Inst. of the Arts; 2005 Cambridge, Massachusetts Inst. of Technology; Boston, School of the MFA; 2006 Maryland Inst. College of Art, Baltimore; Seattle, Amer. Inst. of Graphic Artists. Preise: 1999, 2002 Chicago Underground Film Festival; 1999, 2003 New York Underground Film Festival; 2007 Rena Hort Mann Award, New York. Mehrfach Mitgl. in Musikgruppen. – C. arbeitet seit 1994 mit Film. M. der 1990er Jahre kombiniert sie gefundene Filmclips zu einer neuen Aussage, z.B. *Asthma* (1995). Bald geht sie dazu über, statische Bilder durch Kameraführung, sukzessive Übermalungen und Stop-Motion zu animieren, z.B. *Evil Of Dracula* (1997) und *There's A Pervert In Our Pool!* (1998). Die Themen entstammen der Populär- und Untergrundkultur. C. sammelt Figuren und Szenarien aus Nachrichten, Comics, Märchenwelt u.ä. und collagiert sie zu einer sprunghaften, filmischen Handlung. Die Animationen sind vom Puppentheater inspiriert. Viele der durch ausgeschnittene Fotos kreierten Charaktere weisen separierte Gliedmaßen auf, die durch Gelenke beweglich gemacht werden. Die Unterlegung durch hektische Punk- oder experimentelle Musik ist ein wesentliches Element des oft chaotischen Eindrucks. In jüngerer Zeit auch politisch engagierte Thematiken. In *Destiny Manifesto* (2006) überzeichnet sie hist. Gem. mit Darst. des amer. Wilden Westen und verknüpft sie mit zeitgen. Fotos der Kriege im Nahen Osten. Häufig sucht sie die kontrastierende Gegenüberstellung des personifizierten Bösen und betont harmloser, unschuldiger Opfer, die gegen alle Erwartung siegreich zurückschlagen, z.B. *Triumph of the Wild* (2008) und *Dolls VS Dictators* (2010). C. fertigt auch Tableaux mit ausgeschnittenen Figuren, z.B. *Don't Kill the Weatherman!* (2007). Auch Werbefilme und Musikvideos, z.B. für They Might Be Giants (2005) und Serj Tankian (*Lie, Lie, Lie,* 2008). ⌂ ANTWERPEN, Window Gall. Walter Van Beirendonk: She spider, Acryl/Lw. 2003 (transportables Wand-Gem.). BALTIMORE, Charles Cinema: o. T. Acryl/Holz (Wand-Gem.), 1999. ROTTERDAM, Las Palmas: Sea See, Acryl/Lw. (Wand-Gem.), 2001. ⊙ *E:* 2002 Middelburg, De Vleeshal / 2003 Frankfurt am Main, KV / Antwerpen: 2003 W.I.N.D.O. W. Gall. Walter Van Beirendonk; 2004 Beursschouwburg (mit Anne Course) / 2004 Williamsburg (N. Y.), Sideshow Gall. (mit Jonas Mekas) / New York: 2006 Stux Gall.; 2009 Times Square, MTV Jumbotron Screen; The Stone; Artists Space / 2007 Amsterdam, Gal. Diana Stigter / 2008 Haarlem, Frans Hals Mus.; Zürich, Gal. Bob Van Orsouw / 2009 San Francisco, MMA; Ottawa, SAW Gall. (mit Alyson Mitchell). – *G:* 2002 Vilnius: Baltic Trienn. / 2005 New York, Whitney: Bienn. / 2007 Park City (Utah): Sundance Film Festival.

⊡ The Dutch film show (K Art Space), Auckland 2004; *C. Kuhn*, DU Kulturmagazin 2008 (791). – *Online:* Website C.; Metropolis M (Interview 2007). G. Bissell

Coldwell, *Paul (Paul Victor)*, brit. Graphiker, Zeichner, Bildhauer, Kurator, Hochschullehrer, * 8. 11. 1952 London, lebt dort. Stud.: 1971–72 Canterbury College of Art; 1972–75 Bristol Polytechnic; 1975–77 Slade SchA, London, bei Bartolomeu dos Santos, Stanley Jones; 1978–81 Research Ass. ebd. bei Jones und Peter Daglish. 1995 Artist in Residence, Madrid, Found. Olivar de Castillejo. Lehrtätigkeit in London: 1980–94 Byam Shaw SchA; 1994–97 Camberwell College of Arts; seit 2001 Prof., Univ. of the Arts. Gast-Prof.: 2010 Chinese Univ., Hongkong; 2011 SchA, Inst. of Chicago. – C. erforscht in eig. Arbeiten, Lehre und Projekten als Ausst.-Kurator (z.B. Digital Responses, 2002–03, V & A, London) den Einsatz von Computern in der bild. Kunst und bes. von digitaler Technologie im Bereich der Druckkunst. Für Zchng und Fotogr. nutzt C. teilw. alte Techniken wie Intaglio oder Kollotypie, daneben entstehen kleinformatige Skulpt. von Alltagsobjekten (Bronze, Papier, Stoff), die auch in der Graphik zu Themen wie Verlust, Vertreibung und menschliche Isolation als visuelle Metaphern erscheinen. 1985–2005 arbeitet er eng mit Paula Rego zus., deren Graphik er druckt. Für das Künstlerbuch *Freud's Coat* (1996, Lith.) montiert C. die Fotogr. des von Sigmund Freud zur Auswanderung nach London gekauften Mantels vor Abb. und Druckgraphik aus dessen Kunstsammlung. Das Künstlerbuch *With the melting of the snows* (1998; Tate, London) basiert auf einer Installation aus 19 kleinformatigen skelettartigen Bronze-Elementen wie z.B. einem einzelnen Schuh, einem Schöpflöffel oder einem Buch, mit denen C. auf das E. des bosnisch-serbischen Konflikts anspielt (1998 Ausst. Eagle Gall.). Die Fotogr. in dem Buch zeugen von der verlassenen Landschaft. Zus. mit dem Dichter Anthony Rudolf veröffentlicht C. 2007 das Künstlerbuch *Kafka's Doll* mit Siebdrucken und einer Kurzgeschichte. Wie auch in der Ausst. *I called when you were out* in Kettles Yard, Cambridge (2008–09), gestaltet C. ergänzend Bronze-Skulpt. von mit Erinnerungen behafteten häuslichen Objekten bzw. Behältnissen. Mit den Skulpt. versucht er, den lineareren Prozeß des Zeichnens in die Dreidimensionalität zu transferieren (Serie *Lost and Found*, Bronze, 2010). ⌂ BIRMINGHAM, City Mus. CAMBRIDGE, Fitzwilliam Mus. DEN HAAG, Mus. Meermanno. LONDON, Arts Council. – BM. – Camberwell College of Arts. – Imperial War Mus. – St. Thomas Hospital. – Tate. – V & A. NEW HAVEN, Yale Center for Brit. Art. NEW YORK, MMA. – Public Libr. WINCHESTER, Winchester College. ✉ P. Rego, in: Printmaking today 2:1993 (1) 9–11; An artist's diary, in: ArtRev 48:1997 (Dez./Jan.) 50 s.; Cultural shape-shifting, in: ibid. 14:2005, 24 s.; Finding spaces between shadows, Lo. 2005; In exciting times, Printmaking today, 19:2010 (3) 9–11; Printmaking. A contemp. perspective, Lo. 2010. ◉ *E:* 1989 Nikosia, Brit. Council Gall. / London: 1993, '98, 2007 Eagle Gall. (K); 1994 Economist Building; 1996 Freud Mus.; 2002 London Print Studio (K) / Dublin: 1999 Arthouse (K); Gra-

phic Studio Gall. / 2002 New Delhi, Queens Gall.; Kalkutta, Gal. 88 / 2005 Edinburgh, Edinburgh Printmakers; Univ. of Nottingham / Cambridge: 2008 Kettles Yard; 2013 Univ. of Kent, Studio 3 / 2008 Seoul, Andante Gall. ⊡ GEA, Printmakers, 1985. – *G. Whale*, Print quart. 14:1997 (3) 303–306; ArtRev 1997 (Dez./Jan.) 50 s.; *R. Anthony*, Mod. painters 11:1998 (4) 96; *E. Lovatt*, Printmaking today 8:1999 (1) 16; *C. Courtney*, Speaking of book art, Los Altos Hills, Calif. 1999; *S. Turner*, Art and Australia 37:1999 (1) 147 s.; Concerning memory (K London Inst.), Lo. 2000; Poliitiline/poeetiline. Tallinna XIV Graafikatriennaal (K), Tallinn 2007; I called when you were out (K Kettle's Yard), C. 2008; Lost and found (K Chelsea College of Art and Design), Lo. 2010; *F. Singer*, Print quart. 27:2010 (1) 79 s. – London, BM: Archival Sound Recordings v. 26. 2. 1997, 21. 5. 1997 und 23. 7. 1997.
 H. Stuchtey

Cole, *Archibald George* cf. **Cole,** *Richard*

Cole, *Dave*, US-amer. Bildhauer, Installations- und Konzeptkünstler, * 1975 Lebanon/N. H., lebt in Providence/R. I. Stud.: bis 1997 Landmark College, bis 2000 Brown Univ. Ausz.: 2009 Rappaport Prize. – C. gestaltet mit aufwendigen Herstellungstechniken Installationen und Objekte zu den Themen Patriotismus, Gewalt, Krieg, Religion und Identität. Zentral ist seit 1998 die Stricktechnik (*Steel Wool Cap and Muffler*, 1998), die er durch überdimensionale Arbeiten aus einer eigentlich priv. Handarbeit in den öff. Raum transferiert. In einer Installation vor dem Massachusetts MCA, North Adams, fertigen 2005 zwei Bagger mit Telephonmasten als riesige Stricknadeln eine ca. 11 x 6 Meter große US-amer. Flagge. Für Babykleidung verstrickt er Para-Aramid-Fasern, aus denen sonst schußsichere Westen hergestellt sind (*Bullet-Broof Sweater*, 2001), für einen fast 5 Meter hohen und breiten *Teddybear* (2003) rosafarbene Glasfaserisolierungswolle und für das *Money Dress* (2006) 879 aus zu Fäden aufgeschnittene Eindollarscheine. U. a. als Hommage an Jasper Johns beschäftigt sich C. wiederholt mit Darst. der US-amer. Flagge und kreiert sie z.B. aus farbig gemalten minutiösen Plastiksoldaten (*Memorial Flag*, 2005), aus Geschossen in metallischen Farbtönen (*Bullet Flag*, 2008) sowie bes. eindrucksvoll aus gesammelten rostigen Kleinmetallteilen wie Schrauben, Unterlegscheiben, Zahnrädern und Stahlbolzen (*American Flag [Rust]*, 2010). Seine größte Flagge fertigt er aus 192 internat. Flaggen, die er auseinanderschneidet, farblich sortiert und zu einem 8,5 Meter langen Patchwork-Wandbehang zusammensetzt (*Flags of the World*, 2008). Krieg und Gewalt sind 2008–10 Thema in *Knitting with loaded shotguns (Safeties off)*, einem mit Schrotgewehren gestrickten Schal aus speziell für diesen gesponnenen Bronzefäden, in *Leaves of Grass* (2010), einer „Wiese" aus Geschossen, sowie in aus verflüssigtem Salz gegossenen Platten (*Salt Print Flag [La Somme 1916]*) mit Abdrücken der ersten militärischen Panzer. C. zeigt mit der Verarbeitung intellektuell bedeutsamer Mat. neue Perspektiven und Konnotationen auf und überbrückt die Spanne zw. politischer Assemblage und konzeptuellem künst-

lerischem Schaffen. ⌂ FRAMINGHAM/Mass., Danforth Mus. LOUISVILLE/Ky., 21C Mus. NORTH ADAMS, Massachusetts MCA. PROVIDENCE, Rhode Island School of Design, Mus. of Art. ◉ *E:* 2006, '08 Boston, Judi Rotenberg Gall. / 2010 New York, Dodge Gall. / 2011–12 West Palm Beach, Norton Mus. of Art. ▭ *S. Hill,* Art New England 24:2003 (6) 18; 30:2008/2009 (1) 43; *D. Plummer,* ibid. 28:2007 (1) 34; *D. R. McFadden u.a.,* Radical lace and subversive knitting (K), N. Y. 2007; *S. Hung/ J. Magliaro,* By hand. The use of craft in contemp. art, N. Y. 2007; *N. Banai,* Mod. painters 20:2008 (9) 99; *J. R. Epstein,* Art news 107:2008 (9) 175; *J. Poser,* Art education 61:2008 (2) 80–86; *F. Koslow Miller,* Artforum internat. 47:2008 (3) 356; *D. Norris,* Art New England 31:2010 (2) 12 s.; *M. Perkins,* Textile fibre forum 29:2010 (3) 32 s.; *R. Ayers,* Art news 110:2011 (1) 116; *M. Israel,* AiA 99:2011 (Jan.) 113. – *Online:* Website C.

H. Stuchtey

Cole, *Ernest* (Kole, *Ernest Levi Tsoloane*), südafrikanischer Fotograf, Fotojournalist, * 21. 3. 1940 Township Eersterust b. Pretoria, † 18. 2. 1990 New York. Bis 1955 wächst C. bei seiner Tante in Onverwacht b. Pretoria auf. 1960 wird er im Zuge des Group Areas Act mit der Fam. nach Mamelodi (Township b. Pretoria) umgesiedelt. Angesichts der diskriminierenden Bantu-Erziehung verläßt C. 1956 die Schule. Nach einer Lehre bei einem chin. Fotografen und Hilfstätigkeiten in der Red. der Zs. Zonk arbeitet er 1958–60 als Dunkelkammer-Ass. für Jürgen Schadeberg, den leitenden Fotografen der Zs. Drum. Parallel belegt er einen Fernkurs am New York Inst. of Photogr.; anschl. ist er für die Ztg Bantu World (heute The Sowetan) sowie als Freelancer für Associated Press tätig (u.a. Bild-Veröff. in Drum, Rand Daily Mail, Sunday Express und New York Times). Nachdem es ihm gelingt, seinen Status von „black" auf „coloured" ändern zu lassen, hat C. 1959–66 die Möglichkeit, landesweit die Auswirkungen des Apartheid-Regimes auf die schwarze Bevölkerung Südafrikas zu dokumentieren. 1966 verläßt er das Land mit der Absicht, seine Aufnahmen in einem Buch zu veröffentlichen, das 1967 auf Vermittlung der Agentur Magnum in New York erscheint und seine Ausbürgerung zur Folge hat. Fortan ist C. staatenlos. In den USA erhält er zw. 1967 und '71 wiederholt Förderungen der Ford Found. für zwei geplante Buchprojekte u.d.T. *A Study of the Negro Family in the Rural South* und *A Study of Negro Life in the City,* die jedoch nicht realisiert werden. 1969–75 reist er mehrfach nach Schweden, wo er mit der Gruppe Tio fotografier zusammenarbeitet. Ab M. der 1970er Jahre sind keine weiteren fotogr. Arbeiten bekannt. C. lebt teilw. obdachlos in New York, unterbrochen von mehreren Aufenthalten in Europa. Biogr. Fakten sind nur bruchstückhaft bek. (cf. Knape 2010). C.s südafrikanische Fotogr. aus den 1960er Jahren werden wiederholt vom African National Congress (ANC) und versch. and. politischen Organisationen abgedruckt. – C. gilt als erster schwarzer Fotojournalist in Südafrika. Sein schmales Werk umfaßt neben den Aufnahmen aus seinem Heimatland nur die Arbeiten aus den USA zw. 1967 und A. der 1970er Jahre. Es sind keine erhaltenen

Negative und nur wenige Originalabzüge bekannt. – Foto-Publ.: *House of Bondage,* N. Y. 1967; *My Country, My Hell!* In: Ebony 23:1968 (4) 58–72 (ill. mit zahlr. eig. Fotogr.). ⌂ GÖTEBORG, Hasselblad Found. LONDON, V & A. STOCKHOLM, Mod. Mus. ◉ *E:* 1985 Göteborg, Fotograficentrum / 2010 Johannesburg, AG (Retr.; Wander-Ausst.; K). –. *G:* Stockholm: 1970 Liljevalchs KH: Foto/Film/Bild (K; in reduzierter Form 1971 in der KH Göteborg gezeigt); 2009 Mod. Mus.: Reality Revisited / 1990 Göteborg, Hasselblad Center: Arbete pågår (K). ▭ *D. Willis-Thomas,* An ill. bio-bibliogr. of black. photographers, N. Y./Lo. 1989; *P. M. Saint Léon/N. Fall* (Ed.), Anthologie de la photogr. africaine et de l'Océan indien, P. 1999. – *R. Hassner,* E. C., 1969 (Interviewfilm im Rahmen der Reihe Bilder för miljoner, Erstausstrahlung am 8. 6. 1969 im schwed. Fernsehsender SR); *J. Lelyveld,* Move your shadow, N. Y. 1985; New York Times v. 19. 2. 1990 (Nachruf); *M. Panzer,* Things as they are. Photojournalism in context since 1955, Lo. u.a. 2005; *M. Parr/G. Badger,* The photobook. A hist., II, Lo. 2006; *D. Newbury,* Defiant images. Photogr. and apartheid South Africa, Unisa 2009; *F. Asfour,* Camera Austria 112:2010, 69–71; *G. Knape* (Ed.), E. C. Photographer, Göttingen 2010 (Lit.); *D. Newbury,* Hist. of photogr. 35:2011 (1) 76–80; *S. Stein,* Aperture 204:2011, 74 s. P. Freytag

Cole, *Richard (Richard Anthony),* brit. Cartoonist, Karikaturist, Illustrator, Graphiker, Maler, Bildhauer, Kunsterzieher, * 19. 8. 1942 Wimbledon/London, lebt in London. Sohn des Holzschnitzers Archibald George C. Gestaltet bereits als Schüler ab 1957 Titelbilder für das Mag. Audio Record Rev. (später Hi-Fi News). Stud. (Malerei): 1960–63 Wimbledon SchA, London; 1964 Brigthon College of Art, Brighton. 1965–70 Kunsterzieher an der France Hill Comprehensive Grammar School, Camberley/Surrey, und an der Woking Grammar School, Woking/Surrey. 1970 Publ. erster politischer Karikaturen in der Ztg Kingston Borough News, Kingston-upon-Thames. Cartoons, Karikaturen und Ill. entstehen seither u.a. für die Ztgn The Times (1973–87), Sunday Times (1973–95), Daily Express (1978–80), Daily Telegraph (1988–2001), The Guardian und Sunday Telegraph (beide ab 1995). Auch Arbeiten für die TV-Sendungen Panorama und Tonight der BBC sowie für Channel 4 News und CBS News. Zudem humoristische Buch-Ill., u.a. zu *George Brown's Rules for Vintage Golfers* (Pulborough 1997) v. David Atkins; *For the Time Being* (Lo. 1998) v. Dirk Bogarde. – C. zeichnet linienbetonte, z.T. mit kräftigen Schraffuren versehene, anfangs noch von David Low und der Druckgraphik des dt. Expressionismus beeinflußte Portr.-Karikaturen, die meist starke Übertreibungen in der Darst. der Physiognomie zeigen (Tuschfeder und -pinsel; Kreide; Aqu.). Auch freie Malerei (u.a. Motive aus St-Geoiren-Valadine; karikierende Portr.); Druckgraphik; Holz-Skulpt. ⌂ BASEL, Karikatur & Cartoon Mus. CANTERBURY, Univ. of Kent, Brit. Cartoon Arch. LONDON, Bank of England Mus. – BM. – Wimbledon Lawn Tennis Mus. ◉ *E:* 1981, '82 Cambridge, Heffer Gall. / 1989 London, Edwin Pollard Gall. – *G:* 1968 Belfast, Northern Ireland

Arts Council Gall.: Open Paint. Exhib. ⌑ *M. Bryant/ S. Heneage* (Ed.), Dict. of Brit. cartoonists and caricaturists 1730–1980, Aldershot 1994; *M. Bryant*, Dict. of twentieth-c. Brit. cartoonists and caricaturists, Aldershot 2000; *Buckman* I, 2006. – *P. Maddocks*, Caricature and the cartoonist, Lo. 1989. – *Online:* Brit. Cartoon Arch., Univ. of Kent, Canterbury; Commission a Portr., London.

H. Kronthaler

Cole, *Willie*, US-amer. Assemblagekünstler, Installationskünstler, Graphiker, * 1955 Somerville/N. J., lebt in Mine Hill/N. J. Stud.: 1974–75 Boston Univ. School of FA; danach in New York 1976 School of Visual Arts, bei Rosalind Jeffries, und 1976–79 Art Students League. Artist in Residence: 1989 Studio Mus., Harlem/New York; 2000 John Michael Kohler AC, Sheboygan/Wis. Ausz.: 2006 David C. Driskell Prize, High Mus. of Art, Atlanta/Ga. – Nach kommerziellen graph. Arbeiten und Ill. arbeitet C. ab 1983 freischaffend, 1982–87 mit eig. Gal. („Works") in Newark. Mit Wiederholung, Stapelung, Symmetrie- und Musterbildung und einer durchdringenden, kunstfertigen Konstruktion verwandelt C. prosaische Objekte in originelle, elegante, visuell ansprechende und humorvolle Assemblagen und Installationen, die sinnbildlich seine afro-amer. Identität widerspiegeln oder Kritik an der Konsumkultur und politischen Strukturen ausdrücken. Seit M. der 1980er Jahre ist das Dampfbügeleisen als häusliches, künstlerisches (Ready-made) und symbolisches Objekt (Dienstmädchenarbeit) sein Medium, mit dem er ab 1988–89 Muster auf Papier, Lw., Matratzenauflagen und Gips druckt bzw. einbrennt und so dekorative Blüten (*Sunflower*, 1994), aber auch ethnogr. erscheinende Masken kreiert (*Domestic I. D., IV*, 1992: New York, MMA). Konstruktionen aus Bügeleisenteilen (*Sunbeam*, 1989; Stanford, Cantor AC) spielen an anthropomorphe Fetischfiguren und Masken der afrikanischen Kunst oder aus Neuguinea an. Der 2,7 Meter lange Holzblockdruck *Stowage* (1997) bezieht sich auf eine Zchng des überfüllten Sklavenschiffs Brooke; um die schiffsförmige Kontur eines Bügelbretts sind hierzu 12 Medaillons mit verschiedenartigen Bügeleisenflächen angeordnet, die von in den Druckstock eingelassenen echten Bügeleisen gedruckt werden. C.s weitere bevorzugte, seriell hergestellte Arbeits-Mat. sind Haartrockner (*Wind Mask East II*, um 1990), hochhackige Schuhe, die oft kreisförmig zu großen Wandbildobjekten angeordnet sind, sowie die rassistischen schwarzen „Lawn Jokeys", Zierfiguren für den Garten, die C. dekoriert, um z.B. an die nigerianische Gottheit Eshu-Elegba anzuspielen oder sie für überdimensionale Brettspiele zu verwenden (*To get to the other side*, 2001). 2002 gestaltet er eine afrikanischen Tieren ähnelnde Assemblage-Serie aus Fahrradteilen (*Speedster tji wara*, 2002) und 2001 in Orig.-Größe das Auto H2O aus 3000 Plastikwasserflaschen. Die Titel geben Hinweise auf die Bed. der Assemblagen und verweisen mehrfach auf C.s Beschäftigung mit der Theologie und Phil. der Yoruba-Religion. Seit A. der 1990er Jahre reproduziert C. Bügeleisenbranddrucke auch als Lith. und Siebdrucke, so daß durch Farbdruck strahlende Blüten und Mandalas entstehen (*Pressed Iron Bol-*

lom; Stanford, Cantor AC). Innovativ sind C.s Digitaldrucke, auf denen Bügeleisensohlen wie männliche Stammestrachten wirken (*Men of Iron*; *Silex Male, Ritual*, beide 2004) sowie Farb-Lith. mit gitterartigen Mustern aus hochhackigen Schuhen (Serie *Rapture*, 2008), die an bedruckte afrikanische Stoffe erinnern. Zahlr. Tusche-Zchngn mit v.a. schwarzen Flächen und weißen Konturen illustrieren häufig Texte und Titel von Blues-Songs (*Crossroad Blues*, 2010). – Ähnlich wie David Hammons und in der Trad. der Arte povera überbrückt C. mit der Verwendung gebrauchter Objekte Gegenwart und Vergangenheit, integriert das Vermächtnis der afro-amer. Kunst und bezieht Stellung zu ges.-politischen Themen. ⌑ ATLANTA, High Mus. of Art. BIRMINGHAM/Ala., Mus. of Art. CHICAGO, MCA. CLEVELAND, Mus. of Art. DALLAS, Mus. of Art. DETROIT, Inst. of Arts. ITHACA/N. Y., Johnson Mus. of Art. LINCOLN/Nebr., Sheldon Memorial AG. LOUISVILLE/ Ky., Speed AM. METZ, FRAC Lothringen. MINNEAPOLIS, Walker AC. NEWARK/N. J., Mus. of Art. NEW HAVEN, Yale Univ. AG. NEW JERSEY, Montclair AM. NEW YORK, Amer. Acad. of Arts and Letters. – Bronx Mus. of the Arts. – Metrop. Mus. – MMA. – Public Libr. – Whitney. OBERLIN/ Ohio, Allen Memorial AG. PALO ALTO/Calif., Palo Alto Univ. PHILADELPHIA, Mus. of Art. – PAFA. RICHMOND, Virginia MFA. ROCHESTER/N. Y., Memorial AG of the Univ. of Rochester. ST. LOUIS/Miss., AM. SANTA BARBARA, Univ. of California, AM. TAMPA, Mus. of Art. TORONTO, AG of Ontario. WASHINGTON/D. C., NG of Art. WEST PALM BEACH, Norton Mus. of Art. WORCESTER/ Mass., AM. ⊙ *E:* 1992 St. Louis, AM (K) / 1995 Philadelphia, Rosenwald-Wolf Gall. (K) / 1998 Birmingham, Mus. of Art (K) / 1999 Southampton (N. Y.), Avram Gall., Southampton College, Long Island Univ.; Miami, AM / New York: 1990 Inst. for Contemp. Arts, PS1; 1991 Brooke Alexander; 2000, '02, '06, '10 Alexander and Bonin; 2001 Bronx Mus. of the Arts (K); 2008 MAD; 2010 James Gall., City Univ. of New York (Wander-Ausst.) / 2002 Easton (Pa.), Grossman Gall., Lafayette College / 2003 Cornish (N. H.), Saint-Gaudens Memorial Picture Gall. / 2004 Tampa, Mus. of Art (K) / 2004–06 Laramie, Univ. of Wyoming AM (Wander-Ausst., K) / 2006–08 Montclair (N. J.), AM (Wander-Ausst., K) / 2007 Houston, Finesilver Gall. / 2009 Hartford (Conn.), Amistad Center for Art and Culture, Wadsworth Atheneum Mus. of Art; Katonah, Mus. of Art / 2010 Ewing, College of New Jersey, AG; Akron (Ohio), AM; Glassboro (N. J.), Rowan Univ. AG (Wander-Ausst., K) / 2012 East Hampton, Eric Firestone Gall.; Hamilton, Grounds for Sculpt. / 2013 Richmond, Center for Visual Arts, Western Michigan Univ. ⌑ *Delarge*, 2001. – *M. Leach*, W. C. From our house to your house (K Mint Mus. of Arts), Charlotte, N. C. 1991; *R. Upshaw*, AiA 82:1994 (5) 107 s.; *M. Odom*, Artforum 34:1996 (7) 105; *J. Rian*, Flash art 30:1997 (197) 120; *W. Weitman*, New concepts in printmaking 2. W. C. (K MMA), N. Y. 1998; *E.-L. Huberty*, Sculpt. (Wa.) 19:2000 (6) 69 s.; *S. Gaché*, ibid. 20:2001 (1) 24–29; *C. Bernard*, NKA. J. of contemp. African arts 15:2001 (Herbst/Winter) 64–69; *C. Chambers*, Flash art 35:2002 (227) 102 s.; *N. Prin-*

centhal, AiA 91:2003 (3) 117 s.; *S. Hill*, Art New England 25:2003–04 (1) 29; *S. Sumida*, Cantor AC j. 4:2004–05, 45 s.; Anxious objects. W. C.s favorite brands (K Montclair AM), Rutgers, N. J. 2005; *R. D. Cochrane*, Sculpt. 25:2006 (2) 24–29; *M. G. Nichols*, AiA 94:2006 (5) 146–151; *J. Collins*, Sculpt. today, Lo./N. Y. 2007; *W. Koenig*, Art papers 31:2007 (4) 55; *J. Borgatti*, African arts 42:2009 (2) 12–23; *N. Princenthal*, AiA 6:2010 (Juni/Juli) 187; *D. Frankel*, Artforum internat. 48:2010 (9) 249 s.; *J. B. Cutler*, Afterimage 38:2011 (5) 28 s. – *Online:* Website C. H. Stuchtey

Coleman, *Katharine*, brit. Glasgraveurin, * 6. 11. 1949 Sutton Coldfield/West Midlands, lebt in London. Stud.: 1967–70 Cambridge Univ. (engl. Lit.); 1984–87 Morley College, London, Glasgravur bei Peter Dreiser. 2004 und '07 Artist in Residence am Northlands Creative Glass Centre, Lybster. Lehrtätigkeit: West Dean College, Chichester. Mitgl.: 1992 Fellow, Guild of Glass Engravers (2002–05 Vors.); Art Workers Guild. Ausz.: 2006 Bes. Erw., Coburger Glaspreis; 2008 Pearsons Prize for Best Use of Glass in Engraving; 2009 Member of the Order of the Brit. Empire. – C. gestaltet mit Kupfer-, Stein- und Diamantscheiben geschnittenes und poliertes Überfangglas (klares Bleikristallglas mit dünner Haut farbigen Glases), das nach ihren Angaben von Künstlern wie David Hay, Carl Nordbruch, Neil Wilkin und in jüngster Zeit von Potter Morgan Glass und Sonja Klingler geblasen wird. Es entstehen schwere dickwandige Glasgefäße oder Glasstücke (z.B. Briefbeschwerer), deren auf der Außenseite angebrachte Gravuren auch auf der Innenseite sichtbar sind. Inspiriert wird C. v.a. von Naturformen, z.B. der Blütenpracht in den kaiserlichen Gärten in Tokio, die sie 2004 und '05 besuchte (*Chiyodaku*, 2004, Coburg, KS der Veste Coburg) oder dem Meeresleben und der Flora von Südaustralien. Nach Früchten (*Edo Orange II*, 2005) und Tieren (*Waltzing Crabs*, 2008) folgen seit E. der 2010er Jahre auch abstrakte Muster (*Stormy Seas Vase*, 2011) oder graph. Stadt-Lsch. (*City of Glass*, 2004, Kingswinford, Broadfield House Glass Mus.), daneben sind Zchngn des Zoologen Ernst Haeckel eine wichtige Inspirationsquelle (*Light Blue Haeckel Diatomea Bowl*, 2011). Mit hoher Kunstfertigkeit und Gestaltungskraft leistet C. einen bed. Beitrag zur zeitgen. Glasgravierkunst. ▱ Birmingham, City AG and Mus. Cambridge, Fitzwilliam Mus. Cheltenham, AG and Mus. Edinburgh, NM of Scotland. Gateshead, Shipley AG. Kamenicky Šenov, Glass Mus. London, V & A. Lybster/Caithness, North Lands Creative Glass. München, Alexander-Tutsek-Stiftung. Norwich, Castle Mus. and AG. Segovia, Mus. del vidrio, Real Fábrica de Cristales de La Granja. ◉ *E:* 2004 Kingswinford, Broadfield Glass Mus. / 2007 Laonon, Zest Gall. / 2008 (K), '11 Edinburgh, Scottish Gall. / 2009, '12 Paris, Gal. Hélène Porée. – *G:* 2012 München, Alexander-Tutsek-Stiftung: In the name of love (K). ▭ *M. und T. Goodearl*, Engraved glass. Internat. contemp. artists, Woodbridge 1999; *R. Pavey*, Crafts 2004 (Juli/Aug.) 30–33; *J. Neiswander/C. Swash*, The intelligent layman's book of stained and art

glass, Lo. 2005; *K. Weschenfelder* (Ed.), Coburger Glaspreis für zeitgen. Glaskunst in Europa 2006 (K), Coburg 2006; *J. Matcham/P. Dreiser*, Techniques of glass engraving, Lo. 2006; *T. de Beaumont*, La rev. de la céramique et du verre 169:2009 (Nov./Dez.) 52–55; *R. Watban*, Neues Glas 4:2011 (Winter) 40–45. – *Online:* Website C.

H. Stuchtey

Coler, *Peter*, dt. Maler, Graphiker, Zeichner, Bildhauer, * 13. 12. 1940 Fürstenberg (Oder), lebt seit 1945 in Bayreuth. Autodidakt. Nach dem Stud. (Verwaltungs-Wiss.) ist C. bis zur Pensionierung im gehobenen Dienst (Fernmeldewesen) tätig. Hat ab 1957 Kontakt zur Freien Gruppe in Bayreuth, wo er den Maler und Bühnenbildner des Festspielhauses Ferdinand Röntgen kennenlernt, der auf C.s realistische und gegenstandsbezogene künstlerische Haltung Einfluß hat. 1971 erste Ausst.-Beteiligung; ab 1972 Mitgl. im Berufs-Verb. bild. Künstler. Mitbegr. des Ver. Freie Gruppe und 1980 des Bayreuther KV, in denen er aktiv mitwirkt. Lehrtätigkeit: seit 1981 Doz. Volks-HS in Bayreuth; 1988 Lehrauftrag an Univ. ebd. Häufige Malreisen nach Italien, Frankreich, Österreich, Schottland und Skandinavien. Ausz.: 2004 Kulturpreis der Stadt Bayreuth; 2007 Kunstpreis der Ztg Nürnberger Nachrichten. – V.a. von Neuer Sachlichkeit und expressivem Realismus inspirierte Lsch. (auch Bergpanoramen und Seestücke), Archit.-Darst., Figurenbilder und Interieurs. Die mit pastosem, flächigem Farbauftrag versehenen häufig großformatigen, zumeist verortbaren Lsch. (Öl, Acryl, Aqu.) wirken anfänglich einsam, melancholisch, bisweilen seltsam stilisiert und unwirklich (Salzburger Land, Franken, Schottland, Toskana). Char. sind die bisweilen staffagehaft plazierten (Nacht-)Gänger oder sich gegen den Wind stemmenden Figuren in narrativen Winter- und Sommer-Lsch. sowie dahineilende oder in der Ferne verschwindende weibliche Passanten. In den letzten Jahren auch Straßen- und Interieur-Darst. aus ungewöhnlicher Perspektive; der Blick des Betrachters wird dabei auf beschuhte Beine bzw. den unteren Körperteil von dahineilenden oder Hauseingänge betretenden Passanten fokussiert. Im Spätwerk häufig Lsch.-Darst. mit subtil oder kraftvoll erfaßten atmosphärischen Erscheinungen (Abend- und Morgenlicht), auch mit dramatischen Wolkenbildungen (*Abziehendes Gewitter*; *Tiefdrucklage*, beide Öl). Daneben Buch-Ill. (S. Habermann, *Alte Bayreuther Fassaden*, Bayreuth 1983; 31 Zchngn), auch Plastiken (Stein, Bronze) sowie Wand- und Brunnen-Gest. im öff. Raum (u.a. 1989 in der Eingangshalle der Dt. Telekom, Bayreuth; 1991 Kantine Arbeitsamt ebd.). ▱ Ankara, Goethe-Inst. Bad Winsheim, Stadtverwaltung. Bamberg, Diözesan-Mus. Bayreuth, Stadtverwaltung. – Univ. München, Lenbachhaus. Nürnberg, Mus. für Kommunikation. Rauris/Salzburg, Gemeindeverwaltung. Salzburg, Stadtverwaltung. ◉ *E:* 1975 Hof, Hypo-Gal. (Debüt) / 1981 Salzburg, Traklhaus / Bayreuth: 1983, '87, '98 Neues Rathaus; 1988 (K), 2005 KV; 2007 Altes Schloß / 1992 Plauen, Theaterfoyer / 2008 Passau, Diözesan-Mus. – *G:* u.a. 1971 Bayreuth, Ermitage: Kunst-Verb. / 1978 Istanbul, Gal. Taksim Sanat: Malerei und Grafik der Freien Gruppe Bayreuth (K; Ausst. des Dt..

Kultur-Inst. in Ankara und İzmir) / München: 1987 Haus der Kunst: Große Kunst-Ausst.; 1989 Gal. der Bayrischen Landesbank: Bayerns Lsch. heute (K). ⊡ Kürschners Hb. der Bild. Künstler. Deutschland, Österreich, Schweiz, I, M./L. 2007. – *S. Stiehl*, Bayerns Lsch. Von heimischen Malern neu entdeckt (K München), Dachau 1989. – *Online:* Website C. (Ausst.). U. Heise

Coley, *Nathan*, brit. Installations-, Objekt- und Videokünstler, Fotograf, Zeichner, * 1967 Glasgow, lebt dort, 1998–2005 in Dundee tätig. Stud.: 1985–89 SchA, Glasgow. Ausz.: u.a. 1992 Aufenthalt im Crawford AC, St. Andrews; 1997 RSA Art for Archit. Award, London; 2001 Creative Scotland Award, Scottish Arts Council, Edinburgh; Henry Moore Fellowship, Univ. of Dundee; 2007 Nominierung für den Turner Prize, London. – Das Hauptthema von C.s vielfältigen Arbeiten ist die Archit., die er u.a. in Bezug zu politischen und ges. Fragestellungen setzt. Untersuchungsgegenstände sind dabei nicht nur Gebäude, sondern Orte, auf denen Bauwerke errichtet wurden oder werden sollen oder sogar ganze Städte. Dazu nutzt er versch. Medien und Herangehensweisen, denen stets intensive Recherchen vorausgehen. In der Installation *Pigeon Lofts* (1997) werden mittels Dia-Show auf humorvoll-ironische Weise 39 von Laien konstruierte, in Glasgower Hinterhöfen errichtete Taubenhäuser präsentiert und von einer neutralen Stimme im Stile einer Beschreibung für den Immobilienmarkt kommentiert. 1997 erhält C. von der Stills Gall. in Edinburgh den Auftrag, ein Kunstwerk zur urbanen Entwicklung der unmittelbaren Umgebung zu schaffen. C. schlägt die Errichtung eines städtischen Zufluchtsortes *Urban Sanctuary* vor, konsultiert dazu mehrere Experten wie einen Stadtplaner, einen Theologen und einen Polizisten, um alle erforderlichen Baukriterien dafür zu ermitteln. Er verwirklicht den Auftrag letztendlich in Form einer Buch-Publ., die u.a. die oben beschriebenen Interviews enthält. 2000 baut C. für die Installation *The Lamp of Sacrifice. 161 Places of Worship, Birmingham 2000* die Gebäude aller im Birminghamer Branchenverzeichnis aufgeführten Andachtsorte sämtlicher Konfessionen und Glaubensgemeinschaften als Pappkarton-Modelle nach; das gleiche Projekt führt er 2004 für die Stadt Edinburgh durch (*The Lamp of Sacrifice. 286 Places of Worship, Edinburgh 2004*). 2002 wird er im niederl. Kamp van Zeist inoffizieller Artist-in-Residence-Beobachter beim Prozeß um den Lockerbie-Anschlag (1988), einem Bombenanschlag auf ein US-amer. Personenflugzeug, das im schott. Lockerbie abstürzt. Für das gleichnamige Projekt von 2003 fertigt er wie ein Gerichtszeichner Zchngn von Fotogr. einiger Beweisstücke und fertigt eine maßstabs-, detail- und mat.-getreue Nachbildung des Zeugenstandes an. Des weiteren initiiert er den Ankauf des orig. Zeugenstandes durch die Imperial War Mus. in London. Zu C.s letzten Arbeiten gehören neben einer Serie von Bleistift-Zchngn u.a. die Arbeit *The Ballast Project* (2011), eine gemauerte Wand an der nördlichen Eingangshalle des neuen Gebäudes des Scheepvaart-Mus. in Amsterdam, ausgef. mit aus der Kolonialzeit stammenden, aus den ehemaligen niederl. Kolonien zu C.s

Zwecken reimportierten Ziegelsteinen, sog. IJsselsteentjes. ⊡ EDINBURGH, NG of Scotland. LEIPZIG, Gal. für Zeitgen. Kunst. LONDON, Brit. Council Coll. ◉ *E:* 1992 St. Andrews, Crawford AC (K) / 1996 Stockholm, Gall. Index (K) / 1997 Berlin, Pavillon der Volksbühne (mit Thomas Bechinger; K) / Edinburgh: 1997 Stills Gall. (K); 2004 Fruitmarket Gall.; 2007 Doggerfisher Gall. / 1998 Stirling, The Changing Room (K) / 2001 Lissabon, Centro Cult. de Belém (K) / 2003 Portsmouth, Portsmouth Cathedral (K) / 2005, '12 London, Haunch of Venison Gall. / 2006 Isle of Bute, Mount Stuart (K) / 2009 Bergen, KH / 2010, '11 (K) Melbourne (Vic.), Austral. Centre for Contemp. Art. – *G:* 1990 Bergen, Hordaland Kunstsenter: Fem fra Glasgow / Glasgow: 1991 Seamen's Mission: Windfall (K); 1994 Centre for Contemp. Arts (Wander-Ausst.; K); 1996 Old Fruitmarket: Girls' High (K); 1997 Glasgow Print Studio: Blueprint (K) / 1994 Llandudno, Oriel Mostyn Gall.: Riviera (K) / Edinburgh: 1995 Travelling Gall., City AC: Swarm (K); 1999 City AC: Without Day (K); 2009 Scottish NG of Mod. Art: The enlightenments (K) / 1997 Berlin, Martin-Gropius-Bau: Korrespondenzen (Wander-Ausst.; K) / 1998 Liverpool, Tate Gall.: Artranspennine (K); Melbourne, MMA at Heide: Strolling (K) / 1998 (I skuggan av ljuset; K), 2000 (What if; K) Mod. Mus. / Birmingham: 1999 Bournville Centre for Visual Arts : In the Midst of Things (K); 2000 Ikon Gall.: as it is (K) / 2000 Münster, Westfälischer KV: Inside Out (K); Jahresgaben; New York, Printed Matter: Contemp. Scottish Artists Books (Wander-Ausst.; K) / 2001 Karlsruhe, ZKM, Medien-Mus.: Circles 3 (K); Dundee, Dundee Contemp. Arts: Here and Now (K); Luxemburg, Casino Luxembourg: Audit (K) / 2002 Warschau, Zachęta: Szczęśliwi outsiderzy z Londynu i Szkocji (K); Manchester, Cube Gall.: Fabrications (K) / 2003 London, Tate Britain: Tate Trienn. of Contemp. Brit. Art (K) / 2005 Gateshead: Baltic Centre for Contemp. Art: Brit. Art Show (K) / 2008 Friedrichshafen: Trienn. zeitgen. Kunst Oberschwaben (K); Leeds, Henry Moore Inst.: Prospects and Interiors (K) / 2009 (Nichtorte, Orte), '10 (Häuser, Gesichter) Leipzig, Gal. für Zeitgen. Kunst / 2011 Hamburg, Deichtorhallen: Wunder (Wander-Ausst.; K). ⊡ *Buckman* I, 2006. – *U. Loock*, Glasgow (K), Bern 1997; *J. Strømodden* (Ed.), Nettverk – Glasgow (K Mus. for Samtidskunst), Oslo 1998; *R. E. Pahlke* (Ed.), The Gap Show. Junge zeitkrit. Kunst aus Großbritannien (K), Dortmund 2002; *I. Carlos* (Ed.), Bienn. of Sydney 2004. On reason and emotion (K), Sydney 2004; *F. Bradley* (Ed.) N. C. There will be no miracles here, Edinburgh 2004; *T. Dean/J. Millar*, Ort, Hildesheim 2005 (Art works); *J. Collins*, Sculpt. today, Lo./ N. Y. 2007. – *Online:* Website C. J. Niegel

Colin, *Gianluigi*, ital. Fotograf, Performancekünstler, Copy-art-Künstler, Videokünstler, Publizist, * 13. 9. 1956 Pordenone, lebt in Mailand und Rom. C. ist Art-Dir. der Ztg Corriere della sera (Mailand), für die er auch Kritiken über Fotogr., Visuelle Kommunikation und Design schreibt (u.a. G. C. [Ed.], *Formato Corriere*, Ud. 1990); auch zahlr. Beiträge u.a. in Kat. und eig. Künstlerbüchern. Lehrtätigkeit: 1989–96 Univ. Cattolica, Mailand;

1998–2000 Ist. di Conservazione dei Beni Cult., Univ. di Parma. Ausz.: 1999, 2001, '02, '03 Award of Excellence – The News Design; 2000 Premio Friuli Venezia Giulia per la Fotogr.; 2001 Premiolino – giornalista del mese nell'anno; 2001, '03, '04 The Europ. Newspaper Design Award. – C. arbeitet mit der Dekonstruktion von aktuellen Presse-Fotogr. und von Bild-Mat. aus der Kunstgesch., das im kollektiven visuellen Gedächtnis verankert ist. C. sucht damit im Gegensatz zum täglichen Umgang mit der globalen Bilderflut bei seiner Red.-Arbeit den Fluß der Bilder anzuhalten und die Realität dahinter auszuloten. Er montiert und überlagert dafür bek. Ikonen aus der Kunstgesch. von Schmerz, Leid und Kriegsgreueln (u.a. von Francisco Goya, Eugène Delacroix, Piero della Francesca) mit aktuellen und hist. (Presse-)Fotografien. Dabei sucht er bildliche Archetypen herauszuarbeiten, indem er auf wiederkehrende Motive und Pathosformeln abhebt (z.B. *Presente stor.*, ab 1998; *Piero e il suo doppio*, 2004; *Mythografie*, 2009–11). Mit *Flash back* (2002) reagiert C. auf den Anschlag des 11. 9. 2001; für *I bambini di Roman* (2003) bearbeitet er Kinder-Portr. von Roman Vishniak aus dem jüdischen Alltagsleben im Osteuropa der 1930er Jahre, mit *Liturgie* (2008) hinterfragt er politische Wahlpropaganda. C. bearbeitet dabei schwarzweiße und farbige Bilder und Seiten aus Ztgn, die er fotokopiert, collagiert oder in Überlagerungen montiert. Er knüllt auch Schlagzeilenseiten und Druckfotos und installiert sie objekthaft auf Bildträgern im Raum, oder er reproduziert und kopiert diese, auch in Bewegung oder mit Verzerrungen. Bei Copy-art-Performances bezieht er auch das Publikum und dessen private Dok. wie Fotos oder Briefe ein (*Vie di memoria*, ab 2001). Auch Videoarbeiten, wofür er seine Bildmontagen und –überlagerungen in das Bewegtbild überträgt und auch Filmausschnitte verfremdet, etwa bei *White noise* (2009) mit einem Film von Pier Paolo Pasolini. Für *Ti puoi fidare* (2008) fährt er eine kilometerlange Wand von Wahlplakaten mit feststehender Kamera ab. – Eig. Publ. und Kat: *Il disegno delle parole*, Mi. 1994; *Imprimatur. La fabbrica del presente* (K), Mi. 1998; *Presint storic* (K), s.l. 1999; *La fabrique du present* (K), Valence 2000; *Manufacturing the present* (K), Mi. 2002; *Wor(l)ds* (K), Va. 2009; *Cronos. Quel che resta della memoria* (K), Vr. 2011; *Borderline*, Mantua 2011. – ✉ Design delle pagine. La grafica, scrittura invisibile, in: F. Cevasco/D. de Stefano (Ed.), Come si scrive il Corriere della Sera, Mi. 2003; La tirannia della visione, in: U. Lucas (Ed.), L'immagine fotogr. 1945–2000, T. 2004, 685–700. – 👁 *E:* 1994, '96 Pordenone: Edit Expo / Mailand: 1998 Pal. dell'Arengario (K); 2003, '09 Fond. Mudima; 2007 Gall. Fotogr. Ital. (Wander-Ausst.; K) / 1999 New York, Uma Gall. / 2000 Villacaccia di Lestizza, I Colonos / 2003 St. Petersburg, Manege / 2003 (Wander-Ausst.), '05 (K; mit Danilo de Marco) Passariano, Villa Manin / 2008 Venedig, Spazio Thetis; Sansepolcro, Pal. Pichi Sforza (Wander-Ausst.; K) / 2011 Valencia, Ist. Valenciano de Arte Mod. (K); Verona, Centro Internaz. di Fotogr. Scavi Scaligeri (K). – *G:* Venedig: 1976 Fond. Bevilacqua la Masa: La memoria del Friuli; 2009, '11 Bienn. / Mailand: 1995 Circolo della Stampa: Omag-

gio a Buzzati; 2001 Pal. dell'Arengario: Tutto l'odio del mondo (K); 2006 Bel Vedere Fotogr.: Immaginario contemp. (K); 2009 Trienn. / 1999 Udine, Spazio San Francesco: Art design Italia / 2004 Sansepolcro, Pal. Inghirami: Piero e il suo doppio (Wander-Ausst.; K) / 2009 Valencia, Inst. Valenciano de Arte Mod.: Confines / 2010 Pordenone, Sale espos. provinciale: Il paesaggio ital. in fotogr. (Wander-Ausst.; K). ⌂ Non è mia moglie (K), s.l. 1989; Copyright FVG (K), Passariano 2000; Interrogatus respondit desiderava che fusse uno mondo nuovo (K), Montereale Valcellina 2003; Orientamenti (K), Villacaccia di Lestizza 2003; *M. Gentili* (Ed.), Vie di memoria (K), Mi. 2003; *G. C. u.a.*, Piero e il suo doppio. A proposito di Piero (K Sansepolcro), Bo. 2004; *A. Fiz* (Ed.), L'etica dell'immagine, T. 2006; *C. Ernè/W. Liva* (Ed.), Italia 1946–2006 (K), Ud. 2006; *F. Castelli* (Ed.), Assenze (K), Mi. 2007; *A. C. Quintavalle* (Ed.), Liturgie (K), Mi. 2008; *B. Rose* (Ed.), G. C. Déi (K Neapel), Mi. 2011 (Lit.). – *Online:* Website C. – Mitt. C. T. Koenig

Colina Puyol, *Miguel de la,* span. Architekt, Ingenieur, Apotheker, Fachpublizist, * 10. 12. 1885 Sopuerta/Vizcaína, † 28. 12. 1976 ebd. Ausb./Stud.: bis 1904 Inst. Prov. de Vizcaya; 1904–13 Esc. de Ing. Industriales, bei de Bilbao; 1914–19 Pharmazie an den Univ. von Oviedo, Barcelona, Madrid und Santiago de Compostela. In Sopuerta als Inspector Mpal de Farmacia, 1924 als Stadtrat und 1944–46 als Bürgermeister tätig. In den 1960er und 1970er Jahren veröff. er Artikel zu phil. und pharmazeutischen Fragen in El Oriente de Asturias (Llanes), La farmacia vizcaína (Bilbao) und Farmacia nueva (Ma.). – C. übernimmt neben ing.-technischen Arbeiten (u.a. in den 1920er Jahren Wasserbau; in den 1940er Jahren Stahlbetonverschalung) in Sopuerta mehrere archit. Projekte. Im Stadtteil La Baluga entwirft er die Umgestaltung der eig. Apotheke (1922) sowie zweier Gebäude, die er in Ferienhäuser begüterter Auftraggeber umwandelt (Fam. Iierro-San Martín, 1928–30; Fam. José María Quintana Garay, 1933). Diese großzügig ausgebauten Häuser orientieren sich an trad. Archit., v.a. an dem sog. regionalismo montañés, aber auch am engl. Landhausstil. Zur Ausstattung des ersten zählen u.a. ein repräsentativer Kamin, keramische Wanddekorationen (u.a. von Juan Ruiz de Luna), Kunstglasfenster (Wkst. Vidrieras de Arte in Bilbao) und von C. entworfene Tischlerarbeiten. Für die Fam. Quintana gestaltet er u.a. die Garage, 1952 einen Pelotaspielplatz im Garten und das Fam.-Grab in La Baluga. 🏛 Sopuerta, Arch. Mpal. ⌂ Bizkaia. Arqueol., urbanismo y arquit. hist., III, Bilbao 1991; *I. Etxabe Oribe*, Monogr. de pueblos de Bizkaia. Sopuerta, Bilbao 1997; *M. Paliza Monduate*, Los ingenieros y la práctica de la arquitectura. La obra de C., in: Espacio, tiempo y forma (Ma.), Ser. 7: Hist. del arte 13:2000, 401–430. M. Nungesser

Coll, *Juan* → **Col,** *Juan*

Collett, *Susan,* kanad. Keramikerin, Metallgestalterin, Graphikerin, * 1961 Toronto, lebt dort. Stud.: bis 1982 Central Technical SchA ebd.; 1985 KSch, Lacoste/Dept. Vaucluse; 1986 Cleveland Inst. of Art, Ohio. 2003 Artist in Residence, Sanbao Ceramic Art Inst., Jingdezhen/

Prov. Jiangxi. 2007 auf Einladung des FuLe Internat. Ceramic Mus. Aufenthalt in Fuping/Prov. Shaanxi, China (mit Reise-Stip. des Canada Council for the Arts). Ausz.: 2001 Winifred Shantz Award for Ceramists; 2002 2. Preis, Ernst and Young Great Canad. Printmaking Competition; 1992–94, '96, 2004, '06–09 Ontario Arts Council; 2009 Ehrenvolle Erw., World Ceramic Bienn. Korean Internat. Competition (CEBIKO), Icheon. Mitgl.: 2008 R. Canad. Acad. of the Arts; Internat. Acad. of Ceramics. – Die beiden Aufenthalte in China prägen C.s Schaffen in bes. Weise. Als Keramikerin arbeitet sie bevorzugt mit Paperclay (Papierton) und entwickelt ihre von Hand modellierten Formen in einem Spannungsfeld zw. Figuration und Abstraktion, Barock und Minimal art (A. Balint-Babos, 2011), Stabilität und Fragiliät, Stärke und Verletzbarkeit. Ferner sind Licht und Bewegung sowie Assoziationen an Naturvorgänge (Werden, Verwandeln, Vergehen) bei ihren Werken von Bedeutung. Die Plastiken der ersten Serien orientieren sich an klassischen Gefäßformen (z.B. Vasen oder Schalen), konterkarieren jedoch durch durchbrochene und damit lichtdurchlässige, rhythmisch bewegte Oberflächen deren Funktion als Behältnis (*Moire*, 2005–08; *Shale*, 2006–07) und bekunden somit C.s Interesse an konzeptuellen Ansätzen. C. präsentiert ihre Serien häufig in installativer Weise und postiert dabei die hellen Plastiken auf dunklen Sockeln (*Labyrinths*, 2007–09). Einige Werke sind direkt von Naturformen inspiriert, wie z.B. die farbig gestaltete Serie *Maze* (2009–10) von Korallenriffs oder Muschelclustern. Die mit dem keramischen Schaffen korrespondierenden graph. Bll. (Monotypien, Kaltnadel) in einer bizarren Formensprache vereinen gegenständliche Motive (Bäume, Zweige, Wolkengebilde, Brücken etc.) mit abstrakten linearen Elementen (Serien: *Thicket*, 2006–07; *Navigation*, 2008–10; *Tracing*, 2008–10; *Lineage*, 2010–11). 2004–07 gestaltet C. aus Kupfer die Serie *Flying Carpets*. 2007 entstehen in Fuping mit Strick umwickelte Keramikobjekte, wobei der mit Engobe getränkte und während des Brennvorgangs ausgebrannte Strick auf der Oberfläche ein netzartiges Gespinst hinterläßt. ⌷ BURLINGTON/Ont., Burlington AC. FUPING/Prov. Shaanxi, FuLe Internat. Ceramic Mus., Canad. Mus. ICHEON/Korea, World Ceramic Centre. LOS ANGELES, Kamm Coll. MIAMI/Fla., Trump Tower Miami. MONTREAL, Queen Elizabeth Hotel. – Bank of Montreal. OWEN SOUND/Ont., Tom Thomson Memorial Gall. SEVRES, MN de Céramique. TORONTO, Gardiner Mus. of Ceramic Art. – Open Studio Arch. – Koffler Gall. – Gladstone Hotel. WATERLOO/Ont., Canad. Clay and Glass Gall. ◉ *E:* Toronto: 1993, 2004 Prime Gall.; 1994 Gardiner Mus. of Ceramic Art; 1997 Faktorie Gall.; 2004 Open Studio; 2006 David Kaye Gall.; 2007 Sandra Ainsley Gall. (mit Anong Migwan) / 2004, '07 Waterloo, Canad. Clay and Glass Gall. / 2005 Montreal, Gal. Elena Lee / 2006 Burlington, Burlington AC (Installation Impluvium) / 2006, '09, '11 Bloomfield (Ont.), Oeno Gall. / 2008 Owen Sound, Tom Thomson Memorial Gall. / 2009, '11 Calgary, Weiss Gall. – *G:* Toronto, Ontario Crafts Council: 1989, '95 Ontario Craft '89 bzw. '95; 2007 A Vital

Mix. Celebrating 30 years / SOFA (The Internat. Expos. of Sculpt. Objects and Functional Art): 1999 Chicago, Mobilia Gall.; New York: 2006 Barbara Silverberg; 2008 Andora Gall. / 2011 Kecskemét: Internat. Trienn. of Silicate Arts / 2012 Yingge, New Taipei City Yingge Ceramics Mus.: Taiwan Internat. Ceramics Bienn. ⌑ *E. Cooper*, Contemp. ceramics, Lo. 2009; *A. Balint-Babos*, Ceramic rev. 2011 (Juli/Aug.) 60–63. – *Online:* Website C.

C. Rohrschneider

Collette, *Aubrey,* austral. Cartoonist, Comiczeichner und -texter, Illustrator, Maler, Kunsterzieher, * 5. 9. 1920 Colombo/Ceylon (Sri Lanka), † 8. 1. 1992 Melbourne. Sohn eines Fotografen. Vater der Textilkünstlerin *Cresside C.* (* 1950 Ceylon, lebt in Melbourne). Nach der Ausb. am R. College in Colombo zunächst dort selbst als Kunsterzieher tätig. 1943 Mitbegr. der avantgardistischen 43 Group. 1945–49 politischer und sozialkritischer Cartoonist der Ztg Times of Ceylon, danach des Ceylon Observer. 1961 emigriert C. nach einem einjährigen Aufenthalt in Großbritannien nach Australien, wo er anfangs als Illustrator für das Education Dept. of Victoria arbeitet. Publiziert Cartoons und Comic strips im Wochen-Mag. The Bull. (Sydney). Ab 1964 Editorial Cartoonist der Tages-Ztg The Australian, ab 1971 des Herald (Melbourne). Zeichnet auch Cartoons für zahlr. weitere Ztgn und Zss., u.a. für Asia Mag.; New York Times; Saturday Evening Times; The Straits Times (Singapur). Autor des humoristisch-satirischen Comic strips *Sun Tan, the Asian Sensation.* Ausz.: 1970 Walkley Award, Best Cartoonist of the Year. Ehren-Mitgl. der Cartoonists' Soc. of America. – Stark strichbetonte Bleistift- sowie Tuschfeder- und -pinsel-Zchngn. Auch expressiv-figurative Malerei, u.a. Motive aus Sri Lanka (z.B. *Tamil Labourers,* ca. 1954, Öl/Lw.), Tierbilder, Stilleben und karikaturhafte Portr. von Künstlerkollegen der 43 Group und der Ceylon Soc. of Arts (z.B. *Harry Pieris,* 1950er Jahre, Aqu.). ⌷ BRISBANE, State Libr. of Queensland. BALLARAT, AG of Ballarat. CANBERRA, Nat. Libr. of Australia. SYDNEY, State Libr. of New South Wales, Mitchell Libr. ◉ *G:* 1956 Venedig: Bienn., Ceylon Section (K). ⌑ *C. A. Gunawardena*, Enc. of Sri Lanka, New Dehli 2003. – *W. Stone*, 50 years of the newspaper cartoon in Australia, Adelaide 1973; *J. King*, The other side of the coin. A cartoon hist. of Australia, Stanmore, N. S. W. 1979; *J. Ryan*, Panel by panel. A hist. of Australian comics, Stanmore, N. S. W. 1979; *A. Dharmasiri*, Mod. art in Sri Lanka. The Anton Wickremasinghe Coll. (K), Colombo 1988; The Straits Times (Singapur) v. 16. 1. 1992 (Nekr.); *R. Phiddian/H. R. Manning*, Comic commentators. Contemp. political cartooning in Australia, Perth 2008. – *Online:* Art Sri Lanka, 43 Group; Design and Art Australia; Lambiek Comiclopedia. H. Kronthaler

Collette, *Cresside* cf. **Collette,** *Aubrey*

Collie, *William,* brit. Fotograf, * Okt. 1810 Skene/ Aberdeenshire, † 7. 4. 1896 St. Helier/Jersey. Lt. Helwig ist 1825–37 ein W. C. als Buchbinder in Aberdeen nachg.; McEwan erwähnt darüber hinaus einen Maler desselben Namens 1830 in Edinburgh. Spätestens 1841 ist C. als Porträtmaler und Zeichenlehrer in St. Helier belegt. Der erste

Nachweis fotogr. Tätigkeit ist eine Serie von Kalotypien mit dem Titel *French and Jersey Market-women* (ab 1847), die im Sujet den bek. Newhaven-Bildern von Hill & Adamson (um 1845) ähneln, im Gegensatz zu diesen jedoch im Atelier arrangiert und aufgenommen wurden. Im Verlauf der 1850er Jahre wendet sich C. dem Nassen Kollodium-Verfahren zu und arbeitet mindestens bis 1878 als Porträtist (Fotogr. und Gem.) in St. Helier. Die letzte bek. Fotogr. ist eine Aufnahme der Totalen Sonnenfinsternis im Jahr 1860. ⌂ BRADFORD, R. Photogr. Soc. Coll., NM of Photogr., Film and Television. OTTAWA, NG of Canada. ST. HELIER/Jersey, Jersey Mus. – Soc. Jersiaise. ◉ *G:* 1851 London: Great Exhib. / 1989 New York, MMA, und 1990 Cleveland (Ohio), Mus. of Art: Photogr. Until Now (K: J. Szarkowski). ▭ *McEwan*, 1994; *J. Hannavy* (Ed.), Enc. of nineteenth-c. photogr., I, N. Y./Lo. 2008. – *Helwig* I, 1953; *Helwig* II, 1954; *E. Heyert*, The glasshouse years. Victorian portr. photogr., 1839–1870, Montclair, N. J. 1979; *J. Carter*, Annual bull. of La Soc. Jersiaise 28:2002 (127) 226–233; *R. Taylor*, Impressed by light. Brit. photogr. from paper negatives, 1840–1860 (K Wander-Ausst.), N. Y. u.a. 2007 (Quellen). – St. Helier, Jersey Mus., Jersey Heritage: Test. C. P. Freytag

Collin, *Pierre,* frz. Maler, Graphiker, Zeichner, * 27. 9. 1956 Paris, lebt seit 1999 in Vannes (Halbinsel Conleau). Stud.: 1975–80 ENSBA, Paris. Artist in Residence: 1980–82 Casa Velázquez, Madrid; 1982–83 Cité internat. des Arts, Paris. Lehrtätigkeit: 1990–97 Ec. supérieure d'Art, Cambrai; seit 1997 Ec. supérieure d'Art, Lorient. – C. gestaltet bevorzugt Rad. (auch Hschn. und seit 2005 vereinzelt Siebdrucke), die häufig großformatig und selten farbig sind, sowie Monotypien (z.B. Serie *Visagesmiroir*, 1990) und überarbeitete Fotogr. (z.B. Serie *Reflet-Portr.*, 1996–97). Sein malerisches Werk umfaßt Arbeiten in Öl, Acryl und Mischtechnik (Kohle, Tusche, Tempera), die ebenso wie die Graphiken abstrahierte gegenständliche Motive (Interieurs, Lsch., Stadtansichten, Portr.), häufig in verzerrter Perspektive, zeigen (z.B. *Paysage urbain et Atelier*, Öl/Papier, 1992). Char. sind fragmentarische Darst. und eine düstere und einsame Stimmung (v.a. bei den Interieurs) sowie z.T. ein comicartiger Stil, der sich in der Formsprache sowie in einer ausschnitthaften, szenischen Erzählweise äußert (z.B. *Corinne à Florence I, Le Laocoon*, Triptychon, Rad., 1988). ⌂ AMSTERDAM, Sted. Mus. GRAVELINES, Mus. du Dessin et de l'Estampe Orig. MADRID, BN. – Mus. Mpal de Arte Contemp. MULHOUSE, Cab. des Estampes. PARIS, BN. – FNAC. SETE, Mus. Paul Valéry. TOLEDO, MAC. TOULOUSE, MAMC. VANNES, MBA. ◉ *E:* 1981 Madrid, Gal. Torculo / 1983 Orléans, Gal. Harmonie / Paris: seit 1983 regelmäßig Gal. Biren; 1997, 2000 Gal. Vieille du Temple; 2004, '07 Gal. Prodromus / 1984, '88 Washington, Brody's Gall. / 1990 Brüssel, Gal. Abras / 2003 Nîmes, EcBA / 2009 Vannes, Gal. Doyen. –. *G:* Paris: 1980 Salon des Réalités Nouvelles; 1981, '83 Salon de Mai; 1982 Salon du Trait; 1985 Salon de la Jeune Gravure contemp. / 1982 Toledo: Bienn. (Ausz.) / 1985 Madrid, Sala Mpal de expos. del Ayuntamiento de Leganés: Estampas de la Calcografía Nac. 100 aguafuertes

del siglo XIX (K). ▭ *Bénézit* III, 1999; *Delarge*, 2001. – *V. Bertrand*, P. C. Vertiges ordinaires (K Wander-Ausst.), P. 2007; *L. Fauchereau*, Nouvelles de l'estampe 213:2007, 45–47 (Interview); *M.-F. Le Saux*, ibid., 42–44. F. Krohn

Collins, *David Chittenden,* US-amer. Daguerreotypist, * 26. 8. 1825 Connecticut, † 1909 West Haven/Conn. Sohn des Buchhändlers und Daguerreotypisten *Simeon C.* (* 18. 11. 1786 North Guilford/Conn., † 14. 12. 1866 West Haven/Conn.). Bruder des Daguerreotypisten *Thomas Painter C.* (* 12. 4. 1823 Connecticut, † 21. 5. 1873 Westfield/Mass.). 1840 ziehen Thomas P. und Simeon C. von Connecticut nach Philadelphia. Der Sohn, zunächst Drucker-Lehrling, erlernt dort die Daguerreotypie und führt 1845–46 ein gemeinsames Atelier mit Montgomery Pike Simons (1845 Silber-Med. des Franklin Inst., Philadelphia). C. ist ab 1845 als Kompagnon von Marcus Aurelius Root in Philadelphia nachg. (Roots & Collins); Norris (2006) vermutet, daß beide Brüder mit Root zusammengearbeitet haben. Ab 1846 betreibt Thomas P. C. ein eig. Atelier in der Stadt; wohl noch im selben Jahr assistiert ihm C., bevor die beiden das Geschäft 1847–51 als Partner unter dem Namen „T. P. & D. C. Collins" führen (gelegentlich fotografiert auch Simeon C.; zu den Angestellten zählt u.a. Howard Peale, mit dem C. später in Springfield/Mass. zusammenarbeitet). 1847 heiratet Thomas P. C. Elizabeth Weatherby Chapin und bereist 1848 England und Frankreich; 1849 verläßt er die Stadt und arbeitet ab 1850 als Wanderdaguerreotypist in New England, bevor er sich in Westfield/Mass. (1852, 1860 sowie von M. der 1860er Jahre bis 1871; 1853–55 zus. mit *Otis H. Cooley* [1820–1860]) und Springfield/Mass. (1853 und ca. 1864–66) niederläßt. 1849–47 führt C. das Atelier in Philadelphia unter dem Namen D. C. Collins & Co. allein weiter. 1856 heiratet er Theresa Oggelsby. Nach der Geburt des Sohnes zieht die Fam. nach West Haven/Conn., wo C. bis 1880 als „Fotograf" nachg. ist. – Die früheste dat. Daguerreotypie von einem der beiden Brüder (Zuschr. unklar) stammt aus dem Jahr 1842 (*Dog Albus*, Nelson-Atkins Mus. of Art, Kansas City/Mo.). In Philadelphia entstehen zahlr. Portr. und Stadtansichten wie das bek. *Fairmount Waterworks Panorama* (1846), bestehend aus sechs halben Platten. In West Haven fotografiert C. zw. 1860 und 1880 v.a. Ambrotypien. Der Graphiker Albert Newsam hat zahlr. Motive der Brüder C. lithographiert. ⌂ ATHENS, Univ. of Georgia Libr., Reverend John Jones Coll. KANSAS CITY/Mo., Nelson-Atkins Mus. of Art. NEW YORK, Internat. Center of Photogr. – Metrop. Mus. PHILADELPHIA/Pa., Franklin Inst. – Libr. Company of Philadelphia. ROCHESTER/N. Y., George Eastman House (Thomas Painter C.). WEST CHESTER/Pa., Chester County Hist. Soc. ◉ *G:* 1846, '47 (Ausz.), '52 (Ausz.) New York: Amer. Inst. / 1846, '52 (Ausz.) Philadelphia (Pa.), Franklin Inst. / 1995 Washington (D. C.), NM of Amer. Art: Secrets of the Dark Chamber. The Art of the Amer. Daguerreotype (K: M. Foresta/J. Wood). ▭ *C. C. Baldwin*, The Candee genealogy, Cleveland/Ohio 1882; *K. Finkel* (Ed.), Nineteenth-c. photogr. in Philadelphia, N. Y. 1980; *F. und M. Rin-*

hart, The Amer. daguerreotype, Athens, Ga. 1981; *A. H. Eskind* (Ed.), Index to Amer. photogr. coll., N. Y. ³1996; *R. Norris*, Daguerreian ann. 2006, 36–71; *K. F. Davis*, The origins of Amer. photogr. From daguerreotype to dry-plate, 1839–1885 (K Kansas City), New Haven, Conn. u.a. 2007. – Ann Arbor, , Univ. of Michigan, William L. Clements Libr.: C. Fam. Papers / New Haven, Conn., New Haven Mus.: Painter-C. family coll., 1802–1866 / Worcester, Mass., Amer. Antiquarian Soc., Ms. Coll.: C. daguerreotype business registers, 1845–1854. – *Online:* Craig's daguerreian registry. P. Freytag

Collins, Phil, brit. Installations- und Videokünstler, Fotograf, * 1970 Runcorn, lebt in Glasgow. Stud.: 1990–94 Univ. of Manchester (Drama, engl. Lit.). Er geht nach London und schließt sich der Performancegruppe Max Factory an. Umzug nach Belfast und 1998–2000 Stud. an der Univ. of Ulster bei Alistair Maclennan und Willie Doherty. Mitgl. der Künstlerorganisation Catalyst Arts. 2000 kurzzeitig in Belgrad ansässig. Preise: 2000 Absolut Prize, Ormeau Baths Gall., Belfast; Arts Council of Ireland Visual Arts Award; 2001 Paul Hamlyn Award for Visual Arts; 2003 Illy Prize. 2006 in der Endauswahl für den Turner Prize. Artist in Residence: 2002 PS1 Contemp. AC, New York; 2004 Al-Ma'mal Found. for Contemp. Art, Jerusalem; IASPIS, Stockholm; 2005 Platform Garanti Contemp. AC, Istanbul; 2006 Columbus (Ohio), Wexner Center for the Arts. – Politisiert und sozial engagiert reist C. in versch. Krisenherde und filmt zumeist Jugendliche. Als Katalysator wirkend ruft er oft außergewöhnliche Zusammentreffen ins Leben. 1999 dreht er in Makedonien das Video *How to Make a Refugee*. Für *Baghdad Screen Tests* (2002) besucht er den Irak noch vor dem Beginn des Krieges und filmt Bewerber für einen nicht existierenden Hollywood-Film. In Ramallah/Palästinien organisiert er einen Tanzmarathon für *They Shoot Horses* (2004; Zweikanalvideo). In ähnlicher Weise organisiert er anderenorts Karaoke-Veranstaltungen mit Liedern der Smiths. *The Return of the Real* entsteht 2006 anlässlich der Ausst. für den Turner Prize in der Londoner Tate Britain. C. etabliert hier das funktionierende Fernsehstudio Shady Lane Productions, in das er frühere Teiln. von Reality-TV-Programmen einlädt, um ihre Erfahrungen offenzulegen. Für *Marxism Today* zieht er 2009 nach Berlin und dokumentiert junge Deutsche, die dem Verlust des Sozialismus nachtrauern. Weitere Drehorte sind u.a. die Türkei, Indonesien und Kolumbien. ☐ LONDON, Tate. ◉ *E:* 2001 Derry, Context Gall. / 2002 Athen, Kappatos Gall. / New York: 2003 Maccarone Inc.; 2006, '09 Tanya Bonakdar Gall. / 2005 Austin (Tex.), Cinematexas; Columbus (Ohio), Wexner Center for the Arts; Milton Keynes, Milton Keynes Gall. / 2006 Rotterdam, Nederlands Foto-Mus.; Gent, Sted. Mus. voor Actuele Kunst; San Francisco, MMA / 2007 Pittsburgh, Carnegie Mus. of Art / London: 2007 Victoria Miro Gall.; 2011 Brit. Film Inst. / 2010, '11 Stockholm, Jarla Partilager / 2010 Manchester, Cornerhouse; Lincoln (Lincs.), The Collection / 2012 Sligo, Model AC; Brisbane, Queensland Gall. of Mod. Art. *G:* 2000 Ljubljana: Manifesta. ☐ Vitamin Ph. New perspectives in photogr.,

Lo. 2006; *R. Furness* (Ed.), Frieze projects, Frieze talks 2006–2008, Lo. 2009. – *Online:* Shady Lane Productions; Tanya Bonakdar Gall., New York. G. Bissell

Collins, Simeon cf. **Collins, David Chittenden**

Collins, Susan Alexis, brit. Computerkünstlerin, Installationskünstlerin, * 15. 1. 1964 London, lebt dort. Stud. ebd.: 1982–83 Chelsea SchA; 1983–87 Slade School of FA; 1990–91 School of the Art Inst. Chicago; 2001 Promotion, Univ. of Reading. Ab 1995 Dir. Electronic Media, seit 2010 Dir., Slade School of FA. 2010 Artist in Residence, Bangkok Univ. Gall. – C. gestaltet seit 1993 mit Computeranimation, interaktiven Videoprojektionen und Internet sowie Tonaufnahmen ortsspezifische Installationen in öff. Räumen und in der Natur und thematisiert das Zusammentreffen von realer und künstlicher bzw. virtueller Welt. In der Woolwich-Unterführung unter der Themse lösen Fußgänger durch Sensoren Geräusche von meckernden Schafen, hörbaren Fußstapfen und rauschendem Wasser aus und überschreiten videoproduzierte „Pfützen" (*Introductory Exchanges*, 1993), in der Ausst. *Touched* (1996 Newcastle, Zone Gall.; Linz, LM) werden Besucher von virtuellen Händen gestreichelt oder gekitzelt. 2002–03 zeigt C. in der Ausst. *Transporting Skies* den Besuchern in der Newlyn AG Penzance und in der Site Gall., Sheffield, simultan und in realer Zeit Kameraaufnahmen und Projektionen von Himmel, Gal.-Raum und Besuchern des jeweils and. Ausstellungsorts. Die Tintenstrahldrucke der Serie *Fenlandia* (2004–06) entstehen durch die im Silicon Fen/Cambs. für ein Jahr installierte Digitalkamera, die Fotogr. jeweils über 20 Stunden langsam Pixel für Pixel aufzeichnet und so von der Natur gemalte Lsch. kreiert. Diese Technik wendet C. auch bei der Serie *Seascape* (2009) an, wofür Kameras an der engl. Südküste aufgestellt sind. Sie übernimmt ferner Auftragsarbeiten, wie ein Wildbeobachtungssystem für Sarah Wigglesworth Architects (*Classroom of the Future*, 2001–05), und mit *Underglow* realisiert sie ein Netzwerk von illuminierten Straßengullis für die City of London (2005–06). Die Lichtanimation *Chaser* entsteht für den Tyne Bridge Tower in Newcastle (2007). *Love Bird* (2009) und *Found Footage, Whitechapel* (2011) gehören in eine Reihe von animierten aus Digitalaufnahmen bestehenden Arbeiten, die mit der Beziehung zw. dem starren und dem bewegten Bild experimentieren. Auf dem Gebiet der digitalen Medien ist C. eine führende brit. Künstlerin. ◉ *E:* 1995 Warrington, Mus. and AG / 1994 Hull, Paragon Train Station / 1993–94 Manchester, Mus. of Science and Industry / 2001 Canterbury, Whitefriars Information Centre / 2002 Sheffield, Site Gall. (K) / 2008 Hamburg, Osterwalders Art Office (mit Tim Head) / 2009 , De la Warr Pavilion (K) / 2010 Bangkok, Univ. Gall. (mit Tuksina Pipitkul) / 2011 London, Idea Store Whitechapel. ☐ *D. Curtis* (Ed.), A directory of Brit. film and video artists, Lo. 1996; *Buckman* I, 2006. – V-topia. Visions of a virtual world (K Tramway), Glasgow 1994; Triplicate. Three galleries, six artists (K City AG), Southampton 1996; *E. Safe*, Art monthly 262:2002/ 03 (Dez.-Jan.) 31 s.; The new media handbook, Ox. 2006; *S. Willmoth u.a.*, Silicon fen, Lo. 2008; *R. Unruh*, Kunstfo-

rum internat. 194:2008, 368 s.; *P. Coldwell*, Printmaking. A contemp. perspective, Lo. 2010. – *Online:* Website C.

<div align="right">H. Stuchtey</div>

Collins, *Thomas Painter* cf. **Collins,** *David Chittenden*

Collis, *Susan*, brit. Installationskünstlerin, Bildhauerin, * 1956 Edinburgh, lebt in London. Zunächst Produktionsleiterin im Verlagswesen. Stud. in London: 1997–2000 Chelsea SchA and Design; 2000–02 R. College of Art. Ausz.: 2002 Jerwood Drawing Student Prize. – Inspiriert von Charles Ray kombiniert C. widersprüchliche Bed., Mat. und Ästhetik in konzeptionellen Installationen und Objekten. Ihre Alltagsobjekte zeigen scheinbar zufällig entstandene Gebrauchsspuren, die jedoch von ihr in zeitaufwendiger und kunstfertiger Weise hinzugefügt sind, wie z.B. gestickte „Flecken" auf einem Arbeitsoverall (*100% Cotton*, 2002). Die Installation *Love is a charm of powerful trouble* (2008, Edinburgh, Ingleby Gall.) erscheint zunächst als ein verlassener Galerieraum mit Bilderhaken an den Wänden, doch die Schrauben in den Wänden sind aus Gold, die Dübel aus Türkisen oder Korallen, die Farbspritzer auf dem staubigen Besen Opale und Diamanten und die weißen Flecken auf den Holzdielen erweisen sich als eingelassene Perlmuttstückchen. Seit ca. 2008 imitiert C. Objekte, z.B. in der Performance *Sweat* (2008, Seventeen Gall., London), bei der Helfer das Muster von massenproduzierten karierten Wäschetaschen mühevoll auf Papier zeichnen und daraus Taschen fertigen. Auch entstehen hyperrealistische „Bauabfälle", die sie aus edlen Hölzern kreiert (*Forever young*, 2009). C. spielt bei ihren konzeptionellen, dynamischen Arbeiten mit den Erwartungen und Wahrnehmungsveränderung des Betrachters, daß nichts so ist, wie es erscheint, und daß z.B. ein langer Herstellungsprozeß oder edle Mat. keinen Wertzuwachs bedeuten müssen. ▢ JERUSALEM, Israel Mus. LONDON, Arts Council. – London Inst. – Zabludowicz Coll. PARIS, FNAC. ◉ *E:* London: 2003 Beaconsfield Gall.; 2007, '08, '09, '10 Seventeen Gall. (K) / 2004 Portsmouth, Aspex Gall. / 2008, '11 Austin (Tex.), Lora Reynolds Gall. / 2008 Edinburgh, Ingleby Gall. / 2009 Madrid, Espacio Minimo / 2010 Birmingham, Ikon (K); Torrance (Calif.), AM (K); Paris, Gal. Frank Elbaz. ▭ *L. B. Newell*, Out of the ordinary. Spectacular craft (K V & A), Lo. 2007; *C. Millard*, Art and auction 2010 (März) 52–56; Lifelike (K Walker AC), Minneapolis 2012. – *Online:* Website Seventeen Gall.

<div align="right">H. Stuchtey</div>

Collomb, *Guy*, schweiz. Architekt, * 29. 1. 1950 Payerne/Vaud. Stud.: bis 1975 Ec. polytechnique fédérale, Lausanne; Centre de la conservation du patrimoine, Brügge. Lehrtätigkeit: 1996 Gast-Prof., Univ. of Pennsylvania. 1982 Gründung des Archit.-Büros Atelier Cube in Lausanne (zu unterscheiden von and. Büros gleichen Namens in Fukuoka/Japan und Tullins/Frankreich) mit dem Bruder *Marc C.* (* 21. 10. 1953 Payerne; Stud.: bis 1979 Ec. polytechnique fédérale, Lausanne, Cooper Union, New York, bei John Hejduk und Robert Slutzky; Gast-Prof.: 1986 Ec. polytechnique fédérale, Lausanne, 2000 Univ. of Pennsylvania; Prof. Accad. di archit., Univ. della Svizzera ital., Mendrisio) und *Patrick Vogel* (* 4. 12. 1952 Lausanne;

Stud.: Ec. polytechnique fédérale, Lausanne, ETH, Zürich, bei Aldo van Eyck, 1979 Dipl.). – Das Büro entwirft v.a. öff. und Verwaltungsbauten sowie Wohngebäude. Char. ist eine betonte Materialsichtigkeit (Beton, Metall, Holz); damit verbunden ist meist eine sichtbare Konstruktion (Tragwerk beim Druck- und Verlagsgebäude ABC, Schönbühl/ Bern; gemauerte Wände ohne Verputz bei den Sozialwohnungen Chemin de Boissonnet 32, 34–46 in Lausanne, 1982–85, 1987–89). Die Entwürfe sind oft geprägt von großen, klaren Formen (1. Preis im Wettb. für den Neubau des Parlamentsgebäudes des Kt. Waadt in Lausanne, 2009, mit Bonell i Gil Arquitectes), auch bei Kombination mehrerer Baukörper (Zentrum für Plasmaphysikforschung der Ec. polytechnique fédérale de Lausanne, Ecublens, 1986–89); teilw. als Reihung gleichartiger Baukörper (Arch. des Kt. Waadt, Chavannes-près-Renens/Vaud, Route de la Mouline 32,1981–84; auch Umbau des Lesesaals, 2000–02). Das Büro entwickelt außerdem Prototypen, z.B. ein modulares Kraftwerk (Signy/Vaud, 1989) und das Jeunotel (Lausanne-Près-de-Vidy, 1991–93). ▭ BIÈRE/ Vaud: Arsenal, 1994–98. ECUBLENS/Vaud: Pferdesportzentrum La Garange 1982–84 (mit Julius Natterer). – Fahrzeughallen für TSOL (Tramway du Sud Ouest Lausanne), 1987–89. – Univ. Lausanne: Gebäude der Chemie-Fak., 1992–94 (mit Ivo Frei). LAUSANNE: Rue de la Borde 16–22b: Umbau eines Wohn- und Aufstockung eines Geschäftshauses, 1987–92. – Haltestelle Pont Chauderon: Aufzüge und Passerellen, 1991–93. – Chemin de Martinet: Schulgebäude, 1998–2002. – Chemin de Maillefer 101–125: Siedlung, 2008. MORGES/Vaud, Grand Rue 72: Wohn- und Geschäftshaus, Rest. und Umbau, 1980–83. SCHÖNBÜHL/Bern: Druck- und Verlagsgebäude ABC, 1992–94. URNERSEE, Weg der Schweiz, zw. Sisikon und Morschach: Abschnitt Kt. Waadt, 1991 (mit Frei). ◉ *E:* 1988, '94 Zürich, Archit.-Forum / Lausanne: 1989 Ec. polytechnique fédérale, Dept. d'archit.; 2009 Forum d'archit. / 1997 Zürich, ETH, Inst. für Gesch. und Theorie der Archit. (Wander-Ausst.). ▭ Dict. de l'archit. du XXᵉ s., P. 1996; *Rucki/D. Huber* (Ed.), Architekten-Lex. der Schweiz 19./20. Jh., Basel u.a. 1998. – Werk, Bauen und Wohnen 72/39: 1985 (7/8) 8–11, (11) 52–57; 76/43:1989 (6) 54–61, 68 s.; 78/45:1991 (6) 39–43, (7/ 8) 1–4, (9) 16–20; 83/50:1996 (7/8) 53–55, (10) 1–4; Techniques et archit. 380:1988, 146–148; *G. Barbey*, Habitation 1991 (1) 6–10; Un Centre d'arts plastiques contemp. à Lausanne, Lausanne 1992; Archithese 23:1993 (4) 12 s.; 25:1995 (4) 34 s.; *S. Schneider*, Baumeister 90:1993 (6) 24–28; 91:1994 (5) 22–25; *S. Malfroy*, Baumeister 93:1996 (11) 16–23; Atelier Cube, Z. 1997 (Lit., WV); Detail 37:1997 (8) 1353–1357; Archit. Wettb. 187:2000 (Juni) 18–23. – *Online:* Website Atelier C.

<div align="right">N. Buhl</div>

Colman, *Stéphane*, belg. Comiczeichner und -autor, * 20. 4. 1961 Lüttich. Stud.: Acad. R. des BA ebd. Mit Stephen Desberg (Autor) entsteht 1979 eine erste Version der Funnyreihe *Billy the Cat* für das Mag. Spirou. 1980 zeichnet er *Marsouin et Petzouille* für Aïe! und veröff. Comics im Musik-Mag. En Attendent. 1981 erscheint *White,*

le choc! (dt. *White, der Schock*) bei Magic Strip. Für einige Jahre arbeitet C. in der Werbung, kehrt 1987 zu Spirou zurück, wo neue Geschichten von *Billy the Cat* entstehen, die auch als Album veröff. werden (1997 wird eine TV-Zeichentrickserie mit der Figur ausgestrahlt). 2002 übernimmt Péral die Zchngn dieser Serie. 2003 zeichnet C. gemeinsam mit Batem das erste Album der Serie *Sam Speed*, für die Folge-Bde schreibt er das Szenario. Bei der Serie *Marsupilami* ist er für die Hintergründe zuständig, und 2006 übernimmt er ebenfalls das Szenario. Auch die Serie *O'Boys* betreut er seit 2012 als Autor. – C. zeichnet in einem trad. franko-belg. Funnystil, u.a. dynamische, rundliche Figuren. ⊡ *P. Gaumer/C. Moliterni*, Dict. mondial de la bande dessinée, P. 1997; *H. Filippini*, Dict. de la bande dessinée, P. 2005. – *Online:* Lambiek Comiclopedia.

K. Schikowski

Colognese, *Gianmaria*, ital. Architekt, Maler, Keramiker, Bildhauer, Designer, Fotograf, * 1947 Verona, lebt dort. Stud.: ABA, Venedig (1972 Dipl.-Architekt). 1984 Ausst.-Debüt als Bildhauer in Verona (Gall. Cinquetti). Ab 1989 als Designer, Aussteller und Mitorganisator von „Abitare Il Tempo" beteiligt. Unterrichtet seit 1994 an der ABA G. B. Cignaroli (ab 1998 Lehrstuhl Plastica ornamentale); 1998 und 2002 Vize-Dir. der Akademie. Publ. seit 1996 in der Zs. Artigianato. 2001 ist er Mitbegr. der Scuola di Design, wo er Mat.-Kunde, Design und Innen-Archit. lehrt. – C. arbeitet in unterschiedlichen Medien. Indem er die Grenzen der Kunstgattungen, hist. Stile, Oberflächen und Volumina durchbricht, gelangt er zu Unabhängigkeit und Offenheit v.a. gegenüber fremden Kulturen. Dabei ist es ihm immer ein Anliegen, sich in Aktion zu zeigen und seine Vorgehensweise nachvollziehbar zu machen. Aus seiner Arbeit als Architekt (Planung, Ausf., Rekonstr. oder Rest. von Industrie- und Wohnungsbauten, Messebau, Möbelentwürfe etc.) wirken befruchtend v.a. strukturelle Impulse und die Dreidimensionalität auf die and. von ihm ausgeübten Medien. Als Bildhauer vorwiegend abstrakt- geometrische Gebilde (Bronze, Keramik), die aufgerissen und aufgekratzt werden. C.s Bilder verraten eine Vorliebe für Paradoxes und Märchenhaftes; häufig sind sie von entwaffnender Naivität und Heiterkeit. Die Gegenüberstellung von geometrischen Formen und flüchtigen Materialien (bis an die Grenze zum Informel) durch Malerei inspiriert wiederum C.s Archit. und Bildhauerei. Alle Arbeiten sind char. durch eine reichhaltige Farbigkeit. C. wird in seinen Überzeugungen maßgeblich durch Jurgis Baltrušaitis geprägt und beeinflußt. ⌂ CALDOGNO: Municipale, 1984. CASTELVECCHIO, Mus. CEREA, Villa Dionisi, Mus. delle Arti Applicate nel Mobile contemp.. COLOGNO MONTESE: Serena S. A. S., Centro Commerciale, 1983. LUGAGNANO: Cimitero, Erweiterung, 2001. MALCESINE, Parco della Mignola. – Hotel Bellevue S. Lorenzo. VERONA, Fond. Cariverona: Struttura archit., Metall, 1998; Bandiere, Metall, 2004. ◉ *E:* Verona: 1984, '86 Gal. Cinquetti; 2001 Gall. dello Scudo (K: R. Bellini) / 1985 Trento, Pal. Pretorio / 1990 Piacenza, Gall. Ricci Oddi / 1992 Mantua, Gall. Einaudi / 1999 Hamburg, Gal. Eduard Bittorf / 2000 Rovereto, Gall. Le Due Spine. – *G:* 1988 Malta, Mus. Mystique: Omaggio al Caravaggio / Verona: 1988 Gall. Ponte Pietra: Vivarte; 1991 Gall. Arteb: Flying carpets / 1993 Wien, Künstlerhaus: Parabole indifferenti / Mailand: 1997 Gall. Arte Struktura: 20 x 20; 2001 Pal. della Ragione: Dai giornali ai portal / 2000 Bologna, Spazio del Tenente: Vibrazione n. 2 / 2009 Urbino, Pal. Ducale: Nuova Icona (K: B. Bandini/I. Siboni). ⊡ *J. Baltrusaitis*, Il medioevo fantastico. Antichità ed esotismo dell'arte gotica, Mi. 1973; *C. L. Ragghianti*, Arte essere viventi, Fi. 1984; *L. M. Barbero*, Immagine Progetto Tessitura, Vr. 1986; *A. Lui*, Quando la decorazioine diviene Arte. Quando l'Arte viene decorazione, Vr. 1991; *G. Gramiga u.a.*, Il Design in Italia, T. 1999; *R. Bellini*, Al di là dello specchio di Alice, Vr. 2001; *G. Cortenova* (Ed.), Scultori a Verona. 1900–2000 (K Verona), Mi. 2001. – *Online:* Website C.; Arch. Monogr. dell'Arte ital.

S.-W. Staps

Colombai, *Carlo*, ital. Fotograf, * 18. 3. 1882 Livorno, † 27. 4. 1968 Neapel. Bruder von *Egisto* C. (* 19. 2. 1862 Livorno, † März 1932 Neapel) und *Gilberto* C. (* 1871 Livorno, † Mai 1953 Neapel); Vater von *Aldo* C. (* 19. 7. 1916). Nach ihrer Übersiedlung aus Livorno betreiben die drei Brüder ab 1894 in Neapel als „Fratelli C." ein gemeinsames Fotostudio am Corso Garibaldi, wobei sich C. v.a. dem Porträt und der zu dieser Zeit unentbehrlichen Retusche widmet. Gilberto ist für topogr. Reportagen zuständig und Egisto, der seine Ausb. im Studio von Luigi Montaboni erhalten hatte, kümmert sich um die Abzüge. Das fotogr. Œuvre der Brüder, das sich nicht genau zuordnen läßt, umfaßt neben der Dokumentation hist. Ereignisse (z.B. *Inaugurazione del Mon. a Giuseppe Garibaldi*, 1904) v.a. Portr. von Kindern und bek. Zeitgenossen, aber auch Lsch.- und Archit.-Ansichten (z.B. *Caserta, Pal. Reale*). Ab 1898 häufig Teiln. an Ausst., u.a. in Turin, London, Salerno, Paris, Neapel und Brüssel (mehrfach mit Ausz.). Von König Vittorio Emanuele III. erhalten sie als Ausdruck der Wertschätzung ein Chronometer mit Goldkette; 1925 wird C. zum Cavaliere del Regno d'Italia ernannt. Der wachsende Erfolg ermöglicht die Eröffnung weiterer Studios in Neapel. In Zusammenarbeit mit dem Lombardo widmen sie sich auch dem Film (Gilberto C. realisiert 1920 den Film *Santa Lucia luntana*). Zw. den 1920er und 1940er Jahren entstehen zahlr. Portr. von prominenten Sängerinnen und Sängern (*Elvira Donnarumma*; *Bice Ardea*, um 1928; *Maria Gemmati*, 1935; *Enrico Caruso; Carlo Galeffi; Enzo di Murolo Lomanto*), Schauspielern (*Ermete Zacconi*), Dichtern und Politikern (*Giovanni Bovio*). 1943 werden das Studio und das hist. Foto-Arch. durch einen Bombenangriff zerstört. 1945 entsteht unter Ltg von C. ein neues, heute noch bestehendes Studio am Corso Garibaldi. 1948 kehrt Aldo C., ein Überlebender des Massakers auf Kefalonia, aus der Gefangenschaft zurück und wird Mitarb. des Vaters. Er widmet sich v.a. dem Portr. und der Industrie-Fotogr., bekleidet Funktionen im Berufs-Verb. der Fotografen, publ. in Fach-Zss. und verarbeitet in mehreren Büchern seine traumatischen Kriegserlebnisse (u.a. *Cefalonia e Corfu : ... quei giorni di settembre*, Poggibonsi 1990; *Balcania. Settembre '43: tre modi diversi per onorare la patria*, R. 2002). 1958 arbeitet

er als Fotograf in dem Film *Io, mammeta e tu* von Carlo Ludovico Bragaglia. Zu den Schülern und Mitarb. im Studio der Brüder C. gehört u.a. Egisto Giulio Dall'Armi; nach dem Ausscheiden von Aldo C. wird das Studio von dessen Tochter *Carla C.*weitergeführt und befaßt sich jetzt v.a. mit digitaler Fotografie. 🕮 NEAPEL, Bibl. Lucchesi Palli. 📖 Nord e Sud 47:2000, 41; *M. Picone Petrusa* (Ed.), Arte a Napoli dal 1920 al 1945 (K), N. 2000. – Neapel, Arch. C.; Arch. di Teatro. E. Kasten

Colombai, *Egisto* cf. **Colombai,** *Carlo*
Colombai, *Gilberto* cf. **Colombai,** *Carlo*
Colombet, *Vicky*, frz. Malerin, Zeichnerin, * 16. 2. 1953 Paris, lebt in New York. Zunächst als Designerin tätig. 1982 Hinwendung zur Malerei und Schülerin von Henri Dimier. Ausz.: 2000 Direction régionale des affaires culturelles (DRAC), Langedoc et Roussillon; 2001 Adolph and Esther Gottlieb Foundation. – C.s abstrakte Komp. entstehen in einem von ihr entwickelten Malprozeß, bei dem sie eine heiße Mischung von Öl, Alkyd und Wachs auf die zuvor gefaltete bzw. geknitterte Lw. aufträgt. Bei ihren zur Monochromie tendierenden Gem. bevorzugt sie gedämpfte Töne in Blau, Schwarz, Creme und Purpur. Die Bilder, die aus jahrelangen Naturbeobachtungen resultieren, evozieren Lsch.-Formationen und deren Erosionen durch Wind, Eis oder Wasser (*From the Winds 11–08–04*, 2004; *Water Falls 1189–06*, 2006). N. Tsouti-Schillinger (2004) konstatiert aufgrund der streng reduzierten Bildsprache und der repetitiven Motive eine Nähe zur Minimal art und sieht Parallelen zum Werk von Agnes Martin, Brice Marden und Robert Ryman. Einige Gem. der *Urban Landscapes series* (2002) erinnern lt. Sarah King (2003) an die Wolkenabstraktionen der Fotoserie The Equivalents von Alfred Stieglitz sowie an die verschwommenen Darst. in den abstrakten Bildern von Gerhard Richter. Von der Natur inspirierte Themen behandelt C. auch in Zchngn (Tusche, Kohle/Pergament oder Transparentpapier) bzw. in digitalen Drucken auf Pergament (*Cloud*, 2010). Darüber hinaus auch Arbeiten auf Glas (z.B. mon. Glasbild für die vom Architekten Enric Ruiz-Geli entworfene Villa Nurbs in Empuriabrava/Prov. Girona, 2006–07, dessen Darst. auf die von Meer und Flüssen geprägte Umgebung der Villa anspielt). 🕮 ST. PETERSBURGH/Fla., MFA. 👁 E: 1985 Liège, Excentric Gal. / Paris: 1986, '88, '89 (K: C. Rochefort), '92 Gal. Corinne Timsit; 1990 Gal. Rolf Wah; 1995 Gal. Alain Margaron; 2001 Ec. de Cinéma, ESEC; 2009, '10 Gal. Dutko / 1987 Nizza, Mossa Gal. / 1988 Antibes, A. O. Gal. / 1990 San Juan (Puerto Rico), Gal. Corinne Timsit / 1991, '93, '99 Montreux, Gal. J. Guhl / 1991, '93 Berlin, Gal. Busch / 1997 Marseille, Assoc. Château de Servières / 2000 Bordeaux, Gal. Zographia / 2002, '04 (K: N. Tsouti-Schillinger), '06, '08 Santa Fe (N. Mex.), Evo Gall. / 2003 Greenwich (Conn.), Meserve Coale Gall. / 2004, '07 New York, Haim Chanin FA / 2007 Barcelona, Gal. Fidel Balaguer (K: L. Rexer) / 2009 Tampa (Fla.), Bleu Acier. 📖 *Bénézit* III, 1999; *Delarge*, 2001. – *S. S. King*, AiA 2003 (Juni/Juli) 59–61; *N. Tsouti-Schillinger*, Nothing to see from the ground (K Haim Chanin FA), N. Y. 2004. – *Online:* Website C. C. Rohrschneider

Colombo, *Gilberto*, ital. Konstrukteur, Designer, Ingenieur, Unternehmer, * 28. 8. 1921 Mailand, † 10. 11. 1988 ebd. Sohn von Angelo Luigi C. (1919 Gründer einer Wkst. für Stahlrohre ebd.); Bruder des Designers und Unternehmers *Antonio C.*(* 1950 ebd.), Vater des Architekten und Designers *Marco C.* (* 26. 2. 1952 ebd.). 1928 Übersiedlung der Fa. A. L. Colombo nach Turin; dort produziert sie unter der Marke Columbus u.a. Stahlrohrmöbel nach Entwürfen von Pietro Bottoni, Marcel Breuer und Le Corbusier. Ab 1938 ist C. als Mitarb. im väterlichen Betrieb tätig (ab 1946 technischer Dir.; ab 1950 Ltg der Fa. zus. mit dem Vater). Ab 1940 Stud. am Politecnico Mailand; lernt hier Mario Speluzzi, Doz. und technischer Dir. der Sportwagen-Abt., kennen. 1940 entwirft C. das Haus der Fam. in Lierna/Comer See. 1946 kreiert C. seine eig. Marke Gilco, unter der er z.B. den Maserati Formel 1 für den Rennstall Milan der Brüder Ruggeri umgestaltet. In Modena lernt er Enzo Ferrari kennen, mit dem er bis 1956 bei der Entwicklung von Rennwagen eng zusammenarbeitet. Ab 1947 verwendet die Fa. Ferrari die Fahrgestelle von Gilco (u.a. für Ferrari 125, 1947; Formula 1–125 GPC, 1948; Ferrari 340 Mexico, 1952; 250 Mille Miglia, 1952). Als Anerkennung widmet E. Ferrari 1953 C. eine Trophäe mit dem Markenzeichen des springenden Pferdes und Plakette. C. entwickelt auch Rahmen für and. Firmen wie Alfa Romeo (u.a. 6C 2500 SS Turbolare), Maserati (A6G. CS, 1947), Zagato und Lancia. Den Gesamtentwurf eines Automobils, das neue Technologie mit mod. Design verbindet, stellt er 1951 mit dem *Gilco 230 Competizione* vor. In den 1950er und 1960er Jahren widmet sich C. auch dem Entwurf von Möbeln (*Poltrona-letto*, 1952; nicht realisiert) und Booten (u.a. Starboote *Roberta II* und *Roberta III*, mit denen sein Sohn *Marco C.* mehrfach ital. Meister wird). 1961 Entwurf eines zweiten Hauses in Lierna. 1966 eröffnet er hier eine kleine Werft, später projektiert er auch Starboote für die Werften Folli und Lillia. Nachdem er sich in den 1960er Jahren mit der Entwicklung von Sportwagen, z.B. für Ghia (u.a. *Prototyp Ghia 230 S*, mit Gitterrohrrahmen, 1963 im Autosalon Turin präsentiert) beschäftigt hatte, gilt seine nachfolgende Tätigkeit v.a. der Ltg des Unternehmens. 1966 wird C.s Labor aus dem väterlichen Unternehmen herausgelöst und als Zweig-Fa. Trafiltubi in Novegro etabliert (für Rohre mit speziellen Profilen). 1977 übernimmt sein Bruder Antonio C. die mittlerweile auf die Projektion von Rennrädern spezialisierten Firmen Colombus und später auch Cinelli. In den 1980er Jahren beschäftigt sich C. mit der Entwicklung von Rahmen für Rennräder, z.T. mit innovativen Neuerungen (Master-Rahmen mit sternförmigem Querschnitt, 1983; *Master Pista*, 1985; *Master Dual*, 1987; Rahmenserie *Multishape* für Columbus, 1986/89; *Laser* für Cinelli, Entwurf 1985; 1991 postum mit dem Compasso d'oro ausgezeichnet). Ab 1984 wird die von Marco C. zus. mit Mario Barbaglia entworfene Designer-Lampe *Dove* durch Trafiltubi gefertigt. – C.s Design ist, im Unterschied zu den Entwürfen der Architekten, die in diesen Jahren als Designer tätig waren, immer aus der Technologie der jeweiligen Produkte entwickelt. 👁 E: 1993 Mailand, Ist. Europ. di Design. 📖 *A. Panse-*

ra (Ed.), Diz. del design ital., Mi. 1995. – *S. Grayson* (Ed.), Ferrari. The man, the machines, Lo. 1975; *D. Moretti* (Ed.), Gilco. Le macchine di G. C., Novegro di Segrate 1993; ²2006; *A. Pansera*, Storia del disegno industriale ital., Bari 1993; Abitare 325–327:1994, 69 s.; *P. D'Alessio*, Fantastic Ferrari, Lisse 2004; Gericke's 100 Jahre Sportwagen 1905–2005, Dd. 2004; Keith Martin on collecting Alfa Romeo, St. Paul, Minn. 2006; *S. Massaro*, Ferrari, un mito, Fi. 2006; *G. Cancellieri*, Ferrari 1947–1997. Il libro ufficiale, Vimodrone 2007; Ital. cycling J. v. 23. 11. 2007; *L. Acerbi/ L. Greggio*, Ferrari 1947–2007, Vimodrone 2008. – Novegro di Segrate, Arch. Stor. Gilco. – *Online:* Website Gilco Design; Modelfoxbrianza; ForumAuto. E. Kasten

Colombo, *Gioacchino (Gioachino),* ital. Automobilkonstrukteur und -designer, * 9. 1. 1903 Legnano/Mailand, † 27. 4. 1987 Mailand. Beginnt bereits 14jährig eine Ausb. als Motor-Ing. und technischer Zeichner bei Franco Tosi. M. der 1920er Jahre gewinnt er einen von Nicola Romeo gestifteten Zeichenwettbewerb. Ab 1924 bei Alfa Romeo tätig, wo er als Mitarb. von Vittorio Jano an der Entwicklung des Rennwagens *Alfa Romeo P2* mit einem kompressorgeladenen 8-Zylinder-Motor beteiligt ist, der als einer der besten Grand-Prix-Wagen seiner Zeit gilt. 1928 wird er Chef der Zeichen- und Design-Abt. von Alfa Romeo und setzt hier v.a. die Ideen von V. Jano um. Als 1933 die Scuderia Ferrari in Maranello von Alfa Romeo wegen wirtschaftlicher Schwierigkeiten deren Rennaktivitäten übernimmt, wird C. Verbindungsmann zw. beiden Standorten. In den 1930er Jahren ist er für die Entwicklung und den Bau der Alfa-Romeo-Monoposto-Rennwagen verantwortlich. 1937 entwickelt er den legendären schlanken Einsitzer *Alfa Romeo Tipo 158*, gen. *Alfetta,* der seinen Siegeszug nach dem 2. WK fortsetzt und 1950 den ersten Formel-1-Titel holt. Es folgen die Modelle *Alfa Romeo Tipo 308, 312* und *316* (alle 1938). 1945 wechselt C. zu Ferrari und konstruiert einen 12-Zylindermotor, den sog. Colombo-Motor (*Motore Ferrari Colombo*), der über 15 Jahre lang in den Sportwagen von Ferrari in versch. Ausf. Verwendung findet (z.B. dem berühmten *Ferrari 250*). Als sich dieser Motor für die Formel-1-Rennwagen der Scuderia Ferrari als ungeeignet erweist, überwirft sich C. mit Enzo Ferrari und kehrt zu Alfa Romeo zurück. Hier ist er 1950/51 als technischer Dir. mitverantwortlich für die Weltmeisterschaftserfolge von Giuseppe Farina und Juan Manuel Fangio. 1953 geht er zu Maserati und entwickelt zus. mit Vittorio Bellentani den Formel-1-Rennwagen *250 F,* der in den Rennen bis 1960 zahlr. Erfolge erzielt. 1955 entwickelt er den *Bugatti 251.* 1957–70 leitet er die Entwicklungs-Abt. des Motorradherstellers MV Agusta. ✉ Le origini del mito. Le mem. del progettista delle prime Ferrari, Fi. [1985]; The story of the Ferrari Colombo V12 engine, Sparkford [1987]. ⌑ *A. Pansera* (Ed.), Diz. del design ital., Mi. 1995; *D. Tremayne/M. Hughes*, The concise enc. of Formula One, Bristol 1998. – *S. Grayson* (Ed.), Ferrari. The man, the machines, Lo. 1975; *R. Taylor*, Modern classics, N. Y. 1988; *D. Adler*, Ferrari, Königswinter 1998; *S. Bellu*, Hist. mondiale de l'automobile, P. 1998; *P. Casamassima*, Die Gesch. der Scuderia Ferrari, Königswin-

ter 1999; Gericke's 100 Jahre Sportwagen 1905–2005, Dd. 2004; *C. Oppermann*, Ferrari. Das schnellste Unternehmen der Welt, Ffm. 2005; *M. Zumbrunn/R. Heseltine*, Ital. Auto-Legenden, M. 2006; *L. Acerbi*, Ferrari. All the cars. A complete guide, Vimodrone [ca. 2008]; *G. Raupp*, Ferrari. 25 years of calendar images, Kempen 2008. – *Online:* Alfa Romeo, Arch. Stor.; Cuoralfisti; Modelfoxbrianza.
 E. Kasten

Colombres, *Ignacio,* argentinischer Maler, * 22. 3. 1917 Buenos Aires, † 22. 6. 1996 ebd. Ausb.: 1941 Zeichnen beim katalan. Maler Vicente Puig in Buenos Aires. 1968–69 Präs. der Soc. Argentina de Artistas Plásticas. 1971 Großer Ehrenpreis des Certamen de Investigaciones Visuales für das Objektkunstwerk *Made in Argentina. Picana eléctrica* (mit Hugo Pereyra; 1998 rekonstr.). Da die Militärdiktatur das Urteil der Jury annulliert (erst 2004 Vergabe des Preisgeldes) und die Exposition der prämierten Arbeit verbietet, emigriert C. nach Madrid. – C.s von Rembrandt, Goya und José Gutiérrez Solana angeregte figurativ-expressive Malerei stellt in dunklen, erdigen, bisweilen auch kräftigen Farbtönen und lockeren Pinselstrichen am Rande der Ges. lebende Menschen sowie Lsch. und Dörfer in Bolivien und im Nordwesten Argentiniens dar. 🏛 BUENOS AIRES, MNBA. MADRID, CARS. SALTA, MBA. SAN MIGUEL DE TUCUMÁN, Fund. Miguel Lillo, Centro Cult. Alberto Rougés. SANTA FE, MBA „R. Galisteo de Rodríguez". 👁 *E:* Buenos Aires: 1954 Gal. Comte; 1961, '72 Gal. Van Riel; 1967 Gal. Lascaux; 1969 Gal. Nexo; 1970 Gal. Scheinsohn; 1973 Gal. Carmen Waugh; 1974 Gal. Perla Marino; 1998 Pal. de Glace (Retr.; K) / 1968 Rosario, Gal. Espacio / 1973 Mendoza, Gal. Nuevo Teatro / Madrid: 1975 Gal. Zodiaco; 1977 Gal. Durbán (K: J. M. Moreno Galván u.a.); 1980 Gal. El Coleccionista / 1976 Santander, Gal. Trazos 2 / 1981 Bogotá, Gal. Diners / 1982 Mexiko-Stadt, Friedrich-Ebert-Ges. / 2011 Salta, MBA. – *G:* 2002 Buenos Aires, Pal. de Glace: Arte y política en los años 60. ⌑ EAAm I, 1968; *Gesualdo/Biglione/Santos* I, 1988. – *J. J. Hernández Arregui u.a.* (Ed.), Argentina, como matar la cult. Testimonios, 1976–1981, Ma. 1981; Artisti latinoamer. in Europa, Ve. 1982; ABC (Ma.) v. 27. 6. 1996, 63 (Nekr.); *F. Lebenglik*, Página 12 (Bs.As.) v. 21. 4. 1998, 33; *R. Vera Ocampo u.a.*, I. C. 1917–1996, Ma. 1998. – *Online:* Caminos Cult., Salta. M. Nungesser

Colomer Pagés, *Raimon,* katalan. Maler, Zeichner, * Okt. 1940 Vilafranca del Penedés/Barcelona, lebt dort. Ökonomie-Ausb. am Colegio de Sant Ramon de Penyafort. 1958 Karikaturen für das Wochen-Bl. Acción ebd. 1959 Zusammenarbeit mit dem Zeichner Manuel Baró. 1964–81 Entwürfe für zahlr. Plakate. Stud.: 1965 Real Cercle Artistic, Barcelona. 1980 Mitbegr. der Grup d'Art Bargalló. 1991 Ehren-Mitgl. des Mus. of Contemp. Hispanic Art in San Francisco. Zahlr. Ausz.: u.a. 1971 Premio de la Feria de Mayo, Vilafranca del Penedés; 1986 Premio Internac., Tossa del Mar/Girona; 1991 Benicassim. – Von Spätimpressionismus und Fauvismus inspirierte Gem. (Öl, Aqu.) von stimmungsvoller Heiterkeit, v.a. (Stadt-)Lsch., Interieurs, Stilleben und weibliche Akte; leuchtende, von Blau,

Rot, Grün und Malve dominierte Farben und lockerer Pinselstrich. ⌷ BARCELONA, Creu Roja a Catalunya, Fons d'Art. SAN FRANCISCO, Mus. of Contemp. Hispanic Art. TOSSA DEL MAR, Mus. VILAFRANCA DEL PENEDÉS, Mus. del Vi. ◈ E: Vilafranca del Penedés: 1984 Sala Milà i Fontanals; 2007 Fòrum Berger Balaguer / Barcelona: 1985 (K: X. Morros), '94, '96 Gal. Grifé & Escoda; 1992, '93 Gal. Ciutat Vella / 2010 Cambrils (Tarragona), Ajuntament, Sala Agora. – G: 2011 Cambrils, Sala Agora: 30 anys de Premi de Pint. Vila de Cambrils. ⌷ DPEE, Ap., 2002. – J. Llop Sellarés, C. P., Ba. 1994. – Online: Website C. M. Nungesser

Colonna Gamero (Gamero Colonna), *Pinetta*, ital. Malerin, * 11. 4. 1909 Turin, † 1996 Venaria Reale/Turin. Verh. mit dem Maler Mario Gamero. Ausb. bei Giovanni Guarlotti aus Galliate; Dipl. des Politecnico Turin. Lehrerin für Kunstgesch. und Zeichnen am Ist. Tecnico Femminile „Clotilde di Savoia" in Turin. Malt zunächst v.a. postimpressionistische Lsch. und Veduten (*Venezia, Canal Grande*; Rosebery's, London, Aukt. v. 7. 8. 2007); später kommt sie unter den Einfluß des Novecento zu formklaren und die Plastizität betonenden, farblich harmonischen Darst. von Archit. und Lsch. (*La cappelletta*, Casa d'Aste Meeting Art, Vercelli, Aukt. v. 11. 5. 2011); auch Sport-Darst. (*Ciclisti su strada*, 1936) und Portr. (*Ritratto di giovinetta*). – Ausz.: 1935 Premio Principessa Piemonte, Concorso Sogno di madre, Genua; 1936 Silber-Med. auf Kunst-Ausst. Olympische Spiele, Berlin; 1939 Silber-Med. Minist. Educazione Naz., Turin; 1957 Gold-Med. Raduno Artist., Triest. ⌷ LATINA, Gall. civ. d'arte mod. e contemp.: Disco sul ghiaccio, 1936. ◈ G: Turin: 1930–41, '61-'67 Promotrice delle BA; 1930–42 Soc. Amici dell'Arte; 1957 Quadrienn.; 1961 Gall. Gazzetta el Popolo / 1932 Nizza Marittima: Espoz. Internaz. di Arte Mediterranea / 1933 Florenz: Mostra Interregionale / 1934 Bologna: Bienn. Internaz. del Paesaggio / Rom: 1935 Quadrienn.; 1935–40 Mostra Internaz. d'Arte Sportiva / 1937 Paris, Jeu de Paume: Origines et développment de l'arte internat. indépandant / 1953 Lecco: Quadrienn. ⌷ *Padovano*, 1951; *Arnaud/Busignani* II, 1962 (s.v. Gamero Colonna, Pinetta); AIC II, 1966; Gente nostra I, 1968; II, 1969; EU SEDA IV, 1969; CatBolaffiMod IX. 2, 1974; *E. Bellini*, Pittori piemontesi dell'Ottocento e del primo Novecento. Dalle Promotrici torinesi, T. 1998; *Breda*, 2001. – Emporium 85:1937, 160; *L. Iamurri/S. Spinazzé* (Ed.), L'arte delle donne nell'Italia del Novecento, R. 2001; *R. Bossaglia*, Ritratto di un'idea. Arte e archit. nel Fascismo (K Rom), Mi. 2002. – Rom, Arch. Bibl. Quadrienn. E. Kasten

Çolpan, *Nusret*, türkischer Maler, Miniaturist, Architekt, * 1. 10. 1952 Bandırma, † 31. 5. 2008 Istanbul. Verh. (1979) mit Husniye Ç. Stud.: Zincirlikuyu Meslek Lisesi bei A. Suheyl Ünver und Azade Akar; später Archit. an der Yildiz Univ., Istanbul. Mehrere Reisen nach Europa. Ausz. u.a.: Großer Preis des Kultur-Minist.; Großer Preis der türk. Kulturstiftungen (Türk Kültürüne Hizmet Vakfi Büyük Ödülü), Mevlana Erfolgspreis (Achievement). 1979 eröffnete er in Istanbul ein Atelier für Innen-Archit.

zus. mit Semih Irtesim. – Ç. arbeitete zunächst als Kellner und als Maler an einem Zeitungsstand, wo er detaillierte Ansichten von Moscheen auf hölzerne Löffel malte. Den Kontakt zu seinem Lehrer Suheyl Ünver entstand durch einen Onkel (Ali Oztaylan). Ç. ist v.a. durch seine Stadtansichten bek. (meist Aqu., selten Öl/Lw.), die sich deutlich an Werke des berühmten osmanischen Min.-Malers Matrakçı Nasuh aus dem 16. Jh. anlehnen. Kennzeichnend dafür sind kompositorische und inhaltliche Motive wie spiralförmige Wellen, anachronistische Segelschiffe, stets ein Fluß oder das Meer, die Gest. der Wolken oder die Einansichtigkeit von Gebäuden; neu hingegen ist bei Ç. die Kombinationen versch. Perspektiven oder ein Blick durch die Wolken. Ç. wählt neben hist. Themen aus der osmanischen Geschichte (z.B. Fall von Konstantinopel) oder relig. Motiven (Arche Noah) v.a. auch Ansichten mod. Städte im gleichen trad. Stil, u.a. von New York, Istanbul, Medina oder Konya. 1999 entsteht zur Eröffnung der U-Bahn in Istanbul in Zusammenarbeit mit der Keramikfabrik Iznik Found. ein großflächiges Fliesen-Wandbild. Ç.s Beliebtheit resultiert aus der Bekanntheit der Vorlagen und deren Aktualisierung. Seine Werke dienten u.a. als Staatsgeschenke, z.B. eine Fliese an den frz. Präs. Jacques Chirac oder eine Ansicht von Moskau an Vladimir Putin. ⌷ BANGKOK: Turkish Garden. DUBAI: Zabeel Park. ISTANBUL, Kadir Has Univ., Cibali Campus. SANTA BARBARA/Calif., Mus. of Art. K. Schmidtner

Colruyt, *Camille (Camille Henri Véron)*, belg. Bildhauer, Goldschmied, * 22. 9. 1908 Lembeek, † 15. 6. 1973 ebd. Bruder des Malers, Zeichners, Graphikers, Glasmalers, Keramikers, Goldschmieds und Bildhauers *Joseph (Jozef) C.* (* 1900 Lembeek, † 1988 Brüssel), Vater des Bildhauers *Gustave (Gustaaf; Staaf; Staf) C.* (* 1948 Halle/Brabant, lebt in Antwerpen. Stud.: Koninkl. ASK, Antwerpen; Hoger Inst. voor Schone Kunsten ebd. Seit 1986 unterrichtet er an der Sted. Acad. voor Schone Kunsten, Turnhout. Figurative Plastiken aus Bronze, Terrakotta, Stein und Kupfer). Abend-Stud.: 1924–27 Ec. supérieure des Arts, Brüssel (Ec. St-Luc); 1929–31 Acad. royale des BA ebd., bei Jean Delville und Victor Rousseau. Gleichzeitig (1925–31) Ausb. zum Goldschmied bei Henri Holemans. 1932 Rückkehr nach Lembeek und Eröffnung eines eig. Ateliers. – Zunächst v.a. liturgisches Gerät; nach der Heirat 1936 wendet sich C. bevorzugt der Bildhauerei zu und widmet sich zeitweilig privateren Themen wie z.B. Mütterlichkeit; weiterhin entstehen Portr.-Büsten, u.a. von Freunden (z.B. von *Jean Huet*, Stein, 1946). Des weiteren zahlr., z.T. mon. Skulpt. mit relig. Sujets, v.a. aus Kupfer (v.a. Treibarbeiten), Holz, Stein, Bronze und Elfenbein (z.B. Christusfigur, 1934, Stein, Essenbeek), häufig in reduzierter Formsprache. Zu C.s Hauptwerken gehören die Innenausstattung der Sint-Trudokerk in Meerhout sowie die Rekonstr. des Schreins der Hl. Gertrude in Nivelles. ⌷ BRÜSSEL, Cathédrale St-Michel-et-Gudule: Christi Himmelfahrt, Kupfer, getrieben, 1968. HALLE, Zuidwest-Brabants Streek-Mus.: Kreuzweg. NAZARETH, Verkündigungsbasilika: Baldachin, Monstranz, Tabernakel, 1967. VILLERS-DEVANT-ORVAL, Abbaye d'Orval: Re-

liquienschreine, Kreuze, Osterleuchter, Kelche, Portr.-Büste. WOLUWE-SAINT-PIERRE, Eglise St-Paul: Hll.-Statuen Peter und Paul, 1946. ◉ *E:* 1970 Neder-over-Heembeek, Sint-Niklaaskerk / 1981 Brüssel, Cathédrale St-Michel-et-Gudule / 1983 Lembeek, Sint-Veroonskerk / 2008 Villers-devant-Orval, Abbaye d'Orval / 2009 Halle, Zuidwest-Brabants Streek-Mus. – *G:* 1958 Brüssel: WA (Statue Papst Pius XII) / 2008 Antwerpen, Zilver-Mus. Sterckshof: Fifties Zilver. Belg. zilver rond 1958 (K). ▭ Vol, 1953. *Arto*, 1978. *T. Denoël* (Ed.), Le nouv. dictionnaire des Belges, Br. 1992; *Bénézit* III, 1999; *C. Engelen/M. Marx*, Beeldhouwkunst in België, I, Br. 2002; *Pas* I, 2002. – Nouv. Biogr. nat., III, Br. 1994. F. Krohn

Colruyt, *Gustave* cf. **Colruyt,** *Camille*

Colruyt, *Joseph* cf. **Colruyt,** *Camille*

Colson → **Hélin,** *Florent* [AKL]

Colson, *Greg,* US-amer. Maler, Objektkünstler, Assemblagekünstler, * 23. 4. 1956 Seattle/Wash., lebt in Venice/Calif. Stud.: bis 1978 California State College, Bakersfield/Calif.; bis 1980 Claremont Graduate School, Claremont/Calif. – Nach humorvollen, sparsam gezeichneten Cartoons befaßt sich C. mit der Bedeutung und Wirksamkeit von den Alltag organisierenden Zeichensystemen. Er gestaltet formal geordnete Wandassemblagen aus Fundstücken wie Reifenschläuchen, gebrauchten Holzstöcken, -spänen und -platten, Schiefertafeln sowie aus Metallabfällen, die er sorgfältig bemalt, beschriftet oder beklebt und zur Befestigung häufig Armaturen aus Holz konstruiert (Serien *Stickmaps; Pie charts; Solar Systems; Intersections*). Die Landkarten, Pläne und Diagramme erwecken den Eindruck von realistischer Information von Dingen, die in der Trad. von Kurt Schwitters oder Robert Rauschenberg ihren eigentlichen Zweck nicht mehr erfüllen, aber durch die Kombination mit alltäglicher graph. Ikonogr. vertraut erscheinen. So gestaltet C. beispielsweise eine Karte mit den Straßenachsen von Berlin aus bemalten Stöcken (*Berlin Map*, 2001; Slg Rosenkranz, Berlin), einen Stadionsitzplan auf einem luftgefüllten Autoschlauch (*Riverfront Stadium*, 1989) oder das Kreisdiagramm *Vanishing surplus* (2002) mit illustrierenden Symbolen und Schriftsätzen zur Rezession. Die Objekte sind bildnerisch und inhaltlich sorgfältig ausbalanciert und werden durch Zchngn (Aqu., Tusche, Bleistift) vorbereitet. Mit satirischem oder sozialkritischem Unterton zeigt C. die Absurdität und die täglich größer werdende Stimulation durch allgegenwärtige Informationssysteme und ges. Analysen. ▭ LONG ISLAND CITY/N. Y., Fisher Landau Center for Art. LOS ANGELES, MCA. LUGANO, Panza Coll. MOSKAU, Tsaritsino MCA. NEWPORT BEACH/Calif., Orange County Mus. NEW YORK, Metrop. Mus. – MMA. – Public Libr. – Whitney. OAKLAND, Oakland Mus. of California. PORTLAND/Ore., AM. SAN DIEGO/Calif., MCA. SANTA MONICA, Getty Research Inst. – Peter Norton Fam. Found. SEATTLE/Wash., Henry AG. STOCKHOLM, Mod. Mus. URBANA-CHAMPAIGN/Ill., Krannert AM. VANCOUVER, AG. WASHINGTON/D. C., Hirshhorn Mus. and Sculpt. Garden. ◉ *E:* Santa Monica: 1987, '90, '93, '95, '97 Angles Gall.; 2008, '10 Wil-

liam Griffin Gall. (K) / 1988 Lake Worth (Fla.), Lannan Mus. (K) / 1990, '91, '94 New York, Sperone Westwater / 1992, '99 Rom, Gian Enzo Sperone / 1994 Loppen-Zedelgem, KH / 1996 Bakersfield (Calif.), Thayer Gall.; Urbana-Champaign, Krannert AM / Mailand: 1998 Milleventi; 2001, '05 Gall. Cardi (K) / 1998, '99, 2001, '04, '06 Venice (Calif.), Griffin Contemp. / 1999 San Francisco, John Berggruen Gall. / 2001 London, Gall. Sprovieri / 2002, '06, '12 Aspen, Baldwin Gall. / 2002 Amsterdam, Art Affaires Gall. ▭ *Bénézit* III, 1999. – *M. Anderson*, AiA 77:1989 (7) 144 s.; *B. Butler*, New art examiner 16:1989 (März) 53; *D. Pagel*, ArtsMag 64:1989 (2) 40–43; *R. Mahoney*, ibid. 1990 (April) 109 s.; *J. Saltz*, Flash art 152:1990 (May-Juni) 150; *L. E. Nesbitt*, Artforum 28:1990 (April) 173; *E. Heartney*, Art news 89:1990 (Mai) 210; *G. Kamiya*, ibid. 90:1991 (9) 96–101; Mapping histories (Newport Bienn., K Newport Harbour Mus.), Newport Beach/Calif. 1991; *R. Storr*, Mapping (K MMA), N. Y. 1994; *G. Melrod*, AiA 82:1994 (Sept.) 112; Print collector's newsletter 26:1995 (2) 64 s.; *P. Kosenko*, Art papers 19:1995 (Mai/Juni) 37 s.; *K. Marzahl*, New art examiner 24:1997 (März) 47 s.; *D. Hunt*, Flash art 31:1998 (203) 105; *C. Miles*, Artweek 29:1998 (5) 23; Panza. The legacy of a collector (K MCA), Los Angeles 1999; Art on paper 5:2001 (Mai-Juni) 71 s.; *J. Caniglia*, Artforum 39:2001 (6) 152; The Pontus Hulten Coll. Stockholm (K Mod. Mus.), Sth. 2004; G. C. The archit. of distraction (K William Griffin Gall.), L. A. 2006; *K. Beil*, Artweek 39:2008 (5) 18 s. – *Online:* Website C. H. Stuchtey

Colt de Hume (Hume), *Blanca (Blanche),* argentinische Malerin, Illustratorin, Exlibriskünstlerin, Dichterin, * 27. 2. 1879 San Isidro/Buenos Aires, † 5. 5. 1964 Buenos Aires. Priv. Malerei-Ausb. bei versch. Prof. und fünf Reisen nach Europa. Mitarb. an versch. Ztgn im In- und Ausland. Mitgl. vieler Vrgn der Frauenbewegung, u.a. Unión Feminista Nac. und Asoc. Pro Derechos de la Mujer, außerdem Präs. des Comité Femenino de Ayuda Soc., Dir. der Liga Argentina de Temblanza und Präs. der Comisión de BA des Congreso Internac. Femenino. ✉ Flores silvestres. Poesías escogidas, Bs.As. 1916; El alma de la tarde, Bs.As. 1918. El jardín del ensueño, Bs.As. 1919; Songs from Argentina (mit eig. Ill.); Songs of wedded love, beide Lo. 1920; La lámpara en las sombras, Bs.As. 1924 (mit eig. Ill.); Consejos maternales, Bs.As. 1929; Canciones de cuna, Bs.As. 1932 (mit eig. Umschlag-Gest.); Rosas de mi senda, poesías escogidas, Bs.As. 1940 (mit eig. Exlibris und Ill.); Incienso de oración. Versos, Bs.As. 1941; Hacía la altura. Poesías, Bs.As. 1942; La luz del mundo. Poesías, Bs.As. 1943; Canto de gratitud y de alabanza. Poesías, Bs.As. 1944; Páginas peronistas, Bs.As. 1951. ◉ *G:* Buenos Aires: 1916 Salón Nac.; 1932 Salón Femenino de BA. ▭ *Merlino*, 1954; EAAm I, 1968; *Gesualdo/Biglione/Santos* I, 1988; *Shipp*, 2003. – *J. Bustos*, Semblanza de la poetisa B. C. de H., Bs.As. 1934. – *Online:* Dicc. de la discriminación de la mujer.

M. Nungesser

Colta, *Onisim,* rumänischer Maler, Zeichner, Graphiker, Objektkünstler, Szenograph, Kunstpublizist, * 10. 6.

1952 Baia Sprie/Bez. Maramureş, lebt in Arad. Stud.: bis 1976 HBK I. Andreescu, Cluj(-Napoca), bei Paul Sima (2006 ebd. Promotion). 1978–80 externes Szenographie-Stud. in Bukarest. Als Kostüm- und Bühnenbildner am Staatstheater Arad an etwa 70 Inszenierungen beteiligt (z.B. 2010 bei der erfolgreichen Erstaufführung von Anna Maria Bambergers „Belvedere"). 1998–2005 Doz. an der Fak. für bild. Künste, Oradea. Seit 2000 Mitarb. bei der Zs. Arca. 1994–98 Präs., ab 1998 Vize-Präs. des Künstler-Verb. in Arad. Ausz.: 1988 Preis für junge Künstler, Bienn. Arad; dort in Folge mehrfach Excellence-Preise. Seit 1989 Teiln. an mehreren nat. Malereisymposien. – In ihrer aufwendigen, feinen, eigtl. graph. Struktur erinnert C.s Malerei (Acryl/Lw.) der letzten Jahre an alte Stiche. Zu den bevorzugten Themen gehören (fiktive) Sakralbauten, bes. Kuppelsituationen, und detailreiche Stilleben. Seine Buch- bzw. Bibelobjekte, z.B. *Biblia de la Aksum* (Holz, Karton, Sand, 2005), sind noch deutlicher als seine Bilder vom Surrealismus inspiriert. Arbeiten von ihm befinden sich in rumänischen Mus. und in der Kunst-Slg des Vatikans. ☉ *E*: zahlr. seit 1976, u.a. 1982 Athen, Gal. Diogenes / Bukarest: 1986 Căminul Artei; 2003 Ungar. Kulturzentrum / 1988 Aachen, Gal. Severin Rautenberg; Timişoara, Gal. Helios / 1989 Bielefeld, Gal. Rosengarten; Tîrgu Mureş, Gal. Vatra / 1994 Budapest, Rumänisches Kulturzentrum; Gyula, Gal. Noi / 1996, 2006 Cluj-Napoca, MN de Artă / 1998 Oradea, Muz. Ţării Crişurilor / 2005 Baia Mare, Muz. de Artă / 2009 Plzeň, StG: 3 x Arad (mit Rudolf Kocsis, Dumitru Şerban) / 2011 Sibiu, MN Brukenthal. –. *G*: u.a. 1981, '82 Barcelona: Joan-Miró-Wettb. / 1984, '86 Rom, Fund. Sinaide Ghi: Internat. Aqu.-Wettb. / 1985 Valparaiso: Bienn. / 1987 São Paulo: Bien. / 1988 Wrocław: Trienn. / 1992 New York City, Bibl. Româna; Yokohama: Graphik-Bienn. / 1993 Györ: Internat. Graphik-Bienn. / 2003 Prag: Szenographie-Quadrienn. / 2005 Kraków: Trienn. Icon Data World Prints / 2012 Mogoşoaia, Palatul Brâncovenesc: Semnificaţii (mit Sorin Dumitrescu, Marin Gherasim, Silviu Oravitzan). ▱ *A. Cebuc u.a.*, Enc. artiştilor români contemp., II, Bu. 1998; *C. Prut*, Dicţ. de artă mod. şi contemp., Bu. 2002. St. Schulze

Coltro, *Davide*, ital. Fotograf, Computerkünstler, * 21. 3. 1967 Verona, lebt in Mailand. Autodidakt. Ab 1997 abstrakte Malerei. Siedelt 2000 nach Mailand über. Verkauft dort günstig spielerische Figurenbilder (*Diffusa*) in großen Mengen und unterläuft damit den Wertanspruch des Kunstwerks. 2001 beginnt er, mit Digitaltechnik zu arbeiten (Portr., Lsch., Stilleben), ab 2003 mit Verbindungen von Fotogr. und digitaler Malerei. 2011–12 Mitgründer der Gruppo On, die versch. Formen von Energie nutzt. – C. versteht sich als Medienkünstler, der für seine „digitale Malerei" das „elektronische Bild" (auch in Großformat) als „interaktive Lw." benutzt. C. sieht den Bildschirm nicht nur als technisches Wiedergabegerät, sondern als ein mod. komplexes *System*, das er als offenes Dialogfeld zw. Künstler und Betrachter und als dynamisches Repräsentationsmittel nutzt. C. zeigt Monitor-Abb. auch in ständigem ästhetischem „Fluß", den er von seinem digitalen

Studio (*Alghe blu*) aus situativ steuert. Auch überträgt er Handy-Fotogr. auf den Bildschirm oder läßt die Betrachter Arbeiten aus einer Datenbank wählen. Bei *Colore medio* (*Medium color landscape*) ermittelt er die dominierende Bildfarbe von auch unscharf gehaltenen Lsch.-Fotogr. mathematisch aus den im Bild enthaltenen Farbwerten; bei seiner Installation von solchen Lsch. auf 96 Monitoren an der Bienn. in Venedig (*Res_publica 1*, 2011), deren Farbigkeit auch monochrom in die drei Landesfarben überwechselt, fotografiert C. während der Ausst. eine große Anzahl weiterer Bilder und speist sie aktuell in das Werk ein. Bei *Viventi* (*Living shrouds*) schafft C. Portr. mit dem Fotokopiergerät durch Auflage der Porträtierten auf die Glasscheibe; Abzüge der Kopien installiert er unter Klarsichtfolie an der Wand und gibt sie als Streaming mit zufällig wechselnden Überblendungen auf einem Monitor wieder. Für *Misteri* fotografiert er Personen im Sinne von Anti-Portr. von hinten. C. versucht auch, mit inszenierter Fotogr. die Aura altmeisterlicher Malerei zu evozieren und so die Kunstgesch. digital zu re-interpretieren, indem er Modelle nach Vorbild alter Gem. posieren läßt und die Bilder dann digital bearbeitet. ▱ BIUMO SUPERIORE, Coll. Panza di Biumo. FRANKFURT am Main, VAF-Stiftung. ISERNIA, MAC. MAILAND, MCiv. d'Arte Contemp. (CIMAC). – Coll. Unicredit Banca. REVERE, Young Mus. ROM, Coll. Farnesina. SEREGNO, Gall. Civ. Ezio Mariani. ROVERETO, MART. VERONA, GAM. ☉ *E*: 2001 Revere, Young Mus. (Wander-Ausst.) / 2003 Verona, Gall. La Giarina (Wander-Ausst.) / 2005 Turin, Gas AG (Wander-Aust.) / 2006, '10 San Francisco, M. Wolfe Contemp. Art / 2007 Triest, Gall. Planetario / 2009 Parma, Pal. della Rosa Prati. – *G*: Mailand: 2003 Pal. Anagrafe: Città Zioni; 2010 Fond. Durini: Living shrouds / 2004 Rom: Quadrienn. / 2005 Seregno, Gall. Civ. E. Mariani: Refresh / 2006 Shanghai, Urban Planning Exhib. Center: Nature & Metamorphosis (Wander-Ausst.); Florenz, Fortezza da Basso: Anima digitale; Mantua, Pal. della Ragione: Realismo magico / Verona, GAM: 2006 (L'infinito dentro lo sguardo); 2011 (Invisibilia und Ritratti imperfetti) / 2007 San Diego, Lyceum Theatre Gall.: Art of digital show / 2008 Moskau: Internat. Bienn. for Young Art, Qui vive? / 2009, '11 Venedig: Bienn. / 2009 Karlsruhe, ZKM: Collector's choice / 2010 San Francisco, Ist. Ital. di Cult.: IT Italian art today / 2011 St. Petersburg, Loft Project Etagi: Senza rete (K) / 2011 Rovereto, MART: 800 versus '900; Percorsi riscoperti dell'arte ital. nella VAF-Stiftung 1947–2010; Prati, Centro per l'Arte Contemp. L. Pecci: III Ed. Premio Maretti / 2012 Trezzano sul Naviglio, Hangar 6: On. ▱ *M. Sciaccaluga*, Flash art (Ital.) 38:2005 (253) 76 s.; Art ltd. mag. 2010 (Mai-Juni) 18 s.; Arte (Ital.) 2010 (Juli). – *Online*: Website C. – Mitt. C. T. Koenig

Colvin, *Neville (Neville Maurice)*, neuseeländischer Cartoonist, Comiczeichner, Illustrator, Maler, * 17. 12. 1918 Dunedin/Otago, † Nov. 1991 London. Stud.: Univ. of Otago, Dunedin. C. strebt zunächst eine Laufbahn als Kunsterzieher an, wird aber im 2. WK in die Second New Zealand Expeditionary Force eingezogen. Während des Militärdienstes zeichnet er Karten und den Cartoon strip

Fred Clueless für die Armee-Ztg NZEF Times. Ab 1946 gestaltet er politische Karikaturen und Sport-Cartoons für die Ztg The Evening Post (Wellington). Wegen der Zensur einiger die konservative Politik der neuseeländischen Reg. kritisierender Zchngn tritt er als Cartoonist des Bl. zurück. 1956 Übersiedelung nach Großbritannien, wo C. zunächst für die Ztg Daily Sketch arbeitet. Später freischaffend für zahlr. weitere brit. Ztgn und Zss. tätig, u.a. für Daily Express; Daily Telegraph; Evening Standard; News Chron.; News of the World; Sunday Express. Für die Zs. Swift Weekly entsteht 1960–62 der Comic strip *Ginger & Co.*, für den Evening Standard zeichnet C. 1980–86 in der Nachf. von James Holdaway und Enrique Badia Romero den populären Agenten-Comic strip *Modesty Blaise* (Text v. Peter O'Donnell). Auch humoristische Buch-Ill., u.a. zu *Struth. The Harbinger of Truth, Beauty and Goodness* (Dunedin 1939) v. J. F. McDougall; *Johnny Enzed in Italy. Libels and Lyrics* (Rotorua 1945) v. E. G. Webber; *The Songs We Sang* (Wellington 1959) v. Les Cleveland; *Kiwi Down the Strada* (Christchurch 1963) v. Leslie Hobbs; *A Welcome to Britain* (Lo. 1970); *Sleep Clinic. A Strip Cartoon Analysis of Insomnia and its Causes* (Lo. 1975) v. Ridwan Aitken. Außerdem Portr.-Malerei. – Während C.s stark konturbetonte politisch-satirische und humoristische Tuschfeder-Zchngn deutlich in der Trad. von David Low stehen, orientieren sich die dynamisch-realistischen Comic-Zchngn v.a. an Vorbildern wie J. Holdaway und Yaroslav Horak. ⌂ LONDON, Nat. Portr. Gall. ⌘ *M. Bryant*, Dict. of twentieth-c. Brit. cartoonists and caricaturists, Aldershot 2000. – *L. Blackmore*, The Modesty Blaise companion, Lo. 2005; Peter McIntyre, 2nd NZEF war drawings 1941–1944. The C. coll. (K Jonathan Grant Gall.), Auckland 2010. – *Online:* The Art of C.; Lambiek Comiclopedia; New Zealand Cartoon Arch.

H. Kronthaler

Colwell, *Guy*, US-amer. Maler, Zeichner, Graphiker, Comiczeichner und -texter, Illustrator, * 28. 3. 1945 Oakland/Calif., lebt in Berkeley/Calif. Nach einem zweijährigen Stud. am California College of Arts and Crafts, Oakland, arbeitet C. ab 1966 zunächst u.a. als Figurengestalter für die Spielzeug-Fa. Mattel. 1968 wird er wegen Kriegsdienstverweigerung zu zwei Jahren Haft im Federal Prison auf McNeil Island/Wash. verurteilt. Die dort gemachten Erfahrungen von ges. Unterdrückung und Gewalt fließen ebenso wie das Lebensgefühl einer Drogen konsumierenden und freie Sexualität propagierenden Hippie-Ges. später in die Gesch. des ab 1972 ersch. Underground-Comic books *Inner City Romance* ein (5 Hefte, 1972–78). In den 1970er Jahren in San Francisco/Calif. als Illustrator für das Underground-Mag. Good Times tätig. Seit M. der 1980er Jahre entstehen verstärkt Gem., einige weitere Comics und Ill. für Mag. und Anthologien der Rip Off Press sowie das eig. erotische Comic book *Doll* (8 Hefte, 1989–92; Einzel-Ausg. *The Further Adventures of Doll*, 1989). 1986 Teiln. am von dem Bürgerrechtsaktivisten David Mixner initiierten Great Peace March for Global Nuclear Disarmament; zeichnet Karten und Portr. von Teilnehmern. Ab 1988 in Auburn/Calif. ansässig. Unternimmt

seither mehrere Reisen durch Europa und Afrika und widmet sich seit A. der 1990er Jahre hauptsächlich der Malerei. – Vertreter einer figurativ-realistischen Malerei mit meist manieriert erscheinenden Figuren-Komp., die politische, sozialkritische oder ökologische Themen aufgreifen (z.B. *Litter Beach*, 1995–2001, Acryl und Öl/Lw.; *Bread Line*, 2008, Öl/Lw.). Das 2004 entstandene Gem. *The Abuse*, das die Folter von Gefangenen im US-amer. Gefängnis Abu Ghraib im Irak thematisiert, führt zu Drohungen und gewalttätigen Übergriffen auf C.s Galeristin Lori Haigh. Auch surrealistische Gem. (z.B. *Painter with Genet*, 2007, Acryl/Lw.), Tier- und Pflanzenmotive, Stilleben und Wandmalerei (z.B. *Rain Forest*, Oakland Zoo; *Sierra Mammals*, Placer Nature Center, Auburn/Calif.). Außerdem Tusche-Zchngn (z.B. *Gas Mask*, 2001; *African Scrape*, 2009); Hschn. (z.B. *Outer Office*, 1984); Linolschnitte (z.B. *Rain Forest*, 2002); Plakate; Buch-Ill. (u.a. zu *Peace Like a River. A Personal Journey Across America*, Santa Fe 1991, v. Sue Quist). ⌂ OAKLAND, Oakland Mus. of California. SACRAMENTO/Calif., Crocker AM. SAN FRANCISCO/Calif., Pritkin Mus. SWARTHMORE/Pa., Swarthmore College, Peace Coll. ◉ *E:* 1989 Auburn (Calif.), AC. ⌘ *P. Rosenkranz/H. van Baren*, Artsy, fartsy, funnies, Laren 1974; *B. Sherman*, The comics j. 1978 (43) 70 s; *T. Albright*, Art in the San Francisco Bay area. 1945–1980, Berkeley, Calif. u.a. 1985; *J. O'Sullivan*, The great Amer. comic strip. One hundred years of cartoon art, Boston, Mass. u.a. 1990; Central body. The art of C., including work from the years 1964 to 1991, Auburn, Calif. 1991; *M. J. Estren*, A hist. of underground comics, Berkeley, Calif. ³1993; *D. Kerekes/D. Slater*, Critical vision. Random essays & tracts concerning sex, religion, death, Stockport 1995; *M. Whyte/C. Geerdes*, The underground comix fam. album, S. F. 1998; *P. Rosenkranz*, Rebel visions. The underground comix revolution, 1963–1975, Seattle, Wash. ²2008; *F. L. Aldama*, Multicultural comics. From Zap to Blue Beetle, Austin, Tex. 2010; *W. J. T. Mitchell*, Cloning terror. The war of images, 9/11 to the present, Chicago, Ill. 2011. – *Online:* Lambiek Comiclopedia; Website C.

H. Kronthaler

Comand, *Patrizia*, ital. Malerin, * 1949 Corbetta, lebt in Mailand. Stud.: bis 1972 (Dipl.) Accad. di Brera, Mailand, bei Gianfilippo Usellini, Antonio Vittorio Marchese, Ilario Rosso und Guido Ballo. 1974 Ausst.-Debüt in Desenzano del Garda (Gall. Duomo). Arbeitet figürlich und ist anfangs geprägt durch Lorenzo Vespignani und Giuseppe Guerreschi, über den sie ihre Magisterarbeit schreibt. Inspiriert füjhlt sie sich von H. Bosch und P. Bruegel d.Ä., v.a. durch Arbeiten von Paul Cadmus und Gustave Moreau. Geht 1987 nach Venedig und lebt 1991–94 in El Salvador, Guatemala und Mexiko. Arbeiten aus diesen Jahren zeigt sie 1995 auf Madeira. 2007 Installation zweier Leinwände mit Engeln in magisch wirkender Farbigkeit (10 x 20 m) auf der Fassade des Mailänder Domes. – C. stellt enorm füllige, zur Fettleibigkeit neigende, meist weibliche Figuren in ironisch verfremdeten, surreal anmutenden Situationen dar, die charakterisiert sind durch eine ambivalent wirkende Eleganz und Schwere-

losigkeit. Die Palette ist psychologisierend und reichhaltig. C.s Frauengestalten, häufig Athletinnen und Akrobatinnen, assoziieren barocke Sinnenlust; sie bevölkern leere, undefinierbare Räume, wodurch ein reizvoller Kontrast entsteht. Auch Porträts, u.a. von kirchlichen Würdenträgern, so das Portr. von *Papst Benedikt XVI.* (Acryl, Tempera/Lw., 2005; Turin, Basilica di Superga). C. reflektiert in ihren ideenreichen Arbeiten die Unwägbarkeiten menschlichen Bemühens um Gleichgewicht, das Leben als Risiko und ständigen Wettkampf sowie die Freude an Körperlichkeit. ☐ ATRIPALDA, Azienda Vinicola Mastro Berardino. AURONZO DI CADORE, Sala Consiliare. COPPARO, Gall. Civ. d'Arte Contemp. CORBETTA, Pal. Mun. FERRARA, Arcispedale S. Anna, Quadreria Melotti. FUNCHAL, Universo da Memòrias. GRUYÈRES, Château. NOCCIANO, Mus. delle Arti del Castello. SAN PIETRO IN CERRO, Mus. in Motion (MIM). TREZZO D'ADDA, Bibl. Com. TURIN, Basilica di Superga. – Mus. di Superga. WASHINGTON, NM of Women in the Arts, Arch. ◉ *E:* 1995 Funchal, Pal. del Governo / 2000 Gruyères, Château / 2001 Mailand, Spazio Guicciardini (K: R. Bossaglia) / 2004 Pavia, Gall. Sansoni. – *G:* 1995 Ferrara, Gall. Civ. del Castello di Mesola: Il Po del '900. Arte, Lett., Cinema (K) / 2002 Triest, Mus. Revoltella: Da De Chirico a Leonor Fini. Pitt. fantastica in Italia (K: V. Sgarbi) / 2006 Sulmona, MCiv. Diocesano: Premio Sulmona / 2010 Paris, Grand Pal.: One Million Dollars / Riegersburg (NÖ), Barockschloß: 2010 Die Macht der Phantasie; 2011 L'ange exquis. ☐ *Falossi*, PPC, 1975; Enc. dei pittori e scultori ital. del '900, I, 1991. – *C. Munari*, La brezza dell'ironia nella corte dei miracoli (K), Magenta 1991; *M. De Micheli*, Reale e immaginario. Convergenze e fratture nell'attuale arte lombarda, Cremona 1994; *id.*, Nel segno dell'immagine, Mi. 1995; *M. De Stasio*, Senza frontiere (K), To. 1998; *É. Chatton*, L'incommensurable légèreté del'être (K), Fribourg 2000; Immagina (K), Reggio Emilia 2000; Tra sogno e magia. Arte fantastica e visionaria dal Castello di Gruyères (K), Piombino/Rapolano 2001; *L. Gavioli*, Il Po in controluce Arte padana, alluvione e dintorni, Ve. 2001; *V. Sgarbi* (Ed.), Surrealismo padano (K Piacenza), Mi. 2002; *C. Lepere*, Parfums de femmes, P. 2002; *V. Sgarbi*, I giudizi di sgarbi. 99 artisti dai cat. d'arte e dintorni, Mi. 2005; *F. Gualdoni*, Visioni (K), Corbetta 2005; *F. Fanelli*, Corriere della Sera v. 12. 5. 2005; *C. Cussac*, Regard fantastique, P. 2006; Art en capital. Comparaisons, P. 2007; *L. Gavioli*, Visionari. Reale fantastic nell'arte ital.. contemp., Bp. 2007; *P. Levi*, Per … bacco, Fi. 2007; *id.*, L'illusione del sogno, Mi. 2007. – *Online:* Website C. S.-W. Staps

Comani, *Daniela*, ital. Fotografin, Zeichnerin, Video-, Installations- und Objektkünstlerin, * 1965 Bologna, lebt und arbeitet in Berlin. Stud.: 1984–88 ABA, Bologna; 1985–88 Univ. ebd. (Discipline delle Arti della Musica e dello Spettacolo); 1989–93 HdK, Berlin; 1992 Surikov-Kunst-HS, Moskau. 1994 und 2001 Arbeits-Stip. des Berliner Senats. 2001, '05 Artist in Residence in Japan (Gunma; Kanazawa). – Beschäftigt sich mit dem Facettenreichtum von einzelnen Aussagen, indem sie u.a. 1997 die „Logik" des Fernsehens untersucht, wo Daten und Informa-

tionen einem ständigen Wechsel unterliegen. Die gleichzeitige Verfügbarkeit einer unendlichen Fülle von Bildinformationen führt zur Auflösung der konkreten Inhalte. In der gleichzeitig entstandenen Folge *Double drawings* verknüpft C. mehrere übereinandergelegte Bll. mit Motiven aus der Bilderwelt der Massenmedien zu einer disparaten Einheit. Um 2000 erstellt sie in Porträtfolgen, z.B. *Printed Women*, neue Typologien und Klassifikationen. C.s wichtigste ikonogr. Quelle sind die Medien. Die Verfremdung von Schriften und Werken der (Welt-)Lit. etwa durch Veränderung einzelner Buchseiten, Buchtitel oder des Geschlechtes der handelnden Personen stellt den bildungsbürgerlichen Lit.-Betrieb und die trad. Geschichtsschreibung sowie deren Wahrheitsansprüche in Frage. C.s künstlerische Eingriffe in soziale und hist. Ordnungen sind vielschichtige Konzeptarbeit. Neben Installationen und Objekten realisiert sie auch Videos, z.B. *100 Jahre. 100 Sekunden* (2008). ✉ Ich war's. Tagebuch 1900–1999, Ffm. 2005; Neuerscheinungen, Z. 2009. ◉ *E:* 1996, '99, 2000 Bologna, Gall. Studio G 7 / 1997 Braunschweig, KV / Berlin: 2003 Murata & Friends; 2005 plattform; 2007 U2-Alexanderplatz NGBK; 2009 Gal. Laura Mars; 2010 Souterrain / 2006 Reggio nell' Emilia, MCiv. / 2008 Mailand, Neon. La Fabbrica del vapore. – *G:* 1996 St. Gallen, KH: Lesen / 2001 Maebashi (Japan): Festival of Arts; Gonzaga, Ex-Convento di S. Maria: Tranches de vie (K: M. Zanelli) / Bologna: 2002 Gall. Neon, Pal. Albiroli: Entr'acte; 2005 Gall. Studio G 7: Rigorosamente bianco e nero / 2004 New York, Esso Gall.: Portraits / 2007 Dortmund, Medien KV: History will repeat itself (K: I. Arns); Wien, Foto-Gal.: Bodytalk / 2008 Ulm, Ulmer Mus.: Liebe, Love, Paare. Von Munch bis Warhol; Salzburg, KV: Bildpolitiken; Karlsruhe, ZKM, Medien-Mus.: Vertrautes Terrain / 2009 Berlin, Carrè am Alexanderplatz: Fake or feint. Szenario 5 / 2010 Zürich, Shedhalle: Überblendungen / 2011 Dallas, Kirk Hopper FA: Sex-Twist; Graz, KV Medienturm: Schon wieder und nochmal?; Venedig: Bienn. ☐ *E. Karcher*, Art 1996 (10) 46; *L. Guerrini*, Arteletta 2000 (4); *H. Loreck*, in: Goldrausch Art IT, B. 2005; Permanent zeitgen. Atelierpreisträger 1996 bis 2005 (K), B. 2005; *F. Wagner u.a.* (Ed.), Das achte Feld. Geschlechter, Leben und Begehren in der Kunst seit 1960 (K Köln), Ostfildern 2006; *S. Mauri*, Flash art Italy (Dez.) 2012, 70 ss. – *Online:* Website C.

S.-W. Staps

Combres, *Loul*, frz. Keramiker, Bildhauer, * 11. 2. 1937 La Garenne-Colombes, lebt in Prades-le-Lez. Verh. mit der Keramikerin Aline Labeyrie-C. Vater der Keramikerin *Sophie C.* (* 23. 10. 1960 Nîmes, † 21. 12. 2006 Saint-Quentin-la-Poterie). Stud.: 1955–56 Ec. supérieure des BA, Nîmes. 1960–64 Atelier in Faubies, 1964–75 in Pesquis, 1975–2000 Méjantel. Ausz.: 1964 Prix de la Fond. de la Vocation pour les Travaux sur l'Argile; 1984 Prix régional des Métiers d'Art Languedoc-Roussillon. Seit 1982 Mitgl. der Acad. internat. de la Céramique, welche C. seit 1995 bei der UNESCO repräsentiert. 1983 Mitbegr. der Gruppe TER (Terre/Environnement/Réalisation); 1998 Initiator und künstlerische Ltg des Festival internat. du Film sur l'Argile (seit 2006: Festival internat. du Film sur

l'Argile et Verre). – Unglasierte Keramiken, die häufig mit figurativen Motiven engobiert werden, sowie Plastiken, bei denen das Mat. Ton durch Beton, Holz und Metall ergänzt wird. ⌷ SEVRES, MN de Céramique. ✉ 3564038. Nouvelles Poétiques, Narbonne 1967. 👁 *E:* 2000 Mende, Maison Consulaire (mit A. Labeyrie-C.) / Montpellier: 2003 Inst. Universitaire de Formation des Maîtres (mit A. Labeyrie-C.); 2011 Réseau Education sans Frontières / 2005 Frontignan, Mus. mun. (mit A. Labeyrie-C.) / 2010 Pézenas, Maison des Métiers d'Art (mit Nicole Pernet, Kebir). – ⌸ *F. Lefort u.a.,* D'argile et de feu. L. C., Montpellier 2007 (DVD). – *Online:* Céramiques contemp. franç., 1955–2005. Coll. du MN de Céramique, Sèvres, 2008; Website C. F. Krohn

Combres, *Sophie* cf. **Combres,** *Loul*

Commandeur, *Jan (Johannes Thomas Martha),* niederl. Maler, Collagekünstler, Freskant, Fotograf, * 29. 4. 1954 Avenhorn, lebt in Amsterdam. Stud.: 1975–77 Gerrit Rietveld Akad., Amsterdam; 1977–79 Ateliers '63, Haarlem, u.a. bei Ger van Elk, Jan Beutener und Toon Verhoef. Seit 1979 freischaffend in Amsterdam. 1981 Stip. des niederl. Königshauses für Malerei. 1981–94 häufige Malaufenthalte in Südfrankreich gemeinsam mit der Malerin, Graphikerin, Objektkünstlerin und Lebenspartnerin *Cecile van der Heiden* (* 1951 Amersfoort). Reisen in die USA und nach Norwegen (1983), seit 1995 regelmäßige (Atelier-)Aufenthalte in Berlin und Potsdam. Ausz.: 1980 Titia-Buning-Brongers-Preis (u.a. mit Toon Verhoef). – V.a. expressive, meist starkfarbige, großformatige Komp. und Figurationen (Öl/Lw., Gouachen, Collagen), die in einer Spielart des abstrakten Expressionismus zw. Abstraktion und Gegenstandsbezogenheit changieren. Die der Natur entlehnten Motive und Sujets (Blüten, Strauchwerk, Laub, Gestein, Fauna u.a.) bleiben für den Betrachter assoziierbar. A. Neumann (2005) resümiert: „J. C. malt keine Naturgegenstände, er findet und erfindet adäquate künstlerische Formen, in denen sich Naturkräfte offenbaren und in souveräner künstlerischer Gestalt manifestieren. Seine Farbflächen, Farbbahnen und Strukturen vibrieren, sind Nervenbahnen voller vitaler Dynamik." Einen eigenständigen Beitrag zur zeitgen. niederl. Kunst leistet C. darüber hinaus mit seinen mehrdeutigen, z.T. ironisierend-hintergründigen Darst. von scheinbar topogr. (Welt-, Wetter-)Karten (*Grey Water,* 2008), deren Inhalte er u.a. zu (geo-)politischen Metaphern steigert (*Deep,* 2010; *Oost-West,* 2010). Auch Wandbilder und Siebdrucke. ⌷ BERLIN, Niederl. Botschaft. HAARLEM, Kunstcentrum. SCHIEDAM, Sted. Mus. VENLO, Mus. van Bommel van Dam. ZANDAM, Ahold Kunststichting. 👁 *E:* Amsterdam: 1980 Art & Project Gall. (Debüt); 1982 Sted. Mus. / Eindhoven: 1985 Van Abbe-Mus. (temporäre Wandmalerei); 2007 (K), '10 Gal. Willy Schoots / 1993 Laren, Singer-Mus. (K) / Potsdam: 2005 Inter-Gal.; 2011 Kunsthaus. –. *G:* 1982 Venedig: Bienn. / 1993 New York, Frank Bustamante Gall.: Variations in abstraction. ⌸ Mus.-j. 26:1981 (3) 138–145; *A. Colpaart u.a.,* J. C. Wilde dromen/Wilde Träume (K Potsdam/Amstelveen), Am. 1999; *R. Janssen u.a.,* J. C. Een keuze 1977–2004 (K),

Eindhoven 2004; *A. Neumann,* Märkische Allg. Ztg (Potsdam) v. 10. 1. 2005; *R. Janssen u.a.* (Ed.), J. C. Schilder (K), Eindhoven u.a. 2006. – *Online:* Website C.
 U. Heise

Commandeur, *Ursula* (geb. Krenz), dt. Keramikerin, Bildhauerin, * 1958 Dortmund, lebt in Castrop-Rauxel. 1981–87 als Floristin tätig. 1990–2000 Design-Stud. (Keramik) an der FHS Niederrhein, Krefeld (mit Unterbrechungen), bei Dieter Crumbiegel. Seit 1992 eig. Wkst. in Castrop-Rauxel (dort jährlich zwei Ausst.). Seit 2008 Mitgl. im Dt. Werkbund. Ausz.: 2006 Preisträgerin des Wettb. 100% Fantasie des Keramik-Mus. Westerwald, Höhr-Grenzhausen; 2007 Staatspreis des Landes NRW für Kunsthandwerk (Keramik); 2009 Grand Prix du Parcours Céramique Carougeois (1. Preis); 2010 Preis der Neuen Keramik, Internat. Keramiktage, Oldenburg. – V.a. freie Arbeiten, die aus unglasiertem Porzellan (Biskuit) gefertigt und z.T. mit Engoben versehen sind. Mit den in Schwarzweiß gehaltenen, aus mehreren Einzelteilen zusammengesetzten Keramiken hat C. um die M. der 2010er Jahre ihre char. Formsprache gefunden. Als typisches Gest.-Merkmal sowie zur Verbindung der einzelnen Elemente (z.B. *Herzklappen*) verwendet sie Draht und Kautschuk (z.B. *Flirrkästchen; Köcherwald,* beide 2010). Die Erg. dieser beiden Mat. sowie das oft angebrachte, schwarze linien- oder punktförmige Engobendekor ergeben einen effektvollen Kontrast zum weißen Biskuitporzellan (z.B. *Observation*). Die meist kegelförmigen Einzelteile entstehen in zahlr., kaum veränderten Varianten auf der Töpferscheibe und werden, häufig auf rechteckigem Grundriß, zu kissenartigen Plastiken zusammengesetzt (z.T. aus bis zu 384 Basisformen). Neben den vielzähligen trichterförmigen Ausstülpungen sind es die ebenso zahlr. feinen Drahthaare, die den Keramiken den char. Ausdruck verleihen und die an Zellstrukturen oder Meeresgetier erinnern (z.B. *Virus,* 2007). Bei der Gruppe *Die Anderen,* welche zu den neueren Werken gehört, handelt es sich um längliche Objekte, die aus weniger Einzelformen montiert sind. Auch sie sind mit tentakelartigen Auswüchsen versehen und mit Drahthaaren verziert, die zus. mit den gebogenen Hälsen zoomorphe Gestalten assoziieren. Des weiteren angewandte Arbeiten u.a. Gebrauchsgegenstände wie Dosen, Schalen, Vasen, Blumentöpfe, Löffel, Salz- und Pfefferstreuer, meist in klaren geometrischen Formen mit schlichtem, häufig linearem Schwarzweiß-Dekor, z.T. durch eine weitere Farbe akzentuiert. 👁 *E:* 1999 Neuss, Kulturamt / 2008, '10–11 Gelsenkirchen, Gal. Idelmann / 2009 Hattingen, Henrichshütte / 2010 Almelo, Keramiekcentrum Westerdok; Oldendorf, Gut Ostenwalde, Orangerie / 2011 Oldenburg, LM; Dortmund, Gal. Dieter Fischer (mit Monika Pfeiffer); Castrop-Rauxel, Gal. Art. Ist (mit Dan Hepperle). – *G:* 1999 World Competition of Arts, Kanazawa (Ausz.) / 2002, '03, '04, '06, '07, '10 (1. Preis) Aragon: Cerco / 2004 Stuttgart: Internat. Syrlin Kunstpreis (Ausz.) / 2005 Kevelaer, Niederrheinisches Mus. für Volkskunde und Kulturgeschichte: Komplementär / 2007, '09 Kapfenberg: Keramik-Bienn. / 2008 Lübstorf, Schloß Wiligrad: Weißes Gold / Höhr-Grenzhausen: 2009 Kasino:

Hitzebeständig; 2009 (Keramik Europas, K), '10 (Mixed Media) Keramik-Mus. Westerwald / 2011 Oldenburg: Internat. Keramiktage; Johannesberg b. Aschaffenburg, Gal. Metzger: Sag mir, wo die Blumen sind; Milsbeek: Keramisto. ▭ Über Kopf. 20 Jahre Kunst bei Flottmann (K), Herne 2006; *A. Soléau*, Neue Keramik 2007 (5) 30 s.; *ead.*, Kunsthandwerk und Design 2008 (5) 12–17; Auswahl 2008. Ausst. Herner Künstlerinnen und Künstler in den Flottmann-Hallen (K Herne), Bönen 2008; *E. Kessler-Slotta u.a.*, U. C. Die Anderen (K), Herne 2008. – *Online:* Boesner TV (meet the artist; Schulterblick, beide v. 13. 3. 2009); Website C. F. Krohn

Compagnon, *Philippe*, frz. Maler, Bildhauer, * 12. 12. 1951 Jonzac/Charente-Inférieure, bis 1984 in La Rochelle, seither in Paris ansässig. Autodidakt. – Um 1970 Beginn mit gegenständlicher, tendenziell symbolistischer Malerei. Schließt sich M. der 1970er Jahre der Neuen Gegenständlichkeit an, deren Potential C. 1978 ausgeschöpft zu haben glaubt. Geht daher allmählich zu einer abstrakt-minimalistischen Malweise über, in deren Entwicklungsprozeß er gekrümmte Linien und Diagonalen eliminiert und sich auf wenige klare Farben, Schwarz und Weiß beschränkt. Nun entstehen durch den rechten Winkel streng strukturierte und dominierte geometrische, oftmals rasterartig aufgebaute Strukturen. Häufig kombiniert C. Kohle- oder Bleistift-Zchng mit Öl, Acryl oder Gouache. Bei Skulpt. spielen die Faktoren Gleichgewicht und Positionierung des Objektes eine wesentliche Rolle. Auch Fotogr., Möbeldesign, Zchng, graph. und Videoarbeiten sowie Hrsg. von Künstlerbüchern. ◉ *E:* Paris: 1985–2012 mehrfach Gal. Bernard Jordan; 2001, '06 Gal. Pixi / 1990 New York, Condeso-Lawler Gall. / 2001 São Paulo, Fund. Armando Alvares Penteado (mit C. Poncin und Joël Ducorroy; K) / 2005 La Rochelle, Espace d'Art contemp. (K) / 2008 Loudon, Stiftsk. Ste-Croix (K). – *G:* Paris: 1991 Cité internat. des Arts: 50 artistes pour le 25ᵉ anniversaire; 1999 Assemblée nat.: 30 artistes 1969–1999 (Wander-Ausst.). ▭ *Bénézit* III, 1999; *Delarge*, 2001; Dict. internat. de la sculpt. mod. et contemp., P. 2008. – *M. Pleynet/M. Ragon*, L'art abstrait, V, P. 1988. – *Online:* Website C.
R. Treydel

Company Barber, *Arturo*, span. Maler, Zeichner, Illustrator, * 28. 7. 1919 Tabernes de Valldigna/Valencia, † 5. 5. 1988 Valencia. Stud. ebd.: 1931–34 Esc. de Artes y Oficios; 1934–36 und ab 1940 EBA de S. Carlos. 1944–45 mit Stip. der Prov.-Verwaltung von Valencia in Granada und Madrid. Dort Ill. für die Wochen-Bll. El español und La estafeta lit. sowie für das Buch *Un mundo de papel* von Fernando Castán Palomar. Ab 1950 Prof. (Zeichnen) an der Esc. de Artes y Oficios in Algeciras, ab 1958 in Ceuta, ab 1973 am Inst. de Bachillerato Luis Vives in Valencia (später Dir.). Zahlr. Ausz.: u.a. 1941 1. Preis für Zchng und Aqu., Soc. Lo Rat Penat. – C. ist ein figurativer Maler mit bes. Interesse für soziale Themen. Zu seinen frühen Werken zählen *Desnudo de mujer* und ein Portr. seines Bruders, des Musikers *Antonio Company* (beide 1940) sowie die Genreszenen *Parada de coches* (1943) und *La bendición de la mesa* (1944). Danach malt er ein Selbst-Portr. (1944) und *Retrato del escultor Rubio* (1945) sowie zahlr. Bilder aus der Arbeitswelt (z.B. *Sembradores*, 1945; *Primera fila),* wobei er v.a. Bauern, Minen- und Hafenarbeiter, Steinmetze und Fischer darstellt. ▥ ALGECIRAS, Inst. de Enseñanza Media; Hotel Cristina: Wandbilder, 1954. CEUTA, S. José, Hauptaltar: Wandbild, 1970. ◉ *E:* Valencia: 1923 Casino Republicano Radical-Socialista; 1946 Sala Mateu; 1989 Círculo de BA, Salón Dorado; Inst. de Bachillerato Luis Vives (Retr.; K) / 1948 Bilbao, Sala de Arte Bilbao. ▭ *Agramunt Lacruz* I, 1999; DPEE, Ap., 2002. – *C. Alonso*, Tesela. Bol. del Colegio Oficial de Doctores y Licenciados en BA y Prof de Dibujo 1989 (7) 19. M. Nungesser

Comparini, *Valerio*, ital. Maler, Bildhauer, Video- und Installationskünstler, * 9. 9. 1957 Fucecchio, lebt in Santa Croce sull'Arno. Seit 1976 als Maler, seit 1981 als Bildhauer und seit den 1990er Jahren als Videokünstler tätig. E. der 1970er Jahre Performances auf öff. Plätzen, um auf politische Mißstände hinzuweisen. Ab den 1980er Jahren Zusammenarbeit mit Romano Masoni, Antonio Bobò, Ivo Lombardi, Giulio Greco bei Installationen, Graphik und Malerei. Stellt mit der Künstler-Vrg Gruppo del Pestival aus. Arbeitet als Bildhauer anfangs in Holz und Stein sowie in Kunststoffen, die wie veränderte organische Substanzen aussehen (*Herpes*, 1984), später auch in Eisen und Stahl, z.B. verarbeitet er Platten aus dem Gerbereigewerbe (*Industrial Exhibit*, 1996). Montiert rohe, teils mit Buchstaben versehene Bretter, welche das Aussehen von Türen oder Fenstern haben; behandelt das Holz mit einem gipsähnlichen, zartfarbigen Anstrich und fügt Aluminium-Med. und Reliefs in seine Objekte ein. Ironisch verfremdete Objekte sind Stahlblumen mit gläsernen Knospen, Phantasie-Reliquiare oder Metallköcher mit schwarzen Holzstäben und eine Serie von großen *Sarcofaghi*, spielerisch vermittelnd zw. Behälter und Inhalt sowie zw. Komik und Bedeutungsschwere. Seit A. der 1990er Jahre verstärkte Hinwendung zum Kurzfilm. Nutzt das Video als Installation in Ausst. (erstmals in Fuchecchio mit *Le Celle*) und betrachtet den Film als ihm gemäßes Mittel, die Gegenwart abbilden und ein breites Publikum erreichen zu können. Anfangs überwiegt in seinen Kurzfilmen das erzählerische Moment (*La macchine del pittore*, 1991), später verfeinert er die spezifischen filmischen Mittel immer weiter. C. greift aber auch tragische Themen auf wie den Kosovokrieg in *Fuochi a scoppio* (1993). Pointierter Einsatz von Tönen und Musik. Produziert 2003 u.d.T. *Una storia di pere* und *Pere Rock* seine ersten Animationsfilme, dessen „Protagonisten" animierte Birnen-Skulpt. sind. Teiln. an Video- und Filmfestivals und Wettb. u.a. in Canzo Como (1997), Fano (2001), Florenz (1996), Pescara (1994), Pisa (2001), Rom (1993) und Siena (2000). ▥ SAN DONATO (San Miniato), Pfarrk. S. Quintino. SANTA CROCE SULL'ARNO: Denkmal Enzo Ferrari, 1991. ◉ *E:* 1998 Nizza, Gal. Qvadrige / 2000 Amberg, StM (mit Günter Dollhopf und Romano Masoni; K: G. Dollhopf) / 2001 Empoli, Pal. Ghibellino / 2002 Santa Croce sull'Arno, Saletta San Rocco / 2005 Pontedera, Centro per l'arte Otello Cirri / 2006 Pietrasanta, Ar-

te Splash. – *G:* Santa Croce sull'Arno, Villa Pacchiani: 1980 Immagini di un territorio; 1982 Tra parola e immagini; 2004 Intorno ad un'opera del Banti / 1984 Viareggio, Pal. Paolina: Carnevale e maschere / 1989 Florenz, Stamperia Bezuga: Navigazioni / 1990 Mailand, Saletta R. della Stazione: Contro l'apartheid; Gualtieri, Pal. Bentivoglio: Trasmettendo segnali di libertà / Maggiano, Ex Ospedale Psichiatrico: 1991 Il gioco delle occasioni; 1997 Occasioni di volo / 1998 Volterra, Pal. Pretorio: I Traghettamenti / 2009 Lari, Castello dei Vicari: Il muro vent'anni dopo. ⌑ *Delarge*, 2001. – *N. Micieli* (Ed.), In-magg'in-azione. Quattro segni per un maggio attraversato (K), Capannoli 1985; *T. Paloscia*, Accadde in Toscana, II, Fi. 1997. – *Online:* Website C.; Cassa di Risparmio di San Miniato; Visionaria. S.-W. Staps

Compton, *Carl Benton*, US-amer. Maler, Illustrator, Bildhauer, Graphiker, Schriftsteller, Hochschullehrer, * 10. 12. 1905 Estherville/Ia., † 1981 Denton/Tex. Ehemann der Malerin und Schriftstellerin *Mildred Norris C.* (s.u.; Heirat 1935). Stud.: u.a. bis 1929, '35–36 (Pädagogik) Notre Dame Univ., Ind.; 1929 Acad. de la Grande Chaumière bei Antoine Bourdelle; 1930 Acad. Colarossi, beide Paris; 1935 Art Inst. of Chicago bei Boris Izrailevič Anisfel'd; 1943 La Esc. Universitaria de BA, San Miguel de Allende/Mexiko; 1943–44 Louisiana State Univ., Baton Rouge (parallel dazu als Lehrkraft tätig). Weitere Lehrtätigkeit: u.a. 1935–36, '40 Midland Acad. of Art, South Bend/Ind.; 1936–43 Southwestern Univ., Georgetown (Leiter der Kunst-Fak.); 1944–69 North Texas State Teachers College, Denton. 25 Jahre reist und lebt C. in Mexiko, leitet archäol. Ausgrabungen und gilt als Experte für taraskenische Kunst. Außerdem wirkt er im Vorstand der Texas Archeol. Society. Ehrendoktor der Univ. Interamericana und der Accad. di Sc. ed Arti, Rom. – V.a. Lsch., Genreszenen (*Donna of the Prairie*, Öl/Lw., 1932) und Figurenstudien in realistischer Auffassung (Gouache, Öl, Aqu.); auch surreale Motive mit skurrilen anthropomorphen Kreaturen (z.B. *Stars*, Lith., um 1950). – *Mildred Norris C.* (* 1912 Vernon/Ill., † 1976 Denton/Tex.) studiert an der North Texas State Univ. in Denton. Malt Genreszenen und Portr. (Öl) in realistischer Auffassung, gelegentlich mit stilisierten Formen. Publiziert Kunst-Beitr. im Austin Amer.-Statesman. ⌸ BATON ROUGE, State of Louisiana. CAMBRIDGE/Mass., Harvard Univ. NEW YORK, Metrop. Mus. PINE RIDGE/S. D., Heritage Center. SAN DIEGO, Heritage Center. SEATTLE/Wash., AM. SPRINGFIELD, State of Illinois. ◉ *E:* 1943 Dallas (Tex.), MFA. – *G:* 1938 New York, Rockefeller Center: Nat. Exhib. of Amer. Art / 1942, '44–45, '47–48 Dallas, MFA: Texas General Exhib. / 1998 Denton (Tex.), Center for the Visual Arts: Hock Shop Collection. Rediscovering Texas Artists of the Past (auch Mildred Norris C.) / 2006 Dallas (Tex.), Valley House Gall.: A Collector's Eye. The John Stone Coll. of Paint. by Early Texas Artists. ⌑ *Falk* I, 1999; *Powers*, 2000 (auch zu Mildred Norris C.). – *Online:* AskART (auch zu Mildred Norris C.); Art of the print; Valley House Gall. C. Rohrschneider

Compton, *Mildred Norris* cf. **Compton,** *Carl Benton*

Comrie, *Henri Pierre*, südafrikanischer Architekt, Stadtplaner, * 22. 12. 1965 Pretoria, lebt in Kapstadt. Stud.: 1986–91 Univ. of Pretoria; 1994–95 Univ. of the Witwatersrand; 2000–03 Stip. des Centre for Urban Design, Oxford, und der Univ. of Greenwich, London. Mitarb. bei Michael Haskoll, London (1989–90); Erhard Roxin, Swakopmund/Namibia (1992–94); Taljaard Carter, Johannesburg (1994–95). Ab 1996 eig. Büro in lockerer Partnerschaft mit Ora Joubert, Pretoria, zugleich Doz. an der Univ. ebd.; seit 1999 dort (2006–10 auch in Kapstadt) Partnerschaft mit Chris Wilkinson. Ab 2003 in Kapstadt ansässig; dort Mitarb. bei Stauch Vorster als leitender Stadtplaner; Doz. an der School of Archit. ebd. Ausz.: 1995 Merit Award, Namibian Inst. of Architects (NIA); 1995, '99, 2006 Merit Award, South African Inst. of Architects (SAIA); 2002 Nat. Dulux Colour Award. – C. gewinnt 1992 als Mitarb. des Büros Roxin den Wettb. für das Verwaltungsgebäude Swabou in Windhoek/Namibia (fertiggestellt 1994). Fortan erhält er Aufträge v.a. über Wettb., so 1995 für das PFG Glass Centre in Midrand (Abriß 2004), ein experimenteller, als Scherbenanhäufung konzipierter dekonstruktivistischer Bau, der unter Einfluß des Feuerwehrhauses (1991–93) von Zaha Hadid auf dem Vitra-Gelände in Weil am Rhein entsteht. C. interessiert sich v.a. für die archit. Erfordernisse und Identifikationsmerkmale Südafrikas nach der Apartheid und sucht nach einer zeitlosen Architektur. Wie seine Vorbilder Charles Correa in Indien und Ricardo Legorreta in Mexiko bekennt er sich zu einfachen Bauverfahren und Mat., räumlicher Vielfalt und Unbegrenzheit. Zudem ist er passionierter Zeichner und hält am trad., handwerklich betriebenen Archit.-Studio mit wenigen Mitarb. fest. Aufgrund der wachsenden Reputation auf dem Gebiet des nachhaltigen, kontextuellen Städtebaus wird C. zunehmend zu Großprojekten hinzugezogen. Er wird um 2005 leitender Stadtplaner für die Anlage des Fußballstadions für die Weltmeisterschaft 2010 in Kapstadt und ist als lokaler Architekt an dessen Ausf. beteiligt (Entwurf 2006: Gerkan, Marg und Partner, Hamburg). Zeitgleich führt er die Sanierung des Hauptbahnhofs ebd. durch. 2010 bearbeitet C. das Projekt Galleria, das die durchmischte, integrative Entwicklung des 11,5 Hektar großen Velodrome-Geländes in Belleville b. Kapstadt umfaßt (zus. mit C. Wilkinson, Van der Merwe Miszewski und R & L Architects). ⌸ BENONI/ Gauteng, Armenschule Van Ryn Place of Safety, 2001 (mit O. Joubert, C. Wilkinson, VMR Architects). JOHANNESBURG-Illovo, Gordon Inst. of Business Sc., 1998–2000 (mit T. Carter) und 2006–08 (mit C. Wilkinson). – Melrose Arch. Office Building, 2001 (mit C. Wilkinson). – Univ. of the Witwatersrand: Wits Art Gall., 2005 (mit C. Wilkinson, VMR Architects). KAPSTADT-Big Bay, Haus Coetzee, 2010. PRETORIA, Haus Comrie, 1997. – Haus Steyn, 1998. ⌑ *J. Cargill Thompson*, 40 architects around 40, Köln u.a. 2006. – *Online:* Website C.+Wilkinson.

 A. Mesecke

Comte, *Louis*, frz. Lithograph, Illustrator, Kunstkritiker (unter Pseud. Barret, *Marcel*), * 9. 10. 1866 Nîmes, bis 1914 nachw., tätig in Paris. Stud.: Ec. mun. des BA in Nî-

mes bei Alexis Lahaye und Léopold Mérignargues; erhält im Studienjahr 1895/96 fünf Ausz., u.a. den Preis der Soc. des Amis des Arts und den 1. Preis im Fach dekorative Komp.-Lehre. Läßt sich in Paris nieder; Schüler des Malers und Graphikers Alexandre Lunois. Ab 1905 Leiter eines Mal-, Zeichen- und Graphikkurses (Cours du Faubourg Saint-Germain). 1914 erfolglose Bewerbung um das Amt des Dir. der EcBA in Nîmes. Mitgl. der Soc. des Artistes franç.; Generalsekretär der Assoc. franç. des artistes lithographes. – C. arbeitet sowohl nach eig. Vorlagen als auch reproduzierend und fertigt u.a. Tierszenen (*Combat de sangliers*, Farb-Lith., um 1907), Lsch. (*Le soir, les bords de la Loire*, Lith., um 1911), Interieurs, mythologische und genrehafte Darstellungen. Unter dem Einfluß von Lunois widmet er sich häufig den seinerzeit beliebten Orientszenen (*Intérieur arabe à Moghar [Sud Oranais]*, um 1907; *La prière pendant le ramadan*, um 1910). Als Buchillustrator ist C. an mehr als 150 Werken beteiligt, v.a. an der ab 1903 von Ernest Lavisse veröff. mehrbändigen Abh. *Hist. de France ...* und einer Ausg. von Honoré de Balzac, *Eugénie Grandet* (sechs Orig.-Lith., um 1914). Liefert auch zahlr. Ill. für Zss. wie La Chasse ill., Les lectures de la semaine und La pêche illustrée. ◉ G: 1903–14 Paris, SAfr. (1909 ehrenvolle Erw.). ⌑ *Edouard-Joseph* I, 1930; *Camard/Belfort*, 1974; *Bénézit* III, 1999; *Lepage*, 2008.

R. Treydel

Comte, *Michel*, schweiz. Fotograf, * 19. 2. 1954 Zürich, lebt in Los Angeles. Ausb. zum Kunstrestaurator; bis 1979 in diesem Beruf tätig. Als Fotograf Autodidakt. Bek. für Mode- und Werbe-Fotogr. sowie Portr. von Stars aus Film, Sport und Kunst, oft vor neutralem Studiohintergrund. Arbeitet in Farbe und Schwarzweiß. 1979–81 in Paris. Hier u.a. Aufnahmen für die Modedesigner Gianni Versace, Karl Lagerfeld und Giorgio Armani, die in zahlr. Mode-Mag. veröff. werden. 1981 Umzug in die USA, lebt in New York und Los Angeles. 2000–01 erotische Portr.-Serie *Aiko T.* Ab den 1990er Jahren außerdem Reisereportagen aus Krisengebieten (Bosnien, Afghanistan, Irak) und Engagement für Hilfsorganisationen (Internat. Rotes Kreuz; Ärzte ohne Grenzen). Später auch Natur- und Lsch.-Aufnahmen in Schwarzweiß und Farbe, oft mit intensiver Farbigkeit und starken Kontrasten, u.a. Motive aus den Schweizer Bergen. Zahlr. Publ. in Zss. und Büchern. – Fotobücher u.a.: *Shots*, Mi. 1995; *Kontraste*, Ha. [um 1998] (Portfolio, 10); *Michelcomte. Twenty years 1979–1999*, M. u.a. 1999; *Aiko T.*, Göttingen 2000; *People and places with no name*, Göttingen 2000; *Michael Schumacher*, Z. u.a. 2006; *The classics*, Lachen 2007; *On women*, Lachen 2007; *Thirty years and five minutes*, Kempen 2009. ⌖ WINTERTHUR, Foto-Mus. ◉ E: Hamburg: 2004 Camera work; 2007 Gal. Lumas; 2011 Flo Peters Gall. / München: 2006 PM; 2007 Gal. Lumas / 2008 Moskau, Winzavod; Zürich, MfG (K) / 2009 Düsseldorf, NRW-Forum (K) / 2009 Brüssel, Young Gall. / 2010 Lucca, Center of contemp. art (K) / 2011 Gstaad, Gal. Lovers of FA (K). ⌑ *R. Misselbeck* (Ed.), Prestel-Lex. der Fotografen, M. u.a. 2002; *M. Koetzle*, Fotografen A-Z, Köln 2011. – *U. Zapelloni*, Formula Ferrari, Lo. 2004; *S. Arack-*

al, Photogr. (Ha.) 32:2008 (7/8) 102–109; *M. Koetzle*, Photo internat. 2009 (6) 28–37; Profifoto 2009 (3) 34–39; *M. Zollner*, Foto-Mag. 2009 (2) 6–11; (4) 20–22 (Interview); C. 360°, DVD-Video 2010; *H. Christmann*, Weltkunst 81:2011 (4) 36 s.; *W. Keller* (Ed.), C. Crescendo fotografico (K), Poggibonsi 2011. – *Online:* Website C.

N. Buhl

Conceição (C. Júnior), *António*, portug. Maler, Graphiker, Designer, Fotograf, Modegestalter, * 1951 Macau, lebt dort. Wächst in einem intellektuell gebildeten Elternhaus auf; seine Mutter ist Macaus erste Schriftstellerin, der Vater Journalist. C. gibt bereits 1967 sein Debüt mit Öl-Gem. in Macau. Stud.: ab 1968 Esc. Superior de BA, Lissabon. Wendet sich 1982–91 der künstlerischen Fotogr. zu. Ab den 1980er Jahren mehrfach Koordinator portug.-chin. Ausst., u.a. in Zusammenarbeit mit der Fund. C. Gulbenkian. Entwirft die Med. zur Eröffnung des Inst. Emissor in Macau (1982). Zeigt ab 1990 in Lissabon, Porto und Brüssel seine Modeschöpfungen, entwirft die Livree für das Flughafenpersonal von Macau. C. bekleidet div. öff. Ämter, u.a. Rats-Dir. des Mus. von Macau. ⌖ MACAU, Mus. Macau. ✉ Portugal à beira da estrada, Macau 1986; Ung Vai Meng. Desenhos, Macau 1989; Encontro em Macau. Artistas portug. contemp. no Oriente, Macau 1997; Trajes das minorias étnicas da China (K Mus. Luís de Camões), Lissabon 2001. ◉ E: 1981 Macau, Hotel Lisboa; Hong Kong, AC / 1991 Lissabon, Missão de Macau. – G: Lissabon: 1970 Cooperativa Gravura; 1975 Gal. S. Francisco; 1988 Gal. de Livraria Portug. / 1976 Lucca: Congresso de Banda Desenhada / Hong Kong: 1988 AC; 1989 Círculo dos Amigos da Cultura. ⌑ *Tannock*, 1978; *M. M. Matias*, Macau – séc. XX. Dic. de artistas plást., I, [Li.] 1999.

R. Petriconi

Conde (C. Cruz), *Mario*, bolivianischer Maler, Zeichner, Graphiker, Restaurator, indigener Abstammung, * 22. 7. 1956 La Paz, lebt dort. Stud.: 1977–84 Esc. Superior de BA „Hernando Siles" ebd. Mitgl.: Gruppe Nervio. Rest. kolonialer Gem. in der Kirche von Puerto Carabuco/La Paz. Ausz.: u.a. 1990 ehrenvolle Erw., Dibujo España 90, Inst. de Cooperación Iberoamer.; 1992 Gran Premio, Salón Pedro Domingo Murillo; alle La Paz. – C. gestaltet realistisch-figurative Bilder (Aqu.) in kräftigen, klar konturierten Farben und bildfüllenden Komp., die in symbolischer, surreal-barocker Manier ironisch-satirisch die Mächtigen in Politik und Religion und ihre Institutionen angreifen, v.a. den seit der Conquista herrschenden Konflikt zw. indigener und span. Kultur. Seine Bilder haben oft den Char. von gemalten Collagen, da sich Menschen, Tiere und Dinge miteinander verbinden oder versch. Raumebenen ineinander übergehen. ⌖ LA PAZ, Casa de la Cult. Arturo Borda. – MN de Arte. PUNTA DEL ESTE, Fund. Ralli, MAC Latinoamer. SANTA CRUZ DE LA SIERRA, Casa de la Cult. Raúl Otero Reiche. ◉ E: 1989 Dallas (Tex.), Nedda Gall. / Santa Cruz: 1991, '93 Casa de la Cult.; 1996 Gal. Icono; 2007 Manzana 1, Espacio de Arte / La Paz: 1994, '99, 2000 Centro de Cult., Arquit. y Arte Taipinquiri; 1997, 2003 (mit Enzo de Lucca) MN de Arte; 2004 Inst. Cult. Boliviano-Alemán; 2006 Salón Cecilio Guzmán

de Rojas; 2009 Acad. Nac. de BA Hernando Siles (Retr.); Artespacio CAF (Corporación Andina de Fomento) / 1998 Cochabamba, Espacio Simón I. Patiño / 2003 Sucre, Casa de la Libertad (mit Claudia Peñarana). – *G:* 2002, '06 Mexiko-Stadt: Bien. Internac. de Acarela / 2010 Asunción, Centro de Artes Visuales, Mus. del Barro: Pintores bolivianos del s. XXI. ⚏ *G. Columba Medina*, El Mundo (Santa Cruz de la Sierra) v. 4. 7. 1993; *M. A. Aranda*, Rev. Pulso (La Paz), 25.–29. 6. 2002, 30; *D. Ostermann*, Propuestas y tendencias del arte boliviano a fines del milenio, La Paz 2002; *H. C. Buechler*, Entre la pachamama y la gal. de arte, La Paz 2006; *E. Díaz*, La jiribilla (Havanna) 6:2007 (340); *H. Suárez Llápiz*, Los Tiempos (Cochabamba) v. 3. 7. 2011. – *Online: E. Blanco Mamani* (Ed.), Dicc. cult. boliviano, La Paz; Habana Radio.							M. Nungesser

Condie, *Richard*, kanad. Trickfilmgestalter, -regisseur, -produzent, Drehbuchautor, Komponist, * 24. 10. 1942 Vancouver/B. C., lebt in Winnipeg/Man. Dort aufgewachsen. Studiert ab 1961 Soziologie an der Univ. of Manitoba in Winnipeg und ist ab 1967 zunächst in Vancouver als Soziologe an der Univ. of British Columbia, später u.a. als Sozialarbeiter und Musiker tätig. Ab 1969 wieder in Winnipeg beginnt C. als Autodidakt mit der Gest. von Zeichentrickfilmen. Bekanntschaft mit Cordell Barker und Brad Caslor. 1974–75 Mitarb. an der TV-Serie *Sesame Street*. Mit Hilfe einer Förderung des Canada Council produziert er den kurzen Animationsfilm *Oh Sure* (1977), der vom Nat. Film Board of Canada (NFB) angekauft wird. Seither entstehen mehrere weitere Trickfilme: *John Law and the Mississippi Bubble* (1978; zus. mit der Schwester Sharon C.); *Getting Started* (1979); *Pig Bird* (1981); *The Big Snit* (1985; ausgezeichnet mit dem Genie Award und zahlr. weiteren Preisen); *Heart Land* (1987; zus. mit Norma Bailey); *The Cat Came Back* (1988; zus. mit C. Barker; ausgezeichnet mit dem Genie Award); *The Apprentice* (1991). In den 1990er Jahren Mitarb. des NFB in Montréal. Im Auftrag der kanad. Reg. entstehen Animationsfilme zu den WA 1988 in Brisbane und 1992 in Sevilla. Seit 1996 arbeitet C. mit computergenerierten Animationen (z.B. *La Salla*, 1996; *The Ark* bzw. *The Apocalypse*, 2002). Komponiert auch Filmmusik für Trickfilme and. Regisseure. In jüngerer Zeit v.a. als Maler und Zeichner von Cartoons tätig. Mitgl.: Acad. of Motion Picture Arts and Sc.; Internat. Animated Film Assoc.; R. Canad. Acad. of Arts; Winnipeg Film Group. – Trotz eines relativ schmalen Œuvres gilt C. als einer der innovativsten kanad. Trickfilmgestalter der Gegenwart. In seinen von einer karikaturhaft-naiven Bildsprache geprägten Arbeiten erzählt er meist absurde, oft bizarr anmutende und von schwarzem Humor beherrschte, z.T. auch auto-biogr. Erfahrungen verarbeitende Gesch., etwa die von zwei Männern, die sich beim Versuch, sich gegenseitig zu imponieren, nur lächerlich machen (*Oh Sure*) oder die eines älteren Ehepaares, das über alltäglichem Gezänk über ein Scrabble-Spiel den atomaren Weltuntergang verpaßt (*The Big Snit*). ⌂ WINNIPEG, Univ. of Manitoba Arch. & Special Coll. ⚏ *J. Lenburg*, Who's who in animated cartoons, N. Y. 2006. – *L. Smith*, ASIFA News 11:1998 (1) 5; *K. Mazurkewich*, Cartoon capers. The hist.

of Canad. animators; Tor. 1999; *B. D. Waldman*, in: Ottawa 99. Internat. student animation festival, Ottawa 1999, 89–91; *W. Wise*, Take One's essential guide to Canad. film, Tor. u.a. 2001; Animation 2002 (6) 18; *W. Beard/J. White*, North of everything. English-Canad. cinema since 1980, Edmonton 2002; *J. Beck* (Ed.), Animation art. From pencil to pixel. The hist. of cartoon, anime & cgi, Lo. 2004. – *Online:* Animation World Network; Canad. Enc.; Website C.							H. Kronthaler

Conev, *Stefan Chadži Stojanov* → **Chadžistojanov,** *Stefan*

Confino, *François*, schweiz.-franz. Szenograph, Ausstellungsgestalter, Architekt, * 18. 8. 1945 Genf, lebt in Lussan/Gard. Stud.: 1966–70 ETH, Zürich. 1971–76 Aufenthalt in New York, dort ab 1972 Lehrtätigkeit an der Columbia Univ. in the City of New York. Zusammenarbeit mit Haus-Rucker-Inc. Seit 1977 in Frankreich ansässig. Eig. Büro, ab 1996 mit Sohn *Raphaël C.* (* 1971). – Neben Archit.-Entwürfen für das eig. Haus und Atelier in Lussan (1982) sowie für Mauthäuschen an Autobahnen (mit Jean-Pierre Duval, 1984–88) v.a. Ausst.-Gestaltung. Char. sind dabei aufwendige Inszenierungen mit suggestiven Effekten. 1977 erste Ausst.-Gest. (Archéologie de la Ville; Paris, MNAM; zus. mit Haus-Rucker-Inc.). Es folgen zahlr. weitere Wechsel- und Wander-Ausst., darunter in Paris: Cités-Cinés (La Villette, 1987); Les Dessous de la Ville (Arsenal, 1990); Paris Sonore (Arsenal, 1994); L'Athlète dans les étoiles (La Villette, 1993); Cités Cinés 2 (Colline de La Defense, 1995); Les Ingénieurs du Ciel (Cité des Sc. et de l'Industrie, 1996) und Le Temps Vite (Centre Pompidou, 2000). Dauer-Ausst. gestaltet C. u.a. für das Archäol. Mus. in Bougon (1993), den Audi-Pavillon in Wolfsburg (2000), das MN del Cinema in Turin (2000) oder das Mus. dell'Automobile ebd. nach Umbau und Erweiterung (2011). Für die frz. Bahn entwickelt C. die Ausst.-Züge Le Train du Cinéma (1990), Le Train olympique Club Coubertin (1991) und Sega Train (1993). Weitere Werke: Gest. der Parade Paris libéré (1994) und eine Live-Show mit Philippe Genty auf der Expo in Lissabon (1998). 1996–98 ist C. künstlerischer Leiter des Themenparks für die Expo 2000 in Hannover. ⚏ *F. Mathey*, Archéologie de la ville, P. 1977; Techniques & archit. 382:1989, 80–85; 385:1989, 70; 401:1992, 90 s.; Archit. d'aujourd'hui 241:1985, XC, 1, 26–46; Archit. méditerranéenne 29:1986 (Sept.) 117–119; *E. Cardani*, Arca 145:2000, 91; *S. Casciani*, Domus 830:2000, 40; *S. Redecke*, Bauwelt 91:2000 (35) 18–27; *L. Zevi*, L'archit. 557:2002, 152–166; *C./F. Sabelli u.a.*, Explosition C. scénographe, P. 2005; *F. den Oudsten* (Ed.), Space, time, narrative (K), Burlington u.a. 2011. – *Online:* Website C.							N. Buhl

Congost (C. Feliú), *Carles*, katalanischer Maler, Zeichner, Fotograf, Video- und Installationskünstler, * 13. 11. 1970 Olot/Girona, lebt in Barcelona. Stud.: bis 1994 Fac. de BA der Univ. de Barcelona. – C.s Arbeiten bilden einen eig. Kosmos, dessen ästhetische Quellen der Pop- und Clubkultur entstammen, v.a. Musik, Film, Fernsehen, Mode und Comics. Thematisch handelt das Werk vom Jung-

sein in einer technisierten und globalisierten Welt, bes. vom Klischee des aufsteigenden Künstlers (artista emergente), wobei C. selbst in versch. Rollen als Alter ego auftaucht und auch in der von ihm mitbegründeten Musikgruppe Congosound spielt. Im Zentrum von C.s Werk stehen Videos, an denen and. bild. Künstler sowie Musiker, Modegestalter, Filmausstatter und Schauspieler mitarbeiten. In ihnen herrscht eine artifizielle, von Werbe-Clips, Abenteuer- und Fantasyfilmen angeregte, von Discomusik unterlegte Atmosphäre, bestimmt von Ironie, Humor und Melancholie. *Jessie is thinking about it* (1997) und *Jessie formula sport* (1998) handeln vom Leben eines jungen Mannequins; *Supercampeón* (2000), eine Persiflage auf die Fernsehserie Sesamstraße, zeigt den Popsänger Genís Segarra im Gespräch mit *Mr. CD eyes*, einer Puppe mit CDs als Augen. *Love & F/X* (2001) spielt im Milieu eines Fitnesscenters, *Kratter's* (2001) und *Tonight's the night* (2003) entführen in märchenhafte Naturräume. *Un mysthique determinando* (2003) ist die Parodie auf eine Rockoper (mit Musik der Gruppe Astrud), in der ein junger Fußballer sich zum Videokünstler berufen sieht. Kritische Reflexionen über den zeitgen. Kunstbetrieb finden sich in *That's my impression* (2001), *Synthesízers* (2002) und *Memorias de Arkaran* (2005, u.a. mit Amanda Lear), das in einem fiktiven Land von Künstlern spielt. C.s Projekt *We are tomorrow* faßt diese Kritik in die Form einer Ausst. (2006 in Turin) mit jungen Künstlern, die in Wirklichkeit wie die im Kat. gen. Kuratoren und Sponsoren frei erfunden sind. Auch surreal anmutende Objekte (z.B. *CD eyes; Natural audio equipment*, beide 1995) und inszenierte Farbfotos sowie Bildgeschichten in Form von Fotoromanen, u. a *Bravo. Leben in einem Traum* (1998), eine Anspielung auf die dt. Jugend-Zs. Bravo, und *Robots* (2007), in der die eig. Gruppe Congosound sich entschließt, ihre Musik von Robotern spielen zu lassen. ▯ ALCOBENDAS/ Madrid, Stadtverwaltung. DUBLIN, Irish MMA. GIRONA, Stadtverwaltung. GRANOLLERS, Mus. LEON, MAC de Castilla y León. MADRID, CARS. – Col. l'Oreal de Arte Contemp. – Fund. Caja Madrid. – Fund. Coca-Cola España, Col. de Arte Contemp. MÁLAGA, Centro de Arte Contemp. MÓSTOLES, Centro de Arte Dos de Mayo de la Comunidad de Madrid. PALMA DE MALLORCA, Fund. Sa Nostra. POLLENÇA, Mus. SAN SEBASTIÁN, Col. Ordóñez-Falcón de Fotogr. SANTIAGO DE COMPOSTELA, Centro Galego de Arte Contemp. VALENCIA, IVAM. ◉ *E:* Barcelona: 1995 La Cap. de l'Antic Hospital de la Sa. Creu (K: M. Clot); 1997 Studio Meyetta (K: J. Peñafiel/M. Clot); 2000 Fund. Joan Miró, Espai 13; 2005 Centre d'Art Santa Mònica; 2009, '10 Gal. Joan Prats / 1996 Zaragoza, Caz La Gal. / 1999, 2001, '05 Valencia, Gal. Luis Adelantado / Girona: 1999 Casa de Cult. (K: S. Goday); 2004 Sales Mpals d'Expos. (K: D. Santaeulària) / 2001 Sevilla, Centro Andaluz de Arte Contemp. / Málaga: 2001 Sala de Arte Moreno Villa; 2006 Centro de Arte Contemp., Espacio 5 / Madrid: 2001 CARS, Espacio Uno (K: R. Doctor); 2003 Espacio Mínimo / 2002, '05, '09, '10 Palma de Mallorca, Gal. Horrach Moyà / 2003 Bilbao, Fund. Bilbao Arte / 2005, '08 Verona, Artericambi / 2007 León, MAC de Castilla y León (K,

CD: M. Clot u.a.; Ausst.; Bibliogr.) / 2010 London, Civic Room (mit Alejandro Vidal). – *G:* 2002 Berlin, Neue NG, Hamburger Bahnhof: Big Sur. Arte nueva esp. (K) / 2003 Venedig: Bienn. / León, MAC de Castilla y León: 2004 Arquit. efímera. Fangoria (K, CD, DVD); 2007 Existencias (K); 2009 Globalizados – Globalized (K) / 2004 Reykjavik, Listasafn Reykjavíkur: Looking further, thinking through (K M. Peran/D. G. Torres) / 2006 Lleida: Bien. d'Art Leandre Cristófol / 2011 Vitoria, Artium: Video(S)torias; Barcelona, Centre de Cult. Contemp.: Xperimenta '11. ▭ DPEE, Ap., 2002. – *P. Llorca*, La cicatriz interior (K Sala de Expos. de la Comunidad de Madrid), Ma. 1998; *M. Oliveira*, Lost in sound (K Centro Galego de Arte Contemp.), S. Co. 1999; *P. Llorca*, Artforum 40:2001 (3) 152; *J. Hontoria*, El Mundo, Supl. El Cultural (Ma.) v. 21. 3. 2001; *M. Navarro*, ibid. v. 3. 4. 2003; *A. Pérez Rubio*, Bad boys (K La Fontego dei Tedeschi, Ve.), Ma. 2003; *N. Schnaith/A. P. Cohen*, El libro del déficit (K Sala Metrònom), Ba. 2003; *H. Szeemann/A. Heiss*, The Real royal trip. El real viaje real (K P. S. 1 Contemp. AC, Long Island City), N. Y. 2003; *M. Badia u.a.*, Sessió contínua (K Wander-Ausst.), Ba. 2005; *P. Parreno/R. Thomas*, All Hawaii entrées. Lunar reggae (K Irish MAM), Dublin 2006; *B. Espejo*, El Mundo, Supl. El Cultural v. 27. 11. 2009; *A. Arriola u.a.*, Antes que todo. Before everything, (K CA2M Centro de Arte Dos de Mayo), Ma. 2011. – *Online:* Blogspot. M. Nungesser

Conitz (Konitz), *Gerda*, dt. Keramikerin, Glasurkünstlerin, * 14. 1. 1901 Studzyn/Posen (Studzieniec/Polen), † 1982 Geislingen an der Steige. Tochter eines Dorfschullehrers. 1922 Praktikum bei Kurt Feuerriegel in dessen Werkstätte Sächsische Kunsttöpfereien in Frohburg/Sachsen. Stud.: 1922–24 Staatliche Keramik-Berufsschule, Bunzlau (Bolesławiec/Polen), u.a. bei Wilhelm Pukall. 1925 wird C. Leiterin des Malereiliers der Kunstkeramischen Wkst. von Carl Fischer in Bürgel. 1926–28 ist sie in der Steingutfabrik Annaburg b. Torgau angestellt und 1928–31 in der Majolika-Man. Karlsruhe als Spezialistin für Glasuren tätig. Dort Zusammenarbeit mit Martha Katzer, u.a. bei deren innovativ-zeitgemäßer Wiederbelebung des Spritzdekors mit char. weichen Farbverläufen. Für die ab 1925 bei der Württ. Metallwarenfabrik (WMF) in Geislingen etablierte Neue Kunstgew.-Abt. (NKA) die sich mit kunsthandwerklichen Objekten auf dem Markt behaupten sollte, wird C. 1936 als Leiterin der 1935 neu ins Leben gerufenen keramischen Abt. innerhalb der NKA engagiert. Sie setzt sowohl auf neue Gefäßformen (z.B. Kugelvasen), v.a. jedoch auf ihre Spezialität, attraktive und im voraus berechenbare Farbglasflüsse aufzubringen, wobei sie eine der Ikora-Technik ähnliche Oberflächenbehandlung für Keramik entwickelt. Mehrfach trifft sie bei der WMF mit bek. Gestaltern zus. (u.a. mit Fritz August Breuhaus de Groot oder Paul Haustein). Unter C.s Ltg werden bis 1949 über 600 keramische Unikate, Versuchs- und Musterstücke angefertigt (v.a. Vasen und Keramikschmuck). Nach Schließung der Keramik-Abt. der WMF verbleibt C. 1949–62 als kaufmännische Angestellte im Unternehmen bis zur Pensionierung tätig. Ausz.: 1937

Grand Prix auf WA in Paris (für WMF-Vasen zus. mit M. Katzer). – C.s. technisch überragende Oberflächen-Gest. von Keramiken im Stil von Art Déco und Dt. Werkbund finden ihre künstlerischen Höhepunkte in den häufig schwarzschattierten, mattglänzenden Glasuren (Rauchbrandglasuren), die heute ebenso wie ihre char. changierenden Craquelés zu den Designklassikern der 1920er/30er Jahre zählen. Bleibendes Verdienst erwirbt sich C., indem sie trad. kunsthandwerkliche (Glasur-)Techniken für die Erfordernisse des in den 1920er Jahren entstehenden mod. Industriedesigns ertüchtigt. Auch eig. Entwürfe (u.a. Teeservice, Vasen, Schalen). – Monogr. Bearbeitung und WV stehen aus. ⌂ KARLSRUHE, Mus. in der Majolika-Man. LEIPZIG, Grassi-MAK. LONDON, BM. ◉ G: 2009 Geislingen, WMF-Fischhalle: WMF Keramik – vom Schmuck zur Bodenvase. ▭ D. Zühlsdorff, Marken-Lex., Porzellan- und Keramik-Report 1885–1935, I, St. [1988]. – P. Schmitt/D. Lütze, Süd-dt. Gefäßkeramik von 1900 bis heute (K Karlsruhe/Sindelfingen), Ka. 1998; E. Spindler, Fröhlich, sachlich, edel. Martha Katzer, Keramik aus der Majolika-Man. Karlsruhe 1922–1942 (K), Ka. 2001; Karlsruher Majolika. Führer durch das Mus. in der Majolika (K Badisches LM), Ka. 2004; C. Burschel/H. Scheiffele. WMF Ikora-Metall. 1920er bis 1960er Jahre. Externe Künstler und Designer der NKA der WMF AG, St. 2006. U. Heise

Connan, *Georges,* frz. Maler, Seemann, * 1912 Pontrieux/Côtes-d'Armor, † 1987 Marseille. Nicht zu verwechseln mit dem gleichnamigen Maler. Stud.: 1932–35 Ec. nat. des BA, Paris. Kämpft 1936 in den Reihen der Internat. Brigaden im Span. Bürgerkrieg. Weitere Stud.: 1937–39 (Dipl.) Ec. nat. de la Marine Marchande. 1939–60 fährt C. für die frz. Handelsmarine zur See; Tunis ist 1947–60 sein Heimathafen. Daneben widmet er sich weiterhin der Malerei, die er ab 1960 mit dauerhaftem Wohnsitz in Marseille praktiziert. – C.s Werk (Öl, Gouache, Acryl) entwickelt sich in drei klar voneinander unterscheidbaren Schaffensphasen. 1936–40 malt er unter direktem Einfluß von Fernand Léger figurative Bilder in einer geometrischen Formensprache. Ab ca. 1940 folgt unter Einbeziehung von Anregungen der Gruppe Cercle et Carré eine auf Kreis und Quadrat basierende geometrisch-abstrakte Periode mit farbenfrohen Gem. (*Cerclées et carrées,* Öl/Papier, sign.), deren Kolorit C. ab 1947 auf Schwarz und Weiß begrenzt. Parallel dazu entstehen mosaikartig anmutende Komp. in komplex ineinander übergreifenden geometrischen und figürlichen Elementen (*Femme Décomposée en Plais,* um 1939). M. der 1950er Jahre Übergang zu streng symmetrisch aufgebauten Komp., deren minutiöse Gest.-Weise er so weit treibt, daß die polyederartigen Strukturen bzw. Gebilde kinetische Effekte bzw. optische Illusionen hervorrufen (*Stucture rayonnante,* Öl/Papier, 1970; *Composition noire, bleue et jaune*). Obwohl die Arbeiten der letzten Phase mit Werken von Victor Vasarely und Pol Bury verglichen werden, bleibt C. weitgehend unbeachtet bis zu seinem Atelierverkauf 1990, seitdem der Kunstmarkt eine steigende Nachfrage nach seinen Gem. verzeichnet. ▭ *Bénézit* III, 1999; *M. Wolpert/J. Winter,* Mod. figura-

tive paint. The Paris connection, Atglen, P. 2004. – Vente Atelier G. C. De la figuration géometrique à l'art optique (Aukt.-Kat. Drouot Richelieu), P. 1990 (184 Werke aller Schaffensphasen). – *Online:* Artnet. R. Treydel

Connan, *Georges,* frz. Maler, Zeichner, Graphiker, Keramiker, Zeichenlehrer, * 17. 9. 1923 Lézardrieux/Côtes-d'Armor, † E. 2002, ansässig in Pont-l'Abbé/Finistère. Nicht zu verwechseln mit dem gleichnamigen Maler. 1928 läßt sich C.s Fam. in Quimper nieder. Stud.: 1941–43 Medizin in Rennes; ab 1943 und 1948–51 Ec. nat. des BA in Paris. Während des 2. WK mehrfach Unterbrechung des Stud.; engagiert sich in der Résistance; wird am 26. 4. 1944 zus. mit seinem Bruder in Quimper verhaftet. 1952–54 Zeichenlehrer am Gymnasium in Pont-l'Abbé und an der Pädagogischen HS in Quimper. 1954 Mitbegr. der EcBA ebd. und für die dortige Keramik-Man. Keraluc tätig. 1959 eröffnet C. zus. mit dem befreundeten Maler und Fayencier Jos Le Corre die Keramik-Wkst. L'Atelier du Steir. 1964 läßt er sich mit der Ehefrau Maryvonne und den gemeinsamen Kindern in Pont-l'Abbé nieder. 1968 fertigt C. einige ungegenständliche Arbeiten und experimentiert mit Siebdruck. Bis zur Pensionierung 1986 liegt der Schwerpunkt seiner Tätigkeit jedoch auf der Lehre an der EcBA in Quimper. Erst dann widmet er sich ausschl. der Malerei, die neben Portr. und Stilleben v.a. Lsch. mit Motiven von ihm vertrauten Orten in Quimper, Penmarc'h, Le Guilvinec, Léchiagat, Treffiagat, Lesconil und auf den Bréhat-Inseln umfaßt. ⌂ QUIMPER, Mus. dép. breton: Vase, Keramik, um 1955. ◉ E: 1956 Quimper, MBA / 2007 Pont-l'Abbé, Mus. Bigouden. ▭ J. Duroc, G. C. (1923–2002), Spézet 2007. – *Online:* Coll. mém. vives de Bretagne (Kat. Fram [Fonds régional d'acquisition pour les mus.] Bretagne). J. Duroc

Connell, *Will,* US-amer. Fotograf, * 31. 7. 1898 McPherson/Kan., † 25. 10. 1961 Los Angeles/Calif. Nach vielen Umzügen der Eltern gelangt C. 1914 mit der Mutter nach Kalifornien, wo er die Los Angeles High School besucht. Kurz vor Kriegsende verläßt er die Schule, um Soldat zu werden. Neben and. Gelegenheitsarbeiten Ausb. zum Apotheker. Ab A. der 1920er Jahre autodidaktische Beschäftigung mit der Fotogr.; 1925 Gründung eines eig. Ateliers in Los Angeles. Mitgl.: Los Angeles Camera Club (ab 1917); Camera Pictorialists of Los Angeles (ab 1927). 1931 Gründung der Foto-Abt. am Art Center College in Pasadena/Calif., wo C. bis zu seinem Tod lehrt. Redakteur bei der Zs. U. S. Camera; 1938–53 Autor der Kolumne „Counsel by Connell" mit fototechnischen Ratschlägen. – C. greift in seinem Werk versch. Bildsprachen der zeitgen. Fotogr. auf. Anfänglich orientiert er sich an der piktorialistischen Fotogr., bevor er sich im Verlauf der 1930er Jahre mod. Tendenzen annähert. In Los Angeles ist C. Teil eines Kreises von Intellektuellen, Schriftstellern und Künstlern um Jacob Israel (gen. Jake) Zeitlin, zu dem auch Frank Lloyd Wright, Merle Armitage und Arthur Millier zählen. M. der 1920er Jahre fotografiert er zunächst v.a. Lsch. im Süden Kaliforniens, die u.a. in der Zs. Touring Topics erscheinen. Neben diversen Auftragsarbeiten für Illustrierte wie Colliers, Cosmopolitan, Life, Vogue und Saturday Eve-

ning Post fotografiert er zahlr. Werbekampagnen (u.a. für Sunkist) und porträtiert A. der 1930er Jahre Schauspieler für versch. Filmproduktionsfirmen (u.a. Metro-Goldwyn-Mayer). Charakteristisch für viele Atelieraufnahmen der 1930er und 1940er Jahre ist eine aufwendige, effektvolle Beleuchtung. In den 1950er Jahren fotografiert C. auch eine Kampagne in Farbe für die Kaiser Steel Corporation. Neben den Auftragsarbeiten experimentiert C. mit Fotogrammen und Fotomontagen. – Foto-Publ.: *In Pictures. A Hollywood Satire*, 1937; *The Missions of California*, N. Y. 1941; *About Photogr.*, N. Y. 1949. ⌂ LOS ANGELES, County Mus. of Art – Univ. of California. RIVERSIDE, California Mus. of Photogr. ROCHESTER/N. Y., George Eastman House. SAN FRANCISCO, MMA. ◉ *E:* 1930 Los Angeles, Jake Zeitlin Gall. and Bookstore / 1981 San Francisco, MMA (K: V. D. Coke) / 1991 Birmingham (Mich.), Halsted Gall. (K) / 2003 Riverside, California Mus. of Photogr. – *G:* Los Angeles: ab 1922 jährlich Mus. of Hist., Sc., and Art: Salon der Camera Pictorialists of Los Angeles; 1987 County Mus. of Art: Masters of Starlight (Begleit-Publ.) / 1977 (California Pictorialism; Wander-Aussst.; K), '84 (Portr. of Artists; K) San Francisco, MMA/ 1992 Santa Barbara (Calif.), Mus. of Art: Watkins to Weston. 101 Years of California Photogr. 1849–1950 (Wander-Ausst.; K) / 2002 Paris, Hôtel de Sully: La Photogr. et le Rêve amér. 1840–1940 (K) / New York: 2003–04 Internat. Center of Photogr.: Only Skin Deep. Changing Visions of the Amer. Self (K); 2008 Keith de Lellis Gall.: Making it Real. Photomontage before Photoshop / 2008 San Marino, Huntington Libr. and AG: This Side of Paradise. Body and Landscape in Los Angeles Photographs (Wander-Ausst.; K). ⌂ U. S. Camera Internat. Ann., 1963; *R. R. Littman*, Life. The first decade. 1936–1945, Boston 1979; *J. Tearnen*, The photogr. of W. C. Reflections of Southern California, 1928–1950, Univ. of California, Riverside, 1992 (unveröff.); *M. G. Wilson/D. Reed*, Pictorialism in California. Photographs 1900–1940 (K), Malibu, Calif. 1994; *S. Ehrlich* (Ed.), Pacific dreams. Currents of surrealism and fantasy in California art, 1934–1957 (K Wander-Ausst.), L. A. 1995; *C. A. Peterson*, After the Photo-Secession. Amer. pictorial photogr. 1910–1955 (K Wander-Ausst.), N. Y. u.a. 1997; *S. McCarroll*, California dreamin'. Camera clubs and the pictorial photogr. trad. (K), Boston 2004; *W. Deverell/G. Hise* (Ed.), Land of sunshine. An environmental hist. of metropolitan Los Angeles, Pittsburgh, Pa. 2005. – Los Angeles, Univ. of California, Charles E. Young Research Libr.: W. C. papers / Riverside, California Mus. of Photogr.: W. C. Arch. P. Freytag

Conner, *Angela (Angela Mary)*, brit. Bildhauerin, Malerin, Zeichnerin, * 1935 London, lebt dort und in Monnington-on-Wye/Hereford. Verh. mit John Bulmer; Mutter der Designerin Georgia B. Ferreira. Autodidaktin; Ass. bei Barbara Hepworth. – Hauptsächlich abstrakte Skulpt., meist organische Formen, aus versch. Mat., u.a. Marmor, Stahl und Kunststoffglas, z.B. *Corona* (Resin, Messing). Bekannt sind v.a. ihre mon. kinetische Arbeiten im öff. Raum, in die sie Naturkräfte wie Wasser, Wind und Sonne einbezieht, z.B. das 35 Meter hohe Wasser-

spiel *Irish Wave* (Carbonfaser, Stahl, Blei, 2001) und das aus zwei Kugeln von 1,80 Meter Durchmesser bestehende Wasserspiel *Rolling Stones* (Schieferstaub, Marmorstaub, Resin, Stein-Grundplatte, 2003), beide Park West, Dublin. Daneben Bronzebüsten und -statuen bek. nat. und internat. Persönlichkeiten wie Königin Elizabeth II., Charles de Gaulle, Noël Coward, Laurence Olivier und Lucian Freud. Außerdem figurative Gem., u.a. Pferde und Stadtansichten (z.B. *London Street*, Öl/Lw., 1957), Zchngn und Ill., u.a. in *R. W. B. Lewis*, The presence of Walt Whitman, N. Y. 1962. ⌂ LONDON, Arts Council. – London Libr. – Nat. Portr. Gall. NEW YORK, Jewish Mus. PARIS, Mus. de l'Armée. PITTSBURGH/Pa., Carnegie Mus. ◉ *E:* London: 1959 Walker's Gall.; 1986 Browse & Darby; 2001 Hirschl Gall.; 2004 Inner Temple Gardens (K) / 1971 New York, Lincoln Center / 2008 Paris, Gal. Pièce Unique. – *G:* 1979 London, Tryon Gall.: Horse Artists of the World / 2010 Cambridge, Fitzwilliam Mus.: Sculpt. Promenade (K) / 2011 Leicester, Univ. of Leicester, Botanischer Garten: A Decade of Sculpt. in the Garden; Aarhus: Sculpt. by the Sea. ⌂ *Mitchell*, 1985; *Wingfield*, 1992; *Windsor*, Sculptors, 2003; *Buckman* I, 2006. – *R. Hopwood*, Fountain and water features, Lo. 2009. – *Online:* Website C.
J. Niegel

Connert, *Senta*, dt. Objekt- und Installationskünstlerin, Zeichnerin, * 6. 3. 1957 Stuttgart, lebt in Meinersen und Düsseldorf. Stud.: 1983–85 ABK, Stuttgart; 1985–90 KA, Düsseldorf, bei Fritz Schwegler (Meisterschülerin). 1998/99 Lehrauftrag am Inst. für Textil-Gest. und ihre Didaktik, Univ. Dortmund. Seit 2006 Vors. der Dt. Ges. für künstlerische Therapieformen. Stip.: u.a. 1987 Projektförderung der Stadt Düsseldorf; 1996 Arbeits-Stip. Kunstfonds e. V., Bonn; 2000 Stip. Kultur-Minist. NRW; 2006 Kunststiftung NRW. – Über die Beschäftigung mit den fünf Sinnen gerät die Auseinandersetzung mit textilen Webstoffen in den Fokus von C.s Arbeit. Ihre Werke reflektieren die Wahrnehmung von Textilien jenseits ihrer alltäglichen Präsenz und Funktionalität. Von der Stofflichkeit ausgehend leiten die Werke teilw. in and. Medien (Zchng, Installation, Fotogr.) über. 1990 kombiniert C. den spätmittelalterlichen Gobelinzyklus Die Dame mit dem Einhorn (Mus. Cluny, Paris) mit dem Etikett der Hemden- und Blusen-Fa. Einhorn. Die Kombination unterschiedlicher Inhalte, Zeiten und Techniken ist ein char. Element ihres Ansatzes. 1999 entwirft C. das Multiple *Millimeterpapier* in Jacquardtechnik aus eingefärbten Wollfäden. Indem das eine Mat. durch ein völlig and. Mat. ersetzt wird, entsteht ein Spannungsverhältnis zw. mathematischer Rationalität und sinnlicher Oberflächenbeschaffenheit. Das durch die Beschäftigung mit der maschinellen Textilherstellung angeregte Thema des Lagerns und Stapelns bearbeitet C. 1998–2000 in den Installationen *Regal I–V* (weiße Oberhemden und Handtücher in wandfüllenden Regalen) und *Schnitte* (mehrere Tischwagen mit zugeschnittenen und aufgestapelten Einzelteilen karierter Herrenoberhemden). In großformatigen Zchngn u.a. nach Gehirnschnitten (*Flechsig*, 2003) und weiteren Installationen (*Wollvitrine*, 1999) untersucht C. das Verhältnis zw. den generativen Prinzipien Chaos

und Ordnung. In den Fabriken versch. Textilhersteller (u.a. 1996 in der Fa. Seidensticker) entstehen Fotoserien, welche Produktionswege und Fertigung der Textilien dokumentieren. Der Aspekt des Prozeßhaften ist für C.s Vorgehensweise entscheidend und verbindet die einzelnen Werkreihen stets auch untereinander. ⌂ DÜSSELDORF, Mus. Kunst Pal. FRANKFURT am Main, Slg Dt. Bank. ◉ *E:* 1995 (mit Maria Anna Dewes), '99, 2003 Düsseldorf, Gal. M+R Fricke / 1997 Düsseldorf, Shiseido (K) / 1997, 2000, '01 Berlin, Gal. M+R Fricke. – *G:* 1999 Hall in Tirol, KH: Space Place; Schwäbisch Gmünd, Mus. im Prediger: Das Einhorn. Mythos und Signet (K) / Bonn, Kunst- und Ausst.-Halle der Bundesrepublik Deutschland: Herbarium der Blicke / 2006 Rabat (Marokko), Goethe-Inst.: Gesprächsstoff (Wander-Ausst.; K). ▭ Finger. Newsletter für aktuelle Kulturphänomene 1999 (4) 12 ss.; Hand-Arbeit (K Haus der Kunst), M. 2000. – *Online:* Website C. H. Uhr

Conrad, *Christiane,* dt. Malerin, Graphikerin, Zeichnerin, * 1949 Gießen, lebt und arbeitet in Berlin. Stud.: 1984–90 HdK, Berlin (Malerei), 1990 Meisterschülerin von Walter Stöhrer. Stip.: 1991–93 Atelier-Stip. der Karl-Hofer-Ges., Berlin. Mitgl.: Dt. Künstlerbund. – C. spürt seit A. der 1990er Jahre in scheinbar monochromen, meist großformatigen Arbeiten (Öl/Lw. und Öl/Baumwolle) dem Phänomen Farbe nach, dessen Stofflichkeit und Materialität sie in mehreren, meist vertikal aufgetragenen Schichten untersucht. Dabei streicht sie die dünnflüssige Ölfarbe mit dem Spachtel in relativ kurzen Zügen in bis zu zehn Lagen über den Malgrund, was u.a. zu minimal abweichenden Farbflächendifferenzen, v.a. jedoch zu vertikalen Farbgraten, feinen Texturen sowie mehr oder weniger reliefartigen Oberflächendifferenzierungen (häufig Gitterstrukturen) führt (*Hellblau,* 2007), die in ihrer Komplexität und Tiefe dem universalen Anspruch der sog. monochromen Malerei in bes. Weise gerecht werden. Bleyl (2003) spricht C.s Bildern „gemalte Stille" zu, womit er deren meditativen Char. hervorhebt. Meinhardt (2009) faßt in seinem Essay „Die Eigennamen der Farben" zusammen, daß C.s „Einschreibungsspuren der Hand ... weder Träger von Expression noch Träger von Bedeutung [sind]: sie koppeln sich nicht an ein expressives Innen an, das sich in der Bewegung der Hand artikuliert, noch bezeichnen sie Umrisse, Formen, piktogrammatische oder symbolische Zeichen oder and. Typen von Bedeutungsträgern". C.s konzeptueller wie prozessualer Ansatz beschränkt sich konsequent darauf, pro Bild ausschl. einen Farbwert und dessen Zuständlichkeit zum Gegenstand zu machen, wobei sie mit Bildtiteln wie *Sand, Schneespur, Tagblau* oder *Rotbuche* durchaus auch auf tageszeitliche oder saisonale Farbanalogien in der Natur verweist. Auch erkundet sie standortspezifische urbane und archit. Farbwerte an Ausst.-Orten, die sie dann in Projekten ausführt (z.B. 2007 im Staatlichen Mus. Schwerin oder 2010 im Mies-van-der-Rohe-Haus in Berlin). C. gehört zu den wenigen Künstlern ihrer Gen. in Deutschland, die sich in konsequenter Weise mit dieser sehr speziellen Form der Analytischen Malerei auseinandersetzen. ⌂ DEN HAAG, Mi-

nisterie van Buitenlandse Zaken. HAGEN/Westf., Osthaus-Mus. KAISERSLAUTERN, Pfalz-Gal. KARLSRUHE, KS Reg.-Präsidium. SCHWERIN, Staatliches Mus. ◉ *E:* Berlin: 1997 Kommunale Gal. Treptow (mit Eva Niemann); 2000 Gal. im Turm; 2010 Kunstquartier Bethanien (mit Anke P. Neumann); 2010–11 Mies-van-der-Rohe-Haus (K); 2011 Gal. Dittmar / 2007 Schwerin, Staatliches Mus. / 2009 Staphorst, Gal. Hein Elferink; Gaggenau, Schloß Rotenfels. – *G:* 2004 Hagen/Westf., Osthaus-Mus.: Die Farbe hat mich II (nicht nur rot) (K) / Potsdam, KunstHaus: 2007 Jetzt. Damals; 2008 Zum Quadrat. Im Quadrat; 2009 Das Licht. Der Schatten. Die Kunst; 2011 Colour and Paint. Sensation Farbe / 2009 Osnabrück, KH Dominikanerkirche: Magie der Farbe. Pastose Malerei, Farbkörper, Farbräume (K). ▭ *L. Peter,* HdK Berlin. Kl. Stöhrer. C. C. [...], B. 1989; *M. Bleyl,* C. C. Malerei 2001–2003, B. 2003; *B. E. Buhlmann u.a.,* Thomas Brummett Fotogr. – C. C. Malerei (K Pfalz-Gal.), Kaiserslautern 2005; *J. Meinhardt,* in: *W. Noack u.a.,* C. C. mo-no-chrom (K Mies-van-der-Rohe-Haus). B. 2011. – *Online:* J. Meinhardt, Die Eigennamen der Farben, 2009. U. Heise

Conradi, *Helmuth,* dt. Architekt, * 27. 2. 1903 Wuppertal-Barmen, † 24. 12. 1973 Seeshaupt/Obb. Sohn des in Wuppertal-Barmen tätigen Architekten *Ludwig C.* (* 25. 9. 1864, † April 1942), Vater des Architekten und Politikers *Peter C.* (* 10. 12. 1932 Schwelm, lebt in Stuttgart; Stud.: 1953–61 TH ebd.; ab 1963 Reg.-Baumeister, 1999–2004 Präs. der Bundesarchitektenkammer). Stud.: 1923–26 TH Stuttgart, Archit. bei Paul Schmitthenner und Paul Bonatz; auch Studien in Danzig (Gdańsk). Anfänglich arbeitet C. v.a. im Stil der sog. Stuttgarter Schule, u.a. E. der 1920er Jahre für die Junkerswerke in Dessau. Dort entwirft er z.B. für die Gartenstadt Dessau-Siedlung (Architekten u.a. Leberecht Migge, Theodor Overhoff) die mit einem Dachreiterglockenstuhl versehene mehrfunktionale Auferstehungskirche. Nach der zweiten Staatsprüfung erhält C. 1931 eine Anstellung bei der Dt. Reichsbahn; in den Folgejahren ist er für deren Direktionen in Hamburg, Mainz und Königsberg/Ostpreußen (Kaliningrad) tätig; nach 1938 wird er zum Reichsverkehrs-Minist. nach Berlin versetzt. 1938 gewinnt er den Wettb. zur Errichtung eines weiblichen Angehörigen des Reichsarbeitsdienstes im ostpreußischen Grieslienen (Gryźliny/Polen). 1940–45 Kriegsdienst und brit. Kriegsgefangenschaft, wo er Werner Düttmann kennenlernt (später Senatsbau-Dir. in Berlin), mit dem er Pläne für den Wiederaufbau Deutschlands ausarbeitet. Nach der Repatriierung ist C. 1946–48 bei der Bahn-Direktion in Köln und 1948–65 als Hochbaudezernent bei der Bundesbahn-Direktion in Stuttgart angestellt. – Ab 1948 leitet C. den Wiederaufbau des im 2. WK stark zerst. Stuttgarter Hauptbahnhofes. In den 1950er/60er Jahren entwirft er mehrere sowohl baukünstlerisch wie betriebstechnisch vorbildhafte Bahnhof-Empfangsgebäude (Bietigheim-Bissingen, 1958–61; Leonberg/BW, 1969), die u.a. durch großzügige Verglasung der Längsfassaden (Heidelberg) oder durch kühn auskragende Schwebevordächer (Pforzheim) Leichtigkeit und Eleganz, Transparenz

und Modernität ausstrahlen. Sie stehen beispielhaft für die Archit.-Auffassung der 1950er Jahre, wobei C. auch durchaus konservativ-mon. Stilmittel einsetzt (u.a. ungegliederte Flächen, Verzicht auf Sockel). Auch Wohnbauten, z.B. für die Eisenbahnsiedlungs-Ges. vier baugleiche 11- bis 15geschossige Hochhäuser in Stuttgart (Mönchstr., 1954–56) oder die Lungenheilanstalt der Bundesbahn-Versicherungsanstalt in Schömberg (1958–61). Unter den typologisch und funktional innovativen technischen Bahngebäuden sind das kommandoturmartige, im dritten Stockwerk mit schräggestellten Panoramafenstern auf vorkragender Plattform ausgestattete Stellwerk in Schorndorf/ BW (1962) und das Bahnbetriebswerk in Esslingen bes. erwähnenswert. – Monogr. Bearbeitung und WV stehen aus. ⌼ DESSAU, Ziebigker Str.: Auferstehungskirche, 1930. HEIDELBERG, Hauptbahnhof (Empfangsgebäude), 1955. PFORZHEIM, Hauptbahnhof (Empfangsgebäude), 1958. ✉ „Großstädte der Zukunft". Grundsätzliche Betrachtungen zum Wiederaufbau, in: Baumeister 43:1946 (5) 51–54. ⌺ Dt. Bau-Ztg 72:1938 (24) 651 s.; *G. Ziegler*, Anhaltische Baumeister – Baumeister in Anhalt, Dessau 1992 (Zw. Wörlitz und Mosigkau 34); *M. Schack*, Neue Bahnhöfe. Die Empfangsgebäude der Dt. Bundesbahn 1948–1973, B. 2004; *H. Erfurth u.a.*, 100 Jahre Siedlungs-Gesch. in Dessau, Dessau 2005; *J. Kaiser u.a.*, 50 Jahre neuer Heidelberger Hauptbahnhof, Ludwigshafen 2005; *B. J. Lattner*, 500 Jahre Heilbronner Archit., Heilbronn 2005; *R. Feitenhansl*, Denkmalpflege in BW 39:2010 (3) 134–139. – Mitt. Peter C., Stuttgart.

<div style="text-align: right">U. Heise</div>

Conradi, *Ludwig* cf. **Conradi,** *Helmuth*
Conradi, *Peter* cf. **Conradi,** *Helmuth*

Conrado, *Martim*, portug. Maler, zw. 1640 und 1659 auf Madeira und in Lissabon aktiv. Biogr. Daten sind nicht bekannt. Pereira (1989) hält eine Verwandtschaft mit dem Maler João Conrado, der sich 1613 in der Acad. S. Lucas in Lissabon einschrieb, für möglich. C. unterhielt eine Wkst. in Funchal und war für lokale Auftraggeber (v.a. den Jesuitenorden) sowie für die einflußreiche Fam. Berenquer u.a. auch mit Votivbildern tätig. Zu seinen ersten Arbeiten zählt ein Gem. für das Retabel der Kap. S. Gonçalo de Amarante im Kloster S. Clara in Funchal – eine anmutige Arbeit in ital. Manier. Für das Kloster entstand auch das Gem. *Ávrore de Jessé*. Zu C.s bed. frühen Werken zählt *Imaculada Conceição, S. Ana e S. Joaquim, com doadores* (sign., dat. 1646) für die Mutterkirche in Caniço in anspruchsvoller Farbigkeit. 1647 ist er mit einer Gem.-Serie (erh. ein Todo, rest.) für die Kap. Santíssimo Sacramento in der Kathedrale von Lissabon dokumentiert. Serrão (2000) nimmt an, daß der Hofmaler Avelar Rebelo ihn für eine Mitarbeit in seiner Wkst. gewinnen wollte; auch wird eine Reise C.s nach Sevilla nicht ausgeschlossen. C. kehrte jedoch nach Funchal zurück und fertigte für die Pfarrk. in Ribeira Brava das Gem. *Arcanjo S. Miguel e as almas do purgatório* (1649) sowie *Nossa Senhora da Boa Morte* (heute Rathaus, Lobos) und *Imaculada* für die Mutterkirche in Calheta. Als Hw. wird das Gem. *O Martírio de S. Úrsula e das onze mil virgens* (sign., dat. 1653; heute Mus. de Arte Sacra, Funchal) für die Ursulinen-Kap. des Jesuitenkollegs S. João Evangelista in Funchal angesehen; Bildaufbau, Pinselführung und Farbchromatik sind hervorhebenswert. Zur Legende der hl. Ursula entstanden nahezu zeitgleich nach einen Stich von Johann Sadeler, dem das Altar-Gem. in der Jesuitenkirche St. Michael in München zu Grunde liegt, drei Gem. (Funchal, Coimbra, Lissabon). 1653 fertigte C. zudem *Nossa Senhora da Piedade* für die Kap. S. José in Camacha, *Noli me tangere* für die Mutterkirche in Porto Santo und *Nossa Senhora das Mercês* (verschollen). – C. zählt zu den bed. Proto-Barockmalern der ersten H. des 17. Jh. in Portugal. Er konkurrierte zeitlebens mit Lissabonner Wkstn, wobei in der Komp., der detaillierten Durchbildung und der subtilen Farbigkeit seiner Gem. Zusammenhänge mit Rebelo sichtbar werden. Darüber hinaus ist eine stilistische Nähe zu den Sevillianern Francisco Pacheco, Juan de Roelas und Juan del Castillo sowie den Italienern Giovanni Battista Paggi und Pietro Sorri unverkennbar. ⌺ *J. F. Pereira* (Ed.), Dic. da arte barroca em Portugal, Li. 1989; *P. Dias*, Hist. da arte portug. no mundo (1415–1822) I, Li. 1999. – *V. Serrão*, A pint. protobarroca em Portugal 1612–1657, Li. 2000, 417–419; *id.*, A trans-memória das imagens. Estudos iconológicos de pint. portug. (séc. XVI-XVIII), Chamusca 2007, 249, 253.

<div style="text-align: right">R. Petriconi</div>

Consolazione, *Ettore*, ital. Bildhauer, Installationskünstler, Maler, Graphiker, Bühnenbildner, * 1941 Rom, lebt dort. Stud.: Univ. La Sapienza, Rom (Archit.); gleichzeitig ABA ebd. (Bühnenbild) und Ist. Superiore Statale, Urbino (Graphik). 1975 Ausst.-Debüt in Rom (Quadrienn.). – C.s Erfahrungen in versch. künstlerischen Bereichen kulminieren in der Beschäftigung mit Bildhauerei. Experimentiert mit unterschiedlichsten Mat. (von Terrakotta, Eisen, Bronze, Holz, Schaumgummi, Zement bis hin zu Textilem), wobei er von der den Mat. innewohnenden Eigenschaft, sich auf versch. Weise zu verändern, fasziniert ist. Auch bezieht er Klänge in seine Arbeiten ein. Die (oft ironisch gemeinte) Inszenierung von seinen bildhauerischen Objekten erinnert an C.s Ausb. als Bühnenbildner. Seine Stoffarbeiten sind dabei flexibel einsetzbar. In den 1970er Jahren tragen sie Titel wie *Comizio, Bandiere* oder *Bottiglie Molotov* und stellen der Schwere der polit. Auseinandersetzungen jener Zeit bewußt eine spielerische Leichtigkeit gegenüber. Oft sind C.s Objekte char. durch metaphysischen Beziehungsreichtum und eine Stimmung zw. Traum und Wirklichkeit. Auch mit christlichen Themen setzt sich C. häufiger auseinander (*Il Paradiso; Il Crocefissione; La città di Dio*). In den letzten beiden Jahrzehnten zunehmende strukturelle Vereinfachung von C.s Arbeiten und deutlichere Korrespondenz mit dem jeweiligen Umfeld. ⌼ BRUFA-TORGIANO, La Strada del Vino e dell'Arte: Contro tutti i terrorismi, 2010. ROM, Gall. Com. d'Arte Mod. e Contemp.: Neun Bronzen (Ankauf 2000). – Banca Naz. del Lavoro: Bronzo 2000, Bronze (Ankauf 2008). – Piazza Esquilino, Unipol Bank: Enigma a terra, Bronze, 2008. SPOLETO, Hotel Albornoz: Sciame, Bronze, 2008 (14-teilige Fassaden-Skulpt.). VENTIMIGLIA, Neue Wache der Vigili del Fuoco: Relief, Bronze, 2011.

⊙ *E:* 1984 Bari, Gall. Centro Sei / 1995 Spoleto, Chiesa S. Carlo (mit Mauro Folci) / 1997 Viterbo, Gall. Miralli / 2000 Brescia, Gall. Valentina Zatta / Rom: 1991 Gall. Banchi Nuovi; 1996 L'Officina di Gorgia; 2003 Gall. Il Bulino; 2008 ph7 art gall. / 2005 Montecarlo, Gall. Maretti Arte Monaco (Retr.; K) / 2007 Perugia, Gall. Artico. – *G:* 1976 Venedig: Bienn. / 1981 Lecce, Pal. Ducale S. Cesario: Presenza e memoria / Rom: 1981 Pal. delle Espos.: Linee della ricerca artist. in Italia 1960–1980; 1986 Pal. dei Congressi: Quadrienn.; 1995 Pal. Falconieri: Hortus conclusus; 2002 Archit. Arte Mod. (AAM.): Oggetti smarrati e ritrovati (K: F. Moschini); 2006 Centro espositivo cavea: Donnart. Arte per Roma; 2009 Pal. Colonna: Artisti per Luchu; 2010 Gall. Ricerca d'Arte: Itinerari di arte astratta / 1994 Gubbio: Bienn. / 2001 Maccarese, Castello di S. Giorgio: Scult.-Pitt. / 2004 Amelia, Mus. Archeol.: Frammenti Tessili / 2005 Foggia, MCiv.: TramArte / 2008 Brolo, Sala multimediale: Presenze / 2009 Matera, MUSMA: L'arte del presepe (K: G. Appella). ⌸ Argomenti per la scult. (K Studio Ghiglione), Ge. 1987; *M. De Candia*, Semplice forme di C., R. 1991; *M. Crescentini*, L'ambiente Romano. La pitt. in Italia '900, II, Mi. 1994; *P. Ferri* (Ed.), E. C. Opere 1973–2003, s.l. 2005; *E. Bilardello/F. Franzè*, La Coll. Banca Naz. del Lavoro. I Contemp., II, Mi. 2007; *E. Bilardello*, E. C. Contro tutti i terrorismi (K Brufa), s.l.e.a. [2010]. – *Online:* Website C. S.-W. Staps

Constante García, *Teobaldo,* ekuadorianischer Maler, Graphiker, Pressezeichner, Karikaturist, Bildhauer, Zeichenlehrer, * 23. 7. 1881 Babahoyo/Los Ríos, † 26. 8. 1965 Guayaquil. Vater des Malers *Theo Constante Parra* (* 10. 4. 1934 Guayaquil) und Großvater der Malerin und Bildhauerin *Hellen C. Palacio* (* 1960). Ab 1897 in Guayaquil ansässig. Beginnt autodidaktisch zu malen und zu zeichnen, u.a. Kolorierung von Diplomen. 1906 Ausb. bei dem Maler Raúl Pereira. Ab 1910 Karikaturen für die Zs. El Guante und ab 1915 für Patria. 1917 als Delegierter des Congreso Latinoamer. de Periodistas Reise nach New York und dort über ein Jahr als Pressezeichner tätig. Ab 1918 Mitgl. der Freimaurer. 1919 mit dem Karikaturisten Cyrano Tama Paz in Guayaquil Gründung der kurzlebigen Zs. Momo, 1921 Co-Dir. der Zs. Siluetas. Lehrtätigkeit: ab 1926 Doz. für technisches Zeichnen (später auch für Ethik) am Colegio Vicente Rocafuerte; zeitweise Doz. (Zchng, Kalligraphie) am Inst. Nac. in Guayaquil. Ab 1934 Karikaturen für die Zss. Caritas y Carotas und Tribuna. – Anfangs malt C. v.a. Portr., tropische Lsch. und Akte in Aqu. und Gouache und zeichnet feinlinige Komp. in Kohle und Pastell. Dann widmet er sich v.a. der Pressekarikatur. Nach 1918 auch realistische Skulpt. und Aqu., u.a. eine Serie über das Alltagsleben des späten 19. Jh. in Guayaquil. Mehrere bildhauerische Arbeiten (meist Köpfe und Büsten) werden im öff. Raum aufgestellt, z.B. des Insektenkundlers *Francisco Campos Rivadeneira* (1928), des Befreiers *Simón Bolívar* (1933), des Politikers *Vicente Rocafuerte* (1942) und des Pharmazeuten und Bibliophilen *Carlos A. Rolando* (1952). Unter den Portr. in Öl/Lw. ragt sein *Selbstbildnis* (1957) in natürlicher Größe hervor, das ihn zus. mit seiner Frau zeigt. ⌂ Guayaquil, Bibl.

Mpal. – Colegio Vicente Rocafuerte. – Mus. Mpal. ⊙ *E:* 1960 Guayaquil, Bibl. Mpal. ⌸ *H. Rodríguez Castelo*, Dicc. crít. de artistas plást. del Ecuador del s. XX, Quito 1992. – *G. Arosemena Arosemena*, El fruto de los dioses, Guayaquil 1991. – *Online: R. Pérez Pimentel* (Ed.), Dicc. biogr. del Ecuador. M. Nungesser

Constantinescu, *Ştefan,* rumänischer Videokünstler, Maler, Dokumentarfilmer, Schriftsteller, * 1968 Bukarest, lebt dort und in Stockholm. Stud.: bis 1996 Univ. der Künste, Bukarest; bis 1998 Kgl. AK, Stockholm. In den 1990er Jahren Übersiedlung der Fam. nach Schweden. Stip: 1999, 2004, '09 The Swedish Arts Grants Committee; 2007 Romanian Nat. Film Board; 2008 Media Desk Broadcast; 2011 Kultur-Stip. Stockholm. 2010 Ausz. für den Videofilm *My Beautiful Dacia*: Jurypreis auf dem Dokumentarfilmfestival in Mexiko City und 2. Preis auf der Documenta Madrid. Häufige Teiln. an (Dokumentar-)Filmfestivals, u.a. in Cluj-Napoca, Göteborg, New York City, Paris und Stockholm. – Für seine zeitgeschichtlich intendierten Filmprojekte *Archive of Pain* (2000; Regie: Christi Puiu; Graphikdesign: Ariana Stoenescu), *Dacia 1300 – My Generation* (2003; 62 Min.) und *The Passage* (2005; 62 Min.) bedient er sich jeweils der „oral history" als Methode. Interviews mit ehem. politischen Gefangenen, früheren Nachbarn oder drei Chilenen, die in den 1970er Jahren nach Rumänien emigrierten, bilden den Kern der einzelnen Filme. Beide erstgenannten Filmen sind zudem mit einem Buch (Essays) kombiniert. C. bekennt 2011 in einem Interview, daß er seinen Kunstbegriff sehr weit auslegt. *Dacia 1300*, eine Montage, die auch altes Propaganda- und Werbematerial beinhaltet, ist C.s persönlichste Arbeit. Er spürt seiner eig. Kindheit im Bukarest der Ceauşescu-Ära nach. Mit einer Serie aktueller Kurzfilme (z.B. *Middag med Familjen*, Schweden, 2012) und einem Feature, begonnen 2011, thematisiert er u.a. Verhaltensnormen in öff. Räumen oder zwischenmenschliche Beziehungen in Zeiten der globalen Kommunikation im Internet. Diese Arbeiten entstehen in Zusammenarbeit mit Xandra Popescu, die auch Partnerin bei dem Bienn.-Beitrag *Memory Box* in Venedig war. – Weitere Filme: *The Baron*, 2002 (45 Min.; Konzept: Cristi Puiu); *My Beautiful Dacia*, 2009 (mit Julio Soto Producers u.a.); *Troleibus 92*, 2009. ⌂ Bukarest, MNAC. Malmö, Mod. Mus. Paris, Fond. Louis Vuitton. Stockholm, Mod. Mus. ✉ Archive of pain, Sth. 2000; C./T. Sandqvist/A. M. Zahariade, Dacia 1300 – My generation, Bu. 2003; Northern lights, Cluj-Napoca 2006; The Golden Age of children, Sth. 2008. ⊙ *E:* u.a. Bukarest: 2000 Sala Dalles; 2003 Muz. Ţăranului Român; 2007 MNAC; 2008 Gal. Posibila / 2003–04 Stockholm ID: I Gall.; Malmö, KM; Norrköping, KM; Iaşi, Gal. Vector; Timişoara, Projektraum der Gruppe H-Arta (alle: Dacia 1300 – My Generation) / 2008 Stockholm, Botkyrka Konsthall / 2009 Tel Aviv, Art Space Gall. / 2011, '12 London, Gall. 8. – *G:* zahlr. nat. und internat., u.a. 2002 Bukarest: MNAC: COOP_02 Media Festival / 2004 München, KV: Blick 04. Neue Filme / 2006 Kassel, MHK, Mus. Fridericianum: 5 Tage bis zum Ende der Kunst / 2007 Zürich, Cabaret Voltaire: Dada East? /

2008 Umeå, Bild-Mus.: The Map. Navigation the Present / 2009 Rotterdam, Witte de With, Centrum voor Hedendaagse Kunst: Morality, Act III; Venedig: Bienn. (mit Andrea Faciu und Ciprian Muresan); Visby, Gotlands KM: Going Places. Re-thinking Tourism / 2010 Tel Aviv: Videozone V / 2011 Curitiba: Bienn. / 2012 León, MAC: One Sixth of the Earth. ▭ *S. Neuburger*, Springerin 2004 (3); *S. Nastac*, Flash art 2007 (256); C. [The Romanian Cult. Inst. of Stockholm], Sth. 2009; *M. Liosi*, Drome mag. 2011; *R. Unwin*, The art newspaper 2011 (Juni); *A. Bojenoiu/A. Niculescu* (Ed.), Romanian cult. resolution (K), Ostfildern 2011; East Europ. film bull. v. 1. 11. 2011 (Interview). – *Online:* Website C. (Ausst.; Lit.). **B. Scheller**

Constantino, *Nicola* → **Costantino,** *Nicola* (1964)

Cónsul y Requejo (Cónsul), *Juan Nepomuceno*, span. Maler, Zeichner, Unternehmer frz. Abstammung, * 5. 11. 1747 Oviedo, † 13. 7. 1807 ebd. Natur-wiss. und künstlerische Ausb. in Oviedo. Anschl. bis 1771 Weiterbildung (v.a. Zeichnen und Malerei) in Frankreich, von wo C. zahlr. Neuerungen und künstlerische Anregungen mit nach Asturien bringt und verbreitet. Mit diesem Wissen und ausgeprägtem Unternehmergeist modernisiert er mehrere von seinem Vater († 1771) geerbte Landwirtschafts- und Handwerksbetriebe, darunter eine von letzterem in Villar b. Oviedo gegr. Feinsteinzeug-Man., die C. weiterführt. In Anerkennung dieser Leistungen wird er 1782 Mitgl. (1786 Ehren-Mitgl.) der Soc. Económica de Amigos del País, unter deren Schirmherrschaft er 1785 die erste Esc. de Dibujo in Oviedo gründet und als Dir. leitet. Er engagiert sich nachdrücklich für die Entwicklung beider Institutionen, v.a. der Zeichenschule, die unter seiner Führung einen großen Aufschwung nimmt und 1802 zur EBA wird (bis 1805 Dir., dann Ehren-Dir.), womit C. einen entscheidenden Beitr. zur Förderung der bild. Kunst in Oviedo leistet. Auch kommunalpolitisch aktiv, erwirbt er v.a. als Ratsherr weiteres öff. Ansehen. Eng befreundet mit dem Politiker, Schriftsteller und Dichter Gaspar Melchor de Jovellanos. – Das in C.s Man. gefertigte Steinzeug zeichnet sich durch einen bemerkenswerten Formen- und Farbenreichtum sowie qualitätvolle Glasuren aus. Als Maler vertritt er eine trad.-akad. Auffassung und gilt v.a. als geschickter und einfühlsamer Porträtist, zu dessen wenigen bek. Werken ein Bildnis von *Jovellanos* und das *Retrato ex-voto del arquitecto Manuel Reguera González* (1793) gehören. Erh. ist ein technisch korrekt und in kühlem Kolorit ausgef. Altarbild (*Dolorosa,* 1792; Oviedo, Kathedrale S. Salvador, Cap. del Rey Casto). Auch Entwurf von Bühnenbildern für Inszenierungen der Dramen *Pelayo* und *El delincuente honrado* von Jovellanos im Theater von Gijón. ▭ *C. Suárez,* Escritores y artistas asturianos, Ma. 1936; Oviedo ²1959. – *J. Tolivar Faes,* Nombres y cosas de las calles de Oviedo, Oviedo 1985; *J. Barón Thaidigsmann/ J. González Santos,* Liño 7. Rev. anual de hist. del arte (Oviedo) 1987; *F. Crabiffosse Cuesta,* in: *J. Barón* (Ed.), El Arte en Asturias a través de sus obras, Oviedo 1996. – *Online: J. A. González-Pola,* in: Oviedo enc. **R. Treydel**

Conte, *Bernard,* frz. Maler, * 22. 7. 1931 Cézens/Cantal, † 13. 5. 1995 Sèvres (?). Ab 1947 Ausb. als Innendeko-

rateur im Centre d'Art et de Techniques Camondo in Paris bei Pierre Lardin. Arbeitet anschl. in versch. Dekorationsfirmen und beim Innenarchitekten Louis Süe. Ab 1961 ausschl. als Maler tätig mit Atelier in Sèvres. 1969 Kauf eines alten Fischerhauses auf der Atlantikinsel Noirmoutier/Vendée; ab M. der 1980er Jahre weiterer Wohnsitz in Südfrankreich. Intensive Reisetätigkeit im In- und Ausland, z.B. 1970 Marokko, 1992 Kalifornien, 1994 Mexiko. Zahlr. Ausz.: u.a. 1963 Preis des Conseil gén. de Seine et Oise; 1967 Preis der Fond. Taylor und Prix Marthe Orant; 1971 Grand Prix der Bienn. des Yvelines, Versailles; 1974 Chevalier du Mérite cult. et artist.; 1984 Preis der Gal. La Palette d'Or, Strasbourg. – C. praktiziert eine konsequent gegenständliche Malweise, die er nur geringfügig weiterentwickelt, ab M. der 1960er Jahre wird sie freier und gelöster. Der pastose Farbauftrag in großzügigem Duktus und leuchtenden, kräftigen Tönen führt zu einer subtilexpressiven Ausstrahlung, die die ruhige Atmosphäre der Bilder nicht beeinträchtigt. Um 1970 vorübergehende Aufhellung der Farbpalette und leichte formale Vereinfachung. Der Aufenthalt in Marokko bewirkt erneut ein nuancenund kontrastreicheres Kolorit. Neben Figurenbildern (*Jeune femme au miroir*) und Stilleben (*Nature morte au compotier blanc*) entstehen v.a. Lsch. aus den bereisten Regionen mit bes. Vorliebe für Ansichten der frz. Atlantik- und Mittelmeerküste (*Pêcheurs en Bretagne*), Vendée, bes. der Insel Noirmoutier, wo C. einen großen Teil seiner künstlerischen Anregungen findet, von der Ile de Ré und der Côte-d'Azur (*Pins sur les Calanques*). Weitere Motive stammen aus Paris, Venedig, Amsterdam, der Provence (*Sur le canal du midi*) und den norwegischen Fjordgebieten (*Fjord en Norvège*). ▭ COURBEVOIE, Mus. Roybet Fould. L'ISLE-ADAM, MAH Louis Senlecq. PARIS, MAMVP. SAN FRANCISCO/Calif., Mod. Master's Gall. SEVRES, Cité de la Céramique. VERSAILLES, Coll. du Conseil gén. des Yvelines. – Préfecture des Yvelines. VILLE-D'AVRAY, Mus. mun. ◉ *E:* 1963 Cannes, Gal. franç. / Paris: 1963 Gal. d'Atri; 1966 Gal. Prestige des Arts; 1970, '73 Gal. Régis Langloys; 1972 Mus. du Luxembourg; 1976 Gal. Colette Dubois; 1985, '89 Gal. Denise Valtat; 2004 Gal. René François Teissedre / Tokio: 1970 Gal. Nichido; 1971 Nihon Koeki Gal.; 1973, '74 Isetan Gal. / 1975 Vevey, Gal. Alpha / ab 1987 Honfleur, Gal. de la Lieutenance / 1994 Cannes, Gal. Gantois / 1999 Sèvres, Sel (Hommage). – *G:* Paris: ab 1958 Salon de la Soc. nat. des BA; ab 1959 Salon de la Marine; ab 1960 Salon d'Automne (1995 Hommage); ab 1963 Salon des Indépendants; 1972 SAfr. (Silber-Med.) / 1999 Montargis: Bienn. d'Art contemp. ▭ *Bénézit* III, 1999; *Delarge*, 2001. – *Y. Le Pichon,* B. C., Suresnes 1981. – *Online:* Website C. **R. Treydel**

Conthe (C. Gutiérrez), *Belén,* span. Malerin, Fotografin, Bildhauerin, Videokünstlerin, * 10. 12. 1951 Madrid, lebt dort. Stud.: bis 1975 Pharmazie (später z.T. auch im Beruf tätig); Esc. de Cerámica La Tinaja; 1994–99 Malerei und Fotogr., 2007 Dipl. am Dept. de Pint. de la Fac. de BA der Univ. Complutense, Madrid. 2000 Stip. der Univ. del Escorial. 2003 bildet C. mit vier Künstlerinnen den Colectivo Iocus, seit 2005 auch gemeinsame Arbeiten mit

Ana Troya Guerrero als Colectivo de Arte Gnomon. Ausz., u.a. 1. Preise: 1998 Malerei, Stadtverwaltung, Colmenar Viejo/Madrid; 2000 Premio Iberdrola, Univ. de Castilla-La Mancha, Toledo; 2004 Asoc. Internac. de Mujeres en las Artes, Madrid. – C.s von der Malerei der Romantiker, William Turner und Mark Rothko inspirierten abstrakt-atmosphärischen Gem. nach 2000 entstehen aus einer oder wenigen fließend ineinander übergehenden Farben, die Stimmungen erzeugen (*Verde: Mece; Turquesa: Amansa; Ocre: Nostalgia*), Himmelserscheinungen andeuten (Serien *Mar de nubes; Sol de medianoche*, beide Öl/Lw.; *El día y la noche*, Öl/Holz) und auch als dreidimensionale Werke erscheinen (Serie *Las puertas del aire*, Öl auf freistehenden Holzplatten). Parallel und z.T. in Kombination mit der Malerei stellt C. zeichenhafte Plastiken her, die auf schlanken Metallstäben angebracht sind, so die Serie *Desierto de estrellas*, Metalle (Eisen, Zink, Kupfer) oder Holz. Auch Bilder in Form von Leporellos und mit aufgedruckten alten Darst. des Kosmos. Mit A. Troya gestaltet C. abstrakt anmutende Farb-Fotogr. auf Aluminium Dibond (z.B. die Serie *Comunicaciones*), teils ergänzt durch Zchngn (Serie *Paisajes*), Collagen aus Azetat auf Papier und Stahlplastiken, die an Kleidungsstücke erinnern; außerdem Videos. ⌂ COLMENAR VIEJO/Madrid, Stadtverwaltung. MADRID, Col. Paradores Nac. – Minist. de Economía. – Prov.-Verwaltung. – Stadtverwaltung. MAJADAHONDA/Madrid, Stadtverwaltung. PARIS, Colegio de España. SAN MARTÍN DE LA VEGA/Madrid, Stadtverwaltung. TORRELEDONES/Madrid, Stadtverwaltung. ⊚ E: Madrid: 1998 Gal. Balboa 13; 2001 Gal. Altalen; 2001, '03 (K: M. Carabias Alvaro), '05 (K: I. Terol/M. Carabias Alvaro) Ansorena, Gal. de Arte; 2006 Gal. Barbarín; 2009 Univ. Complutense, Bibl. de la Fac. de BA; 2012 Mus. del Traje (mit A. Troya) / 1999 Majadahonda, Sala Carmen Conde; San Martín de la Vega, Stadtverwaltung / 2000 Villanueva de la Cañada, Sala La Despernada / 2002 Paris, Colegio de España / 2003 Santander, Gal. Fernando Silió / 2006 Guadalajara, Pal. Ducal de Pastrana / 2007 Toledo, Pal. San Pedro Mártir / 2008 Móstoles, Centro Cult.; La Coruña, Espacio BCA. ⌨ DPEE, Ap., 2002. – Online: Ansorena, Gal. de Arte, Madrid; Colectivo Iocus.

M. Nungesser

Conti, *Gastone*, ital. Maler, Graphiker, * 2. 1. 1905 Livorno, † Juli 1981 (Suizid) ebd. Autodidakt. Malt seit 1952. Auseinandersetzung mit Werken der toskanischen Impressionisten und v.a. der Macchiaioli. Löst sich bald von deren Einflüssen und arbeitet unabhängig von allen weiteren mod. Kunstströmungen. Reduzierung der Form und lebhaft-kräftige Palette. 1957 Ausst.-Debüt. Vorübergehende, vorsichtige Annäherung an abstrakte Malerei. Danach malt C. in kraftvoll-robuster Art v.a. Stilleben, Blumenstücke, charaktervolle Portr. und bodenständige Lsch. als Huldigung an Vitalität und alltägliches Leben. Freundschaft u.a. mit Giovanni Bartolena und Giovanni March. Gestaltet den ersten Gedichtband von Bruno Cosentino (*Istinto d'uomo è di comunicare*, Livorno 1962). 1962 Mitbegr. der Künstler-Vrg Gruppo Oggi in Livorno (u.a. mit Daniel Schinasi und Paolo Luca Donati). Mitgl.

der Accad. dei 500 und der Accad. Tiberina Rom. Beteiligt an über 150 Gruppen-Ausst.; Einzel-Ausst. u.a. in Ancona, Florenz, Pisa und Venedig. ⌂ LIVORNO, Pin. del Mun. MONTECATINI, Nuova Accad. ⊚ E: Livorno: 1958 Gall. Cocchini; 1963 Gall. Gino Romiti; 1974 Gall. Gino Fremura (K: R. Monti). – G: 2011 Livorno, Studio d'Arte dell'800: L'Accad. Livorno e il mare. Pitt. dall'Ottocento ai nostri giorni. ⌨ C. E. Bugatti, G. C., Ancona 1974 (Protagonisti dell'arte contemp.); F. Donzelli, Pittori livornesi. Secondo Novecento, Bo. 1987; T. Paloscia, Accadde in Toscana, II, Fi. 1997. S.-W. Staps

Conti, *Paolo Guglielmo*, ital. Bildhauer, Performance- und Videokünstler, Kunsterzieher, Publizist, * 9. 2. 1952 Budrio, lebt in Viadana. Stud.: ABA, Bologna (Dipl.). Unterrichtet Bildhauerei und Kunsterziehung am Liceo Statale d'Arte Paolo Toschi in Parma. Als „Doktor der Pataphysik" gründet er ein Ist. Patafisico Vitelianense. 1995–2001 Dir. der Gall. Civ. Girolamo Bedoli in Viadana; kuratiert zahlr. Ausst. und versteht sich als „poeta multimediale". Arbeitet in Eisen, Bronze, Stein, Holz und Glas, die er nach synästhetischen Prinzipien zu realistischen oder abstrakten Gebilden montiert, teils unter Einbeziehung von Geräuschen, beweglicher Teile oder spezieller Lichteffekte (*La macchina dell'aria*; *La macchina delle bolle di sapone*). Leichtigkeit, Dynamik und Instabilität sind char. Merkmale von C.s Plastik. Bezieht sich lt. Selbstäußerungen u.a. auf Constantin Brancusi, Alexander Calder, Fausto Melotti und Bruno Munari als Vorbilder. Ab 1997 zahlr. Aktivitäten auf dem Gebiet von Mail art und Performances; Gründung der Gruppo del POI, deren Mitgl. zumeist auch seine Schüler sind, z.B. Cocco Franco, Monica Maresca und Florida Skendaj. Die Gruppierung ist seit 2003 verstärkt in der Öffentlichkeit aktiv und beteiligt an ephemeren Aktionen von Zerotre Movimento. Zusammenarbeit mit Vertretern experimenteller Musik; Aktionen von Body art und Auseinandersetzung mit neuen Kunstformen. C.s jüngste *Pittoplastiche* gen. Performances sind unspektakuläre Bemalungen durchsichtiger Malgründe mit deutlichen Vanitasbezügen. ⌂ BUDRIO, PCiv. Domenico Inzaghi. BUENOS AIRES, MAM. CAVALESE, Centro d'Arte Contemp.. DETROIT, Mus. of New Art. FORNAZZO DI MILO/Catania, Laboratorio d'Arte Contemp. GENUA, Villa Croce MAC. GIBELLINA, MCiv. d'Arte Contemp.. L'AQUILA, Mus. Internaz. Mail Art. VIADANA, Oratorio del Sacro Cuore. – Parco delle Scult. ⊚ E: 1994 Budrio, Castel S. Pietro (Werke 1974–1994; K) / 1989 Forlì, Rocca di Caterina Sforza / 2002 Windhoek, Nat. AG of Namibia (K: G. Granzotto/L. Conti) / 2005 Rosignano Marittimo, Pal. Marini. La Casa dell'Arte / 2007 Piombino Dese, Fabrikarte / 2008 Suzzara, MAM (Performance 12. 7.) / 2009 Ponte Nossa, Artestudio Morandi. – G: 2002 Bedonia: Collettiva di Scult. / 2004 Udine, Artestudio Clocchiatti: Artists of Fun; Florenz, Caffè stor. lett. Giubbe Rosse: Zerotre; Cosenza, Casa delle Cult.: Invadere le invasioni / 2008 Gradara, Piazza Rubini: L'amore e la colpa (Performance 21. 8.) / 2011 Monselice, Mus. delle Macchine Termiche Centanin: LIVE#02/C. ⌨ F. Giampaolo, P. G. C.. Scult. 1970 – 1985, s.l. 1985; R. Barilli/L. Meneghini,

P. G. C. Nell'occhio di Galileo, Fi. 1993; *A. Doppelgänger* (Ed.), Le carte di C. 1973–1993, Bo. 1993; *C. Castellaneta*, P. G. C., Varese 1993. – *Online:* Arch. Mail Art; Multimedia 91; Guzzardi. S.-W. Staps

Conway, *Ros,* brit. Schmuckgestalterin, Silberschmiedin, * 15. 1. 1951 Bristol, lebt in London und Woodbridge/Suffolk. Stud.: 1969–70 Somerset SchA, Taunton; London: 1970–73 Central SchA; 1973–75 R. College of Art (Goldschmiedekunst). 1991 Freeman der Goldsmiths' Company und der City of London. Seit 1975 eig. Werkstatt. Lehrtätigkeit: 1980–89 Brighton Polytechnic; 1983–85 Epsom College/Surrey; seit 1986 Middlesex Univ., London. Ausz.: 1975 Goldsmiths' Company Award; 1977 Brit. Craft Award, Sunday Telegraph; 1994 Maximum Exposure Price, Photographers' Gall. (mit Simon Read). – C. gestaltet M. der 1970er Jahre v.a. Silberschmuck mit Einlagen aus versch. Goldlegierungen, z.B. Broschen in Form von Lastwagenhecks, die detailgenau die Faltung der Plane, Seile und die Holzkonstruktion zeigen (*Lorry Brooch,* London, Worshipful Company of Goldsmiths, 1975), Broschen in Form von Gefäßen sowie Schmuck in Drachenform (*Kite Earings,* 1976, ebd.). Angeleitet von Jane Short konzentriert sie sich ab ca. 1980 auf Emailtechnik und fertigt v.a. farbige Broschen mit zackigen, übereinandergeschichteten linearen Elementen, die auf Gem.-Komp. von Hugh O'Donnell basieren. Mit dem Metallkünstler Michael Lloyd gestaltet sie 1990 ein silbernes Prozessionskreuz für die Kirche St. Francis, Sheffield. Häufig sind maritime Motive, z.B. eine Meeresfrüchte-Servierschaufel aus Silber (1994), die mit einer Email-Garnele dekoriert ist. Mit S. Read entwickelt sie 1994 die auf Fotogr. basierenden Emailtafeln *To Forgotten Fleets* (1995), die im Bereich des Hafens von Felixstowe/Suffolk installiert werden. Daneben befaßt sich C. seit M. der 1990er Jahre auch mit der Technik des Glasschmelzens (pâte de verre), die sie, inspiriert von den Arbeiten von Henri Cross, bei Diana Hobson 1995–97 lernt und stetig verfeinert (*Nereid III,* 1997, London, Crafts Council). Als Auftragsarbeiten entstehen ein silberner Pokal mit 56 Diamanten und emaillierten Szenen von Rennen für das King George VI and Queen Elizabeth Diamond Stakes in Ascot (2003, für De Beers) sowie in Zusammenarbeit mit Chris Burr 2008 ein Hostienbehälter für die Goldsmiths' Company. C. ist eine anerkannte Lehrerin mit großen technischen Fertigkeiten. 🏛 BIRMINGHAM, Mus. and AG. GATESHEAD, Shipley AG. HOUSTON/Tex., MFA. KENDAL, Abbott Hall AG. LEEDS, AG. LONDON, V & A. – Goldsmiths' Company: 9 Arbeiten, u.a. Paar Salzgefäße mit Löffeln, 1992–93. NOTTINGHAM, Castle Mus. and AG. ✉ *C./J. Short,* Video über Emailtechnik, 1997. 👁 *E:* 1978 Bristol, Arnolfini (K) / London: 1984 V & A (K); 1989 Marlborough Gall. (mit H. O'Donnell); 1995 Photographers' Gall. – *G:* 2006 Birmingham, AG: Treasures of today (Wander-Ausst.). ▢ Dict. internat. du bijou, P. 1998. – Crafts 21:1976 (Juli/Aug.) 20–22; *S. Osborn,* Arnolfini rev. 1978 (Mai/Juni) 1 s.; *A. McPherson,* Crafts 34:1978 (Sept./Okt.) 48 s.; *M. Ingham,* ibid. 46:1980 (Sept./Okt.) 32; *E. Allington,* ibid. 70:1984 (Sept./

Okt.) 40–42; *A. Frost,* ArtsRev 36:1984 (11) 282; Crafts 1990 (März/April) 11; Out of this world. The influence of nature in craft and design 1880–1995 (K Crafts Council), Lo. 1995; *G. Rudge/R. Pavey,* Crafts 153:1998 (Juli/ Aug.) 34; *J. West,* Made to wear. Creativity in contemp. jewellery, Lo. 1998; *B. S. Rabinovitch/H. Clifford,* Contemp. silver, Lo. 2000; *M. Hall,* Country life 195:2001 (48) 64 s.; Particle theories. Internat. Pate de verre and other cast glass granulations (K Mus. of Amer. Glass), Millville, N. J. 2005; *C. Strauss,* Ornament as art. Avant-garde jewelry from the Helen Williams Drutt Coll. (K Wander Ausst.), St. 2007. – London, Crafts Council: Dokumentation. – Mitt. C. H. Stuchtey

Conzett, *Jürg,* schweiz. Bau-Ing., * 28. 9. 1956 Schiers/ Graubünden, lebt in Chur. Stud.: 1976–80 Bau-Ing., ETH, Zürich. 1981–87 Zusammenarbeit mit Peter Zumthor. 1988 eig. Büro in Haldenstein. 1992 Zusammenschluß mit dem Ing.-Büro Melcherts und Branger, heutiger Büroname C. Bronzini Gartmann in Chur mit den Partnern *Gianfranco Bronzini* (* 1967, Bau-Ing.) und *Patrick Gartmann* (* 1968, Bau-Ing. und Architekt). Lehrtätigkeit: ab 1985 HS für Technik und Wirtschaft, Chur. Ausz.: u.a. 1999 Großer Preis für Alpine Archit.; 2004, '07 Holzbaupreis Graubünden; 2011 Aargauer Heimatschutzpreis. – Bek. für innovative Brückenkonstruktionen, v. a. Fußgängerbrücken, auch Straßen- und Bahnbrücken. Ausgehend von technischen und lokalen Voraussetzungen entwickelt C. eine auf die einzelne Bauaufgabe zugeschnittene Lösung, oft als außergewöhnliche Anwendung bek. Prinzipien (Fußgängerbrücke über den Coupurekanal in Brügge, die durch Aufwickeln der Tragseile auf drehbare Rollen angehoben wird, 2001/02). An der Via Mala in Graubünden entwirft C. die Surasuns-Fußgängerbrücke, eine Spannbandbrücke, und den Traversinersteg: Der 1996 errichtete erste Steg war eine Holz-Seil-Fachwerkkonstruktion (1999 zerst.), der neue Steg von 2005 ist zur Überwindung des Höhenunterschieds eine Seil-Fachwerkkonstruktion mit treppenartigem Gehweg. 2010 Gest. des Schweizer Pavillons auf der Archit.-Bienn. Venedig mit einer Foto- und Mat.-Slg (Lsch. und Kunstbauten). 2011 Projekt Höhenrausch mit temporären Holzbrücken über den Dächern von Linz. Außerdem zahlr. Tragwerksplanungen in Kooperation mit Architekten (Haus Meuli, 1997–2001, Fläsch/Graubünden, mit Bearth & Desplazes; Markthalle Färberplatz, Aarau, 2002, mit Miller und Maranta; Neuapostolische Kirche, 2003/04, Zuchwil/Solothurn, mit smarch Architekten) sowie denkmalpflegerische Instandsetzung von Verkehrsbauten (Maillartbrücke, Donat/Graubünden, 2011/12). Daneben Forsch. zu Sicht- und Wärmedämmbeton sowie Untersuchungen zu Stützmauern und Bauten der Rhätischen Bahn. 🏛 BERN: Bahnhof, Passerelle „Welle", 2001–05 (mit smarch Architekten). CHUR, Böschen-Str. 5: Haus Gartmann, 2003. RAPPERSWIL-JONA/St. Gallen: Sportanlage Grünfeld, Tribüne, 2002–04 (mit Zulauf + Schmidlin Architekten). MURAU/Steiermark: Mursteg, 1993–95. PEIDEN-BAD/Graubünden: Glennerbrücke, 2000–02. PONTRESINA/Graubünden: Bahnhof, zwei Perrondächer, 2007/ 08. SOAZZA/Graubünden: Eisenbahnbrücke Riale della

Rasiga, 2004/05. VALS/Graubünden: Milchbrücke 2007/08. – Valserrheinbrücke, 2008/09. WINDISCH/Aargau: Aaresteg Mülimatt, 2009/10. ✉ Die Albulabahn, Bern 1989; Brückenbau, in: Schweiz, M. u.a. 1998 (Kat. Frankfurt/Main), 73–77; Archithese 32:2002 (6) 34–37; Dt. Bau-Ztg 137:2003 (12) 84–98; Faces 61:2005/06, 28–31; Appenzellische Jbb. 136:2008, 39–47; Bemerkungen zum Umgang mit Konstruktion, in: Marcel Meili, Markus Peter. 1987–2008, Z. ²2009, 442–451; Werk, Bauen und Wohnen 96: 2009 (10) 24–27; Lsch. und Kunstbauten, Z. 2010; Tec21 138:2012 (21) 23–25. ◉ E: 2010 Stuttgart, Gal. f75: Dorfbrücke Vals (Fotogr. von Wilfried Dechau) / 2012 St. Gallen, Kraftwerk Kubel. – G: 2002 Wien, Ausst.-Zentrum im Ringturm: Neues Bauen in den Alpen. ▭ Archit. in der dt. Schweiz 1980–1990, Lugano ²1991; G. Caminada, Archithese 26:1996 (5) 52–57; J. L. Moro, Baumeister 97:2000 (9) 68–71 (Interview); I. Noseda, Werk, Bauen und Wohnen 87:2000 (5) 42–47; M. Argenti, Area 12:2001 (57) 96–103; R. Bellini, C. Un ponte contemp., Vr. 2002; S. Spier, Swiss made, M. 2003; M. Mostafavi (Ed.), Structure as space, Lo. 2006; Archit. Rev. 221:2007 (1320) 74–81; I. Bösch, Hochparterre 22:2009 (4) 54 s. (Interview); W. Dechau, Baumeister 107:2010 (7) 16 s.; id., Dorfbrücke, Tb. u.a. 2010; Werk, Bauen und Wohnen 2009 (10) 24–27, 97:2010 (9) 66 s.; A. Simon, Hochparterre 23:2010 (8) 48–51; C., Gianfranco Bronzini, Patrick Gartmann. Forme di strutture, Mi. 2011. – Online: Website C. Bronzini Gartmann.

N. Buhl

Cook, *Diane,* US-amer. Fotografin, Fotojournalistin, Bildredakteurin, * 1954 Queens Village/N. Y., lebt in New York. Seit 1983 mit dem Fotografen Len Jenshel verheiratet. Stud.: 1972–76 Douglas College, Rutgers Univ., New Brunswick/N. J. Ausz.: u.a. 1987, 2003 New York State Council on the Arts Grant. Zahlr. Bild-Veröff., u.a. in den Zss. Nat. Geographic und Geo. – Schwarzweiße Lsch.-Aufnahmen. Anfänglich fotografiert C. in den Vorstädten, wendet sich aber später den Nat.-Parks zu. Seit 1993 Zusammenarbeit mit L. Jenshel, wobei er das gemeinsame Thema jeweils in Farbe und C. in Schwarzweiß fotografiert. Jüngst widmen sich beide wieder der bebauten Umwelt, so in Serien über den New Yorker Hafen und die Grenzanlagen zw. Mexiko und den USA. – Fotobücher: *Hot Spots. America's Volcanic Landscape* (mit L. Jenshel), Boston u.a. 1996; *Aquarium. Black-and-White Photographs by D. Cook. Color Photographs by L. J.,* N. Y. 2003. ☎ HOUSTON/Tex., MFA. Los ANGELES/Calif., County Mus. of Art. SAN DIEGO/Calif., Mus. of Photogr. Arts. SAN FRANCISCO/Calif., MMA. ◉ E: 1986 Chicago, Mus. of Contemp. Photogr. / 1986, '94, 2000 Portland (Ore.), Blue Sky Gall. / 1995 New York, Yancey Richardson Gall. / 1997, 2004 Washington (D. C.), Kathleen Ewing Gall. (jeweils mit L. Jenshel) / 2004 Los Angeles, Paul Kopeikin Gall. (mit L. Jenshel). – G: 1983–84 New York, Internat. Center of Photogr.: High Light. The Mountain in Photogr. from 1840 to the Present / 1992 Boston, Huntington Gall., Massachusetts College of Art: The Country between Us. Contemp. Amer. Landscape Photo-

graphs / 2009–10 Portland (Ore.), Portland AM: Beyond Place (mit L. Jenshel). ▭ A. Foerstner, Chicago Tribune v. 11. 4. 1986; Wo liegt der Himmel auf Erden? Nat.-geographic-Fotografen zeigen ihr persönliches Paradies, Ha. 2009. – Online: Website C./L. Jenshel. P. Freytag

Cook, *Mariana (Mariana Ruth),* US-amer. Fotografin, * 1955 New York, lebt dort. 1973–75 Kurse in Portr.- und Dokumentar-Fotogr., Yale Univ., New Haven/Conn.; 1976–78 Stud., Barnard College, Columbia Univ., New York; 1978–84 Privat-Stud. bei Ansel Adams. – C. ist in erster Linie für ihre Schwarzweiß-Portr. bek., darunter solche von Persönlichkeiten aus den Bereichen der bild. Kunst, Lit., Natur-Wiss. und Politik, z.B. der ehem. Kurator für Fotogr. am MMA, New York, John Szarkowski (1982) sowie Barack und Michelle Obama (1996). Seit 2007 konzentriert sie sich auf Natur- und Lsch.-Motive, die sie mit Hilfe von Nahaufnahmen und starken Kontrasten stilisiert. – Fotobücher/Foto-Publ.: *Manhattan Island to My Self,* N. Y. 1977; *Fathers and Daughters in their own Words,* S. F. 1994; Yale rev. 83:1995 (3); *Mothers and Sons in their own Words,* S. F. 1996; *Generations of Women in their own Words,* S. F. 1998; *Faces of Science,* N. Y./Lo. 2005; *Close at Hand,* N. Y. 2007; *Stone Walls. Personal Boundaries,* Bo. 2011. ☎ LOS ANGELES/Calif., J. Paul Getty Mus. NEW YORK, Metrop. Mus. – MMA. SAN FRANCISCO, MMA. TUCSON/Ariz., Center for Creative Photogr. WASHINGTON/D. C., Nat. Portr. Gall. ◉ E: 1981, '83, '86, '88 Los Angeles, Ankrum Gall. / New York: 1986 Jewish Mus.; 2007 Deborah Bell Photographs / Washington (D. C.), 1996 Kathleen Ewing Gall.; 2007 Nat. Acad. of Science / 2000 Tucson (Ariz.), Center for Creative Photogr. / 2005 Santa Monica (Calif.), Rose Gall. –. G: 2009 Paris, Centre cult. Calouste Gulbenkian: Au féminin. Women Photographing Women 1849–2009 (K). ▭ Online: Website C. P. Freytag

Cook, *Martin,* brit. Bildhauer, Schnitzer, * 1958, lebt und arbeitet in Bolter End/Bucks. 1979–82 Ausb. zum Steinmetz. Anschl. tätig im Dept. of Environment Carving Studio, London; 1984 Ass. von Alec Peever, 1990 von Michael Harvey für Inschriften im Sainsbury-Anbau der NG, London. Seit 1994 Wkst. in Loudwater/Bucks., später in Bolter End/Bucks. – C. ist spezialisiert auf die Gest. von vertieft gehauenen archit.-bezogenen Inschriften, ferner entstehen z.T. zus. mit seinem gleichnamigen Sohn versch. Garten-Skulpt., Bänke, Sonnenuhren, Hinweisschilder, Grabsteine und Epitaphe in versch. Steinarten, Holz und Glas. Zu den Auftraggebern gehört auch die brit. kgl. Familie. E. der 1990er Jahre arbeitet C. mit Hamilton Finlay an Steinobjekten in dessen Garten Little Sparta (Dunsyre/Lanarkshire), und 2000 führt er für den Architekten Norman Foster im BM alle Inschriften mit über 2000 Buchstaben im neu überdachten Innenhof und der Außenwand des Lesesaals aus. ☎ BLAIR CASTLE/Perths.: Sonnenuhr, 2011. GREAT MISSENDEN, Kirchhof: Steindenkmale, 2012. LONDON, Foreign and Commonwealth Office: Bali Bombing Memorial, 2006 (mit Garry Breeze). – Guy's Hospital: John Keats Mon. – 30 St. Mary, Axe Gebäude (Gherkin): Roman girl carving,

2007. ▭ *Buckman* I, 2006. – Stone words (K Wolseley FA), Lo. 2002; Sculpt. in the garden (K Bohun Gall.), Henley-on-Thames 2004; The standing stone (K Wolseley FA), Lo. 2005. – *Online:* Website C.; Memorials by Artists. H. Stuchtey

Cook, *Rajie (Roger),* US-amer. Graphikdesigner, Assemblagekünstler, Fotograf palästinensischer Herkunft, * 1930 Newark/N. J., lebt in Washington Crossing/Pa. Stud.: 1949–53 Pratt Inst., New York (1997 Alumni of the Year; tätig im Pratt Advisory Board). 1967 Mitbegr. von Cook and Shanosky Assoc., einer Fa. für Graphikdesign, die für bed. US-amer. und internat. Konzerne arbeitet. M. der 1980er Jahre zahlr. Reisen in die West Bank, nach Jordanien, Israel und Syrien im Rahmen einer von der Presbyterian Church gebildeten Arbeitsgruppe für den Mittleren Osten. Ausz.: 1984 Presidential Award for Design Excellence von Präs. Reagan für den Entwurf von Piktogrammen für das Dept. of Transportation. – C. widmet sich v.a. dem palästinensisch-israelischen Konflikt und dem Kampf der Palästinenser für Frieden und Freiheit. Nach eig. Aussage konzentriert er sich dabei auf die vier Themen Human Condition, Human Emotions, Human Reflection und Human Reaction (Website C.). Gestaltet zunächst Plakate (*Two Symbols, One Message; The Kaffiyah Speaks its Peace,* beide 1996). U. a. inspiriert durch Künstler wie Joseph Cornell, wendet sich C. 1999 der in Kästen arrangierten Assemblage zu, verwendet dabei v.a. Fundstücke bzw. industriell hergestellte Produkte, bevorzugt Spielzeug und Spielfiguren (*Home Sweet Home; Checkpoint Checkers,* beide 2003), in jüngster Zeit arbeitet er zusätzlich mit Licht und Bewegung. Daneben entstehen Objekte wie *A Time to Cast Stones,* 2003, eine mit Steinen gefüllte nachgebildete US-Munitionskiste, um den ungleichen Kampf zw. Palästinensern und Israelis aufzuzeigen. ▭ NEW YORK, Smithsonian Cooper-Hewitt Nat. Design Mus. ◉ E: Newtown (Pa.): 2002 George School Walton Gall.; 2005 Pennswood Gall. / 2003 Dennis (Mass.), Cape Cod MFA; Fort Washington (Pa.), Germantown Acad. AC; Washington (D. C.), Jerusalem Fund Gall. / 2006 Livingston (N. J.), Newark Acad., McGraw Gall. – G: seit 1966 zahlr. nat. und internat., u.a. 2003 Houston (Tex.), Station Mus.: Made in Palestine (auch Gest. des Ausst.-Kat.). ▭ F. S. *Oweis,* Enc. of Arab Amer. artists, Westport, Conn./Lo. 2008 (Lit.). – *Online:* Website C.; Electronic intifada v. 12. 1. 2005. C. Rohrschneider

Cooke, *Betty,* US-amer. Schmuckgestalterin, Juwelierin, Designerin, * 1924 Baltimore/Md., lebt dort. Verh. mit dem Designer William O. Steinmetz. Stud.: John Hopkins Univ. ebd.; bis 1946 Maryland Inst., College of Art ebd. (1946–66 dort Lehrtätigkeit). 1946 eröffnet C. ebd. das erste Geschäft, in dem sie u.a. eig. Schmuck und Gerät verkauft. Seit 1965 betreibt sie den Laden The Store Ltd., welcher noch heute existiert. Ausz.: 1979, ʼ81 De Beers Award; 1987 Alumni Med. of Honor, Maryland Inst., College of Art. – Geometrisch-abstrakter Schmuck (Ketten, Ringe, Broschen, Ohrringe, Armreifen, Manschettenknöpfe) in mod., reduzierter Formsprache, zunächst v.a. aus Messing und Kupfer, später aus Gold und Silber,

häufig in Kombination, sowie erg. durch and. Mat. wie Holz, Edelstein und Email. Bes. für die linearen Arbeiten aus gebogenen Silber- oder Goldstreifen dienen Zchngn als Ausgangspunkt. Bisweilen gestaltet sie auch figurative Schmuckstücke mit abstrahierten Tier- und Pflanzenformen, z.B. Silberbroschen, die Eulen oder Vögel sowie stilisierte Blumen darstellen. Weiterhin fertigt C. Haushaltsgegenstände (z.B. Glocken, Kaminböcke und -gitter) sowie Lederhandtaschen und -gürtel. ▭ BOSTON/Mass., MFA. MINNEAPOLIS/Minn., Walker AC. MONTREAL, MAD. NEW YORK, MAD. ◉ E: 1995 Baltimore (Md.), Maryland Inst., College of Art (Retr.; K). – G: 1951 Bloomfield Hills (Mich.), Cranbrook Acad. of Art Mus.: Alumni Exhib.,Textiles, Ceramics, Metalwork / 2008 Fort Wayne (Ind.), Mus. of Art: Amer. Modernist Jewelry, 1940–1970 (K). ▭ Dict. internat. du bijou, P. 1998. – E. *Lee,* The Washington Post v. 16. 5. 1954. F. Krohn

Cooke, *Darwyn,* kanad. Comiczeichner, Cartoonist, Animationsfilmzeichner, * 1962 Toronto. Erste Comic-Veröff. 1985 in dem Heft *New Talent Showcase 19,* danach arbeitet C. zunächst als Graphik- und Produktdesigner. In den 1990er Jahren Mitarb. an Zeichentrickserien von Warner Brothers, u.a. an *Batman. The animated Series* und *Superman. The animated Series.* Für DC Comics zeichnet C. 2000 die Graphic Novel *Batman. Ego.* Auch folgen Arbeiten für Marvel Comics, u.a. einzelne Hefte der Serien *X-Force, Wolverine/Doop* oder *Spider-Man's Tangled Web.* 2004 erscheint die sechsteilige Miniserie *DC. The New Frontier,* die mit mehreren Comicpreisen ausgezeichnet und 2007 auch als Zeichentrickserie umgesetzt wird. 2006 zeichnet er *Batman/Spirit* (Szenario: Jeph Loeb), ein Aufeinandertreffen zweier Serienhelden. Im Anschluß übernimmt C. die neue *Spirit*-Serie als Texter und Zeichner. Für Tim Sale schreibt er *Superman Confidental.* 2009 erscheint der erste Bd mit Adaptionen der Kriminalgeschichten von Donald Westlake (*Richard Stark's Parker. The Hunter*) für IDW Comics; weitere Adaptionen folgen. 2012 schreibt C. für DC die Serien *Silk Spectre* und *Minutemen,* letztere zeichnet er auch. C. hat für sein Werk mehrere Eisner und Harvey Awards gewonnen sowie den kanad. Joe Shuster Award. – Seine Zchngn sind stilistisch stark vom Animationsfilm beeinflußt, daraus schafft C. einen modern-eleganten Retrolook. ▭ *Online:* Lambiek Comiclopedia. K. Schikowski

Cooke, *Liadin,* irische Objekt- und Installationskünstlerin, Zeichnerin, Graphikerin,* 1958 County Kilkenny, lebte ab 1993 in London, seit 2000 in Huddersfield/West Yorks. Tochter von Barrie C. Stud.: 1983–87 Nat. College of Art and Design, Dublin; 1994–96 Goldsmiths, Univ. of London. Ausz.: u.a. 1989 P. S. 1 Internat. Studio Program, Long Island City (N. Y.); 1992 Stip. des Arts Council, Dublin. – Anfänglich hauptsächlich Installationen, teils ephemerisch angelegt, die u.a. auf den Status der Frau Bezug nehmen. Seit ca. 2000 vorrangig selbstgeschaffene Objekte, meist organische Formen (u.a. aus Ton, Aluminium und Wachs), z.T. mit detailreicher oder ornamentaler Oberfläche, die C. häufig zusammen mit geometrisch-abstrakten Zchngn in Mischtechnik (Aqu., Bleistift, Tu-

sche) oder Collagen in installativen Aufbauten präsentiert und mit denen sie u.a. hist. oder emotionale Bedeutsamkeiten von speziellen Orten, Objekten oder Kunstwerken beleuchtet, z.B. *Housement* (Filz, Plexiglas, Stahl), *Plan Drawings* (Aqu., Bleistift) und *Holden* (Holz, Stickerei), alle 2010. Des weiteren Arbeiten im öff. Raum, u.a. 1997 *The Great Irish Famine*, eine Gedenktafel zur Erinnerung an die irische Hungersnot von 1845–52, in der Camden Town Hall, London. Außerdem das Künstlerbuch *M—* (1999) sowie Graphiken. ⌑ LEEDS, Leeds Mus. and Gall. ◉ E: Dublin: 1988 Project AC; 1992 City AC; 1994 Green on Red Gall. / 1989 Limerick, Belltable AC / 1990 Long Island City (N. Y.), P. S. 1 Contemp. AC. / 2003 Leeds, Henry Moore Inst. (Falt-Bl.) / 2006 Wakefield, Yorkshire Sculpt. Park (K) / 2010 Huddersfield, Huddersfield AG. – G: 1986 Newcastle-upon-Tyne, Polytechnic: Alive and Kicking / London: 1986 Battersea AC: Irish Women Artists; 2007 RA: Summer Show / Cork: 1987 Crawford Mun. AG: S.A.D.E.; 1990 Triskel AC: Mail Art / 1988 Galway, Galway AC: Meta-furniture (Wander-Ausst.) / 1988, '93 (EV⁺A), '96 (Nat. Coll. of Contemp. Drawing; Wander-Ausst.; K) Limerick, Limerick City AG / Dublin: 1988 Douglas Hyde Gall.: GPA Awards for Emerging Artists (K); 1989 Solomon Gall.: Prints from the Black Church; 1996 Royal Hibernian Acad., Gallagher Gall.: NCAD 250, Drawings 1746–1996 (K); 2006 Temple Bar Gall.: The Square Root of Drawing / 1993 Carlisle (Pa.), Trout Gall.: Fields of Vision / 1999 Belfast, Ormeau Baths Gall.: Contemp. Responses to the Burlington Cartoon; Berkeley (Calif.), Berkeley AM: A Measured Quietude (Wander-Ausst.) / 2004 Sligo, Sligo AG: Birds / 2005 Salisbury (Wilts.), New AC: New Sculpt. from Ireland (K) / Leeds: 2008 Henry Moore Inst.: Prospects and Interiors; 2011 Leeds AG: Northern Art Prize Exhib. / 2010 York, The New Schoolhouse Gall.: Home. ⌑ *Buckman* I, 2006. – *P. Murray* (Ed.), 0044. Irish artists in Britain (K New York/Cork), Kinsale 1999. – *Online:* Nat. Irish Visual Arts Libr., Artists database; Website C. J. Niegel

Cooke, *Nigel,* brit. Maler, Bildhauer, * 17. 7. 1973 Manchester, lebt in London. Stud.: 1991–94 Nottingham Trent Univ., Nottingham; 1995–97 R. College of Art, London (Malerei); 1999–2004 Goldsmith's College ebd. (Promotions-Stud. FA). – In seiner Malerei verbindet C. Techniken der min.-artigen Feinmalerei mit monochromer Malerei und bezieht auch Graffiti oder Fotogr. ein. Formale Anleihen an die Kunstgesch. finden sich ebenso wie Zitate aus der Pop-art. Lt. C. beschäftigen sich seine Bilder mit den Auswirkungen des urbanen Raums auf die Natur, wobei er sein Interesse als „pathologisch" bezeichnet (Matt, 2007). Das Gem. *Silva Marosa* (Acryl/Lw., 2002–03; Athen, Slg Joannou), auf den ersten Blick eine subtil dargestellte Lsch., erweist sich bei genauerer Betrachtung als Horrorszenario oder apokalyptische Vision: Die wuchernden Pflanzen vor dem Mauerwerk bilden die Form eines Totenschädels, auf der Erde liegen verstreut zw. Steinen menschliche Köpfe. Eine gemalte Betonwand, auf die fliegende Vögel Schatten werfen, ver-

schließt den Hintergrund des Bildes *Smokestack in the Sun's Eye* (Acryl/Lw., 2003; ebd.). Damit steht C. in der Trad. der provokativen Kunst der Young British Artists. Die nachfolgend entstandenen Arbeiten zeigen vorwiegend düstere, in Nebel getauchte Traum-Lsch. oder Archit. (*To work is to play,* 2008) , in denen einzelne Gestalten, u.a. Künstler und Philosophen, umherirren (*The paintis on the road to Tarascon,* 2007; *Heavy Beret; Experience,* 2009; *In Da Club – The Vision,* 2010; alle Öl/Lw.). Auch surrealistische Plastiken (*Big Predecessor,* 2009; *Protégé,* 2010, beide patinierte Bronze, bemalt). ⌑ ATHEN, Dakis Joannou Coll. Found. BRISBANE, Queensland AG. DALLAS/Tex., Mus. of Art. LONDON, British Council. – Tate Gall. LOS ANGELES, MCA. – Univ. of California, Hammer Mus. MIAMI, Rubell Coll. MÜNCHEN, Slg Götz. NEW YORK, Guggenheim. – MMA. OSLO, Astrup Fearnley MMK. PARIS, François Pinault Coll. SOUTHAMPTON, City AG. STOCKHOLM, Mod. Mus. TEHERAN, Honart MCA. ✉ Versch. Art. in: Art review (Dez. 2010 – Jan. 2011). ◉ E: London: 2000 Chapman FA; 2002, '05, '08, '10 (K) Stuart Shave. Mod. Art; 2004 Tate Britain, Art Now; 2006 South London Gall. (K) / 2004, '06, '09, '12 New York, Andrea Rosen Gall. / 2006 Fort Worth (Tex.), Mod. Art Mus. / 2007 Stockholm, Mod. Mus. / 2011 Dallas (Tex.), The Goss-Michael Found.; Los Angeles, Blum and Poe (K). – G: 2002 Santiago de Chile u.a.: Still life (Wander-Ausst. des British Council in S-Amerika; K) / 2004 Mexiko-Stadt, Mus. Tamayo Arte Contemp.: Sodium and asphalt (K); Athen, Deste Found.: Mon. to now. Works from the Dakis Joannou Coll. (K) / 2006 Karlsruhe, ZKM, Medien-Mus.: Slg Götz (K) / 2007 New York, Chelsea AM: The incomplete (K) / 2010 Shanghai, Minsheng AM: The future demands your participation. Contemp. art from The British Council Coll. (K) / 2012 Prag, Gal. Rudolfinum: Beyond reality, British paint. today; Düsseldorf, Arthena Found.: Hidden Stories. ⌑ New Contemp. 98 (K), Lo. 1998; *J. Chapman,* The new spirit in death painting. The work of N. C., Lo. 2002; *N. DeVille,* Contemporary 2002 (2) 18–23; *B. Seymour,* Frieze 2002 (65) 74 s.; *B. Schwabsky,* Artforum 2002 (Mai) 193; *C. Garrett,* Flash art 2004 (236) 88–91 (Interview); *M. Herbert,* Now and then. Art now at Tate Britain, Lo. 2004; *D. Kunitz,* Scottish art review 2006, 94–97; *S. Malik/D. Suhil,* N. C. paint. 01–06, Lo. 2006; *C. Townsend,* New art from London, Lo. 2006; *G. Matt u.a.* (Ed.), Traum & Trauma. Werke aus der Slg Dakis Joannou, Athen (K Wien), Ostfildern 2007; Der Symbolismus und die Kunst der Gegenwart (K), Wuppertal 2007; Tema Celeste 2007 (April) 74 s.; *C. Milliard,* Scottish art review 2008, 70–79; *M. Wilson,* Artforum 2009 (Sept.) 291 s.; *E. Wood* Flash art internat. 2011 (März/April) 123 s. – *Online:* Andrea Rosen Gall., New York; Blum and Poe, Los Angeles; *O. Koerner von Gustorf,* db artmag (2004). E. Kasten

Cooke, *Regina Tatum,* US-amer. Malerin, Publizistin, * 22. 8. 1902 Corsicana /Tex., † 3. 9. 1988 Santa Fe/N. Mex. Aufgewachsen in Dalhart/Tex. Stud.: Ward-Belmont Junior College, Nashville/Tenn.; Bethany College, Lindsborg/Kans., bei Sven Birger Sandzén; Broad-

more Art Acad.; bis 1925 Colorado College, beide Colorado Springs; 1934–36 bei Walter Ufer in Taos/N. Mex. Ab 1925 in Denver (1925–30 dort verh. mit Bronson Frey C.), 1932 in Dalhart, ab 1933 in Taos ansässig. Im Auftrag der Works Progress Administration (WPA) entstehen neben Tafelbildern 1935 Lsch.-Hintergründe für Dioramen (Santa Fe/N. Mex., MFA) sowie Beitr. für *Portfolio of Spanish Design*. 1942–47 Lehrtätigkeit an öff. Schulen in Palm Springs und Los Angeles. Ab 1948 wieder in Taos, war sie bis 1988 vorrangig als Kunstpublizistin tätig, deren Kolumnen wertvolle Zeitzeugnisse sind (Art. u.a. in Southwest Art, New Mexico Mag., Mademoiselle, Libertad). Arbeitete 1948 für Taos Star, 1949–59 für El Crepúsculo de la Libertad, 1949–71 für Taos News als Redakteurin für Kunst und Gesellschaft. 1948 initiierte sie die Slg von Kunstwerken an öff. Schulen in Taos. Mitbegr. der Taos Artists Assoc. (1952) und des Taos Little Theater. Ausz.: 1969 Woman of Achievement Award, New Mexico Press Women. – Beeinflußt von W. Ufer, malt sie in dem in den 1930er Jahren in den USA populären Regionalist style v.a. Gebirgs-Lsch. von Colorado, New Mexico und Texas, Straßenszenen, Archit.-Ansichten sowie Stilleben mit Gartenblumen, Keramik oder indianischen und mex. Artefakten. Von dok. Wert ist C.s Gem.-Serie über die Rekonstr. der frühen Missionsstationen in New Mexico (1941–42) für die School of Amer. Research, Mus. of New Mexico, Santa Fe, im Rahmen des von der WPA geförderten Projekts (reprod. in Mission Mon. of New Mexico von E. L. Hewett und R. G. Fisher, Albuquerque 1943). ▣ AUSTIN, Univ. of Texas. CANYON/Tex., Panhandle-Plains Hist. Mus. ROSWELL/N. Mex., Roswell Mus. and AC. SANTA FE/N. Mex., MFA. – Mus. of New Mexico. – *Wand-Gem.:* DALHART/Tex., County Courthouse. RATON/N. Mex., Court House. ◉ *E:* 1939 Lubbock, Texas Technological College (jetzt Texas Tech Univ.). ☐ *P. Kovinick/M. Yoshiki-Kovinick*, An enc. of women artists of the Amer. West, Austin 1998; *Falk I*, 1999; *Powers*, 2000. – *D. A. Porter u.a.*, Taos artists and their patrons 1898–1950 (K Wander-Ausst.), Notre Dame, Ind. 1999; *J. Hoefer*, A more abundant life, Santa Fe 2003. – *Online:* Texas State Hist. Assoc.

<div align="right">C. Rohrschneider</div>

Cookson, *Bernard,* brit. Cartoonist, Illustrator, Werbegraphiker, Schriftsteller, * 3. 1. 1937 Manchester, lebt in Henley-on-Thames. Stud.: 1953–56 Manchester Art School. Zunächst in einer Werbeagentur und, im Rahmen des Militärdienstes, als Fotograf bei der R. Air Force auf Zypern tätig. Ab 1965 zeichnet C. politische und humoristisch-satirische Cartoons für die Ztg Daily Mirror und das Mag. Punch. 1969–76 politischer Cartoonist der Ztg Evening News. Außerdem übernimmt C. in der Nachf. von Eric Burgin den Cartoon strip *The Niteleys* in der Ztg Daily Sketch. Ab den 1980er Jahren erscheinen C.s Zchngn u.a. in The Sun (ab 1982) und Daily Express (ab 1996). Außerdem Beitr. in zahlr. weiteren Ztgn und Mag., u.a. in The Spectator; Sporting Life; Today. Buch-Veröff. mit Cartoons: *Till Divorce Us Do Part* (Lo. 1976); *Wine Lovers* (Vorden 1981). Auch Werbegraphik,

Kalender, Postkarten und humoristische Ill. zu Büchern and. Autoren, u.a. zu *Great Country House Disasters* (Lo. 1983) v. Hugh Vickers und Caroline McCullough; *The Lighter Side of Today* (Lo. 1983) v. John Timpson; *Great Desasters of the Stage* (Lo. 1984) v. William Donaldson; *Great Legal Desasters* (Lo. 1985) v. Stephen Tumin; *Knightsbridge Woman* (Lo. 1995) und *Mayfair Madams* (Lo. 1999) v. Maria Perry. Zus. mit Stanley McMurtry schreibt er Sketche für die Comedians Ronnie Barker und Ronnie Corbett (The Two Ronnies). Zudem Autor des Kriminalromanes „The Fifth Day" (C. 2009). Mitgl.: Cartoonists' Club of Great Britain. – Routinierte, stark strichbetonte Tuschstift-Zchngn in der Trad. von E. Burgin. ▣ CANTERBURY, Univ. of Kent, Brit. Cartoon Arch. ☐ *M. Bryant/S. Heneage* (Ed.), Dict. of Brit. cartoonists and caricaturists 1730–1980, Aldershot 1994; *M. Bryant*, Dict. of twentieth-c. Brit. cartoonists and caricaturists, Aldershot 2000. – *J. Noakes u.a.*, Britain and Germany in Europe 1949–1990, Lo. 2002. – *Online:* Brit. Cartoon Arch., Univ. of Kent, Canterbury; Website C.

<div align="right">H. Kronthaler</div>

Coolen, *Susan,* kanad. Fotografin, Installationskünstlerin, * 16. 7. 1955 Halifax/N. S., lebt seit 1991 in Montréal. Stud.: bis 1977 Kommunikationsdesign, Nova Scotia College of Art & Design, Halifax; bis 1995 Fotogr., Concordia Univ., Montréal; bis 1999 Columbia College, Chicago. C. arbeitet seit 1990 mit Fotografie. 1994–95 Stand-Fotogr. für den Film Momiji (Nancy Tatabe). 1994–96 Ass. von Angela Grauerholz in Montréal. Ausst.-Organisation, u.a. 2000–01 für die Künstlergruppe Fovea (Mitgl.). Auch Zus.-Arbeit mit dem Dichter und Künstler Childe Roland. Lehrtätigkeit: Univ. of Lethbridge; Concordia Univ., Montréal; 1997–2000 Columbia College, Chicago. Artist in Residence: 1990 Maine Photo Workshops, Rockport; 1995 The Banff Centre for the Arts, Banff/Alberta; 2004, '10 Gibraltar Point Centre, Toronto. – C. ist interessiert an Natur-Wiss., Archäol., Astronomie, Museologie und der frühen wiss. Verwendung von Fotografie. Sie sammelt systematisch Naturobjekte wie Steine, Pflanzenteile, Knochen und tote Tiere, die sie mumifiziert; auch Treibgut und Fundstücke des städtischen und ländlichen Alltagslebens (u.a. *Paper airplanes*), die sie reproduziert und künstlerisch transformiert. Dabei arbeitet sie, angeregt auch von Zyanotypien von Anna Atkins aus dem 19. Jh., häufig mit kameralosen analogen Fotogrammen und digitalen Scanner-Abb.; diese bringt sie in eig. narrative, poetische oder spielerisch-ironische, auch metaphorische Kontexte; bei formvergleichenden Anordnungen erfindet sie auch pseudo-wiss. Nomenklaturen. C. bezieht sich dabei u.a. auf den Surrealismus. Anfangs untersucht sie auch ihren eig. Körper (*Out of the shadows,* 1991); mit selbst inszenierten Serien wie *Exploring the self* (1992) und *Dreaming* (1993) beginnt sie, Objekte mit imaginären Bedeutungen zu belegen. Bei *Astral projections* (1998–2000) und *Celestial travellers* (1997–2004) suggeriert sie etwa durch schwarze Hintergründe und verfremdende Mikro- und Makrosichten Weltall-Objekte. Mit *Primordia* (2004) will sie menschliche Gendefekte und

Science-fiction-Motive von außerirdischen Keimen thematisieren. Bei *La spectacle de la nature. A collector's compendium* (2000–02) oder *Speciation* (2006) greift sie konzeptionell mit vergleichenden Foto-Tableaus und fiktionalisierten visuellen Ordnungssystemen Anschauungsmodelle von hist. Enzyklopädien, Wunderkammern und frühen naturkundlichen Slgn auf. Auch multimediale Installationen mit Abzügen, Projektionen, Videofilmen und Audio-Begleitung, in die sie z.T. Naturobjekte und Fundstücke integriert. Foto-Publ.: *D. Danis/S. C.*, Terre Océane, Ml. 2003. ▭ KITCHENER/Ont., Kitchener-Waterloo AG. MONTRÉAL, Hydro-Québec. – Nat. Film Board of Canada. OSHAWA/Ont., Robert McLaughlin Gall. OTTAWA, Canad. Mus. of Contemp. Photogr. PARIS, Gal. du Jour. ◉ *E:* 1997 Chicoutimi (Que.), Gal. Séquence; Kingston (Ont.), Mod. Fuel Gall.; Annapolis Royal (N. S.), Arts Place / 1998 Chicago, Lallak + Tom Gall. / 2001 Winnipeg (Man.), The Floating Gall. / Toronto: 2002, '07 Harbourfront Centre; 2006 DeLeon White Gall.; 2007 Premier Dance Theatre / 2008 Ottawa, Canad. Mus. of Nature (K; Wander-Ausst.) / 2009 Kitchener (Ont.), Kitchener-Waterloo AG. – *G:* Montréal: 1994 Centre Internat. d'Art Contemp.: Meme & autres; 1997 Fe Mail Art Inc.: Whirling derviches; 1999 Maison de la Cult.: Hist. naturelles, und Gal. Vox: Cosmogonies (K); 2001 Mois de la Photo: Le pouvoir de l'image (K); 2002 Maison de la Cult. Frontenac: Invitation au voyage; 2003 At Neuf: Fables du Parc Lafontaine / 2000 Ottawa, Canad. Mus. of Contemp. Photogr.: Shifting sites (Wander-Ausst.; K) / 2003 Vancouver, Presentation House Gall.: Sphere (K) / Kitchener (Ont.): 2003 Kitchener-Waterloo AG: In the light of (K); 2004 Contemp. Art Forum: CAFKA, Peace of mind (K) / 2004 Barcelona, Metrònom: Beyond sc. / 2007 Toronto, Harbourfront Centre: Re-collect. ▭ *P. Cousineau-Levine*, Faking death, Ml./Lo. 2003; *L. Rieppel*, Scrivener Creative Rev. (Ml.) 2004 (28); *Columbia College, Photogr. Dept.* (Ed.), Mementos, Chicago 2006; *M. Camilleri u.a.* (Ed.), Carte blanche. Photogr. 1, Tor. 2006; *J. Knechtel* (Ed.), Trash, C., Mass. 2006; *A. Carlevaris*, Locus suspectus (Edmonton) 2007 (4) 10–13 (Interview); Ascent (Ml.) 2009 (41); *K. Hobza u.a.*, The new millennium paper airplane book, N. Y. 2009; River grand chronicles. Six/seven/eight (K Kitchener Waterloo AG), Kitchener 2010. – *Online:* Website C. (Publ.; Published Works). – Mitt. C.

T. Koenig

Cooley, *Otis H.* cf. **Collins,** *David Chittenden*

Coolidge, *Miles*, kanad. Fotograf, * 22. 12. 1963 Montréal/Que., lebt in Los Angeles. Stud.: bis 1986 Harvard Univ., Cambridge/Mass.; bis 1992 California Inst. of the Arts, Valencia/Calif.; 1993–94 KA, Düsseldorf. Lehrtätigkeit: u.a. Otis College of Art, Univ. of California; California Inst. of the Arts, Valencia. Stip.:1993–94 DAAD; 1998–99 City of Los Angeles. – C. steht in einer US-amer. dokumentarischen Trad. und zählt unter Einfluß von Pop-art (Ed Ruscha) und politisch-konzeptionellen Arbeiten mit Fotogr. (Allan Sekula) zur kritischen topogr. Fotogr. seit den 1970er Jahren (u.a. Lewis Baltz, Robert Adams, Stephen Shore). Lt. Nadja Rottner (2001) wen-

det diese sich von humanistischen und politischen Inhalten ab und registriert wie teilnahmslos zivilisatorische „Archiscapes", wobei gerade aus der vorgeblich zurückgenommenen Autorenschaft eine Irritation entstehen soll. Angeregt von seinen Düsseldorfer Lehrern Bernd und Hilla Becher fotografiert C. seriell und mit festen Parametern unspektakuläre Alltagsmotive. So etwa *Street furniture* (ab 2006): umgestürzte Sperrmüllmöbel, die er mit verkippter Kamera „objektgerade" aufnimmt, wodurch fiktive Raumbilder entstehen. Weiter zeigt er menschenleere Funktionsorte, kommerzielle und industrielle „Nicht-Orte" (Marc Augé) im suburbanen Niemandsland. C. dekonstruiert, so Rottner, vordergründige Traumwelten im Zeitalter der globalisierten Kontrollgesellschaft. Früh zeigt er mit Freizeit- und Hobbyobjekten überfüllte Interieurs priv. Garagen in präzisen großformatigen Panoramatriptychen (*Garage pictures*, 1992). Bei *Safetyville* (1994–95) fotografiert er irreal wirkende Veduten einer maßstäblich verkleinerten Kulissenstadt für die Verkehrserziehung von Kindern; ähnlich wirken Fotogr. von Containersiedlungen für Wanderarbeiter (*Mattawa*, 2000). Die technischen Infrastrukturen der industrialisierten Agrarwirtschaft im kalifornischen *Central Valley* (1998) betont er durch lange schmale Breitwandformate. Mit streng frontalen, modularen Einstellungen zeigt C. leere Büro-Fahrstühle bei geöffneter Tür (*Elevator pictures*, 1993), er fotografiert in abstrahierend flächiger Aufsicht hochgezogene Zugbrücken (*Drawbridges*, 2003) oder die mobile Fahrwand von Motorradartisten (*Wall of death*, 2006), ähnlich auch skulptural in der Lsch. stehende Fassadenmuster für Neubauten der Univ. of California (2011). Seit 1997 fotografiert C. amer. prä-hist. Grabhügel, die in die Gest. von Golfanlagen einbezogen wurden (*Mounds*), 2001 ergänzt er dieses Thema mit der Tableau-Installation *Ancient hist.* von Postkarten-Reprod. solcher ethnogr. Kultstätten. Auch Organisation der Ausst. *Decomplexion* (2009) und *defamiliar* für die Gal. Silvershed, New York. ▭ BALTIMORE/Md., Mus. of Art. BUFFALO/N. Y., Albright-Knox AG. LOS ANGELES, County Mus. of Art. – MCA. NEW YORK, Guggenheim. – Metrop. Mus. NEWPORT BEACH/Calif., Orange County Mus. of Art. SAN FRANCISCO, MMA. SANTA FE/N. Mex., Lannan Found. SEATTLE, Henry AG. WICHITA/Kan., Ulrich Mus. of Art. ◉ *E:* 1992 Valencia (Calif.), California Inst. of the Arts; Cambridge (Mass.); Carpenter Center for the Visual Arts, Harvard Univ. / 1994 Hollywood (Calif.), Solution Gall. – LA Center for Photogr. Studies / 1996 Santa Monica (Calif.), ACME Gall. / 1996, '97, '98, 2000, '03, '07 New York, Casey Kaplan / 1998, 2001, '02, '03, '06, '08, '11 Los Angeles, ACME Gall. / 2000 Paris, Gal. J. Flay; Newport Beach (Calif.), Orange County Mus. of Art (K) / 2001 Witchita (Kan.), Ulrich Mus. of Art; Santa Fe (N. Mex.), Lannan Found. / 2002 Köln, Gal. Capitain / 2004 Wien, Gal. L. Ruyter; Taos (N. Mex.), Harwood Mus. of Art; Bordeaux, Gal. I. Bree. – *G:* zahlr. u.a. 1996 Santa Barbara (Calif.), Univ. AM: The lie of the land / 1997 Buffalo (N. Y.), Albright-Knox Gall.: The big picture; Minneapolis (Minn.), Walker AC: Stills (K); Leipzig, Dogenhaus Gal.: Angel hair; Pittsburgh

(Pa.), Carnegie Mus. of Art: Elsewhere / 1998 Long Beach (Calif.), Mus. of Art: L. A. or Lilliput? (K); Ridgefield (Conn.), Aldrich Contemp. AM: Pop surrealism (K); Cambridge, Kettle's Yard: Thinking aloud (Wander-Ausst.); San Francisco, MMA: Picturing modernity (K) / 1999 Krems, KH: Tomorrow forever (K) / New York: 1999 Guggenheim: Photogr. An expanded view (Wander-Ausst.; K); 2003 Internat. Center of Photogr.: Only skin deep; Metrop. Mus.: 2006 (Mod. Photogr. from the coll. XII), 2007 (Hidden in plain sight), 2009 (Surface tension) / 2000 Long Beach (Calif.), Univ. AM: Beyond bounderies (Wander-Ausst.); Kraichtal, Ursula-Blickle-Stiftung: Escape-Space (K); North Adams, Massachusetts MCA: Supermodel / Los Angeles: MCA: 2000 (Flight patterns; K); 2003 (Conversations); LA County Mus. of Art: 2000 (Made in California 1900–2000; K); 2007 (Re-SITE-ing the west) / 2001 Winterthur, Foto-Mus.: Trade (K) / 2002 Pasadena, Pasadena Mus. of California Art: Majestic sprawl; Chicago, MCA: Out of place (Wander-Ausst.; K) / 2003 Baltimore (Md.), Contemp. Mus.: Imperfect innocence (Wander-Ausst.; K); Bilbao, Guggenheim: Imágenes en movimiento – Moving pictures (K) / Graz: 2003 Österr. Trienn. der Fotogr. (K); 2006 Kunsthaus: First the artist defines meaning / Cambridge (Mass.): 2006 Dunster House: Artists of a class; 2007 Carpenter Center for the Visual Arts: Visiting faculty exhib. / 2007 Riverside, California Mus. of Photogr.: ELOI; Moskau, Projekt Fabrika: Now is the winter; Shanghai, Shanghai Mus. of Art: Art in America now / 2008 Las Vegas, AM: Los Angeles now / 2010 Düsseldorf, NRW-Forum: Der rote Bulli (K). ▭ *Delarge*, 2001. – The affordable housing challenge, Boston, Mass. 1988; *D. Fogle*, Camera Austria 1998 (62/63); *H. Molesworth*, Frieze 1999 (Febr.) 57–59; *T. McGovern*, afterimage 27:1999 (Juli-Aug.) 5; *F. Colpitt*, AiA 2001 (Okt.) 171 s.; *N. Rottner*, Camera Austria 2001 (76) 3–15; *P. Colombo*, tema celeste 2003 (Mai/ Juni) 102 s.; *M. Wilson*, Contemp. 2003 (49) 84 s.; *M. Coetzee*, Not afraid, Lo. 2004; *C. Cotton*, The photograph as contemp. art, Lo. 2004; *M. Lübbke-Tidow*, Camera Austria 2004 (86) 87 s.; *S. Valdez*, AiA 2007 (Okt.) 205; *A. Klein* (Ed.), Words without pictures, L. A. 2010. – Mitt. C.

 T. Koenig

Coonley, *Jacob Frank (J. F.),* US-amer. Daguerreotypist, Fotograf, Maler, * 21. 1. 1832, † 1908 Nassau(?). Informationen über C.s wechselvolle Biogr. sind rar, teilw. widersprüchlich und schlecht belegt. Vermutlich aufgewachsen in Syracuse/N. Y., arbeitet er bis zur Wirtschaftskrise 1857 als Lsch.-, Dekorations- und Schildermaler im US-Bundesstaat New York. 1856–57 lernt er bei George N. Barnard in Syracuse die Grundlagen der Daguerreotypie und betreibt anschl. ebd. ein eig. Atelier (lt. Davis [1990] bis 1859 nachg.). Ab 1858 führt C. die Stereoskopie-Druckerei der Fa. E. & H. T. Anthony & Company in New York und fotografiert ab 1860 auch eig. stereoskopische Lsch.-Bilder. 1861 geht er im Auftrag von Anthony mit Barnard nach Washington/D. C., wo beide zunächst im Studio von Mathew B. Brady Visitkarten-Portr. nach Negativen and. Fotografen herstellen. 1862 Atelier-

gemeinschaft mit W. A. Wolfersberger in Philadelphia/Pa. (Coonley & Wolfersberger). 1864–65 dokumentiert C. im Auftrag des Militärs (General Montgomery C. Meigs) den Bürgerkrieg in Tennessee, Alabama und Georgia von einem eigens ausgerüsteten Eisenbahnwaggon aus; die Bilder vertreibt er über die Anthony Company in New York. M. der 1860er Jahre arbeitet er kurzzeitig für das Atelier Quinby & Co. in Charleston/S. C. Nach einem ersten Besuch der Bahamas in den 1870er Jahren übersiedelt C. 1880 nach Nassau, wo er ein eig. Atelier betreibt, das er 1904 an seinen Lehrling James Osborne Sands weitergibt. – Auf den Bahamas fotografiert C. Nassauer Stadtansichten, Lsch., Alltagsszenen und Portr.; außerdem reist er im Auftrag des New Yorker Mus. of Natural Hist. wiederholt nach Kuba. – Eine außergewöhnliche Quelle zur Fotogr. im US-amer. Bürgerkrieg stellen lt. Zeller zwei autobiogr. Texte von C. dar: *Photogr. Reminiscences of the Late War, No. 2,* in: Anthony's Photogr. Bull., Sept. 1882, 311; *Pages from a Veteran's Note-Book,* in: Wilson's Photogr. Mag., March 1907, 105–106. ▭ ATHENS, Univ. of Georgia, Hargrett Rare Book and Ms. Libr. CAMBRIDGE, Univ. Libr., R. Commonwealth Soc. Libr. LINCOLN, Univ. of Nebraska, Libr. LOS ANGELES/Calif., J. Paul Getty Mus. NASSAU, Nat. AG of the Bahamas. PHILADELPHIA/Pa., Libr. Company of Philadelphia. PRINCETON/N. J., Univ. AM. ROCHESTER/N. Y., George Eastman House. WASHINGTON/ D. C., Nat. Portr. Gall. ⊙ *E:* 2003 Nassau, NG of the Bahamas (mit William Henry Jackson, J. O. Sands; K: Bahamian Visions. Photographs 1870–1920). ▭ *K. F. Davis,* George N. Barnard. Photographer of Sherman's campaign, Kansas City, Mo. 1990; *M. A. Sandweiss* (Ed.), Photogr. in nineteenth-c. America, Fort Worth 1991; *M. Craton/ G. Saunders,* Islanders in the stream, II (From the ending of slavery to twenty-first c.), Athens, Ga. 1998; *H. S. Teal,* Partners with the sun. South Carolina photographers, 1840–1940, Columbia, S. C. 2001; *R. G. Lightbourn,* Reminiscing II, Photographs of Old Nassau, Nassau 2005; *B. Zeller,* The blue and gray in black and white. A hist. of Civil War photogr., Westport, Conn. 2005; *K. A. Thompson,* An eye for the tropics. Tourism, photogr., and framing the Carribean picturesque, Durham, N. C. 2006. – *Online:* R. Commonwealth Soc. Photograph Project, Cambridge Univ. Libr. P. Freytag

Cooper, *Diana,* US-amer. Installationskünstlerin, Zeichnerin, * 30. 5. 1964 Greenwich/Conn., lebt in New York. Stud.: 1982–86 Harvard College, Cambridge/Mass. (Gesch., Lit.); in New York: 1988–90 New York Studio School; 1993–97 Hunter College (Malerei). Artist in Residence: 2003 Wimbledon SchA, London; 2011 Atlantic Center for the Arts, New Smyrna Beach/Fla.; 2012 School of Visual Arts, Virginia Tech, Blacksburg. – C. überträgt ab 1996 zunächst kleine Filzstiftkritzeleien aus Notizbüchern auf ihre großformatigen, abstrakten, monochromen Acryl-Gem. und beklebt die Lw. ab ca. 1998 mit Filz, Pompoms, Klettverschlüssen und Pfeifenputzern, wobei sie ihre Arbeiten zunehmend über den Bildrand hinausgehend auf die Wand ausdehnt (*The black one,* 1997). Ab ca. 2002 verzichtet sie ganz auf die Lw. und gestaltet in einer

Verbundenheit mit Piet Mondrian, Donald Judd und Tony Smith raumgreifende, visuell reichhaltige, vielschichtige Installationen und dreidimensionale Wandreliefs. Diese basieren auf der konzentrierten Wiederholung, Multiplikation und geometrischen Abstraktion von versch. zugeschnittenen Teilen aus Acrylkunststoff, Leichtschaumplatten und Wellplastik. Inspiriert wird C. von Archit., Baustellen, Industriedesign, Maschinenbau, Natur sowie Musik und generell der Infrastruktur des heutigen Lebens, wie sie sich in elektrischen Leitungen, Untergrundrohrleitungen, Farbkodierungen, Transportsystemen und v.a. Computer-Leiterplatten zeigt. Sie hinterfragt die Funktionalität dieser Systeme, wie z.B. in der ganz in orangenen Farbtönen ausgef. Rauminstallation *Orange Alert UK* (voll. 2007), die sich auf die Anschläge in London im Juli 2005 bezieht. C. ist fasziniert von der makroskopischen und mikroskopischen Bildwelt und der graduellen Transformation ihrer Arbeiten während des Entstehungsprozesses. Ihre Fotogr., Zchng, Malerei, Installation und Plastik einbeziehenden Arbeiten sind sehr arbeitsintensiv und detailgenau dokumentiert, erscheinen abstrakt, lassen jedoch stets figürliche Assoziationen und narrative Elemente zu. C.s erste Auftragsarbeit entsteht 2008–09 für das Schulzentrum Jerome Parker Campus in Staten Island, New York. Die acht 2,4 Meter hohen schmalen Glasfenster zeigen von der Natur und Technik inspirierte komplexe Systeme und Muster. ⌂ BALTIMORE/Md., Mus. of Art. CLEVELAND, The Cleveland Clinic. ITHACA/N. Y., Johnson Mus. of Art. LONDON, BM. MÜNCHEN, PM. NEW YORK, City Department of Education. WASHINGTON/D. C., Amer. Univ. Mus. ◉ E: 1997 Philadelphia, Yearsley Spring Gall. / New York: 1997 Space Gal.; 1998, '99, 2002, '05, '06, '07 (mit David Herbert), '08 Postmasters Gall. / London: 2000 Hales Gall.; 2003 Centre for Drawing, Wimbledon SchA / 2000 Paris, Gal. Evelyne Canus / 2001 Richmond, Bradford-Renick Gall., Virginia Commonwealth Univ. Gall. / 2003 Zürich, Rolf Staub Gal. für zeitgen. Kunst. ▭ *T. Griffin*, AiA 86:1998 (11) 129 s.; *M. Dailey*, Artforum internat. 38:1999 (4) 149; *R. Urkowitz*, Artext 68:2000 (Febr./April) 85 s.; *S. Kaneda/ S. Ostrow*, Bomb 83:2001 (Frühjahr) 47–49; *D. Ryan*, Art papers 25:2001 (6) 70; Vivid (K Richard Salmon Gall.), Lo. 2001; *M. Falconer*, ArtRev 52:2001/02 (Dez./ Jan.) 63; *J. Caniglia*, Artforum internat. 41:2002 (4) 139; *N. Princenthal*, AiA 90:2002 (11) 159; *M. Rizk*, Art papers 27:2003 (2) 44; *R. Weil*, Art news 104:2005 (9) 182; Plan D (K Viscondes de Balsemão), Porto 2005; *A. Armetta*, Flash art 38:2005 (Mai/Juni) 93; Beyond the line. The art of D. C. (K MCA), Cleveland, Ohio 2007; *D. M. Utter*, Art papers 32:2008 (1) 54; *D. Carrier*, Artforum internat. 46:2008 (6) 295 s.; *L. Wei*, AiA 96:2008 (4) 154–157; *ead.*, Urban Glass art quart. 116:2009 (Herbst) 57; *K. Bitterli/ R. Wäspe* (Ed.), Global world, priv. universe (K St. Gallen), Nü. 2004. – *Online:* Website C.; Postmasters Gall. – Mitt. C. H. Stuchtey

Cooper, *Robert*, brit. Keramiker, * 4. 9. 1949 Sheffield, lebt in London. Stud.: 1969–72 Kingston upon Thames College of Art (Innen-Archit.); 1979–82 R. College of Art

(Keramik), London. Anschl. Wkst.-Eröffnung ebd. In den 1980er Jahren zahlr. USA-Reisen. Lehrtätigkeit: seit 1990 City Lit, London. – C. nutzt Fundstücke und wiederverwertbare Mat. wie Keramikscherben, Glasur- und Schlickerabfälle und Oxyde sowie Transferdruck- und Siebdruckverfahren für dekorative Objekte und Gefäße. In den 1980er Jahren entstehen niedriggebrannte (Raku) phantasievolle, farbig glasierte Wandreliefs mit Abdrücken von Textilien und v.a. handaufgebaute kleine Gefäße und Objekte (Kästen). Daneben erhält er Aufträge für Wand-Gest. u.a. von Banken (Lloyds Bank, Counting House, 1988; Hayes Gall., 1987) und Museen (vier drehbare Wandpaneele, 1984, Leeds, Lotherton Hall; Fliesen-Gest., 1997, Glasgow, Gall. of Mod. Art, Fire Gall.) sowie von London Transport. 1986 entwirft er die von Bühnen-Archit. inspirierte farbige Wanddekoration der U-Bahnstation Leicester Square in London (Northern und Piccadilly Lines) und 1985–88 zus. mit David Hamilton die emaillierte Wandvertäfelung der U-Bahnstation der Northern Line (Charing Cross Zweig) im Bahnhof Euston, die auf dem Wappen der Herzöge von Grafton basieren. In den 1990er Jahren scheinen die Formen aus locker gelegten Textilien geformt, die komplexen Oberflächen weisen häufig durch Gipsabbrücke erhaltene Dekore der ostasiatischen Hmong-Kultur, koptischer Textilien und afrikanischer Shoowa-Baststoffe auf. Dies entspricht C.s erzählerischem, spielerischem, hist. und experimentellem Vorgehen, das oftmals von einem Fundstück initiiert ist oder ein solches imitiert (*African medieval jug*, 1991). Zudem werden die Arbeiten mehrfach gebrannt, um vulkanartige Effekte zu erreichen. In der M. der 1990er Jahre kreiert er abstrakte Assemblagen aus Fundstücken vom Themseufer (u.a. Metallteile, keramische Fragm.), so in der Arbeit *Construction* (1994, London, Crafts Council). ⌂ BRAINTREE, Public Libr.: Wandfries (Flying Books), 1996. GATESHEAD, Shipley AG. LEICESTER, R. Infirmary: Keramikwand, 1995. ◉ E: London: 1986, '99 Anatol Orient; 1988, '90 Michaelson and Orient; 1992 V & A, Crafts Council Shop; 2007 Metre Square Gall. / 2008 Rochester, AG (mit Stella Harding). ▭ *Buckman* I, 2006. – *A. Suttie*, Crafts 65:1983 (Nov./Dez.) 49 s.; *G. Dewald*, ibid. 1994 (Jan./ Febr.) 50 s.; *A. Briton*, ibid. (März/April) 22–24; *T. Peters*, Studio pottery 17:1995 (Okt./Nov.) 32–40; Firing imagination. Ceramica Britanica (K Brit. Council), Lo. 2000; *P. Johnson*, Ceramic rev. 187:2001 (Jan./Febr.) 32–35; *A. Carlano*, Contemp. Brit. studio ceramics. The Grainer coll., New Haven/Lo. 2010; *D. Whitting*, Ceramic rev. 249:2011 (Mai/Juni) 54–59. – *Online:* Website C. H. Stuchtey

Coorevits, *Raf*, belg. Graphiker, Zeichner, * 26. 4. 1934 Sint-Niklaas, lebt und arbeitet in Waas. Stud.: Sted. ASK, Sint-Niklaas, u.a. bei Georges Fonteyn; Hoger Inst. Sint-Lucas, Gent, u.a. bei *Gerard Hermans* (* 1901 Gent, † 8. 2. 1978 ebd.). Mit Reise-Stip. in Österreich und Spanien. Lehrtätigkeit: 1959–94 Doz. für graph. Techniken am Hoger Inst. Sint-Lucas, Gent; 1964–80 Zeichnen und Malen an der ASK, Sint-Niklaas. Zu seinen Schülern gehört der Maler Jan Vermeiren. Mitgl.: Koninkl. Wase Kunst-

kring. C. zeichnet und aquarelliert häufig in der Natur und unternimmt, teilw. im kunstpädagogischen Kontext, zahlr. Studienreisen (Deutschland, Großbritannien, Italien, Frankreich, Irland, Balkan, Malta, Rußland). Er skizziert in seiner Heimatregion ebenso wie auf den Reisen v.a. Lsch., Stadt- und Dorfansichten, häufig romantisch abgelegene Waldstücke mit stillen Wasserflächen, auch üppige Vegetationen und uralte solitäre Baumruinen, die ihm später als Motive für Druckgraphik dienen. Ausz.: 1957 Prijs Fonds Baron van Ackere; 1961 Provinciale Prijs voor Grafiek van Oost-Vlaanderen (zus. mit Paul van Gyseghem). – C.s Œuvre umfaßt Figurenbilder, Akte, Porträts, (Reise-) Lsch., Stilleben und Tiere (v.a. Vögel) in allen gängigen zeichnerischen und (druck-)graph. Techniken. Anfänglich nonfigurative Arbeiten. Später hauptsächlich Hschn. in der Trad. der fläm. Schule und Spezialisierung auf in linear-impressionistischer Stichmanier ausgef. Rad. und Mezzotinten. Markant sind bei letzteren archit. Motive (u.a. ruinöse Gebäude) und die detaillierte Wiedergabe von einsam gelegenen, häufig wuchernden Natur- und Lebensräumen, die C. mittels dichter, teils gespinstartiger Strukturen bis in geheimnisvolle, bisweilen beunruhigende Tiefen führt. Hervorhebenswert sind C.s Porträtstiche, die er in einer virtuos beherrschten (foto-)xylographischen Technik ausf., wobei er brillante Hell-Dunkel-Schattierungen erzielt. Seine Baum- und Tier-Darst. bestechen durch Sensitivität, gelegentlich auch durch hintergründigen Humor (*Rabe*, Rad., 1975). Wenige Buch-Ill.: M. Verhulst, *De hemel zit van binnen*, Zele 1980 (Einband); C. D'Haen (Ed.), *Ik ben genoemd Meisje en Vrouw*, Tielt u.a. 1980. – C. gilt als handwerklich versierter Peintre-graveur der 2. H. des 20. Jh. in Ostflandern. Monogr. Bearbeitung und WV stehen aus. ⌂ ANTWERPEN, MSK. – Prov. Antwerpen, Dep. Cultuur. BRÜSSEL, Koninkl. Bibl. Albert I. – Prenten-Kab. – Vlaamse Gemeenschap. DEN HAAG, Rijks-Coll. SINT-NIKLAAS, Salons voor Schone Kunsten. ◉ *E:* 2002–03 Sint-Niklaas, Salons voor Schone Kunsten (K). – *G:* 2011 Aalst, Sted. Mus.: Mens en Tijd (K). ▭ *Bénézit* III, 1999; *Pas* I, 2002. – R. C. Tekeningen, aquarellen, etsen, Br. 1978; *G. Gyselen*, Septentrion (Rekkem) 8:1979, 28; *E. Aerts*, R. C. (K Sint-Niklaas), Ant. 2002; *I. Vander Cruyssen*, R. C., Ant. 2009. U. Heise

Coover, *Colleen (Colleen Ann)*, US-amer. Comiczeichnerin und -texterin, Illustratorin, * 14. 7. 1969 Iowa, lebt in Portland/Ore. C. veröffentlicht nach einem abgebrochenen Stud. 1994 ihren ersten Comic in der von Slave Labor Graphics verlegten Anthologie „Attitude Lad". 2000–03 zeichnet sie die vom Verlag Fantagraphics innerhalb des Imprints Eros Comix publ. Comic-Serie *Small Favors*, die in z.T. explizit pornographischen Episoden von den erotischen Erlebnissen des lesbischen Paares Annie und Nibbil erzählt (8 Hefte; 2 Sammel-Bde; dt. Ausg. im konkursbuch-Verlag, Tb. 2003–04). Für Oni Press entsteht 2005 die vierteilige humoristische Comic book-Reihe *Banana Sunday* (Texte v. C.s Ehemann Paul Tobin; dt. Ausg. Brandenburg 2008). Seither zeichnet C. v.a. einige Episoden der Superheldenserien *The Amazing Spider-Girl* (2006) und *X-Men: First Class* (2007–09) des Ver-

lages Marvel. Erneut nach einem Szenario von P. Tobin entsteht 2011 der Independent-Comic *Gingerbread Girl*. Auch Beitr. in versch. Zss. (u.a. in Curve; Girlfriends; Nickelodeon Mag.; On Our Backs; Out) und Anthologien (u.a. in True Porn; What's Right?, beide 2003; Sexy Chix, 2006) sowie Buch-Ill. (u.a. zu *The Anxious Gardener's Book of Answers*, Portland 2012, v. Teri Dunn Chace). Mitgl. des Künstlerkollektives Periscope Studios. – Stark konturbetonte Zchngn in der Nachf. von Comiczeichnerinnen und -zeichnern wie Jaime und Gilbert Hernandez, Stan Sakai, Seth (Pseud. v. Gregory Gallant) und Rumiko Takahashi. ▭ *P. D. Lopes*, Demanding respect. The evolution of the Amer. comic book, Ph. 2009. – *Online:* Comic Vine; Website C. H. Kronthaler

Copeland, *Ivy (Ivy Margaret)*, neuseeländische Malerin, * 15. 6. 1888 Auckland, † 28. 8. 1961 ebd. Im Alter von zehn Jahren nimmt C. Unterricht bei Charles Frederick Goldie am Ladies' College, Remuera, später beim engl. Künstler Dennis Seaward an der Wanganui Technical School. Stud.: Elam School of FA, Auckland, bei Edward Friström und Archibald Nicoll. 1930 Studienreisen nach London, Paris und Edinburgh, wo sie durch Besuche von Kunst-Gal. (u.a. Gem. von Millet) Anregungen für die eig. Malerei erhält. Lehrtätigkeit: ab 1933 Canterbury College, Christchurch; 1936–40 Dunedin Training College. Danach Rückkehr nach Auckland und vollst. Hinwendung zur Malerei. 1946 Bledisloe-Med. für das Ölbild *Back of beyond*. Mitgl. der Auckland Soc. of Arts (hier bes. in den 1940er/50er Jahren aktiv; Ausst.; Vize-Präs.). – C.s Motivwahl entspricht dem klassischen Repert. einer Malerin der damaligen Zeit. Neben Stilleben (u.a. Blumenstudien) entstehen Lsch. ihrer nächsten Umgebung sowie auf Reisen. Bek. wird sie jedoch v.a. durch ihre Bildnisse, bes. von Maori-Frauen, eine vermutlich auf Goldie zurückgehende Vorliebe (*Rita Hikiora*, 1973). In der Ausf. ihrer Gem. (Öl, Wasserfarben) bleibt sie einer konservativen Auffassung verpflichtet. ⌂ AUCKLAND, AG Toi o Tāmaki. HAMILTON/N. Z., Waikato MAH. ◉ *G:* 1940 Wellington: Nat. Centennial Exhib. of New Zealand Art (K) / 1968 Auckland, Auckland Soc. of Artists: New Zealand Women Painters 1845–1968 (K: J. Stacpoole) / 1993 Christchurch, Robert McDougall AG: White Camellias. A c. of women's artmaking in Canterbury (K). ▭ *P. Jackson*, Art New Zealand 1994 (70) 82–85. – *Online:* Dict. of New Zealand Biogr.; Auckland AG. C. Rohrschneider

Coppes, *Martino*, ital.-schweiz. Fotograf und Installationskünstler, * 24. 3. 1965 Como, lebt in Mendrisio/Tessin. Stud.: ABA Brera, Mailand, bei Luciano Fabro. Einfluß der Arte povera. Für seine inszenierten Aufnahmen von imaginären Räumen fotografiert C. Plastikfolien, deren Großaufnahme durch den fehlenden Maßstab Assoziationen an Lsch. wecken; anfangs auch mit Figuren. In den Fotoserien *e-motion, U. A. P.* und *N. N/E. E. S/E. S. S/O. O. N/O.* (alle 2003) schweben Blätter und Pflanzenteile in undefinierten farbigen Räumen. ⌂ LAUSANNE, MBA. LUGANO, Mus. Cantonale d'Arte. ◉ *E:* 1992 Brescia, L'aura arte contemp. / Mailand: 1993, '96, '97, 2000 Gal. de Cardenas; 1993 Geografia / 1995 Bellinzona, Centro d'arte

contemp. / 1997 Paris, Gal. Rizzo / 1999 Genf, Art & Public / 2000 Solothurn, KM (K) / 2003 Triest, Gall. Lipanje-Puntin / 2005 Lugano, Mus. Cantonale d'Arte. ☐ KVS, 1991; BLSK I, 1998; *Bénézit* III, 1999; *Delarge*, 2001. – *L. Beatrice u. a.*, Nuova scena. Artisti ital. degli anni '90, Mi. 1995; L' altra metà del cielo (K Chemnitz u.a.), Z. 2000; Codici virtuali (K Bologna), Ferrara 2000; Kunst-Bull. 2000 (5) 48; Analog, Dialog (K), Solothurn 2001; Arte 32:2002 (348) 104–107; L'immagine ritrovata, Ostfildern 2002; L'immagine del vuoto (K Lugano), Genf 2006.

N. Buhl

Coppola d'Anna (C. d'Anna Pignatelli, C. Pignatelli), *Paola*, ital. Architektin, Wissenschaftlerin, * 27. 8. 1927 Rom, lebt dort; verh. mit dem Psychoanalytiker Marcello Pignatelli. Stud.: 1944–50 Fac. di Archit. La Sapienza Univ., Rom (ab 1963 Doz., ab 1981 Prof., 1982–90 Dir., 1998 Gründung und Ltg des Multimedia-Labors für Archit. ebd.). 1950–54 Red. der Fach-Zs. Rassegna Critica dell'Archit.; 1973–94 Mitarb. am Internat. Council for Educational Development, New York, und 1974–79 am Aspen Inst., Aspen/Colo. Gründung und Ltg von GREIS (Gruppo Ricerche Edilizie Istruzione Superiore), Rom (1973–95). Mitgl.: 1991–2005 World Acad. of Arts and Sc., Minneapolis/Minn.; 1993–2000 im wiss. Beirat der Archit.-Fak. der Eduardo Mondlane Univ., Maputo. C. veröff. zahlr. wiss. Publ. und ist weltweit tätig als Beraterin an Univ. zu erziehungs- und bildungs-wiss. Themen in bezug auf Archit., ab 1976 auch unter feministischen Aspekten. Ausz.: 1962 Premio regionale, Ist. Naz. di Archit. (INARCH), Catania. – Die Aufbruchstimmung nach dem Faschismus motiviert C. schon während des Stud., sich einen erweiterten Blick auf die Archit. anzueignen. Ab 1953 arbeitet sie für den CNR (Consiglio Naz. delle Ricerche) an dem interdisziplinären Forsch.-Projekt „Archit. und Pädagogik", mit dem sie wiss. Neuland betritt. Ihr Interesse richtet sich dabei nicht auf den künstlerisch-archit. Entwurf als autonomes ästhetisches Produkt, sondern auf den gebauten Lebensraum mit seinen physischen, emotionalen und psychischen Auswirkungen. Diese Haltung korrespondiert prinzipiell mit der Kritik junger europ. Architekten gegenüber der orthodoxen Moderne. C. versucht, den existentiellen Inhalt ihrer Bauten mit deren symbolischem Wert und der spezifischen Umgebung in einen Dialog zu setzen. 1955–69 entwirft sie ca. 20 Bauwerke, in denen sich strenge Geometrie und Funktionalität ebenso offenbaren wie das Experiment, auf die Besonderheiten des menschlichen Verhaltens wie des Ortes einzugehen, z.B. 1962 in der terrassenartig, aus Einzelhäusern angelegten Siedlung Colonia marina Ente Zolfi in Terrasini (Sizilien). Bereits 1963 und 1964 erprobt sie vorgefertigte Bausysteme für Grundschulen in Magione (Umbrien) und Florenz. Auch das Gebäude des Ist. Tecnico Industriale in Piscille (Perugia) von 1965 repräsentiert eindrücklich die Avantgarde-Archit. der 1960er Jahre in Europa, indem es sowohl die zunehmende Industrialisierung der Bauwirtschaft als auch C.s individualisierte Ausdrucksform abbildet. C.s letztes ausgef. Projekt ist der Krankenhausbau (1966–80) in Tarent, der als mehrgeschossiger,

strukturell gegliederter und aufgebrochener Betonkubus mit flachem Vorbau ein selbstbewußtes Beispiel des Brutalismus ist. Ab den 1970er Jahren konzentriert sie sich fast ausschl. auf ihre internat. Lehr- und Forsch.-Tätigkeit und leistet u.a. mit Studien über Organisation und Gest. von HS einen bed. Beitr. zu deren Planung. ☐ GELA, Colonia marina Ente Zolfi, 1956. PIZZO: Wohnanlage INA-Casa, 1958. ROM, Via Lucchini: Mehrfamilienhaus, 1955. TAURIANOVA: Wohnanlage INA-Casa, 1957. ☒ L'univ. in espansione, Mi. 1969; Roma. Esperienza di lettura urbana, R. 1973; I luoghi dell'abitare, R. 1977; Donna e potere. Un confronto fra paesi, R. 1978; Spazio e immaginario. Maschile e femminile in archit., R. 1982; L'identità come processo. Cult. spaziale e progetto di archit., R. 1992; La sfida archit., R. 1992; L'archit. delle Univ., R. 1997. ☐ R. Antohi, Archit. 11:1965–66,76–83; R. Belibani u.a. (Ed.), Le frontiere dell'archit. P. C. P. scritti progetti ricerche 1950–2005, R. 2006. – *Online:* W3 Uniroma.

A. Mesecke

Coquillay, *Jacques,* frz. Bildhauer, Maler, Zeichner, * 3. 6. 1935 Châteauroux, lebt seit 1972 in Les Essarts-le-Roi. Stud. (Bildhauerei): 1956–58 Ec. supérieure des BA, Tours; 1958–60 ENSBA, Paris, bei Marcel Gimond. 1983–91 Vize-Präs. der Soc. des Artistes franç. Ausz.: 1961 Prix de Rome; Prix de la Jeune Sculpt.; 1972 (Skulpt.), '80 (Malerei) Med. d'Or, Soc. des Artistes franç.; 1980 Sandoz Prize, Taylor Found.; 1981 Prix Claude Raphaël Leygues, ENSBA, Paris; 1993 Prix Jean des Vignes-Rouges, Acad. de Versailles; 1995 Peintre de la Marine. Regelmäßige Teiln. an Salon-Ausst., u.a. SAfr., Salon d'Automne (1992 Retr.), Salon de la Marine, Salon des Peintres Témoins de leur temps, Salon du Dessin et de la Peint. à l'Eau. – C.s plastisches Werk besteht hauptsächlich aus Bronzeakten (z.T. auch Arbeiten in Terrakotta), die den weiblichen Körper in zahlr. Varianten in wirkungsvollen, häufig erotisierenden Posen abbilden. Die idealisierte Darst. der jungen Frauen (*Vénus*; *Christine*; *Les Cheveux longs*) erinnert an antike Skulpturen. Zahlr. mon. Plastiken im öff. Raum (u.a. auch in Stein und Holz), v.a. Brunnenfiguren (*La Vague*, 1990, Fontaine du C. E. S., Ram-bouillet; *La Naissance de Vénus*, Place de la Gare, Angers; *La Pomme d'Amour*, Place Clemenceau, Marmande; *L'Heure bleue*, Rue Napoléon, Sarrebourg). Auch in kleinformatigen Rötel-Zchngn widmet sich C. dem nackten weiblichen Körper (*Sophie*; *Valérie*; *Marianne*; *Olivia*). Weiterhin expressive, detailreiche Pastelle, v.a. Marinen (*Saint Malo*; *Voiles rouges à Port Goulphar*) und Lsch. (*Le Moulin de la Herpinière*); bisweilen auch Stadtansichten (*Le Soir sur Paris*). ☐ FONTAINEBLEAU, Mus. d'Art figuratif contemp. MENTON, MBA. PARIS, MAMVP. VERSAILLES, Mus. Lambinet. VILLENEUVE-SUR-LOT, Mus. Gaston Rapin. – *Im öff. Raum:* VERSAILLES, Conseil Général des Yvelines: Mon. du Souvenir. VIROFLAY, Eglise Notre-Dame-du-Chêne: Altar, Tabernakel, Ambo (alle aus Stein); Marienstatue, Holz (Iroko). – Mairie: Marianne; Buste d'Hippolyte Maze. ⊙ *E:* seit 1966 regelmäßig Paris, Gal. Artfrance / 1998 Carpentras, Chap. du Collège (Retr.) / Versailles: 2000 Orangerie (Retr.); 2011

Gal. Anagama / 2001 Menton, MBA (Retr.) / 2008 Saint-Langis-lès-Mortagne, Vieux-Moulin (mit Michel Jouenne; K); Lyon, Gal. St-Hubert; Brive, Gal. St-Martin / 2010 Bois-Colombes, Gal. en Ré / 2011 Le Bourget-du-Lac, Le Prieuré; Crécy-la-Chapelle, Gal. de Crécy. ⌑ *Bénézit* III, 1999; *Delarge*, 2001. – J. C. (K Palm Desert, Calif.), Versaille 2008. F. Krohn

Coralli, *Suzi* (eigtl. Coralli Moreira, *Suzi*), brasil. Malerin, Graphikerin, Hochschullehrerin, Kuratorin, * 22. 11. 1963 São Paulo, lebt in Niterói. Stud.: 1985 Malerei und 1999 Mag.-Abschluß in Kunstgesch. und Visuelle Kommunikation an der Univ. Federal do Rio de Janeiro; 1991–93 Rad., Bildhauerei und Video an der Esc. de Artes Visuais do Parque Lage. In versch. Künstlerateliers tätig, u.a. 1986 bei Katie van Scherpenberg und Campos Mello. Fertigt 1986 im Rahmen eines Projekts (Murarte. Arte nos Muros) eine Wandarbeit für die Estação Flamengo do Metrô. 1994 Intervention im öff. Raum an der Praia do Arpoador sowie Realisierung des Videos Jornal Eletrônico de Arte. Unterrichtet Malerei 2001–02 an der Univ. Federal do Rio de Janeiro und 2002–05 an der Esc. de Artes Visuais do Parque Lage. Seit 2001 regelmäßig als Kuratorin tätig. – C.s Gem. und Graphiken sind dem Hard Edge bzw. der Farbfeldmalerei zuzuordnen. Kennzeichnend für ihre Collagearbeiten sind die konstruktivistisch anmutenden Kompositionen. ⌑ Curitiba, MAC. Niterói, Mus. do Ingá. Rio do Janeiro, Inst. Brasil. de Arte e Cult. – MNBA. ◉ *E:* Niterói: 1986, 2005 Centro Cult. Paschoal Carlos Magno; 1989 Mus. do Ingá; 2000, '02 Gal. do Poste / Rio de Janeiro: 1986 Espaço Cult. Petrobrás; 1987 Gal. do Centro Empresarial Rio; 1989 Klee Gal. de Arte; 1991 Pal. do Catete; 1993 Mus. da República; 2001 Gal. Lana Botelho / 1991, '93 Curitiba, MAC. –. *G:* ab 1985 zahlr., u.a. Rio de Janeiro: 1985, '86 Salão da Esc. Nac. de BA; 1987 Centro Empresarial Rio: Novos Novos; 1988 MNBA: Arte Hoje; 1989 Salão Nac. de Artes (Ankaufs-Preis); 1990 Gal. Montessanti: Doze Caminhos; 2003 Conjunto Cult. da Caixa: Sete Essências para o Híbrido do Hoje / Belo Horizonte: 1986 Salão Nac. de Artes Plást.; 1987 Salão Nac. de Arte / 1993 São Paulo, SESC: Pinturas / Niterói: 1996 Gal. de Arte do Ingá: 48 Contemporâneos; 1999 Gal. de Arte da Univ. Federal Fluminense: Confluência. A Pintura nos Anos 80; 2000 Espaço Cult. Conselheiro Paschoal Cittadino: Ângulos de uma Cidade; 2002 MAC: Niterói Arte Hoje; 2003 Centro Cult. da Caixa: Sete Essências para o Híbrido do Hoje. ⌑ *Ayala*, 1997. – *Online:* Inst. Itaú Cult., Enc. artes visuais, 2012. M. F. Morais

Coray, *Richard*, schweiz. Konstrukteur, * 30. 7. 1869 Trin/Graubünden, † 3. 10. 1946 Wiesen/Graubünden. Ausb.: bis 1889 Zimmermannlehre; 1889–92 Technikum, Winterthur (Holzbau). – C. konstruiert und baut bis E. der 1890er Jahre v.a. Seilbahnen (Seilriesen). Danach spezialisiert er sich auf Entwurf, Konstruktion und Ausf. von Lehrgerüsten für den Brückenbau, bes. für Entwürfe weitgespannter Beton- und Eisenbetonbrücken in schwierigen Terrains (Gebirge, Schluchten). In Zusammenarbeit mit Architekten und Brückenbau-Ing. leistet C. auf diesem speziellen Gebiet der Baukunst Pionierarbeit. Die

1908 zus. mit dem Ing. Emil Mörsch (1872–1950) errichtete Gmündertobelbrücke ist bei Einweihung das größte derartige Bauwerk weltweit. Für die von Robert Maillart (1872–1940) entworfene Salginatobelbrücke (1928–30) bei Schiers, die zu den elegantesten und schönsten Brücken der Welt zählt (1991 von der Amer. Soc. of Civil Engineers zum World Monument erklärt), entwickelt C. gemeinsam mit seinem Sohn Richard C. jun. ein spezielles Lehrgerüstsystem, das aufgrund der radikalen Minimierung aller Bauteile leicht und effektiv bes. bei Bogenbrücken zu handhaben ist (System Coray). C.s gleichermaßen imposante und kühne wie elegante Lehrgerüste sind nicht nur ingeniertechnische und handwerkliche Meisterleistungen, sondern als ephemere Archit. auch ästhetisch bedeutsam. Von den ca. 40 Lehrgerüsten, die C. zw. 1898 und 1938 für Brücken und Viadukte v.a. in der Schweiz, aber auch in der Türkei (Bagdadbahn, 1916) oder in Montenegro errichtet, sind aufgrund ihrer Schönheit bes. erwähnenswert bei Vernayaz das für den Pont de Gueuroz (Ing. Alexandre Sarrasin, 1932–34) oder das für die Tarabrücke (1938–41) bei Đurđevic'a in Montenegro. ◉ *E:* 2008 Wiesen (Graubünden), Hotel Bellevue. ⌑ *I. Rucki/D. Huber* (Ed.), Architekten-Lex. der Schweiz 19./20. Jh., Basel u.a. 1998. – *G. Bener*, Gerüst- und Seilriesenbauer R. C. von Trin (Graubünden). Zu seinem erfüllten siebzigsten Jahr, 30. Juli 1939, Chur 1939; *R. C.*, Schweiz. Bau-Ztg 118:1941 (22) 260–61; *J. Conzett*, R. C. (1869–1946), in: *U. Widmer u.a.*, Fünf Schweizer Brückenbauer, Z. 1985, 33–57 (Schweizer Pioniere der Wirtschaft und Technik, 41); *A. Kessler u.a.*, Vom Holzsteg zum Weltmonument. Die Gesch. der Salginatobelbrücke, Schiers 1996. U. Heise

Corbella, *Ferdinando*, ital. Comiczeichner, Maler, * 21. 10. 1915 Mailand, † 29. 8. 1995. Bereits als 15jähriger illustriert C. Postkarten und bemalte Werbeplakate. 1933 arbeitet er für das Animationsstudio Million Film und arbeitet am Film La Rosa di Bagdad mit. Ab 1948 erste Comics (*La Formula 37, Cucciolo, Biancaneve*). Zw. 1949 und 1953 entstehen die Serien *Piccola Frecchia* (Szenario: Dalmasso) und *Tigre Bianca* für den Verleger Gianni de Simoni. Ab 1950 zeichnet er für das Verlagshaus Universo, u.a. die Seefahrerabenteuer *Roland Eagle* und *Narciso Putiferio* sowie *Rick Provvidenza* und *Commissario Grasset*. Zudem auch Arbeiten für den brit. und frz. Markt. 1965 zeichnet er drei Episoden von *Diabolik*. Mit seinem Sohn *Roberto Peroni C.* (* 24. 4. 1940) produziert er in den 1970er Jahren einige Comics für Scarpantibus. Ab den 1980er Jahren widmet er sich nur noch der Malerei. – Begonnen hat C. in einem Funnyzeichenstil, später hat er sich einem realistischen Stil verschrieben. ⌑ *H. Filippini*, Dict. de la bande dessinée, P. 2005. – *Online:* Lambiek Comiclopedia. K. Schikowski

Corbella Peroni, *Roberto* cf. **Corbella,** *Ferdinando*

Corbet, *Christian Cardell*, kanad. Maler, Bildhauer, Medailleur, Kunsthistoriker, Kurator, * 31. 1. 1966 Ajax/Ont., lebt in Corner Brooks/Nfld. und Kent/England. Stud.: 1992–95 Univ. of Guelph, bei June Clark-Greenburg; 1996 McMaster Univ., Hamilton/Ont. (Anatomie); 1998–2001

Portr.-Skulpt. bei Elizabeth Mary Bradford Holbrook. Ab 1994 in Vancouver/B. C. ansässig, wo er sich mit Jack Shadbolt und Jack Reid anfreundet. Später wieder in Ontario tätig. Wiederholte Reisen nach Großbritannien, v.a. nach Guernsey/Channel Islands, woher seine Vorfahren stammen. Mitgl.: seit 1996 R. Soc. of Arts, London/ England; 1996 (Mitbegr.) Canad. Portr. Acad. (1996–2001 Präs.; seit 1998 regelmäßige Teiln. an Jahres-Ausst.); 2000 Gründungs-Mitgl. der Medallic Art Soc. of Canada sowie der Canad. Group of Art Medalists; Fédération Internat. de la Méd. d'Art (FIDEM). Seit 2003 forensischer Künstler an der Univ. of Western Ontario, Anthropology Dept., London, wo er sich mit Gesichts-Rekonstr. befaßt (u.a. 2003/04 von einer ägypt. Mumie). – C.s Schaffen ist bes. von E. M. B. Holbrook und Emanuel Otto Hahn geprägt. Er malt Lsch. in dekorativen, stark vereinfachten Formen, u.a. Darst. von Eisbergen (*Ice Sails*, Öl/Lw., 2002), und abstrakte Motive, die Einflüsse von Isabel McLaughlin und Alexandra Luke zeigen. Einen Namen macht sich C. v.a. durch seine Portr. in realistischer Auffassung. Seinen ersten großen Erfolg verzeichnet er mit dem Ölbildnis *Elizabeth Holding Her Ribbon* (1995). Dem Porträtfach widmet er sich auch als Bildhauer mit Büsten (*Charles Darwin*, 2011) und Reliefs, v.a. Bronzemedaillons (*Winston Churchill*; *Sir Hugh Casson*, London, RIBA), außerdem figürliche Sujets und Medaillen. Sowohl durch die eig. Bildnisse als auch sein Engagement im Rahmen der Canad. Portr. Acad. (kuratierte einige von deren Ausst.) hat er maßgeblich zu einer Renaiss. der Porträtkunst in Kanada beigetragen. ⌂ ABERDEEN, AG and Mus. ATHEN, Numismatisches Mus. CAMBRIDGE, Fitzwilliam Mus. CHATHAM/Ont., Chatham-Kent Mus. GUERNSEY, Mus. and AG. LONDON, BM. – Imperial War Mus. OWEN SOUND/Ont., Tom Thomson AG. OTTAWA, Canad. War Mus. UTRECHT, Geld-Mus. (ehem. in Leiden, RM Het Koninkl. Penning-Kab.). WIEN, KHM, Münz-Kab. ⊙ *E:* seit 1995, u.a. 2003, '04 (mit Wilkins und Winton) Ajax, Ajax Public Libr. / 2009 St. Peter Port (Guernsey), Priaulx Libr. / 2011 St. Catharines (Ont.), Brock Univ., James A. Gibson Libr. (Gesichts-Rekonstr.). ⌷ *M. Heidemann* (Bearb.), Internat. Med.-Kunst. XXVII FIDEM 2000 (K Weimar), B./ Weimar 2000; Elizabeth Bradford Holbrook. Seven decades of art (K Hamilton Conservatory for the Arts), Lo., Ont. 2001. – *Online:* Website C.; Assoc. of Cultural Industries Newfoundland and Labrador.

C. Rohrschneider

Corbijn, *Anton,* niederl. Fotograf, Filmregisseur, * 20. 5. 1955 Strijen/Zuid Holland, lebt in London. Bruder des Fotografen *Corb!ino* (eigtl. Cornelis Maarten C. van Willenswaard [Pseud. Kooos], * 1959 Strijen). 1972 erste Fotogr. bei Rockkonzerten. Stud.: 1974–76 School voor Fotogr. en Fotonica, Den Haag (nicht abgeschlossen). 1976 Ass. des Fotografen Gijsbert Hanekroot bei der Musik-Zs. Oor; ab 1977 dort selbst als Fotograf tätig. 1979 Umsiedlung nach London. 1980–85 Veröff. v.a. im New Musical Express. Ausz.: u.a. 1993 Hugo-Erfurth-Preis; 1994 Capi-Lux Alblas Prijs. – Seit A. der 1980er Jahre etabliert sich C. als einer der führenden Porträtfoto-

grafen der internat. Rock- und Popmusik. Seine Aufnahmen erscheinen in Zss. wie Rolling Stone, Elle, W und Stern. Außerdem gestaltet er zahlr. Schallplattenhüllen, v.a. für U2 (z.B. *The Unforgettable Fire* [1984], *The Joshua Tree* [1987] und *Rattle and Hum* [1988]) und Depeche Mode (*101* [1989] und *Violator* [1990]). Bis E. der 1980er Jahre arbeitet er ausschließlich in Schwarzweiß. Das Frühwerk (35mm) zeichnet sich durch die Verwendung grobkörnigen Films, starke Hell-Dunkel-Kontraste und gezielte Unschärfe aus. Seit 1983 dreht C. auch Musikvideos (u.a. für Depeche Mode, U2, R. E. M und Nirvana) sowie zuletzt Spielfilme (*Control*, 2007; *The American*, 2010). Außerdem entsteht ein Kurzfilm über Captain Beefheart. 2002 fotografiert C. in seinem Heimatort Strijen eine Reihe von Selbst-Portr., auf denen er versch. berühmte Musiker des 20. Jh. verkörpert (*A. Somebody, Strijen, Holland*, M. 2002). – Foto-Publ.: *Famouz. Photographs 1976–88*, M. 1989; *33 Still Lives*, M. 1999; *Star Trak*, M. 2002; *U2 & I*, M. 2005. – DVD-Slg der Musikvideos: *R. Brown/J. Larthe*, The work of director A. C., s.l. 2005 (Directors label, 6). ⌂ AMSTERDAM, Stichting voor Fotogr., Huis Marseille. PARIS, FNAC. SITTARD, Mus. Het Domein. ⊙ *E:* 1982 Sheffield, Untitled Gall. / Amsterdam: 1989, '96, 2000, '02, '05 Torch Gall.; 1994 Sted. Mus.; 2011 Foam Fotogr.-Mus. (K) / Paris: 1989 FNAC Gal.; 1991 Inst. Néerlandais / 1993 Rotterdam, Kunsthal / 1996 Hamburg, Deichtorhallen / 2000 Ghent, Sted. Mus. voor Actuele Kunst (mit Marlene Dumas); Groningen, Groninger Mus. (K) / 2001 Düsseldorf, NRW-Forum (Retr.; Wander-Ausst.; K) / 2003 Hannover, Kestner-Ges. (Wander-Ausst.; K) / 2009 Budapest, Ludwig Múz. (K) / 2012 Dresden, GG NM. – *G:* 1986 Arles: Rencontres internat. de la Photogr. / 1988 Boston (Mass.), Photogr. Resource Center: Around Sound / 1992 Esslingen: Foto-Trienn. / 1993 Leverkusen, Mus. Morsbroich: Hugo-Erfurth-Preis (K) / 1998–99 Tokio, Hara MCA: The Promise of Photography. The DG Bank Coll. (Wander-Ausst.; K) / 1999 Bremen, KH, und München, Lenbachhaus: Von Beuys bis Cindy Sherman. Slg Lothar Schirmer (K); Groningen: Noorderlicht Photofestival / 2000 Dresden, Dt. Hygiene-Mus.: Bilder, die noch fehlten. Zeitgenössische Fotogr. (K) / 2001 Madrid: Photo España / 2003 Barcelona, Fund. Foto Colectania: Como si nada. Col. Juan Redon (K) / 2004 Köln, Photokina / 2009 Wien, KH: Das Porträt. Fotogr. als Bühne (K) / 2010 Essen, Mus. Folkwang: A Star is Born. Fotogr. und Rock seit Elvis (Wander-Ausst.; K). ⌷ *R. Mißelbeck* (Ed.), Prestel-Lex. der Fotografen, M. u.a. 2002; *W. van Sinderen* (Ed.), Fotografen in Nederland, Am. u.a. 2002 (auch zu Corb!no); *H.-M. Koetzle*, Fotografen A-Z, Köln 2011. – *L. Merlo*, New Dutch photogr., Am. 1980; Visual Gall. at Photokina (K Köln), Ha. 2004; *P. Breebaart*, First focus. De coll. fotogr. van de Haagse HS, D. H. 2005; *D. Santamaria* (Ed.), Bienn. di Alessandria (K), Albissola Marina 2008; *K. Quirijns*, A. C. Inside out, 2012 (Dokumentarfilm); *F. Gierstberg u.a.* (Ed.), The Dutch photobook. A thematic selection from 1945 onwards (K Nederl. Foto-Mus.), Rotterdam 2012. – *Online:* Website C. P. Freytag

Corciulo, *Andrea Giuseppe,* schweiz.-ital. Maler, Zeich-

ner, Installations-, Multimediakünstler, * 6. 2. 1972 Teufen, lebt in St. Gallen. Stud.: 1994–98 Höhere Schule für Gest., Zürich. Ausz.: 2001, '08 Kunstpreis der Stadt, 2002 des Kt. St. Gallen; 2005 Stip. für Rom, 2006 für die Cité internat. des Arts, Paris; 2007 Förderpreis der Kulturstiftung der UBS-Bank. – In eindringlich wirkenden surrealistischen und fotorealistischen Gem.-Serien, teilw. auch Installationen, setzt sich C. intensiv mit dem Thema des Fremdseins in all seinen Facetten auseinander, v.a. mit Problemen um Heimat, Ausgrenzung, Flucht und Migration sowie der transzendenten Wahrnehmung von Alltagserlebnissen. Die suggestive Kraft der Darst., die geschickte, oftmals provokante Motivkombination, das virtuose Spiel mit prägnanten Kontrasten und hintergründigen Andeutungen erzeugen eine bes. spannungsgeladene Atmosphäre (*Congr. internat. de folklore*, 2010). ✉ *C. u.a.*, The nearest faraway place (K), Chur 2007. ◉ *E:* St. Gallen: 1997 Gal. vor der Klostermauer; 2003 Katharinen; 2004 Gal. Werkart; 2010 Gal. Paul Hafner / 2002 Bern, Gal. Artraktion; Basel, Gal. Michel Fischer / 2003, '07 Chur, Gal. Luciano Fasciati / 2004 Zürich, Plattform 22 / 2008 Genf, ARTenILE; Athen, Gal. Martinos / 2009 Arbon, KH. ▣ *D. Denaro*, Surréalités (K CentrePasquArt), Biel 2007; *D. Messmer*, Dessin-moi und mouton. Imagination und Gegenwelten in zeitgen. Zchngn (K KM Thurgau), Ittingen 2007. – *Online:* SIKART Lex. und Datenbank; Website C. R. Treydel

Corda, Mauro, frz. Bildhauer, Zeichner, * 27. 7. 1960 Lourdes, lebt in Paris. Stud.: 1976–79 EcBA, Reims, bei Charles Auffret; 1981–85 ENSBA, Paris, bei Jean Cardot. Ausz.: 1983 Prix de Portr. Paul-Louis Weiller; 1985 Prix Paul Belmondo; 1985–87 Aufenthalt in der Casa Velázquez, Madrid; 1989 Prix de Dessin Charles Malfray; 1992 Prix Fond. Princesse Grace. – V.a. figurative Plastiken in Bronze, z.T. polychrom, vergoldet, versilbert, patiniert und akzentuiert durch weitere Mat. wie z.B. Glas und Keramik; weiterhin Arbeiten in Marmor, Aluminium, Eisen, Terrakotta, Glas, Blei, Wachs und Gips. Ein Hw. der polychromen Bronzefiguren ist die überlebensgroße Plastik *Cyrano de Bergerac* (mit Blattgold und Pâte de verre, 2004), die sich auf der Place Pélissière in Bergerac befindet. C. widmet sich bevorzugt der Darst. des menschlichen Körpers (auch einzelner Körperteile wie Hand, Fuß, Arm), den er z.B. in der Gestalt des Schlangenmenschen in zahlr. Posen und versch. Mat. wiedergibt. Char. Gest.-Merkmale der typisierten Figuren sind Deformation (*Boxeur*, 1988), partielle Abstraktion und Zerlegung in geometrische Formen (*La Passion*, 1991; *M et Mme Monotype*, 1996) sowie eine fragmentarische Wiedergabe (*Herido*, 1989, alle Bronze). Bes. deutlich wird das Motiv der Verfremdung in den Metamorphosen, Mischwesen und androgynen Figuren. Obwohl Gewalt selten deutlich thematisiert wird (wie z.B. im Zyklus *Petite Boucherie*, 1997), erzeugen viele Figuren eine bedrohliche Stimmung (*Le Cobaye*, 1996; *Mimetisme*, 2004, beide Bronze, Glas). Daneben humorvolle, z.T. ironische Werke (*Couple Palm Beach*, 2004) sowie Tierplastiken, v.a. Hunde und Fische (*Boston Terrier*, 2008, beide Bronze, versilbert, vergoldet). Zudem Zchngn in

klassischer Manier (Rötel, Silberstift/Papier bzw. geweißtes Holz; überwiegend Akte). ▣ MONT-DE-MARSAN, Mus. Despiau-Wlérick: La marche, Bronze, 1989. – *Im öff. Raum:* ÉLAINCOURT, Av. de la Villedieu: L'Ecuyer, polychrome Bronze, 2010. MONT-DE-MARSAN, Place des Arènes: Le Torero, Bronze, 1992. PARIS, Assemblée nat.: Le Taureau, 1990. ◉ *E:* 1989 Vervins: Mairie / 1991 Mont-de-Marsan, Mus. Despiau-Wlérick (K) / 1994 Chambéry, MBA / 1996 Lourdes, Mus. Pyrénéen (K) / 1998 Guebwiller, Mus. du Florival (K) / Reims: 1999 MBA (K); 2010 Gal. du Cardo u.a. (Retr.; K) / 1999, 2000, '01 (K), '03, '05, '08 Den Haag, Gal. De Twee Pauwen / 2004 Bergerac, Presbytère St-Jacques (Retr.; K) / 2005 Barcelona, Mus. F. Marès (K) / 2010 Paris, Opéra Gal. (K) / 2011 Forte dei Marmi, Piazza Garibaldi, Via Spinetti, Via Carducci. – *G:* 1992 Anglet, Hôtel de Ville: Taureau en Tête / Paris: 1995 Trienn. europ. de Sculpt.; 2000 Jardin du Pal. Royal: L'Homme qui marche (K); 2001 Gal. Michelle Broutta: Dessins de Sculpteur; 2010 Univ. Paris Descartes: Le visage dans tout ses états (K) / 2005 Beijing: Internat. Art Bienn. / 2010 Barbizon, Espace cult.: 150 ans de l'Angélus de Millet / 2011 Beirut, Gal. Mark Hachem: Retro-Active. ▣ *Bénézit* III, 1999; *Delarge*, 2001. – *P. de Méritens*, Le Cyrano de Corda et autres personnages, P. 2005. – *Online:* Website C. F. Krohn

Cordero (C. Cepero), *Raúl (Raúl Ernesto)*, kubanischer Maler, Videokünstler, Fotograf, Zeichner, Graphiker, * 25. 9. 1971 Havanna, lebt dort. Stud.: 1982–85 Esc. Elemental de Artes Plást.; 1985–89 ENBA „S. Alejandro“; 1989–94 Inst. Superior de Diseño; alle ebd. Im Jahr 1995 mit niederl. Reg.-Stip. am Graphic Media Development Centre, Den Haag. Mitgl.: Unión de Escritores y Artistas de Cuba; Next Generation (ICOGRADA). Lehrtätigkeit: Gast-Prof. für Malerei und neue Medien 1994 am Inst. Superior de Arte in Havanna und am San Francisco Art Inst.; 2001 am Contemp. AC in Cincinnati/Ohio. Ausz.: u.a. 1995 Preis, Salón Nac. de la Gráfica, Havanna. – In C.s Werk steht Malerei im Zentrum, begleitet von Video, Fotogr. und and. Medien, beeinflußt u.a. von Pop-art, John Baldessari, David Salle und Vito Acconci. Nicht Inhalte, der soziale oder politische Kontext seines Schaffens spielen eine Rolle, sondern das trad. Medium und die ihm eig. Produktions- und Wahrnehmungsaspekte. Als Quelle von C.s Öl-Gem., die figurative Szenen (meist mit verwischten Konturen) darstellen, dienen neben eig. Fotos triviale Bilder der Massenmedien, z.B. aus Reklame, Kino (v.a. Hollywood-Filme), Fernsehen und Internet, die C. in spielerisch-ironischer Weise im Sinne des Zappings oder des Sampelns verwendet (in den 1990er Jahren arbeitet C. v.a. in New York auch als Disc Jockey). In den Bild-Komp., die teilw. wie filmartige Sequenzen angelegt sind, erscheinen zeichenhafte, verfremdend wirkende Elemente, meist gemalte Texte, die gedruckte oder digitale Schriften nachahmen, punktierte Körperumrisse und collagierte Fotokopien (z.B. *Self portr. as a murderer*; *Three suicide guys/Sleeping persons*, beide 1997; *Tres manchas en la carne*, 1999). Zw. den versch. Bildebenen entsteht eine geheimnisvolle Spannung, die nur schwer aufzulösen

ist. Das Video untersucht C. v.a. als künstlerisches Medium. *Déjarme contarte un vídeo* (1997) sind Kontaktbögen von Fotos, die ihn sprechend und gestikulierend auf einem Bildschirm zeigen. In *Un vídeo con dos defectos* (2001) nähert sich eine Frau dem Kameraobjektiv und verdeutlicht, daß eine Videoaufnahme weder den Geruchs- noch den Tastsinn anspricht. Malerei und Video bringt C. auch in einen realen Zusammenhang. In *Superpainting* (2000) steht das Gem. der Filmfigur Superman neben ihrem gefilmten Ebenbild; eine Fernbedienung macht Einstellungsänderungen, also gleichsam einen Eingriff des Betrachters in das Bild, möglich. *Lo que pasaba en el banco mientras pintaba el retrato de Yuri Gagarin* (2001) konfrontiert C.s Portr. des sowjetischen Raumfahrers mit dem Video einer von ihm beim Malen durch das Atelierfenster beobachteten Straßenszene. Mehrfach beschäftigt sich C. in seriellen Arbeiten mit der Bed. des malerischen Prozesses, so gibt er z.B. in Gem. per Text an, wieviel Kilokalorien und Fett er während des Malens am jeweiligen Bild verloren hat (*Expenditure series*, 2003), läßt den Betrachter zw. versch. Bildtiteln wählen (*Optional title series,* 2005–06) oder malt Bilder in exakt den Maßen eines and., meist berühmten Gem., u.a. von Leonardo, Caravaggio, Gustave Courbet, Edward Hopper oder Jackson Pollock (*A painting the same size as ...*, 2008–10). C.s Vorgehen ironisiert konzeptuelle Strategien und gibt Bilderrätsel auf, die die heutige visuelle Massenüberflutung konterkarieren. ⌷ ARNHEM, MMK. BADAJOZ, Mus. Extremeño e Iberoamer. de Arte Contemp. COLUMBUS/Ohio, Mus. of Art. GENT, Stedelijk Mus. voor Actuele Kunst. FORT LAUDERDALE/Fla., MFA. HAVANNA, Centro Cult. Wifredo Lam. – MNBA. KÖLN, Heinrich-Böll-Stiftung. LOS ANGELES/Calif., MAC. MONTREAL, Champ Libre Found. NEW YORK, Neuberger Berman AC. ORLANDO/Fla., Univ. of Central Florida Libr. Coll. SAN DIEGO/Calif., MAC. ZÜRICH, Daros Latinamerica. ⊙ *E:* Havanna: 1990 Univ. (K: I. de la Nuez); 1992 Centro Prov. de Artes Plást. y Diseño; 1994, '98, 2003 Gal. Habana; 1996 Centro Cult. Wifredo Lam (K: M. I. González Mora/J. M. Noceda Fernández); Gal. 23 y 12 (mit José Angel Vincench; K: B. Martínez/O. Pascual Castillo); 2006 Gal. Servando (K: O. Pascual Castillo); 2009 Gal. Acacia (K.: M. Machado) / 1997 (K: C. Vives), '99 (ead./E. Arratia), 2000 (K: B. W. Ferguson), '02, '03 Los Angeles, Iturralde Gall. / 2000 Ithaca (N. Y.), Herbert F. Johnson Mus. of Art (K: B. W. Ferguson/S. M. Ulmer) / New York: 2000 LiebmanMagnan Gall. (K: B. W. Ferguson); 2010 Magnan Metz Gall. (mit Amelia Beiwald) / 2001 San Francisco, Art Inst., Walter & McBean Gall. (K: K. Moss/M. Scully) / 2002 Salamanca, Univ. de Salamanca, Centro de Fotogr., Sala de Expos. Pal. de Abrantes; Pamplona, Ciudadela, Pabellón de Mixtos (beide K: C. Vives/F. J. Panera Cuevas; Ausst.; Bibliogr.) / 2004 Grenoble, Fluid Espace de Création Contemp. / 2007 Madrid, Gal. Casado Santapau (mit Angel Masip) / 2008 Mexiko-Stadt, Myto Gall. / 2011 San Diego (Calif.), MCA. – *G:* 1995 Las Palmas de Gran Canaria, Centro Atlántico de Arte Mod.: Cuba s. XX (K) / 1996 Grenchen: Internat. Trienn. für Originalgrafik; Cuenca: Bien. Internac.;

Quito, Bien. del Afiche / Havanna: 1996, 2000, '06, '09 Bien.; 2002 Centro Cult. de España: Copyright (K) / 2001 Madrid, Fund. Telefónica: Atravesados. Deslizamientos de identidad y género (K) / 2001 Northridge, California State Univ., AG: Cuba. Five odysseys (K) / 2003 Columbus (Ohio), Wexner Center for the Visual Arts: Away from home (K: J. Avgikos u.a.) / 2007 Salamanca, Domus Artium 2002: Barrocos y neobarrocos. El infierno de lo bello (K) / 2008 Los Angeles, Mun. AG: Tropics. A contemp. view of Haiti, Cuba and Brazil. ⌶ *V. Alberdi*, Arte cubano (Havanna) 1995 (2) 61–62; *J. García Sánchez*, Revistart (Ba.) 8:2002 (67) 14–16; *B. W. Ferguson*, Papel alpha. Cuad. de fotogr. (Sal.) 2003 (6) 81–103; *F. J. Panera Cuevas*, ibid. 2003 (6) 104–110; *M. MacMasters*, La Jornada (Méx.) v. 5. 5. 2008; *O.-P. Castillo* (Ed.), R. C., Ma. 2009; *M. Heinzelmann*, Slow paint. (K Mus. Morsbroich, Leverkusen), Nü. 2009; *B. W. Ferguson u.a.*, R. C., Ma. 2011. – *Online:* Website C. M. Nungesser

Cordero Benavidez, *Julio Gonzalo* cf. **Cordero Castillo,** *Julio*

Cordero Castillo (Cordero), *Julio,* bolivianischer Fotograf, Filmemacher, * 17. 8. 1879 Pucarani/La Paz, † 27. 10. 1961 La Paz. Vater der Fotografen *Julio C. Ordoñez* (* 22. 2. 1906, † 1963 La Paz) und *Gregorio C. Miranda* (* 12. 3. 1922 La Paz, † 1979 ebd.) sowie Großvater von *Julio Gonzalo C. Benavidez* (* 27. 5. 1938 La Paz). Bis 1898 fotogr. Ausb. im Studio für Porträt-Fotogr. Valdez Hermanos, La Paz. 1900 Eröffnung eines eig. Foto- und Filmateliers ebd. Über „Foto C." (ab 1910) steht im Guía gen. de Bolivia (La Paz 1918) von Viscarra: „Direktimport aus Europa und den USA; Laden für Fotogr. und Kino-Fotogr. (...); Große Preise von Sucre, La Paz und Potosí; Kunstarbeiten, Vergrößerungen, Repr. etc.; Verkauf von Fotozubehör, Fotoansichten und Postkarten von Bolivien." Als Mitgl. der Partido Liberal hatte C. zahlr. Ämter inne, u.a. 1911–13 Bürgermeister eines Stadtteils von La Paz. Gründer der Unión Sindical de Fotógrafos, Mitgl. der Vrg Amigos de la Ciudad und 1951 Präs. der Soc. de Socorros Mutuos S. José. 1961 Übernahme des Fotostudios durch die Söhne; nach C. Ordoñez Tod führte es dessen Sohn C. Benavidez mit seinem Onkel C. Miranda bis 1992 fort. Ein Teil des Arch.-Bestands (5000 von ca. 100000 Negativen) wurde vom Projekt Portr. of Bolivia des Earthwatch Inst. for Field Research in Houston/Tex. digital erfaßt und beim FotoFest 2002 in Auswahl erstmals einer internat. Öffentlichkeit gezeigt. 2009 Dipl. S. Pablo al Mérito Cult., Dep. de Cult. y Arte der Univ. Católica Boliviana für das Arch. Estudio Fotogr. J. C. – C. war ab 1909 als offizieller Fotograf unter mehreren Reg., u.a. von Präs. Eliodoro Villazón, Ismael Montes und José Gutiérrez Guerra, einer der bedeutendsten Dokumentarfotografen Boliviens. 36 Jahre arbeitete er für die Brigada Dep. de Policía (u.a. Profil- und Frontal-Portr. von Delinquenten zur kriminalistischen Identifizierung). Er fertigte im eig. Atelier und in Privathäusern zahlr. Portr., z.B. in den 1940er Jahren von dem bek. Schriftsteller Franz Tamayo Solares (C.s Foto diente als Vorlage für Tamayos Portr. auf der 200-Bolivianos-Banknote v. 1987), weiterhin Bildnisse von Paaren, Fam.

und Gruppen versch. sozialer Schichten, häufig im Rahmen von Hochzeiten, Erster Kommunion und and. Feierlichkeiten. C. fotografierte darüber hinaus Stadtansichten, einzelne Gebäude, Innenräume von Fabriken und Kirchen, Märkte, Sport- und and. Festveranstaltungen, Militärparaden, Straßenszenen und hist. Ereignisse (u.a. die öff. Hinrichtung eines Mörders), die einen Einblick in die ges. und politischen Verhältnisse Boliviens bis A. der 1940er Jahre geben. C.s Fotos illustrieren das zweibändige Buch *La Paz. Sus rostros en el tiempo* (La Paz 1993) von R. Costa Ardúz. Neben der Fotogr. machte C. auch die ersten Filmaufnahmen von Festumzügen, Fußballspielen und ähnlichen öff. Ereignissen in Bolivien. ⌑ Bogotá, Bibl. L. A. Arango. La Paz, Cinemateca Boliviana. – Mus. Tambo Quirquincho. ◉ *E:* La Paz: 1994 Mus. Tambo Quirquincho; 2011 Casa de la Cult. / 2002 Houston (Tex.), One Allen Center AG / 2008 Zaragoza, Gal. de Arte Pilar Ginés. ⌑ Aperture (N. Y.) 173:2003; *R. Bajo*, La Prensa (La Paz) v. 11. 4. 2004, 4 s.; *J. Cordero*, Retornos. Rev. de hist. y ciencias soc. (La Paz) 2004 (4) 183–188; *M. Galindo*, Estudio Arch. C. Bolivia, 1900–1961 (K Casa de América), Ma. 2004; *S. Boulanger/E. Azcuy Domínguez*, Fotográfica '06. Una mirada a la fotogr. en Bolivia, La Paz 2006; *E. Conde*, La esquina, Supl. Cult., Cambio (La Paz) v. 10. 7. 2011, 4 s. – *Online:* Luminous-lint. World photogr., 2008; *L. Oporto Ordóñez/C. Campos Lora*, Dicc. biogr. de arch. y archivistas bolivianos, 2010. M. Nungesser

Cordero Cepero, *Raúl Ernesto →* **Cordero,** *Raúl*

Cordero Miranda, *Gregorio* cf. **Cordero Castillo,** *Julio*

Cordero Ordoñez, *Julio* cf. **Cordero Castillo,** *Julio*

Cordes, *Wilhelm (Johann Wilhelm),* dt. Architekt, Gartenarchitekt, * 11. 3. 1840 Wilhelmsburg, † 31. 8. 1917 Hamburg. Sohn eines Bauern und Mühlenbesitzers. Zimmermannslehre und Baugewerkeschule in Buxtehude. Stud.: 1858–61, 1865–66 Archit. am Polytechnikum Hannover bei Conrad Wilhelm Hase. 1862–63 als Bau-Ltr seines renommierten Lehrers an dessen Neubau der ev. Kirche St. Trinitatis in Liebenburg tätig. 1874–79 ist C. bei der Ersten Ing.-Abt. in der Hamburger Bauverwaltung unter Ober-Ing. Franz Andreas Meyer angestellt, wo er u.a. an der Schaffung der Außenalsteranlagen und möglicherweise an ersten Planungen für den Friedhof in Hamburg-Ohlsdorf beteiligt ist. Wegen Majestätsbeleidigung 1892 zu einer zweimonatigen Festungshaft verurteilt. Mitgl.: ab 1907 Bauhütte Zum weißen Blatt in Hannover; Bauhütte in Hamburg. – Hw. ist der 1875 nach Plänen der Baudeputation unter F. A. Meyer eingerichtete, ab 1877 belegte Ohlsdorfer Friedhof, auf dem C. ab 1877 zuerst als Bauleiter, ab Juni 1879 als Verwalter, ab 1898 als Dir. tätig ist. Inspiriert von amerik. Großfriedhöfen (Greenwood Cemetry, New York; Spring Grove, Cincinnati) und den wegweisenden Landschaftspark-Gest. des Gartenarchitekten Hermann Fürst zu Pückler-Muskau (Andeutungen über Landschaftsgärnerei, L. 1834) legt C. 1881 einen Gesamtplan zur Gestaltung eines „Friedhofsparks" vor. Dieser vollständig nach landschafts-archit. Gesichtspunkten gestaltete Stadtpark mit Friedhof von bis dahin unbekannter

Größe (bei Eröffnung 126 Hektar; heute 403) strebt mit den natürlich geschwungenen Wegen und Wasserläufen, den Kap.-Standorten an Wegkreuzungen oder der natürlich wirkenden Gehölzbepflanzung die harmonische Synthese von Natur, Kultur und moderner Technik (z.B. in der Wasserversorgung) an. Von C.s Park-Archit. (u.a. sechs Kap.) in eklektizistischen oder reform-archit. Stilen (u.a. neubarocke geschwungene Treppenanlage am *Cordesbrunnen*; mehrere Gebäude im späthistoristischen Heimatstil) bes. hervorhebenswert ist der 1898 in Betrieb genommene 34 Meter hohe, von einer welschen Haube bekrönte Wasserturm im Stil der Neu-Renaiss., der am Ende der Hauptallee sowohl als Landmarke wie als begehbarer „point de vue" dient (Aussichtsturm 1989–92 saniert). Die 1905 zus. mit Albert Erbe entworfene Friedhofs-Kap. 6 gehört dagegen zu den frühesten Belegen der seit 1904 aufkommenden sog. Heimatschutz-Archit., die in Deutschland den Beginn des Neuen Bauens markiert. Mit dem neubarocken Verwaltungsgebäude (1911) am Haupteingang kehrt C. nochmals zur üppigen Formensprache seiner Anfänge zurück. ⌑ Flensburg, Friedhof am Friedenshügel, 1908–11. Hamburg-Ohlsdorf: Friedhof, 1877–1911. – H.-Bergedorf: Friedhof, 1907. ◉ *G:* 1897 Hamburg: Internat. Gartenbau-Ausst. (K) / 1900 Paris: WA (Grand Prix). ⌑ *G. Gröning/J. Wolschke-Bulmahn*, Grüne Biogr., B. 1997. – *J. W. C.,* Friedhöfe und deren Denkmäler, in: Hamburg und seine Bauten, Ha. 1890; *A. Obst*, Der Schöpfer des Ohlsdorfer Friedhofes J. W. C., Ha. 1911; Berlin und seine Bauten, 10, Bd A 3, B./M. 1981, 23–27; *W. R. Dodegge*, J. W. C. (1840–1917). Zum 75. Todestag des Architekten des Ohlsdorfer Friedhofes, in: Die Insel (Ha.-Wilhelmsburg) 27:1992, 12–20; *G. Kokkelink/ M. Lemke-Kokkelink*, Baukunst in Norddeutschland. Archit. und Kunsthandwerk der Hannoverschen Schule, Hn. 1998; *H. Schoenfeld*, Ein Reformfriedhof und die neue Gartenkunst. Das Bsp. Friedhof Ohlsdorf in Hamburg, in: *B. Leisner (Ed.)*, Vom Reichsausschuß zur Arbeitsgemeinschaft Friedhof und Denkmal, Kassel 2002, 87–95. – Hamburg, StsA: 331–3, Sign. 3334 S (Strafakte C.). Bismarckdenkmal: StaH, Senat CL VII Lit. Fc N0 21 Vol. 17 Fasc. 1.
U. Heise

Cordón (C. Fernández), *Fernando*, span. Maler, Autor, Hochschullehrer, * 26. 11. 1963 Logroño/La Rioja, lebt in Valencia und Anguiano/La Rioja. Stud. in Valencia: Musik (Klavier); bis 1989 Fac. de BA de S. Carlos der Univ. Politécnica (ab 1990 Doz., 1993 Diss., seit 2002 Prof. am Dept. de Pint.). 1989 Mitbegr. der multidisziplinären Gruppe L3C. Ausz.: u.a. 1998 1. Nat.-Preis Edición Univ. für die beste CD (Hülle), Buchmesse Barcelona. – C. gestaltet von Pitt. metafisica, Diego Rivera und Miquel Navarro inspirierte Gem. metaphysischen Char., die als sog. schematische Malerei bes. die Kunst der 1990er Jahre in Valencia dominieren. In seinen von der Linie bestimmten Gem. in wenigen kühlen Farben finden sich min.-haft wirkende, surreale archit. Szenen mit anonymen Figuren (*El barco demediado; El piano*, beide Öl und Tempera/ Lw., 1994). Auch Gest. digitaler Medien, experimenteller Musik und zahlr. Texte in Büchern und Ausst.-Katalogen.

ALICANTE, Prov.-Verwaltung. LOGROÑO, Fund. Caja Rioja. – Stadtverwaltung. TOLEDO, Col. Caja Castilla-La Mancha. – Junta de Castilla-La Mancha, Fondos de Arte. VALENCIA, Cortes Valencianas. – Fund. Bancaja. – Univ. Politécnica. ✉ Aportaciones para la autorreflexión de la obra pictórica propia y su proceso creativo (Diss.), Va. 1993; *C. u.a.*, Sirio multimedia. Sistemas de recuperación de la inf., Va. 1996; Vigilia (mit DVD), Ma. 2004; Arte y técnica. Iniciación a la programación con Lingo, Va. 2005 (mit Ill. und DVD); Arte algorítmico y multimedia. Programación con Processing y Lingo, Va. 2007. ◉ *E:* Valencia: 1986 Círculo de BA (K: C.); 1987 Gal. Post-Pos (K: R. Martínez Artero); 1988 Univ. Politècnica, Fac. de BA; 1994 Gal. Parallel 39; 2003 Club Diario Levante (K: D. Pérez); 2009 Kessler-Battaglia Gal. de Arte / 1992 Alicante, Gal. Cromo (K: J. B. Peiro) / Madrid: 1995 Gal. Detursa (K: C.); 1999 Gal. Diéz de Tejada; 2004 Gal. Muelle 27 (K: M. de Valvanera) / 2005 Logroño, Centro Cult. Caja Rioja. – *G:* 1985 Logroño: Bien. / 1992 Calahorra (La Rioja), Mus.: 1950–90 Arte en la Rioja. Jóvenes tendencias; Sevilla: WA, Pabellón Generalitat Valenciana / Valencia: 1994 Certamen Nac. de Pint. Premio José Segrelles ehrenvolle Erw.); 2002 Mus. del s. XIX: Miradas distintas, distintas miradas. Paisaje valenciano en el s. XX. ⌑ *Agramunt Lacruz* I, 1999. – *M. Mira u.a.*, El gobierno de los pies (K Gal. Valgamedios), Ma. 1991; *P. Escanero*, Información (Alicante) v. 26. 12. 1992; *N. Pellicer*, El Mundo (Ma.) v. 15. 4. 1994; *N. Sánchez Durá/J. M. Bonet*, Muelle de Levante (K Wander-Ausst.), Va. 1994; *J. M. Miranda*, El Punto de las artes (Ma.) v. 23. 10. 1995; *D. Pérez*, F. C. F. (Wander-Ausst.), Va. 1998; *I. Martínez*, La Rioja (Logroño) v. 30. 11. 2003, 66. – *Online:* Website C. – Mitt. C.

M. Nungesser

Corea (C. Rodríguez), *Carlos (Carlos Adolfo)*, honduranischer Maler, Zeichner, Gebrauchsgraphiker, Illustrator, * 23. 12. 1963 Tegucigalpa, lebt dort. Stud. ebd.: ab 1981 ENBA. Mitgl. der Asoc. Hondureña de Artistas Visuales. Als Kunsterzieher und Gebrauchsgraphiker tätig. 1992 im Auftrag des Schulbuchverlages Edición Ramsés fertigt C. Gem. von nat. Helden und Symbolen von Honduras an, die als Repr. zu pädagogischen Zwecken dienen. Ausz.: 1993 1. Preis, Wettb. für Logotipo conmemorativo al 20 Aniversario del Inst. Nac. de Formación Profesional; 2003 Bronze-Med., Gal. Hors Serie Univers des Arts, Paris. – Anfänglich mit lockerem Pinselstrich, später naturnah gestaltete gegenständliche Gem. in Öl/Lw. zw. Lsch. und Stilleben mit symbolisch-surrealen, teils figürlichen Elementen (z.B. *Música; La paz en ruinas*, beide 1990), später v.a. zu ökologischen Themen (z.B. *Cohesión humana*, 1998; *Imágenes y selva*, 2005). Auch sozialkritische Zchngn, die meist als Buch-Ill. dienen, u.a. Serie zur pädagogischen Aufklärung, hrsg. vom Centro de Documentación de Honduras in Tegucigalpa: z.B. *Transparencia y corrupción* (1999), *La mentira política de los políticos* (2003), *Migra, migrante* und *La mara marabunta* (beide 2004) von Eduardo Bähr; *Violencia e inseguridad ciudadana en Honduras* (2003) von Oscar Armando Valladares; *Regresa migrante* (2009) von Marvin Ba-

rahona. TEGUCIGALPA, Banco Central de Honduras. ⌑ *M. R. Argueta Dávila*, Dicc. de artistas plást. hondureños, Choluteca 1996; *Delarge*, 2001. – Generaciones que marcaron huellas. Antología de la Col. de Arte del Banco Central de Honduras, Tegucigalpa 2007; *V. Castro*, El Heraldo (Tegucigalpa) v. 4. 9. 2010. – *Online:* Centro de Documentación de Honduras; Centro Cult. de España, Antologías.

M. Nungesser

Coresi (gen. Diacon Coresi; Diaconul Coresi), Buchdrucker, Holzschneider und Übersetzer in Siebenbürgen/Rumänien, † 1583 Kronstadt/Braşov. Arbeitet von 1556 bis 1583 in der ersten, von Johannes Honterus gegr. Kronstädter Druckerei. Setzt in seinen Titel-Hschn., Ornamenten und Initialen die Trad. des orthodoxen Buchschmuckes und des in Tîrgovişte 1508–12 tätigen Buchdruckers Makarios (Macarie) fort. Arbeitet wahrsch. zeitweise mit dem Drucker Laurentius Fronius zusammen. C. gilt als bedeutendster rumänischer Buchdrucker des 16. Jh. aufgrund seiner ersten Verschriftlichungen der rumänischen Sprache. Ein C.-Denkmal befindet sich vor der Nikolaikirche in Braşov. BRAŞOV, Muz. Prima şcoală românească. ⌑ *P. Binder/A. Huttmann*, Forsch. zur Volks- und Landeskunde 11:1971 (1) 45–47; *I. Gheţie/A. Mareş*, Diaconul Coresi şi izbânda scrisului în limba română, Bu. 1994; Istoria limbii române literare. Epoca veche (1532–1780), Bu. 1997; *id./id.*, De când se scrie româneşte? Bu. 2001; *G. Nussbächer*, Beitr. zur Honterus-Forsch., 3 Bde, Kronstadt/He. 2003 (2:2005; 3:2011). – *Online:* Cimec C. (Verz. aller Drucke).

St. Schulze

Cormand, *Martí*, katalan.-US-amer. Maler, Zeichner, Illustrator, Performancekünstler, * 11. 12. 1970 Barcelona, lebt seit 2003 in Brooklyn/N. Y. Stud.: 1992 Leeds Univ.; bis 1994 Fac. de BA, Univ. Barcelona, u.a. bei Joan Descarga, Gerard Sala, Joaquim Chancho, Joan Hernández Pijuan. Stip.: 2000 Pollock-Krasner Found.; 2004 Generalitat de Catalunya; 2010 New York Found. for the Arts. 2003, '05 Gast-Doz. in Barcelona. Ausz.: u.a. 2007 Emerging Artist Award, Aldrich Contemp. AM, Ridgefield/Conn. – C. gestaltet Gem. und Zchngn, die auf Bildern aus dem Internet basieren. Sie zeigen meist idyllische oder erhabene Naturansichten in altmeisterlich genauer Darst., z.B. Wälder (*Untitled, talking to Polidori*, 2005; *Gordon Glen Forest Park, Ireland*), arktische und marine Regionen (*Iceberg; Offside; Tide*) oder tropische Zonen (*Macaws*, alle Öl/Lw., 2006), in denen abstrakte, der digitalen Welt verwandte Strukturen auftauchen, als seien sie deren verborgene Bauelemente. Mit diesen Mitteln der Verfremdung verweist C. sowohl auf veränderte Wahrnehmungsmuster im Zeitalter der Massenkommunikation als auch auf die wachsende Umweltverschmutzung. In Zchngn erscheint pflanzliche Natur oft in Nahsicht in Schwarzweiß, während filigrane farbige Rohrgeflechte durch sie hindurchgehen (*Leafe weave; Close up in red, yellow and blue*, beide 2007; *Scaffolding*, 2009, alle Graphit und Aqu./Papier). Danach konfrontiert C. einzelne, in Trompe-l'œil-Manier dargestellte Gegenstände mit abstrakten Hintergründen (*Crumpled paper; Magazine*, beide Öl/Lw., 2009) und malt auf auseinandergefaltete

Kartonkisten (z.T. auf Lw. aufgezogen) Spuren ihrer Benutzung wie Einrisse, Klebebänder oder Fußspuren, die täuschend echt erscheinen (*Footstep; White box; Do not bend or fold*, alle 2011). Auch Buch-Ill.: u.a. *El mandarí i jo* (Ba. 1992) und *El mandarín* (Ba. 1993) von Rosa Maria Colom; *La brujita Teresita* (Ba. 1993) von Josep Gregori. 🏛 ALCOBENDAS/Madrid, Stadtverwaltung. BARCELONA, Fund. La Caixa. – Fund. Vila Casas. LA GARRIGA, Col. Honda. MADRID, Fund. Arte y Naturaleza. – Fund. Caja Madrid. – Fund. ICO. MAYFIELD VILLAGE/Ohio, The Progressive Art Coll. NEW YORK, Judith Rothschild Found. – MMA. 👁 *E:* 1998 Vic (Barcelona), Gal. Introit; Valencia, Gal. Luis Adelantado / 1999–2001 Barcelona, Gal. Alejandro Sales / 2003, '05, '06, '09, '11 New York, Josée Bienvenue Gall. / 2003, '06 San Francisco, Gregory Lind Gall. / 2007 Ridgefield (Conn.), The Aldrich Contemp. AM / 2010 Hospitalet de Llobregat (Barcelona), Fund. Arranz-Bravo (K: M. Wilson); Santa Fe (N. Mex.) Lew Allen Projects (mit Saul Becker und Steve Robinson). – *G:* 2000 New York, 123 Watts Gall.: Microwave, two (K: J. Bienvenu) / 2001 Madrid, Casa de América: Generación. ▱ *M. L. Borràs*, La Vanguardia (Ba.) v. 19. 11. 1999; *A. Molina*, ABC Cataluña (Ba.) v. 7. 7. 2001; *J. Bufill*, La Vanguardia v. 28. 9. 2001; *K. Baker*, San Francisco Cronicle v. 3. 6. 2006; *L. Turvey*, Artforum 45:2007 (7) 319; *M. Wilson*, ibid. 46:2008 (März); *H. Hammond*, Albuquerque j. v. 28. 5. 2010. – *Online:* Josée Bienvenue Gall., New York. – Mitt. C. M. Nungesser

Čornagalova, *Natallja Arsenc'eŭna* (russ. Černogolova, *Natal'ja Arsen'evna*; im Ausland auch: Chernogolova, *Natalja*), weißrussische Malerin, Zeichnerin, * 15. 5. 1954 Žitkoviči (Žytkavičy/Gebiet Gomel'), lebt in Brèst. Stud.: bis 1976 Kunst-FS „Aleksej Konstantinovič Glebov", Minsk; bis 1982 künstlerisch-graph. Fak. der Pädagogischen HS, Vitebsk (Vicebsk), bei Al'gerd Adamavič Mališeŭski und Aleg Vikenc'evič Lucèvič. Unterrichtet parallel zum Stud. in Vitebsk 1976–82 an der Kinder-KSch in Brèst. Seit 1978 Teiln. an Republik- und internat. Ausstellungen. Seit 2005 regelmäßige Aufenthalte in Großbritannien. – Die in den 1980er Jahren ausgestellten Gem. und Aqu. bleiben zunächst den Themen und stilistischen Formeln der sowjetischen Realismus-Doktrin verpflichtet. In den 1990er Jahren wendet sich Č. jedoch konsequent der figurativen bzw. gestischen Abstraktion zu und verzichtet weitgehend auf Vor- und Komp.-Skizzen, wobei spätimpressionistischer Gestus, Farbexpressivität und -symbolik Anknüpfungspunkte zu Vertretern der Ersten Éc. de Paris zeigen. Zuletzt bedient sie sich zur Steigerung des unmittelbaren, spontanen künstlerischen Ausdrucks hauptsächlich der Fingermalerei. 🏛 BRÈST, Heimatkunde-Mus. MINSK, Nat. KM. 👁 *E:* 2006 Manchester, Central Libr. / 2009 Minsk, Kunst-Pal. / 2011 Brèst, Ausst.-Saal. – *G:* 2009 Teddington (Greater London), Landmark AC: Midsummer art fair. ▱ BSM, 1998. – *M. K. Kon'kov u.a.* (Ed.), Chudožniki Brestčiny, Minsk 2002. S. Görke

Cornaz, *John-Théodore (Jack)*, schweiz. Architekt, Gartenarchitekt, Designer, * 26. 5. 1886 Lausanne, † 14. 11. 1974 ebd. Berufliche Ausb. ist kaum dokumen-

tiert. 1907–08 (oder früher) arbeitet C. als Zeichner bei dem Architekten Albert Naef auf Schloß Chillon in Veytaux und in Locarno, wo er u.a. Rest.-Methoden kennenlernt. Nicht ausgeschlossen wird ein gleichzeitiger Besuch der ETH, Zürich. Stud.: 1911–18 EcBA, Paris (mit Unterbrechung; ohne Abschluß). 1919–26 dort Mitarb. von Emilio Terry. 1927 eig. Bürogründung in Lausanne in Partnerschaft mit Walter Baumann (bis 1930). – C. begegnet den Umwälzungen seiner Zeit als Traditionalist, für den archit. Modernität sich innerhalb eines hist. Kontinuums aus der „Evolution der Formen" entwickelt. Sein Wirken ist formal durch den Neuklassizismus und reg. Bezüge char., inhaltlich durch den Anspruch, zeichenhafte und ideell durchdrungene Bauwerke zu erschaffen. Er beruft sich auf den Modell-Char. der Bauten von Andrea Palladio oder Claude-Nicolás Ledoux und findet auf dieser Grundlage zu einer formalen Reduktion, die entfernt an Adolf Loos, André Lurçat oder Robert Mallet-Stevens denken läßt, z.B. bei dem Atelierhaus Jean Clerc, 1932–33 (Lutry, Chemin de la Toffeyre 19), oder dem originellen Sommerhaus für den Verleger Mermod, 1933 (Puidoux). Demgegenüber spiegeln die großen herrschaftlichen Villen und Landhäuser am Genfer See eher ihre hist. Vorbilder wider, teils als Nachahmung, teils mod. transformiert. C. entwirft auch mehrere priv. Gärten nach ital. Vorbild. Von seinen zahlr. Möbelentwürfen bed. ist v.a. die Inneneinrichtung (1927–29) der Villa André Fluckiger (Saint-Imier) im Biedermeier-(Wohnen) und Art-Déco-Stil (Büro, Bibliothek). 🏛 AURIBEAU-SUR-SIAGNE/Frankreich, Château de Clavary: Torruine, 1929. EPALINGES, Chemin de Ballègue 71, 58 und 65: Häuser am Golfplatz, 1953–54, '57–58, '64. LAUSANNE, Quai d'Ouchy 1: Pavillon und Villa Walter Mermod, 1926/27 (mit W. Baumann). – Av. de l'Elysées 10: Villa Cérenville, 1934 (zerst.). – Chemin Edouard-Marcel Sandoz 3: Haus Denantou (Umbau), 1930–32; Nr. 5: Atelierhaus, 1941. LUTRY, Route de Lavaux 394: Badehaus Auguste Brandenburg, 1923–24 (mit E. Terry). – Route de Lavaux 354: Sommerhaus Gilbert Brustlein, 1929 (mit W. Baumann). – PULLY, Av. Guisan 61: Haus Devrient, 1938. ROLLE, Route de Genève 75: Pav. Maurice Barbezat, 1929 (mit W. Baumann). SAINT-SULPICE, Chemin des Chantres 46: Haus Jacques Roux, 1935. ▱ *N. Maillard*, J. C. Un architecte à contre-jour, Lausanne 2006. – Lausanne, ETH: Archives de la Construction (ACM). A. Mesecke

Cornbread (eigtl. McCray, *Darryl*), US-amer. Graffitikünstler, * 1954 Philadelphia/Pa., lebt dort. Künstlerisch aktiv 1967–71; heute als Sozialarbeiter tätig. Das Pseud. geht auf einen Spitznamen zurück, den C. als Minderjähriger in einer Erziehungsanstalt aufgrund seiner Vorliebe für Kornbrot erhält. Diesen Namen schreibt C. in gelängten Buchstaben, die auf einer Art Sockel stehen, auf die Wände und in Bücher der Anstalt, was ihm die Anerkennung der Gangs einbringt. 1967 beginnt er als Erster im öff. Raum von Philadelphia mit dem Sprühen von Graffitis, u.a. um die Aufmerksamkeit eines Mädchens zu erringen z.B. den Satz „Cornbread loves Cynthia". Nach einer irrtümlichen Todesnachricht sprüht er die Worte „Cornbread lives" im

Zoo von Philadelphia auf Wände, Bänke, selbst auf einen Elefanten. Das „taggen" des Privatflugzeugs der Jackson-Five-Brüder vor den Augen tausender Jacksonfans ist der Höhepunkt seiner Sprüherkarriere. C. gilt als Begründer des subversiven Graffiti-„writing", bei dem das „taggen" immanenter Bestandteil des subkulturellen Selbstverständnisses ist. Er ist zudem der erste „writer", der nach Erlangen von Ruhm (Fame) sein „tag" mit einer Krone verziert. Als Begründer des Philly Style (Stil von Philadelphia) beeinflußt C. nicht nur die Szene ebd., z.B. Kool Earl und Top Cat, sondern auch die in New York, die seinen Stil A. der 1970er Jahre adaptiert und unter dem Namen Broadway Style oder Broadway Elegant bekanntmacht. 1971 beendet C. seine Sprüherkarriere. In den 1980er Jahren ist er Mitarb. einer Anti-Graffiti-Kampagne in Philadelphia. □ *B. van Treeck*, Das große Graffiti-Lex., B. 2001; *Y. Bynoe*, Enc. of Rap and Hip Hop cult., Westport 2006. – *H. Chalfant/J. Prigoff*, Spraycan art, Lo. 1987; *S. McKnight*, Cry of the city crew. The legend of Cornbread, N. Y. 2007 (Film). S. Prou

Corne, *Eric*, frz. Maler, Zeichner, Filmemacher, Kurator, * 30. 10. 1957 Flixecourt/Somme, lebt in Paris. Stud.: 1976–79 Ec. de Médicine; bis 1983 Ec. Nat. supérieure des Arts Décoratifs, Tourcoing; 1983–85 Ec. supérieure des Arts Decoratifs, Paris. 2001–04 Gründung und Ltg des Zentrums für zeitgen. Kunst Le Plateau, Paris. Lehrtätigkeit: 2005–08 Ec. supérieure des BA, Genf; Ec. supérieure des BA, Bourges. – C. malt von Reisen und aktuellen Themen inspirierte Gem.-Serien, die sich jeweils durch Maßstab, Fluchtpunkt und Farbgebung unterscheiden. Char. sind Akt-Darst. vor einer von Kanälen durchzogenen weiten Lsch. und Nachtszenen (*Lost Light II*, 2008) mit einem mystischen, paradoxen Unterton. C. zitiert u.a. Eugène Leroy, Otto Dix, Giorgio Morandi und Picasso als seine Vorbilder sowie den Dichter Edward Estlin Cummings. Ferner befaßt er sich mit Videofilmen (*Fallen Sparrow*, 2007). ▱ AMIENS, FRAC Picardie. PARIS, FRAC Île-de-France. STRASBOURG, MAMC. ◉ *E*: Paris: 1995, '97 Gal. Alessandro Vivas; 2000 Immanence; 2007, '08–09, '10 Gal. Patricia Dorfmann (K) / 1995 Fresnes, Maison d'art Contemp. Chaillioux / 1999 Hénin-Beaumont, Espace Lumière; Lyon, Gal. Confluences / 2001 Vassivière, Centre nat. d'art et du Paysage / 2008 Saint-Etienne, Le 9 bis / 2010 Luxemburg, Gal. Nosbaum & Reding (K). □ *Delarge*, 2001. – *C. Boulbès*, Art press 268:2001 (Mai); *C. Morineau*, ibid. 265:2001 (Febr.) 87; *P. Amine*, ibid. 279:2002 (Mai) 88; *M. Maertens*, L'Oeil 559:2004 (Juni) 10; Family jewels (K Gal. der Stadt, Villa Merkel), Esslingen 2009. – *Online*: Website C.
H. Stuchtey

Cornelissen, *Robbie*, niederl. Zeichner, * 1954 Utrecht, lebt und arbeitet dort. Stud.: 1973–80 Rijks-Univ. ebd. (Biologie, Ökologie). Danach bis 1987 als Biologielehrer tätig. Daneben Kurse 1982–84 Vrije Akad., Den Haag; 1984–87 Gerrit Rietveld Akad., Amsterdam. Lehrauftrag 2006–11 an der KHS ArtEZ in Zwolle. – C. beginnt E. der 1980er Jahre aufgrund einer vorübergehenden Arbeitsunfähigkeit mit meditativ-unbewußten

Bleistift-„Kritzeleien", deren schöpferisches Potential ihn fortan inspiriert, seinen inneren Welten, v.a. den vergessenen Erinnerungen als Quelle der Erkenntnis von sich selbst, in seiner Kunst nachzuspüren. Analog den Surrealisten, die über die Ecriture automatique versuchten, die Tiefen ihrer Persönlichkeit zu entdecken und zu erforschen, läßt C. seiner zeichnenden Seele freien Lauf bei der Aneinanderreihung von elementaren Zeichen, Reihungen, Schraffuren, Figurationen. Seither entwickelt er v.a. mit Bleistift und Kohle minutiös und kleinteilig ausgef. bizarre, anfänglich auch karikatureske Szenerien und (Tier-)Figurenbilder, die aus (Alp-)Träumen stammen könnten. So entsteht ab 1996 die Serie *Het Reservaat*, die mehr als 180 Zchngn versch. Formate umfaßt, u.a. die *12 Gedachten over een Reservaat voor een nog onbekende Diersoort*. Biomorphe Gestalten und Mischwesen (halb Mensch, halb Tier) bewegen sich u.a. im Dschungel, im Zirkus, in verödeten Fabrikhallen und Ausst.-Räumen, die gleichzeitig real wie surreal erscheinen. Gelegentlich beleben bizarre Kleinlebewesen mon. archit. Szenerien (*When the Circus comes to Town*, Aqu., Bleistift/Papier, 1998). Zunehmend entstehen archit.-zellulär aufgebaute komplexe Raumimaginationen, die C. mittels aneinandergereihter Lineaturen, Raster und Schraffuren auf kleinen und großen Formaten erschafft, häufig verstärkt er den Eindruck durch versch. Anwendungsformen von Zentral-, Linear-, Vogel- oder Froschperspektive. Teilw. sind die Archit.-Motive als (Sport-, Empfangs-, Hotel-)Hallen, Gänge, offene oder geschlossene Räume oder Abgründe (die Abgründe bilden) identifizierbar. C.s riesig und endlos erscheinenden menschenleeren Archit., die meist aus seriell gez. vielstöckigen Systemen und Versatzstücken gefügt sind, gleichen bisweilen undurchschaubaren Universen, allerdings ohne vordergründiges Bedrohungspotential, in denen man verloren gehen könnte. Ein char. Bsp. für seine Motive, die auf Reales im Grenzbereich zw. Drinnen und Draußen verweisen, bildet die Zchng *The Secret Nucleus (Pergamon, Berlin)*, 2012, bei der C. einen Ausst.-Raum des Berliner Pergamon-Mus. abbildet, in dem heute unter einem Glasdach die Mon.-Archit. ausgestellt ist, die in der Antike belebte urbane Grenzen markierte (Markttor von Milet, Säulenhalle aus Ephesos). Mit der komplexen inhaltlichen Verquickung von Vergangenheit und Gegenwart und seiner melancholischen Sicht auf die Undurchschaubarkeit und Absurdität der Welt rekurriert C. u.a. auch auf trad. Vanitasmotive, ohne allerdings auf diese direkt zu verweisen. So zeichnet er kaum einzelne ikonogr. tradierte entsprechende Motive, z.B. alte Bücher, wohl aber gigantische Bücherhochregale als labyrinthische Bibl.-Räume, die an Raumphantasien von Franz Kafka oder Louis Borges denken lassen. Anläßlich seiner Einzel-Ausst. 2011 in Den Haag und Utrecht entstehen über mehrere Monate mit Unterstützung von Ass. zwei mon. Hand-Zchngn von 13,20 Meter bzw. 20 Meter Länge (z.T. 4,40 Meter Höhe), die C.s originellen Beitrag zur niederl. Zeichenkunst der Gegenwart unterstreichen. Lt. Selbstäußerung soll der Betrachter durch diese mon. Kunstwerke angeregt werden, ein „Teil der Zchng zu werden und im Labyrinth herum-

zuwandern" (R. C., 2011), wodurch C.s Nähe zum trad. Medium der Panoramabilder des 19. Jh. evident wird. Daneben mehrere Animationskurzfilme nach seinen Zchngn: *The Boy*, 1998; *Het Grote Geheugen*, 2006 (mit Daniel Dugour u.a.); *The Labyrinth runner*, 2009 (mit D. Dugour u.a.). ⌂ UTRECHT, Centraal Mus. ◉ *E: (alle K)* Utrecht: 1990 Gal. Trajekt (Debüt); 2008, '11 (Retr.) Centraal Mus. / 2004 Kolderveen, Stichting Kik / 2005 Pietrasanta, Gall. Enrico Astuni; Oss, Mus. Jan Cunen (mit Karin van Dam und Roland Sohier) / 2011 Den Haag, Gemeente Mus. – *G: (alle K)* Utrecht, Centraal Mus.: ab 1992 Salon van Utrechtse kunstenaars; 2004 Zwart op Wit; 2008 Allemaal Engelen / 1994 Deurne, Mus. De Wieger: Het getekende Gelaat (Wander-Ausst.) / 2007 's-Hertogenbosch, Sted. Mus.: Comfort – Discomfort. De tekening als intiem verblijf / 2011 Lyon: Bienn. ⌑ *M. Baltser/G. Van Colmjon*, R. C. About silent heroes and idiots, Utrecht 1995; Contour. Continuïteit (K Delft), Delft/Zwolle 2007; *W. Teschmacher u.a.*, Roland Sohier, R. C., Harm Hajonides. Ontmoeting (K), Schiedam 2010; *L. Ter Braak u.a.*, R. C. Het groote geheugen (K Utrecht/Den Haag), Rotterdam 2011. – *Online:* Website C. U. Heise

Cornelius, *Michael*, dt. Maler, Graphiker, Objektkünstler, * 5. 3. 1950 Neumorschen, † 29. 8. 2002 Kassel. Ausb./Stud.: 1968–72 Staatliche Werk-KSch, Kassel (ab 1970 HBK), Graphik und Design, u.a. bei Karl Oskar Blase. Im Nov.-Dez. 1969 vermutlich in Cadaqués/Spanien als Ass. von Salvador Dalí tätig. 1972–78 ABK, Wien, u.a. bei Rudolf Hausner (Meisterschüler). Mehrfach Reisen nach Spanien. – Bis M. der 1990er Jahre v.a. Arbeiten im Stil des Wiener Phantastischen und Symbolischen Realismus, für deren Gest. sich C. intensiv mit ma. Symbolik und mystisch-christlichen Vorstellungswelten im Kontext von Leben-Tod-Auferstehung beschäftigt, u.a. mit Transfigurationen und Alchimie. Nach 1996 v.a. experimentelle Abeiten mit Licht. Auch Mat.-Bilder sowie Boden-Skulpt. aus Holz. – Monogr. Bearbeitung und WV stehen aus. ⌂ KASSEL, Mus. f. Sepulkralkultur. ◉ *G:* 1994 Erlangen, SM: Realismus heute. Malerei – Graphik – Skulpt. (K). ⌑ *P. Schmaling*, Künstler-Lex. Hessen-Kassel 1777–2000, Kassel 2001. U. Heise

Cornelius, *Violette*, niederl. Fotografin, * 17. 3. 1919 Batavia (heute Jakarta), † 23. 1. 1998 St. Maximin-la-Sainte-Baume/Var. Besuch der Oberschule in Genf; anschl. mit den Eltern Umzug in die Niederlande. Stud.: 1937 ABK, Den Haag (Malerei); 1938 Nieuwe Kunstschool, Amsterdam, bei Paul Guermonprez (Fotogr.). Mitarb. in der von Guermonprez und Hajo Rose 1934 gegr. Werbeagentur Co-op 2 ebd. Um 1940 entstehen in Zusammenarbeit mit dem Autor Maarten ("Mik") van Gilse erste Fotoreportagen. Während der dt. Besatzung ist C. an versch. Aktivitäten des Widerstands beteiligt, so an der Zs. De vrije kunstenaar, an der Persoonsbewijzen Centrale, die gefälschte Dok. für verfolgte Künstler herstellt und am Nederland Archief (auch Central Beeldarchief gen.; nachträglich als De Ondergedoken Camera bez.), einer Gruppe von Amsterdamer Fotografen, die das letzte Jahr der dt. Besatzung dokumentiert. 1945–49 verheiratet mit

dem Pianisten Jan Huckriede. In den Nachkriegsjahren fotografiert C. v.a. Kinderporträts. Um 1950 kommt C. über Jan Rietveld in Kontakt mit einem Kreis von Architekten rund um die Zs. Forum und avanciert zu einer der führenden Archit.-Fotografinnen des Landes; u.a. fotografiert sie den Sonsbeek-Pavillon von Gerrit Rietveld für die Internat. Skulpt.-Ausst. in Arnhem, 1955; cf. Küper/van Zijl, 1992) und das Amsterdamer Städtische Waisenhaus von Aldo van Eyck (1959; cf. Jaschke, 2006). 1952 lernt C. bei der Arbeit an einem Fotobuch über die Stadt Delft (*Delft*, Wormerveer 1954; Text A. Greidanus; Gest.: J. W. Schrofer); ihren zwischenzeitlichen Lebensgefährten, den Grafiker und Buchgestalter *Jurriaan Willem Schrofer* (* 15. 4. 1926, † 1. 7. 1990), kennen (1964 Trennung). 1956 fotografiert sie zus. mit Ata Kandó ungar. Flüchtlinge an der Grenze zu Österreich, veröff. in dem Fotobuch *Hongaarse vluchtelingen* (Am. 1956; Text: H. J. A. Hofland; Gest.: J. W. Schrofer). Von E. der 1950er bis M. der 1960er Jahre entstehen im Auftrag großer Firmen mehrere Fotobücher mit Aufnahmen von C., u.a. *100 jaar Grasso*, 's-Hertogenbosch [1958] (mit Carel Adriaan Blazer; Text: E. Eberle); 1958 fotografiert sie zus. mit Ed van der Elsken, Paul Huf, A. Kandó und Cas Oorthuys Arbeiter an Hochöfen für das einflußreiche Fotobuch Vuur aan zee (Gest.: J. W. Schrofer; Text: Paul Rodenko). 1964 begleitet C. die sog. Tellem-Expedition nach Westafrika (H. Haan, *Tellem. Verkenning van een oude Afrikaanse cultuur*, Rotterdam 1964 [mit Fotogr. von C.]); es folgen längere Aufenthalte mit Sean Wellesley in Indien, dem Irak, Iran, in Afrika und Peru, wo sie das Phänomen der Landflucht in Farb-Fotogr. dokumentiert. 1979 Umzug nach Paris; ab 1992 in Südfrankreich ansässig. – C. zählt zu den bedeutendsten niederl. Fotografinnen des 20. Jahrhunderts. Gemeinsam mit P. Huf, E. van der Elsken und C. Oorthuys prägt sie als Mitgl. der Fachgruppe Fotogr. im Verb. für Angew. Kunst (Gebonden Kunsten federatie) maßgeblich die niederl. Dokumentar-Fotogr. in der zweiten H. des 20. Jahrhunderts. Durch das Stud. bei P. Guermonprez und die Mitarb. in dessen Agentur Co-op 2 kommt sie früh in Berührung mit der Fotogr. des Bauhauses, deren Bildsprache sie, etwa in den Archit.-Fotogr. der 1950er Jahre, nachhaltig beeinflußt; weitere Impulse erhält C. vom engagierten Fotojournalismus der Nachkriegszeit. Bis in die 1960er Jahre fotografiert sie schwarzweiß, zuletzt auch in Farbe. – Fotobücher: J. G. Elburg, *Weesp*, s.l. 1957; Lucebert, *Dag nacht. Vijftig stadsfoto's van 's-ochtends tot 's-avonds met gedichten*, Hilversum 1959; J. G. Elburg, *De verbinding*, Hilversum 1963. ⌂ LEIDEN, Prenten-Kab. der Univ. ROTTERDAM, Nederlands Archit.-Inst. – Nederlands Foto-Mus. (Arch. C.). UTRECHT, Centraal Mus. ◉ *E:* 2006 Budapest, Hungarian House of Photogr., Mai Manó House (mit A. Kandó; Wander-Ausst.). – *G:* Amsterdam: 1945 Atelier Marius Meijboom: Ondergedoken Camera; 1978 Fotogr. in Nederland 1940–75 (K); 1980 Pal. op de Dam: Ondergedoken Camera; 1991 Nieuwe Kerk: Het beslissende beeld. Hoogtepunten uit de Nederl. fotogr. van de 20e eeuw (K) / 1957 Eindhoven, Van Abbe-Mus.: Fotogr. als Uitdrukkingsmiddel / 1958 Leiden, Rijks-Univ.:

Gebonden Kunstenfederatie / 1999 Montreal, Maison de la culture Côtes-des-Neiges: L'hist. et les jours. La photogr. documentaire des femmes Néerlandaises 1904–1953 (im Rahmen des Mois de la Photo; K) / 2002 Rotterdam, BvB: Fotodocs. Photogr. between Commission and Autonomy / 2003 Groningen: Noorderlicht Photofestival / 2003–04 Leiden, Sted. Mus. de Lakenhal: Foto's van vijftig (Begleit-Publ.) / 2011–12 Den Haag, Foto-Mus.: Gare du Nord. Nederl. fotografen in Parijs 1900–1968 (K). ▢ *Jacobs*, Benelux III, 2000; *W. van Sinderen* (Ed.), Fotografen in Nederland, Am. u.a. 2002. – *M. Boom*, Foto in omslag. Het nederl. documentaire fotoboek na 1945, Am. 1989; *R. van Venetië/A. Zondervan*, Geschiedenis van de nederl. archit.-fotogr., Rotterdam 1989; *M. Küper/I. van Zijl*, Gerrit Th. Rietveld. The complete works. 1888–1964 (K Wander-Ausst.), Utrecht 1992; *V. Hekking/F. Bool*, De illegale camera 1940–1945. Nederl. fotogr. tijdens de Duitse bezetting, Naarden 1995; *L. van Harrevelt*, Nieuwsbrief Nederl. Fotogenootschap 28:2000, 4–18; *M. Thijsen*, Het bedrijfsfotoboek 1945–1965. Professionalisering van fotografen in Nederland (K BvB), Diss. Utrecht 2000, Rotterdam 2002; *K. Jaschke*, Archit. as artifice, in: *J. Madge/A. Peckham* (Ed.), Narrating architecture. A retrospective anthology, Lo. u.a. 2006; *F. Bool u.a.* (Ed.), Dutch eyes. A crit. hist. of photogr. in the Netherlands, Ostfildern 2007; *F. Gierstberg u.a.* (Ed.), The Dutch photobook. A thematic selection from 1945 onwards (K Nederl. Foto-Mus.), Rotterdam 2012. – *Online:* RKD (Lit.). P. Freytag

Cornell, *David*, brit. Bildhauer, Medailleur, Maler, * 18. 9. 1935 London, lebt in Tunbridge Wells/Kent. Stud.: 1952–62 Central School of Arts and Crafts, London, bei Roger Hilton und Philip Turner, sowie Harrow SchA, Harrow on the Hill/Middx.; 1968–70 Univ. of Pennsylvania, AFA, Philadelphia (Anatomie). 1965–69 Coin and Medal Engraver/Sculptor in England (nach Sieg in einer nat. Ausschreibung der R. Mint). Ab ca. 1970 Dir. of Sculpt. bei John Pinches Ltd., Medallist and Trophy Makers, die mit der Franklin Mint und später mit Warner Communications assoziieren. Mitgl.: 1971 R. Soc. of Brit. Sculptors (Ausst.); Soc. of Portr. Sculptors (1977 Vize-Präs.). – Malerei (Öl) und Bildhauerei (v.a. Bronzestatuen und -büsten) mit lebensnahen Portr. (u.a. offizielle Portr. der brit. Königs-Fam.), figürlichen Motiven (Tänzer, weibliche Akte, Reiter), Tier-Darst. (bes. Pferde, Einhörner) sowie abstrakt-organoiden Gebilden (*Abstract Mysticism*, für den Bronzeguß vorgesehene Plastik). C.s bildhauerische Werke zeichnen sich lt. Windsor (2003) durch weiche, fließende Formen aus. Außerdem Entwürfe für Med. (zahlr. für Japan) und Münzen (1997 Sieg im Wettb. der R. Mint um die Fünf-Pfund-Gedenkmünze für Prinzessin Diana) sowie Kameen (mit Portr. der Mitgl. der niederl. Königs-Fam.). ⌂ CROWBOROUGH, Crowborough Town Council: Sir Arthur Conan Doyle, Bronzestatue, 2001. LONDON, Wellcome Found.: Einhorn, Bronze, 1985. ▢ *Windsor*, Sculptors, 2003; *Buckman* I, 2006. – *Online:* Website C., 2011 (Werke, Ausst.). C. Rohrschneider

Cornet, *Heleen*, niederl. Malerin, Graphikerin, Installationskünstlerin, Freskantin, Illustratorin, * 1945 Niederlande, lebt auf Saba/Antillen. Nach einem pädagogischen Kunst-Stud. in den Niederlanden (Gorinchem, Amersfoort) und längerem Aufenthalt in Norwegen ist C. seit 1974 auf Inseln der ehem. Niederl. Antillen beheimatet (1974–84 Bonaire, 1984–85 Curaçao, 1985–86 Sint Maarten). Seit 1986 lebt und arbeitet sie mit ihrem Mann (Meeresbiologe) auf der abgeschiedenen Berginsel Saba, wo sie auch eine Öko-Lodge betreibt. Atelier auf dem Mount Scenery. – V.a. farbintensive Gem. und Aqu. mit gegenstandsbezogenen, häufig realistisch, auch naturwiss.-illustrativ wiedergegebenen einheimischen Motiven (tropische und submarine Flora und Fauna, Inselblicke, Archit.-Ansichten); z.T. Anklänge an Surrealismus und Magischen Realismus. Bild-Klang-Installationen auf den Bienn. in Santo Domingo de Guzmán (1992, '94, '96) zu den Themen Regenwald und Unterwasserwelten. Relig. Sujets unter Verwendung des kath.-devotionalen Formenschatzes. Daneben auch Buch-Ill. (meist Aqu.). ⌂ LEVEROCK (The Bottom)/Saba, Herz-Jesu-Kirche: Wandfresken. ◉ *G:* 1996 São Paulo: Bien. / 2005 Rio de Janeiro: Arte Américos / 2010 Santo Domingo, MMK: Trien. Internac. del Caribe (Förderpreis). ▢ *Delarge*, 2001. – *A. Martis/J. Smit*, Arte. Dutch Caribbean art, Am. 2002. – *Online:* Website C. (Ausst.).
 U. Heise

Cornish, *Norman (Norman Stansfield)*, brit. Maler, Zeichner, * 18. 11. 1919 Spennymoor/Durham, lebt dort. Als Künstler Autodidakt bis 1966 als Bergmann tätig. Mit 15 Jahren Mitgl. des Spennymoor Sketching Club (Teil des Bildungs- und Kult.-Projektes Spennymoor Settlement, bek. als Pitman's Acad.). Seit 1966 ausschließlich künstlerisch tätig; Freundschaft mit L. S. Lowry 1966 Lehrtätigkeit am Sunderland College of Art (heute Univ. of Sunderland). Ausz.: 1974 Honory Master of Arts, Newcastle Univ.; 1995 Ehrendoktor der Univ. of Northumbria, Newcastle; 2003 Member of the Order of the Brit. Empire; 2012 Ehrendoktor der Univ. of Sunderland. – Öl-Gem. und Zchngn (u.a. Pastell, Aqu., Kohle und Tusche), meist in gedeckten Farben; hauptsächlich Szenen aus dem Alltag der Einwohner von C.s Heimatstadt, häufig Pubszenen, und Darst. aus dem Leben der Bergarbeiter, Portr. von Familienangehörigen und Dorfbewohnern sowie Straßenansichten von und Lsch. um Spennymoor, z.B. *Pit Road with Telegraph Poles and Lights* (Öl/Lw.) und *Smoker Leaning on Bar* (Pastell/Papier). Mehrere Arbeiten im öff. Raum, u.a. 1962 ein Wand-Gem. für die Town Hall des Durham County Council (eröffnet 1963). Außerdem Ill. in: *S. Chaplin*, Leaping lad and other stories, Harrow, Essex 1981. ⌂ DARLINGTON, Darlington Borough City Coll. DURHAM, Durham County Council Coll. GATESHEAD, Shipley AG. HARTLEPOOL, Mus. of Hartlepool. NEWCASTLE-UPON-TYNE, Laing AG. – Newcastle Univ. – Northumbria Univ., Univ. Gall. SUNDERLAND, Mus. and Winter Gardens. ✉ A slice of life, Wallingford 1989. ◉ *E:* Newcastle-upon-Tyne: 1946 People's Theatre; 1959 Stone Gall.; seit 1989 regelmäßig Northumbria Univ., Univ. Gall. (teils auch Wander-Ausst.); 2003 Red Box Gall. / 1994 Hexham, Queen' Hall AC (Wander-Ausst., Falt-Bl.) /

1996 Spennymoor, Town Hall / 2000 South Shields, Customs House Gall. / 2004 Sunderland, Mus. / 2010 Newton Aycliffe, Greenfield Gall. / 2010 (K), '12 (K) London, Kings Place Gall. – *G:* 1950 Carlisle, Tullie House Mus. and AG: The Northern Realists; London, AIA Gallery: The Coal Miners / 1951 Gateshead, Shipley AG: Contemp. Artists of Durham County (K). 🕮 *Buckman* I, 2006. – *R. McManners/G. Wales*, The quintessential Cornish, Wadebridge, Durham 2009. – *Online:* Website C.

J. Niegel

Cornu, *Frédéric,* frz. Fotograf, * 8. 2. 1959 Boulogne-sur-Mer, lebt in Rosult/Nord-Pas-de-Calais. Ausz.: 1987 Prix Tamron; 1991 Bourse Essai, Centre Régional de la Photogr. Nord-Pas-de-Calais, Douchy-les-Mines; Bourse Fiacre, Min. de la Cult.; Bourse Creation, Région Nord-Pas-de-Calais. – C. arbeitet v.a. mit streng typologisch-thematischen Portr.-Serien, oft in Verbindung mit ebenso serieller Archit.-Fotogr. Nach ersten Erfahrungen mit Reportage-Fotogr. (*Les Charitables,* 1989–91; Publ. [Kat.] Calais u.a. 1991) entwickelt er seinen systematischen Ansatz: Bei *Cours* (1991–94) zeigt er in der Trad. der soz.-dokumentarischen Fotogr. die Armen von Roubaix in Frontalansicht; Alain Réveillon vergleicht C.s Methode mit Lewis W. Hine, August Sander und Walker Evans, seine Konsequenz auch mit Bernd und Hilla Becher (in: *Cours,* [Kat.] Roubaix 1996). 1995–96 porträtiert C. die Einwohner der Eisenbahnersiedlung *Délivrance* von Lomme (Publ. [Kat.] Lomme 1996) vor neutralem Hintergrund und stellt ihnen eine Serie formstrenger Häuseransichten zur Seite. Für *Balnéaires* (seit 1992; Publ. [Kat.] Quimper u.a. 1993) fotografiert er, vergleichbar der Arbeit von Rineke Dijkstra, egalitär Ganzkörper-Portr. von Badenden am Strand. C. arbeitet auch mit friesartigen Installationen von Portr., etwa bei Sporttreibenden (*Sportifs,* 2002–03) im Auftrag der Stadt Valenciennes, oder er stellt frontale Aufnahmen von Supermärkten und ihren Zeichen abfotografierten Bildschirmen und Portr. der Einkaufenden in Triptychonform gegenüber (*Discount écran boîte,* 2006). Für das Projekt *Chroniques Partagées* (2008–09; Publ. [Kat.] Nancy u.a. 2009) der Assoc. Surface Sensible fotografiert er auf den Spuren des frz. Kolonialismus in Afrika Reisende in Nahsicht im Zug Dakar-Bamako und als Ganzfiguren-Portr. auf Bahnhöfen. 🕮 BETHUNE, Mus. d'Ethnologie. CHALON-SUR-SAONE, Mus. de la Photogr. Nicéphore Niépce. CHARLEROI, Mus. de la Photogr. DOUCHY-LES-MINES, Centre Régional de la Photogr. Nord-Pas de Calais. DUNKERQUE, Maison de la Cult. LAUSANNE, Mus. de l'Elysée. LILLE, Conseil Gén. du Nord. LOMME, Ville de Lomme. PARIS, FNAC. QUIMPER, Mai-Photographies. ROUBAIX, Centre Nat. des Arch. du Monde du Travail. SALLAUMINES, Maison de l'Art et de la Communication. TOULOUSE, Forum de l'Image. ⊙ *E:* 1989 Dunkerque, Maison de la Cult. (Wander-Ausst.) / 1991 Calais, Gal. de la MPT (Wander-Ausst.; K) / 1992 Toulouse, Forum de l'Image (Wander-Ausst.) / 1993 Quimper, Mai-Photographies (K) / 1995 Nancy, Gal. R. Doisneau (Wander-Ausst.; K) / 1996 Lomme, Hôtel de Ville (K) / Roubaix: 1996 Centre Nat. des Archives du Monde du Travail (K); 2008 La Plus Petite Gal. (K) / 1998 Béthune, Espace Saint-Pry / 2007 Rennes, Gal. Le Carré / 2009 Nancy, Gal. Lillebonne (Wander-Ausst.; K). – *G:* 1995 Lausanne, Mus. de l'Elysée: Comme dans un miroir (Wander-Ausst.; K) / Châlon-sur-Saône, Mus. de la Photogr. Nicéphore Niépce: 1997 Mais pour vivre il faut; 2003 Le pire est à venir; 2004 La nuit de l'image / 2000 Paris, MN de la Marine: Désirs de rivages (K) / 2007 Beijing, Capital Mus.: Hist. of photogr. 🕮 *B. Bosch,* Artistes en Nord-Pas-de-Calais, Lille 1991; *P. Bazin,* Images 1993 (3); *D. Cussenot,* Rev. de litt. et arts 1996; *G. Vercheval,* Mus. de la photogr. Charleroi, Br. 1997. – *Online:* Website C. T. Koenig

Coronado, *Héctor M.,* mex.-US-amer. Industriedesigner, * 1938 Mexiko, lebt in Los Angeles. Verh. mit Olga C. Zweijährige Ausb. bei Florence Knoll. Zusammenarbeit mit Olga C. und längere Studienreisen durch Spanien, Mexiko und die USA. Seit 1987 Mitgl. der Industrial Design Soc. of America. C.s Entwürfe sind Teil der H. C. Accessory Coll. und werden von der CMF Group in Los Angeles hergestellt, deren Eigentümerin Olga C. ist. Er führt viele Aufträge von US-Firmen aus, u.a. 2002 Entwürfe für Stühle, Tabletts, Schalen, Mag.-Ablagen, Papierkörbe und Kindermöbel für Benetec in Los Angeles sowie Spice und BX-Serien von Bürostühlen in Plastik und Metall für Scope Seating Technologies in Elkhart/Indiana. Zahlr. Ausz., u.a. 1. Preise: 1970 Inst. Mex. del Seguro Social; 1974 Polycron de México, beide Mexiko-Stadt; 1978 Premio Michelangelo, Fiera di Milano. – C. ist auf die Gest. von laminiertem gebogenem Holz spezialisiert, für das er seit 1982 zahlr. Patente erwirbt. Seine Arbeiten sind einfach, elegant und praktisch gestaltet, in wenigen Farben und teilw. stapelbar. 🕮 NEW YORK, Cooper-Hewitt Nat. Design Mus. – MMA. 🕮 *M. Byars,* The design enc., Lo./N. Y. 2004. M. Nungesser

Corpet, *Vincent,* frz. Maler, Zeichner, * 20. 3. 1954 Paris, lebt dort. Stud. 1979–81 EcBA ebd. – C. malt figurative, ausdrucksstarke, z.T. mythische Bilder, die bis 1988 v.a. ikonogr. Elemente (*Pietà au cardinal*) beinhalten und seither Portr., frontale ganzfigurige weibliche Akt-Darst. sowie v.a. Serien freier figürlicher Komp. umfassen. 1989–94 entsteht eine Serie Rundbilder mit ineinander verschlungenen und inspirativ weiterentwickelten Körperteilen, Tieren, Gemüsen oder archit. und natürlichen Formen, Alltagsgegenständen, die auch in zahlr. späteren Serien die Basis seines Gem.-Aufbaus sind. Erotische Anspielungen und z.T. realistische Darst. wie in den 602 Zchngn zum Buch Die 120 Tage von Sodom (Marquis de Sade) zeugen von einer genauen anatomischen Erfassung des menschlichen Körpers. C. überträgt mentale Visionen, indem er spielerisch und reichhaltig mit Analogien, mit freier, je nach Stimmung gewählter Farbgebung und ohne formale oder logische Regeln arbeitet. In Serien wie *Enfantillages* (1997–98), *Matrices* (2000–02), *Totems* (2006–11), *Analfabets* (2003–08) zeigen sich ein großes malerisches Gespür und eine auf Picasso, Francis Bacon und im Symbolismus auf Hieronymus Bosch verweisende Darstellungsart. 🕮 DUNKERQUE, MBA. MONTBÉLIARD, MAH. NIZZA, MAMC. PARIS, FNAC. –

FRAC Franche-Comté. – FRAC Ile-de France. – FRAC Rhône-Alpes. – MNAM. ◉ *E:* 1982 Montpellier, Gal. Mesdames-Messieurs / Saint-Etienne: 1984 Gal. R. C. des Fossés; 2002 MAM (K) / Brüssel: 1992 L'Autre Mus.; 2011 Mazel Gal. / Paris: 1995, '96, '98 Gal. Daniel Templon / 1998, 2001, '02, '05, '10 Genf, Gal. Charlotte Moser / 2000, '10 Nizza, MAMC (K) / 2001 Athen, Frissiras Mus. / 2002 Meymac, Abbaye St André, Centre d'art contemp. (K) / 2005 Cajarc, Maison des Arts Georges Pompidou / 2007, '12 Perpignan, Acentmètresducentredumonde / 2007, '08 Rouen, G. Jerome Ladiray / 2008 Périgueux, Centre François Mitterand / 2009 Arcueil, Centre Julio Gonzales / 2010 Epinal, La Lune en Parachutte / 2011 London, Ladiray Gall.; Romainville, Les Salaisons. ⌑ *Bénézit* III, 1999; *Delarge,* 2001. – *A. Hill,* Artscribe 1983 (44) 27–32; C., Marc Desgrandchamps, Pierre Moignard (K MNAM), P. 1987; Bewegungen. Fünf Künstler aus Frankreich (K BASF Feierabendhaus), Ludwigshafen 1991; Les pictographes (K Mus. de l'Abbaye Sainte Croix), Les Sables-d'Olonne 1992; 602 dessins d'après les 602 passions racontées par les 4 historiennes des 120 journées de Sodome de D. A. F. de Sade, Perreux sur Marne 1994; *L. Pythoud,* Cimaise 41:1994 (Sept./Okt.) 76 s.; *J. Clair,* Art press 194:1994 (Sept.) 51–53; *E. Suchère,* BA mag. 127:1994 (Okt.) 110 s.; *B. Foucart,* Connaissance des arts 532:1996 (Okt.) 94–99; 4ᵉ bienn. d'art contemp. de Lyon (K), P. 1997; *L. Attias,* Art news 97:1998 (11) 159 s; *L. Hurwitz-Attias,* ibid. 101:2002 (9) 166; *E. De Chassey/ F. Minadinada,* L'Œil 533:2002 (Febr.) 68 s.; *R. Leydier,* Art press 276:2002 (Jan.) 26–31; *L. Laguzet,* La composition dans les peint. relig. de V. C., Magisterarbeit Sorbonne, P. 2003; *C. Millet,* Art press 341:2008 (Jan.) 79. – *Online:* Website C. H. Stuchtey

Corrêa, *Walmor* (eigtl. Corrêa, *Walmor Bittencourt*), brasil. Maler, Zeichner, Installationskünstler, * 1961 Florianópolis, lebt in Porto Alegre. Stud.: 1980–83 Archit. und Städtebau, 1985 Kommunikationsdesign an der Univ. do Vale do Rio dos Sinos ebd., sowie Zeichnen und Malerei am Atelier Livre der Prefeitura Mpal. 1989 Studienreise durch Europa. 1999 Reisen durch das Amazonasgebiet, um die dortige Flora und Fauna zu studieren. Ausz.: 2008 Prêmio Açorianos, Porto Alegre. – Die Reflektion natur-wiss. Themen mit künstlerischen Mitteln steht im Mittelpunkt von C.s Werk. Seine feinen, zieliert wirkenden Malereien und Zchngn, letztere überwiegend in Bunt- und Bleistift, gleichen dabei dok. Bestandsaufnahmen. Seine Motive stammen überwiegend aus der Natur und zeigen häufig seltene Tiere und Pflanzen, die anatomisch genau festgehalten werden, wobei versch. Perspektiven ein und desselben Motivs auf einem Bl. dargestellt sind, z.B. in der Serie *Naturalizando* (Zchngn, 2009). Doch auch phantastische Mischwesen zw. Mensch und Tier, die C. der Sagenwelt des Amazonas entlehnt, bevölkern seine Bilder, so etwa in der Serie *Unheimlich* (2006). Häufig präsentiert C. seine Bilder als Teil raumbezogener Installationen, die ab 2010 verstärkt in eigenständige Arbeiten münden (*Você que Faz Versos,* 2010). ◉ *E:* Porto Alegre: 1993 Gal. Arte & Fato; 2003 Mus. de Arte; 2007, '10 Goethe-Inst. / 1997 Brüs-

sel, Espaço Cult. Banco do Brasil; Aalst, Gal. Cacco Zanchi / 2004 São Paulo, Centro Univ. Mariantônia / 2008, '10 Rio de Janeiro, Laura Marsiaj Arte Contemp. / 2009 Florianópolis, Fund. Cult. Badesc / 2010 Brasília, Gal. Picolla / 2011 Pelotas, Gal. do Centro de Artes. –. *G:* 1988 Pelotas, Salão de Pelotas (Prêmio Leopoldo Gotuzzo) / Porto Alegre: 1993 Mus. da Reitoria da Univ. Federal do Rio Grande do Sul: Cinema e Pintura; 2002 Santander Cult.: Apropriações-Coleções; 2007 Gal. Zouk: A Margem do Real; 2009 Bien. do Mercosul; 2011 Mus. de Arte: Do Atelier ao cubo Branco / Berlin: 1998 Fabrik Schlegelstraße: Panorama zeitgen. brasil. Kunst II; 2008 Martin-Gropius-Bau: Die Tropen / São Paulo: 2005 MAM: Panorama de Arte Brasil.; 2008 Fund. Bien. de São Paulo: Arte pela Amazônia Arte e Altitude / 2005 Wien, ABK: Expedition of Thomas Ender Reconsidered / 2006 Belém, Mus. de Arte Sacra: Entorno de Operações Mentais; Lewiston (Me.), Bates College Mus. of Art: Cryptozoology / 2007 Rio de Janeiro, Centro Cult. Banco do Brasil: Os Trópicos. Visões a partir do centro do globo / 2011 Valencia, Inst. Valenciano de Arte Mod.: Gigante por la Propria Naturaleza. ⌑ *R. Rosa/D. Presser,* Dic. de artes plást. no Rio Grande do Sul, Porto Alegre ²2000 (* 1960). – *A. Hug* (Ed.), 26ª Bien. de São Paulo. Artistas convidados (K), S. P. 2004. – *Online:* Inst. Itaú Cult., Enc. artes visuais, 2011.

<div align="right">M. F. Morais</div>

Corregan, *Daphne (Daphné),* US-amer. Keramikerin, Bildhauerin, Malerin, Zeichnerin, * 27. 12. 1954 Pittsburgh/Pa., tätig in Draguignan/Var und Monaco. Lebt seit 1971 in Frankreich. Verh. mit dem Keramiker und Bildhauer Gilles Suffren. Stud.: 1972 Ec. supérieure d'Art, Toulon; 1973 Ec. supérieure des BA, Marseilles; 1974–77 Ec. supérieure d'Art, Aix-en-Provence (1977 bei Jean Biagini). 1978 Studienreise durch die USA (u.a. Kurse bei Paul Soldner). 1978/79 Atelier mit G. Suffren in Lourmarin/Vaucluse. Lehrtätigkeit: seit 1989 Ec. supérieure d'Arts plast., Monaco. 2005 Artist in Residence, Fuping. Ausz.: 1987 Ehren-Med., Concorso internaz. della Ceramica d'Arte contemp., Faenza; 1989 Bienn. internat. de Céramique d'Art, Chatearoux; Méd. du Mérite Cult. de la Principauté de Monaco. Mitgl. der Acad. Internat. de Céramique. – Aus Tonplatten aufgebaute oder in Wulsttechnik gestaltete Keramiken (bevorzugt Raku). Mit Messern und Nägeln ritzt C. Motive in den noch weichen Ton, die nach dem Brand und dem Räuchern als schwarze Zchngn hervortreten. Sie verziert die Arbeiten durch Bemalung mit Farbkörpern, die Schlicker und hitzebeständigen Glasuren beigemengt werden und die freskoartige Oberflächen erzielen. Neben den gemalten oder geritzten, zeichenhaften und floralen Mustern setzt sie Lochdekore ein. Große Flächen bleiben unbedeckt und erscheinen nach dem Räuchern in silbrig-glänzender bis tiefschwarzer Färbung (z.B. *Two bellies,* Steinzeug, 2008), welche die farbigen und gemusterten Teile wirkungsvoll kontrastieren. Von der Gebrauchskeramik ausgehend fertigt C. zunächst verfremdete Gefäße, bei denen häufig bestimmte funktionale Details stark betont werden (z.B. die Tülle einer Kanne), weiterhin Plastiken (auch in Kombination mit and. Mat. wie

Glas und Bronze), die teils geometrisch-abstrakte, teils anthropomorphe Formen aufweisen (z.B. *Casques noires*, Steinzeug, 2011). ▭ CAEN, FRAC Basse-Normandie. DEIDESHEIM, Mus. für mod. Keramik. DUNKERQUE, Lieu d'Art et d'Action Contemp. LACAPELLE-BIRON, Mus. Palissy. MONTPELLIER, FRAC Languedoc-Roussillon. PARIS, Centre Pompidou. – FNAC. – MAD. ROUBAIX, Mus. d'Art et d'Industrie. SOISSONS, Mus. mun. STUTTGART, LM Württ. ◉ *E:* 1981 Biarritz, Gal. Le Rond dans l'Eau / 1995 Dunkerque, MAC (K) / 1996 Mulhouse, Maison de la Céramique / 1997 Marseille, Gal. Hyaline / 2002 Bochum, Gal. m Bochum / 1999, 2002, '04, '07 Carouge, Gal. Marianne Brand / 2004 Hüfingen, SM (mit G. Suffren) / 2005 Hastingues, Abbaye d'Arthous / 2006, '11 Solothurn, Kunstforum / 2007–08 Nizza, Gal. Sandrine Mons (mit G. Suffren) / 2009 Beauvais, Espace cult. François Mitterrand. – *G:* Paris: 1981–82 MAD: Céramique franç. contemp. (K); 2008 Ateliers d'Art de France: Retour de Fuping (K) / 1988 Darmstadt, Hessisches LM: Ton in Ton / 1992 Hannover, Gal. Böwig: Die Dose / 1994 Louvain-la-Neuve, Mus.: Poterie Nègre / 1997 Roanne, Mus. J. Déchelette: Regard sur la Céramique contemp. / 2002 Carcès, Maison des Arts: Couleurs de Terres / 2006 Brest, MBA: Terres de Feu / 2011 Cabrières d'Avignon, Gal. 22: Céramique. ▭ *J. Wolgensinger*, Neue Keramik 1990 (6) 374; ibid. 1995 (12) 796–799; *F. Bodet*, ibid. 2001 (12) 711–715; *H. Dähler*, ibid. 2011 (3) 50 s.; *T. Andrews*, Raku. Gesch., Techniken und zeitgen. Schaffen, Bern u.a. 1997; Ceramics monthly 51:2003 (1) 43–47; *E. Cooper*, Contemp. ceramics, Lo. 2009. – *Online:* Céramiques contemp. franç., 1955–2005. Coll. du MN de Céramique, Sèvres, 2008. F. Krohn

Correia, *Algerine* cf. **Correia**, *Steven V.*

Corréia, *Charles*, portug. Bildhauer, * 22. 3. 1930 Setúbal, † 3. 2. 1988 (Autounfall) Moita b. Lissabon. Stud.: ab 1950 ENSBA, Paris, bei Marcel Gimond. Läßt sich in Nantes nieder. Ausz.: 1973 Prix Wlérick-Despiau; Chevalier des Arts et Lettres. Zahlr. Werkankäufe und Ausf. von Auftragsarbeiten, zumeist von Bronzestandbildern für Denkmäler im öff. Raum. Bek. sind auch einige Statuetten. – Homogenes, trad.-gegenständliches Œuvre (v.a. Bronzeplastik), das dem naturalistischen frz. Bildhauerschule verbunden ist und von mod. Stilentwicklungen weitgehend unberührt bleibt. Bei seinen ausgewogen und maßvoll gestalteten, authentisch wirkenden Arbeiten orientiert sich C. v.a. an Gimond, zudem assimiliert er Anregungen weiterer bed. frz. Vorbilder ganz unterschiedlicher Schaffenszeiten, von Antoine Coysevox und Nicolas Coustou bis zu Auguste Rodin und Antoine Bourdelle. ▭ MONT-DE-MARSAN, Mus. Despiau-Wlérick: Cheval à l'amble; Femme nue, Statuetten, Bronze. – *Werke im öff. Raum:* ASNIERES-SUR-SEINE, Rue de la Station: Charles de Gaulle et André Malraux, Denkmal, Bronze, 1982. BEAUVAIS, Esplanade de Verdun: 4 Statuen von Marschällen, Bronze, 1982, '84. EPINAY-SUR-SEINE, Collège d'Enseignement secondaire: Denkmal für Maximilien de Robespierre, 1978. – Pl. de l'Hôtel de Ville, Brunnen: La Génèse, Frauenakt; Les Forces vives, 2 Pferde,

alles Bronze, 1983. LAFAYETTE/La., Univ. Ave. 1: Denkmal für Marquis de La Fayette, 1987. NANTES, Rue Scribe: La Danse, Gruppe, Bronze, 1981. PARIS, Kirche Notre-Dame-du-Travail: Christus, Statue, Eisen, 1982. – Jardin du Ranelagh: Hommage à Jean de La Fontaine, Denkmal, Bronze, 1983. SETÚBAL, Av. Luísa Todi/Praça do Bocage: Ninfa do Bocage, Bronze, 1988. ◉ *E:* Paris: 1965 Centre cult. de Belleville; 1987 Gal. Alain Daune. – *G:* Paris: ab 1965 Salon d'Automne; SAfr.; Salon de la Soc. nat. des BA; Grands et Jeunes d'aujourd'hui; Salon de la jeune Sculpt.; Salon Comparaisons. ▭ Dict. des mon. de Paris, P. 1992; *Bénézit* III, 1999. – *P. Kjellberg*, Le nouv. guide des statues de Paris, P. 1988. R. Treydel

Correia, *Gaspar*, portug. Chronist, Zeichner, * 1496 (1492/1495?), † 1565? (Angaben zw. 1550-ca. 1565) Malakka. 1506 kgl. Kammerdiener, schifft sich 1512 nach Indien (Goa) ein. Ebd. Sekretär des Vizekönigs Afonso de Albuquerque. Nach dessen Tod 1515 bekleidet C. diverse Ämter im Staatsdienst in Goa, Ribeira de Cochim und Malakka. Bed. als Autor, u.a. der *Lendas da India* (um 1550–63), die erst im 19. Jh. veröffentlicht werden (6 Bde, Li. 1856–66). C. vermittelt darin kulturhistorisch und soziographisch wichtige Informationen über die Präsenz der Portugiesen im Malaiischen Archipel und in Indien. Zw. 1532 und 1533 stellt er u.a. auch eine Slg *Chrónicas dos Reys de Portugal e Sumários das Suas Vidas* zusammen. Darüber hinaus ist C. ein begabter Zeichner. Er fügt den *Lendas da India* qualitätvolle topogr. Zchngn (u.a. aus Malakka, Kalkutta, Coulão, Hormos, Judá, Ceylon, Cananor, Chalé, Diu und Baçaim) sowie zwölf Porträts hinzu (1866 gingen fünf Zchngn von Cochim, Sokotra und Sao Tomé de Meliapor sowie fünf Portr. verloren; Lissabon, BN). Bemerkenswert ist die lavierte Feder-Zchng von Diu; sie stammt aus der Zeit der zweiten Belagerung und zeigt auf präzise Weise die unter Ltg von Francisco Pires wiederaufgebauten Stadtmauern nach dem Modell der Befestigung von Ceuta. Diese Zchng wurde wahrsch. von João de Castro aufgrund einer Bitte João II von 1546 in Auftrag gegeben. De Castro bestellte 1547 bei C. sein Porträt, das dieser zus. mit einem einheimischen Maler ausführt. ▭ LISSABON, Arquivo Nac. da Torre do Tombo. ▭ GEPB VII, 1940; *L. de Albuquerque* (Ed.), Dic. de hist. dos descobrimentos portug., I, Li. 1994; *Á. M. Machado* (Ed.), Dic. de lit. portug., Li. 1996. – *P. Dias*, Hist. da arte portug. no mundo (1415–1822) II, Li. 1999.
R. Petriconi

Correia, *Jeffrey* cf. **Correia**, *Steven V.*

Correia, *Steven V.*, US-amer. Glaskünstler, Lichtkinetiker, Performancekünstler, * 14. 2. 1949 San Diego/Calif., lebt in Santa Monica/Calif. Stud.: 1969–72 San Diego State Univ.; 1972, '79 Univ. of Hawaii, Honolulu; 1977 Univ. of California, Los Angeles. C. gründet 1973 die eig. Fa. Correia Art Glass mit Sitz in Santa Monica, 1987 dann Correia Crystal. Lehrtätigkeit: u.a. 1975, '83 Long Beach State Univ., Calif.; 1977–78 Univ. of Hawaii, Honolulu; 1984 Univ. of California, Los Angeles. C.s soziales Engagement kommt in der Unterstützung der Steven V. Correia Junior High School Found. zum Ausdruck (für diese

Schule in San Diego hat er auch das Logo [1983], Brief-köpfe etc. entworfen). Ausz.: 1971 Hawaii State Found. of the Arts Purchase. – Frei geblasene, elegante Gebrauchs- und Ziergefäße (Parfümflakons, Vasen, Schalen, Briefbe-schwerer etc.) sowie Lampen, die ihre Wirkungen durch das Zusammenspiel von Farbe, Form und Licht entfalten und ästhetischen als auch funktionellen Ansprüchen ge-recht werden. Die ornamentalen oder auch figurativen De-kore werden in die Glasoberfläche geätzt und nie gemalt. Jedes dieser Stücke ebenso wie C.s Skulpt. aus Kristallglas werden als authentische Kunstwerke sign., dat. und regis-triert. Daneben kreiert C. mon. kinetische Laser-Skulpt. (*Eastern Lights*; *Southern Lights*, 1986 installiert an ei-nem elfstöckigen Gebäude in La Jolla/Calif.). Auch Per-formances unter Einbeziehung von Kristall, Tanz, Musik und Licht. – Die Fa. wird derzeit von C.s Nachkommen, der Tochter *Algerine C.* und dem Sohn *Jeffrey C.*, fortge-führt. ▯ CORNING/N. Y., Corning Mus. of Glass. HO-NOLULU, Hawaii State Found. of Cult. and Arts. – Acad. of Arts. INDIANAPOLIS/Ind., Mus. of Arts. LOS ANGE-LES, Craft and Folk AM. NEW YORK, Metrop. Mus. NOR-FOLK/Va., Chrysler Mus. of Art. PALM BEACH/Fla., Lannan Found. Mus. TEMPE, Arizona State Univ. AM. WASHING-TON/D. C., SI. ▯ WWCGA, 1993. – *Online:* Stained glass garden; Mālamalama. The mag. of the Univ. of Ha-waii 2005 (Mai); Crystal sign.; Website C.

C. Rohrschneider

Correvon, *Adèle* cf. **Correvon**, *Henry*

Correvon, *Ferdinand* cf. **Correvon**, *Henry*

Correvon, *Henry*, schweiz. Landschaftsarchitekt, Bo-taniker, * 15. 8. 1854 Yverdon, † 11. 5. 1939 Herisau. Lehre in Yverdon im Gartenbaubetrieb seiner Fam. und in Genf. Absolviert anschl. Praktika in Zürich (bei Otto Fröbel), Frankfurt am Main, Erfurt und Paris (am Mus. d'Hist. naturelle). 1875 Übernahme der Gärtnerei in Yver-don. Spezialisiert sich bald auf die Anzucht und Kulti-vierung alpiner Pflanzen; intensive Forsch. und ab 1876 Publ.-Tätigkeit auf diesem Gebiet. 1879 Gründung eines Gartenbaubetriebs in Genf. In Anerkennung seines En-gagements im Naturschutz und als Verfasser von 28 Bü-chern mit gartentheoretischen Abh. erhält er 1931 die Eh-rendoktorwürde der Univ. Genf. Sicher verwandt mit der schweiz. Zeichnerin und Illustratorin *Adèle (Anna Adè-le) C.* (* 3. 8. 1858 Yverdon, † 30. 3. 1930 ebd.; lt. BLSK Ehefrau des Malers Ernest C.) und dem schweiz. Lsch.-Architekten und Zeichner *Ferdinand (Fernand) C.* (* 1879, † 1964), die Ill. u.a. zu mehreren Fachbüchern C.s beisteuern. – Auf der Basis umfassender Kenntnisse auf den Gebieten Geologie und Botanik widmet sich C. der Konzeption botanischer Alpen- und von Steingärten sowie der Gest. von mit Polsterstauden bepflanzten Tro-ckenmauern und führt mehrere alpine Wildpflanzenarten in die Gartenkultur ein. Als sachkundiger und einfühlsa-mer Beobachter der alpinen Flora gelingt ihm die authen-tische Nachbildung alpiner Hochgebirgs-Lsch. und deren nachhaltige Entwicklung auch unter ungünstigen klimati-schen und Standortbedingungen. Mit einem zus. mit dem Lsch.-Architekten Jules Allemand zur Schweiz. Landes-

Ausst. 1896 in Genf angelegten Alpengarten begründet C. sein hohes Ansehen in der frz. Schweiz. Internat. bek. wird er als Vorreiter bei der Gest. von zu wiss. Zwecken ge-nutzten, zumeist in botanische Gärten integrierten Alpina-rien. ▯ GENF, am Völkerbund-Pal.: Gartenanlage und Zedernallee, 1936. – *Alpengärten:* CHENE-BOURG/Genf: Parc Floraire, um 1902 (Hw., das C. internat. Ansehen bringt). GROSSER ST. BERNHARD: La Linnaea, 1889 (ältes-ter erh. Alpingarten der Westalpen). KLEINER ST. BERN-HARD: La Chanousia, 1897. ROCHERS-DE-NAYE: La Ram-bertia, 1896. ✉ Les plantes des Alpes, Genève 1885; Les plantes alpines et de rocailles, P. 1895; Atlas de la Flore alpine, Genève 1899; Fleurs et montagnes, Genè-ve 1902; Par monts et vaux, Genève 1904 (beide mit Ill. von A. C.); Nos arbres, Genève 1906 (dt.: Unsere Bäume, Bern 1920 [mit 100 farbigen Abb. nach Orig. von A. und F. C.]); Les plantes des montagnes et des rochers, leur ac-climatation et leur culture dans les jardins, Genève 1914 (mit 19 Ill. von F. C.); Floraire, genèse et développement d'un jardin séculaire, Genève 1936. ▭ BLSK I, 1998 (zu C., Adèle); *I. Rucki/D. Huber* (Ed.), Architekten-Lex. der Schweiz 19./20. Jh., Basel u.a. 1998. – *P. Ruedin*, in: *B. Sigel u.a.* (Ed.), Nutzen und Zierde. Fünfzig hist. Gär-ten in der Schweiz, Z. 2006 (zu C., Ferdinand). – *Online:* Hist. Lex. der Schweiz; SIKART Lex. und Datenbank (zu C, Adèle). R. Treydel

Corsep, *Walter (Walter Martin)*, dt. Maler, Zeichner, Karikaturist, Offizier, Publizist, * 20. 11. 1862 Witten-berg, † 19. 5. 1944 Erfurt. Sohn eines Artillerieoffiziers. Kindheit und Grundschule in Düben. Weitere Schulbesu-che in den Garnisonsstädten Erfurt, Wittenberg, Königs-berg (heute Kaliningrad) und Berlin. Ab 1882 militäri-sche Laufbahn mit wechselnden Aufenthalten v.a. in Erfurt (1883, '86–90, '94, 1901–04, '06–11) und Sondershausen (1885–86, '91–94, '96, '98–1900). Über eine künstlerische Ausb. vor 1895 ist bislang nichts bekannt. 1895 ist C. in Berlin (Kriegs-Minist.) stationiert; hier erhält er die Gele-genheit, ein knappes Jahr lang an der AK ebd. zu studieren; er besucht die Mal-Kl. von Paul Meyerheim und Anton von Werner. C. scheint ein begabter Schüler zu sein, denn 1896 wird er als Militärerzieher nach Plön abkommandiert, wo er in der „Prinzenschule" u.a. den preußischen Kronprin-zen Wilhelm und dessen Bruder Eitel Friedrich im Zeich-nen unterrichtet. 1904–06 in Tianjin/China als Kompanie-führer der Besatzungsbrigade im 2. Ostasiatischen Infan-terieregiment des Dt. Reiches. 1904 stiftet er ein Präsent (Taschenuhr) für die Dübener Schulabgänger, das bis 1942 alljährlich einem „würdigen, fleißigen Schüler" ausgehän-digt wird. 1910 Beförderung zum Major. 1912 pensio-niert. 1914–18 erneut als Bataillonskommandeur im akti-ven Kriegsdienst. Ausz.: 1917 Eisernes Kreuz (I. Kl.). In-tensiv widmet sich C. in den Kriegsjahren der Publizierung von dt.-nat. und (militaristisch-)erzieherischen Schriften. Nach dem 1. WK (Entlassung aus dem Heer als Oberst-leutnant) versteht sich C. als „kerndeutscher" Vertreter bürgerlich-konservativer Interessen und mischt sich in zu-nehmend aggressiver Weise als „zentraler und radikaler Exponent der bürgerlichen Beharrungskräfte" (Raßloff)

in die öff. Debatte um die mod. Kunst ein, insbesonde-
re um den in Erfurt von den dortigen Mus.-Dir. Edwin
Redslob und Walter Kaesbach, dem Buch- und Kunst-
händler Max Friedland und dem jüdischen Schuhfabri-
kanten Alfred Hess geförderten Expressionismus (Grup-
pe Jung-Erfurt). C.s zügellos antisemitisch formulierten
Überzeugungen manifestieren sich in diesem Kontext u.a.
in dem Aufsatz „Steine statt Brot! Ketzer-Gedanken über
den Expressionismus" (Mittel-dt. Ztg v. 7. 11. 1920) und in
der von ihm organisierten anti-expressionistischen Kunst-
Ausst. Das malerische Erfurt (Juli 1921), auf der auch sei-
ne eig. Bilder und Zchngn gezeigt werden. Bis ins hohe
Alter bleibt C. seinen radikalen Überzeugungen treu, u.a.
setzt er sich 1933 nach der Machtübergabe an die Nati-
onsalsozialisten vehement für die Entlassung von Reichs-
kunstwart E. Redslob und die Auflösung von dessen Amt
in Berlin ein (Laube, 1997). – C.s bildkünstlerisches Œu-
vre umfaßt flüchtig oder sorgfältig ausgef. (Reise-)Skizzen
(*Surpris, Campagne dans la Normandie*, Zchng, 1886;
Weimar), Figuren- und Soldatenbilder, Idyllen im Bieder-
meierstil bis hin zu stimmungsvollen Lsch. oder in war-
mes Licht getauchte detailfreudige Stadtansichten mit (his-
torisierender) Staffage (*Dom und Severikirche*, Öl, 1932).
Häufig sind topogr. exakt erfaßte Veduten, die in zarten
Pastelltönen und feinem Pinselduktus in einem impressio-
nistisch anmutenden, jedoch stets linienbetonten realisti-
schen Stil ausgef. sind. Über ein Dutzend Stadtansichten
von Sonderhausen entstehen allein im Jahr 1927 (Schloß-
Mus. Sonderhausen). Das Lsch.-Mus. in Bad Düben hat
über 20 Gem. im Bestand, darunter v.a. militär-hist. Sze-
nen mit Motiven (mehrfach nach fremden Vorlagen) aus
der Zeit der Napoleonischen Befreiungskriege, z.B. die
Besetzung der Stadt durch russ.-preußische Truppen un-
ter General Blücher oder Plünderungen durch frz. Sol-
daten. Hervorhebenswert sind C.s routiniert und kennt-
nisreich dargestellten Kavalleriepferde (*Napoleon auf der
Freitreppe des Amtshauses (in Düben)*, Öl, um 1930.).
Daneben politisch-satirische, v.a. antisozialdemokratische
und antisemitische Karikaturen. Etliche Reiseskizzen, u.a.
die aus China, führt er später als Gem. aus (*Chin. Mauer
[Kü-yong-huan] Menkau-Pass*, Öl, 1905/1926). – Mono-
gr. Bearbeitung und WV stehen aus. ⌂ BAD DÜBEN,
Lsch.-Mus. der Dübener Heide. ERFURT, Anger-Mus. –
StA. – SM. SONDERSHAUSEN, Schloss-Mus.WEIMAR, SM,
GrS. ✉ Ist es möglich, in Jugendvereinen Bajonett
Fechten zu treiben?, Erfurt s.a.; Die Erziehung unseres
Armee-Nachwuchses, Erfurt [3]1915; Wahrnehmungen auf
dem Galizischen Kriegsschauplatz, Br. 1915; Volksschule
und Staatsbürgerlehre, Erfurt 1915, [2]1917; Die Pflicht im
Leben des Kindes. Eine militärische Betrachtung, Erfurt
1917; Vorschlag zu einem Gesetz für die Erziehung der dt.
Jugend, s.l.e.a. [1918]; Irrtümer der Vorkriegszeit, Erfurt
1929. ▭ ThB7, 1912. *Bénézit* III, 1976. – *J. Bohrmann*,
Ausschnitte aus der Heimat-Gesch. der Stadt Düben. Die
Gem. des Oberstleutnants a. D. C., Düben (Mulde) 1935;
G. Laube, Der Reichskunstwart. Gesch. einer Kulturbehör-
de 1919–1933, Diss. Univ. Kiel, Ffm./B. 1997, 132–138;
W. May, W. C. [Persönlichkeiten in Sondershausen], Son-

dershausen/Thür. 1998 (Falt-Bl.); *C. Nowak u.a.* (Ed.), Ex-
pressionismus in Thür. (K Erfurt), Jena 1999; *S. Raßloff*,
Flucht in die nat. Volksgemeinschaft. Das Erfurter Bürger-
tum zw. Kaiserreich und NS-Diktatur, Diss. Univ. Erfurt
2001, Köln u.a. 2003, 177, 227 s., 263 ss., 328 ss., 351,
417; *E. Herrbach* (Ed.), Der Erfurter KV. Zw. Avantgar-
de und Anpassung, Erfurt 2009. – Berlin, Bundes-Arch.:
Reichskunstwart: R 32/253 (1922–26: Beleidigungspro-
zesse des RKW gegen den Oberstleutnant a. D. W. C.
u.a.) / Erfurt, StA: Nachlaß. U. Heise

Corsucci, *Umberto*, ital. Bildhauer, * 1951 Sassocor-
varo, lebt und arbeitet in Montefiore Conca. Stud.: Ist.
d'Arte Pesaro (Keramik; 1970 Dipl.); ABA, Rom; Ac-
cad. di Brera, Mailand (1974 Dipl. als Bildhauer). Sei-
nem Atelier in Montefiore Conca ist eine Gießerei ange-
schlossen; er hält hier seit 2008 internat. besuchte Kur-
se für Bildhauerei ab (Accad. della Scult.). Ausst.-Debüt
1973 in Rom (Gall. Il Grifo). Als Ausst.-Organisator be-
teiligt in Montefiore Conca 1977 an „Montefiore '77" (K:
E. Crispolti) und 2000 ebd. an der „Rass. Internaz. del Boz-
zetto", auch 1991–92 an „La Pietra e il Mare" in Riccio-
ne (K: M. Corgnati u.a.). C. publiziert 1992 ein umfassen-
des Werk über den Metallguß mittels verlorener Wachs-
formen und stellt darin neue und alte Techniken einander
gegenüber. 1999 gründet er die Ges. Montemaggiore Ar-
te, um ein Freilicht-Mus. für Plastik auf dem Montemag-
giore zu installieren und organisiert ab 2001 zu diesem
Zweck den internat. Wettb. La Giovane Scult. 2007 ge-
winnt C. den Wettb. für ein Denkmal für die Carabinieri in
Lomaso. – Häufig nutzt C. bei seinen meist großformatigen
bildhauerischen Arbeiten schlichte geometrische Grund-
formen und kombiniert dabei versch. Mat., z.B. Marmor,
Keramik, Metall und Holz. In jüngster Zeit entwirft er
u.a. auch kleinplastische Kunstobjekte mit Leuchteffekt
und -funktion. ⌂ BRUFA/Torgiano, La strada del vino e
dell'arte: Vitalità, um 2009. CARPEGNA, Parco delle Quer-
ce: Denkmal Conte Mario Carpegna, Travertin/Bronze,
2000. CASTEL DI LAGO: Brunnen, Travertin, 1999. CAT-
TOLICA, Fa. Fom Industrie: Brunnen, Stahl/Stein, 2001,
zus. mit Mario Battelli. LAMBRATE, Cimitero: Capp. Vetto-
ri (Gest.), 1995. MORCIANO DI ROMAGNA, Banca Popolare
Valconca: Bronzeplatten, 1980. – S. Michele: Bronzetüren,
1994. – Piazza Umberto I: Brunnen Umberto Boccioni,
Bronze, 1999. RICCIONE, Parco del Comune: Mon.-Skulp.,
Stein, 1991. RIMINI, Hafen (Ostmole): Sposa del pesca-
tore, Bronze, 2010. SAN CLEMENTE: Denkmal Giustinia-
no Villa, Travertin/Bronze, 1988. – Parco delle Magnolie:
Brunnen, Travertin/Bronze, 2001. – Fond. G. Del Bianco:
Denkmal für Anwalt Del Bianco, 2007. SAN GIOVANNI IN
MARIGNANO: Brunnen, Travertin, 2005, zus. mit Mauro
Landi. TARCENTO: Denkmal für die Erdbebenopfer, Bron-
ze, 1978. VISERBA, Fonte Sacramora: Gedenkstein, 1971.
✉ Manifesto della Neo-Metafisica nella scult., Morciano
di Romagna 1988 (lt. Website); *C./U. Zampino*, L'arte del
fondere a cera persa. Tecniche, segreti, sistemi per fonde-
re in bronzo le proprie scult., Osimo 1992. ◉ *E:* 1978
Lecce, Gall. L'Esagono / 1980 Rom, Gall. Fiumarte (K:
E. Crispolti); Den Haag, Gal. Edison / 1988 San Clemente,

Sala del Consiglio Com. (K: E. Crispolti); Rimini, Gall. Sigismondo / 1989 Riccione, Hotel Villa Giardinetto / 1990 Mailand, Gall. Nuova Aleph (K: S. Cuppini) / 1992 Ferrara, Gall. Civ. di Arte Mod. del Pal. dei Diamanti (K: F. Farina/M. Corgnati) / 1994 Florenz, Ex-Studio Giambologna / 1998 Montefiore Conca, Rocca Malatestiana / 2001 Mantua, Gall. A. Sartori (K: F. Farina) / 2002 Montegridolfo, Castello / 2010 Sant'Ippolito, Pal. Bracci. – *G:* 1974 Gubbio: Bienn. della Ceramica / Rom: 1975 Quadrienn. La nuova generazione; 1979 Parco Gall. Sala 1: Scult. all'Aperto; 1984 ebd.: In materia, proposte di sei scultori (K: E. Crispolti); 1993 Pal. Ruspoli: Art e Tabac (K: P. Restany) / 1976 Florenz: Espos. Internaz. della Medaglia / 1977 Mailand, Gall. S. Fedele: Situazione / 1979 Faenza: Mostra Internaz. Della Ceramica / 1981 Castellanza di Legnano: Mostra Internaz. all'Aperto Mus. Internaz. d'Arte Mod. Sissa Pagani / 1988, '89, '90, '92 Sassoferrato, Pal. Oliva: Rass. d'Arte G. B. Salvi / 1990 Turin: Premio La Telaccia d'Oro / 1990, '91, '92 Bologna, Padiglione Ceramica: Artefiera / 1992, '94 Savona, Fortezza Priamar: Mostra Internaz. di Ceramica (K: D. Tiglio) / 1997 Cesena: Bienn. d'Arte Romagnola / 1998 Sangemini, Parco della Fonte: L'Arte C'è / 2000 San Benedetto del Tronto, Gall. Civ.: Scult. Viva (K: C. Melloni) / 2001 Torre Strozzi: Bienn. di Scult. in Ferro. ▭ *M. Agnellini* (Ed.), Emilia-Romagna. Artisti e opere dall'Ottocento a oggi, Mi. 1995. – *Online:* Website C. (Ausst., Lit.); Scultura; Il FoRomagno; Chiamami Città. S.-W. Staps

Cortázar y Urruzola, *Ramón*, baskischer Architekt, * 12. 12. 1868 San Sebastián, † 1944 (auch 12. 3. 1945) ebd. Sohn des Architekten Antonio de C. y Gorria. Stud.: bis 1891 (Abschluß) Esc. Superior de Arquit., Madrid. Architekt der Prov. Guipúzcoa als Nachf. seines Schwagers Manuel Echave Zalacain, der zuvor C.s Vater abgelöst hatte. Korr. Mitgl. der RABA de San Fernando, Madrid. – C. gilt neben seinem Cousin *Luis Elizalde Urruzola* (* 1857 Madrid, † 1934 San Sebastián) als Hauptvertreter des Modernismo in San Sebastián. V.a. im Wohnungsbau experimentiert er mit dekorativen Elementen, die am Formengut der Wiener Secession, des dt. Jugendstils und des katalan. Modernisme sowie an arabischen und regionalen ma. Vorbildern orientiert sind. Bei repräsentativen öff. Gebäuden unterstützt er mit Blick auf den wachsenden internat. Fremdenverkehr die archit. und städtebauliche Ausrichtung am frz. Neubarock. C.s qualitativ beachtliches, stilistisch jedoch uneinheitliches Werk trägt daher wesentlich zum romantisierenden Bild von San Sebastián bei. Technologisch und konstruktiv stehen seine Bauten auf der Höhe der Zeit; so sind die meisten Großprojekte aus Eisenbeton und mit modernster Gebäudetechnik versehen. Für die Prov. entwirft C. Schulen, Bahnhöfe und Rathäuser im moderaten, zweckmäßigen Eklektizismus. ▭ AZPEITIA, Calle Julián Elorza: Bahnhof (heute Baskisches Eisenbahn-Mus.), 1926. EIBAR: Rathaus. SAN SEBASTIAN, Calle Urdaneta: Schule (heute Koldo Mitxelena Kulturunea), 1896–98 (mit L. Elizalde Urruzola). – Kathedrale Buen Pastor: Turm (voll.), 1899. – Av. de la Libertad 21: Banco Guipuzcoano, 1900. – Calle Prim 33: Schule,

1901. – Calle Garibay 21: Mehrfamilienhaus, 1903. – Calle Prim 17: Mehrfamilienhaus, 1904. – Calle Easo 20: Kloster Madres Reparadores, 1904. – Calle Zubieta 1: Mehrfamilienhaus, 1906. – Calle San Bartolomé 37: Mehrfamilienhaus, 1909. – Paseo de la Concha: Kurhaus La Perla, 1912; Kgl. Badehaus, 1912. – Kino Salón Miramar, 1913 (Abriß 1987). – Calle Prim/Calle Urbieta: Pal. BA, 1914–15. – Pl. Guipúzcoa 1: Pal. Diputación Prov. (Erweiterung), 1914. – Calle San Martín 50: Mehrfamilienhaus, 1915; Nr 61: Erweiterung der Villa Uruia, 1926 (mit Domingo Aguirrebengoa). – Calle Arrasate 12: Wohn- und Geschäftshaus Caja de Ahorros (Umbau), 1915. – Calle Aldámar: Pal. del Príncipe (Theater, Bar, Hotel, Mietwohnungen), 1921–22. – Pl. Centenario 2: Mehrfamilienhaus, 1924. – Paseo de Francia 11: Einfamilienhaus, 1926. – Calle Usandizaga 21: Mehrfamilienhaus, 1926. ZARAGOZA, Calle San Jorge/Calle San Andrés: Caja de Ahorros y Monte de Piedad de Zaragoza, Aragón y Rioja, 1910; Umbauten, 1913 (beide mit L. Elizalde Urruzola). ZUMAIA: Bahnstation, 1926 (Rest. 1997). ▭ *J. Martínez Verón*, Arquitectos en Aragón, II, Zaragoza 2001. – *M. Ordóñez Vicente*, Ondare. Cuadernos de Artes Plást. y Mon. 20:2001, 111–159; 23:2004, 267–278; *A. Cendrero Iraola*, ibid., 23:2004, 255–265. A. Mesecke

Corte, *Enrico*, ital. Maler, Bildhauer, Zeichner, Fotograf, Film-, Video- und Installationskünstler, Kunstpublizist, * 21. 6. 1963 Cagliari, lebt und arbeitet in New York, Berlin und Italien (Bologna, Mailand, Rom). Ausb./Stud.: 1977–81 Liceo Artist., Cagliari; 1981–88 Univ. degli Studi ebd. (publ. 1988 seine Abschlußarbeit u.d.T. Azionismo Viennese); 1999 als Assoc. Artist am Atlantic Center for the Arts, New Smyrna Beach/Fla. In Cagliari 1981 erster öff. Auftritt (zus. mit Andrea Nurcis) bei der multimedialen Installation *Rarità botaniche* (Botanischer Garten) und 1982 Ausst.-Debüt in der Gall. Com. d'Arte; Auseinandersetzung mit Arbeiten von Vincenzo Agnetti, Enrico Castellani und Giulio Paolini. 1988 Übersiedlung nach Rom. Eines von C.s Ateliers (bei Ravenna) ist gleichzeitig Sitz der von ihm mitbegr. Stiftung für zeitgen. Kunst. – Arbeitet in den 1980er Jahren häufig mit industriell bearbeitetem Mat. und blok. fotogr. den eig. Schaffensprozeß. In der Folgezeit Hinwendung zur Darst. menschlicher Körper und psychischer Konditionierung der Abgebildeten in Auseinandersetzung mit dem Rezipienten. Bisweilen intensive Zus.-Arbeit mit Kollegen, die sich and. Gattungen widmen. C. selbst beherrscht und variiert unterschiedlichste künstlerische Techniken, Mat. und Medien; gegenwärtig beschäftigt er sich v.a. mit Zchng und Bildhauerei. Als Filme- und Videomacher häufige Zus.-Arbeit mit A. Nurcis, so 1996/97 bei *No Light,* 1997 bei *Homevideo* und *Pino Piercing wears a sculpture,* 1998 bei *Natura inurbata* und 1999 bei *Demoniac Conjunctivas.* Eigenständig produziert C. u.a. die Filme und Videos *The Intericon File* (1998), *Videoache* (1999–2001), *Intericon Coll.* (2001) und *Beneath the shadows of Intericon* (2003). C. setzt sich intensiv mit dem Thema Selbstzerstörung auseinander bei gleichzeitiger Wahrung von schöner Form und der Erfindung von tragikomischen Metaphern für soziale Mißstän-

de. Seit 2002 arbeitet er mit Kriminellen in Rom zus., um mit ihnen gänzlich and. und neue Sichtweisen und Aspekte von Kunst zu definieren. ⊙ *E:* 1986 Cagliari, Borderline Gall. / Rom: 1989 Gall. Planita (mit Objekten aus Gedichten, die Luigi Ontani C. gewidmet hatte); 1995 Sergio Raggio Private; 2001, '03 2RC Gall. / 2010 Lugo, Rocca Estense. – *G:* Rom: 1986 Pal. delle Espos.: Quadrienn.; 1999 Caffè dell'Angelo: Denomiac Conjunctivas; 2001 Romberg Gall.: Contemp. Figurative Sculpt.; 2004 2RC Gall.: Intericon Drawings; 2006 Studio Stefania Miscetti: A Band A Part / 1990 Gubbio, Pal. dei Consoli: Arte inutile / 1997 Mailand, Gall. Bianca Pilat: Pour Artaud / 1998 Taormina: Internat. Filmfestival / 1999 Venedig: Bienn. / 2001 Bologna, Salara – GAM: Trends / 2002 Nuoro, Mus. d'Arte della Prov. di Nuoro: Casa Dolce Casa / 2003 New York, Buia Gall.: Young Ital. Genome; Siena, Pal. delle Papesse: Melting Pop / 2004 New York, Buia Gall.: Primo / 2011 Sassari, MAC: Padiglione Sardegna. ▢ *T. Suggate,* Arte ital. degli anni Novanta, R. 1991; *L. Beatrice u.a.,* Nuova scena. Artisti ital. degli anni '90, Mi. 1995; *G. Marziani,* Melting Pop, R. 2001; *id.,* E. C. Spectrospective, Bo. 2007. – *Online:* Website C.

S.-W. Staps

Côrte Real, *Ju (Renato Ferreira),* brasil. Maler, Graphiker, * 6. 7. 1949 Campinas, † 5. 6. 2012 São Paulo. 1963–64 Teilnahme an den freien Kunst-Kl. der Fund. Armando Álvares Penteado; in den 1970er Jahren Kurse an der Esc. de Arte Brasil und im Atelier von Carlos Fajardo und Dudi Maia Rosa. Fertigt 1981–82 zus. mit José Luiz Queiros Telles eine Reihe von Serigraphien. 1984–85 verantwortlich für die Koordination des MAC in Campinas. 2000 Performance im Rahmen des Programms Musikaos der TV Cult. an der Sede Pompéia. – Neben seinen gestischen, sowohl figurativen wie abstrakten Malereien, widmet sich C. auch konzeptuellen Arbeiten. Dabei experimentiert er mit versch. Techniken, wie etwa der Assemblage, den Strategien des Ready made oder der digitalen Bildbearbeitung. ⊙ *E:* São Paulo: 1968 English Cult. Center; 1981 Auditório da Cidade; 1984 Espaço L'Arnac; 1994, '96 A Hebraica; 2001 Gal. Tênis Club Alphaville / 1982 Campinas, Gal. Castro Neves; Campos do Jordão, Auditório do Pal. do Governo / 2001 Ubatuba, Espaço Cult. Yatch Club. –. *G:* São Paulo: 1982 Salão Nac. de Artes Plást. Santos Drumond (Gold-Med.); 1987, '89 Bien.; 1988 Paço das Artes: Contempoarte; 1996 Fund. Armando Álvares Penteado: Ubu Patafísica nos Trópicos; 1997 A Hebraica: Encontros de Artistas; 2001 Chapel Art Show: Arte Contemp.; 2002 Casa das Rosas: México Imaginário. O Olhar do Artista Brasil. / 1982 Campinas, Mus. de Arte: Noite Espaço Aberto / 1987 Ribeirão Preto: Salão de Arte Contemp.; Rio Claro: Salão de Artes Plást. / 1991 Tabuaté: Salão de Artes Plást. ▢ *Online:* Revistabrasileiros, 2012. M. F. Morais

Cortés, *Pepe,* katalan. Designer, Innendekorateur, Möbelgestalter, * 1946 Barcelona, lebt dort. Stud.: Esc. Eina ebd. (später Prof.). A. der 1970er Jahre Gründer der Grupo Abierto de Diseño. Zusammenarbeit u.a. mit den Gestaltern Oscar Tusquets Blanca und seit 1981 mit Javier

Mariscal. 1984–88 Mitgl. Fomento de las Artes Decorativas. Eig. Büro: P. C. Asociados. Ausz.: u.a. 1983 Premio Foment de les Arts i del Disseny del Jurado y de la Opinón Popular; 2002 Premio Santiago Marco, Colegio Oficial de Decoradores y Diseñadores de Catalunya, beide Barcelona; 2006 Premio Nac. de Diseño, Fund. Barcelona Centro de Diseño und Minist. de Industria, Turismo y Comercio, Madrid. – C. gehört mit seinen dynamisch gestalteten Werken zu den bedeutendsten Designern der Gegenwart in Spanien. Mit der Grupo Abierto de Diseño entstehen zahlr. Ladeneinrichtungen, u.a. der Juweliere Cubic und Oriol, des Schallplattengeschäfts Werner und des Poliglas-Büros. In den 1990er Jahren entwirft er die Büros des Konsortiums der zollfreien Zone in Barcelona, außerdem Innenausstattungen von Bars, Restaurants und Cafeterien (z.B. Tragaluz, 1990; Tatí im Pal. de Congresos de Catalunya, 2001; Mus. Olímpico, 2007, alle ebd.), von Möbel- und Schuhgeschäften, Banken, Einkaufszentren und Privathäusern, die Erneuerung von Park, Sportanlagen, Schwimmbecken und Terrassenbar des Hotels Juan Carlos I (1999) in Barcelona sowie Ausst.-Archit. für die Generalitat de Catalunya (z.B. Catalunya, pais de trobada, 2003, Pal. Moja ebd.). Zu seinen wichtigsten Möbelentwürfen, die im Auftrag bek. internat. Möbelhersteller entstehen, zählen das dreieckige Eckmöbel *Roberto* (1983), die *Carito Bar,* ein zweirädriger Rolltisch (mit J. Mariscal, 1984), das Sofa *Morsillon* in Form einer Metallröhre (1986), der *Trampolin-Stuhl* aus Stahl und Holz auf kreisförmiger Basis (mit J. Mariscal, 1986–87), der *Jamaika-Barhocker* (1993) und die Garten-Pollerleuchte *Chimseta i Piqueta.* ⊙ *G:* 1989 Barcelona, Colegio de Arquitectos: 14 diseñadores para el mueble / 1992 London, Archit. Assoc.: 4 studios in Barcelona. Alfredo Arribas, P. C., Enric Miralles, Oscar Tusquets (K) / 2006 Lissabon, Pal. da Ajuda: 300% Span. Design (internat. Wander-Ausst.). ▢ *Kjellberg,* 1994; Dict. internat. des arts appliqués et du design, P. 1996; *M. Byars,* The design enc., Lo./N. Y. 2004. – Design in Catalonia (K Wander-Ausst.), Ba. 1988; El croquis (Ma.) 1990 (42) 152–161; *U. M. Reindl/G. Rivet,* Kunst in Spanien, Köln 1992; *L. Andreini* (Ed.), Cafés & Restaurants, Kempen 2000. – *Online:* Website C.

M. Nungesser

Cortés Pérez (Corté Pérez; Cortés), *Daniel,* span. Maler, * 1873 Valencia, † vor 20. 7. 1919 ebd. Stud.: EBA de S. Carlos ebd. Anschl. im Atelier des Malers Joaquín Sorolla in Valencia tätig. Arbeitet dann mehrere Jahre in Madrid. Um 1895–1900 in Paris ansässig; verkehrt dort im Umfeld renommierter Künstler wie Ferdinand Roybet und Francisco Domingo y Marqués. Die Beschäftigung mit dem Schaffen von Jean-Joseph Benjamin-Constant weckt C.s Interesse an der Orientmalerei. Um 1901 erster Besuch in Oran, wo er sich nach einem Aufenthalt in London und einer Rundreise durch Algerien mit eig. Atelier niederläßt; schreibt auch für die Rev. mondaine oranaise. Gegen Lebensende Rückkehr nach Spanien. – Vom intensiven Licht, den prächtigen warmen Farben und der von Lebensfreude geprägten Atmosphäre in Nordafrika stark inspiriert, schließt sich C. der Strömung der Orientmalerei

an. In minutiöser Manier gestaltet er v.a. pittoreske Genreszenen (*Conversation au Harem*, 1899; *La partie aux osselets*, sign., dat. 1903, beide Öl/Lw.; *Les joueuses de tarots, Afrique du Nord*, 1904) und Volkstypen (*Africain menant son âne*, Öl/Lw.). Dazu kommen oftmals mit Staffage belebte Lsch. und Stadtansichten (*Scène de Rue, Maroc*, Öl), auch aus Spanien (*Le Port, la Plage et le Marché aux poissons à Tarragona*, um 1908). Versch. Motive werden als Reprod. auf Postkarten populär. ⌂ ORAN, Opernhaus: mon. Plafondmalerei, um 1907. ⊙ *G:* 1900 Madrid: Expos. Nac. de BA (3. Med.) / 1901 Paris, SAfr. ⊡ Cien años II, 1988; Spanish artists I, 1993; DPEE III, 1994; *Agramunt Lacruz* I, 1999; *E. Cazenave*, Les artistes de l'Algérie, P. 2001. – Annales africaines v. 20. 7. 1919 (Nekr.). – *Online:* Arcadja; Artnet; Artprice.

R. Treydel

Cortesão, *Gil Heitor*, portug. Maler, * 1967 Lissabon, dort tätig. Stud.: bis 1990 EBA, Lissabon (Malerei); 1991–92 Accad. Albertina delle BA, Turin. Ausz.: 2004 Premio del Golfo der Bienn. europea Arte Visive, La Spezia. – Anfänglich kleinformatige Zchngn; 1992 entstehen für die Gal. Módulo in Porto Kästen aus versch. Gläsern, Acetaten und Texten. Dabei wird bereits die Arbeit mit transparenten Effekten und versch. Oberflächen erprobt, die für C.s Werk bestimmend ist. Für die Komp. seiner Gem. verwendet er Fotos versch. Proveninez, u.a. aus Zs.und Archit.-Büchern, auch Postkarten. Er verändert deren Umrisse und Oberflächen und stellt die Motive in neue Zusammenhänge, wobei er mit umgekehrten Perspektiven, doppelten Blickpunkten und unausgeglichenen Symmetrieverhältnissen spielt; seine imaginären Räume sind dysfunktional. Die auf den ersten Blick fotorealistischen Gem. enthalten Störfaktoren, die ein vages Gefühl des Unbehagens erzeugen: nicht zu identifizierende Möbelstücke, dunkle Flecken, Bilder, die sich von den gemalten Wänden zu lösen scheinen. Seit 1996 malt C. mit Öl auf die Rückseite von durchsichtigem Kunststoffglas und nutzt die Transparenz des Materials. Dabei erhalten seine Hinterglasbilder eine glatte Oberfläche; Spuren des Malvorgangs und die Textur der Farbe werden unkenntlich gemacht und der Betrachter am direkten Kontakt mit der Materialität des Gem. gehindert. Der umgekehrte Malprozeß, der eine genaue Überlegung voraussetzt, reflektiert zugleich die künstlerische Arbeit als solche. Seine oft gleichgroßen, als Serien gedachten Gem. in teils gedeckten, dunklen, teils stechend bunten Farben versteht er als Spiel möglicher Konstruktionen, je nachdem, in welcher Reihenfolge sie zusammengestellt werden. So bezieht sich C. mit der Serie *Modelo para Armar* auf den gleichnamigen Roman von Júlio Cortazar (62/Modellbaukasten, 1968) und spielt auf die vielfachen Weisen der möglichen Weltinterpretation sowie auf die Unmöglichkeit an, zw. Traum, Erinnerung und erfundener Erinnerung, also zw. Wirklichkeit und Virtualität zu unterscheiden. Individuelle Figuren spielen in C.s Werk eine untergeordnete Rolle, wiederholt tauchen aus der Ferne gesehene, anonyme Menschenmassen auf. Seine distanziert-zeitlosen Bilder – meist leere, urbane Lsch., öff. Plätze und küh-

le, meist priv. Innenräume, ruinöse Schwimmbäder, Kinosäle, Hochhaussiedlungen oder Städte aus der Vogelperspektive – sind entvölkert und konfrontieren den Betrachter mit teilw. phantastischen Zusammenhängen. Für seine Ausst. Mnémopolis in der Fund. Gulbenkian 2004 verwendet C. als Motive auch Maschinen, elektrische Geräte oder Ballons, die, nebeneinander gehängt, ein buntes Kaleidoskop ergeben. ⌂ LISSABON, Fund. Calouste Gulbenkian, Centro de Arte Mod. LUXEMBURG, MAM Grand-Duc Jean (Mudam). PORTO, Col. Fund. Ilído Pinho. ✉ Harper's mag. 2009 (5). ⊙ *E:* Lissabon: 1988 (Debüt), '90 Gal. Módulo; 1996 Mus. Botânico; 2004 Fund. Calouste Gulbenkian, Centro de Arte Mod. (K); 2007, '09 Gal. Pedro Cera / 2002 (mit Luiz Zerbini), '07, '11 São Paulo, Gal. Fortes Vilaça / 2008 Paris, Gal. Suzanne Tarasiève / 2009 Dubai, Gal. Carbon 12. –. *G:* Lissabon: 1999 Fund. Calouste Gulbenkian, Centro de Arte Mod.: Linhas de sombra; 2005 ebd.: Densidade relativa (Wander-Ausst., K); 2011 ebd.: Casa comun.; 2007 Gal. Pedro Cera: Some stories on paper; 2010 Gal. João Esteves de Oliveira: O Arquit. de nuvens / 2003 New York, Exit Art Gall.: Collector's Choice / 2007 Luxemburg, MAM Grand-duc Jean: Portugal Agora. À propos des lieux d'origine. ⊡ *L. Nazaré*, G. H. C. Pinturas 2002–2010, Li. 2010. – *Online:* Fund. Calouste Gulbenkian.

C. Melzer

Cortina Capella, *Eduardo*, span. Bildhauer, Möbelrestaurator, Fotograf, * 5. 5. 1955 Godella/Valencia, lebt in Burjassot/Valencia. Stud.: Esc. de Artes y Oficios, Burjassot; EBA de S. Carlos, Valencia. Ausz., u.a. 1. Preise: 1982 Certamen Nac. de Arte, Caja de Ahorro de Guadalajara; 1986 Expos. Nac. de Segorbe; 1989 Certamen Internac. Jacinto Higueras, Santiesteban del Puerto/Jaén. – C.s Skulpt. der 1980er Jahre, meist in Kalkstein und versch.-farbigem Marmor, sind geometrisch-abstrakt und mittelgroß. Sie bilden blockartige Kuben mit glatten oder punktierten Außenseiten und liegen auf der Basis auf. Unregelmäßige Durchbrüche, Einschnitte, Abrundungen und schräge Oberflächen beleben die Gest. und verbinden sie mit dem Raum. Danach kombiniert C. Holz und leuchtend rot oder blau lackierte Kunststoffteile zu archit. anmutenden und vom Konstruktivismus beeinflußten stelenartigen Skulpt., die z.T. bis zu über zwei Meter Höhe erreichen. Außerdem macht er Schwarzweißfotos, in der verlassene, ruinöse Industrie-Archit. im Zentrum steht (Serie *La Central*). In jüngster Zeit gestaltet C. aus zerklüfteten, zylindrischen Formen aufgebaute polierte Holz-Skulpt. (v.a. Zypresse, Wacholder, Birke), die bio- oder anthropomorphen Char. haben. ⌂ BOLLULOS DEL CONDADO/Huelva, Stadtverwaltung. BURRIANA/Castellón, Stadtverwaltung. CASTELLÓN DE LA PLANA, Prov.-Verwaltung. GUADALAJARA, Caja de Ahorros Prov. OROPESA DEL MAR/Castellón, Centro de Iniciativas Turísticas. ROTA/Cádiz, Fund. Zoilo Ruiz-Mateos. – Stadtverwaltung. SANTIESTEBAN DEL PUERTO, Mus. Jacinto Higueras. SEVILLA, Caja de Ahorros de San Fernando. VALENCIA, Bancaja. VILLENA/Alicante, Stadtverwaltung. YECLA/Murcia, Mus. Prov. ⊙ *E:* 1982 Burjassot, Sala Mpal / 1984 Guadalajara, Caja de Ahorros

Prov. / 1985 Yecla, Casa Mpal de Cult. / Paterna (Valencia): 1985 Sala El Palau; 2001 Espai Cult. Coves del Batà / 1989, '98, 2004, '11 (K: M. Silvestre) Castellón de la Plana, Sala de Arte Pictograma / 1991 Villena (Alicante), Casa de la Cult. (K: B. Gutschke) / 1995 Xàtiva (Valencia), Gal. Tábula / Godella: 1996, '98 (K: R. Prats Rivelles) Gal. Grupo Efe; 2001 Centre d'Arts Plàst. (K: M. Pastor/J. Pallardó). ▭ *Agramunt Lacruz* I, 1999; DPEE, Ap., 2002.

M. Nungesser

Corvaja, *Giovanni*, ital. Goldschmied, Schmuckgestalter, * 30. 9. 1971 Padua, lebt in Todi. 1998 Heirat mit der brit. Schmuckgestalterin Jacqueline Ryan. Ab 1992 gemeinsame Wkst. in Padua, seit 2001 in Todi. Stud.: 1985–90 Ist. Statale d'Arte Pietro Selvatico, Padua, bei Francesco Pavan; Mitarb. in den Ateliers von F. Pavan und Paolo Maurizio; 1990–92 R. College of Art, London, bei David Watkins. Lehrtätigkeit: seit 1998 als Gast.-Doz. an versch. Univ. (v.a. Kurse zu Granulationstechnik). Seit 2005 freischaffender Goldschmied und Ltg des eig. Ausb.-Zentrums in Todi. Ausz.: 1992 Herbert-Hofmann-Preis, München; 1997 Bayerischer Staatspreis ebd.; 1998 Internat. Jewellery Design Competition, Tokio; Ausz. der Unione Regionale delle Camere di Commercio dell'Umbria, Terni. – In der Trad. der Paduaner Schule gestaltet C. seit 1988 geometrisch-abstrakte Schmuckstücke (v.a. Broschen, auch Ohr- und Armschmuck, Ketten sowie Ringe), zunächst aus Titan und Palladium, später bevorzugt aus Gold und Platin. Für die Herstellung des überwiegend aus dünnem Gold- und Platindraht bestehenden Schmucks fertigt C. die Werkzeuge und Maschinen größtenteils selbst (z.B. eine Drahtziehmaschine für bes. feinen Draht sowie einen Webstuhl) und entwickelt Techniken wie die des dreidimensionalen Strickens, für das er 20–60 Nadeln verwendet. So entstehen in geometrische Körper eingespannte vielfach verschlungene Strukturen, die an Flechtwerk, Haare und Quasten denken lassen. Farbige Akzente setzt C. v.a. durch Granalien aus and. Mat. (z.T. im abgewandelten Nielloverfahren), die er häufig fühlerähnlich auf Golddraht anbringt, in jüngeren Arbeiten durch bunte Kugeln oder unregelmäßige längliche Formen aus Email. Weiterhin erzielt er Farbverläufe durch Legierungen (Weiß-, Rot- und Gelbgold). In der jüngsten Serie mit dem Titel *Das goldene Vlies* gelingt es C., die Grenzen des Mat. weiter auszudehnen und ihm textile Eigenschaften zu entlocken, indem er aus hauchzarten Golddrähten fellartige Oberflächen erzeugt. ▭ CANBERRA, NG of Australia. EDINBURGH, NM of Scotland. FLORENZ, Pal. Pitti. GRAZ, Joanneum. HAMBURG, MKG. LONDON, V & A. MONTREAL, MAC. MÜNCHEN, PM, Neue Slg. NEWARK/N. J., Newark Mus. PARIS, MAD. PFORZHEIM, Schmuck-Mus. ◉ *E:* 1993, '98 Berlin, Gal. Treykorn (mit Giampaolo Babetto) / 1996 Paris, Gal. Hélène Porée; Zürich, Studio Herta Zaunschirm (beide mit J. Ryan) / 1997, 2000 Wien, Gal. Slavik (beide mit J. Ryan) / 1998 Amsterdam, Gal. Louise Smit (mit J. Ryan) / 2000 Genf, Mus. de l'Horlogerie et de l'Emaillerie (mit J. Ryan) / 2002 Kopenhagen, Gall. Tactus (mit J. Ryan) 2006 Barcelona, Gal. Hipótesis / 2007 Perth, Gall. Katherine Kalaf / 2008 Basel,

Gal. Anna Schmid / 2009 Middlesbrough, Middlesbrough Inst. of Mod. Art. – *G:* 1990, '92 Paris: Trienn. europ. du Bijou / 1996–97 Pforzheim, Schmuck-Mus.: Granulation (K) / 1997 Hanau, Dt. Goldschmiedehaus: In neuer Reihung (K) / 1998 Graz, Joanneum: Schmuck aus Padua (K); Edinburgh, NM of Scotland: Jewellery Moves (K) / München: 1999 Gal. Handwerk: Hommage an Dr. Herbert Hofmann; 2001 Bayerischer KV: Mikromegas (Wander-Ausst.; K) / 2002–03 Wien, Gal. Slavik: Winterreise / 2005 Lucca, Villa Bottini: Lucca preziosa (K). ▭ Dict. internat. du bijou, P. 1998. – *R. Ludwig* (Ed.), Schmuck 2000. Rückblick, Visionen, Ulm 1999; *R. Joppien/P. Nickl*, J. Ryan. G. C. Schmuck, Treviso 1999; *G. Folchini Grassetto*, Contemp. jewellery. The Padua School, St. 2005; Wertzeichen. 75 Jahre Ges. für Goldschmiedekunst, Hanau 2007; *B. Schmidt*, Goldschmiede-Ztg 107:2009 (6) 57; *R. Slavik/H. Welz* (Ed.), Art meets jewellery. 20 Jahre Gal. Slavik Wien, St. 2010. – *Online:* Website C. F. Krohn

Cory, *Ken (Kenneth)*, US-amer. Schmuckgestalter, * 1943 Kirkland/Wash., † 16. 1. 1994 Ellensburg/Wash. Stud.: 1963–67 California College of Arts and Crafts, Oakland (1971 ebd. Lehrtätigkeit); 1967–69 Washington State Univ., Pullmann, bei George Alois Laisner (1972–94 ebd. Lehrtätigkeit). – Beeinflußt durch die Bewegung der Beat-Generation gestaltet C. v.a. skulpturale Schmuckstücke mit Objets trouvés (vorwiegend Broschen), die der Junk- und Funk-Art nahestehen. Im Frühwerk (1967–71) experimentiert er mit gegossenem Kupfer sowie Silber und fertigt Broschen mit gegenständlichen, alltäglichen Motiven (*Tongue*, Silber, Bernstein, Leder, 1967), die häufig an Maschinen erinnern (*Hose*, Silber, Kunststoff, 1968). In Zusammenarbeit mit dem Illustrator und Graphikdesigner Leslie LePere (1969–71 als Art Team und 1972–86 als Pencil Brothers) entstehen v.a. assemblageartige, narrative „wall pieces" (*Egypt*, Email auf Kupfer, Glas, Bleistift-Zchng, Holz, 1974) und Broschen (*Hommage to Bob Helm*, Kupfer, Messing, Silber, Holz, Acrylglas, Zchng, Fotogr., Seide, 1969) in comichafter Formsprache, bei denen C.s Emailbilder (v.a. Champlevé-Email) durch Zchngn von L. LePere erg. werden. C.s eig. Arbeiten aus den 1970er Jahren zeugen von der Auseinandersetzung mit trad. indianischem Schmuck (*Squash Blossom Necklace*, Messing, Leder, Fundstücke, 1974); weiterhin Gürtelschnallen mit narrativen, emaillierten Darst., oft mit ironischen und sexuellen Anspielungen (*Route 66*, Email/Kupfer, Messing, 1976). 1979–86 widmet sich C. v.a. der Herstellung von Werkzeugen und Gebrauchsgegenständen wie Stiftspitzer, Ausstechformen, Bilderrahmen, Brieföffner. Das Spätwerk besteht aus Broschen in abstrahierten und reduzierten Formen, für die C. auf trad. Mat. wie Gold, Silber, Kupfer, Gold, Granat, 1988). ▭ ATHENS, Univ. of Georgia Mus. of Art. BOSTON/Mass., MFA. NEW YORK, MAD. PULLMAN, Washington State Univ. Mus. of Art. TACOMA/Wash., AM. WASHINGTON/D. C., Smithsonian Amer. AM. ◉ *E:* 1970 New York, MAD (K) / 1971 Erie (Pa.), Erie AC / 1972 Boulder, Univ. of Colorado / 1986 Spokane (Wash.), Cheney Cowles Mus. (mit Leslie W.

LePere; Wander-Ausst.). – *G:* 1967 Scranton (Pa.), Everhart Mus.: Amer. Jewelry Today (Ausz.) / 1969 Washington (D. C.), SI: Objects (Wander-Ausst.; K) / New York: 1969 (Young Americans 1969; Wander-Ausst.), 2011–12 (Crafting Modernism. Midcentury Amer. Art and Design; Wander-Ausst.; K) MAD / 1971 Oakland, Oakland Mus. of California: The Metal Experience / 1987 Tulsa (Okla.), Philbrook Mus. of Art: The Eloquent Object (Wander-Ausst.; K) / 1993 Seattle (Wash.), AM: Documents Northwest. Six Jewelers (K) / 1996 London, Crafts Council Gall.: New Times, New Thinking. ☐ Dict. internat. du bijou, P. 1998. – *B. Mitchell*, The jewelry of Ken Cory. Play disguised (K), Tacoma 1997; *C. Strauss*, Ornament as art. Avant-garde jewelry from the Helen Williams Drutt Coll. (K Wander-Ausst.), St. 2007. – *Online: N. Worden*, Metalsmith 14:1994 (3) 12 (Nachruf); *M. Kangas*, ibid. 15:1995 (4) 14–21; *id.*, ibid. 31:2011 (2) 22–25; *D. Standish*, ibid. 18:1998 (5) 50 s. F. Krohn

Cosandey, *Dominique (Dominique Jean René)*, schweiz. Zeichner, Maler, Lithograph, Serigraph, * 28. 5. 1953 Riaz/Kt. Fribourg, lebt in Les Sciernes-d'Albeuve/Kt. Fribourg. Nach Besuch der Schule in Bulle/Kt. Fribourg Lehre als Dekorateur. Als Künstler Autodidakt. Auf seinen Reisen in der Schweiz, auf Korsika, v.a. aber durch Skandinavien entstehen zahlr. Skizzen, Zchngn und Aqu. von Tieren, Lsch. und Pflanzen, die durch eine vereinfachende, das Wesentliche betonende Darst. charakterisiert sind. Für eine Ausst. über Wildgänse (*En suivant les oies sauvages*, Lausanne, 1995) reist er mit seiner Fam. im Wohnmobil sechs Monate durch Skandinavien. V.a. aber widmet C. sich der Lithogr.; er zeichnet die Tiere und Pflanzen direkt auf den Stein und druckt sie vor einem tonigen Fond auf einer Lithogr.-Presse aus dem 19. Jahrhundert. ☒ Croquis de terrain, Lausanne 1991; Neiges, ebd. 1988; Primitif, ebd. 2000. ⊚ *E:* 1980, '96 Bulle, Mus. gruérien / 2005 Lausanne, Zoologisches Mus. (K) / 2008 Estavayer-le-Lac, Le Cube. – *G:* 1996–97 La Chaux-de-Fonds, Mus. d'hist. naturelle: Nature d'artistes (K) / 1998 Neuchâtel, Mus. d'hist. naturelle: Artistes animaliers / 2007 Yverdon-les-Bains, Gal. de l'Hôtel de Ville: Salon de la Vallée de la Jogne et du Parc naturel régional Gruyère Pays-d'Enhaut / 2008 Charmey, Mus. du Pays et Val de Charmey. ☐ KVS, 1991; BLSK I, 1998. – *M. Durussel*, La Liberté v. 17. 5. 2000, 17; 1. 2. 2002, 31; 3. 12. 2005, 20; Neue Zürcher Ztg v. 20. 8. 2005. E. Kasten

Coser, *Luca*, ital. Maler, Zeichner, Kurator, * 7. 8. 1965 Trient, lebt dort. Stud.: ab 1983 ABA, Venedig, Malerei bei Emilio Vedova; 1987 (Dipl.) ABA, Florenz, Malereikurs bei Gustavo Giulietti. 1997 und '99 Ass. am Lehrstuhl für künstlerische Anatomie der ABA, Palermo; außerdem Lehraufträge an den Akad. in Venedig, Verona, Foggia und gegenwärtig in Rom. 1999 und 2000 entstehen Videos über sein künstlerisches Schaffen. 2000–04 Art Dir. des Verlages Nicolodi. 2001–02 Doz. für Step Design der Accad. Design Bozen. Ab 2001 Doz. für Kunstgesch. am Ist. Regionale di Studi e Ricerca Sociale der Prov. Trient. 2003–06 Creative Designer der Xgroup.comunicazione. 2004–06 Mitarb. beim Corriere del Trentino. 2005, '08

Workshops am MART, Rovereto, und Museion, Bozen. – In seinem vielschichtigen Schaffen, das häufig aus Zyklen besteht, verwendet C., der sich als Vertreter einer Generation versteht, die nur noch mediale Gefühle erlebt, Anregungen aus Film, Lit., Kunst und dem alltäglichen Leben als Filter zur Beschreibung der eig. Realität und Befindlichkeit. Auf blassen, mitunter durchsichtigen Bildflächen skizziert er geometrische oder freie lineare Formen, die scheinbar schwebende Bild- oder Textfragmente überlagern. Manchmal überdeckt er die z.T. leeren Flächen zw. den Fragmenten mit Kunstharz oder bezieht Videobilder aus Filmen in seine poetischen Kreationen ein. In dem Werkzyklus *Untitled Love Story* (2005; 500 Zchngn und Arbeiten in Mischtechnik und Kunstharz auf Holz) widmet er sich den weiblichen Hauptfiguren aus drei berühmten Filmen: *Elsie* oder die verletzte Unschuld aus „M" von Fritz Lang (1931), *Anna* oder die Abwesenheit aus „L'avventura" von Michelangelo Antonioni (1959) und *Norma* oder die wiedergefundene Erinnerung aus „Sunset boulevard" von Billy Wilder (1950). Der Zyklus *Del genere traditore* (2005) ist eine Reflexion über einen Essay von Michel Butor zu dem Thema Vanitas. Figuren aus der eig. Kindheit und Darst. von Kriegspropaganda kombiniert C. in dem Zyklus *Comedians* (2008). Der 100teilige Gem.-Zyklus *1+1=1* (2010; ausgezeichnet mit dem Premio Combat) bezieht sich auf den Film „Der amer. Freund" von Wim Wenders; der Titel ist ein Zitat von Andrej Tarkovskij, wonach die Summe von zwei Öltropfen einen großen Öltropfen ergibt. Die kleinformatigen Gem., die sich jeweils als Fragmente auf der Suche nach einem and. Fragment verstehen, behandeln u.a. die Themen Vaterschaft, Tod und Angst vor dem Tod, Verlust der Unschuld. 1999 entstehen im Auftrag des Mus. di Sc. Naturali, Trient, die Ill. zu G. Sartori, *Diluvio* (Rovereto 1999). Auch als Ausst.-Kurator tätig. ☒ Altreversioni, Rovereto 2005; Untitled love story, Rovereto 2005; Da trentatre a Lunatico 1997–2007, Bolzano 2007; First & second, Bolzano 2008; Your names, my game, Bolzano 2008. ⊚ *E:* 1989, '94 Verona, Gall. Ponte Pietra / 1990, '98 Innsbruck, Gal. Orms / Trient: 1991, '95 Gall. Cenacolo; 2000 Gall. Civ. di Arte Contemp. (K: V. Coen/R. Turrina); 2005 Collegio Arcivescovile (K) / Bozen: 1992 Gall. Spatia; 2001 Südtiroler Künstlerbund; 2006 Gall. Goethe 2; 2008 Museion (mit Arnold Mario Dall'O) / 1994 Wien, Gal. Peter Lindner (mit Ulrich Egger und Ricardo Curti) / 1998 Mailand, Lattuada Studio; Bologna, Gall. Il Campo delle Fragole; Albenga, Gall. Ristori / 2001 Palm Beach (Fla.), Cima Gall. (mit Jane Manus) / 2002 Belgioioso, Castello / 2005 Egna, Kunstforum; Neumarkt, Gal. der Bez.-Gemeinschaft / 2007 Kaltern, Gal. Le Carceri (mit A. M. Dall'O); Teramo, Banca di Teramo / 2008 St. Ulrich, Kreis für Kunst und Kultur / 2010 Neapel, Gall. Overfoto; Mailand, Whitelabs; New York, Kip's Gall. (alle mit K) / 2011 Prato, Lato Arte; Livorno, Blob Art (K: F. Baboni/S. Taddei); Modena, D406 Arte Contemp. (K). – *G:* 1986 Padua: Bienn. giovani / 1992 Ferrara, GAM e Contemp.: Notizie di pitt. (K) / Trient: 1992 Gall. Civ. d'Arte Contemp.: Artisti salisburghesi e trentini (K); 1995 ebd.: Percorsi; 2000

Pal. Trentini: La vetta e gli orizzonti (K); 2001 Assoc. Cult. Formato Arte (K); 2003 Mart: Situazioni. Trentino Arte 2003 (K) / 1998 Gazoldo degli Ippoliti, MAM: Bienn. Postumia giovani (K) / 1999 Conegliano Veneto, Pal. Sarcinelli: Sulla pittura. Artisti ital. sotto i 40 anni (K); Rovereto, GA: Il moderno. Da Van Gogh a Warhol (K); San Marino, GAM: Le vie e le ricerche (K); Sassari, MAC: Atlante, geografia e storia della giovane arte ital. (K) / 2000 Andora: Paraxo 2000 (K) / 2002 Aschersleben, KV: Outdoor. Ital. Künstler in Deutschland (K); Villa Lagarina, Cimana Arte: 4 da Everest (K) / 2011 Cosenza, Gall. Naz.: Ente Comunale di Consumo (K); Venedig: Bienn. ⌑ *L. Beatrice u.a.*, Nuova scena. Artisti ital. degli anni '90, Mi. 1995; *S. Zanella*, Questo Trentino v. 9. 10. 2000; *G. Kowa*, Mittel-dt. Ztg v. 6. 11. 2002; *C. Perer*, Sentire v. 4. 11. 2010; *G. Fattorini*, Arskey v. 13. 4. 2011 (Interview). – *Online:* Website C.; ABA Rom; Trient, Fond. Bruno Kessler. – Mitt. C.

E. Kasten

Cosey Fanni Tutti (eigtl. Newby, *Christine Carol*), brit. Performance-, Aktions-, Installations- und Videokünstlerin, Musikerin, * 4. 11. 1951 Kingston-upon-Hull, lebt seit 1973 in London. 1973 nimmt sie den Künstlernamen C. in Anlehnung an die Oper Così fan tutte von Mozart an. 1973–80 ist sie an Mail-art-Aktionen beteiligt (zumeist Fotos von ihren Performances). 1976 Gründung der Musikgruppe Throbbing Gristle mit Chris Carter, Peter Christopherson und Genesis P-Orridge. Ab 1981 konzentriert sie sich auf Musikvideos zus. mit dem Lebensgefährten C. Carter als Chris & Cosey, später Carter Tutti. – In ihren Performances, die sie oft nackt ausführt, untersucht C. ihr Selbstbild und das Konzept der Schönheit im Kontext der Sexindustrie. Mehrere Rollen spielend, präsentiert sie Schönheit in Situationen, die zur (simulierten) Verstümmelung führen, z.B. *Prostitution* (1976, London, Inst. of Contemp. Art). Sie verwendet Musik als Mittel des Genusses wie der Qual. Nach langer Pause beschäftigt sie sich seit 1994 erneut mit Kunst. 2010 Aufführung einer audiovisuellen Performance in der Turbine Hall der Tate Modern, London. ◉ *G:* 1975 Paris: Bienn. ⌑ *Buckman* I, 2006. – Arte inglese oggi (K), Mi. 1976; *T. Holert/H. Munder* (Ed.), The future has a silver lining (K), Z. 2004; Slg Migros Mus. für Gegenwartskunst Zürich 1978–2008 (K), Z. 2008; *R. Furness* (Ed.), Frieze projects, Frieze talks 2006–2008, Lo. 2009. – *Online:* Website C.; Red Bull Acad. Radio (Interview 8. 2. 2010).

G. Bissell

Coşkun, *Halil,* türkischer Maler, * 1963 Divriği/Sivas, lebt in Ankara. Stud. ebd.: bis 1985 (Abschluß) Malerei-Abt. der Gazi Univ. ebd.; 1987–90 Fak. der Bild. Künste der Hacettepe Univ. – C. malt in Öl/Lw., um 2008 entsteht die Serie *Variationen* mit Tauben als Hauptmotiv in abstrahierender Manier. Die Komp. zeigen einerseits eine Anordnung der Motive in Registern, andererseits arabische Schrift und kleine Symbole im Hintergrund; vereinzelt erinnern die Vögel an kauernde Frauen, eingehüllt in einen Umhang. Signiert mit vollem Namen und Jahreszahl. ◉ *E:* Ankara: 1994 Akbank Sanat Gal.; 1997–2010 häufig Gal. Soyut; 1998 Gal. Ilayda; 2003 Keşif Sanat Gal. /

1995 İzmir, Temizocak Sanat Gal. / 2001 Eskişehir, Scala Sanat Gal. / 2003 Bursa, Kitabevi / 2006 Bodrum, Cam Sanat / 2007 Istanbul, Ziraat Bakası Tünel Sanat Gal. ⌑ *Online:* Orig. Turkish paint. gall. K. Schmidtner

Cosman, *Octavian,* rumänischer Maler, Graphiker, Szenograph, Keramiker, Freskant, * 26. 9. 1940 Ocna Mureş/Bez. Alba, lebt in Cluj-Napoca. Stud.: bis 1967 HBK I. Andreescu, Cluj-Napoca (Malerei). Ausz.: 1975 Malerei-Preis der Zs. Tribuna (Cluj); 2006 Artist in Residence, Vermont Studio Center, Johnson. Mitgl.: Gruppe Stigma. 1968–74 Redakteur der Kultur-Zs. Echinox in Cluj. 1973–74 Graphiker beim Verlag Dacia (Cluj). Seit 1996 Lehrtätigkeit an der Fak. bild. Künste an der Univ. Oradea. Auch als Kurator tätig. – C. gestaltet zunehmend abstrakter in Öl oder Aqu. Stilleben, Lsch. und Figurenbilder (v.a. Harlekine). Er beschäftigt sich außerdem mit lit. Stoffen (z.B. Don Quijote) und bes. intensiv mit relig. Themen. 1970–71 ist er Szenograph am Puppentheater in Sibiu. Ab 1974 entwirft er (bis 1978 angestellt, dann freischaffend) Dekorationen und Kostüme für Inszenierungen des Nat.-Theaters in Cluj-Napoca, u.a. für Die Perser von Aischylos (1979) und Shakespeares Macbeth (1982). Bes. zw. den Jahren 1984 und 1998 ist er Autor mon. Keramikmosaiken und Fresken, u.a. im orthodoxen Stil. ▣ *Mosaiken:* BAIA-MARE, Bischofssitz, 1988. DEVA, Romtelecom, 1998. ORADEA, Bischofssitz, 1988. ROHIA/Bez. Maramureş, Kloster (zus. mit Paul Sima), 1977. ◉ *E:* zahlr. nat. und internat., u.a. 1972 Brüssel, Gal. Regard 17 / 1990 London, St. John's Bloomsbury Found. / 1991 (Retr.; K: A. Rus), '97 (Retr.; K: L. Drăgoi) Cluj-Napoca, MN de Artă / 1996 Boston, Guildhall Mus. / 1997 Budapest, Rumänisches Kulturzentrum / 2007 Sibiu, Gal. de Artă Passe-Partout / 2011 Rom, Accad. di Romania. – *G:* zahlr. nat. und internat., u.a. 1991 Sheffield: Synthesis. ICMC '91 (K: E. K. Augsburger) / 1992 St. Petersburg: Sacred Fire (K: C. Harbinson) / 1997 Cluj-Napoca, MN de Artă: Apocalipsia. ⌑ *A. Cebuc u.a.*, Enc. artiştilor români contemp., III, Bu. 2000. – *Online:* Website C. B. Scheller

Costa, *Claude,* frz. Graffiti- und Street-art-Künstler, Maler, * 1955 L'Estaque, lebt in Paris (Sportlehrer). Stud.: 1976–79 EcBA, Marseille. C. wird ab A. der 1980er Jahre in Paris durch seine provokativen „affiches détournées" im öff. Raum bekannt. Er bearbeitet großflächige Werbeplakate, indem er deren Bildträger zweckentfremdet und deren Botschaften subversiv umdeutet. er ist 1983–86 v.a. nachts in den Pariser Metrobahnhöfen und -schächten aktiv. – C. ergänzt seine Übermalungen (Pinsel, Farbe) mit speziele figurativen und typogr. Elementen, die z.T. der antiken Mythologie entlehnt sind, u.a. Göttertochter Pasiphae mit Sohn Minotaurus. Darüber hinaus spielen der Exhibitionist und die Vogelfrau eine zentrale Rolle in C.s Motiv- und Formenkanon als Stilmittel einer persönlichen Mythologie. Mit humoristischer und ironischer, nicht selten erotisch intendierter Ikonogr. möchte C. Aufmerksamkeit erregen, denn er versteht sich als Provokateur, der die subversive Arbeit im öff. Raum zur künstlerischen und individuellen Existenzbestätigung nutzt. ◉ *E:* 1984

Saint-Paul-de-Vence, Gal. Catherine Issert. ▯ *B. van Treeck*, Das große Graffiti-Lex., B. 2001. – *D. Riout/ D. Gurdjian/J. P. Leroux*, Le livre du graffiti, P. 1990; *S. Metze-Prou*, Graffiti in Paris, B. 2000 (Graffiti Art, 11).

S. Prou

Costa, *Cláudio Martins*, brasil. Bildhauer, Hochschullehrer, * 1932 Porto Alegre, lebt dort. Vater von Clóvis Martins Costa. Stud.: 1963–66 Kunst an der Univ. Federal do Rio Grande do Sul, Porto Alegre; 1973 ebd. Kurse in Keramik, Tapisserietechnik, Serigraphie, Rad. und Malerei an der Esc. Superior de Artes Santa Cecília. Unterrichtet 1971–90 am Inst. de Artes der Univ. Federal do Rio Grande do Sul. Fertigt u.a. eine Skulpt. des Malers Oscar Boeira sowie Wandarbeiten für das Colégio Farroupilha in Porto Alegre und für die Praça Santo Antônio in Cachoeira do Sul. – C.s expressionistisch anmutende Skulpt. thematisieren grundsätzliche Fragen des menschlichen Daseins. Neben seinen mon. Arbeiten widmet er sich bes. der Kleinplastik, z.B. *Aba pe ndê – Quem somos nós*, die sich mit den afrikanischen Wurzeln eines Großteils der Brasilianer beschäftigt. ☉ *E:* 1986, '97 Cachoeira do Sul, Esc. de Arte Santa Cecília / 1999 Porto Alegre, Saguão do Centro Mpal de Cult. –. *G:* 1969 Cachoeira do Sul: Salão de Artes (1. Preis) / Porto Alegre: 1981 Atelier Livre Mpal: Rumos da Arte; 1985 Alfred Hotel: Coletiva de Escultores; 1996 Inst. de Artes da Univ. Federal de Rio Grande do Sul: O Inst. de Artes Expõe a Sua Hist.; 1997 Mus. de Arte: Arte Sul / 1997 Buenos Aires, Centro Cult. Récoleta: Porto Alegre en Buenos Aires. ▯ *R. Rosa/D. Presser*, Dic. de artes plást. no Rio Grande do Sul, Porto Alegre ²2000.

M. F. Morais

Costa (Vieira Costa), *Cléa*, brasil. Zeichnerin, Graphikerin, Malerin, Bildhauerin, * 1946 Goiânia, dort tätig. Stud.: 1962–67 EBA der Univ. Federal de Goiás, Goiânia (Malerei bei Clever Gouvêa); bis 1973 ebd. (Zchng). Lehrtätigkeit ebd. seit 1976 (Zchng, Druckgraphik, Malerei) und seit 2001 an der Fund. Jaime Câmara ebd. Ausz.: 1973, '75 Prêmio de Desenho des Concurso de Artes Plást. Caixega, Goiânia. – C. schafft neben Gem. und Zchngn auch Metall-Skulpt. (Eisen, Aluminium). Sie abstrahiert Formen der Natur, etwa Laubblätter, die als kreis- und halbkreisförmige, konkave und konvexe Metallplatten aneinander gefügt und mit Bündeln von dünnen Stäben oder treppenartigen Gebilden verbunden oder erg. werden können. Eine hellbraun gefärbte Metall-Skulpt. (Mus. de Arte de Goiânia) zeigt eine sich rückwärts an einen Baum lehnende und in den Himmel blickende Figur, wobei zw. den Oberflächen von Pflanze und Mensch kein Unterschied besteht und beide gleichsam miteinander verschmelzen. C.s Formensprache sucht nach harmonischen Konturen; die Farbigkeit ihrer hüfthohen bis lebensgroßen Skulpt. ist zurückhaltend und erdig, wobei die Oberflächen der im Freien aufgestellten Eisen-Skulpt. mit dauerhafter Lackschutzfarbe überzogen sind. Des weiteren figurative Zchngn (Bleistift, Tusche, Wachskreide, Graphit, Acryl). Ausgeprägte Parallelschraffen markieren sowohl in der Zchng als auch im Gem. Flächen und Volumina, etwa bei Stilleben und Figuren. C. setzt auch Airbrush-techniken ein und erzielt bei einigen Figurenstudien einerseits weich gez., verschwimmende Konturen (*Mulher de Bolsa*), andererseits scharf gegeneinander abgegrenzte Bildobjekte (*Carrega que esse mala é sua*, beide auf Pappe; Mus. de Arte de Goiânia). Daneben auch abstrakte Arbeiten, so monochrome Gem. in warmen Farbklängen mit nebeneinander gesetzten oder im Zickzack verlaufenden Farbstreifen und -flächen, die mit rauhen Oberflächenstrukturen (z.B. Kratzspuren) spielen. ▯ *Im öff. Raum*: GOIÂNIA, Mus. de Arte: Homenagem ao Braulino, Metall-Skulpt. – Univ. Federal de Goiás, Rektorat: Metall-Skulpt. – Setor Oeste, Jardim do Edifício Aton: Metall-Skulpt. ☉ *E:* 1988 Brasília, Gal. Jornal do Brasil (K) / São Paulo: 1989 Gal. Paulo Prado (K); 1993 Gal. de Arte do Brasil Interior / Goiânia: 1991 Gal. Marina Potrich; 1998 Fund. Jaime Câmara; 2008 Euro Working Concept (Retr., K); 2009 Mus. de Arte. –. *G:* 1978 Rio de Janeiro: Salão nac. de artes plást. / 1988 São Paulo, Mus. do Imagem e do Som: Mulheres abstratas / Goiânia: 1988 MAC: Bien. nac. de artes plást.; 1990 Mus. de Arte: 20 Anos do Mus. de Arte de Goiânia; 2000 Fund. Jaime Câmara: Mulheres; 2011 Centro Cult. Oskar Niemeyer: Festival para todos os tribos / 2011 Britânia, Mus. de Arte: A cara da arte. ▯ *Ayala*, 1997. – *Online*: Inst. Itaú Cult., Enc. artes visuais, 2008.

C. Melzer

Costa, *Clóvis Martins* cf. **Costa**, *Cláudio Martins*

Costa, *Giacomo*, ital. Fotograf, Computerkünstler, Szenograph, * 5. 10. 1970 Florenz, lebt dort. Sohn eines Prof. für Rechts-Gesch.; verläßt 1986 das Liceo Classico, beschäftigt sich mit Motorsport und Alpinistik. 1992 läßt er sich in Courmayer nieder und beginnt, Berg-Lsch. zu fotografieren. Kehrt 1993 nach Florenz zurück, befaßt sich mit mod. Kunst und eröffnet ein eig. Fotostudio. 1994 trifft er den span. Fotografen Richard Nieto. Für die in den Folgejahren entstehenden thematischen Serien bearbeitet er seine Fotos digital: in der Serie *Agglomerati* (1996) montiert er mit einem Bildbearbeitungsprogramm kaleidoskopartig Anhäufungen städtischer Bauten; die *Paesaggi* (1997) sind urbane Lsch. mit einzelnen überdimensionalen Betonblöcken; in *Palazzi* (1997) zeigt er einzelne Gebäude im Gebirge oder in der Wüste; 1998 folgen *Visioni rotonde* und *Archi*. 1999 wendet sich C. der 3D-Technologie zu und nutzt deren Möglichkeiten, um phantastische z.T. apokalyptische Lsch. (*Landscapes*, 2012) oder Ansichten ausgestorbener Städte (*Particolari*, 2001) entstehen zu lassen. In düsteren, bedrohlichen Szenarien, die an Bilder aus Science-fiction-Filmen erinnert, reflektiert C. die Probleme unserer Welt, wie Umweltverschmutzung, Bedrohung der Natur (*Community gardens*, 2009) und des Menschen, den Verlust menschlicher Maßstäbe (*Atti*, 2006), Menschenfeindlichkeit und Anonymität städtischer Ballungsräume (*Megalopoli*, 2002), Naturkatastrophen (*Fusioni*, 2007; *Persistenze*, 2008). In der aus 24 Lichtkästen mit C-prints bestehenden Installation *Private Gardens* (Bienn. Venedig 2009) überwuchert die Natur die Ruinen einer verlorenen Kultur, die die unsere sein könnte. 2011 präsentiert er in der Folge *Post Natural* Unterwasserszenarien mit Ruinen und Archit.-Fragmenten. C.

ist auch als Szenograph tätig, z.B. am Teatro della Pergola in Florenz. – Fotobücher: *G. C. land(E)scape*, [Mi.] 1999. ⌂ EBERDINGEN-NUSSDORF, Slg Alison und Peter W. Klein. HOUSTON/Tex., Contemp. AM. NEW ORLEANS/La., Contemp. AC. PARIS, Centre Pompidou. – MNAM. PRATO, Centro per l'Arte Contemp. Luigi Pecci. ROM, Nomas Found. ⊙ *E:* 1997 Arezzo, Gall. Marsilio Magiacchi / 1999 London, Photology / 1999, 2002 New Orleans, Arthur Roger Gall. / 2000 New York, Laurence Miller Gall. / 2002 Florenz, Sergio Tossi Arte Contemp. (K) / Genua: 2003 (K), '06, '09, '12 Gall. Guidi & Schoen arte contemp.; 2004 Studio La Città (mit Eelco Brand) / 2004 Turin, GNAM: Anteprima Quadrienn. di Roma / 2005 Florenz, Quarter-Centro Produzione Arte; Ciampino (Rom), Gall. Civ. d'Arte Contemp.; Salerno, Gall. Paola Verrengia / 2006, '07, '09, '12 Luxembourg, Gal. Clairefontaine / 2008 Alassio, Ex Chiesa Anglicana / 2010 Rom, Gall. Emme Otto; Sydney, Dominik Mersch Gall. / 2011 Düsseldorf, Gal. Voss.; Seoul, Hangaram AM. – *G:* 1999, 2004 Rom: Quadrienn. (K); Turin: Bienn. della Fotogr. (K) / 2001 New Orleans, Contemp. art Center: Photogr. now (K) / 2004 Florenz, Pal. Pitti: Col segno di poi. Fotogr. in Toscana 1980–2002 (K) / 2006 Genua, MAC di Villa Croce: Suoni e visioni 3; Paris, Centre Pompidou: Le peintre de la vie mod. (K); Venedig: Bienn. di archit. (K) / 2007 New York, Phillips De Pury: C-Photo exhib. / 2008 Pietrasanta, GAC: Città panico (K) / 2009 Bielska: FotoArtFestival; Seoul, Internat. Photo Festival / 2010 Dresden: Ostrale 2010 (K). ⌷ Enc. dell'arte Zanichelli, Mi. 2004. – *L. Pratesi*, La Repubblica v. 3. 1. 1999; *S. Zannier*, Mountain Way. I sentieri dell'arte per la montagna, Trieste 2002; *M. Sciaccaluga*, Arte 361:2003, 126–132; *id.*, Flash art (Ed. ital.) 38:2005 (253) 76 s.; *C. Antolini*, Arte 399:2006, 134–139; *P. Gagliano/G. C.*, 3d cities. G. C. four years, two gall., Pontedera 2006; *C. photo mag.* 3:2007, 8 ss.; *L. Beatrice*, G. C. The chronicles of time, Bo. 2008 (Vorw. von N. Foster); *M. Zollner*, Foto-Mag. 2008 (3) 124–129; Photomeetings Luxembourg 2009, Luxembourg 2009; *L. Spagnesi*, Arte 427:2009 (März); *P. Jodidio*, Archit. now!, VII, Köln u.a. 2010; *E. Piatti*, Zoom Internat. (Mi.) 2011 (104) 48–53; *R. C. Morris*, The New York Times v. 12. 6. 2012. – *Online:* Website C.; *F. Busdraghi*, Camera obscura v. 5. 6. 2008 (Interview). – Mitt. C. E. Kasten

Costa, *Guido*, ital. Fotograf, Lehrer, * 12. 6. 1871 Sassari, † 1. 11. 1951 Cagliari. Sohn des Schriftstellers und Historikers Enrico C. Seit etwa 1900 ist C. als Englischlehrer in Cagliari tätig. Als Fotograf Autodidakt; auch Werbung, daneben Gem. und Zchngn. Foto-Publ. in Le vie d'Italia (Touring Club Ital.), in Mag. und Ztgn (Ill. del popolo; L'unione sarda; Mediterranea), auch auf Postkarten. Bekanntschaft mit dem Schriftsteller Salvatore Cambosu, dem Maler Felice Melis Marini und dem Keramikkünstler Federico Melis. – Schon seit 1913 fotogr. C. für das ital. Rote Kreuz eine Dokumentation der sardischen Trad., bes. der volkstümlichen Sitten und Gebräuche. 1923 publ. er den Aufsatz *The island of Sardinia and its people* (in: The nat. geographic mag. 43:1923[1]1–75), der z.T. mit Bildern des Red.-Fotografen Clifton Adams ill. ist. Die vorangegangene Begegnung mit diesem professionellen Fotografen wird als entscheidend für C.s eig. Fotoproduktion angesehen. C. hatte C. Adams während dessen Sardinienaufenthalt 1921–22 begleitet und dabei evtl. fototechnische Kompetenzen erworben und seinen eig. Stil entwickelt. Einige seiner Fotogr. nehmen Komp.-Prinzipien der Malerei auf, während and. an den Piktorialismus denken lassen (Cicalò, 2007, 21 s.). V.a. Ortsansichten aus dem Inneren von Sardinien und Lsch.-Veduten (Campidano; Barbagia), auch Städte (v.a. Cagliari), Kirchen (Nostra Signora di Bonaria, Cagliari; San Gavino, Porto Torres), hist. Mon. (Casa di Garibaldi, Caprera; Nuraghen), Prozessionen und Volksfeste. Ferner fotografiert C. Frauen und Männer bei der Arbeit (u.a. ambulante Händler, Hausputz, Textilverarbeitung), auch trad. Porträts in Festtagskleidung. Wenige Fotogr. zeigen öff. Bauvorhaben (Staudamm am Tirso, 1924). Für das Rote Kreuz fotografiert C. u.a. die Anti-Malaria-Kampagnen im Inland und Ferienkolonien für Kinder. C.s Aufnahmen gelten als herausragend für die zeitgen. Fotogr. auf Sardinien; er zeigt einfache Bilder eines archaischen Lebens und liefert einen Querschnitt durch die volkstümliche Kultur ohne pittoreske Klischees. R. Campanelli (in: Cicalò, 2007, 12) vergleicht C.s Fotogr. mit dem Reisebericht des Schriftstellers D. H. Lawrence (Sea and Sardinia, 1921), dessen Text C. evtl. kannte, und betont seinen wachen Autorenblick. Der erh. Fondo C. in Nuoro besteht überwiegend aus Fotogr. der 1920er und 1930er Jahre; nur drei Negative sind mit 1916 datiert. ⌂ CAGLIARI: Arch. Erben C. NUORO, Ist. Superiore Regionale Etnogr. (ISRE): Fondo C. URBANIA, Bibl. Com. ⊙ *E:* 2007 Nuoro, Locali dell'ex tribunale (Wander-Ausst.; K). ⌷ *B. M. Bechis*, Un vero angelo di carità, Casale Monferrato 1929; *R. Bigi* (Ed.), Foto d'archivio, Mi. 1982; *O. Maccioni*, Cagliari fra cronaca e immagini, Cagliari 1982; *id.*, Visioni di Sardegna, Cagliari 1983; *G. Carta Mantiglia u.a.*, Il Mus. etnogr. di Nuoro, Sassari 1987; *A. Cuccu*, Cento anni di caramica, Nuoro 2000; *G. Podda*, Ajò, a su poettu, Cagliari 2003; *H. D. Wright*, Sardegna quasi sconosciuta, Sestu 2005; *R. Cicalò* (Ed.), C. Fotogr. della Sardegna nel primo Novecento (K), Nuoro 2007 (Bibliogr.). – *Online:* Sardegna digital Libr.
 M. A. Murgia

Costa, *Nadir da (Nadir Barbosa Machado da)*, brasil. Malerin, * 13. 10. 1944 Aquidauana, lebt in Campinas. 1960 Übersiedelung nach Rio de Janeiro. Stud.: Inst. de BA ebd.; Esc. Convívio de Arte, Campinas, bei Bernardo Caro und Francisco Biojone. – In ihren naiv-folkloristischen Malereien imaginiert C. einen idealisierten, von Frauen beherrschten Kosmos, der einer poetisch-feministischen Weltanschauung zu entspringen scheint. ⊙ *E:* Campinas: 1977 Centro de Ciências, Letras e Artes; 1986 Gal. Giglio; 1988 Espaço Cult. Sanasa; 1989 Gal. La Palette; 1990, '99 Tribunal Regional do Trabalho; 1992 Gal. Picturesque; 1993, '95 Gal. Vera Ferro; 1997 Espaço Cult. Oliva / 1997 São Paulo, Sesc Pinheiros. –. *G:* Campinas: 1971 Salão do Artista Jovem; 1985 Salão de Arte Contemp.; 1989 MAC: Expos. Mokiti Okada; 1990 Thé-

bis Curi Gabinete de Arte: Projeto Brasil Novo; 1992 Gal. Pictoresque: Grupo Hoje; 1997 Gal. Vera Ferro: Reprografia 97 / 1973, '74, '87 Piracicaba: Salão de Arte Contemp. / 1974, '86, '87 Santo André: Salão de Arte Contemp. / 1974, '75 São Paulo: Bien. / 1984 Rio de Janeiro: Salão Cristóban Cólon / 1985 (Gold-Med., Ankaufs-Preis), '87 (Silber-Med., Ankaufs-Preis) Araras: Salão Araraense de Artes Plást. / 1999 Porto Alegre, Gal. Tina Zappolli: Arquétipos. ⌑ *Cavalcanti* I, 1973. – *Online:* Website C. (Ausst.). M. F. Morais

Costa, *Nadir Barbosa Machado da* → **Costa,** *Nadir da*

Costantini, *Carlos,* argentinischer Comiczeichner, Illustrator, Animationsfilmzeichner, Musiker, * 8. 12. 1935 Buenos Aires, † 5. 9. 2005. Für die Mag. Matralla, Tia Vicenta, 4 Patas, Satiricón und das Jugend-Mag. Billiken zeichnet er Comics. Als Animator arbeitet er u.a. an *Doña Tele* und *Mac Perro.* Die Hundefigur *Mac Perro* wird sein bekanntester Charakter; dieser ist in den 1970er Jahren Titelfigur der Billiken-Beilage El Clan de Mac Perro. – C. ist als humoristischer Zeichner bekannt. Seine Zchngn weisen Einflüsse von amer. Animationsfilmen und Werbegraphik auf. ⌑ *Online:* Lambiek Comiclopedia.

K. Schikowski

Costantini, *Egidio,* ital. Glasgestalter, * 22. 4. 1912 Brindisi, † 8. 10. 2007 Venedig. Nach Ausb. in Rundfunk- und Fernmeldetechnik in versch. Berufen tätig, im 2. WK u.a. als Pförtner, daneben Botanik-Stud. (Dipl.) an der Univ. in Parma. 1945 Übersiedlung nach Carnia/Friaul. C. findet Interesse am Glas, wird Vertreter mehrerer Man. von Murano-Glas und nutzt die Gelegenheit zur Mitarb. bei Glasbläsern. Mit dem Ziel, die Glasbläserei der Malerei und Bildhauerei ebenbürtig werden zu lassen, vermittelt er zw. Künstlern und Glasbläsern und gestaltet selbst Glas-Skulpt. nach Zchngn zeigten. Künstler. Daraus entsteht 1950 das Centro Studio Pittori nell'Arte del Vetro di Murano. 1954 geht er nach Paris und gewinnt hier führende Künstler der Zeit für die Mitarb., u.a. Hans Arp, Alexander Calder, Max Ernst, Pablo Picasso und Gino Severini. Nach Auflösung des Centro Studio gründet C. 1955 seine Wkst. Fucina degli Angeli (mit Schmelzofen und Gal.), die er zwar 1958 schließen muß, aber bereits 1961 mit Förderung der Sammlerin Peggy Guggenheim wieder eröffnen kann. Noch in den 1990er Jahren gilt C. als singuläre Autorität, die als „Meister der Meister" den führenden Künstlern seiner Zeit die Umsetzung ihrer Kunstwerke in Glas-Skulpt. vermitteln kann. ⌕ AUGSBURG, KM Walter: 118 Arbeiten. COBURG, KS der Veste, Europ. Mus. für Mod. Glas. VENEDIG, Fond. Peggy Guggenheim. ⌑ *Delarge,* 2001. – Art internat. 11:1967 (10) 35; Glas-Skulpt. Fucina degli Angeli (Schmelzofen der Engel) von E. C. (K), Dd. 1968; Sculpt. in glass of the Fucina degli Angeli ... (K New York), Ve. [1968]; E. C. (K Ferrara), Cento [1976]; L'immortale. I capolavori di E. C. della Fucina degli Angeli (K Pal. Sanvitale), Parma 1984; E. C. a Torgiano con la Ficina degli Angeli (K), s.l. [1985]; *R. Ballarfin* (Ed.), Vetro, un amore. E. C. e la sua Fucina degli Angeli (K), Ve. [1986]; Da Chagall a Max Ernst. Maggi di vetri, Mi. 1990; Un sogno della materia, la mat. del sogno (K Gall.

Aedes), [Cassino 1990]; E. C. Vetro, un amore. La Fucina degli Angeli 1948–1992 (K), Ve. 1992; E. C. e i suoi artisti. Scult. in vetro della Fucina degli Angeli (da Picasso a Fontana) (K), Piacenza 1996; E. C. il maestro dei maestri. Scult. d'arte in vetro (K Pal. Frisacco), Tolmezzo 1999; *C. Schack von Wittenau,* Neues Glas und Studioglas. Ausgewählte Objekte aus dem Mus. für Mod. Glas, Rb. 2005. – *Online:* Peggy Guggenheim Coll. D. Trier

Costantini, *Sonia,* ital. Malerin, * 18. 11. 1953 Gazzo Bigarello/Mantua, lebt in Mantua. Nach Abbruch eines Stud. seit den 1970er Jahren künstlerisch tätig. 1979 Ausst.-Debüt; 1986 zum Salon de la Jeune Peint. nach Paris eingeladen. C. beschäftigt sich seit ihren malerischen Anfängen kontinuierlich mit dem Stud. der Farbfeldmalerei. Für sie ist die Farbe ein absoluter Wert, zugleich Thema, Substanz, Materie und Lichtspender. In ihren monochromen, in einer Mischtechnik aus Acryl- und Ölfarben ausgef. Malerei erprobt sie die Farben in ihren unterschiedlichsten Nuancen, die im Laufe der Jahre immer subtiler werden. Sie arbeitet mit flüssigen Farben, die sie mit der Spachtel gleichmäßig auf Papier oder Lw. in unterschiedlichen Formaten bis hin zum Großformat (z.B. *Rosso cadmio chiaro,* Acryl und Öl/Lw., 230 x 190 cm, 2004) aufträgt. Die dichten, gesättigten oder transparenten, leuchtenden Farboberflächen scheinen mitunter zu vibrieren, die körperhafte Farbe verströmt gleichsam ein inneres Licht. Häufig verwendet C. Farbbezeichnungen als Bildtitel (z.B. *Rosso Tiziano,* 2006; *Magenta,* 2008; *Viola minerale,* 2008). In der Ausst. *Pagine di colore* (2011) zeigt sie kleinformatige monochrome Pastelle auf Papier. ⌕ CONEGLIANO, Mus. Pal. Sarcinelli. FERRARA, GAM. GAZOLDO DEGLI IPPOLITI, MAM. MALO, Mus. Casabianca. MANTUA, Mus. Casa del Mantegna. – Mus. Diocesano. MODENA, Gall. Civ. NOCCIANO, Mus. delle Arti. ROM, Coll. Banca Naz. del Lavoro. SALÒ, MCiv. SESTO CALENDE, PCiv. SUZZARA, Gall. Civ. d'Arte Contemp. VIRGILIO, Mus. Virgiliano. ◉ *E:* Mantua: 1981 Gall. La Torre; 1983 Centro di Cult. Einaudi (K); 1993 Atelier Arti Visive; 2008 Pal. Pretorio; 2010 Pal. Te (mit Lucia Pescador und Gabriella Pauletti); 2011 Pal. Beccaguti Cavriani; Arch. di Stato. Sacrestia della SS. Trinità; Gall. Disegno / 1989 Viadana, Gall. Bedoli / 1992 Verona, Studio Rossi (K); Gualtieri, Pal. Bentivoglio / 1993 Brescia, L'Aura Arte Contemp.; Portogruaro, Studio Delise / 1993, 2002 Bergamo, Gall. Vanna Casati / 1994 Pordenone, Centro d'Arte Grigoletti / 1995 Ravenna, Artestudio Sumithra (K) / Mailand: 1995, '99, 2006 Gall. Il Milione; 2003 Cavenaghi Arte Contemp.; Gall. Rubin / 1996, 2000 Salò, Centro d'Arte Santelmo / Köln: 1999 Projektraum Triloff; 2000, '03 Gal. Stracke / 2000 Frankfurt am Main, Westend-Gal. / 2001 Ferrara, GAM (K: F. D'Amico); Civitanova Alta, Gall. Centofiorini / 2002 Münster, Gal. Ventana / 2003 Sesto Calende, Pal. Comunale / 2003, '04 Crespano del Grappa, Andrea Pronto Arte Contemp. / 2004 Diessen (Ammersee), Gal. Florian Trampler / 2007 Turin, Gall. Salzano / 2009 Freiburg, Gal. Artopoi (mit R. Balda und I. Dick) / 2010 Brescia, Lagorio Arte Contemp. (mit H. Kleeb und R. Dahinden; K). – *G:* 1982 Palidano

(Mantua), Villa Strozzi: Giovane arte mantovana / 1983 Suzzara, Gall. Civ. Arte Contemp.: Otto giovani artisti / 1985 Reggio Emilia, MCiv.: Restart / Mantua: 1985 Casa del Mantegna: Sulla linea dell'orizzonte (K); 2011 ibid.: Arte a Mantova 2000–2010; Pal. Ducale: So cos'è: può diventare arte / 1986 Paris, Salon de la jeune peint.; Ljubljana, Internat. Center of Graphic Arts: Papirnate sanje / 1995 Nocciano, Castello: In nome dell'astratto (K) / 1997 Salò, Pal. Comunale u.a.: Sogni di carta / 1999 Suzzara: Premio Suzzara / 2000 Quistello, Pin. Comunale: Il disegno a Mantova 1950–2000 / 2002 Soncino, Rocca: Rigore del colore (K) / 2005 Gubbio, Pal. Ducale: Il paesaggio ital. contemp. (K) / 2008 Cittadella, Pal. Pretorio: Continuità di un impegno nella pitt. Nove artisti del colore (K). ▭ DizPittMantovani I, 1974. – *C. Cerritelli u.a.*, S. C., s.l. 1993; *G. M. Accame* (Ed.), Differenze nella pitt. (K), [Trento] 1996; *B. Bandini/C. Cerritelli* (Ed.), In carta, Trento 1996; *id./id.* (Ed.), Fermare lo sguardo sulla giovane pitt. ital. (K), Mi. 1996; *C. Cerritelli/A. Madesani*, La pitt. dipinta. S. C., Gianni Pellegrini, Rovereto 2003; *A. Madesani* (Ed.), Trilogia del colore. Cecchini, C., Shanahan (K), Mi. 2003; *C. Cerritelli/G. Panza di Biumo*, S. C., Rovereto 2005; *G. Bonomi* (Ed.), Doc. di pitt. 2. C., D'Oora, Iacchetti, Mi. 2008 (Boll. della Gall. del Milione, 179); *F. Sardella*, S. C. Armonie per accordo (K), Mantova 2010. – *Online:* Gal. Florian Trampler, München. – Mitt. C.; A. Portesi, Lagorio Arte Contemp., Brescia.

E. Kasten

Costantino (Constantino), *Nicola*, argentinische Objektkünstlerin, * 1964 Rosario, lebt und arbeitet seit 1996 in Buenos Aires. Stud.: Fac. de Artes y Humanidades (Abschluß mit Schwerpunkt Skulpt.). Durch die Arbeit in der Kleiderfabrik ihrer Mutter entwickelt C. Gespür für Design und Muster. Mit ihrer kontinuierlichen Erkundung neuer Mat. und (Abguß-)Techniken (Bronzeguß, Eisen-Skulpt., Kunststoffe etc.) in anerkannten Wkstn legt sie die Grundlage für vollkommen real erscheinende Objekte, die ein char. Element ihrer Kunst bilden. Seit 1989 produziert sie 80 Zentimeter hohe Puppen, die das Thema ihrer ersten Einzel-Ausst. bilden. 1995 Teiln. am CORE-Programm der Glassell SchA, Houston (1996 CORE Exhib.). 1997 Stip. des Fondo Nac. de las Artes; 1999 Einladung zum Premio Fortabat, dessen Ergebnisse im MNBA von Buenos Aires präsentiert werden. – C.s Werk thematisiert gleichermaßen Schönheit und Perversion in Alltag und Kulturindustrie. Man kann Brustimplantate wie auch den Film Das Schweigen der Lämmer assoziieren. Erste Kleidungsstücke entstehen auf der Basis von Hühnerhaut. Internat. bek. wird C. v.a. durch ihre Modelle für die Haute Couture mit künstlicher Haut, täuschend nachgeahmt mit Silikon und menschlichem Haar. *Peleteria* (2000) zeigt eine Corsage, gebildet aus Brustwarzen und Hautstücken; bei *Cajas* (2000) scheinen große Holzkisten mit eingequetschten Tierleibern gefüllt. Aktuell präsentiert sie auf YouTube versch. surreale Videos, in denen es weiter um echte und künstliche Körper geht (z. B. *Vanity con tocador*). Ferner hat sie, wie Cindy Sherman, berühmte Bilder der Kunstgesch. nachgestellt (z. B. die Venus von

Velázquez). ▭ NEW YORK, MMA. ▭ *M. E. Pacheco u.a.*, Mus. de Arte Latinoamer. de Buenos Aires (K), Méx. 2001; *J. Collins*, Sculpt. today, Lo./N. Y. 2007; *H.-M. Herzog/K. Steffen* (Ed.), Face to face. The Daros coll. (K Zürich), Ostfildern 2008. – *Online:* Website C.; XXIV Bien. de São Paulo, Representações nac. Biogr. 2000.

M. Scholz-Hänsel

Costazza, *Josef*, ital. Maler, Graphiker, Zeichner, * 26. 11. 1950 Neumarkt/Bozen, lebt in Bozen. Autodidakt. V.a. Malerei (Öl, Gouache) in einem kühlen, realistischen Stil, der anfänglich von Neuer Sachlichkeit und Magischem Realismus inspiriert ist, später von zunehmender Reduktion und Stilisierung geprägt wird. Ausz.: 1994 Premio Arte Mondadori, Mailand. – C.s Lsch. und Archit.-Darst. sowie Figurenbilder befassen sich nahezu ausschließlich mit Themen und Motiven aus seiner Heimatregion Trentino-Südtirol, insbesondere aus dem Bozener Unterland. Die Farbpalette der formreduziert und häufig farbflächig vorgetragenen Figurenbilder (*Der Milchmann*, Öl/Lw.) und Lsch. (Fels-, Wiesen-, Tal- und Waldstücke, einsame Gehöfte und Weiler zu allen Jahreszeiten, häufig Winter-Lsch. bei Mondlicht) ist dabei auf wenige Töne beschränkt (v.a. Weiß, Grau, Braun, Blau). Auch (Wild-)Blumenstücke und Blumenstilleben. Die Form- und Farbreduktion wird im Spätwerk ohne Aufgabe der Gegenständlichkeit bis zur Abstraktion und Monochromie gesteigert, was teilw. mon. Wirkungen hervorruft (*Schnee-Lsch.*, Öl/Lw., 2010). Ein häufiges Motiv sind stilisierte Reiter und Reitergruppen (*Cavalli e cavalieri*, Öl/Holz, 2010; beide im Kunsthandel). Auch (Gebrauchs-)Graphik, u.a. Entwürfe für Sonderpostwertzeichen der Republik San Marino, darunter die zu Weihnachten 2006 aufgelegte dreiteilige *Engel*-Serie in den san-marinesischen Landesfarben Weiß und Blau. – C.s Werk stellt einen eigenständigen Beitrag in der zeitgen. bild. Kunst von Südtirol dar. ◉ *E:* Bozen: 1989 Dominikaner-Gal.; 1991, 2009 Gal. Leonardo / seit 1997 häufig Innsbruck, Gal. Augustin. – *G:* 2006 Bruneck, SM: Künstler und Atelier. ▭ *E. Tscholl u.a.*, J. C. (K), Bozen 1995; *R. Stein/H. Reichart*, J. C. (K), Bozen 2001; Kürschners Hb. der Bild. Künstler. Deutschland, Österreich, Schweiz, I, M./L. 2007.

U. Heise

Coster, *Jocelyne*, belg. Malerin, Graphikerin, Serigraphin, * 1955 Brüssel, lebt in Linkebeek, Atelier in Brüssel. Stud.: 1972 ABA, Watermael-Boitsfort/Brüssel, Atelier Jean-Pierre Point; ab 1972 Ec. nat. supérieure des Arts visuels de La Cambre, Brüssel, Atelier Marc Mendelson (Dipl.: 1977 Serigraphie; 1981 Lehramt). Lehrtätigkeit: 1981–87 ABA, Namur; 1983–87 ABA, Charleroi; seit 1989 Ec. des Arts d' Ixelles, Brüssel. Ausz.: u.a. 1978 Bourse de la Vocation belge; 1988 Grand Prix der Bienn. Jeunes Talents, Charleroi, MBA; 1990 Prix Médiatine, Communauté franç., Woluwe-Saint-Lambert/ Brüssel; 1995 Prix Jos Albert, 2006 Prix Camus, beide Acad. R. des Sc., des Lettres et des BA de Belgique; 1996 Prix Marie-Louise Rousseux, Ixelles. – Von weiten, endlos scheinenden Räumen fasziniert, macht C. Luftbildaufnahmen von zumeist großzügigen Gebirgs-Lsch. (anfangs analog, später digital), druckt die Motive im Siebdruck-

verfahren, bearbeitet sie mit Acrylfarbe nach und bezieht schließlich auch geogr. Karten in ihre Arbeiten ein. Seit E. der 1990er Jahre dehnt sie ihre geogr. Erkundungen auf das Organ der menschlichen Haut aus, deren „Geographie", die augenfällige strukturelle Ähnlichkeiten mit der der Erde aufweist. Zur Veranschaulichung macht sie vergleichende Studien zw. Luftbildern von Lsch. oder geogr. Karten und digitalisierten Hautabdrücken, die zu frappierenden Ergebnissen führen. Zudem gestaltet sie temporäre und dauerhafte Installationen und thematisiert u.a. das Zusammenspiel von Wind und Licht (*En de wind van achter*, Windmühlen und Serigraphien auf Aluminiumspiegel; Oostende, Hafenmauer, 2000, als Beitr. zum Wettb. Arti-val). BRÜSSEL, Belgacom Art. – Flughafen, Zugang VIP-Salon : Astrolabe, Spirale, Serigraphie auf Aluminium und Inox-Stahl, 1999. – Minist. de la Cult. franç. – Mus. d'Ixelles. CHARLEROI, MBA. LA LOUVIERE, Centre de la Gravure et de l'Image imprimée. WOLUWE-SAINT-LAMBERT/Brüssel, Artothèque de Wolubilis. E: Brüssel: 1986 Centre d'Art contemp.; 1990, '93 Gal. Miroir d'Encre; 1997 Gal. Pierre Hallet; 2001 Gal. Artitude; 2004 Gal. Bastien; 2009 Centre d'Art Chap. de Boondael (Installation); 2011 Univ. libre de Bruxelles (mit Françoise Schein) / 1990 Namur, Maison de la Cult. / 2006 Waterloo, Gal. Its Art Ist. – *G:* 1976 Kortrijk: Bienn. / 1998 Prag: Internat. Print Trienn. (Labyrinth) / 2009 Lüttich: Graphik-Bienn. *Bénézit* III, 1999; *Delarge*, 2001; *Pas* I, 2002. – *Online:* Website C. R. Treydel

Costi, *Rochelle*, brasil. Fotografin, Video- und Installationskünstlerin, * 1961 Caxias do Sul/Rio Grande do Sul, lebt seit 1988 in São Paulo. Stud.: 1978–81 Fac. de Comunicação Soc., Pontifica Univ. Católica do Río Grande do Sul, Porto Alegre (Publizistik und Werbe-Wiss.); 1982 Esc. Guignard, Belo Horizonte (audiovisuelle Künste bei Marco Túlio Resende und George Helti); Univ. Federal de Minas Gerais ebd. (fotogr. Techniken des 19. Jh. bei Marcelo Kraiser); 1991–92 St. Martins SchA und Camera Work, beide London. Fotogr. Mitarb. bei Theater-, Film- und Musikproduktionen sowie Gest. von Bühnenbildern. Seit 1988 fotogr. Beiträge für versch. Periodika, u.a. Bizz, Rev. da Folha und Interview. 2000 Stip. der Fund. Vitae für Fotogr., São Paulo. 2010 Gastkünstlerin an der WBK Vrije Acad. in Gemak/Holland. Ausz.: u.a. 1998 Preis Marc Ferrez für Fotogr.; 1999 Nat.-Preis für Fotogr., Fund. Nac. de Artes (Funarte), Rio de Janeiro. – C. beginnt in den 1980er Jahren mit Installationen aus gefundenen Fotos und gebrauchten Alltagsgegenständen, verbunden mit Performances; auch verwendet sie Fragm. von Bildmaterial, z.B. Ausschnitte eig. Fotos, für abstrakte Collagen (u.a. Serie *Bandeja*, 1995–96). Hauptthemen ihrer Fotos sind die Lebenssituation und die Identität des heutigen Menschen in der Großstadt, v.a. in Brasilien. In Serien von Farbfotos zeigt C. z.B. alltägliche Mahlzeiten in Nahaufnahme von oben (*Pratos tipicos*, 1994–97) oder gibt Einblicke in Schlafzimmer (*Quartos*, 1998); mit dieser Typologie des Privaten schafft sie sozialpsychologische Portr. von Menschen, ohne daß diese anwesend sind. Vom priv. wendet sich C. dem öff. Raum als Ort versch. Überlebens-

strategien zu. In inszenierten Fotos plaziert sie selbstgezimmerte Hütten auf bek. öff. Plätzen oder in der Natur (*Casa própia*, 1999), fotografiert durch Zumauern unbewohnbar gemachte Häuser (*Casa cega*, 2002–03), improvisierte Unterkünfte (*Arquit. informal*, 2003) und von Waren überquellende kleine Einkaufsläden (*Escolha*, 2005). Danach arbeitet sie z.T. erneut mit vorgefundenem Foto-Mat., um Schönheitsklischees in Frage zu stellen (*Desvios*, 2007) und jegliche Repr. als Neuschöpfung erkennbar zu machen, in dem sie z.B. Besucher zum Nachzeichnen von Fotos anregt (*Reprodutor*, 2008). Sie lichtet eig. Objektinstallationen ab, um die Beziehung zw. Mensch und Raum auf surreale Weise zu hinterfragen (*Desmedida*, 2009; *Residência*, 2010). In ihrem Werk, das auch Videos umfaßt (z.B. *Vigília*, 2004, *Convite ao infinito*, 2005), verwischt C. die Grenzen zw. Kunst und Leben und setzt sich intensiv mit der Ikonogr. und Ästhetik der Alltagskultur auseinander, u.a. durch eine meist ungerahmte Präsentation der Fotos in mon. Abzügen, auch an ungewöhnlichen Orten (z.B. eine ruinöse Fabrikhalle). BRUMADINHO/Minas Gerais, Centro de Arte Contemp. Inhotim. LA JOLLA/Calif., MCA San Diego. LISSABON, Caixa Geral de Depósitos. LONG BEACH/Calif., Mus. of Latin Amer. Art. MADRID, Fund. Arco. MARSEILLE, FNAC. MIAMI/Fla., Cisneros Fontanals Art Found. RIO DE JANEIRO, MAM. SAN DIEGO/Calif., MCA. SANTIAGO DE COMPOSTELA, Centro Gallego de Arte Contemp. SÃO PAULO, Inst. Cult. Itaú. – MAM. – Mus. de Arte. WIEN, MUMOK. E: Porto Alegre: 1983 MARGS; 1985 Centro Mpal de Cult.; 1987 Gal. Arte & Fato / Belo Horizonte: 1984 Itaú Gal.; 2008 Celma Albuquerque Gal. de Arte / 1984, '86 Curitiba, Fund. Cult. / Rio de Janeiro: 1984 Mus. da Imagem e do Som; 1995 Funarte, Gal. Sérgio Milliet; 2006 Gal. Silvia Cintra / São Paulo: 1984 Funarte; 1992 Fund. Bien. de São Paulo; 1998, 2003 Gal. Brito Cimino; 2005 Inst. Tomie Ohtake; 2007 Centro Univ. Maria Antônia; 2008 Mus. da Imagem e do Som; 2009 Luciana Brito Gal.; 2010 MAM / 1994 Niterói (Rio de Janeiro), Gal. Uff / 1999 Mexiko-Stadt, Gal. Nina Menocal / 2003 Natal (Río Grande do Norte), Espaço Cult. Casa da Ribeira. – *G:* São Paulo: 1985 Quadrienal de Fotogr. (ehrenvolle Erw.); 1998, 2010 Bien. / 1996, 2000 Curitiba: Bien. Internac. de Fotogr. / 1997 Tokio: Internat. Photo-Bienn. / 1997, 2000 Havanna: Bien. / 1999 Porto Alegre: Bien. de Artes Visuais do Mercosul / 2000 Pontevedra: Bien. Internac. de Arte / 2007 Ushuaia: Bien. del Fin del Mundo. *R. Rosa/D. Presser*, Dic. de artes plást. no Rio Grande do Sul, Porto Alegre ²2000 (s.v. Costi, Rocheli). – *P. Weiermair* (Ed.), Auf der Suche nach Identität. Aktuelle Kunst aus Brasilien (K Wander-Ausst.), Z. 2000; R. C. Sem título/untitled/sin título, S. P. 2005; *T. J. Demos u.a.*, Vitamin Ph. New perspectives in photogr., Lo. u.a. 2006; Zeitgen. Fotokunst aus Brasilien (K Wander-Ausst.), He. 2006. – *Online:* Website C.; Inst. Itaú Cult., Enc. artes visuais. M. Nungesser

Costin, *Simon*, brit. Schmuckkünstler, Bühnendesigner, Konzeptkünstler, Kurator, * 28. 3. 1964 London, lebt dort. Erlernt als Teenager das Handwerk der Taxidermie am Nat. Hist. Mus. in London. Stud. ebd.: 1980 East Ham Art Col-

lege; 1982–85 Wimbledon College of Art (Theaterdesign, Kunstgesch.). 1994–98 Künstlerischer Dir. des 1993 gegr. Modeunternehmens von Alexander McQueen. – C. gestaltet in den 1980er Jahren originellen und provokanten Schmuck aus Mat. wie Knochen, Tierskeletten, Fischköpfen und menschlichen Sekreten, kombiniert mit Edelsteinen und -metallen. Für Halsschmuck verwendet er Hühnerbeine und Rubine, für das Collier *Incubus* (1987, New York, Metrop. Mus.) u.a. mit Sperma gefüllte Ampullen. E. der 1980er Jahre entstehen auch Skulpt. (*A Weasel in High Heals attempts the Disection of a painted finch*, ca. 1990), die z.B. an ma. Reliquiare erinnern. 1985 fertigt C. Schmuck für den Film Caravaggio von Derek Jarman. Seit ca. 1990 befaßt er sich mit der Ausstattung von Modeschauen und wird v.a. mit außergewöhnlichen Kreationen für A. McQueen bek., z.B. 1997 mit durchsichtigen, von unten beleuchteten wassergefüllten Plastiktanks, in die schwarze Tinte einfließt, während es auf die Models regnet. Zu seinen Kunden zählen Modehäuser und Designer wie Hermès, Lanvin, Maison Martin Margiela, Alice Temperley, Stella McCartney und in den letzten Jahren Gareth Pugh. Ferner arbeitet C. häufig mit dem Modefotografen Tim Walker zus., für den er außergewöhnliche Sets realisiert. Farben und Kulissen sind dabei fein und effektvoll aufeinander abgestimmt, z.B. das überlebensgroße Requisit eines Modemagazin, aus dem die Models steigen. C.s morbide Horrorphantasien und extreme Konfrontationen werden auch in digital manipulierten hyperrealistischen Fotogr. deutlich, z.B. bei einer Serie, für die er Stunt-Techniken einsetzt und sich brennend auf einem Stuhl sitzend darstellt (*Burning*, Triptychon, 1996). Zur Eröffnung der neuen Damenmode-Abt. im Kaufhaus Selfridges konzipiert C. 2012 sieben Räume im leerstehenden Old Selfridges Hotel, in denen Kurzfilme versch. Modedesigner gezeigt werden. Gegenwärtig sucht er einen festen Standort für das von ihm gegr. Mus. of Brit. Folklore, das bisher durch seine eig. Slg und temporäre Ausst. in versch. Gal. Aufmerksamkeit erregt (Firework, 2011 Compton Varney/ Warwicks.). – C. gehört durch seine konzeptionell ehrgeizigen, extravaganten, fesselnden Inszenierungen auf Laufstegen, in Ausst., Sets und Schaufenstern zu den internat. anerkannten Bühnendesignern. ⌂ GLASGOW, Kelvingrove Mus. LONDON, V & A. NEW YORK, Metrop. Mus. ⊙ *E:* 1985 New York, Bergdorf Goodman / London: 1987 Silver Gall.; 1989, ’93 Rebecca Hossack Gall.; 1992 Abia; 1995 Inst. of Contemp. Art; 1996 Hidden Gall.; 1998 Tomato Gall. / 1999 St. Ives, Tate / 1995 Los Angeles, Security Pacific Gall. / 1997, 2000 Paris, Gal. Patricia Dorfmann / 1999 Glasgow, Grand Central Hotel. ⌺ Dict. internat. du bijou, P. 1998; *Delarge*, 2001; *Buckman* I, 2006. – *P. Carson*, Creative rev. 16:1996 (Mai) 45; *L. Blackwell*, ibid. 17:1997 (Nov.) 109 s.; *A. Bradley/ G. Fernandes*, Unclasped. Contemp. Brit. jewellery, Lo. 1997; *C. Maume*, The Independent v. 17. 8. 1997; *R. Armstrong*, Art and design 12:1997 (Sept./Okt.) 6 s.; *R. Turner*, Crafts 151:1998 (März/April) 60 s.; *R. Thomas*, World of interiors 23:2003 (12) 104–111; *M. O’Flaherty*, Blueprint 279:2009 (Juni) 34; *D. J. Smith*, Times mag. v. 23. 5. 2010;

S. Patience, World of interiors 30:2010 (3) 140–149; *P. Sayer*, Mus. j. 112:2012 (1) 32–35. H. Stuchtey

Costinescu, *Augustin,* rumänischer Maler, Zeichner, Graphiker, * 28. 4. 1943 Lipova/Bez. Arad. Stud.: bis 1969 HBK N. Grigorescu, Bukarest, u.a. bei Aurel Vlad und Ion Popescu-Negreni. – C.s Schaffen ist durch große Themenvielfalt gekennzeichnet. Hellfarbige postimpressionistische Stadt-Lsch. (u.a. Paris), Genreszenen (Cafés), figürliche Komp. (Harlekine) gehören ebenso dazu wie weibliche Akte und (Selbst-)Porträts. Bes. bei Darst. von Mädchen und Ballerinen (Öl oder Pastell) bezieht er sich deutlich auf Degas. ⌂ BOTOŞANI, Muz. Judeţean. BUKAREST, MN de Artă. CRAIOVA, Muz. de Artă. ORADEA, Muz. Ţarii Crişurilor. RÂMNICU VÂLCEA, Muz. de Artă. SFÂNTU GHEORGHE, MN Secuiesc. SINAIA, Cazinoul Regal. ZALĂU, Muz. ⊙ *E:* zahlr. seit 1968, u.a. Bukarest: 1974 Gal. Galatea; 1977 Căminul Artei; 1980 Gal. Simeza; 1983, ’86 Gal. de Artă ale Municipiului; 1994, ’97, 2000, ’02 Gal. Orizont; 2004, ’12 Gal. Cercului Militar; 2005 Sala Irecson; 2006 Bibl. Centrala Univ. Carol I / 1987 Cluj-Napoca, MN de Artă / 1996 Paris, Rumänisches Kulturzentrum / 1997 Oradea, Muz. Ţării Crişurilor / 2000 Constanţa, Muz. de Artă / 2003 Craiova, Muz. de Artă. – *G:* zahlr. seit 1968, u.a. Bukarest: 1975 Atenul Român: Expoz. Tineretului (Malerei-Preis); 2003 MN Cotroceni: Peisajul în picture românească din collecţiile de artă particulare / 2004 Paris: Internat. Kunstfestival. ⌺ *A. Cebuc* u.a., Enc. artiştilor români contemp., I, Bu. 1996. – *M. Mihalache*, Pictura românească contemp., Bu. 1976; *V. Florea*, Arta românească modernă şi contemp., Bu. 1982; *A. Titu*, Arta 1983 (5); *A. Cebuc*, A. C., Bu. 2006. – *Online:* Website C. B. Scheller

Coter, *Ernesto,* ital. Maler, Graphiker, * 26. 11. 1936 Bergamo, lebt bei Menaggio. Sohn von Costante C., Bruder des Malers und Bildhauers *Francesco C.* (* 15. 11. 1937 Bergamo, lebt dort; mehrere Jahre in Tibet, Nepal und Deutschland; Atelier im Pal. Terzi; u.a. kalligraphisch anmutende Motive auf großen Formaten). Erster Unterricht bei seinem Vater. Stud.: ab 1954 Accad. Carrara di BA, Bergamo, bei Trento Longaretti (zus. mit seinem Bruder, mit dem er später mehrfach zusammenarbeitet). Abschluß mit Diplom. 1955 Ausst.-Debüt in Mailand (Incontri della gioventù). Publ. 1968 mit Gianpietro Fazion und Francesco C. über visuelle Poesie, unterzeichnet mit diesen 1970 das Manifest zum gewaltlosen Protest (Dichiarazione di guerra all’umanità); ist beteiligt an mehreren provokanten Ausst. im Geist der 1968er Bewegung, u.a. in Martinengo (Pluralità viva). Lebt und arbeitet 1972–2004 in Apia auf Upolu/Samoa; Lehrtätigkeit an der dort von ihm gegr. School of FA des Leulumoega Fou College, später deren Leitung. Dekoriert Kirchen und den Flughafen von Apia mit Glasfenstern. Nach neoexpressionistischen Anfängen malt C. später v.a. lichtvolle, romantisch-sensible (See-)Lsch. seiner Wahlheimat. ⌂ BERGAMO, Collegio di Celana: Le scienze et les mestieri, Mosaik, um 1961 (zus. mit Francesco C.). NOUMÉA/ Neukaledonien, Tjibaou-Kulturzentrum (erb. von Renzo Piano): Lsch. (Auftragswerk). VERTOVA, S. Domenico

Savio: Fresken, 1956 (zus. mit Francesco C.). ✉ *C./ F. Coter/G. Fazion*, Dichiarazione di guerra all'umanità. Opere documento 1969–1972, Assisi 2005. 👁 *E:* Bergamo: 1957 Gall. della Torre (zus. mit Vater und Bruder; ab 1960 ebd. Einzel-Ausst.); 1980 Gall. L'Antenna; 1983 Gall. Alexia; 1990, '96 Centro Cult. S. Alessandro (K: A. Pizzigoni/F. Noris); 2000 Centro Cult. S. Bartolomeo; 2004 Sala Camozzi und Sala di Porta S. Agostino (K: F. Noris) / 1963 Riva del Garda, MCiv. / 1964 Torbole, Gall. Kaldor / 1979 Vancouver, Centro Ital. di Cult. – *G:* 1957 Francavilla: Premio Michetti / 1966 Mailand, Gall. Il Giorno: Pittori in Lombardia / Bergamo: 2002 Pal. della Ragione: Arte a Bergamo 1960–1969; 2010 GAMC: Coter Fazion Coter. ⊡ AIC III, s.a. – E. C., Francesco Coter. Interventi visivi, Bolzano 1969; *F. Rossi* (Ed.), Maestri e artisti. 200 anni dell'Accad. Carrara (K Bergamo), Mi. 1996; *M. Dini/R. Righetti*, Le isole dell'Eden. Ieri e oggi tra mito e realtà nei Mari del Sud, Mi. 1996; Corriere della Sera v. 30. 12. 1999; Arte a Bergamo 1960–1969, Be. 2002; L'Eco di Bergamo v. 30. 9. 2009. S.-W. Staps

Coter, *Francesco* cf. **Coter,** *Ernesto*

Cotoşman, *Roman*, rumänischer Maler, Zeichner, Graphiker, Plastiker, Installationskünstler, * 1. 10. 1935 Jimbolia/Bez. Timiş, † 8. 12. 2006 wahrsch. in Philadelphia/Pa., lebte dort seit 1972. Entstammt einer bek. Theologen- und Historiker-Fam. aus dem Banat. Stud.: bis 1963 am Theol. Inst. der Univ. Sibiu. Nimmt Mal- und Zeichenunterricht bei dem bek. Maler und Graphiker Julius Podlipny in Timişoara, sonst Autodidakt. A. der 1960er Jahre mehrere längere Aufenthalte in Paris; dort erste bewußte Auseinandersetzung mit konstruktivistischer und kinetischer Kunst. Gründet 1966 zus. mit Ştefan Bertalan und Constantin Flondor die Gruppe 111, eine Vrg mit konstruktivistisch-kinetischem Ansatz, die bis 1969 existiert. 1970 Emigration in die USA und Niederlassung in New York, seit 1972 in Philadelphia, beheimatet. Ausz.: 1991 Kritikerpreis des rumänischen Künstler-Verbandes. – In den frühen 1960er Jahren beginnt C. seine Arbeit an konstruktivistischen Serien. Er fällt in den 1960er Jahren mit ungewöhnlichen Lichtexperimenten und Ausstattungen für das Theater Mic in Bukarest und den Jazzclub in Timişoara auf. Später sind es auch experimentelle kinetische Arbeiten, mit denen er im damaligen Rumänien für Furore sorgt. Großen Einfluß üben die Theorien des Mathematikers und Kybernetikers Norbert Wiener aus. Mit dem Objekt *Quaternar I* (1968) setzt er innerhalb seiner Lichtexperimente einen Höhepunkt. In seinen räumlichen Installationen verbindet er u.a. Elemente aus Holz und geschmiedetem Stahl. In den USA überwiegen konkrete und expressiv-minimalistische Arbeiten, auch als Collagen. ⊡ BUKAREST, MNAC. INGOLSTADT, Mus. für Konkrete Kunst. TIMIŞOARA, Muz. de Artă. 👁 *E:* Bukarest: 1968 Sala Ziariştilor (Debüt); 2006 Gal.-Anticariat Curtea Veche (Kleine Retr.) / 1995 (K: I. Pintilie), 2008 Timişoara, Muz. de Artă / 1998 New York City, East-West Gall. –. *G:* Bukarest 1969 Gal. Kalinderu (erste Ausst. konstruktivistisch-kinetischer Kunst in Rumänien); 1997 Sala Kalinderu: Rezultate Concre-

te; 2006 MNAC: George Apostu, R. C., Paul Neagu. Artists in Exile / 1969 Nürnberg: Bienn. Konstruktive Kunst (Gruppe 111) / Philadelphia (Pa.): 1975 Annual Award Paint. Exhib.; 1979 Contemp. Drawings / 1982 Bilbao: Internat. Graphik-Ausst. / 1992 Karlsruhe, Gal. Emilia Suciu: Konstruktive Kunst in Europa nach 1920 / 1995 Venedig: Bienn. / 1997 Murska Sobota: Kleinplastik-Bienn. ⊡ *A. Cebuc u.a.*, Enc. artiştilor români contemp., III, Bu. 2000; *C. Prut*, Dicţ. de artă mod. şi contemp., Bu. 2002. – Arta plastică 1967 (5) 25; 1968 (5) 35, 38; (7) 6–8; Arta 1992 (2) 2–7 (mit Statement); Experimentiul în Arta Românească după 1960 (K), Bu. 1997; *L. Barcan*, Adevărul v. 22. 11. 2006; *I. Pintilie*, Observator cult. 2006 (Dez.) 352 s. – *Online:* Observator cult. St. Schulze

Cottinelli, *Vincenzo*, ital. Fotograf, * 3. 8. 1938 Brescia, lebt dort. Autodidakt. Fotografiert seit E. der 1980er Jahre, v.a. Reise-Fotogr. (u.a. Naher Osten, USA, Indien, Brasilien), Portr. und Reportagen zu sozialen Themen. Veröff. in Zss. und Ztgn, u.a. in Linea d'ombra, Il diario, L'unità, Corriere della sera, D (La repubblica), La stampa, Focus, Il giornale dell'arte, Le monde, Frankfurter Allg. Ztg, Rheinischer Merkur, The independent, The european, Slow, Airone, FotoGraphia, Lit. monthly of Israel, Graphis New York, Vanity fair, Asiaweek, Uniòn (Kuba); v.a. Fotogr. für die Zs. Nostro Lunedì der Stadt Ancona. Mitbegr. von Biancoenero Ass. per la Fotogr. und Leiter des Non-Profit-Ausst.-Raums La stanza delle biciclette in Brescia. – C. porträtiert zahlr. Schriftsteller, Künstler und Intellektuelle (u.a. Norberto Bobbio, Alda Merini, Erri De Luca, Dario Fo, Giosetta Fioroni, Giorgio Bertelli, Amos Oz). 1986 fotografiert er den Dichter Mura Nino (A. Zanzotto [Ed.], *Colloqui con Nino*, Pieve di Soligo 2005). 1995–2004 begleitet er mit der Kamera den Journalisten und Schriftsteller Tiziano Terzani, was in mehreren Publ. Niederschlag findet, u.a. in *T. Terzani. Ritratto di un amico* (Mi. 2005). Autoren-Portr. entstehen u.a. auch beim Lit.-Festival in Mantua. Auch kult. und politische Reportagen, z.B. 1988 über eine Carmen-Aufführung von Antonio Gades, 1997 über Zuckerrohr-Erntearbeiter mit dramatischen Schwarzweißaufnahmen in Trad. von Sebastião Salgado, um 2000 über den Arabisch-Unterricht von Immigranten in Italien (*La domenica, arabo*, Legnago 2005) oder 2001 über den Zirkus Orfei. 2007 dokumentiert er Spuren der Herrschaft der Roten Khmer in Kambodscha. 2008 fotografiert C. mit *Povera patria* eine kritische Bestandsaufnahme des ital. Alltags zur Zeit von Silvio Berlusconi. – Foto-Publ.: G. Cherchi (Ed.), *Sguardi*, Brescia 1995; *Volti dell'impegno*, Brescia 1998; *Philobiblon*, Mantua 2001; *Ritratti d'Autore* (K), Ancona 2002; F. Scarabicchi (Ed.), *Trenta ritratti*, Colli del Tronto 2005. ⊡ LEGNAGO, Coll. Riello. MANTUA, Bibl. del Centro Baratta. 👁 *E:* 1994 Perugia, Pal. Penna / Mailand: 1994 Libreria Feltrinelli (Wander-Ausst.); 2001 Bibl. Dergano-Bovisa; 2005 Gall. G. Neri (Wander-Ausst.; K) / 1995 Iseo, Gall. Arsenale; Otranto, Centro Cult. Regionale / 1996 Bern, Univ.-Bibl.; Havanna, Pal. del Segundo Cabo / 1997 Jerusalem, Hebrew Univ. (Wander-Ausst.) / Brescia: 1998 Sala Ss. Filippo e Giacomo (K); 1999 Gall. Primo Pia-

no (mit Giorgio Bertelli); 2009 Gall. La Stanza delle Biciclette / 1999 Siena, Pal. Pubbl.; Florenz, Pal. Corsini-Suarez / 2000 Mirano, Villa Morosini / 2001 London, Ist. Ital. di Cult.; Mantua, Centro Baratta (K) / 2002 Ancona, Mole Vanvitelliana (K); Piacenza, Gall. Civ. Ricci-Oddi; Sarnico, Gall. La Torre und MCiv. / 2005 Colli del Tronto, Colli Arte (K); Legnago, Teatro Salieri und MCiv. (Wander-Ausst.; K) / 2005, '07, '09 Gussago, Pal. Nava / 2006 Genua, Pal. Ducale / Udine: 2006, '08 Teatro Giovanni / 2008 Piacenza, Bibl.-Mediateca Grazia Cherchi / 2009 Carpenedolo, Pal. Laffranchi / 2010 Sarnico, Torre Civ. / 2012 Venedig, Fond. Giorgio Cini. – *G:* 2001 Mailand, Pal. dell'Arengario: M'impiego ma non mi spezzo / Brescia: 2008 Mus. Diocesano: Quel colpo di luce; 2009 Mus. S. Giulia: L'immagine de reale (K). ▱ *S. und B. Cherchi u.a.* (Ed.), Per Grazia Cherchi, Piacenza 2002; *W. Szymborska*, Posta letteraria, Mi. 2002; *A. Manzoni* (Ed.), Magistratura democratica. Agenda 2006, '07, '08, Turin 2006–08; *T. Terzani*, Fantasmi, Mi. 2008; *C. Ossola*, Nessun consuntivo, Crocetta del Montello 2011. – *Online:* Website C. – Mitt. C. T. Koenig

Cottingham, *Keith*, US-amer. Fotograf, Computerkünstler, * 25. 5. 1965 Los Angeles/Calif., lebt in San Francisco/Calif. Stud.: 1987–88 Center for Computer Art; 1988 Center for Interdisciplinary Programs; 1989 Computer Arts Inst., alle San Francisco. Ausz.: 1994 Ars Electronica, Linz. Stip.: 1995 Western States Arts Federation, Santa Fe (N. Mex.); Art Matters Found., New York. – C. unterläuft mit hybriden digitalen Fotomontagen den Repräsentationsanspruch und Glauben an die Wahrheit der fotogr. Abbildung. Er konstruiert seine virtuellen Bildwelten am Computer, wobei er zugleich dem Betrachter Authentizität suggeriert wie den fotogr. Referenten generell in Frage stellt und damit den trad. Subjektbegriff und Mythos der festgeschriebenen persönlichen Identität verunsichert. Bei *Fictious portr.* (1992) ahmt C. Modelle der repräsentativen Personen-Darst. nach, indem er auf Basis von Tonmodellen, anatomischen Zchngn, gefundenen Fotogr. und Digitalretuschen Bilder collagiert, die auch aus versch. Rassen, Geschlechtern und Altersstufen synthetisiert sind. Im Zuge einer „post-mod. Krise in der bildlichen Darst.", will C. mit seiner künstlerischen Strategie „den fotogr. Traum von der Wiedererlangung einer verschwundenen Vergangenheit einerseits" wahren, „andererseits aber auch zunichte machen" (H. Walker, in: Kat. Persona, Chicago/Basel 1996). C.s Arbeit fragt auch nach dem Verhältnis zw. innerer Persönlichkeit und externer physischer Erscheinung, sie berührt ebenso die „Cyborg"-Debatte um die willentliche Definierbarkeit menschlicher Identität wie bio-ethische Fragen der Genmanipulation. Bei *Hist. repurposed* (1999) simuliert C. mit versch. Quellen eine hist. Slg von ethnogr. Dok., für *Future pre-purposed* (2004) entwickelt er modellhafte Computerbilder von Archit.-Interieurs und Personen-Darstellungen. Die großformatige Installation *Growth* (2007) mit Audiobegleitung zeigt Standbilder von Digitalanimationen fiktiver Motive bei gewaltsamen und sanften Transformationsmomenten in Zeitlupe, Echtzeit und mit Zeitraffer-Effekten. ▭ Ishøj,

Arken MMA. Long Island City/N. Y., Fisher Landau Center. Los Angeles, County Mus. of Art. Paris, Paris Audio-Visuel. ◉ *E:* San Francisco: 1992 Gall. LaGreca; / 1994, '98 Santa Monica (Calif.), C. Grimes Gall. / 1999, 2004 New York, R. Feldman FA / 2000 Paris, Espace d'Art – Y. Palix / 2000 Zürich, Gal. R. Mangisch. – *G:* San Francisco: 1988 Artist Television Access: The self and the other; 1989 Eye Gall: New directions in photogr.; 1991 Fillmore Center Arts Intervention: Anonymous portraits; 1993 Intersection for the Arts: New works in photogr. / 1994 Linz, LG: 15 Jahre Ars Electronica (K); Cambridge (Mass.), MIT List Visual Arts Center: The ghost in the machine (K) / Los Angeles, County Mus. of Art: 1994 New acquisitions, 2000 Made in California (K); Ghost in the shell (K) / 1995 Berkeley (Calif.), Univ. AM: We look and see / 1996 Chicago, The Renaiss. Soc. at the Univ. of Chicago: Persona (Wander-Ausst.; K) / 1997 Milwaukee (Wis.), AM: Identity crisis / 1999 Krems, KH: Tomorrow forever (K) / 1999 Bern, KM: Missing Link (K) / 2000 Karlsruhe, ZKM: Der anagrammatische Körper und seine mediale Konstruktion (Wander-Ausst.) / 2001 Summit (N. J.), Center for Visual Arts: Identities (K) / 2002 Pittsburgh (Pa.), R. Gouger Miller Gall., Carnegie Mellon Univ.: Paradise lost (Wander-Ausst.) / 2004 London, Hayward Gall.: About face (K). ▱ *S. J. Norman,* Artpress 1994 (Juni) 20 s.; *S. Igelhaut/H. von Amelunxen* (Ed.), Fotogr. nach der Fotogr. (K Wander-Ausst.), M. 1995; *R. Platt,* wired 3:1995 (10) 142 s.; Die Zeit [Mag.] 1996 (11) 28–34; Unreal person. Portraiture in the digital age (K), Huntington Beach, Calif. 1998; *M. Rush,* New media in late 20th-c. art, Lo. 1999; Manbody in art from 1950 to 2000 (K), Arken 2000; *J. L. Brea,* Exit 4 (2001) 114–135; *M. W. Marien,* Photogr., Lo. 2002; *L. Schneider Adams,* The making and meaning of art, Upper Saddle River, N. J. 2006; *C. Guesdon,* Leonardo 39:2006 (3) 193–197. – *Online:* Website C. (Lit.); Luminous-lint. World photogr. T. Koenig

Cotton, *Shane (Shane William),* neuseeländischer Maler, Graphiker, * 3. 10. 1964 Upper Hutt, lebt in Palmerston North. Stud. in Christchurch: 1985–88 School of FA, Univ. of Canterbury; 1991 College of Education. Ausz.: u.a. 1987 Seager Prize in FA, Univ. of Canterbury; 1989 Wilkins and Davies Young Artist of the Year Award ebd.; 1998 Seppelt Contemp. Art Award (Visual Arts), MCA, Sydney; Frances Hodgkins Fellowship, Univ. of Otago, Dunedin; 1999 Te Tohu Mahi Hou a Te Waka Toi/Te Waka Toi Award for New Work, Māori Arts Board for Creative New Zealand, Wellington; 2012 Officer of the New Zealand Order of Merit. Lehrtätigkeit: 1992–2005 Massey Univ., Palmerston North (Māori Visual Arts). – Anfänglich abstrakte Arbeiten, meist biomorphe Formen, z.B. *Cell, Block, and System* (Mischtechnik, 1989). Mit Beginn der Lehrtätigkeit zunehmend figurative, von der trad. Mal- und Schnitzkunst der Māori beinflußte Acryl- und Öl-Gem., z.T. mit Anklängen an surrealistische Bildsprachen, z.B. *Hide and Seek* (Acryl/Lw., 2007); zunächst in gedämpfter, teils monochromer, später in wechselnder Farbgebung, u.a. E. der 1990er Jahren in den trad. Farben Schwarz, Weiß

und Rot. In den Werken setzt C. sich mit der eig. indigenen Herkunft, der kolonialen Vergangenheit und den Folgen der Christianisierung Neuseelands sowie mit Fragen der heutigen bikulturellen Identität seiner Heimat, speziell der neuseeländischen Nordinsel, auseinander. Die Gem. spielen meist auf Familienanekdoten, Stammeserzählungen, Legenden der Māori oder geschichtliche Ereignisse an, z.B. *Needlework* (Öl/Leinen, 1993). Oftmals dargestellt in einem Nebeneinander von Maßstäben, zeigen sie u.a. neben bek. trad. Symbolen und Mustern wie der Farnspirale (koru) und Abb. konservierter tätowierter Köpfe der Ureinwohner (moko mōkai) auch Vögel, Lsch.-Elemente oder Alltagsgegenstände wie Stiefel, Topfpflanzen und Stühle. Seit M. der 1990er Jahre versieht C. diese Komp. häufig mit Buchstaben, Wörtern und Textfragmenten in engl. und Māori-Sprache, u.a. Bibelzitate und Orts- und Personennamen, z.B. *Kenesis. Kotahi Ki Kotahi* (Öl/Lw., 1999). Außerdem Graphiken in ähnl. Ausf., z.B. *A Walk in Paradise* (Lith., Tusche, 2004). ⌂ AUCKLAND, AG Toi o Tāmaki. BRISBANE, Queensland AG/Gall. of Mod. Art. CANBERRA, NG of Australia. CHRISTCHURCH, Christchurch AG. DUNEDIN, Dunedin Public AG. MELBOURNE, NG of Victoria. NEW PLYMOUTH, Govett-Brewster AG. PALMERSTON NORTH, Te Manawa Mus. of Art, Science and Hist. SYDNEY, MCA. WELLINGTON, City Council Art Coll. – Nat. Libr. of New Zealand, Alexander Turnbull Libr. – Mus. of New Zealand Te Papa Tongarewa. ☉ E: Auckland: 1992 (mit Peter Robinson; K); '94 Claybrook Gall. ; seit 1998 regelmäßig Gow Langsford Gall. / Christchurch: seit 1990 regelmäßig Brooke Gifford Gall.; 2003 School of FA Gall., Univ. of Canterbury / Wellington: 1990 Last Decade Gall.; seit 1993 regelmäßig Hamish McKay Gall. / 1995 New Plymouth, Govett-Brewster AG (Wander-Ausst.; K); Palmerston North, Manawatu AG (mit Robert Jahnke; Wander-Ausst.; K) / Sydney: 1997 (K), '99, 2002 Mori Gall.; 2005, '07 Sherman Gall. (beide K) / Dunedin: 1999 Univ. of Otago, Hocken Libr. (K); 2000 Dunedin Public AG (Wander-Ausst.; K) / 2010 London, Rossi & Rossi (K). – *G:* Christchurch: 1987 (Young Contemporaries), '92 (Te Kupenga) CSA Gall.; 1991 (Recognitions), '92 (Prospect Canterbury; Latent Realities), '98 (Skywriters and Earthmovers; K), 2000 (Canterbury Paint. in the 1990s) Robert McDougall AG / Wellington: 1991 Nat. AG: Kohia Ko Taiakaka Anake; 1992 (Shadow of Style; K), '95 (A Very Peculiar Practice ; K; Stop Making Sense), '96 (Patua), 2000 (Parihaka, The Art of Passive Resistance; K), '01 (Techno Māori; Wander-Ausst.; K), '10 (Roundabout; Wander-Ausst.) City Gall.; 1998 (Dream Collectors; K); 2002 (Taiāwhio, Continuity and Change) Mus. of New Zealand Te Papa Tongarewa / 1994 Wanganui, Sarjeant Gall.: Tacking Stock of the 90s / Sydney: 1994 (Localities of Desire; K); '99 (Word, Artists Explore the Power of the Single Word), '10 (Bienn.; K) MCA / Auckland: 1994 City AG: Parallel Lines; 1995 (Korurangi, New Māori Art), '99 (Home and Away; Wander-Ausst.; K), 2000 (Eloquent Polarities), '01 (Pūrangiaho, Seeing Clearly; K), '07 (Trienn.) AG Toi o Tāmaki / 1995 (The Nervous System; K), '98 (Takeaway Symbols; Leap of Faith), '99 (Wonderlands;

The Raising of the Noxious), 2001 (Te Maunga Taranaki, Views of a Mountain; K) New Plymouth, Govett-Brewster AG / 2000 Missoula (Mont.), AM: Te Ao Tawhito, Te Ao Hou, Old Worlds, New Worlds (Wander-Ausst.); Langwarrin (Vic.) McClelland AG: Darkness and Light (Wander-Ausst.; K) / 2001 Pori, KM: Empathy, Beyond the Horizon (Wander-Ausst.) / 2001 (Colin McCahon's Time for Messages), '06 (2006 Contemp. Commonwealth) Melbourne, NG of Victoria / 2002 Porirura, Pataka Mus. of Arts and Cultures: The Koru and the Kowhaiwhai / 2003 New York, Asia Soc. Mus.: Paradise Now? (K) / 2005 Prag: Bienn. (K). ⌶ *K. McGahey,* The concise dict. of New Zealand artists, Wellington 2000. – *M. Dunn,* New Zealand paint., Auckland 2004; *L. Strongman* (Ed.), S. C. (K Wander-Ausst.), Wellington 2004; Date line. Zeitgen. Kunst des Pazifik (K Wander-Ausst.), Ostfildern 2007. J. Niegel

Cottrell, *Marsha,* US-amer. Zeichnerin, Computerkünstlerin, * 1964 Philadelphia/Pa., lebt seit 1994 in Brooklyn/N. Y. Stud.: bis 1988 Tyler SchA, Temple Univ., Elkins Park/Pa.; 1988–90 Univ. of North Carolina, Chapel Hill. 1994, '96, '99, 2002 Artist in Residence, MacDowell Colony, Peterborough/N. H. – C. befaßt sich zunächst mit Lsch.-Malerei, bis sie durch ihre editorische Tätigkeit die Typogr. als künstlerisches Medium entdeckt. Sie manipuliert ab 1998 Satzzeichen mit einem Textverarbeitungsprogramm in fragmentierte haardünne Linien und druckt sie mit einem Laserdrucker auf Japanpapier, so daß chin. Kalligraphie oder utopischen Archit.-Zchngn ähnelnde abstrakte Arbeiten entstehen (Serie *Untitled,* 1998). In den folgenden Jahren arbeitet sie mit versch. Papierarten (Maulbeer-, Baumwollpapier) und an einer Verdichtung der Zeichen, die dann die gesamte Bildfläche bedecken (*Gale,* 2002), und läßt die Arbeiten professionell drucken, wobei die Originaldatei stets vernichtet wird. Seit ca. 2005 benutzt sie ihren eig. Laserdrucker und experimentiert mit Mehrfachdrucken, leicht verschobenen Ausdrucken derselben Datei sowie seit 2009 mit Moiré- und Verwischungseffekten. Durch die seit ca. 2012 nach dem Druck ausgef. Falzungen und Knitterungen zeigen sich auf dem nun vorwiegend schwarzem Grund dünne weiße Linien. Diese sphärischen Himmelsbilder (*Under the illuminating Hydrogen,* 2012) sind aus mehreren Papieren zusammengesetzt und z.T. mit Farbschichten übermalt (über 150 x 260 cm). – C. begeht mit ihren computer-unterstützten, nicht computer-generierten Arbeiten einen innovativen Weg innerhalb der zeitgen. Zeichentechnik. ⌂ DALLAS, Southern Methodist Univ., Pollock Gall. NEW YORK, MMA. SAN FRANCISCO, MMA. WASHINGTON/D. C., NG. ☉ *E:* New York: 1998, 2009 Derek Eller Gall.; 2000 Alan Wiener; 2003 Henry Urbach Archit. / 2000 Detroit, Revolution Gall. / 2003 Paris, g-module / Düsseldorf: 2008 Site Gal. (mit Ferdinand Ahm Krag); 2012 Petra Rinck Gall. (K). ⌶ *S. Schmerler,* Art on paper 4:2000 (5) 81; *T. Moody,* ibid. 25:2001 (6) 20–24; *J. Helferstein/J. Fineberg* (Ed.), Drawings of choice from a New York coll. (K Wander-Ausst.), Champaign, Ill. 2002; Art on paper 7:2003 (6) 86; *K. Baker,* Art news 104:2005 (2) 142; *C. Rattemeyer,* Compass in hand. Selec-

tions from the Judith Rothschild Found. Contemp. drawings coll. (K MMA), N. Y. 2009. – *Online:* Website C.; Petra Rinck Gall. H. Stuchtey

Cottrell, *Simon,* austral. Gold- und Silberschmied, Schmuckgestalter, * 1975 Melbourne/Vic., lebt dort. Stud.: 1994–97, 2005–10 RMIT Univ. ebd. Ass.: 1995 von Mark Edgoose, 1997 von Frank Bauer, 1997, 2008 von Robert Baines. Lehrtätigkeit: seit 2001, u.a. RMIT Univ., Melbourne; Monash Univ. ebd. Ausz.: 1996 Lazlo Puzsar Award for Best Jewelry Design in Gold and Silversmithing; 1999 Johnson Mathey Award for Exellence in Silversmithing, beide RMIT Univ.; Koodak Peoples Choice Award, Jewellers and Metalsmith Group of Victoria; 2010 The Nat. Contemp. Jewellery Award, Griffith Regional AG, Griffith/N. S. W. – C.s Schmuckstücke (v.a. Broschen) bestehen meist aus mehreren miteinander verbundenen Hohlkörpern in geometrischen Formen. Er arbeitet bevorzugt mit dem in der Schmuck-Gest. untypischen Werkstoff Monel sowie mit Stahl, Kunstharz (z.B. *Awkward profile, mirror,* 2005–06) und Gold (z.B. *Village of gold teeth with tail,* 2008). Bisweilen werden einzelne Elemente lackiert (z.B. *Blobs, white shadows and tubes,* 2006), verspiegelt oder mit Email verziert (z.B. *100 mm deep concave circle,* 2008). Die Art der Konstruktion und v.a. die Auswahl des Mat. verleihen den Werken ein technisches Erscheinungsbild. Häufig sind die einzelnen Körper mit Deckeln versehen, die durch versch. Fassungen gehalten werden, die üblicherweise zur Anbringung von Edelsteinen verwendet werden. ⌘ ADELAIDE, AG of South Australia. MELBOURNE, NG of Victoria. – RMIT Univ. ◉ *E:* 2003, ’11 Melbourne (Vic.), Gall. Funaki / 2005 Auckland, Objectspace Gall. / 2012 München, Gal. Wittenbrink (mit Mielle Harvey). –. *G:* 1996 Melbourne, Customs House: Toy, Toy, Toy / 1998 Darwin, Mus. und AG of the Northern Territory: Nat. Craft Acquisition Award / 2001 Mumbai, Taj AG: Foundations of Gold (Wander-Ausst.; K) / 2002 Brisbane (Qnsld.), Brisbane City Gall.: Less is More. Less is a Bore (K) / 2004 Cohasset (Mass.), South Shore AC: Design Down Under / 2007 Chennai, Lalit Kala Acad.: Beyond Metal. Contemp. Austral. Jewellery and Holloware (K; Wander-Ausst.) / 2009 Nijmegen, Gal. Marzee: Melbourne Hollow Ware. More snakes than you can poke a stick at! (Wander-Ausst.; K) / 2010 München, Gal. Handwerk: Schatzkammer Australien (K). ⌑ Cicely & Colin Rigg Contemp. Design Award (K), Mb. 2006. F. Krohn

Coty (eigtl. Barletta de Kattán, *Ana María*), honduranische Malerin, * 29. 9. 1956 San Pedro Sula/Cortés, lebt dort. Stud. der Malerei und Bildhauerei: Esc. Preparatoria der Univ. Autónoma, Guadalajara/Mexiko; College of New Rochelle, New York; Esc. de Arquit. der Univ. Priv., San Pedro Sula, Malerei bei Elías Noyola Turcios. Präs. der Asoc. de Mujeres en la Plástica Hondureña. Ausz.: u.a. 2003 Preis, Semana Cult. Hondureña, Organización de Estados Amer., Washington/D. C. – C.s Malerei (Öl, Acryl) ist gegenständlich mit symbolistisch-surrealen Einflüssen, u.a. von Marc Chagall. Im Zentrum stehen starkfarbige Stilleben und Meeres-Lsch.; außerdem

jährlich im September das Bild eines Engels, da ihr Geburtstag in der kath. Kirche den Erzengeln gewidmet ist. ⌘ TEGUCIGALPA, Banco Central de Honduras. ◉ *G:* 2005 Salcoatitán (El Salvador), Adonasy, Gal. Est.: La expresión artística. ⌑ Generaciones que marcaron huellas. Antología de la Col. de Arte del Banco Central de Honduras, Tegucigalpa 2007. – *Online:* La Prensa, San Pedro Sula. M. Nungesser

Coulibeuf, *Pierre,* frz. Filmemacher, Fotograf, * 16. 2. 1949 Elbeuf/Seine-Maritime, lebt in Paris. Stud.: 1969–71 Univ. Paris VII (mod. Lit.; 1972–77 postgraduierte Stud. und Doktorarbeit über Pierre Klossowski und Leopold von Sacher-Masoch). Teiln. an zahlr. Festspielen für Film und Videokunst. Künstlerresidenzen: 1993 Italien (Leonardo-da-Vinci-Stip. des frz. Außen-Minist.);1995–96 Domaine de Kerguéhennec/Bretagne. Ausz.: 2001 Chevalier de l’Ordre des Arts et des Lettres. – Beginnend mit *Klossowski, peintre-exorciste* (1987–88) konzentriert sich C. auf Filme, die er z.T. in Installationen mit Fotos präsentiert. Eine Vielzahl von Genres wie Road Movie, Film noir und Performance vermischend, arbeitet er zus. mit Künstlern, denen er eine kreative Freiheit zugesteht. Dennoch ist ihm die spannungshafte Interaktion von Dokumentation und Fiktion wichtig, die letztlich zu einer Unterwerfung der Porträtierten und ihrer Kunstform unter C.s filmische Sicht führt. So handelt es sich bei *Les guerriers de la beauté* (2002) nicht um das Abfilmen eines choreographierten Tanzes, sondern um das Reagieren des Choreographen Jan Fabre auf die von der Kamera gesetzten Parameter. In *Balkan Baroque* (1999) erzählt Marina Abramović ihre Lebensgeschichte anhand wesentlicher wie banaler Fakten, Träume, Wünsche und Anekdoten. Die Narrative ist eine sprunghafte Collage, die immer wieder von einer Zeitlinie in eine Abfolge gestellt wird. Abramović schlüpft stets in and. Identitäten, in denen sie sich selbst stilisiert darstellt oder als Künstlerin Performances aufführt. Teilweise dominiert die Sprache, dann eine bildhafte Einstellung, dann wieder die choreographierte Bewegung. Weitere Kooperationen u.a. mit Michelangelo Pistoletto (*L’homme noir,* 1993–98), Michel Butor (*Michel Butor Mobile,* 2000), Jean-Marc Bustamante (*Lost Paradise,* 2002) und Meg Stuart (*Somewhere in between,* 2004). In der Filminstallation *Crossover* (2009) kreuzen sich mehrere Filme in einem Raum und führen so zu neuen Ausdrucksmöglichkeiten. Auch Künstlerbücher, z.B. *Le bureau de l’homme noir* (1994). ⌘ BERLIN, Neuer Berliner KV. CHAMARANDE, Fonds Dép. d’Art Contemp. de l’Essonne. MÜNCHEN, Slg Goetz. PARIS, Centre nat. des arts plastiques. – MNAM. RENNES, FRAC Bretagne. TURIN, GAMC. ◉ *E:* Paris: 1991 NMAM; 2008 Gal. Michel Journiac / 2004 Arles: Rencontres Arles photogr. (Wander-Ausst.) / 2005 Ottawa, Saw Gall. / 2006 Hamburg, Deichtorhallen (Wander-Ausst.); Barcelona, LOOP Video Art; Caracas, Periférico; Taipei, Poetry Festival / 2007 Mississauga, Blackwood Gall.; München, Gal. Traversée; Locarno, La Rada (mit Knut Asdam); Rio de Janeiro, Mercedes Viegas arte contemp. / 2008 Lugano, Cinema Lux; Brest, MBA; Poznań, Stary Browar AC / 2009 Madrid, La casa encendida; Por-

to Alegre (Brasilien), Fund. Iberê Camargo; Saint-Etienne, MAM / 2010 Lissabon, Mus. Col. Berardo. ⌒ P. C. PAB l'enchanteur, Alès 1991; P. C. C'est de l'art, P. 1993; P. C. Le grand récit, Bignan 1997; *G. Breteau-Skira*, Zeuxis 2000 (1; Interview); *M. Aidan/L. Logette*, Jeune cinéma 2000 (265; Interview); Janus (Ant.) 2002 (11; Interview); P. C. Les guerriers de la beauté, Crisnée 2003; *L. Le Bon* (Ed.), P. C. Le démon du passage, P./Crisnée 2004; P. C. Pistoletto. L'homme noir, Arles 2004; P. C. ... wie ein Schatten in der Ferne, Zug 2006; P. C. Michel Butor mobile, Crisnée 2006; P. C. Pavillon noir, P. 2006; *I. Goetz/S. Urbaschek*, Fast forward. Media Art Slg Goetz (K Karlsruhe), Ostfildern 2006; *E. Reiter*, art'O 2006 (20; Interview). – *Online: J. Anterrieu*, Film de culte (Interview 2003); PLAY, Berlin; Ubuweb. G. Bissell

Coulon, *Léon-Alphonse-Auguste (Léon)*, frz. Schmuckgestalter, Juwelier, vor 1879 bis um 1914 in Paris tätig. Zunächst Gehilfe im Juwelierhaus von Frédéric Boucheron. 1879 Übernahme der Fa. Félix Samper zus. mit dem Zeichner Jules Debut als Geschäftspartner, mit dem C. fortan als Debut et Coulon firmiert. Mit einem breit gefächerten Angebot hochwertiger, bes. phantasievoller und extravaganter Schmuckstücke und and. Kunstwerke sichert sich die Fa. alsbald einen wohlhabenden, anspruchsvollen Kundenkreis und erlebt einen schnellen Aufschwung. Nach dem Weggang von Debut 1890 leitet C. die Fa. zunächst allein weiter als L. Coulon et Cie, ab 1895 zus. mit seinem neuen Partner R. Deverdun. Zur Pariser WA 1900 Mitgl. der Jury und zum Ritter der Ehrenlegion ernannt. – Nach Beginn mit eklektizistischen, v.a. von der Renaiss. inspirierten Arbeiten und der Einbeziehung naturalistischer Gest.-Elemente wendet sich C. dem Zeitgeist entsprechend konsequent dem Jugendstil zu und entwickelt sich in seinem Fach zu einem bed., technisch virtuosen Vertreter dieser Richtung. Neben Silber und (mitunter patiniertem) Gold verarbeitet er Eisen und geschwärzten Stahl; das oftmals üppige Dekor besteht mehrheitlich aus Schmucksteinen, vorrangig Diamanten, zudem Brillanten und Saphiren, sowie emaillierten Partien und tauschierten Motiven. Häufig gestaltet C. Kameen, gelegentlich mit figürlichen Darst. (bemerkenswertes Armband mit einem Kinderreigen, WA 1889). Zu den aufsehenerregendsten Stücken gehört ein edelsteinbesetztes Hundehalsband mit Pfauenfedern (WA 1900). 🏛 KÖLN, MAK: Anhänger in Bienenform, Silber, Karneol, vergoldet (Zuschr.). 👁 *G:* 1883 Amsterdam: WA (Ehren-Dipl.) / Paris: 1889 WA (Gold-Med.); 2008 MAD: Aussi rouge que possible ... / 1891 Moskau: Ausst. frz. Industrieerzeugnisse (Ehren-Dipl.) / 1897 Brüssel: WA (Ehren-Dipl.) / 1906 Mailand: WA (Grand Prix). ⌒ Dict. internat. du bijou, P. 1998. R. Treydel

Coupey, *Pierre*, kanad. Maler, Zeichner, Graphiker, Fotograf, Dichter, Hochschullehrer, * 1942 Montreal, lebt seit 1993 in West Vancouver/B. C. Aufgewachsen in Montreal. Stud.: bis 1964 McGill Univ. ebd. (Englisch/Kreatives Schreiben); 1964–65 Acad. Julian (Zchng) und Atelier 17 bei Stanley William Hayter (Druckgraphik), Paris; bis 1971 Univ. of Brit. Columbia, Vancouver (Englisch/Kreatives Schreiben); 1992 Art Inst., Capilano Univ.

(Druckgraphik), North Vancouver; hier 1970–2003 Lehrtätigkeit am English Department. 1967 Mitbegr. und Red. der Publ. The Georgia Straight, 1972 Begründer und Red. der lit. Zs. The Capilano Review. Ausz.: 1968–69 Arts Grant for Poetry, 1970 Short Term Visual Arts Grant, 1973, '76 Short Term Grant for Poetry, 1980–81 Visual Arts Grant, alle Canada Council; 2000 Millennium Print Project, North Vancouver Arts Council. – C.s bildkünstlerisches ungegenständliches Schaffen (Malerei in Öl, Enkaustik, Aqu., Mischtechnik; Tusch-Zchngn; Rad.) ist eng mit der Dichtkunst verbunden, sowohl seiner eig. als auch der ihn inspirierender Kollegen. Dies zeigt sich in der Darst. von (mitunter unlesbaren) Schriftzeichen, z.B. als gekritzelte horizontale Linien (Serie *Field*, Öl/Lw. auf Holz, 2010–12), oder in Bildern, die gleichsam als Hommage an Dichter (*Riverbank [for RB]*, Öl/Lw. auf Holz, 2008/09, dem Dichter Robin Blaser [† 2009] gewidmet) gestaltet sind (cf. J. Donaldson, 2010). Als weitere C.s Arbeiten beeinflussende Faktoren führt D. Martens (2006) die Lsch., atmosphärische und Lichtverhältnisse der kanad. Westküste sowie die Kalligraphie der Kamakura-Periode an, die C. bei seinen Japanaufenthalten 1998 und 2003 studiert hat (*On the Rainy River I-XX*, farbige Tusche, 2005). Das Kolorit von C.s gestisch-expressiven, assoziationsreichen, häufig schwer zu entschlüsselnden Gem. variiert von Buntfarbigkeit (*Notations*, Öl/Lw., 1990er Jahre) bis hin zu dominierenden dunklen Tönen, z.B. Grau, Braun oder Schwarz (Serie *Komyo*, Öl/Lw. auf Holz, 2007/08). Bll. der Serie *Requiem Notations I – IX* (Heliogravüre, 1996–97) zeigen wie auf einer aufgeschlagenen Buchseite Verse von C. auf der linken und lineare Strukturen oder auch Handabdrücke auf der rechten Bildhälfte. 🏛 BURNABY/B. C., Burnaby AG. – Simon Fraser Univ. AG. COQUITLAM/B. C., AG at the Evergreen Cultural Centre. EDMONTON, Univ. of Alberta. KAMLOOPS/B. C., Kamloops AG. KELOWNA/B. C., Kelowna AG. LETHBRIDGE/Alta., Univ. of Lethbridge AG. NANAIMO/B. C., Nanaimo AG. NORTH VANCOUVER/B. C., Capilano Univ., Art Inst. – North Vancouver Mus. OTTAWA, Carleton Univ. AG. PRINCE GEORGE/B. C., Two Rivers AG. VANCOUVER, Contemp. AG. – Vancouver AG. VICTORIA/B. C., Univ. of Victoria. WEST VANCOUVER/B. C., West Vancouver Mus. ✉ Bring forth the cowards, Ml. 1964; Circle without center, Vn. 1968; Four island poems, Prince George 1975; Terminal series, Prince George 1973. 👁 *E:* zahlr. ab 1980, u.a. North Vancouver: 1980/81 Presentation House Gall. (K: C. Knight); 1981, '91, '97, 2004, '10 Capilano Univ. AG / Vancouver: 1990, '92, '94, '95 Atelier Gall.; 2008 (K), '10, '11, '13 (K) Gall. Jones / 1998 Tokio, Canad. Embassy Gall. (K: P. Gustafson) / 1999 (K: P. Montgomery), 2012 (K: A. Heyerdahl/D. Morrison) Coquitlam, AG at the Evergreen Cultural Centre. ⌒ *A. Rosenberg*, P. C. and Harry Stanbridge. Recent works (K Surrey AG), Surrey 1988; *D. Martens*, Tangle. The paint. of P. C. (K Burnaby AG), Burnaby 2006; *J. Donaldson*, The Dependent v. 16. 9. 2010; *L. Wylie*, The point is (K Kelowna AG), Kelowna 2011. – *Online:* Website C.; Centre for Contemp. Canad. Art. C. Rohrschneider

Coupon, *William,* US-amer. Fotograf, Filmemacher, Journalist, Autor, * 3. 12. 1952 New York, lebt dort. Stud.: Syracuse-Univ., Syracuse/N. Y. 1994–98 in Santa Fe/N. Mex. Zunächst als Journalist und Textautor tätig. Ab E. der 1970er Jahre Portr.-Fotogr., auch Reise- und Werbe-Fotogr. sowie Werbefilme, CD-Cover sowie Ill. für Mag. (u.a. Rolling stone; New York mag.; Graphis; Esquire; The economist; Forbes; Fortune; Newsweek; Vanity fair; Amer. photographer). Auch Akt-Fotogr. und Stilleben. – C. erstellt zunächst Fotogr. mit Ton-Installation (*Audiographs*); für die Schaufenster eines Kaufhauses entstehen mit Motoren bewegte Fotogr. (*Kinetographs*). 1978 dokumentiert er die New Yorker Diskothek Studio 54. Ab 1979 beginnt C. mit einem mobilen Studio, Portr.-Serien als *Social studies* zu fotografieren: Anfangs soz. und ethnische Gruppen oder Minderheiten in den USA (Punk und New Wave in New York, Native Americans, Todeskandidaten in Gefängnissen, Cowboys) sowie auf Reisen u.a. in Australien (Aborigines und Drag Queens, 1980), Skandinavien (Samen, 1981), Israel (1981), Marokko (Berber, 1982), Peru (Indios), Mexiko (1988), Libyen (1989), Türkei (Kurden, 1991), Malaysia und Neu Guinea (1991), Zentralafrika (Pygmäen, 1991). 1992 porträtiert er Stammesfürsten beim Earth Summit in Rio de Janeiro. C. fotografiert auch amtierende US-Präsidenten und Politiker (Yasser Arafat, Benazir Bhutto, Kofi Annan) sowie Schriftsteller (Elie Wiesel, Octavio Paz), Musiker (u.a. Miles Davis, Mick Jagger, George Harrison), Künstler (Keith Haring, Jean-Michel Basquiat), Sportler und Geschäftsleute. C. arbeitet bei seinen Portr. häufig mit braun- oder blaugetönten Schwarzweißabzügen, die den Fotogr. eine trad. Aura verleihen. Die Verwendung oft nur einer Lichtquelle und eines dunklen (auch selbstbemalten) Hintergrundes lassen Vorbilder aus der Portr.-Malerei erkennen: C. bezieht sich selbst u.a. auf Holbein und Rembrandt. Mit den Serien *Postcards* zeigt C. auch (z.T. farbbearbeitete und –reduzierte) topogr. Ansichten. ◉ *E:* 1980 Buffalo (N. Y.), CEPA Gall.; Syracuse (N. Y.), Syracuse Univ.; Covington (Ky.), Northern Kentucky Univ. / New York: 1981 Chase Manhattan Bank; 2003 W. Channing Gall. / Mexiko City: 1989 MCA; 2006 Auditorio Nac. / Washington (D. C.): 1994 The Senate Rotunda; 2005 Govinda Gall. / 1995 Santa Fe (N. Mex.), G. Peters Gall. / 2004 Amsterdam, Art and Commerce; Paris, Hôtel de Ville. – *G:* New York: 1978 Internat. Center of Photogr.: Fleeting gestures; 1982 The Alternative Mus.: Face to face / 1981 Long Island City (N. Y.), P. S. One: The New York – New Wave / 1985 Cincinnati (Ohio), Cincinnati AM: Cincinatti collects / 1986 Boston (Mass.), Photogr. Resource Center: Group portr.; Chicago (Ill.), Inst. of Contemp. Photogr.: Portr. / 1996 Houston (Tex.): FotoFest 96 / 1998 Antwerpen, Foto Mus. / 1999 Athen, Hellenic Center for Photogr. / 2004 Tucson (Ariz.), Arizona State Univ. Mus.: Democracy in America. ▭ *S. Hager,* Art after midnight, N. Y. 1986; *L. Frascella,* Communication arts 1989 (Sept./ Okt.) 50–59; H. Brockington, NY arts 2003 (Mai) 14 s. – *Online:* Website C.; Luminous-lint. World photogr. – Mitt. C. T. Koenig

Couret, *Miguel Angel,* kubanischer Maler, Graphiker, Kurator, * 12. 10. 1964 Pinar del Río, lebt dort. Stud. ebd.: bis 1988 Graphik am Inst. Superior de Arte, Havanna. Mitgl.: Asoc. Hermanos Saíz; Unión de Escritores y Artistas de Cuba. 2005 Kurator der Ausst. 2+2 no siempre es paisaje, Gal. Villa Manuela, Havanna. Zahlr. Ausz.: u.a. seit 1988 mehrfach Salón Prov. 20 de Octubre, Pinar del Río; 2005 Salón Nac. de Arte Erótico, Gal. Fayad Jamís, Havanna; 2006 Med., 20 años de la Asoc. Hermanos Saíz, Pinar del Río. – C. malt gegenständlich-surreale Bilder, meist Acryl/Lw. oder Karton, in kontrastreicher, kräftiger Farbigkeit. Sie beziehen sich in ausgewählter, oft mehrdeutiger Symbolik auf die Instabilität der menschlichen Existenz und indirekt häufig auf die prekären politischen und sozialen Realitäten im eig. Land (*El coloso; Espacio vital*), teilw. mit Anspielungen auf Mythologie (*El hijo pródigo; Nuevo Icaro*) und Kunstgesch. (*Molino de chocolate*). Oft stehen vor diffusen schwarzen oder roten, manchmal auch gemauerten Hintergründen Sessel und Stühle im Zentrum, auf denen sich alltägliche, aber auch geheimnisvolle Objekte befinden (*Verdad no es de nadie; Silencio,* 2002; *El calor con que vivo,* 2006). Sinnbildliche Hinweise sowohl in Gegenständen als auch figuralen Darst. auf die geogr. und ges. Situation Kubas (*Descanso insular,* 2000; *Retrato insular,* 2002; *Mi silla insular,* 2008) verbinden sich mit der Metapher des Seiltänzers (Serie *En la cuerda,* seit 1998; *Nuestro circo,* 2008). Auch Buch-Ill.: u.a. Julio M. Llanes, *Las palomas de Guillén,* Pinar del Río 2008. ⌂ DULUTH, Univ. of Minnesota, Tweed Mus. of Art. HAVANNA, Fondo Cubano de Bienes Cult. – MNBA. STANISLAUS/Calif., California State Univ. ◉ *E:* Pinar del Río: 1988 Gal. de Pinar del Río; 1994–96 Centro de Arte; 2004 Gal. Alturo Regueiro; 2005 Gal. Ateneo / Havanna: 1989 Gal. Domingo Ravenet; 1993 Sede la UNESCO para América Latina; 1997 Gal. Taller de Serigrafía René Puertocarrero; Centro de Desarrollo de las Artes Visuales; 1998 Centro Prov. de Artes Plást. y Diseño; 1999 Gal. La Acacia; 2006, '09 Gal. Fayad Jamis; 2007 Dt. Botschaft; 2009 Gal. Luz y Oficios (Retr.) / 1994 Varadero (Matanzas), Gal. Sol y Mar / 2000 Girona, Colegio Arquitectos y Técnicos, Gal. La Punxa / 2007 Hagen, Allerwelthaus (mit Jairo Alfonso Castellanos); Barcelona, Gal. Paret / 2008 Santiago de Cuba, Gal. La Confronta. – *G:* Havanna: 1991 Mus. de Arte Colonial: Grabado contemp. cubano; 1997 Gal. Domingo Ravenet: No son todos los que están; 2007 Casa del Habano: Deja que los dioses tocan tu alma / 1994 Cuenca: Bien. Internac. de Pint. / 1998 San Juan: Bien. del Grabado Latinoamer. y del Caribe / Mérida (Mexiko), SoHo Gall.: 2009 Arte de Cuba; 2010 The art of change. Interpretations of time and space by artists from Cuba, USA and Mexico. ▭ *A. Alvarez/P. P. Porbén,* Vitral (Pinar del Río) 2:1995 (9); *O. M. Pérez* (Ed.), Cincuenta artistas plást. cubanos, Havanna 2002; *D. Mateo,* Rev. digital convivencia (Pinar del Río) 1:2008 (4) 9–11. – *Online:* Website C. M. Nungesser

Courrèges, *Christian,* frz. Fotograf, * 28. 7. 1950 Aix-en-Provence, lebt in Paris. Stud.: 1969–73 Soziologie. Als Fotograf Autodidakt. – V.a. Portr., oft von Mitgl. versch.

Berufsgruppen in Arbeitskleidung vor neutralem Hintergrund, auch von Paaren und Familien. 1992 arbeitet er in Innsbruck für das Inst. Franç. und die Tirol-Werbung. Danach porträtiert er u.a. Gefängnisinsassen in Les Baumettes (Marseille, 1995), Musiker im Théâtre des Champs-Elysées, Haitianer (Publ.: *Seul le couteau connaît le secret au coeur de l'igname. Portr. de Haïti*, P./Douchy-les-Mines 2001), frz. und brit. Staatsanwälte (*Les magistrats*, 2004) und Prälaten der röm. Kurie (*Les prélats*, 2006). 1993 fotografiert er die Beteiligten vor und nach den Stierkämpfen (*Autour de la Tauromachie*, 1995), wobei ihn das Verhältnis zw. sozialer Gruppenidentität und Individuum interessiert. Er fotografiert oft mit einer plastischen Ausleuchtung und starken Schatten im dunklen Raum. C. fertigt auch Polaroid-Großformat-Portr. vor Ort in Ausst.-Räumen an. E. der 1990er Jahre nimmt er mit Portr.-Fotogr. von prominenten europ. Politikern auch am Dokumentarprojekt über den Kanaltunnelbau Mission Photogr. Transmanche teil. Seit 2002 lehrt C. an der Ec. nat. supérieure des Arts Decoratifs, Paris. Zahlr. Ausz., u.a. 1993 Bourse Léonard de Vinci. – Foto-Bücher: *Portr. de familles*, P. 1992; *Portr. de prison*, P. 1998; *Capitale Europa*, Douchy-les-Mines 1998. ⌂ CHALON-SUR-SAONE, Mus. de la Photogr. Nicéphore Niépce. LAUSANNE, Mus. de l'Elysée. LONDON, Nat. Portr. Gall. PARIS, Caisse des Dépôts et Consignations. – MNAM. ⊙ *E:* Paris: 1991, '93, '94 Gal. Pons; 1994 Salon Découverte; 1996 Théâtre des Champs Elysées; 1998, 2001, '04, '06 Gal. Baudoin Lebon; 2000 Fond. COPRIM / 1992 Innsbruck, Inst. Franç. (K) / 1995 Calais, Centre Régional de la Photogr. du Nord-Pas-de-Calais (K); Lausanne, Mus. de l'Elysée / 1996 Montreuil, Mus. de l'Hist. vivante Parc Montreau / 1997 Bordeaux, Arrêt sur Image Gal. / 1998 Douchy, Centre Régional de la Photogr.; Luxemburg, GAC am Tunnel / 1999 Villeneuve d'Asq, Centre Cult. / 1999, 2000 Villetaneuse, Univ. de Paris / 2001 Mont-Saint-Michel, Abbaye / 2003 Philadelphia, Seraphin Gall. / 2004 London, R. Court of Justice; Turin, Gal. Photo & Co.; Mailand, Gal. M. Voena; Saint-Martin-d'Hères, Espace J. Vallès / 2006 Moskau, Ščusev-Archit.-Mus. / 2008 Constantine (Algerien), Centre Cult. Franç. – *G:* 1993 Arles: Rencontres Internat. de la Photogr. / 2002 Groningen: Noorderlicht Photofestival (K); Saloniki: Rencontre Photogr. / 2003, '07, '09, '11 Paris: Paris Photo. ⌷ Amnesty Internat. (Ed.), Défenseurs des droits humains, P. 2008. – *Online:* Website C. – Mitt. C. T. Koenig

Courtenaye, *Catherine*, US-amer. Malerin, Zeichnerin, Graphikerin, Hochschullehrerin, * 18. 9. 1957 Madrid, lebt seit 2010 in Bozeman/Mont. Vater US-Diplomat; ab 1958 in den USA, 1972–73 in Tanger lebend. Stud.: 1977 Univ. of Bath/England; 1979 Colby College, Waterville/Me.; 1980 Massachusetts College of Art, Boston; 1980–84 Malerei und Zeichnen an der Univ. of Iowa, Iowa City, bei Hans Breder und John Dilg. Stip.: 1982–84 Ford Found.; 1989 Nat. Endowment for the Arts. Seit 1982 Lehrtätigkeit, u.a. Univ. of Iowa in Iowa City, California College of Arts and Crafts in Oakland/Calif. und Southern Oregon State Univ. in Ashland/Oregon. 1984–2001

in Emeryville/Calif. ansässig. 1985 Gastkünstlerin am Virginia Center for the Creative Arts in Sweet Briar/Va., 1991 an der Ucross Found. in Clearmont/Wyo. und 2001 am Experimental Workshop in Emeryville/California. – C.s abstrakte Gem., inspiriert von Kurt Schwitters, Antoni Tàpies und Cy Twombley, bestehen aus zwei eng miteinander verschränkten bildlichen Ebenen. Die eine bezieht sich auf graph. Vorlagen aus dem 19. Jh. der USA, u.a. Schönschreibbücher, Alphabete und and. Musterbücher für Bankleute, Inspektoren und Tischler (z.B. Manual of social and business forms. A guide to correct writing, 1865; Spencerian key to practical penmanship, 1866), aber auch handschriftliche Dok. und geometrische Berechnungen einschließlich Randnotizen und Kritzeleien. Diese überträgt C. ausschnittweise über digitale Fotos in Siebdruck auf grundierte Leinwand. Darüber setzt sie, oft in mehreren Schichten, eine gestisch-expressive, lichtvolle Ölmalerei in zur Monochromie neigender, zarter Farbigkeit, die auf die skripturalen Vorlagen als alltägliches kult. Zeugnis einer vergangenen Zeit in versch. Form reagiert. Durch Übermalen, Wischen, Einkreisen oder Klecksen entstehen neue meditative Komp., in denen sich Ordnung und Chaos, Linie und Bewegung, Kontrolle und Freiheit die Waage halten. ⌂ CHARLOTTE/N. C., Bank of America. LONG BEACH/Calif., Farmers and Merchants Bank. NAPA, Westin Verasa Hotel. OAKLAND, Oakland Mus. of California. OSAKA, Matsushita Investment & Development Corporation. PHOENIX/Ariz., Frontier Adjusters of America. RENO/Nev., Renown Health Center. – Stadtverwaltung. SAN FRANCISCO, Achenbach Graphic Arts Council. WALNUT GREEK/Calif., Stadtverwaltung. WASHINGTON/D. C., Nat. Endowment for the Arts. ⊠ Provisional structures, Diss., Iowa City 1984. ⊙ *E:* 1984 Iowa City, Iowa Internat. Center / San Francisco: 1988 Iannetti-Lanzone Gall.; 1990 Bank of America World Headquarters; 1992 Paule Anglim Gall.; 2009 Modernism; 2011 Modernism West / New York: 1989 Kouros Gall. (Falt-Bl.: C. Shere); 2007, '09 (mit Charles Ramsburg) Cheryl Pelavin FA / 1993 Berkeley (Calif.), Design Works / 1994 Salinas (Calif.), Hartnell College / 1997 Seattle (Wa.), Grover-Thurston Gall. / 2000 South Union (Ky.), Shaker Mus.; Santa Monica (Calif.), Hunsaker-Schlesinger FA / 2002 Oakland (Calif.), Latham Square Building / 2004 (K), '07 (mit Dale Livezey und Randall Shiroma) Reno (Nev.), Stremmel Gall. / 2005 Phoenix (Ariz.), Bentley Projects / 2008 Scottsdale (Ariz.), Bentley Gall. / 2011 Boise (Ida.), AM (K: M. Corriel/S. Harthorn). – *G:* 1987 Richmond (Calif.), Richmond AC: Bay Area drawing; Pittsburg (Calif.), Los Medanos College: Ten women artists of the Bay Area / 2002 Berkeley (Calif.), Kala Art Inst.: Solos. The contemp. monoprint / 2006 Honolulu (Hawaii), The Contemp. Mus.: Contemporarities; San Francisco, State Univ. FA Gall.: Cali/Graffi. A California calligraphy summit. ⌷ *D. Nadaner*, Artweek (Palo Alto) v. 30. 5. 1987; *P. Bragdon*, Marin Independent J. (Novato) v. 6. 7. 1987; *K. Baker*, The San Francisco Chronicle v. 10. 5. 1990; 14. 11. 2009, E2; *C. Roth*, Artweek 2001 (Jan.). – *Online:* Website C. (Ausst.; Lit.). M. Nungesser

Cousens, *Cynthia,* brit. Silberschmiedin, Schmuckgestalterin, Installationskünstlerin, * 1956 Ipswich/Suffolk, tätig in Brighton/East Sussex. Stud.: 1974–75 Ipswich College of Art, Ipswich; 1975–78 Loughborough College of Art and Design, Loughborough/Leicestershire (Silberschmieden); 1979–82 R. College of Art, London (Schmuck-Gest.). Seit 1982 selbständig. Lehrtätigkeit: 1985–91 und seit 2000 Univ., Brighton/East Sussex; 1991–93 R. College of Art, London. 1988–91 Ltg der Nexus Gall., Brighton. Ausz.: 1994 South East Arts Major Award for Crafts. – C.s konzeptueller Ansatz verbindet versch. Medien wie Schmuckstücke aus klassischen (v.a. Silber, häufig geschwärzt; auch Gold) und unkonventionellen Mat. (Natur-Mat., Textilien, Papier) mit Zchngn, Fotogr. (z.B. *Kare Kare,* 1999), Videoarbeiten (z.B. *Turning,* 2002) und Installationen (z.B. *The Waves,* 2000). Ausführliche Recherchen begleiten die Projekte und werden zus. mit den Schmuckarbeiten präsentiert. C. fertigt u.a. linearen und fragil wirkenden Schmuck in organischen Formen wie Blätter, Blüten, Körner, Gräser (z.B. *Garland Nest,* geschwärztes Silber, 1996), andererseits verwendet sie Natur-Mat. (z.B. *Postcard Necklace Series,* 2003). Typisch sind lange Ketten mit verästelten Strukturen (z.B. *Trail Necklace,* geschwärztes Silber, Leinen, 1996). ⊞ BIRMINGHAM, Mus. and AG. EDINBURGH, NM of Scotland. GATESHEAD, Shipley AG. GENF, Mus. de l'Horlogerie et de l'Emaillerie. HOVE, Hove Mus. and AG. LONDON, Brit. Council Coll. – Crafts Council. – The Goldsmith's Company. – V & A. NORWICH, Castle Mus. ☉ *E:* 1983 Colchester (Essex), The Minories AG (mit Trevor Jennings) / 1986 Basel, Gal. Atrium (mit Alistair McCallum; Vicki Ambery-Smith) / 1990 Tokio, Gal. Pousse (mit V. Ambery-Smith, Jane Adam) / 1993 Lausanne, Gal. No / 1994 (mit Susan Cross), '98 Barcelona, Hipòtesi / 1992, '96 Edinburgh, Scottish Gall.; Firle (East Sussex), Charleston Gall. (mit Kate Blee) / 2001 Worksop (Notts.), Harley Gall. / 2003 Hove, Hove Mus. and AG (Retr.; Wander-Ausst.; K); Manchester, Univ., Manchester Mus. – *G:* London: 1978 Goldsmith's Hall: Synthetics; Crafts Council Gall.: 1989 Brit. Jewellery (Wander-Ausst.; K); 1996 New Times, New Thinking. Jewellery in Europe and America (K) / 1980–81 Bracknell (Berks.), South Hill Park AC: Colour for Christmas / 1994 Paris, Gal. Hélène Porée: Bagues / 1995, '97 München: Schmuckszene (Sonderschau der Internat. Handwerksmesse) / 1997 Köln, MAK: Highlights. Design aus Großbritannien (K) / 2005 El Paso (Tex.), Stanlee and Gerald Rubin Center for the Visual Arts: Hanging in Balance. Forty-two contemp. Necklaces / 2008 Itami, Mus. of Arts and Crafts: Masters and Protegees. Contemp. Brit. Jewellery (Wander-Ausst.; K). ☐ Dict. internat. du bijou, P. 1998. – *D. Watkins,* The best in contemp. jewellery, Lo. 1993; *P. Dormer,* The new jewellery. Trends and trad., Lo. 1994; *A. B. Chadour-Sampson* (Ed.), Schmuckkunst der Mod. – Großbritannien (K LM), Mainz 1995; *A. Game/E. Goring,* Jewellery moves. Ornament for the 21st c. (K), Edinburgh 1998; *D. O'Day,* Metalsmith 27:2007 (1) 20–27. – *Online:* Univ. of Brighton. F. Krohn

Cousins, *Michael A.* cf. **Cousins,** *Morison S.*

Cousins, *Morison S. (Morison Stuart),* US-amer. Designer, * 10. 4. 1934 Brooklyn/N. Y., † 10. 2. 2001 Orlando/Fla. Stud.: bis 1955 Pratt Inst. Brooklyn (Industrial Design). 1955/56 und 1958/59 als Designer für den Nutzfahrzeughersteller Internat. Harvester in Fort Wayne/Ind. tätig; dazwischen zwei Jahre Militärdienst. 1960–62 Entwerfer bei der Fa. Ira Schwartz in New York. 1963–90 ebd. zus. mit dem Bruder *Michael A. (Michael Alan) C.* (* 1938 Brooklyn/N. Y.) Atelier unter dem Namen Cousins Design Inc. Ab 1990 Chefdesigner (Vice President of Design) der Fa. Tupperware in Orlando/Fla. Lehrt als Gast-Prof. u.a. 1986 an der Ec. nat. supérieure de création industrielle (ENSCI), Paris, und an der Rhode Island School of Design, Providence. Lebte zuletzt in Winter Park/Florida. Ausz.: 1984 Rom Prize, Amer. Acad., Rom; 1995 Gold Award, Industrial Designers Soc. of America; 1999 Good Design Award, Chicago Athenaeum (für *Tupperware T. 2 Mixer,* 1996–98). – Inspiriert vom gestalterischen Gestus der Designerinnen Rowena Reed Kostellow und Eva S. Zeisel sowie von Raymond Fernand Loewy entwirft C. (zw. 1963 und 1990 häufig zus. mit dem Bruder) im Auftrag versch. Firmen (u.a. General Electric, Heller & Co., Dictaphone) erfolgreiche Massenkonsumprodukte (meist aus Kunststoff) für Haushalt und Büro, die sich durch Funktionalität und klare Formen auszeichnen. Von dem 1970 für die Amer. Can Company gestalteten Pappbecherspender *Dixie cup dispenser* werden bis 1990 über 100 Millionen Stück verkauft. Für die Gillette Company in Boston/Mass. entsteht der Haartrockner *Promax Compact* (Kunststoff, Gummi, Metall, 1976–77; ab 1978 produziert) in der geometrisch simplen Form von zwei im rechten Winkel zueinander gefügten Zylindern. Aus ähnlich einfachen Grundelementen setzt sich auch ein Tischstaubsauger zusammen (*Vacuum cleaner,* 1981). Ebenso markant reduziert ist das flache *Space-Tel Telephone* (Modell ST-5001 T/P, Kunststoff, Gummi, 1984; ab 1985 produziert). Ab 1990 gibt C. als Chefdesigner der als nicht mehr zeitgemäß wirkenden Erzeugnispalette des 1938 gegr. Unternehmens Tupperware innerhalb kurzer Zeit ein mod. Gesicht, wobei er u.a. sowohl trad. Produkte des Hauses einem Redesign unterzieht als auch Neuheiten einführt, z.B. bei der Farbgebung oder der Konstruktion des typischen luftdichten Behälterverschlusses. Zu C.s bed. Entwürfen für diese Fa. gehören das skulpturale Qualitäten aufweisende Küchensieb *Double Colander* (1992) und die auf geometrische Grundformen reduzierte kegelförmige Küchenuhr *On the Dot* (1993–95). Daneben auch Entwürfe für limitierte Geschenkartikel, z.B. Objekte aus mundgeblasenem Muranoglas (*Venini Glass Vase,* 2000). ⊞ CLEVELAND/Ohio, Mus. of Art. ESSEN, Red Dot Design Mus. HAMBURG, MKG. LONDON, Design Mus. – V & A. MÜNCHEN, PM. NEW YORK, Brooklyn Mus. – Cooper-Hewitt, Nat. Design Mus. – MAD. – MMA. PARIS, MAMVP. PHILADELPHIA/Pa., Mus. of Art. PITTSBURGH/Pa., Carnegie Mus. of Art. RICHMOND, Virginia MFA. ROTTERDAM, BvB. ☉ *E:* 1963 Washington (D. C.), SI. / New York: 1985 Whitney; 1992 Me-

trop. Mus.; 1997 Moss Shop / 1985 Denver (Colo.), AM /
1992 London, Design Mus. – *G:* 2003–04 New York, Art
Dir. Club Gall.: FAAR (Fellows of the Amer. Acad. in
Rome) Out. Six Months in Rome / 2009 Essen, Red Dot
Design Mus.: Tupperware. Sophisticated simplicity advan-
ced through engineering. ▢ ContempDesigners, [3]1997;
M. Byars, The design enc., Lo./N. Y. 2004. – *D. Martin*,
The New York Times v. 18. 2. 2001 (Nachruf); *M. Byars/
L. Wolff*, Graphis 2002 (337) 88–95; *M. E. Bucquoye u.a.*,
Tupperware. Transparent (K Gent), Ostfildern-Ruit 2005.
 U. Heise

Cousseau, *Jean-Yves*, frz. Fotograf, Videokünstler,
* 27. 7. 1953 Nantes, lebt in Janvry/Essonne. Stud.:
1971–74 Ec. régional des BA, Nantes. Lehrtätigkeit:
1981–82 Inst. nat. d'Arts graph., Paris; 1989 Ec. supéri-
eure de l'Image, Angoulême. C. zerstört 1976 den Groß-
teil seiner Arbeiten. – Zunächst entstehen reportagearti-
ge Schwarz-Weiß-Fotogr. (1974–90). Seit 1995 dominie-
ren großformatige Farb-Fotogr. (oft mehrteilige Werke)
mit Naturdetails, die so stark vergrößert werden, daß die
Motive sich in abstrakten Strukturen auflösen. Besondere
Effekte erzielt C. durch die Bearbeitung der Fotogr. (v.a.
durch Oxidation, Staubablagerung, Kratzen), die er z.T. an
ungewöhnlichen Orten vornimmt, z.B. im Bassin des Jar-
din des Bronzes der zugleich als Ausst.-Ort fungierenden
Fond. Coubertin in Saint-Rémy-lès-Chevreuse. Die Expos.
„Un Regard sur Rodin" zeigt Fotogr. von Plastiken Au-
guste Rodins, die mit Rostspuren versehen sind. In eini-
gen Arbeiten kombiniert C. die Naturmotive mit Details
von menschlichen Körpern (z.B. *Hommages et petites Po-
ses*). Publ. der Fotogr.: u.a. J.-P. Nouhaud, *Lieux d'écrits*,
Luzarches 1987; J.-F. Piquet, *Élégie à la mémoire de trois
étrangères*, Vayres-sur-Essonne 2006. Weiterhin Videoar-
beiten, z.B. *Le Sablier*, 1985 (nach Robert Walser); *Ves-
tiges*, 2002. ⌂ PARIS, BN. ☉ *E:* 1987 Asnières-sur-
Oise, Fond. Royaumont / 1989 Lyon, Bibl. mun. / 1991
Marseille, Centre internat. de Poésie / 1997 Frankfurt am
Main, Fotogr. Forum Frankfurt / 1998 Bièvres, Mus. franç.
de la Photogr. (Wander-Ausst.; K) / 1999, 2002 (K) Pa-
ris, Gal. Pierre Brullé / 2000 Brest, Centre d'Art Passerel-
le / 2003 Viviers, Centre d'Art contemp. / 2006 Martigny,
Fond. Pierre Gianadda / 2011 Saint-Rémy-lès-Chevreuse,
Fond. de Coubertin. –. *G:* Paris: 1985 MAMVP: Nouv.
Fictions Vidéo en France; 2009 Mus. de l'Orangerie: Eaux
dormantes? / 1987 Saint-Etienne, EcBA: Formes en Œu-
vre / 1997 Blérancourt, MN de la Coopération franco-
amér.: Une Fleur, des Photographes, l'Arum / 1998, '99
Frankfurt am Main, Fotogr. Forum Frankfurt: Paris Pho-
to / 2005 Budapest, Bolt Gall.: Still life (K). ▢ *Delarge*,
2001. – *A. Le Normand-Romain/A. Madeleine-Perdrillat/
A. Rebours*, Manière noire. J.-Y. C. Photogr. & fragments,
Lyon 2006; Quantités discrètes. J.-Y. C. (K Gap), Lyon
2006. – *Online:* Website C. F. Krohn

Coutausse, *Jean-Claude*, frz. Fotograf, * 15. 8. 1960
Monpazier. C. lernt Fotogr. an einer Berufsoberschule in
Orthez. Während des Militärdienstes ist er Fotograf im
Etablissement Cinématographique et Photogr. des Armées
(ECPA). 1982 erste Reportage vom Libanonkrieg. Ab

1983 freier Fotograf. Als Reporter arbeitet er für Agence
France-Presse (ab 1984), 1985–89 für die Ztg Libération,
1989 für die Agentur Editing, seit 1990 für Contact Press
Images. Zahlr. Veröff. in Ztgn und Zss. (u.a. Independent
mag., Sunday times mag., Time, New York Times mag.,
L'express). Ausz.: 1985 Prix AFP, Paris; 1988 Grand Prix,
Ville d'Arles; 1993 Prix Niépce; 1997 Stip. Villa Médicis
des frz. Außen-Min.; Mother Jones Award, San Francisco;
2000 Humanity Photo Award, Beijing; Prix SCAM, Paris.
Mitgl.: Fedephoto; ab 2011 Observatoire du Photojourna-
lisme. – C. fotografiert zunächst v.a. in Kriegs- und Kri-
sengebieten. Früh reist er für Newsweek nach Afghanis-
tan. In Frankreich entstehen politische Reportagen (Stu-
dentenunruhen 1986; Präsidentenwahl 1988 und 2012). Er
fotografiert in Libyen (1986), Haiti (ab 1987), Chile (1988)
und Japan (1999). C. berichtet von der ersten palästinensi-
schen Intifada (Publ.: *La danse des pierres*, P. 1990), vom
Fall der Berliner Mauer und der Revolution in Prag (1989),
dem Golfkrieg (1990–91), von den Bürgerkriegen in Ex-
Jugoslawien und Somalia sowie von der Hungerkatastro-
phe in Äthiopien (1992). Ab M. der 1990er Jahre wendet
er sich vom Krisenjournalismus ab und fotografiert v.a.
für Zss. wie Geo und die frz. Nat. geographic. 1994–97
zeigt C. mit suggestiven Fotobildern Voodoo-Riten in Hai-
ti; dort dokumentiert er 2010 die Folgen des Erdbebens.
2007 folgt er in Südamerika den Spuren von Che Gueva-
ra, 2008–10 fotografiert er relig. Riten in Israel, 2011 die
arabische Revolution in Ägypten und Libyen. Foto-Publ.:
Loas. Esprits d'Haïti, Nantes 1999; *Chemin de mort, che-
min de vie*, P. 2004. ⌂ LAUSANNE, Mus. de l'Elysée.
PARIS, Maison Europ. de la Photogr. ☉ *E:* Paris: 1988
Pal. de Chaillot; 1993 Centre Nat. de la Photogr.; 1994
FNAC; 2004 Halles Saint-Pierre / 1990 Lausanne, Mus.
de l'Elysée / 1993 Chalon-sur-Saône, Mus. de la Photogr.
Nicéphore Niépce. / 1997 Gap, Gal. La Passerelle / 1998
Basse-Terre, Scène Nat. de la Guadeloupe; San Francisco,
The Studio Gall.; Nantes, Maison du Change; Lille, Hos-
pice Comtesse / 1999 New York, Inst. Franç. / 2005 Bas-
tia, Centre Cult. Una Volta; Elche (Spanien), CAM, Ca-
ja Mediterráneo / 2012 Ribérac, Collégiale Notre Dame.
▢ *Auer*, 1997. – Cahiers de la Photogr. 1986 (19) 5–15;
Art Press (Special Edition) 1990, 95–102; *J.-J. Sirkis*, Les
années Deslys, Marseille 1990; The best of photojourna-
lism 17, Ph. 1992; *S. Marion*, L'école de la vie ou la France
autodidacte, P. 1993; *C. Lang* (Ed.), Le cercle des intimes,
Boulogne 1995; *K. Kuramochi* (Ed.), Europ. eyes on Ja-
pan, 1 (K), To. 2000. – *Online:* Website C. T. Koenig

Coutaz, *Jean-Pierre*, schweiz. Maler, Graphiker, Illus-
trator, Entwerfer, Kunstpädagoge, Autor, * 2. 3. 1951
Saint-Maurice/Wallis, lebt dort. Stud.: EcBA, Genf (Dipl.).
Seit 1976 ist C. in Saint-Maurice als Kunstpädagoge am
College de l'Abbaye und seit 2005 als Dir. und Kura-
tor der Schloßstiftung ebd. tätig. Er gehört der 1984 ge-
gr. Künstler-Vrg Le Nouvelliste an. Als Mitgl. der Gilde
Schweizer Bergmaler nimmt er seit 1995 an deren Ausst.
und Wettb. teil. – Neben der gegenstandsbezogenen Berg-
malerei (häufig in Acryl und mehrteilig) v.a. abstrahieren-
de Entwürfe für Farbverglasungen in Sakralräumen, u.a.

für die Chorfenster der kleinen Chap. de Champoussin in Vernayaz oder für Fenster (2001) der Eglise St-Sigismond in Saint-Maurice. Ein Hw. seiner Glasfenster-Gest. sind in den 1990er Jahren die Entwürfe für die oberen Fenster der ma. Abteikirche ebd., die die dort vorhandenen figuralen musivischen Fenster aus mehreren Jahrhunderten (darunter die von Edmond Bille vom E. der 1940er Jahre) ergänzend kommentieren. C. wählte eine Verglasung mit abstrakten Komp. aus energischen Lineamenten und farbflächigen Strukturen in lichtem Blau und Grau sowie Blutrot und Goldgelb, die inhaltlich auf die Gesch. der Soldaten der Thebäischen Legion unter ihrem Anführer Mauritius rekurrieren, die hier am Ort im 3. Jh. n. Chr. den Märtyrertod gefunden haben sollen, wobei C. direkten Bezug nimmt auf die neutestamentliche Textpassage „Das sind die, die aus der großen Drangsal kommen, und sie haben ihre Gewänder gewaschen und hell gemacht im Blut des Lammes" (Offenbarung 7,13). Diese Fenster gehören mit ihrem umfänglichen Assoziationspotential (Bergwelt, Himmel etc.) zu den gelungensten künstlerischen Lösungen mod. Sakralfenster-Gest. in der Region. Daneben Lsch.-Aqu. und Gouachen mit Motiven aus dem Wallis, auch Buch-Ill. (C./J. Tornay, *A vieuw of ... Saint-Maurice*, Ayer 2001). C. ist auch kunstpublizistisch und kuratorisch tätig. ⌂ SION, Mus. Cantonal des BA. ✉ 200 ans d'enseignement au Collège Saint-Maurice 1806–2006, Saint-Maurice 2006. ◉ *E:* 2001 Lausanne, Gal. du Chêne (mit Jean-Claude Chaperon, K) / 2010 Vercorin, Maison bourgeoisiale (mit Marie Escher-Lude) / 2011 Sion, Gal. Grande Fontaine (mit Françoise de Torenté). –. *G:* 2007 Zermatt, Alpines Mus.: Bergwelt 2007 (1. Preis für *Nord-Est*, Acryl, dreiteilig, 2006–07; K) / 2007 Saint-Maurice, Château: Samivel. L'âme du monde (K) / 2012 Appenzell, Kunsthalle Ziegelhütte: Alpstein (K). ⌂⌂ KVS, 1991; BLSK I, 1998. U. Heise

Couto, *Olímpia*, brasil. Malerin, Graphikerin, * 1947 Estrela do Indaiá/Minas Gerais, lebt in Belo Horizonte. Stud.: 1972 EBA da Univ. Federal de Minas Gerais ebd., u.a. bei Yara Tupynambá, für die sie auch als Ass. tätig ist. 1982 fertigt sie Wandarbeiten für die Präfektur der Univ. sowie für die Assoc. dos Servidores. Auch Umschlag-Gest., u.a. 2002 für die Zs. Ventura. Ihre poetischen Blumen-Stilleben und Lsch. sind stilistisch vom graph. Werk beeinflußt. ⌂ BELO HORIZONTE, Fund. Clóvis Salgado. ◉ *E:* Belo Horizonte: 1973 Gal. A Priori; 1975 Conservatório Mineiro de Música; 1982 Gal. Guignard; 1987 Gal. Corpo; Gal. de Arte Marchand d'Art / Brasília: 1986 Visual Gal. de Arte; 1995 Gal. Visual / 1993 San José, Gal. Valanti / 1995 Passos, Casa de Cult. –. *G:* u.a. Belo Horizonte: 1971 Salão do Artista Plást. Mineiro (1. Preis, Rad.); 1979 Gal. Otto Cirne: Folclore Mineiro; 1980 Pal. das Artes: Visão do Jequitinhonha; 1982 Gal. Guignard: Artistas Mineiros Contemp.; 1992 Mus. de Arte da Pampulha: Terra, Minas, Terra; 2000 Mus. Abílio Barreto: Os 500 anos do Brasil; 2002 Gal. Telemig: Acervo Newton Paiva / Rio de Janeiro: 1988 Gal. Borghese: Brazil. Artists; 1992 MAM: Eco Art (Gold-Med.) / São Paulo: 1979 Bien.; 1982 Chapel Art Show: Noite de Arte; 1983 Gal. Carlos A. Uint: Seis Mineiros em São Paulo / 1985 Niterói, Casa da Cult.: Artistas Brasil. / Goiânia: 1986 Época Gal. de Arte: A Poesia nos Caminhos do Gerais; 1991 Gal. de Arte Casa: Sete Mineiros / 1992 Brasília, Gal. da Caixa Econômica Federal: Natureza Viva / 1996 Timóteo, Centro Cult. da Fund. Acesita: Encontro / 1998 Juiz de Fora, Gal. Renato de Almeida. Paisagens Mineiras. ⌂⌂ *Online:* Inst. Itaú Cult., Enc. artes visuais, 2008.
M. F. Morais

Couto, *Tânia*, brasil. Malerin, Graphikerin, Zeichnerin, * 1940 Porto Alegre, lebt dort. Stud.: 1963 Journalismus an der Pontifícia Univ. Católica do Rio Grande do Sul ebd.; 1978–81 Atelier Livre da Prefeitura Mpal de Porto Alegre, u.a. bei Armando Almeida, Cláudio Martins Costa, Clébio Sória und Anestor Tavares; 1980–83 Malerei bei Fernando Baril. Gründet 1985 das Atelier de Arte Garatuja. Realisiert 1995 eine Installation aus Kunststoffobjekten für die Kuppel des Café Concerto Majestic in der Casa da Cult. Mario Quintana in Porto Alegre. – C.s abstraktexpressionistischen Gem., Graphiken und Zchngn stehen in der Tradition des Informel, so z.B. *A propósito* (Lith., 1991). ⌂ BAGÉ, Mus. Nac. da Gravura. BUENOS AIRES, Mus. Nac. del Grabado. FLORIANÓPOLIS, Mus. Nac. de Santa Catarina. PASSO FUNDO, Mus. de Artes Visuais. PORTO ALEGRE, MARGS. RIO DE JANEIRO, MNBA. ◉ *E:* 1985 São Paulo, Gal. Art Brut / Porto Alegre: 1992 Gal. da Caixa Econômica; 2002 Gal. da Vera / 2001 Passo Fundo, Mus. de Arte Ruth Schneider. – *G:* Porto Alegre: 1991 (lobende Erw.), '93 (lobende Erw.), 2001 (1. Preis) Bien. de Artes da Assoc. Leopoldina Juvenil; 1997 Kanagawa (Japan), Internat. Independant Exhibit. of Prints / Rio de Janeiro: MNBA: 1990 (Projeto Atelier); 1999 (Arte Gráfica Gaucha); 2002 Mus. Castro Maya: Trilhando a Gravura / 1999 Florianópolis, Univ. Federal de Santa Catarina: Vertentes Gráficas Sul-Riograndenses. ⌂⌂ *R. Rosa/D. Presser*, Dic. de artes plást. no Rio Grande do Sul, Porto Alegre ²2000. M. F. Morais

Coutu, *Jack (Raymond John)*, brit. Bildhauer, Schnitzer, Maler, Graphiker, * 1924 Farnham. Stud.: 1947–51 Farnham SchA; in London: 1951–54 R. College of Art (Glasmalerei); 1951–55 Central SchA, bei Merlyn Oliver Evans. Lehrtätigkeit: 1957–65 Central SchA; 1965–85 West Surrey College of Art and Design, Farnham. Mitgl.: R. Soc. of Painter-Etchers and Engravers; Netsuke Kenkyukai Soc. of America. – Mit einer Ausb. als Schnitzer und Bildhauer arbeitet C. zunächst im Bereich der Kirchenrestaurierung (z.B. Tier-Skulpt. an Kapitellen) und schnitzt ab 1968 kunstfertige Netsuke-Skulpt. aus Wildschweineckzähnen, Hirschhorn, Buchsbaum und Mahagoni. Seine graph. Arbeiten (Rad., Lith., Kpst.) sind beeinflußt von orientalischer Kunst und inspiriert von engl. Gesch. und Legenden sowie Naturbeobachtung; char. sind Tier-Darst., unterschiedlich abstrakte Naturimpressionen mit figürlichen Details (u.a. von Vögeln) sowie Phantasieformationen mit einer floral inspirierten, teilw. auch feinen Mechaniken und Getrieben ähnelnden Oberfläche (*Red monolith*, 1964; Sydney, AG of New South Wales). ⌂ BOSTON, MFA. BRADFORD, Cartwright Hall AG. DUMFRIES, Grace-

field AC. FARNHAM, Univ. for the Creative Arts. LON-
DON, Arts Council. – Govt. AG. – V & A. SYDNEY, AG
of New South Wales. ◉ *E:* London: 1965 Alecto Gall.
(mit Michael Rothenstein); 1968 Graphics AG / 2004,
'11 Farnham, Univ. for the Creative Arts. ▭ WWArt,
1972–1984; RoyalAcadExhib II, 1977; *Windsor*, Sculp-
tors, 2003; *Buckman* I, 2006. – *D. Burditt*, Netsuke Ken-
kyukai study j. 15:1995 (4) 26–39. H. Stuchtey

Couture, *Lise Anne*, kanad. Architektin, Stadtplanerin,
Designerin, * 1959 Montréal/Québec, lebt in New York.
Stud.: bis 1986 Carleton Univ., Ottawa; Yale Univ., New
Haven/Conn. (seit 2004 Prof.). Stip.: 1988–89 Univ. of
Michigan, Ann Arbor; 1992 New York Found. for the
Arts. 1989 begründet C. in New York zus. mit dem Ar-
chitekten Hani Rashid ein eig. Büro unter dem program-
matischen Namen Asymptote Architecture (ASY). Inter-
nat. Lehrtätigkeit: Gast-Doz. u.a. an den Univ. von Mon-
tréal, Princeton/N. J., Virginia und Cambridge/Mass. so-
wie am Berlage Inst. in Amsterdam. Ausz. u.a.: 2004 Ös-
terr. Friedrich-Kiesler-Preis für Archit. und Kunst (Wien);
2004, '08 Amer. Archit. Award (Athenaeum, Chicago). –
C. und H. Rashid gehören seit A. der 1990er Jahre zu
den internat. führenden Architekten der jüngeren Genera-
tion. Ihre visionären Archit.- und Designentwürfe basie-
ren vermehrt auf computergestützten Technologien, mit
denen sie räumliche Kontinua aus verformten Oberflä-
chen schaffen, was bald internat. Aufmerksamkeit erregt.
1992 erhalten sie von der Ztg New York Times den Auf-
trag, ein hypothetisches Gebäude für den Times Square in
New York zu entwerfen. In den experimentellen, multi-
medialen Arbeiten scheint das Atelier an konstruktive und
formale Innovationen aus der Vergangenheit anzuknüpfen
wie z.B. an das von Eero Saarinen entworfene Terminal
(1956–62) am Flughafen John F. Kennedy in New York,
den Dt. Pavillon der WA 1967 in Montréal (Frei Otto,
Konrad Rolf Dietrich Gutbrod) oder die 1970 entstande-
ne Wohn-Lsch. „Visiona 2" (Verner Panton), in der De-
cke, Boden, Wand, Sitz- und Liegeflächen in einer Raum-
Skulpt. zusammenfließen. Bahnbrechend sind C.s virtuelle
Archit.-Projekte wie das Solomon-R.-Guggenheim-Mus.
(2000), die New Yorker Börse (Kommandozentrale und
Handelsparkett, 1999–2001) oder die interaktiven Ausst.-
Räume für die Fa. Volkswagen in Wolfsburg (2006). Ers-
tes ausgef. Bauwerk ist der Hydra Pier (2002) im niederl.
Haarlemmermeer. Neben zahlr. nicht realisierten Wettb.-
Beitr. werden versch. Innenräume gestaltet (Carlos Miele
Flagship Store, 2003; Alessi Flagship Store, 2006, beide
New York) und zunehmend städtebauliche Direktaufträge
bearbeitet, u.a. die visionären Gebietsentwicklungspläne
für Monterrey (City Center Master Plan, 2005), Prag (Zen-
trumsbereich, 2006) und Bergamo (The Azzano, San Paolo
Master Plan, 2008). Auch die archit. Entwürfe beinhalten
meist ganzheitliche Großstrukturen von kleinstädtischen
Ausmaßen oder zumindest städtebaulicher Relevanz (Vake
Multifunctional Center, Tbilisi, Entwurf 2007). Der Bau
des bizarr geformten Penang Global City Center (2006)
in Malaysia wird 2007 gestoppt, so daß die Fertigstellung
des aus zwei zwölfgeschossigen elliptischen Baukörpern

zu beiden Seiten der Formel-1-Rennstrecke bestehenden
Yas Island Marina Hotels (2007–09) in Abu Dhabi als
bisher größter Erfolg des Büros gilt. Signifikantes Erken-
nungsmerkmal ist der futuristisch wirkende „Schleier", ein
amorphes Glas-Stahl-Dach, dessen dynamisches Gitter-
werk von 217 Meter Länge sich wie eine transparente Pla-
ne über den Gesamtkomplex, einschl. Verbindungsbrücke
über die Rennstrecke, zu legen scheint (Dachkonstruktion
von Waagner-Biro, Wien). Es symbolisiert neben der hand-
werklichen Trad. des Islam „Geschwindigkeit, Bewegung
und Ereignis" und fungiert zugleich als Klimahülle. Daß
dabei kein Glasmodul dem anderen gleicht, ist der frei ver-
formten Geometrie geschuldet und char. für C.s und Rashi-
ds Entwurfsmethode. Gegenwärtig entsteht der 560 Me-
ter hohe World Business Center Solomon Tower in Busan/
Südkorea (2007–13), ein skulpturales, aus drei schlan-
genartig „tanzenden" Körpern bestehendes Wolkenkratz-
erbündel. Im Bereich Ausst.- und Produktdesign gestaltet
das Büro u.a. das offene Bürosystem Knoll A3 (2002) so-
wie Möbel und Leuchten. ▭ ABU DHABI: Strata Tower,
2006–11. MÜNCHEN, PM. NEW YORK, MMA. – Perry St.
166: Luxus-Apartments, 2006–10. ORLEANS/Frankreich,
FRAC Centre. PARIS, Centre Pompidou. SAN FRANCIS-
CO, MMA. ✉ Asymptote. Works and projects, Mi./Lo.
2002. ◉ *G:* 2002 Kassel: documenta / 2004, '08, '09
Venedig: Bienn. ▭ *P. Jodidio*, Archit. now!, III, Köln
u.a. 2004; *J. Cargill Thompson*, 40 architects around 40,
Köln u.a. 2006. *W. Jones*, Unbuilt masterworks of the 21st
century, N. Y. 2009. – *Online:* Asymptote (WV, Lit.).
 A. Mesecke

Couturier, *Michel*, belg. Fotograf, Zeichner, Installa-
tions- und Performancekünstler, * 28. 8. 1957 Lüttich, lebt
in Brüssel. Stud.: 1976–77 Fotogr., Bildhauerei, Video, Ec.
supérieure des Arts St-Luc, Lüttich; 1978–80 Ec. nat. su-
périeure des Arts visuels de La Cambre und Ec. de Rech.
graph., Brüssel. C. arbeitet 1978 (Videoprogramm Stu-
dio) und 1983–85 für das belg. Fernsehen. Lehrtätigkeit:
1986–90 Univ. Lüttich. Ausz.: 1981 Prix spécial, Festival
des Jeunes Cinéastes, Brüssel. – C. arbeitet multimedial
graph. und mit technischen Medien sowie mit Performan-
ces, Installationen und soz. Interventionen. In seinem Werk
befaßt er sich mit dem urbanen Raum (z.B. *Hitting the city*,
2005–08), der Ges. und ihren Interaktionsformen. Die Pa-
lette reicht von strengen topogr. Fotogr. urbaner und kom-
merzieller Räume (Publ.: R. Balau/M. C., *Zones de cha-
landise*, Crisnée 2009) in der Trad. der New topographics
(1975) über schwarzweiße oder monochrome Zchngn mit
schemenhaft kontrastreich vergrößerten fotogr. Elementen
bis zu Multiple-Editionen (z.B. *Un Euro*, 2003). A. der
1980er Jahre arbeitet er zunächst mit Rauminstallationen
als Kunstform und inszeniert kinematographische Bildrei-
hen. Es folgen große hochformatige Fotoserien, bei de-
nen er Texturen und Materialien, Plastizität und Abstrak-
tion von Objekten, Horizontalität und Vertikalität thema-
tisiert wie auch die Metaphern des medialen Fensters und
der Lw. oder Fragen von Ausschnitt und Rahmung; 1986
zeigt C. Großvergrößerungen von Steinen (Dubois, 1986).
1989 entstehen die Videoessays *Synopsis* und *Atlantide*

mit Marc-Emmanuel Melon. 2001–05 begeht C. die *Périphéries* von Städten und dokumentiert mit Fotogr. und Video Parkplätze, Autobahnen und Einkaufszentren, auch auf der Suche nach Schauplätzen für ein (fiktives) Remake des Films De la nuée à la Résistance (Jean-Marie Straub/ Danielle Huillet, 1979, nach Texten von Cesare Pavese); die Fotogr. läßt C. in versch. Städten im Großformat plakatieren. Bei *Shadow piece* appliziert er überdimensionale menschliche Silhouetten auf Hauswände und den Boden und evoziert so auch die auf Wänden eingebrannten Zeichen von Hiroshima-Opfern. In *Negative shadow piece* arbeitet er mit einer wandernden nächtlichen Projektion von weißen Figuren (2005–07). Für die Performance-Videos *Bonfire I* (vor 2011) läßt C. Gruppen in zahlr. Städten brennbares Mat. für ein Feuer zusammentragen. Mit *La conjuration* (2006 für Mus. d'Ixelles, Brüssel) baut er einen nicht betretbaren, aber durch eine angelehnte Tür einsehbaren geheimnisvollen Kubus im Gal.-Raum. Publ.: *Figures*, Gent 2009. ⌂ AMSTERDAM, Sted. Mus. BRÜSSEL, Communauté Franç. de Belgique. CHARLEROI, Mus. de la Photogr. GENF, Kt. Genf. MONS, Prov. de Hainaut. ◉ *E:* Lüttich: 1981 Mus. d'Archit.; 1999 Espace Les Brasseurs (K); 2007 Espace Flux / 1986 Venedig, Bienn., Pavillon belge (K) / 1987 Paris, Gal. 666 / 1988 Rotterdam, Gal. Perspektief / 1989 Montreal, Dazibao / 1991 Genf, Centre de la Photogr. (Wander-Ausst.) / Brüssel: 1994 Gal. C. Mayeur; 2001 Gal. G. Ledune; 2005 Comptoir du Nylon; 2009 Gal. 105 Besme; Gal. Rossicontemporary; 2010 Mus. du Point de Vue / 1996 Antwerpen, Prov. Mus. voor Fotogr. (Wander-Ausst.) / 1998 Strasbourg, Ancienne Douane / 2001 Lille, Artconnexion / 2003 Charleroi (Installation im öff. Raum); Marseille, Bureau des Compétences et des Désirs / 2005 Beijing, Imagine Gall.; Tourcoing, MBA / 2005, '11 Roubaix, Bureau d'Art et de Rech. / 2009 Gent, Croxhapox / 2010 Couillet, Gal. Cerami. – *G:* 1995 Arles, Rencontres Internat. de la Photogr.: Photo, peint. & Cie. ⌺ *H. Visser*, Perspektief 1989 (34); Centre de la photogr., Genève, '84–'94, I-II (K), Lugano 1993; *L. Polegato*, Flux-News 1998 (Juni); 2005 (36); *S. Goyens de Heusch* (Ed.), XXᵉ s., L'art en Wallonie, Tournai/Br. 2001; *P.-O. Rollin*, L'art même 2001 (Mai); *C. Loire*, Flux-News 2002 (27); Belg. fotografen, 1840–2005 (K), Ant. u.a. 2005; *R. Balau*, Archistorm 2005 (12); *T. Trémeau*, L'art même 2005 (26); *C. Dubois/N. Stefanov*, Flux-News 2007 (43); *C. De Naeyer*, L'art même 2007 (36); 2011 (52). – *Online:* Website C. T. Koenig

Couwenberg, *Annet*, US-amer. Textil- und Installationskünstlerin, * 1950 Rotterdam, lebt in Baltimore/ Md. Stud. Textilkunst: bis 1974 School for Textiles De Windroos, Rotterdam; bis 1983 Syracuse Univ., New York; bis 1986 Cranbrook Acad. of Art, Bloomfield Hills/ Mich. Lehrtätigkeit: 1986–89 Cleveland Inst. of Art; seit 1986 Maryland Inst. College of Art, Baltimore, dort Gründung des Smart Textile Lab. Artist in Residence: 2008 PAN Kunstforum Niederrhein, Emmerich; 2010 Cross-Lab, Willem de Kooning Acad., Rotterdam; Kantfabriek Mus., Horst; Gyeonggi Creation Center, Ansan/Korea. – C. entwirft A. der 1980er Jahre für den Modedesigner Ri-

chard Kolodzie Stoffe mit komplizierten Faltungen und befaßt sich mit der Verbindung von Schneiderei und Archit. sowie mit Kleidung als Metapher für den Körper. In Skulpt. verbindet sie die sozialen Normen, kult. Trad. und Arbeitsethik ihrer niederl. Herkunft mit der Verwirklichung individueller Sehnsüchte und Wünsche. Zunächst dominieren Korsage- und bustierähnliche Skulpt. aus von Kupfernetzen überzogenen Holzkonstruktionen und Seide (*B. U. G. [Body Under Garment]*, 1989; *Public Apparel/Private Structures*, 1995) und ab M. der 1990er Jahre Wandstücke. Seit 1998 verwendet sie für serielle Arbeiten Computerstickerei (Serie *Embroidery Frolic*, 2000) und setzt die von holl. Mustertüchern inspirierte Digitalstickerei kombiniert mit Federn und Spitze in kragen- oder wappenförmige Rahmen ein wie z.B. bei der Serie *Family Air* (1998). Ihre kunstfertige, arbeitsintensive Handarbeit wird bes. in Installationen mit ca. 80 cm Durchmesser fassenden Rüschenkragen deutlich, die von den gestärkten Kragen aus Portr. des 17. Jh. inspiriert sind und nun geschlechterunspezifisch auf soziale Normen anspielen. *Act normal and that's crazy enough* (2002) besteht aus sieben (jeweils aus drei übereinander gestapelten Rüschenkreisen gefertigten) Kragen aus gestärktem Baumwollorganza; jede Mitte ist digital im Zentrum bestickt mit einem Wort des Titels. In einigen Installationen zeigt sie Objekte, die wie überdimensionale weibliche Cowboyhosen erscheinen, gefertigt aus mehreren hundert konisch gerollten Papierspitzendeckchen (*Dutch Shotgun chaps*, 2006), welche als preiswert hergestellte und schnell weggeworfene Mat. z.B. als Metapher für den Umgang mit Frauen stehen. Seit 2010 konzentriert sich C. auf interaktive Projekte mit muslimischen Bewohnerinnen von Rotterdam, indem sie Nähklassen organisiert und diese Frauen zur Erfahrung mit und Identität von Kleidung befragt und damit ihren eig. Forsch. über Kleidung als Schutzschicht und als ein Ort der Selbsterfahrung und Kultur nachgeht (Video *Clothing as Interface. Cross-Cultural Muslim Identity*, 2010). ⌂ ANSAN, Gyeonggi MMA. – Gyeonggi Creation Center. HORST, Mus. de Kantfabriek. TILBURG, Nederlands Textiel-Mus. YEOSU, Jinnam Art and Culture Center. ⌺ Smart textiles at MICA, in: Fiberarts 36:2010 (5). ◉ *E:* 1983 Syracuse, Arti Sera Gall. / 1988 Tilburg, Nederlands Textiel-Mus. / Baltimore: 1994 Gormley Gall., College of Notre Dame; 1995 Maryland Art Place (mit David Page); 2005 Gal. Françoise / 1996 Atlanta, City Gall. / 1999 Newark (Del.), Recitation Hall / 2000 Brooklandville (Md.), Park School Gall. / 2003 Millersville (Pa.), Millersville Univ.; New York, 28th Street Studio (mit Piper Shepard) / 2005 Catonsville (Md.), Dundalk AG; Wilmington, Delaware Center for the Contemp. Arts / 2007 Kansas City, Belger AC; Stevenson (Md.), Villa Julie Gall. (K) / 2010 Rotterdam, CrossLab; Ansan, Gyeonggi Creation Center; Horst, Mus. de Kantfabriek. ⌺ *D. D. Keyes*, Fiberarts 1996 (Sept./Okt.) 61; *K. Hileman*, Surface design 1998 (Frühjahr) 34 s.; *G. Howell*, Sculpture (Wash.) 17:1998 (1) 64 s.; *J. G. Broske*, ibid. 18:1999 (8) 67 s.; *id.*, Fiberarts 1999 (Sept./Okt.) 58; Surface design 25:2000 (Jan./Febr.) 56; *S. Isaacs*, ibid.

25:2000 (1) 29–35; *J. Robertson*, ibid. 39–46; *V. Suit*, Embroidery 53:2002 (Juli) 26–30; *E. Auther /A. Lerner/D. Rubino*, A. C., Winchester 2003; *C. Tate*, Surface design j. 29:2005 (4) 58 s.; *D. R. McFadden u.a.*, Radical lace and subversive knitting (K), N. Y. 2007; Hothouse. Expanding the field of fiber at Cranbrook 1970–2007, Bloomfiled Hills, Mich. 2007; *N. Haddad*, Amer. craft 67:2007 (5) 73–78; *M. Fricke*, Surface design j. 32:2008 (2) 50–53; *N. K. Monem*, Contemp. textiles. The fabric of fine art, Lo. 2008; *B. Quinn*, Textile futures. Fashion, design and technology, Ox. 2010; *K. O'Dell*, Textile. The j. of cloth and culture 10:2012 (1) 28–43. – *Online:* Website C. H. Stuchtey

Covaciu, *Octavian*, rumänischer Karikaturist, Zeichner, Animationsfilmer, * 13. 2. 1941 Tecuci, lebt in Bukarest. Ausb.: bis 1959 Militär-Lyzeum D. Cantemir, Breaza/Bez. Prahova; bis 1962 Offiziers-HS N. Balcescu, Sibiu (Topogr., Geodäsie); bis 1974 Inst. für Theaterkunst und Cinematographie I. L. Caragiale, Bukarest, u.a. Animationsfilm bei Mihai Dimitriu. Mitgl. des rumänischen Künstler-Verb. und seit 1990 Mitgl. der Vrg rumänischer Cineasten. Ist für das rumänische Fernsehen tätig (u.a. für Antena I). Bei mehr als 100 Filmen hat C. außerdem als Regisseur, Produktionsleiter und Szenarist mitgewirkt. Zahlr. nat. und internat. Ausz., u.a. 1981, '82, '88 Preise beim Yomiuri Internat. Cartoon Contest in Tokio; 1982 Karikaturpreis der Zs. Urzica; 2003 Hauptpreis beim Festival Cartoons and Foto Undercover in Bree (Belgien); 2007 Ehrenpreis beim Pressekarikatur-Salon in Galaţi. – Seine erste Karikatur erscheint in der rumänischen illustrierten Ztg Sport v. 15. 11. 1962. Publiziert danach in in- und ausländischen Tages-Ztgn, Zss. und Satire-Mag., bes. zu Themen aus den Bereichen Politik, Militär und Sport. Arbeiten C.s befinden sich in den Karikatur-Mus. von Tokio und Gabrovo. ⊙ *E:* u.a. Bukarest: 1969 Teatrul C. Tanase; 1970, '75 Casa Centrala a Armatei; 1995 Gal. Caminul Artei. – *G:* zahlr. im In- und Ausland, u.a. 2001, '02 Slatina: Internat. Political Cartoon Contest I. Ratiu. St. Schulze

Covarrubias (C. Alvarez del Castillo), *Felipe de Jesús*, mex. Gebrauchsgraphiker, Plakatgestalter, Fotograf, Hochschullehrer, * 1945 Guadalajara, lebt dort. Bruder des Fotografen *Mito C.* (* 1947 Guadalajara) und der Gebrauchsgraphikerin *Rosa Margarita C.* (* 1950, † 1974). Stud.: 1963–65 Univ. Iberoamer., Mexiko-Stadt (Archit.); 1965–69 Univ. ITESO (Inst. Tecnológico y de Est. Superiores de Occidente), Guadalajara; 1974–76 Gebrauchsgraphik an der EBA ebd., bei Mauro Kunst und Hans Baumeister; 1977 Croydon College of Design and Technology, London (Typogr., Fotogr.); 1995 Centro Internac. de Est. Profesionales para Editores y Libreros, Univ. de Guadalajara. 1969–73 Archit.-Zeichner im Büro von Fernando González Gortázar ebd. Umfangreiche Lehrtätigkeit: 1969–84, 1991–98 Prof. an der Univ. ITESO; 1991–95 Prof. an der Univ. de Guadalajara; seit 1969 Lehraufträge u.a. in Montreal, Havanna, Bogotá, Rosario, Córdoba und Buenos Aires. 1973–77 Dir. der Abt. Diseño Gráfico des Dep. de BA de Jalisco, Guadalajara. Mitbegr. des Graphikbüros Arcoiris, der Design-Zs. Ma-

genta (1982–88 Dir.), der Gal. Azul für zeitgen. Kunst (1984–2007 Dir.) und der Organisation Trama Visual, die seit 1988 die Bien. Internac. de Cartel en México veranstaltet. Seit 1993 Koordinator des Salón de Diseño im Centro de Arte Mod. in Mexiko-Stadt. 1999–2002 Koordinator der Licenciatura de Diseño an der Univ. ITESO; dort derzeit Dir. der Esc. de Diseño. Ausz.: u.a. 1985 Premio Nac. de Diseño México, Acad. Mex. de Diseño, Mexiko-Stadt; 1998 Premio Jalisco in las Artes, Guadalajara; 2010 Gold-Med. Excelencia en Diseño „J. G. Posada", Mexiko-Stadt. – C. zählt zu den bedeutendsten Gebrauchsgraphikern Mexikos in der zweiten H. des 20. Jh., beeinflußt von Julio Ruelas und José Guadalupe Posada sowie den Zeitgen. Vicente Rojo, Germán Montalvo und Rafael López Castro. Zu seinen bevorzugten ästhetischen Mitteln zählen Collage, visuelle Wortspiele sowie z.T. Rückgriff und Verfremdung hist. Muster oder Bilder. C. entwirft u.a. Plakate für kult. Veranstaltungen, Logos für Unternehmen oder gestaltet Zss. (z.B. Foto Zoom, 1986) und Bücher (u.a. A. Guerrerosantos, *El arte urbano en Guadalajara*, Guadalajara 2003). In seinen Fotos, u.a. von Reisen und Archit., dominieren Montage, Collage und Farbverfremdung. ✉ Diseñando 30 años, Tlaquepaque u.a. 1998; Sí aquí es. Diseño popular, Guadalajara 2010. ⊙ *E:* Guadalajara: 1975 Ex Convento del Carmen; Centro de Arte Mod.; 1983 Gal. Clave; 1988, '93, '96 Gal. Azul; 1990 Inst. Anglo Amer.; 2008 Bibl. de la Univ. ITESO / Mexiko-Stadt: 1975, '78, '81 Gal. Juan Martín; 1998 Bibl. de México (Retr.) / 1981 Guanajuato, Gal. Hermenegildo Bustos / 1984 Pachuca (Hidalgo), Centro Cult. Efrén Rebolledo / Colima: 1988 Casa de la Cult.; 2009 Pin. Univ. / Tijuana (Baja Calif.): 1989 Gal. Río Rita; 2005 Inst. Mpal de Cult. / 1995 Mérida, Inst. de Cult. – *G:* 1975 London, Croydon College of Design and Technology: 7 fotógrafos mex. / seit 1990 mehrfach Mexiko-Stadt: Bien. Internac. de Cartel en México (alle K). ⊡ América hoy. 500 años después (K Wander-Ausst.), Méx. 1992; *R. Paez Cano*, Fotogr. F. C., Mito Covarrubias u.a., Guadalajara [ca. 1995]; 100 carteles mex. (K Wander-Ausst.), Méx. 1996; *G. Caban*, World graphic design, M. 2004; 50 diseñadores de Jalisco, Guadalajara 2000; Diseñadores graficos mex., Méx. 2005; *F. Taborda/J. Wiedemann*, Latin Amer. graphic design, Köln 2008; *G. Troconi*, Diseño gráf. en México ... 1900–2000, Méx. 2010; *L. del C. A. Vilchis Esquivel*, Hist. del diseño gráf. en México 1910–2010, Méx. 2010. – *Online:* Website C. M. Nungesser

Coventry, *Keith*, brit. Maler, Zeichner, Graphiker, Bildhauer, Galerist, Ausstellungskurator, * 30. 12. 1958 Burnley/Lancs., lebt in London. Stud.: 1978–81 Brighton Polytechnic; 1981–82 Chelsea SchA, London. Danach zunächst in versch. Gelegenheitsjobs tätig, u.a. als Dekorationsmaler für Besitzungen von Nicholas van Hoogstraten. 1988 Mitbegr. und Kurator der nichtkommerziellen Gal. City Racing in London, die bereits sehr früh Werke u.a. von Fiona Banner, Sarah Lucas oder Gillian Wearing zeigt. Ausz.: u.a. 2010 John Moores Paint. Prize, Liverpool. – C. konzipiert seit den 1980er Jahren formal wie inhaltlich geschlossene Werkgruppen oder Serien, die in postmoder-

ner Manier Stilprinzipien avantgardistischer Kunst des 20. Jh. wieder aufgreifen und mit zeitgen. sozialen und politischen Belangen verknüpfen. So erinnern z.B. die sog. *Estate Paint.* aus den frühen 1990er Jahren an konstruktivistische bzw. suprematistische Komp. von Ėl' Lisickij oder Kazimir Malevič, stellen tatsächlich aber schematische Lagepläne bzw. Grundrisse brit. Liegenschaften dar (z.B. *Newling Estate*, 1992, Öl/Lw. und Holz, in weißem Rahmen hinter Glas präsentiert, Walker AC, Minneapolis/Minn.). Auch in der Werkgruppe *White Abstracts* wird C.s Absicht, eine zeitgemäß-aktuelle hist. Malerei zu schaffen, sichtbar. So erweisen sich die auf den ersten Blick wie reine, pastos-strukturbetonte Abstraktionen erscheinenden Gem. bei näherer Betrachtung als figurative Darst., die Motive aus Fotogr. oder älterer Kunst aufgreifen (z.B. *Sir Norman Reid Explaining Mod. Art to the Queen*, 1994). Einen ironisch-kritischen Blick auf Phänomene der gegenwärtigen Ges. zeigen auch die Arbeiten aus der sog. *Junk Series*, in welchen Fragm. des Logos der Schnellrestaurantkette McDonald's wie suprematistische Abstraktionen behandelt werden (z.B. *Junk IV*, 2002, Öl/Lw. und Holz; *Junked*, 2011, Farbsiebdruck). Weitere jüngere Werkgruppen C.s beschäftigen sich z.B. mit Prostitution und Drogenmißbrauch (*Echoes of Albany*, 2004–08, mit formalem Bezug auf die Malerei von Walter Sickert) oder mit der Darst. von Wohnräumen von Sammlern mod. Kunst im frühen 20. Jh., die allerdings in Farben präsentiert werden, die Psychiater in dieser Zeit bei der Behandlung ihrer im 1. WK traumatisierten Patienten eingesetzt haben (*Anaesthesia as Aesthetic*, 2007–08). Neben Malerei und Druckgraphik entstehen gelegentlich auch skulpturale Arbeiten. ⌂ LONDON, Arts Council Coll. – Brit. Council Coll. – BM. – Cell Project Space. – Contemp. Art Soc. – Hiscox Art Projects. – Saatchi Coll. – Tate Modern. MINNEAPOLIS/Minn., Walker AC. NEW YORK, MMA. PROVIDENCE, Rhode Island School of Design. SAN DIEGO/Calif., MCA. ◉ *E:* London: 1992, '94 (K: A. Wilson) Karsten Schubert Gall.; 1997 The Showroom (K); 1998 A22 Gall.; Richard Salmon Gall.; 2000, '02 Emily Tsingou Gall.; 2004 Kenny Schachter Rove; 2006, '08 (K) FA Soc.; 2008–09 Haunch of Venison (Retr.; K: M. Bracewell u.a.); 2008 Paul Stolper Gall.; 2010 Mus. of London / 1997 Exeter, Spacex Gall.; Los Angeles (Calif.), Kohn/Turner Gall. / 1998 Kopenhagen, Gal. Frahm (K) / 2002 Edinburgh, Dogger Fisher Gall. / 2006 Glasgow, Tramway Gall. (Retr.; K: L. Wilson) / 2007 Berlin, Gal. Julius Werner / 2008 Seoul, Seomi & Tuus Gall.; Zürich, Haunch of Venison (K: R. Dyer) / 2010 Woking, The Lightbox. – *G:* London: 1995 Saatchi Gall.: Young Brit. Artists V; 1997 RA: Sensation (Wander-Ausst.; K: N. Rosenthal/R. Stone). ▭ *Delarge*, 2001; *Buckman* I, 2006. – *J. Stallabrass*, High art lite. Brit. art in the 1990s, Lo. 2001; *M. Hale u.a.*, City Racing. The life and times of an artist-run gall., 1988–1998, Lo. 2002; *R. Cork*, Breaking down the barriers. Art in the 1990s, New Haven, Conn. 2003; *S. Andress*, Art on paper 13:2009 (4) 89 s.; *M. Bracewell*, The space between. Selected writings on art, Lo. 2012. – *Online:* Paul Stolper Gall., London. H. Kronthaler

Coville, *Jacky*, frz. Keramiker, Bildhauer, Maler, * 20. 3. 1936 Sèvres, lebt seit 1976 in Biot/Alpes-Maritimes. Bruder von Marcoville (eigtl. Marc C.), Vater des Keramikers *Martial C.* (* 31. 7. 1959 Paris). Zunächst als Flug-Ing. bei dem frz. Luftfahrtunternehmen Sud Aviation tätig. 1964–58 Atelier in Aulnay-sous-Bois/Seine-Saint-Denis, 1970–76 in Coaraze/Alpes-Maritimes, anschl. übernimmt er in Biot die Wkst. von Roland Brice (* 1911, † 1989), dem Keramiker von Fernand Léger. Ausz.: 1974 Gold-Med., Concorso internaz. della Ceramica d'Arte contemp., Faenza; 1984, '88 Gold-Med., Bienn. internat. de Céramique d'Art, Vallauris. – Angeregt durch die Werke des Kubismus und Surrealismus widmet sich C. zunächst der Malerei, bevor er sich der Keramik zuwendet. Er gestaltet farbenfrohe figurative keramische Plastiken, häufig in (geometrisch-)abstrahierter Formensprache. Zu C.s bevorzugten Motiven gehören Tiere und menschliche Darst. (*Femme bleue*, 2006), in jüngeren Arbeiten auch als Mischwesen, sowie Pflanzen (*Tulipe*, 2006). Die Orientierung an kubistischem Formen-Repert. verdeutlichen bes. die für den öff. Raum gedachten großformatigen Arbeiten wie z.B. *Grande Ange* (2006). ⌂ BIOT, Espace des Arts et de la Cult. FAENZA, Mus. Internaz. delle Ceramiche (MIC). NIZZA, Mus. Internat. d'Art Naïf Anatole Jakovsky. PARIS, BN. – FRAC Ile-de-France. – MAD. SEVRES, MN de Céramique. ◉ *E:* 1973, '80 Paris, Gal. Daniel Sarver / seit 1982 regelmäßig Nançay, Gal. Capazza / 1991 Châteauroux, Chap. des Cordeliers / 1998 Mont-de-Marsan, Mus. Despiau-Wlérick / 2000 Libourne, Mus. mun. (Retr.) / 2006 Cagnes-sur-Mer, Mus. Renoir (K) / 2007 Biot, Mus. d'Hist. et de Céramique Biotoises / 2010 Hastingues, Abbaye d'Arthous / 2011 Scy-Chazelles, Maison de Robert Schuman. – *G:* Paris: 1982 Centre Pompidou: Archit. du Midi; 1983 Espace Cardin: Les Années 80 / 1988 Lille, Gal. Quinze: Le Franc symbolique / 1989 Nizza: Art Jonction internat. (Ausz.) / 1995 Cabriès, Mus. Edgar Melik: Hist. d'Artistes / 1997 Roanne, Mus. J. Déchelette: Regard sur la Céramique contemp. / 1998 Fréjus, Villa Aurélienne: 10 Artistes de la Terre (K) / 1999 Aix-en-Provence, Gal. du Conseil Général des Bouches-du-Rhône: Petites Baies et grandes Fenêtres / 2003 Carcès, Maison des Arts: Matières à sculpter. ▭ Neue Keramik 1988 (5) 211; *U. Weiss*, ibid. 1990 (4) 242. – *Online:* Céramiques contemp. franç., 1955–2005. Coll. du MN de Céramique, Sèvres, 2008. F. Krohn

Coville, *Martial* cf. Coville, *Jacky*

Cowan, *John (John Anthony)*, brit. Fotograf, * 22. 4. 1929 Gillingham/Kent, † 26. 9. 1979 East Hagbourne/South Oxon. C. besucht mehrere Schulen, u.a. 1937–45 in Ramsgate/Kent, bevor er sich 1945 für kurze Zeit bei der R. Air Force verpflichtet. Nach versch. Gelegenheitsarbeiten wendet er sich M. der 1950er Jahre der Fotogr. zu. 1958 macht er sich mit ersten Portr.-, Dokumentar- und Theateraufnahmen selbständig. 1959 richtet er ein eig. Studio ein (Cowan Photographic Studio Ltd) und widmet sich nach einem ersten Auftrag für Vogue (1960) ab 1961 v.a. der Mode-Fotogr., ab 1962 für mehrere Jahre hauptsächlich mit dem Modell Jill Kennington. 1965 bezieht C. unter

der Adresse 39 Prince's Place ein Atelier, das ein Jahr später als Kulisse für Michelangelo Antonionis Film Blow-up dient. 1968 arbeitet er für einige Zeit in Mailand, 1969 in Paris und im darauffolgenden Jahr in New York. – C. zählt neben den sog. Terrible Three, David Bailey, Terence Donovan und Brian Duffy, zu den führenden brit. Modefotografen der 1960er Jahre; Veröff. u.a. in Vogue, Queen, Harper's Bazaar, Elle, Evening Standard, The Observer, Sunday Times, Daily Express, Daily Mail und Daily Mirror. Er arbeitet bevorzugt im Freien. Seine Schwarzweiß-Fotogr. zeichnen sich durch eine ausgeprägte Dynamik und starke Hell-Dunkel-Kontraste aus. Neben den Modeaufnahmen fotografiert C. auch Portr. und Werbung. In den 1970er Jahren gerät seine Bildsprache zunehmend aus der Mode. – Foto-Publ.: *Abu Dhabi 1965–1976*, Sheffield 1976. 🏛 LONDON, V & A. ☉ E: London: 1959 Mac's Camera Shops; 1964 Gordon's Cameras; 1976 Heron Gall. / 1974 Wallingford (Oxon.), Flinthouse. – G: London: 1983 Photographers' Gall.: Brit. Photogr. 1955–1965. The Master Craftsmen in Print; 2004 Tate Britain: Art and the 60s. This was Tomorrow (Wander-Ausst.; K). 📖 H.-M. *Koetzle*, Das Lex. der Fotografen, M. 2002; Oxford DNB, 2004. – *P. Garner*, J. C. Through the light barrier (K London), M. u.a. 1999. P. Freytag

Cox, *George Collins (George C.)*, US-amer. Fotograf, * 1851 Princeton/N. J., † 1902 (lt. Landgren [1963] begr. 1903 ebd.). Ab M. der 1870er Jahre führt C. ein Atelier in East Orange/N. J. (1874–80 und 1883–85) und arbeitet E. der 1870er Jahre als Fotograf für das New Yorker Metrop. Museum. 1883–97 besitzt er auch ein Atelier in New York sowie zeitgleich weitere in Orange (1887–89) und West Orange (1889); 1900–1902 ist er mit eig. Atelier in South Orange (heute Maplewood/N. J.) nachgewiesen. – C. galt zu Lebzeiten als einer der führenden Porträtisten des Landes. Er fotografierte zahlr. Persönlichkeiten des öff. Lebens wie *William T. Sherman* (um 1890) und *Henry Ward Beecher* (um 1885; beide Nat. Portr. Gall., Washington/D. C.), bes. aber Literaten und bild. Künstler, darunter Augustus Saint-Gaudens, für die er auch vielfach fotogr. Vorlagen lieferte. Anders als zu seiner Zeit üblich verwendete er kaum Atelierhintergründe oder and. Requisiten und verzichtete auf jegliche Retusche. Heute ist C. in erster Linie für ein Portr. von *Walt Whitman* aus dem Jahr 1887 mit dem Beinamen „The Laughing Philosopher" bekannt. In seinen Ateliers in Orange annonciert er auch Stadtansichten. 🏛 BOSTON/Mass., Hist. New England. FORT WORTH/Tex., Amon Carter Mus. NEW YORK, Metrop. Mus. – MMA. – Public Libr. PROVO/Utah, Brigham Young Univ., Harold B. Lee Libr., L. Tom Perry Special Coll. WASHINGTON/D. C., Arch. of Amer. Art. – Nat. Portr. Gall. – NM of Amer. Hist. ☉ E: 1939 New York, Mus. of the City of New York. 📖 *I. M. Tarbell*, McClure's mag. 9:1897 (1) 558–564; *M. E. Landgren*, Walt Whitman rev. 9:1963 (1) 11–15; *E. Folsom*, Notes on the major Whitman photographers, in: Walt Whitman quart. rev. 4:1986 (2) 63–71; *M. A. Sandweiss* (Ed.), Photogr. in nineteenth-c. America, Fort Worth, Tex./N. Y. 1991; *R. G. Pisano*, William Merrit Chase. The complete cat. of known

and documented work [...], II (Portr. in oil), New Haven, Conn. u.a. 2006. P. Freytag

Cox, *Morris (Morris George)*, brit. Maler, Graphiker, Buchkünstler, Illustrator, Zeichner, Schriftsteller, * 3. 5. 1903 London, † 31. 3. 1998 ebd. Ausb.: 1916–23 West Ham Technical Inst. (Dept. of Art), East London (Zeichnen, Malerei, druck-graph. Techniken, Kunsthandwerk; auch engl. Lit.). Seitdem freischaffend im eig. Studio, das er sich in einem Gewächshaus einrichtet und The Ark nennt. In den 1920er/30er Jahren arbeitet er unter schwierigen finanziellen Bedingungen als Graphiker (Bucheinbände), Reklamezeichner sowie als Cartoonist für Kinderkalender. Auch versucht er sich ein Jahr lang erfolglos als Buchladenbetreiber. Über Jahre engagiert er sich an einer freikirchlichen Sonntagsschule, u.a. organisiert er dort Puppenspiele und Theateraufführungen, deren Texte er z.T. selber schreibt (*Kalyl the witch and other plays*, Lo. 1952). Als Schriftsteller beschäftigt sich C. intensiv u.a. mit phonetischer Poesie, Atem- und Stimmtechnik beim Lautlesen, onomatopoetischen Lautumsetzungen (*9 poems from nature*, 1937) oder den realen und symbolischen Beziehungen und Mikrostrukturen zw. Schriftart, Typogr., Bild und Inhalt. 1940 Heirat mit der Amateurfotografin Wyn Cres(s)well. Im 2. WK ist C. in London Leiter eines Brandschutzkommandos. 1957 gründet er einen eig. Verlag und gibt 1966–71 gemeinsam mit drei and. Künstlern, u.a. Alan Tucker (Schriftsteller, Ill. und Buchhändler in Stroud/Glos.) das lit. Mag. Format heraus. – C.s bildkünstlerisches Œuvre umfaßt gegenstandsbezogene Malerei (Öl, Tempera, Gouache), Graphik und Ill. in linien- und flächenbetonter Formgebung, die sowohl von der klassischen Moderne wie von dem engl. Arts and Craft Movement und der ostasiatischen Hschn.-Kunst inspiriert ist. In den 1930er Jahren auch experimentelle Fotogr. und bildhauerische Versuche. Daneben verfaßt C. romantisch inspirierte, auch experimentelle lit. Texte, die seine weitläufige Bildung wie seinen Witz und tiefgründigen Humor verraten. In den bis M. der 1950er Jahre zumeist unveröff. bleibenden Dichtungen stützt er sich u.a. auf archaisches brit. Erzählgut (Sagen, Balladen, Kinder- und Gassenlieder, Moritaten; Geoffrey Chaucer) oder sentimentale, auch makabre viktorianische Themen (u.a. Witwe, Schatten, Geister). Da er aufgrund seiner unzeitgemäßen Texte (vgl. B. Haas) keinen Verleger findet, gründet er schließlich 1957 einen priv. Pressendruckverlag als Einmannbetrieb unter dem Namen der mythischen Wächter von London (Gogmagog Press), um seine oder fremde Texte nach eig. Vorstellungen zu publizieren (*Magogmagog. Being random examples of the innumerable, incredible ideas & guises of Gog, Ma, Gogma & Magog*, 1973; *Intimidations of mortality. Poems on Victorian themes with psychological implications*, 1977). Bis 1983 gibt er hier 35 Pressendrucke heraus, die meisten davon mit Ill. (Hschn., Acrylstich, Linolschnitt, Lith.) oder im Figurensatz typogr. inszeniert. Die limitierten Aufl. der z.T. mit kostbaren Einband-Mat. (u.a. Seide, semitransparente Japanpapiere) versehenen Normal- und Vorzugs-Ausg. liegen zw. 5 und 100 Exemplaren. Häufig druckt C.

auf handgeschöpfte engl., ind. oder ostasiatische Papiere, u.a. auf Tonosawa (*Conversation pieces. Humorous situations revealed in fragments of dialogue*, 1962). Ab 1982 benutzt er anstelle der Tiegelpresse einen Bürokopierer, mit dem er in den Folgejahren 38 Bde (unter dem Label Gogmagog Photocopy Libr.) herstellt und u.a. seine tagebuchartigen Typoscripte aus den 1920er Jahren und collagierte Text-Komp. aus den 1930er Jahren in jeweils wenigen Expl. vervielfältigt. – Eine char. Werkgruppe stellen darüber hinaus C.s serielle *Blind Drawings* dar, die er wohl seit M. der 1970er Jahre als experimentelle Übung bei völliger Dunkelheit anfertigt und z.T. später überarbeitet. Noch kurz vor seinem Tod entstehen über 250 vital gezeichnete *Night Drawings* (Feder/Papier, 1996). Aus dem graph. Werk ragen seine mehrfarbigen, z.T. kleinkerbig geschnittenen Linoldrucke heraus, die mehrfach von derselben Platte in immer dunkleren Farben gedruckt und zw. den einzelnen Druckgängen neu geschnitten werden (*Magog's Forest*, 1991). – C. gehört als Pressendrucker zu den bed. brit. Buchkünstlern der 2. H. des 20. Jahrhunderts. ⌂ LONDON, British Libr. – V & A. WASHINGTON/D. C., Libr. of Congress, Press Coll. ◉ *E:* 1994 London, Nat. Art Libr., V & A (K) / 2005 Marlborough (Wilts.), Katharine House Gall. (K). ▢ *Horne*, 1994; *Buckman* I, 2006. – *D. Chambers* (Ed.), Gogmagog. M. C. & the Gogmagog Press, Pinner, Middlesex [Lo.] 1991 (WV); *A. Tucker*, The Independent v. 4. 4. 1998 (Nachruf). – *Online:* Trustees of the Morris Cox Estate; *B. Haas*, The Whirligig by M. C. (Flashpoint mag.). U. Heise

Cox, *Paul*, brit. Zeichner, Buchgraphiker, Illustrator, Maler, * 31. 7. 1957 London, lebt in Sussex. Stud.: 1975–79 Camberwell SchA, London, bei Linda Kitson; 1979–82 R. College of Art ebd. – C. liefert Entwürfe und Zchngn u.a. für Buchcover, Werbung, Briefmarken und Sachbücher (T. Heald, *The Character of Cricket*, Lo. 1986). V.a. illustriert er Belletristik (z.B. J. K. Jerome, *Three Men in a Boat*, 1989; P. G. Wodehouse, *Leave It to Psmith*, 1989, K. Grahame, *The Wind in the Willows*, 1993; *The Folio Book of Comic Short Stories*, 2005, alle Lo.) und ist für Zss. und Ztgn tätig (u.a. Blueprint Mag., Country Life, Daily Telegraph, Esquire, Punch, The Spectator, The Sunday Times Mag., The Times, Vanity Fair). C.s nostalgisch anmutende Zeichentechnik (Feder, Tusche und Wasserfarben), skizzenhaft und dynamisch, betont pointiert das Charakteristische von Figuren und Situationen. 2004 gestaltet C. zum 50jährigen Jubiläum die Bühnenbilder für die Aufführung des Musicals Salad Days von J. Slade und D. Reynolds (Bristol, 1954). ◉ *E:* 1989, '93, 2001 (K: E. Freeman), '06 London, Chris Beatles Gall. ▢ *Horne*, 1994. – Folio 40. A checklist of the publ. of the Folio Soc., 1947–1987, Lo. 1987. – *Online:* Website C. P. Böttcher

Coye, *Lee Brown*, US-amer. Bildhauer, Maler, Zeichner, Graphiker, Illustrator, Fotograf, * 24. 7. 1907 Syracuse/ N. Y., † 5. 9. 1981. 1908 zieht die Fam. nach Tully/N. Y. um. 1926 inoffizielle Teiln. an Kunst-Kl. an der Syracuse University. 1927 geht C. nach New York. 1928 Heirat, danach läßt sich das Paar in Leonia/N. J. nieder. Dort er-

lernt C. bei Howard McCormick die Techniken von Hschn. und Schab-Zchng (scratch-board drawing), wobei diese zu seinem bevorzugten Medium werden sollte. Ab 1930 wieder in Syracuse ansässig, erteilt er Kunstunterricht am Syracuse MFA. In den 1930er Jahren entstehen im Rahmen des Förderprogramms der Works Progress Administration mehrere Wand-Gem., u.a. 1934 eines in der Cazenovia High School (zerst.). 1936 Ausb. in Rad. bei Hibbard Kline in der Syracuse Printmakers Guild. E. der 1930er Jahre fertigt er medizinische Ill. für Zss. und Bücher, wofür er Anatomie studiert und Operationen beiwohnt. 1940 Art Dir. des Syracuse Symphony Orchestra. 1941 tätig für die William Spitz Advertising Agency in Syracuse. 1959 Umzug nach Hamilton/N. Y., wo er Reprod. antiker Skulpt. für ein Unternehmen fertigt, was ihn u.a. zur Herstellung von Holz-Skulpt. anregt. 1975, '76 World Fantasy Award for the Best Artist. – C.s vielgestaltiges Schaffen reicht von Malerei in Aqu., Öl bzw. Eitempera, Wandmalerei, Zchng, Graphik (Hschn., Rad.), Bildhauerei (Holz, Metall), Fotogr. über Silberschmiedearbeiten (Schmuck) bis hin zur Gest. von Dioramen. Ebenso vielfältig sind die von ihm behandelten Themen (phantastisch-groteske Szenen, Archit.-Ansichten, Lsch., Figürliches, Portr., Tier-Darst. wie Ratten etc.), wobei bestimmte wiederkehrende Motive wie Holzstöcke (häufig gitterartig angeordnet), Halbmond oder Wal (letzterer als Holz-Skulpt., Silberanhänger, Anstecknadel, Darst. in graph. Bll., Zchngn, Gem.) zu seinen bes. Kennzeichen werden. Alle Arbeiten sind versiert ausgef., zeugen von seiner Originalität, Phantasie, seinem Sinn für das Makabre und Groteske, aber auch für Humor. Berühmt wird er v.a. durch seine Schwarzweiß-Ill. (bevorzugt als Schab-Zchngn, Tusche, Pinsel) zu Phantasie- und Horrorgeschichten, die ab den 1940er Jahren entstehen, z.B. für Mag. wie Weird Tales (1945–52), Fantastic und Amazing (beide 1960er Jahre) bzw. für Bücher von Ray Bradbury, H. P. Lovecraft und weiteren Autoren des Fantasy- und Horrorgenres sowie für die Sammel-Bde *Sleep No More*, N. Y. 1944; *The Night Side*, 1947; *Who Knocks*, N. Y. 1946, alle ed. A. Derleth. 2011 gibt die Centipede Press (Lakewood, Colo.) ein auf 100 Exemplare limitiertes Portfolio mit Reprod. fast seiner gesamten Ill. u.d.T. L. B. C. Artist Portfolio heraus. ⌂ HAMILTON/N. Y., Colgate Univ., Picker AG. MORRISVILLE/N. Y., SUNY, Morrisville State College Libr.: u.a. Moby Dick, Kiefer, 1965; Madison Hall, Öl, 1965; zahlr. Zchngn; Fotogr. NEW YORK, Metrop. Mus. OSWEGO, State Univ. of New York. SYRACUSE, Everson Mus. of Art. – Onondaga Hist. Assoc. Mus. and Research Center. – Syracuse Univ. ◉ *E:* 1939, '55 Syracuse, MFA (jetzt Everson Mus. of Art) / 1940 Saratoga Springs (N. Y.), Skidmore College / 1946, '68 (Retr.) Hamilton, Colgate Univ. / 1956–58 Oswego, State Univ. of New York, Teachers College. – *G:* 1936–46 Syracuse, Syracuse Assoc. of Art (1937, '38, '44–46 Preise). ▢ WWAA, 1953–1962 (Ausst., Ill.); *Falk* I, 1999. – *T. Rayfield*, The Mage 1985 (Sommer) 28–41; *L. Ortiz*, Arts unknown. The life and art of L. B. C., N. Y. 2005. – Washington, D. C., SI, Arch. of Amer. Art: Interview v. 26. 5. 1964. – *Online:* Pulp artists. C. Rohrschneider

Coyle, *Gary*, irischer Zeichner, Fotograf, Performance-künstler, * 23. 3. 1965 Dún Laoghaire/County Dublin, lebt dort. Stud.: 1985–89 Nat. College of Art and Design, Dublin; 1990 New York Studio School und 1991–93 Art Students League, New York; 1994–96 R. College of Art, London. Artist in Residence: 1998 Irish MMA, Dublin; 2003 Ballinglen Artists Found., Ballycastle. Ausz.: 1999 R. Hibernian Acad. (RHA) Drawing Prize.; 2007 Portr. Award RHA and Irish US Council for Commerce; 2008 Davy Portr. Award. Mitgl.: 2009 RHA. – C. nutzt Zchng, Fotogr., Film und seit ca. 2006 auch Performance für Arbeiten, die sich mit Lsch.-Erfahrung in Dublin und Umgebung sowie Szenen aus den Massenmedien befassen. Zunächst fertigt er atmosphärische Kohle-Zchngn von leeren, banalen Interieurs sowie von Meer und Himmel nach Fotogr. an (Serie *Ad Marginem*, 1999–2000); die Arbeiten sind häufig von einem gezeichneten breiten Rand eingerahmt. Seit 1999 schwimmt er fast täglich am Strand Forty Foot in Sandy Cove und dokumentiert dieses Ritual durch Zchngn, Karten und in Tagebüchern sowie v.a. durch Farb-Fotogr., die er aus der Perspektive des Schwimmers aufnimmt, so daß v.a. Wellen und Himmel zu sehen sind (Serie *Lovely Water*, 2002). Diese Arbeiten sind auch Teil seines Beitrags für ein im Rahmen der dt. EU-Präsidentschaft vom Goethe-Inst. beauftragten Projekts, bei dem Künstler einen für sie wichtigen Ort für eine virtuelle Tour durch Europa vorstellen (*Odysseus. A quest for Europe*, 2007). In der Performance *At Sea* (2009–10) mit projizierten Fotogr. spricht C. über das Schwimmen und eine Art Verschmelzung mit der Lsch., in der gleichnamigen Installation in der RHA Gall. in Dublin 2010 zeigt er neben den Fotogr. und Kohle-Zchngn auch täglich mit Meerwasser gefüllte Plastikflaschen (*Omphalos*, 2010). Die großformatigen, detailliert und fein ausgeführten dunklen Kohle- und Bleistift-Zchngn befassen sich mit aus Fotogr. der Massenmedien entnommenen voyeuristischen Blickwinkeln, beunruhigenden Verbrechensszenen, Vorstadtmilieus und Sets von pornographischen Filmen; sie erzeugen eine verstörende Wirkung, ohne wirklich Details preiszugeben (*The Wild Wild Wood, Crime Scene no 74*, 2004). Char. ist ein blätterartiges Netz (*Porn Foliage*, 2003–04), bei jüngeren Zchngn kleine integrierte Vignetten (*Southside Gothic 4*, 2009/10) und generell ein analytisches Vorgehen, wie z.B. bei der Portr.-Zchng eines jungen Mannes in Nahaufnahme (*Head of a man*, 2006). ⌂ BALLYCASTLE/Mayo, Ballinglen Arts Found. CORK, Crawford AG. DUBLIN, Arts Council of Ireland. – Irish Contemp. Art Soc. – Irish MMA. – Office of Public Works. – RHA. ◉ *E*: Dublin: 2004, '05, '07 Kevin Kavanagh Gall. (K); 2009 Concourse, County Hall und Projects AC; 2010 RHA Gall. / 2007 Cork, Fenton Gall. ⌺ Representing art in Ireland (K Fenton Gall.), Cork 2008; Death in Dun Laoghaire (K Project AC), Dublin 2006; *D. Maguire*, Irish arts rev. 24:2007 (2) 62; *R. Kennedy*, ibid. 26:2009 (4) 86–89; At sea. The daily practice of swimming (K Kevin Kavanagh Gall.), Dublin 2009; *C. Graham*, Source 70:2012 (Frühjahr) 64 s. – *Online:* Website C. – Mitt. C. H. Stuchtey

Cozzi, *Napoleone*, ital. Maler, Aquarellist, Freskant, Zeichner, Dekorateur, Alpinist, Höhlenforscher, Schriftsteller, * 5. 2. 1867 Triest, † 22. 12. 1916 Monza. Sohn eines Schmiedes. Schüler von Eugenio Scomparini. Bereits 1880 entstehen die ersten drei erh. Zchngn (Mus. Revoltella). 1887 entwirft C. die Titelseite der Zs. Il Palladio der Soc. Ginnastica Triestina, der er ab 1888 als Mitgl. angehört. 1888–89 Militärdienst in Tolmezzo; ein erstes Aqu.-Tagebuch entsteht. 1893 dekoriert er zus. mit Eugenio Scomparini und Josip Varvodić das Innere des neu erb. Städtischen Theaters in Split. Zugleich widmet sich C., der als Instruktor bei der Soc. Ginnastica Triestina angestellt ist (1897 in leitender Stellung, 1901 zeitweise Dir.), erfolgreich dem Sport und beteiligt sich auch an internat. Wettkämpfen (u.a. Fechten, Schlittschuhlaufen). Bek. wird er v.a. als Alpinist (zeitweise im Vorstand der Soc. Alpina delle Giulie); zus. mit Freunden bildet er die sog. Squadra Volante, die sich auf Erstbesteigungen spezialisiert. 1899 und 1910 erneuert er die Dekoration der Turnhalle der Soc. Ginnastica Triestina (v.a. die nur durch Fotogr. dok. Decke der Fechthalle). 1900 Teiln. an der WA Paris. Als engagierter Vertreter der irredentistischen Bewegung kämpft er für den Anschluß der unter habsburgischer Herrschaft stehenden Stadt Triest an Italien. 1904–05 wird er deshalb inhaftiert, 1914 muß er aus Triest nach Italien fliehen. – Die Erforschung von C.s bemerkenswertem künstlerischen Schaffen ist v.a. M. Lunazzi (2000 ss.) zu verdanken. Während C.s Reisen und Bergtouren entstehen vier einzigartige Tagebücher mit Aqu., so 1898 am Monte Chiampon b. Gemona in den Julischen Alpen (Ostern) und an der Kleinen Zinne (Cima Piccola di Lavaredo) in den Sextener Dolomiten (Sommer), 1902 in den Friauler und Clautaner Dolomiten (Monte Toro, Campanile di Val Montania, Duranno), 1907 beim Aufstieg an der N-Wand des Cjanevate und dem ersten ital. führerlosen Aufstieg über die N-Wand der Kleinen Zinne. Die lichtvollen, manchmal verklärt und visionär wirkenden Aqu. erinnern z.T. an Bilder von Caspar David Friedrich; Einflüsse von Jugendstil und Symbolismus verweisen u.a. auf das Vorbild von Arnold Böcklin, über den C. 1902 einen Art. schreibt. Umfangreiche Dekorationen, die in der durch seinen Lehrer E. Scomparini vermittelten Trad. von Tiepolo und der venez. Malerei stehen, realisiert C. im Frenocomio civ. [Städtische Irrenanstalt], Triest (Malereizyklus, 1905/06), im Ospedale di S. Giovanni ebd. (1910), in den Theatern von Piran/jetzt Slowenien (1910) und Pisino/jetzt Kroatien (1912) sowie im trad.-reichen Literatencafé San Marco in Triest (1913), einem wichtigen Treffpunkt der Irredentisten (Ausstattung erh., 1997 rest.). Erst kürzlich wurde ein weiteres Deckenfresko von C. im Erdgeschoß eines Hauses in der Via Rossetti in Triest mit allegorischen Figuren (*Agricoltura; Industria; Scienza; Arte*), Tondi mit Engeln und Grotesken entdeckt (Gardonio, 2007; Entwurf von 1895 im Mus. Revoltella). Viell. ist er auch Autor der Dekoration in der Villa von Giuseppe Caprin in Triest. Auch einige Gem. (Portr. und Veduten) von C. sind erhalten. ⌂ TRIEST, Mus. Revoltella: Zchngn, Bozzetti. – Soc. Alpina delle Giulie: drei Aqu.-Tagebücher. – Caffè San Marco: Aktbilder in Medaillons, 1913. – Mus. del Risorgimento. ◉ *E:* 2007

Toppo di Travesio, Pal. Toppo Wassermann (K). – *G:* 1911 Turin, Espos. alpina. ▭ *S. Cella*, Piccola enc. giuliana e dalmata, 1962; *F. De Battaglia/L. Marisaldi* (Ed.), Enc. delle Dolomiti, Bo. 2000. – *A. Angoletta Berti*, Emozioni semplici, s.l. 1986 (Aqu. von C.); *M. Masau Dan/ G. Pavanello* (Ed.), Arte d'Europa tra due secoli, 1895–1914. Trieste, Venezia e le bienn. (K), Mi. 1995; *C. Magris*, in: Literarische Kaffehäuser, Kaffeehausliteraten, W. 1999; *M. Lunazzi*, in: *C. Ferri u.a.*, Alpi Carniche e Dolomiti Friulane. Itinerari alpinistici dell'Ottocento, Gorizia 2000, 53–62; *S. Dalla Porta Xidias*, Montanaia. Cento anni di storie e segreti del Campanile, Belluno 2002; 120 anni in grotta, Trieste 2004; *M. Lunazzi*, Ardimenti e incantevoli ozi. Le Dolomiti friulane negli acquerelli di N. C., Belluno 2004; *ead.* (Ed.), Da Trieste alle Alpi. N. C. artista, alpinista, patriota; acquerelli, fotogr., dipinti e disegni dal 1880 al 1916 (K), Travesio 2007; *ead.*, Sot la nape 58:2006 (3/4) 53–60; *M. Gardonio*, Arte in Friuli, arte a Trieste 26:2007, 239–242; Messaggero Veneto Pordenone v. 29. 3. 2007; *G. Cosolini*, L'Ospedale pchichiatrico di S. Giovanni a Trieste, Mi. 2008. – Mitt. A. Avoledo, Consorzio Arcometa, Travesio; A. Serafino, Bibl. Travesio.

E. Kasten

Cozzolino, *Ciro*, brasil. Maler, Zeichner, Illustrator, Animationszeichner, Graphiker, * 24. 2. 1959 São Paulo, lebt dort. Stud.: 1975–79 Inst. de Artes e Decorações ebd., 1979 Lith. bei Paulo Menten; 1980–81 EBA ebd.; 1983–85 ENSBA, Paris, u.a. bei Pierre Alechinsky. 1977 Teiln. am Festival de Cinema in der Kategorie Experimentelle Animation. Aufenthalte 1981 in Madrid, wo er mit Leonilson (José Leonilson Bezerra Dias), Sérgio Niculitcheff und Luis Zerbini arbeitet, und 1982–85 in Paris. Schließt sich 1990 der Gruppe Tupinãodá an. 1992 zus. mit Carlos Delfino und Arthur Lara Mitbegr. der Gruppe Rastronautas. Veröff. u.a. 1995 ein Kindermalbuch mit Ill. und Texten (*Seres da Luz*). – C.s bunt-poppige Malerei, zumeist ungerahmt, setzt sich auf humorvoll-ironische Weise mit der mod. Kunstgesch. auseinander. In seinen Bildern mischen sich die unterschiedlichsten Einflüsse aus Comics, Animation, der Rock-Gesch. sowie der mod. Freizeit- und Konsumkultur. Zuweilen unterzieht C. die Bilder einem starken Bearbeitungsprozeß, indem er die Lw. schlitzt oder einschneidet oder mit nassen Farben operiert. ◉ *E:* 1981 Madrid, Casa do Brasil / São Paulo: 1987 Gal. Subdistrito; 1989 Gal. Suzanna Sassoun. –. *G:* São Paulo: 1976 Salão da Esc. Art Pop (Ankaufs-Preis); MAM: 1980 (Panorama da Arte Atual Brasil.); 2003 (2080); MAC: 1983 (Pintura como Meio); 1994 (Migrações); 1986, '89 Salão Paulista de Arte Contemp.; 1986 Gal. Luisa Strina: Doze Anos da Gal.; 1987 Gal. Subdistrito: Trip; 1990 Gal. São Paulo: Oswideo; 1994 Mus. de Arte Brasil.: Ubu; 2002 Casa das Rosas: Rendam-se, Terráqueos!; 2008 Paço das Artes: I/Legítimos / 1977 Taubaté: Salão de Artes Plást. de Taubaté / 1980, '88 Curitiba: Salão Paranaense / 1980, '81 Santo André: Salão Jovem de Arte Contemp. / 1983 Havanna: Bien. / Rio de Janeiro: 1990 Gal. Cândido Mendes: Tupinãodá; 1992 Paço Imperial: A Caminho de Niterói-Coleção João Sattami; 2004 Centro Cult.

Banco do Brasil: Onde Está Você, Geração 80? / 1985 Paris, Atelier L'Hermitage: Atelier Ouvert / 1986 Porto Alegre, MARGS: Coleção Rubem Knijnik-Arte Brasil. Anos 60, 70, 80 / 1989 Florianopolis, Mus. de Arte de Santa Catarina: Submarino; Valparaiso: Bien. Internac. / 1993 Genf, Gal. Aphone: Migrations à Travers les Codes Internat. / 1997 Belo Horizonte, Mus. de Arte Popular: Infláveis / 2008 Americana, MAC: Nova Realidade. ▭ *Ayala*, 1997. – *Online:* Website C. M. F. Morais

Cracco, *Antoine* cf. **Cracco**, *Ernest*

Cracco, *Charles* cf. **Cracco**, *Ernest*

Cracco, *Ernest*, belg. Dekorationsmaler, Maler, Freskant, Lehrer, * 23. 8. 1864 Mouscron/Hainaut, † 22. 1. 1944 ebd. Sohn des Dekorationsmalers *Louis C.* (* 29. 5. 1833 Kortemark, † 1. 9. 1913 Mouscron), Bruder des Dekorationsmalers *Charles C.* (gen. Oscar, * 22. 7. 1867 Mouscron, † 28. 4. 1943 ebd.), Enkel des Dekorationsmalers Pierre C., Urenkel des Glasmalers *Antoine C.* (* 1781 Roeselare, † 1839), Ururenkel des Glasmalers und -graveurs *Jacques C.* (* 1745 Italien, † 1817 Roeselare). Ausb./Stud.: 1878–82 im Atelier des Vaters; Abendkurse an der KA in Kortrijk; 1882–85 Hoger Inst. Sint-Lucas, Gent; 1985–88 Hoger Inst. voor Schone Kunsten, Antwerpen, bei Jules Devriendt (Ausz.: Premier Prix de Peint.; Méd. de la Ville). 1888–89 Italien-Reise (v.a. Aufenthalt in Florenz und Rom). Lehrtätigkeit in Mouscron: ab 1890 Collège épiscopal Saint-Joseph; Inst. des Dames de Marie; Collège des Peres Jésuites; 1911–17 erster Dir. der Ec. industrielle et commerciale. 1938–44 Begründer und Präs. des Comité des BA de la Ville de Mouscron und des Cercle artist. Mouscronnois. – Portr.-Gem. von Persönlichkeiten und Fam.-Mitgl. (in Öl und Pastell) sowie Dekorationsmalerei in neogotischem Stil, v.a. in Mouscron (z.B. Hôtel de Ville [Hall d'Entrée, Salle du Conseil communal]; Chap. de la Congrégation des Sœurs de St-Charles Borromée [Fresken]; Chap. de l'Orphelinat [Gewölbe]), häufig in Zusammenarbeit mit seinem Bruder. ▭ DOULLENS, Eglise St-Martin: Couronnement de la Vierge. LEEDS, St. Patrick's Church: Triomphe de la Croix, 1897. MOUSCRON, Mus. Communal de Folklore Léon Maes. ▭ *Online:* Mem. La lettre mensuelle (Lille) 2003 (April). F. Krohn

Cracco, *Jacques* cf. **Cracco**, *Ernest*

Cracco, *Louis* cf. **Cracco**, *Ernest*

Craenenbroeck, *Patrick van*, belg. Bildhauer, * 17. 5. 1953 Ixelles/Brüssel, lebt in Affligem/Vlaams Brabant. Autodidakt. Nach Unfall als Leistungssportler (belg. Meister im 400-Meter-Hürdenlauf) ab 1975 Hinwendung zur Kunst, v.a. zur Plastik. Ausz.: 1990 Silber-Med. Bildhauer-Wettb., Oostende; 1998 Kulturpreis der Gemeinde Affligem; 2001 Gold-Med. Bildhauer-Wettb., Vermeylenfonds. – Debütiert mit surrealistischen Gemälden. Seit E. der 1970er entstehen in unterschiedlichen Werkgruppen expressiv-kraftvolle, häufig surreal und biomorph wirkende z.T. (über-)lebensgroße Skulpt. und Figurengruppen in versch. Techniken und aus versch. Mat. (u.a. Keramik, Duro- und Thermoplastik, Stein, Bronze). Seine u.a. in martialischen, sportiven, lauerjägerhaften oder meditativen Posen z.T. wie erstarrt wirkenden befremdlichen Fi-

gurationen scheinen aus mythischen Zeiten zu stammen. Arbeiten wie *Hij ... en zijn volgelingen* (Bronze, 1995) verweisen auf Kriegerfiguren aus nicht-europ. Kulturkontexten. C. nennt die Skulpt. dieser Werkgruppe ein „nieuw volk" und bezeichnet sie als „reizigers in de tijd" (Zeitreisende); in ihrer archaischen Anmutung rekurrieren diese ebenso auf Sagengestalten wie sie gleichzeitig von der apotropäischen Bauplastik vergangener Jh. wie von mod. dekorativen Theaterplastiken inspiriert zu sein scheinen (*Hij troont als God*, 1997). Für den öff. Raum fertigt C. im Auftrag von belg. Unternehmen und Kommunen auch Denkmal-Skulpt., die lokalen Bezug haben, so entsteht „met klompen en in lompen" *De Papeter. Van de Essenaren. Voor de Essenaren* (Bronze, 2007; Essene, Kerkplein) eine kleine Plastik, die auf humorige Weise den Spottnamen der Dorfbewohner verkörpert. – Monogr. Bearbeitung und WV stehen aus. ▣ *Im öff. Raum u.a.:* AFFLIGEM-Hekelgem, Culturzaal: Ik, Gij, Wij, 2000. – A.-Teralfene: Openluchtkapel. BOSSCHENHOOFD/Noord Brabant, Landgoed Maple Farm, Gal. & Beeldentuin. DENDERHOUTEM, Dorp: Driekoningenviering ... een Atomse traditie, 1999. DENDERMONDE, Aymonshof: Lebensloop, 2003–04. OOSTROZEBEKE, Fa. Squisito. ROOSDAAL-Pamel: De Dikke van Pamel, 2001 (alle Bronze). ⊙ *E:* 2010 Damme, Stadshallen. – *G:* 1997 Valetta (Malta): Bienn. ▢ *J. M. C. van Berkum/M. van Ool*, Koppelingen. Ontmoetingen tussen professionele beeldende kunstenaars en beeldend getalenteerde mensen met een verstandelijke handicap [...] (K Amsterdam), Zwolle 1999; *C. Engelen/M. Marx*, Beeldhouwkunst in België, III, Br. 2002. – *Online:* Website C. U. Heise

Craft, *Liz,* US-amer. Bildhauerin, Installationskünstlerin, * 1970 Los Angeles/Calif., lebt dort. Stud. ebd.: bis 1994 Otis College of Art and Design; bis 1997 Univ. of California, u.a. bei Charles Ray. – C. gelangt über Installationen zu narrativen Skulpt., mit denen sie „eine Welt voller Phantasien, Halluzinationen und Anspielungen" (Steinbrügge, 2007) gestaltet. Dabei läßt sie sich vom kalifornischen Flair, von versch. Orten (Watts Towers in Los Angeles, Venice, Ocean Beach), der Hippie-Bewegung und Kultfiguren wie Lonely Cowboy oder Easy Rider, aber auch von Mythen, Märchen und Kunstzitaten inspirieren und „setzt dem Alltäglichen phantastische Energien und Mythen entgegen" (a. a. O.). C.s wohl bekanntestes Werk *Death Rider (Virgo)* (Bronze, 2002) knüpft an das klassische Sujet vom Tod und Mädchen an, weckt aber auch Assoziationen an die Hell's Angels oder das Roadmovie Easy Rider von Dennis Hopper (Garrels, 2007). Das Thema des Todes klingt in mehreren Werken an (*Treasure Chest [A Real Mother for Ya]*, Holz, Stahl, Leder, Gips, Bronze, Samt, Vorhängeschlösser, 2002), weitere wiederkehrende Motive sind idolartige Frauenfiguren (*Mountain Mamas*, Fiberglas, 2003), die skurrile Gestalt des Hairy Guy (z.B. *Hairy Guy [with Babies]*, Bronze, glasierte Keramik, 2005), anthropomorphe Objekte (*Ladder Guy*, 2005; *Table Guy*, 2006, beide Bronze), Pflanzen oder Tiere. Neben dem trad. bildhauerischen Werkstoff Bronze (den sie mitunter mit Ölfarbe bemalt) verwendet (und kombiniert) C. ganz

unterschiedliche Mat. wie Perlen aus Muranoglas, Gips, Fiberglas und Maschendraht sowie vorgefertigte Objekte wie Kunstblumen oder einen Vogelkäfig. ▣ LOS ANGELES, MCA. ⊙ *E:* Los Angeles: 1998 Richard Telles FA; 2005 Peres Projects / 2001 Linz, O. K. Centrum für Gegenwartskunst (K: M. Sturm); Paris, Gal. Nathalie Obadia / New York: 2002 Public Art Fund; 2003, '07 Marianne Boesky Gall.; 2007 Lever House / London: 2002 Sadie Coles HQ; 2006 Alison Jacques Gall. – *G:* 2000 Santa Monica (Calif.), Mus. of Art: Mise en Scéne: New L. A. Sculpt. (K) / 2001 London, Barbican Centre: The Americans: New Art (K) / 2004 New York, Whitney: Whitney Bienn. 2004 (K) / 2006 Stockholm, Milliken Gall.: L. A. Trash and Treasure / 2009 Amersfoort, Kunsthal: Wonderland. ▢ *B. Steinbrügge* (Ed.), L. C. 95–06 (K), Z. 2007 (ed. im Zusammenhang mit der Ausst. L. C. Fantasy Archit.; KV Halle für Kunst, Lüneburg); *J. Collins*, Sculpt. today, Lo./N. Y. 2007; *G. Garrels*, Eden's edge. Fifteen LA artists (K), L. A. 2007. C. Rohrschneider

Craglietto, *Giovanni,* ital. Maler, Zeichner, * 1889 Verteneglio, † 1975 Triest, tätig in Gorizia und Verona. Zw. 1903 und 1908 wird C. in Triest an der Scuola per Capi d'Arte in Malerei von Eugenio Scomparini unterrichtet. Stud.: 1908–11 KGS, Wien (bei Berthold Löffler, Emerich Selch, Hermann Vinzenz Heller); 1920 ABA, Venedig (Kunsterziehung). Lehrtätigkeit: 1920–37 Ist. Tecnico, Gorizia. – C.s frühe Gem. sind von der Secession sowie dem Expressionismus und dem Symbolismus beeinflußt. Von seinem Lehrer Scomparini übernimmt C. die Behandlung des Lichts und einen akad. Realismus. Wahrscheinlich lernt er in Wien Oskar Kokoschka kennen. Im 1. WK dient C. in der Armee und macht Bleistift-Zchngn v.a. von Kameraden. In den 1920er Jahren entwickelt sich C.s introspektive Malerei, die Auswahl der Motive bleibt zunächst auf seine priv. Wohnräume, das Selbst-Portr. und Erinnerungen an seine Kindheit begrenzt. Später kommen Bildnisse (*Portr. eines jungen Mannes*, Öl/Lw., 1926) und Gruppenbilder (*Der Chor*, 1930; *Sechs Männer vor einem Brunnen*, 1943, beide Öl/Lw.) hinzu. Der anfängliche Hang zur expressionistischen Deformation der Figur mit teilw. karikaturhaften Zügen wandelt sich hin zu einem zurückgenommenen, an das 19. Jh. angelehnten, fast magischen Realismus mit fester Geometrie, klaren linearen Strukturen und gedeckter Farbigkeit. Außerdem schafft C. zahlr. Zchngn, bevorzugt in Bleistift, aber auch mit Feder und Kreide, sowie Karikaturen. Die frühen Bl. sind mit nervösen, lockeren, meist langen nebeneinander gesetzten Strichen ausgef., die sich nach und nach beruhigen. Der Motivkreis beschränkt sich hier im Wesentlichen auf Figurenstudien und Porträts. C. sign. und dat. alle seine Zchngn. ▣ GORIZIA, Mus. Provinciali. TRIEST, Mus. Revoltella. UDINE, GAM. ⊙ *E:* Gorizia: 1935 Gall. La Bottega d'Arte (mit Bruno Trevisano); 1966, '67 Gall. d'Arte Pro Loco; 2000 Mus. Provinciali (Retr., K) / Triest: 1949 Gall. d'Arte Trieste; 1956, '59, '60 Gall. d'Arte Lonza; 1989 Gall. d'Arte S. Michele; 1990 Gall. d'Arte Al Bastione; 2000 Ist. Regionale per la Cult. Istriana (K) / Verona: 1957 Gall. d'Arte Scala; 1958, '59 Gall. d'Arte

La Cornice; 1968, '70, '74, Gall. d'Arte Notes. – *G:* 1926
Udine: Bienn. Friulana d'Arte / 1932 Gorizia, Mostra Giu-
liana d'Arte / 1945 Triest, Prima Mostra Assoc. Belle Ar-
ti / 1956 Mailand, Mostra del Circolo artistico di Trie-
ste. ▭ *Maggiore*, ArtViventi, 1955; *M. Cordeschi*, G. C.
La formazione e l'opera pittorica e graf. degli anni Venti e
Trenta, Magistrarbeit, Triest 1997; *A. Delneri/V. Gransi-
nigh* (Ed.), G. C. 1889–1975. Disegni e dipinti (K), Mon-
falcone 2000. C. Melzer

Craig, *Chase (W. Chase),* US-amer. Comiczeichner und
-texter, Trickfilmzeichner, Illustrator, Redakteur, * 28. 10.
1910 Ennis/Tex., † 2. 12. 2001 Thousand Oaks/Calif.
Stud.: 1933–34 School of the Art Inst., Chicago/Ill. Ab
1935 in Hollywood/Calif. Trickfilmzeichner im Studio von
Leon Schlesinger und Walter Lantz; u.a. Mitarb. an der
Cartoon-Serie *Oswald the Lucky Rabbit.* Ab 1936 Mitarb.
von Tex Avery bei Warner Brothers. Ab 1938 zeichnet
C. versch. Comic strips, u.a. *Hollywood Hams* (zus. mit
Carl Buettner; für die Ztg Los Angeles Daily News); *Little
Chauncey* (1938–42 für die Ztg The Christian Sc. Moni-
tor, Boston/Mass.); *Mortimer Snerd and Charlie McCar-
thy* (zus. mit Buettner; bis 1940). 1941–42 schreibt C. die
Szenarien zu dem von Fred Fox gez. Comic strip „Odd
Bodkins". 1942–45 Militärdienst in der US Navy; zeich-
net Ill. für Lehr-Mat. der Marine. Ab 1945 v.a. als Texter
und 1950–75 auch als Red. des Verlages Western Printing
and Lith. tätig, u.a. für die populären Comic books Bugs
Bunny; Looney Tunes und Merrie Melodies; Walt Dis-
ney's Comics and Stories; Uncle Scrooge; Chip 'n' Dale;
Tarzan; Korak, Son of Tarzan; Magnus Robot Fighter. In
den späten 1970er Jahren entstehen Szenarien und Layouts
für vom Trickfilmstudio Hanna-Barbera lizenzierte Comic
books des Verlages Marvel. Ab ca. 1980 im Ruhestand
in Westlake Village/Calif. Ausz.: 1982 Inkpot Award, San
Diego Comics Convention. – Routinierte lininenbeton-
te, humoristische Tuschfeder- und -pinsel-Zchngn in der
Nachf. von Tex Avery. ▭ *J. Bails/H. Ware* (Ed.), The
who's who of Amer. comic books, Detroit 1973–76; *H. Fi-
lippini*, Dict. enc. des héros et auteurs de BD, I, Greno-
ble 1998; *Horn*, Comics, 1999; *H. Filippini*, Dict. de la
bande dessinée, P. 2005. – *D. Thompson/D. Lupoff* (Ed.),
The comic-book book, Iola, Wis. 1998. – Northridge, Cal-
ifornia State Univ., Oviatt Libr.: C. coll., 1924–1980. –
Online: Lambiek Comiclopedia; Miscellaneous Ventura
County, California Obituaries. H. Kronthaler

Crailsheim, *Liselotte von* (geb. Horstkotte, verh. Bro-
wers, *Else Liselotte*), dt. Malerin, Graphikerin, Freskan-
tin, Textilkünstlerin, Objektgestalterin, * 24. 6. 1926 Biele-
feld, beigesetzt Okt. 2007 ebd. Lehre als Keramikma-
lerin. Stud.: FHS für Gest., Bielefeld (Textil-Kl.); danach
KA, München, bei Carl Crodel. Daneben Studien im Ate-
lier von Heinrich Kropp ebd. Lebt später in Salzburg, da-
nach in München. Ab 1968 eig. Ausstellungen. Lernt in
München A. der 1970er Jahre ihren späteren Mann, den
Kunsterzieher Berthold von Crailsheim, kennen, mit dem
sie zwanzig Jahre verheiratet ist. 1979 wird das Paar im
ehem. Amtshaus eines Crailsheimschen Hofgutes in Fran-
ken ansässig. Zus. widmen sie sich v.a. der Kunstthera-

pie. Aufenthalte in Italien (v.a. Toskana), wo sie Mal-
und Zeichenunterricht gibt. – C.s heterogenes Œuvre um-
faßt in unterschiedlichen, häufig abstrahierenden Stilen so-
wohl Tafelbilder als auch Keramikdekorationen oder in-
stallative Arbeiten, die bisweilen dem Informel naheste-
hen. Etliche Fresken in Franken, u.a. in kleinen Kirchen
und im Schloß Castell. Im Wandbild bleibt C. von der
arkadischen Dekorativität der Arbeiten ihres Münchner
Lehrers C. Crodel inspiriert. Im Weinkeller des Schlos-
ses Castell freskiert sie z.B. in leuchtenden Farben eine
Wand mit der Darst. von Jesus als Weinstock. Auch an-
gewandte Graphik, z.B. Jahrgangsweinetiketten. – Mono-
gr. Bearbeitung und WV stehen aus. ▭ CASTELL, Graf-
schaftskirche. FEUERBACH/Unterfranken, Pfarrk. FRÖH-
STOCKHEIM/Unterfranken, Pfarrk. GEROLZHOFEN, Pfarrk.
HAMM/Westf., Stadtkirche. KITZINGEN, Finanzamt. –
Landratsamt: Fresko, 1992. – Stadtkirche. REHWEILER,
Pfarrk. RÖDELSEE, Pfarrk. WÜRZBURG, Industrie- und
Handelskammer. ✉ *A.-C. Warnke/E. L. Browers/
H. Probst*, Das Bogenhausener Modell [...], M. 1974; *C./
R. Gutmann* (Ed.), Heinrich Frieling. Farbe. Bekentnnis-
se und Erkenntnsse, Göttingen 1980. ⊚ *E:* 2008 Wie-
sentheid, Hist. Pfarrhaus (Gedenk-Ausst. zum 1. Todes-
tag); Rödelsee, Schloß Crailsheim. ▭ Dt. Kunsthandel
57:1965 (9) 40 (s.v. Browers, Else Liselotte); Kürschners
Hb. der Bild. Künstler. Deutschland, Österreich, Schweiz,
I, M./L. 2007. U. Heise

Cramer, *Ulf,* dt. Maler, Graphiker, Zeichner, Illustra-
tor, * 1944 Łódź, lebt in Karlsruhe. Stud.: 1963–64 Freie
KSch, Stuttgart; 1965–71 KA, Karlsruhe, u.a. bei Her-
bert Kitzel und Horst Egon Kalinowski. 1973–75 Lehr-
tätigkeit in Köln. Seit 1976 freischaffend. – Anfänglich
Malerei und Graphik unter Einfluß seiner Lehrer (Karls-
ruher Figuration). Danach wendet sich C. zunehmend,
seit den 1980er Jahren wohl nahezu ausschließlich einer
Zeichenkunst zu, die von der Écriture automatique maß-
geblich beeinflußt bleibt und sich konsequent darauf be-
schränkt, den grundlegenden Elementarphänomenen von
Struktur und Wachstum in Mikro- und Makrobereichen
zeichnerisch nachzuspüren. C. überzieht seine z.T. groß-
formatigen Zeichengründe mit schraffurähnlich eng, kurz
und prägnant gesetzten u.a. rhythmisch schwingenden, in
Zickzackformen ausgebildeten oder wirbelartig kreisen-
den Strichelungen, Strichlagen, die wiederholt und va-
riiert sowie in vielen Bildpartien verschränkt (auch pa-
limpsestartig) und gegenläufig überzeichnet werden (Blei-
und Farbstift, Feder, schwarze und farbige Tusche, selten
Ölkreide). Die kleinstteilig, bisweilen ornamentartig wu-
chernden zellulären Strukturen bilden dabei in ihrer Ver-
teilung auf der Gesamtfläche letztlich größere Kontexte,
die vieldeutig u.a. auf musikalische, textile, archit. oder
organoide Formen, Figurationen (*Worpel*, 1994) oder Ge-
bilde rekurrieren, die auch gegenständlichen Bezug haben
können bzw. direkt oder indirekt darauf verweisen. Die
Aneinanderreihung der graph. Mikrostrukturen, in denen
C. auch skurrile oder hintergründig-ironische Figurationen
oder Zeichen implantiert (*Der kleine Geier*, 1994), stei-
gert er in manchen Arbeiten bis zur Bildung geschlosse-

ner Farbflächen, was z.T. malerische Effekte hervorruft. Die teilw. in Großserien angelegten Zchngn legt C. in Ausst. als Bodenobjekte aus. Daneben craqueléartige Entwürfe für Fayencen, u.a. für die Majolika-Man. in Karlsruhe. Auch Buch-Ill. (W. Menzel, *Am Rand der Spott*, Ka. 1985). ⌂ ALBSTADT, StKS. KARLSRUHE, Badisches LM. – SKH. – StG. ✉ Über mein Zeichnen, in: V. Mertens, 2009, 5–7. ◉ *E:* 1992 Kornwestheim, Gal. Geiger (K: C. Riedel) / Karlsruhe: 1999 (K), '08 (mit Harald Sieling, Walter Stöhrer), '10 (mit Wilhelm Neußer) Gal. Alfred Knecht & Burster); 2008 Zehnthaus Jockgrim (mit Manfred Emmenegger-Kanzler) / 2000 Konstanz, Gal. Geiger. *G:* 1974 Köln, Allianz-Haus: Grafik und Plastik. Alfons Allard, U. C. ... (Falt-Bl.). ⌶ Kunstförderung des Landes BW. Erwerbungen 2001–2004 (K Wander-Ausst.), Schwäbisch Gmünd 2006; *J. Thaler/R. Vorderegger* (Ed.), Gedichtet – gezeichnet. Dichter und Künstler im Dialog (K Vorarlberger Landes-Bibl. Bregenz, Slg. Hartmann), Feldkirch/Graz 2006; *V. Mertens*, U. C. Linie, Struktur, Zeichen. Zchngn 1965–2006 (K), Albstadt 2009 (Lit., Ausst.). U. Heise

Crane, *Ralph (Rudy)*, US-amer. Fotograf, Fotojournalist, * 30. 7. 1913 Halberstadt, † 16. 3. 1988 Genf. 1931–32 Fotografenlehre; anschl. Ass. bei der US-amer. Fotoagentur Wide World Photos in Berlin. Nach einem Auftrag als Kriegsberichterstatter in Abessinien zieht C. nach London und 1936 weiter nach Genf. 1941 erhält er ein Visum für die USA (ab 1948 amer. Staatsbürgerschaft) und beginnt in New York für die Agentur Black Star zu arbeiten (bis 1973); bald erste Aufträge für die Zs. Life, für die er bis zu deren Einstellung 1972 zahlr. Reportagen und Titelbilder fotografiert (1951–72 angestellt bei der Agentur Time/Life), u.a. Berichte aus Hollywood, politische Themen wie der Bau des Assuan-Staudamms sowie zahlr. Aufträge in Europa. Nach 1972 arbeitet C. u.a. im Auftrag der Smithsonian Inst. und des Internat. Herald Tribune. ⌂ ESSEN, Mus. Folkwang. NEW YORK, Internat. Center of Photogr. – Metrop. Mus. ROCHESTER/N. Y., George Eastman House. ◉ *G:* New York: 1950 (Color Photogr. Exhib.), '55 (The Family of Man; K: E. Steichen), '65 (The Photo Essay) MMA; 1989 Internat. Center of Photogr.: Master Photographs from the „Photogr. in the Fine Arts" Exhib., 1959–1967. ⌶ *R. Mißelbeck* (Ed.), Prestel-Lex. der Fotografen, M. u.a. 2002. – Los Angeles Times v. 19. 3. 1988 (Nachruf); *H. Neubauer*, Black star. 60 years of photojournalism, Köln 1996; *K. Honnef/F. Weyers*, Und sie haben Deutschland verlassen ... müssen (K Bonn), Köln 1997; *J. Loengard* (Einf.), Die großen LIFE-Photographen, M. 2004. P. Freytag

Crasset, *Matali* (eigtl. *Nathalie*), frz. Designerin, * 28. 7. 1965 Châlons-en-Champagne/Marne, lebt in Paris. Stud.: 1988–91 Ec. nat. supérieure de Création industrielle, Paris. Zusammenarbeit mit Raul Barbieri (1990) und Denis Santachiara (1992) in Mailand und mit Philippe Starck (1993–97) in Paris. Ausz.: 1991 Premier Prix, Concours Louis Vuitton; 1996 Grand Prix de la Création de la Ville de Paris; 1997 Bourse Carte Blanche, VIA (Valorisation de l'Innovation dans l'Ameublement), Paris; 1999

Grand Prix de la Presse Internat. de la Critique du Meuble contemp. (für *Quand Jim monte à Paris*, Domeau & Pérès); 2002 Internat. Designpreis BW, Design Center Stuttgart; 2004 Internat. Interior Designer of the Year, London; 2006 Créateur de l'Année, Salon du Meuble, Paris. Seit 1994 Lehrtätigkeit, u.a.: EcBA, Bordeaux; Ec. Supérieure d'Art et de Design, Reims; Gerrit Rietveld Acad., Amsterdam; 2008–09 Gast-Prof. an der Peter Behrens School of Archit. der FHS, Düsseldorf. Seit 1998 eig. Designbüro in Paris. – C. ist eine der bedeutendsten Vertreterinnen der zeitgen. frz. Designszene. Sie widmet sich v.a. dem Produktdesign (überwiegend Möbel, auch Leuchten, Geschirr), weiterhin entwirft sie Ausst.-Szenographien (z.B. 2003 Monaco, Grimaldi Forum: Superwarhol) und Innenausstattungen (z.B. *Maison du Lac*, 2001; *Hotel Hi*, Nizza, 2003). C. hinterfragt die trad. Verwendung von Gegenständen und möchte mit innovativen Lösungen die Lebensweise beeinflussen, um u.a. die Qualität zwischenmenschlicher Beziehungen zu verbessern. Eine frühe Arbeit zum Thema Gastlichkeit ist *Quand Jim monte à Paris* (1995), eine 1,90 m hohe Säule, die als Stehlampe dient und ausgeklappt zu einem Gästebett mit Leselampe und Wecker wird. C. bemüht sich um die Erweiterung der Funktionen, die den Nutzer zu einem experimentellen und kreativen Umgang anregen sollen. Dementsprechend sind variable Arbeiten char. wie z.B. das aus sechseckigen Prismen in zahlr. Varianten zusammensetzbare, modulare Sofa *Digitspace* (2003) sowie das aus Aluminium und Kunststoff gefertigte Regal *Duepuntosette* (2005), welches als Bücherregal mit integriertem Leseplatz, als Schreibtisch sowie als Küchenarbeitstisch verwendet werden kann. Die hinsichtlich der formalen, schmuck- und schnörkellosen praktischen Gest. minimalistischen Entwürfe sind auf die Funktion hin konzipiert. Lebendigkeit erhalten die Arbeiten durch Mehrfarbigkeit (z.T. in unerwarteten Kombinationen) und die Bevorzugung knallig bunter Farbtöne sowie durch eine vielfältige Mat.-Auswahl. Dabei liegt C.s Hauptaugenmerk nicht auf der Konzeption einzelner Möbel, sondern auf der Planung von Wohnszenarien, die sich durch eine variable Raumnutzung mit fließenden Übergängen zw. den einzelnen Bereichen und optimierter Platzausschöpfung auszeichnen (z.B. *Cuisine Fraich' Attitude*, 2004). ⌂ 's-HERTOGENBOSCH, SM's (Innenausstattung, 2005). HORNU, MAC's. INDIANAPOLIS/Ind., Mus. of Art. LAUSANNE, Mus. de Design et d'Arts appliqués contemp. LISSABON, Mus. de Design e da Moda. LONDON, Design Mus. – V & A. MOUZON, Mus. du Feutre. NEW YORK, MMA. PARIS, FNAC. – MAD. – MNAM. PRAG, UPM. WIEN, MAK. ◉ *E:* 1998 Berlin, Modus / 2002 Lausanne, Mus. de Design et d'Arts appliqués contemp. (K); Köln, Gal. Ulrich Fiedler (K) / 2003 Hornu, MAC's; London, V & A / 2006 New York, Cooper-Hewitt, Nat. Design Mus.; 's-Hertogenbosch, SM's / 2007, '09 Salzburg, Gal. Thaddeus Ropac / 2009 Enghien-les-Bains, Centre des Arts (K) / 2011–12 Paris, Centre Pompidou, Gal. des Enfants. –. *G:* 1992 Mailand: Trienn. / 1994 Amsterdam, Sted. Mus.: Young industrial Designers / Paris: 1996 Centre Pompidou: Les Portes du Design ou

l'Aventure de l'Objet; 2007 Grand Pal.: Design contre Design; 2012 Le Lieu du Design: Sous les Pavés, le Design / 2000 Bordeaux, MAD: Objets en Mutations / 2003 London, Design Mus.: Somewhere else totally different / 2006 Lausanne, Mus. de Design et d'Arts appliqués contemp.: Bêtes de Style / 2008 Herford, Mus. Marta Herford: Ad Absurdum / 2011 Sevres, Cité de la céramique: Mise en œuvre, le quotidien et l'exceptionnel sous l'œil du design. ⊡ Dict. internat. des arts appliqués et du design, P. 1996; *M. Byars*, The design enc., Lo./N. Y. 2004. – Art (Ha.) 1998 (6) 72 s.; *P. Cassagnau/C. Pillet*, Beef, Brétillot/Valette, M. C., Patrick Jouin, Jean-Marie Massaud. Petits enfants de Starck?, P. 1999; *D. Fischer*, Atrium 2004 (3) 46–56; *E. Franzoia*, Abitare 442:2004, 150–154 (Interview); *C. Reinewald*, Items 2004 (3) 30–36; *M. Vissault*, Cremers Haufen. Alltag, Prozesse, Handlungen. Kunst der 60er Jahre und heute (K Münster), Bielefeld 2004; *G. Williams u.a.*, M. C., P. 2004; *P. Jodidio*, Mod. painters 2005 (1) 38–41; *J. Du Pasquie*, M. C. Frz. Möbeldesignerin, 2005 (Film Arte; Dok. aus der Reihe Künstler hautnah); L'art du verre contemp. (K Mudac), Lausanne 2006; *A. Bokern*, Design-Report 2007 (4) 38–41; *E. Lallement*, M. C. Spaces 2000–2007, Köln 2007; *A. Lleonart* (Ed.), Ultimate Paris design, Kempen 2007; elles@centrepompidou. Artistes femmes dans la coll. du MNAM, Centre de création industrielle (K), P. 2009; *H. Maier-Aichen* (Ed.), New talents. State of the arts, Ludwigsburg 2009. – *Online:* K. Schamun, Designline (Interview 2008); Design-Lex. internat.; Website C. F. Krohn

Crawford, *Hilary*, austral. Glaskünstlerin, * 13. 5. 1973 Sydney/N. S. W., lebt in Stepney/South Australia. Stud.: 1994–95 Alberta College of Art, Calgary; 1996, '99 Univ. of South Australia, Adelaide; 2001 Austral. Nat. Univ., Nat. Inst. of the Arts, Canberra. 1997–98 Designerin im Glasatelier der JamFactory, Contemp. Craft and Design, Adelaide. Lehrtätigkeit: 2004–05 Glass Dept., Univ. of South Australia, ebd. Ausz.: 2000 Certificate of Outstanding Achievement, Alumni Assoc., Univ. of South Australia, Adelaide; 2006 Cowra Art Prize, Cowra AG, Cowra/N. S. W.; 2007 Austrade New Exporters Development Grant, Adelaide; 2008 Established Artist Professional Development Grant; 2011 Established Artist Project Grant for New Work, beide Arts South Australia. – Inspiriert von Natur-, bes. Himmelsbeobachtungen oder auch von Alltagsgegenständen (z.B. Teebeutelformen), gestaltet C. skulpturale Glasobjekte mit gewölbten Oberflächen in einer reduzierten Farbpalette, meist in dunklen Blau- oder Grautönen. Die Objekte sind in der sehr aufwendigen Murrine-Technik gearbeitet, bei der aus Glasstäben gewonnene Mosaikplättchen (die sog. Murrinen) auf eine geblasene Form aufgeschmolzen werden. Durch anschl. Schleifen und Polieren erzielt C. sinnlich wirkende, samtartig schimmernde Oberflächen (Serien *Strange Skies*; *Bocconcini grey*, 2005; *Floating cellules*, 2006; *Green Tea*, 2007). Die Arbeiten bestechen durch ihre präzise Ausf. und die sorgfältig aufeinander abgestimmten Komponenten. ⬠ ADELAIDE, AG of South Australia. CANBERRA, Canberra Mus. and Gall. – Univ. of Canber-

ra. PALM SPRINGS/Calif., Palm Springs AM. ⊚ *E:* 1995 Calgary, Marion Nicholl Gall. / 2005 Adelaide, JamFactory. – *G:* seit 1994 zahlr. nat. und internat. ⊡ Ranamok Glass Prize 2008 (K), Sydney 2008; H. C. A little piece of sky (K Chappell Gall.), N. Y. 2007. – *Online:* Beaver gall. C. Rohrschneider

Crécy, *Nicolas de* (De Crécy, *Nicolas*), frz. Comiczeichner und -texter, Illustrator, Trickfilmzeichner, Maler, * 29. 9. 1966 Lyon, lebt in Paris. Bruder des Trickfilmgestalters Geoffroy de C. und des Filmregisseurs Hervé de C. Stud.: 1984–87 EcBA Angoulême. Im Auftrag der Städte Vitoria-Gasteiz und Angoulême gestaltet C. zus. mit dem Szenaristen Sylvain Chomet 1989 eine Comic-Adaption des Romanes *Bug Jargal* von Victor Hugo. 1990–91 Mitarb. des frz. Walt Disney-Studios in Montreuil. Gleichzeitig entsteht das Comic-Album *Foligatto* (1991; Text v. Alexios Tjoyas; ausgezeichnet mit dem Prix du meilleur dessinateur, Festival d'Athis-Mons, dem Prix des Libraires, Genf und dem Prix du Lion, Centre Belge de la Bande dessinée, Brüssel). Für das Mag. (à suivre) entsteht ab 1993 die Comic-Serie *Léon la Came* (3 Alben, 1995–98; Gesamt-Ausg. 2005; Text v. S. Chomet; ausgezeichnet mit dem Grand Prix de la Ville de Sierre). Zahlr. weitere Comic-Alben und ill. Bücher: u.a. *Le Bibendum céleste* (3 Alben, 1994–2002; Gesamt-Ausg. 2010); *Monsieur Fruit* (2 Alben, 1995–96; Gesamt-Ausg. 2007); *La Nuit du grand méchant loup* (Jugendbuch; 1998; Text. v. Rascal [Pseud. v. Pascal Nottet]); *Prosopopus* (2003); *Période glaciaire* (2005; im Auftrag des Louvre, Paris); *Salvatore* (4 Alben, 2005–10; Gesamt-Ausg. 2010); *Les Carnets de Gordon McGuffin* (2009; Text v. Pierre Senges). Auch Publ. mehrerer Bücher mit Reiseskizzen, Zchngn, Aqu. und Pastellen, u.a. *500 dessins* (2011). Die 2008 anläßlich eines fünfmonatigen Aufenthaltes in der Villa Kujoyama in Kyoto entstandenen Arbeiten werden in den Bänden *Esthétiques du quotidien au Japon* (P. 2010), hrsg. v. Jean-Marie Bouissou, und *Carnets de Kyoto* (2011) vorgestellt. Zudem Mitarb. an bzw. Konzeption von Zeichentrickfilmen (u.a. *La vieille dame et les pigeons*; *L'Orgue de barbarie*). – C. verarbeitet in seinen oft absurd, grotesk, surreal und düster anmutenden Arbeiten in eklektizistischer Manier formale Einflüsse verschiedenster bild. Künstler wie z.B. Otto Dix, James Ensor, Francisco de Goya oder Henri de Toulouse-Lautrec, aber auch von Filmemachern wie Marcel Carné oder David Lynch. In seinen oft sehr malerisch aufgefaßten Comics verwendet er die Technik der Direktkolorierung (u.a. Acryl, Pastell, z.T. auch Collage). Daneben entstehen auch stark linienbetonte, manchmal flüchtig-skizzenhafte Bleistift- und Tusche-Zchngn (z.T. laviert oder sparsam kol.). ⬠ ANGOULÊME, Centre Nat. de la Bande Dessinée et de l'Image. ⊚ *G:* 1993 Hamburg, 1. Internat. Comic-Salon: Couleur directe (K) / 2000 Hildesheim, Roemer- und Pelizaeus-Mus.: Asterix, Barbarella & Co. (K: T. Groensteen) / 2007 Luzern, KM: Fumetto Internat. Comix-Festival. ⊡ *H. Filippini*, Dict. enc. des héros et auteurs de BD, III, Grenoble 2000; *P. Gaumer*, Dict. mondial de la BD, P. 2010. – *T. Groensteen*, La bande dessinée, Toulouse 1996; *V. Bernière*, BA mag.

2003 (231) 40 s.; *D. Hérody*, 9e art. Les cah. du Mus. de la Bande Dessinée 2003 (8) 76–86; *R. Meltz/L. Bianchi*, C. Monogr., Angoulême 2003; *M. Béra u.a.*, Trésors de la bande dessinée. Cat. enc. 2007–2008, P. 2006; 20 Jahre Fumetto, Luzern 2011; L'Œil 2012 (648) 168–170 (Interview). – *Online:* Bedetheque; Lambiek Comiclopedia; Website C.																							H. Kronthaler

Creed, *John*, brit. Metallgestalter, Silberschmied, * 1938 Heswall/Cheshire, lebt in Glasgow. Vater von Martin C. Stud.: 1955–59, '62–63 SchA, Liverpool (heute Liverpool John Moores Univ.); 1961–62 College of Art, Sheffield (heute Sheffield Hallam Univ.). 1959–60 Ausb. in der Wkst. des Silberschmieds Francis J. Cooper, Kent; 1988 Mitarb. in der Wkst. von Albert Paley, Rochester/ N. Y. Im gleichen Jahr Gründung einer eig. Schmiede-Wkst. in Milton of Campsie/Dunbartonshire. Lehrtätigkeit: M. der 1960er Jahre College of Art, Wakefield/West Yorks.; 1971–95 SchA, Glasgow. Seit 1981 regelmäßige Teilnahme an Gruppen-Ausst. der Scottish Gall., Edinburgh. Ausz.: u.a. 1994 Stip. des Scottish Arts Council; 2000 Inches Carr Craft Award, Inches Carr Trust, beide ebd. – Vorrangig Gebrauchs- und Einrichtungsgegenstände in Silber, später auch in Komb. mit Stahl, wie Besteck, Schmuckdosen, Vasen, Kleider-, Hut- und Notenständer, häufig in unkonventioneller, künstlerischer Formgebung. Daneben abstrakte Skulpt. hauptsächl. aus Stahl, auch mon. Obj. im öff. Raum, u.a. mit kreisförmigen, geschwungenen und gewölbten Elementen, z.B. das Paar dekorativer Trennwände *Acceleration* (Cortenstahl, Edelstahl, 2005) auf dem Old Town Hall Square, Gateshead/ Tyne & Wear. Des weiteren archit. Gest. der Innen- und Außenbereiche von Gebäuden (z.T. in Zusammenarbeit mit and. Künstlern), wie Tore, Geländer und Beschilderungen, meist in Stahl, u.a. 2006 für das Gebäude der Kelvingrove AG and Mus., Glasgow, Eingangstore aus Edelstahl und Handläufe für die Innentreppen aus Edel- und Weichstahl, versehen mit skulpturalen Objekten. Außerdem liturgische Geräte, u.a. 2003 Abendmahlskelche und Patenen in Silber und Bronze für die Pfarrk. in Cardross/Argyll & Bute. ⌷ BIRMINGHAM, Mus. and AG. EDINBURGH, Bute House. – NM of Scotland. – Scottish Crafts Coll. LONDON, Crafts Council Coll. ◉ *E:* 1999 Glasgow, Roger Billcliffe Gall. / 2008 Wakefield, AG. – *G:* 1960 Birkenhead (Ches.), Williamson AG: Silverware / 1968 Bradford/West Yorks., Univ. of Bradford: Silverware / London: 1975 (Loot; K), '88 (Hallmark) Goldsmiths' Hall; 1993 Crafts Council: 20th C. Silver; 2000 (A Feast of Silver), '08 (Wish List) Contemp. Applied Arts; 2001 Lesley Craze Gall.: Spoons Big and Small; 2007 V & A: Silver of the Stars (Wander-Ausst.; K) / 1986 Hanau, Dt. Goldschmiedehaus: Europ. Silber-Trienn. (Wander-Ausst.; K) / Glasgow: 1990 Mitchell Libr.: Church Art Today; Kelvingrove AG and Mus.: Carousel; '93 People's Palace: Making Glasgow's Future; 2011 SchA: Forty Years in the Tower / 1991 Lincoln, Usher Gall.: Forging Links / 1991 (Riveting Metalwork), '97 (Room with a View) Liverpool, Bluecoat Display Centre / 1992 Edinburgh, Rias Gall.: Arts and Crafts in Archit. / 1997 Aberdeen, AG: Silver from Scot-

land (Wander-Ausst.; K) / 2005 Cambridge (Mass.), Mobilia Gall.: 100% Proof (Wander-Ausst.; K). ⌷ *Buckman* I, 2006. – *G. Dalgleish/H. S. Fothringham*, Silver. Made in Scotland (K), Edinburgh 2008. – *Online:* Website C.
																							J. Niegel

Creed, *Martin*, brit. Konzeptkünstler, Installationskünstler, Maler, Komponist, Musiker, * 1968 Wakefield, lebt in London und Alicudi. Kindheit ab 1971 in Glasgow. Stud.: 1986–90 Slade SchA, London. 2012 Artist in Residence, Chicago, MCA. Ausz.: 2001 Turner Prize. – C. ist beeinflußt von der Fluxus-Bewegung der 1960er Jahre bes. hinsichtlich der Kritik an der Repräsentation von Kunst in Gal. und Museen. Mit subversivem Witz, trockenem Humor und formaler Eleganz geht C. der Frage nach, was Kunst ausmacht. Er befaßt sich v.a. mit dem Ursprung, der Herstellung und dem Begriff von Dingen sowie der Spannung zw. dem Etwas und dem Nichts. Seit 1987 numeriert C. seine Arbeiten ohne lineare Ordnung, die Titel beschreiben häufig exakt das Dargestellte, wie z.B. *A sheet of A4 paper torn up (Work 140)*, 1995–2004; New York, MMA). Er nutzt Mat. wie Papier, Luft, Licht, Texte und gleichermaßen als Musiker und bild. Künstler seit 2000 vermehrt Musik, bes. bei Performances. 1994 gründet er die Band Owada mit zwei Musikern, später eig. Musiklabel wie 2011 Telephone Records. 1995–2000 stellt er in Gal. zeitversetzt schlagende Metronome auf (*Work 180*). *Work No. 200. Half the air in a given space* (Ausst. 1998 Genf, Gal. Analix B & L Polla) ist ein zur Hälfte mit weißen Luftballons gefüllter Raum, eine Installation, die C. wiederholt und zuletzt 2011 im MAC in Vigo unter dem gleichen Titel mit versch. Raumaufteilung und Farben zeigt (*Work 247*). Für einen leeren Raum, in dem alle fünf Sekunden das Licht an- und ausgeht erhält C. 2001 den Turner Prize (*Work No. 227. The lights going on and off*). 2008 durcheilen in der Tate Britain im Rahmen des *Work No. 850* Läufer so schnell sie können und Besuchern ausweichend den Hauptgang entlang und unterbrechen damit alle 30 Sekunden die Erhabenheit des Raumes. Manche Arbeiten bestehen aus Neonleuchtschriften, z.B. 2000 der Slogan *'the whole world+the work=the whole world"* an der Fassade der Tate Britain (*Work No. 232*). Seit ca. 2006 setzt C. auch Video und Fotogr. ein und nimmt nach einer Pause seit Studienzeiten die Malerei wieder auf; er malt vorwiegend geometrische Muster aus breiten Farbstreifen (Acryl/Lw.), z.T. mit Farbenroller großflächig direkt auf eine Gal.-Wand. Im Auftrag der Fruitmarket Gall., Edinburgh, läßt er 2011 die Scotsman Steps, die den Übergang zw. Altstadt und Neustadt bilden, mit 104 versch. Marmorarten aus aller Welt neu gestalten (*Work No. 1059*, City of Edinburgh Council). Anläßlich der Eröffnung der Olympischen Spiele in London am 27. 7. 2012 läuten um 8. 12 Uhr von C. initiiert alle möglichen Glocken in Großbritannien drei Minuten lang so schnell und laut als möglich (*Work No. 1197: All the bells in the country rung as quickly and as loudly as possible for three minutes*; Auftragsarbeit). – C. ist ein bed. zeitgen. Konzeptkünstler, der sich als Komponist versteht und die Interpretation den Betrachtern, Kuratoren und Technikern über-

läßt. 🔲 BERN, KH. BRISBANE, Queensland AG. BUS-
CA, Coll. La Gaia. DUNKERQUE, FRAC Nord-pas-de Ca-
lais. EDINBURGH, Scottish NG of Mod. Art. EINDHOVEN,
Van Abbe-Mus. KLEVE, Mus. Kurhaus. LIVERPOOL, Tate.
LONDON, Brit. Council. – Contemp. Art Coll. – Govt. Art
Coll. – Portico, Clapton Girls' Acad. – Southbank Cent-
re. – Tate. – V & A. – Zabludowicz Coll. MONTPELLIER,
FRAC Languedoc-Roussillon. MÖNCHENGLADBACH, StM
Abteiberg. NEW YORK, MMA. OOSTENDE, Vanmoerker-
ke Coll. PARIS, FNAC. – Kadist Art Found. – MNAM.
STRASSBURG, MAMC. SOUTHAMPTON, City AG. STUTT-
GART, KM. TURIN, GAM. VANCOUVER, Rennie Coll. WAL-
SALL, New AG. WARSCHAU, CSW. 👁 E: London: 1994
Cubitt Gall. und Marc Jancou; 1995 Camden AC; Javier
Lopez; 1997 Victoria Miro Gall.; 1999 Cabinet. Gall.;
2000, '08, '09 Tate Britain (K); 2004, '10, '11 Hauser and
Wirth; 2006 Tate Modern / 1995, '97 Mailand, Gall. Paolo
Vitolo / Genf: 1995 Gal. Analix; 1998 Gal. Analix B & L
Polla / 1997 Rom, Brit. School / 1999 Turin, Alberto Peo-
la Arte Contemp.; Los Angeles, Marc Foxx Gall. / 2000
Southampton, City AG (K) / 2000, '03 Bern, KH (K) /
Liverpool: 2000, Bluecoat Gall.; 2012 Tate / 2001, '05
München, Gal. Rüdiger Schöttle / New York: 2002 Wrong
Gall.; 2003, '05, '10 Gavin Brown's enterprise / 2004,
'06, '11 Berlin, Johnen Gal. / 2004 Warschau, CSW (K) /
2005 Sheffield, Graves AG; Eindhoven, Van Abbe. Mus. /
2005, '08 Birmingham, Ikon Gall. / 2006, '07, '09 Zü-
rich, Häuser und Wirth / 2008 Manchester, Ikon Gall.
(K) / 2009 Hiroshima, City MCA (K) / 2010 Edinburgh,
Fruitmarket Gall. (K) / 2011 Madrid, Cosas Sala Alcalá;
Nizza, MAMC; Truro, Tardis House / 2012 Landskro-
na, Conceptual AC; Chicago, MCA. 🔲 Delarge, 2001;
Buckman I, 2006. – S. Kyriacou, Art monthly 208:1997,
24 s.; C. Pichler (Ed.), Crossings. Kunst zum Hören
und Sehen (K KH Wien), Ostfildern 1998; I. MacMil-
lan, Mod. painters 13:2000 (1) 42–45; L. Buck, Artforum
38:2000 (Febr.) 110 s.; A. Coles, AiA 88:2000 (11) 176;
Turner prize 2011 (K), Lo. 2001; K. Thorne, C mag.
(Tor.) 73:2002, 38–40; E. Schmitz, Kunstforum internat.
158:2002 (Jan.-März) 380–382; S. Nairne, Art now. Inter-
views with mod. artists, Lo. 2003; S. O'Reilly, Art monthly
281:2004 (Nov.) 34 s.; F. Bonami, Tate etc. 15:2005 (Früh-
jahr) 30–37; M. Cattelan, Flash art 38:2005 (Mai/Juni) 110
s.; A. Coles, Frieze 89:2005 (März) 130 s.; U. Grose-
nick/B. Riemschneider (Ed.), Art now. 81 artists at the
rise of the new millennium, Köln u.a. 2005; M. E. Ve-
trocq, AiA 94:2006 (8) 146–149; L. Bruni, Arte e Cri-
tica 45:2006 (Jan.-März) 54 s.; J. Slyce, Contemporary
89:2006, 48–51; J. Bardt, Kunst aus Papier. Zur Ikono-
gr. eines plast. Werkmaterials der zeitgen. Kunst, Hildes-
heim u.a. 2006; A. Coulson, ArtRev 4:2006 (Okt.) 162;
T. Stott, ibid. 17:2007 (Dez.) 143; J. Collins, Sculpt. to-
day, Lo./N. Y. 2007; J. Slyce, Flash art 40:2007 (256) 125
s.; T. Pearson, Mod. painters 19:2007 (7) 98; N. Serota,
The Turner prize and Brit. art, Lo. 2007; J. Avigokos, Art-
forum 46:2007 (2) 368 s.; Frieze 122:2009 (April) 128;
J. Clegg, ArtRev 44:2010 (Okt.) 145; N. Conibere, Dance
theatre j. 23:2010 (4) 47–51; M. Cashdan, Mod. painters

22:2010 (2) 16–19; M. Gioni, M. C. Works, Lo. 2010;
Apollo 173:2011 (März) 126–130; J. White, Flash art
44:2011 (277) 125; D. Hughes, Sculpture j. (Liverpool)
20:2011 (1) 101–103; C. Richmond/W. Chang (Ed.), M. C.,
Vancouver 2011. – Online: Website C. H. Stuchtey

Creischer, *Alice,* dt. Malerin, Installations- und Anima-
tionskünstlerin, Autorin, Kuratorin, * 1960 Gerolstein (oft
auch Santa Fé in den USA bzw. Argentinien gen.), lebt
und arbeitet in Berlin und Buenos Aires. Stud. in Düssel-
dorf: Univ. (Phil., Lit.); KA (bild. Kunst, 1987–88 Meis-
terschülerin von Fritz Schwegler). 1997–98 Gast-Prof. an
der KA in München. 2002 kuratiert sie zus. mit Andreas
Siekmann die Ausst. Violence on the Margin of All Things
in der Wiener Generali Foundation. 2006 erhält sie den
Edvard-Munch-Preis, worauf sie 2007 zur Teiln. an der do-
cumenta 12 eingeladen wird. – C. beschäftigt sich in ih-
ren (oft in Kooperationen mit and. erstellten) Arbeiten v.a.
mit Themen wie Wirtschaft und Geld, Macht und Macht-
losigkeit sowie Armut und Reichtum, die nach dem Mau-
erfall 1989 wieder allgemein mehr Aufmerksamkeit ge-
funden haben. Ein Schwerpunkt liegt auf ungenutzten Al-
ternativen in Umbruchzeiten, wie der Nachkriegssituation
oder der Wiedervereinigung. Die multimediale Installation
Mach doch heute Lobby (1998–2007) für die documenta
2007 analysierte auf der Grundlage von Zchngn, Collagen,
Drucken, Fotogr., Hörstücken und Mat.-Experimenten im
Posterformat politisch fragwürdige Kontinuitäten in der dt.
Wirtschaft. Im selben Rahmen präsentiert sie in Kassel am
2., 3. und 4. Juli in der Shopping Mall am Königsplatz ge-
meinsam mit A. Siekmann sowie dem Komponisten und
Dirigenten Christian von Borries *Auf einmal & gleichzei-
tig. Eine Machbarkeitsstudie.* Dabei wurde unter Betei-
ligung des Landesjugendsinfonieorchesters in fünf musi-
kalischen Szenen der heutige Arbeitsbegriff kritisch be-
leuchtet. Ferner setzt sich C. auch auf einer theoretischen
Ebene mit Kunstfragen auseinander, wie ihre Beitr. in den
Zss. Texte zur Kunst (u.a. Nr 80, Dez. 2010), springerin
und ANYP zeigen. 👁 E: 2001 Wien, Secession / 2005
Bremen, Ges. für aktuelle Kunst (GAK) / 2008 Barcelo-
na, MAC / 2009 Madrid, CARS / 2012 Berlin, Gal. Kow.
🔲 R. Noack/R. M. Buergel (Ed.), Die Regierung. Para-
diesische Handlungsräume (K), W. 2005; Kunstforum in-
ternat. 187:2007 (Aug./Sept.) 138, 360, 426 s.; Documen-
ta Kassel 16/06–23/09 2007 12 (K), Köln 2007. – On-
line: E. Bippus, Zu den Textproduktionen von A. C., 2005
(Kunstaspekte). M. Scholz-Hänsel

Crelier, *Romain,* schweiz. Bildhauer, Graphiker, Zeich-
ner, Installationskünstler, * 15. 8. 1962 Porrentruy, lebt in
Chevenez/Jura. Stud.: 1986/87 Ec. cantonale des BA, Si-
on; 1987–90 Schule für Gest., Basel, bei Johannes Bur-
la und Jürg Stäuble. 1991/92 mit Stip. Aufenthalt in Pa-
ris, Cité internat. des Arts, Atelier des Kt. Jura. 2005 auf
Initiative C.s und seiner Ehefrau Patricia C. Gründung
des Buchverlags Les Ed. du Goudron et des Plumes, dem
C. sein Graphikatelier zur Verfügung stellt. Mitgl.: seit
1994 Soc. des Peintres, Sculpteurs et Architectes suisses
(SPSAS; heute Visarte), Sektion Jura. Ausz.: 1989 Ideen-
preis, Kunstkredit Basel-Stadt; 1997 Preis der Fond. Jo-

seph et Nicole Lachat. – Von Schwarz- und Grautönen dominierte, minimalistisch-strenge Arbeiten, mit denen C. nach Anregung von Stäuble seit A. der 1990er Jahre gezielt den Dialog mit der Archit, zunächst. im konkreten Rahmen abbruchreifer Bauwerke, sucht. Die Bezugnahme auf Archit. wird zum Grundprinzip seiner Tätigkeit, später kommen Möbel in Form von „Betonsesseln" dazu, mit dem sich aufgrund des als Mat. verwendeten Rohbetons der Kreis zur Archit. wieder schließt. Aus verdichtet angeordneten Bleistift-Zchngn mit formal vereinfachten monochromen Motiven fertigt C. Installationen, die sich voluminös im Raum ausbreiten. Bei druck-graph. Arbeiten (Rad., Aquatinta, Heliogravüre) experimentiert er v.a. mit Schwarz- und Weißwerten. CEL DELEMONT, FHS Westschweiz HES-SO, Verwaltungsgebäude: Unplusunégaltrois, Parallelepiped, Beton, 2005. MOUTIER, Mus. jurassien des Arts. ◉ E: 1991 Grandgourt (Jura), ehem. Priorat / 2002 Chevenez, Gal. Courant d'Art. CED BLSK I, 1998. – V. Reymond/M. Rampini, R. C. (K Mus. jurassien des Arts), Moutier 2005. – Online: SIKART Lex. und Datenbank. R. Treydel

Cremaschi, *Carlo,* ital. Bildhauer, Maler, Performancekünstler, * 7. 12. 1943 Modena, dort tätig. Stud.: Ist. Superiore d'arte Adolfo Venturi, Modena; ABA, Bologna. – C. geht von experimentellen Thematiken aus und schafft bis zu seiner Teiln. an der Bienn. in Venedig 1972 v.a. Skulpt. und Installationen. Für Venedig entsteht gemeinsam mit Giuliano Della Casa, mit dem er weitere Installationen, Filme und Ausst. realisiert, ein Buchprojekt (Ed. Geiger). Danach widmet sich C. verstärkt der Erprobung trad. Malereitechniken und ihrer neuen expressiven Anwendung. Er verwendet dafür z.B. Sand, Erden, Zement und versch. Klebstoffe, die er mit Farbe vermengt und anschließend pastos aufträgt. Seine Gem. (Mischtechnik/ Lw., Mischtechnik und Kohle/Papier) weisen eine kühle, graublaue Farbigkeit auf. Zu den sich wiederholenden Motiven, die in überraschenden räumlichen Zusammenhängen gruppiert werden, zählen Bretter oder Ablagen etwa für einen Sack Mehl oder eine Muschel sowie in den Hintergründen von der Zeit angegriffene Mauern. C. verwendet außerdem meist einzelne blockhafte, stark vereinfachte Figuren, die ohne individuelle Charakteristika, dafür teilw. mit karikaturhaften Zügen versehen sind. Seine enigmatischen, mit wenigen Strichen gez. oder mit farbigen Flächen gemalten Figuren verharren statisch im einfarbig gegebenen Raum und verweisen auf die Verlassenheit des mod. Menschen. In *Segno* (2006) trägt eine in ihren kubischen Volumen nur angedeutete, weit ausschreitende, in schwarz gez. Figur ein leuchtend blaues Bildfeld mit roten Chiffren, das den gesamten oberen Bereich des Papiers in großen Pinselschwüngen abdeckt; das Bl. evoziert Assoziationen an die griechische Figur des Atlas. C. fertigt auch Zchngn, so die großformatige Wand-Zchng *Lenz Rifrazioni* (1993) für die Veranstaltung Musique in Parma. 1999 entwirft er das Bühnenbild für das Ballett Lettera A (Choreographie: Teri Weikel; Teatro S. Leonardo in Bologna). Ein Jahr später erneute Zusammenarbeit mit Weikel während des internat. Tanzfestivals in Bologna bei einer von

Italo Calvinos Roman Le città invisibili inspirierten Performance mit Carlo Sabbadini. 2003 gibt C. mit Andrea Sessa eine weitere Performance (Lavagna) während des Festival della filosofia im Pal. dei Musei in Modena. Gemeinsam mit Claudio Parmiggiani führt C. die Gall. Alpha ebd. CEL CENTO, GAM Arnoldo Bonzagni. ◉ E: Modena: 1966 Pal. dei Musei; 1981 Palazzina dei Giardini; 1985 Gall. Rossana Ferri (K); 2006, '08 (mit Anke Feuchtenberger, Simone Pellegrini) GAM D406; 2008 West Village Gall.; MCiv. di Storia e Arte Medievale e Mod. (K) / 1972 Ferrara, Pal. dei Diamanti (K) / 2010 Rovereto, Gall. Transarte. – G: 1967 Paris: Bienn. elementarer Poesie / 2004 Ravenna, Gall. Ninapi': Matinée / Modena: 2004 Pal. S. Margherita: Arte in città; 2006 GAM D406: Il lavoro del mito; Gall. 42 contemp.: Bau Bau; 2007 Laboratorio d'arte graf.: I 130 anni del Laboratorio / 2009 Sovramonte, Gall. Lab 610 XL: Degli uomini selvaggi e d'altre forasticherie. CED PittItalNovec/3, 1994; M. Agnellini (Ed.), Emilia-Romagna. Artisti e opere dall'Ottocento a oggi, Mi. 1995; A. Barbieri, A regola d'arte, Md. 2008.
 C. Melzer

Crémière, *Léon* (Pseud. Lazare), frz. Fotograf, * 1831, † 1913(?) C. lernt das fotogr. Handwerk bei André-Adolphe-Eugène Disdéri und eröffnet 1861 gemeinsam mit *Erwin Hanfstaengl* (1838–1904), dem Sohn von Franz Hanfstaengl, in Paris sein erstes Atelier (Crémière & Hanfstaengl). 1861–64 Mitgl. der Soc. franç. de Photographie. Hoffotograf von Napoleon III. 1871 beendet C. seine fotogr. Tätigkeit. In den 1860er Jahren arbeitet er auch als Verleger und gibt u.a. die Zss. Le Centaure (1866) und Le Petit Sportsman (1868) sowie Snob à Paris (1866) und Snob à l'Exposition (1867) des Karikaturisten Crafty heraus. – C. spezialisiert sich auf Tier-Fotogr., insbesondere Aufnahmen von Jagdhunden und Rennpferden im Auftrag des Kaisers Napoleon III. und and. Aristokraten und Großbürger des Zweiten Kaiserreichs, was ihm den Beinamen „le roi de la photogr. canine" einbringt; u.a. dokumentiert er zahlr. Treibjagden des Kaisers (u.a. veröff. in dem Album *La Vénerie franç. à l'exposition de 1865*, P. 1865). Darüber hinaus fertigt er Porträtaufnahmen, u.a. von Soldaten der kaiserlichen Armee (veröff. in: *Album militaire de l'Empereur*, 1861, mit E. Hanfstaeengl). CEL BOSTON, MFA. LONDON, V & A. LOS ANGELES/Calif., J. Paul Getty Mus. NEW YORK, Metrop. Mus. PARIS, BN. – Orsay. ◉ G: 1861 Marseille: Soc. Photogr. / Paris: 1861–65 Soc. franç. de Photogr.; 1986 BN: Le Corps et son image (K) / 1862 London (ehrenvolle Erw.) / 2000 Ithaca (N. Y.), Cornell Univ., Herbert F. Johnson Mus. of Art: One Man's Eye. Photographs from the Alan Siegel Coll. (Begleit-Publ.) / 2003 Stanford (Calif.), Iris & B. Gerald Cantor Center for Visual Arts: Time Stands Still. Muybridge and the Instantaneous Photogr. Movement (Wander-Ausst.; K) / 2010–11 Evian, Pal. Lumiére: Le bestiaire imaginaire. L'animal dans la photographie. De 1850 à nos jours (K). CED Auer, 1985; Dict. mondial de la photogr., P. 1994; J. Hannavy (Ed.), Enc. of nineteenth-c. photogr., I, N. Y./Lo. 2008. – J. Lattes, Sport-Photogr. 1860–1960, Luzern/Ffm. 1970 (Bibl. der Photogr., 10);

K. *Jacobson*/A. J. *Hamber*, Etude d'après nature. 19th c. photographs in relation to art, Petches Bridge 1996; *S. Aubenas* (Ed.), Portr., visages. 1853–2003 (K), P. 2003; *A.-M. de Brem u.a.*, Le monde de George Sand, P. 2003; *S. J. Foster u.a.* (Ed.), Imagining paradise. The Richard and Ronay Menschel Libr. at George Eastman House, Göttingen 2007. 　　　　　　　　　　　　　　　P. Freytag

Creo, *Leonard E.*, US-amer.-brit. Maler, Bildhauer, * 20. 1. 1923 New York, lebt in Ross-on-Wye/Hereford and Worcester. Stud.: nach 1945 Art Students League, New York; anschl. drei Jahre in Mexiko-Stadt u.a. bei David Alfaro Siqueiros (mit ihm in den 1950er Jahren Ausf. von Wand-Gem.); A. der 1950er Jahre bei Pietro Annigoni in Rom. C. hat als Geher auch eine erfolgreiche sportliche Laufbahn absolviert. – Ölbilder und Monotypien mit Genreszenen (v.a. Tanz, Musik, Spiel u.a. Vergnügungen), auch Portr., Lsch. und Archit.-Ansichten in reduzierter Farbgebung, mitunter mit einem Hang zur naiven Manier. Außerdem figürliche Bronzeskulpturen. 　▥ AMHERST/Mass., Amherst College, Mead AM. ATHENS, Univ. of Georgia Mus. of Art. HAGERSTOWN/Md., Washington County MFA. LARAMIE, Univ. of Wyoming AM. LONG BEACH/Calif., Mus. of Art. MINNEAPOLIS/Minn., Frederick R. Weisman AM. NEW BRITAIN/Conn., Mus. of Amer. Art. NEW LONDON/Conn., Lyman Allyn AM. NEW YORK, Univ. of New York. NORFOLK/Va., Chrysler Mus. of Art. ORONO, Univ. of Maine AM. SYRACUSE/N. Y., Univ. Art Coll. WICHITA/Kan., Wichita State Univ., Edwin A. Ulrich Mus. of Art. 　◉ *E:* New York: 1958–63 Chase Gall.; zw. 1965 und '75 ACA Gall. / Rom: 1954–56 Gall. Margutta; 1966, '68, '70 ACA Gall. / zw. 1959 und '76 Los Angeles, Carter Gall. / zw. 1964 und '79 London, Portal Gall. / 1981–82, '85, '89, '91–2005, '07 Montreal, Shayne Gall. 　▢ *Falk* I, 1999. – Washington, D. C., SI, Arch. of Amer. Art. – *Online:* Shayne Gall.; Essex FA Gall.; Centurion Vereniging Nederland. 　　　　　C. Rohrschneider

Cres, *Claus* (eigtl. Cres-Schmid, *Klaus*), dt. Maler, Graphiker, Bildhauer, Sänger, * 4. 10. 1938 München, lebt in Ammerland/Starnberger See. Als bild. Künstler Autodidakt. 1957–70 Musik-Stud. (mit Unterbrechungen) in Detmold und New York. Nach Beendigung der aktiven Sängerlaufbahn wendet sich C. der Malerei zu. – Das heterogene Œuvre umfaßt gegenstandbezogene Ölmalereien in versch. Stilen sowie großflächige, farbintensive Collagen. Neben Portr., Figurenbildern und (semi-)abstrakten Komp. auch (Stadt.)Lsch. u.a. in pointillistischer Manier. Auch bildhauerische Arbeiten. 　▥ KOPENHAGEN, Coll. Krestensen. MÜNCHEN, SM. 　◉ *E:* München: 1970, '74 Gal. Franke; 1976 Fa. Messerschmidt-Bölkow-Blohm; Gal. Hanfstaengl; 1977 Gal. Schöninger. – *G:* München: 1977 Haus der Kunst: Große Kunst-Ausst.; 2010 Gal. der Künstler (BBK). 　▢ *Gorenflo* I, 1988; Kürschners Hb. der Bild. Künstler. Deutschland, Österreich, Schweiz, I, M./L. 2007 (Lit., Ausst.). – *S. Beyer u.a.*, C. C. Die Malerjahre, M. 2008. 　　　　　　　U. Heise

Crespo (C. *García*), *Ana*, span. Malerin, Fotografin, Installations- und Videokünstlerin, Bildhauerin, * 5. 4. 1964 Madrid, lebt in Talavera de la Reina/Toledo. Stud.:

1982–87 Malerei an der Fac. de BA der Univ. Complutense, Madrid; 1993–2004 Fac. de BA der Univ. Castilla-La Mancha, Cuenca. Ausb. in Dramaturgie und Tanz. Seit 1988 Prof. an der Esc. de Artes y Oficios in Mahón/Menorca, Soria und Talavera de la Reina. – C.s Kunst ist von Zen-Buddhismus, Sufi-Mystik, Alchimie und and. transzendentalen Lehren beeinflußt und bedient sich versch., aufeinander abgestimmter Techniken, Gegenstände, Formen und Farben, die in symbolisch-magischer Form eingesetzt werden. C.s Ausst. gleichen Installationen. In *¡Luz, más luz!* (2001) bezieht sich C. z.B. auf den Mystiker Muhjiddin Ibn Arabi (1165–1240) aus Murcia und schafft Räume der Kontemplation, die Pilgerwegstationen ähneln. Sie zeigen u.a. Mat.-Collagen, künstlerisch präparierte Alltagsobjekte, inszenierte Fotos und zweifarbige Kissen auf dem Boden zum Ausruhen und Meditieren. Technisch und ästhetisch ähnliche Serien enthalten die Ausst. *Alquimia* (1997) und *Rituales de sanación* (2000) mit zeichenhaft-abstrakten Bildern in Mischtechnik sowie *En el corazón del rubí* (2008), eine Hommage an die Komponistin María Escribano, mit Fotos auf Aluminium, die jeweils ein zusammengeknülltes weißes Papier mit einem roten Punkt zeigen. Es geht um die mystische Vereinigung von Rot und Weiß, rotem König und weißer Königin, Rubin und Perle, Feuer und Wasser. Das Projekt *Los cuatro pájaros del árbol del universo* (2009–10) ist eine Tetralogie und beschäftigt sich in versch. Mat. mit der Kombination der Emblemfarben Rot, Weiß, Grün und Schwarz. 　▥ CÁDIZ, Fund. Rafael Alberti. HAVANNA, BN. MADRID, BN. – Mus. de la Ciudad. MARBELLA, Mus. del Grabado Esp. Contemp. NEW YORK, The Center for Bookarts. PUNTA UMBRÍA, Stadtverwaltung. SANTIAGO DE COMPOSTELA, Fund. Eugenio Granell. SOPUERTA/Vizcaya, Mus. de las Encartaciones. TOLEDO, Prov.-Verwaltung. TURIN, GAM. VALENCIA, IVAM. VITORIA, Artium. 　▣ La realidad y la mirada. El zen en el arte contemp., Ma. 1997; Los bellos colores del corazón. Color y sufismo, I. Pistas para un itinerio sagrado, Ma. 2008 (Überarbeitung von C.s Diss. 2004). 　◉ *E:* 1994 Soria, Pal. de los Castejones / Madrid: 1997 Gal. Carmen de la Guerra (K: C.); 2000 (K: C./M. Escribano), '09 Gal. Astarté; 2002 Gal. Arteara / Palma de Mallorca: 1999, 2001 Gal. Antonio Camba; 2004 (K: R. Blecua u.a.), '10 ABA Art Contemp. / 2001 Toledo, MAC (K: P. Beneito) / 2008 Kairo, Pal. de Amir Tas. – *G:* 1987 Toulouse: Bienn. des Ec. d'Arts d'Europe / 1989 Sydney: Australien Video Festival / 2000 Turin: Bienn. Arte Emergente / 2010 Recife (Pernambuco), Santander Cult.: Novos mundos novos (K: G. Habib de Oliveira u.a.). 　▢ DPEE, Ap., 2002. – *C. Pallarés*, ABC Cult. (Ma.) v. 24. 6. 2000; *P. Ribal*, El Cultural, Supl. de El Mundo (Ma.) v. 27. 1. 2005; *V. Zarza*, ABC de las Artes y las Letras (Ma.) v. 12.–18. 12. 2009. – *Online:* Gal. Astarté, Madrid. – Mitt. C. 　　　　　M. Nungesser

Crestou, *Nicole*, frz. Bildhauerin, Installationskünstlerin, Keramikerin, * 26. 4. 1957 Vierzon/Cher, lebt in La Borne. Ausb./Stud. 1979–80 EcBA, Bourges, u.a. Keramik im Atelier Lerat (1986 Dipl.), 1988 Rakutechnik bei Elisabeth Meunier, 1991 Emailltechnik bei H. Klug; 1986–88

Stud. der Kunstgesch. an der Univ. Panthéon-Sorbonne, Paris, 1992 Promotion. 1988–96 in der Museumspädagogik in Paris tätig, seit 1989 regelmäßig Veröff. in der Zs. Rev. de la céramique et du verre. Parallel arbeitet C. an Gebrauchskeramik, an keramischen Objekten, meist in Terrakotta mit farbigem Glasurüberzug, und an Installationen. Bevorzugte Themen sind der menschliche Körper und Tierfiguren. ⊕ *E:* 1986 Vierzon, Maison de l'habitant (Debüt) / 2000 Coulanges, Maison du Coulangeois / 2009 Paris, Gal. Vitoux. – *G:* 2002 Paris, Gal. Lélia Mordoch: Le Corps et ses métaphores. ⌷ *Bénézit* IV, 1999; *Delarge*, 2001. – *R. Deblander,* Rev. de la céramique et du verre 90:1996, 53. – *Online:* Céramiques contemp. franç., 1955–2005. Coll. du MN de Céramique, Sèvres, 2008.

K. Schütter

Creten, *Johan,* belg. Bildhauer, Keramiker, * 25. 7. 1963 Sint-Truiden, seit 1991 in Frankreich ansässig, lebt in Paris. Stud.: 1982–86 Koninkl. ASK, Gent (Malerei); 1986–88 ENSBA, Paris (Bildhauerei); anschl. bis 1991 Rijks-Akad., Amsterdam. Artist in Residence, u.a.: 1986 Cité internat. des Arts, Paris; 1991 Villa Saint Clair, Sète (Ausst.-Kat.); 1993 Ec. nat. supérieure d'Art (Villa Arson), Nizza; 1994, 2008 Europ. Keramisch Werkcentrum (EKWC), 's-Hertogenbosch; 1996–97 Villa Medici, Rom; 2004–07 Man. nat. de Sèvres. Lehrtätigkeit (Gast-Doz.), u.a.: 2000 Arizona State Univ., Tempe; 2001 Alfred Univ., New York; 2006–07 Ec. régionale des BA, Rouen. In Paris betreibt C. eine Wkst. mit mehreren Mitarbeitern. – C. fertigt Keramiken sowie Bronzeplastiken in abstrahierten Formen, die v.a. die Konturen des weiblichen Körpers aufnehmen, weiterhin Darst. von Pflanzen, Tieren (v.a. Vögel und Meeresgetier, z.B. *Octo,* Bronze, 2001; *Oiseau, Guantanamo,* glasierte Keramik, 2011) u.a. Naturgebilden wie z.B. Wellen (z.B. *Vague moyenne pour Palissy,* glasierte Keramik, 2008–10); z.T. mon. Arbeiten (z.B. *Pliny's Sorrow,* Wachs, Bronzeimitat, 2011). Im Frühwerk auch Installationen mit keramischen Objekten und Objets trouvés. Seit 1999 entstehen Bronzeplastiken im Wachsausschmelzverfahren (z.B. *Why does Strange Fruit always look so Sweet?*). Die oft durch Deformation verfremdeten Figuren mit wachsähnlich zerfließenden Strukturen erinnern bisweilen an barocke Sandstein-Skulpt., deren Konturen unter Witterungseinfluß undeutlich geworden sind. C.s Orientierung am Formenrepertoire von Renaiss., Manierismus und Barock wird bes. in den mit zahlr. Blättern, Blüten und kugelartigen Elementen besetzten Plastiken deutlich (z.B. *Camélia,* Porzellan, 2007; *Odore di Femmina: The Changing Light,* patinierte Bronze, 2010). Weitere figürliche Werke sind die in Muscheln eingeschlossene Köpfe der Serie *La Perle Noire* von 2007. Die Keramiken werden meist farbig glasiert, die Bronzeplastiken z.T. patiniert oder partiell vergoldet. ⌂ CARQUEFOU, FRAC Pays de la Loire. CLERMONT-FERRAND, FRAC Auvergne. LEEUWARDEN, Keramiek-Mus. Princessehof. MAGDEBURG, KM Kloster Unser Lieben Frauen. MIAMI BEACH/ Fla., Bass Mus. of Art. MONTPELLIER, FRAC Languedoc-Roussillon. OOSTENDE, KM aan Zee. ⊕ *E:* Paris: 1987, '88 (K) Gal. Meyer; 1997 MAD; 2008 Mus. de la Chas-

se et de la Nature; 2010 Gal. Emmanuel Perrotin / seit 1990 regelmäßig Mechelen, Gal. Transit / 1995 Sheboygan (Wis.), Kohler AC / 1998 Genf, MAMC / 1998 (K), 2001 New York, Robert Miller Gall. / 2003 Miami Beach (Fla.), Bass Mus. of Art / 2007 Leiden, Sted. Mus. de Lakenhal (K) / 2008 Leeuwarden, Keramiek-Mus. Princessehof / 2011 Brüssel, Almine Rech Gall. (K). – *G:* 1990 Frechen, Keramion: Zeitgen. Keramik aus Nordrhein-Westfalen, Belgien, Luxemburg und der Niederlande / Paris: 1995 Centre Pompidou: Fémininmasculin; 1997 MAD: Retour d'Italie; 2005 Louvre: Contrepoint 2; 2012 Grand Pal.: Beauté animale, de Dürer à Jeff Koons / 1997 Istanbul: Internat. Istanbul Bienn. / 2003 Reims, MBA: Fragile / 2006 Rouen, MBA: Céramique Fiction / 2008 Arles, Mus. Réattu: Christian Lacroix / 2011 London, Timothy Taylor Gall.: Archetypes. ⌷ *L. Rademakers,* Neue Keramik 1990 (6) 361; *U. J. Gellner,* Ton (K Hundisburg), Staßfurt 2000; *N. Viot/C. Pontbriand,* J. C. Sculpt. Man. nat. de Sèvres, P. 2008.

F. Krohn

Crétot-Duval, *Raymond,* frz. Maler, * 1895 Menton, † 1986 Bordeaux. Aufgewachsen auf Madagaskar, Mauritius, La Réunion, in Indochina und im Senegal. Freiwilliger im 1. WK. Ab 1918 künstlerisch tätig; arbeitet u.a. mit Glasarbeiten und Dekorationsmalereien für Theater (Opernhaus in Monte Carlo, Comédie-Franç. in Paris). Lebt auf Korsika, dann in Marseille. Kindheitserinnerungen rufen Fernweh hervor; geht nach Nordafrika, zuerst nach Tunis, ist von der orientalischen Atmosphäre und vom kolonialen Gepräge begeistert. Bereist Algerien, zieht weiter nach Marokko und wird dort ein angesehener Maler der orientalischen Lsch.; unter den hochrangigen Auftraggebern sind frz. Politiker und Offiziere. Läßt sich in den 1960er Jahren in Bordeaux nieder; im Alter erblindet. Mitgl.: Salon des Artistes français. Ausz.: Nicham Iftikar (Tunis); Offizier des Ordens Ouissam Alaouite (Marokko). – Nach Beginn mit in lodernden Farben gemalten lichterfüllten Lsch. und Marinen der Provence (*Port de pêche en Méditerrannée,* sign., Öl/Lw.) und Ansichten von Korsika (*Rue d'Ajaccio*) entdeckt C. seine wahre Berufung in Nordafrika in der Orientmalerei. Er fertigt teils mit Staffage versehene Lsch., Stadt- und Archit.-Ansichten (Öl, Aqu., Gouache), bei denen gleißendes Licht mit sehr dunklen, oft schwarzen Schatten in starkem Kontrast steht, der für Lebendigkeit sorgt, und vielfältige Blau- und warme Gelb- bzw. Sandtöne dominieren. Die Motive stammen aus Marokko (*Le marché de Fez vu des toits,* Aqu.; *Artisan tisseur dans un souk marocain,* um 1930; *Rabat-Salé,* dat. 1938, beide Öl/Lw., sign.) und Algerien, hier v.a. aus Constantine (*Pont de pierre* und *Jardin du Dey*), Algier (*L'Amirauté, au balcon d'El-Biar*) und Meknès (*L'Entrée de Meknès,* Aqu.). Auch Akte und Portr. (*Jeune fille en Afrique,* Öl/ Holz). ⌂ ALGIER, MNBA. BORDEAUX, MBA. CONSTANTINE, MN Cirta. MARSEILLE, Mus. Cantini. NARBONNE, MAH. PARIS, MAH d'Judaïsme. – MAMVP. – MN des Arts africains et océaniens. ⌷ *Camard/Belfort,* 1974; *P. C. Giansily,* Dict. des peintres corses et de la Corse 1800–1950, Ajaccio 1993; *Bénézit* IV, 1999;

E. Cazenave, Les artistes de l'Algérie, P. 2001. –
Online: Artnet; Artprice; Base Joconde. R. Treydel

Creutzfeldt, *Fritz,* dt. Maler, Graphiker, Werklehrer,
Kunsterzieher, * 12. 4. 1907 Berlin, † 3. 4. 1985 Bad Harz-
burg. Stud.: um 1930–32/33 Staatliche Akad. für Kunst
und Kunstgew., Breslau, bei Oskar Schlemmer und Johan-
nes Molzahn. Gehört dort zum engeren Kreis um Paul Holz
(Erinnerungen an Paul Holz, Typoscript 1983; lt. Förs-
ter, 1998, 228). C.s an der Breslauer Akad. entstandene
Schülerarbeit *Farbige Studie* (Tempera, um 1932) wird als
Umschlag-Abb. für die Publ. von P. Hölscher (2003) ge-
wählt. Nach dem Werklehrerexamen in Leipzig, in des-
sen Zusammenhang C. im Jahr 1935 seine Assessorar-
beit „Werkunterricht im Dienst der Kunsterziehung" vor-
legt, ist er als Lehrer und Kunsterzieher tätig. Über weite-
re künstlerische Betätigung bis 1945 ist bisher nichts bek.
geworden. Er publiziert zu kunstpädagogischen Themen
und veröffentlicht nach dem 2. WK in regionalen Jbb. so-
wie in der Zs. Unser Harz mehrere Artikel über regionale
Künstler aus dem westlichen Harz (v.a. aus Goslar), u.a.
über den Bildhauer Walter Volland oder *Wilhelm Engel-
mann* (* 5. 5. 1904 Seesen, † Mai 1980 Goslar) sowie über
den Graphiker und Kunsterzieher *Horst W. König* (* 1944
Lauenstein), der 1984 die Sommer-Akad. in Goslar grün-
dete. In der gen. Zs. für Harzer Heimat-Gesch., Brauchtum
und Natur stammen mehrere Titelbilder von C.s Hand, u.a.
Bad Harzburgs „Bummelallee" im Frühling (Nr 4/1984).
V.a. Lsch., auch Portr. und Stilleben. – Monogr. Bearbei-
tung und WV stehen aus. ⌺ GOSLAR, Goslarer Mus. RE-
GENSBURG, Kunstforum Ost-dt. Gal. ✉ Die Kunst ist gar
nicht heiter! Die Malerin Marie-Luise Bieberstein (in Bad
Harzburg), in: Heimatbuch für den Land-Kr. Wolfenbüt-
tel 16:1970, 78–82; ◉ *E:* 2011 Bad Harzburg, Rathaus-
Gal. (mit Hans-Hubertus Lichter). ⌶ *Schweers,* 2008. –
E. Strassner, Der Künstler F. C., in: Heimatbote des Land-
Kr. Braunschweig, Bg. 1974, 109–113; *id.,* Heimatbuch
für den Land-Kr. Wolfenbüttel 20:1974, 123–127; *S. und
U. Gehrecke,* Der Harz, gesehen von Malern (1850–1950),
Göttingen 1990; *A. Förster,* Paul Holz. Zeichner. Monogr.
zu Leben und Werk, Rostock 1998, 228; *P. Hölscher,* Die
Akad. für Kunst und Kunstgew. zu Breslau, Kiel 2003, 266
(Abb. XIX). U. Heise

Crevoisier, *Hubert,* schweiz. Glaskünstler, * 14. 4. 1963
Lausanne, lebt in La Chaux-de-Fonds. Zunächst Kranken-
pfleger in einer Klinik in Genf, bis die Beschäftigung mit
der Glaskunst zum richtungweisenden Schlüsselerlebnis
wird. 1991 verändert C. sein Leben grundlegend, gibt den
Beruf auf und geht nach Schweden. 1991–93 Ausb. als
Glasbläser an der Glasschule b. Orrefors. Nach mehrjähri-
ger Tätigkeit in Dänemark und Frankreich Rückkehr in die
Schweiz. 1997 Gründung eines eig. Ateliers in La Chaux-
de-Fonds. 2000/01 Weiterbildung an der New York Studio
School of Drawing, Paint. and Sculpture. Ausz.: 1998 Preis
beim Eidgenössischen Wettb. für Design, Schweiz, und
Aufenthalt im Mus.-Atelier du Verre im frz. Sars-Poteries/
Nord; 2001 Stip. der Stiftung Scarsella, der IKEA Stiftung
und des Kultus-Minist. des Kt. Neuchâtel und der Stadt
La Chaux-de-Fonds; 2003 Aufenthalt in der Cité internat.

des Arts, Paris (Atelier Le Corbusier). – C.s Arbeit basiert
auf der Faszination von der klaren Form des zumeist von
einem feinen Fadengespinst umwobenen Kokons, das zu
seinem Markenzeichen wird und ihn internat. bek. macht.
Bereits 2000 wird ein solcher Kokon in der New Yorker
New Glass Rev. 21 als eines der besten Kunstwerke des
Jahres gekürt (für das Mus. of Glass in Corning/N. Y.
einbehalten). Neben der Form inspiriert ihn das Innenle-
ben des Kokons als Quelle für Träume und Nährboden für
die Umsetzung seiner gestalterischen Ideen. Im künstleri-
schen Schaffensprozeß läßt er breiten Raum für Spontani-
tät und Zufall, so daß die fertigen farbigen oder farblosen
länglichen Gebilde überraschende Ergebnisse, neue Iden-
titäten hervorbringen. Nach Beginn mit mundgeblasenen
Objekten arbeitet C. mit einem Wachsausschmelzverfah-
ren, bei dem Glaspaste in eine Brennform gegossen wird.
Die Praxis mit diesen beiden trad. Methoden ermöglicht es
ihm, genau in die inneren Strukturen des Mat. Glas vorzu-
dringen. Vor dem Hintergrund dieses Wissens vollzieht er
ab 2000 in New York einen weiteren wichtigen Entwick-
lungsschritt mit dem Übergang von der handwerklichen
Glaskunst zum Industrieglas. Diese fundamenteale Erfah-
rung verstärkt er dort durch eine experimentelle Arbeit auf
dem Gebiet der konzeptuellen Fotogr. zum Thema Trans-
parenzen, mit dem er sich fortan beschäftigt (Gest. einer
Fotoinstallation). Seit 2004 behandelt er dieses Thema im
Kontext der Einbindung von Glas- in Archit.-Objekte; seit
ca. 2007 arbeitet er an einem „Transparenz gestalten" gen.
ambitionierten Projekt mit dem Ziel der Schaffung großer
begehbarer Zellen, die das Erleben von Licht- und Farbvi-
brationen vom Innenraum aus ermöglichen. C.s Tätigkeit
wird von den Spannungsverhältnissen zw. Glashülle und
Hohlraum, Licht und Schatten, Fülle und Leere bestimmt.
Neben Kokonformen fertigt er gravierte Kugeln, „Wir-
belsäulen" und in monochrome Glasreliefs geschnittene
Schriftzüge. ⌺ COESFELD, Glas-Mus. Herding. EBEL-
TOFT, Glas-Mus. GENF, Mus. Ariana. KÜNZELSAU, Mus.
Würth. NEUCHATEL, Slg des Kt. SARS-POTERIES, Mus. du
Verre. ◉ *E:* 1998 Sars-Poteries, Mus. du Verre / 2001
Delémont, Gal. de la FARB / Paris: 2001 Gal. Sarver;
2004 Cité internat. des Arts / 2002 Sinzheim, Gal. B /
2012 Lausanne, Flon Square Gal. – *G:* 2003 La Chaux-
de-Fonds, MBA: Bienn. (Fotoinstallation). ⌶ *C. Save,*
Verre 10:2004 (2); *C. S. Weber,* Glas der Gegenwart in der
Slg Würth (K), Künzelsau 2007. – *Online:* SIKART Lex.
und Datenbank; Website C. R. Treydel

Criado, *Angel* (C. Ballesteros, *Angel Baltasar*), span.
Bildhauer, * 5. 2. 1955 Madrid, dort tätig. Stud. ebd.: bis
1979 Fac. de BA der Univ. Complutense. 1982/83 Sti-
pendiat an der Acad. Esp. de BA in Rom. Lehrtätigkeit
in Madrid: ab 1986 Esc. de Arte La Palma; 1995–2002
Fac. de BA, Univ. Complutense; seit 2003 Prof. an der
Esc. de Cerámica Franciso Alcántara. Ausz., alle Madrid:
u.a. 1975 Premio Molino Higueras, RABA de S. Fernando;
1977 Stip. beim Concurso Emiliano Barral, Univ. Complu-
tense; 1981 Stip. für junge Künstler, span. Kultus-Minist.;
1993 1. Preis für Bildhauerei, Muestra Cult. del Mundo
Laboral, Unión Gen. de Trabajadores (UGT). – Von der

menschlichen Figur ausgehend, modelliert C. formverein-
fachte, teils auch abstrahierte, in jedem Fall auf das We-
sentliche reduzierte Torsi, Köpfe, einzelne Frauengestal-
ten, Paare und Gruppen, die größtenteils im Cire-perdue-
Verfahren in Bronze gegossen werden. Bes. eindrucksvoll
sind seine in dynamischen, fließenden Beziehungen darge-
stellten Figuren- bzw. Liebespaare, die kraftvoll, aber den-
noch anmutig erscheinen (*Te quiero*, Bronze, 2006). Durch
das geschickte Spiel mit Licht und Volumen entsteht zu-
dem der Eindruck von Leichtigkeit und Harmonie (*Abra-
zo*, Bronze, 2001). Gelegentlich auch Zchng, Malerei, Col-
lage. ⊙ *E:* Madrid: 1980 Univ. Complutense, Fac. de
BA; 1984 Caja Madrid; 1985 Esc. Oficial de Cerámica;
1989 Sala Triángulo; 1990 Gal. La Tour; 2000, '09 Esc. de
Cerámica F. Alcántara; 2002 Esc. de Arte La Palma. – *G:*
1983 Rom, Acad. Esp. de BA: Pensionados Esp. en Italia /
2003, '04, '07 Madrid: ESTAMPA Salón Internac. del Gra-
bado y la Ed. de Arte Contemp. / 2006 Dubai: Index Dubai.
▭ DPEE III, 1994; Dicc. de artistas contemp. de Madrid,
Ma. 1996. – *Online:* Website C. R. Treydel

Cribbs, *Kéké*, US-amer. Glaskünstlerin, * 1951 Colora-
do Springs, lebt in Langley/Wash. Mutter der Glaskünst-
lerin *Alicia Lomne* (s.u.). Lebt ab 1966 in Irland, nach
fünfjähriger Europareise auf Korsika, dann in den USA.
Weitgehend Autodidaktin. 1984, '85, '86 und '91 Kur-
se an der Pilchuck Glass School, North Seattle/Wash. bei
Dan Dailey, Bertil Vallien, Ginny Ruffner, Klaus Moje,
Jiři Harcuba, Clifford Rainey sowie 2001, '02 an der Pen-
land School of Crafts, Penland/N. C. bei Yih-Wen Kuo
und Sergei Isupov. Lehrtätigkeit: 1993 Penland School
of Crafts; 1986–89 Swain School of Design, New Bed-
ford/Mass. Mit Ross Richmond 2010 Artist in Residence,
Mus. of Glass, Tacoma, und Toledo Glass Mus., Ohio.
– C. debütiert 1980 mit sandgestrahlten Phantasiefiguren
und Motiven auf Glastafeln, die sie danach bemalt; ab
1985 setzt sie die Tafeln in aus Holzplatten ausgesägte
große Figuren ein (*Raymondo*, 1988, New York, Corning
Mus.). Seit 1995 schneidet sie mit Emailfarben bemal-
tes Glas in kleine Mosaiksteinchen und dekoriert damit
Skulpt. und Gefäße oder Tafeln aus Keramik, Papierma-
ché, Holz und Fiberglas (bes. häufig Boote: *Sailing to By-
zantium*, 1986; Los Angeles, County Mus. of Art). Sie
kombiniert mehrfach Hinterglasmalerei mit Mosaik und
Goldlüster und kreiert von der Mythologie und versch.
Religionen inspirierte, humorvolle Arbeiten, indem sie
eig. Träume, Erinnerungen und Ideen in eine magische,
eklektische Bildwelt übersetzt (*Raggedy Man Down Un-
der*, 2009). Unter dem Produktnamen Rosskiki arbeitet C.
seit 2009 mit dem Glasbläser Ross Richmond zus. und
entwickelt u.a. einen wäremintensiven Druckproceß auf
Glas (hot printing), bei dem sie das Gefäß in kunstvoll
arrangierten versch.-farbigen Glaspulvern wälzt. C. ist ei-
ne experimentierfreudige, originelle und in den USA bed.
zeitgen. Glaskünstlerin. – *Alicia Lomne* (* 1972 Bastia/
Korsika) besucht Glaskurse an der Pilchuck Glass School.
1990 Lehre bei John Ligget am Richard Marquis Studio,
1991–93 Stud. am California College of Arts and Crafts,
Oakland, anschl. Kurse am Pratt Inst., New York, und

Penland School of Crafts. Sie gestaltet mit Pâte de ver-
re farbintensive Gefäße mit organischen und geometri-
schen Mustern. ▭ ALBUQUERQUE/N. Mex. Mus. CHAR-
LOTTE/N. C., Mint Mus of Art. CORNING/N. Y., Mus. of
Glass. INDIANAPOLIS, Mus. of Art. KANAZAWA, MCA.
LA JOLLA/Calif., James Copley Libr. NEW YORK, MAD.
SAPPORO, Hokkaido MMA. TACOMA, Mus. of Glass. TO-
LEDO/Ohio, Mus. of Art. RACINE/Wis., Charles A. Wu-
stum MFA. SPARTA/N. C., Kamm Teapot Found. ⊙ *E:*
1980 Santa Fe, Dewey Kofron Gall. / 1982 Albuquerque,
Mariposa Gall. / Los Angeles: 1984, '86, '92 Kurland
Summers Gall. / Seattle: 1986 Foster White Gall.; 1995
Grover-Thurston Gall.; 2005 Pacini Lubel; 2011 Traver
Gall. (K) / 1987, '90, '93 Farmington Hills (Mich.), Ha-
batat Gall. / 1990, '94, '95, 2003 Boca Raton (Fla.), Haba-
tat Gall. / 1992 Stockbridge (Mass.), Holsten Gall. / 1993
Palm Beach (Fla.), Helander Gall. / 1995 Pontiac (Mich.),
Habatat Gall. / 1996, '99, 2001, '06 Chicago, Marx Saun-
ders Gall. (K) / 2000, '02, '03, '04, '05 New York, Leo Ka-
plan Mod. / 2012 Ketchum/Ida., Friesen Gall. ▭ Neues
Glas 1995 (3) 38–45; *M. und T. Goodearl*, Engraved glass.
Internat. contemp. artists, Woodbridge 1999; *N. Princen-
thal*, Amer. craft 61:2001 (1) 102 s.; *S. Waggoner*, Glass
art 16:2001 (2) 4–8; *L. Kohler*, Women working in glass,
Atglen, Pa. 2003; *A. Murphy*, Glass 101:2005/06 (Win-
ter) 56 s.; Voices of Contemp. Glass. The Heineman Coll.
(Corning Mus.), N. Y. 2009; Rosskiki. K. C. and Ross
Richmond (K), Toledo, Ohio 2010. – *Online:* Website Ha-
batat Gall. H. Stuchtey

Criegern, *Axel von*, dt. Maler, Zeichner, Illustrator,
Installations- und Objektkünstler, Kunstpädagoge, Hoch-
schullehrer, Fachautor, * 1939 Berlin, lebt in Tübingen.
Vater des Malers und Graphikers *Marc von C.* (* 1969
Stuttgart. Stud.: 1990–94 KHS Braunschweig; 1994–98
KA Düsseldorf, lebt dort). Stud.: Kunsterziehung. Danach
im Beruf tätig. 1970 Promotion. Lehrtätigkeit: ab 1972
Prof. an den Pädagogischen HS in Reutlingen und Karlsru-
he, danach bis zur Emeritierung an der Univ. Gießen. Ver-
öffentlicht mehrere kunstpädagogische Schriften, bes. zur
Didaktik einer mod. ästhetischen Erziehung, u.a. zu Fra-
gen von Bildbetrachtung, Ikonogr. des Unbewußten sowie
zu Kitsch und Kunst. Mitgl.: Tübinger Künstlerbund (bis
2011 Vors.; dort auch Kurator). – Debütiert A. der 1970er
Jahre mit abstrakten Arbeiten. Ab den 1980er Jahren auch
Ill. und Buchgraphik, u.a. gestaltet er Sprach- und Lese-
bücher. Daneben gegenstandsbezogene Malerei und Gra-
phik, deren Spektrum von duftig-leichten Aqu. bis hin zu
skripturalen Arbeiten reicht, die z.B. in den 1990er Jah-
ren im Kontext des Nachspürens von „Vor-Schriften" und
„Vor-Bildern" entstehen. Seit 1995 setzt sich C. mit dem
Thema seiner Diss. (Ikonogr. im Werk von Jan Steen) u.a.
aus kunstpädagogischen Beweggründen heraus in Gem.,
seriellen Zchngn, plastischen Arbeiten, Performances und
Theaterstücken (Tableaux vivants) auseinander. So entste-
hen in einer ersten Werkgruppe 1995–99 zu Steens Bild
Wie die Alten sungen (Den Haag, Mauritshuis) u.a. ein
wissenbasiertes Leporello zur Ikonogr. des Bildes, meh-
rere vollplastische Figurationen (u.a. aus Knet-Mat.) so-

wie digital bearbeitete Bildvariationen mit dem erklärten Ziel, „dem hist. Bild neues Leben einzuhauchen, es zu 'animieren" (Website C.). Zw. 1999 und 2004 stehen die Steenschen Gem. „Abschied vom Wirtshaus" (Stuttgart, Staats-Gal.), 2004–06 die „Lustige Ges. auf der Gartenterrasse" (New York, Metrop. Mus.) und 2006 das „Dreikönigsfest" (Kassel, GG) im Mittelpunkt von C.s Schaffens. Bei den unterschiedlich angelegten „Belebungen" dieser Orig.-Bilder spielen linienbetonte, bisweilen skripturale De- und Rekonstruktionen in Arbeiten auf Papier (Feder, Aqu., Mischtechniken) ebenso eine Rolle wie die Umsetzung von deren narrativen lebensnahen Inhalten u.a. in abstrahierenden Collagen, farbenfrohen Kleinplastiken aus Zinkblech (2006), als Comic (*Abschied vom Wirtshaus*, Aqu., Feder/Papier) oder Bühnenstück. Zuletzt beschäftigt sich C. mit der Legende und Rezeptionsgeschichte des hl. Martin, u.a. entstehen über 100 Bilder, Skulpt. und Zchngn, auch der Comic strip *Der Gänsebischof von Tours* (2010–11). – Sein künstlerisch-wiss. Lebenswerk faßt C. 2009 in der „999 biogr. Augenblicke" umfassenden Publ. *Meine Bilder* zusammen, die seine char. Stellung zw. didaktisch angewandter Kunsterziehung und freier Kunstausübung unterstreicht. – Buch-Ill. u.a.: D. Segebrecht (Ed.), *Buchstapfen. Buch und Bibl.*, Bad Honnef 1982; *Begegnung mit einem alten Mann*, Tb. 1992 (mit F. Waller). ⌂ GIESSEN, Oberhessisches Mus. TÜBINGEN, SM. ✉ *Abfahrt von einem Wirtshaus. Ikonogr. Studie zu einem Thema von Jan Steen*, Diss. Univ. Tübingen 1969, Tb. 1971; *Struktur und Politik. Grenzwerte der Kunstpädagogik*, B. 1975; *Fotodidaktik als Bildlehre*, B. 1976; *Bilder interpretieren*, Dd. 1981; *Vom Text zum Bild. Wege ästhetischer Bildung*, Weinheim 1996; *Lustige Ges. auf einer Gartenterrasse. Ein Bild- Bild-Diskurs über ein Gem. des niederl. Malers Jan Steen (1626–1679)*, M. 2006. ◉ *E*: 1992 Gießen, Oberhessisches Mus. (K) / 1995 Rottenburg, Kultur-Ver. (K) / Tübingen: 1999 (mit Jürgen Mack), 2004, '09 (Retr.) Kulturhalle / 2004 Gießen, KH (Wander-Ausst.; K [*Abfahrt von einem Wirtshaus*]). 🕮 *J. Kirschenmann u.a., Ikonologie und Didaktik. Begegnungen zw. Kunstwiss. und Kunstpädagogik. Festschr. für A. v. C. zum 60. Geburtstag*, Weimar 1999 (Lit.). – *Online:* Website C. U. Heise

Crişan-Matei, *Camelia,* rumänische Malerin, Zeichnerin, Performance-, Installations- und Happeningkünstlerin, Restauratorin, * 19. 6. 1954 Dej/Bez. Cluj, lebt in Timişoara. Stud.: bis 1979 HBK I. Andreescu, Cluj-Napoca. Spezialisierung als Gem.-Restauratorin: 1986–89 MN de Artă, Bukarest; 1992, '94, '95 Bundesdenkmalamt Wien. Arbeitet 1979–86 als Museographin, 1986–2002 als Restauratorin am Muz. Banatului in Timişoara. Lehrtätigkeit: 1993–94, '98–99 Univ. Timişoara, Fak. Kunst; 1996–2001 im Auftrag des rumänischen Kultur-Minist. Grundkurse Konservierung und Restaurierung. Ausz.: u.a. 1990 Malerei-Preis des rumänischen Künstler-Verb.; 1991 Stip. der ital. Regierung (Venedig, Rom). Symposien: u.a. 1986 Câmpulung Moldovenesc; 1994 Agropoli. – Ihre eindringlichen Darst. (Gem., Zchngn) gewaltbedrohter nackter Menschen, häufig gepaart mit relig. Symbolik, wei-

sen C. schon während der Ceauşescu-Ära als couragierte und politisch engagierte Künstlerin aus. 1989 ist sie in Majdanek an der Ausst. „Zchngn gegen den Krieg" beteiligt. Bekanntheit erlangt C. mit dem Happening *Linteolum for Water, Stone, Body and Spirit*, mit dem sie 1986 in Câmpulung Moldovenesc, einen Monat nach der Reaktorkatastrophe in Tschernobyl, auf kontaminiertes Wasser in Moldawien aufmerksam macht. Performances kombiniert sie mit Videoarbeiten (*White Zone*, 1993) oder Installationen (*Reliqvarium*, 1993). In letzterer Arbeit bezieht sie sich auf alttestamentarische Erzählungen. Relig. Sinnbildhaftigkeit geht z.T. auch von abstrahierten, dunkelfarbigen Lsch.-Darst. (Gouache) der 1990 Jahre aus. ⌂ LUBLIN, Muz. Lubelskie. TIMIŞOARA, Gedenkstätte der Revolution von 1989. ULM, Donauschwäbisches Zentral-Mus. ◉ *E*: u.a. 1978 Cluj-Napoca, Casa Matei Corvin / Timişoara: 1980 Press Gal.; 1982 Gal. Bastion; 1991 Gal. Helios; 1993 First Gall. / 1981 Lugoj, Pro Art Gal. / 1988 Bukarest, Gal. Orizont / 1992 Venedig, Fenice Gal. / 1992 Bonn, Gustav-Stresemann-Inst. / 1994 Mol, Oude Post Gal. / 1994 Neapel, Cult. AC Poein / 1998 Tokio, Showa Gall. – *G*: u.a. 1986, '87, '88, '89 (Ehrenpreis) Toronto: Exhib. of Artistic Min. / Timişoara, Muz. de Artă: 1991 Nameless State of Mind. Internat. Performance and Happening Festival; 1992 The Earth, Internat. Performance Festival (K); 1993 German and Romanian Artists; 1993 Internat. Video Performance Festival; 1994 Orient-Occident (K); 2001 Self Portrait / Bukarest: 1996 Teatrul Naţ.: Experiment in Romanian Art since 1960 (K); 1997, '99 Parlament, Brâncuşi Gal.: The Sacred in Art (K). 🕮 *A. Cebuc u.a.*, Enc. artiştilor români contemp., III, Bu. 2000. – Orizont 1980 (46); 1986 (26); 1987 (3); 1988 (20) [Interview: *I. Pintilie*]; *W. Auer*, Generalanzeiger (Bonn) v. 20. 11. 1992. – *Online:* Website C. (Bibl.). St. Schulze

Crisfield Chapman, *June,* brit. Malerin, Graphikerin, Illustratorin, Dozentin, Autorin, * 1934 Kent, lebt in Billericay/Essex. Stud.: Glasgow SchA (Hschn.). Malt v.a. offizielle, neoimpressionistische Portr. (*Elizabeth Hart Chairman of Essex County Council; Henry Goodman as Shylock*, Garrick/Milne prize 2003, beide Öl/Lw.). Gestaltet daneben in Gem. und Graphik (v.a. expressiv-realistische Hschn.) Themen aus Lit. (*Mrs Ogmore Pritchard and her two ghostly husbands*, A. 1960er Jahre, Hschn., nach Dylan's Thomas's „Under Milk Wood") und Theater (z.B. *A tribute to Scottish Theatre* , Folge von 20 Gouachen für Glasgow als europ. Kulturhauptstadt, 1990). Ihre Gouachen kombiniert sie z.T. mit Pastell. Sujets ihrer Graphik und Aqu. sind häufig Wildpflanzen (z.B. *Purple Irises*, Aqu.), für die sie bereits vor dem Stud. bes. Interesse hatte. ⌂ CAMBRIDGE, Fitzwilliam Mus. LONDON, V & A. OXFORD, Ashmolean Mus. WINDSOR, R. Coll. ◉ *E*: 1979 Middlesborough, Mun. Gall. / 1982, 2010 Chelmsford, Essex Mus. / 1985 Westcliff, Beecroft Mun. Gall. / 1988 Aberdeen, Peacock Printmakers Gall. / Edinburgh: 1990 Nairn Gall., College of Art; The Scottish Poetry Centre; 2003 R. Botanic Garden (K); Natural Hist. Mus. at Walter Rothschild Mus. / Glasgow: 1990 R. Scottish Acad. of Music & Drama; 1992 Roger Billcliffe FA / London:

1991 The Nat. Theatre, Olivier Gall.; 1993 The Shakespeare Internat. Centre; 1997 The Pal. of Westminster; 2001 Chelsea Physic Garden (K); 2008 Guildhall AG / 1993 Glasgow, Kelvingrove AG and Mus. / 1999 Dorchester, Dorset County Gall. / 2012 Barnard Castle, Bowes Mus. ▭ *Buckman* I, 2006. – *Online:* Hughson Gall., Glasgow; Website C. E. Kasten

Crisse (Crisse, *Didier*; eigtl. Chrispeels, *Didier*), belg. Comiczeichner und -texter, Illustrator, * 26. 2. 1958 Brüssel, lebt in der Vendée. Aufgewachsen in Anderlecht. Autodidakt. Zunächst als Textildesigner in Lyon tätig. 1978 veröffentlicht C. den ersten Comic *La clef mystérieuse* in der Zs. Curiosity Magazine. 1979 zeichnet er für das Mag. Spirou die Gesch. *Ocean's Kings* (Album 1987). Zus. mit Bom (Pseud. v. Michel De Bom) gestaltet er 1980–87 die phantastische Serie *Nahomi* für das Mag. Tintin (3 Alben, 1985–87; Gesamt-Ausg. 2009). Nach einem Szenario von Natacha entsteht 1986 das hist.-realistische Album *Les Ombres du passé: Crimée 1920*. In den folgenden Jahren zeichnet C. zahlr. weitere Comics: u.a. *L'Ombre des damnés: Ungern Kahn* (1988); die Heroic Fantasy-Serie *L'Epée de cristal* (Text v. Jacky Goupil; 5 Alben, 1989–94; 2 Sonder-Bde, 1991 und 1995; Gesamt-Ausg. 1995); *Cosmos Milady* (Text v. Jean-Claude de La Royère; 1993); *Lorette et Harpye* (Text v. J. Goupil; 3 Alben, 1993–97); den humoristischen Strip *Ghost Town* (im Mag. Gotham, 1995; Album 2009); die Kriminal-Gesch. *Perdita Queen* (1995); die Science-fiction-Serie *Kookaburra* (3 Alben, 1997–98; danach von Nicolas Mitric fortgesetzt); *Les Compagnons de la Taïga* (1999); die Fantasy-Serie *Atalante* (4 Alben, 2000–09); *Ishanti, Danseuse sacrée* (2005). In jüngerer Zeit schreibt er v.a. Szenarien zu Comics and. Zeichner, u.a. zu „Luuna", gez. v. Nicolas Keramidas, und zu „Cañari", gez. v. Carlos Meglia. Publiziert auch mehrere, z.T. erotische Ill.-Slgn und Skizzenbücher (u.a. *Fantaisie erotique*, 2000; *Erotiques*, 2003; *Or et flammes*, 2008, zus. mit Frédéric Besson). Außerdem Ill. zu Kinderbüchern; Character Design; Storyboards; Werbegraphik. – Detailreiche semirealistische, meist sehr dynamisch angelegte und aufwendig kol. Tuschfeder-, -pinsel und -stift-Zchngn in der Nachf. der Ec. Marcinelle mit stilistischen Einflüssen zeitgen. Fantasy-Trickfilme und jap. Manga. ▭ *H. Filippini*, Dict. enc. des héros et auteurs de BD, III, Grenoble 2000; *id.*, Dict. de la bande dessinée, P. 2005; *P. Gaumer*, Dict. mondial de la BD, P. 2010. – *D. Fouss*, Portr. de BD, Braine-l'Alleud 1990; *A. C. Knigge*, Comics. Vom Massenblatt ins multimediale Abenteuer, Reinbek 1996; Dossier C., Les cah. de la bande dessinée 2000 (9), cah. 2 (WV); Utopia, l'univers de C., Toulon 2003; *M. Béra u.a.*, Trésors de la bande dessinée. Cat. enc. 2007–2008, P. 2006. – *Online:* Bedetheque; Lambiek Comiclopedia; Website C. H. Kronthaler

Cristofaro, *Ricardo*, brasil. Graphiker, Bildhauer, Hochschullehrer, * 16. 11. 1964 Juiz de Fora, lebt dort. Stud.: 1983–87 Univ. Federal de Juiz de Fora (Kunst); 1996–98 Univ. de Brasília (Kunst, Bildtechnik). Seit 1984 Zusammenarbeit u.a. mit Arlindo Daibert, Leonino Leão, Rubem Grilo, Amilcar de Castro, Marcos Coelho Benjamin,

Carlos Fajardo, José Resende. Lehrt seit 1988 Kunst und Design an der Univ. Federal de Juiz de Fora. Seit 1996 Graphikdesign, insbes. Briefmarken-Gest., für die Empresa Brasil. de Correios e Telégrafos. 2007 Promotion an der Univ. Federal do Rio Grande do Sul. Ausz.: u.a. 1997 (3. Preis), '98 (2. Preis) beim Concurso Nac. Arte em Selo der Fund. Bien. de São Paulo; 2003 Prêmio Rumos Itaú Cult. Pesquisa Categoria Artemídia ebd.; 2006 Prêmio Fiat Mostra Brasil, São Paulo. – C.s Skulpt. aus Holz und Eisen erinnern an verfremdete Alltagsgegenstände. Tatsächlich handelt es sich dabei häufig um Neuschöpfungen, Hybride aus Werkzeugen und dekorativen Objekten, die jeglicher Funktion beraubt als kritische Auseinandersetzung mit Duchamps Ready-made-Konzept interpretiert werden können. ▭ BELO HORIZONTE, Inst. dos Arquit. do Brasil. – Mus. da Pampulha. BRASÍLIA, Mus. de Arte Brasil. RIO DE JANEIRO, Funarte. – Rede Ferroviária Federal. ◉ *E:* Belo Horizonte: 1987, '88 Gal. de Arte Paulo Campos Guimarães; 1992, '99, 2000 Pal. das Artes; 1993 Itaú-Gal.; 1997, '99 Fernando Pedro Escritório de Arte / 1988 Florianópolis, Casa da Alfândiga / Juiz de Fora: 1990–92 Casa de Papel; 1995 Gal. da Caixa; 2000 Espaço Cult. Bernardo Mascarenhas; 2002, '03 Espaço Cult. Reitoria; 2004 Centro Cult. Bernardo Mascarenhas / 1990, '97 Vitória, Itaú-Gal. / 1993, '94 Brasília, Itaú-Gal. / 2008 Novo Hamburgo, Pin. da Feevale. –. *G:* zahlr., u.a. Recife: 1985–87 Salão de Arte Contemp. de Pernambuco; 1986 Salão de Artes Plást. de Pernambuco / Belo Horizonte: Pal. das Artes: 1986 (2. Preis), '87 Salão Esc. Guignard; 1988 Pessoa Pessoas; 2001 Brasil no Novo Milênio / 1986 Novo Hamburgo, Casa das Artes: Arte de Minas / Rio de Janeiro: 1987 Salão da Ferrovia (Ankaufs-Preis); 1989 MNBA: Cada Cabeça uma Sentença; 1990 Gal. de Arte do Ibeu: Novos Artistas; 1992 Salão Nac. de Artes Plást.; 1993, '94 Inst. Brasil. Arte Cult. Funarte: Projeto Macunaíma / Brasília: 1991 Salão Nac. de Artes Plást. (Ankaufs-Preis); 1996 Itaú-Gal.: Zamboni et al; 1998 Espaço Cult. 508 Sul: Panorama das Artes de Brasília; 2002 Pal. das Artes: Brasil do Novo Milênio / 1991–93 Curitiba: Salão Paranaense / Buenos Aires: 1992 Centro Cult. Recoleta: 500 años de Repression; 2001 Salon Mercosur / Juiz de Fora: 2001 Centro de Estudos Murilo Mendes: Urbi et Orbi; 2011 Centro Cult. Bernardo Mascarenha: Múltiplos Olhares / 2003, '05 São Paulo, Itaú Cult.: Cinético Digital / 2005 Porto Alegre, MAC: Mapeamento / 2010 Muriaé (Minas Gerais), Centro Cult. Doutor Pio Soares Canêdo: Objeto(s) à Deriva. ▭ *Online:* Inst. Itaú Cult. M. F. Morais

Critchley, *Paul*, engl. Maler, Designer, * 29. 5. 1960 Rainford, lebt dort, in Merseyside und Farindola/Italien. Sohn des Malers *Harold William C.* (* 2. 2. 1925, † 20. 4. 2001) und der Malerin und Stickerin *Joan Whittle C.* (* 1924, † 2011); Bruder des Fotografen und Gebrauchsgraphikers *Michael C.* (* 17. 6. 1949). Ausb.: beim Vater; 1978–79 St. Helens College of Art & Design; 1979–82 Coventry Polytechnic, Coventry, bei Harry Weinberger (Malerei) und Ted Atkinson (Skulpt.). 1984 Mitgl. der Manchester AFA. Auslandsaufenthalte: 1986 in Berlin (West), 1987–89 in Venlo und 1990 bei Padua. 1991 Über-

siedlung nach Callosa d'Ensarrià/Alicante; 1992–2008 in Altea/Alicante ansässig. 2005 Bildaufträge für das Kreuzfahrtschiff The Enchantment of the Seas der US-amer. Reederei R. Caribbean Cruise Lines; 2008 ca. 100 Gem. für das Kreuzfahrtschiff Ventura der engl. Reederei P & O Cruises. Ausz.: 1982 1. Preis, Stowells Trophy, London; 1993, '97 2. Preise, Premio Nac. de Pint. Villa de Teulada, Teulada/Valencia; 2005 The People's Prize, Oldham Gall., Oldham. – C.s malerisches Werk spiegelt naturalistisch genau in warmen Farben seine Lebensstationen wider. Es zeigt in ungewöhnlichen Perspektiven und Ausschnitten menschenleere Interieurs, (häufig eig.) Wohnungen, Ansichten von Kleinstädten und der Natur, z.T. gleiche Motive zu versch. Tageszeiten. Fast immer haben seine Gem. (Öl/Lw., aufgezogen auf Holz) unregelmäßige Formate, die sich aus der Kombination perspektivisch verzerrter Blickwinkel und versch. Raumebenen ergeben. In einem einzigen Gem. kombiniert C. wie in einem Ausschnittbogen Bilder mehrerer Räume eines Hauses (z.B. *Johanniter Str. 7*, 1986; *Rauric 12*, 1998) oder setzt versch. Wandansichten eines Zimmers fächerförmig zus. (*Interior en Holanda*, 1987). Selten tauchen Menschen oder Tiere auf, u.a. in Badezimmern (*Stray dog*, 1985; *The voyeur*, 2004). Häufig nehmen Bilder die Umrisse von Türen und Fenstern an und zeigen Zimmer oder Treppenhäuser, urbane oder landschaftliche Umgebung. Auch entsprechen sie Gebäudekonturen und lassen durch enge Straßen auf Häuser oder das Meer blicken; auch mit separat gemalten Türen, Fenstern, Balkonen u.a., die sich im leeren Umriß eines Hauses befinden (*La calle lateral*, 1993). Manche Bilder bestehen aus mehreren durch Scharniere verbundenen Teilen, z.B. ein Interieur mit Tür, die sich schließen läßt und beidseitig bemalt ist (*La puerta abierta*, 1990; *La ventana rota*, 1996). Zu diesem Werkkomplex gehören auch zahlr. Lsch.-Ausblicke (*The taste of summer*, 1999; *From my window*, 2001; *Panorama from El Cautivador*, 2003). Weiterhin gibt es Bilder, die über Eck zusammengesetzt sind und Häuser- oder Straßenecken (*La casa en la esquina*, 1994; *El reloj del sol*, 1996) sowie Eckfenster darstellen (*The view in the corner*, 2003). Menschliche Schatten, angeschnittene Körperteile, Tiere, auffällig platzierte Gegenstände oder dramatische Lichteffekte lassen Räume wie inszenierte Schauplätze erscheinen (*Somebody has been here ...*, 1998; *Midnight visit*, 2002). Später malt C. auch einzelne Möbel in Originalgröße, z.B. Sofas, Sessel oder Schränke, deren Umrisse denen des Gem. entsprechen und sie als real erscheinen lassen. Dieser augentäuschende Effekt potenziert sich durch geöffnete Schubladen, Türen, Gegenstände wie Telefone und Fotos, echte Spiegel und Collagen (*Reflect on yourself*; *Conversing with the past*, beide 2003) sowie Personen, z.B. ein liegender Akt (*Miss America*, 2005). ⌂ Alfaz del Pí/Alicante, Stadtverwaltung. Amsterdam, Baker & McKenzie. Brüssel, Océ Belgium N. V. Hilden, Stadtverwaltung. Leicester, Leicester Educational Authority. London, Smith & Williamson. Maassluis, Van Mierlo Bouwgroep. Miami/Fla., R. Caribbean Internat. New York, Barry Friedman Ltd. Rubí/Barcelona, Stadtverwaltung. Tarascon/

Arles, Stadtverwaltung. Teulada/Valencia, Stadtverwaltung. Venlo, Océ-van der Grinten N. V. Vladikavkaz, M. S. Tuganov Art Mus. ⊚ E: London: 1985 White Space Gall.(mit Michael Downs; K); 1990 Hall Richards Gall. / 1987 Hilden, Haus Hildener Künstler / 1988, '89 Köln, Gal. Rath / 1991 Fontvieille, La Gal. / 1993 Alicante, Casar Gal. de Arte / 1994 Lüneburg, Haus Havemann; Valencia, Gal. del Este (mit Artur Duch i Puig) / 1995 Brisbane, Object Art Enterprises / 1996 Castellón de la Plana, Gal. Asensi; Madrid, Summer (K) / 1997 L'Alfàs del Pi, Casa de Cult. / 1997, '99 (mit Harold C.) Barcelona, Gal. d'Art Mar / 1998 Lérida, Gal. Terra Ferma / 2002 New York, Michelle Rosenfeld Gall. (mit Sheila Elias und Massimo Barzagli) / 2003 Eindhoven, Stichting voor Kunstlicht in de Kunst / 2005 Amsterdam, Gal. Vieleers / 2008 Manchester, Wendy J. Levy Contemp. Art / 2011 Oldham, Gall. Oldham; Wigan (Lancashire), Drumcroon Gall. (mit Patrick Hughes; K; A.-M. Quinn/M. MacDonald). – G: 2005 Barcelona: Artmar Bienn. de la Mediterrània. ⌑ *Agramunt Lacruz* I, 1999. – A. Baumann, Rheinische Post (Dd.) v. 15. 9. 1987; P. Brown, Brisbane News v. 31. 5. 1995; P. C., Ma. 1996; P. Hughes u.a., P. C. Paintings, s.l. 2006; *id.*, Left to write. Collected writings, Lo./N. Y. 2008; J. Drage, The art observer (Ba.) 2008 (3); K. Pilkington, St Helens Star v. 29. 7. 2011. – *Online:* Website C. M. Nungesser

Croak, *James*, US-amer. Bildhauer, Zeichner, * 20. 10. 1951 Ohio, lebt in New York. Stud. in Chicago: 1970–74 Ecumenical Inst. (Phil., Theologie) und Univ. of Illinois (Bildhauerei). Lebt 1976–84 in Los Angeles, danach in Brooklyn und New York. – C. gestaltet 1970–78 über 70 abstrakte blütenartige Skulpt. aus gepresstem, grellfarbig bemaltem Aluminium, konzentriert sich seitdem jedoch auf narrative figurative Arbeiten. Beginnend mit der Assemblage *Vegas Jesus* (1979–81, zerst.) aus einem ausgestopften, auf einem roten Kreuz gekreuzigtem Widder im Smoking, der vom griech. Buchstaben Omega eingeschlossen ist, entsteht eine Serie von Arbeiten mit lebensgroßen, ausgestopft wirkenden mythologischen Kreaturen wie Sphinx, Zentaur und Pegasus. In *Pegasus. Some loves hurt more than others* (1982–83) stößt Pegasus als Symbol für Freiheit und Unabhängigkeit aus dem Dach eines 1963er Chevy Lowrider heraus und verbindet so die griech. Mythologie mit der Gegenwart. Seit M. der 1980er Jahre ist C. bek. für menschliche Skulpt. aus Schmutz und Abfall, hergestellt durch einen von ihm entwickeltem Prozeß, bei dem er zunächst ein Abbild modelliert und dann in einen Abguß eine Mischung aus Schmutz und Bindemittel gießt. Nach der ersten so hergestellten Arbeit *Dirt Man with fish* (1986) folgt die Serie expressiver, lebensnaher *Dirt Babies* (1986–2000), eine *Hand*-Serie (1998/99) und bis heute weitere Schmutz-Figuren, die sich stets im Übergang von Stehen und Gehen befinden und auch Teil größerer Installationen sind. 1991/92 befaßt sich C. mit eher minimalistischen Arbeiten der *Window*-Serie, bei der er Fenster versch. Stilrichtungen mit Schmutz nachbildet und um die M. der 1990er Jahre gestaltet er eine Skulpt.-Serie aus Latex (*Trash Suit*; *Child Skin*, beide 1995). Daneben be-

nutzt C. Schmutzpartikel auch als Zeichenmittel, wie 2010 in einer Serie, in der er die „Desastres de la Guerra" von Goya mit der Bildwelt des 20. Jh. fortführt. – C.s konzeptuelle Arbeiten sind eigenwillig, originell und innovativ in Mat.-Wahl, Technik und Ausstrahlung. ⌂ KANSAS CITY, Kemper MCA. OAKS/Pa., West Coll. ✉ The hist. of everything, in: C. Leigh, The silent baroque (K Gal. Thaddaeus Ropa), Sg. 1989. ◉ E: 1978 Century City (Calif.), Century City Gall. / Los Angeles: 1978 Janus Gall.; 1980 Kirk de Gooyer Gall.; Otis Art Inst. of Parsons School of Design / 1981 Riverside, Riverside Mus. / 1982 San Diego, San Diego State Univ. / New York: 1989–90 Hudson River Mus.; 1991 Blum Helman und Fernando Alcolea Gall.; 1994, '99, 2001, '12 Stux Gall.; 2000 Brenda Taylor Gall. / 1991 Berlin, Gal. Van der Tann / 1994 Boston, Howard Yezerski / 1995 San Francisco, Rena Branston Gall. / 1996 Amsterdam, Gal. de la Tour (K) / 2004 Seattle, Atelier 31 Gall. / 2006 Miami (Fla.), Bernice Steinbaum Gall. – G: 2012 New York, MAD: Swept away. ⊡ J. C. New myths and heroic allegories (K Otis Art Inst. of Parsons School of Design), N. Y. 1980; C. Gardner, Artweek 14:1983 (40) 16; T. McEvilley, J. C., N. Y. 1999; J. Goodman, Sculpt. (Wa.) 21:2000 (4) 64 s.; New York Classizism now (K Hirschl and Adler), N. Y. 2000; J. Gilmore, AiA 90:2002 (1) 104 s; J. Collins, Sculpt. today, Lo./N. Y. 2007. – Online: Website C. H. Stuchtey

Crockett, Bryan, US-amer. Bildhauer, Installationskünstler, * 1970 Santa Barbara/Cal., lebt in Brooklyn. Stud.: bis 1992 Cooper Union, New York (bei Hans Haacke); 1992–94 Yale Univ., New Haven (bei Ron Jones und John Newman). Ausz.: 1997 Louis Comfort Tiffany Found. Award. – Als Sohn eines Leichenbestatters befaßt sich C. zunächst mit eher düsteren und unheimlichen Themen sowie biomorphen abstrakten Skulpt. und Installationen. Die raumgreifende Skulpt. Ignis Fatuus (Whitney Bienn., New York, 1997) und weitere Arbeiten aus den Jahren 1997–2000 bestehen aus in Kunstharz getauchten organfarbigen Ballons und Schläuchen aus Latex, die menschlichen Gedärmen und Organen ähneln und sich z.T. ausdehnen und zusammenziehen (Untitles, Installation mit Video; Ausst. Fotouhi Cramer Gall., New York, 1997). 2000 entsteht mit Ecce Homo die erste Arbeit aus einem marmor-imitierenden Kunststoff und zum Thema der Dominanz der Natur-Wiss. über die spirituelle Welt in der westlichen Gesellschaft. C. konzentriert sich auf die für medizinische Forschungen entwickelte Krebsmaus und gestaltet überlebensgroße, anthropomorphe haarlose Babymäuse z.B. für die Serie Seven Deadly Sins (2002), mit u.a. einer fettleibigen Maus (Gluttony), einer mit sehr empfindsamer Haut (Lust), Envy mit menschlichen Ohren und Sloth mit deformierten Gliedmaßen. Der Bezug zur Renaiss.- und v.a. zur Barock-Skulpt. wird hier wie auch in späteren Arbeiten deutlich, in denen sich C. mit großem handwerklichen Können und kunsthist. Detailkenntnissen u.a. mit dem Mythos von Daphne und Apollo auseinandersetzt (Solipsist, 2005). Aqu. und Zchngn vorbereiten und ergänzen die Skulpturen. ◉ E: New York: 1997 Fotouhi Cramer Gall.; 2002, '05 Lehmann Maupin Gall.

⊡ Biovoid (K MN de Hist. Natural), Lissabon 1998; Flash art 31:1998 (198) 116; S. Cash, AiA 86:1998 (4) 121; Terrors and wonders. Monsters in contemp. art (K DeCordova Mus. and Sculpt. Park), Lincoln, Mass. 2001; R. Gladman, Artext 77:2002, 82 s.; E. Leffingwell, AiA 90:2002 (7) 89; K. Raney, J. of art and design education 22:2003 (2) 195–207; C. Kotik/T. Mosaka (Ed.), Open house. Working in Brooklyn (K Brooklyn Mus.), Brooklyn 2004; B. K. Rapaport, Sculpt. (Wa.) 25:2006 (3) 50–57; J. Collins, Sculpt. today, Lo./N. Y. 2007. – Online: Website Lehmann Maupin Gall. H. Stuchtey

Croes, Frans, belg. Maler, Graphiker, Zeichner, * 30. 4. 1936 Heffen, † 19. 3. 2011 Mechelen. Lehre als Holzschnitzer. Als Maler Autodidakt. In den 1960er/70er Jahren in der alternativen Kunstszene in Mechelen als „Paps Kabouter" aktiv. Gründet dort u.a. 1964 das Mechelse Jeugdstudio, ist danach kreisbildende Persönlichkeit in seinem subkulturellen Café Den Herten Aas und beteiligt sich 1970 mit einer Nieuwe (Kabouter) Partij an den Kommunalwahlen. Seine Arbeiten hat C. bis wenige Jahre vor seinem Tod vom Kunstmarkt ferngehalten. – V.a. Aqu., Gem. und Zchngn im Stil des Magischen Realismus. Daneben u.a. Mixed media und farbintensive konkrete Bilder. Auch realistische (Fluß-)Lsch., v.a. mit naturgetreuen, lichterfüllten Motiven der pittoresk-idyllischen Umgebung seines Atelierhauses in einem Vorort von Mechelen, wo C. über dreißig Jahre lang lebt und regelmäßig Sommer-Ausst. veranstaltet. ⌂ MECHELEN, Erfgoedcel: Nachlaß. ◉ E: 2006 Mechelen, Cultuurcentrum (Retr.). ⊡ Pas I, 2002. U. Heise

Croitoru, Alexandra, rumänische Fotografin, Zeichnerin, Video- und Performancekünstlerin, Printdesignerin, * 1975 Bukarest, lebt dort. Stud.: 1993–98 HBK ebd. (Graphik). Ab 1999 Ass.-Prof. ebd. in der Fachrichtung Fotogr. und Video. Vortragsreisen in West- und Osteuropa. 2001 Spike Island Internat. Fellowship. Artist in Residence: 2006 Kopenhagen (DIVA); 2006 Sinaia (mit Ştefan Tiron; Pro Helvetia); 2007 Wien (Kultur-Kontakt). Workshops u.a. 1994 Glasgow (Archit.), 1997 Erfurt („Ostzillograph"). – Politischen und sozialen Veränderungen in Rumänien und and. Ländern begegnet C. in ihren Arbeiten mit metaphernreicher Ironie. In größeren, auch miteinander verknüpften Projekten wie Another Black Site (2005) verbindet sie versch. Kunstformen, z.B. Fotogr. mit gedruckten (semifiktionalen) Texten und einem Hörstück. Hier und in einigen folgenden (interdisziplinären) Projekten arbeitet sie konzeptionell mit Ş. Tiron zusammen. Politisch ambitionierte Performances nach 2000 richten sich insbesondere gegen die Bedrohung durch staatliche Gewalt. In and. Arbeiten fragt C. nach identitätsstiftenden Momenten: für das Individuum, die Gruppe, eine Nation oder das Geschlecht. Für das Ballett „Orpheu" (Bukarest, 2000) wird sie als künstlerische Beraterin berufen. 2002–03 ist C. mit dem Design der ersten beiden Ausg. des Mag. Artphoto (Bu.) beauftragt. 2004 gestaltet sie den Slg-Kat. anläßlich der Eröffnung des MNAC Bukarest. ⌂ LUXEMBURG, MAM Grand-Duc Jean (Mudam). ◉ E: Bukarest: 1997 GAD Photo-Gall.; 2001 In-

ternat. Centre for Contemp. Art; 2005 Gal. Noua; 2007 Andreiana Mihail Gal.; MN de Artă (On the past and present use of psychotronic weapons of mass destruction in Romania; Performance mit Ş. Tiron) / 2005 Bratislava, Gal. Veza / 2006 Cluj-Napoca, Gal. Plan B (mit Ş. Tiron) / 2007 Prag, Futura Centre of Contemp. Art; Wien, Siemens_artLab / 2009 Kopenhagen: Gall. Tom Christoffersen und Overgaden, Inst. for Samtidskunst (mit Ş. Tiron und Mircea Nicolae). – *G:* zahlr. nat. und internat., u.a. 2001 Zagreb: Woman's Room – Woman's View / 2003 Sofia: Bienn. of Contemp. Visual Arts by Balkan Female Artists / Bukarest, MNAC: 2004 Romania Artists (and not only) Love Ceauşescu's Palace?!; 2005 At the Border; 2010 Young Artist's Bienn. / 2007 Timişoara, Muz. de Artă: Surexpositions / 2008 Pančevo: Art Bienn. / 2009 Katowice: Bienn. / 2010 Cluj, Muz. de Artă: Col. Mircea Pinte; Haifa: Mediterranean Bienn.; Warschau, NG: Gender Check / 2011 Venedig, Fond. Bevilacqua La Masa: Where is my place? ▭ Idea (Cluj) 2005 (22); Omagiu (Bu.) 2005 (1); Flash art internat. 2006 (251) 90; *R. Hellwig-Schmid* (Ed.), Ars Danubia [...] (K), Rb. 2007, 62. – *Online:* Gal. Plan B Cluj-Napoca (Ausst.). B. Scheller

Cromheecke, *Luc,* belg. Comiczeichner, Illustrator, Werbegraphiker, * 2. 8. 1961 Antwerpen, lebt in Kapellen b. Antwerpen. C. studiert A. der 1980er Jahre Malerei, Graphik und Werbegraphik an der Koninkl. ASK, Antwerpen. Unter dem Pseud. Maf zeichnet er erste Comics für die Zss. Blondie (*Zap*) und Robbedoes (*Bob Burk,* 1978). Zus. mit dem Mitstudenten Fritzgerald (Pseud. v. Gert Wijninckx) konzipiert er das Comic-Mag. Flan Imperial, das aber bereits nach einer Ausg. wieder eingestellt wird. Ab 1983 zeichnet C. für Robbedoes sowie für die Ztgn De Morgen und De Volkskrant den humoristisch-absurden Comic strip *Taco Zip* (4 Alben, 1989–93; Anthologie, 2005). Ebenfalls für Robbedoes und für das niederl. Mag. Sjors entsteht 1985 die Comic-Serie *Tom Carbon* (Szenarien v. Laurent Letzer; 7 Alben, ab 1991). Zus. mit Letzer gestaltet C. ab 1996 auch den Comic *Ben le Forestier* für das frz. Mag. Astrapi und das belg. Suske en Wiske Weekblad (als *Ben de Boswachter*; Album 2006). Ab 2003 zeichnet er für die Zss. Spirou, Suske en Wiske Weekblad und Taptoe die Reihe *Roboboy* (Text v. Willy Linthout; 6 Alben). Ebenfalls für Spirou entsteht ab 2006 zudem die Serie *Plunk*, die eine Nebenfigur aus *Taco Zip* präsentiert (Text v. Letzer; 3 Alben seit 2007). Gestaltet auch Ill. und Titelbilder für versch. Mag., CD-ROMs und Werbegraphik. Ausz.: u.a. 2002 bester Autor, '03 bestes Jugendalbum, Prix St-Michel, Brüssel; 2003 bestes Jugendalbum, Stripdagen, Alphen aan den Rijn. – C. zeichnet humoristisch-absurde, z.T. slapstickartige, dynamisch-konturbetonte und meist auf das Wesentliche reduzierte Comic strips in der Trad. der Ec. Marcinelle, aber auch US-amer. Comiczeichner wie Charles M. Schulz oder Johnny Hart. ◉ *E:* 2006 Turnhout, Strip Turnhout (Wander-Ausst.). – *G:* 1994 Angoulême: Festival Internat. de la Bande Dessinée. ▭ *H. Filippini,* Dict. enc. des héros et auteurs de BD, I, Grenoble 1998; *id.,* Dict. de la bande dessinée, P. 2005. – *R. Booms,* Stripschrift 1990 (Dez.) 12–16;

A. C. Knigge, Comics. Vom Massenblatt ins multimediale Abenteuer, Reinbek 1996; La nouvelle BD flamande, Berchem 2003; *M. Béra u.a.,* Trésors de la bande dessinée. Cat. enc. 2007–2008, P. 2006; *B. van der Moeren,* Tekenaars! 40 stripmakers gefotografeerd, Turnhout 2007. – *Online:* Bedetheque; Lambiek Comiclopedia; Plunkblog.

H. Kronthaler

Cromie, *Robert,* brit. Architekt, * 1887, † 1971, tätig in London. Stud.: Archit. Assoc. School of Archit., London, bei Alfred John Wood. 1910–14 Mitarb. von Bertie Crewe. Danach profiliert sich C. als Architekt der Kinoketten Ritz, ABC (Assoc. Brit. Cinema), Regal u.a., für die er v.a. in den 1930er Jahren englandweit ca. 50 Lichtspielhäuser (z.T. mit Musiktheaterbühnen) entwirft bzw. umbaut. Seine „Tempel des Zeitvertreibs" sind größtenteils durch die variationsreiche, elegante Formgebung des Art Déco char., bes. die mit stromlinienförmig gerippter Stuckdekoration ausgestatteten Innenräume. Von außen präsentieren sich die Filmtheater je nach Größe und Lage als kubische Komp. mit achsensymmetrisch angelegten Eingängen und sparsamer flächiger Dekoration. Als eines der größten und modernsten Kinos im Königreich wird 1932 das bis heute erhaltene Hammersmith Apollo (ehem. Gaumont Pal.) in London (Queen Caroline Str. 45) eröffnet. Die knapp 60 m breite Front mit neun Doppeltüreingängen resultiert aus einer raffinierten inneren Distribution mit ausgezeichneten Sichtbeziehungen, einfacher Wegeführung und spektakulären Foyers auf zwei Ebenen (einziges erh. Hw.). Bedeutend ist auch das Prince of Wales Theatre ebd. (Coventry Str. 31), das C. 1937 an der Stelle des alten Hauses von 1884 mit markantem Eckturm errichtet (2003 Rest.). Mehr als die H. seiner Kinobauten ist nicht erhalten, u.a. die in Eltham, Winchmore Hill, New Southgate, Dalston, Wimbledon, Golders Green, Lewisham (alle London); Chelmsford, Southend-on-Sea (beide Essex); Southampton/Hants.; Coventry/Warwicks.; Sidcup, Bexleyheath, Bleckfen, Margate, Chatham (alle Kent). Neben Filmtheatern entwirft C. um 1935 im Auftrag des Teeherstellers Sir Thomas Lipton am Ufer des Hamble für die Crew-Mitgl. des America's Cup Sailing die vom dt. Bauhaus inspirierte Wohnsiedlung Crowsport (ca. 25 Häuser). Gleichzeitig errichtet er 1934–37 in Hove/East Sussex im Auftrag eines Fabrikanten das eigenwillig komponierte Landhaus Barford Court (Kingsway 157; Rest. 1996, seitdem Pflegeheim) im strengen neugregorianischen Stil mit mod. Art-Déco-Innenausstattung, eine meisterhafte Synthese aus Trad. und Mod. von hoher handwerklicher und haustechnischer Qualität. Die meisten der erh. Bauten von C. zählen heute zum nat. Kulturerbe. ▭ Aylesbury/Bucks., High Str. 36: Granada Aylesbury (Grand Pav. Cinema; Umbau), 1936 (seit 1991 Bingo Club). Beckenham/Kent: Odeon (ehem. Regal Cinema), 1930. Canterbury/Kent: Odeon (ehem. Regal Cinema), 1933. Chichester/West Sussex: Granada Exchange (Neu-Gest.), 1948 (heute Einzelhandel). Crawley/West Sussex, High Str. 100: Embassy Cinema (ehem. ABC Cinema), 1938 (heute Nachtclub). Oxford, Cowley Road 300: Regal Cinema, 1937 (heute Nachtclub). Dagenham/

Essex, Princess Parade 12: Princess Cinema, 1932 (seit 2005 Kirche). FELIXSTONE/Suffolk: Palace Cinema (ehem. Ritz Cinema), 1937. LONDON, Catherine Str.: Theatre R. Drury Lane (Umbau), 1922 (mit J. Walter Emblin, Frederick Edward Jones); Streatham High Road 386: Eisstadion, 1931; Richmond Road: Regal Cinema, 1932 (1991 Umbau, seit 2010 leerstehend); Bruce Grove 117: Cinema (Umbau), 1933 (heute Kirche u.a.); Regent Str. 4–12: Paris Cinema, 1939 (1945–95 BBC Studios, seit 2000 Fitness-Studio). Chelsea: R. Court Theatre (Umbau), 1952. OXFORD, George Str.: Odeon (ehem. Ritz Cinema), 1936 (stark mod.). SCUNTHORPE/North Lincs., Doncaster Road 25: Ritz Cinema (auch ABC), 1937 (heute Nachtclub). TUNBRIDGE WELLS/Kent, Mount Pleasant Road: Ritz Cinema, 1934 (seit 2009 auf Abrißliste). ☉ G: 1979–80 London, Hayward Gall.: Thirties. Brit. Art and Design Before the War (K). ▭ Johnson/Greutzner, 1976; Royal-HibAcad I, 1986; M. Byars, The design enc., Lo./N. Y. 2004. – Online: Cinematreasures (WV). A. Mesecke

Cronan, *Michael (Michael Patrick),* US-amer. Graphikdesigner, Maler, * 9. 6. 1951 San Francisco/Calif., lebt in Berkeley. Ehemann der Designerin Karin Hibma. Stud.: California College of the Arts and Crafts, San Francisco; 1971 Archäologie in Israel (tätig als Ausgrabungsleiter der Hebrew Univ. in der Negev-Wüste und am Toten Meer); 1974 California State Univ., Sacramento. 1980 mit Karin Hibma Gründung des Ateliers Michael Patrick Cronan Design sowie 1991 Cronan Artefact. 1982–99 Prof. für Graphikdesign am California College of the Arts, San Francisco. Gründungs-Mitgl. und Präs. der Filiale San Francisco des Amer. Inst. of Graphic Arts (AIGA). Ausz.: 1992, '93 Internat. Design Mag.'s Consumer Product of the Year Gold Award; 2009 AIGA Fellow Award. – Gehört zu den Begründern der als Pacific Wave bez. postmodernen Strömung im Graphikdesign in der San Francisco Bay Area. Mit der Gest. des Buches *Sushi* von Mia Detrick (S. F. 1981, Chronicle Books) kreiert C. eine char. neue Form von Coffee-Table-Books. 1989 erweitern C. und Hibma mit Entwürfen für die eig. Modekollektion *Walking Man* (1992 Consumer Product Gold Award des Internat. Design Mag.; 1993 Honorable Mention, Cooper Hewitt Nat. Design Mus., New York) ihr Arbeitsspektrum, das bisher von graph. Entwürfen (Logos, Buchgraphik etc.) bis hin zur komplexen Gest. von Corporate identity die char. Produkte des Graphikdesigns umfaßt hat (bed. Klienten u.a. Amazon Kindle, Silicon Graphics, San Francisco MMA [1998 Logo]). Seit 2005 konzentriert sich C. auf die Entwicklung von Namen, visuellen Erscheinungsbildern und Markenstrategien für neue Produkte, Firmen und aufstrebende Technologien. Darüber hinaus beschäftigt er sich mit Ölmalerei in realistischer Auffassung (Portr., Akte, Stilleben, Lsch., Motive mit Segelbooten etc.). ▥ DENVER/Colo., AM. LONDON, V & A. SAN FRANCISCO/Calif., MMA. WASHINGTON/D. C., Libr. of Congress. – Smithsonian Nat. Postal Mus. ☉ G: 1985 Venedig, Mus. Fortuny: Pacific Wave / 1993 San Francisco (Calif.), MMA: In the Public Eye – the work of Four Graphic Designers (mit Michael Manwaring, Gerald Reis und Michael Vander-

byl) / 2002 Denver (Colo.), AM: US Design. 1975–2000. ▭ Communication Arts 35:1993 (1) 126–129. – *Online:* Website C.; AIGA San Francisco; Herman Miller; San Franisco MMA. C. Rohrschneider

Cronenberg, *Wilhelm,* dt. Fotograf, * 18. 1. 1836 Frankfurt am Main, † 1915 (?). 1857 und 1859 ist das Atelier Cronenberg & Cie. in Darmstadt durch Inserate belegt. 1858 Gründung einer Praktischen Lehranstalt für Photogr. auf Schloß Grönenbach im Allgäu; 1898 Umzug der Schule nach München-Pasing, wo C. auch eine Reprod.-Anstalt betreibt. 1860 erhält C. das Darmstädter Bürgerrecht; 1863–73 betreibt er ebd. ein Atelier in der Steinstraße (ab 1871 unter der Bez. Hof-Photograph); auch in Bad Kissingen und Baden-Baden tätig. – Lsch., Archit.-Ansichten und Portr., u.a. als Stereoskopien. Sign.: W. Cronenberg. – Fotogr. Publ.: *Photogr. Bad Kissingens & Umgegend von W. Cronenberg, Hofphotograph,* Bad Kissingen 1879. ▥ DARMSTADT, Stadtarchiv. UNIVERSITY PARK, Pennsylvania State Univ., Special Coll. Libr., William C. Darrah Coll. of Cartes-de-visite, 1860–1900. ▨ Die Praxis der Autotypie auf amer. Basis, Dd. 1895 (engl. Ausg. Lo. 1896; frz. Ausg. P. 1898). ▭ Frühe Photogr. im Rhein-Main-Gebiet 1839–1885 (K), Ffm. 2003 (Lit.). P. Freytag

Croner, *Ted,* US-amer. Fotograf, * 5. 12. 1922 Baltimore/Md., † 15. 8. 2005 New York. Jugend in Charlotte/N. C.; erste Fotogr. für das Highschool-Jb. und die Lokalzeitung. Während des 2. WK Dienst als Luftbildfotograf im Südpazifik. Auf Anraten des Fotografen Fernand Fonssagrives 1946 Umsiedlung nach New York, wo C. gemeinsam mit Bill Helburn unter dem Namen Speed Graphics ein Atelier für Mode-Fotogr. gründet. Wiederum angeregt durch Fonssagrives, studiert C. ab 1947 bei Alexey Brodovitch an der New School for Social Research. – Gemeinsam mit New Yorker Zeitgenossen wie Lisette Model, Diane Arbus, Richard Avedon und William Klein wird C. der sog. New York School of Photogr. zugerechnet. Er ist in erster Linie für seine abstrahierenden Schwarzweißaufnahmen aus den späten 1940er und 1950er Jahren vom New Yorker Nachtleben in den Straßen, Cafés und U-Bahnen bekannt. Ähnlich wie zeitgleich etwa Saul Leiter, experimentiert er mit Langzeit- und Mehrfachbelichtungen und verdichtet so nach dem Vorbild Brodovitchs die Dynamik des großstädtischen Lebens mit Hilfe von Bewegungsunschärfe, Umgebungslicht (Straßenlaternen, Leuchtreklame, Autoscheinwerfern u.ä.), Regenschleiern oder Schneefall zu atmosphärischen Komp. wie in seinem wohl bekanntesten Bild *Taxi, New York Night, 1947–48.* Neben der freien Arbeit fotografiert C. Mode (u.a. für Vogue und Harper's Bazaar) und Werbung (z.B. für Coca-Cola und die Chase Manhattan Bank). ▥ MILWAUKEE/Wis., AM. NEW YORK, Metrop. Mus. – MMA. ☉ E: New York: 1995 Howard Greenberg Gall. – G: New York: 1948 (In and Out of Focus; Four Photographers), '50 (Color Photogr.), '78 (New Standpoints. Photogr. 1940–1955), 2000 (Walker Evans & Company; K) MMA; 1999 Whitney: Amer. C. Part II; 2002 Jewish Mus.: New York. Capital of Photogr. (Wander-Ausst.; K) / 1951 Köln: Pho-

tokina (Ausz.) / 1982 Tokio, Seibu Mus. of Art: Twentieth Century Photographs from the Museum of Modern Art (K) / 1985 (The New York School, Photographs, 1935–1963, Part II), '86 (The New York School, Photographs, 1935–1963, Part III) Washington (D. C.), Corcoran Gall. of Art / 1995 Berlin, Kunst-Bibl.: Amer. Photogr. 1890–1965 from the MMA, New York (Wander-Ausst.; K) / 1996 Paris, Fond. Cartier pour l'Art contemp.: By Night (K) / 2009 Madrid, La Casa Encendida: Picturing New York. Photographs from the Museum of Modern Art (Wander-Ausst.; K) / 2010 Milwaukee (Wis.), AM: Street Seen. The Psychological Gesture in Amer. Photogr., 1940–1959 (K). □ *H.-M. Koetzle*, Das Lex. der Fotografen, M. 2002. – *L. Fonvielle*, Aperture 81:1978, 60–73; *M. Harrison*, Appearances. Fashion photogr. since 1945, Lo. 1991; *J. Livingston*, The New York School. Photographs 1936–63, N. Y. 1992 (Lit.); *M. Loke*, New York Times v. 17. 8. 2005 (Nachruf); *A. Hopkinson*, The Guardian v. 30. 8. 2005 (Nachruf). P. Freytag

Cronholm, *Ellen,* schwed. Graphikerin, Buchkünstlerin, * 1971 Sollentuna, lebt in Stockholm. Seit 2005 mit Anders Gudmundson verheiratet. Stud.: 1990–91 Nyckelviksskolan, Lidingö (2002 Gast-Doz.); 1991–94 Grafikskolan, Stockholm; 1994–96 Univ. ebd. (u.a. Kunstwiss.). Techn. Mitarb. des Mod. Mus. ebd. Ausz.: u.a. 1996 Aufenthalts-Stip. für das Schwed.-Finn. Kulturzentrum Hanasaari, Espoo; 2002 Lilla Grafikpriset, Grafikens Hus, Mariefred. – Figurative, meist großformatige Graphiken (teilw. in Farbe), bevorzugt Rad. und Lichtdrucke, die häufig durch bes. Herausarbeitung von Licht und Schatten gekennzeichnet sind. Wiederkehrende Motive sind u.a. Türme, Treppen, Industriegebäude und leere Kanäle, z.B. *Vattenformation* (Lichtdruck, 2003) sowie morbide wirkende Innenräume, die elektrische Leitungen, Wasserrohre oder teils defekte Wasserbecken zum Bildgegenstand haben, z.B. *Kar med hål* (Lichtdruck, 2003). Daneben objektartige transparente Drucke mit röntgenbildartigen Darst. menschlicher Körperteile und Gefäßsysteme. Außerdem 2000 ein orig.-graph. Kunstbuch ohne Titel (Rad., Bleisatz auf handgeschöpftem Papier). ✪ DUBLIN, NG. LONDON, BM. STOCKHOLM, Mod. Mus. – NM. – Statens Konstråd. VÄSTERÅS, KM. ◉ *E:* Stockholm: 2002 Konstnärshuset; 2004 Grafiska Sällskapets Gall. – *G:* 1995: New York, Manhattan Graphics Center: Identities; Norrköping, Kunstforum: Inside-outside / 1996 Valkeakoski, Voipaala Kunstzentrum: Metamorfoser-förvandlingar (Wander-Ausst.) / Stockholm: 1997 NM: Unga tecknare (K); 2000 Grafiska Sällskapets Gall.: Papperslöst; 2003, '10 KA: Graphik-Trienn. / 1998 Vaasa, Österbottens Mus.: Grafinnova (K) / 1999 Mariefred, Grafikens Hus: 111+1, etthundratolv år svensk grafik / 2004, '07 Tallinn: Graphik-Trienn. / 2004 (Intergraf), '07 (Åtta samtida grafiker), '08 (13 grafiker från KKV) Upplands Väsby, Väsby KH / 2005 (Svensk grafik), '06 (Transit 2) Sollentuna, Edsvik KH. □ Poliitiline/poeetiline. Tallinna XIV Graafikatriennaal (K), Tallinn 2007. – *Online:* Website C. J. Niegel

Croninger, *Cara,* US-amer. Schmuckgestalterin, Bildhauerin, Designerin, * 1939 Alto/Mich., lebt in Garnervil-

le/N. Y. Um 1959–61 Stud. an der Amer. Acad. of Art, Chicago/Ill. (lt. Dict. internat. du bijou); C. bezeichnet sich selbst als Autodidaktin. Ausz.: 1980 Cachet Award for Design. Gründungs-Mitgl. der Gruppe Artwear in New York. – Seit 1972 fertigt C. skulpturale, geometrischabstrakte Schmuckstücke in ihrer Wkst. in Brooklyn. Es entstehen v.a. voluminöse Armreifen (z.T. mit handbemaltem Dekor) und Ringe in unregelmäßigen runden und quadratischen Formen und zahlr. Farbvarianten sowie Ohrringe, Anhänger (u.a. in Herz- und Tropfenform) und auf Lederbänder gefädelte Perlenketten. C. arbeitet hauptsächlich mit Kunstharz und gilt auf diesem Gebiet als Wegbereiterin für nachfolgende US-amer. Schmuckgestalter. Ebenfalls aus diesem Mat. gestaltet sie abstrakte Plastiken, z.B. die säulenförmigen *Talking Stone Sculpt.* mit expressiven Farbverläufen, zudem massive Schalen sowie fetischartige Tier-Skulpt., die mit Lederbändern, Perlen, Federn und Fell geschmückt sind. Die Oberflächen der in selbst gefertigten Formen gegossenen Objekte werden nach der Aushärtung durch Schneiden, Schnitzen, Schleifen und Polieren bearbeitet. Je nach Behandlung wirkt das Mat. wie farbiges Glas (z.B. die Schalen), Kunststoff (z.B. Ringe aus ungefärbtem Acrylharz) und Metall (z.B. mit Metallfarben gefärbter bzw. bemalter und mattierter Armschmuck). ✪ BOSTON/Mass., MFA. MONTREAL, MAD. NEW YORK, MAD. ◉ *E:* New York: regelmäßig 1976–88, '92 Julie Artisans' Gall.; 1977–79, '83, '85 Allan Stone Gall.; 1996 Robert Lee Morris Gall.; 1999 Atmosphere Gall. / 1992 Tokio, Isetan AG (Wander-Ausst.) / 1994 Mill Valley (Calif.), Art and Soul Gall. / 1995 Scottsdale (Ariz.), Joanne Rapp Gall. – *G:* 1973 Boston (Mass.), Inst. of Contemp. Art: Jewelry as Sculpt. as Jewelry (K) / 1976 La Jolla (Calif.), MCA: Sculpt. to Wear / New York: 1975 The Clocktower: Artists make Toys (K); 1991 Fashion Inst. of Technology: Jewels of Fantasy; 2000 Julie Artisans' Gall.: Color. □ Dict. internat. du bijou, P. 1998. – *Online:* Website C. F. Krohn

Crook, *Linda,* brit. Medailleurin, Bildhauerin, Malerin, Graphikerin, * 21. 3. 1946 England, lebt in London. Stud. ebd.: 1979–83 Camberwell SchA and Crafts (jetzt Camberwell College of Arts); 1984–86 Goldsmiths, Univ. of London. 1984 Gründungs-Mitgl. der Künstlerinnengruppe Redder Splash ebd. 2009 Craftsmanship & Design Award (Silber), Goldsmiths Craft and Design Council ebd. Seit 1994 regelmäßige Beteiligung an Gruppen-Ausst. der Brit. Art Med. Soc. (BAMS) und der Fédération Internat. de la Médailles d'Art (FIDEM); für beide mehrfach Auftragsarbeiten. – Hauptsächlich Med. in Silber und Bronze (auch patiniert oder versilbert), bevorzugt mythologische Motive, z.B. *Leda and the Hat Pin* (Silber, 1999); daneben Portr., z.B. *Joe Cribb* (Bronze, 2010). Außerdem figurative Stein-Skulpt., u.a. *Big Cat* (Alabaster, 1998). Des weiteren Gem. und Graphiken in div. Techniken, auch Collagen. ✪ BERLIN, Münz-Kab. LONDON, BM. – BAMS. – The Goldsmiths Company Coll. – V & A. NEW YORK, Amer. Numismatic Soc. Coll. ◉ *E:* 1996 Bridport (Dorset), Bridport AC, Allsop Gall. (K) / 2003 London, V & A (Einzelvitrine). – *G:* London: 1992 South London Gall.:

Second Coming (K); 1993 Barbican: Inner City Blues (K); 1998 Simmons Gall.: Animal Kingdom ; 1999 Tate Modern: Bankside Browser; 2010 V & A: New Medallists / 1999 Seixal: Bien. Internac. de Med. Contemp. (K) / New York: 2000 The Pen and Brush Inc.: Annual Sculpt. Exhib. (Ausz.); 2009 Medialia Gall.: Ron Dutton with 8 Contemp. Brith. Medallic Sculptors / 2006 Beijing, Capital Mus: Treasures of the World's Cultures (Wander-Ausst.; K). ▭ *Buckman* I, 2006. – *W. Steguweit*, Europ. Med.-Kunst von der Renaiss. bis zur Gegenwart (K), B. 1995; *M. Heidemann* (Bearb.), Internat. Med.-Kunst. XXVII FIDEM 2000 (K Weimar), B./Weimar 2000; *M. L. Bourne*, The medal 45:2004, 74–77. – Mitt. C. J. Niegel

Crooks, *Bob,* brit. Glaskünstler, * 1965 London, lebt in Thelbridge, Crediton/Devon. Stud.: 1984–85 Humberside College of Higher Education; 1985–89 West Surrey College of Art and Design, Farnham. 1986–87 Ass. von Ronnie Wilkinson, Glasshouse, London; 1989–90 dort Wkst.-Leitung. Ab 1990 Wkst. First Glass in Newent/ Glos., 1994–2002 in London, seitdem in Thelbridge. – Inspiriert von Archit. und Geometrie setzt C. mit großer Kunstfertigkeit originelle und z.T. riskante Ideen um, hebt hervor und kombiniert versch. Qualitäten des Mat. Glas und erzielt so dynamische und innovative Formen und Muster. Die frei geblasenen dekorativen Glasobjekte und -gefäße (Flakons, Vasen, Schalen, Krüge, Leuchter, Becher, hängende Platten) weisen leuchtende Farben mit artifiziell-linearen, v.a. durch Fadeneinlagen entstandenen Mustern auf. Außerdem führt C. Aufträge aus für Trophäen, Pokale, Beleuchtungen für Hotels und mehrere Glasarbeiten für Kreuzfahrtschiffe (Queen Victoria, Cunard Line, 2003) sowie den National Trust. C. gehört zu den führenden zeitgen. Glaskünstlern in Großbritannien. ⌂ ALABAMA, Mobile Mus. of Art. CAMBRIDGE, Fitzwilliam Mus. COBURG, Europ. Mus. für Mod. Glas. EDINBURGH, NM of Scotland. KINGSWINFORD, Broadfield House Glass Mus. LIVERPOOL, Walker AG. LONDON, Brit. Council. – Crafts Council. – V & A. MANCHESTER, Metrop. Univ. STOURBRIDGE, Ruskin Glass Centre. ◉ *E:* 1998, '99, 2003 Glasgow, Roger Billcliffe / London: 2000 V & A Crafts Council Shop; 2002 Flow Gall. (mit Zoe Hope); 2003, '06 Contemp. Applied Arts; 2007 Cecilia Colman Gall.; 2011 Neville Johnson / 2002 Brighton, White Gall. / 2004 New York, Susan Megson Gall. / 2005 Devon, Church Gall. / 2006, '08, '10 Edinburgh, Scottish Gall. (K) / 2006 Chipping Campden (Glos.), Susan Megson Gall. / 2007 Eton, Eton Applied Arts / 2009 Cowdy Gall. / 2010 Beer (Devon), Steam AG (mit Siddy Langley); Ambleside, Old Courthouse Gall. / 2011 Swansea, Mission Gall. ▭ *J. Opie,* Crafts 153:1998 (Juli/Aug.) 28–31; *D. Whiting,* ibid. 155:1998 (Nov./Dez.) 53 s.; *J. Hawkins Opie,* Contemp. internat. glass (K V & A), Lo. 2004; *K. Weschenfelder* (Ed.), Coburger Glaspreis für zeitgen. Glaskunst in Europa 2006 (K), Coburg 2006; *L. Abel-Smith,* Country life 204:2011 (8) 44–49. – *Online:* Website C. H. Stuchtey

Cross, *Helen* → **Clark,** *Laurence*

Cross, *Peter,* brit. Graphiker, Zeichner, Buchillustra-

tor, Autor, * 1951 Guildford. Ausb. als wiss. Zeichner (Botanik). Danach als technischer Zeichner bei der brit. Flugzeugbau-Fa. Hawker Siddeley angestellt. Seit M. der 1970er Jahre selbständig tätig. – C. illustriert seit 1982 Kinderbücher, darunter 1985 vier Bücher über Dinosaurier und 1986–88 fünf über die Schlafmaus Dudley (u.a. *Dudley goes flying,* Lo. 1986). Für die beiden Publ. für Erwachsene *1588 and all this …* (Lo. 1988) und *The boys' own battle of Britain* (Lo. 1990) verfaßt er auch die Texte. Char. sind cartoonartige Situationen mit einer lebensnahen Wiedergabe der Fauna, phantasievolle, originelle und vielseitige Details und bes. ein skurriler Humor (Aqu., Tusche). Daneben gestaltet C. 1977–92 neun Plattenhüllen für den Gitarristen Anthony Phillips (u.a. *The geese and the ghost,* 1977); des weiteren entstehen 1992–94 auch Verkaufs-Kat. der Fa. Wine Rack, 1995–2000 Grußkarten (Harbottle Hamster) von Gordon Fraser und anschl. eine Grußkarten-Kollektion für die Great Brit. Card Company. ◉ *G:* seit 1988 regelmäßig London, Chris Beetles Gall. (K). ▭ *Horne,* 1994. – The illustrators. The Brit. art of illustration 1800–1997 (K Chris Beetles), Lo. 1997. – *Online:* Website Chris Beetles; Anthony Phillips.

H. Stuchtey

Cross, *Susan,* brit. Schmuckgestalterin, * 1964 Ledbury/Herts., lebt in Edinburgh/Lothian. Stud.: 1980–82 Herefordshire College of Art and Design; 1982–86 Middlesex Univ., London (Jewellery). Ab 1986 Wkst. in London, seit 1989 in Edinburgh. Lehrtätigkeit: 1986–88 Crewe & Alsager College of Higher Education, Alsager/Ches.; 1988–89 Southwark College of Art and Design, London; seit 1989 Edinburgh College of Art. Ausz.: 1987, '88 Platinum Award; 1995 Scottish Arts Council Award; 2007 Jerwood Applied Arts Prize. – C. gestaltet Schmuckstücke aus geschwärztem Silber und Gold (meist als Draht) in Verbindung mit textilen Mat. wie farbigen Garnen. Zur Fertigung der bisweilen an gegossenen Eisenschmuck des 19. Jh. erinnernden Arbeiten nutzt sie hauptsächlich Techniken der Textilverarbeitung wie Häkeln, Stricken, Flechten, Knüpfen, Weben und Wickeln. ⌂ BIRMINGHAM, Mus. and AG. EDINBURGH, NM of Scotland. LONDON, Crafts Council. - V & A. – Worshipful Company of Goldsmiths. ◉ *E:* 1989 Aberystwyth, AC (K) / 1989, '91, '95 (K), 2001 Edinburgh, Scottish Gall. / 1991 Glasgow, Third Eye Gall. / 1994 Barcelona, Hipòtesi (mit Cynthia Cousens). –. *G:* Edinburgh: 1998 NM of Scotland: Jewellery moves (K); 2005 Scottish Gall.: Interface (Wander-Ausst.; K) / London: 1999 Worshipful Company of Goldsmiths: Treasures of the 20th c. (K); 2003 Contemp. Applied Arts: Jewellery meets Textiles; 2005 Lesley Craze Gall.: Edinburgh comes to Clerkenwell (K); 2009 Goldsmiths' Hall: Creation II. An Insight into the Mind of the mod. Artist-Jeweller (K) / Kyōto, NMMA: Edinburgh Makers (K) / 2004 Bristol, City Mus. and AG: Jewellery unlimited (K) / 2007 Hatfield, Univ. of Hertfordshire, Art and Design Gall.: Process Works (Wander-Ausst.; K). ▭ Dict. internat. du bijou, P. 1998. – Interface. An exhib. of contemp. art textiles (K), Edinburgh 2005. F. Krohn

Crosthwaite, *Hugo,* US-amer. Zeichner, * 1971 Tijua-

na/Baja Califorría, Mexiko, lebt dort und in Brooklyn/ N. Y. Aufgewachsen in Rosarita. Stud.: bis 1994 Southwestern College, Chula Vista/Calif.; bis 1997 San Diego State Univ., SchA, San Diego/Calif. – In seinen großformatigen Zchngn mit Bleistift und Kohle thematisiert C. v.a. menschliches Leiden und Gewalt, verbindet dabei mythologische und zeitgen. Motive in trad. Bildsprache mit abstrakten Elementen, was seinen Darst. häufig etwas Spontanes und Unbestimmtes verleiht. Bei C. treffen „Realität, Gesch. und Mythologie" aufeinander, wenn er die Vielgestaltigkeit menschlicher Lebenssituationen erkundet (cf. Website C.). Als ihn inspirierende Künstler nennt er Francisco Goya, Eugène Delacroix, Théodore Géricault, Gustave Doré und Arnold Böcklin. Zu Beginn des 21. Jh. zeichnet C. heroische, muskuläre männliche und weibliche Figuren in klassischen Posen in urbanen Szenerien, die durch Chaos und provisorische Lebensumstände, wie sie in seiner Heimatstadt Tijuana vorherrschen, gekennzeichnet sind (cf. K Strange new world, 2006). Daneben entstehen auch menschenleere Stadtansichten mit Wohnblocks, Hochspannungsleitungen bzw. Silhouetten der Stadt (*The Border: Tijuana Cityscapes 1–4*, 2003). In Zchngn ab ca. 2007 thematisiert C. durch Szenen mit brutalen Figuren, mitunter mit grotesken Verzerrungen oder losgelösten Körperteilen, Gewalt in versch. Lebensbereichen (*The Kiss; Work House*, beide 2009). 2010/11 entsteht der aus 30 Taf. bestehende *Death March* als Auftragswerk für Morbid Curiosity. The Richard Harris Coll. (2012 im Chicago Cult. Center ausgestellt). In der Serie *Tijuanerías* (2012) widmet sich C. den abgründigen Seiten der Grenzstadt Tijuana und entfaltet ein breites Panorama von Menschen in sozialen Problemzonen mit grotesk-surrealen Zügen. Von ihm stammen ferner die Ill. zum Gedichtband *Guerra* von A. Gonzáles Bolaños, Tijuana 2000. ▣ BOCA RATON/Fla., Mus. of Art. LONG BEACH/Calif., Mus. of Latin Amer. Art. LOS ANGELES, California State Univ., Luckman Gall. MIAMI/Fla., Miami AM. SAN DIEGO/Calif., MCA. – Mus. of Art. ◉ *E:* Tijuana: 1997/98 Gal. Multiforo del Inst. de Cult. de Baja Califorría; 2000 Centro Cult. Tijuana sowie die von diesem Zentrum finanzierte Wander-Ausst. Más allá de lo Etéreo / 2001 Solana Beach (Calif.), Gal. d'Art Internat. / Los Angeles (Calif.): 2002 Daniel Saxon Gall.; 2003, '04 Tropico de Nopal Gall. / San Diego (Calif.): 2003 David Zapf Gall.; 2010 Mus. of Art; Noel-Baza FA Gall. / Miami (Fla.): 2005 ArtSpace – Virginia Miller Gall.; 2006–08 Bass Mus. of Art / 2008 Atlanta (Ga.), Mason Murer FA / 2009 Brooklyn (N. Y.), Pierogi Gall. / 2012 Santa Monica (Calif.), Luis De Jesus Angeles. – *G:* u.a. 2004–05 Mexiko-Stadt, Mus. Tamayo de Arte Contemp.: Bien. Rufino Tamayo / 2005–06 Monterrey (Nuevo Leon), Centro de las Artes: Bien. Monterrey FEMSA de Pint., Escult. e Instalación / 2006–07 Tijuana, Pal. de Cultura: La Primera Bien. de Dibujo de las Americas „Rafael Cauduro". ▭ Strange new world. Art and design from Tijuana (K Wander-Ausst.), San Diego 2006; Transactions. Contemp. Latin Amer. and Latino art (K Wander-Ausst.), La Jolla, Calif. 2006; *B. Dijkstra*, Naked. The Nude in America, N. Y. 2010. – *Online:* Website C., 2009;

Pierogi; Art daily v. 25. 5. 2012. C. Rohrschneider

Crotty, *Russell*, US-amer. Zeichner, Installationskünstler, * 1956 San Rafael/Calif., lebt in Ojai und Upper Lake/ Calif. Verh. mit der Graphikdesignerin Laura Gruenther. Stud.: bis 1978 San Francisco Art Inst.; bis 1980 Univ. of California, Irvine. Lehrtätigkeit: 1998/99 Univ. of California, Los Angeles; 2001, '03 California Inst. of the Arts, Valencia. Ausz.: 1991 Nat. Endowment for the Arts; 1999 Peter Reed Found., New York (beides Stip.); 2008 Artists' Fellowship Programme, The Ballinglen Arts Found., Ballycastle/Co. Mayo. – C.s motivisches Repert. wird von seinen Interessen für Astronomie, Lsch. und Natur sowie Surfen bestimmt. Ausgehend von Skizzen vor der Natur, gestaltet C. Zchngn, Künstlerbücher oder die für sein Schaffen char. Globen. Die mit Archivpapier beschichteten Globen aus Fiberglas, auf die er seine Motive direkt mit einem speziellen Kugelschreiber über einer Aqu.-Lasur aufbringt, sind in der Regel installationsartig angeordnet (z.B. drei große, von der Decke hängende Globen mit Lsch. von Kalifornien als ortsspezifische Installation für die US-amer. Botschaft in Beijing, 2007). Mitunter ergänzt C. die Zchngn mit Prosatexten, die er als „bad poetry" bezeichnet, oder auch mit Zeitungsausschnitten, die seine Haltung zu Themen wie Ökologie oder Umweltzerstörung zum Ausdruck bringen. Darüber hinaus fertigt C. auch Monotypien. ▣ ATLANTA/Ga., High Mus. of Art. BALLYCASTLE/Co. Mayo, Ballinglen Arch., The Ballinglen Arts Found. DES MOINES/Ia., AC. KANSAS CITY/Mo., Kemper MCA. LAGUNA BEACH/Calif., Laguna AM. LITTLE ROCK, Arkansas AC. LOS ANGELES, MCA. – County Mus. of Art. MIAMI/Fla., MCA. – Miami AM. NEW YORK, MMA. – Whitney. – New York Public Libr. PARIS, MNAM. PRINCETON/N. J., Princeton Univ. AM. SAN DIEGO/Calif., MCA. SAN FRANCISCO, MMA. – San Francisco FA Mus., Achenbach Found. SANTA BARBARA/Calif., Mus. of Art. TEMPE, Arizona State Univ. AM. VALENCIA, Arte Contemp. e Inversion, S. L. ◉ *E:* New York: 1991 Bess Cutler Gall.; 2000, '02, '06 CRG Gall. / Los Angeles (Calif.): 1991 Bess Cutler Gall.; 1992 Dorothy Goldeen Gall.; 1998 Dan Bernier Gall. / 1992 Phoenix (Ariz.), Radix Gall. / 1993, '96 London, Cabinet Gall. / 1994 St. Louis, Univ. of Missouri, Gall. 210 (K) / Santa Monica (Calif.): 1994, '96 Dan Bernier Gall.; 2000, '05, '09 Shoshana Wayne Gall. / 1997 Glasgow, Transmission Gall. / 2000 Brüssel, Sabine Wachters FA / San Francisco (Calif.): 2002, '06, '10 Hosfelt Gall.; 2008 Aurobora Press / 2003 Kansas City, Kemper MCA; Houston (Tex.), Contemp. AM / 2004 Miami, Miami AM / 2005 Rennes, La Criée, Centre d'Art Contemp. / 2005, '11 Paris, Gal. Suzanne Tarasiève / 2007 Düsseldorf, Gal. Schmela / 2010 Madrid, Michel Soskine. ▭ Art issues (USA) 1991 (20) 17–19; The universe from my back yard (K AC College of Design), Pasadena, Calif. 2001. – *Online:* Website C.; CRG Gall.; Gal. Suzanne Tarasieve.

C. Rohrschneider

Crouzet, *Jean-Louis*, frz. Schmuckgestalter, Juwelier, * 1782 Paris, † 1862 ebd. Vater des Zeichners und Malers *Louis-Eugène C.* (* 1813 Paris, bis um 1875 dort tätig). Um 1804 Eröffnung eines Geschäfts in Paris. Im Ersten

Kaiserreich Herstellung von kleinen Gebrauchsgegenstän-
den (Kämme, Schlüssel, Stempel, Siegel, diverser Zierat).
Während der Restauration ergänzt C. sein Repertoire durch
phantasievollen Modeschmuck und fertigt mit technischer
Virtuosität abwechslungsreiche, originelle und sehr deko-
rative Stücke mit raffinierten Details. Hauptauftraggeber
ist Jean-Baptiste Fossin, ab 1830 dessen Sohn Jules-Jean-
François Fossin. Ab ca. 1848 wird C. von seinem vielseitig
begabten Sohn unterstützt, der das Modellprogramm durch
neue Anregungen bereichert und sich von orientalisch an-
mutendem prächtigen Schmuck aus Marokko und Alge-
rien inspirieren läßt. Armbänder und Halsketten werden
nun v.a. mit Korallen und Schmuckplättchen mit in Halb-
relieform ausgef. mythologischen Darst. verziert. Nach
C.s Ausscheiden aus der Fa. beliefert der Sohn renom-
mierte Pariser Schmuckgestalter, bes. Frédéric Boucheron,
als dessen Mitarb. er auf der WA 1867 eine Med. erhält.
□ Dict. internat. du bijou, P. 1998. R. Treydel

Crouzet, *Louis-Eugène* cf. **Crouzet,** *Jean-Louis*

Crowe, *Nick,* brit. Installations-, Objekt-, Video-, Com-
puter- und Glaskünstler, Fotograf, Zeichner,* 1968 Barns-
ley/S. Yorks., lebt in Manchester und Berlin. Stud.:
1989–95 Univ. of Hull (u.a. Engl. Lit.). 1989–95 (Grün-
dungs-)Mitgl. der Index Theatre Co-Operative. Seit 1992
zahlr. (Gast-)Dozenturen, u.a. seit 2008 Goldsmiths, Univ.
of London. 1995–2000 zus. mit Martin Vincent Leiter des
Annual Programme in Manchester, einer priv. Kunstin-
itiative, die monatl. wechselnde Ausst. in den Wohnräu-
men der jeweiligen Künstler zum Ziel hat. 2001 Mitin-
itiator des Manchester Pavilion bei der Bienn. in Vene-
dig (eröffnet 2003). 2003 Ko-Kurator des überregionalen
Kunstfestivals Artranspennine. – 1989–95 Performances
und Experimentelles Theater mit der Index Theatre Co-
Operative (1994–95 mehrere Gruppen-Ausst.). Seit 1994
Zusammenarbeit mit Ian Rawlinson; in den gemeinsamen
Arbeiten, die Videos, Objekte aus Alltagsgegenständen,
Texte, Zchngn und Fotogr. umfassen, untersuchen die bei-
den Künstler kulturelle Werte der heutigen Ges., indem sie
sich u.a. mit den Themen Politik, Glaube und nat. Identi-
tät auseinandersetzen, wobei der bes. Fokus auf die Spra-
chen der Macht gerichtet ist. Bek. ist v.a. ihre Serie von
Fotogr., Installationen und Filmen, auf denen ausgesuchte
Bilder, Objekte oder auch Wörter paarweise nebeneinan-
der gezeigt werden, z.B. *Two Public Art Proposals* (Wand-
Zchng., Text, 1999) und *Two Options* (Kletterseile, Befes-
tigungsteile, 2010). Daneben weitere Zusammenarbeiten,
u.a. mit Graham Parker in *Mugger Music* (1996, mit I.
Rawlinson und Jane Gant) und *Mugger Music New York*
(1997, mit I. Rawlinson), 24-Stunden–Performances, die
46 bzw. 48, von den Künstlern begleitete Stadtrundgän-
ge durch Manchester bzw. New York beinhalten, sowie ei-
genständige Werke, in denen C. sich u.a. mit dem Einfluß
von Technik und Medien auf den Alltag auseinandersetzt.
Diese Arbeiten umfassen u.a. mehrere Internet-Projekte,
z.B. *Services 2000* (2000), für die er 29 Websites erstellt,
deren Domainnamen bek. Londoner Kunst-Gal. ähneln,
Glas-Skulpt. und gravierte Glastafeln, meist beleuchtet ge-
zeigt, z.B. *Common Occurances* (2005) sowie die in ei-

nem digitalem Bilderrahmen ablaufende Diashow *Pom-
pei* (2007), in der C.s virtuelles Alter ego Rückblick auf
frühere Internetarbeiten hält. Des weiteren Buchprojekte,
z.B. *The Reporters of the BBC Website* (B./Z. 2006), das
stark gerasterte Portr. von 365 BBC-Journalisten enthält,
entstanden durch eine 600-fache Vergrößerung von deren
Internet-Porträts. ▥ CHICAGO/Ill., SchA Inst. of Chica-
go, Joan Flasch Artists' Book Coll.LONDON, Arts Council
England Coll. – Govt. Art Coll. MANCHESTER, Whitworth
AG. ◉ E: (z.T. mit I. Rawlinson): 2000 Cardiff, Chapter
Gall.; San Francisco (Calif.), MMA (mit Gary Hill) / Lon-
don: 2000 Lux Gall.; 2003 Chisenhale Gall.; Mobile Ho-
me Gall. / 2001 Wakefield, Yorkshire Sculpt. Park; Wigan,
Turnpike Gall. (mit Kenny Hunter) / Manchester: 2002
Tmesis Gall.; 2006 Cornerhouse Gall. (Wander-Ausst.;
K) / 2007 Liverpool, FACT (K) / Berlin: 2005 contempora-
ry; 2008 Axel Lapp Projects / 2008 Newlyn, Newlyn AG /
2010 Liverpool, Ceri Hand Gall. / 2011 St. Louis (Mo.),
Isolationroom-Gallerykit / 2012 Lissabon, Plataforma Re-
vólver. – G: (z.T. mit I. Rawlinson): Leeds: 1998 Henry
Moore Inst.: Artranspennine (K); 2009 Leeds AG: Nort-
hern Art Prize Exhib. (beide K) / Manchester: 1998 Cast-
lefield Gall.: AbsolutNew; 1999 CUBE: Mart (K) ; 2000
(Endings), '02 (Travelogue) Whitworth Gall.; 2002 Man-
chester AG: Atmosphere; 2003 The Lowry: Thermo; 2008
Artranspennine / 2000 Birmingham, The Works Gall.: Bo-
ring / 2000 (In Memoriam), '04 (Futurology; K) Walsall,
New AG / 2001 Preston, Harris Mus. and AG: The Digi-
tal Aesthetic / Istanbul: 2001 Contemp. AM: A Fair Place;
2005 Bienn. / 2002 Liverpool: Bienn. / 2004 Long Island
City (N. Y.), P. S. 1 Contemp. AC: Romantic Detachment /
2007 AG of the Central Acad. of FA: Ni Hao / 2007 (Re-
view), '08 (A Season of Film) Berlin, Axel Lapp Projects /
2008 Whitstable: Bienn. / 2009 Portsmouth, Aspex Gall.:
Stranger Things Are Happening / 2010 Sunderland, Nat.
Glass Centre: Re-Make, Re-Model / 2011 Dresden, HBK:
Kritische Masse (K). □ *Buckman* I, 2006 (irrtümlich
* 1965 Macclesfield). – *N. Howes* (Ed.), N. C. and Ian
Rawlinson (K Wander-Ausst.), Manchester 2003. – *On-
line:* Website C.; Website C./Ian Rawlinson; Website Gra-
ham Parker. J. Niegel

Crozat, *Christine,* frz. Zeichnerin, Malerin, Graphi-
kerin, Fotografin, Bildhauerin, Installations- und Video-
künstlerin, * 26. 7. 1952 Lyon, ebd. und in Paris tätig.
Stud.: bis 1972 Ec. nat. des BA, Lyon. Ausz.: 1985 Prix
du MBA, La Chaux-de-Fonds; Prix Lacourière, BN, Pa-
ris. – In versch. Techniken (v.a. Bleistift-Zchngn, Aqu.,
Fotogr., Rad., Lith., Wachs-, Kunstharz- und Glasplas-
tiken [Pâte de verre], Installationen sowie Videofilmen)
widmet sich C. den Themen Zeit und Bewegung. Da-
bei bevorzugt sie alltägliche Motive wie Schuhe, Zäh-
ne (*La dent de St Bernadin*, Kunstharz, 2002), Sitzmö-
bel und Verkehrsschilder. Auf den regelmäßigen Pendel-
fahrten mit dem Hochgeschwindigkeitszug TGV zw. Pa-
ris und Lyon entstehen Fotogr. und Zchngn mit flüchti-
gen Darst. von Lsch. und Details der Umgebung, die wie-
derum Ausgangspunkt für minimalistische Graphiken sind
(*Paysage du T. G. V.*, 1992–2000). In ähnlicher Weise die-

nen Fotogr. von Verkehrs- und Hinweisschildern als Vorlage für Zchngn und Graphiken, u.a. collageartige Komp. mit Piktogrammen aus versch. Ländern (*Chaussée inondable*, 2008). Ein zentrales Motiv in C.s Œuvre sind Schuhe, die sie in allen verwendeten Medien darstellt: Zchngn (*De chez moi à la gare St Paul*, 2006), Aqu. (*et la reine ... conte de Grimm*, 2011), Fotogr. (*Portr. en pieds*, 2003–06), Plastiken (*Les patins de M. Van Eyck*, Wachs, 2002), Videoarbeiten (in Zusammenarbeit mit Pierre Thomé, z.B. *Bananas*, 2004) und Installationen (*Les tournis de Minnie*, 2003). Weitere Installationen entstehen z.B. mit Zahnplastiken oder zahlr. gebrauchten Seifenstücken (*Mine de rien*, 2002). – Auch Ill., z.B. zu Y. Ritsos, *Jeux du ciel et de l'eau*, Caen 1990. ⌗ Arles, Mus. Réattu. Caen, FRAC Basse-Normandie. Ceret, MAM. Lausanne, Mus. de Design et d'Arts appliqués contemp. Lyon, MAC. Paris, BN. – FNAC. – MAMVP. Romans-Sur-Isere, Mus. de la Chaussure et d'Ethnographie Regionale. Selestat, FRAC Alsace. Villeurbanne, FRAC Rhône-Alpes. ◉ *E:* 1989 Caen, Artothèque (Wander-Ausst.; K) / 1993 Paris, Hôtel de Ville (K) / 1998 Romans-sur-Isère, Mus. de la Chaussure et d'Ethnographie Regionale (K) / 1999 Gravelines, Gal. mun. Edouard Manet (Wander-Ausst.; K) / 2002 Arles, Mus. Réattu (K) / 2006 Fougères, Gal. des Urbanistes (K) / 2010 Chambéry, Mus. des Charmettes / 2012 Vénissieux, Espace Arts plast. –. *G:* 1997 Chatou, Centre nat. de l'Estampe et de l'Art imprimé: Heureux le Visionnaire (K) / 1998 Paris, Espace Electra: Jeux de Genres (K) / 2002–03 Lausanne, Mus. de Design et d'Arts appliqués contemp.: Chaussés-croisés (Wander-Ausst.; K) / 2004 Angers, Artothèque: L'Empereur, sa Femme et le petit Prince ... (K) / 2006 Lyon, Le Rectangle: Sept. de la Photo (K) / 2009 Villefranche-sur-Saône, Mus. Paul Dini: Une Histoire des Histoires / 2011 Arles, Mus. Réattu: Sur Mesures / 2012 Reims, Gal. Marie-José Degrelle: Identité de Genre. ⌑ *Bénézit* IV, 1999; *Delarge*, 2001 (* 1960 Paris). – *H. Gaudin*, Jusqu'à nous, Montigny-lès-Metz 1994; *M. Badet*, Nouvelles de l'estampe (P.) 164:1999, 50–56; *C. Joubert/E. Pessan/P. Thomé*, Et à partir de là (K MBA Caen), Lyon 2009. – *Online:* Website C.
F. Krohn

Cruz, *Angela de la*, span. Malerin, Installationskünstlerin, Bühnenbildnerin, * 2. 3. 1965 La Coruña, lebt seit 1989 in London. Stud.: 1985–89 Univ. Santiago de Compostela (Phil.); 1989–90 Chelsea College of Art; 1991–94 Goldmiths College; 1994–96 Slade SchA, alle London. 2001 Entwurf des Bühnenbilds für *At any time. New work*, Ballett Rambert im Lindbury Studio des R. Opera House, choreographiert von Rafael Bonachela. Gastkünstlerin: 2002 Church Gall. in Perth/Western Australia; 2004 Irish MMA, Dublin. 2005 liegt C. infolge einer Hirnblutung mehrere Monate im Koma; danach muß sie einen Rollstuhl benutzen, kann nicht sprechen und erst 2009 wieder ihre Arbeit aufnehmen. 2010 Finalistin beim Turnerpreis in London. Ausz.: 1999 John Moores Paint. Prize, Liverpool; 2010 Preis der Paul Hamlyn Found., London; 2001 Großer Preis AECA (Asoc. Esp. de Críticos de Arte), Madrid. – C.s Werk steht u.a. in der Trad. von Lu-

cio Fontana und bedeutet eine Dekonstruktion der Malerei, die zu Objekten und Installationen werden, eine Art Verbindung von Farbfeldmalerei, Objet trouvé und Junk sculpture. Ausgangspunkt sind monochromatische Gem. (Öl, Acryl) und ihre Bestandteile (Lw., Keilrahmen), deren Verwandlung in plastische Präsenz einen engen, auch emotionalen oder erotischen Bezug zum menschlichen Körper aufweist und von Slapstickszenen des Films inspiriert ist. Die Bildtitel zeugen z.T. von sardonischen Humor. In der Serie *Everyday paintings* ist die Lw. z.B. gefaltet und in eine Raumecke geklemmt (*Ashamed*, 1995), sie liegt zusammengeknüllt auf dem Boden (Serie *Nothing,* 1998–2005) oder unter einem Stuhl (*Misery*, 1998). Lw. und Spannrahmen sind geknickt und stehen auf dem Boden (*Homeless*), sind auseinandergerissen (*Vomit paint.*, beide 1996), von einander gelöst (*Knackered*, 1998) oder mit Zerstörungen versehen (*Dislocated paint.*, 2001). Die Wiederverwendung bemalter Leinwände und Keilrahmen führt zur Serie *Clutter*, in der sie in Säcken oder Kästen verstaut oder, auf dem Boden liegend, mit einem weißen Tuch abgedeckt sind, als läge ein Leichnam darunter (*Clutter [with white blanket]*, 2004). Das Werk *Larger than life* ist ein mon., einen Saal von Wand zu Wand ausfüllendes, mehrfach geknicktes Gem., das als Auftrag für spezifische Orte realisiert wird (Ballsaal der R. Festival Hall, London, 1998; Espacio Anexo, Vigo, 2004); es wirkt, als sei es für den Raum zu groß und könne nur so darin verstaut werden. Der skulpturale Char. der Arbeiten steigert sich in den Bildern, die von Tischen oder Stühlen durchdrungen sind (Serie *Still-life*, 2000–01), in Möbeln, die aufeinander stehen (*Three-legged chair on a stool*, 2000; *Upright piano*, 2002) oder die übereinandergestapelt an der Wand hängen (*Clutter with wardrobes*, 2004; *T piece; Hold*, beide 2005). C. arbeitet häufig mit Assistenten, nach Krankheit und Klinikaufenthalt ist sie auf diese ganz angewiesen. Die in den letzten Jahren entstandenen Werke wirken weniger brutal und anstößig, eher ausgewogen und gediegen, meist in monochromer heller Farbigkeit, mit Anspielungen auf C.s eig. Behinderung, z.B. in einem Plastikstuhl, dessen Beine gänzlich verbogen sind, als habe ein Gewicht seine Sitzfläche fast auf den Boden gedrückt (*Flat*, 2009). Auch bemalte, frei aufgehängte oder gespannte und verzogene Leinwände (*Deflated; Hung*) oder an der Wand hängende, bildähnliche, durch Pressung gestauchte, farbige Aluminiumkästen (*Compressed*, 2011) sowie eine Objektinstallation, in der ein schrankähnlicher Kasten auf Sessel und Stuhl aufliegt (*Transfer [Ivory]*). ⌗ Barcelona, Fund. La Caixa, Col. de Arte Contemp. Brügge, Univ. Dunkerque, FRAC Nord-Pas de Calais. La Coruña, Banco Pastor. London, Brit. Council Coll. – Contemp. Art Soc. – Cubitt Gall. and Studios. Madrid, Col. Iberdrola. Melbourne, NG of Victoria. Queensland, AG. Siero/Asturias, Fund. Ma. Cristina Masaveu Paterson. Valencia, Caja de Ahorros del Mediterráneo. Valladolid, Patio Herreriano. Vigo, Banco Pastor. Vitoria, Artium. ◉ *E:* 1993 Hackney (London), Premises Studios / London: 1998 R. Festival Hall, Queen Elizabeth Hall (K: A. Searle); 1998, 2001 (K: K. García-Antón/E. Tan) Anthony Wil-

kinson Gall.; 2004 (mit Fernando Ortega), '11 (mit Rashid Rana; K: P. Barlow u.a.) Lisson Gall.; 2010 Camden AC / 1997 Aalst, Gal. in Situ / 1998, 2000 New York, John Weber Gall. / 1999, 2003 Wien, Gal. Krinzinger / 2002 Perth (Western Australia), The Church Gall. / 2002, '05, '12 Melbourne, Anna Schwartz Gall. / 2003 Stockholm, Heland Wetterling Gall. (mit Maria Chevska; K: J. P. Nilsson) / 2004 Basel, Gal. Nicolas Krupp; Vigo, MAC, Espacio Anexo (K: C. Alvarez Basso) / 2005 Tel Aviv, Loushy Art & Editions; Sevilla, Centre Andaluz de Arte Contemp. / 2006 Lissabon, Edifício-Sede da Caixa Geral de Depósitos, Lisboa Gall. (K: M. Wandschneider u.a.) / 2011 Madrid, Gal. Helga Alvear. – *G:* 1998 Wien, Gal. Krinzinger: UK maximum diversity (K) / 2001 Brighton, Univ. of Brighton Gall.: Makeshift (K: D. Green u.a.) / 2004 San Sebastián: Manifesta 5 / 2008 Vigo, MAC: Priv. passions, public visions / 2009 Canberra, NG of Australia: Soft sculpt. (K: L. Ward) / 2010 London, Tate Britain: Turner prize (K). ⌑ *R. Smith*, New York Times v. 30. 1. 1998; *W. Feaver*, The Observer (Lo.) v. 14. 6. 1998; *J. Hall*, Artforum (N. Y.) 40:2001 (2) 169; Vitamin P. New perspectives in paint., Lo./N. Y. 2002; *M. Amado*, Artforum 45:2006 (1) 387; *M. Reilly/L. Nochlin* (Ed.), Global feminisms. New directions in contemp. art (K Brooklyn Mus.), Lo./N. Y. 2007; Art news 109:2010 (9) 104; *K. Kemp-Welch*, Art monthly (Lo.) 2010 (336) 33–34; *A. Searle*, The Guardian (Lo.) v. 5. 4. 2010; *C. Darwent*, The Independent (Lo.) v. 11. 4. 2010; *B. Otero*, El País, Supl. Babelia (Ma.) v. 14. 8. 2010: The Times (Lo.) v. 4. 12. 2010. – *Online:* Lisson Gall., London. M. Nungesser

Cruz, *José* → **Cruz Ovalle,** *José*

Cruz (C. Díaz), *José Guadalupe (José G.)* (Pseud. Rolf Stein), mex. Comiczeichner und -autor, Maler, Fotograf, Illustrator, Filmautor, Schauspieler, Sänger, * 31. 1. 1917 Teocaltiche/Jalisco, † 22. 11. 1989 Los Angeles/Calif. Als Kind mit der Fam. Übersiedelung nach Kalifornien. Ab 1929 Stud. in Orange/Calif., als Zeichner Autodidakt. Ab 1934 in Mexiko-Stadt ansässig und als Illustrator für die Verlage Juventud und Ediciones Panamericana tätig, anfangs als Werbe-, dann als Comiczeichner (zuerst unter dem Pseud. Rolf Stein). Veröff. von Comics in versch. Zss., u.a. Paquin, Paquito und Pepín, ab 1943 auch Fotocomics und Fotonovelas (Bildromane), u.a. *Carta Brava, Percal, Tango, Ventarrón, Dancing, Revancha* und *Niebla.* Ab 1948 schreibt C. Skripte und Drehbücher für Kino und Radio und ist als Schauspieler und Sprecher tätig, u.a. in Filmen von Agustín P. Delgado, Chano Urueta, Fernando A. Rivero und Juan Orol. 1952 Gründung des eig. Verlages Ediciones J. G. C. (bis A. der 1980er Jahre) und u.a. Hrsg. der Fotonovela-Hefte Muñequita, La Pandilla, El Vampiro Tenebroso, Canciones Inolvidables, Adelita y las guerrilleras, El Valiente und Santo, el enmascarado de plata. Außerdem Veröff. von Comic-Books und A. der 1960er Jahre zus. mit seinem Sohn José Gustavo C. die Zs. Hist. del Rock and Roll, die erste zu diesem Thema in Mexiko. – C. zählt zu Mexikos bedeutendsten Verf. populärer Bildgeschichten, anfänglich inspiriert u.a. von US-amer. Zeichnern wie Alex Raymond, Harold Foster und Milton

Arthur Caniff. Neben Comics umfaßt sein Werk v.a. in der wachsenden Metropole Mexiko-Stadt spielende, auf Fotomontage beruhende Bildromane, die auf eig. und gefundenen Fotos basierten und zeichnerisch bearbeitet wurden, z.T. mit Elementen von Science-fiction und Fantasy. Manche Heftumschläge gehen von C.s Öl- oder Acryl-Gem. aus. Protagonisten sind archetypische männliche Antihelden, z.B. *Carta Brava* und *Ventarrón*, den C. erfand, zeichnete, fotografierte, teils auch darstellte, sowie emanzipierte Heroinen, u.a. *Adelita* und *La Tigresa del Bahío.* Zur Gruppe der Mitarb. zählten u.a. seine Schwester Josefina C. und die Zeichner Horacio Robles (auch Dir. artíst. des Verlags), Manuel del Valle, Ramón Valdiosera Berman, Guillermo Marín und Alfonso Tirado. C.s bekannteste Figur und Comic-Ikone ist *Santo, el enmascarado de plata*, der gleichsam als Kreuzritter des Guten auftritt. 1952–82 erscheint das gleichnamige Heft mit dem Untertitel ¡Una rev. atómica! mit José Trinidad Romero als Zeichner und Gestalter. Vorlage für den Protagonisten ist der legendäre Lucha-libre-Kämpfer Rodolfo Guzmán Huerta (1917–84), der seit 1942 als „El Santo" auftritt und teilw. für die Bildgeschichten posiert. Manche Comics bearbeitet C. für Radiohörspiele und Filme, z.B. *Carta Brava* (1948, Regie: A. P. Delgado), *Percal* (dreiteilig, 1949, Regie: J. Orol) und *El enmasacarado de plata* (1952, Regie: R. Cardona). Außerdem Wandbilder, u.a. eine allegorische Darst. der Kultur der Mayas und Azteken für das Theater des Untersuchungsgefängnisses in Mexiko-Stadt, Plakatentwürfe, plastische Arbeiten, Ill. u.a. für Büchern und Broschüren versch. politischer Gruppen sowie für Pin-up-Kalender, weiterhin Komponist und Sänger von Tangos. ⌑ CUAUTLA/Morelos, Mus. de la Caricatura y la Historieta. MEXIKO-STADT, Mus. de la Caricatura. – Mus. del Estanquillo. ☉ *G:* 2009 Mexiko-Stadt, Univ. Iberoamer., Edificio S, Gal. del Sótano: Santo, leyenda de plata; Buzón de Arte: Santo de mi devoción. Una expos. atómica. ⌑ AKL XXII, 1999, 495. – *O. S. Suárez*, Inv. del muralismo mexicano, Méx. 1972; *F. Curiel*, Fotonovela rosa, fotonovela roja, Méx. 1980; *I. Herner*, Mitos y monitos. Historietas y fotonovelas en México, Méx. 1979; *M. Vázquez González*, La historieta. Todo lo relativo al lenguaje lexipictográfico, Méx. 1981; *A. Barón-Carvais*, La historieta, Méx. 1989; *J. M. Aurrecoechea/A. Bartra*, Puros cuentos. Hist. de la historieta en México, 1934–50, III, Méx. 1994; *A. Bartra*, Luna cornea (Méx.) 1999 (18) 181–198; Iconofagia. Imaginería fotogr. mex. del s. XX (K Sala de Expos. Canal de Isabel II), Ma. 2005. – *Online: I. López Cruz*, J. G. C. artista del cómic y el arte fantástico mex. Interpretación gráfica, Mex. 2009; Escritores del cine mex., UNAM. M. Nungesser

Cruz, *José Maria Dias da*, brasil. Maler, Hochschullehrer, * 1935 Rio de Janeiro, lebt dort. Sohn des Schriftstellers Marques Rebelo. Stud.: 1955–56 Malerei bei Jan Zach, Aldary Toledo, Thomás Santa Rosa und Flávio de Aquino; 1956 mit Stip. des Erziehungs-Minist. an der Acad. de La Grande Chaumiére, Paris, u.a. bei Johnny Friedlaender und Emílio Petorutti. 1958 Rückkehr nach Brasilien. 1968–73 Abkehr von der Malerei, die er 1974

unter dem Einfluß von Carlos Scliar und Abelardo Zaluar wieder aufnimmt. Lehrtätigkeit: 1983–86 Malerei am MAM, Rio de Janeiro.; 1987–99 und seit 2003 Prof. für Malerei an der Esc. de Artes Visuais do Parque Lage. – C.s konzeptuelle Malerei, die geometrische Komp. ebenso umfaßt wie Schrift- bzw. Zahlenbilder und Porträts, setzt sich mit grundsätzlichen Fragen nach den formalen, inhaltlichen und historischen Bedingungen von Bildern auseinander. Häufig folgen seine Gem. dem Prinzip der malerischen Reprod., wobei ihm v.a. an der Übertragung theoretischer Modelle, Systeme oder Farbwelten in die Malerei gelegen ist, so z.B. in der Werkgruppe der *Formulários*, in denen er die Vordrucke der Armazens Gerais Ferroviários, für die er zeitweilig tätig war, malerisch umsetzte. ⌂ FLORIANOPOLIS, Mus. de Arte de Santa Catarina. NITERÓI, MAC. ☉ *E:* Rio de Janeiro: 1975 Gal. Quadrante; 1977 Gal. Luiz Buarque de Hollanda e Paulo Bittencourt; 1979 Gal. Toulouse; 1981 Gal. Dezon; 1985 Gal. Arte Espaço; 1986 Espaço Cult. Petrobrás; 1989 Gal Saramanha; 1991 Esc. de Artes Visuais Parque Lage; 1998 Paço Imperial; 2001 Gal. Lhália / 1976 Santos, Centro Cult. Brasil-Estados Unidos; Resende, MAM / Cataguases (Minas Gerais): 1977 Gal. Domus; 2001 Centro Cult. Francisca Peixoto / 1978 São Paulo, Gal. Ipanema / 1981 Porto Alegre, Bolsa de Arte / 1994 Florianópolis, Mus. de Arte de Santa Catarina / 1995 Teresópolis, Gal. do SESC. –. *G:* Rio de Janeiro: 1974 Salão de Verão JB-Light; Paço Imperial: 1993 (A Caminho de Niterói Col. João Sattamini); 1994 (Artistas Cariocas); 1996 (Geometria); 2000 MAC: Obras do Acervo / São Paulo: 1976, '79 MAM: Panorama de Arte Brasil. / 2000 Niterói, MAC: Obras do Acervo. ▭ *Medeiros*, 1988; *Ayala*, 1997. M. F. Morais

Cruz, *Juan,* span. Videokünstler, Fotograf, Performance- und Installationskünstler, Kunstkritiker, Übersetzer, * 1970 Palencia, lebt in Liverpool. Seit dem 8. Lebensjahr in England lebend. Stud.: 1990–93 Chelsea College of Art ebd. (Malerei); 1992 HdK, Berlin. Seit 1997 Gast-Doz. an versch. Univ. in Großbritannien. 1999 Girton College Artists Fellowship für Kettle's Yard in Cambridge. 1999–2002 Mitgl. der London Arts Visual Arts Advisory Group und ab 2002 des Arts Council NTP Selection Panel. Seit 2002 Doz. am Goldsmiths College und seit 2008 Dir. der Kunst-Abt. der SchA and Design der John Moores Univ. in Liverpool. Ausz.: u.a. 1999 Paul Hamlyn Found. Award. – C. stellt auf multimediale Weise Geschichten dar, die durch Erzählstruktur und Handlung neue Aspekte aufzeigen und Reales und Fiktives untrennbar miteinander mischen. Mehrere Werke beziehen sich auf Spanien: u.a. *Translating Don Quijote* (1996), bei dem C. in mehreren öff. Sitzungen den berühmten Cervantes-Text ins Englische überträgt; *Sancti Petri* (1998), das in Dia-Schau und gesprochenen Texten von dem verlassenen andalusischen Fischerdorf gleichen Namens und seiner Entwicklung handelt; *Port. of a sculptor* (2001), das mit DVD, Fotos und Texten eine vertrackt-absurde Annäherung an ein Bild von Velázquez und eine Reiterstatue Philipps IV. darstellt. *Application for planning permit. Proposal to build a metaphor* (2001) entsteht als Auftragsarbeit für das Mel-

bourne Festival, wo C. im öff. Raum eig. Textplakate aufhängt, die exemplarisch typische Eigenschaften and. Orte beschreiben. In den 1990er Jahren zahlr. Kunstkritiken, v.a. in der Zs. Art monthly. ⌂ LONDON, Arts Council Coll. – Brit. Land and Priv. Coll. – Govt. Art Coll. – Hayward Gall. – South London Gall. Coll. ✉ F. García Lorca, The last poems, Lo. 1996 (Übersetzung). ☉ *E:* London: 1996 Inst. Cervantes; 1996, '97 Genesta; 1998, 2001 Matt's Gall. (K); 2000 Camden AC (CD); 2004 Tabernacle Theatre; 2005 Peer / 1999 München, Künstler-Wkst. (mit Lucy Gunning; K: S. Gaensheimer/A. Cross) / Cambridge: 1999 Matt's Yard (K); 2000 Kettle's Yard / 1999, 2002, '08 Madrid, Gal. Elba Benítez / 2000 Southampton, Hansard Gall. / 2005 Bristol, Room (mit Sam Fisher; K: M. Phillipson) / 2009 Murcia, Mus. de Santa Clara; Kent, Crate. Studio and Project Space (mit Naama Yuria) / 2010 Tokio, Inst. of Technology, Center for the Study of World Civilizations. – *G:* 1996 London, Genesta: An eternity with boundaries / 1999 Göteborg, KH: From where, to here (K) / 2001 Rotterdam, Witte de With, Centrum voor Hedendaagse Kunst: Squatters (K) / 2009 Edinburgh, Dean Gall.: The enlightenments. ▭ *Delarge*, 2001. – *A. Cros*, Art monthly 1996 (197) 44 s.; *M. Pesch*, Kunstforum internat. 1999 (147) 433 s.; *G. Worthington/R. Hopper* (Ed.), Here and now. Experiences in sculpt. (K Henry Moore Found.), Leeds 1999; *L. Cumming*, The Observer (Lo.) v. 30. 4. 2000; *S. Morley*, The Independent (Lo.) v. 5. 8. 2001; *J. Hall*, Artforum 40:2001 (3) 157; *J. Engberg/A. Defert*, J. C. Application for planning permit, proposal to build a metaphor, Melbourne 2002; *J. Hontaria*, El Mundo, Supl. El Cultural (Ma.) v. 19. 12. 2002, 48; *F. Castro Flórez*, ABC Cult. (Ma.) v. 28. 12. 2002, 26; *T. Dean/J. Millar*, Ort, Hildesheim 2005 (Art works – zeitgen. Kunst); *R. Withers*, Artforum 2006 (Jan.). – *Online:* Matt's Gall., Cambridge. – Mitt. C. M. Nungesser

Cruz, *Luis Vieira da,* portug. Bildhauer, Schnitzer, * Braga, nachw. 1704–29. Hatte ebd. eine Wkst. unweit der Kirche Nossa Senhora-a-Branca. Zw. 1704 und 1729 sind fünf Aufträge dok. und erhalten: Am 16. 5. 1704 das Retabel für die Kap. S. Francisco Xavier in der Kollegiatskirche S. Lourenço in Porto und 1705 zwei Seitenaltäre für die Kirche S. Maria in Cárquere. Für die Kollegiatskirche S. Paulo in Braga 1709 das Retabel der Chor-Kap., 1710 für die Epistelseite zus. mit dem Bildschnitzer João da Rocha den Altar Nossa Senhora da Boa Morte und 1729 das möglicherweise durch seinen Tod nicht mehr ausgef. Retabel S. Francisco. Auftraggeber waren die Rektoren der jeweiligen Jesuitenkollegien, wobei Cárquere dem Kollegiat von Coimbra unterstand. – C.s Retabel sind in Form von Ädikulen aufgebaut: mit ausladendem Korpus, Kassettenbogen, Attika, beidseits von Weinreben, Putti und Vögeln umrankte Salomonika und einem Thron über dem Altartisch. Es sind hochbarocke (portug. barroco nac.), in sich geschlossene, polychrom gefaßte Werke feinster Schnitzkunst (sog. Talha-dourada-Arbeiten), die noch keine aufgebrochenen Strukturen der Spätformen des Barocks aufweisen. Nicht durch Schnitzereien verzierte Flächen wurden (z.B. in der Chor-Kap. der Kirche S. Paulo) mit blau-

weißen narrativen Fliesentableaus geschmückt. – C. zählt in der Region Beira neben João Soares, Manuel da Rocha und Matias Rodrigues de Carvalho zu den bed. Meistern der ersten H. des 18. Jahrhunderts. ⊡ *F. Lameira*, O retábulo da Compania de Jesus em Portugal. 1619–1759, Faro 2006, 45, 49, 198–201, 218 s. R. Petriconi

Cruz, *Raul* (eigtl. Borges da Cruz, *Raul*), brasil. Maler, Graphiker, Zeichner, Szenograph, Autor, * 15. 2. 1957 Curitiba, † 27. 4. 1993 ebd. Stud.: 1977–80 Esc. de Música e BA do Paraná; 1982–84 Rad. und Lith. am Solar do Barão. Fertigt auch Bühnenbilder für versch. Inszenierungen, u.a. für das Stück *Olha o delírio* (1984), und schreibt das Theaterstück *Cartaz a Pierre Riviére* (1987). – C. zählt zu den bed. Künstlern Curitibas. In seinen Zchng lotet er häufig die Ausdrucksmöglichkeiten des Mediums aus, so etwa in der Serie von Tusche-Zchng *Sem título* (1988–89), in denen er die Strichführung zum Thema erhebt. Im Mittelpunkt auch seines malerischen Werks steht dabei die menschliche Figur, die C. als Ausgangspunkt für seine Erörterung der Rolle der Kunst dient, v.a. im Hinblick auf die ges. und politischen Umwälzungen der 1980er Jahre in Brasilien. ◉ *E:* Curitiba: 1982 Fund. Cult.; 1985 Gal. de Arte Banestado; 1986 Mus. Guido Viaro; 1987, 2006 MAC; 1992 Solar do Barão; Gal. Casa da Imagem. – *G:* Curitiba: 1981, '83, '84 (Ausz.) Salão Paranaense; 1982 Sala de Expos. do Teatro Guaíra: Mostra de Arte Bicicleta; 1984 Fund. Cult. de Curitiba: A Rosa – Litonovelas; 1985 Mus. Guido Viaro: O Erotismo nas Artes Plást. do Paraná; 1988 MAC: Olho / 1981 Porto Alegre, MARGS: Desenhistas do Paraná / 1986 São Paulo, Pin. do Estado: Seis pintores contemp. do Paraná. ⊡ *Ayala*, 1997.

M. F. Morais

Cruz, *Teddy*, US-amer. Architekt, Stadtplaner, Theoretiker, * 1962 Guatemala-Stadt, lebt in La Jolla/Calif. Stud.: bis 1982 Univ. Rafael Landívar, Guatemala-Stadt; bis 1987 California Polytechnic State Univ., San Luis Obispo. Stip.: 1991 Rome Prize in Archit. (Amer. Acad. in Rome). 2000 Gründung des eig. Büros Est. T. C. Cruz in La Jolla. Gastlehre und Vorträge in den USA, Lateinamerika und Europa, u.a. City College of New York; 1997 Harvard Univ. Graduate School of Design, Cambridge/Mass.; 2000–05 Woodbury Univ., San Diego (Gründung des Border Inst. ebd.); 2009 Berlage Inst., Rotterdam. Derzeit Doz. an der Univ. of California, San Diego. Mitgl. der Urban League in New York City. Ausz. für Archit.-Lehre und Forschung: 2004–05 James Stirling Memorial Lecture On The City, Montréal, New York, London; Robert Taylor Teaching Award, ACSA (Ass. of Californian School Administrators), Sacramento/Calif.; Architectural League of New York Young Architects Forum Award, New York. – Der seit 1982 in San Diego lebende C. ist beidseitig der US-amer.-mex. Grenze tätig und forscht gemeinsam mit div. Nichtregierungsorganisationen wie z.B. Casa Familiar, San Ysidro/Calif., über alternatives Wohnen im Zusammenhang mit Bodenpolitik. Das Grenzgebiet sieht er als übergreifendes Experimentierfeld für radikale städtebauliche Strategien. C. plädiert für städtische Komplexität, Mischformen und Gleichzeitigkeit als Gegenentwurf

zur Gentrifizierung und zur sterilen, die Landschaft bedrohenden Suburbanität. Seine Visionen faßt er als fiktionale Landschaften in seinen *Hybrid Postcards*, die in Fotocollagen das städtebauliche Potential leerer Flächen spiegeln, zusammen. Die Utopie zielt auf neue Lösungen zur Durchbrechung der obsolet gewordenen Funktionentrennung, die mit inneren Grenzen und Verkehrssystemen große ungenutze Areale hinterlassen hat. Auf mehreren Ebenen soll dort mit Blick auf das starke urbane Wachstum eine Mischung aus Wohnen, Handel, Gewerbe und Grünflächen zu Flexibilität, Verdichtung und Nachhaltigkeit beitragen. Einen praktikablen Schritt in diese Richtung repräsentiert die in Gemeinschaftsarbeit entwickelte Idee des *Manufactured Site* mithilfe eines vorfabrizierten, flexiblen Bausystems für Wohnraum und Gewerbe nach dem Vorbild illegal aus wiederverwendeten Mat. gefertigen Bauten in Tijuana. C. verfolgt mit seinen Ideen zugleich eine ges. Neuordnung, denn es geht ihm nicht um ein neues Stadtbild, sondern um sozio-ökonomische und politische Prozesse im Sinne der auf den Städtebau übertragenen Mikroökonomie. Die Theorie des Mikro-Urbanismus zielt auf die Umwandlung der diskriminierenden grenzüberschreitenden Dynamik in eine nachbarschaftliche Zusammenarbeit zur Überwindung globaler Grenzen zw. Wohlstand und Armut. Diesen Zielen gemäß erstellt C. 2007–08 zus. mit den betroffenen Einwohnern einen Entwicklungsplan für Hudson/N. Y. ⊞ BARCELONA, Centre de Cult. Contemp. de Barcelona (CCCB). NEW YORK, MMA. ⊠ Mikro-Urbanismus an der Grenze zw. San Diego und Tijuana, in: Bauwelt 98:2007 (48) 56–65; Pratiche di occupazione abusiva. I rifiuti dell'urbanizzazione muovono verso sud, lo zoning illegale filtra lentamente a nord, in: Domus 2008 (10/918). ◉ *E:* 2008 San Francisco (Calif.), Art Inst. (mit Pedro Reyes); New York, The Park Found. Gall. – *G:* 2005–06 Chicago (Ill.), MCA: Massive Change / 2006 Tijuana, Inst. de Cult. de Baja California: Otra – Another / 2007 Istanbul: Internat. Bienn. (K); Santa Monica (Calif.), Mus. of Art.: Dark Places; Rotterdam: Internat. Archit. Bienn.; Lissabon: Trienal de Arquit. / 2008 Valencia (Spanien), IVAM: Construir, habitar, pensar. Perspectivas del arte y la arquit. contemp.; Barcelona, CCCB: Post-it City. Ciudades ocasionales; Minneapolis (Minn.), Walker AC: Worlds Away. New Suburban Landscapses (K); Venedig: Bienn. / 2010 Denver (Colo.): Bienn. of the Americas / 2011 San Ysidro (Calif.), Casa Familiar: Small Scale Big Change. New Archit. of Social Engagement. ⊡ Strange new world. Art and design from Tijuana (K Wander-Ausst.), San Diego 2006; *N. Ouroussoff*, New York Times v. 19. 02. 2008. – *Online:* Website C.

A. Mesecke

Cruz Díaz, *José Guadalupe* → **Cruz**, *José Guadalupe*

Cruz Ovalle, *José*, chilenischer Architekt, Architekturtheoretiker, * 1948 Santiago de Chile, lebt dort. Stud.: 1968–70 Univ. Católica, Valparaíso; 1970–73 Esc. Técnica Superior de Arquit., Barcelona (1982–86 Doz.). Gründet 1975 das eig. Büro ebd. und arbeitet als Autor für die Fach-Zs. Jano Arquit. (Ba.). 1987 Rückkehr nach Chile und Büro in Santiago mit der katalan. Innenarchitektin

und Ehefrau Ana Turell Sanchez-Calvo; Partnerschaft mit dem Architekten und Fotografen Juan Purcell Mena (seit 1994) und dem Architekten und Maler Hernán Cruz Somavia (seit 2000). Ausz.: 1992 Publikumspreis WA, Sevilla; 2004 1. Preis Bien. de Arquit. Iberoamericana, Santiago de Chile; 2008 Spirit of Nature Wood Archit. Award, Lathi. – C.s Wirken ist bestimmt durch die Verbundenheit mit der unbezwungenen Natur Chiles, die ihn auch im Exil beschäftigt. Die gemeinsame Lehrtätigkeit mit dem span. Philosophen Eugenio Trías Sagnier in Barcelona in den 1980er Jahren (Fach Ästhetik) führt ihn zur Auseinandersetzung mit dem Begriff der Abstraktion, den er, auf den Raum bezogen, an eig. Skulpt. untersucht. Mit Blick auf die fehlende Archit.-Trad. in Lateinamerika entwickelt er unter Berufung auf die Moderne, die mit den elementaren Formen der Geometrie Universalität anstrebte, eine Theorie der „neuen Abstraktion". Im Unterschied zur Moderne unterstreicht C. jedoch die Einzigartigkeit jedes Bauwerks, das aus der archit. Beobachtung singulärer Ereignisse heraus entstehe. Analogien, semiologische Interpretationen und symbolische Verweise negiert er dabei vehement. Die anfängliche Schwierigkeit, die geometrische Projektion in gebauten Raum zu übersetzen und eine stimmige Beziehung zw. Körper, Raum und Licht herzustellen, überwindet er mittels skulpturaler Experimente. Diese Vorgehensweise erinnert an die Hängemodelle von Antoni Gaudí i Cornet oder die Drahtmodelle von Frei Otto. C.s bevorzugtes Bau-Mat. ist Holz, da es den Anforderungen an Konstruktion und Ausbau gleichermaßen entspricht. Erste Bauten verwirklicht er in Chile zus. mit Germán del Sol Guzmán. In der dramatischen Lsch. des Nat.-Parks Torres del Paine in Patagonien errichten sie 1991–93 das Hotel Salto Chico (Hotel explora Patagonia; 2005 Umbau des Interieurs durch C.) als radikal mod. Gebäude, das sich, gestuft und geknickt, mit seinem weißgestrichenen, langen Baukörper überzeugend in die Szenerie der Bergmassive einfügt. Mit dem chilenischen Pav. auf der WA 1992 (mit G. del Sol Guzmán), einer anmutigen, leicht geschwungenen Holzkonstruktion, erlangt C. internat. Aufmerksamkeit. Bed. ist der Bau des Campus Peñalolén (2000–02) der Univ. Adolfo Ibañez in Santiago de Chile, eine kleinteilig wirkende organische Großstruktur, die sich flach über das Hügelland breitet (weitere Bauten 2003, ’05, ’07). Der kreative, strukturelle Gebrauch von Holz führt hier zu expressiver Strenge jenseits der reinen Lösung und läßt poetische Gebäude von technischer Perfektion entstehen. Es sind fließende Komp. aus rational in Beziehung gesetzten Kreissegmenten, Ellipsen und geraden Linien, die sich zu schiefen Ebenen, gebogenen Wänden, Verjüngungen und Durchdringungen verbinden und trotz ihrer Kunstautonomie mit der Umwelt im Einklang stehen. Bemerkenswert ist C.s Lösung für 101 Sozialwohnungen im Stadtviertel Carabanchel in Madrid (ab 2007). Das große Eckgebäude dieser innerstädtischen Blockrandbebauung setzt sich aus zwei leicht gekurvten, nach oben hin gewellten Baukörpern zusammen, die sich elegant aneinanderfügen und den mon. Char. der Blockstruktur durchbrechen.

🏛 Arauco: Fa. Paneles Arauco, 1996–97. Lo Barne-

chea, Valle Escondido: Haus, 2006–07. Monte Patria: Grundschule Villa El Palqui, 2001–02. Paine: Weinkellerei Viña Pérez Cruz, 2002. Palmilla (Colchagua), Weinkellerei Fundo Los Robles, 2000–02. Puchuncavi: Casa Ocho al Cubo, 2002–03. Rapa Nui (Osterinsel), Lodge Posada de Mike Rapu, 2007. San Pedro De Atacama: Hotel de Larache (Umbau Interieur), 2008. Santiago De Chile: Holz-Man. Centro Maderas, 2000. – Merced 395: Restaurante Opera, Bar Catedral, 2005–06. Viña Del Mar, Univ. Adolfo Ibañez: Campus, 2011. ⊙ E: 2008 Lahti, Pro Puu Gall.; Jyväskylä, Alvar Aalto Mus. – G: 1998 New York, MMA: The Mies van der Rohe Award for Latin Amer. Archit. 📖 M. Alfieri, Controspazio N. S. 30:1999 (2) 50–61; E. Bennett/A. Crispiani (Ed.), J. C. O. Hacia una nueva abstracción, S. Ch. 2004; J. C. O. Spirit of nature wood archit. award 2008, Helsinki 2008 (WV). – Online: arqchile. A. Mesecke

Csák, *Máté,* ungar. Architekt, Denkmalpfleger, Maler, Graphiker, Kunstsammler, Autor, * 1938 Budapest, lebt und arbeitet dort. Verh. mit der Kunstsammlerin Anna Körmendi; Vater des Kunsthistorikers Ferenc Cs. (* 1974). Die Fam. lebt während des 2. WK im slowakischen Kassa (Košice) bei Verwandten. Seit Kriegsende ist sie im Budapester Stadtviertel Terézváros ansässig, dessen reiche Altbausubstanz Cs. bis heute inspiriert. Stud.: 1958–62 TU, Budapest, Bauwesen bei Máté Major und Frigyes Pogány. Daneben Kunst-, Mal- und Zeichenunterricht (v.a. Aqu.) bei Antal Nemcsics und Iván Máriási. Schon als Student engagiert sich Cs. als Sekretär des Népi Építészeti Tudományos Diákkör (Nat. Studentenrat der Bau-Wiss.) für den Denkmalschutz. 1962–63 arbeitet er als Bauleiter im Burgviertel von Buda, wo die Umgestaltung nach den schweren Kriegsschäden in Gang kommt. 1963–67 ist er für die Budapester Denkmalbehörde als leitender Bau-Ing. tätig. 1967 Promotion. In Folge ergibt sich die enge Zusammenarbeit mit Denkmalpflegern (u.a. Piroska Czétényi, Dénes Komárik) sowie Kunstwissenschaftlern (Dezső Dercsényi) oder Archäologen (László Zolnay). 1973–2003 arbeitet Cs. als Bau-Sachverständiger für das Justizministerium. Des weiteren ist er u.a. als Sachverständiger für Kunst am Bau oder Vorstands-Mitgl. im ungar. Kunsthandwerker-Verb. sowie als Publizist tätig (u.a. für die Zss. Építőművészet oder Műemlékvédelem). Gemeinsam mit seiner Ehefrau gründet er 1991 die einflußreiche priv. Kunst-Slg und Gal. Kortárs Magyar Gyűjtemény, die sich auf ungar. bild. und angew. Kunst spezialisiert hat. Ausz.: 1973 mit Stip. in Helsinki als Praktikant im dortigen Amt für Baudenkmäler; 1999 Gold-Med. des Präs. der Ungar. Republik; 2005 Magyar Ingatlan Szövetség (Preis vom Immobilien-Verb. für Lebenswerk); 2008 Preis von Sopron. – Cs. plant, realisiert bzw. rekonstruiert als Architekt und Bau-Ing. zahlr. Wohngebäude und mehrere kleinere Gebäudeensembles in Buda (u.a. Bimbó út, Terassenhäuser, 1973; Szeréna út, Wohn-und Bürohaus, 1990; Nagybányai út, Mehrfamilienhaus, 1991, für eig. Nutzung; Csatárka út, Restaurant Mágnáskért, 1997). Seine Entwürfe für Neubauten zeigen den Einfluß der trad. landestypischen Archit. sowie Einflüsse des Bauhauses (Fullánk átri-

um, 1986; alle Buda). Seine einfühlsamen Rest. hist. Gebäude, bes. ab den 1990er Jahren in Sopron (u.a. Templom utca, Stadtpalast Artner ház) finden hohe Anerkennung. Daneben entsteht ein zeichnerisches und malerisches Œuvre (v.a. Archit.-Zchngn und Aqu.); oft werden Reiseeindrücke festgehalten, zunehmend auch nonfigurative Darstellungen. ⌂ BUDAPEST: Israelische Botschaft, Fullánk átrium, 1986; Pálffy Palota, 1996 (Rekonstr.). – Gal. Kortárs Magyar Gyűjtemény. SOPRON, Hajnóczi-Bákonyi ház, 1999; Anna Átrium Rendezvényház; Haydn-Haus, beide 2008. ZÁNKA, Aranyhíd, Nyaraló, 1992. ▣ Kortárs Magyar Művészet, Bp. 1997; A jövő csillagai, Bp. 1999. ◉ E: Budapest: 1960 TU (Műszaki Egyetem); 1986 MNG (K); Sowjetisches Kulturhaus; Innen-Minist. Dunapalota; 2004 Múzsa Gal. / 1960 Veszprém, Kastell Festetics / 2003 Sopron, Hajnóczy-Bakonyi Ház / 2010 Keszthely, Helikon Kastélymúz. – G: Budapest: 1997 Ungar. Journalisten-Verb.: Pünkösdi Anzix; 1998 Vigadó Gal.: Ungar. Kunsthandwerk / 2010 Sárvár, Burg Nádasdy, Gal. Arcis: Valentin nap a képzőművészetben. ☐ F. Csák, Cs. M. építész (K Körmendi Gal.), Bp. 2003; id., Cs. M. soproni épületei, Bp./ Sopron 2008. C. Wendt

Csánk, *Elisabeth (Elsa)* (geb. Hinterleitner, verh. Lesigang), öster. Zeichnerin, Malerin, * 1876 Wien, † 1963 ebd. Verh. (1908) mit Eduard Csánk (zweite Ehe). Ausb.: 1885–95 priv. Zeichenunterricht bei ihrem Schwager Alois Raimund Hein; 1891 Priv.-Stunden bei Alois Trost (Kunstgesch.); 1896–98 priv. Malunterricht bei Martha Schrottenbach. 1905–07 mehrmonatige Reisen nach Italien (Friaul, Trentino) und in die Schweiz. 1908–32 Lebens- und Ateliergemeinschaft mit Eduard C.; wohnt mit ihm zuerst im mährischen Zwittau (Svitavý), danach 1909–32 in Brünn (Brno). Ab 1933 wieder in Wien ansässig. – C.s Werk entfaltet sich unter dem Einfluß ihres Jugendfreundes und zweiten Mannes Eduard C., der seit 1909 an der Zweiten Dt. Staats-Realschule in Brünn (Brno) als Zeichenlehrer (Freihandzeichnen) tätig ist und 1921–30 neben Viktor Oppenheimer den Vorsitz im Brünner Künstlerbund Mährische Scholle führt. Bewußt wählt das Künstlerehepaar gleiche Motive und Standorte im gemeinsamen Atelier, bei Naturstudien auf einer der häufigen Mal- und Kunstreisen, u.a. 1914 nach Oberitalien, 1929 nach Paris und in die Bretagne. C. beteiligt sich 1911–34, '40 und '44 an den Jahres-Ausst. der dt. Künstler in Brünn. Ihre zeichnerische und malerische Intention liegt im Unterschied zu der ihres Mannes in der naturgetreuen, detailreichen Wiedergabe der Motive (Lsch., Archit., Portr., Tiere). Von hoher Qualität zeugen C.s präzis gezeichneten und aquarellierten botanischen Illustrationen. ⌂ BRNO, Muz. města: Das Mädchen mit den Rosenbändern, Aqu./Karton, 1931; Der Mann mit dem Schnurrbart, Kreide/Papier, 1916. ◉ E: 1914 Brünn, Künstlerhaus (mit Eduard C.); 1933 Wien, Hofburg: Segantinibund. – G: 1936 Wien, Hofburg: Segantinibund (Jahres-Ausst.). ☐ *Toman* I, 1947; *Fuchs*, Geb. Jgg. I, 1976. – Dt. Tagblatt (Brünn) v. 20. 2. 1914; *E. Brunnthaler*, Vom Eheschatten in der Kunst? Der Maler Eduard Csank und seine Frau Elisabeth in und auf dessen malerischen Spuren, W. 2005 (Lit., WV). U. Heise

Cseke, *Szilárd,* ungar. Maler, Installationskünstler, * 25. 3. 1967 Pápa, lebt und arbeitet in Budapest. Stud.: 1987–92 Wiss. Univ. Janus Pannonius, Pécs, Malerei bei Ilona Keserü, Skulpt. bei István Bencsik; 1992–95 Meisterkurs bei Gyula Konkoly. Mitgl.: ab 1995 Ungar. Verb. Bild. Künstler (MAOE); Verb. Studio junger bild. Künstler (FKSE; 2001–03 Vorsitzender). Stip.: 1996 Röm.-Ungar. Akad.; 1997 Derkovits-Stip.; 1998 Nat. Kulturfonds (NKA); 2007 Kunststiftung des Landes BW; Ausz. KristArt Programm für Bild. Kunst, Budapest. – Heterogenes Œuvre zu vielfältigen, ambitionierten Themen, die Cs. häufig in (Bild-)Serien untersucht (Malerei, Objekte). So im 2006 voll. Bildzyklus *Erdő*/Wald (Strabag-Preis für Malerei), in dem er in teils großen Formaten (Öl bzw. Acryl/Dibond) den Wald als Makro- und Mikrokosmos thematisiert, dabei mit Perspektiven experimentiert oder z.B. Farbschichten aufträgt, die an Camouflagen erinnern. Die Darst. von sich endlos wiederholenden, vertikal betonten Baumstrukturen vor monochromen Hintergründen, bisweilen von Laubflächen horizontal unterbrochen, bewegt sich zw. gegenstandsbezogener und abstrakter Malerei. Durch Ignorieren realer Farben (Einsatz von Inversion und Falschfarben) erzeugt Cs. unterschiedliche Stimmungsräume, die dem Betrachter überlassen, was er sehen will, die aber an der Schutzlosigkeit von Natur und Umwelt keinen Zweifel lassen. Cs. führt in den Bildfolgen *Relaxcentrum* (Vác, Tragor Ignác Múz., Gyula-Hincz-Slg, 2006) und *Reményfutam*/Mein Hoffnungslauf (Budapest, Molnár Áni Gal., 2010) die Problematik mit Alltags-Situationen weiter. Erzählerisch werden menschliche Schicksale und Themen von Anpassung an ges. Veränderungen dargestellt (Freizeit, Integration), z.B. 2010 in der Arbeit *Magyar hentesek Németországban*/Ungar. Fleischer in Deutschland, in der sich Cs. dem sozialen Thema länderübergreifender Leiharbeit zuwendet. Auch hier setzt Cs. konsequent digitale Medien ein, deren Duktus mittels kräftiger Pinselführung überformt wird. Oft unterstreicht er die Aussage mit ironisierenden oder phil.-metaphorisch gewählten Titeln wie *Ha csak ennyi gyönyört kínál ... is megéri*/Auch dann würde sich das Leben lohnen, wenn es nur ein solches Amüsement bereithielte (Budapest, Boheme Art Hotel). Globale Probleme und seine Zweifel am Fortschrittsglauben thematisiert Cs. zudem mittels Installationen, bei denen er zufällig gefundenen Wohlstandsmüll in bewegliche, minimalistische, dem eigentlichen Zweck der Gegenstände widersprechende Objekte umwandelt, z.B. in der Ausst. *A haladás illúziója*/Die Illusion des Fortschritts (Budapest, MOM Park, Park Gal., 2012). ⌂ BUDAPEST, Kovács-Gábo-Kunststiftung. – Verb. Studio junger bild. Künstler. EISENSTADT, Esterhazy-Stiftung. HATVAN, Lajos Múz. PÉCS, Brit. Zentrum. – Univ., Fak. Kunst. SZÉKESVEHÉRVÁR, Univ., Fak. für Geoinformatik. SZOMBATHELY, Szombathelyi Képtár. ◉ E: Budapest: 1995 Barcsay Terem; 1997, 2000 Stúdió Gal.; 1998 Óbudai Társaskör Gal.; 1998 Inkubátor Ház; Duna Gal.; 2001 (K: O. Hegedüs),'02 Vadnai Gal.; 2008 Molnár Ani Gal.; 2010 Krisztina Pa. – G: u.a. 1994 Berlin, Collegium Hungaricum Haus Ungarn: Pecs stellt sich vor / 1997 Rom, Röm.-Ungar.

Akad.: Fuoco / Budapest : 1999 Vízivárosi Gal.: Mobi-
lok, tárgyak (Mobiles, Gegenstände); 2001 Gal. Lajos u.:
Rövid történetek (Kurze Geschichten); Műcsarnok: Szo-
brászaton innen és túl ; 2006 Ludwig Múz.: 10 Jahre Stra-
bag Preis für Malerei; 2009 Molnár Ani Gal.: Várostájak
(Stadt-Lsch.); 2011 Kogart Ház, Kovács Gábor Kunststif-
tung: Ungar. Badeleben / 2001 Szombathely, Szombathe-
lyi Képtár: A kert (Der Garten) / Jyväskylä, Art Mus.: Ma-
gyart (K: M. Mäkinen) / 2005 Pécs, eMKá Gal.: Emlékmű
(Erinnerung an Tolvaly Ernő); E10 Gal.: Eleven fény
(Lebendiges Licht) / 2008 Stuttgart, Ungar. Kultur-Inst.:
Künstlerbegegnungen. ⌑ KMML I, 1999. – K. Szipőcs,
Lágyított paradicsom. Cs. S. tárgyairól (K), Bp. 1998;
J. Készman, Kultúra és kommunikáció új határok felé (K),
Bp. 2000. – Online: Website Cs. C. Wendt

Csikós, *András*, ungar. Maler, Kunsterzieher, * 3. 6.
1947 Hódmezővásárhely, † 23. 3. 2006 ebd.; Sohn des
Malers Miklós Cs. Stud.: 1966–70 FS für Lehrerbildung,
Szeged, bei László Vinkler und Ernő Fischer. 1970–73
als Kunsterzieher tätig. Seit 1973 freischaffend. Mitgl.:
ab 1973 Künstler-Verb.; 1992 Ungar. Stiftung der BK.
Ausz. u.a.: 1974, '83 József-Koszta-Gedenk-Med.; 1975,
'85 Preis der Hatvan Tájfestészeti Bienn.; 1989 Preis für
Gest. des Bez. Csongrád: 1996 Preis der Herbst-Ausst.
in Vásárhely. – Cs. gilt als bed. Maler der sog. Schule
von Vásárhely, die u.a. von István D. Kurucz, Gyula Bé-
la Almási und Ferenc Berényi repräsentiert wird und die
für ihre spätimpressionistisch-realistischen, häufig lyrisch-
melancholischen Schilderungen der ungar. Tiefebene, ins-
besondere der weiten, sumpfigen Lsch. bek. ist, die von
der breit dahinströmenden Theiß mäanderartig durchflos-
sen und häufig großflächig überschwemmt wurden. Cs.s.
poetische Bildwelten (Öl, Aqu.) drücken seine enge Ver-
bundenheit mit dieser markanten Lsch. und ihren Bewoh-
nern aus. Hauptmotive sind u.a. Lsch. vor weiten Ho-
rizonten, Flußufer im Morgennebel, bei nahendem Ge-
witter oder bei strömendem Landregen, Kleinstadtwinkel
oder Dorfansichten im vollen Sonnenlicht, stille Bauern-
höfe, gespenstisch anzuschauende Schwemmholzgebilde,
Interieurs, auch Stilleben (Frühstückstische, Werkzeuge)
und (Selbst-)Porträts. Auch fließen zuweilen surrealisti-
sche Elemente in seine Bilder ein (*Várakozó*/Wartende,
1974). Die nuancen- und kontrastreiche Farbpalette, die
Cs. mit den and. Tieflandmalern teilt, äußert sich v.a. in
warmen Braun- und Orangetönen, in die sich häufig blei-
ernes Grau, auch bisweilen fleckenhaftes Rot mischt. Cs.s.
Motive stammen darüber hinaus auch aus Orten am Mittel-
meer (u.a. Tanger, Dubrovnik), deren Küsten- oder Berg-
dörfer er ebenso detailfreudig, bisweilen in hyperrealer
Manier abbildet. Seine genaue Beobachtungsgabe, gepaart
mit Anteilnahme und Achtung vor dem Sujet, und die
realistische Darst. ohne Verklärung machen sein Œuvre
auch wertvoll als ethnographische Bildquelle der ländli-
chen Lebensweise, die ungeachtet politischer und techni-
scher Neuerungen in Europa weiter existiert. Seine Bilder
finden internat. Beachtung (u.a. ab 1973 mehrfach Ausst.
in Tokio). ⌑ BUDAPEST, MNG. HÓDMEZŐVÁSÁRHELY,
Tornyai János Múz. – StKS. ◉ E: 1973, '83 Hód-

mezővásárhely, Tornyai János Múz. / 1974 Békéscsaba,
Munkácsy Mihály Múz. / Budapest: 1975 Fényes Adolf
Terem; 1977 Derkovits Terem; 1982, '84 Csók Gal.; 1988
Mednyánszky Terem; 1996 Kortárs Gal. / 1976 Pécs, Fe-
renczy Terem / 1977 Szigetvár, Szentesi Gal. / 1978, '91
Szeged, Gulácsy Gal. / 1979, '81 Gyöngyös, Mátra Múz. /
1980 Kalocsa, Városi Képtár; Veszprém, Dési Huber Te-
rem / 1983 Sindelfingen, Schloß / 1985 Kaposvár, Bernáth
Aurél Terem / Debrecen: 1999 Kortárs Gal.; 2001 Holló
László Gal. / 2000 Balatonakali, Art Genius Gal.; Matsudo
(Tokio), Shinooku Isetan Gal. – G: ab 1974 u.a. regelmä-
ßige Teiln. an Sommer- und Herbst-Ausst. in Békéscsa-
ba, Hódmezővásárhely, Szeged / 2010 Kecskemét, For-
rás Gal.: Kecskeméter Künstler. ⌑ MűvÉlet, 1985; Ma-
gyFestAdat, 1988, 1997; KMML I, 1999. – G. Pogány,
Cs. A., Bp. 2002. C. Wendt

Csikós, *Tibór* (Laslosson, *Tiburtius*), ungar.-serbischer
Maler, Graphiker, Keramiker, Kunsterzieher, * 22. 8. 1957
Martonoš/Jugoslawien, lebt und arbeitet seit 2005 in Göte-
borg. Stud.: 1972–76 FS für angew. Kunst (SAF), Novi Sad
(Gebrauchsgraphik; Animationsfilm [*Bumeráng*, mit Nen-
ad Milinov, 1974]); 1977–81 HBK, Budapest, Malerei bei
Pál Gerzson. Arbeitet 1983–86 und 1988–91 in Jugosla-
wien als Kunsterzieher an einer Mittelschule in Subotica/
Vojvodina. Zwischendurch weiterführende Studien in Pa-
ris mit einem frz. Staats-Stip. 1986–87 im Atelier 63 (bei
Joëlle Serve) und 1987–88 im Atelier 17 (bei Stanley Wil-
liam Hayter). Ab 1991 in Budapest als Kunsterzieher an
versch. Schulen sowie an der Freien KSch in Zebegény
angestellt. 2004 erster Arbeitsaufenthalt in Göteborg, ebd.
2007–08 als Lehrer tätig. 2007 Artist in Residence mit ei-
nem Stip. der Västra Götelandsregionen in Kunming/China
(drei Monate). – Der Maler Tihamér Dobó, mit dem er bis
zu dessen Tod 1987 in enger Beziehung steht, ermutigt ihn
zum Kunst-Stud. im Nachbarland Ungarn. 1980 wird er
dort Mitgl. der avantgardistischen Künstlergruppe Indigó
(gegr. 1978) und kommt dadurch in Kontakt zu wichti-
gen ungar. Künstlern, Philosophen und Wissenschaftlern
(u.a. zum Architekten und Holistiker Miklós Erdély), die
in enger Anlehnung an die Kommunikationstheorie von
Paul Watzlawick und Ernst Landau das interdisziplinäre
Wirken innerhalb der Kunstpädagogik ausloten. Cs.s. erste
Arbeiten sind trad. Öl-Gem. (Stilleben, Portr., Akte). Bald
jedoch bestimmen Darst. von Spielzeug, Marionetten und
Clowns in verhaltenen Tönen sowie expressiv gemalte
Motorradszenen seine Bildwelt, die auch in plastischen Arbei-
ten thematisiert werden (*Bohóz zsákban*/Clown im Sack,
Keramik, 1980; Serie *Motoros*/Motorräder, Terrakotta be-
malt, 1984). Der Parisaufenthalt 1986–88 führt zu einem
Wandel der Bildauffassung, die sich von gegenständlicher
zur nonfigurativen Malerei und Graphik entwickelt. Far-
ben, Linien und Texturen werden nunmehr Gegenstand der
künstlerischen Untersuchungen, ab 1992 widmet er sich
auch dem Kreis als einem archetypischen Zeichen von
Unvergänglichkeit und Vollkommenheit. Der Pinselduktus
erinnert teils an rhythmisch-rotierende Bewegungen, teils
an expandierende Universen in gold-braunen oder ultra-
marinfarbenen Tönen, aus denen zuweilen Konturen erha-

ben hervortreten (*Folyamat*/Fluß, Öl, Plextol, 2002). Cs. arbeitet in allen gängigen Mal- und Drucktechniken (u.a. Öl, Tempera, Acryl, Tusche-Zchngn, Assamblagen, Fotogramme, Email; Siebdruck, Hschn., Lith., Farb-Rad.) und beschäftigt sich seit A. der 1990er Jahre mit computergenerierter Kunst. Auch Aqu. und Collagen, in denen symbolhaft typogr. Elemente auftreten; diese Werkgruppe intensiviert Cs. 2007 während seines China-Aufenthaltes, indem er sich dort mit der trad. chin. Schreibkunst auf Reispapier und Seide beschäftigt. Seit etwa 2000 verstärkter experimenteller Umgang mit Drucktechniken, z.B. bei der Nutzung von CDs als Bildträger für Kaltnadelradierungen. Auch Land-art-Objekte (*Homokrajzok*/ Sand-Zchngn, 2004–06) und Plakat-Gest. (*Amazing graph.*, 2011; Mimers Konsthall, Kungälv). Führt seit etwa 2007 seinen ins Schwedische übersetzten Namen (Tiburtius Laslosson).
🏛 BUDAPEST, Hotel Opera. DJEVDJELIJA, Slg Grafička kolonija. NOVI PAZAR, Slg Sopocanska vidjenja. SUBOTICA, StM. ZENTA, StM. ⌕ *E:* 1984 Pécs, Ifjúsági Ház / 1985 Szezsana, Mala Gal. / Subotica: 1990 Stadt-Bibl.; 2008 Likovni Susret Gal. / Kanjiža: 1990 Heilbad Ausst.-Halle; 2009 Dobó Tihamér Gal. / Budapest: 1989 Internat. Digit Art Computer (Anerkennung); 1992 Gal. 11; 1993 Mű-terem Gal.; 1994 A HÁZ Gal.; 1996 FMK Gal.; 1997 Duna Gal.; 1998 Merlin Színház Gal.; 1999 Ujlipótvárosi Klub-Gal.; 2003, '11 Gal. IX.; 2004, '09 (mit Åke Staffansson) ART9 Gal. / 1995, '97 Szeged, IH Gal. / 1998 Zenta, Stadt-Bibl. / Göteborg: 2004 Cosmopolitan Gal.; 2005 KCV Gal. / 2007 Kunming (China), Nordica Gall. / 2011 Lerum (Schweden), Dergårds Gall. – *G:* Budapest, Ernst Múz.: 1990 Digit Art Internat.; 1992 Studio '92 (K); 1996 Vigadó Gal.: Moholy-emlékkönyv / 1994 Debrecen: Aqu.-Bienn. / 1996 Eger: Aqu.-Bienn. / 1997 Prag: Graphik-Bienn. / 2012 Göteborg, Cosmopolitan Gall.: Retro a Hu.se. t8. ⊞ KMML I, 1999. – *Online:* Website Cs.; Saatchi Gal. (Portfolio Cs.). C. Wendt

Csikós Nagy, *Márton*, ungar. Bildhauer, Holzschnitzer, * 11. 1946 Abádszalók, lebt und arbeitet in Somogysárd (dort zeitweise auch Bürgermeister). Als Künstler Autodidakt. Stud.: Agrar-Wiss. am Landwirtschaftlichen Technikum, Karcag (1964 Abschluß). Mitgl.: Szent György lovagrend (Ritterorden Sankt Georg). Ausz.: 1970 Aranyalma (Goldener Apfel) auf der Landes-Ausst. in Nyíregyháza; Derkovits-Stip.; 1987 Stip. der Eötvös-Stiftung; 1994 Kunstpreis des Komitats Somogy. – Früh beschäftigt sich Cs. sowohl mit Malerei als auch mit künstlerischer Metallbearbeitung. Ab 1970 wendet er sich endgültig der plastischen Gest. und der Skulpt. zu (Holz, Stein, Ton). Eine Werkgruppe besteht aus geschnitzten Holz-Skulpt. der heimischen Wildtiere, denen er lebhaften Ausdruck verleiht. Auch spielen Kindheits- und Jugenderinnerungen an die ländlichen Feste und Bräuche in and. Werkgruppen eine Rolle. So stellt er das Alltagsleben mit figürlichen Szenen aus Handwerk, Fam. (Mutterschaft, Eltern und Kinder), Krankheit und Tod in kleinen Plastiken dar. Ab den 1980er Jahren greift Cs. auch zunehmend hist. und mythische Themen auf. Er gestaltet kraftvoll-mon. Holzbildwerke für den öff. Raum, z.B. einen hohlen Baumstamm

als Glockenstuhl. Char. für das Werk sind hoch aufgerichtete Holzsäulen, die auch aus hist. Bauensembles transloziert sind. Diese sind als Denkmale im öff. Raum mehrfach mit grob behauenen Findlingen kombiniert und erinnern in der Gest. bisweilen an ornamentierte Torbalken oder reliefierte Totenbretter. Cs. dekoriert diese Holzsäulen mit teilw. archaisch anmutenden Lineaturen und Ornamenten sowie Stern-, Blüten- und Rankenformen, die in der ungar. Volkskunst seit dem 15./16. Jh. bek. sind. Bewußt knüpft Cs. dabei an Schnitz-Trad. und das transdanubische Formenrepertoire von Müllern, Lebküchlern, Hirten und Möbeltischlern an. Sein 18 Meter hohes geschnitztes Ungar. Doppelkreuz (Patriarchenkreuz; Bestandteil des ungar. Staatswappens), das 2001 anläßlich des 1000jährigen ungar. Staatsjubiläums in Kaposvár aufgerichtet wurde, stellt in der ornamentalen Gest. ein diesbezügliches Hw. dar.
🏛 DÖBRÖKÖZ, Röm.-Kath. Kirche: Bethlehem-Gruppe, Holz. KAPOSVÁR, Táncsics-Gymnasium: Gedenk-Skulpt. für verstorbene Schüler und Lehrer, Holz/Metall, 1983. – Imre-Nagy-Park: Gedenkstele und -stein für die Gefallenen in der Schlacht am Don, Holz/Stein/Metall, 1993. – Mihály-Munkácsy-Gymnasium: Gedenk-Skulpt. zum 75. Jubiläum, Holz/Bronze, 1994. ⌕ *E:* 1996 Kaposvár, Szín-folt Gal. (mit Klára Csörsz) / 2004 Budapest, Toldi Gal. / 2006 Segesd, Árpád-ház, Szent Margit Múz. – *G:* Budapest: 1990 Magyar Mezőgazdasági Múz.: Landwirtschaft in der Kunst (2. Preis); 1994 Vigadó Gal.: Kleinplastik '94. ⊞ KMML I, 1999. – *L. Szántó*, Száz magyar falu könyvesháza. Somogysárd, Bp. 2001, 143–145.
 C. Wendt

Csíkszentmihályi, *Réka*, ungar. Malerin, Textildesignerin, Emailkünstlerin, Kuratorin, * 8. 5. 1966 Szentendre, lebt und arbeitet in Pilisborosjenő. Tochter des Bildhauers Róbert Cs., Nichte des Architekten Peter Cs., Schwester der Illustratorin *Berta Cs.,* der Textilgestalterin *Sára Richter* (* 4. 8. 1969 Szentendre, geb. Cs.) und des Werbefotografen *Márton Cs..* Entstammt einer bek. ungar. Künstler-Fam. und wächst in Szentendre auf. Stud.: 1984–90 Ungar. HS für angew. Kunst, Budapest, Stoff- und Teppichweberei bei Anna Pauli und Anna Szilasi. Ausz.: 1990 2. Preis Pest Megyei Iparművészeti Tárlat; 1991 Kozma-Lajos-Stip.; 1995 Moholy-Nagy-Stip. für Form-Gest.; 1998 Rózsa-Anna-Preis. – Bevorzugte Motive für ihre handgewebten Teppiche und Wohnraumtextilien sind geometrische Formen wie Quadrate, Spiralen, Mäander, Kreise und Dreiecke, die sie variantenreich und mit kräftigen Farben umsetzt. Die graph. Arbeiten (Tempera, Ölpastell/Papier) thematisieren das gleiche Formenrepertoire. A. der 1990er Jahre erlernt Cs. die Kunst des Emaillierens. Neben Emailassemblagen und z.T. bespielbaren, skulpturalen Wandobjekten aus Textil und Email fertigt sie auch Bekleidungsaccessoires (u.a. Knöpfe, Schnallen, Verschlüsse). Mit der Textilgestalterin Katalin Nyíri entstehen phantasievolle Kollektionen handgewebter Kleidungsstücke. Ab M. der 1990er Jahre implantiert Cs. auch bei Wandteppichen und -bildern versch. emaillierte Elemente, die sie teilw. einwebt bzw. appliziert oder mit Holzflächen kombiniert. 1994 ist sie ne-

ben u.a. Hedvig Harmati, Gábor Munkácsi und Szilvia Szigeti Mitbegr. der auf Textil- und Raumkunst spezialisierten Gal. Eventuell in Budapest. 2009 reicht sie an der Univ. der Künste Moholy-Nagy (MOME) ebd. eine Dipl.-Arbeit ein, in der sie eine von ihr entworfene und durch den Möbelstoffhersteller Aste-Meritum (Kőszeg) realisierte Kollektion von sehr eleganten Jacquardstoffen vorstellt. ▯ BEREKFÜRDŐ, Reformierte Kirche: Wand- und Bodenteppiche, Handweberei, 1991. BUDAPEST, Minist. für Verteidigung, Sitzungsraum: Wandteppich, Handweberei, 1996. – Konditorei Hauer: Raumtextilien, Jacquartweberei, bestickt, 1996. KISKUNFÉLEGYHÁZA, Ungar. Telekom: Raumtextilien, 1993–95. MÁTÉSZALKA, Fa. Tre Esse Euromobili: Teppiche, 1991. ◉ E: Budapest: 1994 Végállomás Gal.; 2005 Hegyvidék Gal. / 1996 Szeged, B Gal. / 2003, '11 Pilisborosjenő, Kulturhaus József Reichel / 2004 Szentendre, Péter Pál Gal. – G: 1986, '90 Szentendre, Szentendrei Képtár: Pest Megyei Iparművészeti Tárlat / Budapest : 1991 Ernst Múz.: Nemzetközi Minta Trienn.; 1994 Margitsziget Víztorony Gal: Textivál; Fal-és Tértextil Bienn.; 1996 VAM Design Center: Moholy-Stipendiaten; 1996 Eventuell Gal.: Schmuckknöpfe; IMM: 1998 Wohntrend '98; 2006 Ungar. Meisterkünstler von heute; Hegyvidék Gal.: Robert Cs. und seine Fam. / 1998 Szombathely: Ungar. Textil-Bienn. ▭ KMML I, 1999. – *L. Schenk*, II. Pest Megyei Iparművészeti Tárlat (K Szentendre), Bp. 1990. – *Online:* Gal. Művelődési Ház Pilisborosjenői.

C. Wendt

Csipes, *Antal*, ungar. Graphiker, Textilkünstler, Fotograf, Modezeichner, Kunstdozent, * 18. 11. 1953 Budapest, lebt und arbeitet dort. Ausb.: 1971–82 Freie KSch István Szőnyi, Zebegény, Sommerkurse Malerei und Druckgraphik u.a. bei József Bakallár und József Kórusz. Stud.: 1982–87 Ungar. HS für angew. Kunst, Fach-Kl. Textil- und Leder-Gest., bei Margit Szilvitzky und Árpád Molnár. Lehrtätigkeit ebd. 1988–93 Doz. für Farblehre, ab 1994 Ass. am Lehrstuhl für Textil; unterrichtet als Doz. an versch. Budapester Mode- und KSch die Fächer Kostüm-Gesch. und zeitgen. Mode. Ausz.: 1984 1. Preis MIF Foto-Wettb.; 1985 Sonderpreis Nemzetközi Diaporáma Fesztivál, Vác. 1987–88 arbeitet Cs. kurzzeitig als Formgestalter in der Lederfabrik Rákospalota. Im Kontext seiner Lehrtätigkeit spürt Cs. seit den 1980er Jahren bis heute dem Thema Renaiss., v.a. der ital. Portr.- und Figuren-Darst. aus dem 15./16. Jh., in unterschiedlichen Werkgruppen nach (Malerei, Druckgraphik, Textilobjekte). Daneben entstehen Plakate und Cover für Musik-CDs (u.a. Hobo Blues Band, Nina Hagen). Ab 1991 widmet er sich neben klass. Mode-Zchng und Gebrauchsgraphik (u.a. Wimmelbilder, Buch-Ill.) auch heterogenen Mixedmedia-Arbeiten, zu denen die drei Werkgruppen fotogr.-gestützte textile Bildkunst (häufig paraphrasierte Renaiss.-Themen), Mat.-Collagen und Fotomontagen (*Organikus forma*, 1992) gehören. Auch serielle Farbuntersuchungen (*Experimentum*, 1991–93). Char. für einige freie graph. Arbeiten sind würfelförmige Raster bzw. der Einsatz von Isoheli. ▯ BUDAPEST, Pesterzsébet Múz., Gaál Imre Gal. ✉ Divattükör, Bp. 2006; A divatról komolyan, Bp.

2011. ◉ E: Budapest: 1985 Budapesti Művészetbarátok Egyessület; 1989 Fiatal Művészek Klub; Fészek Klub; 1992 Benko-Korda Gal.; 1993, '99 Gaál Imre Gal.; 1997 Suzuki House Gal.; 1996 Tölgyfa Gal.; 2009, '12 Barabás Villa / 1995 Szentendre, Peter-Pal Gal. – G: Budapest: 1987 Vigadó Gal.: Festival; 1991 Ernst Múz.: Internat. Design-Trienn.; 1994, '95 Margitsziget Víztorony: Textival; 1998 Vigadó Gal: Silence / 1994 Szekszárd, Kulturzentrum: Farbdrucke / 1997 Zebegény, Szőnyi Múz.: 30 Jahre István Szőnyi Akad. ▭ KMML I, 1999. – *Online:* Website Cs.

C. Wendt

Csóka (Brandner-Csóka), *Angela*, österr. Malerin, Graphikerin, Kunstpädagogin, * 30. 3. 1966 Wien, lebt und arbeitet in Perchtoldsdorf. Wächst ebd. als Tochter eines Malermeisters und einer Klavierlehrerin im Kreise mehrerer Schwestern auf. Seit dem 7. Lebensjahr erhält sie Geigenunterricht. 1984 ebd. Matura. Stud.: 1984–88 (Dipl.) HS (heute Univ.) für angew. Kunst, Wien, Malerei bei Carl Unger und Adolf Frohner; ebd. auch Gasthörerin bei Maria Lassnig in derem Trickfilm-Lehrstudio. 1988 mit einem Stip. für Wandmalerei in Mexiko-Stadt. 1990–91 Philosophie-Stud. in Wien. Seitdem freiberuflich und als Kunstpädagogin u.a. in christlichen Einrichtungen (auch Kindergärten und Sommercamps) oder Priv.-Schulen tätig, u.a. 1996–98 an der internat. Vienna Christian School. Versch. Reisen und Studienaufenthalte, u.a. 1998–2000 in den USA. 2003 Gründungs-Mitgl. der Druckgraphikgruppe Strenningerhof in Perchtoldsdorf. – V.a. sowohl farbintensive wie zur Monochromie neigende Figurenbilder. Häufig betont C. die Körperlichkeit, die sie intensiv und wuchtig vorträgt wie in der Serie *Hiob* (Öl/Lw., 2001–02). Daneben Lsch., Portr. und Stilleben. Ihre dem Informel nahestehenden abstrakten Arbeiten zeichnen sich durch pastosen, gestisch bewegten Farbauftrag aus. Bühnenbilder und Animationsfilme entstehen mehrfach häufig im kunstpädagogischen Kontext. ◉ E: 2006 Tulln (NÖ), Kunst-Wkst. – G: 2002 Waidhofen (Ybbs), Gal. Riz: Gott, Mensch und mod. Kunst / 2003 Perchtoldsdorf, Kulturzentrum: Print – Printemps – Perchtoldsdorf. ▭ *Fuchs*, Maler (20. Jh.) Erg.-Bd I, 1991. – *P. Katzberger*, Perchtoldsdorf in Gem., Zchng und Druckgraphik, Perchtoldsdorf 2003.

U. Heise

Csókás, *Emese*, ungar. Malerin, Graphikerin, Textilkünstlerin, Kunstpädagogin, * 23. 2. 1961 Szeged, lebt und arbeitet in Leányfalu. 1975–79 Gymnasium in Szeged. Stud.: 1980–85 Ungar. HS für angew. Kunst, Budapest, Tapisserie bei Károly Plesnivy und Lenke Széchényi. Seit 1997 Kunstpädagogin am Tóparti Művészeti Gimnázium, Székesfehérvár. Ausz. und Stip.: 1985 1. Preis Dióssy-Nagyajtay-Wettb. Aqu.-Malerei; 1987 Sonderpreis Idegenforgalmi Propaganda- és Kiadóvállalat; 1989 Stip. Studio junger Kunsthandwerker; 1991–94 Lajos-Kozma-Stip. für Kunsthandwerk; 1997 1. Preis Ausst. Élő Gobelin, Kategorie Klein-Gobelin. – Cs. verbringt ihre Kindheit in dörflicher Umgebung. Vielfältige Eindrücke unmittelbarer Natur spiegeln sich bis heute in ihren Textilarbeiten und Tapisserien wider, die sie selbst entwirft und realisiert. Mithilfe klassischer Webtechniken der Bildwirkerei for-

muliert sie elementare Prozesse des Werdens und Verge-
hens. Bevorzugte Mat. sind (Baum-)Wolle, Seide und Lei-
nen (auch in Kombination mit Aqu., Gouache und Misch-
techniken), mit denen sie abstrakte wie gegenstandsbezo-
gene Komp. schafft, die häufig den Anschein fragmen-
tierter Lsch.-Ausschnitte wie tektonisch geschichteter auf-
brechender oder fließender Strukturen sowie geologischer
Formationen oder Spiegelungen erwecken. Anfänglich do-
minieren figürliche Darst., die sich in den 1980er Jahren
zu abstrakten Formulierungen wandeln, z.B. in Themen-
bearbeitungen (Horizont, Wolken, Wasseroberflächen, at-
mosphärische Ereignisse). Ab 1998 Rückkehr zu figura-
tiven Elementen. Unterstützt von Mat.-Strukturen werden
abstrakte, symbolhafte Formen zu narrativen Bewegungs-
mustern gesteigert, wobei Raster, Punkte und Linien kon-
trastreich gegen weiche, malerisch gestaltete Hintergründe
stehen. Anläßlich der EU-Ratspräsidentschaft Ungarns im
Jahr 2011 entsteht (initiiert u.a. von der Ildikó-Dobrányi-
Stiftung und dem Belg.-Ungar. Kultur-Inst.) das internat.
Textilkunstprojekt *Web of Europe – Zeit-Brücke*, an dem
Cs. zeitgleich mit 27 and. europ. Gobelinkünstlern, u.a.
Maria Almanza (Belgien), Anet Brusgaard (Dänemark),
Judit Nagy (Ungarn), Sarah Perret (Frankreich) und Re-
nata Rozsívalová (Tschechien) arbeitet. Ideelle Grundlage
dieser internat. Kooperation ist der berühmte Bildteppich
aus der Brüsseler Wkst. des Jacob van der Borght „Mer-
kur übergibt das Kind Bacchus den Nymphen" (18. Jh.;
IMM, Budapest), aus dem 27 viereckige „Fragm." virtu-
ell ausgewählt wurden, die von je einem der 27 Künstler
als Grundlage einer neuen, zeitgen. Deutung und Reali-
sierung genutzt wurden. Cs. entwirft und führt dafür ei-
nen Bordürenteil aus; die Gesamtarbeit befindet sich heu-
te im Mus. für angew. Kunst [IMM] in Budapest. Cs. ge-
hört zu den profiliertesten Textilkünstlern ihrer Gen. in Un-
garn. ⌂ *Auswahl* AJKA, Rathaus: Gobelin, 1989. BUDA-
PEST, Hilton Hotel: Gobelin, 1991. – IMM. ESZTERGOM,
Christl. Mus. SALGÓTARJÁN, Rathaus: Gobelin, 1986.
⊙ *E:* 1997 Székesfehérvár, Tóparti Művészeti Gimnázi-
um / 2006 Ballassagyarmat, Mikszáth Kálmán Művélődési
Központ. – *G:* 1986, '87 Csongrád: Fiatal Iparművészek
Stúdiója-kiállítás / 1988, '98 Szombathely: Textil-Bienn. /
1990 Szentendre, Pest Megyei Iparművészeti Tárlat / Bu-
dapest: 1991 Vigadó Gal.: A Ferenczy család; 1994 IMM:
Kozma Lajos-ösztöndíjas iparművészek kiállítása; 1996
Csók Gal.: Gobelinkiállítás / 2008 Tournai: Internat. Tri-
enn. des Arts et de la Tapisserie (Preis) / 2011 Brüs-
sel, Mus. royaux d'Art et d'Hist.: Web of Europe (K:
I. Hegyi u.a.). ⌷ KMML I, 1999. – II. Pest Megyei
Iparművészeti Tárlat (K), Szentendre 1990. – *Online:* Web
of Europe. C. Wendt

Csomós, *Zoltán*, ungar. Maler, Graphiker, Illustrator,
* 11. 7. 1961 Sárospatak, lebt und arbeitet in Budapest.
Stud.: 1989–96 HBK ebd., Malerei und Graphik bei Ala-
jos Eszik, Róbert Kőnig und Tibor Rozanits. Mitgl.: Un-
gar. Verb. Bild. Künstler; Verb. Ungar. Graphiker; Ges. Fe-
renc Kazinczy. Seit 1993 regelmäßige Teiln. an nat. und
internat. Graphik-Ausst., Bienn. und Wettb. (u.a. in Bar-
celona, Bitola, Győr, Kanagawa, Miskolc, Tihany [1992

2. Preis], Ourense, Prag und Tokio). Seit M. der 1990er
Jahre Veröff. von Ill. und Karikaturen in der Zs. Hitel so-
wie in den Zss. Magyar Napló, Lyukasóra und Élet és Iro-
dalom. Ausz.: u.a. 1991, '95 Barcsay-Gedenk-Med.; 1992
Preis István-Szőnyi-Stiftung; 1993 Preis der Stadt Sátoral-
jaújhely; 1994 Oszkár-Glatz-Preis. Seit 1998 leitet Cs. die
Graphiksektion der Sommer-Jugend-Akad. in Encs. – Cs.
arbeitet in versch. (sur-)realistischen Stilen. Seine zahlr.
Stilleben (häufig Öl/Lw.), die von der (foto-)realistischen
Malerei ebenso inspiriert scheinen wie von der artifiziellen
und symbolträchtigen Aussagekraft trad. Stillebenmotive
(Spiegel, Gläser, Musikinstrumente), sind in feinen Farb-
harmonien ausgeführt. Cs. rekurriert in diesen Stilleben
auch auf Vorbilder aus der Kunstgesch., indem er u.a. ver-
steckte Selbst-Portr. unterbringt. Aus der Abstraktion na-
türlicher Formen und Vorgänge entwickelt er des weite-
ren lyrisch anmutende Motive, die er v.a. mittels versch.
graph. Techniken umsetzt (u.a. Hschn., Rad.). Char. da-
bei sind Linolschnitte, deren stark abstrahierte Motive von
schraffurartig gesetzten bzw. durch Mehrfachdruck erziel-
ten dichten Binnenstrukturen leben (*The rain again*, Lin-
olschnitt; 2012 im Kunsthandel bei Saatchi). Seit 2000
auch naiv anmutende, stark farbige Pastell-Zchngn, in de-
nen er das Verhältnis Mensch-Umwelt thematisiert. Auch
Buch-Ill. (Gedichtbände, Kinderbücher), u.a. *A sátán fat-
tya* (Bp. 2003), *Az utolsó villamoskalauz* (Bp. 2004) und
Szépet szépen (Miskolc 2005). ⊙ *E:* Encs: 1993, 2001
Városi Képtár; 2001 Városi Gal. / Sátoraljaújhely: 1993
Kazinczy Ferenc Múz. / Sárospatak: 1999 Tanítóképző
Főiskola Patak Gal. / 2000, '02 Kőbánya: Szabó Ervin
Könyvtár. – *G:* Budapest: 1995 Vigadó Gal.: Különös nyo-
matok/Besondere Drucke; 1997 Műcsarnok: Ungar. Sa-
lon; 2007 HBK: 100 Graphiken – 100 zeitgen. Künstler /
1997 Szekszárd, Művészetek Ház: Landes-Ausst. Farb-
druck. ⌷ KMML I, 1999. C. Wendt

Csonka, *Béla*, ungar. Fotograf, Ingenieur, * 15. 9. 1936
Kaposvár, lebt und arbeitet dort. Autodidakt. Stud.: Ma-
schinenbau (Ing.). 1964–92 Technischer Leiter im Elek-
trizitätswerk Kaposvár. Dort seit 1960 Mitgl. im Foto-
klub; seit 1964 im Fotoklub Somogy (1973–85 Sekre-
tär). Teiln. und Mitorganisator der internat. Ausst.-Reihe
Barátság Hídja (Brücke der Freundschaft) in Kaposvár.
Mitgl.: u.a. 1981 Verb. Ungar. Fotokünstler (seit 1987
Jury-Mitgl.). Ausz.: 1985 Kunstpreis Pro Arte Somogy;
1985–86 Lajos-Kassák-Stip., Budapest; 1990, 2001 Ar-
tist FIAP (Fédération Internat. de l'Art Photogr.); 2001
Kaposvár Városért; 2001 Excellence-Preis der FIAP. –
Cs. fotografiert Menschen, v.a. in ihren Beziehungen zur
Umwelt. Dabei stehen ästhetische Faktoren wie Bild-
Komp. oder Licht-Schatten-Effekte im Hintergrund, v.a.
geht es Cs. um das Hinterfragen und Beschreiben von
sozialen Zuständen und Empfindungen. Seine Fotos gel-
ten als wichtige Zeitdokumente, was ihn zu einem Reprä-
sentanten der regionalen Reportage-Fotogr. macht. Er ist
auf zahlr. internat. Foto-Ausst. vertreten, u.a. zw. 1972
und 1997 auf der Internat. Exhib. of Photogr. in Edin-
burgh, Novi Sad und Riga sowie auf Ausst. u.a. in Bra-
silia, Lissabon, Hongkong, Calgary, Reims, Tokio, Kal-

kutta und Seoul. Auch Fotomontagen, v.a. für zeitkriti-
sche Themenbearbeitungen wie *Anno 2000* (Astronaut im
Müll, 1979). ✉ Kaposvár, Bp. 1986, ²1991; Montázsok-
Átváltozások (K), Kaposvár 2001. 👁 *E:* Budapest: 1981
Kunstzentrum; 1987 Kunstzentrum der Armee / Kapos-
vár: 1991 Somogy Megyei Múz.; 1992, 2012 Megyeház
Gal.; 1994, 2009 Kaposfüredi Gal.; 1997 FS József Rippl-
Rónai; 1999 Inst. für Facharbeiter-Ausb. / 1993 Marca-
li, Marcali Múz. – *G:* 1978, '80 Jičín: Bien. Infota /
Budapest: 1979 Haus der Fotogr.: A gyermek itthon és
a nagyvilágban; 1985 Vásárhelyi Pál Kollégiuma: Ausst.
der Lajos-Kassák-Preisträger; 1986 Fotómüvészeti Gal.:
Ungar. Fotogr.; 1987 Mücsarnok: Látható jelen / 1982
San Sebastián: Trofeo Guipuzcoa / 1990 Berlin: Inter-
nat. Pentacon–Orwo-Foto-Wettb. / 1991 Kaposvár, Kunst-
zentrum Árpád Együd: Groteszk Kiállítás / 1997 Bangla-
desh, Bangladesh Photogr. Soc.: Internat. Photo Contest.
📖 KMML I, 1999; Révai Új Lex., 4, Szekszárd 1999. –
Online: Artportal (Lit.; Ausst.). C. Wendt

Csótó, *László*, slowakisch-ungar. Graphiker, Keramik-
ker, * 23. 4. 1954 Rimavská Sobota, lebt und arbeitet in
Kráľovský Chlmec. Gehört der ungar. Minderheit im Sü-
den der Slowakei an. Stud: 1972–76 Univ. Nitra, Pädago-
gik (bild. Kunst). Arbeitet seit 1976 als Kunsterzieher an
der KSch (Volksschule) in Kráľovský Chlmec. Seit 1977
stellt Cs. seine Arbeiten regelmäßig aus. Mitgl.: 1979 Mit-
begr. des slowakisch-ungar. KV Ticce (bis 1988 dessen
Vors.); Slowakisch-Ungar. Verb. Bild. Künstler, Dunajs-
ká Streda; Union Slowakischer Bild. Künstler, Bratisla-
va. – Cs. wächst im Palóczenland auf, einem uralten Kul-
turland, heute grenzübergreifend zw. Ungarn und der Slo-
wakei gelegen, was für seine abstrahierende und bisweilen
konstruktiv anmutende Kunst von entscheidendem Einfluß
bleibt. In seinen Graphiken spielen die Motive und Mus-
ter der in diesem abgeschiedenen Landstrich tief verwur-
zelten Volkskunst eine Rolle. V.a. läßt sich Cs. von der
lokalen Textil-, Schnitz- und Töpferkunst und deren ural-
ten Symbolzeichen und Lineaturmuster (z.B. Labyrinthe,
Knoten- und Flechtbänder) inspirieren, die er in flächig-
konstruktiver Form in heutige Kontexte bringt (z.B. Kreis/
Fußball, Mondsichel/Hutkrempe). Gedrungene, puppen-
ähnliche Figurationen sind mittels einfacher Umrißlinien
und geometrischer Strukturen gestaltet. Cs. thematisiert
dabei mit seinen z.T. stark abstrahierten, jedoch immer
noch gegenstandsbezogenen Bilderfindungen (oft spiele-
risch) Gedanken und Gefühle aus dem mod. Alltagsleben.
Mittels unterschiedlicher graph. Techniken werden die Fi-
guren auf eine symbolhafte, u.a. an abstrakte Figuratio-
nen oder mod. Icons erinnernde Darst. reduziert. Er be-
vorzugt neben der Zchng auch Linol- und Kartonschnitt
sowie die Radierung. Daneben nutzt Cs. die bes. Art des
Farbdrucks von einem Druckstock (Puzzle-Druck). Seine
Motive kehren auch in zahlr. keramischen Arbeiten wie-
der, von denen einige an Collagen, Reliefs oder farblich
fein-abgestimmte Aqu. erinnern. 🏛 DUNAJSKÁ STRE-
DA, Kortárs Magyar Gal. HOLLÓHÁZA, Grundschule Istvá-
nyi Ferenc, Sporthalle: Csillagképek/Sternzeichen, Wand-
bild, Porzellan, 1989 (heute teilw. beschädigt). KOMÁR-

NO, Magyar Kultúra és Duna Mente Múz. MISKOLC, Her-
man O. Múz. 👁 *E:* Komárno: 1978 Duna Mente Múz.;
1997, 2009 Csemadok Gal. / 1981 Rimavská Sobota, Gö-
möri Múz.; Dunajská Streda, Csallóközi Múz. / 1986 Sáros-
spatak, Müvelödési Ház / 1987, 2012 Kráľovský Chlmec,
Kunstzentrum / 1988 Budapest, Klub junger Künstler /
1994 Sátoraljaújhely, Városi Gal. – *G:* 1987 Budapest, Bu-
dapest Gal.: Art Today / Györ: 1991, '93 Internat. Graphik-
Bienn. / 1993 Miskolc: Graphik-Bienn. / 1997 Osaka: Tri-
enn. Druckgraphik; Prag: Praha Graphic '97 / 1997–98
Tatabánya: Kárpát-medencei Grafikai Tárlat (Graphik von
Künstlern des Karpaten-Beckens) (Wander-Ausst. durch
Ungarn). 📖 KMML I, 1999. – *K. Nagy*, L. Cs. (K Mini
Gal.), Miscolc 1985. – *Online:* Website Cs. C. Wendt

Csupó, *Gábor*, US-amer. Trickfilmregisseur, -gestalter
und -produzent, Graphikdesigner, Musiker ungar. Her-
kunft, * 29. 9. 1952 Budapest, lebt in Los Angeles/Calif.
C. studiert zunächst Musik und Kunst in Budapest, be-
vor er 1971 Mitarb. des Pannonia-Filmstudios wird. 1975
flieht er nach Österreich und kommt über Deutschland und
Dänemark nach Schweden. Dort Mitarb. im Trickfilmstu-
dio eines Freundes in Stockholm. 1978 Begegnung mit
der US-amer. Graphikdesignerin und Trickfilmgestalterin
Arlene Klasky (* 26. 5. 1949 Ungarn, lebt in Los Ange-
les/Calif.), die er 1979 heiratet (1995 geschieden). 1979
Emigration in die USA, wo C. zunächst als Trickfilm-
zeichner im Hanna-Barbera-Studio in Hollywood/Calif.
arbeitet. 1981 gründet C. zus. mit seiner Ehefrau das eig.
Studio Klasky C., Inc., das anfangs v.a. Werbetrickfilme,
Firmenlogos und Kinofilmtrailer produziert. Ab 1988 ge-
staltet die Fa. Matt Groenings Zeichentrickfilmserie *The
Simpsons*, zunächst einige kurze Episoden für die TV-
Sendung „The Tracey Ullman Show", dann die ersten drei
Staffeln als eigenständige Reihe (mit zwei Emmy Awards
als Outstanding Prime Time Animated Ser. ausgezeich-
net). In den folgenden Jahren produziert C. zahlr. weite-
re populäre TV-Animationsserien: z.B. *Rugrats* (zus. mit
Paul Germain; 1991–97); *Duckman* (nach Motiven des
gleichnamigen Independent-Comics v. Everett Peck; zus.
mit Jeff Reno und Ron Osborn; 1994–97); *Aaahhh!!! Re-
al Monsters* (1994–98); *Santo Bugito* (1995–96); *Rocket
Power* (1999–2004); *The Wild Thornberrys* (1999–2001);
As Told By Ginger (2000–04). Gründet die weiteren Fir-
men Klasky C. Publishing und Kachew! Commercials so-
wie 1994 das Schallplattenlabel Tone Casualties und Ca-
sual Tonalities, für die er auch selbst Cover gestaltet (z.B.
zu *The Lost Episodes* v. Frank Zappa). Seit 1998 zudem
Produktion abendfüllender Kinotrickfilme: u.a. *The Rugrats
Movie* (1998); *Rugrats in Paris: The Movie* (2000); *The
Wild Thornberrys Movie* (2002); *Rugrats Go Wild* (2003);
Immigrants [L. A. Dolce Vita] (2008). – C. gilt als ei-
ner der innovativsten unabhängigen Trickfilmproduzenten
der Gegenwart, der in seinen TV-Serien häufig Stilmit-
tel von Underground-Comics und -Trickfilmen aufgreift.
📖 *J. Lenburg*, Who's who in animated cartoons, N. Y.
2006. – *J. Beck* (Ed.), Animation art. From pencil to pi-
xel. The hist. of cartoon, anime & cgi, Lo. 2004; Computer
graphics world 30:2007 (3) 44. – *Online:* Internet Movie

Database; Website Klasky C. H. Kronthaler

Csurgai, *Ferenc*, ungar. Maler, Fotograf, Bildhauer, Designer, Hochschullehrer, * 1. 10. 1956 Cegléd, lebt und arbeitet dort. Stud.: 1979–84 Ungar. HBK, Budapest, bei Károly Klimó und János Blaski; 1985 ebd. Meisterschüler bei Ignác Kokasa am Lehrstuhl für Wandmalerei. Stip.: u.a. 1990 Soros-Stiftung; 1990–93 Derkovits. Ausz.: u.a. 1988 Stúdió '88 (Preis für ausgezeichnete künstlerische Leistungen); 2004 Articum-Preis (Skulpt.), Internat. Bienn., Szolnok; Jury-Preis Internat. Trienn. Silikat-Kunst, Kecskemét; 2005 3. Preis Kleinplastik Bienn., Pécs; 3. Preis Freilicht-Skulpt., Kecskemét; 1. Preis Wettb. Holocaust-Denkmal, Cegléd. Mitgl.: 1985 –93 Studio junger bild. Künstler, Budapest (dort jährlich Ausst.-Teilnahme); ab 1985 Landes-Verb. Ungar. Künstler; 2000 Verb. Ungar. Bildhauer; 2001 Verb. der Kunsthandwerker Ungarns. Lehrtätigkeit: Doz. 2002–07 Univ. Pécs (Skulpt.); 2003 West-Ungar. Univ. Sopron (Silikat-Kunst); 2010–11 Leiter des Meisterkurses Beton im Internat. Keramikstudio, Kecskemét. – Cs.s vielseitiges Schaffen ist von Experimentierfreudigkeit geprägt. Er nutzt nahezu alle künstlerischen Medien, um Strukturen, Mat. und Erscheinungsformen auszuloten (u.a. Pastell, Tusch-Zchng., Öl; Fotogr., Skulpt.). Er führt die bed. Experimente seines künstlerischen Vorbilds, des Malers und Bildhauers László Peri (eigtl. Ladislas Weisz, 1899–1967), hinsichtlich Beschaffenheit und freier Formbarkeit von Beton fort und erzielt, auch durch den zusätzlichen Einsatz von Kunststoffen, samtartige oder metallisch glänzende Oberflächen. Seit den 1990er Jahren arbeitet er bei seinen plastischen Arbeiten v.a. mit eingefärbten oder bemalten Betonmischungen. Daraus formt Cs. biomorph, oft auch technisch anmutende, bisweilen turm- oder walzenförmige, durchbrochene Bildwerke oder u.a. an Masken erinnernde skulpturale, häufig allansichtige Objekte. Mehrfach fertigt er seine Arbeiten in Serien, z.B. eine Reihe von monolithisch wirkenden kleinen Kriegerbüsten, die von ma. Rüstungen inspiriert sind (E. der 1980er Jahre), oder er projiziert Malereien auf Beton-Skulpt., die auf organische Formen oder vegetabile bzw. geometrische Strukturen und Gebilde rekurrieren (*Vor dem Regen nach dem Feuer*, I-IV, 2009). Um Wechselwirkungen von Mat. und Bildfläche zu verdeutlichen, stellt er den Plastiken oft collagierte Fundstücke gegenüber, die er fotografiert und deren Vergrößerungen er schließlich übermalt. In einer Werkgruppe widmet sich Cs. dem sog. magischen Quadrat, wobei er sich u.a. mit kabbalistischen Zeichen und Symbolen beschäftigt. Auch ist Cs. als Designer tätig, u.a. erhält er 2001 einen Preis für Entwurf und Realisierung einer Sportbogen-Serie. ⚏ BUDAPEST, Freilichttheater Margitsziget: Relief, Waschbeton, 1984. CEGLÉD, Toldi-Ferenc-Krankenhaus: Architektonikus forma, farbiger Beton, 1991; Új architektonika, Skulpt., 2004. HAMILTON/ N. J., Grounds For Sculpt.: Over Writable Past, Relief, 2005. ⊙ *E:* Cegléd: 1985 Kossuth Múz. (Debüt) 1988, '95, 2004 Ceglédi Gal. / 1985 Amsterdam, Gal. Imago / 1986, 2010 Tápiószele, Blaskovich Múz. / Budapest: 1988 Stúdió Gal.; 1994 Carmina Gal.; 2003 Ungar.

HBK; 2010 Fészek Gal.; 2011 Godot Gal. / 1989 Jászberén, Kortárs Gal. / 1995 Kisújszállás, Alkotóház / Vác: 2001 Görög templom; 2003 Duna-Dráva Cement Kft. Váci Gyára / 2002 Wien, Collegium Hungaricum / Szolnok: 2005 Művésztelepi Gal.; 2009 Kert Gal. / 2008 Visegrád, BASF Konferencia / 2010 Vasvár, Nagy Gáspár Kultúrális Központ. – *G:* seit 1985 zahlr. nat. ▭ MagyFestAdat, 1988; KMML I, 1999. – *J. Bárdosi*, Tulajdonságok nélküli művészet, Bp. 2005; *B. Lengyel*, F. Cs. (Film-Portr., Szolnok TV), 2009; *J. Bárdosi*, Kortársak a templomban, Bp. 2010; *T. Wehner*, Modern Magyar Szobrászat 1945–2010, Bp. 2010. – *Online:* Website Cs. (Ausst.); *J. Bárdosi*, Artportal, 2012. C. Wendt

Csurka, *Eszter*, ungar. Malerin, Fotografin, Medien-, Installations-, Objekt- und Performancekünstlerin, * 27. 9. 1969 Budapest, lebt und arbeitet dort. Stud. ebd.: 1991–98 HS für angew. Kunst (Fotogr., Gebrauchsgraphik); 1992–94 HS für Theater- und Filmkunst (Regie, Kamera). Stip./Ausz.: 1999 Fiatal Iparművészek Stúdiója (FISE); 2001 Strabag-Preis für Malerei; 2003, '04 Derkovits-Stip.; 2004 Hauptpreis Aqu.-Bienn., Eger. Mitgl.: 1997 Studio junger Künstler; Ungar. Künstlerverband. – Cs. arbeitet von Anfang an genreübergreifend in versch. Medien. Sie kombiniert figurative Malerei (Öl, Aqu.) mit übermalten oder am Computer digital bearbeiteten fotogr. Vorlagen (Positiven wie Negativen). Mittels phantasievoller Collagetechniken und Videoinstallationen erzielt sie dabei beklemmende, surreale, an Filmsequenzen erinnernde Arbeiten, wobei ein vorrangiges Thema die Darst. drangvoller Bewegungen ist, die z.B. Flucht oder Befreiung assoziieren (Serie *A test és a semmi*/Der Körper und das Nichts, 2009). Enge Zusammenarbeit mit der 1998 gegr. Theatercompagnie Szkéné (im Merlin Színház), bei der sie auch als Regisseurin, Schauspielerin und Bühnenbildnerin tätig ist. Bei ihren Performances hebt Cs. die Distanz zw. Zuschauer und Schaffensprozeß auf. In frei assoziierten Aktionen, die u.a. an volkstümliche Trad. des Bleigießens und Wahrsagens erinnern, entstehen dabei u.a. große, an lebendige Wesen erinnernde Wachs-Skulpt. oder filigrane Schmuckgegenstände. So tritt sie z.B. 2003 mit den der Eat-art nahestehenden interaktiven Ausst.-Aktionen *ZabArt* und 2005 mit *Blade* im Múz. Ludwig in Budapest auf. Auch in ihrer jüngsten Personal-Ausst. *Vágy*/Begierde (2011 Kiscell Múz.) zeigt Cs. neben großen Metallobjekten, die u.a. als biomorphe Gebilde auf durchsichtige Planen inszeniert sind, v.a. Malerei und Videoinstallationen, die z.T. auf verstörende Weise auf Vages, Unklares und Verborgenes deuten. ⚏ BUDAPEST, Strabag Coll. DEBRECEN, Modern és Kortárs Művészeti Központ (MODEM). EGER, Dobó I. Vár-Múz. ⊙ *E:* Budapest: 1991, '95 Petőfi Csarnok; 1995 Végállomás Gal.; Pro Cultura Stiftung (K); 1996, '97 Merlin Színház; 1998 Dynasoft Gal.; Gal. Lajos; FISE Gal.; 1999 Műcsarnok; 1999–2011 (jährlich) Kiscelli Múz.; 2000 Duna Gal.; 2002, '05, '06 Várfok Gal.; 2010–11 Kiscelli Múz. / 2001 Wien, Gal. H. Kollmann / 2002 Pécs, Gal. Pécs / 2006 Eger, Zsinagóga Gal. / 2007 Esztergom, El Greco Gal. / 2007 Szeged, Reök Palo-

ta. – *G:* Budapest: 2002 Ernst Múz.: Jövőkép; 2005 Szinyei Szalon: AKTuális / 2010 Debrecen, MODEM: Panno-Panoramas. ▭ KMML I, 1999. – *P. Fitz*, Cs. E. képei (K), Bp. 2000; *J. Sturc*, Testre rótt üzenet (K), Bp. 2003. – *Online:* Website Cs. (Ausst.); Centre for Modern and Contemp. Arts (MODEM), Debrecen. C. Wendt

Cuadra e Irízar, *Fernando de la*, span. Architekt, Stadtplaner, * 7. 12. 1904 Utrera/Sevilla, † Mai 1990 Jerez de la Frontera. Vater der Architekten Fernando, Javier, José Marja und Federico de la C. Durán. Stud.: bis 1928 (Abschluß) Esc. Superior de Arquit., Madrid, bei Teodoro de Anasagasti y Algán und César Cort Boti. Zus. mit Vicente Traver y Tomás und José Granados de la Vega Teiln. an der Expos. Iberoamericana in Sevilla 1929 mit mehreren Pav.-Bauten (teilw. zerst.). Danach in Jerez de la Frontera ansässig. Mitarb. (bis 1931) und Nachf. (1950) von Francisco Hernández-Rubio y Gómez als Restaurator der Kartause Sa. María de la Defensión ebd. 1935–71 Stadtarchitekt, danach bis ca. 1980 im Büro seiner Söhne tätig. Architekt des Minist. für Wohnungsbau und des Inst. Nac. de Colonización sowie Abgeordneter des Inst. Nac. de la Vivienda für die Prov. Cádiz und der Obersten Behörde für Stadtplanung der Prov. Cádiz. Mitgl.: RABA de San Fernando, Madrid; RABA de Santa Isabel de Hungría, Sevilla; RABA, Cádiz; Acad. San Dionisio, Jerez de la Frontera. Ausz: 1928 Premio Fin de Carrera, Fund. Aníbal Alvarez Bonquel. – C. gilt in Jerez de la Frontera als erster Stadtplaner im Sinne einer wiss. Disziplin. Mit ca. 220 Projekten prägt er die Entwicklung der Stadt und umliegender Ortschaften maßgeblich. Neben städtebaulichen Neuordnungen auch priv. Bauten entwirft C. Siedlungen des soz. Wohnungsbaus, Schulen und and. öff. Einrichtungen sowie Kirchen mit innovativen Grundrissen. Bemerkenswert angesichts des agrarisch geprägten Umfeldes ist C.s radikal mod. Haltung, die er in der Arbeitersiedlung La Plata von 1940 konsequent umsetzt. Formal wie konzeptionell greift er auf das Bsp. dt. Siedlungen der 1920er Jahre zurück, ohne wesentliche Konzessionen an die lokale Bau-Trad. zu machen. La Plata wird zum Vorbild für spätere Planungen und signalisiert die Überwindung des utopischen Gartenstadtmodells in Andalusien. In den nachfolgenden Jahren entspricht C.s Werk den staatlich empfohlenen neubarocken Tendenzen des Franco-Regimes, mit denen er sachlich umgeht – z.B. in dem Büro- und Geschäftshaus „La Gallina blanca" (1958, Pl. Esteve) -, bevor er gegen E. der 1950er Jahre zu einem moderaten Funktionalismus in klarer geometrischer Formensprache zurückfindet. Hierzu zählen u.a. die Schule El Pilar (1957, Av. Marianistas 1) und die Kellerei Tío Pepe (1960–63, Calle Manuel María González 16), ein langgestreckter, auf vier quadratischen Modulen von 42 m Seitenlänge basierender Industriebau aus Stahlbeton mit horizontal gegliederter Ziegelverkleidung und einer innovativen Dachkonstruktion aus vier flachen Stahlbetonkuppeln nach einem Entwurf des Ing. Eduardo Torroja y Miret. ▭ ALGECIRAS: Busbahnhof. BARBATE: Markthalle. JEREZ DE LA FRONTERA, *Siedlungen*: España, um 1940; Federico Mayo, 1950; La Constancia, 1953; La Vid, 1953; Pío XII, 1956; La Unión, 1969; La

Asunción; Cerrofruto. – Hotel Los Cisnes, 1938 (Fassade). – Calle Porvera: Handelsschule, 1939; Wohnungsbau Bohórquez, 1950. – Schule Al-Andalus (ehem. Grupo escolar Franco), 1940. – Kino Maravillas (Fassade erh.), nach 1940. – Neuer Friedhof, 1942. – Pl. de las Angustias: Gest. und Denkmalsockel, 1947. – Hauptfiliale Banco Popular, 1947. – Alameda de las Angustias: Denkmal für Juan Manuel Durán González, 1951 (Piedestal). – Pl. de la Asunción: Denkmal La Asunción, 1952 (Piedestal). – Pl. del Mamelón: Denkmal San Juan Bautista de la Salle, 1952 (Piedestal). – Calle Ramón y Cajal 16: Wohnungsbau, 1954. – Calle Corredera: Hostal Imar, 1955. – Kino Riba, 1960 (zerst.). – Carretera Sanlúcar: Bodega Bertola, 1962. – Calle Medina: Bodega Williams, 1962. – Pfarrk. Nuestra Señora de Fátima, 1966–67. – Schule La Salle, 1969. – Pl. Arenal: Filiale Banco de Santander, 1969. – Calle Arcos: Wohnungsbau, 1971. – Pfarrk. San Benito, 1973. – Pfarrk. Virgen de la Asunción. TAHIVILLA: Kirche. ◉ *E:* 2006 Jerez de la Frontera, Sala Callejón de los Bolos (K). ▭ *S. Olives Canals/S. S. Taylor* (Ed.), Who's who in Spain, Ba. 1963; *J. Martínez Verón*, Arquitectos en Aragón, II, Zaragoza 2001. – *J. J. López Cabrales*, Rev. de Hist. de Jerez 1995 (1) 13–20; Arquit. del movimiento mod. Registro Docodomo Ibérico 1925–1965, Ba. 1996; *J. M. Aladro Prieto*, Siedlung periférica, o la traducción de modelos alemanes al sur de Esp., in: Modelos alemanes e italianos para España en los años de la postguerra, Pamplona 2004, 137–146. A. Mesecke

Cubbino, *Mario*, ital. Comiczeichner, * 14. 1. 1930 Gorizia, † 2. 5. 2007 Rimini. 1952 assistiert C. bei der Serie *Pantera Bionda.* 1954 ill. er *Nat del Santa Cruz* für den Verlag Tristano Torelli. Er tritt dem Studio Rinaldo Dami bei und hält sich längere Zeit in England auf. Dort zeichnet er u.a. Mädchencomics für den brit. Markt wie *Shirley* oder *My friend Sara.* 1963 kehrt er zurück nach Italien und zeichnet die Reihen *Roy Dallas, Pecos Bill, Zip e Jungla.* In den 1970er Jahren entstehen *Wallenstein il Mostro* und die Parodie *Karzan.* Ab 1973 arbeitet er für die ital. Ztg Il Corriere dei Ragazzi. Dort zeichnet er u.a. die realistische Serie *L'Ombra* (Szenarist Alfredo Castelli). Auch liefert er Comics für das Mag. Corrier Boy und Episoden von *Zagor* und *Dylan Dog* für Bonelli sowie für das frz. Verlagshaus Lug *Rick Ross, Rod Zey, Roi des Profondeurs, Roxy* und *Tahy Tim.* Danach wird er einer der regelmäßigen Zeichner von Diabolik. – Die Comics von C. sind in einem realistischen Stil gehalten. ▭ *H. Filippini*, Dict. de la bande dessinée, P. 2005. – *Online:* Lambiek Comiclopedia.

 K. Schikowski

Cube, *Gustav (Gustav Hermann) von*, dt. Architekt, * 25. 10. 1873 Menton/Alpes-Maritimes, † 31. 3. 1931 (Suizid) München. Stud.: ab 1892 TH, Hannover; 1895–97 Studien in München. Heiratet 1898 Maria Sternheim (1. Ehe) und ist ab 1901 in München ansässig. Wird 1906 an der TH Hannover promoviert (Dr. Ing.) mit einer Arbeit über pompejische Wandmalerei. 1921–29 Bürogemeinschaft in Duisburg mit dem Architekten *Arthur Buchloh*, um 1924 in München auch assoziiert mit Georg Persch. – C. entwirft im Münchner Umland vor dem 1. WK mehrere

prachtvolle Villen im neoklassizistischen Stil. Für Aufsehen sorgt 1908 das schloßartig ausgestattete 35-Zimmer-Pal. *Bellemaison* in Höllriegelskreuth, das C. als „Gesamtkunstwerk" für seinen Schwager, den Schriftsteller Carl Sternheim, errichtet. 1912–13 entsteht die elegante *Villa Seewies* in Feldafing für den Dir. des Russ. Lloyd. Das wichtigste Werk aus den 1920er Jahren ist die Dreiflügelanlage des Schifferkinderheims Nikolausburg in Duisburg, die C. im Stil des sog. Backstein-Expressionismus errichtet. – Monogr. Bearbeitung und WV stehen aus. ⌂ u.a. DUISBURG, Sonnenwall 73: Büro- und Geschäftshaus Alfred Bergk (sog. Mercedes-Haus; heute Bezirksrathaus Mitte), 1922–24 (verändert). – Fürst-Bismarck-Str. 42: Kath. Schifferkinderheim Nikolausburg (mit A. Buchloh), 1923–27. FELDAFING, Seewies-Str. 65: Villa Seewies, 1912–13. HÖLLRIEGELSKREUTH, Zugspitz-Str. 15: Bellemaison Carl Sternheim, 1907–08. – Josef-Breher-Weg 2: Villa Kurt Grelling, 1912–13. – Josef-Breher-Weg 3: Villa Otto Luppe, 1913–14. MÜNCHEN, Poschinger-Str. 6: Villa Heymel, 1910. – Brienner Str. 47: Villa, 1910. ⊠ Die röm. „Scenae Frons" in den pompejanischen Wandbildern 4. Stils, Diss., B. 1906 (Beitr. zur Bau-Wiss., 6). ⎘ *F. Donatus*, in: Dt. Bauhütte 14:1910, 273, 275; Dt. Bau-Ztg 1912 (20) 192 (zu A. Buchloh); *A. Ziffer*, Nymphenburger Moderne (K SM München), Eurasburg 1997; *A. Pophanken/F. Billeter* (Ed.), Die Mod. und ihre Sammler. Frz. Kunst in dt. Privatbesitz vom Kaiserreich zur Weimarer Republik, B. 2001; *G. Escher u.a.*, Denkmalpflege im Rheinland 28:2011 (3) 110–118. U. Heise

Cucé, *José*, brasil. Bildhauer, * 1900, † 1961, tätig in São Paulo. Stud. ebd: 1917 Malerei und Bildhauerei am Liceu de Artes e Ofícios, u.a. bei Amadeu Zani, Adolfo Bonone und Henrique Vio. 1918 auf Einladung von Ettore Ximenes Mitarb. am Denkmal zur Unabhängigkeit Brasiliens in São Paulo. Mitbegr. der EBA ebd., wo er später auch unterrichtet, sowie des Salão Paulista de BA. Präs. der Künstlergewerkschaft. – Fertigt versch. Standbilder für öff. Plätze in São Paulo, z.B. die Bronze-Skulpt. des Schriftstellers Rui Barbosa auf der Praça Ramos de Azevedo (1930), das Bronzedenkmal des portug. Dichters Camões auf der Praça D. José Gaspar (1942) sowie das Denkmal für den ersten Erzbischof von São Paulo Dom Duarte Leopoldo e Silva am Largo de Santa Cecília (1949). Ausz.: 1922 1. Preis für Skulpt. des Unbekannten Soldaten, Catania/Italien; 1923 2. Platz beim Wettb. für das Denkmal an Santos Dumont, Rio de Janeiro. ◉ *G:* 1934 (Prêmio Prefeitura de São Paulo), '57 (Große Gold-Med.; Ankaufspreis), '58 (Ankaufspreis), '67 (posthum ehrenvolle Erw.) São Paulo: Salão Paulista de BA. ⎘ *Cavalcanti* I, 1973. – *M. Escobar*, Escult. no espaço público em São Paulo, [S. P.] 1998. M. F. Morais

Cucerzan, *Horea*, rumänischer Maler, Freskant, Restaurator, * 7. 7. 1938 Blaj/Bez. Alba, lebt in Bukarest. Stud.: bis 1963 HBK, Cluj. Ausz.: u.a. 1983 Kunstpreis, Padua; 1987 Kunstpreis, Manfredonia; 2008 Ehrenbürger der Stadt Blaj. 1999 Stud.-Aufenthalt in der Accad. di Romania, Rom. 1997 Ltg des Malerei-Symposiums in Blaj. – C. hat sich in der Malerei auf Portr. hist. Persön-

lichkeiten spezialisiert (u.a. *Gh. Enescu*; Bukarest, Muz. Gheorghe Enescu). Im nicht angewandten Bereich gestaltet er in Mischtechnik oder Öl/Lw., unterschiedlich stark expressiv-abstrahiert, hellfarbige figürliche Komp., aber auch sakrale Motive (Madonnen, Engel) und Ansichten rumänischer und ital. Städte. 1989 restauriert er die ma. Fresken im Pal. Lippomano in Padua. ⌂ ALBA IULIA, Sala Unirii: Portr. hist. Persönlichkeiten, Wandbilder, 1993–95. BLAJ, Muz. de Artă: 10 Arbeiten. LANCRĂM, Casa Memoriala Lucian Blaga: Portr. L. Blaga, Öl/Lw. NEW YORK CITY, UNO-Gebäude: Denker, Mischtechnik. ROM, Vatikanisches Mus.: Geburt, Öl/Lw. STATIUNEA VENUS/Constanţa: Muzica, Wandbild, 1968. ◉ *E:* zahlr. seit 1963, u.a. Bukarest: 1979 Teatrul de Comedie; 1982 Gal. Caminul Artei; 1988 Gal. Simeza; 1996 Gal. Orizont; 2000 Muz. Enescu; 2001, '03 Cercul Militar Naţ.; 2002 Gal. Apollo; 2006 Gal. Senso; 2006, '07 Gal. Galatea; 2011–12 Gal. Veroniki / 1983, '88, '93, '98 Rom, Accad. di Romania / 1986 Padua, Gal. Civica Cavour / 1987 Frankfurt am Main, Gal. ARC / 1992 Cluj-Napoca, Complexul Expoz. / 1998 Venedig, Inst. de Cult. N. Grigorescu. –. *G:* zahlr. nat. und internat., u.a. Bukarest Salons / 1991 Piteşti: Expoz. 22 Decembrie (1. Preis für Malerei) / 1998, 2001 Rom, Accad. di Romania: Arta contemp. italo-română. ⎘ *Barbosa*, 1976; *A. Cebuc u.a.*, Enc. artiştilor români contemp., I, Bu. 1996; *id./ibid.*, IV, Bu. 2001. – Album Omagiul H. C., Iaşi 2008. – *Online:* ArtLine (Interview mit Adrian Lepadatu, 2005). B. Scheller

Cucinella, *Mario*, ital. Architekt, Stadtplaner, Designer, * 29. 8. 1960 Palermo, lebt in Bologna. Stud.: bis 1987 Univ. Genua. Danach bis 1991 Projektkoordinator bei Renzo Piano in Paris und Genua. Eig. Bürogründungen 1992 in Paris und 1999 in Bologna, ab 1997 Partnerschaft mit der irischen Architektin Elizabeth Francis (seit 2010 eig. Büro), seit 1998 Zusammenarbeit mit Edoardo Badano. Gast-Prof. an der Nottingham Univ. sowie Vorlesungen an versch. europ. Universitäten. Ausz.: u.a. 1992 Gold-Med. des Forums für junge Architekten, Buenos Aires; 1999 Förderungspreis der AK Berlin; 2004 Outstanding Archit. Award (World Renewable Energy Congress VIII, Denver/Colo.); 2009, '11 Mipim Awards, Cannes. – Durch die erfolgreiche Teilnahme an bed. Wettb. erwirbt C. schon früh einen internat. Ruf im Bereich des klimagerechten, nachhaltigen Bauens. Sein Wirken basiert auf eig. Forschungen zur Klimakontrolle sowie auf der Verwendung innovativer Technologien und entspricht dem Anliegen, ökologische, ethische und soziale Nachhaltigkeit mit einem qualitätvollen Entwurf zu verbinden. Mit der Univ. Nottingham entwickelt er das „passive, hybride Abwind-Kühlungssystem", das er in seinen Bauten erprobt. C.s beispielhaft integrativen Projekte der Archit. und Lsch.-Gest. werden auf Kongressen weltweit vorgestellt. Auch Gebietsentwicklungspläne entstehen unter energetischen Kriterien: Gewerbepark Pioltello b. Mailand (2005); Dongtan Eco City, Shanghai (2007); Città dei Creativi, Bologna (2009); Città delle Colonie di Ponente, Cesenatico (2010). Seit 1992 ist C. zudem im Bereich Industriedesign tätig und entwirft neben Interieurs auch Leuchten für

iGuzzini Illuminazione. – Abgesehen von diversen, den Gebäuden inhärenten Strategien für eine natürliche Belichtung und Belüftung und die Nutzung geothermischer oder and. Energien sind C.s Bauten durch individuelle Entwürfe mit leicht wirkenden Fassaden gekennzeichnet. Das Technologiezentrum für nachhaltige Energie auf dem Campus der Univ. Nottingham in Ningbo/China (2008) ist mit seiner vielfach gefalteten Form durch trad. chin. Lampions und hölzerne Wandschirme inspiriert. Tatsächlich besteht es vollständig aus einer doppelten Glashülle, deren Scheiben in Form schmaler Holzbretter mit einem Muster bedruckt sind; die Fassadenwirkung des kleinen Turmhauses verändert sich mit den Lichtverhältnissen ständig. Beeindruckend gestaltet C. auch das auf einem quadratischen Grundriß um zwei Innenhöfe beruhende Gebäude der Regionalbehörde für Umweltschutz (ARPA) in Ferrara (2008), dessen kaminartige Sheddachkonstruktionen der natürlichen Belüftung sowie der Reduktion mechanischer Heizkraft dienen. Eine zeitgemäße Weiterentwicklung der dt. Experimentalbauten aus den 1960er Jahren (Jochen Brandi, Richard J. Dietrich, Otto Steidle) ist C.s Konzept eines bioklimatischen Experimentalhauses auf 100 Quadratmeter Grundfläche mit variabler Wohnungsgröße und niedrigen Herstellungskosten dank vorfabrizierter mobiler Elemente, die in einem Rahmenwerk verankert werden. 🏛 BEIJING, Tsinghua Univ.: Chin.-Ital. Haus für Ökologie und Energie (SIEEB), 2006. BOLOGNA: Städtischer Ausst.-Pavillon eBO, 2003. – Gebäude Stadtverwaltung, 2008. CAMPOTENESE: Nat.-Park-Haus Pollino, 2010. CREMONA: Wohn- und Geschäftshaus Casa di Bianco (Sanierung, Umnutzung), 2005. MAILAND, Via Ambrogio da Fossano Bergognone 53: Multifunktionsgebäude, 2003. OTRANTO: Fährstation, 2001. PADUA: Hauptverwaltung Uniflair, 2004. PARIS: Metrostation Villejuif-Leo Lagrange, 2000. PIOLTELLO, Malaspina Business Park: Hauptverwaltung 3M, 2010. RECANATI, Verwaltungsgebäude iGuzzini Illuminazione, 1997–98. RIMINI: Büro- und Geschäftshaus Centro Direzionale Forum, 2006 . – Hauptverwaltung Focchi, 2007. ✉ Space and light, Mi. 1998; Works at MCA. Buildings and projects, Bo. 2004. 👁 *E:* 2001 Paris, La Gal. d'archit. / 2002 Dublin, RIAI Archit. Centre / 2003 Turin, Castello del Valentino. – *G:* 2005 Mailand: Trienn. / 2008 Venedig: Bienn. 📖 *C. Slessor*, The archit. review 207:2000 (1235) 63–65; *M. Brizzi*, More with less (K), Fi. 2002. – *Online:* Website C.

A. Mesecke

Cucullu, *Santiago,* argentinischer Maler, Zeichner, Video- und Installationskünstler, * 1969 Buenos Aires, lebt in Milwaukee/Wis. Stud.: bis 1992 Hartford Art School, Hartford/Conn.; bis 1999 Minneapolis College of Art and Design, Minneapolis/Minn. 2001–02 Gastkünstler des Glassel Core Program in Houston/Tex. und der School of Paint. and Sculpt. in Skowhegan/Me. sowie 2006 des Headlands Center for the Arts, Sausalito/Calif. Ausz.: u.a. 2000 Jerome Found. Fellowship, Minneapolis; 2007 Greater Milwaukee Found. Mary L. Nohl Fund Fellowship; 2009 Art Matters Travel Grant, New York. – In C.s multimedialem Werk stehen ortsspezifische, meist tempo-

räre Wand-Zchngn in Vinyl auf Klebefolie im Zentrum, die auf die Ausstellungsräume und ihre archit. Elemente bezogen sind; hinzu treten Aqu., Skulpt. aus Alltags-Mat., Graphiken und and. Medien. Thematisch verbindet C. hist. Ereignisse, Erlebnisse aus seiner unmittelbaren Lebensumgebung und biogr. Erinnerungen zu neuen komplexassoziativen, collageartigen Bildern, die sich aus der Ästhetik von Hoch- und Massenkultur speisen. Häufig bezieht er sich auf vergessene hist. Personen, z.B. im *Hammer Project* (2004) auf den argentinischen Anarchisten Severino di Giovanni, der von der Polizei erschossen wurde. C. vermischt visuelles Mat. aus der Bibl. der Federación Libertaria de Argentina über anarchistische Utopien mit eig. Schüler-Zchngn und der zeitgen. Reportage über eine entlassene Polizistin zu einer die Wände unregelmäßig bedeckenden flächig-bunten Komposit-Komp., die teilw. fast schon abstrakten Char. annimmt. Auch der titellosen Arbeit für die Whitney-Bienn. (2004) liegen ges. Visionen zugrunde, basierend auf Bildern vom Schlaraffenland, von argentinischen Anarchisten und Archit. der Moderne aus Argentinien und Japan. In *MF Ziggurat* (2008) konfrontiert er die mit dem städtischen Außenraum kommunizierende, einsehbare Schroeder Gall. des eleganten Mus.-Gebäudes von Santiago Calatrava in Milwaukee mit Wand-Zchngn, Objekt-Skulpt., bemalter Plastikfolie an der Decke und Videos mit Endlosschleife, in denen sich Bilder von der umgebenden urbanen Lsch. und ihren als mod. Zikkuraten verstandenen Wolkenkratzern, fiktive Szenen und Fernsehbilder mischen. *The black car and the green waters of Lethe* (2008), eine schwarzweiße Wand-Zchng in der Berliner Loock Gal., bezieht sich auf den Fluß der griech. Mythologie, dessen Wasser, wenn man es trinkt, die Erinnerung löscht; er kombiniert darin bildliche Zitate u.a. aus bek. Gedichten, Gem. und Filmen. Die zentrale Wand-Zchng des Projekts *The outhouse* (2011; Green Gall. East, Milwaukee) verbindet die Darst. eines schematischen Zaunes, der auf ein unscheinbares Frauengefängnis in C.s Nachbarschaft anspielt, mit großen blutroten Flecken, entstanden durch aufgeplatzte Farbbomben. Im Alltag übersehene Probleme werden im musealen Raum ästhetisch provokativ in Szene gesetzt. 🏛 MINNEAPOLIS (Minn.), Walker AC. NEW YORK, MMA. 👁 *E:* Houston (Tex.): 2002, '03 Glassel SchA; 2002, '04 Barbara Davis Gall.; 2010 Optical Project / Minneapolis (Minn.): 2000 Walker AC (mit Bonnie Collura; K: D. Fogle/L. Thomas); 2001 Midway Contemp. Art (mit Jorge Queiroz); 2003 Franklin Art Works / 2003 Chicago, Julia Friedman Gall. / Milwaukee (Wis.): 2003 Inst. of Visual Arts; 2008 AM; 2011 Green Gall. East / Tokio: 2004 Mori AM (K: M. Kataoka); 2010 Inst. of Technology, Center for the Study of World Civilizations / 2004 Los Angeles, Armand Hammer Mus. of Art and Cult. Center (K: B. Sholis) / 2005, '08 New York, Perry Rubenstein Gall. / 2005 Seattle (Wash.), Henry AG / 2006 La Jolla (Calif.), MCA / 2007 Kansas City, The Dolphin / 2008 Berlin, Loock Gal. / 2010 Salina (Kan.), AC (mit Martin Ayos); Boston (Mass.), Emerson College / 2011 Neapel, Gall. Umberto DiMarino. – *G:* 2001 Minneapolis, College of Art & Design: Five Jerome ar-

tists / 2002 Brescia, Pal. Martinengo: Dubuffet e l'arte dei graffiti (K: R. Barilli) / 2004 New York: Whitney Bienn. / 2005 Burgos, Centro de Arte Caja de Burgos: Entre líneas (K: E. Navarro) / 2006 Singapur: Bienn. / 2007 Madison: Wiscon Trienn.; Lissabon, Fund. Calouste Gulbenkian: Um atlas de acontecimentos (K: A. Pinto Ribeiro u.a.) / 2010 Düsseldorf, K 21 Kunst-Slg im Ständehaus: Intensif-Station. 26 Künstlerräume. ⌒ How latitudes become forms. Art in a global age (K Wander-Ausst.), Minneapolis 2003; *P. Briggs*, Artforum 41:2003 (10) 174 s.; *G. Clark/ P. Malamud* (Ed.), Art on the edge. 17 contemp. Amer. artists, Wa. 2004; Art news 104:2005 (2) 131; GQ Japan (To.) 2004 (Mai) 159; Hammer projects, 1999–2009, L. A. 2009; *M. Grabner*, Artforum 2009 (Sept.). – *Online:* The Green Gall., Milwaukee. M. Nungesser

Cuéllar Costa, *Juan,* span. Maler, Zeichner, Graphiker, * 2. 9. 1967 Valencia, lebt in La Cañada/Valencia. Stud. ebd.: 1987–92 Malerei an der Fac. de BA de S. Carlos der Univ. Politécnica, bei José Luis Albelda, Horacio Silva, Juan Barberá, Joaquin Aldás und José María Yturralde. 1999 Stip. Alfons Roig der Prov.-Verwaltung von Valencia. 2001–02 mit Stip. in der Accad. di Spagna di BA in Rom. 2002 Stip. Fortuny, Venedig. 2007 mit Roberto Mollá Gründung von Encapsulados, einer Plattform für tragbare Kunst. Zahlr. Ausz., u.a. 1. Preise: 1993 Fund. Cañada Blanch, Valencia; 1994 Salon de Otoño de Pint. Bancaixa, Sagunto; 1998 Certamen de Pint. Vila de Benissa/ Alicante. – C.s figurativen Gem. (Öl/Lw., auch mit Acryl), z.T. als Tondi ausgef. (Öl/Holz), die einer bes. in Valencia in den 1990er Jahren verbreiteten sog. schematischen Malerei verwandt und von der Pop-art angeregt sind, haben symbolisch-surrealen Char. und stellen v.a. eine Kritik und Parodie an der zeitgen. US-amerikanisierte Konsum-Ges. dar. In leuchtend metallischen Farben und klaren Konturen erscheinen Menschen wie Playmobilfiguren in künstlichen Welten mit rätselhaften Konstellationen aus Gegenständen wie Haushaltswaren, Werkzeugkästen, Spielzeug und fleischfressenden Pflanzen (u.a. *Embriones, La prueba; Plegaria para una nueva era,* alle 1995–96); sie werden geklont oder erscheinen als Raumfahrer. Seit ca. 2000 malt C. kalt anmutende urbane Szenarien, die Bürokratie und Anonymität hervorheben (*Europa; Multinacional; Trasnochadores*) sowie märchenhafte Silhouetten von Tannenwäldern mit miniaturhaften Wohnwagen oder Häusern (*Clase media; Red north,* alle 2005). Nach einem Aufenthalt in Japan entstehen ironische Bilder mit klischeehaften Darst. der Welt der Waren und Marken (*Tokyo style; Kyoto style; Hipoteca jap.*), die auch trad. Werte kontaminiert (*La flor del cedro; Toru, Midori, Fuji,* alle 2008) und eine Kultur à la Disneyland hervorbringt (*Jap. suburbial,* 2010). Zahlr. Zchngn, u.a. die der Sequenz eines Kriminalfilms gleichende Serie von Szenen mit Personen ohne Gesichter oder in Form eines Mickey-Mouse-Kopfes (*La huida,* Graphit oder Tusche/Papier, 2008). Ähnliche Motive finden sich auch in Gem., die das Alltagsleben in den USA persiflieren (*Fam. life; Suburbial dream; Summer night,* alle 2010). ⊞ ALBACETE, Stadtverwaltung. AVILA, Caja de Ahorros. CÁDIZ, Prov.-Verwaltung. CASTELLÓN DE LA

PLANA, Prov.-Verwaltung. MADRID, Fund. Coca-Cola España, Col. de Arte Contemp. – Col. Ars Fundum. – Mus. de la RABA de S. Fernando. – Mus. Mpal Contemp. PEGO/Alicante, NAC. ROM, Accad. di Spagna di BA. SABADELL, Fund. Banco Sabadell. SAGUNTO, Bancaixa. VALDEPEÑAS/Ciudad Real, Mus. Mpal. VALENCIA, Col. Club Diario Levante. – Fund. Cañada Blanch – Inst. Valenciá de la Joventut. – Mus. Valenciá de la Ill. i de la Modernitat. – Prov.-Verwaltung. – Stadtverwaltung. – Univ. Politécnica. VALLADOLID, Junta de Castilla y León. VITORIA, Artium. ◉ *E:* 1993 Torrent, Caja Rural de Torrent, Sala de Expos. (mit Nieves Cuéllar Fores und Rafael Gallent Mezquida; K) / Madrid: 1995 Gal. Detursa; 1997, 2000 (K) Gal. My Name's Lolita Art / Valencia: 1996 Club Diario Levante (K: V. Jarque); 1997 (K: A. M. Charris), '98 (K: E. Guigón), 2002 (K: F. Huici/R. Forriols) Sala Parpalló; 2003 La Linterna; 2008 Inst. Franç. (K: L. F. Navarro/P. Berthier); 2011 Gab. di Dibujos / 1996 Xàvia, Espai d'Art A. Lambert (K) / 1997 Alfafar, Gal. Edgar Neville / 2000 Buriana (Castellón), Centro Cult. La Mercè / 2001 Tarragona, Stadtverwaltung (K); Orense, Gal. Marisa Marimón; Malvarrosa (Valencia), Espai Paral·lel / 2002 Venedig, Bugno AG / 2004 Chicago, Gala AG / 2005 Vigo, Gal. Bacelos (K: C.) / 2006 Barcelona, Gal. Hartmann / 2008 Santander, Gal. Nuble (K: R. Mollá). – *G:* 1992, '94 Xàtiva (Valencia): Bien. / 1993, '95 Quart de Poblet (Valencia): Bien. de Pint. / 1993, '97 (1. Preis) Meliana (Valencia): Bien. / 1994 Zamora: Bien. de Pint. (ehrenvolle Erw.) / 2000 (Ankaufspreis), '07 Albacete: Bien. de Pint. / 2009 Valencia, IVAM, Centre del Carme: La fotogr. en la nueva pint. realista (K: F. Martínez u.a.). ⌒ DPEE III, 1994. – *N. Sáncez Durá/ J. M. Bonet,* Muelle de Levante (K: Club Diario Levante; Wander-Ausst.), Va. 1994; *J. M. Bonet,* Figuraciones de la Valencia metafísica (K Caja Madrid Obra Social), Ma. 1999; *id. u.a.,* Arte emergente (K Estación Marítima), La Coruña 2001; *J. C./L.-F. Navarro,* Huidas, Va. 2010. – *Online:* Website C. M. Nungesser

Cuenca (C. González), *Liliam,* kubanisch-US-amer. Malerin, Zeichnerin, Graphikerin, * 25. 6. 1944 Havanna, lebt seit 1986 in Miami/Fla. Stud.: 1974 ENBA de „S. Alejandro"; Intaglio-Drucktechnik an dem Taller Experimental de Gráfica (TEG), beide Havanna; 1980–85 Univ. Nac. Experimental Simón Rodríguez; Taller de Artistas Gráficos Asociados (Taga), beide Caracas. In Havanna als Frz.-Lehrerin tätig. 1983 Teiln. am Programm von Artes Gráficas Pan-Amer. (AGPA). 1987 Gastkünstlerin des South Florida AC, Miami/Fla. 1990 Stip. der Oscar B. Cintas Found., New York. Ausz.: u.a. 1990 Asahi Broadcasting Corporation Award, Osaka. – Anfangs tritt C. als Graphikerin hervor und stellt v.a. reale oder erfundene Tiere dar sowie Fam.-Bilder, die durch alte Drucke oder Fotogr. angeregt sind. M. der 1980er Jahre beginnt sie zu malen und entwickelt eine gestisch-abstrakte, Henri Michaux und Hans Hartung verwandte Bildsprache mit figürlichassoziativen Elementen. In diffusen, von wenigen düsteren, von Schwarzblau, Violett und Grautönen dominierten Farbräumen (Acryl/Lw.) erscheinen zeichenhafte, verwischte Silhouetten und lassen die Darst. geheimnisvoll,

oft auch dramatisch erscheinen. Die Schatten deuten Tiere (*Caballos*; *On the other side*, 2003; *Birds of passage*, 2010) und Menschen an *(Flutters of beings*; *Sleeping body*; *An effort of lucidity*, 2010) oder lassen Gebautes erkennen (*Esperando*; *The chapel*). Mit der Zeit werden sie immer flüchtiger und expressiver, so daß die Komp. Gegenständliches nur noch erahnen lassen (*No exit; Runaways*; *Hidden places*, 2010). Auch zahlr. ähnlich gestaltete Bilder in Tusche oder Acryl auf Papier (z.B. *Memory from before; It was late at night*, beide 2010), z.T. landschaftlich-atmosphärischen Char. (*Dawn*; *Mist*; *Clear waters*, 2010). ⌂ BRIDGEPORT/Conn., Housatonic Mus. of Art. HAVANNA, MNBA. MIAMI/Fla., Lowe AM. NEW YORK, Oscar B. Cintas Found. Coll. NORTH MIAMI/Fla., MCA. OSAKA, Found. of Cult., Contemp. Art and Cult. Center. VÉLEZ-MÁLAGA, MAC. ☉ E: 1978 Havanna, MNBA / 1982, '86 Caracas, Fund. Mendoza / 1990 San Juan, Ridel Gall. / Miami (Fla.): 1993 Adamar AG; 1995 Metro Dade Cult. Resource Center; 1997 Cuban Coll.; 2000 Broman Gall.; 2003 Books & Books; ART @ Work; 2007 Fairside Gall.; 2010 Miami Dade College, Freedom Tower (K: C. Damian) / 1998 Bogotá, Alonso Gal. de Arte. – G: 1979 Havanna: Trien. de Grabado Víctor Manuel (Erw.) / 1987 Chicago, Art Inst.: Recent developments in Latin Amer. drawing (K: A. Ruiz-Ramón) / 1990, '94 Osaka: Internat. Trienn. Competition of Print / 1995 San Juan: Bien. del Grabado Latinoamer. y del Caribe / 2000 Chapel Hill (N. C.), Center for Internat. Stud.: Three cuban artists. ⌷ *J. Veigas u.a.*, Memoria. Cuban art of the 20th c., L. A. 2002; *C. M. Luis*, El Nuevo Herald, Artes y Letras (Miami, Fla.) v. 15. 2. 2004; *id.*, Encuentro de la cult. cubana (Ma.) v. 26. 4. 2010. M. Nungesser

Cüppers, *Albert*, dt. Architekt, Maler, Zeichner, Hochschullehrer, * 1932 Den Haag, lebt in Blaustein. Tischlerlehre in Uelzen. 1953–58 Archit.-Stud. in Hamburg und Berlin. 1958–64 Mitarb. im Archit.-Büro von Egon Eiermann in Karlsruhe; hier als Architekt u.a. beteiligt an der Realisierung des Gebäudekomplexes der Raffinerie Dea-Scholven (Karlsruhe-Knielingen, Miro-Bauten, 1961–63) oder an den Entwürfen für ein neues Rathaus in Essen (1964). Lehrtätigkeit: ab 1967 Staatliche Werk-KSch, Kassel; ab 1971 Prof. für Ästhetische Theorie und Praxis an der Gesamt-HS Univ. ebd. Seit 1997 (Emeritierung) in BW ansässig. – Das zeichnerische und malerische Œuvre (Öl, Aqu., Gouache, Bleistift, chin. Tusche) ordnet C. nach eig. Systematik v.a. drei Werkgruppen zu, die er „Vielbilder", „Bauchbilder" und „Hemdbilder" nennt. Hinter den ersten beiden verbergen sich u.a. collageartige Komp. (Bilder in Bildern), archit. inspirierte Zchngn und Aqu. (z.B. *Palladianische Anlässe*, 1982), auch narrative Gem. in versch. Stilrichtungen (u.a. Magischer Realismus). Einen originellen Beitrag leistet C. mit seiner Werkgruppe *Hemdbilder*, die zw. abstrakter und konkreter Kunst anzusiedeln sind. Schon in den 1980er Jahren beschäftigt ihn das Thema „Hemd", das er intensiv seit 1995 in umfangreichen Bildzyklen bearbeitet, wobei er immer wieder der grundsätzlichen Frage nachgeht, „ob es mittels Abstraktion eine Annäherung an die menschliche Gestalt gibt, ohne das In-

dividuum mit seinem Ebenbildlichkeitsanspruch aufscheinen zu lassen" (Website C.). In einer Art wiss. forschender Kunstausübung dekliniert C. dabei mit konsequent angewandten konkret-konstruktiven Mitteln in z.T. extrem reduzierter, jedoch immer noch erkennbarer gegenstandsbezogener Weise die inhaltlichen und gestalterischen Deutungsmöglichkeiten der (T-Shirt-)Hemdform mit entsprechenden Assoziationen und Ableitungen, z.B. als Antoniuskreuz, Auferstehungshemd (von spätgotischer Kunst inspiriert), Totenhemd (*Hemd über sechs Gruben*) oder als archit. Form (*Hemdbild, sechsfach mit Haus*). Strenge vertikale oder horizontale Lineaturen, Spiegelungen, Reihungen (*Giotto-Teppich mit 266 Hemden*) oder geometrisierende Flächenaufteilungen stehen dabei für mehr oder weniger meditative, häufig chiffrenhafte Inhalte, die C. bisweilen mit skurrilen Einzeichnungen (u.a. mit Piktogrammen) hintergründig kommentiert und auflockert. Seit 2006 entsteht in dieser Werkgruppe der Bilderzyklus zum Gedenken an die während der nat.-sozialistischen Gewaltherrschaft unter dem Deckmantel der „Aktion Gnadentod" in Grafeneck bei Münsingen umgebrachten 70000 psychisch Kranken (*Gedenkbilder Grafeneck. Zwangshemd mit Grube*, Öl/Lw., 2006). Im umfangreichen zeichnerischen Werk von C. auch Künstlerbücher (Leporellos). ⌂ BURGENRIED-ROT, Mus. Villa Rot. FRANKFURT am Main, Dt. Archit.-Mus. KARLSRUHE, ZKM. KASSEL, Ev. Kirche von Kurhessen-Waldeck. – Landeszentralbank. – Mus. für Sepulkralkultur. – Stadtverwaltung. – SM. – Univ. TÜBINGEN, Reg.-Präsidium. ✉ Kasseler Bilderzyklus (Mappe), Kassel 1990. ☉ E: Kassel: 1976 KV (Debüt); 1997 Kulturbahnhof; 2003, '07 Mus. für Sepulkralkultur / 1977 Bremen, Paula-Modersohn-Becker-Mus. / 1986 Frankfurt am Main, Dt. Archit.-Mus. (mit Jürgen Müller; K) / 1999, 2006 Ulm, Gal. Cuenca / 2001 Minden, KV / 2002 Berlin, St.-Matthäus-Kirche (Wander-Ausst.; K) / 2007 Ehingen-Mochental, Gal. Schloß Mochental / 2008 Freiburg, Kath. Akad. / 2009 Lausanne, Église de Villamont / 2011 Ulm, Münster. – G: 1984 Paris, Centre Pompidou: Images et imaginaires d'archit. (K) / 2006 Burgenried-Rot, Mus. Villa Rot: Kunst-Lsch. Oberschwaben (K). ⌷ *Gorenflo* I, 1988; *P. Schmaling*, Künstler-Lex. Hessen-Kassel 1777–2000, Kassel 2001. – *J. Müller u.a.*, A. C. Palladianische Anlässe. Aqu. (K), Kassel 1982; *W. Schirmer* (Ed.), Egon Eiermann 1904–1970. Bauten und Projekte, St. 1984; A. C. Über Archit. hinaus (K), Ffm. 1986; *D. Ipsen/F. Naumann*, A. C. Konferenzskizzen, Kassel 1987; A. C. Hand-Zchngn 1991–1992 (K), Kassel 1992; Kunstförderung des Landes BW. Erwerbungen 2001–2004 (K Wander-Ausst.), Schwäbisch Gmünd 2006. – *Online:* Website C. U. Heise

Cuevas (C. Abeledo), *Garikoitz*, span. Maler, * 1968 Sanlúcar de Barrameda/Cádiz, lebt dort. Stud.: Malerei an der Fac. de BA Sa. Isabel de Hungría der Univ., Sevilla. Mit Stip. 1990 am Birmingham Polytechnic; 1992 am Colegio de España in Paris; 1997–99 in der Residencia de Estudiantes in Madrid. Ausz.: u.a. 1999 Ankaufspreis, Premio Internac. de Pint. Eugenio Hermoso, Badajoz; 2005 1. Preis, Certamen Internac. de Pint. Royal Pre-

mier Hotels, Torremolinos/Málaga; 2006 Preis für Malerei, Fund. Focus-Abengoa, Sevilla. – C.s Malerei besteht aus abstrakten, dicht getupften Farbstrukturen, die die gesamte Lw. bedecken; darauf werden ähnlich bearbeitete Leinwände geklebt und z.T. mehrfach in der Art der Dé-Collage wieder abgerissen, so daß daraus palimpsestartige Komp. mit reliefierter Oberfläche hervorgehen. Sie weisen komplexe bunte Muster auf, die versch. Stimmungen und oft naturhafte Anmutungen assoziieren (z.B. *Tubelarios marinos*; *Horizonte en la selva*; Serie *Cosmoginas*, alle 2008), teils durch Titel auch relig. Konnotationen erfahren (*Apóstoles involuntarios*, 2006; *Vestir santos*, 2010) und durch lit. Texte, z.B. von María Zambrano, inspiriert sind (*El pasado de los dioses [cascada]*, 2007). Manche Bilder weisen große, ovale Formate auf (*Agonía cósmica*, 2009) oder sind kleine, niedrige Querformate (Serie *Verso breve*, 2010). ▥ ALCORCÓN, Stadtverwaltung. ALMONTE/Huelva, Pin. CÁCERES, Caja de Extremadura. – Univ. de Extremadura, Col. Iberdrola. CÁDIZ, Prov.-Verwaltung. – Pal. de Expos. y Congresos. CUENCA, Caja de Ahorros de Castilla-La Mancha. DOS HERMANAS/Sevilla, Stadtverwaltung. FREGENAL DE LA SIERRA/Badajoz, Stadtverwaltung. LLEIDA, Fund. Sorigue. MADRID, CARS. – Fund. Wellington. – Minist. de Asuntos Exteriores. – Mus. Mpal Contemp. – Mus. Postal y Telegráfico. – Residencia de Estudiantes. PAMPLONA, Mus. de Navarra. PARIS, Colegio de España. SANLUCAR DE BARRAMEDA/Cádiz, Fund. Prov. de Cult. SEVILLA, Fund. Focus-Abengoa. – Inst. Francés. UTRERA/Sevilla, Stadtverwaltung. ◉ E: Sevilla: 1992, '95 Gal. de Arte Niel-Lo; 1993 Inst. Francés; 2007 Gal. Full Art / 1997 Melilla, Centro Cult. Federico García Lorca / 1998 Jaén, Colegio Ofical de Arquitectos / Madrid: 2000 (K: R. Doctor), '02 (K) Pilar Parra Gal. de Arte / 2005, '07 Cádiz, Gal. de Arte Isla-Habitada / 2008 Almería, Mediterráneo Centro Artíst. / 2008 (K: J. M. Caballero Bonald), '10 Barcelona, Gal. Trama; 2009 Gal. MS / 2009 Córdoba, Colegio de Abogados. – G: 1997 Jerez de la Frontera, Claustros de Santo Domingo: Tribulaciones (K) / 1999 Alcorcón (Madrid): Bien. de Artes Plást. (Ankaufspreis) / 2001 Zamora: Bien. de Pint. / 2004, '06 Albacete: Bien. de Artes Plást. / 2006 Almería: Bien. Internac. de Arte Contemp. Parque Natural Cabo de Gata-Níjar (Ankaufspreis). ▭ *Delarge*, 2001. – *E. Alaminos López*, Madrid contemp., Adquisiciones 1999–2001. Mus. Mpal Contemp. de Madrid, Ma. 2001; *J. Hontoria*, El Cultural, Supl. de El Mundo (Ma.) v. 23. 9. 2004;*A. González-Barba*, ABC (Ma.) v. 6. 12. 2006, 65; *A. H. Pozuelo*, El Cultural, Supl. de El Mundo v. 17. 5. 2007; *C. G. Frigolet*, Diario de Cádiz v. 11. 12. 2007. – *Online*: Website C. – Mitt. C. M. Nungesser

Cuevas, *Gaspar de* (1619) cf. **Cuevas, Ginés de**

Cuevas, *Ginés de*, span. Maler, Vergolder, * um 1619 Murcia, † zw. 22. 9. 1667 (Test.) und 20. 1. 1668 (postume Geburt eines Sohnes) ebd. (?). Sohn des Malers *Gaspar de C.* und wahrsch. dessen Schüler und Mitarb., Schwiegersohn des Schnitzers Luis Ruiz. 1633–39 Lehre beim Zimmermeister Alonso Minguez Osorio in Murcia. 1640 ebd. Heirat. Spätestens ab 1641 als Maler tätig, übernimmt C.

im Auftrag des Bilderhändlers Diego Felices die Staffage von ca. 13 Gemälden. 1647 trägt er bereits den Titel „maestro del arte de pintor". 1662 verpflichtet er sich zur Gest. von Tribünen für den Stierkampf. 1664 malt er wahrsch. Bühnendekorationen für die Casa de Comedias. Im selben Jahr von der Stadtverwaltung für ein weiteres Jahr zum Alcalde der Hermandad del Estado Llano ernannt. 1665 für die Vergoldung eines Zepters und einer Krone für die Trauerfeier von König Felipe IV bezahlt (Zusammenarbeit mit dem Maler Nicolás de Villacis). ▭ *J. C. Agüera Ros*, Pintores y pint. del Barroco en Murcia, Murcia 2002.

R. Treydel

Cuevas, *Minerva*, mex. Fotografin, Video- und Performancekünstlerin, * 28. 3. 1975 Mexiko-Stadt, lebt dort und in Berlin. 1993–97 Stud. der Artes Visuales in der Esc. Nac. de Artes Plást. der UNAM, Mexiko-Stadt. Stip.: 1996 FONCA; 1998 Banff Center for the Arts; 2007 Artist in Residence in São Paulo (Bien.). – C.s. Schaffen zeichnet sich durch soziales, auf humanistischen Ideen basierendem Engagement und Humor aus. Sie verfolgt zwei Strategien, die sie in einem engen Wechselverhältnis sieht. Einerseits interveniert sie mit ihren künstlerischen Aktionen (microactivist strategies) gezielt im öff. Raum, andererseits dokumentiert sie diese in Ausst., weil ihr die Kunsträume Zugang zu einem spezifischen Publikum verschaffen (so im Interview mit H. U. Obrist auf der 24. Graphik-Bienn. in Ljubljana). Für diese Arbeitsweise gibt es auf globaler Ebene schon seit den 1990er Jahren zahlr. Parallelen, etwa bei Christian Boltanski. – 1998 startet sie das Projekt *Mejor Vida Corp*/Firma für ein besseres Leben, in dessen Rahmen sie von einer Geschäftsstelle in Mexiko-Stadt aus ungewöhnliche Dienstleistungen anbietet: U-Bahntickets und Tränengas zur Selbstverteidigung. Im „Webshop" ist zudem ein Code-Sticker erhältlich, der auf die Strichcodes von Supermarktprodukten geklebt deren Preise beim Scannen an der Kasse reduziert. 2000 verteilt sie in Havanna Poster mit der Aufschrift *Nada con exceso. Todo con medida*; ein von ihr legitimiertes Foto zeigt eines der Poster auf der berühmten Ufermauer zum Meer klebend und weckt Assoziationen an die gefährlichen Fluchtversuche vieler Kubaner. Ein gelungenes Bsp. für das Zusammenspiel zw. Innen- und Außenraum bildet *S. COOP* (2009), das im Auftrag der Londoner Whitechapel AG entstand. Kunden konnten in einer von der Künstlerin gestalteten Eisdiele eine vorher an Händler eines Marktes ausgegebene Währung gegen Naturalien tauschen. Parallel dazu untersucht sie in ihrer Ausst. in der Whitechapel AG die Gesch. der Genossenschaftsbewegung in London. ▥ LONDON, Tate. ◉ E: 2002 Mexiko-Stadt, Gal. Kurimanzutto: Dodgem / 2007 Basel, KH: Phenomena / 2008 Eindhoven, Van Abbe-Mus. / 2012 Manchester, Cornerhouse: Landings. ▭ Cream 3. Contemp. art in cult., Lo./N. Y. 2003; *C.*, in: *I. Carlos* (Ed.), Bienn. of Sydney 2004. On reason and emotion (K), Sydney 2004, 70–73; *E. Treviño* (Ed.), 160 años de fotogr. en México, Méx. 2004; *L. Hoptman u.a.* (Ed.), The art of tomorrow, B. 2010, 80–93. – *Online*: Website C. M. Scholz-Hänsel

Cuevas, *Ximena*, mex. Videokünstlerin, * 1963 Mexiko-

Stadt, lebt dort. Tochter von José Luis C. Novelo. In Paris aufgewachsen. 1979 Ausb. in Filmschnitt an der Cineteca Nac., Mexiko-Stadt. 1981 künstlerische Ass. beim Film *Missing* von Costa Gavras. Stud.: 1983–84 New School for Social Research; Columbia Univ., beide New York. Ausz.: u.a. 1993 ehrenvolle Erw., Chicago Internat. Film Festival Intercom; 2001 Barbara Aronofsky Latham Memorial Award, Art Inst. of Chicago. – C. zählt zu den bedeutendsten Videokünstlerinnen in Lateinamerika. In den 1980er Jahren arbeitet sie in versch. Funktionen an Drehbuch, Regie oder Produktion zahlr. Filme mit, u.a. *Under the volcano* von John Huston, *The falco and the snowman* von John Schlesinger und *Mentiras piadoses* von Arturo Ripstein. Danach konzentriert sie sich auf ihre eig. Videokunst. Sie widmet sich den Mikrostrukturen des Alltagslebens, den Grenzen zw. Wahrheit und Fiktion sowie der Frage, was Realität ist angesichts von Lüge, Illusion und Subjektivität. Sie untersucht unter ironischem Rückgriff auf die triviale und kitschige Ästhetik der Massenmedien die Fiktion von nat. Identität und Geschlecht. Ihr Werk bedeutet zugleich eine Neudefinition des Dokumentarischen. Zu ihren ersten Videos zählen *Antes de la televisión* (1983), *Las tres muertes de Lupe* (1984), *Cuad. de apunte* und *A la manera de Disney* (beide 1992). Das Video *Corazón sangrante* (1993) handelt von der Sängerin Astrid Hadad und stellt eine Parodie nat. mex. Symbole und Ikonogr. dar. Kritisch-humorvoll untersucht C. in *Medias mentiras* (1995) den von der globalen Kultur beeinflußten Alltag der mex. Ges. in Verbindung mit ihren Erinnerungen, in *Víctimas del pecado neoliberal* (1995) parodiert sie die typischen mex. Seifenopern im Fernsehen. Weitere bed. Videos sind *Cuerpos de papel* (1997), *El diablo en la piel* (1998), *Natural instincts, Contemp. artist, Alamas gemelas, Hawaii* (alle 1999), *La puerta, Turistas* (beide 2000), *Tómbola, Staying alive* (beide 2001), *El mundo del silencio* (2002) und *New York, New York* (2005). Den Einfluß der US-amer. Kultur thematisiert C. in den Videos *Cinépolis, la capital del cine* (2003) und *Someone behind the door* (2005). Auch ein Hörbuch (*Escalofriantes cuentos de horror*, 1994). ▭ LOS ANGELES, Getty Center. NEW YORK, MMA. ZÜRICH, Daros Latinamerica Coll. ◉ E: Mexiko-Stadt: 2003 Laboratorio de Arte Alameda; 2005 Mirador, Explanada Metro Insurgentes (mit Fabiola Torres Alzaga) / 2003 Barcelona, L'Alternativa / 2004 Berkeley (Calif.), Pacific Film Arch.; Stuttgart, GEDOK. – G: 1999 New York, Guggenheim: Frames of reference (Wander-Ausst.) / 2001 São Paulo: Internat. Videobrasil Festival / 2004 Barcelona, Fund. Antoni Tàpies: Sutures and fragments. Bodies and territories in science fiction (Wander-Ausst.; K) / 2007 Vitoria, Centro Cult. Montehermoso: Disparos eléctricos (K: S. Blas). ▭▭ *M. Huacuja u.a.*, Half-lies, paper illusions. A selection of videos, Méx. 1997 (Video); *S. Berger*, Something happened, N. Y. 2000; *S. de la Mora*, Jump cut. A rev. of contemp. media 2000 (43) 102–105; *L. G. Gutiérrez*, Latin Amer. lit. rev. (Pittsburgh, Pa.) 29:2001 (57) 104–115; *ead.*, Feminist media studies (Lo.) 1:2001 (1) 73–90; Nueva/Vista. Videokunst aus Lateinamerika (K Ifa-Gal.), B. 2003; *K. High*,

Risk/Riesgo, N. Y. 2003 (Video); *H. Horsfield/L. Hilderbrand* (Ed.), Feedback, Ph. 2006; Ice cream. Contemp. art in cult., Lo. 2007; *A. Abelleyra*, La Jornada (Méx.) v. 13. 5. 2007; Cine a contracorriente. Un recorrido por el otro cine latinoamericano, Ba. 2010 (DVD); *L. G. Gutiérrez*, Performing mexicanidad. Vendidas y cabareteras on the transnational stage, Austin, Tex. 2010. – *Online:* Video Data Bank, Chicago. M. Nungesser

Cuevas Abeledo, *Garikoitz* → **Cuevas,** *Garikoitz*

Cui *Guotai*, chin. Maler, * 1964 Shenyang/Prov. Liaoning, lebt in Beijing. Stud.: bis 1998 Northeast Normal Univ., Changchun; 1999 Central AFA, Beijing; 2000 Acad. of Art and Design, Tsinghua Univ. ebd. – C. debütiert mit monumentalen Bildserien, die den ruinösen ehem. staatseigenen Industriearealen in und um seine Heimatstadt Shenyang gewidmet sind (*Portr. of Industry*, Acryl oder Öl/Lw., 2003–05). Die durch betont emotional geladene, z.T. kalligraphisch anmutende, stark gestisch-expressive Pinselführung mit breiten und schlierigen Strichen in einer Grauschwarzpalette ausgef. Portr. der industrie-archäol. Giganten vermitteln ein Gefühl von Unsicherheit, Bedrohung und Nostalgie angesichts der zwar nun verwaisten, aber von menschlicher Schaffenskraft und Leidensfähigkeit zeugenden Monumente. Die Relikte industrieller Vergangenheit, u.a. Lokomotiven (*Nat. Celebration*, Triptychon, 2007) und Lastkraftwagen, auch Archit.-Fassaden oder Schornsteine, zeigt C. häufig aus der Froschperspektive, was den Motiven repräsentative Würde verleiht. Jüngere Arbeiten mit Darst. von Flugzeugen und Ortschaften (*Pagoda Mountain in Yan'an*, 2006) knüpfen an dramatische hist.-politische Ereignisse an, z.B. den Abschuß eines amer. Spionageflugzeugs durch chin. Streitkräfte 1969 (*Debris of U2*, 2006). *Little Nest* (2008) rekurriert angeblich auf das für die Olympischen Spiele in Beijing durch die Schweizer Architekten Herzog & de Meuron realisierte Monumentalprojekt „Birds Nest". ▭ BEIJING, Red Mansion Found. KLOSTERNEUBURG, Slg Essl. SAN FRANCISCO, MMA, Logan Coll. ◉ E: Beijing: 2001 Nat. AM of China; 2007 White Space / 2005 Aschaffenburg, Gal. 99 (mit Gao Qiang) / 2007 Berlin, Alexander Ochs Gal. (K) / 2008 New York, China Square Gall. (K). – G: u.a. Beijing: 2001 Nat. AM of China: Nature and Science; 2004 Ai Yun Tang Gall.: Northern Artist's Artworks Exhib.; 2005 Alexander Ochs Gall.: Asia. The place to be? / 2002 Changsha, Hunan Mus.: China 100 Year's Oil Paint. Exhib. / 2008 San Francisco, MMA: The Half-Life of a Dream:. Contemp. Chin. Art from the Logan Coll. / 2009 Augsburg, KV: China. Ein and. Blick (Wander-Ausst.). ▭▭ C. 2003–2005 (K), B. 2005; China now (K Slg Essl), Klosterneuburg 2006; *P. Karetzky*, Beijing boogie woogie, N. Y. 2007, 8; *R. C. Morgan*, C. Evidence of a lost era. (K), N. Y. 2008; *P. Eichenbaum Karetzky*, Yishu. J. of contemp. Chin. art 8:2009 (Juli/Aug.) 32–40. K. Karlsson

Cui *Xiuwen*, chin. Malerin, Computergraphikerin, Foto- und Videokünstlerin, * 1970 Harbin/Prov. Heilongjiang, lebt in Beijing. Stud.: Northeast Normal Univ., Harbin (Graphik); 1994–96 Central AFA, Beijing (Ölmalerei). –

C. debütiert mit ausdrucksstarken Öl-Gem., in denen sie Bezüge zur eig. Kindheit, Pubertät und Jugend herstellt, die in der Öff. als Provokation und radikaler Ausdruck eines starken feministischen Bewußtseins rezipiert werden. C. setzt sich in diesen Bildern mit sexuellen Gefühlen und Beziehungen (weibliche Homosexualität, Pädophilie und v.a. Genderrollen) auseinander (*Rose and Watermint*, 1996; *Intersection Series*, 1998). Seit etwa 2000 wendet sie sich konzeptuellen Arbeiten (Video, Fotogr.) zu, die die Situation und das Seelenleben der Frau im heutigen China thematisieren: Identität, Sexualität (*Toot*, Video, 2001), Erwachsenwerden und Mutterschaft sind Schwerpunkte. Die Videoinstallation *Xi shou jian*/Ladie's Room, 2000, die ihren Ruf als kühne Vertreterin der chin. Experimentalkunst internat. begründet, dokumentiert mittels eines versteckten Camcorders in der öff. und zugleich priv. Sphäre einer Damentoilette in einem noblen Beijinger Nachtclub das weitverbreitete, jedoch tabuisierte Thema der Prostitution in China. Zu sehen sind junge Prostituierte z.B. beim Schminken, Geld zählen oder Geld verstecken. Diese zuweilen als beißende Sozialkritik und feministische Kunst gerühmte Arbeit (Zhu Qi) wurde anläßlich der Guangzhouer Trienn. 2002 zensuriert und entfachte in China eine juristische und akad. Kontroverse. C.s Angel-Serie *Tian shi* (Digitaldrucke, 2006) thematisiert die Problematik von jungen, ungewollt schwangeren Frauen, die eine Lösung häufig nur in einer Abtreibung sehen. Hier arbeitet C. mit einer Schauspielerin, die einzeln oder vervielfältigt zuweilen vor einem topogr. definierten Hintergrund (Verbotene Stadt, Platz des Himmlischen Friedens) ins Bild eingesetzt wird und deren unterschiedliche Position, Haltung und Gestik Apathie, Provokation, Zweifel und Ängste evozieren. ⌂ BEIJING, Platform China. MAUENSEE/Schweiz, Slg Sigg. NEW YORK, Brooklyn Mus. of Art. PARIS, Centre Pompidou. – MNAM. SHANGHAI, MCA. ☉ *E:* 2004 London, Tate Modern / 2005, '06, '07 Beijing und Mailand, Marella Gall. / 2006 Los Angeles, DF2 Gall. (K). – *G:* u.a. 1996 Brisbane, Queensland AG: Asia-Pacific Trienn. of Contemp. Art (K) / 1997 Chicago, Artemisia Gall.: Between Ego and Soc. (K) / 1998 Beijing, Nat. AM of China: Century Women (K) / Hongkong: 1998 Schoeni Gall.: Sense and Sensibility; 2001 AC: Constructed Reality. Beijing Conceptual Photogr. / 2002 Duisburg, Mus. Küppersmühle – Slg Grothe: Chinart (K: W. Smerling) / 2003 Paris, Centre Pompidou: Alors, la Chine? / New York: 2004 Internat. Center of Photogr.: Between Past and Future (Wander-Ausst.; K); 2006 P. S 1 Contemp. AC: The Thirteen. Chin. Video Now (Wander-Ausst.; K) / 2005 Bern, KM: Mahjong. Chin. Gegenwartskunst aus der Slg Sigg (Wander-Ausst.; K) / 2007–08 Wien, MUMOK: China. Facing Reality (K) / 2009–10 Brüssel, Elektriciteitscentrale: Attitudes. Female Art in China. ▭ *U. Grosenick/C. H. Schübbe* (Ed.), China art book, Köln 2007. – *Xu Hong*, Art Asia Pacific 2:1995 (2) 44–51; *C. Driessen/H. van Mierlo* (Ed.), Another long march. Chin. conceptual and installation art in the nineties (K), Breda 1997; *Wu Hung u.a.* (Ed.), Reinterpretation. A decade of experimental Chin. art 1990–2000 (K), Guangzhou 2002, 60–66; *K. Mami* (Ed.),

Under construction. New dimensions of Asian art (K), To. 2002; *E. Battiston*, Zoom 65:2004, 24–33; *K. Smith*, C., Hong Kong 2007; China heute. Chin. Kunstwochen in Wien (K), W. 2007; *W. Rhee u.a.* (Ed.), Thermocline of art. New Asian waves (K Karlsruhe), Ostfildern-Ruit 2007; *C. Albertini*, Avatars and antiheroes. A guide to contemp. Chin. artists, To. u.a. 2008. K. Karlsson

Cuijpers, *Raymond,* niederl. Maler, Graphiker, Fotograf, Mixed-media- und Videokünstler, Autor, * 1973 Geleen, lebt und arbeitet in Amsterdam. Stud.: 1991–95 ABK, Maastricht; 1996–97 Rijks-ABK, Amsterdam. Auf Reisen (Basel, Barcelona, Berlin, USA, Italien, Norwegen) führt C. Reisetagebücher, die er z.T. veröffentlicht (auch online). – V.a. Gem., Graphiken, Fotogr. und Videos zum Thema Fußball, zu dem sich C. enthusiastisch hingezogen fühlt, da er 1989–93 beim Fußball-Club Roda JC Kerkrade spielte und eine Karriere als Profifußballer anstrebte, die er zugunsten der Kunst aufgab. Bis heute ist C. dem Fußball als Spieler und Trainer verbunden. 1996 Ausst.-Debüt mit expressiv-realistischen Bildern u.d.T. *Het bovenbeen van Johan Cruijff.* Zwei Jahre später folgen 1998 Portr. der *Weltmeister* und 2000 solche von *Spielmachern.* Auch Videos (*Kick*, 1998; *Dutch Football*, 2006; *Laduma*, 2010). Daneben dynamisch und farbintensiv vorgetragene gegenstandsbezogene und abstrakte Komp., Assemblagen, Computergraphik und Mixed-media-Arbeiten. ⌂ VENLO, Océ Coll. ✉ Wat denk je als je Duits spreekt?, Maastricht 2000; Kunstenaar op Kaalheide. Roman, Am. u.a. 2004. ☉ *E:* 1996 Enschede, Villa De Bank / 1998, 2000 (mit Jessica Voorsanger), '02 Berlin, Gal. Paula Böttcher / 1998 Leiden, LAK Gal. / 2000 Chemnitz, voxxx Gal. (mit Jacques Julien) / 2001 Nijmegen, Paraplufabriek (mit Joao Onofre) / Amsterdam: 2004 Buro Empty (mit Lukas Gröthman); 2007 Reinier van Ewijk Projects (ehem. Buro Empty); 2012 Van Zijll Langhout. – *G:* 1998 Berlin, Kunstraum: Die holl. Welle / 2000 Rotterdam, Kunsthal: Ieder z'n voetbal. Het voetbal in de beeldende Kunst (K); Maastricht, Bonnefanten-Mus.: Samenscholing / 2004 Hamburg, Feld für Kunst: Spielfeld / 2008 Wien, Künstlerhaus: HerzRasen. ▭ Die Schönheit der Chance. Positionen und Tendenzen 2006 (K), Nü. 2006. – *Online:* Website C. U. Heise

Cuisset, *Thibaut,* frz. Fotograf, * 19. 3. 1958 Maubeuge/Nord, lebt in Montreuil/Seine-Saint-Denis. Ausz.. 2009 Prix de la Photogr., ABA, Paris. Stip.: u.a. 1992/93 Villa Medici, Rom; 1997 Villa Kujoyama, Kyoto; 2000, '04 Fiacre, Paris; 2006 Gastkünstler Gal. Pôle Image, Rouen. – Seit 1985 klassische Lsch.-Fotografie. V.a. Natur-Abb., teilw. auch mit Besiedlung. Char. sind eine ausgewogene, ruhige Bild-Komp., gleichmäßiges Licht und gedämpfte Farben. Neben den Regionen Frankreichs (u.a. Normandie, Bretagne, Korsika, Loire [von der Quelle bis zur Mündung aller 50 km eine Fotogr.]) bereist C. zahlr. Länder wie Spanien, Italien, Griechenland, Schweiz, Marokko, Ägypten, Venezuela, Australien, Syrien, Türkei und Japan. C. gehört zu den bed. Lsch.-Fotografen seiner Generation. ⌂ CHALON-SUR-SAONE, Mus. de la Photogr. Nicéphore Niépce. LAUSANNE, Mus. de l'Elysée. LE HAVRE, MBA.

Paris, BN. – FNAC. – Mus. Carnavalet. – Mus. Europ. de la Photogr. – MNAM. ◉ *E:* 1997 Sapporo, Continental Gall. / 1998 İzmir, Inst. franç. / Paris: 2001, '02, '05, '05/06, '10 Gal. Les filles du calvaire; 2010 ABA / 2005 Lille, Pal. des BA / 2006 Montreuil, Rathaus; Braga (Portugal), Gal. Sequeira / 2007 Brüssel, Gal. Les filles du calvaire / 2009 Rouen, Gal. Pôle Image / 2010 Vernon, Mus. mun. / 2011 Evreux, Maison des arts; Lannion, Gal. L'Imagerie; La Bouilladisse, Rathaus; Le Havre, Mus. Malraux / 2012 Clermont, Espace Séraphine Louis. ▭ *G. Mandery* (Ed.), Siracusa. Una città quattro fotografi, Pescara 1988; *A. Müller-Pohle* (Ed.), Europ. Photogr. Award, Göttingen 1991; *C.-H. Favrod u. a.*, Nouveaux itinéraires [...] (K Mus. de l'Elysée), Lausanne 1991; C., Paysages d'Italie, R. 1993; Maisons d'exception, P. 1994; Les bouches de Bonifacio, P. 1995; Le temps du panorama, Trézélan 1996; Campagne jap., Trézélan 2002; Connaissance des arts 590:2002, 60–69; L'Oeil 556:2004, 6 s.; Le dehors absolu, Trézélan 2005; La rue de Paris, Trézélan 2005; Un hérault contemp., Br. 2007; Le seuil des villes, Béziers 2007; Une campagne photogr., Trézélan 2009; Campagne franç., P. 2010. N. Buhl

Cukier, *Stanisław,* poln. Bildhauer, Medailleur, * 11. 2. 1954 Zakopane, lebt dort. Ausb.: 1971–76 Państwowe Liceum Sztuk Plastycznych im. Antoniego Kenara ebd. (heute Zespół Szkół Plastycznych; dort seit 1991 Lehrer für Bildhauerei und Zeichnen, seit '94 Dir.). Stud.: 1976–81 ASP, Warschau, bei Stanisław Słonim, Tadeusz Łodziana, Oskar Hansen, Piotr Jan Gawron und Zofia Demkowska; 1981–86 dort Lehrtätigkeit; Mitbegr. der Guß-Wkst. ebd. Seit 1983 regelmäßig Gruppen-Ausst. der Fédération Internat. de la Méd. d'Art (FIDEM). – Neben figurativen Skulpt. v.a. Plaketten und Med., überwiegend mittels Wachsausschmelzverfahren in Bronze gegossen (teils patiniert oder bemalt); schlicht komponierte Reliefs, deren glatter Hintergrund nur manchmal von ein paar Kratzern, wenigen senkrechten Linien oder durch den Gießprozeß entstandenen Unebenheiten unterbrochen wird und oftmals einen unregelmäßig verlaufenden Rand aufweist. Hauptsächlich Portr., häufig von Fam.-Mitgl., in reduzierter Formensprache mit Herausarbeitung eines für den Künstler bedeutungsvollen Details wie eine Hand, ein Mund oder ein Hut, z.B. *Staś* (Bronze, 1999); auch Selbstporträts. Daneben u.a. von Orten inspirierte Arbeiten wie der ehemaligen poln. Königsresidenz Wawel in Krakau in der Med.-Serie *Krypty Wawelskie* (Messing, 1995). Seit den 1990er Jahren auch relig. Themen in ähnlicher Ausf., z.B. Kreuzweg-Stationen und eine Serie von Madonnen-Figuren. ▭ KRAKAU, MN. LONDON, BM. WARSCHAU, MN. WROCŁAW, MN. ◉ *E:* 1987 Toruń, BWA, Gal. B / Krakau: 1989 Gal. Inny Świat; 2000 Muz. Książąt Czartoryskich (K); 2002 Gal. Krypta u Pijarów; 2009 Gal. Kamieniołom (mit Andrzej Grabowski und Ireneusz Wrzesień) / Zakopane: 1991 Gal. Yam; 1992 Gal. Antoniego Rząsy / Kielce: 1991 BWA; 2009 Gal. Współczesnej Sztuki Sakralnej / 1995, 2011 Ciechanów, Gal. C / 2010 Białystok, Muz. Rzeźby (mit Patricia Meunier) / 2011 Częstochowa, Miejska Gal. Sztuki. – *G:* 1986; '89 (Grand

Prix) Sopot: Trienn Rzeźby Portretowej / Warschau: 1989 Muz. ASP: Profesor Zofia Demkowska i jej uczniowie; 2010 Gal. Delfiny: Propozycja na lato 2010 / 1992 Ravenna: Bien. Internaz. Dantesca (Gold-Med.) / 1994 Krakau, MN: 44 współczesnych artystów wobec Matejki (K); Lyon, Pal. de Bondy: Salon de printemps / 1998 Wrocław, Muz. Archidiecezjalne: Hommage à Edith Stein (Wander-Ausst.) / 2001 Nowy Sącz, Mała Gal.: Artysta Zaprasza / 2003 Częstochowa, Miejska Gal. Sztuki: Trienn. Sztuki Sacrum / 2005 Nowy Targ, BWA Gal. Jatki: Most zamiast murów (Wander-Ausst.); New York, Medialia: Contemp. Medallic Sculpt. from Poland / 2012 Zakopane, Miejska Gal. Sztuki: Tadeuszowi Brzozowkimu, Koledzy i przyjaciele artyści. ▭ *M. Heidemann* (Bearb.), Internat. Med.-Kunst. XXVII FIDEM 2000 (K Weimar), B./Weimar 2000; *J. Pol-Tyszkiewicz*, The medal 57:2010, 24–29. J. Niegiel

Culebro (C. Bahena), *Ulises,* mex. Zeichner, Graphiker, Karikaturist, Comiczeichner, Bildhauer, * 1963 Mexiko-Stadt, lebt in Madrid. Stud.: UNAM, Mexiko-Stadt (Graphik, Design). 1984 Gebrauchsgraphiker in der Druckerei Madero sowie Mitbegr. und Cartoonist der Ztg La Jornada, beide ebd. Veröff. in der New York Times und zahlr. Ztgn in Mexiko, Spanien, Frankreich, Polen und Südamerika. Seit 1991 Mitarb. der Ztg El Mundo in Madrid und Leiter der Bildredaktion. – C.s Karikaturen beschäftigen sich v.a. mit hist. und sozialen Themen, z.B. Konquista, zeitgen. Migrationsbewegungen, Grenzprobleme und Armut. Er bezieht in seine Zchngn auch Fotos und alte Bildrucke mit ein, gestaltet farbige Cartoons, z.B. Prominenten-Portr., sowie Comic strips, u.a. zum US-amer. Showbusiness (Serie *Sinatra está resfriado,* 2007). Auch humorvolle Holz-Skulpt. (*El tercer hombre,* 2005). – Zahlr. Buch-Ill. u.a.: R. Sanz, *Cuentos descontentos,* Méx. 1987; J. Bonilla, *El búho y el bosque,* Sevilla 1995; E. Freire/R. del Pozo, *La diosa del pubis azul,* Ba. 2005; R. del Pozo, *La rana mágica. Grandes maestros de la hist. De Sócrates a Savater,* Ma. 2006. ▭ MEXIKO-STADT, Mus. de la Caricatura. ◉ *E:* Mexiko-Stadt: 1988 UNAM, Fac. de Ciencias Sociales; 1992 Bibl. México (Retr.) / Madrid: 1996 Casa de América; 2003 Inst. de México; 2004 Buena Vistilla Club Social; 2006 Gal. Panta Rhei; 2007 Mex. Konsulat; BN; Gal. Tribeca. ▭ El Mundo v. 27. 4. 2006. – *Online:* Letras libres; Séptima Cumbre Mundial de Diseño en Prensa, Mexiko-Stadt 2011. M. Nungesser

Culemann, *Carl,* dt. Architekt, Siedlungs-, Stadt-, Gebiets- und Raumplaner, * 22. 4. 1908 Vlotho/Kr. Herford, † 19. 11. 1952 Hannover. 1926–31 Stud. der Archit. an der TH Hannover sowie an der TH Berlin, dort u.a. bei Heinrich Tessenow, der als ein Vertreter der dt. Reform-Archit. und der Gartenstadtbewegung mit Interesse für kleinstädtisches und dörfliches Bauen C. in dessen Interesse an diesen Arbeitsbereichen bestärkt. 1931–34 Ass. am Lehrstuhl für Raumkunst der TH Hannover. 1934–36 beim Preußischen Staatshochbauamt in Stuhm/Sztum (Westpreußen) und der Stadtverwaltung Hildesheim tätig. Zur Erarbeitung der Diss. 1936/37 Ass. am Lehrstuhl für Handwerkskunde und landwirtschaftliches Bauen der TH Hannover (Dr. Ing.). Anschl. bis 1939

Stadtplaner in Marienburg/Westpreußen. 1939 stellv. Bez.-Planer des Reg.-Präsidenten im Land-Kr. Marienwerder/Westpreußen. 1940–45 Sachbearbeiter für Stadtplanung beim Generalreferenten für Raumordnung Ewald Liedecke im 1939 aus annektierten Gebieten gebildeten Reichsgau Danzig-Westpreußen. Angeblich 1942–45 zeitweise bei der Infanterie an der Ostfront in der Sowjetunion; es ist aber anzuzweifeln, daß ein Staatsbeamter in C.s Stellung an der Front eingesetzt wurde. 1945 nach der Flucht aus Westpreußen in Eyershausen/Kr. Alfeld Wiederaufnahme des Berufes. 1949–52 freier Architekt in Hannover. Teiln. an versch. Ausschreibungen: 1. Preis beim Wettb. für den Wiederaufbau der Innenstadt von Bielefeld; 3. Preis im Wettb. der Stadt Uelzen; Ankauf eines Projektes für den Wiederaufbau zerst. Bereiche Hannovers. – Seit den späten 1920er Jahren degradiert C. die durch ihn praktizierten Bereiche der Archit. im Reichsgau Danzig-Westpreußen zu einem Instrument der Nationalsozialistischen Deutschen Arbeiterpartei (NSDAP), im Besonderen der Politik von Heinrich Himmler, Reichsführer SS. C. definiert unmißverständlich, was er unter Siedlungs- und Raumplanung versteht: Gliederung des dt. Volkes in seinem „Lebensraum", gesäubert von fremden Ethnien, eine Hierarchie vom Einzelnen bis zum Führer Adolf Hitler. 1941 führt er aus: „Die Gest. des Lebens im Raum ist Teil der allg. Aufgabe, das Leben des Volkes zu gestalten, und läuft also parallel zu der Gest. des Volkes durch die politische Organisation. Die Gest. der Siedlungsmasse durch den Städtebau und die Gest. der Masse des Volkes durch die Partei sind gleichlaufende und verwandte Aufgaben." (cf. H. Weihsmann 1998, 590). Bei C. ist nur von Deutschen die Rede. Die Wirklichkeit im Verantwortungsbereich von E. Liedecke und C. war 1939 die schrittweise Vertreibung der poln. Einwohner aus dem Reichsgau Danzig-Westpreußen in das nicht zum dt. Reichsgebiet zählende Generalgouvernement Ost. Die poln. Juden aus dem Reichsgau wurden in Großaktionen zur Zwangsarbeit in das Generalgouvernement deportiert bzw. in dortige Konzentrationslager eingeliefert. An ihre Stelle traten unter der Parole „Heim ins Reich!" dt. Rücksiedler u.a. aus dem Baltikum, der Slowakei, Ungarn und S-Europa. ✉ Grundlagen kleinstädtischer Bauberatung. Die äußere Gest. des kleinstädtischen Wohnhauses seit der Zeit vor 1800 (Diss. TH Hannover), Oldenburg 1937 (Niedersächsischer Heimatbund E. V. Schr.-R., H. 16); Funktion und Form in der Stadtgestaltung, Bremen 1956 (Dt. Akad. für Raumforschung und Raumordnung; weitere Lit.). ⊚ G: 1951 Hannover: constructa (mit Josef Umlauf Gest. des Ausst.-Komplexes Stadt-Land-Struktur für die Abt. Städtebau). ⌑ R. Mattausch-Schirmbeck, Siedlungsbau und Stadtneugründungen im dt. Faschismus, Ffm. 1981; W. Durth/ N. Gutschow, Träume in Trümmern, I, Bg./Wb. 1988; B. Wasser, Himmlers Raumplanung im Osten. Der Generalplan Ost in Polen, Basel/B./Boston 1993; H. Weihsmann, Bauen unterm Hakenkreuz: Archit. des Untergangs, W. 1998; N. Gutschow, Ordnungswahn. Architekten planen im „eingedeutschten Osten" 1939–1945, Gütersloh 2001. V. Frank

Cullen, *Shane,* irischer Installationskünstler, Bildhauer, * 1957 Mostrim/Co. Longford, lebt in Dublin. Stud.: bis 1976 Regional Technical College (heute Inst. of Technology). Aufenthalte: u.a. 1993 Studios of Young Artists Assoc., Budapest; 1995–96 Centre d'art contemp. de Vassivière en Limousin, Beaumont du Lac; 1996–97 Centre Mondial de la Paix, Verdun; 1998–99 P. S. 1 Internat. Studio Program, Long Island City/N. Y. – C. präsentiert in seinen teils mon. Installationen überwiegend vorgefundene Texte, u.a. Irland und Nordirland betreffende politische Dokumente, die er auf versch. Weise auf meist großformatige Tafeln überträgt. Zu den bekanntesten Werken zählen *Fragmens sur le Institutions Républicaines IV* (1993–97) und *The Agreement* (2002). Bei dem ersten handelt es sich um Abschriften von auf Zigarettenpapier geschriebenen Botschaften, bek. als „comms", die politische Gefangene des nordirischen Maze-Gefängnisses bei Lisburn während des Hungerstreiks von 1981 aus dem Gefängnis schmuggeln ließen. Von 1993 bis 1997 schreibt C. mit Pinsel und weißer Farbe den Text der in David Beresfords Buch Ten Men Dead (Lo. u.a. 1987) veröff. Botschaften auf insgesamt 96 Tafeln aus Styropor und präsentiert sie während dieser Zeit als laufende Arbeit in versch. Ausst., zuerst 1996 im Tyneside Irish Centre, Newcastle upon Tyne. Bei der zweiten Arbeit handelt es sich um die Abschrift des Good Friday Agreement von 1998, einem brit.-irischen Friedensabkommen, computergesteuert gefräst in 55 Tafeln aus Polyurethan, 2002–04 in mehreren Ausst. gezeigt, zuletzt im Millennium Court AC, Portadown/Co. Armagh; 2004 beim Kilkenny Arts Festival durch einen Sturm zerstört. Außerdem Skulpt. im öff. Raum, z.B. 2005 eine Gedenktafel für den irischen Freiheitskämpfer The O'Rahilly (Bronze; O'Rahilly Parade, Dublin). ⌂ DUBLIN, Arts Council of Ireland. – Irish MMA. ⊚ E: Dublin: 1987 Hendriks Gall.; 1992 City AC (Wander-Ausst.) / 1996 Wien, Gal. Hubert Winter (K) / 1997 Glasgow, Centre for Contemp. Art / Cork: 2005 Nat. Sculpt. Factory; 2009 Triskel at ESB Substation / 2008 Portadown, Millenium Court AC (Wander-Ausst.) / 2011 Berlin, Haus am Lützowplatz, Studio-Galerie.-. G: Dublin: 1980 Peacock Gall.: Mixed Media; 1982 Hugh Lane Gall.: Independent Artists; 1988 Douglas Hyde Gall.: Art on the Dart; 2001 Gall. of Photogr.: Ben Smythe Memorial Scholarship Exhib.; 2006 Temple Bar Gall.: The Square Root of Drawing; 2012 Nat. College of Art and Design Gall.: Document! / 1989 (Limerick Soviet), '92 (EV+A) Limerick, Limerick City Gall. of Art / 1990 Sligo, Sligo AG: Íontas (K) / 1991 Krakau, Pałac Sztuki: Europa Nieznane (K) / 1993 Wien, Secession: Real Real (K) / 1995 Venedig: Bienn. (K); Bytom, Gal. Kronika: Prawda i Metoda (K) / 1996 Paris, ENSBA: L'Imaginaire Irlandais / 1997 Berlin, Künstlerhaus Bethanien: Caoc, Front Art, Unwahr / 1998 Warschau, Zachęta: Bez paszportu (Wander-Ausst.) / 1999 Long Island City, P. S. 1 Contemp. AC: Nineteen Ninety Nine / 2002 Chicago (Ill.), Gall. 400, Univ. of Chicago: Settlement. The Cult. and Conflict Group / 2003 Charlottesville, Univ. of Virginia AM: Re-Imagining Ireland (K) / 2004 Łódź: Bienn. (K) / 2007 Belfast, Golden Thread Gall.: Things We

May Have Missed. ⌑ *Delarge*, 2001. – *L. Kelly* (Ed.), S. C. Fragmens sur les institutions républicaines IV, Derry [1997]; *J. Stallabrass u.a.*, Locus solus. Site, identity, technology in contemp. art, Lo. 2000. – *Online:* Nat. Irish Visual Arts Libr., Artists' database; Website The Agreement. J. Niegel

Cullerne, *Harold*, brit.-kanad. Architekt, * 24. 5. 1890 Slaithwaite/Yorks., † 8. 3. 1976 Burnaby/B. C. 1906–09 Lehre bei dem Architekten Ernest G. Davies in Hereford; anschließend Stud. der Archit. und Baukonstruktion am Regent Str. Polytechnical Inst., London; gleichzeitig bei den Architekten R. Langton Cole und W. Ernest Hazell tätig. 1912 Auswanderung nach Kanada. In Vancouver Mitarb. von H. S. Griffith; dort trifft er auf seinen späteren Kompagnon *Joseph H. Bowman* (s.u.). Gleichzeitig ist C. 1913–15 bei der Pacific Great Eastern Railway tätig; dort u.a. Entwurf der Pacific Great Eastern Train Station in North Vancouver (1913/14, ursprünglicher Standort Lonsdale Ave., jetzt Carrie Cates Court 107). 1916–19 Kriegsdienst. 1919–34 eig. Büro mit Bowman, danach bis um 1967 ohne Partner tätig. – V.a. in Vancouver und Umgebung tätig. Das Büro C. & Bowman errichtet v.a. öff. Bauten wie Schulen, Wohngebäude und Kirchen (Seaforth Public School, 1922; jetzt im Burnaby Village Mus.). Bekanntestes Werk ist das Kino Hollywood Theatre in Vancouver (W. Broadway 3123, 1935/36), ein auffälliger Bau in reinem Art Déco-Stil. Art-Déco-Formen zeigen auch die Kirche Metropolitan Tabernacle (heute Church of the Good Shepherd in Vancouver-Mount Pleasant, 1931) und die Legion Hall in Mission/B. C. (1936), während die Kirche St. Francis of Assisi von der Rezeption romanischer Formen geprägt ist (Vancouver, Napier Str. 2025/Semlin Str. 1020, 1938). In den 1930er Jahren beschäftigt sich C. mit preiswertem Wohnungsbau und entwickelt neben Plänen den Prototyp The Ideal Bungalow für die Pacific Nat. Exhib., Vancouver (1934, ebd. verändert wiederaufgebaut in Dundas Str. 2812). 1938 Ausz. bei einem Wettb. im Rahmen des Dominion Housing Act. – *Joseph H. Bowman* , * 24. 1. 1864 London, † 10. 5. 1943 Vancouver; Ausb.: South Kensington Art School, 1884–86 bei William Rendell; danach Ass. seines Vaters, eines Baumeisters. 1888 Emigration nach Kanada; dort als Zimmermann und Zeichner tätig; ab 1908 Archit.-Büro in Vancouver, v.a. Schulgebäude. 1919–34 mit C. assoziiert. ⌂ BURNABY, Howard Ave. 361: Capitol Hill Community Hall, 1944–46 (verändert). – 18th Ave. 7651: Edmonds Junior High School (jetzt Edmonds Community School; mit George Norris Evans), 1949. – VANCOUVER: Moravian Evangelical Church, 1936 (verändert). ⌑ *D. Luxton* (Ed.), Building the West, Vn. 2007. N. Buhl

Cumming, *Rose Stuart*, US-amer. Innendekorateurin, * 1887 b. Sydney/Australien, † 1968 New York. Kommt 1917 nach New York, dort Tätigkeit in der Einrichtungs-Abt. des Kaufhauses Wanamaker. Gründet einen eig. Laden für Innendekoration und Antiquitäten. – C. entwickelt einen außergewöhnlich glamourösen, eklektischen Einrichtungsstil mit surrealen und filmsetähnlichen Bestandteilen. Sie kombiniert kräftige Farben (Limonen-

grün, Blaugrün, Aubergine, Blutrot), Mobiliar in versch. Stilrichtungen und Dekorationen (Gotik, Fernost, Chippendale, Louis XV, österr. Barock, gefaßte venezianische Möbel) sowie aus London und Paris importierte Chintz- und Seidenstoffe. Sie ist in den 1920er Jahren äußerst innovativ und einflußreich. Zu ihren Kunden gehören Andy Warhol, Rudolf Nureyev und Filmschauspieler wie Marlene Dietrich und Norma Shearer. ⌑ *M. Byars*, The design enc., Lo./N. Y. 2004. – *E. Hobart*, Vogue 70:1927, 68; *C. R. Smith*, Interior design in 20th-c. America, N. Y. 1987; *M. Hampton*, House and garden 162:1990 (Mai) 145–149, 214; *J. Esten/R. Bennett Gilbert*, Manhatten style, Boston 1990; *M. Hampton*, Legendary decorators of the twentieth c., N. Y. 1992; *A. Tapert*, Archit. digest 57:2000 (1) 144–147; *C. Prisant*, World of interiors 28:2008 (12) 150–157. H. Stuchtey

Cummings, *Dale*, kanad. Cartoonist, * 1948 St. Thomas/Ont., lebt in Winnipeg/Man. Studiert zunächst Trickfilm-Gest. und Ill. am Sheridan College Inst. of Technology and Advanced Learning, Oakville/Ont. Danach als Trickfilmzeichner tätig; u.a. Mitarb. am Dokumentarfilm *Trude North*. C. kommt A. der 1970er Jahre nach New York und zeichnet Ill. und Cartoons für die Tages-Ztg New York Times. 1976 Rückkehr nach Toronto/Ont.; dort als freischaffender Cartoonist für versch. Ztgn und Mag. tätig, u.a. für Canad. Forum; Canad. Mag.; The Last Post; Maclean's; This Mag.; The Toronto Star. Seit 1981 Editorial Cartoonist der Ztg Winnipeg Free Press. Publiziert mehrere Sammel-Bde seiner politischen und sozialkritischen Cartoons: u.a. *Best of a Bad Lot* (Winnipeg 1993). Ausz.: 1983 Nat. Newspaper Award. Mitgl.: Assoc. of Canad. Editorial Cartoonists. – Linienbetonte, z.T. schraffierte und mit grotesken Übertreibungen in der Darst. der Physiognomie porträtierter Persönlichkeiten arbeitende Tuschfeder- und -pinsel-Zchngn. ⌂ OTTAWA, Libr. and Arch. Canada, C. Fonds: 4880 Zchngn, 1982–2003. ⌑ *Horn*, Cartoons, 1999 (* 1947). – *P. Desbarats/T. Mosher*, The hecklers. A hist. of Canad. political cartooning and a cartoonists' hist. of Canada, Tor. 1979; *N. M. Stahl* (Ed.), Best Canad. political cartoons, 1984, Tor. 1984. – *Online:* Assoc. of Canad. Editorial Cartoonists; Libr. and Arch. Canada, Ottawa. H. Kronthaler

Cunéaz, *Giuliana*, ital. Malerin, Fotografin, Bildhauerin, Multimedia-, Installations- und Videokünstlerin, * 24. 9. 1959 Aosta, lebt in Noviglio/Mailand. Stud.: Accad. di BA, Turin. – C. beginnt 1990 mit installativen Arbeiten (*Il silenzio delle fate*), ab 1991 bezieht sie auch Videofilme ein (*Lucciole*, 1991). Mit Video-Skulpt. wie *In corporea mente* (1993) unternimmt sie Rech. über imaginierte Körper, bei denen sie auch medizinische Operationsfotos zeigt (*Sub rosa*, 1995–96). Seit 2000 verwendet sie fotogr. Bilder nicht mehr nur als Dok., sondern zur Entwicklung von Geschichten. So erforscht sie mit *Biostory* (2000) zwischenmenschliche Emotionen, inszeniert Darsteller für utopische Visionen (*Terrains vagues*, 2003; *Zona franca*, 2004), verweist auf archaische soz. Formen (Rudel) in *Punkabbestia* (2003) oder verarbeitet mit Video und Fotogr. Schamanenkulte (*Riti sciamanici*,

1999–2002). Zunehmend interessiert sich C. für Wiss. (Astronomie, Biologie, Genforschung, Chemie) und sucht mit ihrer Kunst den Blick auf das Nicht-Sichtbare im Mikro- und Makro-Bereich auszudehnen und bedient sich dabei natur-wiss. Visualisierungstechniken (Mikroskopie, Nanotechnologie). Dafür geht sie von gefundenen Bildern aus, die sie modifiziert, weiterentwickelt und mit eig. Elementen ergänzt. Seit 2003 arbeitet C. hierbei mit digitalen 3D-Darstellungen. G. Iovane (2008) vergleicht C.s Vorgehen mit Karl Blossfeldt, Ernst Haeckel oder Paul Klee; auch C. wurde früh von der Arte povera und dem Interesse an elementaren Formen beeinflußt. C. entwickelt die Technik des Screen paint. für Videoarbeiten, bei denen sie die Bildschirme bemalt, wodurch ein Kontrast zw. den animierten dreidimensionalen „virtuellen Skulpt." im Videobild, u.a. Nanopartikel, Neuronen oder Sporen, und deren statischen manuellen Zeichen auf der Oberfläche entsteht (*Occulta naturae*, ab 2006). Sie läßt menschliche Figuren in solchen molekularen Lsch. agieren (*Quantum vacuum*, 2005), wobei sie auch die Kunstgesch. zitiert, etwa Van Gogh bei *I mangiatori di patate* (2005). Zuletzt thematisiert C. auch Nanostrukturen von Erdwellen (*Matter waves*, 2009) und, mit Bezug auf jap. Malerei, ökologische Fragen (*Waterproof*, 2011). ◉ *E:* 1990 Forte di Bard (K); 1993 Chiesa di S. Lorenzo (K); 2000 Torre del Lebbroso (K) / 1993 Turin, Gall. l'Uovo di Struzzo / Clermont-Ferrand: 1995 Gal. l'Art du Temps (K); 1996 Théatre des Guetteurs d'Ombre (K); Ljubljana, Gal. Anonimus / 2000 (K), '03 Mailand, B & D Studio / 2001 Catania, Castello Ursino; Ferrara, Zuni Arte Contemp. (K); Rom, Mus. Laboratorio d'Arte Contemp.; Univ. La Sapienza / 2002 Catania, Gall. Arte Contemp. / 2003 Berlin, Play Gall. for still and motion pictures / 2005 (K), '08 (K) Turin, GAS AG / 2009 Prag, Gal. Vernon City (K) / 2010 Parma, Temporary Pal. – *G:* 1994 São Paulo: Bien. / 1999 Liège: Bienn. Internat. de la Photo [...] / Clermont-Ferrand: 2000 MBA: Videoformes; 2010 La Tôlerie: Videoformes (K) / Prato, Centro per l'Arte Contemp. Luigi Pecci: 2000 Fotoalchimie (K), 2011 Premio Maretti (K) / Turin: 2002 Fond. Sandretto Re Rebaudengo: Exit (K); 2004 Pal. della Promotrice delle BA: Quadrienn. di Roma Anteprima (K); 2009 PAV Centro d'Arte Contemp.: Greenhouse; 2010 GAMC: Video Dia Loghi / Mailand: 2005 Pal. della Trienn.: Il corridoio dell'arte (K); 2011 Piazza Duomo: Principia (K); 2012 Trienn. (K) / 2007 Marseille, Polygone Etoilé: Fem-Link (Wander-Ausst.) / 2008 Sevilla, Centro Andaluz de Arte Contemp.: Youniverse, Biacs 3 (K) / 2009 Aosta, Mus. Archeol. Regionale: Memoria sottotraccia (K); Lugano, Mus. d'Arte: Corpi automi robot (K) / 2010 Venedig, Arsenale Nuovissimo: TINA B. at the Venice Bienn. 2010. ▭ *G. Politi/L. Beatrice*, Diz. della giovane arte ital., 1, Mi. 2003. – *E. Lagnier*, Il filo di Arianna (K), Aosta 1990; *G. Dorfles*, Ultime tendenze nell'arte oggi, Mi. 1999; *L. Meneghelli*, Caprice, Legnago 2001; *M. Bertoni*, Videotape (K), T. 2001; *T. Conti* (Ed.), Il peso del virtuale, Pinerolo 2002; *S. Zannier*, Maravee, Mi. 2002; *E. Di Mauro*, Una Babele postmoderna, Mi. 2002; *M. Bertoni/ W. Darko*, Europa video art, T. 2003; *G. Marziani*, Re-

gionevolmente (K), Formia 2005; *A. Busto*, Flower power, Cinisello Balsamo 2009; *L. Cherubini/G. Cipolla*, Entre glace et neige (K), Aosta 2010; *K. Lein Kjølberg/F. Wickson* (Ed.), Nano meets macro, Singapore 2010; *G. Iovane/ J. Putnam/S. Risaliti* (Ed.), C. (K), Cinisello Balsamo 2008 (Bibliogr.; Ausst.-Verz.); G. C. (K), s.l.e.a. [Prag 2010]; *C. Canali*, C. Photosynthesis, Parma 2010; *ead.*, Arteractive (K), Mi. 2011. – *Online:* Website C. T. Koenig

Cunha, *Eduardo Vieira da*, brasil. Fotograf, Maler, Graphiker, Hochschullehrer, * 6. 3. 1956 Porto Alegre, lebt dort. Stud.: 1974–83 Univ. Federal do Rio Grande do Sul (Kunst, u.a. bei Pamela Barr); 1988–90 Brooklyn College, City Univ., New York (Magister of FA); 1997–2001 Doktorat an der Univ. Paris I Panthéon-Sorbonne (Promotion 2001). 1978–87 als Fotoreporter für die Ztg O Globo tätig. Liefert Ill. für versch. Ztgn, u.a. für Zero Hora. Unter dem Eindruck seines Aufenthalts in New York auch Hinwendung zur Malerei. Fertigt A. der 1990er Jahre eine Serie von Gem., die sich thematisch mit den Mythen und Metaphern in Rio Grande do Sul beschäftigen. Seit 1992 Prof. für Fotogr. am Inst. de Artes der Univ. Federal do Rio Grande do Sul. – C.s surrealistisch anmutenden Malereien in kontrastreichen Farben werden von Wolken, Riesenrädern, Wasserflächen, Flugzeugen u.ä. bevölkert, die an pop-art-ähnliche Phantasmagorien erinnern. ▣ PORTO ALEGRE, MARGS. ◉ *E:* Porto Alegre: 1987 Gal. do Inst. Cult. Brasil. Norte-Amer.; 1991, '93 Bolsa de Arte; 1996 Gal. Cezar Prestes; 2000 Gal. Garagem de Arte; 2003 MARGS; 2005 Gal. Gestual / New York: 1989 Brooklyn College Gall.; 1990 Westbeth Gall. / Paris: 1999 Gal. Leonardo; 2001 Gal. Debret / 2003 São Paulo, Mus. Brasil. da Escult.; Rio de Janeiro, Gal. Lana Botelho / 2007 Basel, Gal. Fischer-Rohr. –. *G:* 1980, '81 Pelotas: Salão de Arte / Porto Alegre: 1982 MARGS: Selecão Verde-Amarelo; 1985 Salão do Jovem Artista (1. Preis Zchng); 1991 Casa de Cult. Mário Quintana: Arte Gaúcha Contemp.; 1993 (Paradoxos Artificiais); 1994 (Águas de Março); 1995 (A Arte vê a Moda) MAC; 2002 Gal. Iberê Camargo: Porto 230; 2003 Garagem de Arte: Vida, Povo, Fome, Trabalho e Religião / 1983 São Paulo, Mus. de Arte: Prêmio Pirelli de Pintura Jovem / 2001 Buenos Aires, Centro Cult. Recoleta: Plást. Latinoamer. / 2005 Montenegro, Pin. Enio Pinalli: Mix 2005. ▭ *Online:* Inst. Itaú Cult., Enc. artes visuais, 2008. M. F. Morais

Cunha, *João da*, portug. Maler, 1640–81 in Beja dokumentiert. 1663 malt C. drei Gem. (eines dat., sign., nach Vorlagen von Lucas Vorstermann) für einen Altar in der Kap. S. José in der Quinta do General in Borba. Für Bruderschaften und den Klerus fertigt C. relig. Andachtsbilder und faßt Skulpturen. Er malt die Portr. der Herzöge von Beja D. *Fernando* und D. *Brites* (Beja, Mus. Mpal). Zugeschr. werden ihm vier Prozessionsbanner für die Kirche Misericórdia in Vila Nova de Baronia/Alvito und ein Gem. für den Kreuzgang im Kloster Conceição in Beja; darüber hinaus das Gem. *Cristo perante Caifás e Negação de Pedro* für die Klosterkirche Nossa Senhora do Socorro in Portel, für das lt. Serrão Kpst. von Cornelis Cort als Vorlagen dienten. Diese Stiche unterlagen, da aus den protestantischen

Niederlanden kommend, einer strengen Prüfung durch die Inquisition von Évora. – C. ist ein talentierter Maler, dessen künstlerische Entfaltung bedingt durch trad. Auftraggeber von regionaler Bedeutung bleibt. ☐ *V. Serrão*, A trans-memória das imagens. Est. iconólogicos de pint. portug. (séc. XVI-XVIII), Chamusca 2007, 227, 230, 232 s.

R. Petriconi

Cunha (Brito e Cunha), *José Carlos* (de) (Pseud.: J. Carlos), brasil. Karikaturist, Graphikdesigner, Illustrator, Autor, Liedtexter, * 18. 6. 1884 Rio de Janeiro, † 2. 10. 1950 ebd. Als Zeichner Autodidakt. C. debütiert 1902 in Rio de Janeiro als Karikaturist bei der Zs. O Tagarela. Bereits 1903 gestaltet er sein erstes Titelblatt und avanciert zu einem der produktivsten und bewundertsten Karikaturisten Brasiliens. Er sign. seine Arbeiten (Feder, Tinte, Bleistift, Aqu., Radiertechniken) mit „J. Carlos". Inspiriert wird er von dem frz. Illustrator Georges Goursat (gen. Sem) sowie von der eleganten und verschlungenen Linienführung des Jugendstils und der stilisierten Formensprache des Art Déco. Seine volkstümlichen Zchngn in klarem, flächenhaftem und ausgesprochen linearem Stil erlangen große Popularität. Walt Disney versucht 1941 vergeblich, C. für Hollywood zu verpflichten. C. befreit sich vom üblichen sfumato der lithogr. Techniken seiner Zeit und entwickelt eine eig. freie und lockere Zeichenweise. Er konzentriert sich auf die Konturen der Figuren und arbeitet präzise, psychologische Charakterisierungen aus (z.B. Gandhi). Durch seine Beobachtungsgabe entstehen von den Einwohnern Rio de Janeiros inspirierte Typen: Politiker (Marechal Hermes, Nilo Peçanha, Barão do Rio Branco), Schwiegermütter, Sambatänzer oder Vagabunden, aber auch Figuren für Kinder wie Jujuba, Borboleta, Lamparina und Gibi. C. porträtiert alle ges. Schichten., die er in den Straßen Rios trifft, und schafft so ein Abbild der sozialen und politischen Realität Brasiliens der 1. H. des 20. Jahrhunderts. Zu seinen Themen zählen auch der Karneval, das Strandleben und die aktuelle Mode. C. arbeitet für alle großen brasil. Ztgn; in seiner fruchtbarsten Periode (1902–21) zeichnet er in Rio de Janeiro für A Avenida (1903–04), O Malho, Século XX, Leitura para Todos, O Tico-Tico (1905–07), Fou-Fou! (1907–08), Carêta (1908–21), O Filhote da Carêta (1910–11), Rev. da Semana und Rev. Nac. Daneben publiziert er auch Cartoons, Ill. und Karikaturen in Mag., u.a. in A Vida Mod., Illustração Brasil., Cinearte und A Noite. Einige seiner Karikaturen werden auch in ausländischen Zss. veröffentlicht. 1922–30 ist C. Art Dir. aller Publ. der O-Malho-Verlagsgruppe. In den 1930er Jahren zeichnet er wiederum Comics für O Tico-Tico und kreiert die Figuren Melindrosa und Almofadinha. 1933 erscheint sein Kinderbuch *Minha Babá* mit eig. Texten und Illustrationen. 1935 bis zu seinem Tod kehrt C. als regulärer Cartoonist zur Zs. Carêta zurück, für die unzählige Ill. und Karikaturen entstehen. Kurz vor seinem Tod erscheint eine Anthologie seiner Zeichnungen. Auch Ill. zu Gedichten von Olavo Bilac, Alberto de Oliveiro, Emílio de Meneses und Olegário Mariano. C. führt zeitweise eine eig. Werbeagentur. ⊙ *E:* Rio de Janeiro: 1911 Gal. Brasil; 1950 Salão Assírio do Teatro Mpal (Retr., posthum); 2008 Gal. de Ar-

te Prochownik / São Paulo: 1914 Gal. der Zs. A Cigarra; 2004 Arte Pedrosa. –. *G:* 1982 Rio de Janeiro, MAM: Universo do Futebol / São Paulo: 1997 Itaú Cult.: O Humor Gráfico nos Anos 30, 40 e 50 (Wander-Ausst.); 2001 Inst. Cine Cult.: Caricaturistas Brasil.; 2004 CCSP: O Humor de J. Carlos. ☐ *Horn*, Cartoons, 1999. – *H. Lima*, J. C., Rio 1950; *P. M. Bardi*, Hist. da arte brasileira, S. P. 1975; *L. Trigo/C. Loredano*, Carnaval J. C., Rio 1999; *dieselben*, Lábaro estrelado. Nação e pátria em J. Carlos, Rio 2000.

C. Melzer

Cunha, *Luís*, portug. Architekt, Stadtplaner, Maler, * 14. 4. 1933 Porto, tätig in Lissabon. Stud.: bis 1957 EBA, Porto, u.a. bei dem Architekten Fernando Távora und dem Maler Simão César Dórdio Gomes. Ab 1952 aktive Teiln. an dem von Nuno Teotónio Pereira gegründeten Movimento de Renovação da Arquit. Religiosa (MRAR); 1954 Mitkoordinator einer Ausst. dieser Erneuerungsbewegung in der EBA; nach dem Stud. bis 1966 Stadtplaner der Stadt Porto. In dieser Funktion führt er zahlr. archit. wie städtebauliche Projekte aus, u.a. den Jardim do Ouro (1960), die Praça da Trindade und die Fußgängerunterführung zur Praça da Liberdade. Bed. ist auch seine Beteiligung am ersten Masterplan für die Stadt (1961). Ab 1966 arbeitet C. freischaffend in Porto, später in Lissabon. Dort ist er 1995–2004 Prof. in der Abt. für Archit. und Städtebau des Inst. Superior de Ciências do Trabalho e da Empresa (ISCTE). – C. wird heute als identitätsstiftender Architekt Portugals gesehen. Sein Interesse gilt der harmonischen Beziehung zw. Moderne und Trad. unter Berücksichtigung des regionalen Kontextes. Ausgehend von einem mod. Regionalismus gelangt er mit konsequent eklektizistischer Haltung über den Brutalismus und die stark historisierende Postmoderne zu einer portug. Variante der zeitgen. Archit., die in ihrer ganz eig. expressiven, z.T. spirituellen Formgebung künstlerische Freiheit und Pragmatismus verbindet. Ein Großteil seines Werkes umfaßt neben Gebäuden für Verwaltung, Kultur, Tourismus und Wohnen v.a. kirchliche Bauwerke. C. widmet sich auch der Malerei. ▥ ALMADA, Santuarium Cristo Rei: Empfangszentrum mit Büros, Kap., Ausst.-Gal., ab 1984 (mit Domingos Ávila Gomes). AVEIRO: Pfarrk. Sa. Joana Princesa, 1972–76. BRAGA: Red.-Gebäude des Diário do Minho, 1972. – Kloster und Priesterseminar, 1979. FÁTIMA: Dominikanerkloster und -kirche, Nonnenwohnheim, 1978. LISSABON: Neubauten der Univ. Católica Portuguesa, ab 1971. LOURES-Sacavém: Kirche Cristo Rei de Portela, ab 1982. OLIVEIRA DE AZEMÉIS: Kirche Pindelo. PAREDE/Cascais: Nonnenwohnheim, 1977. PENAFIEL: Wohnungsbau, 1978–80. PONTA DELGADA/Azoren: Auditorium, 1971–78. – Av. Marginal: Wassersportzentrum, 1977. – Kirche, 1980. PORTO-Carvalhido: Kirche Herz Jesu, Maria und Joseph, 1967–69; P.-Nevogilde: Kirche. SÃO MIGUEL/Azoren: Ferienanlage Praia do Pópulo. VILA DO CONDE: Neubebauung des Platzes. VISEU, Kathedrale: Altar, 1991–92. ⊙ *E:* 2011 Lissabon, Inst. Univ. de Lisboa (ISCTE). ☐ Arquit. mod. portug., 1920–1970, Li. 2004.

A. Mesecke

Cunningham, *Earl*, US-amer. Maler, * 1893 Edge-

comb/Me., † 29. 12. 1977 (Suizid nach einer psychischen Erkrankung) St. Augustine/Fla. C. übt versch. Gelegenheitsarbeiten aus. Fasziniert vom Meer, ist er viele Jahre als Schiffsmann an der Ostküste tätig. Nach der Heirat 1915 lebt das Paar in Maine und in den Wintermonaten in Florida (Tampa Bay, Cedar Key und St. Augustine). 1937 erwirbt C. eine Farm in Waterboro/S. C. Während des 2. WK Geflügelzüchter für die US-Armee in Georgia. 1949 zieht er nach St. Augustine und eröffnet einen Kuriositätenladen, gen. Over-Fork-Gallery. – Um 1909 beginnt C. auf Stratton Island/Me. als Autodidakt in naiver Manier zunächst auf Treibholzbrettern zu malen. Bevorzugte Sujets seiner ca. 450 Bilder (Öl/Holzfaserplatte) sind idyllische Hafenszenen mit Segelbooten oder Dampfschiffen bzw. Küsten-Lsch. von New York, Nova Scotia, Michigan, North und South Carolina, Georgia und Florida, häufig mit genrehaften Elementen. Seine Gem., bei denen sich Realität und Phantasie (z.B. Flamingos in Maine) mischen, reflektieren eine ganz eig., idyllisch-nostalgische Weltsicht und strahlen eine optimistische Grundhaltung und Harmonie aus. Char. sind kräftige, leuchtende, mitunter nicht naturnahe Farben (weshalb C. als „Amer. Primitive Fauve" bez. wird) sowie Räume mit geringer Tiefenwirkung. ⌂ BOSTON/Mass., John F. Kennedy Libr. and Mus.: The Everglades (1961 von C. an Jacqueline Kennedy in das Weiße Haus gesandt). NEW YORK, Metrop. Mus. ORLANDO/Fla., Mennello Mus. of Amer. Art. WASHINGTON/ D. C., Smithsonian Amer. AM. WILLIAMSBURG/Va., Abby Aldrich Rockefeller Folk AM. ◉ E: 1970 Orlando (Fla.), Loch Haven AC / 1974, '88 (Retr.) Daytona Beach (Fla.), Mus. of Art and Sc. / 1986 New York, New York Univ. Gall.; Mus. of Amer. Art (Retr.). ⌶ Falk I, 1999; Bénézit IV, 1999. – E. C. The Marilyn L. and Michael A. Mennello coll. (K Huntington Mus. of Art), Huntington, West Va. 1990; W. Garrett u.a., E. C.'s America (K Wander-Ausst.), Wa. 2007. – Online: Art knowledge news; Mennello Mus.; Winter Park Public Libr.; Michael Arnold art. C. Rohrschneider

Cunningham, *Keith,* brit. Maler, Buch- und Werbegraphiker, Ausstellungsdesigner, * 7. 8. 1929 Sydney, lebt in London. Tätig in der Werbe-Abt. des Kaufhauses David Jones, Sydney. Zieht 1949 nach London, dort 1949–52 Stud. an der Central SchA and Crafts und 1952–56 am R. College of Art bei Rodrigo Moynihan (1956 Reise-Stip.). Lehrt ca. 40 Jahre lang zwei Tage wöchentlich am London College of Printing. – 1950/51 arbeitet C. ein Jahr als Ass. von Gordon Andrews, u. a. beim Ausst.-Design für das Science Mus. im Rahmen des Festival of Britain. Er beteiligt sich in den 1950er Jahren in London mit Gem. an Ausst. in der Beaux Arts Gall., mit der London Group (1958, '59) sowie bei der Sommer-Ausst. der R. Acad.; er malt figurative Serien (*Dogs*, 1950er Jahre), Lsch. und in den letzten Jahrzehnten täglich Himmelsstudien. Sein Hauptengagement gilt jedoch graph. Arbeiten, so gestaltet C. als beratender künstlerischer Dir. der Werbeagentur John Collins Anzeigen für die Flugline El Al, 1950 Poster für London Transport, Titel-Bll. und Leitartikel für die Zss. New Economist und Tatler. Ab 1963 entstehen Buchumschlä-

ge für den Verlag Peter Owen (Marquis de Sade, *Quartet,* Lo. 1963); diese zeichnen sich durch eindrucksvolle, schlichte und sparsame, die Essenz des Textes erfassende Motive (z.T. mit von C. angefertigten Photogrammen) sowie durch einen überaus wirkungsvollen Zweifarbendruck aus, bes. in Kombination mit Schwarz. C. entwirft das bis heute verwendete Verlagslogo für Peter Owen und befaßt sich weiterhin mit Zchng., Malerei und gestalterischen Arbeiten. ⌂ LONDON, London Transport Mus. OLINDA/Pernambuco, MAC. ✉ Priv. views, in: Very mag. 10:2005, 18 s. ⌶ RoyalAcadExhib II, 1977; *Buckman* I, 2006. – *M. Dempsey*, Design week 16:2001 (33) 20–24; *R. Poynor* (Ed.), Communicate. Independent Brit. graphic design since the sixties (K), Lo. 2004; *M. Dempsey*, Very mag. 10:2005, 20 s. – Mitt. C.; Uscha Pohl, Very mag.
 H. Stuchtey

Cuny, *Philippe,* frz. Designer, Bildhauer, * 9. 3. 1961 Neuilly-sur-Seine/Hauts-de-Seine, lebt in Paris. Stud.: bis 1984 Univ. Paris Ouest Nanterre La Défense (Betriebswirtschaft). Seither autodidaktisch als Künstler tätig. – Auf der Suche nach adäquaten Ausdrucksformen beginnt C. 1984 mit stilisiertem Graphikdesign (Tusche, Gouache) und malt 1985 abstrakt-geometrische Komp., ehe er sich für das Produktdesign entscheidet. Er entwirft Möbel, zumeist Tische, und v.a. Beleuchtungskörper entweder in einer minimalistisch klaren Formensprache, deren elegante Ausstrahlung durch Mat. wie Edelholz, Metall, Glas und Kunstharz dezent unterstrichen wird, oder in Anlehnung an Naturmotive wie Korallen, Blattmotive und Algen. Im Nachklang des Cold Wave der 1980er Jahre und im Kontext des New Age entwickelt C. 1989 die für ihn richtungweisende Wandleuchte *Mouvement libre,* deren großzügig geschwungene Formen er für Unikate oder limitierte Stückzahlen immer wieder aufgreift, z.B. für die Tischleuchte *Lyre.* Von diesem, von C. als ebenfalls exemplarisch für sein Schaffen erachteten Modell entwickelt er für die Serienfertigung eine kleinere Variante, die er lt. eig. Aussage in mehr als 35 Ländern verkauft hat. Fortan kümmert er sich selbst um Produktion und Vermarktung. 2001 Unterbrechung der Entwurfstätigkeit zwecks intensiver Beschäftigung mit der Skulpt., v.a. mit Unters. zu formalen Aspekten. Bei den nun entstehenden Arbeiten aus Polyurethanschaum, Spiegelglas, Gips und einem matten Acrylüberzug sind die Grenzen zw. bild. und angew. Kunst fließend (*Red Room,* 2001). C. entwirft 2009 eine Luxuskollektion von skulpturalen Leuchten, die er z.T. mit Blattgold oder Palladium überzieht, wobei Leuchte und Skulpt. formal zu „Leucht-Skulpt." (sculpt. lumineuses) verschmelzen. C.s Leuchten werden auch als Dekoration in Filmkulissen verwendet (z.B. Erwerb der Lampe *Lyre* durch Pedro Almodóvar für *Kika,* 1993) und regelmäßig in der Fachpresse vorgestellt (u.a. Elle Décoration, Marie Claire Maison, Homes & Gardens). ⌂ GENF, Organisation mondiale de la Propriété intellectuelle (OMPI). PARIS, Inst. nat. de la Propriété intellectuelle (INPI). ⌶ *Online:* Artnet; Artprice; Website C. (Werke). – Mitt. C. R. Treydel

Cuny, *Philippe (Philippe Gaudenz),* schweiz. Multimediakünstler, * 16. 3. 1966 Basel, lebt dort. Ausb. im Bank-

fach. Gründet 1990 zus. mit zwei and. Künstlern in Basel die Aktions-Ges. Protoplast AG, die er seither mit wechselnden Mitstreitern federführend betreibt. – Vor dem Hintergrund immer fragwürdiger und absurder erscheinender, subtiler und kaum durchschaubarer Mechanismen zur Steuerung und Manipulierung des Konsumverhaltens der Verbraucher gegr., hinterfragt Protoplast diese Situation kritisch und provokant. Die Ges. agiert als konzeptuell angelegte Scheinfirma, die fiktive Produkte entwickelt, herstellt und wirkungsvoll in Szene setzt bzw. vermarktet. Dies sind Marken und deren Zeichen, Verpackungen, Inserate, Schlagworte und Signets. Dabei wird Kunst durch Werbestrategien und -kampagnen so definiert, daß ganz gezielt lancierte Angebote und neue Werte entstehen, die als Alternative zum realen Kunstbetrieb und Warenkonsum funktionieren. Protoplast strebt damit die Durchdringung des Alltags mit imaginären und virtuellen Produkten an, um dem materiellen einen ideellen Warenwert entgegenzusetzen. Die Präsentation erfolgt durch Installationen, Performances, Objekte und Videos (z.B. *Bobo*, 1995, Basel, KH; *Grau*, 1999, Kulturhauptstadt Weimar; *Index*, 2001, Zürich, MfG). ◉ *E:* Basel: 1990 HS für Gest. und Kunst; 1996 Univ.-Bibl.; 2003 Plug.in; 2010 Dock: aktuelle Kunst aus Basel / 2004 Riehen, Kunst Raum; Langenthal, Kunsthaus / 2006 Biel, Centre PasquArt (alle mit Protoplast). ▢ BLSK I, 1998. – *A. Zwez*, Kunst-Bull. 2000 (Juli/Aug.) 40 s. – *Online:* SIKART Lex. und Datenbank (auch s.v. Protoplast AG); Website Protoplast AG.

 R. Treydel

Cuoghi, *Roberto*, ital. Maler, Zeichner, Multi-media-Künstler, * 1973 Modena, lebt in Mailand. Stud.: ABA di Brera, Mailand. Auf der Suche nach einer eig. künstlerischen Ausdrucksweise bedient sich C. verschiedenster Techniken und Methoden: er malt (z.B. Comic-Figuren wie Charlie Brown oder die Simpsons, z.B. *David Bowie*, Zigarrenschachteln), zeichnet, gestaltet Plastiken, bezieht Fotogr. und Videos sowie Töne und Geräusche ein (*Mei Gui*, 2006), entwirft Installationen (*Suillakku*, 2008) und verwendet ungewöhnliche Mat., wie z.B. bei den auf der Berlin-Bienn. ausgestellten männlichen Porträts, die er in einer speziellen Technik mit Säure auf schwarzes Glas ätzt und die bei Licht ein gespenstisches Aussehen bekommen. Auch beschäftigt sich C. mit dem Phänomen und Problem der Zeit, wobei er auch sich selbst einbezieht: 1998 startet er eine spektakuläre mehrjärige Performance, färbt sich Haare und Bart weiß, steigert sein Gewicht auf 140 kg und nimmt das Aussehen seines 60jährigen, schwer erkrankten Vaters an. Im Mittelpunkt seiner Ausst. in Rivoli (2008) steht der assyrische Dämon *Pazuzu*, eine Personifikation des kalten Windes, dessen Ikonogr. über versch. Verwandlungen und Formen er bis in unsere Zeit reichen läßt. C.s Blick auf aktuelle Themen oder Probleme ist ironisch (*Portr. des Sammlers Megas Dakis*, 2007) bisweilen auch zynisch, z.B. bei der Betrachtung der Medien und ihrer Auswirkungen. Mitunter karikiert er auch sein eig. Schaffen (*Selbstbildnisse*; Ausst. Los Angeles, 2011; Ausst. zum Thema *Zoloto*, 2012). ▣ ATHEN, Coll. Dakis Joannou. NEAPEL, Fond. Morra Greco. PARIS,

Coll. François Pinault. – MNAM. WIEN, Mus. in Progress. ◉ *E:* 1997 Bologna, GAM, Spazio Aperto (mit Alberta Pellacani) / 2003 Bergamo, GAMC (K) / 2003, ’06, ’12 Mailand, Gall. Massimo De Carlo / 2005 New York, The Wrong Gall. / 2007 Beaumont du Lac, Centre Internat. d’Art et du Paysage de l’Île de Vassivière / 2008 Rivoli (Turin), Castello di Rivoli; London, ICA / 2011 Los Angeles, UCLA Hammer Mus. – *G:* 1996 Modena, Pal. della Prefettura: Orizzontale-Verticale (K) / 2001 Tirana: Bienn.; Bergamo, GAMC: In fumo. Arte, fumetto, comunicazione (K); Florenz, Manifattura Tabacchi: Espresso. Arte oggi in Italia (K) / 2002 Trient, MART: Nuovo spazio ital. (K) / 2003 Prag, NG: Italy. Out of order (K) / 2004 Venedig, Fond. Bevilacqua La Masa: Paradiso e inferno (K) / 2005 Rom: Quadrienn. / 2006 Modena, Gall. Civica e Palazzina dei Giardini: Egomania (K); Turin: Trienn. / 2007 Tel Aviv, Mus. of Art: Mentalgrafie. Viaggio nell’arte contemp. ital. (K) / Venedig: 2007 Pal. Grassi: Sequenze 1; 2008 ebd.: Italics. Arte ital. fra tradizione e rivoluzione, 1968–2008 (K); 2009 Bienn. / 2008 Frankfurt am Main, KV: The great transformation (K) / 2011 Paris, Maison Rouge: Les recherches d’un chien; Valencia, IVAM Centre Julio Gonzalez: Surreal versus surrealism in contemp. art (K) / 2012 Mailand, Pal. Reale: Gli artisti ital. della Coll. ACACIA. ▢ *L. Pratesi/C. D’Orazio* (Ed.), Verso il futuro. Identità nell’arte ital. 1990–2002 (K), Mi. 2002; *M. Farronato*, Tema Celeste 100:2003 (Nov./Dez.) 113; *C. Laubard*, Artforum Internat. v. 9. 1. 2003; *A. Rabottini*, Flash art (Ed. ital.) 36:2003 (238) 112–114; *A. M. Gingeras*, Artforum Internat. 2005 (Sommer) 316 s.; *M. Cattelan u.a.* (Ed.), Von Mäusen und Menschen (K 4. Berlin Bienn. für Zeitgen. Kunst), Ostfildern-Ruit 2006; Mousse Mag. 5:2006 (Dez.) 24–26 (Interview mit M. Cattelan); *U. Thon*, Art 2006 (4) 18–27; *M. Beccaria* (Ed.), R. C., Mi. u.a. 2008 (Lit.); *L. C. Cherubini*, Flash art (Ed. ital) 41:2008 (270) 72–75; R. C., [Dijon] 2010 (Void, Nr 1); – *Online:* Ital. area. Ital. contemp. art arch.; Ital. network v. 20. 1. 2011. E. Kasten

Cường, *Lê* (Lê C.), vietnamesischer Fotograf, Historiker, * 1947 Hanoi, lebt dort. Sohn des Fotografen Lê Vượng. Lehrtätigkeit an der KHS, Hanoi. 1990–2005 Leitungs-Mitgl., zeitweise stellv. Vors. des Fotografen-Verbandes. – V.a. Archit.- und Lsch.-Fotogr., in die C. die vergängliche Schönheit trad. Dorfanlagen, alter Stadtviertel und hist. Baudenkmale festhält. ◉ *E:* 2005 Hanoi, L’Épace (mit Lê Vượng). – *G:* Hanoi: 1985 40 Jahre vietnamesische Fotogr.; 1991 Leben in Hanoi; 1996 Nat. Foto-Ausst. (2. Preis). ▢ Vietnam art photogr., Hanoi 1988; Vietnam Album, Hanoi 1991; Lịch sử Nhiếp ảnh Việt Nam (Gesch. der vietnamesischen Fotogr.), Hanoi 1993, 122, 151; Tạp chí nhiếp ảnh 2000 (143); Vietnamese photogr. in the 20th c., Hanoi 2006. A. Friedel-Nguyen

Cương, *Nguyễn Nghĩa* (Nguyễn Nghĩa Cương), vietnamesischer Maler, * 1973 An Bình/Bắc Ninh, lebt dort. Bruder des Graphikers Nguyễn Nghĩa Phương. Stud.: 1991–96 KHS, Hanoi. Seitdem freischaffender Künstler. – C. nähert sich mit seinen Arbeiten der aktuellen, konsumgeprägten Realität, in der das Denken und Han-

deln der meisten Menschen von kommerzieller Werbung dominiert wird auf ironische Weise. Dieses Hauptthema bedingt C.s Arbeitsmittel. Er malt seine Bilder auf Handelsverpackungen, Kartons und Ztgn unter Einbeziehung der dort vorhandenen Werbung, was die Arbeiten in die Nähe der Pop-art rückt. Seine Haupttechniken sind Gouache/Altpapier und Öl/Lw.; daneben zahlr. Selbstporträts. ▭ HANOI, Art Vietnam Gall. ◉ *E:* Hanoi: 1998 FCAC Gall.; 2002 Salon Natasha; 2005, '10 Art Vietnam Gall. / Ho-Chi-Minh-Stadt: 1999 Gal. Không gian Xanh (mit Đinh Lực); 2001 Tự Do Gall. – *G:* 2003 Melbourne: Urban Art / 2007 Pyongtaek: SosaBeol internat. Art Expo / 2008 Singapore, Singapore AM: Post Doi-Moi. ▭ Lao động v. 21. 11. 2001, 20. 3. 2005; Thể thao & văn hóa v. 20. 11. 2001, 12. 6. 2010; Tạp chí Mỹ thuật 28:2005 (130) 39 s. – Mitt. N. Kraevskaia.

A. Friedel-Nguyen

Cường, *Quan* (eigtl. Quan Lạc; Pseud. Quan Tồn Chí), vietnamesischer Tuschzeichner, Kalligraph, Maler, Bühnenbilder chin. Abstammung, * 2. 3. 1932 Nam Hải/Quang Tung, lebt in Ho-Chi-Minh-Stadt. Autodidakt. Lehrtätigkeit u.a. 1970er Jahre KSch Huỳnh Kiến Hoa, Chợ Lớn. Mitgl. der 1989 von Lý Tùng Niên gegr. Kalligraphengruppe Nam Tú Nghệ Uyển. Ausz.: 2002 Verdienst-Med. des Künstler-Verb. Ho-Chi-Minh-Stadt. – C.s in chin. Trad. stehende Tusch-Zchngn sind z.T. allegorische Deutungen von Passagen aus dem Buch der Wandlungen (*Tam Dương Khai Thái* /Drei friedliche Ziegen). Seine kalligraphische Handschrift gilt als sehr ursprünglich und temperamentvoll. C. malt auch in Öl und auf Seide. ▭ HO-CHI-MINH-STADT, Thảo Đường Thiền Tự-Pagode: Arhats, Wandmalerei, 1993. – Hoa Nghiêm-Pagode: Quan âm (Guanyin), Wandmalerei, 2003. ▭ Ho Chi Minh City Art Diary 96–97, Ho-Chi-Minh-Stadt 1996; Nghệ sĩ Tạo hình Việt Nam hiện đại – Kỷ yếu Hội viên (Mod. Bild. Künstler Vietnams – Verb.-Verzeichnis), Hanoi 1999; Saigon Giải phóng thứ bảy 1999 (421). – *Online:* Sách xưa. A. Friedel-Nguyen

Curchod, *Ronald (Ronald Max)*, schweiz. Graphikdesigner, Zeichner, Illustrator, Graphiker, Maler, * 16. 8. 1954 Lausanne, lebt seit 1979 in Toulouse. Ab 1971 Ausb. als Graphikdesigner im Atelier von César Rey (AE atelier-éc.) in Lausanne; 1974 Eidgenössisches Diplom. 1975–78 Reise durch Südfrankreich. Ab 1979 freier Illustrator, zunächst für Werbung und Industrie, 1985–89 v.a. für frz. und internat. Kultur- und and. öff. Einrichtungen (z.B. das frz. Kultus-Minist. und das Centre nat. d'Et. spatiales [CNES]); tourt zwischenzeitlich als Saxophonist durch die Welt. Seit 1989 verstärkte Hinwendung zur Zchng, Plakat-Gest., Fotogr., Ill. für Bücher (für Verlage wie Seuil, Milan, Syros, l'An2) und Zss. (u.a. Télérama, Courrier internat., Le Monde, Libération), zum Bühnenbild- und Kostümentwurf für Theater (v.a. Garonne in Toulouse, Le Parvis in Tarbes, Théâtre nat. de Toulouse [TnT], l'Arsenal in Metz). Später auch mit Malerei beschäftigt. Artist in Residence: 1998 Centre cult. franç., Jakarta; 2007 Inst. franç., Istanbul. Gast-Doz. u.a. an den EcBA in Toulouse, Valence und Nancy. Seit 2005 Mitgl. der Alliance graphique internat.

(AGI). Mehrfach Juror bei internat. Plakatwettbewerben. Zahlr. Ausz., v.a. mehrere Grand Prix für Plakate: 1996 Internat. Theaterplakat-Wettb. in Osnabrück; 2001 Festival internat. de l'Affiche in Chaumont; 2006 Taiwan Internat. Poster Design Award; 2007 China Internat. Poster Bienn. in Hangzhou; 2008 Internat. Plakat-Bienn. in Warschau; zudem v.a. 2012 Yusaka Kamekura Internat. Award, Internat. Poster Trienn. in Toyama/Japan. – C. praktiziert eine klare, gegenständlich-plakative und auf wenige Bildelemente reduzierte flächige Darst.-Weise, wobei die einzelnen Genres ineinandergreifen und sich gegenseitig beeinflussen, oftmals kombiniert er versch. Techniken unkonventionell miteinander. Sein internat. Ansehen basiert auf den zahlr., meist als Auftragswerke von Kulturbetrieben ausgef. und von einer unverwechselbaren Handschrift geprägten Plakaten. Deren Botschaft vermittelt er gemäß dem eig. Credo, demzufolge der Mensch dem Traum entspringe, oftmals mit Darst. von überzeichneten fiktiven Figuren wie Monstern, Schimären, hybriden Gestalten und Fabelwesen, die aus einer mystischen Welt bzw. einer längst vergangenen Zeit zu stammen scheinen. C.s Malerei ist teilw. surrealistisch übersteigert und technisch sehr vielfältig (Gouache, Öl, Tempera, Aqu., Schlicker, Mischtechnik, Arcyl, z.B. *Les oiseaux*, zehnteilige Serie). Die Farbgebung wählt er je nach Verwendungszweck klar und leuchtend (bei Plakaten) oder verhalten in subtil abgestuften Tönen. Als Zeichner arbeitet C. vorzugsweise in Schwarzweiß (Kohle). Das facettenreiche Œuvre umfaßt v.a. Werbegraphik, zumeist Veranstaltungsplakate (zudem Ausst.-Kat., Programme, Werbepräsentationen und Logos für Firmen, Internetseiten). Seine Ill. sind außer für Ztgn und Mag. v.a. für Bücher und komplett von ihm gestaltete Kat. bestimmt: *Le silence des yeux*, I (Buch), II (Kat.), Reims 2000; Benoît Reynaud, *C'est pour offrir*, P. 2003 (Gouachen); R. C., *Chorégraphie du baiser*, Angoulême 2004 (Kohle-Zchngn, Ölbilder); Michel Séonnet, *Le vent vivant des peuples*, P. 2006; *L'iris du geai*, 2011 (Publ. zum Festival Ausst. Eté photogr., Lectoure). Zudem entstehen mehrere Serien mit Druckgraphik, z.B. *Le toucan*, Lith. für das CNES, und *Les chimères*, Serigraphien in Zusammenarbeit mit dem Atelier Tant & Temps, Orléans, 2005. ◉ *E:* 1994 Paris, Gal. Michel Lagarde / 1994, '97 (K), 2007 Lausanne, Gal. Humus / 1998 Bordeaux, Gal. 90° (K) / 2000 Chaumont, Les Silos. Maison du Livre et de l'Affiche (K) / 2007 Taichung (innerhalb des Taiwan Internat. Poster Design) / 2008 Toulouse, MAMC / 2009 Clermont Ferrand, Conseil gen. du Puy-de-Dôme; Rennes, EcBA; Fusing (Taiwan; innerhalb der Internat. Bienn.) / 2010 Warschau (innerhalb der Internat. Plakat-Bienn.); Grisolles, Mus. Calbet / 2011 Lectoure (beim Festival Eté photogr.). – *G:* 1998 Paris: Grand Prix nat. de l'Affiche cult. (2. Preis) / 1999 Rzeszów: Internat. Bienn. of Theater Poster (3. Preis) / 2000 Toyama: Internat. Plakat-Trienn. (Bronze-Med.) / 2002 Monflanquin (Lot-et-Garonne), Résidence d'Artistes: Bienn. du Livre d'Artiste / 2003 Mumbai, Ambassade & Alliance franç. en Inde: L'affiche franç. (K) / 2006 Luzern: Fumetto / 2011 Chaumont: Festival internat. de l'Affiche (Preis der Jury). ▭ BLSK I, 1998. –

Les illustres (K Wander-Ausst.), 2003; Plakate, Theater. Zeitgenössisches aus Frankreich (K), Hn. 2003; R. C., Shenzhen 2004 (chin. Monogr.); Handmade (K MfG), Z. 2005 (Poster Coll., 11); *J. He* (Ed.), AGI – new voice, B. 2006; *A. Jordan* (Vorw.), R. C., P. 2006 (Design & Designer, 42). – *Online:* SIKART Lex. und Datenbank; Website C. (WV, v.a. Buch-Ed., Ausst.). R. Treydel

Cure, *Alfred Capel* (Capel-Cure, *Alfred*), brit. Amateurfotograf, Offizier, * 8. 12. 1826 Blake Hall, Ongar/Essex, † 29. 7. 1896 Badger Hall, Shifnal (heute Badger)/Shrops. Neffe von Robert Henry Cheney und Edward Cheney. 1844 Eintritt in die Armee; 1846–51 in Irland stationiert, anschl. in Gibraltar; 1855 Teiln. am Krimkrieg (Verwundung). Wahrsch. ab 1850 Beschäftigung mit der Fotogr., die C. nach produktiven Jahren 1860 unvermittelt wieder aufgibt. 1867 verläßt er die Armee im Rang eines Colonel der Grenadier Guards; 1884 erbt er das Anwesen der Fam. Cheney, Badger Hall in Shifnal, von seinem Onkel E. Cheney und verbringt dort die letzten Jahre seines Lebens. – C. erlernt die Fotogr. wahrsch. gemeinsam mit seinem Onkel, R. H. Cheney. Anders als die meisten Amateurfotografen ihrer Zeit gehören C. und Cheney keinen fotogr. Ges. an, stellen ihre Arbeiten nicht öff. aus und publizieren keine Art. in fotogr. Zeitschriften. Erste Kalotypien sind aus dem Jahr 1850 bek. (erh. im Album *Photogr. Experiments*); im weiteren Verlauf der 1850er Jahre arbeitet C. überwiegend mit dem Kalotypieverfahren, es sind nur wenige Experimente mit dem Nassen Kollodium-Verfahren aus dem Jahr 1854 erhalten. Vor dem Einsatz im Krimkrieg entstehen hauptsächlich Aufnahmen seines Regiments, darunter zahlr. Portr. von Offizieren in Irland und Gibraltar (dort u.a. auch ein Panorama des Hafens). Anschl. konzentriert sich C. auf romantische Ansichten oft verfallener hist. Bauten wie Landsitze, Burgen, Kathedralen und Klöster, die er auf mehreren ausgedehnten Reisen durch England, Schottland, Wales und Frankreich fotografiert. Dabei arbeitet er wahrsch. oft mit R. H. Cheney zus., von dem sehr ähnliche Motive erh. sind; eine exakte Zuschr. einzelner Aufnahmen ist nicht immer möglich. Von E. der 1850er Jahre sind mehrere Alben mit Albuminabzügen C.s nach Papiernegativen von Cheney erhalten. ⌂ AUSTIN/Tex., Harry Ransom Center. CLEVELAND/Ohio, Mus. of Art. LOS ANGELES/Calif., County Mus. of Art. – J. Paul Getty Mus. – Univ. of California, Dept. of Special Coll., Charles E. Young Research Libr. MONTREAL, Canad. Centre for Archit. NEW YORK, Metrop. Mus. – MMA. ROCHESTER/N. Y., George Eastman House. ⊙ *E:* 1981 New York, MMA. – *G:* 1999 Cambridge (Mass.), Houghton Libr., Harvard Univ.: Salts of Silver, Toned with Gold. The Harrison D. Horblit Coll. of Early Photogr. (K). ▭ *J. Hannavy* (Ed.), Enc. of nineteenth-c. photogr., I, N. Y./Lo. 2008 (s.v. Capel-Cure, Alfred). – *J. J. Howard/F. A. Crisp*, Visitation of England and Wales, II, [Lo.] 1893, 23 (digitalisierte Version unter archive.org); Times (Lo.) v. 31. 7. 1896 (Nachruf); *P. Roberts*, Cameron, Fenton and others (K Colnaghi), Lo. 2006; *R. Taylor*, Impressed by light. Brit. photographs from paper negatives, 1840–1860

(K Wander-Ausst.), N. Y. u.a. 2007. P. Freytag

Čurilov, *Igor' Stanislavovič,* russ. Maler, Graphiker, * 1959 Vladivostok, lebt in St. Petersburg. Seit 1960 ebd. (Leningrad) ansässig. 1975–77 Ausb. im Studio von Gennadij Semenovič Čerepovskij ebd. Stud. dort: 1978–86 (mit Unterbrechungen) experimentelles Design HS für angew. Kunst bei E. N. Lazarev. Lehrtätigkeit: ab 1983 an Kinder-KSch (u.a. in Levašovo, Osinovaja Rošča, Leningrad); 1992–93 Pädagogische HS St. Petersburg; 2003–06 Malerei an der HS für Fernsehen, Internat. Business und Design ebd. Mitbegr. und Ltg der informellen Vrg junger Künstler Nasledie (Ausst., u.a. 2008 Roza vetrov). Bis 1993 Mitgl. der Künstlergruppe Mit'ki. – Zunächst neben Stadt-Lsch., die u.a. durch die Schule von Barbizon geprägt waren und nur im Frühwerk deutlich Petersburger Motive assoziieren, auch Stillleben (meist Blumen). Zus. mit Aleksandr Florenskij Interesse für die Moskauer Künstlergruppe Makovec, v.a. die Werke von Sergej Michajlovič Romanovič. Č.s Werke jener Jahre wirken weich, gleichsam changierend. Später dekorative Arbeiten im Geiste von Henri Matisse sowie genrehafte Darst. zu hist., relig. und mythologischen Themen; auch Hinwendung zur russ. Heldendichtung (sog. bylina). Trennung von der Vrg Mit'ki, da sich deren Weg der spielerischen, humoristischen Primitivierung der Darst. für Č. als ungeeignet erweist. Hinwendung zu Fragen der plastischen Darst.; Č. strebt dabei eine Verbindung von Malerei und Formanalyse in der Trad. von Vladimir Vasil'evič Sterligov sowie eine ganzheitliche, nicht-simplifizierende Sicht mit plastisch-fließender Verallgemeinerung an (u.a. Geometrisierung, teils mit gekrümmten Linien), die den urbanen Raum zur poetischen Metapher werden lässt. Ab den 1990er Jahren zeigen Č.s Lsch. weniger Archit.-Ensembles oder Konglomerate von Bauten, sondern begrenzte Bildausschnitte aus der Perspektive höherer Stockwerke oder Mansardenfenster, wodurch eine Distanz zum Menschen und seinen Alltagsproblemen geschaffen wird. Emotion und Leidenschaft der Stadtbewohner finden dabei ihren eigenwillig gebrochenen Widerhall in der Darst. teils morbid anmutender hist. Höfe und Fassaden im ehemals schönen Stadtteil Petrogradskaja storona. Meist gedämpfte Töne sowie expressives Spiel mit Lichteffekten. Bemerkenswert sind u.a.: *Gorodskie okna*, 1996; *Begonija cvetet*, 1999, beide Öl; *Neva*, Pastell, 2003; *Mart*; *Petrogradskaja storona*, beide 2005; *Kanal Griboedova*, 2007, alle Ölpastell; *Siren'*, Pastell, 2008. ⌂ ARCHANGEL'SK, MBK. CHVALYNSK, Petrov-Vodkin-Mus. PUŠKIN, MMK „Carskosel'skaja kollekcija". ST. PETERSBURG, Mus. für Stadt-Gesch. – Zentrale Ausst.-Halle Manež. – Slg I. Ja. Kušnir. SARANSK, Mordwinisches MBK. SARATOV, KM. VORONEŽ, MBK. ⊙ *E:* u.a. St. Petersburg: 1995 Mus. für Stadt-Skulpt.; 1998 Druck-Mus.; 1999 HM; 2002 Gal. Aėrosoft; 2008 Mus. der Künstlergruppe Mit'ki, Glas-Gal. und dt.-russ. Kulturzentrum Peterkirche / 2011 Saratov, KM. – *G:* ab 1979, u.a. 1989 Leningrad: Leningrader Underground. Von der inoffiziellen Kunst zur Perestrojka / Moskau: 1990, '91 Art-Mif; 1990, '92 Bienn. der neuesten Kunst. ▭ *L. Ju. Gurevič,* Chudožniki leningradsko-

go andergraunda, StP. 2007. – Peterburg-2000 (K), StP. 2001. – *Online:* Website C. D. Kassek

Curlet, *François*, frz. Objekt-, Installations- und Videokünstler, Maler, Graphiker, Bildhauer, * 18. 2. 1967 Paris, ebd. und in Brüssel tätig. Läßt sich als 22-Jähriger in Brüssel nieder. Ausz.: 2004 Prix Altadis. – C.s heterogenes Werk vereint Konzeptkunst mit dadaistischen Ideen, Elementen der situationistischen Bewegung und Motiven aus Popkultur, Medienwelt und Werbebranche. Er kombiniert eine Vielzahl von Techniken und Mat. wie Objektkunst (*Big Corn*, 2007), Gem. (*Whassup!*, 2002), Graphiken (*Ebay*, Siebdruck, 2007), Keramiken (*Moonboot*, 2008), textile Arbeiten (*Charlie's Flag*, Wolle, Bambus, 2005), Installationen (*Chaquarium*, 2003) und Videofilme (*French Farce*, 2007) und verwendet u.a. Objets trouvés (*Accident Island*, 2001). Die Arbeiten bewegen sich im Spannungsfeld von Realität und Fiktion, ohne sich eindeutig zuordnen zu lassen. C. karikiert die Konsumwelt und spielt mit Logos und Markenzeichen, z.B. in der Arbeit *Djellabas Nike, Adidas, Fila* (1998), die trad. nordafrikanische Kleidung mit Markenzeichen versch. Sportartikelhersteller schmückt. Der Nike-Slogan „Just Do It" wird in *Just Donuts* (Siebdruck, 2002) umgewandelt, und auch in and. Werken nutzt er Wortspiele wie z.B. bei *Homeless is more*. Das Design-Motto „Less is more" aufgreifend, zeigt das wie ein Kinoplakat wirkende sozialkritische Acryl-Gem. von 1992 einen schlafenden Mann im Hahnenkostüm. Häufig Zusammenarbeit mit and. Künstlern (v.a. Frank Scurti, Michel François, Pierre Huygue sowie mit dem Graphikstudio Donuts aus Brüssel). ⌷ ALBI, Centre d'art Le LAIT. ANTWERPEN, Mus. van Hedendaagse Kunst. BORDEAUX, FRAC Aquitaine. DUNKERQUE, FRAC Nord-Pas-de-Calais. EINDHOVEN, Van Abbe-Mus. HORNU, MAC's. LONDON, V & A. MONTPELLIER, FRAC Languedoc-Roussillon. NORTH MIAMI/Fla., MCA. PARIS, FNAC. – FRAC Ile-de-France. – MNAM. REIMS, FRAC Champagne-Ardenne. ⊙ *E:* Antwerpen: 1991 Gal. Inexistent (mit F. Scurti); 2004, '07, '08, '10 Gal. Micheline Szwajcer / Paris: 1993 Centre Pompidou (mit F. Scurti; K); 2003, '08 Gal. Air de Paris (Guy de Cointet); 2005 La Maison Rouge; 2013 Pal. de Tokyo / 1997 Reims, FRAC Champagne-Ardenne (K) / 2001 Stuttgart, KV (mit Régis Pinault) / 2004 Barcelona, Centre d'Art Sa. Mònica / 2007 Villeurbanne, Inst. d'Art contemp. (K) / 2012 Lille, Gal. Camoufleur (K). –. *G:* 1993 Venedig: Bienn. / Paris: 1997 Fond. Cartier: Coïncidences (K); 2006 Pal. de Tokyo: Une Seconde, une Année; 2012 Gal. Hussenot: Blabla et Chichi sur un Bateau / 2000 Toulouse, MAMC: L'œuvre collective / 2002 Zürich, KH: No Ghost just a Shell / 2004 Rennes, Univ., Galerie Art & Essai: Doubtiful. Dans les plis du Réel (K) / 2005 Hornu, MAC's: Le tableau des éléments (K) / 2008 North Miami (Fla.), MCA: Pivot Points (Part 1) / 2010 London, Tate Modern: No Soul For Sale. ⌷ *Bénézit* IV, 1999. – *N. Carron,* Flash art (Mi.) 196:1997, 122; *A. Magnin,* F. C., Dijon 2003; F. C., Arles 2005; *C. Bezzan,* Art press 337:2007, 44–47; *C. Delaume,* F. C. Spezialität (K), P. u.a. 2008. – *Online:* Website C. F. Krohn

Curneen, *Claire*, brit. Keramikerin, Zeichnerin, * 1968 Tralee/Co. Kerry, lebt in Cardiff. Stud.: 1987–90 Crawford College of Art, Cork; 1990–91 Univ. of Ulster, Belfast; 1991–92 Univ. of Wales Inst., Cardiff. Lehrtätigkeit: Cardiff SchA and Design. Artist in Residence: 2000 Crawford AC, St. Andrews und Clay Studio, Philadelphia. Ausz.: 2001 Le Prix de l'Assoc. Amis des Mus. de Nyon (AMN), Porcelain Trienn., Nyon; 2001 Gold-Med., Nat. Eisteddfod of Wales; 2005 Creative Wales Award. – C. gestaltet durch Zusammensetzen von in der Handfläche geformten dünnen Plättchen ca. 50–60 Zentimeter hohe freistehende androgyne Figuren aus Porzellan (seltener aus Terrakotta), wobei Ansatzstellen, Fissuren, Daumenabdrücke und zunächst auch kleinere Öffnungen sichtbar bleiben. Die Hände sind deutlich vergrößert und detaillierter modelliert und werden zunehmend in der Gestik expressiver, Glasuren verwendet sie wenig und nur in kleinen Bereichen. Seit ca. 2000 befaßt sich C. intensiv mit christlicher Ikonogr. und ihrer eig. kath. geprägten Jugend und gibt den melancholisch-expressiven Figuren durch Anspielung an die christliche Bildwelt eine neue Aussagekraft (Leben, Tod, Schmerz und Freude). Es entstehen von der Renaiss.-Ikonogr. inspirierte Figuren wie *Daphne* (2007) und v.a. kontemplative Figuren wie St. Sebastian, St. Barbara sowie weitere Märtyrer und Madonnen (*Pieta*, 2010), die bereichert sind mit rinnendes Blut symbolisierende Goldlüsterglasur und feinen modellierten Blütenblättern. Ferner gestaltete sie um 2001 eine glänzend transparent glasierte Büsten-Serie mit blauem oder goldenem floralem Dekor (*Büste*, 2002; V & A) sowie 2002 die *Tools*-Serie aus mit dicht mit Porzellanstacheln überzogenen Werkzeugen. Im Auftrag des Boston Borough Council/Lincs. fertigt C. 2006 für eine Nische im Westfenster der ma. St. Mary's Guildhall eine vier Meter hohe Madonna mit Kind aus Terrakotta mit Details wie Flügelspitzen in Goldlüsterglasur. C. gehört zu den führenden brit. Keramikkünstlern. ⌷ ABERYSTWYTH, AC, Aberystwyth Univ. ATHEN, Benaki Mus. BELFAST, Ulster Mus. CAMBRIDGE, Fitzwilliam Mus. CARDIFF, NM and Gall. of Wales. CHARLOTTE/N. C., Mint Mus. CORK, Crawford Mun. AG. EDINBURGH, NM of Scotland. GATESHEAD, Shipley AG. ICHEON, Icheon World Ceramic Centre. LIMERICK, City AG. LONDON, Crafts Council. – V & A. MIDDLESBROUGH, Inst. of Mod. Art. OLDHAM, Gall. Oldham. PHILADELPHIA, Clay Studio. TAIPEI, Ceramics Mus. TEMPE, Arizona State Univ. AM, Sara and David Lieberman Coll. YORK, Castle Mus. ⊙ *E:* 1996 (mit Philip Eglin), 2002 (mit Heather Belcher), '11 (mit Alice Kettle) London, Contemp. Applied Arts / 1997, 2004, '08 Ruthin, Ruthin Craft Centre / 1998 Aberystwyth, Aberystwyth AC; Middlesborough, Cleveland Crafts Centre / 2010 Le Fel (Aveyron), Le Don du Fel; Cardiff, Bay / 2011 Bath, BA. ⌷ *S. James,* Ceramics. Art and perception 38:1999, 3; *M. Vincentelli,* Women and ceramics. Gendered vessels, Manchester/N. Y. 2000; *M. Brettle,* Ceramic rev. 190:2001 (Juli/Aug.) 56; *N. Lees,* ibid. 195:2002 (Mai/Juni) 22–25; *N. Mayo,* Kerameiki techni 42:2002 (Dez.) 23–26; *M. Flynn,* Ceramic figures. A direc-

tory of artists, Lo. 2002; Crafts 174:2002 (Jan./Febr.) 64; *I. Wilson*, Keramik mag. 25:2003 (4) 38–41; *A. Fielding*, Neue Keramik 5:2005, 22–25; *A. McErlain*, Ceramics. Art and perception 62:2005/2006 (Dez.-Febr.) 93–96; *E. Cooper*, Contemp. ceramics, Lo. 2009; *A. Gröppel-Wegener*, Pairings. Exploring collaborative creative practice, Manchester 2010; *A. Carlano* (Ed.), Contemp. Brit. studio ceramics. The Grainer coll., Lo./New Haven 2010; *C. Temin*, Ceramics. Art and perception 20:2011 (2) 62; Crafts 235:2012 (März/April) 11. – *Online:* Website C.

<div align="right">H. Stuchtey</div>

Currall, *Alan*, brit. Videokünstler, * 1964 Stoke-on-Trent, lebt in Glasgow. Stud.: 1982 Newcastle-under-Lyme SchA; 1989–92 Staffordshire Univ., Stoke-on-Trent; 1993–95 Glasgow SchA. Lehrtätigkeit ebd. Ausz.: 1992 Benjamin Boothroyd Prize, Staffordshire Univ.; 1995 Richard Ellis Prize, Glasgow SchA. – Mit einfacher Handkamera-Technik filmt C. (meist mit sich selbst als Hauptdarsteller) z.T. komische Szenen ohne bes. Bedeutung des Schauplatzes. So versucht er im Video *Sit* (1993), sich auf einen von ihm auf eine Tafel gemalten Stuhl zu setzen. Er interessiert sich bes. dafür, wie Wissen verarbeitet, akzeptiert und kommuniziert wird (*Video Word Processing*, 1995) und spricht die Zuschauer seiner Videos sehr direkt und persönlich an. Im Monolog *Lying about myself in order to appear more interesting* (1999) übernimmt C. den Aufbau der Sendung „Antique Roadshow" und präsentiert in einem Video interessante, vermeintlich bed., aber dennoch wertlose Objekte. Seine Erläuterungen zur Bedeutung und Herkunft der Objekte sind jedoch frei erfunden. In der CD Rom *Encyclopaedia* (2000) präsentiert C. eine Analyse menschlichen Verhaltens und ein demokratisches und evolutionäres Kunstprojekt, in dem Menschen (dem Alphabet folgend) die Bedeutung von Begriffen wie Blut, Eis und Wasser erklären und damit subjektives, erlerntes Wissen wiedergeben. Ähnlich den Videoarbeiten von Bruce Nauman, William Wegman und Bas Jan Ader regt C. mit einfachen Mitteln und filmischen Wiederholungen die Phantasie und Kreativität des Betrachters an, die Lücke zw. Dargestelltem und Vorstellung zu schließen. ⊙ *E:* 1996 Glasgow, Fringe Gall. / 1998 New York, Rupert Goldsworthy Gall. / 2000 Malmö, Signal Gall.; Stoke-on-Trent, Potteries Mus. and AG / 2001 Melbourne, Australian Centre for Contemp. Art (K); Bedford Creative Arts; München, Gal. Zink / 2002 London, Jerwood Gall. (K) / 2004 Glasgow, Gall. of Mod. Art / 2005 Göteborg, KM / 2011 Birmingham, Rhubaba Gall. ⌺ *Buckman* I, 2006. – *K. Gough-Yates*, Art monthly 200:1996 (Okt.) 63–65; *G. T. Turner*, AiA 87:1999 (1) 97 s.; *R. E. Pahlke* (Ed.), The Gap show. Junge zeitkrit. Kunst aus Großbritannien (K), Dortmund 2002; *B. Judd*, Art monthly 260:2002 (Okt.) 30 s.; *H. Martin*, ibid. 326:2009 (Mai) 27 s. – *Online:* Website C.

<div align="right">H. Stuchtey</div>

Currin, *John*, US-amer. Maler, * 1962 Boulder/Colo., lebt in New York. Verh. mit der Bildhauerin Rachel Feinstein. Stud.: bis 1984 Carnegie Mellon Univ., Pittsburgh; bis 1986 Yale Univ., New Haven. – C. malt, inspiriert von

hist. und zeitgen. Vorlagen, figurative Gem. mit provokanter sexueller und teilw. sozialer Thematik. 1989–90 entsteht nach Vorlagen aus HS-Jbb. eine Serie mit Schulter-Portr. von Absolventinnen vor einfarbigem blassen Hintergrund, die gepflegt, aber ausdruckslos und flach erscheinen. Es folgt 1991 eine ähnlich silhouettierte Portr.-Serie von Frauen mittleren Alters, die altbacken, mit spitzen Nasen, verdrehter Haltung unvorteilhaft und eher karikaturartig dargestellt sind (*Nadine Gordimer*, 1992; *Ms Omni*, 1993). Vorlagen für ganzfigurige Frauen-Darst. und ab 1995 zunehmend bärtige Männer und Paare stammen aus populären Zss., Werbung und Pornographie, wobei C. die erotischen Partien des Frauenkörpers deutlich übertreibt (*Bra Shop*, 1997). Char. sind blonde, kurvige, klischeehaftige Schönheiten mit riesigen Brüsten. Neben fein gemalten Bereichen läßt C. rauhe, mit dem Palettenmesser gemalte Flächen bes. in den Gesichtern stehen (*The invalids*, 1997). Die exzessiven Phantasien, die Ausdruckslosigkeit der Frauen und parodierte Darst. vermitteln einen psychologisch beunruhigenden Effekt. Seit E. der 1990er Jahre orientiert sich C. an Gem. und bes. Akt-Darst. des 16. und 17. Jh. wie z.B. Lucas Cranach d.J. und Hans Baldung; mehrere Akt-Gem. entstehen um 1998/99 vor schwarzem Hintergrund; häufig steht ihm seine Frau Modell (*Honeymoon Nude*, 1998). C. zitiert offen Rubens, Botticelli, Tiepolo oder Rembrandt, wobei die verdrehten, manierierten Posen mit bes. überlängten Fingern im Gegensatz zu den deutlich der Gegenwart entnommenen und fast comicartigen Gesichtern stehen. Seit 2008 malt er v.a. laszive erotische Szenen, die auf pornographische Darst. zurückgreifen (*The Conservatory*, 2010). – C. ist ein internat. bek. und gefeierter Künstler, der sich für z.T. altertümliche, aber typ. US-amer. Klischees interessiert und diese ironisch und süßlich in technisch perfekter Malweise darstellt. ⌺ DENVER/Colo., Univ. of Denver, SchA and Hist. Gall. LIMOGES, FRAC Limousin. LONDON, Tate. LOS ANGELES, MCA. MINNEAPOLIS, Walker AC. NEW YORK, MMA. PARIS, MNAM. WASHINGTON/D. C., Hirshhorn Mus. and Sculpt. Garden. ⊙ *E:* New York: 1992, '94, '95, '97, '99, 2001, '09 Andrea Rosen Gall.; 2006, '10 Gagosian Gall. (K) / San Francisco: 1994 Gal. Jennifer Flay; 1995 Jack Hanley Gall. / London: 1995 Inst. of Contemp. Arts; 2003 Serpentine Gall. (K); 2000, '08 Sadie Coles Headquarter / 1995 Seattle (Wash.), Donald Young Gall.; Limoges, FRAC Limousin / 1996, '99, 2002 Los Angeles, Regen Projects / 2000 Köln, Monika Spruth Gal. / 2002 Tokio, Taka Ishii Gall. (K) / 2003 Aspen, AM. ⌺ *U. Grosenick* (Ed.), Art now, 2, Köln u.a. 2005; *Bénézit* IV, 1999; *Delarge*, 2001. – Not so simple pleasures, C., Mass. 1990; *F. Bonami*, Flash art 25:1992 (164) 100 s.; *J. Decter*, Artforum 32:1994 (9) 100 s.; J. C. Œuvres 1989–1995, Limoges 1995; *K. Seward*, Flash art 28:1995 (185) 78–80; *M. van der Walle*, Parkett 50/51:1997, 240–248; *B. Schwabsky*, AiA 85:1997 (12) 80–85; *id.*, Artforum 37:1999 (Mai) 182 s.; *E. Leffingwell*, AiA 2000 (2) 124 s.; *J. Higgie*, Frieze 54:2000 (Sept.-Okt.) 115; *J. Becker*, Vogue (N. Y.) 190:2000 (11) 480–485; Naked since 1950 (K C & M Arts), N. Y. 2001; The honeymooners. J. C. and Rachel

Feinstein (K), Hydra 2002; *D. A. Greene*, Mod. paint-
ers 15:2002 (3) 66 s.; *L. Hoptmans*, Drawing now. Eight
propositions (K MMA), N. Y. 2002; *R. Storr*, Artpress
280:2002 (Juni) 45–50; *D. Frankel*, Artforum 41:2002
(März) 137; *D. Rimanelli*, ibid. 42:2003 (Sept.) 218 s.;
R. Cumming/M. Palin, ArtRev 1:2003 (12) 101; J. C.
(K MCA), Chicago 2003; *S. Wallis*, BurlMag 154:2003
(1209) 883–885; New criterion 22:2004 (5) 44; *R. Rubin-
stein*, AiA 2004 (Juni/Juli) 160–163; *M. Hawkins*, Artnews
103:2004 (Febr.) 117; *G. Politi*, Flash art 38:2005 (Juli-
Sept.) 96–100; *A. C. Danto*, Unnatural wonders. Essays
from the gap between art and life, N. Y. 2007; *M. Rappolt*,
ArtRev 21:2008 (April) 50–59; *E. Badura-Triska/S. Neu-
burger* (Ed.), Bad painting. Good art, Köln 2008; *S. Kent*,
Art world 5:2008 (Juni/Juli) 118–120; *J. Panero*, New cri-
terion 30:2011 (4) 18–21; Vitamin P. New perspectives
in paint., Lo./N. Y. 2002; *U. Grosenick/B. Riemschneider*
(Ed.), Art now. 81 artists at the rise of the new millenni-
um, Köln u.a. 2005; *C. Mullins*, People. Kunst heute, Köln
2006; *R. Klanten u.a.* (Ed.), The upset. Young contemp.
art, B. 2008. H. Stuchtey

Cursaro, *Enzo*, ital. Maler, Kunsterzieher, * 1953 Paes-
tum, lebt seit 1989 in Verona. Stud.: Scuola d'Arte, Saler-
no; ABA, Neapel, bei Domenico Spinoza (1978 Dipl.). Be-
zieht anfangs Objekte in seine Malerei ein und beobachtet
deren unterschiedliches Verhalten im Licht. Um 1985 Re-
duzierung der Palette auf Schwarz, Grau, Ocker und Rot;
spiralförmige Zeichen, Auffächerung des Raumes, intimes
Licht. Später zunehmende Farbenvielfalt und um 1995 ge-
radezu expressive Palette mit lichtreflexartigen Effekten.
In der Folge *Sospensioni* (1999–2006) dominiert schwar-
ze, lackähnliche Farbe. Die Arbeiten werden unter nur ei-
nem Titel zusammengefaßt und führen in Bereiche jen-
seits von Rationalität. Etwa gleichzeitig entstehen die Zy-
klen *Nero-Argento* und *Rosso Oro*, in denen z.T. geheim-
nisvoll wirkende unterschiedliche Lichteffekte auf geome-
trische Formen im Mittelpunkt von C.s Interesse stehen.
Um 2005 gelangt er zu einem lyrischen Symbolismus mit
zahlr. Metaphern, Trauminhalten und Anklängen an Mini-
mal art mit Aufhellung der Palette und betonter Emotiona-
lität. Später, in der Folge *Tondi*, Auseinandersetzung mit
unterschiedlichsten Arten von Sand als Form von Urma-
terie der Erdgeschichte. Durchgängiges Hauptthema von
C. bleiben Energie und Materie als Trägerinnen von Licht,
Archetypen und Symbolen; seine Arbeiten sind häufig von
elegant-mon. und meditativer Wirkung. ⊙ E: 1978 Sa-
lerno, Gall. Il Campo / 1983 Neapel, Gall. S. Carlo / 1986
Porno, Gall. Internaz. / 1989 Poitiers, Gal. Diane Grimaldi
(K) / 1995 Strasbourg, Gal. Brulée / 1996 Riva del Gar-
da, Gall. La Firma / 1997 Barcelona, Gal. Prisma / 1998
Mantua, Mus. di Pal. Ducale / 1999 Bassano del Grap-
pa, Mus. Pal. Agostinelli / 2000 Verona, Gall. Scala Ar-
te; Venedig, Mus. Scuola Grande di S. Rocco / 2004 Nea-
pel, Villa Com. / 2005 Piombino Dese, 12 Fabrika / 2010
Villafranca, Mus. del Risorgimento Pal. Bottaggisio (K). –
G: 1978 Minori, Gall. Il Vecchio Mulino: Una matrice as-
tratta / 1982 Neapel, S. Chiara: Internaz. di Grafica / 1986
Genazzano, Castello Colonna: Internaz. d'arte / 1994 Bo-

zen, Gall. Civ.: Jardins d'hiver / 1995 Arezzo, Assoc. pro
Anghiar: Vie Toscane / 2000 Genf, Gal. Dumont: Livre ob-
jet – Livre d'artiste / 2001 Salerno, Gall. Studio '34: Prin-
cipali espos. collettive. ⌑ *P. Lorusso* (Ed.), E. C. Ner-
oargento (K Salerno), Mi. 2001; *G. Cortenova u.a.*, E. C.,
Mi. 2009. – *Online:* Website C.; 12 Fabrika.
 S.-W. Staps

Curtis, *Matthew*, austral. Glaskünstler, * 17. 8. 1964
Luton/Beds., lebt in Queanbeyan/N. S. W. C. geht 1981
nach Australien und erwirbt sich seine beruflichen Grund-
lagen als Ass. von Robert Wynne im Denizen Glass Stu-
dio, Sydney (1991–98), von Lino Tagliapietra in Adelai-
de (1996), im Workshop von Benjamin Edols und Kathy
Elliott am Corning Mus. of Glass, Corning/N. Y., und im
Robert Carlson Workshop in Sydney (beide 1998). 1998,
2000 Tutor am Sydney College of the Arts. Unterhält seit
2004 ein gemeinsames Atelier mit Harriet Schwarzrock
in Queanbeyan. Ausz.: 1999 Stip., Creative Glass Centre
of America, Millville/N. J.; Thomas Found. Glass Artist
Grant; 2002, '04, '06 New Work Grant, Australia Coun-
cil. – Die Formen von C.s geblasenen Glas-Skulpt. er-
innern nach eig. Aussage (Website C.) entfernt an ver-
größerte organische Strukturen (z.B. den Rückenschild
oder Thorax eines Käfers wie in *Red Thorax*, 2007) bzw.
sind von minimalistischer Archit. beeinflußt. C. arbeitet
mit Überfangtechnik, wobei die versch. kontrastierenden
Farbschichten durch Abschleifen und Bohren mittels ei-
nes präzis gesetzten, gepunkteten Rasters freigelegt wer-
den (*Grid Series*). Stücke der *Segmented Structures series*
sind aus einzelnen, formgeblasenen Komponenten zusam-
mengesetzt, das Objekt wird anschl. geschliffen und po-
liert, wobei durch die versch. Stärken des Glases und Luft-
einschlüsse reizvolle Licht- und Farbwirkungen entstehen.
⌂ CANBERRA, NG of Australia. COESFELD, Glas-Mus.
Herding. PALM SPRINGS/Calif., Palm Springs AM. SAN
FRANCISCO/Calif., de Young, Saxe Coll. WAGGA WAGGA/
N. S. W., AG, Nat. Glass Coll. ⊙ E: 2001, '04 Zü-
rich, Sanske Gal. / 2003, '05 Melbourne, Axia Mod. Art /
2003 Sydney, Quadrivium Gall.; Canberra, Beaver Gall. /
2008 Cleveland (Ohio), Thomas R. Riley Gall.; Aspen
(Colo), Pismo Gall. ⌑ *P. Schmitt*, Austral. Impressio-
nen (K Gal. Rosenhauer), Göttingen 2006; Ranamok Glass
Prize 2009 (K), Sydney 2009. – *Online:* Axia Mod. Art;
Website C. C. Rohrschneider

Cusi, *Annibale*, ital. Goldschmied, Juwelier, * 1863
Mailand, † 1930 ebd. Lehrling, Geselle und Meister in der
Goldschmiede-Wkst. Galletti. 1886 Eröffnung einer eig.
Juwelier-Wkst. und -handlung, die in den folgenden bei-
den Jahrzehnten stark expandiert. 1906 Großer Preis der
WA in Mailand für ein spektakuläres Kollier aus Platinu-
ralium (Legierung aus Platin, Gold, Silber und Alumini-
um) mit ca. 15000 Diamanten besetzt in einem vom Liber-
ty inspirierten Girlandenstil. Ab 1915 Mitarb. des Sohnes
Rinaldo C. (* 1895, † 1979) und Hoflieferant des Herzogs
von Savoyen. 1929 Eröffnung einer Filiale in San Remo.
Nach C.s Tod wird die noch existierende Fa. von Rinaldo
C. unter Mitarb. von dessen Söhnen *Ettore C.* (* 1922) und
Roberto C. (* 1926, † 1996) geführt, gefolgt von *Rinaldo*

C. (* 1950). ▭ Dict. internat. du bijou, P. 1998 (s.v. Cu-si); *G. Vergani* (Ed.), Diz. della moda, Mi. ³2004. – A. C. Gioielliere in Milano. Pietre preziose ed oggetti speciali (K), Mi. [nach 1922]; Milano 70/70 (K), I, Mi. 1970.

D. Trier

Cusi, *Ettore* cf. **Cusi,** *Annibale*
Cusi, *Rinaldo* (1895) cf. **Cusi,** *Annibale*
Cusi, *Rinaldo* (1950) cf. **Cusi,** *Annibale*
Cusi, *Roberto* cf. **Cusi,** *Annibale*

Cussol, *Béatrice,* frz. Zeichnerin, Malerin, Schriftstel-lerin, * 21. 10. 1970 Toulouse, lebt in Paris. Stud.: bis 1988 Ec. nat. supérieure d'Art, Bourges; 1993 Ec. Pi-lote internat. d'Art et de Recherche Villa Arson, Nizza. 2009–10 Artist in Residence, Villa Medici, Rom. Lehr-tätigkeit: Ec. régionale des BA, Rouen. – Skurrile weib-liche Figuren mit verzerrten Körperformen, hermaphrodi-tischen Merkmalen und hervorgehobenen Geschlechtstei-len (z.B. *Mlle Cucu et sa Sœur,* 1996) bevölkern C.s groß-formatige Komp. auf Papier (v.a. Tusche und Aqu., z.T. auch Filzstift und Gouache), die meist vor weißem Hin-tergrund angeordnet sind. Die z.T. provozierenden homo-erotischen Motive zeigen bevorzugt versch. Körperflüssig-keiten (z.B. *Poulette mal assise,* 1996) sowie die Penetrati-on von Körperöffnungen durch spitze Formen wie Hausdä-cher. ▭ Genf, MAMC. Marseille, FRAC Provence-Alpes-Côte d'Azur. Nizza, MAM et d'Art contemp. Pa-ris, FNAC. ▭ *Romane:* Merci, P. 2000; Pompon, P. 2001; Diane ?, P. 2003; Sinon, P. 2007; Les souffleuses, P. 2009. ◉ *E:* 1994 Nizza, Villa Arson / 1996 Neuchâtel, Centre d'Art / 1999 Genf, MAMC / 1999, 2003, '06 Paris, Gal. Rachlin-Lemarié / 2000, '03 (mit Paul-Armand Gette; K), '06 Marseille, Gal. Porte Avion / 2008 New York, En-voy Gall. / 2012 Saint-Denis (Réunion), Gal. Béatrice Bi-noche; New York, Elga Wimmer PCC. –. *G:* Nizza: 1993 Villa Arson: Les Passants du Phalanstère; 2007 MAM et d'Art contemp.: Nice to meet you (K) / 1994 Villeur-banne, Gal. Georges Verney-Carron: Scènes de Ménage / 1999 Genf, MAMC: Patchwork in Progress 7 et dernier / 2004 Tourcoing, MBA: De leur Temps / 2005 Lyon, MAC: My Favorite Things. Peint. en France (K) / 2007 Kera-va, KM: Conversations; New York, Brooklyn Mus.: Glo-bal Feminism / 2010 Douala (Kamerun), Centre d'Art con-temp. Doual'art: Figures de Rêve. ▭ *Delarge,* 2001. – *B. Lamarche-Vadel/J.-P. Vienne,* B. C. (K Gal. La Box), Bourges 1999; *R. Leydier,* Art press 261:2000, 44–46; Prêts à prêter. Acquisitions et rapp. d'activités 2000/2004, FRAC Provence-Alpes-Côte d'Azur, P./Marseille 2005. – *Online:* Synesthesie (Interview v. 3. 9. 2001). F. Krohn

Cutler, *Amy,* US-amer. Malerin, Zeichnerin, * 1974 Poughkeepsie/N. Y., lebt in New York. Stud.: 1994–95 Staatliche HBK, Städelschule, Frankfurt am Main; bis 1997 Cooper Union SchA, New York; bis 1999 Skowhe-gan School of Paint. and Sculpt., Skowhegan/Me. – Mit Anklängen an die naive Kunst malt C. in Gouache mi-niaturhaft fein ausgef. Motive mit Frauen, die meist skur-rilen Beschäftigungen nachgehen bzw. sich in unwirkli-chen Situationen befinden, dadurch jedoch reale Emotio-nen erlebbar werden lassen (*Tiger nähen,* 2003; *Above the*

Fjord, 2010). Die auch mit Tieren und Mischwesen be-völkerten narrativen Szenen wecken Assoziationen an sur-reale Traumwelten ebenso wie an Fabeln oder Märchen. ▭ Greensboro/N. C., Weatherspoon AG. Indianapo-lis/Ind., Mus. of Art. Kansas City/Mo., Hallmark Coll. Lincoln/Nebr., Sheldon Memorial AG. Los Angeles, Univ. of California (UCLA), Hammer Mus. Minneapo-lis/Minn., Walker AC. New York, MMA. – Public Li-br. – Metrop. Mus. – New Mus. of Contemp. Art, Altoids Coll. – Whitney. Overland Park/Kan., Johnson County Community College, Nerman MCA. ◉ *E:* 2000 Bos-ton, Miller Block Gall. / 2002 Philadelphia (Pa.), Inst. of Contemp. Art; Minneapolis, Walker AC (mit David Rath-man) / 2002, '04, '07, '11 New York, Leslie Tonkonow Artworks + Projects / 2003 Sheboygan (Wis.), John Mi-chael Kohler AC / 2004 Kansas City (Mo.), Kemper MCA / 2006 Providence (R. I.), Brown Univ., David Winton Bell Gall., und Indianapolis (Ind.), Mus. of Art (K: L. D. Frei-man, ed. Ostfildern-Ruit) / 2007 Madrid, CARS, Espacio Uno / 2008 Brunswick (Me.), Bowdoin College Mus. of Art / 2010 Greensboro, Univ. of North Carolina, Wea-therspoon AG / 2011 Stockholm, Gall. Magnus Karlsson. ▭ *C. Mullins,* People. Kunst heute, Köln 2006 (Lit.); A. C. Turtle fur (K Santa Fe und Santa Barbara), Ostfil-dern 2011. – *Online:* Tonkonow; David Winton Bell Gall.

C. Rohrschneider

Cutsem, *Louis van* (Van Cutsem, *Louis*), belg. Bild-hauer, Medailleur, * 1909 Evere/Brüssel, † 1992 Scha-erbeek/Brüssel. Ausb. in der väterlichen Steinmetz-Wkst. (Grabdenkmäler). Danach Abendkurse an der Acad. in Sint-Joost-ten-Noode bei den Bildhauern Gustave Fontai-ne und Bernard Callie. Daneben ist C. ein enthusiastischer Freizeitsportler (Fußball, Radrennen), was sein künstle-risches Werk prägt. Ausz.: 1931 1. Preis der Prov. Bra-bant. 1936 Heirat und Umzug nach Schaerbeek (Atelier in der Rue Gallait 106). 1935–36 Wettb.-Beteiligung (z.B. Entwürfe für eine Bronze-Med.) im Kontext der Olym-pischen Spiele in Berlin. Im 2. WK steht C. dem belg. Widerstand nahe, indem er mehreren von der dt. Besat-zung verfolgten Personen (u.a. einer jüdischen Fam.) Un-terschlupf gewährt, wofür er und seine Frau Jeane 1974 vom Staat Israel mit dem Ehrentitel Gerechter unter den Völkern (Chassid Umot ha-Olam) ausgezeichnet werden. – C.s Œuvre umfaßt drei bildhauerische Werkgruppen. V.a. realistische, bisweilen ins Monumentale gesteigerte figür-liche Plastiken, Skulpt., Reliefs, Med. und Trophäen mit Sujets aus der Sportwelt, darunter reliefierte, z.T. abstra-hierte Darst. von Sportlern (Ruderer, Basketballer, Fech-ter), auch Portr.-Büsten und Skulpt. (häufig aus belg. oder frz. Blaustein [petit granit], auch Marmor, Gips, Bronze) von berühmten, meist belg. Sportlern. Mit einigen von ih-nen ist C. befreundet, so mit dem Boxer *Pierre Charles* (Europameister) oder dem Radrennfahrer *Joseph Sche-rens* (Sprintweltmeister), die ihm mehrfach Modell sitzen. Auch der bek. frz.-schweiz. Schauspieler *Michel Simon* sitzt ihm tagelang Modell ebenso wie *Eddy Merckx.* Das Hw. unter den Sportplastiken ist die mon. Skulpt. des 1953 bei einem Rennen tödlich verunglückten *Stan (Constant)*

Ockers op zijn fiets. C.s zweite Werkgruppe besteht aus humoristischen oder karikierenden Portr.-Plastiken u.a. von Politikern (Stalin, Churchill, Roosevelt), auch von Sportlern oder Lokalpolitikern. Die dritte Werkgruppe umfaßt Sepulkral-, Sakral- und Erinnerungsplastik, u.a. (Grab-) Denkmale zu Ehren der Opfer des 2. WK zu den Themen Deportation und Résistance. Auch Zchngn und Karikaturen. – Monogr. Bearbeitung und WV stehen aus. ⌂ COURT-SAINT-ETIENNE, Av. des Combattants: Mon. aux Morts (Mon. de la Résistance), 1966. ⌷ *C. Engelen/M. Marx*, Beeldhouwkunst in België, III, Br. 2002.

U. Heise

Cuville, *Fernand*, frz. Fotograf, * 12. 11. 1887, † 25. 6. 1927 Bordeaux. Jugend in Bordeaux. Zunächst Klarinettist (1907 Ausz. des Konservatoriums von Bordeaux). Lernt bei den Fotografen Auguste Léon und Georges Chevalier. 1915–19 Soldat. Für den fotogr. und kinematografischen Dienst der Armee fotografiert C. Autochrom-Platten an der Front im Nordosten Frankreichs (u.a. 1917 in Reims) und in Belgien sowie 1918 in Südosteuropa, wo er u.a. einige Ansichten vom Berg Athos aufnimmt. 1919–21 arbeitet C. für das Projekt „Les Arch. de la Planète" des Bankiers Albert Kahn: Er fotografiert in Versailles, Paris und England (evtl. zus. mit G. Chevalier) und dokumentiert den Wiederaufbau in den kriegs-zerst. Dépt. Marne, Meuse, Aisne und Haute-Rhin; 1919–20 entstehen Aufnahmen im Südwesten Frankreichs. Nach 1921 ist keine weitere fotogr. Arbeit dokumentiert. ⌂ BOULOGNE-BILLANCOURT, Mus. Albert Kahn. MONTIGNY-LE-BRETONNEUX, Fort de Saint Cyr: La Médiathèque de l'Archit. et du Patrimoine, Arch. photogr. ☉ *G:* 1997–98 Thessaloniki, Inst. franç.: 1913 & 1918. Autochromes du mont Athos (Wander-Ausst.; K) / 2003–04 Canberra, Australian War Memorial: Captured in Colour. Rare Photographs from the First World War (K) / 2011 Antony (Hauts-de-Seine), Maison des Arts: Guerre et Vie. ⌷ *C. Bouqueret/F. Livi*, Le voyage en Italie. Les photographes franç. en Italie 1840–1920, Lyon 1989; Italie. Points de vue, 1912–1925 (K Espace Albert Kahn), Boulogne-Billancourt 1991; *A. Fleischer*, Couleurs de guerre. Autochromes 1914–1918, Reims et la Marne (K Reims), P. 2006; *P. Roberts*, 100 Jahre Farb-Fotogr., B. 2007. – *Online:* La Médiathèque de l'Archit. et du Patrimoine. P. Freytag

Cuyper, *Herman (Hermanus Josephus) de*, belg. Bildhauer, Maler, Zeichner, Keramiker, * 22. 11. 1904 Blaasveld, † 17. 6. 1992 ebd. Stud.: 1920–23 (Malerei, Zeichnen, Bildhauerei) Koninkl. ASK, Mechelen, u.a. bei Théo Blickx, Pierre Henri van Perck und Jan Willem Rosier; 1923 Roger Langbehnprijs und Mitgl. der Lukasgilde ebd.; 1924 Sted. Vakschool ebd. bei Emile Bourgeois (Holzschnitzen, Drechseln, Möbelskulptierung). 1925 Militärdienst in Brüssel; dort gleichzeitig Abendkurse an der Koninkl. ASK bei Arsène Matton. 1926–30 als Holzbildhauer für versch. Möbelhäuser in Mechelen tätig. Danach freischaffend. Mitgl. der bis 1931 bestehenden kath. Künstlergruppe De Pelgrim. 1933 Heirat (acht Kinder). 1984 Eröffnung des eig. Mus. am Heimatort (Plastiken, Gem., Zchngn). – C.s bildhauerisches Œuvre umfaßt figurative Arbeiten in Gips, Bronze, Holz, Marmor und Stein (meist Kalk-, Sand- oder Kunststein), wobei er häufig en taille directe arbeitet. Ab 1930 erhält er Aufträge für Sakralplastiken, u.a. für Hll.-Figuren (*Sint-Job*, Holz, 1930) und Kreuzwege (z.B. 14 Basreliefs, Kalkstein, 1942–44; Ruisbroeck, Hof ter Zielbeek). Zu seinen bed. Arbeiten gehört der mon. Rosenkranzweg im Außenbereich der Onze-Lieve-Vrouw-ten-Traankerk in Kalfort, der aus 15 lebensgroßen Skulpt.-Gruppen (Kalkstein, 1951–52) besteht und als char. Beispiel mod. relig. Bildhaukunst der frühen 1950er Jahre in der Prov. Antwerpen gilt. Auch die häufig intimistischen Porträtbüsten und figürlichen Plastiken (Kinder, Mütter, Schwangere, Akte) sind anfangs im realistischen Stil seiner Lehrer, später zunehmend formreduziert und abstrahierend ausgeführt. C.s Grabplastiken v.a. auf den Friedhöfen in Blaasveld und Puurs. Ab 1962 auch keramische Arbeiten. Der künstlerische Nachlaß wird im C.-Mus. in Willebroek-Blaasveld bewahrt. ⌂ BOOM, Sint-Catharinakerk: Kreuzweg, 1939. BORNEM, Oorlogs-Mon., Bronze/Stein, 1934. – B.-Mariekerke, Jan-Hammenecker-Mon., Kunststein, 1957. TISSELT, Sint-Jan-de-Doperkerk. WILLEBROEK-Blaasveld, Sint-Amanduskerk. – Mus. Herman de Cuyper. – Oorlogs-Mon., 1929. – Park Bel-Air. ☉ *G:* 1937–38 Antwerpen, Stadsfeestzaal: Kunst van Kongo (K) / 2008–09 Lier, Timmermans-Opsomerhuis: Pelgrimkunst. Religie en moderniteit 1910–1940. ⌷ *C. Engelen/M. Marx*, Beeldhouwkunst in België, I, Br. 2002; *Pas* I, 2002. U. Heise

Cuyvers, *Wim*, belg. Architekt, Archit.-Theoretiker, * 19. 2. 1958 Hasselt/Limburg, lebt in Châtillon/Jura. Stud.: 1977–82 Archit., Hoger Archit.-Inst., Gent. Lehrtätigkeit: 1995–98 Acad. voor Bouwkunst, Tilburg; 1995–2003 Design Acad., Eindhoven; 1996–2000 Sint Lucas, Gent; 2004 TU, Delft; 2004/05 Ec. d'Archit., Paris-Malaquais; 2005–08 Jan van Eyck Acad., Eindhoven. Ausz.: u.a. 2006 Vlaamse Cultuurprijs (Archit.). Mitarb. von u.a. Venturi, Rauch & Scott Brown, Philadelphia/USA und Paul Robbrecht und Hilde Daem, Gent. 1984 Gründung des eig. Büros in Gent. 2000 Umzug nach Frankreich. – V.a. Beschäftigung mit dem Verhältnis von Mensch und (gebauter) Umwelt, dem öff. Raum und seiner Nutzung sowie Städtebau; dazu Untersuchungen, Dok. und Publ., u.a. zum spezifischen öff. Raum in Städten wie New York, Sarajevo, Belgrad, Paris und Tirana. Teilw. Zusammenarbeit mit and. Künstlern wie bei dem Projekt *The Stone Road* (2009) über die Nat.-Straße N6 in Belgien mit Veröff. der Ergebnisse als Ausst. (Fotogr., Modelle, Video, Installation), Ztg und Performance. Weitere Projekte: *The Impossibility of Planning* (2003) über das Stadtviertel Transvaal in Den Haag, eine Installation mit 20 Zelten auf dem Friedhof von Zwalm-Rozebeke (2007) und die Ansiedlung Montavoix/Jura, die C. als öff. Raum und Zufluchtsort definiert und in der Bewohner auf Zeit leben und arbeiten. Außerdem Entwurf und zahlr. Umbauten von öff. Gebäuden, Wohn- und Geschäftsräumen, u.a. für das Atelier der Grafikdesign-Fa. Blauwe Peer mit einem beweglichen,

raumbeherrschenden „Supermöbel" (Gent, New-York-Str. 7–9) und das Büro- und Wohnhaus Fa. Namahn (Brüssel, Grens-Str. 21, 2006–09), beide in ehem. Industriegebäuden. ▯ DEN HAAG, Hogewal 1–9: Neu-Gest. des Kunst- und Archit.-Zentrums Stroom, 2004. GENT, Vlanderenstraat 94: Boutique Oona, 1990 (mit Dirk de Meyer). – Maria Middelares Hospital: Empfangs- und Warteräume. GITS: Doppelhaus Baete, 1999/2000. ▭ Archis 2001 (3) 72–76; (5) 66–68; (6) 58–62; 2002 (1) 80 s.; (3) 54–56; 2004 (4) 39–45; *C./M. DeBlieck*, [ohne Titel, Textbeginn: The house is in the town], Br. 2002; A + 183:2003, 78–82; Archit. and urbanism 392:2003, 20–23; Tekst over tekst, D. H. 2005; Domus 896:2006, 66–73; Oase 70:2006, 20–29; 81:2010, 121–126. ◉ *E:* 1995 Antwerpen, deSingel (K) / 2005 Den Haag, Stroom (K). ▭ *A. Van Loo* (Ed.), Dict. de l'archit. en Belgique, Ant. 2003. – Jonge architekten in Vlaanderen, Gent 1991; *L. Melis*, Architect (D. H.) 22:1991 (5) 63; *W. Mann*, Archis 1995 (10) 12–14; *A. Wortmann*, Archis 1998 (8) 29–37, 2000 (10) 55–59; Homeward. Contemp. archit. in Flanders, Ant. 1998; Stadbeeld Eindhoven, Rotterdam 1999; Moniteur archit. AMC 108:2000, 134 s.; *E. Melet*, Architect (D. H.), 32:2001 (2) 66–69; Archit. and urbanism 392:2003, 36–39; AV monografias 102:2003, 86–89; *C./F. Tacq*, Beograd – Den Haag, D. H. 2003; *M. Dubois*, Architect (D. H.) 34:2003 (11) 80 s.; *E. vanHinte* (Ed.), Artificial arcadia, Rotterdam 2004; *M. Quinton*, Moniteur archit. AMC 146:2004, 110 s.; A + 183:2003, 30, 200:2006, 50–59 (Interview); Archit. in Vlaanderen, Jb. 2006/07 u. 2008/08, Br. 2008–10; Brakin. Brazzaville – Kinshasa, Baden 2006; *J. Lagae*, Oase 69:2006, 32–45. – *Online:* Blog C. N. Buhl

Cvetkov, *Anatolij Borisovič*, russ. Maler, Karikaturist, * 1923 (1922?), † 1976. Stud.: bis 1941 Künstler-graph. Fak. Goznak-FS, Moskau. Teiln. am 2. WK (Artillerie). Ab 1958 im Kunststudio der Zs. Krokodil Karikaturen und humoristische Zchngn, die C. ebd. publiziert. Zusammenarbeit mit Jurij Nikolaevič Fedorov und Aminadav Moiseevič Kanevskij. Teiln. an zahlr. Reisen mit der Zs.-Red., u.a. ins Chemiefaserwerk Barnaul, nach Petropavlovsk/ Kasachstan, ins Papierkombinat Balachna b. Nižnij Novgorod. Auch Zchngn für Kinder-Zss., u.a. Veselye kartinki (1975). – Neben meist kleinformatigen lyrischen Lsch. und Portr., die stimmungsreich und in der Farb-Gest. subtil sind, bevorzugt Karikaturen, für die sich C. schon frühzeitig interessiert hatte. Char. sind ein optimistischer Grundgestus und eine verdichtete Darst. kritischer, sozialtypischer Details, die C. durch treffende Bildunterschriften noch zusätzlich betont. Bemerkenswert sind z.B. seine Karikaturen menschlichen Fehlverhaltens (z.B. parasitärer Lebensweisen, Bürokratie, z.B. *Godovye kol'ca odnogo tresta*) und alltäglicher Schwächen (üble Nachrede, z.B. *Strašnyj sud*, 1968), deren spezieller Humor sich teils aus Bezügen auf archetypische Gem.-Inhalte (z.B. I. I. Šiskin, Utro v sosnovom boru) oder Märchen (z.B. Kolobok) speist. ▯ MOSKAU, Zs. Krokodil, Archiv. ▭ *Bown*, 1998 (s.v. Tsvetkov, Anatoli Borisovich). – *I. P. Abramskij*, Smech sil'nych, Mo. 1977. D. Kassek

Cvetkov, *Cvjatko (Cvjatko Donev)*, bulg. Maler, Bühnenbildner, * 27. 11. 32 Brăšljan b. Ruse, † 1989 Ruse. Stud. der Malerei an der KA Sofia bei Marčo Kirov. Mitgl. der Ortsgruppe Ruse des Verb. bulg. Künstler; neben einigen Einzel-Ausst. in Ruse (1960, '65, '76) ab 1960 sporadische Teiln. an den Ausst. des Landes-Verb. bulg. Künstler und vertreten in Präsentationen bulg. Kunst im Ausland (Moskau, Riga, Bratislava, Hamburg, Wien, Warschau). Zeitweise künstlerischer Leiter des Puppentheaters Ruse (wohl in den 1960er und 1970er Jahren), für das zahlr. Bühnendekorationen entstehen: u.a. 1968 *Junakăt i zlatnata jabălka*; 1969 *Razgnevenoto žitie*, beide nach Ivan Teofilov; 1972 *Željaznoto momče* nach Jordan Radičkov; 1973 *Dvuboj v gorata* nach Nikolaj Hajtov; 1978 *Kăde otivaš konče* nach Rada Moskovska. 1980 Bühnendekaration für eine Bearb. von *Alice's Adventures in Wonderland* nach Lewis Carroll am Puppentheater in Sofia. Mit seinen Bühnenentwürfen nimmt C. an internat. Wettb.-Ausst. in São Paulo, Buenos Aires, Prag, München und Moskau teil. Ausz.: 1971 Orden „Kiril i Metodij" 2. Stufe; 1976 3. Preis für Szenographie des Komitees für Kultur und des Minist. für Bildung; 1978 Preis für Szenographie des Verb. der bulg. Architekten. – C.s szenographische Arbeiten für das Puppentheater nehmen das Märchenhafte und Phantastische der Stücke in effektvollen Raum-Gest. auf, zielen auf die Einbeziehung des jungen Publikums und dessen Anteilnahme am Spielgeschehen. Vorwiegend widmet er sich jedoch der Malerei. Neben einer Reihe von Portr., häufig von jungen Frauen aus dem Theaterumfeld (*Portret na Momiče*, 1961; *Marija*, 1962; *Aktrisa s kukli*, 1971; *Portret na aktrisata G. Kr.*, 1973; *Portret na Emilija*, 1975; *Portret na učitelkata M. V.*, 1976), entstehen mehrere melancholisch gestimmte Selbstbildnisse, deren graph. und malerische Textur die düster-bizarre, fast morbide Bildatmosphäre unterstreicht (*Avtoportret*, 1980; Sofia, Städtische KG). Als Landschaftsmaler sieht sich C. nicht einem Abbild der Natur, sondern vielmehr der Schaffung einer kreativen Entsprechung verpflichtet. Er greift v.a. die einfachen konstruktivistischen und archit. Formen in Natur und urbaner Wirklichkeit auf, wodurch die Lsch.-Bilder den Eindruck einer statisch geordneten, von keinem dramatischen Linienspiel bewegten, robust-soliden Theaterkulisse vermitteln (*Južen grad*, 1977; *Pejzaž ot Riga*, 1978). ▯ RUSE, KG. SOFIA, Nat. KG. – Städtische KG. VARNA, KG. ◉ *G:* 1967 (3. Preis), '74 (1. Preis) Sofia: Leistungsschau der Puppentheater in Bulgarien / 1969, '78 Varna: Internat. Puppentheaterfestival „Goldener Delphin" (jeweils Ausz.) / 1978 Zagreb: Internat. Puppentheaterfestival (1. Preis) / 2011 Ruse, AC Mega Mol: Rusenski sjuželi. Edin vek. ▭ EIIB III, 2006. – Obšta chudožestvena izložba '72 posvetena na 90-godišninata ot roždenieto na G. Dimitrov (K), Sofija 1973; Obšta chudožestvena izložba posvetena na 30-godišninata ot 9. 9. 1944 (K), Sofija 1975; Obšta chudožestvena izložba „Čovekăt i trudăt" (K), Sofija 1978; Živopisna Poezija, 1982 (Film); *A. Antonov* (Regie), Nezasăchvašta palitra, o. J. (Film); Sofijska gradska chudožestvena gal. Kat. živopis, Sofija 2003.

S. Jähne

Cvetkova, *Kostadinka (Kostadinka Detkova)*, bulg. Malerin, Zeichnerin, Kunsterzieherin, * 19. 6. 1929 Sofia, † 2006 ebd. Stud.: bis 1953 KA Sofia (Malerei bei Ilija Petrov und Panajot Panajotov; Abschluß mit Ausz.). Seit 1954 Mitgl. des Verb. bulg. Künstler. 1958–63 Zeichenlehrerin in Sofia. Akad. Lehrtätigkeit: ab 1963 Doz., HS für Frühpädagogik, Sofia; ebd. 1976–83 Ltg des Lehrstuhls Frühpädagogik. Verfasserin bzw. Mitautorin zahlr. Publ. zur Methodik des Zeichenunterrichts für Vor- und Grundschulkinder. Ab 1965 auf Ausst. vertreten, u.a. bei Präsentationen bulg. Kunst im Ausland (Paris, Moskau, Damaskus, Ankara, Bratislava, Algier). Ausz.: 1979 (2. Stufe), '84 (1. Stufe) Orden „Kiril i Metodij". – C. malt vorwiegend Lsch., sporadisch auch Portr., u.a. wenig bek. Selbstbildnisse, die tiefe Traurigkeit und Einsamkeit offenbaren. Eine gewisse Massigkeit in der Form der Lsch.-Bilder der 1960er und 1970er Jahre wird in späteren Darst. durch grazile, luftige Unbeschwertheit abgelöst (*Pejzaž*, 1970; *Pejzaž kraj rekata*, 1974; *Dvor*, 1977; *Boženci*, 1977; *Kraj selo Kalotina*, 1984, beide Sofia, Städtische KG; *Lodki v Sozopol*; *Natjurmort*; *Rozovo listo*; *Lodki*, alle 1980er und 1990er Jahre). In ihrer Naturwahrnehmung lässt sich eine im Grunde unbewußte, nahezu kindliche Sicht auf die Welt erkennen, möglicherweise bedingt durch ihr pädagogisches Wirken. C.s Œuvre wird in der bulg. Kunstkritik vereinzelt mit Henri Matisse und den frz. Postimpressionisten verglichen. Zurückhaltende Nachklänge des Fauvismus spürt man allerdings im freien Umgang mit Farbe, Licht und Linie. Obwohl C. gern und viel zeichnet, dominiert in ihren Arbeiten nicht die graph., sondern die malerische, über Experimente mit Licht- und Farbsetzung entfaltete Formbestimmung. Char. sind grelle und schrille Farben sowie ein kompliziertes, aber doch harmonisches Zusammenspiel von nicht verwandten Farbtönen (Weiß, Beige, zartes Grün, Türkis, Lila, Hell- und Dunkelblau, Transparent- und Sattrosa). Mit der Auslotung solcher Gest.-Mittel entwickelt sie eine lebensbejahende Poesie des Sichtbaren und überwindet die hermetische Enge nat. Tradition. ⌂ BLAGOEVGRAD, KG. GABROVO, KG. DOBRIČ, KG. DEN HAAG, Bulg. Botschaft. KÄRDŽALI, KG. RUSE, KG. SLIVEN, KG. SILISTRA, KG. SMOLJAN, Pädagogische HS. SOFIA, Bez.-Rathaus Serdika. – Haus des Lehrers. – Minist. für Bildung, Jugend und Wiss. – Nat. Wiss. – Städtische KG. ŠUMEN, KG. VARNA, KG. VIDIN, KG. 👁 *E:* Sofia: 1976 Gal. Bulevard Ruski 6; 1993, 2001, '09 (Retr.) Gal. Šipka 6. – *G:* 1975 Boženci b. Gabrovo: Internat. Malereisymposium / Sofia: 1983 Nat. Kunst-Ausst. Kunsterzieher (1. Preis für Malerei); 1984 Izložba „Sofia". ⌑ Koj koj e v bălgarskata kultura, Varna 1998; EIIB III, 2006. – Obšta chudožestvena izložba '72 posvetena na 90-godišninata ot roždenieto na G. Dimitrov (K), Sofija 1973; Obšta chudožestvena izložba posvetena na 30-godišninata ot 9. 9. 1944 (K), Sofija 1975; Retrospektivna izložba 30godini bălgarsko socialističesko izkustvo (K), Sofija 1976; Obšta chudožestvena izložba „Čovekăt i trudăt" (K), Sofija 1978; Sofijska gradska chudožestvena gal. Kat. živopis, Sofija 2003; *N. Timova*, Kultura (Sofija) v. 1. 6. 2007. S. Jähne

Cvetkova, *Svetlana (Svetlana Borisova; Svetla*; in Deutschland: Zwetkowa, *Swetlana*), bulg. Bühnen- und Kostümbildnerin, * 4. 6. 1954 Bern, † 31. 5. 2001 Mainz. Tochter des Diplomaten Boris Cvetkov und der Opernsängerin Rosica Emanuilova; Nichte der Bildhauerin Vaska Emanuilova. Nach der Trennung der Eltern erste Kindheitsjahre bei der Mutter in der DDR; lebt ab 1960 mit ihr in Sofia und verbringt dort den größten Teil der Schulzeit (Abschluß am frz. Gymnasium). Zwischenzeitlich auch Besuch von Schulen in Algier und Strasbourg sowie sechsmonatiger Aufenthalt in New York, wo der Vater als Vertreter Bulgariens bei der UNO tätig ist. Stud.: 1972–77 KHS Berlin-Weißensee. 1977/78 Gastengagements am Friedrich-Wolf-Theater Neustrelitz, am Hans-Otto-Theater Potsdam und am Theater Rudolstadt. 1978/79 Rückkehr nach Bulgarien und Engagement am Theater Blagoevgrad (u.a. Gesamtausstattung von *Ostrovăt*/Die Insel nach A. Fugard; Regie: Werner Buhss). 1979–85 Bühnen- und Kostümbildnerin am Theater „Sofia", Sofia, mehrfach für Produktionen des Regisseurs Leon Daniel (u.a. *Velikdensko vino*/Osterwein nach K. Iliev, 1980). Daneben Ausstattungen für das Ivan-Vazov-Nationaltheater ebd., die Nationaloper in Ruse sowie die Theater in Veliko Tărnovo und Pazardžik, u.a. für Inszenierungen des Regisseurs Vili Cankov (*Yerma* nach F. García Lorca, 1981). Die bulg. Erstaufführung von *Philoktet* (H. Müller) unter der Regie von Dimităr Gočev am Theater „Sofia" (1982), für die C. Bühne und Kostüme entwirft, findet bes. in der dt.-sprachigen Theaterlandschaft enorme Aufmerksamkeit und führt zu ersten Kooperationen mit west-dt. Theaterhäusern. Nach einem Gastengagement am Staatstheater Darmstadt (Kostümbild zu *Das alte Land* nach K. Pohl, 1985; Regie: Ansgar Haag) übersiedelt C. schließlich in die BRD. 1985–90 festes Engagement an den Vereinigten Bühnen Krefeld-Mönchengladbach; daneben mehrere Gastspiele am Basler Theater. 1986 markieren die außergewöhnlichen Kostümentwürfe für den nach antikem Vorbild eingesetzten Theaterchor in D. Gočevs Bühnen-Bearb. des Trauerspiels *Emilia Galotti* nach G. E. Lessing (Gastspiel am Schauspiel Köln) einen weiteren frühen Höhepunkt in C.s Schaffen. 1988 Heirat mit dem Dramaturgen und Übersetzer Dirk H. Fröse, mit dem sie bis 1990 in Köln, anschl. in Frankfurt am Main und zuletzt in Wiesbaden lebt. Ab 1990 ist C. freischaffend tätig, u.a. für die Freie Volksbühne Berlin (*Rosmersholm* nach H. Ibsen, 1991), das Theater Bremen (*Hoffmanns Erzählungen* nach J. Offenbach, 1994), das Théâtre Nat. de la Colline Paris (*Dostoïevski va à la plage* nach M. A. de la Parra, 1995; jeweils Regie: Frank Hoffmann), die Sächsische Staatsoper Dresden (*Melusine* von A. Reimann, Libretto: C. H. Henneberg nach dem gleichnamigen Schauspiel von Y. Goll, 1994; Regie: Fred Berndt), Oper und Schauspiel Bonn (*Hamlet* nach W. Shakespeare, 1996; *Die Hochzeit des Figaro* von W. A. Mozart; jeweils Regie: András Fricsay Kali Son) sowie das Burgtheater Wien (*Merlin oder Das wüste Land* nach T. Dorst, 1999; Regie: Karin Beier). 1999 Erkrankung an Leukämie. 2000 entsteht mit den Kostümentwürfen für *Flieg, Oberst, flieg* nach Ch. Bojčev

(Premiere Jan. 2001, Schauspiel Bonn; Regie: F. Hoffmann) C.s letzte Arbeit. – C.s erste Berufsjahre in Bulgarien sind geprägt von der Auseinandersetzung mit theaterpraktischen Erfordernissen sowie überkommenen und neuen Regiekonzeptionen, die auch im Bühnen- und Kostümentwurf unterschiedliche Abstraktionsprozesse erforderlich machen. Wegweisend für die Festigung eig. künstlerischer Positionen und deren Vereinbarkeit mit jeweils versch. inszenatorischen Ansätzen sind u.a. die Begegnungen mit dem zeitgen. bulg. Dramatiker Konstantin Iliev sowie dem Regisseur Dimitär Gočev, mit dem sie auch nach der gemeinsamen Übersiedlung in die BRD mehrfach zusammenarbeitet. In Deutschland verbringt C. ihre produktivsten Jahre und realisiert den größten Teil ihrer insgesamt 102 szenischen Arbeiten. Zunächst entstehen v.a. Gesamtausstattungen, wobei die Bühnenentwürfe in Abhängigkeit von Spielort und dramaturgischer Interpretation wechselnd opulent, intim oder stark reduziert gestaltet sind. Eine Besonderheit in diesem Bereich ist der Verzicht auf Entwurfsskizzen; C. erprobt und variiert ihre szenischen Ideen nahezu ausschl. in dreidimensionalen Modellen. Im Unterschied zur kompositorischen Strenge der meisten Bühnenbilder zeigt C. im Kostümentwurf bereits seit den Studienjahren eine bes. Vorliebe für Überzeichnungen ins Groteske bzw. Burleske (u.a. Figurinen für die Oper *Il matrimonio segreto/Die heimliche Ehe* von D. Cimarosa; Regie: Wolfgang Schaller; Dipl.-Arbeit, 1977/78), die in wechselnd verhalten-komischer oder entlarvend-deftiger Betonung auch spätere Arbeiten prägt. Ab 1990 wird das Kostümbild ihr Hauptarbeitsfeld. In zahlr. Figurinen über mehrere Entwurfsphasen entwickelt, stützt sich C. dabei nicht nur auf hist. Quellen und damit assoziiertes Bild- und Text-Mat., sondern berücksichtigt bereits frühzeitig auch Wesen und Statur des vorgesehenen Schauspielers. In zeichnerischer Expressivität, differenzierter Charakterisierung bzw. karikaturhafter Typisierung herausragende Entwürfe entstehen v.a. für Inszenierungen des Regisseurs Frank Hoffmann, so für *Ödipus, Tyrann* nach Sophokles in einer Bearb. von H. Müller (Basler Theater, 1988) oder *Geschichten aus dem Wienerwald* nach Ö. von Horváth (Schauspiel Bonn, 1993). ⌘ SOFIA, Bulg. NB (vollst. künstlerischer Nachlaß). ◉ *E:* 2002 Bonn, Theater der Bundesstadt (Gedenk-Ausst.) / Sofia: 2003 Bulg. NB (Präsentation des Gesamtbestandes an Zchngn, Figurinen sowie fotogr. Dok. von Bühnenmodellen und Inszenierungen); 2004 Ausst. Zentrum Šipka 6 (Retr. zum 50. Geburtstag); 2009 Gal. Vaska Emanuilova. ⌘ EIIB III, 2006. – *N. Vandov*, Kultura v. 5. 3. 2004; *B. Asiova*, 24 časa v. 9. 6. 2009; *D. Ch. Frjoze* (d. i. D. H. Fröse; Ed.), S. C. Život prez risunkata. Scena i kostjum, Sofija 2009 (Monogr.; Verz. der szenischen Arbeiten). S. Jähne

Ćwiertnia, *Jerzy,* poln. Maler, Zeichner, Dichter, Essayist, * 9. 1. 1928 Kielce, † 2009, lebte in Warschau. Vater der Malerin *Ewa Ć.* (s.u.). Als 16jähriger zur Zwangsarbeit im Dt. Reich verpflichtet; nach Kriegsende in Frankreich. Stud.: 1947–53 ASP, Warschau, bei Aleksander Rafałowski (Malerei). Nimmt 1955 an der denkwürdigen Ausst. nonkonformer Kunst u.d.T. Junge Kunst. Gegen Krieg gegen Faschismus im Arsenal von Warschau teil. 1955–57 (Auflösung der Red.) Mitarb. der Zs. Po prostu. Danach gibt er bis ca. 1966 die künstlerische Tätigkeit auf und beschäftigt sich mit fernöstlichen Phil. und Religionen. Nach der erneuten Hinwendung zur Malerei arbeitet er zurückgezogen im Atelier, beteiligt sich bis 1980 gar nicht und später nur selten an Ausst. (1982, während des Kriegszustandes in Polen, Teiln. an der Ausst. Świadectwo obecności in der Marienkirche, Warschau). Verkauft ungern Bilder, da sein Werk auf eig. Wunsch an einem Ort erh. bleiben und nicht zerstreut werden solle. – Ć.s schwer zu entschlüsselnde Malerei ist stark von seinen phil. Studien, seiner Beschäftigung mit Symbolismus und Mystizismus geprägt. Er ist bestrebt, transzendentale, in der Meditation gewonnene Erfahrungen in eine Symbolsprache zu übertragen und in der Malerei mit Worten nicht ausdrückbare Geschehnisse wiederzugeben (*Kontemplacja*, Öl). Obwohl das Schaffen v.a. von fernöstlichen Religionen beeinflußt ist, widmet er sich auch christlichen Themen wie dem Jüngsten Gericht. Im Frühschaffen entstehen v.a. Stillleben, Portr., Lsch. und Blumenstücke; außerdem malt Ć., der seit der Kindheit Vegetarier ist, expressive Bilder, bei denen er sich für die Tierwelt einsetzt. Komp. der 1980er Jahre zeigen lt. B. E. Wódz (2008) in ihrer Monumentalität unverkennbar den Einfluß von Michelangelo und El Greco. Nach 2000 entstehen einige Akt-Darst. mit symbolischen Hinweisen (*Venus et la Lune*, 2001; *Trzy gracje*/Drei Grazien, Öl/Lw., 2002). Im Spätschaffen sucht er nach einer Synthese von fernöstlicher Geisteswelt und Ausdrucksmitteln westlicher Kunst-Trad. und nähert sich dabei der Abstraktion (Wódz, 2008). Von der geplanten Serie zur pythagoräischen hl. Dekade kann Ć. als letztes Werk nur noch das Gem. *Treiz* realisieren (Rogozińska, 2011). Neben der Malerei widmet sich Ć. der Ill. in Zss. (Po prostu, Kierunki, Życie i Myśl, Współczesność, Przegląd Kulturalny) und Büchern, z.B. Ill. zum ersten Werk von Marek Hłasko, *Pierwszy krok w chmurach*, War. 1956; *Biały pył* von L. E. Stefański, War. 1956. – *Ewa Ć.* (* 1951 Warschau, † 1994 ebd.) studiert bis 1976 an der ASP ebd. bei Stefan Gierowski. Sie ist dem Vater geistig tief verbunden, ohne daß sich beide künstlerisch unmittelbar beeinflussen. In ihrer Kunst will Ewa Ć. v.a. die Grenze aufzeigen, an der sich die irdische und außerirdische Welt berühren, und ihre persönlichen relig. Erfahrungen zum Ausdruck bringen. Als Buddhistin greift sie auf versch. ikonogr. Trad. zurück, z.B. auf christliche (*Ukrzyżowanie wśród aniołów*/Kreuzigung unter Engeln, 1991) oder auch jüdische Motive. Von Ewa Ć. stammen auch Landschaften. ⌘ GORZÓW WIELKOPOLSKI, Muz. Lubuskie. SANDOMIERZ, MO. ✉ Na wspólnej ścieżce, Sandomierz 1998 (mit Ewa Ć.; Gedichtband). ◉ *E:* 1991 Warschau, Gal. Zachęta (mit Ewa Ć.) / 1995 (mit Ewa Ć.), 2008 Sandomierz, MO. – *G:* 1994 Gdańsk, MN: Biblia we współczesnym malarstwie polskim. ⌘ SłArtPlast, 1972; *A. Lewicka-Morawska u.a.*, Słownik malarzy polskich, II, War. 2001 (auch zu Ewa Ć.). – *R. Rogozińska*, Konteksty 2011 (2/3). – *Online:* Artwatch; *B. E. Wódz*, J. Ć. w zbiorach MO w Sandomierzu, 2008 (cf. Zamek Sandomierz). C. Rohrschneider

Cybikov, *Sanži-Cybik*, burjatischer Bildhauer, * 1877 Ulus Očir-Bulag (Verchnjaja Ivolga/Burjatien), † 1934 ebd. Ab 1884 Chuvarake (Mönchsanwärter) der 1784 gegr. buddh. Tempelanlage Jangažin-Dazan b. Ulaan Orongo (Orongoj). Mit ca. 15 Jahren an der Phil. Fak. ebd. Beginn des Stud. von Tschoira/Zannit. Um 1908 wurde C. der Gelehrtentitel gabži (tibetisch: dge-bshes) verliehen. Beschäftigung mit buddh. Phil. und Ikonographie. Ab 1907 künstlerisch tätig. Aus ideologischen Gründen 1931 verhaftet (wie alle Angehörigen des Jangažin-Dazan, von denen viele hingerichtet wurden); Freilassung nach einem Monat. – C.s Schaffen war für die Herausbildung der burjatischen Strömung der buddh. Kunst von großer Bedeutung. In der Zeit seines Wirkens wurden im überwiegend aus Holzbauten bestehenden Jangažin-Dacan zahlr. Tempelgebäude errichtet (Cokčen[Dzogchen]-Dugan [Versammlungshaus], einziger Steinbau, 1913; Tschoira-Sume, 1910; Devashin-Sume, 1911; Gunrig-Sume, 1916; Manba-Sume, 1917; Dara-eche-Sume; Dujnchor-Sume, beide 1918; Majdari-Sume, 1920; Dshud-Sume, 1923), für die er (zus. mit Schülern) zahlr. Statuen schuf, die als C.s wichtigste Schöpfung gelten. Ferner polychrome Verzierungen des In- und Exterieurs der Tempelbauten (Schnitzwerk). Von der 1938 zerst. Tempelanlage ist lediglich die allerdings nahezu vollst. Komp. (34 von 37 Skulpt.) des Mandala-Pal. Gunrig erh. (NM Burjatiens, s.u.; 1979–81 Rest. durch M. N. Lebel', Ermitage Leningrad [St. Petersburg]; Statuen am Boden sign., daher eindeutige Zuschr.). Die Skulpt. des Mandala-Pal. Gunrig bildeten eine pyramidale Konstruktion im Zentrum des Tempels, bestehend aus der weißen, viergesichtigen Vairocana-Figur (burjatisch: Gunrig; nicht erh.), umgeben von vier Gottheiten mit begleitenden Prajna und weiteren darum gruppierten 16 Gottheiten. Diese folgen in ihrer Gest. der ikonogr. Trad. (sitzende Haltung, Kleidung, Bodhisattva-Schmuck) und sind in einer komplizierten Technik ausgeführt; Torso, Kopf und Lotusbasis bilden einen durchgehenden Hohlkörper mit einer Wandstärke von 3–5 mm. Entlang der angenommenen Hauptenergiezentren des menschlichen Körpers (Chakren) werden von innen geheiligte Gegenstände (Mantra, Kräuter, rituelle Chadaktücher) angeordnet; daraufhin wird die Lotusbasis verschlossen. Ushnisha, Arme (bisweilen acht) sowie Beine (knieabwärts) bestehen aus Massivholz (meist sibirische Zeder). Die dünnen Korpuswände müssen daher statisch so ausgelegt sein, dass sie dieses Gewicht tragen; sie bestehen aus Pappmaché (Holzmehl, Kartonmasse, organische Leime, Kreide, Ton), das in feuchtem Zustand auf die Form aufgetragen wird. Durch eine matte polychrome Bemalung (Mineralfarben, vergoldet, Intarsien aus Edelsteinen) werden evtl. Nähte der Form verdeckt. Die Herstellung eines skulpturalen Mandala-Pal. galt als seltener ritueller Akt. C. interpretiert in seinen Darst. buddh. Gottheiten die kanonischen Vorgaben relativ frei; char. sind Schlichtheit und betont geometrische Formgebung, die von der trad. Holzschnitzerei inspiriert sind. ⌘ Kižinga, Tempelanlage Kižinga-Dazan: Devashin, Skulpt.-Komp. Ulan-Udė, NM Burja-

tiens: ca. 40 Werke. Verchnjaja Ivolga, Tempelanlage Ivolga-Dazan: Grüne Tara. ☉ *G:* 1970 Paris, UNESCO-Hauptquartier: Burjatische Kunst. ⌑ *G. D. Nacov*, Materialy po istorii i kul'ture burjat, Ulan-Udė 1995; Ikonografija Vadžrajani, Mo. 2003; S.-C. C., Ulan-Udė 2006; Zemlja Vadžrapani. Buddizm v Zabajkal'e, Mo. 2008. – *Online:* Sangha Russia. L. Nikolaeva

Cybińska, *Krystyna (Krystyna Leokadia)*, poln. Keramikerin, * 17. 3. 1931 Dakowy Suche, lebt in Wrocław. Stud. ebd.: 1949–54 Państwowa Wyższa Szkoła Sztuk Plastycznych (heute ASP), bei Julia Kotarbińska; 1954–2003 Lehrtätigkeit in der Wkst. für Keramik ebd. (ab 1991 Prof.). Ausz.: u.a. 1961 Aufenthalts-Stip. des Minist. für Kultur und Kunst für Finnland; 2012 Gloria Artis-Med. in Gold. – Gefäße in schlichten Formen, teilw. inspiriert von antiken Vorbildern, hauptsächlich aus Ton und Schamotte, meist farbig, z.T. matt glasiert und krakeliert, u.a. Schalen, Vasen, Flaschen und Krüge. Daneben skulpturale Objekte, überwiegend aus Schamotte, Porzellan und Porzellit, fast ausschl. organische Formen, z.B. *Stół* (glasierte Schamotte, 1992) und die Serie *Otoczak* (kristallin glasiertes Porzellit, alle 1995). Des weiteren Arbeiten für die Kepka Group Ceramika, Buzyń, u.a. kleine Gefäße in runden Formen. ⌘ Genf, Mus. Ariana. Olsztyn, Muz. Warmii i Mazur. Poznań, MN. Prag, UPM. Warschau, MN. Wrocław, MN. – Muz. ASP. ☉ *E:* Wrocław: 1956 Gal. BWA; 1973 MN; 1977 Gal. Jatki; 1995 BWA Gal. Design; 2007 BWA Gal. Szkła i Ceramiki / Warschau: 1977 Gal. Koszykowa (K), 2008 Gal. Inspiracje (mit Hanna Keller Tomaszewska) / 1996 Bielsko-Biała: Gal. Bielska BWA /1999 Lubin, Gal. Wzgórze Zamkowe / 2003 Krakau, Muz. Archeologiczne. – *G:* Wrocław: 1954, '60 (2. Preis) Ogólnopolska Wysrawa Ceramiki i Szkła Artystyczne; 1958 Gal. CBWA: Meble, ceramika, szkło (K); 1962 MN: Kamionka bolesławiecka w twórczości plastyków ceramików (K); 2012 BWA Gal. Szkła i Ceramiki: Kolekcja czyli emocje II (Wander-Ausst.) / Warschau: 1957 Ogólnopolska Wystawa Archit. Wnętrz (K); 1963 Zachęta: Polskie Dzieło Plastyczne w XV-lecie PRL (K; Ausz.) / 1965 Dresden, Mus. für Kunsthandwerk: Moderne Keramik, modernes Glas aus Polen (K) / 1965, '77 (Gold-Med.) Faenza: Concorso internaz. della Ceramica d'Arte (beide K) / 1968, '70 Vallauris: Bienn. Internat. de Céramique d'Art (beide K) / 1970 Sopot: Międzynarodowa Wystawa Ceramiki (K) / 1974 Duisburg, Wilhelm Lehmbruck Mus.: Poln. Gegenwartskunst 1945–1973 (K); Ystad, KM: Actual Art, Wrocław, Poland (K) / 1996 Poznań, Gal. Techne: Ceramika wrocławska (K) / 2003 Krakau, ArtiDo Tuum Gall.: Wrocław w Krakowie / 2006 Elbląg, Gal. El Centrum Sztuki: Figura a struktura / 2012 Jelenia Góra, Mus. Karkonoskie: Światło i materia. ⌑ *K. C.,* Ludwik Kiczura. Polskie współczesne szkło i ceramika (K), Wr. 1973; K. C.. Céramique (K), P. 1974; *L. Becela u.a.* (Red.), Kto jest kim w Polsce 1984, Wr. 1984; Ceramika i szkło polskie XX wieku (K MN), Wr. 2004. – *Online:* Ceramikon Polski. J. Niegel

Cypriano, *André*, brasil. Fotograf, * 1964 São Paulo, tätig in New York und Rio de Janeiro. Stud.: 1990 College of

Marin City, San Francisco (Fotogr.). Ausz.: 1998 En Foco's New Works Photogr. Award; 1999 Preis des Mother Jones Internat. Fund for Doc. Photogr.; 2002 Bolsa Vitae de Arte da Fund. Vitae, São Paulo; 2003 Stip. der Kulturstiftung des Bundes; 2005 All Roads Photogr. Award des Nat. Geographic. – Nach einem Stud. der Betriebswirtschaft widmet sich C. der Fotografie. Seine Arbeiten sind meist schwarz/weiß und ausschließlich dok. angelegt. Sie konzentrieren sich auf die Erhaltung bedrohter trad. Kulturen oder wenig bek. sozialer Praktiken. C. fängt komplexe Realitäten und alltägliche Situationen ein, so in der Serie *Gente de Nias*); die indonesische Insel Nias ist durch eine Megalithkultur geprägt; ihre indigene, kriegerische Bevölkerung pflegt eine tausend Jahre alte Kultur. In Rio de Janeiro hat C. 1994 den Gefängniskomplex Cándido Mendes auf der Ilha Grande acht Monate vor dessen Abbruch in einer Serie dokumentiert (*La Caldera del Diablo*). Die kontrastreichen Fotos geben Einblicke in den Alltag der Gefangenen, lichten Zellen ab und zeigen Portr. der Anführer des Comando Vermelho, eine der größten Verbrecherorganisationen Brasiliens, die in jenem Gefängnis entstand, wo politische Gefangene und Kriminelle zus. unter miserablen Bedingungen untergebracht waren. Weitere Fotoserien mit meist rund 30 Aufnahmen behandeln Favelas und Stadtviertel in Latein- und Südamerika, etwa die Serien *Rocinha* und *Caracas*. Bes. Augenmerk liegt auf Kriminalität und Drogenhandel, die die Bevölkerung einerseits terrorisieren, ihr aber andererseits Unterhalt verschaffen. C.s Fotos zeigen riesige Slumgebiete sowohl als Panorama aus der Luft als auch aus der Nahperspektive mit Fokus auf Körpern und Gesichtern, die das Format vollständig ausfüllen. Seine Werke kreisen um den uninszenierten Alltag der Favela-Bewohner. In der Reihe *Quilombolas* spürt C. dem meist ärmlichen Leben der Nachkommen afrikanischer Sklaven in Brasilien nach; elf Gemeinschaften besucht C., ihn beschäftigen hier nicht nur Fragen nach deren Alltag, sondern auch nach dem legalen Status der geschützten Territorien, nach ihrer Selbstverwaltung und den Trad. des Widerstands. Ebenfalls afro-brasil. Trad. thematisiert *Capoeira* , eine Kunstform aus Elementen von Kampfkunst, Musik und Tanz, die in der Quilombo-Region Palmares entstand und deren Protagonisten C. fotografiert. Er thematisiert zudem das Leben der Hunde auf Bali, die wegen Tollwut zu Tausenden eingeschläfert werden. Eines seiner jüngeren Projekte beschäftigt sich mit dem Zus.-Spiel von Mode und dok. Fotogr. (*Genuine*). C. engagiert sich außerdem in ökologischen Projekten, z.B. zum Schutz der Wale an den nördlichen Küsten Brasiliens. – Foto-Publ.: *O caldeirão do diabo*, S. P. 2001; *Rocinha. Fotografias – Photographies*, S. P. 2002; R. S. Araújo dos Anjos (Text), *Quilombolas. Tradçiões e cult. da resistência*, S. P. 2006; R. de Almeida/L. Pimenta (Text), *Capoeira. Luta, dança e jogo da liberdade*, S. P. 2009. ⌂ SÃO PAULO, Mus. Afro Brasil. – MAM. – Mus. de Arte. ⊙ *E:* 1994 San Francisco, Exposed Gall. / São Paulo: 2002 Pin. do Estado de São Paulo; 2010 Casa da Cult.; 2011 Caixa Cult. / 2003 Caracas, MCA / 2009 Montevideo, Ateneo / 2010 Porto Alegre, Centro Cult. Usina do Gasômetro –

Gal. dos Arcos; Rio de Janeiro, Caixa Cult. Rio / 2011 Curitiba, Gal. Portfolio. –. *G:* 2002 Köln: Photokina / 2005 Washington (D. C.), Nat. Geographic Soc.: All Roads Program / 2006 Venedig: Archit.-Bienn.; Lüttich: Internat. Bienn. of Photogr. and Visual Arts (Einzel-Ausst.) / 2010 São Paulo, MAM: Dez Anos do Clube de Colecionadores de Fotogr. / 2011 Rio de Janeiro, Centro Cult. Correios: FotoRio 2011 / 2012 Brüssel, Centre for FA (Bozar): Extremos. ▢ *A. Castellote* (Ed.), Mapas abiertos. Fotogr. latinoamer. 1991–2002 (K), Ba./Ma. 2003; *C. Franzoni*, Zoom internat. 88:2008, 52–57. – *Online:* Website C.

C. Melzer

Cyrus, *Gerald*, US-amer. Fotograf, * 13. 5. 1957 Los Angeles, lebt in Philadelphia/Pa. C. beginnt 1984 zu fotografieren. Stud.: Univ. of Southern California, Los Angeles; 1990–92 Fotogr., School of Visual Arts, New York; dort auch Praktikant am Schomburg Center for Research in Black Culture. Fotograf für The City Univ. of New York Graduate Center. Foto-Publ. u.a. in The New York Times. Lehrtätigkeit: Haverford College, Haverford/Pa. Stip.: 1995 Light Work Artist Residency, Syracuse/N. Y.; 1998 New York Found. for the Arts; 2002 Sacatar Found und Polaroid Corporation; 2005 Pew Fellowship in the Arts. Mitgl.: Kamoinge Inc., New York. – C. fotografiert seit 1990 in den Straßen von Manhattan, Harlem und Brooklyn und beginnt sein Projekt *Kinship* über das Fam.-Leben der Afroamerikaner. Ab 1994 auch Aufnahmen in Nachtclubs, der New Yorker Jazz-Musikszene (Publ.: *Stormy Monday*, s.l. [Ph.] 2008) und in der U-Bahn. Er beruft sich u.a. auf Roy DeCarava, Robert Frank, Gilles Peress und Lee Friedlander. 2000 zieht C. nach Philadelphia und fotografiert dort und im benachbarten Camden/N. J., auch im brasil. Bahia und in New Orleans vor und nach dem Hurrikan Katrina. Seine Schwarzweiß-Fotogr. in Trad. der soz.-dok. Beobachtung (z.B. von Walter Rosenblum von der Photo League; Bruce Davidson) zeigt v.a. Portr., soz. Gruppen und Alltags-Straßenszenen. ⌂ CLARKSDALE/Miss., Delta Blues Mus. HARTFORD/Conn., The Amistad Center for Art & Cult. – Wadsworth Atheneum. MEMPHIS/Tenn., Stax Mus. of Amer. Soul Music. NEW ORLEANS/La., Mus. of Art. NEW YORK, Mus. of the City of New York. – New York Public Libr. – Schomburg Center for Research in Black Cult. PHILADELPHIA/Pa., Mus. of Art. PLEASANTVILLE/N. Y., Reader's Digest Corporation. SYRACUSE/N. Y., Light Work. WALTHAM/Mass., Polaroid Corporation. ⊙ *E:* New York: 1992 Visual AG; 1995 Midtown Y Gall.; 2000 Amer. Mus. of Natural Hist.; 2008 Leica Gall. / 1995 Bronx (N. Y.), En Foco Touring Gall. / 1996 San Francisco, Univ. of California Extension Center / 1999 San Bernardino (Calif.), Valley College / 2002 Suffern (N. Y.), State Univ. of New York, Rockland College / 2005 Philadelphia (Pa.), S. Mednick Gall. – *G:* 1998 New York, New Mus. of Contemp. Art: Keeping track of the Joneses / 2009 San Francisco (und New York), Jenkins Johnson Gall.: Connections / 2012 Haverford (Pa.), Cantor Fitzgerald Gall.: Bodies and spirits. ▢ *S. Sharp*, Typing in the dark, N. Y. 1991; *D. Willis*, Reflections in black (K), N. Y./Lo. 2000; *B. Head Millstein* (Ed.), Committed to the

image (K New York), Lo. 2001; *G. Sullivan/H. M. Shannon*, In the spirit of Martin (K), Atlanta 2002; *A./T. Gore*, The spirit of fam., N. Y. 2002; *D. Willis*, Black, Irvington 2004; *F. Steward u.a.*, The sweet breath of life, N. Y. 2004. – *Online:* Website C. T. Koenig

Czakó, *Margit*, ungar. Textilkünstlerin, * 23. 9. 1946 Kecskemét, lebt und arbeitet in Szentendre. Ausb.: 1967–69 Lehre als Weberin bei Erzsébet Arató: 1972 Weiterbildung an der Man. Nat. des Gobelins, Paris. Seit 1983 freischaffend tätig. Ausz.: 1990 2. Preis Kunstgew.-Ausst. Pest; 1992–93 Stip. Ungar. Kreditbank. – Cz. debütiert in den 1970er Jahren mit der Ausf. von Entwürfen bed. Textilkünstler aus Szentendre (u.a. J. Barcsay, L. Balogh, L. Hajdú, D. Korniss). Seit 1983 lebt und arbeitet sie ebd. in der Neuen Künstlerkolonie und nimmt ab 1985 regelmäßig an den Gruppen-Ausst. teil. 1986 ist sie Mitbegründerin der Künstlergenossenschaft Szentendre und der angeschlossenen Péter-Pál-Galerie. – Cz. entwirft Gobelins und Wandbilder, aber auch u.a. Täschnerwaren wie Gürtel, Hand- und Schultertaschen. Holzrahmen dienen gelegentlich gleichzeitig als Webstuhl und Bilderrahmen. Die eingesetzten Mat. sind vorwiegend Wolle, Seide und Leinen in gedämpften, manchmal auch reinen Farbtönen, deren Wirkung zusätzlich von matten und glänzenden Strukturen verstärkt wird. Ihre Arbeiten gründen sich auf profunde Kenntnisse trad. flächiger Gobelinweberei, treten oft aber auch aus dem strengen Rahmen heraus in die Dreidimensionalität. Häufig werden spez. Themen in Serien umgesetzt. Inspiriert von der Vielfalt der Tore und Portale ihres Wohnsitzes webt Cz. unter Einbeziehung einer speziellen Schärtechnik auch die Gobelins *Kapu I-III*/Tor I-III, deren Motive als Gest.-Vorlage für das Plakat der Internat. Gobelin-Ausst. La Porte in Frankreich 1991 dienen. ▭ LÁBTALAN, Papierfabrik: Vizjelek/Wasserzeichen, 1970. SZENTENDRE, Ferency Múz.: Beszélgetők/Unterhaltung, 1982/83. Virrasztók/Leichenwärter, 1984; Meditáció/Meditation, 1986/87. ◉ *E:* Szentendre: 1992 Péter-Pál-Gal.; 2001 Gal. der Barcsay-Schule. – *G:* Szentendre: 1985, '86, '90 Péter Pál Gal.: Kunstgew.-Ausst. Pest / 1988 Meiningen, Staatliche Mus.: Kunstgewerbler aus dem Komitat Pest (K) / Budapest: 1992 Csók Gal.: Sommer-Ausst. Textil; 2006 Magyarországi Németek Háza: Hajdú/Cz. 2+2=4xart / 1993 Böblingen, StG Contact: Über Grenzen; Gödöllő, Gödöllői Gal.: Lebendiger Gobelin / 1994 Szombathely, Képtár: Ungar. Bienn. für Wand- und Bodentextilien / 1996 Routot, La Maison du Lin in Normandie: Leinen-Bienn. ▭ KMML I, 1999. – *I. Kulinyi*, Magyar Design 92, I, Bp., 1992; *A. Shelly*, The New York Times (Travel) v. 18. 11. 1990. C. Wendt

Czakó, *Rita*, ungar. Bildhauerin, Environment- und Land-art-Künstlerin, * 23. 6. 1966 Hódmezővásárhely, lebt und arbeitet freischaffend in Budapest. Stud.: 1985–92 HBK (heute Magyar Képzőművészeti Egyetem [MKE]) ebd., in der Bildhauer-Kl. bei Pál Kő. Ausz.: 1991 Preis der Gellért-Endre-Stiftung. C. erhält versch. staatliche Stip. und unternimmt Studienreisen u.a. nach Italien (1991), Indien (1994), Finnland (1997, '98, 2000), Schweden (2000)

und Spanien (2002). – Von Beginn an arbeitet Cz. in unterschiedlichen Mat. (v.a. Holz, Stein, Bronze, Keramik). In den 1990er Jahren entstehen Werke im öff. Raum u.a. in Szeged (Hotel Kass, Fassaden-Gest., 1990 [mit and.]) oder in Esztergom (Pfarrk., *Kreuzweg*, Holz, 1995). Auf Sardinien bearbeitet Cz. während des internat. Bildhauersymposiums Scultura su Pietra in Quartu S. Elena den dort anstehenden Stein (*Weibliche Figur*, Basalt, 1991). Ab E. der 1990er Jahre Hinwendung zu Environmentprojekten. Angeregt durch Studienaufenthalte in Finnland verwendet Cz. bei diesen bevorzugt vergängliche Mat. (wie Torf, Holz, Moos, Lehm, Pflanzenfasern), die sie teilw. kombiniert mit trad. Plastik und Malerei, so *Sonnenzeichen* (1998) in Ráros-Kenyerepart oder *Fußweg* (1999) und *Obstgarten* (2001) in der FS für Forstwirtschaft in Mátrafüred, aber auch mit den Wegwerfprodukten der mod. Industrie-Ges. (*Sack I*; *Sack II*, 2001, Vajdahunyadvár; *Netz I*; *Netz II*, 2003, Budapest). Auch 2005 Mitarb. an der Ausst.-Gest. des Hist. Bergbau-Mus. Nograd in Salgótarján. ▭ DUNAHARASZTI, Baktay-Mus. für zeitgen. Kunst: Geburt, Keramik, 1999. HÓDMEZŐVÁSÁRHELY, FS József-Eötvös: József Eötvös, Bronzerelief, 2000. OZORA, Grundschule: Vilmos Csapa, Bronzerelief, 1998. ◉ *E:* 1997 Csongrád, Csongrád Gal. / 2003 Hódmezővásárhely, Stadt-Bibl. – *G:* 1987 Heves, Hevesi Múz.: Die Schüler von Pál Kő / 1989 Budapest, KHS, Barcsay-Saal: Gedenk-Ausst. für König Szt. István / 1993 Esztergom, Balassa B. Múz.: Pastell-Bienn.; Pécs, Kleinplastik-Bienn. / 1994 Ravenna, Bienn. Dantesca für Kleinplastik / 1995 Békéscsaba, Munkácsy M. Múz.: Transdanubien / 1997 Hódmezővásárhely, Alföli Gal.: Neun junge Bildhauer / 1998 Kankaanpaa (Finnland): Torf-Skulpturen. ▭ KMML I, 1999. – *Online:* Artportal (Lit.). C. Wendt

Czakó, *Zsolt*, ungar. Typograph, Gebrauchsgraphiker, Buchgraphiker, Webdesigner, Filmgraphiker, Plakatgestalter, * 17. 6. 1965 Pécs, lebt und arbeitet in Budapest. Stud: 1984–89 Ungar. HS für Angew. Kunst ebd. Mitgl.: MATT (Ungar. Verb. der Designer und Typographen). Reisen u.a.: 1996 zweimonatiger USA-Aufenthalt mit einem Stip. des Chicago Artists Internat. Program; 2011–12 in London. In Budapest Mitbegründer des Studio Articsók. Versch. Lehraufträge. Ausz.: 1994 lobende Erwähnung beim nat. Wettb. Buch des Jahres (G. Pálinkás, *A városban esik az eső*, Bp. 1994); MŰKÉP-Ausst.-Preis; 1998 Hauptpreis Graphik-Bienn. Békéscsaba. – Cz.s Œuvre ist von der trad. Typogr. und Buch-Gest. inspiriert, wobei er die Methoden der mod. visuellen Kommunikationsmedien (u.a. digitales Design und Fotogr.) genreübergreifend einbezieht und für seine typogr. Inszenierungen sowohl in den Printmedien wie in bewegten (Titel-)Sequenzen (u.a. Film, Fernsehen, Video) nutzt. Seine streng aufgebauten Arbeiten sind deutlich von den Gest.-Grundsätzen László Moholy-Nagys geprägt (z. B. Jb. der Moholy Nagy Univ. of Art und Design, Bp. 2003; Kat.-Buch zur gleichnamigen Ausst. in Pécs und Berlin *Die Ungarn im Bauhaus. Von Kunst zu Leben* , Pécs 2010). Neben Buch-Gest. (u.a. für die Verlage Kortárs Kiadó und Kijárat Kiadó) v.a. Corporate Design für Institutionen und Firmen, u.a. Logos, Pla-

kate (*New Vieuws & Conversationen ... in Graphic Design*, Melbourne 2008), Imagekampagnen, Druckerzeugnisse, v.a. Webdesign und typogr. dominierte Titelsequenzen für die ungar. Fernsehsender MTV und Duna Television (*Mindentudás Egyeteme 2. 0*/Univ. des Wissens für Alle, 2011). Daneben Schrift-Gest., auch Bühnenbild und Kostümentwürfe für Theater (Kaposvár und Pécs) sowie Set-Design und Typogr. für Filmproduktionen (u.a. Dokumentarfilm und 30 einminütige Kurzfilme 1997 anläßlich des 40jährigen MTV-Jubiläums, zus. mit Kristóf Asbóth). Internat. bek. wird Cs. aufgrund der Gest. von Logo und Corporate für die *Europ. Kulturhauptstadt 2010 [Pécs]*. In Experimenten verschiebt er in den letzten Jahren zunehmend die Grenzen zw. Design und Fotogr. und lotet die Möglichkeiten und Strategien der Kinetic Typogr. aus, so in animierten Logos (Konzeptstudie *World Archit. Day*, 2008) oder einem 12seitigen visuellen Essay *Identity* (10th issue of Visual Communication, 2011). Auch arbeitet er gelegentlich im Bereich Produktdesign, indem er z.B. 2009 innovative Designstudien für die Porzellan-Man. Zsolnay in Pécs vorlegt. ◉ *E:* Pécs: 1986 Kulturzentrum Dozso; 2010 Nádor Gal. / Budapest: 2005 Art IX Gal.; 2006 Alexandra Könyvesház; 2007 Uránia-Filmtheater. – *G:* 1992 Budapest, Tölgyfa Gal.: Technology and Human Hand / 1993 Rom, Magyar Akad.: 10 magyar művész/10 ungar. Künstler / Pécs: 1993 Művészetek Háza: Trizájn (mit T. Erky-Nagy und T. Molnár); 1994 Gal. Pécs: New Typogr.; 2009 Parti Gal.: Lantos Ferenc 80 éves – Lantos Ferenc és tanítványai kiállítása / 1996 Chicago, CAIP: Transparence (mit K. Somogyi) / 1997 Ljubljana: Internat. Bienn. of Graph. Art / 2012 Brno: Internat. Bienn. ▭ KMML I, 1999. – Reklám és Grafika 1995, Chicago Sunday, 1996/4; *R. Poyner* (Ed.), Typogr. now two. Implosion, Lo. 1996, 6; *Á. Vándor u.a.* (Ed.), Reklámvonal Évkönyv, Bp. 1998; *T. Triggs* (Ed.), The typogr. experiment, Lo. 2002; *L. Pogony*, Népszabadság (online) v. 4. 5. 2007 (Interview). – *Online:* Website Cz. C. Wendt

Czapla, *Marian*, poln. Maler, Zeichner, * 28. 7. 1946 Gacki b. Szydłów, lebt in Warschau und Szydłów. Stud.: bis 1972 ASP, Warschau, bei Stefan Gierowski (Malerei), Halina Chrostowska und Józef Pakulski (Graphik). Seit 1972 Lehrtätigkeit ebd., Fak. für Malerei. Mitbegr. und 1974–79 Mitgl. der Gruppe Sympleks S4. 2004 Preis Duma Regionu des Wojewoden von Kielce. – Von Beginn an arbeitet C. in Zyklen, häufig entstehen mehrere Versionen eines Bildes, auch als Diptychen und Triptychen (Öl, Acryl). Seinem Lehrer S. Gierowski verpflichtet, gestaltet C. in den 1970er Jahren abstrakte Bilder, die er mit metaphorischen Titeln versieht (Zyklen *Misterium figury czteroramiennej*/Mysterium der vierarmigen Figur; *Cykl Romantyczny*/Romantischer Zyklus, Öl/Lw., 1972). Entwickelt dann einen eigenständigen Malstil, der sich durch kräftiges Kolorit und sinnliche, expressive, gedrungene, häufig bildfüllende Figuren auszeichnet. C. widmet sich in seinen Bildern v.a. den tragischen Seiten der menschlichen Existenz, die er durch die Körpersprache seiner Figuren zum Ausdruck bringt: Sie sind meist nackt, massig, mit vor Schmerz angespannten Mus-

keln, leidenden Mienen und kantigen, verallgemeinerten Formen. Gleichzeitig kündet C.s Schaffen von seiner tiefen Religiosität und Hoffnung auf Erlösung. Seit Kindheit beeindruckt von der ma. und barocken christlichen Bildwelt, malt er biblische Gestalten, die er dem Farbund Formempfinden des 20. Jh. anpaßt. So entstehen mod. anmutende Christus- (Zyklus *Ecce Homo*, Öl/Lw., 1990/91) und Madonnenbilder, Kreuzwege oder Prophetendarstellungen. Spätere Werke stehen der Malerei der Neuen Wilden nahe, wobei das Kolorit ansprechend bleibt (cf. I. Rajkowska, Kat., 2002). ▥ BIAŁA PODLASKA, MO. ITHACA/N. Y., Herbert F. Johnson Mus. of Art. KIELCE, MN. – Świętokrzyskie Towarzystwo Zachęty Sztuk Pięknych. – BWA. SZCZECIN, MN. WARSCHAU, MN. – Gal. Sztuki Współczesnej Zapiecek. – Muz. Archidiecezji Warszawskiej. – Uniwersytet Warszawski, Instytut Historii Sztuki. – SBWA. – Gal. Studio. ◉ *E:* Warschau: 1973 Gal. Krzywe Koło; 1976/77 Gal. Sztuki Współczesnej (K: K. Sułkowska); 1978 Gal. Sztuki MDM (K); 1980, 2011 (K: J. Golik u.a.) Dom Artysty Plastyka; 1981 Gal. Zapiecek; 1985, 2001, '09 Gal. Piotra Nowickiego; 1989 Gal. Studio; 1997/98 Gal. Rzeźby; 2001 ASP, Gal. Aula; 2006 Gal. U / Kielce: 1978 BWA; 1984 Gal. BWA Piwnice; 1996–97 BWA w Kielcach 100; 2002 (Wander-Ausst.; K: M. Maćkowska/I. Rajkowska), '12 MN; 2010 Centrum Kultury, Gal. Winda (K: I. Rajkowska/A. Matynia) / 1981 Białystok, BWA; Koszalin, BWA / 1991 Legnica, BWA (Wander-Ausst.; K: M. Karcz) / 1993 Gdańsk, Bartholomäuskirche, Stiftung Pro Arte Sacra / 1996 Elbląg, Gal. EL; Włocławek, Państwowa Gal. Sztuki Współczesnej; Bydgoszcz, BWA / 1996–97 Częstochowa, Miejska Gal. Sztuki / 1997 Łódź und Płock, jeweils Państwowa Gal. Sztuki; Sandomierz, BWA (K) / 2002 Krakau, Gal. Krypta u Pijarów (K) / 2003 Sopot, Państwowa Gal. Sztuki / 2004 Lublin, Katolicki Uniwersytet Lubelski, Gal. Sztuki Sceny Plastycznej / 2009 Szydłów, Gminne Centrum Kultury (mit Wacław Stawecki; K: J.); Rzeszów, Muz. Diecezjalne. ▭ *A. Lewicka-Morawska u.a.*, Słownik malarzy polskich, II, War. 2001. – Oto człowiek (K Muz. Archidiecezji Warszawskiej), War. 1993; *Z. Taranienko*, Kolekcja Studio. Dzieła i twórcy (K), War. 1997; Ecce homo (K BWA), Ostrowiec Świętokrzyski 1997; M. C. Malarstwo, War. 2009. – *Online:* Kompas sztuki; Kultura polska.
 C. Rohrschneider

Czarkowski, *Radosław*, poln. Objekt-, Installationsund Performancekünstler, Maler, Graphiker, Zeichner, * 16. 12. 1966 Zielona Góra, lebt dort. Ehemann der Malerin *Agnieszka Graczew* (* 1970 Zielona Góra). Stud.: 1987–92 HBK, Poznań, Dipl. mit Ausz. bei Jarosław Kozłowski. 1990–92 Zusammenarbeit mit der Künstlergruppe SDS (Ausst.). Lehrtätigkeit: seit 1992 Pädagogische HS (jetzt Univ.), Zielona Góra, zunächst am Inst. für Kunsterziehung, jetzt an der Fak. für Kunst, Fachbereich Visuelle Künste (seit 2010 Prof.). Gründet und betreibt zus. mit and. 1992–99 die intermediale Gal. GI ebd. 1994 und '98 Stip. der Stadt Zielona Góra. 1999 Promotion, 2009 Habilitation an der Fak. für Multimediale Kommunikation der ABK in Poznań. – C.s in der Regel narrativ an-

gelegte Werke, heterogen in der Form und oft mehrdeutig in der Aussage, gehen lt. L. Kania, der C.s Schaffen intensiv verfolgt und mehrfach darüber publiziert hat, existenziellen menschlichen Erfahrungen wie Leben und Tod, Liebe, Leiden und Schmerz nach. Gefühlszustände oder Phänomene, denen C. visuelle Gestalt verleiht, basieren in der Regel auf einem kult. Hintergrund und nehmen Bezug auf Mythologie (*Leda bez Łabędzia*/Leda ohne Schwan, Installation, 1993), Religion bzw. Anthropologie. Häufig arbeitet C. mit dualen Gegensätzen wie heilig-profan, männlich-weiblich, Kultur-Natur. Unabhängig vom gewählten Medium bildet er eine ganz eig. Ikonogr. aus, z.B. mit der Rose als wiederholt aufgegriffenem Motiv wie in *Toksyny*/Toxine, Objekt aus getrockneten Rosen, Folie, Medikamenten, 1991. Häufig gestaltet er seine Werke aus repetitiven Elementen, Zeichen oder Symbolen (*126 Trupich Główek*/126 Totenköpfe, Öl/Lw., 1993; *Ogród*/Garten, Acryl/Lw., 2002). C.s Performances haben aufgrund ihrer speziellen Dramaturgie häufig den Char. eines Rituals oder einer geheimnisvollen Zeremonie, obwohl er ganz alltägliche Geräte wie Bohrmaschine oder Säge dabei verwendet. Diese Aktionen evozieren Archetypisches und urspr. menschliche Ausdrucksformen (cf. Kania, 2003). Von C. stammen ferner die Ill. (Zchngn) zum Gedichtband *Ale i tak* von C. Markiewicz, Zielona Góra 2007. ☐ ZIELONA GÓRA, Muz. Ziemi Lubuskiej: 25 Arbeiten (Öl-Gem., Zchngn, Installation Arteria). ◉ *E:* 1990, '93 Suwałki, Gal. Chłodna 20 / 1993 Wrocław, Gal. Miejska / 1994 Słubice, Gal. Prowincjonalna (Faltkarte) / 1995 Poznań, Gal. ON / 1996 Łódź, Gal. ASP / 1998 Lublin, Gal. KONT / Zielona Góra: 1997 Gal. GI; 2002 Muz. Ziemi Lubuskiej, Gal. Nowy Wiek; 2011 Gal. Pro Arte / 1999 Szczecin, Gal. Amfilada / 2010 Gorzów Wielkopolski, Gal. BWA. – *G:* 1991, '93 Zielona Góra: Bienn. Neuer Kunst. ☐ *J. Dłuzewski* (Ed.), Wystawa pracowników Inst. Wychowania Plastycznego (K), Zielona Góra 1993; *L. Kania*, de-tocsin, Zielona Góra 2003 (Dokumentation der Ausst. 2002 in der Gal. Nowy Wiek); *id.*, Begrab mein Herz (K BWA), Zielona Góra 2007. – *Online:* News. o. pl. – Mitt. L. Kania, Zielona Góra, 2012.

C. Rohrschneider

Czeglédi, *Júlia,* ungar. Textilkünstlerin, Malerin, * 20. 6. 1952 Budapest, lebt und arbeitet dort. Stud.: 1972–77 Magyar Iparművészeti Főiskola (Ungar. HS für Kunstgew.) ebd., Handmalerei und Stoffdruck bei István Eigel, Csaba Polgár und Erzsébet Bakay. Seitdem freischaffend tätig. Ausz.: 1978 2. Preis beim Wettb. junger Kunsthandwerker, Budapest; 1984 (Sonderpreis), '87 (Ausst.-Preis) Studio junger Kunsthandwerker ebd.; 1996 Preis von Szombathely. – Ihren ersten künstlerischen Erfolg erzielt Cz. mit ihrer Dipl.-Arbeit (Corporate Identity der Textilausstattung [von der Tischwäsche bis zu den Vorhängen] für die Restaurantkette Krumplis Fáni). Für die Gest. ihrer Arbeiten, v.a. Vorhangstoffe, Wandbilder und Tapeten, die sie seit E. der 1970er Jahre auf zahlr. Ausst. zeigt, wendet sie Sieb- und Filmdruckverfahren, aber auch konventionelle Maltechniken an. Unter den freien Textilarbeiten sind es v.a. gegenstandsbezogene wie abstrahierende Wandbilder

mit Relief- bzw. Gitterstrukturen, die auf sehr versch. Weise mit textilen Applikationen versehen sind (u.a. Einbeziehung von Bändern, Schleifen und Knoten). Versch. repräsentative Gebäude in einigen Städten Ungarns sind mit Cz.s Arbeiten ausgestattet, u.a. in Budapest (Hilton Hotel und Hotel Wien), Visegrád (Silvanus Hotel, Restaurant Beatrice) oder in Hédervár (Schloßhotel). Ein char. und häufig wiederkehrendes Motiv in Cz.s Œuvre sind (Staats-) Flaggen, deren abstrakter Anordnung von Farben und Flächen sie ebenso nachspürt wie deren Symbolwerten. Cz. verleiht den tradierten Mustern und Formen aus vergangenen Jahrhunderten mittels ungewöhnlicher Formensprache (u.a. Verflechtungen, plastische Formen, Gitterstrukturen) eine spezifische und originelle Ausdruckskraft. Auch als Kuratorin tätig, z.B. 2011 für das 12. Plein-Art-Festival zeitgen. Künstler in Budapest. ☐ BUDAPEST, IMM. SZOMBATHELY, Savaria Múz. ✉ Textilművész, Bp. 2006. ◉ *E:* Budapest: 1984 Budavári Gal.; 1987 Derkovits-Saal; 2004 Park Millenáris; 2012 Újbuda Gal. / 1981, '89 Nyíregyháza, Benczúr-Saal. – *G:* Budapest: KH: 1980 Die Intelligenz der Hand; 1983 Landes-Ausst. für Kunsthandwerk; 1980 Magyar NG: Kunst in der Industrie; Duna Gal.: Junge Künstler für eine kulturvolle Umwelt; 1988, '91 Internat. Minta-Trienn.; 1997 Magdolna-Turm: Textil – Raum; 2011 Kispesti Helikon Kulturális Egyesület: Helicon Herbst-Ausst. / 1998 Sopron: Ungar. Textil-Bienn. / 1980, '86 Szombathely: Internat. Bienn. Min.-Textil; 1996 Flaggen-Bienn. / 2011 Balatonfűzfő, Kraftwerk: Zeitgen. Kunst / 2011 New Dheli: Internat. Arts Festival. ☐ KMML I, 1999. – *I. Kulinyi* (Ed.), Magyar Design '92, I, Bp. 1992; *H. N. Dvorszky,* Magyar Iparművészet 2002 (2) 36 s.; *J. Cz.* (Ed.), Vexillum Hungaricum, Bp. 2004; *G. Kottra,* Magyar Iparművészet 2004 (4) 29–31.

C. Wendt

Czernin, *Adriana,* bulg.-österr. Malerin, Zeichnerin, * 1969 Sofia, lebt in Wien und Rettenegg/Stmk. Nach Besuch eines Kunst-Gymnasiums in Sofia 1990 Übersiedlung nach Wien. Stud.: Univ. für angew. Kunst, Wien, bei Mario Terzic. – C.s häufig großformatige, akribisch genaue Zchngn auf Papier sind zartfarbig, oft monochrom. Prägend wirken florale Ornamente, später geometrische Formencluster, als Mittler zw. Freiheit und Zwang, Ästhetik und einer ständigen Wiederholung, die keine Freiräume zuläßt. Meist haben C.s Arbeiten weibl. Figuren zum Inhalt, deren ornamentale Einbindung gleichzeitig Tapete, Kleiderstoff, Hinter- und Vordergrund sein könnte und eine tiefen- und schwerelose Raumsituation erzeugt (Erinnerungen an Gustav Klimt und Egon Schiele sind möglich). Diese Vieldeutigkeit erlaubt, die Grenzen zw. Bewußtem und Unbewußtem bzw. Sichtbarem und Unsichtbarem, Abstraktem und Gegenständlichem zu untersuchen und zu erkennen. Gleichfalls scheinen in den floralen Ornamenten auch Naturvorstellungen früherer Kulturen eingewoben zu sein. Anfangs waren C.s Zchngn von intensiven Rot- und Rosatönen geprägt, später dominieren Grautöne, um den Formen ein größeres Gewicht zu geben. Ab 2008 verfolgt C. das Projekt *Investigation of the inside*, das (Serien von) Zchngn umfaßt sowie einen Film, in dem unterschiedli-

ches Bild-Mat. zusammengetragen wird, um psychische Vorgänge und Hintergründe zu erhellen. In jüngster Zeit Hinwendung zum Aqu. und der Darst. von Schatten, Knoten und Seilen. ⌂ FRANKFURT am Main, Slg der Dt. Bank. KRAICHTAL, Ursula-Blickle-Stiftung. WIEN, Albertina. – Gal. Martin Janda. ☉ *E:* 1997 Linz, Gal. Maerz / 2001 Köln, Gal. Almut Gerber / 2003 Sofia, Inst. for Contemp. Art (ATA-Center) / Wien: 2001, '02, '06, '09, '12 Gal. Martin Janda / 2007 Schruns, Kunstforum Montafon (mit Werner Feiersinger). – *G:* 2002 North Adams/Mass., MCA: Uncommon denominator. New art from Vienna / 2003 Bonn, KV: tanzbar / Wien: 2004 (Sieben Frauen), '08 (Nach 1970) Albertina; 2005 Gal. Martin Janda: Silent stories; 2009 Unteres Belvedere: Die Macht des Ornaments / 2008 Innsbruck, Raiffeisen-Landesbank (RLB) Kunstbrücke: narrative (K) / 2009 Krems (NÖ), KH: Das Portr. im Wandel der Zeit / 2011 Stuttgart, ifa-Gal.: Political patterns. Ornament im Wandel. ⌷ OÖ Nachr. v. 24. 4. 1998; Die Presse v. 11. 7. 2003; A. C., Ffm. 2005. – *Online:* Albertina; kfm (Karlheinz Pichler, Nov. 2007); Gal. Martin Janda; Kunstaspekte. S.-W. Staps

Czerny, *Ulrich,* dt. Taschendesigner, * 1962 Frankfurt am Main, lebt in Mittweida. 1980–84 Ausb. zum Werkzeugmacher in Saarbrücken. Ab 1997 als freier Täschner ebd. tätig. Seit 2006 Ateliergemeinschaft mit der Buchgestalterin Cornelia Beate Ahnert in Lichtenau. Ausz.: 1999, 2000 '01, '02, '03 Form, Messe Tendence, Frankfurt am Main; 2000 Bochumer Designpreis; 2002 Hessischer Staatspreis für das Dt. Kunsthandwerk; 2005 Saarländischer Staatspreis für Design; 2007 Preisträger beim Gest.-Wettb. „Augenweide" der Handwerkskammern der Regionen Saarland, Lothringen, Luxemburg. – C. erlernt die Grundlagen der Lederverarbeitung vom Vater, dessen Werkzeuge er bis heute nutzt. Weitere Fertigkeiten eignet er sich autodidaktisch an, indem er zunächst Reparaturen ausführt sowie Jagd- und Patronentaschen anhand hist. Vorbilder anfertigt. Die kofferartige *Sahara A4*, eine seiner ersten eig. Entwürfe, ist einer Expeditionstasche von 1900 nachempfunden. Sie ist aus ungefärbtem, hellem Sattelleder gearbeitet und mit Gurten sowie mehreren Außentaschen versehen. Auf der Suche nach einer zeitgemäßen Gest. läßt sich C. v.a. durch Bauhaus-Entwürfe inspirieren und gelangt so zu geometrischen Grundformen, die seitdem meist den Ausgangspunkt bilden. Das Modell *3D* z.B. basiert auf gleichseitigen Dreiecken. Seit der Ausz. mit dem Bochumer Designpreis heißt die Handtasche *3D-Bochum* und wird in versch., z.T. verspielten Designvarianten angeboten (z.B. mit Ziegenfell als *3D-Wild West* oder in roter Ausführung mit schwarzen Punkten als *3D-Marienkäfer*). Dieses auffallende Dekor ist selten in C.s Werk. Vereinzelt gibt es eine zurückhaltende Ornamentierung durch Federkielstickerei, die der Salzburger Federkielsticker Walter Grübl ausführt, ansonsten zeichnen sich C.s Taschen, Geldbörsen und Brieftaschen durch eine stark reduzierte, nahezu minimalistische Form aus, die sich bis in die schlichten Verschlüsse und Tragevorrichtungen fortsetzt. Die handgenähten Arbeiten (Handnähte außen, innere Nähte z.T. maschinell) sind aus pflanzlich

gegerbtem Rindsleder hergestellt und werden fortlaufend numeriert. Es überwiegen einfarbige Modelle in Schwarz und Rot sowie Taschen, bei denen diese beiden Farben wirkungsvoll kombiniert sind (weiterhin in Anthrazit, Bordeaux und Grün). Eine Besonderheit sind Arbeiten, die aus einem Stück Leder gefertigt sind, sog. One-Cut-Taschen. ⌂ AMSTERDAM, Tassen-Mus. Hendrikje. DEIDESHEIM, Mus. für mod. Keramik. OFFENBACH am Main, Dt. Leder-Mus. ☉ *E:* Saarbrücken: 2005, '06 (mit Susanna Loew, Cornelia Ahnert) Gal. Marlies Hanstein; 2009 Handwerkskammer (mit Traudel Hennig) / 2009 Bad Schwartau, Atelier Jörn Hassner. – *G:* 2003 Saarbrücken, Saarländisches Künstlerhaus: Angew. Kunst Saar (K) / 2005 Püttlingen, Püttlinger Schlösschen: Zeitlos. 50 Jahre Berufs-Verb. Handwerk Kunst Design Saar / 2005–06 Deggendorf, Handwerks-Mus.: Die Handtasche (K; Ausz.) / 2006 Bochum, Maschinenhalle Friedlicher Nachbar: 10 Jahre Bochumer Designpreis / seit 2006 Reinbek, Schloß: Kunstwerk – Werkkunst / 2007 Castrop-Rauxel, Gal. Grosche: Weiss / 2009–10 Bad Godesberg, Craftkontor: Wunderkamer / seit 2007 Stuttgart, LM Württ.: Mus.-Messe für Angew. Kunst / seit 2009 Karlsruhe: Eunique / 2010 Chemnitz, Wasserschloß Klaffenbach: 51°Ost – 49°West / 2010, '11 Ludwigshafen, Zollhaus: Form. ⌷ *S. von Gwinner*, Kunsthandwerk und Design 2003 (1) 36–39; *E. M. Hoyer* (Ed.), Grassimesse Leipzig 2008. Internat. Forum für angew. Kunst (K), L. 2008. – *Online:* Website C. F. Krohn

Czerwenka, *Oskar,* österr. Sänger, Maler, Illustrator, Publizist, * 5. 7. 1924 Vöcklabruck/OÖ, † 1. 6. 2000 ebd. Stud.: HS für Welthandel, Wien. 1947 Debüt als Sänger in Graz. 1951–86 Mitgl. der Wiener Staatsoper. Gastierte an den bedeutendsten Opernhäusern der Welt und moderierte auch im Fernsehen. 1962 Kammersänger, 1976 Prof., 1999 Goldenes Verdienstzeichen des Landes OÖ und Ehrenbürger von Vöcklabruck. Als Maler Autodidakt. Ausst. u.a. in Graz, Innsbruck, Linz, Salzburg und Wien. – Anfangs Komp. von Farbvielecken und Farbblöcken, die sich zu Lsch., Blumen, Portr., Akten oder abstrakten Gebilden verdichten (*Sommertag*, 1976; *Blauer Akt*, 1977; Bildserie der *Kirche von Maria Schöndorf*, 1977). Später zunehmende Abstrahierung; gespachtelte und gebürstete Farbmischungen und Strichtechniken. Im Paul-Walter-Jacob-Arch. befindet sich eine 1957 (in Lissabon) dat. Zchng von C. mit der Bez. „Leider kein Charakterkopf! Pardon!". Auch Buch-Ill., u.a. zu *Kon-Figurationen* (Text E. Pichler, Vorw. H. Weigel, W./B. 1963); *... und es lächeln die Götter. Das neue Bayreuth in Anekdote und Bonmot* (Bremen 1966) sowie zu seinem eig. Buch *Wo's mir schmeckt. Eine kulinarische Reise durch OÖ und Salzburg* (Mühlacker 1982). ⌂ HAMBURG, Univ., Paul-Walter-Jacob-Arch. LINZ, KS des Landes OÖ, Landeskulturzentrum Ursulinenhof. VÖCKLABRUCK, StG im Lebzelterhaus. ✉ Lebenszeiten. Ungebetene Briefe, W. 1988; Jenseits vom Prater. Erlebtes – Erlittenes – Empfundenes, W. 1998 (Auto-Biogr.). ☉ *E:* 1979 München, Gal. Christoph Dürr (K). ⌷ *Fuchs*, Maler (20. Jh.) Erg.-Bd I, 1991; *K. J. Kutsch/L. Riemens*, Großes Sänger-Lex., I, M. ³1999; Österr. Musik-Lex., I, W. 2002. S.-W. Staps

Czerwonka, *Witosław,* poln. Maler, Graphiker, Zeichner, Installations-, Performance- und Videokünstler, * 4. 6. 1949 Wrocław, lebt in Sopot. Stud.: 1967–72 Fak. für Malerei und Bildhauerei, HBK (jetzt ABK), Gdańsk (Dipl. bei Jacek Żuławski [Malerei] und Witold Janowski [Graph. Entwurf]). Seit 1976 Lehrtätigkeit ebd.: zunächst Ass. von Kiejstut Bereźnicki; 1980–82 mit Roman Usarewicz Erarbeitung eines innovativen Programms für den Fachbereich Grundlagen des Entwerfens; seit 1992 Ltg des von ihm gegr. Intermedialen Fachbereichs; 1993–99 Dekan der Fak. für Malerei und Graphik; 1990–93 Prorektor; 1996 außerordentlicher Prof.; daneben Lehrauftrag an der Uniwersytet Warmińsko-Mazurski (UWM) in Olsztyn. 1978–80 zus. mit Adam Haras und Jerzy Ostrogórski Gründung und Ltg der multimedialen Gal. AUT in Gdańsk, anschl. der Gal. OUT in Sopot. – In den 1970er Jahren beschäftigt sich C. v.a. mit Malerei, Zchng und Fotogr., gelegentlich auch mit graph. Entwürfen und Typographie. In den 1980er Jahren entstehen Klanginstallationen (*Przestrzeń przenośna II,* 1988, Łódź, Gal. Wschodnia u.a.) und erste Videoarbeiten, in den 1990er Jahren Mehrkanalvideoinstallationen, Videoobjekte und -bilder (z.B. *Kilimandżaro,* 1991; *Videolustro sentymentalne,* 1995, beide Konin, Pracownia Chwilowa, Momentary Studio). ⌦ ŁÓDŹ, MSZ. ◉ *E:* 1975 Elbląg, Gal. EL / Gdańsk: 1979 Gal. GN; 1995 Gal. Wyspa / 1980 Wrocław, Gal. Fotomedium ART / 1983 Łódź, Gal. Wymiany / 1984 Poznań, Gal. ON / 1987 Lublin, Gal. BWA / Sopot: 1989 Gal. BWA; 2012 Państwowa Gal. Sztuki (PGS) / 1995 Toruń, Gal. Na Piętrze. – *G:* 2006 Łódź: Bienn. ⌺ IDEA. Internat. directory of electronic arts, P. 1992. – *J. Ciesielska/D. Godycka* (Red.), W. C. O braku symetrii (K Gal. PGS), Sopot 1999; *P. Krajewski/V. Kutlubasis-Krajewska* (Red.), Ukryta dekada. Polska sztuka wideo 1985–1995, Wr. 2010. – *Online:* ASP Gdańsk; Leksykon kultury Warmii i Mazur.

C. Rohrschneider

Czinkotay, *Frigyes,* ungar. Maler, * 22. 6. 1932 Kaposvár, lebt und arbeitet dort. 1950–55 Stud. der Landwirtschaft in Budapest (Abschluß als Dipl.-Ing.), danach zehn Jahre in der Lebensmittelbranche in Kaposvár tätig. Daneben erhält Cz. 1959–63 eine künstlerische Ausb. bei dem in Kaposvár geborenen bek. Maler und Bildhauer Ferenc Martyn. Seit 1965 arbeitet Cz. als freischaffender Künstler. Ausz.: 1980 Kunstpreis der Stadt Kaposvár. – Cz.s Œuvre umfaßt v.a. gegenstandsbezogene, z.T. farbflächige Malerei (häufig in Blautönen), die bisweilen Einflüsse des Lehrers F. Martyn erkennen läßt. Char. für seine Lsch. (z.B. vom Balaton) und Stilleben (Öl/Lw. und Öl/Pappe bzw. Holz) sind der gestische Farbauftrag wie die reduzierte Formensprache, deren Strenge durch Schatten in einem warmen Kolorit aufgelöst sein kann. Regelmäßige Ausst.-Beteiligung in den Regionen Somogy und Transdanubien. ⌦ KAPOSVÁR, Rippl-Rónai-Mus. ✉ Gedenkschrift für Rippl-Rónai, Kaposvár s.a., 58–62. ◉ *E:* Kaposvár: 1988 Gal. Kaposvár; 2012 Inst. für Nachhaltigkeit (Bez. Somogy); Kormányhivatal Gal. – *G:* 2004 Szeged, Ital. Kulturzentrum: Bienn. Tafelmalerei. ⌺ MagyFestAdat, 1988; KMML I, 1999. – *J. Horvath,* Cz. F. A szülőföldről

ecsettel, Somogy 1982; *id.,* Cz. F. gyűjteményes kiállítása (K Rippl-Rónai Múz.), Kaposvár 1992; *A. Laczkó,* Cz. F., Kaposvár 1991; *M. Géger,* Cz. F. (K), Kaposvár 1992; *id.,* Képzőművészet Somogyban 1945–1990, Kaposvár 1998.

C. Wendt

Czosnowska, *Monika,* poln.-dt. Fotografin, * 1977 Szczecin, lebt und arbeitet in Berlin. Verh. (2009) mit dem dt. Schauspieler Jens Münchow. Stud.: 1997–2004 Univ. Essen, bei Bernhard Prinz und Herta Wolf (2004 Dipl.). Stip./Preise: 2006 Künstlerhaus Lukas, Ahrenshoop; 2008 Stip. der ZF Kunststiftung, Friedrichshafen; 2009 Förderpreis der Sparkassen-Kulturstiftung Rheinland. – C. debütiert mit Farb-Fotogr. aus ihrer Dipl.-Arbeit, für die sie Novizinnen und Novizen in deren jeweiligen Ordenskleidern in poln. Klöstern porträtiert (*Novizen,* 2004). Sowohl die Wahl des Sujets von introvertiert wirkenden jungen Menschen wie die des Bildausschnitts (Dreiviertelporträt) vor hellem, monochromem Hintergrund als auch die indirekte Ausleuchtung, v.a. jedoch die sehr ruhige, häufig verinnerlicht wirkende Inszenierung der Modelle werden char. für C.s Porträtstil, der an die ital., fläm. und holl. Bildnismalerei des 16./17. Jh. erinnert. So rekurriert die fotogr. Aufnahme der *Novizin Larissa* an ein bek. Gem. von Jan Vermeer (Mädchen mit Perlenohrring) mit vergleichbar subtil-erotischen Konnotationen. In Folge entstehen weitere Porträtserien von Kindern und Jugendlichen (*Chorknaben; Eleven 1; Eleven 2*), deren Darst.-Absicht ebenfalls nicht das Individualporträt ist, sondern in denen es C., wie schon bei der Novizen-Serie, um die Visualisierung von grundsätzlichen Werten der allgemeinen Humanitas geht, u.a. von Reinheit, Anmut und Unberührtheit. In *Matrosen*-Porträts untersucht sie z.B. den Symbolgehalt von Sehnsucht und Fernweh. Indem sie bei allen ihren Porträts auch dem jeweiligen irritativen Assoziationspotential unter den Oberflächen der Gesichter nachspürt, entstehen ohne konkrete Verortung der Modelle bemerkenswert zeitlose Sinnbilder, die die Porträtierten zu Referenten sowohl heutiger als auch grundsätzlich existenzialer Werte und Wirklichkeiten macht. ⌦ HERFORD, Mus. MARTa. FRIEDRICHSHAFEN, ZF Kunststiftung. VITORIA, Artium. ◉ *E:* 2005 Köln, Gal. Otto Schweins / 2006 Krakau, Gal. Krypta Pijarów / 2008 Friedrichshafen, Zeppelin Mus. (K). – *G:* 2004 Wolfsburg, StG: Warm up. Klasse Prinz / Hamburg, Haus der Photogr.: Gute Aussichten 2004–05. Junge dt. Fotogr. (Wander-Ausst.; K) / 2007 Neunkirchen, StG: Im Angesicht (K) / 2009 Herford, Mus. MARTa: Hellwach gegenwärtig – Ausblicke auf die Slg / 2011 Burghausen, Haus der Fotogr. Dr.-Robert-Gerlich-Mus.: Damenwahl. ⌺ TAZ v. 15. 1. 2005; *R. Michel/M. Stoeber,* Eleven. M. C. (K), Friedrichshafen 2008; *S. Becht/J. Raab,* Gute Aussichten 10–11. Junge dt. Fotogr. (K), Norderstedt 2012.

U. Heise

Czwartos, *Ignacy,* poln. Maler, Zeichner, Illustrator, * 1966 Kielce, lebt in Krakau. Stud.: bis 1993 Inst. für Kunsterziehung, Kalisz, Außenstelle der Adam-Mickiewicz-Univ., Poznań (Dipl. bei Tadeusz Wolański); Schüler von Jerzy Nowosielski. 1995 Mitbegr. der Gal. und Künstlersozietät Otwarta Pracownia (Offenes Ate-

lier; seit 2006 Vors. des Vorstands). – Verwurzelt in poln. Trad., Gesch., Kultur und Lsch., zu denen er aber in seinen Bildern auch eine ironisch-kritische Distanz wahren kann, orientiert sich C. in seiner Porträtmalerei an dem die poln. Adelskultur des 17./18. Jh. prägenden Sarmatismus. Er übernimmt den für die sarmatische Porträtkunst char. statisch-hieratischen Aufbau, die Posen und dunkle Farbgebung. Einen großen Einfluß üben bes. die barocken Sargporträts aus jener Zeit aus. In einer rein abstrakten Phase widmet sich C. dann u.a. Komp., die durch ihre Titel Lokalbezüge suggerieren (*Abstrakcja polska; Abstrakcja małopolska; Polski pejzaż żałobny*). Nach der Rückkehr zur Porträtmalerei fließen die Erfahrungen mit abstrakten Motiven in seine Darst. ein. Neben Portr. von Fam.-Mitgl. bzw. Selbstbildnissen (*Wariat i zakonnica/* Verrückter und Nonne, ein Doppel-Portr. von sich und der Ehefrau, Öl/Lw., 2008) und von Künstlerkollegen bilden einen Schwerpunkt die Bildnisse von Fußballanhängern, die er mit „Standesattributen" (z.B. Vereinsschal) versieht (*Kielce, Kielce Korona*, Öl/Lw., 2007). C. malt vorzugsweise in gedämpften, reduzierten Farben. Daneben arbeitet er als Illustrator für Ztgn und Zss. wie Świerszczyk, Przekrój (2000–02), Gazeta Wyborcza, Charaktery, Psychologia w szkole und Rzeczpospolita sowie für Bücher, z.B. *Historia Krakowa dla każdego* von J. M. Małecki, Kraków 2007; *Nóż w palcu* von W. Feleszko, War. 2010. ⌂ KRAKAU, Gal. Zderzak. ⊙ *E:* Krakau: 1997 (K), ʼ99, 2002, ʼ05, ʼ10 Otwarta Pracownia; 2003 Gal. Zderzak / Poznań: 1998 Gal. Miejska Arsenał; 2008 ABC Gall. / 2001 Gdańsk, Gal. Koło / 2008 Warschau, Gal. LeTo / 2009 Kielce, BWA Gal. Piwnice (K: K. Czerni). – *G:* seit 1995 nat. und internat. ⊞ *M. L. Pyrlik/M. Gardulski*, I. C. Obrazy religijne (K Gal. Grodzka BWA), Lublin 2000; *K. U. Schierz* (Ed.), Otwarta pracownia – Offenes Atelier (K), Erfurt 2007; *K. Jankowiak-Gumna*, Exit 2009 (4).

<div align="right">C. Rohrschneider</div>

E F G H

N O P R

W X Y Z

A B C D

I K L M

S T U V